YALE LAW LIBRARY SERIES IN LEGAL HISTORY AND REFERENCE

# REPRESENTING JUSTICE

Invention, Controversy, and Rights in
City-States and Democratic Courtrooms

JUDITH RESNIK *and* DENNIS CURTIS

Yale UNIVERSITY PRESS

*New Haven and London*

Published with assistance from the Ronald and Betty Miller Turner Publication Fund,
Furthermore: a program of the J. M. Kaplan Fund,
the Oscar M. Ruebhausen Fund at Yale Law School, and the Lillian Goldman Law Library, Yale Law School.

Designed and set in Minion, with Requiem display,
by Princeton Editorial Associates Inc., Scottsdale, Arizona.
Printed in the United States of America by Sheridan Books.

Library of Congress Control Number: 2010934588
ISBN 978-0-300-11096-8

A catalogue record for this book is available from the British Library.
This paper meets the requirements of ANSI/NISO Z39.48-1992 (Permanence of Paper).

10 9 8 7 6 5 4 3 2 1

With thanks to all who have taught us so much,
and with hopes for more prudence, temperance, fortitude, and justice in the world

# SUMMARY OF CONTENTS

CONTENTS  ix
PREFACE  XV

CHAPTER I    A Remnant of the Renaissance: The Transnational Iconography of Justice  I

CHAPTER 2    Civic Space, the Public Square, and Good Governance  18

CHAPTER 3    Obedience: The Judge as the Loyal Servant of the State  38

CHAPTER 4    Of Eyes and Ostriches  62

CHAPTER 5    Why Eyes? Color, Blindness, and Impartiality  91

CHAPTER 6    Representations and Abstractions: Identity, Politics, and Rights  106

CHAPTER 7    From Seventeenth-Century Town Halls to Twentieth-Century Courts  134

CHAPTER 8    A Building and Litigation Boom in Twentieth-Century Federal Courts  154

CHAPTER 9    Late Twentieth-Century United States Courts:
             Monumentality, Security, and Eclectic Imagery  169

CHAPTER 10   Monuments to the Present and Museums of the Past: National Courts
             (and Prisons)  193

CHAPTER 11   Constructing Regional Rights  225

CHAPTER 12   Multi-Jurisdictional Premises: From Peace to Crimes  247

CHAPTER 13   From "Rites" to "Rights"  288

CHAPTER 14   Courts: In and Out of Sight, Site, and Cite  306

CHAPTER 15   An Iconography for Democratic Adjudication  338

ENDNOTES  379
NOTE ON SOURCES  603
SELECTED BIBLIOGRAPHY  607
INDEX OF IMAGES  629
SUBJECT INDEX  633

# CONTENTS

PREFACE  XV

**CHAPTER 1  A Remnant of the Renaissance: The Transnational Iconography of Justice  1**

A PICTORIAL PUZZLE  1
A VIRTUOUS VISUAL COMPETITION  8

The Cardinal and Theological Virtues in
a *Psychomachia*  8
The Cohort  9
Justice's Ascent  12

JUSTICE'S VIOLENCE  12
VISUALIZING JUSTICE'S PAIN AND CHALLENGES  13
ADJUDICATION'S TRANSFORMATION:
ACCESS FOR ALL BEFORE INDEPENDENT
JUDGES IN OPEN COURTS  14

Celebrating and Understanding
New Demands  15
Building Idioms: Transparency, Access, Identity,
and Security  15

DEMOCRACY'S CHALLENGES  16

Privatizing Process and Controlling Access  16
The Decline of Adjudication  16

RE-PRESENTING JUSTICE  17

**CHAPTER 2  Civic Space, the Public Square, and Good Governance  18**

A LONG POLITICAL PEDIGREE: SHAMASH, MAAT,
DIKÊ, AND THEMIS  18

The Scales of Babylonia and of the Zodiac  18
The Balance in Egyptian *Books of the Dead*  20
Embodied Greek and Roman Goddesses  21

JUSTICIA, ST. MICHAEL, AND THE CARDINAL
VIRTUE JUSTICE  22
CIVIC SPACES, ALLEGORIES OF GOOD AND BAD
GOVERNMENT, AND FOURTEENTH-CENTURY SIENA  25

Public Buildings Fashioning Civic Identities  25

Lorenzetti and the Palazzo Pubblico  26
"Love justice, you who judge the earth"  28
Justice Bound by Tyranny  29
Theories of Governance: Aristotle, Cicero, Aquinas,
Latini, God, and Political Propaganda  29
Good Government on the East and West
Coasts of the United States: Reiterations by
Caleb Ives Bach and Dorothea Rockburne  30

LAST JUDGMENTS IN TOWN HALLS  33

Civic, Public, and Christian  33
"For that judgment you judge, shall redound
on you": The Magdeburg Mandate  34
Conflating the Last Judgment with Trials  34

**CHAPTER 3  Obedience: The Judge as the Loyal Servant of the State  38**

FLAYED ALIVE OR MAIMED: JUDICIAL OBLIGATIONS
INSCRIBED ON TOWN HALL WALLS IN BRUGES
AND GENEVA  38

Controlling Judges: A Fifteenth-Century Cambyses
in the Town Hall of Bruges  38
Bribes, Gifts, and Budgets  39
Skeptical about Law and Distrustful of Judges  42
The Unjust Prince: Plutarch's Theban Judges and
Alciatus's Emblems  43
Dogs, Snakes, and Virgins: Even-handedness in
Ripa's *Iconologia*  43
Hands Cut: Disfigured Judges and Regal Justices
for Sixteenth-Century Geneva  44
Judicial Subservience and Dependence  47

THE CHALLENGE AND PAIN OF RENDERING
JUDGMENT: AMSTERDAM'S SEVENTEENTH-CENTURY
TOWN HALL  48

An "undertaking of megalomanic proportions"  48
The Virtues of Prosperity: Justice, Peace, and
Prudence Reigning over an Expanding
Municipality  49

"The free state flourishes, when the people
   honor the laws"  51
Harming Your Children in the Name of the Law:
   Solomon, Zaleucus, Brutus, and Death  55
   The Judgment of Solomon  56
   The Blinding of Zaleucus and His Son and the
      Execution of Brutus's Children  57
"So shall you be judged"  61

CHAPTER 4  Of Eyes and Ostriches  62

Blind to the Light and Blindfolded by
   the Fool  62

   The Blindfolded Justice in the Amsterdam
      Tribunal  62
   "Open the eyes that are blind"  64
   Synagoga: Blind to the "Light" of Christianity  65
   Justice and Judges as Fools  67
   Alciatus's Theban Judges and Ripa's Injunctions:
      "A Steely Gaze," the Eye of God, and
      Bandaged Eyes  69
   Bruegel's Justice (or Injustice?)  70
   Damhoudere's Janus-Faced Justice  72
   Turning a Critical Eye  74

Transcendent, Wide-Eyed, and Amidst the
   Animals  75

   Raphael's Glory of Justice  75
   Symbolism's Caprice: The Many Animals
      of Justice  76
      The Proud and the Dead Bird: Giulio
         Romano's Justice with an Ostrich in the
         Vatican and Luca Giordano's Justice
         Disarmed  76
      Sheep and Foxes, Dogs and Serpents: Rubens's
         Wide-Eyed Justice  79

The Past as Prologue: Sighted or Blindfolded,
   and Tall  79

   Venice as Justice, Justice as Venice  79
   Across the English Channel  83
      Queen Anne as Justice  83
      The Lord Mayor's Show  84
      Dublin's Justice  85
      Old Bailey's Open-Eyed and Wide-Armed
         Justice  87
   Across the Atlantic Ocean: Kansas's Sharp-Eyed
      Prairie Falcon and Vancouver's Peaceable
      Justice  87

A Resilient, Albeit Invented, Tradition  89

CHAPTER 5  Why Eyes? Color, Blindness, and
Impartiality  91

Iconographical Conventions, Pictorial Puzzles,
   and Justice's Blindfold  91

   Commitments to Representation  91
      Impossible to Depict: An Exchange between
         Mantegna and Momus  93
      Creating the Canonical Elements  94
   Sight, Knowledge, and Impartiality  95
      "Suppose a Man born blind . . . be made
         to see": Locke, Diderot, and Molyneux's
         Problem  97
      Rawlsian Veiling  98
      Ambiguity and Self-Help: Joshua Reynolds's
         Justice in Oxford and Diana Moore's Justice
         in New Hampshire  98

Constitutional Metaphors and Injustices  102

   Color-Blind  102
   Impartial or Unjust? The "Festering Sores" behind
      the Blindfold in Langston Hughes's Justice  103
   Confrontation, Eyewitnesses, Prison Garb,
      Spectators' Badges, and Ostrich Imagery  104

CHAPTER 6  Representations and Abstractions:
Identity, Politics, and Rights  106

Juridical Rights and Iconography  106

   Public Art and Popular Dismay  106
   Batcolumns and Mariannes  107

Breaching the Conventions of Justice when
   Decorating the Public Sphere  108

   Unblindfolded: A "Communist" Justice Raises a
      "Newark Row"  108
   Hiding a "Mulatto Justice" in Aiken,
      South Carolina  110
   Life in Mississippi, Draped  113
   An "Indian" Hung in Boise  116
   Muhammad in Midtown and at the United States
      Supreme Court  117
   Lady of Justice but No Moco Jumbie in the
      Virgin Islands  121
   The Safety of Abstraction: Ellsworth Kelly
      in Boston  124

Judging Judges: From Spectator to Critical
   Observer  126

   The Appearance of Impartiality  127
   Duck Blinds in 2004  128

Restructuring Law's Possibilities  130
Systemic Unfairness in Individualized Justice  131
Structural Interventions: Judicial Task Forces
    on Bias in the Courts  132
GLIMPSING THE GAPS  133

CHAPTER 7  From Seventeenth-Century Town Halls
to Twentieth-Century Courts  134

PUBLIC AND SOCIAL TRADITIONS IN TOWN AND
    COUNTRY COURTS  134
BUILDING A NEW LEGAL SYSTEM IN THE UNITED
    STATES  136

A Grounding in Colonial and State Court
    Systems  136

Purpose-Built Structures: From Houses
    and Taverns to Courts  136
Segregating Interiors by Roles and Race  136
Architecture and Adornment  137
Juridical Privilege, Exclusion, and Protest  137

Marking a "Federal Presence"  139

Borrowing Space, Rules, and Administrative
    Support  140
Custom Houses, Marine Hospitals, and
    Post Offices  140
Professional Architects and Public Patronage  142
Courts—From California to the New York
    Island  142

Statehood for Texas and a New Federal Building
    in Galveston  143
Building and Rebuilding in Des Moines and
    Biloxi  144

Moving Further, Farther, and Higher  145

Westward Expansion: Denver, Missoula, and
    San Diego  145
Offshore and Across Land: Puerto Rico and
    Alaska  147
Sky High in New York City  149

ARCHITECTURAL STATEMENTS AND OBSOLESCENCE  152

CHAPTER 8  A Building and Litigation Boom in
Twentieth-Century Federal Courts  154

INSTITUTIONAL GIRTH: IN-HOUSE ADMINISTRATION,
    RESEARCH, AND A CORPORATE VOICE  154

William Howard Taft's Innovations  154
Building the Administrative Apparatus  155
"Court Quarters"  156

PUTTING CASES INTO COURTS: THE SECOND
    RECONSTRUCTION  157

Rights across the Board  157
From a Three-Story Courthouse in Grand Forks
    to Twenty-Eight Floors in St. Louis and 760,000
    Square Feet in Boston  158
Housing the Corporate Judiciary  161

REDESIGNING FEDERAL BUILDINGS  163

The Peripheral Role of "Fine Art"  163
John F. Kennedy, Daniel Patrick Moynihan,
    and Government Space: The 1960s Guiding
    Principles  164
Inelegant Design: The National Endowment for
    the Arts as Architectural Critic  165
Subsequent Precepts: Preservation, Conservation,
    Accessibility, Sociability, and Security  166
GSA's Design Excellence Program  168

CHAPTER 9  Late Twentieth-Century United States
Courts: Monumentality, Security, and Eclectic
Imagery  169

RENOVATION, RENT, AND WILLIAM REHNQUIST  169
"Judicial Space Emergencies"  169

Court Design Guides  171

Rescaling the Proportions  171
Routing Circulation to Avoid Contact  173
Dedicated Courtrooms  174

Negotiating Rent and Space  174

Cutting into the Judicial Dollar  176
Inter-Agency, Inter-Branch Oversight
    or Intrusion  178
"Rent Relief"  178
A Courtroom of One's Own  180

Judicial Political Acumen and Incongruity:
    The Rehnquist Judiciary's Monuments to
    Federal Adjudication  181

"ART-IN-ARCHITECTURE"  182

Selecting Community-Friendly Art to "stand the
    test of time"  183
Collaborative Diversity  183
Quietly Quizzical: Tom Otterness in Portland,
    Oregon and Jenny Holzer in Sacramento,
    California  184
"Plop art" and Building Norms  191

CHAPTER 10 **Monuments to the Present and Museums of the Past: National Courts (and Prisons)** 193

COMPARATIVE CURRENTS 193

Singularly Impressive, Diverse, and Homogeneous 193
The Business of Building Courts: The Academy of Architecture for Justice 194

JUSTICE PALACES FOR FRANCE 195

Legible Architecture for an Evolving Justice 195
"Le 1% décoratif" 200
Jean Nouvel and Jenny Holzer in Nantes 204

CREATING NEW SYMBOLS OF NATIONHOOD: A SUPREME COURT BUILDING FOR ISRAEL 208

"Circles of Justice" and Laws That Are "Straight" 209
Roman Cardos, British Courtyards, Moorish Arches, and Jerusalem Stone 210
Judgment at the Gate 213
"The Symbols" 213
Reiterating Familiar Motifs 215

NEW AND RECYCLED FROM MELBOURNE TO HELSINKI 216

"Australian in concept and materials": Melbourne's Commonwealth Law Courts 216
From a Liquor Factory to a District Court in Helsinki 220

"JUSTICE FACILITIES": JAILS, PRISONS, AND COURTS 222

CHAPTER 11 **Constructing Regional Rights** 225

JUDGING ACROSS BORDERS 225
"MIXED COURTS," THE SLAVE TRADE, AND SPECIAL VENUES FOR FOREIGNERS 225
NATION-STATES ALLIED THROUGH COURTS 227

Luxembourg and the European Court of Justice 227

Enduring (and Expanding) Authority: Le Palais Plus 228
Dominique Perrault's Golden "morphological development" 229
"Under the watchful eye of paintings and sculptures" 233

Strasbourg and the European Court of Human Rights 235

Le Palais des Droits de L'Homme 235
Building-in Expansion (for Space and Rights) 237
Richard Rogers's "monumental cylinders" 237
"Easier to see your neighbor's human rights violations than your own" 238

The ECtHR and the ECJ: The Form of Resources 239
Regional Law: The Organization of American States and the Inter-American Court of Human Rights 239

The 1907 Central American Court of Justice: A "permanent court of justice" 240
Shaping a Pan-American Convention on Human Rights 242
Parallels and Distinctions: Human Rights Adjudication in Europe and the Americas 243
Costa Rica and the Inter-American Court: Linked "not only by conviction, but by action" 246
Engineering a $600,000 Renovation 246

CHAPTER 12 **Multi-Jurisdictional Premises: From Peace to Crimes** 247

MODELING THE FUTURE: EPIC ARCHITECTURE AND LONELY BUILDINGS 247
THE PEACE PALACE AND THE INTERNATIONAL COURT OF JUSTICE 248

Convening for Peace 249
The Amsterdam Town Hall Redux: "Dutch High-Renaissance Architecture" for the World's Library and Court 249

Competing and Litigating for Building Commissions 249
National Artifacts for the World Court 253

Tribunals to Which No Country Can Be "Bidden" 255

The Misnomer of the Permanent Court of Arbitration and the Puzzles of International Adjudication 255
The Small Hall of Justice and the PCA 256
The League of Nations' Permanent Court of International Justice 257

Nationality and Judicial Selection 257
Inaugurating the "World Court" and the Hague Academy for International Law 259
Lawmaking through Advisory Opinions and Contentious Cases 259

The Great Hall of Justice and the United Nations' International Court of Justice 261

Nationality's Continuing Import 261
A Celebratory Iconography 262
Renovations, Modernization, and Expansion: Carnegie's Library at Last 263
A Home for Living Law or a Museum? 264

Transnational Courts with Specialized
  Jurisdictions 265

  An International Tribunal for the Sea, Seated
    in Hamburg 265

    A "Constitution for the Oceans" 267
    Alternatives for International Disputes about
      the Sea 268
    Form before Function 269

  International Human Atrocities 272

    The International Tribunals for the Former
      Yugoslavia, Rwanda, and Sierra Leone 272
    Designing for a Future of Crimes:
      The International Criminal Court 275

      Operationalizing a Criminal Court System 277
      Occupying Permanent Quarters Rather Than
        Riding Circuit 279
      "One site forever": A Timeless Image and Four
        Security Zones 280

  The Logos of Justice: Budgets, Caseloads,
    Scales, and Buildings 281

CHAPTER 13  From "Rites" to "Rights" 288

The Triumph of Courts 288
The Democracy in Adjudication 289

  "Hear the Other Side" 289
  "Judges as free, impartial, and independent as
    the lot of humanity will admit" 292
  "That justice may not be done in a corner nor
    in any covert manner" 293
  Reflexivity: Transnational Signatures
    of Justice 294

Theorizing Openness: From Unruly Crowds
  to Bentham's "Publicity" 295

  Observing and Cabining Authority:
    The Dissemination of Knowledge through
    Codification and Publicity 296
  The Architecture of Discipline: From "Judge & Co."
    to the Panopticon 297

Forming Public Opinion through Complementary
  Institutions: An Uncensored Press and a
  Subsidized Postal System 299
Developing Public Sphere(s) 299
Adjudication as a Democratic Practice 301

  The Power of Participatory Observers to Divest
    Authority from Judges and Litigants 301
  Public Relations in Courts 302
  Dignifying Litigants: Information-Forcing through
    Participatory Parity 303

The Press, the Post, and Courts: Venerable
  Eighteenth-Century Institutions Vulnerable
  in the Twenty-First 304

CHAPTER 14  Courts: In and Out of Sight, Site,
and Cite 306

Adjudication's Challenges to Democracy 306

  Demand and Distress 307
  The Data on Privatization: The Vanishing Trial 310
  The Methods of Privatization 311

    Managerial Judges Settling Cases 311
    Unheard Arguments and "Unpublished"
      Opinions 313
    Devolution: Administrative Agencies as Courts 314
    Outsourcing through Mandatory Private
      Arbitration 318

Regulatory Options: Public Access to
  Alternative Dispute Resolution 321
Multi-Jurisdictional Premises (Again) 322

  Tracking, Managing, and Obliging Mediation:
    Lord Woolf's Reforms in England and Wales 322
  Outsourcing to Tribunals 324
  Competing for Transnational Arbitration 324
  Mediation under the Direction of the European
    Union 325

Transnational Procedural Shifts 326
The Continuum on Which Guantánamo
  Bay Sits 327

  The Appointing Authority's Adjudicatory
    Discretion 327
  Court-Like, Court-Lite: "Honor Bound to
    Defend Freedom" 328

Foucault's Footsteps 334

CHAPTER 15  An Iconography for Democratic
Adjudication 338

Transitional and Transnational Idioms 338
Symbolic Courts with Facades of Glass 340

  Opaque Transparency 341
  The Politics of Glass 341
  Zones of Authority 342

Replenishing the Visual Vocabulary 344

  An Interdependent Collective: The Cardinal
    Four of Justice, Prudence, Temperance, and
    Fortitude 344
  The Burdens of Judging: The Nails of a Nkisi
    Figure 348

Facing Justice's Injustice  349

    Nelson Mandela's Jail as South Africa's
    Constitutional Court  350

        Aiming to Capture the Humanity of Social
        Interdependence  350
        Prison Vistas of Barbed Wire  352
        Splashes of Color and References to
        Oppression  355
        The Challenge of Crime and Caseloads  355

    Visually Recording (in)Justice in Mexico's
    Supreme Court  356

        Mexican Muralists, Orozco, and "Profoundly
        National" Paintings  356
        George Biddle's Redemption from the Horrors
        of War  361
        Cauduro's Vision: Torture, Homicide, and Other
        Crimes, Unpunished  362
        Impunity and Insecurity  365

Open Tents, Tattered Coats, and the
Challenges Entailed in Democratic Promises
of Justice  366

    "If performed in the *open air*": The Federal Court
    of Australia's Ruling on the Ngaanyatjarra Land
    Claims  367

Terra nullius and the Native Title Act  367
Commemorating Power, Witnessing
    Compromise  369

    An Icon of Free Legal Services in Minnesota  372

        More Courthouses than Counties  372
        A Jacket, Worn  373

Facets of Judgment  374

ENDNOTES  379
NOTE ON SOURCES  603
SELECTED BIBLIOGRAPHY  607
    *Books, Monographs, Articles, and Dissertations*  607
    *Caselaw*  626
    *International Conventions and Treaties*  627
INDEX OF IMAGES  629
    *Painters, Printmakers, and Engravers*  629
    *Sculptors*  629
    *Photographers*  630
    *Cartoonists*  631
    *Buildings*  631
    *Logos and Seals*  632
    *Brochures and Other Objects*  632
    *Graphs and Charts*  632
SUBJECT INDEX  633

*Color plates follow page 142.*

# PREFACE

The relationship between courts and democracy is at the center of this book, and the principal claims can be set forth simply. First, adjudication is proto-democratic in that courts were an early site of constraint on government. Even when judges were required to be loyal servants of the state, they were instructed to "hear the other side" and told not to favor either the rich or the poor. When resolving disputes and sanctioning violations of their laws, rulers acknowledged through public rituals of adjudication that something other than pure power legitimated their authority.

Second, democracy changed adjudication. "Rites" turned into "rights," imposing requirements that governments provide "open and public" hearings and respect the independence of judges. Courts developed alongside the press and the post as mechanisms for the dissemination of knowledge about government. Yet adjudication made a special contribution, offering a space in which ordinary persons gained, momentarily, the ability to call even the government to account. The circle of those eligible to come to court enlarged radically, and the kinds of harms recognized as wrongful multiplied.

Not only did all persons gain rights to equal treatment and dignity; they were also recognized as entitled to occupy all the roles—litigant, witness, lawyer, judge, juror—in courts. The nature of rights changed as well, as whole new bodies of law emerged, restructuring family life, reshaping employee and consumer protections, and recognizing indigenous, civil, and environmental rights. Courts rescaled in local and national contexts to cope with rising filings. Crossing borders, governments came together to create multi-national adjudicatory bodies, from the "Mixed Courts of Egypt" and the Slave Trade Commissions of the nineteenth century to the contemporary regional and international courts, such as the International Court of Justice and the International Criminal Court. The evolving norms reorganizing the role of the judge and imposing new obligations for courts moved from local to national to regional and trans-national institutions.

Third, both the longevity and the transformation of courts can be seen through tracing the shared political icons of the female Virtue Justice and of buildings called courthouses. Looking at the evolution and changing configurations of places designated courts enables one to map dramatic shifts in the scope and ambitions of governments. Over time Justice became a symbol of government and courts an obligation of governance. Further, as everyone became entitled to use courts, conflicts emerged about how to personify Justice, what "she" should look like, and what symbols deserved places of honor.

Fourth, democracy has not only changed courts but also challenges them profoundly. Most governments do not adequately fund their justice systems to make good on promises of equal justice before the law. Contemporary responses depend on various modes of privatization, including reconfiguration of court-based processes to manage and settle disputes outside the public purview, devolution of factfinding to agencies and tribunals where judges are less visible and independent and the processes less public, and diversion of decisionmaking to private arbitration and mediation. These incursions are masked by a spate of courthouse building projects creating architecturally important structures that are, in some respects, distant from the needs for adjudication and the daily activities of judges. Most of the new courthouses, often clad in glass to mark justice's transparency, celebrate courts without reflecting on the problems of access, injustice, opacity, and the complexity of rendering judgments.

Fifth, the movement away from public adjudication is a problem *for* democracies because adjudication has important contributions to make *to* democracy. Adjudication is itself a democratic process, which reconfigures power as it obliges disputants and judges to treat each other as equals, to provide information to each other, and to offer public justifications for decisions based on the interaction of fact and norm. Thus Jeremy Bentham's insistence on "publicity," Jürgen Habermas's interest in the "public sphere," and Michel Foucault's understanding of the power of surveillance inform our thesis of the distinct place for courts in producing, redistributing, and curbing power.

Sixth, courts as we know them today are recent inventions. The possibility offered—of what Nancy Fraser has called "participatory parity"—is an outgrowth of social movements pressing governments to treat all persons with dignity and accord them equal status under law. Yet, while monumental in ambition and often in physical girth, the durability of courts as active sites of public exchange before independent judges ought not be taken for granted. Like other venerable institutions of the eighteenth century—the postal service and the press—courts face serious challenges in the twenty-first.

Our task is to document these six claims. In this book, we trace the imagery that became the political iconography of town halls as well as the elaboration of purpose-built structures that came to be called courthouses. We move across oceans and ideas to map the emergence of rights that shifted the paradigm of legitimacy for governments. From the eighteenth through the twentieth-first centuries, interactions among lawyers, architects, judges, and government administrators captured political commitments and economic support for courthouses. We illustrate these phenomena through sketches of the development of courts in the United States, of major building projects in France, Israel, Finland, and a few other countries, and of the regional and international courts of the Americas, Europe, and the United Nations. After examining transnational efforts to develop alternatives to adjudication, we turn to the future of courts, which occupies the final segment of the book. Drawing on examples from South Africa, Mexico, Australia, and Minnesota, we provide images of what a democratic iconography of justice—struggling to deal with failures and challenges as well as authority—could entail.

\*　　　\*　　　\*

This work emerged from our teaching, focused on courts and the function of judges and lawyers in criminal, civil, and administrative cases in both domestic and transnational justice systems. We have also worked as lawyers in courts, testified to legislative and judicial committees about court and sentencing reform, and been involved in projects for courts. Throughout, we have been the grateful recipients of knowledge from many people who have been generous with their time. While we cannot name them all, we would be remiss in not identifying several who have contributed to this project.

Aspects of these materials have been presented at seminars and workshops at our home base, Yale Law School, as well as at our prior home, the University of Southern California (USC). The deans at both institutions—Dorthy Nelson and Scott Bice of USC, Anthony Kronman, Harold Koh, and Robert Post of Yale—provided sustaining support, as did the librarians, specifically Camilla Tubbs, Mike Widener, Gene Coakley, and Blair Kauffman of Yale and Albert Brecht, Fannie Fishlyn, and Pauline Aranas of USC, all of whom enabled access to diverse, eclectic, and hard-to-

find materials. Technology has also been required and, but for Susan Monsen who heads Yale Law School's Information Technology Services, and her colleagues Kevin Bailey and John Zito, we would not have been able to do the research and amass the materials for this volume. Their help, coupled with assistance from Marilyn Cassella, Lucinda Currell, Aaron Weiss, and Cassie Klatka, brought the pieces together.

In addition, we benefited from exchanges at colloquia and lectures at Yale's Global Constitutionalism Seminar; the American Philosophical Society; Benjamin N. Cardozo School of Law; Columbia Law School; Indiana University's Maurer School of Law; Villanova Law School; Princeton University's Program in Law and Public Affairs; Hebrew University's Faculty of Law; the Academic Center of Law and Business at Ramat Gan, Israel; Birkbeck College of the University of London; the London School of Economics and Political Science; and University College London (UCL); as well as from meetings of the Law and Society Association and at the Association of American Law Schools. At UCL, we had the good fortune to receive help from Philip Schofield, who is the head of its Bentham Project. Our forays into Renaissance iconography were launched under the tutelage of Jennifer Montagu and Elizabeth McGrath at the Warburg Institute of the University of London and prompted, in part, by conversations with Robert Cover.

Many scholars, judges, lawyers, court administrators, government officials, architects, artists, art experts, editors, photographers, librarians, archivists, colleagues, students, and friends have given advice, provided access to materials, taken pictures, or read chapters related to their expertise. The Note on Sources identifies various of the venues, libraries, and collections that contributed to this project, and we are grateful for their welcome and support. In addition, thanks are due to Rosalie Silberman Abella, Leslie Alden, Joseph Anderson, Michael Asimow, Caleb Bach, Emily Bakemeier, Aharon and Elika Barak, Emily Bazelon, Seyla Benhabib, Myriam Besnard, Michael Black, Laurence Blairon, Celeste Bremer, Stephen Breyer, Lea Brilmayer, Thomas Buergenthal, Guido Calabresi, Paul Carrington, Rafael Cauduro, Oscar Chase, William Clift, Morris Cohen, Moishe Cohen-Eliya, Judith Colton, Olga María del Carmen Sánchez Cordero de García Villegas, Paola Pineda Cordova, John Darcy, José Ramón Cossío Diaz, Alexander Dyck, Steven Croley, Stephanie Curtis, Jonathan Curtis-Resnik, Geoffrey Davies, Joseph A. DiClerico Jr., Olivier Dutheillet de Lamothe, Ross Eisenman, Kathryn Erickson, Arthur Eyffinger, Dana Fabe, Michael Fein, Ruth and Rashi Fein, Eugene Fidell, Owen Fiss, Steven Flanders, Steven Fraade, Nancy Fraser, Christopher Fretwell, Marc Galanter, Antoine Garapon, Lech Garlicki, Hazel Genn, Nancy Gertner, Charles Geyh, Richard Gilyard, Ruth Bader Ginsburg, Eymert-Jan Goossens, Linda Greenhouse, Dieter Grimm, Thomas Grooms, Douglas Guilfoyle, Monica Hakimi, Piyel Haldar, Brenda Hale, Gábor Hamza, Susan Harrison,

Oona Hathaway, Katherine Hayden, Deborah Hensler, Rosalyn Higgins, Matthew D. Hofstedt, Jenny Holzer, D. Brock Hornby, Frank Iacobucci, David Insinga, Vicki Jackson, Robert Jacob, Peter Jaszi, Diane Jones, Hans-Peter Kaul, Judith Kaye, Michael Kirby, Karen Knop, Nicola Lacey, John Langbein, Marcia Greenman Lebeau, Andrea Leers, Peter Lindseth, Jane Loeffler, Jeffrey Lubbers, Wyatt MacGaffey, Miguel Poiares Maduro, Elizabeth Magill, Kate Malleson, Fedwa Malti-Douglas, Nancy Marder, Daniel Markovits, Jerry Mashaw, Guillermo I. Ortiz Mayagoitia, Wayne Meeks, Christine Mengin, Yigal Mersel, Mary Miller, William Miller, Martha Minow, Jean-Paul Miroglio, Jan Mitchell, Diana Moore, Les Moran, Linda Mulcahy, Gerald Neuman, Riitta Nikula, David Noce, Tom Otterness, Arlene Pacht, Robert Post, Uriel Procaccia, Francis Raday, Bruce Ragsdale, J. Mark Ramseyer, Karen Redmond, Michael Reisman, Lauren Robel, Simon Roberts, Dorothea Rockburne, David Rosand, Tanina Rostain, Barbara Rothstein, Nina Rowe, Michael Rozenes, Albie Sachs, Steven G. Saltzgiver, Larry J. Saur, Kim Lane Scheppele, Garth Schofield, Richard Schottenfeld, Peter Schuck, Barbara Shailor, Fred Shapiro, Reva Siegel, Jessica Silbey, Susan Silbey, James Silk, Kathryn Slanski, Elinor and Robert Slater, Simon de Smet, Christina Spiesel, Alec Stone Sweet, David Tait, Ulysses Gene Thibodeaux, Cheryl Thomas, Herdis Thorgeirsdottir, Gerald Bard Tjoflat, Anne Tompkins, Frank Turner, William Vickery, Patricia Wald, James Waldron, Janet Walker, Angela Ward, Marilyn Warren, Patrick Weil, Ruth Weisberg, Laura Wexler, Luzius Wildhaber, Joan Winship, Douglas Woodlock, Harry Woolf, William Young, Theodore Ziolkowski, and Elizabeth Zoller.

We have been able to use materials in languages other than English and French because of translations from colleagues, friends, and students. Special thanks are owed to Chavi Keeney Nana (Dutch); Kirsti Langbein (Finnish); Stella Burch Elias (German, old and new, and French); Elinor, Rachel, and Robert Slater (Hebrew); Allison Tait, Julia Schiesel, and Tess Dearing (Italian and French); Nicholas Salazar (Latin); and Laurie Ball, Tina Esteves-Wolff, and Sophie Hood (Spanish).

A legion of students, past and present, have supported our efforts and educated us. Thanks do not capture all that we owe to one of them, Allison Tait, nor is the appellation "student" quite right for her. Allison Tait received her Ph.D. in French from Yale before becoming a member of the Yale Law School class of 2011. During the past three years, Allison collaborated on all aspects of this work, offering wisdom, research, and editorial suggestions based on her many literacies as she kindly guided others in bringing this production to fruition. In addition, Adam Grogg, Elliot

Morrison, Kathleen Claussen, and Phu Nguyen, when law students at Yale, took on major roles in research and in editorial management, as did Yale undergraduates Naima Farrell, Dane Lund, Rose Malloy, Nicholas Makarov, and Lauren Ross. We were all joined in this work by many other students in years of research forays, both far-flung and conventional. Our thanks to Tanya Abrams, Kate Andrias, Laurie Ball, Grant Bermann, Joseph Blocher, Chesa Boudin, Elizabeth Brundige, Maria Burnett, Cassie Chambers, Josh Civin, Laura Coppola, Travis Crum, Victoria Degtyareva, Katherine Desormeau, Stella Burch Elias, Ruth Anne French-Hodson, Joseph Frueh, Jason Glick, Laura Greer, Hanna-Ruth Gustafsson, Katherine Haas, Laura Heiman, Paige Herwig, Brian Holbrook, Sophie Hood, Hannah Hubler, Johanna Kalb, Marin Levy, Kamila Lis, Alison Mackenzie, Carole Martens, Bonnie Meyersfeld, Elliot Morrison, Chavi Keeney Nana, Anna Horning Nygren, Joseph Pace, Matthew Pearl, Jennifer Peresie, Natalie Ram, Bertrall Ross, Julia Schiesel, Laura Smolowe, Brian Soucek, Vasudha Talla, Emily Teplin, Larisa Terkeltaub, Alana Tucker, Sarah Jordan Watson, and Steven Wu.

Aspects of various chapters have been published in different forms, including Dennis E. Curtis and Judith Resnik, Images of Justice, 96 *Yale Law Journal* 1727 (1987); Judith Resnik and Dennis E. Curtis, Representing Justice: From Renaissance Iconography to Twenty-First-Century Century Courthouses (the Jayne Lecture), 151 *Proceedings of the American Philosophical Society* 139 (2007); Judith Resnik and Dennis E. Curtis, From "Rites" to "Rights" of Audience: The Utilities and Contingencies of the Public's Role in Court-Based Processes, in *Representations of Justice* (Antoine Masson and Kevin O'Connor, eds., Brussels: P.I.E. Peter Lang, 2007); Judith Resnik, Courts: In and Out of Sight, Site, and Cite, 53 *Villanova Law Review* 771 (2008), and Managerial Judges, Jeremy Bentham and the Privatization of Adjudication, in Common Law, Civil Law and the Future of Categories (Janet Walker and Oscar G. Chase, eds., Markham, Can.: LexisNexis Canada, 2010), also published in 49 S.C.L.R. (2d) 205 (2010). Editorial suggestions came from all those venues, with special thanks owed to Susan Babbitt of the American Philosophical Society.

We have had the generous support and thoughtful engagement of Michael O'Malley at Yale University Press; our thanks also to Jenya Weinreb and Jack Borrebach and to Peter Strupp and the staff of Princeton Editorial Associates. Finally, Yale University itself has provided us with remarkable resources, support, and colleagues.

Judith Resnik and Dennis E. Curtis
*New Haven, Connecticut, June, 2010*

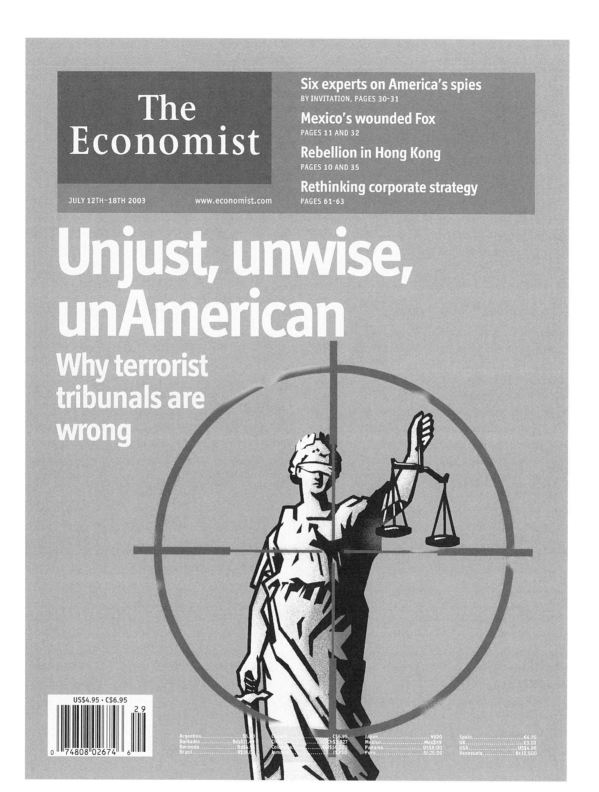

FIGURE 1　"Justice in the Cross Hairs," *The Economist,* Ivan Allen, July 12, 2003.

# A Remnant of the Renaissance:
# The Transnational Iconography of Justice

## A PICTORIAL PUZZLE

The image shown in figure 1 ran during the summer of 2003 on the cover of the English magazine *The Economist*. As the headline, "Unjust, Unwise, Un-American," makes plain, the cover story criticized the government of the United States for using an ad hoc "terrorist tribunal" instead of its regular courts to try individuals accused of being terrorists.[1] The editors assumed that readers would understand the visual accusation—the picture of a blindfolded woman, draped in Grecian robes and holding scales and a sword, seen through the crosshairs of a rifle's scope aimed at her heart.

One purpose of this book is to explain why the publishers of *The Economist* had the confidence to rely on this image to sell their magazine internationally. They were not, after all, marketing only to people familiar with this remnant of Renaissance iconography. The editors knew that viewers would connect the picture to justice gone awry rather than to warrior princesses or Roman deities. The confidence that consumers would be neither bewildered nor confused came from the fact that this publication was not alone in appropriating the image of Justice. One can find her everywhere—in courts and in commerce, as a serious emblem or a foil.

A rapid world tour shows her ubiquity. Another example, the statue *Iustitia* (Justicia, or Justice) (fig. 2), is from North America. Along with a figure called *Veritas* (Truth), she is one of two large stone statues chosen to bracket the entrance to the 1946 building of the Canadian Supreme Court in Ottawa.[2] By traveling thousands of miles to Brisbane, Australia, one can see another such statue, labeled *Themis* after a Greek goddess of Justice (fig. 3) and placed in front of a court complex in 1987. Her photo also graces the cover of the holiday card of the Supreme Court of Queensland, which explains that, in order to "emphasise that the statue is an emblem of Justice in this State, the seal of the Supreme Court is embossed on the buckle of the belt worn by the Goddess."[3]

Farther south in Melbourne, Australia, a huge aluminum *Lady of Justice* (fig. 4) can be seen from a busy street to mark the County Court of Victoria.[4] Indicating no specific "age, race or religion," she becomes, according to the sculptor, the image of "equality and fairness."[5] Moving to Zambia, Africa, one finds another *Lady Justice* (fig. 5), which was placed in front of one of its courts in 1988.[6] The message, as described by one of the justices of Zambia's Supreme Court, is that "the judiciary will dispense justice and fearlessly defend the rule of law without favour."[7] The Zambia Association of Women Judges then used the figure for its logo, transferring it as a repeated pattern to brightly colored orange and black cloth used for dresses (fig. 6, color plate 1).[8]

This travelogue continues with two European images from Azerbaijan, where a statue labeled *Themis* (fig. 7) sits in the Constitutional Court; another rendition, with scales, sword, and blindfold, is the centerpiece of a 2000 calendar (fig. 8) provided by the Ministry of Justice.[9] Crossing land and oceans to South America, a *Justice* (fig. 9) outside Brazil's Supreme Court identifies the courthouse building within the complex of government buildings in Brasilia.[10] Moving west across the Pacific Ocean, one can see the entrance (fig. 10) to the 1974 building for the Supreme Court of Japan. There, another *Justice* (fig. 11)—with distinctive elements—sits inside the foyer.[11]

Figure 12 returns us to the popular media. Taken in April of 2003 during the first phase of the war in Iraq, the photograph of a defaced Saddam Hussein mural accompanied a story titled "U.S. Seeks Solid Core to Fix Iraq's Broken Legal System."[12] The *New York Times* captioned the photo "Saddam Hussein with the Scales of Justice in a mural in Baghdad." Like the large wall sculpture of *Lady Justice* in Melbourne, this imposing mural was to be seen from city streets. Its disfigurement captures a regime just toppling.[13] The mural recorded Hussein's intent to personify a modernized version of legal, cultural, and religious authority by joining Western garb with a shaykh's robe while holding scales of justice. Hussein here repeated a gesture used over centuries by an array of political leaders, such as in a

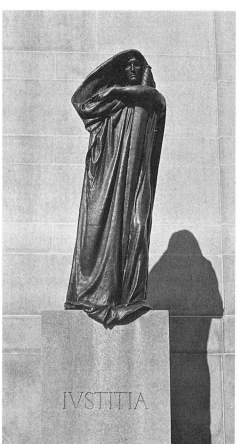

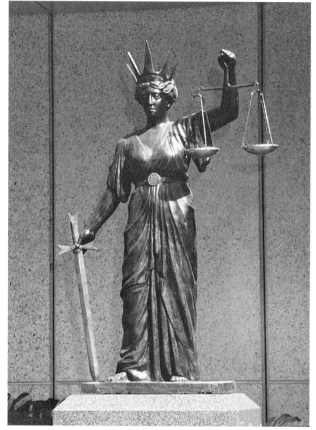

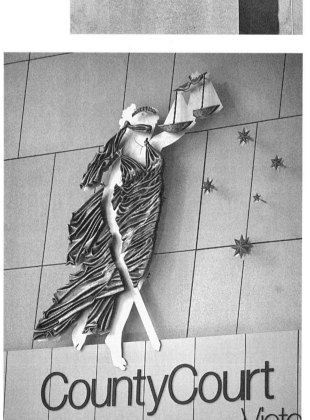

Figure 2 *IUSTITIA*, Walter S. Allward, 1946, Supreme Court of Canada, Ottawa, Canada.

Photographer: Philippe Landreville. Copyright: Supreme Court of Canada. Photograph reproduced with the permission of the court.

Figure 3 *Themis,* Maria I. Papaconstantinou, 1987, Supreme Court of Queensland, Brisbane Courts Complex, Australia.

Copyright: Supreme Court Library, Queensland. Photograph reproduced courtesy of the Supreme Court of Queensland and of its Chief Justice Paul de Jersey.

Figure 4 *Lady of Justice,* William Eicholtz, 2002, Victoria County Court, Melbourne, Australia.

Photographer: Ken Irwin. Photograph reproduced with the permission of the sculptor and of the Liberty Group, owner and manager of the Victoria County Court Facility.

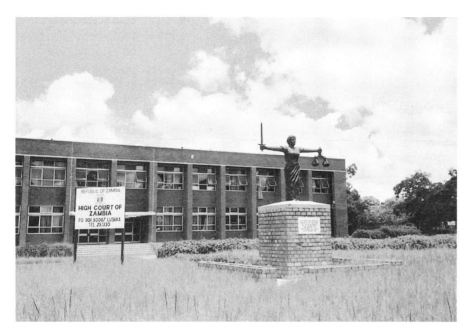

FIGURE 5 *Lady Justice,* circa 1988, High Court of Zambia, Lusaka, Zambia.

Photographer: Elizabeth Brundige. Photograph reproduced courtesy of the photographer and of the court.

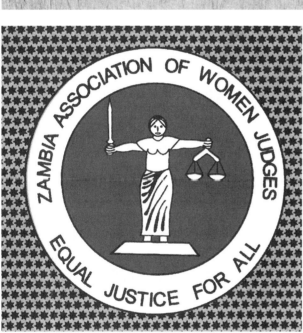

FIGURE 6 Decorative cloth with repeated pattern of the High Court's figure *Lady Justice,* made for the Zambia Association of Women Judges, circa 2004.

Cloth provided by Elizabeth Brundige and reproduced courtesy of the Zambia Association of Women Judges. Facsimile by Yale University Press. See color plate 1.

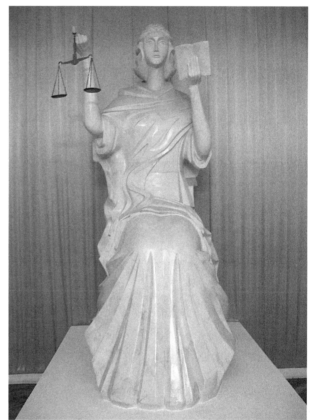

FIGURE 7 *Themis,* undated, Constitutional Court of the Azerbaijan Republic.

Photograph reproduced courtesy of Raouf Guliyev, Head of the International Relations Department, Constitutional Court of the Azerbaijan Republic.

22 noyabr –
Ədliyyə işçilərinin peşə bayramı günü

FIGURE 8   Calendar, 2000, Ministry of Justice, Government of the Azerbaijan Republic.

Image reproduced with the permission of Toghrul Musayev, Deputy Minister of Justice, Azerbaijan Republic.

AZƏRBAYCAN ƏDLİYYƏSİ

1918       2000

AZƏRBAYCAN RESPUBLİKASI

ƏDALƏT MÜHAKİMƏSİ

2001

| | Yanvar | | | | |
|---|---|---|---|---|---|
| B.e. | 1 | 8 | 15 | 22 | 29 |
| Ç.a | 2 | 9 | 16 | 23 | 30 |
| Ç. | 3 | 10 | 17 | 24 | 31 |
| C.a | 4 | 11 | 18 | 25 | |
| C. | 5 | 12 | 19 | 26 | |
| Ş. | 6 | 13 | 20 | 27 | |
| B. | 7 | 14 | 21 | 28 | |

| | Avqust | | | | |
|---|---|---|---|---|---|
| B.e. | | 6 | 13 | 20 | 27 |
| Ç.a | | 7 | 14 | 21 | 28 |
| Ç. | 1 | 8 | 15 | 22 | 29 |
| C.a | 2 | 9 | 16 | 23 | 30 |
| C. | 3 | 10 | 17 | 24 | 31 |
| Ş. | 4 | 11 | 18 | 25 | |
| B. | 5 | 12 | 19 | 26 | |

| | Fevral | | | |
|---|---|---|---|---|
| B.e. | 5 | 12 | 19 | 26 |
| Ç.a | 6 | 13 | 20 | 27 |
| Ç. | 7 | 14 | 21 | 28 |
| C.a | 1 8 | 15 | 22 | |
| C. | 2 9 | 16 | 23 | |
| Ş. | 3 10 | 17 | 24 | |
| B. | 4 11 | 18 | 25 | |

| Mart | | | |
|---|---|---|---|
| 5 | 12 | 19 | 26 |
| 6 | 13 | 20 | 27 |
| 7 | 14 | 21 | 28 |
| 1 8 | 15 | 22 | 29 |
| 2 9 | 16 | 23 | 30 |
| 3 10 | 17 | 24 | 31 |
| 4 11 | 18 | 25 | |

| Sentyabr | | | |
|---|---|---|---|
| 3 | 10 | 17 | 24 |
| 4 | 11 | 18 | 25 |
| 5 | 12 | 19 | 26 |
| 6 | 13 | 20 | 27 |
| 7 | 14 | 21 | 28 |
| 1 8 | 15 | 22 | 29 |
| 2 9 | 16 | 23 | 30 |

| | Oktyabr | | | |
|---|---|---|---|---|
| B.e. | 1 8 | 15 | 22 | 29 |
| Ç.a | 2 9 | 16 | 23 | 30 |
| Ç. | 3 10 | 17 | 24 | 31 |
| C.a | 4 11 | 18 | 25 | |
| C. | 5 12 | 19 | 26 | |
| Ş. | 6 13 | 20 | 27 | |
| B. | 7 14 | 21 | 28 | |

| | Aprel | | | | |
|---|---|---|---|---|---|
| B.e. | 2 | 9 | 16 | 23 | 30 |
| Ç.a | 3 | 10 | 17 | 24 | |
| Ç. | 4 | 11 | 18 | 25 | |
| C.a | 5 | 12 | 19 | 26 | |
| C. | 6 | 13 | 20 | 27 | |
| Ş. | 7 | 14 | 21 | 28 | |
| B. | 1 8 | 15 | 22 | 29 | |

| May | | | | |
|---|---|---|---|---|
| 7 | 14 | 21 | 28 | |
| 1 8 | 15 | 22 | 29 | |
| 2 9 | 16 | 23 | 30 | |
| 3 10 | 17 | 24 | 31 | |
| 4 11 | 18 | 25 | | |
| 5 12 | 19 | 26 | | |
| 6 13 | 20 | 27 | | |

| İyun | | | |
|---|---|---|---|
| 4 | 11 | 18 | 25 |
| 5 | 12 | 19 | 26 |
| 6 | 13 | 20 | 27 |
| 7 | 14 | 21 | 28 |
| 1 8 | 15 | 22 | 29 |
| 2 9 | 16 | 23 | 30 |
| 3 10 | 17 | 24 | |

| İyul | | | |
|---|---|---|---|
| 2 9 | 16 | 23 | 30 |
| 3 10 | 17 | 24 | 31 |
| 4 11 | 18 | 25 | |
| 5 12 | 19 | 26 | |
| 6 13 | 20 | 27 | |
| 7 14 | 21 | 28 | |
| 1 8 | 15 | 22 | 29 |

| Noyabr | | | |
|---|---|---|---|
| 5 | 12 | 19 | 26 |
| 6 | 13 | 20 | 27 |
| 7 | 14 | 21 | 28 |
| 1 8 | 15 | 22 | 29 |
| 2 9 | 16 | 23 | 30 |
| 3 10 | 17 | 24 | |
| 4 11 | 18 | 25 | |

| | Dekabr | | | | |
|---|---|---|---|---|---|
| B.e. | 3 | 10 | 17 | 24 | 31 |
| Ç.a | 4 | 11 | 18 | 25 | |
| Ç. | 5 | 12 | 19 | 26 | |
| C.a | 6 | 13 | 20 | 27 | |
| C. | 7 | 14 | 21 | 28 | |
| Ş. | 1 8 | 15 | 22 | 29 | |
| B. | 2 9 | 16 | 23 | 30 | |

FIGURE 9   *Justice,* Alfredo Ceschiatti, 1961, Supreme Federal Tribunal, Three Powers Square, Brasilia, Brazil.

Photograph provided and reproduced courtesy of the Directoria de Patrimônio Histórico e Artístico–DePHA.

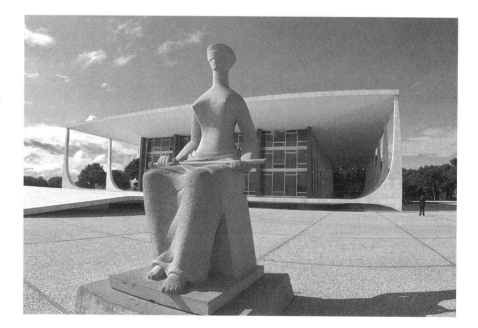

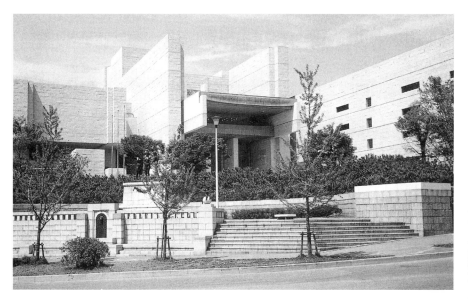

painting by Rubens of the French Queen Marie de Medici and one by Verrio of Queen Anne of England, both also posed as the embodiment of Justice.[14]

The cover of *The Economist* is a reminder that, in addition to adorning government buildings, Justice is readily deployed as a stock figure in the media and in advertisements. Iconography invoking Justice is a staple in a brisk trade aimed at selling books, briefcases, and jewelry to lawyers. One example is a catalogue cover (fig. 13) for a law publishing house, Matthew Bender. The photograph is of *Justice,* a statue that has stood (first in wood and then in copper) since 1812 on top of New York's City Hall.[15] Her presence was initially noteworthy, as recorded in a nineteenth-century travel guide invoking verse from a once-famous poem of 1819:

> "And on our City Hall a Justice stands—
>     A neater form was never made of board—
> Holding majestically in her hands
>     A pair of steelyards and a wooden sword,
> And looking down with complaisant civility
>     Emblem of dignity and durability."[16]

Justice also plays a role in whimsy, which is evident from a dip into contemporary North American pop culture. In 2002, in celebration of cartoonist Charles Schulz, creator of the comic strip *Peanuts,* the city of St. Paul placed *Lady Justice Lucy* (fig. 14, color plate 2) in front of the William Mitchell College of Law.[17] Alongside such friendly renditions, satirists regularly rely on Justice iconography to make less happy references, as can be seen from cartoons that were published over a fifty-year period in the United States.[18]

In 1956, a brief-lived magazine called *Facts Forum News* used a cartoon (fig.15) of a blindfolded likeness of Earl

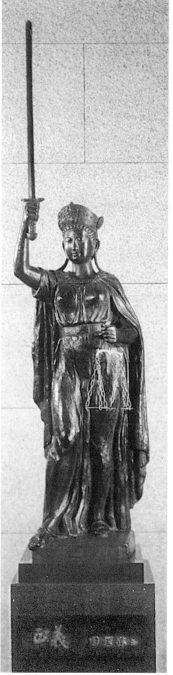

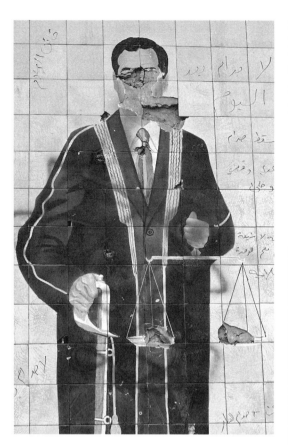

FIGURE 12 "Mural of Saddam Hussein with the scales of justice," *New York Times,* April 27, 2003, at A24, accompanying the news story "U.S. Seeks Solid Core to Fix Iraq's Broken Legal System" by Bernard Weinraub.

Photographer: Ozier Muhammad. Copyright: The New York Times Agency. Photograph reproduced with the permission of the New York Times Agency.

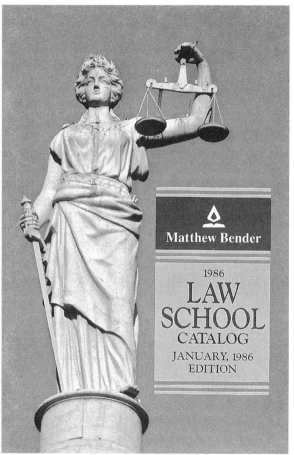

FIGURE 13 *Justice,* on the New York City Hall, from the cover of a Matthew Bender *1986 Law School Catalog.* Sculpted, circa 1812, John Dixey.

The photograph is reprinted with the permission of Matthew Bender & Company Inc., a member of the LexisNexis Group. Matthew Bender claims no copyright as to any part of the original photographic or architectural works depicted in this image.

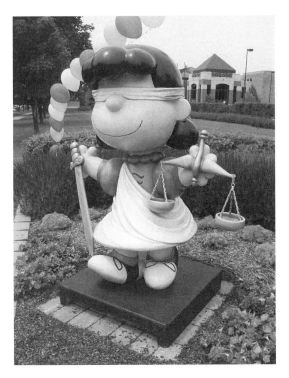

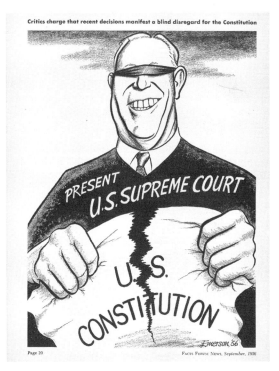

FIGURE 14  *Lady Justice Lucy,* Jim and Judy Brooks, 2002, William Mitchell College of Law, St. Paul, Minnesota.

Photograph courtesy of the William Mitchell College of Law and reproduced with its permission. See color plate 2.

FIGURE 15  "Critics charge that recent decisions manifest a blind disregard for the Constitution," Emerson, 5 *Facts Forum News* 20 (Sept. 1956), accompanying the article "Supreme Court Under Fire."

Digital reproduction obtained from the Rare Book and Manuscript Library, Columbia University.

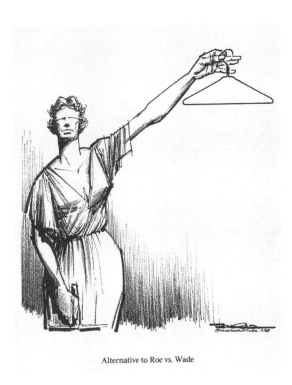

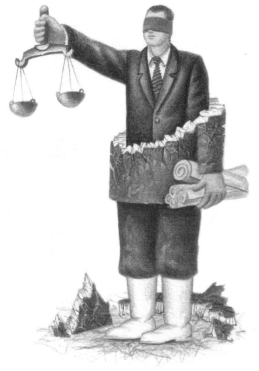

FIGURE 16  "Alternative to Roe vs. Wade," Paul Conrad, *Los Angeles Times,* November 21, 1988, at II 5.

Copyright: Tribune Media Services, 1988. Image reprinted with the permission of Tribune Media Services.

FIGURE 17  Cartoon by Ray Bartkus, *Wall Street Journal,* May 29, 2003, at A18, accompanying the article "A Trial for Chinese Justice" by Karby Leggett.

Image reproduced with the permission of the artist.

Warren, then Chief Justice of the United States Supreme Court, to accuse that Court of a "blind disregard for the Constitution."[19] In 1988, the *Los Angeles Times* ran the Paul Conrad cartoon shown in figure 16. Its Justice holds a coat hanger instead of scales to suggest the cruder methods used to induce abortions prior to the Supreme Court's recognition that abortion rights (here invoked through the case named *Roe v. Wade*) were constitutionally protected.[20] Moving forward almost three decades, in 2003 the *Wall Street Journal* relied on scales and a blindfolded man (fig. 17) to echo the text of a story about the "flawed" aspects of the justice system in China.[21]

These dozen-plus images, the tip of a visual iceberg, anchor a first point. Throughout the twentieth century and into the twenty-first, Justice imagery has been used on government buildings and in representations of political personages in magazine articles, newspapers, advertisements, and cartoons. These various deployments all rely on the fact that we (people living in Europe, North and South America, Africa, Australia, and Asia) can "read" them. We recognize an oddly dressed woman with her various attributes (scales, sword, and sometimes a blindfold) as representing or referring to law and justice. Designers of contemporary courts, purveyors of goods and services, and cartoon artists know that placing this figure in front of their building or on a placard prompts viewers to make an immediate association with law. This linkage of state power with Justice images spans continents and differently constituted polities.

## A Virtuous Visual Competition

### The Cardinal and Theological Virtues in a *Psychomachia*

As those steeped in European history know, the Justice recognized today dates from the Medieval and Renaissance periods. The sixteenth-century print of *Iusticia* (fig. 18) by Cornelis Matsys, showing her with scales, sword, and billowing garments,[22] is one of hundreds of classical images available in archives and on museum and building walls.[23]

Consider that image alongside another engraving by Matsys (fig. 19) showing two figures.[24] One is an easily recognized Justice. The other woman is looking in a mirror, which is not a clue useful to many contemporary viewers. For art historians, however, the mirror with its reflecting gaze pegs her as Prudence.

In many centuries, Justice and Prudence, joined by Fortitude and Temperance,[25] formed a quartet called the Cardinal Virtues, grouped together so often that commentators sometimes referred to one as "missing" when only three were presented. Derived from discussions by Plato, Cicero, and St. Thomas Aquinas,[26] the foursome was shown in paintings and engravings and on decorative objects. Some-

FIGURE 18    *Iusticia (Justice),* Cornelis Matsys, circa 1543–44.

times, they appeared alongside the theological trio of Faith, Hope, and Charity.[27]

Those Virtues, in turn, overlapped with other sets now less well known. One group, the "Gift Virtues," was usually listed in an order beginning with Fear of God and followed by Piety, Knowledge, Fortitude, Prudence, Understanding, and Wisdom.[28] Another, the "Four Daughters of God"—Mercy, Truth, Justice, and Peace—taken from an Old Testament psalm, was featured in many Medieval texts.[29] Various of these Virtues were regularly depicted in an epic battle called the *Psychomachia* (after a famous fifth-century allegorical poem by Prudentius describing Christianity's triumph over paganism), enacting the moral struggle for a person's soul, which pitted seven Virtues against a symmetric group of seven Vices.[30]

In practice, which Virtues and Vices were in combat varied in numbers, names, and pairs. In any given battle scene, Abstinence, Discipline, Humility, Loyalty, Largesse, Mag-

FIGURE 19   *Justice and Prudence,*
Cornelis Matsys, circa 1538.

Copyright: Warburg Institute,
University of London.

nanimity, Modesty, Obedience, Patience, Peace, Simplicity, or Sobriety might be substituted or added to some of the Cardinal, Theological, or other Virtues.[31] Their opposites, in turn, included an array of Vices—Anger, Avarice, Deceit, Despair, Discord, Envy, Extravagance, Gluttony, Greed, Inconstancy, Infidelity, Lechery, Lust, Pagan Idolatry, Pride, and Sloth.[32]

These figures are sometimes identified through labels and sometimes by attributes—such as scales for Justice, armor or a broken column for Fortitude, an olive branch for Hope, or a bridle and a pitcher for Temperance.[33] But the imagery varied by period, place, and artistic impulse, such that any particular Virtue can be found with an odd lot of attributes. Images of Justice are shown, for example, holding cornucopias, lictor rods, orbs, books, and tablets; nearby are a mix of animals and birds including dogs, snakes, ostriches, and cranes.

As for their gender, Virtues typically took the female form—thereby reflecting their roots in Egyptian, Greek, and Roman goddesses,[34] the feminine gender of the Latin nouns that they represented, and the gender ascribed to them by various early literary personifications such as the *Psychomachia.* By the late Middle Ages, artists had come to use the male form for certain Vices.[35] How and why words, activities, or abstractions came to be gendered is a topic of feminist theory, for the iconography reflected, produced, and codified sex-role distinctions.[36]

## The Cohort

Justice is central to this book but did not become a regular participant in the conflict between the Virtues and Vices until the twelfth century.[37] In time, scenes of battles were replaced by more static displays of opposing forces, or the Virtues and Vices were shown on branches of a tree.[38] Images of the triumph of goodness came to prominence, with the Virtues depicted as standing above their corresponding Vices, laid low, destroyed or humiliated through

conquest.[39] As the Virtues became parts of Christian scenes of the Last Judgment[40] and then adorned the portraits of various earthly rulers, the Vices receded from view (politically more than theologically).[41]

The long list of the many Virtues, accompanied by elaborated philosophies addressing their interdependencies, hierarchies, and distinctions, provides evidence of a competition that once existed for our visual education and our political imagination. By the late Medieval period, Church leaders were providing these images as part of their instructional programs to wide and diverse audiences that were schooling on moral and religious obligations embodied in various Virtues such as Hope, Faith, Charity, Prudence, Temperance, and Fortitude, as well as in Justice.[42]

As town leaders began to erect new civic structures to augment the meeting places provided by churches and markets, they put pictures of the Last Judgment, sometimes accompanied by depictions of Virtues, on those walls. Over time, Justice became the emblem prominently displayed on many an exterior of a European town hall.[43] By the sixteenth century, allegorical engravings were distributed in print, and various Virtues graced the designs for the coats of arms of many burgher states and some of the ruling families in middle Europe.[44]

That a host of Virtues were once part of the "common currency"[45] can be seen by turning to a well-known series painted by Raphael for a room in the Vatican called the Stanza della Segnatura[46] and reproduced through hundreds of engravings. The 1516 print by Veneziano after Raphael's *Prudence* (fig. 20) shows her again as an imposing woman looking at herself in a mirror.[47] In this rendition, Prudence has been given a second face (that of a bearded old man) at the back of her head. Looking back, she is said to be able to comprehend the past. Through the mirror, she is supposed to be able both to contemplate the present and to look to the future. These self-reflective and multiply focused gazes were to indicate Prudence's practical wisdom, grounded in knowledge both introspective and wide-ranging.[48]

Veneziano's *Temperance* (fig. 21) has a bridle, one of her stock attributes used to symbolize self-restraint.[49] *Fortitude* (fig. 22), from around the same period and by the school of the artist Marcantonio Raimondi, wears a helmet with a small lion perched on top and holds a broken column —all intended as references to power, endurance, and strength.[50] The imagery from the Vatican is illustrative of the governing ideology of the era, in which the Cardinal Virtues adorned spaces that were simultaneously religious and political.[51]

But one did not need to travel to Rome in order to see such displays. Joining an array of other Renaissance images, the Virtues were catalogued and popularized in the com-

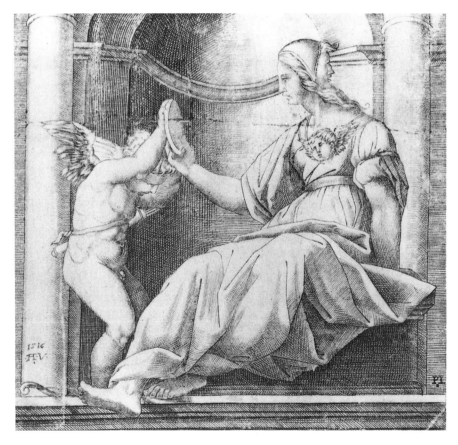

FIGURE 20  *Prudence,* Agostino Veneziano, 1516.

Copyright: Warburg Institute, University of London.

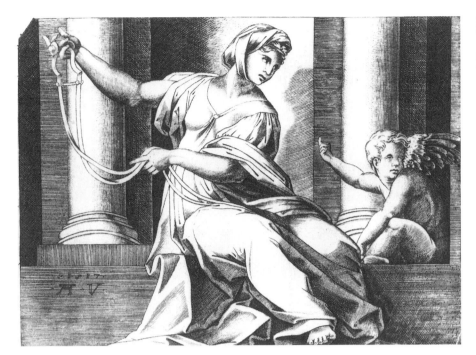

FIGURE 21  *Temperance,* Agostino
Veneziano, 1517.

Copyright: Warburg Institute,
University of London.

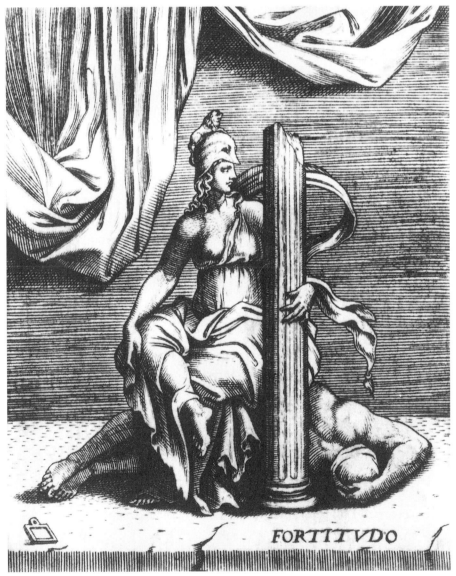

FORTITVDO

FIGURE 22  *Fortitudo (Fortitude),*
Marcantonio Raimondi, circa 1520.

Copyright: Warburg Institute,
University of London.

pendia of graphic allegories and emblems produced during the sixteenth century by Andreas Alciatus, Cesare Ripa, and others. Their works were illustrated, embellished, and widely reproduced as the printing press permitted many editions and extrapolations in various languages.[52] Through didactic and repetitive invocations in art and literature, on tarot cards, and in political and theological theory, these Virtues provided a common set of references across a broad geographical span.

Yet the many Virtues, save Justice, are largely lost to general knowledge. Most of the people walking into courthouses, reading cartoons, or buying magazines would not look at a woman holding a mirror and know either that she represented Prudence or that this Virtue was once posited as a requirement of good government.

## Justice's Ascent

What accounts for Justice's visual accessibility? Why is she a part of today's popular knowledge while other Virtues (and Vices)—all also with their own distinctive attributes, myriad depictions by governing powers, and substantial interpretive literatures about their philosophical implications—are lost to contemporary view? Why has Justice eclipsed her sibling Virtues not only as a kind of shingle to hang outside a government building but also as a central theme of modern governments? Why are law and political theory not awash with ideas about the necessity of engaging in practices of Temperance, Fortitude, Prudence, Wisdom, or Charity as well as of Justice?

In addition to the first purpose of this book, which is to map how the pre-democratic emblem of Justice became an icon for twentieth-century governments, a second objective is to respond to questions about why her siblings dropped from sight in the law. Some argue for the naturalness of Justice's ascendancy to the apex of a hierarchy of Virtues.[53] Further, as Aristotle's *Ethics* became integrated into Christian theology and political theory, this Virtue (sometimes translated as Righteousness)[54] related to various state activities, from enforcement of criminal laws ("penal justice")[55] to regulation of commerce.

Moreover, for centuries, discourses about justice have sought to explain what it means to be "just" through delineating relationships among ideas of equity, charity, mercy, retribution, and justice. Writing in the thirteenth century, St. Thomas Aquinas famously distinguished between two forms of justice. "Distributive justice" was the provision of "honour, money, benefit, or other thing semblable"[56] to render "what is due to each person, as determined by a criterion of proportionality between individual worthiness and the goods being distributed."[57] In contrast, "commutative justice" dealt with inequalities by "an arithmetical mean . . . [such that] the suffering or loss of one is balanced by the suffering or loss of another."[58] Seeking to apply these "notoriously unclear" distinctions,[59] some classified distributive

justice as the "allocation of common goods to individuals in proportion to their contribution to the common good,"[60] while commutative justice concerned "transactions between two persons," with the losses suffered by one compensated by the other in proportion to the injury incurred.[61] The sixteenth-century French political theorist Jean Bodin added "harmonic justice" to mediate between distributive and commutative justice.[62] Questions of the purposes and effects of these many facets of justice were replayed in literary works, such as Spenser's *The Faerie Queene*,[63] and in debates over centuries among religious and political philosophers.[64]

But Justice was not the sole Virtue promoted as superior. Plato can be read to have put Sapientia (Wisdom) in "first place," followed by Temperance; from the union of these two with Courage "issues justice."[65] Or one might understand Platonic Virtues to function as a set, always interdependent and all equally essential for a polity to thrive.[66] Some Christian theologians identified Caritas (Charity) as the "mother of all the virtues."[67] Others placed Prudentia (Prudence or practical wisdom) "first" among the Cardinal Virtues, serving as the "Lantern" that preceded the others.[68] Temperance also had a claim to top billing as the "one necessary before any of them *are* virtues."[69] Alternatively, it was Concordia (Peace) that was said to be the "central value of civic life."[70] Rankings also varied with categories, such that Justice was the highest "moral" virtue, Wisdom the highest "intellectual" virtue, and Charity led the list of "theological" virtues.[71]

## Justice's Violence

The shifting hierarchies among various Virtues make it simplistic to assume that her contemporary ubiquity was inevitable. Instead we argue that Justice's remarkable longevity stems from her political utility, deployed because of a never-ending need to legitimate state violence.[72] The imposition of law in both civil and criminal contexts disrupts ordinary persons' lives. Not all political theories of leadership require wise, restrained, and generous governance, but all rely on authority to maintain order by sanctioning those deviating from communal norms. During ages in which faith in various conceptions of a god were pervasive, the premise that the king (and his judges) were earthly representatives of a divinity cushioned the violence of law. In Medieval town halls, scenes of the Last Judgment adorned walls, often with parallel depictions of decisions made on the ground.

But debates emerged about what powers were properly held by monarchs and how authority was delegated to lower officials.[73] Problems of legitimacy came alongside the growth of republican governance. The judgments of all-too-mortal judges were in need of anchors beyond sheer power. As beliefs shifted and conflicted when localities and states separated from religious empires, and as popular consent gained some relevance to legitimate government,[74]

a different imagery developed. Localities created dedicated spaces for judgment—courthouses—and used them not only functionally for trials and meetings but symbolically to underscore their economic girth and political aspirations. New public spaces, typically accessible to spectators, sought to assuage concerns about the imposition of authority through a promise of even-handed treatment for those who came within their ambit, either as criminal defendants charged with violating the state's peace or as civil litigants seeking state assistance in resolving disputes.

Behind the increasingly imposing facades of town halls and courthouses adorned with the decorative figure of Justice lay an economic story of competition for commerce, a political effort to generate civic identities, and less cheerful facets of law's import. Every act of judgment results in state imposition of force, reallocating property from one civil claimant to another or depriving criminal defendants of their liberty and (in some eras and places) of their lives. Every government seeks to demonstrate its ability to provide peace and security by employing such violence, and every government needs to legitimate its own use of force against the disobedient by demonstrating that those who have breached the ruler's law are identified and sanctioned after being found responsible.

In the chapters that follow, we map the ascendancy of Justice as a marker of governments and the ascendancy of adjudication, enshrined in courthouses around the world, as a *sine qua non* of democratic governance. We turn to pictures on the walls of European town halls to understand how rulers claimed that Justice was essential to good governance and how they used public demonstrations of the power to impose punishment in the name of "peace and security." Over time, those performances helped produce norms that law's violence be justified rather than arbitrarily inflicted.

## VISUALIZING JUSTICE'S PAIN AND CHALLENGES

A third objective of this book is to show contemporary viewers that more has been lost than recognition of the many Virtues that once dotted public places. Today's austere and celebratory courthouses offer few clues to the consequences, challenges, or failures of justice systems. Rulers once paraded before local audiences a much harsher understanding of what doing justice entailed. Various allegorical paintings linked Renaissance governments to classical and biblical ancestors, and a few—such as depictions of the Last Judgment and the Judgment of Solomon—remain familiar. But other pictures, once easily comprehended, focused on the pain that rendering judgment imposed not only on those judged but also on those who served as judges.

Several European Renaissance town halls (including the monumental seventeenth-century building still extant in Amsterdam) featured the narratives of the Judgment of Brutus, a Roman envoy who sent his sons to their deaths

because they violated the laws of the state.[75] Also on display was Zaleucus, a Greek lawgiver who, when obliged to punish his son for breaching edicts, gouged out one of his own eyes rather than inflict total blindness on his son. People who walked into the Town Hall at Bruges saw a large painting of a corrupt judge, Sisamnes, vividly being flayed alive at the order of the Persian King Cambyses. Those who entered the Town Hall of Geneva were greeted with a long mural aptly named *Les Juges aux mains coupées* (*Judges with Their Hands Cut Off*), for it showed several judges whose limbs had been severed.

What did such scenes try to teach, and why are they now gone from sight? During the Renaissance, the good judge was the obedient judge, loyal to a king or emperor and holding office only at the pleasure of rulers.[76] Rulers used classical stories not only to remind the populace of religious and historical traditions grounding their authority but also to remind judges of their servitude to the state. Rulers offered analogies of their guardianship of subjects to parental responsibility for children, both in authoritarian hierarchies obliged to enforce rules.[77] The resulting punishments were also meted out in public, with stockades, racks, and guillotines providing gruesome spectacles that counseled against disobedience.[78]

In subsequent centuries, a very different conception of the judge came to prominence, as that jurist was repositioned to be independent of the executive and empowered to serve as a check against government. Political theories celebrated not only the desirability but the necessity of separation of powers and of judicial constraints on executive action. By 1701, for example, England protected judges by statute.[79] That idea traveled across the Atlantic, where it was adapted in the Massachusetts Constitution of 1780, then enshrined in the United States Constitution's guarantee of life tenure for its federal judiciary,[80] and thereafter migrated around the world. Punishment, in turn, moved indoors, as the construction of large penitentiaries accompanied a wave of courthouse building. Personifications of Justice continued to be used to mark a building as a court of law. Stony figures, occasionally blindfolded, were explained to denote the appropriate distance between judge and government.

What have been lost from sight are expressions of the pain entailed in doing justice. As the opening travelogue of contemporary courthouses suggests, governments that are so welcoming of adjudication as essential to their work do not put on display the many challenges entailed within the democratic promise of "equal justice for all." With a few exceptions, such as the murals in Mexico's Supreme Court building and the decision to site South Africa's Constitutional Court where a prison from the Apartheid era had stood, governments mostly proffer impressive courthouses as affirmations of the justice of their authority.

Justice iconography thus serves as a testament both to the longevity of political symbolism and to its plasticity, as

some attributes are reread and others attrit.[81] During the Renaissance, Justice came with a motley array of flora, fauna, and objects. Once she was displayed with an ostrich, explained by reference to the bird's reputed ability to digest everything and to its feathers of equal length. Today suggesting that a courthouse show an ostrich would prompt quizzical amusement.

In contrast, many contemporary commentators presume that a blindfold is not only an appropriate but a necessary appendage, always worn by Justice to signify law's impartiality. But, as we detail, clear-sightedness was valorized in Medieval Europe, while covered eyes denoted an inability to see the light of truth. A fool was shown putting a bandage over Justice's eyes to capture how easily law could be led astray. Thereafter telescopes, microscopes, and photography demonstrated the complex relationship between sight and knowledge, and psychologists and philosophers puzzled about how fair judgments were shaped. The blindfold then gained a new valence as an emblem of a desirable "veil of ignorance," to borrow the metaphor of political theorist John Rawls.[82] But others—such as the poet Langston Hughes—protested that Justice's blindfold hid "festering sores / That once perhaps were eyes," because legal systems failed to confront the injustices of social and political inequalities.[83] Contemporary constitutional conflicts over whether legal rules ought to be "color blind" or to take differential circumstances into account are captured in artistic renditions in which the eyes of Justice are sometimes shaded, sometimes obscured, and sometimes clearly sighted. What Justice ought to "see," and inferentially to know, continues to be contested.

## ADJUDICATION'S TRANSFORMATION: ACCESS FOR ALL BEFORE INDEPENDENT JUDGES IN OPEN COURTS

As this book makes plain, adjudication is an ancient practice. Our fourth aim is to show that the practice of adjudication helped to shape democratic norms about government's relationship to the public. We trace how some features of old-style judging (even-handed treatment of those affected, some constraints on arbitrary power, and a degree of public accounting for actions) contributed to democratic ideas. The many visual displays that adorned town halls repeated themes of power grounded in knowledge, wisdom, and uncorrupted judgment. Injunctions to "Hear the Other Side," inscribed in Latin (*Audi et Alteram partem*) on town halls of the seventeenth century, became embedded in constitutional obligations termed "due process."

But democracy has radically transformed adjudication. A fifth purpose of this volume is to document the profoundly challenging impact that democratic precepts have on courts. We have already noted the shift in the role of the judge, who gained a kind of independence unique for government employees. Two other aspects of modern adjudication—public access and political equality—are also novel. During the Renaissance, the public was invited to watch spectacles of judgment and of punishment. Yet, while witnessing power, the public was not presumed to possess the authority to contradict it. Unruly crowds were a possibility, prompting (as Michel Foucault analyzed) the privatization of punishment.[84] In contrast, court judgments became obligatorily public, as illustrated in the 1676 Charter of the English Colony of West New Jersey, which provided that "in all publick courts of justice for trials of causes, civil or criminal, any person or persons . . . may freely come and attend."[85]

A century later, the new states in North America took this precept to heart, as the words "All courts shall be open" were reiterated in many of their constitutions. Interacting with a new sense of entitlement was the practice of "publicity," to borrow Jeremy Bentham's term. Accessible courts, along with the press and the post, enabled what Bentham called the "Tribunal of Public Opinion"[86] to assess government actors. As Bentham explained, while presiding at trial a judge is "under trial."[87] From the baseline of the Renaissance, the public's new authority to sit in judgment of judges and, inferentially, of the government that empowered them, worked a radical transformation. As "rites" turned into "rights," spectators became active participants. Courts were one of many venues contributing to what twentieth-century theorists termed the "public sphere"—disseminating information that shaped popular opinion of governments' output.[88]

It was not until the twentieth century, however, that all persons gained rights in many countries to be *in* courts—as litigants, witnesses, jurors, lawyers, and (even more recently) as judges. Formal principles of equal treatment entitled a host of claimants, regardless of race, class, ethnicity, and gender, to fair hearings. As the transnational codification of the 1966 United Nations Covenant on Civil and Political Rights proclaimed, "everyone shall be entitled to a fair and public hearing by a competent independent and impartial tribunal established by law."[89]

One measure of the success of these new commitments has been a rising number of filings in courts. A few numbers from the United States are exemplary. As of 2010, state courts dealt with some 45 million filings annually. While the federal courts handled a much smaller number—about 325,000 civil and criminal filings, and more than a million bankruptcy petitions—tracing the development of the federal system permits one to watch the role played by courts in shaping a national polity. Fewer than 30,000 cases were brought before the federal courts in 1901; ten times that number were filed by 2001.

Growing dockets beget judges. In the middle of the nineteenth century, fewer than forty federal (as contrasted with state) trial judges sat in courtrooms around the entire United States. By 2001, more than 650 judgeships existed at the trial level. Judges and cases—and money and politicians —beget courthouses. In 1850, virtually no buildings owned

by the United States government (again, not the states) bore the name "courthouse" on their doors. The occasional federal courtroom was tucked inside custom houses or in spaces borrowed from states or private entities. By 2010, more than 550 federal courthouses—so named—existed.[90]

## Celebrating and Understanding New Demands

Civic leaders of recent centuries (like their Renaissance counterparts) sought to create symbols of presence, power, and prosperity. During the nineteenth century, facilities housing judges, postal services, town records, and jails were grafted onto the landscapes in cities and counties around the world. In both common law and civil law jurisdictions, these buildings served as social gathering places and "theaters of justice."[91] Over time, multi-purpose town halls and municipal centers no longer sufficed to contain expanding functions. In response, governments erected segregated, "purpose-built"[92] facilities today called courthouses, jails, prisons, government office buildings, post offices, tribunals, and agencies. Again using the federal system in the United States as illustrative, the federal judiciary once decamped in what were modestly termed "court quarters" for judges.[93] By the end of the twentieth century, the federal government had funded the largest building program since the New Deal for the renovation and construction of new courthouses. "Excellence in design" became the byword,[94] as courthouse commissions went to high-profile architects rewarded for crafting signature buildings.

A parallel expansion of court resources can be found in many countries. During the latter part of the twentieth century, France launched a program resulting in several "palais du justice modernes," Israel commissioned a new building for its Supreme Court, and Australia funded a new federal courthouse.[95] Courthouse building (as well as prison construction) became a major industry, with specialized associations focused on designs for the justice system.[96] Local variations were complemented by a transnational idiom propelled by a marketplace of lawyers, judges, architects, and court administrators crossing national boundaries and shaping construction plans at the regional, national, and international levels.[97]

Projects for a "world court" began with hopes for dispute resolution to take the place of war. In 1899, Andrew Carnegie funded the "Peace Palace" in the Netherlands at The Hague to house the Permanent Court of Arbitration. Later, that impressive space was shared by the international courts of the League of Nations and the United Nations. A hundred years later, planning for another new court reflected less hope and more of the century's horrors, as countries joined the treaty establishing the International Criminal Court, with jurisdiction over genocide and other crimes against humanity. Advocates for a fixed site for that court argued the need for a building that could last "forever."[98]

## Building Idioms: Transparency, Access, Identity, and Security

In short, while an ancient practice, adjudication has been reconstituted and acquired four attributes—independent decisionmakers, requirements of public processes, a new ideal of fairness, and equal access for and equal treatment of all. A tour of the many new courthouses, serving as the new icons of justice, captures adjudication's centrality. Governments explain their decisions to case their courts in glass and to bathe them in light as representing the values—transparency, accessibility, and accountability—that undergird the exercise of force. These facilities often marry old Renaissance forms with newer technologies and aesthetics as they embrace the iconography of the Virtue Justice, augmented by an eclectic array of objects created through materials ranging from cloth and clay to bronze and steel.

Two ideals entailed in the democratic commitment of access to justice—playing out in the buildings and their use—need to be disentangled. One is that all persons have access to using the law. This new equality puts pressure on the visual displays within courthouses. Social movements about equality and identity reshaped both the images of justice and the dockets of courts. As women of all colors gained recognition as rightsholders, entitled to sue and be sued, to testify, and to judge, the stone female figure of Justice became less an abstraction and more a representation of a person, embodied. But who should decide how "she"—Justice—was to look?

Once, elite groups of rulers and patrons controlled commissions—filling courthouses with portraits of elder statesmen along with the draped (or naked) female figure of Justice. But twentieth-century ideologies produced conflicts over Justice's color and shape. Protests erupted in the 1930s about a "mulatto" Justice in a federal courthouse in Aiken, South Carolina,[99] as well as about a statue in Newark, New Jersey, that was said to smack "blatantly of Communism."[100] By the 1960s, civil rights advocates found offensive a 1930s mural in the federal courthouse in Jackson, Mississippi, where a scene portrayed the segregated South.[101] In the 1950s, Muslims objected to the display of Muhammad outside a courthouse in Manhattan,[102] and in 2006, debate ensued about a display in an Idaho courthouse of a mural showing an "Indian" about to be lynched.[103]

A second aspect of access to courts shifts the focus from those authorized to bring claims to court to those who watch—the audience. Edification of viewers (courts as theaters or schools) remains an objective of open courts, as do democratic objectives that power be constrained, transparent, and accountable. In the late twentieth century, courthouse construction became enmeshed in security concerns that shaped three separate circulation patterns to segregate judges from the public and criminal defendants from everyone. Yet, designers of major buildings continue to feature large open courtrooms, providing material references

to the political and legal commitment that courts are venues in which government and the populace interact.[104]

## DEMOCRACY'S CHALLENGES

The narrative of "adjudication's triumph" and its celebration is, however, complemented and complicated by an alternative understanding that emerged in the late twentieth century. Egalitarianism poses deep problems for polities that have thus far been unwilling to commit the resources that would support all the adjudicatory opportunities promised. As the ranks of rightsholders expanded, nations responded not only by creating more judgeships and by building yet more specialized structures but also by moving some forms of adjudication offsite, to administrative tribunals and to procedures that have come to be known by the acronym ADR—alternative dispute resolution. Our sixth task is to map the resulting fragmentation and privatization of adjudication and its implications for courts.

### Privatizing Process and Controlling Access

With soaring demands for adjudication, governments have responded by diversifying the venues for adjudication. Magnificent courts welcome some rights seekers to their halls but send others to much less visible and impressive settings—administrative agencies or tribunals where lower-tier hearing officers work. In the federal system in the United States, for example, in 2008 four times more judges (often termed hearing officers) sat in federal agencies than in federal courts, and these administrative judges rendered tens of thousands of decisions in disputes brought by recipients of government benefits, such as veterans, employees, and immigrants seeking adjustment of their status.

In some respects, this evolution has served to increase the domain of adjudication, because agencies have modeled their own decisionmaking processes after those of courts. Yet this work occurs with judges less insulated from oversight by the executive and at sites generally inaccessible to outside onlookers. Many other claimants are dealt with by private providers, such as associations of arbitrators, where no rights of access for third parties exist and where no obligations of transparent accounting are imposed.

For those cases that remain within the courts, judges press litigants to avoid the public processes of adjudication whenever possible. In the 1990s, England and Wales reformatted procedural rules to facilitate settlements,[105] and in 2008, the European Community issued a directive that all national courts promote mediation of cross-border disputes.[106] Parallel movements across borders have shifted the ideology of judging away from the public acts of adjudication toward more private managerial roles, overseeing lawyers and promoting conciliation.[107] With the devolution of adjudication to agencies, the outsourcing to private providers, and the reconfiguration of court-based processes toward settlement for both civil and criminal cases, the occasions for public observation of and involvement in adjudication are diminishing. By 2002, in the federal courts of the United States, trials began in only two of a hundred civil cases, and the decline in the rate of trials (despite decades in which filings had risen) gained the moniker of the "vanishing trial."[108]

### The Decline of Adjudication

The narration of adjudication's triumph, marked by hundreds of impressive courthouses around the world and the many guarantees of open and public courts in national and international conventions, gives an impression of invulnerability. But the contemporary fragility of two other institutions—the press and the post—also developed during the Enlightenment, ought to give one pause. The criticisms leveled against them—inefficiency and a preference for private ordering—are regularly applied to courts as well. Even as new courthouses provide aspirational monuments to a system of government-based public justice, they are becoming venues for the resourced elites and the outliers. On many a day, the austere hallways of various grand courthouses on both national and international levels are empty. Demand and use, however, remain high in lower level courts, as trial level and administrative judges in many systems report overload and inadequate resources.

Dramatic evidence of the retreat from courts came from policymaking by the Executive Branch of the United States government after the terrorist destruction of the World Trade Center's Twin Towers in September of 2001. Eschewing both federal criminal trials and the military court system, the Department of Defense created a detention camp at Guantánamo Bay, a United States naval base in Cuba. The United States government first argued that persons there detained could not bring challenges to their detention or to the conditions of their confinement, including claims of torture.

Our opening image—a Justice shown in the crosshairs of a rifle scope (fig.1)—was accompanied by commentary objecting to that "shadow court system outside the reach of either Congress or America's judiciary."[109] Rebuffed by the Supreme Court, the Executive Branch set up a process for classifying individuals alleged to be "unlawful enemy combatants."[110] Government officials asserted that they could control the access of detainees to courts, to their lawyers, and to the press. Further, the tribunals, deemed "administrative," were initially closed to the public.

Although one might be tempted to bracket the rules for alleged terrorists as unique responses to horrific events, analysis of other government regulations shows the continuum on which the decisionmaking regime at Guantánamo Bay sits. Ordinary prisoners confined in the United States, ordinary claimants under various federal laws, and ordi-

nary individuals in administrative agencies also have few opportunities for independent judges to decide claims of right in public. Despite the many affirmative iterations in state, national, and international documents of "open courts" and independent judges for "everyone," these aspects of adjudicatory processes are in jeopardy.

Explanations of the shift toward privatization of adjudication are multiple, from a lack of resources to the view that alternative forms of conflict resolution are more accurate, less expensive, and more user-friendly. Others see a political backlash, in that some "repeat players" found the glare of adjudication disruptive to business practices or governance policies, and successfully "played for the rules" by limiting the reach of courts and by constricting access.[111]

Nineteenth-century theorist Jeremy Bentham shared with twentieth-century theorist Michel Foucault an appreciation of the role architecture played in the exercise of power. Bentham celebrated the placement of the judge before the public eye, as he argued the remarkable potential of "publicity" to discipline "Judge & Co." Foucault in turn watched governing powers seeking to maintain control through privatizing the technologies of punishment.[112]

Today, adjudication is being removed from public purview, making the exercise and consequences of public and private power harder to ascertain. Although built with cutting-edge technologies, new courthouses are at risk of being anachronistic. Illustrative is the docket of one new transnational court—the International Tribunal for the Law of the Sea (ITLOS). From its creation in the 1990s through 2008, a total of fourteen cases had come before it.[113]

## RE-PRESENTING JUSTICE

The final focus of this book is on the implications of our analysis for the future of courts and their material embodiments. Courts are artifacts *of* democracy that are overwhelmed *by* democratic promises. Yet courts are also important contributors *to* democracy. Adjudication is one site of democratic practices, redistributing power from government to individual, from one side of a case to another, and from participants to the audience. Through such participatory parity, public processes both teach about democratic practices of norm development and offer the opportunity for popular input to produce changes in legal rights. The redundancy of various claims of rights enables debate about the underlying legal rules.

But to create public spaces as active sites requires normative commitments predicated on a political theory about the role played by judges, disputants, and the audience in juridical proceedings. What the Renaissance images teach is that adjudication's purposes and norms have long transcended geography and political jurisdictional authority.

Yet the visual traditions of Justice have their political roots in governments that were hierarchical, non-democratic, and tolerant of profound inequalities. It is therefore not surprising that the icons of Justice that have come down to us signal little about access to justice or about rights-seeking, and that figurative portrayals during the twentieth century began to spark debate about the images of which people, with what features, should be placed on display inside courthouses.

The precepts of good democratic governance encoded and iterated in the symbolism of Justice are far too narrow. In the closing chapter of this volume, we offer alternatives. To the extent that Renaissance iconography is of use, we would be better served were our leadership to see itself needing to invoke the range of values personified in Prudence, Fortitude, Temperance, Wisdom, and Charity, as well as the power of Justice. Would that governments thought they had to show commitments to "mildness and compassion" by relying on eloquence and persuasion before imposing their will by force.[114] Entailed would be an understanding that Justice, if the only attribute of government, becomes reduced to power rather than working as one of a set of principles and obligations that constitute good governance.

Admissions of justice's failings, in turn, could serve to discipline power with a self-consciousness about its own potential for fault. Imagery drawn from Mexico and South Africa, where both erected courts in the wake of popular revulsion against prior regimes, offers examples insistent on acknowledging the injustice that has gone forth in the name of the state.[115] But such constructions have come in extraordinary moments reflecting national upheavals rather than forming a part of the regular idiom of justice buildings. In contrast, the celebratory glass of many contemporary courthouses seeks to signal access without acknowledging the conflicts, the risks of error, and the lack of resources that freight justice systems.

In closing, we offer but a few of the ways to invoke the challenges of democratic justice in the twenty-first century and the diverse means to make accessible processes, ranging from settlements negotiated under the aegis of courts to rulings by judges. By traveling from the Great Victorian Desert in Australia to the northern corner of Minnesota, we identify examples of efforts to visualize the work of opening doors to courts. Presented in this amalgam are not only acts of memory—reclaiming the stories of justice and injustice—but also efforts to advance a vision that democratic justice is not simply continuous with the practices of adjudication predating democracy. To practice justice today is an ambitious project, and to represent it requires devising ways to acknowledge what democracy brings to adjudication: a new and genuinely radical aspiration to find ways to make earthly justice available to more people, if not to all.

# Civic Space, the Public Square, and Good Governance

Chapter 1 demonstrated Justice's ubiquity. Our focus here is on her history. Whether emperors, kings, queens, dictators, burghers, presidents, or prime ministers, and whether leading charismatic governments, rationalizing bureaucracies, or constitutional democracies, sovereigns of all kinds have wrapped themselves in Justice symbols. The implements that Justice came to hold reflect a changing mix of theological and political ideas about the sources and nature of legal obligations and about the function of judges. In this chapter, we track the development of Justice iconography, as varied deployments proved sufficiently capacious to sustain continuity across very different conceptions of deities, government, women, and adjudication. As a form of political propaganda, Justice has had a remarkable and distinctive run.

## A LONG POLITICAL PEDIGREE: SHAMASH, MAAT, DIKÊ, AND THEMIS

### The Scales of Babylonia and of the Zodiac

Egypt is often cited as the source of the particular attributes that have come to be associated with Justice. Drawings of Maat—a word used for both a female goddess and a concept important to Egyptian cosmology—often depict a female with scales. But one can also find traces of Justice imagery even earlier, in Babylonia.[1] The line drawing in figure 23 (color plate 3)[2] is one such example, taken from a small cylinder seal from the Akkadian period and dated between 2350 and 2100 BCE. Seals were rolled over the surface of clay tablets to certify recorded transactions.[3] The seated figure shown near the scales has been identified as the god Shamash (also called, in English, Utu)—the judge of heaven and earth—identified with sun, light, and an ability to divine the truth.

The extant images of Shamash do not regularly show him holding scales. Rather, as in figure 23, he often had a special saw, called a shasharu. This tool has been explained poetically, as employed to open up mountains in the East

at daybreak, and, perhaps, more generally to delineate truth from falsity.[4] Depictions of Shamash also show him holding a ring of coiled rope and a rod, objects ascribed to surveyors and therefore, when linked to rulership, denoting the act of setting things right.[5] The Akkadian words *kittu* and *misharu,* translated into English as "truth," "equity," or "justice," described the "straightening out" of a situation whose equilibrium, put out of balance, had became "crooked."[6]

The connections between Shamash and state activities are plentiful. Shamash is prominently depicted on the famous Babylonian stele inscribed with the Code of Hammurabi, which stood around 1750 BCE in a public courtyard in the main temple of Babylon, Hammurabi's capital city. Apparently a few copies of the stele were set up throughout the realm. One, brought around 1150 BCE to Susa (a city in modern-day Iran) by a neighboring king as a trophy, was taken to France in 1901 and stands in the Louvre in Paris. The black, seven-foot-high stone has some 275 statements, akin to legal decisions imposing social order and bracketed by a prologue and an epilogue.[7] The large bas-relief that covers the upper third of the obverse of the stele shows Hammurabi standing before Shamash, who is seated on a throne and extends a rod and ring toward the king.[8] The text proclaims that Hammurabi will, like "the sun-god Shamash," rise and "illuminate the land," for Hammurabi is the "king of justice, to whom the god Shamash has granted (insight into) the truth."[9]

In addition to the royal monument, thousands of tablets with cuneiform writings incised into clay provide details of the Mesopotamian legal and religious systems.[10] Some descriptions analogize the king, serving as a judge, to Shamash,[11] and others require that oath-takers in conflicts invoke Shamash as they swear to speak the truth.[12] Mesopotamian imagery of scales, rods, and saws are sources of objects today used to denote Justice. Moreover, when Justice is shown with a book, said to denote written law, the reference could be read back to the law stele of Hammurabi's code as well as to later iterations, such as the tablets

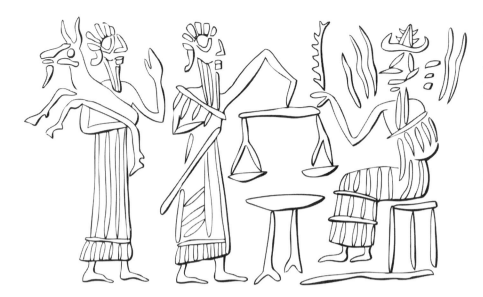

of the Ten Commandments, the Old and New Testaments, or the Justinian Code of the Roman Empire.[13]

Another set of images—the zodiac, also traced to Mesopotamia—regularly included scales. Many ancient cultures had pictures and texts referencing mythic figures to stars in the night sky.[14] At some point, perhaps as early as 2000 BCE, people linked the autumnal equinox (when day and night are "equal" in time) and the pattern of stars visible in the fall season (particularly the constellation now called Libra) to the time at which god(s) made judgments about the fates of people (either living or newly dead).[15]

Which cultures were the first to forge these associations and how these ideas moved from place to place are not clear.[16] Mesopotamians shaped a calendar relating to the movement of stars and developed the idea that stars affect human life.[17] Those beliefs influenced the ancient Jewish lunar calendar, which put its New Year and "day of judgment" in the months called (by the Christian calendar) September and October.[18] That season is when the constellation Libra—which came to be signified by scales—is in the sky. The zodiac is the visual translation of some of these connections, mapping "the annual course of the Sun."[19] The word zodiac comes from the Greek *zodiakos* that can be translated as "a circle of animals or little pictures of animals." Several zodiac mosaics from the Roman and Byzantine periods survive, including those in synagogues built in an area now in Israel.[20] In the center of such depictions was a male sun god figure, seen in a frontal position, crowned by a halo with emanating rays and sometimes accompanied by a chariot and horses.[21] The outer circle typically had twelve radial units, with one animal for each zodiacal sign. At the four corners, heads of women represented the four seasons, often indicated by different vegetation—such as grapes, pomegranates, and an olive branch for autumn.

In the mosaics identified to date, "the sign of Libra is shown as a human figure holding a pair of scales."[22] This motif can be found in a host of settings, from ancient temples, synagogues, and churches to Renaissance halls of justice.[23] The import of the twelve signs is debated; they may have been objects of worship, ancient calendars marking time, or had both functions.[24] What these images show us is that the picture of a particular kind of scales and the act of judgment became entwined in an area between the Euphrates and the Tigris more than four thousand years ago. Via the Roman Empire, this imagery moved across both land and many political configurations to form symbols that remain recognizable today.

Another link between scales and judgment comes from analysis of various ancient legal codes that imposed punishments supposed to be the equivalent of a particular injury. Whether "an eye for an eye" or a more complex system of monetized penalties, ancient and Medieval societies specified sanctions in terms of measurements.[25] Restorative justice under these conditions focused on identifying a quantum of vengeance or compensation necessary to restore a just balance. Of course, scales were talismatic of another kind of judgment—a commercial one.

Today scales are commonplace, but the actual objects used as weights and scales were once scarce and precious, carefully guarded to protect their precision.[26] Given their centrality to economic life, these tools of trade were often deposited with official keepers such as local rulers. One might thus understand the practice of justice not only as commercially useful but as a kind of commercial exchange itself. Judgments fixed the price of a wrong, and scales aptly captured this form of weighing while also measuring how to set a fee for items of trade.

But not all of the actual scales took the form of a balance with two pans, which has become commonly recognized as what scales "look like" and is also the source of the word balance, derived from the Latin *bi-lanc* (also *bi-lanx*, or *bilancia*)—two plates or pans. In ancient times, the steel-

yard, with its long bar and a pan on one side and a weight on the other, was a popular shape of the measure. A few artists chose that form of the balance (as Joshua Reynolds did in his *Justice* of 1778, shown in Chapter 5). But the steelyard, with its two sides of "impressive inequality,"[27] is not Justice's logo. Rather, the even-armed scales, whose trail we follow from Shamash and the Egyptian Maat to the Christian St. Michael and then the Renaissance Virtue Justice, has been the form repeatedly chosen for an image now seen as denoting both fair and equal treatment.

### The Balance in Egyptian *Books of the Dead*

The area around another river—the Nile—is the more commonly acknowledged source for the figure of Justice and her scales. There the Egyptian ideal Maat was also linked to judgment and shown through images of balances.

Because the "universal sense" of the term Maat has no precise equivalent in other languages,[28] Egyptologists offer several words to capture what Maat encompassed: "truth, justice, righteousness, order, balance, and cosmic law,"[29] a "divine order,"[30] a "stability,"[31] and an "evenness"[32] that stood in contrast to and overcame chaos. The concept was depicted by a feather alone,[33] with a pedestal or base denoting foundational importance,[34] and by a woman with an ostrich feather tucked under a band on her head. At times that female (who was also called Maat) can be seen holding a balance or, as in figure 24 (color plate 4),[35] she herself forms the centerpiece of the scales.[36]

The detail in figure 24 comes from one of hundreds of papyri sheets within what is now called the Egyptian *Book of the Dead*.[37] Dated from about the fifteenth century BCE, this is one of the "best-known scenes from funerary papyri."[38] An oft-repeated explanation for such depictions

FIGURE 24    Maat, detail from the Papyrus Nodjnet, *Book of the Dead,* circa 1300 BCE.

is that a person's heart (said to direct a person's will, feelings, thoughts, and character) was, at death, weighed against a feather (representing Maat) to determine where that person would go in the afterlife.[39] Various Egyptian deities, including Maat, Osiris, Thoth, and Ra, have been connected to that decisional process, shown or described as holding the balance, figuratively being the balance, or being placed in the pans of the balance.[40] Moreover (and akin to the associations around the Mesopotamian god Shamash), "[m]easuring, weighing, and counting" were "intimately linked with *maat*."[41] The reading of the scene in figure 24 as a judgment made upon a person's death fits within subsequent religious and literary traditions that posit an assessment and a "last judgment" at a person's death and that rely on images of weighing.[42] A line in the *Book of Proverbs*—"But Yahveh weigheth the hearts"—may echo the Egyptian image of the heart and the feather on a balance.[43]

Dozens of other quotes from the Old and New Testaments and from the Koran use the imagery of weighing, balances, and scales to capture judgments about religious or moral worth.[44] In the *Book of Job,* we read the plea, "Let God weigh me in the scales of justice, and he will know that I am innocent!"[45] From *Psalms,* we learn that the "Lord weighs just and unjust and hates with all his soul the lover of violence."[46] In the Koran, from *The Prophets,* comes this description: "And We will set up a just balance on the day of resurrection, so no soul shall be dealt with unjustly in the least."[47] Greek and Roman literary texts reiterate this imagery. In the *Iliad* Homer recounted: "Then Jove his golden scales weighed up, and took the last accounts [o]f Fate for Hector."[48]

These traditions share a belief that a divine judgment takes place at death, thereby supporting an interpretation that Maat shown with scales represents a "test" in which a person had to "affirm his innocence."[49] But debate remains about whether such a judgment was individualized and broadly available or limited by caste, whether the verdict depended on personal conduct or magic and ritual,[50] whether a decision about the person was rendered at death,[51] and whether such scenes depicted an act of judgment entailing weighing or, rather, that the values of cosmic equipoise embodied in Maat had been achieved.[52]

The nexus of Maat and law comes as well from other Egyptian sources. The vizier, the "highest legal official" during certain dynastic periods, was called a "priest of Maat," and Maat was sometimes "synonymous with the law itself."[53] Further, when Egyptian kings exercised punitive powers, "the image of Pharaoh as the personal messenger of justice" was often accompanied by Maat. Through many dynasties, pharaohs held a crook and a flail, objects associated with the god Osiris, who was also sometimes part of the *Book of the Dead*'s scenes involving Maat and the balance. Whether Egyptian iconography provided a basis for Justice's sword remains a question; pharaohs were also depicted "wielding a club, scimitar or sword to kill" foes, shown cringing at their feet.[54]

## Embodied Greek and Roman Goddesses

Mesopotamia may have begun the tradition of scales, as well as of a saw that later became a sword, and kings in both Babylonian and Egyptian cultures were shown with rods or staffs. But it was Maat's female form that served as a predecessor to a series of Greek and Roman goddesses (Themis, Dikê, and Iustitia),[55] all justice-engaged and all linked to ruling powers.

Themis, daughter of Uranus and Gaea (representing Heaven and Earth, respectively), sided with Zeus as her parents lost their battle with the Olympians. Thereafter, Themis served as Zeus's counselor and consort.[56] Depicted as clear-eyed, she held the authority to call an assembly of gods and to maintain order within that court.[57] Her female form enabled analogies to the moral influence attributed to mothers.[58] Themis has been credited with providing a kind of collective conscience informing religion and morality.[59] Themis and Zeus had a group of "golden daughters," identified as the Horae (Horai) or Seasons, who were also associated with justice.[60] One daughter, Dikê, was associated with "just retribution" or "right and justice," while another daughter, Eunomia, was said to embody "well ordering."[61] Dikê and her sister Astraea shared the title of "Princess of Justice."[62] (Astraea was also linked to the constellations in the zodiac. Centuries later, given her embodiment of both the heavens and justice, Astraea formed a part of the hagiography of Elizabeth I of England.[63])

The wealth of Greek personifications enabled distinctions among justice-identified goddesses. Some commentators, for example, associate Themis with divine justice, societal order, and written rules[64] and place Dikê in the context of individualized applications of justice.[65] Echoes of the grand cosmological themes of orderliness associated with Shamash and Maat can be found in descriptions of Themis and Dikê, to whom were also ascribed the maintenance of a stable world and a state of being that entailed righteous order.[66] Moreover, just as Maat was sometimes symbolized as a pedestal or base, the idea of themis (as contrasted with the goddess Themis) was likewise understood to provide a "base" or a "foundation" and (along with a concept called dikê) a "just, upright way" essential to sustaining relationships in a polis.[67] As Max Weber later argued, positing these deities to represent appropriate "ethical" obligations was requisite to maintaining "large and pacified polities" as economic and social development came to depend on being able to rely on oral promises and written words.[68]

A pause is in order to attend to the risk of reading back from contemporary theory and practices and making attributions about ancient images and writings. First, the recoveries to date of both images and words are partial,

dependent upon the happenstance of preservation and discovery.[69] Moreover, much of what constitutes today's knowledge of antiquity is of remarkably recent vintage. The Hammurabi stele, for example, was found in 1901. Thus, even as we construct this rounded narrative, the current pieces must be understood as the fragments that they are, brought together to form a genealogy made plausible from a particular standpoint.

Second, the extant bits once had a different import. Iconic and symbolic imagery in a pre-print, pre-internet environment could not have been experienced as they are in a world awash with pictures accessible from thousands of miles away through internet connections that bring home (literally) sites from around the world. One of our reasons for detailing debates about how to translate terms and images of Akkadian cuneiform, Egyptian hieroglyphs, Hebrew, ancient Greek, and Roman script is to provide a cushion against a too-ready equation of such images and words with contemporary meanings.

Third, much of what we recount in this chapter is about the relationship between the power of a ruler or god and the imposition of judgment itself. Throughout this book, we trace the movement from gods, fate, and nature to authority frankly based on human agency that entails choice, coercion, community, obligation, democracy, and justice. Over time, the idea of judgment became increasingly linked not only to the act of imposing an outcome but also to concepts about what practices constitute just and legitimate governance. The term justice emerged as a preoccupation, vivid centuries ago in Greek literary personifications of the Virtues and the philosophical traditions they have come to embody.

Whether Greek justice and "our" justice have parallel entailments is contested—readily apparent through a brief review of scholarly disagreement about the meaning of dikê. For some, dikê is a reference to a process of orderliness, perhaps providing an analogue to a "rule of law" ideology that imposes authority to maintain social organization. Others believe dikê embodied a broader understanding of values that required underlying justifications for decisions and hence embodied ideas closer to contemporary views of justice.[70] In short, as we move from ancient justice-connected language and personifications (bequeathed to us through the happenstance of preservation) through the centuries of the first millennium and beyond, we also move toward arguments that the continuing displays of Justice imagery were efforts to sustain claims not only to power but also to virtue and legitimacy.

## JUSTICIA, ST. MICHAEL, AND THE CARDINAL VIRTUE JUSTICE

Rome's power brought to the fore the Latin word *ius*, often translated as "law," and the shift from Dikê to Iustitia, Justitia, and eventually the familiar Justice. Etymologists report that *ius* referred to "human as opposed to divine law"

and denoted a "formula of normality" to which conformity was required; this "state of regularity" was foundational to law in Rome.[71] When the Romans renamed various Greek gods, two—Themis and Dikê—folded into Justitia. Some evidence exists of a cult of Justitia, although sculptural remnants are hard to find,[72] and she appears to have played a lesser role in Roman culture than Dikê did in Greece.[73] But we know that some Roman emperors broadcast their special relationship with Justitia through their coins.[74]

Images of Justicia (or Justitia), categorized in several genres, have been found on coins made under fifteen of the Roman emperors who ruled between the first and fourth centuries CE.[75] On one side of many coins is a representation of a particular ruler identified by his name; on the other side is a figure of Justicia, sometimes standing, other times seated on a throne, and holding various objects including a cornucopia,[76] a sceptre, scales, and a bundle of rods called fasces that was emblematic of the authority of Roman government officials.[77] One scholar of this coinage argued that it was a perfect form of political propaganda, available in daily life but controlled by what an emperor wanted to put into circulation.[78] As for what Justice looked like, the classicist Helen North concluded that Dikaiosynê/Justicia was the sole personification among the Virtues that had a recognizable "type" in ancient art.[79] (More generally, to the extent that personifications existed, very few of the attributes that subsequently came to be associated with various Virtues in the wake of Renaissance iconographical codification were acquired before the Hellenistic period.[80])

North cited Aulus Gellius as emphasizing Justicia's "stern appearance and keen gaze."[81] Literary critic Theodore Ziolkowski translated the Gellius description ("luminibus oculorum acribus") as giving Justicia a "piercing gaze"—congruent with a line from an Athenian author, Menander, who ascribed to Dikê an "eye that sees everything."[82] And, according to art historian Michael Evans, Aulus Gellius provided the Middle Ages with the only information about how Justice had been portrayed in antiquity.[83] (Chapters 3 and 4 detail the evolution of Justice iconography through various editions of the compendia by Cesare Ripa, who denominated one of his seven descriptions of that Virtue "Justice according to Aulus Gellius.")

Moving forward in time, Justice imagery came to be entwined with the Catholic Church, reliant, unlike Jewish traditions, upon human personification. Female figures identified as Justice can be found in Christian art from as early as the fifth century.[84] These stern-gazed women did not, however, always come with scales. Rather, Medieval European art frequently affixed scales to another figure, the oft-winged male St. Michael, who also stood as an exemplar of a moment of judgment (figure 25, color plate 5).[85] The use of a balance to represent judgment is shared by Babylonian, Egyptian, Greek, Roman, Jewish, and Christian texts and imagery. But it was St. Michael, "assuming the rôle of 'Master of the Balance' which Thoth" (and Maat) had

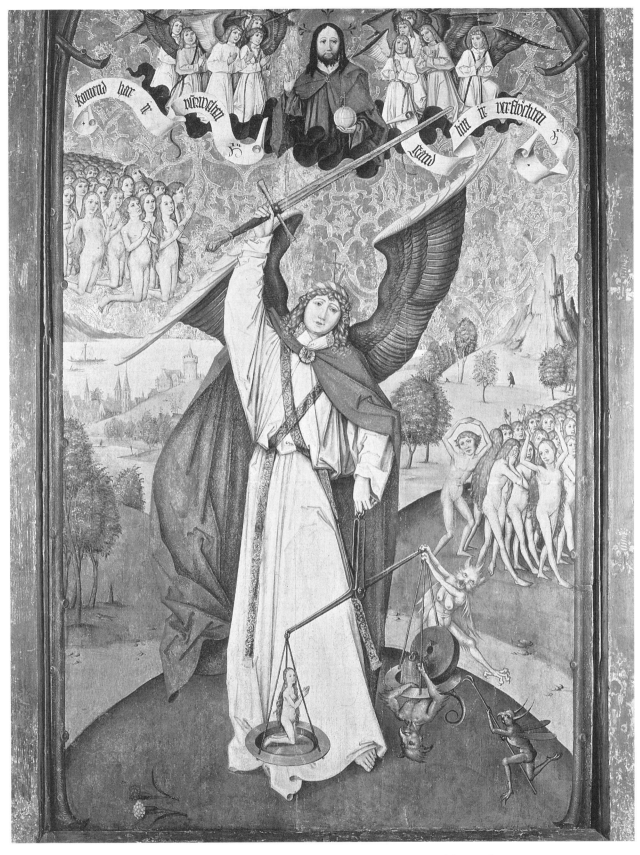

FIGURE 25  *Saint Michael Weighing the Souls at the Last Judgment,* Master of the Zurich Carnation, circa 1500, Kunsthaus, Zurich, Switzerland.

held before,[86] who formed the bridge from Egyptian eschatology across Christian imagery to the Renaissance Virtue of Justice.

In the Old Testament, Michael was one of a group of seven archangels (joining Gabriel, Raphael, Uriel, Chamuel, Jophiel, and Zadkiel) who assisted God.[87] Michael gained prominence as the captain of the heavenly hosts and as an especially wise counselor.[88] The New Testament names St. Michael the angel in the "great battle in heaven" with the dragon (the anti-Christ) who sought to "seduce the whole world."[89] Further, St. Michael was a "psychopomp," serving as a protector and conveyor of souls to God for judgment.[90] Some traditions placed St. Michael along with other angels as messengers who "delivered the Law" from God to the people.[91] In other legends, St. Michael had a special relationship with the Virgin Mary, whose "spirit was consigned" to his care "until it was permitted to reanimate the spotless form, and with it ascend to heaven."[92]

The cult of St. Michael spanned several centuries and many parts of Europe.[93] Some of the earliest images of St. Michael date from the seventh or eighth century,[94] but it is the imposing Romanesque abbey at Mont-St.-Michel, erected after 1023 on an island at the edge of Normandy, that attests to the degree to which St. Michael had by then become adored in France. His centrality can also be seen from his role as a major literary figure in John Milton's *Paradise Lost,* where, inter alia, Michael takes charge of an army of angels battling Satan in a war reminiscent of the *Psychomachia* of Prudentius.[95] Paeans to St. Michael can be found in Medieval Irish homilies as well as in Egypt's Coptic churches, and he became the patron saint of the City of Brussels.[96] These transborder commonalities have prompted some to trace the roots of Europe's cult of St. Michael to Celtic monks who returned from Egypt to Ireland with Michael as their focus.[97] Others mark a path for his adoration from the East through Southern Italy to central Europe.[98]

The portrayal of St. Michael weighing souls and the broadening of his following after the sixth century coincided with a shift in Christian theology about what occurred at death. One understanding, predicated on the Letter of Paul to the Romans and on the Nicene Creed of 381 CE, is that because Jesus died for the "sins of man," acceptance of Jesus was itself the source of salvation that put a person on the trajectory to heaven.[99] But if "eternal salvation" was guaranteed to devotees through the "sacrificial death of the saviour,"[100] images of angels holding scales are not obviously relevant, nor does this perspective easily support the common deployment of pictures of the Last Judgment in the "earthly" courts of many town halls. Indeed, scholars report relatively little Christian art dated from the fourth and fifth centuries that portrayed the judgment of the dead.[101]

In contrast, if judgments after life are based on individualized assessments of the worthy acts of particular people, the motif of St. Michael holding scales becomes usefully didactic, as do pictures of the Last Judgment set in places where judicial rulings are made. Starting around the sixth century, images of the weighing of souls can be found. Possible sources include Job's claim of being "weighed in a just balance"[102] and a fourth-century liturgy of St. Augustine describing "good and evil deeds weighed against each other."[103] In the tenth century, examples became more frequent,[104] and in 1336 the idea of God's specific evaluation of individual action at a person's death became a doctrine of the "immediate, individual judgment after death," endorsed by the Pope in the bull *Benedictus Deus.*[105]

This theological position corresponds to many depictions of the Last Judgment with St. Michael; these images date from the late Middle Ages and the Renaissance, when the psychostasy—the Weighing of the Souls—became a standard feature of Last Judgment iconography. The images have been characterized as of two types, one showing the process of judgment by "depicting the weighing of the soul" and the other showing the consequences of that judgment, with some souls en route to heaven and others to hell.[106] Figure 25, *Saint Michael Weighing the Souls at the Last Judgment,* from early sixteenth-century Switzerland, falls within the first genre focused on the process of judgment.[107] Jesus holds the orb of sovereignty above St. Michael, who has in his right hand a sword raised high. In his left hand, St. Michael holds slightly tilted scales with the "heraldic right side, as the good, against the diabolical left."[108] In this image and many others, tiny humans sit on either side, one shown with hands raised in prayer, the other either "miserable . . . or devilish."[109] On occasion, St. Michael is not directly holding scales—they hang instead from other supports, both material and divine.[110] Moreover, sometimes the Virgin Mary is nearby, helping to tip the balance of the scales toward heaven.[111] At times, as in figure 25, St. Michael (like Justice, who came to replace him in a secular pantheon) can be found with both sword and scales.[112]

In thousands of such carvings and paintings, St. Michael is personified as a young and beautiful male, often winged, sometimes clad in white robes, and holding scales. In other versions he is dressed as a warrior with sword, mail, spear, and helmet.[113] As the conduit for bringing the "elect to Paradise," St. Michael may owe his wings not only to his angelic role in the Bible but also to Greek and Roman traditions. Greek vases show Hermes weighing fates, and in some legends Hermes and then his winged Roman successor, Mercury, the messenger, can also be seen conducting souls to another world.[114] In other depictions reflecting St. Michael's role as a warrior and his conflation with the English St. George, Michael subdues or conquers a dragon (symbolizing Lucifer), who lies at his foot.[115] On occasion, St. Michael himself became the embodiment of authority, holding an orb or a staff.[116] Images of St. Michael were also inscribed on merchants' weights, which, after the time of William the Conqueror, became standardized through seals and marks.

For example, a tiny (nineteen-millimeter) winged Michael figure holding scales has been found stamped on lead weights from the Plumbers Guild of London.[117]

The account thus far has focused on images of judgment as artifacts of religious or cosmological beliefs. These traditions developed in an interaction with political power, manifest in Europe through imperial, papal, and local authorities. Judgments on earth—from those made by magistrates to those of the Inquisition—provided models for the imagined theological judgments of various gods. Because Catholicism was a dominant force in Western Europe for the Medieval period, its theology about the processes of judgment played a special role. Posited were three phases: the Second Coming of Jesus, the separating of the blessed from the damned, and the Resurrection.[118] Depictions of these moments drew on earthly counterparts including tribunals in Rome and elsewhere.[119] Moreover, the tools shown for punishment in pictures of hell resembled real implements used on earth to inflict pain.[120] With a "heightened consciousness of legalism throughout the medieval world," judgment scenes became a dominant feature of late Medieval imagery.[121]

Reflecting rulers' needs both to judge and to punish, earthbound Justice appropriated not only Michael's scales but also his sword. The sword, in turn, was linked to other justice-connected figures. Some associate a sword or axe with the Greek Dikê,[122] while others cite the biblical heroine Judith, who cut off the head of Holofernes; the Roman heroine Lucretia, who killed herself after she was raped; and images of God brandishing a sword, as well as pictures of real Medieval justices shown with swords.[123] Through late Renaissance codifications, scales and swords came to be Justice's particular markers that distinguished her from other Virtues.[124] She then ascended to a position in which she has survived the past five centuries, while her counterpart Virtues have not. Her image—read from then to now as Justice—can be found in thousands of manuscripts, wood pieces, paintings, frescoes, and stone facades, and in contemporary courts and cartoons around the world.

## CIVIC SPACES, ALLEGORIES OF GOOD AND BAD GOVERNMENT, AND FOURTEENTH-CENTURY SIENA

A passage from Book 18 of Homer's *Iliad* reads:

> And the people were gathered in an assembly,
> and there a quarrel had arisen; two men were
> quarreling about blood-money for a slain man:
> one claimed he had paid it all, declaring it to
> the people, but the other denied he had
> received anything. And they both desired to
> get a settlement through an arbitrator. And the
> people approved and encouraged both sides,
> and the heralds restrained the people. And the

> elders sat on smooth stones in a sacred circle
> and held in their hands the staffs of the loud-
> voiced heralds; and then with these (staffs)
> they stood up and in turn proposed a
> settlement. And in the middle lay two talents
> of gold to be given to the one (elder) who
> proposed the straightest settlement.[125]

This passage leads us from a focus on the history of Justice iconography to consideration of the spaces in which she came to be found and the places in which judgments were made. A variety of sources from a range of societies give evidence that, centuries ago, resolutions of some disputes occurred in what we would today call public settings. We know from Greek poems (such as this excerpt from Homer) and analyses of Greek governance;[126] understandings of Mesopotamian practices;[127] research into Roman "civil procedure";[128] histories of the roles played by English "lay judges"[129] and of prosecutions;[130] extensive descriptions of the pageantry surrounding biblical, Medieval, and Renaissance rituals;[131] and the rich literature on city-states in Europe[132] that through either voluntary or mandatory procedures, some decisions, some pronouncements of judgments, and many punishments occurred in places (fields, open markets, town squares, portals of churches, and courthouses) to which those who were not parties to the disputes had ready access.

Our aim here is not to provide a comprehensive history of the development of legal processes, of various methods of proof and punishment in public and private settings, or of the many governments that engendered them.[133] We cannot capture the heterogeneity and nuances of the diverse jurisdictions with their differing relationships to imperial and Church rule, to various economies, charters, populations, and senses of their own corporate identities. Rather, we track how and why, across time, place, and political organization, ruling powers sought to present and to represent their authority to impose law to a viewing audience that at times included not only earthly spectators but heavenly overseers shown proffering approval.[134] We dwell not on the details of the procedures but on the fact of open processes housed in governmentally supported venues that dealt with conflict and enforced law. Over time, states gained monopolies over legal jurisdiction[135] and, through the display of judicial authority, rulers sought to bond individuals to them and to legitimate their powers.

## Public Buildings Fashioning Civic Identities

During the late Middle Ages, European town leaders began to construct civic spaces to add to the churches, market squares, and private residences that were sometimes used for communal business.[136] Evidence of public buildings devoted to forms of daily governance dates from the end of the twelfth century in Italy and a bit later in North-

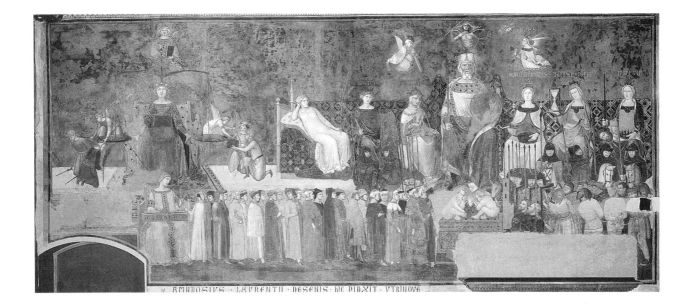

ern Europe.[137] Arguably, the "first municipal governments were courts"—brought into being by the need to decide disputes, and then acquiring additional administrative functions.[138] Construction projects stemmed from the growth of urban centers, the development of interest in and the need for law, and conflicts over power in which ruling empires sprawled and receded.

Law boomed in Europe as nascent city-states sought to order developing economies[139] and regulate social interactions; the results were a mixture of local customs and codifications promoted by jurists trained in universities in Italy, France, and Germany.[140] Courts proliferated, making municipal control visible through enactment and enforcement of regulations. These public "performances" of law included a range of activities, including formal agreements to dismiss prosecutions, oath takings, and the dramas of executions.[141] The pictorial remains and the reenactments via modern cinema have made scenes of scaffolds and hangings familiar, but other events rarely reproduced were also once part of such spectacles. In the mid-sixteenth century in Germany, for example, "rulers staged public readings of basic rights as a *quid pro quo* for obtaining the loyalty oath from their subjects."[142]

The setting for these displays was initially the outdoors, at times deliberately proximate to a particular part of a church.[143] As civic leaders became intent on expressing (sometimes competitively) their locale's prosperity, they invested in building projects and planned towns to mark and to make their identities. This interest in "civil self-fashioning"[144] resulted in structures "clearly designed to dominate" their environs.[145] Inscribed within were didactic scenes aiming to legitimate the power exercised. In a world without a printing press and with many illiterate people,[146] the visual arts were a key medium of instruction. Designs served as mnemonic aids aimed at instilling

beliefs.[147] In their buildings (styled a town hall or town house, a rathaus, or a civic palace), rulers relied on depictions of the Virtues and allegorical scenes of religious stories and classical myths to link their regimes to prosperity, peace, and history.[148]

Many town halls were built, but given the deterioration of wood and stone as well as recycling, renovation, and alterations over time, only a few remain to instruct us about their original shapes and interiors. (For example, one estimate is that less than 2 percent of German painting from the Medieval period survives.[149]) What we know from a range of sources and a few buildings is that town halls were multi-function buildings in which city officials created spaces for communal, commercial activities as well as for running a city's affairs.[150] Each surviving example is a testament to the prosperity of a locality that was able to finance the construction of a robust public space. Our central example in this chapter is Siena's (aptly named) Palazzo Pubblico, constructed during the fourteenth century. Thereafter we will move forward to the fifteenth century in Bruges and then to seventeenth-century Geneva and Amsterdam to detail other civic spaces.

## Lorenzetti and the Palazzo Pubblico

Siena's Palazzo Pubblico served as a "fortress, meeting place, office building, symbol of the commune, and centerpiece of a long campaign of public redevelopment that transformed the urban core."[151] Its impressive frescoes are well documented and debated in the annals of art and history.[152] The views in figures 26 and 27 (color plates 6 and 8) are from of a series of murals in what is called the Hall of the Nine (Nove), named after a revolving group comprised of nine citizens who used this room as their meeting chamber.[153]

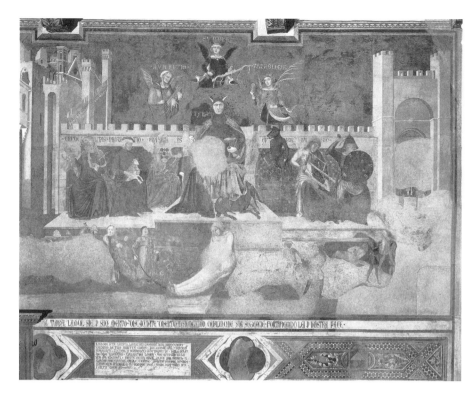

The two frescoes of particular interest here were painted by Ambrogio Lorenzetti and date from about 1339.[154] Their modern titles are the *Allegory of Good Government,* seen in figure 26, and the *Allegory of Bad Government,* shown in figure 27.[155] The frescoes, drenched in Justice iconography (Justice herself appears twice and is named seven times), were statements about a relatively new form of leadership—a republic claiming some distance from both the Emperor and the Pope. The amalgam of picture and script served as a shrine to the power of the Nine, who relied on the "prerogatives of a literate elite of clerics, academics, and officials" to rule.[156]

The rich imagery, embellished with many texts, has given rise to dozens of interpretative quests to decode this "acknowledged masterpiece of medieval secular painting and one of the consummate political statements in the history of Western art."[157] As political propaganda, the room extols the virtues of republican government over despotism in the "first realistic landscape of modern times."[158] The frescoes are a window into which forms of philosophy and ideology influenced the "great political project of the medieval Italian city-states,"[159] or, in the words of Quentin Skinner, whether the Renaissance "owes a far deeper debt to Rome than to Greece."[160] However one resolves the debate on Siena's rulers' affiliations with Aristotle, Cicero, and Christian theology, we know that these rulers wanted to be understood as entwined with Justice.

By the end of the thirteenth century, Siena was a republic governed by an oligarchy of merchants in a council that was first formed around 1287 and, before being reduced to "the Nine," numbered twenty-four.[161] Siena's ruling families produced a legal system through a written constitution and detailed legislation, implemented by a General Council, issue-specific sub-councils, various officials, and judges.[162] The "civic investment" extended from the Palazzo Pubblico to the city's walls, churches, fountains, and drainage systems.[163] Siena also asserted jurisdiction over the area within a thirty-mile radius of the city.[164] The 1330s were years of prosperity during which Siena started several communal building projects, some of which did not come to fruition because of agricultural crises, famine, and then the "Black Death of 1348."[165]

Construction of the Palazzo Pubblico began in 1297. Sometime around 1310, the Nine took up their residence in the hall where the frescoes appear. The Nine commissioned their painting and approved both the imagery and the many textual inscriptions. Most of the personages depicted are named in Latin (the language used along with the Italian vernacular for Sienese official documents), while long verses adorning the frescoes were written in Italian.[166] These pictures, perhaps somewhat altered through repairs,[167] provide one of the earliest surviving examples of European didactic art displayed at the direction of rulers attenuated from the Church.

The *Allegory of Good Government* (shown in part in figure 26 and spread across two walls) is populated with fifty-six people and fifty-nine animals in a countryside dotted with inscriptions. The style of this well-preserved fresco is categorized as late Medieval realism, even as it is replete with utopian visions of prosperity and security.[168] Efforts to

interpret the imagery's meaning are legion. One piece of the puzzle is about the central bearded male figure seated on a throne. He wears an impressive robe, holds a scepter and a shield, and resembles a mixture of Jesus and an emperor.[169] To some, he is not a royal or religious personage but the Common Good (Buon Commune or Ben Comun), a metaphoric illustration of Aristotelian ideals (translated through St. Thomas of Aquinas) showing that Siena would, given its good communal leadership, be a place of prosperity and peace.[170]

For others, the male figure's political roots hark back to Cicero's Rome, invoked in an effort to legitimate the exercise of power by the Nine. Because the enthroned male figure wears the black and white colors of the Commune of Siena[171] and has its lettering on his shoulders,[172] he can also be read as Siena itself and, inferentially, as representing the Nine who commissioned his depiction.[173] Further, because his placement echoes the famous Giotto *Last Judgment* fresco in the Arena Chapel in Padua, the scene could be a "secularised image of the Last Judgement" uniting divine and human judgment.[174] The stature of the male figure (and arguably thus of the ruling Nine) is indicated by the verses at the bottom of the fresco, which state, "everyone grants him taxes, tributes, and lordships of lands."[175] Under this reading, the didactic goals of the Nine were not Aristotelian but predicated on Cicero, insistent that peace, security, and civic unity are the results of virtuous and powerful leadership.[176]

### "Love justice, you who judge the earth"

Whether reading the male figure as a reference to the Common Good of Aristotle or as the embodiment of the Nine's leadership in the mode of Cicero, one must appreciate the degree to which the vision of political success was tied (literally and metaphorically) to Justice. In this fresco, awash with Virtues and textual inscriptions,[177] Justice plays an unusual role. The male figure is surrounded by the Cardinal Virtues of Fortitude, Prudence, Temperance, and Justice (all with Latin labels) and two other figures, Peace and Magnanimity.[178] But only Justice is portrayed twice, and written into the text seven times.[179]

One views a Justice sitting at the end of a line-up of Virtues and then again on her own throne surrounded by figures and script. In the first of her incarnations, Justice is seated alongside other Virtues, shown both at their level and of their size. Looking straight forward and crowned, she is labeled "Justice." She holds another crown in her lap and displays a sword, pointing upward.[180] On her knee lies a severed head, prompting one commentator to describe her as "the personification of . . . Vindictive Justice"[181] and to note that beheading was a punishment reserved for "kings, queens, and nobles accused of treason," while "hanging by the neck was the punishment reserved for vulgar disturbers of the public peace."[182] Below Lorenzetti's sword-holding Justice are soldiers on horses and a group of scruffy-looking people, presumably prisoners,[183] held together by a rope. Some read this grouping as emblematic of the power of secular justice to enforce its edicts.[184] The Lorenzetti rendition also demonstrates that by the 1340s St. Michael's sword had become one of the emblems used to denote a figure as Justice.

The second Justice in the *Allegory of Good Government* sits at the other end of the scene from the first. She has a throne of her own and a ring of flowers on her head.[185] This Justice is higher and larger than the other Virtues; she is almost on the same level and of the same size as the male figure, and, like him, she is attended by other Virtues.[186] Above the male figure's head are the theological Virtues of Faith, Hope, and Charity. Paralleling them above Justice's head and inhabiting her "heavenly zone"[187] is Wisdom (Sapientia), holding a balance and a book, attributes now associated with Justice. Below this Justice is another Virtue, labeled Concord, along with a group of twenty-four well-dressed people over whom Justice may be ruling. Justice turns her eyes upward toward Wisdom. The quote above her head, from the *Book of Wisdom*, reads: "Love justice, you who judge the earth."[188]

Scanning the fresco vertically, one sees that from Divine Wisdom comes Justice, producing Concord.[189] Further, the painted balance that surrounds Justice in a semicircular embrace supports a thesis that Justice is herself divine rather than secular.[190] Concord takes two cords from each of the pans on that balance and weaves them together before handing them to the twenty-four people assembled below. That group may serve as a reference to the former Sienese council of that number, to citizens more generally, or to the Elders (also numbering twenty-four) that the New Testament described as sitting beside the Lord on Judgment Day. This group carries the cords to the Common Good / Nine. He holds them in his right hand—thereby making material the link running from Wisdom through Justice, Concord, and the people, to the rulers and to the City itself.[191]

The enthroned Justice is also accompanied by a good deal of written explanation that, given the levels of literacy at the time, empowered those able to read. In addition to the text above her head, labels are affixed near each of the pans of the balance that encircles Justice. On one side is what can be made out to be the word "Distributive" ([DIS]TRIBUTIVA), close to a winged female using one hand to put a sword to the neck of a man and the other hand to crown the head of a kneeling figure. Near the other pan, the term "Commutative" (COMUTATIVA) appears next to another winged female who seems to be giving a round object (arguably a box holding money) to one kneeling figure and some kind of weapon (possibly two spears) to another.[192] Beneath this Justice and along the base of the fresco run several verses, translated as:

Wherever this holy virtue [Justitia] rules,
she induces to unity many souls; and these,
gathered together for such a purpose; a
common good for their master undertake; who,
in order to govern his state, chooses never to
keep his eyes turned from the splendor of the
faces of the virtues which around him stand.
For this, with triumph are given to him taxes,
tributes, and lordships of lands; for this,
without wars, is followed then by every civil
result, useful, necessary and pleasurable.[193]

On the wall next to all the figures and forming a part of the *Allegory of Good Government* is a scene of a light-infused and thriving locality[194] filled with builders, dancers, and cobblers in a rolling landscape[195]—presumably resulting from the joint rule of the enthroned male and female figures.[196] A large woman labeled "Security" (Securitas) hovers over the countryside along with a scroll that reads, "Without fear, let each man freely walk, and working let everyone sow, while such a commune this lady will keep under her rule, because she has removed all power from the guilty."[197] Another script near the bottom of the landscape and read to refer to the enthroned Justice notes:

Turn your eyes, you who are governing, to gaze
attentively at her who is here represented, and
for her excellence is crowned; who always
renders justice to everyone. Behold how many
good things come from her, and how sweet life
is, and how full of repose is that of the city
where is observed this virtue, which more than
any other shines. She guards and defends those
who honor her, and nourishes and feeds them.
From her light is born the rewarding of those
who do good, and giving to the iniquitous due
punishment.[198]

### Justice Bound by Tyranny

If the detailed imagery and many texts on Justice's special relevance to a thriving polity failed to bring home the link, the scene that stands in contrast makes it again. When Sienese viewers turned away from the *Allegory of Good Government,* they could contemplate the harms that flowed in the *Allegory of Bad Government* (see fig. 27). At the center of a desolate and dark scene sits another male figure on a throne, but this one is horned, fanged, and labeled "Tyranny" (TYRAMMIDES).[199] Holding a dagger, he is surrounded by Vices labeled Avarice, Pride, Vainglory, Cruelty, Treason, Fraud, Fury, Discord, and War.[200] Further, in contrast to the figure of Security floating in the air in *Good Government,* one finds a haunting figure of Fear (Timor) above the bleak countryside. Next to Timor is the text: "For wanting his

own good on this earth, he subjected justice to tyranny; wherefore along this road passes no one without dread of death; because robbery is without and within the gates."[201]

Justice also appears in this fresco, but here she is bowed and bound. Moreover, below Tyranny's feet is a goat, serving either as a reference to the damned or to the Vice Lust (Luxuria), further degrading the bound Justice figure. Her hair is disheveled, and she wears a white, unadorned dress; she looks at the two pans severed from their balance. Rather than holding cords linking her to Wisdom, Concord, and Good Government, she is the one bound by a rope. Other harms flowing from Bad Government in which Justice is cowed are portrayed nearby, where armed men injure both persons and property. Once again, script hammers home the point. Near Tyranny is a text explaining, "There, where bound is Justice, no one for the common good ever joins together, nor goes straight ahead for the right, but is agreeable that Tyranny should rise."[202] Another text completes the contrast between Siena's promotion of peace and security and the disarray occasioned by bad government. At the bottom of the fresco, below the bundled Justice, are the words ". . . where is tyranny and great suspicion, wars, rapines, treacheries, and deceptions gain the upper hand."[203]

### Theories of Governance: Aristotle, Cicero, Aquinas, Latini, God, and Political Propaganda

Efforts to decode the frescoes focus on the broader political claims as well as the enigmatic central male in the *Allegory of Good Government.* These frescoes were among the first authored by a fourteenth-century European secular government seeking to instantiate political propaganda. But what were the Nine aiming to teach? In addition to disagreement about how to interpret the central male figure, another major puzzle is what to make of the enthroned Justice, the two labels "Distributive" ([DIS]TRIBUTIVA) and "Commutative" (COMUTATIVA) near the scales' pans, and the two winged females, one close to the label "Distributive" and holding sword and crown, and the other near the word "Commutative" and giving or taking some objects.

Again, one view is that we are looking at St. Thomas Aquinas's description of Aristotelian concepts of justice embodied in the prime example of a "new" civic imagery in which political (as contrasted with religious) leadership has secured stability.[204] The vision is that through "natural sociability," citizens join together under a rule of law that will be imposed upon them equally.[205] The small winged women would thus represent the commune, rewarding or punishing citizens who excel or fail in their public duties and deciding on fair exchanges among equals.[206] Further, the cords (moving from Wisdom through Justice to Concord and then through the assembled councilors or citizens

to the Common Good) may symbolize how divine law inspires human law.[207] In short, the Sienese government produced peace and prosperity by "placing common welfare above private interest."[208]

Yet the actions taking place near the labels "Commutative" and "Distributive" do not fit easily within the philosophy associated with Aristotle and Aquinas. While one might decipher the winged figure under the word "Comutativa" to be distributing or allocating goods, one could also see her as receiving offerings. Moreover, punitively severing a head in an act of punishment was not associated with "iustum distributivum," understood to be a rule of fairness for allocating common goods among community members.[209] One view is that the confusion spawned by the words "Distributiva" and "Comutativa" affixed near the pans is a distraction caused either because these terms were later additions replacing earlier inscriptions or were flipped during repairs.[210] Alternatively, the words were originally placed there by Lorenzetti, who had misunderstood the Aristotelian message he had been commissioned to depict.[211] Other historians argue that neither Aristotle nor St. Thomas Aquinas but another political theorist—Brunetto Latini— was the author of relevance for the Nine. This interpretation posits that Latini's discussions of law and politics better explain the pictures of Justice rectifying inequality and punishing misbehavior.[212]

One could also read the pictures as insisting on the importance of communal rule through a powerful group, such as the Italian body of signori rather than a single podesta. The governing documents of Siena gave its rulers unconstrained authority to "promote the good and pacific state of the people and commune of Siena,"[213] even as those documents charged them with being men "who are lovers of peace and of justice."[214] Based on the political literature and practices then current, this analysis puts Cicero at the center of the iconographic message, read to be less sanguine about innate sociability and more insistent on the need for wise (and imperial) leaders to achieve peace by relying on justice as the "ultimate bond of human society."[215]

A different interpretation posits the political ideology expressed to be less secular than the Aristotle/Cicero debate suggests. These frescoes could be read as the effort of the Nine to convince viewers that their authority was religiously sanctioned because their commission was for a vision of the Day of Judgment. Given the echoes of Dante's *Inferno* and biblical symbolism,[216] Siena could be the Heavenly City of Jerusalem, serving as the center of its own world.[217] Under this approach, the contrasting vision of Tyranny is Hell and the central horned figure a representation of Lucifer.[218] The sequence could also reflect the link between divine judgment and secular authority, which imposed its justice as would God and which was empowered to do so through words from the Book of Wisdom, "curving over Ambrogio's Justice" and providing evidence of God's presence:[219] "love justice, you who judge the earth."[220]

Yet another theory sees Peace (Pax), holding an olive branch, as the focus of the frescoes. This thesis relies in part on the titles, *Peace* and *War,* that were used to describe the two frescoes in centuries closer to their creation. Unlike the other labeled females, the figure of Peace neither sits straight nor faces viewers. Rather, she glances about as she reclines, gazing "dreamily" at the scene.[221] Perceiving her to have a "pride of place at the center of the fresco" as well as serving as the spectator from whose vantage point the scene is viewed, one could be looking at a "vision of Peace" meditating on the contrast of her realm with that of War.[222]

Other commentary turns our gaze toward the landscape and its distinctive features (including a group of dancers, sometimes described as female and other times as male) to see in the frescoes an inventive and lyrical celebration of Justice's sustenance and the rebirth of culture.[223] Alternatively, approaching the imagery from the perspective of contemporary political economy, one could argue that the frescoes encouraged citizens to affiliate with and give tribute to Siena, fiercely competitive with its neighbors and especially its larger rival, Florence.[224]

We recount these debates not to decide them but to demonstrate that, whether based in Greek or Roman political thought, in Christian theology, or not reducible to a single ideological program, the frescoes pronounced that Justice was central to good governance, communality, powerful leadership, peace, and/or access to heaven. Yet, despite the aspirations and the artistry, Siena's effort to sustain the frescoes' promises did not succeed. The Republic of Siena lasted about seventy years, ending in 1355, when a revolt occurred as Emperor Charles IV visited the city.[225] That popular unrest had many sources, including the inability of the Nine to "deal effectively with the increased violence and disorder that followed the plague."[226] Yet some aspects of the republic's system continued, with forms of authority shared by oligarchs until Siena was absorbed into the Florentine state of the Medicis in the mid-1500s.[227]

## Good Government on the East and West Coasts of the United States: Reiterations by Caleb Ives Bach and Dorothea Rockburne

The duration of the government promised by Siena's leaders was brief, but their display of civic virtue has endured, as can be seen from its influence on the art commissions for two contemporary United States courthouses, one on the West Coast in Seattle, Washington, and the other on the East Coast in Portland, Maine.[228] For the northwest courthouse, the muralist Caleb Ives Bach drew inspiration from Lorenzetti as well as from Byzantine mosaics and Mexican muralists (fig. 28, color plate 9). His large-scale paintings were installed in 1985 on the first floor to mark the entry to a courtroom when that courthouse was newly dedicated.[229]

FIGURE 28 *The Effects of Good and Bad Government,* Caleb Ives Bach, 1985, in the interior of the William Kenzo Nakamura Federal Courthouse, Seattle, Washington.

Photographs reproduced courtesy of the United States General Services Administration and with the permission of the artist. See color plate 9.

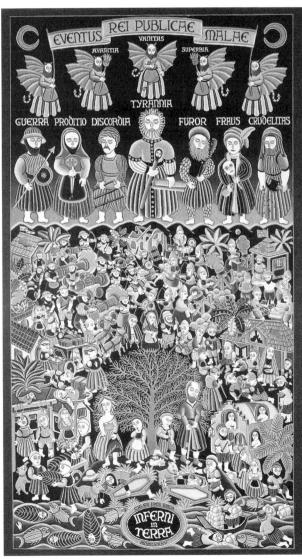

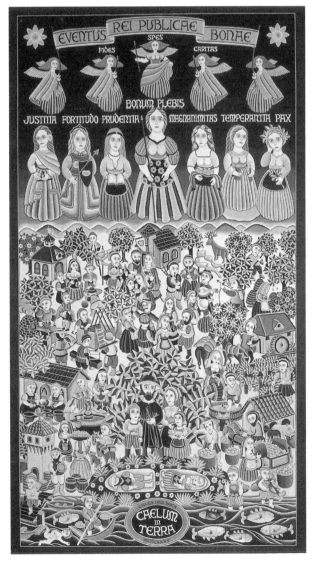

The brightly colored, densely patterned, flat-surfaced pair of allegories is populated by more than 100 figures. In *The Effects of Good Government,* Virtues labeled in Latin (Justitia, Fortitudo, Prudentia, Magnamitas, Temperantia, and Pax, translated as Justice, Fortitude, Prudence, Magnanimity, Temperance, and Peace) surround a female named Bonum plebis (Good People) and join the Theological Virtues identified as Fides, Spes, and Caritas (Fidelity, Hope, and Charity) and two angels in the top third of the painting. The landscape below teems with people, food,

music, and other signs of prosperity, all in celebration of what good government can produce—described at the bottom as "Caelum in terra" (Heaven on Earth).

In *The Effects of Bad Government,* the Vices Avaritia, Vanitas, and Superbia (Avarice, Vanity, and Pride) float about the head of the central male, Tyrannia (Tyranny). Other Vices (Guerra, Proditio, Discordia, Furor, Fraus, and Crudelitas, translated as War, Treason, Discord, Rage, Fraud, and Cruelty) surround him. The bottom two-thirds of the painting show the harms done to the population, cen-

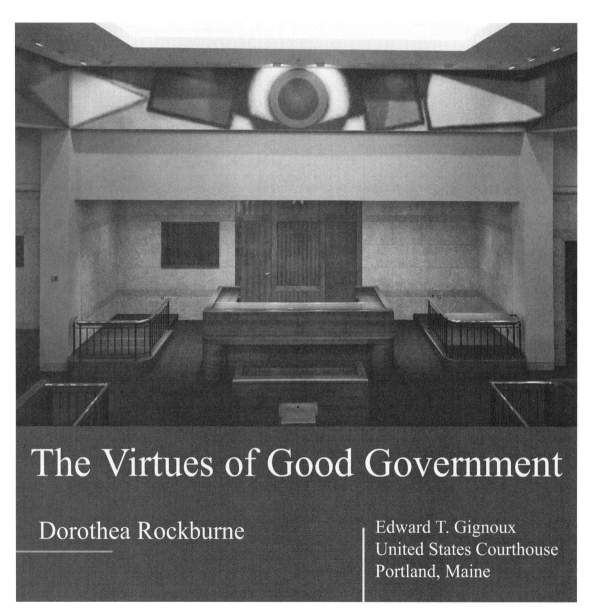

# The Virtues of Good Government

Dorothea Rockburne

Edward T. Gignoux
United States Courthouse
Portland, Maine

FIGURE 29   *The Virtues of Good Government,* Dorothea Rockburne, brochure cover for the 1996 renovation of the Edward T. Gignoux United States Courthouse, Portland, Maine.

tered around a barren tree. The script at the bottom ("Inferni in terra") speaks of "Hell on Earth."[230]

For the renovation of a federal district courthouse in Maine,[231] artist Dorothea Rockburne also drew on the Siena scenes but turned instead to abstraction.[232] Rockburne's proposal to bring the "great history of law and civic order, which Siena had established by the thirteenth century, into a present day courtroom" won approval from the government selection panel.[233] The resulting wall painting, measuring 99 feet long and 4.5 feet high, bears the name *The Virtues of Good Government,* which are also the words headlined in the brochure (fig. 29, color plate 7) produced by the United States government to describe that courthouse's 1996 renovation and artwork. One commentator at the dedication ceremony described the painting as a "modern contemplation of the virtues of prudence, faith, common good, hope and magnanimity, using pure geometry and vibrant color as meditative devices."[234]

Rockburne had proposed affixing labels (as in Siena) to identify some of the Virtues represented in the abstraction. But in light of a judge's concern that lawyers might opportunistically use posted words to persuade jurors of the rightness of their clients' causes, she did not add inscriptions.[235] Rockburne's decision to use abstract imagery may not have been the only reason to provide labels. Even if she had used figurative images of the specific Virtues, most people would have needed labels to identify various female forms as Prudence, Faith, and Magnanimity.[236] But when artists place women with scales and swords in today's courthouses, no such signs are needed. The Lorenzetti frescoes are one of several markers of Justice's ascendancy as the key Virtue of the secular state. Although Charity was "the highest of the theological virtues" in Corinthian ideology and Wisdom the highest of the intellectual virtues,[237] Justice initially ranked highest only when grouped among the "moral virtues." Over time Justice has displaced the others to become an international hallmark of the state. Before mapping her codification and rise through a "process of secularization" aimed at teaching "civil virtues,"[238] more needs to be understood about the religious manifestations that she displaced.

## Last Judgments in Town Halls

The fourteenth-century scene in Siena was unusually majestic in its artistic achievement (and luckily well preserved), but the effort it represented—conveying political messages through expressive imagery—was not exceptional. From the fourteenth century onward, comparable depictions of "Allegories of Good Government" greeted those who walked into civic buildings throughout Europe.[239] Before sketching other themes that emerged over time, we need to clarify what it means to call these buildings "civic" and "public" so as to avoid anachronistic implications.

## Civic, Public, and Christian

As illustrated in the context of Siena, "civic buildings" were town-built, multi-function structures that were dedicated neither as churches nor as marketplaces. Yet to *describe* them as not churches or markets is not to *ascribe* to them the absence of either religious or commercial purposes. These late Medieval and Renaissance buildings were not secular in the contemporary sense of denoting a separation between church and state, nor were they public in the sense of providing space only for activities today associated with government. Rather, communal governance and theological authority were conflated, with power scattered through familial and associational ties nested in religious, economic, and social connections and transacted in buildings sometimes denoted "churches" and other times "town halls."[240]

This constant intermingling of civic and religious life is captured by one historian's phrase, "civic Christianity," which threaded throughout Europe.[241] In that "Christian society—i.e., one more than perfunctorily attached to the gospel as its source of inspiration—law and justice could never be categories wholly temporal or purely religious."[242] Not only did the courts of governing bodies work in "theological-juridical terms,"[243] but religious texts and sermons were peppered with references to legal processes. A 1404 catechetical treatise by Dirk van Delf stressed the relationship between the apostles of the Last Judgment and local leaders: "So shall come the twelve apostles, quite as senators, councilors, or aldermen, who on beautiful thrones and at the bidding of the judge shall sit, and before whose judgment all the world shall stand."[244] A 1552 sermon was even more direct: "Christ steps into the courtroom, invites the sinner to approach him, lifts him on his shoulders and carries him to his father who sits in the judge's seat."[245]

The conflation can be seen in the buildings that governing powers used, the pictures commissioned, and the texts and oral incantations issued. For example, Siena's "Nine" met in a church before the construction of the Palazzo Pubblico in the early 1300s,[246] as did the councils of northern cities such as Geneva.[247] Designated areas at the sides of cathedrals in France were used for outdoor court proceedings, and some churches held court inside. Moreover, once town halls were built, many included chapels where councilors attended mass before turning to the town business of deciding disputes, overseeing warehouse facilities, and maintaining scales and weights.[248] Some of the rooms within looked churchlike, and the main halls of such buildings opened onto squares serving as stages for public ceremonies reflective of the business within.[249]

Our interest is the inscriptions and paintings on the walls of places that welcomed the public as witnesses. As Siena's Palazzo Pubblico has already illustrated, the use of space for political instruction was not casual. Thirteenth-century statutes of Padua, for example, decreed that "the four main

doors [of its civic building] . . . which were directly accessible from the two public squares by four exterior staircases, had to be continuously open."[250] On market days, a "specified number of judges had to be available to the public." The "visual coherence" of the "spatial proximity" of Padua's law courts to its public square was designed to materialize the political unity of the commune itself.[251]

## "For that judgment you judge, shall redound on you": The Magdeburg Mandate

Two differences from contemporary deployments of the iconography of Justice need to be underscored. First, late Medieval and Renaissance town halls "spoke" in a preliterate and pre-print world.[252] Many people could not read, and hence pictures were imbued with iconic properties that are hard to imagine given the contemporary flood of visual images from around the world. Today's viewers may reason about how allegorical pictures translate intellectual messages into visual form, but for those who looked at only a few paintings over the course of their lifetimes, these images may well have had a visceral correspondence with abstract ideas.[253]

Second, the pictorial educative mission was aimed not only at the general populace but also at the decisionmakers. As we elaborate in later chapters, today's courthouses rarely employ imagery seeking to instruct judges and lawyers about how to behave. The assumption is that law schools, statutes, ethical codes, and professionalization do that work. But in earlier eras, judges and other local council members were as much the target audience for the displays as was the public. Judges were repeatedly warned that they were put at risk as they rendered judgment. Judges, as well as those whom they judged, were subject to superior powers (God and the state) that required obedience and loyalty.

That point was made through a pictorial mix that in Italy included classical historical narrative scenes from Greece and Rome, some biblical narratives of which the most prominent was the Judgment of Solomon,[254] and depictions of the Last Judgment.[255] Not only did pictures of the Last Judgment gain a particular place of honor in northern Europe, but in some city-states written laws *required* that they be posted in courtrooms.[256] One example comes from a system of municipal laws originally written between 1330 and 1386 in Magdeburg Province,[257] which were then adopted in various localities. As a 1537 version stated, "the last judgment shall be painted in all court places. The judges should judge fairly."[258]

In a further reference to that obligation, the Magdeburg Law elaborated:

> When and where the judge sits in judgment, in the same place and in the same hour, God sits in his heavenly court, above the judges and above the magistrates. And so a judge in the

town hall should have painted the strict court of our Lord Jesus Christ. This is so that he should think of the Court of our Lord; and that he should also think that he is a judge of the people, that God has saved with his precious blood. And so David speaks: "Juste judicate filii hominum." Judge fairly, you children of men, when you judge according to worldly measures (that is, you judge men on the earthly level, God will judge whether your judgment was just or unjust) the same judgment will be passed in the same hour over you, it is fair, and so it was of you that the Prophet David speaks.[259]

This statutory requirement was explained by Ulrich Tengler in his German treatise *Laienspiegel* (or *Layman's Mirror*), first published in Augsburg in 1509 and reprinted many times.[260] A subpart of a section "On Criminal Proceedings" bears the title "On the Last Judgment." From a 1514 edition,[261] we know that pages were devoted to the theological and moral reasons for the "truth" of that event, its relevance for judges in towns following the Magdeburg Law, and discussion of the regulation requiring display of an image of the Last Judgment. The author concluded the section with the admonishment that "each judge should think about the cruelest court of God, and have it before his eyes, so that he judges fairly."[262]

As a consequence of this provision, Tengler explained, it was "common in the council chambers and in courtrooms where capital cases and other matters are judged, where oaths are sworn, and where other legal, corporal, and civil matters are decided, that a figure of the Last Judgment be depicted."[263] That "praiseworthy custom"[264] joined the display of other classical and biblical narratives, shown so as to "move the councillors and judges to do justice."[265] Throughout "the fifteenth and especially the sixteenth century in northern Europe it became standard practice to have a Last Judgment painted on the wall behind the judges' bench."[266] Exploring the stories told in painted Last Judgments is thus in order before tracking the other narratives once prominent in government buildings as well as their eventual eclipse through the domination of Justice.

## Conflating the Last Judgment with Trials

The iconography of the Last Judgment, like that of Justice, developed over the centuries and varied in form and content.[267] The *Gospel of Matthew* is an oft-cited textual source that described the "Son of Man . . . will sit in state on his throne," surrounded by angels, with the nations gathered about him.[268] "He will separate men into two groups, as a shepherd separates the sheep from the goats," and "he will say to those on his left hand, 'The curse is upon you; go from my sight to the eternal fire that is ready for the devil and his angels.' "[269] Other biblical references, such as verses

from *Psalms,* identified the Lord "seated on [his] throne," as a "righteous judge."[270]

How were these phrases translated pictorially? During many centuries after the lifetime of Jesus, the answer was not much. Art historians have found relatively few images from before the thirteenth century that referenced the Last Judgment. Thereafter, the theme of the Last Judgment became common in many churches,[271] featured both on cathedral doors and church interiors. Such scenes often show either Jesus separating sheep from goats or apocalyptic endings of the world.[272] Dante's *Divine Comedy,* completed in 1314, provided additional inspiration, prompting some fine details on the horrors of hell.[273] Many famous renditions—such as Michelangelo's *Last Judgment* in the Vatican's Sistine Chapel—focused on resurrection rather than on the act of judgment.[274]

But when depictions of the Last Judgment moved into courts and onto the printed books of a locality's laws and regulations, the scenes came to resemble the places and the work that the pictures were to influence.[275] Settings much like courtrooms became common. In some Last Judgment paintings, Mary was specially positioned as an intercessor akin to a defense lawyer, pleading for mercy.[276] Court settings, in turn, were arranged to mirror how Jesus and the apostles appeared in scenes of the Last Judgment. In Pistoria, for example, trials were held outdoors, "under the open heavens, once again likening them to the appearance of Christ in Glory at the Last Judgment."[277] In Spain, the rituals of the Inquisition were shaped to mirror the dramas associated with the "eschatological moment of judgment," with ceremonial enactments drawing thousands to "witness the indictment of souls."[278]

The literality of the convergence of worldly and heavenly justice can be seen in pictures such as the fifteenth-century painting, the *Courtroom Scene with Last Judgment and Portrait of Niclas Strobel* (fig. 30, color plate 12), that hung on a wall of the Town Hall of Graz in Austria.[279] The format of this painting is not unique but represents a formula in which the bottom half depicts human judgment paralleled by a divine court above.[280] An inscription dates the painting to 1478, more than a decade after the central worldly figure identified as Niclas Strobel had held the town offices of judge and mayor.[281]

The ambiguity of the Graz version makes it particularly intriguing. It could be read as a horizontal diptych with two discrete scenes. On the bottom, the jurist (Strobel) presides over what has been identified as an oath-taking, with counselors and spectators (the two figures standing behind the benches on which the others are seated) watching. Above is Christ, arms outstretched, who sits on a heavenly throne. He is surrounded by seated counselors, as well as by Mary kneeling on his left and a male kneeling on his right. The symmetry created through the layout and coloration (red drapery for both the jurist and Christ, with beige, black, and red clothes for figures in both earth and heaven) could sug-

gest that one kind of judgment parallels the other. As Erwin Panofsky explained, the figures on either side of Jesus serve as his "associate justices," and they provide a parallel to the jurists and councilors below.[282]

But the two male spectators, leaning over the sides of the benches and plausibly representing the public, have their gazes focused heavenward, as do three of the seated councilors. By following their eyes and looking at the middle section of the painting, in which the spectators share space with small, naked embodied souls (either being raised to heaven or condemned to hell), one can understand the picture as showing a single integrated scene in which Jesus is present in the earthly court.[283] In this interpretation, Christ is not offering a parallel to the human judge but is waiting on the court's earthly decision in order to render his own judgment on the living characters in the courtroom.[284] Moreover, the midground depiction of human souls in transit—to heaven or hell—underscores the consequences of being subjected to heavenly judgment.

The links between the divine judgment to be imposed at the end of days and the daily business of dispute resolution were thus made explicit, and those to be reminded of the gravity of decisionmaking were not only alleged wrongdoers and the public but the judges as well. Text and image worked in tandem to make the point. In Regensburg, Germany, during the fifteenth and sixteenth centuries, local burghers took an oath swearing "to keep only God and the Law before my eyes, as I must answer for that before God at the Last Judgment."[285] Lest they forget, pictures of the Last Judgment were in view as they worked.[286] Thus, when "the judge pronounces justice, God sits above him, judging judges and jurors."[287]

Moreover (and as in the displays in Siena), images were often accompanied by texts so that viewers who could read received the point in words as well as pictorially. The mural of the *Last Judgment* in the Lüneberg Town Hall was inscribed with a biblical passage reading: "For judgment is without mercy to you who has shown no mercy."[288] Below a 1497 *Last Judgment* that hung above the magistrates' bench in a court in Hamburg were the words: "You, who are about to judge others, consider what you do; for you judge not for humankind, but for the Lord," followed by the verses "for that judgment you judge, shall redound on you," and "with what measure you mete, it shall be measured back to you."[289]

A similar admonition appeared on Last Judgment paintings in the Town Halls of Bruges and Nuremberg.[290] In Regensburg's Town Hall, a Latin inscription charged: "Senator, when you enter this council chamber in your capacity as public official put aside your private sentiments before the door, put aside anger, violence, hatred, alliance, and flattery and take up the persona and cares of the Republic, for as you have been impartial or inequitable, so shall you be judged by God."[291] The *Last Judgment* displayed in 1628 in the Breslau Town Hall made reference to the legal obliga-

FIGURE 30  *Courtroom Scene with Last Judgment and Portrait of Niclas Strobel,* fifteenth century,
Stadtmuseum Graz, Austria.

Image reproduced courtesy of the Stadtmuseum Graz. See color plate 12.

tion to post the image, "as is demanded by Magdeburg Law."[292] In woodcuts and words, books on legal procedure reiterated these analogies "between the last Judgment and actual court trials."[293]

Through oaths, admonitions, and Last Judgment paintings, judges were positioned to identify with the judged, for both were at risk of damnation. At the end of time, judges' own worth would be decided in light of the decisions that they had rendered.[294] Art historians debate whether the

deployment of the Last Judgment in town halls was an effort to use religion to bolster the legitimacy of secular rule[295] or evidence of the intermingling of the secular and the religious.[296] Our interest is in how the selection of text and image reflected an understanding of the position of a judge. Then, judges did not sit as do their contemporary counterparts—independent personages chartered to judge but insulated from superintendence by government. Rather, the walls that surrounded judges provided insistent public admonish-

ments of the vulnerability of judges and of the judged, both positioned as subjects before a higher authority.

The imagery of the Last Judgment lost its centrality in town halls before its religiosity became problematic for secularizing societies. In Germany and elsewhere, Last Judgment scenes were replaced with other historical narratives harkening back to classical and biblical traditions and then the abstraction of Justice.[297] Explanations for the eclipse vary depending on the emphasis placed on the effects of changing economic conditions, political theories, and religious ideology in the Reformation's wake. One could read the retreat from Last Judgment depictions to represent a secularization of the act of judging, a decline in religious authority, and an embrace of a humanism enamored with classical narratives of heroic personages and communities.[298] As we will explore in Chapters 3 and 4, rulers in both Amsterdam and Venice analogized themselves to the Israelites and the Romans rather than to souls awaiting God's grace.

Alternatively and at least for certain parts of Protestant Europe, one could claim the continuing relevance of faith to courthouse iconography but a change in the premises. In Lutheran ideology, earthly piety required obedience and punishment but did not necessarily predict entitlement to eternal life.[299] While real judges gained their authority from God, predestination drove their own ultimate fate. Because judges' work on earth no longer provided the basis for salvation or damnation, Last Judgment trial scenes were less instructive. The Last Judgment as "a statement of the causal relationship between temporal and eternal event[s] was now only one of several possible analogies and exempla for the temporal judge."[300] Moreover, not only was salvation derived more from virtue than from any particular act, but judgment itself came to be seen as more "disinterested."[301] That ideology made appealing the didacticism provided by exemplary figures from history and by personifications of various Virtues. In eras when women could not themselves be judges, Justice's female embodiment facilitated a focus on abstractions rather than on worldly realities.

From the perspective of the history of Justice iconography, the Last Judgment stands at the front of a line of images speaking to judges about their work. The decline in reliance on that scene did not mark the end of imagery warning judges about how to discharge their tasks, nor did it immediately result in the dominance of displays of the Virtue Justice. Rather, as we explore in Chapter 3, other biblical and classical narratives continued to teach about the challenges and obligations of judgment as well as the risks to judges that, if they breached their duties of loyalty to higher authorities, they too would meet a gruesome fate. As Last Judgment images moved backstage, the ideology of judicial subservience materialized through other narratives.

# Obedience:
## The Judge as the Loyal Servant of the State

Today's courthouses generally celebrate the practice of adjudication and rarely advert to the pain entailed in rendering judgment. But the visual themes that once adorned places of judgment were not always so upbeat. Darker elements acknowledged both the possibility of justice gone awry and the burdens of being a judge. Last Judgment scenes reminded judges that their fate, like that of the litigants, rested in God's hands. Justice images included frank acknowledgment of judicial corruption.

In addition, many town halls made plain that judges were subservient to, rather than independent of, their employing state. The royal overtones of the word *court* (like the French term for courtrooms, *salles d'audience*) were then appropriate. Today such words are deployed unselfconsciously, though a few—such as Jeremy Bentham—commended an escape from their history through a new vocabulary with the alternative term "judicatories."[1] Like the formerly royal words, the inspirational image of Justice as a virtuous goddess is commonplace in contemporary buildings. But few of the weighty allegorical depictions that were ubiquitous from the fourteenth through the seventeenth centuries have come down to us.

These complex images were part of a tradition called *exempla virtutis* (examples of virtue) that identified acts "worthy of imitation" and therefore appropriate to display on town hall walls.[2] By unearthing the classical myths, biblical stories, and Renaissance emblems that make decipherable pictures that might otherwise be ignored, one can find many references to the violence entailed—both for the judged and for judges—in adjudication.

### Flayed Alive or Maimed:
### Judicial Obligations Inscribed on Town Hall Walls in Bruges and Geneva

#### Controlling Judges: A Fifteenth-Century Cambyses in the Town Hall of Bruges

*The Judgment of Cambyses,* depicted in figures 31 and 32 (color plates 10 and 11[3]) provides a first example. The story

comes from the *Historiae* (*The Histories*), written by Herodotus around 440 BCE. Herodotus described the rule of King Cambyses, said to have lived some 525 years before the Common Era.[4] According to Herodotus, upon learning that the judge Sisamnes was corrupt, Cambyses ordered him flayed alive. Thereafter, Cambyses appointed Otanes, the son of Sisamnes, to serve as a jurist and forced the son to preside on a seat made from his father's skin.[5]

From the thirteenth century onward, versions of this story appeared in European compilations of classical stories. As these anthologies came to be organized alphabetically, thereby facilitating access, this exemplum came to be featured in paintings, drawings, and prints. By the sixteenth and seventeenth centuries, the story of Cambyses was a theme regularly portrayed in European town halls.[6] Dozens of images exist, but the vividness of the *Judgment of Cambyses* by the Flemish artist Gerard David is noteworthy.[7] This work, commissioned in the late fifteenth century for the Town Hall of Bruges, was hung in 1498 and can now be seen in the city's museum, the Groeningemuseum.[8] The painting, a diptych with each panel almost six feet high and five feet wide, includes four scenes.[9]

The story begins in the left-hand panel of figure 31. Toward the back of the frame, behind the arches and under a canopy, a red-robed judge, Sisamnes, stands near another figure from whom he accepts a bag of money. In the central scene, Cambyses (dressed not as a Persian emperor but as a king, "wearing a royal coronet in German fashion"[10]) both accuses Sisamnes, now seated on a high-backed chair, and orders his arrest—shown by a man strong-arming the judge from his authoritative seat. In the right-hand panel (fig. 32), the corrupt judge is being flayed alive. (Reproductions cannot duplicate the experience of looking at the larger-than-life, brilliantly colored original, offering gory details startling in their specificity.[11]) Toward the back of the panel, on the right side, is a smaller scene situated, as in the first panel, under painted arches and providing the denouement. The new judge—Otanes, the son of Sisamnes—is seated on his father's skin, draped over the judge's bench.

Competing interpretations explain both the Cambyses story and the reasons for its placement in 1498 in Bruges. Classical historians identified Cambyses as a king gone mad—a monarch condemned to a perpetual state of rage and drunkenness because, wrongly drawn into war with Egypt, he had killed its sacred bull. Herodotus described how Cambyses desecrated tombs and committed various atrocities, including the murder of his siblings.[12] After leading his soldiers astray, Cambyses died at the very place where he had killed Egypt's sacred animal.[13] Seneca invoked Cambyses when discussing "Anger"—describing Cambyses's drunkenness, labeling him a "bloodthirsty king," and counseling against emulating him.[14]

If the flaying of the judge is put in the context of these many noxious acts, the diptych shows the crazed king using his power in gruesome ways.[15] An alternative reading, and one that dominated the story's deployment during the Medieval and Renaissance periods, was that Cambyses wisely sanctioned an unjust judge. The scene—set forth in town halls, on commemorative medals, and in tapestries—regularly served as an *exemplum iustitiae* (justice exemplars), warning all judges about how to behave appropriately.[16] Indeed, in a major Danish tapestry of 1581, Cambyses was deployed as the embodiment of Prudence.[17]

Scholars do not all agree about which sources influenced the many depictions of Cambyses. Whether or not copies of Herodotus's *Historiae* were easily obtained, at least some materials in circulation during the late fifteenth century offered variations on the story that interpreted the punishment appropriately applied to the "unjust judge." For example, in *Gesta Romanorum* (subtitled "Remarkable Stories Deriving from the Acts and Chronicles of the Romans"),[18] a tale about a "corrupt judgment" described how an "emperor established a law that every judge convicted of a partial administration of justice should undergo the severest penalties." Thereafter followed a story about a "certain judge" (unnamed) who, "bribed by a large sum, gave a notoriously corrupt decision." The emperor then ordered him flayed and his skin "nailed upon the seat of judgment," where the corrupt judge's son was required to sit.[19] Similarly, inscriptions on Renaissance medals of the scene explained, "Cambyses maintained the law and administered it justly, as one can perceive here from the punishment."[20] Further, some editions of the iconographic anthology by Cesare Ripa (detailing how to depict Virtues and Vices) referred, when illustrating Injustice, to the "venal" and "unjust judge" Sisamnes, flayed by Cambyses, who was described as the "great practitioner of justice."[21]

The Bruges version has distinctive features. Many other renditions show the denouement—Otanes sitting on the throne of judgment with the skin of his father draped below or above him—but do not detail either the arrest of the corrupt judge Sisamnes or the ghoulish specificity of his flaying,[22] arguably laid out to be evocative of a crucifixion.[23] Further, the decision to put this particular iteration into place in 1498 in the Town Hall of Bruges provides a puzzle for art historians. One theory, reliant in part on identifying various of the men portrayed to resemble locally prominent personages,[24] takes the picture as a reference to specific events. Given the unsuccessful effort ten years earlier (1488) by citizens of Bruges to revolt against then-Archduke Maximilian (who later became Emperor), the 1498 painting could be read as a warning by pro-Maximilian forces not to cross kingly authority again.[25] Alternatively, if one focuses on Cambyses's madness, the scene, commissioned by the town's aldermen, might be taken as an oblique protest against the unjust exercise of kingly power.

But linking the commission of the Cambyses painting with specific events in Bruges may be misguided. This diptych was not the only image in that Town Hall. Gerard David was also commissioned to paint a *Last Judgment* (now lost), and we know that the plan was in accordance with the commendation that judges surround themselves with pictures to "display good, old, wise adages conveying wisdom and knowledge; for . . . seeing provokes reflection."[26] Moreover, portrayals of the Cambyses story can be found in many other town halls, including those of Mons, Gdańsk (Danzig), and Brussels[27]—appearing near other exempla such as the *Judgment of Solomon* and the *Punishment of Zaleucus* (discussed later in conjunction with their display in the Amsterdam Town Hall). Prints and etchings disseminated these allegories more widely.[28] The purpose of the Bruges *Cambyses* may thus have been to make the more general points that judges ought not take bribes and that were judges to get out of line, rulers had the power "to guarantee the utter impartiality of the judgments handed down."[29]

## Bribes, Gifts, and Budgets

One other explanation (not mined by art historians, who generally assume that impartiality and anti-corruption norms were extant) is that the *Judgment of Cambyses* was put on display in an effort to generate *new* understandings of what constituted illicit action by judges. Rather than presuming that the picture documented the prohibition of paying money to judges and the power of rulers to control local magistrates, the image could have been an effort to instill these ideas.

Giving money to judges was not necessarily considered wrong at the time. As Natalie Zemon Davis explained in her book *The Gift in Sixteenth-Century France*: "Gifts were everywhere in the movement of French politics, justice, and appointment in the sixteenth century."[30] Under French law, gifts "to do honor to new officers were perfectly acceptable"[31]—making difficult a distinction between a "good gift" and a "bad one."[32] Indeed, local judges supported themselves by receiving provisions from disputants, a practice recognized by law. Prior to 1560, France "forbade judges to accept any present from litigants in a current case under penalty of loss

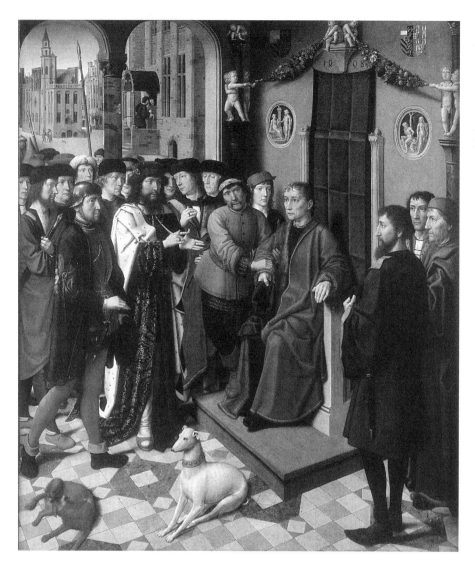

of their office . . . *except* for gifts of food, wine, and other perishables."[33] Further, as Davis explained, to obtain a judgeship required making a payment to the king for the "gift" of that office.[34] Indeed, as John Noonan put it in his book titled *Bribes:* "Reciprocity is in any society a rule of life, and in some societies at least it is *the* rule of life."[35]

The problem is not only one for history. Determining an appropriate relationship between judicial output, judges' incomes, and institutional budgets remains problematic today, centuries after debates in France about licit and illicit gifts. For example, during the 1920s in the United States, some localities provided that judges could receive bonuses by imposing fines on criminal defendants. In the course of trying to enforce Prohibition, the unpopular federal campaign against the consumption of alcohol (subsequently repealed through a constitutional amendment), Ohio passed a law permitting local law enforcement officials, including judges, to receive extra remuneration from fines imposed on and collected from violators. One such defendant challenged his conviction by the Village of North College Hill, where the mayor, who was also the village court judge, received about twelve dollars per fine imposed and had, over seven months, thereby augmented his salary by about $100.[36]

Was that illegal? The Supreme Court of Ohio dismissed the claim as presenting no "debatable constitutional question."[37] The United States Supreme Court reversed in a well-known decision, *Tumey v. Ohio,* which concluded that a "direct pecuniary interest . . . and . . . official motive to convict and to graduate the fine to help the financial needs of the village" violated the promise of due process of law.[38] Yet to do so, the Court spent pages canvassing English and American practices. Only after that survey did the Court decide that the custom of gaining fees and costs from convictions was not so embedded in the law as to be permissible.[39]

Moreover, while the idea of making payments to individuals has since become antithetical to conceptions of judicial integrity, institutional benefits are still gained

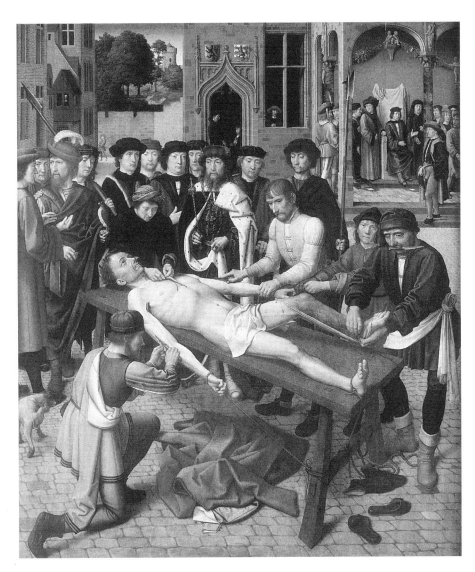

through payments, no longer called "gifts" but "user fees," that are tied to court-based activity. In some countries (such as England and Wales), "full-cost pricing" is in vogue. That system aims to have civil justice costs, including judicial salaries and administration, supported through fees paid into court rather than by national budgetary allocations.[40] If judges are reliant on such schedules with their payments by the hour for court time, incentives exist (as illustrated by the Ohio statute at issue in *Tumey*) to conduct more proceedings.

Paying judges directly is also not foreign. As is detailed in Chapter 14, disputants in many countries are encouraged to turn to privately paid arbitrators; a program in California is called "rent-a-judge." Some consumer and employment contracts require the use of conflict resolution systems funded by private companies against which the claims are brought. And for those judges who stand for election, campaign contributions may come from interest groups hoping to shape the law.[41] In some countries, appointment

processes are also not immune from economic influences. Judicial appointees can be supported—or opposed—by particular sectors running campaigns on their behalf. And when judiciaries render unpopular decisions, legislators sometimes threaten budgetary cuts. In short, some of the puzzles about the relationship between the financing of adjudication and the conditions for independent and impartial judging remain.

Yet one proposition has long been ruled out—bribery—defined from ancient Egypt through today as making a gift that wrongly influences and thus perverts judgment.[42] As the *Cambyses* narrative illustrates, such injunctions are directed specifically at judges, admonishing them not to take bribes. A related but distinct concept with a comparably long pedigree is that judges ought to be even-handed when rendering judgments. Throughout history, judges have been enjoined not to favor the rich (who have the capacity to give bribes, bestow rewards, or otherwise make appeals) or to be especially sympathetic to the poor (who because of their needi-

ness may engender special concern).[43] Yet relatively little historical evidence of enforcement mechanisms can be found, and the issue of line-drawing was (and is) ever-present.

## Skeptical about Law and Distrustful of Judges

*The Judgment of Cambyses* was not the only image of judicial misbehavior. Within the earlier tradition of placing *Last Judgment* paintings in town halls (see fig. 2/30) to remind judges that they too would be judged, a few images also warned against taking bribes. For example, in Maastricht, a 1499 *Last Judgment* showed local aldermen presiding at trial, with a demon and an angel nearby. The inscriptions have the demon tempting them to accept bribes, while the angel warns:

> You who are counsellors, . . .
> Do not allow, for favor or hate,
>    with bribes to hire,
> Else you go, who justice are,
>    to hellish fire.[44]

That motif can be found elsewhere, standing as a freeform sculpture called *Judge with a Rich Man and a Poor Man* (likely from a design by Albrecht Dürer) that was commissioned in 1518 for the renovations of the Nuremberg Town Hall. *Judge with a Rich Man and a Poor Man* stood in a room in which business was conducted and verdicts rendered; a painted *Last Judgment* hung on the wall.[45] The sculpture has several figures. At its center is a bearded man in robes who holds a baton in one hand and scales in the other. On one side, a poorly dressed man with upturned hands appeals for help, while on the other, his well-dressed counterpart appears to be reaching into a bulging purse. Paired nearby are a devil and an angel, joined by a griffin.

One could read the sculpture's message to admonish town leaders to be even-handed. Alternatively, one could view the angel as weighing in on the side of the poorer applicant, reminding those in power to take care of those in need. Further, just as some read the placement of the *Judgment of Cambyses* in Bruges to be a local reference, the Nuremberg scene may also refer to a particular incident. In 1514 a Nuremberg Council member had been found to have taken bribes. Or one could enlarge the focus by looking more generally to the literature of the time, which presumed that "corruption was rife in contemporary courts."[46] Whichever of these readings is embraced, the devil's image served as a reminder of the risk of evil that lurks near power while the rich man's purse showed the threat of corruption. Thus, unlike contemporary decoration in courthouses, this portrayal suggests that authorities are fallible.

In sixteenth-century France, even if "gifts" were "everywhere," Davis detailed a few prosecutions of judges alleged to have taken bribes, as well as admonitions in emblem books warning against accepting bribes or ignoring poorer litigants.[47] For example, one of the images in Hans Holbein's *Pictures of Death* (in circulation in mid-sixteenth-century France) was of a corrupt judge accepting coins from a rich litigant and ignoring a poor one.[48] In a 1547 facsimile of Holbein's *Unjust Judge,* the skeletal figure of Death pulls a judge off the bench in a gesture reminiscent of the arrest of Sisamnes in Gerard David's *Judgment of Cambyses.* The accompanying verse explains:

> From out thy seat thou shalt be taken,
> So oft bribed to iniquity—
> Thy ill-got gains must be forsaken;
> No bribe can buy thy life of me.[49]

Prohibitions against bribery are, as we have noted, ancient. But pictures of flayed judges were not regularly displayed until after the Middle Ages. Why did anti-corruption messages become prevalent in the decoration of town halls during the late fifteenth and sixteenth centuries? The fourteenth-century walls of Siena's Palazzo Pubblico praised Justice and detailed the injustice flowing from Tyranny but did not rail against the misuse of power. We cannot know whether other buildings of that era, no longer standing or now with illegible script, bore such admonitions. But what we do know is that judicial fallibility through corruption and bias became a major visual motif in the century thereafter.

These paintings, sculptures, and prints of corrupt judges display anxiety about the fairness of the application of laws, as well as suspicion of lay judges, lawyers, and municipal officials. The currents of unease in imagery and text ran through France, Germany, and England. In sixteenth-century France, the "open sale of judicial office exhaled the breath of corruption. . . . Not only was it felt that a magistrate who bought his office was not far removed from one who would sell his justice, but the multiplication of judicial office was thought to encourage unnecessary litigation."[50] A fifteenth-century German text, replete with proverbs creating a "spiritual encyclopedia,"[51] made the point in poetic form: "Water harms flames, sun snow, the south wind flowers, smoke light [and] money justice."[52] Even more pointedly: "Money, love [and] fear are often [the cause of] the judge's error."[53]

Similar concerns led to efforts at reform in England. Abolition of the "sale and purchase of office by judges," while not accomplished, was one goal of the popular movements of the 1640s.[54] An ordinance encompassing a broader idea of judicial integrity was embraced in 1648 and soon repealed,[55] but half a century later, the 1701 Act of Settlement sought to insulate judges from currying the king's favor. Rather than serving at the pleasure of a monarch, judges were to keep their offices contingent on "good behavior." A vote of both Houses of Parliament was required to terminate their position.

The politics of the time—struggling over the legitimate exercise of power, with rulers trying to control judges and some popular efforts to constrain rulers—had a literary tra-

dition and a visual idiom to express these concerns. Classical literature gave literate Europeans stories of the misuse of authority, as illustrated by the account of Herodotus that launched the many depictions of the *Judgment of Cambyses*. Those exempla worked in tandem with encyclopedias of emblems and icons to furnish standard tropes by which to translate the distress about power into a vocabulary shared across many jurisdictions.

## The Unjust Prince: Plutarch's Theban Judges and Alciatus's Emblems

Holbein's depiction of the *Unjust Judge* may well have been influenced by warnings against bribery in the works of Plutarch, writing in the first century CE and greatly admired during the Renaissance. Plutarch reported that in Egypt "statues of judges erected at Thebes [had] no hands; and the chief of them had also his eyes closed up, hereby signifying that among them justice was not to be solicited with either bribery or address."[56] A parallel reference comes from the first-century BCE Sicilian historian Diodorus Siculus, who also spoke of closed-eyed judges in Thebes in his world history, *Bibliotheca historica*.[57] Diodorus described a room in which "there were many statues of wood, representing the pleaders and spectators, looking upon the judges that gave judgment. . . . In the middle sat the chief justice, with the image of truth hanging about his neck, with his eyes closed, having many books lying before him. This signified that a judge ought not to take any bribes, but ought only to regard the truth and merits of the cause."[58] In the 1530s, these descriptions gained a visual counterpart through editions of Andreas Alciatus's emblem book. As discussed in Chapter 1, those volumes were joined by the 1593 *Iconologia* by Cesare Ripa[59] and a few other volumes[60] in providing a shared vocabulary of imagery and anecdote.

Andreas Alciatus, a professor of law in Bourges, France, and then in Pavia, Italy, and a friend of Erasmus (who called him a "shining light of Learning, not only the Law"),[61] was a figure central to both the history of art and legal humanism. Alciatus was a systematizer of law ("the man who introduced the historical method into university education"[62]) who shaped a humanistic jurisprudence through an extensive body of publications. His 1531 treatise, an anthology of a diverse collection of moralizing short poems or epigrams to which his publisher added illustrations, was reproduced in some 150 editions.[63] Each "emblem" (a term that Alciatus appears to have coined[64]) consists of pictures accompanied by texts. The pictures were more than illustrative; the images were to be "read" (albeit with different levels of comprehension) by both the illiterate and the philosophically trained.[65]

Among the emblems, which in some editions are numbered, is one called *The good Prince in his Council*. There shown is a royal figure seated on a throne and surrounded by a few other men who are handless. Depending on which edition one sees, the central figure has no eyeballs in his open eye sockets or has one eye, or arguably (given the state of a particular edition's engravings) a patch or some kind of bandage covering part of one or both eyes. Figure 33 reproduces an example from a 1582 Latin edition; the central figure is wearing a bandage obscuring part or all of his eyes, and his colleagues lack hands.[66] In contrast, in the 1542 edition from Paris and the 1621 edition from Padua, the prince has no bandages over his open eyes. Whatever the visual depictions, these editions describe the figure as sightless.[67]

The accompanying epigram varies with the edition. In the leading English compilation of five editions, published between 1536 and 1621, one finds this elaboration:

> These men without hands who are seated are
> those by whom justice is administered. They
> should have well-balanced sense; nothing is
> received from them in response to a bribe.
> Their prince, deprived of his sight, cannot
> see anybody, and he judges by due sentence
> according to what is said in his ear.[68]

This parable (which echoes Plutarch's story of the Theban Judges) places the act of judgment in the hands of the sightless "prince" or "judge" in a world in which no doctrine of separation of powers existed and executive and judicial authority were combined.

## Dogs, Snakes, and Virgins: Even-handedness in Ripa's *Iconologia*

Moving from judges to Justice, themes of the perversion of judgment through special connections to one party in a dispute or from bribes appear in the iconographical compendium of Ripa. A volume was first published in 1593 without illustrations and republished in 1603 and thereafter with accompanying pictures. Ripa set forth several kinds of Justice, each with her own description.[69] In discussing one, "Strict Justice" ("Giustitia Retta"), Ripa advised that Justice be shown as a "woman with a raised sword, regal crown, and scales; on one side of her, there is a dog signifying friendship and a serpent on the other signifying hate. The raised sword denotes that Justice should not bend to either side, neither for friendship nor for hatred of any person and is therefore praiseworthy and able to maintain authority."[70]

Another of Ripa's Justices was "Justice According to Aulus Gellius," a second-century CE Latin grammarian who, as we noted in Chapter 2, described Justice's "piercing gaze." Ripa said she ought to be portrayed as a "woman who is a beautiful virgin . . . [because] in the manner of virgins, [she] must be exempt from passion, not . . . corrupted by flattery, gifts, or anything else . . . . To indicate Justice and intellectual integrity the ancients used a jug, a basin, a column—as is

In Senatum boni Principis,
DIALOGISMVS.

verified on old sepulchers of marble and by diverse antiquities, such that Alciatus said: A good judge must be pure of soul and clean of hands, if he wishes to punish crime and avenge injury."[71] One can hear through these admonitions an interconnected critique of judges. Anxiety about judgment laced the depictions of Gerard David's *Cambyses* in Bruges, of the *Last Judgment* in Maastricht, the Dürer-modeled sculpture in Nuremberg, Holbein's woodcuts circulating in France, and the texts and pictures of Alciatus and Ripa, reprinted in many languages and disseminated around Europe. Geneva's version, *Les Juges aux mains coupeés* (*Judges with Their Hands Cut Off*) (fig. 34), gives such concerns a particularly spectacular expression.

### Hands Cut: Disfigured Judges and Regal Justices for Sixteenth-Century Geneva

*Les Juges aux mains coupées,* sometimes called the *Tribunal of Thebes,*[72] is a startling scene. Dated 1604, the fresco is attributed to Cesar Giglio, a painter from Vicenza.[73] The imagery starts right above a door-height balustrade, reaches the ceiling, and fills the top third of the room's walls. The presiding judge is centered on one of the walls and seated on a high-backed bench. He is shown in the detail provided in figure 35 with open eyes, an upright scepter in one hand,

and the other hand cut off. On each side of that judge sit three others, also depicted handless, so that thirteen stumps of arms are visible. At least two of the six judges have their eyes cast down if not closed.

Two scrolls unfold, on the left behind a figure identified as David and on the right near a figure of Moses.[74] The scroll near David has text in French, with lines citing to *Isaiah* 33:14 and *Psalm* 82. The legible words from *Isaiah* can be read as "Who among us will dwell in the eternal flames?"[75] A few letters are legible in the second passage, as is the attribution to *Psalm* 82. One scholar presumed that the text read, "God stands in the assembly and judges among judges."[76] (A standard English translation of *Psalm* 82 reads instead: "God stands in the assembly and judges among the gods.")

As can be seen in the larger view (fig. 34), the text near Moses is in French and readily legible. The passage, from the Old Testament's *Exodus* 23:8, can be translated as "Thou shalt not accept gifts, for a present blinds the prudent and distorts the words of the just."[77] In terms of the specific explanations for this display, local stories of treason or perfidy are a possibility.[78] But, as the alternative title—*Tribunal of Thebes*—suggests, a textual basis could have been the Greek Plutarch as recycled through Alciatus and others.[79] That the Geneva fresco has its central judge open-eyed is

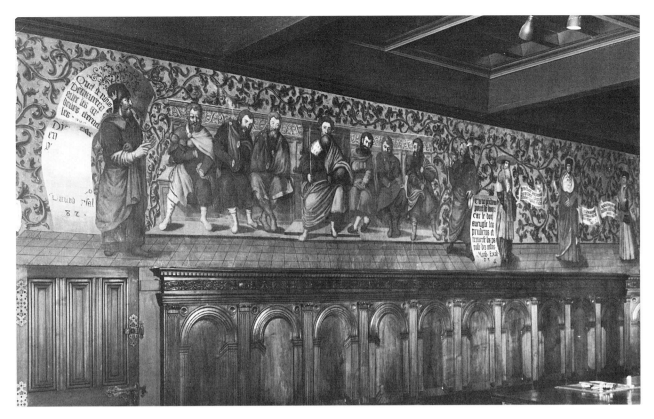

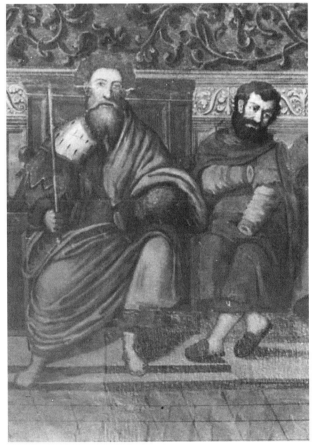

FIGURE 34  *Les Juges aux mains coupées* (*Judges with Their Hands Cut Off* ), Cesar Giglio, circa 1604, Geneva Town Hall, Geneva, Switzerland. Painting in the chamber of the Conseil d'Etat (Council Chamber) in the Baudet Tower.

Photograph reproduced courtesy of the Centre d'iconographie genevoise.

FIGURE 35  *Les Juges aux mains coupées* (detail).

explained either as poetic license taken by the original artist or as an error of repainting during a restoration.[80] Moreover, because some of the editions of Alciatus's emblems do not clearly provide a sightless judge (although the accompanying texts generally do describe him as such), Giglio could have worked from an image that showed eyes.

*Les Juges* is a particularly vivid and now well-preserved rendition, but images of handless judges were not unique to the Geneva Town Hall. Other examples of "Theban judges" could be found in town halls in Germany and Poland, including at Ulm, Augsburg, Regensburg, and Gdańsk.[81] In addition to the Alciatus reference, historians have found another source—a dictum by John of Salisbury that "officials and judges [were] the hands of the state," invoked in a fifteenth-century "council poem" by Johannes Rothe, the town clerk of the City of Erfurt.[82] Rothe used the metaphor to explain that officials and judges were to take money and gifts given in honor of the community, while clerks (such as himself) were to serve as the city's "eyes" to supervise the

receipt.[83] Moreover, in some southern German cities, "severing hands or fingers served as punishment for corrupt officials"—providing a reminder that one should not read the depictions of handless judges only as allegories, for the "gory threat . . . could be taken quite literally."[84]

The effort to constrain judgment was not limited to depictions of judges but could occasionally be found in drawings of the abstract Virtue Justice herself. Two German manuscripts of the fifteenth century portrayed a female Justice with her arms severed around the elbow.[85] In both she is surrounded by men who are shorter than she, and in both, the men hold scrolls with the same Latin text, that the "woman is tall . . . because the judge must remember the judge in heaven; she is blind so that she shall not be influenced by wealth or poverty, friendship or hatred; and she has no hands so that she shall not be too gentle or too harsh."[86] Another armless female is shown in an image by Marten de Vos, who worked in Antwerp and drew a personification of the Virtue Integrity in that fashion.[87]

*Les Juges aux mains coupées* hung in the Chamber of the Conseil d'Etat in the Baudet Tower of the Geneva Town Hall, which was the "seat of the government of the old Republic and Canton of Geneva."[88] The General Council of Geneva emerged from an assembly of citizens that began meeting in 1364 in the cloisters of the Cathédrale de St.-Pierre.[89] In 1387, Bishop Adhémar Fabri issued a charter recognizing Geneva as a citizen republic with jurisdiction over certain matters. Geneva gained its discrete political identity after 1499, when its leading families allied and obtained protection from the free cities of Bern and Fribourg. The result, in 1526, was independence from both the Holy Roman Empire and the House of Savoy,[90] whose prince-bishop of Geneva fled the city in 1533. John Calvin arrived in 1536, and within the decade this Protestant republic had adopted his *Ecclesiastical Ordinances*.[91]

Central to Geneva's identity were Calvin's edict "Let every soul be subject to the higher powers," his insistence on political obedience as a bulwark against anarchy,[92] and his hostility to the Catholic Church. As its motto, *Post tenebras lux* (*After darkness light*) might suggest, this "Reformed community in Geneva considered itself to be a better expression of the pure church than the corrupted Catholic Church it replaced."[93] Seen by Catholics as defiant, Geneva aspired to a disciplined church and state conforming to God's will, a "Christian commonwealth" functioning as a thriving republican city-state.[94] Whether this ideology provided a source for the fresco or not,[95] the Republic of Geneva's Town Hall was replete with admonitions that judges ought not take bribes.

The building itself dates from sometime during the early fifteenth century and provided a discrete structure in which the town's governing bodies (including a Small Council of Twenty-Five, a Council of Two Hundred, and a General Council) worked. Inscribed on one of its walls is a passage from *II Chronicles* 19:5–7, translated as:

Jehoshaphat . . . said to [the judges]: "Be careful what you do; you are there as judges, to please not man but the LORD, who is with you when you pass sentence. Let the dread of the LORD be upon you, then; take care what you do, for the LORD our God will not tolerate injustice, partiality, or bribery."[96]

The room where *Les Juges aux mains coupées* was displayed (and then obscured via redecoration until its rediscovery in 1901) was used to pronounce judgments and to impose sentences.[97] The room's other frescoes were executed in 1488 at the direction of local authorities. More than a century later, *Les Juges* covered over a part of the original décor.[98] What remained visible included philosophers, historians, religious figures, Justice, and other Virtues, all accompanied by instructional texts.[99] The figures arrayed on the three walls could be read to refer, in turn, to the magistrates of Geneva, to Justice and other Virtues, and to the Last Judgment.[100]

As in Siena, Justice dominates Geneva's communal effort to express its own good governance.[101] On a wall adjoining the handless judges, the 1488 frescoes feature Justice, placed on that wall's center (fig. 36) and discussed in various texts explicating the other images. Reminscient of Giotto's figure, she is shown clear-eyed, wearing robes of crimson and gold as well as a large gold crown; she holds a balance in her left hand and a raised sword in her right.[102] Seated on a high-sided throne, Justice is flanked by two figures, identified as Aristotle and Cicero.[103] By deploying both men, the frescoes avoided the debate (detailed in Chapter 2) surrounding the iconography of the Palazzo Pubblico in Siena. Rather than be read as preferring either Aristotle or Cicero, Geneva embraced them both.

As in Siena, many maxims accompany the pictures, offering a mixture of Latin and the vernacular, as did the lettering of the scrolls complementing *Les Juges aux mains coupées*. But, unlike in Siena, a good many of the Geneva messages are about buffering judges from bias. For example, at Justice's feet is a partially destroyed scroll with Latin text that can be reconstructed to read, "If a controversy arises before a judge, maintain the balance of judgment; do not let yourself be bent by affection or by the influence of gifts. A judge of firm mind does not give preference to anyone."[104] Above Justice's head runs, in Latin, "I am Justice, who gives to each that which he deserves."[105] Near Cicero is a Latin text translated as "No occasion arises that can excuse a man for being guilty of injustice."[106]

More instructions (not all focused on biased judgment) swirl about. Close to Aristotle is a passage from his *Nicomachean Ethics*—that "Justice is the greatest of the virtues."[107] (The same words are etched on the facade of a 1916 federal courthouse in Denver, Colorado, shown in Chapter 7.) Facing Justice is Virgil, who appears near the Latin words "Be warned: learn justice and help the afflicted."[108] And along-

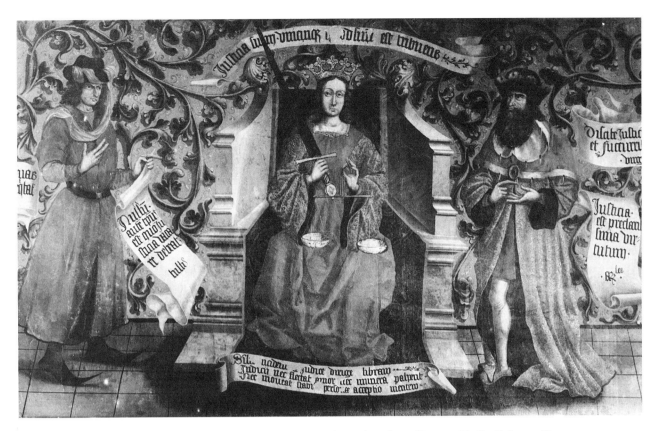

FIGURE 36   *Peinture murales avec la Justice entourée de gauche à droite d'Aristote, Virgile, Cicéron et Alanus*
(*Mural with Justice Surrounded by, from Left to Right, Aristotle, Virgil, Cicero and Alanus*), circa 1488,
Salle du Conseil d'Etat (Council Chamber), Geneva Town Hall, Geneva, Switzerland.

Copyright: Centre d'iconographie genevoise (coll. MAH), Genève, rue de l'Hôtel-de-Ville n° 2.

side an image of Lactantius, a Christian who authored *Divinarum institutionum* (*Divine Institutions*) in the early fourth century CE, is a Latin passage from that work that reads, "Justice has two veins: piety and equity."[109] Another Virtue featured prominently in the frescoes is "L'Amitié" (friendship), explained as a likely reference to Aristotle's premise that friendship, like Justice, is a necessary precondition for a healthy polity.[110] Thus Geneva did not portray an uncomplicated picture of government but adverted repeatedly to the struggle to be just and to the temptations judges faced. The walls bear witness to the possibility of judicial betrayals of the Virtue Justice and to the greater powers evaluating the justice rendered.

### Judicial Subservience and Dependence

Return to the puzzling relationship among gifts, bribes, and support of judges. Focused on France, Natalie Zemon Davis was intrigued by the fact that, unlike England, where the word *bribe* had negative connotations dating from Chaucer's time, old French lacked a term for bribery.[111] Davis argued that the emergence of the mid-sixteenth-century effort to prohibit gift-giving ought not be under-

stood simply as a triumph for judicial integrity but rather as a means of rendering judges more dependent on central royal authority. Cutting off support from litigants by recasting gifts as bribes was "as much related to the king's efforts to control his judicial officers and win their loyalty as it was to popular complaint."[112] Prohibiting gifts tightened "the judges' ties to the monarch [who paid their salaries] as against their competing ties to local aristocracies."[113]

The images in Bruges of Sisamnes flayed and in Geneva of handless judges should be put into this context of a struggle for loyalty. These paintings and frescoes for town halls express the power of rulers to judge their judges, to arrest and evict them from their offices, to maim and to flay them. Add Last Judgment scenes, the ambiguity surrounding donations and gifts to judges, the complexity of sorting permissible from impermissible gifts, and the pervasive evidence of unease about "fear or favor" corrupting judgment, and one can see that several of the narratives in town halls aimed to instill an ideal of judicial subservience to higher powers. Just as Last Judgment scenes instructed judges to fear God, so did deployment of the Cambyses story and pictures of maimed men remind judges and councilmen to obey earthly ruling powers.[114]

Furthermore, as Davis pointed out, forbidding gifts shifted magistrates' dependence from local populations to royal authority. But where should judges get their support? Take a proposition that seems to leap from the picture of Cambyses: judges cannot be paid by the litigants before them, for that payment is an illicit bribe. But a modern assumption is that judges can be appointed by the state, draw their salaries from the state, work in buildings provided by the state, have jurisdictional competencies defined by the state, and yet be called independent and impartial. We have come to conceive of judges as holding a peculiarly distinctive form of employment and of the judge as simultaneously a subject and employee of the state yet able to sit in judgment of the very entity that authorizes that task. Elaborating the growth of this idea of independence, translated through the separation of powers and interrelated to ideas of impartiality, is one of the aims of this book, as is explaining how observers today also look at images such as the *Judgment of Cambyses* and *Les juges aux main coupées* and find not only anti-corruption premises but also obligations of what we call fairness and equal treatment. Medieval and Renaissance adjudication provided opportunities for the development of proto-democratic practices, to which we return after examining more narratives of Justice that once were commonplace.

## THE CHALLENGE AND PAIN OF RENDERING JUDGMENT: AMSTERDAM'S SEVENTEENTH-CENTURY TOWN HALL

Judicial corruption was one leitmotif within European town halls, and a second was that judging entailed pain, both professional and personal. This theme can be seen by moving forward from the sixteenth century to the middle of the seventeenth and by traveling from Bruges and Geneva to Amsterdam, where city leaders made that point through an extraordinarily self-conscious project that produced their town halls.[115]

We know from local records (cited in Katharine Fremantle's 1959 classic volume on the Amsterdam Town Hall) that the city's leaders (burgomasters) as well as the building's principal architect (Jacob van Campen) took seriously the Roman architect Vitruvius's instruction that "public and private buildings [should] correspond to the grandeur of our history, and will be a memorial to future ages."[116] The burgomasters wanted their building to "proclaim the city's accomplishments and reflect its wealth and prestige."[117] They hoped that, as "the ultimate embodiment of the dominion and civilisation of their era," their Town Hall "would eclipse even the finest architecture of the past."[118]

Their aspirations were, for a time, fulfilled in that the Amsterdam Town Hall became a "secular temple as well as a trophy"; its chambers were of unprecedented "refinement and grandeur,"[119] displaying the impressive resources of the Dutch during the seventeenth century.[120] The Amster-

dam Town Hall was promptly dubbed the "eighth wonder of the world."[121] The burgomasters had a story to tell—of their prosperity and power linked to commerce, peace, and justice.[122]

### An "undertaking of megalomanic proportions"

The view of the Amsterdam Town Hall in figure 37 shows its imposing facade facing Dam Square. Now also called the Royal Palace, because it later served as the residence for Louis Napoleon,[123] it remains (like the Palazzo Pubblico in Siena) open to the public. And, like Lorenzetti's frescoes in Siena, the iconography of the Royal Palace has been unusually well documented and explicated.[124] Moreover, because Amsterdam became a center of European graphic arts and "townscapes" became a popular genre,[125] paintings and illustrated city guides published in the 1660s and thereafter brought images of the Amsterdam Town Hall to many parts of the world.[126]

The building shown in figure 37 was not Amsterdam's first Town Hall. Another had existed since at least 1395 on what is now Dam Square. In 1418 a "separate court of justice" called the "Vierschaar" (Tribunal) was added, and by the 1550s the complex included prisons.[127] There continued the tradition, once enacted in open fields, of public displays of rulers' power.[128] During the fourteenth and fifteenth centuries, "public punishments were carried out in the Vierschaar, where a post for scourging [or flogging], surmounted by a figure of Justice, was set up."[129] Executions, with the sheriff and others watching, took place in front of the Town Hall.[130]

In 1585 Amsterdam's population was about 30,000; by 1609 it had more than doubled, to 70,000, and in 1640 it had grown to about 140,000.[131] Yet "it was not because it was overcrowded that the city council decided to replace the old Town Hall, but because it was derelict."[132] Fremantle tells us that burgomasters wanted their city's building to be "worthy of her status and of the virtues of her government, which might declare her greatness within the city and to the admiring world."[133] Their commission of a building of unprecedented size for the city[134] prompted another historian of the building, Eymert-Jan Goossens, to call the effort "an undertaking of megalomanic proportions" that united "the arts in an architectural context on a scale hitherto unknown in the Netherlands."[135]

Whatever one's critical stance toward the ruling class of Amsterdam and their ambitions, their building and its interiors constitute a remarkable didactic exercise, aimed at marking and making power by instructing its viewers and its users. In terms of the authorship of the plans (and in contrast to contemporary courthouse buildings, whose design and art are often specified by internationally recognized architectural firms), we know that the thirty-six members of the city council studied proposed plans for the building, and further that the city's rulers, the burgomasters, directed

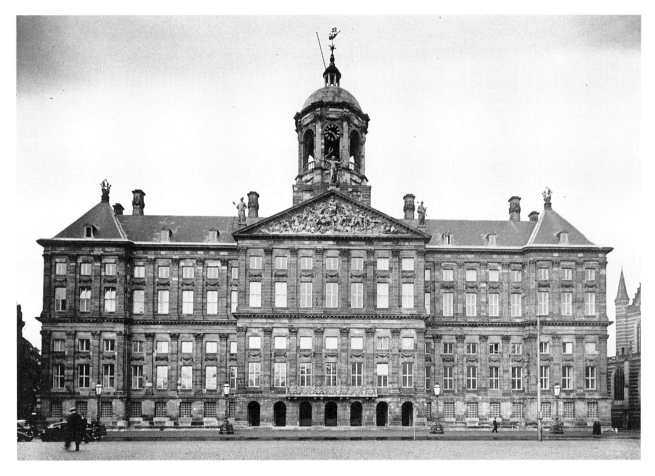

FIGURE 37    Exterior of the Town Hall (Royal Palace) of Amsterdam. Architect: Jacob van Campen,
1648–1655, Amsterdam, the Netherlands.

Photograph reproduced with the permission of the Amsterdam City Archives.

many of the decisions.[136] And, whether laudatory or skeptical of the result, commentators concur on one point: the city governors succeeded in making their building Amsterdam's major visual symbol.[137] The Town Hall was the "largest public building project undertaken in the Republic in the seventeenth century";[138] it was not only built to "serve as the seat of the government but also served as a meeting place for the citizens."[139] Further, the Town Hall was Holland's first structure in "a classical style of architecture in which buildings were considered in the round and as a whole, in relation to their setting, and with their decoration as an integral part of the design."[140]

The interior allegorical didacticism offered a mixture of classical and religious themes. Ripa's *Iconologia,* translated and published in Dutch in 1644,[141] was a major influence, as was the Bible. Much has been written about the Republic of the Netherlands as an embodiment of the Old Testament's Israel.[142] (As discussed in Chapter 4, Venetian leaders also claimed that their city was the "New Rome" in a special relationship to the Pope.) Amsterdam's leaders saw their city as the "latter-day holy city of Jerusalem," with its

Town Hall as the "seat of 'righteous' authority" embodying "divinity on earth" and serving as the "the heart of a harmonious community."[143] Yet the burgomasters also saw themselves as "successors to the consuls of the Roman Republic."[144] Thus the Town Hall's designers laid claim to Greek and Roman traditions, recycled through Christian iconography,[145] as they retold their own history through a series of paintings and displays of various gods.[146]

### The Virtues of Prosperity: Justice, Peace, and Prudence Reigning over an Expanding Municipality

The Amsterdam Town Hall was not the city's only civic structure. By the seventeenth century, the increase in municipal functions required that some activities previously housed under one roof be relocated. Thus, the new Town Hall was one of a series of buildings that included a weigh house, market halls, warehouses, an orphanage, an old-age home, a theater, and a house of correction.[147] Yet even with that proliferation, multiple functions remained in the one dominant building. In "modern terminology, the Town

Hall was court of justice, house of detention, police headquarters, ministry of justice, public prosecutor's office and place of execution [and housed yet other functions] all rolled into one."[148] Indeed, what occurred inside the building affected townspeople from their youth to their old age.[149] Rooms were designated to match the services provided, with spaces dedicated to the Commissioners for Matrimonial Affairs, the City's Trustees of the Orphans, Marine Affairs, the Burgomasters, the City Council, a Commissioner of Petty Affairs, a Bankruptcy Office and, on the top floor, the display of art.[150] Space was marked not only by function but also by import; Van Campen is credited with allocating offices to express the "power relations" among them.[151]

The new building's construction began in 1648, before the fire of 1652 that so damaged the prior Town Hall.[152] The first stone was laid around the time of the Peace of Münster, which concluded a war with Spain[153] and thereby freed up funds to finance the project.[154] Although the building's design was not finalized until sometime thereafter, "13,659 trunks of Scandinavian conifers, each some 12 metres long, were driven by hand into a marshy ground at an average rate of sixty per day."[155] The floor plan shaped a building measuring 280 by 200 feet, with two inner courtyards.[156] The building was not complete when inaugural ceremonies that entailed a great deal of pagentry took place in 1655. A

commemorative medal was coined and poems composed, including a 1378-line poem by Joost van den Vondel and other odes by Jan Vos.[157]

The Town Hall's symmetrical facade announces that the government it celebrated was entwined with Justice. She sits as one of three large figures, all attributed to Artus Quellinus and all crowning the tympanum of the building, below the cupola facing Dam Square.[158] Peace, put into place around 1660, is at the center,[159] with Prudence on one side and Justice on the other, both of which can be seen in figure 38 and both of which were by then "traditional elements in the decoration of a town hall."[160] On the back side of the building's roof, facing away from Dam Square, sit Temperance and Vigilance (in lieu of the fourth Cardinal Virtue, Fortitude),[161] flanking a figure of Atlas holding up the world. On the front facade, beneath Peace on the twenty-meter marble pediment is one of many personifications of the "Maid of Amsterdam."

Inside, the themes made plain on the facade—authority and prosperity derived from Peace and Prudence linked to Justice—are echoed many times. The grand "Citizens' Hall" (Burgerzaal) at the center of the first floor above street level has ceilings 90 feet high and runs 120 feet long and 60 feet wide.[162] That the building was "a representation of the world" and mirrored the universe can be seen from the central statue—another Atlas, again holding the world on his

FIGURE 38 *Prudence and Justice,* attributed to Artus Quellinus, circa 1655, crowning the front tympanum (looking toward Dam Square) of the Town Hall (Royal Palace), Amsterdam, the Netherlands.

Photograph reproduced with the permission of the Amsterdam City Archives.

shoulders, surrounded by Peace and the Four Cardinal Virtues.[163] Below Atlas stands a major sculptural relief—the *Glory of Amsterdam*—with a second rendition of the Maid of Amsterdam, shown holding branches from olive trees and palms, denoting "peace and prosperity."[164] Placed in a large sculptural setting, she is guarded by lions and attended to by many figures, including the Virtues of Justice, Freedom, Discipline, Religion, Peace, Trade, Plenty, Wealth, Unity, and Faithfulness.[165] On the floor of this room is a huge mosaic made from wooden inlay showing the hemispheres, and a zodiac can be found on its ceiling.[166]

Throughout the many rooms flowing off corridors and stairways, the program of self-conscious symbolism relying on the traditions with which Amsterdam allied itself ("from God's sacred pages, and the antiquity of the Romans"[167]) continued, with deities such as Diana, Mercury, Venus, and Apollo; historical allegories; and various Virtues strategically deployed. As Gerard de Lairesse put it in 1778, "for each piece (chiefly sculpture) is so ordered, as to allude to the rooms; whence we know, what uses the rooms are put to, and by the rooms, what the paintings, stone-figures and bas-reliefs signify."[168] For example, Venus guards the passageways to two rooms "that lead up to the Chamber of Matrimonial Affairs and that of Marine Affairs, both of which fall under her jurisdiction."[169] Two Last Judgment scenes were commissioned, one painted by Adriaan Backer for the lunette in the Citizens' Hall[170] and a second, by the building's architect-artist Jacob van Campen, for the Tribunal on the floor below.[171] The Cardinal Virtues of Fortitude, Temperance, Prudence, and Justice can be found in various places. One ceiling in the Citizens' Hall is a painting by Nicolaes van Helt Stockade "showing Amsterdam, personified as Justice, expelling vices . . . from heaven"; assistance comes from several other Virtues.[172] Roman histories also were plentiful.[173]

The theme of anti-corruption was (as in the Town Halls of Geneva and Bruges) reiterated throughout, aimed at enjoining all who governed to be above accepting bribes. In the Burgomaster's Council Room, a painting by Ferdinand Bol featured the Consul Luscinus, who provided a model of civic virtue because he had rejected a bribe from Pyrrhus and rebuffed the threat posed, as the picture showed, by a fearsome elephant.[174] Another image, about the "incorruptibility of the Roman consul Marcus Curius Dentatus," who was known to have preferred the "humble" turnip to expensive gifts, repeats the message.[175]

### "The free state flourishes, when the people honor the laws"

Justice dominates several spaces,[176] as can be seen by turning to the two rooms dedicated to the administration of justice—the large Magistrates' Chamber on the first floor (at the same level as the grand Citizens' Hall) and the Tribunal on the ground floor.[177] The Magistrates' Chamber

was the place in which disputes were heard, statutes set forth, and marriages performed.[178] Its entrance is shown in figure 39. The room is marked by a large sculptural relief dated about 1662 called *Justice, Wealth, Retribution, Greed, and Envy* and attributed to Artus Quellinus. The Justice at its center has an unusual place of honor in that the large sculpture sits in view of and parallel to another large relief depicting the City of Amsterdam. Therefore, the statue of Justice above the western entrance to the Citizens' Hall serves as a "counterpart to the figure of Amsterdam which ornaments its eastern entrance."[179]

This stone Justice is a large, draped, clear-eyed woman who holds both scales and an upturned sword. On one side is a cherubic angel, and on the other is a figure described as a harpy, paired to denote good and evil. Below Justice's feet, bent and curled, are two figures said to be "tormented souls symbolising greed and envy"[180] over whom Justice plainly triumphs. To her right is a skeleton, "Death," with an empty hourglass. On Justice's left is a figure called "Punishment" who "turns her face away from Justice"[181] and holds various implements, including lictor rods, that could be used for "shattering the kneecaps."[182] Under the group are detailed symbolic carvings that are hard to see in most reproductions. Included at the center above the door is an eye—a reference to the "all-seeing eye of God,"[183] flanked by "two wooden measures of length."[184] On the arch to the Magistrates' Chamber is a clock, which could be understood as suggesting that "time to repent" remained.[185] Carved on the entrance passageway to the room are the sword of Justice, a bridle to link Temperance's moderating influences to judgment, and a lion's pelt to reflect Fortitude's strength.[186]

Inside the large (eighty by thirty-two feet) and lavishly appointed Magistrates' Chambers,[187] Justice can again be found. One or two painted Justices, clear-eyed, once existed on panels in the ceiling.[188] In addition, as can be seen today and is shown here in figure 40 (color plate 14), a large canvas has Justice at the center of a scene. This 1662 painting, *Justice* (or *Prudence, Justice, and Peace*), is by Jürgen Ovens.[189] As figures 37 and 38 show, huge statues of this same threesome sit atop the building's facade, crowning the building's tympanum. While outside Peace presides in the middle, indoors, in Ovens's rendition, Justice is the enthroned central figure, once again clear-eyed and holding scales and sword.

Ovens's Justice, wearing a yellow (or gold) dress that is set off by a red drapery across her lap, is attended by the other two Virtues, both shown seated and lower in the picture's frame. Wrapped in a white robe with pearls on her arm, a wreath of olive branches on her head and another in hand, Peace leans on Justice's knee. Prudence, dressed in brown and blue and carrying a "snake staff,"[190] places a hand on, and perhaps thereby restrains, Justice's sword.[191] One of Ovens's contemporaries explained in 1664 that the painting made clear "that Justice's work, without Prudence to guide it, is in all ways very dangerous; and experience overwhelmingly shows, that often when judges do not act with suffi-

FIGURE 39 *Justice, Wealth, Retribution, Greed, and Envy,* attributed to Artus Quellinus, circa 1662, entrance to the Magistrates' Chamber, Town Hall (Royal Palace), Amsterdam, the Netherlands.

Photograph reproduced with the permission of the Amsterdam City Archives.

cient prudence, they make disgraceful mistakes, and following their imprudently declared judgments, which are even more imprudently carried out with great insensitivity, until finally, far too late, they are complained about."[192]

Other paintings in the room elaborated Amsterdam leaders' embrace of law and reiterated the Dutch's special connection to the Israelites of the Old Testament. On the wall above what is now a fireplace[193] is a frieze crafted in 1656 by Artus Quellinus depicting the Old Testament story of the Israelites worshipping a false idol, a golden calf.[194] Above it is a painting, *Moses Descends from Mount Sinai* (fig. 41), by Ferdinand Bol, who had trained in Rembrandt's studio.[195] On the huge canvas, about fourteen by nine feet, Moses is positioned against rocks that could be taken for a throne. He is draped and appears godlike, surrounded by several winged cherubic angels emerging from the clouds in a darkened sky. Moses holds the tablets of the Ten Commandments, which became a symbol of law through their repeated use in Chris-

tian art.[196] Below his feet and seen through a shaft of light are supplicants—women and men of various ages appealing to, pleading with, and welcoming him.

Historian Simon Schama bemoaned this imagery, describing it as "stilted and ungainly," with "its pretension at baroque monumentalism . . . [that] far outstripped Bol's native ability to deliver."[197] But, while terming the artistry "second-rate," Schama thought the painting provided "first-rate historical evidence" of the relative power-holders in Amsterdam. The selection of this narrative marked the ascendency of the moderating forces of the Burgomasters, opposing the conservative Calvinists' efforts to prohibit various forms of art.[198] Their choice to ignore Aaron and to lionize Moses ("the lawgiver and political leader" who transferred his own authority to the Israelites' judges rather than to priests) can be read as an implicit rebuke against the Calvinist clergy.[199] Through appropriating a biblical Ten Commandments scene and thereby borrowing "the ideological

FIGURE 40    *Justice* (or *Prudence, Justice, and Peace*), Jürgen Ovens, 1662, Magistrates' Chamber, Town Hall (Royal Palace), Amsterdam, the Netherlands.

Photograph copyright: Stichting Koninklijk Paleis Amsterdam. See color plate 14.

vocabulary" of their opponents,[200] the Burgomasters pronounced themselves the true guardians of lawfulness.

That this painting encapsulated the Burgomasters' insistence on the rule of (their) law is plain from the poetry that described it. Amsterdam's leading poet, Vondel, published verse to explain the scene:

> Hebrew Moses has received the law from God,
>    With which he returns from above
>       to the people,
> Who greet him reverently, and welcome
>       him eagerly.
>    The free state flourishes, when the people
>       honor the laws.[201]

Another poem, by Jan Vos, also composed to honor the painting, read:

> He who governs the people requires
>    a strong hand
> The Laws are to intimidate all whose ways
>    are wicked
> Where wise Laws obtain, virtue shall
>    be upheld.[202]

Above the place where the magistrates sat when examining parties was a representation of the Last Judgment.[203] Also painted in gold lettering on the wall above the entrance were the words "Audi & Alteram partem" (Hear the Other Side),[204] found in other town halls such as those at The Hague and in Gouda, in books providing exempla of justice, and (as displayed in Chapter 13) in twentieth-century courthouses.[205]

Any prisoner who did not admit guilt was examined in another room, with carvings of the "instruments of torture"

FIGURE 41  *Moses Descends from Mount Sinai,* Ferdinand Bol, circa 1663–1666, Magistrates' Chamber, Town Hall (Royal Palace), Amsterdam, the Netherlands.

Photograph copyright: Royal Palace Foundation Amsterdam.

on the wall. There the accused was tortured in the presence of the "sheriff, burgomaster and magistrates" to extract a confession.[206] Torture rooms exemplified the point made by legal historian John Langbein, that "judicial torture" was "part of the ordinary criminal procedure, regularly employed to investigate and prosecute routine crime before the ordinary courts."[207] When admissions of guilt were not forthcoming or eyewitnesses unavailable, torture was used as a predicate to, rather than a punishment after, conviction.[208]

Minor punishments were imposed in the Magistrates' Chambers, but death sentences (followed by executions on scaffolds erected outside the Town Hall) were pronounced in an orchestrated ceremony on the floor below in a second room, called the Tribunal (the Vierschaar in Dutch), also specially appointed to suit its function in the administration of justice.[209] The room was situated so that the Burgomasters could look down through windows on the second floor into it and thereby "give their sanction to the sentencing of the prisoner."[210] Once sentences of death were pronounced in that room, they were irrevocable.[211] The verdicts were "called out . . . so that the crowds outdoors could hear."[212] Not only could passers-by look in and watch the proceedings in the Tribunal from windows that faced the street. Public visibility was the point of the room, providing

the ceremonial setting for the local population to observe the imposition of state power.[213]

## Harming Your Children in the Name of the Law: Solomon, Zaleucus, Brutus, and Death

The Tribunal's iconography tells stories not much heard today—of the pain that those who render judgments must endure. As can be seen from figure 42,[214] a photograph taken from its entrance, the Tribunal is a relatively small marble room. The walls describe what awaited the accused and how making such decisions burdened the judges. On the door used to enter the room are "crossed bones and skulls" and an inscription from Virgil's *Aeneid* that reads, "Be warned; learn to be just, and do not slight the gods."[215] A serpent coiled around bars at the entrance gate represents humankind's fall into sin; executioners' swords and skulls inscribe the themes of guilt, remorse, and pain that run through the room.

The western wall of the room (see figs. 42 and 43) faced the accused, and was what those outside on the street could see. Four large female figures ("two upright . . . and two hiding their faces in shame"[216]) represent caryatids —women enslaved by the Greeks as an "eternal warning" against those conspiring against the state.[217] They not only serve to echo a sense of injury but also appear to hold up the heavy projecting cornice above. Joined by two narrower pillars carved in a floral pattern, the caryatids frame three narrations on the panels behind the magistrates' bench. Told there are stories of Solomon, Zaleucus, and Brutus in reliefs attributed to Artus Quellinus and presumed to have been designed by Jacob Van Campen.[218]

Missing from the room is a commissioned "triptych of the Last Judgment" that was to have been placed above the three

FIGURE 42    Interior of the Tribunal (Vierschaar) on the ground floor of the Town Hall (Royal Palace), Amsterdam, the Netherlands, circa 1655.

FIGURE 43    The west wall of the Tribunal.

Photograph copyright: Royal Palace Foundation Amsterdam.

marble carvings so that the "representations of divine justice would together have completed the significance of the scenes of human justice."[219] The "Chosen" were to have been on the right and the Damned "on the left."[220] That plan changed when the room was redesigned and the center panel, painted by Jacob van Campen, was "never actually installed" but was instead transferred in 1662 to the Amersfoort Town Hall.[221]

As many of the rooms in the Amsterdam Town Hall illustrate, it had become "the fashion" in the Netherlands to follow Ripa's advice that "things written" under iconic images enhanced the viewer's engagement,[222] and therefore that artists should "add verses to a painting's frame to explain its significance and/or symbolic meaning."[223] Yet such written texts are notably absent from the Tribunal, where the images framing the ceremonies of death were thought to suffice.[224] Portrayed by Quellinus are three then-famous stories—the Judgment of Solomon, the Blinding of Zaleucus, and the Judgment of Brutus[225]—designed to appear to onlookers from outside "as a background to the events that took place

within the court."[226] The three panels, spanning Judeo-Christian, Greek, and Roman literature, produce an "international pictorial tradition."[227] While unusual given the marble artistry and the grandeur of the Amsterdam Town Hall, they are of interest because they are in other respects ordinary. The *exempla iustitiae* in this Tribunal were used repeatedly in other buildings and in print.[228] Similarly, scenes of the Last Judgment were, by law and custom, to be posted on town hall walls so that judges could literally see their own fate were they to err. As a Renaissance medal explained, "When kept in view, the punishments of the unjust teach justice."[229]

### *The Judgment of Solomon*

Alongside scenes of the Last Judgment, depictions of Solomon were commonly featured in town halls.[230] Both of these stock images often graced the portals of churches, placed near the outdoor spaces where courts of law were

FIGURE 44 *King Solomon's Justice,* Artus Quellinus, circa 1652, the west wall of the Tribunal.

Copyright: Stichting Koninklijk Paleis Amsterdam; photography: Erik & Petra Hesmerg / Amsterdam.

convened.[231] By the Renaissance, Solomon had come to provide a prototype for the embodiment of wisdom,[232] and he appeared twice in the Amsterdam Town Hall, once in the Council Chamber, where the painting *Solomon Praying for Wisdom* by Govaert Flinck hung.[233] The second, *King Solomon's Justice,* was the centerpiece of the west wall of the Vierschaar. This middle panel (fig. 44) depicts the familiar biblical story of two women, each of whom had given birth to a child. One baby had died, and both women claimed to be the mother of the surviving infant. Solomon's proffered solution—"fetch me a sword" to cut the baby in two—is rejected by one woman, revealing herself to be the true mother through her willingness to give up her child to protect its life.[234] As a Renaissance medal from the 1620s explained: "God's wisdom can be seen in Solomon the pious man, for truly wise is his judgment which adjudicates to the mother her child."[235]

*King Solomon's Justice* served as a reminder that divining truth requires skilled, practical wisdom grounded in knowledge of human emotions.[236] By proposing to kill the child, Solomon elicited new information, as one of the women was said to have responded: "It shall be neither mine nor thine; divide it," while the other offered to forsake her child ("Give her the living child"). Solomon's intervention, in turn, proved his wisdom and confirmed the legitimacy of his service as ruler and judge.

### The Blinding of Zaleucus and His Son and the Execution of Brutus's Children

More challenging than the story of Solomon—for those with the burden of judgment—are the lessons to be learned from the stories of Zaleucus and Brutus, which bracket *King Solomon's Justice* and also depict parent-child stories, but of

a different sort. Zaleucus, shown in figure 45, was known as a "law-giver" in the Greek colony of Locri (in what is now Southern Italy) in the seventh century BCE.[237] He issued an edict that anyone found to have committed adultery was to be blinded.[238]

After his son was found guilty of that crime, Zaleucus, unyielding, insisted on the prescribed punishment. Over protests from his colleagues, who respected and pitied him, Zaleucus ordered his son to lose only one eye and gouged out one of his own as well.[239] Thus, according to the Roman author Valerius Maximus in his *Memorable Doings and Sayings,* Zaleucus "rendered to the law a due measure of retribution, by admirable balance of equity dividing himself between compassionate father and just lawgiver."[240]

But mercy did not protect the next set of sons, executed at the order of their father. The *Judgment of Brutus* (fig. 46), another of the "traditional subjects for decorating" tribunals,[241] comes from the Romans by way of the historians Livy and Valerius Maximus. Lucius Junius Brutus was the first consul of the Roman Republic following the overthrow of the monarchy in Rome in 510 BCE.[242] Brutus's two sons—Titus and Tiberius—joined a conspiracy to return the monarchists (the Tarquins) to Rome. According to Livy, Titus and Tiberius preferred the benefits of affiliation with the royal family to the strictures of the Roman Republic's law, which "was impersonal, inexorable. Law has no ears."[243]

Upon learning of his sons' treachery (according to Maximus), Brutus "put off the father to play the Consul, and preferred to live childless rather than fail to support public retribution."[244] To comply with his duties, he sentenced his sons—along with their co-conspirators—to death. In the Amsterdam panel, Brutus is shown ordering the punishment to proceed and watching its infliction.[245] Looking into the Tribunal from the street, observers could see one dead son and the second bound and about to be decapitated by a man wielding a large axe. Behind them in the center is the symbol of Rome, the she-wolf with Romulus and Remus at her feet.[246]

Whether the *Judgment of Brutus* was a lesson to be embraced has been debated. One interpretation is that justice and punishment ought to supersede family ties, making fathers who order and watch their children's executions admirable. Yet, not long after Livy wrote, both Dionysius of Halicarnassus and Plutarch focused not only on Brutus's commitment to the Roman Republic's law but also on the beastliness of the execution scene.[247] By early "Christian times, doubts gather[ed]" as "divergent variants" of the story emerged.[248] Centuries later, however, Machiavelli insisted on its merits: "*When Liberty has been newly acquired it is Necessary in Order to maintain it to 'Kill the Sons of Brutus'* . . . and he who establishes a free state and does not kill 'the sons of Brutus', will not last long."[249]

The story of Brutus continued to have currency in France and England during the era of the French Revolution, when its "democratic" implications as well as its insistence on the righteousness of executing those who wronged the state had special appeal.[250] Jacques-Louis David, likely inspired by Voltaire's play *Brutus,* painted the scene in 1789 (*The Lictors Returning to Brutus the Bodies of his Son*),[251] and the composition of that painting, in turn, was the basis for a staging of the play.[252] In debates in the 1780s about the framing of the Constitution in the United States, a pamphleteer opposed to ratification used the pseudonym Brutus when publishing eighteen essays.[253] In the following century, Wordsworth (who had been in Paris in 1791) approvingly invoked Brutus's judgment in his *Sonnets upon the Punishment of Death.*[254] In England in the 1860s, the popular public preacher Charles Spurgeon relied on Brutus for his admonition: "See you not here how he loves his country better than his son, and he loves justice better than either."[255]

The proposition that sacrifice out of loyalty to a republic entailed placing the state's law before one's familial attachments (choosing "patriotism" over "paternity"[256]) was reiterated through other images in the Amsterdam Town Hall. In the Burgomasters' own chambers they viewed a painting *Quintus Fabius Maximus Orders His Father to Dismount,* by Jan Lievens. There told was another Roman story, coming from Livy as well as Plutarch,[257] and explained in lines inscribed beneath that were written by the poet Vondel:

> The Son of Fabuius bids his own Father
> Dismount from his horse, before the city's
>     honor and dignity
> Which knows no blood, and demands that he
>     approach respectfully.
> Thus a man honors the State in the office laid
>     up for him.[258]

The narratives of the painful burdens entailed in administering justice were found in much plainer town halls, sometimes joining other such stories to insist that leaders and judges prove their fidelity to the law by harming their families or themselves. Proof of the even-handedness of judgment came from ordering the execution of one's relatives, friends, subordinates, or soldiers. In addition to many renditions of Zaleucus and Brutus, local governments surrounded themselves with pictures of other leaders who were then well known, such as the Judgment of Trajan and the Judgment of Count Herkinbald.

Renditions were painted by Rogier van der Weyden sometime between 1430 and 1440 for the Brussels Town Hall[259] and placed to face the judges, while the accused saw a scene of the Last Judgment behind the jurists. Trajan gained his heroic stature through ordering that his own soldier, accused of murdering a widow's son, be executed. Thereafter, the story went, Trajan's tongue (the "instrument of just judgment") was miraculously preserved in his skull and discovered by Pope Gregory the Great.[260]

Herkinbald, too, was the subject of special grace. When he was close to death, he cut his nephew's throat because

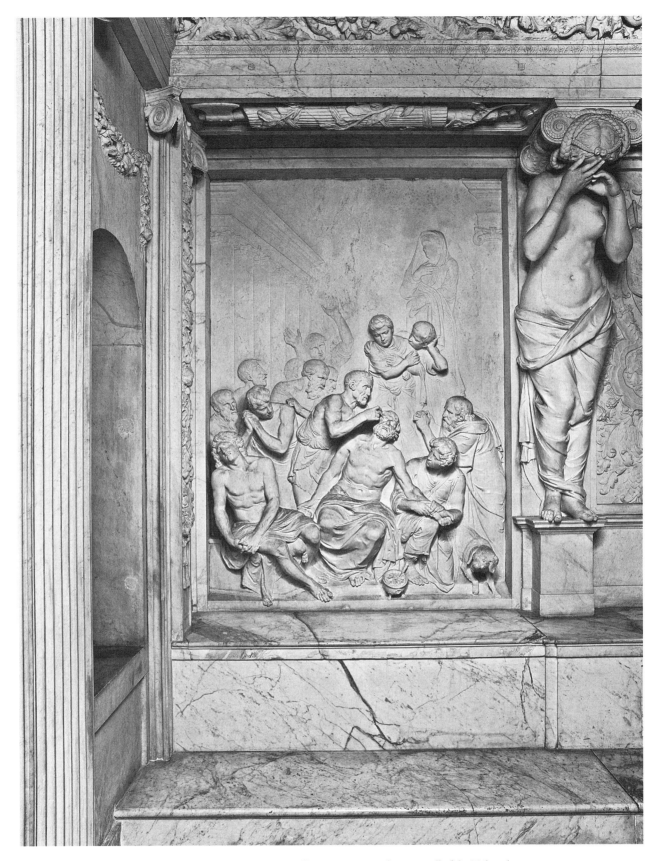

FIGURE 45    *Zaleucus,* Artus Quellinus, circa 1652, the west wall of the Tribunal.

Copyright: Stichting Koninklijk Paleis Amsterdam; photography: Erik & Petra Hesmerg / Amsterdam.

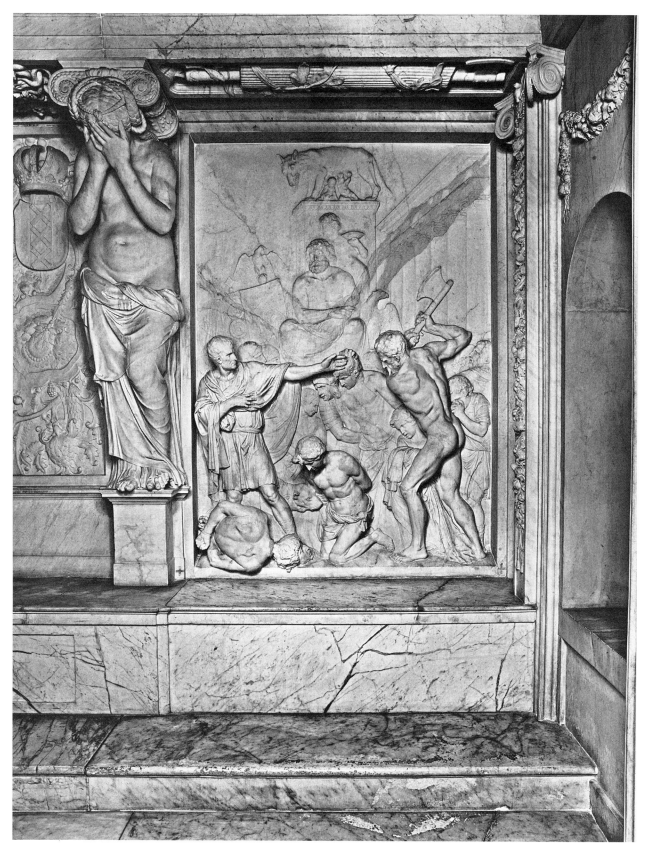

FIGURE 46  *Brutus,* Artus Quellinus, circa 1652, the west wall of the Tribunal.

Copyright: Stichting Koninklijk Paleis Amsterdam; photography: Erik & Petra Hesmerg / Amsterdam.

that nephew had raped a woman. But because the murder of a relative is a mortal sin, a bishop refused to administer the last rites. Herkinbald's vindication came through "divine intervention"—the heavenly "Host" flew "into his mouth," and thus last rites were administered.[261] When these paintings were hung in Brussels, Latin texts accompanied them to underscore the justness of the judges.[262]

The Basel Town Hall provided a yet more dramatic commitment to the rule of law in the personage of Charondas of Catanea, who joined Zaleucus and others on the walls.[263] A law-giver from Thurii, he decreed that no one could wear armor in a public assembly. When he inadvertently violated his own rule, he was said to have exclaimed: "By Zeus! The law shall be master," and then killed himself.[264] As Ian Donaldson put it, "celebrated acts of Roman virtue tended to be acts of extraordinary self-control, self-mutilation, or self-destruction."[265]

## "SO SHALL YOU BE JUDGED"

Just as the images of Cambyses and *Les Juges aux mains coupées* were hortatory efforts to establish norms, the many displays of narratives putting law above family were normative efforts to lay claims to ideals not fully actualized. Amsterdam was a "family town" run by members of a few families. Four burgomasters, chosen from a pool of former burgomasters and magistrates, governed; as a result, "the same people" served "again and again."[266] These officials, in turn, had the power to select the town's sheriff and virtually all employees of public institutions.[267]

The ideology of the familial pervaded the self-understanding of both Amsterdam and the Dutch Republic, of which it was a part. By showing scenes of fathers enforcing laws at the price of doing harm to their sons, leaders of the Dutch Republic sought to explain that imposing punishments on their surrogate children—the local populace—in the name of the law[268] gave them no joy. Yet they were obliged to do so, for as Vondel had written: "The free state flourishes, when people respect the laws." But they were also trying to persuade themselves to make good on a promise of law-before-self—to put the state before loyalty to their families.[269]

One distinction between Justice narratives in European town halls and those presented by contemporary courts is this refrain—that the imposition of judgment is hard, taking a deeply personal toll as one serves the state. Judges were always themselves on the line ("so shall you be judged"), at risk of damnation for errors.[270] And even when upright and incorruptible (neither to be flayed as Cambyses nor delimbed like the Thebans), they were burdened by their obligations. Devotion to the law came at a cost.

Modern-day rulers turn less often to allegory but, when they do, they rarely offer scenes reflecting on the burdens of judgment. Contemporary observers recognize a statuesque woman with scales and sword as Justice but have not been schooled in Cambyses, Zaleucus, and Brutus or provided with comparable sagas about the harshness of law and the weight of imposing judgment.

By skimming centuries and moving across jurisdictions, we have captured the motifs about the imposition of justice. We do not ignore the diversity within the various allegorical paintings, statues, frescoes, and friezes. Not only were the visual depictions varied, they sat in differing polities and legal systems. And, of course, reading the images—then and now—one can find different kinds of messages proffered. Some served as warnings to judges, threatening them with the loss of life, limb, and skin if they failed to be honest or loyal and subservient to the power of the state. Other scenes demonstrated that to be the loyal servants of the state, applying its laws, judges had to inflict pain on themselves. In contrast, the paintings of the *Judgment of Solomon* capture something about what it takes—practical wisdom and a deep understanding of human emotions—to generate the information necessary to make good judgments.

But note the constants: these messages were set, time and again, in settings created for the public. Ruling powers created spectacles and built structures to link themselves to history and religion so as to convey the legitimacy of (rather than to render opaque or obscure) the violence of the law.[271] Violence, death included, was part of a legal system's prerogatives. Law was used to justify authority, and that authority was produced and reinforced through public representations of law as an explanation for violence.

# Of Eyes and Ostriches

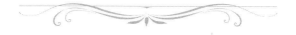

## BLIND TO THE LIGHT AND BLINDFOLDED BY THE FOOL

Subservience to the state and the pains of judging were not the only messages that the allegorical imagery of the Renaissance sought to entrench. Calls for judges not to favor the rich over the poor and injunctions against bribery reflected aspirations for some form of even-handedness. Maxims such as "Hear the Other Side" ("Audi & Alteram partem") in the Amsterdam Town Hall stressed that the legitimate exercise of authority should be grounded in knowledge gained from disputants. Fair and transparent decisions by democratic governments in the current sense(s) of those words were centuries away, yet adjudication provided one prototype for how rulers ought to behave. Thereafter, shifts in sovereignty under democratic precepts replaced the norm of judicial subservience, elaborated in Chapter 3, with that of judicial independence, as discussed in Chapters 5, 6, and 13.

Because aspects of Renaissance judicial ideology have contributed to contemporary thought about judicial obligations, some modern viewers look at the occasions in which Renaissance Justices were shown blindfolded and assume that covered eyes then denoted what they are claimed to represent today—impartiality. As explored in the next chapter, whether a blindfold is appropriately deployed in service of that value is a distinct, and a contested, question. Before moving to that debate, a richer understanding of the use of blindfolds is in order. Like many other symbols, blindfolds were demonstrably polysemic, which is to say that their import changed over time and place.[1] Although the blindfold has come to be valorized, it was once seen—as cartoonists often use it today—to denote a disabled Justice, blind to or hiding from the truth. In this chapter, we trace that shift in meaning.

To do so, one more aspect of the Tribunal in Amsterdam —its *Justice* (fig. 47[2])—needs to be analyzed. Carved and positioned to face the magistrates as they pronounced the sentence of death, she is one of many Justices in Amsterdam's Town Hall. But she alone is shown blindfolded.

## The Blindfolded *Justice* in the Amsterdam Tribunal

The *Justice* shown in figure 47 is one of two Virtues that stood across from the sheriff and magistrates in Amsterdam's Tribunal. In the photograph of the Tribunal's east wall (fig. 48[3]), one can see these two full-size marble female figures by Artus Quellinus—looking "like statues although they are carved in low relief."[4] They grace the shallow niches that bracket the windows through which spectators outside could see the proceedings within. *Prudence* looks at her mirror[5] and (perhaps) across at *Justice,* who has an upright sword in her left hand. This Justice is no longer intact, missing both her left hand and the scales that she once held.[6]

Like *Prudence, Justice* appears to be leaning into the room as if to watch the proceedings. But she cannot see, for her eyes are covered with what today we call a blindfold (or "the Blindfold of Justice"[7]), and what in earlier centuries was sometimes termed a "bandage." Not only is she unlike all the other Justices inside and outside the Amsterdam Town Hall; her blindfold was not then a standard attribute for Justice. Nor, we believe, was that blindfold intended to be read unambiguously as celebrating Justice's impartiality. Rather, for Medieval and Renaissance audiences, the blindfold was laden with negative connotations. Sight was the desired state, connected to insight, light, and the rays of God's sun. That point is made repeatedly in the Amsterdam Town Hall, itself rich with a visual didacticism referencing the value of sight.

The Town Hall's designers used pictures to preach, and several of the images that they chose underscored the importance of sight. *King Solomon's Justice* (fig. 3/44) was proof that the wise judge was a keen observer of human behavior. He gained new evidence of an infant's maternity by proposing to split the baby in half and then watching the responses of the two women claiming the child. Furthermore, the punishment that Zaleucus (fig. 3/45) was to impose on his son—and that he mitigated by mutilating himself as well—was the loss of sight.

FIGURE 47  *Justice*, Artus
Quellinus, 1655, the east
wall of the Tribunal
(Vierschaar) of the
Amsterdam Town Hall
(Royal Palace), Amsterdam,
the Netherlands.

Copyright: Stichting Koninklijk
Paleis Amsterdam;
photography: Erik & Petra
Hesmerg / Amsterdam.

As for the Virtue Justice, the attributes that had by then
come to mark a statuesque woman as Justice were her scales
and sword. The point of even-handedness was made
repeatedly through the balanced pans on Justice's scales, as
is reflected in the three Justices in the Town Hall that are
attributed to Artus Quellinus and that share common
detailing.[8] The clear-eyed *Justice* who sits on top of the
Town Hall's roof (fig. 3/38), another with unobstructed
vision sculpted to mark the door of the Magistrates' Cham-
bers (fig. 3/39), and the one inside the Tribunal (fig. 3/40)
all wear Grecian robes and have similarly styled hair. Each
holds a sword in one hand and scales in the other, just as
Quellinus's two *Prudences*—on the roof (fig. 3/38) and

inside the Tribunal (fig. 48)—wear similar garb. Although
Ripa's *Iconologia*, a resource for much of the imagery in the
Amsterdam Town Hall, mentioned a blindfold as a possible
accoutrement (there explained as a protection from "temp-
tation"[9]), that suggestion was generally not followed—
except in the Tribunal.[10]

Why was a blindfold imposed on this *Justice* but not on
others? The addition should be read in the context of the
dominant pre-humanist tradition in which the blindfold
signified a disability. Moreover, because the blindfolded
*Justice* is buffered from seeing the violent pain meted out in
her name, those who selected that design could have qui-
etly questioned what transpired in the one room in the

FIGURE 48    The east wall of the Tribunal with *Justice* and *Prudence*.

Copyright: Stichting Koninklijk Paleis Amsterdam; photography: Erik & Petra Hesmerg / Amsterdam.

Town Hall dedicated to rendering irrevocable sentences of death. For, just as a lack of sight could limit "temptation" undermining even-handedness, so could it facilitate error. The blindfold could denote either a Justice gone awry or one averse to seeing punishments (even when lawful) imposed in her name.

### "Open the eyes that are blind"

The idea that sightlessness is problematic, and sometimes unequivocally bad, can be found throughout the cultures and literatures explored in this volume. In Babylonia and Egypt, sun gods—the sources of light that enabled sight—were also gods of justice;[11] thereafter, the Greeks and Romans put a representation of the sun at the center of their zodiacs. Christianity embraced "sol justitiae"—Christ—as the God of Light, who will "appear ablaze when he will judge mankind."[12] Medieval Europe saw depictions of the Virtue Charity holding a torch to denote the light of

God.[13] Within the Amsterdam Town Hall itself are carvings of the "eye of God"—seeing and knowing all.[14]

Such imagery is predicated on classical and biblical texts that repeatedly cast light as representing truth and darkness as misguidedness.[15] The parallel was that the sighted were informed and the blind limited. As either fact or metaphor, blindness signified a variety of deficits. Blindness is not the equivalent of the willful act of being blindfolded. Yet, the rare mentions in biblical texts of blindfolded persons make plain that they were disadvantaged.[16]

Examples come from the Old and New Testaments, in which blindness precluded a person's entry into holy areas. Further, no blind animals could be offered to God.[17] To be struck blind[18] was, in turn, a form of punishment imposed by God. Moreover, when humans punished each other, they sometimes put blindfolds on their victims. Jesus himself was made sport of—blindfolded, beaten, and mocked.[19] Metaphorically, blindness exemplified ignorance or abandonment (to "turn a blind eye"[20] or to rush blindly for-

ward[21]) and impaired judgment.[22] Bandaged eyes also served as a disguise, misleading the viewer,[23] and blind persons were themselves dependent ("A curse upon him who misdirects a blind man").[24]

Canonical stories exemplify these motifs. The Old Testament patriarch Isaac was deceived because he could not see and therefore bestowed his blessing on his son Jacob instead of on Esau, his elder son.[25] At Mount Sinai, when the people had turned away from their god, Moses veiled his face.[26] In contrast, the revelation at Sinai of God's commandments is rich with references to the "appearance of God"; a text from *Exodus* explains that "on the third day the Lord will descend upon Mount Sinai in the sight of all the people."[27] Parallels can be found in the New Testament, for Paul described his beliefs in visual terms; "whenever he [Moses] turns to the Lord the veil is removed."[28] Isaiah promised "to open eyes that are blind" and to "lead blind men on their way."[29] At several points, God, Jesus, or faith itself cured those who were blind.[30] Turning to classical texts, in *Oedipus Rex* the hero, who has blinded himself, was told, "You would have been better off dead than blind."[31] And blindness was the punishment that Zaleucus decreed for violations of his law (fig. 3/45).

As for the relationship between judgment and sight, according to *Exodus,* "bribery makes the discerning man blind and the just man give a crooked answer."[32] Further, the *Book of Job* explains: "The land is given over to the power of the wicked, and the eyes of its judges are blindfolded."[33] Isaiah proclaims: "The prophets should be the eyes of the people, but God has blindfolded them."[34] These biblical lessons became fixtures in Medieval and Renaissance literature and art, which reiterated that bandaged, covered, or blindfolded eyes—as well as those who were physically blind—signified profound limitations.

Exceptions exist. "The bard is expected to be blind,"[35] and a few literary figures were ennobled by or compensated for their blindness so as to become gifted seers. Sightless seers dot Greek epics,[36] and both Homer and Milton provide conspicuous examples of visionaries whose insights came from sources other than their eyes.[37] Blindness sets a person apart, perhaps suggesting that gifts of prophecy make the blind closer to God. Yet in *The Iliad* and *The Odyssey,* metaphoric blindness also denoted folly, infatuation, and disaster brought about by impairment of the sense of sight.[38]

More generally, the physically blind were portrayed as objects of pity in need of charity. Alternatively, by the Middle Ages, blind personifications were sometimes "endowed with terrifying power."[39] (A blindfolded Death was shown to be a female disemboweling victims, Lust a blindfolded female nude, and Night a woman whose eyes were covered with a bandage.[40]) Such imagery prompted Moshe Barasch —in his book devoted to exploring the idea of blindness— to conclude that "blindness is indissolubly linked with distress."[41]

## Synagoga: Blind to the "Light" of Christianity

Two female figures—Synagoga and Ecclesia—and the iconography and literature that surrounded them inscribed blindness as a liability. Synagoga, "a purely Christian creation," was deployed to signify the Old Testament and, sometimes, Jews in general.[42] Ecclesia stood for the New Testament and, at times, Christianity. These two were familiar fixtures in Medieval Europe, to be found "on ivory tablets, in stained-glass windows, on church implements, in manuscript miniatures, and in monumental statuary."[43]

The examples reproduced in figures 49 and 50 are a famous pair,[44] crafted around 1230 and in place today on the south portal of the Strasbourg Cathedral,[45] near the border of France and Germany in the City of Strasbourg, which is now in France.[46] The statues were placed near two areas (one outside and the other indoors) that served "as courts of law" in the thirteenth century, where marriages were ceremonialized, municipal laws determined, oaths taken, and tributes given.[47] A sculpture of Solomon sat between the doors to the south entrance.[48] Comparable sets of Ecclesia and Synagoga—in stone or on stained glass— from roughly the same period can be found at the Cathedrals of Rheims and of Bordeaux in France, as well in several German Cathedrals, including in Bamberg, Magdeburg, and Worms, and in England at Lincoln, Salisbury, and Canterbury. The well-known figures on the west facade of the Cathedral of Notre Dame in Paris (near a door called the "Portal of the Last Judgment") are nineteenth-century versions, perhaps replicating earlier images.

The variation in depictions of Synagoga reflect the complexity of relations between Christianity and Judaism. Because the Old Testament is an important source for New Testament traditions, some versions of Synagoga have a measure of dignity, acknowledging that the New Covenant built on as well as (from the vantage point of Christianity) rose above the Old Covenant.[49] Echoes of that approach can be seen in figures 49 and 50, for *Synagoga* is almost the same height as *Ecclesia.* But unlike that ramrod-straight, crowned, sharp-eyed, regal woman (the "bride of Christ"), *Synagoga* is a fallen queen, shown slumped with her rod broken and her eyes covered by a blindfold.[50] Their hierarchical relationship is plain.[51]

Among Synagoga's attributes, the blindfold was her "principal motif," demonstrating that she was blind to the "light" of Christianity.[52] Yet, the bandage around her eyes suggested that her fault could have been remedied. Synagoga was not blind but blindfolded—willfully obstinant, refusing (rather than unable) to comprehend the "light of redemption."[53] Other versions of Synagoga were more aggressively hostile, reflecting antagonism toward Jews and the spread of anti-Semitism.[54] In those iterations Synagoga is not only blindfolded but made to look demonic—shown with a serpent wrapped around her head, on a donkey, holding a goat's head (denoting lust) or disheveled, with

FIGURE 49    *Ecclesia,* circa 1230, Cathedral,
Strasbourg, France.

Photograph copyright: Foto Marburg/Art Resource, New York, NY.

FIGURE 50    *Synagoga,* circa 1230, Cathedral,
Strasbourg, France.

Photograph copyright: Foto Marburg/Art Resource, New York, NY.

transparent draped clothing reminiscent of that worn by prostitutes.[55] At Bamberg Cathedral, Synagoga stands on a pillar near a "figure of a Devil blinding a Jew, identified by standarized iconography—beard and pointed hat."[56] Other imagery associated her with various Vices, such as falling like Pride, or linked to Greed.[57] Given these many statues on Medieval churches, Synagoga was an image that "almost everybody, whether educated or illiterate," recognized.[58]

Synagoga was also featured in Medieval dramas in which biblical characters (Elijah and Enoch) remove her "veil, which until then has covered her eyes. Her blindness is cured, and she perceives her error," declaring her belief in Christ's gospel.[59] Synagoga's blindness reflects Catholic liturgy going back centuries. A prayer to be said on the Friday before Easter calls on God to "remove the veil" from the hearts of Jews and to be merciful; given "the blindness of that people; that, acknowledging the light of thy truth, which is Christ, they may be delivered from their darkness."[60] (After World War II, the text was revised, so that individuals prayed "for the Jews: Our Lord God deign to let your face shine upon them, so that even they may recognize the redeemer of all, our Lord Jesus Christ."[61] In 2008 the prayer was again reworded to call on "God to enlighten their hearts so that they may acknowledge Jesus Christ, the savior of all men."[62])

Synagoga was not alone as an embodiment of the harm that blindfolds imposed. Renaissance images of romance and love placed a blindfold on Eros to mark the misguided nature of love, engendering foolishness and confusion.[63] Renaissance depictions of the female image of Fortuna—including illustrations in some versions of Ripa's *Iconologia*—often showed her blindfolded to denote Fortune's irrationality and randomness, indifference to human suffering, and at times its destructive force. Fortuna's caprice resulted in unfairness, "without any apparent rhyme or reason."[64] Blindfolded Eros and Fortuna expressed a fusion of supernatural power and sinfulness."[65]

Closer to law, images of executed criminals showed them hanging, blindfolded and disgraced. Lorenzetti's *Allegory of Good Government* (fig. 2/26) in Siena is one such example.[66] The negativity associated with blindfolds prompted Erwin Panofsky to conclude that, aside from a valorized blindness in Homer and the blindfolded Justice herself (a "humanistic concoction of very recent origin"), blindness was "always associated with evil."[67]

## Justice and Judges as Fools

Panofsky's suspicion of the positive slant put on Justice's blindfold is borne out by turning to another important European image, *The Fool Blindfolding Justice* (fig. 51). This woodcut, sometimes attributed to Albrecht Dürer,[68] was one of more than a hundred illustrations for a book called *The Ship of Fools*.[69] Written by Sebastian Brant in 1494, sub-

sequently printed in many languages,[70] and full of "middle-class moralizing," the volume was remarkably well known through the seventeenth century,[71] and the metaphor of its title has endured in contemporary books and movies.[72] Brant's 112 chapters of stories and images[73] offer a host of instructions aimed at sustaining the moralism of the Reformation's civic authorities in their battle with "sin and crime in the name of God."[74]

*The Fool Blindfolding Justice* is one of the earliest images known to show a Justice with covered eyes.[75] The deployment is derisive, evident not only from the fool but from the chapter that the illustration accompanied—"Quarreling and Going to Court."[76] Indeed, a reader of *The Ship of Fools* can have no doubt of the author's attitude toward blindness. Brant, who was a noted lawyer and law professor, trained (as he said at the front of the book) in both civil and canon law, saw blindness as a fault. He prefaced the book with a warning against "folly, blindness, error, and stupidity of all stations and kinds of men."[77] In the chapters that follow, Brant repeatedly equated blindness with sin, ignorance, and mistakes.[78]

The artist who created *The Fool Blindfolding Justice* was not the only one of his era to deploy a blindfold as a warning against judicial error. An illustrated 1507 volume, *Die Bambergische Halsgerichtsordnung* (also known as the *Bambergensis Constitutio Criminalis*), setting forth the criminal law and municipal ordinances of the City of Bamberg,[79] included a parallel woodcut, *The Tribunal of Fools* (fig. 52).[80] A presiding judge (marked by his clothing, his rod of office, and his place of honor on the throne) and four lay colleagues are all blindfolded; they also wear jesters' caps. The legend on the scroll shown above their heads reads: "Out of bad habit these blind fools spend their lives passing judgments contrary to what is right."[81]

This woodcut is one of more than twenty appearing in editions of the *Bambergensis* published in 1507, 1508, and 1510.[82] Near the volume's opening is a scene of the Last Judgment in which Jesus sits on what looks like a rainbow.[83] Angels are at both of his sides, while supplicants, at the bottom, are either being called up to heaven or damned to hell. Other illustrations show various devices for punishment, their use, and several courtroom scenes.[84] *The Tribunal of Fools* was not the only critical image; two in a 1507 edition make a point about corruption, as rich litigants make payments to judges.[85] The illustrations in these turn-of-the-sixteenth-century German volumes are among the first (identified to date) that show either Justice or judges blindfolded. Their circulation grew by virtue of the printing press, but the confidence that readers would see the blindfold as derisive relied on the negative associations gained from blindfolds placed on Synagoga, Fortuna, and Eros.

Various hypotheses have been advanced about why the blindfold gained currency in law and how its meaning shifted over time.[86] Skepticism about law and justice has been linked to the Reformation, the Inquisition, human-

FIGURE 51 *The Fool Blindfolding Justice,* sometimes attributed to Albrecht Dürer, 1494, a woodcut illustrating Sebastian Brant's *The Ship of Fools,* printed in Basel, Switzerland.

Image courtesy of Beinecke Rare Book and Manuscript Library, Yale University.

ism, the codification of Roman law, the growth of the legal profession, and the diversity of universities training new lawyers, as well as to conflicts developing around city-states in their relations to religions and to more distant secular authorities. *The Ship of Fools,* reflected Brant's loyalty to Roman law and his view that the German legal system was in disarray, plagued by local and foreign advocates able to manipulate lay judges.[87] Brant made his arguments in the vernacular German so as to reach an audience of lay judges and to teach them the "essentials of Roman as well as customary law." He urged that they not "vacillate in their opinions or believe that law grows on trees or dream that one does not heed what our parents thought."[88]

In 1495, the year after the publication of the first edition of *The Ship of Fools,* Emperor Maximilian formally adopted Roman law,[89] and in 1507 the *Bamberg Code* was instituted in another effort to guide lay judges. Its illustration of blindfolded and dunce-capped judges leveled a critique parallel to that of Brant.[90] The *Bambergensis,* in turn, was followed in 1532 by the *Consitutio Criminalis Carolina,* modeled after the *Bamberg Code* and adopted by Charles V in an attempt to standardize criminal procedure in parts of Germany.[91] Nicknamed the *Carolina,* adopted in many city-states including Cologne and Frankfurt, and cited elsewhere as authority,[92] this code continued the effort "directed against abuses caused by the legal ignorance of local court personnel" by informing "unlearned practitioners about the rules of law."[93]

Auff böß gewonhat vrteyl gebar
Die dan rechten widarstreben
Ist disar blinden narren leben

Abb. 76. Verspottung der ungerechten Richter. Holzschnitt aus: Bambergische Halsgerichtsordnung. Mainz, Joh. Schöffer, 1510.

By putting blindfolds over judges' eyes, the illustrators of *The Ship of Fools* and the *Bambergensis* reminded viewers of the ease with which such judges could be deceived. Their visual injunctions could be translated to read that "rather than be a buffoon, use your eyes to follow the written rules." These materials were part of a larger effort to professionalize law, to dispossess lay jurists of their authority, and to promote law's codification. The negativity of the blindfold was part of a message about the superiority of Roman statutory law over the customary law used by German lay judges.[94]

### Alciatus's Theban Judges and Ripa's Injunctions: "A Steely Gaze," the Eye of God, and Bandaged Eyes

The project of codifying law, exemplified by *The Ship of Fools* of 1494 and the *Bamberg Code* issued in 1507, came shortly before a parallel effort to codify visual imagery. As explained in earlier chapters, two major catalogues—the 1531 *Index Emblematicus* of Andreas Alciatus and the 1593 *Iconologia* by Cesare Ripa[95]—joined a few books on Egyptian hieroglyphs (published between 1499 and 1505)[96] in standardizing an emblematic lexicon for artists and viewers.[97]

Through our discussion of *Les Juges aux mains coupées* (figs. 3/34 and 3/35), we began to explore the impact of Alciatus's emblem called *The good Prince in his Council* (fig. 3/33), with its central figure who might (or might not, depending on the edition) be shown with covered eyes, joined by his fellow judges, shown with their hands cut off. Alciatus's book was published a few decades after the *Bambergensis,* and the jurists depicted with the prince bear some resemblance to those shown in figure 52, *The Tribunal of Fools.* In the two German volumes, the blindfolded, dunce-capped Justice or judges are mocked. But in the various editions of Alciatus, the sightless central figure (called a prince, a king, or a judge and described as "without eyes," "deprived of his sight," or "blind") is presented as better positioned to judge because of his lack of vision. The explanation (given via a 1542 German version) was "that he may recognise no-one's status and . . . judge according to his council."[98] A French edition of 1536 put it slightly differently: "Their prince, deprived of his sight, cannot see anybody, and he judges by due sentence according to what is said in his ear."[99]

Yet elsewhere in Alciatus's work sightlessness and blindness were shown to be a punishment. For example, in the emblem called "Just Vengeance" Ulysses puts his stake into the eye of the Cyclops and blinds him.[100] The 1549 Italian version explains that the wrong-doer "may suffer bad things, since he caused them." As noted, the blindfold also has a negative valence, linked to the dishonorable lust of an amorous Cupid.[101] Further, in another emblem, "Mutual Aid," blindness is an incapacity; a blind man and a lame man help each other, one providing sight for guidance and the other feet for mobility.[102] A few decades later, toward the end of the sixteenth century, Ripa reiterated the theme of blindness as a disability. Although the first publication of his *Iconologia* in 1593 was without illustrations, the more than forty subsequent versions in different languages came with various drawings and embellishments.[103]

Ripa described the bandage or blindfold on "Fortuna" as evidence of the arbitrariness of caprice, and he (like Alciatus) provided a blindfold for Eros to represent the foolishness of emotions. Ripa proffered a blindfold to exemplify the indiscriminate force of Ambition ("Ambizione")[104] and put a blindfold on a man called Error ("Errore"), who—cloaked and with covered eyes—accompanied Ignorance ("Ignoranza"),[105] a female who was sometimes also blind, as that lack of knowledge put her in "the shadows" rather that in the "light" of wisdom.[106] The blindfold that Ripa put on Furor ("Furore"), a large, angry, blindfolded man holding various weapons, denoted the loss of control from rage.[107] Prodigality ("Prodigalità") is shown with veiled eyes as she pours out the contents of a cornucopia.[108] Simony ("Simonia," the selling of Church offices), enveloped by a black veil, is a woman covered with sores.[109] Slander is also a woman, open-mouthed and shading her face with a veil.[110] In a later edition of Ripa, Sin is shown as a blindfolded man because "the blindfold is an obvious allusion to the willful blindness to God's commandments of the man who sins."[111] Injustice herself has one blind eye.[112]

And yet Ripa accorded the blindfold a positive valence when placed on the face of one of his seven iterations of Justice. In an illustrated edition published first in Padua in 1611, Ripa described one Divine Justice ("Giustitia Divina") and six variations on "Worldly Justices"[113]—Justice ("Giustitia"), Justice According to Aulus Gellius ("Giustitia . . . che riferisce Aulo Gellio"), Principled (or Strict) Justice ("Giustitia retta"), Rigorous Justice ("Giustitia rigorosa"), Justice of Pausanias in the Eliaci ("Giustitia di Pausania ne gl'Eliaci"), and Justice on the medals of Hadrian, Antoninus Pius, and Alexander ("Giustitia delle Medaglie d'Adriano, d'Antonio Pio, & d'Alessandro").[114] All but one were clear-sighted, and sight itself is specifically admired for various of the Justices. For example (as noted in Chapter 3), Ripa's "Justice According to Aulus Gellius" is supposed to have "acute vision" or "piercing eyes."[115] She also wears a necklace where "an eye is portrayed" because "Plato said that Justice sees all and that, from ancient times, priests

were called seers of all things."[116] The sole blindfolded one, called simply Justice and detailed in various editions, had many other attributes. A 1611 version is excerpted below.

> A woman dressed in white with bandaged eyes; in her right hand she holds a bundle of rods, with an axe, and in her left hand a fiery flame, together with these things she has an ostrich at her side, and holds a sword and scales.
>
> This is the type of Justice that is exercised in the Tribunal of judges and secular executors.
>
> She is wearing white because judges should be without the stain of personal interest or of any other passion that might pervert Justice, and this is also why her eyes are bandaged— and thus she cannot see anything that might cause her to judge in a manner that is against reason. The bundle of rods with the axe, used in ancient times in Rome to show . . . that justice must not be remiss in punishing wrongdoing but that justice must also not be precipitous . . . .
>
> The ostrich teaches us that the things that come before justice, however intricate they may seem, must be tirelessly unraveled with a patient spirit, as the ostrich digests iron, that most durable material, as many authors recount.[117]

Later editions of Ripa reiterated versions of this description. For example, the 1644 Dutch edition reads: "Her eyes are bound to show that the judge, in evaluating a given case, is not tempted away from using reason."[118]

Where did Ripa get this blindfold, and why did he put it on one of his seven Justices? One possible source is Alciatus, who was not mentioned by Ripa in connection with the blindfolded Justice but was cited as a source for other attributes of Justice—a river and a pillar, purportedly denoting purity and uprightness and therefore appropriate for law and justice.[119] Ripa may also have used the same sources as Alciatus—the "Egyptian" allegory "transmitted by Plutarch and Diodorus Siculus in which the chief justice was shown eyeless in order to illustrate his impartiality, while his colleagues had no hands with which to take bribes."[120] But as Erwin Panofsky argued, blindfolds were not generally valorized in the Renaissance, and the "motif [of the blindfold] is limited to representations of Worldy Justice, whereas Divine Justice has 'occhi miri' "[121]—"piercing and awe-inspiring eyes."[122]

## Bruegel's Justice (or Injustice?)

The varied import accorded blindfolds by Alciatus and Ripa makes plain that twentieth-century theorists were not the first to appreciate that the meaning of symbols differs

with contexts conveying conflicting connotations.[123] Even before Alciatus and Ripa, one can find occasions on which veiled eyes indicated humility rather than humiliation.[124] The blind love of the Renaissance expressed not only adoration's folly but also its unquestioning acceptance, sometimes associated with divinity, illustrated by *Proverbs* 10:12: "Hate is always picking a quarrel, but love turns a blind eye to every fault."[125] Even Fortune's blindfold had an upside, for she "does not favor one over the other,"[126] although the results were profoundly arbitrary.

If looking back from contemporary assumptions that the blindfold denotes impartiality, one may miss the contradictory meanings that could be drawn from the layers of bandages on Justice's eyes.[127] Our sense that the Amsterdam Tribunal's one blindfolded Justice could both be influenced by Ripa and be grounded in the traditions of Synagoga, Fortune, and Death is predicated on her singularity in that building and the relative rarity of blindfolds in that era.

Another derisive application comes from Pieter Bruegel the Elder, whose *Justice*, drawn around 1539, was reproduced many times in prints of his series of Virtues and Vices.[128] In an engraved version (fig. 53[129]) by Philip Galle from the late 1550s, a figure labeled "Justicia" is at the center of a large crowd. The densely populated scene includes persons whose garb indicates their class, with the well-to-do seeming to control or direct the actions of poorer people.[130] Administrative details (adding a "documentary-like" quality) are everywhere,[131] such as officials recording information and marking criminals for execution.

In the foreground, to the left of Justice, a man is shown stretched on a rack while fluid is poured down his throat. The picture thus details some of the "law of torture" as it was then, with the injuries inflicted in the presence of a magistrate and a registrar who were charged with monitoring the degree of pain imposed as well as hearing and recording the confessions extracted.[132] In addition to that interrogation,

FIGURE 53 *Justice,* etching attributed to Philip Galle, circa 1559, after the 1539 drawing by Pieter Bruegel the Elder. Rosenwald Collection.

Image copyright: 2005, Board of Trustees, National Gallery of Art, Washington, D.C.

one can see the imposition of various punishments including hanging, beheading, flogging, and burning.

Although she stands on a pedestal, Justice is not larger in size than other figures in the foreground. Moreover, she is accompanied (or constrained) by a retinue of armed men. Justice's raised sword is poised above the individual being tortured, but her scales hang much lower than her sword and close to the ground. The pans are tipped rather than even, bracketing the head of one of the men who is torturing the accused. Justice wears an odd, two-pointed cap evoking fools, courtesans, or dunces. Below her is a Latin inscription, likely taken from the preface of a 1551 edition of the book *Praxis rerum criminalium* (*Legal Practice in Criminal Matters*), a manual of sorts by the Flemist jurist Joost (or Josse) de Damhoudere. The text can be translated: "It is the aim of the law that it shall correct him whom it punishes, or that his punishment shall make the others better, or that, after the elimination of the wicked, the rest shall live the more securely."[133]

The ambiguity of the scene has prompted disagreement about the artist's intent. Relatively little is known about Bruegel's personal history and political attitudes.[134] Some commentators see in Bruegel's *Justice* a naturalistic and unproblematic portrayal of the ordinary administration of criminal justice. "If these incidents seem unduly harsh to us, they were accepted by Bruegel's contemporaries as necessary to maintain public law and order."[135] The large cross in the far left background has been read as a "guarantee that justice thus administered has the sanction of the Supreme Judge."[136] Further, the image could have served (as did the reality it portrayed) as a painful reminder of what mortal sinners believed they would suffer after their death,[137] thereby legitimating violence in the name of Justice, both earthly and divine.

The conflicts about the rulership of the Netherlands and between Reformation and Inquisition forces ("political events between 1559 and 1564 were of the sort to stir up any Netherlander"[138]), provide a predicate for other readings. Some commentators note that other images within Bruegel's Virtues and Vices series were plainly satiric.[139] Seeing his work more generally as oppositional,[140] they argue the scene to be a critique of the administration of justice, unanswerable to either "some higher (or lower) morality."[141] One could see "carnage," in that the "judge sentences innocent as well as guilty to the most cruel punishments."[142] The placement of the large cross at the far back corner of the frame could denote that the state's violence takes place without the sanction of God's righteousness, rendering this picture a "representation of perverted justice and perhaps a condemnation of the Inquisition."[143] Although titled *Justice,* the scene could be its inversion, Injustice, signaled not only by the female figure's odd garb and dangling scales but especially by the blindfold, which was then unusual. This Justice, like her counterpart in the Amsterdam Town Hall, is unable to see the many injuries imposed in her name. Encumbered and encircled, she lacks the power to curb those invoking her authority.[144]

## Damhoudere's Janus-Faced Justice

*Mundanae iustitiae effigies* (*A Portrait of Worldy Justice*) is the title placed above an intriguing Janus-faced Justice (fig. 54) from a sixteenth-century book, *Praxis rerum civilium* (*Legal Practice in Civil Matters*).[145] This enthroned Justice can be found in the volume after the book's preface and the author's salutations to the readers as a predicate to a lengthy interpretative essay placed before the opening chapter (titled "Quae personae necessariae in Iudicio," or "Persons necessary in a legal action").[146] The book, by Damhoudere, was published in Latin in 1567 and subsequently in French, Dutch, and German.[147]

The author, who was born in Bruges, lived from 1507 to 1581. Today Damhoudere, who was a civil servant and Flemish jurist, is known for his *Praxis rerum criminalium* (*Legal Practice in Criminal Matters*), which had "enormous authority and went through over 30 editions in Latin, French, Dutch and German, the last in 1693."[148] Indeed, as noted earlier, the text at the bottom of the Bruegel *Justice* is likely taken from that book.

The rare depiction in figure 54 literally puts two faces—one sighted and the other with eyes covered by a blindfold—onto the body of Justice. Damhoudere's use of this two-faced Justice has drawn attention from others interested in Justice iconography; the image has been reproduced but without discussion of the labeled figures in the woodcut or on the many pages of text Damhoudere provided to explicate the imagery.[149] From these accompanying materials, a sense of the negativity of the blindfold becomes plain, even as Damhoudere acknowledged some positive connotations.

The face of the sighted Justice looks toward her large sword, held upright in her right hand, while the face of the blindfolded Justice turns toward her left side, where her left hand holds tipped scales. Neither face is directed toward the figures before Justice, who stand below her, positioned as disputants or supplicants. The faces also do not look at the flaming monster at the bottom left-hand corner, at the dog and the man who recline in the center foreground, or to her right and backward at a man chasing a person who seems to be fleeing on horseback as another man behind her and to her left points toward the chase. Also on the right is a bird hovering between two men sitting on clouds, one of whom holds a cross. These three figures likely represent the Holy Trinity, with the dove denoting the Holy Ghost, proximate to God the father and Jesus the son.

The Latin titles for the figures before Justice explain them as personifications. Most of the well-clad figures are on the side where Justice is sighted. Several embody self-promoting and largely negative qualities, specified as Favor (Favor), Kinsman (Cognatus); Money (Argentum); Lawyer (Causidicus, with the negative connotation of a self-interested

## MVNDANAE IVSTITIAE EFFIGIES.

Fauor, Cognatus.
Argentum.
Caufidicus, Aduocatus.
Tutor, Receptor.

Defpectus, Miferia.
Paupertas.
Innocentia, Veritas.
Vidua, Pupillus.

Vnufquifque
Popellus, aut
Communitas.

Infernus.                    Paradifus.

FIGURE 54  *Mundanae iustitiae effigies* (*A Portrait of Worldly Justice*) in Joost de Damhoudere's *Praxis rerum civilium* (*Legal Practice in Civil Matters*), 1567 edition.

Image courtesy of the Rare Book Collection, Lillian Goldman Law Library, Yale Law School.

pleader of causes), Advocate in Law (Aduocatus, a supporter or witness); Guardian (Tutor), and Receptor (today's Trustee, a person holding and managing property for others).

On the side where Justice is blindfolded are figures labeled Contempt (Despectus), Misery (Miseria), and Poverty (Paupertas). The children may denote Innocence (Innocentia) and Truth (Veritas); one appears either disabled or propped up on some kind of chair. Also included in this group are Widow and Ward/Orphan (Vidua and Pupillus)—the former presumably the woman holding a handkerchief as if to wipe away tears and clutching the hand of a child looking up at her. In the central foreground is a man, fatigued and lying on the ground, and under him is a phrase with negative connotations—"Everyone, the Common People," as if rabble ("Unusquisque Popellus, aut Communitas"). Two inscriptions at the bottom provide labels for the

fire-breathing monster at the left, Inferno or Hell (Infernus) and for the group in the clouds, the Holy Trinity at the top right, Heaven (Paradisus).[150]

This imagery is accompanied by more than a dozen explanatory pages that open with a quote from Cicero that can be translated as "Justice is the virtue, by which is granted to each what is his own."[151] The next portion begins with a heading, "Division (Divisio)," and the text "Justice is considered according to the nature, condition, office, state and person of each. Justice is therefore twofold."[152] In the discussion that follows, Damhoudere sprinkled his commentary with quotes adapted from both the Old and the New Testament as well as maxims, some attributed to or echoing Cicero, Aristotle, St. Augustine, and classical poets.[153] Through that melange, Damhoudere detailed his views on both divine and human justice and then offered a narrative for each of the characters in the print.

God's justice demonstrates that "he is not deaf to the cries of the oppressed"[154] and that he judges with equity "the poor man as for the rich man." Human justice (which ought to aspire to be like divine justice) has its own two components, the judicial and the general. General justice consists of loving one's neighbor and treating others as one would want to be treated one self. When one comes to the second kind of human justice—judicial justice—Damhoudere focused on the men (judges, kings, and magistrates) "ordained by God for the regulation of human affairs." But "certain unworthy things have crept into human laws and regulations, . . . on account of the blindness of men" that God will need to correct. He also, at his pleasure, "remove[s] out of the community tyrannical and stupid princes," some of whom "reign in blindness and tyranny."

After this general commentary, Damhoudere offered his explanation of "the image of human justice." The "various persons" before Justice sought to "win justice herself over to their side." But "Justice is repeatedly blind and deaf" to those with just causes, while she is more available or attentive to others, "for the most unfair reasons." Justice is "two-faced," acting in a manner that appears fair but is dissembling. "Where she is depicted with eyes," she welcomes "wealthy persons" and the "more powerful." And where she is "bound by a blindfold," her eyes are shut to "clemency." Furthermore, "because we are showing Justice here as two-faced with eyes on one side and blind on the other, we give an image of worldly justice, certainly corrupt and not at all fair." Moreover, the sighted Justice turns her eyes "toward her friends and kinsmen." Money—the figure of the man with two bags—is offering up bribes, and the commentary cites the Old Testament's *Book of Exodus,* as did the frescoes in the Geneva Town Hall (fig. 3/34), for the proposition that bribes "blind the eyes of wise men."[155] Meanwhile, the Widow and Orphan beseech Justice to "turn the eyes of your clemency" and "look mercifully upon our tears and our sobs."

Yet the text also drew attention to ambiguities in the blindfold by noting that other portrayals of Justice blind-folded were to represent "the part of justice to be blind to each party, and to provide a mien either of favor or of hatred to neither." At another point, Damhoudere commented that Justice was "two-faced" to signify that "justice's governors must provide a friendly face or intent eyes not only to one of the parties, but must attend to each of the parties equally."

Moreover, while today a Janus-faced image connotes a deceitful persona, Damhoudere might have drawn on a tradition viewing Janus more positively. The month of January is named for Janus, imagined (as we know from the Roman poet Ovid) to hold the keys that unlocked the gates to the new year and, by looking backward and forward, to ease transitions.[156] Further, when "Rome was at peace, the doors of Janus' Forum temple remained closed; during war, they stood open."[157] But the potential for such positive implications is dwarfed by the scene in which the sighted Justice appears to be corruptible and the blindfolded Justice impervious to the needy before her. Thus, even as late as the middle of the sixteenth century, the blindfold was available to mark earthly Justice's limitations.

## Turning a Critical Eye

A summary of several points spanning these many centuries is in order before we move forward in time. First, before the sixteenth century, images of Justice were shown with their eyes open. During the Medieval and Renaissance periods, blindfolds had a deeply derisive symbolism that was readily appreciated and reinscribed. Second, by the seventeenth century, closed or covered eyes for Justice were uncommon but not unknown. In the imagery identified to date, the blindfolds in Bruegel's 1530s drawing *Justice* (etched in the 1550s by Galle, fig. 53) and in Damhoudere's 1567 Janus-faced image (fig. 54) were atypical for their time. In the years that followed, a few other blindfolded Justices appeared, and some likely stemmed from Ripa's admonition that a blindfold enabled better judgment.[158]

For example, an *Allegory of Justice* from 1589 in the Magistrates' Chambers of the Oudenaarde Town Hall in Holland showed an enthroned Justice with even scales and upright sword, a book on her lap, and a blindfold over her eyes. On one side is a woman who could be identified as Prudence (with her mirror) and on the other, Faith with a cross.[159] Beneath her scales are the letters "M" and "T," for Meum (mine) and Tuum (thine), while beneath the scales is the Latin "suum cuique tribuo," or "I give to each what is his due." Near Justice's head is inscribed "praemium et poena," or "reward and punishment." Another positive deployment of the blindfold can be found in the antechamber in the old Tübingen Town Hall, where two murals from 1596 are above doorways. A Justice sits above the door to the Council Chamber. Seated on a throne, holding a sword upright in one hand and evenly balanced scales in the other, Justice is blindfolded. The inscription below explains:

I am known as justice
I know the rich and poor equally
My eyes are bound
So that rich and poor appear the same.[160]

At the center of the other mural above the antechamber is a female personification of Wisdom (who could also be Prudence), also enthroned and under a canopy, holding a mirror. She is clear-sighted, and the inscription again refers to the obligation to be even-handed:

Here I sit in God's stead
Through me the town and land finds counsel
I really cannot favor
The wants of every man
Thus my knowledge is pure.
And God alone my comfort and reward.[161]

Other blindfolded Justices, sometimes with diaphanous coverings for their eyes and other times with their vision completely obscured, can be found from the seventeenth century.[162] One, in wood from about 1600, stood outside the City Hall of Veere.[163] Another Justice, who holds scales and a sword and wears a see-through blindfold, was put into place in 1633 as part of the renovation of the Haarlem Town Hall, a building in whose design Jacob van Campen—the designer of the Amsterdam Town Hall—likely played a role.[164] From a decade later, in 1644, a painted and blindfolded Justice in the Magistrates' Chambers of the Town Hall at The Hague sits beneath a painting called the *Eye of Justice,* from about 1682.[165] One can also find a few Justices with bandaged eyes as well as scales and sword in engravings in books of *exempla iustitiae* (exemplars of justice) and on lawyers' bookplates.[166]

Thus, by the mid-1650s, the blindfolded *Justice* (fig. 47) in Amsterdam's Tribunal was unusual, but had a few counterparts in the Netherlands and in Germany.[167] One possibility is that blindfolded images became prevelent in relatively new city-states as more complex and ambivalent attitudes toward law and authority were developing.[168] But to detail the blindfolded Justices is to underscore their minority status. Open-eyed Justices were typical, shown outside town halls, in manuscripts, and on tarot cards,[169] in northern Europe[170] and elsewhere.

Third, the artistic and literary sources of Plutarch, Alciatus, and Ripa provided arguments for the special utility of sightlessness to Justice. These stories, axioms, and images gained currency as popular anxiety about law's processes resulted in efforts to generate norms of judging. But, and fourth, the texts offered somewhat different rationales for the blindfold. Recall that Alciatus recommended sightlessness for the prince/judge so "that he may recognise no-one's status and . . . judge according to his council"[171] or "according to what is said in his ear."[172] Deprivation of sight resulted in even-handedness, a maxim repeated elsewhere,

as in the inscription from the old Tübingen Town Hall that the Justice's "eyes are bound [s]o that rich and poor appear the same."[173] Blindfolds also made it harder to solicit or receive bribes. But what, then, was to be the basis for decision?

The answer, at least from Alciatus, was that the judge/prince ought to listen to his advisors. That admonishment may have curbed the absolutism of the power of the judge/prince/king but also reaffirmed that power lies with ruling authorities (councils) and that judgment did not have to flow (as we might assume today) from the interaction of facts, based on evidence, and law. In contrast, by 1593, Ripa had introduced what could be read as a different rationale for the blindfold—that (like Homer's blindness) it clarified knowledge: "[Justice's] eyes are bandaged and thus she cannot see anything that might cause her to judge in a manner that is against reason."[174] The reference to "against reason" could be to bribery or to status (treat the "rich" and the "poor" alike) or, as some translations of Ripa noted, to "passion" rather than reason.

Thus, even within a convention of the blindfold as a positive attribute, the polysemic quality of representation permits diverse interpretations. Further, conflict about whether the blindfold ought to be valorized has persisted. In Chapters 5 and 6, we map arguments about whether metaphors of "blindness" and blindfolds are appropriate in contemporary discussions of justice. But before doing so, we move forward in time to trace aspects of Justice iconography that have proved stable across forms of government around the world.

### TRANSCENDENT, WIDE-EYED, AND AMIDST THE ANIMALS

#### Raphael's Glory of Justice

From the Renaissance through today, clear-sighted Justices have been commonplace, with several well-known renditions prominently adorning major edifices. Return, for example, to the Vatican, discussed in Chapter 1 when we explored the place that Justice occupied among the Four Cardinal Virtues. There, we provided illustrations of *Prudence* (fig. 1/20), *Temperance* (fig.1/21), and *Fortitude* (fig. 1/22). In the assembled group, the famous Raphael *Justice* (fig. 55, color plate 13) is on the ceiling of the Stanza della Segnatura. That room was used for a time by Pope Julius II as a private library and office; in the mid-sixteenth century, it became the meeting place for the Segnatura Gratiae et Iustitiae (the Council of Grace and Justice), the highest court of the Holy See.[175]

Raphael's *Justice* graces a lunette above frescoes on a wall known as *Jurisprudence.*[176] Painted between 1508 and 1511, the imagery forms a deliberate, didactic program that has spawned a literature debating both its authorship and import. Most commentators agree that depicted below Jus-

FIGURE 55 *Justice*, Raphael, 1508–1511, detail of the ceiling of the Stanza della Segnatura, Vatican Palace, Vatican State.

Copyright: Scala / Art Resource, New York, NY. See color plate 13.

tice are her Renaissance siblings, the other Cardinal Virtues, toward whom she looks.[177] Justice holds balanced scales in one hand and an uplifted sword (pointing toward the heavens) in her other. On either side, putti (cherubs, one winged and the other not) prop up and partially obscure engraved plaques, read together to mean "To everyone his own justice" or "Justice is rendering to each what befits him."[178]

This *Justice* is a part of a visual parade on the ceiling that includes female personifications of the disciplines of Poetry, Theology, and Philosophy.[179] In addition, in rectangular frescoes are images identified as Adam and Eve (or The Fall of Man), Apollo and Marsyas, the Judgment of Solomon, and a personification of a woman with her hand on a globe and variously identified as the Universe, Astrology, or Wisdom.[180] Inscribed texts augment the pictures by providing additional references to Greek and Roman classicism from Plato and Aristotle to Cicero and Virgil.[181]

Like the iconography of the Amsterdam Town Hall a century later, the Stanza della Segnatura's program laid claim to many historic lineages.[182] As in Siena's Palazzo Pubblico, the benefits that flow from good governance are depicted.[183] Some read the particular choices in the Vatican as an effort by Pope Julius, in a moment of political fragility, to appropriate Greek and Roman philosophical traditions. Under this interpretation, Julius claimed "a grandiose con-

cordance or harmony" as the earthly representative of the divine Christian God.[184] The room aimed to convey that Julius's "right to rule Rome could be sanctioned and extended, at least subliminally, to a universal power over not only canon law but also civil law."[185]

In the unity of these reconciled traditions, Justice again rises to the fore. Her portrayal above the other Virtues is said to convey a Platonic idea that Justice represents the sum of all the others.[186] She could also be seen as dominating the disciplines—Poetry, Theology, and Philosophy—through a reading of the room as depicting the ideal Christian world, in which "all branches of knowledge unite in the service of Justice."[187] Moreover, because her place on the ceiling puts her between frescoes of secular and divine Justice, she is the bridge between or the embodiment of both.[188] And, as she looks down, no blindfold obscures her eyes.

## Symbolism's Caprice: The Many Animals of Justice

### The Proud and the Dead Bird: Giulio Romano's Justice *with an Ostrich in the Vatican and Luca Giordano's* Justice Disarmed

Another clear-eyed *Justice* (fig. 56, a preparatory drawing) appears in a fresco in the Vatican's Sala di Costantino (Room of Constantine).[189] This room was completed after

FIGURE 56 *Justice,* Giulio Romano (School of Raphael), 1520, detail of the ceiling of the Sala di Costantino, Vatican Palace, Vatican State.

Image reproduced courtesy of the Library of Congress, Washington, D.C.

Raphael's death by assistants, including Giulio Romano, to whom this *Justice* is attributed.[190] Within its walls are four large allegorical scenes[191] set off as if by pillars in an architectural trompe-l'oeil. On those painted columns sit various Virtues, this image included, shown in the elongated Mannerist style and identified by two attributes—evenly balanced scales and an ostrich.[192]

The Romano depiction was not then extraordinary.[193] As quoted earlier, various editions (or embellishments) of Ripa's *Iconologia* mention the ostrich (along with a white robe, sword, scales, bandages, and other attributes) as appropriate for Justice. Ripa explained the bird's presence as demonstrating that Justice had to unravel problems through a "patient attitude" like that of the ostrich, reputed to be able to digest everything, if it did so slowly.[194] As one invocation of Ripa put it, "the ostrich ruminates its food as

Justice should testimony put before her."[195] Like other attributes, ostriches served more than one personification. For example, Ripa used an ostrich for "Digestione" (Digestion), described as a woman "of robust complexion" and pictured with her right hand on an ostrich, which is "even able to digest iron."[196]

Scholars have offered various explanations about why the ostrich was once plausible for Justice. A possible source is the Egyptian Maat (fig. 2/24), sometimes represented by an ostrich feather[197] or shown as a woman holding or forming scales on which a feather was weighted against an individual's heart.[198] Renaissance artists made the Egpytian link partially through the *Hieroglyphics* of Horapollo, another of that era's emblem books, with its special focus on decoding the "hidden meanings or lost secrets" in various ancient reliefs and inscriptions.[199] The Renaissance painter and

author Giorgio Vasari relied on a version of Horapollo linking Justice and the ostrich allegedly based on Egyptian views of the bird's "plumes' evenness of length and design."[200] Hence, the feathers' equal length denoted law's treatment of disputants.[201] Moreover, "ancient writers associated the ostrich with the symbol of Justice because it was believed that this animal could even chew or digest iron nails."[202] Therefore, when Giorgio Vasari painted *Astraea* as embodying divine justice, he capped her with a helmet adorned with ostrich plumes and reminiscent of that worn by Minerva; alongside, books represented legal codes.[203] Vasari wrote to a patron in 1543 to explain the placement of an ostrich near Justice in another painting. The bird was "aerial and terrestrial as she is human and divine, he smelts the iron because he purges for her any ignominy. He has even wings and proper features, positioned in the pyramids as a symbol of Justice by the Egyptians."[204]

A second source for a connection between the ostrich and Justice comes from Christianity. "Actual ostrich eggs were imported into Europe in surprisingly large numbers," and Medieval texts mention them hanging from church vaults.[205] A few well-known paintings show large objects hung near the altar; they are identified by some as eggs, which were a common symbol of the Conception of Jesus.[206] Further, Medieval lore posited that ostriches deserted their eggs, which hatched only through the warmth of the sun—providing Albertus Magnus with the aphorism "If the sun can hatch the eggs of the ostrich, why cannot a virgin conceive with the aid of the true sun?"[207] Under this line of interpretation, Guilio Romano's Vatican *Justice* has scales to represent the exacting nature of Justice and the bird to reference Christian mercy.[208] Moving from theology to political economy, another explanation for the ostrich is its connection to the powerful family of the Medicis, whose own emblems included a diamond ring with three bird feathers, identified as from an ostrich.[209] Some circularity is at work here, in that the Medicis were said to have used that emblem to show that the "bearer is eternally just, since ostrich feathers (believed all to be the same length) symbolized Justice."[210]

A sequence of images executed by Luca Giordano further documents the role that ostriches once played as proper companions for Justice.[211] Giordano, who lived from 1634 to 1705, worked on dozens of commissioned allegories, and his many Virtues display Ripa's influences.[212] One image, called *Allegoria della Guistizia oppressa* (*Allegory of Justice Disarmed, Justice Disarmed,* or *Justice Oppressed*) (fig. 57),[213] survives in several iterations. Each portrays a large disheveled

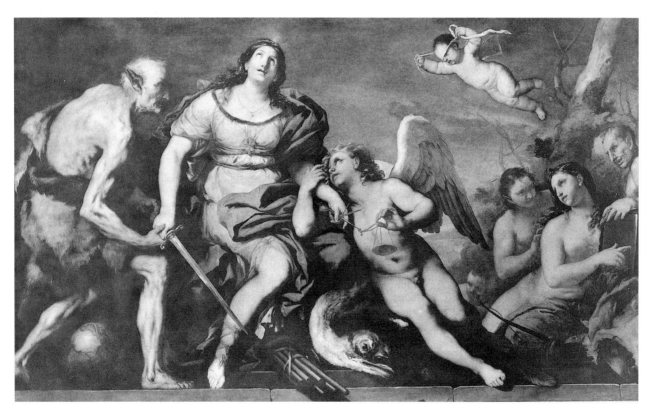

FIGURE 57   *Allegoria della Guistizia oppressa* (*Justice Disarmed*),
Luca Giordano, circa 1670, Budapest Museum of Fine Arts, Hungary.

Image reproduced with the permission of the Szépmûvészeti Múzeum, Budapest.

Justice with all her attributes awry. According to art historians, Giordano intended to depict the injustice that occurred when the Turks took Crete from Venice.[214] Giordano, well schooled in Ripa's *Iconologia,* relied on various objects to tell the story of Justice's capture and subjugation.

Shown on one side of Justice is a puckish, winged young man, either taking the scales from Justice's limp hand or tipping them. On her other side, the figure of an old male (who might be Ignorance) has either wrestled Justice's sword to the ground or is grabbing it from her. A small naked boy (evoking the tradition of putti and specifically Eros) flies above, with Justice's blindfold in his hands. At Justice's feet, fasces, which Ripa commended for signaling authority, are on the ground next to a disconcerted, sleeping, or dead ostrich.

That ostriches were once relevant to Justice underscores the plasticity and variety of Justice symbolism. Like the blindfold, the link between Justice and ostriches was visceral, referencing a relationship between corporeal sensations and decisionmaking. The blindfold relies on deprivation of the sense of sight to protect Justice's obligation of even-handedness, while the ostrich—with an analogy to digestion—insists that slow and deliberate processing of information results in better outcomes. And just as the blindfold was initially read negatively but has now gained positive connotations (or not, as we discuss in Chapters 5 and 6), were one to put an ostrich next to a Justice today, most contemporary readers would assume the point was critique—that a decisionmaker's head was in the sand. Indeed, the rare mention today of ostriches in relationship to law comes by way of American criminal docrine, discussed in Chapter 5; an "ostrich charge" is an instruction to a jury about the relevance of a defendant's willful ignorance.

### Sheep and Foxes, Dogs and Serpents: Rubens's Wide-Eyed Justice

The ostrich was not the only bird in Justice's repertoire, nor are birds the only animals now gone from sight. Ripa instructed that "Heavenly Justice" (or Divine Justice, a woman of uncommon beauty) have a dove near her head to symbolize the Holy Ghost.[215] Other Justices (including on tarot cards) appeared with a crane holding a rock.[216] (Cranes could also be found near Faith and Vigilence.[217]) Cranes were assigned the task of guarding the flock; were the crane to fall asleep, the rock would fall out of the crane's grip and awaken the bird. Ripa also described the figure of a judge as an old man with an eagle nearby because that bird had a "sharp and discerning eye," denoting that judges needed to "sift through often unclear material to get to the real and honest truth."[218]

Other animals are part of Justice's pack. Sixteenth-century editions of Ripa recommended that, to show that Giustitia Retta ("Right Justice") was "not affected by friend or enemy," one should include a dog nearby for friendship and a snake "symbolizing hate" under foot; Justice's "raised

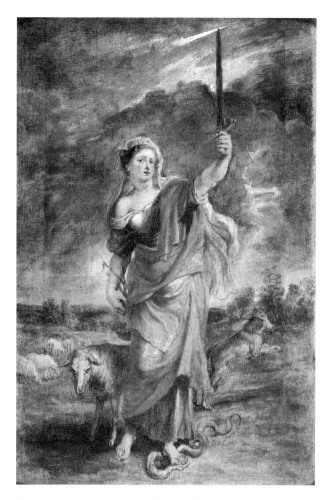

FIGURE 58    *Allegory of Justice,* Peter Paul Rubens, circa 1625.

Image reproduced courtesy of Noortman Master Paintings, Maastricht, the Netherlands. See color plate 15.

sword," poised higher than the scales, showed her unbending for either friend or foe.[219] That description comes close to what Peter Paul Rubens painted circa 1625. The wide-eyed Justice at the center of his *Allegory of Justice* (fig. 58, color plate 15) crushes a snake at her feet and has her sword held high, as if breaking through the clouds to catch the sun. (That the sword is in her left hand rather than her right suggests that the design was for a tapestry and therefore would have been reversed in a final rendition.[220]) This Justice stands between a sheep, often referencing the faithful, and a fox or wolf denoting heresy and scampering away.[221]

### THE PAST AS PROLOGUE: SIGHTED OR BLINDFOLDED, AND TALL

### Venice as Justice, Justice as Venice

Open-eyed Justices remained commonplace, as can be seen by moving farther north in Italy to Venice, where the iconography of Justice played a prominent role in the elab-

orate pageantry of that city. In Medieval Europe, Venice served as a route and a way station for the Crusaders. During the course of several centuries, Venice succeeded in carving out its own identity, distinguishing itself successively from the Byzantine Empire and from Germanic and Papal forces; its republican form of government lasted from the end of the thirteenth century to 1797.[222] Controlled by a small, elite group, the government's titular leader was the Doge, a person posited as the embodiment of Venetian authority yet given limited power through the conceit that he was *primus inter pares* (first among equals).[223]

Reflecting the "civic Christianity" that permeated much of Europe,[224] the seat of Venice's government was in the Basilica of San Marco.[225] In the first half of the sixteenth century, through an architectural "reorganization" of the ceremonial space in the Loggetta of San Marco, Venetian leaders proffered a visual representation of their political premises.[226] As figure 59 demonstrates, city leaders showed *Venetia/Iustitia* (*Venice as Justice*) on the central panel of the facade in a stone relief sculpted by Jacopo Sansovino.[227] In this carving Justice is solidly grounded, supported by the two lions of the city's patron, St. Mark. The personifications carved in stone near *Venice as Justice* represent the two mainland rivers of Venice. In the two other major panels are "Venus as queen of Cyprus and Jupiter as king of Crete [to] signify the pillars of Venice's maritime empire."[228] Nearby are embodiments of Minerva, Mercury, Apollo, and Peace.

Other seated, enthroned women, denominated Venice, Justice, or Venice as Justice, dot the Ducal Palace. Similar to the *Venice as Justice* is another statue of a woman who offers an open gaze, holding an upright sword and a scroll as she sits crowned and bracketed by lions. Some commentators label her "Venice"[229] and others "Venice as Justice."[230] A third woman, called "Justice," is again open-eyed, crowned, and enthroned; she holds both a sword and scales and is accompanied by Venice's ubiquitous lions.[231] A fourth stands on an enormous balcony,[232] while yet another Justice on the piazzetta wall of the palace holds a law book and a rod.[233] In short, Justice iconography "dominates the public facades of the Ducal palace, which was explicitly defined as a palace of justice."[234]

Justice was not the only heroine in Venice's hagiography. Rather, she joined personifications of the Virgin Mary, Venus, and Dea Roma ("the goddess Rome").[235] The imagery provided an amalgam of Christian and classical themes illustrating that, like many of the other polities we have discussed, Venice laid claim to an array of protectors. Moreover, Venetian allegories (like those of Amsterdam) posited a familial connection between Venetians and their rulers, thereby relying on gendered Christian discourses of the bonds between Jesus Christ and the Church (Ecclesia as the "bride" of Christ), exercising control through an implied affective political relationship. The overall point was to have Venetians "read the figural equations of Justice = Venice or Virgin = Venice or lion = St. Mark = Venice, or the interpretive complex of Solomon, Justice, and Wisdom as embodying the highest virtues of their Republic."[236]

Venice also insisted on its own special position as the "New Rome" and on its unique relationship to the Pope.[237] Amid the various historical legends that constituted Venetian self-understanding was that, in 1177, Pope Alexander III had given three gifts ("trionfi") to the Doge in recognition of his help and protection in the Pope's battles against Emperor Fredrick Barbarossa. The gifts included "rights" to carry white candles in processions on major feast days and to marry the sea ceremonially in recognition of the

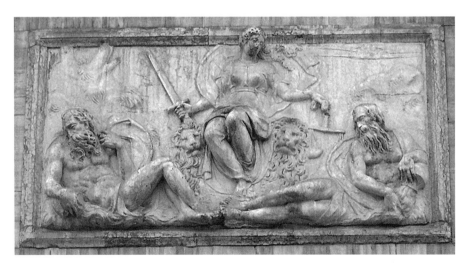

FIGURE 59 *Venetia/Iustitia* (*Venice as Justice*),
Jacopo Sansovino, 1549, Loggetta of the Campanile, Venice, Italy.

Photographer: David Rosand. Photograph courtesy of David Rosand,
Meyer Schapiro Professor of Art History Emeritus, Columbia University.

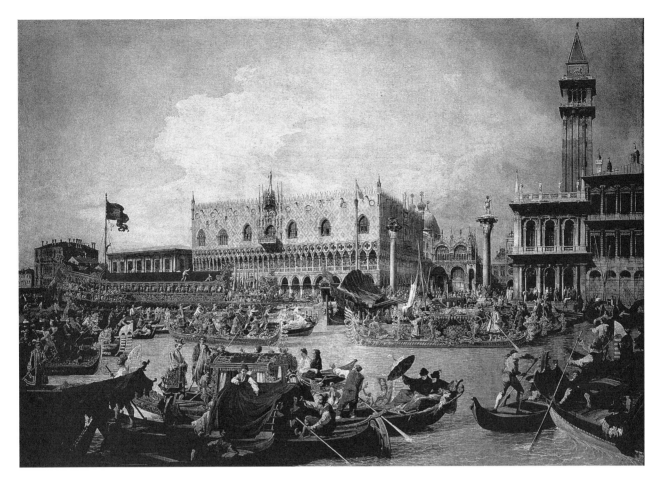

FIGURE 60    *The Basin of San Marco with the Bucintoro,*
Giovanni Antonio Canaletto, circa 1750, Collezione Crespi, Milan, Italy.

Doge's "lordship of" and "perpetual dominion over" the sea.[238] According to the legend, Pope Alexander III provided a special ring for the marriage ceremony and a special sword "symbolic of the justice of the doge's cause," assuring salvation to those who touched it.[239] By 1319 this legend had made its way into visual narratives in the Ducal Palace and by the sixteenth century, it was a part of the "official dogma" of Venice, providing a "standard historical justification for the Venetians' jurisdictional privilege" to control trade routes and its colonies.[240]

The gifts conveyed in legend were part of Venice's central pageants, as its rulers presented an unusual number of public spectacles reflective of a "Neoplatonic belief that outward beauty was a sign of inward virtue."[241] In such rituals, Justice iconography was prominently on display. In the ducal processions marking the "constitutional" authority in Venice,[242] a specially-designated nobleman carried the "sword of justice" as an emblem of law's obligations of equal treatment.[243] Furthermore, upon investiture, a new Doge stated that he would "govern well and to the best of his ability observe justice," as he strove for "peace and well-being

for all the subjects."[244] A 1435 meeting of Venice's Council began with a motion that the "principal foundation of our city and its singular ornament is justice, both at its heart and in its subject lands."[245]

Moreover, in the annual "great communal ritual" of the marriage to the sea, Justice herself led the procession. This formally orchestrated regatta—famously depicted in the eighteenth century by Canaletto in paintings such as the 1750 *The Basin of San Marco with the Bucintoro* (fig. 60)[246] —was a yearly event celebrated on Ascension Day, when, according to Catholic belief, Jesus entered heaven.[247] After a mass at San Marco, the Doge boarded his special barge, called the Bucintoro.[248]

This craft, first built in the thirteenth century, described in 1449 as gaining grandeur and gilt,[249] and replicated a few times thereafter with yet more elaborate models, had ornamentation that included the lions of Venice's St. Mark and emblems of the sea.[250] The Bucintoro had a special compartment for the Doge and dozens of seats for foreign and local dignitaries.[251] Near the Doge's throne were statues of Prudence and Fortitude and depictions of Apollo and nine

FIGURE 61   Maquette of the bow of the Bucintoro with *Justice,*
undated, Venice, Italy.

Reproduced courtesy of the Venice Museum of Naval History (Museo
Storico Navale di Venezia).

Muses.[252] The barge and its replacements were used annu-
ally beginning in the thirteenth century and ending in 1798
when Napoleon's French troops destroyed the last ver-
sion.[253] As the many boats crowding the bay in Canaletto's
rendition make plain, other vessels joined to form a festive
parade to the sea.[254] Each year, the Doge dropped a gold
ring into the sea and made statements of espousal, thereby
enacting the political point that Venice had "legitimate
rights of domination over trade routes" in the Adriatic.[255]
(The ceremony endured long after its claims had any plau-
sibility, and the Canaletto painting illustrates the festivities'
importance to the Venetian tourist trade.[256])

Justice sat—literally—at the forefront of this ceremonial
enactment of jurisdiction and authority.[257] Canaletto's
painting captures the liveliness of the event. Harder to see
in this rendition is the Bucintoro's large golden Justice,
seated on a great throne in front of the Doge's compart-
ment. Figure 61, a maquette (or model) from the Museo
Storico Navale di Venezia (the Venice Museum of Naval
History), makes more easily visible the features of the
Bucintoro's prow. This open-eyed Justice held an upright

sword and scales while lions sat at her feet. In figure 62, a
much earlier and simpler edition (also from the collection
of Venice's Museum of Naval History), the 1526 wood
frontpiece (*Venezia sotto forma di Giustizia,* or *Venice in the
Form of Justice*) from a Bucintoro of that date, shows her in
the same position.[258] Both at sea and on land, in "the visual
arts a female personification of Justice holding a scale and
sword ranked second only to the winged lion of Saint Mark
as a symbol of the republic."[259] Many cities took Justice as
one of their standards, but for Venice the identification was
both literal and abstract; Justice "became the prime model
for the figure of Venetia herself."[260]

FIGURE 62   *Venezia sotto forma di Giustizia* (*Venice in the Form of
Justice*), from a 1526 Bucintoro, Venice, Italy.

Reproduced courtesy of the Venice Museum of Naval History (Museo
Storico Navale di Venezia).

### Across the English Channel

Equating a nation with Justice and parading her about were not practices of Venice alone. Moving across the English Channel to Great Britain, one finds that many of its political leaders displayed their association with Justice.[261] Having noted Elizabeth I's link to Astrea and Justice in earlier chapters, here we turn to a second English queen, positioning herself in relationship to both Elizabeth and Justice.[262]

### Queen Anne as Justice

*Queen Anne as Justice* (fig. 63), painted in 1704 by Antonio Verrio, hangs in the Queen's Drawing Room in Hampton Court Palace, built during the reign of Henry VII.[263] The restoration of the palace, under the guidance of the

architect Christopher Wren, began when William III and Queen Mary ruled England in the late seventeenth century.[264] After William's death in March of 1702, Anne—qualified because she was a Protestant—took the throne until her own death, in 1714.[265] For the latter part of her reign, Hampton Court was "a focus of attention."[266]

Anne ordered the refurbishing of the Queen's Drawing Room, a room measuring about forty-one by thirty-five feet that functioned as a public space where she presided over formal assemblies.[267] In addition to the large ceiling painting (here shown only in part), the walls depicted "Britannia enthroned, receiving homage from the four corners of the globe,"[268] as well as images of the British fleet and another of Queen Anne, "dispensing Mercy and Justice and flanked by Christian Truth and a Sybil" while supplicants from America, Asia, Europe, and Africa were

FIGURE 63  *Queen Anne as Justice,* Antonio Verrio, circa 1704, Queen Anne's Drawing Room Ceiling, Hampton Court Palace, Surrey, England.

Copyright: Historic Royal Palaces. Image reproduced with the permission of Historic Royal Palaces under license from the Controller of Her Majesty's Stationery Office.

arrayed as heroes crushing the Vices of Evil, Sedition, Envy, and Hatred.[269]

The Verrio ceiling puts Anne at the center, looking out at the viewer while three Graces or Muses rest at her feet. Above her head, figures representing Neptune and Britannia hold a crown that they are to bestow upon her. Other personifications—arguably Peace because of the laurel she holds, Fame, and Plenty—float in the clouds. Anne's regal purple dress is lined with ermine,[270] and she holds Justice's signature attributes, the upright sword and balanced scales. Other Virtues, including Prudence with a mirror and Temperance with her pitcher, are on one side of Anne, while Fortitude, marked by her lion, is on the other. That cluster underscores the iconographical decision to select the Virtue Justice for the personification of the monarch. The addition of the cornucopia could refer to merciful generosity; Ripa advised its display with Charity and Abundance.[271] A crane, at the bottom, sits near a personification of Faith.

Anne's identification with Justice also comes through her familiar stance. Her pose echoes the 1526 frontpiece (fig. 62) of the Bucintoro and some of the other Justices of (or as) Venice. Furthermore, the composition of Verrio's painting is reminiscent of another image of Europe's famous queens—Maria de Medici in *The Felicity of the Regency*, which was part of a cycle of twenty-four paintings by Peter Paul Rubens. That queen, surrounded by supplicants and putti, holds scales in one hand and an orb with a rod in the other.[272] By choosing this position, Verrio placed Anne within a tradition of monarchs appropriating symbols of Justice. And their imagery was, in turn, appropriated hundreds of years later when Saddam Hussein (fig. 1/12) repeated the gesture of displaying himself holding a sword and scales.

Critics have not showered praise on Verrio's work at Hampton Court. This, his "last work, has been widely judged his least successful."[273] One story attributed its aesthetic failures to deliberate aggression. The hypothesis is that Verrio, a Roman Catholic who had been barred from holding an office at court under the Test Acts of 1689,[274] was underpaid by Queen Anne and showed his anger in his art.[275] For some period of time, the paintings were "thought so indifferent" that they were "covered over with hangings of green damask."[276] Whether esteemed or disliked as art, the painting of Anne (like Ferdinand Bol's *Moses Descends from Mt. Sinai* (fig. 3/41) in the Amsterdam Town Hall) is helpful as history. *Queen Anne as Justice* documents the queen's self-conscious efforts to revive the "ceremonial and symbolic life of the court" through a "carefully crafted public image."[277] While Anne is often positioned as "vestigial, the last of the Stuarts vainly resisting the inevitable triumph of [political] party and limited monarchy,"[278] her ability to obtain the cordial good will and sympathy of her subjects and her efforts to "keep the monarchy above partisan politics" made her a "harbinger of the future."[279] Part of that

process was to present herself as the heir to Elizabeth I, who had likewise claimed to be a truly just and a truly "English" queen.

### The Lord Mayor's Show

While the Venetian lagoon offered a unique backdrop for the Doge's voyage on the Bucintoro, other polities staged their own versions of such civic "commitment ceremonies" —to borrow a modern phrase. England's leaders continued Queen Anne's practices, by wrapping themselves in Justice imagery.[280] One such display was (and is) an annual procession by the Lord Mayor of London, who has formal authority over about a square mile of that city. Each fall, the Lord Mayor goes from the City of London to Westminster Abbey to "swear fealty to the crown."[281] Begun as a condition imposed by King John in 1215 in return for permitting election of a mayor by the citizenry, the "Lord Mayor's Show" remains a yearly activity, uninterrupted despite "two bouts of the plague, the great fire of London," and the bombs of World War II.[282]

The event was once a "simple processional" through London during eras before the building of theaters enabled many spectacles to move indoors.[283] By the seventeenth-century reign of James I, with the elaboration of state pageantry, the Lord Mayor's Show came to include specially written speeches and plays praising the sovereign.[284] The Lord Mayor initially proceeded by decorated barge and horseback. But in 1711, after one mayor fell off his horse, the tradition shifted to making the trip by coach.[285] The 1757 version of that coach continues to be used in this annual event and is otherwise on display at the Museum of London. That "New Grand State Coach," designed by architect Sir Robert Taylor, has panels painted by Giovanni Battista Cipriani.[286] There appear the female personifications of Justice, Fortitude, Temperance, and a woman called "Truth" (with "her mirror" and thus looking like what others call Prudence).[287] These four continue to be paraded along a route specified in 1952 for the procession that moves from the streets of the City to the Royal Courts of Justice, where the Lord Mayor takes an "oath of allegiance to the Sovereign before the Lord Chief Justice and the Judges of the Queen's Bench Division."[288]

The Lord Mayor's Show served not only as a space for municipal government to enact its loyalty to the state and to demonstrate its own authority but also as a site for public protest. One can make the psychological claim that "spectacles *compel* a response"[289] or the political point that spectacles create circumstances permitting voices that undermine the monological perspective proffered by the state. The unruly crowds that Michel Foucault named in his classic *Discipline and Punish*[290] can be seen in some of the mid-eighteenth-century engravings depicting mobs that almost overwhelmed the coach during the Lord Mayor's

FIGURE 64 *Lord Mayor's Day,* George Cruikshank, in *Comic Almanack,* 1836.

Reproduced courtesy of the Beinecke Rare Book and Manuscript Library, Yale University.

Show. This 1836 print of Lord Mayor's Day (fig. 64) by George Cruikshank[291] exemplifies the potential for protest at this kind of ritual, which was more physically accessible than other royal spectacles. As this scene suggests, although the parades of power were replayed over the centuries, the role of the audience changed. In Venice, the "marriage to the sea" came to be a show for tourists; in London, a comparable pageant sometimes provided occasions on which spectators asserted political agency.

Cruikshank offered an ambiguous scene, with people dressed to mark their lower class pressing forward either to gain a better view or to attack the parading dignitaries. The armored horseman appears oblivious of the horse and may be casting an intrigued eye toward the crowd. This print was one of several artistic satires of the Lord Mayor's processional that showed crowds surrounding the coach. Another, by William Hogarth, portrayed a boisterous crowd unconstrained by the City's militia,[292] and another Cruikshank print had the Lord Mayor stripped of his coach and carried in a litter held by two foot soldiers. That print foreshadowed the "downfall of the City's power."[293] In Chapter 13, we explore how public rituals of adjudication came to frame expectations of rulers as "rights" of partici-

pation replaced "rites" of spectatorship. A graphic embodiment of aspects of this shift could be found by the early nineteenth century through prints such as this one by Cruikshank, which also illustrated the roles played by the press, cartoons, and pamphleteering in the construction of what has come to be called the "public sphere."[294]

Returning to London in the nineteenth century, that criticism and conflict produced some reforms of municipal government, including the establishment in 1888 of the London County Council. But, instead of being relegated to London's past, the Lord Mayor's Show gained yet more formal grandeur,[295] paralleling the increased extravagance of the Venetian "marriage to the sea," which also became more elaborate as the power of that city waned. These reconfigurations running from the thirteenth century to the twenty-first, all embraced under the nomenclature of the Lord Mayor's Show, bear out David Cannadine's observation that civic rituals are constant in neither content nor meaning.[296]

### Dublin's Justice

Moving from staged events back to Justice statuary, one can find multiple meanings—depending on where one stands

FIGURE 65    *Justice,* John van Nost the Younger, 1753, view from the inner court in the Great Courtyard, Dublin Castle, Ireland.

Photographers: Dennis E. Curtis and Judith Resnik. Photograph reproduced with their permission.

FIGURE 66    *Justice,* John van Nost the Younger, 1753, view from the street in the Great Courtyard, Dublin Castle, Ireland.

Photographers: Dennis E. Curtis and Judith Resnik. Photograph reproduced with their permission.

(literally and metaphorically)—in the placement of a clear-eyed *Justice* (figs. 65 and 66) on top of a building complex called the Four Courts in Dublin, Ireland. Before 1695, "the courts of law in Ireland were itinerant,"[297] which is to say that no permanent and specific buildings were set aside for Irish judges to hear cases. Two legal systems prevailed: English law within "the Pale, with Dublin at its centre" and Irish (old "Brehon") law in the outlying areas.[298]

Irish "Inns of Court"—where lawyers and judges worked in chambers and documents were kept[299]—came into being during the reign of Edward I in the thirteenth century. After attacks by bandits were said to have burned every record, the Inns were moved from outside the walls of the city to inside the Castle of Dublin[300] and then to a former monastery that deteriorated over time.[301] Disputes were then heard in a building adjoining Christ Church Cathedral.[302] After efforts to convert another of Dublin's cathedrals to a hall of justice failed, a decision was made to site "one of the noblest structures in Dublin" near that city's river where the monastery had housed the Inns of Courts.[303]

The Four Courts, a "stupendous neo-classical monument,"[304] was originally completed in 1791. After battles during the 1922 civil war, the complex was restored.[305] The building, described as "at once Palladian and Baroque," reflects the style, dubbed "Ultimus Romanorum," of one of its architects, James Gandon.[306] Its interior decorations include allegorical emblems such as Ireland's harp shown on a shield "resting on volumes of law books, bound together by a serpent entwined around them," and personifications of "Justice, Security, and Law."[307] On the front pediment were statues (few of which have survived) identified as Moses, Justice, and Mercy. On piers of the interior dome were "colossal statues of . . . Punishment, Eloquence, Mercy, Prudence, Law, Wisdom, Justice, and Liberty"; above were medallions of "eight distinguished legislators, Moses, Lycurgus, Solon, Numa, Confucius, Alfred, Manco-Capac, and Ollamh-Fodhla."[308] The quest for politically authorizing ancestors—shared by Siena, Geneva, Amsterdam, and Venice—thus widened its net to reflect a broad multicultural claim to legitimacy that would, in the twentieth century, be repeated in the United States, with examples discussed in Chapter 6.

One of the eighteenth-century sculptures of Dublin that remains is *Justice* (fig. 65), given a "prominent position" standing over a gateway into Dublin Castle, "the centre of political power in Ireland."[309] This 1753 statue, almost nine feet tall, made of lead, and painted to look like stone,[310] is by John van Nost the Younger.[311] Figure 65 shows Justice as she is seen from inside the court, with scales in one hand (complete with drainage holes to keep water from tipping the pans) and a sword in the other. If, however, one is looking at her from the city outside the courtyard walls, one sees her back (fig. 66).[312] Popular Dublin lore proffers the explanation that her positioning served as a protest against English rule lurking beyond the castle's walls. That gloss

supposes that Justice statuary was used to assert Ireland's rightful ownership of its own major monuments of law. Architectural commentators propose an alternative explanation—that because the mid-eighteenth-century terrain made it difficult to see the roof's statues from outside, the appropriate didactic focus was to position them to be viewed by people working in the buildings.[313]

### Old Bailey's Open-Eyed and Wide-Armed Justice

Whatever their differences, the English and the Irish both rely on Justice to mark their seats of authority. In London, a twelve-foot bronze *Justice* covered with gold leaf (fig. 67) stands almost two hundred feet above the street at the summit of the city's central criminal courthouse.[314] Her arms span another eight feet; she holds a sword in one hand and equally balanced scales in the other.[315]

FIGURE 67    *Justice,* Frederick William Pomeroy, 1907, Central Criminal Court (Old Bailey), London, England.

The building, the New Sessions House, is also known (as were its predecessors) as the "Old Bailey," and it occupies a site first used for such purposes in 1673.[316] As far as available records indicate, the building's architect, Edward Mountford, selected the sculptor, Frederick William Pomeroy, and directed the design.[317] In addition, Pomeroy sculpted a sequence of allegorical figures (Mercy, Charity, Temperance, and Justice) for the dome, as well as another Justice that joined other figures in the interior. Lunettes were painted by Gerald Moira. In one, Justice (with eyes cast downward) is among the many figures shown on the steps of St. Paul's Cathedral in London where she is "receiving the homage of all classes and professions."[318] A circular window is bracketed by "Time protecting Truth from Falsehood" and by "Justice, Righteousness and Crime."[319] When rebuilt in 1907, the building had four courtrooms; by the end of the twentieth century, it had nineteen.[320]

Like the *Justice* in figure 67, none of the other Old Bailey Justices are blindfolded; rather most share the open-eyed vision of the version at the summit, although they lack her distinctive stance. This Justice's outstretched arms and spiky headdress echo the Statue of Liberty[321] (built in France and erected in the New York Harbor in 1886), and other iterations have similarly entwined Liberty and Justice. Old Bailey's *Justice* reflects a shift in aesthetics that can be found in many courthouse buildings erected during the twentieth century.[322]

### Across the Atlantic Ocean: Kansas's Sharp-Eyed Prairie Falcon and Vancouver's Peaceable Justice

Two examples from North America complete the scan of this five-hundred-year sweep in which the mix of technology and political aspirations produced ever taller and heavier Justices. As detailed in Chapter 1, Justice is the one Virtue who remains readily recognizable, providing a transnational sign that a building is a courthouse. And despite theories of republicanism arguing that democratic principles ought to have generated a "different language,"[323] Justice continues to serve as a common idiom. Hundreds of statues erected over the past century illustrate this point, and here we proffer only two more, bringing us closer to the current era.

Like the 1907 Pomeroy *Justice* for the Old Bailey, the 1978 Bernard Frazier *Justice* (fig. 68) for the Kansas Judicial Center (housing that state's Supreme Court in its capital city of Topeka) reflects sculptural modeling of a particular aesthetic moment.[324] Bernard Frazier was a sculptor-in-residence at Kansas University who had initially proposed a nude female figure, but a committee member of the Capital Area Planning Authority objected. The revision, carved from Carrera marble under the supervision of the sculptor's son Malcolm after his father's death,[325] sits on a fifteen-foot-high base in a "sixty-foot cube of space."[326]

FIGURE 68   *Justice,* designed by Bernard Frazier and completed by his son, Malcolm Frazier, 1978, Kansas Judicial Center, Topeka, Kansas.

Photograph reproduced courtesy of the Kansas Judicial Branch.

FIGURE 69   *Themis, Goddess of Justice,* Jack Harman, 1982, Vancouver Law Courts, British Columbia, Canada.

Copyright: Harman Sculpture Foundry Ltd., Alberta, Canada. Photograph copyright: The Law Courts Education Society of British Columbia. Photograph reproduced with the permission of both copyright holders.

This cloaked and kneeling Justice has a bird in hand, as did some of her predecessors. But this one—held aloft—is not the ostrich found in the paintings of Giulio Romano (fig. 56) and Luca Giordano (fig. 57) nor the dove of Damhoudere but a prairie falcon. According to an official of the Kansas courts, because that particular species has the "sharpest eyesight," it was chosen "to represent the all-seeing eye of justice."[327] Poised for flight, the bird's potential motion

draws Justice's own eyes. As a brochure for visitors explains, the statue depicts "Kansas justice as lofty, dynamic, and idealistic, with clear vision and swift action."[328]

The other example comes from the Vancouver Law Courts, a 1979 building in British Columbia, Canada. The designers created a large open hall on its fourth floor, sheltered by a glass roof and bordering terraces.[329] The bronze Justice there (fig. 69), installed in 1982, stands near one of

the entrances. Its sculptor, Jack Harman, called his work *Themis, Goddess of Justice*.[330] He shaped a floor-length cloak around the shoulders of this many-tonned bronze, covered her eyes with a blindfold, placed evenly balanced scales in one raised and outstretched hand, and tucked a scroll, half hidden by drapery, in her other. The court's website explained that "the artist, who was against capital punishment, replaced the sword with a scroll."[331]

These statues from Kansas and Vancouver show that, by the late twentieth century, the various allegories of good and bad government, of noble or imprudent leadership, and of virtuous and corrupt judging had been compressed into a single image—Justice. Rendered in styles that fit their age, homogenized with a few other goddesses ranging from older Greek ones to the more recently crafted Liberty, holding birds as well as scales and swords, and only episodically blindfolded, Justice has survived as the easily intelligible sign that a particular place is a public government building devoted to law.

## A Resilient, Albeit Invented, Tradition

A summary of the premises of this chapter is in order as a predicate to the next. Through a trek from Bruges in the fifteenth century to Vancouver in the twentieth, we have mapped "invented traditions"[332] of transnational proportions. Shared by monarchies and democracies, by city-states and nations, polities shaped their legal identities by seeking to incorporate or appropriate a visual vocabulary legitimating their authority. The imagery and its explanations substantiate five propositions.

First, European public authorities once put forth a much richer pictorial array than a lone Virtue, Justice, as they sought to anchor their authority and to dictate behavior appropriate for judges. Through an iconographic and emblematic tradition that spanned a large part of that continent, ruling powers gained the capacity to select images and stories (*exempla*) to make many points. Justice was not the sole Virtue with which governments allied themselves; good governance required signifying that it was constituted from Prudence, Fortitude and Temperance, Peace and Prosperity, Concord and Harmony as well.[333] Nor were the Virtues the only message offered. Cautionary tales were regularly broadcast when Cambyses, Zaleucus, and Brutus served as readily cognizable warnings, delivered in town halls around Europe. Repeatedly, rulers depicted their authority and sought to instantiate its legitimacy through symbolizing their legal system's imposition of judgment.[334] On occasion, books were proffered as references to codes of law, but the acts of codification and legislation have not lent themselves to personification as readily as have moments of judgment. (Occasionally, large-scale paintings show crowded rooms of parliamentarians.) Justice iconography thus gained a special place in the civic buildings erected.

Second, the deployment of such imagery was ambitious, aimed at consolidating power by shaping new norms for judges to function as obedient servants, loyally implementing the laws of the state. In eras in which judgeships were sold (along with other positions), when judges were paid on a fee-for-service basis, and when popular distress with courts and law was high, commissioned art nonetheless aimed at making certain kinds of behavior illicit. Imagery—then and now—seeks to generate commitments to developing norms rather than to express only those that are secure.

Third, the standard bearers that have dropped out over the centuries are those foreboding reminders of the burdens of working in the name of the law. Once shown were judges ordering the deaths of their own children, gouging out their own eyes, or sitting handless to preclude accepting bribes. Once delivered were instructions to fear God and rulers whose laws judges ought not risk disobeying.

Fourth, the attributes that surround the surviving icon, Justice, were more various and variously justified than they are today. Recall that a 1611 edition of Ripa provided descriptions of six versions of "Worldly Justice" and one who was "Divine." That crew of Justices came wearing white or gold dresses, adorned with crowns or bracelets, seated or standing, and holding scepters, chalices, flames, or fasces as well as occasionally swords and scales. Only one had a blindfold, but that Justice (whom Ripa credited with being "the type of Justice that is exercised in the Tribunal of judges") also had "a bundle of rods, with an axe, . . . a fiery flame, [and] . . . an ostrich, a sword and scales."[335] Fasces and flames are now rare, and an ostrich near a Justice is no longer comprehensible. Moreover, the attribute now assumed to be common—the blindfold—was once deployed derisively and, we have argued, as a subtle signal of the pain inflicted in the name of Justice—as in Peter Brueghel's *Justice* (fig. 53) and in Quellinus's relief of *Justice* (fig. 47) in Amsterdam's Tribunal. The valorization of the blindfold came thereafter and, as we detail in the next chapter, that symbolism remains contested, and only episodically attached. As the images from Venice, England, Ireland, and Kansas exemplify, many clear-eyed Justices continue to reign over palaces and courts.

Fifth, even as the allegorical and emblematic tradition waned,[336] the remnant of the Renaissance that has survived provides a complacent celebration of the power of the state. Rather than suggesting a struggle (*The Judgment of Cambyses* or *Les Juges aux mains coupées*) to render judgment "without fear or favor" or the personal toll that judging takes (scenes of Last Judgments, Zaleucus, and Brutus) or a need for a range of Virtues (Prudence, Temperance, and Fortitude), Justice generally stands alone, presumptively at ease with her role. Although her sword signals the violence governments impose when rendering judgment, swords rarely draw objections or analysis, and the scales are presumed to embody fair decisionmaking. Those who commission her placement have confidence (undaunted by

postmodern skepticism) that, if noticed, such a Justice is inoffensive and reassuring.[337]

Yet a few twentieth-century depictions of Justice have prompted controversies, to which we turn next. One set of questions revolves around sight, as artists continue to puzzle about whether to show Justice clear-eyed or blindfolded. Other issues emerged when egalitarian movements enabled persons of all kinds to bring claims to court that rendered problematic the question of whose faces and bodies ought to be seen as iconic. As we will examine, although bulked up in tonnage and height, Justice iconography is ill-equipped to symbolize all that democractic orders seek from adjudication. However well she once served monarchies and however fascinating her history or aesthetically engaging her depictions, this sole icon can no longer carry the weight of the obligations she marks.

# Why Eyes? Color, Blindness, and Impartiality

This chapter's first purpose is to explore the remarkable reduction of Justice iconography into the form of a hefty female figure, decked out with scales, sword, and the occasional blindfold. We begin with a 1515 text, *On the Painting of Justice,* animated by a debate about how artists assigned by rulers to portray Justice ought to respond. This fictive discourse makes plain that the question of how to make a figure recognizable as "Justice" was then still an open one. That point was reiterated at the end of the sixteenth century when Ripa's *Iconologia* (described in earlier chapters) proffered not one but seven different versions of what various Justices looked like. Today that variety has evaporated. Over the intervening centuries, rulers produced the current distillation that serves as a transnational and trans-temporal political icon of government.

This chapter's second focus is on understanding why blindfolding Justice has been and remains a source of contestation. Both the many clear-eyed versions of Justice and the satiric 1494 woodcut of *The Fool Blindfolding Justice* (fig. 4/51) are premised on the same idea—that sight produces first-hand knowledge. What flows from this proposition, however, is contested. Blindness as a *deficit* presumes that sight is requisite to understanding, whereas blindness as an *asset* assumes that sight can corrupt judgment. This pictorial conflict mirrors a doctrinal one in which real judges debate whether the law ought to be "blind" or to "see" certain facets of conflicts or of disputants.

Disputes about how to show Justice's "face" and about Law's "sight" reflect the analytic challenges that have engaged philosophers from John Locke to John Rawls, as they parsed the relationships among sensory perceptions, intuition, evidentiary truths, and cognition. The question of sight has also been engaged by leaders of justice systems acknowledging histories of exclusion and unfair subordination based on the gender, race, ethnicity, and class of disputants. Although most of the iconography of Justice

placed around courthouses is complacent rather than provocative, the controversies over blindfolding unveil a persistent disquietude about state application of laws. This point was eloquently put by the twentieth-century poet Langston Hughes, who charged that the blindfold hid "festering sores / That once perhaps were eyes."[1]

## Commitments to Representation

A once popular twentieth-century English writer, Bernard O'Donnell, who had "attended every big murder trial in Great Britain during his professional career,"[2] took it upon himself to account for why the twelve-foot-tall Justice at the pinnacle of London's Old Bailey (fig. 4/67) is wide-eyed. He called her "a unique figure, for it is the only statue of Justice in the world which is not blindfolded. When the new building was opened by the late King Edward VII in 1907, the Corporation of London was concerned to impress upon the world that Justice, as administered at the Old Bailey, was not blind."[3]

The exuberance of O'Donnell's error is belied by our several hundred–year pictorial journey that mapped how, beginning in the seventeenth century, the blindfold came to be attached, episodically, to Justice. But he was not the only one to believe that a Justice without a blindfold is a depiction in need of explanation. Across the Atlantic, writers of a booklet celebrating the centennial of a county courthouse in Aspen, Colorado, took a similar tack, describing their statue as "one of the very few figures of justice to appear without a blindfold."[4]

The six-foot-tall *Justice* in Aspen (fig. 70) was made from silver to mark the Pitkin County Courthouse, which opened as the county's seat of government in Aspen in 1891.[5] According to the local lore, silver miners had been leery about ceding their own powers to convene miners' courts. They paid for the new courthouse's statue of Justice, whom they insisted be shown with scales and clear-eyed. Perhaps influenced by their own dependence on weights and measures of silver, the "miners believed that Justice was

FIGURE 70    *Justice,* Pitkin County Court House, 1890–1891, Aspen, Colorado. Architect: William Quay.

Photograph copyright: William Clift, 1976. Image made for the Seagram
County Court House Project, reproduced with the permission of the photographer.

not blind and that she could weigh justice without being blindfolded."[6] Apparently ministers in Prussia had a similar attitude when, in 1907, they ordered that, in all new courthouses, Justice not be shown wearing a blindfold.[7]

In contrast, in the 1950s spectators complained about an "open-eyed" Justice painted in the 1890s as part of a mural in a Manhattan criminal court. Audience members wanted a blindfold to be added.[8] Viewers in London, Aspen, and Manhattan thus shared the impression that sight—obscured or not—has some relationship to knowledge and in turn to the fair administration of justice. Moreover, despite the presumption that allegory is "dead,"[9] attention continued to be paid to whether Justice's eyes were open, shut, or blindfolded. Those debates follow a tradition established centuries ago, and hence we return briefly to the sixteenth century.

### Impossible to Depict: An Exchange between Mantegna and Momus

Battista Fiera, an Italian doctor and man of letters, published a curious pamphlet, written in Latin and called *De Iusticia Pingenda* (*On the Painting of Justice*). The monograph consists of a fictitious dialogue set around 1488–1490 between the painter Andrea Mantegna (who died in 1504) and his interlocutor, Momus.[10] Their debate centers around whether a painter can properly create a pictorial version of this Virtue.

Justice needs no further introduction. But the other three participants in *On the Painting of Justice* do. Its author, Fiera, was from Mantua and personally knew Mantegna, who was renowned in his day as well as in ours and who had done at least two paintings in which a Justice appeared. In 1488, while in Mantua, Mantegna was appointed a court artist under the patronage of Ludovico II Gonzaga. Soon thereafter, Mantegna left for Rome, where he had been summoned to paint a series of frescoes (including a Justice) for the Vatican Chapel of Pope Innocent VIII. Because those frescoes were subsequently destroyed, documentation is sketchy,[11] but another Justice by Mantegna is well known. Mantegna's *Pallas Athena (or Minerva) Expelling the Vices from the Garden of Virtue,* a version of the epic battle (the *Psychomachia* discussed in Chapters 1 and 2) between the Virtues and Vices, hangs today in a place of honor at Paris's Louvre.[12] Mantegna put Justice in the clouds along with Fortitude (denoted by her column) and Temperance (with water pitchers). Holding scales and sword, Justice is a clear-sighted, solid-looking woman.

Fiera's second character, Momus, was also once well known, albeit allegorical; he was the Renaissance's stock personification of a carping critic.[13] That was the posture in which Plato evoked Momus in an exchange in the *Republic.* Socrates asked whether anyone could offer objections to a description of the philosopher as "a friend and relative of truth, justice, courage, and moderation." His interlocutor

replied: "Not even Momus could find one."[14] Momus was also a character in a story by the first-century Greek writer Lucian, who described a quarrel among Athena, Poseidon, and Hephaestus about their artistic skills. Momus, appointed as the judge, criticized each in a fashion generally read as raising ridiculous objections. For example, Momus complained that the man painted by Hephaestus lacked windows on his chest, thereby precluding a viewer from peering inside to see whether the man lied or spoke the truth.[15]

One could put Momus in another posture by interpreting his comment about needing a window as a sly criticism of the general challenge of eliciting "spiritual and intellectual honesty."[16] But because Momus gained popularity in the Renaissance through an essay written in 1446 by Leon Battista Alberti that cast Momus negatively,[17] he came to personify the "malevolent, ever-watchful critic."[18] As the annotation under one print explained: "My name is Momus, born of Night, without a father, the comrade of Envy. I enjoy criticizing each individual thing."[19]

Return then to Fiera's dialogue, prompted by the fictional Mantegna's quest for advice after receiving a commission to paint a Justice that paralleled Pope Innocent's request of the real Mantegna to paint frescoes for his Vatican Chapel.[20] The conceit is that Mantegna had "heard so many conflicting accounts of Justice" that he decided to consult a series of "philosophers"—which, Momus noted, showed Mantegna's "good sense in avoiding [asking] the lawyers."[21] The following exchange is offered:

MANTEGNA: I began with Saxus Hippolytus. He said Justice should be represented with one eye; the eye being rather large and in the middle of the forehead; the eyeball, for sharper discernment, deep-set under a raised eyelid.

MOMUS: Suppose something happened behind her back? [M]ight she not be taken in the rear? [W]ill she be safe enough with only one eye in front? . . . [I]f she had an eye at the back as well, she'd be still more queenly and majestic. . . .

MANTEGNA: Erasmus the Stoic [said that] . . . she ought to be shown seated, and holding scales in her hand. . . .

MOMUS: The grocer coming out in him! . . .

MANTEGNA: "But [Erasmus advised] . . . make her one-handed . . . [s]o that she couldn't throw in a makeweight, of course." . . . [Marianus] instructed me to depict her standing, and with eyes all over her as Argus was of old. . . . And brandishing a sword in her hand to ward off robbers, and to protect the innocent and the unfortunate. . . .

MOMUS: What did Fiera say? . . .

MANTEGNA: [He] enjoined me to depict her covered with ears as well.

MOMUS: Why? Was he afraid that she might become deaf?

MANTEGNA: He was. . . . [A Carmelite theologian] maintained that Justice cannot be depicted at all.

MOMUS: And there he is certainly right. If all these different opinions of philosophers were so, I also agree with him. For how can you represent Justice both with one eye and many eyes; and how can you depict her with one hand only, and yet measuring, and at the same time weighing, and simultaneously brandishing a sword?—unless, of course, they are all raving mad. Flatly, the thing can't be done. . . .

MANTEGNA: Justice [the Carmelite said] is the will of God. . . .

MOMUS: . . . [W]hat about human Justice?

MANTEGNA: He spoke about human Justice too, and no less to the point. Man, within the limits of his frail and fallible nature, is not unaware of Justice, and is subject to her laws; nor can he, by any deviation however slight, escape them. . . . He did say that [Justice] was imprinted [on the human mind]; from the outset so fixed in the core of our nature that Justice and Life might be reckoned sisters. For, he said, everyone is born with the instinct of self-protection, and with the desire to avoid pain. But why should someone impose upon another what he dislikes himself; and why should he grudge to others what he himself desires? . . .

MOMUS: [D]id [your theologian] ever mention any decree of this divine Justice that is so perfect and entire, whereby all men alike should be put on their guard . . . ?

MANTEGNA: Death, Momus, for everyone the last necessity, to be avoided by none. Sooner or later we die, Momus; Death levels us all, the lowest and the highest: so sacred and stern is Justice.[22]

Thus, the pamphlet (echoing Platonic divisions) decries the failure of earthly Justice, inevitably corrupted by human wants and desires. But God's Justice, represented by Death, is the great equalizer; with that "sacred" Justice comes a rigor that earthly Justice cannot maintain.

This dialogue has puzzled those who have studied it because neither its audience nor its purpose is self-evident. It could have reflected real events, both because Mantegna had, in fact, been commissioned to paint frescoes for the Vatican and because he had a reputation for seeking "advice from his humanist friends."[23] Fiera may also have styled the dialogue as a promotional piece for his hometown of Mantua, from whence Mantegna hailed, as did the theologian invoked as giving sage advice in the exchange.[24] Fiera could have meant the dialogue as satire, replete with (now indecipherable) inside jokes. Ernst Gombrich, the twentieth-century art historian who brought the dialogue into contemporary focus, read it as such—"slight and half-humorous" and "intended to echo the hunt for Justice in Plato's *Republic* rather than to tell us about the relation of artists to humanists . . . ."[25] One of its translators was harsher, finding it "no prose masterpiece" but rather a "curiosity of literature" that offered "cryptic" references, "indifferent" Latin, and a "mass of mythology, quasi-philosophy and Thomist theology."[26]

*Creating the Canonical Elements*

Whatever its literary merits, the dialogue's interest for us is twofold. First, it is a forerunner of the contemporary discussions, exemplified by the felt need to explain the appearance of clear-sighted Justices at the Old Bailey in London and in Aspen, Colorado, and bespeaking investments in what Justice "should" look like. We pick up this theme in Chapter 6 when we examine a series of twentieth-century controversies sparked by artists' renditions of Justice that—whether lacking a blindfold or with dark skin—violated conventions.

Second, Fiera's dialogue serves as a reminder that the reduction of Justice to a set of relatively stable markers was not inevitable five hundred years ago. One can plot a trajectory from Fiera's wide-ranging ruminations of the early 1500s to the tidy didacticism of Ripa, writing at the end of that century and proposing that objects and animals be attached as attributes of his seven Justices as if the connections appropriately distinguished the various incarnations. Ripa's positivism provided a step along the way to a codification, but his seven Justices (again Platonic with one divine and the rest earthly) did not predict a single canonical version. By giving us a window (as Momus commended) into the world before Justice attributes had settled into a universally recognizable formula, Fiera and Ripa illuminate the puzzles presented by the subsequent conventions that came to surround Justice iconography.

Why did a female holding scales and sword survive as a recognizable icon over the course of the centuries skimmed here? During that time, intense conflicts erupted over the control of religious orthodoxy, new political theories developed about the sources of legitimacy for ruling powers, and radical ideas about the acquisition of knowledge proliferated. Yet Justice iconography gained and maintained an identifiable core, transcending (literally and

metaphorically) the new perspective of the Renaissance, the iconophobic ideas of the Reformation,[27] periods of absolutism, the invention of modern democracy, and the development of probability, psychological, and cognitive theories. Given the many competing claims of righteous governance and sources of knowledge, depictions of Justice might well have proliferated and become diffuse, akin to the instability in Christian iconography of the Devil, around whom swirled a host of different descriptions and no one particular materialization.[28]

But pictorial perplexity neither served the political need to legitimate state power nor captured resilient aspects of adjudicatory practices that survive across social organizations. Within a century after Ripa, his seven Justices (sometimes crowned, wearing various necklaces, holding different objects, and surrounded by a range of animals) had been distilled into one stock figure identified by scales and sword. And Ripa's mention of a blindfold as a possible marker of impartiality eventually came to be an expected accoutrement. At the pictorial level at least, the nuances among kinds of Justice, as well as the point that Earthly Justice failed to achieve Divine Wisdom, had been obliterated.[29]

The singularity of depiction has been sustained not only by rulers' power but also by the stability of certain ethics adhering to the judicial role despite its place within diverse political systems. Although the concepts of judicial independence and accountability are modern,[30] other expectations of judges developed early and have remained constant across time and place, shaping a judicial culture with aspects that were and are universal. The legitimacy of the exercise of law's violence (the sword) has long rested on even-handed treatment of disputants (the scales) and on judgments predicated on information about a given conflict rather than corrupted by bribes and status relationships. With limited roles for women of any color in political orders, a female form rendered in classical style could be deployed to embody this abstract posture. Given a polity's dependence on maintaining order through actual practices of judgment that produced socially tolerable decisions, the Virtue Justice holding scales and sword came to mark the delivery of a particular governmental service—adjudication.[31]

It is a part of our thesis that these "proto-democratic" elements of pre-democratic adjudication contributed to the development of democratic practices. Popular demands increasingly aspired to fair treatment and constrained the power of government more generally. Moreover, the advent of democracy added to the expectations of judges by developing aspirations for judges to be independent of the powers that appointed them, yet accountable to the public by means of transparent processes that came to entail providing reasons for the decisions rendered. Yet even under systems obliging fair treatment, problems of judgment remain acute.

## Sight, Knowledge, and Impartiality

Suppose a Man born blind, and now adult, and taught by his touch to distinguish between a Cube, and a Sphere of the same metal, . . . be made to see.
John Locke, 1694[32]

It is possible that the law, which is clear-sighted in one sense, and blind in another, might, in some cases, be too severe.
Montesquieu, 1748[33]

Justice is blindfolded too, to avoid being dazzled by imposters.
Goethe, 1790[34]

But in view of the Constitution, in the eye of the law, there is in this country no superior, dominant, ruling class of citizens. There is no caste here. Our Constitution is color-blind.
Justice John Marshall Harlan, 1896[35]

That Justice is a blind goddess
Is a thing to which we black are wise.
Her bandage hides two festering sores
That once perhaps were eyes.
Langston Hughes, 1923/1932[36]

The principles of justice are chosen behind a veil of ignorance.
John Rawls, 1971[37]

Whether pre-democratic or post-democratic, the task of judging entails enormous difficulties in gaining sufficient knowledge about past events, sorting and weighing information and, if legally cognizable injuries have occurred, finding proportionate, effective, and wise responses. As suggested by this subsection's epigrams that span three hundred years, acknowledgment of these challenges comes through debates over what Justice ought to "see." Goethe aspired to a blindfolded Justice so that she would not be "dazzled by imposters," while Justice John Marshall Harlan relied on the metaphor of a "color-blind" Constitution. The political philosopher John Rawls called for self-imposition of a "veil of ignorance," but Langston Hughes derided the failure of Justice to see the injustice about her.

Hughes's disdain for blindness had deep historical roots. As we traced in Chapter 4, to be shrouded in darkness was a burden in Medieval Europe. The blind were to be pitied, and a purposeful imposition of a blindfold signified that a person was either ignorant or condemned to punishment. In contrast, light was equated with truth; judgments were to be "clear . . . as the morning light."[38] In times when people believed in an all-knowing God as the source of judgments and in the existence of a truth both universal and absolute, the image of an all-seeing Justice mirrored such a divine being. One had little need to mark the problem of sorting

good from bad information because judges—doing God's Justice on earth—were to know all that they could through whatever means available.

These precepts were reflected in various depictions of Justice. Fiera's *On the Painting of Justice* recommended a Justice covered with eyes (as well as ears) to see and hear everything. Of the seven Justices whom Ripa described in 1593, only one was blindfolded. The rest (including one labeled Divine Justice) were clear-sighted, with one especially praised for her piercing gaze. In a parallel fashion, Albrecht Dürer's *Sol Justitiae* of 1499 made the large eyes of his Judge/Christ dominant. The halo formed through the rays of the sun around his head underscored his wisdom. Even when a judge appeared blind, as he did in a 1530s Alciatus emblem (fig. 3/33) that analogized the Prince's Council to the Judges of Thebes and showed the Prince/Judge with vision obscured, all the other council members on whom that princely judge relied could see.[39]

But as earthly justice came to the fore and the instances of its application proliferated in the growing urban centers, so did a preoccupation with the quality of knowledge and the caliber of those who made judgments. Eyes could play tricks and, as science had begun to demonstrate, new optical instruments could enhance sight. The camera obscura gained currency in the sixteenth century,[40] followed around 1600 by the invention of the telescope and the microscope[41] and by interest in the idea of probability.[42] Moreover, in addition to being inadvertently misled, judges could be looking for bribes. Ripa put a blindfold on one Justice "so she can not see anything that might be used by judges in a way that is against reason."[43] Descartes wrote of the desirability of escaping the confusion of the senses.[44] Lutheran theology could also be cited as supporting the need to affix a blindfold to Justice, for truth was to come from inner light.[45]

Of course, humanism and the movement toward an Enlightenment sensibility was not the first occasion when people worried about either the correctness of a legal rule or the quality of information on which decisions rested. Ancient biblical sources specify evidentiary standards for oral testimony and physical observations,[46] with prohibitions such as the rule in *Deuteronomy* that a "single witness may not give evidence against a man in the matter of any crime or sin which he commits: a charge must be established on the evidence of two or of three witnesses."[47] But scholars of that period argue that none of the "biblical law codes . . . envisage judicial error"; the focus was on the "possibility of falsified evidence by lying witnesses."[48]

Epistemological doubt—about the import of facts, the uncertainty of recollection, the imperfect interpretation of law, the flaws of decisionmakers—contributed to anxiety about judicial failures. As theorists from various disciplines became quizzical about the nature of knowledge, authority, God, and truth, the valence of open eyes to denote unimpeded receipt of knowledge shifted. During the sixteenth century, the blindfold came to be reconceived, on occasion, as a useful addition.[49]

By the eighteenth century, the blindfold on Justice had shed its connections to the blindness of Synogoga failing to see the light of Christianity, to jesters made buffoons because they could not see, and to the condemned blindfolded before execution. Instead, when placed on Justice, the blindfold was turned into a symbol of law's commitment to rationality and even-handedness.[50] The depiction of a Justice whose vision was obscured came to represent something sought after—a needed neutrality, inner wisdom, a lack of distraction, or incorruptibility. The absence of a blindfold, in turn, came to be seen as an omission in need of explanation.

Not yet mentioned on the list of justifications for the blindfold is what today we call "separation of powers." Once, the roles of judge and ruler were seen to be deeply and appropriately intertwined; Alciatus's sixteenth-century emblem (fig. 3/33) is exemplary. The sightless presiding jurist (called the Prince, King, or Judge, depending on the translation) was to render judgment according to the advice of his council, a group of men all shown sighted. Judges were the servants of ruling powers, and the stories of Zaleucus, Brutus, and Cambyses (figs. 3/45, 3/46, 3/31, 3/32) taught judicial *subservience* to the law of the state.[51]

The development of the idea that judges were deployed by states but sat somehow independent of state power was an ideological shift in political theory, often credited to Montesquieu's proposition that "there is no liberty, if the judicial power be not separated from the legislative and executive."[52] A yet more radical notion is that judges have the power to sit in judgment of the state, their own employer. A few famous "folktales of jurisdiction," as Robert Cover called them, can be found in biblical and common law narratives in which brave judges stood their ground against threats of tyrannical kings. Those judges insisted on their own authority to "speak truth to power."[53] But until the Enlightenment, those extraordinary confrontations did not represent a required facet of the judicial role, which was not then insistently positioned to be at a critical distance from the state. Indeed, the term "state" was not in "normal usage" until around 1600, when it referred to the powers within the exclusive purview of a small set of ruling elites.[54] Over time and through many struggles among cities, local aristocracies, and imperial and religious authorities, the power of popular voices grew, as did ideas that judges ought not to be totally dependent on the authority of ruling powers. Aspirations for "glory and greatness" were leavened by quests for civil order in which some degree of individual liberty and popular opinion had value and in which kings were not the only incarnations of sovereign interests.[55] Conceptions of civil liberty came to entail limitations on the state, including governments ruled by monarchs.[56]

In this "march to modernity" (to borrow Theodore Rabb's book title), sovereignty shifted. Illustrative is the eighteenth-

century preamble of the American Constitution opening with the phrase "We the People of the United States." That document also specified an independent sphere for judges. Building on the English Act of Settlement of 1701 and on state constitutions, the United States Constitution of 1789 required that judges, once appointed, were to keep their jobs "during good Behaviour" and were to receive salaries that could not be diminished while they served.[57] The provisions sought to protect judges from over-reaching by executive and legislative authorities. In the wake of these new understandings of government, the blindfold gained a different import, marking not only a judge's neutrality between parties but also his untethered stance, standing apart from the government that employed him.[58] This metaphoric distance derived from deliberate restrictions on sight continues to be invoked, as illustrated by a 2004 volume entitled *The Blindfold of Lady Justice: Judicial Independence and Impartiality in Light of the Requirements of Article 6 ECHR [European Charter of Human Rights].*[59]

But not all unequivocally celebrate obscured vision, as can be gleaned from a brief overview of debates about sight's relationship to knowledge and of knowledge's relationship to justice and democracy. As we detail, both the iconography of justice and legal doctrine reflect these debates. The instability around Justice's eyes (sometimes shown clear-sighted, sometimes closed, and sometimes draped by bandages or blindfolds) has its counterpart in the difficulties of formulating fixed rules about which facets of human experience law ought to take into account when judges render decisions that reorganize other people's lives.

### "Suppose a Man born blind . . . be made to see": Locke, Diderot, and Molyneux's Problem

The centrality of sight to theories of knowledge is captured by John Locke's query about what a man, "born blind" and then able to see, would know. That puzzle has come to be called the "Molyneux problem," because Locke's friend William Molyneux "put to him" that issue in 1688.[60] The specific example was whether a blind person who had often held in his hands a metal cube and a metal sphere would, if vision were restored, be able upon first sight to distinguish between the two objects.

Writing at the end of the seventeenth century, Locke's puzzlement reflected an epistemology that classified knowledge in relationship to its source and attended (following in "the footsteps of Aristotle"[61]) to the number of senses (e.g., touch, sight, and smell) that could bring ideas to mind. Locke built on discussions from biblical traditions, Aristotle, and the Medievalist Ockham in assuming that vision had a primary place in the hierarchy of senses[62] from which intuition, cognition, wisdom, and judgment all derived.[63] Arguing that understanding came from mixing sensory perceptions and analytic interpretation, Locke responded to Molyneux's problem by positing that a person without the experience of seeing the cube and the sphere could not, at first sight, make the judgment required to distinguish and name the two objects.[64]

Molyneux's problem was not only a heuristic device. Physicians of the eighteenth century were beginning to devise medical cures for the form of blindness caused by cataracts.[65] Blindness, once a state of irredeemable "otherness,"[66] became a "subject of intense cultural interest"[67] in science, philosophy, and the arts. In 1749 Diderot published his *Lettre sur les aveugles à l'usage de ceux qui voient* (*An Essay on Blindness in a Letter to a Person of Distinction*).[68] He pursued and arguably deconstructed (to borrow a term from a later age) Molyneux's problem and Locke's response.

Positing that a blind person was profoundly different from a person with sight, Diderot shared the views of Locke and Molyneux that "the blind" were members of a discrete category.[69] But Diderot's analysis rebutted the idea that "the blind" lacked knowledge from experience; he argued instead that those who were blind, like those who see, had understandings informed by their own "bon sens" (good sense or, as he noted, lack thereof).[70] Blindness did not result in a mind that was a tabula rasa,[71] although blindness could inhibit the ability to provide names ("denomination"[72]) for various objects. Moreover, Diderot reminded his readers that the blind were comprised of a diverse set of individuals who ought not be used as "univocal symbols . . . for any single position."[73] The more general proposition (and one important for thinking about juridical challenges to render judgments both fair and understood to be so) was that no "single discursive mode of understanding or communication [was] common to all individuals."[74]

In another essay, *Promenade d'un sceptique* (*A Skeptic's Promenade*), Diderot turned from the state of blindness to the agency entailed in blindfolding and invoked the Christian imagery that had put a blindfold on Synagoga as the embodiment of the Old Testament (fig. 4/50) against his religious compatriots. Diderot argued that Christians were the new Jews, "since the Christians themselves wear a blindfold signifying their refusal of the evidence of reason and the senses."[75] That view (so to speak), coupled with much else in the *Letter on the Blind,* did not endear Diderot to the authorities, who jailed him as a result of the publication.[76]

Now, more than 250 years later, Locke, Molyneux, and Diderot serve as touchstones for another generation of scholars who continue to puzzle about the relationship of sight to conceptualization.[77] Contemporary work refers to sensory perception as either "amodal"—relying on audible, visual, or tactile sensations singularly—or "inter-modal," in which sensory information is "transferable from touch to vision."[78] How these senses interact to form knowledge and judgment, and in what order these processes occur remain contested by scientists focused on the workings of the brain ("still heirs of the 17th century"[79]); by psychologists and behaviorists attentive to framing, heuristics, schema, and implicit biases;[80] and by political and legal the-

orists engaged in the consequences that ought to flow from what we claim to know.[81] References to blindness (willful or by default) and sight continue to lace discussions about how democracies ought to allocate goods and how courts ought to render legitimate judgments.

## Rawlsian Veiling

In the late twentieth century, John Rawls turned to the relationship between limited knowledge and judgment in his book *A Theory of Justice*. That volume, published in 1971, aimed to generate a methodology for deciding the basic premises of a just social order. Rawls argued that principles of justice had to be developed "behind a veil of ignorance" so as to ensure that no one would be "advantaged or disadvantaged in the choice of principles by the outcome of natural chance or the contingency of social circumstances."[82]

Rawls explained that the veil put one in an "original position" by excluding "knowledge of those contingencies which sets men at odds and allows them to be guided by their prejudices."[83] Metaphorically, the veil precludes knowledge of one's own class, social status, abilities, intelligence, life plan, or generational situation, and of the surrounding social, economic, or political order.[84] Yet, Rawls explained, reasoning from such an "original position" was not transcendent but tied to human life, "situated in the world" with others facing the "natural restrictions" of "moderate scarcity and competing claims."[85] From that leveling and equality, Rawls argued, emerged the possibility for "a unanimous choice of a particular conception of justice,"[86] achieved by reasoning in stages about principles of justice.

Relying on the language of contracts whose terms were specified, Rawls posited that, if principles of justice were bargained for and then enforced, they would be both more stable and fair.[87] Rawls further explained that agreements reached about justice should be accompanied by "publicity" (a term also central to Jeremy Bentham, as discussed in Chapter 13), by which Rawls meant that "citizens have a knowledge of the principles that others follow."[88] According to Rawls, courts were also required to perform in public. Adjudication had to be "fair and open"[89]—enabling the public to see that the judges were "independent and impartial."

Rawls's use of the "veil of ignorance" serves both as a measure of the strength of visual metaphors for modern readers and as an example of how a stance of publicly displayed impartiality (associated over centuries with judges) has become a desired quality for governance more generally. Rawls's veil intersects with Justice's blindfold in that both are volitional efforts to impose an artificial limit on knowledge so as to enable better decisions, whether retrospective or prospective. Rawls sought to block out information that would result in self-serving judgments on justice, and the blindfold has a parallel aim, to prevent giving weight to what might be true (such as a litigant's status) but

ought not affect outcomes. Both Rawls's veil and Justice's blindfold depend on the assumption that the wearer can, in fact, see but is committed to bounded knowledge. Further, some of the facets of Rawls's method—even-handedness among conflicting interests, public displays of outcomes, and enforcement—reiterate practices that inhered in predemocratic adjudication.

## Ambiguity and Self-Help: Joshua Reynolds's Justice *in Oxford and Diana Moore's* Justice *in New Hampshire*

Artists have sought to acknowledge the complex relationship between knowledge and judgment by shaping what could be described as a visual dialogue between sight and blindness.[90] One such effort is the *Justice* (fig. 71, color plate 16) that Joshua Reynolds painted in 1778 as part of a series of Virtues (along with a Nativity scene) commissioned for the anteroom of the New College Chapel at Oxford University.[91] Rather than supplying customary sketches ("cartoons"), Reynolds executed oil paintings from which Thomas Jervais completed the stained-glass window versions in 1787.[92]

There Justice joins her Cardinal siblings (Fortitude, Prudence, and Temperance) and the three Theological Virtues (Faith, Hope, and Charity) in a series known as the *Seven Graces* that occupies the lower compartments in the room's great west window.[93] Ripa is cited as the source for the iconography of the Virtues[94] who are classically garbed. As Reynolds explained in a 1778 letter to a fellow of New College, they are placed beneath the Nativity, which filled the window's upper chambers, so as to make a "proper rustic base or foundation for the support of the Christian Religion."[95]

Recognizable as Justice, this figure is not entirely conventional. Her eyes are in a shadow cast either by her arm or by her balance, which she holds up, perhaps to shade her eyes.[96] Reynolds used a steelyard rather than the commonly shown two-panned scales, and some perceived Justice's balance as slightly askew. Negative reviews followed, that the image was "'repugnant to the ancients' idea of justice'" and painted "'in imitation no doubt of the wife of a [market] butcher weighing out a leg of mutton to his dainty customer.'"[97]

As for Justice's shading her own eyes, the gesture could be protective—as if to maintain balance, Justice needed to insulate herself from the glare of the sun. One could also read her raised arm and balance as authoritative, indicating the power to decide what light (information or knowledge) ought to be brought before her. Or Justice's stance could be seen as putting her in a quizzical posture, requiring her to peer out to decipher what comes before her eyes.[98] With any of these interpretations, this Justice constitutes a departure, and she was one of "several unconventional female personifications" that Reynolds painted, which garnered some criticism when first displayed, perhaps because viewers saw the transformation of "formulaic

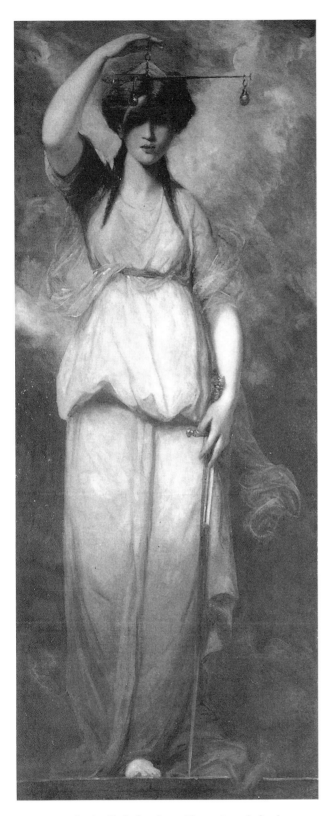

FIGURE 71 *Justice,* Sir Joshua Reynolds, 1778, study for the west window, New College Chapel, Oxford University.

Image reproduced with the permission of Thomas Agnew and Sons, Ltd. See color plate 16.

allegories into powerful embodiments of feminine majesty, resolution, and intellect."[99]

Artistic invention and some local disquietude can also be found in a 1996 steel sculpture, *Lady Justice* (fig. 72), by Diana Moore. It stands in the center of the renovated Warren B. Rudman United States Courthouse in Concord, New Hampshire (fig. 73),[100] a building designed, in the words of architect Jean Carlhian, with proportions that indicate "a use that is serious."[101] The athletic and muscular female form looms large in the entryway, standing eight feet tall on a ten-foot pedestal of granite. Greeting visitors upon their entry, the statue is visible from several angles and floors of the four-story courthouse, which was renovated in 1997.[102]

The United States General Services Administration (GSA), the entity in charge of federal building, described the "highly original interpretation" as focused on the "action of blindfolding as an emblem of clear and impartial judgment."[103] While referencing ancient Egyptian, Greek, and Roman sculpture as well as Asian religious art,[104] Moore's *Justice*—like that of Joshua Reynolds—breaks with some of the conventions, for she holds neither sword nor scale.[105] Her hands are otherwise occupied in tying the diaphanous blindfold that covers her closed eyes, visible through the thin covering (figs. 74 and 75, color plate 17).[106] As detailed in Chapter 4, some Justices dating from the northern European Renaissance also wore diaphanous blindfolds, but none that we have located offer Justice the agency of placing the blindfold on herself.[107]

The GSA described this volitional blindfolding as a "self-imposed neutrality . . . repeated in her unadorned robe."[108] Moreover, because the blindfold is diaphanous, suggestive of a mask, and reveals that Justice has closed her own eyes, the blindfold "is not an imposed hindrance, through which she struggles to see. Rather, it is a sign that she draws upon an inner source of wisdom, to allow for a fair and prudent administration of the law."[109] The government's brochure also detailed that "the understated shape of this dress is strikingly modern [but] its finely ribbed cloth also mimics the fluted columns of classical architecture—ancient symbols of strength and stability befitting a court of law." According to the GSA, Moore wanted the garment to be read as a constraint, representing "our civilized and rational sensibilities, which are imposed over our primordial and intuitive temperaments, symbolized by the body. Moore's *Justice* thus becomes a metaphor of the struggle for equilibrium, undertaken by both individuals and society as a whole,"[110] offering hope for self-abrogation. As a comment on another of Moore's sculptures described, she has sought to reiterate the "simplicity of form, and a sense of stillness and self-containment evident in many ancient works."[111]

Yet the development of the *Justice* for Concord entailed struggle. As in many of the government commissions discussed in Chapter 6, artists' conceptions sometimes unnerve those involved in approving the imagery. Moore's initial plan had been to provide a more specific rendition of the

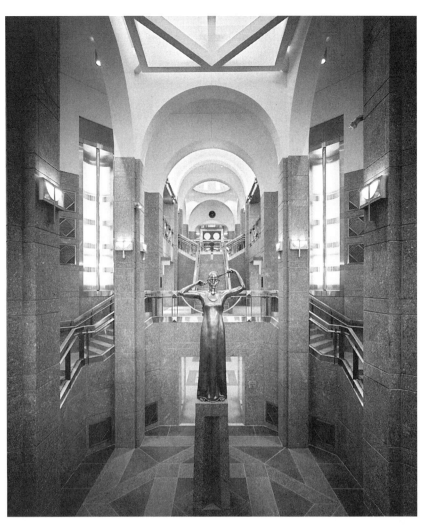

FIGURE 72   *Lady Justice,* Diana K. Moore, 1996, Warren B. Rudman Federal Courthouse, Concord, New Hampshire.

Photographer: Nick Wheeler. Photograph provided by the architectural firm of Shepley Bulfinch Richardson and Abbott. The image is reproduced courtesy of the artist, Diana Moore, and with the permission of the architectural firm.

FIGURE 73   Warren B. Rudman Federal Courthouse, Concord, New Hampshire. Architect: John D. Detley, 1965.

Photographer: Nick Wheeler. Photograph provided by the architectural firm of Shepley Bulfinch Richardson and Abbott. Image reproduced with the permission of the architectural firm.

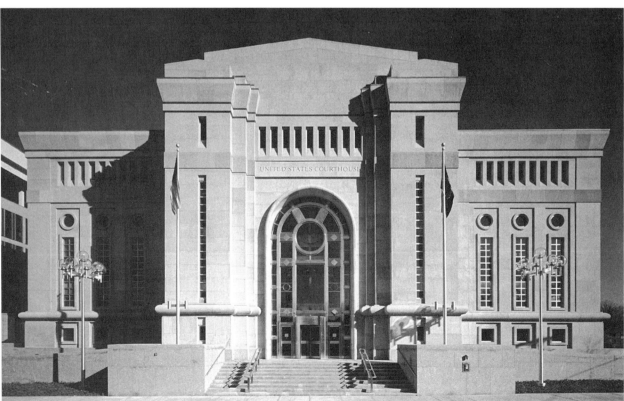

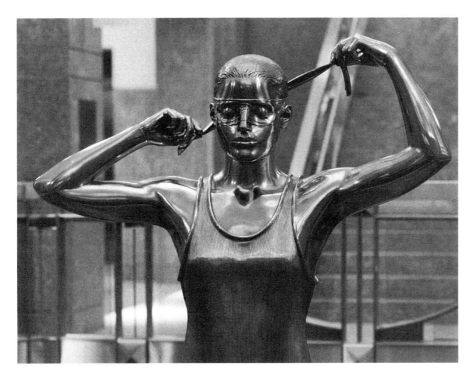

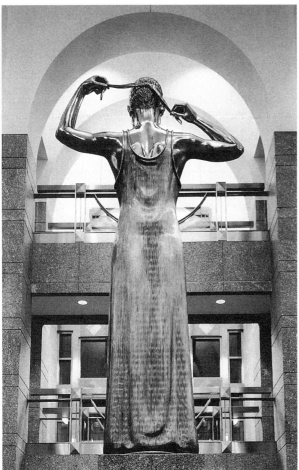

FIGURE 75 *Lady Justice* (detail), back view, Diana K. Moore.
See color plate 17.

female form. One newspaper reported that Moore had suggested that her Justice wear "nothing at all,"[112] and another quoted the building's architect, Jean Paul Carlhian, as saying that "the judges fell over backwards so in the next step she had to be clothed."[113] The GSA, in turn, described the initial naked mockups as only a method to enable decisions on how the figure ought to be garbed.[114]

Thereafter, Moore proposed clothes that some viewers thought resembled a running outfit. The model of a bared midriff (echoing the Asian traditions Moore cited as an important influence) showed an athletic female form that some linked to a Greek *kore* figure and others to a contemporary marathon runner (which Moore herself is). The media described the judges as unhappy about being greeted at the courthouse by a woman whose navel could be seen. According to the architect, "there were three women on our committee who absolutely said the navel had to be shown because woman is the mother of civilization and Justice is a woman, but the judges couldn't swallow that so [Moore] put a dress on her."[115] The clerk of the district court offered the explanation that a public building ought "not to offend anyone."[116]

The result is a full, ribbed body gown, albeit with a top that looks informal, cloaking but not hiding the outlines of breasts. In crafting the face, Moore cited influences of the Khmer figures of Cambodia and of Etruscan, Greek, and Egyptian statues as the basis of her effort to blend many traditions to denote both diversity and universality.[117] The closely cropped hair of the Concord *Justice* could also lend an air of androgyny were it not for the breasts with nipples, less visible than had been originally planned but still discernible through the drapery.

Whether Moore's and the GSA's metaphors—of containment, strength, stability, and neutrality—aptly captured the authority of federal trial courts was questioned by the editors of a legal magazine, *Legal Times*. Like the editors of the *Economist* (fig. 1/1), they used the iconography of Justice as a way to launch their critique. An editorial argued that Moore's effort to revalorize the blindfold could not erase the "negative connotations of the symbol"; obscured vision, they opined, continued to undercut fairness.[118] Their example was federal sentencing legislation in 2003 that aimed to limit judicial discretion. The newspaper saw those provisions as requiring judges to apply the law "blindly" rather than being able to weigh "the mitigating details that can't be seen through the blindfold." Objecting to "stripping federal judges of the discretion" to shorten prison sentences, the editors argued that "Diana Moore's *Justice* may be free to adjust her blindfold as she sees fit, but the federal judges who sit on the bench" in that courthouse had "their hands tied."[119]

## Constitutional Metaphors and Injustices

### Color-Blind

Like journalists, theorists, and artists, judges also turn to metaphors of sight as they struggle with judgment. In 1896, when protesting the Supreme Court's approval of segregated railway cars, Justice John Marshall Harlan spoke of the "eye of the law" as he insisted that the United States was a place without caste; the country had no "superior, dominant, ruling class of citizens" because the Constitution was "color-blind."[120]

At that time, "colored" had a specific referent—dark skin. That point was made in 1909 in the name chosen by the National Association for the Advancement of Colored People (NAACP), committed to securing "the protection for black Americans of the basic rights to life and liberty."[121] In 1925, twelve black lawyers (including the "first black female attorney to practice in the State of Iowa"[122]) met in Des Moines, Iowa and formed the National Bar Association, an organization of "practicing attorneys of the Negro race"[123] that sought to eradicate the second-class citizenship of "the American of Color."[124]

Only much later, as critical race theorists explored the social constructions solidifying the relevance and content of the meaning of race, did the idea develop that everyone has a "color"—whether white, black, or part of the "rainbow" in between. Toward the end of the twentieth century, white students, white employees, and white contractors went to courts to advance what are called "reverse discrimination" claims, as they argued that they, too, had been subjected to unfair treatment based on the color of their skin.[125]

In 1896, when Justice Harlan aspired that the law's "eye" be "blind," he knew that, were the law to "see," it would (and did) discriminate against dark-skinned peoples.[126] But in

2007, on behalf of a majority of five, Chief Justice John Roberts adapted Justice Harlan's metaphor to invalidate an affirmative action plan that had taken into account the races and ethnicities of schoolchildren so that the lower schools in Seattle, Washington, and St. Louis, Missouri, would be somewhat diverse.[127] Both the 1896 and the 2007 references to blindness are part of a long tradition in constitutional interpretation. The trope was used, for example, in a 1793 decision rejecting the idea that a state had "sovereign immunity" and therefore could not be sued by a citizen of another state. Justice James Wilson explained that courts had to evaluate the merits of claims rather than to focus on whether a state was one of the parties, because "[t]o the latter, [justice] is, as she is painted, blind."[128]

But while various justices have valorized the law's blindness, other Supreme Court jurists have insisted that clear vision—and inferentially the ability to take in all relevant information—was the quality required. In 1803, in the famous constitutional opinion of *Marbury v. Madison*, expounding on the authority of judges to review the constitutionality of congressional statutes, Chief Justice John Marshall explained the need for open eyes. "Those then who controvert the principle that the constitution is to be considered, in court, as a paramount law, are reduced to the necessity of maintaining that courts must close their eyes on the constitution, and see only the law."[129] More than two centuries later, in 1947, Justice Wiley Rutledge wrote an impassioned dissent when the majority held that the constitutional right to counsel did not require states to provide lawyers to indigent defendants faced with prison terms.[130] Rutledge protested that "judges . . . owe something more than the negative duty to sit silent and blind while men go on their way to prison, for all that appears, for want of any hint of their rights."[131]

As the iconography of Justice is transnational, so are the metaphors of blindness. Jurists outside the United States also use the image to express concern about ignoring important and relevant facts. Exemplary are opinions from two European courts, the European Court of Human Rights and the European Court of Justice (discussed and depicted in Chapter 11). In a 2005 decision, the European Court of Human Rights wrote that "treating racially induced violence and brutality on an equal footing with cases that have no racist overtones would be to turn a blind eye to the specific nature of acts that are particularly destructive of fundamental rights."[132] And, in the European Court of Justice, the Advocate General (whose published opinion serves as a preface to that of the court, which must be unanimous) also deployed the phrase "blind eye" to criticize those unwilling to take into account discriminatory patterns in the employment of women and men when elaborating the jurisprudence of equality.[133]

As one traces the malleability of the trope, the context—blind to what?—matters. That point was made in 1950 by Justice Felix Frankfurter of the United States Supreme Court

when he concurred in the decision that the Equal Protection Clause of the Fourteenth Amendment prohibited racial discrimination in the selection of grand jurors (who hold the power to vote a bill of indictment against criminal defendants). The court's decision found illegal the process for choosing grand jurors in Dallas County, Texas. Explaining that the large number of blacks eligible for service meant that their exclusion could have come about only intentionally, Frankfurter commented: "If one factor is uniform in a continuing series of events that are brought to pass through human intervention, the law would have to have the blindness of indifference rather than the blindness of impartiality not to attribute the uniform factor to man's purpose."[134]

## Impartial or Unjust? The "Festering Sores" behind the Blindfold in Langston Hughes's *Justice*

Justice Frankfurter's distinction (the blindness of indifference, the blindness of impartiality) assumes that the metaphor can, at times, capture an appropriate stance. He reasoned that whether blindness contributes to fairness depends on the context—the facts and claims of a particular case and the background assumptions or knowledge of a particular decisionmaker. Given the ability to construct narratives to explain how depictions of Justice either blindfolded or sighted can denote the work of filtering knowledge, one could be agnostic about whether Justice is shown with or without a blindfold.

In contrast, a keen sense of law's unfairness has propelled objections to the trope of blindness and to the imagery of the blindfold. Pointing to the role courts played in perpetuating discrimination, critics argued that placing a blindfold on Justice, as if law were committed to equal treatment of all, lends the state an undeserved legitimacy. An eloquent statement of this position came from Langston Hughes, author of the poem *Justice* quoted at the outset of this section. His *Justice,* first published in the *Amsterdam News* in 1923, was later included as one of a series of poems and a play in verse in Hughes's 1932 collection called *Scottsboro Limited.*[135] The title is a reference to the convictions of nine black young men ("the Scottsboro Boys") who had been taken from a freight train, charged in Alabama courts, found guilty of raping two young white women, and in 1931 sentenced to death.[136]

Hughes visited the prisoners while they were on death row.[137] He sparked and joined a chorus of protests, both national and international, about their treatment.[138] In 1937 Alabama released four of the nine; in 1948 one of those still incarcerated escaped from prison. Captured in 1950 in Michigan, that state's governor refused to return him to the South.[139] A half-century later, Alabama's Governor George Wallace pardoned the last living defendant, who was then still in prison.[140]

In 1971, some 130 black judges met in Atlanta, Georgia. They were part of the National Bar Association that (as noted earlier) was founded in the 1920s for the advance-

ment of black lawyers.[141] The judges formed an "autonomous unit"—their own Judicial Council, dedicated to the "eradication of racial and class bias from every aspect of the judicial and law enforcement processes."[142] As the first Chair of the Judicial Council explained, they felt the need to create a distinct organization of judges who understood the degree to which "the quality of justice in America has always been and is now directly related to the color of one's skin as well as to the size of one's pocket book."[143] Given that courts were, they believed, a significant source of that unfairness, they hoped that, as judges, they could also contribute to a remedy.[144]

At their inaugural events, the Judicial Council embraced Langston Hughes's imagery. They chose as their pledge the statement "Let us remove the blindfold from the eyes of American justice." For an emblem, they selected a depiction of Justice taking her blindfold off her eyes (fig. 76).[145] As the Honorable George W. Crockett, addressing that first convention, explained: "Justice is supposed to be blind. It treats all individuals alike—rich or poor, black or white, male or

"Let us remove the blindfold from the eyes of American justice. Too long has it obscured the unequal treatment accorded poor people and black people under our law."

FIGURE 76    Logo of the Judicial Council of the National Bar Association, 1971.

Image reproduced courtesy of the Judicial Council of the National Bar Association.

female. Well, it's time to remove the blindfold that gives the illusion of fair treatment. We want to expose to the full glare of reality the inequities superimposed on that great but unrealized objective. We want to see its errors, to identify its prejudices and to expose those who would pervert just laws with unjust penalties."[146]

That position continues to have force as critics of the justice system document the ways in which race affects judgments and as they reiterate the objection to valorizing a Justice who is blind.[147] The acronym DWB—"driving while black"—makes the point that law enforcement officers rely on race when assessing whether to stop a person.[148] Further, social scientists have shown how the intersection of race, gender, and other dimensions of personal identity are important variables that affect various stages of the enforcement of the criminal law, from arrests and detention through sentencing.[149] Asked whether a judge ought to know that one party to a dispute is the government and another a person whose skin is dark, some insist that disclosure is therefore essential, given that identity markers affect how evidence and arguments are credited.

Because no one is without perspective,[150] "blindness perpetuates unfairness by turning a blind eye to what everyone else sees: that 'there is no exit from race.'"[151] But, if sighted, other tensions arise; one can see that the "scales are tipped" and the sword brings "havoc."[152] In short, as women and men of all colors protest mistreatment by law and debate which distinctions ought to bear legal weight, some commentators object to efforts to make the law "color-blind." For them, Justice "ought" to be clear-sighted.

## Confrontation, Eyewitnesses, Prison Garb, Spectators' Badges, and Ostrich Imagery

Issues of exactly what should be made known haunt judges on a daily basis. The point of trials is to invite information to enable decisionmakers to draw important distinctions while blocking out forms of knowledge that either are distracting or could undermine impartiality. Hence, tensions abound as cases are adjudicated. Legal doctrines respond with a myriad of rules dealing with questions of what judges or jurors can hear and see, as well as what witnesses and disputants can be presumed to know.[153]

The practices of trials themselves are rooted in visual and personal exchanges in which disputants, witnesses, decisionmakers, and the audience come together. Regulations of what happens when the group has assembled have varied across history—ranging from secret inquiries into evidence to public displays.[154] By the eighteenth century, the United States Constitution turned traditions of public disclosure of witnesses into a right for criminal defendants "to be confronted with the witnesses" against them.[155] The courts have since been insistent that face-to-face opportunities are required.[156]

Obligations that evidence be tested through personal exchanges have become part of both civil and common law practices, reflected in provisions of the European Convention of Human Rights.[157] In addition, common law courts insist that sentencings take place in person; the convicted defendant has a "right of allocution," to speak directly to the judge. Confrontational opportunities are linked to concerns about how to weigh information provided by witnesses. For example, common law traditions are suspicious of "hearsay evidence," received from one person relating information from another who cannot be cross-examined in person. Indeed, much of the "law of evidence" stems from concerns about the quality of knowledge proffered and the view that some information ought not be available because it can unduly influence judgment.[158]

Examples of attempts to balance these tensions are numerous; we point to a few decisions to illustrate how the conflicting impulses to insist either on blindfolds or on clear-eyed Justices reflect legal dilemmas struggling to regulate the relationships of sight to knowledge. Take the obligation, also enshrined in the United States Constitution, that criminal defendants are entitled to be tried by jurors from the vicinage, the locality.[159] Historically, the line between juror and witness was blurry. Local jurors were valued for what we would today call "extrajudicial knowledge" of the context, including the people and the events in dispute.[160] What they knew and saw outside of court was thought to contribute to deciding the merits in court. In the United States, the requirement of coming from the local geographical area remains, yet persons who actually have personal knowledge of the disputants or events are now disqualified as impermissibly tainted.[161]

Juries are selected through a process known as the "voir dire." Questions are asked about the ability to be impartial, and judges are positioned to serve as a filter, authorized to prevent some materials from coming before jurors. One general evidentiary proviso in the law of the United States, for example, obliges judges to decide whether, even if information is relevant, its "probative value" is substantially outweighed by a "danger of unfair prejudice."[162] The underlying idea—that information can be both useful and biasing—is the same that animates ambivalence about the imagery of the blindfold.

Cognitive studies sharpen the point by showing how humans rely on "scripts" and "schema" to sort and process information rapidly.[163] But what we know both informs and predisposes. As several experiments with eyewitness identifications have demonstrated and as the discussion of the Molyneux problem suggested, what we "see" can be predicated on what we "know." Within the past several decades, those understandings have prompted new rules about testing the reliability of eyewitness identification, as well as about how to assess the demeanor of witnesses.[164] Eyes that see, like eyes that are blind, can mislead.

One of the central predicates to the regulation of eye-witness identifications is that visual cues and context play a part. The sequencing of persons (a lineup or a set of individuals introduced seriatim) and their dress and posture affect who is identified as a culprit, as do the persons who put the questions to a witness. Awareness of the relevance of context has also shaped rules about what clothes litigants may wear in court. One case, decided in the 1970s by the Supreme Court of the United States, concluded that it was fundamentally unfair—and therefore a violation of the Due Process Clause—to try a person dressed in prison garb, for that clothing was suggestive of guilt rather than protective of the presumption of innocence.[165]

To recount these precepts of law is not to suggest that they are predicated only on new developments in the cognitive sciences or in the law of fairness. Indeed, some echo longstanding precepts, such as an injunction in the Old Testament, *Leviticus* 19:15: "In righteousness shalt thou judge thy neighbor." As explicated by the *Code of Maimonides,* a twelfth-century compilation of Jewish law, a judgment should be "marked by perfect impartiality to both litigants . . . not to show courtesy to one, speaking softly to him, and frown upon the other, addressing him harshly. . . . If one of the parties to a suit is well clad and the other ill clad, the judge should say to the former, 'Either dress him like yourself before the trial is held or dress like him, then the trial will take place.' "[166]

Returning to the twenty-first century, new questions of implementation of the injunction to render "righteous" judgments come from technological developments. For example, in 2005 the United States Supreme Court considered but did not disturb a conviction returned after a jury was exposed to spectators who sat in court and wore badges displaying the picture of the dead victim.[167] The use of pictures of any kind has, in turn, generated debate. Once photography appeared to provide a marvelous solution to prob-

lems of knowledge, but whether a photograph is a uniquely helpful "mirror with memory" or a powerful tool of deception has generated dozens of opinions. Digital technologies intensify the questions of how to treat a photograph, and those problems are now reiterated in other forms of visual evidence, including 3-D reenactments.[168]

The criminal law doctrine of "willful blindness," used to support a conviction,[169] is another illustration of the degree to which the imagery and problems of sight lace the law. Recall that, like the Giulio Romano *Justice* (fig. 4/56) in the Vatican, Justices once were accompanied by ostriches, birds then said to represent many desirable qualities, including the ability to process food slowly, as Justice did knowledge.[170] But today, when charging jurors to consider whether a defendant deliberately avoided knowing something, judges sometimes give what is called an "ostrich" instruction: "You may infer knowledge from a combination of suspicion and indifference to the truth. If you find that a person had a strong suspicion that things were not what they seemed or that someone had withheld some important facts, yet shut his eyes for fear that he would learn, you may conclude that he acted knowingly."[171] As one jurist distinguished the improper use of the ostrich instruction ("to enable convictions for mere negligence") from its appropriate deployment, he relied on the popular image that ostriches were not "careless birds" but "deliberately" put their heads in the sand to avoid knowledge.[172]

The fascination with Justice's eyes can be explained by the ambiguity that resides within the relationships of knowledge to judgment and of judges to the states that deploy them. Today's answers to Molyneux's problem—what would happen if a blind man could see—are that (a) we still do not know the relationship of sight to knowledge and (b) even if we did, no "we" can agree on what information is requisite for, and what a hindrance to, wise and legitimate judgments.

# Representations and Abstractions:
## Identity, Politics, and Rights

### JURIDICAL RIGHTS AND ICONOGRAPHY

We turn from questions about what Justice ought to "see" and law ought to admit into evidence to another set of conflicts—about how Justice ought to "look." As democratic regimes came to power, governing bodies continued to insist on their own authority to select and direct artists to shape symbols claimed to signify their principles. During the twentieth century, however, as women and men of all colors came to be recognized as rightsholders, the decision about which female body was to be called Justice became more complex.

Unlike spectators at Renaissance rites of trial and punishment, modern observers began to exercise new forms of sovereignty by insisting on participatory rights in decisions about government displays. The elites of officialdom—who had previously displayed portraits of white men and statues of naked women—had to cede some power because the former imagery no longer sufficed. Not only were committees at local and national levels assigned roles in selection processes for courtroom iconography but segments of the public decided, through protests, to claim ownership of what was placed on the walls.

Five centuries after Fiera, other Momus-like critics (who could be understood either to be carping or questing for "spiritual and intellectual honesty"[1]) emerged to raise questions about artistic renditions of Justice. Yet, rather than asserting that depiction was impossible (echoing Momus's conclusion, "Flatly, the thing can't be done"[2]), twentieth-century objectors argued that Justice was definitely representable, but that artists had failed to do so properly.

### Public Art and Popular Dismay

Unpacking those conflicts—as the pictorial moved from abstraction to depictions of women whose faces mattered—is the first task of this chapter. Our focus is on the United States, where many such debates were occasioned when the government commissioned public art for new courthouses and post offices built around the country. Conflicts were sparked as observers saw that the bodies painted on the walls resembled real persons whose identities were coming to be respected. The fights over how Justice looked and whether to impose or strip off a blindfold intersected with social movements making claims for recognition on a justice system that had, de jure and de facto, mistreated many.

We detail controversies over displays of a Justice in Newark, New Jersey, said to look like a "Communist"; a "mulatto Justice" on a courthouse wall in Aiken, South Carolina; the offensively segregated murals in Jackson, Mississippi; the scenes of a lynching of an "Indian" in Boise, Idaho; and the depiction of Muhammad in midtown Manhattan and at the United States Supreme Court. Lessons unfolded (literally and figuratively) as governments tried to evade controversy through their power to cover some of the disturbing images with drapes[3] and to escape through retooling classicism or by turning to abstractions. These iconographical battles provide one means of expressing the disjuncture between the state's insistence on the legitimacy of its authority and the experiences of those subjected to it.

These controversies also attest to the role courts play in providing ceremonial environments that shape public narratives. But the ability of members of the public to move from the misery of silent witnessing to objection requires new understandings of self-sovereignty, group identification, and political agency or what the anthropological literature on dispute resolution calls "naming, blaming, and claiming"—identifying a wrong, understanding it to be caused by actions of another, and perceiving oneself as authorized to hold the wrongdoer to account.[4]

Thus, the later part of the chapter is devoted to how social movements and legal innovations produced collective challenges to the fairness of the state's law. The results both widened the circle of persons seen as equal rightsholders and repositioned the judge once again, by seeking to respect judicial independence while imposing constraints on how

judges could treat litigants. Some interventions came through litigation campaigns, such as the efforts that produced the Supreme Court's 1954 decision of Brown v. Board of Education,[5] finding segregated schools unconstitutional. Other transformations are marked by legislation, such as a series of Civil Rights Acts mandating nondiscrimination in public accommodations, housing, education, and employment.[6] New interpretations of federal court power and new procedural devices, such as rules permitting class actions, enabled enforcement of these legislative mandates.[7]

Lawyers and judges themselves joined in identity-based organizations such as the National Bar Association and its Judicial Council, detailed in Chapter 5, which shared Langston Hughes's sense of the unjust treatment of African-Americans (fig. 5/76). Parallel organizations focused on mistreatment based on gender, ethnicity, and sexual orientation. In some respects, these organizations were comprised of "insiders"—accomplished and prominent attorneys and judges—but they also identified with "outsiders" because their members had learned by firsthand experience that law was not even-handed. From their professional perches, they pressed courts to commission special "task forces" to interrogate how women and men of all colors were treated inside courtrooms. Intersecting with concerns about improving the stature of lawyers and judges and about regulating professionals more generally, the results have been the development of ethical codes, statutory restrictions, and case law focused on judges.

By the twentieth century's end, judges were constrained by more than a blindfold, for they were subjected to judgment by a populace whose role had changed (to build on art historian Jonathan Crary's insights[8]) from passive spectator to critical observer. Even those sitting on the highest courts have been challenged for failing to see their own partiality. Thus, the themes of Chapter 5—the complexity of the relationships among knowledge, sight, and impartiality—continue to haunt the problem of judgment, and drapes and blindfolds have proven insufficient responses for those experiencing the injustices of law.

## Batcolumns and Mariannes

Distress about public art erupts episodically, as critics complain that objects are ugly, expensive, inappropriate, or disorienting.[9] In the 1960s, a federally funded public art program was suspended after one of its commissions, Robert Motherwell's mural in the John F. Kennedy Federal Building in Boston, was interpreted as referencing the blood spilled at Kennedy's assassination.[10] A few years thereafter, when the program was reinstated, critics objected to the fact that public funds were spent on Claes Oldenburg's twenty-ton, ninety-six-foot-tall steel and aluminum Batcolumn, erected in the plaza of the Social Security Administration building in Chicago.[11] In the 1980s, complaints about Richard Serra's Tilted Arc, a curved steel wall about

120 feet long and 12 feet high that obstructed the walkway through a plaza near New York's City Hall, resulted in its removal and demolition.[12]

Justice is our focus here, but she is not the only female figure to have occasioned debates about ownership and identity. Parallel questions have been raised about depictions of France's icon of Liberty—Marianne. That female symbol was popularized by Eugène Delacroix's rendition of a bare-breasted female warrior, painted in 1830 to symbolize that year's July Revolution. Over the subsequent century, his version had competition from more sedate and conservatively posed females who were replaced in the twentieth century by likenesses of French actresses and models.[13]

The recognition of women's rights, intersecting with acknowledgment of racial subordination and colonialism, produced challenges to this emblem of the state. By 2003, in part responding to efforts by a movement focused on empowering underclass women ("Ni Putes Ni Soumises"—Neither Whores nor Doormats), the National Assembly of France placed huge photographs of fourteen different women—"Mariannes of Today"—on the front of its building, the Palais-Bourbon.[14] Included were pictures of women whose families had emigrated from North Africa.[15] The press noted the irony of the display; women's faces decorated the front of the building, but those sitting inside—as members of the lower house of France's legislature—were "overwhelmingly male, white, and middle-aged."[16]

The President of the Assembly explained that its purpose was "remaking the iconography" of the French Republic[17] to reflect the government's commitments to citizens "of foreign origin" and their loyalty to France. The photographs captured some of that diversity, yet the variously featured women were not portrayed with their diverse cultural accoutrements. No veiled heads were shown. Rather, all wore the Phrygian cap, the ancient Roman headgear given to slaves when freed and thus insistently supplied as a "universal" symbol of liberty.[18]

Parallel concerns about designs for Justices portrayed on courthouse walls developed in the United States in conjunction with complaints about the unfairness of the government-sponsored justice system that the icon represented. As women gained juridical capacity (as litigants, witnesses, staff and, eventually, as jurors and judges), the appropriation of the female form became problematic. When a Justice bore little resemblance to the men entitled to press claims in courts, the statuary of Justice—naked or clothed—served as an abstract reference.[19] But when real women sought legal recognition as rightsbearers, the abstraction dissolved.

A woman presented as Justice had to look like someone. No longer only a disembodied goddess serving as a vessel to legitimate authority, she occasioned real debates about what kind of woman could be a stand-in for Justice. Fiera's questions—about how many eyes and ears she should have—were replaced by conflicts about skin color, kind of hair,

and shape of features. The choices made had freight, for they marked one sort of woman as the embodiment of iconic Virtue and excluded others from that sphere.

## BREACHING THE CONVENTIONS OF JUSTICE WHEN DECORATING THE PUBLIC SPHERE

As part of the New Deal response to the Depression in the United States in the 1930s, the federal government created public work projects to generate employment opportunities. One program, called the Works Project Administration (WPA), commissioned projects from artists. For a decade, under various names and with changing criteria, the government issued thousands of mandates for artists to craft works that were incorporated into various institutions (new federal buildings, state housing projects, local schools, hospitals, and a few detention centers) around the United States.[20] The program sparked the creation of some 4,000 murals, 18,000 sculptures, more than 100,000 easel paintings, and 13,000 prints produced by more than 10,000 artists.[21] Justice-related paintings, murals, and sculptures thus made their way into new courts and post offices around the United States.[22]

The federal project's ambitions rivaled those of the great Medieval and Renaissance patrons—the Nine of Siena, the Popes of the Vatican, the Burgomasters of Amsterdam—in using art for their own normative agendas. Federal support stemmed from the view that the arts went "hand in hand with a strong economy"—both of which were key to developing a "distinctly American culture."[23] The leaders of the Treasury's Section of Fine Arts wanted to fund art that was accessible, contemporary, and democratic, as they understood those terms. Hoping to promote a populist idiom celebrating America's history and future, they sought imagery that was local in character yet embodied national ideals.[24] Their preference was for "literal representation of 'the American scene.'"[25] Federal economic support aimed to inspire competitive individual entrepreneurship that, government officials believed, would demonstrate the utility of productive work.

What role artists' own political views and aesthetics played in obtaining commissions is debated. One of the program's founders, George Biddle, who was both a painter and an enthusiast of Mexican political murals, thought that American artists could contribute to and express "in living monuments the social ideals" of the New Deal.[26] Yet in response to traditions of free expression and the specter of the Soviet Union's control of the arts, many in the United States sought to distance themselves from government superintendence. The leaders of the federal grants programs sought instead to create what they deemed a nonpolitical and open process by which to award commissions.

Some commentators conclude that, despite fear of "socialist" influences and the deep ideological conflicts of the time, awards were made to "artists of every political persua-

sion."[27] Other historians disagree, arguing that "competitive procedures for securing Section commissions let Treasury officials weed out Mexican partisans, abstractionists, academics and other extremists."[28] As they recount, "foreign subjects" were disdained, nudity avoided, and inspirational scenes applauded[29] with the frequent embrace of "patriotic and chauvinistic themes."[30] Federal funds brought federal supervision for many artists who were not well known as well as for well-established artists.[31] The final versions often varied from the proposed designs as modifications were made in light of concerns expressed by officials.[32]

Whatever the range of views tolerated at the program's inception, over time concerns grew about New Deal support of "leftist" artists. One newspaper headline is illustrative: "WPA Murals under Fire as a Study in Red."[33] Such attitudes, coupled with more general hostility to President Franklin Delano Roosevelt's programs, resulted in the imposition in 1939 of a requirement that those employed be citizens of the United States and sign affidavits swearing that they were not Communists.[34] Political attacks also reduced funding for some projects and eliminated others.[35] (As for aesthetics, critics have viewed much of the art to be of great historical interest but artistically "bad,"[36] in part because the realism of WPA art was superseded by preferences for abstraction, which won the "battle of styles."[37]) Courthouse art was at the center of some of these debates. We turn to installations, some of which were controversial at their inception and others that became a source of distress decades later, when new rightsholders looked at the walls and saw demeaning portrayals of persons they resembled.

## Unblindfolded: A "Communist" Justice Raises a "Newark Row"

In 1935, the United States Treasury Department offered $6,500 for the winning design of a Justice statue to be placed in a new federal courthouse and post office in Newark, New Jersey.[38] Romuald Kraus, a sculptor described as having "been on the relief rolls," won the competition;[39] the statue that resulted from his fourteen-inch model can be seen in figure 77 (color plate 18).[40] As the *New York Times* explained, Kraus's proposal trumped the sixty-some other entries by depending "upon gesture and expression to convey his meaning, dispensing entirely with the conventional trappings of justice—the sword, scales, blindfolding."[41] Members of the Washington, D.C.–based committee that had selected Kraus praised his figure for alluding to the "compassionate nature of justice and not just judicial decisions."[42] A Washington official explained: "We hope that an innocent man on trial for his life might look up to this figure for hope and courage and the assurance that Justice prevails."[43] The plan was for a gilded bronze rendition to stand seven feet tall "behind the judge's chair in Court Room No. 3."[44]

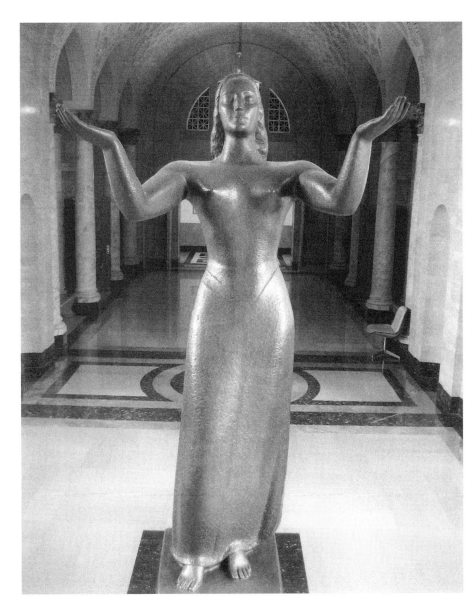

FIGURE 77  *Justice,* Romuald Kraus, 1938 (photograph taken 2006), United States Federal Courthouse and Post Office, Newark, New Jersey.

Image reproduced courtesy of the court and James J. Waldron, Clerk of the United States Bankruptcy Court for the District of New Jersey and Director of the Historical Society for the United States District Court for the District of New Jersey. See color plate 18.

But the tiny model *Justice* was met with a barrage of criticism.[45] George O. Totten Jr., one of the building's architects and the spouse of an artist who had also submitted a design for the competition, objected that the commission looked like a "woman with biceps like a heavyweight prize fighter and a neck like a wrestler."[46] A resident federal district court judge, Guy L. Fake, in whose courtroom the figure was supposed to have been installed (and whose name might have been chosen by a novelist), pronounced the model " 'horrible' and asserted that it smacked 'blatantly of Communism.' "[47] He argued that the statue did not show the "spirit of Justice but that of ruthless confiscation."[48]

After the conflict emerged, the Newark Museum put the work of competing artists on view. A 1935 news article provided pictures of the model by Kraus, under the heading "Communistic," amplified by quotes from Judge Fake. The paper included photos of some of the other works. Isamu

Noguchi had proposed a Justice with a book as a blindfold and a dagger in lieu of a sword, while Milton Horn (said to have been the local committee's choice) had proffered a large seated woman with scales and long robes. Another photo showed the submission of Mrs. Vicken von Post Totten (identified as the architect's wife) of an imposing standing figure of a Justice with a large sword strapped to and centered at her waist and her arms spread out, hands and head tilted upward.[49]

Kraus, "a rather shy man of early middle age, Austrian born,"[50] was reportedly surprised by the turmoil and accusations. He was said to have responded, "I am a Catholic. To me justice has something of Christ. Christ would not have a sword."[51] A 1935 account quoted his explanation that the figure "represents love of humanity, the great mother principle which has been the guiding force of all civilization. . . . To me justice is clear-eyed, not blind, and she is reaching

out, as I conceived her, in an earnest supplication for truth. She is not a threatening figure; that to me seemed certainly most un-American."[52] Commentators picked up the theme of mercy by describing the sculpture as stretching out her hands "as if she were receiving a blessing from above"— "a far departure from the stern Roman goddess fitted with sword and scale. Kraus's concept of Justice ranked first the thankfulness he felt for the freedom this country offers."[53] A *New York Times* writer added that it was "hard to understand where any hint of communism comes in, unless it come[s] automatically with any and every departure from hide-bound custom."[54] And, while onlookers in the 1930s celebrated the statue's Christian roots, ancient Egyptian art could also have been a referent. As had some sculptors of Maat (fig. 2/24), Kraus used the sculpture itself to form a balance. As he said: "The whole thing is a scales. Her arms—they weigh, they balance."[55]

In its final seven-foot-tall, almost 700-pound form, the figure departed somewhat from the fourteen-inch maquette. The proposed *Justice* had been clothed and draped in something like a sarong and positioned contrapposto, with one leg clearly ahead of the other.[56] The cast version (seen in figure 78, alongside the artist) is more frontally columnar.[57] *Justice,* with eyes closed, is naked from the waist up and, like many other Kraus works, shows the influence of the artists Wilhelm Lehmbruck and Aristide Maillol.[58]

The placement in the Newark courthouse was initially short-lived. Judge Fake's objections that the statue was the embodiment of class warfare succeeded in relegating it to "a darkened room" in the courthouse. At the behest of an architect in the Treasury Department, Kraus's sculpture went on tour for an art show organized in 1938.[59] When shown as part of group of modern art in 1939 in San Francisco, Kraus's *Justice* won an award,[60] and the warm reviews prompted a request that it be installed in another new federal building in Covington, Kentucky.

In October of 1940, Kraus's *Justice* landed back in Newark in the court's third-floor hallway, thereby freeing the protesting judge from her immediate presence.[61] (A Newark newspaper explained the statue's travels by dubbing it a "Cinderella among works of art which, . . . banished to obscurity," was "rescued from its humble corner and elevated to prominent pinnacles at two world's fairs."[62]) The Covington Post Office and Courthouse in Kentucky got its copy in 1941,[63] and in 2008, the Newark version was relocated to the center of the rotunda on the third floor, outside what had once been Judge Fake's courtroom.[64] *Justice* is lit to show off her contours and stands between and beneath two Art Deco–style medallions, with female figures labeled *Light* and *Darkness* (figs. 79 and fig. 80) designed by the architect's wife, who received about $1,200 for her work.[65]

Five decades later, Newark finally also got its own monumental "blindfolded Justice" in the form of an eleven-foot, five-ton colossal gray head—*Justice*—by the sculptor Diana Moore. Unlike the artist's full-figure *Lady Justice* (fig. 5/72),

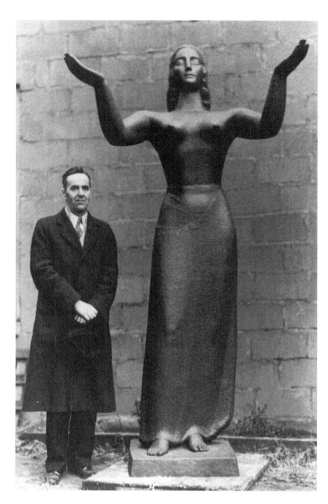

FIGURE 78    Romuald Kraus with full-sized bronze cast of *Justice,* circa 1937.

Photograph courtesy of the Romuald Kraus Papers at the Margaret M. Bridwell Art Library, University of Louisville, Kentucky.

which stands tall on a pedestal in the Rudman Courthouse in New Hampshire, the Newark head sits "flush with the granite slabs" on the plaza across the street at the front of the Martin Luther King Jr. Courthouse, which opened in 1992.[66] At its base is a 1991 inscription by Mark Strand, poet laureate of the United States in that year. It reads:

> When Justice does its public part
> It educates the human heart;
> The erring human heart in turn
> Must do its private part and learn.[67]

### Hiding a "Mulatto Justice" in Aiken, South Carolina

The distress that greeted Kraus was paralleled by anger in Aiken, South Carolina, where another artist, Stefan Hirsch, painted the mural *Justice as Protector and Avenger* (fig. 81, color plate 19) for a federal courthouse and post

FIGURE 79  *Light,* Vicken von Post Totten, 1935 (photograph taken 2008), United States Federal Courthouse and Post Office, Newark, New Jersey.

Images courtesy of the court and James J. Waldron, Clerk of the United States Bankruptcy Court of the District of New Jersey and Director of the Historical Society for the United States District Court for the District of New Jersey.

FIGURE 80  *Darkness,* Vicken von Post Totten, 1935 (photograph taken 2008), United States Federal Courthouse and Post Office, Newark, New Jersey.

office.[68] In March of 1937, Hirsch had been invited to submit drawings for a mural;[69] soon thereafter, he received the commission and was paid $2,200.

The town of Aiken had garnered national attention in the 1920s, when a mob killed black teenagers after their convictions had been overturned by the South Carolina Supreme Court.[70] A decade later, in the 1930s, some community members were not eager for a new federal building, perceived as a colonizing effort by an "alien bureaucracy."[71] Moreover, the artist who won the commission had no Southern roots. Rather, Hirsch, born in 1899, had spent part of his youth in Germany and, upon his return to the United States, lived in the Northeast where he was a successful artist.[72]

Administrators at the Department of the Treasury also raised concerns about Hirsch's initial proposal. The Superintendent of the Section of Painting & Sculpture wrote Hirsch in 1938 that the images of crime were too harsh; "even though the necessity of their presentation may be valid to your theme," wrongdoers need to be "portrayed with more subtlety. Please remember that the people sitting in the courtroom are compelled to look at the mural over a period of several hours, and any obvious treatment of crime and horror would be asking too much of the public."[73] In response, Hirsch made several changes, some of which he described as "radical," so as to make the mural less disquieting.

In September of 1938, Hirsch helped to install the mural, measuring more than twelve by twelve feet, behind a judge's bench in the new federal building. Justice, labeled as such, is at the center of a triptych. She is presented as an imposing figure, open-eyed, hair drawn back in a bun, barefoot, and tanned. She wears a loose-fitting blue skirt and bright red shirt. She gestures upward with one arm, downward with the other. Some critics call the style cubist,[74] while others see social realism[75] and the influence of the Mexican muralists with whom Hirsch had studied.[76] Given the contrast between the bucolic imagery on Justice's right side under the label "Protector" and the aggressive vision on the left, under the heading of "Avenger," the mural calls to mind Siena and Lorenzetti's fourteenth-century *Allegories of Good and Bad Government* (figs. 2/26 and 2/27, color plates 6 and 8).

Interpretative materials from the 1990s came from the United States General Services Administration (GSA), the entity now in charge of federal government buildings. The GSA describes this Justice as raising a "nurturing right hand to those who live righteously," while her left hand "repels miscreants with a condemning gesture."[77] The scenes under the heading "Protector" include rolling hills, cows near a barn or house, children playing, a man smoking a pipe, a woman holding a baby, and a lamp and plow at the bottom of the frame. In contrast, under the label "Avenger," Hirsch portrayed what he had called "the two major kinds of crimes"—those against persons and those against property; the scene includes "robbery, murder and arson."[78] A house burns, a man with a hat and coat holds open a door to a prison cell through which a man (garbed in prison stripes) appears to be either entering or leaving. Another man is crouching in the foreground, where a woman's body lies, and a shotgun below.[79]

As for the center figure, Hirsch explained that he created "a symbolic figure of 'Justice' with gestures indicating the meting out of justice to the deserving and the undeserving"[80] and that his "gigantic female figure" was "without any

FIGURE 81    *Justice as Protector and Avenger*, Stefan Hirsch, 1938, Charles E. Simons Jr. Federal Courthouse, Aiken, South Carolina.

Image reproduced courtesy of the Fine Arts Collection, United States General Services Administration. See color plate 19.

of the customary or traditional appurtenances of such symbolic representations (scale, sword, book . . .) apparently stepping forth from an area of light into a dimmer world."[81] Further, Justice was a "healthy, young person striding out forward with a determined step, clad in a simple garment which is neither modish nor classical, which displays the sturdy shape and balance without flaunting it, she carries her head proudly and in her glance shows no partiality. . . . [T]he only allegory I permitted myself was to use the red, white and blue [of the United States flag] for her garments."[82]

That was not how others saw it. After the mural was installed, a local newspaper objected to the "barefooted mulatto woman wearing bright-hued clothing," while the sitting federal judge termed it a "monstrosity,"[83] resulting in a "profanation of the otherwise perfection" of the courthouse.[84] The panel called "Avenger" garnered complaints that it glorified crime by showing a "shyster lawyer" (potentially a coded reference either to a lawyer who was Jewish or from the North, or both) wrongly freeing crooks.[85] (Hirsch protested that the scene displayed a "sheriff putting a convict into custody."[86]) Within the month, the judge had "ordered that the mural be hidden with a cloth until it could be removed."[87]

As the GSA subsequently described the events, federal officials attributed the criticisms to "ignorance" but offered a "compromise"—that the artist would "lighten Justice's skin color and cover the mural while court was in session."[88] That suggestion appears to have come in part from the artist, who recorded his surprise and dismay at the controversy. Indeed, as Hirsch wrote to the Superintendent of the Section of Painting & Sculpture, he had been "leaning over backwards to understand" and respond to criticism, "precisely in order to avoid something like this incident. But I suppose we cannot figure out in advance *all* the perversities of *all* people at *all* times."[89]

In his statement for the press, Hirsch argued that his Justice was an abstraction, "far from any ideas of caricature or racial issues."[90] In correspondence, Hirsch credited the racialized description of his "majestic female" Justice to a reporter.[91] Hirsch challenged the government administrators to find "ten reputable citizens of Aiken, not under the influence of the judge" who would "feel that the figure's face really appears to have negroid traits. I should not only be willing but anxious to obliterate this 'blemish,' because I had certainly intended nothing of the sort."[92]

The presiding judge insisted that he was not racist but offended by the avenging posture of the mural, imposed by a federal government that had failed to consult local community members or to respect states' rights. For a time, serious consideration was given to repainting. As the head of the Section of Painting & Sculpture wrote to Hirsch: "I must confess that the palette of the head of the figure of Justice, the dark shadow and the vivid red lips, made me see the criticism of the local individuals involved as it would be easy to come to the conclusion that the figure is mulatto. This is especially true if one approached the work with suspicion to begin with. In the interests of your mural and its ultimate acceptance by Aiken I am asking you . . . [to] see if you cannot change the flesh tones of the main figure so that no one could possibly interpret the figure as a thrust at the South."[93] Reminding Hirsch that a "federal judge has complete authority in his court room," he told Hirsch that, as an interim measure, he had recommended a "good velvet curtain on a pole with drawstrings" so the image could be covered when the judge wanted and otherwise "readily available" to be seen.[94]

The mural was not, however, repainted. By way of explanation, the GSA cited the concern that "the artist's return would inflame the controversy."[95] Apparently the judge had also urged the artist not to return, as "it would be impossible to touch that painting without running into more uncalled for publicity."[96] The "controversy" was indeed attracting attention from various quarters, including members of Congress, the Artists' Union of Baltimore (which had sent a letter to the judge demanding that he uncover the mural[97]), and the National Association for the Advancement of Colored People (NAACP). Walter White of the NAACP argued, "If Judge Myers' sole objection to the mural is the fact that the central figure is that of a person who is not white, then a new low in judicial conduct and racial prejudice would seem to have been reached."[98] The judge countered that he was concerned that the imagery would be disruptive, particularly when sentencing criminals. Although the judge, aided by South Carolina's governor, sought removal, the denouement was a tan velvet curtain covering the imagery.[99]

These 1930s conflicts about depiction—which left images of "mulattos" in Aiken and "Communists" in Newark behind drapes or outside a courtroom—made plain that these figures could not pass, uncontested, into the deserving ranks of those who qualified to represent Justice. Nor, in that era, could real members of groups labeled "mulattos" or "Communists" gain much protection from the courts. Fifty years later, some legal precepts and many attitudes had been revised. In the 1980s, members of the Aiken community involved with local history took a different stance. They raised money to make the mural visible by relocating it to the Aiken County Judicial Center.[100] Senator Strom Thurmond (who represented South Carolina in Congress from 1954 to 2003 and was once famous for his

racist views) wrote on their behalf to obtain permission from the GSA for the move.

Conservators, however, deemed the mural too fragile to relocate, and it remains behind curtains. According to a local newspaper reporter, writing in 2001, the mural was not displayed during court sessions because the "flamboyant green background and the vibrant clothes on Lady Justice" made the "power of the gavel pale." Instead, the curtains are parted and the mural shown only "by request."[101]

## Life in Mississippi, Draped

Debates about status can also prompt reappraisal of images that were once tolerated. When first installed in Jackson, Mississippi in 1938 in a building now called the James O. Eastland United States Courthouse, *Pursuits of Life in Mississippi* (fig. 82) was not seen as problematic.[102] But by 2008 it had been covered with drapes (shown in fig. 83, color plate 20[103])—added in the 1960s when protestors challenged the mural's version of life in Mississippi.[104]

The artist, Simka Simkhovitch, was born in the Ukraine in 1893 and came to the United States in 1924, where he lived in the Northeast as he gained recognition for his painting.[105] In 1936, despite the distress of the local selection committee, which wanted a Southern artist, Simkhovitch won the contract.[106] Paid $4,450 for the depiction, Simkhovitch organized the twelve-and-a-half-foot mural around a door through which a judge enters the fourth-floor courtroom. The cut-out center helps to shape what has since been called a "segregated triptych."[107]

If Stefan Hirsch's mural *Justice as Protector and Avenger* offered one vision of reality by including crimes of violence, Simkhovitch provided another. His stated goal was to represent "typical people and life in Mississippi during his time."[108] What others saw was race, gender, and segregation. On one side, a group of African-American men and women are shown in the fields as they pick and weigh cotton while a banjo player—the only dark face in full view—strums nearby.[109] The one white person on that side could be an overseer supervising the harvesting. On the opposite side of the mural are several white males who appear to be construction workers, reading blueprints and building a house, a symbol of an expanding economy.

In the middle is an odd assortment of white individuals in front of a classical-columned building shaped to duplicate the "marble coping behind the judge's bench over which the mural hangs." The GSA's documentation explains that the two men—a "court representative and a minister"—are addressing an older woman and a younger woman (who holds a child in her arms while another is nearby) to respond to the "social problems" of a family.[110] An alternative understanding proffered by a scholar of the South is that while the occupation of this "suit-clad white man . . . is a mystery," his function is clear: he is "surrounded by waiting females,"[111] paying deference.[112]

FIGURE 82 *Pursuits of Life in Mississippi,* Simka Simkhovitch, 1938,
Post Office and Courthouse, Jackson, Mississippi.

Archival photograph courtesy of the Fine Arts Collection, United States General Services Administration.

Beginning in the late 1940s, the federal courthouse in Jackson, Mississippi, was the site of important challenges to the racist system then in place. There Constance Baker Motley and Robert Carter, lawyers for the NAACP's Legal Defense Fund who worked with Thurgood Marshall, tried a case objecting to the state's refusal to pay black teachers, then working only in all-black schools, the same salary as white teachers in all-white schools. (Both Motley and Carter later became judges, appointed to sit on the federal bench in the Southern District of New York. Thurgood Marshall went on to become the first African-American to serve as the Solicitor General of the United States and as an Associate Justice on the Supreme Court.)

In the 1940s, federal courthouses did not have segregated seating, while some state courthouses did. As Motley described in her autobiography (titled *Equal Justice . . .*

*under Law*), when she entered the Jackson courtroom with her co-counsel, the room was packed. Yet because the "black citizens did not know that there was no racial segregation in a federal courthouse" and found no balcony in which to sit, they stood along the walls.[113] Having learned the following day that they could sit where they wanted, blacks filled the courtroom seats. As Motley recounted, the trial judge then opened the doors to the courtroom so that "whites could parade by during the day . . . to see the 'Negra' lawyers from New York, one of whom was a woman."[114]

Motley detailed how looking at the Simkhovitch mural was "not only emotionally agonizing but disconcerting in that it was contrary to Mississippi reality."[115] Unlike the mural's depiction of "the separation of the races" and the "inferior social status of blacks," Reconstruction in Mississippi had been "run by blacks, and blacks were part of the

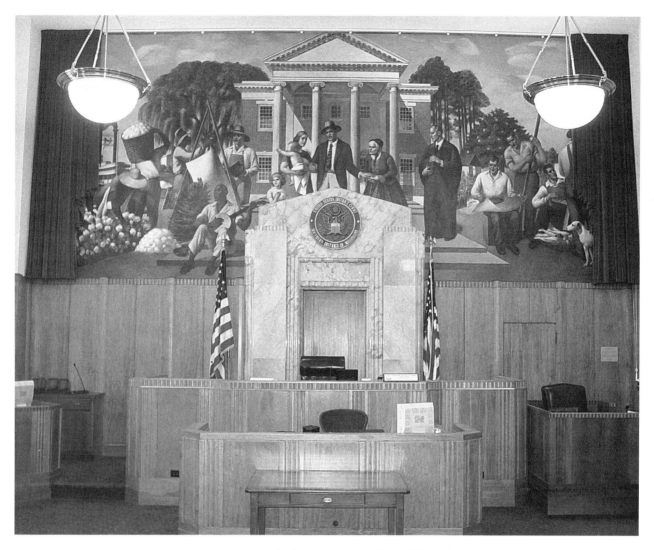

FIGURE 83    *Pursuits of Life in Mississippi,* Simka Simkhovitch, 1938,
shown in 2008 in the renamed James O. Eastland United States Courthouse, Jackson, Mississippi.

state's middle class."[116] Yet in 1949, no one commented "in open court" about the oppression represented on the walls, which served as a "stark reminder . . . [that] notwithstanding the no-segregation policy with respect to seating," the courthouse was very much a part of a racist system.[117] As Motley explained, she thought it would "take another century before the mural's depiction of Mississippi society would be erased."[118]

As she wrote later, her prediction proved wrong. By the 1960s, Jackson had become the "eye of the storm"—serving as "a crossroads for those who upheld segregation and those who vowed to dismantle it."[119] In the early part of that decade, the town was the site of boycotts aimed at ending segregated public services; in June of 1963 Medgar Evers, the head of the state's chapter of the NAACP, was

killed as he returned from a meeting. As for the judiciary, one of the federal judges sitting in the Jackson Courthouse was infamous for making racist comments from the bench.[120] In the wake of those events, civil rights groups were vocal in their objections not only to their treatment by judges and other government officials but also to representations in federal buildings of blacks, including Simkhovitch's imagery. Motley noted that, from the vantage point of 1949, the speed with which authority shifted was remarkable: "None of us could have foreseen that, within a short time, blacks would . . . gain enough political leverage to shame the federal courthouse crowd into making [a] change."[121]

The response—as in Aiken, South Carolina—was drapes. Covered in the 1960s, the mural was briefly on view in the

1970s, but after renewed protests, the curtains were drawn again.[122]

## An "Indian" Hung in Boise

Drapery covering disquieting courtroom imagery is not a phenomenon unique to the South. In 2006 another WPA mural, "depicting an Indian being lynched" (fig. 84, color plate 21), generated controversy when the Idaho State Legislature used what had been the Ada County Courthouse in Boise as its temporary residence.[123] Among the two dozen WPA murals is one showing an "Indian in buckskin breeches, on his knees with his hands bound behind his back . . . flanked by a man holding a rifle and another armed man holding the end of a noose dangling from a tree."[124]

In the 1990s the Chief Justice of the Idaho Supreme Court had ordered the mural covered; the flags of the state and of the United States were used as drapes. He explained that the imagery "would be offensive, and rightfully offensive, to some people."[125] In 2006, when the Idaho Legislature was using the building, the question debated was whether the mural ought to be painted over, preserved as reminders of atrocities of the past, or displayed in new educational programs.[126] Exactly what lessons ought to have been drawn was also in question. As the chair of Idaho's Council on Indian Affairs remarked, the history of the state

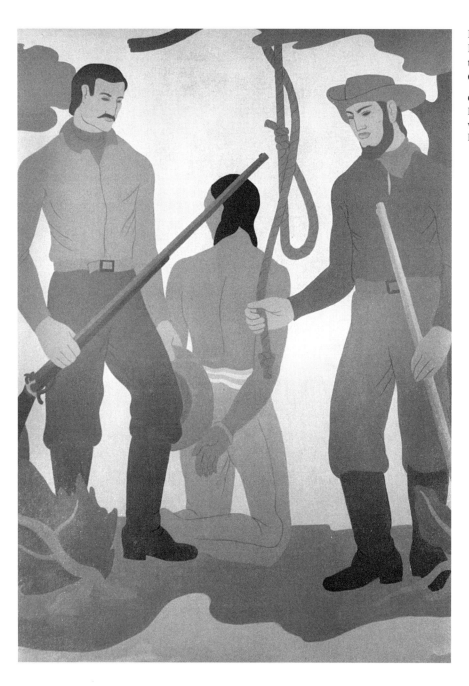

FIGURE 84    Mural, attributed to Ivan Bartlett, circa 1939 (photograph taken 2007), Old Ada County Courthouse, Ada, Idaho.

Copyright: Paul Hosefros for Lemley International. Photograph reproduced with the permission of photographer Paul Hosefros. See color plate 21.

was not fairly presented. In fact, the "first man hung in Idaho was a white man who had been convicted of murdering an Indian."[127] In 2007 the state legislative committee, reportedly guided by the views of local Indian tribes, decided that the murals were to remain on view, framed through "official interpretive signs."[128] One state official explained: "They reflect our values at the time."[129]

Thus, unlike in Aiken and Jackson, where the government literally rendered the problematic depictions invisible, officials in Idaho raised the possibility of conversation. Although the minutes of discussions within the Idaho legislature do not cite Michel Foucault, the outcome—displaying murals of lynching—opens up what he termed a "fissure" in law's authority, providing current opportunities to glimpse what the state once displayed—a lynching scene, shown as if that activity were not despicable.

Returning to Newark, New Jersey, the display of Kraus's *Justice* occupies a middle ground between the responses in the South and the West. Artistry that might have been somewhat adventuresome in the 1930s was tamed by public praise, rendering it closer to a classical reinterpretation. One can argue that putting that *Justice* in the hallway gives her a grander stand, but her 1930s placement there mollified judicial objections to her appearance. Her relocation to the central rotunda in 2008 is a form of vindication for an object that was, by then, no longer seen as provocative.

Across the Atlantic Ocean, the use of draperies can also be found in the International Court of Justice at The Hague. There a portrait of Czar Nicholas II hangs in the entryway to the small chamber used by the Permanent Court of Arbitration, discussed in Chapter 12. In 1899, the Czar was a moving force for the creation of both that court and its building, completed in 1913 and still called the "Peace Palace."[130] But when subsequent Russian governments sought to distance themselves from their past, drapes provided a measure of tact.

## Muhammad in Midtown and at the United States Supreme Court

In 1902, a group of heavy stone statues ("ten famous lawgivers" and "six allegorical statues"[131]) were placed on the roof of a New York state courthouse that opened in 1900 in midtown Manhattan (figs. 85 and 86).[132] The building was notably expensive; the architect, James Brown Lord, was "given the then unheard of sum of $700,000," a third of which he devoted to "decorative features, like statues and murals."[133]

Lord's interests put him in the midst of an architectural sculpture movement aimed at the "great unwashed in art"— members of the public in need of "moral lessons" that they "could not learn on their own."[134] Enthusiasts drew on Renaissance examples of didactic artistry, which they praised for achieving aesthetic and cultural unity. These architects and sculptors, supported by business interests, hoped to influence urban design as well as to "familiarize people with the best aspects of past and present cultures."[135] They created organizations such as the Sculpture Society, founded in 1893 and in 1896 renamed the National Sculpture Society, and worked with the Municipal Art Society of New York and the National Society of Mural Painters.[136] These groups were a part of "the City Beautiful Movement," which aimed to design vital city centers expressive of "civic values."

Lord exemplified the role architects could play in shaping opportunities for courthouse art and, often, in controlling the commissions awarded.[137] In 1898 Lord became a member of the National Sculpture Society, and he provided many of his sculptor colleagues with commissions for the new courthouse. Some of the statuary was to stand against the sky, akin to that setting off the roof line of the seventeenth-century Amsterdam Town Hall (figs. 3/37, 3/38). Sixteen sculptors and ten painters worked to implement the theme, "World Law," that Lord had selected for his building,"[138] expressed through the building's neo-Palladian design and in its thirty sculptures.

To "imbue the viewer with a sense of the majesty, purpose, and righteousness of the Law,"[139] Lord chose a statue of Justice to crown the pediment. Clear-eyed, Justice holds two torches of equal height above her head. One of the two men at her feet can be seen in figure 86; they represent "Power" and "Study."[140] Beneath her a group called the *Triumph of Law* includes, in the middle, a seated female called "Law" holding tablets in each hand, with one inscribed "Lex scripta" (Written law) and the other "Lex tradita" (Customary law). Kneeling men, some with swords and shields, are placed about Justice, as are two reclining nude men.[141] Below, at street level and symbolizing their role as the "foundation of the courthouse" and the "triumph of law," are huge statues of men representing Wisdom (with an open book) and Force (attired as a Roman soldier).[142]

The building's roof sculptures, each about eight feet tall, once included the Spartan leader Lycurgus, the Athenian Solon, the Byzantine Justinian, the Hindu Manu, the Saxon Alfred the Great, the French Louis IX, and religious figures including Moses, Zoroaster, and Muhammad. This sequence of lawgivers is a motif that can be found in many law buildings, from Ireland's 1790s Four Courts building to state capitols and the United States Supreme Court.[143]

A photograph of the Muhammad statue accompanied a 1955 story in the *New York Times* that described the protests then occurring. That picture portrayed him garbed in robes, sporting a flowing beard, wearing a turban, and holding a book and a scimitar. How many viewers from the street, three stories and more than fifty feet below, recognized him or any of the other figures or perceived the message that law was "triumphant" is not clear. Lycurgus, Solon, Justinian, and the others were (and are) not regularly invoked in popular culture. But in the early 1950s when New York City's renovation plans brought the official identity of each of the stone statues into public view, the 1902 statues became a subject of discussion.

FIGURE 85   The New York
State Supreme Court, Appellate
Division, First Judicial Department,
New York City, 1900. Architect:
James Brown Lord.

Photograph courtesy of and reproduced
with the permission of the Appellate
Court and the photographer, Jon Fisher.

FIGURE 86   Statuary on the roof of the New York State Supreme Court, Appellate Division,
First Judicial Department, New York City, 1900.

Photograph courtesy of and reproduced with the permission of the Appellate Court and the photographer, Jon Fisher.

The publicity about the persons represented by the sculptures prompted complaints that the figurative display of Muhammad violated Muslim religious practices. The ambassadors of Egypt, Pakistan, and Indonesia registered objections on behalf of their countries. In response, the eight-foot, half-ton Muhammad was taken down and, unlike other statues that were removed for repairs, was not restored to a pedestal.[144] In 2006, in the wake of protests against aggressive cartoons linking Muhammad's image to violence, the *New York Times* returned to the story with a photo showing an empty pedestal and reporting that the statue was last seen lying sideways on the ground.[145]

In contrast, another sculptor's version of Muhammad remains in place in Washington, D.C. It stands in a line of eighteen lawgivers depicted across two forty-foot friezes that run on the south and north interior walls near the ceiling of the room in which the United States Supreme Court hears cases. Cass Gilbert, the building's architect, relied on Adolph A. Weinman, a Beaux-Arts sculptor, to "choose the subjects and figures that best reflected the function of the Supreme Court building,"[146] that opened in 1935.[147] The Supreme Court's website—distancing the Court from the content—stressed that "Weinman's choice of symbols and figures were his own."[148]

From available materials, the details of the design do appear to have been left to Weinman. In a June 15, 1932, file memo that Gilbert dictated, he reported that he had encouraged Weinman to make the panel above the Supreme Court justices' bench "the most important sculptural group" and proposed that it "would probably be composed of a single idealistic figure with supporters on each side."[149] (Gilbert's idea of using a lone figure was not taken up by Weinman.) Further, Gilbert suggested that

> the work [should] be very serious and classical,
> and impersonal in character. . . . I especially
> wanted to avoid the picturesque or anything
> that might be a matter of passing fancy. As I
> see it, these panels should be rather flat in their
> general achievements, perhaps more of the
> character of some early Renaissance, like the
> work of . . . Donatello, but strictly classical in
> character and not too heavy or robust. . . .
> [T]he type of Michelangelo would be too
> rugged and forceful, and the frieze of the
> Parthenon, for example, would be too active
> in movement. What I did tell him was that it
> should be very serious, dignified, beautiful in
> line, and of the most perfect modeling. . . .
> [T]he pictorial element should be subordinated
> to a sculptural character of the design.[150]

Gilbert then stated his "absolute confidence" in Weinman's "skill as a designer and as an artist." He remarked that he would feel "free to express" his views, and Weinman should be "equally free in combatting them if he thought differently"—although Gilbert "doubted if there would be any differences of opinion."[151] Before completion, Weinman submitted photographs of scale models to the group forming the Supreme Court Building Commission, which did request minor alterations.[152]

Weinman designed four friezes to form an integrated narrative rich with historical and allegorical figures associated with the rule of law.[153] Of equal lengths and carved in Spanish ivory-colored marble, the friezes are framed by twenty-four large interior Ionic marble columns, each thirty-two feet tall, which encircle the room.[154] Were the lawyers and spectators who face the justices to gaze up at the frieze high on the eastern wall, they would see two enthroned male figures. One is called the *Majesty of the Law*. Under one elbow he holds what could be part of the Ten Commandments but is described instead in the Supreme Court's literature as a tablet to "symbolize the first ten amendments"—the Bill of Rights—to the United States Constitution.[155] The second seated male, the *Power of Government*, holds fasces, the Roman symbol of authority (detailed in Chapter 2). These men are bracketed by two Virtues, this time incarnated as two bare-chested, muscular men—Wisdom with a lantern and Justice, whose shield has scales carved onto it. On each side of the courtroom are groups of figures. In the set called *The Defense of Human Rights and Protection of Innocence*, figures (including one, judge-like, holding a book) stand around a woman sitting on the ground with a child clinging to her. On the other side is *Safeguard of the Liberties and Rights of the People in their pursuit of Happiness*, comprised of men, women, and children.

The justices, in turn, look at the west wall; its frieze, *Good Versus Evil*, echoes the Medieval *Psychomachia*, the battle for the soul (described in Chapters 1 and 2), with the Virtues arrayed against the Vices. Two female figures are at its center; Justice, "staring down the forces of Evil," leans on a sheathed sword, while Divine Inspiration holds scales.[156] These two, in turn, are flanked by Wisdom, with an owl; Truth (or Prudence), with a mirror; and figures called Defense of Virtue, Charity, Peace, Harmony, and Security. The group of male figures representing Evil includes Corruption, Slander, Deception, and Despotic Power.

On the south and north walls (to the left and the right of the justices and the spectators) are eighteen lawmakers, punctuated by eight allegorical figures named Fame, Authority, Light of Wisdom, History, Liberty and Peace, Right of Man, Equity, and Philosophy. Like the number of justices who now sit on the Supreme Court, the famous lawmakers are grouped in sets of nine. Each has an attribute that marks his association with law. Those on the south wall frieze date from 3200 BCE to the beginning of the Common Era and include Menes of Egypt, Hammurabi of Babylon, Moses (holding tablets with Hebrew lettering) and Solomon from the Old Testament, Lycurgus of Sparta, Draco of Athens,

Confucius of China, Solon the Athenian, and Octavian of Rome.[157] The group in the north wall frieze spans the last two millennia and features (in order) the Byzantine Emperor Justinian (with his Code), Muhammad, Charlemagne, King John (with the Magna Carta), Louis IX, Hugo Grotius, Sir William Blackstone, John Marshall, and Napoleon. As the repetition of the lawgiver theme in the courthouses in New York and Washington suggests, the motif was a popular Beaux-Arts method of linking a building to law. The wide-ranging cluster could also be seen as ecumenically embracing what today we call diverse traditions.

Whether all the figures should be understood as appropriate for a government committed to keeping a critical distance from religion is a question that has been raised in various contexts. Several lawsuits have challenged displays —alleged to be religious—in public buildings; a series opposed deployment of the Ten Commandments, whose texts differ depending on traditions in different faiths.[158] Judges have thus considered the propriety of depictions of the Ten Commandments on the walls of school classrooms,[159] in courthouses, and outdoors. One lawsuit involved the installation of a "two-and-one-half ton monument" of the Ten Commandments erected, at the behest of the then–Chief Justice of the Alabama Supreme Court, as the "centerpiece of the rotunda of the Alabama State Judicial Building."[160] Another case dealt with a Ten Commandments momument, about six feet tall and three and a half feet wide, located along with sixteen other monuments on twenty-two acres around the buildings of the Texas State Capitol and the Texas Supreme Court.[161] A third opinion addressed two "large, gold-framed copies of an abridged text of the King James version of the Ten Commandments including a citation to the Book of Exodus," one mounted in the McCreary County Courthouse and another in the Pulaski County Courthouse, both in Kentucky.[162]

The Supreme Court's doctrinal response distinguishes between a display impermissibly advancing a religious agenda and one appropriately forwarding a "secular purpose."[163] When discussing that divide, a few of the justices have adverted to the Supreme Court's own iconography. Justice John Paul Stevens alluded to the Weinman frieze in a footnote in a 1989 decision, explaining that:

> a carving of Moses holding the Ten
> Commandments, if that is the only adornment
> on a courtroom wall, conveys an equivocal
> message, perhaps of respect for Judaism, for
> religion in general, or for law. The addition of
> carvings depicting Confucius and Mohammed
> may honor religion, or particular religions, to
> an extent that the First Amendment does not
> tolerate any more than it does the "permanent
> erection of a large Latin cross on the roof of
> city hall." . . . Placement of secular figures such

as Caesar Augustus, William Blackstone, Napoleon Bonaparte, and John Marshall alongside these three religious leaders, however, signals respect not for great proselytizers but for great lawgivers. It would be absurd to exclude such a fitting message from a courtroom . . . .[164]

Justice David Souter also referenced the Weinman frieze in the 2005 litigation about the Ten Commandments on the walls of county courts (which the Court found impermissible): "We do not forget, and in this litigation have been frequently reminded, that our own courtroom frieze was deliberately designed in the exercise of governmental authority so as to include the figure of Moses holding tablets exhibiting a portion of the Hebrew text of the later, secularly phrased Commandments . . . in the company of 17 other lawgivers, most of them secular figures." He concluded that there was "no risk that Moses would strike an observer as evidence that the National Government was violating neutrality in religion."[165]

In contrast, when upholding the placement of the Ten Commandments monument on the Texas State building grounds, Chief Justice William Rehnquist wrote for a different majority that

> acknowledgments of the role played by the Ten
> Commandments in our Nation's heritage are
> common throughout America. We need only
> look within our own Courtroom. Since 1935,
> Moses has stood, holding two tablets that
> reveal portions of the Ten Commandments
> written in Hebrew, among other lawgivers in
> the south frieze. Representations of the Ten
> Commandments adorn the metal gates lining
> the north and south sides . . . as well as the
> doors leading into the Courtroom. Moses also
> sits on the exterior east facade of the building
> holding the Ten Commandments tablets.[166]

In the 1990s, it was the Supreme Court's depiction of Muhammad that drew criticism. The Council on American-Islamic Relations protested the sculpture, "shown with the Quran, Islam's Holy Book, in one hand and sword in the other, reinforcing long-held stereotypes of Muslims as intolerant conquerors."[167] In response, Chief Justice Rehnquist noted that swords were symbols of justice used throughout the building ("a dozen swords appear in the Courtroom friezes alone"), that remodeling would impair "the artistic integrity of the whole," and that laws specifically protected the Supreme Court's architecture from alteration.[168] Subsequently, some commentators also argued that Islamic legal sources did not necessarily render the depiction improper and that it ought to be seen as a gesture

of recognition from a culture that relied on imagery to celebrate authority.[169]

The sculpted frieze remains in place, but the accompanying written materials, more easily changed, have been revised with the help, as the Chief Justice explained in his 1997 response, of "numerous Muslim groups."[170] The Supreme Court's literature on the building had read that Muhammad was the "founder" of Islam;[171] instead the description was revised so as to describe Muhammad as the "Prophet of Islam . . . depicted holding the Qur'an, the primary source of Islamic Law." The materials explained that the figure was "a well-intentioned attempt by the sculptor, Adolph Weinman, to honor Muhammad, and it bears no resemblance to Muhammad. Muslims generally have a strong aversion to sculptured or pictured representations of their Prophet."[172]

### *Lady of Justice* but No Moco Jumbie for the Virgin Islands

One artistic rendering of a non-white Justice—commissioned and federally funded—is in plain view. That statue (fig. 87, color plate 23), installed in 1993, stands at the door of the federal courthouse in St. Croix in the Virgin Islands,[173] a territorial possession of the United States. Bought in 1917 from the Danes, the islands continue to reflect the influence of the colonial Dutch who once dominated the West Indies.[174] Of the 110,000 people who live in the U.S. Virgin Islands, about three quarters are black,[175] and many are descendants of slaves brought from Africa and emancipated in 1848.[176]

In regular federal courts created under Article III of the United States Constitution, district judges are appointed for life. In contrast, the federal court for the Virgin Islands is a "territorial court" operating under Congress's wing. The court's two judges serve renewable ten-year terms.[177] The case load in the Virgin Islands is also relatively small. While life-tenured judges elsewhere averaged about 540 cases filed per year as of 2009, the two territorial judges sitting in the Virgin Islands have fewer than half that amount on their dockets.[178]

Jan Mitchell, the artist who designed the Virgin Islands' *Lady of Justice,* comes from Philadelphia; she has lived for many years in St. Croix.[179] Mitchell received a commission for artwork from the contemporary federal art program called Art-in-Architecture, run by the GSA (discussed in Chapter 9) as the successor to the 1930s WPA program.[180] Under federal guidelines, one-half of one percent of the estimated construction costs of new federal buildings is set aside for public art and awarded through a competitive process.[181] The GSA describes the Mitchell sculpture as a "modern-day version of Themis" shown "as a local resident of St. Croix." She holds her "traditional scales," but her "unconventional . . . attire" underscores the "civil responsibility that every citizen has in maintaining a democratic society."[182]

FIGURE 87 *Lady of Justice,* Jan R. Mitchell, 1993, Almeric L. Christian Federal Building, St. Croix, United States Virgin Islands.

Photographer: Steffen Larsen. Photograph reproduced with the permission of the artist and the photographer and courtesy of the United States General Services Administration. See color plate 23.

Although Mitchell's *Lady of Justice* is innovative in bringing a dark-skinned Justice into view in a federal courthouse, the figure was selected in lieu of two gritty alternatives proffered by the artist to evoke the Virgin Islands' ties to African history and the struggles for freedom by enslaved Africans. Some of the government-sponsored art discussed—such as the Justices by both Kraus and Hirsch—underwent minor modifications by virtue of the interaction between patron and artist.[183] Mitchell's completed work is at the end of that continuum, for it is wholly different from what had originally been proposed by the artist.[184]

In the early 1990s, Mitchell suggested a nine-foot-tall bronze statue (fig. 88) based on an island legend of "Moco

FIGURE 88   *Moco Jumbie,* Jan R. Mitchell, 1993.

Photographer: Steffen Larsen. Photograph reproduced with
the permission of the artist and the photographer.

need to assist islanders. One theory of the Moco Jumbie's origin traces the figure to the cultures of the Upper Guinea region (specifically those of the Kono, Toma, and Dan peoples) that came to the Virgin Islands through the enslavement of West Africans in the Caribbean.[186] The name Moco Jumbie may be derived from the language of the Kimbundu tribe; Moco Jumbie could be a combination of the English word *mock* and a corruption of the word *zumbi,* used by the Kimbundu to denote a ghost or departed spirit.[187] Moco may also come from a word used by the Kongo to refer to a "doctor or curer." Alternatively, moco (or moko) may be a corruption of macaw—a tall palm tree covered with thorns.

In the Virgin Islands, Moco Jumbies are "thought to bring good luck and bestow beneficence."[188] Records from the 1790s indicate their display in Caribbean festivals, and drawings from the 1870s show a masked "stilt dancer in a woman's dress" wearing a conical hat and holding a whip in hand.[189] Figure 89 (color plate 22), an evocative photograph by Robert Nicholls, whose extensive scholarship informs this discussion, was taken in 1997 during the Virgin Islands Carnival and provides a modern-day incarnation.[190] Nicholls described the Moco as a "supernatural scarecrow—that ridicules ghosts and spirits and scares them away."[191] Their elongated height enables them to oversee a village, perhaps also enabling them to "mediate disputes among the living when all else has failed."[192] Moco Jumbies sometimes sport mirrors, which in "both European and West African cultures . . . dispel evil."[193] Further, like the Renaissance Virtue Prudence (fig. 1/20), who was regularly shown with a mirror and at times a second face looking backward, Moco Jumbies can "metaphorically . . . see what is happening both in the present and in the future."[194] In carnivals the figure can represent "fun, laughter and merriment," at times performing as a "sort of clown on stilts."[195]

That association was part of the basis on which Mitchell's proposal was rejected. According to records from the GSA, the "District Court family" thought that putting a statue of a Moco Jumbie outside of its court would be "unsuitable as a symbol of justice." While "definitely Caribbean," it was "a jester of sort" whose name was associated with mockery. In the view of court personnel, their building was a place for the community to "look for fair play and justice, tempered with mercy—hardly a place for clowning or jesting."[196]

When news of that disapproval became public, supporters protested that the rejection was itself a display of ignorance about local culture. Under the headline "Moko Jumbie: No Mockery of Justice," a St. Croix paper published a letter arguing that jesting was but one of the roles of the character, who could also transform into a "village ancestor" with the power of judgment to "reprimand those who violated the laws."[197] An editorial in the *Virgin Islands Business Journal* went further, insisting that the use of the Moco Jumbie figure would be an antidote to the oppressive conditions that had reduced its historical significance to that of

Jumbie," an African folklore figure that, as Mitchell explained to the local committee members assembled by the GSA, had become specially and uniquely connected to the Virgin Islands.[185] Mitchell's exuberant proposal reflected myths that the Moco Jumbie descended from trees in times of

FIGURE 89  *Mystical Mocko Jumbies,*
United States Virgin Islands
Carnival, 1997.

Photographer: Robert W. Nicholls,
University of the Virgin Islands. Image
reproduced with the permission of the
photographer. See color plate 22.

a carnival figure. As the editors explained, Moco Jumbies had traditionally been a source of protection but were relegated to carnivals by plantation owners who prevented slaves from observing their religions. Supporting the project, the newspaper argued that using the figure would be a "reclamation by the oppressed of a measure of justice."[198]

When the protests failed, Mitchell proffered alternatives. One, titled *Reaching Man* (fig. 90), was a bare-chested man shown struggling to free himself from the block in which he was sculpted, explained by the artist as symbolizing the

Islanders' "struggle for freedom."[199] The other, called *Market Woman,* was a woman with market scales and a basket.[200] After beginning work on *Reaching Man,* Mitchell received an order to suspend activities because the court preferred *Market Woman,* who emerged with the name *Island Themis* and is now called *Lady of Justice.*[201]

This Justice stands, in bronze, six feet tall and on a pedestal to the right of the doors of the courthouse. Her skirt is cropped at the knees, belted at the waist, and slightly swirled. Her shirt is open-collared, and on her feet

FIGURE 90 *Reaching Man,* Jan R. Mitchell, 1991.

Photographer: Steffen Larsen. Photograph
reproduced with the permission of the artist and the
photographer.

are sandals. As the close-up of her torso and head (fig. 91)
makes easily visible, this Justice has her hair mostly cov-
ered in a bandana-like scarf, with a few curls visible at the
top of her head. Her vision is unobstructed, and she looks
at the evenly balanced scales held in her hand. Comments
from selection committee members noted her "good,
strong features," reflecting the role of women in the fam-
ily and serving as a representative of "the culture."[202]

FIGURE 91 *Lady of Justice* (detail), Jan R. Mitchell.

Those descriptions suggest that the mix of classic Justice
iconography and darker skin can feel comfortable when
associated with roles once assigned specially to black
women, such as service providers and caretakers for white
children.[203]

## The Safety of Abstraction:
## Ellsworth Kelly in Boston

In the early 1990s, the architect Henry Cobb was selected
to design a new courthouse for the federal appellate and
trial courts that sit in Boston, Massachusetts. His enthusi-
asm for creating a special building was shared by Douglas
Woodlock, a judge on the district court, and by Stephen
Breyer, who sat on the Court of Appeals for the First Cir-
cuit before he was appointed Associate Justice on the
United States Supreme Court.[204] Eager for a contemporary
building to serve a public role, Cobb, Woodlock, and Breyer
took as their model a one-room courthouse in Virginia
that, in 1735, had been "the center of its community."[205]

The result in Boston was a ten-story building with twenty-
seven courtrooms supported by "three quarters of a million
square feet of bureaucratic support space" that opened in
1998.[206] A huge conoidal section of glass forms one wall of
the courthouse, emblematic (in the architect's words) of the

effort to have the building perceived as "open and accessible to all," yet also specially situated as distinct and separate from "everyday life of the street."[207] As can be seen from figure 92 (color plate 25), the glass wall dominates the public space by sheltering an atrium that permits views of seven stories.[208] Since its opening, the courthouse, which includes some 150,000 square feet aimed at providing "meaningful spaces" for visitors and community programs, has sponsored several outreach initiatives, including a series of programs for school children.[209]

The art commission went to Ellsworth Kelly, one of the United States' most prominent contemporary artists who is also recognized around the world in both public buildings and major museums. Kelly's twenty-one aluminum and enamel panels of varying colors (fig. 93, color plate 26) installed in seven locations within the building, are intended to function as a single work of art.[210] In the 1930s, federally funded arts programs had avoided abstraction—preferring "representational" to "nonrepresentational" art.[211] By the 1990s, the design committee chose *The Boston Panels*, as they are called, rather than overtly didactic images.[212] The nine horizontal panels in the central rotunda are about eleven feet by thirteen and a half feet, while the verticals are about the same height but narrower—just under seven and a half feet wide; they hang in pairs at the ends of the hallways on several floors.

Ellsworth Kelly's monochromes—bright blue, green, yellow, orange, and black—avoid the questions of what Justice might, could, or does look like.[213] As for what "she" might say, carved into stone are English texts from Abigail Adams, John Adams, Louis D. Brandeis, William Cushing, Frederick Douglas, Felix Frankfurter, Oliver Wendell Holmes, Sarah M. Grimké, John F. Kennedy, Leila Josephine Robinson, and Daniel Webster, as well as from

FIGURE 92   The Great Hall, John Joseph Moakley United States Courthouse, Boston, Massachusetts, 1998. Architect: Henry N. Cobb.

Photographer: Steve Rosenthal. Photograph copyright: Steve Rosenthal, 1998, reproduced with the permission of the photographer and the courtesy of the court. See color plate 25.

FIGURE 93    *The Boston Panels,* Ellsworth Kelly, 1998, in the John Joseph Moakley United States Courthouse, Boston, Massachusetts.

Photographer: Steve Rosenthal. Photograph copyright: Steve Rosenthal, 1998, reproduced with the permission of the photographer and the artist and the courtesy of the court. See color plate 26.

the constitutions of Maine, Massachusetts, New Hampshire, Rhode Island, and Puerto Rico, thus representing an array of diversely situated historic figures and all of the geographic entities that comprise the First Circuit (if not all of their languages).[214]

Kelly explained that *The Boston Panels* were themselves governed "by measure and balance."[215] The architect Cobb praised them for their serenity. The GSA described the colors as without "symbolic" purpose while aiming "to provoke an emotional, and even spiritual, response from viewers . . . left . . . to create their own meanings for the work"; as the artist had not specified a meaning, his work was "inherently democratic."[216] As one commentator suggested, the horizontals are landscapes and the verticals portraits, waiting to be inscribed.[217]

While some commentators enthused—describing the paintings as "stark yet lush, [with] the visual punch of traffic lights"[218]—others were dismayed, objecting to their "decorative neutrality and hunkered-down presence."[219] If their blank expanses of color can be read as potential

portraits, they could equally well be read as portraits stripped of individuals. The Kelly panels offer a safe haven, for their abstraction avoids having to choose any particular body type to be iconic. What the WPA formerly considered avant-garde, ironically, can now be read as conservative.

## JUDGING JUDGES:
### FROM SPECTATOR TO CRITICAL OBSERVER

Various shifts in perspective materializing across many disciplines have been linked to modernity. The cubism of twentieth-century art broke the linear planes of earlier conventions and offered views from multiple perspectives. (Cezanne's still-life paintings permit one to see simultaneously pears, tables, and table cloths from angles not available through one's own eyes.) Deconstructionism objected to the hegemony of a single meta-narrative confidently promulgated by one authoritative voice.[220] These intellectual shifts can be understood as constituting a "rupture with

Renaissance, or *classical* models of vision,"[221] which had posited an objectivity borne from a single point of view, sometimes exemplified by the fixed vantage point of a person looking through a camera obscura.

A modern understanding, both reflected and produced through the multiplication of images and texts, makes palpable the subjectivity of what is seen. As theorist Jonathan Crary has argued, a "spectator" sits passive, while an "observer" produces as well as receives information. Observers are not, however, autonomous, nor are their eyes "innocent";[222] "embedded in a system of conventions and limitations," they (we) are situated to see "within a prescribed set of possibilities."[223] Linking his work to some aspects of Michel Foucault's *Discipline and Punish,* Crary examined how "new methods for administering large populations" dispersed power— including to observers—yet disciplined their behavior through the development of norms in a host of fields.[224]

In Chapter 14, we examine the fragmentation of adjudicatory functions that could serve as analogues to these theoretical and visual perspectival shifts. In this chapter, we focus on how this new stance authorizes critical appraisals of judges. In some respects, judges have long been subject to oversight, warnings (as detailed in Chapters 2 and 3) against bribes and mandates for even-handed treatment of disputants. But the injunctions thickened over time to elaborate the judicial role. By 1654, Matthew Hale, a circuit judge in England, recorded "eighteen Rules to be observed in his conduct as judge."[225] Drawing in part from biblical sources, Hale insisted on honesty, impartiality, and compassion. Moreover, he described the business of judgment as "full of labor and pains," requiring "incessant attention" and "a steadfast resolution and courage to do what is just."[226] Hale reflected that no matter how just decisions were, judges could "never escape the imputation of partiality and unjustice from some party."[227] (Hale's actual "sentencing of two witches to death" has been a lasting source of criticism of his judgment.[228]) Hale argued, however, that as a judge he answered only to God, on whose behalf all judges judged and by whom all judges would be judged.[229]

## The Appearance of Impartiality

No longer can judges presume that they have only heavenly powers as overseers. Democracy empowers a "demos," a people making decisions about the institutional framework and obligations under which they live and authorizing governments to implement their will.[230] Renaissance spectators have been replaced by observers empowered to critique rather than only to watch. The public, including disputants, have gained forms of authority over judges, even as judges themselves have also gained degrees of insulation from the rulers (executive and legislative) who are the sources of their jurisdiction.

In contemporary terms, some of the public power over judges operates at an institutional level—when decisions are made about judicial selection or retention. In some jurisdictions in the United States (including California, Ohio, and Wisconsin), judges are elected or their appointments are approved by popular vote.[231] In others, the executive's appointment powers are somewhat constrained by special committees (often called "merit selection commissions"), typically comprised of professional and lay members creating lists of candidates from which appointments are made.[232] In the United States federal system, the Constitution authorizes the President to nominate persons but gives to the Senate, another popularly accountable branch of government, the power of confirmation.

Once individuals are empowered to judge, the question of the degree to which observers can exercise control turns on questions of whether judges sit for fixed or renewable terms, the forms of reappointment, and the conditions under which judges serve. English judges once lost their positions when the king who had appointed them left office. The 1701 Act of Settlement, which required a vote of Parliament to remove a judge from office, is an oft-cited marker of judicial independence.[233] The 1789 United States Constitution translated the concept of judicial independence into tenure "during good behaviour" (understood to guarantee jobs for life) and salaries protected from diminution. Federal judges cannot lose their jobs unless bills of impeachment are voted and a trial is held by the Senate, and the Constitution limits removal to certain grounds —"Conviction of, Treason, Bribery, or other high Crimes and Misdemeanors."[234] Over the course of more than two hundred years, few (about a dozen) federal judges have been impeached.[235] Further, as rights developed to enforce government obligations through lawsuits, judges themselves shaped doctrines of their own immunity from suit, as they reasoned that such liability would undermine the ability to discharge their duties.[236]

Yet critical viewers (from a range of perspectives) found these forms of judicial accountability too thin. One watershed in the United States is a famous speech delivered in 1906 to the American Bar Association by Roscoe Pound, who called his talk "The Causes of Popular Dissatisfaction with the Administration of Justice."[237] Pound's critique ranged from substantive rules of law to the organization of courts and the work of lawyers. "Popular dissatisfaction," then as now, was wrapped up with views about the merits of decisions that judges rendered on matters of great moment (whether early twentieth-century property rights claims or late twentieth-century judgments on same-sex marriage). But one cause of "dissatisfaction," judicial misbehavior, is more readily subject to responsive regulation than are complex questions of the scope of judicial authority and the roles courts ought to play in a democracy. In 1924, in an express effort to shore up public confidence after particular scandals, the American Bar Association promulgated "Canons of Judicial Ethics," which built on a 1908 code of ethics for lawyers.

Even though the reforms were circumspect (the Canons described what judges "should" do and initially imposed no absolute mandates),[238] the fact of their promulgation demonstrated the importance accorded to the observer. "Popular opinions" had come to matter. And although federal judges could banish a "Communist" Justice (fig. 77), or drape darker-skinned "avenging" Justices (fig. 81), judges themselves could be—and were—subject to a barrage of publicity when they did. Whether the audience was constituted via the immediacy of live proceedings or from afar and mediated through the press, public perceptions could undermine judges'—and hence the state's—authority.

The 1924 code made the idea of critical judgment explicit by insisting that judicial behavior be free not only of "impropriety" but also of the "appearance of impropriety."[239] By the twenty-first century, that standard of the "appearance of impropriety" included, for example, admonitions that judges not hold memberships in exclusionary clubs that did not welcome all persons in those informal settings where public and private powers mixed.[240] Further, the hortatory language of the Canons had shifted to suggest that compliance was obligatory,[241] and judges were expressly charged with striving to "maintain and enhance confidence in the legal system."[242] Indeed, by 2007 the ABA Model Code of Judicial Conduct put judges to the tasks of initiating and participating in "community outreach activities for the purpose of promoting public understanding of and confidence in the administration of justice."[243]

## Duck Blinds in 2004

The audience now understands itself as positioned to assess whether judges are adequate to their jobs and whether their substantive and procedural rules deliver on promises of equal treatment. In response, some jurisdictions developed "performance reviews" for judges, at times through surveying lawyers and litigants. Court systems also provided mechanisms for individuals to level complaints against judges who engaged in "conduct prejudicial to the effective and expeditious administration of the business of the courts."[244]

Litigants in individual cases gained the power to object to the assignment of a particular judge to a specific case. English common law had long recognized that "no man shall be a judge in his own case" but had interpreted that precept narrowly, to instances of direct monetary interests, and had not applied it to all levels of courts.[245] Through the evolution of doctrine and statutory provisions, broader "objective" criteria have been specified, including whether a judge has an indirect financial stake (for example, as a shareholder in a corporation) or a range of personal ties (for example, a familial relationship to litigants or their lawyers).[246] Thus, in contrast to Amsterdam's deployment of Zaleucus and Brutus (discussed in Chapter 3 and shown in figs. 3/45 and 3/46), who were idealized as judges because

they stood in judgment of their children, contemporary judges are not put in the position of having to prove loyalty to the state by ordering punishment of their own kin. Rather, such relationships and other connections prompt disqualification, because a "judge's impartiality might reasonably be questioned."[247] Over the past century, the bases for "reasonable questioning" have been elaborated, often prompted by specific incidents of revelations about economic or other ties between judges and disputants.[248]

In some jurisdictions, the power to remove a judge is "peremptory" in that each disputant can strike a judge without explaining why.[249] In addition, judges may voluntarily recuse themselves, and litigants can request disqualification based on specified grounds. Although the right to bring such a challenge against a judge bespeaks modernity in that it accepts the validity of multiple points of view, the method of deciding the question does not. Some courts refer disqualification requests to another judge, but in many jurisdictions it is the very judge challenged who decides. Presumed loyal to the judicial role and with firsthand knowledge of the facts, that person is to assess the propriety of continuing to work on a given case.[250]

Many questions exist about the criteria for evaluating the appearance or the fact of partiality. For example, ought judges to recuse themselves if they have accepted paid travel to attend seminars aimed at educating them on economic theory, environmental hazards, anti-trust doctrine, or human rights?[251] What about participation on boards, friendships with lawyers or litigants, public speeches commenting on questions relevant to a lawsuit, or connections with issues based on work prior to becoming a judge?[252] Litigants have asked judges to step aside for a range of reasons that have prompted public debate about what "the appearance of impropriety" could mean.

One such episode that garnered enormous attention is recorded in a Jeffrey Danziger cartoon, "Don't Worry, She's Blind" (fig. 94), appearing in newspapers in March of 2004.[253] Shown sitting on the pans of Justice's scales are two figures, each wearing a hunting cap and holding a shotgun. One is a caricature of then–Vice President Richard Cheney and the other of Supreme Court Associate Justice Antonin Scalia. At the time the Supreme Court was considering a lawsuit filed by two organizational plaintiffs, the Sierra Club Judicial Watch, challenging the refusal of a committee, called the National Energy Policy Development Group (NEPDG) and chaired by Vice President Cheney, to provide access to information about its proceedings.[254] The plaintiffs named Vice President Cheney as one of the defendants and charged that the NEPDG, created by the President to develop a "national energy policy designed to help the private sector, and government at all levels, promote dependable, affordable, and environmentally sound . . . energy,"[255] inappropriately permitted "private lobbyists" to participate.[256] At issue was whether the Vice President had improperly constituted the group and then failed to dis-

FIGURE 94 "Don't Worry, She's Blind," Jeff Danziger, 2003.

close (or, as one legal ethics professor put it, had been "lying about") how the group was constituted.[257]

One of the legal questions raised was whether the NEPDG fell within the parameters of a federal statute, the Federal Advisory Committee Act, requiring public disclosures of meetings.[258] If so, the public would have been able to learn about the role played by private lobbyists in shaping the Energy Group's report to the President. If the Vice President had a nondiscretionary duty to provide such disclosure, a federal court had the power to mandate compliance with that obligation.[259] Under federal law, through a process called "discovery," opponents in lawsuits have to give each other information on matters relevant to establishing claims or defenses. The plaintiffs sought to use discovery to learn about the Energy Group's membership and structure. But the Vice President resisted, arguing that his position in the Executive Branch immunized him from having to comply with such discovery requests. A trial-level court disagreed and ordered the Vice President to provide the information.

That order was enforceable immediately. Because federal law generally permits appellate review only when a case is over and a "final judgment" has been rendered, the decision could not be challenged through that route. Instead, the Vice President invoked an unusual legal proceeding called mandamus and asked the intermediate appellate court (the Court of Appeals for the District of Columbia) to halt the lower court's discovery order. The Court of Appeals for the D.C. Circuit refused, and the Supreme Court agreed to review the appellate court's unwillingness to "mandamus" the trial judge.[260]

Two levels of revelation were thus at issue—whether the National Energy Policy Group was the kind of "advisory committee" to which the public had a statutory right of access, and whether the Vice President was the kind of litigant required to comply with court-ordered discovery. But what came to light was another disclosure: that Justice Scalia had joined the Vice President on his official jet, Air Force Two, when both had flown to Louisiana for a duck-hunting trip hosted by a businessman.[261] Indeed, as Justice Scalia later explained, because he was "well acquainted (from our years serving together in the Ford administration)" with Vice President Cheney, Justice Scalia knew that both shared an enthusiasm for duck hunting. Justice Scalia had proposed to his friend, the host, that the Vice President be asked to join the trip. The Vice President, in turn, had suggested that the Justice travel with him aboard Air Force Two. Justice Scalia also reported that the trip arrangements (including invitations for Scalia's son and son-in-law to fly on Air Force Two) had been made before the Supreme Court agreed to hear Cheney's appeal.[262]

When the trip came to light, the Sierra Club (one of the litigants seeking public access to the Energy Group) asked Justice Scalia to recuse himself because his impartiality could "reasonably be questioned."[263] As evidence of reasonableness, the Sierra Club cited the call from "20 of the 30 largest" newspapers for the Justice to step aside.[264] In a written memorandum filed on March 18, 2004, Justice Scalia declined to do so. He provided additional details, including how the hunters were in "two- or three-man blinds," and that he "never hunted in the same blind with the Vice President."[265] Further, Justice Scalia reported that he had spent no time alone with Cheney and that "we said not a word about the present case."[266]

Justice Scalia provided a lengthy account of why friendship was not and ought not to be a ground for recusal by

justices when issues of "official action" were the predicate— "no matter how important the official action was to the ambitions or the reputation of the Government officer."[267] Further, Justice Scalia explained that he had neither gained monetary benefit nor spent taxpayer funds. He had purchased round-trip tickets and, he noted, the expense to the government was that of using the Vice President's jet, whether filled or not. Moreover, while doubts might be resolved in favor of recusal on lower courts, Justice Scalia relied on the idea that his presence was essential ("a duty to sit") to avoid a four-to-four split, which would mean the lower court's decision would stand.[268] Noting that he had "received a good deal of embarrassing criticism and adverse publicity," Justice Scalia commented that it would be tempting to silence the critics by "getting off the case," but in his judgment, no basis existed for doing so.[269]

As for the merits of the case, on June 24, 2004, the Vice President won, with seven justices supporting his point of view. The majority decision, written by Justice Anthony Kennedy, sent the case back to the appellate court to rethink whether, in light of the separation of powers, it had the discretion to tell the trial judge that the Vice President ought to be protected from being forced to make disclosures.[270] Justice Clarence Thomas wrote a concurrence in which Justice Scalia joined. They agreed with the return to the appellate court but urged the court to consider whether the trial court even had jurisdiction to address the merits.[271] Justices Ruth Bader Ginsburg and David Souter dissented, arguing that the defendants had been overly broad in resisting all discovery and that the trial court's ruling had been appropriately limited. When the case was returned to the D.C. Circuit, the Vice President won again.[272]

Much debate among legal ethicists followed about whether the Justice ought to have stepped aside, whether the decision to do so ought to have rested solely with him as contrasted with the Supreme Court as a whole, and how to evaluate Justice Scalia's testimonial descriptions of the events that transpired.[273] Objectors protested rules that gave a member of the court both the power to narrate the events and the sole and unreviewable discretion to assess their import.[274]

Justice Scalia's response can be analogized to John Rawls's conception of adopting an "original position" and to Moore's *Lady Justice* (fig. 5/72) in Concord, New Hampshire. Justice Scalia claimed that he was able to tie the blindfold's knot himself, and that he could bracket his situation at both personal and institutional levels when assessing the merit of the legal claims. In his twenty-one-page response, Justice Scalia provided a historical account of what he saw as comparably embedded justices working in close relationships with various officials. He described the many judges who had obtained their positions through such connections and then continued to socialize with their powerful colleagues in both public and private settings.

But, as Brian Barry has explained in *Justice as Impartiality,*[275] a "common sense" definition of impartiality for judges both obliged them "to be unmoved by personal interests or the congeniality or otherwise of those who appear before them" and disqualified them "from hearing a case if they have financial interests in it or if they have personal connections with any of those involved."[276] The issue was not congeniality but connections, which is the point made by Danziger's cartoon, capturing the widespread sense that friendship between a justice and a government official, especially one forged when both served together in a prior administration, undermines the perception of the fairness of the judgments rendered. Justice Scalia's efforts to resort to the impersonality of the judge and the official, functioning within a Weberian bureaucracy as if they were strangers, seemed counterintuitive to many.

In Danziger's depiction, the blindfold is a wholly negative attribute, as can be seen from the posture of and the words assigned to the caricature of Justice Scalia. He turns away from the blindfolded Virtue, a large, robed Justice on whose scales the two men perch, as he offers his compatriot the reassurance "Don't Worry, She's Blind." Danziger's use of the blindfold is paralleled by that of hundreds of other cartoonists over the last century,[277] and the ease with which they retrieve its negative associations raises questions about the effort to revalorize it in this, a post-Enlightenment era. However pragmatic were Justice Scalia's justifications, the outpouring of concern from more than two dozen newspapers reflected an audience acutely uncomfortable with the revealed interplay of public and private authority in making law. Like the blindfold of Bruegel's Justice (fig. 4/53), the gesture of covered eyes, claimed to buffer the decisionmaker from seeing (and perhaps therefore from fully knowing) what has occurred, does not obscure from other viewers the very activities that have invoked unease.

For John Rawls, the point of veiling was to enable impartial judgments that took into account perspectives beyond oneself and one's time. "Purity of heart, if one could attain it, would be to see clearly and to act with grace and self-command from this point of view."[278] What Justice Scalia failed to see was that the trip to hunt ducks was a reflection of a set of relationships that seem unremarkable to those encircled by power and yet are troubling to those who stand outside that circle. The underlying litigation revolved around the same point, for the statute requiring public disclosure of committee meetings of governmental bodies was enacted in recognition of the potency of informal opportunities to affect decisions. The Rawlsian approach would have been, at the least, to forgo the trip and other opportunities for private socializing while issues of access to the Vice President's power were pending before the court. The time for veiling had come long before the case was argued.

## Restructuring Law's Possibilities

The development of professional ethics and of rules governing judges was an element of many twentieth-century

changes in the legal landscape, to be previewed here and elaborated in other chapters. The growing numbers of lawyers and judges sought to maintain control over professional norms through canons shaped in response to "popular dissatisfaction" with the legal system. But criticism also came from within, as women and men of all colors became lawyers and judges. These new entrants questioned prevailing assumptions about the acceptability of various practices, from courtroom etiquette (such as whether women litigants should be addressed as "hon" or "girl") to the substance of legal rules (such as whether marital rape ought to be a crime and alimony a right) to the extrajudicial activities of judges (such as the propriety of membership in exclusionary clubs).

As the conflicts over who should be shown on courthouse walls as "Justice" made plain, the demographic transformations in the last decades of the twentieth century were dramatic. Until the 1960s, the bench and the bar had themselves been exclusionary clubs. In 1965 in the United States, women made up less than 5 percent of entering law school classes; forty years later, women were more than 40 percent of entering students. In 1965, women and men of color composed less than 1 percent of the student body in law schools; it 1995 that figure was almost 20 percent.[279] The trend is similar in other common law and civil law countries.[280]

But it was not only who was becoming a lawyer that changed; it was also how they lawyered and who had rights to bring claims to court. The lawsuit against Vice President Cheney was made possible by one of hundreds of federal statutes that conferred new rights enabling individuals and groups to challenge governmental action. Those would-be plaintiffs were able to proceed because of new opportunities for representation afforded by a diverse public interest bar that had developed over the preceding century as both a product and a producer of new rights. Some organizations, such as the NAACP Legal Defense Fund, the American Civil Liberties Union, and the National Resources Defense Council, are small, specialized entities focused on particular kinds of legal problems. Others aim to provide services to the poor, such as the Legal Aid Society of New York and, since 1974, the federally financed Legal Services Corporation. On the criminal side, in the wake of the 1963 Supreme Court decision in *Gideon v. Wainwright* concluding that the constitutional right to counsel required that poor criminal defendants be provided lawyers, public defender organizations came into being.[281] In the 1970s, law schools expanded their clinical programs to assist indigent clients; in addition, individual lawyers and firms around the United States contributed their time to enable representation for those otherwise without counsel.

Not only did lawsuits multiply but their shape and aspirations changed as new procedures and statutes opened the doors to courts. Claimants came together in class actions and other kinds of aggregations to raise issues that single plaintiffs did not have the resources to pursue. They sought new and varied remedies in cases involving school desegregation, equal pay, and prisoners' rights.[282] As litigants pressed issues related to their intersecting collective identities (plaintiffs or defendants, employers or employees, women, blacks, children, prisoners), questions emerged about whether judges accorded fair treatment to all who appeared before them. As segments of the population questioned the justice of the law, they developed an array of mechanisms—filing lawsuits, bringing class actions, and participating in identity-based organizations, including those composed of lawyers and judges—to give voice to their complaints.

Judiciaries, in turn, reorganized, coming to resemble other government agencies seeking funds, facilities, and staff. Judges no longer operated as solo actors but became part of institutional contexts in which they were subject not only to ethical rules but also to administrative regimes. In the 1950s, administrators within the federal court system thought that "the idea of a 'school for judges' would lend itself to ridicule"; judges were, by definition, learned. But by the 1970s, judges in both the state and federal systems regularly attended educational and professional training programs.[283] The question changed from whether judges needed education to whether regulation of providers was in order, given that certain purveyors had the resources to pay for judges to travel to pleasant locations for seminars on subjects such as law and economics or the use of scientific data as evidence.

## Systemic Unfairness in Individualized Justice

On occasion, when rendering judgments in cases, judges have intervened as they recognized structural injustices, such as legally mandated segregation of schools. But often, when confronted with evidence of systemic unfairness, courts have retreated—refusing to focus on more than particular evidence of harm to a particular individual. That approach is exemplified in the United States by a 1987 decision, *McCleskey v. Kemp.*[284] At issue was whether Georgia courts imposed the death sentence in a racially discriminatory fashion, demonstrated by statistical patterns showing that defendants charged with killing white victims were more likely to be sentenced to death than those charged with killing black victims and that black defendants were more likely to be sentenced to death for that crime than their white counterparts.[285]

A five-person majority of the Supreme Court declined to find those data demonstrative of "a constitutionally significant risk of racial bias affecting the Georgia capital sentencing process."[286] The majority stated that it would consider evidence that a particular person was sentenced to death because of intentional and manifest racial prejudice directed at him or her but blinded itself to the claim that the judicial administration of the death penalty—as a whole—violated the Equal Protection Clause. By way of explanation, the majority argued that, were racism in death penalties to be considered, judges would also have to consider the

effects of racism in sentencing more generally, and, moreover, "the irrelevant factor of race easily could be extended to apply to claims based on unexplained discrepancies that correlate to membership in other minority groups, and even to gender."[287] Of course, that was in fact the point—that a confluence of factors that law aspired to make "irrelevant" systematically produced unfair outcomes.

### Structural Interventions: Judicial Task Forces on Bias in the Courts

Critics read the *McCleskey* decision as willfully blind, as well as oblivious to the intersection of race and gender. Moreover, the ruling "largely eliminated the federal courts as a forum for the consideration of statistically based claims of racial discrimination in capital sentencing,"[288] as if such claims were not as "susceptible" as others "to identification, to adjudication, and to correction."[289] The 1987 *McCleskey* opinion marked a wider retreat from court-based efforts to remedy the residue of slavery through adjudication.

But members of organizations such as the National Bar Association (founded in the 1920s), the National Organization for Women's Legal Defense and Education Fund (begun in 1970), and the National Association of Women Judges (founded in 1979) had an understanding very different from that of the *McCleskey* majority. As the logo for the National Bar Association's Judicial Council (fig. 5/76) displayed, these lawyers and judges had personally experienced courts as places of partiality. Fully appreciative of what critical theorists call "the subjectivity of the observer,"[290] the members of these groups knew (as Constance Baker Motley recounted in her autobiography) that stereotypes not only hung on the walls of courthouses in Jackson, Mississippi (fig. 83) but also animated the decisions of many judges.

By the 1960s and 1970s, as litigators pressed claims for gender and racial equity, they repeatedly experienced some of the pain of discrimination in the very places to which they brought claims—the courts. For example, some jurists shared with defendants the view that women's place in the world was at home, with children. Time and again, judges ignored claims of violence in households, belittled the value of women's contributions of household labor, and rejected employment discrimination cases challenging policies that kept pregnant women from teaching elementary school or working in various jobs.

In response, associations of women lawyers and judges crafted special education programs aimed at helping judges to understand their own stereotypes and biases.[291] But when given real cases illustrating problems, judges often dismissed them as anecdotes that did not demonstrate a systemic dysfunction. Moreover, if the example came from one jurisdiction (such as New York), judges in another state (such as New Jersey) might offer a jurisdictional disclaimer—that perhaps judges in New York behaved that way, but those in New Jersey did not. Consistent in some ways with *McCleskey*'s rejection of statistical patterns, programs on bias found that judges were likewise loath to take individual instances of real cases in real courts as evidence of system-wide problems.

How could those who experienced the unfairness of adjudication get judges to see such problems? These identity-based organizations pressed the chief justices of state courts to move beyond educational programs to research by commissioning special projects to study, jurisdiction by jurisdiction, problems of partiality. "Gender bias in the courts" and "race and ethnic bias task forces" became the short-hand terms attached to the issue, with task forces as the primary means for gathering information specific to a particular court system. In 1982, the New Jersey Supreme Court led the way by being the first to create a gender bias task force. Within a decade, court-based task forces devoted to race and ethnicity followed, as did efforts in some of the federal courts.[292]

These official commissions looked at the application of substantive legal doctrine, courtroom interactions, the demography of courthouses, and courts' roles as employers. As one state's chief justice explained, it was the "duty" of the task force "to determine the presence and extent of gender bias" in that state's courts and to "develop strategies for its eradication."[293] Within fifteen years about sixty thick reports had been produced, some focused on gender, others on race and ethnicity, and a few on the intersection of various forms of subordination.[294] Many studies relied on survey data, complemented by focus group reports and research into case law and statutes.[295] Thousands of lawyers, judges, and staff were surveyed; much less information came from litigants, who were harder to find and therefore more expensive subjects from whom to seek information. Most of the reports proffered parallel answers—that despite emblems of equal justice under law, many litigants, lawyers, and even some judges found courts, at certain times and in specific ways, venues of discrimination. By reading the set of reports together, one can find that in states as disparate as California, Georgia, Kentucky, Maryland, and Minnesota, women seeking redress for "domestic" violence reported that they were blamed, accused of provoking their attacks, treated as if their experiences were trivial, or disbelieved.

A 1986 Report of the New York Task Force on Women in the Courts detailed the ways in which identity undermined the fairness of the justice system in that state. As the New York Report explained, "gender bias against women . . . is a pervasive problem with grave consequences. . . . Cultural stereotypes of women's role in marriage and in society daily distort courts' application of substantive law. Women uniquely, disproportionately, and with unacceptable frequency must endure a climate of condescension, indifference, and hostility."[296] Five years later, Connecticut's gender report reached a parallel conclusion: "Women are treated differently from men in the justice system and, because of it, many suffer from unfairness, embarrassment, emotional pain, professional deprivation and economic hardship."[297]

Similar findings came from task forces focused on race and ethnicity. Studies indicated that people of color detained on charges for certain offenses were less likely to be released on bail than whites held for similar offenses and more likely than whites to be jailed while awaiting sentencing. Despite the court's rejection of statistical evidence in *McCleskey*, some state court reports found a "perception, supported in some aspects by research findings, that there is a disparity that can be attributed only to race in the rate of convictions and the types of sentences."[298] Michigan's 1989 report illustrated what several others concluded: that "there is evidence that bias does occur with disturbing frequency at every level of the legal profession and court system."[299]

As a result of these various inquiries and the social movement that supported them, some courts changed their rules of practice, their ethical obligations for judges and lawyers, and their methods of selecting judges. In many jurisdictions, courts developed sexual harassment policies; revised processes for employee orientation, training, and selection; promulgated local rules mandating fair treatment of witnesses and lawyers; rewrote canons of ethics; enacted legislation; and created special programs on the problems of victims of violence. Gender, race, and ethnicity became topics of judicial conferences, of meetings and continuing education programs for lawyers, and of private discussions. Moreover, a few courts overturned decisions by concluding that jurists had predicated their judgments on unacceptable biases and stereotypes. A small body of case law now speaks about how proceedings can be infected by stereotyping, such as addressing women lawyers and litigants in demeaning terms[300] and making racial and ethnic slurs.[301] Task forces "saw" the problems and moved criticisms of courts from allegation to fact, making discernible the patterns that judges had been loath to face.

Such affirmative efforts to deal with disparities produced through court-based projects were eventually met by critics pressing to limit their reach and effect. Even though task forces were professionally based, judicially sponsored, and generally well mannered in tone, opponents (some within the courts and others from outside) began to attack them. In Chapter 5, we discussed the debate about whether law should be "color-blind" and what such a phrase could mean. The reproach leveled against gender and race bias task forces was part of a broad effort to undermine race-conscious and gender-conscious remedies that fall under the heading "affirmative action." Critics objected that to identify bias was to produce it and that blindness to difference, rather than identification of its impact, was the route to take. In the mid-1990s, at the behest of a member of the Senate, the United States General Accounting Office launched an investigation into federal funds spent on task forces.[302] Other attacks came through litigation challenging remedies spawned by task forces. For example, in the wake of a report from a task force in Florida, that state's legislature required that judicial selection panels include non-white, non-male members. The lower federal courts held that the statute unconstitutionally created a forbidden quota.[303]

Attacked from the "right" for being too aggressive, task forces were also criticized from the "left" for being too mild-mannered and too nested within an ideology committed to judicial legitimacy. Although task forces proffered patterns and instances of discrimination, many of the reports insisted that such discrimination was extrinsic to the basic structure of courts. Seeking to cushion the discomfort caused by even inquiring into instances of discrimination, task forces in the United States chose for their titles "fairness," "justice," "equality," or "gender bias" rather than referring to discrimination, subordination, or sexism. In contrast, a parallel project in Canada styled itself as a Commission on Systemic Racism in the Ontario Criminal Justice System.[304]

## GLIMPSING THE GAPS

Our excursion into the law and institutions of twentieth-century judging in the United States has illustrated why the blindfold continues to serve cartoonists well. The blindfold retains an ability to jar and to disturb, providing (ironically given that it serves literally as a cover) a Foucauldian "gap" or "rupture" that can remind a viewer of potential breaches in the state's claim to neutral impartiality.[305] Whether on the walls in Jackson or Boise or in reports from late twentieth-century task forces, evidence of law's unfairness requires debate about whether and how to respond. Even when critical, lawyers and judges retain strong commitments to the aspirations of law. The logo of the Judicial Council (fig. 5/76) shows a Justice pulling the bandages off. Yet, unlike Langston Hughes's image of "festering sores" beneath the blindfold, the Justice displayed is regal, facing the viewer squarely, with two open eyes.

The blindfold's continuing saliency underscores that, like the question of financing judging (detailed in Chapter 3), the tensions about knowledge's relationship to power and judgment (Chapter 5), and the debate set forth in this chapter over whose stories of Justice would make it onto the walls and into decisions, these questions are not only unresolved but not subject to any single or fixed resolution. Yet, as the Idaho legislature understood when deciding to show rather than to drape the mural of an Indian about to be lynched, covering up problems sits uncomfortably with contemporary aspirations for democratic transparency and accountability. The risk of festering sores, of unfairness in the name of Justice, is too great to continue to celebrate obstructions. Willful obliviousness and reliance on role provide no solution. Before further exploration of what law should "see" and how its aspirations should be represented, we consider more of what law has come to "do" over the course of the twentieth century.

# From Seventeenth-Century Town Halls to Twentieth-Century Courts

## PUBLIC AND SOCIAL TRADITIONS IN TOWN AND COUNTRY COURTS

*Dutch Law and Practice in Civil and Criminal Matters,*[1] a book written by the prominent legal scholar Bernhard van Zutphen, was published in Europe in 1655, the year in which the Amsterdam Town Hall opened. The volume begins with an engraved title page (fig. 95[2]) displaying a densely populated courtroom scene. In the foreground, some spectators focus on the court proceedings, others chat, and dogs hang out. At the center, the presiding jurist is seated behind a table and beneath a statue of Justice, who holds scales and a sword; her thin blindfold is dimly visible. This very scene can, with minor variations, be found in several other volumes of that era,[3] all illustrating how these seventeenth-century town halls served as public gathering places in which court proceedings were ordinary events.

Accounts of England during that era detail comparable uses of scores of town halls (also called guild-halls, moot halls, and court halls) where courts and assemblies convened, testimony was taken, decisions rendered, fines imposed, weights and measures housed, and records kept.[4] The magnitude of the construction projects "in relation to the small size and relatively meagre resources" of many towns made the commitment to civic building all the more impressive.[5]

And the point was to impress. Some buildings, such as the Amsterdam Town Hall, announced the surplus capital of prosperity as well as the power (briefly) to impose peace. In contrast, in other towns, spending funds for construction stretched a locality's coffers. The decision to build a civic hall reflected a need to "symbolize a particular administrative reality"—that a municipality had a degree of autonomy and could collect taxes and convene judicial proceedings.[6] Holding court also promoted commerce. "Judicial sessions especially brought a great multitude of people to the town, not only for the conduct of business or in litigation, but also to partake in the public occasion provided by such meetings."[7] Therefore, in addition to running its own local courts, English towns competed to host the assizes or quarter sessions so as to attract an influx that helped their innkeepers, shopkeepers, and farmers.

Civic halls, providing "the stage for the ceremonial display of power,"[8] came to mark city centers. In seventeenth-century England, a parade of horsemen and coaches announced the approach of the "circuit-riding justices from the King's Bench in London," who joined the local establishment in prayers and meals before setting down to business.[9] By then, administering justice in civic halls had become the norm rather than the exception.[10] As we have recounted, the pageantry and publicity that surrounded the work of these courts were not the result of democratic commitments to transparent and accountable decisionmaking by governing powers. Nor were judges independent of the executive branch. What the "elaborate ritualism of civic ceremony"[11] aimed to make plain was the hierarchy of authority that enabled local rulers to give content to the practices with which they sought compliance. Buildings served not only as stages but also as constraints. Bringing rituals (theatrical performances included) indoors undercut the opportunities for subversive eruptions of large audiences gathering in outdoor spaces.[12]

In Chapters 13 and 14, we examine how attributes of predemocratic adjudication influenced the development of democratic values and how democracy alters the work of courts as it also challenges their capacities. Here, we focus on some of the continuities between Renaissance town halls and the courthouses that came to replace them.[13] For centuries after the 1655 Zutphen engraving, courts provided sites for socializing and draws for commerce.[14] They served to anchor local governance activities and to inculcate the value of deference to authority. One testament to those roles is a rich literature documenting courthouses over time and place,[15] intersecting with more general analyses of the social meaning of civic spaces.[16] Some accounts position the courthouse as a venue for dramatic encounters, while others are more skeptical, counseling against "taking theatrical

FIGURE 95 Engraved title page,
*Dutch Law and Practice in Civil
and Criminal Matters* (*Practycke
der nederlansche rechten van de
daghelijcksche soo civile als criminele
questien*) by Bernhard van Zutphen,
1655.

Image courtesy of the Rare Book
Collection, Lillian Goldman Law Library,
Yale Law School.

dramaturgy too literally."[17] For example, in colonial Virginia, "[c]onfrontation was rare, ceremonial oaths at the start of court day were as tedious as reading the fine print of a contract, and the court docket was enveloped in a monotonous litany of procedural motions uttered before a distracted audience that could barely hear or care."[18]

Whether boring or engrossing, courts defined the "status, rights, and obligations" of local residents.[19] Further, in eras before archives were commonplace, courts served as repositories for records of both personal and public life.[20] The wealth of surviving materials demonstrates the importance attached to the very creation of written records ritualizing authority.[21] In the United States, as in Europe, a court also marked the seat of local power. As an 1881 account of the development of the state of Nevada put it: "A king without a kingdom, a general without an army, a county without a Court House—What are they?"[22] Thus, like the seventeenth-century burgomasters of Amsterdam, local leaders continued to establish notable public spaces in competitive efforts to bring people to towns, to draw attention to their prosperity, and to legitimate their authority. Committed to monumentality when resources permitted, communities deployed prominent architects to showcase their corporate identities and their legal authority.[23]

The deployment of courthouses to signify government was not simply an outgrowth of the expansion of political

and economic power. Rather, this special form of building reflects the intersecting interests of three professions—lawyers, judges, and architects—that generated the building type now known as a courthouse. Jurists pressed for unique sites in which to work, and architects sought commissions and crafted subspecialties (exemplified in the twentieth century by the "Academy of Architecture for Justice") to mark their expertise in crafting this particular genre.[24] Together, these professionals shifted courthouse layouts to elaborate a distinctive building type with separate spheres of circulation for various participants.

The old town hall or municipal building split into various structures, with prisons sited further afield, more capacious jails built to hold detainees, and courthouses distinguished from other edifices of law enforcement by prominent central settings and gracious architectural embellishments.[25] The interior layouts gave formal recognition to the power of judges by putting them on pedestals and behind tables or benches, delineated the place of lawyers and judicial staff by assigning them special stations, and segregated observers behind railings. The designs not only reflected but also shaped professional identities through increasing the isolation of judges, their staffs, and lawyers from the other participants within courthouses and through the separation of courts from other buildings that provided different kinds of government services.

In the preceding chapters we focused on Justice as a symbol of law and government. Here we show how she came to compete with courthouses, which have become in her stead the major iconic markers of government. The growth in the numbers of courts and the size of the buildings reflects new understandings of whom law will hear and what law can do. Although jails and prisons have likewise proliferated, they are hidden from view, leaving courts as the primary public displays of law enforcement. Our example in this chapter is the development of courts in conjunction with the creation and expansion of the United States, and thus we sketch changes from the seventeenth century to the first decades of the twentieth century.

## BUILDING A NEW LEGAL SYSTEM IN THE UNITED STATES

### A Grounding in Colonial and State Court Systems

The early courts in what became the United States date from the colonial era. Architectural historians identify the "first building in North America designed for governmental purposes" to be the 1610 Palace of Governors in Santa Fe, New Mexico; it served as the territory's executive office under Spain, Mexico, and the United States.[26] During the seventeenth century, local magistrates or judges presided in houses, in taverns, or in buildings with layouts borrowed from churches and English town halls, capturing that their authority also rested on an amalgam of religious and secu-

lar legal precepts.[27] Long-term incarceration of prisoners was not then routine, and detainees were generally kept in holding cells near or in these buildings.

Occasionally, structures were "purpose-built" to serve as either courts or jails and prisons.[28] In those called courthouses, the central space was devoted to courtrooms, where rules of decorum sought to impose order and rules of address aimed to confirm the authority of presiding jurists.[29] Judges often sat behind wooden tables, sometimes elevated. As professional roles and bureaucracies thickened during the eighteenth century, spaces began to be delineated for lawyers, clerks, sheriffs, and jurors, and sometimes the area for observers was set off by wooden bars.[30]

### Purpose-Built Structures: From Houses and Taverns to Courts

When local communities prospered during the eighteenth century, their civic buildings became more substantial structures, usually made of bricks and adorned with towers and turrets.[31] Although court spaces had once been homogenized with religious, commercial, or other public spaces, by the 1730s "the inside of the county courthouse could be mistaken for nothing else."[32] A sense of what was "proper" for courthouses had developed as familiar formulae reassured onlookers that a building was meant to serve its particular purpose.[33] Sometimes courts nested near local stores; at other times they were sited at a distance to create a new "landscape of justice" aiming to "legitimize lawyers' claims of professionalism by defining law as separate from, and untainted by, market transactions."[34]

One can read such buildings both as monuments to the growing clout of lawyers and judges and as efforts, born from distaste for unscrupulous lawyers, to imbue jurists with professional values by using the space to organize their interactions.[35] Upholstered chairs designed by furniture makers denoted the distinctive roles and hierarchies of the various actors.[36] The increasingly commodiously appointed rooms reflected not only the impact of lawyers but also the emergence of craftmakers producing new consumer goods and of professional architects influencing views about appropriate urban aesthetics.

### Segregating Interiors by Roles and Race

Law played a central role in shaping the identity of the United States, willed into being in the late eighteenth century through legal documents of separation from England and committed by its Constitution to add federal courts to the extant state court systems. Nineteenth-century lawyers and judges, embedded in the political structure and secure in their monopoly over the processes of courts, were invested in having places in which to "ply their trade" and to make plain the import of their work.[37] Early courtrooms permitted a ready mix of participants and spectators but,

over time, courtroom interiors developed rigidly delineated spaces to enhance formality. Lawyers sought to be placed proximate to judges, and the public was moved a degree away. To denote the professionalizing of clerks, magistrates, and lawyers and the special status of jurors, "face-to-face proceedings were restricted to only a very few."[38] Moreover, some activities moved "backstage" to enclosed judicial chambers and to clerks' offices.[39]

The privilege of the insiders was visually confirmed by a barrier walling off those who lacked authority from entering the gated area without permission.[40] Jury-based procedures did put some lay people in a "box" (also set off by railings) near the front, close to lawyers and judges. Witnesses were also often situated close to the judge, with lawyers grouped about, confining drama and conflict, if they emerged. "Strict policing of the gates of the bar created a hard line of authority, which in turn led to the provision of bench seating for the public near the public entrance, sometimes supplemented by a public balcony above."[41] The public, however, was differentiated. In segregated state courthouses, if blacks were admitted, they were consigned to those upstairs seats or to standing alongside the walls.

By the nineteenth century, the rules of decorum and the special status of courthouses made plausible the term "Temples of Justice," which provided a general reference to the Neoclassical style then in vogue and sometimes a specific acknowledgment of the influence of Thomas Jefferson's designs.[42] Because designation as sites of courts gave communities resources and recognition, localities fought "courthouse wars" to obtain "the honor of being the county seat."[43] Those ambitions were fueled in the westward expansion by federal legislation permitting counties to keep hundreds of acres as seats of government and to sell certain parcels exclusively to fund their "public buildings."[44] Thus settlers had opportunities to create "courthouse squares" to embody their hopes (realized only some of the time) for permanence and prominence.

The patterns of building courthouses have been traced in several states. In Massachusetts, for example, between "1780 and 1830, every county in Massachusetts . . . acquired a new courthouse" as buildings "devoted only to court proceedings and containing strictly specialized spaces such as jury rooms and judges' rooms took the place of multipurpose town houses and small courthouses."[45] Locations continued to provide connotations. Some courthouses were sited at a distance from commercial and other governmental functions (so as to be "distinct and isolated from the taint of commerce and politics"[46]), and others were placed in town centers in self-conscious status-seeking efforts (akin to those of the Burgomasters of Amsterdam) to make the public building the largest in town. The physical embodiment of the "pride and resourcefulness of the community" sometimes also represented the significant debt occasioned to fund such imposing structures.[47]

## Architecture and Adornment

The courthouses that sprouted around the United States in the nineteenth century were wildly eclectic—multi-storied, turreted, towered, gabled—as various architects embellished styles known as Greek Revival, French Second Empire, Italianate, Gothic, Neoclassical, Victorian, and Beaux-Arts.[48] Some buildings included a range of municipal services, while others, dedicated solely to holding court, were often placed in a cluster with other government buildings. One way to denote that a building housed a court was to display a statue of Justice—often set aloft at the top of a tower or turret.[49]

To capture some of the vast and varied buildings marked by a Justice, we reproduce a two-page brochure (figs. 96 and 97, color plate 28) of fifteen courthouses built in New York State between 1837 and 1959.[50] Published in 2008 by the Historical Society of the Courts of New York,[51] the set includes four statues on the tops or the exteriors of courthouses,[52] a few from interior murals and paintings,[53] and some displayed as part of replicas of the Great Seal of New York on which Justice is depicted.[54] As this montage suggests, courthouses remained very important to community life into the twentieth century—arguably serving as the "most prominent and widely experienced example of public architecture."[55]

A description from an account of Nebraska's ninety-three county courthouses explained how such buildings served "every public purpose, including political meetings, home talent plays, school and entertainment, school examinations, social and church gatherings."[56] Ohio's eighty-eight county courthouses formed "an essential part of its landscape and history" (even as they are no longer sufficient to meet the demands for judicial services),[57] and a book dedicated to Minnesota reported that the state had more courthouses (eighty-nine) than counties (eighty-seven).[58] The relevance of county courthouses continued in some areas into the twenty-first century—made evident by comments of a then relatively newly elected governor of Indiana. He told a gathering of chief justices and administrators from all fifty state courts that, during his election efforts in 2005, he had paid visits to all of the ninety-plus county courts of that state.[59]

By the end of the twentieth century, the number of courts and the volume of matters brought to them were impressive. By one count, some thirty-six million cases (not including traffic violations or certain family conflicts) were filed annually in state courts around the country.[60] California alone had 450 buildings with trial facilities in its fifty-eight counties; more than 2,000 courtrooms provided 10 million square feet of usable space.[61]

## Juridical Privilege, Exclusion, and Protest

Before embracing either an uncomplicated image of courthouses as cheerful community centers or the critical stance that they embodied professional prerogatives, one

**Appellate Division, First Department**

This mural of Justice by artist Robert Reid was completed in 1899 and is one of a series of murals painted on the walls of the courthouse of the Appellate Division, First Department, on Madison Avenue in New York.

**Ontario County Courthouse**

On the dome of the Ontario County Courthouse in Canandaigua stands this statue of Lady Justice, crafted by Dexter M. Benedict, of cast aluminum covered in gold leaf.

**Lady Justice**

In celebration of the 50th anniversary of Law Day, the New York Unified Court System is highlighting works of art depicting Lady Justice in courthouses throughout New York State. Some are in the form of murals adorning interior walls of our courthouses, some are carved into the very stone of the buildings, and some are free-standing sculptures in or around the courthouses. Since ancient times, Justice has been depicted as a woman-often blindfolded to indicate impartiality-holding scales in one hand and a sword in the other. The scales symbolize neutral deliberation of two sides in a legal dispute while the sword symbolizes the power of Reason and Justice, which may be wielded either for or against any party. Both as tangible expressions of New York's deep commitment to the rule of law, and as works of art, these images of Lady Justice are part of New York State's rich and historic heritage.

**Downtown Albany, NY**
Eagle, Lodge, Columbia, Pine & Elk Streets
**Summer 2008**

(cover)
Appellate Division, First Department
To the left of the entrance is Willard Leroy Metcalf's mural, Justice, represented by a winged woman, standing upright and holding a sword in both hands.

**Appellate Division, First Department**

This Lady Justice is part of the central segment of a 62-foot wide mural, The transmission of the Law by H. Siddons Mowbray. Completed in 1899, it graces the lobby of the courthouse of the Appellate Division, First Department, on Madison Avenue in New York.

**Bronx County Courthouse**

A Works Progress Administration (WPA) project designed by Max Hausel and Joseph Freelander, Bronx County Courthouse was completed in 1934. This figure of Lady Justice appears on the Great Seal of New York repeated on all four sides of the building.

**Court of Appeals Hall**

This Lady Justice is carved into the side of a table in the H.H. Richardson-designed courtroom now located in Court of Appeals Hall in Albany. It was wrought to Richardson's specifications by craftsmen working in the basement of the New York Capitol.

**Borough Hall**

Brooklyn Borough Hall is an 1835 Greek revival building. In 1902, under the direction of architect Axel Hedman, a new ceremonial courtroom in the beaux-arts style was built for the Appellate Division, Second Department. This Lady Justice is a carving on the courtroom's bench.

FIGURE 96     Brochure for Lady Justice banner exhibit, Albany, New York, Summer 2008.
Photographer and designer: Teodors Ermansons.

Image reproduced with permission of the New York Court of Appeals. See color plate 28.

also must account for their role as exclusionary sites of privilege to which all were not welcome. As a volume dedicated to courthouses in California explained, "African Americans were barred by law from giving testimony in California courts until 1863; Asians and Native Americans were excluded until 1872."[62] Courts not only segregated their spaces by walling professional people away from laypeople; in some parts of the United States, they also sorted people by race. In several Southern states, the courts were segregated, de jure or de facto,[63] and blacks were consigned either to standing or sitting in a back section or upstairs. Moreover, courts were not only sites of discrimination, but also *sources* of legal rulings upholding that regime.[64]

These practices lasted well into the twentieth century. As we discussed in Chapter 6, Jackson, Mississippi's federal courthouse featured a segregated scene on its walls (figs. 6/82, 6/83 and color plate 20). When trying a case in Jackson, Mississippi in the 1940s, Constance Baker Motley

observed that members of the black community assumed that the federal courthouse would be segregated and were surprised to learn that, unlike in the state courts, they could take seats.[65] In Virginia in the early 1960s, Ford T. Johnson Jr. refused to comply with the request of a bailiff who had asked him to move to the "section reserved for Negroes."[66] The City Attorney for Richmond, Virginia defended the "long established practice" of segregated seating on the grounds that it avoided friction and preserved "order and decorum in the courtroom."[67] He explained to the United States Supreme Court that the "same number of seats [were] available for citizens of each race." But by then, the Supreme Court had already concluded that segregation of public facilities was unconstitutional and invalidated Mr. Johnson's contempt conviction for refusing to move out of a section reserved for "Whites."[68]

Mr. Johnson's quiet protest has been paralleled by noisier dramas, such as when the citizens of Massachusetts rebelled

**Chenango County Courthouse**

*Chenango County built its Greek revival courthouse in Norwich in 1837 and crowned the structure with a seven-foot white pine statue of Lady Justice. In 1977, the original statue was restored and moved inside the courthouse. This replica now graces the dome.*

**New York County Courthouse**

*Rendered in trompe l'oeil, this Lady Justice decorates the pendentives supporting the courthouse dome. It was painted in 1934 as part of the Works Progress Administration (WPA) by artist Attilio Pusterla, born in Italy in 1862.*

**Borough Hall**

*Brooklyn Borough Hall was designed in 1845 by architect Gamaliel King, a major figure in Brooklyn civic and ecclesiastical architecture in the 19th century. The statue of Justice, part of the original plan, was finally installed on top of the cupola in 1988.*

**Court of Appeals Hall**

*This depiction of Lady Justice is part of the "Romance of the Skies" mural that adorns the inside of the dome in Court of Appeals Hall. It was designed and painted by Eugene F. Savage and was installed during the 1959 renovation.*

**Ontario County Courthouse**

*Located in Ontario County, this bronze statue of Lady Justice may have been the model for or a replica of a statue of Lady Justice that stood atop the courthouse dome.*

**Montgomery County Courthouse**

*This Lady Justice is part of the Great Seal of New York installed in 1910 on the gable above the entrance to the old Montgomery County Courthouse in Fonda, New York.*

**Court of Appeals Hall**

*This bronze of Lady Justice now hangs on the marble walls of the main lobby in Court of Appeals Hall. In 1917, when State Hall became Court of Appeals Hall, the bronze coat of arms was installed on the exterior wall over the main entrance.*

**Kings County Supreme Court**

*Carved into the stone of the 1958 Kings County Supreme Courthouse, this Lady Justice graces the limestone and granite building designed by Shreve, Lamb & Harmon, best known as the designers of the Empire State Building.*

**Onondaga County Courthouse**

*When Archimedes Russel of Syracuse, New York designed the Beaux Arts Onondaga County Courthouse in 1901, Gustav Gutgemon was commissioned to paint this mural of Lady Justice.*

FIGURE 97    Brochure for Lady Justice banner exhibit, Albany, New York, Summer 2008.

See color plate 28.

in the nineteenth century against the enforcement of federal laws that required the return of fugitive slaves to their owners. In 1836, "two women, detained as slaves, were rescued from the Boston courthouse during their trial."[69] The "mainstream Boston newspapers," recording distress at the disruption, insisted on the " 'importance of sustaining the dignity and supremacy of the public tribunals' " on which the state depended.[70] That act of resistance came in the name of liberation, but other mobs have stormed courts and threatened to take African-American defendants away to lynch them. Such violence—recurrent through the first part of the twentieth century[71]—is now kept at bay, in part by policing the space. Legislation bans popular protests within a certain distance of a courthouse.[72]

### Marking a "Federal Presence"

During the pre–Civil War period, the federal court system was a small addition to the pre-existing state courts that

had grown from the colonial period.[73] The Declaration of Independence had listed as one of its grievances that English judges were beholden to the Crown.[74] The 1789 United States Constitution, in contrast, provided a measure of insulation by giving judges security of tenure during good behavior and salaries that could not be diminished.[75] The Constitution also created one Supreme Court but, by way of a compromise about what kind of lower court system to craft, the Constitution left to Congress decisions about when to "ordain and establish" lower courts.[76] The Congress did so in the First Judiciary Act of 1789 by creating a two-layer system.[77]

Each state was given a single trial-level judge, who was to "reside in the district for which he was appointed" and to sit as the "district court" within its territorial boundaries.[78] (In 1801, Congress added a judge for the District of Columbia.[79]) Congress also created three "circuit courts," which had a mix of trial and appellate jurisdiction. After 1793, each circuit court was staffed by district judges joined by

one of the Supreme Court justices "riding circuit."[80] While this system might have been "economical," it did not prove pleasant.[81] Unlike the stately parades described for the arrival of English judges who came to town, the accounts of the movements of justices in the new America report inelegant and, given road conditions, at times unsafe transit.[82]

### Borrowing Space, Rules, and Administrative Support

In terms of the place in which the justices of the United States Supreme Court presided, no building was dedicated to their exclusive use when they first began their work in New York or moved to Philadelphia, or thereafter to the nation's capital. In New York, the justices camped in a market hall; in Philadelphia during the 1790s, the justices worked inside city hall, borrowing the courtroom of that state's Supreme Court.[83] (There, acting in its constitutional capacity to exercise "original jurisdiction," the United States Supreme Court had a few jury trials.[84]) Upon moving to Washington, the justices first worked in a committee room inside the Capitol and then took up residence in 1810 in the remodeled former chambers of the Senate.[85] Thus, although the Congress and the President had "their own distinct accommodations, the Supreme Court made do with borrowed space for fourteen decades"[86]—until 1935.

As for where the justices alighted when they rode circuit, "designating places of courts ignited political conflicts between municipal competitors," just as localities in the states fought to use court sitings to mark (and to make) their import.[87] But even when a federal court was "seated" in a designated spot, federal judges presided in borrowed quarters and used local hotels, homes, or state buildings[88] whose availability "depended on cooperation from a separate government"[89]—the host state. The federal justice system was similarly dependent on local jailers from whom it rented space, sometimes on an as-needed weekly basis.[90]

The physical environment made plain what the Constitution's drafters had known well—ambivalence surrounded the making of a national judicial force. To cushion the potential abrasion, federal courts assimilated local litigation practices by using the procedural rules of the various states in which they sat. Thus, the federal district court in Virginia operated as did the state courts there, while the federal court in New Jersey relied on New Jersey rules.[91] But relying on state procedures and borrowing state housing and jails did not avoid all conflicts. The federal courts brought some forms of federal law that provoked animosity in some jurisdictions, such as the opposition in Massachusetts to the enforcement of national fugitive slave laws.

Just as judges shared space for their work, they also borrowed administrative support from Executive Branch institutions that were not singularly focused on their needs. In 1789, Congress authorized its new Department of Treasury to deal with all finances of the new government, including those of federal judges.[92] The requirement that clerks of the federal courts provide a list of all judgments to which the United States was a party marked the beginning of a measure of central recording. In 1849, responsibilities for federal court administration shifted from Treasury to the newly created Department of the Interior,[93] authorized to pay the bills for renting spaces for judges as well as for their salaries and travel. Between 1789 and 1888, the State Department also played a role, issuing commissions to and keeping records on those persons appointed to serve as federal judges.[94]

### Custom Houses, Marine Hospitals, and Post Offices

The United States Constitution did contemplate some dedicated spaces for and some construction by the federal government. Article 1, Section 8, authorized Congress "to establish Post Offices and post Roads," as well as to create a capital city and to acquire land for both civilian and military purposes ("the Erection of Forts, Magazines, Arsenals, dock-Yards, and other needful Buildings"). The Constitution also stated that Congress could implement its various powers by making all laws "necessary and proper" to their effectuation.[95] The work of building fell under the auspices of the Treasury Department and Customs Services that, like the federal judiciary, came into being in 1789. In that year, Congress also created a fund for marine hospitals to take care of "men, who, by their labor and perth in peace and war, contribute so largely to the wealth and power of the nation."[96]

Thus, before federal post offices and courthouses became familiar outposts of the national government, the first wave of buildings that created what Lois Craig termed a "federal presence" across the country were custom houses and marine hospitals,[97] joining the other national buildings in Washington, D.C., that were dedicated to the legislative and executive branches.[98] During much of the nineteenth century, Congress proceeded in an ad hoc fashion through an independent authorization for each construction project,[99] some of which also required cooperation from states that owned the parcels of land to be purchased.[100] Commissions awarded in this piecemeal process by Congress varied; sometimes the legislature prized ornamentation, at other points economy, and, on occasion, sought to control the designs.[101]

As revenues grew and the nation gained a modicum of stability, ambitions for more building followed. Like their European predecessors, the leaders of the new country were self-conscious about their image. Repeatedly, they saw the best expression of the virtues of the United States to be captured through a somber architectural Classicism acknowledging the country's debt to "the ancient Greek republic."[102] In 1803, President Thomas Jefferson named Benjamin Henry Latrobe to be the "Surveyor of the Public Buildings." Latrobe designed and supervised the construction of the Capitol and the expansion of the White House.[103] By the 1830s, as both the federal budget and the professions related

to buildings grew,[104] Robert Mills "served more or less officially" in a position sometimes called Architect of the Public Buildings.[105] Mills designed several custom houses as well as the George Washington Monument.[106] Mills was committed to making Jefferson's ideal of classical architecture the "national style," and "when the full temple form was not used, at least the great colonnade was."[107] Mills was also a source of centralization in that he sought to impose standards, such as requiring that buildings be made of materials more fireproof than not.[108]

Congressional legislation funding the various projects of the first half of the nineteenth century made minimal mention of courthouses. Some federal legislation authorizing construction of custom houses did make reference to paying for furnishings for judges[109]—thus revealing the assumption that a courtroom was to be tucked inside. In addition, Congress occasionally provided expressly for the construction of courts and jails in its territories.[110]

By mid-century, the federal government owned eighteen marine hospitals and twenty-three custom houses, and fifteen more buildings were underway.[111] The meager references to facilities for judges were appropriate when considered against the backdrop of the size of the federal courts of that era. In 1850, some thirty-seven federal trial judges were dispatched to the forty-five district courts in the states,[112] including two to California, which had gained statehood that year.[113] Beginning around 1850, government planners called specifically for courthouse construction.[114] That interest in courthouses dovetailed with new goals—for more federal building in general and for the centralization of decisionmaking about such building. In 1852, the Treasury Department created a unit called the Office of Supervising Architect, which affected the shape of structures for the nation in the century that followed.[115]

The government's ambitions had to be put on hold for a period, as the violence and financial stress of the Civil War required a hiatus in national construction. But in the war's aftermath, two creations of the first Congress of 1789—the lower federal courts and the Treasury Department—came into closer contact as Congress repeatedly turned to the federal courts as instruments for enforcement of federal norms.[116] In 1867 Congress gave federal courts authority to hear habeas corpus petitions from individuals held in state custody;[117] in 1871 Congress endowed the federal courts with the power to hear cases alleging deprivations of civil rights;[118] and in 1875 Congress authorized federal courts to exercise "general federal question jurisdiction," enabling them to hear various kinds of claims alleging rights under federal law as long as a certain amount of money was in controversy.[119]

The implementation of federal rights required more organization for the lawyers representing the national government. In 1870, Congress created the Department of Justice to add a layer of control over the dispersed system that had long existed by virtue of individual appointments, made by the President, of United States Attorneys for each of the federal districts.[120] The 1870 legislation also centralized most of the court-related work in the Justice Department by transferring "supervisory powers . . . over the accounts of the district attorneys, marshals, clerks, and other officers of the courts of the United States" from the Secretary of Interior to the Justice Department.[121] To gain efficacy in requesting funds from Congress on behalf of the judiciary, the Justice Department began to compile statistical information about the federal courts. Beginning in 1871, the Attorney General provided annual reports to Congress on cases pending as well as those terminated. Hence, we know that in 1876 almost 29,000 cases were on the docket and, by 1900, that number had risen to just under 55,000.[122]

The number of judges increased along with the docket. While several federal districts continued to have only one judge, between 1857 and 1886, Congress gave thirteen states a second judgeship.[123] The result was some sixty-four judgeships by 1886. That expansion was part of the growth in the paid civilian employment of the federal government. In 1861, some 37,000 individuals were employed; by 1891, almost 160,000 were on the federal payroll.[124]

New construction was a complementary technique to materialize this new federal authority. "Between 1866 and 1897 . . . the federal government built nearly three hundred new buildings throughout the Union."[125] Spaces inside (and sometimes whole buildings) went to courts, used by Congress as a colonizing force to make meaningful the North's victory over the South. Appropriations for buildings rewarded loyal members of Congress by giving them funds—"federal presents"—to bring to their local constituents. ("For example, Memphis received a courthouse even though no federal courts were held there."[126])

In the early part of the twentieth century, Congress "opened the floodgates . . . by inventing . . . the 'omnibus' public building bill, which replaced for the most part the previous practice of enacting individual bills for each building."[127] In the 1902 act alone, Congress supported more than 150 new buildings. That "wholesale authorization" gave every member of the House "the possibility of providing their district with a federal building, regardless of need."[128] (Not until 1926 did Congress authorize surveys for "needs" prior to appropriations.[129]) The chartering of new judgeships to sit in those buildings was a part of the patronage packet—creating jobs that Presidents, with senatorial input, doled out.[130]

Given these pork-barrel opportunities and hopes for commercial development, towns and cities sought to be the sites of federal construction.[131] Congressional records reflect regular calls for courthouse construction from state officials asking for permanent accommodations for their federal judges,[132] as well as occasional reports from grand juries complaining of a lack of ventilation and space.[133] In response, "appropriations for courthouses and other federal buildings . . . often reflected local political considerations

rather than the requirements of the court or the design decisions of the supervising architects, several of whom resigned in exasperation."[134] The impact can be measured in various ways. One is a building count. By 1892, the federal government had an inventory of almost three hundred buildings, with another ninety-five projects underway.[135]

### Professional Architects and Public Patronage

Localities were not the only ones lobbying for funds. "Private architects insistently sought a piece of the public action."[136] Within a decade of the creation of the Office of Supervising Architect in the 1850s, architects aimed for federal patronage as they also sought to avoid government control. In 1867, the American Institute of Architects (AIA), which had (despite its name) functioned more as a local New York group until then,[137] became national in scope and ambition as it pressed for government design contracts for private architects.[138] How to get awards was a matter of debate, as some but not all AIA members were enthusiastic about competitions for building contracts. Accusing the Office of Supervising Architect of producing repetitive designs (with an "apparent sameness . . . even [if] picturesque"[139]), private architects argued that their proposals, positioned as more adventuresome and inventive, should be funded by the government. The Office of Supervising Architect also faced other accusations—of wasting public money and of corruption.[140]

When the AIA was launched in the 1850s, its membership consisted of twenty-three men; the 1850 census reported 591 people identified as architects. By 1890, more than 8,000 architects were counted in the census, and ten architectural journals served their specialized interests.[141] That growth helped to sustain the AIA's "legislative battle . . . against the federal architecture program." The AIA was occasionally victorious via congressional directives requiring, in specific bills, that private architects provide the building designs. More generally, those efforts came to fruition with the passage in 1893 of legislature called the Tarsney Act that enabled the federal government to use independent architects selected through competitions.[142]

For a time, the victory was more on paper than in practice. Government officials were not eager to implement the Tarsney Act (which had used language of discretion rather than requiring the selection of private architects), and relatively few projects were immediately affected.[143] In 1912, over the objections of the AIA but in the wake of accusations that competition awards were biased in the AIA's favor at the expense of taxpayers, the act was repealed.[144] In its stead, a year later Congress delegated to its Public Buildings Commission the task of recommending processes for decisionmaking on the construction of federal structures,[145] and the resulting procedures yielded a mix of private and public designs.

The rate of building in the pre–World War I era was impressive. In 1899, about 400 building projects were underway; by 1912, the number of projects had grown to 1,126, producing a "new building every fourth day in the year."[146] By the 1920s, enough architects were government-based to create their own "Association of Federal Architects" that aspired to improve the esprit de corps of civil service personnel involved in construction.[147]

Although the Tarsney Act did not last, the preference for private design that it embodied did. In 1926 and again in 1930, just after the Depression began, Congress funded buildings and renewed authorizations for the Department of Treasury to use private architects as it desired.[148] While a boom in private building made government contracts less appealing for a time,[149] the market crash of the 1920s left many eager to gain commissions under the New Deal. The various struggles for control over design, episodic challenges to a particular person serving as the Supervising Architect, occasional allegations of mismanagement or of corruption in particular projects, and the transformation of public needs in the wake of the Depression resulted in an administrative reconfiguration.

In 1939, the Office of Supervising Architect was folded into the Public Buildings Administration.[150] In 1949, that entity became part of the General Services Administration (GSA),[151] which continues to be the government unit charged with overseeing federal buildings, from land purchase to construction and maintenance. Functioning now as the "landlord" for other federal agencies, the GSA is (as detailed in Chapters 8 and 9) sometimes a co-venturer and other times in conflict with the federal judiciary.[152]

### Courts—From California to the New York Island

Many of the best-known examples of national building are in Washington, D.C.,[153] but our focus is the work that courthouse facilities play in demonstrating changing roles of judges and of governments. As this overview has detailed, federal judges were (and are) a small set of individuals in the federal bureaucracy. In the late nineteenth and early twentieth centuries, many district judges remained solo actors, with one assigned to states as large as Indiana, Massachusetts, and Maryland and hardly needing a building of his own.[154] But handsome buildings could offer "prestige to the federal courts, which previously had met in an assortment of state offices and rented buildings."[155]

Thus, for several decades after the Civil War, courtrooms were built into multi-purpose federal spaces that, akin to Renaissance town halls, often combined "the functions of courthouse, customhouse, and post office."[156] These single structures housing various federal services provided "tangible evidence of the national government's new responsibilities and a reminder of its supremacy,"[157] as Washington sought to extend its "authority . . . to every region of the

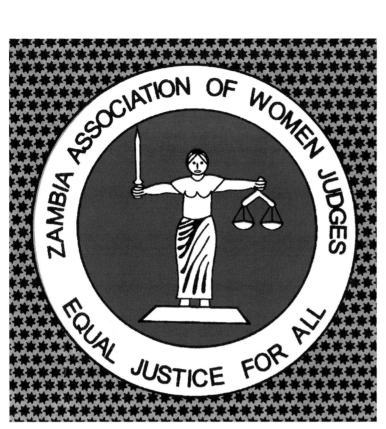

PLATE 1    Decorative cloth,
Zambia Association of Women Judges, circa 2004.

Courtesy of the Association. See figure 1/6.

PLATE 2    *Lady Justice Lucy,*
Jim and Judy Brooks, 2002,
William Mitchell College of Law,
St. Paul, Minnesota.

Photograph courtesy of William Mitchell
College of Law. See figure 1/14.

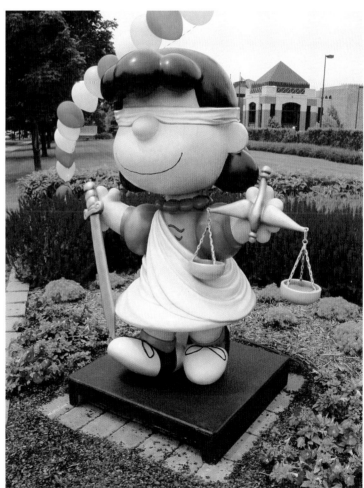

PLATE 3    "Mesopotamian Scales," Akkadian period, circa 2350–2100 BCE,
from *Gods, Demons, and Symbols of Ancient Mesopotamia: An Illustrated Dictionary.*

PLATE 4    Maat detail, the Papyrus Nodjnet, *Book of the Dead,* circa 1300 BCE.

PLATE 5    *Saint Michael Weighing the Souls at the Last Judgment,*
Master of the Zurich Carnation, circa 1500.

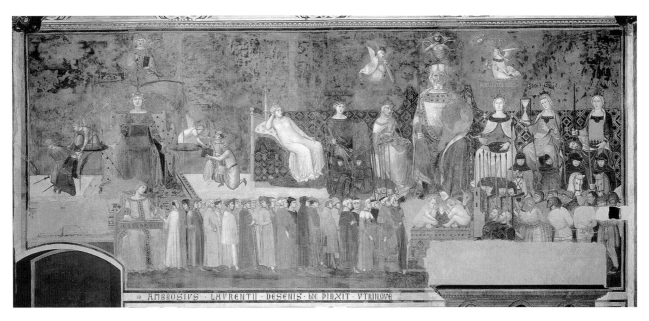

PLATE 6 *Allegory of Good Government,* Ambrogio Lorenzetti,
circa 1339, Palazzo Pubblico, Siena, Italy.

Copyright: Scala / Art Resource, N.Y. See figure 2/26.

PLATE 7 *The Virtues of Good Government,* Dorothea Rockburne.
Brochure cover, Edward T. Gignoux United States Courthouse, Portland, Maine.

Copyright: Dorothea Rockburne / Artists Rights Society, N.Y.
Photographer: Don Johnson. See figure 2/29.

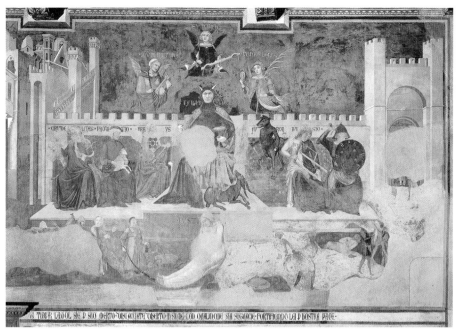

PLATE 8    *Allegory of Bad
Government,*
Ambrogio Lorenzetti, circa 1339,
Palazzo Pubblico, Siena, Italy.

Copyright: Scala / Art Resource, N.Y.
See figure 2/27.

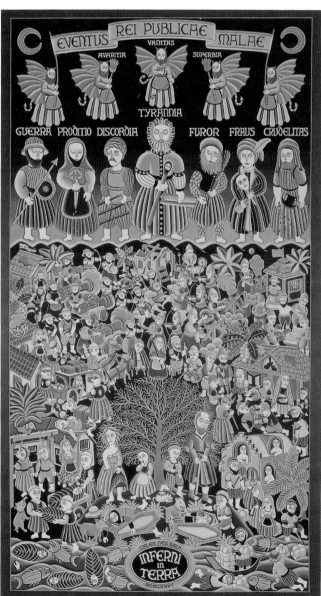

PLATE 9    *The Effects of Bad Government,*
Caleb Ives Bach, 1985, William Kenzo
Nakamura Federal Courthouse,
Seattle, Washington.

Photograph courtesy of the United States General
Services Administration and with the artist's
permission. See figure 2/28.

PLATE 10    *Arrest of the Corrupt Judge,* left panel, *The Justice (Judgment) of Cambyses,*
Gerard David, 1498.

Copyright: Musea Brugge, Groeningemuseum. See figure 3/31.

PLATE 11  *Flaying of the Corrupt Judge,* right panel, *The Justice (Judgment) of Cambyses,*
Gerard David, 1498.

Copyright: Musea Brugge, Groeningemuseum. See figure 3/32.

PLATE 12   *Courtroom Scene with Last Judgment and Portrait of Nicolas Strobel,*
fifteenth century, Graz, Austria.

Image courtesy of the Stadtmuseum, Graz. See figure 2/30.

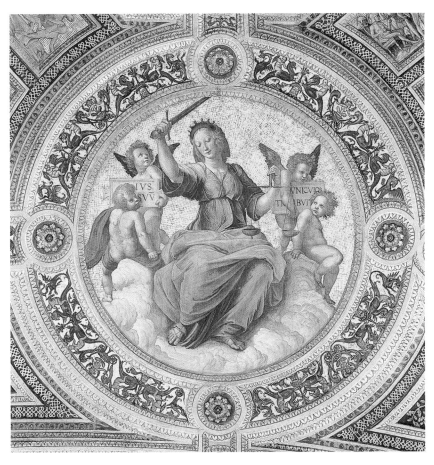

PLATE 13  *Justice,* Raphael, 1508–1511, ceiling detail, Stanza della Segnatura, Vatican Palace.

Copyright: Scala / Art Resource, N.Y. See figure 4/55.

PLATE 14  *Justice* (or *Prudence, Justice, and Peace*), Jürgen Ovens, 1662, Magistrates' Chamber, Town Hall (Royal Palace), Amsterdam, the Netherlands.

Photograph copyright: Stichting Koninklijk Paleis Amsterdam. See figure 3/40.

PLATE 15   *Allegory of Justice,* Peter Paul Rubens, circa 1625.

Image courtesy of Noortman Master Paintings. See figure 4/58.

PLATE 17   *Lady Justice,* Diana K. Moore, 1996,
Warren B. Rudman Federal Courthouse,
Concord, New Hampshire.

Photographer: Nick Wheeler. Reproduced courtesy
of the artist. See figure 5/75.

PLATE 16   *Justice,* Sir Joshua Reynolds, 1778,
study for west window,
New College Chapel, Oxford University.

Image by permission of Thomas Agnew and Sons, Ltd. See
figure 5/71.

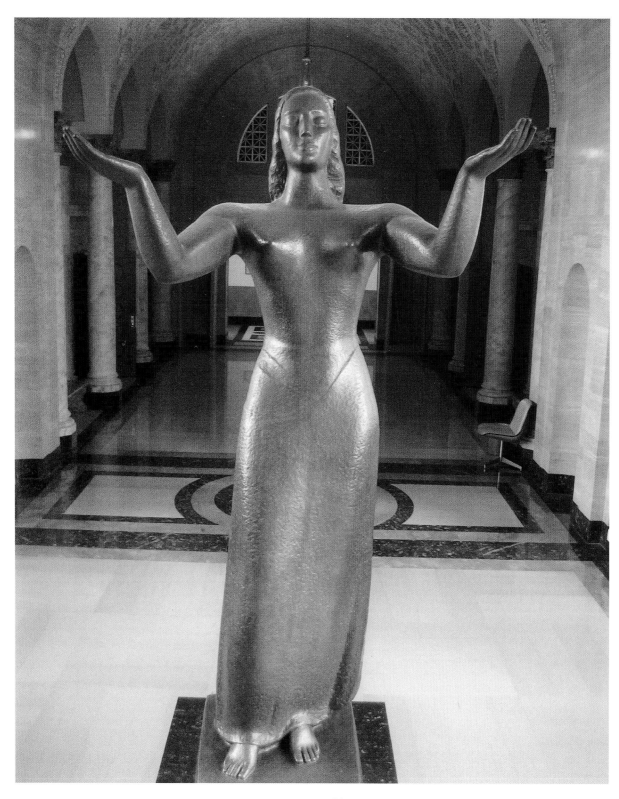

PLATE 18   *Justice,* Romuald Kraus, 1938.
United States Federal Courthouse and Post Office, Newark, New Jersey.

Image courtesy of the court. See figure 6/77.

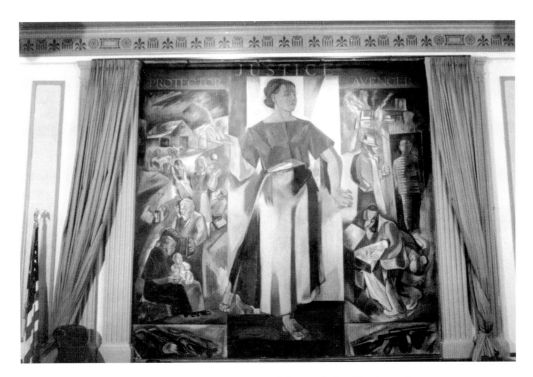

PLATE 19    *Justice as Protector and Avenger,* Stefan Hirsch, 1938,
Charles E. Simons Jr. Federal Courthouse, Aiken, South Carolina.

Image courtesy of the Fine Arts Collection, United States General Services Administration. See figure 6/81.

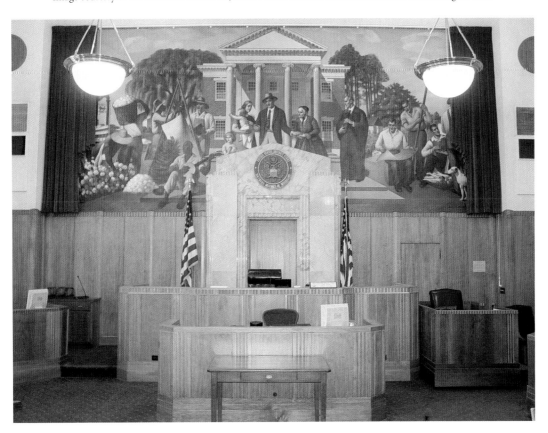

Plate 20    *Pursuits of Life in Mississippi,* Simka Simkhovitch, 1938,
James O. Eastland United States Courthouse, Jackson, Mississippi.

Photograph courtesy of the United States General Services Administration. See figure 6/83.

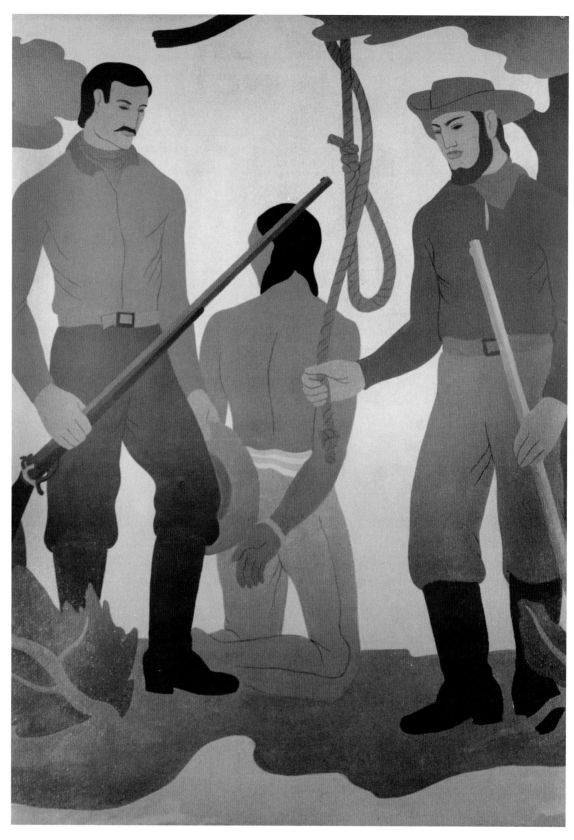

PLATE 21    Mural attributed to Ivan Bartlett, circa 1939,
Old Ada County Courthouse, Ada, Idaho.

Copyright: Paul Hosefros for Lemley International. See figure 6/84.

PLATE 22    *Mystical Mocko Jumbies,* United States Virgin Islands Carnival, 1997.

Photograph copyright: Robert W. Nicholls. See figure 6/89.

PLATE 23    *Lady of Justice,* Jan R. Mitchell, 1993, Almeric L. Christian Federal Building,
St. Croix, United States Virgin Islands.

Photographer: Steffen Larsen. Reproduced with the permission of the artist, the photographer,
and the United States General Services Administration. See figure 6/87.

PLATE 24  *Law of Nature,* Tom Otterness, 1997.
Mark O. Hatfield United States Courthouse,
Portland, Oregon.
*Cat on Trial* (top)
Photographer: Laurie Black.

*Tree of Knowledge* (left, detail)
Photographer: Michael Mathers.

Images courtesy of Tom Otterness Studio.
See figures 9/121, 9/124.

PLATE 25   The Great Hall, John Joseph Moakley United States Courthouse,
Boston, Massachusetts, 1998. Architect: Henry N. Cobb.

Photographer and copyright: Steve Rosenthal, 1998. Reproduced with permission of the photographer
and the court. See figure 6/92.

PLATE 26  *The Boston Panels,*
Ellsworth Kelly, 1998, John
Joseph Moakley United States
Courthouse,
Boston, Massachussetts.

Reproduced with permission of
the artist. See figure 6/93.

PLATE 27  Courtroom, John Joseph Moakley United States Courthouse.

### Appellate Division, First Department

This mural of Justice by artist Robert Reid was completed in 1899 and is one of a series of murals painted on the walls of the courthouse of the Appellate Division, First Department, on Madison Avenue in New York.

### Ontario County Courthouse

On the dome of the Ontario County Courthouse in Canandaigua stands this statue of Lady Justice, crafted by Dexter M. Benedict, of cast aluminum covered in gold leaf.

# Lady Justice

In celebration of the 50th anniversary of Law Day, the New York Unified Court System is highlighting works of art depicting Lady Justice in courthouses throughout New York State. Some are in the form of murals adorning interior walls of our courthouses, some are carved into the very stone of the buildings, and some are free-standing sculptures in or around the courthouses. Since ancient times, Justice has been depicted as a woman-often blindfolded to indicate impartiality-holding scales in one hand and a sword in the other. The scales symbolize neutral deliberation of two sides in a legal dispute while the sword symbolizes the power of Reason and Justice, which may be wielded either for or against any party. Both as tangible expressions of New York's deep commitment to the rule of law, and as works of art, these images of Lady Justice are part of New York State's rich and historic heritage.

### Downtown Albany, NY
Eagle, Lodge, Columbia, Pine & Elk Streets
### Summer 2008

(cover)
Appellate Division, First Department

To the left of the entrance is Willard Leroy Metcalf's mural, Justice, represented by a winged woman, standing upright and holding a sword in both hands.

### Appellate Division, First Department

This Lady Justice is part of the central segment of a 62-foot wide mural, The transmission of the Law by H. Siddons Mowbray. Completed in 1899, it graces the lobby of the courthouse of the Appellate Division, First Department, on Madison Avenue in New York.

### Bronx County Courthouse

A Works Progress Administration (WPA) project designed by Max Hausel and Joseph Freelander, Bronx County Courthouse was completed in 1934. This figure of Lady Justice appears on the Great Seal of New York repeated on all four sides of the building.

### Court of Appeals Hall

This Lady Justice is carved into the side of a table in the H.H. Richardson-designed courtroom now located in Court of Appeals Hall in Albany. It was wrought to Richardson's specifications by craftsmen working in the basement of the New York Capitol.

### Borough Hall

Brooklyn Borough Hall is an 1835 Greek revival building. In 1902, under the direction of architect Axel Hedman, a new ceremonial courtroom in the beaux-arts style was built for the Appellate Division, Second Department. This Lady Justice is a carving on the courtroom's bench.

### Chenango County Courthouse

Chenango County built its Greek revival courthouse in Norwich in 1837 and crowned the structure with a seven-foot white pine statue of Lady Justice. In 1977, the original statue was restored and moved inside the courthouse. This replica now graces the dome.

### New York County Courthouse

Rendered in trompe l'oeil, this Lady Justice decorates the pendentives supporting the courthouse dome. It was painted in 1934 as part of the Works Progress Administration (WPA) by artist Attilio Pusterla, born in Italy in 1862.

### Borough Hall

Brooklyn Borough Hall was designed in 1845 by architect Gamaliel King, a major figure in Brooklyn civic and ecclesiastical architecture in the 19th century. The statue of Justice, part of the original plan, was finally installed on top of the cupola in 1988.

### Court of Appeals Hall

This depiction of Lady Justice is part of the "Romance of the Skies" mural that adorns the inside of the dome in Court of Appeals Hall. It was designed and painted by Eugene F. Savage and was installed during the 1959 renovation.

### Ontario County Courthouse

Located in Ontario County, this bronze statue of Lady Justice may have been the model for or a replica of a statue of Lady Justice that stood atop the courthouse dome.

### Montgomery County Courthouse

This Lady Justice is part of the Great Seal of New York installed in 1910 on the gable above the entrance to the old Montgomery County Courthouse in Fonda, New York.

### Court of Appeals Hall

This bronze of Lady Justice now hangs on the marble walls of the main lobby in Court of Appeals Hall. In 1917, when State Hall became Court of Appeals Hall, the bronze coat of arms was installed on the exterior wall over the main entrance.

### Kings County Supreme Court

Carved into the stone of the 1958 Kings County Supreme Courthouse, this Lady Justice graces the limestone and granite building designed by Shreve, Lamb & Harmon, best known as the designers of the Empire State Building.

### Onondaga County Courthouse

When Archimedes Russel of Syracuse, New York designed the Beaux Arts Onondaga County Courthouse in 1901, Gustav Gutgemon was commissioned to paint this mural of Lady Justice.

PLATE 29    United States Courthouse Buildings and Renovations:
A Sampling, 1998–2002.

Photographs by Taylor Lednum, Thomas Grooms, and Frank Ooms,
and provided courtesy of the Design Excellence Program, Office of the Chief Architect,
United States General Services Administration. See figure 9/118.

OPPOSITE:

PLATE 28    Brochure for Lady Justice banner exhibit; Albany, New York, 2008.

Reproduced with permission of the New York Court of Appeals
and the photographer and designer, Teodors Ermansons. See figures 7/96, 7/97.

PLATE 30    Palais de Justice, exterior view, Nantes, France. Architect: Jean Nouvel, 2000.

Photographer: Olivier Wogenscky. Copyright: APIJ, April 2000. Reproduced with the permission of the
AMOTMJ / Ministère de la Justice. See figure 10/135.

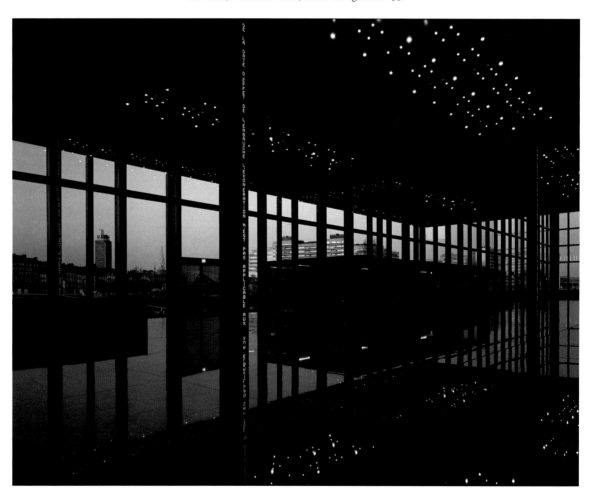

PLATE 31    Installation for the Nantes Courthouse, Jenny Holzer, 2003.

Photographer: Philippe Ruault. Copyright: Jenny Holzer Studio / Art Resource, New York. See figure 10/137.

PLATE 32    Salle d'audience (courtroom), Palais de Justice, Nantes, France.
Architect: Jean Nouvel, 2000.

Photographer: Olivier Wogenscky. Copyright: APIJ. See figure 10/138.

PLATE 33    *Stories*, Maryvonne Arnaud, 1998, Palais de Justice, Melun, France.

Photographer: Jean-Marie Monthiers. Copyright: APIJ. See figure 10/131.

PLATE 34    Le Palais, 1973, Court of Justice of the European Communities, City of Luxembourg, Luxembourg. Architects: Jean-Paul Conzemius, François Jamagne, and Michel Vander Elst.

Photograph courtesy of the Court of Justice of the European Communities. See figure 11/156.

PLATE 35    Towers of the Court of Justice of the European Communities, 2008. Architect: Dominique Perrault.

Photographer: G. Fessy. Copyright © Court of Justice of the European Communities. See figure 11/159.

PLATE 36    Main courtroom, Court of Justice of the European Communities,
in the 1973 Palais. Panels *Justice and Peace* by André Hambourg.

Photograph courtesy of the Court of Justice of the European Communities. See figure 11/162.

PLATE 37    The Great Courtroom of the Court of Justice
of the European Communities, 2008.

Photographer: G. Fessy. Copyright © Court of Justice of the European Communities. See figure 11/160.

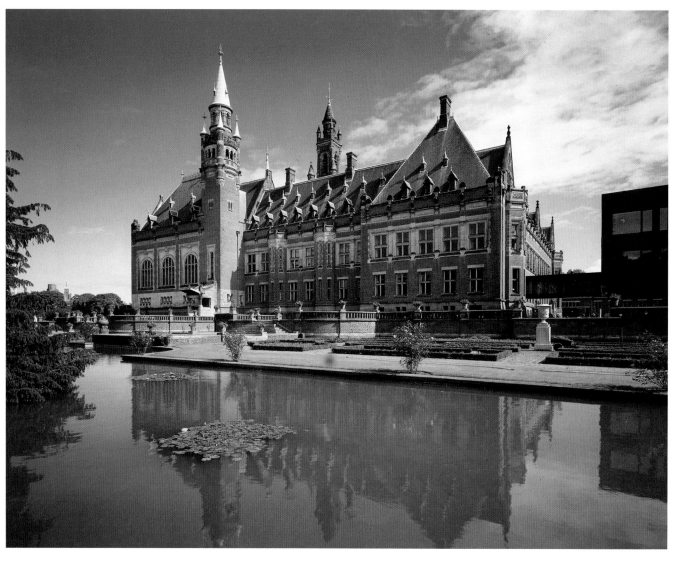

PLATE 38    The Peace Palace, International Court of Justice, The Hague, the Netherlands.
Architect: Louis M. Cordonnier. Modified J. A. G. van der Steur, 1913.

Courtesy of the Carnegie Foundation. See figure 12/168.

PLATE 39    Logo of the International Court of Justice.

Courtesy of the International Court of Justice. See figure 12/186.

PLATE 40   *Justice,* ceiling ornament,
Herman Rosse, circa 1913, Peace Palace.

Courtesy of the Carnegie Foundation. See figure 12/171.

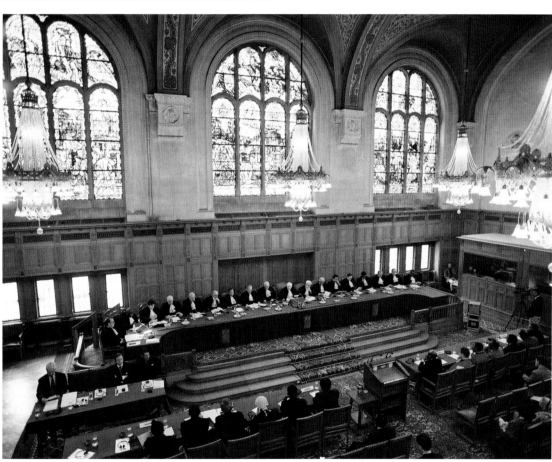

PLATE 41   A Sitting of the International Court of Justice in the Great Hall, Peace Palace, March 8, 1996.

Photograph by D-VORM.NL, provided by the Carnegie Foundation. See figure 12/174.

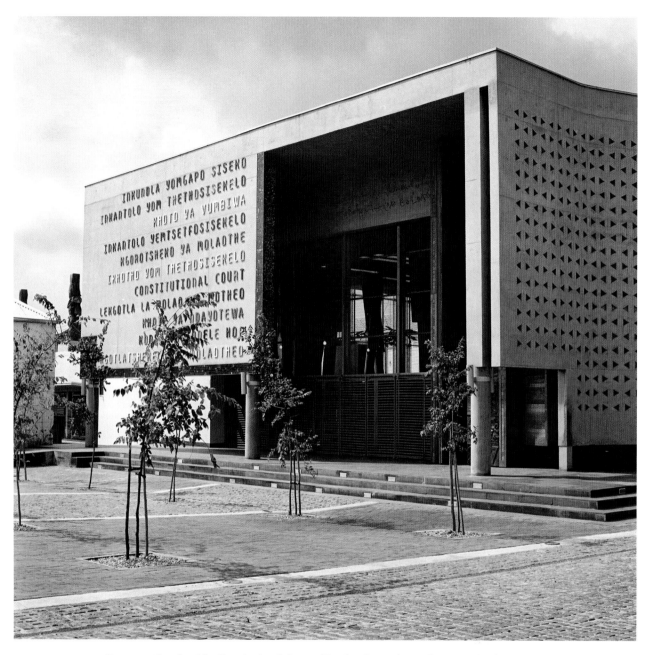

PLATE 42   Facade of the Constitutional Court of South Africa, Johannesburg, South Africa, 2004.
Architects: Janina Masojada and Andrew Makin, OMM Design Workshop,
and Paul Wygers, Urban Solutions.

Photographer: Angela Buckland. Copyright: Constitutional Court Trust.
Photograph courtesy of the Constitutional Court Trust and David Krut Publishing, 2005. See figure 15/211.

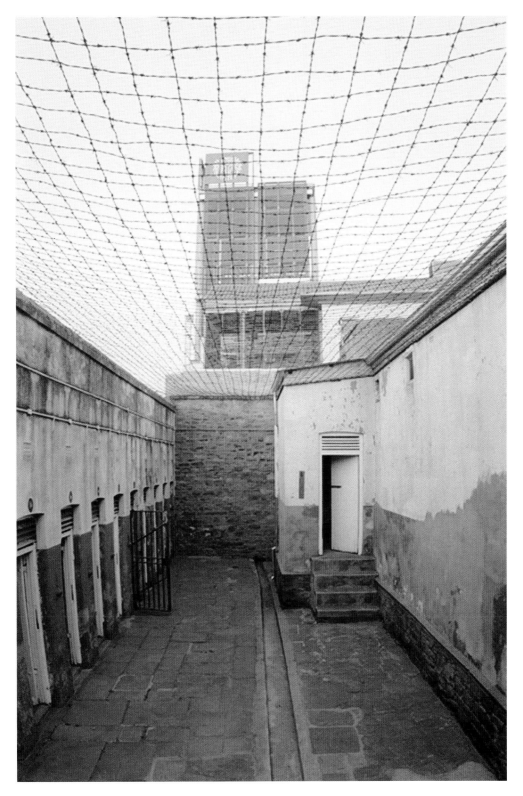

PLATE 43    Cell block in the interior courtyard, Old Fort Prison within the Constitutional Court
and Complex of South Africa.

Photographer: Angela Buckland. Copyright: Constitutional Court Trust, 2005.
Photograph reproduced courtesy of the Constitutional Court Trust and David Krut Publishing. See figure 15/214.

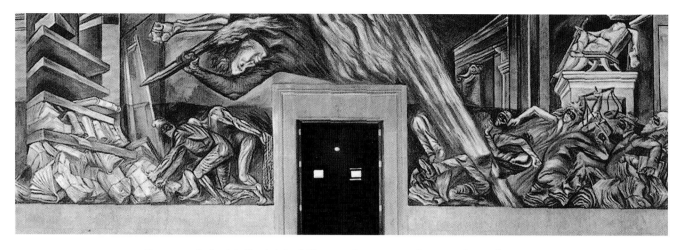

PLATE 44    *La Justicia* (*Justice*), José Clemente Orozco, 1941, Supreme Court of Mexico.

Reproduced with permission of the Committee of Government and Administration of the
Supreme Court of Justice. See figure 15/219.

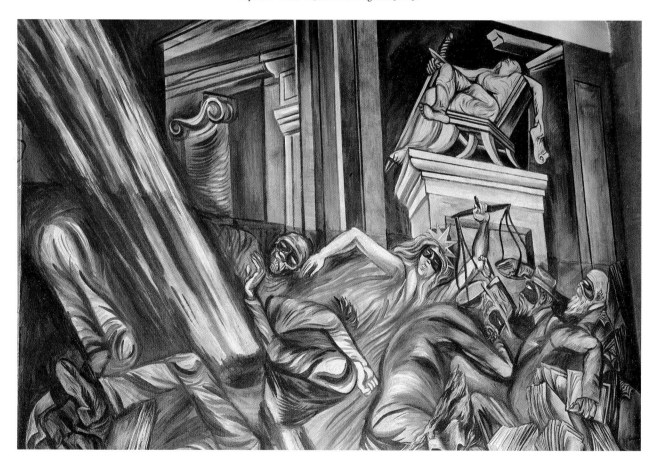

PLATE 45    (Detail) *La Justicia* (south wall).
See figure 15/220.

PLATE 46 *Rape, Corrupt Processes, and Skulls* (top).

PLATE 47 *Torture, Homicide* (bottom)

in *The History of Justice in Mexico,* Rafael Cauduro, 2009,
Supreme Court of Mexico.

Reproduced with permission of that court. See figures 15/222 and 15/223.

PLATE 48    Cook County
Courthouse, Grand Marais,
Minnesota. Architects: Kelly
and Lignell, 1912.

Photographer: Doug Ohman,
Pioneer Photography, 2007.
Reproduced courtesy of the
photographer.
See figure 15/226.

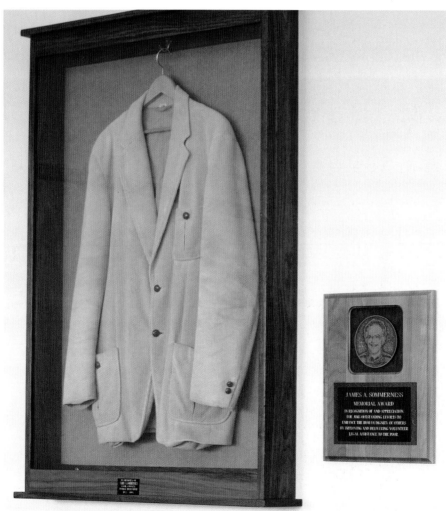

PLATE 49    James A. Sommerness Memorial, Cook County Courthouse, Grand Marais, Minnesota.

Photographer: Glenn Gilyard, 2006. Photograph permission of Richard Gilyard
and courtesy of the Cook County Court Administration. See figure 15/229.

country."[158] As for their aesthetics, of "the more than two hundred and fifty [federal] buildings erected . . . between 1876 and 1897 the predominant style was some form of medieval architecture to which each architect gave his own interpretation."[159] In contrast to the pre–Civil War era buildings self-consciously devoted to classic Greek design, those of the later part of the nineteenth century were eclectic, with turrets and towers deployed to varying effects. Buildings ranged from Romanesque fortresses to classical Renaissance and Gothic knock-offs as different Supervising Architects "scrambled their historical allusions."[160] The "panoply of federal buildings stretching across the nation" shared only "the common bond . . . that they all owed their parentage to a single office in Washington."[161]

Some of the results can be seen by looking at federal buildings around the United States in the years from shortly before the Civil War through the 1930s. During that period, federal construction was under the aegis of the Office of Supervising Architect in the Treasury Department, which enlisted both public and private architects for design.[162] Further, with the benefit of the recordkeeping on the federal docket begun in the 1870s under the fledging Department of Justice, we can trace the rise not only of buildings but also of the numbers of lawsuits filed. In the 1870s, about 30,000 civil and criminal cases were filed. By the 1930s, court business had grown to include some 150,000 cases.[163] Through the mix of new buildings and new cases, courthouses themselves came to replace Justice as icons of government. To document this proposition, we offer an abbreviated travelogue of the rise and proliferation of such edifices around the United States.

## Statehood for Texas and a New Federal Building in Galveston

We begin with the 1861 United States Custom House in Galveston, Texas (fig. 98),[164] because it was the "first federally owned building for civic purposes"[165] that was built in Texas after it gained statehood in 1845.[166] In 1854, legislation authorized construction for the "accommodation of the custom-house, post-office, and United States courts" and directed that the building be made of brick.[167] Providing space for several uses, the structure's title—Custom House—denoted the centrality of the "oldest federal agency"[168] to the national fisc in the era before the Sixteenth Amendment (ratified in 1913) authorized Congress to create a federal income tax system to "lay and collect taxes on income, from whatever source derived."[169]

Also evident in the two-story Classical Revival–style building was the success of the senators from Texas, who in 1857 had obtained an appropriation of $100,000 from Congress to fund construction that was to entail the "best quality mahogany" for interior counters.[170] Situated not far from the waterfront, the exterior walls were made (as required) from hand-fired bricks, its columns were Ionic and Corinthian, and most of the exterior decorative elements were cast iron, fabricated in New York and sent to Galveston.[171]

The building reflects the imprint of the Office of the Federal Architect. The initial plans were executed by Ammi Burnham Young, who served as Supervising Architect from 1852 to 1862 and who created similar (and in some instances close to identical) multi-use federal facilities in Cincinnati, Ohio; Newark, New Jersey; and Oswego and

FIGURE 98   United States Custom House, Galveston, Texas. Supervising Architect: Ammi B. Young. 1861; converted for use as a federal courthouse in 1917.

Image reproduced courtesy of the National Archives and Records Administration.

Buffalo, New York.[172] Under Young's tenure, the federal style drifted away from the classicism of Thomas Jefferson and Robert Mills toward "Renaissance villas" that came to "house the federal presence."[173]

The Galveston building weathered the Civil War,[174] and its changing uses over time capture the variation in the demand for services provided at the national level. Initially both a custom house and post office with a courtroom tucked inside, the building was converted into and renamed a federal courthouse in 1917. That space proved insufficient and, in 1937, a new U.S. Post Office, Custom House, and Court House opened that remained in use throughout the remainder of the century.[175] (The 1861 building now serves as the home of the Galveston Historical Foundation.)

BUILDING AND REBUILDING IN DES MOINES AND BILOXI

This pattern of building, recycling, and building anew can be found repeatedly, as shown by a few examples drawn from around the country. In 1871, a United States Courthouse and Post Office (fig. 99) designed by Alfred B. Mullett (the "best known of the fifteen men who served as supervising architect of the Treasury Department"[176]) opened in Des Moines, Iowa. That building was enlarged soon thereafter

but, in 1902, the federal government urged new construction and, in 1913, Congress allocated funds in its Public Buildings Act.[177] When the next building (designed in Classical Revival style) opened in 1929, it was named a "courthouse" even though it also housed several offices for administrators from the Departments of Agriculture and Commerce) as well as a post office.[178] In 1995, the federal government wanted more space and built an annex.[179]

James Knox Taylor, who held the position of Supervising Architect from 1897 until 1912, designed the three-story 1908 Post Office, Court House, and Custom House for Biloxi, Mississippi (fig. 100). He was personally responsible for courthouse designs at many sites ("nearly all . . . classical or colonial revival"[180]) and oversaw the selection of private architects for the designs of thirty-five other federal buildings.[181] That "Taylor could provide such a diversity of high-quality buildings . . . at the breakneck speed demanded by the largess of Congress, is a tribute to his talents both as architect and administrator."[182]

The Biloxi building was one of many that sparked complaints of "pork-barreling" as new federal construction outpaced the growth in population and in the volume of services.[183] The initial low volume of business may explain

FIGURE 99   United States Court House and Post Office, Des Moines, Iowa. Supervising Architect: Alfred B. Mullett. 1871; enlarged 1890, demolished 1968.

Image reproduced courtesy of the National Archives and Records Administration.

why the 1908 arched and columned building remained in use until 1959, when a new United States Post Office and Court House was built. The 1908 building became Biloxi's City Hall.[184] In 2003, the court for the Southern District of Mississippi moved to the town of Gulfport, where, in 2003, the Judge Dan M. Russell Jr. Federal Building and Courthouse opened. (Its "abundance of natural light" was described as fostering "a sense of openness between the public building and the surrounding community."[185])

### Moving Further, Farther, and Higher

#### WESTWARD EXPANSION: DENVER, MISSOULA, AND SAN DIEGO

In 1892, a three-story federal building, once seen as monumental, opened in Denver, Colorado. Designed by two men, Mifflin E. Bell and Will. A. Freret, who served as Supervising Architects, the building (fig. 101) was crowned with a tower at its top and appointed with columns.[186] Yet by 1900, it was considered "outdated,"[187] and shortly thereafter Congress authorized a new building.[188] As supporters in the Senate explained, Denver was the "largest city between the Missouri River and the Pacific coast. It was therefore the capital, as it were, of a vast empire."[189] The Senate Report also cited complaints of a federal judge that the building's other uses interfered with the court: "The post-office draws a crowd at all hours of the day, and it is the favorite point for newsboys and vendors, whose cries constantly disturb the sessions of the court."[190]

The Tarsney Act had by then shifted more work to the private sector and, after funds were appropriated in 1909,

Supervising Architect James Knox Taylor picked a private firm to design the structure (fig. 102). Completed in 1916 and called, when it first opened, the Denver United States Post Office and Courthouse, the building is four stories high and occupies a city block.[191]

The building remains in use. For several decades, the press of work in the United States Postal Service resulted (with the exception of one courtroom) in devoting the structure to that use. But by 1994, the Post Office had left and the facility, reopened after renovations, was renamed in honor of Byron R. White, the first person from Colorado to serve on the United States Supreme Court. The revamped facility serves as the headquarters for the Court of Appeals for the Tenth Circuit; it houses four appellate courtrooms and one trial courtroom.[192]

The size, scale, and elegance of the Neoclassical architecture made the 1916 building a major landmark of the federal government. The structure features a three-story portico that is formed by sixteen symmetrical Ionic columns decorated with eagles at their tops. The classical theme celebrating federal power continues in the street-side inscriptions, invoking Cicero in Latin ("Lex Nemini Iniquum, Nemini Injuriam Facit"—"The law causes wrong or injury to no one") and the Magna Carta ("Nulli Negabimus, Nulli Differemus, Jutitiam"—"To no one shall we deny justice, nor shall we discriminate in its application").[193]

The classics return inside, with four Latin inscriptions in a courtroom now used by the district court. There inscribed are "Justitia Virtutum Regina" (Justice is the Queen of Virtues); "Justitiae Soror Fides" (Faith is the Sister of Justice); "Nemo Est Supra Leges" (No One is Above the Laws),

FIGURE 101 United States Post Office (United States Court House and Post Office), Denver, Colorado. Supervising Architects: Mifflin E. Bell and Will. A. Freret. 1892.

Image reproduced courtesy of the Denver Public Library, Western Historical Collection, WH-1573. Photographer: Wm. Henry Jackson.

FIGURE 102 United States Post Office and Courthouse, Denver, Colorado. Architects: Tracy, Swartwout & Litchfield. 1916; renamed in 1994 the Byron R. White United States Courthouse.

Image reproduced courtesy of the National Archives and Records Administration.

and "Ita Lex Scripta Est" (Thus is the Law Written).[194] In the original appellate courtroom, the judges hearing appeals look at the words "Peace Dependeth on Justice," while litigants looking at the judges can read the inscription "Reason Is the Soul of All Law."[195] On the walls of another room, once a library and now used as an appellate court, are the names of various lawgivers including Blackstone, Cicero, Moses, Justinian, Coke, Napoleon, and Grotius. (The first floor, once dedicated to the Post Office, has the names of famous Pony Express riders, Bill Cody included, carved in marble at both ends of the lobby.) Fasces—the Roman symbol of governmental authority—can be found throughout the building, dotting clocks and brass fittings for curtains.

Farther north, a Post Office and Courthouse in Missoula, Montana (fig. 103), shows both the imprint of Supervising Architect James Knox Taylor and the success of local politicians in bringing a federal building to the city less than thirty years after it was incorporated.[196] The town's newspaper called the "classically-inspired" three-story building in a Renaissance Revival style an "ornament to the city."[197] It was indeed a highly ornamented building, with arched entrances and two-story attached columns (pilasters) crowned with ornate Corinthian capitals. Completed in 1913, the federal building has also provided housing for the Northern Region of the United States Forest Service, in part as the structure was expanded in 1929, 1937, and 1952.[198]

James Knox Taylor was also responsible for the U.S. Post Office and Customs House of 1913 in San Diego, California (fig. 104). When first constructed and not then called a courthouse, the building sheltered the federal district court as well as the Immigration and Naturalization Service and the Weather Bureau. Taylor thought the Spanish Colonial Revival building of stucco-brick masonry, adorned by ten two-story columns and crowned by a red tile roof, appropriate for the state's history as well as the "climate and the desires of the people."[199]

Expanded in 1928, reconfigured after the Post Office left in 1938, and abandoned in the 1970s in favor of a new court and office complex, the building was renovated and returned to use as a courthouse in the following decades.[200] Those efforts garnered a "TOBY" (The Office Building of the Year) award for the GSA in 1996,[201] and another award in 2003 from a jury that worked under the umbrella of the GSA Design Awards Program and that was led by architect Moshe Safdie.[202]

OFFSHORE AND ACROSS LAND:
PUERTO RICO AND ALASKA

Taylor designed another version of a Spanish Colonial Revival–style building for the territorial court in San Juan, Puerto Rico (fig. 105).[203] During its planning stages in 1908, the building was heralded by a newspaper as "one of the largest and best buildings constructed by the American government in its insular possessions."[204] Once again, pilasters mark the facade, and the roof is tiled, but the smaller windows and grill work, aimed at protecting the building from the winds and rains of the Atlantic Ocean, lend something of a fortress look to the 1914 building.

Augmented by an "Art Deco high-rise addition completed in 1940," the courthouse also provides space for the Court of Appeals for the First Circuit when it sits annually in Puerto Rico.[205] Renamed in 2000 the José V. Toledo Federal Building and United States Courthouse, the building received a prize, in 2002, for preservation from the federal government's Society for History. Soon thereafter, the Academy of Architecture for Justice cited the design's reclamation for public use of the "deep porches that shade the windows from the strong tropical sun" and awarded it another prize.[206] One could also see its massive structure as reinforcing the scope of federal power over the "unincorporated territory" of Puerto Rico, which remains in a complex relationship with the United States.[207]

FIGURE 103  Federal Building, United States Post Office and Courthouse, Missoula, Montana. Supervising Architect: James Knox Taylor. 1913.

Image reproduced courtesy of the National Archives and Records Administration.

FIGURE 104  United States Post Office and Customs House, San Diego, California. Supervising Architect: James Knox Taylor. 1913; renamed in 1986 the Jacob Weinberger United States Courthouse; renovated 1994.

Image reproduced courtesy of the National Archives and Records Administration.

FIGURE 105  United States Post Office and Courthouse, San Juan, Puerto Rico. Supervising Architect: James Knox Taylor. 1914; enlarged 1938–1940; renamed in 1999 the José V. Toledo Federal Building and United States Courthouse.

Image reproduced courtesy of the National Archives and Records Administration.

Moving from the Atlantic seaboard to the far Northwest brings us to the other territorial extreme of the United States, Alaska, which, during the same era, had a courthouse of very different dimensions. The former territory of Alaska's 1914 United States Courthouse and Jail (fig. 106) stood adjacent to the Bank of Alaska in Fairbanks.[208] This building was the second federal facility for this part of Alaska; a first, erected in 1904, was destroyed by fire in 1906. Before then, the court had met "in the Episcopal log church and hospital,"[209] as well as in a warehouse of the North American Trading and Transportation Company.[210]

Credit for both structures is given to James Wickersham, who served as the first judge of that part of the territory that spanned 300,000 square miles (half of Alaska) and stretched 2,000 miles from the "Arctic Ocean to the Aleutians."[211] As Wickersham explained, Congress had "empowered the district judge to reserve a tract of public land, forty by one hundred feet for a court-house site, and another of equal size for a jail."[212] With congressional authorization, Wickersham funded the first courthouse with license fees collected from saloons and other stores; the building cost $8,000.[213]

A second site in Fairbanks—which by 1905 was the largest city in Alaska[214]—was authorized; Congress eventually provided about $15,000 for construction.[215] By 1932, the structure, seen by city officials as poorly constructed and in bad shape, was demolished. Its 1933 replacement was an "Art Deco monument symbolic of the federal government's role in establishing Fairbanks."[216] That facility, built for $393,000, was used as a post office and courthouse from 1933 until 1977.[217]

SKY HIGH IN NEW YORK CITY

The tour ends with a return to the East Coast, where, in 1936, a Neoclassical high-rise United States Court House (fig. 107) for New York City was "among the first federal skyscrapers ever constructed."[218] The building is emblematic of the changes in the number of federal judges and of federal cases. Between 1910 and 1940, the number of federal judges rose from 141 to 257, and filings in the district courts increased from under 30,000 to some 70,000 cases annually.[219]

The building was designed by Cass Gilbert who, although a private architect, is likely the best-known "federal architect" for his design of the United States Supreme Court building, which also opened in 1935.[220] Aspiring to create a monument in New York, Gilbert provided the courthouse with its "version of Saint Mark's campanile" in Venice. The New York Court House also has local referents, for it resembled the Nebraska State Capitol and the Custom House Tower in Boston.[221]

The New York City building houses judges who sit on the District Court for the Southern District of New York and on the Court of Appeals for the Second Circuit, overseeing federal decisions in New York, Connecticut, and Vermont. Colloquially called Foley Square (where it is sited), the building was named in 2001 in honor of Thurgood Marshall, the first African-American to serve on that circuit before his appointment in 1967 to the United States Supreme Court, where he remained until 1991. The Thurgood Marshall Courthouse rises 590 feet; its six-story base supports another two dozen stories above. Ten four-story Corinthian columns mark its entrance, and, like the frieze discussed in Chapter 6 in the United States Supreme Court, some "law-givers"—Plato, Aristotle, Demosthenes, and Moses—are on display on outdoor roundels shaped to look like antique coins.

The original structure had sixteen courtrooms; the expanded building contains thirty-five. Those spaces did not suffice, and, in the 1990s, an additional building—the Daniel P. Moynihan United States Courthouse, also known as "Pearl Street" (on which it sits)—opened. One commentator who worked in the 1935 Gilbert building described its provision of "psychic income": "Everyone who enters a Gilbert building designed for public use realizes that they have arrived at a significant place."[222]

Gilbert designed the New York City building as he was also working on what has become his signature edifice, the United States Supreme Court (fig. 108). On October 7, 1935,

FIGURE 106  United States Courthouse and Jail and adjacent Bank of Alaska, Fairbanks, Alaska. Circa 1914; demolished 1932.

Image reproduced courtesy of the National Archives and Records Administration.

Figure 107    United States Courthouse, New York City, New York. Architect: Cass Gilbert, 1936; renamed in 2001 the Thurgood Marshall United States Courthouse.

Image reproduced courtesy of the National Archives and Records Administration.

the justices began hearing cases in the building, the first dedicated exclusively to their use. Credit for its existence is regularly given to William Howard Taft, who, after serving as President from 1909 until 1913, was appointed in 1921 by Warren Harding as the Chief Justice. Taft found the "twelve rooms for offices and records . . . scarcely adequate" for the Court's work.[223] While serving as President, Taft had been a strident advocate for "a change in judicial procedure,"[224] and as Chief Justice he carried that agenda forward while also pressing for the Supreme Court to have its own home. In a 1925 appropriations bill for public buildings, Taft found a vehicle in which to insert authorization for the Secretary of the Treasury to "acquire a site for a building for the Supreme Court of the United States."[225]

When testifying before the House of Representatives in 1928, Chief Justice Taft detailed his argument for the

Supreme Court to have a building of its own. In part, his claims were functional. Taft noted that the courtroom provided in the Senate sufficed but the Supreme Court needed to have a "place for our consultations," for "our records," and for the lawyers who appeared before the court.[226] But Taft was also in the market for symbolism; he wanted a structure exclusively devoted to the Supreme Court to mark its "independent existence."[227] In the 1920s, the Department of Justice still provided all administrative services for the federal courts, yet Taft rejected the suggestion of sharing space. Noting that Department of Justice cases "comprise[d] about two-fifths" of the Court's docket and insisting on the need to "hold ourselves independent of the Department of Justice," Taft offered the rhetorical flourish that "to be tied up with them would be a good deal worse than to be tied up with the Senate."[228]

FIGURE 108    United States Supreme Court, Washington, D.C. Architect: Cass Gilbert, 1935.

Archival image from 1935 reproduced courtesy of the National Archives and Records Administration.

The Architect of the Capitol would have been expected to guide the project, but Taft secured a seat for himself as Chief Justice (as well as for an associate justice) to serve on the new Supreme Court Building Commission authorized to oversee the design and construction.[229] Taft was chair, and the Building Commission hired Cass Gilbert, who had been President of the AIA from 1908 to 1909. Gilbert also had a long relationship with Taft who, when President, had appointed Gilbert to serve as a charter member of the Commission on Fine Arts created in 1910.[230] Moreover, Gilbert was a "loyal Republican."[231] Gilbert's 1929 submission met Taft's expectations by proposing a courtroom of "impressive proportions and monumental style."[232]

In 1930, Congress appropriated funds for a building of "simple dignity."[233] Some justices and architects later had reservations about its "chilly opulence,"[234] and one called it "almost bombastically pretentious."[235] The Corinthian architecture, with "its semiotic allusions to Greek temples" aiming to evoke reverence,[236] returned to the style deployed for federal buildings during the early years of the Republic. Although Gilbert insisted that the "building's principal claim to beauty lies in its proportions, not its adornment,"[237]

it is also rich with iconographical detail. In addition to the frieze of the many lawgivers that, as we discussed in Chapter 6, prompted concerns in the 1990s for its depiction of Muhammad, the building has several sculpted Justices.[238] Other allegorical figures (such as "Liberty Enthroned, Guarded by the figures of Order and Authority" on its West Pediment) appear at its main entrance, and ten sets of bronze gates in the courtroom include scales, tablets (with the Roman numerals I–X), torches, eagles, acorns, oak leaves, and lions' heads.[239] As for the costs, the 1939 final report filed on behalf of the Supreme Court Building Commission recorded their coming in about $100,000 under the $9,740,000 that had been budgeted.[240]

Before 9/11, the building had 890,000 visitors a year. By 2007, the number hovered around 300,000, augmented by more than 12,500,000 hits on its internet site.[241] The response from architectural critics has been mixed. John Brigham commented that the adoption of a classical form associated with the South was ironic in that it came at a time when "the traditional temple was least expressive of what courts in America were doing."[242] He argued that the triadic shape of the roof—as if law through doctrine con-

tained and deflected "the discontent of the losing party"—was belied by the shift toward rationalization and bureaucratization of justice.[243] As Paul Spencer Byard put it, Gilbert's "problem was that the modernists were on to something very important . . . that the world had had enough of pomp and papering over."[244] Yet, over time, the building has come to be "treated with almost excess affection . . . as officially old—even though it is not very old."[245] One admiring writer is illustrative: "Austere, gleaming white in all weather, it stands watch on Capitol Hill, a national monument to the virtues of clarity, integrity, and fairness."[246]

## ARCHITECTURAL STATEMENTS AND OBSOLESCENCE

When the collage provided by the images of these eleven federal buildings constructed between the 1860s to the 1930s is set against the backdrop of the pre–Civil War construction efforts, several propositions become clear. First, courts were not in the initial wave of federal construction; hospitals, custom houses, and post offices were. Only during the latter part of the eighteenth century did courthouses become a part of the effort to demonstrate the importance of the national government through the erection of distinguished buildings.

Second, the chronology illustrates the change in the kind of services provided by the national government. Once, major federal buildings were called custom houses, but that name is now relegated to architectural history as the function of revenue collection through import fees has been eclipsed by the national taxing authority. The successor nomenclature for federal government buildings was often "post offices" rather than "courthouses"; the "judicial, customs, and other federal functions" were tucked inside rather than put on the nameplate.[247]

Further, as the two Denver buildings of 1892 and 1916 (figs. 101 and 102) illustrate, many of what had been large-scale and impressive buildings in the nineteenth century were, in relatively short order, seen to be obsolete. A few were lost to fires, and some were torn down or recycled for other uses as politicians succeeded in getting resources for expanded replacements or augmentation.[248] Moreover, the multi-function buildings were superseded by facilities dedicated to specific uses. Both postal and court services outgrew their allotted spaces and spun off into separate facilities, purpose-built and purpose-named.

Third, the span between the 1860s and the 1930s reveals the shift from the centralization of building services to diffusion through outsourcing. During the second half of the nineteenth century, the contours of the federal government gained definition at the same time as professionals in law and in architecture were also defining their own institutions and gaining sway. The building stock of the Office of Supervising Architect increased "seventeen-fold" in the forty years between 1853 and 1892.[249] And from the 1850s to

1913, the personnel of that office had increased more than forty-fold. In the 1850s, the Office of Supervising Architect consisted of two architects, "one clerk, six draftsmen, and one bookkeeper-draftsman"; by 1913 it employed about 350 people, 250 in Washington and another hundred in the field.[250]

Although the number of federal employees involved in building projects continued to rise, their control diminished. Federally employed architects designed projects during the first decades of the Office of Supervising Architect, but the AIA's several decades of efforts to dislodge them succeeded in the twentieth century and continues to do so in the twenty-first. Building design has been outsourced and, as we detail in Chapter 14, so have court services.

Fourth, courthouses have come to the fore as monumental statements of government authority because the federal judiciary has had remarkable success in lobbying for these buildings. Credit for obtaining the funds from Congress must go (as we explain in Chapters 8 and 9) to the leadership of the federal judiciary working in conjunction with colleagues around the country. Credit for the infrastructure that generated that leadership goes to William Howard Taft, who not only pressed for a building for the Supreme Court but also laid the groundwork for the bureaucratic form of today's federal courts.

Taft helped to turn a scattered lot of federal judges into a corporate force able to forward its agendas, including need for more space. Decades later, Taft's worthy successor was Chief Justice William Rehnquist, who shepherded the development of the judicial administrative apparatus able to capture more than $8 billion dedicated to courthouse renovation and construction. One feature of the late twentieth-century spate of federal building—the names—reflects the success of the first wave. During the first period of federal building, the point was to instantiate federal authority, and the buildings did so by putting the words "United States" front and center. By the later part of the twentieth century, federal structures referred to members of Congress or to judges in whose honor the facilities are named.[251] That shift assumes that federal power is stable (no longer in need of announcing itself), so that buildings instead can be named after specific members of Congress funding the structure or after judges from a particular locality.

Fifth, art has taken a backseat to the architecture. Unlike the unified conception of architecture and art exemplified by the Amsterdam Town Hall, interior decorations in United States federal buildings were not generally planned at the outset.[252] Public commissions of major murals or sculpture have been "occasional . . . and isolated."[253] Although the federal government committed itself to an Office of Supervising Architect in the 1850s, it created no comparable national office for art during that century. Not until the twentieth century did a sufficient number of interests coalesce in support of national programs aiming to conceptualize "American" artists as offering a distinctive

aesthetic to be displayed at major public sites. Yet, as we detail in Chapters 8 and 9, the art is conceived to be "in" the architecture, a decorative element dominated by the buildings that are intentionally designed as the vehicles for didacticism about the justice system.

Sixth, the discussion of federal courthouse buildings needs to be put into a larger context historically, in part by way of a preview of the materials to come. Courthouses are both majestic and disproportionately salient on various metrics. The several hundred federal court facilities extant by the end of the twentieth century were a small subset of the national footprint, as measured by either the number of facilities or the area in square feet. In 2006, the GSA oversaw "40 percent of Federal workspace, adding up to over 337 million square feet" (about half owned and half leased), resulting in what the GSA described as its supervision of the "largest office real estate portfolio in the world."[254] The inventory of federal buildings ranged from visitor centers and fish hatcheries to space labs; by the 1970s, more than 400,000 buildings were on the roster.[255] Similarly (as discussed in Chapter 14), the number of federal cases filed—some 350,000 civil and criminal cases and another million or so bankruptcy petitions—was dwarfed by the volume in state courts and in federal agencies.

On the other hand, the resources devoted to federal courts bespeak their political and social import. To complete an understanding of these functions in contemporary times, more must be explained about the interactions among architects, artists, lawyers, judges, and politicians during the second half of the twentieth century, producing the largest federal building program since the New Deal.

# A Building and Litigation Boom
# in Twentieth-Century Federal Courts

## INSTITUTIONAL GIRTH:
## IN-HOUSE ADMINISTRATION, RESEARCH,
## AND A CORPORATE VOICE

The 1935 Supreme Court building (fig. 7/108) marked the ascendancy of the federal courts in the national pantheon of institutions and the beginning of a much greater expansion in the caseload, staff, facilities, and import of the federal judiciary. The building is emblematic not only of that court but also of the lower courts it oversees, the administrative structures it has sprouted, and the twentieth-century imagery that enshrined it as the model of how courts should look. The ambitions and achievements of federal judicial leaders can be seen through the twentieth-century history of the courthouses they brought into being. By the end of that century, the federal judiciary had succeeded in obtaining the "largest public-building construction campaign since the New Deal: a 10-year, $10 billion effort to build more than 50 new Federal courthouses and significantly to alter or add to more than 60 others."[1]

To construct the narrative of this work entails tracking three interrelated streams of activity. One is the growth in federal adjudicatory authority, enabled by an institutional infrastructure shaped to respond to expanding dockets. A second is the expansion of the federal building program as the national government turned itself into a major real estate owner and manager. A third is the aspiration for a national identity expressed through architecturally significant buildings and government-funded art. Hence three agencies—the Judicial Conference of the United States with its Administrative Office (AO); the General Services Administration (GSA) with its subdivisions, the Public Buildings Service and the Art-in-Architecture Program; and the National Endowment for the Arts—come to the fore as they cooperated and competed for authority and for dollars to shape representations of the federal government and its justice.

## William Howard Taft's Innovations

From his term as President through his time as Chief Justice, William Howard Taft was pivotal in generating an administrative apparatus and a collective judicial identity that, in turn, helped to document the need for new facilities. In classic Weberian fashion, the increasing number of buildings also provided a rationale for more resources in-house. Recall that through the 1930s, the federal judiciary relied on the Department of Justice for administrative services.[2] In 1922, soon after Taft became Chief Justice, he complained in a speech to the American Bar Association about the isolation of federal judges—each left "to paddle his own canoe."[3] Taft's metaphor made the point that no structure wove federal judges into a collective body. Trial level judges, scattered around the United States, had little that linked them together in a shared enterprise. They used the diverse procedures of the states in which they sat; a federal judge in Connecticut relied on different rules of court than did a federal judge in New York, Texas, or California. And when judges wanted a clerk, a typewriter, or a travel stipend, they asked the Department of Justice.

Taft's agendas included increasing the number of federal judges and gathering them under his wing by adding the role of chief administrator of the federal judiciary to the chief justiceship. Taft lobbied Congress to authorize eighteen new lower-court positions for what he called "judges at large"[4] (dubbed a "flying squadron") that he, as Chief Justice, could dispatch to districts as needed.[5] Taft also sought authority and funding to bring senior judges together yearly in Washington, where their discussions of workload demands would help make the case to Congress for yet more new judgeships and support. Taft wanted a national procedural regime to supplant the practice of using the variety of rules in place wherever federal judges sat. Further, he sought to unify the treatment of cases, whether requesting legal or equitable relief.[6] To deal with the Supreme Court's docket, Taft wanted discretion to select cases through the device known as "cer-

tiorari," in which petitioners request that the court take a case, in lieu of the obligation under a system of mandatory jurisdiction to hear so many appeals. Over time (but with only some of these changes taking place during his lifetime), Taft's aspirations have materialized.

In 1922 Taft obtained congressional authorization to convene what was then called the Conference of Senior Circuit Judges, chartered to meet once a year in Washington to advise the Chief Justice on "the needs of [each] circuit and as to any matters in respect of which the administration of justice in the courts of the United States may be improved."[7] Congress also created twenty-four new lower court judgeships which, given the 126 judgeships that had been authorized as of 1914,[8] increased the workforce by more than a fifth.

But Congress did not accede to Taft's request to leave the assignments of those new judges to the discretion of the Chief Justice. As Taft explained, given conflicts over Prohibition, some worried that he would "send dry judges to wet territory and wet judges to dry territory."[9] Instead, Congress specified (as it continues to do), line by line in legislation, what particular districts and circuits received new judgeships.[10] Yet Congress did give the Chief Justice the authority, on a request from a borrowing court and with the permission of the lending court, to "designate" a judge to sit elsewhere temporarily.[11] That power has since been used for hundreds of ad hoc assignments, deploying (in some measure as Taft had hoped) a "flying squadron" of federal judges to give relief to their sibling jurists in specific districts or circuits.[12]

To garner the power to create shared federal rules, Taft worked with lawyers aiming to nationalize their profession. Just as architects had created the American Institute of Architects (AIA) in the 1850s and moved it to a national level in the 1860s, attorneys shaped professional organizations aimed at national markets. In 1878, the American Bar Association (ABA) was founded,[13] and its annual conventions became occasions for setting agendas that included responding to "popular dissatisfaction" with the courts.[14] In the first decade of the twentieth century, the ABA championed several projects, such as the crafting of legal ethical codes, discussed in Chapter 6, as well as "court reform" that promoted legislation to give federal judges the power to promulgate one set of nationwide rules of procedure. Strong populist opposition prevented enactment of such authorizing legislation until 1934,[15] when Congress passed the "Rules Enabling Act," giving the Supreme Court the power to set forth such rules.[16] In 1938, the Court issued its first set—the Federal Rules of Civil Procedure.[17]

Those rules reflected concerns that the means of getting into court were overly cumbersome, intricate, and technical, reflecting the remnants of the English system's juridical categorization of causes of action.[18] To lower barriers to entry, the reformers crafted a trans-substantive set of procedures that provided the same governing regime regard-less of the kind of lawsuit (contract, tort, patent, federal statutory right) or the form of relief (damages or injunctions). Further, liberal rules of pleading and joinder permitted different kinds of claims and various parties to be brought together in a single lawsuit, thereby widening the parameters of lawsuits. In addition to relaxing the risk of procedural errors, the Federal Rules reshaped the course of lawsuits by adding a system of information exchange ("discovery") among parties in advance of trial,[19] as well as an occasion (called a "pre-trial") for lawyers and judges to meet informally in advance to plan for trial.[20]

Rulemakers did not only aspire to change how lawyers brought cases to courts. They wanted to shape how federal judges saw their role. But more than rules are needed to change behavior. The infrastructure that Taft had helped to build—the Conference of Senior Circuit Judges—created its own subcommittees and programs to implement new ideas. Energetic and evangelistic judges, who were committed to revamping the attitudes and practices of their peers, promoted a new vision of judging. By the 1960s, they had convinced their colleagues to create a "school for judges"[21] to teach new ways of being judges—in terms of their daily practices in court and their persona vis-à-vis other branches of government.

## Building the Administrative Apparatus

Under the leadership of a succession of Chief Justices (from Taft to Charles Evans Hughes to Harlan Fiske Stone and Fred Vinson),[22] the Conference of Senior Circuit Judges pressed for more capacity to minister to its own understanding of judicial needs.[23] In 1939, Congress permitted the judiciary to bring its management in-house by authorizing the creation of the Administrative Office (AO) of the United States Courts.[24] Initially working with a staff of twenty, the AO took over tasks from the Department of Justice and the districts' own clerks offices. The AO expanded the data collected as it submitted budgets and oversaw the operations of the courts, from clerks to probation offices, from supplies to caseloads.[25] In addition, the AO monitored congressional legislation related to the judiciary. Over time, the AO became the liaison between the judiciary and Congress, sometimes expressing views on behalf of the judiciary about pending proposals and other times initiating requests for legislation.[26]

In 1948, a general recodification of federal statutes related to the federal courts produced a new name for the Conference of Senior Circuit Judges, which became the Judicial Conference of the United States. By statute, each of the chief judges of the now thirteen circuits gained a seat on the Judicial Conference. In the 1950s, Chief Justice Earl Warren persuaded that group to accede to adding representative district judges, such that one district judge is elected from each circuit. By serving as the chair of the Conference, the Chief Justice has significant forms of

authority that augment the powers of opinion writing on the Supreme Court.[27] The "Chief" appoints members to committees in a structure that has expanded over time. In the twenty-first century, the Judicial Conference has some twenty-five subgroups focused on projects ranging from rulemaking, facilities, technology, public defenders, and security to relations with judiciaries in other countries. The Conference uses formal voting rules as it approves policy positions on behalf of the judiciary.

In 1967, the judiciary's bureaucratic apparatus expanded through the congressional addition of another entity—the Federal Judicial Center (FJC)—charged with education and research for the federal courts.[28] The FJC runs what is informally called "baby judge school" to orient new judges, conducts specialized programs, and undertakes—at the behest of the various committees of the Judicial Conference—targeted research projects. By the early twenty-first century, the AO had more than 1,100 employees as a central resource for the 30,000 judicial workforce;[29] the FJC staff relied on about 120 staff,[30] and Congress supported the work of both offices with some $80 million annually.[31]

### "Court Quarters"

From its inception in the 1920s, the judiciary's leadership focused on augmenting the resources of the courts. Acting as a corporate voice for judges, the Judicial Conference repeatedly asked Congress to create new judgeships for those circuits or districts it identified as particularly needy.[32] The Conference also sought to equip judges with law books and staff and to gain support for travel and other expenses.[33] But buildings—courthouses—were not a focus point of discussion in the formal reports made to Congress until after the creation of the AO in 1939.

The AO's enabling statute had given it several tasks, including to provide "accommodations for the use of the courts" and their staff. As the AO's Director explained in 1941, it was "well known" that the AO was not "equipped to construct or operate buildings" but would instead "discharge its duty" by obtaining "suitable provision from the agencies" that managed the building system, specifically from the Public Buildings Administration of the Federal Works Agency as well as the Post Office Department, which then had independent authority to obtain property.[34] As of the early 1940s, World War II limited what could be done, save for requests to attend to the serious need for a new courthouse in the District of Columbia, "which long ago outgrew its present quarters and is seriously hindered in its work by their utter inadequacy."[35]

In 1944, the problem of lack of space prompted the Judicial Conference to authorize the appointment of what would be its first of many committees devoted to the question of facilities.[36] That committee's assessment in 1945 was that several spaces were "seriously inadequate" and that an "urgent need" existed for improvement in what were then called "quarters for the courts."[37] Within a year, the Conference's "Committee on Postwar Building Plans for the Quarters of the United States Courts" circulated a manual on courthouse design that was published by the Public Buildings Service. That template proved to be the first of many such design guides.[38]

Exchanges in the 1940s and 1950s detail efforts of the judiciary to work with its sibling agencies to improve "quarters," as well as concerns that the general building regime was insufficiently attentive to the special needs of the judiciary. For example, although the Judicial Conference obtained a commitment in 1949 from the Commissioner of the Public Buildings Service that the federal courts were one of "the highest of priorities" for allocations of space,[39] the Conference objected to the Commissioner's proposal to "reduce the public space in the courtrooms . . . from 80 seats to 48 seats."[40] On the other hand, complaints were also leveled against judges, some of whom had failed to "permit the use of court facilities in public buildings by other Government agencies."[41]

Air conditioning became a bone of contention in the 1950s. As the judiciary went to Congress for more judgeships, some members of Congress questioned that need, given the practice of closing courts during the summer months. Such long adjournments undercut the justification that workloads required more courthouses. The Judicial Conference responded by arguing that "extreme heat" interfered with "the efficiency and output of the courts during the hot months of the year"[42] and requested air-conditioned facilities. In 1952 and again in 1953, the Commissioner of the Public Buildings Service met with the Judicial Conference and reported that funds for air conditioning were lacking—with little prospect for a change in the coming year.[43] Thereafter the Conference created its own Committee on Air Conditioning, surveyed the need, and went directly to Congress for funds, coming back in 1955 with a direct appropriation of $1,150,000.[44]

Upgrading available space was a leitmotif of the reports over the 1950s and 1960s. The Judicial Conference did not request separate courthouses but instead focused on finding facilities within the building stock extant or planned. For example, in 1958, the Director of the AO listed seventeen new buildings that would include court quarters.[45] Further, he counseled appreciation for the GSA, which he said merited praise for its "skill and ingenuity in adapting the space available, often unpromising on first sight, to the needs of the courts. . . . [W]hile sometimes the new quarters are smaller or different in shape from what would have been ideal . . . they are usable, they have a high degree of functional efficiency, and they are fitting and attractive in appearance."[46] Throughout the 1960s, a growing number of life-tenured judges as well as the creation of the auxiliary role of judicial magistrates drove the need for more "court quarters."

Time and again, the locution of the Judicial Conference was to refer to "buildings containing court quarters" or to "court facilities" rather than to courthouses themselves.[47]

## PUTTING CASES INTO COURTS:
### THE SECOND RECONSTRUCTION

In Chapter 7 we provided a brief tour of federal building from the Civil War era through the 1930s. Those many images (figs. 7/98–7/107) made the point that, despite variations in style, America's leaders reiterated what European rulers had done before them—constructing imposing public spaces to represent their authority. Moreover, as all the windows and doors suggest, these buildings were readily accessible to foot traffic, such as the person mailing a letter, or the litigant filing a lawsuit. And up until the 1980s, one could enter those buildings freely—without emptying one's pockets or passing screening devices.

The pre–World War II building program also tells us something about the demand for adjudication (as well as for postal services). Cass Gilbert's 1935 New York City courthouse, ascending stories beyond its predecessor three-story models, is emblematic of the evolving contours of legal rights. Dockets—the increasing numbers of cases filed—are but one measure. Not only did filings increase but the content of cases changed over time, driven by dynamic variables including the kinds of legal rights recognized, access to legal services, and government regulatory policies.[48]

### Rights across the Board

In the wake of the Depression, many saw federal governance as a necessary and desirable response to political and economic conditions. Expansion of federal jurisdiction was a mechanism by which to spread and enforce a national legal regime. In the 1940s, the Civil Rights movement turned to the federal courts and, under the leadership of Chief Justice Earl Warren in the 1960s, constitutional interpretation looked favorably upon court-based processes to enable racial equality and to enhance human dignity. Congress not only supported but expanded this project, time and again authorizing government officials and private parties to bring lawsuits as a means of enforcing federal law.

This commitment to rights assertion spanned both civil and criminal dockets. The procedural requirement in the Sixth Amendment of a right to the "Assistance of Counsel,"[49] which had sat substantively vacant in the United States Constitution for almost two hundred years, was suddenly given new meaning. The Constitution was read to insist on state subsidies for criminal defendants to protect their constitutional rights. The Supreme Court required that indigent criminal defendants be provided with state-paid lawyers who (in theory) were to be accorded respect and the requisite resources, including experts if necessary, to mount a defense.[50] Further, the idea that individuals ought to be empowered and equipped in the contest with the state migrated from the criminal side to civil litigation. The Supreme Court—borrowing Charles Reich's insight that statutory entitlements were forms of "property" to be protected from state deprivation by "due process of law"[51]—required that final decisionmaking about government entitlements employ judicial modes of process to ensure fairness.[52]

Rulemakers revamped other kinds of civil litigation to reflect a concern about the need to equip litigants and to welcome them as rights seekers, whether in conflict with the government or disputing others. Fees for access to courts were lowered, mostly by statute.[53] Congress established a Legal Services Corporation that employed lawyers, paid by the government, to represent poor litigants in certain kinds of civil disputes.[54] And a very small sliver of civil litigants—individuals faced with state efforts to terminate their status as parents—gained constitutional rights to have state-paid lawyers under certain conditions.[55]

Aggregate processing became another vehicle for enhancing access to courts. Class actions generate subsidies for litigants by relying on economies of scale to induce lawyers to serve a wider set of claimants.[56] In the 1960s, the Federal Rules were modified to facilitate large-scale litigation through a new rule on class actions,[57] which was complemented by statutes authoring consolidation across federal district courts.[58] Together these provisions reshaped the prospects of what litigation might accomplish, as did the growth in the number of lawyers, providing a diversified set of professionals who both fueled and staffed the regulatory state and ferreted out forms of injury imposed on a diverse array of individuals.

Through new information technologies, patterns of problems experienced by large numbers of individuals became visible, permitting the connection of incidents previously perceived as isolated or idiosyncratic events. Individual "cases" came to be understood as parts of "a litigation" comprising dozens or hundreds of claims. Phrases like "the asbestos litigation" or the "tobacco litigation" capture the practice of court recognition of an enormous array of parties and of varying forms of injury prompting interrelated judgments. Proceedings with hundreds and thousands of individuals, some in search of institutional reform and some in search of money, became routine. While some claims arose from tort or contract, many litigants entered the federal courts because Congress had welcomed them through enactment of new rights. The legislature embraced adjudication by authorizing litigants to bring—whether as individuals or as parts of aggregates—a widening array of lawsuits aimed at enforcing civil rights, environmental rights, consumers' rights, and workers' rights.

Another factor, under-appreciated in the literature on courts, is women's rights. As we discussed in Chapter 6, the many images of Justice as a woman did not reflect women as participants in courts. Women gained full juridical voice only in the last century, and the radical reconception of women as rightsholders, both in and outside of their families, drove up the volume of disputes. Whole fields of litigation now taken for granted—the arena denominated "family law" is exemplary—did not much exist in the nineteenth century. A growing circle of "persons" of all ages and ethnicities, sometimes as single actors and at other times in groups, obtained recognition of their rights in court. They pursued both private stakeholders and governments. State officials were themselves reconceived as subject to lawsuits holding them to their obligations. The result has been an avalanche of claimants, ranging from veterans seeking benefits within administrative tribunals to victims of crimes against humanity seeking acknowledgment of horrific wrongdoing in domestic as well as in international courts.

Adjudication's flowering in the United States can be seen through the congressional creation of hundreds of new federal rights and the filing of more cases.[59] As tracked by figure 109, the docket of the federal courts grew from under 30,000 civil and criminal filings in 1901 to more than 90,000 in 1950 and almost 320,000 in 2001.[60] Moreover, the mix changed. In 1901 more criminal than civil cases were filed; by the 1950s, the civil docket had begun to surge and, by 2001, the number of civil filings (roughly 250,000) was more than four times that of criminal filings.[61]

## From a Three-Story Courthouse in Grand Forks to Twenty-Eight Floors in St. Louis and 760,000 Square Feet in Boston

To complement the caseload bar graph, another graph (fig. 110) charts the growth in the numbers of life-tenured federal judges in the United States over one hundred years. At the beginning of the twentieth century, seventy trial judges staffed all the country's district courts nationwide. The change in the judicial landscape can be seen through a few more pictures. In the days of fewer federal filings and fewer federal rights, courthouses like the three-story 1906 federal building (fig. 111[62]) in Grand Forks, North Dakota, sufficed. As the GSA described, this "imposing architectural statement" included a courtroom whose "monumental proportions" represented "a dignity apropos of its function as a Federal courthouse."[63]

But dignity (and its employees) soon required more space. As the bar graph in figure 110 shows, during the first half of the twentieth century, the number of trial judges roughly tripled every fifty years, jumping from 70 to 212 between 1901 and 1950 and then moving up to 665 by 2001. During the second half of the twentieth century, staff for the judiciary far outpaced judgeships. About 2,770 individuals were employees of the federal judiciary (judges included) in the early 1900s, and about 5,000 were in the workforce by 1960.[64] In contrast, by 2001, more than 30,000 were so employed—creating what one (concerned) jurist calculated was a ratio of ninety-two support personnel per judge.[65]

That employment spike is reflected by the height of the Thomas F. Eagleton Federal Courthouse (fig. 112), which opened in 2000 in St. Louis, Missouri.[66] Standing 557 feet, it became the tallest and the "largest Federal courthouse in the United States,"[67] with more than one million square feet that took $200 million to construct.[68] Further, unlike the 1906 Grand Forks structure that was emblematic of its era through the denomination "Federal and Court Building," the St. Louis courthouse represents the shift to naming a federal building for a person (either a member of Congress or a local judge).[69] Here, the honor went to Thomas F. Eagleton, who served three terms in the Senate before returning to St. Louis in 1987. The architects explained their design as continuing the civic traditions of St. Louis, where "domes and columns are the icons of civic architecture."[70] The GSA termed the result a "noble Federal building . . . [that] enhances the vitality and quality of the city's downtown, and it presents the judiciary, a cornerstone of our democratic system, as both dignified and approachable."[71]

FIGURE 109    Civil and Criminal Filings
in United States District Courts, 1901, 1950, 2001

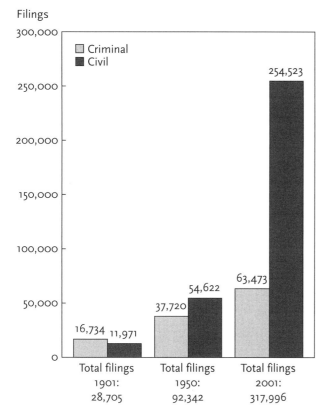

Copyright: Judith Resnik, 2008.

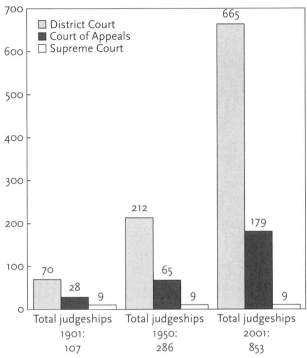

A description enables insights into the normative messages provided. One enters a towering five-story rotunda in which two-story marble columns mark a series of balconies. Inscribed on the wall are the statements "The Place of Justice Is a Hallowed Place" and "The Administration of Justice Is a Firm Pillar of Government."[72] The entry to each courtroom also has considerable stature; the vestibules outside the courtrooms have two-story windows, responsive to the judges' insistence on natural light.[73] At the sixth floor and above, the windows are sufficiently high above street level to meet security demands. Inside the courtrooms, windows also permit daylight to enter.

Twenty-five courtrooms were built for use by the District Court, the Court of Appeals of the Eighth Circuit, bankruptcy and magistrate judges, as well as by the Tax Court. Reconfigurations could make space for an additional thirteen courtrooms.[74] Although "equipped with the latest audio-visual and digital technologies, other aspects of courtroom configuration are traditional."[75] Jury boxes are near judges' benches, and some public seating is at the opposite side of the room.

The building was designed to accommodate a large number of non-judge staff. The court's tower, which the architects described as echoing nineteenth-century predecessors, has twenty-first-century functions. The many floors provide space for seven hundred judicial employees. As for the art, GSA booklets on new courthouses described installations as an "important feature of great architecture" rather than as important in and of itself.[76] According to the GSA, plans for the Eagleton building had called for an "untitled landscape project" by the artist Mary Miss.[77] What came to

FIGURE 111   The Grand Forks Post Office and Federal Courthouse, Grand Forks, North Dakota. Architect: James Knox Taylor, 1906; renamed in 2002 the Ronald N. Davies Federal Building and United States Courthouse.

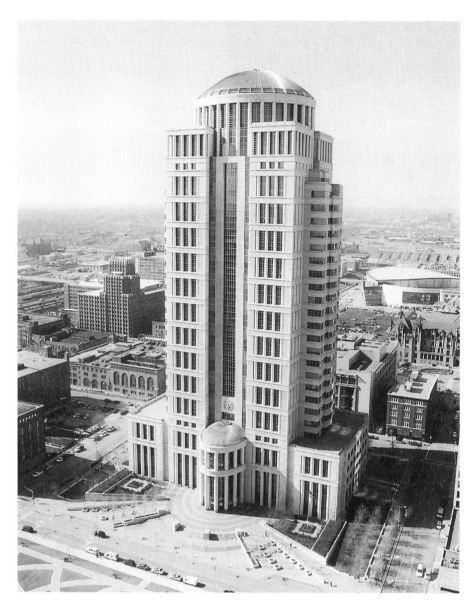

Figure 112  Thomas F. Eagleton
Federal Courthouse, St. Louis,
Missouri. Architects: Hellmuth,
Obata + Kassabaum Inc., 2000.

Photographer: The Honorable David
D. Noce, U.S. Magistrate Judge for
the Eastern District of Missouri, 2006.
Photograph courtesy of and reproduced
with the permission of the photographer.

fruition were two outdoor gardens, both named for former judges.[78]

Another late twentieth-century design aiming at the iconic is the Boston Courthouse (fig. 113[79]), which opened in 1998; in Chapter 6, we discussed it as the site of the abstract Ellsworth Kelly panels (fig. 6/93). The Boston Courthouse provides space for both the federal district court for Massachusetts and the headquarters of the United States Court of Appeals for the First Circuit, embracing Maine, New Hampshire, Massachusetts, Rhode Island, and Puerto Rico. Because the planning for the building entailed an unusual degree of deliberation and became both a model for and target of criticism about federal court construction, details of its contours are in order.

Two judges, Stephen Breyer (then on the Court of Appeals and thereafter an Associate Justice on the United States Supreme Court) and Douglas Woodlock (on the District

Court) launched and then documented the design process. The judges went outside what had been standard government procedures (detailed later) for selecting architects and enlisted expert consultants. Together they identified historic examples of courts that "were not ostentatious, flamboyant, or overbearing . . . but simple, warm, and inviting."[80] Although fully aware that historical buildings also represented courts' roles in perpetuating discrimination,[81] Breyer and Woodlock sought designs that would invoke a "conversation between generations."[82] They also had other concerns. Given that "the surrounding bureaucratic space" could "flood the building,"[83] Judge Woodlock worried that a structure might appear to be the "empty raiment of an office building" rather than a courthouse focused on the courtroom (the "pearl within the shell"[84]). Another challenge was how to craft "a secure environment without burying the courthouse's important civic program in a bunker."[85]

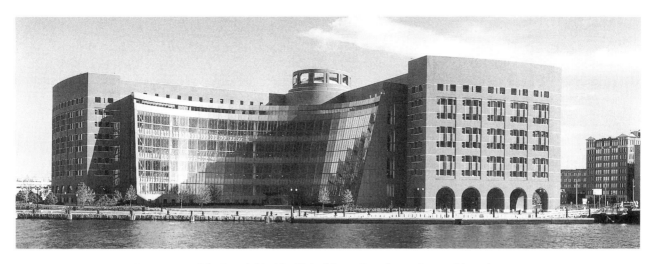

FIGURE 113    John Joseph Moakley United States Courthouse, Boston, Massachusetts.
Architect: Henry N. Cobb, 1998.

Photograph copyright: Steve Rosenthal, 1998. Photograph reproduced
with the permission of the photographer and courtesy of the court.

They settled on Henry Cobb as their architect, who cited as his inspiration a one-room 1735 building, the Hanover County Courthouse in Virginia. Translated into late twentieth-century terms, Cobb said that its "big idea" was that "every courtroom should be visible from the outside of the building and from the main space on the inside of the building."[86] The point was to give a "sense of accessibility, of transparency of the system of justice"—which was what the "courthouse is about."[87]

Thus Cobb produced twenty-seven such courtrooms in a 760,000-square-foot building named in honor of Congressman John Joseph Moakley.[88] Adorned by the Ellsworth Kelly panels, the building has garnered both praise for its architecture and criticism for its cost.[89] As the GSA's monograph on the building details, a "132-foot-high glass-domed cupola rising above the building distinguishes the entrance to the courthouse. It is a beacon that further proclaims the special status of the courthouse and the Federal Judiciary."[90] "The masonry walls connote the permanence, solemnity, and probity of the judiciary," and the craft-work reflects the "same respect for tradition" that characterizes judicial proceedings.[91]

The site overlooks Boston harbor. As the GSA explained, the building's "siting, form, layout and materials express the fundamental democratic principles of equality, fairness, openness, and accessibility."[92] The courthouse's two ten-story wings of brick form an L-shape, with windows overlooking the water; the wings are joined in the middle by a large cylindrical "hinge."[93] The entry is marked by a flat arch, and the interior is dominated by the vista of the harbor, revealed through a curving many-storied glass wall—a conoid section 88 feet high and 394 feet long that is supported by steel frames (fig. 6/92).[94] As a consequence, the entrances to the twenty-seven courtrooms on different floors

are visible from the outside. Further, to "signal the importance of the courtrooms, elliptical brick recesses with half domes—a derivation of the Greek and Rome exedra—define the entrances that lead to vestibules, which in turn lead to the courtrooms."[95] Inside, the motif of arches reappears to outline each of the four sides of the interior space of each courtroom.

The designers wanted to provide a place for community events in addition to court proceedings. The courthouse and the surrounding 2.3-acre park have "more space dedicated to public use than any other Federal courthouse in the nation."[96] On the inside, a crescent-shaped Great Hall is available for educational and cultural programs, many of which are run by a specially incorporated lawyer-supported organization.[97] Forty inscriptions—giving "permanent voice" to some of "New England's most articulate sons and daughters"—are carved into exterior and interior walls.[98] A central Registry of Designers and Builders listing the 2,500 people involved "is the final democratic element a visitor encounters before leaving the building through the main street entrance."[99] As Justice Breyer put it, the point was to provide a building that "belongs not just to the judges or courts or lawyers but to the public as well."[100]

## Housing the Corporate Judiciary

These monumental courthouses are not the only corporal embodiments of the federal judiciary generated toward the end of the twentieth century. In addition to dozens of new or renovated facilities, another building marks the judiciary's presence in Washington—the Thurgood Marshall Federal Judiciary Building, located on Columbus Circle next to a 1907 landmark, Union Station, designed by Daniel Burnham for travelers entering the nation's capital.[101] As one

FIGURE 114    Thurgood Marshall Federal Judiciary Building, Washington, D.C.
Architects: Lee/Timchula Architects, 1992.

Image courtesy of the Federal Judicial Center.

can see from the photograph in figure 114, the massive 1992 structure picked up the train station's motif of arches in a stone facade.[102] Further, it sought to establish a comparable presence, designed, as the AO put it, "to last two hundred years—proof that beauty and economy can coexist."[103]

The opening of the Marshall Building provided a new landmark reflecting two propositions—the expansion of the administrative apparatus of the federal judiciary and the judiciary's ability to garner support from the government to fund so many new facilities. The Marshall Building thus serves as the gateway to our discussion of how, in the 1980s, Chief Justice William Rehnquist, working with AO Director Leonidas Ralph Mecham and with federal judges around the country, designed the strategy that produced the most important federal building program since the New Deal.[104]

When the AO began in 1939, it shared space in the then-new Supreme Court building.[105] As the AO staff rapidly grew to number more than one hundred, employees were dispersed to various buildings in Washington.[106] Employees of the FJC (created thirty years after the AO) worked in the Dolley Madison House (fig. 115), a Federal-style structure named after the wife of President James Madison and built by her brother-in-law in the 1820s.[107] The contrast between that quaint townhouse ("one of Washington's most historic buildings"[108]) and the million square feet constituting the "monumental" Marshall Building reflects the legislative sophistication of the judiciary, which in 1975 called for the construction of a building proximate to the Supreme Court to house support services. By 1981 the Architect of the Capitol had identified the site adjacent to Union Station,

and in 1984, the Judicial Conference formally called on Congress to authorize the project.[109]

In 1988 the judiciary obtained congressional authorization to enter a public-private partnership that produced the Marshall Building ("one of the largest construction projects to be completed on Capitol Hill in over a decade").[110] Senator Daniel Patrick Moynihan of New York sponsored the legislation and then chaired the Commission for the Judicial Office Building formed to oversee construction.[111] Designed by Edward Larrabee Barnes,[112] the building cost $101 million to construct.[113] Its exterior is "clad with light grey granite that complements the stone used for Union Station," and its interior wood finish was to "look like that used in the Supreme Court Building."[114] Initially denominated the "Judiciary Office Building,"[115] a decision was made after Justice Thurgood Marshall's death to name it in his honor. The federal courthouse designed for lower Manhattan in the 1930s by Cass Gilbert was also renamed to honor Justice Marshall.[116]

The glass atrium (rising several stories and fifty-five feet) shelters green plantings as it welcomes daily some two to three hundred visitors. The building's seven floors provide space for 1600 "tenants"[117]—offering conference rooms on each floor and an auditorium for large sessions. In addition to the AO and the FJC, the building houses "other Judicial Branch agencies" such as the United States Sentencing Commission and the Panel on Multidistrict Litigation. AO Director Mecham described the Marshall Building as putting "a face on a branch of government that is spread out across the nation, and serves as a strong testament to the important

FIGURE 115  The Dolley Madison House, Washington, D.C., 1820.

Image courtesy of the Administrative Office of the United States Courts.

work that is accomplished here."[118] There the central staff of the federal judiciary compiles data, convenes meetings, plans educational programs, drafts impact statements on the possible effects of proposed legislation, and lobbies Congress on behalf of the federal courts.[119]

The AO thus deserves a special place—now literal as well as metaphorical—in any narrative on the federal courts. Under the leadership of William Rehnquist, who served as Chief Justice from 1986 until his death in 2005, the AO and the Judicial Conference impressed on the public a sense of a crisis in judicial facilities and advocated for solutions involving monumental buildings that conformed to standards set by judges. To put that process into perspective and to understand the normative implications of the current instantiations of federal justice—the buildings and the peripheral role played by their art—requires picking up the thread of federal building activities in general and sorting out the respective roles of other twentieth-century inventions: the Commission on Fine Arts, the General Services Administration, and the National Endowment for the Arts.

### Redesigning Federal Buildings

#### The Peripheral Role of "Fine Art"

In Chapter 7 we detailed the creation in the 1850s of the Office of the Supervising Architect. In contrast, no expert government body existed to provide oversight of govern-

ment commissions for other art forms.[120] The absence of an art-focused institution comparable to that dedicated to building meant that federal facilities were not laden with symbolic art. The structures—not their art—were the intended icons of the "federal presence."

By the end of the nineteenth century, however, interests aligned to press for national legislation to create an arts commission. The 1893 Chicago World's Fair appears to have energized the AIA which, joined by the National Academy of Design and the National Sculpture Society, wanted to obtain government authorization to use their own members' expertise to shape an American identity around the arts.[121] In 1901 the Senate responded with a charter for its own Parks Commission to give advice on artistic design; in large measure, the Parks Commission deployed architects to do so.[122]

Pressed further by many (including a committee chaired by Cass Gilbert), in 1910 Congress established the Commission on Fine Arts[123] that again put architects at the fore, giving them authority to design the sites for public art and often roles in awarding contracts to artists.[124] Then-President William Howard Taft appointed Gilbert to serve as one of "seven well-qualified judges of the fine arts"[125] and chose for the Chair of the Commission on Fine Art another leading architect, Daniel Burnham (who had designed Washington's train station, discussed as a model for the Thurgood Marshall Building, fig. 114).[126] Working without pay for four-year terms, commissioners were to "advise

upon the location of statues, fountains, and monuments" and the "selection of artist" for the nation's capital as well as to "advise more generally upon questions of art" when asked to do so by the President or Congress.[127] But the minimal budget and a mandate to focus on the District of Columbia limited the Commission's impact. Described in the 1970s as a "cheerleader for good design,"[128] the Commission on Fine Arts continues to function. It superintends the "development . . . along the lines of good order, good taste, and with due regard to the public interests involved" and imposes "a reasonable degree of control . . . over the architecture of private or semipublic buildings adjacent to public buildings and grounds of major importance" in the District of Columbia.[129]

A broader focus on the arts grew out of the Depression. As mapped in Chapter 6, the New Deal response produced national funds for architecture and art across the United States. For about a decade, the Section of Painting and Sculpture (in 1938 renamed the Section of Fine Arts) within the Treasury Department shaped an energetic program through running competitions as well as providing commissions. Under an executive order, the Treasury Department reserved one percent of new building construction "for 'embellishments' or public art" and over the course of its nine years sponsored more than 300 sculptures and 1,100 murals.[130] But the Section of Fine Arts had complex and conflicting relationships with the Office of Supervising Architect and, over time, was beset by anti–New Deal complaints about its support for art perceived to lean left.[131]

That Cold War shadow constrained federal support for the arts.[132] When reporting to President Dwight D. Eisenhower in 1953, the Commission he had chartered on "Art and Government" explained: "Here we have had no centralized control of art activities on the part of the Government, such as exists in many other countries. For that reason the Commission is opposed to efforts to create a Ministry of Fine Arts or to combine in a single bureau art activities now carried on effectively in a number of Government agencies."[133] But that report did call for "greater use . . . of sculpture, mural painting, mosaics, ceramics and stained glass in the decoration of public buildings."[134] Further, the Commission on Art and Government picked up the Treasury Department's concept of what came to be called a set-aside for art. The Commission recommended that the GSA reserve "an adequate amount, in relation to the cost of each building," as well as that it give "an occasional opportunity . . . to select the architect, painter, and sculptor by means of competition and in this way to discover new and promising talent."[135]

A reminder is in order, however, about the relationship between the judiciary and the various government forays into fine art. The 1953 Commission surveyed the art related to various departments of government, including the Departments of State, Treasury, Defense, Post Office, Agriculture, Interior, and Health, Education and Welfare, as well as the Veterans' Administration and the Federal Communications Commission. The report of the Eisenhower Commission made no mention of courts or their art.[136] Rather, just as the Judicial Conference of that era had spoken about "court quarters" rather than freestanding federal courthouses, neither the buildings of the judiciary nor their art were focal points. Yet fifty years later, courthouses were the signature monuments of the federal government and central sites for major government commissions to artists. Having shown some pictures of those results, we need to explain more about how they came into being.

### John F. Kennedy, Daniel Patrick Moynihan, and Government Space: The 1960s Guiding Principles

Most accounts identify the election of President John F. Kennedy in 1960 as the beginning of a new appreciation for the contributions that art and architecture could make to the civic life of the country. Prompted in part by concern about the "precarious financial underpinnings" of major cultural institutions and in part by the national government's own need for more space, in 1961 President Kennedy chartered the Ad Hoc Committee on Government Office Space.[137]

The Committee's work resulted in "Guiding Principles for Federal Architecture"—"a new quality-conscious federal attitude toward architecture . . . that led directly to a mandate for fine art in public buildings."[138] The Ad Hoc Committee was chaired by Arthur Goldberg, then Secretary of Labor, who later served on the United States Supreme Court and thereafter as the United States Ambassador to the United Nations.[139] The lead staffer was Daniel Patrick Moynihan, who later served as a Senator from New York and who helped bring the Thurgood Marshall Judiciary Building and many others into being.[140] Moynihan is given credit for the vision represented by the report[141] as well as for drafting a one-page set of "Guiding Principles" that is regularly invoked in contemporary discussions of federal buildings.[142]

The precepts that Moynihan laid out in 1962 have served since then as the touchstone for discussions of federal building in general and, when courthouse construction came in the 1990s to dominate government projects, Moynihan's presence was both literal and symbolic. The 1962 Guiding Principles also constituted a rebellion of sorts. They reflected particular distaste for the Beaux-Arts buildings that had become commonplace in federal construction as well as a dislike of uniformity in general. The Ad Hoc Committee concluded that government buildings were often undistinguished and sometimes mediocre. Further, the Committee was concerned about the banality of urban architecture and about the harms inflicted on neighborhoods by programs styled "urban renewal," which stood in contrast to certain admirable private-sector buildings.[143] The causes included, the Committee argued, unwise pressures to economize that had produced government buildings that were "the least efficient use of public money."[144]

What should the federal government seek to buy? The premise, shared across centuries by leaders of European city-states, the early American republic, and the maturing United States, was that public architecture should exemplify values. What were those values? Shadowed by the Cold War, the 1962 goals set forth a mantra repeated in the decades to follow. Federal buildings were to "provide visual testimony to the dignity, enterprise, vigor, and stability of the American Government."[145] The implicit comparison to the Soviet Union, coupled with distaste for "faceless Modern style buildings"[146] and for cookie-cutter repetition (whether Beaux-Arts or Modern), produced another premise: the need to avoid adoption of a new "official style."[147]

Rather, the "Government should be willing to pay some additional cost to avoid excessive uniformity in design of Federal buildings."[148] Preference should be accorded to designs incorporating "regional architectural traditions."[149] When wearing his academic hat, Moynihan had been a critic of highway construction that had torn neighborhoods apart;[150] the Ad Hoc Committee called for buildings to be thoughtfully sited with a "generous development of landscape" so as to be part of the "general ensemble of streets and public places."[151] Where was art in the discussion? Where "appropriate, fine art should be incorporated in the designs with emphasis on the work of living American artists."[152]

To accomplish these goals, the Guiding Principles argued that the government should not be seen as a source of "standards" for quality building. Instead (and consistent with the premises of the 1893 Tarsney Act[153]), the private sector was the place to look: "Design must flow from the architectural profession to the Government and not vice versa."[154] Competitions for design were to be held, "where appropriate," and the "advice of distinguished architects ought to, as a rule, be sought prior to the award of important design contracts."[155]

But these principles were neither recorded in law nor implemented in practice in the 1960s and 1970s; "the leading architects of the day were not bidding for government work or being asked to do it."[156] The impact and continuing vitality of the Ad Hoc Committee's work thus requires explanation. Moynihan, "a master of the arts of publicity as well as government,"[157] gave the Ad Hoc Committee's report an unusual presence for a government document. When he became a senator in 1977, his political acumen helped to produce appropriations for "expensive buildings" and legislation authorizing design competitions for various new courthouses.[158]

## Inelegant Design: The National Endowment for the Arts as Architectural Critic

Although regularly invoked in the two decades after their issuance in 1962, the Guiding Principles had relatively little operational bite. The GSA endorsed those premises under the nomenclature of "Standards for Federal Architecture," but few buildings met the goals because (as GSA publications later explained) the chief "concerns" of the GSA remained "efficiency and economy."[159] Critical attention, however, returned to federal construction as a result of President Kennedy's attention to other forms of art.

Kennedy's special consultant, August Heckscher, reported in 1963 on his survey of museum acquisitions and of publicly commissioned art ranging from stamps and performances to paintings in post offices.[160] His monograph, entitled *The Arts and the National Government,* concluded that the arts were under-appreciated and under-funded. Heckscher recommended what the 1953 Eisenhower Commission's majority report had expressly declined to do—the establishment of a national arts foundation providing federal subsidies for artists.[161] Within a few weeks, President Kennedy issued an Executive Order creating the President's Advisory Council on the Arts. After Kennedy's assassination and under the presidency of Lyndon B. Johnson, Congress established the National Endowment for the Arts (NEA) to fund (often amidst controversy) a wide range of activities.[162]

By the early 1970s, staff of the NEA had become critics of government-funded architecture. NEA staff saw that the federal government was "'into' building" rather than "'into' architecture" and hence that the 1962 Guiding Principles had not gone "far enough" to ensure that public buildings would "never repel" citizens.[163] Under the authority of a White House directive,[164] the NEA chartered its own "Task Force on Federal Architecture."[165] That group raised several concerns, including that the deliberate abandonment of distinctive national templates for government buildings during the pre–World War II era had undercut the "federal presence" by erasing the "line between the federal and private style." Both corporate and public sectors used similar styles and materials to denote important buildings.[166] The Task Force also worried about the quality of government construction, the selection of sites that isolated federal buildings from community life, the lack of attention to landscaping and art, and the inattentiveness of the "clients" (federal agencies) to the needs of the diverse users of the buildings.[167] As ameliorative efforts, the NEA group produced a series of staff reports and a major book whose title, *The Federal Presence,* we have invoked. The NEA shaped its own "Federal Design Improvement Program," encouraged agencies to open competitions for buildings and, for a period of time, gave awards for the "best" designs.[168] (That program lapsed but, in 1990, the GSA established another one.[169])

The NEA activities were part of a cycle of critique akin to the efforts that had resulted in the enactment of the Tarsney Act toward the end of the nineteenth century. Critics complained that federally commissioned buildings were miserable places either to look at or in which to work. Further, they argued that design choices were made because of patronage rather than quality. Some of the discomfort stemmed from distaste for the austerity of International-style buildings, erected to replace older buildings as part of "urban renewal."[170]

Such concerns were central to congressional hearings in 1977. There, various senators expressed concerns about the quality of federal buildings[171] as the President of the AIA called for the federal government to be "a leader in establishing high design standards and in exemplifying good design."[172] The NEA staff, in turn, reported that communities did not "fondly" regard federal buildings in their midst.[173] And, as the GSA would later describe architectural choices made into the 1980s, federal government building veered to "'safe'" and "noncontroversial designs."[174]

## Subsequent Precepts: Preservation, Conservation, Accessibility, Sociability, and Security

The focus of design was on buildings, not art. But how to identify "safe" designs (with the several possible meanings of that phrase) was becoming less clear, and the 1962 Guiding Principles had not forecast all the challenges. One could no longer rest comfortably on the assumption that if one built a building, people would come to use it. The Amsterdam Town Hall, which had centered a city through the many services under one roof, had once provided a model emulated around Europe and across the Atlantic. But the volume and specialization of government services prompted a proliferation of single-use buildings. Post offices split off from courthouses, cities sprouted suburban sprawl, and local municipal centers became less places in which people stayed to chat and more venues of long and lonely lines of those waiting for help in obtaining licenses or deeds.

The 1974 NEA Task Force report recommended that buildings have more inviting atmospheres so that federal workplaces could be both functional for and attractive to government employees while also serving to reduce the "diminished human vitality" of many downtowns.[175] In response, in 1976 Congress enacted the Public Buildings Cooperative Use Act.[176] The "cooperative" in the act's title reflected the new authority given to the GSA to lease federal building space to tenants for "social and commercial uses"— to wit, shops and restaurants[177] aiming to respond to the "perceived barrenness"[178] of federal offices. The slogan "living Buildings" captured the hope that varied activities (eating, shopping, and working) would bring people in.[179]

That 1976 legislation also picked up concerns from the 1966 National Historic Preservation Act, instructing that attention be paid to "acquiring and reusing historic and architecturally interesting buildings."[180] Therefore, before proposing new construction, the GSA was required to consider whether historic buildings could satisfy federal needs for space. The impact of the 1976 legislation was reflected more than two decades later in the GSA mission statement that it was

> responsible for providing work environments
> and all the products and services necessary to
> make these environments healthy and

productive for Federal employees and cost-effective for the American taxpayers. As builder for the Federal civilian Government and steward of many of our nation's most valued architectural treasures that house Federal employees, GSA is committed to preserving and adding to America's architectural and artistic legacy.[181]

In addition to sociability and historicity, attention turned in the 1970s to the environment and to the challenges of persons with disabilities. In 1969 Congress had enacted the National Environmental Policy Act,[182] which required federal construction to address the impact of new building on natural resources and habitats. Within a few years, the GSA came to describe its buildings as incorporating "energy conservation technology."[183] Aiming to save costs, to commit federal funds to support urban centers, and to encourage use of public transportation, the GSA developed performance goals and energy conservation standards. Words such as "sustainability" and "green" entered the lexicon. Further, worried about their own health and comfort, office workers sought better lighting, ergonomic works stations, and control over room temperatures.[184]

The 1962 Guiding Principles had called for buildings to "be accessible to the handicapped,"[185] but no enforcement mechanism had followed. Earlier aspirations for grandeur made courthouses particularly challenging to negotiate. Many staircases forming processional entries to public spaces functionally barred those who could not walk. In 1968 Congress took up the aspirational terms of the Principles and required (in the obliquely named Architectural Barriers Act of 1968) that any building constructed for or used by the United States government had to meet standards to ensure "that physically handicapped persons will have ready access to, and use of, such buildings."[186] Congress instructed the GSA and other federal agencies to prescribe guidelines for accessibility design that resulted in uniform federal accessibility standards.[187]

In 1990 federal law went further in the Americans with Disabilities Act (ADA), which mandated accessibility in state and private facilities.[188] But problems of compliance were pervasive. For example, in public hearings convened in the late 1990s at the behest of the Chief Justice of California, some 60 percent of the speakers reported on physical barriers to courts followed by mobility problems for those who could make it past the entrance.[189] California's specially chartered task force detailed the many courts that could be entered only by traversing stairways that sometimes lacked even handrails. The state's Access and Fairness Advisory Committee recommended that a "substantial improvement in physical access" be a priority, along with changing signage, providing transportation, and educating staff to make accommodations for people with disabilities.[190]

In 2004 the United States Supreme Court upheld a provision of the ADA that permitted individuals to seek monetary damages from states for failing to comply with the federal law requiring accommodations to enable persons with disabilities to use courts.[191] As the bare majority described the underlying facts of the case at bar (a sadly apt phrase), the plaintiff George Lane, who was wheelchair-bound because he was a paraplegic, had "crawled up two flights of stairs to get to the courtroom" in Tennessee where he was to answer to criminal charges.[192] When the case was argued before the Supreme Court, several newspapers ran photographs of the grand steps of that building as demonstrators climbed those stairs on their hands and knees (fig. 116).[193] Determining that states were not immune from damage actions, the Court explained that "affirmative obligations" flowed because access to courts was such a foundational constitutional value.[194]

In addition to sociability for workers and users, environmental friendliness, preservation, and accessibility, the other factor that reformatted federal buildings during the last decades of the twentieth century was security. In 1975 a bomb was found in a locker at Grand Central Station in New York City—prompting what in hindsight were very modest measures of security at federal courthouses. As a former Chief Judge of the Eleventh Circuit (the federal courts in Alabama, Florida, and Georgia) noted, the public could then easily enter courthouses; "in the South, anyone could walk into a district judge's chambers, the door was open."[195] By the 1990s, the vulnerability of federal sites became painfully evident. In 1995, Timothy McVeigh bombed an Oklahoma City federal building that also housed a day care center and killed more than 160 people.[196]

Although Daniel Moynihan insisted, "We will not let Timothy McVeigh be our most influential architect,"[197] the

GSA and the federal judiciary have since focused a good deal on barriers and fortification.[198] The part of the federal judiciary's budget devoted to security grew from $42 million in 1989 to $185 million in 1999, representing a 335 percent increase, adjusted for inflation.[199] Indeed, security became the "Objective No. 1" in a late 1990s GSA guide for architects and engineers competing to obtain commissions.[200] That guide emphasized the importance of physical barriers, surfaces that could withstand "ballistic or blast attacks," and it also required control over vehicle access, enclosed parking for federal personnel, screening for both persons and parcels, and installing surveillance devices to monitor movements about buildings. In addition, designers were to provide "dedicated, separate, and restricted corridors" as well as elevators for the exclusive use of judges to provide "safe movement within the building."[201] The September 11, 2001, attack on the World Trade Center in New York reinforced these concerns.

More generally, and reflecting an amalgam of precepts from the 1962 Guiding Principles and the post-1970s developments, the GSA listed the other facets it would evaluate when making selections among design proposals. After security, the other criteria were (in the order discussed) "Optimum Tenant Productivity," "Space Flexibility," "Acoustic Quality," "Accessibility," "Fire/Life Safety," "Seismic Safety," "Building Structure Integrity, Durability, and Maintainability," "Building Systems Energy Efficiency," "Emergency Systems/Reliability," "Materials Handling Efficiency," "Building Automation," "Innovative Technologies," and "Project Cost Containment."[202] Thus the GSA was seeking proposals of "architectural merit" ("sensitive to the art and architecture of the region") that created "a community presence" while ensuring a "safe, efficient, flexible, comfortable, and healthy environment."[203]

FIGURE 116  Photograph of demonstrators on the plaza and steps of the United States Supreme Court, accompanying the news story "Court to rule on protections for disabled," Associated Press, January 14, 2004.

Photographer: Gerald Herbert. Copyright: Associated Press. Reproduced with the permission of the copyright holder.

## GSA's Design Excellence Program

To accomplish its goals, the GSA retooled its processes for awarding architectural commissions as it responded to criticisms from the NEA, various senators, and the AIA. The agency acknowledged the dearth of "creative or imaginative" government design work.[204] While some great buildings had been built in various states (such as the 1950s Marin County Civic Center in San Rafael, California by architect Frank Lloyd Wright[205] and the 1970 Paul Rudolph courthouse in Goshen County, New York[206]), relatively few impressive federal buildings stood alongside them.

For example, in 1990, when the GSA revived what had been the NEA program of giving awards for notable structures, the first set of honors went primarily to "historic buildings designed by dead architects."[207] Those words come from the explanation by the GSA of its decision to shift to the "excellence" model. As its model, the GSA relied in part on the process crafted by Justice Breyer and Judge Woodlock, who had enlisted sophisticated consultants when shaping the Boston Courthouse, designed by Henry Cobb and adorned with panels by Ellsworth Kelly.[208] In 1994 the GSA formally adopted its Design Excellence Program—aiming to attract world-renowned architects to federal projects.[209]

Recall that Daniel Moynihan is credited with coupling political acumen and creative commitment that reshaped federal building aspirations in the 1960s. His counterparts in the 1990s were Robert Peck, Commissioner of the GSA's Public Buildings Service from 1995 to 2001, and Ed Feiner, the GSA's Chief Architect from 1996 to 2005.[210] Peck, who graduated from Yale Law School, had gone on to work at the NEA before becoming Chief of Staff for Senator Moynihan and then spending time practicing real estate law; Peck also had deep connections to the AIA, which he had served as a Vice President.[211] His admirers saw him as an "unusual friend of cities" and praised his commitments to "preservation, downtown revitalization, [and] fostering civic spaces."[212]

Peck put Ed Feiner ("Uncle Sam's design conscience"[213]) in the role of Chief Architect; Feiner oversaw government building until his retirement in 2005.[214] Running "the biggest federal building program since the New Deal,"[215] Feiner rejected the "concrete bunkers and gun-slit windows of the Great Society buildings" in favor of innovation aimed at inspiring "esteem" for the government. Advocates of "progressive, humane design in the civic sphere,"[216] Feiner and Peck made "the GSA more hospitable to design-minded architects."

The GSA reengineered procurement procedures that had produced a "cumbersome, time-consuming, and costly process that relegated creativity and quality to the bottom of the evaluation criteria."[217] The GSA shifted from submissions of building mockups to selections based on architects' portfolios and their brief statements of intent.[218] As it explained in its "Design Excellence Program Guide," competitors went through a three-stage process—submitting portfolios, being interviewed by a team of evaluators, and then entering the "Vision Competition"—by making proposals for "design concepts."[219] The GSA occasionally advertised its program ("Design Competition New United States Courthouse, Los Angeles, California—700,000+ gross square feet, $220M+ construction cost"[220]), as the GSA both invoked Moynihan's aspirations for buildings that would provide "visual testimony to the dignity, enterprise, vigor, and stability of the American Government"[221] and added another goal, "diversity."[222]

Feiner mediated between traditionalist federal judges and contemporary architects as he sought to wean judges from the classical Greek idiom. As Feiner explained, the judges "come to see that these buildings represent not Greek or Roman ideals but American ideals.... [W]e are using American statements and iconography for the first time."[223] Feiner also convinced architects that it was worth their while to work with judges to develop buildings acceptable to both. ("I like to tell architects that they get one opportunity to make their lasting presence on the landscape of this country."[224])

Under the Design Excellence Program, the GSA invited "distinguished private-sector professionals . . . to serve as 'peers'" to review proposed concepts for buildings.[225] The National Register of Peer Professionals began with twenty-three architectural experts in 1994; by 2002 the National Register included 350 and had expanded to include "engineers, interior designers, landscape architects, urban planners, and artists."[226] Initially used in relationship to buildings costing $25 million or more, the Design Excellence approach came to apply to "virtually all new GSA construction projects" as well as to renovations.[227] By 2004 the GSA Design Excellence Program had been "responsible for the selection of architects for several hundred federal projects worth more than $10 billion."[228] The roster of designers succeeded in attracting world-famous architects. Federal courts have been designed by several, including Henry N. Cobb (in Boston, Massachusetts); Richard Meier (in Islip, New York, and Phoenix, Arizona); Robert Stern (in Savannah, Georgia, Beckley, West Virginia, and Youngstown, Ohio); Thom Mayne (in Eugene, Oregon); and many others.[229]

The GSA's stated goals were to create federal buildings that were "welcoming, accessible, and participatory," facilitating a sense of openness through "clear glass that allowed views of interiors" and making plain a "cost-conscious, nonauthoritarian, sensitive and inclusive government."[230] By 1998, the GSA argued that it had succeeded in providing "the American public with government office buildings and courthouses that are not only pleasing and functional, but that also enrich the cultural, social, and commercial resources of the communities where they are located. Such public statements of American culture are meaningful contributors to the vibrancy of our democracy."[231] Buildings—not imagery, allegorical or not—provided the normative thrust and, in the 1990s, federal courthouses became the signature government projects and the sites of much of the public art commissioned during that decade.

# Late Twentieth-Century United States Courts: Monumentality, Security, and Eclectic Imagery

### "Judicial Space Emergencies"

The next landmark in a narration of the history of federal courts and of federal building is the commitment by Congress to replace, expand, and renovate hundreds of courthouse facilities.[1] In constitutional law circles, Chief Justice William Rehnquist is appreciated for his strategic capacity to change the contours of many legal doctrines. He should also be appreciated as an equally brilliant administrative strategist who, working with judges across the country and the judiciary's D.C. staff, had a profound impact on the budgets for and the footprints of courthouses. Rather than complain as architectural critics might (and have) about how dreary the buildings were, the federal judicial leadership conveyed a sense of urgency—that the inadequate housing for the judiciary put both the system and the safety of its workers in jeopardy.

During the Rehnquist era, plans were made for 160 courthouse constructions or renovations, to be supported by $8 billion.[2] While not all those plans came to fruition, the federal judiciary tripled the amount of space it occupied in the largest buildings program since the Great Depression.[3] As portrayed in figure 117, borrowed from the federal judiciary's monthly newsletter *The Third Branch*, construction projects were sited around the United States.[4] In the decade between 1996 and 2006, the judiciary gained "46 new courthouses or annexes at a cost of $3.4 billion," with more underway.[5]

Recall that from the 1940s through the 1960s, the focus had been on "court quarters," not courthouses. Furthermore, in the post-war period, Judicial Conference committees had reported their confidence in the General Services Administration's (GSA) Supervising Architect, who was praised for his "painstaking care" and "thorough understanding," reflected in the 1946 manual he had prepared.[6] Working under that system for over thirty years, the judiciary accumulated a fair amount of space. By 1972, staff of the Administrative Office (AO) of the United States Courts

reported that the appellate courts had 33 courtrooms and the trial courts 661, providing a total of 694 courtrooms for use by federal judges.[7]

Yet, during the 1970s, the AO became increasingly distressed with the GSA. In hearings before a House Subcommittee in 1983, AO staff member James Macklin reported on persistent "problems in the delivery of services" that caused expensive delays.[8] Further, Macklin testified that some judges believed that housing delays were "caused by incompetence or intransigence at the regional level of GSA."[9] Cooperative efforts at the national level were part of a solution, Macklin opined, and one such example was the drafting in 1979 of design guidelines for courts that the AO had developed in coordination with the GSA.[10]

The parameters of that guide were shaped, in part, by the views of Chief Justice Warren Burger (Chief Justice Rehnquist's predecessor) and the Judicial Conference's Ad Hoc Committee on Court Room Facilities and Design,[11] as they dealt with more demands for space and limited dollars. In 1968, Congress had created the auxiliary position of "magistrate" (later renamed "magistrate judge") to license a cadre of judicial officers without life tenure—initially with a more limited mandate that grew over the decades that followed.[12] In 1978, Congress authorized a major increase in new life-tenured judgeships—adding 117 district and 35 new appellate appointments.[13] These expanding judicial resources reflected growing numbers of filings, including various kinds of high-profile cases such as those involving civil rights.

In the 1970s, the judicial leadership responded to the influx of new judges with proposals to downsize courtrooms and to share space. In light of an increase in building costs, new technologies, and needs for "greater security and to simplify court room control," the Judicial Conference recommended that the size of courtrooms be "cut back substantially" as long as each courthouse had "one or two large court rooms for special cases."[14] The 1970s Conference adopted a policy that judges could share courtrooms when possible: courtrooms needed to be "available on a

FIGURE 117   Construction and/or Site & Design Projects, 1985 to Present,
graphic, *The Third Branch: Newsletter of the Federal Courts* (Dec. 2002).

Facsimile, Yale University Press.

case assignment basis to any judge. No judge of a multiple judge court should have the exclusive use of any particular courtroom."[15] That injunction can also be found in a 1979 federal court *Design Guide* prepared by the GSA in cooperation with the AO.[16] This less courtroom-centric approach also fit with Chief Justice Burger's commitment to "alternative dispute resolution" (ADR) programs such as mediation or arbitration and, more generally, with his interest in retreating from an expansive role for federal adjudication that is identified with Earl Warren's chief justiceship during the 1960s.

In the late 1980s, Chief Justice Rehnquist and his senior staff took another tack on courtroom size and allocation—that dedicated, more, and larger spaces were needed. Instead of the policy of courtroom sharing embraced under Chief Justice Burger, the judiciary shifted to the presumption that each judge needed a courtroom of his (or her) own.[17] Specifically, "one courtroom must be provided for each active judge,"[18] including magistrate and bankruptcy judges and ideally those "senior judges" who had formally shifted from "active" status to make another slot available for the constitutional appointment process. Extra courtroom spaces were also needed for "visiting judges" who augmented a district's workforce. Given the increased number of judgeships, the one-courtroom-per-judge approach translated into a more severe housing shortage than did a shared courtroom policy.

During the late 1970s, the GSA, working with the AO, had developed guidelines for court construction.[19] But, by the late 1980s, the AO reported "excessive delays and costs related to the acquisition and management of space and facilities."[20] Enlisting the National Academy of Public Administration, the AO explored whether responsibility for "defining requirements, designing, leasing, constructing, managing, and performing other functions related to space and facilities" could be transferred from the GSA to the AO.[21] Thereafter, the judiciary sought to distance itself from the GSA by gaining authority to expand its own building stock and to take charge of courthouse design.[22]

In 1989 the judiciary proffered the term "Judicial Space Emergency" to capture concerns about its "housing crisis"[23] stemming in part from what it saw as the GSA's failures. As Ralph Mecham, Director of the AO, explained, "During the 1980s, when the federal judiciary experienced its greatest caseload growth in history, very few courthouses were built, which resulted in a proliferation of court facilities with varying degrees of deteriorating and overcrowded conditions."[24] The AO complained of the "years of lack of attention from GSA"[25] and estimated that (as of 1994) "186 court buildings will be unable to accommodate additional judicial officers within the next five to 10 years."[26] (The judiciary was not the only unhappy "customer"; the GSA's "much advertised and deplored deficiencies" had prompted congressional oversight and intra-agency evaluations.[27])

To resolve what had become a "vexing relationship" with the GSA, the judiciary sought legislation to wrest power from the GSA.[28] The goal of obtaining independent real property authority became "a top legislative priority" in 1991,[29] as the judiciary argued that the "provision of space and facilities" by the GSA left it "a separate and independent branch of government . . . fully dependent on another branch."[30] Members of Congress (including Daniel Patrick Moynihan) proposed

companion bills in the Senate and the House to give the judiciary authority to buy land "independent of GSA" so as to turn the Public Buildings Service into the "judiciary's agent rather than its landlord."[31] Despite Senator Moynihan's support, GSA objections sent the question back for negotiations between the AO and the GSA.[32] Although the provision did not become law, in 1991 the judiciary won "a comprehensive review of court space needs and the initiation of a major courthouse construction program."[33]

To garner support for expansion, the judiciary made the case for more and better space to various audiences, with diverse and important exchanges between federal judges at the local level in contact with members of Congress.[34] Both media reports and congressional appropriations reflect the success of the judiciary's framing of the problems. As one reporter explained, facilities were inadequate given the "complicated modern trials in which teams of lawyers crowd federal courtrooms to litigate multi-party mob and drug conspiracy sagas burdened with casts of expert witnesses."[35] Further, staff had no place to work; the size of the judicial workforce had "jumped 76 percent" over twelve years.[36] Moreover, went the popular descriptions, the old courthouses were "nightmares for the federal marshals in charge of security, mainly because existing circulation forced the public, judges, and defendants to traverse the same corridors and use the same restrooms."[37]

Some accounts also acknowledged the judiciary's strategic efforts, reporting that the AO "alerted the GSA in 1989 that a massive construction project would be needed just to keep the courts functioning. Ever mindful of the pork potential, Congress bought into the idea" and underwrote 169 courthouse renovations and new buildings, launching the "largest public construction spree since the New Deal."[38] In 1991 (called by the AO "a watershed" year), the judiciary secured $868 million in new construction and, between 1985 and 1999, it secured approval for projects "totaling $3.5 billion."[39] As funding flagged in the late 1990s when the Executive Branch did not prioritize courthouse construction, the AO described how it "launched a full court press," enlisted judges to obtain funds directly from Congress, and was "ultimately successful."[40] The GSA concurred, reporting in 2006 that, in the decade before, it had "delivered 46 new courthouses or annexes . . . at a cost of $3.4 billion."[41]

## Court Design Guides

Another (wise) step taken by Chief Justice Rehnquist was, in 1987, to use his position as Chair of the Judicial Conference of the United States to charter a standing subcommittee devoted to "space and facilities."[42] That committee was charged with the oversight of long-term planning, construction priorities, and design standards. Further, while Congress did not enact the judiciary's 1991 bill to extricate itself from the GSA, the judiciary found an alternative route to increasing its authority over courthouse building. The AO created its own Space and Facilities Division and recruited former GSA employees to take leadership roles.[43] To document space needs, the AO developed "guidelines and worksheets" for judges to explain their problems, district by district and courthouse by courthouse. Such "long-range facility planning" was, according to the AO, "an essential building block toward the Judiciary's successfully managing its own space and facilities program."[44] By 1994, the judiciary had thus "identified approximately 200 of 731 existing court facilities as 'out of space'" within the coming decade.[45]

Another "building block" in the process of gaining judicial authority over space was the drafting by the judiciary of its own "design guide." First published in 1991 and revised several times thereafter,[46] the U.S. Courts Design Guide put judges at the forefront by issuing "policy guidance for the overall planning, programming, and design of federal court facilities throughout the United States and its territories."[47] As the introduction explained, one of the Design Guide's "three major objectives" was to provide "relevant information" to the GSA and architectural/engineering teams "to effectively plan, program, and design a functional, aesthetically appropriate, and cost-effective court facility."[48] In addition, to improve in-house expertise, the Administrative Office approved requests for judicial circuits to hire their own architects, who then worked with GSA personnel to oversee proposed and pending projects.[49]

## Rescaling the Proportions

The U.S. Courts Design Guide's dozen-plus chapters detailed "state-of-the-art design criteria for courthouses."[50] By creating its own manual, the judiciary trumped GSA planners who had long set forth standards for public buildings,[51] including the 1979 and 1984 Design Guides that the GSA had written "in cooperation with the Administrative Office of the United States Courts" for "architects and engineers who design federal courts."[52] Flipping back and forth between the 1979 and 1984 GSA Design Guides and the subsequent U.S. Courts Design Guides produced by the federal judiciary clarifies how the vision for federal courthouse buildings changed and the size of courtrooms grew under the aegis of Chief Justice Rehnquist.

What were the GSA "design goals" expressed in the 1979 and 1984 volumes? "An important characteristic in a court's design is flexibility within its operational space. . . . The designer is encouraged to use open planning techniques in areas where specific function permits."[53] Moreover, while emphasis had been placed on "expressing the dignity and solemnity of the administration of justice," that aspiration needed to be balanced by designs aiming to enhance the "efficiency of performance."[54] The utilitarian 1979 and 1984 GSA manuals described aspects of the federal judiciary[55] and suggested a decentralized process by which the "design team" would sort out how to accomplish what was

needed.[56] The 1984 *Design Guide,* which, unlike the 1979 version, was formally approved by the Judicial Conference, did put judges a bit more in view. The 1984 discussion included a paragraph recommending that architects, before design began, "meet with the chief judge" and other court representatives to gain an understanding of courthouse functions.[57]

In contrast, the importance of the federal courts and their judges are central to the judiciary's *U.S. Courts Design Guides.* As the 1991 *Guide*'s discussion of "Aesthetic Considerations" explained:

> Federal Court architecture should symbolize the Judiciary as a co-equal branch of Government. Courthouse design should reflect the seriousness of the judicial mandate and the dignity of the judicial system.
>
> The scale of a courthouse should be monumental, and the materials used on its exterior durable. The spirit of the architecture should be impressive and inspiring. . . .[58]

The 1997 version modified but expanded on those ideas under its "General Design Guideline." Instead of monumentality, the 1997 *Guide* explained:

> The architecture of federal courthouses must promote respect for the tradition and purpose of the American judicial process. To this end, a courthouse facility must express solemnity, stability, integrity, rigor, and fairness. The facility must also provide a civic presence and contribute to the architecture of the local community.
>
> To achieve these goals, massing must be strong and direct with a sense of repose, and the scale of design should reflect a national judicial enterprise. All architectural elements must be proportional and arranged hierarchically to signify orderliness. The materials employed must be consistently applied, natural and regional in origin, durable, and invoke a sense of permanence. Colors should be subdued and complement the natural materials used in the design.[59]

The 2007 *Design Guide* offered a modest variation, by replacing the sentence "massing must be strong" with the admonition that "[c]ourthouses must be planned and designed to frame, facilitate, and mediate the encounter between the citizen and the justice system."[60]

Moving from overall aspirations to specific provisions, both the GSA and the judiciary's design guides address courtroom and building layouts.[61] The *GSA Guides* had dis-cussed two areas within a courtroom, the "activity zone" for formal proceedings and the "public zone" where observers could sit.[62] For courtroom sizes, the 1984 *GSA Guide* relied on Judicial Conference decisions under Chief Justice Warren Burger who, as noted, supported alternative dispute resolution and had proposed small ("Tom Thumb") courtrooms. While the 1946 Judicial Conference guidelines had called for 2,200-square-foot courtrooms,[63] in the 1980s when Chief Justice Burger presided, the Judicial Conference downsized somewhat, settling on four sizes of courtrooms ranging from 1,120 square feet to 2,400 square feet.[64] The 1984 *GSA Design Guide* incorporated those standards and also detailed the height for ceilings—twelve feet, except for the large courtroom, where heights of sixteen feet were recommended.[65] As for the number of courtrooms, the 1979 *GSA Design Guide* had specified that, in accordance with Judicial Conference resolutions, "no judge of a multiple-judge court will have the exclusive use of any particular courtroom."[66] Although it was tacitly still the policy, that comment was not included in the 1984 version formally approved by the Judicial Conference.

Once the judiciary was the author of its own *Design Guide,* the dimensions changed and the commitment to a courtroom for each judge became entrenched. The judiciary's 2007 *Guide* prescribed 2,400 square feet for a district judge's courtroom, with ceilings sixteen feet high; 1,800 square feet for magistrate and bankruptcy courtrooms, and appellate courts varying from 3,000 square feet for the full ("en banc") court to 1,800 square feet for three-judge panels.[67] The ceiling heights were to "contribute to the order and decorum of the proceedings,"[68] and the 1997 *U.S. Courts Design Guide* noted that ceilings could be raised higher than sixteen feet if additional height space was "available at minimal additional cost."[69]

The judiciary's design guides also detailed the layout of courtrooms as well as some of the decor of judges' benches, jury boxes, witness stands, and lawyers' tables: "Finishes in the courtroom must reflect the seriousness and promote the dignity of court proceedings."[70] Millwork similarly needed to "complement the aesthetics and dignity of the courtroom."[71] Capacious jury boxes were required, designed to accommodate eighteen jurors so as to be useful for grand juries as well as petit juries and to provide space for alternates.[72] While a few items such as lecterns could be movable, most of the furnishings were to be affixed to the floor.

Public space was also specified, with benches for observers set at the far back of the room. The presumption was that "spectator and media attendance" at most appellate hearings would be "minimal"; forty to eighty seats sufficed for regular appellate courtrooms.[73] At the trial level, constitutional guarantees of "public" trials necessitated "a certain volume of general public seating," so sixty-five to eighty-five seats ought to be made available.[74] The cost of each such courtroom and its adjacent office spaces was estimated to

be, on average, about $1.5 million.[75] Translating that figure (and many others for the rest of the spaces in courthouses), the forty-five projects planned for the time span between 2002 and 2006 were budgeted to require $2.6 billion.[76]

In keeping with its "more aggressive role in managing its own space program,"[77] the Judicial Conference also provided for "variances" that permitted courtrooms larger than the standards set forth in its own design guides. The Conference empowered its standing Committee on Space and Facilities to authorize changes.[78] For a few years, terms such as "exceptions," "deviations," "waivers," or "departures" were instead described as "special requirements."[79] (That euphemism was rescinded in 2005 in the wake of conflicts with Congress over space, and the Committee returned to its earlier terminology.[80])

In addition to the dimensions of courtrooms, the size of judicial office space also grew over the years. The 1979 and 1984 *GSA Design Guides* had proposed the standard of 1,600 square feet for trial judges' chambers and 1,800 to 2,200 for appellate judges' suites, a figure that included areas for a secretary, law clerks, and books.[81] The 1997 *U.S. Courts Design Guide* called for more capacious rooms: chambers for trial judges were to be 1,840 square feet and chambers for appellate judges to be 2,480 square feet.[82] The winds of austerity (detailed later) prompted some scaling back; by 2007, appellate chambers were to be closer to the 1984 GSA numbers.[83]

### Routing Circulation to Avoid Contact

Segregation of space inside a courtroom—with litigants separated from the lawyers and judges by a bar—is a perennial topic; movement into courtrooms and around buildings is another. Congressional records from the 1830s reflect judicial distress at having to "pass through the courtroom to get to the bench." Federal architect Robert Mills responded by redesigning the access route so judges went "through the marshal's room" to enter the courtroom.[84] A century later, the 1984 *GSA Design Guide* accorded judges "a private passage" into courtrooms.[85]

More generally, in 1984 security concerns were reflected in calls for chambers to be located above the ground-floor level and for judges to be able to get from the parking lot to their office spaces "without public contact."[86] Other details —the need for alarms, emergency lighting, the keying of elevators to permit private use by judges and, in new construction, the provision of one or more elevators exclusively for judges—were consigned to an appendix.[87] That approach mirrored that era's annual reports of the Judicial Conference, which noted that security was needed and commended an "appropriate separation" for participants so that judges, juries, witnesses, and the public need not all share the same entrance. Yet those issues were not at the forefront.[88] As one judge recalls, during that era "[p]ublic access was practically . . . unlimited."[89]

Tragic shootings of judges and bombings of federal buildings brought security to the forefront by the 1990s. By twentieth century's end, the pattern of three circulation routes—"public, restricted and secure"[90]—had become a common feature of courtroom construction, both state and federal. New design standards provided for separate entries, elevators, and corridors for the public (civil litigants included), for judges, and for criminal defendants. Passage in and out of courthouses was also to be secured. Design proposals were to specify how judges could enter buildings through "a restricted parking structure within the confines of the building. From this restricted area, they have access to a restricted elevator system that transports them to their chambers and courtrooms," all connected to clerks' offices through a "restricted and private judges' circulation system."[91] Prisoners were likewise walled off, entering through a secured sally port and held in a central cellblock.

While the public was to have a sense of "free movement"[92] after passing through security at entrances to courts, and while the interiors were to be "barrier free" and "accessible" to persons with disabilities,[93] boundaries were thus guarded.[94] The courtroom (when in use) served as the place for "interface" among the differently routed individuals, but that space remained segregated internally, with each group entering through different doors and sitting in designated areas.[95] Courthouses were also vertically segregated (or "stacked"), with offices for judges placed on higher floors and the public and staff on the floors below.[96]

The segregation of spaces aimed to avoid what the press had described as the "nightmares" of the public, judges, and defendants mingling. Inscribed through the various routes is the premise that these different users ought not—either sequentially or concurrently—be in the same halls, elevators, or other spaces.[97] As interior spaces are so allocated, a sense of security presumably flows from warding off what one critic called the "contamination" emanating from criminal defendants and potentially disruptive spectators.[98] Rather than trying to disaggregate the relatively small number of terrifying individuals from the many law-abiding ones, all defendants are classed as potential risks. Moreover, to the extent that any of the texts or imagery inscribed on the walls aim at didacticism or that windows and skylights bespeak transparency, the narrow path through secure tunnels and bridges taken by defendants excludes them from the normative prescriptions offered.

Because the three circulatory patterns buffer against the possibility of such contact, "circulation space often accounts for 30 to 50 percent of the usable space in a building."[99] Indeed, the multiple paths and security add significantly to the costs; as early as 1993, the GSA estimated that courthouses cost "at least $44 per gross square foot more to build than a comparably sized federal office building," and thus estimated that courts cost about $160 per gross square foot.[100] Not only are remarkable amounts of space devoted

to ensuring that people do not meet each other; remarkable amounts of funds are allocated for that separation.

## *Dedicated Courtrooms*

The other central judicial policy decision of the 1990s was to revisit the idea that judges could share courtrooms. Instead of the premises of the Burger years that courtrooms were to be "available on a case assignment basis to any judge" and that no judge on multi-judge courts was to have "the exclusive use of any particular courtroom,"[101] Chief Justice Rehnquist's Judicial Conference took the position that a courtroom had to be dedicated to each judge.[102] As recorded in the 2007 *U.S. Courts Design Guide:*

> Recognizing how essential the availability of a courtroom is to the fulfillment of the judge's responsibility to serve the public by disposing of criminal trials, sentencing, and civil cases in a fair and expeditious manner, and presiding over the wide range of activities that take place in courtrooms requiring the presence of a judicial officer, the Judicial Conference adopts the following policy for determining the number of courtrooms needed at a facility:
> With regard to all authorized active judges, one courtroom must be provided.[103]

Further, until 2008 the Judicial Conference left the question of dedicated courtrooms for "senior," "visiting," and magistrate judges to decentralized decisionmaking.[104] Then, faced with conflicts over rent and congressional oversight (detailed later), the Conference moved to the position that in new court construction, senior trial judges were to share courtrooms, as might magistrate judges and possibly others.[105]

As the courtroom-of-one's-own discussion suggests, the late twentieth-century courthouse focused on the courtroom as its centerpiece—the "pearl within the shell" to borrow Judge Douglas P. Woodlock's terminology.[106] For a brief period of time, the judiciary's *Design Guides* also called for "alternative dispute resolution suites"—spaces designed for mediation, arbitration, or settlement conferences rather than courtrooms laid out for trials.[107] Amendments were formally made in 1994 to incorporate that change, but 2007 revisions—made in a context of fiscal limitations—deleted those provisions rather than calling for courtroom sharing or reducing the size of courtrooms.

On many metrics, the judiciary's work—intersecting with the retooled GSA Design Excellence Program—succeeded, garnering praise for both agencies. As the judiciary's monthly newsletter reported in 2002, the new procedures and guidelines provided a "Renaissance" for federal courthouses that had previously been "box-like structures."[108] Allusions to pre-Enlightenment Europe also came from architectural critics, who described the era as the "golden age of federal architecture"[109] and invoked the parallel of the patronage of the Medicis.[110] The Design Excellence Program itself received awards from the National Design Museum and the American Architectural Foundation, among others.[111] In 2004, the Center for Architecture in downtown New York City held an exhibit, "Civic Spirit: Changing the Course of Federal Design," displaying drawings, models, and photographs of some twenty buildings, all exemplary of the "future of federal design."[112] Of the courthouses shown, several broke with various conventions, departing either from a "linear layout" or from a single structure for chambers and courtrooms.[113] Descriptions invoked the openness provided by the glass that, after dark, lent some of the new buildings a resemblance to beacons or lanterns.

Amidst the celebrations, some conflicts existed between the "trads" (traditionalists) and "rads" (post-modernists), prompting the Office of Chief Architect of the GSA and the Design Excellence and the Arts Program to convene a conference, "Function, Form, and Meaning: Design Excellence in Federal Courthouses," to review the portfolio of buildings and to reflect on future directions.[114] The 350 people assembled in 2007 by Chief Architect Les Shepherd and Director Tom Grooms renewed the commitments to the vision of Daniel Moynihan, Ed Feiner, and Robert Peck—that courthouses provide "a sense of place and vitality [through] appropriate scale and symbolic value."[115] The montage in figure 118 (color plate 29) of nine courthouses that were built or renovated between 1998 and 2008 by world-renowned architects (such as Henry Cobb, Richard Meier, Thom Mayne, Michael Graves, and Robert Stern) captures some of the exuberance.[116]

## Negotiating Rent and Space

More than a century ago, in 1878, a member of the House Committee on Public Buildings and Grounds noted that forty-one proposed bills had come before that body for construction of federal buildings. In support of such proposals, he argued that the government was then "paying about $1,300,000 annually for rent of public buildings" and that "this enormous rent should be decreased as much as possible" through its own construction programs.[117]

In retrospect, those were halcyon days in terms of the cost of space. For fiscal year 2005, the federal judiciary reported paying the GSA more than 20 percent of its budget ($990 million) in "rent" for occupying forty million square feet[118]—albeit with some significant amount of that money recycled to the federal judiciary as part of new building funds. Readers might well be perplexed at the idea that rent is the word used in a discussion of funding for federal buildings. Hence, a brief overview of how that word became apt is in order.

As detailed in Chapters 7 and 8, Congress allocated building funds through site-by-site appropriations to be spent under the aegis of various entities such as the Office

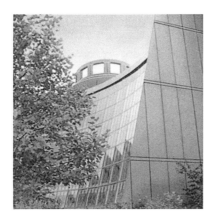  

FIGURE 118 United States Courthouse Buildings and Renovations: A Sampling, 1998–2002.
Office of the Chief Architect, United States. General Services Administration (2008).
Top (left to right): John Joseph Moakley United States Courthouse (Boston, Massachusetts); Alfonse D'Amato United States Courthouse (Central Islip, New York); United States Courthouse (Tallahassee, Florida).
Middle: Wayne Lyman Morse United States Courthouse (Eugene, Oregon); William B. Bryant United States Courthouse Annex (Washington, D.C.); Wilkie D. Ferguson Jr. United States Courthouse (Miami, Florida).
Bottom: United States Courthouse (Corpus Christi, Texas); Roman L. Hruska United States Courthouse (Omaha, Nebraska); Spottswood W. Robinson III and Robert R. Merhige Jr. Federal Courthouse (Richmond, Virginia).

Photographs taken by Taylor Lednum, Thomas Grooms, and Frank Ooms. Courtesy Design Excellence Program. See color plate 29.

of the Supervising Architect and the GSA. But in the early 1970s, Congress reorganized its rules to require agencies to pay "rent" to the GSA for the buildings used. Those monies were to support a Federal Building Fund to finance new acquisitions as well as construction and maintenance; Congress sought to have agencies internalize the costs of whatever space they inhabited.[119] Under the 1972 amendments to the federal building laws, the GSA, as owner and landlord, set the rent for its tenants (federal siblings included) in a manner determined by its Administrator.

The GSA developed a measure of what it termed "commercially equivalent charges" in an effort to create incentives for agencies to minimize the amount or cost of office space they occupy.[120] Because this revenue did not result in the full internalization of building costs, Congress continued to appropriate funds for new work as well as to rely on contract-lease arrangements using private monies for construction, such as for the Thurgood Marshall Federal Judiciary Building (fig. 8/114). To impose control over the GSA as well as its federal tenants, Congress required that for projects over a certain value (as of 2008, pegged at $1.5 million), the GSA needed approval through resolutions from the Senate's Committee on Environment and Public Works and the House's Committee on Transportation and Infrastructure.[121]

### Cutting into the Judicial Dollar

The rent provisions went into effect in July of 1974, and the judiciary thus began to pay for space and related services.[122] If measured by the responses from the judiciary, the new accounting system made an impact. Within a year, the annual reports of the Judicial Conference, which had before then regularly noted requests for construction and appropriations, began to include data on building costs. For example, in 1975 the judiciary reported paying $46,148,500 in rent for its 400 buildings with their 7.5 million square feet of space. Noting that the rent costs represented 15 percent of its budget and seeking to reduce those costs, the Judicial Conference also released more than 84,000 square feet of "unneeded space."[123]

The budgetary and psychic impact of the new rent arrangement can be readily seen by comparing various versions of the depiction of the "Judicial Dollar" provided annually for several decades in the Report of the Director of the AO. As the 1957 "Dollar" shows (fig. 119), the judiciary's budget allocations went to salaries, staff, and miscellaneous costs (including travel and the air conditioning for which the Conference had obtained direct appropriations), all represented as cents on the Dollar diagram.[124] At the time, no cents were allocated to represent the cost of courthouses. But in 1975, the year after the new rent provisions became effective, the Judicial Dollar (fig. 120) showed 22 cents allocated for "Space and Facilities,"[125] and as long as

the AO used that depiction, it continued annually to mark the percentage spent on its buildings.[126]

Over time the data became a source of distress. Concerns about rent came to feature in the Annual Reports of the Judicial Conference. In the decade between 1985 and 1995, rent bills grew from $128 million to $460 million, or from 16 to 19 percent of the judiciary's budget, with projections that rent would soon account for almost a quarter of the judiciary's expenditures.[127] On the other hand, for much of that period the judiciary's budget was also growing. While in the 1960s, about $60 million had been allocated to the federal judiciary, by 1995 the judiciary received more than $2.5 billion in funding.[128] (By 2008 the judiciary's budget topped $6 billion.[129])

But what space was "needed," and what was extra? And how much should it cost? In the late twentieth century, as in the seventeenth, construction project funding depends

## THE JUDICIAL DOLLAR
### AMOUNTS OBLIGATED
#### FOR
### UNITED STATES COURTS AND THE ADMINISTRATIVE OFFICE
#### FISCAL YEAR 1957

FIGURE 119   The Judicial Dollar, 1957 Annual Report of the Director of the Administrative Office of the United States Courts.

Facsimile, Yale University Press.

# THE JUDICIAL DOLLAR

## OBLIGATIONS INCURRED* – FISCAL YEAR 1975

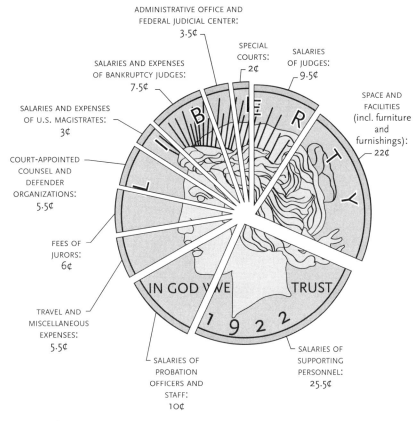

ADMINISTRATIVE OFFICE AND
FEDERAL JUDICIAL CENTER:
3.5¢

SPECIAL
COURTS:
2¢

SALARIES
OF JUDGES:
9.5¢

SALARIES AND EXPENSES
OF BANKRUPTCY JUDGES:
7.5¢

SALARIES AND EXPENSES
OF U.S. MAGISTRATES:
3¢

SPACE AND
FACILITIES
(incl. furniture
and
furnishings):
22¢

COURT-APPOINTED
COUNSEL AND
DEFENDER
ORGANIZATIONS:
5.5¢

FEES OF
JURORS:
6¢

TRAVEL AND
MISCELLANEOUS
EXPENSES:
5.5¢

SALARIES OF
PROBATION
OFFICERS AND
STAFF:
10¢

SALARIES OF
SUPPORTING
PERSONNEL:
25.5¢

*Exclusive of the Supreme Court

FIGURE 120    The Judicial Dollar, 1975 Annual Report of the Director of the
Administrative Office of the United States Courts.

Facsimile, Yale University Press.

on a polity's sense of its own wealth and its attitude toward judges. While at some points Congress felt flush, during hearings in 1998 a member of Congress recounted that requests for appropriations for courthouses included "Savannah, $253 a square foot; Brooklyn, $256 a square foot; Eugene, Oregon, $231 a square foot; Springfield, $224 a square foot; Denver, $217 a square foot. This is just too much."[130] Such political complaints, inter-branch conflicts, and fiscal constraints that accelerated after 9/11 prompted the Executive Branch to pause when the judiciary put in its requests for courthouse construction. Some planned projects went unfunded, while others carried forward as building costs rose.

Questions about needs are embedded not only in questions about finances and about the function of adjudication but also in the politics of judicial selection. Given the constitutional provisions that presidents nominate individuals to serve as life-tenured federal judges and that the Senate must confirm, congressional decisions to add slots give a particular occupant of the White House patronage opportunities. On the other hand, sometimes the politics of "judge bashing"—claiming that judges overstep their authority when making decisions—results in calls for cutting back on judgeships. For example, during the 1990s, Congress held hearings on whether to decrease the number of federal judges or to delay filling vacancies. Added to the mix were conflicts about whether some federal courts ought to be closed. The GSA complained to Congress that more than seventy facilities "occupied by the Judiciary" were not in fact occupied in that no full-time judge was a resident.[131] But the judiciary responded that it was Congress—not the courts—that specified the number of judges and designated so many sites (presumably reflecting constituent requests) at which courts were to be held.

## Inter-Agency, Inter-Branch Oversight or Intrusion

As dislike for paying "rent" grew within the judiciary, complaints by judges about the GSA as a landlord did as well. That inter-agency conflict spilled over to the two other branches of the federal government, with questions raised about both the expenses of and the needs for courthouse building.

Concerns about building costs became acute in the mid-1990s, during what the AO termed "times of severely limited financial resources and enhanced fiscal accountability."[132] Voices from both the Executive and Congress questioned decisions about the number of courthouses and courtrooms and the size of chambers.[133] Furthermore, a 1994 Senate "investigation of the federal courthouse construction program" had found wasteful practices: "Judges have regularly intervened with GSA to have larger courtrooms and offices built, the addition of private kitchens . . . and Terrazzo marble tile."[134] Criticism was also leveled against the GSA for failing to control "excessive, duplicative, erroneous, unallowable, or poorly documented" costs.[135] Targets of criticism included federal courthouses in New York City and Boston; newspaper stories described their embellishments as too elegant and too expensive. (Which entity—the judiciary or the GSA—was to blame was another question, producing "inter-agency finger-pointing" about the approval of items such as a $5,900 bronze fire hose holder, a $13,000 stone engraving with gold lettering, and an out-sized courtroom with seating for forty judges.[136])

A Senate report recommended that a moratorium be imposed and no new construction be permitted absent reform.[137] A proposed statute sought to give more power to the GSA, which would be obliged to submit to Congress design guide standards specifying "the characteristics of court accommodations that are essential to the provision of due process of law and the safe, fair, and efficient administration of justice by the federal court system."[138] In addition, members of Congress wanted to put the Commission on Fine Arts in charge of reviewing the "conceptual design" of new courthouses so as to advise whether new designs both comported with Moynihan's principles—"the dignity, enterprise, vigor, and stability of the American Government" —as well as with "the accepted standards of courthouse design."[139]

To respond to congressional oversight and to ward off a suggested "moratorium or restriction on the acquisition of space for the courts,"[140] the judiciary took four tacks. One was to downsize through centralizing control over reformulated design requirements, space needs, and priorities.[141] A second was to lobby individual members of Congress to enlist support for building. A third was to seek direct budget subsidies for rent and to renegotiate the formulas producing the charges for rent.[142] The fourth was to try to separate from the GSA. When pursuing these paths,

members of the judiciary regularly invoked constitutional commitments to an independent judiciary and separation of powers.[143] They argued against management by other branches and that needs for more judges, based on workload measurements,[144] and for more buildings stemmed from obligations to discharge duties imposed by Congress and the Constitution.[145]

For example, in 1996 the judiciary reported on efforts to reduce "the overall growth of rental costs"[146] by decreasing the size of new buildings through the elimination of certain kinds of spaces within new construction. Specifics included cutting out meeting rooms for each circuit's judicial council as well as suites for alternative dispute resolution. In addition, the 1997 version of the *U.S. Courts Design Guide* proposed that judges share auxiliary spaces and books so as to decrease the dimensions of chambers.[147] Attention was also given to the expensiveness of decor: revisions to the *U.S. Courts Design Guide* ruled out "the use of exotic hardwoods"[148] in favor of low-maintenance and highly durable materials. And when prioritizing among building requests coming from judges across the country,[149] the Conference raised the possibility of returning to earlier practices of sharing facilities with state and local governments.[150]

The Judicial Conference also stepped up efforts to control individual project spending. The 1997 *Design Guide* stressed the need for projects to come in on budget, as the Judicial "Conference prohibited any action taken by a court or circuit judicial council that would lead to extravagance in courthouse construction or renovation."[151] Shifting from a liberal "variance" policy, the Conference ruled that no changes in designs adding costs above a specified level were permissible without multiple levels of approval within the judiciary and then from the GSA.[152] Chief Justice Rehnquist also appealed for direct funding from Congress.[153] Seeking $500 million for fourteen projects, he explained that the projects were critically needed "if the federal courts are to adequately and safely carry out the responsibilities placed upon them by the Constitution and statute[s]."[154] The judiciary detailed the five-year priorities and specified courthouses lacking facilities for witnesses or attorneys and those with acute security issues.[155] Repeatedly, the AO reached out to leaders on Capitol Hill and to the President, and such efforts resulted in "substantial success" as new projects were funded.[156]

### "Rent Relief"

The judiciary's insistence on the need for space was coupled with efforts to fund or to reduce its significant rent bills. One option was to obtain additional appropriations directly from Congress to pay the GSA, and another was to change the way rent was calculated so as to lower the charges. The Judicial Conference tried both, with some measure of success.

As the AO reported, between 1985 and 2000 (during "times of fiscal restraint"), it was able to increase "the judiciary's budget fourfold from about $1 billion in 1985 to approximately $4 billion in 2000."[157] In 2004 the judiciary also went directly to Congress for courthouse funding and obtained $205 million for nine new courthouses and $17 million for office buildings and repairs.[158] In support of such requests, the judiciary registered its views that critical analyses of its use of space were "seriously flawed."[159] Testifying before Congress, the Chair of the Judicial Conference Committee on Space and Facilities explained that between 1990 and 2005, appellate filings had "increased 66 percent; civil filings 29 percent; criminal filings 44 percent; bankruptcy filings 118 percent; and . . . [the] total number of judges increased 25 percent and total court staff increased 45 percent."[160] Thus, Congress was the source of demands for judicial services as well as its sites, with statutes designating more than four hundred places for holding court.[161] At many locations, facilities had "outdated horizontal and vertical circulation patterns that mingle court personnel, persons in custody, and the general public."[162] Even as the judiciary had tightened its own budget controls, changed its design guide, and was indeed reconsidering courtroom utilization (whether each judge needed a dedicated courtroom),[163] more facilities were needed.

From the GSA's perspective, however, the rent bills were doing just the job Congress had intended—creating incentives for more efficient use of space.[164] Indeed, in 2008 the AO developed a database called "JRent" to enable court executives to monitor costs. As one clerk of a federal district court explained, "Space can no longer be viewed as a free commodity, but rather we must view it as we do all other items purchased from a private vendor . . . subject to the same spending decisions."[165]

But in terms of paying for space, the judiciary disagreed with the GSA's method for calculating the amounts due. The GSA set the rent by what it termed "investment pricing," which it keyed to the costs of commercial rent space for comparably high-quality offices and to the cost of construction, which was especially high for the judiciary given security and other architectural demands.[166] The charges imposed on the judiciary, under the GSA calculations, appropriately tracked the increase in space, growing from 2000 to 2005 by 19 percent, or from 33.6 million to almost 40 million "rentable square feet."[167] With its "2159 courtrooms in 39 million square feet in 333 owned and 128 leased buildings,"[168] the judiciary was a major user of space. As the GSA reported in 2006 to Congress: "Measured in terms of the square feet of space provided," the federal judiciary was its "second largest customer," occupying 13 percent of the total footage in the GSA inventory.[169] Congress asked the General Accounting Office (GAO, whose abbreviation remained after the name later changed to the Government Accountability Office[170]) to report on these issues. The GAO concurred that the rent increase corresponded

more or less to space increases. Under the GAO calculations, charges for rent rose about 27 percent (controlling for inflation), or from about $780 million to $990 million.[171] That rent somewhat outstripped space reflected the unusually high cost of judicial building, with its three discrete circulation patterns.[172]

Both the GSA and the GAO noted that courthouses were unusually and, in some respects, unduly expensive.[173] Various "architectural elements make courthouses among the most expensive federal facilities to construct in GSA's inventory."[174] Some cost came from perceived judicial excesses; the GSA cited an example of rent for 4,600 square feet of office space for a judge who also had chambers of 4,300 square feet in another court.[175] Complaints were also directed at space allocations for libraries, "rarely used" due to the shift to electronic databases, and for dedicated appellate courtrooms not planned to hold argument daily.[176] One member of Congress commented that the judiciary had "failed to manage their space requirements"—by acting as if it were a family wanting a "10,000 square foot mansion, but . . . able to afford the more conservative 3,000 square foot home."[177]

The judiciary, however, had a different view of what numbers were relevant to understanding how high rents had soared.[178] Rather than basing calculations on a 2000–2005 time frame, the more "meaningful" analysis came from a twenty-year span during which rent had "increased 333 percent, adjusted for inflation." In contrast, the judiciary's space had grown at half that rate—by 166 percent in square footage.[179] Further, the judiciary argued that the high cost of space stemmed from "escalating rent charges for the existing inventory," including many older facilities, not new space.[180] And through an analysis of 15 of its 800 facilities, the judiciary reported some $38 million in GSA overcharges[181] that GSA acknowledged to some extent.[182]

Further, as Ralph Mecham, Director of the AO, testified, the federal courts were faced with a "funding crisis," and despite "heroic efforts . . . some degradation in service" was occurring because of the GSA rent.[183] The judiciary's newsletter encapsulated the claim in its headline "Either Pay Staff or Pay Rent."[184] Eleven "senior members of the Senate Judiciary Committee" wrote to the GSA to request rent relief.[185] When Chief Justice John Roberts took office in the fall of 2005, he joined the chorus protesting rent. In January of 2006, in the first of his annual reports on the state of the judiciary, he took up the topic[186] and contrasted the budget outlay by the judiciary to the GSA—then 16 percent—with what the Department of Justice spent— 3 percent of its budget.[187] The Chief Justice argued that while the GSA charged $926 million in rent, the "actual cost for space to the judiciary was $426 million."[188] He argued that the "federal judiciary cannot continue to serve as a profit center for the GSA," as he pointed to a reduction of about 1,500 employees that he attributed, in part, to the budgetary drain of rent.[189]

The real problem was that Congress was not funding the transfer from one federal agency to another at a rate sufficient to make it a wash for the courts. As the Chair of the Committee on Space and Facilities told members of Congress, the courts faced "the situation where mandatory rent payments to GSA have been increasing at a faster rate than the Judiciary's appropriations increased."[190] What the judiciary wanted was "rent relief."[191] Unsuccessful in gaining sufficient reimbursements through appropriations, the judiciary focused on another route—changing the way rent was calculated. The judiciary argued that the GSA "investment pricing" policy failed to take into account the unique and special needs of courts, making "commercially equivalent" values the wrong metric for court facilities.[192] Moreover, even if one used a commercial rate, the relevant baseline, argued the judiciary, ought to be what would be paid by a long-term tenant, leasing a facility that was "built-to-suit," rather than a short-term renter in a building constructed for speculation.[193]

In 2004 the judiciary asked the Administrator of the GSA for a "permanent annual rent exception" under which the courts would pay operating costs (utilities and security) but not a separate fee for rent.[194] The amount requested was about half the annual rent payment, or "a permanent, annual rent exemption of $483 million from rent that the [GSA] charges the judiciary to occupy space in courthouses."[195] In 2005 the Office of Management and Budget turned the judiciary down.[196] Losing in the Executive Branch, the judiciary went directly to Congress, where Senator Arlen Specter, the Republican chair of the Judiciary Committee, introduced a bill to "provide relief for the Federal Judiciary from excessive rent charges," to make the GSA charge on the basis of "actual costs of operating" rather than on a commercial rent basis.[197] Further, a group of senators led by Specter called on the GSA to provide its own rent exemption.[198] Although legislation passed the Senate in 2006, members of the House—and prominently Eleanor Holmes Norton—objected to the "'rear guard' action" to try to cap rent when the House had asked for government investigation of the use of space. That bill was not enacted.[199]

Thus the 1972 Public Building legislation again seemed to fulfill its promise by creating incentives inside agencies to reduce the costs of their operations.[200] The judiciary imposed its own "annual cap on rent" by provisionally aiming to limit growth to an annual rate of 4.9 percent.[201] The Conference further revised its design parameters as it looked to close facilities that had no full-time resident judge and imposed a moratorium on several projects.[202] Yet, in 2008, the judiciary was able to obtain a revision in the way the GSA billed its rent that would reduce the pressures. Negotiations under a new director of the AO, James C. Duff, resulted in a revised rent calculation that the AO "expected to translate into tens of millions of dollars in annual rent reductions for the Judiciary."[203] A "memorandum of agree-

ment" between the two agencies set forth that for a ten-year period, new court construction was to be priced on a modified "return on investment" system rather than the market-based approach that had been used.[204] In turn, within a few months thereafter and "in furtherance of its aggressive cost containment efforts," the Judicial Conference announced that it would retreat somewhat from its fierce opposition to judges' sharing courtrooms.[205]

## A Courtroom of One's Own

During the 1990s, "courtroom sharing" had become a particular point of contestation, as members of Congress questioned the judiciary's insistence that a dedicated courtroom be provided for each authorized judgeship as well as for judges who had taken senior status and thereby opened up a vacancy. As of 2003, 1,366 courtrooms were available for district court judges,[206] with others for magistrate and senior judges—in total, about 1,800 to 2,000 courtrooms. Estimates were that building new courtrooms cost about $1.5 million, and the question was how often judges used them. In 1997 a federal appellate court reversed a conviction because a judge in the Virgin Islands had refused to grant a continuance, explained as denied in part because of the unavailability of courtroom space at a later time.[207] That ruling came while a "Republican-held Congress" continued to "cast a skeptical eye on courthouse construction and use," as one journalist put it.[208] Focused on what it called "courtroom utilization,"[209] Congress commissioned studies from both the GAO and the Congressional Budget Office (CBO). Examining seven districts and using as a metric "lights on" for any event from full-day trials to activities that "lasted less than an hour," the GAO reported that as of the late 1990s, courtrooms were in use about half the time.[210]

The judiciary then hired a firm, Ernst and Young, to conduct its own study.[211] Its report concluded that courtroom sharing would not be feasible in small districts and would impose serious scheduling problems in larger ones. That analysis was criticized by the GAO, which described the Ernst and Young report as based on a flawed mathematical formula (lacking "data, rationale, or analytical basis").[212] Yet another study, from the CBO, modeled the effects of a reduction in courtroom space based on trial rates as of 1995; the CBO concluded that some delays would occur but that overall, even with fewer courtrooms, no one would be using them between about 20 and 40 percent of the time.[213]

Congressional inquiries were complemented by concerns from the Executive. To the chagrin of the judiciary, on more than one occasion the Executive Branch did not forward judicial requests to Congress for buildings.[214] By 1997, while maintaining its commitment to dedicated courtrooms, the Judicial Conference announced a "space cost containment plan" through which it would explore whether courtroom sharing was feasible.[215] At issue was whether

circuits or districts might ask senior or visiting judges to share courtrooms.[216]

In the fiscal year 2001 budget request, the Executive did include funding for seven courthouse construction projects but proposed a budget that assumed two courtrooms for every three judges.[217] The Judicial Conference objected that the proposal was a "direct contradiction" of the judiciary's policy that had been "developed after analysis of two major studies on courtroom utilization and case management," and that had recognized "the indispensible need for a courtroom to fill the essential judicial responsibilities."[218] The Conference "strongly condemned the unilateral efforts" of the Office of Management and Budget to "impose a courtroom sharing policy on the judicial branch, as an unwarranted and inappropriate intrusion into the constitutionally mandated independence of the judiciary."[219]

The judiciary also tried to ward off proposed legislation obliging it to submit detailed plans to Congress for building projects of a certain value.[220] Instead the Conference determined to present its housing needs by way of a "formal narrative statement" directly "to educate key legislative and executive branch decision makers."[221] As it made its case, the judiciary relied on the vocabulary developed in the late 1980s by deploying the concept of a "judicial space emergency," which it defined as impairing "the ability of each court to execute its responsibilities . . . by the unavailability of space."[222] The Judicial Conference identified certain courts (such as those with heavy immigration dockets stemming from efforts to close the Southwest border) as having such emergencies and requiring funds in light of "intolerable security and operational problems."[223]

The other two branches pushed back. In response, the Judicial Conference imposed its own internal two-year moratorium on planning for upgraded projects in order to reevaluate the "underlying assumptions" in light of "constrained budgetary environments."[224] In 2004 the Conference called on chief circuit judges to cancel space requests wherever possible.[225] (In 2006 some exemptions from that moratorium were authorized.[226]) In an effort to take the theory of internalizing the costs of buildings from the national to the circuit level, the Conference also imposed a "rent budget cap" per circuit.[227]

In 2005, at the request of the chair of the House subcommittee focused on federal building, the Federal Judicial Center (FJC) undertook yet another study of courtroom utilization.[228] To answer the "ultimate question" of whether judges could "share courtrooms without compromising the administration of justice,"[229] the FJC looked at 422 courtrooms in twenty-three districts. When evaluating those facilities, the FJC added to the metric of "actual courtroom use" the concept of "latent use" to denote time scheduled in a courtroom and then not used.[230] Availability, rather than use, was relevant because "a firm trial date

and availability of a courtroom 'often' prompt parties to settle or plead."[231] Further, the FJC distinguished among users, separately assessing how much time active, senior, and magistrate judges spent in court.

The FJC reported widespread enthusiasm for dedicated courtrooms from the judges surveyed (as well as from lawyers).[232] Moreover, the 2008 study found a higher rate of use (69 percent of work days for district judges) than had earlier studies.[233] On any given day, "50 to 74 percent of courtrooms were in use . . . for either actual or scheduled trials or case proceedings."[234] On the other hand, in a courthouse where judges shared courtrooms, there "were no days on which a courtroom was not available. . . ."[235]

While the study was underway, the relevant House subcommittee passed a resolution that directed the revision of the *U.S. Courts Design Guide* to provide in new court construction "for one courtroom for every two senior judges."[236] Not surprisingly, the denouement was the reshaping of Conference policy to require some sharing of space. In 2008, the Judicial Conference committed itself to revised "planning assumptions" that entailed some courtroom sharing for senior judges and magistrate judges, exploration of "opportunities" for courtroom sharing for active district judges if on large (ten or more) multi-judge courts, and studying "courtroom allocation policies" for bankruptcy judges.[237] As the AO's relatively new Director, James Duff, explained, those provisions struck "the appropriate balance between the Judiciary's fundamental responsibility of ensuring the fair and efficient administration of justice and the general governmental responsibility to be good stewards of the taxpayers' money."[238] But as the judiciary retreated somewhat from its one-courtroom-per-judge stance, what it got in return was a new way in which to calculate the money it paid to the GSA in rent—estimated to save the courts some 140 million dollars over the coming two decades.[239]

## Judicial Political Acumen and Incongruity: The Rehnquist Judiciary's Monuments to Federal Adjudication

This review of the thirty years from the late 1980s through 2010 demonstrates the judiciary's success in obtaining dozens of new and renovated facilities and in securing a new method of financing that substantially lowered (and made somewhat less vivid) the dollars spent for its facilities. From the 400 facilities in use in the 1960s, the judiciary grew to be housed in some 800 locations by 2006.[240] Over a thirty-year period, the courts tripled their dedicated space and, between 1996 and 2006, nearly doubled it.[241] As architects involved in courthouse construction put it, federal courthouses provided "[v]isible expression of this third branch of government as separate from the legislative and executive branches."[242] New and renovated courthouses

thus demonstrated the prestige and power of the federal judiciary, richer on various measures (fewer cases, more staff, larger facilities, often better salaries and pensions) than its state counterparts.

Along the way, Congress imposed a modest degree of supervision on the judiciary's building plans. Some projects were cut back,[243] and the Judicial Conference stepped up its own monitoring of what had been decentralized and delegated decisionmaking.[244] When restating its aspirations in 2006, the judiciary espoused "core values" for space and facilities that sounded somewhat more utilitarian than the call in the *U.S. Courts Design Guide* for "solemnity, stability, integrity, rigor, and fairness."[245] The new goals were "availability, function, adequacy, sufficiency, cost, and structural security."[246] Moreover, by 2008, the judiciary acceded to reducing space demands somewhat through requiring senior judges to share courtrooms and considering a return to the 1970s presumption under Warren Burger that, in large districts, judges would share courtrooms. Yet the judiciary's leadership also returned to what Chief Justice Rehnquist had sought in 1989—"independent real property authority" to get out from under the GSA.[247] But even as some projects were scaled back, a new cycle of building proposals came into shape for fiscal years 2008–2012.[248] By then, the AO and the GSA had became joint venturers in the quest for first-rate federal architecture. In 2010, both sought to deflect criticism from the Government Accountability Office in congressional hearings questioning spending and construction.[249]

One could assess the decades either as a remarkable victory for the judiciary or as evidence that the conflicts were bureaucratic rather than ideological. The repeated investment in courthouses is evidence that the judiciary's sibling branches were also committed to a thriving independent federal court system and to instantiating the nation's identity through its facilities. As one long-time observer and former chief judge of a circuit explained, in "the end . . . , the authorization for courthouse construction has been the product of compromises between the Judiciary, GSA, and Congress, salted with considerable amounts of lobbying (of Congress) by the judges and others in the local community."[250] Federal courthouses succeeded in conveying something of the relative material wealth of the federal government, able to retain world-renowned architects to produce buildings of impressive dimensions.

Given that government spending could be (and was) also devoted to prisons, border stations, and other facilities, devotees of the rule of law should take pride in the political commitment made to the federal judiciary. In the quantity, the dollar value, and the quality of designs, the buildings made a statement that the federal government was prepared to invest specifically in marking the importance of adjudication.

For those steeped in the doctrine of the federal courts, some irony attends the fact that the building program for the judiciary took place under the aegis of Chief Justice

Rehnquist and gave the courts the "fastest growth in square footage" of any sector the GSA served. In his role on the court, Chief Justice William Rehnquist was a major architect of legal rules that limited access to the federal courts. In a variety of different contexts, he led the court in crafting doctrines, often argued under the rubric of "federalism," that ceded authority to state courts. For example, major Rehnquist decisions narrowed access to habeas corpus and limited remedies for civil rights plaintiffs.[251]

But even as the agenda for facilities succeeded, another goal—increased salaries—was not achieved. To the frustration of the judiciary's leadership, support for buildings was not complemented by raises in pay. Throughout the twentieth century, federal judges repeatedly complained that their remuneration was too low. Focusing on the same thirty years that spawned the remarkable tripling of its facilities, judges' "real" dollar income declined. Despite repeated pleas to Congress and the creation in the late 1990s of a special commission chaired by the former head of the Federal Reserve, Paul Volcker, to document the economic loss in judicial pay, and despite numerous appeals by Chief Justice Rehnquist,[252] Congress refused to provide raises and sometimes withheld cost-of-living increases.

As of 2008, life-tenured appellate judges earned about $180,000 a year and district judges about $170,000 a year. While better compensated than many state judges, federal judges saw their former law clerks, hired as associates by law firms, making more money. To capture the problem, the judiciary switched its nomenclature from seeking "pay raises" to pressing for "salary restoration."[253] In 2006, Chief Justice Roberts devoted a good deal of his first annual address to salaries, as he argued that the levels set "threaten[ed] to undermine the strength and independence of the federal judiciary."[254] But Congress did not respond with higher salaries. Buildings and staff—that represented not only courts but also federal investment in localities across the country—were the places where Congress spent federal funds, rather than for salaries or significant increases in the number of life-tenured judgeships.[255]

"ART-*IN*-ARCHITECTURE"

This chapter's narrative has been architecture-centric because buildings were the vehicles chosen to express federal norms. Continuing the pattern discussed in Chapters 7 and 8, twentieth-century lawyers, judges, staff, and architects obtained funds for courthouses, with art as an afterthought if considered at all. Some of that lack of interest can be attributed to intellectual disdain for the didacticism of allegory, to dislike of ornamentation, and to aesthetic affection for line and form, as well as to the absence of institutional structures pressing for art production.

During the last four decades of the twentieth century, however, a market in government art came into being. As discussed in Chapter 8, in the early 1960s the Ad Hoc Com-

mittee on Government Office Space that produced Moynihan's Guiding Principles had considered proposing that budgets for buildings include reserve funds for art, which had been the practice of the Treasury Department in the 1930s and had also been proposed by the 1953 Eisenhower Commission on Fine Art. On the table for the 1960s Ad Hoc Committee was a recommendation that "up to one percent of a building's cost" be devoted to art.[256] That statement, however, did not become part of the final report. Rather, Bernard Boutin, who was then the head of the GSA as well as a member of the Ad Hoc Committee, instituted a set-aside directly pegged at one-half of 1 percent of a construction budget.[257] Between 1962 and 1966, the GSA program (called Fine Arts in New Federal Buildings) commissioned forty-five artworks for installation around the United States.[258] That set-aside lapsed amidst budget cuts and complaints that the government had funded Robert Motherwell's mural *New England Elegy,* interpreted by some to be inappropriately referential to the Kennedy assassination.

In the 1970s, GSA Administrator Jay Solomon revived and expanded funding under the nomenclature of Art-in-Architecture (AiA),[259] a phrase repeated in federal regulations.[260] The set-aside for art (at one-half of 1 percent of the building projected costs) could be understood as appropriately small, a minor outlay in large projects. In 1995, for example, the GSA committed $6.8 billion for construction and renovation that qualified for AiA funds, creating a sum of $34 million available for art. Even then, the GSA spent less than it could have; actual outlays were two-tenths rather than one-half of 1 percent.[261]

But using the baseline of funds spent on construction could mislead, because that small percentage nonetheless rendered the federal government the "nation's No. 1 art patron in direct commissions."[262] Like Peck and Feiner who mediated between judges and architects, senior administrators such as Marilyn Farley and Susan Harrison of the AiA program shepherded renowned artists through procedures that resulted in installations of art, some of which were adventuresome and a few of which provoked criticism.[263] Harrison provided what artist Jenny Holzer described as a "shield," advising artists about how to deal with skeptical responses and how to help judges in particular to see the qualities of an artistic contribution.[264]

As a result, the government supported a roster of artists that "read like a Who's Who of American Art: Calder, Oldenburg, di Suvero, Nevelson, Noguchi,"[265] and those whose work we have shown, including Ellsworth Kelly in Boston (fig. 6/93), Dorothea Rockburne in Maine (fig. 2/29), Diana Moore in New Hampshire (figs. 5/72, 5/74, 5/75), and Jan Mitchell in the Virgin Islands (figs. 6/87, 6/88, 6/90). This national patronage created a "network of consultants, commissioners, and other professionals committed to spreading the work of contemporary artists throughout the public domain."[266]

## Selecting Community-Friendly Art to "stand the test of time"

Putting significant money into art does not resolve the questions of how to select either artists or art. As detailed in Chapter 6, when a diverse group of persons gained rights of access to courts, they rebelled against what they saw on the walls and insisted on participatory roles in shaping their environment. Reflecting the democratization of adjudication, the government's selection procedures evolved as the "fine arts program" of the 1930s developed into the late twentieth-century process entailed in AiA.[267]

Different constituencies pressed for procedures to enhance artistic quality and community engagement, goals that sometimes are seen as in conflict with each other. In the 1970s, the National Endowment for the Arts (NEA)—which had revived the Moynihan quest for better architecture—sought a wider range and more adventuresome choices for public art. In turn, when communities protested various installations, members of Congress reacted to damp down constituent distress. In 1979, for example, five thousand people petitioned to remove a $25,000 abstract sculpture installed in front of a federal building in Huron, South Dakota.[268] Critics described *Hoedown* by the artist Guy Dill as "four large steel plates propped up by telephone poles."[269]

That artwork remained in place but the procedures for selection changed. Members of Congress proposed to give residents of the communities where art was to be sited a majority of seats on selection committees.[270] That statute was not enacted,[271] but in 1980 a joint GSA-NEA task force developed new processes to identify high-quality art ("able to stand the test of time") that would also be appreciated by local communities.[272] For a time the NEA convened the panels and GSA staff participated in advisory roles. The coordination was not tension free. For example, the NEA did not want to let project architects vote on artists.[273] By the late 1980s, authority shifted to a GSA-run process[274] in which some selections were made through the designation of two panels, one with GSA staff and art experts and another (the "community arts panel") composed of local actors who were either officeholders or people involved in cultural activities.[275] The revamped process was "a matter of public policy" that, as the GSA explained, reflected "its responsibility to U.S. citizens" to seek their "support and involvement . . . in the selection of appropriate artwork" for their localities.[276]

## Collaborative Diversity

What those committees were to look for in art is another question. The Code of Federal Regulations (detailed later) provided only the general mandate that federal agencies "must incorporate fine arts as an integral part of total building concept."[277] Various memoranda and documents from

the GSA repeated what Daniel Moynihan had set forth for architecture in his 1960s Guiding Principles: art, like architecture, should "reflect the dignity, enterprise, vigor, and stability of the American National Government."[278]

As part of an overhaul of the Art-in-Architecture program in the mid-1990s, another description was proffered as better suited to a post-modern period sensibility—that public art was to be a "collaboration between artist and community to produce works of art that reflect the cultural, intellectual and historic interests and lifeways of a community."[279] The GSA wanted "meaningful cultural dialogues" between art and "diverse architectural vocabularies"[280]; it enabled that collaboration in part through diversifying the contributors, as is reflected in GSA lists of the numbers of "women and ethnic minorities commissioned through the Art-in-Architecture Program."[281]

In the late 1990s, selection processes were reconfigured again; the prior procedures meant that art selections came too late to be integrated into construction concepts. Early selections were encouraged to achieve "a more holistic approach towards art and architecture."[282] The GSA developed its own registry of "peers" as it put together a mix of GSA officials, experts, and community members charged with developing short lists of artists. To capture the effort to "foster closer collaborations between architect and artist in order to integrate artwork more fully into each building," the GSA renamed the program "the Center for Design Excellence and the Arts."[283] Proposals for building commissions needed to have "an art in architecture statement" provided at the outset.[284] Further, the GSA created its first "traveling exhibit" of art commissioned specifically for federal courthouses as it sought to bring attention to the importance played by historically rich as well as newly crafted imagery.[285]

The 2008 regulations explain the basic policies:

> Federal agencies must incorporate fine arts as
> an integral part of the total building concept
> when designing new Federal buildings,
> and when making substantial repairs and
> alterations to existing Federal buildings, as
> appropriate. The selected fine arts, including
> painting, sculpture, and artistic work in other
> media, must reflect the national cultural
> heritage and emphasize the work of living
> American artists.[286]

Funding, as the regulations explained, came through the allocation of "a portion of the estimated" building cost within "a range determined by the Administrator of General Services,"[287] which is to say that the amount of the set-aside remained a matter of discretion and convention and not of law.

In terms of the process, the official regulatory statement (reiterating the 1990s goals) was that to "the maximum extent practicable, Federal agencies should seek the support and involvement of local citizens in selecting appropriate artwork" so that artists, in collaboration with communities, "produce works of art that reflect the cultural, intellectual, and historic interests and values of a community."[288] The regulations also acknowledged roles in selection for the "architect of the building and art professionals" and the aspiration that the artwork be "diverse in style and media."[289] Moreover, federal agencies have responsibility to "facilitate participation by a large and diverse group of artists representing a wide variety of types of artwork."[290] As AiA has described these efforts, the GSA sought "the fullest possible spectrum of aesthetic, conceptual, and theoretical movements" in America's contemporary art; it had melded "creative disciplines" through commissioning poet laureates to collaborate on projects with artists—winning accolades as an "enlightened sponsor" of public art.[291]

## Quietly Quizzical: Tom Otterness in Portland, Oregon and Jenny Holzer in Sacramento, California

The eclecticism in the selection of materials and genres is well captured by the GSA publication *An Oklahoma Tribute,* published in 2003. The monograph commemorated the art that had adorned the Alfred P. Murrah Federal Building, partially destroyed in 1995 by a truck bomb that killed 168 people.[292] For that building, the GSA design selection process had settled on thirty-two artworks from more than twenty-five artists, many of whom were from Oklahoma. As the GSA also noted, the group was "almost equally divided between women and men, and represented racial diversity, including several artists of Native American descent."[293]

Some twenty-two pieces survived the bombing and were restored for display.[294] Sculptures of "wood, clay, metal, stone, and acrylic" thus joined tapestries, weavings, photographs, and quilts.[295] The work ranged from a quilted pattern of oil derricks, windmills, and buffaloes to a six-foot assemblage of oak carved to create an abstract mural and a set of three ten-foot stainless steel panels swiveling to reflect the light.[296] Some of the pieces made references to United States history and to the region in particular, but none were provocative comments on justice and the legal system.

The GSA thus succeeded in bringing contemporary aesthetics and innovative artists into federal buildings. But, despite staff efforts supportive of more politically engaged projects, the selection procedures generally weeded them out or damped them down. Gentle and ironic exceptions to the celebratory posture of most of the art selected can nonetheless be found in the installations of works by Tom Otterness[297] in 1997 for a courthouse in Portland, Oregon and by Jenny Holzer[298] in 1999 in a courthouse in Sacramento, California. Both are world-famous artists who came to the fore in the 1980s when they worked in New York as

part of a group called Collaborative Projects Inc. (Colab), composed of some fifty "politically engaged young artists who rejected the cool muteness of Minimalist abstraction and saw art as a force to change society."[299]

Otterness has been described as an artist "who could say something serious about our world without scowling or pointing fingers."[300] By the early 1980s, he had developed a sculptural motif of "Ur-people," plump, small figures that had heads, hands, and feet and were "in all kinds of antic activity—mostly working, cavorting, and fighting."[301] These forms enabled him to provide a "universal image of man, a figure that is not specific as to sex, race, or culture."[302] Rejecting some of the "sphinx-like" impenetrability of some modernist sculptures, Otterness offered an accessible vocabulary.[303] He then moved from deploying "pneumatic volumes . . . compared to the Pillsbury doughboy" to "robots with wind up keys."[304]

Thereafter Otterness turned to small bronze animals that have since been sited in outdoor locations "coast to coast and throughout Europe."[305] Commentators sometimes categorize his work as a "riff on capitalist realism," reflecting the interaction between mass media and the art market in commodifying "supposedly autonomous objects of disinterested contemplation."[306] Yet, unlike some artists whose appropriations have an air of condescension, Otterness "demonstrates kinship with viewers of all stripes."[307]

Holzer ("one of America's best-known artists"[308] and "the first woman artist to fill the U.S. pavilion at the Venice Biennale"[309]) is famous for her "truisms"—statements posted on placards, etched into stone, projected onto walls, or put into motion through LEDs or other electronic forms around the world.[310] Typically the different aphorisms are presented with a strict sameness that implies neutrality about their deployment. The visual structure—clear and uncluttered—could be perceived as decoration before being understood as text.

In art critic Arthur Danto's view, Holzer's "medium is language rather than words," used to remind viewers that there is no escape from "considerations that belong to rhetoric or to poetry, and issues of truth and falsity."[311] Danto described Holzer's "singular symbolic imagination" as sending "messages from an oracle, or a sibyl, or a fortune teller or someone's slightly dotty aunt" who might possibly get us "to believe what is false."[312] By placing "incompatible and contradictory ideological positions in direct conflict," Holzer achieves an interaction between text and context that exposes "the mechanics by which linguistic power catches hold."[313] The words themselves are simultaneously authoritative yet potentially banal. One commentator saw the body of her work as "involved in a delegitimation of power,"[314] while it can also be seen as requiring that attention be paid to the sources of and claims made for authority.

As the descriptions of both artists suggest, Otterness and Holzer are innovative critics puzzling about politics and life. Both found imagery that raised questions about fair-

ness, and both have had—remarkably in some respects—commissions for more than one federal project.[315] After the give and take of GSA selection committees, both Otterness and Holzer settled on a discourse that was more subdued and subtle than had been their initial proposals.[316] (In addition, Holzer's moving LED texts grace a courthouse in France—the Nantes Palais de Justice designed in the late 1990s by Jean Nouvel and discussed in Chapter 10.)

*Law of Nature* is what Otterness named a sequence of small bronze sculptures of various animals comprised of "vignettes" on the roof terrace of the Mark O. Hatfield United States Courthouse in Portland, Oregon.[317] In one scene (*Cat on Trial*, fig. 121, color plate 24), a shackled cat—with a feather in its mouth—sits on what is termed a witness box, shaped as a small platform. The cat sits near an owl, perched higher and placed as would be a judge, close to the testifying witness. Watching from another slab is a group akin to a jury; this one is comprised of four bronze animals—a bird, a dog, a mouse, and a crouched figure looking something like a mix of a dog and a walrus. The prosecutor, wearing a jacket and questioning the defendant cat, is a dog.

In another scene called *Tree of Knowledge* (fig. 122), Otterness has used scales, a blindfold, and a sword to turn a small bronze bird into Justice, shown perched on a limb near the top of a pole-like tree barren of leaves. Otterness's blindfolded Justice holds scales upright; two small helmeted turtles sit in each of the balance's pans, as one detail (fig. 123) makes plain. But Justice's other hand, behind its back, hides a menacing sword-like knife pointed upward (fig. 124, color plate 24).

That vengeful posture could either be a job requirement, a response to the particularly precarious position occupied by this bird-Justice, or a more general comment about the vulnerability of justice. The bird sits on a lonely limb in what may be a vain effort to avoid both an assault by a serpent creeping upward with its mouth close to the turtles hanging in the balance, as well as an attack by a beaver (an animal Otterness often uses to denote lawyers) gnawing the trunk below.[318] Alternatively, the efforts to topple this Justice could be justified by the fact that it holds a dagger behind its back and that its counterpart, a figure nearby arguably representing Law, is upside down—an opossum-like animal with its head, hanging toward the ground, behind a book. Another beaver, suited, watches from afar as another sits on top of a pile of books and bronze figures that look like television or computer screens with extended outreached hands that could be signaling for help or expressing distress. Small figures representing a "paper and a computer flee the scene."[319]

One critic called the imagery "playful,"[320] which was what the artist had hoped. In his own description of the project, Otterness wrote of the need to offer "relief from the often stressful life of the courts" and how humor, if "used judiciously," can provide "reflection and relaxation at the

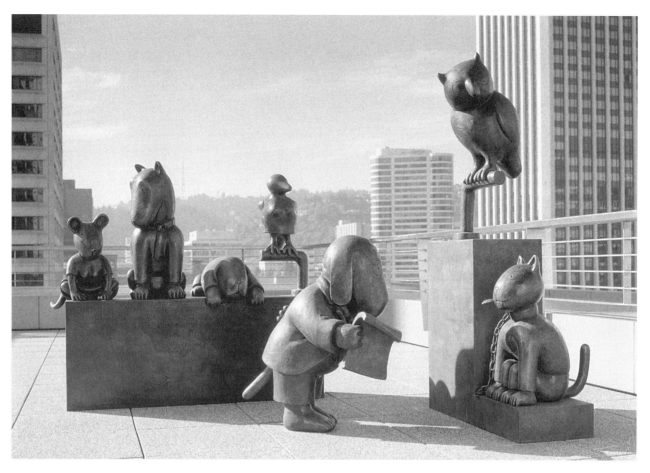

FIGURE 121    *Cat on Trial* in *Law of Nature,* Tom Otterness, 1997, Mark O. Hatfield United States Courthouse, Portland, Oregon.

Photograph copyright: 1997 Laurie Black. Photograph provided by Laurie Black and Tom Otterness Studio. See color plate 24.

same time."[321] Moreover, by using bronze ("a particularly seductive material—hard, resilient, able to withstand hundreds of years of abuse"), Otterness invited the public to touch the objects as a "source of delight."[322] Whether the public can do so is a question, as the artwork is placed on a terrace on the eighth floor of the building, accessible only after passing through security and obtaining directions to its location. (One blogger called the setting a "secret sculpture garden" entered only after being "frisked" at the gate; there one finds the small figures, "outside the building, outside the law . . . the opposite of the ghosts in black robes which haunt the interior halls."[323])

Otterness described this work as upholding "the dignity and purpose of the law," but it also combines what one critic called his general style of "cute and cutting" commentary.[324] (Another noted that one must look for some time at Otterness's art "to realize just how dark its content can be."[325]) Justice is both threatening and tottering, and the dogs and owls seated to judge the cat do not signal the impartiality of the law, which is likely why one of the federal judges involved in commissioning the work asked Otterness not to

focus too much on a "court" or to be too "literal" in its depiction.[326] Otterness appears to have followed some of that advice; earlier sketches for that vignette had laid out an unmistakable courtroom complete with a flag, a seal behind the bird-judge's bench abutting a full witness box, and spectator seats on which could be found an anxious-looking cat and a baby kitten. The final version, in contrast, has eliminated most structural markers of a courtroom and thus requires the viewer to situate the scene.

The selection of animals was not without freight, some from the artist and some from the audience. Otterness deliberately chooses creatures both wild and domesticated. As one journalist explained: "Although the animals inhabit these roles with differing degrees of civility, it is still the political state, not the state of nature, which defines them."[327] The political implications were not lost on one judge, worried that showing an owl would raise hackles in Oregon, where litigation over the habitat of spotted owls had been intense.[328] (Otterness reported that he told the judge it was a barn owl, not a spotted owl.[329]) In another Otterness installation, the GSA had cautioned against an

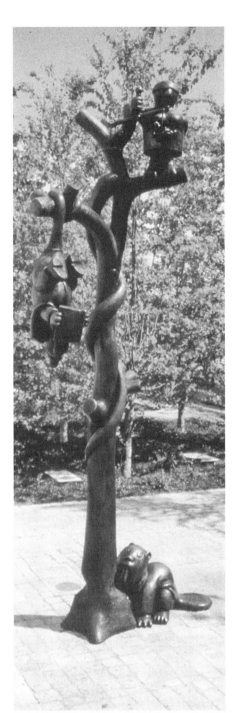

FIGURE 122 *Tree of Knowledge* in *Law of Nature,*
Tom Otterness, 1997, Mark O. Hatfield United
States Courthouse, Portland, Oregon.

Photographer: Tom Otterness. Photograph provided
courtesy of Tom Otterness Studio.

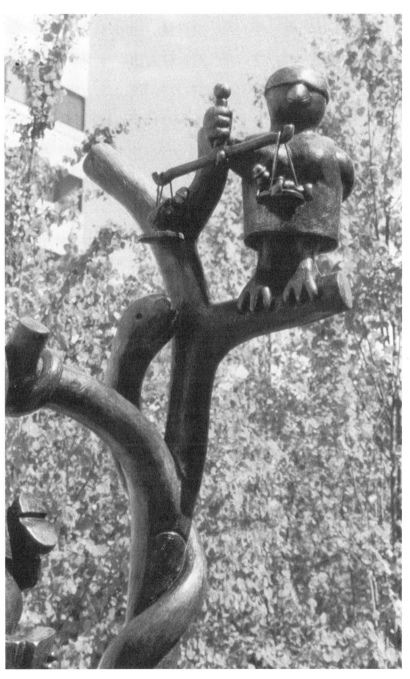

FIGURE 123 *Tree of Knowledge* (detail).

Photographer: Tom Otterness. Photograph provided courtesy of Tom Otterness Studio.

FIGURE 124  *Tree of Knowledge* (detail).

Photographer: Michael Mathers. Photograph provided courtesy of Tom Otterness Studio. See color plate 24.

elephant, potentially perceived as a "Republican."[330] On the other hand, showing lawyers as obsessive beavers seems not to have prompted objections, even though the beaver-lawyer in Portland is trying to bring the bird-Justice down by gnawing destructively on the tree-like pole where it sits.

Otterness had negotiated criticism before his Oregon drawings. In 1991, when his small, round-bellied, naked, bronze human-like figures were installed in a display titled *The New World* in front of the Roybal Federal Building in Los Angeles, federal officials (including a judge and Edward Roybal, the member of Congress for whom the building was named) objected vehemently.[331] That semi-circular sculpture entailed about two hundred small male and female figures surrounding a naked bronze baby holding up a globe. Nearby a female figure in chains crouched in a cave, named by Otterness the "Hermit Philosopher" and representing "chained intellectual freedom."[332] The GSA described the group as "boisterously active figures," scrambling about a 150-foot pergola frieze that connected a new

federal building to an older one.[333] The infant at the center provided a presence that "portends the need within society for continual rebirth and renewal through truth, freedom and democracy."[334]

In contrast, Congressman Roybal said the figures would attract "perverts," while a judge described the imagery as a "shrine to pedophiles."[335] After a GSA regional administrator, citing the risk of vandalism, ordered removal of two of the small nude sculptures,[336] the Mayor of Los Angeles raised free speech concerns and the American Civil Liberties Union became involved.[337] The denouement included the deletion of six figures (again explained as responsive to "the possibility of vandalism") and the addition of guardrails.[338] Otterness was reportedly not surprised; the "basic rules for government commissioned public sculpture do not allow nudes."[339]

Otterness also showed flexibility for another courthouse installation in Sacramento, California. In 1996 he had proposed a chess set of characters, "rooks as banks, bishops as lawyers, king and queen as rich entrepreneurs," arrayed against "an army of working-class pawns bearing shovels, mallets and serving trays."[340] As Otterness explained to the GSA selection committee, the knights were "shaped like police in police cars, the bishops symbolize politicians or lawyers."[341] The knights, kings, and queens were shown with a "'money bag' head imprinted with a dollar sign," whereas the pawns were imprinted with cent signs. Otterness hoped that viewers would ask, "'what is the game' and 'what are the rules?'" and thus discuss the implications of the class system in the United States.[342] As a GSA staff member noted, the proposal could also read as "if you have money, you can win in court."[343]

Otterness was thus offering his signature mixture of the playful and the resistant, a stance some described as the "reliability of Otterness's narrative" taming the content.[344] But the proposal was not tame enough for the Sacramento arts panel, which rejected it. Some of the members (including the sitting federal judge who was on the committee) explained that even though one could think that money had an effect on outcomes, "it was not an appropriate message for the courthouse"[345] to send. As discussions about modifying the chess game were underway, the judge argued that he "did not want viewers to draw the analogy that being in court was a game." After the group deemed "the idea inappropriate and asked [the artist] to try again, a normal part of the back-and-forth nature of public projects,"[346] Otterness offered various revisions before pursuing a different design.[347]

The result in Sacramento—called *Gold Rush*—is a "tableau depicting the history of Sacramento, with salmon, gold miners, a covered wagon and scenes from the building of the railroad."[348] Populated by "knee-high characters" ranging from pioneers to fish and birds near flowing water, the imagery aimed to remind viewers of the role played by migrants to California.[349] That piece joined several others,

including Daniel Galvez's mural *Golden Mountain / Golden Fields,* that pursued the theme of immigration by focusing specifically on the role of "Chinese pioneers" in the city's history.[350] The other motifs for the art selected were "the concepts of justice and law,"[351] exemplified by several pieces such as Jack Nielsen's *The Agreement,* a mixed-media sculpture symbolizing the letters and books of the law, and writings chosen by Jenny Holzer.

The Sacramento installation was not Holzer's first GSA courthouse commission. In 1995 Jenny Holzer had selected various aphorisms (from her works called *Truisms* and *Survival*) for inscription on fourteen granite benches in the federal courthouse in Allentown, Pennsylvania.[352] But "a resident federal judge . . . crossed out a number of the proposed sayings."[353] Among the deletions were "Men don't protect you anymore" and "Romantic love was invented to manipulate women."[354] Among the substitutions were "a positive attitude makes all the difference in the world."[355] As GSA memos recorded, the proposed texts were reviewed "in detail" by the court's chief judge, working closely with Holzer "to arrive at inscription text that could be supported by the Court" and memorialized in an "editorial agreement" between the two that was then approved by the community arts panel.[356] As a consequence, "most of the messages that evoked political themes" were replaced with "more benign phrases" that the artist provided as alternatives.[357]

Holzer's installation in the Robert T. Matsui Courthouse in Sacramento—where it eventually joined the Otterness *Gold Rush* scene—followed a similar path of editorial deletions and substitutions.[358] Rather than excerpt dozens of lines from her 1980s *Truisms* and *Survival* as she had done for the Allentown benches,[359] Holzer initially proposed engraving "every fourth stone" of the granite pavers on the plaza to provide 210 quotations. Holzer's plan was to cull commentary from "over the last twenty-three centuries" on the themes of "the nature of law, truth and justice."[360] But the community arts panel found too many quotations "unacceptable." At a meeting in 1996, one judge raised the concern that visitors would read the words as "sanctioned by the Court."[361] He thought it would be preferable to have "inspirational" comments, albeit perhaps with texts that " 'play with paradox and balance.' "[362] Another suggested that, rather than be "critical of the court," Holzer use excerpts from the "Constitution, the Bill of Rights and the Declaration of Independence."[363] Under the guidance of the GSA's Susan Harrison, the denouement was to ask Holzer to return with another proposal.[364]

The revised submission in 1997 reduced the number of aphorisms to ninety-nine, a group that Holzer hoped would "educate and inspire with words about law, truth, and justice" and "spark both reflection and passion in all who approach."[365] Again shepherded by Harrison, that submission—along with those made by Tom Otterness, who had shifted from his chessboard to pioneer wagons,

and submissions by several other artists—gained the approval of the designated GSA panel. But even then, settling on specific texts for Holzer's installation proved difficult. Panel members, including one of the court's judges, objected to many of the epigrams. Indeed, several judges were "hostile to the whole project."[366] (One judge commented to the press: "Personally, speaking as an individual, I don't think much of it. I'm not sure at all just where the art is, or what she did that merits $75,000 or $85,000."[367]) Holzer was amenable to some editing, but one sticking point was her desire to keep a quote from Susan B. Anthony that said, "It was we, the people, not we the white male citizens . . . who formed this Union."[368] One judge (attempting to mediate) argued that litigants could be offended. He gave as an example that the court heard cases alleging "reverse discrimination" brought by white men aiming to halt affirmative action; singling out "white male citizens" as a group could be seen as making an inappropriate reference.[369] What was needed, advised the judge "caught in the middle," was to appreciate that a good many of the accepted commentaries were "provocative, contemporary and tense" and that the Anthony quote ought to be deleted in favor of a saying with a "more positive tone."[370]

Other statements also raised ire. Objections were registered to "Poverty or wealth will make all the difference in securing the substance or only the shadow of constitutional protections"; to "I am ashamed that law is such an ass," and to "The law sees and treats women the way men see and treat women."[371] After many back-and-forths, the statements inscribed in stone included "It is a fair summary of history to say that the safeguards of liberty have frequently been forged in controversies involving not very nice people," shown in figure 125 and taken from a 1950 dissent by Justice Felix Frankfurter.[372] Ninety-eight other statements, from a wide array of commentators, were placed so as to be "oriented at various angles, allowing pedestrians traveling from any direction across the plaza the opportunity to read a sampling of quotations."[373] A GSA monograph summed them up as aiming to "elicit both reflection and passion from readers," with maxims that both "compliment and contradict one another" from "the vast network of interlocking texts that constitute legal and judicial discourse."[374]

Some of the sayings draw on ancient texts, akin to what had been put in Renaissance town halls. Seneca's injunction "A judge is unjust who hears but one side of a case, even though he decides it as a judge" is inscribed, as is Aristotle's "It is best that laws should be construed as to leave as little as possible to the decision of those who judge."[375] Leaping forward centuries, concern about law's capacity can be found in a 1860 comment by suffragist Elizabeth Cady Stanton: "To make laws that man can not, and will not obey, serves to bring all law into contempt."[376] Law's dependency on popular obedience is explained by a 1965 statement by Hubert Humphrey: "There are not enough jails, not enough

policemen, not enough courts to enforce a law not supported by the people."[377]

Criticism of the government is also implied by the line "Great nations, like great men, should keep their word," but only if one knows it came from a 1943 dissent by Justice Hugo Black, protesting that an Indian tribe had been wrongly treated. (In the opinion, Black added, "I regret that this Court is to be the governmental agency that breaks faith with this dependent people."[378]) Similarly, the power of a 1978 comment by Russian Aleksandr Solzhenitsyn, "After a certain level of the problem has been reached, legalistic thinking induces paralysis,"[379] relies on knowing his experiences in the Soviet Gulag.

Some sense that the texts engaged and elicited inquiry, as Holzer had hoped, came from commentary responding to the reproduction of excerpts from the 1848 Declaration of Sentiments—propounded in Seneca Falls and calling for women's equality—that is also chiseled into the pavers. "We hold these truths to be self evident that all men and women are created equally" is the quote that prompted a story in the local newspaper, the *Sacramento Bee,* which noted that uninformed visitors might assume the text was a "politically corrected misquote of Thomas Jefferson."[380]

If the Otterness and Holzer installations required viewers informed by background knowledge and attentive to details to interpret the import, other objects in the Sacramento building did not. A "monumental, golden scale of justice" by Larry Kirkland that dominated the courthouse rotunda provided, as the GSA monograph on the art noted, "an unambiguous emblem of the building's function."[381] The twenty-three-karat gold surface also referenced the city's Gold Rush history, while the twelve marble chairs beneath the huge scales denoted a jury. On the other hand, those empty chairs, set in a circle with inscriptions on their backs, did reiterate some of Holzer's critiques. Some of the texts, composed by United States poet laureate Rita Dove,

invoked the pain of judgment: "Did my job, then / looked into / their eyes / what had I / become?"[382]

The various pieces inside the federal courthouse joined other displays of public art that a construction boom had brought to Sacramento, which had been "one of the first cities in the country to adopt a public art ordinance" to protect set-asides in budgets as did the federal Art-in-Architecture program.[383] Responses to the Sacramento courthouse's assemblage were mixed. News reports focused on the cost—$842,400 that "taxpayers plunked down"—as well as on a dislike of the installation ascribed to some courthouse personnel.[384] One unnamed staffer called some of the art "just as ugly as can be," while another referred to a sculpture as a "bunch of rusty iron imported from France."[385]

The exchanges over the proposals by Otterness and Holzer parallel the conflicts detailed in Chapter 6 but with an important difference. During the 1930s, artists wandered into controversies they had not expected. Neither archival nor contemporary discussions of their work reveal interest in provoking reflections on the unfairness of the justice system or the failures of law. Indeed, when criticized, Romuald Kraus protested that he had sculpted a Christian image of Justice, not a "Communist" one (figs. 6/77 and 6/78), and Stefan Hirsch disavowed intending to depict a "mulatto" Justice in *Justice as Protector and Avenger* (fig. 6/81). Yet Kraus's *Justice* was sent to a government attic in Washington and then to a corner hallway in Newark, New Jersey, while Hirsch's *Justice* was put behind drapes in Aiken, South Carolina.

Late twentieth-century artists, in contrast, did have questions about the history and practices of the justice system. But, when raised, these artists were subjected to pre-installation editing that obviated the need for post-installation coverings. The examples of Otterness and Holzer join several other instances in the 1980s and 1990s when "potentially inflammable content" in provocative or challeng-

ing art was censored from federal installations.[386] Despite efforts of some GSA staff, the interactions between community panels and artists provided occasions for local and government commentators to resist displays they found disquieting.

To make it into courthouses, artists responded by modifying their art to mollify the critics. Once deemed to have put insufficient or inappropriate clothes on her *Justice* for a federal courthouse in New Hampshire, for example, Diana Moore added different garb (figs. 5/72, 5/74, 5/75). When Jan Mitchell's proposed figure of a Moco Jumbie (fig. 6/88) was rejected for lacking gravitas and her *Reaching Man* (fig. 6/90), referring to slavery, was seen as too provocative for the Virgin Islands court, her *Lady of Justice* (fig. 6/87) resembling a friendly local resident, took their places.[387]

In many instances the critics were *right* to worry that viewers could find the imagery unsettling. That was the point. The tensions between community arts panels and artists bespeak their shared commitment to what political theorists term the "public sphere." Both sides of the debate took seriously that they were trying to constitute civic environments that had didactic messages. They disagreed about what lessons to provide. While some commentators—Jürgen Habermas (discussed in Chapter 13) is emblematic[388]—called for dialogues that engaged complex questions of social ordering in democracies, many of those constructing courthouses wanted celebration. Otterness and Holzer thought to reflect on law's failures and to raise questions about the legitimacy of power but were met by art patrons who, while open to whimsy, wanted comfort and inspiration.

## "Plop art" and Building Norms

How might one assess the results of thirty years of AiA efforts? One measure can be the public acclaim for the art. Unlike many of the WPA artists, the artists on AiA's list included internationally appreciated artists who contributed distinguished works to public buildings and museums in various countries. Several commissioned works garnered critical praise,[389] albeit some of it derived from a circle of congratulation in which commissions awarded by the GSA receive citations from juries convened by the GSA.[390] Another measure would be the variety of artists supported and the diversity and eclecticism of the genres engaged. What Daniel Moynihan's 1960s Guiding Principles had commended for architecture became true for the art; no one "official" style prevailed. Courthouses now display a wide array of materials, ranging from inscriptions to mosaics and murals, from clay and cloth to bronze shaped into representational images (Justice included) and abstractions.[391] If anything, eclecticism is the signature.

Yet another metric could be popular enthusiasm, or at least acceptance, in the localities where the works are sited. Relatively few of the late twentieth-century commissions generated public protests from either communities or members of the judiciary. In some instances the absence of controversy denoted that the GSA procedures had succeeded in producing a generative exchange between audience and artist; in others (exemplified here by Otterness and Holzer) the process defused conflicts by editing the art before its display. On yet other occasions, proposals were aborted altogether.[392]

Looking for enthusiasm or acceptance presumes that attention has been paid to the art. But it is also possible that the art has been seen as either too tangential or too deeply integral to the building to elicit engagement. As an architect involved in the GSA Design in Excellence program put it, many selections were "plop art . . . set in front of a wall designed to be a backdrop" rather than integrated into the concept of a building.[393] As one critic described the art in the Oregon courthouse where Otterness's *Law of Nature* perched on an eighth-floor outdoor patio, "these elements are only add-ons to architecture."[394]

Moreover, on occasion the art itself served as a wall—functioning as a literal barrier to entry. In a few instances the allocation for AiA went to artistically designed bollards, stanchions that form barricades against direct entry.[395] The art funding was used in one courthouse "to provide [an] external vehicle standoff."[396] As GSA administrators testified, money was thus saved "by reducing the distinctions between an architectural element and a security element."[397]

If some art was "plopped" and a few pieces guarded entries, other selections were so deeply a part of structures that they were rendered invisible. When choices moved beyond "abstract lumps of metal in plazas" and took form as "glass windows, skylights, murals, plaza designs, and even lighting installations,"[398] that art's import was lost to some viewers. GSA building-specific monographs reflected the positioning of the art by repeatedly describing it as an "important feature of great architecture"[399] rather than objects independently aspiring to offer instruction on or insight into a building's purposes. Didacticism came, instead, from the buildings, designed to express the normative program of Moynihan's mantra—America's "dignity, enterprise, vigor, and stability"—or the aspirations of the 2007 *U.S. Courts Design Guide* to capture "solemnity, stability, integrity, rigor, and fairness." But architectural critic Paul Spencer Byard took a different lesson from the constructions: "Like our times, contemporary court architecture is about effect, not substance; about how great we have been, not how great we might become."[400]

What might one have hoped for? When bringing national attention to art in the 1960s, President John Kennedy argued that art not only served to enrich and celebrate the nation but was also a method to "question power." Evoking a long-standing romantic view of the artist, Kennedy proposed funding those "last champion[s] of the individual mind and sensibility against an intrusive society and an officious state."[401] Late twentieth-century federal courthouses, how-

ever, did not herald individual freedoms but rather made plain what President Kennedy called the "officious state"—guarding access to its officials, shuttling defendants to enclosed byways, and displaying its sense of self-satisfaction through rich detailing. Both public purposes and private-sector interests converged to create federal monuments to national authority, security, and prosperity. The primal motif is the courtroom itself, which remains the centerpiece, as if litigants, lawyers, and judges still regularly inhabited those spaces.

But after scanning the globe (in Chapters 10 through 13) to find shared premises of commitments to adjudication embodied in major buildings (and the parallel growth in prison construction), we explain in Chapter 14 that, while courtrooms are still dedicated to judges, judges are no longer dedicated only to adjudication. Instead they have devolved or outsourced much of the factfinding of adjudication to decisionmakers in administrative agencies and tribunals, to lawyers negotiating settlements, and to private dispute resolution centers. The public processes of courts are fading even as monuments to their role are built. And in the structures created, as one can see from the quieting of the Otterness and Holzer critiques, there is little willingness to engage frankly in the challenges that are entailed were one to recenter conflict resolution in courts. In contrast, as we explore in Chapter 15, one can use both buildings and art to bring lessons about law's history and its failures into courthouses and invite questions about how courts can become vibrant centers of democratic debate. Courts could remain important sites within the public sphere(s) to provide opportunities to practice democracy by acknowledging rather than ignoring justice's shortfalls.

# Monuments to the Present and Museums of the Past: National Courts (and Prisons)

## COMPARATIVE CURRENTS

The judicial building project in the United States has worldwide counterparts, with scale and scope varying by place and resources. Around the globe, government leaders have chosen to house some of their adjudicatory services in buildings designed to be unique, impressive, and secure.[1] This chapter picks up the transnational tour begun in Chapter 1 to provide a comparativist perspective on how, during the second half of the twentieth century, courthouses came to be icons of government. Our national examples are drawn from France, Israel, Finland, and Australia,[2] to be paralleled in Chapters 11 and 12 by an overview of the development of regional and transnational courts.

As the end of the twentieth century approached, many court systems focused on "long range planning"[3] or "futures" projects, sparked by anticipation of the new millenium coupled with anxiety about the "quiet crisis" of aging facilities in poor condition that were required to respond to a growth in caseloads and prison populations.[4] In long-established countries, extant facilities were criticized for providing an insufficient number of courtrooms, inadequate rooms ("undersized and windowless") for staff, too few holding cells for detainees, and too limited citizen services, "compromised" by congested waiting rooms and corridors.[5] In newer nations, pressures for court construction stemmed from interests in marking their sovereign authority.

Four factors influenced their concerns. First, growing numbers of people have gained entitlements to seek redress through courts. The increase in dockets has put pressure on jurisdictions to expand facilities. Second, on the criminal side, courts incarcerate growing numbers of people. As detailed in Chapter 7, in earlier centuries, city planners put jail cells in or near courts. But with the decline of public punishments and the turn to incarceration for convicted offenders, purpose-built prisons—placed away from towns' centers—came to the fore. The spurt in courthouse building has thus been accompanied by an expansion in the number and size of prisons. An increase in detention rates and in the length of prison sentences can be found in many countries, albeit most pronounced in the United States where, as of 2008, "one in 100 adults was in prison or jail" and "a stunning 1 in every 31 adults, or 3.2 percent, [were] under some form of correctional control."[6] Third, as the market for building courts and prisons expanded, its participants shaped professional interest groups that crossed borders and formed networks focused on the construction of facilities for "justice" that came to be defined to encompass both courts and detention centers. Fourth, late twentieth-century governments aspired to distinctive buildings symbolizing the role played by law[7] and hence marking courts' function as "the new fulcrum around which the mechanism of self-representation in the various modern states" pivoted.[8]

## Singularly Impressive, Diverse, and Homogeneous

Governments around the world presumed that ever-larger footprints would be required for courts to continue their historic functions as centers of public proceedings and as warehouses for paper documents.[9] Architects, court professionals, and various national and international bodies developed manuals for the "design and image" of courts,[10] akin to those detailed in Chapter 9 for the United States federal system. These materials placed judges at the visual center of courtrooms,[11] while setting forth rules on passageways that secluded judges from the public and that separated detainees from everyone. Throughout, builders aspired to create structures recognizable as special sites—courthouses.

These projects included a smattering of lay involvement but were run by professionals. The three groups—judges, lawyers, and architects—that had launched courthouse architecture in the seventeenth and eighteenth centuries continued to dominate the discussions. By the end of the twentieth century, they were joined by another group—

court administrators who served either within the judicial branch or under the executive branch. Professional organizations formed to represent various court administrative subgroups such as clerks, public information officers, in-house building managers, and executives.[12] Some staff gained sufficient prominence to obtain their own dedicated spaces, as in the Thurgood Marshall Building (fig. 8/114) in Washington, D.C.

Specifications for courthouses and the rooms therein varied somewhat across jurisdictions. Some embraced historical continuity with Neoclassical designs, while others sought novelty. As for the layouts of courtrooms, the plans for common law countries that, like England and the United States, relied on juries were not identical to those in civil law countries. French courtrooms, for example, often place the prosecution at the level of the judge, whereas common law countries put the litigants (government included) at the same level, typically lower than the judges, who are often seated on a raised bench. Further, French planning guides detailed somewhat different seating arrangements for civil and criminal proceedings, while common law countries generally use the same room for both kinds of cases.[13]

Various other distinctions can be drawn.[14] Some courthouses in Finland had movable furnishings, readily reconfigurable, while American courtrooms typically provided furniture anchored to the floor. A distinctive pattern was proffered by the Israeli Supreme Court, which denoted the equal status of participants by shaping a two-square courtroom layout, with one square shared by judges and lawyers and the other occupied by the public.[15] English courtrooms often isolate a criminal defendant in the "dock,"[16] whereas American courtrooms put a defendant, accompanied by a lawyer, behind a table across the central aisle from the prosecution's table. Within the United States itself, the federal system's guidelines called for larger courtrooms than did many other manuals.[17] Further, during the 1970s and 1980s, reconfigurations of the courtroom were imagined, as designers offered courtrooms "in the round" or put judges' benches in a corner.[18] Yet conventional layouts, often echoing churches, continued to dominate alongside one less uplifting innovation—the crafting of extraordinarily secure courtrooms for "terrorists" and other defendants thought to be especially dangerous.

Overall, the variations are minor compared to the homogenization in construction and interior design driven by architects, artists, judges, and expert consultants who moved from jurisdiction to jurisdiction in the globalizing market for "justice architecture." They relied on transnational engineering standards and parallel legislative mandates, such as requiring energy efficiency and access for persons with disabilities.[19] Their patterning was also influenced by shared norms (some transmitted through conquest and colonialism) that spoke to the respective roles of judges, lawyers, witnesses, litigants, and spectators.[20] Across borders, builders sought to control movement and to isolate one group from another within courthouses.

## The Business of Building Courts: The Academy of Architecture for Justice

The business of architecture, like the precepts of accessibility, security, energy conservation, and efficiency, is not geographically bounded. In 1948 (the year celebrated for the proclamation of the Universal Declaration of Human Rights[21]), the International Union of Architects came into being. By 2008 it counted more than a million architects as members in more than one hundred countries.[22] Beginning in the 1970s, the American Institute of Architects (AIA) fostered various architectural sub-specialties called "knowledge communities."[23] One—the Academy of Architecture for Justice—focused on "effective project delivery, team building, . . . and cutting-edge design issues for architects providing the diversified services associated with justice architecture."[24] Over many years and with various names, the group convened meetings and gave awards for building designs that were featured in its publication, *Justice Facilities Review,* begun in the early 1990s.

A review of materials from the Academy of Architecture for Justice makes plain that its reference to "justice" encompasses jails and prisons as well as courts. Indeed, the group's roots go back to a 1972 Task Force on Correctional Architecture that worked in conjunction with lawyers and judges to develop standards for criminal justice facilities.[25] The goals of the Academy of Architecture for Justice include "elevating the stature" of justice institutions "within society,"[26] and much of the business of its members stems from dollars devoted to correctional facilities, as those amounts frequently outstrip the sums budgeted for courts.

Toward the end of the twentieth century, the Academy of Architecture for Justice joined with court administrators to host a series of international conferences. One aim was to help architects and engineers understand how to comply with various government standards so as to bid successfully for commissions. As materials from one conference explained, "Throughout the world, justice architecture has always been an expression of national pride and responsibility."[27] Workshops' titles capture shared concerns transcending national borders: topics ranged from the "greening of justice" to "modern jails make good neighbors"[28] and the "customer-friendly courthouse."[29] In New York in 2007, at the "Sixth International Conference on Courthouse Design" (subtitled "Sustainable Excellence"), the participants shared designs for secure, "green" buildings.[30] Judges, architects, and academics took traveling tours of courthouses that facilitated the borrowing of ideas and architects.[31]

This transnational market has produced pervasive commonalities, from technologies permitting heavy reliance on glass to regular displays of the scales of justice. Further, sev-

eral jurisdictions either have set-asides for art or accept donations of artworks that are proudly displayed.[32] Many buildings include eclectic works, and a few of the artists have crossed borders. For example, the work of conceptual artist Jenny Holzer, shown in Chapter 9 in a courthouse in Sacramento, California, can also be seen in Nantes, France where a new "Palais de Justice"—discussed in the next section—opened in 2000.

## JUSTICE PALACES FOR FRANCE

### Legible Architecture for an Evolving Justice

In the late 1980s, the French Ministry of Justice reviewed its 723 operating sites as it began a series of projects, defined by "a certain architectural ambition," to rationalize the services provided by courts through administrative reform and new construction.[33] The goals of modernizing justice and affirming the commitment to law and "the values of democracy"[34] entailed making more space for judges,[35] improving conditions for decisionmaking, reorganizing first-tier tribunals and courts (sometimes through consolidation into a single facility), creating energy-efficient buildings,[36] reducing delay, accommodating rising filings, and providing more functional, secure, and welcoming facilities[37] that were readily legible to users.[38]

The plan was to renovate some facilities and build others anew. Like the leadership of the judiciary in the United States, French officials obtained significant economic support. A budget of about $1.5 billion (6 billion francs) supported the projects from 1995 to 1999.[39] In the early 1990s, twenty-seven regions in France were flagged for renovations that would run through 2015. By 2000, fifteen major buildings had been completed, with individual structures costing from about $5 million to $40 million (28 million to 240 million francs); and more were in progress.[40]

The courthouse building projects in France and the United States have many parallels, despite differences in the organization and conception of those countries' judiciaries.[41] France is a civil law country that deploys an elite corps of specially trained jurists to serve for most of their careers in the structured hierarchy of a unitary national court system.[42] The United States, a common law federation, relies on judges who are selected via appointment or election and who come from practice and occasionally the academy. Further, even as some convergence or harmonization of procedures across civil and common law countries may be underway,[43] the etiquette of lawyering and the discursive styles of opinion writing in the two countries vary considerably. The procedures for criminal cases and the role of judges also differ, and juries are a feature of justice in the United States but not in France. Yet despite these and other distinctions, the two countries followed similar paths in courthouse construction, as key administrators led self-

conscious efforts to create important public buildings,[44] employed world-renowned architects, and protected budgetary set-asides for art—known in the United States as "Art-in-Architecture" and in France as the "1% décoratif."[45]

The outcome in France, as in the United States, has been the creation of an impressive array of monumental buildings whose exterior shapes vary dramatically. Their interiors, however (again, paralleling the experiences in the United States), reiterate the theme of shuttling people along their separate and segregated paths toward standardized courtrooms and offices. And while funds were set aside for art in each country, art took second seat to the buildings, styled to be the symbols of justice.

When starting the new construction in the early 1990s, French designers self-consciously asked questions about what ought to be built. The goals included shaping new structures and art to capture France's commitments to an evolving justice entailing a multitude of laws and tasks for jurists who worked inside a diversifying culture committed to transnational obligations of fairness. Leaders raised concerns—akin to those put forth in the United States in the 1960s by Senator Daniel Moynihan—that public construction in France had become banal, producing undistinguished structures that conflated justice with bureaucratic administration.[46] To map an agenda for improvements, officials undertook studies, convened conferences, and developed manuals to shape plans for a new set of "palais de justices"—the French term for courthouses.[47]

Such future planning ("imagining courts for the 21st century," as Antoine Garapon put it[48]) prompted reflections on the history of courthouses. Traditions of courthouses in France, developed out of Medieval culture, had produced three successive eras of courthouse styles, described by one commentator, Vincent Lamanda, as evocations of the Royal Palace, the Temple of Thémis, and the more contemporary Hall of the Rights of Man.[49] Another commentator, Robert Jacob, detailed the openness of Medieval and Renaissance judicial architecture, which was integrated into cities to facilitate a fluid exchange between commerce and law in an era rich with jurisdictional overlaps.[50] Under Louis XII, courthouse space became more luxurious to denote the import and power of the regal system that sought to centralize authority.[51] The buildings relied on monumental entryways and dedicated doorways, "framed by columns" and long stairways, architectural attributes that all helped to elevate law and put it at a distance from the ordinary person. The setting denoted the seriousness of the "extraordinary act" of "going to law."[52]

By the eighteenth and nineteenth centuries, courthouse exteriors relied on Neoclassical architecture to stand out from, rather than blend with, neighboring structures.[53] The interiors denoted the hierarchical superiority of some actors over others. Akin to traditions in England and the United States, the progression in France toward modern

courts imposed increasingly segregated spaces for professionals: wooden bars, witness stands, and benches adorned courtrooms to delineate boundaries and specify roles.[54] As Christine Mengin has documented, separate offices for judges and libraries for lawbooks first made their appearances during the nineteenth century; the specific allocation of space reflected organizational hierarchies.[55] But unlike other public buildings in France, whose configurations were dictated by public commissions, Jacob noted that courthouse styles developed through a kind of evolutionary naturalism reflecting changing societal functions of justice.[56]

Antoine Garapon has argued that French courthouses were reconfigured in relationship to the political shift from a sovereignty centered on the nation (and earlier upon the king—the emblematic "L'État, c'est moi"[57]) to a representative democracy committed to individual authority. According to Garapon's schematization of French traditions, under the Ancien Régime, courthouses were basilica-like, with courtrooms akin to chapels.[58] Judges, as if priests with powers implicitly derived from God, sat on high to superintend the confrontation between man and law, and the attachment to the Civil Code had cult-like elements.[59] Garapon further suggested that the subsequent, more democratic vision produced courthouses resembling parliaments. A judge served (as would a speaker of an assembly) to oversee exchanges that, through procedural commitments, acknowledged and valorized the autonomy of individuals in horizontal relationship to each other.[60]

The challenges of designing new public spaces for justice were hence substantial. Marc Moinard, the Director of Legal Services in the Ministry of Justice, underscored that viewers had "to be able to identify the building as a place where justice is meted out,"[61] a commitment that Jacob ascribed to the "universal need . . . for a clearly marked place where good can be distinguished from evil."[62] Yet Garapon worried that courthouses were increasingly becoming "indistinguishable from other public buildings" and that such "architectural silence" was "dangerous."[63] The "erosion of legal symbolism . . . threaten[ed] the very foundations of the legal system." Garapon called for architects and lawyers to "unite to find new ways to express a democratic legal process"[64] that reflected that a court is "simultaneously a theatre, a temple and a forum."[65]

While drawing on history, both Jacob and Garapon warned against unreflective recycling of the past. Jacob argued that traditions marking the isolation and grandeur of justice no longer fit contemporary commitments to the shared ownership of law's promulgation and application. Garapon, in turn, thought that historic symbols of authority and majesty failed to capture justice's efforts to be responsive to social conflict. But he was skeptical about the ability to represent either the Anglo-American "due process" or its parallel in Article 6 of the European Convention on Human Rights.[66] Architecture and art could not readily capture

ideas such as protecting individuals' opportunities for public hearings before impartial and independent judges obliged to make decisions based in law.[67] Another difficulty, noted by Jacob, was capturing the decentralization of judicial activities,[68] which included research and discussions (often taking place in offices "dans le cabinet" where papers were reviewed) and interventions that veered toward the therapeutic in a mode that was decreasingly social.[69]

Other challenges (set forth in commentary from a 2000 colloquium on the topic) were about capturing facets of justice that indirectly echoed Thomas Aquinas's conceptual differentiation between retributive and commutaive justice.[70] One aspiration—frankly embraced within French discussions—was to embody the institutionalized force of law, aiming to impose order on passion, even as law itself did violence through criminal sanctions rendered in the name of the French people. The other aim was to express conciliatory modalities that the judicial system was coming to entail.[71] Discussions focused on how to materialize the new judicial obligation to search for solutions, sometimes through negotiations and mediation,[72] yet create inspirational spaces worthy of bearing the name of the Virtue Justice.[73] Some sought massive designs that denoted the rigor, power, order, and authority of courts, while others wanted to temper those expressions with ways to welcome the vulnerable,[74] to emphasize the values of conciliation,[75] and to maximize flexibility.[76] Rationalization through combining various tribunals in one space had appeal as a way to make those tribunals more visible and accessible.[77]

Adding to the amalgam of aspirations were concerns that justice buildings had to be "legible"—readily understood to be important public spaces reflecting justice's ambitions while serving as functional edifices that housed many offices as well as courtrooms.[78] The need for all those offices, however, was in tension with the goal of marking the buildings as specially and distinctively about justice. Commentators in France, like those across the ocean, worried about how to protect the courtroom (what one United States judge had called "the pearl within the shell"[79]) from being obscured by the square footage devoted to administrative functions.[80]

Goals for new buildings thus ran from expressing justice's solemnity, transparency, and openness to making plain courts' roles as educators, interpreters, experts, conciliators, mediators, and adjudicators functioning at times on behalf not only of France but also of Europe, of which France is a legal part through both the Council of Europe and the European Union.[81] As the first President of the Appellate Court for Caen explained, new construction had to represent a justice that continued to condemn criminals while taking into account the suffering and difficulties of people as it tried to bring about reconciliation.[82]

In terms of concrete (pun intended) alterations, one plan was reconfiguring a traditional space in a palais de justice—

the entry foyer or waiting area adjacent to courtrooms that in French is called "la salle des pas perdus" (literally the room of lost steps). Commentators noted its historic function as an intermediate space between the street and "les salles d'audiences," or courtrooms, a term that, like the word for a courthouse (*palais*), reflects French courts' monarchal past.[83] For many, la salle des pas perdus is associated with the anxiety of waiting for verdicts or with wasted time. (The term is also regularly used in reference to railway stations, where people stand to catch trains, and other Romance languages use the same phrase for these various areas.) Commentators urged courthouse designers to reconceive these foyers as places that welcomed and informed litigants and the public[84] as well as to create "salles de réunion," conference rooms in which people came together.[85]

In response to this melange of goals, the Justice Ministry acquired more sites and looked to the private market for great architects, who were directed in some respects while invited to invent in others.[86] In the United States, the federal judiciary had drafted a design guide. In France it was the administrative building-arm of the Ministry that developed detailed dossiers that provided precise recommendations for each function within a courthouse, as well as specifications as to the sizes of rooms while leaving limited discretion to architects for designs of entry areas[87] and exterior aesthetics. Flexibility was one goal, and another was to group related uses in modules or pods (one area for offices, another for courtrooms).[88] Builders were asked not to rely on a single template but to capture the government's ambitions in diverse ways. That strategy was later criticized by some as producing undue fragmentation,[89] a concern that one also heard in the United States where the array of styles meant that none served to announce the "federal presence."[90]

Working in a fashion parallel to the Design Excellence Program of the General Services Administration (GSA) in the United States, the administrative entity in France charged with overseeing courts and prisons sought outstanding architects for the renovation and expansion of facilities.[91] The architects commissioned through competitions (the customary mode for public building in France) included Henri Ciriani for Le Palais de Justice de Pontoise, Bernard Kohn for Montpellier's facility, Richard Rogers for Bordeaux's courthouse, Henri Gaudin for the Besançon facility, Francoise Jorda and Gilles Perraudin for Melun's Palais de Justice, and Jean Nouvel for the courthouse in Nantes.[92]

In 2002, to manage the projects that were well underway, the country chartered a new entity, L'Agence de Maîtrise d'Ouvrage des Travaux du Ministère de la Justice (AMOTMJ, or the Building Works Agency of the Ministry of Justice); a different group was devoted exclusively to work in Paris.[93] The AMOTMJ provided administrative services for prisons, halfway houses, youth facilities, and courts.[94] By the end of 2004, eighty-nine buildings (forty-seven related to prisons and forty-two for courts) were

under construction or had been completed in both France and its territories abroad (Guadeloupe, Martinique, La Réunion, Mayotte, and French Polynesia) at a cost of more than 2 billion euros (about $3 billion).[95] As the pie charts provided (fig. 126) indicate, prison buildings and operation garnered more euros than did the judiciary. These charts also make plain government commitments to revamping and enlarging both courts and prisons.[96]

Some of the buildings were familiar echoes of eras past, and others were unique architectural objects,[97] built in modules rather than as single unified structures. The designs of several are deliberate departures from the Neoclassical Greek style in an effort to express that the "modern" courthouse is "not only a place of judgment" but also "a place of welcome, information, and guidance for citizens."[98] Many were located in city centers ("justice at the heart of the city"[99]) to mark that "justice is at the center of citizens' concerns and public life."[100] The facilities ranged from an "audacious"[101] and novel conception in Bordeaux (fig. 127) of cone-like modular units (described as looking like "wine casks, eggshells, or beehives"[102]) by Richard Rogers to a recycled parliament building in Rennes (fig. 128)[103] and a renovated Justice Palace in Nice.[104]

Some buildings were deemed successful, "upsetting habits and symbols . . . [and] aiding in the emergence of another justice, one that is more open, more democratic,"[105] while others were criticized for failing to take those very concerns into account.[106] A few of the new buildings—in Bordeaux and in Avignon, for example—segregated spaces so vividly that critics worried about the appearance of a judicial workforce inscribed as autonomous rather than interactive.[107] Further, some deemed much of the interior space banal, reflecting little architectural thought or ingenuity.[108]

To document the work, the Ministry of Justice commissioned studies of both the buildings and their decor.[109] In addition, the Ministry published pamphlets on individual buildings, similar to those produced by the Design Excellence Program in the United States. On both sides of the Atlantic, the architectural choices of each structure were couched in symbolic terms. Some of the courthouses were described as affirming the accessibility and humanity of justice; the new facility in Fort-de-France, Martinique (fig. 129), was termed a place that "inspires confidence and respect."[110] Other buildings were praised for their monumental expressions of justice's authority and dignity. Grenoble's new court, for example, was called a "perfect isosceles triangle" of blue-gray aluminum.[111] The courthouse in Melun (fig. 130) is an imposing parallelepiped, 236 by 177 feet (seventy-two by fifty-four meters) with a two-story, glass-cloaked entry fronted by six tree-like pillars supporting an overhang (some eighty feet, or twenty-four meters, from the ground) that echoes the symbolism of trees in French justice iconography and that serves both to shelter pedestrians and to define the building's facade.[112]

# Budget d'investissement 2004

### Répartition de crédits de paiement
### obtenus : 140,8 M euros

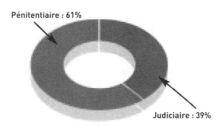

Pénitentiaire : 61%

Judiciaire : 39%

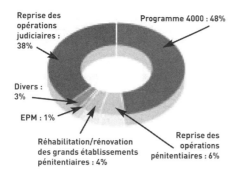

Reprise des opérations judiciaires : 38%

Programme 4000 : 48%

Divers : 3%

EPM : 1%

Réhabilitation/rénovation des grands établissements pénitentiaires : 4%

Reprise des opérations pénitentiaires : 6%

### Répartition d'autorisations de programme
### obtenues : 822,3 M euros

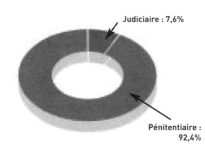

Judiciaire : 7,6%

Pénitentiaire : 92,4%

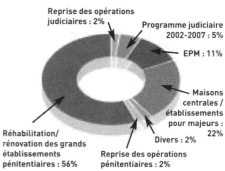

Reprise des opérations judiciaires : 2%

Programme judiciaire 2002-2007 : 5%

EPM : 11%

Maisons centrales / établissements pour majeurs : 22%

Réhabilitation/ rénovation des grands établissements pénitentiaires : 56%

Reprise des opérations pénitentiaires : 2%

Divers : 2%

FIGURE 126    Pie chart depicting budget allocations (Budget d'investissement 2004) from the Annual Report of the Public Agency for Justice Buildings (Agence Publique pour l'Immobilier de la Justice, APIJ) in the Agence de Maîtrise d'Ouvrage des Travaux du Ministère de la Justice (AMTOMJ).

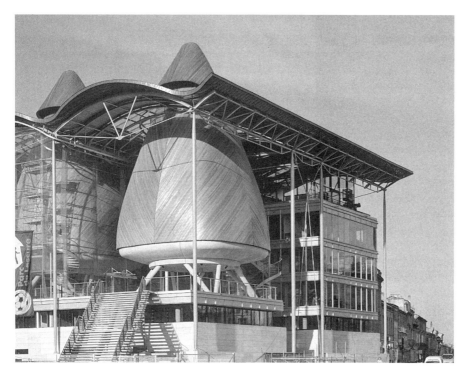

FIGURE 127    Palais de Justice, Exterior, Bordeaux, France. Architect: Richard Rogers, 1998.

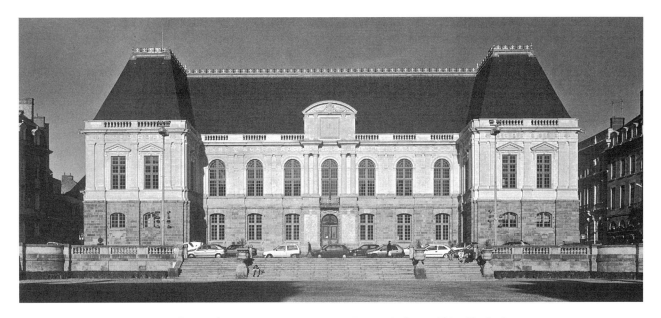

FIGURE 128    Parlement de Bretagne, Exterior, Rennes, France. Architect: Alain-Charles Perrot, 1999.

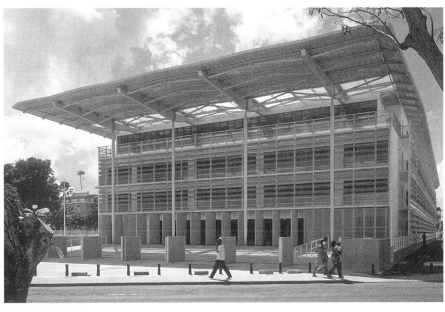

FIGURE 129    Palais de Justice, Main Entrance, Fort de France, Martinique. Architect: Paul Chemetov and Borja Huidobro, 2002.

FIGURE 130    Palais de Justice, Exterior, Melun, France. Architect: Françoise Jorda and Gilles Perraudin, circa 1998.

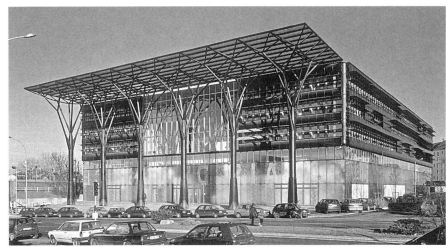

In a few instances, historic buildings, seen as classical monuments, were recycled for courthouses. In Aix-en-Provence, for example, the Justice Ministry retrieved part of a centrally located, old, defunct prison (that remained government property).[113] Reference to the prior use came only by preserving a wall for the new structure. The courthouse was said to reflect "functionality, legibility, and sobriety" and hence, the "solemnity necessary for the exercise of modern justice."[114] In Rennes, the building that had housed Brittany's parliament and had been used for coronation rituals since the sixteenth century was reclaimed after a fire in 1994 and renovated for the appellate courts.[115] In Besançon, a Renaissance facade from the sixteenth century was integrated into a huge new structure[116] where arches (like those in Henry Cobb's Boston Courthouse) were chosen by architect Henri Gaudin to express the social harmony that modern justice pursues.[117] And, whether describing new or renovated old structures, the brochures and journal articles focused not on the artwork within but on the symbolism of the buildings themselves.[118]

As in courthouses in the United States, certain features criss-cross the diverse structures. Many are clad in glass,[119] explained as one of the most "modern materials" that served well to symbolize justice.[120] Despite the transparency of the exteriors, the interiors feature only a few discrete areas for shared use because a good deal of space is devoted to protected and separate passageways ("trois flux")[121] for judges, the public, and detainees. Several buildings rely on hierarchies; the public enters and remains on the bottom floors, and judges and administrators occupy the higher levels.[122] More of the usable space is devoted to administrative and other offices rather than courtrooms.[123] Airy glass designs may suggest easy accessibility, but rules governing the movement of people wall off space, as video surveillance controls and superintends users.[124]

Furthermore, however varied the exteriors, the interiors are similar and traditional. Most courtrooms are autonomous, isolated, enclosed spaces aiming for solemnity and devoid of iconographical ornamentation. Further, despite discussions questioning the practice of putting the presiding jurist above and at a distance, and even while insisting on new roles for judges as negotiators,[125] many courtrooms remained true to the prior configuration. The judge remains elevated, even if perhaps not quite as high or as far from the participants as had been the practice. One critic surveying various buildings called the courtrooms "ordinary and repetitive" and "almost interchangeable"[126] from one facility to the next. Sources of light vary somewhat, as natural light comes either through windows or only through skylights. As for spectators, many courtrooms offer hard wood benches, ramrod straight.

## "Le 1% décoratif"

As of 1980, the French government provided that its "1% décoratif"—the 1 percent of public building budgets devoted to art—applied to the judiciary.[127] Under the Ministry of Justice, efforts were made to avoid art becoming an afterthought. The architect, in conjunction with the Ministry, was to develop an integrative plan early in a building's design that, as in the United States, reflected the central role architects played in selection.[128] In addition, and again paralleling procedures in the United States, the Ministry convened committees comprised of participants from different sectors.[129] As of 2000, committee approval was required for projects costing more than $710,000 (762,250 euros).[130] Each committee included three representatives from the Ministries of Justice and of Culture as well as an architect, two artists, the mayor of the relevant locality, a jurist from the designated court, and a Counselor from the regional office of the Ministry of Culture.[131] The charge was twofold: to select art that contributed to the quality of public buildings through the relationship between the art and architecture and to enable the public to have contact with new contemporary art.[132]

In the United States, public support for art began only in the second half of the twentieth century and the federalist political arrangement resulted in eclectic expressions of justice imagery in state and federal courthouses—with the female Virtue Justice as a common denominator. In contrast, the French had a specified tradition of court decoration (paralleled in other arenas of government building) that included a larger set of standard symbols. The Ministry of Justice's website provided an account[133] that divided the imagery into categories—"religious" (Christ and the cross[134]), "divine" (Medieval traditions of trees and other vegetation denoting the relationship between the earth and the sun, life cycles, and immortality[135]), "royale" (monarchical images of the lion, the color red, and the fleur de lys), "laïque" (Enlightenment texts or precepts of equality and rights coupled with statues of famous jurists[136]), and "attributs de Thémis" (Justice, with a book or a balance and the sword symbolizing power).[137] Other commentators detailed the melange that had developed. Court decor frequently relied on wood to invoke both the "tree of Justice" and Christ's cross while displaying lawgivers and gods (Zeus, Thémis, St. Louis, Solon, Justinian, and Napoleon), symbols of abundance and prosperity (such as the cornucopia),[138] various animals (the serpent representing knowledge, the lion for power), attributes such as a mirror for knowledge and torches for truth,[139] words (*Lex, Jus*), and the virtue Justice, with scales, sword, and blindfold.[140]

What was the new production resulting from the 1% décoratif? In 2000, the Ministry of Justice commissioned a law professor, Laurence Depambour Tarride, to survey the art commissioned since 1993 for French courthouses.[141] Her review began by noting the power of the architecture, which created the context for the artwork and, in many respects, dominated it.[142] As for the art in the new buildings, the selections often departed—like the buildings themselves—from the older symbolism. She reported a great variety of

imagery and materials, perhaps evocative of law's new diver-sification of modalities[143]—or denoting the lack of clarity of vision about contemporary aspirations to do justice.[144] Thus, as commentators had forecast, old imagery was thought insufficient to capture new tasks such as concilia-tion and experimentation.[145] As in the United States, vari-ous contemporary artists relied on a mix of media for their sculptures, photographs, glassworks, light displays, and gar-dens, arrayed in configurations that ranged from abstrac-tions to representations of objects such as balls, bells, hands, and human figures.[146]

In the Palais de Justice in Melun, for example, a layout of oversized photographs by Maryvonne Arnaud produced an enormous outstretched hand (fig. 131, color plate 33) that lines a significant part of the floor of its grand salle des pas perdus. The gesture aims to welcome entrants,[147] although some may experience the hand as engulfing rather than a friendly beckoning. In Avignon, Brigitte Nahon created a huge balance titled *Équilibre* (*Equilibrium*), formed by enormous round balls made of stainless steel that resemble those used in the French lawn game, "boules."[148] Although

many more balls are stacked on one side than the other, the balance beam (sitting on another such ball) appears stable and even. Nahon attributed the equilibrium of her balance beams to "mysterious energies" or will power.[149]

An immense bronze bell (*Grosse Cloche*, or *Great Bell*), about six and a half feet or two meters in circumference (fig. 132), by Pascal Couvert, sits on a floor in Richard Rogers's Palais de Justice in Bordeaux.[150] Couvert explained his effort to create a symbol legible to all, linking the new court with America's Liberty Bell, church bells, and Bordeaux's own Old Town belfry that still hangs in the city and also bears the name *Grosse Cloche*.[151] (Another commentator, Lamanda, thought the bell echoed the Ancien Régime.[152]) Couvert inscribed words in the style of a Japanese haiku. The lines, by Hélène Ilkar, said to have been inspired by Inès de la Cruz and Franz Kafka, read: "Jour / Vert / Flottant au Poignet / Seul le Bond se Connaît" (Day / Green / Fluttering Cuffs / Only the Bound Knows Itself).[153] Tarride remarked that Couvert had deployed a breadth and diversity of references, drawing on Europe, Japan, and the United States as well as the secular and the sacred.

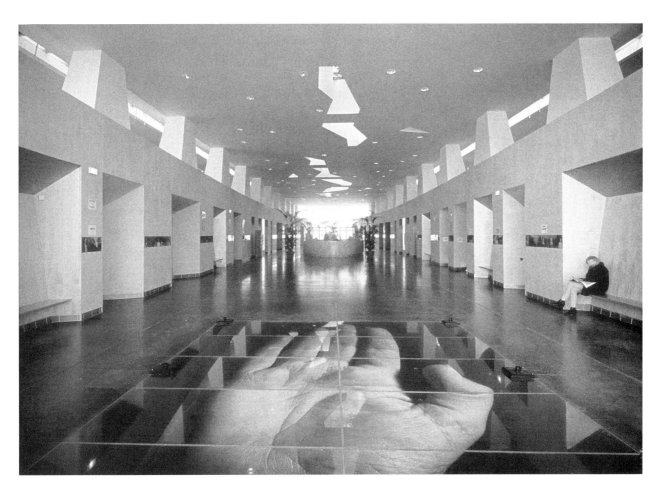

FIGURE 131   *Stories*, Maryvonne Arnaud, 1998, Palais de Justice, Melun, France.

Copyright: APIJ. Photographer: Jean-Marie Monthiers. Photograph reproduced with the permission of the APIJ and the photographer, and reproduction without the written permission of the copyright holders is forbidden. See color plate 33.

Moreover, bells are usually seen from afar, on high, but this one sits on the ground.[154]

For Lyon, Gérard Garouste created what he called *Les Droits de l'Homme* (*Rights of Man*)[155] (fig. 133) and what the local tourism office has dubbed *Pacte entre Justice et Société* (*Pact between Justice and Society*).[156] Displayed in Lyon's salle des pas perdus are thirty-five identically sized ceramic and wrought iron panels. Arrayed are plants, Justice's scales, the God Hermes, and the tree found commonly in classical French judicial imagery.[157] The texts include the words Truth (Veritas), Virtue (Vertu), Equality (Égalité), Liberty (Liberté), and Fraternity (Fraternité) and the name Louis IX,[158] as well as excerpts from various legal documents.[159] As one commentator put it, one can find the "seventeen articles voted in by the Constituent Assembly of 26th August 1789 escaping from [the mouths of the figures] in strips of black writing."[160] Garouste also "added irreverent extracts from the fables of La Fontaine."[161] On some panels, the

FIGURE 133  *Pacte entre l'homme et la société* (*Pact between Man and Society*),
Gérard Garouste, 1994, Palais de Justice, Lyon, France.

words are partially covered by or mixed with wrought-iron overlays. For example, the sentence from the 1948 Universal Declaration of Human Rights—"We will not permit torture or the imposition of cruel, inhuman, or degrading punishments"—can be read above and through the leaves of a winding vine (fig. 134).[162]

In an interview on this work, Garouste explained that he had specifically eschewed abstraction in favor of a plentitude of literary, historic, and religious references.[163] He credited his meetings with jurists from the Lyon court with influencing his choices. As Garouste explained, he wanted to preserve the memories of the historic symbols but realized that the judges sought symbols not only of authority but also of their commitments to conciliation.[164] Garouste added that everyone agreed that references to human rights contributed to images of justice both reassuring and protective.[165] Yet he worried about how to shape new imagery to remind judges of the difficulty of their work, of human suffering, and of the tragedies that could result if they erred.[166] (Tarride found the work successful—an "uninterrupted renewal of the symbolism of justice."[167])

Amidst the diverse depictions, some thematic repetitions cut across the new courthouses' installations. Many feature imagery of vegetation as well as displays of water; the invocations of nature aim to convey a sense of serenity. Natural light is also regularly engaged. Several pieces make direct reference to the French Declaration of the Rights of Man of 1789 and to the Universal Declaration of Human Rights of 1948.[168] A few suggest a dialogue between old and new forms. Brigitte Nahon's balance playfully insists that, despite all odds (the huge balls lined up on one side, perhaps a reference to the power differential between some litigants), the balance remains level, rather than tipped. Further, the "1% décoratif" was regularly committed to contemporary artists, who themselves avoid a singular or unified aesthetic.[169]

What is absent can also be catalogued. In the United States, the art developed under the GSA's Art-in-Architecture program often invoked local history (for example, in Sacramento's courthouse, migrations from Asia to California play a role in the artistic displays[170]). In contrast, Tarride's overview of the new art in French courts noted that the human figure is rarely seen—perhaps replaced in some

FIGURE 134  *Pacte entre l'homme at la société* (panel), Gérard Garouste.

instances by technologies of motion. Aside from Louis IX, the Revolution, and the Declaration of Human Rights, few references are made to noted judicial personages or to particular moments of history of either France or its regions, nor is the rationality in legal analyses and of law itself much celebrated.[171]

Competing interpretations across the set of installations are possible. The variety of materials and imagery, if seen together across buildings, can be understood as embracing the theme that justice is multiply faceted, requiring a diversity of expressions that ought not be dominated by any single representation. One could find that perspective liberating—that a host of competing points of view are to be taken into account by law. Further, given that some of the art invokes aspects of French history (such as Louis IX and the Revolution), one can see the entirety as showing

the movement from, rather than a rupture with, the past. To the degree that some of the art requires explication—inviting questioning because of a lack of easy legibility—that quality could appropriately reflect law's openness and indeterminacy.[172]

Alternatively, one could pronounce the output an undue rejection of legal traditions that bespeaks a failure of vision, a troubling uncertainty, or an inappropriate unleashing of idiosyncratic artistic preferences over public values.[173] Tarride, for example, objected to the impenetrability of various objects, which she deemed poor signification of the obligation of law to speak clearly. Further, she noted that the crucifix that had once hung behind the judge denoted that the judge acted in the name of either God or the monarchy, but the new imagery had not yet found a way to represent that principled judges, bound by law, speak in the name of the people.[174] Moreover, as she catalogued the many texts that decorated the walls of new buildings, she regretted that the word *loi* (law) was rarely to be seen.[175] Yet, as the discussion below of the Nantes courthouse makes plain, law's power is patent in many of the new buildings.

### Jean Nouvel and Jenny Holzer in Nantes

The authority of law (as well as the prosperity of France at the time) is on display in the massive new courthouse constructions, scaled to dominate a vista. Our prime example is the building (fig. 135, color plate 30[176]) designed by the architect Jean Nouvel, who in 2008 received one of architecture's most prestigious awards, the Pritzker Prize.[177] His Nantes courthouse shares many features of the Henry Cobb design for Boston. Both are sited near water to anchor the hoped-for development of their respective cities. The Boston Courthouse aimed to attract commerce to an area near that city's waterfront. The Nantes Courthouse sits on the banks of the Loire River on an island, Île Sainte Anne, accessible by a long footbridge and near a cluster of old warehouses, the "detritus of a thriving industrial and maritime past" that once spelled prosperity for the town.[178] Further, both Cobb and Nouvel understood themselves as reinterpreting and adhering to traditional forms. Cobb used a one-room courthouse in Virginia as iconic and borrowed details from other historic courts; Nouvel relied on "the typology of the temple form, [with] its ceremonial porch, and symmetrical composition" aiming to "recall the steps and portico of the traditional courthouse."[179]

The Nantes building is a square rectangle of almost 100,000 square feet whose dimensions (372 by 265.75 feet or 113.4 by 81 meters) are apt given the building's title—palais.[180] One enters the pavilion, which faces the city, from a large stone patio into a vast salle des pas perdus (fig. 136) that is also paved in stone, clad in glass, and described as expressing "the solemnity of justice through its transparent, clear and balanced character."[181] One of the jurists who worked there called it a monumental and transparent sym-

FIGURE 135    Palais de Justice, exterior, Nantes, France. Architect: Jean Nouvel, 2000.

Photographer: Olivier Wogenscky. Copyright: APIJ, April 2000. Reproduced with the permission of L'Agence de Maîtrise d'Ouvrage des Travaux du Ministère de la Justice / Ministère de la Justice, the photographer, and APIJ. See color plate 30.

FIGURE 136    Palais de Justice, Salle des pas perdus (foyer), Nantes, France. Architect: Jean Nouvel, 2000.

Photographer: Olivier Wogenscky. Copyright: APIJ, April 2000. Reproduced with the permission of L'Agence de Maîtrise d'Ouvrage des Travaux du Ministère de la Justice / Ministère de la Justice, the photographer, and APIJ.

bol of authority.[182] The point, Nouvel explained, was that a "justice center represents the power of justice,"[183] even as he aspired to show that justice occurs in a public environment both democratic and welcoming.[184] The stone, the metal framing of the glass walls, and the interior walls of the open areas are all charcoal black. The geometry is relentless, with the walls themselves lined in a slightly raised cubic pattern. The "immense lobby running the width of the building" (about 370 feet) permits entry into three box-like contained areas housing seven courtrooms and auxiliary offices.[185]

Words on Jenny Holzer's yellow LED screens (fig. 137, color plate 31) travel along thin columns inside the visually stunning and austere grand entrance hall.[186] The Ministry's booklet celebrates that Holzer's art is in a "true dialogue" with

the architecture; "the texts seem to surge from the floor and traverse the building until they reach the sky, reflected on the floor and the glass panels."[187]

As in the United States, Holzer proposed excerpts from diverse legal writings appropriate to the French context.[188] In some respects, Holzer offered a twenty-first-century version of the pluralism found on the frieze on the wall of the courtroom in the United States Supreme Court in Washington and in the sculptures on the roof of the New York Appellate Division Courthouse in Manhattan (fig. 6/86). Those buildings feature a company of great lawgivers from Muhammad and Justinian to Confucius and European and American leaders. Holzer's citations, in turn, range from the Code of Hammurabi (circa 1760 BCE) to quotes from victims of the Rwandan genocide (1994). From the interven-

FIGURE 137 *Installation for the Nantes Courthouse,* Jenny Holzer, 2003.

Photographer: Philippe Ruault. Copyright: Jenny Holzer Studio / Art Resource, New York, NY. Image provided with the assistance of Art Resource, New York. Reproduced with the permission of Jenny Holzer Studio, member, Artists Rights Society (ARS). See color plate 31.

ing years, Holzer included comments from an array that included Confucius, Plato, Aristotle, Jean Bodin, Michel de Montaigne, Hugo Grotius, René Descartes, Thomas Hobbes, Baruch Spinoza, Voltaire, Denis Diderot, Montesquieu, Jean-Jacques Rousseau, Cesare Beccaria, Thomas Jefferson, Thomas Paine, Maximilien Robespierre, George Sand, Karl Marx, Victor Hugo, Simone de Beauvoir, and Human Rights Watch. In addition, Holzer provided excerpts from several French legal documents, including the 1789 Declaration of the Rights of Man and of the Citizen, the 1791 Constitution, Louis Napoleon's 1852 Constitution, the 1905 law on separation of church and state, the 1958 Constitution, and laws on the environment, crimes, and people with disabilities. Additional lines come from various documents produced by the United Nations, such as the 1946 United Nations Charter, the 1957 Abolition of Forced Labor Convention, the 1967 Dec-

laration on the Elimination of Discrimination against Women, and the 1973 Anti-Apartheid Convention.[189]

Not all the material that Holzer proposed made it into the display, but the range is significantly greater than the phrases inscribed in federal courthouses in California and Pennsylvania. For example, in the LED installation in Nantes are words such as Jules Ferry's 1870 insistence that in a society founded on liberty, one must suppress class distinctions ("Enfin, dans une société que s'est donné pour tâche de fonder la liberté, il y a une grande nécessité de supprimer les distinctions de classes"); Victor Hugo's nineteenth-century aphorism that, by filling the schools, one would empty the prisons ("Remplissez les écoles, vous viderez les prisons"); and Simone de Beauvoir's 1949 comment that "when we abolish the slavery of half of humanity, together with the whole system of hypocrisy it implies, then the

'division' of humanity will reveal its genuine significance and the human couple will find its true form" ("C'est au contraire quand sera aboli l'esclavage d'une motié de l'humanité et tout le système d'hypocrisie qu'il implique que la 'section' de l'humanité révélera son authentique signification et que le couple humain trouvera sa vraie figure"). Holzer juxtaposed such calls for minimally humane treatment with documents seeking to inscribe such rights and searing details of some of law's failures. The horrors experienced in the 1990s by victims of genocide in Rwanda are included: "I lost my three children and my husband" ("J'ai perdu mes trois enfants et mon mari") as well as Human Rights Watch's descriptions of murder, extermination, slavery, deportation, torture, and inhumane acts.

In its brochure, the Ministry of Justice praised Holzer's choice to present "texts from philosophers and writers, both male and female, from Antiquity to modern times."[190] The Ministry spoke of how the assemblage presented contradictory points of view prompting critical reflections on the human condition. The resulting anthology enabled the public, jurists, and litigants to reflect on the "evolution of the idea of law, of duty, and of . . . the spirit of the law" in relation to different historical eras.[191] In contrast, Tarride thought the project misguided[192] and worried that Holzer

had been permitted (through too little control by the Ministry of Justice) to present images of justice that were either contradictory or ill-defined and that lacked an organizing principle. Tarride argued that the serenity of justice ought to have been invoked by fixed texts rather than electronically propelled perpetual motion. As for the words chosen, Tarride argued that the full dossier read more like an academic course on justice over the millennia than its distillation. Moreover, she complained that the flashing words were unduly polemical, that religious elements were out of place,[193] and that the absence of citations presented risks of "inexactitude."[194] Tarride also bemoaned the lack of attention paid to lawyers. According to her count, they were mentioned only twice and not enthusiastically, such as the question posed: "Wouldn't that be a fine thing, the honesty of a lawyer who demanded his client's conviction?"[195] In sum, Tarride objected: "What justifies seeing this sentiment upon entering a courthouse?"[196]

The courthouse, in turn, provokes other sentiments. The exterior spaces are black stone and metal that reflect light off hard-edged surfaces. The vast salle des pas perdus is ornamented by Holzer's LED text designs, and the courtroom interiors (fig. 138, color plate 32) are wood, stained deep red.[197] The color is reminiscent of French royalty, the

FIGURE 138    Salle d'audience (courtroom), Palais de Justice, Nantes, France. Architect: Jean Nouvel, 2000.

Photographer: Olivier Wogenscky. Copyright: APIJ, April 2000. Reproduced with the permission of L'Agence de Maîtrise d'Ouvrage des Travaux du Ministère de la Justice / Ministère de la Justice, the photographer, and APIJ. See color plate 32.

paint bathing the walls of the Richelieu wing of the Louvre, and "the colour of blood."[198] (Nouvel explained the hue and volume of the rooms as providing the requisite noble aesthetic.[199]) The courtrooms have no windows; skylights in the ceilings bring small amounts of natural light into the room. One sits on a hard wooden bench enclosed by tall, dark red walls, perhaps previewing the rigors of an imprisonment to come. One critic added: "You must wonder whether Breton crime levels deserve so brooding a vision of Nemesis (locals complain on entering that they are already in prison)."[200]

How is one to understand the building's import? Ought it to be celebrated for its "refusal to deal in euphemisms"[201] — "designed without compromise on an 8×8m grid"[202] that embodies "a severe and powerful judicial presence"[203] providing a "powerful sense of judicial authority"?[204] Or ought it to be criticized for its harsh vision that ignores the aspirations for a symbolism welcoming those in need and sheltering the vulnerable? Our own visceral experience was of entombment, from the claustrophobia of the courtrooms to the prison bar-like motif of the grids in the waiting areas, prompting fantasies of escape and concerns about how dismal it would be to work in the facility.

Moving beyond Nantes to survey the array of new buildings, some French commentators have questioned whether they constitute a category of contemporary judicial architecture or rather should be tallied within an array of monumental buildings constructed for diverse purposes.[205] One might admire the variety as illustrative of the inability to reduce justice to a singular expression[206] or, like Bels, conclude that the "extraordinary diversity of the projects" evidences a "fundamental lack of conceptual direction."[207] Criticism has also been directed at the dichotomization between "public and private spaces"; while the separation and compartmentalization of offices from courtrooms could be read as simple and transparent, it may also mask the complex interaction by which "the law court institution really operates."[208] Furthermore, aspirations for flexibility have rarely been realized. Instead, as Bels put it, a "stratified layout . . . expresses the operation of an institution that superimposes the different and contradictory work methods represented by the . . . 'business' side of the legal system and the technical aspects that allow the justice 'machine' to function."[209]

Moreover, the line between public and commercial construction has proven thin. The goal had been to make buildings that were unmistakably courts. But commentators have noted the continuities between various architects' designs for courts and their commercial work; cited as an example are the resemblances between Nouvel's work in Nantes and his design for the Cartier Foundation in Paris, a grid-based "ethereal glass and steel building."[210] Others are concerned that the new courthouses remain symbolically silent, not only because they fail to distinguish themselves from other public buildings,[211] but also because they

valorize transparency without distinguishing the facade from the obligations of enabling public accountability.[212] Paralleling architecture critic Paul Byard's view of monumental late twentieth-century courthouses in the United States, Antoine Garapon viewed the French courthouses as evidence that the means of expressing universal values recognizing individuals' dignity in courthouse configurations remains elusive.[213]

## CREATING NEW SYMBOLS OF NATIONHOOD: A SUPREME COURT BUILDING FOR ISRAEL

Completed in 1992, the Israeli Supreme Court sits on a ten-acre "dramatic hilltop site that is the locus of the government center."[214] Akin to the complex designed by Oscar Niemeyer in the late 1950s for Brasília (fig. 1/9), the location concentrates the branches of the government "at a single site in the nation's capital, Jerusalem."[215] The building (fig. 139[216]), a 236,000-square-foot "poured-in-place reinforced concrete structure," is in view of the Knesset (the Israeli Parliament), the Prime Minister's office, the offices of the various ministries, and the Bank of Israel.[217]

The Israeli Supreme Court had been housed at the "Russian Compound" in buildings owned by the Russian Orthodox Church. The cluster included a former monastery that had also served as a hostel for pilgrims visiting the Holy Land.[218] Funding for the new construction came from the Rothschild family's foundation, Yad Hanadiv (Hand of the Benefactor)[219] that superintended the international competition won by the architects (and siblings) Ada Karmi-Melamede and Ram Karmi.[220] The competition reflected the transnationality of the architecture market. Expert advisors and jurors came from Canada, the United States, England, and Israel.[221] Submissions came from Israeli and international firms, including two American firms (Richard Meier and Partners and I. M. Pei and Partners) that have become well-known courthouse designers in the United States.[222]

A less elaborate set of design guidelines than in France or the United States matched a much smaller country. Israel's court system then included some 276 judges working on the Supreme, District, Magistrates, and Labour Courts.[223] These jurists served a population of residents, citizens, and aliens (variously delineated given the contested territorial boundaries of the state) of some ten million.[224] The goals for the building were, nonetheless, familiar. The section of the design materials entitled "The Nature and Symbolism of the Building" explained the aspirations. A new structure had to "convey a sense of comfort and well-being," with "spaciousness" in its passages and "loftiness" in the courtrooms and entrance ways.[225] "The building should be impressive but not ostentatious, or in the words of the builders of the Supreme Court of the U.S.A.: dignified."[226]

Accessibility was stressed. The "process of administering justice is open to all. . . . Hearings are public and anyone

FIGURE 139   Supreme Court of Israel, Jerusalem, Israel. Architects: Ada Karmi-Melamede and Ram Karmi, 1992.

Photographer: Michael Fein. Image reproduced with the permission of the photographer and the assistance of the court.

may observe the proceedings."[227] Flexibility was another requirement so as to "accommodate changes in volume of activity, spheres of responsibility and technology."[228] Another concern—security—was described as "in conflict with the principle of exposure of the Supreme Court to the public, and may impair its appearance."[229] Nonetheless, plans called for a building to be "surrounded by a fence, at a minimum distance of 15 meters [about fifty feet] from the building's walls." Parking was to be open and unconnected to the building. Both cars and persons had to pass through security gates, and, "during sensitive trials," guards might need to be stationed on the roof or in courtyards.[230] Further, the building had to house a bomb shelter.[231] Designers were told to meet such security requirements "as inconspicuously as possible, and with a minimum of impact on the appearance and access to the courthouse."[232]

### "Circles of Justice" and Laws That Are "Straight"

The winning design was assumed to be modifiable in light of the "dialogue between client and architect" to ensue.[233] The jury commended them for their "respect for Jewish justice and tradition," translated by some to mean an insistent nationalism[234] and by others to reflect the building's "relative modesty."[235] Rather than adopt a style that equated monumentality with power (vivid in Nantes), Karmi-Melamede and Karmi relied on a smaller scale to echo vistas in Jersualem, a city filled with tightly packed buildings of varying sizes surrounded by walls, gates, and arches.[236] As the architects explained: "The building should not assume power but deserve it."[237]

Reminiscent of Henry Cobbs's interest in historicity for the Boston Courthouse and Jean Nouvel's commitment to classicism in Nantes, the Karmi design relied on motifs familiar to Jerusalem.[238] But unlike both the United States and France, the State of Israel, begun in 1948, did not have an "accepted paradigm of a courthouse."[239] Indeed, architectural critic Paul Goldberger noted the "paradox, given the Roman presence in the history of this land, that classi-

cism is more legitimately a part of the architectural heritage of America" than of Israel.[240] Alternatively, in light of the Roman conquest and destruction, the rejection of such "master's tools" can be appreciated as a sensible distancing from an oppressive past. Nonetheless, aspects of the Israeli Supreme Court's new building have been explained as referring to various of the successive empires that brought a sequence of styles, including arches echoing the Roman deployment of that shape as a triumphal sign.

In Israel, biblical sources are oft-cited. Passages in the Old Testament make mention of "judgment at the gate," the "circles of justice"[241] and "laws [that] are straight,"[242] as well as of judgments that "run down as waters, and righteousness as a mighty stream."[243] Such phrases do not provide building blueprints. Indeed, the various biblical references to the act of judgment did not detail the "architectural components" of earthly decisionmaking, in part because (as in many societies) those narratives describe many rituals that took place in public areas under the open skies.[244]

Were one to look to building traditions of the place (rather than of the Torah—the "Book"), structures in Jerusalem draw on various sources representing eras of rule by the Roman, Byzantine, Ottoman, and British empires. Legal principles from those polities as well as from Jewish and international law are also relevant to Israeli court doctrine. Further, were one to seek guidance from inhabitants, in addition to those born in the country, twentieth-century settlers came from around the world. Thus, unlike some European colonies that had one dominant occupying country (such as France in Martinique and certain parts of Africa) or some countries with a longstanding, relatively stable, and somewhat homogeneous population, Israel has inherited a hodgepodge of legal, political, and architectural regimes.

But diverse layers of history and biblical imagery have left footprints upon which the architects relied, as they have described in essays and interviews.[245] Ada Karmi-Melamede identified three factors informing the design: the location with its vistas of the city; the "unique historical and cultural significance" of "the basic values of law, justice,

truth, mercy, and compassion"; and biblical images with a "theatricality inherent in the tradition of Hebrew law."[246] The architects also identified "four specific images" to bring into the building: a courtyard akin to that of the Rockefeller Museum of the British Mandate period, thick walls reminiscent of alleys in the Armenian quarter of the Old City, and two biblical sites, Absalom's Monument and Mary's Tomb.[247]

In their work, Karmi-Melamede and Karmi sought to replicate the experience of looking at Jerusalem's edifices, "part of which are hidden from view by the city wall"; one can see "their skyline but not where they touch ground."[248] As Ram Karmi later described, they wanted a building that generated a "sense of 'belonging' " functioning as a " 'small city,' a Jerusalem in miniature." They planned a "cardo," or Roman street—called the "Knesset Passage" as its view extends directly to the parliament—built from white stone that both symbolized "eternity" and was infused with a "softer, more subtle light, one that is tamed and more humane."[249] Further, and unlike the embrace of transparency that surrounds discussions of courthouses in the United States and France, the architects aimed to capture an appreciation for the "unknown" and the "hidden layers" that could lend an air of "mystique"[250] (or perhaps spirituality) to the building. Their design offered "an introverted walled-in" layered building, related to and integrated into its landscape, which (as the celebratory tome about the building argued) provides "a powerful and serene architectural image, unique to Jerusalem."[251]

A different aspect of the effort to be unique comes from the contested sovereignty with which Israel wrestles, in politics and in law. As we discussed in analyzing the construction of town halls in Medieval and Renaissance Europe, in the context of efforts in the United States to display a "federal presence" and in France to construct temple-like structures, public buildings are one way to anchor government authority. Court construction in Israel had a comparable goal, affected by ongoing disputes about the authority of Palestinians and Israelis. Thus, building the court elicited criticism that its insistent historicity aimed to legitimate the hegemony of Israel by suppressing competing sovereigntist claims.[252]

## Roman Cardos, British Courtyards, Moorish Arches, and Jerusalem Stone

The Roman cardo (the north-south street) that bisected parts of the Old City of Jerusalem is reflected in the four sections of the Israeli Supreme Court—its "library, the judges' chambers, the courtrooms, and the parking area."[253] Each of the building's four parts has its own orientation; for example, judges' chambers face an inner courtyard, lined with symmetrical columns sheltering walkways so that users can enjoy quiet contemplation. The four "autonomous blocks" are also delineated on the other axis (the "decumanus," or east-west street of a Roman city) that leads toward the city.[254] The two axes create one facet of the building's geometry, contrasted with the circular shape of the indoor corridors.

The entrance area is a "stone stair . . . more evocative of a walk through a Jerusalem alley than an ascension to the gates of heaven or the front door of the U.S. Supreme Court."[255] Rather than asking individuals to walk up steps so as to ascend to justice (as was the deliberate style in nineteenth-century France), the point was to create an egalitarian sense at the entry. By doing so, the architects reflected concerns of the Israeli Supreme Court's President, Meir Shamgar: "You could create something Kafkaesque, a court somewhere, high up, distancing itself from people, but we didn't want it."[256] On the other hand, as security now plays out in both the United States and France, the Israeli Supreme Court also puts its judges' chambers on upper floors. Prisoners are in holding cells on the lowest level and hence do have to ascend when they go to courtrooms.[257]

The relatively small entrance (fig. 140[258]) to the ground-floor foyer does not permit many people to come through the portal at the same time. This feature is one of many quiet security measures, complemented by a long, narrow walk to the entry.[259] Inside, high ceilings create a more monumental space, as do large windows on the first floor providing panoramic views of the city.[260]

Figure 140 shows the outside of a copper-clad pyramid (green-tinted to give the appearance of metal aged from oxidation) that, inside the court, is both an object of art and a functional space: it crowns the ceiling located between the entrance and the foyer areas leading to the courtrooms, to the administrative wing (the Registry) housing offices for the court's three divisions (civil, criminal, and "High Court"), and to the library. The placement of the library near the entrance—not typical in courthouses in either the United States or France—was explained by the architects as underscoring "the importance of 'the Book' in the history of the Jewish people."[261] From the inside, the pyramid appears to be a freestanding room with various layers. From the floors above, the pyramid becomes a "copper-clad object."[262] The book documenting the Israel Supreme Court building reports that the choice of the pyramid, a shape used in many sites, refers both to law's own transnational relevance and sources ("The law itself has no locality" is the quote proffered[263]) and to a specific biblical site, "Zacharia's Tomb and Yad Avshalom" (Absalom's Tomb) in the Yehoshafat Valley of Jerusalem.[264]

The organization of the building is "complex,"[265] with a mix of geometric shapes and areas identified through signage in Hebrew, Arabic, and English. The architects explained: "Public movement towards the building and within, is a combination of circular and linear patterns."[266] Thus, the public has ready access to the first floor of the library (its higher floors are exclusively for the court),[267] to the offices of the Registry, and to the five courtrooms.

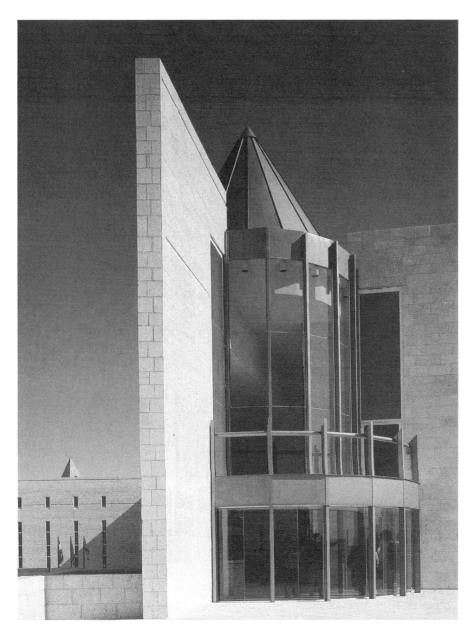

FIGURE 140    Supreme Court of Israel, entrance. Architects: Ada Karmi-Melamede and Ram Karmi, 1992.

Photographer: Richard Bryant / arcaid.co.uk. Photograph reproduced with the permission of the photographer and the assistance of the court.

The building is made from materials that are a motif in Jerusalem, where light-colored stone exteriors have been a requirement for much of the city's building since the early part of the twentieth century.[268] Moreover, the stone gates and walls that surround the Old City of Jerusalem serve as major landmarks. For the Israeli Supreme Court, the architects eschewed imported stone and instead selected a local limestone roughly chiseled for the exterior walls and more finely hammered for the interior arches and entryways. The result is a variety of textures.[269]

The interior corridors (fig. 141[270]) are faced on one side with large, rough blocks; the other side, painted white, offers visitors a place to sit in a sequence of fourteen cylindrical bays that receive natural light from skylights.[271] As a practical matter, the niches also provide a modicum of pri-vacy for quiet or confidential discussions. The light stone, white walls, and skylights create serious yet bright spaces said by the architects to symbolize the "enlightenment of the judge seeking just judgment."[272]

The public also has access to the "Courtyard of the Arches" (fig. 142[273]), open to the skies as were ancient judgments. Its shape and content are attributed to many sources. One is specific—the Rockefeller Museum, built while the British controlled the area from 1917 to 1948 and housing archaeological artifacts. But multicultural references abound, linking the place with Jewish, Christian, and Muslim traditions. The walkways, under covered, rounded arches, and the southern apse are explained as referencing synagogue construction from the Roman and Byzantine eras, as well as monastic foyers or as a reclamation of a Roman triumphal

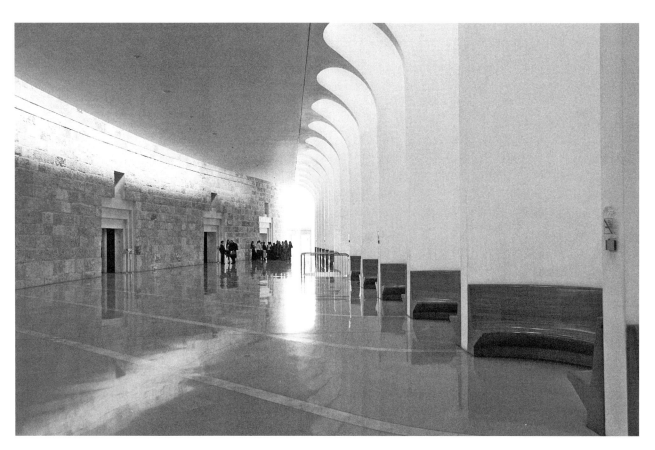

FIGURE 141    Supreme Court of Israel, interior corridor. Architects: Ada Karmi-Melamede and Ram Karmi, 1992.

Photographer: Michael Fein. Image reproduced with the permission of the photographer and the assistance of the court.

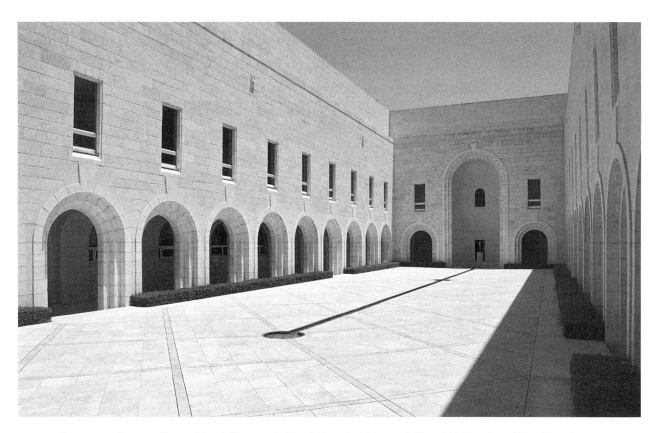

FIGURE 142    Supreme Court of Israel, Courtyard of the Arches. Architects: Ada Karmi-Melamede and Ram Karmi, 1992.

Photographer: Jonathan Curtis-Resnik. Image reproduced with the permission of the photographer and the assistance of the court.

arch.[274] The thin center line of flowing water that pools in a circle at one end is ascribed to the "wells and cisterns of Jerusalem's Islamic and Christian buildings."[275] The use of water is also, according to the court, a reference to *Psalm* 85: "Truth will spring up from the earth and justice will be reflected from the heavens."[276] Given that the floor stones come from the desert and the arches shelter visitors from the sun, the water may also be seen as critical nourishment in the arid climate. The architects also imagined the area might be used for exhibits.[277] In practice, it has proved useful for television cameras, broadcasting from the courthouse and also in need of shelter from the sun.

## Judgment at the Gate

As in courthouses around the world, primacy is given to the courtroom, which Ram Karmi called the "most important station," to be "quieter than the foyer."[278] In contrast to many supreme courts, the Israeli Supreme Court still hears, as a first-instance "High Court of Justice," challenges to legislative and executive acts.[279] Thus, while functioning as the final appellate bench, the court also rules annually on thousands of petitions challenging government actions. In one six-month period, the court rendered more than 2,500 rulings.[280] To do so, its fourteen jurists sit in panels generally of three, with larger groups (up to eleven) reserved for especially important cases.[281]

As a consequence, the building has five courtrooms that come in three sizes. The entrance to each is marked by "three flat arches carved into the great stone wall, accentuating the transition from an ancient, unhewn element to the courtrooms' static and symmetrical spaces."[282] The carved arches are said to denote gates "in the wall to represent where judges actually presided in biblical times."[283] All of the courtrooms are similarly structured, relatively modest in size, white-walled, naturally lit, and appointed with wood tables and leather furniture.[284] Their interiors (fig. 143[285]) evoke Middle Eastern traditions through vaulted ceilings associated with Romanesque and Moorish architecture. Once again, "ancient synagogues during the Talmudic period" (200–600 CE) are cited as inspirational.[286]

The layout within each courtroom depends on "two equal squares," with one for the judges and lawyers and the public in the other.[287] In the United States, lawyers typically sit at rectangle tables facing the judge; in these courtrooms, lawyers sit at semi-circular tables that offer a more conversational posture. Further, the movement of people departs from a "basilica layout."[288] Rather than using a single central aisle, "as in most houses of worship,"[289] people circulate by way of two side aisles. In addition, unlike the hard church-like wooden pews found in French and many United States courts, warm-hued brown leather upholstered seating is provided.[290] Wood screens, a Moroccan reference, soften the acoustics.[291] Light comes by way of skylights "between the outer walls and the columns,"[292]

enabling a softer and less intense brightness than in other parts of the building.

## "The Symbols"

Reflective of Jewish traditions, allegorical figurative paintings and sculptures are not featured. Indeed, while a few objects are in fact on display, little attention is paid to them in the book devoted to the building or in other commentary. Before entering on the ground floor, visitors are welcomed by a large mosaic, "discovered at the ancient synagogue of Hamat Gader and restored by the Israel Antiquities Authority" and featuring lions, trees, and inscriptions in Aramaic (fig. 144).[293] The choice to put this particular mosaic up front came in part from its inscription, which speaks of the righteousness and generosity of the donor who had supported the Byzantine synagogue from which it came before a fire destroyed the building and damaged the mosaic.[294] As Dorothy de Rothschild, whose Yad Hanadiv Foundation funded the Israeli Supreme Court building, did not want her family name on it, the mosaic offers a subtle reference to that form of generosity. Attentive viewers might notice the Rothschilds' own small logo, five crossed arrows (fig. 145), embossed on a nearby plaque.[295]

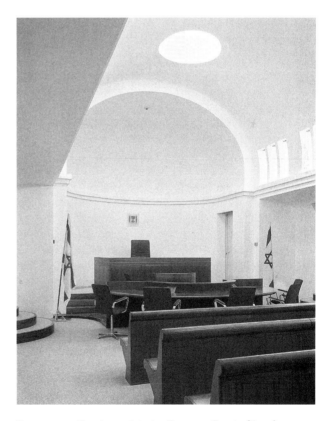

FIGURE 143 Courtroom interior, Supreme Court of Israel. Architects: Ada Karmi-Melamede and Ram Karmi, 1992.

Photographer: Richard Bryant / arcaid.co.uk. Photograph reproduced with the permission of the photographer and the assistance of the court.

FIGURE 144  Mosaic from the Hamat Gader synagogue, Supreme Court of Israel.

Photographer: Jonathan Curtis-Resnik. Image reproduced with the permission of the photographer and the assistance of the court.

FIGURE 145  Supreme Court of Israel, Plaque at entrance.

Photographer: Jonathan Curtis-Resnik. Image reproduced with the permission of the photographer and the assistance of the court.

FIGURE 146  *The Symbols,* designer, Peter Szmuk, Supreme Court of Israel, 1992.

Photographer: Jonathan Curtis-Resnik. Image reproduced with the permission of the photographer and the assistance of the court.

Once inside the building, a Samarian mosaic that was found during construction is displayed on a wall near one of the courtrooms. President Shamgar explained that it was reminiscent of mosaics in the Knesset building; the stone design created "some connection between history and this court," thereby expressing the "continuity" and the "permanence of our people."[296] In addition, another wall hanging called *The Symbols* (fig. 146) is near the entrance to the Registry and the arched courtyard.[297]

Nine symbols designed by graphic artist Peter Szmuk are affixed to a large nine-square glass grid. One purpose of the symbols is to reflect the care taken in the building's production. Each symbol is made from a different material, emblematic of a particular area of the building. The hanging grid provides a kind of map of the structure, evident at

least upon reading the webpage, if not leaping to one's awareness at first glance. The wood diamond at the top corner, for example, denotes the justices' chambers on the top floor, while the middle symbol of oxidized copper (fig. 147) represents the pyramid that greets visitors. A piece of Jerusalem stone has a three-tiered pattern carved to evoke the courtrooms' opening arches, which in turn were designed to remind viewers of the city's gates.

Just as the names of all those who built the Boston Courthouse, from construction workers to architects, are inscribed on that building, the Szmuk design also denotes a range of actors. One symbol is for the maintenance department of the building, another for the cafeteria and courtyard on the lower level. But unlike in most court displays, the court's role as a temporary jail makes its way into this subtle iconographic display. A symbol made of iron represents the "detention area for prisoners who come to the Supreme Court to hear their appeals."[298] In addition, *The Symbols* offered a subtle historical reference; the artist cited as inspiration an eighteenth-century engraving of the First Temple from biblical times, described as a "symmetrical structure divided into equal 'courts.'"[299] On the wall to the left of the grid is inscribed a verse from *Leviticus*: "Just balance, just weights, just ephah and a just hin shall you have" (ephah and hin were ancient measures).[300]

The court also houses a small museum, near the entry to the first floor. This Jewish Heritage Museum provides a series of display cases filled with various objects from the court's history and its prior building to illustrate "how the judicial system constitutes one of the cornerstones of society at any time or place."[301] Included are legal documents from the Ottoman period (1516–1917) and from the British Mandate (1917–1948), as well as post-1948 photo-

graphs of Israeli courts, including "new custom-built court houses—numbering 11 in all."[302] In addition, materials are provided on major Supreme Court decisions; an area with interactive computer materials offers educational programs for school children.

Inside each courtroom, the flag of the country (blue and white with a six-sided "Star of David") stands on each side of the judge's bench (fig. 143). Israel's official symbol, a seven-branched menorah—historically linked to the reconsecration of the Second Temple during the Roman era—hangs behind the bench. A white plaque provides the backdrop for the golden-hued menorah, flanked on either side by olive branches; the menorah also provides the logo for the court's stationery.[303] The Israeli Supreme Court's art is thus like that of other countries, a minor footnote, but in this instance, deliberately so.

## Reiterating Familiar Motifs

In an effort to make the building a new national symbol, the court disseminates information and welcomes tourists with video descriptions in several languages; estimates were that as of 2005 more than half a million visitors had seen how "justice, democracy, and openness" are represented throughout the building.[304] (A tour of the court is typically part of the program for Israeli Army soldiers.) The structure has come to be well known at the national level, in part because of the court's thick docket of deeply controversial issues.[305] Under the leadership of Aharon Barak, who was appointed to the court in 1978 and who became President after Shamgar, and served from 1995 to 2007, the Israeli Supreme Court's jurisprudence developed a transnational reputation as it issued judgments about security, detention, torture, religious rights and obligations, and equality.[306] Hence the court has rendered its own building familiar— "at least to all Israeli television viewers"—for it provides a backdrop for news reports[307] either about petitioners filing against the government or about the many complaints leveled at the court's decisions.[308]

Architectural critics who have focused on the court generally bathe the structure in praise. Reviewers lauded it for achieving a "sense of political order and cultural permanence."[309] *New York Times* architecture critic Paul Goldberger concluded that the building set "a standard of its own [by achieving] a remarkable and exhilarating balance between the concerns of daily life and the symbolism of the ages."[310] Goldberger thought the courtrooms offered a "sense both of crispness and of calmness"[311] as part of an overall structure produced by "a series of wise and knowing gestures pulled off with consummate sensitivity and intelligence."[312] Barbara Perry admired the "architects' commitments to public comfort and dignity," demonstrated by the provision of more comfortable resting places than those in the Supreme Court of the United States.[313] And while critical of some workmanship (the use of "cheap-looking spat-

FIGURE 147    *The Symbols* (detail).

ter paint to hide imperfections"), Ziva Frieman extolled the "symphony of spaces" and the "transcendent light" that provides a "renewal of hope."[314]

A few dissents have been registered, including that the "overall style is visually inconsistent and sometimes irritating," with "odd" elements and at times a "mismatched" daintiness of detailing.[315] A critical analysis of the "discourses" about the building argues that it is not visually self-narrating but instead needs to rely on many explanatory texts for a viewer to see its architectural referents.[316] But Goldberger's appraisal—"rich both in pure abstract form and in historical allusion"[317]—captures much of the applause.

While culturally specific in some respects, the Israeli building also resembles other contemporary courthouses. Some of the references are intentional. For example, the architects cited the idea that in their corridors "footsteps still fade away and vanish, as in the large foyer (salle des pas perdus) of Paris' supreme court building."[318] Other features come from shared symbols and ideologies. As in the Boston Courthouse, the arch is a central architectural element used to mark the entries to the courtrooms. The courtroom interiors, like those in many countries, create a "tangible distance" between ordinary persons (including lawyers) and the judiciary.[319] The judges are given center stage, elevated as "intended by the architects to promote deference toward the jurists."[320] The professional space of lawyers and judges is, in turn, visually delineated from the public space. The rounded benches for lawyers denote an appreciation, shared by many jurisdictions, of a less aggressively adversarial exchange. Further, just as French designers sought to enclose courtrooms, so did the Israeli architects.[321] The courtrooms—relatively dimly lit—were to feel both protected and protective, as if "tucked away, deep in the rocky terrain."[322]

The courthouse layout offers a subtle variation on the familiar separate routes. Its segregated circulation patterns are accomplished through "vertical layering of the building which defined the public, the judges' and the prisoners' levels."[323] Moreover, in contrast to security arrangements in the United States, France, and the international architecture market, the focus on security in the Israeli Supreme Court is notably quieter. Either despite or because of living with a history of acute conflicts and terrorist violence within the city, the structure of the building is secure without advertising itself as such. The court's echoes of the walls and alleys of Jerusalem enable its winding paths and corridors to appear evocative rather than controlling.

Yet the purposes for construction are deeply familiar. The point of a monumental courthouse is to claim the legitimacy of violence undertaken through legal judgments of states. In the seventeenth century, the Amsterdam Town Hall reflected that city's claim to be "the new Jerusalem"; the burgomasters offered displays of Artus Quellinus's *King Solomon's Justice* (fig. 3/44) and of Ferdinand Bols's *Moses Descends from Mount Sinai* (fig. 3/41) alongside classical and Christian imagery. Questing for legitimacy, the Doges of Venice likewise linked themselves with ancient Israel. Modern states—the United States, France, and Israel —similarly ground their powers in history, law, and tradition. Israel's courthouse has drawn criticism for the effort to be hegemonic. But that building's "ideological agenda"—aiming to serve as "an . . . instrument for 'taming' time and space"[324]— is shared by every polity deploying courthouses to buttress the assertion of authority that imposes violence in the name of law.

To the extent that the Israeli Supreme Court "reproduces the antimonies that frame Israeli space and transform it into 'our place,' "[325] it has deliberately done so even as it engages, through its judgments, with heterogeneity and conflicts about borders and powers. The critique of Israel's court for its insistent "nationalism" has been leveled at the concept of nationality more generally. Commitments to equality and to global human rights and needs are genuine challenges to the reliance on borders and on historical narratives of nationhood to justify the exercise of authority over persons. Were Israel part of a multi-national or multi-cultural state or federation, it might well have structured its courthouse differently so as to represent another kind of polity. (Whether court buildings can capture layers of sovereignty is a question explored in Chapters 11, 12, and 15.)

## NEW AND RECYCLED FROM MELBOURNE TO HELSINKI

Around the world, new and renovated courts aim to combine significant architecture, national symbolism, and functional space. For example, between 1972 and 1996, England had the "most ambitious court-building programme ever attempted," supported by more than 500 million pounds (or more than $700 million).[326] In addition, in the fall of 2009, a newly constituted Supreme Court for the United Kingdom came into being.[327] The former Law Lords became the first Justices of the twelve-person court. Leaving the Parliament, they moved across the street to take up residence in what had been Middlesex Guildhall. The carefully designed renovation is detailed in a volume similar to those documenting the building of Israel's Supreme Court and other courthouses.[328]

Here, however, we highlight only two more buildings, thousands of miles apart, to capture both the breadth of activity and the overlap. These courts, in Australia and in Finland, also make plain a challenge faced by court designers in many countries: the difficulty of making a structure that announces itself to be a courthouse.

### "Australian in concept and materials": Melbourne's Commonwealth Law Courts

In the 1990s, the Chief Justice of the Australian Federal Court, Michael Black, explained the goals for the new court-

house in Melbourne.[329] He spoke of the need to depart from the colonial traditions of the country, exemplified by the nineteenth-century building (fig. 148[330]) that houses the Supreme Court of Victoria but could be at home on the streets of London as well as in Melbourne. That building was inspired by Dublin's Four Courts,[331] and its interior courtroom (fig. 149), detailed lovingly in wood, could readily serve as a film setting for a courtroom drama.

FIGURE 148   Supreme Court of Victoria, Melbourne, Australia, 1884. Architect: Alfred Louis Smith.

FIGURE 149   Courtroom, Supreme Court of Victoria.

Photographs provided by and reproduced with the permission of Chief Justice Marilyn Warren.

FIGURE 150    Commonwealth Law Courts, Melbourne, Australia. Architects: HASSELL,
Tim Shannon and Paul Katsieris, 1998.

Photographer: Martin Saunders Photography. Photograph reproduced with the permission
of the photographer and courtesy of the Commonwealth Law Courts.

Toward the end of the twentieth century, however, the judiciary sought a "distinctive Australian element" for its new courthouse.[332] Rejecting a plan for a "second-rate" conversion of an office building,[333] judges, lawyers, and architects met to shape a new structure that would mark both the "importance of the law" and "the accessibility of the law."[334] As the Chief Justice explained, the goals were to be "dignified but . . . not to be intimidating, and certainly not pretentious."[335] As in many jurisdictions, light was to "play a central conceptual role" to reveal both the architecture and the visibility and accessibility of justice; as Chief Justice Black put it: "Light is symbolic of truth."[336] By centering the building in the city, the relatedness between law and the world would also be plain. The goal was a structure, energy-efficient and respectful of a limited budget, that provided a "sense of permanence" demonstrated through a building that "was to be Australian in concept and materials."[337]

In the late 1990s, cooperative planning produced a new building complex, the Commonwealth Law Courts (fig.

150[338]), to house Melbourne's Family and High Courts as well as the Federal Court. The architects, Tim Shannon and Paul Katsieris of HASSELL (a firm committed to "Modernism in the context of changing societal values"[339]) saw the commission as "the opportunity to explore the notion of what a public building should look like at the outset of the 21st Century."[340] They produced a brightly colored building. Its "copper, sea green, and grey" were said to have been inspired by Giotto, and its entry area aimed to evoke "Mondrian's palette."[341] A lively facade included balconies projected "in a random fashion" from several floors.[342]

"Australia's most important legal building outside the national capital"[343] is the description proffered by a book about HASSELL that also admired the "witty and intelligent complexity behind a syncopated façade."[344] The imposing size (occupying a city block measuring 100 by 100 meters or 328 by 328 feet) resembles a large apartment building but provides space for forty-three courtrooms and hearing rooms. The patio open to the street features stone columns

inscribed to proclaim the building's purpose as a court. The stones also display Australia's distinctive Coat of Arms, a shield with six segments representing the six states, a seven-pointed star (including a reference to the Territories), and standard bearers—in this case an emu on the right and a kangaroo on the left.[345]

One enters the courthouse through a "transparent box beneath a solid steel clad portal" to be greeted by a chapter of the Constitution engraved on the wall ("casting its shadow like a light veil over the judiciary and public alike"[346]). As in the federal courthouse (fig. 8/112) built in 2000 in St. Louis, Missouri, the central atrium (fig. 151[347]) of Melbourne's Commonwealth Law Court relies on several stories (six in this case) to make its statement of authority. The lower floors house courtrooms, the higher floors judges'

chambers. The judicial hierarchies are marked: "Most senior judges are afforded a symbol of their status with an individual balcony."[348] As in courts in France that are set up in modular fashion, Melbourne's has two building blocks, one for the courtrooms and the other "for offices and public areas."[349]

The book featuring the Melbourne architects' work lauds the building for capturing the "character and dignity of the law" and for projecting optimism about the future.[350] Chief Justice Black pronounced the space a "great new federal courthouse."[351] On the other hand, the architectural critic Hamash Lyon questioned the institutional symbolism produced through the "anonymous outcome of market economics"; the "major infrastructure in Victoria is now built, owned and operated through private sector financing, with

FIGURE 151   Commonwealth Law Courts, Atrium, Melbourne, Australia. Architects: HASSELL, Tim Shannon and Paul Katsieris, 1998.

Photographer: Mary McIlwain, Federal Court of Australia. Photograph reproduced with the permission of the photographer and courtesy of the Commonwealth Law Courts.

the government as nothing more than an end user."[352] Indeed, Lyon noted the resemblance between the new law building and corporate towers.

## From a Liquor Factory to a District Court in Helsinki

If Melbourne's building looks something like an apartment house, the resemblance of the Helsinki District Court (fig. 152[353]) to a factory is not happenstance. While the judiciary in Melbourne rejected the idea of converting an old building for the Commonwealth Law Courts, Helsinki's leadership recycled a 1940 factory owned by "the Finnish alcohol monopoly, Alko" and designed by architect Väinö Vähäkallio.[354] That "Modern Movement behemoth" looked like the power station nearby, and during its "50-odd years of spirited life, the Alko plant probably generated enough booze to fill Finland's 188,000 lakes."[355] The switch from alcohol plant to courthouse cost about $60 million.[356]

The new judiciary facilities occupy a seafront brick landmark—a "building that was once the biggest in Finland."[357] Opened in its new capacity in 2004, the structure was renovated by a Finnish architect, Tuomo Siitonen, who treated the building's pedigree with respect. For example, "cut surfaces were left unpainted" to reveal the "building's historical levels."[358] Provided are easy working areas for some eighty professional judges, often joined by lay judges and supported by more than two hundred personnel.[359] Space is also available for artworks from the Museum of Contemporary Art Kiasma,[360] and some of the building is rented for commercial uses.[361]

The new court was part of a more general program of legal reforms in the 1990s that unified various lower courts and created geographically organized district courts.[362] The Helsinki facility serves a busy trial court with a docket that bridges civil and criminal matters and ranges from family to maritime conflicts. The district court receives some 60,000 cases annually and disposes of about a fifth of the filings in the country.[363] As one can see from the stairway corridors (fig. 153), the Helsinki District Court shares with Melbourne's Law Courts an embrace of glass; the material dominates the interiors of both.[364] The openness creates a lively space, as people on one floor can see the coming and goings of others. Architectural critic Jonathan Glancey pronounced the result to be a "transparent, truly public feel, . . . uncluttered . . . [without] even a hint of the kind of wilfully banal, bureaucratic décor."[365] As illustrated by the new courts in Melbourne and Helsinki, glass walls can be found in many new buildings, offering (as analyzed in Chapter 15) opportunities for surveillance as well as for transparency.

In times past, court days were sometimes held in inns. One of the trial courts in Sydney uses a converted department store whose facade still advertises "corsets" and "gloves." Still, the Helsinki court's liquor factory heritage is unusual. Yet the siting of the building and its courtroom layout are familiar in many respects. The renovation, like the projects in Nantes and in Boston, aimed to turn an industrial area of the city into an "extension of the existing city centre."[366]

Further, as the courtroom view (fig. 154) suggests, the rooms inside conform to arrangements found elsewhere. Judges sit at the front on a bench long enough to accommodate lay members joining professional judges. As in other courtrooms, their bench is elevated, but here only modestly so. The courtrooms are graced by columns, albeit reinterpreted in asymmetrical shapes ("a magnificent forest of concrete columns with mushroom-like capitals"[367]) seeming to lift ceilings that needed additional support to provide light through canti-levered edges of the light well. The furnishings, by Studio Yrjo Wiherheimo, however, depart from conventions elsewhere. The chairs and tables are movable rather than fixed and hence reconfigurable—thereby making good on the promise of flexibility touted by many countries but rarely realized.

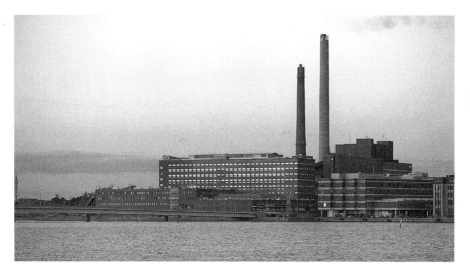

FIGURE 152   Helsinki District Court, Finland. Architect: Tuomo Siitonen Architects, 2004.

Photographer: Mikael Linden. Photograph reproduced with the permission of the architect, providing the photograph.

FIGURE 153    Helsinki District Court, Interior, Finland. Architect: Tuomo Siitonen Architects, 2004.

Photographer: Jussi Tiainen. Photograph reproduced with the permission of the architect, providing the photograph.

FIGURE 154    Courtroom, Helsinki District Court, Finland. Architect: Tuomo Siitonen Architects, 2004.

Photographer: Jussi Tiainen. Photograph reproduced with the permission of the architect, providing the photograph.

This survey of courts in various countries raises questions about a claim well put by American architect Robert Stern: "A courthouse should look like a courthouse. . . . It's not a drive-in bank."[368] While the translation in Stern's context proved to be "Neoclassical 18th and 19th century buildings,"[369] his statement encapsulates a widely shared view. Around the world, the professionals we identified at this chapter's outset—judges, lawyers, architects, and court administrators—aim to design structures that are distinctive and legible spaces dedicated to particular ideals that they understand courts of law to entail. From the United States through France, Israel, Australia, and Finland, the results are often buildings that are striking—but not in ways that render them self-identifying.

## "Justice Facilities": Jails, Prisons, and Courts

This book is not the occasion to trace the creation and growth of prisons over the millennia from Egypt and Greece through Medieval Europe to the present day.[370] But one cannot account for courts without commenting on the interdependencies between courthouse building booms and prison expansion. Both kinds of purpose-built structures emerged from a common core of the multi-function civic building, and their spin-offs reflect changing ideas about the functions of each.

The purposes of punishment and the expansion of the practice of incarceration have been well theorized, with writers exploring the ideas and political economies of deterrence, education, rehabilitation, retribution, and incapacitation.[371] Further, historians have mapped the shift in modes of punishment from public shaming to private incarceration, often in large, isolating, and isolated prisons, some of which are run by private entities. One of the purposes of this book, in turn, is to redress the relative lack of a similar overview of the shifts in the size, scale, ideologies, and functions of courts. In addition, in Chapter 13, we will draw analogies between the privatization of punishment over the last four centuries and contemporary trends privatizating adjudication. Given the parallels between and interdependencies of courts and prisons, a brief comment is in order on the development of buildings that are so unselfconsciously—today—called prisons.

Before the nineteenth century, long-term incarceration was less common than it became thereafter. Historians of Medieval England describe "some kind of prison" as a "natural part of the equipment of every town," with such facilities often "tucked away in the cellar or attic of every fifteenth century guildhall."[372] But risks to health and noxious smells, as well as aspirations that town halls not be too closely associated with such detention (with its literal and metaphysical contamination), prompted a turn to discrete structures for incarceration.[373]

From the Renaissance through the mid-nineteenth century, jails were generally built as "short-term accommodations" to house a variety of marginal people, including both criminal defendants and debtors.[374] Even those staying in "correctional facilities" for longer terms and seen as requiring discipline were not necessarily conceived to be "criminals."[375] Variations existed by jurisdictions, however, and England relied more on incarceration than did some of its European counterparts. In the sixteenth century the English Parliament required houses of corrections for every shire, and many were too large to be proximate to town halls.[376] Facilities that served as jails or prisons were (like those used for courts) sometimes extant buildings leased and recycled for the purpose of detention.[377] Indeed, crossing the Atlantic, just as United States federal judges once decamped in state facilities, so federal prisoners were once housed in state prisons. Not until 1896 did the United States Congress fund the construction of federal penitentiaries, starting with one at Leavenworth, Kansas.[378]

Form follows not only function but also funds, and economic prosperity created opportunities to do more. When communities could afford to finance the building of multiple-cell prisons and pay for prison keepers and guards, wooden structures gave way (literally in some cases) to brick, stone, and metal.[379] Design came to the fore as eighteenth- and nineteenth-century English reformers—including Jonas Hanway, John Howard, and Jeremy Bentham—advocated that convicted criminal defendants needed solitude and hard work to enable redemption. Their work intersected with new ambitions for the state, dealing with growing classes of laborers and urbanization. An amalgam of concerns contributed to proposals for new buildings to provide private confinement in cells.

During the nineteenth century, the term "penitentiary" came into use,[380] with variations in terms of the kind of long-term confinement imposed. In the United States, two dominant models went under the names of the Pennsylvania and the Auburn systems. The buildings fit the theories, for these institutions relied either on complete isolation, work, and enforced silence (Pennsylvania) or included a modicum of collective activity (Auburn).[381] The word "correction" was deployed to capture goals of confinement that included preparing inmates for useful work upon their release.[382] In France, Claude Nicolas Ledoux is credited with the "original idea" of building a prison "totally independent of the courthouse."[383] Construction, begun in the late eighteenth century, produced a prison that opened in 1832. The prison, in use for almost 160 years, provided the setting for Émile Zola's *Les Mystères de Marseille*.[384] As detailed earlier, one of its walls has been recycled to serve as a part of a new courthouse in Aix-en-Provence.

In England, Jeremy Bentham proposed the "Panopticon" (a circular structure with a control module in the middle), designed so that inmates could be observed, night and day,

from the center. Those subject to observation would never know whether or when they were seen, and the uncertainty about when surveillance would take place was thought to be a useful prompt to developing self-discipline. (In Chapter 13, we return to Bentham, who also advocated that legislators and judges be in full view and that such "publicity" would serve to discipline them as well.) Bentham's Panopticon was never built. Some nineteenth-century facilities reflected the idea through designs with tiers of open cells emanating from a control center like spokes of a wheel,[385] and late twentieth-century prisons—relying on new technologies—have gone much further in putting the principle of continual observation into practice.

The development of styles of architecture to meet various punitive rationales and the growing demands for beds criss-crossed national boundaries. For example, English prisons not only influenced the building of those in the United States but the Eastern Penitentiary in Philadelphia, designed by John Haviland, provided a model for an English prison, Pentonville, an (in)famous facility designed by Joshua Jebb.[386] These large institutions (housing hundreds of prisoners) relied on various configurations, such as central spines and radials. Over the decades, whatever the design that had been conceived, reconfiguration was commonplace as new wings were built, sometimes in response to demands for classifications that separated prisoners by sex or age and other times simply to add more room for a growing number of detainees.[387] During the twentieth century, as "new generation designs" emerged, some jurisdictions replaced the large warehouses with configurations offering prisoners smaller cell blocks, access to outdoor space, and more communal places.[388] In some countries, rehabilitative goals reshaped prisons to move them closer to hospitals, farms, residential centers, and the like. Further, "half-way houses" offered lesser forms of confinement, moderated through daytime activities (work included) in the community. But one can still regularly find a "600- or 800-place monster . . . that occupies a huge site and is surrounded by a super-secure perimeter wall or walls."[389]

Overcrowding has become a problem of critical proportions, causing a cascade of issues from violence and disease to lack of programs and fresh air. In the twenty-first century, the prison construction business is "booming,"[390] fueled by the incarceration of record numbers of individuals and the funding of facilities, some of which are part of "law enforcement centers" sprawling over a larger area, often removed from town centers, to house detention as well as other government functions. The United States offers a disturbing example, even as it is distinctively punitive rather than typical.[391] Between the 1930s and the 1970s, prison populations had stayed relatively stable and then soared thereafter. In 1980 some half million prisoners were incarcerated in the United States.[392] By 1997, the population of prisoners had risen to 1.6 million,[393] and by 2004, the country housed more than 2 million prisoners.[394] As of 2005, the country devoted more than $50 billion per year to the jails and prisons of the states and the federal government,[395] with estimates that each prisoner cost on average $54 per day or about $20,000 per year.[396] California spent about a tenth of its operating budget on prisons, which consumed more of its resources than did higher education.[397]

Most detainees were state prisoners, yet even the (relatively) small federal prison system had, according to its chief of design and construction, experienced a fourfold increase in population. In the years between 1980 and 2000, the population went from 24,363 to 145,416.[398] By then, the federal system had completed thirty-eight new institutions that represented "a planned capacity of over 40,000 bed spaces at a cost of over $2 billion," with a similar additional expansion in sight.[399] In addition to federal prisoners, another set of detainees—immigrants—were either housed in specially dedicated detention facilities or outsourced to state and private providers. In 2008, daily population counts averaged about 31,000, children included, and over the course of a year, some 350,000 persons had been through detention facilities for immigrants.[400]

As is the case for court construction, multiple circulation routes are expensive. The most expensive prisons focused on isolation, and twentieth-century prisons far outstripped the aspirations of nineteenth-century penitentiaries in imposing extreme isolation. Moreover, these new versions no longer confine inmates with the hope of reforming them. Incapacitation and retribution, rather than rehabilitation, are more often invoked as the goals. Punitive control is the point of "supermax" prisons, whose layers of restrictive environments employ technologies that permit unremittent surveillance from central locations.[401] As of 2005, more than 25,000 people were housed in the United States in supermax facilities. The description provided by the United States Supreme Court of one—the Ohio Supermax —captured the dimensions, "more restrictive than any other form of incarceration" in the state.[402] "Inmates must remain in their cells, which measure 7 by 14 feet, for 23 hours per day," with a light on continually. Further, the cells "have solid metal doors with metal strips along their sides and bottoms which prevent conversation or communication with other inmates. . . . It is fair to say [supermax] inmates are deprived of almost any environmental or sensory stimuli and of almost all human contact."[403]

Cost containment (in addition to personal containment) remains a concern. For some, deincarceration is an answer, while others focus on what are called "private prisons."[404] The idea is not novel: one might imagine privatization as a return to the smaller scale of pre-nineteenth-century local jails, when private jailers made their living supplying detention facilities on an as-needed basis and convict labor was sometimes leased to private enterprises.[405] The more recent

version, however, takes form through businesses such as the Corrections Corporation of America or the Wackenhut Corrections Corporation, itself a part of a transnational "security" company.[406] The owners and staff of such facilities are private contractors, while the prisoners, detained at the behest of the state, are supported by the public fisc. Whether turning to the private sector is useful depends on one's metric. The arguments for privatization of prisons rely on comparative efficiencies. The debate is about whether dollar reductions in costs per prisoner derive from better operations or from compromises on safety and the quality of conditions. Critics also argue that delegation to the private sector undermines the legitimacy of state sanctions.[407]

Although the United States has outstripped most countries in incarceration rates, it is not unique in expanding its capacity to house prisoners. New construction of prisons is, like that of courts, transnational.[408] At this chapter's outset, we focused on courts in France. The specialized entity (AMOTMJ) charged with construction also had prisons in its bailiwick. In 1994 France had planned to create six new institutions with 600 prison beds apiece and, by 2002, it had provided 13,200 new spaces for inmates.[409] A 2002 law called for the construction of twenty-seven new prisons.[410] Increased penalties for various offenses and overcrowded facilities drive calls (and sometimes judicial mandates) for yet more buildings[411] as, around the world, countries pre- sume that the number of detainees will expand rather than contract.

How those buildings will be designed reflects ideas about the functions of punishment and the forms of suffering appropriate to inflict on human beings. Analyses of the various approaches historically have looked at the political economy of institutions of punishment. One critic modeled early prisons to have functioned as "pseudohouseholds" and later ones as "capitalist manufactories."[412] By the late twentieth century, the massive economic commitment to prisons yielded descriptions of the "prison-industrial complex," with communities relying on nearby correctional facilities as major sources of employment, with manufacturers seeking markets for their wares, and with private providers selling the ability to house inmates at prices that permit them to make a profit.

Variations exist across jurisdictions, in that some countries still rely on a template closer to the household while others use much larger institutions. All of these projects for prisons are gathered under the rubric of the architecture of "justice facilities" and serviced by groups of professionals with expertise and experience in building such institutions. But funds are not distributed evenly across the set of "justice facilities," making for intriguing thought experiments that imagine an investment in courts and in rehabilatative support equal to the funds spent on prisons.

# Constructing Regional Rights

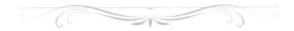

## Judging Across Borders

By considering courts within municipal or national regimes, we have thus far worked under a rubric that lawyers call "comparative law," focused on legal regimes in different countries and attending to inter-country variations and convergences in court structures and processes.[1] Subsumed within are discussions of federated nations such as the United States. Federations accord a degree of autonomy to subparts (such as provinces, states, cantons, or länders) rather than concentrating all legal authority in the center. Federated systems often, but not invariably, have separate courts for their subparts.[2] For example, the Supreme Court of Victoria (fig. 10/148) in Australia and the courts of New York (fig. 7/96) function as distinct legal entities, subject to some oversight but not complete control by the national system.

This chapter explores the role played by courts in other political configurations and thereby engages directly in questions that can be conceptualized as either layered sovereignty or the transformation of sovereignty's meaning. Our examples are drawn from regional courts in Europe and the Americas. In Chapter 12 we turn to various international courts, ranging from the generalist (and relatively old) International Court of Justice to specialty courts formed in the 1990s, such as the International Tribunal for the Law of the Sea and the International Criminal Court. Just as national courts have a long history, transnational adjudication also has deep roots, and both had parallel growth spurts during the twentieth century.

Tracing the origins of border-spanning courts depends on definitions. One could style the Roman ecclesiastical law in Medieval and Renaissance Europe or the common law of the British Empire within the genre, just as one can identify courts based on Jewish and Muslim traditions as parts of transnational legal regimes. Commercial tribunals created through guilds offer other parallels.[3] Systems of ad hoc rules assigning foreigners to the discrete legal authority of "consular courts" could be included, such as a 1290 exam-ple from the Middle East that if "a Sarrazin (Egyptian) or a Christian of a foreign state, has a litigation with a Genoise, the consul shall decide the case."[4]

## "Mixed Courts," the Slave Trade, and Special Venues for Foreigners

Our focus is on government-created courts that cross borders. Nineteenth-century antecedents to twentieth-century multi-national courts often bore the name "mixed courts" (or "mixed commissions"),[5] in reference to the fact that the presiding jurists came from different countries to constitute freestanding tribunals created through inter-sovereign agreements. For example, the Jay Treaty between Britain and the United States authorized an arbitral commission to deal with claims arising out of the American Revolution.[6]

The clearest precedents for contemporary transnational human rights courts are nineteenth-century anti-slavery courts[7] that dealt with the legality of the peacetime seizures of ships trafficking in slaves.[8] Great Britain entered into a series of multilateral and bilateral treaties authorizing such seizures and providing methods of inquiry into the legality of those captured under international law. Different treaties specified legal predicates of where ships could be seized, and the proof requisite for release, as well as created mixed courts to decide disputes. The term "mixed" referred to provisions for contracting nation-states to contribute judges, for example, through calling for service by "an equal number of Individuals of the 2 nations, named for this purpose by their respective Sovereigns."[9]

Such courts, sited in various locales (such as Sierra Leone, Havana, Brazil, and Suriname), took evidence to determine the lawfulness of searches and seizures and the nature of the persons or objects transported and applied legal precepts either to condemn or to release ships and their cargo.[10] As legal scholar Jenny Martinez has detailed, between 1817 and 1871 such courts dealt with "more than 600 cases and freed almost 80,000 slaves found aboard."[11]

These courts, like their contemporary counterparts, had a deeply normative agenda—to treat as unlawful inhuman practices that had not before been subjected to international legal sanctions. As is the case today, these courts were dependent on participation by nation-states, and some countries were more reluctant than others to sign accords.[12] Then, as now, questions of participation relied on the language of sovereignty. The issue was whether joining undermined national control.[13] Further, some such courts were, and are, specialized tribunals focused on a particular kind of problem or arena of activity, while others have had a broader reach. The heirs of the Slave Trade Tribunals include the European Court of Human Rights and the Inter-American Court of Human Rights, discussed in this chapter, as well as the International Tribunal for the Law of the Sea, addressed in Chapter 12.

Other transnational courts have a more general jurisdiction, as diplomatic agreements of the nineteenth century generated tribunals prompted by another "mix"—that of colonialism and trade.[14] One such institution, the "Mixed Courts of Egypt," began in 1875 and disbanded in 1949.[15] Chartered by an agreement of fourteen countries (including France, Germany, Greece, Russia, Spain, and the United States),[16] its judges were nominated by the "foreign powers" and named and commissioned by the Egyptian Government.[17] The Mixed Courts of Egypt operated (as international courts continue to do) through "chambers" of judges working at trial and appellate levels. The court had four official languages—French, English, Italian, and Arabic—and worked in French.[18]

In terms of reach, the jurisdictional predicates of the Mixed Courts of Egypt paralleled what is known as "diversity jurisdiction"—dependent on the citizenship status of the parties—in the United States.[19] The Mixed Courts had authority over controversies between "Egyptians and foreigners and between foreigners of different nationalities."[20] As for its law, jurists applied their own law, influenced by a range of sources,[21] again presaging contemporary international courts. And while that court is no longer extant, parallels in the twenty-first century can be found in bilateral investment treaties ("BITs") carving out legal enclaves in an effort to attract foreign capital,[22] as well as in private contractual agreements that designate laws or jurisdictions to govern disputes arising elsewhere.[23] A global version is the Dispute Settlement Understanding of the World Trade Organization (WTO), in which parties agree to a range of dispute resolution mechanisms, including binding judgments, through the WTO panel and an appellate body that has functioned, as of 2008, to produce thousands of pages of decisions.[24]

Just as municipal and national courts borrowed quarters in their early days, some mixed courts did so as well. Yet the Mixed Courts of Egypt had its own impressive building befitting its status as "the most cosmopolitan legal forum in the world."[25] Above the "columned portals" of the 1886 edifice (fig. 155), the words "Palace of Justice" were inscribed in French, Arabic, English, and Italian.[26] Many of today's "mixed courts" follow that path, occupying purpose-built structures to express their aspirations, embellished by ornamentation reflecting the multiple nationalities they serve.

These late twentieth-century buildings—analyzed in Chapter 12—follow a pattern made familiar in Chapters 7, 8, and 9 as we charted the expansion of courts in the United States. Construction tracks political hopes or political confidence intersecting with economic capacity. The buildings provide an interface between the nation-states and transnational entities and reveal, even as they seek to mask, the complex relationships entailed.[27] For example, the European Court of Justice, established in the early 1950s, camped out for some twenty years before moving in 1973 to its own building, modeled in the tradition of Greek temples. That once modest housing hinted at Member States' reluctance to cede space for monumental structures that could compete with national edifices. About twenty-five years later, in 2008, that court's site took on sweeping proportions. Its gold-sheathed buildings both reflected and shored up a growing sense of the "European" as a legal-political identity (a *demos*) formed as a union not only of states but also of individuals, each of whom was "a citizen of the Union" under the 1992 Maastricht Treaty if "holding the nationality of a Member State."[28]

Court buildings make plain the resources devoted to transnational institutions; the designer buildings made for the European Court of Justice and the European Court of Human Rights in Strasbourg reflect the economic wherewithal of Europe. The modest headquarters for the Inter-American Court of Human Rights in Costa Rica (renovated in 2004 without high-end architectural design) serves as a reminder that when the Organization of American States established the court in 1978 but gave it no budget, Costa Rica generously provided a recycled home. The small site for the Inter-American Court denotes its fragile status, even as it produces innovative law across countries allied through a regional organization but lacks shared legal "pillars" akin to those of the European Union (EU). The buildings thus tell stories of political regimes either ambivalent about transnational legal commitments or eager to display their hopes for participation and adherence.

The insistence on establishing permanent buildings for both the regional courts discussed here and the international tribunals of the next chapter represents efforts to anchor the norms that the authorizing conventions and treaties seek to promote and enforce. Big footprints express the hope of enduring over time. This brief survey of the transnational project of court-building teaches that large, imposing facilities aim to buffer against the historically transient nature of multi-national institutions, courts included.

FIGURE 155   "Main Entrance to
Courthouse at Alexandria," 1886.

Reprinted from Jasper Y. Brinton,
*The Mixed Courts of Egypt*
(Yale University Press, 1930).

## NATION-STATES ALLIED THROUGH COURTS

### Luxembourg and the European Court of Justice

Europe has its own Court of Justice, colloquially referred to as the ECJ (the European Court of Justice).[29] The ECJ is authorized to interpret treaties, conventions, and other measures of the European Union at the behest of national courts and to hear certain disputes between Member States and against Member States and the European Commission.[30] Begun in the early 1950s by the founding six members (Belgium, France, Germany, Italy, the Grand Duchy of Luxembourg, and the Netherlands) of the European Coal and Steel Community (ECSC), the court's initial charter was to adjudicate disputes arising within that association.[31] Since then, the ECJ has grown in jurisdictional authority with the expansion and transition of the ECSC into the European Community (EC) and then the EU.

Over the decades, the ECJ also elaborated its own substructure as statutory enactments allowed it to devolve some of its work to lower tier tribunals.[32] Its law has had an ever-widening impact,[33] prompting a great deal of debate about the appropriate role of the ECJ as a source of authority in Europe. Akin to discussion about the authority of the federal courts in the United States, arguments about the reach of the ECJ's judgments decry or celebrate "judicialization," the desirability of judicial review of legislative acts, and the import of constitutionalism.[34]

Celebration was the response of the leaders of the European Commission which, in 2002, published a book about the architecture and the art of the ECJ in honor of its fiftieth anniversary.[35] As that volume chronicles, at its inception in the 1950s the ECJ sat in a villa that "had belonged to the diocese of Luxembourg."[36] At the time, the choice of that city, with its population of about 60,000, appeared both

safe and potentially temporary; it was assumed that Luxembourg "would never be recognized as a 'real' capital of Europe."[37] By 1973, however, the ECJ had put an end to its "somewhat nomadic life"[38] when it occupied its own purpose-built permanent home there.[39]

Luxembourg has since evolved into the "Judicial Capital of Europe,"[40] providing a site for other institutions, including the European Investment Bank.[41] The ECJ's 1973 building proved, however, temporary in another sense in that it was soon too small, given the growth of the EU and the expansion of the ECJ's mission and staff. The ECJ's facilities grew, even as they continued to reflect ambivalence about the potential that European identities could eclipse national sovereignties. The architecture and art of the first buildings of the ECJ were more focused on marking individual states' contributions, while the newer architecture aims to embody a collective persona.[42]

### Enduring (and Expanding) Authority: Le Palais Plus

In 1973, as Denmark, Ireland, and the United Kingdom joined the six original members of the EC, the ECJ moved into its first major building, called Le Palais (fig. 156, color plate 34[43]), located some distance from the City of Luxembourg on the Kirchberg Plateau, where it joined other EU buildings. The book documenting the court's architecture and art describes it as an "imposing skeleton of steel, copper, chromium, and nickel alloy . . . [that] stands as a symbol of enduring authority, serenity and harmony."[44]

In 1964 architects had been invited to participate in a design competition—a first "for a united Europe"[45]—that was won by Jean-Paul Conzemius of Luxembourg in affiliation with François Jamagne and Michel Vander Elst of Belgium. They are credited with providing a "rare exception to the nondescript architecture" of the buildings of Europe that were in Luxembourg.[46] The result was "an isolated horizontal building reminiscent of a Greek temple at the top of

a slope."[47] The symmetrical building[48] has a "dark bronze appearance" from the coat of rust that forms on the metal alloy to produce a maintenance-free veneer.[49]

To understand why, within a decade, that building no longer sufficed, one needs to know something about the expansion of the EC and the structure and jurisdiction of the ECJ. In 1973, when Le Palais opened, the EC had nine members. By 1986 Greece, Portugal, and Spain had joined, and by 1995 the membership had expanded to fifteen through the addition of Austria, Finland, and Sweden. In 2004, several years after the fall of the Berlin Wall, Cyprus, the Czech Republic, Estonia, Hungary, Latvia, Lithuania, Malta, Poland, Slovenia, and Slovakia were added, for a total of twenty-five. Bulgaria and Romania joined in 2007, bringing the complement to twenty-seven Member States.

The Member States were ambivalent about materializing European identity through "the creation of monumental buildings" that could comprise a permanent new center overshadowing their own national capitals.[50] Yet another question was which country would be the site of such a European center. (Other federations have had the same problem, sometimes resolved through moving capitals or by picking a place to develop into a city so as to avoid choosing among competitive locations.) Rather than centralizing European institutions in one place, dispersion was Europe's solution, with the Commission of the European Economic Community in Brussels, the Court of Justice in Luxembourg, and the Human Rights Court in Strasbourg. That arrangement remained technically "provisional" until the 1992 Treaty of Maastricht gave the three cities official status as capitals. Through this polycentric arrangement, no one country is symbolically dominant. And, in terms of construction, national and local levels retained substantial control over decisions.[51]

Le Palais was one of several buildings on the Kirchberg Plateau that European organizations found too small for their needs.[52] The number of judges and the size of the ECJ

FIGURE 156   Le Palais, Court of Justice of the European Communities, City of Luxembourg, Luxembourg, 1973.
Architects: Jean-Paul Conzemius, François Jamagne, and Michel Vander Elst.

Photograph reproduced courtesy of the Court of Justice of the European Communities. See color plate 34.

docket grew substantially over the later part of the twentieth century. Because each Member State is entitled to have a jurist on the ECJ,[53] the court needed more chambers. As of 2008, twenty-seven judges served for six-year renewable terms and worked in groups (chambers) of three or five. When deciding cases involving Member States as parties, the court sits as a "Grand Chamber" of thirteen; in rare instances involving certain provisions of EC law, the entire cadre of judges participates.[54] In addition, eight Advocates General, a specialized set of expert lawyers, serve as part of the court, providing published independent opinions that often include scholarly overviews of areas of law that the ECJ can adopt or not, and their decisions are published alongside the obligatorily unanimous judgments of the ECJ.[55]

The procedure for obtaining the European Court of Justice's consideration is complex; many cases come to the ECJ through references from national courts that are required to apply EC law if relevant.[56] Other cases are brought directly, challenging Community institutions' actions. Between 2000 and 2007, the ECJ received about five hundred or more new filings and rendered a similar number of decisions each year.[57] Pressure for additional judicial capacity came from distress about case-processing time, slowed by the growing volume of filings invoking European law.[58] In 1987 a new body, the Court of First Instance, was established. Operational in 1989, it took over certain kinds of cases, including actions by individuals against Community institutions, actions by Member States against the European Commission, and certain breach-of-contract and trade cases.[59] As its name suggests, its judgments can be appealed to the ECJ, which also retained exclusive jurisdiction over references from national courts.

Each Member State also sends to the Court of First Instance a judge who serves renewable six-year terms. About 80 percent of the completed cases are heard by three-judge benches; on rare occasions, a single judge makes a decision, and equally unusual are the occasions when a Grand Cham-

ber of thirteen jurists sits.[60] The Court's docket grew from about 780 pending cases in 2000 to more than 1,150 in 2007.[61] That volume, in turn, prompted the creation in 2005 of yet another body, the Civil Service Tribunal that, as of 2005, took over cases involving EC employees who, previously, had sought relief in the ECJ and then the Court of First Instance.[62] From its inception through 2007, the Civil Service Tribunal's docket averaged about 150 filings,[63] and most of the cases are heard by three judges.[64] Decisions of that tribunal can be appealed to the Court of First Instance, rendering that name no longer completely descriptive.

Litigants of each state can file papers in the official language(s) of their country.[65] The working language for jurists is French,[66] but the growth in the number of Member States has produced an intensified need for translators to make information accessible in more than twenty languages.[67] Indeed, about 45 percent of the institution's workforce (over eight hundred people)[68] is devoted to translation, and housing the staff for that function was a major impetus for new construction.

### Dominique Perrault's Golden "morphological development"

The EC's expansion and its evolution into the EU can be tracked through the ECJ's buildings.[69] In 1988, the Erasmus Building (fig. 157) went into service to supplement the 1973 Palais and to house the ECJ's then-fledgling Court of First Instance. Clad in pink granite, and linked to Le Palais by a 165-foot (fifty-meter) tunnel that was appointed with art, Erasmus added "350 cellular offices, a restaurant, two small (80 seat) court rooms, a print shop, bank branch and parking."[70] The courtroom layouts were dominated, in familiar fashion, by the judges' bench, and its courtrooms were distinguished by furnishings that varied in color (pink or blue tones). The two courtrooms were denoted by the art within (the "Pessoa courtroom" and the "Dalsgaard courtroom").[71]

FIGURE 157    The Erasmus Building, Court of Justice of the European Communities, 1988. Architects: Bohdan Paczowski, Paul Fritsch, Jean Herr, and Gilbert Huyberechts.

Photograph reproduced courtesy of the Court of Justice of the European Communities.

The "character" of Erasmus came, according to the court-house book, from its "internal courtyards and its bridges and corridors of steel and glass."[72]

A third building, also linked by corridors to Le Palais, is named after Thomas More and featured courtrooms (blue and green) as well as office spaces.[73] Opened in 1992, Thomas More was followed in 1994 by Annex C, again a composite of courtrooms and offices.[74] Thus by 2002, facilities once sufficient for two hundred people had grown to accommodate the more than one thousand people working there. The court's book pronounced the arrangement a "coherent and harmonious range of buildings" that gave a "concrete reality" to the influence and role of the court.[75] Architectural critics praised the building's legibility; the "linear sequences of courtrooms and meeting places" were "good for orientation and ease of circulation," while much of the interior was "predictably corporate in character—not unlike Luxembourg's numerous banks."[76]

By 2002 the existing space was seen to be insufficient.[77] As the construction site photograph (fig. 158) depicts, a major new edifice—designed by the French architect Dominique Perrault—was underway in 2006; it opened toward the end of 2008,[78] eclipsing the older buildings by wrapping "a new building around the existing complex" and thereby putting the staff (by then numbering close to two thousand) "under one roof."[79] The goals, according to the architect, included creating a "large public square" through cultivating a sense of urbanity across a set of buildings.[80] What was added to the 25,000 square meters was another "37,000 sqm of occupied space in the covered areas, 10,500 sqm office space for the President, court members and court clerks, 4,400 sqm audi-torium space, a 5,000 sqm gallery—which acts to link surrounding zones, a 23,000 sqm public esplanade, 770 parking spaces, and most significantly, two 12,000 sqm towers to house the translators."[81] In other words, more than a million square feet have become available—including 80 stories that stretch 350 feet (107 meters) towards the sky—for use by the court and its entourage (fig. 159, color plate 35).[82] That new space entailed a major commitment of funds (about 500 million Euros or some 600 million dollars) – constituting about half of the court's annual budget in 2006.[83]

Perrault demurred from calling his design a fourth extension; he described it instead as a "progression" in that it represented the "sedimentation" of the role that the ECJ played in Europe.[84] The court's deepening import, he argued, could been seen through the repeated reconstructions of its buildings. His layering on top of Le Palais intentionally provided historical evidence of its "morphological development."[85] Perrault was also responding to the demands of the users, who had a strong connection with the building. As the ECJ President Vassilios Skouris explained at the new building's inauguration in December of 2008, "[al]though the Court as a whole met there for only ten years or so, the institution's attachment to that building, with its steel feet and glass covering hoisted onto its base, was such that . . . the Court expressed its wish that the old courthouse retain its emblematic jurisdictional function. . . . The old, restructured courthouse, whose exterior and original structure have been preserved . . . is entirely dedicated to the public face of justice. Here is where we will hold hearings that the public can attend; here justice will be seen, read, and rendered."[86]

FIGURE 158    Court of Justice of the European Communities, construction site, 2006.

Photographer: Judith Resnik, 2006. Photograph reproduced with the permission of the photographer.

FIGURE 159   Towers of the Court of Justice of the European Communities, 2008. Architect: Dominique Perrault.

Photograph: G. Fessy, © Court of Justice of the European Communities. See color plate 35.

Perrault's work has been greeted in many quarters with rave reviews. At its opening President Skouris saw it as the embodiment of the court's commitment to transparency, access, and restraint: "May this beautiful edifice, with its pure lines and its harmonious spaces, be for the Court an inspiration in rendering a justice that is solid and consistent, yet nevertheless measured in full respect for the competences accorded it by the treaty."[87] The President of the European Commission spoke of the new Palace (as well as the buildings it encircled) as "the very symbol of a Europe based on the guarantees of impartial justice"; the new structures represented both the "evolution of the work" of the court and Europe's "political progress . . . modernized and enlarged."[88] The Prime Minister of the Grand Duchy of Luxembourg picked up on the theme of the "vastness of the premises," as he noted its size was that of "18 soccer fields."[89]

An architectural critic from *The Guardian* in London called it a "shining beacon," as he praised its "shimmering palace" and its "pencil-thin" golden towers that "light up like a pair of giant candles."[90] Another commentator pronounced the gold sheathing an "evening gown" and praised the "translucent softness" of the new buildings.[91] The building has been heralded as "not just a new addition . . . but an

'injection' that proclaims the primacy of linking over juxtaposition and of unification over densification."[92]

The new main courtroom is a "timber-lined chamber" (fig. 160, color plate 37) whose ceiling is adorned by a glass screen with a "giant gold flower" (fig. 161) of woven steel that swoops down, umbrella-like, in a dramatic flourish.[93] Other courtrooms were also added, "encircled by a new two-story corridor or internal street" with cafes, libraries, and judges' chambers.[94] The four buildings that predate the 2008 addition had departed from the modularity found in many new French courthouses that isolate courtrooms from administrative offices by mixing these functions within the same buildings. In contrast, the new ECJ configuration puts the "600 legal writers from across the EU" into their own separate office space, the twin high-rise towers clad, like the new courthouse, in gold.[95]

Scholars of the court described its movement from being "for many years the least known institution" in Europe to becoming the "chief architect of the Community's legal order."[96] By the late 1990s, survey data reported that the ECJ had become one of the EU's better recognized institutions.[97] Recall that the Supreme Courts of both the United States and Israel are major tourist destinations. Before its new building opened, the ECJ made its mark primarily through its legal output. The setting is hard to visit—and not by happenstance, in that the choice of Luxembourg aimed to avoid eclipsing national capitals. To gain direct access to the EU enclave on the Kirchberg Plateau, outside

FIGURE 160    Interior of the Great Courtroom of the Court of Justice of the European Communities, 2008.

Photograph: G. Fessy, © Court of Justice of the European Communities. See color plate 37.

FIGURE 161    Mesh above the Great Courtroom of the Court of Justice of the European Communities, 2008.

Photograph: G. Fessy, © Court of Justice of the European Communities.

the city proper, requires a special trip.[98] In 2005 some 12,000 visitors made that journey,[99] directed (depending on capacity and the language of proceedings) by the court's "Visits Service" to hearings. Some commentators had argued that the ECJ ought to put itself more in the public eye.[100] Its gold splash is surely aiming to catch attention.[101]

What Perrault's new structures thus represent is the ECJ's success in responding across diverse legal traditions to generate an institution that is comprehensible as a "court," distinct from other branches of government. On behalf of the Union, the ECJ renders judgments that bridge a vast set of differences, even as (not surprisingly) they are met with varying degrees of implementation at national levels.[102] The ECJ has become one of the dominant institutions of the European Union, aiming to be understood in political and sociological terms as a *demos*—a polity encompassing and representing a citizenry.[103]

*Imagined Communities* is the title of Benedict Anderson's book about the idea of nation-states[104] weaving together diverse individuals by building a sense of connection out of shared histories, languages, cultures, and/or ethno-religious identities, sometimes translated through emblems—including, as we have shown, the transnational iconography of justice. New amalgams like the EU have used legal, administrative, and executive regimes to bring into being a political imaginary that entails "a matrix of values"[105] representing aspects of their identity. European law speaks of the "pillars" of the Union, of which the Community is one, and its law is the particular competence of the ECJ. The metaphysical pillars have become literal through the two towers for translators designed by Perrault, and his gold mesh that wraps the court and high-rise columns may well become the icon of the EU. The ECJ's new golden "ring, which extends the suspended, noble floors of the heart of the pre-existing building,"[106] could well be understood as aspiring to encircle the Member States.

## *"Under the watchful eye of paintings and sculptures"*

True to European town hall traditions, the ECJ brimmed with art. As the commemorative book that documented the art as of 2002 explains: "Justice is not dispensed in a vacuum and the Court's judgments are handed down under the watchful eye of paintings and sculptures which speak of their origins and symbolize the importance each Member State attaches to the preservation of its identity and history."[107] Some of the objects were loaned,[108] some were gifts,[109] and some resulted from invitations to artists or from purchases by the Luxembourg Government. As in courthouses elsewhere, materials ranged from bronze, marble, aluminum, iron, stainless steel, sheet metal, and wood to oil paintings and cloth tapestries, with both representational and abstract styles in view. When Le Palais opened in 1973, artists from the original six EC states were

asked to "embellish the interior and exterior."[110] Since then, many new Member States have added to the ECJ's displays.

Renaissance Virtues—with twentieth-century glosses—were to be found in several places. Like the models provided from the fourteenth century in Siena to the seventeenth in Amsterdam, Justice is a common component, often shown with Peace. A first such example was displayed in Le Palais; a bronze relief, *Justice and Peace,* completed in 1972 by Italian artist Giacomo Manzù, has these two figures "drawn on the same scale" and similarly attired in drapery, echoing figures from antiquity.[111] Both have outstretched arms—Justice holds scales and Peace a child. Justice also takes center stage on the landing of the main staircase in Le Palais as part of a series of larger-than-life wood carvings, four on each of her sides.[112] These black-ink figures—xylographs—by HAP Grieshaber of Germany are set against a red background evocative of Greek urns.[113] Holding scales and a sword (and not blindfolded), a large Justice is central, accompanied by eight "enigmatic and exuberant figures with hats, musical instruments and foliage," perhaps forming part of a "Dionysian procession."[114]

Another kind of representation of law was provided by the Greek government, which donated three replicas of parts of the Gortyn Code, large stone-cast steles inscribed with some of the fifth-century BCE laws of the city of Gortyn in Crete.[115] Words also come into play in a layered oil calligraphy by Danish artist (and poet) Sven Dalsgaard that graces one of the courtrooms. The phrases "With Love / and Justice / A United Europe," in a variety of bright colors, are "spread across three large triptych-like canvasses" in various languages of the community.[116] The overlaying makes them "indecipherable" as they are "so entangled that they cannot be read."[117] The President of the ECJ's Court of First Instance explained that, "'by giving first place to love, Sven Dalsgaard tells us that justice without human warmth and understanding cannot be the right basis for a European Community.'"[118]

Some of the pieces not obviously "about" justice are explained as such. For example, the tapestry *Migration* by Mary Dambiermont (a Belgian artist) is populated by a flock of birds in close formation, "representing the first six countries to join the Community" as they carry an "injured bird on their wings."[119] The theme is Europe-focused rather than obviously judicially centered, yet the imagery is said—by its "unity, balance, and solidarity"—to illustrate justice.[120]

The layout within the courtrooms also reflects the breadth of the community. An ultra-long bench is provided in the main courtroom to accommodate judges coming from all of the Member States.[121] The new central courtroom, opened in 2008, measures 1,026 square meters, or more than 11,000 square feet; its bench has room to seat forty-one judges, with three hundred seats available to the public. (The courtroom could thus be viewed as predicting the expansion of the EU beyond the twenty-seven Member

FIGURE 162    Main courtroom with panels from André Hambourg's 1972 painting *Justice and Peace,*
Le Palais, Court of Justice of the European Communities.

Photograph reproduced courtesy of the Court of Justice of the European Communities. See color plate 36.

States; even when joined by all eight Advocates General, the current complement does not fill all the chairs.) In addition, twenty-three booths house translators who provide simultaneous translations—making headphones appropriate gear for jurists.[122]

Depicted in figure 162 (color plate 36) is the main courtroom of Le Palais in its incarnation before the 2008 renovation; shown are some fourteen jurists seated below three of six allegorical panels created in 1972 by the French artist André Hambourg and bearing the familiar title *Justice and Peace*.[123] Both the layout of the courtroom and its iconography were familiar, didactic in the traditions of Lorenzetti in Siena (fig. 2/26) and Quellinus in Amsterdam (fig. 3/38).

At the center of the Hambourg murals is a large, draped, clear-sighted Justice, seemingly floating in space (or the heavens) and holding evenly balanced scales in one hand. Her hair is red, and she is garbed in white. The background of clouds and blue sky coupled with various figures and objects in the visual array provides plentiful references to virtuous acts and to godly justice. Near Justice's scales are two men who could be Moses and Aaron, holding tablets unmistakably evocative of the Ten Commandments. Rays of light emanate from Justice's right hand, pointing toward

a woman and child who appear as supplicants. Law books are below, while another woman wearing white and holding a dove (evoking Peace) can be seen in the background. On both sides at the bottom, beneath Justice's feet, are men —one face down and one face up—reminiscent of the vanquished in the Siena murals, in which Lorenzetti's enthroned, vindictive Justice (fig. 2/26) has prisoners tied below her. Yet other supplicants reach toward the Hambourg Justice from each of the corners of the panel.

The central mural of Justice hangs between two side panels that also provide a backdrop for the judges' bench. Both include views of open skies and cities of Europe. At the far left corner of the left panel, a male sculptor chisels rock, while at the far right of the other a male artist paints. Peace gets her own set of three panels, all of similar size to those of Justice. Like Justice, Peace is at the center. Smaller in size, she holds a sheaf of corn as two men (larger than she) shake hands. To her right, a woman pours wine from a pitcher (as Temperance does in many images), while another woman is shown as Charity would be, holding a child and near fruits and foodstuffs. The panels also include buildings known to European spectators, such as France's Notre-Dame Cathedral and St. Mark's Cathedral in Venice. More specific homage is paid to one of the

founders of the EC, Robert Schumann, by putting his house in the landscape.[124] The imagery, in bluish tones with light rays glowing yellow and rainbows, celebrates Europe through a painterly style that recalls a mix of Marc Chagall and of Picasso in his blue period.

Not all the art displayed was unremittingly cheerful. A 1953 tapestry by Jean Lurcat of France titled *The Little Fear* adorned the Grieshaber courtroom in Le Palais. The large tapestry, depicting the Apocalypse, is filled with flora and oversized fauna fleeing the end of time; they appear on a black background that, with a densely patterned red foreground, creates a Medieval aura. Discussion of the piece attributes its mix of references to the New Testament coupled with the artist's personal references. One sees "cosmic plagues: the scorpion, the eagle, the locusts with 'women's hair' and 'lion's teeth,'" joined by a cockerel, explained by the artist as an emblem for those for "'whom hope is not simply a word shunted into a vague future.'"[125]

While the art strives to be didactic as it evokes its European iconographical roots, none of the images became a signature of the building. At the renovations' end (around 2010), the new building became the emblem. One should thus understand the 2002 volume about the ECJ buildings of 1973 through 1994 and their artwork as commemorative in the sense that it documented structures on the cusp of their eclipse. Only one page of that book quietly adverts to the future, by providing a model of the Perrault building as it was then forecast.[126]

Tourists in Europe have long been able to purchase trinkets, such as tiny Eiffel Towers and small Leaning Towers of Pisa. Competition has just emerged from the glimmering gold mesh towers of the ECJ. Recall the decision in 1992 to create a polycentric set of capitals for Europe, the earlier reticence to build impressive structures that could shift attention away from national landmarks, and the discretion of the 1973 Le Palais, with its practical rusted hues of brown quietly repeating the symmetry of an ancestral past in Greece and Rome. Whatever Member States' ambivalence—expressed as the proposed constitution for Europe went down to defeat in 2006—Europe gained its own monument in 2008: a court.

The ECJ has been the source of implementing and expanding the law of Europe to make a constitution, whether or not a document so named is officially adopted. (As of 2010, proposals for such a constitution had failed to gather sufficient support to be enacted.) In that respect, the ECJ well merits the light shone on it through its new buildings. Yet, while efforts have been made to draw attention to its central courtroom by planting a floating gold flower in its ceiling, the towers and rings are aptly emblematic of twenty-first-century judging. The administrative apparatus overshadows judges around the world, just as the two towers for translators and other staff stand above the structures encapsulating the courtrooms.

## Strasbourg and the European Court of Human Rights

One can think of Richard Rogers's 1989 design for the European Court of Human Rights (ECtHR) for a site provided by Strasbourg, France, as an appropriate bookend to the 2008 Perrault configuration, as both are deliberately adventuresome and admired. The ECtHR (fig. 163[127]) was the "first building for a united Europe to receive architectural attention."[128] Perrault and Rogers had competed for the commission in a process prompted in part by dislike for the "lumpen administrative buildings" then housing the Council of Europe.[129] Rogers's design gained praise for its "explicit transparency and populism" that contrasted with the design for the 1973 Le Palais, which had (at the time) taken a more "conservative view," aiming for a "gravitas befitting" the court's function.[130]

Further, akin to the experience in the United States when the Boston Courthouse made a splash that shaped subsequent selection procedures, the competitive process producing Rogers's ECtHR building paved the way for others ("path dependency" is the political theory term). Within a year of the opening of the ECtHR structure, Strasbourg shaped a competition for what became Europe's new parliament buildings, put into use in 1998.[131] Rogers, in turn, went on to win architecture's sought-after Pritzker Prize[132] after designing dramatic courthouses in France (fig. 10/127) and in Belgium.[133]

As of 2008, Europe had thus gained two major architectural statements named "courts," albeit in buildings that look neither like courthouses of eras past nor sufficiently like each other so as to generate a prototype for other buildings bearing that name.[134] Instead, the designs by Perrault and Rogers could each be read as grand sculptural architecture providing space for what viewers should divine to be an important, yet unspecified, purpose.

### *Le Palais des Droits de L'Homme*

The two courts with overlapping names could well be confused with each other.[135] Strasbourg's ECtHR is older and, despite its specialty designation denoting a jurisdiction keyed to human rights, has a broader reach than the ECJ on another dimension. The ECtHR serves as the principal juridical organ for the Council of Europe, with its forty-seven members—to be distinguished from what was called the European Community (EC) and, as of 1992, is known as the European Union (EU) with (as of 2010) twenty-seven Member States. In practice, the law of the two courts interacts in some areas, and efforts have been made to convince the EU to join the Council of Europe.[136]

The Council of Europe dates from the mid-1940s. In September of 1946, in a speech at the University of Zurich,

FIGURE 163    European Court of Human Rights, Strasbourg, France, 1984. Architect: Richard Rogers.

Photograph by Sandro Weltin. Reproduced courtesy of the Council of Europe.

Winston Churchill spoke of "the tragedy of Europe," describing it as "once united" but then fraught with "nationalistic quarrels" that "wreck the peace and mar the prospects of all mankind. . . . We must build a kind of United States of Europe," he concluded, calling for the formation of a "Council of Europe" to unite the "European family."[137] In May of 1948, Churchill presided over a gathering of eight hundred delegates from around Europe at the Hague Congress, or the "Congress of Europe," where plans for a council—including a parliament, a court, and a human rights convention—were laid.[138] A year later, in May of 1949, a group of states (Belgium, Denmark, France, Ireland, Italy, Luxembourg, the Netherlands, Norway, Sweden, and the United Kingdom) signed the Treaty of London, and the Council of Europe came into being.[139]

The human rights focus had both longer-term and immediate predicates. The Slave Trade Tribunals, described at the outset of this chapter, are exemplary of three centuries of transnational efforts pressing for abolition of slavery and for women's equality. Both social movements were predicated on arguments about essential rights that belonged to all human beings.[140] The tragedies of World Wars I and II inspired a new "age of rights," to borrow words from the title of Louis Henkin's book.[141] In 1946 the United Nations (U.N.) was created; in 1948 the U.N. issued its Universal Declaration of Human Rights with its preamble that "reaffirmed" the "fundamental" precepts predi-

cated on "recognition of the inherent dignity" of all persons.[142] Moral and political philosophers debate the foundations and reach of human rights, some reading these events as remarkably innovative and others understanding the efforts as reviving a conservative humanism rooted in European history.[143] Post–World War II human rights proponents had the goal of making the idea of human rights universal through internationalism, so that countries would both agree to and apply these precepts. To do so, human rights advocates relied on various techniques aiming to build institutions such as treaty bodies, expert committees, monitors, study commissions, rapporteurs, and courts.[144]

In 1950, the European group committed its members to its own European Declaration on the Rights of Man and Fundamental Freedoms (which has come to be called the European Convention on Human Rights, or ECHR) that outlined protections for human dignity, the privacy of family life, the freedoms of the press and of association, and safeguards for detainees, including rights of access to public trials and prohibitions on discrimination, torture, and inhumane or degrading treatment.[145] How to organize the Council and implement these provisions proved contentious, and the mechanisms have changed over time. Where to do the work was yet another question, and the choice of Strasbourg came in part from its symbolic freight. The city dates from Roman times, and the Latin origin

of its name—Strateburgum—means "fortified place of roads."[146] Fortification was indeed needed; between 1870 and 1948, the city's nationality changed four times, moving back and forth from France to Germany. The Council's pick of Strasbourg as its center was both a proclamation of victory over Nazi Germany and a recognition of the need to reintegrate the new Germany into a unified Europe.[147] Strasbourg also became one of the headquarters for both the Council of Europe and the Parliament of the EU.[148]

### Building-in Expansion (for Space and Rights)

While the commitment to human dignity was one response to World War II, the shape of mechanisms for enforcement of human rights was not easily agreed upon. States did not want to subject themselves to suits either by each other or by individuals alleging violations of the ECHR. Instead, the chartering parties initially provided for a voluntary system through an optional protocol that provided for both a European Commission on Human Rights, which began its work in 1954, and a European Court of Human Rights, begun in 1959.[149]

For several decades the Commission functioned as the path to the court, an "intermediary organ of a semi-judicial nature," which meant that petitions were filed there first and could not proceed to the ECtHR without a finding of admissibility.[150] But by the early 1990s, after the fall of the Berlin Wall, the expansion of the Council of Europe, and domestic elaboration of human rights in many countries, the Commission was seen less as an effective tool than as an institution overwhelmed by complaints.[151] Its abolition was the response and, in 1998, the Commission formally ceased to be, giving individuals rights of direct access to the ECtHR for claims that states parties had failed to "secure to everyone in their jurisdiction" the rights enumerated under the ECHR.[152]

Each state party is entitled to have a judge serve on the ECtHR and does so by nominating a slate of three individuals from whom the Council of Europe's parliamentary assembly makes the selection.[153] Judges serve renewable six-year terms until the mandatory retirement age of seventy.[154] (In 2004 the Council of Europe passed Protocol 14 to revise the system and provide for nine-year nonrenewable terms.[155] The last country to ratify was Russia, which gave its consent in 2010, bringing Protocol 14 into force later that year.[156])

With forty-seven Council of Europe members as of 2008, the forty-seven-judge court serves as a supra-national juridical body with final authority over "all matters concerning the interpretation and application of the Convention."[157] Council members agree to comply, and the result is a rich and complex set of judicial doctrines seeking to enforce the Convention, albeit with a "margin of appreciation" tolerant of some differences in application.[158] The ECtHR has used that approach to accord some latitude in ECHR precepts in recognition of the challenges of implementation in the diverse contexts of the various nations formally agreeing to adhere to the Convention.[159]

### Richard Rogers's "monumental cylinders"

Richard Rogers is a global player, with many public buildings to his credit.[160] He gained transnational fame in the early 1970s when he joined Renzo Piano in designing Paris's Pompidou Centre,[161] pronounced an "entirely new building" credited with revolutionizing architecture during the later part of the twentieth century.[162] Rogers also described his proposal for the Strasbourg court as seeking novelty. Even as he wanted to provide an "architectural image for the 'new' Europe,"[163] he also "wanted the building to break from the traditional monumentalism associated with Palaces de Justices by placing emphasis on accessibility with a central, transparent assembly hall and by boldly expressing the functions of the Institution."[164] Moreover, Rogers aimed to create a "futuristic image not limited by the national styles" of the member States.[165] Further, Rogers anticipated that he would need a building that could be expanded, if politics permitted, and hence he had to conceive of a design (with foundations that could bear the extra weight) that could grow when nation-states joined the Council of Europe.[166] All told, he sought to shape a "welcoming and humane" space.[167]

The result is a biomorphic asymmetrical form, in part shaped to follow the curve of the River Ille beside which the court sits.[168] As Rogers put it, he had made "two great salles [rooms] acting as 'head,' the chambers as 'neck,' and administration as 'tail.'"[169] The smaller of the "two large drums,"[170] for the Commission, was to capture its role as monitor of the ECHR, while the larger module, for the court, was to signify its distinct function of rendering judgments.

Construction of the new building began in 1991 but, in short order, the design was obsolete on one dimension and inadequate on another.[171] The decision to abolish the Commission left one of the two great drum-shaped rooms unnecessary, and the growth in the number of members from twenty-five to more than thirty in the early 1990s (and to forty-seven as of 2010) made the provisions for judges and staff insufficient. "Everything had to change: the chambers had to be larger, the tails had to be extended and a storey added."[172] The result, when completed in 1994 at a cost of 455 million French francs ($78 million in 1994 dollars),[173] was an increase of office space by 40 percent and in other areas by 25 percent.[174]

The building may be unusual within the canon of courthouse construction but, as commentators have noted, it is familiar within Rogers's oeuvre, resembling other designs made "from strongly articulated concrete, tubular steel, stainless steel panels and suspended glass."[175] The main materials were not "opulent" but "basically cheap."[176] The steel girders of blue, red, and white could be read as a ref-

erence to the lineal primary colors of Russian Constructivism of the 1920s.[177] For its time, the building was notably "green," eschewing air conditioning for natural ventilation and using blinds to protect the interior from the sun. The building lagged, however, in terms of easy access for people with disabilities.[178]

While innovative in shape and in the mix of industrial and nautical motifs, the interior is familiarly court-like. The spaces are deeply segregated, with security measures made apparent in part by virtue of the many glass windows, explained (as always) to denote transparency—albeit with a "bullet-proof glass screen inside the suspended glass envelope."[179] One commentator described passing through "a battery of security guards in a glass box" that served as a "rather formidable obstruction,"[180] attributed in part to one instance in which a distressed litigant came to the court armed with a gun.[181]

After screening, one comes into an open area with glass permitting views of trees, the river, and the spiral staircase and elevator shafts that mark the vertical lines of interior passageways that bridge the modules of the building. The courtroom, with places for some three hundred people including the judges, is a "closed volume, with a great undulating fibrous plaster acoustically-reflective ceiling."[182] The room measures about 9,250 square feet (860 square meters); it is conventionally arranged, albeit with a bench shaped like a large "horseshoe"[183] to accommodate a judge from each of the many member States. Only the entrance, the courtroom, and the library are accessible to the public, and a good deal of the building's square footage is devoted to offices.

Art is not part of the design, and those entering the building to go to the courtroom would not necessarily encounter allegorical images. If one walks the grounds or is shown which window to look at, a few sculptural objects can be seen, including a moving, graffitied fragment from the Berlin Wall.[184] Another sign of the conflicts that produced the court is a large bronze sculpture of a group of prisoners, titled *Les 7 Petrifiés*, that stands in the garden area outside the court's library. The artist, the Swiss sculptor Carl Bucher,[185] created a similar sculpture that can be found in the International Red Cross and Red Crescent Museum in Geneva. Bucher has explained both of these works as depicting prisoners who have "lost their dignity: their hands have been cut off, their shoes have been removed to humiliate them. They are covered by a sheet to prevent them from seeing and speaking, and thus from testifying, and bound so that they do not escape."[186]

Little mention has been made of the artwork, but the building itself has provoked mixed reviews. Its admirers praise Rogers as "a defender of the modernist tradition"[187] who has embraced "ecological harmony" ("Long life, Loose fit, Low energy").[188] Some like the building, "encased in glass . . . designed as an antithesis to the claustrophobic nature of major legal institutions."[189] Others are skeptical: "What has architectronic gymnastics got to do with an institution whose function is to protect the human rights of Europeans? What petitioner, approaching this cluster of interlocking, monumental cylinders, does not have a sense of foreboding that he is about to become enmeshed in the clogs of a huge machine? What does it tell him about such an institution when, through its mullionless glass facade, he sees bullet-proof screens and a dense web of colored metal?"[190]

In fact, this court was not designed to provide much by way of public space. Unlike many courthouses that offer waiting and gathering places, the ECtHR does not. Rather, its 300,000 square feet (28,000 square meters) are devoted to the two chambers, a series of smaller conference rooms (holding not more than fifty people each), and 420 offices.[191] And unlike the Perrault building for the ECJ, Rogers's design did not include auxiliary services beyond a cafeteria. In some sense, the lack of areas for the public reflects that the public—800 million Europeans—is an abstraction, residing across forty-seven states and unlikely to come in person to this court.

### "Easier to see your neighbor's human rights violations than your own"

As explained by Luzius Wildhaber, President of the ECtHR during its first decade without the Commission, the goals have been pragmatic and aspirational.[192] The hope was to create a "European Human Rights Space" in which member States protected dignity and equality in a manner respectful of their "different cultures and traditions."[193] How to do so has been an ongoing challenge.

What constitutes a violation of human rights requires interpretation, spawning debates familiar in the literature on constitutional courts about the relationship between methodologies of interpretation and the nature of judicial discretion and authority.[194] Some commentators advocate a focus on a constitution or convention when it was originally crafted and agreed upon, while others speak of the evolution of rights. Wildhaber described the ECtHR as committed to the latter view ("a living instrument"),[195] recognizing the possibility of applications not necessarily anticipated in 1950. One ready example is that the concept of equality has come to embrace protections for persons regardless of sexual orientation.[196] Of course evolutionary interpretations need not only be expansive but may also narrow rights.

Problems of decisionmaking come not only from methodological questions of interpretation but also from the challenges of identifying which cases to consider. In 1999, when the ECtHR took on the task of determining the "admissibility" of petitions,[197] it "inherited" 6,500 applications from the Commission, which were added to the 89 pending before the reforms took effect.[198] Major contributors to the heavy docket were, ironically in light of the ECtHR's own backlog, complaints that at the national level, countries were failing to live up to what are called "Article

6" obligations—relating to individuals' rights to go to court and obtain fair trials in a reasonable time.[199]

Docket growth is one measure of success. While in the 1960s the European Commission on Human Rights received 49 applications, by 2006 more than 50,000 individual applicants claimed violations of the ECHR.[200] By then, pursuant to Protocol No. 11,[201] access was eased for individuals to seek damages for state violations of the Convention. Given structural problems in some states, "often hundreds of virtually identical complaints" have been filed.[202] The pace of rendering judgments, not surprisingly, struggled to keep up with filings;[203] for example, in 2000 the court issued 695 decisions,[204] and by 2006 it had made some 1,500 rulings in that calendar year.[205] Between 1999 and 2007, violations of the Convention were found in more than 80 percent of the court's judgments, and its decisions came disproportionately from a subset of States Parties. More than half related to four countries, with about 20 percent coming from Italy and from Turkey, 7 percent from France, and 6 percent from Poland.[206]

Many filings do not meet the criteria for consideration, but sorting requests takes time. The ECtHR has lacked sufficient means to identify which filings are proper.[207] Decisionmaking has relied on chambers, typically of seven judges and, in cases of great import, "grand chambers" of seventeen. The court has sought to find new ways to process cases,[208] including dealing with similarly situated claims as a set,[209] and hence has shaped new provisions (as part of Protocol No. 14) that devolve decisionmaking to smaller numbers of judges. The goals include permitting an individual judge to decide if a claim is "clearly inadmissible" and to increase the authority of three-judge panels. Another option is the development of a system of appeal by permission (akin to certiorari in the United States context) and varying the extent and nature of review depending on the claim.[210] The debate about reforms as well as the challenges are captured in a 2008 volume: *The European Court of Human Rights Overwhelmed by Applications: Problems and Possible Solutions.*[211]

In addition to attracting litigants, the ECtHR has (like the ECJ) spawned a substantial literature analyzing its decisions and its relationship with national courts.[212] Evaluations report more compliance in terms of payments to individuals (often in relatively small amounts) than in prophylactic action.[213] The ECtHR is dependent on the Committee of Ministers and Parliamentary Assembly for the implementation and enforcement of its orders, and problems of compliance—for example, that a country does not revamp its procedures on access to court to mitigate violations—are commonplace.

Nonetheless, one empirical assessment of the effects of Europe's Convention on Human Rights, as interpreted by the court, concluded that the provisions functioned as a "shadow constitution,"[214] with substantial uptake in several national systems. Moreover, as states adopt laws parallel to Europe's Convention (such as the United Kingdom's Human Rights Act of 1998, and Ireland's European Convention Human Rights Act of 2003[215]), these norms are filtered through domestic regimes, generating dialogues about their application in a fashion that two American legal scholars called "dialectical federalism."[216] As early as 1996, the ECtHR's President Rolv Ryssdal proclaimed the Convention the "single most important legal and political common denominator of the States of the continent of Europe."[217]

## The ECtHR and the ECJ: The Form of Resources

Importance, the demand for services, and the resources to support institutions are not always in sync. Both of the European courts are dependent on their respective legislatures for budgets, and both worry about resources. The Council of Europe has a smaller economic base than the European Union, and the Council is a less cohesive political unit. Further, the ECtHR's specialized mandate does not bring it deeply into the commercial transactions with which other kinds of courts engage in thriving economies.

The respective structures of the two European courts, in both legal and architectural terms, reflect those differentials. As its filings expanded, the ECJ sprouted additional courts—its Court of First Instance and its Civil Service Tribunal—as well as new buildings to house them and then a golden ring encircling them, complemented by two shimmering towers for staff. That the ECtHR remains a poor relative can be seen not only in the contrast between the steel girders of the ECtHR and the glittering gold of the 2008 ECJ building. The ECJ has a budget of about 250 million euros annually,[218] while the ECtHR (with its larger caseload) relies on about 50 million euros annually.[219]

How that money is allocated is yet another distinction. Until 2009, the Council of Europe provided no pensions for the judges of the Strasbourg Court. This lack of security in retirement, as President Wildhaber explained, rendered judges who left the bench "wholly dependent on the very Government, in respect of whom he or she must be perceived to be independent during his or her term of office."[220] More generally, this problem of resources haunts the project of adjudication. That point is made again by crossing the Atlantic Ocean to consider the Inter-American Court for Human Rights, which ambitiously aspires to enforce another convention on human rights across nation-states.

## Regional Law: The Organization of American States and the Inter-American Court of Human Rights

Both the ECtHR and the Inter-American Court of Human Rights, shown in figure 164, are the outgrowths of post–World War II agreements among countries in regions com-

FIGURE 164    Inter-American Court of Human Rights, San José, Costa Rica, circa 1960; expanded in 2004.

Photograph reproduced courtesy of the Secretariat of the Inter-American Court of Human Rights.

mitting themselves to common legal precepts.[221] Dr. Gerard Wiarda, the Vice President of the ECtHR, speaking in 1979 at the opening of the Inter-American Court of Human Rights in Costa Rica, described both institutions as the "children of the United Nations Declaration of Human Rights."[222] Yet the Member States of the Organization of American States are less connected with each other than many of those participating in the Council of Europe, which overlaps with the European Union. The twenty-seven European countries that are also part of the EU share common legal rules governing the movement of labor, goods, and persons.

Consider a continuum of courts that runs from national institutions, such as in the United States, France, and elsewhere to institutions such as the International Criminal Court exercising global jurisdiction. The Inter-American Court is a step away from confederations such as Europe and closer to what has become more common in the late twentieth century: international courts. Indeed, the Inter-American Court's 1907 predecessor, the Central American Court of Justice, has been celebrated by some commentators as the "first permanent international court ever known,"[223] especially to be appreciated because it was founded in the "New World" as a "Latin-American institution."[224] The region has also produced one of the fledgling transnational courts of the twenty-first century—the 2001 Caribbean Court of Justice,[225] as well as conferences bringing together members of the supreme courts of the countries of the Americas.[226]

### The 1907 Central American Court of Justice: A "permanent court of justice"

By hosting the Inter-American Court of Human Rights, Costa Rica committed itself to providing an annual budgetary supplement as well as the building, which had once been a private home.[227] This welcome was the second time in the twentieth century that the country had offered its resources to a transnational court. Costa Rica had also housed the Central American Court of Justice from its inception in 1907 until its dissolution in 1918.[228] That body first sat in Cartago, in a "palace built for its seat" that was funded by Andrew Carnegie, who donated $100,000.[229] Carnegie also supported the "Peace Palace" in The Hague, where the Permanent Court of Arbitration and the International Court of Justice operate, as discussed in Chapter 12.

The Central American Court received a share of Carnegie's funds because, like the Peace Palace, it aimed to use law to resolve conflicts between countries as a "permanent court of justice."[230] The Central American Court was a byproduct of a series of meetings convened in Washington, D.C. in 1907 that produced several treaties.[231] Costa Rica, Guatemala, Honduras, Nicaragua, and El Salvador entered into a ten-year convention (Convención para el Establecimiento de una Corte de Justicia Centroamericana)[232] establishing the Central American Court of Justice (Corte de Justicia Centroamericana) (CACJ). That group of coun-

tries authorized the CACJ to decide controversies among them[233]—"all controversies or questions which may arise among them, of whatsoever nature and no matter what their origin may be, in case the respective Departments of Foreign Affairs should not have been able to reach an understanding."[234]

To do so, five judges (one from each of the five countries) constituted a new court.[235] Its jurists were not to hold other public offices during their five-year renewable terms, for which they were annually paid "8,000 pesos a year, in American gold."[236] Because the "Central American Court of Justice represent[ed] the national conscience of Central America," its judges were authorized to sit in judgment of their own republics, even though they owed their appointment to them.[237] The five countries also committed to support the CACJ with yearly contributions of 2,000 pesos and to accord the judges immunity equal to that of members of their domestic supreme courts.[238]

The CACJ's jurisdictional grants were impressive compared to those provided to other transnational courts and some domestic courts, then and now. Recall that complainants did not gain direct access to the ECtHR until 1998, some forty years after it was established. In contrast, at the CACJ, individuals who had exhausted domestic remedies or could show a "denial of justice"[239] could bring claims of treaty violations or other "cases of an international character" against "contracting Governments."[240] In addition, states could sue each other, to be judged through fact-finding and relevant international legal principles. Further, as a commentator of that era put it, there was "no reservation of 'questions of national honor or vital interests,' as is

the vogue in so many treaties of arbitration," and, moreover, provisional remedies were also made available.[241]

But the CACJ had a rocky time, literally and legally. Its first building, in Cartago, was destroyed (figs. 165 and 166) in 1910 by an earthquake that toppled both the building and its statuary. Thereafter the court was relocated to San José.[242] Despite its ample jurisdictional mandate, its docket was small—albeit no smaller (as discussed in the next chapter) than that of the International Court of Justice in its early years or of the International Tribunal for the Law of the Sea in its first decade. The CACJ heard a total of ten cases in ten years before it went out of existence.

Early reports on the CACJ were enthusiastic. Its first case in 1908 addressed a conflict between Honduras and Nicaragua on one side and Guatemala and El Salvador on the other.[243] The complainants alleged that the two defendant countries had contributed to a revolution on Honduran soil. The CACJ required a response and then issued a unanimous interlocutory order enjoining the defendant countries from engaging in military efforts that "might directly or indirectly imply interference in the Republic of Honduras."[244] One commentator reported that a final judgment found defendants "guiltless of the offenses charged" and "friendly relations were reestablished between the contracting parties."[245] Another described the outcome as producing the end of the revolution, proving that law could "triumph over arms."[246]

Individual petitions met with no success; four such attempts to gain the court's help (such as for wrongfully expelling a national of another country) were declared inadmissible[247] on various grounds.[248] In 1917, as the CACJ

Terremoto de Cartago C.R., 4 Mayo 7. p. m. 1910.
Palacio de Paz-Centro-Americano

FIGURE 165    Palacio de la Paz (Central American Court of Justice), Cartago, Costa Rica, after the 1910 earthquake.

Photograph reprinted from *Terremoto de Cartago 1910* (Publicaciones de la Universidad de Costa Rica, Serie Historia y Geographia n. 21, Ciudad Universitaria Rodrigo Facio, 1974), with the permission of the University of Costa Rica Press.

FIGURE 166    Palacio de la Paz (Central American Court of Justice), Cartago, Costa Rica, after the 1910 earthquake.

Photograph of fallen statue and other debris, reprinted from *Terremoto de Cartago 1910* (Publicaciones de la Universidad de Costa Rica, Serie Historia y Geographia n. 21, Ciudad Universitaria Rodrigo Facio, 1974), with the permission of the University of Costa Rica Press.

was coming to the end of its tenure, it decided that Nicaragua had violated the rights of El Salvador by conceding a naval base to the United States in the treaty of Bryan–Chamorro, but Nicaragua asserted a lack of jurisdiction and refused to comply.[249] Thus the court's broad mandate was not matched with broad support.[250] And despite recommendations and a "vote of sympathy" proffered by the American Institute of International Law at a 1917 meeting in Havana,[251] World War I was then underway; the Convention that had produced the CACJ was not renewed.

Within a decade, promoters of a "world" court identified defects in the CACJ that would inform the structure of the transnational courts that followed. The right of private individuals to bring suit was seen as a mistake, as were the short (five-year) terms for judges and the limited tenure of the court itself. In 1923 another proposal was put forth for the group to form a court again.[252] But by then the Peace Palace in The Hague had opened, and concerns arose that a regional court could undercut efforts in Europe for a "world court."

### Shaping a Pan-American Convention on Human Rights

The CACJ proved not to be permanent, but successor institutions have followed in its wake. In the Mexico City Conference of 1945, the Inter-American Juridical Committee proposed a constitution with a Declaration of the Rights and Duties of Man,[253] thus recognizing that "essential rights of man are not derived from the fact that he is a

national of a certain state, but are based upon attributes of his human personality."[254] In 1948 the Ninth Conference of American States, which also established the Organization of American States (OAS),[255] adopted the American Declaration of the Rights and Duties of Man. Its preamble reads: "All men are born free and equal, in dignity and in rights, and, being endowed by nature with reason and conscience, they should conduct themselves as brothers one to another."[256]

The questions—akin to those raised in Europe—were what kind of legal effects such commitments could have. The 1948 Pan-American Conference also resolved that American freedom rested on "two undeniable postulates: the dignity of man as an individual and the sovereignty of the nation as a state."[257] Therein lies the conflict. Then as now, sovereign states worried about submitting to binding authority; they preferred "declarations" that were hortatory rather than obligatory.[258] The subsequent elaboration of a regional commitment to human rights accompanied the movement toward the establishment of an Inter-American system to strengthen cooperation more generally.[259] Despite various calls to action, few states were in favor of incorporating the American Declaration of the Rights and Duties of Man into the pan-American organizational charter (what would later become the OAS Charter).[260] A proposal for a new treaty on human rights was rejected, twelve to eight. Three years later, the Charter affirmed the importance of social justice and the existence of "fundamental rights of the individual without distinction as to race, nationality, creed or sex."[261]

In the late 1950s, a successor OAS agreement approved an Inter-American Commission on Human Rights,[262] just as the Council of Europe had chartered the European Commission on Human Rights in 1954. While the purpose of the Inter-American Commission was clear—"to promote the observance and protection of human rights"—its methods and status were not. According to one scholar, the accord was predicated on the understanding that an Inter-American Commission might do studies or convene symposia but would be "remaining always in the safe realm of generalities, without descending to the particulars of specific countries and their observance of human rights. The OAS made it clear that it had no desire to create a body that would interfere in any way with the 'domestic affairs of the member states.'"[263]

The Inter-American Commission was (and is) based in Washington, D.C., where it began to function in 1960.[264] Comprised of seven commissioners from member states serving for four years, with one renewable term permitted,[265] at its inception the Commission faced enormous challenges and had few resources to confront "gross, systematic violations of human rights."[266] In 1967 the Commission gained more status when, through the Protocol of Buenos Aires, the Commission became an "organ" of the OAS.[267] Two years later, in 1969, the OAS convened an Inter-American Specialized Conference on Human Rights in San José, Costa Rica, at which a "juridical instrument"—The American Declaration of the Rights and Duties of Man—became a "convention on human rights," to wit an effort to enumerate "the obligations of the States as well as the individual rights which fall under its protection."[268] Articulated in this American Convention on Human Rights (ACHR) were obligations to respect persons, all of whom were entitled to civil and political juridical status; to humane treatment; a fair trial; freedom of conscience, religion, and association; equal protection; and to much more.[269]

Also authorized were two implementation mechanisms, the continuation of the extant Inter-American Commission, and the addition of a court in a system modeled after that of Europe.[270] In the late 1970s, the ACHR entered into force when a sufficient number of states had ratified it.[271] In 1979 the Inter-American Court of Human Rights, as distinguished from the Commission, came into being when the states parties elected the first group of judges. The Inter-American Court began to hear cases soon thereafter, initially at the OAS's headquarters in Washington, D.C. and later moved to Costa Rica. Like the D.C.-based Commission, the Inter-American Court is comprised of seven members; its judges serve for six-year terms, again renewable only once.[272] Ad hoc judges are added when no sitting judge is a national of a state that is a party to a dispute.[273]

The United States, which hosts the Commission in D.C., is often credited as a moving force behind the Convention but was not, as of 2010, among the ratifiers. President Jimmy Carter signed the ACHR on behalf of the United States but ratification never followed, in part because the drafting conference did not, as the United States had wanted, remove the prohibition of capital punishment for certain age groups.[274] Ambivalence about the document by those who did ratify it can be gleaned from the fact that the General Assembly of the OAS did not provide a budget for its new court; Costa Rica lent both a building and funds to support it.[275]

Economic support was not the only challenge; at the time these provisions took effect, "much of Central America and South America was ruled by dictatorships either of the right or the left."[276] Those regimes were rife with forms of "injustice and exploitation" that produced gross human rights violations,[277] "extremes of poverty and wealth," and a caseload struggling with government-sponsored disappearances of people.[278] Some commentators raised concern that the OAS tolerated noncompliance with court judgments, citing the lack of criticism in OAS reports on countries' failures to adhere to directives.[279]

### Parallels and Distinctions: Human Rights Adjudication in Europe and the Americas

The Inter-American system has a structure similar to that adopted in the 1960s by the Council of Europe for its human rights convention. Drafters of the Inter-American system used Europe as their example, and the Inter-American Court has evoked the law of Europe (as well as other sources) when interpreting provisions of the ACHR, which is similar but not identical to the ECHR.[280] Further, both transnational systems have evolved in relation to the legal systems of the states that are parties to their agreements, as some domestic courts have become involved in elaborating human rights under national constitutions. In addition, the ECtHR and the Inter-American Court share a jurisprudential point of view that the documents they interpret are "living" and subject to understandings that evolve over time.[281] Judges of both institutions aspire for their work to be understood and read as part of transnational networks in which doctrinal approaches and principles are imported and exported. Their output, in turn, has spawned a critical literature analyzing its impact.

The Inter-American system is understood, from within and without, to be more fragile than that of Europe. "Within the Council of Europe, military and other authoritarian governments have been rare and short-lived, while in Latin American they were close to being the norm until the changes that started in the 1980s."[282] Concerns have been voiced about the lack of jurisdiction over many OAS members and the slow procedures of the Commission, a body that is not our focus here but whose role is pivotal. Critics commented that, while the court's work was symbolically important, the challenges were too great, given "gross, systematic violations."[283]

By the early twenty-first century, prospects were brighter, as the OAS had adopted other conventions—to prevent and

punish torture, to redress disappearances, to respond to violence against women, to abolish the death penalty, and to combat discrimination against persons with disabilities.[284] The Latin American governments, save those of Belize and Cuba, had ratified the Convention on Human Rights, although the United States, Canada, and the Commonwealth Caribbean countries also remained nonparticipants. Many of the ratifying States Parties have undergone political transformations, making them more welcoming of domestic as well as transnational rights regimes. Further, the Commission, which had been seen as loath to send cases on to the court, developed a procedural presumption that, if it found that a State Party had not complied with its recommendation, the Commission would refer the case to the court[285]—in part to respond to problems of "timeliness and victim representation" before that court.[286]

A more optimistic view of the jurisprudence of the Inter-American Court of Human Rights emerged, seeing the American court as at times in dialogue with and sometimes offering more expansive remedies than its European counterpart.[287] But by 2007, the Inter-American Commission sounded a note of concern, as it warned of the "public insecurity and fragility of the judicial power in the majority of the countries in the region," as well as what it termed "attacks" against judicial independence.[288] Problems of "unequal justice, slow legal procedures, impunity in serious cases of violations of fundamental rights and of violations of due process" remained acute.[289]

The European and Inter-American models diverge in several dimensions. First, as mentioned at the outset, the European system overlaps with the EU, and thus some of its States Parties are tied to each other through economic and social policies as well as human rights. Legal agendas are coupled with political and cultural efforts to weave an identity for Europe in which human rights are part of its persona. Furthermore, to be in the Council of Europe is to be a party to the European Convention on Human Rights. In contrast, not only are the members of the OAS structurally more separate but, as of 2010, only twenty-five of the thirty-five members of the OAS had ratified the Convention on Human Rights,[290] and just twenty-two recognized the jurisdiction of the Inter-American Court of Human Rights.[291]

Further, reflective of the commitment to human rights, the European system relies on a court staffed by full-time judges, with one from each member State. A jurisprudential embodiment of these relationships is, as noted, the "margin of appreciation" permitting member States some divergence in the enforcement of European Convention precepts, relaxed (for better or worse) in light of the context and the absence of a regional consensus on a particular problem. That approach is not one generally shared by the Inter-American Court, committed to reading the ACHR as setting standards less readily modified.[292]

A second distinction is that the Council of Europe abandoned the Commission model in the late 1990s and consolidated the functions in the European Court of Human Rights. In contrast, the Inter-American system continues to rely on a two-step process; the Commission is the requisite route to the Inter-American Court for what are termed contentious cases, brought by individuals against States Parties.[293] That route can be slow; in 1986 the Inter-American Commission forwarded a first case seven years after the Inter-American Court came into being.[294] Individuals have no recourse when the Commission is slow or does not issue a final decision.[295] States Parties may go directly to the court for advisory opinions,[296] and in the rare instances when states bring contentious cases against other states to the Commission, either the Commission or the states can refer a contentious case directly to the Inter-American Court.[297] Commission staff investigates facts, and the commissioners decide the admissibility of petitions. As is the case in Europe (with and then without the European Commission on Human Rights), admissibility criteria include exhaustion of domestic remedies unless adequate or effective remedies at the state level are unavailable. But even when cases are deemed admissible because of a preliminary ruling by the Commission that the state was at fault, the Commission generally seeks to have the state respond to a list of recommended actions so as to make amends.[298] The Commission then assesses compliance or refers cases of noncompliance or of particular importance to the Inter-American Court.

Third, unlike the European system, which brings States Parties under the jurisdiction of the ECtHR as a consequence of joining the Council of Europe, the Inter-American model resembles some of the international courts discussed in Chapter 12 in that it requires agreement to jurisdiction when disputes are brought by states against each other.[299] The Commission can send a complaint to the Inter-American Court of Human Rights only "if the State has accepted the Court's jurisdiction."[300] The Inter-American Court, again like some international courts, has authority to issue opinions in contentious cases as well as advisory opinions requested by party states.[301] The court's advisory function enables it to respond to consultations submitted by OAS agencies and member states, including those that have not ratified the ACHR or generally accepted the court's jurisdiction. Its power includes interpretation not only of the Convention but also of other instruments governing human rights in the Americas. The Inter-American Court can give advice on domestic laws and proposed legislation as to their compatibility with human rights provisions.[302]

Not only does the advisory jurisdiction of the Inter-American Commission and court have a different reach than the largely retrospective efforts of the ECtHR, the American system also had authority from the outset to hear complaints from individuals or family members of victims against member states as well as disputes among member states.[303] While it had awarded damages before the late 1990s, the ECtHR then began to receive complaints directly from individuals; compensation ordered remains modest

in scale. The European system also has a narrower remedial range, whereas the Inter-American Court has developed a broad set of structural injunctions and remedies (one commentator described "its enthusiastic exercise" of such powers[304]) that include "reform of legal structures, promotional activities such as human rights training, development projects for massacred villages, public apologies, and commemoration of victims,"[305] as well as reparations.[306]

Compliance is a problem for both systems, as is measuring effectiveness.[307] A comparison of methods of enforcement, however, permits analysis of a fourth distinction. The Inter-American Court has only itself to oversee enforcement, whereas in Europe forms of structural relief, if ordered by the ECtHR, come under the authority of the Council of Ministers, authorized to monitor compliance. In this respect, even though the European system collapsed the Commission in 1998 into its Human Rights Court, Europe continued to diffuse obligations for human rights enforcement across different institutional actors given distinct roles.

The Commission and the Court in the Inter-Americas have a complex relationship, stemming in part from the broad mandate of the Inter-American Commission, which had functioned for almost two decades before the Court began to work. The Commission continues some of its own independent monitoring work, including considering human rights in countries that are OAS members but have not ratified the ACHR.[308] Moreover, both the Inter-American Court and the Commission have interpreted each other's powers and have disagreed with each other over fact and law.[309]

The much weaker set of political alignments that forge the OAS have produced a court less well supported, structurally and economically, than its European counterpart. The composition of the ECtHR puts a judge from every one of the member States on the bench, thereby giving each country a voice through having "its" person on the court. In contrast, the Inter-American Court is comprised of seven judges who, while nationals of OAS states, need not be nationals of OAS states that have ratified the Convention.[310]

Moreover, while the courtroom (fig. 167[311]) appears familiar, albeit simpler than many, the working conditions of the Inter-American Court's judges are not. In 2004 the President of the ECtHR complained that his court's judges lacked pensions,[312] but the Inter-American Court judges lack even salaries. They are paid honoraria of $150 for each of their trips four times a year to sit in the court's headquarters in Costa Rica.[313] Those provisions make the court "the only such international body that still uses that system."[314]

The effects of resources and political fragility can be seen by contrasting the work of the two courts as measured by filings, judgments, and staff. In 2005, after the ECtHR requested an additional seventy-five staff positions, the Council of Europe provided funding for only forty-six new positions, resulting in about 120 jobs.[315] In contrast, in that year the Inter-American Secretariat was comprised of fifty-six permanent staff.[316] Further, while Article 72 of the

FIGURE 167    Courtroom, Inter-American Court of Human Rights, San José, Costa Rica, 2006.

Photograph reproduced courtesy of the Secretariat of the Inter-American Court of Human Rights.

American Convention provides that "the Court shall draw up its own budget and submit it for approval to the General Assembly,"[317] the OAS provision of under $2 million a year is not sufficient to support the system.[318] As the Inter-American Court noted in its 2007 annual report, its budget is augmented by financial support from "Permanent Observers" including Denmark, the European Union, Finland, France, Ireland, Italy, Korea, and Spain.[319] Funds have also been provided by the Open Society Institute and the Inter-American Development Bank.[320] In addition, Costa Rica makes an annual donation of $100,000, as provided in the Headquarters Agreement in 1983.[321]

Resources, as well as legal rules and political realities, affect output. In terms of the volume of filings and decisions, many new courts have low caseloads and issue relatively few rulings. Further, the Inter-American Commission is a first step in referring cases. In the first decade of the Inter-American Court, it rendered fifteen judgments, of which twelve were advisory opinions,[322] a track record not dissimilar from the early years of the European Commission on Human Rights or the International Court of Justice and the International Tribunal for the Law of the Sea, discussed in Chapter 12. After an initial period, many courts pick up speed (so to speak), and their caseloads bloom. By the late 1990s, when the ECtHR took over from the Commission, tens of thousands of petitions were pending. As detailed earlier, as of 2006, the ECtHR had some 50,000 individual applications and issued some 1,500 rulings that calendar year. Yet the volume in the Americas has remained lower. Between 1979, when it began to function, and 2007, the Inter-American Court rendered 162 judgments in contentious cases and 19 advisory opinions.[323]

Given that human rights rulings come from the Commission as well, its volume of activity—ranging from reports

to decisions—also needs to be considered. While the ECtHR had more than 50,000 applicants seeking attention in 2007, the Inter-American Commission received 1,456 complaints, which was a higher number than in any of the prior ten years.[324] Its four sessions included "94 hearings and 80 working meetings," and the Commission issued 51 reports or final decisions.[325] As the Commission also noted, such reports can include decisions on "several individual cases."[326] The Commission then presented 14 cases to the Court, as well as participating in court hearings about both contested cases and compliance with prior orders.[327] The Inter-American Court's 2007 docket of 14 new cases was close to what it had averaged over the decade, albeit with a low in 1997 of 2 cases and a high of 15 submissions in 2003.[328] In 2007, those cases involved eight countries; an additional 16 cases were underway, involving ten countries, while 87 were in the "compliance stage, with 43 cases having provisional measures in force."[329]

The combination of efforts to get more cases to the Inter-American Court and its minimal resources for dealing with them regularly prompts concern. In 2002, with some 35 pending contentious cases and new rules that were likely to produce more cases, the Commission's President Antônio A. Cançado Trindade noted the "shortage of professionals" to respond, as he warned about a looming "paralysis of the Inter-American system" without a "substantial increase in the Court's budget" to permit it to sit for longer periods of time.[330]

### Costa Rica and the Inter-American Court: Linked "not only by conviction, but by action"

Compliance is one problem, and a place in which to do the work another. In 1978 the OAS General Assembly approved a court without providing a budget to support its workplace or staff. But Costa Rica offered a building, thereby making plain that, in the words of that country's President, Rodrigo Carazo Odio, it was "linked . . . not only by conviction, but by action"[331] to the Convention on Human Rights. In November of 1978, the member states agreed.[332] The Court has resided in Costa Rica since then, and in 1993 the Government of Costa Rica officially donated the building.[333] Its setting is modest, and neither the building nor its art is documented in the kinds of books produced by similar courts.[334]

The speeches that celebrated the court's opening in Costa Rica in 1979[335] are replete with reminders of the challenges. The Deputy Secretary General of the OAS reflected not only on the "long fight for justice on our Continent" but also on "recent upheavals suffered by human rights" that made for a future "as full of problems and difficulties as it is of faith in what the common will of the American family can achieve."[336] Urgency was the tone of President Carazo Odio, who called for the development of a "progressive jurisprudence" of human rights that dealt with "the notorious procedural deficiencies" in the Convention's statutes.[337]

Rodolfo Piza Escalante, a Costa Rican who served as the Inter-American Court's first leader, delivered another sobering speech. Calling the court's inauguration the "historical culmination of an important phase in the long battle fought by the American community for the fundamental rights and liberties of man," President Piza Escalante spoke of "our disturbed continent"[338] filled with "very disparate political regimes, diverse socio-economic structures, complex geographical, geological and even climatic contrasts."[339] Only fourteen of the twenty-eight OAS states had ratified the court's creation by 1979, and "only one—Costa Rica—has formally recognized the jurisdiction of the Court in general."[340]

Another jurist, Thomas Buergenthal, emphasized the limits of the court's powers and its dependency on the member states. A survivor of Nazi Germany, Buergenthal was elected to serve despite the fact that his country, the United States, had not ratified the Convention on Human Rights.[341] Buergenthal reminded his audience that the "Court has no army; it has no police; it has no prisons; and even when it enters a judgment decreeing that an individual is entitled to a specific sum of money as compensation for violations of his human rights, that judgment is not *ipso facto* enforceable on the domestic plane of the country against which it was decreed. Besides, the Court does not have the power to punish the individual wrongdoers or to hold specific government officials in contempt."[342]

### Engineering a $600,000 Renovation

Another way to understand the differences between the Inter-American Court of Human Rights and the European Court is to compare where they work. Like its counterparts in Europe, the Inter-American Court of Human Rights outgrew its original space. Unlike its European counterparts, the Inter-American Court is permitted to sit elsewhere and occasionally has done so, for example, if witnesses are unable to travel to the court's seat in Costa Rica.[343]

In 2002, the OAS agreed to renovate its three-story building from the 1960s. But that project bears little resemblance to the work of either Dominique Perrault or Richard Rogers. The 2002 resolution committed $600,000 from the OAS.[344] Details of the construction do not suggest that architects were asked to compete by designing models of various options. Rather, one learns of the architectural and engineering firm employed, Construction Company Navarro y Avilés S.A., only through a mention in a quarterly report that the building was progressing on time and in compliance with the allotted budget.[345] The resulting renovation and a three-story annex provided an additional hearing room, more courtrooms for judges, and office spaces.[346] The project took a year and came in on budget.[347]

# Multi-Jurisdictional Premises:
# From Peace to Crimes

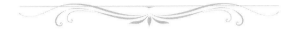

## MODELING THE FUTURE: EPIC ARCHITECTURE AND LONELY BUILDINGS

The short-lived Central American Court of Justice (fig. 11/165) called itself the first "permanent" international court. In existence from 1907 to 1917, it proved transient but the idea that it represented produced another institution, also supported by Andrew Carnegie and also aspiring to longevity, the Permanent Court of Arbitration (PCA). Extant now for more than a century, the PCA is housed at The Hague in an amazing building, the Peace Palace (fig. 168,[1] color plate 38) that has helped to make the Netherlands a home for international justice. The PCA has shared space with two other institutions bearing the title "court"—the Permanent Court for International Justice (the PCIJ, or "World Court"), begun under the League of Nations in 1922, and the United Nations' International Court of Justice (ICJ), which superseded the PCIJ in 1946 and took up residence at the Peace Palace soon thereafter.

This chapter moves along the continuum that began with city, national, and regional courts to international institutions. These entities, which represent themselves through epic architecture, call themselves "courts" or "tribunals," as they assert forms of jurisdiction that span the globe. During the course of the twentieth century, the authority asserted by such "world courts" expanded. Initially such institutions heard only civil disputes between nation-states but, by century's end, some entertained petitions from non-state entities, and others exercised criminal jurisdiction.

These transnational courts hearken back to the grand town halls of Siena and Amsterdam, using spacious structures to proclaim and produce authority. The new institutions also forecast the twenty-first-century confusion about what the mandates and powers of courts might be. The titles Peace Palace and Permanent Court of Arbitration are exemplary, for "peace" and "arbitration" rely on the consent of disputants, whereas "court" implies the compulsion of the state, forcing attendance and compliance. Moreover, "palace" well captures the majesty of the building but also the autocratic history of adjudication rather than its democratic future.

Dozens of institutions spawned during the twentieth century adopted variations on these terms; the Olympic Committee's Court of Arbitration and the dispute panels and Appellate Body of the World Trade Organization are illustrative.[2] To simplify rather than be comprehensive, this chapter begins with a sketch of the development of the three institutions that were resident at The Hague—the PCA, the PCIJ (that existed from the 1920s through the 1940s), and its successor institution, the ICJ—each competent to hear an array of subject matters if brought by consenting nation-states. We then turn to five specialized tribunals, one devoted to the Law of the Sea and four asserting jurisdiction to prosecute criminals accused of gross violations of human rights.

We provide some details about the internal operations and physical settings of each in order to probe how the term "court" has been deployed and what it might mean. As will become plain, some of these institutions are either not "courts" in various respects or, as we examine in Chapter 14, they alter the connotations of the term by shifting the judicial role into conciliator and manager operating outside the public purview. Moreover, the proliferation of these various institutions signals the development of intense competition for business among various dispute-resolution providers. In some of these courts, the grandeur of the buildings and the hopes there expressed outstrip current dockets.

The chapter's sweep of twentieth-century institutions ends with the creation of several criminal courts, and hence with a disheartening epilogue to the exuberance that crafted the Peace Palace. The arc of the twentieth century moved from tribunals aiming to quiet conflict to those seeking to bring to account persons committing atrocities. As we forecast in the opening chapter, this multi-century review aims to put the question of adjudication's longevity on the table. This chapter can be read as continuing to catalogue the triumphs of the model, but the discussion of each such court also entails questions about costs, delays,

FIGURE 168    The Peace Palace, International Court of Justice, The Hague, the Netherlands.
Architect: Louis M. Cordonnier. Design modified and construction supervised by J. A. G. van der Steur, 1913.

Photograph reproduced courtesy of the Carnegie Foundation. See color plate 38.

and, more profoundly, the desirability of the mode of decisionmaking proffered. The name of one of the institutions discussed—the Permanent Court of Arbitration—makes the point by demonstrating the utility of deploying the symbolism of the word "court" even as the PCA's mission divested that term of its attributes of obligation, compulsion, and publicity and replaced them with voluntarism, negotiation, and privacy.

## The Peace Palace and the International Court of Justice

From the Renaissance until relatively recently, town halls and court buildings took their names from their functions and the places where they were located. During the second half of the twentieth century, federal courthouses in the United States gained new appellations, named after government officials such as judges who worked within or legislators who had helped to secure construction funds. Moreover, courthouses in various parts of the world came to be associated with the architects who designed them, so that one speaks about Henry Cobb's Boston Courthouse and the Palais de Justice by Richard Rogers in Bordeaux and by Jean Nouvel in Nantes.

In contrast, the building known as the Peace Palace (fig. 168) and housing the PCA and the ICJ is linked to the name of its central sponsor and funder, Andrew Carnegie. Committed from the 1880s to the peace movement, Carnegie became an "enthusiastic and outspoken advocate" for an international court of arbitration.[3] Another person central to the formation of the PCA was Czar Nicholas II of Russia, who championed conciliation for various reasons, includ-

ing concern about losing the arms race.[4] His foreign minister extended a request in "the name of the Czar" to Queen Wilhelmina of the Netherlands to host the 1899 "Disarmament Conference" that, in turn, produced the Peace Palace.[5] Nicholas's full-size portrait remains in the room dedicated to the Permanent Court of Arbitration, but the Russian Revolution of 1917 relegated its placement to an entry corner and, at times, it has been shrouded in drapes.[6]

## Convening for Peace

The 1899 Hague Conference was the outgrowth of a half-century of work by what are now called NGOs (nongovernmental organizations) in shaping a social movement. A General Peace Convention held in 1843 in London was followed in 1849 by a second Congress in Paris, with Victor Hugo as its chair, which culminated in resolutions calling for the peaceful settlement of disputes. Across the Atlantic Ocean, state legislators took up the issue, with proposals for an international court of justice coming in 1844 from the Massachusetts Legislature as well as from other states,[7] to be paralleled in 1867 by the International League of Peace and Freedom, founded in Geneva.[8] The Bar Association of the State of New York formally supported the idea a few decades later when, in 1896, it proposed an international body with nine judges from nine nations.[9] Support over several decades also came from various lawyer-based entities, such as the International Law Association, the American Society for the Judicial Settlement of International Disputes, and the American Society of International Law.[10]

Efforts to generate means to settle disputes were not only on paper. In practice, many countries had turned to arbitration, especially when arguing about territory.[11] One account identified more than 136 international arbitrations that had, by the late 1890s, taken place either through ad hoc arrangements or under treaties.[12] For example, in 1896 a conflict between Argentina and Chile over the Andean border was formally submitted for resolution to the English Queen Victoria, succeeded after her death by Edward VII who then took over her role as arbitrator of that dispute.[13]

The 1899 Conference began that July when the Dutch government welcomed "one-hundred diplomats, military men, jurists and politicians from all over the world" who met at the Royal Palace of Huis ten Bosch in The Hague.[14] The media and various activists were excluded[15] when representatives from twenty-six countries assembled. All came from European countries except three from Asia (Japan, China, and what was then called Siam), two from the Americas (the United States and Mexico), and one from the Middle East (the country then called Persia). As various discussions note, the "only woman to be invited" was Bertha von Suttner,[16] an "undisputed leader of the Peace Apostles" who was an Austrian suffragette and author of the book *Lay Down Your Arms*.[17] This "Convention for the Pacific Settlement of International Disputes" produced "61 articles for curbing the arms race, the humanisation of the conduct of war and the founding of the Permanent Court of Arbitration."[18]

A second conference, held eight years later in 1907, had a broader array of participating nations and a good deal of support from Elihu Root, then the United States Secretary of State. Forty-four states sent representatives; and eighteen came from Latin America.[19] That same year, the Central American Court of Justice (discussed in Chapter 11) was founded as the "first permanent international court."[20] It survived for a decade and was, more briefly, housed in another "palace" funded by Carnegie until that building (fig. 11/165) was destroyed by an earthquake. Hopes for peace were similarly upended by World War I in 1914. Nicholas II was forced to abdicate and died in the Russian Revolution of 1917 that followed.

## The Amsterdam Town Hall Redux: "Dutch High-Renaissance Architecture" for the World's Library and Court

In the United States, Andrew Carnegie is identified with education.[21] Consistent with that persona, he was initially focused on building an open library dedicated to international law but was persuaded to provide funds for housing both a library and the newly crafted Permanent Court of Arbitration.[22] Carnegie created a Dutch foundation (*stichting*)[23] to which he gave $1.5 million (about $38 million in 2008 dollars). The donative transfer document of June 9, 1903, explained that "the establishment of a Permanent Court of Arbitration by the Treaty of 29th of July, 1899, is the most important step forward of a worldwide humanitarian character which has ever been taken by the joint Powers, as it must ultimately banish war, and further... that the cause of the Peace Conference will greatly benefit by the erection of a Court-House and Library for the Permanent Court of Arbitration."[24] That text is reflected in the drawings on the 1903 certificate (fig. 169[25]) awarding Carnegie an honorary membership in the Dutch Society called Vrede door Recht (Peace through Law). The certificate is adorned with a dove of peace, who flies about a Justice (her eyes obscured by the scales she holds high), below whom sits Peace, crowned with a laurel wreath and holding a palm branch, a quill, and a book. No swords are in sight.

### *Competing and Litigating for Building Commissions*

The building of the Peace Palace proved to be the paradigm for what developed thereafter in twentieth-century national and regional court construction.[26] And, like the Amsterdam Town Hall, the Peace Palace has been richly documented, in large part through the scholarship of Arthur

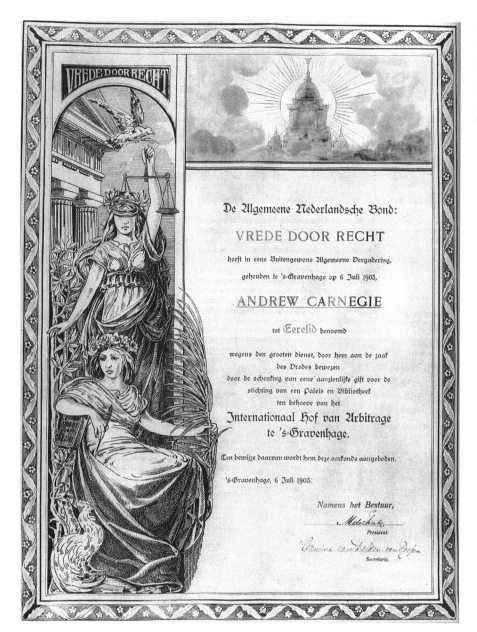

FIGURE 169   Certificate awarding
Andrew Carnegie honorary
membership in the Dutch Society
Vrede door Recht (Peace through
Justice), July 6, 1903.

Photograph reproduced courtesy
of the Carnegie Foundation.

Eyffinger.[27] As described in prior chapters, architectural
competitions for courthouse designs embodied both the
founders' economic capacities and their political and legal
aspirations for quieting conflicts through third-party inter-
ventions. Further, as became the pattern for transnational
courts, the host country played a major role in planning and
in providing substantial funding. In 1905, the Dutch Par-
liament voted to spend 700,000 guilders (or what would
have been more than $7 million in 2008 dollars) to pur-
chase the land.[28] Carnegie's Dutch foundation (which
included the Dutch Minister of Foreign Affairs and some
members of the Dutch royalty) and a Dutch committee
oversaw the public competition, inviting architects to pro-
pose designs.[29]

The "Conditions of Competition" sought submissions,
due by March of 1906, for the court and the library. The
competition was formally "open to architects of all nations,"
but several individuals were specifically invited to com-
pete.[30] The six best were to receive monetary prizes on a
sliding scale.[31] The rules called for anonymous submissions
of scaled drawings, with the front "in colours" and expla-
nations in French.[32] Proposals were to detail a "Great hall
with main staircase," a "Large Court of Justice with or with-
out an anteroom, with a removable podium, and a gallery
either along a side wall or at the end," a "Small Court of Jus-
tice," a council room adjoining each,[33] and rooms for dis-
putants to meet.[34] An upper story was to have spaces for the
"Administrative Council of the Permanent Court of Arbi-

tration" to accommodate more than thirty people around a table.[35] The library was to be a separate building accessible from the park but connected through the interior to the courthouse. Requirements included 10,000 meters (more than 32,000 feet) of bookshelves and two reading rooms, as well as dedicated rooms for maps, a catalogue of materials, and for foundation staff.[36] Failure to "comply with one or more of the provisions of the present programme" was to result in being "excluded from the competition."[37]

Again setting the pattern for the late twentieth-century competitions, the jury was comprised of architectural experts drawn from various countries—Great Britain, the Netherlands, Germany, Austria, France, and the United States.[38] Led by the Dutch Piet Cuypers, who had designed both the Rijksmuseum in Amsterdam and that city's Central Station,[39] the jury also included the chair of the Carnegie Foundation Board. The decisions were published in a 1907 volume on the "designs chosen" that explained the winnowing down of thousands of submissions to six finalists. At the time, commentators wondered whether the aesthetic for an international building should rely on European or classical references.[40] Some thought that, as a political matter, the building should not remind viewers of a particular country. Eighty years later, when Richard Rogers designed the "biomorphoic" European Court of Human Rights (fig. 11/163), he too spoke of efforts to move beyond any one national style.[41] (After the fact, his building was described as reminiscent of Russian Constructivism.[42])

More than two hundred contributors submitted some 3,000 designs,[43] numbered to provide anonymity.[44] All the winners, however, came from the group invited to participate, and the first prize went to Louis M. Cordonnier, an architect who had also won an "international competition for the New Exchange at Amsterdam."[45] The jury provided details of the best, with brief comments on the pros and cons of the various designs.[46] For example, the jury objected that one design departed "noticeably . . . from the noble simplicity that should characterise a building devoted to the serious and dignified purposes of the Peace Palace."[47] Among the top forty-four designs were submissions from some of the luminaries of twentieth-century architecture, such as the innovative Eliel Saarinen from Finland,[48] but the two that the jury preferred were by French architects tending toward the more traditional, and neither was simple.[49] The jury forwarded its conclusions to the building committee to "use as a basis from which to proceed in finally obtaining from the architect, whom they would employ, a design for execution."[50] This phrasing was a polite way of explaining that no design, as submitted, could actually function as a "definite plan for the building."[51]

A major debate then ensued about whether to follow the jury recommendation or choose another design, but the building committee confirmed Cordonnier as its choice.[52] Far from the jury's embrace of "noble simplicity,"[53] Cor-

donnier proposed an extravagant amalgam of various European traditions. With tall, castle-like towers at its front and two smaller ones at the back corners, Cordonnier's design bore a family resemblance to the Amsterdam Town Hall of 1652 and to various French chateaux.[54] The jury commended it for doing so—"This design is an attractive one" and of a style "follow[ing] the local traditions of XVI century architecture"—even as the jury criticized the proposal's failure to provide "sufficient unity of character" to the portions of the structure devoted to the court and to the library.[55] Other commentators of the era agreed that the drawings evoked the "High Renaissance Dutch architectural style" as well as that of a "northern French medieval town hall."[56] Heavily detailed and decorated, admirers thought it captured "much of the vivacity and prettiness of the Low Countries."[57]

Critics, however, saw the Cordonnier design as parochial and backward-looking rather than "an epoch-making building . . . international in character and free as far as possible from local influence."[58] A 1913 *New York Times* review called it "wholly imitative of the architecture of another era, without the slightest effort at large symbolism of modern life."[59] Some thought the Cordonnier building looked like an overwrought French chateau, "crowded with picturesque towers, gables, and roofs, most of which were quite unnecessary."[60] Others thought it a pale imitation of the Hôtel de Ville (Town Hall) of Ypres, albeit with a facade the color of "much-visited Flemish town halls."[61] Later commentators would call the style "Flemish Gothic"[62] or a "blend of the Romanesque and Byzantine styles,"[63] and describe the structure as "rather excessive, if not to say baroque."[64] Thomas Edward Collcutt, who then chaired the Royal Institute of British Architects and had served on the jury (evidently unhappily), pronounced the decision-making a "disastrous failure."[65]

The design was also unbuildable, as well as too expensive for the sum provided by Carnegie. Had the proposal gone forward, funds might have covered the courthouse but not Carnegie's treasured library.[66] One of the six finalists, the renowned Otto Wagner from Austria, volunteered to retool his proposal, and others had come in less expensively, albeit not truly within budget.[67] Cordonnier then agreed to revisions,[68] supervised by Dutch architect J. A. G. van der Steur of Haarlem, who "sobered down [the building] both in terms of aesthetics and in terms of finance."[69] The four large towers were reduced to one great spire, shown in figure 170, that looms over the other roof turrets and spikes. The great tower, 263 feet or 80 meters, is graced by a clock (with a face that spans eleven by seven feet) donated by Switzerland.[70] Those reductions, however, did not abate the construction challenges; "shortage of finances was a perennial problem and shortcuts to economize were sought everywhere,"[71] including in the gardens designed by Thomas Mawson.[72]

FIGURE 170   The Peace Palace,
inner courtyard with polar
bear fountain, a gift
from Denmark, circa 1913.

Photograph reproduced courtesy
of the Carnegie Foundation.

Aesthetics and finances were not the only sources of the "storm of indignation amongst both the participants and the general public"[73] that ensued. Critics sought to enjoin construction based on the claim that jurors had violated the rules when making the selection.[74] An essay on the litigation noted the irony of ending up in the courts: "Not even the foundation of a monument for Peace had been able to avoid squabbles, strife and controversy."[75] Eight architects served a "bailiff's writ" on the Carnegie Foundation and argued that the winners had "departed from the stipulations of the Programme for participation" by not providing designs appropriate for the site and by exceeding the building budget that had been advertised.[76] They sought to dissolve the competition, disqualify some sub-

missions, and receive costs and damages.[77] In 1909 a Dutch court concluded that a legal relationship did exist between the foundation sponsoring the competition and the participants, but that the duty owed to entrants entailed only announcing results. Various parameters, such as the statement of a budget, were guidelines rather than "a condition for participation."[78]

The court's decision came two years after the first stone of the Peace Palace had been laid, in 1907.[79] The building was completed in 1913. A brochure documenting its opening praised the "slender towers rising up to its canopied dome" and noted that "the rows of sturdy pillars that line its arches . . . combine to give this creation an air of spirit and strength."[80] The original competition plan had called for a

separate library, connected to but distinct from the Peace Palace. But in the end, the Carnegie Library stood at the rear of the Palace, with its own entrance from the back. Within a decade, pressure to expand the office spaces for the court-oriented side of the building required the library to yield space.[81] As one account detailed, the following decades were a "continuous struggle by librarians desperately trying to adjust the lofty ideals of the founding fathers to the modest means" provided to the "World Library of International Law."[82]

### National Artifacts for the World Court

The Peace Palace shares with the Amsterdam Town Hall a remarkably large footprint; by "Dutch standards," both are buildings of "uncommon grandeur."[83] The Peace Palace's quadrilateral seventy-eight square meters (or about 65,000 square feet), has an inner courtyard (fig. 170) of forty-four square meters (or more than 20,000 square feet).[84] Yet unlike the burgomasters of Amsterdam and the builders of other national courts insistent on controlling interior as well as exterior designs, the planners of the Peace Palace wanted to inspire joint ventures. All Contracting Powers to the 1899 and 1907 Hague Conventions were invited to send materials for construction and ornamentation as expressions of good will and as representations of the enterprise's diversity.[85]

Any current visitor to the building will be struck by the result, a dazzling (and motley) array of various world arts. What meaning to take depends upon one's vantage point. The Carnegie Foundation posits that what "the Court lacked in authority as an international judicial institution in the early years, was more than compensated by the formidable character, the artistic furnishings and exuberant symbolism of its housing."[86] Other commentators have been less sanguine, opining that the "lack of world harmony is reflected in the architecture of the building,"[87] whose interior has "amassed splendiferous clutter."[88]

The Netherlands provided the site as well as some of the windows and steps, and has also loaned major works of art. Floor mosaics on the entry level were laid by young French girls (today likely understood as too young to work) "crawling on hands and knees."[89] France also supplied paintings. Twenty-three kinds of marble came from Italy; wooden railings and gates from Germany;[90] a polar bear porcelain fountain from Denmark (seen from above in figure 170); teak from Indonesia; cloisonné vases from China; and rugs from Turkey. Fabulous silks provide a 295-foot wall tapestry for what is called, in honor of the donor, the Japanese Room. The "efforts of 50,000 dyers and weavers" produced the work over some five years.[91] An acknowledged pièce de résistance is the contribution from Russia, a "massive" gold-trimmed jasper vase, adorned with the Romanov two-headed eagle. At two-and-a-half tons, it "by far outweighed

the floor capacity" where it was to have rested; the vase was relocated to an area with a reinforced floor.[92]

As its national gift, Argentina provided a "massive statue of Christ"[93] that is one of several references to the Old and New Testaments and the classical age, akin to those in Amsterdam's Town Hall. The 1652 Amsterdam Town Hall displayed a Ferdinand Bol painting, *Moses Descends from Mount Sinai* (fig. 3/41). The 1913 Hague Peace Palace has three Bol paintings hanging in a space that has been variously used and now serves as a conference room. His grand Renaissance renditions, on canvasses some thirteen by thirteen feet, show two Old Testament scenes, *The Finding of Moses* and *The Presentation of Gifts in Solomon's Temple,* alongside a Greek myth, *Aeneas Receiving His Armour from Venus in Vulcan's Forge.*[94] The ceiling continues the Renaissance iconography through a triptych by Gerard de Lairesse. The panels—*Concordia Tramples on a Chained Mars, Minerva Conquers the Harpies Violence, Envy and Deception,* and the *Maiden of Amsterdam*—denote the virtues of "urban free trade."[95]

Other Renaissance Virtues are scattered about. One can find Hope, Faith, and Love in stained-glass panels along with many a Peace and a Justice, such as the terra cotta ceiling ornament by Herman Rosse shown in figure 171 (color plate 40).[96] Another Justice, joined by Amity, Peace, and Concordia, adorns the monumental cast-iron gates that guard the entrance.[97] In addition, a large female personification of *Peace Through Justice* (fig. 172), by the American sculptor Andrew O'Connor, provides a 6,614-pound match for the monumentally proportioned central staircase.[98] The building is also appointed with attributes of Virtues, carved in wood and stone (such as Justice's scales or Peace's olive and laurel leaves) and Latin texts (such as "Pax Belli Extinguit Flammas," or "Peace Extinguished the Flames of War").

Outside, the Mawson gardens offer yet other images of peace,[99] and over the years the Carnegie Foundation—which continues to own and operate the Peace Palace—has received many gifts. In 2005, South Africa donated a bust of President Nelson Mandela that has been placed close to one of Mahatma Gandhi, near busts of other historical figures, Andrew Carnegie included.[100]

How might one read this interior? By the end of the twentieth century, the building's excesses had garnered affectionate tolerance; observers commented that the "vast Neo-Gothic" or "Disney gothic"[101] structure had fulfilled "the Victorian era's canon that it is always a good idea to decorate the decoration." Books by the Carnegie Foundation celebrate the Peace Palace for telling the stories of "peace, faith and justice."[102] While that narrative encompasses diversity in some respects, Arthur Eyffinger described the Peace Palace's iconographical compendium as loyal to "the pillars of the Dutch Golden Age: Christian faith, the wealth of the merchant class, and classical learning."[103]

FIGURE 171 *Justice,* ceiling ornament, designed by Herman Rosse, circa 1913 for the Peace Palace.

Photograph reproduced courtesy of the Carnegie Foundation. See color plate 40.

FIGURE 172 *Peace Through Justice,* Andrew O'Connor, circa 1913. Main staircase of the Peace Palace.

Photograph reproduced courtesy of the Carnegie Foundation.

## Tribunals to Which No Country Can Be "Bidden"

Even more monumental than the building is the question it provokes: What combination of practices permits one to use the appellation "international court"?[104] By delving into the details of the institutions that have lived inside the Peace Palace, we explore debates about that issue as well as how the creation of new institutions called "courts" has begun to change what that term means.

A recap of the institutions that have used the Peace Palace is in order. Since its opening in 1913, the Peace Palace has continued to house one entity—the Permanent Court of Arbitration—and hosted two other "courts." A first, called the "Permanent Court of International Justice" (PCIJ) of the League of Nations, proved (despite its name) to be transient, extant from 1922 until its formal dissolution in 1946. The other, which followed within a week of the demise of the PCIJ, is the United Nations' International Court of Justice (ICJ) that remains in operation. Given the hopes that all represent for "peace through law" and the enormous political freight, the scale of the Peace Palace fits its courts.

But institutional dockets and the structure make interpretations more complex. Over its hundred years, the PCA publicly reported fifty-four "cases conducted" under its auspices.[105] The PCIJ's output from 1922 to 1940 (when, upon the occupation of The Hague in World War II, it effectively went out of business) numbered about fifty-five judgments. From 1947 until 2008, the ICJ received some 140 cases or, on average, under three a year. Each of these institutions relies on parties' consent to their jurisdiction, and none has coercive authority to enforce decisions.

Despite the relatively small number of disputes addressed, these courts have prompted discussion and debate worldwide on what courts can (and cannot) do. Moreover, as we argue in Chapter 14, the international courts analyzed here have a good deal in common with various national courts that are also dependent on litigants to seek them out and largely reliant on acceptance of their orders to obtain compliance. Further, the methodology embodied in the PCA—seeking conciliation—has been embraced by domestic courts around the world. Thus, while the PCA and ICJ share the Peace Palace, whose nineteenth-century architecture looks back to the Renaissance, their workings forecast twenty-first-century debates about how to select judges and what judges should be asked to do.

### The Misnomer of the Permanent Court of Arbitration and the Puzzles of International Adjudication

The phenomenon of international courts has generated a large literature addressing a range of concerns about the coherence and reach of such entities. Courts are typically defined as coercive institutions imposing judgments in the name of the law, even if implementation belongs to the executive branch. Arbitration—in twentieth-century terminology—denotes a voluntary process aiming to compromise disputes. Nineteenth-century usage sometimes referred to judges as arbitrators, for example in common law jurisdictions when judges sat without juries to decide legal claims. Calling an institution a "Permanent Court of Arbitration" is, thus, ambiguous at best.

So was the status of the the PCA at its inception. Those who served were to be called "Members of the Court," not "judges."[106] Membership, in turn, simply put them on a long list as individuals who were nominated by states and available to mediate disputes—upon request—through international legal precepts to open up the "possibility of substituting law for war."[107] As one scholar of the institution during its early years explained, the "Permanent Court of Arbitration is not in any sense a tribunal," and hence its name was a "misnomer."[108]

In addition to the puzzle about the term "court of arbitration," other questions came then (as now) from speaking about courts as "international." Reformers of the nineteenth and twentieth centuries were ambitious in crafting a new international law regime and their output has been applauded by some for reaching across a world rich with differences and criticized by others for its colonial past and its undemocratic or non-representative present.[109] Identifying international precepts that ought to be called "law" adds another level of complexity. The previous chapters described courts in national and regional regimes that, whether founded by aristocratic, republican, or democratic polities, had mechanisms—from fiats to legislation—for generating and enforcing norms of primary conduct. What makes a rule that spans governments "law"? Is it plausible, as some international law proponents suggest, to share a "legal conscience" across boundaries?[110]

One response is that some customs and usages are so widely entrenched that they should be accorded the status of law, known as *jus cogens*. Proponents cite deeply shared practices as evidence. As governments affirmatively conduct themselves in accordance with such precepts, they do so with an understanding that their conduct is obligatory. The prohibition on piracy is an oft-cited example of such a worldwide legal norm. In addition, treaties—contracts among governments —set forth some provisions as positive precepts to which states affirmatively consent. Hundreds of disparate nations adhere to various of the United Nations' conventions and treaties. Yet to the extent that those commitments are operationalized, they are expressed in radically diverse ways. Thus, international law critics argue, to speak of authoritative obligations and shared practices may ascend to levels of generality that drain out real rules. Moreover, compulsion —presumed to be a facet of "law"—is absent, in that legal remedies for violations are sparse.

Another puzzle is the relationship of "world courts" to politics. One stated aspiration is that international judicial institutions come "with no political entanglements."[111] That

referent aims both to protect judicial independence and to insulate such entities from the dominance of some nation-states at the expense of others. But courts actually need "political entanglements" of some kinds. As our account of the last many centuries has made plain, judicial institutions are anchored in political commitments forming particular social orders. Something called a "court" has to be moored in government regimes, for its legitimacy to render judgments requires support fairly termed "political."

One response is to conceive of international courts as located in a distinct form of politics reflective of their unusual composition and objectives. For example, legitimacy could be gained by providing a venue for strategic interaction among nation-states to demonstrate that mutually enforcing legal and moral precepts are beneficial.[112] Further, testimonies to the political import of international courts come from a comparison between their saliency and their use. As noted, their dockets are relatively small. According to public records, fewer than 250 proceedings over the course of a century have come before the three dispute resolution courts at The Hague. Nonetheless, discussions and political actions either supporting or opposing these institutions—as well as the next generation (such as the International Criminal Court and the International Tribunal for the Law of the Sea)—have an intensity evidencing the substantiality of symbolic and practical stakes.

Yet another preliminary framing issue is about whether to aspire to singularity (the "World Court") or seek to develop a series of complementary and competing institutions. In practice, even as early twentieth-century efforts focused on a World Court, the Peace Palace itself housed two institutions for dispute resolution. Since then, several other international courts have been forged. In addition, competition comes from the domestic level; the highest-level courts in domestic settings are hegemonic, claiming for themselves not only final but also exclusive authority to render certain kinds of decisions.[113] How does overlapping and incomplete authority square with the concept of a court and the finality of its judgments?

Responses to this array of questions can be found in various theoretical accounts as well as in the workings of courts styled "international," as they reflect a mix of shared aspirational norms, political alliances, and economic self-interest.[114] One response to questions of legitimacy comes from the establishment of the PCA. Its arbitrators derive their authority from the consent of those participating, who pick that venue, select their decisionmakers, generally pay for them, and often choose the rules that govern.

## The Small Hall of Justice and the PCA

The PCA came into being in 1899 and expanded through the 1907 Convention for the Pacific Settlement of International Disputes. The PCA has three parts: a panel of arbitrators (in "no sense judges"), an "International Bureau" with a small staff akin to a court's registry or clerk's office, and an "Administrative Council" that includes diplomatic representatives from member states charged with adopting rules and organizing the financial support for the PCA.[115] Nation-states nominate no more than four persons willing to serve as arbitrators; they may choose individuals from anywhere. (For example, as of the 1940s, some 500 individuals were listed; of the twenty from the United States, five had been selected by the King of Siam.[116]) The number of potential arbitrators outstripped the number of arbitrations. During the PCA's first thirty-three years of operation, some 450 individuals were listed and twenty-nine served.[117] Before 1914, the PCA had heard seventeen disputes.[118]

The PCA operates episodically, when disputants bring conflicts to it. The initial spurt of activity ended with World War I, with a resurgence in the 1980s. One of the explanations for the limited demand is that, from its inception, the PCA has functioned alongside other institutions that also offer arbitration. Even signatories to the Hague Conventions of 1899 and 1907 could go "wholly outside" those frameworks to use other arbitrators.[119] The PCA, in turn, has also accepted disputes that involved non-signatories.[120] Further, after the League of Nations created a Permanent Court of International Justice at the Peace Palace, that entity extended its offices in the 1930s to "mixed arbitrations." That mix was not of judges from different countries (as the Mixed Courts of Egypt had done) but rather a mix of parties—state and non-state parties including private corporations.[121]

All told, by 1940, forty-seven state parties had used the PCA[122] for some twenty-plus publicly reported arbitrations.[123] Then (as described by a member of the PCA in 2007 at the celebration of the court's hundredth anniversary), the PCA "fell into a state of lethargy,"[124] listing only six cases in which awards were made between 1931 and 1970.[125] But during the later part of the twentieth century, the PCA entered into a series of "cooperation agreements" with other transnational arbitral organizations, such as the International Centre for Settlement of Investment Disputes (ICSID), the Multilateral Investment Guarantee Agency, and the International Council for Commercial Arbitration.[126] Further, in the 1980s, the PCA gained greater currency, in part when it played a role in dealing with claims arising out of the taking of American hostages by Iran and the seizure of Iranian assets by the United States.[127]

Looking at the span thereafter from 1990 to 2007, the PCA listed almost thirty cases involving disputes between Eritrea and Ethiopia; Ireland and the United Kingdom; Belgium and the Netherlands; Guyana and Suriname, and many more, and may have been involved with others not disclosed.[128] By 2008, the PCA reported it had had a "dynamic year," as it functioned as a "registry" for thirty-four cases, as well as was requested to become involved in several others.[129] (As of 2009, more than forty-five matters

were pending.) Commentators thus speak of the two eras of the PCA and describe the post-1990 era as "unparalleled" in the expansion of membership (to 107 states) and in the volume of filings.[130] Taking a longer view, over the first hundred years of its existence, the PCA lists more than fifty matters, some related to contracts between nations, some involving treaties and boundary disputes, and many about investment disputes. (As noted, the PCA only publishes information with parties' consent; further it does not provide full information on interim decisions, and hence may have a larger volume of work than its lists indicate.)

The PCA now uses the Small Hall of Justice (fig. 173) at the Peace Palace. The top panel shows the room configured court-style and permits a glimpse at the portrait of Nicolas II. The second scene is a 1987 meeting of the Iran–United States Claims Tribunal, which rented the space for some of its proceedings.[131] As that view makes plain, the Small Hall is dominated by *Glorification of Peace,* a cartoon for what was to have been a tapestry from France.[132]

Sources for new business for the PCA include a growing number of non-state entities. International organizations, regional confederations such as the European Union, and a host of commercial entities are active participants in transnational transactions, interfacing with nation-states and looking for legal frameworks beyond national borders. In 1976 the United Nations' Commission for International Trade Law (known to many as UNCITRAL) provided rules for arbitration that have been used by the PCA,[133] which also gained a boost as colleagues and competitors developed an active market for dispute resolution services. As we noted, the PCA has agreements with other organizations that are both competitors and tributes to its model. The ICSID, under the World Bank, and the arbitral panels created through the United Nations Convention on the Law of the Sea, detailed later, proffer similar to services to the PCA as it rejuvenated during the first decade of the twenty-first century.[134] These various arbitration centers not only compete with each other but also with court-based adjudication.

Delineating the processes of arbitration sharply from, rather than overlapping with, adjudication would be misleading. Commentators speak of the PCA's "substantive law" and that its principles, put forth in various disputes, remain "good law."[135] Further, its practice resembles that of international courts, which do not issue decisions that bind their successors as would courts that use the system of precedent (such as in the United States). Nonetheless, international courts build bodies of legal principles. Moreover, some arbitrations can involve large numbers of lawyers and take a considerable amount of time, thus sharing features—expense and delay—of litigation that many bemoan.

In some respects, however, the PCA offers disputants specific qualities that are different from those traditionally associated with courts: the opportunity to choose their own decisionmakers and, if they desire, to conduct proceedings in private and obtain results that are private.[136] Those con-sumers able to shop and to pay for services may obtain more flexible remedies than they would from courts and can keep those resolutions confidential. But these distinctions may also not endure for, as we argue in Chapter 14, domestic courts are reconfiguring to look more like the PCA.

## The League of Nations' Permanent Court of International Justice

Even as internationalists built the PCA during the early part of the twentieth century, they thought reliance on arbitration insufficient, for they wanted an institution that was more like a court. Some criticized the PCA for being too willing to render decisions based on "compromise" rather than insisting on adherence to international precepts.[137] What was needed was "justice under accepted law"[138] through the "appointment of a permanent salaried international judiciary . . . [to] add immensely to the importance, dignity and labors" of the occasionally deployed and otherwise employed members of the PCA.[139] In 1907 The Hague Conference had considered a Court of Arbitral Justice with these features but could not garner enough support for it. Instead, what was produced in 1920 through the League of Nations was another voluntary court, the Permanent Court of International Justice. Unlike the PCA, however, this court did have full-time judges who were neither paid by nor selected by the parties.[140]

The League of Nations took up the question of a court in 1919, shortly after it was formed. The League established an Advisory Committee of Jurists to shape proposals to be "submitted to the world for its approval."[141] Several proponents wanted a court with "compulsory jurisdiction from the very start, at least in certain cases,"[142] but their view did not prevail. The final version of the PCIJ created an opt-in institution, competent to hear disputes only between sovereign states—and then only if those states agreed, and only if their disputes implicated treaties or other principles or breaches of international law.[143] On the other hand, a few treaties did "confer obligatory jurisdiction on the court" (including the Arms Convention of 1919 and another on Navigable Waterways[144]) and states could also bind themselves, in general, to consent to jurisdiction.[145]

The PCIJ not only lacked compulsion over disputants; it also lacked another feature thought intrinsic in courts—powers of enforcement. Litigants at The Hague "promise[d] in advance to abide by the judgment when rendered," but broken promises incurred no sanctions "unless other nations use[d] their combined force to coerce or crush the offender."[146] In short, this new court was plainly much "less than a supreme court" of the world.[147]

### NATIONALITY AND JUDICIAL SELECTION

A major issue—one that "threatened to prove insuperable"[148]—was what judges from which countries would sit on the court. The "great powers" wanted permanent seats,

FIGURE 173    Top panel: The Small Hall of Justice in the Peace Palace used by the Permanent Court of Arbitration.
Bottom panel: A 1987 meeting of the Iran–United States Claims Tribunal in that Hall.

Photographs reproduced courtesy of the Carnegie Foundation and the Iran–United States Claims Tribunal.

while the "small powers" objected.[149] The conceptual question underlying this debate is an important one faced by international bodies, then and now. A new court could be another version of the "mixed courts" of the past, with national judges bringing their identities to form a coalition court that gains legitimacy from being a collage of various countries' officials.[150] In addition to garnering political support, this model also enables national judges to bring country-specific knowledge about relevant domestic norms and practices. Alternatively, an international court could be conceived to be a supranational body that transcends nation-states, making irrelevant individual judges' countries of origin, just as the applicable transnational legal principles would similarly be denuded of their heritage.[151] Legitimacy under this configuration flows from the very lack of affiliation. As was argued in the 1920s, for judges to be seen as unbiased required that they be selected in a manner that did not privilege their status as citizens of particular nations.[152] One could take this proposition further and disqualify any jurist whose nationality was the same as a disputant from sitting on a particular case.[153]

In 1907 the Central American Court of Justice (fig. 11/165) took one judge from each of the seven countries that formed the court. The two European courts of the second half of the twentieth century have done the same. The European Court of Justice (fig. 11/156) and the European Court of Human Rights (fig. 11/163) have chosen the route of representation, akin to the mixed courts of the nineteenth century.[154] Both the 1899 PCA and the 1922 PCIJ adopted some version of the second, transnational position, seeking to lessen the relevance of nationality in various respects. Their model, in turn, has been followed by the Inter-American Court of Human Rights (fig. 11/167) and other U.N. courts, discussed later. The decision to avoid the national route has been seen by some commentators as explaining why some of these courts lack support and use. When countries do not put "their" judges on the courts, they have a smaller stake in and less affiliation with them.

The decisionmaking process that was used to lessen the relevance of nationality in the PCIJ is credited to Elihu Root, who worked on drafting the statute for the PCIJ on behalf of the United States. He brokered a compromise by spreading powers of selection across large and small states.[155] Under the agreement negotiated, both the Council (the smaller chamber of ten states, of which the "great Powers— Great Britain, France, Italy, and Japan"—were permanent members)[156] and the Assembly (the larger chamber, then with some fifty members) of the League of Nations played a role in choosing individuals from lists of nominees proposed by states.[157] Election was to be "regardless of their nationality from among persons of high moral character, who possess the qualifications required in their respective countries for appointment to the highest judicial offices or

are jurisconsults of recognized competence in international law."[158] Moreover, even if a state were not then a party to the League of Nations, it could (as the United States did[159]) have a jurist on the bench, for the judges were "not chosen as official representatives of nations, but on their merits as jurists and public men."[160]

One should not, however, overread the "regardless of nationality" clause, for no two judges could come from the same country. Moreover, if a dispute involved a country that had no national on the bench, a judge from that country would be appointed "ad litem" for the litigation, a practice used in various other regional and international courts.[161] The result for the PCIJ was a fifteen-person bench of eleven full-time judges and four deputy judges serving nine-year renewable terms.[162]

## INAUGURATING THE "WORLD COURT" AND THE HAGUE ACADEMY FOR INTERNATIONAL LAW

The judges first met to organize themselves in 1922 at the inauguration ceremonies of the PCIJ (dubbed the "World Court"), which formally became an "organ" of the League of Nations and took up residence in the Peace Palace.[163] Wearing "black robes relieved with velvet, but without ermine,"[164] the judges took their seats to hear Sir Eric Drummond, Secretary-General of the League, praise their participation in "an international judicial organ . . . entirely free of political influence and absolutely independent of any political assembly in its deliberations."[165] Part of that independence came from fixed salaries (of about $6,000 per year, or $64,461 in 2008 dollars),[166] pensions, and stipends for travel and living. Despite the "insecurity and the precarious financial situation" of the time, the PCIJ's overall budget was about 921,196 florins in 1925, or about $4 million in 2008 dollars.[167]

A year later, The Hague Academy of International Law was established to shape a community of persons knowledgeable in international law.[168] As a brochure—issued in six languages—explained in 1923, in light of the "immense bouleversement" that the world had experienced, "unbiased research to help lift standards of law and international relations" was especially needed.[169] The Academy sponsored publications, courses, and conferences. As one scholar of the Peace Palace concluded in the 1980s, of "all the institutions . . . on the premises, the Academy has . . . been the most successful" in providing a center for advanced international studies.[170]

## LAWMAKING THROUGH ADVISORY OPINIONS AND CONTENTIOUS CASES

The PCIJ was an add-on, joining the PCA at the Peace Palace; the new court was expressly crafted to operate "in addition to the Court of Arbitration" rather than in lieu of it.[171] But unlike the PCA, the PCIJ would meet at least once

a year, for its judges formally held office and were to sit on all the cases to come before the court.

What were they to do? Like the PCA (as it understood the boundaries of its role at the time), the PCIJ's jurisdiction extended only to cases brought by states. But, unlike the PCA, the PCIJ was to render public decisions explained by references to law. Its sources for decisionmaking were statutorily specified. Read through the lens of debates in the twenty-first century about the power of judicial review, the 1920 charter to the PCIJ is an impressive commitment of authority. Under Article 38 of the statute, judges were to apply "international conventions, . . . international custom, as evidence of a general practice accepted as law, the general principles of law recognized by civilized nations," and, when appropriate, "judicial decisions and the teaching of the most highly qualified publicists of the various nations, as subsidiary means for the determination of rules of law."[172]

Moreover, judges could also, if the parties agreed, decide —ex aequo et bono—as equity and goodness required. These parameters gave generous interpretative space for judges to identify precepts as legally obligatory and to borrow from others—worldwide—to shape legal rules. Judges were thus to be active participants in developing a body of law that had grown "very rapidly" since the end of World War I.[173] Moreover, judges sitting together on a court dealing with different cases could render decisions that, while not formally binding precedents, would be foundational.[174]

Meeting at least once yearly, the PCIJ also had the power to give advisory opinions in addition to ruling on "contentious" cases, a term of art used in international courts to delineate that genre from requests for advisory decisions.[175] The court was to sit as a whole,[176] to work in its official languages of French and English unless a party requested another,[177] to hear witnesses (presumptively in public, subject to requests for privacy), to provide provisional remedies, and to render written decisions, including dissents.[178] What the court lacked, as noted earlier, was both compulsion to participate and any means of enforcement aside from whatever proposals to do so might come from the Council of the League of Nations.[179]

As has been common in United States history in relation to participation in international organizations, the question of joining the PCIJ (and whether doing so would lead to joining the League of Nations) sparked heated debate.[180] One question was whether a country could impose "reservations," a term denoting that a treaty is signed with caveats that limit a country's obligations. Many groups within the United States were actively part of social movements of the time that had varying degrees of commitment to joining the League of Nations, to the PCIJ, to international law, to feminism, and to peace. The American Bar Association undertook "consistent and persistent" efforts to have the United States participate in the PCIJ;[181] support also came from the Chamber of Commerce of the United States, several labor unions, various religious groups that had been part of peace movements, and women's groups.[182] Making arguments for joining, proponents assured listeners that the court was "an independent judicial body" that was not controlled by the League of Nations.[183]

Presidents Woodrow Wilson, Warren G. Harding, Calvin Coolidge, and Herbert Hoover all urged ratification—albeit with some reservations and differing levels of enthusiasm.[184] But Charles E. Coughlin, a Catholic priest from Michigan, was one of many who raised the flag of United States sovereignty (a gesture that has been repeated many times since). In 1935 the Senate rejected the proposal to join. Fifty-two senators had voted for it, but that number fell seven votes short of the supermajority constitutionally required for ratification of treaties.[185] Thus the United States did not add its name to the roster of the sixty-one nations then members.[186] The debate about the PCIJ was a forerunner of later conflicts about the participation of the United States in the United Nations and its various Conventions. As was the case with the PCIJ, representatives of the United States have been actively involved in drafting many agreements that the Senate has declined to ratify, including (as of this writing) the Convention of the Law of the Sea and the International Criminal Court.

The PCIJ had a broad legal mandate to apply and to interpret international law, but to do so it needed cases. The court's lack of obligatory jurisdiction was a factor in the dearth of filings, for countries desiring international dispute resolution "had no difficulty" creating ad hoc mechanisms to do so.[187] Even as supporters of the PCIJ at the time reminded colleagues that new courts—including the Supreme Court of the United States—were slow to start up,[188] the PCIJ never gained a large docket. Rather, although imagined to be wholly independent, the PCIJ proved to be like every other court—dependent on litigants to seek it out and then conform to its judgments. As one commentator put it at the time, in the "last analysis," the PCIJ had to rely on the "political bodies with which it is affiliated."[189]

Between 1922 and 1935, the court sat for thirty-six sessions, and although nominally permanent, it met only when it had business to do.[190] All told, from 1922 until the late 1930s, it heard twenty-nine contentious cases and delivered twenty-seven advisory opinions.[191] Its work has been compiled in some two hundred volumes, making it "one of the best-documented public institutions in the world."[192] The PCIJ's last public sitting was in December of 1939, but it "did not in fact deal with any judicial business."[193] After Nazi Germany occupied The Hague in May of 1940, the court moved to Geneva, with "a single judge remaining at The Hague."[194] The PCIJ was officially disbanded in 1946; its judges resigned on January 31, 1946. On February 5, 1946, the first members of the International Court of Justice—our next topic—were elected.[195]

How might one assess the PCIJ? Some have dismissed it as "pseudo-constitutionalism,"[196] rendering little important law. Others see it as the foundational juridical institu-

tion on which contemporary international courts have been built.[197] On this account, the PCIJ "put international law into practice"[198] as lawyers and judges sought to apply treaties and argued over international legal precepts. When measured against the docket of its successors rather than of national courts, the PCIJ's caseload is unexceptional. Moreover, the PCIJ has been credited with shaping modes of thinking about international law and forming a conception of the international lawyer and the international judge as persons in special relationships with international law. In turn, the PCIJ was a contributor to a growing body of material distinct from the national frameworks that had preceded and remained concurrent with it.[199]

The PCIJ should also be understood in its context as representing remarkable aspirations, given what many of its supporters had just experienced. During World War I, more than fifteen million people died. As one proponent commented in 1924, peace was slowly returning to the "disorganized and disintegrated world"; with the new court "machinery" in place, he hoped that the "tradition of international judicial decision should . . . at last take root and begin to grow."[200]

## The Great Hall of Justice and the United Nations' International Court of Justice

The court that replaced the PCIJ was, as Philip Jessup put it, "in a very real sense the continuation" of the PCIJ.[201] In 1946, the United Nations chartered the International Court of Justice (ICJ)[202] as a body of that organization.[203] The charter required that parties to disputes that are "likely to endanger the maintenance of international peace and security, shall, first of all, seek a solution by negotiation, enquiry, mediation, conciliation, arbitration, judicial settlement," and other "peaceful means of their own choice."[204] Like the PCIJ, the ICJ is a court whose jurisdiction is limited to nation-states, both as applicants and as respondents.[205] International and private organizations or individuals cannot bring claims directly to it. Further, and in the PCIJ tradition, the ICJ is an optional court,[206] again with the authority to issue advisory opinions[207] and provisional remedies,[208] and again with fifteen justices serving nine-year terms.

The charge to jurists is similarly broad, providing what in the United States are called common law powers to develop legal rules. Specifically, the ICJ Statute authorizes judges to derive principles from U.N. treaties and conventions, from "international custom, as evidence of a general practice accepted as law; the general principles of law recognized by civilized nations," and (with some caveats) from "judicial decisions and the teachings of the most highly qualified publicists of the various nations."[209] Further, like the PCIJ, the ICJ has authority to decide matters *ex aequo et bono*—by equity and goodness.[210]

In contrast to the provisions of the PCIJ, a country does not join the court separately through a treaty but rather becomes subject to its jurisdiction by becoming a member of the United Nations.[211] Further, under the U.N. Charter, each Member State "undertakes to comply with the decision of the International Court of Justice in any case to which it is a party."[212] But like the PCIJ, the ICJ is dependent on parties' choosing to use it and then complying with its judgments. Failure to do so is not a direct issue for the court. Parties frustrated by opponents that have not discharged obligations imposed by a judgment "have recourse to the Security Council" which, in turn, can "make recommendations or decide upon measures to be taken to give effect to the judgment."[213] As of 2004, the Security Council had not undertaken any enforcement actions.[214]

Thus, by virtue of being a U.N. Member State, the United States is within the orbit of the ICJ. The United States has qualified its participation with a "reservation" to decline jurisdiction for legal disputes arising out of multilateral conventions unless "all parties to the convention affected by the Court's decision were also parties to the case before the Court."[215] Moreover, the United States famously withdrew from ICJ's jurisdiction in a case involving its shipment of arms to Nicaragua.[216] Further, while the United States Supreme Court has described ICJ rulings to be deserving of "respectful consideration," in 2006 the court expressly declined to find them binding on courts in the United States.[217]

### Nationality's Continuing Import

As had been the practice for the PCIJ, ICJ judges are elected through a process aiming to dim the relevance of nationality while preserving more authority for some states than others—in this case, the states that make up the Security Council.[218] The voting rules have generally enabled the five permanent members of the Security Council to have judges on the court. Nationals from the United States and the Soviet Union/Russia have always served.[219] Continuous with what was the PCIJ practice, if a case involves a nation that has no judge on the ICJ, an ad hoc judge from that nation is appointed to join the bench.[220] One study of the voting behavior of judges argued that ICJ decisionmaking showed the footprints of nationality. A review of "every vote in every case" (excluding advisory opinions) in a total of seventy-six cases decided by early 2004 concluded that, when a judge's nation appeared before the court as a party, the judge voted in favor of that party more than 80 percent of the time.[221] Ad hoc judges voted in favor of their appointing nations some 90 percent of the time.[222]

States can influence the composition of the ICJ in another manner. When parties assent to the court's sitting in chambers,[223] they can also condition resort to the ICJ on having "a five member-chamber, made up solely of judges mutually acceptable" to both sides of the dispute[224]—thereby blur-

ring the line between arbitration and adjudication. Yet other concerns about the ICJ's party-dependency have been voiced in relationship to how judgments were made in a case in which the ICJ appeared to be seeking to broker agreements in a diplomatic mode.[225]

One aspect of the ICJ bench bears special mention. The Peace Palace has a rich decorative assemblage, full of Virtues personified as women. But until the end of the twentieth century, its jurists were all men. In 1995, Dame Rosalyn Higgins was the first woman elected to serve on that court and, in 2006, she became the first to chair it—making the ICJ the first organ of the General Assembly of the United Nations to have a woman at its head. She served as President from 2006 to 2009.[226] Her work, and that of the court, was supported by a staff of about one hundred.[227]

### A Celebratory Iconography

The ICJ sits, as did the PCIJ, in the Peace Palace. While the PCA uses the Small Hall of Justice, the ICJ occupies the aptly named Great Hall of Justice. As figure 174 (color plate 41) reveals, the room is enormous, as are its appointments.[228] Six Bohemian crystal chandeliers illuminate the room,[229] and the long bench accommodates the fifteen judges, with additional room for ad hoc judges. As in Siena's Palazzo Pubblico (figs. 2/26, 2/27), Latin maxims are strewn throughout, and large pictorial allegories aim to edify the viewers.

Recall that in Siena, spectators saw both tyranny and good government and, in the Amsterdam Town Hall, they were invited to witness the challenges and pain of judgment by looking at Brutus ordering his sons to their death (fig. 3/46) and Zaleucus gouging out one of his eyes (fig. 3/45). In contrast, the audience at the Peace Palace views the triumph of Peace and Justice over evil, portrayed in both stained glass and in paint.

Monumental glass windows (figure 174) by Scottish designer Douglas Strachan run 132 feet by 102 feet, detailing the *Development of the Peace Ideal,* in which Peace is "Realised" after wars and other evils.[230] Four stages—"the Primitive Age, the Age of Conquest, the Present Age, and the Achievement of Peace" —are shown in successive windows, with highly colored depictions set against a white

FIGURE 174    A Sitting of the International Court of Justice in the Great Hall, the Peace Palace, March 8, 1996.

Photograph by D-VORM.NL, Leidschendam, the Netherlands. Photograph reproduced courtesy of the Carnegie Foundation.
See color plate 41.

backdrop.[231] One can also contemplate a "huge painting," twenty-three by fifteen feet, *La Paix par La Justice* (*Peace through Justice*) that adorns another wall. There "three wise men [are] ousting combating parties, with a triumphant female Peace in the foreground."[232] (The picture is explained as a reference to arbitration as the room was to be used by the PCA.[233]) Peace holds a child in one arm and an olive branch in the other, providing what one writer at the time called "symbols [that] are by no means cryptic."[234]

This is the room not only for taking evidence but also where the court renders its decisions, from which no judicial appeals can be taken. Under the rules of the ICJ, its judgments "shall be read at a public sitting of the Court and shall become binding on the parties on the day of the reading."[235] The information can then be transmitted in a press room equipped with a live feed for verbatim recordings in French and English to the world.

### Renovations, Modernization, and Expansion: Carnegie's Library at Last

By the 1950s, the Peace Palace was less palatial; the aging building had "[r]ust-eaten gates" as well as outdated elevators and "insufficient heating."[236] During the same decade, the European Community was in formation, and some thought the ICJ should move to Geneva, while others wanted what was to become the European Court of Justice to join the ICJ at The Hague.[237] Finances remained a perennial problem, and the Dutch government responded with support.[238] Repair rather than relocation was the response along with a new, but far more modest, building.

The result (fig. 175) was a new wing, designed by Arnhem Architects Bureau Brouwer and Deurvorst and funded by the State of the Netherlands, which gave the building to the Carnegie Foundation in 1978.[239] With none of the drama that had produced the Peace Palace, the committee directing its building reviewed three models and selected one in 1975, with work beginning soon thereafter.

The building, measuring 3,760 square meters (40,472 square feet), looks like those of its generation. Its exterior three stories, slightly curved to nestle in the gardens, are adorned with glass picture windows surrounded by brown Brazilian marble; the roof is mostly flat, with an occasional sloped angle.[240] The white walls and recessed lighting of the interior provide a marked contrast to its neighboring Palace. The facility provides chambers for judges, conference space, and a dining room. Compared to the space available in the 1940s, the facilities available to the ICJ in the 1990s were triple the size.[241]

The space at the Peace Palace expanded again in 2008, when a new building opened to allow the Library to provide conference facilities for shared use by the Hague Academy of International Law. The Carnegie Library describes itself as the "first" (from 1913) to house a collection of "international, comparative and foreign national law."[242] Replacing a demolished 1929 building, the the new structure, by architect Michael Wilfold, has received praise for its functionality and frank insistence on new architectural forms— "reinforced by the bright yellow pilotis [stilts or columns that raise a building off the ground], arranged in two Vs, that support the reading room, and the no-nonsense purple rendering that picks out the upper galleries."[243] As one commentator put it, the new building combines "very precise rational planning with expressive elements that stand out for their chutzpah."[244] The reading room has a stainless-steel skin set off through an "aggressive" use of sharp

FIGURE 175    Annex to the Peace Palace, International Court of Justice, The Hague, the Netherlands, 1978. Architects: Brouwer and Deurvorst.

Photograph reproduced courtesy of the Carnegie Foundation.

angles.[245] The lecture hall, with a vertical wall of glass, seats more than three hundred, and a bas-relief designed by Irene Fortuyn, provides maps randomly arranged of the world's countries. Remembrances of times past can be found in the building's connection, through a renovated reading room, to the Peace Palace, thereby fulfilling what the 1906 competition had sought—access internally between the Library and the World Court.

Sorting out the economic support of the various parts of the Peace Palace is in order. The Dutch Carnegie Foundation, founded in 1903, continues to own and administer the Peace Palace, its Library, and the grounds.[246] The Foundation's seven-person board includes a representative of the PCA. In 2008 that foundation's budget was roughly six million euros (about $8.2 million).[247] The United Nations pays rent for the use of the facilities by the ICJ and more generally supports the ICJ from the U.N. annual budget.[248] For example, two years of operation (2008 and 2009) were supported at about $41 million; rent and maintenance accounted for $2.7 million.[249] The PCA also makes financial contributions to the Foundation. The Hague Academy for International Law, while housed alongside the Peace Palace and governed by an administrative council comprised of some of the Carnegie Foundation's board members, is funded by international institutions and private individuals.[250] Its 2008 budget was 1.2 million euros or $1.76 million.[251]

### A Home for Living Law or a Museum?

Commentators and jurists have evaluated the work that has been generated through the hearings in the Great Hall of Justice, and a vast body of material is devoted to the ICJ.[252] Some of the analyses are delineated by periods or legal arguments and others by topic,[253] some by quantitative descriptions and others based on qualitative impact studies. All debate the import and nature of decisions that range from the law of laying mines in the waters near Corfu and in the harbors of Nicaragua to the legality of building walls in disputed territories in Palestine and Israel and of threatening to use nuclear weapons.[254]

As is true for courts in many countries, evaluations of the decisions of the ICJ run the gamut from praise for their quality to dismay that the court's doctrines are "arbitrary and incoherent."[255] In addition to the kinds of criticism domestic courts face, the ICJ has special challenges as "the world's court." Thus, it has been cited for being too attentive to some of the world's legal regimes and insufficiently embracing others. For example, one analysis found that, while some mention was made of considering Islamic norms to assess the existence of international norms, the ICJ had not engaged deeply in those bodies of law.[256] Others have admired the ICJ for helping to change the "fabric of the international community"[257] through its quiet yet persistent voice.[258]

The context in which the ICJ operates has also changed over time, as the ICJ has been joined by several other courts, including a few (discussed later) created by the United Nations. Given legal precepts that decisions of one such court do not bind another (or indeed subsequent rulings of its own court), differing interpretations of international law have on occasion emerged. One can understand this development as contributing to an appropriate debate about the meaning of international obligations or as producing a disquieting cacophony.[259]

Compliance is another way to assess a court's impact, albeit one that entails nuanced evaluations.[260] One study of fourteen ICJ judgments in contentious cases, for example, concluded that no state had been openly defiant, and that a good deal of deference had been accorded to ICJ judgments.[261] On the other hand, in about a third of the cases considered, states had not complied with various decisions, such as following orders related to disputed territorial boundaries or providing consular notifications when the death penalty was charged.[262]

A few infamous cases are regularly cited as showing the ICJ's vulnerability. One often-cited example is the 1986 Nicaragua case assessing whether the United States had violated international law by playing a role in supplying arms and laying mines in a harbor to destabilize the Nicaraguan government.[263] After losing at the jurisdictional phase, the United States responded with "open defiance."[264] Further, problems of compliance stem from other jurisdictions. Various countries, from the Americas, Africa, and Eastern and Western Europe, have declined to follow aspects of ICJ rulings.[265] Yet one scholar also noted that as of 2004, the focus on noncompliance had not diminished the docket of the court, and hence concluded that its credibility remained intact[266] as it continued to try to win "over its state clientele through the quality and legitimacy of its work."[267]

Usage is another metric, but also one that is hard to assess. We opened our discussion of the PCA, the PCIJ, and the ICJ with some numbers on filings; here we return to the specifics coming from various sources. The ICJ reports on the number of states that have appeared before it; from 1946 to 2004, seventy-four states came before the court in contentious cases.[268] One analysis noted that, while the number of states that were members of the United Nations grew from 55 in 1946 to more than 190 in 2004, filings and decisions have not kept pace.[269] On the other hand, a larger membership would not necessarily produce more conflicts; indeed, membership could be evidence of conciliative approaches that would avoid disputes.

As for the number of decisions, between its opening in 1946 and July 2004, the ICJ issued a total of eighty judgments and 385 orders in 106 contentious cases and twenty-five advisory opinions.[270] Looking to the more recent past, from August 1999 to July 2006, the court disposed of twenty-four contentious cases (counting various forms of disposition) and rendered one advisory opinion.[271] Disaggregated

by year, in the twelve months beginning in August 2005, the ICJ received three filings and made two dispositions.[272] The numbers for the following year were similar, with one filing and one disposition.[273] If 2007 is the baseline, in 2008 filings tripled (to three), as did dispositions.[274]

What ought one make of these numbers? What sets of disputes could come before the ICJ, and when do disputants seek the ICJ as contrasted with other courts or arbitral fora that also are competent to hear cases?[275] What variables such as an increase in the number of states, in the number of non-state transnational actors, and in the development of domestic courts as well as other dispute resolution providers could affect the docket? Should the work of the ICJ be compared to that of its predecessor the PCIJ, that, over an eighteen-year period, heard thirty-eight contentious cases and rendered twenty-seven advisory decisions?[276] Should usage data be mapped in intervals to look at trends?[277]

Commentators are deeply divided on these issues. Some argue that a focus on decisions rendered is too narrow because it is an institution nested in a political framework of alternatives. One such study, reviewing twenty-four PCIJ cases and thirty-one ICJ cases, also looked at dispute settlement at the League of Nations (thirty-five instances) and at the United Nations (thirty-one instances) to try to understand what variables prompted selection of which path to take for resolution.[278] Another way to frame the case count is by a focus on disputes that could have culminated in armed conflict but were quieted and on disputes that were avoided because of either the legal principles developed or practical political accommodations.[279] Yet another metric is reliance by other legal systems and international courts on ICJ judgments.

Given these interpretative variables, the data on the court's caseload have produced very different appraisals. In 2000, citing the figure of twenty-one "contentious cases" involving countries on four continents, one commentator concluded: "Business is booming."[280] In the late 1970s, another had dubbed the ICJ "a court without cases," as he argued that its docket was virtually empty.[281] A more recent analysis posits that the court has "unmistakably declined," lacking trust from states to apply law impartially and lacking the ability to please the major powers whose support it requires.[282] For others, such overall assessments are themselves questionable, for the "most striking feature of the pattern of use of the International Court of Justice . . . [has been] its irregularity."[283] Not surprisingly, the host organization for the ICJ—the Carnegie Foundation—is insistent that the Peace Palace, which "looks like a museum, lavishly devoted to the theme of peace, is in reality the housing of living institutions engaged in the area of international law."[284] Further, as the chair of that foundation noted, the Peace Palace provides an "unmistakeable icon of the will to grant international law the authority that so many people deem necessary."[285]

Our questions are broader than an internal assessment of the ICJ. We are interested in how the emergence and prac-

tices of the ICJ inform an understanding of the changing roles and functions of courts in general. Before sorting out the import of the transnational judicial project of which the ICJ is a part, however, more about the development of the ICJ's younger, sibling institutions is in order.

## Transnational Courts with Specialized Jurisdictions

The ICJ offers itself up as a court of general jurisdiction, meaning that a variety of kinds of cases can come before it. As noted, it once functioned as the exclusive entity that the United Nations created as a court. But through transnational agreements or at the direction of the United Nations Security Council beginning in the 1990s, a series of specialty courts now focus on particular kinds of problems. We consider five such courts, one with civil jurisdiction related to the Law of the Sea and four addressing the horrors of genocide and crimes against humanity.

### An International Tribunal for the Sea, Seated in Hamburg

In some instances, the ambivalence about cross-border adjudication is reflected in the fact that the construction of buildings to house that work lags, coming many years after the decision to create an adjudicatory body. The European Court of Justice (ECJ) provides an example; its first permanent residence opened in 1973 (fig. 11/156), about two decades after the ECJ began its work. In contrast, ambitions for a joint venture at times simultaneously sustain both an agreement for a juridical institution and a plan to memorialize the accord through the construction of a new building. Within a few years of the Hague Convention of 1899, the elaborate Peace Palace and Library welcomed visitors to The Hague.

The building for the International Tribunal for the Law of the Sea (ITLOS), shown from the air in figure 176 but dedicated to the ocean, offers a variation.[286] ITLOS was sited in the port city of Hamburg, Germany in 1981,[287] more than a decade before a forty-year debate produced sufficient agreement among major maritime nations to shape a legal regime that would include a court as one of various implementation and dispute resolution mechanisms.[288] Indeed, the "Free and Hanseatic City of Hamburg"[289] had campaigned to provide a home to ITLOS before Germany became a member of the 1994 Convention on the Law of the Sea. Hamburg had, of course, the "expectation that the Federal Republic of Germany" would ratify the Convention[290]—as it did in 1994.[291]

In the early 1980s, when eager to be the tribunal's site, Hamburg distributed a brochure, "Introducing Hamburg,"[292] to all delegates to explain why it was the appropriate city to host ITLOS. One was history: Hamburg's "maritime tradition" included its 1189 "right to free access to the sea,"

FIGURE 176  International Tribunal for the Law of the Sea, aerial view, Hamburg, Germany. Architects: Baron Alexander Freiherr von Branca and Baroness Emanuela Freiin von Branca, 2000.

Photograph copyright: YPScollection, 2005. Photograph reproduced courtesy of the International Tribunal for the Law of the Sea.

granted by the "legendary Emperor Barbarossa."[293] More-over, "names such as . . . Georg Phillipp Telemann and Johannes Brahms" were part of the city's culture.[294]

Moving to modern times, Hamburg described itself as "one of the first cities to establish close relations with the young states in Asia and Latin America" through conclud-ing trade treaties "independently" with them.[295] Hamburg also invoked its contemporary function as a commercial center,[296] providing excellent hotels, regular train service to cities across Europe and north to Scandinavia, and an "all-weather" airport.[297] Hamburg described its history and laws, its "open door for the persecuted" and its research institutes and legal rules for shipping and the seas.[298] Fur-ther, the city argued that because Germany had a "short coast-line," the country had few stakes in the merits of underlying conflicts about the law of the sea, for it could not "derive any benefit from the enlargement and readjustment of sea areas."[299]

Those efforts, enhanced by pledges from both Hamburg and Germany to provide the site (followed by a formal com-mitment of full funding in 1986[300]) prevailed.[301] The deci-sion in 1981 was followed in 1983 by the formation of a

commission to deal with the "practical arrangements nec-essary for the establishment of the Tribunal."[302] By the time the International Convention on the Law of the Sea entered into force in 1994 through the ratification of a sufficient number of states, more than a dozen architects had imag-ined what its building could look like.[303] Two—Alexander Freiherr von Branca and Emanuela Freiin von Branca, both of Munich—had been selected, funds had been guaranteed, and construction was underway.

Just as European institutions are dispersed to more than one site, Hamburg is not the exclusive center of activity related to the Sea Convention. The Commission on the Limits of the Continental Shelf convenes twice yearly at the U.N. Headquarters in New York. The International Seabed Authority, also coming into existence officially as of 1994, is based in Jamaica, which was the site where the 1982 Con-vention on the Law of the Sea "opened for signature." The Seabed Authority has administrative oversight of the min-ing of the ocean floor. It holds its meetings at the Jamaica Conference Center.[304]

In many respects, Hamburg's push to be the seat of the court is reminiscent of the cities and counties in the United

States and Europe that sought to become venues for courts as a means of promoting the economy and visibility of their localities.[305] Hamburg's effort had a special subtext. As the jury that chose the architects noted in the September 1989 session, its deliberations took place fifty years after the start of World War II; the "foundation of the United Nations was as an answer to the horrors of war and the millions of dead."[306] Thus, special note is made by Germany's Foreign Office, as well as various ITLOS documents, that the selection of Hamburg resulted in "the first significant legal institution from the broader UN sphere" to be headquartered "on German territory."[307]

When Germany sought to be the site of the court, some of the parties negotiating the Sea Convention had hoped that use of the planned court would be mandatory. But the agreement that emerged made much of ITLOS's jurisdiction optional for the parties, and even with some mandatory jurisdiction, it ruled on fewer than fifteen cases during its first decade of operation. The building plans and court procedures enable us to probe the puzzles generated by the distance between court construction (literal and legal) and practices.

## A "Constitution for the Oceans"

International customary law has long recognized the illegality of piracy. Further, the Slave Trade Courts of the nineteenth century represent multi-national adjudication of another kind of illegality—making plain the interrelationship between human rights and economies. ITLOS should thus be understood as one of the heirs to those mixed courts, alongside the transnational human rights courts of Europe and the Inter-Americas (discussed in Chapter 11) and the criminal courts such as the International Criminal Court (discussed later in this chapter).

Problems such as seizure by one nation of a ship owned by another, staffed by a crew from a third, and carrying cargo from a fourth, were also not novel.[308] Yet the varying interests of maritime and land-locked states, of industrialized and less industrialized countries, of archipelagos and countries bordering straits, and of private commercial entities and public governance proved hard for twentieth-century nation-states to negotiate. The stakes rose with the growing awareness of the limits of resources, the risk from pollutants, and the potential wealth of deep-seabed mining—given "more dormant nickel and cobalt . . . on the bed of the Pacific Ocean than in all terrestrial deposits currently being exploited."[309] The eventual agreements came with many caveats and narrow provisions for enforcement through a range of dispute resolution systems, of which ITLOS is but one.

In 1958, when the United Nations convened its first Conference on the Law of the Sea, the focus was on "zones" rather than on "uses" of the seas.[310] As scholars explain, when European countries dominated the seas in the late Renaissance,

ships were few in number and fish were thought to be inexhaustible in quantity.[311] Twentieth-century shifts in power, accompanied by increased demands for resources and scientific appreciation of the fragility of the sea, produced conflicts about what (if any) rules to adopt. Mid-century, the central topics were the rights of states in relationship to the continental shelf, the high seas, and their own territorial reach. By century's end, the dominant concerns had shifted to pollution, deep-seabed mining, and protection of fishing stock.[312] Pollution and depleting stocks have become vivid problems, while the prospect of mining the seas remains alluring but technology has yet to make it economically feasible.

Transnational efforts to develop a legal regime governing the seas—a "Constitution for the Oceans"[313]—date back to 1924, when the League of Nations appointed a "Committee of Experts" to set forth proposals for codification that produced a 1930 conference but not an agreement on territorial waters.[314] The 1930 discussions were, in turn, used by other international law experts, appointed in 1948 by the United Nations to serve on its International Law Commission (ILC). They shaped a 1958 United Nations Conference on the Law of the Seas, known as UNCLOS I. For that meeting, more than eighty states came together and generated four conventions—the Convention on the Territorial Sea and the Contiguous Zone, on the High Seas, on the Continental Shelf, and on Fishing and the Conservation of the Living Resources of the High Seas.[315]

Successive meetings (UNCLOS II, in 1960, and UNCLOS III, beginning in 1973) addressed the control states were to have over waters and fish in their proximity, loosely defined.[316] Resources, political power, degrees of industrialization, and the diverse physical settings of states prompted significant disagreements about regulations on both zones and uses. Some degree of agreement was represented in the 1982 United Nations Convention on the Law of the Sea (UNCLOS), joined by more than 150 countries as well as what was then the European Community (EC).[317] But major maritime states—such as Australia, China, Germany, and the United States—stood apart from the accord, which set up a system for twelve-mile territorial sea zones and a 200-mile fishing jurisdiction.[318]

UNCLOS described itself as not permitting adherence with reservations; it insisted that States Parties agree to all the provisions rather than condition their ratification on limits. But the 1994 "Implementation Agreement"[319] (focused on seabed minerals) could be understood as permitting reservations.[320] The Agreement's provisions enabled states ratifying UNCLOS after 1994 to avoid certain aspects of the Convention, thereby posing puzzles for international lawyers on how to construe the treaty provisions and their caveats.[321] In addition to rules for "the management of mineral resources beyond the limits of national jurisdiction," the 1994 accord created a multiple-step implementation mechanism, in which ITLOS is one

of several endpoints that winnows out many possible disputes.[322]

The 1994 Agreement creating ITLOS has been heralded as the "most important development in the settlement of disputes" since the creation of the ICJ.[323] Countries such as Australia, China, Finland, Germany, India, and the United Kingdom joined; among "the major maritime States,"[324] only the United States continued to refuse to ratify. As of 2010, it remained outside the formal structure, with domestic opponents arguing that participation in the Sea Convention would threaten the sovereign authority of the United States.[325] (Similar concerns are the basis for opposition to the International Criminal Court, discussed later.)

## Alternatives for International Disputes about the Sea

Whether ITLOS was either necessary or desirable was debated during the course of negotiations. Maritime disputes between nation-states had been brought to the ICJ as well as to ad hoc tribunals convened to resolve particular disputes between countries.[326] Proponents insisted on the need for specialization, while others worried about the splintering of international authority through competition or conflicts.[327] Negotiators "had hoped to entrench compulsory judicial settlement of ocean disputes," but that precept was "unacceptable."[328] The denouement was a compromise that has produced yet another puzzle—how to describe what ITLOS is, for it combines features of courts, administrative agencies, and private arbitration.

Disputes related to the sea could be—and were—settled bilaterally through special ad hoc investigations, in domestic courts, and through the PCA or the ICJ at The Hague.[329] What the Law of the Sea Convention produced between 1982 and 1994 was an additional range of specialized dispute resolution mechanisms aiming to attract participants by offering disputants a good deal of control. Some speak of the "compulsory procedures" of the U.N. Convention on the Law of the Sea.[330] What is compulsory is the agreement to resolve disputes peacefully. The means, however, are optional; disputants can pick among the ICJ, two kinds of arbitral tribunals (domestic courts willing to take jurisdiction included), and ITLOS.[331] In short, ex ante or ex post, disputants were authorized to deploy arbitration, extant courts, or the new ITLOS,[332] and parties can make forum selections "at the time they sign, ratify, or accede to the Convention, or any time thereafter."[333]

When the parties cannot settle by "means of their own choice,"[334] then "compulsory procedures entailing binding decisions" follow, albeit with a host of important issues (boundaries, security, resources) excluded from the mandatory regime.[335] Yet even when a conflict resolution system is "compulsory," the use of ITLOS is generally not, except when seeking to obtain "prompt release" of seized vessels and crews and when making requests for provisional measures,

such as efforts to halt environmental hazards or overfishing.[336] On those issues, as ITLOS's President P. Chandreskhara Rao explained, the tribunal was given "a prominent position" through its "special competence."[337] The two areas for which ITLOS is obligatory have provided the only cases decided by the tribunal, and the numbers are small. From the Tribunal's inception in 1996 through the end of 2008, fifteen cases came before it. Nine related to prompt release of vessels, and five sought provisional measures (none fully granted). One involved swordfish stocks; the case was listed on the docket while the parties negotiated.[338]

Given the entrenched interests of the ICJ and the jurisdictional overlap, the creators of ITLOS did not strip that court of its authority. Indeed, as President Rao of ITLOS carefully explained at the building's opening in 2000, the Convention had given the Tribunal a "prominent position," but it had not created "any hierarchical relationship" among the various international bodies.[339] He also noted his hopes that "harmonious development of the law of the sea" would come from the "mutual respect" to be accorded among international courts with overlapping jurisdictions.[340] The lack of clarity on the relationship among tribunals reflected both preexisting interests in the authority of the ICJ and uncertainty about what ITLOS would become.

While not displacing the ICJ, ITLOS competes in some instances with the ICJ as well as with other courts. Given its specialization, ITLOS has a narrower reach than various courts, yet its openness to conflicts with non-state parties gives it a broader scope on other dimensions. For example, unlike the ICJ, whose jurisdiction is generally limited to state-to-state conflicts, ITLOS has authority over various entities (international organizations, natural and legal persons) when such entities explore or exploit the International Seabed Area.[341] That facet of ITLOS's jurisdiction has been applauded as reflecting an appropriate pluralist development; "many international disputes are no longer between states alone, but may involve international organizations, NGOs, corporations and individuals."[342] Moreover, ITLOS can gain jurisdiction not only from the Law of the Sea Convention but also from "any international agreement related to the purposes of the Convention" that specifies use of ITLOS, including by non-parties.[343] (As of 2007, nine multilateral agreements had done so;[344] the Straddling Fish Stocks Agreement, for example, also enlarged the authority of ITLOS to impose provisional remedies to protect fish.[345]) Further, like other transnational courts, ITLOS can author advisory opinions as well as render judgments. And like the ICJ, ITLOS renders judgments that do not generate law with "binding force beyond" the dispute,[346] although both international tribunals draw on their prior judgments, and commentators speak about the growth of their jurisprudence.[347]

Another aspect of the comparison between the ICJ and ITLOS relates to their judges. The fifteen ICJ judges are

selected by the U.N. General Assembly and Security Council. As noted, jurists who are nationals of the five permanent members (China, France, the Russian Federation, the United Kingdom, and the United States) generally secure seats.[348] ITLOS, an artifact of a free-standing treaty, has twenty-one judges selected by State Parties for nine-year terms.[349] Those jurists must be "persons enjoying the highest reputation for fairness and integrity and of recognized competence in the field of the law of the sea"[350] and must represent "the principal legal systems of the world" so as to ensure "an equitable geographic distribution."[351]

To implement this provision (as well as to attract business and legitimacy), the States Parties agreed to "elect five judges each from Africa and Asia, four each from Latin American and Caribbean States, as well as Western European and Other States, and three from the Group of Eastern European States."[352] Hence, the group is more diverse and representative than that assembled at the ICJ.[353] The ITLOS bench is also specialized; several jurists were former delegates to the U.N. conferences that produced that court, and some are "renowned authors in the field of the law of the sea."[354] That very specialization makes ITLOS also resemble an administrative agency that advises as well as adjudicates in a particular field.[355] Further, inside this specialty court are yet other subspecialty courts, including the Seabed Disputes Chamber. As of 2008, that potential had not been realized because the Chamber had not heard any cases.

In various ways, however, ITLOS is closer to a private provider of dispute resolution services than it is to a court. Under the Sea Convention, disputants can opt for arbitral panels, with each side designating one arbitrator and then together selecting the remaining three "by agreement."[356] The arbitral panel then determines the details of its own procedure.[357] If disputants are also members of the European Union (EU), they can (and may have to, under EU law) turn to the European Court of Justice (ECJ) as an arbitral body or use it as a court.[358] Moreover, a state can opt to go to the ICJ[359] or choose what are known under the Convention as "Annex VII arbitral tribunals" or "Annex VIII 'special arbitral tribunals'" for claims related to fisheries, environmental protection, marine research, and ship-created pollution.[360] Because the use of these provisions need not occur at ITLOS, tracking their numbers is more difficult; as of 2008, several such proceedings had taken place.

The Sea Convention also provided that, under certain provisions, parties can pick the judges to sit on their dispute, and one party can obtain an "ad hoc" judge if none of the ITLOS judges are members of the nationality of that party.[361] (The presumption was that ITLOS would sit in chambers; the practice has been for it to sit as a whole.) The Tribunal can also form "special chambers" to handle "particular categories of disputes," and disputants can tailor the rules and specify the questions to be answered.[362] Further, if they agree, parties in any of the Convention's fora can

"instruct courts and tribunals to ignore international law" and decide cases *ex aequo et bono*—as can other international tribunals, including the ICJ.[363]

In some respects, ITLOS thus resembles what Californians call "rent-a-judge"—a system by which litigants can hire a private judge of their choosing to make a decision in their case that then operates as a legal judgment.[364] As in the California system, ITLOS permits state-party disputants to pick their judges, but unlike in California, ITLOS provides them "rent-free": parties can use the Tribunal's facilities and its judges without bearing case-specific expenses.[365] (Non–state parties using ITLOS services have to contribute to the "expenses of the Tribunal,"[366] whereas members make regular prorated contributions.[367]) Indeed, if States Parties have not specified a dispute resolution mechanism, arbitration—not adjudication—is the default specified under the Convention.[368]

ITLOS is thus a court (of sorts) that rarely must be used and to which few have turned. This review of the complex procedural structure of ITLOS underscores that the framers built in many alternatives to adjudication. Thus, the outline of ITLOS provisions undercuts an assumption (easily made, given our survey thus far of the many courts created) that twentieth-century authorities embraced adjudication as the decisionmaking model par excellence. ITLOS forecasts the themes of Chapter 14, where we map the many efforts to curtail adjudication through outsourcing, devolution, and "alternative dispute resolution"—producing the kind of jurisdictional competition for cases that ITLOS exemplifies.

### Form before Function

What might a building for such a hybrid as ITLOS provide? The courthouse was planned in the 1980s and a design selected in 1989, before all the caveats on jurisdiction and ways to resolve disputes outside of ITLOS were finalized in the 1994 Agreement. As the aerial photograph (fig. 176) suggests, ITLOS is sited in a state-owned park, rich with foliage and already housing an 1871 villa listed as a historic site that required the architects to design around it.[369] The park abuts a residential area (accessible by public transportation) on the banks of the River Elbe. Germany paid 80 percent of the $123 million building costs, with the city contributing the rest.[370]

Decisionmaking on how to construct the building came through a design competition reminiscent of the one in 1906 for the Peace Palace. By the 1980s the protocol was "carried out according to the UNESCO recommendations for international architectural and urban planning competitions."[371] In lieu of thousands of potential submissions, ten German architects and ten "foreign architects" (including Jean Nouvel from France and Richard Rogers from England,[372] whose national courthouses can be seen in Chapter 10) were invited in 1989 to submit designs,

anonymously[373] and, in compliance with prospectus requirements, to a jury composed mainly of German specialists in architecture and planning and of U.N. officials.[374]

In terms of what was wanted, the construction documents that detailed parameters for the building required a mixture of uses, recalling the multiple functions of town halls of earlier eras. ITLOS's main chamber was to be able to flip from courtroom to session room, should State Parties want to use it for meetings. For a courthouse, the office spaces were relatively small: architects were to create a building to house under 120 people. While about a fifth of those were judges, only the tribunal's president was to take up permanent residence at the building.

The architects were told to assume that ITLOS would generally operate in chambers, with one devoted to seabed disputes. In addition, the building needed to accommodate provisions for parties to designate their own choice of ad hoc judges for certain conflicts, as well as space for technical experts who could be asked to join on special issues. Because the Law of the Sea Convention provided that "arbitral tribunals"[375] would be free to decide where they wanted to sit (they would have "neither seat nor site"[376]), space was to be provided in case they wanted to use the facilities.

The main courtroom thus was to accommodate the tribunal as a whole—twenty-one judges plus four ad hoc judges and experts. In addition, chamber courtrooms were needed, with benches for nine (five judges plus four ad hoc judges and experts), as well as areas for disputants, the public and the press, and interpretation and technical assistance booths.[377] Each courtroom needed adjacent space for private meeting rooms for deliberation. The architects were to propose various possible layouts, as well as how to devise an appropriate arena for translators at a time when debate was ongoing about what scope of translation would be provided. The presumption was that "only a limited number of working and official languages" would be used—to wit, the two[378] (English and French) also used by the ICJ, which later became the official languages of ITLOS as well.[379]

In addition to specifying court structure and translation space, the "Design Brief" called for the creation of a "practical and efficient" structure[380] that would provide a "representational and unique character, suitable for a place of international litigation" to implement the "rule of law in the oceans which cover 70% of the earth's surfaces."[381] Given the objective of peaceful settlement, the building should "radiate calm and composure, sovereignty and dignity."[382] To do so, the building needed to be "open (communicative)" and to provide space "equally suitable and attractive to the public and to the judges of the tribunal, its officers and staff."[383]

The design brief envisioned various uses for the spaces. The entrance hall was to accommodate receptions, visitors coming for meetings, and disputants waiting for tribunal proceedings. The public was to be welcomed as well as screened by security officers.[384] Accommodations were also needed to enable "film and electronic media coverage."[385] A library was an important part of the design. It was "a mainstay and custodian of interests concerning the law of the sea,"[386] and hence was to serve (as the architects later put it) as one of the "principal representative functional banners in addition to the actual courtrooms."[387] Aside from the import of the open reception hall, the hearing rooms, and library, the only decorations detailed were the requirements for flagpoles and a "suitable place" for "the Emblem" of the court. Other specifications for the building were the familiar aims of security and sociability. Designs were to include secure spaces as well as restaurants, fitness centers, banks, and service facilities.[388] Further, "expansion space" for "unspecified" purposes was to be built into the plan.[389]

In September 1989, the Mayor of Hamburg welcomed the architectural jury even as he noted that the Federal Republic of Germany had not yet signed the Sea Convention because "of certain reservations concerning the deep sea-bed mining part."[390] (Germany ratified, as noted, in 1994.[391]) After reviewing the fifteen proposals before them,[392] the jury selected two German architects, Alexander Freiherr von Branca and Emanuela Freiin von Branca. Their design was admired for integrating the 1871 villa on the site with the new building, in part through English-style gardens, and for underscoring the "significance" of the tribunal through a three-story entry atrium.[393]

As required, the proposal was then submitted to the United Nations,[394] and in the fall of 1996 the foundation stone was laid.[395] The court began functioning before it had its own building; in 1997 it sat in the Great Salon of the Hamburg Town Hall. A ceremonial opening of the building (fig. 177) took place in July of 2000, and a few months later ITLOS took up residence in the facility,[396] provided rent-free and supported by a budget of about (17.5 million euros ($24.5 million) for the 2007–2008 biennium contributed by States Parties and the EC.[397]

As the architects explained in their submissions, they put courtrooms in the center to make them the "focal point of the complex."[398] The main courtroom (fig. 178), shown with arguments underway during a 2001 dispute,[399] has a large semicircular bench that can accommodate the entire tribunal; its movable walls[400] permit it to host delegates to Sea Convention conferences.[401] The two chamber courtrooms and the main courtroom can "be transformed into one large auditorium for meetings."[402]

The exterior, offering views of the River Elbe, is adorned with pivoting glass slats for circulation.[403] The layout has segregated the functions in a manner similar to that found in courthouses elsewhere. Administrative offices were placed in separate pavilion-type buildings connected to the

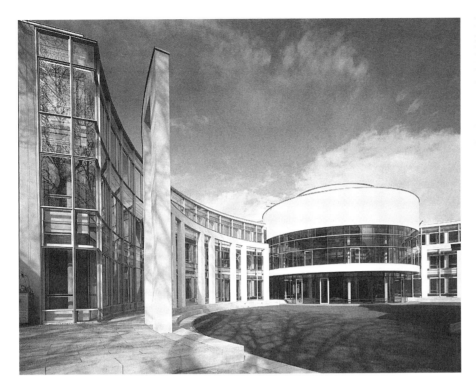

FIGURE 177   International Tribunal for the Law of the Sea, exterior, Hamburg, Germany. Architects: Baron Alexander Freiherr von Branca and Baroness Emanuela Freiin von Branca, 2000.

Photographer: Hans Georg Esch, Bad Hennef, 2001. Photograph reproduced courtesy of the International Tribunal for the Law of the Sea.

main complex with bridges. Public functions are also accommodated in the three-story 1871 villa, dedicated for use by the tribunal's president and for receptions.

As the final design brief explained, the architects mixed "strictly linear and freely expansive components"[404] and various colors to invoke the sea.[405] Stone came from "all five continents . . . to symbolize the worldwide significance of this international institution."[406] As for the art, a few items were built in—a floor mosaic and a coral sculpture—and several are on loan, including a mosaic from Tunisia, a silk embroidery from China, a Kente cloth from Ghana, and paintings from Belize and Singapore. The architects explained their commitment to "visual access" and "sweeping lines" through the use of features that lent a "bright and accessible character" and colors that "introduce softness and fluidity."[407]

While open in design, spirit, the law to be developed, and opportunities for users, ITLOS is often empty. As one journalist described the building on its eighth "birthday," the courtroom's "seating, capable of holding an audience of 250, is unoccupied. The state of the art communications technology lies mute. The glass-fronted galleries, equipped for banks of translators, stare blankly down on the empty chamber."[408] Despite the elaboration of many procedural options and dozens of volumes and articles analyzing the tribunal and its procedures, very few disputants have come to ITLOS. Thus the impressive and large building functions as a lonely monument to the potential for agreement. A single jurist—the president—is resident there, working alongside a registrar and thirty-seven permanent staff.[409]

Assessing ITLOS's impact is difficult. Some of its jurists have noted that "new" courts start slowly, with few cases.[410] Moreover, ITLOS's task is to enable settlements, so one would need to consider various of its dispute mechanisms to think through its effects. A few numbers are available: as of 2007, twenty-three States Parties (of more than 150 Convention signatories)[411] had "accepted the Tribunal's compulsory jurisdiction."[412] Some disputes (exact numbers are not available) had gone to arbitral panels.[413] But the specialized system of ITLOS Chambers had not "proven particularly successful,"[414] in that they had not been used. The tribunal generally sat as a whole. As noted, during its first decade of work it decided fewer than fifteen cases,[415] and the ECJ had rejected its competency over one of them.[416]

As was the case in thinking about the ICJ, whether size of caseload is a metric of success is another question. For cases involving "prompt release" of seized ships, ITLOS operated quickly, rendering several orders within thirty days.[417] Commentators have credited the tribunal with discouraging "unilateral actions" and with upholding "the human rights of crews" as well as affecting how countries handle questions of the ownership of foreign fishing vessels.[418] One could thus understand ITLOS as a court of last resort whose rare use bespeaks its success. Alternatively, one can focus on the decision by at least some disputants to turn to other tribunals. In ITLOS's first several years, maritime boundary conflicts continued to go to the ICJ and elsewhere.[419]

Rosemary Rafuse offered a different assessment—that ITLOS's "most significant contribution" has been to provide a "*modus operandi* for institutionalized compulsion and

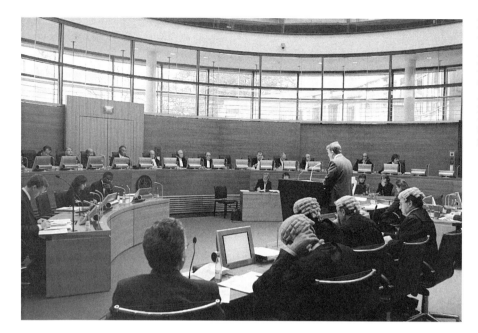

Figure 178   Oral proceedings in the *Mox Plant* case (*Ireland v. United Kingdom*), Provisional Measures, International Tribunal for the Law of the Sea.

Photographer: Stephan Wallocha, Hamburg, 2001. Photograph reproduced courtesy of the International Tribunal for the Law of the Sea.

supervision of political negotiations, rather than a judicial . . . mechanism" for deciding "disputes in accordance with international law."[420] In her view, ITLOS was used as part of a strategic interaction in which litigation was begun to prompt negotiation. Thus ITLOS had not done much to contribute to the "development of the law of the sea and international law in general."[421]

That assessment may not, however, make ITLOS idiosyncratic for current "courts." In Chapter 14, we explore the declining rate of trials in the United States and elsewhere and the embrace of alternative dispute resolution, including pressing parties to settle, and outsourcing disputes to private providers. ITLOS is the transnational counterpart, exemplifying why one could read some of the courthouse construction at the end of the twentieth century—in various parts of the world—as the erection of monuments to the past.

## International Human Atrocities

### *The International Tribunals for the Former Yugoslavia, Rwanda, and Sierra Leone*

During the same decade that brought ITLOS into being, the United Nations supported the creation of a series of specialized criminal courts to deal with ethnic and national conflicts that resulted in tragedies of horrific proportions. Illustrative—but sadly not exhaustive of the set[422]—are four tribunals. Three were created by the U.N. Security Council to be time-limited and focused by geography (with jurisdiction over events in the former Yugoslavia, Rwanda, and Sierra Leone). One—the International Criminal Court (ICC)—is to be a permanent institution in which states join to authorize global jurisdiction over crimes against humanity. Just as ITLOS reveals aspects of both the triumph and

diffusion of adjudication, these specialized transnational criminal courts need to be brought into view to reveal another facet of courts—the degree to which they remain deeply enmeshed in the enterprise of discipline and control.

Like the international courts discussed thus far, the late twentieth-century specialized criminal courts are also the outgrowths of earlier efforts, in this context not to avoid armed conflict but rather to prohibit certain forms of behavior even when countries are at war. *The Law of War and Peace* (*De Jure Belli ac Pacis*), a 1625 volume by the Dutch lawyer Hugo Grotius (whose bust is displayed in the Peace Palace) made the link between state sovereignty and legality—two factors used to justify war as a right of states.[423] As the Slave Trade Tribunals detailed in Chapter 11 suggested, seventeenth-century practices also shaped precepts that came to be called the "law of nations," protecting free passage on the seas by imposing prohibitions on piracy and eventually on slavery. "Modern" military codes are often dated in reference to Francis Lieber, an American who wrote a set of rules for war in 1863.[424] The next year brought another benchmark, the Geneva Convention of 1864, focused on protecting victims and wounded soldiers.[425]

Atrocities of the early part of the twentieth century produced the concept of "crimes against humanity," used as a basis for proposals for prosecuting Turks for the Armenian massacres of 1915.[426] In 1920 when, as discussed earlier, the League of Nations convened an advisory body of jurists to craft a statute for what became the Permanent Court of International Justice, that group also recommended the creation of a High Court of International Justice "competent to try crimes constituting a breach of international public order or against the universal law of nations."[427] Discussions and drafts followed during the 1920s, along with some support from various institutions, such as the Inter-

national Law Association.[428] In 1937, the League of Nations adopted a Convention for the Creation of an International Criminal Court,[429] but an insufficient number of states were willing to ratify it, and it never came into force.[430]

In 1944 a Polish prosecutor, Raphael Lemkin, invoked the term "genocide" to describe "the destruction of a nation or of an ethnic group,"[431] and a *Draft Convention for the Establishment of a United Nations War Crimes Court*[432]—based in some measure on the 1937 League of Nations draft—was put into circulation.[433] Rather than a comprehensive court, however, at the end of World War II two specialized courts were set up that, as commentators have noted, were institutions created by victorious nations to prosecute those they had defeated.[434]

In 1945, Britain, France, the United States, and Russia authorized an International Military Tribunal that presided over the Nuremberg Trials, held in that German city.[435] Prosecutors there charged four crimes—"conspiracy to commit crimes against peace; planning, initiating and waging wars of aggression; war crimes; and crimes against humanity."[436] On the Pacific front, the International Military Tribunal for the Far East (the Tokyo Tribunal) operated under a charter promulgated by United States General Douglas MacArthur as an agent of the Allied Forces.[437] The eleven judges of that court came from Australia, Canada, China, France, India, the Netherlands, New Zealand, the Philippines, the USSR, the United Kingdom, and the United States.[438] Prosecutions there included crimes against peace, war crimes, and crimes against humanity.[439]

The post–World War II era saw development of substantive international law, some focused specifically on crimes against humanity. In 1947 the U.N. General Assembly created an International Law Commission (ILC) consisting of thirty-four learned persons serving five-year terms to develop and codify legal precepts.[440] In 1948, over the course of two days, the U.N. General Assembly adopted the Convention on the Prevention and Punishment of the Crime of Genocide (Genocide Convention)[441] and the Universal Declaration of Human Rights (UDHR).[442] Although an early draft of the Genocide Convention had proposed a criminal court; as enacted the Genocide Convention called for prosecution at either the national or international level, before "a competent tribunal of the State in the territory of which the act was committed, or by such international penal tribunal as may have jurisdiction with respect to those Contracting Parties which shall have accepted its jurisdiction."[443] The following year, four Geneva Conventions developed more parameters for war to make plain that certain "grave breaches" of conduct were subject to prosecution.[444]

Efforts in the 1950s and thereafter to shape an international criminal court met with the complexities of negotiating the Cold War.[445] A similar response greeted efforts to create "world habeas corpus" to enable individuals to seek redress from unlawful confinement.[446] After the fall of the Berlin Wall, renewed interest in determining how to deal with massive injustices prompted intense debates about how law could be in any way responsive to the horrors that had been inflicted or plausibly fair to those accused.[447] Some debates focused on criminal justice models that would document atrocities, identify culpable actors, and impose punishments. Others favored "truth commissions" that could provide a record and accountability through an array of narratives but that might seek "reconciliation" rather than punishment and vengeance. South Africa famously relied on "truth and reconciliation," while critics worried about an exchange of "amnesty for peace."[448] In the 1990s, sufficient support existed for using international criminal law, such that the United Nations authorized the three geographically focused institutions detailed below (we do not address the special court in Cambodia) and, eventually, helped to shape one permanent court.

One other prefatory note about the criminal courts is in order. Each of these new institutions comes with an extrajudicial staff of investigators and prosecutors specially designated to bring cases. Each must also have arrangements for detaining defendants awaiting trial, as well as places for imprisonment of those convicted. Although international civil courts have some mechanisms to help states needing funds to pursue their claims, to date these institutions have not encompassed ancillary bodies, such as free legal and investigative staffs to support litigants. In contrast, the design of international criminal courts include infrastructure systems that propel their work.[449]

The International Criminal Tribunal for the former Yugoslavia (ICTY), chartered in 1993, was the first criminal tribunal spawned as a "subsidiary body" of the United Nations.[450] Located in The Hague not far from the Peace Palace, its surroundings are much more austere. The ICTY works in a recycled building that had been the "headquarters of an insurance concern."[451] Built in the 1950s, the ironwork of its spiral staircase lends an art deco flavor to the interior of the otherwise "anonymous three-story, rough white-brick building."[452] While the ICJ and ITLOS rely on disputants to seek them out, their criminal court counterparts have their own prosecutorial and investigatory branches, charged in the case of the ICTY to initiate proceedings against persons "responsible for serious violations of international humanitarian law" committed after 1991 in the territories of the former Yugoslavia.[453] The ICTY—joined by domestic courts and now by other transnational criminal courts—must determine which acts are so horrific as to warrant transnational prosecutions that cross the boundaries of nation-states.

As with the other specialized U.N. tribunals, the ICTY draws judges from different countries, and it also looks to a range of legal traditions for legal rules.[454] Diversity is required by the ICTY statute, which specifies that the sixteen permanent judges must all be of different nationalities.[455] Staffed by 174 personnel representing twenty-seven

nationalities in June 1995 (two years after its inception),[456] by 2008 the ICTY had expanded to a staff of more than 1,100 from some eighty nations.[457] The ICTY is organized in a pattern common to international courts—in this case, with four sets of chambers, three devoted to trials and the fourth to appeals. The appeals chamber, which also has authority over appeals from Rwanda, consists of seven permanent judges, including two from the International Criminal Tribunal for Rwanda, discussed later.[458]

As is familiar from other international courts, start-up takes time. The gathering and assessing of information before indicting individuals meant that during its first six years of operation the ICTY tried only six offenders.[459] But since then, the building's three courtrooms have been regular venues for trials. The courtrooms are also familiar in some respects. The bench for judges dominates the center, lawyers' tables are arrayed before them, and translator booths (a common feature of transnational courts) line one wall. What is unusual is that the area for observers is separated from the rest of the room by a floor-to-ceiling bullet-proof glass pane, which can be shuttered closed when witnesses need to be protected or their information kept confidential.[460] Further, defendants are surrounded by a cadre of blue-shirted guards who change shifts at short intervals during the proceedings.

Members of the public can observe the proceedings and listen through headphones offering French, English, and Bosnian/Croatian/Serbian. Witnesses' voices are scrambled when their identities need to be protected for their safety.[461] Throughout the former Yugoslavia, one can watch proceedings from closed-circuit television via web links in French, English, and Bosnian/Croatian/Serbian.[462] The high profiles of some defendants have brought a great deal of attention to the proceedings. In 2002, Slobodan Milošević, who had been both the former president and commander of the army of the Federal Republic of Yugoslavia, went on trial. He faced charges of genocide for "ethnic cleansing" in Kosovo, as well as for other crimes in Croatia, and Bosnia and Herzegovina.[463] Milošević died of a heart attack on March 11, 2006, four years into his trial,[464] and the proceedings were terminated three days later.[465]

The task for the ICTY (and the other international criminal courts) is to delineate boundaries of unlawful behavior during war and other forms of conflict; to police the prohibitions on torture and inhumane treatment, targeted attacks against civilians, and to define a small subset of acts as "crimes against humanity." When creating the ICTY, the United Nations specified its jurisdiction to reach "grave breaches" of the 1949 Geneva Conventions (including torture, inhuman treatment, and extensive destruction of property[466]), violations of the laws of war, genocide, and crimes against humanity.[467] The definitions of what constitutes such acts are not static. For example, it was the ICTY that first recognized that deployment of mass rapes and sexualized violence constituted crimes against humanity.[468]

The United Nations made the ICTY—and then the other courts that followed it—optional in the sense that its jurisdiction is concurrent with, though primary to, that of national courts.[469] But it is not the parties who control access. Rather, ICTY prosecutors determine whether to proceed or defer to nationally based remedies.[470] Echoing the pattern established by the Mixed Courts of Egypt (fig. 11/155), the rules for pre-trial and trial proceedings reflect a mix of national legal traditions in which the civil and common law systems of Europe dominate.

In our discussion of the ICJ and ITLOS, we considered—as have others—the size of their caseloads. Some level complaints against the ICTY as too expensive,[471] even though its volume looks relatively large when compared to that of ITLOS, whose lifespan coincides with that of the ICTY. From the founding in 1993 through 2008, the ICTY had concluded proceedings against 116 of a total of 161 individuals.[472] Trials or appeals were underway for about forty-five more, with two fugitives at large.[473] Another assessment points to the "thousands of pre-trial, trial, and post-trial decisions" that have developed a significant jurisprudence on international criminal law, including distinguishing levels of culpability and the requisite proofs.[474] Yet others note the general creation of a body of lawyers and judges committed to operationalizing international precepts "to make some coherent legal sense of the worst humanitarian disasters and help create incentives to prevent them."[475]

The ICTY—like other criminal courts focused on specific conflicts—is designed to close. Its target is to complete all proceedings, including appeals, by the end of 2013.[476] To facilitate that "completion strategy," at the end of 2008 the U.N. Security Council unanimously extended the terms of several judges.[477] The United Nations has supported the costs of the court, estimated to be more than $1.6 billion during its first fifteen years of operation,[478] with a biannual budget of some $300 million.[479] Another way to look at the numbers is to add the funds supporting the ICTY to those for the Rwanda tribunal (detailed later). Together the two comprise some $550 million annually, or "one-seventh of the regular UN budgets for a comparable period."[480] Thus, while some complain that the ICTY has done too little ("relatively few trials despite substantial annual budgets"[481]), others have countered that to create a court with a new agenda and to charge it with transnational cases involving victims, defendants, and lawyers from around the world made the initially high costs understandable.[482]

A substantial literature questions the enterprise more broadly, asking whether prosecution is wise given the need to reconstitute polities.[483] Some commend "truth and reconciliation" commissions, with South Africa as the model.[484] Others have praised the ICTY for putting its proceedings before a remarkably wide audience. One commentator, Samual Totten, reported: "Viewing the trial of Slobodan Milošević . . . [enabled] me to observe the procedural oper-

ations of a remarkable judicial process . . . that can serve as a major brake on those who might consider genocide in the future because they will know full well that . . . [they] are no longer likely to walk away . . . with impunity."[485]

But ethnic cleansing did not stop in 1993, when the ICTY was charted, nor has it been limited to the former Yugoslavia. The optimism of the observer of the Milošević trial—that prosecution would be a "major brake" on genocide —has not come to fruition. Crimes against humanity are unabated, and violations have brought forth other specially chartered courts. In 1994, about a year after establishing the ICTY, the U.N. Security Council created the International Criminal Tribunal for Rwanda (ICTR).[486] It is the first U.N. court to sit in Africa—specifically in Arusha, Tanzania.[487] Like the ICTY, the court is to be limited by time and place. Like the ICTY, the court is physically distant from the conflict that brought it into being.[488] And like the ICTY, the ICTR uses facilities built for others—in its case, the Arusha International Conference Centre.[489]

The ICTR's charter also parallels that of the ICTY: to adjudicate cases involving "persons responsible for serious violations of international humanitarian law committed in the territory of Rwanda and Rwandan citizens responsible for such violations committed in the territory of neighbouring States, between 1 January 1994 and 31 December 1994."[490] The structure of the two tribunals is similar, with chambers for trials and appeals,[491] a prosecutor,[492] and a registry.[493] The court also works in three languages, in this instance French, English, and Swahili. The ICTR has sixteen permanent and nine ad litem judges, with two appellate judges based at The Hague.[494] The initial group came from around the world.[495] And, like the ICTY, the ICTR struggled to secure the cooperation of officials in the country where the atrocities had taken place.[496]

During the ICTR's first fourteen years, its administrative and attorney staff grew to number almost 900.[497] To support their work, the budget of the ICTR paralleled the upward slope and size of the ICTY's budget.[498] The ICTR's budget in 2008–2009 was almost $270 million.[499] The docket, though, has been smaller. The court reported that it had secured the arrest of more than seventy people and "laid down legal principles" that have provided precedents for other tribunals.[500] As of November 2008, the ICTR had nine cases awaiting trial; twenty-nine pending, including on appeal; and thirty-four completed, with five detainees acquitted.[501] Some of the judgments have come through guilty pleas rather than trials.[502] The ICTR was initially projected to work for about ten years. In 2009, the U.N. Security Council expressed its intent to extend the tenure of some of the Rwanda judges' tenures (as it had for ICTY judges) in this instance to December 2012.[503]

Our next example, the Special Court for Sierra Leone (SCSL), varies on three dimensions. First, it is both a national and an international court: national judges sit alongside international ones and deliberate on cases arising under both kinds of law.[504] Second (and relatedly), the SCSL has come to operate in two locations. The primary base was, as of 2010, in Freetown, Sierra Leone,[505] but one of its cases, the prosecution of former Liberian president Charles Taylor, is underway at The Hague.[506] Third, the ICTY and the ICTR are financed by dues of U.N. Member States. The SCSL is funded by volunteers, including some thirty countries and three foundations.[507]

In 2002 the SCSL was chartered jointly by the Government of Sierra Leone and the United Nations.[508] Its docket is to deal with "persons who bear the greatest responsibility for serious violations of international humanitarian law and Sierra Leonean law committed in the territory of Sierra Leone" since November of 1996,[509] "including those leaders who, in committing such crimes, have threatened the establishment of and implementation of the peace process in Sierra Leone."[510] Once again, the court relies on trial chambers and an appeals chamber, as well as a registry and prosecutor. The international-national structure is played out in the selection of judges. Three judges sit on each of the two trial chambers; the U.N. Secretary-General appoints two, and the Sierra Leonean government selects a third.[511] The five jurists sitting on appeal are likewise appointed— three by the Secretary-General and two by Sierra Leone.[512]

Within a year of the court's existence, the prosecutor brought charges against thirteen individuals,[513] and those cases were organized into four trials based on the offenses involved.[514] By the end of 2008, the SCSL had completed proceedings against eight out of a total of thirteen indictees.[515] The court has done this work with a smaller budget and staff than those of either the ICTY or the ICTR. Over four hundred staff posts are supported for the year ending in 2008 with funds of about $36 million.[516]

### Designing for a Future of Crimes: The International Criminal Court

In introducing the specialized criminal courts of the 1990s, we sketched a history that should also serve as the preface to the 1998 Rome Statute of the International Criminal Court, described by one commentator as the culmination of a "fifty-year struggle to establish a permanent body capable of prosecuting international crimes."[517] As we noted, in 1947 the General Assembly created the International Law Commission to make recommendations for developing and codifying international law.[518] In the early 1950s, the ILC submitted a draft code of offenses against mankind and accompanied it with a proposal for an international criminal court.[519] But little progress toward enactment of a code or a court occurred until the 1970s, when discussion resumed, in part through the efforts of non-governmental organizations such as Amnesty International and Human Rights Watch. In 1981, at the direction of the General Assembly, the ILC returned to the drafting of a criminal code.[520]

By 1993, the ILC forwarded a proposal for a permanent international criminal court. The recommendation was recommitted for further study[521] so as to be considered at a conference to be held in Rome in 1998. Many commentators note the interaction between the creation of the ICTY and the ICTR and the development of a political context able to establish an international criminal court and, perhaps, rendering it somewhat anticlimactic. Yet those tribunals could—from the perspective of states not directly involved in either conflict—appear relatively safe, in that their own nationals would not be implicated as they might were a court to have a less bounded mandate. In contrast, a permanent standing court could subject any national to the possibility of prosecution. Yet to "the surprise of many participants and observers,"[522] the negotiations with more than 150 states represented reached an agreement (the Rome Statute) that creates a world court for "the most serious crimes of concern to the international community as a whole."[523] Opened for signatures on July 17, 1998, the requisite sixty signatures were obtained by 2002 to establish the court. Before turning to its operations and its quarters, several features of the court and its jurisdiction bear mention.

First, the International Criminal Court (ICC) is a "treaty court," akin to ITLOS and functioning as a body independent of the United Nations, with which it has an agreement formalizing a relationship.[524] Second, unlike the PCIJ, the ICJ, and ITLOS, the ICC has distinct kinds of authority not derived from participants' consent. A degree of compulsion has been accorded the ICC for it has jurisdiction over a defendant if (a) that person is a resident in a territorial state that has become a member; (b) the person is a national of a State Party; (c) the conduct occurred in the territory of a State Party (or on board a vessel or aircraft); or (d) that state has agreed on an ad hoc basis to jurisdiction.[525] As critics have pointed out, these provisions could also be seen as "loopholes" in that "traveling tyrants" can avoid prosecution if they stay at home in a country that has not ratified the ICC. Another caveat to the ICC's jurisdiction is a principle known as "complementarity," which cedes the ICC's jurisdiction to national criminal justice systems if they are able and willing to prosecute.[526] Thus, the ICC is to defer when possible.

The question of the scope of authority bears further discussion. The prefatory comment that is in order is that the ICC was to have no jurisdiction to prosecute crimes committed before its enabling statute entered into force, which occurred in July of 2002.[527] While the ICC lacks the retroactive authority of the ICTY and the ICTR, the ICC has broader jurisdiction over four categories of crimes—genocide, crimes against humanity, war crimes, and aggression.[528] For example, rather than requiring as a predicate that all crimes take place during war, the linkage is somewhat broader. Further, "crimes against humanity" are defined as acts that are part of "a widespread or systematic attack directed against any civilian population, with knowledge of the attack."[529] Eleven acts are listed as falling within the frame of crimes against humanity; included are murder, extermination, enslavement, deportation, imprisonment, torture, rape, persecutions on political, racial, and religious grounds, apartheid, and enforced disappearances.[530] These details circumscribe the authority of the ICC to some extent.

The Rome Statute is also noteworthy for making gender plainly relevant, in that sexualized violence is understood to fall within the set of both war crimes and crimes against humanity.[531] Rules of evidence also take the genders and ages of victims into account.[532] Further, women do not appear only as victims. Rather, the Rome Statute is the first international treaty of this kind to put "principles of female participation" explicitly into the governance structure.[533] The statute calls on countries, when nominating judges and prosecutors, to seek a "fair representation" of both women and men knowledgeable in international criminal law, including violence against women and children.[534] Geographical distribution is also called for, as well as knowledge of different legal systems.[535]

Problems of definitions of crimes haunt all statutory prohibitions,[536] but one of the ICC's crimes remains without detail. As Benjamin Schiff explained, the "overwhelming sentiment at the Rome Conference [was] to include aggression in the Statute, but there was also adamant opposition to it, particularly from the United States and other Security Council permanent members."[537] The compromise was to include aggression but not permit the ICC to exercise jurisdiction over such a crime until at least seven years after the ICC existed and then upon a two-thirds vote of the Assembly of States Parties agreeing on the definition and conditions for its use.[538]

The question of the power of initiation, and hence the role of the prosecutor, is at the heart of international criminal courts. Debated was whether the prosecutor had to await references or would be free to pursue crimes independently; at issue in part was whether to rely on or to meld continental or common law traditions. The denouement, over objections from the United States,[539] was to authorize the prosecutor to investigate preliminarily and, upon finding a reasonable basis to proceed, to obtain authorization from a group of ICC judges called the "Pre-Trial Chambers" to investigate further.[540] Some tensions can thus exist between the "OTP"—Office of the Prosecutor—and the "PTC"—the Pre-Trial Chambers. Further, the Registry retained significant control over personnel hiring, budgets, and translation capacity.[541] In addition, a State Party or the U.N. Security Council can refer alleged crimes falling under the jurisdiction of the ICC to be investigated.[542] But the Security Council can also put a stop to ICC investigations and trials. Under Article 16 of the Statute, the Security Council, with a resolution adopted under Chapter VII of the U.N. Charter, can suspend ongoing investigations or

prosecutions for twelve months if the court's involvement is believed to threaten efforts to create peace.[543]

The reach of the ICC—and specifically its authority to prosecute crimes while conflicts are underway—complicates its work. Like all courts, the ICC needs cooperation from witnesses to prosecute. Unlike domestic courts that are arms of the state, keeping its "peace and security," the ICC needs to have States Parties cooperate with it. When the leaders of a nation-state may themselves be implicated in investigations or hope to maintain neutrality among insurgent groups, working with the ICC could be difficult.[544] In addition to challenges of initiation, the ICC can face interruption or abortion of prosecutions underway if, for example, domestic movements press for alternative responses, such as truth and reconciliation commissions.

The ICC treaty crafted remedies in addition to imprisonment; the Rome Statute created a Trust Fund for Victims and gave victims (including institutions dedicated to religion, education, charity, and humanitarian purposes) standing.[545] As in some domestic criminal justice systems, the ICC's provisions can order forfeiture of property to be used for victims and (more expansively) for their families. The ICC can acquire such funds not only from perpetrators but also from unspecified other sources. Unlike the detail provided for the ICC's criminal prosecution and judicial functions, the content of the remedial system was left to future elaboration by the States Parties.[546]

### OPERATIONALIZING A CRIMINAL COURT SYSTEM

For the Rome Treaty to become effective ("enter into force"), sixty states had to ratify it. That number was reached in April of 2002.[547] As it had in the 1920s when asked to join the PCIJ, the United States, which had been instrumental in the negotiations leading up to the ICC, stood outside the body. President William Clinton signed,[548] but then his successor, President George W. Bush "unsigned"[549] as the United States began its campaign against the ICC by seeking to persuade other countries to decline to participate. In addition, the United States government interpreted a provision of the ICC statute, Article 98, providing that countries need not surrender individuals to the court if to do so would be inconsistent with other international obligations, as permitting bilateral agreements not to transfer United States citizens to the ICC.[550] The United States then persuaded—in part through the threat of loss of economic or military aid—some one hundred states to sign these agreements.[551] On the domestic front, the United States enacted laws to prevent funding efforts to assist the ICC, to prevent ready transfer of information, and to permit the United States President to use appropriate means to free American soldiers if they were arrested by the ICC.[552]

Nonetheless, the ICC has been up and running since 2003, housed temporarily in a fifteen-story office building (fig. 179) in The Hague, which "was the only State to offer its services."[553] The Netherlands gave the ICC the use, for ten years,[554] of a former building of a Dutch telecom company that, like the ICTY, is not secluded from the neighborhood in which it is sited. The ICC also rents cell space from the Dutch government for a jail. As figure 180 details, the interior has been reconfigured to create a courtroom of about 65 square meters (688 square feet).[555] The various cameras denote the ability to broadcast proceedings; the high walls indicate that spectators do not share space with the participants but, along with the press, can sit in a glass-enclosed arena above.

To do its work, the ICC has four offices—the Presidency, the Divisions (a term chosen in lieu of "chambers" but one that is sometimes used interchangeably with it[556]), the Office of the Prosecutor, and the Registry.[557] Its governing body is the Assembly of States Parties (ASP), which consists of one representative from each state that has ratified the Rome Statute.[558] Like ITLOS, the ICC gains its judges through elections by its States Parties. Like the ad hoc tribunals, the ICC is constituted by separate groups of judges denoted by the stage of proceedings—to wit, Pre-Trial, Trial, and Appeals Divisions—and the presidents of the three together are "the presidency" of the ICC.[559]

Nationality and power remain relevant for judgeships and for the prosecutor. As in the other U.N. courts, no two judges can come from the same country, and all must be of "high moral character," qualified domestically for high office, diverse in terms of geography and gender, and knowledgeable in either criminal law or international humanitarian law.[560] Voting rules operationalize the requirements through separating candidates by lists. For example, to achieve "a fair representation of female and male judges," each State Party "shall vote for a minimum number of candidates of each gender," resulting in a bench that, as of the end of 2009, included women and men in close to equal numbers.[561]

On the various international courts, an insistence on regional, national, legal, and gender diversity could be understood in different ways. One might take a requirement of judges from various sectors to be a recognition of difference—that universalism has limits and that judges are situated, with points of view that alter judgments. Thus, one could aspire to "culturally diverse deliberations," an idea to which we return in Chapter 15. Alternatively, one might think that universalism runs deep; that jurists identified by region, gender, legal systems, and expertise are united by shared legal precepts;[562] and that their diversity enhances legitimacy (as well as national and regional support) but does not result in substantively different reasoning, processes, or results.[563]

Judges need to work in the languages of the ICC, English and French, but additional official languages include Arabic, Chinese, Russian, and Spanish.[564] Judges are to hold their positions full-time and to be paid (when the court is

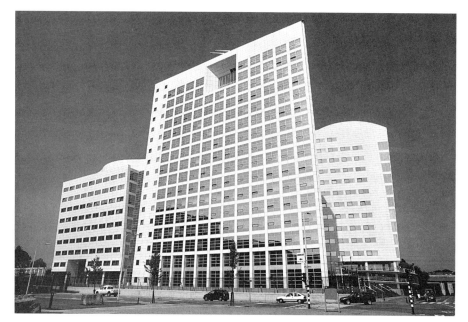

FIGURE 179 International Criminal Court, interim premises, The Hague, the Netherlands, circa 2006 (using the former offices of the Dutch telecom company KPN).

Photograph copyright: ICC-CPI / Wim Van Cappellen. Photograph reproduced with the permission of the International Criminal Court.

FIGURE 180 Courtroom, International Criminal Court, The Hague, the Netherlands, circa 2006.

Photograph copyright: ICC-CPI / Wim Van Cappellen. Photograph reproduced with the permission of the International Criminal Court.

fully operational) around $240,000 (180,000 euros).[565] To get the right mix of jurists requires a complex voting system with lists,[566] and to select the first set of eighteen judges for the ICC, the ASP went through more than two dozen ballots before settling on a full slate of judges.[567] Terms are to be nine years, nonrenewable, but were staggered somewhat and, in addition, the presidency has the authority to increase the number of judges.[568]

The ASP also has the power to select the chief prosecutor, who serves a nine-year nonrenewable term.[569] Concerns about the overbearing role of the Security Council and the prevalence of prosecutors from the Anglo-American heritage at the ICTY and the ICTR prompted interest in looking broadly for a person who would be expert in crim-

inal international law, an able spokesperson and manager and, if possible, a person who would not elicit the ire of the government of the United States.[570] In the spring of 2003, Luis Moreno Ocampo of Argentina, who had been involved in the prosecutions there of crimes of the former military junta, was elected to serve as the first Chief Prosecutor of the ICC. He did not want for work, for as soon as the ICC began to function, complaints of alleged crimes—many not within its jurisdiction—were presented. Within the first year, the prosecutor reported more than 450 communications.[571] The court lacked authority to investigate, for example, alleged crimes by the United States in Iraq because neither the United States nor Iraq was a party to the Rome Statute. The first investigation, begun in July 2003, focused

on reports of crimes taking place in Ituri, Democratic Republic of the Congo.[572] The Congo is a party to the statute and referred the issue to the ICC. Two other states, Uganda and the Central African Republic, also sent references of events in their territories to the ICC, and the U.N. Security Council referred a conflict in Darfur while excluding crimes committed elsewhere in the territory of the Sudan.

"Situations" is the term of art that developed for such inquiries, aimed at not prejudging the outcomes. In July 2005, the ICC issued its first arrest warrants with regard to the situation in Uganda.[573] As of 2008, cases were moving toward the trial stage and hence requiring elaboration of the legal rules and judicial roles in the new court.[574] By then, 108 states had ratified the Rome Statute, and an additional forty states had signed but not ratified.[575] Aside from the judicial chambers, more than 550 women and men from eighty states[576] staffed the ICC. While in 2002–2003, the ASP had pegged the initial budget at some thirty million euros ($40 million), by 2007 the ASP had authorized eighty-nine million euros ($120 million) for support.[577]

The institutional authority that the ICC hopes to create is complicated by its dependence on the prosecution, whose jurisdiction, in turn, has mixed political and practical limitations. It can pursue specified crimes committed in states that are parties or by their nationals, but its principle of complementarity means that it will not do so if the crime is pursued in the courts of a State Party having jurisdiction. Whether a State Party is pursuing a prosecution in good faith or is just going through the motions can be a ticklish problem. The need to answer this kind of question could be understood as putting the ICC in a quasi-supervisory position vis-à-vis a State Party and its courts, with all the potential for generativity or conflict that such a relationship implies. (Putting the point in a favorable light, some refer to this facet as "positive complementarity" to embody the potential that the ICC will serve as a catalyst for domestic prosecutions.) One could measure the ICC's success, for example, through its ability to prompt domestic prosecutions rather than move cases rapidly into its own court.

Moreover, although ICC is independent of the United Nations, the looming presence of the U.N. Security Council, which has the power to suspend investigations and trials, is a factor that induces a cautionary approach to prosecution. On the other hand, unlike some of the other international courts discussed, the ICC is distinct from an arbitration body in its exercise of coercive power, with its authority supported by the Security Council. But that independence from the United Nations extends to funding in some respects. The ICC relies on assessments of States Parties based on the scale in use by the United Nations, as well as on voluntary contributions from organizations (the United Nations included) and from private individuals and corporations.[578]

In other words, the ICC needs to raise money as well as legitimacy for its existence as a judicial body. Conscious of its many audiences, ranging from states to the NGOs that were instrumental in bringing it into being, as well as the hostility of the United States and the complexity and tensions of its own multi-part structure, the ICC has developed its own strategic plan.[579] Its goals are familiar within the lexicon of courts, albeit also showing how dependent the ICC judges are on the ICC prosecutor. The aims are to undertake investigations, prosecutions, and trials "fairly, effectively, and impartially"; to act "transparently and efficiently" to contribute to the enforcement of international criminal justice; and to remain attentive to the "rights of participants." As an early twenty-first-century court, the ICC also demonstrates its need for popular support through gaining attention; its officialdom hopes it will be seen as a "model of public administration," providing an accountable yet non-bureaucratic working culture.[580]

## Occupying Permanent Quarters Rather Than Riding Circuit

Article 3 of the Rome Statute provides that the ICC has its "seat" at The Hague, but can, "whenever it considers it desirable," sit elsewhere.[581] Thus the Netherlands could serve a limited purpose as headquarters for a court that nimbly decamps to various parts of the world, riding circuit to at least the region if not the state in which various events took place. One can make an argument for this approach on symbolic grounds, that to do so would diminish the sense of international criminal law as Euro-centric. Further, on practical grounds, it could be sensible for judges to travel to witnesses and victims rather than the other way around.

While the possibility of holding hearings and trials at diverse sites remains an option, the decision was made for a permanent and impressive site. In 2003 the ICC briefly established its own "Inter-Organ Committee on the Permanent Premises,"[582] which in 2005 reported—in conjunction with the Netherlands—that the ICC should be "housed with the *best possible working conditions* over an extended period of time."[583] Hence the options of staying in its borrowed office building (which had come to be nicknamed "the Arc") or of using the premises of the ICTY were rejected.[584] Further, new purpose-built permanent premises would "fully reflect the unique character and identity of the International Criminal Court and symbolize in a dignified way the eminence and authority of the Court for the international community as a whole."[585] Because the ICC was to be a "prestigious institution on the world stage," it needed a building to enable it to serve as an "enduring symbol of international criminal justice. . . . [P]ermanent premises will . . . become the public face of the institution—an emblem of fairness and dignity and a symbol of justice and hope."[586]

The ICC's building group detailed the need for a facility to house staff ranging from 950 to 1,300 people and the desirability of housing various organs of the ICC at a single

site proxmate to the Scheveningen Prison—some 900 meters (2,900 feet) away—for detaining individuals. Moreover, the premises needed to be "completely secure but at the same time remain open and welcoming."[587] The point was to be "perceived as secure (but not as a fortress), people-friendly, comfortable and accessible to all."[588] In 2007, the plan was confirmed through a call for architects to design a space of no more than 46,000 square meters "with 1,200 workstations";[589] the projected budget in 2007 euros was just over 100 million for materials, labor, and construction, including "specialized representational features," such as "large sculptures, mosaics, or other large pieces integrated into the architecture."[590]

## "One site forever": A Timeless Image and Four Security Zones

Like the drafters of design guides in the United States, the briefs in France, and the competition program for the Peace Palace, the ICC building group specified its objectives for a building that was adaptable, with a "high-quality design" that was low in maintenance costs and "environmentally friendly."[591] The premises—"one site forever"[592]—were to be "unobtrusive and on a human scale, while at the same time symbolizing the eminence and authority of the Court" through a facade that "serve[d] as a timeless image symbolizing its principal mission" of bringing perpetrators to justice.[593] The design was to provide a "well-balanced representation of the entire international community"—"a place at the heart of that community."[594]

To accomplish these goals, the new building's entrance needed to be "open and spacious" so as to make visitors "feel welcome, despite the security checks," and public galleries were to be "comfortable and spacious," with room for the press, observers from either governments or NGOs, and others. Moreover, the press was to be given special accommodations as a "prime witness for the wider world." Students and scholars were also to be welcome so as to establish "an intellectual link between the Court and the outside world."[595]

Further, the building was to provide clear distinctions between and separations of the chambers of the ICC and the Office of the Prosecutor ("clearly and visibly separated from each other"[596]) and to offer dedicated spaces for defense counsel, victims, and witnesses, again to be separated from the court and its prosecutor.[597] The need for "distinct identities" for the various divisions suggested a "campus-like arrangement."[598] The presumption was that when operating at full capacity, the ICC would handle six hearings a day, and hence should be built to accommodate space for those activities. Dedicated rooms needed to be provided for judges, staff, the press and conferences, prosecutor, registry, a secretariat for the ASP, and holding cells for detainees. The protocol called for two "normal" courtrooms and one larger one, and areas allocated for more if needed. Thus, about 3,350 square meters or about 36,000

square feet would be required for both the courtrooms and its "supporting functions."[599] In lieu of the "trois flux" or three zones of courthouses in France and in the United States, courthouses, four were needed: a "public zone" to which general screening would apply, a "semi-public zone" that required identification and encompassed "public galleries of the courtrooms" and conference areas, a "restricted zone" for staff, and a "high security zone"—including the courtrooms themselves as well as holding areas—for specially authorized persons.[600] All of the various needs resulted in a building projected to measure about 44,820 square meters (480,000 square feet).[601]

These requirements were, of course, costly—prompting exploration of tradeoffs between moving or remodeling. The ICC building group did comparative calculations of the yearly costs for the use of its current space, occupation of the ICTY building, and construction of a new one and then concluded that new construction would be more expensive but only marginally so, given the limitations of the other sites.[602] The ASP agreed to support a new permanent and purpose-built structure, were funds and land to become available.[603]

As it had a century earlier (we have come full circle, albeit for war atrocities rather than for peaceful resolutions), the Dutch government again proved to be a welcoming host, offering some 72,000 square meters (17.7 acres) of land on the site of the Alexanderkazerne in The Hague.[604] After many exchanges, funding for the competition and loans for construction came from the Dutch government.[605] In the tradition of the ICJ, a competition was launched in 2008, with cash prizes proffered on a sliding scale.[606] Organized by the Chief Architect of the Netherlands, an international jury was convened that culled twenty submissions from a group of 171.

As the glossy brochure on the competition reported, those selected came from "five different continents and twelve different countries."[607] The third prize went to Weil Arets Architects & Associates of the Netherlands for a building that was evocative of a series of angled pyramids (the architects termed them "four vertically extruded, lit cones").[608] The second prize went to Schmidt Hammer Lassen / Bosch & Fjord of Denmark, which had proposed several boxed towers (a "sculptural composition of square towers"[609]) in the International style. The first prize went to Ingenhoven Architects of Düsseldorf, Germany, for a grouping of buildings, circular and square, embraced by latticework that linked them[610] in a fashion akin to the golden mesh ring provided by Dominique Perrault for the ECJ. As the architects explained, they had separated the ICC organs in discrete structures inside an "open house" that was "light, careful, elegant and at the same time transparent." Further, it was "detached from any specific cultural context" and not too "defensive" and hence expressive of the "fairness" of a court of law.[611] The jury returned its verdict with an odd description given the context—that the winner had provided a "happy building."[612]

In 2010, the ICC chose instead the second-prize winner —Schmidt Hammer Lassen. That design is described as providing "a safe place that captures the ICC's core values of justice, independence, universality, diversity, and transparency" while also "melting into the natural environment" and, thereby, transmitting "the feeling of harmony and peace."[613] Further, rather than be "anonymous," the building had the "courage to express the values and the credibility of the ICC."[614] When making the announcement, the Registrar reported that the ICC hoped that by 2015 it would be in its own building. The effort to obtain a "site forever" sadly symbolized the presumption of human atrocity ad infinitum.

## THE LOGOS OF JUSTICE:
### BUDGETS, CASELOADS, SCALES, AND BUILDINGS

One measure of the investments in worldwide support for transnational courts can be seen from a snapshot of budgets in 2006 that compiles information from the three regional courts discussed in Chapter 11 and the six international courts addressed here.[615] Figure 181, *Regional and International Courts: Budgets in 2006,* captures the spread, with the European Court of Justice supported by more than $300 million,[616] as contrasted with the budget of the European Court of Human Rights that was less than a sixth of that amount.[617] Far below both were the funds of the Inter-American Court of Human Rights and the Inter-American Commission on Human Rights that, together, worked with just over $5 million.[618]

Looking across the international courts, the oldest court in this group, the ICJ, had a budget of some $18 million in 2006.[619] The two treaty bodies—the ICC and ITLOS—had vastly different economic bases that echoed their differential volumes and that criminal court budgets include prosecutorial offices with investigative staff. The ICC was allotted just over $100 million in 2006,[620] and ITLOS's budget was around $10 million.[621] Turning to the criminal courts under the United Nations' umbrella, the ICTY and the ICTR had somewhat similar funding. The ICTY received over $150 million[622] and the ICTR about $135 million.[623] The hybrid court, the SCSL, was funded at $25 million, coming from voluntary contributions.[624] These figures reflect that the SCSL and the ICC had just begun their work in the first years of the twenty-first century.

Caseloads offer another measure of investment. We provide one snapshot in figure 182, *Regional and International Courts: Pending Caseloads in 2006,* to compare dockets for just one year.[625] (Of course, snapshots are just that. For example, while the PCA had nineteen pending cases in 2006, it had about forty-eight in 2009.[626]) In 2006, the two caseload peaks come from Europe where the European Court of Human Rights—which in the late 1990s took over the task of sorting cases for admissibility from the European Commission on Human Rights—had a backlog that

gave it almost 90,000 pending cases, including some 48,000 new applications lodged in 2006.[627] The European Court of Justice, functioning as the judicial voice of the European Union, represents the next in volume, as it listed almost 2,000 cases including those pending at its three levels —the Civil Service Tribunal, the Court of First Instance, and the Court of Justice.[628]

The third peak comes from the Americas, where, in 2006, the Inter-American Court of Human Rights had 88 contentious cases in monitoring phases and another 13 without judgment, for a total of 101 pending cases (including, as noted, enforcement proceedings).[629] Because the Inter-American Commission on Human Rights continued to sort the eligibility of certain matters for filing, we counted (as noted on the chart) the Commission's then pending 1,237 cases.[630] As is illustrated, the other courts had a much smaller number of pending cases. The International Court of Justice had 13 pending contentious cases in 2006[631] and the Permanent Court of Arbitration had 19 matters before it.[632] One case was pending at International Tribunal for the Law of the Sea.[633] No new cases were filed that year; at

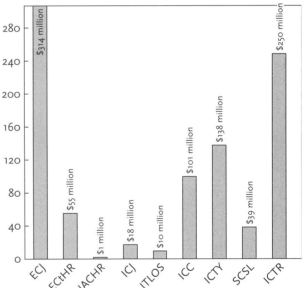

FIGURE 181    Regional and International Courts: Budgets in 2006

Millions of U.S. dollars

**ABBREVIATIONS USED IN FIGURES 181 AND 182**
ECJ: European Court of Justice
ECtHR: European Court of Human Rights
IACHR: Inter-American Court of Human Rights
ICC: International Criminal Court
ICJ: International Court of Justice
ICTR: International Criminal Tribunal for Rwanda
ICTY: International Criminal Tribunal for the former Yugoslavia
ITLOS: International Tribunal for the Law of the Sea
PCA: Permanent Court of Arbitration
SCSL: Special Court for Sierra Leone

Copyright: Judith Resnik, 2009.

FIGURE 182    Regional and International Courts:
Pending Caseloads in 2006

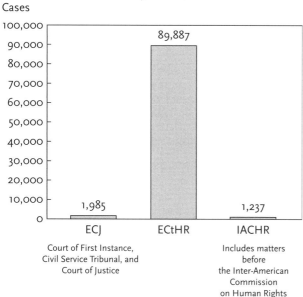

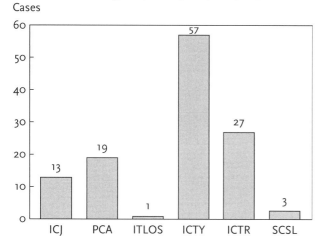

Copyright: Judith Resnik, 2009.

the time, ITLOS had then heard thirteen matters since its 1994 inception.[634]

Turning to the international criminal courts, the oldest, the International Criminal Tribunal for the former Yugoslavia, dating from 1993, reported that, as of 2006, 161 persons had been charged; proceedings had concluded against 94, and 57 cases were in progress.[635] As of 2006, the International Criminal Tribunal for Rwanda, chartered in 1994, was dealing with twenty-seven defendants whose cases were then in progress.[636] In 2006 four cases were underway at the Special Court for Sierra Leone, involving a total of ten defendants.[637] In that year, the International Criminal Court reported three "situations" in judicial proceedings, involving a total of eight accused.[638] This chart reflects that, in the first years of the twenty-first century, the SCSL and the ICC had just begun their work.

The charts provide a window into the interaction among funding, buildings, other activities, and cases in transnational courts. Given the tens of thousands of cases in national courts, one is thus able to understand the dual narrative presented by these courts. On one dimension—size of docket—the courts are relatively marginal as compared to national courts. On another, political and symbolic import, the creation of these institutions (admidst controversies about whether to do so) and the size of the buildings bespeak a commitment to courts as special institutions designed to engage with the public. Further, one can see that the heaviest volume does not always correspond to the resources provided—forecasting the problems we address in Chapters 14 and 15 about the challenges of supporting courts at the domestic as well as the transnational levels.

The effort to weave a transnational commitment to justice through practices and symbolism and the difficulties of giving expression to the depth of the problems these courts address can be seen from a collection of the various courts' logos. The international courts have embraced the historic traditions we mapped at the outset, put most plainly on display by the choices made in the oldest logo in the set, that of the Permanent Court of Arbitration (fig. 183).[639] Its design is modeled after the frontispiece (fig. 184) of a 1726 book titled *Corps universel diplomatique du droit des gens* by Jean Dumont.[640]

That volume is a compilation with commentary of European treaties related to political alliances, commercial trans-

FIGURE 183    Logo of the Permanent Court of Arbitration (PCA) before October 18, 2007.

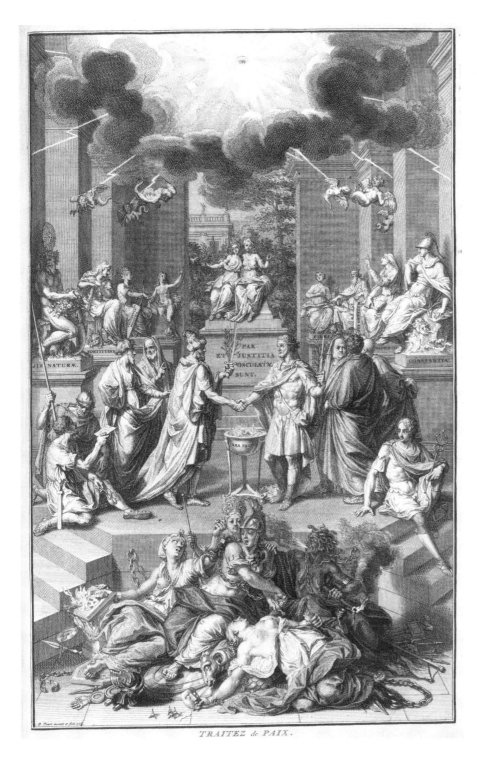

FIGURE 184 *Traitez de Paix,* Bernard Picart, 1726. Frontispiece, Jean Dumont, *Corps universel diplomatique du droit des gens.*

Image provided courtesy of the Rare Book Collection, Lillian Goldman Law Library, Yale Law School.

TRAITEZ de PAIX.

actions, and agreements of "peace" and "neutrality" entered into from the time of Charlemagne (around the tenth century) through the eighteenth century.[641] The engraving is by Bernard Picart, who was born in Paris in 1673, also lived in Antwerp, The Hague, and Amsterdam, and died in 1733. Considered a "magnificant engraver,"[642] Picart was known for his depictions of "religious ceremonies and customs of diverse peoples."[643] He created the print the *Traitez de Paix*

(*Peace Treaties*) in 1726. In addition to being found in many treaty compilations, a variation was also used in seventeenth-century wedding poems, with husband and wife clasping hands to symbolize their pact.[644]

In the background of figure 184, the Virtues Justice and Peace embrace. They are seated on a pedestal and surrounded by other labeled Virtues (including Fortitude, Wisdom, Natural Law, and Truth). The French text below

(too small to reproduce) explains that the two male figures at the center are two kings "swearing an alliance," confirmed through a handshake above a chalice-shaped urn within which a fire burns. Each of the men bears a palm, symbolizing peace, and each is surrounded by ministers and counselors. At the bottom, enchained, are War, Ambition, Discord, Fraud, and Impiety. At the top of the frame, the eye of Providence looks down from thundering clouds from which harpies emerge. The scene recalls the battles between Virtues and Vices of the Medieval Psychomachia (detailed in Chapters 1 and 2) and the frescoes in Siena by Lorenzetti extolling Good Government in which Justice also sits on a throne with prisoners below her (fig. 2/27).

The PCA's renditions are much more subdued. The first version, in use during the PCA's first hundred years (fig. 183), provides clouds and a halo surrounding the eye of Providence, looming behind a drawing of the Peace Palace and its gardens. Thus the PCA version dropped Virtues and Vices and substituted its building. The male figures in the foreground adopt the positions in the Picart engraving, albeit without a retinue of advisors. Text has been added to help onlookers glean the intended message: the French name ("Cour Permanente d'Arbitrage") as well as the PCA's founding date in Roman numerals (1899) encircle the scene as a border. The 2007 revision (fig. 185) is less cluttered.[645] The sky is empty (and thus without religious connotations); the grounds are no longer delineated with a grid, and the typeface of the name (again in French) is simpler.

One logo of the courts discussed in this chapter features Justice, thereby giving evidence of the trans-temporal and transnational travel of the iconography. The ICJ's Justice is marked by her scales that hearken back to Babylonia and Egypt (figs. 2/23, 2/24 and color plates 3 and 4), and were then taken up by St. Michael (fig. 2/25, color plate 5) and then affixed to the Renaissance Justice. The Justice logo was first created for the Permanent Court of Justice at the Peace Palace[646] and has since been used (as has the courtroom) by the International Court of Justice. Appearing blindfolded when on the PCIJ logo and clearsighted for the ICJ rendition displayed here (fig. 186, color plate 39), Justice is at the center.[647] A book about the Peace Palace explains that the background is a "rising sun, casting its rays onto the Symbol of Justice," who sits on a pedestal above two hemispheres denoting the world, with the continents outlined.[648] One side shows the Americas and the other Europe, Africa, Asia, and Australia.

The female at the center of the ICJ logo could be seen as a fusion figure; she holds Justice's familiar scales as well as a palm frond, an attribute often held by the personification of Peace. The leafy branches growing to encircle the scene from below are laurel, also associated with Peace. The rays emanating from the sun to touch the bordering circles of the logo echo those around the words "sol justitia" (the light of justice) inscribed on the floor of the Peace Palace. The pointed rays can also be found in various depictions of Jesus, memorably in Albrecht Dürer's print. The sun's rays—

FIGURE 185   Logo of the Permanent Court of Arbitration (PCA) after October 18, 2007.

FIGURE 186   Logo of the International Court of Justice, developed from the 1922 design by Johannes Cornelis Wienecke for the logo of the Permanent Court of International Justice.

along with an eye—are depicted atop a pyramid on the back of a United States dollar bill. Like the scales, the sun has a link to Justice that is ancient, traced back (as detailed in Chapter 2) to the Zodiac and to the Egyptian and Babylonian gods Re and Shamash.

In contrast to these complex depictions, the logos from the more recent courts, created in the 1990s and presented in sequence, show the markings of graphic designers aiming for clear messaging. As such, these logos are akin to an emblem once shown by the League of Nations and another regularly used by the United Nations. Flat backgrounds and basic colors do the work. From 1939 to 1941, a flag containing a pentagram pointing to the five continents and enclosing two five-pointed stars, alternating in blue and white, with the words League of Nations at the top and Société des Nations at the bottom, marked the pavilion of the League at the New York World Exposition.[649] The United Nations relies on a flattened gridded globe, again with continents outlined and encircled by olive branches.[650]

The emblem for ITLOS (fig. 187) keeps the U.N. branches and the scales of Justice but adds four rows of waves below the scales that support the balance rather than tilting it.[651] In contrast, the logos for the criminal courts of the 1990s for the former Yugoslavia, Rwanda, and Sierra Leone are mute on their specialized subject matter. They use scales to denote that they are dealing with justice, but the legal questions at issue—crimes against humanity—remain opaque.

The logo of the ICTY (fig. 188) eschews the two hemispheres of the ICJ logo and replaces them with a blue-and-white geometric globe, with latitude and longitude evoked by the lines drawn. The blue, white, and black diamond-shaped logo is composed of a square, five triangles, a circle,

and straight lines and is to be shown (as we do here) in conjunction with the U.N. logo.[652] The logo of the ICTR (fig. 189) brings back an evocation of peace; the black scales are set against a backdrop of a white dove of peace, all wrapped in the U.N. leaves, with the tribunal's initials in English and French at the top.[653] The SCSL's logo (fig. 190) denotes that court's hybridity: the U.N. peace branches frame two proud, silhouetted lions—outlined upright, with tails pointing to the sky—facing each other across scales.[654] The lions and the text below—"Unity, Freedom, Justice"—are taken from the official coat of arms of Sierra Leone. The logo for the ICC (fig. 191) is a simple iteration, in blue against a white background, of the now familiar scales encircled by leafy branches.[655]

FIGURE 188   Logo of the International Criminal Tribunal for the former Yugoslavia (ICTY), circa 1993.

The logo of the ICTY (bottom panel), belonging to the ICTY and the United Nations, is to be used in conjunction with the U.N. logo (top). These images are reproduced with permission of the ICTY.

FIGURE 187   Logo of the International Tribunal for the Law of the Sea, circa 1996.

Image reproduced courtesy of the International Tribunal of the Law of the Sea.

FIGURE 189  Logo of the International Criminal Tribunal for
Rwanda, circa 1995.

Image reproduced courtesy of the International Criminal Tribunal
for Rwanda.

FIGURE 190  Logo of the Special Court for Sierra Leone,
circa 1996.

The use of this image has been granted for illustrative purposes only.
Copyright: Special Court for Sierra Leone.

FIGURE 191  Logo of the International Criminal Court,
circa 1998.

Image reproduced courtesy of the International Criminal Court and
provided courtesy of its Public Information and Documentation Section.

FIGURE 192  Logo of the European Court of Justice, circa 1952.

Image reproduced courtesy of the Court of Justice of the European
Communities and provided courtesy of the Administrator Press and
Information Service.

Scales are the leitmotif at a transnational level, and hence
we add to this collage the logo of the ECJ (fig. 192), which
has scales held together by a sword pointing down toward
a book below.[656] Branches of leaves (sometimes described
as olive and other times as oak) cluster at the bottom, along
with the text "CVRIA" (court). An earlier version (used in the
1950s) wrapped the display in the words "Europea Carbo-
nis Ferriqve Communitas"—or Court of the European
Coal and Steel Community—the first incarnation of what
is now the EU. Some attribute the design to the first Presi-
dent of the tribunal, Massimo Pilotti of Italy, who served
from 1952 to 1958 and was described as "attached to the

Roman tradition"[657]; the emblem therefore appropriates a
sword, scales, and an oak-leaf garland. The use of the Latin
word "curia" for court evokes the once common reliance on
Latin as the official language of law in parts of Europe. The
word is also part of the ECJ's other "logo"—its website
address, http://curia.europa.eu.

A final example returns us to the national level and serves
as a reminder that courts search for legitimacy by linking
themselves to historic legal systems. Thus, akin to the Jus-
tice figure found in the Supreme Court of Japan (fig. 1/11),
a country occupied after World War II by the United States,
the Provisional Seal of the Iraqi Special Tribunal (fig. 193)

FIGURE 193    Provisional Seal
of the Iraqi Special Tribunal.

Image reproduced, in accordance
with an order of July 18, 2006,
courtesy of the Iraqi High Tribunal,
the legal owner of the seal of its
predecessor court, the Iraqi Special
Tribunal.

also echoes cross-cultural traditions.[658] The Iraqi Special Tribunal was short-lived; it was established by the Coalition Provisional Authority in December of 2003 and then replaced after the Coalition Provisional Authority ceded power to an Iraqi interim government in June 2004.[659] That government created the Iraqi High Criminal Court (often referred to as the Iraqi High Tribunal) in response to the sense that the Special Tribunal belonged to the occupying authority.[660] The stele of the Code of Hammurabi, with the Shamash outlined at its top, forms a pedestal to support the scales of Justice, standing in front of the country's map. Across the top of the emblem, above the name "Special

Criminal Court" and the date, are the words "If you rule among the people, then rule fairly."[661]

This sequence of logos shows the retreat from Renaissance iconography and allegories. Justice and her sword are rarely evoked in the twenty-first century. The universalism of scales—from the Libra of the Zodiac to the logo of the ICC—captures a set of concerns about judgment across time and place, and the balance lends itself to abstraction and simplification. Yet one knows little about the particular jurisdictional grants a court might have—such as crimes against humanity—from the balance encircled in leaves that wistfully evoke peace.

# From "Rites" to "Rights"

## The Triumph of Courts

One way to summarize the narrative thus far is that we have mapped adjudication's "triumph" as a marker of governance. The details of the expansion of the court system in the United States, coupled with sketches of other countries and transnational courts, illustrate the embrace of judging by political leaders of various stripes. Of course states have turned to courts to enforce their own rules of law, protect property interests, and maintain the security of their residents. But self-aggrandizement does not explain the configuration of adjudication that developed. Beginning before the Enlightenment, political theories came to comprehend a unique character for judging and a distinctive role for adjudication.

In this chapter, we trace the migration of legal precepts that made judges specially situated employees, given protection against retribution for their judgments and obliged to listen to both sides in a dispute. As judges performed various of their functions in view *of* the public, they came to be subjected to judgments *by* the public about whether they, as embodiments (and in that sense representatives) of the governing powers, were living up to the ideals of the nonarbitrary imposition of authority.

Indeed, even when judges are not independent, public instances of judgment are occasions for critical evaluation. As Hannah Arendt observed about twentieth-century Stalinist Russia, show-trials were a crack in totalitarianism. They demonstrated a need to provide explication, however contrived, rather than impose government power without a facade of justification.[1] "The very fact that members of the intellectual opposition can have a trial (though not an open one), can make themselves heard in the courtroom and count upon support outside it, do not confess to anything but plead not guilty, demonstrates that we deal here no longer with total domination."[2]

Thus, interactions among judges, litigants, and their audiences of citizens contributed over centuries to democratic ideas that sovereigns ought to be affected and con-

strained in some respects by popular will. Adjudication is a particular form of constraint, and this chapter examines some of its qualities that structure the exercise of power. We sketch the inter-relationships among deepening norms of fair treatment, new ideas about judicial independence, and the conception that judicial processes had to be put before the public. Over the course of a few centuries, the pageantry and spectacle ("rites") entailed in Renaissance adjudication became entitlements ("rights") to processes of certain kinds that entailed making courts open to anyone who wanted to watch.

We also explore the normative implications of these new rights and some of the complexity of judicial interaction with popular will. Political theorists from Jeremy Bentham and Immanuel Kant to Jürgen Habermas and Nancy Fraser have underscored the importance of what Bentham termed "publicity" to government's legitimacy. More recent commentary underscores the challenges entailed in constituting "a public" able to form opinions and influence democratic decisionmaking.[3] Bentham offered a detailed reform program for courts that, he thought, should be one of several institutions disseminating knowledge about government functions. Joining James Madison and other theorists of his era, Bentham also promoted an uncensored press and subsidized postal systems as additional mechanisms to enable a citizenry to understand, support, or constrain its leadership.

Our argument is that public litigation is one of many practices contributing to the public sphere*s* (appropriately pluralized, as Nancy Fraser has advised[4]). Public litigation provides one venue where information shapes societal norms. Through open processes, courts divest the litigants and the government of exclusive control over conflicts and their resolution. Empowered audiences can see and then debate what legal parameters do and should govern. Further, the obligations of litigants (the government included) to treat their opponents as equals, and of judges to accord equal treatment to all, are themselves democratic practices of reciprocal respect. The concept of judicial independence

offers another wrinkle, for judges are simultaneously obliged to perform before and to account to the public, while also structurally insulated from certain forms of public control. With such nuances, adjudication also models the complexity of relationships between governing authorities and those governed in democratic social orders.

## THE DEMOCRACY IN ADJUDICATION

When considering the role of judges in pre-Enlightenment Europe, we argued that the norms surrounding adjudication had elements that can fairly be described as proto-democratic, serving as vectors toward popular constraints on political power. As detailed in Chapters 2–4, dispute resolution was an early function of city-states as they developed methods to deal with conflicts and to centralize power.[5] Within the various oligarchies, judges were regularly and publicly admonished to deal appropriately with those who stood before them—to judge "as ye shall be judged," to treat the poor as one would the rich, and to refuse bribes.

Here we examine the development of other precepts—the deepening obligation that judges hear both sides of a dispute, legal requirements that judicial independence be protected, and rules insistent that courts be open to the public. These constraints regulated judges and therefore governments, compelled to legitimate their actions by more than divine injunction. Because the public processes of adjudication undermined status hierarchies (both among disputants and between disputants and ruling authorities), adjudication served as one paradigm for responsible, popularly responsive, and hence democratic governance. The more people were understood as entitled to equal treatment

and fair procedures, the more plausible became the shift in the sources of sovereignty from authority predicated on power to authority founded in public participation.

### "Hear the Other Side"

In discussing the 1650s Amsterdam Town Hall, we described a maxim, *Audi & alteram partem* (Hear the Other Side), that was inscribed in gold lettering on the wall above the entrance to a room used for the magistrates' court.[6] Some sources ascribe the concept to biblical narratives and Greek and Roman law,[7] with specific attributions to St. Augustine of Hippo, a Roman Christian theologian of the fifth century.[8] The maxim, found with slight variations on civic buildings in Germany[9] and various parts of the Netherlands,[10] is shown here on an entryway of the Gouda Town Hall (fig. 194) built in the decade from 1449 to 1459; this text was likely added in a late-seventeenth century renovation.[11]

What does "hear the other side" signify? Its import has changed over time. Analyses of its origins in classical texts connect the notion to wisdom and perhaps to prudence, in that a decision based on one-sided information could be erroneous.[12] With accuracy as its justification, "unwisdom rather than injustice" may have been the "uppermost idea."[13] Solon of Greece has been credited with the view that humans were more interested in accusations than in defenses; to ward off that tendency, judges needed reminders to show "an equal degree of attention to both parties."[14] Embodied in the precept was a concern for procedural regularity and some form of respectful treatment that could be grounded in civility rather than in various analytic premises associated with modernity. "Hear the other side" may not, then,

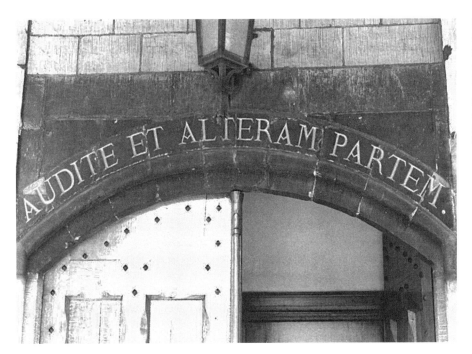

FIGURE 194   Arch above the entrance to the Gouda Town Hall (Staudhius), Gouda, the Netherlands, 1459. Architect: Jan Keldermans. Inscription circa 1695.

Image reproduced with the permission of the Streekarchief Midden-Holland (Regional Archive Middle Holland), Gouda, inv.nr 6668.

have entailed either skepticism about the ultimate truth of a judgment or the distinct idea that disputants were themselves equals.[15]

The obligation to listen to both sides came to be associated with the scales of Justice, typically depicted not as a steelyard but as evenly balanced pans. Of course, two-sided exchanges—and scales—were not unique to law courts. Dueling and certain sports included organized adversarialism, and commercial transactions often relied on weights and measures. Yet adjudication became a special site in which the judge, as the state's umpire, was subjected to detailed regulation, including the injunction to hear both sides.[16]

Iconic imagery was one vehicle for the transmission of these ideas, and legal texts were another. Jurists regularly invoked the phrase *audi alteram partem,* which was "implied by natural justice,"[17] along with the precept that "no person should be a judge in his own cause" (*nemo iudex in causa sua*).[18] A 1799 English decision explained that *audi alteram partem* was "one of the first principles of justice"[19] that had particular relevance to the criminal law: "every man ought to have an opportunity of being heard before he is condemned."[20] By the mid-twentieth century, "hear the other side" was a feature of English administrative decision-making that was proud of its lineage: "That no man is to be judged unheard was a precept known to the Greeks, inscribed in ancient times upon images in places where justice was administered, proclaimed in Seneca's *Medea,* enshrined in the Scriptures, embodied in Germanic proverbs, ascribed in the Year Books to the law of nature, asserted by Coke to be a principle of divine justice, and traced by an eighteenth-century judge to the events in the Garden of Eden."[21]

In the United States, the mandate to hear both sides moved into textual mandates by way of judicial interpretations of the Constitution. The Fifth Amendment of the eighteenth-century Bill of Rights specified that criminal defendants were not to be "deprived of life, liberty, or property, without due process of law."[22] The Sixth Amendment offered content for "due process" guarantees for criminal defendants by detailing rights to a "speedy and public trial, by an impartial jury," to be "informed of the nature and cause of the accusation," "to be confronted" with accusing witnesses, and to have the "Assistance of Counsel."[23]

The term "fairness," used primarily in English-speaking countries,[24] was not much in focus in United States Supreme Court decisions before the Civil War.[25] Similarly, the term "fair trial" was not common in England until the nineteenth century,[26] and then it was used to denote the provision of procedures prescribed by law. "Fair trial" was not at that time an independent metric to evaluate whether the state had properly discharged its obligations to accord disputants equal and dignified treatment.[27] In the United States, the law of "fair" procedures began to take shape after the Civil War. The courts began to interpret the protections set forth

in the Bill of Rights against takings of property and in the newly enacted Fourteenth Amendment, which prohibited states from violating personal rights to due process and equal protection ("nor shall any State deprive any person of life, liberty, or property, without due process of law; nor deny to any person within its jurisdiction the equal protection of the laws").[28] For example, in an 1878 decision about the legality of a state tax assessment, the Supreme Court concluded that a claimed deprivation of property could be lawful if a person had been provided with "a fair trial in a court of justice, according to the modes of proceeding applicable to such a case."[29] What was meant by "fair" was —as then in England—that the procedures provided comported with those prescribed.[30]

During the twentieth century, the "opportunity to be heard" gained new prominence as United States Supreme Court justices debated the kinds of government decisions that required "due process" and the quantum of process "due." The doctrine shifted to encompass a role for the court to assess the quality and kind of procedural opportunities prescribed.[31] *Audi alteram partem* was the *cri de coeur* of Justice Felix Frankfurter who, in a mid-twentieth-century opinion, dissented when the majority upheld a California statute permitting a prison warden to rely solely on reports from prison psychiatrists when deciding the mental capacity of a prisoner sentenced to death.[32] Justice Frankfurter argued that such a procedure was essentially flawed: "*Audi alteram partem*—hear the other side!—a demand made insistently through the centuries, is now a command, spoken with the voice of the Due Process Clause of the Fourteenth Amendment, against state governments" even when claims "may turn out not to be meritorious."[33]

By the 1970s, a version of Frankfurter's concerns had become law, as the Supreme Court concluded that the state could not deprive individuals of various kinds of property, including statutory entitlements to government benefits, jobs, or licenses, without "fair" hearings.[34] Phrases such as "an opportunity to be heard" and "fundamental fairness," as well as the term "fairness," became fixtures of the jurisprudence, appearing in hundreds of decisions rendered after the 1960s.[35] The maxim *audi alteram partem* also became a component of rules governing judges, who were prohibited from "ex parte" (or one-sided) contacts with disputants. Statutes and ethical rules disqualified judges who gained information outside the "hearing" (via papers or orally) of an opponent. More generally, the precept of fairness reached beyond courtrooms. Democratic discourse regularly and variously subjects government to criticism for policies argued to be "unfair."[36] For example, pressures to provide "equal opportunity" for access to education and employment stem in part from commitments to fairness,[37] and the ideas encompassed by the word "equality" interact with ideas about fairness that are elaborated in courts and in other sites.

One other aspect of due process theory in the United States bears noting. A distinction exists between what is

called "procedural due process" and "substantive due process." Procedural due process acts as a constraint on arbitrary judgments; a government cannot take one's person or property without a certain form of decisionmaking to legitimate that outcome. What in American constitutional law is known as "substantive due process" imposes a deeper constraint—that the government simply cannot undertake a certain action. In part because the United States Constitution's text does not include terms that can be found in more recent constitutions (such as rights to dignity and certain kinds of welfare rights), proponents of certain kinds of rights have looked to the "due process" clauses as sources of constraints on government action. Thus, questions like whether the United States Constitution protects a "right to life" or a "right to die" turn in part on analyses of substantive due process—that the government can (or cannot) control an individual in that respect. The issue is not whether a hearing or other mechanism for making the decision was provided and was fair but whether, instead, the government can act at all.

As for operationalizing procedural fairness, the Renaissance tradition of affixing the mandate to hear both sides to walls of town halls carried forward, as can be seen from a richly adorned courthouse in Springfield, Illinois, where that state's Supreme Court sits in a 1908 building. *Audi Alteram Partem* is inscribed at the rear of a courtroom below a mural called *Precedent, Justice, and Record* (fig. 195) that portrays three classically draped women.[38] At the center, a woman is shown holding two equally balanced candle flames, invoking or conflating the scales of Justice and the light of Wisdom. She is flanked by one woman shown with book and quill and another with an oil lamp giving off an arc of light.[39] The mural faces that court's justices, who have on occasion referred to looking at those words when debating what it means to "abide by" the phrase's injunction.[40]

The precept *audi alteram partem* has been credited as a source of, and justification for, the adversarial system in the United States and in Great Britain,[41] but the concept is a facet of other legal systems as well. Several of the transnational courts discussed in Chapter 12 invoke the phrase in their judgments. For example, the International Court of Justice did so when puzzling about what to do when one side to a dispute does not appear and participate.[42] Likewise, the Inter-American Court of Human Rights considered the principle when assessing whether a party's failure to appear was prejudicial.[43] The Court of First Instance of the European Communities voided a decision of the European Commission for its failure as a public authority to enable those "whose interests are perceptibly affected" to have an opportunity to "express their views effectively."[44] The European Court of Human Rights also cited *audi alteram partem* when explaining that, under Article 6 of the European Convention on Human Rights, criminal defendants are entitled to a fair hearing on bail.[45]

In short, contemporary case law emanating from diverse courts continues, in the tradition of the Greeks and Romans, to locate the mandate to "hear the other side" in concerns about accuracy and wisdom. Yet the modern translation contemplates a broader principle of a personal right to fair treatment and the correlative obligation of the government to provide it as a matter of procedural and substantive justice. The ancient formulations produced wall inscriptions,

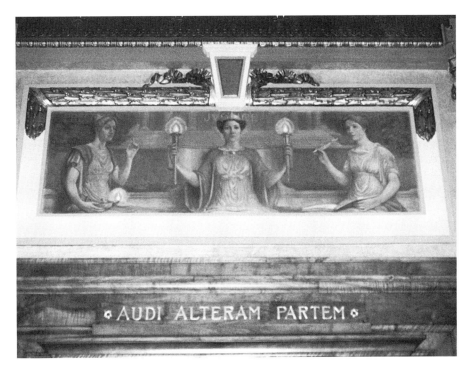

FIGURE 195 *Precedent, Justice, and Record,* Albert H. Krehbiel, 1909, Courtroom mural, Supreme Court Building, Springfield, Illinois.

Photo reproduced with permission from the Administrative Office of the Illinois Courts and the Krehbiel Corporation.

displays of balanced scales, and judgments of courts that, over time, shaped the conviction that governments were to ground their judgments in knowledge predicated on listening to disputants who gained equal status and the entitlement to be heard.

## "Judges as free, impartial, and independent as the lot of humanity will admit"

In contrast to the continuity and deepening of the precept *audi alteram partem,* some of the iconographic lessons proffered during centuries of pre-democratic adjudication are useful reminders of the *disjuncture* between current practices and those of earlier eras. Recall the histories (detailed in Chapters 2, 3, and 4) of public judgments serving the didactic purposes of rulers eager to demonstrate their capacity to enforce their own edicts. Town halls provided communal gathering spots to tell stories (*exempla iustitiae*) of judges' proving their loyalty to the state at great personal expense. Amsterdam's Town Hall (like many others) featured both the story of the Greek Zaleucus (fig. 3/45), who mitigated the penalty of blindness that was to be imposed on his son by gouging out one of his own eyes as well as one of his son's, and the narrative of the Roman envoy Brutus (fig. 3/46), who sent his sons to death because they had joined a conspiracy against that city.

In addition, executive control of judges was the point of the frequently displayed scene of the *Judgment of Cambyses* (figs. 3/31, 3/32). According to Renaissance lore, the "wise" or "prudent" king ordered a corrupt judge flayed alive, then anointed that judge's son to serve as the new judge, and thereafter forced the son to sit on a seat made from his dead father's skin. Instruction against corruption also came from the stark 1604 fresco *Les Juges aux mains coupées* (*Judges with Hands Cut Off*) (figs. 3/34, 3/35) in the Town Hall of Geneva. In case the specter of handless judges did not suffice, the banner at their side inscribed the warning from the Old Testament—that the taking of gifts "blindeth the wise, and perverteth the words of the righteous."[46] These various allegories embodied authoritarian instructions that rulers required obedience even at the price of personal pain, to be paid by judges as well as the accused. The patriarchal and aristocratic offered familial scenes to analogize rulers to parental figures, obliged to impose punishments when violations of the law occurred. The sword held by the ubiquitous Justice reiterated law's power and its violence, turned sometimes against judges who were themselves subjects of executive authority.

Yet within a few hundred years, this vision of the judicial role was replaced by a different understanding of the relationship between the executive and judicial branches, as discussed in Chapter 6. In the list of grievances set forth in the 1776 Declaration of Independence, the American colonists charged King George III with having "made Judges dependent on his Will alone, for the tenure of their offices, and the amount and payment of their salaries."[47] While judges in the colonies served at the pleasure of the king, by the early eighteenth century, English judges of certain ranks obtained new protections. The 1701 Act of Settlement provided that English judges held office "during good behavior," subject to discharge only upon a vote of both houses of Parliament.[48]

That sentiment was embraced and fortified across the Atlantic. The 1780 Constitution of Massachusetts insisted that it was "essential to the preservation of the rights of every individual, his life, liberty, property and character, that there be an impartial interpretation of the laws, and administration of justice. It is the right of every citizen to be tried by judges as free, impartial and independent as the lot of humanity will admit . . . ."[49] To implement these rights (as discussed in chapter 6) judges were to be given tenured positions and "honorable salaries."[50] In addition, early constitutions afforded judges another form of protection—separation of powers, often credited to Montesquieu, whose *The Spirit of Laws* was first published in 1748.[51]

Illustrative implementation can be found in the 1776 Constitution of North Carolina, which provided that the "legislative, executive, and supreme judicial powers of government, ought to be forever separate and distinct from each other."[52] Parallel provisions were set forth in the early constitutions of Georgia,[53] Maryland,[54] Massachusetts,[55] New Hampshire,[56] and Virginia.[57] Of course independence was actually inter-dependence, in that judiciaries relied on the executive not only to enforce court orders but also for their budgets, staff, facilities, and, often, their jurisdiction to hear various categories of cases.[58]

The vision of the judicial role became a pillar of the 1789 United States Constitution; the first articles outline the government's branches (legislative, executive, and judicial, respectively) and accord specific protection to judges. Article III provides that federal judges, commissioned through presidential nomination and Senate confirmation, "shall hold their Offices during good Behavior, and shall, at stated Times, receive for their Services a Compensation which shall not be diminished during their Continuance of Office."[59]

Just as the injunction *audi alteram partem* has been embedded worldwide in norms of procedural fairness, the obligation to ensure judicial independence has also traveled transnationally. The 1948 Universal Declaration of Human Rights states that, in criminal cases, "[e]veryone is entitled in full equality to a fair and public hearing by an independent and impartial tribunal."[60] The 1950 European Convention on Human Rights requires that tribunals be "independent and impartial."[61] The point is reiterated in a 1985 U.N. document titled "Basic Principles on the Independence of the Judiciary" that warns against "any inappropriate or unwarranted interference with the judicial process."[62]

As many commentators (ourselves included) have noted, the resiliency of judicial independence cannot be attributed to texts alone.[63] Political culture is critical, as illustrated by experiences of the United States. The Constitution requires independent judges and protects salaries once allocated, but imposes no protection for work budgets and facilities. Moreover, one could read the text as leaving to Congress much (if not all) of the authority about what cases federal courts can decide. Yet a robust judicial branch—detailed in Chapters 8 and 9—came into being through legislative and executive efforts, popularly supported, that have dramatically expanded federal judicial power.

Why politicians offer such support to judges not readily subjected to their control remains a puzzle, addressed by a diverse group of theorists. Some see a transnational morality of fairness at work—requiring impartial actors to legitimate judgments. Others explore the political economy of judicial independence for elected officials, who have a transient grip on power and hence could derive benefits from established mediating institutions capable of resolving conflicts.[64] And, depending on how judges are selected, politicians can use the longer terms of judicial positions to entrench their partisan views through populating the bench with individuals sharing their attitudes.[65]

## "That justice may not be done in a corner nor in any covert manner"

A third precept—that the public has a "right" to see what happens in courts—can be traced back to the Fundamental Laws of West New Jersey of 1676, which were enacted about a decade after the Amsterdam Town Hall (fig. 3/42) had opened. That charter provided: "That in all publick courts of justice for tryals of causes . . . any person or persons, inhabitants of the said Province may freely come into, and attend the said courts, and hear and be present, at all or any such tryals as shall be there had or passed, that justice may not be done in a corner nor in any covert manner . . . ."[66]

The custom of open processes is longstanding; Roman law had conceived of criminal proceedings as *res publicae* —public events. Further, accounts of civil trials describe the public posture of jurists and *advocati,* garbed in special togas and speaking in distinctive rhetorical modes.[67] Medieval and Renaissance rulers had sometimes decreed that judgments be pronounced beneath the skies (in part to gain divine blessings).[68] Even the "law of torture"—used as an investigatory tool in England—required oversight by the inclusion of magistrates to superintend.[69] The Inquisition marked the profound retreat to secrecy in parts of Europe and has become a synonym for unjust procedures.[70]

The excerpt quoted from the Fundamental Laws of West New Jersey located public access as an obligation of the state, which derived legitimacy not from divinity but from relationships with a body politic. That principle, coupled

with common law traditions of jury trials and rights to confront adverse witnesses, became engines of open court proceedings in America. A century after the 1676 Fundamental Laws, state constitutions insisted on such rights. An early example comes from the 1792 Delaware Constitution, proclaiming that "all courts shall be open."[71] By the middle of the nineteenth century, many states had followed suit;[72] as of 2008, the words "all courts shall be open" could be found in nineteen state constitutions.[73] Further, jury rights, guaranteed by the original states' constitutions,[74] worked in concert to open courts to the public.

The 1789 federal Constitution included no such generic right to "open courts," a phrase found only in one infrequently read section on treason: "No Person shall be convicted of treason unless on the Testimony of two Witnesses to the same overt Act, or on Confession in open Court."[75] Regular criminal defendants were protected in the original Constitution by the right to a jury trial.[76] The Sixth Amendment, added in 1791, gave additional entitlements to a "speedy and public trial, by an impartial jury of the State and district wherein the crime shall have been committed . . . ."[77] The Seventh Amendment, likewise part of the Bill of Rights, continued English common law traditions through its preservation of rights to juries in civil cases "where the value in controversy shall exceed twenty dollars."[78] These guarantees, coupled with First Amendment and Due Process rights, have since been interpreted to ensure public rights of audience for both civil and criminal trials, as well as access to evidentiary pre-trial hearings and to court records.[79] (Attitudes in the United States diverged somewhat from English procedure which did not, until recently, make available pleadings filed with courts.[80])

This discussion has focused on the common law, and English traditions of open procedures were intertwined with rights to jury trials. On the "equity" side of the docket, in which English and continental practice both drew on "Roman-canon tradition,"[81] masters or judges took testimony outside the hearing of the parties and kept it "secret until all the witnesses had been examined."[82] Crossing the Atlantic, the new Americans were distrustful of royal judges and embraced the common law tradition—albeit with some resurgence of "out-of-court, ex parte examination" for a few decades thereafter.[83]

More generally, principles of public access to government decisionmaking encompass more than rights to court-based procedures. Sections of the 1789 federal Constitution, for example, also imposed public disclosure obligations on Congress. Each House was required to "keep a journal of its Proceedings, and from time to time publish the same, excepting such Parts as may in their Judgment require Secrecy."[84] Several early state constitutions also proclaimed that legislatures should be "open."[85] Further, the federal Constitution required that a "regular Statement and Account of the Receipts and Expenditures of all public

Money" be "published from time to time."[86] The Constitution also keyed states' obligations to give "Full Faith and Credit" to each others' legal acts; that injunction flowed to the "public Acts, Records and judicial Proceedings of every other State."[87] In addition, the First Amendment right of the people to "petition the government for a redress" created opportunities to forge public spheres of debate.[88]

Civil law jurisdictions—working without juries and relying on judges dealing with litigants in stages rather than in a single, concentrated trial—developed varying approaches toward the openness of their courts. Further, as they elaborated special constitutional courts during the twentieth century, those bodies also shaped particular rules. Thus, while in some jurisdictions the public has generally been welcome, in others entry is not generally available for civil proceedings, even when courts are in session. For example, the Conseil Constitutionel of France does its work without an audience in a small room in the Palais Royale.[89] Its judgments are public, and transcripts of deliberations are preserved for release after a set period of years. Hearings at the European Court of Human Rights are technically public but, as discussed in Chapter 11, that court has tens of thousands of pending matters; groups of more than two must contact the court to arrange their attendance.[90] The German Constitutional Court, discussed in Chapter 15, also has limited public activities, and the Spanish Supreme Court designates special days, advertised at the court's website, for visitors.[91] Returning to common law jurisdictions, as judges move toward managerial, administrative modes (discussed in Chapter 14), meetings with litigants and lawyers take place in settings (such as chambers) to which the public is not invited.

But like fair hearings and judicial independence, the concept of public access, often translated as rights to attend court proceedings, became embedded in law around the world, as have precepts of freedom of information.[92] By the middle of the twentieth century, Article 6 of the European Convention on Human Rights required that, "[i]n the determination of his civil rights and obligations or of any criminal charge against him, everyone is entitled to a fair and public hearing within a reasonable time by an independent and impartial tribunal established by law. Judgment shall be pronounced publicly."[93] Article 6 also made a "virtual transplant" of the common law right of confrontation, as it guaranteed to criminal defendants a right of examination of witnesses[94] that, implicitly, was to be undertaken in public. A statute of the European Court of Justice similarly provides for hearings to be "public, unless the Court of Justice, of its own motion or on application by the parties, decides otherwise for serious reasons."[95] The 1966 International Covenant on Civil and Political Rights, promulgated by the United Nations, summarizes the broad principle that "everyone shall be entitled to a fair and public hearing by a competent, independent and impartial tribunal established by law."[96] Of course, such provisions also recognize the legitimacy of closures under specified circumstances.[97]

### Reflexivity: Transnational Signatures of Justice

The term "reflexivity" from social theorist Pierre Bourdieu[98] is apt here, in that the practices of open courts have become a signature feature that helps to define an institution *as a court*. While in the seventeenth and eighteenth centuries courts relied on foot traffic and personal visits, new techniques of dissemination developed thereafter.[99] In addition to the open doors and windows of courtrooms, the development of the newspaper business and of commercial publishers for court decisions created paths to knowledge about what took place in courts. Requirements of publication became codified, as did practices that judgments be "pronounced in public" in courts around the world.[100] One of the newest transnational courts, the International Criminal Court, details the various decisions that must be "pronounced in public." Included are rulings on admissibility, jurisdiction, responsibility, sentences, or reparations. Also specified is the makeup of the audience: "wherever possible," readings shall be "in the presence of the accused, the Prosecutor, the victims . . . and the representatives of the States which have participated in the proceedings".[101]

Today's technologies have amplified the options. In addition to electronic databases available on the internet[102] and "public information officers" briefing the press, televised court proceedings are, in some jurisdictions, available.[103] Examples include the Supreme Court of Canada,[104] the International Criminal Tribunal for the former Yugoslavia,[105] many state courts in the United States,[106] and an occasional federal appellate court.[107] Transnational courts often provide that judgments be published in more than one language; the European Court of Justice, for example, requires publication in more than twenty languages.[108]

The right of public access to courts is synergistic with the obligations to protect judicial independence and to hear both sides. Open processes can make plain that a government must acknowledge the independent power of the judge or, alternatively, can reveal state efforts to try to impose its will on judges. Further, with the public watching, the promise to "hear the other side" is subject to oversight. Open processes also complicate the idea of judicial independence by inviting public scrutiny that can impose forms of control over judges. (For example, in the United States, media campaigns have been launched to recall or impeach judges whose decisions—on the death penalty or abortion—are unpopular.) Yet these interrelated features—access, independent judges, and fair hearings—have created distinctive institutional arrangements that constitute a "court."

A fourth attribute is perhaps the most disjunctive from earlier practices of courts. Seventeenth-century courts did

not operate under mandates that "all persons" could come and be heard, as well as participate as witnesses, lawyers, and judges. But twentieth-century democracies broadened the idea of equality and recognized entitlements to seek legal redress—including, at times, against the government itself. The newness of this precept bears emphasis. Only in the last half century have courts understood themselves to be required to admit women and men of all colors, ethnicities, religions, and other forms of affiliation or identity into their halls with authority to serve in any and all roles, from judges and lawyers to litigants, witnesses, and staff.

## THEORIZING OPENNESS: FROM UNRULY CROWDS TO BENTHAM'S "PUBLICITY"

How does one account for the rise of norms that subject judges and disputants to public scrutiny? One catalyst for these changes was the reliance of Medieval and Renaissance European rulers on open spectacles—from public hangings to royal pageants—to reinforce their claims to authority.[109] As Michel Foucault has famously observed, those who produce spectacles do not control their meanings or effects.[110]

A much-studied illustration of this proposition is the practice of public executions, which would seem to be an excellent vehicle for the display of sovereign authority. In seventeenth-century Amsterdam, the burgomasters positioned onlookers in Dam Square to watch the ceremony of sentencing through windows onto a marbled room on the ground floor of the Town Hall (fig. 3/42) that was dedicated to that activity, and then to view the executions that followed out front.[111]

But other authorities achieved less by way of decorum. In England, executions "lurched chaotically between death and laughter," as crowds generated carnivalesque atmospheres that undermined the "script" of a solemn ritual of state authority.[112] As Mikhail Bakhtin put it, the large crowds produced "the suspension of all hier-archical rank, privileges, norms, and prohibitions."[113] Authority shifted; hangings could take place only "with the tacit consent of the crowd."[114] Scholars of the English legal system point out that, while executions have drawn historians' attention, "many more people of all ranks of society . . . came into contact with the legal system through the civil rather than the criminal courts."[115] Expansion of the private sector, coupled with that of government's administrative apparatus and the growth in the legal profession,[116] brought people into court. As diverse audiences participated and watched, they came to believe that they had a role to play.

To borrow from Jonathan Crary, "spectators" abandoned their passivity and took on a more active posture as "observers," engaging not only in the carnival of the crowd but also in critique, expressive of their developing authority.[117] Courts were but one site of changes across a broad spectrum. As we explored in Chapter 5 when puzzling about

the fixation on a blindfold for Justice and the power of the Rawlsian metaphor of a veil of ignorance, the importance of hearing both sides became entangled with changing epistemological claims about the nature of knowledge and human psychology. Technologies such as photography made palpable the existence of competing "truths" depending on one's vantage point. Organizing rules for courts served to cushion and to channel the exercise of power. Resolution—by judges or juries, insulated from the ordinary exercise of state authority, obliged to operate under norms of procedural fairness, and subject to public scrutiny—helped to legitimate law's violence.

The upheavals are marked by the French and American Revolutions, offering an array of ideas about democratic governance. Jeremy Bentham, who was formulating his thoughts on public participation in governance as these revolutions were underway, was one of the few of his generation to provide a sustained examination of openness—or "publicity," as he termed it—in a variety of venues, courts included.[118] Because Bentham proposed the Panopticon design for prisons, he is associated with oppressive state surveillance regimes that, as Foucault analyzed,[119] subjected individuals to observation without knowing when or by whom.[120] Yet Bentham also advocated designs of buildings and rules that would have put judges and legislators themselves before the public eye. Through such openness, the public could maximize self-interest and thwart the "sinister interest" of the political and legal establishments that collaborated to advance their own concerns rather than those of the "community in general."[121]

Bentham's trust in the public prompted him to make myriad proposals for parliamentary and legal reforms. His tens of thousands of pages of writings include suggestions for law codification in various countries, as well as aspirations (at least in theory) to universal suffrage.[122] The " 'ultimate end—political salvation,' could only be achieved by democratic ascendancy,"[123] and the goal of his many designs was "dependence of rulers on subjects."[124] His centrality for our discussion stems from a considerable set of materials focused on courts, judges, procedure, evidence, and the common law.

Here we trace the development of the political theory of the public sphere, first by way of Bentham and then by crossing the Atlantic to the United States, where James Madison promoted the press and national mail system to foster public exchanges. We then turn to how Bentham's appreciation for subjecting activities to public scrutiny intersected with Immanuel Kant's "publicity principle," and its more recent take-up by Jürgen Habermas, Nancy Fraser, Seyla Benhabib, Robert Post, and others. These theorists bring us to the challenges of communication in a hierarchical social order, even if democratic, in which the manipulation of information by special interests makes less plausible Bentham's optimism about publicity's effects. This

account will serve as a predicate for our argument about the benefits that courts, operating within democratic orders, can provide one of several public spheres committed to debates about legal norms.

## Observing and Cabining Authority: The Dissemination of Knowledge through Codification and Publicity

Jeremy Bentham's advocacy of publicity entailed the deployment of various techniques. Famous for his utilitarian calculus,[125] Bentham had a passion for codification (a word he is credited with inventing[126]) deployed in service of public knowledge.[127] Illustrative is Bentham's objection to the common law, never to be "known or settled."[128] The unpredictability and lack of specification meant that by going to court, a man was taking a "chance . . . although his right be as clear as the sun at noon-day."[129] Bentham's proposed cure was statutory law: if all the rules were "put into one great book," knowledge of the rules would be available to all rather than in the "clutches of the harpies of the law."[130] By replacing the common law with codes, legal parameters would be made plain and would truly be derived from the "consent of the whole."[131]

Bentham's zeal for clarity prompted his offers to codify the laws of many countries, including the then-nascent United States. Bentham wrote to President James Madison in 1811 that he would provide a "body of statute law" to liberate the country from "the yoke"[132] of English common law's various precedents.[133] In 1816 Madison replied, dryly noting that the War of 1812 had delayed his response. Declining, he wrote: "I find myself constrained to decide, that a compliance with your proposals would not be within the scope of my proper functions."[134] Bentham made similar offers to write codes for Russia, Poland, Geneva, Spain, Portugal, Greece, and Guatemala.[135]

Bentham was particularly attentive to, and appalled by, judicial procedures in English courts. In one essay, he quoted an English judge who had asserted: "No man is so low as not to be within the law's protection."[136] Bentham disagreed; the "truth" was that "[n]inety-nine men out of a hundred [were] thus low" because they could not risk spending so much of their hard-earned wages on the chance of winning under the common law.[137] The system crafted by judges formed "so thick a mist" that, if "not in the trade," negotiating the procedures to get to justice was too difficult.[138] Bentham charged judges and lawyers ("Judge & Co.") with creating "artificial rules"[139] producing a "factitious" system[140] full of procedural obfuscation at the expense of their clients and the public.[141] Civil courts were thus "shops" at which "delay [is] sold by the year as broadcloth is sold by the piece."[142]

Bentham sought instead to make procedure as "natural" as possible,[143] and during the decade from 1803 to 1812, he drafted revised rules.[144] He also proposed replacing the term "court" with the word "judicatory" so as to avoid an association of judges with the monarchy.[145] In lieu of fragmented rules of evidence, made through common law judges, Bentham turned to his favored technique of codification.[146] In lieu of piecemeal adjudication, Bentham wanted judges to preside over a whole case (through what today is called the "individual" calendar system, as contrasted with the "master" calendar system) so as to dispense justice swiftly. And in lieu of written motions and judgments on the papers, Bentham wanted oral procedures; he proposed that all evidence be taken through "oral interrogation before the judge in public."[147]

Bentham also called for subsidies for those too poor to participate.[148] He proposed that an "Equal Justice Fund" be established, supported by using the "fines imposed on wrongdoers," government funds, and charitable donations.[149] Bentham wanted not only to subsidize the "costs of legal assistance but also the costs of transporting witnesses" and of producing other evidence.[150] He proposed that judges be available "every hour on every day of the year"[151] (today, termed 24/7). Bentham also suggested that courts be on a "budget" for evidence to produce one-day trials and immediate decisions.[152] Bentham's advocacy of simplifying procedure—in part through legislative control[153]—aimed to enable public opinion to function as a "direct check" rather than to be deflected through the technically abstruse system replete with "jargonization."[154] Publicity, "underwritten by simplicity," would be the "main security against misdecision and non-decision."[155]

Bentham's focus was on trials in courts, but he also appreciated aspects of what was then described as "conciliation" for its resemblance to the more "natural" procedure he favored.[156] Examples of "conciliation courts" came from several countries, including Denmark and France, but details of their actual practices are somewhat hard to come by. One model, from France, involved witnesses testifying before lay jurists.[157] Bentham noted that under the Danish procedures, the conciliation courts efficiently resolved a good many claims, heard together.[158] In *Principles of Judicial Procedure,* Bentham called for judges to "exercise a conciliative function" to attempt to extinguish "ill-will."[159]

Yet, as William Twining's reading of Bentham's manuscripts identifies, Bentham preferred "rectitude of decision, that is, a strict adherence to justice under the law," and thus accorded "only a grudging place to compromise."[160] Amalia Kessler has specified various bases for Bentham's "anxiety" about conciliatory approaches. The lack of the formality of oath-taking and the absence of public scrutiny put honesty at risk.[161] Moreover, the informality of conciliation courts left decisionmakers free to make personal judgments rather than be constrained by legal rules.[162] Thus a judge charged with compromise could permit "partiality" for one side to provide that party a "partial victory . . . under

the pretext of conciliation."[163] As a consequence, in some instances, settlements could be "repugnant to," and a "denial of," justice.[164]

## The Architecture of Discipline:
## From "Judge & Co." to the Panopticon

Bentham's commitment to publicity in trials was fierce: "Without publicity all other checks are insufficient: in comparison with publicity, all other checks are of small account."[165] But more needs to be said about how—from his vantage point—"publicity" did its work. Bentham made various kinds of claims about publicity's utilities as he argued for its application to diverse activities.

One rationale for publicity was truth. Bentham argued that the wider the circle of dissemination of a witness's testimony, the greater the likelihood that a falsehood ("mendacity") would be ferreted out.[166] ("Many a known face, and every unknown countenance, presents to him a possible source of detection."[167]) Moreover, through face-to-face examinations in tribunals readily accessible across the countryside,[168] judges could apply "substantive law to true facts," adducing more information at lower costs.[169]

A second product of publicity for Bentham was education. He believed that the public features of adjudication would generate a desirable form of communication between the citizen and the state. While not legally obliged to deliver opinions, judges would, Bentham thought, want their audience to understand the reasons behind their actions. Thus it would be "natural" for judges to gain "the habit of giving reasons from the bench."[170] Courts provided a stage for such dialogic exchanges and thereby functioned as "schools" as well "theatres of justice."[171]

A third function was disciplinary; "the more strictly we are watched, the better we behave."[172] Bentham proposed that ordinary spectators (whom he termed "auditors"[173]) be permitted to make notes that could be distributed widely. These "minutes" could serve as insurance for the good judge and as a corrective against "misrepresentations" made by "an unrighteous judge."[174] More generally, "notification" of the public[175] imposed oversight by opening up the possibility of reform. Once informed, public opinion could exercise its authority to "enforce the will of the people by means of the moral sanction"—akin to "judges operating under the Common Law."[176]

Bentham's views on the importance of publicity were not limited to courtrooms, for he believed that its benefits—truth, education, interaction, and superintendence—were useful in diverse settings across a vast swath of social ordering. The "doors of all public establishments ought to be thrown wide open to the body of the curious at large—the great *open committee* of the tribunal of the world."[177] Bentham's invocation of door-opening was more than a metaphor; he literally described in detail how to design structures to ensure that a host of activities took place before the public. These many and varied plans used architecture as "a means of securing publicity, while publicity was a means of securing responsibility."[178]

As mentioned in Chapter 10, Bentham is (in)famous for promoting the "Panopticon," a prison that was designed to subject incarcerated inmates to continual observation.[179] Bentham proposed similar configurations for "mental asylums, hospitals, schools, poor-houses, and factories"[180]—subsequently prompting the Foucauldian fear of the power that the state could wield over individuals.[181] Yet Bentham was not intent on designing buildings facilitating only the observation of persons confined in institutions. He also wanted to put lawmakers before the public eye.

Bentham specified several methods for getting information about government officials to the public. One was direct observation: he called for a debating chamber that was " 'nearly circular' with 'seats rising amphitheatrically above each other.' "[182] A second was to enlarge the "audience" by facilitating the flow of public information to persons not physically present. The proposal noted earlier—that observers be "auditors" in court, taking notes to be circulated—was one example. For legislatures, Bentham suggested that buildings include a "separate box for the reporters for the public papers."[183] Third, Bentham wanted to require a legislature to provide information through an "official report of its proceedings, including verbatim accounts of speeches where the subject was considered to be of sufficient importance."[184] While creating such information-forcing methods, Bentham did not want government officials to be the sole sources of such accounts. His proposal to build in designated space for newspaper reporters freed them "to produce unofficial records of the proceedings and thereby 'prevent negligence and dishonesty on the part of the offi-cial reporters.' "[185] As for the executive branch, Bentham designed a way to link the ministers of government, physically, through "boxes and pulleys" to permit "instantaneous intercommunication."[186] He also wanted to have the state administrative apparatus compile records of and statistical information about the government's output.[187]

Bentham's enthusiasm for openness did not render him insensitive to the burdens of public processes and the need for privacy. He advocated closure in various contexts, such as secret ballots for voting, and listed several specific instances that made closure of trials appropriate. His justifications for privacy included protecting participants from "annoyance," avoiding unnecessary harm to individuals through "disclosure of facts prejudicial to their honour" or about their "pecuniary circumstances," and preserving both "public decency" and state secrets.[188] Thus, the presumption in favor of public trials should, upon occasion, give way. (Bentham's list of circumstances for closure, like his arguments for openness, parallel those made in contemporary courts.[189])

Moreover, Bentham thought secrecy occasionally appropriate. Courts were always presumptively open, with clo-

sures only under specified circumstances. The executive (or administrative) sphere was "intermediate" in that secrecy could be appropriate when issues of diplomacy and the military were involved.[190] In contrast, Bentham advocated an exception to the principle of publicity for voting; the secret ballot was a protection against corruption.[191] The end state of the various sources of information was to inform Bentham's "Public Opinion Tribunal"[192]—a "half real and half imaginary"[193] image of the general public serving as a committee that, when knowing the basis for decisions, the process of decisionmaking, and the outcomes, could assess whether lawmakers' decisions comported with its interests.

Before turning to other theorists of publicity and mechanisms of information dissemination, we should note that Bentham's eagerness to subject judges (and their common law) to particular scrutiny is in some tension with contemporary understandings of judicial independence. Bentham proposed a justice minister, appointed for life but subject to dismissal by the other branches of government, to oversee judges who could, in turn, be suspended, transferred, or dismissed.[194] Further, in the context of his draft code for France, Bentham posited additional legislative oversight. Were a judge to find strict application deeply wrong, a judge was to "suspend" the case so as to report the problem to the legislature for guidance; judges might also suggest amendments to the law.[195]

Today, some of what Bentham advocated falls within the rubric of "accountability" for judges, seen at times as constraining their independence.[196] Bentham's insistence on publicity paved a route to what, in the late twentieth century, became systematic evaluations of judges. One example is a 2008 study that reviewed surveys from several European countries assessing "the quality of court performance" in providing public services. The research relied on measures aiming to capture fairness and efficiency.[197] The reference to judicial "performance" echoed the Benthamite conception that courts are "theatres of justice." The worry from the perspective of judicial independence is that judges might pander to the crowd, rendering rulings that are less autonomous from politics.[198] (A good deal of literature on judicial review responds with the argument that judges are more or less in sync with the social orders of which they are a part, as well as deeply in conversation with the other branches, often as joint venturers in elaborating or limiting rights.[199])

Another facet of Bentham's analysis relevant to our argument about understanding adjudication as a democratic practice is his attitude toward democracy.[200] Skeptics of Bentham's commitments to democracy point to his distrust of natural rights. Bentham was what today is called a positivist, seeking law from affirmative enactments. As such, he was a vocal opponent of natural rights, which he termed "nonsense upon stilts."[201] He leveled criticism at the French Declaration of the Rights of Man and the Citizen and argued that people were born not "free and equal" but

rather in "absolute subjection"; he cited helpless infants, dependent on adults, as a case in point.[202] As Philip Schofield has explained, natural law or natural rights for Bentham were claims made by proponents that such rights "*ought to* exist," and such a moral claim should be put straightforwardly rather than "ambiguously expressed."[203]

The specter of surveillance through Bentham's proposed Panopticon also lends an air of totalitarianism, underscored by Foucault's focus on constant visibility as a method for the quiet exercise of the disciplinary powers exercised by modern states.[204] But Bentham's advocacy of similar treatment for legislators—who, like prisoners, he thought ought to be required to sit before the public eye—provides a reciprocity that undermines a view of Bentham as antidemocratic. Bentham's commitment was to the public, for whom publicity was the means to maximize self-interest and escape the "sinister interest" of the political and legal establishments, collaborating to advance their own concerns rather than those of the "community in general."[205] Indeed, as Bentham scholars have noted, his commitment to "common sense" and reliance on "*observation, experience, and experiment*" have a good deal in common with John Locke's attachment to knowledge based in empiricism.[206] Both men were optimistic (or naïve) about the complex relationship between knowledge and judgment.

Bentham's trust in the public prompted not only his proposals for parliamentary and legal reforms but also, as noted earlier, a commitment to universal suffrage.[207] Further, Bentham's advocacy of subsidies for access to courts and roles for the audience opened up institutions to a wider range of persons.[208] Bentham had a keen appreciation of the multiple venues in which information needed to be produced to enable the citizenry to gain what Robert Post has called "democratic competence," which is one of the rationales underlying commitments to speech uncontrolled by the government.[209] For Bentham, the "'ultimate end—political salvation', could only be achieved by democratic ascendancy"[210] in which the hierarchy shifted, resulting in "dependence of rulers on subjects."[211] Hence Bentham can be read not only as a proponent of democracy in the sense of endorsing popular electoral sovereignty[212] but also as aiming to "broaden the scope of democratic theory" by expanding the means of making elites accountable.[213]

Bentham's insights were plainly radical when measured against the baseline of the historical context in which he wrote. In marked contrast to the adjudicatory proceedings of Renaissance Europe, when people watching trials were not seen as having the power to sit in judgment of judges or to assess the decency of the state's procedures, Bentham raised the possibility that the state itself could be subjected *to* judgment. Bentham's widely quoted statements made that point directly: "Publicity is the very soul of justice. . . . It keeps the judge himself, while trying, under trial."[214] By Bentham's era, the responses of participatory observers were gaining weight and relevance. Popular opinion was

coming to matter through the elaboration of what has come to be called a "public sphere" that could affect political rulers.

## FORMING PUBLIC OPINION THROUGH COMPLEMENTARY INSTITUTIONS: AN UNCENSORED PRESS AND A SUBSIDIZED POSTAL SYSTEM

While Bentham's attention to courts makes him specially relevant for this discussion, he was not the only political theorist of his century specifically interested in the function of publicity.[215] For political philosophers, Immanuel Kant's "publicity principle" may be the more salient, with his well-known claim that all "actions relating to the right of other human beings are wrong if their maxim is incompatible with publicity."[216] As David Luban has explained, Kant's formulation required policies to be subjected to public debate as a constraint.[217] Both Kant and Bentham wrote in the wake of David Hume, regularly cited for the proposition that it is "on opinion only that government is founded."[218]

Yet "opinion," in Hume's thought, can be read as referring to the need of governments to gain public confidence, to be produced through private exchanges and institutional arrangements balancing or checking different sets of interests so as to maintain an equilibrium.[219] That concept is distinct from the active agency that subsequent writers attributed to public opinion (embodied, for example, in Bentham's Public Opinion Tribunal[220]) and a considerable distance from the "intersubjectivity and mutual understanding" of contemporary theorists such as Jürgen Habermas[221] and Nancy Fraser.

How does the public, in any of these postures, obtain information? Bentham's suggestions, as noted, included permitting note-takers ("auditors") in court and reporters in the legislature so that the public would have sources of knowledge independent of the government.[222] Bentham explained that "the distinction between a government that is despotic, and one that is not so" is that "some eventual faculty of effectual resistance, and consequent change of government, is purposely left, or rather given, to the people."[223] Another was an unfettered press that would help, Bentham thought, promote the requisite "*instruction, excitation, correspondence.*"[224] Indeed, Bentham thought the "newspaper was a far more efficient instrument than pamphlets or books" because of the " 'regularity and constancy of attention' " it provided to unfolding events.[225]

Bentham's enthusiasm for an exchange among citizens, via press and post, was shared by others on both sides of the Atlantic. James Madison's short essay, *Public Opinion*, extolled the virtues of the press as "the real sovereign in every free" government.[226] To enhance the "general intercourse of sentiments," Madison wanted the ready "*circulation of newspapers through the entire body of the people.*"[227] This exchange could enable the public to monitor their rep-

resentatives (in a Benthamite fashion) or provide a means for citizens to gain a sense of affiliation with their government (akin to Hume's aspiration of gaining public confidence).[228] Thus scholars of the theories of both Bentham[229] and Madison[230] analyze the degree to which they hoped to inspire participatory debate as contrasted with disciplinary control. Post, press, and courts could be means of engendering cohesion with the "imagined community" of the nation-state,[231] either to debate its norms or to bring into being Madison's "united public reason"[232] with the political force to support the government.[233]

In the United States, these various aspirations made their way into some state constitutions, with commitments to a free press that sometimes sat—as in Georgia's 1777 Constitution—next to jury rights ("Freedom of the press and trial by jury to remain inviolate forever"[234]). The 1791 Bill of Rights also provided protection for the free press,[235] complementing congressional authority under the 1789 Constitution to "establish Post Offices and Post Roads."[236] Pursuant to its constitutional mandates, Congress enacted the Post Office Act of 1792,[237] which expanded the network of communications (mostly via stagecoaches) by giving newspapers "unusually favorable terms, hastening the rapid growth of the press," as the act also prohibited government surveillance of posted exchanges.[238]

As was the case with federal courts, post offices initially camped out in other facilities such as in Baltimore, "in the basement of a popular hotel; in Philadelphia, in a corner of the mercantile exchange; in Boston, on the first floor of a dilapidated colonial state house."[239] One of the early purpose-built post offices was in Washington, D.C. The building was designed—replete with marble, a first among all federal buildings—by architect Robert Mills, who (as discussed in Chapter 7) served as the nation's first semi-official architect.[240] As the number of newspapers distributed though the mails increased—from 1.9 million in 1800 to 39 million in 1840[241]—post offices gained a place of honor in the pantheon of federal architecture.[242]

In Europe, a "national network of symbolic communication" was put into place in the eighteenth century.[243] By the early 1700s, a "cross-post system" linked cities and, by 1760, most major towns boasted daily mail service. Key to the utility of mail was literacy, evidenced by the fact that in 1630 an estimated 400 books were available and, by the 1790s, some 56,000 were in print.[244] In the contemporary world, those achievements may be hard to gauge, but in 1832 Francis Lieber pronounced the postal system "one of the most effective elements of civilization," along with the printing press and the compass.[245]

## DEVELOPING PUBLIC SPHERE(S)

The subsequent transformations in social, political, and technological orders have been enormous, and courts were but one site of change. Technologies (such as the telescope,

the microscope, and the camera) made palpable the existence of competing views depending on one's perspective. Politics (such as the 1867 England Reform Act) gave "most of the urban working class the vote,"[246] and the emergence of women's suffrage admitted more persons, with their varying vantage points, seeking recognition.[247]

Bentham's optimism about public knowledge gave way to concerns about the need to revitalize the public sphere, elaborated during the second half of the twentieth century by Jürgen Habermas.[248] Habermas credited Bentham with forging "the connection between public opinion and the principle of publicity."[249] Habermas also read Bentham as seeking a transparency in parliamentary debates so that deliberations there would be continuous with those of the "public in general."[250] Habermas likewise credited Kant for identifying publicity as the mechanism for a convergence of politics and morality that could produce rational laws.[251] But Habermas argued that, because only property owners were admitted to the public debate, the public sphere had become a vehicle for "ideology"[252] and could no longer serve as a means for the "dissolution of power."[253]

Law was central to Habermas, but details of the practices of courts—in which Bentham was interested—were not.[254] That difference may reflect German traditions of civil inquisitorial law that put the processes of evidence-taking in the hands of judges who can proceed in a series of discrete intervals—thus making the impressions of the observer, acute for Bentham in the common law, seem remote for Habermas. The absence of attention to lower courts could also stem from a tradition in political theory of treating courts and politics separately. What engaged Habermas was how law bound "state functions to general norms" that protected capital markets.[255] He cited practices in Austria and Prussia as examples of when "public scrutiny of private people come together as a public" had helped to shape civil codes relating to property.[256] When "legislation . . . had recourse to public opinion," it could not be "explicitly considered as domination."[257] Over time, a variety of "basic rights" (such as voting, a free press, and freedom of association) protected access to the public sphere.[258] But without "universal access,"[259] which nineteenth-century Europe did not provide, the public sphere could not do its work.

Habermas both admired and critiqued "public opinion," for he saw it as subject to manufacture through the intertwined forces of the market and the state. Publicity that had once served to enable opposition "to the secret politics of the monarchs" came instead to be used to earn "public prestige" for specially situated interests.[260] The press became entangled with "public relations" efforts, as advertisements promoted consumerism.[261] The resulting consensus that might exist was superficial, "confusedly enough . . . subsume[d] under the heading 'public sphere.'"[262] The public sphere thus served as a space for the performance of prestige rather than as a forum for "critical debate."[263]

Habermas could draw on many instances of government deployment of publicity in service of its aims. A self-acknowledged example comes from President Theodore Roosevelt, who, in his first annual congressional message, explained: "The first essential in determining how to deal with the great industrial combinations is knowledge of the facts—publicity."[264] He established a "publicity bureau" as a "Department of Congress" to investigate and disseminate data on the administrative work of federal agencies. Soon thereafter, advertising became a favored form of publicity, followed by a "science" of publicity, as well as firms marketing themselves as experts in advertising and public relations.[265]

Habermas sought to interrupt those developments through prescriptions aiming to facilitate public reasoning as members of pluralist polities communicated discursively so as to reach a genuine consensus. According to Habermas, individual private interests themselves were not capable of being "adequately formulated, let alone politically implemented, if those affected have not first engaged in public discussions to clarify which features are relevant in treating typical cases as alike or different . . . ."[266] Positive law needed legitimacy derived through a "procedure of presumptively rational opinion- and will-formation."[267] Thus, because such discursive space was essential in the current social order, the public sphere needed to be reconstituted. Without gods and monarchs, one looked to a vibrant public sphere to establish that the relationship between the "rule of law and democracy" was more than a "historically contingent association."[268]

The trajectory from Bentham and Kant to Habermas is important for our inquiry into the role of courts in democratic orders. Borrowing from political theorist Nancy Fraser, we have added an "s" to the term "public sphere" in the subtitle of this section to underscore that no single "public" exists. Rather, a pluralistic social order, replete with racial, gender, class, and ethnic hierarchies, is constituted through a series of spheres in which norms are debated.[269] Moreover, as Fraser has pointed out, the exchanges in these various and sometimes overlapping spheres are not equally participatory; certain voices dominate in stratified societies.

Fraser also focused on the disparate capacities of those who need to be heard, as she called for "participatory parity" and argued for more structures to enable a "multiplicity of competing publics" to emerge, rather than aspiring to the formation of a "single, comprehensive public sphere."[270] Courts are one site that is responsive in some measure to the inequities that undermine the "discourses" to which Habermas and Fraser aspire. The obligations of equal treatment and open proceedings are expressly designed with participatory parity in mind. Thus, we bring back a Benthamite focus on courts in their educative and legitimating modes, while moving beyond Bentham to make an argument that adjudication *in* democracy can be a source *of* democracy.

In this discussion, we are not speaking of democracy defined only through popular sovereignty principles expressed by electoral processes. Rather, we are interested in a broader conception. Part of what makes a social order democratic is a political framework striving to ensure egalitarian rights, attentive to risks of minority subjugation, and engendering popular debate about governing norms. Deep and genuine disagreements exist about what rules ought to prevail and which forms of behavior ought to be sanctioned. Uncensored exchanges in the press and through the mails have become familiar conditions of democracy; our argument here is that adjudication is likewise a condition of democracy. The normative obligations of judges in both criminal and civil proceedings to hear the other side, to be impartial, and to provide public processes enable two forms of democratic discourse. A first comes from the authority of the audience, empowered to watch the direct participants —litigants and judge—in an adjudicatory exchange; the second stems from rules that structure the discourse among the disputants and jurists.

## ADJUDICATION AS A DEMOCRATIC PRACTICE

Jeremy Bentham claimed that public processes were useful in generating more accurate outcomes, and he also posited that publicity helped produce legitimacy. One could concur or demur on various grounds, both empirical and normative.[271] We take a somewhat different tack. Our argument is focused not on the relationship between openness and truth but instead on how public processes of courts contribute to the functioning of democracies and give meaning to democratic aspirations that locate sovereignty in the people, constrain government actors, develop processes for norm elaboration, and insist on the equality of treatment under law.[272] While Bentham stressed the protective side of adjudication (policing judges as well as witnesses), we are interested in how the public facets of adjudication engender participatory obligations and enact democratic precepts of equality.

One other prefatory comment is in order. A good deal of the literature on trials is focused on the criminal docket, where the encounters between individuals and the state are seen as politically freighted. Governments are understood to have special obligations toward the accused, in addition to victims and the public at large.[273] The question of structuring procedures to legitimate violence against those breaching social norms in the criminal context[274] has sometimes deflected attention from the civil side and from the state power that inheres in judgments requiring the transfer of assets, the reconfiguration of families, the legitimacy of the receipt of government benefits, or the regulation of commercial transactions. Thus our interest is in shaping an understanding of the political import of adjudication—whether denoted criminal or civil, public, administrative, or private.

## The Power of Participatory Observers to Divest Authority from Judges and Litigants

Consider the interaction between observers and courts. Open courts and published opinions permit individuals who are neither employees of courts nor disputants to learn, first hand, about processes and outcomes. Indeed courts— and the discussions that their processes produce—are one avenue through which private persons come to-gether to form a public,[275] assuming an identity as participants acting within a political and social order. Courts make a contribution by being what could be called non-denominational or non-partisan, in that they are one of rela-tively few communal spaces not organized by political, religious, or social affiliations. Open court proceedings enable people to watch, debate, develop, contest, and materialize the exercise of both public and private power.

Moreover, courts provide a unique service in that they create distinctive opportunities to gain knowledge. Conflicts have many routes into the public sphere. The media (including bloggers) or members of government may initiate investigations. Courts may help uncover relevant information in these arenas (as we have seen in the litigation related to individuals detained after 9/11, discussed in Chapter 14). But courts distinguish themselves from either the media or other government-based investigatory mechanisms in an important respect: the attention paid to ordinary disputes.[276] Courts do not rely on national traumas, scandals, or on selling copies of their decisions. Courts do not respond only when something "interesting" is at issue.

What is the utility of having a window into the mundane? That is where people live, and that is where state control can be both useful and yet overreaching. The dense and tedious repetition of ordinary exchanges is where one finds the enormity of the power of both bureaucratic states and private sector actors. That power is at risk of operating unseen. The redundancy of various claims of rights and the processes, allegations, and behaviors that become the predicates to judgments can fuel debate not only about the responses in particular cases but also about what the underlying norms ought to be. The treatment of so-called domestic violence provides one ready example of the role of public processes in reorienting an understanding of what was once cabined as "private" and tolerated as within the familial realm. Civil and criminal litigation about violence against women has helped to shape an understanding of how gender-based violence is a mechanism of subordination and an abuse of power.[277]

Public knowledge gathered from open dispute resolution ought not, however, to be presumed to be generative of policies running in any particular direction or of attitudes supportive of judicial rulings. Public awareness can generate new rights, such as protection against violence, as well as new limitations, such as "caps" on monetary awards for torts because of a popular view that courts (and specifically

juries) over-compensate victims.[278] Moreover, because even a few cases can make a certain problem vivid, social policies may respond in extravagant ways to harms that are less pervasive than perceived.

Criminal sanctions are exemplary here, as public disclosure of particular crimes produces anger and vengeful consequences. Publicity can be a fuel *for* punishment as well as a mode *of* punishment. In many jurisdictions, press coverage of individuals found to have sexually assaulted children prompted new laws that require individuals convicted of a wide array of offenses to register so that their names and photos can be broadcast and potential neighbors forewarned about their presence.[279] Furthermore, some critics of judges have used public procedures to launch attacks on their judgments and, at times, targeted particular judges in an effort to have them removed from office. For example, an anti-immigration prosecutor in Arizona repeatedly accused the local courts and specific judges of failing to enforce laws on unlawful entry into the United States.[280]

Thus we cannot conclude, as Bentham appears to have, that expanding the flow of information will enable public opinion to become "more and more enlightened"[281] so as to advance society's interests. Public displays do not necessarily trigger reasoned discourses, nor does increased information necessarily "produce an improvement in the quality of the opinions held by the people."[282] Further, the harms of false accusations (vivid during the 1950s as individuals were accused of being Communists, to pick but one example) are substantial,[283] rendered all the more powerful through the distribution mechanism of the internet.[284] Webcasting live testimony (as contrasted with legal arguments) raises yet other problems, for it may leave persons called as witnesses inappropriately vulnerable.

But the need to regulate audienceship is not new, as reflected in legal rules and doctrine insistent on decorum within the courtroom itself. Concerns about trials devolving into political demonstrations engendering sentiment weighted sharply toward one party have generated obligations that observers be silent and, upon rare occasion, have resulted in exclusion of the press.[285] An example discussed in Chapter 5 was whether observers who wore badges depicting a victim of a crime had prejudiced a jury.[286] Others involve courtroom-packing to convey positive impressions that a particular individual is a valued member of a community.[287] In short, the development of new methods of producing public events—through web databases and broadcasts—requires the elaboration of premises already in place as well as consideration of when audiences may be virtual instead of physically present. Again, that work is underway. For example, because some jurisdictions make electronic filings available on the web, requirements now direct that certain kinds of information (such as social security numbers) be deleted.[288]

While the forms of publicity may need to be varied, the practice of publicity needs to be in place so as to enable

audiences to undermine, in the Foucauldian sense, the power and prerogatives that closed procedures give to the disputants and the state. Discipline and control may—not will, but may—follow, because openness changes the relationships between the participants and their audiences by denying the government and disputants unchecked authority to determine the social meanings of conflicts and their resolutions.

A disquieting example of this shift in power comes from the broadcast of the video of the death of Saddam Hussein. Hussein was hanged on December 30, 2006, five days after he lost an appeal of his sentence.[289] At first, the media reported that "14 Iraqi officials had attended the hanging" at an unspecified location and that witnesses said Mr. Hussein "was dressed entirely in black and carrying a Koran and that he was compliant as the noose was draped around his neck."[290] But within a day, a "video . . . appeared on the Internet . . . apparently made by a witness with a camera cellphone."[291] The tape showed the "mocking atmosphere in the execution chamber" and recorded the taunts hurled at Hussein at his death.[292] The organized media in different countries debated whether to air that video[293] but did not control all of the channels of distribution. Dissemination was decided by others, who posted the video on the web. The disclosures resulted in a torrent of reaction about the timing, fact, and process of the execution.

The uncontrollability of the dissemination of that video has its counterpart in thousands of ordinary actions that take place in low-level tribunals. Once events are accessible to an audience of third parties who are "spectators and auditors" (to borrow Bentham's categories),[294] these observers can put their descriptions and commentary into the public realm. These exchanges are rich, albeit sometimes pain-filled, sources of communicative possibilities. Diverse speakers, some of whom may respond by seeking vengeance and others by offering reasoned discourses, all understand themselves as speaking authoritatively, based on what they have witnessed or read. In contrast, without direct access, nonparties must rely on insiders—government officials or disputants—for their information, inevitably filtered through their perspectives. Public procedures teach that conflicts do not belong exclusively to the disputants or to the government; they give the public a place in which to interpret, own, or disown what has occurred.

## Public Relations in Courts

We are not naïve. Habermas understood efforts to manipulate public opinion,[295] and sophisticated users of courts know well the opportunities to use public relations as a tool in litigation. Disputants with the resources regularly hire media consultants to shape popular views of conflicts. Self-interested participants can attempt to exploit the opportunities courts provide to enlist audiences, immediate and more distant, to press judges to be more responsive to pub-

lic perceptions and preferences than to litigants' factual proofs and legal arguments. In this sense, David Luban's reformulation of Kant's publicity principle bears mention—that publicity can be used to undercut the legitimacy of the very institution making the knowledge public.[296]

In short, to appreciate the political and social utilities of the public dimensions of adjudication is neither to ignore the costs and burdens imposed (Bentham listed many[297]) nor to underestimate the potential for the exploitation of courts. The immediate participants in a dispute may find the exposure to the public disquieting. Even the disclosure of accurate information can be uncomfortable. Moreover, the public dimensions of adjudication may inhibit parties' abilities to find common ground, thereby deepening discord. And despite Bentham's confidence that public disclosure reveals falsehoods, many court records are subsequently impeached after lies by witnesses are revealed.

Further, one should not romanticize spectatorship. As we discussed, watching state-authorized processes can prompt celebration, action, or dialectic exchanges that develop new norms of diverse kinds. But it can also result in boredom. Locating judgment in courthouses with windows to the streets and open doors makes publicity possible, but questions remain about how to secure an audience whose members understand themselves as participatory observers, functioning politically as responsible "auditors"[298] rather than as indifferent viewers or partisans.

Who will volunteer to see full proceedings? What levels of understanding and accuracy will mark knowledge transmitted to the public? The competition for attention is acute in a world rich or overwhelmed with visual materials offering windows into so many dramas that one can lose focus through what Jonathan Crary has called a "suspension of perception."[299] Even before technologies that have expanded the visual field, Bentham had identified the problem of gaining "an audience for the 'judicial theatre.' "[300] He proffered various options, such as public authorities' requiring attendance as a matter of duty, providing compensation for attendance, or devising some other "factitious means" to bring people in.[301] Further, Bentham advocated that permission be liberally granted for the publication of information obtained—and for its re-publication as well.

New technologies, such as the web, reduce the challenges for those seeking to observe court proceedings. But virtual capacities also permit snippets of information to be consumed in private without the sense of community and of decorum to which the architecture of courtrooms aspires. Thus, if one set of problems stems from getting an audience and sustaining its attention, another relates to eliciting attention of the wrong kind, as high-profile cases create misimpressions about the frequency or depth of particular kinds of harms. Yet litigation develops narratives that have been shown to affect and to generate public agendas addressing the intersections of private interests and public rights. Open processes that welcome audiences mark courts as one

of many arenas in which to construct shared and sustained experiences of the interactions between "facts and norms" (to borrow, again, from Habermas) and hence, as one of many public spheres.

## Dignifying Litigants: Information-Forcing through Participatory Parity

Contributions *by* courts to public discourses may not be sufficient to support a commitment *to* courts in the future. Recall the centrality of the Renaissance town hall or the colonial courthouse, where commerce and political life mixed on a small scale, where records were kept, and where communal rituals were shared. Contrast contemporary conditions—an array of specialized public buildings providing different services, the organized press, televised broadcasts of legislative proceedings, reality TV, and diverse online media. Places other than courts can spark debate, even as courts offer a special contribution through responding to a volume of mundane matters along with high-profile disputes.

A distinct facet of what makes courts especially useful in democracies comes from shifting attention from what potential observers may see and do to the interactions among litigants, judges, witnesses, and jurors. This aspect of our argument about the utility of open courts hinges on the view that adjudication is itself a democratic practice—an odd moment in which individuals can oblige others to treat them as equals as they argue in public about their disagreements, misbehavior, wrongdoing, and obligations. Litigation forces dialogue on the unwilling (including the government) and momentarily alters configurations of authority. Social practices, etiquette, and myriad legal rules shape what those who enter courts are empowered to do.[302]

When cases proceed in public, courts institutionalize democracy's claim to impose constraints on state power. More than that: in criminal trials, the theory of trial is that defendants are enabled, by procedures, to "*contest the common interpretation*" of their actions and to oppose government-imposed meanings.[303] Many commentators note that the jury, as well as lay judges more generally, infuses adjudication with democratic participation by citizens who gain the stature of judges, ad hoc.[304] But consider also the democratic constraints imposed on professional jurists. If working in open courts, the government employees we call judges have to account for their own authority by letting others know how and why power is used. Recall Bentham's admonition: "Publicity is the very soul of justice . . . . It keeps the judge himself, while trying, under trial."[305]

Courts can be a great leveler in another respect, in that participatory parity[306] is an express goal of courts, even when not achieved. "Hear the other side" has been augmented, in many jurisdictions, by obligations to *equip* "the other side"—sometimes by means of appointing free lawyers for criminal defendants or poor civil litigants or targeting

funds for witnesses and transcripts. Moreover, when government officials are parties to litigation, they are forced, as either plaintiffs or defendants, to comply with court rules, to divulge information, and to respond to questions posed by opponents or the court. In countries requiring disclosures of documents through discovery, government litigants must also produce documents, files, emails, and other records.

Courts' processes render instruction on the value accorded to individuals and, on occasion, reveal that courts cannot or do not make good on commitments of equal treatment and respect. For example, as discussed in Chapter 6, during the 1970s and 1980s, as claims of discrimination based on race, ethnicity, and gender were brought to courts, some judges responded as though differential treatment was natural. Lawyers and litigants sometimes found that, because of their gender and race, they were subjected to treatment they found demeaning. In response to such concerns, the chief justices of many state courts convened special projects, denominated "fairness" or "gender bias" and "racial bias" task forces, to inquire into areas of law (such as violence against women or sentencing) and practices (such as modes of address or appointments to court committees) to learn about variations by gender, race, and ethnicity.[307] Statutes, rulemaking, and case law resulted because transcripts, judgments, and public exchanges documented behaviors at odds with the provision of "equal justice under law."[308]

This function of courts as potentially egalitarian venues can be seen from attempts to avoid them. After 9/11, efforts were made in the United States to enact legislation "stripping" courts of jurisdiction over claims that the government had wrongly detained and tortured individuals.[309] The effort to create a separate "tribunal system" for alleged enemy combatants aimed—as we discuss in Chapter 14—to control access and information as well as to limit the rights of detainees by augmenting the powers of the state.

Of course, to insist on courts as vital facets of democratic functioning also serves as a reminder that, like the democratic output of the legislative and executive branches, adjudication does not always yield wise or just results. Our argument is that it offers opportunities for democratic norms to be implemented through the millions of exchanges in courts among judges, the audience, and the litigants. And, in addition to undermining the state's monopoly on power, forging community ownership of norms, demonstrating inter-litigant obligations, and equalizing the field of exchange, open courts can express another of democracy's promises—that rules can change because of popular input. The public and the immediate participants can see that law varies by contexts, decisionmakers, litigants, and facts. They gain a chance to argue that the governing rules or their applications are wrong. Through democratic iterations—the backs-and-forths of courts, legislatures, and the public —norms can be reconfigured. As a consequence, courts are an important component of functioning democracies seek-ing to demonstrate legitimacy through displaying what qualities of governance are valued.[310]

## THE PRESS, THE POST, AND COURTS: VENERABLE EIGHTEENTH-CENTURY INSTITUTIONS VULNERABLE IN THE TWENTY-FIRST

We end this chapter with a preview of the next by focusing on the relationship between eighteenth-century inventions and twenty-first-century demands. Bentham, Madison, and their cohort helped to frame three institutions of discourse—the court system, the postal service, and the uncensored press. Yet, in this century, all three are under stress.

The stability of national, subsidized postal services has become a question. One report characterized the United States Postal Service as in a "death spiral."[311] In 2009, some 13,000 fewer post offices existed than had in 1951, with more closings planned.[312] As the system continued to lose money (with $2.8 billion cited as the amount lost in 2008[313]), some commentators called for the dissolution of the Postal Service as an obsolete institution, to be replaced by the internet and private providers.[314] Others worried that the Postal Service had already been transformed, favoring "junk mailers and big media over political opinion journals."[315] One might also elaborate patterns of privatization and transformation of other institutions, such as the police, prisons, libraries, and parks.[316]

The contemporary defense of the post office as a public institution rests on arguments akin to those made by Madison and Bentham—that ready communication through public services binds the nation and local communities while servicing the needs of the economy.[317] Indeed, in the 1958 Postal Policy Act, the United States Congress made such a claim—that its establishment of the Postal Service was "to unite more closely the American people, to promote the general welfare, and to advance the national economy."[318] Yet by the 1970s Congress had limited the cross-subsidies that made the exchange of newspapers inexpensive,[319] lessening the degree to which the public fisc subsidized a universal service that facilitated a wide range of exchanges.[320]

A similar narrative of vulnerability envelops the press, with the decline of print media, consolidation of ownership, and diffusion through electronic sources.[321] In 1950, when the United States population stood at just over 152 million, some 1,700 daily newspapers were supported through customers, resulting in a circulation of almost 54 million paper copies. By 2008, census data counted a population that had doubled to 304 million, but the number of papers circulated was down: 1,400 daily newspapers delivered 48 million copies.[322] In 2009, more than a hundred newspapers closed, including large presses such as the Seattle Post-Intelligencer.[323] Well-known and long-solvent publishers of

newspapers filed for bankruptcy,[324] and the revenues of the remaining papers dropped between 2007 and 2009.[325]

Perhaps less well appreciated are the many ways in which governments have subsidized the media—in part through the mails. In the United States, for example, the federal government has supported the mailing of periodicals. Under provisions in place in 1970, the Postal Service paid about 75 percent of mailing costs, but by 2009 the periodical subsidy had declined to 11 percent.[326] Further, governments needed newspapers, which were the avenue by which they posted legal notices—and paid for doing so—before shifting to other means, including the internet. Tax provisions also sheltered publishers, offering special treatment for certain kinds of income or expenses. Free licenses—sometimes accompanied by regulation requiring news services or dissemination of information—were another vehicle through which governments supported access to information. Moving outside the United States, some countries have provided free subscriptions for newspapers or direct financing,[327] aiming to sustain what Edwin Baker termed "democratic distribution of communicative power."[328]

The question is whether the fragility of the press and the post forecasts what awaits courts. Evidence of deep concern about the solvency of courts can be found throughout the state systems. Indeed, in the fall of 2009, the Chief Justice of Massachusetts warned that state courts were at risk of a "slow and painful demise" and that one ought not assume that courts were "too big to fail."[329] Despite the ancient roots of many practices associated with modern courts, they are—as currently understood—relatively new institutions.

We have traced the movement from the pageantry and spectacle (the "rites") entailed in Renaissance adjudication to the entitlements ("rights") of democracies to underscore the dynamic quality of courts. We have also mapped the creation of United States federal courts to capture the rapidity of change. In 1850, fewer than forty federal judges worked at the trial level in the United States, and no building owned by the federal government had the sign "U.S. Courthouse" on its front door. By 2000, more than 1,700 trial-level judges worked in more than 550 federal courthouse facilities. Many of those stone testaments to judicial authority were shared by the Post Office as they were also built in recognition of the importance of that service. Yet many buildings once housing postal services have been torn down or recycled for other uses. Similarly, pressures to shift away from the public processes of courts to alternative forms of dispute resolution abound, which is the topic to which we turn in the next chapter.

# Courts:
# In and Out of Sight, Site, and Cite

## ADJUDICATION'S CHALLENGES TO DEMOCRACY

The project of the twentieth century was getting people into courts. The question for the twenty-first century is what to do with all who became eligible to enter. One response is to expand access, and various segments of the legal profession have crafted a host of efforts such as free legal services, simplified procedures for the "self-represented," and lawyers volunteering their time, "pro bono," to assist individual and institutional litigants. But others became skeptical about the utility and desirability of the forms of adjudication that had come into use. Evidencing a failing faith in formal adjudicatory procedure, they advocated alternatives. Three techniques—reorganizing court-based decisionmaking to focus on settlement, delegating adjudication to other government institutions, and outsourcing—represent a movement toward privatization that removes conflict resolution from public purview.

This chapter explores those shifts and hence offers a counter narrative to the story of the "triumph" of adjudication mapped thus far. We begin with a quick review of adjudication's successes, which have produced demands in excess of the resources provided to courts. We then explore different attitudes toward adjudication converging to support "alternative dispute resolution" (ADR) or "dispute resolution" (DR) mechanisms, often turning to venues other than courts. As the Department of Constitutional Affairs of the United Kingdom defined it, ADR is a "collective term for the ways that parties can settle civil disputes, with the help of an independent third party and without the need for a formal hearing."[1] One form of ADR reconfigures procedures inside courts; the job of the judge shifts from adjudicator to manager and settler, encouraging litigants to resolve cases without court judgments. That conciliative process, reliant on mediation or negotiation, is complemented by other forms, adjudicative on some dimensions. A second mode of ADR channels cases toward administrative agencies, charged with handling thousands of individuals in low-visibility settings. A third trajectory, in some

jurisdictions, comes from court enforcement of consumer and employment contracts requiring the use of private dispute resolution. As a consequence, individuals who might have been eligible to come to court are sent elsewhere.

As forecast by our discussion of the International Tribunal for the Law of the Sea (ITLOS) in Chapter 12, the interest in ADR is worldwide. Below we use examples from the United States as well as England, Wales, and the European Union to glimpse the nature of the reforms that move away from adjudication. We close this chapter with a dramatic illustration from the United States where the government proposed closed procedures to classify and try individuals held after the attacks of September 11, 2001, at Guantánamo Bay. Thus, across various contexts and continents, iconic judges are housed in monumental courthouses. But many are relegated to providing their services to a small, elite slice of disputants—nation-states in conflict, some high-end commercial claimants, certain kinds of criminal defendants, and litigants either in large-scale litigations or seeking interpretations of statutory and constitutional rights.

Lower-level courts have millions more cases. The Commonwealth of Massachusetts, for example, estimated that on any day in 2009, some 42,000 people entered its courthouses.[2] But that state—like most of its counterparts in the United States—was also struggling with ever more limited budgets and cramped spaces in which to work. As we noted in Chapter 13, those problems prompted the Chief Justice of Massachusetts, Margaret Marshall, to warn that, like other institutions scaled so big as to seem invincible, one ought not assume courts were immune from risks of failure.[3]

By the beginning of the twenty-first century, fiscal crises joined social and political critiques in prompting changes in court processes. Public and private sectors shaped new rules dismantling the signature features—independent and protected judges welcoming all persons in a public forum—that have come to mark institutions as courts.[4] Like the press and the post office, courts may also be vulnerable institutions that blossomed in the nineteenth century, and

could prove to be unsustainable in the twenty-first. The questions are whether courts will remain available to ordinary persons seeking to engage in the democratic practices of adjudication; whether courts will continue to attend to individuals as equal and dignified members of a polity; and whether polities will authorize disputants to contest state authority and to use courts to foster debate about both the content and the application of norms.

## Demand and Distress

In prior chapters we mapped how, by the end of the twentieth century, democracies had demonstrated their faith in courts by committing resources for courthouses, authorizing more litigants to file cases, and funding new judgeships. Formal principles of equal treatment required the provision of fair hearings to a host of claimants, regardless of their race, class, ethnicity, and gender. One way to capture this expanded aegis for courts is through figure 196, *Criminal and Civil Filings in United States District Courts: 1901, 1950, and 2001*, that charts the growth in filings in the federal courts of the United States over the twentieth century.

Under 30,000 cases were before the courts in 1901, some 92,000 in 1950, and more than 315,000 in 2001.[5] As demographers would quickly point out, filings need to be considered in relation to population. In 1901, the United States counted some 77 million, in 1950 approximately 151 million, and in 2001 more than 285 million.[6] Court filings thus outstripped population growth, increasing during the century from 4 to 6 to 11 federal filings for every 10,000 people. And the federal data, while easily accessible, reflect but a small percentage of the volume of filings. In 2009, state courts estimated that they received approximately 47 million cases annually.[7]

The demand for decisionmaking has not been limited to the trial level. Again using the United States as an example, in the decade ending in 2008, federal appellate filings rose more than 10 percent, resulting in some 60,000 cases in 2008.[8] Given that the number of authorized appellate judgeships for the thirteen national intermediate appellate courts had remained constant from 1999 to 2009 at under 200,[9] it is not surprising that the number of pending appeals increased about 25 percent during the same decade[10] and that the median time from filing a notice of appeal to disposition was, by 2008, more than a year.[11]

Another way to capture the role of courts comes from comments made by Stephen Breyer, one of the chief judicial architects of the Boston Courthouse (fig. 8/113), who later became a member of the United States Supreme Court.

FIGURE 196    Civil and Criminal Filings in United States District Courts: 1901, 1950, 2001

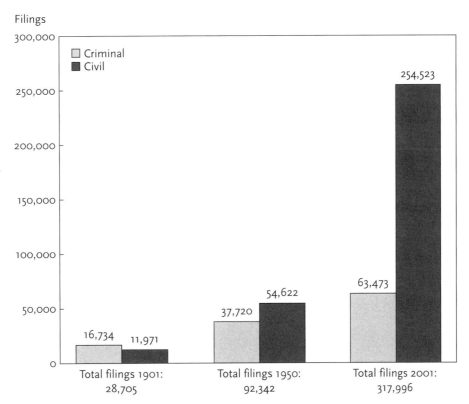

A court, unlike a government agency, deals not with the public en masse but with the individual citizen who appears before it. It devotes as much time and attention to that individual's specific problem as the problem requires. In this modern age, when people fear government's dehumanizing tendencies, it is particularly important to emphasize that the judicial branch of government treats each citizen before it not as a member of a group but as a separate human being with a right to call upon the court's considerable resources to resolve his or her specific dispute with whatever effort that may take.[12]

In short, commitments to adjudication remain robust.

But a disjuncture exists between the constitutional and political precepts that underlie this aspiration (embodied in the many new buildings and the "pearls" within—the courtrooms) and the contemporary adjudicatory processes in the United States and elsewhere. In both public and private sectors, leaders proffer conciliation in lieu of adjudication as the exemplar, and judges and lawyers have been at the forefront of the promotion of mechanisms styled ADR. Under that rubric, as noted, come a range of activities, including court-based efforts to help or rules to insist that litigants try to settle conflicts through mediation, as well as to route some disputes to private arbitration and others to government agencies doing administrative adjudication.

Before detailing these practices, we need to identify what prompts their promotion. One reason for reconfiguration is the very success of courts, attracting large numbers of claimants imposing demands that exceed capacity. Thus, some pressure for diversion comes not from criticism of adjudication but from regret that governments have not allocated adequate funds—either for judges and courthouses or for subsidies to litigants unable to afford court and lawyer fees.

Recognition of the need to support access can be found worldwide. Various projects have been launched to research "paths to justice" so as to understand how individuals come to recognize and to "name" their injuries, and then to make appropriate claims for redress.[13] Empirical work on both sides of the Atlantic has sought to identify baselines for the kinds of injuries that could turn up in courts,[14] and judiciaries regularly produce data on those who end up before them. Concerns about barriers to entry have resulted in interest in lowering the costs[15] and expanding the resources to facilitate access, by either court-based or other mechanisms, so as to achieve "justice for all."[16] "Access to Justice" became a shorthand of global dimensions under the guidance of Mauro Cappelletti and Bryant Garth, who mapped such problems in civil justice systems in countries around the world.[17]

Various metrics document the distance between resources devoted to courts and demands for courts. "Legal needs" studies have sought to evaluate rates at which households have legal problems, and some comparative work addresses the volume of filings. Some commentators bemoan the lack of quality data while concluding the demand is likely higher than supply—in terms of legal aid and access to courts.[18] In the United States, for example, filings in state courts increased between 1987 and 2004 by more than 40 percent, while the ratio of judges to the population decreased somewhat, from ten to nine judges per 100,000 persons.[19] Court budgets provide another barometer; typically, a tiny fraction—under 4 percent—of government spending is devoted to the judiciary.[20] Furthermore, courts are often apportioned a smaller allocation in budgets than are prosecution, defender services, and corrections.[21] Another problem is the source of funding. In many states, revenues come from the county level rather than from a unified stream of statewide funding. As of 2008, about a third of state court administrators reported inadequate budgets,[22] despite repeated calls describing the "crisis" and a need to "save" the system.[23]

These pressures have prompted some courts to find ways to generate their own revenues rather than depend on general appropriations. Beginning in 2004, for example, Florida required its courts to rely on fees for some operating expenses.[24] (During the same decade, user fees also became a major source of revenue for English courts.[25]) Some states sought to tie appropriations to "performance-based budgeting,"[26] a measure that relates awkwardly to the outputs of courts, responding to an array of conflicts that produce child custody arrangements, convictions or acquittals, and the transfers of assets.[27] On occasion, judges have argued that linking budgets to output violates separation of powers, and in a few jurisdictions, judges have filed lawsuits against legislatures and argued the constitutional obligation to fund courts.[28] (A Supreme Court decision in Canada concluded that, as a matter of separation of powers, provincial judicial salaries had to be set by an independent panel whose decisions were also subject to judicial review.[29])

The budget constraints, coupled with legislative authority in many jurisdictions over judicial salaries, have resulted in compensation levels for judges more modest than salaries for comparative cohorts of senior lawyers or of chief operating officials and executives. For example, in 2008 the median salary for justices on states' highest courts was $148,000,[30] a figure that was significantly lower than what lawyers in prestigious practices earned. More dramatically, during recessions, states across the country have suspended certain operations. In the late fall of 2008, New Hampshire stopped providing both civil and criminal jury trials,[31] Vermont closed local courthouses for half a day each week, and Maine both shuttered its clerks' offices for some portions of some days and stopped staffing its metal detectors at court-

house doors.[32] Kansas, too, limited operating hours and reduced services, despite its imposition of surcharges on various court fees.[33] In Michigan, a judge explained the task as "finding revenue in hard times."[34]

Moving from support for courts to support for litigants, many countries have developed "legal aid" programs through which governments subsidize access for some litigants. But the limited availability of funds and cut-offs at relatively low-income levels leave tens of thousands of claimants without assistance.[35] Moreover, resources devoted to such support have declined over the latter part of the twentieth century. For example, after World War II, the United Kingdom created statutory entitlements for legal aid; private lawyers were paid according to a schedule of fees for specific services. But since the 1990s, these programs have been reconfigured and reduced in scope.[36] Back in the United States, judges have raised concerns about the rising number of "pro se" or self-represented litigants, appearing without lawyers and struggling to navigate court procedures.[37] Thus, some champion ADR as a "second-best" response framed in light of inadequate support of adjudication.

Other proponents of ADR, however, focus not on lack of resources for adjudication but instead on adjudication's failings—that it is too expensive, too cumbersome, and too aggressive. Aspects of this form of critique span the twentieth century. In 1906, Roscoe Pound sounded a Benthamite objection to procedural designs that imposed delays and expenses when he gave a famous speech to the American Bar Association on the "causes of popular dissatisfaction" with the courts.[38] Like Jeremy Bentham, Pound distinguished between the external critique of the system and the presumed satisfaction of insiders, the lawyers and judges who had shaped the cumbersome system that they inhabited more comfortably than did outsiders. In contrast, by the late twentieth century, a host of jurists were in the forefront of the attack on the system in which they participated.[39] Some of the complaints focused on how lawyers, if paid well by the hour, had incentives to generate unnecessary conflict that wasted the time of courts, clients, and opponents through strategic interactions laden with interpersonally harsh and unpleasant exchanges. Others objected more generally to the dependence of the adversary model on lawyers and to adversarialism itself.

One strand of reformist critique came from those who situated themselves as humanists in search of processes to develop consensus and to solve problems constructively.[40] Terms such as "collaborative law" reflected the goal of reconfiguring institutional regimes to permit a wider range of techniques to ease conflicts.[41] Concepts like "restorative justice" span criminal and civil litigation,[42] most vividly embodied by "truth and reconciliation" commissions convened in lieu of prosecutions. The hope is to reshape the culture of conflict so as to engender more "pro-

ductive relationships" that provide more "satisfaction" for both disputants and professionals.[43] Some of the mechanisms (such as truth and reconciliation commissions) typically conduct proceedings in public. Class action or large-scale litigations can also produce settlements that entail disclosure of information to the public.[44] Yet others (like mediation) are private and praised for it. The argument is that confidentiality facilitates more frank exchanges and promotes more desirable outcomes than would public processes.[45]

Other commentators register a different kind of objection. They disagree with the premise of ready access to courts and believe that adjudication imposes unpredictable risks of liability that damp down innovation.[46] Moreover, goes the argument, easy paths to courts create cultures of victimhood and accusation.[47] Taking aim at innovations that opened up access to the courts, some commentators (and judges) seek to constrict opportunities, for example, by imposing more demanding standards for filing cases[48] or by leveling economic sanctions on those who fail to succeed or win less than was offered in settlement.[49]

Interrelated with such efforts to limit litigation is a more pervasive interest in reducing legal regulation. Whether aspiring to expand adjudication's aegis (as detailed in Chapters 9–13) or to limit its function (as discussed here), visions of the role for law extend beyond courts. Proponents and critics of courts have focused not only on procedure but also on revising various bodies of substantive law—governing fields such as tort, contract, consumer, environmental, and civil rights. Some of that retrenchment comes by amending statutes and by judicial development of new doctrines.[50]

One can understand such objections as nested in basic attitudes toward the role of government regulation or, alternatively, as motivated by the self-interest of groups with the political capacity to make change. Amy Cohen posited the tension between advocates of "moral deliberation" and those committed to "interest satisfaction."[51] Marc Galanter proffered a political critique: ready access to courts required the proverbial "defendants"—corporate or government entities, which he termed "repeat players"[52]—to disgorge information and respond to claims of wrongdoing. In response, they sought to revamp court rules to "come out ahead," which, from their vantage point, meant decreasing others' ability to haul them into court.[53]

In short, distinct kinds of concerns support the efforts to revise court-based procedures so as to route disputes to methods other than adjudication. What various reformers share is a normative premise that parties' consent, developed through negotiation or mediation, is preferable to outcomes from judges rendering public judgments predicated on state-generated regulatory norms.[54] As a consequence, an array of distinct political and social movements have converged in a worldwide movement toward ADR,

itself now a marketplace populated by lawyers and other professionals in competition with courts for "business."[55]

Clarification of the loci of ADR activities is also in order. Some of this work seeks to revamp procedures *inside* courts where, as we saw in the context of discussion of French courthouses in Chapter 10 and of the International Tribunal for the Law of the Sea in Chapter 12, the judicial role is described as conciliatory as well as adjudicative. The job of judging shifts from deciding competing claims at trial or from documents to multi-tasking. Judges are deployed as managers of lawyers and cases, sometimes acting as super-senior partners to both parties, advising about how to proceed, sometimes functioning as settlement masters or mediators, and at other points serving as referral sources sending disputants either to different personnel within courthouses or to institutions other than courts.

In addition to ADR inside courts, other efforts aim to shift what had been the work of courts to other fora. Some of these alternatives are other public institutions, such as the Permanent Court of Arbitration at The Hague, described

in Chapter 12, or national administrative agencies (sometimes termed tribunals) that have come to include adjudicatory functions. Other endpoints are private entities such as the American Arbitration Association or ad hoc resolution services provided company by company. The outsourcing of what had been a public function is not a phenomenon unique to courts but rather part of a pervasive pattern in which various kinds of services (police, detention, school, and the military) have been shifted to the private sector.[56] With the United States as our primary example, we sketch the decline of adjudicatory "publicity," to borrow, as we did in Chapter 13, that term from Bentham.

### The Data on Privatization: The Vanishing Trial

The Boston Federal Courthouse is a proud example of a commitment to the flourishing of courts. Its central icons are its twenty-five courtrooms that look more or less like the one depicted in figure 197 (color plate 27).[57] Arches of equal height line the four walls to underscore that litigants, the

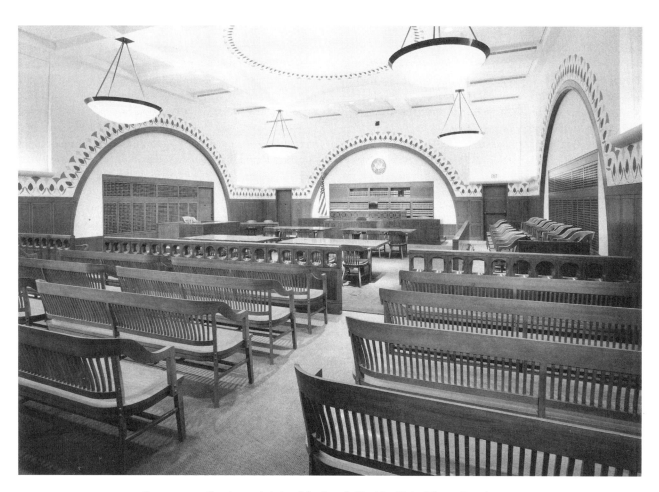

FIGURE 197    Courtroom interior, John Joseph Moakley United States Courthouse, Boston, Massachusetts. Architect: Henry N. Cobb.

Photographer: Steve Rosenthal. Photograph copyright: Steve Rosenthal, 1998. Photograph reproduced with the permission of the photographer and courtesy of the court. See color plate 27.

FIGURE 198    Civil and Criminal Trial Rates, United States Federal Courts, 1976–2000

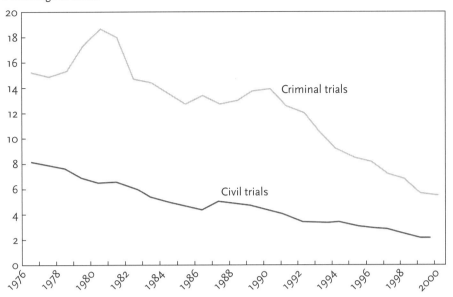

public, the jury, and the judge are all equal participants in the process. Objecting to a "regal procession toward a judicial throne,"[58] the designers also lowered the bench so that it is "elevated by only three steps to enable the judge to easily participate in rather than be set apart from the proceedings."[59] The stenciling, copied from another courthouse in the region, serves as a reminder of the historic role played by courts in New England.

As one views courtrooms such as those in Boston, one should be reminded of the use of the space. In 1998, when that courthouse opened, a total of 142 civil and 48 criminal trials took place in the federal trial courts in Massachusetts.[60] The result was that about 7 or 8 trials were held per courtroom during the new courthouse's inaugural year.[61] Comparable data come from St. Louis, Missouri, where the nation's tallest federal courthouse (fig. 8/112) also has twenty-five courtrooms. In 2007, trials per district judge in that district numbered 11—down from 16 in 2002.[62]

One cannot directly extrapolate from a trial rate to a settlement rate, because cases can be disposed of "on the papers" by judges rendering decisions on issues such as jurisdiction or ruling that one party prevails as a matter of law. Estimates are that judicial decisionmaking occurs in approximately a third of the docket.[63] Moreover, trials are not the only proceeding for which courtrooms are used. Defendants who plead guilty must do so in open court; judges must sentence in public, and oral arguments and other hearings in civil cases take place in courtrooms. Yet, as we discussed in Chapter 9, one study in the late 1990s

found that federal courtrooms have their "lights on"—defined as in use for part of a day—about half of the time.[64]

The statistics on trial rates in Boston and St. Louis are not anomalous but illustrative of national trends. In 1962, on average, federal judges presided at thirty-nine trials a year; by 2002, "the average federal district judge presided over only about nine trials."[65] This downward slope can be clearly seen in a graph (fig. 198), *Civil and Criminal Trial Rates, United States Federal Courts,* which maps the trend in civil and criminal trials between 1976 and 2000.[66] When the types of cases are disaggregated, minor variations exist. But the slope is the same: even as filings have increased, the percentages of cases going to trial have declined, as well as the absolute number of trials.[67] The state courts have a much higher level of filings and of public proceedings, yet data from the states show a comparable pattern of declining numbers of trials.[68] Further, the federal trend line continued beyond 2000. By 2002, in fewer than two of one hundred civil cases filed, a trial began. Lawyers have come to call this phenomenon "the Vanishing Trial."[69]

## The Methods of Privatization

### Managerial Judges Settling Cases

Different modes of ADR limit adjudication's reach. One form is court-based ADR,[70] creating a "new" civil procedure. Before the 1980s, judges in the federal system did not understand themselves to be tasked with settling cases. Rather, their job was to deal with legal questions in advance

of or in lieu of trial and to preside at hearings. Beginning around the middle of the century, however, judges argued the need to "modernize" procedures and chose to emulate businesses as they spoke about the importance of "managing" workloads.[71]

Enthusiastic proponents pushed for judicial education programs to school judges in new techniques for dealing with lawyers and cases. In the late 1940s through the 1960s, self-described evangelistic judges urged their colleagues to conduct "pre-trial" meetings by calling lawyers for opponents together in advance of trial to winnow issues. But the name of the meeting reflected the presumption then still in place: a "pre-trial" meeting presumed that a trial could well come thereafter. To the extent that pre-trial decision-making prompted conciliation, such settlements were a "by-product" rather than the aim of judicial oversight.[72]

During the 1970s and 1980s, however, attitudes shifted. Judges called on their colleagues to become more active managers. Lecturing on the values of settling cases at judicial education seminars, one judge explained: "One of the fundamental principles of judicial administration is that, in most cases, the absolute result of a trial is not as high a quality of justice as is the freely negotiated, give a little, take a little, settlement."[73] Rules of court then changed. In the 1983 revisions to the federal rule governing "pretrials" (with that word's hyphen deleted), language was inserted to recommend that, when meeting with lawyers and litigants, judges raise "the possibility of settlement or the use of extrajudicial procedures to resolve the dispute."[74] By 1993, what had been termed "extrajudicial" the decade before came to be described as "judicial." Procedural rules listed techniques such as mediation and settlement conferences as part of what judges were to speak about with litigants. Indeed, parties were obliged to discuss settlement,[75] and some "local rules" (such as those of the District of Massachusetts) insist that every time judges meet with parties, they raise the question of settlement.[76] Similar provisions can be found in federal trial courts around the United States.[77]

Our focus has been on civil procedure, but those enmeshed in criminal law tell a parallel story of a world enveloped by settlement—plea bargaining, as it is called in that context. Some commentators have argued that the criminal system is so reliant on settlement that its bargains are increasingly lawless.[78] Cited are examples of prosecutors who condition plea agreements on agreements by defendants to waive their rights of appeal or claims of "past and future error."[79] Even claims about allegations of cruel and unusual punishment are "subject to barter."[80] And, n multi-defendant cases, sometimes prosecutors require "package pleas" in which all defendants must acquiesce to get the "deal."[81]

Congress has encouraged ADR through various "civil justice reform" statutes, including one that expressly authorized some federal district courts to adopt "court-annexed arbitration" programs.[82] Under those provisions, certain litigants filing lawsuits were sent to court-appointed lawyers designated to sit as arbitrators and to render decisions that, with parties' consent, became binding. Yet, when compared to mediation, court-annexed arbitration, which is closer to adjudication, was used relatively infrequently. By 2005, about two-thirds of federal district courts had created programs referring cases to mediation.[83]

Form followed function only briefly. In the late 1990s, the *U.S. Courts Design Guide* mentioned the possibility that new courthouses could include "alternative dispute resolution suites" as well as rooms for conferences and "caucusing"— to be "located off the public corridor near a courtroom."[84] More general courthouse design guides also called for "offices for administrative staff, several conference rooms where mediation sessions or arbitration hearings may take place, and waiting areas for parties and their counsel."[85]

But as budgetary constraints prompted cutbacks in courthouse construction, the *U.S. Courts Design Guide* stopped reserving spaces for ADR.[86] Further, as exemplified by the Boston courtroom (fig. 197), interiors were carefully appointed with fixed furniture in a layout made familiar over the past century. Spaces were preserved for juries, witnesses, judges, lawyers, court reporters, and the public, as if trials were ongoing daily.[87] While judges were to multi-task, the rooms in their courthouses were not made to flip back and forth from courtroom to meeting room. Recall, in contrast, that the courtroom designed for ITLOS (fig. 12/178) could be converted into a large meeting hall for delegates to the Sea Convention, and that the Helsinki District Court put movable furniture into its courtrooms (fig. 10/154).

While courtroom design remained impervious to these changes, the job of the judge underwent renovations. Through statutory and rule changes, coupled with training and educational programs, the definition of a "good judge" came to be one focused on and achieving dispositions. Reflective of that focus, data collected at the trial levels often report the time to disposition but not the numbers of opinions issued or written. What is judicial (and judicious) has been transformed, as the tasks of formal adjudication through public processes and reasoned deliberation recede in favor of managerial judging.

These new regimes both created markets for businesses proffering these services and reflected the efforts of such norm entrepreneurs to shape laws helping to generate demand for their wares. The impact of the ADR focus can be measured by its institutionalization through various legal organizations. In addition to becoming a feature of court-based rules over the last decades of the twentieth century, ADR gained institutional status in the American Bar Association and the American Association of Law Schools, both of which promoted the professional development of ADR providers by creating new subdivisions devoted to dispute resolution.[88] Electronic and hardcopy news services specialized in the topic, firms (such as Endispute and JAMS—Judicial Arbitration Mediation Services) advertised their expertise,[89] and various groups convened con-

ferences on topics with titles such as "Court ADR" as they shaped new curricular offerings for law schools and drafted model rules for mediators and other ADR providers.[90]

Measuring the impact of ADR on extant court services has proved complex. One effect—a risk of a "brain drain"—made its way into the press, which compiled information on a few judges who had served in the public sector and then resigned to pursue more lucrative careers in firms offering private judging.[91] Another group affected is lawyers. Some have raised the possibility that pressures toward ADR (including plea bargaining on the criminal side) could alter the pool of individuals interested in becoming lawyers and, eventually, judges. The legal profession prides itself on independence and on the lawyerly role of openly confronting power on behalf of individuals. If such adversarial champions are devalued, persons undaunted by the prospect of conflict may look elsewhere for careers.[92]

As for ADR's effects on the cases in which it is used, assessing the quality of resolutions is notably difficult.[93] The problem, of course, is the lack of baselines for measurement, a problem that also haunts adjudication. ADR enthusiasts, as well as some research, reported that ADR had produced significant cost reductions while not altering outcomes.[94] Other evaluations, however, found that various ADR methods had not fulfilled their promises of reducing costs and time.[95] If cases that would have ended through bilateral negotiations by lawyers were sent to settlement conferences, mandated mediation, or court-annexed arbitrations, outcomes would be delayed as lawyers waited to see how the ADR opportunities affected settlement values. The ADR interventions may have prompted lawyers to prepare more than they might otherwise have done and perhaps thereby to have produced better outcomes but not dispositions that were cheaper or quicker. One response from ADR proponents is that parties' consent is itself the best measure of quality. The presumption is that parties, knowledgeable about their own claims and the underlying facts, are best situated to assess resolutions; when they assent to an agreement, they demonstrate its desirability. ADR skeptics, on the other hand, point to coercive features, such as the high cost of lawyers' fees and the legal promotion of settlement. From this vantage point, in both civil and criminal cases the pressures to form agreements undermine using the fact of agreement as validation of its merits.[96]

The contemporary situation in the federal courts is well described by a distinguished trial-level judge, Brock Hornby, who has played a leadership role in the federal judiciary. Relying, as we have done, on visual terms, he asked how "reality television" ought to portray a federal trial judge. For civil cases, he answered:

> In an office setting without the robe, using a computer and court administrative staff to monitor the entire caseload and individual case progress; conferring with lawyers (often by telephone or videoconference) in individual cases to set dates or limits; in that same office at a computer, poring over a particular lawsuit's facts, submitted electronically as affidavits, documents, depositions, and interrogatory answers; structuring and organizing those facts, rejecting some or many of them; finally, researching the law (at the computer, not a library) and writing (at the computer) explanations of the law for parties and lawyers in light of the sorted facts. For federal civil cases, the black-robed figure up on the bench, presiding publicly over trials and instructing juries, has become an endangered species, replaced by a person in business attire at an office desk surrounded by electronic assistants.[97]

While in his view, judges' "mission to interpret and clarify laws, adjudicate and protect rights, maintain fair processes, and punish" remained the same, "the method of carrying out that mission has changed." Moreover, he urged commentators to "stop bemoaning disappearing trials. Trials have gone the way of landline telephones—useful backups, not the instruments primarily relied upon, if ever they were. Dramatists enjoy trials. District judges enjoy trials. Some lawyers enjoy trials. Except as bystanders, ordinary people and businesses don't enjoy trials, because of the unacceptable risk and expense."[98]

### Unheard Arguments and "Unpublished" Opinions

Before the early part of the twentieth century, many cases were heard, as of right, by the United States Supreme Court. In 1890, for example, the court had 1,800 cases on its appellate docket and was "obligated to decide them all."[99] Under the leadership of Chief Justice William Howard Taft (discussed in Chapter 9), the justices sought docket relief, and, at their behest, Congress responded in the 1920s by authorizing the court to select most of its cases from petitions for certiorari.[100] By century's end, the court had almost complete control over its docket and had reduced its decisions dramatically. In 2001, the court heard arguments in eighty-eight cases and issued seventy-six opinions.[101]

When reorganizing the United States Supreme Court's jurisdiction, Congress also added an intermediate federal appellate level to which litigants could appeal if they were "aggrieved" by a final decision of a trial court. By the end of the twentieth century, those intermediate federal appellate courts received some 60,000 filings each year. As filings grew, so did concerns about handling the volume. Consistent with the approach taken at the trial level during the last few decades of the twentieth century, federal appellate courts also emphasized settlement and dispositions that diminished what the public can see or read. About half of the thirteen federal appellate courts developed "civil appeals management

plans" requiring disputants to meet with staff lawyers to attempt to settle pending appeals.[102] Further, although as a formal matter aggrieved parties unhappy with final judgments have a statutory appeal "as of right,"[103] in practice what constitutes such an appeal varies a good deal. Many appellate courts rely on staff to screen cases and send them to various tracks. Discretionary and low-visibility judgments determine which appeals receive more consideration than others.[104] Cases that make it past such screening do not necessarily proceed to oral argument followed by published decisions. Rather, in many federal appellate courts, oral arguments depend upon courts' permission. By the late 1990s, about 37 percent of cases decided "on the merits" had been orally argued.[105] By 2008, the number was down to 30 percent.[106] Even when litigants were allowed to argue, presentations were sometimes limited to ten minutes per side.

Thereafter, most federal appellate decisions did not result in "published" opinions. The shift away from publication developed during the late 1960s, when the Judicial Conference of the United States (detailed in Chapter 9) proposed that not all decisions needed either to be published or to be available for citation as precedent.[107] One study reported that in 1981, some 90 percent of all opinions were published; by 1995, 25 percent were.[108] While the question of whether litigants may invoke "unpublished" appellate opinions generated constitutional arguments and new rulemaking,[109] as of 2008, the decline in publication continued; only one in five judgments produced an officially published ruling.[110]

Given the internet, what it means for a decision to be "published" has become complex. When the presumption against publication was first put into place, court decisions were sent either to official reporter services that bound them in books or were placed in file drawers accessible only to those who went to look at them. But in 2002, new federal legislation (the E-Government Act) required all appellate opinions to be made available online in a "text searchable format."[111] By 2005, the federal circuits had complied, albeit sometimes denoting opinions as "not for publication" and/or as "not for citation." Entrepreneurial publishers then also created a special bound set of volumes specifically for "unpublished" decisions.[112]

Many commentators (judges included) have argued that accommodations made to deal with the volume of cases have radically changed what it means to have an appeal.[113] Judges rely heavily on staff, delegating decisionmaking internally to lower-level, anonymous government employees. But one of the obvious solutions—a significant increase in the number of judgeships—has not garnered the political support to bring it about.

*Devolution: Administrative Agencies as Courts*

It would be an error to assume that because relatively few trials occurred in the federal courthouses across the United States, evidentiary hearings have vanished. Rather, many such exchanges have migrated from courts into agencies, which are another form of alternative dispute resolution.

The use of Executive Branch officials to do adjudicatory-style work has a long history dating from the country's inception, when Congress authorized certain kinds of private claims to be filed against the United States. If a claimant succeeded, Congress needed to direct payment through "private bills."[114] Shortly before the Civil War, Congress shaped an adjudicatory-like process under the 1852 Steamboat Safety Act. Inspectors had the power to impose sanctions (including the loss of licenses) upon finding unsafe conditions.[115] That provision was the "first statute at the national level to require written reasons for an administrative decision."[116] Three years thereafter, in 1855, Congress created a Court of Claims, a specialized body to deal with a range of monetary claims against the United States.[117]

Details of that court's history provide a glimpse into the expansion of agency adjudication. Given traditions of government immunities, the court represented an acknowledgment that the United States, like private actors, could be subject to suit for failure to perform on contractual or other obligations. Various other measures of the growing entrepreneurial aspirations of the country can be identified. Recall for example that, during the same era, the Treasury Department chartered the Office of Supervising Architect, new federal building projects were launched, and the federal workforce grew in size.

Reflective of its special mission, the 1855 Court of Claims departed in many respects from what were then familiar features of regular courts. Although the Claims Court dealt with monetary claims arising under contracts, it had no juries, as a common law court would have convened when private parties sought damages. Rather, Congress dispatched a separate cadre of three judges to sit to rule on claims.[118] Given that juries are one of the engines of public access to court proceedings, that departure—emulated widely as various other administrative courts gained the authority to level monetary remedies—helped to shape the expectation that administrative proceedings need not always be open. The Court of Claims also moved away from another feature of federal courts, a certain form of judicial independence that gave judicial decisions finality rather than being "advisory opinions," that did not oblige action.[119] In contrast, the Court of Claims had unusual ties to Congress, from which it could receive cases by reference[120] and on which the court's remedies depended because Congress had to appropriate funds to make payments. In short, the Court of Claims had jurisdiction to provide only a particular remedy (monetary awards) for particular harms (breach of contract) by a particular defendant (the United States).

By the end of the twentieth century, a reorganized and renamed Court of Federal Claims[121] had a broader range of cases (including public contracts, tax matters, Fifth Amendment takings, civilian and military pay claims, and vaccine litigation[122]) and a somewhat wider remedial range.

The court was staffed by two layers of non-life-tenured trial judges, one group denoted Court of Federal Claims judges[123] and another set "special masters"[124] dedicated to vaccine cases. Appeals went to a specific life-tenured federal bench, the Federal Circuit. By then, however, what had been distinctive about the Court of Federal Claims was less so because, over the intervening decades, Congress had elaborated many other specialized agency-based courts. Jurisdictional peculiarities, congressional directions about permissible remedies, and special kinds of judges for different kinds of cases had all become the ordinary stuff of various adjudicatory sites within the federal system.[125]

Indeed, the "regular" Article III courts had changed as well. In 1901, those courts were staffed by life-tenured judges. By 2001, Article III courts had become composites in which life-tenured judges were joined by two layers of non-life-tenured judges (magistrate and bankruptcy judges) who, in some districts, outnumbered the life-tenured at the trial level.[126] Congress invented magistrate judges in 1968 by upgrading a small system of United States commissioners and turning them into magistrates.[127] The impetus came, in part, from the focus—discussed earlier—on pretrial processes of civil litigation and docket pressures. Magistrates were given authority over some of the discovery and pre-trial process as well as pre-trial criminal matters.

Initially conceived to be part-time positions, some 450 slots were made available, with relatively few (about 80) full-time jobs. Within thirty years, however, the numbers had flipped, and the name had changed. As of 2000, more than 470 people served full-time as "magistrate judges."[128] The 1990 change in title aptly captured the array of tasks that were delegated,[129] as well as signifying that these judges had the power to issue certain kinds of contempt orders[130] and to preside, with parties' consent, at jury trials.[131] In 1984, Congress elaborated on prior practices for another aspect of the docket by creating new authority for 230 bankruptcy judgeships.[132] By the end of the twentieth century, their number had also grown, as some 325 lines were authorized for bankruptcy judges.

Both sets of "statutory judges" serve for fixed (and renewable) terms. Federal district judges select magistrate judges, and federal appellate judges choose bankruptcy judges. In essence, Congress had devised a way to manufacture significant new judgeships outside the parameters of Article III procedures, in which the President nominated and the Senate confirmed jurists. Instead, statutory judges were selected and reappointed by their life-tenured counterparts.[133] As detailed in Chapter 9, federal courthouse design guides took the new judgeships into account by calling for dedicated courtrooms for those jurists in the specifications for new buildings. Indeed, these new judgeships were part of the argument that such buildings were needed.

Even as one tells the story of growth in the number of judicial personnel in federal courts, the increase is dwarfed by the expansion of the administrative judiciary. As detailed in figure 199, *Authorized Judgeships in Federal Courts and in Federal Agencies in 2001,* far more federal judges work outside than inside federal courthouses.[134] On one side of the graph is a bar representing the 1,650 judges authorized to work in federal courthouses; that number includes the constitutionally appointed, life-tenured judges as well as magistrate and bankruptcy judges. The other column denotes the more than 4,700 administrative judges or hearing officers who work in federal agencies deciding specific kinds of claims, such as those brought by social security recipients, veterans, immigrants, or federal employees.[135] And, reiterating the pattern in courts, state-based adjudicators in administrative agencies far outstrip those situated within the federal system. During the same era, more than 10,000 administrative law judges were based in state and local agencies.[136]

A good deal of the growth in administrative adjudication dates from the 1946 Administrative Procedure Act (APA)[137] creating an infrastructure for agencies both to make rules and to deal with individual claimants. The APA chartered a distinct set of "administrative law judges" (ALJs) to decide cases.[138] Selected through a civil service merit system, ALJs cannot be dismissed except for cause and hence have a layer of statutory insulation that protects their independence.[139] Yet, unlike generalist judges in courts, in the federal system ALJs are assigned to work in (and in some sense for) a specific agency. (Some states do not follow that pattern and instead have generalist administrative law judges working on "central panels.") The largest proportion of federal ALJs staff the Social Security Administration, which, in turn, has also been called the largest court system in the United States.[140] In total, as of 2001, more than 1,350 individuals worked as ALJs in various federal agencies. A significantly greater number—more than 2,600—also decided cases but under the appellation "administrative judges" (not administrative law judges) or "hearing officers." The distinction denotes that these individuals are regular agency employees not afforded the specific protections that the APA gives to its ALJs.[141]

What these sets of new judges in and out of federal courthouses made plain was that the life-tenured judiciary was too small—even as it expanded—to staff the adjudicatory needs of the federal government. Large amounts of what might have been its work were relocated to agencies. As was the case with the promotion of ADR inside courts, some supporters of agency adjudication saw it as a second-best response, a necessary adaptation in the face of demand. Others argued that agency adjudicators provided better dispute resolution either because of their expertise in a particular arena,[142] their greater informality, or the potential for more consistent decisionmaking within bureaucratic structures.[143] Enthusiasm for delegation continued, with new proposals—such as the creation of "health courts"[144]— regularly put forth.

FIGURE 199    Authorized Judgeships in Federal Courts and in Federal Agencies as of 2001

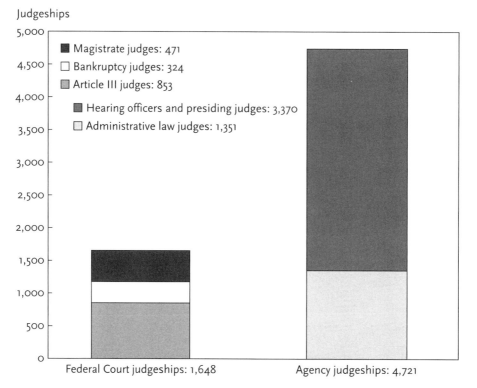

Copyright: Judith Resnik, 2006.

Not all litigants were enthusiastic. Some argued that the delegation of adjudicatory authority violated their rights by cutting off ready access to life-tenured judges. Those claims generally lost, as the life-tenured judiciary upheld congressional delegation of their authority. In a series of decisions rendered over several decades, the United States Supreme Court puzzled about how the constitutional grant of "the judicial power" to courts staffed by judges with life tenure could be squared with agency adjudication. The court relied on various criteria, such as the narrowness of the grant of authority, the oversight provided through appellate review, and the desirability of the more informal procedures, as it generally upheld congressional decisions to vest judicial power in various bodies.[145] When doing so, the court reread the United States eighteenth-century Constitution through a twentieth-century lens to expand the flexibility of national governance.[146] Working in concert, Congress and the courts licensed a host of specialized entities, dedicated to particular areas of law and life, to deliver judicial services.

But the changes have not been uni-directional, as courts were also reformatting their processes. On several dimensions, agency-based adjudication and court-based adjudication overlap. For example, one standard distinction had been that courts were generalized, and agency adjudication was specialized and narrowly focused on one statutory regime. But (as discussed earlier), some agency judges do

not work within a particular agency but serve instead on "central panels."[147] Furthermore, some courts also specialize —exemplified in the federal system in areas such as tax or bankruptcy; in state courts in arenas relating to traffic violations, family life, and probate problems; and at the international level in tribunals dedicated to crimes against humanity or to the law of the sea.

Moreover, as courts delegated adjudicatory work to agencies, they also insisted that the procedural opportunities afforded bear some resemblance to those provided in courts. A "due process revolution" required agency-based decisionmakers to provide "fair" hearings that gave notice to claimants of the basis for proposed decisions and rights to present evidence.[148] Thus agency and court procedure overlapped in terms of factfinding, and both venues came, in the 1990s, to incorporate settlement and other ADR techniques. Moreover, while another distinction had been between factfinding by agency judges and law review by court-based judges, some statutes authorized agencies to develop tiered systems of appeal in which lower-level hearing officers' decisions were reviewed by panels of superiors, and sometimes by courts as well.[149]

The volume of those agency hearings can be glimpsed through another bar graph (fig. 200, *Estimate of Evidentiary Proceedings in Federal Courts and in Four Federal Agencies in 2001*), which compares the numbers of "evidentiary proceedings"[150] in federal courthouses such as those in St.

316    CHAPTER FOURTEEN

Louis (fig. 8/112) and in Boston (fig. 8/113) with hearings in a few federal administrative agencies. A generous calculation counted 100,000 evidentiary hearings over which both life-tenured judges and statutorily chartered magistrate and bankruptcy judges presided in federal courthouses in 2001. That figure includes any occasion on which a witness testified, and hence includes many hearings in addition to trials. The other bar shows some 700,000 evidentiary proceedings in the four federal agencies—the Social Security Administration, the Equal Employment Opportunity Commission, the Immigration Service, and the Department of Veterans' Affairs—that had the highest volume of evidentiary proceedings that year.[151] Thus, while trials may be "vanishing" in federal courts, many evidentiary processes have migrated into agencies that have, functionally, become courts.

Administrative adjudication typically takes place in office buildings that have something in common with Renaissance town halls in that they are multi-function spaces. But, unlike town halls, these office buildings are not often gracious statements of public prosperity and good governance. Many are anonymous institutional facilities. Agency administration is impoverished not only visually (in terms of art and architecture) and spatially (in terms of lack of dedicated courtrooms), but also in terms of the salaries paid to

the judges, the structural protections to insulate judges from oversight, the even greater lack of lawyers for litigants, and the high volume of the proceedings.

While agencies have become a primary venue for tens of thousands of claimants sent to decisionmakers obliged to hear the other side (*audi alterem partem*), two other pillars of contemporary adjudication—structurally independent judges and the rights of public access—are weak. Federal agency jurists, for example, have neither the life tenure of Article III judges nor the statutorily fixed fourteen- or eight-year terms accorded to bankruptcy and magistrate judges. The subset selected formally through the Administrative Procedure Act gain the status of "Administrative Law Judge" and are protected in that role; they are not to be assigned to other kinds of jobs within an agency. Further, as civil servants, they enjoy the status afforded to other government employees, insulated from discharges without cause. But under current legal rules, other kinds of judges— administrative judges or hearing officers—are line employees. For example, "immigration judges" within the Department of Justice could be—and some were—transferred to other positions at the behest of the Attorney General of the United States.[152]

Not only are agency judges less well insulated and the physical spaces less ample, but the processes are also less

FIGURE 200   Estimate of Evidentiary Proceedings in Federal Courts and in Four Federal Agencies, 2001

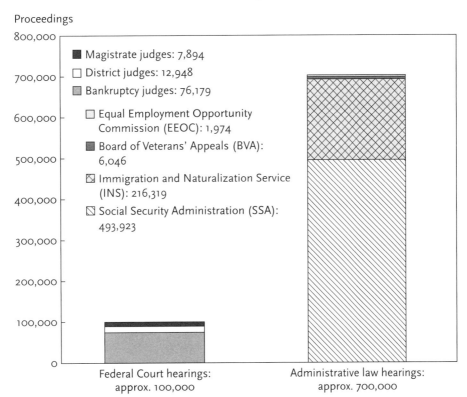

accessible to the general public. No ready way exists to watch the exchanges in which agency hearing officers decide the rights and obligations of hundreds of thousands of persons. In terms of the governing regulatory regime, some administrative hearings are presumptively open and others presumptively closed. For example, special permission is needed to observe hearings by the Equal Employment Opportunity Commission dealing with claims about discrimination in federal employment.[153] Hearings on veterans' claims are generally closed.[154] Immigration hearings may or may not be open, depending on the kind of claim.[155] And, while a subset of Social Security hearings alleging fraud by the recipient are open, the majority of hearings, which involve disability claims, are presumptively closed.[156] In general, the various closures are presumed to be solicitous of the interests of the claimants. As detailed in Chapter 13, the great advocate of "publicity"—Jeremy Bentham —also appreciated privacy concerns but argued for publicity, subject to closure based on specified and narrow grounds in particular instances.

As a practical matter, even when one has the "right" to attend these various proceedings, it is difficult to find them. Government office buildings, unlike courthouses, are not welcoming of street traffic. One cannot even easily know how many such proceedings occur. We termed the numbers in figure 200 an "estimate" because, unable to use a compilation from an extant public database, we produced the assessment ourselves. Unlike the federal courts, served by the Administrative Office in the impressive Thurgood Marshall Building (fig. 8/114) and collating data annually, federal administrative agencies had as of 2010 no shared research division that supplied the public with annual reports detailing their work.[157]

Nor can one easily read—in lieu of seeing—the decisions of federal administrative adjudication. No specialized service collects the judgments of all federal agencies and puts them together in published volumes or online, although a few agencies provide some information through their own websites.[158] A small number of institutions outside of government have taken it upon themselves to collect and disseminate some of the output. For example, one law school located and published the judgments of immigration judges ruling on a subset of applications for asylum.[159] Another group, Transactional Records Access Clearinghouse (TRAC) collected data (in part by filing requests under the Freedom of Information Act) on several agencies.[160] Further, some academics, expert in administrative law, have analyzed sets of decisions or the procedures of specific agencies.[161]

Some of the data collected raise questions about whether the justifications for administrative adjudication (easier accessibility coupled with specialization and, therefore, better decisionmaking) are borne out regularly in practice. Survey data on state administrative adjudication when drivers' licenses were suspended reported criticisms from litigants and lawyers about both the quality and the fairness of decisionmaking.[162] Turning to the federal system, a comprehensive review of 78,459 decisions by immigration judges rendered from 2001 to 2004 found "amazing disparities" in outcomes for similarly situated claimants.[163] Applicants heard in New York had a 52 percent chance of obtaining permission to remain in the United States. Yet similarly situated applicants in Detroit had a 19 percent chance of success.[164] Disparities were not limited to the lower-echelon judges. The researchers examined the reversal rates of decisions coming up to the federal appellate courts. In one federal appellate circuit including states such as Virginia, the reversal rate was 2 percent, in contrast to a rate of 35 percent for a circuit in the Midwest.[165]

In short, and assuming that the 2001 snapshot reflects a regular trend, a larger number of evidentiary hearings took place in federal agencies than in federal courts. Those contexts provide few opportunities for public observation and few resources for the dissemination of the judgments rendered. Add those numbers to the pattern of settlement-focused work of judges inside courts and appellate practices of not publishing decisions and consider the overall trend. Despite growing numbers of persons who use the title "judge" and conflicts called "cases," many state-empowered actors are no longer required to provide their reasons to the public about decisions to validate one side of a dispute and, in tens of thousands of cases, those conflicts are ones to which government is a party.

### Outsourcing through Mandatory Private Arbitration

Yet what occurs within agencies is relatively visible and the judges relatively independent when compared with another form of ADR, exemplified by the excerpt from our own 2002 Cellular Service Agreement, pictured in figure 201.[166] At the time, we had decided to expand phone service. As the text of that document explained, by unwrapping the phone and activating the new service, we waived our rights to go to court and became obligated to "arbitrate disputes arising out of or related to" this or "prior agreements." Even when "applicable law" permitted our joining class actions or class arbitrations, we had also waived our rights to do so. In purported symmetry, this contract also stated that both the provider and the consumer were precluded from pursuing any "class action or class arbitration."[167] Instead of whatever public remedies might be available, customers were required to use the dispute resolution service stipulated by the phone provider, albeit with modifications precluding group-based claims, because at the time the American Association of Arbitration, one of the institutions to which disputes could be sent, had rules providing for aggregating arbitrations. Further, the contract did not provide information on what costs might be charged for using the alternative dispute resolution system.[168]

# Your Cellular Service Agreement

Please read carefully
before filing in a safe place.

### YOUR CELLULAR SERVICE AGREEMENT

This agreement for cellular service between you and [your] wireless [company] sets your and our legal rights concerning payments, credits, changes, starting and ending service, early termination fees, limitations of liability, settlement of disputes by neutral arbitration instead of jury trials and class actions, and other important topics. PLEASE READ THIS AGREEMENT AND YOUR PRICE PLAN. IF YOU DISAGREE WITH THEM, YOU DON'T HAVE TO ACCEPT THIS AGREEMENT.

IF YOU'RE A NEW CUSTOMER, THIS AGREEMENT STARTS WHEN YOU OPEN THE INSIDE PACKAGE OF ANY CELL PHONE YOU RECEIVED WITH THIS AGREEMENT . . . . IF YOU DON'T WANT TO ACCEPT AND BE BOUND BY THIS AGREEMENT, DON'T DO ANY OF THOSE THINGS. INSTEAD, RETURN ANY CELL PHONE YOU RECEIVED WITH THIS AGREEMENT (WITHOUT OPENING THE INSIDE PACKAGE) TO THE PLACE OF PURCHASE WITHIN 15 DAYS.

IF YOU'RE AN EXISTING CUSTOMER UNDER A PRIOR FORM OF AGREEMENT, YOUR ACCEPTING THIS AGREEMENT IS ONE OF THE CONDITIONS FOR OUR GRANTING YOU ANY OF THE FOLLOWING CHANGES IN SERVICE YOU MAY REQUEST: A NEW PRICE PLAN, A NEW PROMOTION, ADDITIONAL LINES IN SERVICE, OR ANY OTHER CHANGE WE MAY DESIGNATE WHEN YOU REQUEST IT (SUCH AS A WAIVER OF CHARGES YOU OWE). . . . YOU CAN GO BACK TO YOUR OLD SERVICE UNDER YOUR PRIOR AGREEMENT AND PRICE PLAN BY CONTACTING US ANY TIME BEFORE PAYING YOUR FIRST BILL AFTER WE MAKE THE CHANGE YOU REQUESTED. OTHERWISE, IF YOU PAY YOUR BILL, YOU'RE CONFIRMING YOUR ACCEPTANCE OF THIS AGREEMENT. IF YOU DON'T WANT TO ACCEPT THIS AGREEMENT, THEN DON'T MAKE SUCH A CHANGE AND WE'LL CONTINUE TO HONOR YOUR OLD FORM OF AGREEMENT UNLESS OR UNTIL YOU MAKE SUCH A CHANGE. . . .

### INDEPENDENT ARBITRATION

INSTEAD OF SUING IN COURT, YOU'RE AGREEING TO ARBITRATE DISPUTES ARISING OUT OF OR RELATED TO THIS OR PRIOR AGREEMENTS. THIS AGREEMENT INVOLVES COMMERCE AND THE FEDERAL ARBITRATION ACT APPLIES TO IT. ARBITRATION ISN'T THE SAME AS COURT. THE RULES ARE DIFFERENT AND THERE'S NO JUDGE AND JURY. YOU AND WE ARE WAIVING RIGHTS TO PARTICIPATE IN CLASS ACTIONS, INCLUDING PUTATIVE CLASS ACTIONS BEGUN BY OTHERS PRIOR TO THIS AGREEMENT, SO READ THIS CAREFULLY. THIS AGREEMENT AFFECTS RIGHTS YOU MIGHT OTHERWISE HAVE IN SUCH ACTIONS THAT ARE CURRENTLY PENDING AGAINST US OR OUR PREDECESSORS IN WHICH YOU MIGHT BE A POTENTIAL CLASS MEMBER. (We retain our rights to complain to any regulatory agency or commission.) YOU AND WE EACH AGREE THAT, TO THE FULLEST EXTENT POSSIBLE PROVIDED BY LAW:

(1) ANY CONTROVERSY OR CLAIM ARISING OUT OF OR RELATING TO THIS AGREEMENT, OR TO ANY PRIOR AGREEMENT FOR CELLULAR SERVICE WITH US . . . WILL BE SETTLED BY INDEPENDENT ARBITRATION INVOLVING A NEUTRAL ARBITRATOR AND ADMINISTERED BY THE AMERICAN ARBITRATION ASSOCIATION ("AAA") UNDER WIRELESS INDUSTRY ARBITRATION ("WIA") RULES, AS MODIFIED BY THIS AGREEMENT. WIA RULES AND FEE INFORMATION ARE AVAILABLE FROM US OR THE AAA;

(2) EVEN IF APPLICABLE LAW PERMITS CLASS ACTIONS OR CLASS ARBITRATIONS, YOU WAIVE ANY RIGHT TO PURSUE ON A CLASS BASIS ANY SUCH CONTROVERSY OR CLAIM AGAINST US . . . AND WE WAIVE ANY RIGHT TO PURSUE ON A CLASS BASIS ANY SUCH CONTROVERSY OR CLAIM AGAINST YOU. . . .

(3) No arbitrator has authority to award relief in excess of what this agreement provides, or to order consolidation or class arbitration, except that an arbitrator deciding a claim arising out of or relating to a prior agreement may grant as much substantive relief on a non-class basis as such prior agreement would permit. NO MATTER WHAT ELSE THIS AGREEMENT SAYS, IT DOESN'T AFFECT THE SUBSTANCE OR AMOUNT OF ANY CLAIM YOU MAY ALREADY HAVE AGAINST US OR ANY OF OUR AFFILIATES OR PREDECESSORS IN INTEREST PRIOR TO THIS AGREEMENT. THIS AGREEMENT JUST REQUIRES YOU TO ARBITRATE SUCH CLAIMS ON AN INDIVIDUAL BASIS. In arbitrations, the arbitrator must give effect to applicable statutes of limitations and will decide whether an issue is arbitrable or not. In a Large/Complex Case arbitration, the arbitrators must also apply the Federal Rules of Evidence and the losing party may have the award reviewed by a panel of 3 arbitrators.

(4) IF FOR SOME REASON THESE ARBITRATION REQUIREMENTS DON'T APPLY, YOU AND WE EACH WAIVE, TO THE FULLEST EXTENT ALLOWED BY LAW, ANY TRIAL BY JURY. A JUDGE WILL DECIDE ANY DISPUTE INSTEAD;

(5) NO MATTER WHAT ELSE THIS AGREEMENT SAYS, IT DOESN'T APPLY TO OR AFFECT THE RIGHTS IN A CERTIFIED CLASS ACTION OF A MEMBER OF A CERTIFIED CLASS WHO FIRST RECEIVES THIS AGREEMENT AFTER HIS CLASS HAS BEEN CERTIFIED, OR THE RIGHTS IN AN ACTION OF A NAMED PLAINTIFF, ALTHOUGH IT DOES APPLY TO OTHER ACTIONS, CONTROVERSIES, OR CLAIMS INVOLVING SUCH PERSONS.

FIGURE 201    Example of cellular phone contract, 2002.

Voluntary arbitration has a long history, some of which we sketched in Chapter 12 in relationship to two transnational institutions, the Permanent Court of Arbitration (creating state-to-state dispute resolution mechanisms) and the International Tribunal for the Law of the Sea (configuring a range of procedural options for state and non-state parties). Inside the United States, arbitrators have been a feature of conflict resolution in various settings, including specific industries that developed their own arbitral systems, and in some communities affiliated by religion or ethnicity.[169] Moreover, labor–management agreements to arbitrate have a special place in American law.[170]

Litigation is also infused with deference to decisions by litigants. Of special reference here are doctrines enforcing contracts that include "forum selection clauses" that send disputants to designated courts.[171] Mandatory arbitration contracts are a variation in that they provide that—before disputes arise—parties commit to resolutions of whatever conflicts emerge without seeking redress in courts. The issue for courts arises when, after alleged breaches of contracts, one side wants to ignore that contract clause and have the dispute resolved by judges.

What law ought to do when parties renege on such agreements to seek redress outside of courts (rather than specifying in which court to file) has prompted varying responses. Courts and legislatures puzzle about the optimal degree of state control over dispute resolution and what level of coercion to impose. During the nineteenth century and much of the twentieth, courts were reluctant to enforce contracts to arbitrate. Protective of their special mandate, judges frowned on agreements to avoid them and concluded that it was against "public policy" to enforce such contracts over the objection of one side.[172] But, through a mixture of statutory innovations and judicial interpretations supporting mandatory arbitration clauses, the cell phone contract reproduced in figure 201 became enforceable by the 1990s.

In 1925, Congress enacted the United States Arbitration Act, which recognized certain kinds of arbitration contracts as enforceable obligations.[173] That statute (now called the Federal Arbitration Act, or FAA) was focused on commercial contracts rather than on consumer or employee relations; indeed, at the time, congressional power over such intrastate transactions was not obvious. By the 1950s, some litigants argued to federal judges that they ought to enforce form contracts proffered by institutional players, such as securities brokers, in which purchasers of stocks agreed that, if alleged violations of federal statutory rights arose, the dispute would be dealt with by arbitration. But

judges declined to do so—objecting to the pro forma contracts seen as "adhesive" because of the overwhelming bargaining power of one party. Judges also explained that arbitration was too flexible, too lawless, and too informal as contrasted with adjudication, which they praised for its regulatory role in monitoring adherence to national norms.[174]

However, in the 1980s the United States Supreme Court reversed some of its earlier rulings, as it reread federal statutes to permit—rather than to prohibit—enforcement of arbitration contracts when federal statutory rights were at stake.[175] Several of the Supreme Court's decisions dealt with consumer contracts, such as between a securities broker and a client or a borrower and a creditor. But a few decisions enforced arbitration between employees and their employers. In 2001, the Court applied that approach to endorse mandatory arbitration despite an employee's claim that his right under state law to be free from discrimination based on sexual orientation had been violated.[176] In addition, when parties disagreed about how to interpret contractual provisions about whether arbitration was required, the Supreme Court held that such issues were to be decided, at least initially, by arbitrators and not judges.[177] Whether invoking rights under state or federal law, as long as the mandatory arbitration provided an adequate mechanism for protecting such rights,[178] the United States Supreme Court insisted on the validity of contracts that put dispute resolution outside of courthouses and away from open and public hearings.

A good many cases have litigated the parameters of the obligation to arbitrate, the kinds of procedures required, the clarity of contract terms, and the costs entailed.[179] Yet to pursue such arguments and challenge the operation of these contract clauses requires both knowledge of the potential for invalidity as applied and resources. Critics argue that when such contracts involve parties with disparate bargaining power (such as when employers require that forms be signed before they will interview an individual for a job), the courts ought not to enforce them.[180] Some legislators have taken up those concerns in proposals, for example, to make such contracts unenforceable for consumers, or for employees bringing civil rights claims. In addition, a few targeted statutes have been enacted to limit their applicability.[181] Further, the enforcement approach of United States federal law is not shared transnationally; several other jurisdictions do not routinely enforce pre-commitments by consumers and employees that enable marketers and employers to avoid courts.[182]

The tension between an adjudication-based model and arbitration is exemplified through a series of events in Nebraska, whose constitution embodied one of the precepts—open courts—with which we began Chapter 13. Like several other states, Nebraska had long required that all "courts shall be open, and every person, for an injury done him in his land, goods, person, or reputation, shall have remedy by due course of law, and justice administered with-

out denial or delay."[183] At the end of the nineteenth century, the Nebraska Supreme Court interpreted this provision to preclude the enforcement of obligations to arbitrate because to do so would "oust the courts" of jurisdiction.[184] A few years later, in 1902, that court explained that to enforce those contracts would "open a leak in the dyke of constitutional guarantees which might some day carry all away."[185]

Almost a century later, in 1991, the Supreme Court of Nebraska held that a statute requiring arbitration violated the state's constitutional requirement that its courts "shall be open."[186] In response, a constitutional amendment was ratified in 1996 that provided for ADR. The text was altered to add the caveat that "the Legislature may provide for the enforcement of mediation, binding arbitration agreements, and other forms of dispute resolution which are entered into voluntarily and which are not revocable other than upon such grounds as exist at law or in equity for the revocation of any contract."[187]

Thus, legal regimes in the United States have been reconfigured through the work of a host of actors, including judges and legislators. Provisions now require that contracting parties, be they co-equals or employees and consumers, use mandatory arbitration programs, some of which are created by employers, manufacturers, and providers of goods and services, so long as the alternatives provide adequate means to vindicate federal or state rights.[188] The change in law reflects a change in attitude about both adjudication and its alternatives. Judges once bemoaned the informality of arbitration but over time came to praise its flexibility. Further, judges once argued the distinctiveness of adjudication as a public regulatory mechanism but came to reappraise what courts did; adjudication and arbitration were homogenized as variations on a theme.

Proponents of mandatory arbitration and various other ADR and DR mechanisms argue that they augment the adjudicatory regime by making opportunities to be heard available to individuals who would otherwise be priced out of court. Given the ever-present challenges of empirical research and baselines, evaluation of that proposition is difficult, made all the more so because providers do not routinely offer either qualitative or quantitative data.

Indeed, secrecy about both processes and outcomes is often a signature of such programs. Commentators describe confidentiality as "an essential element"[189]—designed (as one court put it) to "foster an atmosphere of open discussion" aimed at avoiding trials.[190] Such privacy is protected by the rules of various providers as well as by statutes[191] and court judgments. For example, an organization called JAMS—Judicial Arbitration & Mediation Services—promised that it and the arbitrator "shall maintain the confidential nature of the Arbitration proceeding and the Award, including the Hearing" unless required by courts to do otherwise.[192] As one court explained when enforcing cell phone contracts akin to figure 201, confidentiality was part of the "character of arbitration itself" that

prevented it from having precedential value and gaining the trappings of adjudication.[193]

In addition to banning disclosure by participants, attendance by third-party observers is either presumptively prohibited[194] or depends on the parties and the arbitrator. Moreover, some dispute resolution providers' rules note that if members of the media are permitted to attend, they may not record the proceedings.[195] The absence of public access makes it difficult to assess either the degree of fairness of the process or the neutrality of the decisionmakers.

In lieu of that form of information, some research has focused on another measure—whether mandatory arbitration clauses are used when corporations enter contracts with each other, as contrasted with imposing them on consumers. In one study, researchers looked at 164 negotiated contracts entered into among telecommunications, credit, and financial services companies that also proffered mandatory arbitration clauses to purchasers of their products.[196] In that set of contracts, "less than 10% of negotiated nonconsumer, non-employment contracts included arbitration clauses."[197] By way of contrast, "mass" contracts (such as that offered by our cell phone provider) included obligatory arbitration in three-quarters of the contracts reviewed.[198] The researchers relied on this disparity to conclude that the obligation to arbitrate was imposed more to "preclude aggregate consumer action" than to facilitate access to dispute resolution.[199] One might still justify such clauses, for example, by arguing that litigation lacks social utility in that the costs outweighed the benefits—because transaction costs were high, or regulatory oversight more efficient, or service providers would increase the cost of products or be deterred from entering certain markets.

But sorting out those claims is made difficult because alternative dispute resolution procedures do not regularly produce transcripts, public observers, or reported outcomes.[200] As a consequence, support for the proposition that contractual dispute resolution programs are better than adjudication—in terms of access, costs, speed, or outcomes—is hard to come by. Law has thus outsourced to the private sector services that were once provided through public institutions, although not all who wanted to use courts had the resources to do so. Scant data are available that inform discussions about the volume, the location, the processes, or the outcomes of such proceedings. The kinds of inter-community conversations, norm development, and formal obligations to treat opponents in a dignified fashion, provided through public courts, are less available to the segments of disputants consigned to these other venues.[201]

REGULATORY OPTIONS: PUBLIC ACCESS TO
ALTERNATIVE DISPUTE RESOLUTION

Limited access to information about ADR is not necessarily intrinsic to it. Courts that enforce arbitration contracts require that the alternatives are adequate to "vindicate" the claimant's legal rights.[202] Under that test, judges have concluded that processes that impose significantly higher access fees on litigants than do courts would not be an adequate substitute for courts.[203] One could graft other requirements onto adequate vindication, such as procedures that include a public dimension. Courts or legislatures could, for example, condition enforcement of contracts for arbitration on regulatory interventions enabling public access to arbitration results and processes,[204] as well as insist on data about outcomes produced through other forms of ADR.[205]

Adding such requirements could be understood as consistent with the many ways in which the law has regulated settlement processes. For example, a Florida statute requires that settlements above a certain value of medical malpractice claims be recorded on the web.[206] More generally, in 1990, Florida enacted its "Sunshine in Litigation Act" prohibiting the enforcement of agreements or contracts that have either the purpose or effect of "concealing a public hazard or . . . any information which may be useful to members of the public in protecting themselves from injury which may result from the public hazard."[207] Several other states have similar provisions,[208] with comparable proposals put forth at the federal level.[209] Further, jurisdictions routinely require that criminal defendants enter settlements by pleading guilty "in open court."[210] Some states also insist that litigants record civil settlements by assenting in open court as well.[211]

In addition, many courts prohibit the routine sealing of court documents.[212] And while parties have sought to condition settlements on courts' willingness to vacate prior judgments, some jurisdictions have declined on the grounds that such judgments may not be part of the bargains struck by private parties.[213] On the other hand, many jurisdictions permit and enforce confidential orders governing exchanges of information in discovery,[214] closure of proceedings related to children, and the occasional sealing of court files.

In short, various forms of regulation already set parameters for public and private access to information in negotiation, settlement, and adjudication—and more could be imposed. Proposals include, for example, licensing mediators and arbitrators,[215] imposing court oversight requiring arbitrators to apply substantive law or explain their decisions,[216] and providing parameters for mediators working in and outside of courts[217] so as to circumscribe ADR providers and ensure greater loyalty to the "rule of law."[218] These regulations could enhance accountability, transparency, fairness, and the democratic norm development that are enabled by public court procedures.[219]

Yet the more regulation is imposed on ADR, the more proponents worry that the vitality of the alternative is undermined through over-legalization. Some of that concern is focused on the higher-end commercial arbitration, with illustrations such as the International Bar Association's Rules on the Taking of Evidence in International Commer-

cial Arbitration.[220] Others look at efforts to impose rules on consumer arbitrations. ADR specialists have argued that arbitration is becoming the "new litigation,"[221] meaning that it is increasingly expensive, lawyer-driven, and rule-bound. Some report that repeat players are shifting to a more informal process, mediation, justified as offering "[s]peed, cost, and control."[222] That preference is echoed in court-based ADR, where mediation has "emerged as the primary . . . process in the federal district courts."[223]

"Bargaining in the shadow of the law" is a phrase often invoked,[224] but bargaining is increasingly a requirement of the law of conflict resolution. As a consequence, the distinctive character of adjudication as a discrete activity and a specific kind of "social ordering" (to borrow from Lon Fuller) is diminishing.[225] Through case management, through judicial efforts at settlement and mandatory ADR in courts, through devolution to administrative agencies, and through enforcement of waivers of rights to trial, the framework of "due process procedure," with its independent judges and open courts, is being replaced by what can fairly be called "contract procedure."[226] And, in mimetic symmetry, both court-based judges and their counterparts in the private sector now produce private outcomes that are publicly sanctioned.

## MULTI-JURISDICTIONAL PREMISES (AGAIN)

Our examples have been from the United States, but the phenomenon we have described is not territorially bounded. Complaints about costs, delays, and undue complexity in courts span the globe (as well as the centuries). So do lawyers, some clients, and judges, who are part of an international marketplace.

Some of the networks facilitating exchanges in legal practices are institutional actors, such as the International Bar Association, which was founded in 1947.[227] Others are more recent, such as newly-minted "global" law firms in which hundreds of lawyers work in regional offices sited in major commercial centers around the world. Judges are likewise members of various global conferences and organizations, such as the European Judicial Network.[228] Consumers of legal services, such as governments and corporations, also regularly criss-cross national borders.

In various venues, jurists and their clients articulate concerns about litigation akin to those in the United States, as they propose new initiatives ranging from efforts aiming to enhance access to courts to regimes limiting their use.[229] The remedies have also been parallel—outsourcing and privatization of court processes through the embrace of ADR. Thus, one can map a shift from adjudication to ADR —or the breaking of the courts' monopoly, to borrow from Yves Dezalay and Bryant Garth[230]—at the national and the transnational levels in Europe as well as in international courts such as ITLOS. We illustrate this point with a brief review of some procedural innovations focused on ADR in England and in Europe. Our focus on England comes from its dramatic reconfiguration of procedural rules in the 1990s, its longstanding identification with commercial arbitration, and the enthusiasm of some of its lawyers for voluntary mediation in a range of disputes.[231] Europe offers another example through a 2008 directive for Member States to develop mediation in cross-border disputes. (Various other transnational trends could be mapped, such as the formulation of procedures in many countries for the aggregation of claims to enable group-based litigation bearing a resemblance to American class actions.[232] Aggregate litigation could be understood as a kind of alternative system, but here we focus on the shift in handling individual cases.)

As we move from the United States to other jurisdictions, we do not argue a simple homogenization that ignores distinctive features of discrete legal systems or different understandings of the range and role of courts in a given polity.[233] Rather, our goal is to sketch the shared embrace by judges and legislators of methods other than adjudication that divert disputes eligible to be heard in courts. Success, if measured by declining numbers of trials, can be found in venues other than the United States, for the phenomenon of the "vanishing trial" is not limited to the United States. Researchers in England have also documented "steep increases" in filings accompanied by declining rates of trial.[234] Dame Hazel Genn found, by the 1990s, a reduction in "authoritative" adjudication.[235]

## Tracking, Managing, and Obliging Mediation: Lord Woolf's Reforms in England and Wales

As Jeremy Bentham's nineteenth-century critique illustrated, reflections on the procedural rules of England have a long history. By one calculation, during the twentieth century some sixty official reports were commissioned to evaluate civil processes as reformers wrestled with access, cost, delay, and complexity. In the 1990s, England underwent a great many changes related to courts, from abolishing the office of the Lord Chancellor, a position hundreds of years old, to creating a new Supreme Court. In addition, England changed its procedural system as it also cut back its funding for legal aid.

England had been at the forefront of recognizing access to justice as a civil right, supported through a broad entitlement program. England's 1949 Legal Aid Program was remarkably ambitious, initially aiming to be responsive to need. (Recall that Bentham had called for funding access to justice, including support for transportation and lodging near courts.[236]) Twentieth-century reformers shared some of his ideas; their goal came to be described as putting parties on "an equal footing."[237] To operationalize those aspirations, individuals certified as meeting the means test for eligibility could seek assistance from the private bar, paid according to a schedule of fees. Usage was high; by the

1980s, one study reported that during the course of four years the legal aid budget grew from some 100 million pounds to more than 250 million pounds, with most certificates for legal assistance related to family matters. By the mid-1990s, civil legal assistance cost about 600 million pounds, and public funds represented significant percentages of private lawyers' incomes.[238] That distribution method prevented the segregation of a small cadre of lawyers into a "poverty bar."

The growing budget for legal assistance made visible the high costs of using civil justice processes. One response by the government was to limit eligibility, which fell from 80 to 40 percent of the population. In the 1990s, two more fundamental changes occurred. Through legislation styled "The 1999 Access to Justice Act," new restrictions were imposed that capped the amount of funds to be made available and changed the organizational structure of legal aid providers.[239] The limits placed on legal aid dovetailed with limits placed on litigants seeking to go to court. In the 1990s, Lord Harry Woolf, then a senior jurist in London, was asked by the Lord Chancellor to chair an inquiry into the handling of civil cases. Woolf's two reports—a preliminary and a final version of *Access to Justice*—argued that procedural opportunities were too expansive and expensive and that judges needed to take a more active role in managing cases to curb undue adversarialism.[240] As Hazel Genn has noted, these reports were part of a larger discourse with contradictory elements, in that complaints about "too little access" clashed with distress about "too much law."[241]

Woolf's goals were to shift control over the pace and quantum of litigation away from individual lawyers to judges and to find ways to encourage the use of ADR to achieve settlements. (As another jurist, Randall Cranston, put it, ADR was "the flavour of the decade."[242]) Woolf's final 1996 report proposed that lawyers "front load work"; before filing lawsuits, lawyers were to be obliged to confer with opponents to see if agreements in lieu of litigation were possible. To do so, the report called for detailed "protocols" (to be developed for different kinds of cases through bench-bar committees) specifying the steps to be taken before filing. Further, Woolf urged that judges be given managerial powers to ensure that the costs of proceedings were "proportionate" to the amount at stake as well as the authority to sanction misbehavior by allocating costs based on assessments of the reasonableness of positions taken.

In 1999, pre-action protocols and new rules became effective in England and Wales. Claimants were required to serve demands on opponents, who were charged with investigating and replying.[243] If unsuccessful, litigants were to proceed through different "tracks," tailored in principle to be "proportional" to the needs of cases ("small claims," "fast," and "multi-track").[244] In addition to imposing these pre-filing and post-filing protocols,[245] the Woolf Reforms commended the use of mediation. While initially envi-

sioned as voluntary, rules authorized sanctions for litigants who declined to participate in mediation.[246] These mandatory obligations stood in some tension with two predicates of the report, access to courts and the desirability of voluntary conciliation. Yet, in practice, it appeared that without coercion, mediation was chosen less often by litigants (or their lawyers), who expressed preferences for adjudicatory procedures. And indeed, reports of settlement practices describe exchanges as something other than pastoral moments in which parties come together in warm embrace. As Simon Roberts has observed from his close study of a commercial court in London, conciliation could be a "long, bruising process, characterized by secrecy and suspicion,"[247] at the end of which the court ratifies what the parties have agreed to live with.

Further promotion of ADR came from a 1998 government "White Paper"—called *Modernising Justice*—that explained that "for most people, most of the time, going to court is, and should be, the last resort."[248] All government agencies were to use ADR, when appropriate.[249] As Shirley Shipman, who has studied the shift in procedures explained, the government then used various methods of "encouragement," including education, reprimands to the bar, public promotion, court orders, and sanctions, and put the courts under "political pressure" to adopt modes different from court-based adjudication.[250] Reports of a normative shift come from Roberts, who described the "fundamental reorganization" taking place in English courts as judges embraced a "culture of settlement."[251] Reminiscent of Judge Hornby's comments about changes in the United States federal judicial role, Roberts argued the need to reconceptualize courts from places of public trials to spaces providing "an arena for structured bilateral negotiations" that entailed "protracted conversations" among parties.[252]

Moreover, as in the United States, the English reforms were not limited to the trial level. In the late 1990s, a committee chaired by Sir Jeffery Bowman filed a report on civil appellate procedures.[253] Like the Woolf Report, that committee worried about expense, delay, and complexity, and focused on enhancing efficiency. Concerned about rising numbers of appeals, the Bowman Report concluded that courts were too lenient in granting permission (leave) to appeal. Rejecting an "automatic right of appeal," the report called for a change in culture through court management, a fast track for certain appeals, and constraints on others—all aiming to make the quantum of process "proportionate" to the scope of a given controversy.[254] In 2001, the recommended restrictions were put into place. Litigants were required to seek permission from judges for almost all civil appeals or cross-appeals; moreover, a decision on whether to grant leave to appeal was itself final and not appealable. To gain permission, applicants needed to show a real chance for success or "some other compelling reason."[255] Grants could also be limited to specific issues and accompanied by conditions, such as requiring security for pay-

ment of an opponent's appellate costs or for the judgment itself.

A decade after the Woolf Reforms were put into place, debate about their effects was underway, albeit with little empirical information[256] and more calls for interventions, as government spending on civil and criminal cases reportedly exceeded 2 billion pounds.[257] Commentators described the influence of Woolf's approach in other countries, such as Australia, England, Scotland, and Israel,[258] and some saw the work as related to more general efforts to be less court-centric when imposing the rule of law.[259] As for its impact on cases in England, a small study found that ADR provisions had added somewhat to costs,[260] as did some research in the United States. Other researchers reported that many practitioners found the reforms a "success" in that they provided a clearer structure for work, but that problems of delay and cost remained.[261] A third survey of judges described the views of some that the reforms were themselves a new source of delay.[262] Other critics argued that the new system had rendered an already cumbersome procedural world more complex.[263]

Questions were posed about the rationales for and the utility of the changes. One issue was whether the claimed "crisis" in civil justice existed, and if so, whether it was an artifact of England's budgetary processes that linked criminal and civil justice.[264] When prosecutions increase in a system where the government pays for both impoverished criminal and civil litigants, the obligation to support prosecution and defense puts pressure on the civil side, where funding has been conceived to be discretionary. Other critics of the Woolf Reforms found the revisions too radical, undoing the best of English practices by unduly increasing the discretion accorded judges and yet not responding to the needs to expand access to justice.[265] On the other hand, some complained that the reforms did too little, failing to alter the incentives of lawyers and therefore not able to constrain the fundamental problem of the high cost of process.[266]

Work by researchers based at University College London and the National Centre for Social Research suggested a different critique—that of irrelevance.[267] While ordinary individuals believed that law affected their lives, almost none used court-based processes. Eight out of ten surveyed used neither ADR nor courts, nor did they seek assistance from ombudspersons to remediate the many problems they encountered. Even after the Woolf Reforms and the revamping of legal aid, government funding costs were high but coverage was inadequate.[268] More generally, Genn argued, reforms took place based on too little data, and the result was policymaking "in the dark."[269]

## Outsourcing to Tribunals

As in the United States, a good many disputants in England are sent to "tribunals" akin to administrative agencies in the United States. Under English practice, these tri-

bunals resemble common law courts in some respects, in that independent decisionmakers render judgments after hearing oral evidence.[270] Yet one study of the Social Security Appeals Tribunals reported about the many problems of this alternative to courts—including poor first-tier decisionmaking, a lack of independence of decisionmakers, high error rates that went unchallenged due to claimants' general confusion, lack of knowledge, sense of powerlessness, and stress.[271] Another project considered the Immigration Appeal Tribunal, operating under greater formality than some other tribunals and with support through state-funded representation for claimants. Researchers saw the more court-like procedures as playing a significant role in claimants' success.

The disheartening indications from the research projects were that speed and reduced expenses were associated with losses in fairness, accuracy, and consistency of decisions. Furthermore, the complexity of the administrative regulations meant that specialist tribunals were not havens from legalism but rather depended on it. As a result, when claimants had lawyers, they could rely on them appropriately to buffer against inaccurate and unfair decisionmaking. In 2004, in the wake of the Woolf Report, reforms in some tribunals reformatted procedures to place "greater emphasis on early dispute resolution"[272] and to reduce reliance on "formal oral hearings."[273] Objections were then leveled that cutting back on oral hearings was unwise; critics argued that hearings were both more "user-friendly" than the new alternatives and offered a transparency that constrained government authority.[274] That proposition found support in various studies of disputants, who repeatedly reported their preference for participatory opportunities before a neutral decisionmaker.[275]

## Competing for Transnational Arbitration

The City of London has long been famous for offering its services as a "seat" for commercial arbitrations of disputes arising around the world.[276] Competition for this business became acute over the twentieth century as various private providers (such as the International Arbitration Association) and new courts (such as the Permanent Court of Arbitration and ITLOS) became options. To underscore its continuing desire to attract disputants of this genre, England has repeatedly revised its law of arbitration to give more autonomy to parties.

England's Arbitration Act of 1950 had enabled parties to create their own procedural template but licensed judicial oversight to ensure that arbitrators' substantive decisions would not result in a commercial law different from that of the English courts.[277] Substantial revisions came through the 1996 Arbitration Act, responding to criticism that English arbitration law had become too cumbersome and inaccessible, too judge-controlled, and therefore that it put at risk London's historic centrality to international commercial disputes.

According to commentators, the changes were transformative in valorizing party autonomy and imposing "judicial minimalism" that restricted courts' powers to intervene. In an effort to appeal to arbitrators themselves, new provisions conferred upon them a statutory immunity from liability, like that enjoyed by judges, to insulate them from unhappy disputants. Some constraints on party autonomy remained in place. In contrast to the United States, judicial oversight of consumer arbitrations gave judges the power not to enforce "unfair contraction terms," sometimes defined as those not negotiated individually or those creating a significant imbalance of rights between contracting parties. England's 1996 Arbitration Act also detailed some rules to clarify expectations in the absence of specific tailoring by the parties through contract.

The changes in England followed and interacted with the creation—through the U.N. Commission on International Trade Law (UNCITRAL)—of a model arbitration law, promulgated in the mid-1980s and aimed at harmonizing provisions for international arbitration. Further, efforts were undertaken to shape a "transnational civil procedure" that could be adopted by countries or entities to attract (or reassure) disputants in particular venues.[278] The creation of more rules and entities for dispute resolution was responsive to an increase in international investment treaties that often provided a range of options for settling disputes when national governments were in conflict with claimants from other countries. As noted in Chapter 12, the competition for transnational arbitrations can be intense, as the Permanent Court of Arbitration (PCA), the International Centre for the Settlement of Investment Disputes, the International Arbitration Association, the Paris International Chamber of Commerce, and national commercial courts and dispute resolution organizations seek to attract disputants.[279]

When proffering their services, several of these organizations offer privacy as an asset. UNCITRAL, for example, describes "confidentiality of information" as one of the "advantageous and helpful features" of arbitration.[280] Similarly, the International Bar Association's rules on evidence-taking in arbitrations confirm the obligation to ensure confidentiality.[281] Yet concerns have been raised about the wisdom of keeping secret conflicts that could involve major commercial interests as well as nation-states. Some have argued that at least the "bare facts" of cross-border commercial disputes involving governments ought to be made public.[282] Furthermore, not all international arbitrations entail parties of equal bargaining power. Some of those whom Catherine Rogers calls the "Have-Nots"—employees, consumers, and human rights victims—may also be sent to arbitration when they become involved in cross-border disputes.[283] As for kinds of regulation, UNCITRAL provided something like an "internal" law of arbitration, creating a format for selecting arbitrators and developing a case and the possible structures for awards. These guidelines did not address either what principles should govern or the coercive authority to enforce contractual terms—prompting reconsideration of UNCITRAL's procedural regime in 2009.[284]

Radical reforms in England were not limited to the embrace of ADR. In 1998, Parliament passed the Human Rights Act, domesticating the European Convention on Human Rights (ECHR).[285] As a consequence, elements of the implementation of the Woolf Reforms—such as the imposition of sanctions for those litigants declining to participate in mediation—have been questioned as incompatible with the English tradition of access to courts, as well as with the "fair hearing" rights of Article 6 of the ECHR.[286] In addition, EU understandings of judicial independence have had a major impact. As of the fall of 2009, England's "Law Lords" no longer sat in Parliament but became part of a new Supreme Court for England and Wales, whose new court opened (as discussed in Chapter 10) in 2009 in a refurbished Middlesex Guildhall in London's Parliament Square.

Thus, at one end of the litigation spectrum—its top—the creation of a Supreme Court brought attention to the importance of court-based adjudication. In contrast, throughout the other tiers, efforts were underway to reduce court-centered judgments. At the lower levels, disputants were diverted to various forms of ADR and blocked from bringing appeals to the intermediate courts. And because England hoped to continue to attract a share of the market of commercial disputes, entities or individuals with resources have the ability to shop procedural offerings and to shield both process and outcome from public scrutiny.

## Mediation under the Direction of the European Union

In addition to the procedural opportunities offered by the PCA and ITLOS, another example of the transnational embrace of ADR, intersecting with express admiration for rights and access to justice, comes from the European Commission (EC). In 2008, the EC issued a directive giving Member States three years to develop frameworks for mediation in "cross-border disputes"[287] involving entities or individuals from different EU countries. In 2009, the European Commission appointed a new Commissioner for Justice, Fundamental Rights, and Citizenship, to put a higher profile on those very issues.[288] As the new Commissioner explained in a press release, "EU citizens should not face barriers to justice when they leave their home countries."[289] Thus, in many jurisdictions, a double discourse exists, simultaneously celebrating courts and discouraging claimants from seeking their services in various kinds of disptues.

The attempt to keep both commitments can be found in the Mediation Directive's findings that preface the directive, describing it as an effort to develop a "balanced relationship between mediation and judicial proceedings."[290] But the Directive appeared weighted toward mediation, explained as "a cost-effective and quick extrajudicial resolution of disputes in civil and commercial matters through processes

tailored to the needs of the parties."[291] Further, the Directive argued mediation's greater efficacy: agreements were "more likely to be complied with voluntarily and more likely to preserve an amicable and sustainable relationship between the parties."[292] The EC called on its Member States to create methods to encourage disputants to use mediation. National courts were to "draw the parties' attention to the possibility of mediation whenever . . . appropriate."[293] While the use of mediation was nominally voluntary, a range of provisions imposed pressures to do so. Moreover, the Directive recognized the authority of national courts to make mediation "compulsory or subject to incentives or sanctions provided that such legislation does not prevent parties from exercising their rights of access to the judicial system."[294] In addition, Member States could set forth time frames for parties to mediate, and when judges were themselves not "responsible" for the judicial proceeding, they could directly conduct mediations.[295] Further, parties' agreements to mediate were to be enforced,[296] with the results of mediations to be confidential, in part to protect subsequent opportunities to arbitrate or litigate.[297]

The Directive had limits in that it applied only to cross-border disputes in which parties consented to mediation in civil and commercial matters. In the United States, courts have enforced contracts mandating alternative dispute resolution even if the parties do not have equal bargaining powers. Under the European Directive, mediation was not required where "parties are not free to decide themselves under the relevant applicable law," and thus generally did not apply to disputes in family or employment law.[298] The Directive also noted that European law already regulated "out-of-court bodies" in consumer protection, which were subject to "minimum quality criteria." In addition, the Mediation Directive called for the development of a database of acceptable "out-of-court" schemes.[299] More generally, the EC called for another database by requiring reports on implementation from each country by 2016.[300] Some proponents also hoped that initial efforts to impose a requirement of mediation in cross-border disputes would provide a model for Member States to create domestic legislation to require the same in national courts.[301]

In sum, Europe has pressed national systems to shift procedural formats toward ADR. Initial responses were mixed, with some commentators enthusiastic, others skeptical,[302] and yet others notably critical.[303] One aspect of that concern was the tension between the push toward mediation and the precepts of the European Convention on Human Rights, which under Article 6 guarantees fair and public hearings.[304] Yet, as can be seen by commitments on both sides of the Atlantic, "the development and encouragement of the use of ADR, together with the expansion of techniques for promoting settlements, reflect a view that disputes should be resolved whenever possible outside the courts and by methods other than actual litigation."[305] Furthermore, the managerial model for judges, embraced in the 1980s in the United States and in the 1990s in England, came to be seen as useful in other countries and even in international criminal procedures.[306]

## Transnational Procedural Shifts

Before we turn to the adoption of ad hoc procedural mechanisms for 9/11 detainees and explore the relationship between ADR in ordinary litigation and the processes crafted for alleged terrorists, a summary is in order of the trends identified thus far. First, dissatisfaction with civil processes has become commonplace, resulting in a language of "crisis" that outlasts temporal dimensions implied by that term. Second, much of the discussion of procedural reform borrows from the language of law and economics to focus on incentives and efficiencies rather than relying on a political theory of the role of courts in democratic orders. Even as "rights" of access are formally iterated in national and transnational documents, opportunities for using public courts are diminishing. While Bentham set forth the utilities of publicity and sought to broaden access to courts through subsidies, contemporary procedural modeling puts little value on either.

Third, the interdependence of civil processes and the legal and juridical professions (Bentham's "Judge & Co.") continues. The turn toward "case management" gives judges some degree of authority over lawyers as rules of civil process become prescriptions to lawyers for providing client services and responding to court demands. As judges are given authority to superintend lawyers, they also gain discretion, largely immune from oversight by either the public or appellate courts. Moreover, the practice of judging has itself shifted through the development of administrative infrastructures that focus on dispositions and shield individual judges from visible responsibility for outcomes.

Fourth, providers of process and forms of process have proliferated in both public and private settings. As the volume of claimants rose during the twentieth century, so did the tension between highly individualized inquiries undertaken by relatively visible and costly government actors and the need to produce millions of judgments about disputed claims of obligation and right. One response was to vest decisionmaking authority in government institutions such as agencies. These alternative courts have augmented capacity but have not provided a great deal of confidence in the quality of processes and outcomes, nor have they regularly built in public procedures or accountings.

Another technique is the turn to aggregation of cases through class-action-like devices. Large-scale litigation has demonstrated utilities in redressing adversarial imbalances but brings a host of challenges. The point of bundling claims is often to press opponents to capitulate through settlements to avoid the risk of trials. Yet aggregation is also problematic, as it raises questions about the requisite degree of relatedness of claims, the quality of representation, the loyalty of lawyer-agents often holding economic stakes

larger than do individual claimants, the interests of defendants in precluding subsequent claimants, and the capacity of judges to monitor risks to absentees.

Fifth, the piling up of procedural options, from agencies to private providers and from individual to aggregate processing, demonstrates for some that judicially-based civil processes are anachronistic, predicated on an obsolete nineteenth-century individualistic model. As societies organized through bureaucracies and lawyers moved toward aggregate practices, judges were still peculiarly functioning as solo practitioners, inefficiently engaging in labor-intensive craft-like work. From this vantage point, higher-court judges are appropriately becoming administrators, overseers, and employers—selecting and dispatching their juniors and rationing court attention. First-tier judges are, in turn, seen as properly engaged in multi-tasking, molding processes and inter-personal techniques to fit needs. The tradeoffs, however, are a loss of individualization, and of judges taking personal responsibility for judgments, and hence accountability for the rulings there entailed.[307]

Sixth, assessing the effects of the various new procedures is complicated both by the variety of disputes and by a lack of clarity about what metrics to use. Some critics rest their concerns on usage rates (too much or too little), others on the distribution of usage or of costs (variously measured and charged), and yet others on the forms of remediation possible and achieved. Proponents laud the new initiatives and cite declining percentages of trials and formal appellate rulings as measures of success, while critics bemoan them. In contrast, other empirical work argues the failure of both the earlier and the new models of process as unresponsive and therefore irrelevant to many would-be claimants unable to afford to go to court or to use the alternatives.

A final note is a reminder that a focus on proceduralism ought not to imply an autonomy that does not exist. Reforms of procedure are not "only" about procedure but are also related to the goals of substantive law, the creation of professionalized judiciaries, the institutionalization of courts as corporate actors within governments, the development of agendas by academic and practicing lawyers, and the aims of court users, all of which are also founded in country-specific and in transnational social movements.

## THE CONTINUUM ON WHICH GUANTÁNAMO BAY SITS

During the first years of the twenty-first century, another site—Guantánamo Bay—became important to the discussion about the relationship between adjudication and privatization. For most of the twentieth century, Guantánamo was simply the naval base of the United States in Cuba.[308] In the 1990s, the base gained another identity as the place of detention for thousands of Haitian refugees whom the United States intercepted at sea and sought to exclude from the country.[309]

After the attacks on the United States on September 11, 2001, Guantánamo gained worldwide infamy as a prison for individuals detained there by the United States.[310] Initially, more than 750 persons were housed at Guantánamo; by the end of 2009, fewer than 220 remained.[311] In the intervening years, detainees at Guantánamo alleged that they had been tortured (there or elsewhere).[312] Corroboration emerged when information became available about memoranda—subsequently known as "the Torture Memos" —that had been prepared in 2002 by lawyers in the United States Department of Justice.

In a formal legal opinion, lawyers advised that, under federal law, "for an act to constitute torture [it required the infliction of] pain that is difficult to endure . . . equivalent in intensity to the pain accompanying serious physical injury, such as organ failure, impairment of bodily function, or even death."[313] Further, for "purely mental pain or suffering to amount to torture . . . it must result in significant psychological harm of significant duration . . . lasting for months or even years."[314] As details of conditions of detention were made public, some commentators suggested that surveillance activities in facilities at Guantánamo echoed aspects of Jeremy Bentham's Panopticon.[315]

For constitutional lawyers, "Guantánamo" is also shorthand for a series of cases about the legality of such detention. In an Executive Order issued in November of 2001, the President (then George W. Bush) decreed that the status of Guantánamo detainees was to be determined by ad hoc processes organized under the Department of Defense.[316] A few months later, the Department of Defense issued "Military Commission Order No. 1" describing the Secretary of Defense (or a designee) as the "Appointing Authority," with the power to create special commissions to try detainees.[317] But beginning in 2004, the United States Supreme Court ruled that the federal courts had jurisdiction to consider the legality of detention at Guantánamo[318] and that the constitutional guarantee of due process constrained the government's treatment of at least the detainees who were American citizens.[319] The executive branch then set up various proceedings for those incarcerated at Guantánamo.

## The Appointing Authority's Adjudicatory Discretion

The procedures created bore a resemblance to administrative adjudication in the United States. Under regulations issued by the Department of Defense, an entity termed a "Combatant Status Review Tribunal" (CSRT)[320] was charged with determining whether a detainee was an "enemy combatant" (EC),[321] a category created by United States law and variously defined as including those who have been "part of or supporting the Taliban or al Qaeda forces, or associated forces that are engaged in hostilities against the United States or its coalition partners."[322]

CSRT classification proceedings[323] could (at the discretion of the Department of Defense[324]) be followed by administrative reviews conducted by another new entity, an "Administrative Review Board" (ARB) empowered to make a yearly determination about "whether each detainee should be released, transferred or further detained."[325] As one press briefing explained, the question was whether a detainee remained "a threat to the United States or still [held] intelligence value."[326] Insisting that it had no obligation to provide process, the government outlined its decisionmaking procedures. Before a hearing, the government was to solicit information about an individual detainee from the Department of Defense, other government agencies, and—through the government—from that person's family and national government.[327] A military officer could provide assistance to the detainee[328] at a hearing, where the detainee was permitted to appear in person before a panel of three military officers and "provide information to support his release."[329]

The military officers were the first-tier decisionmakers. They were to be "qualified for the duty by reason of education, training, experience, length of service, temperament, and objectivity," and at least one was to be "experienced in the field of intelligence."[330] Opportunities existed after the hearing for "additional fact-gathering," including obtaining "behavior assessments of the combatant."[331] Thereafter, and based on its "review of all reasonably available information," an ARB was to make written recommendations with reasons and specification of the evidence relied upon.[332] The final decision remained with a "Designated Civilian Officer" (DCO), identified as the Deputy Secretary of Defense.[333]

In addition to the CRST–ARB–DCO procedure, a subset of detainees, "whose actions rise to the level of suspected war crimes,"[334] could also be subjected to another procedure, termed a Military Commission, overseen by three to seven individuals, each of whom had to be "a commissioned officer of the United States armed forces . . . including . . . reserve personnel."[335] Those Commissions were given the power to try any individual "subject to the President's Military Order" and "alleged to have committed an offense" involving "violations of the laws of war" and "all other offenses triable by military commission."[336] The regulations promulgated by the Department of Defense gave the Executive the authority to impose sentences including "death, imprisonment for life or for any lesser term," or another "condition of punishment as the Commission shall determine to be proper."[337]

## Court-Like, Court-Lite: "Honor Bound to Defend Freedom"

Thus, rather than using the regular federal court system (in which other terrorists had been tried in the 1990s) or using the regular military courts that have existed for

decades and have tried individuals in the United States Armed Forces, the Executive created an ad hoc, sui generis set of procedures for anyone whom the government decided to send through them.[338] The CSRTs, ARBs, and Military Commissions made Guantánamo appear somewhat court-like. Echoing the town halls of Europe, the facility was a multi-function site, with some spaces for detention and others for hearings. The United States government produced a spectacle akin to those of yore; individuals branded terrorists might be glimpsed through the barbed wire of the outer fence at detention facilities (fig. 202) on the island.[339] The government thus represented itself as having the power to provide safety to those on the mainland.

To legitimate its detention, the government also offered website images of its deliberation room, complete with its courtroom-like setup, as replicated in figure 203.[340] In 2006, the military proposed building its own courts, estimated to cost between $75 and $125 million, on the base. The plan, circulated through a "presolicitation notice,"[341] called for "up to two new courthouses" and space for 800–1,200 administrative personnel, as well as places for lawyers, journalists, and others to live and eat.[342] As the press detailed architectural renditions of layouts, objectors registered concerns. One commentator noted that, given the number of detainees, the construction price could have been calculated at $1.6 million per detainee.[343]

In February of 2007, Secretary of Defense Robert Gates reported in a Senate hearing that the proposal had been withdrawn, as he acknowledged that his Department would be "handed our hat" if it requested such funds from Congress.[344] Instead, the Department sought $1.6 million to upgrade existing facilities.[345] Yet another courthouse version, a new portable complex dubbed "Camp Justice," was then envisioned to provide for a scaled-down group of 550 court officials, lawyers, security personnel, journalists, and observers.[346] The 2008 presidential election and conflicts about whether to close the facility interrupted discussions of building, and the new President, Barack Obama, announced plans to close the detention facility.[347] Members of Congress objected, and, as of the end of 2009, Guantánamo continued to house detainees and to serve as a site for decisions about their confinement.[348]

The room depicted in figure 203, to be used for procedures related to military commission hearings, is inside the Joint Task Force (JTF) building (fig. 204), which the Department of Defense explained was to house the "first U.S. military commissions in more than 50 years."[349] The 2009 photograph of the flags above the "Camp Justice" sign (fig. 205, left panel) reiterates the effort to invoke the rule of law, as does the logo on that sign (figure 205, right panel[350]). The Camp Justice logo is a variation on the official seal of the Department of Defense, which is, in turn, a variation on the Seal of the United States.[351] In the Camp Justice version, the Defense Department's eagle with a shield of red, white, and blue, three arrows, and thirteen

FIGURE 202    The outer fence and guard tower at Camps 1 and 4 at Camp Delta at the U.S. Naval Station in Guantánamo Bay, Cuba, April 24, 2007.

Photograph copyright: PAUL J. RICHARDS / AFP / Getty Images.

FIGURE 203    Hearing Room Interior, Guantánamo Bay, Cuba, January 2006.

Photograph reproduced courtesy of Major Jeffrey Weir, Deputy Director of Public Affairs, 2006, Joint Task Force Guantánamo Bay.

FIGURE 204    Joint Task Force Guantánamo Commissions Building at Guantánamo Bay, Cuba, photograph posted
October 29, 2004, U.S. Department of Defense website, DefenseLINK News Photos.

http://www.defenselink.mil/photos/newsphoto.aspx?newsphotoid=5763. Facsimile, Yale University Press.

FIGURE 205    Left panel: Camp Justice, Guantánamo Bay, 2009.
Right panel: Logo, Department of Defense, Office of Military
Commissions.

Photographer: Travis Crum; reproduced with his permission.

stars is encircled at the top by the Department's name. Superimposed are scales and a pentagon at the logo's center, and the words "Office of Military Commissions" at the bottom. Under the eagle and scales is the slogan "Freedom through Justice."

Text can also be found above the entry to the JTF building, shown in figure 206.[352] That inscription reads: "Honor Bound to Defend Freedom"; that is also a call ("Honor Bound") and response ("To Defend Freedom") exchanged among soldiers as they walk past each other on the base.[353] (The phrase has also been used as the name of a British play protesting "U.S. abuses of human rights."[354]) The maxims offered at Guantánamo Bay stand in contrast to words found inscribed in regular courts. In 1935, the entrance to the United States Supreme Court was marked by the words "Equal Justice Under Law" (fig. 207[355]). The injunction "Hear the Other Side" can be found in Renaissance town halls, such as the one in Gouda, the Netherlands (fig. 13/194), and in the occasional courthouse in the United States, such as the Illinois Supreme Court (fig. 13/195). The

Missouri Supreme Court features a Latin sentence translated as "Where there is a right, there is a remedy" (Ubi jus, ibi remedium).[356] Another Latin injunction, "Fiat justitia, ruat coelum" (Let justice be done, though the heavens may fall), is also a fixture in courts, most famously pronounced in the English judgment of 1772 in *Somerset's Case* finding slavery illegal.[357] While depicting scales, none of the texts chosen by the Department of Defense refer to obligations of equality, and the repeated use of the term "freedom" is not likely meant to be read as referencing the rights of detainees to be freed if wrongly held.

The distance between the work of those in a building marked by the words "Honor Bound to Defend Freedom" and the requirements imposed on those obliged to provide equal justice and hear both sides is echoed by the Guantánamo procedures, which lack the central normative obligations that define courts. As Bruce Ackerman has commented, the oath taken by officials at Guantánamo tribunals did not affirm commitments specifically to the United States Constitution.[358] Nor were these officials asked to repeat

FIGURE 206    Joint Task Force (JTF) Guantánamo Commissions Building, entrance, February 2006.

Photograph reproduced courtesy of Major Jeffrey Weir, Deputy Director of Public Affairs, 2006, Joint Task Force Guantánamo Bay.

FIGURE 207   United States Supreme
Court, *The Contemplation of Justice*
and the inscription "Equal Justice
Under Law," Washington, D.C., 1935.

Photographer: Lois Long, Collection of
the Supreme Court of the United States.
Image reproduced courtesy of the Office
of the Curator, Photographic Collections,
United States Supreme Court.

what federal judges must say when they take office, that
they "will administer justice without respect to persons,
and do equal right to the poor and to the rich, and will faithfully and impartially discharge and perform all the duties
incumbent . . . under the Constitution and laws of the
United States."[359] The military decisionmakers sat inside
the chain of command, in no way independent from the
Appointing Authority, the Secretary of Defense.[360] Guantánamo's processes harked back to Renaissance Europe,
where judges' charters depended on the ruling powers—

perhaps making paintings of the story of Cambyses (figs.
3/31 and 3/32) object lessons for both litigants and judges.
Indeed, a few military personnel who served as prosecutors
or sat on CSRTs and who disagreed with decisions of the
Department of Defense in charging or detaining individuals, reported publicly (and sometimes in court filings)
about efforts to undermine their independence. Some lost
their jobs as a consequence.[361]

But in the town halls of many city-states, leaders had
been insistent on the public display of authority. In contrast,

the Department of Defense tried to assert its power to hold, classify, and try alleged terrorists at Guantánamo Bay far from the public view. The government seemed not to think it needed to generate legitimacy through procedural formality.[362] Only those with permission from the government were permitted to enter the base,[363] which in turn required travel by either air or sea. Detainees' lawyers lodged complaints about the difficulties of reaching their clients, communicating with them, and working collaboratively,[364] as did the Red Cross.[365] Moreover, at times, the government took the position that it was not obliged to provide information about detainees to federal judges sitting in courts inside the United States.[366]

As for the public, attendance depended on the "discretion of the Appointing Authority."[367] A 2002 Military Commission Order stated that the proceedings "should be open to the maximum extent practicable"[368] but did not recognize a "right" to attend, a presumption of openness, or a requirement that closures be narrowly tailored as needed in particular cases. Instead, the Presiding Officer of the Military Commission was authorized to "close proceedings"[369] to protect classified or "classifiable" information, for the safety of personnel, and based on "other national security interests."[370] The Presiding Officer could make that decision on his or her "own initiative" without notification to prosecution, defense, or others. Further, the Presiding Officer had the power to exclude the accused or "any other person" other than the military defense counsel.[371]

As figure 208 suggests, closed-circuit television had been proposed to permit members of the media to watch the Military Commissions scheduled to have begun in 2004.[372] But, as the press reported, while inviting "journalists and human rights observers to the terrorism trials," the Department of Defense "imposed a censorship policy [that limited] the openness of the first military commissions since World War II."[373] Reporters were to sign a five-page set of "ground rules," agreeing not to "publish or discuss anything mentioned in open court that the presiding officer decides should have been kept secret."[374] The military reserved "the right to seize notebooks from human rights observers."[375] After objections, the compromise was to have the reporters cross out information in their notebooks.[376]

As for observing the classification proceedings through CSRTs and ARBs, the military initially deemed its processes "administrative," as it asserted the right to keep those kinds of processes closed.[377] Even when permitting observers, the Defense Department limited what could be reported,[378] and issued "Media Ground Rules for Coverage of Administrative Review Boards."[379] In 2005, the Associated Press filed a lawsuit under the Freedom of Information Act (FOIA[380]) to obtain transcripts of those proceedings.[381] From published decisions by federal judges addressing that

FIGURE 208    Closed-circuit television system, Joint Task Force Guantánamo hearing room.

Photograph posted October 29, 2004. U.S. Department of Defense website, DefenseLINK News Photos. http://www.defenselink.mil/photos/newsphoto.aspx?newsphotoid=5762. Facsimile, Yale University Press.

claim, one can glean that someone termed a "recorder person" (rather than a "court reporter") made notes at CSRTs and ARBs and that some members of the press in attendance were able to hear testimony proffered by witnesses.[382] But tape recording was prohibited,[383] and the Defense Department tried to block disclosure of transcripts. The government argued that the need to protect the privacy of detainees and their families made the materials exempt under FOIA.[384] A federal district judge disagreed,[385] holding that the government had not met its burden of showing that the detainees had any reasonable expectation of privacy.[386] As the court noted, in dozens of court filings, detainees had provided information about their home life in efforts to establish that they were not appropriately detained.[387]

Between 2004 and 2007, information became available that explained the government's interest in secrecy. The Torture Memos, the mistreatment of detainees at Abu Ghraib prison in Iraq, and congressional inquiries revealed a horrific pattern of abuse. Further, a few individuals who had participated in proceedings at Guantánamo reported routine failures of process. One example, submitted to the courts, came from Lieutenant Colonel Stephen Abraham, a member of the reserves who had been commissioned in 1982 as an officer in the Intelligence Corps. After 9/11, he was assigned to work in the Office for the Administrative Review of the Detention of Enemy Combatants, and he sat on one CSRT panel.

In June of 2007, Abraham submitted an affidavit in court about the poverty of the information provided as a predicate for detention ("often outdated, often 'generic,' rarely specifically relating to the individual subjects of the CSRTs or to the circumstances related to those individuals' status"[388]), the inability to verify whether exculpatory information existed, and the pressures to find a person an "enemy combatant" ("What were purported to be specific statements of fact lacked even the most fundamental earmarks of objectively credible evidence"[389]). In addition, former military prosecutors (such as Colonel Morris Davis and Lieutenant Colonel Darrel Vandeveld[390]) indicated their disquietude with the blanket closures and the degree of control over prosecution exerted by the Pentagon.[391] Thus, disclosures of abuse of persons and process came before the public.

As various domestic and foreign commentators have argued,[392] the procedures at Guantánamo were unfair. They lacked the four signature features of courts: the evidentiary procedures did not ensure that both sides were heard; the judges were not independent; the public had no right of audience; and detainees were not afforded rights equal to those of other criminal or civil litigants. In contrast, these attributes can be found in both international criminal courts dealing with allegations of crimes against humanity and in the United States military court system. As described in Chapter 12, all of the international criminal courts build in public access. The International Criminal Tribunal for the former Territories of Yugoslavia (ICTY), for example, permitted persons to watch behind huge glass walls that secure the courtroom; the court transmits its proceedings to the Balkans, where they are broadcast in English, French, and Bosnian/Serbian/Croatian.[393] Further, the accused had a right of access to the court, personally, to register concerns directly and in public to the international judges.[394] Like Jeremy Bentham, who described reasons to close certain proceedings, such as to protect state secrets, the ICTY also created ways to shelter information. If an individual witness was at risk or security required closure, the blinds closed to preclude the live audience from seeing what transpired, the broadcast screen scrambled, and voices were recalibrated to make them unidentifiable.

As for regular domestic military courts in the United States, the procedure for trials (called "courts-martial") of members of the armed forces are codified in federal statutes and regulations. The 2008 Manual for Courts Martial required that "courts-martial shall be open to the public," including "members of both the military and civilian communities."[395] As those regulations specify, the military judge was not to violate the "accused's right to a public trial" and could authorize closure only by a specific showing of necessity—a "substantial probability that an overriding interest will be prejudiced"—and after "reasonable alternatives to closure were considered and found inadequate."[396] Exclusions required "findings on the record establishing a reason" that they were both "necessary" and "as narrowly tailored as possible."[397] Blanket closures were not permissible; rather case-specific findings had to be made on the record.[398] (In practice, as in other administrative adjudication systems, observers interested in attending may encounter challenges in learning about where hearings are held.[399])

The procedures at Guantánamo thus departed from precedents in both international and domestic law. Recall that pre-democratic powers put on spectacles of authority in an acknowledgment that the sheer imposition of power was insufficient to obtain public acceptance. In contrast, the Appointing Authority initially took no steps to make visible its procedures to legitimate its power. The administration, aided by the Congress,[400] also tried to block detainees' access to life-tenured judges. (As was subsequently revealed, its secrecy was also animated by efforts to hide the treatment of detainees.) Repeatedly, however, the United States Supreme Court concluded that individuals held at the base could bring habeas corpus actions challenging their confinement.[401] Yet those already released and seeking to hold individuals liable for injuries had not, as of 2010, been able to obtain redress in court for past injuries.[402]

## FOUCAULT'S FOOTSTEPS

One might well think of Guantánamo as isolated in both the literal and legal senses. But unfortunately, some of its

procedures are not as foreign to contemporary decision-making as one might wish.[403] Our examples from America's courts and agencies, England's procedural reforms, and European directives to mediate cross-border disputes aim to substantiate the thesis that Guantánamo is radically aberrational,[404] and yet must also be understood to be continuous with developments in much more ordinary and much less high-profile contexts where the exercise of both public and private power is also becoming less visible. Outsourcing, devolution, subcontracting, and facilitating non-public resolutions are increasingly the norm, as courts and legislatures send work to agencies and to private dispute resolution centers. Recall that, when precluding access to the CSRTs and the ARBs, the Department of Defense denoted its processes "administrative," implicitly referencing regulations that presumptively close hearings for veterans and social welfare recipients and operating against the backdrop of confidentiality provisions proliferating in ADR.

Yet an important distinction exists between the procedures at Guantánamo and various forms of ADR in other settings. The closure of ordinary administrative proceedings and the privacy of ADR are argued as benefiting the participants—for example, by shielding from public scrutiny needy individuals seeking the state's financial support. More generally (whether empirically supported or not), the movement toward ADR is justified as offering more than adjudication can—more access for claimants, less cost, and more congenial procedures. In contrast, the government's move to appoint itself the judge and create its own CSRT–ARB–Military Commission activities was claimed to benefit the government and the public and to be safer because of unfettered government control of detainees. No arguments were offered that the process improved the opportunities of detainees to be treated fairly and with respect.

But the lack of publicity in all of these settings leaves outsiders dependent for information on participants. In terms of Guantánamo, one could read government materials extolling Military Commissions as providing "a fair [and] full trial, while protecting national security and the safety of all [those] involved, including [the] accused."[405] Alternatively one can focus on claims made by objectors—such as the Center for Constitutional Rights, the American Civil Liberties Union, some members of the press, the United Nations Special Rapporteur for the Independence of Judges and Lawyers, and the Rapporteur on Torture—condemning the processes as profoundly unfair and illegal. But closure and secrecy dispossessed citizens of their capacity to evaluate these claims directly.

Courts are constituted by practices. The need for independent judges to hear both sides of disputes in public and for judges to be independent does not follow only from a theory of the justice of those attributes. Rather, there remains the need to struggle with the disquieting question at the heart of judicial power with which we began this book: when can violence be used in the name of law? When

that issue is engaged in open court processes, we—those outside the immediate dispute—have a role in understanding, legitimating, delegitimating, and interpreting what law means, what justice entails, what the predicates of its practices are, and what violence is acceptable or intolerable.

Political theorists such as Seyla Benhabib speak of "democratic iterations" as a way to capture a dense set of interactions that can, over time, function as a mechanism to limit the scope of rulers' powers and change normative precepts.[406] In Chapter 13, we proffered the example of the public execution that, along with public pillory, produced what Michel Foucault called a "gloomy festival."[407] Over time, as this "great spectacle of punishment ran the risk of being rejected by the very people to whom it was addressed," the state developed a new form of private punishment. The prison asserted its coercive authority while removing it from public view.[408] Guantánamo provides the vivid contemporary parallel. The fear of terror was repeatedly invoked to justify closed procedures on the naval base, as well as to bar detainees from bringing claims to mainland federal courts. While some judges insisted that detainees had a right to be heard in court, several rebuffed efforts to obtain information and redress for mistreatment and torture. As one explained, the "need for secrecy can hardly be doubted."[409]

The procedures crafted by the Department of Defense at Guantánamo are nested in the developing traditions of various other kinds of closed procedures. Through administrative hearings and the devolution of the power of judgment to private processes, we are watching a larger phenomenon, the imposition of discipline (the power and the law of the state) without state acknowledgment of a need to show its power in order to justify its exercise. The seventeenth- and eighteenth-century French legal regime that framed Foucault's book *Discipline and Punish: The Birth of the Prison*, entailed a more secretive trial procedure than that of the twentieth century. As we mapped in Chapter 13, the establishment of "rights" of access to court is a modern phenomenon, representing a struggle to gain control over both government and private power.

Today, courthouses are so familiar that one might assume that they always existed, just as the rights that they have come to embody feel deeply entrenched. Within these many purpose-built structures sits the "pearl of the courtroom." As building manuals dictate, the courtroom is the one designated space in which judges, otherwise "completely separated from the public," can interact with disputants before the public.[410] Yet even though the exterior glass facades are designed to convey openness,[411] not much remains to be seen. Instead, one finds "too little publicity, with a consequent increase of secrecy, in areas hitherto considered public."[412] A courthouse may remain "public" but only to denote, as Habermas put it, that a structure "simply house[s] state institutions."[413]

In Chapter 13, we pointed to the parallel functions of post offices and courts. Both institutions were once seen as

providing central public services that were used, metaphorically and literally, to build national identities and norms. Both institutions enabled the free exchange of information without government censorship. The impact of the postal service has been impressive, as it secured "the right of every individual and organization in America to send almost anything from anywhere to anyplace else, for a relative pittance [and played] a major role in knitting together the country's economic and social fabric."[414]

The longevity of public post offices—in their incarnation as segregated special buildings and as recipients of government subsidies supporting the mailing of newspapers, magazines, packages, and letters—has been put into doubt by claims that provide yet another parallel to courts. The basic criticisms of the two institutions are the same: inefficiency, the existence of better private alternatives, and technological obsolescence. The proposed remedy for post offices is to end the public subsidies and recycle the buildings. Cutbacks have already taken place as public funding has been reduced, competitive services expanded, and many local post offices closed.[415] Of course, post offices are one of many institutions that, during the course of centuries, came under the public charge and are in the process of being deaccessioned. Other government services, including schools, the military, and prisons, have also been outsourced[416] through what Jody Freeman and Martha Minow have called "Government by Contract."[417]

Courts may be next in line. One intriguing data point comes from a committee of the federal judiciary charged with implementation of that system's 1995 *Long Range Plan* (discussed in Chapter 9). In 1995, worried about a deluge of cases, researchers in the federal judiciary had forecast that, by 2010, more than 600,000 cases would be filed in the federal district courts (holding bankruptcy filings aside).[418] But instead, the number of filings (civil and criminal) for several of the years between 2005 and 2009 averaged about 310,000 to 350,000 annually, which was about where filings had been in the decade before.[419] Thus one can map a move away from courts on various dimensions. Crossing the Atlantic Ocean to England, Simon Roberts's study of "one English civil court in a metropolitan commercial center" provides another image. "The courts—buildings with now often empty courtrooms—take on an increasingly symbolic character, just as judges now appear as 'exemplary,' ceremonial figures, legitimating other peoples' decision-making."[420]

Of course, the shift to alternative procedures might not necessarily be problematic. One could celebrate the multiplication of "diverse governance regimes" that mix public and private functions in what Gunther Teubner has described as a "hybridization"[421] and Martha Minow as a "partnership,"[422] while also acknowledging that the intermingling of public and private is no novelty. Historic examples include the authority of private persons, as well as public officials, to initiate prosecutions in courts.[423] More-

over, the building of roads, the detention of individuals, and schooling were all "private" enterprises that became "public" as the realm of government expanded and as various services came to be understood as state-run or state-regulated because of the "public interest" in such functions.[424]

Yet the violence entailed in conflict resolution cannot be readily assimilated into a model that envisions the ebb and flow of functions between the public and private domains. To borrow again from Martha Minow, "outsourcing power"[425] (there referring to the military) raises troubling questions. Indeed, much of the ideology of ADR suggests that conflict is to be avoided rather than that conflict is not only intrinsic to social ordering but important to its wellbeing. Conflicts are part of how polities legitimate their norms. Rather than seek to avoid or suppress the "liveliness" (per Stuart Hampshire) of conflicts, regimes need to both engage the underlying disagreements and encourage open processes that enable disputants to face their disagreements and explore their differences.[426] As currently formatted, however, ADR procedures cut off the communicative possibilities provided through courts to record, as well as to struggle with, conflicts of meaning, rights, and facts. The new procedures also undermine the discipline to be imposed on decisionmakers. Various private procedures prize "caucusing"—meeting with one side, then the other, "ex parte" (to borrow the Latin)—rather than enabling each side, as well as the judge, to "hear the other side."

The set of pictures and the rights elaborated in this volume make plain that the deployment of courts in the effort to proclaim and to cabin power has both a long history and a recent evolution. Views of the thousands of impressive courthouses around the world and texts guaranteeing open and public courts in national and international conventions suggest a stability rendering the buildings and the precepts invulnerable. Representing an amalgam of law and culture, tradition and ritual, courts could be understood to be all the more entrenched. One could put the rising number of claimants, the development of new information technologies, and the popularity of media portrayals of trials (both real and fictional) into a picture in which courts have an unprecedented scope of authority whose processes and outputs are disseminated through diverse outlets.[427]

That description is both accurate and incomplete. This chapter has offered a different perspective and a competing narrative. In the United States in the 1970s, consumers of goods and services and employees were not required to sign form contracts that imposed bars to bringing claims to courts. In that era, those who did file federal lawsuits were not greeted by judges insistent that they explore alternatives to adjudication. The new approaches leave vulnerable not only claimants alleging violations of rights but also judges who come to resemble other governmental workers engaged in an array of tasks. As judges themselves press to alter juridical modes and thus come to resemble other offi-

cials, it is not clear how they will or why they should sustain special claims on resources or rights of independence from political oversight. More generally, the United States, England, and Europe are exemplary of jurisdictions confident in the stability of their judiciaries, and therefore reformers believe it unlikely that changes would undermine the rule of law and confidence in and respect for judges. But commentators from jurisdictions with newer judiciaries and more recently formed democracies have raised the caution that the kind of judicial intervention promoted on both sides of the northern Atlantic are inappropriate for fragile and overworked systems. On this account, the publicity accorded judicial processes protects judges as much as litigants.[428]

In sum, the mapping of the declining public dimensions of conflict resolution is aimed at undermining the assumption that public access to and transparent proceedings within courts are inevitably enduring features *of* courts. Procedures, laws, and norms have great plasticity. Practices that seemed unimaginable only decades ago (from the mundane examples of the relatively new reliance on court-based settlement programs to the stunning assertions by the United States government of the legitimacy of according few or no procedural rights to individuals at Guantánamo) are now part of the collective landscape.

Yet, as we discussed earlier, privatization of conflict is not inevitable, nor are procedures unchangeable, whether based in courts or their alternatives. Just as the ADR movement in courts has made it implausible, circa 2010, to equate court-based litigation with inherently public processes, it would be erroneous to assume that outsourced procedures must be closed off from public purview. The task is to find methods to protect "collective, diffuse and fragmented interests"[429] at a time when new technologies enable identification of shared problems and recording of information in ways that are radically different from those that were available in earlier eras.[430] In the "intersection of administrative, economic, and social practices,"[431] procedures need to be crafted to operationalize the values associated with democracy—public participation, accountability, transparency, and equality. Further, processes need to protect judges who are at risk not only from rulers' domination but from disinterest and the lack of financial support.

Thus, one ought not assume that secrecy is an essential characteristic of the alternatives—agencies, ADR, private providers—to courts. As the variety of rules and customs surrounding ADR suggests, even as judges and other dispute resolution providers move away from trials and focus on pre-trial management and dispute resolution in chambers and conference rooms, it is possible either to build in a place for the public ("sunshine," to borrow the term that legislators have used) or to wall off proceedings from the public. Whatever the places constituted as authoritative, opportunities exist to engender or to preclude communal exchanges.

In the nineteenth century, Jeremy Bentham explained that "publicity" could occur through "natural" instruments —"without any act done by any person (at least by any person in authority) with the intention and for the purpose of producing or contributing to the production of this effect."[432] Alternatively, decisionmaking in public had to rely on what Bentham termed "factitious" opportunities, which were those "brought into existence or put in action by the hand of power."[433] The creation of buildings—of courtrooms as sites of adjudication—required choosing whether to provide for the public or not. As Bentham described:

> Considered in itself, a room allotted to the reception of the evidence in question . . . is an instrument rather of privacy than of publicity; since, if performed in the open air . . . , the number of persons capable of taking cognizance of it would bear no fixed limits . . . .[434]

Bentham's imagery underscores that the question of public or private proceedings is a political choice. To create a public space as an active site requires normative commitments predicated on a political theory about the roles that judges, disputants, and the audience play in juridical proceedings. This excursion into a melange of cultural history, custom, practice, data, budgets, and rules is aimed at provoking efforts to generate such theories. The display of justice is on the wane in some of the venues in which it was once vibrant, and its relocation elsewhere has not been accompanied by either rites or rights of audience. As the processes of judgment become increasingly rare, they return to the realm of the spectacle. The audience becomes voyeuristic rather than participatory, and power flows back to the spectacle's producers.

# An Iconography for Democratic Adjudication

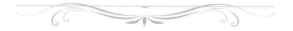

## TRANSITIONAL AND TRANSNATIONAL IDIOMS

We began this volume by detailing the myriad adjudicative activities, over many centuries and across borders, that prompted the creation of discrete government buildings denominated courthouses. Governments deployed architecture and art to attest to their economic wherewithal in efforts to legitimate their authority. Thereafter, we mapped both the ideological predicates for the expanding aegis of courts as well as for the failing faith in adjudicatory procedure. We have shown that, while an ancient form, adjudication is both "new" in important respects and also at risk. The four pillars that have come to mark the political theory of adjudication—individual entitlements for all "persons" to justice, fair hearings, the importance of insulating judges from reprisals, and obligations to provide public access—are deteriorating. Given the disaggregation of adjudication, detailed in Chapter 14, we need to address questions about the future of courthouses as purpose-built, identifiable, and discrete structures. Will this category remain durable? If so, what shapes and imagery might be proffered?

The claim here is not that courts are going out of business. High-visibility constitutional and commercial conflicts continue to command political attention. At the lower levels, the functions of regulating economic transactions and imposing criminal sanctions produce a steady stream of dispositions. But, as we argued in Chapter 14, such decisionmaking increasingly takes place outside the public purview through the devolution to administrative agencies and tribunals, the outsourcing to private providers, and the reconfiguration toward settlement within courts. Many courthouses have become places through which tens of thousands of criminal defendants enter guilty pleas en route to detention, and into which a very few civil litigants make their way to appearances before judges and the public.

Yet even as sovereignties organize other forms of dispute resolution in diverse and less public places, this cross-temporal, cross-border analysis demonstrates that courthouses have become the modern iteration of political inter-est in creating symbolic stages for rituals. Support comes from political and economic interests that, as the World Bank puts it, all rely on the "justice sector."[1] Within the architecture of justice, the functions and forms of buildings have diversified—offering varying degrees of self-announced importance. Aspects of this variety have historical roots. As elaborated by Claire Graham in her detailed account of English courthouses across centuries,[2] "*dignified*" presentations of law were staged in imposing buildings that helped to "excite and preserve the reverence of the population," and the "*efficient*" parts (through which the state "works and rules") took place elsewhere.[3]

By the late twentieth century, dignified and efficient functions were allocated to different buildings. A 1992 review of court architecture in rural areas of England concluded that, while "Crown courthouses celebrate[d] the power of the State," county courthouses had no "architectural identity," and local magistrate courthouses were undistinguished buildings "designed to meet the requirements of staff" but not of consumers.[4] Moreover, as Simon Roberts has explained, by 2009, some of the "great Victorian courts erected during the second half of the 19th century" were lending their "symbolic character," embodied in their substantial physical presence to "legitimize the decision-making of the parties themselves," pressed to mediate their disputes under the aegis of the court.[5]

In the United States, the grand tradition of courthouse-building extended well into the twentieth century as county courthouses in states served as the "indisputable focus" of local government from the country's inception.[6] But by the end of the twentieth century, that function was waning, reflected in the "fading" of the label "courthouse," subsumed by terms such as "Law Enforcement Center" that referred to a cluster of buildings mixing administration, adjudication, and detention.[7] Furthermore, on both sides of the Atlantic, courthouse interiors, especially in elaborate courthouses, became increasingly segregated. As discussed in the context of the United States (Chapters 7–9) and in other countries (Chapter 10), the internal geography of the

courthouse came to delineate hierarchical relations of authority as professional judges and lawyers worked in spaces walled off from lay participants, criminal defendants, and the public.

Today's grand courthouses are not only symbolic of government authority but, as they become empty of the business of judging and evolve into museums for school children and destinations for tourists, they are becoming symbols of courts.[8] In some buildings, court sessions take place only a few days per month and, in some months, not at all.[9] In contrast, in the low-visibility, poorly appointed "law enforcement centers," a vast number of criminal defendants move from arraignment through plea bargaining to incarceration. A dense thicket of civil decisionmaking is likewise underway in parts of the adjudicatory apparatus, including venues other than courts. As detailed in Chapter 14, agencies and private dispute resolution centers do not welcome observers or otherwise put their processes before the public eye.

One conclusion from this multi-chapter analysis is that a radical maldistribution of resources exists. Resources are inadequate for the public in the ordinary courts, tribunals, and administrative agencies that decide so many of the disputes that dot peoples' lives. Absent renewed commitments to what national and transnational constitutions and conventions regularly promise—"open and public hearings" before "impartial" tribunals to which "everyone" is entitled— these texts will become all the more hortatory and distant from individuals' experiences.

Those put at risk by this shift are not only litigants and members of the potential audience. As judges press to alter juridical modes and reconfigure courts as but one of many places for dispute resolution, as judges embrace management and settlement, and as judges stop working before the public eye and producing results subject to public scrutiny, they weaken the arguments for judicial independence from political oversight and for substantial public subsidies for their unique and peculiar function. Given the unending need for "peace and security," state-based criminal justice decisionmaking (now also infused with bargained-for sanctions) is more secure than the public civil justice systems, only recently configured as formally accessible to all persons. Spaces of authority will remain, but little by way of public enactment may be provided to materialize constitutional commitments to independent judges, fair hearings, and open processes for a diverse array of claimants who, under democratic precepts, are entitled to equal access and treatment.

In the first part of this book, we looked back at various representations of Justice, from the glorious iterations such as Raphael's ceiling ornamentation (fig. 4/55) in the Stanza della Segnatura to less distinguished art. This documentation of the iconography surrounding Justice has not been undertaken to romanticize its history. As forecast in Chapter 1, the visual traditions are rooted in social organizations predicated on profound inequalities. Medieval and Renaissance imagery inscribed obligations of judicial subservience, followed by emblems of judicial distance, impassivity, and disengagement. Contemporary deployments rarely signal the difficulties of rendering judgment or the distance between the promises for access and equality and their realization. Only a very few (discussed later in this chapter) of today's courts purposefully make visual references to the problematic circumstances under which they function. Moreover, while tens of thousands of adjudicatory decisions are made in government agencies and tribunals that operate largely outside the public purview, no official agenda aims to celebrate or to dignify the participants, working in cramped quarters not easily accessed by the public.

Should governments try to do otherwise? Government services have multiplied and disaggregated, with a fragmentation forming an analogy to the deconstruction of pictorial space. Photography, microscopes, air travel, and the internet have radically altered what can be seen, just as they have dethroned a centralized, unified perspective, producing a cacophony of administrative functions and of visual opportunities. In law, images have been replaced by texts, as lawyers and judges focus on doctrines and precedents.[10] Yet the spate of courthouses built at the turn of the twenty-first century suggests both an interest in making visual statements and some ambivalence about the privatization of public processes. The many contemporary courtroom-centered buildings aim to instill a sense of legitimacy in state-based processes as though public proceedings were still a major modality of decisionmaking.

Even as the new grand courts are becoming spaces more symbolic than inhabited, they also offer, in some respects, fair representations of the melange of authority, privatization, and public ideology currently promoted by law. The impressive (and often quiet) courtrooms, surrounded by segregated passages and vast amounts of square footage devoted to administrative activities, capture the allocation of work of the modern state—dominated by bureaucratic forms. Further, the dedication of significant funds to a few grand buildings, while a great deal of the business of judging occurs in less well-appointed administrative facilities, is reflective of the maldistribution of resources not only for courts but for all sorts of state services. And the grandeur does "work" to express a political program committed to assimilating new rightsholders— persons of all classes, ethnicities, races—into judicial traditions. The buildings visibly express the idea that courts, once protective of limited classes, are today spaces aiming to dignify a diverse community of rightsholders, expansively defined.

Thus, while some read new courthouses as symbolically silent,[11] they can also be understood as symbolically apt— capturing (advertently or not) the class stratifications reflected in law, the embeddedness of courts in economies reliant on law, the political capital of jurists and architects,

and the aspirations of politicians claiming the capacity to protect all persons. The loneliness of the grand structures and the austerity of the ordinary ones bring into focus the struggle to develop actual practices instantiating rights through public hearings and accountings. Rather than see courthouses as masking the complex interaction by which "the law court institution really operates,"[12] one can find in them revelatory exhibits, commemorating affection for practices of open justice amidst a transformation of legal processes that devotes the vast bulk of usable space to offices. The stratification expresses, as Marie Bels put it, "the operation of an institution that superimposes the different and contradictory work methods represented by the . . . 'business' side of [the] legal system and the technical aspects that allow the justice 'machine' to function."[13]

But the issue is not only whether courthouse construction expresses current trends and ideologies but what law should do. Deeper problems come by way of a return to Jeremy Bentham, who underscored the relationship between publicity and responsive government—entailing public access to the exchanges between jurists and disputants. As currently formatted, conciliation procedures take place in private. Even if (as Simon Roberts has argued[14]) the trip to the massive buildings to confirm a negotiated settlement serves to legitimate parties' decisions, it offers no opportunities for third parties to engage as participatory observers.

The reason to depict the long history of public practices of power and the "short history" of courts as we know them today is to underscore the dynamic nature of adjudication. Although embodied in stone, courts are fragile. We have argued the utilities of adjudication; here we focus on how to reconfigure the many spaces of adjudication so as to signal the weight of the decisions made. In addition to marking power, public spaces have to find modes of acknowledging the struggles to produce readily available and fair processes, as well as the remarkable difficulty of actually rendering judgment and the obligation to account for the implications of doing so.

Law—like education, roads, utilities, and support for health and well-being—is part of a packet of government-based social services. The multiplication of transnational courts is a testament to the proposition that this function is both an artifact of nation-states and crosses borders. Courts (whether denominated criminal, civil, or administrative) do the state's "violence" through their "jurispathic" powers (to borrow Robert Cover's terms[15]) to trump local or individual normativity and to reorganize persons' liberties, personal assets, and public obligations. Making courthouses identifiable in form rather than homogenized with malls and museums is one means of acknowledging the relationship between the intensity of those powers and the potential for constraint through public exchanges that document norm application and enable revisions. Whether recycling a distillery in Helsinki (fig. 10/152) or using a renovated department store in Sydney (with words such as "corsets"

and "gloves" still legible on its facade) or undertaking to make a national statement as in Israel (fig. 10/140),[16] a transnational idiom of courthouse construction pays homage to the Benthamite obligation of "publicity" by placing courtrooms—the public's space—as their centerpieces.

The shared sensibility is, as we argued in Chapters 7–12, partially a result of the market of lawyers, judges, and architects. But it also reflects another form of sharing—of aspirations for law's role in social orders.[17] The first half of this book displayed Renaissance town halls of various city-states in Europe, all relying on emblems of iconic Virtues and narratives reflecting common understandings and shared references. Hulking courthouses became their modern counterpart. In Chapters 13 and 14, we argued that democracy changed and challenged adjudication. Here, by way of conclusion, we explore the implications of these claims for the buildings and art that signal a space as a court. We explore what a "democratic iconography" of courts could entail. Before examining the idioms available, however, we need to address a preliminary issue—for contemporary designers of courts currently claim themselves successful at capturing courts' special attributes, the democratic premises of open and public access.

## Symbolic Courts with Facades of Glass

In the early chapters of this book, we reflected on the transnational idiom of Medieval and Renaissance structures, with shared classical and biblical narratives taken up by localities to provide normative instruction. The contemporary counterpart is the frequent reliance in courts on an "extensive transparent glass skin," admired for providing an "open face to the public."[18] While these words come from a description of the design of the German Constitutional Court, built in the 1960s to provide "almost total transparency" coupled with "a popular feel,"[19] we could have pulled such phrases from descriptions of courts in many locales. In the United States, for example, glass is said to signify the "new openness and accountability of the court to its community,"[20] as well as the justice system's "principles of *transparency, accessibility,* and *civic engagement.*"[21]

Architects have put these precepts into practice. Courthouses with glass walls can be found in a host of locations, such as Boston, Massachusetts; Youngstown, Ohio; and Wyoming County, New York[22] or, when traveling outside the United States, in places ranging from Vancouver, Canada; to Nantes, France; and Reykjavík, the capital of Iceland.[23] In the spring of 2008, when a new courthouse opened in Manchester, England ("the biggest court building to be constructed in Britain since the Royal Courts of Justice in London were opened in 1882"), Europe got its "largest hung glass wall."[24]

Glass is not the only facet of new courthouses to provide a public face, nor is it the only means to denote openness.[25] While seeking to capture both authority and solemnity,[26]

contemporary courts generally make a point of welcoming visitors, at times offering tours and clocking attendance. The media garner special attention, assigned reserved seating or desks inside courthouses. Many buildings include space for public information officers, tasked with disseminating information through electronic postings and webcasts.[27] Like courthouse architects, public information officers have become so common as to gain an acronym (PIO) and their own professional organization.[28] Thus, even as the privatization of process that we outlined in Chapter 14 is underway, the buildings and their staff proclaim commitments to communications with the public, in person and through new technologies.

## Opaque Transparency

Yet an equation of glass with courts of law and access to justice is simplistic, for glass is by no means especially prominent in courthouse construction, and courthouses are not the only structures proclaimed as particularly appropriate for glass. A baseball stadium completed in 2008 in Washington, D.C., has also been praised for using glass, said to have been chosen by the architects to express the relationship of baseball to the "transparency of democracy."[29] Likewise, glass came to dominate many late twentieth-century constructions (for example, the "*Grand Projets* of François Mitterrand, president of France" in the 1980s and 1990s[30]), as it had during the nineteenth century, when glass provided facades for train stations, commercial arcades, and exposition sites including the Grand Palais in Paris and the Crystal Palace in London.[31]

Part of the explanation for the embrace of glass is technological. During the nineteenth century, clear glass became easier to produce, as did other translucent materials. The 1851 Crystal Palace designed for London's Great Exposition provided a grand-scale demonstration of glass's potential.[32] Twentieth-century engineering technologies lowered the price and expanded the possibilities, enabling glass to become commonplace in a variety of structures—houses and their bathrooms included.[33] During the early part of the twentieth century, this turn to glass was celebrated, complete with its own "crystal metaphor."[34] The German author Paul Scheerbart is credited as a source; in 1914 he wrote a couplet about the architecture of Bruno Taut: "Light seeks to penetrate the whole cosmos / And is alive in crystal."[35] Scheerbart has been described as the "theorist" of an "architecture of glass and steel," and Taut "put the skin and bones on the concept."[36] In 1914 Scheerbart published *Glasarchitektur* (*Glass Architecture*), heralding that the "earth's surface will once more be transformed, this time by glass architecture."[37]

Glass was thus deployed not only for "botanical purposes but also for human concourse and habitation."[38] In the early 1920s, Mies van der Rohe designed a model of a glass skyscraper, and in 1928 Frank Lloyd Wright wrote in a vein similar to Scheerbart, calling for reducing the "glooms" of cities through buildings "woven in rich glass; glass all clear or part opaque and part clear, pattered in colour or stamped to harmonize with the metal tracery that is to hold it all together."[39] By 1929, glass was "all the fashion."[40]

Decades thereafter, environmental concerns challenged the wisdom of heating or cooling glass-clad structures. In response, new coatings evolved to reduce "the cost of interior climatological systems."[41] Building with glass continued apace, making plain the degree to which glass bedazzled,[42] even as architectural theorists debated the distinctions between "literal" and "phenomenal transparency"[43] and as some critics objected to the redundancy produced by "contemporary architects . . . obsessed by glass."[44]

## The Politics of Glass

Not only is glass a prevalent feature of a variety of building types, its deployment is also regularly accompanied by explanations about why it is particularly apt for a diverse array of facilities. The choice of glass as a construction material has periodically been complemented with explanations that can be summarized as "form follows philosophy."

For the Renaissance, "transillumination" enabled the "metaphysical implications of light—the divine *lux*" (truth and God's will) to be perceived.[45] Centuries later, Mitterrand's glass buildings for Paris were intended to meet concerns that cultural institutions were perceived as inhospitable to the public. Political statements were made through buildings enabling persons to see and be seen, such as in the multi-story exterior glass-enclosed escalator that adorns Paris's Pompidou Center. As Annette Fierro has explained, every "centimeter between glass and support, every decision to weld rather than screw, every chemical additive to the surface coating of the glass [became] extravagantly significant."[46] Mitterrand's ambitions make plain that the use of glass in service of democratic precepts has not been limited to the courthouse context. Aiming to link his government's authority with the two hundredth anniversary of the French Revolution to signal his embrace of democratic institutions,[47] Mitterrand wanted to make the logic of the building "*transparent*."[48] Whether his methods fit his goals is a question; his projects were dramatically expensive, taxing the public fisc with "disproportionate expenditures" at a time of economic duress ("*la crise*").[49] And just as those glass buildings offered transparency as a metaphor for democracy,[50] so did constructions elsewhere. The architectural historian Jane Loeffler has documented that American embassies built during the Cold War regularly "adopted the glass box as an expression of democracy."[51]

As we discussed in Chapter 5, the relationship between sight and knowledge has been plumbed in religious, scientific, philosophical, and political literatures, and reflected in debates about whether Justice ought to be shown with or

without a blindfold, and about whether law ought to be "color-blind." As for the term "transparency," it has political roots in the philosophy of Jean-Jacques Rousseau, whose arguments paralleled the claims made for "publicity" (detailed in Chapter 13) developed by Jeremy Bentham and by Immanuel Kant. As we have also explored, what should be open or accessible or known to whom and when, as well as what meaning might be drawn from that which is revealed, are complex and politically fraught questions.[52]

The irony of relying on glass for embassies and for courts during an anxious age of terrorism is evident. If glass truly enables openness, it can undercut efforts to make facilities secure. As Loeffler put it, when embassies became "targets for terror," they were turned "into the modern equivalent of frontier stockades."[53] But rather than rule glass out, those concerns have prompted technological innovation. The newer glass skins are "ballistic-resistant." Visibility can shift through "gradations of clear, transparent, and opaque"[54] reflected (pun intended) in the title of this subsection, "Opaque Transparency."[55]

Glass has another politics, foreshadowed in this book by the discussions of Bentham and Foucault, who shared an understanding about the centrality of architecture to power. When glass was used in greenhouses, people spoke of its "nurturing" qualities, providing a habitat that brought plants to life.[56] When covering government buildings, glass is accorded other valences, for it can be deployed to enable or to preclude sight and thereby to permit or to limit opportunities for transparency or surveillance. Yet glass can also be a barrier: the viewer who looks at glass may look at the pane itself, finding one's mirrored reflection rather than what lies through or beyond the glass. As a consequence, art theorists also see glass functioning as a "blockage" imposing a "kind of threshold" that distances the observer.[57]

As eerily shown by the filmmaker Alfred Hitchcock in *Rear Window,* glass is also a mechanism for isolation, as well as for the transfer of voyeuristic control to a viewer watching from a distance. Indeed, complaints were leveled against the Bibliothèque Nationale de France for putting scholarly readers on display, as if " 'animals in a zoo,' exposed to scrutiny from a general public who were too distant . . . to engage reciprocally and meaningfully."[58] And in some courtrooms denoted "high-security," defendants may be required to sit in a glass box expressly to separate and control them. In short, the relationship of glass to access and transparency is complex, captured by the title of a 1990s exhibit at New York's Museum of Modern Art. That show, depicting some thirty glass-clad buildings, was called "Buildings That Hide and Reveal."[59]

## Zones of Authority

In many new courthouse buildings, whatever transparency may be provided by glass skins ends at the court-

house door. Once inside, the aim is—to borrow from commentary on new Italian court design—"to keep the various users of the building (magistrates, judges, lawyers, public, prisoners) as separate as possible."[60] Would-be entrants are screened,[61] and those admitted are sent off into their own zones.

Within, many courthouses are not user-friendly. One courthouse architect explained: "It is remarkable how many existing court facilities have no adequate waiting space outside the courtrooms."[62] While the buildings are to express that " '[y]ou, your liberty and property, are important,' " they are not accompanied by "clear and generous lobbies, corridors, counters, and waiting areas," nor do they denote anything of the "bond between the individual and the justice system upon which all depend."[63] Security is not the only rationale for isolating groups of participants. Patterns of segregation are also argued on socio-political grounds, that judges ought not have to confront those whom they must judge, and that ordinary persons ought not have to see "defendants walked, in shackles, through public corridors in the presence of other citizens who may be there merely to pay a traffic ticket."[64]

In many state court systems in the United States, hallways can be crowded with people standing as they wait to meet lawyers or to enter courtrooms. Yet in other jurisdictions, neither the courtroom nor its waiting areas serve as venues for exchange. Courtrooms are sometimes literally dark (as discussed in Chapters 9, 12, and 14), as jurists and litigants respond to pressures ranging from lawyers' costs to judicial and legislative insistence on using alternative private processes in lieu of trial.[65]

Moreover, the imagined citizen paying a fine may not need a dedicated hallway or a courtroom, for new technologies have rendered a great many "encounters" in courthouses "virtual." Fees can be paid online, just as litigants file documents electronically, and even some "meetings" take place via video or telephone.[66] For those in search of information, record data can often be pulled via computers. Courthouses might nonetheless serve as repositories for older documents, but many materials have been shipped elsewhere or destroyed. And the many administrative personnel—who do much of the work—are largely hidden from public view through modular systems that segregate functions. As a consultant to the World Bank's project on Courthouse Development explained, "the greater percentage of the modern courthouse is composed of general-purpose office space—perhaps 80 to 85%,"[67] with much of the work done behind closed doors.

Thus one of the "unintended . . . consequences"[68] of the rules that shifted the action from oral proceedings in courtrooms to an exchange of papers, discussions in chambers, and outsourcing is that some courthouses are both secure and "lonely."[69] Even as courts lay claim to an architecture of openness made plain through glass, various of the grand

buildings depicted in this book have been reported to convey a feeling of entering an empty "fortress" replete with both perimeter and interior surveillance.[70] Both the exterior glass and the interior circulation patterns mask (per Foucault) the violence inherent in the disciplinary powers of the state.

The many new square feet dedicated to grand symbolic courtrooms ignore the risk of obsolescence, but some smaller-scale projects for lower-level courts are being shaped to assimilate court functions with other work of the administrative state. For example, a survey of construction projects in England reported that "replacement civil courts in particular are deliberately built as anonymous blocks, largely made up of offices and with courtrooms containing movable fittings," so as to be able to recycle those spaces for other uses.[71] An alternative strategy has been to try to repopulate courthouses by multiplying their uses. During the late nineteenth century and the first half of the twentieth, federal courthouses shared space with post offices; one could mail a letter and then drop by a courtroom. County courthouses echoed some of the variety of old European town halls, providing offices for making land transfers, obtaining licenses, or recording life cycle changes. Until the 1930s, the century-old tradition of "court day as a political and social event" continued.[72] Some local courts continue to be multi-function buildings, but many became dedicated to the single purpose of adjudication.

In more recent decades, efforts have been made to retrieve some of the sociability of courthouses by diversifying the activities pursued. The federal courthouse in Boston, for example, hosts educational programs about law for school children and offers lectures. The Mexican Supreme Court and the Constitutional Court of South Africa serve on occasion as performance venues. To enhance the comfort of courthouse employees as well as visitors, designated areas in some courthouses are provided for commercial outlets, cafeterias, and gyms.[73] Another approach is to build what advocates of alternative dispute resolution (ADR, discussed in Chapter 14) call a "multi-door courthouse"[74] into which disputants enter in search of mediators and arbitrators as well as judges. As noted in Chapter 9, the *1997 U.S. Design Guide* for the federal system called for suites specially shaped to accommodate ADR procedures. Mindful of economic constraints, however, revisions in 2007 cut out requirements for mediation and conference rooms while preserving (and sometimes expanding) large areas for courtrooms.[75] The new uses lost out, in part because they were underspecified, in contrast to the detailed descriptions for the size, height, and fixtures of a courtroom.[76]

In other jurisdictions, the work of courts has been reconfigured to bring "auxiliary services" in-house. For example, specialized "drug courts" aim to avoid reincarceration of addicts by requiring offenders to appear repeatedly before judges who superintend programs of detoxification and stabilization.[77] In "family courts," areas are provided for social workers, psychologists, and other experts to offer therapeutic interventions and for children to play. Moreover, one can also find a return to the eighteenth-century model in which courts and jails were merged, housing law enforcement personnel, pre-trial services, and some detainees in the same structure. The term "law enforcement center," mentioned earlier, is one of several used to denote that such buildings are "multi-occupant facilities"[78] or "government centers."[79] The facades, however, often reiterate forms associated with courts. The architect of one late twentieth-century consolidation explained: "While we didn't want to hide the fact that it is a jail, the focus is on the public courthouse entrance of the building."[80]

Yet, if the new labels take hold, the identity of the courthouse could diminish and with it the protective veneer it offers. The "day of the county courthouse might pass, almost without notice, as the word disappears from our lexicon."[81] That comment comes from the United States but was echoed in France, where specialized building complexes came into vogue in the 1960s. By century's end, the focus was on "rehabilitating" the courthouse as an identifiable and discrete legal space,[82] an approach many builders in the United States used as well.

The melding of services is thus an aesthetic, linguistic, and political concern. With "one-stop shopping," courts risk appearing "adjunct to police-related functions"[83]— which, given the expansion of incarcerated populations all over the world, is one way to understand the dominant function of courts. Another is to see courts as subservient to other branches of government. Recall that one of the arguments advanced in support of the 1935 United States Supreme Court building project was that a stand-alone court building would substantiate the idea of judicial independence.[84]

We opened this discussion by raising the question of whether the transparency described by courthouse buildings was materialized in practice. Historically, local courthouses were places of communal activity, generating traditions that developed into the doctrine of public access as a legal right and buildings that were open. Such familiarity helped to breed respect. Social scientists reported that, at least in some countries, those who went to court and used the legal processes had more favorable opinions of the legal system than did nonusers.[85] But despite legal and rhetorical commitments to access, the utilities of public activities for legitimating authority, and the ready deployment of glass by architects around the world, many contemporary courthouses no longer make accessible the processes and practices of judges. The last century of celebratory architecture has generated impressive buildings that mark a worldwide embrace of adjudication but reflect little of the ideological shift entailed in "new" adjudication—

that a host of new claimants now have access and that this democratization *of* courts poses profound challenges *to* courts.

Architectural critic Paul Spencer Byard understood these difficulties when describing new courthouse buildings as "intensely sad," responding to the "huge weight of a system bent toward retribution."[86] He wrote of the "bind" for courthouse architecture: that the "political emphasis on criminalization, prohibition, and retribution as proper responses" puts the architect in a position of meeting demands for "quantities of space for courtrooms and related functions—duplicated and even trebled by requirements for segregation and security—to accommodate all the required adjudication and punishment."[87] Byard explained that courthouse designers had been called upon to celebrate the "authority that generates all the trials and penalties" but, he objected, the "design exercise is reduced to an effort to bury very large volumes of space in symbols that will lend them some legitimacy."[88] Thus, as Byard viewed them, several of the new and monumental buildings had "nothing to say" other than attempting to lend authority through recognizably important architectural forms.[89] Earlier we offered a somewhat different (although also somewhat "sad") reading, that the structures reflect both the hopes that the great aspirations of widening the aegis of courts to welcome all persons but also demonstrate how wide are the gaps between those aspirations and practices.

## Replenishing the Visual Vocabulary

If a first conclusion is that redistribution of resources is required to match the redistribution of authority to multiple venues of adjudication and a second is that contemporary courthouse construction hints at some of the challenges but has not yet found methods to engage with the democratic project of adjudication, our third conclusion is that alternatives are available—in art, architecture, law, and doctrine. The precepts of what constitutes good democratic governance, as encoded and displayed in contemporary courthouse symbolism, are narrow. Many governments continue to deploy large women, in paint or stone and equipped with scales, swords, and sometimes a blindfold. Alternatively, courthouses have a range of decorations in an array of materials, some of which are obliquely referential—such as Pascal Couvert's large bell (fig. 10/132), reminiscent of liberty and religion yet sitting on the floor of the courthouse in Bordeaux, or the movingly beautiful color panels (fig. 6/93) of Ellsworth Kelly in Boston that can be read to invoke universal possibilities. Relatively few aim to engage in normative explication about role and responsibility.

Critique and engagement occur infrequently. In Chapter 6, we identified instances of what could be understood as inadvertently subversive images—such as the 1930s Justice figure (fig. 6/77) accused of representing the "spirit . . . of ruthless confiscation"[90] and hence referencing Commu-

nism, or the 1930s brightly clothed Justice alleged to be a "mulatto" (fig. 6/81) impermissibly breaking a racial barrier in Aiken, South Carolina. In Chapters 9 and 10, we looked at the work of two artists, Jenny Holzer and Tom Otterness, whose art purposely signaled some of the puzzles and challenges of justice. Holzer relied on a selection of famous "truisms," deployed in stone in Sacramento, California (fig. 9/125), and in LED for the installation in Nantes, France (fig. 10/137), while Otterness offered up whimsical bronzes, such as in Portland, Oregon, in a scene of a prosecuting dog examining a defendant cat, shown with a feather in its mouth and sitting in a witness box (fig. 9/121). These works of art, however, required substantial negotiation because judges were reluctant to acknowledge the troubled past or present of courts. Other attempts were rebuffed, such as Jan Mitchell's proposals for a *Moco Jumbie* (fig. 6/88), evoking African traditions of protective spirits, or *Reaching Man* (fig. 6/90), a figure escaping the slavery of sculpted stone, for placement outside a federal courthouse in the Virgin Islands.

Those interventions provide windows into alternatives, and we conclude by expanding on that repertoire. We first consider how visual vocabularies could be built on historical allegories that embrace a wider range of sources and a richer political history about the virtues and obligations attached to government. Thereafter we explore the rare extant courthouses that insist on frankly showing the harms, the inadequacies, and the challenges of justice.

## An Interdependent Collective: The Cardinal Four of Justice, Prudence, Temperance, and Fortitude

Justice was once part of a foursome, detailed in Chapter 1 and seen together again by way of figure 209,[91] a composite of the individual Virtues displayed at the outset (figs. 1/18, 1/20–22). These four were grouped rather than shown in isolation because, together, they captured the ideal attributes needed for governance. Yet that set, and some of what it was said to embody, has dropped from sight. What is lost in terms of the virtues for government, judging included, can be seen by a brief review of why this foursome came to be known as the Cardinal Virtues.[92]

Plato's list of four qualities—"wise, brave, moderate, and just"[93]—were analytically distinct; he showed that "the connection of one virtue to another [achieved] a kind of unity of function."[94] By the fourth century, these attributes were nested in Christian theology, perhaps by way of St. Ambrose's funeral oration for his brother, which analogized the four Platonic Virtues to four periods in the Old and New Testaments and called them "cardinal" to capture their moral freight and cosmological significance.[95]

Thomas Aquinas brought the four down to earth, for he argued that they were "cardinal" not because they were "more

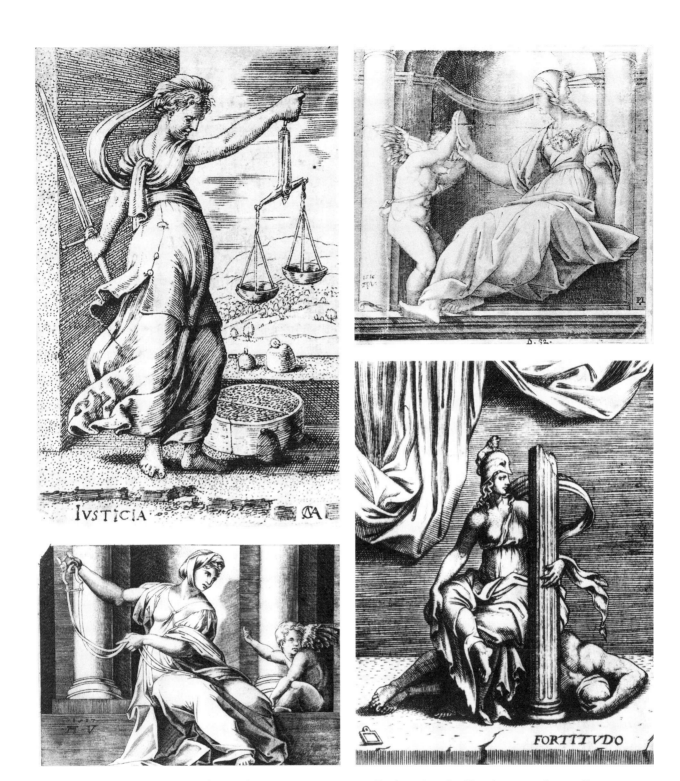

FIGURE 209    Top: *Iusticia (Justice)*, Cornelis Matsys, circa 1543–1544; *Prudence,* Agostino Veneziano, 1516. Bottom: *Temperance,* Agostino Veneziano, 1517; *Fortitudo (Fortitude)*, Marcantonio Raimondi, circa 1520.

Copyright: Warburg Institute, University of London.

perfect than all the other virtues, but because human life more principally turns on them."[96] Aquinas cited Pope Gregory I for the proposition that "unless prudence is just and temperate and brave, it is not true prudence, nor is there perfect temperance which is not brave, just, and prudent, nor complete fortitude which is not prudent, temperate and just, nor true justice which is not prudent, brave and temperate."[97] Indeed, the interrelations were so deep that Aquinas argued they "should not be called the four cardinal virtues" but named as one.[98] Moreover, "all virtues must, simply speaking, be equal for the same reason that they are connected, since equality is a kind of connection in quantity."[99] Artists, in turn, regularly displayed them as a set and, as discussed in Chapter 1, deployed them in various epic battles against a host of Vices.

While the virtues were reciprocal and interactive, a sustained literature aspired to "know the form and outline of each."[100] In Chapter 1, we analyzed debates about the nature(s) of Justice. Hence a bit of elaboration of her siblings is in order. Prudence, a habit "obtained and perfected through practice in deliberation and action,"[101] was especially associated with governance. Yet, because prudence was "knowledge gained from experience, rather than from theoretical speculation,"[102] it was sometimes subordinated to the broader term for wisdom, *sapientia*. But Cicero "elevated the concept" by giving the two parity. He saw prudence as requisite for "the best" citizens,[103] "the first of the virtues possessed by the ideal statesman and the wise man."[104] That proposition has been many times reiterated, with a contemporary literature positing prudence as a "tradition of statecraft" with a "normative," rather than "value-free" content,[105] important for leaders in politics and law.[106] For Ralph Waldo Emerson, prudence was central to all human flourishing because it entailed "the art of securing a present well-being."[107]

Several of the qualities associated with prudence have a ready connection to the work of judges. Commentators speak of prudence as "the humility . . . of unbiased perception; the trueness-to-being of memory; the art of receiving counsel; alert, composed readiness for the unexpected."[108] Aquinas, in particular, is cited for the idea that prudence requires careful inquiry producing wise judgment ("rightly to counsel, judge, and command concerning the means of obtaining a due end"[109]). "Sympathetic understanding" is how one modern commentator put it.[110] Prudence is relevant for judges not only for its association with the investigation of situations and deliberation about action (for Aquinas, "prudence is in reason," while justice is "in will"[111]) but also because prudence was seen as related to the auxiliary virtue *synesis*, or understanding.[112]

Temperance, in turn, moderated the desires and appetites of both the gods and humankind. Helen North traced the development of the Greek term *sophrosyne* to the Roman temperance that came to encompass "soundness of mind"

and self-knowledge, valued attributes for literary heroes.[113] North also noted the close association between temperance and justice in Greek thought.[114] The "*polis* by its very nature required a much greater exercise of restraint" than had a more loosely organized society.[115] Thus *sophrosyne* became a social political attribute as well as an internally desirable mode for conducting one's own life.

Cicero embraced the term *temperantia* as when he called for consistent good sense. The goal of "attaining the mean"[116] required self-reflection[117] or "order within oneself."[118] As North also explained, the qualities of temperance were seen as the opposite of hubris, "considered a characteristic vice of tyrants."[119] Obtaining balance was good for the health of both persons and social orders,[120] and the requisite character of mind produced a degree of sobriety that resulted in moral action. By the end of the sixth century, the association between *sophrosyne* and "the general idea of restraint or even abstinence" was established.[121] As a result, the virtue was especially prized in women, supposed to be loyal to particular men or chaste more generally. Temperance thus came to be linked to the virtues of chastity, sobriety, modesty, and humility.[122] But temperance was also an important "masculine virtue"—as explained by St. Ambrose in his funeral oration for his brother and as imbued with religious as well as secular content by St. Augustine.[123]

The last of the four, fortitude (sometimes equated with courage), came to denote strength and endurance. Fortitude was associated with the virtues of perseverance, patience, and loyalty as well as magnanimity, which was, in turn, explained as resoluteness despite difficulties.[124] Cicero described fortitude as the virtue "by which one (1) undertakes dangerous tasks and (2) endures hardships."[125] But which tasks to undertake or hardships to endure required something more, and thus fortitude had to obtain direction from elsewhere. St. Ambrose is quoted for the propositions that "Fortitude must not trust itself"[126] and that "Fortitude without justice is a lever of evil."[127]

The capacity to do great deeds and to understand the need to perform them was admirable, Aquinas posited, in contrast to the undesirable qualities of ambition, vainglory, or presumptiveness.[128] With fortitude, something worthwhile could come into being through the ability to pursue and execute tasks, so long as a person had a degree of confidence in conjunction with sustained or careful attention over time.[129] Aquinas stressed that fortitude was a steadfastness related not only to work over time but as an aspect of the character of one's mind.[130] More recent analyses have underscored that fortitude comes in the face of vulnerability and even the risk of death.[131]

These virtues encompassed a wide range of human aspirations and, as discussed in Chapters 1–4, Medieval and Renaissance literature and arts offered up personifications coupled with various objects, birds, animals, and flowers.[132] Like the Justices of those eras, the iconography was capa-

cious. A motley array of items was sometimes affixed to more than one Virtue and varied as well across time, place, and setting. Some images remain familiar through famous renditions by Giotto, Botticelli, or Raphael, and some appendages—the ostrich for Justice, the deer for Prudence, the diamond for Fortitude, and hot tongs for Temperance—have dropped from sight.[133]

As shown in figure 209, Prudence often had a mirror, said to capture self-knowledge, as well as two faces to look forward and backward, or sometimes a third eye to watch the present as well. In addition, some Prudences were accompanied by a serpent for wisdom, a dove for innocence, a stag or an eel for strength, a book, and a torch, flame, or lamp that referenced or united Prudence with the theological Virtue Hope.[134]

Temperance, in turn, was regularly shown with a bridle for restraint (as in fig. 209) but could also be found with a pitcher (or two, with one for water to dilute the wine in the other), a goblet, or a sheathed sword. Occasionally, she held a torch, a spray of flowers or a palm or was accompanied by an elephant, a windmill, or an hourglass, and eventually a clock (a "pun on *tempus*"[135]). As North chronicled the imagery, it ranged from objects to denote health and healing to those showing the mastery of beasts or military prowess. The mix of water and wine demonstrated moderation, referencing alcohol specifically and more generally suggesting the desirability of blending and mixing.[136]

Fortitude often had a column (as in fig. 209) that signified endurance and something underfoot, conquered, such as a lion, its trophy skin, or a dragon (echoing St. Michael or St. George). At times Fortitude wore armor and held a sword, dagger, or spear, as well as some kind of vise-like press that required physical strength to use. Myrtle branches occasionally lay about to reference victory or grace.[137]

As we detailed at this book's outset, Justice also once had a richer repertoire than a sword, scales, and the occasional blindfold. Some ancient Justices had a cornucopia that linked Justice to prosperity—an apt signifier given the nexus between economic development and courts. A few were shown with the ever-vigilant crane and the occasional ostrich (fig. 4/56), defined as a bird with a unique digestive system that could handle all forms of matter. The elephant that occasionally followed Temperance was similarly imbued with wisdom from its eating habits. According to the codification of iconography by Cesare Ripa, the elephant was "the most temperate of animals, never eating any more than it need."[138]

Surviving depictions from early Medieval times regularly had Virtues holding various liturgical texts. All could be found at war with the Vices as well as joining a larger ensemble of Virtues, portrayed on schematic Trees or Ladders of Virtue in many illustrated books and on "an infinite variety of small objects."[139] Before the set dropped largely out of sight,[140] the Cardinal Four were part of funerary

sculptures and regularly deployed as symbols of various governments, large and small, as reflected by the title of an early seventeenth-century drawing, *The Cardinal Virtues Presenting a Coat of Arms to a Young Boy,* by Alessandro Tiarini.[141]

Skipping centuries forward, one mostly finds a lone actor—Justice, with a few tidy attributes.[142] One could, however, take the new imagery provided in both French and American courthouses (detailed in Chapters 6 and 10) as the descendants of the older traditions. A remarkable array of items in a host of forms and fabrics is displayed, albeit with less apparent didacticism than in earlier eras, when visual depictions were sparse and references widely shared. As we argued in Chapter 1, the political deployment of Justice as propaganda has rendered her legible but left popular audiences with little else by way of other signifiers of government's mandates. Thus a mirror, a column, or a bridle propped up in a courthouse today would not provide hints for many viewers that a much richer, interconnected set of attributes is requisite to good judging, let alone good governance.

The reasons to widen the range are multiple. As discussed in Chapter 14, courts are seen as impoverished, with too few remedies, undue harshness, and failures of vision. Further, in contemporary accounts of courts, to the extent temperance or restraint is called for, it is usually a code for cutting off judicial power rather than an injunction to deploy it carefully. Various legal doctrines that embody self-abnegation (such as deference to administrative agencies or immunity for sovereigns) are explained as self-protective (insulating judges from being disobeyed) rather than linked to ideas of temperance. And judges are often faulted for their "activism" rather than lauded for their courage. Given the complex roles of courts, theories of justice are not enough. A vocabulary that addresses a wider array of attributes would help to elaborate and parse the qualities entailed in rendering wise and just decisions, far better than what a solitary Justice can invoke. Self-knowledge, patience, endurance, steadfastness, wisdom, moderation, and insight need to be assimilated into the analyses of rights, remedies, liabilities, and sanctions.

In short, the visual reductionism yielding the singular icon Justice reflects an erosion in both theory and practice of the breadth of qualities needed to discharge the tasks asked of courts. The conventional imagery for Justice, coupled with the erection of large courthouse buildings to denote the power and authority of law, projects a barren view of what adjudication entails. Although the admonition to judges to "hear the other side" (figs. 13/194 and 13/195) transcends centuries, guidance about what judges ought to do when listening and deciding has thinned. This brief excursion back to the four Cardinal Virtues offers but a glimpse of a much richer normative and didactic account needed for the doctrine, practice, and imagery of adjudication.

## The Burdens of Judging:
## The Nails of a *Nkisi* Figure

The diverse qualities required for judges and the law that they generate are not the only facets of justice lacking references on courthouse walls. Reminders are in order of the burdens inherent in giving judgment—once displayed in Renaissance town halls through pictures of fathers such as Brutus sending their sons to death (fig. 3/46) or Zaleucus taking out one of his own eyes to mitigate the punishment he had to impose on his son (fig. 3/45). In lieu of the idealization of human death and disfigurement, other traditions have created renditions to invoke the power and the weight of community customs. One illustration is a forty-six-inch wooden Kongo figure from the end of the nineteenth century (fig. 210[143]) studded with screws, nails, blades, cowrie shells, and other materials and described by art historian Robert Thompson as a "lord of jurisprudence."[144]

This figure, generally called a *nkisi* (pluralized as *minkisi* or *bakisi*), comes from the Congo region of Central Africa; similar figures are also found in Gabon and Angola.[145] The purposes of these objects are complex to identify, in part because of a multitude of different uses and a host of invocations and narratives coupled with some traditions of secrecy,[146] and in part because studies in different disciplines have attributed various meanings to these objects, such as "healing, government, divination and the like."[147] Given an underlying question of which objects to put into the category *minkisi,* Dunja Hersak called it the "most baffling notion to reckon with."[148] Some scholars group a wider array of local, spirit-related objects together under that nomenclature, while others delineate *minkisi* as only those figures representing "an 'immanent force of nature,' a seemingly diffuse universal force."[149] Wyatt MacGaffey, an anthropologist who has extensively studied *minkisi,* noted that the effort to understand their import reflects the "contradictions between the social process that produced them and the process that identifies some of them as art."[150]

Whether using a broad or narrower definition, *minkisi* come in a range of sizes and shapes, both human-like and in animal form. A few are affixed, but most are portable.[151] The term *nkisi* is related to "other Central African words often translated as 'spirit,' " capturing the sense that *minkisi* embody personalities "from the land of the dead, through which the powers of such spirits are made available to the living."[152] The form depicted in figure 210 typifies those with a "body element" (in this example a snail shell but sometimes a small gourd) that provides a repository for some specific objects. The container can be metaphoric or literal, in that some hold a bone of a person who has died or a piece of clay, a stone, or grave-dirt.[153]

Many discussions locate the objects as related to healing or fixing (or righting) a situation, such that their use could be translated as referencing medicine, religion, spirituality, justice, or interrelated aspects of all of these functions.[154]

FIGURE 210   Nail Figure, Kongo, circa 1875–1900, The Detroit Institute of Arts, Michigan.

Photograph copyright: The Detroit Institute of Arts, Founders Society Purchase, Eleanor Clay Ford Fund for African Art, 1976. Image reproduced with the permission of the copyright holder.

"The invocation and activation of a *nkisi* inscribes the experience of disease, theft, adultery, or other problem in a standardized cultural register, so that it ceases to be idiosyncratic and unmanageable."[155] To the extent that the figures (especially those serving as containers) are read to express the ability to contain and control evil forces,[156] one can make analogies to law and to medicine.[157] What one attributes to *minkisi* depends in part on what one thinks about the "other category"—law or medicine—as well as how one reads the diverse uses of various objects created by different peoples and classified as *minkisi.*

As illustrated in figure 210, some *minkisi* in both human and animal form have nails or spikes in them. Commentators understand the import differently. Thompson, an authority on African art quoted at the outset, read them to denote the pain and burdens of authority: "He is a spirit so strong he can wear on his stalwart chest the painful, intricate issues of his peoples symbolized by inserted blades."[158] Some commentators believe the nails are driven in through communal rituals as acknowledgment of whatever has transpired that prompted the use of *minkisi*.[159]

According to another art historian, Zdenka Volavkova, evidence of nail *minkisi* in Lower Congo is scarce before the nineteenth century. She posited that nails reflect a mix of local and Christian traditions. In "the complex syncretic process the symbols of Christ's suffering . . . might have been amalgamated by the African system of signs and become instruments inflicting an enemy with serious disease or death."[160] European as well as African traditions displayed powerful figures with spiritual capacity, sometimes mortifying their bodily forms.[161] As Volavkova explained, parallel magical figures are European icons, such as Baroque "images of saints specializing, for instance, in the relief of toothache, [or in the] prevention of fire or lightning."[162] Further, she commented, while the nails could be read to denote injury, they were also deployed to bind materials together. Given the various communities deploying *minkisi* over centuries, she argued for plural understandings, that classifying *nkisi* figures by "functions was useless if not impossible," and that interpreting them as static was misguided.[163]

Some anthropologists demurred, positing that the figures had little or nothing to do with Christian imagery or, for that matter, with justice, but rather were kinds of hunters whose nails represented the suffering that was to be inflicted on others.[164] On their account, the nails "annoy the nkisi, arousing it to action,"[165] and nails were driven in to animate the figures to "seek vengeance on a designated victim."[166] But that very description could be turned into a link with law, for one of the Justices in Siena's fifteenth-century fresco the *Allegory of Good Government* (fig. 2/26), by Lorenzetti, has a severed head on her lap. Scholars likewise debate the political, religious, and moral import and whether to read the murals as references to theories associated with Aristotle or Cicero or others. Whatever the intentions, both the Siena murals and the *minkisi* offer the purposeful display of images of power.

We show the Nail Figure not to claim its intrinsic relationship to law but rather to make the aesthetic point that objects can movingly capture both pain and power. Whatever reading one adopts of the nails in figure 210, the sharp ends intrude. Someone or some group—the wrongdoer, the avenger, the community—is torn, agitated, animated, or reconciled by the exercise of power. The object embodies the proposition that its authority inflicts itself on self and/or others. If viewers attribute to these figures ideas about the weight, the difficulty, the power, and the pain of judgment in its making, its acceptance, and its imposition, *minkisi* provide representations of normative lessons for both judges and the judged.

The Nail Figure thus complements the examples of Prudence, Temperance, and Fortitude, in that all could add to Justice by expanding understandings of both the attributes and the experiences of authority. Buildings can do so as well, and we turn from reconsideration of personifications to the places where courts are held and thus move from classical depictions, both European and African, to courthouses and contemporary adjudication in South Africa, Mexico, Australia, and the United States.

## FACING JUSTICE'S INJUSTICE

Court construction at the national, regional, and transnational levels is deeply self-conscious, engaged with history by seeking either to embrace and link to traditions or to create distance from them. At this chapter's outset, we quoted descriptions of the 1960s Constitutional Court of Germany, celebrated for its glass facade. That court's design is also relevant to this discussion, for it was a "conscious break with the oppressive pathos-filled historical forms in which the authoritarian state had found architectural expression. . . . [T]he new building was intended as both the visual embodiment of the new socio-political start of the young 'Bonn republic' and as an endeavour to symbolize democracy and the rule of law using transparent forms."[167] A parallel decision was made in Spain for its new constitutional court that took up residence in 1981 in a modern building. Once used as a medical center, the structure (consisting of several stories tiered in a metallic drum) looked nothing like the palatial courts associated with the fascist regime of Franco. Similarly, discussions of some of the major new court buildings—such as those in Germany and Israel—make the point that the spaces were deliberately modestly proportioned to avoid intimidation.[168]

This architecture-of-difference aims to disassociate new courts from their predecessors through size, scale, and style. And, on occasion, a few buildings quietly commemorate tragic events through subtle references. For example, in 1985, the Palace of Justice in Bogotá, Colombia was the scene of an attack in which more than one hundred people, including the chief justice and ten of his colleagues, were killed.[169] In the new building, completed in 1998, the justices' names are inscribed to commemorate the siege. In addition, the architect Roberto Londoño retained the inscription that had been on the older courthouse's front facade. There quoted was General Francisco Santander, who fought with Simon Bolivar during Colombia's nineteenth-century war for independence from Spain and later became the President of Gran Colombia. The words read: "Colombians: Arms have given you independence, Law will give you Liberty."[170]

Both the distancing from the past and references made through such quotes require viewers to know or have experienced what is abjured or commemorated. Relatively few court designers, however, have made a point of built-in reminders of injustices, past and present, that viewers cannot avoid confronting. Courthouses in South Africa and Mexico are dramatic exceptions.

## Nelson Mandela's Jail as South Africa's Constitutional Court

In 1994, Apartheid in South Africa ended and the country adopted a provisional constitution, followed in 1996 by a permanent one.[171] As that Constitution's preamble explained, South Africa thereby established "a society based on democratic values, social justice and fundamental human rights" as it took "its rightful place as a sovereign state in the family of nations."[172] South Africa's 1996 Constitution bespeaks a clear commitment to adjudication; the "courts are independent and subject only to the Constitution and the law, which they must apply impartially and without fear, favour or prejudice."[173] Other organs of the state are enjoined from interfering with courts as well as required to "assist and protect the courts to ensure the independence, impartiality, dignity, accessibility and effectiveness of the courts."[174]

In addition, a robust bill of rights insists on access to courts and public processes ("Everyone has the right to have any dispute that can be resolved by the application of law decided in a fair public hearing before a court or, where appropriate, another independent and impartial tribunal or forum"[175]). Disputants also have rights to be given reasons for administrative actions taken,[176] and criminal defendants are specifically cloaked in detailed rights to fair trials.[177] Moreover, access to information is not limited to that produced in court. Jeremy Bentham would have been pleased to see a codification providing everyone "the right of access to any information held by the state" and to "any information that is held by another person and that is required for the exercise or protection of any rights."[178] Further, before legislation can be validly enacted, the public must have opportunities to participate.[179] Atop what some would call these "procedural" rights, "substantive" rights are also robust. While many constitutions protect property holders, South Africa's Constitution also makes commitments to shelter, health care, and education[180]—"social rights" that not all constitutions affirmatively protect.[181]

The constitution shaped a tiered set of courts, including Magistrates' Courts, High Courts, and a Supreme Court of Appeal, as well as a distinct body, the Constitutional Court.[182] South Africa chartered eleven jurists to function as the "highest court in all constitutional matters," to decide questions about the constitutionality of acts of parliament and disputes among organs of the government as well as to interpret the constitution itself.[183] Because of generous endowments that authorize "anyone" acting on behalf of oneself, others, or associations to make legal claims seeking protection of the Bill of Rights,[184] a host of issues come regularly before the Constitutional Court.

In 1994, a few months after the first democratic elections, the new Constitutional Court formally came into being. Over its relatively short life, the court has generated an impressive jurisprudence contributing to transnational discussions of constitutional norms.[185] South Africa's Constitutional Court is generally seen as a remarkably successful "start-up," often praised in academic literature for its thoughtful reasoning.[186] The court has gained a degree of security, albeit (like many of its counterparts in other countries) not always popular approval of particular judgments.[187]

### Aiming to Capture the Humanity of Social Interdependence

Like courts of other countries establishing themselves, the South African Constitutional Court, when first begun, had "no building, no Rules of Court, no library and virtually no administration."[188] It rented space while subcommittees addressed the questions of both a building and its décor. Early on, the plan was for a new structure. As Justice Albie Sachs, who was deeply involved in the design, explained: "Existing court buildings in South Africa possessed well-established ghosts that resisted expulsion."[189] What was needed, instead, was a "radical rupture" with the country's past.[190]

Thus, as one can see, while figure 211 (color plate 42) provides a somewhat familiar court facade,[191] it is unusual, with bright coloration and its name written in the country's eleven official languages. (The Mixed Courts of Egypt, shown in fig. 11/155, also bore four languages—Arabic, Italian, French, and English—above its doorway.) Near the entrance are the words "human dignity, freedom, equality," taken from the Founding Provisions of the Constitution and presented in scripts garnered from the handwriting of the eleven judges on the court. These words are also offered in the eleven official languages as well as translated into Braille on the handle of the large doors to the main entrance.[192] As one viewer—Justice Ruth Bader Ginsburg of the United States Supreme Court—described the facade, its aim was to tell entrants that "whatever your race, language or station, you are welcome here."[193]

The architects, Janina Masojada and Andrew Makin of OMM Design Workshop and Paul Wygers of Urban Solutions,[194] sought to create "a physical representation of the constitutional values" inscribed on the courthouse door.[195] Their work and the art it contains are now memorialized in two books, one dedicated to the building[196] and another to its art.[197] In some respects, the judges and architects sounded familiar themes as they sought to erect a complex of buildings demonstrably about justice. Further, the common element of glass, relied upon in modernism to de-

FIGURE 211 Constitutional Court of South Africa, facade, Johannesburg, South Africa, 2004. Architects: Janina Masojada and Andrew Makin, OMM Design Workshop and Paul Wygers, Urban Solutions.

Photographer: Angela Buckland. Copyright: Constitutional Court Trust. Photograph reproduced courtesy of the Constitutional Court Trust and David Krut Publishing, 2005. See color plate 42.

materialize space and create a sense of transparency, can likewise be found. Yet, as architect Andrew Makin commented, they had designed the group of buildings with a subtlety that rendered them accessible "where appropriate, open where appropriate."[198]

The goal of denoting "justice" was coupled with a second, distinctive aim; the designers wanted to express—in both the structure and its art—a "humanity" grounded in social interdependence.[199] The kind of "access" the builders wanted was not only an entrée to courts but also "free and unencumbered passage" to the fundamental rights of shelter, education, and health care that were requisite for "the dignity of all people," which were protected in the constitution.[200]

The large, airy foyer (fig. 212[201]) aims to materialize those sentiments by offering comfortable seating that distinguishes itself from many austere spaces, such as the *salle des pas perdus* designed by Jean Nouvel for the courthouse in Nantes (fig. 10/136). The South African architects described the foyer as "an easy extension of the adjacent public paths and places," shaded from the sun and, "like a handshake," introducing the other components of the building.[202] Inside—and as in other courthouse interiors such as in Boston (fig. 8/113)—the foyer provides a forum for exhibitions, discussions, dance, and other perform-

ances. The point was to have the public use the court "in all sorts of ways."[203]

As can be seen from the photograph, leafy chandeliers hang high from the ceiling.[204] That design references the court's logo—"justice under a tree"—with its umbrella-like arbor sheltering a human figure "symbolising the people's right to protection under the law."[205] The logo refers to traditions of local communities gathering under trees for dispute resolution by their leaders. As detailed in Chapter 10, trees were a fixture of French justice iconography, referencing Louis IX (St. Louis), also described as dispensing justice under a tree. A modern reinterpretation comes from Gérard Garouste's wall panels in a new courthouse in Lyons; there vines envelop excerpts from the text of the Universal Declaration of Human Rights, including, as depicted in figures 10/133 and 10/134, the prohibition against torture.

Like the glass facades of many contemporary courts, trees are also said to presuppose "openness"[206]—although that proposition depends not only on the status of those who could sit under them but also on whether others could see and hear what transpired. Recall that Jeremy Bentham proffered the open field, accessible to all who wanted to watch, in contrast to enclosed rooms where doors could be used to exclude. Bentham added the caveat that the com-

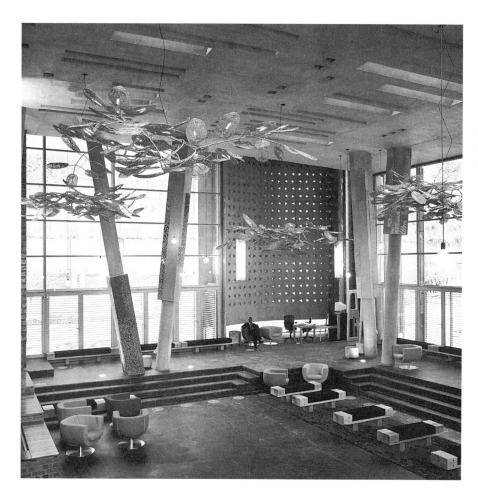

FIGURE 212   Constitutional Court
of South Africa, foyer, Johannesburg,
South Africa, 2004. Architects:
Janina Masojada and Andrew
Makin, OMM Design Workshop
and Paul Wygers, Urban Solutions.

Photographer: Angela Buckland.
Copyright: Constitutional Court Trust.
Photograph reproduced courtesy of
the Constitutional Court Trust and
David Krut Publishing, 2005.

municative capacity of fields depended on the vocal and auditory powers of speakers and listeners.[207]

### Prison Vistas of Barbed Wire

In addition to its welcoming entry, open foyer, and a major courtroom, the Constitutional Court of South Africa offers visitors sights very different from those provided in other courthouses. The court complex was built atop some remnants of the Old Fort Prison, where many Apartheid resisters—including Nelson Mandela and Mahatma Gandhi —were detained.[208] As figure 213 (and color plate 43) shows,[209] barbed wire gives glimpses from some angles of the court's library tower, adorned with the court's logo near the top.[210] The wire marks off the interior cell block (fig. 214[211]). Visitors can also look directly at empty jail cells (fig. 215[212]), with the graffiti and wall scratchings of the prisoners intact.

According to Mandela, who was President of South Africa when the design was selected, its purpose was to incorporate " 'horrid memories of torture and suffering' " to honor the struggle for freedom as well as to express confidence that these practices would not recur.[213] Other courts have used recycled buildings, including (as discussed in

Chapter 10) one in Aix-en-Provence, France, where a late twentieth-century courthouse occupies the former site of a prison known for providing a setting for a novel by Émile Zola. One of that prison's walls was apparently preserved not to interrogate the quality of justice past or present, but rather as "testimony to prison architecture" to be respected within the corpus of French historic buildings.[214]

The Old Fort in Johannesburg dates back to the 1890s. After the Anglo-Boer War, it became a dedicated prison. "It was a place where everybody locked up everybody. Boers locked up Brits, Brits locked up Boers, Boers locked up Blacks."[215] Famously, by the second half of the twentieth century, the prison had a segregated cell block—"a 'native' prison, known as Number Four for sentenced black men"— as well as a jail for women.[216] White male prisoners were, "literally and metaphorically, [in] a higher position" than the black inmates, for whites were kept on upper floors and given better conditions and food.[217] Yet South Africans also describe the Old Fort Prison as a point of community "solidarity" to which "supporters and families brought food and books and clothing to prisoners from various political and cultural backgrounds."[218]

In 1983, the prison was closed, but the building remained an "ominous presence" amidst crowded high-rise apart-

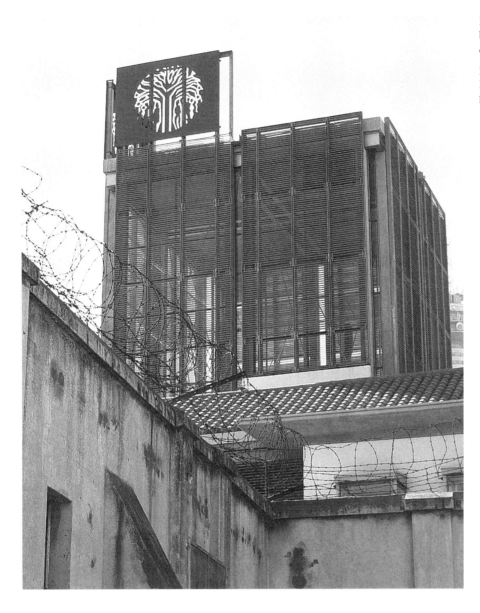

FIGURE 213   Court tower and barbed wire, Constitutional Court of South Africa.

Photographer: Maria E. Burnett, 2004. Photograph reproduced with the permission of the photographer.

ments.[219] In the 1990s, it became a national monument.[220] The committee recounted how it seized on this spot, in part to help "the regeneration of the inner city of Johannesburg" but "primarily [because] it was a site saturated with a history that bore directly on the theme of human rights."[221] The goal was to convert the "intense negativity associated" with the prison into "optimism" about the new commitments to a very different legal regime.[222]

In the tradition of important court construction recounted in earlier chapters, South Africa convened a competition for a building to embody the new democracy.[223] Some two hundred submissions were reviewed by a jury composed of individuals both local and international, expert and lay.[224] One member of the jury was Thenjiwe Mtintso, who then chaired the Commission on Gender Equality and who had herself spent several months in the women's section of the Old Fort Prison. Mtintso saw the challenges—that "courts

have always been frightening buildings for black women in South Africa—the ultimate incarnations of repression," associated with words such as "injustice, exclusion, marginalisation, dehumanisation, humiliation, fear, repulsion, rejection, distrust, unfriendly, cold, ugly, austere, stern."[225] What the jury hoped for was a space that would negate such terms —a building representing "the democratic value of public participation" that was warm and welcoming even as it expressed "the value of power."[226]

The jury selected local architects Janina Masjoda, Andrew Makin, and Paul Wygers because, as Justice Sachs explained, they had shaped a "site-specific, climate-specific, light-specific" solution rather than showing "off what fabulous sculptural visions they had."[227] Within a relatively short time—supported by the local authority, the national government, and a specially created entity—the complex went from its conception in 2001 to its opening in 2004.[228]

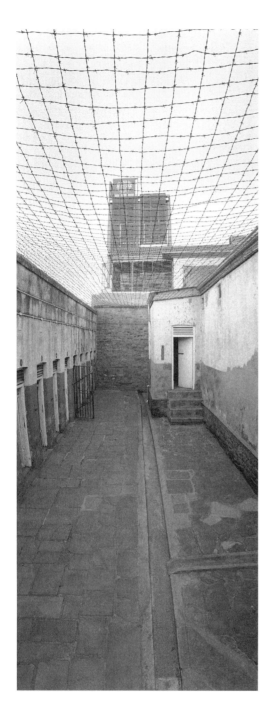

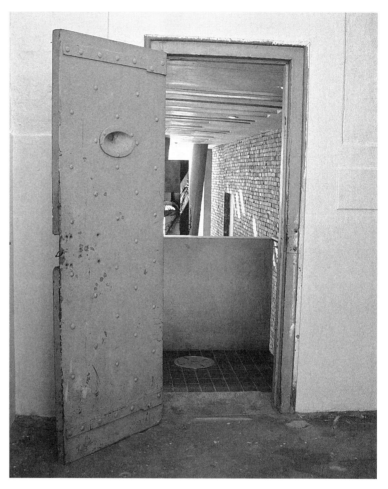

FIGURE 214   Cell block in the interior courtyard, Old Fort Prison within the Constitutional Court and Complex of South Africa.

Photographer: Angela Buckland. Copyright: Constitutional Court Trust, 2005. Photograph reproduced courtesy of the Constitutional Court Trust and David Krut Publishing. See color plate 43.

FIGURE 215   Interior view from an Old Fort Prison cell within the Constitutional Court and Complex of South Africa.

Photographer: Maria E. Burnett. Photograph reproduced with the permission of the photographer, 2004.

Known as Constitutional Hill, the building complex consists of more than a million square feet and cost some $64 million to construct.

What resulted are four areas—the Foyer, the Administration Wing, the Court Chamber, and the Library —linked by arcades with courtyards.[229] Two gathering places —the Foyer and the Court Chamber—are connected by three walkways through the building. One, the Judges' Walkway,[230] can be seen in some areas through transparent glass.[231]

Janina Masojada described the architects' interest in the "complete intermingling of past and present"; for the Foyer,

they used prison bars as climbers for plants and some of the bricks from what had been the "Awaiting Trial Block" of the Old Fort Prison.[232] At some points "new and old stand side by side, indistinguishable from one another."[233] The court chamber, banked and arc-shaped for easy observation, has a thin "long ribbon window."[234] Through that window judges and others in the room can watch the feet of passersby, explained as serving to "keep judges and counsel down to earth."[235]

Decisions on the shape of the building have been described as collaborative. "Each area of the Court developed

by the architects was presented to the judges for comment."[236] In contrast to many new court buildings, the administrative apparatus of the court is not entirely walled off. Rather, people using public spaces such as the Exhibition Gallery can observe court staff or judges, as they are given "glimpses into the more private areas of the Court."[237] Unsurprisingly, the building was designed to be "green," employing passive cooling and other state-of-the-art resource conservation techniques.[238]

### Splashes of Color and References to Oppression

The official budget for art was the equivalent of 1,300 United States dollars.[239] As Justice Sachs reported, those funds were rapidly exhausted by commissioning a tapestry, *Humanity,* to mark the "social interdependence that underlay" the Bill of Rights.[240] Thereafter, with the help of the "cultural departments of various European governments"[241] and foundations in North America,[242] an impressive array of art "collected itself."[242] Postage stamps reproduce some of the art in the collection, and a book documents its contents, managed by curators.[243]

The idea of art "in" architecture went beyond what many countries have done. Deliberately "unmindful of the distinctions between decoration, craft and high art,"[244] the designers worked to integrate craft and art in the doors, security gates, carpets, and lights of the building.[245] Further, they wanted the building to "bear the signs of *making,* a building that would represent the work of South African artisans, . . . the product of human interaction with ideas and materials rather than of systems and technologies of management."[246] To do so, the court advertised that more than two dozen sites in the building were available for proposals on their design.[247]

The proclaimed result is art "of, by, and for 'the people of South Africa,' now 'united in [their] diversity.'"[248] Included are objects from some who died in exile during the Apartheid era as well as donations from collections and newly created, site-specific objects. Some images are festive and flowered, and others record oppression, such as *The Scene of the Crime* by Robert Hodgins, a painting of an interrogation room.[249] The designers aimed to avoid "easy and facile symbolism"[250] and, specifically, what was seen to be "the cliché" of the personification of Justice.[251] Rather, the art needed to reflect that the court and its justices, representing a "diversity of the citizenry as well as a variety of legal opinions," had a common task.[252]

In some respects, the results are familiar in that a range of forms and styles can also be found in new buildings in the United States and France, both of which provide a set-aside for art, as detailed in Chapters 8, 9, and 10. In South Africa, an array of artistic styles and materials—woven fibers, wood, neon, and metals—create patterns to "soften" the building by offering moments of a "bright splash of colour."[253] But unlike many of its counterparts, the South

African court placed an unusual emphasis on collaborative projects, such as a huge hand-beaded flag made by the African Art Centre of Durban to hang behind the judges' bench. In 2006, after months of work by a group of beaders, the flag was installed, complete with the names of its many crafters.[254]

Moreover, in a pointed break from the commonplace effort of uplifting iconography, many of the objects in the South African Constitutional Court are, like the building, grimly referential to the recent past. In *Prison Hacks,* eight slabs of Zimbabwe black granite, shaped by artist Willem Boshoff, mark off the thousands of days served in prison by Nelson Mandela, Walter Sisulu, Ahmed Kathrada, and others of the "Rivonia Trialists."[255] Judith Mason's *The Man Who Sang and the Woman Who Kept Silent* consists of "two oil panels and a dress made from blue plastic bags."[256] The first part of the title refers to Harald Sefola, "electrocuted with two comrades in a field," who sang a freedom song while waiting to die.[257] The second part of the title memorializes an African National Congress member whose story came to light through the Truth and Reconciliation Commission: "Phila Ndwandwe was shot by the security police after being kept naked for weeks in an attempt to make her inform on her comrades. She preserved her dignity by making panties out of a blue plastic bag. This garment was found wrapped around her pelvis when she was exhumed."[258] Mason made a complete dress of blue plastic to cloak Ndwandwe, and the dress is all that is shown.[259] The power "resides not in its figuration . . . but in the absence of a human figure in all three parts of the work."[260] Mason commented that the dress was also a reference to the *Victory of Samothrace,* a monumental headless Greek winged statue that dominates a staircase at the Louvre in Paris.[261]

### The Challenges of Crime and Caseloads

The courthouse and its art have been widely celebrated, providing an emblem for the new nation and inscribing its civic identity as rising above a horrific past.[262] In 2006, the South African Institute of Architects gave the building an Award for Excellence, and commentators have praised its preference for "open-endedness [and] inclusivity" in lieu of "conventionalized grandeur."[263] But the impressive building, the hopes it represents, and the jurisprudence that has been generated stand in tension with another aspect of South Africa's legal order—crime. The country faces the enormous challenges of a transition from Apartheid to democracy that have been mediated by efforts at reconciliation and the embrace of constitutionalism but that have not (yet) produced economic stability, health, and personal safety.

Crime rates are dramatically high, such that the "experience of being violently victimised in South Africa has almost become a normal feature of everyday life in many urban and rural settings."[264] While the Constitutional Court is open

and airy, some well-to-do households are part of gated communities that wall off one area from another in an effort to gain spatial, if not legal, control. As a 2006 book on crime and justice in South Africa noted, the country could be on its way to becoming what Michel Foucault called a "carceral society" in which "pervasive surveillance and supervision" regularly constrain personal freedom.[265]

Of course, private policing denoted by gated entries dots the landscapes of many countries, just as safety on the streets is a challenge around the world. Further, class can provide some buffer, leaving the poorer members of a polity vulnerable. And, like elsewhere, the problems of safety in the streets are challenges for the regular courts. Delays in the criminal courts continued to be "appalling—in 2002 the average case took more than two years to move from referral to sentencing," and a "shocking backlog" of pending cases made the prospect of reform low.[266] The Constitutional Court has also experienced administrative challenges, prompting efforts in 2008 to improve case management and performance as part of its annual planning.[267] In addition, in 2008, the International Bar Association's Human Rights Institute sent a group on a mission to investigate "threats to the independence of the judiciary" and returned to register objections to proposed legislation that would have made the judiciary more "dependent upon the executive branch."[268] Yet the court has also weathered several transitions as founding justices have either retired at the mandatory age of seventy or served out the limited term of fifteen years.[269]

## Visually Recording (in)Justice in Mexico's Supreme Court

South Africa's 2004 Constitutional Court is the rare contemporary building insistent on expressing something about injustices perpetuated by the state. The court has a predecessor, continents away, also embedded in revolutionary politics. In 1941, José Clemente Orozco painted several politically charged murals for the new building of Mexico's Supreme Court.[270]

A sense of the complexity of the expansive configurations is provided by figures 216 and 217.[271] "The dimensions of the central panel, which extends from wainscot to ceiling, are about thirty-five feet wide by ten feet high. The two side panels, also from wainscot to ceiling, are slightly shorter. And the panel over the stairway is approximately eighteen square feet."[272] They sit in the *Sala de los Pasos Perdidos,* the room of "lost steps," the terminology for waiting areas shared by Spanish, French, and other Romance languages.[273]

*La Justicia* (*Justice*), which consists of two scenes, covers the north and south walls, and flanks another mural, *Las Riquezas Nacionales* (*National Wealth*), filled with brightly colored symbols of the country's resources. The Supreme Court's brochure reproducing these images explains that *National Wealth* shows "the most precious and richest metals: gold, silver, copper, steel, and that other element . . . petroleum."[274] Inscribed in Latin at the bottom is a quote from Cicero translated (roughly) as "We are servants of the Supreme Law in order to be free."[275] That mural could be seen as celebrating the minerals' value or, as one commentator suggested, as depicting "the twisted metal remains of twentieth century mechanization or perhaps the natural resources [used] to manufacture . . . implements of destruction."[276]

By the late 1990s, some fifty years after the walls were first painted, the Mexican Supreme Court chose to adorn the cover of one of its brochures (fig. 218) with a detail of the *Justice* mural from the north wall.[277] But when the murals were first installed, the justices then sitting were less than enthusiastic about the vivid criticism depicted in their courthouse.

## *Mexican Muralists, Orozco, and "Profoundly National" Paintings*

Born in 1883 near Guadalajara, Orozco was a leading figure in the Mexican muralist school.[278] Joining Diego Rivera, David Alfaro Siqueiros, Gerardo Murillo, and others, he helped to shape an artistic movement that had a profound impact on painting in many parts of the world.[279] Involved in various ways with Mexican revolutionary movements, these artists' depictions have become iconic of the period.

Orozco had worked as an illustrator for political publications such as *El Hijo del Ahuizote* (*The Son of Ahuizote*—an animal in Aztec myths and the name of Motecuhzoma's predecessor) and *La Vanguardia* (*The Vanguard*).[280] In the 1920s, the first "experiments" of the Mexican mural paintings "blossomed into a full-blown movement,"[281] with installations in 1922 in Mexico City's San Ildefonso College and, in 1926, in the Escuela Nacional Preparatoria (National Preparatory School), also in Mexico City.[282] Those murals "transformed the walls of the school into a gigantic, multicoloured cloth which . . . will forever reproduce the blood-stained image of the fatherland during the tormented days of the revolution."[283] Orozco used the opportunity (as he would again at the Mexico Supreme Court) to caricature justice, both divine and earthly. He painted a "wrathful figure of God the Father" in a Last Judgment scene and a "drunken pair in carnival costume" as human judges.[284] His Justice was "a vulgar prostitute, accomplice of anyone who could pay her."

Orozco spent a few years in New York,[285] where he was equally unabashed in challenging authority. In a series at Dartmouth College called *The Epic of American Civilization,* Orozco depicted skeletons "in academic garb presiding over the birth of useless knowledge, . . . [i]ndifferent to the crises of modern civilization."[286] In 1934, Orozco returned to Mexico and he again received major commissions such as murals for the city hall in Guadalajara.[287]

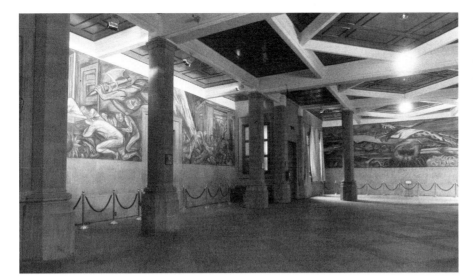

FIGURE 216 Murals *La Justicia* (*Justice*) and *Las Riquezas Nacionales* (*National Wealth*), José Clemente Orozco, 1941, Supreme Court of Justice of Mexico.

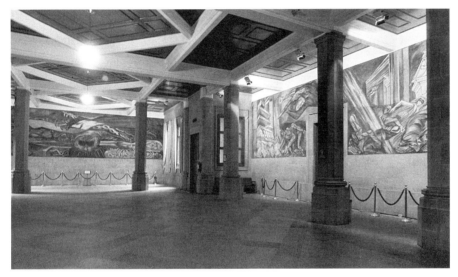

FIGURE 217 Murals *Las Riquezas Nacionales* (*National Wealth*) and *La Justicia* (*Justice*), José Clemente Orozco, 1941, Supreme Court of Justice of Mexico, Mexico City.

Figures 216 and 217 reproduced with the permission of the Committee of Government and Administration of the Supreme Court of Justice, September 29, 2006, Order 2200/2006.

While this discussion is not the occasion for a detailed account of the history of either the Mexican system of justice or the reconstruction of Mexico City after the revolution, situating the Supreme Court and its art is in order. In 1821, Mexico gained independence from Spain and, in 1824, adopted its first constitution. That document formally shaped a federation "consisting of nineteen states, four territories, a federal district, and an independent judiciary."[288] An 1857 constitution included the doctrine of separation of powers and a role for the judiciary in reviewing executive branch decisions, as well as rights of free expression, equal treatment of citizens, and the end of certain privileges for the clergy and military.[289]

These two constitutions are a testament to the role adjudication was coming to play in republican and democratic political theory. Further evidence comes from the history of the 1861 legislation authorizing "*amparo*," a procedure by which an individual could turn to court for protection "against abusive government actions."[290] Historian Linda Arnold attributed its roots to nineteenth-century Mexican jurisprudence based in "Castillan and Indies laws [that] had long empowered judges to inspect prisons [and] review the status of cases."[291] But by the latter part of that century, the legislature and the courts were subservient to the "unlimited" authority of the executive branch.[292] As Pilar Domingo explained, "the principle of judicial independence has been, at least nominally, affirmed in Mexican constitutionalism" since the second half of the nineteenth century, but "the history of political development in Mexico . . . attests to a marked absence of judicial independence."[293] Thus, the proto-democratic elements of justice analyzed in Chapter 13 contributed to ideas that arbitrary government action against individuals was unacceptable, which, in turn, generated conflicts over authority among the branches of government.

A multi-party Mexican revolution erupted in 1910, and battles among armed groups continued until 1920. "In the

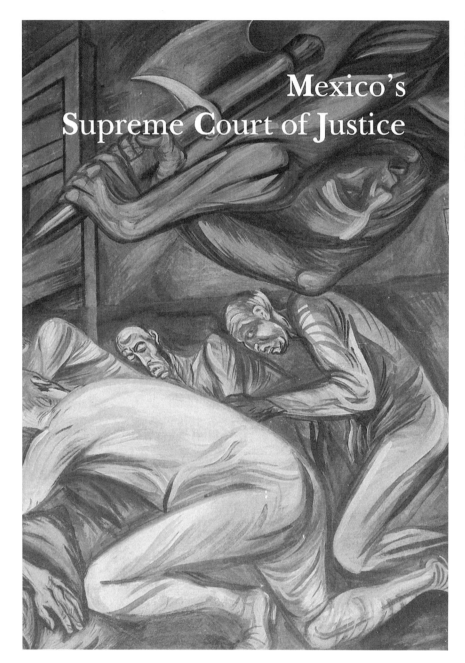

FIGURE 218    Brochure cover, Mexico's Supreme Court of Justice. Graphic design: Teresa Limón García / Retorno Tassier, 1997 (with a detail of Orozco's *La Justicia*).

Reproduced with the permission of the Committee of Government and Administration of the Supreme Court of Justice, September 29, 2006, Order 2200/2006.

decade from 1910 to 1920 some two million people were killed in Mexico."²⁹⁴ In 1917, the country adopted a new constitution that protected various rights, such as universal education, but did not instantiate a more powerful judicial branch.²⁹⁵ "Mexican presidents historically controlled key aspects of the administration of justice," including directing criminal prosecutions.²⁹⁶

When fighting stopped in 1920, Álvaro Obregón was elected President. He turned to new building and art "to show the world . . . that we are capable of reconstructing the country we have half-destroyed."²⁹⁷ Obregón appointed José Vasconcelos the Minister of Public Education. In 1921, he launched a "program of didactic public muralism"²⁹⁸

designed to promote a unified national identity after the fractured years of the Revolution. "Strategies for the creation of a 'Mexican' art . . . openly adopted a propagandistic function: to conform a vision of modern Mexico."²⁹⁹ In the words of one historian: "Only walls, the immense walls of public buildings . . . could serve as rostrums to men who had so much to say."³⁰⁰

An energetic building program supplied such platforms, including plans for the Supreme Court.³⁰¹ As in other countries, courthouse construction was preceded by a design competition. In 1929, Antonio Muñoz García, a well-known architect who in the early 1930s also served in the government's Office of Buildings and Monuments, won the

commission. Muñoz García had designed Mexico's Centro Escolar Revolución (Student Center of the Revolution) and the Mercado Abelardo Rodríguez (Abelardo Marketplace), both of which were completed in 1934.[302] The original conception of the courthouse featured a "monumental neo-Colonial structure,"[303] proposed to have "two immense, somber seated bronze figures," a frieze with a "stylized Mexican eagle and scales of justice at the center, surrounded by kneeling and standing figures representing the various classes of Mexican society."[304]

The new courthouse was located off the main plaza in Mexico City. The first stone was ceremonially laid on November 20, 1936,[305] the national holiday commemorating the start of the Mexican Revolution. The point was to mark "a reclamation of civic space in the name of the revolution, and as a sign of the achievements of the government."[306] While provisionally called a palacio de justicia ("palace of justice," in the Spanish and French tradition), by 1938, that nomenclature seemed inapt for "a government that derived legitimacy from the revolution."[307] (Recall that Bentham had urged using "judicatory" in lieu of the word "court" so as to avoid the royal referent.) Mexico's building came to be known, in terms closer to North American forms, as the "tribunal" or the Supreme Court building.

The title change comported with a revised design that moved away from the perceived political signals that the initial Neoclassical proposal had entailed. The aim was to capture something of the "new policies about race, public health, and civic participation" as Mexican architects worked out their "complex engagements with national architectural traditions, International style modernism, and Art Deco."[308] The completed building, constructed from 1936 to 1941, cost 5 million pesos, or over $1 million at that time.[309] It "featured little of [the] original exterior design";[310] for "solemnity" it relied instead on steel and reinforced concrete.[311] But the three-and-a-half-ton decorated bronze doors that formed the entryway were far from austere. The didactic reliefs, in Art Deco style by Ernesto Tamariz, represented "four momentous stages in the history of Mexico"—evangelization during the sixteenth century, the Federalist Republic, the Reform period, and the modern era.[312]

After President Lázaro Cárdenas came to power, he revamped the structure of the Supreme Court by giving justices six-year terms (the same as that for the President), and he put a new group of justices in power.[313] The point, as one analysis put it, was to have a "compliant Court" committed to a "passive role" and plainly subservient to the ruling political party.[314] The rationale was a need to protect "a highly complex political movement" from "judicial interference" by judges seen as "conservative and reactionary" and hence likely to put up obstacles to "progressive and desirable" social reforms.[315] In the 1930s such concerns were familiar farther north, where the United States Supreme Court was also seen as a roadblock to needed government interventions. While President Franklin Roosevelt's pro-

posal to add more justices to the court (termed "court-packing" by critics) formally failed, the Supreme Court switched gears and approved New Deal legislation as new justices filled seats.[316]

In 1940, President Cárdenas selected Orozco to paint murals because (according to the court's materials) of "the ideological agreement between" the two.[317] In a letter to Cárdenas, Orozco offered to produce "'a profoundly national painting, necessarily based in our cultural origins, but at the same time like a living body, an integral part of our modern manner of being and feeling, a faithful expression of our history, of our daily life, of our desires and ambitions, of our customs, vices and virtues.'"[318]

In these courthouse murals, the vices are more evident than the virtues. The *Justice* mural on the south wall is shown in figure 219 (color plate 44). The mural and its counterpart on the north wall occupy awkward spaces; like Simka Simkovitch, whose mural for the 1938 Jackson, Mississippi courthouse (fig. 6/82) surrounded a door, Orozco too had to work around doorframes. The Mississippi painting was intended to be bucolic even as its segregated scene, with white men constructing houses on one side while black men and women worked in the fields on the other, caused an uproar in the 1960s that resulted in its being shrouded in drapes (fig. 6/83). In contrast, the Orozco murals were seen as stark and disturbing at the outset, even as they were appreciated as great Mexican art.

In both the north and south murals, the front half of an imposing female body (identified by various commentators as Justice) swoops over a doorway lintel and wields, like an avenging angel, an axe (on the north wall) and a flaming torchlike sword (on the south wall). In each scene, figures with "larvae-like bodies . . . painted with gray and flesh color electrified by convulsed, white highlights"[319] cower below, in "a violence of movement and color peculiar to Orozco."[320] On the south wall, the avenging Justice figure is poised over a trio of ghostly figures, one of whom is holding a coiled rope while another male—masked and wearing a red cap (the Phrygian cap of liberty)—is grasping a tied-up bundle of papers.[321] Justice is thus shown attacking someone wearing a symbol of the liberty of the Republic and perhaps gathering up papers, either to protect them or steal them from her.[322] A third smaller, androgynous figure lies on the ground either unconscious or dead. On the north wall, the avenging Justice's axe threatens a group of six males (one masked) who seem to be covering (and perhaps hiding) a body whose star-like headdress is askew. Given that the Statute of Liberty had been standing in the New York Harbor for some fifty years, the figure could also be a reference to that version of Liberty.

Both walls show the back portion of their respective Justices dissolving into a cone of brightly painted rays of orange —fire perhaps—that penetrate figures below it. One interpretation is that the swooping figure is properly attacking— "discharging the full fury of its anger against prevarica-

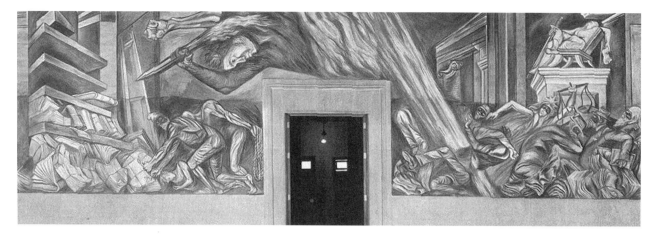

FIGURE 219    *La Justicia* (*Justice*) (south wall), José Clemente Orozco, Supreme Court of Mexico, 1941.

Reproduced with the permission of the Committee of Government and Administration of the Supreme Court of Justice, September 29, 2006, Order 2200/2006. See color plate 44.

tors and corrupt judges"³²³—on both sides. Alternatively, although the rays are continuous with the bodies of the females, the two sides (separated by door frames) could be read as sending different ambiguous messages. For example, the Supreme Court's monograph identifies the front part of each figure, with axe and torch or sword, as representing "human" justice and the tail-end fiery orange rays as denoting a "metaphysical justice"³²⁴ that either animates or contrasts with earthly justice.³²⁵ Whether such a distinction is plausible and what valence to attach to the rays are yet other questions. Some deemed them "cathartic,"³²⁶ while others saw them as threatening.

Given the display, Orozco surely had not taken the occasion to celebrate institutional justice. The bottom level is filled with evildoers, as were the Lorenzetti murals (fig. 2/26) in Siena, where several Justices sat upright; one, with sword raised, had a severed head in her lap—plainly punishing malfeasance. In contrast, the Orozco rendition offers up two dysfunctional Justices. One is elevated as if on a pedestal (detail, fig. 220, color plate 45), at the right corner of the south wall. But she lies back, her sword hanging down, at best inattentive if not asleep, while disorder surrounds her.³²⁷

Another Justice, directly below the oblivious one, is being jostled by the throng of evildoers. This Justice holds scales. Her blindfold is a domino mask with eyeholes, giving her a masked-ball, carnivalesque or cartoonish look.³²⁸ She also wears a diadem reminiscent of Lady Liberty. Two men, both masked, are attempting to put objects in or to take objects out from the pans of her scales. Not only has justice gone seriously awry, but one cannot tell whether this Justice is overborne by the injustice around her or is a willing participant.³²⁹ Whether deliberately referencing predecessors such as Luca Giordana's *Justice Disarmed* (fig. 4/57), with her scales drooping and her sword being taken from her hand, or Bruegel's depiction of a blindfolded, duncecapped *Justice* (fig. 4/53) standing in the midst of mayhem,

Orozco's vision is dark: "Everything is violent: the downthrust of the revengeful spirit of Justice, the flight of the judges, the breaking of the old structures by the revolutionaries. Color itself trumpets the theme of judgement."³³⁰

One historian of Mexican muralists offered the view that one of Orozco's Justices was "a cynical comédienne or a degenerate prostitute, viewing with indifference from the height of her pedestal the crime and injustice committed around her."³³¹Another saw the critique to be aimed at judges, portrayed as "desperadoes. They avert their eyes while the public is tied up and pillaged; wear masks while they tamper with constitutional documents."³³² The various columns strewn about ("elements of classical architecture") make the point "that in ancient and modern times, monuments could be dedicated to a false conception of justice."³³³ One could see Orozco's "prophetic vision . . . [of the] abuses of man-made justice aligned with the evergrowing greed of the monopolists."³³⁴ As a commentator later summed them up, the murals were "aggressively attack[ing] the Mexican justice system, with parodies of bureaucracy, book learning, and even justice itself."³³⁵

The impression that Orozco was referencing contemporary Mexican justice was shared by some of the judges watching as the installation was progressing. Over the course of almost a year of work, Orozco had the occasion to hear "complaints of lawyers and judges who felt he was treating them spitefully in his fresco designs."³³⁶ Critical comments were not the only obstacles: "The new commission [at the court] was a heartbreaking job," for the walls "proved to be awkwardly broken into uneven and inharmonious areas by functional doorways"³³⁷ in the uninspiring "dark vestibule . . . of the upper landing."³³⁸ "Half-hidden behind rows of columns, they were miserably lighted."³³⁹

The unveiling of the first section of murals produced what *Art Digest* called a "fiery reaction" and led "Fair Lady Justice over a merry, bouncing trail."³⁴⁰ One contemporary

FIGURE 220   *La Justicia* (*Justice*) (detail) (south wall).

Reproduced with the permission of the Committee of Government and Administration of the Supreme Court of Justice,
September 29, 2006, Order 2200/2006. See color plate 45.

commentator described the murals as "proof once more of the greatness of Orozco's capacities as a painter," yet given their setting in the court, the murals had a "startling character."[341] Another praised the symbolic freedom they demonstrated; "judges must walk under their own judgment pronounced by Orozco on the walls of the building. What respect of a government for the creative freedom of the artist! Justice on earth is blind, but a Holy Revenger descends with searing flames and chases the bribable judges from the ground."[342]

That "creative freedom" did not last long. According to one historian: "The functionaries of the Supreme Court of Justice . . . [had] expected homage to that divine goddess . . . with the mortar-board and the toga,"[343] but the results—a "blindfolded Justice in a compromising position"[344]—did not meet those expectations. Orozco had completed about 1,400 square feet of the nearly 5,000 reserved for him when the commission was cancelled because of "the disgust that the frescoes . . . provoked" in some of the justices.[345] Apparently some justices wanted more than the cancellation. Several justices were "particularly exercised over the section"[346] detailed in figure 220 and "demanded that the

murals be removed."[347] But, as the reporter put it, in "Mexico, where art is taken almost as seriously as politics, removing Orozco's frescoes was out of the question."[348]

### George Biddle's Redemption from the Horrors of War

Blank walls remained, needing to be filled. In what *Time* magazine called "a curious compromise,"[349] the Mexican government turned to an American painter, George Biddle. As recounted in Chapter 6, Biddle had been instrumental in shaping the Works Progress Administration (WPA) program in the United States that supported art in New Deal buildings of the 1930s.[350] Mexico commissioned Biddle to paint the empty space in the foyer as well as additional murals on the entry-level floor of the courthouse. *Time* quoted the Mexican Minister of Education, Torres Bodet, as exhorting Biddle to "do something constructive!"[351]

The compromise was "curious" because "[n]ever before had a foreigner been invited to decorate a Mexican federal building."[352] On the other hand, Biddle was a great enthusiast and champion of Mexican muralists. In 1929 he had painted a scene, *Shot by Bandits,* that "sympathetically por-

tray[ed] the tragic effect of politics and social unrest on the daily lives of the Mexican peasantry."[353] Moreover, Biddle was not just any "foreigner." In addition to his own government service, his brother Francis was the former Attorney General of the United States, a key northern neighbor and regular financial supporter of Mexico.[354]

The Biddle murals, titled *La guerra y la paz* (*War and Peace*), completed after a year of work in 1945 as World War II ended, covered the pictorial space over the "magnificent High Court Library door."[355] The three panels are dark thematically as well as in tone, reflecting the miseries produced by World War II.[356] On the central panel, over the lintel of the door, a horse is ridden by a disfigured skeleton, holding embryonic prehistoric-looking monsters. Also depicted are an odd lot of animals—a lizard, a jackal, an owl, a vulture, a hippopotamus, an apelike figure, a warthog or wild boar, and a troll or ogre—some of whom are clawing and gnawing at each other. The Supreme Court of Mexico described the scene as symbolizing the fight among nations for dominance,[357] while an art critic saw it as "a fantastic scene of dinosaurs and hideous monsters, galloping over two sculptural reliefs representing downtrodden humanity."[358] The flanking, lateral scenes include more death and destruction, with bodies, skeletons ("which seem to have emerged from photographs of Nazi concentration camps"),[359] dead horses, several gas masks, grenades, and other weapons strewn about. A figuration of the grim reaper—himself spectral in skeletal form—sits atop a pile of skulls and holds a scythe.

The "horrors of war" on those panels are contrasted, at the edges, with the "fertility of peace."[360] Biddle used the far right and the far left of the lateral panels for "male and female deities that float above typical Mexican landscapes."[361] On the right, below the female god are a man and a woman who holds a child—composing what the Supreme Court called the "holy family."[362] The Supreme Court explained: "Mary and Joseph are rocking the baby Jesus who has arrived on Earth and with him, the hope of peace."[363] On the left panel, below the male god are two men and two oxen working a field; as the Mexican Supreme Court put it, they are gathering "an abundant harvest."[364] Thus, while Biddle did not level his critique at Justice, he made humanity appear bestial and warring, in need of salvation through religious intervention.

The inaugural ceremonies for the new courthouse were held on June 2, 1941, a time when, in the words of the President of the Republic, Manuel Ávila Camacho, "hate and destruction [were] hovering over humanity."[365] The published speeches of the President and the Chief Justice reflect anxiety about the fragile role of the judiciary, while making no mention of the import of the vivid images provided by either Orozco or Biddle. Rather, both focused on how the building itself represented a new era for executive-judicial relations. President Ávila Camacho pledged his commitment to the precepts of independent judges. He assured the judiciary that his government would "place all its moral and

material force" at its service "to guarantee the respect for and the execution of the decisions of this Court and of all Federal Tribunals."[366] (Yet he reminded the judges that their authority was limited and that their role was not to make laws but to deal with individuals.) Camacho also used the occasion to call for a revision of the six-year terms for judges, inadequate to "guarantee their independence" because the short tenure "deprive[d] them of the autonomy . . . necessary if they are to be impartial."[367]

In turn, Salvador Urbina, the Chief Justice of the Mexican Supreme Court, noted that the "deteriorated building" in which the court had sat prior to the "splendid new edifice" had been all too "symbolic of its [lack of] institutional significance."[368] He complained of the historic "absorption of all political power by one government branch."[369] The new building was a vast improvement over those "very unsatisfactory buildings, unsuited to the dignity of the Judiciary."[370] Urbina hoped the new era was represented by the new building: "No political or social group should be allowed to bring pressure on the Judiciary under the pretext of defense of our revolutionary principles" and both the legislature and the executive should recognize the "sovereignty of the Judiciary."[371]

The building itself was met with mixed reviews—"the subject of both withering criticism and glowing praise."[372] Some objected that it was both "huge" and "costly." Its 84,000 square feet cost two million pesos (around 371,000 U.S. dollars at that time) over the projected budget.[373] Enthusiasts appreciated the building's geometric forms, seeing its simplicity as appropriately identified with "the character of the High Tribunal."[374] Detractors found it "the coldest building, physically and architecturally speaking," lacking any outstanding element.[375] It also did not mark a change in the relations among the branches. Executive oversight of the judiciary persisted into the late twentieth century and, during periods of one-party control, the Mexican Supreme Court was deferential on various issues, abjuring involvement in electoral and political matters.[376]

### Cauduro's Vision: Torture, Homicide, and Other Crimes, Unpunished

The Orozco murals are now on proud display, described as "representing one of the most important elements of [the court's] artistic patrimony."[377] Materials published by the court that welcome visitors on tour describe the images as a critique of monopolist corporate behaviors and the perpetuation of injustice.[378] Like the South African Constitutional Court, the space is sometimes used for performances.[379] Moreover, like the leaders of the South African Constitutional Court, twenty-first century Mexican justices also took up the theme of law's injustice. In honor of the hundredth anniversary of the Mexican Revolution, the justices asked four artists, Rafael Cauduro, Leopoldo Flores, Luis Nishizawa, and Ismael Ramos to create new art for each

of the four stairwells.[380] Thus, once again, artists were invited to use the "immense walls of public buildings . . . as rostrums."[381] This time, the justices themselves embraced a critique unmistakably speaking to the contemporary failures to secure personal safety and to provide even-handed administration of the law in Mexico.

Our focus is on a series by Rafael Cauduro,[382] an artist born in Mexico City in 1950,[383] who has been the recipient of various public commissions, including a project for the Mexico City subway.[384] For the Supreme Court, Cauduro did a sequence of works that, like Ellsworth Kelly's *Boston Panels* (fig. 6/93), are conceptualized as a whole. But the serenity and balance of the Kelly *Panels* are at the opposite end of the visual spectrum, for Cauduro's series, titled *La historia de la justicia en México* (*The History of Justice in Mexico*) provides graphic depictions of "Los siete crímenes mayores" (The Seven Major Crimes).

Unlike Orozco, who did not explain his sometimes enigmatic imagery, Cauduro wrote about the project in advance and spoke about it when unveiled.[385] Cauduro found the challenges of the site inspiring; "what drove me to enter the competition was the form of the walls, which are not rectangular like most surfaces on which murals are painted. When I saw the walls, I saw what I wanted to paint."[386] Cauduro linked content to location. The "space determined the aesthetics of the project; the structure of the staircase accentuates concepts of ascent and descent in an [elliptical form from] . . . earth to heaven."[387] Further,

> There are various ways to approach the challenge of painting a series of murals on "The History of Justice in Mexico"; . . . perhaps one could narrate important moments, such as the vote for the Constitution of 1857, the promulgation of the Reform Laws, or the ratification of the Constitution of 1917. However, in the history of justice there are also other types of histories, above all those that have been more constant and permanent: the history of its limitations, its failures, its unsolved problems. We continue to search for and demand justice . . . [even] while there are cases in which, due to delay or red tape, someone is denied; while someone is tortured to obtain a confession; while jail is like a game of fate into which some fall for lack of defense; while the law does not check repression and violence. This history is what matters, in so far as it reveals what we want to avoid with justice, its reason for being, the hope that it animates. This is the history that I wanted to present in these seven walls . . . .[388]

The murals, totaling more than 3,000 square feet, extend from the basement to the third floor, to be viewed by the justices as they move from chambers to courtroom (fig. 221[389]). As Justice José Ramón Cossío Diaz of the court explained, the "violent images are the last thing that we see before starting sessions."[390]

Cauduro began his *History* "in the basement (earth)" with *Tzompantli*, which is the Aztec term for a rack (fig. 222, color plate 46) used in some Mesoamerican societies to display the skulls of those sacrificed. Cauduro's *Tzompantli* holds about three hundred skulls, created by a glass-fusion technique[391] that required the pieces to remain in a kiln for over three weeks. (The weight required special supports in the walls.[392]) Also depicted at the lower level is the "underground crime" of *Procesos viciados* (Corrupt Processes),[393] which is partially visible in figure 221 and more clearly shown in figure 222. That mural is filled with file cabinets stacked high with papers. Eerie images of shadowy people, trapped within, peer out from the filing cabinets as evidence of the hell created through bureaucracies formally generating files as human rights are violated.

Also visible in figures 221 and 222 is *Violación* (*Rape*). Cauduro gave the scene a three-dimensional sense by using a fiberglass construction of a fragmented window through which viewers see a blindfolded woman, her head thrown back, with arms apparently tied behind her, strapped in a chair with men standing over her.[394] At another level, one encounters *Homicide*, a broken young female body seen as if thrown down a well (fig. 223, color plate 47). The perspective and the off-center brick walls that surround her create a dizzying effect. To the left of *Homicide* one can see a part of another crime, *Tortura* (*Torture*); a person's head is being forced into a toilet bowl. The mural sequence also includes *Secuestro* (*Kidnapping*), *Represión* (*Repression*), and *El más puro de todos los crímenes* (*The Purest of All Crimes*)[395]—shown as six windows through which one can see "uniformed repressors"[396] or guards in various poses reminiscent of Da Vinci's *Vitruvian Man*. In *The Purest of All Crimes* (the "use of brute force, one of the worst crimes") people flee from a menacing tank—an image evocative of government actions in Mexico and elsewhere.[397] To crown the work, Cauduro added angels at the murals' top around windows—according to one account, to represent the European colonial tradition and perhaps "celestial soldiers" coming to do battle with injustice.[398]

The work thus moves from the basement mural that evokes the pre-Hispanic origins of Mexico through to the subsequent cultural permeation of Europe.[399] The angels did not, however, herald a new age; both victims and oppressors are plainly contemporary, not clad in historical costumes. Moreover, throughout the scenes, officialdom is regularly the source of the violence. Unlike George Biddle's paean to religious salvation, Cauduro has offered what some commentators described as a tour through the circles of Hell in Dante's *Inferno*.[400]

The parallels between the Orozco and the Cauduro murals are plentiful. Both deployed references to pre-

FIGURE 221 *The History of Justice in Mexico: Rape and Corrupt Processes,* Rafael Cauduro, 2007,
Supreme Court of Justice of Mexico.

FIGURE 222 *The History of Justice in Mexico: Rape, Corrupt Processes, and Skulls (Tzompantli),* Rafael Cauduro, 2009.
Supreme Court of Justice of Mexico.

Images reproduced with the permission of Minister Guillermo I. Ortiz Mayagoitia, President of the Supreme Court, and in conformity
with Article 83 of the Federal Law of Author Rights and in virtue of the patrimonial rights of the court. See color plate 46.

FIGURE 223    *The History of Justice in Mexico: Torture, Homicide,* Rafael Cauduro, 2009.

Image reproduced with the permission of Minister Guillermo I. Ortiz Mayagoitia, President of the Supreme Court,
and in conformity with Article 83 of the Federal Law of Author Rights and in virtue of the patrimonial rights of the court.
See color plate 47.

Hispanic Mexico and Europe to cast a critical eye on justice. Cauduro, like Orozco, intended to paint "a reminder, an everyday message of what must be done."[401] While justices of Orozco's era had stopped his work, in 2009, Mexican justices proudly, if somberly, celebrated Cauduro's work, which, they understood, depicted the failures of the system they ran. The panels, made off-site,[402] were installed in groups as they were completed; the installation of the last segment and the formal inauguration of the murals came in July 2009. To complete the piece, Cauduro inscribed on the wall: "I am here to be judged."[403]

At the inaugural ceremony for Cauduro's final section, Justice Ortiz Mayagoitia described the disquieting imagery as a "vision of the author that challenges us to make these scenes disappear forever from our country, such that they last as images, but not as experiences."[404] Justice José Ramón Cossío Diaz "referred to the courage of the work. He said that he and his co-workers, every working day, will see the murals and every one will internalize their message in their own way."[405] Cauduro added that it was important to reflect on the "errors of justice" and that he hoped that (as Justice Ortiz Mayagoitia had suggested) his work would come to exemplify an era that had passed.[406] The justices, in turn, were praised for licensing the work "without censorship."[407]

And the artistry was also "judged" positively, with praise for the boldness of the hyperrealist work.

The Mexican Supreme Court thus stands, along with the Constitutional Court of South Africa, as one of the few institutions to incorporate injustice on the walls of its courthouse. And while the South African court showed the horrors of a recent legal regime, Mexico's justices understood that they were speaking to the present. In the words of one commentator, "the figures [depicted in the *Seven Major Crimes*] are not the product of the imagination of an artist, but human beings with tragic destinies torn from reality to be fixed upon a wall, in view of everyone."[408]

### Impunity and Insecurity

Cauduro's art was both an artifact of political reform and evidence of its failures. In 1994 the newly elected President Ernesto Zedillo helped to put into place constitutional amendments restructuring the Mexican judiciary and its Supreme Court.[409] (Since 1917, the Mexican Constitution has been amended numerous times, and the judiciary reformed on several occasions.[410]) Animated by financial crises and needs for legitimacy, Zedillo's government hoped to buttress its own legitimacy by shaping a more autonomous

court that took "law and order, corruption and impunity seriously."[411]

The size of the Supreme Court was reduced from twenty-six to eleven justices,[412] nominated by the President and approved by the Senate.[413] This format parallels that of the United States, and in both instances, when the party in control of the executive branch also controls the legislature (as was the case for the Zedillo government), that party can choose justices. The 1994 reforms also endowed the Mexican Supreme Court with greater authority than its predecessors by providing a more expansive power of judicial review.[414] Moreover, the justices were given fixed fifteen-year terms,[415] and hence some insulation from political pressures when the government changed hands, which it did in 2000.[416]

The Cauduro murals thus reflect a judiciary exercising its own voice. After the 1994 reforms, the court did so through various decisions that held pieces of legislation violative of the constitution.[417] Whether the court can attain the autonomy to which some aspire,[418] the Cauduro murals bespeak a courageous judiciary[419] that sits at the apex of a judicial structure that consists of 21 circuit courts, about 250 district courts, various administrative or specialized courts, and the state court systems. As a consequence, the court receives thousands of cases a year and, to handle its volume, the court (like the Israeli Supreme Court) operates in both plenary and specialized chambers.[420]

As the startling images of *Corrupt Processes, Homicide,* and the other crimes suggest, volume was but one of the problems. Between the 1990s and 2008, violent crime increased dramatically.[421] Even as the justice system was restructured in various respects, the government and its law enforcement officials could not "effectively guarantee public security, accountability, and access to justice."[422] From "the flagrant disobedience of traffic signals" to a marked increase in serious violent crimes, legal institutions were weakening.[423] By 2000, Mexicans "consistently ranked crime, corruption, and injustice among their top concerns,"[424] as officials proffered the view that the "justice system does not work."[425]

Not only had violent crime increased, but allegations of police brutality had also increased. The Inter-American Commission on Human Rights concluded: "Impunity of torturers is the rule owing to the difficulty of initiating criminal action against them or the leniency of the judicial branch in such cases."[426] Although in 1997 a new "Law against Torture" had gone into effect, not a "single case had been brought to court for such a crime, despite the repeated reports of torture carried out to extract confessions."[427] Moreover, Cauduro's choice of a broken young female body as exemplar of homicide was not happenstance; "poor young females, aged 15 to 25 years old," had been targeted as victims and murdered.[428]

A 1998 report, the *Situation of Human Rights in Mexico,* by the Inter-American Commission on Human Rights (dis-

cussed in Chapter 11), wrote of the special problems of the "right to justice."[429] In particular, the report noted "the politicization of the judicial system and the widespread lack of trust in the administration of justice."[430] A major problem was "impunity"—the commission of crimes without fear of prosecution or punishment.[431] Moreover, "[n]umerous complaints about corruption, lack of independence and impartiality have made the judicial branch in Mexico one of the organs that enjoys the least public prestige."[432]

A 2002 report by the United Nations documented the disorganization of the legal profession, as well as trial procedures using forced confessions, unequal treatment of women, and a general lack of accountability and transparency.[433] Isolation, poverty, and the lack of electricity and roads resulted in "'millions of Mexicans liv[ing] in places that remain largely beyond the law.'"[434] While in 2001 Argentina had 11 judges per 100,000 inhabitants and Costa Rica had 16, Mexico had far fewer, 2.7 judges per 100,000 inhabitants.[435] In 1999, the backlog of pending cases came to 1 million.[436]

By 2008, the World Bank was helping to support an effort to restructure and modernize the judicial system,[437] but the crisis of law was a crisis of politics. Citizens reported "insecurity" linked to perceptions that the government was unable to enforce the law.[438] The government appeared at risk of the "militarization" of civil institutions.[439] In addition, "judicial, prosecutorial, and police authorities" were specifically targeted.[440] The year 2008 was, according to the Trans-Border Institute, "Mexico's bloodiest year on record."[441]

OPEN TENTS, TATTERED COATS,
AND THE CHALLENGES ENTAILED IN
DEMOCRATIC PROMISES OF JUSTICE

The iconography of the South African Constitutional Court reflects a tortured history and great hopes for a better future. One might view the 1940s Mexican Supreme Court's Orozco murals similarly, as negative commentary on the past or, as some of the jurists then felt, as expressing bitterness about their era as well. The completion of the installation of the Cauduro paintings in 2009, as the country struggled with assaults on police and waves of killings that gave new meaning to the term "drug wars," spoke to the present by recognizing the fragility of the justice system. These examples confront injustice masquerading as law-like regimes, law's inability to contain evil, and the failure of countries to secure human dignity and personal safety.

Another iconic vocabulary aims to address the struggle to deliver justice, the persistent problems of inequality of resources within the litigation system, and the puzzles of how to meld private conciliation with public obligations. To look at such efforts again requires travel, to Western Australia and the northern part of the United States.

"If performed in the *open air*":
The Federal Court of Australia's Ruling
on the Ngaanyatjarra Land Claims

In Chapter 14, we quoted Jeremy Bentham's comment that, "if performed in the *open air* . . . , the number of persons capable of taking cognizance of [judicial proceedings] would bear no fixed limits."[442] That proposition was put into practice at the Parntirrpi Bore Outstation in the Great Victoria Desert of Australia, where in 2005 the Federal Court of Australia set up a makeshift court (fig. 224[443]), some 725 arid miles northeast of Perth, the capital of Western Australia.

The photograph shows the ceremonial announcement of a settlement allocating land rights claimed by the Peoples of the Ngaanyatjarra Lands over an area three times the size of Tasmania. Solicitous of the claimants' needs, the Federal Court traveled thousands of miles from its home base in Sydney to hold the session, which recorded the settlement of a multi-party dispute.[444] The agreement recognized the preexisting rights of indigenous peoples to a vast land mass, while enabling use by telecommunication and mining companies and by state and national governments.[445]

Such land claim litigation is an artifact of twentieth-century human rights movements that prompted lawmaking by courts, legislatures, and the executive branch, as well as power-brokering among a host of disputants. What is shown is not a trial but the announcement of judicial approval and entry of the compromise as an enforceable court order. When doing so, the court relied on rituals of law, complete with icons of sovereign authority displayed before the community to which it traveled. Hence the story of what produced the image provides an appropriate coda to these many chapters probing the changing contours of adjudication.

### Terra nullius and the Native Title Act

Riding circuit (noted in Chapter 7) has been a practice of judges over many centuries and in various countries. In England and the United States, some judges continue to travel to hold court in various venues. In Chapter 10, we showed the newly designed courthouse (fig. 10/150) in Melbourne in which the Federal Court of Australia has one of its main registries.[446] But on occasion, the Australian Federal Court decamps to temporary quarters, as figure 224 illustrates.

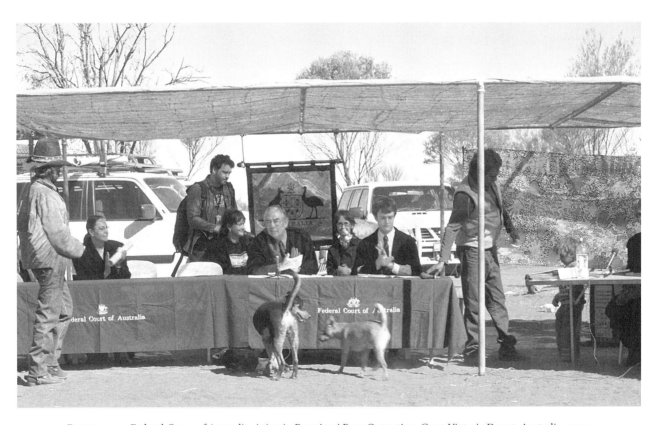

FIGURE 224    Federal Court of Australia sitting in Parntirrpi Bore Outstation, Great Victoria Desert, Australia, 2005.

Photographer: Bob Sheppard, Trial Logistics Manager, Federal Court of Australia. Photograph reproduced with the permission of the photographer and courtesy of the Federal Court of Australia.

The State of Western Australia is (as its name indicates) the entire western side of the continent. Some 2.2 million people reside on almost a million square miles.[447] The dispute that brought the Federal Court so far from any of its home bases was whether the Peoples of the Ngaanyatjarra Lands, the State of Western Australia, its subdivisions, some private entities, or the national government owned various parts of more than 70,000 square miles of land.[448] Native peoples inhabited that area long before the eighteenth century, when Europeans settled and Britain claimed possession.[449] In the late 1970s, the Ngaanyatjarra Peoples began to pursue their titleship rights. At the time, Australian law adhered to a doctrine known as "*terra nullius,*" presuming that colonists found "uninhabited lands," and therefore that indigenous interests did not survive assertion of the sovereignty of the occupying power (in this case England).[450]

The landmark event in Australia on the question of the land rights of indigenous peoples was the 1992 decision of *Mabo v. Queensland* (*Mabo II*).[451] That ruling by the High Court of Australia was the first to recognize that, under Australian law, land rights that predated colonization survived in some form.[452] The ruling was "transforming,"[453] but a host of issues about the kind and nature of such rights and their relationship to sovereignty and self-governance have produced commentary that too much has been "compromised" in its wake.[454]

Befitting our theme that adjudication has long been awash in transnational currents, *Mabo II* followed several other rulings by constitutional courts in Canada, the United States,[455] and other former British colonies recognizing rights of indigenous peoples.[456] In addition, in 1992, the year that *Mabo II* was decided, the United Nations promulgated the Declaration on the Rights of Persons Belonging to National or Ethnic, Religious and Linguistic Minorities,[457] and soon thereafter debate began about a Draft Declaration on the Rights of Indigenous Peoples.[458] (Another transnational current can be found in the subsequent proclamation by the Ngaanyatjarra Council "to an international audience that conservation values exist on their Lands" and that the Council was developing means to protect natural resources.[459])

The *Mabo II* court concluded that indigenous people could hold communal title "against the whole world to possession, occupation, use and enjoyment of the lands,"[460] but that state and municipal laws could operate to extinguish title. As a consequence, questions immediately emerged about how to sort out, in a wide variety of circumstances, which Native groups owned what kinds of rights to specific lands.[461] In response, in 1993, the Parliament of the Commonwealth of Australia enacted the Native Title Act (NTA), which created a range of dispute resolution mechanisms that included methods to assist in negotiating settlements for group-based claims.[462] On the remedial side, the act also chartered Prescribed Bodies Corporate to manage Native title rights on behalf of the many members within titleholding groups.[463]

The Native Title Act created a complex dispute resolution system that bears a familial resemblance to the United Nations Convention on the Law of the Sea (detailed in Chapter 12). Various routes for decisionmaking that emphasize compromise through alternative forms of dispute resolution. The statute chartered a Native National Title Tribunal (NNTT) to function as a research and mediation service rather than as a court of law.[464] The NNTT was to carry out its functions "in a fair, just, economical, informal and prompt way"[465] rather than be "bound by technicalities, legal forms or rules of evidence."[466] Akin to the Permanent Court of Arbitration (PCA, fig. 12/173) and the International Tribunal for the Law of the Sea (ITLOS, fig. 12/176), the NNTT's name implies adjudication-like functions but departs from those traditions. Each of these institutions could be understood as borrowing authority by adopting court-like nomenclature as well as redefining what it means to be a "court" or "tribunal."

Like the PCA and ITLOS, the NNTT interacts with formal litigation mechanisms. Australia's Native Title Act authorized the Federal Court of Australia to entertain claims and to make referrals to the NNTT.[467] Specifically, the Federal Court could send matters to the Tribunal for conferences (by phone, by closed-circuit television, or in person), and the Tribunal, in turn, was obliged to provide a "written report" to the Federal Court.[468] Governmental parties were required to negotiate in good faith and, if they failed to do so, the National Native Title Tribunal was authorized (after notice to the recalcitrant participant) to detail such failures in its annual reports.[469] Although the legislation did not provide for the automatic enforcement of mediated outcomes,[470] within a few years of its enactment, some half-dozen agreements had been reached[471] while a host of other cases made their way through the courts.

Yet claimants faced significant challenges. Both the Australian courts and Parliament recognized Native Title rights, but claims required evidence of a historical connection between peoples and particular lands and waters. Proving history—much of it not preserved in records—is an enormous practical challenge.[472] Atop the difficulties of substantiating particular cases came shifts in the legal regime post–*Mabo II*. Some of the High Court of Australia's opinions were read to expand methods by which Native titles were extinguished.[473]

Beginning in 1998, individuals brought land claims related to the Ngaanyatjarra Peoples, which, according to the Ngaanyatjarra Council's website, is "[a] single social system" (a "Western Desert Cultural Bloc") that shares a degree of "cultural homogeneity" distinctive from some other sets of indigenous peoples.[474] The Ngaanyatjarra Peoples had a precarious economic base; they lived in an area with little by way of mining or export industries. Inhabitants relied on agriculture and emu farming, as well as "an emerging market in bush foods," some arts and crafts, and tourism.[475]

In 2004, a group of applicants led by Stanley Mervyn, Adrian Young, and Livingston West brought a claim "on behalf of the Peoples of the Ngaanyatjarra Lands."[476] Their application was filed against several respondents, including the State of Western Australia, the Shire of Laverton, various private entities such as the telecommunications company Telstra and the Western Mining Corporation, and the Commonwealth of Australia.[477] At issue were the rights of some "2,700 men and women . . . with their descendants" (the Peoples of the Ngaanyatjarra Lands)[478] over those thousands of acres of land and waters. This application consolidated several other claims relating to the same area[479] and resulted in 2005 in the consent order ceremonialized in figure 224.

### Commemorating Power, Witnessing Compromise

The photograph in figure 224 records the setting in which judgment was entered "on behalf of the Peoples of the Ngaanyatjarrra Lands." Viewers might not intuit that the court was exercising its power under the Native Title Act to enter an order turning the settlement into a judgment "without holding a hearing."[480] Depicted, instead, is a public proceeding commemorating a private agreement, and hence looks like, but departs from, some court-based practices in which independent jurists render public decisions following the mandate to "hear the other side." Indeed, as the court's brief opinion explained, it was entering the "terms the parties seek."[481] Through a dozen or so prefatory comments and a nineteen-paragraph statement of reasons, the court explained its role as that of modest overseer. The court praised the parties' agreement for consolidating other claims, for its speed (from filing to disposition "within little more than a year"[482]), and for the provision of clear and "unambiguous" terms that the court adopted verbatim.[483]

Further, the court described the propriety of acceding to the negotiated outcome; the parties had "competent legal advice," and no one had suggested that the "agreement was not freely entered into."[484] More generally, the court took the occasion to repeat from earlier opinions its views on the desirability of settlement itself: "Courts have always encouraged parties to settle their claims amicably. Agreement is especially desirable in native title cases due to the importance, complexity, and sensitivity of the issues involved. Agreement between the parties minimises cost and distress and establishes goodwill between the parties for future dealings."[485]

The proceedings recorded in figure 224 are an antidote to the opaque privatization we questioned in Chapter 14. The ritual is evidence of an effort to legitimate the settlement not only by making it legally enforceable (through the court order) but by using traditions associated with courts to locate the outcome inside law. The settlement was, of course, an artifact of law in the sense that, but for *Mabo II*

and the Native Title Act, the Peoples of the Ngaanyatjarra Lands would have been hard pressed in Australia to have rights to negotiate. On the other hand, *Mabo II* had also provoked angry protests from opponents to its precepts, resulting in retreats by the High Court from some of its broader implications.[486] (One scholar described the newer decisions as generating a "legal fog."[487]) The outcome was thus "bargain[ed] in the shadow of the law,"[488] and that law reflected the legal revolution that produced recognition of Native peoples as rightsholders as well as efforts to reassert ownership rights founded in the last two centuries.

We know from one of the participants—Chief Justice Michael Black—that the court took pains to specify the open-air tent as a court of law. The "symbols of justice" were, as Chief Justice Black wrote, "present just as they would be in one of our courtrooms in the capital cities."[489] The title "Federal Court of Australia" appeared as a ribbon around the cloth that skirted the table behind which the jurist and his staff sat. The Chief Justice, in turn, sat in front of a canvas rendition of the court's symbol—the Coat of Arms of the Commonwealth of Australia, described in Chapter 10. The canvas, which traveled with the court for its "'on-country' hearings," was "designed by an aboriginal artist following the Commonwealth's protocol" permitting replication of the coat of arms,[490] an emblem regulated to preserve its use as an official method of authenticating documents.[491]

Although not easily seen in the photograph, the Australian Coat of Arms includes an emu and a red kangaroo, two animals native to the continent. The animals flank a shield on which appear symbols of the six states of Australia, "enclosed by an ermine border" and adorned at its top by a seven-pointed star to represent the six states plus the territories.[492] Why the emu and kangaroo are deployed has been a subject of discussion. Sounding somewhat like the explanations in Ripa about why Justice has an ostrich and Temperance an elephant, the Australian government noted that the emu and kangaroo could symbolize "a nation moving forward, reflecting a common belief that neither animal can move backwards easily."[493] Alternatively, they could be read as signifying the conquest of the continent.

Chief Justice Black was attired in traditional garb, a ceremonial robe made from Australian merino wool, faced in red silk that was divided into "seven equal segments that symbolise the elements of our federation and also equality before the law."[494] Yet more didacticism was sewn in, for the black robe itself was made of seven segments deliberately "unequal in size, symbolising the diversity of our nation and the circumstance that the elements of different size make for a unified whole."[495] Layers of colonialism (in addition to those producing the underlying dispute) were reflected in these accoutrements. Australia's coat of arms reflected its status as an English colony. The design, somewhat revised in 1912, derived from a "Royal Warrant" granted by Edward VII in 1908.[496] The judicial garb, in

turn, reflected a reinvention of English traditions by dropping the wigs and importing symbolism into the pattern cut in cloth. The totemistic deployment of these Australian symbols turned the tent into a space in which the justice was authorized to exercise government power.[497]

The photograph of the Federal Court sitting on a tiny piece of the contested lands also has a family relationship to the image of the 1655 frontispiece of the Dutch book on civil and criminal procedure. That image, shown initially in Chapter 7 and reprinted as figure 225,[498] stems from another colonial moment, for it was published during the "golden age" of Dutch colonial authority. Both the Australian open tent court and the Dutch courtroom are scenes of sociability. Unlike contemporary "lonely" grand courthouses, these are inhabited spaces, with dogs as well as people milling about, some individuals seemingly attentive to the proceedings and others focused elsewhere. In both scenes, a judge sits at the center, and in both icons mark the court. In the seventeenth-century Dutch scene, Justice—with scale and sword—stood behind the judge. In twenty-first-century Australia, the viewer is supposed to understand that a table under a tent has become the Federal Court of Australia through the display of the emu and kangaroo on the Australian Coat of Arms. In both instances, the appointments and etiquette aimed to communicate authority to the assembled audience.

And assemble they did—in an openness that was literal rather than implied by buildings of glass. The Australian Federal Court convened under a tent, echoing doing justice "under a tree," as would have Louis IX, and as is reflected in the logo of the South African Constitutional Court. The *Ngaanyatjarra Lands Newsletter* reported that "more than 800 people made their way" to hear Chief Justice Michael Black read aloud the court's discussion of "Australia's largest native title application."[499] Given that the "actual population" of the entire area was "only about seven thousand individuals"[500] (of whom 2,700 were claimants), the group's size was impressive.

Further, as the court's opinion recounted, the "substance of the reasons for judgment" was "translated simultaneously into the Language of the Peoples of the Ngaanyatjarra Lands."[501] That translation was important. In a 2003 report about how to work with the Australian government, the Ngaanyatjarra Council described differences in the way language was "used and understood" in its culture as contrasted with one based on English traditions.[502] Political theorists have pondered how distinct communities can bridge such gaps, and one can see the exchange portrayed in the photo as an effort to respect the need to find new ways to provide a "culturally diverse deliberation."[503] Our reports come from those who speak English; if those reported views were shared by the Ngaanyatjarra Council, the ceremony may also have commemorated the achievement of "consensus through deliberation."[504]

What did the settlement entail? The court's published opinion, marked "for general distribution" and hence available on the web,[505] consisted of two parts, a "preface" and the "Reasons for Judgment."[506] The court's order explained that, but for Australia's partial or complete "extinguishment of native title" over particular areas, the Peoples of the Ngaanyatjarra Lands "would have held native title rights and interests conferring the right to possession, occupation, use and enjoyment of the land and waters to the exclusion of all others, save in respect of flowing and subterranean water."[507] The court then reported that it had gained some knowledge (from "uncontested statements") about the "laws and customs of the Peoples of the Ngaanyatjarra Lands,[508] as well as how their "spiritual connection to their Country can be found in the collective belief that the *Tjukurrpa* are responsible for the existence and form of the land itself."[509]

After adopting the parties' settlement, the court concluded its opinion by "emphasiz[ing] to all present" that its order "determine[d] under the laws of Australia, that native title exists, as it always has, according to the traditional laws and customs of the Peoples of the Ngaanyatjarra lands, and that the title is held by the Peoples."[510] The court's preface and statement of reasons are brief when compared to the lengthy appendix (a "minute of consent determination"), composed of various "schedules."

There one can get some explanation of what recognizing Native title means. The Ngaanyatjarra Peoples had the "right to enter and remain," "to take fauna and flora," "to take water for personal, domestic, or non-commercial communal purposes," "to take other natural resources such as ochre, stones, soils, wood and resin," and "to care for, maintain and protect various sites."[511] They also had some rights to exclude others. But the Ngaanyatjarra Peoples did not gain title to the potential commercial uses that might develop in whatever waters existed[512] or to various minerals or oil, governed under other Australian legislation.[513] Rather, under "Schedule 4," subleases and exploration rights enabled the state and national governments and specified private companies involved in mining, telecommunications, and air service to have some use of the land and its minerals.[514] For example, the Gibson Desert Nature Reserve was excluded from the accord.[515] And, while settling rights to a vast area of land (3 percent of mainland Australia), the value of the property appears, as of 2006, to have been relatively low. According to a report on indigenous rights, the "remote nature of the region combined with the relatively austere nature of the surrounding environment and the lack of substantive pastoral or mineral-extraction interests" made the area of limited economic value, and hence not easily inhabited.[516]

The staging for the public pronouncement of the settlement is an example of an "alternative dispute resolution" mechanism that, as we called for in Chapter 14, mitigates the privatization of mediated outcomes. Further, by temporarily seating the court in the Great Victorian Desert, the Australian government underscored that the relevant audi-

FIGURE 225   Engraved title page, *Dutch Law and Practice in Civil and Criminal Matters* (*Practycke der nederlansche rechten van de daghelijcksche soo civile als criminele questien*) by Bernhard van Zutphen, 1655.

Image courtesy of the Rare Book Collection, Lillian Goldman Law Library, Yale Law School.

ence was constituted not only by those who could travel to the court's regular home bases but also by those for whom such a trip would be arduous. (Recall that Bentham had recommended an Equal Justice Fund that would pay the costs of travel to courts and of lodging.[517]) The simultaneous use of two languages when the court announced its approval of the settlement reflected that the agreement was forged between peoples coming from different polities. Moreover, in addition to the ritual based in the tent called the Federal Court of Australia, the participants had the night before shared another ritual on the same spot. As the court's opinion explained, they had all participated in "dance and song, performed last night at the place where the court sits today,

about the emu and the turkey, who met up at a place called Yankal-Tjungku to the north of here, and continued on."[518]

While the spectacle is reminiscent of the court scene from Amsterdam, the colonial regimes had shifted over the three centuries that intervened, as have the demographics of the spectators. The stone figure of Justice was the sole woman present in the Dutch court scene of 1655. In contrast, in 2005, the ruling colonial power traveled to those it had displaced in recognition of their right to that place. The audience included both women and men, of varying social classes and ethnic backgrounds. The agreement was negotiated by the parties rather than decided (as *Mabo II* had been) by a court. Yet the outcome is hardly an example of

private ordering; it is infused with law from more than one sovereign regime. The law of many countries purported to "extinguish" native rights. Laws were then changed to enable reassertion. The Chief Justice underscored (literally) that his order did not "*grant*" native title but "recognises what they have long held."[519] Fifteen years earlier, Australian law was otherwise. The open-air tent court could be seen as gesturing toward indigenous sovereignty as well as Australian authority. The tent also captured, in this case, the transient nature of legal regimes and the ability of law to transform its own entailments.

## An Icon of Free Legal Services in Minnesota

Our final images come from a county courthouse (figure 226, color plate 48[520]) in a small United States town, Grand Marais, that has long served as a county seat in the northern part of Minnesota. The 1912 structure replaced a courthouse from 1889 that had been a two-story, wood-frame building measuring twenty-four by thirty feet.[521] At that time, Cook County had fewer than 1,000 residents,[522] but in the decade that followed some dozen logging camps were set up, swelling the population to more than 1,300[523] —raising concerns about law and order as it also added resources for construction.[524]

By 1910, the earlier "simple" building (augmented by a 640-square-foot one-story add-on) was seen as "obsolete, limited in space, and far too modest an expression of the county's future."[525] Voter-authorized bonds supported the new building. The 1889 courthouse had cost $3,000 to construct. Its replacement, designed by the Duluth architectural firm of Kelly and Lignell, cost $60,000.[526] An additional $3,227 was spent for the jail, a one-story structure a few steps away at the back of the courthouse.[527] In 2005, the building continued to serve the 1,412-square-mile county with its population of some 5,000 people.[528]

Thousands of miles from Australia, Minnesota is also a colonial mix. Minnesota occupies land to which the Dakota (Sioux) and the Ojibwe (Chippewa) tribes, as well as the Spanish, French, British, and the United States have laid claim, as did Virginia, Indiana, Illinois, Missouri, Michigan, Iowa, and Wisconsin.[529] Initially part of the Northwest Territory of the United States and governed under a congressional ordinance of 1787, Minnesota became the name of a federal territory through the Organic Act of 1849, which detailed boundaries three times the size of the current state.[530] In 1858, shortly before the Civil War, a downsized Minnesota became the thirty-second state.[531]

### More Courthouses than Counties

Courts predate Minnesota's statehood, and most of its early court proceedings were, like those of many other places, held in an odd-lot set of buildings—a log school house, a tavern, a trading post.[532] Statehood, in turn, built courts into the system; Minnesota's first constitution of 1857 devoted several provisions to its justice system. In a familiar pattern, Minnesota established three branches of government, one of which was "Judicial,"[533] with judges given constitutional assurance that their salaries could not "be diminished during their term of office."[534] The original constitution set forth a Supreme Court, an intermediary court (at the legislature's option), and lower courts, as well as probate courts and justices of the peace.[535] Guarantees included jury trials in criminal cases[536] and, on the civil side, for "all cases at law without regard to the amount in controversy."[537]

In addition, the 1857 Constitution provided that no "member of this state" could be "deprived of any of the rights or privileges secured to any citizen thereof, unless by the law of the land or the judgement of his peers."[538] Further, "Every person is entitled to a certain remedy in the laws for all injuries or wrongs which he may receive to his person, property or character, and to obtain justice freely and without purchase, completely and without denial, promptly and without delay, conformable to the laws."[539]

FIGURE 226 Cook County Courthouse, Grand Marais, Minnesota. Architects: Kelly and Lignell, 1912.

Photographer: Doug Ohman, Pioneer Photography. Copyright: Doug Ohman, 2007. Photograph provided by and reproduced with the permission of the photographer and courtesy of the Cook County Court Administration, Sixth Judicial District, State of Minnesota. See color plate 48.

This "Remedies Clause" has been interpreted to mean that if lawsuits were "traditionally" available for an alleged wrong, that opportunity could not be precluded without the legislature providing an "adequate substitute."[540]

The Cook County Courthouse depicted in figure 226 is illustrative of many others. As soon as counties became sufficiently prosperous, with populations "large enough to support [the] financing and construction," they built courthouses that were "often the most imposing structure in the county."[541] The result has been that Minnesota has more courthouses (ninety-some) than counties (eighty-seven), and more than half of the older court buildings, including the Cook County Courthouse, are on the National Register of Historic Places.[542]

Like many constructed between 1890 and 1930, Cook County's courthouse is made for longevity—from brick and concrete.[543] For authority it relied on a "Classic Revival" facade, with multi-story Ionic columns supporting a carved cornice. A first-floor porch is sheltered by a second-floor gallery reached only after ascending dozens of steps.[544] The courthouse does not, however, have a "Lady Justice," despite that figure's status as the "favorite of all the statuary figures that adorn Minnesota courthouses."[545] Indeed, an account of Minnesota's courthouses reports that one such Justice, assigned to the "tiptop" of a building, served inadvertently as "a lightning rod"[546] (just as the 1858 Justice that crowned New York's City Hall had burned from fireworks' sparks celebrating the completion of the Atlantic cable[547]—resulting in a rebuilt metal version shown in figure 1/13).

The county courts have served to center many a city, with time kept by the clocks on their towers and with storage for records of births, deaths, marriages, and land conveyances.[548] Many had jails attached or nearby, which "made economic sense."[549] In Benthamite terms, local courts were both "theatres" and "schools," aiming to make plain governing norms and punishments for their violations. During the latter part of the nineteenth century, executions were carried out "in the jail courtyard during the daylight hours"; a crowd of almost two thousand in St. Paul reportedly watched one such event in 1860.[550] Evocative of the WPA murals in Idaho (fig. 6/84) that displayed an "Indian" about to be hung, in 1862 thirty-eight Native Americans were subjected to a "simultaneous hanging"[551] in one Minnesota county. Some half-century later, in 1911, the state abolished the death penalty.[552]

Some of the court buildings of its vintage have been recycled into office buildings or local museums or have been torn down.[553] Cook County's remains in use, serving multiple functions, as do many government buildings in small towns around the United States. In 2005, aspects of the county courts and the building's stewardship changed hands. Minnesota shifted to a "unified" court system centrally funded by the state rather than with resources varying by county.[554] As a 2008 report of the Judicial Branch explained, the goals were to make courts "open, affordable and understandable."[555]

*A Jacket, Worn*

In 2004, we were asked to speak about courthouse architecture at a conference in Minnesota that was convened by the Eighth Circuit, encompassing the federal courts of seven states, including Arkansas, Iowa, Minnesota, Missouri, Nebraska, North Dakota, and South Dakota. We drove through Grand Marais, 110 miles north of Duluth, and came upon the building. Drawn to the structure by its own self-importance ("a majestic building on a hill"[556]) that could have meant it was a courthouse, a bank, or an insurance company, we presented ourselves to a staff person, who in turn introduced himself as a probation officer.

Explaining our interest in courthouses and their iconography, we asked if we might look around. When we inquired about what (if any) icons of justice were displayed, he did not hesitate to bring us to the courtroom (fig. 227) on the second floor, a modestly proportioned room with a judge's bench, flags, and computers that can be glimpsed in the photograph.[557] The probation officer directed our attention to a wall near the public benches. There hung a memorial plaque (fig. 228[558]) in tribute to a local lawyer, James A. Sommerness, who had practiced law as a public defender for more than twenty years in Cook County.[559]

In 1997, as a testament to Sommerness's contributions, a memorial service was held for him in the courtroom. A judge presided in what he described to be "about as formal a setting as Cook County" afforded.[560] The event, transcribed as if a legal proceeding ("In the Matter of a Memorial Service Honoring James A. Sommerness, Attorney and Counselor"), is not only a testament to Sommerness but also to a courthouse providing a gathering place for diverse segments of the community. The judge reassured the audience that, despite the courthouse's deliberately imposing facade, the local practice was not to be "overly formal." Advising the assembled group to feel at home ("we certainly don't want anybody to think that they should be intimidated from speaking"), the judge noted that Sommerness had "probably appeared in this courtroom thousands of times."

Inviting participants to comment, the jurist further opined that to celebrate the work of Sommerness was what in Yiddish is called "a Mitzvah, a Mitzvah being a good thing, a thing that we should do as a community." Many people offered details about Sommerness's work. As one judge explained, Sommerness combined "being a top notch advocate" with "professional kindness." What they described reflects the words on the plaque—Sommerness's personal commitment to the "human dignity of others," expressed through his work in "improving and delivering volunteer legal assistance to the poor."[561] Next to the plaque was a proudly framed corduroy jacket, plainly well worn, shown in figure 229 (color plate 49). Sommerness had been described as a lawyer steeped in the early common law ("familiar with the names of Bracton, Littleton, Coke . . . and Blackstone"[562]), but his sartorial attire was far afield

FIGURE 227    Courtroom, Cook County Courthouse, Grand Marais, Minnesota.

Photographers: Judith Resnik and Dennis E. Curtis, 2003. Photograph reproduced courtesy of the
Cook County Court Administration, Sixth Judicial District, State of Minnesota.

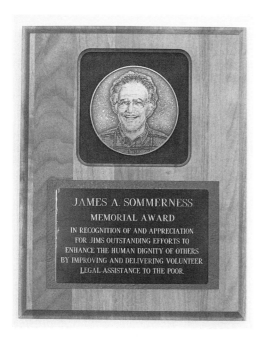

FIGURE 228    James A. Sommerness Memorial Award (detail), Cook County Courthouse, Grand Marais, Minnesota.

Photographer: Glenn Gilyard, 2006. Photograph reproduced with the permission of Richard Gilyard and courtesy of the Cook County Court Administration, Sixth Judicial District, State of Minnesota.

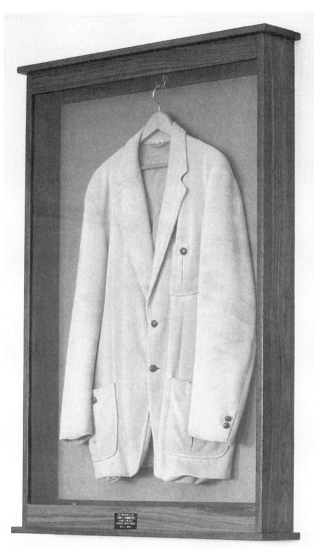

FIGURE 229    James A. Sommerness
Memorial, Cook County Courthouse,
Grand Marais, Minnesota.

Photographer: Glenn Gilyard, 2006.
Photograph reproduced with the
permission of Richard Gilyard and
courtesy of the Cook County Court
Administration, Sixth Judicial District,
State of Minnesota. See color plate 49.

from the formality of English courtroom silks. He wore turtlenecks and the corduroy jacket to court.

This display is the one instance we have located in a courthouse that aims specifically to mark the problem of "legal assistance to the poor," in need of resources in order to seek justice.

## FACETS OF JUDGMENT

What does one learn by looking at the imagery arrayed in this chapter? Why put the Renaissance Virtues of Justice, Prudence, Temperance, and Fortitude next to the Kongo wooden Nail Figure? Or juxtapose barbed wire and cells within South Africa's Constitutional Court, the murals depicting homicide and mayhem in the Mexican Supreme Court, Australia's open-air tent adorned with its coat of arms in the Great Victoria Desert, and a Neoclassical courthouse sitting in the rural Midwest of the United States and housing a corduroy jacket in tribute to a lawyer working for the poor?

These images reflect the complex relationship between adjudication and democracy and capture the three interrelated narratives that thread this book. The first is the remarkable durability of the political icons of justice, launched from early Babylonian, Egyptian, Greek, and Roman depictions and brought forward via Medieval and Renaissance iterations to the age of modern democracies. This visual account records the longevity of the practice of adjudication, its trans-temporal and intercontinental dimensions, and offers hints about its many transformations.

Governments have long struggled to gain legitimacy for their judgments by relating them to facts and norms, but neither the imagery nor the practices have been static. During the past five centuries, judges moved from subservience to a posture of independence. Along the way, justice imagery lost markers of the pain and burdens of judging, as well as of the various components of wise judgment. The brutal allegories denoting the freight of judging (for judges, vulnerable to being flayed alive or obliged to send their sons

to death, as well as for those judged) have been replaced by serene renditions of stony women (clear-sighted or presumed properly blindfolded) to denote the distance of judges from those who seek to influence them.

In contrast, images such as those of Prudence, Fortitude, and Temperance, and the Kongo Nail Figure offer glimpses of what a fuller account of the complexity and inevitable violence entailed in legal judgments could produce. The tidy symmetry of the balance accorded Justice and the linearity of a historical progressivity should, along with her lone(ly) figure, give way. The quest for a broader and more nuanced visual diversity derives in part from a recognition of the wider array of "persons" eligible to be part of adjudication, that a shift is reflected in the conflicts we detailed about whether blindfolds are appropriate attributes and what colors, shapes, genders, and narratives should adorn courthouse walls. But the richer visual array is also needed to acknowledge the diversity of skills, literacies, and capacities needed to make judgments. Social ordering through law requires collegial and communal support—hardly hinted at by an icon that has become notable for her singularity.

The buildings of South Africa and Mexico pick up the second strand of this chronicle, in which the courthouse became the icon of government authority, obligations, and constraints. As we have traced, even in eras when rulers had autocratic power, they sought through public performance to demonstrate both the rightfulness of their judgments and authority to enforce them. Yet while adjudication had proto-democratic elements that sometimes constrained the arbitrariness of power, Enlightenment norms changed adjudication by instantiating the role of the independent judge, by moving the public processes from "rites" of spectatorship to obligatory "rights" of access, and finally—and only under twentieth-century democracy—by imagining that "every person" can take any of the roles within a courthouse, from litigant and witness to lawyer and judge. Reflect back on the lively courtroom scene from Amsterdam (fig. 225) and remember that it included no females, save the depiction of the Virtue Justice. The Australian tent court, in contrast, portrayed some of the variety of persons within democratic adjudication.

But democracy's promise that everyone is an equally entitled rightsholder presents a profound challenge to adjudication, reflected in the images from South Africa, Mexico, Australia, and Minnesota. The revolutionary moments that produced both the South African and the Mexican buildings rejected the tradition of unabashed salutes to state power and aspired, instead, to express legibly the experiences of injury at the hands of the state. In different ways, these buildings replace the authoritarian, patriarchal imagery with a more democratic iconography, inscribing memories of the injustices of "legal" regimes alongside hopes for justice. South Africa's Constitutional Court is self-consciously made from the handiwork of its people and

puts the country's multiple languages in various scripts on its front door in an effort to bridge histories of oppression with new constitutional entitlements. Mexico's murals of 2007–2009 go beyond acts of memory to reflect on the fragility of justice systems through disturbing views of the current world. The depictions of homicide, rape, and torture put human faces on contemporary perpetrators, violating the dignity of identifiable victims.

The open-air tent-court in Australia is one response to the widening gap between form and function inside the new grand courthouses. That public ceremony marked a settlement that involved aggregate rights of hundreds of persons, several corporations, and both state and federal governments. The proceeding acknowledged the reconfiguration of adjudicatory practices to take new demands into account. While some adaptations to volume have relied on managerial judges, delegation to agencies, and outsourcing to private providers, as detailed in Chapter 14, Australia's tent-court opens an alternative vista by placing the disputants and judge before the public to record the accord reached.

This book's third narrative can be seen by comparing the Neoclassical design of the Minnesota county courthouse and Australia's tent. The courthouse in Grand Marais reflects the evolution from the multi-purpose communal meeting places provided by Renaissance town halls to the purpose-built courthouses designed to denote the authority of localities, nation-states, and, more recently, regional groupings and international bodies. Though modest compared with the majestic new courts in the United States and France or transnational institutions such as ITLOS, the Grand Marais court was nonetheless an outsized structure for a small rural county. Such ponderous stone architectural renditions serve as allegories of adjudication's rise and its triumphant expansion and now provide an inadvertent reminder of its fragility.

The showcase courtrooms have grown larger but are often devoid of action, while the dense, high-volume administrative work takes place in less well-appointed and less readily visited spaces. We used two centuries of building projects in the United States to map the construction of imposing marble buildings to house the national postal service and the national courts. But since 1950, more than 13,000 post offices have closed in the United States—supplanted by private services and new technologies that prompt questions about the need for public subsidies. Open-access political orders are a modern development, not to be taken for granted.[563] The solidity of stone and the grandeur of glass mask the vulnerability of the institutions of the post, the courts, and the press—all venerable inventions of centuries past that were flourishing just decades ago but whose durability in the twenty-first century is no longer clear.

New buildings continue to offer testaments to the precepts of openness that have come to define institutions as "courts." Yet the preference for conciliation and consent—for contract

—over regulatory regimes and constitutionalism moves legal resolutions of disputes offstage. This book is filled with pictures of courthouses but provides little by way of a visual account of the decisionmaking undertaken by administrative and private providers. The renditions of the set-up of a hearing room in Guantánamo Bay (fig. 14/203) and of a cell phone contract (fig. 14/201) are placeholders for the opacity of such activities, lacking "publicity"—Bentham's preferred mechanism for the oversight of power.

Australia's ceremonies in an open-air tent return courts to the fields that Bentham admired. The photograph of that event not only marks the arrival of women and men of all backgrounds into the circle of adjudication; it also records that, under democratic principles, individuals and groups have rights against the state. The proceeding itself is evidence that settlements need not, inevitably, be private, nor are they divorced from the state. Rather, the government was ubiquitous in the accord—serving as the source of newly acknowledged but ancient rights, as a party to the settlement, and as the enforcer of the agreements made.

The underlying agreement, like the open-air tent, makes another point—about the transient nature of sovereign power, once dispossessing and now recognizing its own limits through the pressures of national and transnational social movements. The flexible and removable structure was situated for the convenience of the least-well resourced litigants, just as the well-worn corduroy jacket of a Minnesota public defender could be read as a reference to Bentham's Equal Justice Fund, acknowledging the need to subsidize individuals' pursuit of justice.

The many images adorning this volume do not represent a romantic quest into adjudication's past to identify some halcyon days of its flourishing. Rather, they illuminate past practices and contemporary challenges. Because governments do not have an inexhaustible quantum of political and symbolic capital, they need to find points of contact to regenerate their relationships with the polities of which they are a part. The contemporary world is full of what Jonathan Crary has called a "continuum" of "attention and distraction,"[564] splintering one's attention in myriad directions. We have dotted this book with images to underscore

that the familiar is not necessarily enduring. Courts have a shorter history than some imagine and an uncertain future.

Mixing Bentham and Foucault, we want to reclaim a space for public participation to provide experiences of state power, to undermine the control exerted by both public and private powers, and to enact the interdependent reciprocal relationships among and within communities to recognize that discord and conflict are necessary artifacts of healthy social orders. The performativity within open courts provides an antidote to the Foucauldian concerns about decentralized, polymorphous techniques that mask power. Cauduro's murals instruct that injustice relies on bureaucratic anonymity, with wrongs hidden in file drawers and walls that hide interrogations, torture, and assault. Locating adjudication in the open offers occasions for participatory observers to constitute themselves as part of the governing body and to gain firsthand knowledge of where the state's resources and capacities stop. To develop these facets of adjudication entails significant challenges, of which resources are but an obvious example.

In recent decades, in countries around the world, rulers have built courts as the markers of their identity even as they have expanded their prisons, limited their postal services, and fortified their borders. Yet the uses to which courthouses will be put remain unclear. As we closed the pages of this book, the United States Supreme Court closed its front steps. Rather than being greeted by the words "Equal Justice Under Law" (fig. 14/207), entrants are routed to the side to enter "a secure, reinforced area to screen for weapons, explosives, and chemical and biological hazards."[565] One can still walk out from the court down the steps, with the words to one's back.

The forms in which governments represent themselves provide windows into their aspirations. Courts—in democracies—can be a venue that enables discursive public exchanges through procedures aiming for participatory parity. Our hope is that this volume serves as a reminder that law's institutional forms should be structured to teach members of polities to make claims on justice as well as to seek justice—so as to have the capacity to contest and to understand what law can and should do.

# ENDNOTES

One prefatory comment to the endnotes is in order. When titles of books, articles, or objects are not in English, we have provided (in the text, captions, and these endnotes) our own translations in parentheses after the first mention of the original title.

## Chapter 1

**1** The illustration, by artist Ivan Allen and published July 12, 2003, forecast the argument of the magazine's commentary that "America's plan to set up military commissions for the trials of terrorist suspects is a big mistake . . . wrong—illiberal, unjust and likely to be counter-productive," The Economist, under the section "Leaders," at 9 (here-inafter Commentary, The Economist, July 12, 2003). Figure 1 is reproduced with permission of the artist; the headline and the logo are reproduced with permission of The Economist Newspaper Ltd. The conclusion was that the system was the "antithesis of the rule of law which the United States was founded to uphold." Id. Subsequently, the United States Supreme Court held that the President's procedures violated the due process rights of an American citizen held there and that the planned military trials failed to conform to United States statutory obligations. See *Hamdi v. Rumsfeld*, 542 U.S. 507 (2004); *Hamdan v. Rumsfeld*, 548 U.S. 557 (2006). Congress's responses included the Detainee Treatment Act of 2005, Pub. L. No. 109-148, 119 Stat. 2680, the Military Commissions Act of 2006, Pub. L. No. 109-366, 120 Stat. 2600, and the Military Commissions Act of 2009, Pub. L. No. 111-84, 123 Stat. 2190, 2574 discussed in Chapter 14. As of 2010, the question remained about how decisions would be made concerning continuing the detention of some individuals the United States government alleged were terrorists.

The distribution of *The Economist* gives some evidence of the assumption that its cover illustration of a Justice was widely accessible. The magazine began its publication in 1843 in London, England; as of 2009, it reported a global circulation of about 1.4 million readers, with more than half in North America, some 16,000 subscribers in Latin America, 28,000 in the Middle East and Africa, and about 426,000 in Europe. See Economist, http://www.economist.com, citing circulation figures from the Audit Bureau of Circulation.

**2** Figure 2, *Iustitia*, is by a Toronto sculptor, Walter S. Allward, who also sculpted the companion statue *Veritas*. The photograph, copy-right Supreme Court of Canada, is reproduced with the court's permission. Our thanks to Chief Justice Beverley McLachlin, to the Honorable Rosalie Abella, to former Justices Frank Iacobucci and Claire L'Heureux-Dubé, to Registrar Anne Roland, and to the Court's staff for assistance in obtaining the photograph and related materials.

The Supreme Court's building, in front of which the statues stand, was designed by architect Ernest Cormier of Montreal, Canada. The court, initially comprised of six justices, first sat in 1875 in a room of the Canadian House of Commons in Ottawa. In 1882, the court moved to its own facility before, in 1946, taking occupancy in its current (and larger) building, set on a bluff above the Ottawa River. That building includes a courtroom for the Federal Court of Canada.

As of 2010, the Canadian Supreme Court numbered nine justices, including three who, by statute, must come from the Province of Quebec. By tradition, another three justices come from the Province of Ontario, two from the Western Provinces, and one from the Atlantic Coast. The Supreme Court hears appeals from both the Federal Court of Appeal and appellate courts in the provinces and receives cases on "reference" from the government. The court's authority includes both federal and provincial questions of law as well as (since the adoption of the 1982 Canadian Charter of Rights and Freedoms) enforcement issues arising under that Charter. Some of its judgments are subject to legislative revision through what is called a "notwithstanding clause." See The Supreme Court of Canada (Ottawa, Can.: Minister of Supply and Services Canada, 1998) (a monograph distributed by the Canadian government); Lorraine E. Weinrib, *The Supreme Court of Canada in the Age of Rights: Constitutional Democracy, The Rule of Law and Fundamental Rights under Canada's Constitution*, 80 Canadian Bar Review 699 (2001).

**3** The court's website reiterated that point and explained that Themis, "daughter of Uranus and Gaia and the second consort of Zeus [was] . . . a goddess of order and assemblies" and that her name now means "law" in Greek. This statue, unveiled in 1987, was made by Maria I. Papaconstantinou of Greece and presented by "Brisbane businessman Angelo Efstathis." This courthouse includes both trial and appellate level courts for Queensland, of which Brisbane is the capital. See *About the Courts: Tour of the Brisbane Courts Complex*, Supreme Court of Queensland, http://www.courts.qld.gov.au/about/complex.htm. Our thanks to Chief Justice Paul de Jersey and to former Justice Geoffrey Davies of that Court, who provided the photograph in figure 3 and permitted its reproduction.

**4** Figure 4 is a photograph by Ken Irwin of an aluminum *Lady of Justice* that hangs above the front entrance of the Victoria County Court. The figure, "an impressive 6 metres in height," was created in 2002 by William Eicholtz. The Victoria County Court, housed in a building designed by Daryl Jackson of SKM Lyons Architects, is an intermediate trial court with both civil and criminal jurisdiction. See County Court of Victoria, http://www.countycourt.vic.gov.au. Our thanks to Chief Judge Michael Rozenes of the County Court of Victoria for his assistance in obtaining permission to reproduce the

image and assisting us in gathering more information about it, and to the Challenger Financial Services Group and the Liberty Group and the sculptor, William Eicholtz, for permitting reproduction of this figure.

5 See Court Art Walk at http://www.victorialawfoundation.org .au.

6 Figure 5, *Lady Justice*, erected during the presidency of Dr. Kenneth Kaunda, marks the entrance to the High Court of Zambia in Lusaka. The photograph was provided by and is reproduced with the permission of Elizabeth Brundige, the photographer. The "High Court for the Republic" has the authority, under the Constitution of Zambia Act of 1991, as amended in 1996, to "hear and determine any civil or criminal proceeding" assigned to it. See The Zambia Legal Information Institute, http://www.unza.zm/zamlii/const/1996/partvi .htm.

7 Justice I. C. Mambilima, quoted with permission. Email from Elizabeth Brundige to Judith Resnik (June 17, 2005).

8 Our thanks to Elizabeth Brundige who gave us the cloth shown in figure 6, about which she learned while working with the International Association of Women Judges, and to Justice Mambilima of the Zambia Association of Women Judges for allowing Yale University Press to make a facsimile of the material.

9 The Constitutional Court of Azerbaijan came into being in July of 1998, three years after that country adopted a new constitution that, in Article 130, provided for the court. Nine justices have authority over constitutional questions and—upon request from the Parliament, the President, or other officials—authority to review legislation. See The Constitutional Court of Azerbaijan Republic, http://www .constcourt.gov.az/en/. In 1999, the Constitutional Court was admitted to associate membership in the Conference of European Constitutional Courts, an organization created to share information on the development of constitutional jurisprudence. Since then, the court has obtained full membership. According to the Supreme Court of Azerbaijan's Press Service, its courts, like the country more generally, have had significant challenges in realizing "the principles declared by the Constitution," and reorganization efforts took place in 2005. See Supreme Court of Azerbaijan Republic, http://www.supremecourt .gov.az/?mod=1&c=0&lang=en. Under Article 6 of Azerbaijan's Courts and Judges Act, adopted in June of 1997, courts are to display "Symbols of judicial power," which include the state flag, the state stamp, and the "official emblem of justice"; judges are to be in "mantle." See Republic of Azerbaijan, Courts and Judges Act 1997, http:// www.justice.gov.az/eng175.html.

Despite its constitutional provisions, a profile on Azerbaijan reported that its "judicial system is plagued by a vast number of problems, among them profound levels of corruption, lack of infrastructure, and inadequate administrative capacity." Further, the "executive branch of government exercises significant influence on judicial decision making, thereby seriously compromising the integrity and independence of the legal system." Christopher Walker, *Azerbaijan*, in COUNTRIES AT THE CROSSROADS: A SURVEY OF DEMOCRATIC GOVERNANCE 6–7 (Sarah Repucci & Christopher Walker, eds., Washington DC: Freedom House, 2004). Freedom House, founded in 1941 with the participation of Eleanor Roosevelt, began to provide annual reports on political and civil rights in 1973. See Freedom House, http://www.freedomhouse.org/template.cfm?page=249.

Our thanks to Rauf Guliyev, Head of the International Relations Department of the Constitutional Court of the Azerbaijan Republic, for providing us with the photograph of *Themis* in figure 7 and for assisting us in obtaining permission to reproduce it. We first located a copy of the calendar reproduced in figure 8 through the archives of the Office of the Curator of the United States Supreme Court, which mounted an exhibit, "High Courts around the World," between 1998 and 2001. Our thanks to Associate Justice Ruth Bader Ginsburg of the United States Supreme Court and to Associate Curator Matthew D.

Hofstedt of that Court, both of whom facilitated our research into that office's archives. The 2000 Calendar shown in figure 8 is reproduced with permission of Toghrul Musayev, the Azerbaijan Republic Deputy Minister of Justice.

10 Figure 9 is a photograph of a statue by sculptor Alfredo Ceschiatti that was installed in 1961; made of granite, *Justice* measures about 11 feet by 4.6 feet (3.30 meters by 1.48 meters). Our thanks to Director Jarbas Silva Marques of the Office of Historic and Artistic Patrimony of Brazil (Diretoria de Patrimônio Histórico e Artístico–DePHA), who provided us with the image to reproduce. The photograph in figure 9 is reproduced with permission of the Directoria de Patrimônio Histórico e Artístico–DePHA.

The statue sits in front of the Supreme Federal Tribunal, part of Brasilia's governmental complex, in one of several buildings by Oscar Niemeyer. One commentator described Niemeyer's work as "an architecture that celebrates curved and sensual forms" by wrapping an "International Style box with a series of elegant curving supports that gave the building a feeling of ethereal grace. The palaces of Brasilia recall the prototype of the Greco-Roman temple." See DAVID UNDERWOOD, OSCAR NIEMEYER AND BRAZILIAN FREE-FORM MODERNISM 39, 79, and figure 58 (New York, NY: George Braziller, 1994). Niemeyer was quoted as describing the buildings to be "a richness of forms, dreams, and poetry . . . startling visitors by their lightness and creative liberty . . . [and] that would lift the visitor, if only for a few brief instants, above the difficult and at times overwhelming problems which life poses for all of us." Id. at 79. See also NORMA EVERSON, TWO BRAZILIAN CAPITALS: ARCHITECTURE AND URBANISM IN RIO DE JANEIRO AND BRASILIA 204 (New Haven, CT: Yale U. Press, 1973).

The complex of which the Supreme Court is a part was built in 1958. The development of Brasilia included a triangle of government buildings by Niemeyer, each to represent one of the three branches of government. Two office buildings, with more than two dozen floors, provide space for government workers. See David E. Snyder, *Alternate Perspectives on Brasilia*, 40 ECONOMIC GEOGRAPHY 34 (1964); Celina Borges Lemos & Elizabeth A. Jackson, *The Modernization of Brasilian Urban Space as a Political Symbol of the Republic*, 21 J. OF DECORATIVE AND PROPAGANDA ARTS 219 (1995); JAMES HOLSTON, MODERNIST CITY: AN ANTHROPOLOGICAL CRITIQUE OF BRASILIA (Chicago, IL: U. of Chicago Press, 1989). Niemeyer went into exile after the coup of 1964; in the 1980s, he returned to Brazil, where, as of 2009, he continued to live and work.

11 The sculpture in figure 10, by Katsuzou Entsuba, is in the 1974 Supreme Court building by Shin'ichi Okada, who was chosen after a competition to head the design collaborative. Our thanks to Liaison Officer Ikeda Takashi, Secretary Division, General Secretariat of the Supreme Court of Japan, and to Professor Mark Ramseyer for their help in obtaining the photographs in figures 10 and 11, which are reproduced with permission of the Supreme Court and the Financial Bureau, General Secretariat, Supreme Court of Japan.

Andrea Leers, also an architect of courthouses, described the building as seeking to "express civic symbolism and monumentality in the language of modernism"; Entsuba took inspiration from both "Japanese and Western architectural traditions." Andrea P. Leers, *Japan's Palace of Justice*, 25 THE JAPAN ARCHITECT 10 (1997). The Supreme Court, the highest court, sits in the Chiyoda Ward of Tokyo. Included within is a courtroom with a grand bench for all fifteen justices. See COURT SYSTEMS OF JAPAN, THE SUPREME COURT OF JAPAN (a publication of the General Secretariat, Supreme Court of Japan, Tokyo, Japan, 2003). Inside the court's Grand Reading Room are three murals that, according to the court's building guide, have scenes related to the Crown Prince Shotoku "who lived about 1,400 years ago." "Wisdom," "Benevolence," and "Courage" are symbolized through events in his life.

Professor Ramseyer, a legal scholar of Japan, suggested to us that this *Justice* is reminiscent of Kannon (or Kwannon) figures. Some

Kannon figures, like this *Justice,* are shown with flowing robes, jewelry, a crown or halo, and a sword. See Masterpieces of Japanese Sculpture 262–275 (J. Edward Kidder Jr., ed., Tokyo, Japan, & Rutland, VT: Tsu Shuppan-sha & Charles E. Tuttle, 1961). Coming in many forms, Kannon figures represent souls who, having reached enlightenment, remain behind to help others still on earth. Kannon means " 'to watch attentively or to heed the sounds' of the prayers of the world. The compassionate Kannon acts to free all sentient beings from their sufferings." See Yoshiko K. Dykstra, *Tales of the Compassionate Kannon: The Hasedera Kannon Genki,* 31 Monumenta Nipponica 113 (1976). This tradition dates back to at least the introduction of Buddhism in Japan during the sixth century.

**12** New York Times, April 27, 2003, at A24. Figure 12 is reproduced with permission of the New York Times Agency. The article by Bernard Weinraub described a meeting in a "marble government building resembling an oversize mausoleum near downtown Baghdad," where an American army lawyer discussed with an Iraqi lawyer the rebuilding of the nation's legal system. Recounted were brutal aspects of the justice system under Mr. Hussein. One Iraqi reported the frequent payment of bribes to clerks and judges. Id. The article does not specify the street from which the mural could be seen. According to the photographer Ozier Muhammad (interviewed by telephone in November 2005), the picture in figure 12 was transmitted to the *New York Times* during the week of April 20, 2003. He took the picture in the central business district of Baghdad soon after the United States military gained control of the city. Many such large, glorifying pictures of Hussein were visible from Baghdad's streets at that time; this photo was the only one the photographer saw of Hussein holding scales.

**13** As Professor Fedwa Malti-Douglas pointed out to us, both the creation of monumental images of rulers and the destruction of such objects have long histories, with exemplars still visible to those who visit archaeological sites in Egypt. She translated the legible graffiti as including "the traitor to Islam," "no Saddam after today," "down with Saddam," something illegible followed by "no Shia," "yes to Islamic unity," and "no Saddam (after today)." Letter to the authors (Dec. 9, 2005). One cannot see from the photograph what, if anything, had been in the pans of the scales.

**14** Verrio's *Queen Anne as Justice,* Hampton Court Palace, is discussed in Chapter 4.

**15** Matthew Bender & Co. Inc., the vendor that allowed us to reproduce the photograph shown in figure 13, the statue on the New York City Hall, had used it on the cover of a catalogue in 1986; Matthew Bender claims no copyright as to any part of the original photographic or architectural works depicted.

The Municipal Building, dating from 1803–1812, was designed by John McComb Jr. and Joseph Francois Mangin. The original sculpture was a "mass-produced" object made by William H. Mullins's studio and commissioned by the building's architects. According to New York's City Hall records, the sculpture cost $600. "That figure, depicted without a blindfold, was the work of John Dixey, a sculptor trained in London, who received $310 for his work." See City Hall Roof Restoration Project, Office of the Mayor, http://www.ci.nyc.ny .us/html/om/html/cityhall.html. The drawings for the statue are in the archives of the New York Historical Society. Dixey also sculpted *Justice* for Albany's State House.

The first *Justice* burned in August of 1858 in a blaze set off by fireworks celebrating the laying of the Atlantic cable. The *New York Times* reported that *Justice* stood "surrounded and wrapt like a martyr in flames. The balances a minute after whirled around and fell. Then she glowed as if made of iron, and . . . fell with a crash through the tower." Account of the burning of City Hall, Aug. 18, 1858, quoted in Isaac Newton Phelps Stokes, The Iconography of Manhattan Island, 1498–1909, vol. 5 at 1877 (Clark, NJ: Law Book Exchange, 1998) (hereinafter Stokes, The Iconography of Manhattan Island).

That 1998 book republished volumes originally published by R. H. Dodd from 1915–1928. A second wooden statue was then erected. Again commentary is available from the *New York Times,* which described the "figured Goddess, in robes of shining white, . . . [who] invites those who seek her aid to the temple on which she stands." Based on its negative appraisal of some of the city's leaders, the *New York Times* argued that Mercury, "the god of thieves," would be a better image for Manhattan. *City Intelligence,* New York Times, May 7, 1860 (also quoted by Stokes, vol. 5 at 1887).

The 1860 version of *Justice* was later replaced by a copper *Justice* weighing about 170 pounds. Photographs at the New York Historical Society indicate that, at least through 1907, she had a flagpole in her left arm. See Stokes, vol. 3 at 587–588. In 1998, as part of a $4 million roof repair project, the statue was restored and equipped with internal stainless steel and a cleaned, dent-removed exterior. See *Mayor Giuliani Rededicates the Statue of Justice and Celebrates the Restoration of City Hall,* Press Release No. 477-98 (Oct. 14, 1998), Archives of the Mayor's Press Releases, at New York City, http://www.ci.nyc.ny.us/ html/om/html/98b/pr477-98.html. The New York skyline also has a "Civic Virtue" on top of a tower of the Municipal Building, and, of course, the harbor is marked by the Statue of Liberty. See generally Nancy Fox, Liberties with Liberty: The Fascinating History of America's Proudest Symbol (New York, NY: E. P. Dutton, 1986); Marvin Trachtenberg, *The Statue of Liberty: Transparent Banality or Avant-Garde Conundrum?,* 62 Art in America 36 (May/June 1974).

The gesture of putting a Justice on top of a building, and more specifically on a courthouse, was common in the United States as well as in Europe. See, for example, Court House: A Photographic Document plate 69 (Richard Pare, ed., New York, NY: Horizon Press, 1978) (Pitkin County Court House, Aspen, Colorado, 1890–1891); see also id. at plate 133 (Monterey County Court House, Monterey, California, 1937–1938); id. at plate 235 (Merced County Court House, Merced, California, 1874–1875); id. at plate 243 (Belmont County Court House, Saint Clairsville, Ohio, 1885–1888); id. at plate 264 (Stained Glass Window, Courtroom in La Porte Court House, Indiana, 1892–1894).

**16** The quoted excerpt comes from a once-popular satiric epic poem, *Fanny,* by Fitz-Greene Halleck. One biographer described the story as about "the rapid rise into society of a poor merchant and his daughter, Fanny." The many stanzas gave Halleck the means to comment on the "follies of the *nouveau riche*" and on local politics and literature. See Nelson Frederick Adkins, Fitz-Greene Halleck: An Early Knickerbocker Wit and Poet 86 (New Haven, CT: Yale U. Press, 1930). Praised during his time, Halleck was later relegated to obscurity. See John W. M. Hallock, The American Byron: Homosexuality and the Fall of Fitz-Greene Halleck 7, 74 (Madison, WI: U. of Wisconsin Press, 2000). The verse from *Fanny* is cited in William Loring Andrews, The Journey of Iconophiles around New York in Search of the Historical and Picturesque 27–28 (New York, NY: Gilliss Press, 1897). The original of that 124-stanza poem of 1819 can be found as part of a volume that bears the title of both *Arthur Singleton, Esq., Letters from the South and West* (Boston, MA: Richardson & Lord, 1824) and of *Fanny* (New York, NY: G. Wiley, 1819). An 1817 travel guide to New York also mentioned New York City Hall's *Justice,* describing the statue as a "colossal figure." See Edmund M. Blunt, Blunt's Stranger's Guide to the City of New York 45–46 (New York, NY: printed and published by Edmund M. Blunt, 1817). Blunt noted that this Justice was clear-eyed and not wearing a blindfold "as she is represented in Europe." Id. In 1830, the City's Common Council authorized repairs, including replacing the steelyard (a kind of scales that did not have symmetrical pans) with a set of scales that had two pans. See Stokes, The Iconography of Manhattan Island, vol. 5 at 1691.

**17** During the summer of 2002, the artists Jim and Judy Brooks did a series of sculptures called *Looking for Lucy* as a public arts sum-

mer event sponsored by the Capital City Partnership and the City of St. Paul, Minnesota. That year was the third in which the city had paid tribute to cartoonist Charles Schulz. *Lady Justice Lucy* was "statue number 19" out of 103 Lucy statues on the city's "Looking for Lucy" map for the summer of 2002. In 2000, 101 Snoopy statues by local artists were on display. In 2001, Charlie Brown statues were erected. The 2003 project, Linus Blankets Saint Paul, included 92 Linus images. Our thanks to William Mitchell College of Law for providing us with the photograph in figure 14 and permission to reproduce it.

**18** A fifty-year survey including Justice cartoons used during the nineteenth century is provided by Michael Handler's *Tenniel's Allegorical Cartoons*, in The Telling Image: Explorations in the Emblem 138–170 (Ayers L. Bagley, Edward M. Griffin, & Austin J. McLean, eds., New York, NY: AMS Press, 1996).

**19** 5 Facts Forum News at 20 (Sept. 1956). That month's cover ran as its headline "Supreme Court Under Fire" and included a picture of Congressman Frances E. Walter, then chair of the House Committee on Un-American Activities. The cartoon (fig. 15), signed by Emerson, illustrated the story, also titled "The Supreme Court Under Fire," which began by noting that "Justices of the United States Supreme Court have been accused of amending the Constitution rather than interpreting it, substantiating their decisions by citing sociologists and psychologists." Id. at 21. The critical reference was the landmark decision of *Brown v. Board of Education*, 347 U.S. 483, 494 n. 11 (1954), finding segregated schools unconstitutional. In that decision the Supreme Court had—in a footnote—mentioned two experts, Kenneth B. Clark, a psychologist who had attested to the injury to self-esteem imposed by schools segregated by race, and Gunnar Myrdal, a Swedish economist who had written the book *The American Dilemma*. According to *Facts Forum News*, the Court gave evidence of its "usurpation" of state rights through reliance on someone like "K.B. Clark, a Negro so-called social science expert employed by the principal plaintiff in the segregation cases, the NAACP," and Myrdal, who was associated with "Communist and Communist-front organizations." Id. at 22.

This article, accompanied by a photograph of Earl Warren, noted that while Senators James O. Eastland and Joseph McCarthy had not "accuse[d] Chief Justice Earl Warren of being a Communist, his expressed judicial opinions have certainly 'followed the Communist line.'" Id. at 21. Further, the article invoked Senator Sam Erwin Jr., who had previously been quoted as commenting that the lettering on the Court, "Equal Justice Under Law," ought to be replaced by "Not justice under law, but justice according to the personal notions of the temporary occupants of this building." This quote comes from a column by Holmes Alexander published in the *Manchester Union Leader*, a New Hampshire newspaper, on June 20, 1956, at page 21.

*Facts Forum News*, funded by Haroldson Lafayette Hunt from Dallas, Texas, existed for five years (1951–1956); it was a monthly publication with a circulation of about 100,000. The *Forum* described itself as "nonpartisan, supporting no political candidate or party," and also explained that it was "unalterably opposed to the Communist conspiracy, and uses every means within its power to keep the American people aware of the dangers of communism." See, for example, the contents of the September 1956 issue at 1. When *Facts Forum News* closed, *Time* magazine described that publication as "one of the biggest private political-propaganda machines in the U.S."—supportive of McCarthyism as it aimed to provide an antidote to the socialism attributed to both Democrats and those Republicans to whom Mr. Hunt objected. Mr. Hunt also funded radio and television weekly shows, polls, and letter-writers to newspapers. See *The Press: Facts-Forum Facts*, Time, Jan. 11, 1954, at 50–52. Our thanks to Yale Law School Reference Librarian Camilla Tubbs and to the Rare Book and Manuscript Library of Columbia University for locating a copy and enabling the reproduction in figure 15.

**20** *Alternative to Roe vs. Wade*, Los Angeles Times, Nov. 21, 1988, at II 5. The case—*Roe v. Wade*, 410 U.S. 113 (1973)—serves in the United States as shorthand for women's rights to have abortions. The Supreme Court there concluded that, at least during certain phases of a pregnancy, the Constitution prohibited states from making abortions illegal but permitted some forms of regulation. Opposition to that ruling prompted protests, as well as many efforts to have the Supreme Court reverse its position. On November 11, 1988, the Solicitor General of the United States submitted a brief to the Supreme Court on behalf of the Reagan Administration and argued that a then-pending case (*Webster v. Reproductive Health Services*, 492 U.S. 490 (1989)), about the legality of Missouri restrictions on abortion rights, would be an "appropriate opportunity" to reconsider *Roe*, were the Court "prepared to do so." See Associated Press, *U.S. Urges Justices Reconsider Abortion Ruling*, Los Angeles Times, Nov. 11, 1988, pt. 1 at 18. See also Tamar Lewin, *Abortion Foes See Momentum for Their Drive*, New York Times, Nov. 14, 1988, at B10. The following summer, in 1989, the Supreme Court held that aspects of the Missouri law were permissible, including that the state could prohibit the use of public facilities to perform abortions that were not lifesaving for the mother. See *Webster v. Reproductive Health Services*, 492 U.S. 490 (1989). The cartoon in figure 16 is published with the permission of the Tribune Media Services and was given to us by the cartoonist, Paul Conrad.

**21** The accompanying article, "A Trial for Chinese Justice," by Karby Leggett, ran in the *Wall Street Journal* on May 29, 2003, at A18. The focus was on the 1999 conviction of Jude Shao, a naturalized United States citizen convicted of tax fraud in China, whose case was reviewed by a "panel of six prominent Chinese legal scholars"; they determined that his conviction was "deeply flawed" and recommended that he be retried. Id. The cartoon in figure 17 was provided and the reproduction is licensed by Ray Bartkus, the artist.

**22** Cornelis Matsys, the son of the artist Quentin Matsys, was born in 1510, lived in Antwerp, and worked there and in England, Germany, and Italy. He was a landscape painter who became a graphic artist. He used three monograms, "COR.MET," "CME," and "CMA," on prints. His name was also spelled Massys and Metsys. See Jan Van der Stock, Cornelis Matsys, 1510/11–1556/57: Oeuvre Graphique 13 (Eugène Rouir, trans., Brussels, Belg.: Bibliothèque Royale Albert 1er, 1985). This print, signed CMA, explained at page 42, is Cat. no. 91. The image is also catalogued at 9 Adam Bartsch, Le Peintre Graveur (The Painter-Engraver) no. 41, 110 (Leipzig, Ger.: Imprimerie de C. V. Vollrath, 1866) (reprinted as a Nouvelle édition, Hildesheim, Georg Olms, 1970). Figures 18–22 were provided to us by the Warburg Institute, University of London, which authorized their reproduction. Special thanks are due to Jennifer Montagu and to Elizabeth McGrath of the Warburg Institute, who gave us expert and tireless guidance on Renaissance iconography.

**23** In addition to the Warburg Photo Archive Collection, the Victoria and Albert Museum (London, England) also has an archive of Virtue and Vice prints.

**24** This 1538 print is catalogued in Matsys's *Oeuvre Graphique* at no. 7 and explained at 24 to be after a sketch by Raphael. The print, signed COR.MET, also appears in 9 Adam Bartsch, Le Peintre Graveur (The Painter-Engraver) 91.2 (COR.MET, B.2), reprinted in 18 The Illustrated Bartsch (formerly vol. 9, pt. 1) 41 (Jane S. Peters, ed., New York, NY: Abaris Books, 1982).

**25** See generally Adolf Katzenellenbogen, Allegories of Virtues and Vices in Medieval Art 31–36 (Alan J. P. Crick, trans., New York, NY: W. W. Norton, 1964) (reprint of a 1939 monograph published by the Warburg Institute).

**26** Multiple narratives of transmission of these ideas are plausible, with regional variation and the blurring of characteristics attributed to the Virtues. See Helen F. North, From Myth to Icon: Reflections on Greek Ethical Doctrine in Literature and Art 193–

238 (Ithaca, NY: Cornell U. Press, 1979). Many, however, trace the origins of the Cardinal Virtues as a set to Plato's *Republic* IV 427 and to Cicero's *De natura deorum* (*The Nature of the Gods*) III xv and *De officiis* (*On Duties or On Obligations*) I xliii f. See, for example, JENNIFER O'REILLY, STUDIES IN THE ICONOGRAPHY OF THE VIRTUES AND VICES IN THE MIDDLE AGES 112 (New York, NY: Garland Publishing, 1988) (quoting Bloomfield).

The line from Plato's *Republic* (dated around 385 BCE) from which the Cardinal Four are said to emerge calls for both cities and persons to be "wise, brave, moderate, and just." See PLATO, THE REPUBLIC iv, 427e. at 93 (G. M. A. Grube, trans., Indianapolis, IN: Hackett Publishing, 1974). Cicero, *De natura deorum*, is generally dated around 45 BCE. See CICERO IN TWENTY-EIGHT VOLUMES, XIX DE NATURA DEORUM ACADEMICA, WITH AN ENGLISH TRANSLATION BY HARRIS RACKHAM xiii, xviii (Cambridge, MA: Harvard U. Press, 1979). That translation (at 321–323) provides these verses from *De natura deorum*:

> XV. But what can we make of a god not endowed with any virtue? Well, are we to assign to god prudence, which consists in the knowledge of things good, things evil, and things neither good nor evil? to a being who experiences and can experience nothing evil, what need is there of the power to choose between things good and evil? Or of reason, or of intelligence? these faculties we employ for the purpose of proceeding from the known to the obscure; but nothing can be obscure to god. Then justice, which assigns to each his own—what has this to do with gods? justice, as you tell us, is the offspring of human society and of the commonwealth of man. And temperance consists in forgoing bodily pleasures; so if there is room for temperance in heaven, there is also room for pleasure. As for courage, how can god be conceived as brave? in enduring pain? or toil? or danger? to none of these is god liable. God then is neither rational nor possessed of any of the virtues: but such a god is inconceivable!

In *De officiis*, according to a translation by Walter Miller, Cicero also gave an overview of virtues:

> XLIII. Now, I think I have explained fully enough how moral duties are derived from the four divisions of moral rectitude. But between those very actions which are morally right, a conflict and comparison may frequently arise, as to which of two moral actions is morally better.... For, since all moral rectitude springs from four sources (one of which is prudence; the second, social instinct; the third, courage; the fourth, temperance) it is often necessary in deciding a question of duty that these virtues be weighed against one another.
>
> ... [T]he foremost of all virtues is wisdom... for by prudence... we understand something else, namely, the practical knowledge of things to be sought for and of things to be avoided.... [T]hat wisdom which I have given the foremost place is the knowledge of things human and divine, which is concerned also with the bonds of union between gods and men and the relations of man to man. (CICERO, DE OFFICIIS, WITH AN ENGLISH TRANSLATION BY WALTER MILLER 155–157 [London, Eng.: William Heinemann, New York, NY: Putnam, 1928].)

A set of four virtues are also discussed in other passages of *De officiis*. For example, bk. I at 5 reads:

> [A]ll that is morally right arises from some one of four sources; it is concerned either (1) with the full perception and intelligent development of the true; or (2) with the conservation of organized society, with rendering to every man his due, and with the faithful discharge of obligations assumed; or (3) with the greatness and strength of a noble and invincible spirit; or (4) with the orderliness and moderation of everything that is said and done, wherein consist temperance and self-control." (Id. at 17.)

As the art historian Emile Mâle explained, Platonic virtues became a part of Christian thought during the fourth century via the work of St. Ambrose. St. Ambrose drew analogies between four virtues and the "four ages of man." Prudence was linked to a first stage that ranged from the biblical figures of Abel to Noah, Chastity to the interval from Abraham to Jacob, Fortitude to the time of Moses to the Prophets, and Justice to the fourth era, which began with Jesus. Mâle then traced discussions of the Cardinal Virtues that moved from St. Ambrose to Isidor of Seville, Rabanus Maurus, Peter Lombard, and Thomas Aquinas and into many works of art. See EMILE MÂLE, THE GOTHIC IMAGE: RELIGIOUS ART IN FRANCE OF THE THIRTEENTH CENTURY 110, n. 4 (Dora Nussey, trans., New York, NY: Harper, 1958) (reprint of a 1913 volume).

The term *cardinal* derives from the Latin *cardo*, referring to the "earth's poles," in a "cosmological" sense. See R. Edward Houser, *The Virtue of Courage* (IIa, IIae, qq. 123–140), in THE ETHICS OF AQUINAS 305–306 (Stephen J. Pope, ed., Washington, DC: Georgetown U. Press, 2002) (hereinafter THE ETHICS OF AQUINAS). Houser discussed Ambrose's funeral oration for his brother, structured around the "four Platonic virtues," which Ambrose called cardinal to invest "his brother's life with cosmic significance." According to Selma Pfeiffenberger, St. Ambrose "was the first to term the 'Moral Virtues' 'Cardinal.'" Selma Pfeiffenberger, The Iconology of Giotto's Virtues and Vices at Padua, ch. 4, pt. 1, at 3 (Ph.D. dissertation, Department of Fine Arts, Bryn Mawr College, Philadelphia, PA, 1966; UMI Publication No.: AAT6703811). During the thirteenth century, the writings of St. Thomas Aquinas provided another source by bringing Aristotelian virtues into Christian theology. See THOMAS AQUINAS, SUMMA THEOLOGICA (Dominican Fathers, trans., New York, NY: Benzinger, 1947) 819–989 (*Treatise on Habits*); id. at 1169–1385 (*Treatise on Faith, Hope, and Charity*); and the analyses provided in the compendium THE ETHICS OF AQUINAS.

Art historians also cite another thirteenth-century source, the *Somme le roi* (often translated as *The Book of Vices and Virtues* and literally "*Summation for the King*"). The various editions of these vernacular compendia set forth similar elements of the Christian faith, emphasized the Virtues and Vices, and provided variations on the iconographical portrayals of them. See Rosemond Tuve, *Notes on the Virtues and Vices (pts. 1 & 2)*, 26 J. WARBURG & COURTAULD INST. 264 (1963), 27 J. WARBURG & COURTAULD INST. 42 (1964); ROSEMOND TUVE, ALLEGORICAL IMAGERY: SOME MEDIAEVAL BOOKS AND THEIR POSTERITY 57–143 (Princeton, NJ: Princeton U. Press, 1966) (drawn in part from the Warburg essays) (hereinafter TUVE, ALLEGORICAL IMAGERY). According to Tuve's book (at 79), the *Somme le roi* was the "largest single category of mediaeval works through which conceptions of what was included in the subject 'the virtues' and the demands they made in terms of human action, filtered down to the completely unlearned, lodging definitions and lists and images in people's minds [as a] part of the common intellectual apparatus."

The tomes originated as a 1279 compilation for Philip III (the "roi"—king—referenced in the title). These volumes served as confessional manuals that mixed Christian symbolism with "one large image, that of the Christian Knight." Id. at 80. See also Ellen Kosmer,

A Study of the Style and Iconography of a Thirteenth-Century "Somme le Roi," Introduction, at 1–4 (Ph.D. dissertation, Department of Fine Arts, Yale University, New Haven, CT, 1973; UMI Publication No.: ATT 7411756); Ellen Kosmer, *Gardens of Virtue in the Middle Ages*, 41 J. WARBURG & COURTAULD INST. 302 (1978); KATZENELLEN-BOGEN at 31–36. According to Kosmer, the "virtue-garden scarcely exists in art before the *Somme le roi*," whose text likened good men to beautiful gardens, with God the Father as gardener, Christ as the sun, and the Holy Ghost as nourishing Virtue; after that 1279 collection, the imagery becomes prevalent. Kosmer, *Gardens of Virtue* at 302–303. Other important sources for the Virtues and Vices include the works of Theodulf of Orleans and the "sumptuous" manuscripts of Ottonian representations of trees with Virtues and Vices. See NORTH at 200. As discussed in later chapters, during the sixteenth century, the encyclopedic books of Andreas Alciatus and Cesare Ripa offered cod-ifications of various attributes and personifications. We return to the Virtues in Chapter 15 as well.

**27** 1 *Corinthians* is the source cited for the three theological Virtues. One translation provides, "And now abideth faith, hope, charitie, these three, but the greatest of these is charitie." See I *Corinthians* 13:13 (Letter from St. Paul) in the KING JAMES VERSION OF THE HOLY BIBLE (London, Eng.: Robert Barker, 1611). We have used online biblical resources from Yale University Library's data-base that includes more than twenty different versions. See http://jeeves.library.yale.edu/bie/. Another translation of the passage from I *Corinthians* puts the three as "faith, hope, and love," with the "great-est of them all" as love. See THE NEW ENGLISH BIBLE WITH THE APOC-RYPHA (Charles Harold Dodd, ed., Oxford & Cambridge, Eng.: Oxford & Cambridge U. Presses, 1970) (hereinafter NEW ENGLISH BIBLE). Like the other Virtues, the Theological Virtues were typically depicted as females and identified either by labels or by signature attributes—such as an olive branch denoting Hope, a font Faith, and a loaf and pitcher Charity. See O'REILLY at 112; KATZENELLENBOGEN at 56.

Charity was sometimes portrayed as a many-breasted woman nursing a multitude of children, with a bundle of clothes to give away or holding a cornucopia that had a flame, said to symbolize "abundant giving" and the light of God. See R. Freyhan, *The Evolution of the Car-itas Figure in the Thirteenth and Fourteenth Centuries*, 11 J. WARBURG & COURTAULD INST. 68, 74–75, 83–85 (1948). Mâle noted the associ-ation in France between Charity and sheep, which he explained as a reference to the people's use of fleece to keep warm. MÂLE, THE GOTHIC IMAGE at 116–117.

**28** The "Gift Virtues" were named after the "Gifts of the Holy Spirit," as described in *Isaiah* 11.2 (NEW ENGLISH BIBLE):

> The Spirit of the Lord shall rest upon him,
> a spirit of wisdom and understanding,
> a spirit of counsel and power,
> a spirit of knowledge and the fear of the Lord.

"Grace-given," the Gift Virtues could not be "attained by man save through the merits of Christ's Passion." O'REILLY at 200–202. Included in a specific order were Timor Dei (Fear of God), Pietas (Piety or Devotion), Scientia (Knowledge), Fortitudo (Fortitude or Courage), Consilium (Prudence or Discretion), Intellectus (Under-standing or Comprehension), and Sapientia (Wisdom). For a time, these seven were "more important" than the Cardinal and Theologi-cal Virtues, which today have a greater saliency. In other eras, it was the seven Gift Virtues who were in combat with the "seven capital sins, the vices." TUVE, ALLEGORICAL IMAGERY at 85–89. Yet (and perhaps explaining their decline in visibility), unlike the Cardinal and Theo-logical Virtues, the "seven Gift Virtues did not have definitively estab-lished names," nor did they develop a stable iconography. O'REILLY at 180, 192.

The different sets of Virtues also overlapped. For example, Forti-tude was both a Gift Virtue and a Cardinal Virtue. Further, explana-tions of their characteristics linked Virtues in one set to those in another. Illustrative is that the Gift Virtue Knowledge was connected to the exercise of the Cardinal Virtue Prudence. NORTH at 186–187. Similarly, Equity, said to entail inquiry, judgment, thoughtfulness, and discretion, was linked to Cicero's conceptions of Temperance, to its Medieval facet of Moderation, and also to Justice. In terms of visual interconnections, Equity is sometimes given a measuring device, as was Justitia. See TUVE, ALLEGORICAL IMAGERY at 128.

**29** The source generally cited is *Psalm* 84:11: "Mercy and Truth have met each other; Justice and Peace have kissed." THE HOLY BIBLE TRANSLATED FROM THE LATIN VULGATE: DILIGENTLY COMPARED WITH THE HEBREW, GREEK, AND OTHER EDITIONS IN DIVERS LAN-GUAGES, 4 vols. (Richard Challoner, ed., 1750, reprinted as THE BIBLE IN ENGLISH, Cambridge, Eng.: Chadwyck-Healey, 1996). A later trans-lation of the verses, appearing in the renumbered *Psalms* at 85:10, is "Love and fidelity have come together; justice and peace join hands." NEW ENGLISH BIBLE. The allegory, which "enjoyed extraordinary popularity throughout the Middle Ages," can be found in Jewish Midrash stories relating to the story of creation. See Hope Traver, The Four Daughters of God: A Study of the Versions of this Allegory with Especial Reference to Those in Latin, French, and English at 5–7, 13–14 (Ph.D. dissertation, Bryn Mawr College, Philadelphia, PA: John C. Winston, 1907).

In Christian traditions, the story was related to human redemption. Id. at 7. St. Anselm of the eighth century posited that the allegory showed that Justice included compassion; Medieval dramas styled it a debate about the relationships among these Virtues and their import for Judgment Day. See LYNETTE R. MUIR, THE BIBLICAL DRAMA OF MEDIEVAL EUROPE 87–88 (Cambridge, Eng.: Cambridge U. Press, 1995). Our thanks to Rosemary McGerr and to William Miller for help-ing us explore the relationship between the Four Daughters and the pic-torial display of Justice and Peace (or Concord). We have used the nomenclature of the Old Testament in lieu of the Hebrew Bible because much of the literature in art history dealing with Synagoga and Ecclesia (discussed in Chapter 4) and in legal discussions showing the Ten Com-mandments in civic spaces (discussed in Chapter 6) use the terms Old and New Testaments.

**30** Archetypes, or "personified abstractions," of Virtues appeared in Greek art "as early as the seventh century" BCE, with one example "on the Chest of Cypselus, where Dikê (Justice) was represented as dragging, throttling, and beating Adikia (Injustice)." NORTH at 178, n. 3. A fifth-century poem (dated around 405 CE), the *Psychomachia* by Prudentius, became a popular text during the Middle Ages and is frequently cited as a literary source for the visual tradition. See KATZENELLENBOGEN at 1. Prudentius, who lived between 348 and 410 CE, proffered a battle in which "maiden warriors, the Psychomachian Virtues and Vices," were "locked in epic mortal combat on the battle-field which is the soul of man." O'REILLY at 9. His thousand lines of verse have been called the first allegorical poem to move, through appropriation and reconfiguration, from pagan imagery to a Christian epic. See S. GEORGIA NUGENT, ALLEGORY AND POETICS: THE STRUC-TURE AND IMAGERY OF PRUDENTIUS' "PSYCHOMACHIA" 7–16 (Frank-furt, Ger.: Verlag Peter Lang, 1985); MACKLIN SMITH, PRUDENTIUS' "PSYCHOMACHIA": A REEXAMINATION (Princeton, NJ: Princeton U. Press, 1976). Prudentius's invention, to name and personify the Virtues and Vices, replaced abstractions with combatants in conflict offering the "first sustained personification allegory" with a revolu-tionary impact. See SMITH at 3–6.

One eighteenth-century translation of the poem listed the major combatants as Faith versus Idolatry, Chastity versus Lust, Patience versus Wrath, Humility versus Pride, Sobriety versus Luxury, Liberal-ity versus Avarice, and Concord versus Discord. PRUDENTIUS, PSY-CHOMACHIA: THE WAR OF THE SOUL, OR, THE BATTLE OF VIRTUES AND

VICES TRANSLATED FROM AUR. PRUDENTIUS CLEMENS (London, Eng.: 1743), Eighteenth Century Collections Online (hereinafter TRANSLATED PRUDENTIUS). More recent commentators offered different translations. See MORTON W. BLOOMFIELD, THE SEVEN DEADLY SINS: AN INTRODUCTION TO THE HISTORY OF A RELIGIOUS CONCEPT, WITH SPECIAL REFERENCE TO MEDIEVAL ENGLISH LITERATURE 65 (East Lansing, MI: Michigan State College Press, 1952). Included as major Virtues were Fides (Faith), Sobrietas (Sobriety), Humilitas (Humility), Pudicitia (Chastity), Patientia (Patience), Operatio (Reason), and Concordia (Order or Harmony), placed in opposition to Veterum Cultura Deorum (Idolatry), Sodomita (Lust), Ira (Anger), Superbia (Pride), Luxuria (Luxury or Indulgence), Avaritia (Avarice), and Discordia (Discord or Heresy). Bloomfield argued that Prudentius himself crafted pairings that were only vaguely similar to other groupings. Katzenellenbogen offered a slight variation, with a focus on Superbia (the "root of all evil" and translated as Pride or Arrogance), joined by Libido (Violent Desire or Lust), Ira (Anger or Wrath), Luxuria (Excess, Extravagance), Avaritia (Avarice), Discordia (Dissension or Discord), and Veterum Cultura Deorum (Pagan Idolatry), in conflict with Pudicitia (Chastity or Modesty), Patientia (Patience), Mens Humilis (Humble Mind / Judgment), Spes (Hope), Sobrietas (Sobriety, Sensibleness), Ratio (Reasonableness), Parsimonia (Thrift), Pax (Peace), and others. KATZENELLENBOGEN at 1–3. Tuve identified the Gift Virtues as those often depicted in battle against seven sins. TUVE, ALLEGORICAL IMAGERY at 89.

In the Prudentius text, Justice was not a major combatant, although she appeared as one of the warriors in a scene in which Superbia (Pride) was in conflict with Mens Humilis (Humility) and Spes (Hope). NUGENT, ALLEGORY AND POETICS at 35–40. Superbia "taunts Mens Humilis with the worthlessness of the crew . . . assembled" to assist; that "crew" included Prudence, Piety, Justice, Honesty, Sobriety, and Simplicity. Id. at 76. Justice can also be identified with Concordia, one of Prudentius's central figures. Id. at 52, n. 13. In the TRANSLATED PRUDENTIUS at 23, the text reads:

> What feats will Chastity's cold nerves perform?
> In war will Piety support a storm? . . .
> There Justice doom'd to indigence by fate;
> And Honesty, who never will be great;
> Sobriety, just wither'd to a shade;
> And pale-fac'd Abstinence, a pining maid.

In another conflict, between Avarice and Liberality, justice (not personified) is mentioned when Avarice "o'er charg'd with spiteful wrath, exprest / the flood of passion boiling in her breast," (41) in the lines "With justice now, since over-match'd in war, / For Judah's sons I'll bait the fraudful snare." TRANSLATED PRUDENTIUS at 44.

The Prudentius text can be found in sixteen illustrated manuscripts, dating from the ninth century to the thirteenth. O'REILLY at 47. Some illustrations may have existed during Prudentius's era. See MÂLE, THE GOTHIC IMAGE at i, 10 (discussing the classical design of a tenth-century manuscript). Depictions of the Psychomachia scene were common in a variety of media, including wall paintings and architectural church sculptures. O'REILLY at 49–53. Mâle, focused on thirteenth-century France, traced Psychomachia scenes in French churches and the movement away from the combat descriptions of Prudentius as artists turned to ladders and trees to capture the ascendancy of Virtues over Vices. MÂLE, THE GOTHIC IMAGE at 98–105. In her study, O'Reilly considered pictorial representations made between the twelfth and fifteenth centuries in Germany, England, Italy, the Netherlands, Belgium, and France. She described the "variety of allegorical expression" given to the "perpetual conflict" between good and evil. Some scenes showed the Virtues and Vices in battle, while others depicted a "Tree of Adam," rooted in sin and producing "fruits of Vice," as contrasted with a "Tree of the New Adam," bearing the "life-

giving fruits of Virtue." O'REILLY at xv. Following Tuve, O'Reilly cautioned against ignoring this variation; the Virtues and Vices "are, on close inspection, very far from being standard." Id. at 195. Similarly, Katzenellenbogen examined the visual translation of the Prudentius poem and the shift from a dynamic battle scene to more "static" displays of Virtue triumphant. KATZENELLENBOGEN at 6, 72–74. Smith argued that Prudentius's combatants were linked to Jewish and Christian texts, such that Fides was the ancestor of the 1,000 Martyrs and Pudicitia was connected to Judith and Mary, Patientia to Job, Mens Humilis and Spes to David, and the like. SMITH at 179–181.

As noted earlier, in addition to the writings of Prudentius, those of St. Thomas Aquinas and the various versions of the *Somme le roi* influenced depictions of Virtues and Vices. See PFEIFFENBERGER, ch. 4, pt. 1 at 16–20, 31–36; KOSMER at 1–4; TUVE, ALLEGORICAL IMAGERY at 78–90. For a detailed analysis of one example, with animals providing clues to the identify of various Vices, see Maurice L. Shapiro, *The Virtues and Vices in Ambrogio Lorenzetti's Franciscan Martyrdom*, 46 ART BULLETIN 367–372 (1964).

**31** Katzenellenbogen discussed a "system of seven based on Humilitas" that became common in literature in the eleventh and twelfth centuries as "artists steadily increase the number of virtues." Id. at 34, 47. O'Reilly noted that "Humilitas is often added" to the Theological and Cardinal Virtues as a "root or leader," and diverse virtues ranged across the Cardinal, Theological, and Gift Virtues. Id. at 45,170. Sometimes other figures appeared in the scenes. For example, one Psalter showed David with the Virtues as he overcame the "arrogant Goliath." KATZENELLENBOGEN at 9.

Tuve underscored both the variety and the many groupings of Virtues and Vices. Illustrative is Macrobius's account that "Ratio, Intellectus, Circumspectio, Providentia, Docilitas, Cautio" (Reason, Intellect, Consideration, Prudence, Docility, and Foresight) are part of Prudence, while "Temperance has in her train Modestia, Verecundia, Abstinentia, Castitas, Honestas, Moderatio, Parcitas, Sobrietas, Pudicitia" (Modesty, Bashfulness, Abstinence, Chastity, Honesty, Moderation, Parsimony, Sobriety, and Shame). TUVE, ALLEGORICAL IMAGERY at 63, 65. Aquinas proffered other allocations, categorizing aspects of Virtues discussed by Cicero as subparts of others. For example, Aquinas linked Courage, Confidence, Magnanimity, and Magnificence; connected Humility with Temperance; and placed Liberality as a part of Justice. See Houser, *The Virtue of Courage* (IIa, IIae, qq. 123–140), in Pope's THE ETHICS OF AQUINAS at 304, 310–313.

North also examined variations in the depictions, numbers, and postures of the Virtues and Vices. See NORTH at 188–230. While five to twelve were in sets in earlier eras, by the fourteenth century sets of seven became common—perhaps in reference to the seven sacraments. Id. at 214–217. A compendium can be found in *The Index of Christian Art*; listed are 227 different images, including 109 Virtues, arranged from Abstinence to Wisdom, as well as 118 Vices. Collective images include the Tree of Virtue, the Cardinal Virtues, and the Trees and Wheels of Vices. See *Virtue & Vice: The Personifications*, in the INDEX OF CHRISTIAN ART, pt. 2 (Colum Hourihane, ed., Princeton, NJ: Princeton U. Press, 2000). Pages 241–249 are on Justice.

**32** O'Reilly argued that the Vices in Prudentius's *Psychomachia* were not "the Seven Deadly Sins" discussed by others but the set of "Veterum cultura deorum, Sodomita, Ira, Superbia, Luxuria, Avaritia, and Discordia" (Pagan Idolatry, Libido, Anger, Arrogance, Extravagance, Avarice, and Discord), which overlapped somewhat with the Deadly Sins, and then were conflated with them. O'REILLY at 41–43. One reason artists did not use the Cardinal and Theological Virtues in *Psychomachia* illustrations was that not all of those seven had "exact counterparts" among the Deadly Sins. Id. at 43–45. Examples of pairings come from Katzenellenbogen (at 11, n. 1); Idolatria (Idolatry) was opposed by Fides (Faith), Fallacia (Deceit or Fraud) by Justitia (Justice or Righteousness), Blasphemia (Blasphemy) by Fortitudo (Forti-

tude), Ira (Anger) by Patientia (Patience), Ventris Ingluvies (Gluttony) by Sobrietas (Sobriety), and Avaritia (Avarice) by Largitas (Generosity). See also BLOOMFIELD, THE SEVEN DEADLY SINS, and ERWIN PANOFSKY, STUDIES IN ICONOLOGY: HUMANISTIC THEMES IN THE ART OF THE RENAISSANCE 224 (New York, NY: Harper & Row, 1962).

Like their counterpart Virtues, each of the Vices has its own literature. See William Ian Miller, *Gluttony*, 60 REPRESENTATIONS 92 (1997). Miller traced the roots of the "chief sins" in Christian traditions; they once numbered eight, with gluttony having "first billing" until overtaken by Superbia (Pride). Id. at 93–94.

**33** KATZENELLENBOGEN at 48, n. 2, and 49, n. 2. As detailed in Chapters 3, 4 and 5, "emblem books" provided instruction on which attributes identified a particular figure, but idiosyncratic depictions as well as fads affected portrayals. North provided one example of "an independent and highly original method of portraying the personified virtues," when Temperance was shown with an hourglass or "a clock on her head and holding in her mouth a bit to which are attached reins which she grasps with her left hand, while holding a pair of spectacles in her right. She wears spurs on her feet, which rest on a windmill." NORTH at 231. See also *Appendix: Unusual Attributes of Temperantia*, id. at 265–267. Clocks, then an innovative technology popular in France and the Netherlands, were used in relationship to Temperance to indicate order. The bridle—as a restraint—became the dominant signifier, while hourglasses and clocks dropped out. NORTH at 236–238, 237, n. 116. One should, thus, be careful when identifying a personified figure from an attribute. Moreover, even when an attribute had a dense association with a particular virtue, such as the bridle with Temperance, artists have given it to another. A well-known print by Albert Dürer, for example, portrays Fortuna holding a bridle. See THE COMPLETE ENGRAVINGS, ETCHINGS AND DRYPOINTS OF ALBERT DÜRER 76, plate 37 (Walter L. Strauss, ed., New York, NY: Dover Publications, 1972). We return to these attributes in our discussion in Chapter 15 of the contemporary import of the Cardinal Virtues.

**34** Dougal Blyth and Tom Stevenson, *Personification and Allegory in Greek Literature and Art*, in UNDER THE AEGIS, THE VIRTUES 117–124 (Peter Shad, ed., Auckland, N.Z.: Fortuna Press, 1997).

**35** In the 405 CE *Psychomachia of Prudentius*, both Virtues and Vices were female. In 1913, Emile Mâle commented that from "primitive Christian times the Virtues took concrete and living form, and were conceived as heroic maidens, beautiful and simple," who when gaining arms, became the "warrior-maidens struggling with the Vices." MÂLE, THE GOTHIC IMAGE at 98. One of the oft-cited examples of the female-male contrast is Giotto's Virtues and Vices in the Padua Chapel. There, some but not all of the Vices—specifically Folly, Injustice, and Infidelity—were given male form. See Bruce Cole, *Virtues and Vices in Giotto's Arena Chapel Frescoes*, in THE ARENA CHAPEL AND THE GENIUS OF GIOTTO 369–394 (Andrew Ladis, ed., New York, NY: Garland Publishing, 1998). But, as Henry Kraus has noted, the gendering of various allegorical figures was not random. In twelfth-century churches, the Vice Unchastity is a female in hell—"usually shown in a revolting posture, her naked body entwined by serpents which feed on her breasts and sexual organs. Sometimes, too, she is accompanied by the Devil, who assumes an intimate relationship with her." Further, the "typical 'male' Vice, on the other hand is either Pride or Avarice, the former denoting the chief failing of the feudal nobles, the latter that of the middle class." See Henry Kraus, *Eve and Mary: Conflicting Images of Medieval Woman*, in FEMINISM AND ART HISTORY: QUESTIONING THE LITANY 77, 81 (Norma Broude & Mary D. Garrard, eds., New York, NY: Harper & Row, 1982).

A general consideration of "the female form as an expression of desiderata and virtues" comes from MARINA WARNER'S MONUMENTS & MAIDENS: THE ALLEGORY OF THE FEMALE FORM xix (New York, NY: Atheneum, 1985) (hereinafter WARNER, MONUMENTS & MAIDENS). Warner considered representations of Justice, other goddesses and virtues, and more recent deployments of the female body such as the

Statue of Liberty. Warner attributed one source for the female imagery as the "common relation of abstract nouns of virtue to feminine gender in Indo-European languages." Id. at xxi, 63–87, 152–154.

Carol Clover provided an analysis of women in Medieval Norse texts; she argued that "sexual binary" interpretations of those stories missed the complexity of gender roles. Women, seen as householders, were also landholders and in trades and business. Moreover, on occasion, they served as arbitrators in disputes. See Carol J. Clover, *Regardless of Sex: Men, Women, and Power in Early Northern Europe*, 68 SPECULUM 363, 366–368 (1993). Clover pointed to the "social binary" between able-bodied men (and "the exceptional woman") and "everyone else" in constructions that delineated the "powerful and powerless." Id. at 380. See also Carol J. Clover, *Icelandic Family Sagas*, in OLD NORSE–ICELANDIC LITERATURE: A CRITICAL GUIDE 239–315 (Carol J. Clover & John Lindow, eds., Ithaca, NY: Cornell U. Press, 1985), and JENNY JOCHENS, OLD NORSE IMAGES OF WOMEN 1–11 (Philadelphia, PA: U. of Pennsylvania Press, 1996). Thus, the prose and poetry of historical and mythical genealogies, Clover argued, mediated complex attitudes toward female power. Women appeared at times unusually wise and able to perform magic, and at other times to be avenging warriors or inciters of conflict. In short, women's sexuality prompted anxieties evident both pictorially and descriptively in various parts of Medieval and Renaissance Europe.

**36** See EMMA STAFFORD, WORSHIPING VIRTUES: PERSONIFICATION AND THE DIVINE IN ANCIENT GREECE 27–35 (London, Eng.: Duckworth and the Classical Press of Wales, 2000).

**37** KATZENELLENBOGEN at 10–12. See also WARNER, MONUMENTS & MAIDENS at 150–152. Warner traced depictions of Justice in tapestries, book covers, and sculptures as well as in poetry and prose. She saw the adaptation of the Psychomachian conflict in the "literature of chivalry" in which knights took on evil figures from the underworld. By 1502, when Andrea Mantegna painted the *Expulsion of the Vices from the Garden of the Virtues* (now in the Louvre in Paris) for the Duchess of Mantua, Justice was a part of the combat. Id. and plate 37.

**38** Giotto's Padua frescoes offer other examples, with the Cardinal and Theological Virtues on one wall, facing their opposites on another. See GIOTTO IN PERSPECTIVE (Laurie Schneider, ed., Englewood Cliffs, NJ: Prentice-Hall, 1974). The evolution toward increasingly specific symbolic objects to identify the various figures is termed by some a "New Iconography" that developed between the thirteenth and fifteenth centuries and corresponded to literary discussions of the Virtues and Vices during that period. O'REILLY at 119–125. O'Reilly argued that theological developments undermined the utility of the "Psychomachian classification" system because the ideas Church leaders sought to convey were not well captured by battle scenes. Id. at 323–324. Other depictions, such as the "Arbor Virtutum and the Arbor Vitiorum," portrayed a shift in the theological focus toward spiritual life and penitent obligations. Id. at 323–329. For additional analyses of these developments, and specifically of the Tree of the Knowledge of Good and Evil, see NORTH at 198–227.

**39** KATZENELLENBOGEN at 14–17. O'Reilly argued that religious leaders became "more interested in defining the nature of the Virtues and Vices" and in setting forth a "comprehensive scheme of spiritual teaching" than in the defeat of Vice alone. O'REILLY at 53. The scenes of victory parallel the evolution of the depiction of Synagoga, representing the Old Testament, in relationship to Ecclesia, the female figure personifying the New Testament. Initially, Synagoga was shown more sympathetically but, over time, became a demonized figure, bent and blindfolded, over which Ecclesia towered in triumph. In Chapter 4 we discuss this imagery through images from the portals of the Strasbourg Cathedral in France.

**40** As O'Reilly discussed at 131–135, artists often tried to impart a "Christian quality" to the Cardinal Virtues to mitigate their "classical" (i.e., Platonic and Ciceronian) roots. Justice, for example, was linked to religiosity and truth, as Fortitude was with patience and

humble suffering. The Virtues and Vices were also displayed in connection with biblical stories, such as those of Samson, Judith and Holofernes, and Judas. Id. at 140–155. The Virgin Mary, in turn, came to be identified with Wisdom. See also WARNER, MONUMENTS & MAIDENS at 180–182; MARINA WARNER, ALONE OF ALL HER SEX: THE MYTH AND THE CULT OF THE VIRGIN MARY 198–199 (New York, NY: Vintage Books, 1983).

**41** See KATZENELLENBOGEN at 17–18, 28–38. Katzenellenbogen discussed such "static" representations used in portrayals of "notable personages, especially of rulers" such as a late ninth-century painting of "Charles the Bald." Analyzed in depth is the Virtue/Vice Cycle in Notre-Dame de Paris and other French cathedrals. Id. at 75–84.

**42** "To the Middle Ages art was didactic. All that it was necessary that men should know—the history of the world from the creation, the dogmas of religion, the examples of the saints, the hierarchy of the virtues, the range of the sciences, arts and crafts—all these were taught them by the windows of the church or by the statues in the porch." MÂLE, THE GOTHIC IMAGE at vii. O'Reilly argued that the "Western Church" was beset in the thirteenth century with challenges to its authority from a "disaffected population, particularly in the developing towns," from the recovery of classical texts, and from intellectual trends ranging from the "growth of vernacular literature" to contacts with "the Arab world." The Church responded by using classical texts to develop a "systematic theology," embarking on "a huge educational task." Id. at 93. Episcopal decrees followed, as did efforts to summarize theology and to teach parish priests. Id. at 94–107. The role of these depictions as mnemonic devices in the oral culture of Medieval Europe is explored in FRANCE YATE, THE ART OF MEMORY (Chicago, IL: U. of Chicago Press, 1966) and in Kelyn Roberts & Ruth Weisberg, *Medieval Drawing and the Arts of Memory*, 10 CORANTO 28 (1975). Yet, as Mâle reported that by the later part of the sixteenth century, the symbolism, predicated in part on rules of symmetry, grouping, and position and specifically influenced by the texts of Aquinas and Vincent of Beauvais, had become obscure. MÂLE, THE GOTHIC IMAGE at vii, 5, 13, 23–25.

**43** North identified political efforts to incorporate the ancient Virtues as early as Charlemagne's era; the concerns intensified in the fourteenth and fifteenth centuries as political leaders of the city-states in Italy were particularly intent upon linking the Cardinal and the Theological Virtues with their rule. Her examples include the Loggia dei Lanzi, near Florence; the City Hall of San Miniato al Tedesco; the Doge's Palace in Venice; and buildings in Padua, Perugia, Siena, and Naples. NORTH at 223–227. These developments are further explored in Chapters 2–5.

**44** As the four Cardinal Virtues came to prominence, they were sometimes shown at the four corners of an object or as entwined and embracing. KATZENELLENBOGEN at 40–42. When shown in four corners on portraits, the Virtues were like "four nails . . . fixing the main theme as an important piece of moral teaching." Id. at 32. A well-known rendition is by Albrecht Dürer, who put the Cardinal Virtues in voluptuous form in his Coats of Arms of the German Empire and of the City of Nuremberg. See 10 THE ILLUSTRATED BARTSCH (formerly vol. 7, pt. 1), SIXTEENTH CENTURY GERMAN ARTISTS: ALBRECHT DÜRER, plate 162 (168) at 259 (Walter L. Strauss, ed., New York, NY: Abaris Books, 1980). Other such designs for city-states can be found in the collection of the Victoria and Albert Museum in London. Included in one catalogue by C. Kaufmann from a 1988 exhibition are catalog no. 28 (describing Stocklin, Design ca. 1625–1630—arms of the City of Basel supported by two cockatrices) and no. 13 (describing Plepp, Design ca. 1557–1597—arms of the City of Basel supported by two lions rampant). In addition, tapestries also displayed Virtues and their conflicts with the Vices. See D. T. B. Wood, *Tapestries of the Seven Deadly Sins—II*, 20 BURLINGTON MAGAZINE 277–289 (1912).

**45** O'REILLY at 92.

**46** The Stanza della Segnatura, one of the Vatican's often-visited rooms, includes the Raphael fresco *The School of Athens*. See Vatican Museums, http://mv.vatican.va/3_EN/pages/SDR/SDR_03_SalaSegn.html. Raphael, born in 1483 in Urbino, Italy, was a pupil of Pietro Perugino. Both artists were involved in creating the frescoes of the Vatican, which are explained by scholars as exemplifying the efforts by Renaissance humanists to marry the Pope's authority with classical Greek and Roman texts. The Stanza della Segnatura is named for the Pope's Segnatura Gratiae et Iustitiae (or the Signatura of Grace and Justice), the Highest Court of the Holy See, which met there during the sixteenth century. See CHRISTIANE L. JOOST-GAUGIER, RAPHAEL'S STANZA DELLA SEGNATURA: MEANING AND INVENTION (Cambridge, Eng.: Cambridge U. Press, 2002). Pope Julius II, who held office from 1503 to 1513, used the room as a library and private office. The room's frescoes, painted between 1508 and 1511, are interpreted by Joost-Gaugier as offering a unified program that, through scenes personifying the disciplines of poetry, philosophy, jurisprudence, and theology, linked theology with a glorification of intellectual activities. Id. at 16, 43–58.

In the text, we use engravings designed from Raphael's *Jurisprudence* to illustrate attributes associated with Prudence, Temperance, and Fortitude. Several commentators have identified these images as these specific Virtues. See, for example, GIORGIO VASARI, THE LIVES OF THE ARTISTS: A SELECTION 296 (George Bull, trans., London, Eng.: Penguin Books, 1965); Edgar Wind, *Platonic Justice, Designed by Raphael*, 1 J. WARBURG & COURTAULD INST. 69 (1937) (hereinafter Wind, *Platonic Justice*). Wind also suggested that the three are doubled, in that each includes a reference to both a Cardinal and a Theological Virtue. In contrast, Joost-Gaugier identified them as the Three Graces, referring to the three daughters of Zeus—Justice, Peace, and Lawfulness—and linking mortals to the gods. She then linked the "(Greek) Graces, the (Roman) Justinian, and the (Christian) Gregory" to describe the scene as a portrayal of a "grandiose concordance or harmony of Greek law, Roman law, and Christian law." Joost-Gaugier at 146.

Depictions of Justice as well as other Virtues can be found in many of the Vatican rooms. For example, in the Stanza dell'Incendio (The Room of Fire), where another segnatura (the tribunal of the papal curia) sat to decide disputes, Perugino supervised the painting of *Christ Flanked by Justice and Grace* for one of the ceiling quadrants. The walls of that room were painted during the reign of Pope Leo X by Raphael and his pupils. See Marilyn Bradshaw, *Pietro Perugino: An Annotated Chronicle*, in PIETRO PERUGINO, MASTER OF THE ITALIAN RENAISSANCE 293–294 (New York, NY: Rizzoli International Publications and Grand Rapids, MI: Grand Rapids Museum, 1997). Another Justice, painted by Giulio Romano for the Sala di Costantino and portrayed with a large ostrich at her side, is discussed and depicted in Chapter 4. See also Philipp P. Fehl, *Raphael as a Historian: Poetry and Historical Accuracy in the Sala di Costantino*, 14 ARTIBUS ET HISTORIAE 9 (1993); Kurt Badt, *Raphael's 'Incendio Del Borgo,'* 22 J. WARBURG & COURTAULD INST. 35 (1959).

**47** Veneziano (Agostino dei Musi) was born in Venice around 1490 and died in Rome, sometime after 1536. From 1514 to 1536, he worked with Marcantonio Raimondi (discussed later) on the production of prints after Raphael, Michelangelo, Giulio Romano, and others. See THE ENGRAVINGS OF MARCANTONIO RAIMONDI xv (Innis H. Shoemaker, ed., Lawrence, KS: Spencer Museum of Art, U. of Kansas, 1981). As noted, the figure could be read as a reference both to the Cardinal Virtue Prudence and to the Theological Virtue Hope. Wind advanced this thesis in part from the "putti" or cherubic figures next to Prudence, who, in the original Raphael, hold a flame—denoting Hope—as well as the mirror of Prudence. See Wind, *Platonic Justice* at 70. As to the iconography for reading this figure as Prudence, the engraving follows an earlier example by Giotto, which some believe to be the first to associate the mirror with Prudence. See Pfeiffenberger, Chapter 5.

Mirrors, like other objects that came to be connected to the various Virtues, had multiple meanings. In antiquity, mirrors sometimes served to amplify light and hence gained an association with certain of the gods. See Paula M. Hancock, Transformations in the Iconography of the Mirror in Medieval Art (Ph.D. dissertation, Department of Fine Arts, Emory University, Atlanta, GA, 1988; UMI Publication No.: AAT 881 6943). When attached to the Virgin Mary, Humility, Charity, or Faith, the mirror was explained as indicating divine insight, purity, or being unspoiled. When Prudence looked in the mirror, some read it as a "symbol of the Socratic *nosce te ipsum*" (know thyself). See ART TREASURES OF THE VATICAN: ARCHITECTURE, PAINTING, SCULPTURE 22 (D. Redig de Campos, ed., J. Gerber, trans., Englewood Cliffs, NJ: Prentice-Hall, 1975). Cicero is often credited as a source, based on his discussion of Prudentia, a Latin translation of the Greek *phronesis* or "practical wisdom," linked to circumspection requiring memory, intelligence, and foresight. St. Thomas Aquinas provided parallel discussions. See HANCOCK at 108–114; see generally EDGAR WIND, PAGAN MYSTERIES IN THE RENAISSANCE 260 (London, Eng.: Faber and Faber, 1968). When Prudence was shown with a snake and a dove, the attribution was *Matthew* 10:16, "Be ye therefore wise as serpents and simple as doves." KATZENELLENBOGEN at 56. Mirrors can also be found attached to Vices (such as Lust, Vanity, and Vain Glory), explained as symbols of impermissible vanity, delusion, imperfection, false knowledge, deception, or a lack of substance. HANCOCK at 127–158.

The copy of Raphael shown in figure 20 follows Giotto's *Prudence* in that both are Janus-faced, with a female figure on one side and a bearded man at the back. Giotto's Prudence also had a book and a compass, said to indicate experience and scholarly knowledge. See Milton L. Gendel, Giotto's Representation of the Seven Virtues and Vices in the Arena Chapel at Padua (paper submitted in partial fulfillment of the requirements for the degree of Fine Arts, Faculty of Philosophy, Columbia U., Nov. 1940). The images shown in figures 20 and 21, both marked AV for Veneziano, are catalogued in vol. 27, THE ILLUSTRATED BARTSCH (formerly vol. 14, pt. 2): THE WORKS OF MARCANTONIO RAIMONDI AND OF HIS SCHOOL 53, 53 (Konrad Oberhuber, ed., New York, NY: Abaris Books, 1978).

**48** In Tuscan imagery of the fourteenth century, Prudence was also shown with a book, a pair of dividers, a snake, or a lamp. See Quentin Skinner, *Ambrogio Lorenzetti: The Artist as Political Philosopher*, 72 PROCEEDINGS OF THE BRITISH ACADEMY 48 (1986) (hereinafter Skinner, *The Artist as Political Philosopher*).

**49** As noted, Wind argued that Raphael referred to both Cardinal and Theological Virtues with the same image, and hence that the image of Temperance was also Hope, denoted by the gesture of the nearby putti, whose arm is lifted upward, toward the heavens. Wind, *Platonic Justice* at 70. The canonical study of Temperance comes from Helen North, who described her project as "a kind of Ariadne's thread to serve as a guide through the labyrinthine iconography of sophrosyne/temperantia from its beginnings in the coins and sarcophagi of late antiquity to its end in such specimens as the Reynolds window" of 1785 in New College, Oxford. NORTH at 13. As she explained, the Hellenic concept emerged from myths about the punishment of hubris ("wantonness, arrogance, defiance of the gods, contempt for the rights of others") through a principle of "order" that has Platonic roots. Id. at 27. Various narratives posited a "*sôphrôn* hero" fending off advances from older married women (id. at 33) and a "*sôphrôn* heroine" as either a chaste maiden or a loyal and sacrificing wife (id. at 44–49). Sophrosyne then became a value in Greek political thought and a Platonic ideal associated virtually exclusively with men (id. at 91) and later with the state (id. at 105).

The iconography of Temperance was codified through sixteenth-century emblem books, discussed in more detail in endnotes that follow as well as in Chapters 3–5. For example, the compilation by Cesare Ripa explained that the "personification of Temperance is a woman . . .

who holds a bridle. . . . As a bridle restrains a horse, so does temperance hold appetites in check." CESARE RIPA, BAROQUE AND ROCOCO PICTORIAL IMAGERY: THE 1758–68 HERTEL EDITION OF RIPA'S "ICONOLOGIA" 149 (Edward A. Maser, ed., New York, NY: Dover Publications, 1971) (hereinafter RIPA, MASER EDITION). One can also find a palm branch or a bit, such as in the 1628 *Allegory of Temperance* by Domenico Zampiero (Domenichino), in San Carol ai Catinari, Rome, and reproduced by NORTH in plate IX at 246. In works from fourteenth-century Tuscany, Temperance was shown with a vessel, as if pouring liquid, or with an hourglass, both said to express moderation. Skinner, *The Artist as Political Philosopher* at 49. Further, in the Lorenzetti *Allegories* of the 1330s in the Palazzo Pubblico in Siena (discussed in Chapter 2 and shown in part in figures 26 and 27), Temperance is holding a clock, which according to Skinner provided the "earliest known depiction" in Western art of what was then a novel object. Id. at 55.

**50** Marcantonio Raimondi (c. 1480–c. 1534), a prominent engraver of the Italian Renaissance, was an important source for the dissemination of Raphael's designs. See Elizabeth Broun, *The Portable Raphael*, in THE ENGRAVINGS OF MARCANTONIO RAIMONDI 20–42; Lisa Pon, *Marcantonio Printmaking/Printing Marcantonio*, in CHANGING IMPRESSIONS: MARCANTONIO RAIMONDI & SIXTEENTH-CENTURY PRINT CONNOISSEURSHIP 60–71 (New Haven, CT: Yale U. Art Gallery, 1999); LISA PON, RAPHAEL, DÜRER & MARCANTONIO RAIMONDI: COPYING AND THE ITALIAN RENAISSANCE PRINT (New Haven, CT: Yale U. Press, 2004). Some of the prints, taken from drawings or sketches, are not identical to the finished compositions. See ARTHUR M. HIND, MARCANTONIO AND ITALIAN ENGRAVERS AND ETCHERS OF THE SIXTEENTH CENTURY 5 (New York, NY: Frederick Stocks and London, Eng.: William Heinemann, 1912). Wind interpreted the Raphael image to be both Fortitude and Charity, identified by a tree denoting generosity as the fruits could be given away. Wind, *Platonic Justice* at 70.

Fortitude's attributes include a lion, sometimes shown "trampled underfoot" or with "its jaws . . . wrenched open in Herculean fashion"; alternately, a lion's skin is "worn as a trophy" or displayed on a medallion or shield. O'REILLY at 198. At times Fortitude is shown with a broken column or a tower, denoting strength. See Skinner, *The Artist as Political Philosopher* at 51, and TUVE, ALLEGORICAL IMAGERY at 70–72 (discussing Francesco Pesellino's *Fortitude and Temperance*, ca. 1460, at 85, plate 3). Fortitude may also hold a myrtle branch to reference victory and grace. In Cicero's discussion of Fortitude, the subsidiary aspects identified include Patience, Perseverance, Loyalty, and Magnificence. O'REILLY at 125. Later discussions added Magnanimity, Security, Constancy, and Trust. Id. at 126–127, 129. The image shown in figure 22 is indexed in J. D. PASSAVANT, LE PEINTRE-GRAVEUR (THE PAINTER-ENGRAVER), vol. 6, 87, no. 99–015 (Leipzig, Ger.: Rudolph Weigel, 1864). The print can also be found in MADELINE CIRILLO ARCHER, THE ILLUSTRATED BARTSCH: 28 THE ITALIAN MASTERS OF THE SIXTEENTH CENTURY, COMMENTARY 64, entry no. 2801.083 (New York, NY: Abaris Books, 1995).

**51** The mixture of the secular and the sacred can also be found in Northern Europe. For example, in St. Janskirk in Gouda, the Netherlands, Justice (and other virtues) appear in some stained glass windows installed after the Reformation. Society for the Study of Gouda Windows, *The Stained Glass Windows of St. John's Church*, 1–2, 17–18 (pamphlet, undated).

**52** Interest in such illustrations and emblem books spanned about two hundred years from the sixteenth century forward. See NORTH at 250. Two figures—Andreas Alciatus and Cesare Ripa—were key sources of these compendia of pictures and short didactic commentaries, whose imagery and descriptions varied in different editions. We discuss both in Chapters 3, 4, and 5. By way of a brief introduction, Andreas Alciatus (or Andrea Alciato, or Alciun, or Alciati) was born in Italy and was a professor of Roman law who taught at Bourges, France, from 1529 to 1533 and later at Pavia and Bologna, Italy. Alciatus's emblem treatise, a diverse collection of moralizing short poems

or epigrams and illustrations, was first published in 1531 and thereafter in some 150 editions. See ANDREAS ALCIATUS, THE LATIN EMBLEMS: INDEX EMBLEMATICUS vol. 1 & 2 (Peter M. Daly, ed., Toronto, Can.: U. of Toronto Press, 1985). The attention paid to emblems in the sixteenth century was interrelated with an interest in Egyptian hieroglyphs, presumed to have great symbolic value. See ALISON SAUNDERS, THE SIXTEENTH-CENTURY FRENCH EMBLEM BOOK: A DECORATIVE AND USEFUL GENRE 5–6, 71–95 (Geneva, Switz.: Librairie Droz, 1988). Such images were conceived to be accessible (albeit with different levels of comprehension) to both the illiterate and the philosophically trained. See Ernst Gombrich, *Icones Symbolicae: The Visual Image in Neo-Platonic Thought*, 11 J. WARBURG & COURTAULD INST. 163 (1948).

Cesare Ripa, whose original name was Giovanni Campani, was born in Perugia around 1560. Although known today for its illustrations, the first edition of Ripa's *Iconologia* was published without pictures in Rome in 1593. See RIPA, MASER EDITION at ix. The first illustrated "Ripa" was published in 1603, followed by more than forty editions in eight languages, many of which were selective renditions or extrapolations that described and classified images. Scholars believe that it captured for the period the "fairly common agreement on the way in which ideas, often very abstract ones, could be intelligibly and effectively represented visually." RIPA, MASER EDITION at vii. Ripa's centrality to twentieth-century iconography comes through the work of Mâle as well as of ERNST GOMBRICH, SYMBOLIC IMAGES: STUDIES IN THE ART OF THE RENAISSANCE (Oxford, Eng.: Phaidon, 1978), and of ERWIN PANOFSKY, MEANING IN VISUAL ARTS (Garden City, NY: Doubleday, 1955). Access to the various compilations is facilitated by YASSU OKAYAMA, THE RIPA INDEX: PERSONIFICATIONS AND THEIR ATTRIBUTES IN FIVE EDITIONS OF THE ICONOLOGIA (Doornspijk, Neth.: Davaco Publishers, 1992).

These emblem books were important resources for artists during the fifteenth and sixteenth centuries, as can be seen from Vasari's *Lives of the Artists*, cited earlier, and by Spenser's use of these materials in *The Faerie Queene*. See JANE APTEKAR, ICONS OF JUSTICE: ICONOGRAPHY AND THEMATIC IMAGERY IN BOOK V OF THE FAERIE QUEENE (New York, NY: Columbia U. Press, 1969). By the seventeenth and eighteenth centuries, many of the images, sourced in Medieval lore, became obscure. MÂLE, THE GOTHIC IMAGE at vii. Our focus is not on the roles played by Virtues in literary and other genres. Cf. WILLIAM IAN MILLER, THE MYSTERY OF COURAGE (Cambridge, MA: Harvard U. Press, 2000).

**53** Plato is a source for the claim that Justice is the "supreme of virtues." See ERIC A. HAVELOCK, THE GREEK CONCEPT OF JUSTICE: FROM ITS SHADOW IN HOMER TO ITS SUBSTANCE IN PLATO 316, 317–323 (Cambridge, MA: Harvard U. Press, 1978). Others invoke Cicero for this proposition. See *De officiis*, bk. III, 28 at 295, and index at 415: "for this virtue (Justice) is the sovereign mistress and queen of all the virtues." Aquinas is also cited for Justice's supremacy as centered on "one's relations to others" and therefore "the most important moral virtue." See THOMAS AQUINAS, THE CARDINAL VIRTUES, PRUDENCE, JUSTICE, FORTITUDE, AND TEMPERANCE xvii (Richard J. Regan, ed. and trans., Indianapolis, IN: Hackett Publishing, 2005) (hereinafter REGAN'S AQUINAS). Further, by one count, Aquinas devoted "sixty-one questions" to the topic of Justice, "architectonic with respect to the other virtues." See Jean Porter, *The Virtue of Justice IIa-IIae*, in POPE'S THE ETHICS OF AQUINAS at 279, 273. Moreover, Porter noted that Aquinas's discussion of justice "is the longest, the most complex, and arguably the most difficult treatment of a particular virtue in the *Summa theologiae*." Id. at 272. Further, although the other moral virtues are aimed at perfecting "passions," Justice is a "virtue of the will." Id. at 275. Porter resisted a reading of Aquinas that ignored the "exterior" orientation of the other virtues. Id. at 276. She argued that Charity, seen by Aquinas as a distinct virtue, was "architectonic" in turn to Justice. Yet "justice provides a framework for human life" independent of Christian revelation. Id. at 284.

Contemporary political theory echoes the place of Justice at the forefront because it is, in John Rawls's words, "the first virtue of social institutions." See JOHN RAWLS, A THEORY OF JUSTICE 3 (Cambridge, MA: Belknap / Harvard U. Press, 1971), discussed in Chapters 5 and 6. Alternatively one could, as one literary historian put it, see Justice as the "most interesting" for bridging so many traditions—"most violently resist[ing] the attempt to denominate virtues classical or Christian." TUVE, ALLEGORICAL IMAGERY at 66.

**54** TUVE, ALLEGORICAL IMAGERY at 66; Cicero placed within the range of the Virtues Justice and Righteousness several others, including Religio (Reverance), Pietas (Piety or Devotion), Gratia (Gratitude), Vindicatio (Vindication), Observantia (Respect), and Veritas (Truth). The commentator Macrobius added as other related Virtues a group including Innocentia (Innocence), Amicitia (Friendship), Concordia (Order or Harmony), Affectus (Emotions), and Humanitas (Humanity or Kindness). Id.

**55** See T. K. DUNSEATH, SPENSER'S ALLEGORY OF JUSTICE, IN BOOK FIVE OF THE FAERIE QUEENE 211 (Princeton, NJ: Princeton U. Press, 1968).

**56** See DUNSEATH, SPENSER'S ALLEGORY at 210 (quoting Sir Thomas Elyot's statement of Aristotelian categories). See THE SUMMA THEOLOGICAL OF ST. THOMAS AQUINAS (English Dominican Fathers, trans., Allen, TX: Christian Classics, 1981, reprint of an earlier edition), *Secunda secundae partis* at Q. 61, A.3.

**57** Porter, *The Virtue of Justice* at 278. Porter attributed the distinction to Aquinas's reiteration of the idea from Aristotle. See also Joseph Polzer, *Ambrogio Lorenzetti's "War and Peace Murals" Revisited: Contributions to the Meaning of the "Good Government Allegory,"* 23 ARTIBUS ET HISTORIAE 63, 81, and 102, n. 70 (2002).

**58** Porter explained commutative justice as concerning justice between parties such that neither "suffers unduly, nor benefits at the expense of another." Porter, *The Virtue of Justice* at 278. Regan called this "quid pro quo relations between individuals" relating to the issue of restitution. REGAN'S AQUINAS at xviii–xix.

**59** Porter, *The Virtue of Justice* at 278.

**60** REGAN'S AQUINAS at xviii–xix; Polzer, *Ambrogio Lorenzetti's War and Peace Murals Revisited* at 81, 102, n. 70.

**61** Randolph Starn, *The Republican Regime of the "Room of Peace" in Siena, 1338–40*, 18 REPRESENTATIONS 1, 29 at n. 27 (1987).

**62** Jean Bodin described that harmony as coming from the provision of honors to persons based not only on status but on the suitability or fittingness of doing so. See JEAN BODIN, SIX BOOKS OF THE COMMONWEALTH, bk. VI, ch. 6 at 204–205 (abridged by M. J. Tooley, trans., New York, NY: Barnes & Noble, 1967) (hereinafter BODIN/TOOLEY ED.). Bodin contrasted that "fusion" with an "egalitarian order, based on the principle of commutative justice" in which all estates and honors were "equally divided" (id. at 205), and with a regime of "distributive justice" in which "the execution of the law ought to be adapted to the circumstances of each case." Id. at 206. He argued that wise governance—the "monarchical state"—borrowed from both commutative and distributive justice to create a harmonic fusion. Id. at 209. One interpreter argued that Bodin's more general definition of justice was the "right division of rewards and punishments, and of that which of right unto every man belongeth." See J. U. Lewis, *Jean Bodin's Logic of Sovereignty*, in JEAN BODIN 3, 12, n. 4 (Julian H. Franklin, ed., Aldershot, Eng., & Burlington, VT: Ashgate, 2006) (hereinafter ESSAYS ON JEAN BODIN).

A different translation—that of Beatrice Reynolds—quotes Bodin as stating: "Just as God maintains the contrariety of celestial movements . . . in a discordant accord, as of contrary voices in a very pleasant and sweet harmony, keeping the one element from oppressing the other, so the prince, who is the image of God, ought to preserve and rule the quarrels and differences of his magistrates . . . ." See DANIEL ENGSTER, DIVINE SOVEREIGNTY: THE ORIGINS OF MODERN STATE POWER 78–79 (DeKalb, IL: Northern Illinois U. Press, 2001).

Bodin's innovations as a legal and political philosopher, historian, and sociologist are mapped by JULIAN H. FRANKLIN, JEAN BODIN, AND THE SIXTEENTH CENTURY REVOLUTION IN THE METHODOLOGY OF LAW AND HISTORY (New York, NY: Columbia U. Press, 1963). Franklin has criticized the Tooley translation for its selectivity. See JEAN BODIN, ON SOVEREIGNTY: FOUR CHAPTERS FROM THE SIX BOOKS OF THE COMMONWEALTH XXXV (Julian H. Franklin, ed. and trans., Cambridge, Eng.: Cambridge U. Press, 1992) (hereinafter BODIN/FRANKLIN EDITION).

**63** "The great theme of this book is justice, the queen of the four cardinal virtues, without which civilized society as we know it would perish and Faerie Land itself would disappear." DUNSEATH, SPENSER'S ALLEGORY at 8. Dunseath read the central aim of justice to be peace (id. at 190), as he explicated the link between justice, the heavenly order, and the "Astrea-like figure of Elizabeth," the Queen presiding over all. Id. at 209. The "three handmaidens of Mercilla form a hierarchy of justice, a hierarchy partially established by Aristotle and contemplated by Renaissance Neoplatonic jurists." Id. at 210. Dunseath argued that Bodin's three forms of justice (arithmetical, geometrical, and harmonical) were reflected in the book.

Jane Aptekar also saw the influence of Bodin but argued that Spenser's allegory was full of irony—respecting justice's aspirations while objecting to justice's cruelty and hence simultaneously attentive to "justice's orthodoxy and justice's dubiety." See APTEKAR at 7, 52–53. The book was replete with "verbal pictures . . . [that] visually resemble allegorical illustrations and paintings, or emblems." Id. at 3. Spenser's images were a source for English emblem writers of personifications, as were Ripa and Alciatus. See FREEMAN at 79–84, 102–113. See also John D. Staines, *Elizabeth, Mercilla, and the Rhetoric of Propaganda in Spenser's 'Faerie Queene'*, 31 J. OF MEDIEVAL AND EARLY MODERN STUDIES 283, 284 (2001).

**64** TUVE, ALLEGORICAL IMAGERY at 67, n. 11.

**65** See PLATO, THE LAWS, bk. 1, 631D (R. G. Bury, trans., London, Eng.: William Heinemann, 1926). The text reads: "And wisdom, in turn, has first place among the goods that are divine, and rational temperance of soul comes second; from these two, when united with courage, there issues justice as the third; and the fourth is courage." In *The Republic*, Plato also extolled Temperance, in that while courage and wisdom each resides "[i]n a part only, the one making the State wise and the other valiant," Temperance "extends to the whole." PLATO, THE REPUBLIC, bk. IV, 98 (Benjamin Jowett, trans., Champaign, IL: Project Gutenberg, 1994).

Cicero can also be cited when one elevates Wisdom to a first-place position. In *De legibus*, 1.22.58, Cicero described Sapientia as the "mother of all good things," and in *De officiis*, 1.43.153, Sapientia was said to be the "leader of all the virtues." This translation comes from Skinner, *The Artist as Political Philosopher* at 18. Prudentius's *Psychomachia* can also be invoked, for it described the commemoration of the victory of Virtue over Vice through the building of a temple to Sapientia. NUGENT, ALLEGORY AND POETICS at 57–62.

**66** See CHRISTOPHER BOBONICH, PLATO'S UTOPIA RECAST: HIS LATER ETHICS AND POLITICS 34–45 (Oxford, Eng.: Clarendon Press & Oxford U. Press, 2002).

**67** Freyhan at 68.

**68** TUVE, ALLEGORICAL IMAGERY at 69 (citing MORALIUM DOGMA PHILOSPHORUM); Skinner, *Artist as Political Philosopher* at 26 (citing Martin of Braga's Formula that "there are four species of virtue," and "that among these the first is prudence," as well as Guillaume Peyraut's that "prudence is the foundation of all the other virtues"). See also David Depew, *Review of Prudence: Classical Virtue, Postmodern Practice*, 37 PHILOSOPHY AND RHETORIC 167 (2004). See generally Robert W. Cape Jr., *Cicero and the Development of Prudential Practice*, in PRUDENCE: CLASSICAL VIRTUE, POSTMODERN PRACTICE (Robert Harimon, ed., University Park, PA: Pennsylvania State U. Press, 2003), and DANIEL MARK NELSON, THE PRIORITY OF PRUDENCE: VIRTUE AND

NATURAL LAW IN THOMAS AQUINAS AND THE IMPLICATIONS FOR MODERN ETHICS (University Park, PA: Pennsylvania State U. Press, 1992).

**69** TUVE, ALLEGORICAL IMAGERY at 69 (citing Seneca, Martin of Braga, and the *Somme le roi*); Skinner, *Artist as Political Philosopher* at 27 (also arguing the "Senecan roots" for Temperance as the leader, with Justice at the rear, and that magnanimity, an aspect of Fortitude, was "absolutely central." Id. at 29).

**70** Skinner, *The Artist as Political Philosopher* at 8, elaborating on Cicero's comments in *De republica* (*On the Commonwealth*) that Concordia is "the best and lightest rope of safety in society" (id. at 12) and that to achieve such peace, Aequitas was required to "smooth out our differences" so that " 'citizens are considered on level terms rather than being handled in a divisive way' " (translating CICERO, DE OFFICIIS 1.34.124). Under this approach, Justice becomes a means of keeping the peace. Id. at 14.

**71** Nicholai Rubinstein, *Political Ideas in Sienese Art: The Frescoes by Ambrogio Lorenzetti and Taddeo di Bartolo in the Palazzo Pubblico*, 21 J. WARBURG & COURTAULD INST. 179, 183, n. 35, and 185 (1958). Lorenzetti's work is discussed in depth in Chapter 2. Charity's stature as "the greatest of virtues" prompted art historian Emile Mâle to complain that "thirteenth-century [French] craftsmen were unequal" to Giotto and other Italian artists in depicting Charity; the more accomplished Italians showed her nursing a child or giving gifts to the poor. MÂLE, THE GOTHIC IMAGE at 116–117. Unlike the Cardinal Virtues, which can be acquired by individuals through their efforts, the Gift Virtues are "grace-given" and "cannot be attained by man save through the merits of Christ's Passion." O'REILLY at 200–202. That understanding might support political leaders' embrace of the four Cardinal Virtues rather than the Gift Virtues, but not a sole focus on Justice.

**72** Were one open to new imagery, Zeus could replace his daughter, Dikė (subsequently Justitia and discussed in Chapter 2). To maintain order and as the god of justice, Zeus crushed "anyone, god, man, or Titan," who posed a threat. NORTH at 59. Over time, however, the portrayal of Zeus shifted from vengeful purveyor of justice to the embodiment of sophrosyne, doing justice through a range of virtues. Id. at 59–61. Later, Jean Bodin explained that the three virtues "prudence, courage, and temperance" complement each other; under the monarchical sovereignty he admired, it was the king who added the "rational and contemplative elements," doing justice as his prerogative. BODIN/TOOLEY ED., bk. 6, ch. 6 at 212.

**73** Conflicts over power stretch across the centuries. By the Renaissance, political theorists such as Andreas Alciatus and Jean Bodin were developing somewhat different views about the source and nature of the power held by judges. Alciatus argued that all state officials derived their authority from delegation by a ruling prince. Donald R. Kelley, *The Development and Context of Bodin's Method*, in ESSAYS ON JEAN BODIN at 123, 133. Bodin's approach was that judges had some power without delegation. That view might seem in tension with the political theory for which he is famous—that sovereignty was indivisible, residing within a single individual or group. State power could be monarchical, aristocratic, or democratic, but "mixed" systems in which power was shared were a logical impossibility, and confederacies therefore insufficiently unified to constitute a single political system. But relying on the French tradition of holding power through "right of office," Bodin posited that customary law was a source of direct, albeit minor, powers for officials. Bodin conceived of the sovereign prince as holding all the major powers—appointing and assigning duties to magistrates; making and repealing all laws; beginning and ending wars; hearing appeals from magistrates; commuting sentences whether law provided for clemency or not; receiving oaths of fealty; determining coinage, weights, and measures; and imposing taxes. Bodin's theories supported the centralization of power then under way in France.

Franklin argued that viewing Bodin as an untextured absolute monarchist was both empirically and normatively "wrong," missing Bodin's intellectual evolution. See JULIAN FRANKLIN, JEAN BODIN AND THE RISE OF THE ABSOLUTIST THEORY 14–53 (Cambridge, Eng.: Cambridge U. Press, 1973). Instrumentally protective of political stability, Bodin supported religious toleration of significant minorities and taxes that were not unduly oppressive. Over time, Bodin came to the view that, aside from having no control over rules of succession to the throne and no right to alienate royal domains, a monarch held unlimited powers. Constraints (such as they were) came from morality, a responsibility to God, and the wisdom to be prudent and humane, but not from others' resistance. Id. Franklin cited Claude Seyssel as an exemplary French constitutionalist who thought three "bridles" checked royal power. These bridles were Religion, Justice, and "La Police"—a flexible mix of legal precedent and social custom. FRANKLIN at 14–15. The religious wars and the related breakdown of royal power spurred Bodin to develop a more absolutist theory of government. Id. at 41.

Other commentators read Bodin to insist that a monarch had absolute power vis-à-vis positivist legislative enactments but was subject to God's or nature's law. See Lewis at 15–19 and Donald R. Kelley, *The Development and Context of Bodin's Method* at 123–175, both in ESSAYS ON JEAN BODIN.

**74** See generally THEODORE K. RABB, THE LAST DAYS OF THE RENAISSANCE AND THE MARCH TO MODERNITY (New York, NY: Basic Books, 2006). We explore these shifts in Chapters 2–5.

**75** In Chapter 3 we analyze the images in Amsterdam's Town Hall, as well as those in Bruges and Geneva.

**76** Whether a monarch ought to directly dispense justice or to do so through others was one issue Bodin explored. He argued that although the power of lawmaking and the dispensation of justice belonged to the sovereign ("the true function of the prince is to judge his people"), the king ought not personally sit in judgment of his subjects but rather delegate that task to magistrates. Bodin proposed that laws be promulgated to "guide magistrates, who are frequently so blinded by passion, by intrigues, or by ignorance, that they have no conception of all of the beauty of justice." Id., bk. VI, ch. 6 at 207. He also argued that the distance from daily administration enhanced the monarch's focus on statecraft and his power. See BODIN/TOOLEY ED., bk. 4, ch. 5 at 134.

**77** The image of familial relations was deliberately invoked, for "a king's relation to this subject is that of a father to his children, for he does justice among them." BODIN/TOOLEY ED., bk. 6, ch. 6 at 210.

**78** The didactic performativity entailed is the focus of MICHEL FOUCAULT, DISCIPLINE AND PUNISH: THE BIRTH OF THE PRISON (Alan Sheridan, trans., New York, NY: Vintage Books, 2nd ed., 1977), to which we return in Chapters 3, 6, and 13.

**79** See Act of Settlement, 1701, 12 & 13 Will. 3, c. 2, used as the marker of judicial independence and discussed in Chapters 5, 6, and 13. After its enactment, a judge's commission no longer ended at the conclusion of a monarch's reign. Votes in both Houses of Parliament were needed to end a judge's tenure. See David Lemmings, *The Independence of the Judiciary in Eighteenth Century England*, in THE LIFE OF THE LAW: PROCEEDINGS OF THE TENTH BRITISH LEGAL HISTORY CONFERENCE, OXFORD, 1991 at 125 (Peter Birks, ed., Rio Grande, OH: Hambledon Press, 1993).

**80** See U.S. CONST., Art. III, § 1. It provides for tenure during good behavior for federal judges and for salaries that cannot be diminished during terms of office.

**81** As North explained, a "recurring phenomenon in every society is the acquisition of political significance by concepts that originally had none." NORTH at 89.

**82** RAWLS at 514, further discussed in Chapters 5 and 6.

**83** *Justice*, from LANGSTON HUGHES, THE COLLECTED POEMS OF LANGSTON HUGHES (Arnold Rampersad, ed., with David Roessel,

Associate Editor, New York, NY: Knopf, 1994), discussed in Chapters 5 and 6.

**84** See FOUCAULT, DISCIPLINE AND PUNISH, discussed in later chapters.

**85** Charter or Fundamental Laws of West New Jersey, Agreed Upon, ch. XXIII (1676), reprinted in SOURCES OF OUR LIBERTIES 188 (Richard L. Perry, ed., 1959), discussed in Chapter 13.

**86** See JEREMY BENTHAM, CONSTITUTIONAL CODE (1843), in 9 THE WORKS OF JEREMY BENTHAM 41 (John Bowring, ed., Edinburgh, Scot.: William Tait, 1843); and FREDERICK ROSEN, JEREMY BENTHAM AND REPRESENTATIVE DEMOCRACY: A STUDY OF THE CONSTITUTIONAL CODE 26–27 (Oxford, Eng.: Clarendon Press, 1983). Bentham's views are examined in Chapter 13.

**87** See JEREMY BENTHAM, RATIONALE OF JUDICIAL EVIDENCE (1827), in 6 THE WORKS OF JEREMY BENTHAM 355 ("Of Publicity and Privacy, as Applied to Judicature in General, and to the Collection of the Evidence in Particular") (John Bowring, ed., Edinburgh, Scot.: William Tait, 1843), discussed in Chapter 13.

**88** See JÜRGEN HABERMAS, THE STRUCTURAL TRANSFORMATION OF THE PUBLIC SPHERE: AN INQUIRY INTO A CATEGORY OF BOURGEOIS SOCIETY (Thomas Burger, trans., Cambridge, MA: MIT Press, 1991); JÜRGEN HABERMAS, BETWEEN FACTS AND NORMS: CONTRIBUTIONS TO A DISCOURSE THEORY OF LAW AND DEMOCRACY 97–98 (William Rehg, trans., Cambridge, Eng.: Polity Press, 1996); Nancy Fraser, *Rethinking the Public Sphere: A Contribution to the Critique of Actually Existing Democracy*, in HABERMAS AND THE PUBLIC SPHERE at 109 (Craig Calhoun, ed., Cambridge, MA: MIT Press, 1992); DAVID ZARET, ORIGINS OF DEMOCRATIC CULTURE: PRINTING, PETITIONS, AND THE PUBLIC SPHERE IN EARLY-MODERN ENGLAND (Princeton, NJ: Princeton U. Press, 2000). We examine adjudication's relation to the public sphere in Chapters 13, 14, and 15.

**89** International Covenant on Civil and Political Rights, art. 14, Dec. 16, 1966, G.A. Res. 2200A (XXI), U.N. Doc. 1/6316, discussed in Chapter 13.

**90** The expansion of courts is mapped in Chapters 7–12; courts in the United States are the subject of Chapters 7, 8, and 9.

**91** See, for example, KATHRYN FISCHER TAYLOR, IN THE THEATER OF CRIMINAL JUSTICE: THE PALAIS DE JUSTICE IN SECOND EMPIRE PARIS (Princeton, NJ: Princeton U. Press, 1993). As discussed in Chapters 7–9, during much of the nineteenth century and into the twentieth, county courts in the United States served localities in ways reminiscent of European town halls, functioning as multi-purpose government and social spaces. See, for example, MARTHA J. McNAMARA, FROM TAVERN TO COURTHOUSE: ARCHITECTURE AND RITUAL IN AMERICAN LAW, 1658–1860 (Baltimore, MD: Johns Hopkins U. Press, 2004); COURTHOUSES OF CALIFORNIA: AN ILLUSTRATED HISTORY (Ray McDevitt, ed., San Francisco, CA: California Historical Society and Heyday Books, 2001); WILLIAM L. VIRDEN, CORNERSTONES AND COMMUNITIES: A HISTORICAL OVERVIEW OF COLORADO'S COUNTY SEATS AND COURTHOUSES (Loveland, CO: Rodgers & Nelsen, 2001). Further, as exemplified by figure 13, a photograph of the *Justice* atop New York City Hall, many of the courthouses marked their law-related functions by putting such statues out front. Indeed, in many places, "Lady Justice" was a "favorite of all the statuary figures." See DOUG OHMAN & MARY LOGUE, COURTHOUSES OF MINNESOTA 34–36 (St. Paul, MN: Minnesota Historical Society Press, 2006).

**92** See CLARE GRAHAM, ORDERING LAW: THE ARCHITECTURAL AND SOCIAL HISTORY OF THE ENGLISH LAW COURT TO 1914 (Aldershot, Eng.: Ashgate, 2003).

**93** See, for example, Judicial Conference of the United States, Proceedings of the Judicial Conference, Sept. 25–28, 1945, at 18. We discuss the development of the federal judiciary and its buildings programs in Chapters 8 and 9.

**94** See VISION + VOICE: DESIGN EXCELLENCE IN FEDERAL ARCHITECTURE, BUILDING A LEGACY vol. 1 (Washington, DC: U.S. General

Services Administration, Public Buildings Service, Office of the Chief Architect 2002). More discussion of this text and subsequent volumes in the series is provided in Chapters 8 and 9.

95 See LA NOUVELLE ARCHITECTURE JUDICIAIRE: DES PALAIS DE JUSTICE MODERNES POUR UNE NOUVELLE IMAGE DE LA JUSTICE (Paris, Fran.: La Documentation Française, 2000), discussed in Chapter 10.

96 As we detail in Chapters 10–12, architects have developed expertise in this arena, with support from organizations such as the Academy of Architecture for Justice (AAJ), an interest group (termed a "knowledge community") associated with the American Institute of Architects (AIA) and focused on "high-quality planning, design, and delivery of justice architecture." Details are provided at the AIA website, http://www.aia.org/caj_about.

97 Regional courts of the twentieth century are the topic of Chapter 11.

98 See Assembly of State Parties, Report to the Assembly of State Parties on the Future Permanent Premises of the International Criminal Court: Housing Options at 23 (ICC-ASP/4/1, 9 March 2005), http://www.icc-cpi.int/iccdocs/asp_docs/library/asp/ICC-ASP-4-1_English.pdf. That building is discussed in Chapter 12 along with other transnational courts.

99 See JACK IRBY HAYES JR., SOUTH CAROLINA AND THE NEW DEAL 63–64 (Columbia, SC: U. of South Carolina Press, 2001). This image and the conflict are discussed in Chapter 6.

100 "Justice," Unblindfolded, Raises Newark Row, 10 ART DIGEST 17 (1935), quoting a federal district court judge, Guy L. Fake. Chapter 6 explores the controversy over this image and others.

101 See SUE BRIDWELL BECKHAM, DEPRESSION POST OFFICE MURALS AND SOUTHERN CULTURE: A GENTLE RECONSTRUCTION 201, n. 3 (Baton Rouge, LA: Louisiana State U. Press, 1989), discussed in Chapter 6.

102 Ira Henry Freeman, Mohammed Quits Pedestal Here on Moslem Plea after 50 Years, NEW YORK TIMES, Apr. 9, 1955, at 1, 18, discussed in Chapter 6.

103 John Miller (Associated Press), Idaho's Lynching Murals To Get Explanations, INDIAN COUNTRY TODAY, Oct. 19, 2007, discussed in Chapter 6.

104 Spaces for spectators are not, however, always ample, and new construction guidelines in some countries limit the numbers of persons who can attend. See Linda Mulcahy, Architects of Justice: The Politics of Courtroom Design, 16 SOCIAL & LEGAL STUDIES 383 (2007).

105 See LORD WOOLF, ACCESS TO JUSTICE, FINAL REPORT TO THE LORD CHANCELLOR ON THE CIVIL JUSTICE SYSTEM IN ENGLAND AND WALES (London, Eng.: Her Majesty's Stationery Office, 1996), and the discussion in Chapter 14.

106 See Directive 2008/52/EC of the European Parliament and of the Council of May 21, 2008, on certain aspects of mediation in civil and commercial matters, Art. 1, 2008 O.J. (L 136) 3, and the discussion in Chapter 14.

107 See Judith Resnik, Managerial Judges, 96 HARVARD L. REV. 374 (1982), and Chapter 14.

108 See Marc Galanter, The Vanishing Trial: An Examination of Trials and Related Matters in Federal and State Courts, 1 J. EMPIRICAL LEGAL STUDIES 459 (2004), and the discussion in Chapter 14.

109 Commentary, THE ECONOMIST, July 12, 2003, at 9.

110 See the Executive Order of November 2001 and the Military Commissions Act of 2006, Pub. L. No. 109-366, 120 Stat. 2600 (to be codified at various sections of 10 U.S.C. § 948 et seq. and 28 U.S.C. § 2241), and Boumediene v. Bush, 128 S. Ct. 2229 (2008), discussed in Chapter 14.

111 Marc Galanter, Why the "Haves" Come Out Ahead: Speculations on the Limits of Legal Change, 9 LAW & SOCIETY REV. 95 (1974).

112 FOUCAULT, DISCIPLINE AND PUNISH at 8–11, discussed in later chapters.

113 The construction of ITLOS is detailed in Chapter 12, along with the development of other transnational courts.

114 This description comes from North's analysis of how during the Roman period it was "political necessity that really dictated the change—the necessity of fostering the reputation of the absolute ruler" as a temperate and persuasive force rather than relying purely on crude power. NORTH at 112.

115 These buildings are discussed and depicted in Chapter 15.

## CHAPTER 2

1 Our thanks to Dr. Kathryn Slanski for her intellectual generosity in educating us about the legal and iconographic materials on Mesopotamia and about Yale's Babylonian Collection at the Sterling Library and for assisting us in finding the depiction reproduced in figure 23.

2 A photograph of this seal can be found at plate xxxviii, no. 458, and at p. 174 in RAINER MICHAEL BOEHMER, DIE ENTWICKLUNG DER GLYPTIK WÄHREND DER AKKAD-ZEIT (THE DEVELOPMENT OF HIEROGLYPHICS DURING THE AKKADIAN PERIOD) (Berlin, Ger.: Walter de Gruyter, 1965). The seal was once a part of the collection of Mrs. William H. Moore and was also published in XLVII ANCIENT ORIENTAL CYLINDERS AND OTHER SEALS, plate 42 (Chicago, IL: U. of Chicago Press, 1940). Figure 23 is provided and reproduced with the permission of the University of Texas Press and the Trustees of the British Museum; our thanks to Peggy Gough of the University of Texas Press for facilitating our use of this drawing.

3 These cylinder seals, dating from around 3300 BCE, often not larger than an inch or two, sometimes display scenes of communal activities and of the "priest-king." See Kathryn Slanski, Social Class System and the Economy, in WORLD ERAS, vol. 8: ANCIENT MESOPOTAMIA 142 (Farmington, NY: Thomson Gale, 2005) (hereinafter Slanski, Social Class System).

4 Kathryn E. Slanski, The Mesopotamian "Rod and Ring": Icon of Righteous Kingship and Balance of Power between Palace and Temple, in REGIME CHANGE IN THE ANCIENT NEAR EAST AND EGYPT: FROM SARGON OF AGADE TO SADDAM HUSSEIN, 136 PROCEEDINGS OF THE BRITISH ACADEMY 37, 48–49 (2007) (hereinafter Slanski, Rod and Ring). Slanski interpreted the "rod and ring" to be symbols of "righteous kingship sanctified by the gods," communicating "an aspect of the enduring relationship between the palace and the temple." Id. at 41.

5 Slanski, Rod and Ring at 41–51. See also FRANCESCA ROCHBERG, THE HEAVENLY WRITING: DIVINATION, HOROSCOPY, AND THE ASTRONOMY OF MESOPOTAMIAN CULTURE 188–190 (Cambridge, Eng.: Cambridge U. Press, 2004) (hereinafter ROCHBERG, THE HEAVENLY WRITING). Shamash was regularly seen throughout Mesopotamian iconography beneath "astral symbols (lunar crescent, solar disk, and eight-pointed star)." Texts also referred to him as "judge (of the regions) above and below." Id. at 191–192. Various discussions suggested that judgments and decisions emanated from Shamash as well as from other central deities. Id. at 192–196.

6 Martha T. Roth, Mesopotamian Legal Traditions and the Laws of Hammurabi, 71 CHICAGO-KENT L. REV. 13, 17 (1995) (hereinafter, Roth, Legal Traditions); Slanski, Social Class System at 157.

7 See MARTHA T. ROTH, LAW COLLECTIONS FROM MESOPOTAMIA AND ASIA MINOR 71–73 (Atlanta, GA: Scholars Press, 1995) (hereinafter ROTH, LAW COLLECTIONS). Hammurabi, who reigned from about 1792 to 1750 BCE, was the sixth king of Babylon and the first of its Empire. The diorite stele in the Louvre was discovered in 1901 in Susa (within what became known as the Khuzestan province of Iran). That stele has more than forty columns of writing inscribed in bands around the stone. Compilations of laws have been found on other steles and tablets, although not all of the rulers who promulgated them have been identified. See Slanski, Social Class System at 167,

179–180. The texts often begin with a "historical-literary prologue and epilogue," providing information on the ruler's background. A set of detailed rules or what might be called scenarios follows—for example, that if x occurred, y should be the consequence. Id.

**8** See Kathryn E. Slanski, *Classification, Historiography, and Monumental Authority: The Babylonian Entitlement "Narûs (Kudurrus)"* 52 J. Cuneiform Stud. 95, 109 (2000). What this scene represents is a question: whether "god is dictating the laws to the king, or that the king is offering the laws to the god, or that the king is accepting the rod and the ring that are the emblems of temple-building and sovereignty." Roth, Law Collections at 73. For additional discussion of the imagery on the Hammurabi Code, see Slanski, *Rod and Ring* at 49–54.

**9** Roth, Law Collections at 77, 135.

**10** Transactions related to interpersonal and commercial matters were recorded on clay tablets. The relationships among the codes on stele, the clay records, and daily practices are not clear. See Roth, Law Collections at 1–7. What is known is that between 2334 and 2279 BCE, Sargon of Akkad (a city whose site has not yet been identified) conquered city-states and created an empire that was unified in part through its written system. By 2112–2095 BCE, a legal system that encompassed regulations of weights, measures, and trading routes was in place. Between 1391 and 1335 BCE, a "royal archive" documented the interactions among Babylonia, Egypt, and Assyria. Slanski, *Social Class System* at 142–143. Thousands of these inscribed small clay tablets detail the sophisticated organization, with efforts, for example, to standardize production and provide instruction on various forms of manufacture and rules on the treatment of native-born subjects, aliens, and slaves. Id. at 147–156.

**11** See Kathryn Slanski, *Mesopotamia: Middle Babylonian Period*, in A History of Ancient Near Eastern Law, vol. I, 485, 487 (Raymond Westbrook, ed., Leiden, Neth.: Brill, 2003). These materials, from roughly the sixteenth through the eleventh centuries BCE, are in Akkadian, the language of southern Mesopotamia. Slanski explained that the processes of litigation included oath taking, the giving of evidence by witnesses in trials, and the rendering of judgments and penalties related to conflicts about property, status, inheritance, contracts, and misdeeds or crimes. Id. at 485–520. Rather than having absolute power, the king and his deputies were to take advice and behave in ways understood to be just. Slanski, *Social Class System* at 157.

**12** Kathryn E. Slanski, *Representation of the Divine on the Babylonian Entitlement Monuments (Kudurrus)*, pt. I: *Divine Symbols*, 50 Archiv für Orientforschung 308, 318–320 (2003/2004), Slanski noted that with the invocation of divinity, judgments were all the more binding.

**13** Figures denoting "Law" as well as Justice can be found holding books. One example is the *Allegory of Law*, from the 1780s, in the Cour d'appel in Paris, France. See Katherine Fischer Taylor, In the Theater of Criminal Justice: The Palais de Justice in Second Empire Paris at xix, fig. 3 (Princeton, NJ: Princeton U. Press, 1993) (hereinafter Taylor, The Palais de Justice). Taylor argued that over time, the representation of expertise denoted by the book became unpopular. The 1868 *Allegory of Justice* outside the Palais de Justice in Paris instead shows a Justice with an urn into which jury ballots could be cast—thereby denoting a preference for jury evaluation of oral evidence. Id. at fig. 4.

**14** See Rochberg, The Heavenly Writing at 121–163; Erica Reiner, *Astral Magic in Babylonia*, 85 Transactions of the American Philosophical Society 1 (Philadelphia, PA: American Philosophical Society, 1995); Stephen Langdon, Babylonian Menologies and the Semitic Calendars: The Schweich Lectures of the British Academy 1933 (London, Eng.: Oxford U. Press, 1935).

**15** Cultural significance was attached to various parts of the calendar deemed auspicious or unfavorable for different activities. Further, some rituals relied on the presence of the moon and the sun. See Reiner

at 78, 108–118, 136–138. Dating these beliefs is complex, because later Hellenistic sources are sometimes conflated with earlier writings that, in turn, may reflect yet undiscovered predecessors. Mesopotamian culture is an important source of what became, in modern parlance, astrology and astronomy. See generally Rochberg, The Heavenly Writing; see also Langdon at 99–101; Richard Hinckley Allen, Star-Names and Their Meanings, 269–270 (New York, NY: G. E. Stechert, 1899). Reiner's reading of Mesopotamian poetry also suggested that the stars were understood as mediators between people and the gods, a role she likened to the parts played by saints in later theologies. Reiner at 15.

**16** Peoples from Egypt, Babylonia, and China are all cited, sometimes with reference to the development of astronomy and mathematics and other times as demonstrating the universality of Jungian archetypes. The commentary aspiring to document these sources is both popular and academic. See, for example, Rupert Gleadow, The Origin of the Zodiac 17, 25, 88–91 (New York, NY: Castle Books, 1968).

**17** A chronology of the history and references to months and to astral signs is provided by Rochberg, The Heavenly Writing at xxiii–xxvi. As Rochberg explained, Babylonian inscriptions from about 700 BCE refer to the "heavenly writing"—interpreting the stars. Id. at 1–8. Stars and planets were also named. For example, Libra was called the "Star" of Shamash, who was the divine judge. Reiner at 141. See also Gwyneth Heuter, *Star Names—Origins and Misconceptions*, 29 Vistas in Astronomy 237 (1986).

With dramatic flourish, Langdon argued that Babylonia "out of pure imagination saw the sign of the scales," connected the scales and the constellation of the "hypsoma of Saturn" identified with Shamash, and then called the planet Saturn to denote that it was the "'star of justice and righteousness.'" Langdon at 99–100. Gleadow, at 214, described "Zibaniitu, the Scales," as a "well-known Babylonian constellation" corresponding to the "myth of the Last Judgment in the autumn and the weighing of souls. It happens also to be seasonally suitable to Egypt, for the harvest would be weighed, and taxes assessed, when the moon was full in Libra." The words *zib-ba an-na* (or *zibanitu*) can be translated as "balance of heaven." Heuter at 245. Langdon reported that a legend echoed the association, for "'he of the scales'" was an angel who "dwells in the lower world and passes judgment on the souls." Langdon at 99. As for the timing, some believe that the "peoples of the Euphrates region" used a system of constellations similar to what the Greek poet Aratus later described in 250 BCE. See Archie E. Roy, *The Origin of the Constellations*, 27 Vistas in Astronomy 171, 175, 186 (1984). Rochberg discussed Babylonian horoscopes dated from the fifth century BCE. Id. at 98–116. Whether these attributions will be sustained as new materials are found, the "astronomical and astrological traditions of ancient Mesopotamia" have had a significant impact on subsequent astronomy. Id. at 13.

**18** According to Rachel Hachlili, the names of the months on the Jewish calendar are derived from Babylonian words. The earliest calendar that has been found listing the order of months dates from around the first century CE. The Jewish community also adapted its calendar in relationship to the Roman one and borrowed signage. See Rachel Hachlili, *The Zodiac in Ancient Jewish Synagogal Art: A Review*, 9 Jewish Studies Q. 219, 235 (2002) (hereinafter Hachlili, *The Zodiac*). These images later influenced Christian art depicting the seasons. By Roman times, the word *Jagum*, or "Yoke, or Beam, of the Balance," was associated with the sign of the fall equinox. In the Julian calendar dated 46 BCE, the term "Libra" can be found. Allen at 270–271. Langdon also argued that the Jewish time of judgment tradition was "a myth undoubtedly inherited from Babylonia" and that the "same belief is preserved in Arabic tradition" about the observance of Ramadan, where fates are also decided. Langdon at 100.

**19** George M. A. Hanfmann, The Season Sarcophagus in Dumbarton Oaks, vol. I, 246–247 (Cambridge, MA: Harvard U. Press, 1951).

**20** Hachlili, *The Zodiac* at 220–227. See also Zeev Weiss, The Sepphoris Synagogue: Deciphering an Ancient Message through its Archaeological and Socio-Historical Contexts 55–197 (Jerusalem, Isr.: Israel Exploration Society, Hebrew University, 2005). An example from the sixth century CE is a mosaic floor, lettered in Hebrew and Aramaic, of a synagogue in Bet Alpha at the foot of Mt. Gilboa in Israel. Included is a female figure holding scales. See *Bet Alpha National Park* (Israel Nature and Parks Authority, pamphlet, June 2003). In other synagogue floor mosaics, Greek lettering has also been found.

Given that such imagery shares features common with other sites under Roman influence, Jewish traditions are not perceived to have made a distinctive contribution to Justice iconography. See Rachel Hachlili, *Jewish Art and Iconography in the Land of Israel*, in Near Eastern Archaeology: A Reader 445–454 (Suzanne Richard, ed., Winona Lake, IN: Eigenbrauns, 2003). The design of the synagogue zodiac mosaics generally follow the pattern discussed in the text, with a square in which two concentric circles appear. Weiss provided analyses of the depictions of animals, fruits, and scenes of daily activities in the Sepphorois Synagogue. In its zodiac, the male figures, not found in other synagogue mosaics, are similar to personifications in Roman and Byzantine Art. Weiss at 122.

In the four corners of the Sepphoris Synagogue are allegories of the Seasons, shown as females and "based largely on the iconographic traditions known in the Roman-Byzantine world." Id. at 123. The Bet Alpha Synogogue mosaic follows a similar pattern. Its base includes a depiction of the Old Testament story of Abraham and Isaac and a Hebrew passage naming the artist who made the mosaic, as well as the date (during the reign of Emperor Justinus, 517–528 CE) and the cost. Because some of the motifs in synagogue mosaics have not been found outside Palestine, that distinctive pattern suggests "local traditions completely unknown in the synagogues in the Diaspora." Id. at 140. Our thanks to Professor Lee Levine of Hebrew University and Professor Steven Fraade of Yale University for pointing us to these sources, and to Elinor and Robert Slater for facilitating a visit to the Bet Alpha site.

**21** Some scholars interpret the design as a pagan reference to the sun god Helios, and therefore to the supremacy of the laws of nature. In Jewish iconographical schemes, the design is read to refer to God or to denote that the zodiac functioned as a calendar. Hachlili, *The Zodiac* at 233–234. With the rise of Christianity, the design was reinterpreted as the representation of the "Christian creation" in which Christ becomes a central figure. Hanfmann at 264–265. A well-known iteration is Albrecht Dürer's woodcut *Sol Justitiae* (*The Sun of Justice*, also sometimes called *The Judge*), executed around 1499; there a male figure, often described as Jesus, appears as a judge. Sitting atop a lion, he is wide-eyed and holds an upright sword in one hand and scales with uneven pans in the other. A halo and rays of sun surround his head. See The Complete Engravings, Etchings and Drypoints of Albrecht Dürer 52–53, plate 25 (Walter L. Strauss, ed., New York, NY: Dover Publications, 1972) (hereinafter Walter Strauss, Dürer). See also Erwin Panofsky, The Life and Art of Albrecht Dürer 43 (Princeton, NJ: Princeton U. Press, 1943). Dürer may have been inspired by a line from the 1480 *Repertorium morale* of Petrus Berchrious: "The Sun of Righteousness shall appear ablaze when he will judge mankind on the day of doom." Walter Strauss, Dürer at 52–53; Panofsky at 78. The solar disc around the head of Jesus echoes not only Helios but other god figures as well, including the Babylonian Shamash. Panofsky noted the association with the "Islamic East" and the zodiac. Panofsky at 78.

**22** Hachlili, *The Zodiac* at 223–224. Reiner commented that the constellation Virgo, adjacent to Libra, was associated with Dikê and that in Babylonia's astral "magic" the "Scales (the constellation Libra, Akkadian Zibanîtu)" are linked to Shamash's "star of Justice." Reiner at 4.

**23** For example, the zodiac became a decorative element in the Town Hall of Amsterdam, discussed in Chapter 3. See Katharine Fremantle, *Themes from Ripa and Rubens in the Royal Palace of Amsterdam*, 103 Burlington Magazine 258, 263–264 (1961). The zodiac was also on the walls of the room in Padua in which judgments were given and to which the public had access. See Eva Frojmović, *Giotto's Allegories of Justice and the Commune in the Palazzo della Ragione in Padua: A Reconstruction*, 59 J. Warburg & Courtauld Inst. 24, 27–29 (1996).

**24** Gleadow at 15. As Rochberg explained at 126–127, the "zodiac is a beltway through the heavens through which the sun, moon, and planets may be seen to move. In a conception of the sky as a sphere, the zodiac is a circular belt bisected" by an ecliptic and further extending about 8 degrees north and south of it. "Nothing in the astronomical cuneiform texts suggests that the Babylonians thought in terms of a celestial sphere." Some constellations fell within the "zodiac belt" and were identified by Babylonian texts as in "the path of the moon." Id. at 127. Discussion of the zodiac can be found in texts dating from between 500 and 400 BCE. Id. at 130.

By the twentieth century, the term zodiac came to denote "a circle of twelve constellations, each of exactly thirty degrees extent, lying along the path of the sun, and by means of which the positions of the sun, moon, and planets can be measured." Gleadow at 16. The "tropical or moving zodiac" is measured from the tropics, whereas a "fixed or sidereal zodiac" is measured from fixed stars but moves forward by one day "every 72 years." Id. at 19. In Gleadow's view, the zodiac was first a method of measuring time and subsequently became a basis for "divination." Id. at 206.

**25** See generally William Ian Miller, Eye for an Eye (Cambridge, Eng.: Cambridge U. Press, 2006). For example, James Whitman noted that the Laws of Hammurabi on talionic maiming varied with social status and that the medieval Germanic Code of Alfred detailed payments in shillings for particular injuries; for instance, the loss of an eye cost "66 shillings, 6 pence and the third part of a penny as compensation." James Q. Whitman, *Ancient Rights and Wrongs: At the Origins of Law and the State; Supervision of Violence, Mutilation of Bodies, or Setting of Prices?* 71 Chicago-Kent Law Review 41, 48–50 (1995).

**26** See Bruno Kisch, Scales and Weights: A Historical Outline (New Haven, CT: Yale U. Press, 1965).

**27** Kisch at 77.

**28** Erik Hornung, Idea into Image: Essays on Ancient Egyptian Thought 136 (Elizabeth Bredeck, trans., New York, NY: Timken Publishers Inc., 1992) (hereinafter Hornung, Idea into Image). He described the "Sanskrit word rta" as coming "closest." Id.

**29** Geraldine Pinch, Egyptian Mythology: A Guide to the Gods, Goddesses, and Traditions of Ancient Egypt 159 (Oxford, Eng.: Oxford U. Press, 2002). Pinch also described Maat as a regenerative quality, relevant to the gods as well as to humans. What the terms mean, either for those who lived during the early Egyptian period or for modern scholars, remains in dispute. Some argue that ancient Egyptian practices, engaged with nature and the cosmos, would today be described as ascribing magical properties to the world. Others posit that Maat had philosophical and sociolegal dimensions, obliging individuals to behave in ways one would call moral or ethical. See Anna Mancini, Maat Revealed: Philosophy of Justice in Ancient Egypt (Paris, Fran.: Buenos Books International, 2004); Gary A. Stilwell, Conduct and Behavior as Determinants for the Afterlife: A Comparison of the Judgments of the Dead in Ancient Egypt and Ancient Greece (Ph.D. dissertation, Florida State U., Tallahassee, FL, 2000; UMI Publication No.: AAT 9980757).

**30** Pinch at 4, 7.

**31** Joyce Tyldesley, Judgement of the Pharaoh: Crime and Punishment in Ancient Egypt 18 (London, Eng.: Weidenfeld & Nicolson, 2000).

**32** Hornung, Idea into Image at 139. Maat is regularly contrasted with injustice and disorder. See Siegfried Morenz, Egyptian Religion, 110–136 (Ann E. Keep, trans., Ithaca, NY: Cornell U. Press, 1973). Her opposing god was Seth, representing disruption yet retaining some qualities that made him revered. See Tyldesley at 19.

**33** Erik Hornung, *Ancient Egyptian Religious Iconography*, in Civilizations of the Ancient Near East 1711, 1721–1725 (Jack M. Sasson, ed., Miriam Lichtheim, trans., New York, NY: Charles Scribner's Sons, 1995). As in other iconographical traditions, an attribute associated with one figure could also be connected to another. For example, in Egyptian imagery the feather also signified the air god Shu. Pinch at 160.

**34** Hornung, Idea into Image at 134.

**35** Figure 24, copyrighted by the Trustees of the British Museum, is reproduced with their permission. The papyrus from the Nedjmet *Book of the Dead* may have come from the Royal Cache at Deir el-Bahari, Egypt; it is dated around 1070 BCE, the time of the Twenty-First Dynasty. According to the British Museum, robbers were at the Deir el-Bahari site prior to its excavation by Egyptologists. The Prince of Wales (later Edward VII) apparently acquired the scroll around 1869 when he visited Egypt, and in 1903 he gave the papyrus to the British Museum. Parts of this scroll are in other museum collections. According to the museum, the scene shows Nedjmet (also spelled Nodjmet and Nodjnet) and Herihor, who was her husband and the "first prophet-priest of Amon-Re." He is said to have "usurped royal style and power at Thebes and initiated a line of Priest-Kings" in about 1100 BCE. The scene includes the "judgment" of Nedjmet, but "instead of her heart being represented in the pan of the balance against the image of the goddess Maat, there is a kneeling figure of the queen. Thoth, in the form of a baboon, is shown holding a scribe's palette, recording the verdict." T. S. Pattie & E. G. Turner, The Written Word on Papyrus 13 (London, Eng.: British Museum Publications, 1974) (catalogue for an exhibition held in the British Museum). Although this funeral papyrus was in Nedjmet's possession, Herihor is shown in the "primary place." Gay Robins, Reflections of Women in the New Kingdom: Ancient Egyptian Art from the British Museum 13 (Atlanta, GA: Michael C. Carlos Museum at Emory University, 1995). Questions of dynastic succession and women's roles have prompted additional efforts to identify these actors. See John H. Taylor, *Nodjmet, Payankh and Herihor: The End of the New Kingdom Reconsidered*, 82 Proceedings of the Seventh International Congress of Egyptologists 1143 (Leuven, Belg.: Peeters Publishers, 1998).

**36** In some texts Ra, Maat's father, is described as weighing Maat. See Maulana Karenga, Maat, The Moral Ideal in Ancient Egypt: A Study in Classical African Ethics 64 (New York, NY: Routledge, 2004).

**37** The title *Book of the Dead* is a "term coined in the nineteenth century for a body of texts known to the Ancient Egyptians as the Spells for Going Forth by Day." Pinch at 26. In Pinch's view, the oft-made comparison between that text and the Bible was "very inappropriate," because the *Book of the Dead* was not "the central holy book of Egyptian religion" but "just one of a series of manuals composed to assist the spirits of the elite dead to achieve and maintain a full afterlife." Id. The spells or formulas within varied; they were not "fixed" until sometime around 650 BCE. As Carol Andrews put it, the *Books of the Dead* provided a "repertoire" accompanied by illustrative vignettes. The earliest *Book of the Dead* papyri found date from about the fifteenth century BCE; earlier hieroglyphs from 2345 BCE include some of the same rituals or addresses. Introduction to The Ancient Egyptian Book of the Dead 11–12 (Carol Andrews, ed., Raymond O. Faulkner, trans., London, Eng.: British Museum Publications, 1972) (hereinafter Andrews's Book of the Dead). That volume includes many illustrations reproduced from the British Museum's collection of papyri.

Many such books were produced at the behest of wealthy families, and no authoritative version of any of the *Books of the Dead* exists. The practice of placing such writings with a person at death appears to have begun with "Pyramid Texts" made for kings and their families beginning around 2400 BCE. Subsequently, other persons wealthy enough to afford sarcophagi had "Coffin Texts" placed inside. *Books of the Dead* came thereafter, around 1550 BCE during the era of the New Kingdom. The amalgam of texts had a good deal of variation. Indeed, to speak of a "scriptural canon" is to mislead. *Pyramid Texts* were somewhat similar, but *Coffin Books* and *Book of the Dead* texts had "very little textual consistency" as well as "little uniformity in the order in which chapters appear on papyri." See Ogden Goelet Jr., *A Commentary on the Corpus of Literature and Tradition Which Constitutes the Book of Going Forth by Day*, in The Egyptian Book of the Dead, The Book of Going Forth by Day, Being the Papyrus of Ani, Royal Scribe of the Divine Offerings of All the Gods, Written and Illustrated circa 1250 BCE, at 139–141 (Raymond O. Faulkner & Dr. Ogden Goelet Jr., trans., San Francisco, CA: Chronicle Books, 1994) (hereinafter Faulkner and Goelet's Book of the Dead).

The illustrations in these books were likely drawn by "royal and aristocratic women who served as priestesses in the temples." Pinch at 30. These images have been reproduced repeatedly since the early nineteenth century, when, after Napoleon's invasion and the discovery of the Rosetta Stone, "the rage for collecting Egyptian antiquities" spread imagery from papyri and related objects around the world. Id. at 47. See also E. A. Wallis Budge, The Chapters of Coming Forth by Day: The Egyptian Text According to the Theban Recension in Hieroglyphic Edited from Numerous Papyri, with a Translation, Vocabulary, etc. (London, Eng.: Kegan Paul, Trench, Trübner, 1898). One of the many associations between Justitia and Maat can be found in Otto Rudolf Kissel, Die Justitia: Reflexionen über ein Symbol und Seine Darstellung in der Bildenden Kunst (Justitia: Reflections on a Symbol and Its Representation in Sculpture) 19–22 (Munich, Ger.: Beck, 1984).

**38** Andrews's Book of the Dead at 12. In later texts and illustrations related to death and the afterlife, the scales became less central. Christine Seeber, *Untersuchungen zur Darstellung des Totengerichts im Altern Äegypten* (*Examinations of the Representation of the Court of the Dead in Ancient Egypt*), 35 Münchner ägyptologische Studien 58–65 (Munich, Ger.: Deutscher Kunstverlag, 1976) (translation by Chavi Keeney Nana).

**39** An excerpt of this "Judgment," described in Spell 30b, is translated in Faulkner and Goelet's Book of the Dead, text accompanying plate 3:

> O my heart of my different ages! Do not stand up as a witness against me, do not be opposed to me in the tribunal, do not be hostile to me in the presence of the Keeper of the Balance . . . . Do not tell lies about me in the presence of the god; . . . .
>
> Thus say Thoth, judge of truth, . . . : Hear this word of very truth. I have judged the heart of the deceased, and his soul stands as a witness for him. His deeds are righteous in the great balance, and no sin has been found in him.

**40** Pinch at 27. For example, one judgment scene described the balance as "that balance of Ra in which he weighs Maat." The balance was sometimes called the "Scales of Maat." The god Anubis has also been described as the "Master of the Balance." Further, Thoth, the "Lord of Just Measure," was said to have recorded the results. See Karenga at 139, 140–161 (providing translations and commentary on scenes and judgment processes). In other iterations, the gods Ra (or Re) and Osiris dominate. In addition to Spell 30b, a second, Spell

125 ("The Declaration of Innocence Before the Gods of the Tribunal") provided a "formula" for "descending to the great hall of the Double Maat." Once deceased, a person would face a "jury of gods and goddesses and declare himself or herself innocent of forty-two specific sins." PINCH at 27. Pinch also described (and provided in her figure 7) a "vignette to Spell 125" of the *Book of the Dead* that shows Maat bringing in a dead woman, weighed by "Horus and Anubis," with the result recorded by Thoth." Further, if, like Ra, the dead person had Maat in his or her heart, the scales would balance and the deceased would be declared "true of voice" or "justified." Id. at 160.

Thoth was the "god of wisdom and secret knowledge who invented writing and the different languages of humanity." Understood as having great insight, Thoth is sometimes shown as an ibis-headed man holding out the wedjat (also spelled wadjet or wadjit and referring to a representation of a human-looking eye, often outlined and sometimes blue), that in turn could be interpreted to be the Eye of Ra. Id. at 209. According to Hornung, forty-two judges of the dead, as well as Osiris, are addressed in Spell 125. Hornung, *Ancient Egyptian Religious Iconography* at 172ff. A translation of the version of Spell 125 as it appeared in the Papyrus of Ani is provided in FAULKNER AND GOELET'S BOOK OF THE DEAD at 80–81, plate 31 and accompanying text.

**41** HORNUNG, IDEA INTO IMAGE at 140. However, unlike the chaos attributed to Egyptian cosmology, the Mesopotamian cosmos had an "orderliness . . . manifest in the reciprocity of heaven and earth and further conceived of in terms of the rule of regions by designated deities." ROCHBERG, THE HEAVENLY WRITING at 198.

**42** See generally S. G. F. BRANDON, THE JUDGMENT OF THE DEAD: AN HISTORICAL AND COMPARATIVE STUDY OF THE IDEA OF A POST-MORTEM JUDGMENT IN THE MAJOR RELIGIONS (London, Eng.: Weidenfeld & Nicolson, 1967). As noted, Western scholars have sometimes equated Egyptian myths and texts with those of more recent religions but, unlike the Old Testament, the New Testament, and the Koran, no central repository of various Egyptian practices existed. PINCH at 4, 7.

**43** William Stevenson Smith, *The Relationship between Egyptian Ideas and Old Testament Thought*, 19 J. OF BIBLE AND RELIGION 12, 13 (1951). Further, Brandon argued that by the Greco-Roman period, "[g]ood or bad, rich or poor, king or peasant, all alike shared this shadowy consciousnessless existence in the realm of the dead, over which ruled Pluto and his queen Persephone." BRANDON at 81. Jewish traditions also spoke of a shadowy world, she'ol, where the dead resided.

**44** Several translations of both the Old and New Testaments, the Koran, and Apocrypha literature are now online, thereby permitting word searches for scales, balance (also spelled "baulance" in Middle English), and the like. In addition to finding many references to judgments about individuals, we also located many references to weights as important to commercial transactions because honest assessments of value are central obligations in many religious traditions. Further, because databases can be searched by time period, one can trace the changing usage of terms in English. For example, the word "balance" was often used in earlier periods, and the term "scales" came to be used more frequently in later periods. For the biblical quotations we used an English database at Yale, found at Jeeves Library, http://jeeves.library.yale.edu/bie, which includes many versions of the Old and New Testaments, such as THE NEW ENGLISH BIBLE WITH THE APOCRYPHA (Charles Harold Dodd, ed., Oxford & Cambridge, Eng.: Oxford & Cambridge U. Presses, 1970) (hereinafter NEW ENGLISH BIBLE); THE TWENTIETH CENTURY NEW TESTAMENT: A TRANSLATION INTO MODERN ENGLISH, MADE FROM THE ORIGINAL GREEK (New York, NY: Fleming H. Revell, 1902, revised 1904), and a version often called the "common language bible," officially THE GOOD NEWS BIBLE WITH DEUTEROCANONICALS/APOCRYPHA, TODAY'S ENGLISH VERSION (Robert G. Bratcher, trans., New York, NY: American Bible Society, 1976). For the Koran, an electronic English version, THE HOLY QUR'AN (M. H. Shakir, trans., New York, NY: Tahrike Tarsile Qur'an,

1983), is available online through the University of Michigan at http://www.hti.umich.edu/k/koran.

**45** *Job* 31:6, in the Old Testament, from NEW ENGLISH BIBLE. Another translation is "Let me be weighed in an even balance, that God may know mine integrity." See David Daube, *The Scales of Justice*, 63 JURID. REV. 109, 116–117 (1951).

**46** *Psalm* 11:5, NEW ENGLISH BIBLE. See also Mary Phillips Perry, *On the Psychostasis in Christian Art—Part I and Part II*, 22 BURLINGTON MAGAZINE 94–97, 100–105 (Nov. 1912) and 208–211, 214–218 (Jan. 1913) (hereinafter Perry, *On the Psychostasis I/II*).

**47** *The Prophets* 21.47, THE HOLY QUR'AN.

**48** HOMER, THE ILIAD, ch. xxii at 284 (George Chapman, trans. With an Introduction by Henry Morley, London, Eng.: George Routledge & Sons, Ltd. 5th ed. 1895). In a more recent translation by Robert Fitzgerald, relevant portions of text read: "the Father poised his golden scales. He placed two shapes of death, death prone and cold, upon them, one of Akhilleus, one of the horseman, Hektor . . . . Down sank Hektor's fatal day, the pan went down toward undergloom . . . ." HOMER, THE ILIAD, ch. xxii 526, lines 246–252 (Robert Fitzgerald, trans., Introduction by Andrew Ford, New York, NY: Farrar, Straus & Giroux, 2004). See generally Frank Harper Moore, *Astraea, the Scorpion, and the Heavenly Scales*, 38 ENGLISH LITERARY HISTORY (1971) (discussing Homer's use in *The Iliad* of the "golden scales" to weigh the destinies of the Trojans and the Greeks and Milton's invocation of weighing in *Paradise Lost*).

**49** BRANDON at 7–8. He relied on Egyptian "Wisdom Literature" that was supplemental to the "Pyramid Texts" to identify a concept of justice that referred both to rightful behavior during life and to assessments of a person's behavior after death. Id. at 18–20. Brandon described a two-stage "process of judgment," a first in which accusations are made and a second for assessment, based on one's deeds. Id. at 21.

**50** TYLDESLEY, for example, at 168, used the "general list of offenses compiled" for the dead as a source of insight into unacceptable behavior in Egypt. Hornung also described the relevance of individual good deeds, such as providing for the needy and the poor. HORNUNG, IMAGE AND IDEA at 141. Further, Karenga argued that the "idea of everyone being subjected to judgment" was "central to Maatian ethics." KARENGA at 163. Stilwell concluded that a consequential morality existed in both Egypt and Greece and that the relevance of moral character to a judgment made at death served to gain compliance with customary rules that maintained social order. In contrast, Seeber observed that because the scales are generally shown to be level, that evenness indicated the role played by Fate, providing magical help to the dead. Seeber at 69–70.

Moreover, disputes exist about whether "ritual magic" could absolve individuals of misdeeds or that a "moral" assessment was made. BRANDON at 22–23. Brandon read the relevant texts to include the concept that the "inequities" of this world were to be "adjusted" in the next. Id. at 26. In his view, the *Book of the Dead* included conflicting traditions, with Chapter (or Spell) 30 providing a vision of a "divine tribunal" giving judgment based on hearing statements and assessments. Chapter 125 suggested that upon recitals of two "Declarations of Innocence" addressed to forty-two deities ("demonic beings who executed the wicked"), a kind of formulaic release took place. Id. at 26–36. Brandon suggested that a deceased person might first have declared innocence of a long list of offenses, set forth in Chapter 125, and thereafter, that person's heart was weighed against the feather representing Maat "to test its truthfulness." Id. at 40. Thus, ritual magic was not enough, for "the moral quality of one's life on earth" was central to a "happy after-life." Id. at 41.

A parallel discussion questions whether scenes of assessment in Greek literature and art depict evaluations of personal behavior or illustrate the work of fate. One such scene is on a Greek vase, dated from about the sixth century BCE, described by Perry in *On the Psy-*

*chostasis I* at 96, as portraying Hermes with a balance that has, on each of the scales, "a small winged figure, the fate of the combatant." See also Brandon at 91, 76–79, and fig. 5. A caveat is in order about the idea of attributing "magical thinking" to "ancients." Attitudes nested in myths and magic do not necessarily preclude analogic reasoning; we have much yet to understand about what inferences to draw from identifying beliefs as "magical." See Rochberg, The Heavenly Writing at 177–180.

**51** See Jan Assmann, Ma'at: Gerechtigkeit und Unsterblichkeit im Alten Ägypten (Ma'at: Justice and Immortality in Ancient Egypt) (Munich, Ger.: Verlag C. H. Beck, 1990). Assmann read the actual judgment to come at the end of examinations at each of twenty-one gates, where the dead had to prove the right to pass on to enter an afterlife where Maat reigned. The test determined whether one had lived one's life according to Maat. Id. at 135–139 (translation by Chavi Keeney Nana).

**52** Mancini, for example, argued that the symbolic representation in the *Book of the Dead* has been misread. In her view, the picture shows not a process of decisionmaking (weighing and balancing) but rather the "balance obtained through the right circulation of Maat through the heart." These scenes depict the balance of "cosmic energy" in lieu of the moment of judgment. Id. at 59–61. Under this interpretation, "Maat is not justice, but justice consists of letting Maat flow correctly." Id. at 82. For a discussion of Babylonian conceptions of fate, see Rochberg, The Heavenly Writing at 50–52; there Rochberg quoted a prayer addressed to Shamash ("king of heaven and earth, judge of the things above and below, light of the gods") to prevent "anything bad from happening" as a result of an ominous omen.

**53** Hornung, Image into Idea at 140–141; Tyldesley at 3–32.

**54** Tyldesley at 23. She detailed pharonic rules, including a prohibition on rebellion, edicts against thefts, and enforcement of obligations to pay taxes, as well as delegation of authority to deputies who decided disputes. Id. at 16–23, 164–175.

**55** Several scholars have explored their roles. See, for example, Jane Ellen Harrison, Epilegomena to the Study of Greek Religions and Themis: A Study of the Social Origins of Greek Religion (New Hyde Park, NY: University Books, 1962) (reprint of the 1921 and 1927 editions of the two volumes); Hugh Lloyd-Jones, The Justice of Zeus (Berkeley, CA: U. of California Press, 1971); J. Walter Jones, The Law and Legal Theory of the Greeks (Oxford, Eng.: Clarendon Press, 1956); Helen North, From Myth to Icon: Reflections of Greek Ethical Doctrine in Literature and Art (Ithaca, NY: Cornell U. Press, 1979) (hereinafter North, From Myth to Icon); Emma Stafford, Worshipping Virtues: Personification and the Divine in Ancient Greece (London, Eng.: Gerald Duckworth & Classical Press of Wales, 2000). Greek myths have provided a central source for the "European tradition of personifying features of physical nature and of the human psyche, including the moral qualities (the Virtues)." See Dougal Blyth & Tom Stevenson, *Personification in Greek Literature and Art*, in Under the Aegis, The Virtues 117 (Peter Shand, ed., Auckland, New Zeal.: Fortuna Press, 1997).

**56** See Cathleen Burnett, *Justice: Myth and Symbol*, 11 Legal Studies Forum 79, 79–80 (1987) (summarizing other sources).

**57** Harrison at 480–482.

**58** Harrison at 494.

**59** Harrison at 484–488.

**60** Harrison at 477, 521.

**61** Synnøve des Bouvrie, *Book Review of Thémis et les Horai: Recherche sur les divinités grecques de la justice et de la paix*, 43 History of Religions 157, 158 (2003). Hanfmann cited Hesiod as the source of the reinterpretation of the "horae" (denoting for the Greeks either seasons or female powers and spirits) as the daughters of Zeus and of Themis—with the first, Eunomia, representing Good Government; the second, Dikê, Righteousness; and the third, Eirene, Peace. Hanfmann, The Season Sarcophagus at 78, 84. Hanfmann

described their individual importance as greater than their effects as a "triadic combination." Id. In *The Faerie Queene* by Spenser, the three are described as "Just Dice, wise Eunomie, myld Eirene." See Jane Aptekar, Icons of Justice: Iconography and Thematic Imagery in Book V of "the Faerie Queene" 18 (New York, NY: Columbia U. Press, 1969).

**62** Burnett at 81 (summarizing several sources).

**63** Boccaccio identified Astraea as "born of Aurora, because just as the dawn goes before the brightness of the sun, so from the knowledge of things done does justice arise." See Liana de Girolami Cheney, *Giorgio Vasari's "Astraea": A Symbol of Justice*, 19 Visual Resources 283 (2003). In mythical accounts (from Hesiod and others), Astraea/Justice was the last of the gods to leave heaven as the golden age (the world before the fall of man) declined; the time of Astraea's return was said to have been the era in which Christ had likewise returned "as Judge." Id. at 354. See Frank Harper Moore at 353–355. Moore related this myth to Spenser's *The Faerie Queene*, in which Astraea was identified as the constellation Virgo and relied on Libra as "her righteous balance." Id. at 354. In 1599, Sir John Davies dedicated a poem to Queen Elizabeth I. Its title was *Astraea*, and its text read: "By Love she rules more than by Law / Even her great mercy breadth awe; / This is her sword and scepter." Quoted by Aptekar at 20. As Aptekar further explained, Spenser opened "his lesson of Justice" by deploying "the figure of the Dread Soverayne Goddesse (Queen Elizabeth) sitting in judgment." He linked monarchy and justice, although it was his Queen Mercilla to whom he attributed gracious and "merciful justice." Id. at 15, 20.

**64** Harrison, at 483, pointed to the link between the Greek word *"themis"* and the English word "doom" and argued that both entail a sense of fixed judgment. In Stafford's view, the "literary and iconographical record" suggested that Themis had a "firmly established position amongst the Olympian gods, but only a minor role." Stafford at 49.

**65** See Lloyd-Jones at 166, n. 23 (discussing the etymology of dikê and themis and analyzing dikê's seven mentions in *The Iliad*). Harrison, at 520–523, also argued that Dikê has aspects of vengeance, while Theodore Ziolkowski translated *Dikê* as "blood vengeance." See Theodore Ziolkowski, *The Figure of Justice in Western Literature and Art*, 75 Inmunkwahak: The Journal of Humanities 197, 200 (Seoul, Kor.: Institute of the Humanities, Yonsei University, 1996) (hereinafter Ziolkowski, *The Figure of Justice*). Our thanks to the author for providing us with an English copy. See also Theodore Ziolkowski, The Mirror of Justice: Literary Reflections of Legal Crises (Princeton, NJ: Princeton U. Press, 1997).

**66** See, for example, Edward Goldsmith, *Archaic Societies and Cosmic Order—A Summary*, 30 The Ecologist 15, 15 (Jan.–Feb. 2000), translating Pythagoras as stating: "Themis in the world of Zeus, and Dikê in the world below, hold the same place and rank as Nomos in the cities of men; so that he who does not justly perform his appointed duty may appear as a violator of the whole order of the universe." See also Lloyd-Jones at 161–162 (describing dikê as "the order of the universe"); Barry Sandywell, *Presocratic Reflexivity: The Construction of Philosophical Discourse c. 600–450 BC*, in 3 Logological Investigations 59–61 (London, Eng.: Routledge 1996); Jean Rudhardt, Thémis et les Horai: Recherche sur les divinités grecques de la justice et de la paix (Themis and the Horai: An Investigation into the Greek Goddesses of Justice and Peace) (Geneva, Switz.: Librarie Droz, 1999). Rudhardt, at 156, warned against attributing current ideas to Greek understandings that situated these figures as ethical, religious presences: "Themis est une exigence d'équilibre qui surgit dans les esprits," roughly translated as "Themis is a demand for equilibrium emergent in one's spirit."

**67** See Sandywell at 60 and 404, n. 14. For this understanding he relied on the etymological work of Emile Benveniste, who examined the origins of the words themis and dikê in his book Indo-European

LANGUAGE AND SOCIETY 379–388 (Elizabeth Palmer, trans., London, Eng.: Faber & Faber, 1973).

**68** MAX WEBER, ECONOMY AND SOCIETY: AN OUTLINE OF INTERPRETIVE SOCIOLOGY, vol. 1, 430–431 (Guenther Roth & Claus Wittich, eds., Berkeley, CA: U. of California Press, 1978).

**69** A keen sense of new "old" information, as well as of what remains to be known, permeates Michael McCormick's ORIGINS OF THE EUROPEAN ECONOMY: COMMUNICATIONS AND COMMERCE, A.D. 300–900 (Cambridge, Eng.: Cambridge U. Press, 2001). For example, "Some 200 foreign relics, over 100 documentary mentions of mancosi, more than 500 Arab coins and 250 Byzantine coins have expanded, dramatically, the evidence which bears on the great question of Mediterranean communications at the origins of Europe." Id. at 385.

**70** The question of the meaning of justice in the context of the Greeks is debated. For example, Michael Gagarin argued that discussions of dikê were focused less on the development of a theory of morality and justice and more on the creation of a functioning social order, with "effective legal process" as a prerequisite to commercial prosperity. See Michael Gagarin, *Dikê in the Works and Days*, 68 CLASSICAL PHILOLOGY 81, 81 (1973) (hereinafter Gagarin, *Dikê in the Works and Days*). See also Michael Gagarin, *Dikê in Archaic Greek Thought*, 69 CLASSICAL PHILOLOGY 186 (1974). Others disagree. See Matthew W. Dickie, *Dikê as a Moral Term in Homer and Hesiod*, 73 CLASSICAL PHILOLOGY 91 (1978).

A more variable set of meanings is ascribed to dikê in ERIC A. HAVELOCK, THE GREEK CONCEPT OF JUSTICE: FROM ITS SHADOW IN HOMER TO ITS SUBSTANCE IN PLATO 179–232 (Cambridge, MA: Harvard U. Press, 1978). Havelock detailed different meanings of dikê in Homer—that dikê encompassed "propriety" (id. at 179), an attribute of a person (id. at 184), and a sense of process to permit "redress of grievance and the adjustment of claims" (id. at 191). Havelock argued that for Hesiod the focus was on consequences and "redress, readjustment, repayment." Id. at 216. Havelock viewed the justice of both Homer and Hesiod as different from that assumed to be part of the modern concept. On the other hand, contemporary philosophers have seen the tensions between law as order and law as justice as rooted in Greek traditions. See David Luban, *Some Greek Trials: Order and Justice in Homer, Hesiod, Aeschylus and Plato*, 54 TENN. L. REV. 279 (1987).

**71** BENVENISTE at 389. The term *themis* was used for divine law. *Ius*, in turn, derives from the verb *iurare*, meaning "to swear." Id. Further, the Indo-European word *yous* meant "state of regularity, of the normality required by the rules of ritual." Id. at 390–391.

**72** See Barbara Lichocka, *Justitia sur les monnaies impériales romaines* (*Justitia in Imperial Roman Coinage*), 15 TRAVAUX DU CENTRE D'ARCHÉOLOGIE MÉDITÉRRANÉENNE DE L'ACADÉMIE POLONAISE DES SCIENCES 75–86 (Warsaw, Pol.: Pañstwowe Wydawnictwo Naukowe, 1974). Lichocka argued that various statues of other Virtues, such as Abundance and Fortune, provided prototypes. Id. at 62–72. Ziolkowski, in contrast, believed no cult or temple in her honor was maintained. Ziolkowski, *The Figure of Justice* at 201.

**73** Ziolkowski, *The Figure of Justice* at 201.

**74** During the Republican era, Justice images were not much used but in the Imperial period, various leaders of government and particularly emperors linked themselves to Justitia. Lichocka at 11. This connection parallels the views of Slanski about the relationship between "palace and temple" in which Mesopotamian Kings sought validation through the judge/god Shamash. See Slanski, *Rod and Ring*. Emperors also embraced other Virtues. For example, when becoming Emperor Augustus, Octavian proclaimed that he embodied courage, piety, clemency, and justice and put personifications of Fortune, Peace, and other virtues on coins. Lichocka at 15–17. In 13 CE, he established a festival day in honor of Justitia. Ziolkowski, *The Figure of Justice* at 201.

**75** Lichocka at 21–22 (listing the set). She distinguished six major types, including a portrait of the head of a woman; a woman draped in cloth sitting on a throne or chair and holding an object like a scepter; a similarly positioned woman holding a cornucopia; a personage Lichocka identified as Aequitas shown as a matronly woman standing with a balance and either a scepter or a cornucopia; two capricorns with the image of the universe; and a woman or emperor propped up by or seated on an upright shield and holding a scepter in one hand and perhaps a goblet in the other. Id. at 24–74. Ziolkowski argued that some figures identified as Justitia are "her counterpart, Aequitas." Ziolkowski, *The Figure of Justice* at 201. However, at least some of the figures that Lichocka identified as "Aequitas" appear on coins that bear the label "Justitia." See Lichocka at 74 (providing a photograph of one such coin).

**76** See Judith Shaw, Images of Justice in Medieval Art 8 (paper submitted to Professor Robert M. Cover for his seminar, Myth, Law, and History, Yale Law School, April 10, 1980). The cornucopia imagery may come from a Herculean myth in which Hercules fought the river god Achelous, who in the course of battle changed himself into a bull. Hercules prevailed and broke off one of the bull's horns, which he presented to the beautiful Deianira, over whom the fight had taken place. The bull's horn "of plenty" has since become a symbol of fertility and generosity. As described by Ovid:

> This horn, now heaped
> With fruits delicious and sweet-smelling flowers
> The Naiads have held sacred from that hour
> Devoted to the bounteous goddess Plenty . . .
> A lovely nymph . . . brought to them
> All Autumn's plenty in an ample horn . . .

See OVID, METAMORPHOSES, sect. III, vol. II, book 9:1, *Hercules and Achelous* at 871, 874–875 (Brookes More, trans., Francestown, NH: Marshall Jones, rev. ed. 1978).

**77** The word "fasces" comes from the Latin *fas*, a counterpart of *ius*. A government's potential to use legal regulation for oppression is reflected in the modern-day word fascism. The actual objects were, in the Roman era, "a portable kit for flogging and decapitation" that were also "brutally functional," serving as "ceremonial symbols of office [that] also carried the potential of violent repression and execution." See Anthony J. Marshall, *Symbols and Showmanship in Roman Public Life: The Fasces*, 38 PHOENIX 120, 130 (1984). Made of birch or elmwood, these rods measured about a meter and a half and, at times, had axes bundled with them. The bundle could be interpreted to denote the strength that only such a collection, exemplifying unified powers, could provide. Marshall argued that the seriousness of the display of fasces in Roman ceremonial pageantry has been obscured; the many customs involving fasces (such as parades, monthly rotations, and their ceremonial laying down when office terms ended) as well as the occasional smashing of a magistrate's fasces by a mob made plain that fasces expressed very real authority. Id. at 131–137. Marshall also traced the rejection and then the reappearance of fasces under Christianity—first disliked as Caesar's emblem and then again associated with executive power.

Fasces continued long after those eras to be emblems of government; they can be found as decorative items on the Lincoln Memorial in the United States and on Queen Victoria's statue outside the Supreme Court of Canada in Ottawa. Id. at 140. Throughout the Renaissance, some artists depicted Justice holding fasces. See, for example, Battista de Lutero Dossi, *Justice with Fasces and Scales* (1544), reproduced in KISSEL at 13, plate 4. An eighteenth-century edition of Ripa's *Iconologia* put lictor rods with Justice as well as with other personifications. Lictor rods were explained to be an attribute of a special class of guards (Roman Lictors) who attended the magistrates and

carried rods decorated with fasces. See CESARE RIPA, BAROQUE AND ROCOCO PICTORIAL IMAGERY: THE 1758–1760 HERTEL EDITION OF RIPA'S "ICONOLOGIA" WITH 200 ENGRAVED ILLUSTRATIONS (New York, NY: Dover Publications, 1971). Shown with lictor rods are Justice at 120; Aristocracy at 63; Government at 200; Punishment at 60; State Craft at 199; Spiritual Authority at 177; and Victory at 78. That edition built on the eighteenth-century one by Johann George Hertel through an introduction, translations, and 200 commentaries by Edward A. Maser. The nineteenth-century *Justice* in front of the Palais de Justice in Paris, France, has both an urn (to collect juries' ballots) and lictor rods. See, TAYLOR, THE PALAIS DE JUSTICE at xix, fig. 4.

**78** Lichocka at 124. Coins remained a principal source of popular imagery and "important vehicles of propaganda" through the Middle Ages. COLETTE BEAUNE, THE BIRTH OF AN IDEOLOGY: MYTHS AND SYMBOLS OF NATION IN LATE-MEDIEVAL FRANCE 320–31 (Fredric L. Cheyette, ed., Susan Ross Huston, trans., Berkeley, CA: U. of California Press, 1991).

**79** NORTH, FROM MYTH TO ICON at 178, n. 3. North cited the images of Dikê on coins, with attributes of "scales, scepter or cornucopia." See also Lichocka at 51 (reproducing one such image). North, at 184, noted that coins from around 27 BCE provided various personified Virtues, including Clementia, Virtus, Iustitia, and Pietus. In Lichocka's volume, many coins show a clear-eyed woman.

**80** STAFFORD at 14.

**81** NORTH, FROM MYTH TO ICON at 178 n. 3.

**82** Ziolkowski, *The Figure of Justice* at 199.

**83** Michael Evans, *Two Sources for Maimed Justice*, 11 SOURCE: NOTES IN THE HISTORY OF ART 12 (1982).

**84** See ADOLF KATZENELLENBOGEN: ALLEGORIES OF THE VIRTUES AND VICES IN MEDIEVAL ART 28 (Alan J. P. Crick, trans., New York, NY: W. W. Norton, 1964) (reprint of a 1939 monograph published by the Warburg Institute; describing a dome fresco in El Bagawat).

**85** See Perry, *On the Psychostasis II* at 208. See also RICHARD F. JOHNSON, SAINT MICHAEL THE ARCHANGEL IN MEDIEVAL ENGLISH LEGEND (Woodbridge, Eng.: Boydell Press, 2005); Katherine Allen Smith, Footprints in Stone: Saint Michael the Archangel as a Medieval Saint, 1000–1500 (Ph.D. dissertation, Department of History, New York U., New York, NY, 2004; UMI Publication No.: AAT 3127497) (hereinafter Smith, Footprints in Stone); Leif Tengström, *Arkkienkeli Mikael taivaallisen ja maallisen oikeuden henkilöitymä* (*Archangel Michael as a personification of heavenly and earthly justice*) in OIKEUDEN KUVA. BILDEN AV RÄTTEN OCH RÄTTVISAN 51–56 (Harju Virpi, ed., Helsinki, Fin.: Riksdagsbiblioteket, 2007) (translations by Kirsti Langbein); LÉON LECESTRE, SAINT MICHAEL (Paris, Fran.: Henrie Laurens, 1921); ANNA JAMESON, SACRED AND LEGENDARY ART, vol. 1, 87–111 (London, Eng.: Longmans, Green, 1905); CLARA ERSKINE CLEMENT, ANGELS IN ART 46–81 (Boston, MA: L. C. Page, 1898).

One inventory of St. Michael's activities described his four "offices"—the first "to do battle against Satan and his minions"; a second to serve as the "untiring champion of God's chosen people" (the Jews of the Old Testament and then the "Christians of the New"); a third to "protect the souls of the faithful," at death in particular; and a "fourth office . . . to call away men's souls from their earthly life and bring them to judgment." Richard F. Johnson, *Archangel in the Margins: St. Michael in the Homilies of Cambridge, Corpus Christi College*, 53 TRADITIO: STUDIES IN ANCIENT AND MEDIEVAL HISTORY, THOUGHT, AND RELIGION 63, 64 (1998) (hereinafter Johnson, *Archangel in the Margins*). JAMESON, at 109–111, detailed early Christianity's assignment of Michael as the conduit of information between God and Moses. Emile Mâle explained the focus on St. Michael as fueled by the Church, "[a]nxious to divert to St. Michael the worship which the still pagan inhabitants of Roman Gaul paid to Mercury." Therefore, the "Church early endowed the archangel with almost all the attributes of God." EMILE MÂLE, L'ART RELIGIEUX DU 12E SIÈCLE EN FRANCE (RELI-GIOUS ART OF THE 12TH CENTURY IN FRANCE) 378 (Paris, Fran.: Armand Colin, 4th ed., 1940).

**86** BRANDON at 45. Brandon further argued that Egyptian imagery demonstrated a "belief in a judgment after death" that was then adapted by other religious systems.

**87** The Hebrew word *Mi-Cha-el* can be translated as "like unto God" or "who is like God?" In the Old Testament, Michael is described as the prince who "guards your people." *Daniel* 12:1, GOOD NEWS BIBLE. A list of the references to Michael in the Old Testament can be found in JOHNSON, Appendix B at 121–129.

**88** See Glenn Alan Peers, The Iconography of the Archangel Michael on Byzantine Icons (Ph.D. dissertation, Department of Art History, McGill University, Montreal, Can., 1986; UMI Publication No.: ATT ML3 8148).

**89** Then war broke out in heaven. Michael and his angels
        waged war on the dragon:
     The dragon and his angels fought, but they had not
        the strength to win, and no foothold was left them
        in heaven.
     So the great dragon was thrown down, that serpent of
        old that led the whole world astray, whose name is
        Satan, or the Devil-thrown down to the earth, and
        his angels with him.

*Revelation of John* 12:7–9, NEW ENGLISH BIBLE.

**90** See BEAUNE at 169: "St. Michael was soon considered the guardian angel par excellence, the most powerful intercessor at the moment of death—when he would shelter and protect the soul—and at the Last Judgment." Attention to Michael stemmed from a belief in Medieval Christianity that angels were present at the moment of death, when the soul separated from the body. DAVID KECK, ANGELS AND ANGELOLOGY IN THE MIDDLE AGES 203–204 (Oxford, Eng.: Oxford U. Press, 1998) (hereinafter KECK, ANGELS AND ANGELOLOGY). Angels then bore the "elect to heavenly bliss." Id. at 204.

**91** KECK, ANGELS AND ANGELOLOGY at 36.

**92** JAMESON at 112–113. See also Johnson, *Archangel at the Margins* at 72–74 (describing various treatments of St. Michael's protection of Mary's soul).

**93** BEAUNE at 152–171. Beaune credited Charles VII with transforming Michael into a "royal and national saint by publicly choosing him as his protector." Id. at 158. Joan of Arc prayed to him, and in 1469 Louis XI instituted a royal order dedicated to him. Id. at 159–161. Michael served as the "guardian of France" in its conflicts with England, which was sometimes portrayed as aligned with Lucifer. Id. at 180. Beune's account of the relationship between St. Michael and the French king mirrors that provided by Slanski of the relationship of the "temple and palace" to Shamash and the kings in Mesopotamia.

France was not alone in its adoration of Michael. Other shrines were in Monte Gargano, Italy, and in Cornwall, England. Adherents are said to have believed that St. Michael appeared in various places to command the building of churches at those spots. CLEMENT at 77–78. The monuments varied, for the persona of the Archangel filled different roles in response to a particular community's needs. Smith, Footprints in Stone at 5–10. Beyond any one locality, the yearly Christian calendar recognized St. Michael's importance; on September 29, "clerics all across Christendom delivered sermons and offered prayers to Michael" as part of the Feast of St. Michael ("Michaelmas"). Smith, Footprints in Stone at 3–4, 179–180. The cult of St. Michael was particulary intense between 950 and 1050, a period in which interest in the Apocalypse was particularly strong. KECK, ANGELS AND ANGELOLOGY at 45.

**94** See L'ABBÉ A. BOUILLET, LE JUGEMENT DERNIER DANS L'ART AUX DOUZE PREMIERS SIÈCLES (THE LAST JUDGMENT IN ART FROM THE FIRST DOZEN CENTURIES) 56 (Paris, Fran.: J. Mersch, 1894) (describing a parchment at the Vatican's library that dates from the seventh or

eighth century CE and shows St. Michael wearing armor amidst the battles of Joshua). Medieval cameos also depicted St. Michael, including those identified as either Byzantine or Italian from between 1100 and 1400. St. Michael can be found in later cameos as well, including a French seventeenth-century shell cameo. See James David Draper, *Cameo Appearances*, 65 Metropolitan Museum of Art Bulletin 17 and fig. 27, 51 and fig. 111 (2008).

**95** See Roland Mushat Frye, *Milton's "Paradise Lost" and the Visual Arts*, 120 Proceedings of the American Philosophical Society 233, 235–239 (1976). Frye traced the warrior images from sixth century mosaics of Jesus. He is "clad in military costume . . . standing on a lion and a serpent, symbol of Satan and sin." Renaissance depictions provided dramatic renditions of heavenly wars in which Michael gained armor. Frye's thesis was that John Milton's descriptions relied "pervasively upon visual representations," making knowledge of such images requisite to appreciating Milton's "epic imagery." Id. at 233.

**96** A gilded statue, *St. Michael Slaying Dragon*, is on top of the Town Hall of Brussels. The 1996 version replaced one from 1455, which had endured for 541 years, including the destruction of other parts of the building by the French in 1695. See "Brussels: Buildings and Monuments," Town Hall of the Grand Place, http://www.trabel .com/brussel/brussels-town_hall.htm. The original statue, by Martin van Rode, was five meters high, made of brass, and sat atop a spire measuring ninety-six meters. See Martine Calomme-Beginne, Illustrated Catalogue of the Town Hall (Patricia Robins, trans., Brussels, Belg.: Archives de la Ville de Bruxelles, 1980).

**97** Luther Link, The Devil: A Mask without a Face 116, figs. 42 and 43 (London, Eng.: Reaktion Books, 1995). Link described a tenth-century Irish cross monument as providing the "earliest surviving Weighing of Souls." Id.

**98** See Smith, Footprints in Stone at 26, n. 37; Johnson, *Archangel at the Margins* at 88–90. The seventh-century Christian practices of Egypt focused on St. Michael as an intercessor "on behalf of mankind before the Lord." Id. at 88. Some Greek texts may have provided a means for the information to travel north and west. Id. at 89–91. Beaune also concluded that veneration began in Byzantium and that the "cult was at first confined to the Celtic fringe and Italian Lombardy." Beaune at 153.

**99** The text reads: "We know that the man we once were has been crucified with Christ for the destruction of the sinful self, so that we may no longer be the slaves of sin, since a dead man is no longer answerable for his sin." The *Letter of Paul to the Romans* 6:6, New English Bible. In 325 CE, a council at Nicaea endorsed what is called the (first) Nicene Creed, committed to the divinity of Jesus as well as that of his Father. Brandon at 98. A second "Nicene Creed" of 381 CE varied somewhat, speaking of Jesus, who "for our salvation, came down from heaven," and reaffirmed belief in the one Church, the "one baptism for the remission of sins," the resurrection of the dead, and the "life of the world to come." Philip Schaff, The Creeds of Christendom, with a History and Critical Notes, vol. 1, 28 (New York, NY: Harper & Brothers, 1877). One interpretation was that, by positing Jesus as the Messianic savior and baptism as salvation, individuals were rendered "immune to sin." Brandon at 98–107.

**100** Brandon at 108.

**101** Link explained: "You will not find anything in the Scriptures about the Weighing of the Souls." Link at 115. See also Brandon at 118.

**102** Brandon at 122.

**103** Perry, *On the Psychostasis I* at 104 and n. 46. Peers translated the passage from St. Augustine of Hippo, who wrote in the fourth century CE, as "There will be, without a doubt, a balancing of accounts for good and evil just as each of these that are to be separated will be placed on the plates of the scale, and by the motion it turns the deeds shall take one to hell. If their good deeds are truly greater, they will prevail and out-weigh the bad and they shall decree his deeds in the realm of the living even at the very mouth of hell." Peers at 70, n. 69. The oft-cited example is a Last Judgment scene in a sixth-century mosaic in S. Appolinare Nuovo, Ravenna, in which Christ is shown "Separating the Sheep from the Goats," said to indicate the time of judgment. See Frye at 235, fig. 1; Link at 109–110.

**104** See Perry, *On the Psychostasis I* at 100–101, and fig. F (describing church tympana showing scenes of the weighing of souls, including those from the Autun and Bourges Cathedrals); Smith, Footprints in Stone at 160 and n. 296 (noting the earliest "known Continental example" to be from a late tenth-century cloister in La Dauragde at Toulose). Another, dated around 1100, is in the Church of Torcello, near Venice. Shown there is the descent of Christ and the rescue of souls. Floating above Jesus is St. Michael, robed and winged, holding an evenly balanced pan scale, which "two demons try to upset." Brandon at 119. See also Caroline Walker Bynum, The Resurrection of the Body in Western Christianity plates 6–7 (New York, NY: Columbia U. Press, 1995) (hereinafter Bynum, The Resurrection).

Scenes of judgment that included weighing were also relatively rare in the Psalter texts until the twelfth century. See Janis Johnston Ellicott, Infernal Topography: The Evolution of Hell Imagery in the Middle Ages 62 (M.F.A. thesis, U. of Victoria, Victoria, Can., 1991). In Link's view, the image of weighing souls became more common in Last Judgment scenes around 1130. Link at 118–119. See also Frances M. Malpezzi, *The Weight/lessness of Sin: Donne's "Thou Hast Made Me" and the Psychostatic Tradition*, 4 South Central Review 70 (1987). After the eleventh century, the Devil also gained prominence. Bouillet at 57.

**105** Christine Maria Boeckl, *The "Pisan Triumph of Death" and the Papal Constitution "Benedictus Deus,"* 18 Artibus et Historiae 55, 55–58 (1997). Two trials might have then been contemplated, one at the time of death and a second on Judgment Day, when body and soul would (or would not) be reunited. Id. at 59. The debate about whether the body itself, as contrasted with an immortal soul, would be resurrected is traced over the centuries in Bynum's *The Resurrection*. Bynum argued that the Medieval idea of a person "was not a concept of soul escaping body or soul using body; it was a concept of self in which physicality was integrally bound to sensation, emotion, reasoning, identity—and therefore to whatever one means by salvation." Id. at 11. The "extraordinary materialism of early fifth-century eschatology . . . became the basis for the renewal of theological consideration of the body in the twelfth century." Id. at 113. Bynum detailed the discussion of two judgments, suggested by Pope John XXII. Id. at 283–285.

Interrelated was the development of a conception of purgatory, which gained prominence as an "in-between" place between the twelfth and fourteenth centuries. Bynum, The Resurrection at 280–283; Brandon at 112 (citing Dante's *Divine Comedy* of 1308–1321); Boeckl at 61, n. 10. As William Miller pointed out to us, the development of a belief in purgatory mitigated to some extent the binary of heaven or hell and also added another opportunity for judgment. According to Jacques Le Goff, "in the fourth century, the greatest Fathers of the Church conceived of the idea . . . that certain sinners might be saved, most probably by being subjected to a trial of some sort," and thereafter emerged a "new belief" in purgatory, where souls resided after death and before the Last Judgment. Jacques Le Goff, The Birth of Puragatory 3 (Arthur Goldhammer, trans., Chicago, IL: U. of Chicago Press, 1981). The word purgatorium, however, did not come into parlance until the twelfth century, perhaps in relationship to the "spatialization" that developed then, expressed through a focus on maps and territories. Id. at 3–4.

**106** Perry, *On the Psychostasis I* at 94. Perry described the first genre, about consequences, as conforming to the "text of the scripture," while the second, on weighing, derived from "ancient tradition," including that in Egypt.

**107** Figure 25, by an anonymous artist known as the "Master of the Zurich Carnation" and dated about 1500, is assumed to have been

the right panel, called *Michael as the Weigher of Souls*, of an altar of St. Michael. The panel is currently at the Kunsthaus Museum in Zurich, Switzerland. The title, *Saint Michael Weighing the Souls at the Last Judgment*, is provided by the copyholder, Bridgeman-Giraudon / Art Resource, New York, whereas Christophe Eggenberger called the image *Michael as the Weigher of Souls*. See Christoph Eggenberger, *The Swiss Carnation Masters: Anonymity and Artistic Personality—Painters between the Late Middle Ages and the Renaissance*, in 1000 YEARS OF SWISS ART 91, 94 (Heinz Horat, ed., New York, NY: Hudson Hills Press, 1992).

**108** On the good side are the "red and white carnation," and hence the appellation Master of the Carnation. Eggenberger at 94. In 1524 Zurich enacted a law prohibiting religious images. Id. at 92.

**109** Perry, *On the Psychostasis I* at 103.

**110** Perry, *On the Psychostasis I* at 103.

**111** One such image, from a sixteenth-century wall painting in South Leigh Church in England, portrays "St. Michael with the sword in one hand, and in the other a balance for weighing the souls. Four lively little demons are defeated by the intercession of the Virgin Mary, for two beads of Her rosary are weighing down the scale-pan, in which a poor soul is sitting, thus assuring its salvation." See Ellen Ettlinger, *Folklore in Oxfordshire Churches*, 73 FOLKLORE 160, 166 (1962). Comparable images can be found on pilgrimage badges produced from the thirteenth century to the fifteenth by the abbey of Mont-St.-Michel. See Katherine Allen Smith, *An Angel's Power in a Bishop's Body: The Making of the Cult of Aubert of Avranches at Mont-Saint-Michel*, 29 J. MEDIEVAL HISTORY 347, 359 (2003) (hereinafter Smith, *An Angel's Power*).

**112** See Peers at 64 (describing a Serbian icon of 1647 in which Michael has a sword in his right hand and scales in his left).

**113** According to Perry, *On the Psychostasis I* at 102–103, before the fifteenth century St. Michael was generally shown robed, but by "late Gothic art the fully-armed" St. Michael superseded the robed figure. Beaune detailed the use in France of St. Michael as an "anti-English" saint who, during the fourteenth century, appropriated the imagery of St. George (identified with England since the late twelfth century) and slowly gained some of St. George's attributes, including armor, sword, shield, and banner. BEAUNE at 163–166. One often-reproduced example is Raphael's *Saint Michael and the Demon*, painted around 1505 and on display at the Louvre in Paris, France. See Josephine Jungiæ, *Raphael's "Saint Michael and the Demon" and "Savonarola's Flagellum Dei*,*"* 138 GAZETTE DES BEAUX-ARTS 61, 63 fig. 1 (2001).

When robed, St. Michael is sometimes shown wearing a "loros," a flowing dress found in images from about the seventh century and associated with emperors. That cloth later developed into "a long scarf that was richly embroidered on both sides." Peers at 11. Alexander was portrayed so garbed, and representations of later emperors followed suit, albeit through modifications that replaced the cumbersome earlier version with a yoke-like design that did not "slip off the shoulders." See Lyn Rodley, *The Byzantine Court and Byzantine Art*, in COURT CULTURE IN THE EARLY MIDDLE AGES: THE PROCEEDINGS OF THE FIRST ALCUIN CONFERENCE 255, 263 (Catherine Cubitt, ed., Turnhout, Belg.: Brepols Publishers, 2003).

**114** Perry, *On the Psychostasis I* at 102; Peers at 50–53. St. Michael, in turn, is on occasion shown with Mercury's insignia, the caduceus, a staff with a serpent entwined. Id. Archeological and mythical connections among Michael, Mercury, and Apollo are explored in G. F. Hill, *Apollo and St. Michael: Some Analogies*, 36 J. HELLENIC STUDIES 134, 144–147 (1916). MÂLE at 413.

**115** See KECK, ANGELS AND ANGELOLOGY at 45. Keck quoted *Apocalypse* 12:7–9, that Michael and his angels "overcome the dragon 'who is called the Devil and satan.' " Rosemond Tuve noted that the serpent in various depictions of St. Michael could also refer to the expulsion from the Garden of Eden. See ROSEMOND TUVE, ALLEGORICAL IMAGERY: SOME MEDIAEVAL BOOKS AND THEIR POSTERITY 107

(Princeton, NJ: Princeton U. Press, 1966). The image may also derive from Christ trampling the Devil in the underworld, an idea attributed to an apocryphal Gospel of Nicodemus, Acta Pilati, popular in Europe in the ninth century. Ellicott at 51–52. Link posited that the Devil had three tasks in the pscychostasy scenes: to help St. Michael separate the damned from the blessed, to lead the damned to hell, and then to punish them. LINK at 118.

How to portray the Devil was a problem, for Satan was both demonic and tempting. See Frye at 238. One of the earliest identified images, from 586 CE, shows black figures "being cast out as a pair of demoniacs." See JEFFREY BURTON RUSSELL, SATAN: THE EARLY CHRISTIAN TRADITION 102 (Ithaca, NY: Cornell U. Press, 1981). The Devil has made appearances as "a serpent, lion, dragon, dog, or wolf "; as animals with human bodies and faces of crocodiles or scorpions; and as lions, a human giant, and a distorted person. All these various shapes were sometimes seen as themselves disguises for "his complete lack of form." Id. at 190–191. By the Renaissance, very ugly renditions progressed to more dignified ones. Frye at 239. The instability of Devil/Satan iconography is detailed by Link, who tracked the range of images used to signify evil. He argued that the ideological complexity of the Devil—as a product of God, required by the story of redemption, but also as the anti-Christ and in conflict with God—made for an artistic project that was uniquely challenging. LINK at 187–188. "No other creature in the arts with such a long history is so empty of intrinsic meaning. No other sign or supposed symbol is so flat." Id. at 193.

**116** Peers at 7–10.

**117** The weights, dated from before 1692, were found in Kingston Harbor, Jamaica. See C. Wayne Smith, *Iconography of the Archangel Michael on Pail Weights from Excavation at Port Royal, Jamaica*, 28 INTERNATIONAL J. OF NAUTICAL ARCHAEOLOGY 355, 358 (1999) (hereinafter Smith, *Iconography of the Archangel Michael*).

**118** From *Matthew* 24–25, and 30–31 (NEW ENGLISH BIBLE) come the descriptions of three events: the Parousia or the Second Coming of the Lord, the separation of the sheep from the goats, and the resurrection of the dead (either body and soul or just souls):

> Then will appear in heaven the sign that heralds the Son of Man. All the peoples of the world will make lamentation, and they will see the Son of Man coming on the clouds of heaven with great power and glory. With a trumpet blast he will send out his angels, and they will gather his chosen from the four winds, from the farthest bounds of heaven on every side.

> When the Son of Man comes in his glory and all the angels with him, he will sit in state on his throne, with all the nations gathered before him. He will separate men into two groups, as a shepherd separates the sheep from the goats, and he will place the sheep on his right hand and the goats on his left. Then the king will say to those on his right hand, "You have my Father's blessing; come, enter and possess the kingdom that has been ready for you since the world was made."

> Then he will say to those on his left hand, "The curse is upon you; go from my sight to the eternal fire that is ready for the devil and his angels."

**119** BOUILLET at 7–9 (discussing Last Judgment scenes found on frescoes in Roman catacombs); Ellicott traced the imagery and the distinctive format of Byzantine Last Judgment scenes. Id. at 66–70, 107–117.

**120** According to Link, in Giotto's *Last Judgment* in the Scrovegni Chapel, "the grapnel that devils consistently use throughout the centuries is the same instrument used in torture, and flogging criminals

naked through the streets was an event artists would have seen or heard about." LINK at 136.

**121** LINK at 119, citing PHILLIPPE ARIÈS, IMAGES DE L'HOMME DEVANT LA MORT (IMAGES OF MAN AND DEATH) 102 (Paris, Fran.: Éditions du Seuil, 1977). See also KRISTIN ELDYSS SORENSEN ZAPALAC, "IN HIS IMAGE AND LIKENESS": POLITICAL ICONOGRAPHY AND RELIGIOUS CHANGE IN REGENSBURG, 1500–1600 (Ithaca, NY: Cornell U. Press, 1990); CRAIG HARBISON, THE LAST JUDGMENT IN SIXTEENTH CENTURY NORTHERN EUROPE: A STUDY OF THE RELATION BETWEEN ART AND THE REFORMATION (New York, NY: Garland Publishing, 1976).

**122** Ziolkowski described Clytemnestra in Aeschylus's *Oresteia* as holding a bloody axe in a way that the "contemporary audience would surely have seen in her the image of Dikê personified." See Ziolkowski, *Figures of Justice* at 200.

**123** See ZAPALAC at 119–134. Further, a sword was "a proper attribute for a judge" according to some Medieval German sources. Selma Pfeiffenberger, The Iconography of Giotto's Virtues and Vices at Padua, ch. 5 at 26 (Ph.D. dissertation, Bryn Mawr College, Philadelphia, PA, 1966; UMI Publication No.: AAT 6703811).

**124** Swords can be found in a few manuscripts in Italy and in France but apparently were not commonplace in depictions of Justice before the fourteenth century. See Pfeiffenberger at 19–37. By the fifteenth century, statues of Justice regularly equipped her with both scales and swords. See, for example, Shelley E. Zuraw, *The Public Commemorative Monument: Mino da Fiesole's Tombs in the Florentine Badia*, 3 ART BULLETIN 452, 459 (1998). Zuraw also detailed how, despite a tradition of depicting Justice "within a cycle of cardinal and theological virtues," she was repeatedly placed as a single Virtue on tombs—providing additional evidence of Justice's centrality to the state. Id. at 458–462.

**125** The translation of Homer's *The Iliad* (bk. 18, 497–508) is by Michael Gagarin from his article, *Dikê in the Works and Days*, at 84 (footnotes and bracketed explanations of a few translations omitted).

**126** See Gagarin, *Dikê in the Works and Days* at 83–87; Adriaan M. Lanni, *Spectator Sport or Serious Politics? oi periesthkotes and the Athenian Lawcourts*, 117 J. HELLENIC STUD. 183 (1997); JOHN DAWSON, HISTORY OF LAY JUDGES 10–14 (Cambridge, MA: Harvard U. Press, 1960). Recent commentary suggests that the role of courts in ancient Greece has been undervalued. By reviewing some one hundred speeches given in the popular courts of Greece between 420 and 323 BCE, Arianna Lanni concluded that Athenian courts "played a vital role" in enforcing "informal social norms" and that they succeeded in "inducing compliance" through decisions rendered by juries often comprised of more than two hundred adult male citizens. Adriaan Lanni, Law and Order in Ancient Athens, 1–8 (manuscript, 2008). See also Adriann Lanni, *Social Norms in the Courts of Ancient Athens*, 1 JOURNAL LEGAL ANALYSIS 691 (2009).

**127** ROTH, LAW COLLECTIONS; Slanski, *Rod and Ring*. The clay tablets used to record transactions may also have been a source of "publicity, since these stone objects were deposited in public places." Johannes M. Renger, *Institutional, Communal, and Individual Ownership or Possession of Arable Land in Ancient Mesopotamia from the End of the Fourth to the End of the First Millennium BC*, 71 CHICAGO-KENT LAW REVIEW 269, 293 (1995). "Symbolic acts performed in the presence of witnesses gave the act its binding force." Id. at 293.

**128** Understanding which aspects of decisionmaking were public is not easy. An overview that tracked the power of magistrates and identified a broad role for laypersons comes from DAWSON at 14–29. Ernest Metzger described Roman magistrates' obligations to publish materials related to lawsuits, including a calendar of days on which trials could be held and decisions on postponements. See ERNEST METZGER, A NEW OUTLINE OF THE ROMAN CIVIL TRIAL 52–60 (Oxford, Eng.: Clarendon Press, Oxford U. Press, 1997). Metzger examined the public selection of judges (id. at 61–76) and the "one-day" rule that

might have meant that oral proceedings had to be finished within that time (id. at 108–122). In another book, Metzger detailed the activities that occurred in private before magistrates as litigants obtained postponements or failed to appear; he also reviewed three cases in which witnesses testified at trials. See ERNEST METZGER, LITIGATION IN ROMAN LAW (Oxford, Eng.: Oxford U. Press, 2005). According to Benveniste, the Latin term *arbiter* denoted both the arbiter and the witness; "texts show that the arbiter is always the invisible witness, who has the capacity to become, in certain determined judicial actions, an impartial and sovereign iudex," or judge. See BENVENISTE at 389.

**129** DAWSON at 178–275.

**130** R. C. VAN CAENEGEM, LEGAL HISTORY: A EUROPEAN PERSPECTIVE 1–26 (London, Eng.: Hambledon Press, 1991); MICHAEL R. WEISSER, CRIME AND PUNISHMENT IN EARLY MODERN EUROPE (Atlantic Highlands, NJ: Humanities Press, 1979).

**131** See, for example, Beth A. Berkowitz, *Negotiating Violence and the Word in Rabbinic Law*, 17 YALE J. L. & HUMANITIES 125 (2005); MITCHELL B. MERBACK, THE THIEF, THE CROSS, AND THE WHEEL: PAIN AND THE SPECTACLE OF PUNISHMENT IN MEDIEVAL AND RENAISSANCE EUROPE (London, Eng.: Reaktion Books, 1999); PIETER SPIERENBURG, THE SPECTACLE OF SUFFERING: EXECUTIONS AND THE EVOLUTION OF REPRESSION (Cambridge, Eng.: Cambridge U. Press, 1984); SAMUEL Y. EDGERTON JR., PICTURES AND PUNISHMENT: ART AND CRIMINAL PROSECUTION DURING THE FLORENTINE RENAISSANCE (Ithaca, NY: Cornell U. Press, 1985); Richard Joseph Ingersoll, The Ritual Use of Public Space in Renaissance Rome (Ph.D. dissertation, U. of California, Berkeley, CA, 1985); Katharine Fremantle, *The Open Vierschaar of Amsterdam's Seventeenth-Century Town Hall as a Setting for the City's Justice*, 77 OUD HOLLAND 206–234 (1962) (hereinafter Fremantle, *Open Vierschaar*). A different window into such spectacles is provided by detailed descriptions of what legal actors wore. See W. N. HARGREAVES-MAWDSLEY, A HISTORY OF LEGAL DRESS IN EUROPE UNTIL THE END OF THE EIGHTEENTH CENTURY (Oxford, Eng.: Clarendon Press, 1963).

**132** See THE ORIGINS OF THE STATE IN ITALY, 1300–1600 (Julius Kirschner, ed., Chicago, IL: U. of Chicago Press, 1996); DAVID NICHOLAS, THE GROWTH OF THE MEDIEVAL CITY: FROM LATE ANTIQUITY TO THE EARLY FOURTEENTH CENTURY (New York, NY: Addison Wesley Longman, 1997); DANIEL WALEY, THE ITALIAN CITY-REPUBLICS (London, Eng.: Longman, 3rd ed., 1988); GERALD STRAUSS, LAW, RESISTANCE, AND THE STATE: THE OPPOSITION TO ROMAN LAW IN REFORMATION GERMANY (Princeton, NJ: Princeton U. Press, 1986) (hereinafter STRAUSS, LAW, RESISTANCE, AND THE STATE).

**133** Many others have done so, sometimes via case studies and sometimes through overviews. VAN CAENEGEM, LEGAL HISTORY at 71–113.

**134** These traditions, dating from antiquity, ran through Germanic Europe as well as the low countries. See EDGERTON at 131–132. Specifically, in some areas, the sentence of death could be imposed only "under the open sky." See Fremantle, *Open Vierschaar* at 209 (discussing the Town Hall of Hamburg, which had a roof shutter that could be opened to comply with this custom).

**135** The development of nation-states during the Medieval period derived from the need and the ability to control the application of law and to collect taxes, thereby linking "the individual to the centre" in ways that at times added layers of authority and in other instances replaced local obligations with national ones. See Janet Coleman, *Preface*, in THE INDIVIDUAL IN POLITICAL THEORY AND PRACTICE ix, xvii (Janet Coleman, ed., Oxford, Eng.: Oxford U. Press, 1996).

**136** "To obtain a favourable reputation through the hinterland, a town had to provide appropriate facilities for marketing, attentive administration, and enforcement of local rules and by-laws that were seen as both practical and just." ROBERT TITTLER, ARCHITECTURE AND POWER: THE TOWN HALL AND THE ENGLISH URBAN COMMUNITY, c.1500–1640 at 92–93 (Oxford, Eng.: Oxford U. Press, 1991). In addi-

tion, the town hall served as the "tangible formulation" of the notion of civic authority, marking "the center as center" and thereby legitimizing its builders, who succeeded in making some of their authority. Id.

**137** See Colin Cunningham, *For the Honour and Beauty of the City: The Design of Town Halls*, in Siena, Florence and Padua: Art, Society and Religion 1280–1400, vol. 2: Case Studies 29–54 (Diana Norman, ed., New Haven, CT: Yale U. Press, 1995) (hereinafter Art, Society and Religion II); Juergen Schulz, *The Communal Buildings of Parma*, 26 Mitteilungen des Kunsthistorischen Institutes in Florenz 279, 280–282 (1982); Keyvan Claude Rafii, Public Buildings and Civic Pride: Town Halls in Northern Germany, 1200–1618 at 1–2 (Ph.D. dissertation, U. of Illinois, Urbana-Champagne, IL, 2003; UMI Publication No.: AAT 3111629); Horst Adami-etz, The Town Hall of Bremen: A Masterpiece of North German Architektur, Histories and Stories 9–15 (Bremen, Ger.: Verlag Friedrich Röver, 1977) (discussing the 1405–1410 building); Janusz Pazder, Town Halls in Poland 15 (Warsaw, Pol.: Rosikon Press, 2000); Zapalac at 26–55. Localities built both merchant halls and town halls. In northern Europe public buildings were often on the market square whereas, in Italy, public squares were placed on cleared land "distinct from the market." Nicholas at 193–195. Reviewing the late Medieval period in Spain, Weisser reported that "crimes committed in a local settlement were heard in the courtroom of the nearby municipality," while crimes committed in open settings outside of villages were "heard in the courtroom of the royal police." Wherever committed, certain kinds of crimes, such as murder, were heard in "national courts located at the royal chanceries." Weisser at 9.

**138** Nicholas at 141. "Although by 1200 most cities had the right to judge cases involving their citizens, and at least some financial independence, few outside Italy had broadened the right to judge into a right to legislate." Id. His survey spanned England and the European continent; he detailed the "folkmoot" of London, the "alderman" in Denmark, the "scabini" of the Low Country, the "jurés and échevins" in France, the "rat" or council in Germany, and various other configurations of guilds, citizens, councilors, and assemblies. Id. at 141–145.

**139** One measure of development is population. As of the fourteenth century, cities such as Milan, Florence, Genoa, Venice, Cordoba, Granada, Seville, Paris, London, Ghent, and Bruges had more than 50,000 persons. "[P]erhaps twenty such cites, including Padua, Verona, Naples, Rome, Palermo, Barcelona, Lisbon, Valencia in Iberia, Rouen, Toulouse, Bordeaux, and Lyon in France and Cologne, Nuremburg, and Prague in the German areas" numbered between 25,000 and 50,000; many others, including important university towns and provincial centers, had approximately 10,000. Weisser at 32, 36–37.

**140** "Medieval society had law—there was too much of it, if anything—and greatly cared for it." Van Caenegem, Legal History at 115, 119. Scholars debate the degree of variation in legal regimes. Some stress how "remarkably similar" were the systems for policing crime and meting out punishments across "various European countries." Weisser at 173. Others focus on differences that created a "mosaic" of local customs that, in southern and northern Europe, had more salience than did distinctions between Roman and Germanic traditions. See Constantin Fasolt, *Hermann Conring and the European History of Law*, in Politics and Reformations: Histories and Reformations 113, 116–120 (Chrisopher Ocker, Michael Printy, Peter Starenko, & Peter Wallace, eds., Leiden, Neth.: Brill, 2007). Universities were sources of trans-European homogenization. By the early fifteenth century, one could study law in Germany, but "preferred" degrees came from "Padua, Perugia, Bourges, Toulouse, or Orléans." Strauss, Law, Resistance, and the State at 76. Fasolt argued that initially university-taught law had little to do with law in practice but that, over time, the jurisprudence of universities prevailed. Fasolt at 124–134.

**141** Weisser at 52–67. Private parties initiated prosecutions, because crimes were then seen as injuring individuals entitled to obtain redress. "Once the victim felt that his injury had been avenged he could withdraw his complaint and the proceeding would end at this point." Id. at 53. Punishments ranged from fines and banishment to imprisonment and capital punishment. "Medieval court rolls from English counties in the period 1250–1450 suggest that less than half of all felony convictions resulted in a sentence other than banishment, and perhaps one in ten sentences included a decree of execution," but not all persons so sentenced were executed. Id. at 65.

**142** Strauss, Law, Resistance, and the State at 111. Strauss recounts that in 1551, "Duke Christoph of Württenberg convoked in every town and market village 'all our bailiffs, overseers, stewards, foresters, town secretaries, revenue collectors, councilors, also our communes and other subjects,' for a public reading of the 1514 Tübingen Contract, to be followed by declarations of loyalty to this constitution and to the duke." Id.

**143** See Schulz at 282 (describing one such possible "portico of judgment" in Parma).

**144** Fabrizio J. Nevola, *Per Ornato Della Città: Siena's Strada Romana and Fifteenth-Century Urban Renewal*, 82 Art Bulletin 26, 27 (2000).

**145** Art, Society and Religion II at 32.

**146** See Lucien Febvre and Hénri-Jean Martin, The Coming of the Book: The Impact of Printing, 1450–1800 at 21–60 (David Gerard, trans., London, Eng.: Verso Classics, 1997, reprinted 2000). As the authors explained, the utility of presses was dependent on the availability of paper; at some point between 1445 and 1450, print-making came into being in Europe, with workshops located in Mainz and Strasbourg. Febvre and Martin identified about 35,000 surviving printed editions from 1450 to 1500. More than 75 percent of books printed before 1500 were in Latin. Further, about 45 percent were religious. Id. at 248–249. Febvre and Martin estimated that in 1500 about 20 million volumes were available; by 1600, 200 million books were in circulation. Id. at 262.

**147** Art historians are insistent that these images served mnemonic functions that a post-print audience cannot readily appreciate. See Lina Bolzoni, The Gallery of Memory: Literary and Iconographic Models in the Age of the Printing Press (Jeremy Parzen, trans., Toronto, Can.: U. of Toronto Press, 2001); Mary Carruthers, The Book of Memory: A Study in Medieval Culture (Cambridge, Eng.: Cambridge U. Press, 1990); Michael J. Bzdak, Wisdom and Education in the Middle Ages: Images and Traditions (Ph.D. dissertation, Department of Art History, Rutgers State U., New Brunswick, NJ, 2001; UMI Publication No.: AAT 3000814). Pictures in books predate printing presses, as many Medieval manuscripts were "illuminated," that is, illustrated by hand. With presses, printed books could use block-print woodcuts and then copper-plate engravings, which by the late sixteenth century displaced the wood cuts. Febvre and Martin at 90–101.

**148** Art, Society and Religion II at 29. See also Christian-Nils Robert, La Justice dans ses décors, XVe–XVIe siècles (Justice in Its Settings during the 15th–16th Centuries) (Geneva, Switz.: Librairie Droz, 2006).

**149** Robert at 25.

**150** In some areas, the functions were separated, and new town hall buildings "deliberately avoided the market area," to help establish that their functions were "political and ceremonial." See Jürgen Paul, *Commercial Use of Mediaeval Town Halls in Italy*, 28 Journal Society of Architectural Historians 222 (1969). In other instances, town halls in German city-states were used as jails and as venues for local rulers to make various kinds of decisions, pronounce judgments, and impose punishment. Spaces were also provided for shopping stalls, the storage of town weights and standards, and a "municipal supply of local beer and wine" distributed to provide revenue. Rafii at

41. This mixed use was also seen in churches, many of which served simultaneously as places in which various governance functions, dispute resolution included, took place. For example, in the 1160s, judges "appointed for the Commune . . . heard disputes and pronounced judgment in the church of S. Stefano, the Episcopal Palace, and the Emperor's own palace at Parma." Schulz at 280–281. During the sixteenth and seventeenth centuries in England, some ecclesiastical buildings were converted into town halls. See TITTLER at 92–93.

**151** RANDOLPH STARN AND LOREN PARTRIDGE, ARTS OF POWER: THREE HALLS OF STATE IN ITALY, 1300–1600 at 17 (Berkeley, CA: U. of California Press, 1992).

**152** See, for example, Joseph Polzer, *Ambrogio Lorenzetti's "War and Peace" Murals Revisited: Contributions to the Meaning of the "Good Government Allegory,"* 23 ARTIBUS ET HISTORIAE 63 (2002); Jean C. Campbell, *The City's New Clothes: Ambrogio Lorenzetti and the Poetics of Peace,* 83 ART BULL. 240 (2001); Quentin Skinner, *Ambrogio Lorenzetti's Buon Governo Frescoes: Two Old Questions, Two New Answers,* 62 J. WARBURG & COURTAULD INST. 1 (1999) (hereinafter Skinner, *Two New Answers*); RANDOLPH STARN, AMBROGIO LORENZETTI: THE PALAZZO PUBBLICO, SIENA (New York, NY: George Braziller, 1994) (hereinafter STARN, AMBROGIO LORENZETTI); STARN AND PARTRIDGE at 9–59; Randolph Starn, *The Republican Regime of the "Room of Peace" in Siena, 1338–40,* 18 REPRESENTATIONS 1 (1987) (hereinafter Starn, *Republican Regime*); Jack M. Greenstein, *The Vision of Peace: Meaning and Representation in Ambrogio Lorenzetti's Sala della Pace Cityscapes,* 11 ART HISTORY 492 (1988); Quentin Skinner, *Ambrogio Lorenzetti: The Artist as Political Philosopher,* LXXII PROCEEDINGS OF THE BRITISH ACADEMY 1 (1986) (hereinafter Skinner, *Artist as Political Philosopher*); BRUCE COLE, SIENESE PAINTING IN THE AGE OF THE RENAISSANCE (Bloomington, IN: Indiana U. Press, 1985) (hereinafter COLE, SIENESE PAINTING IN THE RENAISSANCE); BRUCE COLE, SIENESE PAINTING: FROM ITS ORIGINS TO THE FIFTEENTH CENTURY (New York, NY: Harper & Row, 1980) (hereinafter COLE, SIENESE PAINTING FROM ITS ORIGINS); Uta Feldges-Henning, *The Pictorial Programme of the Sala della Pace: A New Interpretation,* 35 J. WARBURG & COURTAULD INST. 145 (1972); Nicolai Rubinstein, *Political Ideas in Sienese Art: The Frescoes by Ambrogio Lorenzetti and Taddeo di Bartolo in the Palazzo Pubblico,* 21 J. WARBURG & COURTAULD INST. 179 (1958).

**153** Skinner, *Two New Answers* at 1. See generally WILLIAM M. BOWSKY, A MEDIEVAL ITALIAN COMMUNE: SIENA UNDER THE NINE, 1287–1355 at 21–74 (Berkeley, CA: U. of California Press, 1981) (hereinafter BOWSKY, MEDIEVAL COMMUNE). These "Nine Governors and Defenders of the Commune and People of Siena" were selected in two-month cycles from a group of ruling citizens who worked in "inter-locking councils." Starn, *Republican Regime* at 1. A book of the Nine survives in which the group described itself as wise (Sapientes), aiming to do justice by rendering judgments "to good citizens for their good works and to inspire fear in the malefactors for their offences." Starn, *Republican Regime* at 14, quoting from archived materials. During the two months when a particular group of the Nine held office, the members lived at the Palazzo, apparently in an effort to insulate themselves from the entreaties of other citizens. STARN, AMBROGIO LORENZETTI at 15–16. Over a year, some fifty-four male citizens, coming from the ranks of leading merchant families, would sit on the Nine. STARN AND PARTRIDGE at 17.

**154** The images in figures 26 and 27 are reproduced with permission of Scala / Art Resource, New York, NY. The artist, Lorenzetti, lived from about 1290 to 1348. GEORGE ROWLEY, AMBROGIO LORENZETTI, vol. 1 at 3–5 (Princeton, NJ: Princeton U. Press, 1958) (hereinafter ROWLEY, AMBROGIO LORENZETTI). Payment records indicate that the *Allegories of Good and Bad Government* were completed around 1339. Skinner, *Two New Answers* at 1, n. 5; Polzer at 63–64.

**155** These titles were not provided by Lorenzetti. See Skinner, *Artist as Political Philosopher* at 1, n. 2. Some refer to the second fresco (fig.

27) as the *City-State under Tyranny*, and a fifteenth-century reference called it *War*. STARN, AMBROGIO LORENZETTI at 24. As discussed in the text, apparently the pair was called "War" and "Peace" for two centuries thereafter. See STARN AND PARTRIDGE at 14. A contemporary commentator adopted that nomenclature and views the images as a "dialectical argument on Peace and War." Greenstein at 492, 494. See also Polzer at 84–85. The Palazzo Pubblico had many other frescoes, including the Lorenzetti *Mappamondo* (*Map of the World*) that deteriorated and was removed during the nineteenth century. Polzer at 67–68.

**156** STARN AND PARTRIDGE at 30. The authors focus on the import of the written word, for "Medieval cosmology called the world into being in words and read it as a book." Id. For the rulers of Siena, "writing was a means of producing real and symbolic capital" that rested on privilege and control. Id. at 30–32.

**157** STARN AND PARTRIDGE at 13. Rowley, at 100, described the frescoes as "without precedent in the Middle Ages" for providing a sustained and rich narration through a spatial configuration that integrated so many figures.

**158** Polzer at 70. Panofsky has said that Lorenzetti created a "portrait of Siena," with the "panorama of the fertile, rolling country nearby," and thus provided the "first postclassical vistas essentially derived from visual experience rather than from tradition, memory and imagination." See ERWIN PANOFSKY, RENAISSANCE AND RENASCENCES IN WESTERN ART 142 (New York, NY: Harper & Row, 1972, reproducing a 1960 volume).

**159** Starn, *Republican Regime* at 4. Starn thought the import of the texts within the frescoes had been underappreciated. Id. at 8–10.

**160** Skinner, *Artist as Political Philosopher* at 56.

**161** The Nine functioned as a kind of "coordinating committee and executive board for a large council of three hundred members and three smaller commissions of tax officials, merchants, and knights," all of whom "embodied the sovereign authority of the republic." STARN, AMBROGIO LORENZETTI at 15.

**162** BOWSKY, MEDIEVAL COMMUNE at 85–111. Siena had many courts, including several with specialized jurisdiction; others came and went as the Council tried different approaches. The city's judges were to decide "on the basis of analogy with the closest fitting law" rather than "upon their own whim" and were not to apply ex post facto legislation. Id. at 104–105. As a reminder to the "modern" reader, Bowsky also noted that judges often served as prosecutors and investigators and then presided at trial and sentencing. Id. at 106.

**163** Nevola at 26.

**164** STARN AND PARTRIDGE at 15.

**165** Polzer at 63–64. The assumption is that Lorenzetti died during the plague.

**166** STARN AND PARTRIDGE at 17, 30–48; Starn, *Republican Regime* at 1–11. Because of the Sienese form of government, its art commissions were "civil and communal in origin" as contrasted with the patronage system that generated the artwork of Padua and some other cities. See SIENA, FLORENCE, AND PADUA: ART, SOCIETY AND RELIGION 1280–1400, vol. 1, INTERPRETATIVE ESSAYS 4 (Diana Norman, ed., New Haven CT: Yale U. Press, 1995) (hereinafter ART, SOCIETY AND RELIGION I).

**167** Robert Gibbs, *In Search of Ambrogio Lorenzetti's Allegory of Justice: Changes in the Frescoes of the Palazzo Pubblico,* 149 APOLLO: INTERNATIONAL MAGAZINE OF THE ARTS 11, 11–16 (May–Aug. 1999).

**168** STARN, AMBROGIO LORENZETTI at 30–31; STARN AND PARTRIDGE at 14; Starn, *Republican Regime* at 27.

**169** Rubinstein, at 181, described the many possible interpretations of the figure as including "an aged king, the Good Ruler, Good Government, or Justice, . . . [or] the Commune of Siena" itself. The central male figure "bears the double aspect of king and judge: his mace, his shield, his headdress with its rays, at once call to mind the sceptre, the orb and the crown of a king," affiliating the image with "absolute monarchy" more than the Republican ideology presumed to

be Siennese. See Chiara Frugoni, *The Book of Wisdom and Lorenzetti's Fresco in the Palazzo Pubblico at Siena*, 43 J. WARBURG & COURTAULD INST. 239, 239 (1980).

**170** Rubinstein at 184; Rosemond Tuve, *Notes on the Virtues and Vices, Part 1*, 26 J. WARBURG & COURTAULD INST. 264, 290 (1963). See also Marianna Jenkins, *The Iconography of the Hall of the Consistory in the Palazzo Pubblico, Siena*, 54 ART BULLETIN 430, 431 (1972).

**171** Both colors were on the emblem, or "balzana," of Siena; further, its councilors used a "white or black bean" when voting. BOWSKY, MEDIEVAL COMMUNE at 94.

**172** The initials C.S.C.V. were shorthand for "Commune Senarum, Civitas Virginis." Skinner used Bowsky's translation of the phrase to read "For Siena as the city of the Virgin" and noted that it was a reference to Siena's adoption in 1260 of the Virgin Mary as its special patron. Skinner, *Two New Answers* at 11, n. 43. Starn translated the phrase as "The Commune of Siena, City of the Virgin." Starn, *Republican Regime* at 7.

**173** This position is taken by Skinner, who relied in part on the many implicit references to "the Nine" that appear in the scenes, such as the nine dancing figures, the nine Virtues, the nine Vices in the *Allegory of Bad Government*. He also read the room's narrative and its counterpoints as running from Bad to Good Government. Further, at the male figure's feet is a depiction of a Romulus and Remus, which Skinner took as a reference to the Roman origins of Siena. See Skinner, *Two New Answers* at 10–28. In an earlier essay on the frescoes, Skinner was skeptical about how much the works of Aristotle and Aquinas had been imported into the iconography of the period when Lorenzetti worked. Skinner argued that other approaches, specifically that of Cicero transmitted through Martin of Braga and Prudentius, would have influenced the "pre-humanist rhetorical culture." Skinner, *Artist as Political Philosopher* at 3–7. Those accounts place peace as the prime aspiration of civic life. Id. at 8–12. Further, Skinner commented that Aquinas did not posit the common good as the embodiment of the ruler but rather that rulers were obliged to realize the common good through upholding laws. Id. at 41.

**174** Skinner, *Two New Answers* at 11–14. Skinner saw the layout to be a "conventional design" of the Last Judgment. Id. at 11–13 and n. 56. He noted that the twenty-four citizens in the picture paralleled the twenty-four Elders in the *Book of Revelation* who "sit with the Lord in the Court of Heaven." Id. at 13. Skinner read the posture of the citizens' leader to be that of a supplicant and pointed to the congruence between the fresco and the 1308 *Last Judgment* fresco of Giotto in the Scrovegni Chapel.

**175** Skinner, *Two New Answers* at 11 (his translation) and n. 48.

**176** Skinner, *Artist as Political Philosopher* at 10–12.

**177** Starn and Patridge analyzed the role played by the script and reliance on words. See STARN AND PATRIDGE at 28–46. Latin is used for the labels of the nine Virtues and Vices, for the kinds of knowledge (such as of arithmetic, music, and astronomy), and for the quote from the Wisdom of Solomon. Id. at 39–40. The many long textual comments are in the Italian vernacular.

**178** For discussion of the unusual iconography attendant to those Virtues, see Skinner, *Artist as Political Philosopher* at 47–55. As noted in the discussion of Temperance in Chapter 1, Skinner argued that the picture includes the first clock shown in Western art. Id. at 55.

**179** That count is from Starn, *Republican Regime* at 16. Included are references in both Latin and the vernacular. STARN AND PATRIDGE at 43.

**180** The "crown of justice" is biblical; the sword could come from St. Paul's statement that "no ruler bears the sword in vain." Skinner, *Artist as Political Philosopher* at 47. As for the painting, Rowley believed that this Justice, along with Temperance and Magnanimity, were "turned over to an assistant." ROWLEY, AMBROGIO LORENZETTI at 105. Edgerton, at 39, suggested that this Justice may have been painted after a fire required the room's restoration in the 1350s.

**181** EDGERTON at 39. When Justices appear with only swords, commentators assume that the artist sought to focus on the punitive aspects of the law. See, for example, Helen Weston, *Prud'hon: Justice and Vengeance*, 117 BURLINGTON MAGAZINE 353 (1975). In his nineteenth-century renditions, Prud'hon was "consistent throughout his career in showing Justice with the sword rather than the scales." Id. at 353–354.

**182** EDGERTON at 129.

**183** EDGERTON at 39.

**184** Polzer at 94–98.

**185** Again, Giotto may be a source, for his *Iusticia (Justice)* in the Arena Chapel was also in an enthroned and "focal position." There she was the only Virtue wearing a crown and sitting at the center, with three Cardinal Virtues on her right and the three Theological Virtues to her left; her placement related her to salvation yet also suggested that she was "self-sufficient." See Jonathan B. Riess, *Justice and Common Good in Giotto's Arena Chapel Frescoes*, 72 ARTE CRISTIANA 69, 72 (1984). The garb of Giotto's Virgin Mary in his *Last Judgment* in the chapel is similar to that of the Siena Justice. See Gibbs at 12. The contrast made by Lorenzetti between the benefits that flow from good governance and the harms to the social order from injustice are also echoes of those in Giotto's frescoes portraying the opposition between Virtues and Vices. Giotto's enthroned *Justice* holds scale pans balanced with a figure in each, such that she herself serves as the scale. In the right pan, a "Victory-like" figure crowns a virtuous person; in the left is a "Jupiter-like" figure either brandishing a sword or hurling a thunderbolt at a sinner. Riess at 78, n. 13. At the feet of Giotto's *Justice*, people are evenly arrayed and engage in ordinary life—a scene interpreted to convey the peace produced. Riess (building on the work of Pfeiffenberger at 12–20) linked the display of the benefits of Justice to St. Thomas Aquinas, to the centrality of the study of law in Padua's university, and to the power of judges in the city's life. Id. at 72–75. A text accompanying the picture reads: "Perfect justice balances everything with equal pans. Crowning good men, she brandishes her sword against vices. Everyone enjoys freedom if she reigns. As long as she wants to, she acts pleasantly; then the worthy knight hunts, people sing and trade, the merchant travels." See Frojmovič at 24, 45.

In contrast, Giotto showed violence around the male, blindfolded figure, *Iniustitia (Injustice)*. This figure has fangs, and his head is turned sideways, facing hell as portrayed in the *Last Judgment* fresco. Below his feet one sees murder, rape, and robbery, all set forth in an irregular pattern to depict the disorder entailed.

**186** That size reflected import is an argument put forth by Feldges-Henning at 145–146.

**187** See Jenkins at 431. That placement might indicate that Wisdom was a divine rather than human attribute. Skinner, *Artist as Political Philosopher* at 35.

**188** The text is the opening of the apocryphal *Book of Wisdom* of the Old Testament. The translation of "Diligite iustitiam qui iudicatis terram" is from Skinner, *Artist as Political Philosopher* at 15, as is his deciphering of the lettering on the fresco to be "DILIGITE ([JUSTITIA]M Q[UI] IUDICATES TE[RR]AM." Id. at 36. Starn, who added the bracketed materials to complete the words translated the phrase as "Serve justice you who judge the earth." Starn, *Republican Regime* at 5.

**189** See Frugoni at 240. This vertical reading also shows the relationship between the work of Lorenzetti and the work of Giotto, whose "figures of Justice and Injustice form the base visually of the vertical axes of the South and North walls" of the frescoes in the Arena Chapel. See Howard M. Davis, *Gravity in the Paintings of Giotto*, in GIOTTO IN PERSPECTIVE 142, 147–149 (Laurie Schneider, ed., Englewood Cliffs, NJ: Prentice-Hall, Inc., 1974).

**190** Polzer at 92.

**191** O'Reilly interpreted this scene to show "the benefits of rule directed by the Cardinal and Theological Virtues. The fruits of these

virtues are Pax and Justitia, guided by Wisdom and resulting in Concord." Jennifer O'Reilly, Studies in the Iconography of the Virtues and Vices in the Middle Ages 193 (New York, NY: Garland Publishing, 1988).

192 Rubinstein, at 182, identified the box as money. In contrast, Polzer believed it to be a sieve. Polzer at 79–81.

193 Starn, *Republican Regime* at 7(e). Our translations came from Starn, who relied on Rowley (Rowley, Ambrogio Lorenzetti at 127–129). Translations are also found in Starn and Partridge at 261–266. Several of the texts are also translated, occasionally with variations, in Feldges-Henning as well as in Skinner, *Artist as Political Philosopher*. For example, in his essay *The Artist as Political Philosopher*, Skinner argued that what "the verse states is that, wherever the holy virtue of justice rules, many souls are able to act together in such a way that 'un ben comun per lor sigror si fanno.'" Id. at 45. The venacular he quoted could mean "that they are able to act in such a way as to 'constitute the *ben comun* as their *signor*' or to 'make up the common weal—*Ben Comun*—for their lord.'" Id. at 45–46 (footnotes omitted). For Skinner, the second reading confirmed that the central male figure was intended to personify the ideal yet also the actual ruler, rather than an abstraction of the common good. Id.

194 See John White, The Birth and Rebirth of Pictorial Space 97–98 (London, Eng.: Faber & Faber, 1967). White detailed the contrasts, such as the well-fitting lines of cornices and moldings under *Good Government* and their disarray in *Bad Government*, as well as the diffuse light of *Good Government* in comparison to the darkness of the *Bad Government* fresco.

195 Marina Warner described Lorenzetti's achievement as creating "a dream of well-being that is as captivating today as it was then." Marina Warner, Monuments and Maidens: The Allegory of the Female Form 155 (New York, NY: Atheneum, 1985).

196 The landscape ("of surpassing beauty") was "one of the very first topographical portraits in European painting." Cole, Sienese Painting from Its Origins at 155–156.

197 Translation by Starn, *Republican Regime* at 7(f). See also Edgerton at 129.

198 Starn, *Republican Regime* at 7(h). Rubinstein, at 187, offered a variation of an excerpt through his translation: "Behold the good things that she [that is, justice] provides us with and how sweet and tranquil is life in the city in which she is maintained."

199 The horns may be boars' tusks. See Feldges-Henning at 148.

200 Rubinstein at 188; Skinner, *Two New Answers* at 1–3. Skinner also noted that the Vices depicted depart from some of the regular ones to include social and political failings—fraud, treason, cruelty, war, avarice, pride, and vainglory. Id. Rowley, at 105, makes a parallel point, arguing that the configuration was "chosen with the greatest of care as antitheses of" the Virtues of Good Government.

201 Starn, *Republican Regime* at 7(i).

202 Starn, *Republican Regime* at 7(j), quoting Rowley. That text, punctuated by a semicolon, continues:

> which, in order to carry out her wickedness, is unwilling either to wish or do anything against the dirty nature of the vices, which with her are here joined. She chases those who on the good are intent, and calls to herself everyone who is planning evil. She always defends him who uses force, or robs, or who might hate peace; wherefore every land of hers lies uncultivated.

Because the Latin uses the feminine gender for the nouns that are both Vices and Virtues, the text would in Latin properly refer to the Vice Tyranny as "she" even as the picture posits a large male ruler. The use of the masculine form would further substantiate the Skinner reading that the male figure in *Good Government* was meant to signify the actual persons who ruled, the Nine.

203 Starn, *Republican Regime* at 7(k).

204 Rubinstein at 182–183. Starn and Partridge at 44; the authors report that a translation of Aristotle's *Ethics* was done circa 1250.

205 Skinner, *Artist as Political Philosopher* at 17. The argument is that rules of justice are, in some sense, intuitive.

206 Edgerton at 38–39 (agreeing with and quoting Rubinstein at 182–183).

207 Starn and Partridge at 36; quoting from a then-current source, attributed to *Il tesoretto* of Ser Brunetto Latini, and translated as

> But all in common
> Should pull a rope
> Of Peace and good deeds
> Because there can be no saving
> A land or city broken by faction . . . .

See also Rubinstein at 183–184.

208 This is Rubinstein's reading at 184.

209 Skinner, *Artist as Political Philosopher* at 35–38; Starn, *Republican Regime* at 29, n. 27. As Starn and Partridge, at 44, put it: "Punishment is part of commutative but not of distributive justice (where the frescoes include it); transactions of money or goods belong as much to the latter as to the former."

210 Starn, *Republican Regime*, n. 7 at 28 and n. 27 at 29. Skinner found this claim strained. See Skinner, *Artist as Political Philosopher* at 35–38.

211 Starn and Partridge at 43–45.

212 Skinner, *Artist as Political Philosopher* at 3, 39. Brunetto Latini wrote during the 1260s, and his work was accessible to those in Siena.

213 Skinner, *Artist as Political Philosopher* at 22. Skinner quoted the 1262 Constitution and described similar powers given to the Nove in the vernacular 1309–1310 Constitution.

214 Skinner, *Artist as Political Philosopher* at 31. There, Skinner translated parts of the Sienese Constitution of 1309–1310.

215 Skinner, *Artist as Political Philosopher* at 17–19, 40. Skinner argued that Concordia and Aequitas were Ciceronian views of the "twin foundations of civil life." Skinner, *Two New Answers* at 5. The rope could thus refer to Justice and to Concord, for the "bonds of concord" (also the "best and lightest rope of safety in society") are at risk of breaking when people are not united. Skinner, *Artist as Political Philosopher* at 12 (quoting Cicero). Further, as Pfeiffenberger explained in reference to Giotto's *Justice* in the Arena Chapel, the idea of Distributive Justice "derives from Cicero, is restated by Justinian, and is expounded again" later by others; the placement of Justice at the center as the "queen" evokes "an ancient imperial form of government" in which the Justice figure parallels the goddess Roma, who "dispensed reward and punishment in ancient art and religion." Pfeiffenberger, ch. 4 and 13.

216 Frugoni at 240–241. Skinner's discussion of the resemblance of the fresco to Giotto's *Last Judgment* supports this approach. Skinner, *Two New Answers* at 11–14.

217 This view is put forth by Feldges-Henning, at 159–162, who relied on the narration of the occupations, the dancing, and Albertus Magnus's description of the seven attributes of the Heavenly City of Jerusalem. The *Bad Government* fresco therefore could represent Babylon. Id.

218 Polzer, at 91, suggests an analysis along these lines. The scholarly work reads the depiction not to refer to a particular tyrant but to represent despots in general. Starn and Partridge at 19–21.

219 Polzer at 81.

220 The translation is by Skinner, *Artist as Political Philosopher* at 15.

221 Greenstein at 497–498. Edgerton also saw Peace as the "true center of the whole enframed composition" and as the "focal point not

only of the artistic composition but of the politics of Siena." EDGER-TON at 38, 40.

**222** Greenstein at 497–498. Skinner viewed Peace as the counterpart of the figure War, shown at "alert" with a sword raised in the *Allegory of Bad Government*. Skinner, *Two New Answers* at 3–4.

**223** Campbell, at 251, focused on the underappreciated role played by dancers in the landscape.

**224** A capital investment theory can be found in Nevolo at 30, as a city's appearance was significant to its political and economic success. See also STARN AND PARTRIDGE at 13–15.

**225** BOWSKY, MEDIEVAL COMMUNE at 299. STARN AND PARTRIDGE at 58 (detailing the destruction by "a vindictive crowd" of the records of the Nine).

**226** BOWSKY, MEDIEVAL COMMUNE at 306. The population of Siena, estimated to have been about 50,000, was reduced by about half. ART, SOCIETY AND RELIGION I at 16, n. 21.

**227** Successive governments made alliances. Siena attempted to maintain its commitment to its own independence and—Jenkins argued—to a form of virtue that was republican in the sense that it was not focused on single personalities. In 1557, however, Siena was incorporated into the Grand Duchy of Tuscany under the rule of Cosmo De Medici. Jenkins at 451.

**228** Both of these commissions were completed under a United States government program called Art-in-Architecture, in which set-asides—about one-quarter to one-half of a percent of a construction budget—are provided for public art. We discuss that program and other of its artifacts in Chapters 6, 8, and 9. In addition to deployments in art, contemporary writers argue the relevance of the frescoes to contemporary governance. See, for example, WOLFGANG DRECHSLER, GOOD AND BAD GOVERNMENT: AMBROGIO LORENZETTI'S FRESCOES IN THE SIENA TOWN HALL AS MISSION STATEMENT FOR PUBLIC ADMINISTRATION TODAY (Open Society Institute, Discussion Paper No. 20, Local Government and Public Service Reform Initiative, 2001).

**229** Each painting in figure 28 (linen over masonite board) measures nine by five feet. The paintings, placed in storage during courthouse renovations in 2006, were commissioned in the 1980s and unveiled at a ceremony in 1985. Bach, GSA Archives/AA-15, Project Report (Apr. 21, 2005) (hereinafter Bach, GSA/AA-15). The courthouse was named after William Kenzo Nakamura, who had been "posthumously awarded the Congressional Medal of Honor" in June of 2000 for his "acts of heroism in Italy, on July 4, 1944, that saved the lives of his platoon members, but cost him his life." Bach, GSA/AA-15, file notes. Our thanks to Mr. Bach for providing us with permission to reproduce his murals and to Susan Harrison of the Art-in-Architecture Program of the General Services Administration for directing us to them and providing us with photographs to use.

**230** Bach trained in ceramics and furniture design at the University of California, Berkeley. A teacher of art history, his interests range from Italian painters such as Lorenzetti and Giotto to the Mexican muralists (including Jose Clemente Orozco, whose twentieth-century work for the Supreme Court of Mexico is discussed in Chapter 15). Bach contributes to *Américas*, a bimonthly magazine about Latin American cultural affairs published by the Organization of American States. Mr. Bach explained to us that, during his service for the Central Intelligence Agency, he had become acutely aware of the importance of government and felt deeply the importance of even-handed and transparent democratic processes. Telephone interview (August 2, 2006).

Some of his imagery raised concerns because it had religious connotations. As one judge explained, "our only reservation was that some people might take exception to the angels and the demons at the top and to the crosses which seemed to be among the figures below.... This being a public building, we must be sensitive to any church/state implications and believe that GSA should be aware of this concern." Letter from Chief Judge Walter McGovern to Marilyn Farley of the

"Art-in-Architecture" Program (Apr. 12, 1985); Bach, GSA/AA-15. The artist reassured the judges that angels were a common decorative adornment in paintings of this genre and that no crosses would be part of the painting. Further, he explained that the "paintings are solidly rooted in the <u>secular</u> branch of Western Art; indeed, their prototypes (the Lorenzetti murals) come from a city hall (not a church) in Siena." Letter from Caleb Bach to Judge Donald Voorhees (Apr. 10, 1985); Bach, GSA/AA-15. The judges, in turn, encouraged the display of explanatory materials to help viewers understand the symbolism.

After Bach's *Allegories* were hung, one commentator described the "stubby stylized figures" as suggestive of "carvings on European Romanesque churches," while the "gnarled citizens" in *Bad Government* "owe something to the gothic fantasies of Hieronymus Bosch), while battling soldiers were inspired by the 15th-century Florentine paintings of Paolo Uccello." Irene Clurman, *Epic View of the Art of Government*, 9 FEDERAL BAR ASSOCIATION OF THE WESTERN DISTRICT OF WASHINGTON NEWSLETTER 1, 2 (Summer 1985).

**231** The 1911 building, the first federal courthouse in Maine, was one of several constructed under Supervising Architect James Knox Taylor, who served in that role at the United States Treasury from 1897 to 1912, and who designed the building in a Second Renaissance Revival style. See Edward T. Gignoux, U.S. Courthouse, U.S. General Services Administration, Historic Federal Buildings, http://www.gsa .gov; ANTOINETTE J. LEE, ARCHITECTS TO THE NATION: THE RISE AND DECLINE OF THE SUPERVISING ARCHITECT'S OFFICE 197–216 (New York, NY: Oxford U. Press, 2000). Renovations were undertaken to add space to and to modernize the building in the 1930s, 1970s (when postal services were relocated to another building), and, under the supervision of Leers, Weinzapfel Associates of Boston, in the 1990s. The various expansions were responsive to changes, such as congressional authorization for a second district judge to sit in Portland. Hence, trial courtrooms and offices for the Marshal Service and the GSA were added. The courthouse received its current name in 1988, when it was dedicated to Judge Edward T. Gignoux of that district court. See Andrea P. Leers, *Urban Design and the Courthouse: How Sites Shape Solutions*, in CELEBRATING THE COURTHOUSE: A GUIDE FOR ARCHITECTS, THEIR CLIENTS, AND THE PUBLIC (Steven Flanders, ed., New York, NY: W. W. Norton, 2006). Additional discussion of courthouse building and renovation in the United States can be found in Chapters 7–9.

**232** Dorothea Rockburne, a contemporary artist based in New York City, has work in the collections of many major museums. See Lilly Wei, *Dorothea Rockburne, Stargazer*, 82 ART IN AMERICA 108 (Oct. 1994). She is a student of Renaissance techniques and paintings, and she has a longstanding interest in math, physics, history, and art. See Robert Storr, *Rockburne's Wager*, in NEW PAINTINGS: PASCAL AND OTHER CONCERNS (New York, NY: Andre Emmerich Gallery, March 1988) (exhibit catalogue); Dorothea Rockburne, telephone interview (Feb. 1, 2006). Our thanks to Rockburne, as well as to Don Johnson, the photographer, both of whom authorized our use of the photograph of the mural, and to the Honorable D. Brock Hornby of the District Court in Maine and to Susan Harrison of the GSA for facilitating and enabling reproduction of the GSA-commissioned catalogue cover shown in figure 29.

**233** Rockburne, GSA Archives/AA-320, Project Summary, Submission to the GSA. Rockburne also explained her classical training, her visits to Siena, and her interest in Lorenzetti's frescoes.

**234** These comments are quoted in ROBERT K. SLOANE, THE COURTHOUSES OF MAINE 247 (Woolwich, ME: Maine Lawyers Review, 1998), and in the description of the fresco in the booklet commemorating the ceremony of June 26, 1996, in which the courthouse was formally reopened. See also GSA, http://www.gsa.gov.

**235** Ms. Rockburne recounted and GSA files indicated that the concern resulted in the omission of labels. Rockburne, GSA/AA-320, Email from Susan Harrison to Michelle Young (Sept. 11, 1995).

**236** Some members of the selection panel were also concerned that the abstraction would be met with skepticism, and commended public explanation of the choice. Rockburne, GSA/AA-320, Summary of the Art-in-Architecture Program Third Meeting (Sept. 13, 1995).

**237** See Rubinstein at 185, n. 49, and at 183, n. 35. We also detail theories of the relationships among Virtues in Chapters 1 and 15.

**238** Rubinstein at 183, n. 35, 189, 207. Rubinstein also discussed the work of Taddeo di Bartolo, who in 1413 painted the Siena antechapel that Rubinstein thought continued the political program of the Room of the Nine as it was also replete with images of Justice, other Virtues, and Roman Republican "heroes." Id at 207.

**239** For example, Melchior Brocksberger did two frescoes for the exterior of the chamber of the Town Hall in Regensburg. One was *Judgment of Solomon* and the other *Allegory of Good Government*, based on a woodcut printed in Nuremberg in 1564. At the center is a figure labeled the "RES PUB" (Republic); a Pax (Peace) rests on the floor with her head in the Republic's lap. They are surrounded by an Iusticia (Justice) with sword upright and balanced scale and a Liberalitas (Liberality). A swarm of nearby bees is labeled Concordia (Harmony), and God hovers in the clouds above all. See ZAPALAC at 87–89, fig. 37. A 1592 panel by Isaac Schwendtner replaced the earlier version. Justice and Prudence were in the foreground and linked to Peace and Prosperity. Like the Lorenzetti, one could see that the government functioned under God in the clouds above. Id. at 90–91, fig. 39. The cities of Padua and Florence also set forth iconographic scenes of good government personified by a male figure and accompanied by seven Virtues. ART, SOCIETY AND RELIGION I at 144.

**240** Riess at 75.

**241** David Herlihy used the term "civic Christianity" in reference to the late Medieval buildings. See David Herlihy, MEDIEVAL AND RENAISSANCE PISTOIA: THE SOCIAL HISTORY OF AN ITALIAN TOWN, 1200–1430 at 241 (New Haven, CT: Yale U. Press, 1967). Herlihy tracked the shift in the allocation of funding of institutions in Pistoria and found substantial funds provided to hospitals for the poor and orphaned as well as a "new taste for liturgical splendor." Id. at 257. He attributed these efforts to a new consciousness of social surroundings as well as a focus on "ideal worlds" rather than on the harsh realities of the time. Id. at 268. The use of churches as dispute resolution centers in Parma is detailed by Schulz at 280–294. He also charted how the rise in trade and professional groups created "new demands for space," prompting more communal building. Id. at 295–300. Schulz argued that some structures were decidedly not to be used for religious purposes as a way to build secular civic identity. See also COLE, SIENESE PAINTING FROM ITS ORIGINS at ix (referring to buildings in Siena and elsewhere in Tuscany). Italian town halls typically housed the four intertwined functions of trade, local democracy, adjudication, and public ceremonies. For discussion of these functions in German town halls, see ZAPALAC at 34–35, 38.

**242** STRAUSS, LAW, RESISTANCE, AND THE STATE at 192.

**243** Aldo Mazzacane, *Law and Jurists in the Formation of the Modern State in Italy*, in THE ORIGINS OF THE STATE OF ITALY, 1300–1600 at 62, 63 (Julius Kirshner, ed., Chicago, IL: U. of Chicago Press, 1996).

**244** Janey L. Levy, The Last Judgment in Early Netherlandish Painting: Faith, Authority and Charity in the Fifteenth Century (Ph.D. dissertation, Department of Art History, U. of Kansas, Lawrence, KS, 1988; UMI Publication No.: AAT 890 3130) (hereinafter Levy, Last Judgment) (citing and translating Dirk van Delf's *Tafel van den Kersten Ghelove*).

**245** STRAUSS, LAW, RESISTANCE, AND THE STATE at 194 and n. 4, quoting Andreas Musculus.

**246** See ART, SOCIETY AND RELIGION II at 13.

**247** Geneva's General Council met in the cloisters of the Cathedral of St.-Pierre until the 1440s, when a town hall was built to accommodate them. See CAMILLE MARTIN, LA MAISON DE VILLE DE GENÉVE 5 (Geneva, Switz.: A. Julien, 1906).

**248** See HARBISON at 52–53; Giorgio Chittolini, *The "Private," the "Public," the State*, in THE ORIGINS OF THE STATE IN ITALY at 34–60.

**249** Frojmovič at 25.

**250** Frojmovič at 24, 25.

**251** Frojmovič at 26.

**252** The words, ascribed to St. John of Damascus of the eighth century, are: "Images speak; they are neither mute, nor lifeless blocks like the idols of the Pagans. Every painting that meets our gaze in a church, relates, as if in words, the humiliation of Christ for his people, the miracles of the Mother of God, the deeds and conflicts of the Saints. Images open the heart and awake the intellect, and, in a marvelous and indescribable manner, engage us to imitate the persons they represent." See ADOLPHE NAPOLEON DIDRON, CHRISTIAN ICONOGRAPHY: THE HISTORY OF CHRISTIAN ART IN THE MIDDLE AGES, vol. 1 at 3 (E. J. Millington, trans., New York, NY: Frederick Ungar Publishing, 1965).

**253** Ernst Gombrich argued that onlookers would perceive the concept directly rather than by a pattern of interpretation dependent on sequential thought. The visual symbol not only represented but somehow became interchangeable with what it represented. ERNST GOMBRICH, SYMBOLIC IMAGES: STUDIES IN THE ART OF THE RENAISSANCE 2 at 123–191 (Oxford, Eng.: Phaidon, 3rd ed., 1985). Describing the adulation of icons in the sixteenth century, Merback offered the explanation that "the belief in the 'living presence' of holy persons in the cult image was, for all but a few skeptical minds, a fixture of mental life," inspiring pilgrims to trek across Europe so as to see them. MERBACK at 266. But within that century, Protestant hostility resulted in the destruction of many such displays. This iconoclasm "transformed the visual environment of northern European sanctuaries." Id.

**254** Hugo van der Velden, *Cambyses for Example: The Origins and Function of an exemplum iustitiae in Netherlandish Art of the Fifteenth, Sixteenth and Seventeenth Centuries*, 23 SIMIOLUS: NETHERLANDS QUARTERLY FOR THE HISTORY OF ART 5, 7 (1995); WOLFGANG SCHILD, ALTE GERICHTSBARKEIT: VOM GOTTESURTEIL BIS ZUM BEGINN DER MODERNEN RECHTSPRECHUNG (OLD JURISDICTION: FROM TRIAL BY ORDEAL TO THE BEGINNING OF THE MODERN ADMINISTRATION OF JUSTICE) 29 (Munich, Ger.: Callwey, 1980). All translations of old German cited in this chapter are by Stella Burch Elias. Dutch materials are translated by Chavi Keeney Nana, and French by Allison Tait, Julia Schiesel, and Judith Resnik.

**255** ZAPALAC at 194, n. 8. Several authors, often building on each other's work, have catalogued the many displays of the Last Judgment in German and Dutch Town Halls, sometimes with the deployment of this particular scene as the focal point (such as in Zapalac) and other times as part of narratives about art relevant to law or the role of law more generally. See, for example, Ursula Grieger Lederle, Gerechtigkeitsdarstellungen in deutschen und niederländischen Rathäusern (Representations of Justice in German and Dutch Town Halls) (Ph.D. dissertation, Heidelberg, Ger.: U. Heidelberg Press, 1937); GEORG TROESCHER, WELTGERICHTSBILDER IN RATHÄUSERN UND GERICHTSSTÄTTEN (LAST JUDGMENT PICTURES IN TOWN HALLS AND COURT CHAMBERS), vol. 11 of WEST GERMAN YEARBOOK FOR ART HISTORY at 129–214 (Frankfurt, Ger.: Prestel-Vertel GMBH, 1939); HARBISON; SCHILD; Levy, Last Judgment; KISSEL, DIE JUSTITIA; WOLFGANG PLEISTER & WOLFGANG SCHILD, RECHT UND GERECHTIGKEIT IM SPIEGEL DER EUROPÄISCHEN KUNST (LAW AND JUSTICE REFLECTED IN EUROPEAN ART) (Cologne, Ger.: DuMont Buchverlag, 1988); SUSAN TIPTON, RES PUBLICA BENE ORDINATA: REGENTENSPIEGEL UND BILDER VON GUTEN REGIMENT, RATHAUSDEKORATIONEN IN DER FRÜHEN NEUZEIT (THE WELL-ORDERED PUBLIC SPHERE: IMAGES OF SOVEREIGNTY AND PICTURES OF GOOD GOVERNMENT, TOWN HALL DECORATION IN THE EARLY MODERN PERIOD) (Hildesheim, Ger.: George Olms Verlag, 1996).

Christian-Nils Robert noted the prevalence in France during the fifteenth century of images of the crucifixion in courtrooms as he

traced the linkage of religious themes to civil power. ROBERT at 31–48. He also discussed the regular placement of crucifixes above the chairs in which French judges sat. The deployment of both crucifixes and Last Judgment scenes was a focus of Robert Jacob, who argued that the insistent religious theme helped judges to understand themselves as having some authority independent of the local governing ruler. See Robert Jacob, *Le jugement de Dieu et la formation de la fonction de juger dans l'histoire européenne* (*God's Judgement and the Development of the Function of Judging in European History*), 39 ARCHIVES DE PHILOSOPHIE DU DROIT 87–104 (1995).

**256** Contemporary discussions of German law either refer to this provision as stemming from the Magdeburg Laws or rely on Ulrich Tengler, writing a legal treatise in the early 1500s, for the proposition that the requirement existed. See, for example, ZAPALAC at 48–49, 76–68; STRAUSS, LAW, RESISTANCE, AND THE STATE at 195; TROESCHER at 148. See also GUIDO KISCH, RECHT UND GERECHTIGKEIT IN DER MEDAILLENKUNST (LAW AND JUSTICE IN MEDALLION ART) (Heidelberg, Ger.: C. Winter, 1955). Troescher also cited the fourteenth-century source for the Magdeburg Law as stating that "an honorable judge in the town hall should be reminded of the most serious court of our Lord: and therefore he should think of this court." Id. at 148. Later editions of the Magdeburg Laws reiterate that requirement. Through the able assistance of Yale Rare Book Librarian Mike Widener and of Stella Burch Elias, we were able to identify two of those later iterations, the *Sechsich Weichbild und Lehenrecht* (roughly translated as *Saxon Municipality and Lay Law*)—one from 1537 and the other from 1558—as well as a 1514 volume by Tengler in the Yale Law School's Rare Books Collection. The pagination is slightly different than that of the materials cited by Kisch, but two references to Last Judgment images in courtrooms are provided, as we discuss in the text and in subsequent footnotes. The special place accorded the Last Judgment overlapped with a shift to other narrative scenes. For example, as of the end of the thirteenth century, the Nuremberg Rathaus had historical images from Plutarch and Gellius and a *Last Judgment*. ZAPALAC at 196, n. 22.

**257** TROESCHER at 148. These multi-volume codes in various versions were the laws adopted in different city-states. See, e.g., PAUL LABAND, DAS MAGDEBURG-BRESLAUER SYSTEMATISCHE SCHÖFENRECHT AUS DER MITTE DES XIV (THE MAGDEBURG-BRESLAU SYSTEMATIC MAGISTRATES' LAW FROM THE MID-FOURTEENTH CENTURY) (Berlin, Ger.: Ferd. Dümmlers Verlagsbuchhandlung, 1863, reprinted 1967).

**258** *Sechsich Weychbild und Lehenrecht* (*Saxon Municipality and Lay Law*), Article XVI, folio XXVa (Leipzig, Ger.: Michael Blum, 1537).

**259** *Sechsich Weychbild und Lehenrecht*, Article XVI, folio XXVIIb.

**260** STRAUSS, LAW, RESISTANCE, AND THE STATE provided that translation at 31. *Laienrichter* is the term for "lay judge." The title of Tengler's work is variously spelled Leyenspiegel or Laienspiegel.

**261** See ULRICH TENGLER, DER NEU LEYENSPIEGEL VÖ RECHTMASSIGEN ORDNUNGE IN BURGERLICHEN UND PEINLICHER REGIMETEN (THE NEW LAYMAN'S MIRROR CONTAINING JUST RULES OF CIVIL AND PENAL LAW) (Strasbourg, Ger.: 1514).

**262** TENGLER at folio OELXIII (b), as well as the sections titled "On God's Court" (according to the register, folio cvliv (a), and according to the book's pagination OEXLIX (a)) and "On God's punishment" (according to the register, folio cvliv (b), and according to the book's pagination OEXLIX (b)). Given the challenges in locating original sources and the rarity of full discussions in English about Tengler, more details are in order. In one section titled "On the Last Judgment," Tengler explained that earthly judges made the laws in their courts, but it was God who reigned above all judges in his heavenly court and would address the sins of men and punish them accordingly. The section in the 1514 Tengler "On the Last Judgment" is twenty-eight pages or fourteen double-sided folios. Its introduction reads:

the image of the Last Judgment provides a model that every judge, person judging, person giving counsel, or

other court personnel who administer justice should heed and have before their eyes and pay attention to. For on the last day there will be complete reckoning and they must answer for each and every secret and public action and omission with the threat of the torture of eternal damnation. And so according to regulations, until now in the criminal legal rules, the genuine truth of the Last Judgment was to be shown [or displayed] so that bad laymen would be drawn to justice.

Provided thereafter are detailed descriptions of the content of the *Book of Revelation* and its relevance for judges, including outlines of the Old and New Testament references to God's judgment, the Antichrist, "damnation," the "knowledge of the Jews," and "the Devil." The conclusion, titled "So that the model of the Last Judgment will be useful," admonished judges to "think about the cruelest court of God"—as displayed before their eyes—so that they might judge fairly.

**263** ZAPALAC at 29, translating Ulrich Tengler, whom she noted, authored "the most important German handbook" on legal procedure of that era. See also STRAUSS, LAW, RESISTANCE, AND THE STATE at 31–32.

**264** ZAPALAC at 29, quoting Tengler.

**265** Antje Schmitt, *Painting versus sculpture: the programme of the Lüneburg town hall*, in THE SCULPTED OBJECT 1400–1700 153, 153, 165 (Stuart Currie and Peta Motture, eds., Brookfield, VT: Scholar Press, Ashgate Publishing, 1997) (quoting, as translated, Sigmund Meisterlin's *Nuremberg Chronicle*, written in 1488).

**266** EDGERTON at 32. Such scenes were then less common in Italy. Id. at 33.

**267** In addition to those cataloguing scenes of the Last Judgment, many scholars have documented their development and distinctions. See, for example, BOUILLET; ZAPALAC; TROESCHER; HARBISON. See also Lisa Wade, Representations of the Last Judgement and Their Interpretation (Ph.D. dissertation, Department of Art History and Theory, U. of Essex, Essex, Eng., 2001; UMI Publication No.: AAT C806463). Various versions of Last Judgment scenes were shown in courtrooms, churches, and hospitals. See Janey L. Levy, *The Keys of the Kingdom of Heaven: Ecclesiastical Authority and Hierarchy in the Beaune Altarpiece*, 14 ART HISTORY 18 (1991) (hereinafter Levy, *Kingdom of Heaven*).

**268** *Matthew* 25:31–32. See also EDGERTON at 22–23.

**269** *Matthew* 25:31–46, NEW ENGLISH BIBLE.

**270** *Psalm* 9:4. See also *Psalm* 9:7–8 ("The Lord thunders, he sits enthroned for ever: he has set up his throne, his judgment-seat. He it is who will judge the world with justice)"; *Proverbs* 20:8 ("A king seated on the judgment-throne has an eye to sift all that is evil"); *Luke* 22:30 (in which Jesus tells the disciples, "you shall eat and drink at my table in my kingdom and sit on thrones as judges of the twelve tribes of Israel"). One can also find in The *Second Letter of Paul to the Corinthians* 5:10 a reference to "the tribunal of Christ." Another text, less often cited, is The *First Letter of Paul to the Thessalonians* 4:16–17 ("because at the word of command, at the sound of the archangel's voice and God's trumpet-call, the Lord himself will descend from heaven; first the Christian dead will rise, then we who are left alive shall join them, caught up in clouds to meet the Lord in the air"). All citations are from the NEW ENGLISH BIBLE.

Marcia Hall also pointed to Paul's writing that on the final day "the Lord himself will descend from heaven with a cry of command, with the archangel's call, and with the sound of the trumpet of God. And the dead in Christ will rise first; then we who are alive, who are left, shall be caught up together with them in the clouds to meet the Lord in the air." See Marcia B. Hall, *Michelangelo's Last Judgment: Resurrection of the Body and Predestination*, 58 ART BULLETIN 85, 89–91 (1976). Other possible sources for Last Judgment scenes include catechetical texts, materials from St. Augustine's *The City of God* of 413–426 CE, and literary

texts such as Dante's *Divine Comedy*. See Erwin Panofsky, Early Netherlandish Painting 270–310 (Cambridge, MA: Harvard U. Press, 1953); Levy, *Kingdom of Heaven* at 19–27.

**271** The frequently cited example, noted earlier, of a great early image is the sixth-century Church of St. Apollinare Nuovo in Ravenna, Italy, where mosaics depict Christ separating sheep from goats. See, for example, Bouillet at 10. Another well-known mosaic *Last Judgment* is in the Torcello Cathedral from the twelfth century. Id. at 57.

**272** Bouillet at 60; Edgerton at 23. See Dirk Bax, Hieronymus Bosch and Lucas Cranach, Two Last Judgment Triptychs: Description and Exposition (Amsterdam, Neth.: North Holland Publishing, 1983). Giotto's Scrovegni Chapel *Last Judgment* in Padua has apocalyptic elements as well.

**273** Wade at 93–108.

**274** Hall at 89. Hall linked Michelangelo's work to the debate about whether souls alone, rather than bodies, made their way to heaven. She argued that, by the 1520s, Catholics were moving "toward the doctrine of bodily resurrection," thereby diminishing the divide between Catholics and Protestants on this issue. Id. at 88. Rather than seeing Michelangelo's work as Neoplatonic, she posited his Sistine Chapel *Last Judgment* as depicting religious commitments to bodily resurrection. Id.

**275** See Strauss, Law, Resistance, and the State at 195; Zapalac at 42–51; Edgerton at 23. Displays of the Last Judgment in Northern Europe were found in the Town Halls of Regensburg, Lüneburg, Basel, Kampen, Louvain, Bruges, Nuremberg, Graz, Danzig, Emden, Bautzen, and Haarlem. See Harbison at 54–58, 177–180; Schild at 12–28.

**276** See Zapalac at 55–59 (detailing some of the images of Mary) and Harbison at 54–59 (describing some of the analogies made in the scenes) and at 141–144 (discussing Mary as intercessor in what he termed Catholic Last Judgments); see also Edgerton at 23–24.

**277** Edgerton at 33. Maureen Flynn, *Mimesis of the Last Judgment: The Spanish "Auto-da-fé,"* 22 Sixteenth Century Journal 281, 282 (1991).

**278** Flynn at 288. The *auto-de-fé* was a ceremony "at which the Inquisition judged and punished prisoners for violations of the Catholic faith." Id. at 281. An interest in inscribing obligations of obedience prompted "dramatic production of the Last Day." Id. at 290.

**279** The artist is unknown. Our thanks to Otto Hochreiter, Katharina Gabalier, and Franz Leitgeb, who directed us to the correct source for the image, and to Stadtmuseum Graz for providing us with the image in figure 30 and with permission to use it. The Graz painting has been reproduced and discussed by others, some describing the painting as a seventeenth-century copy. See Zapalac at 46–51 and fig. 14; Troescher at 172–173 and fig. 126.

**280** See, for example, Zapalac at 48–53; Troescher at 157–178; Lederle at 60–65; Harbison at 58–59; Schild at 12–28. Another example, *Himmlisches und irdisches Gericht (Heavenly and Earthly Court)*, from circa 1400, is reproduced in Pleister and Schild at 73, fig. 105. These authors, too, noted that such depictions plainly connected secular and divine judgments.

**281** See Troescher at 172, para. 36–37. Troescher reported that Strobel served as town judge in 1452, 1461, and 1466 and as mayor in 1461.

**282** Erwin Panofsky, Early Netherlandish Painting, Its Origins and Character (Cambridge, MA: Harvard U. Press, 1953) at 211. Schild and Harbison noted the parallels. As Schild put it, Jesus Christ's "heavenly court is painted in complete parallel to the earthly court." Schild at 12. See also Harbison at 59.

**283** As Zapalac explained, the spectators' placement "confused the viewer's perspectival understanding of the scene," making "impossible a comfortably distinct reading of two scenes as discrete events." Zapalac at 49. See also Lederle at 63; Harbison at 58–59.

**284** Zapalac at 48–49.

**285** Zapalac at 32 (translating the German) and at 52. Those who executed wills also told executors that they had pledged honest accountings as "he will give an account of himself to God on Judgment Day." Id. at 52. At the time, Regensburg had a population of about 10,000 and was, like Nuremberg, a "free imperial city," which meant it owed allegiance to the emperor rather than to any particular prince. Id. at 26.

**286** Zapalac and others detailed the various depictions. For example, in Regensburg's Rathaus as of 1536, a *Last Judgment* showed Christ with a sword in his left hand and his feet resting on a globe; angels blew trumpets as the dead "rose from their graves." Mary and John the Baptist were also depicted. Zapalac at 29.

**287** Strauss, Law, Resistance, and the State at 195 (quoting Adolf Weissler).

**288** *James* 2:13, as translated by Harbison at 58. See also Lederle at 17–19. Other quotations proximate to the Last Judgment include: "He who passes judgment too quickly, hastens his own ruin!" and "Before the court be attentive to justice and learn to bear witness appropriately." Schild at 28 and fig. 36. A detailed analysis of the imagery and structure of the Lüneburg Town Hall is provided by Schmitt at 153–171.

**289** Zapalac at 32 and fig. 4, at 33 (citing verses from a panel, now missing, that can be seen in a miniature of a courtroom scene). The verses come from *II Chronicles* 19:6 and *Matthew* 7:2 but are somewhat paraphrased from the Latin. See Zapalac at 196, nn. 24 and 25.

**290** These images are thought to have been made around 1525. The frame in Bruges was inscribed with the words "Take heed what you do: for ye judge not for man, but for the Lord." In Nuremberg, the image bore the inscription "Men should be judged on earth as they will be judged later (by Christ)." See Levy, Last Judgment at 193, nn. 6 and 7 (translation by author).

**291** Zapalac at 75 (translation by author).

**292** Troescher at 148. Lederle commented that the depiction was added to the City Hall "after the Law of Magdeburg required it" and that "judges sat with their backs to it." Lederle at 25.

**293** For example, the section of a 1514 Tengler (discussed earlier) titled "On the Last Judgment" opens with a woodblock image of Christ floating in midair with his arms outstretched. Versions of that image can also be found in other German codes, including the *Bambergensis*, discussed in Chapter 4. Behind the head of Christ stretches a long horizontal bar that ends, on the right side of the picture with a sword and on the left side with a flower (possibly a lily). One of Christ's feet rests on a spherical image, perhaps a globe, and the other foot floats free. Beneath the free-floating foot are two very small figures dressed as peasants, one of whom appears to be tilling the soil while the other may be drawing a bow and arrow. On Christ's right kneels a crowned figure (perhaps a king) behind whom other crowned figures (one of whom is flying a pennant featuring the double-headed Hapsburg eagle) are also arrayed, kneeling. On Christ's left another crowned and cloaked figure is kneeling (perhaps representing the pope), and behind him are a bishop in a miter carrying a crook, as well as what appears to be a monk wearing a habit with a cowl and a straw hat. Over time, the imagery shifted. As discussed later, Zapalac's explanation is that the Protestant Reformation required a different iconographic expression, for predestination did not make as salient as had Catholic theology the connection between the daily rulings of magistrates and whether one went to heaven or hell. Zapalac at 78.

**294** Zapalac at 37. Zapalac argued that for Regensburg, "the Last Judgment itself was present in the courtroom, evidence for that last trial was there being collected and weighed."

**295** Harbison's analysis posited that "the most noteworthy feature of the Last Judgments located in Town Halls is their position in a totally profane environment." See Harbison at 52. Further, he described many of those works as "secular Last Judgments" in that

they had distinctive characteristics. Id. at 62. Similarly, Edgerton argued that the increasingly secular societies of the city-states sought "spiritual affirmation that their urban way of life was just as God-anointed as the old feudal vision of society." EDGERTON at 22. Levy offered a different claim, that some Last Judgment scenes were deployed in relationship to specific political conflicts between local and central authorities. Her example is the *Last Judgment* commissioned between 1420 and 1450 for the town hall in Diest, in which apostles, symbolic of the local aldermen, are arranged to be seen as holding special authority. Levy, Last Judgment at 195–198.

**296** ZAPALAC at 34–35. Zapalac detailed how court-based processes affected Church liturgy, with popular dramas positing trials involving Christ and the Devil and with legal texts portraying Mary as a lawyer defending humanity before Jesus. Further, she compared late fifteenth-century oath-taking scenes of a courtroom and those of the Devil and an angel to show that the boundaries between the secular and the religious were deliberately crossed and obscured. Id. at 45–48 and figs. 11 and 12. More generally, a good deal of scholarship looks at the commingling of religious and secular authority, with efforts made by jurists to show that their edicts conformed to divine revelation as well as senses of fairness and equity. See STRAUSS, LAW, RESISTANCE, AND THE STATE at 35–40. From the vantage point of the history of Germany recounted by Strauss, secular institutions reflected a God-ordained hierarchy that "had an immediacy in sixteenth century Europe"; political rights were similarly "urgent" and "valued" by persons of high and low ranks in society. Id. at 111–112.

**297** ZAPALAC at 27–31, 72–81. See also Heidi Eberhardt Bate, The Measures of Men: Virtue and the Arts in the Civic Imagery of Sixteenth-Century Nuremberg 125–139 (Ph.D. dissertation, Department of History, U. of California, Berkeley, CA, 2000; UMI Publication No.: AAT 3001752). Bate detailed the array of historical models deployed in works by Albrecht Dürer for the Nuremberg Town Hall, for which the Last Judgment was but one part of a "much broader range of iconographical possibility." Id. at 130.

Further, as Zapalac recounted, in some instances representations of the Last Judgment were taken down in favor of other images. For example, in the Rathaus in Regensburg, the *Last Judgment* in which Christ had been central was replaced by a painting of 1592 by Isaac Schwendtner that was an allegory of *The Virtues of Good Government*. Nearby were Caritas (Charity), Justitia (Justice), and Prudentia (Prudence), with Pax (Peace), and Ceres (Prosperity). ZAPALAC at 29, 30, and fig. 3. Last Judgments did not, however, disappear. For example, the major renovation of the Nuremberg Town Hall in 1621 included the placement of an image of the Last Judgment on one of the walls. See Bate at 124. Moreover, as Bate pointed out, Lutheran reformers might not have been pleased by the replacement of Last Judgments with the "pagan material" provided through the imagery of Roman gods and goddesses. Id. at 129.

**298** Harbison argued that in Northern Europe the Reformation and secularization provided impetus for propaganda to reassure members of society that earthly decisions paralleled heavenly ones. HARBISON at 61–64; see also HARBISON, INTRODUCTION TO SYMBOLS IN TRANSFORMATION: ICONOGRAPHIC THEMES AT THE TIME OF THE REFORMATION 15–16 (Princeton, NJ: Princeton U. Art Museum, 1969) (exhibition catalogue).

**299** Zapalac traced the shift from "late-Medieval cosmology in which sacred history and eschatology were emphatically present in the temporal world" to "a Lutheran cosmology in which the two realms were held apart by the concept of predestination." ZAPALAC at xiii. Last Judgment panels in northern courtrooms of the late Medieval period were replaced in Lutheran cities during the sixteenth century by allegories of Justice. That change occurred in Regensburg that, in 1542, became Lutheran. See id. at 195–196, n. 21. Zapalac argued that "Christ the judge disappeared from the council chamber, to be replaced by an image that brought together an older vision of justice revived by the

humanists and a vision of God the Father rather than the Son." Id. at 55. Thus, "the Last Judgment was no longer eminent or present in the temporal judgment" of courts, and those pictures were replaced with images of Justice. Id. at 73. Moreover, texts were altered. For example, in Regensburg in 1554, the charge in the council chamber added (in a "more accessible German") a "final admonition to the councillors: 'as you have been impartial or inequitable, so shall you be judges by God— *a judgment he has completed in eternity*.' " Id. at 75 (Zapalac's translation and emphasis). Further, the pictures that illustrated constitutions and legal rules also shifted to feature abstract Virtues in lieu of images of the Last Judgment. Zapalac's explanation was that the theme of predestination meant that the decisionmaking by judges "no longer determined" their own final judgments. Id. at 75. Rather, "God the father" was positioned above the city, in various woodcuts and frescoes, to show that the regime was under his guidance. Id. at 84–85.

**300** ZAPALAC at 78–79. There she also noted that the Last Judgment came to serve as "a reminder of the difference between eternal and temporal judgment." Id. at 79. Another effect of Lutheran "theology and social policy" was on public executions, which came to engage "para-religious practices" as "popular energies" moved "from altar to scaffold." MERBACK at 271.

**301** HARBISON at 120–123.

## CHAPTER 3

**1** See JEREMY BENTHAM, THE CONSTITUTIONAL CODE (1843), in 9 THE WORKS OF JEREMY BENTHAM, bk. II, ch. XII at 458–459 (John Bowring, ed., Edinburgh, Scot.: William Tait, 1843) (emphasis in the original):

> Art. 11.
>
> For the designation of a *Judiciary*, why employ this term, to the exclusion of the more commonly employed word *Court*?
>
> Answer. Reasons.
>
> 1. In this same signification the word *Judicatory* is already in use.
>
> 2. The word *Judicatory* is clear from all ambiguity: the word *Court*, not.
>
> 3. The word *Court*, besides ambiguity, is liable to produce delusion and mischievous error.
>
> 4. Not that the word *Judicatory* is altogether free from ambiguity . . . . Originally it meant . . . a place in which the person or persons *acted* . . . that is to say, the *usual* place of residence of the functionary acting as such; . . .
>
> 6. In Monarchies in general, and in the English Monarchy in particular, in addition to the sense in which it is synonymous to the word *judicatory* in its *person-regarding* sense, as above, the word *Court* is employed in the designation of the persons following:
>
> > i. The Monarch.
> >
> > ii. The persons most immediately attached to the service of the monarch, in his *private* or say *non-functionary* capacity.
> >
> > iii. Any such other persons as are most frequently in his presence.
>
> 7. *Antecedent* to the *Juridical* sense of the word *Court*, was, as above, its *Monarchical* sense. In the times of

original inexperience and simplicity, all the authorities in the state were, in the supreme grade, exercised by one hand. By degrees, the judicial authority—the Monarch not having time for the exercise of it—was transferred to *subordinate* hands. Name of this functionary—in England, the *Grand Justiciary*. But, his residence was the same as that of the Monarch: to wit, the *Court* in its *king-regarding sense*; and whenever and wherever the Monarch *travelled*, (as for a great part of his time he commonly did,) with him travelled the *Judge*, and what was called *Justice*.

8. A *Court* is the region of favour: of favour, in contradistinction to Justice. A Monarch is above Justice. From his will it is, as from its source, that what in a Monarchy is called *Justice*, emanates: on that same will depends the nature of it: the purport and tenor of the words by which, on each occasion, it stands expressed. Witness the maxim, *Quod Principi placuit legis habet vigorem*:—a maxim, in every pure Monarchy, not only acted upon, but avowed: in the English Monarchy, sometimes avowed, sometimes disavowed: but, by all, more or less acted upon, even when disavowed. . . .

2 See Elizabeth McGrath, Rubens: Subjects from History, vol. 1: Text & Illustrations (London, Eng.: Harvey Miller Publishers, 1997; National Centrum voor de Plastische Kunsten van de 16de en de 17de Eeuw), as part 13 of Corpus Rubenianum Ludwig Burchard at 7, 33–35. As McGrath explained, "history was principally valued for the lessons it taught" (id. at 33). The tradition of didacticism that lined the "walls of Renaissance palaces and town halls" relied on "citation of some deed or saying of the past" (id. at 34). Hugo van der Velden traced the Medieval tradition of such exempla to Cicero's discussion of an "example (that) supports or weakens a case by appeal to precedent or experience, citing some person or historical event," as well as to another classical text, *Ad Herennium*, whose author is not known. See Hugo van der Velden, *Cambyses for Example: The Origins and Function of an Exemplum Iustitiae in Netherlandish Art of the Fifteenth, Sixteenth and Seventeenth Centuries*, 23 Simiolus: Netherlands Quarterly for the History of Art 5, 9 (1995) (hereinafter Van der Velden, *Cambyses for Example*). As we detail, the deployment of Cambyses has drawn the eyes of many theorists. See, for example, Christian-Nils Robert, La Justice dans ses décors (XVe–XVIe siècles) (Justice in its Settings during the 15th and 16th Centuries) 24, 74–80 (Geneva, Switz.: Librairie Droz S.A., 2006). Translations of the French by Allison Tait and Julia Schiesel.

3 The images in figures 31 and 32 are provided and reproduced with permission of the copyright holder, Musea Brugge, Groeningemuseum.

4 Cambyses was the son of Cyrus the Great, who conquered Babylon in 539 BCE. Cambyses ruled from around 530 to 521 BCE. See Herodotus, The Histories, bk. 2, lines 1–2 and bk. 3, lines 1–4 at 95, 170, 171 (Aubrey de Selincourt, trans., as revised by John Marincola, New York, NY: Penguin Classics, 2003) (hereinafter Herodotus, Histories). See also Geraldine Pinch, Egyptian Mythology: A Guide to the Gods, Goddesses, and Traditions of Ancient Egypt 34 (New York, NY: Oxford U. Press, 2002). Pinch reported evidence of a king, apparently Cambyses, who conquered Egypt in 525 BCE, but she thought the story of his contempt for Egyptian gods shown by "stabbing the sacred Apis bull" was a legend.

5 Herodotus, Histories, bk. 5, lines 25–26 at 319. One translation, provided by Hans Joris Van Miegroet, is:

Darius left as general of all the troops upon the seacoast Otanes, son of Sisamnes, whose father King

Cambyses slew and flayed, because that he, being of the number of royal judges, had taken money to give an unrighteous sentence. Therefore Cambyses slew and flayed Sisamnes, and cutting his skin into strips, stretched them across the seat of the throne whereon he had been wont to sit when he heard cases. Having so done Cambyses appointed the son of Sisamnes to be judge in his father's room, and bade him never to forget in what way his seat was cushioned.

See Hans Joris Van Miegroet, Gerard David 143 (Antwerp, Belg.: Mercatorfonds, 1989) (hereinafter Miegroet, Gerard David); Hans J. van Miegroet, *Gerard David's Justice of Cambyses: Exemplum Iustitiae or Political Allegory?*, 18 Simiolus: Netherlands Quarterly for the History of Art 116, 117 (1988). See also Hans Joris Van Miegroet, Gerard David (ca. 1450–1523): Patronage and Artistic Preeminence at Bruges 127 (Ph.D. dissertation, University of California, Santa Barbara, CA, 1980; UMI Publication No.: AAT 8905315). As discussed later, Van der Velden disputed some of Miegroet's conclusions.

6 Van der Velden, *Cambyses for Example* at 11–16; Edward Gans & Guido Kisch, *The Cambyses Justice Medal*, 29 Art Bulletin 121, 122 (1947) (hereinafter Gans & Kisch). One survey of town hall art chronicled this image in various media (painting, glass windows, carvings) in Münster, Emden, Gdańsk, Königsberg, Thorn, and Breslau. Ursula Grieger Lederle, Gerechtigkeitsdarstellungen in deutschen und niederländischen Rathäusern (Representations of Justice in German and Dutch Town Halls) 44–45 (Ph.D. dissertation, Heidelberg, Ger.: U. of Heidelberg Press, 1937).

7 Gerard David lived from about 1460 to 1523. James Weale, a British scholar working in the 1860s, brought attention to David's work: "up to the year 1861, nothing whatsoever was known of Gerard David," whose name was found neither in "any dictionary of artists nor in any modern work on Netherlandish art." Further, his works were attributed to others. See W. H. James Weale, Gerard David: Painter and Illuminator 6–7 (London, Eng.: Seeley, 1895) (hereinafter Weale, Gerard David). In 1902, David's work joined that of others in a major exhibition in Bruges of "Flemish Primitives." Miegroet, Gerard David at 12. Weale explained that effort as aimed at inducing the "civil and ecclesiastical authorities (in Bruges) to devote a little more attention to the many fine works in their care . . . (some of which were) housed in a disgracefully miserable building" and to inspire the creation of a museum appropriate for the quality of the paintings. See W. H. James Weale, *The Early Painters of the Netherlands as Illustrated by the Bruges Exhibition of 1902*, 1 Burlington Mag. 41, 41–42 (1903).

8 Weale documented that the aldermen of Bruges commissioned the painting, which was completed in 1498. Weale, Gerard David at 8–9, 13. David received payments in 1488 and 1490 and, "after arbitration in 1498," an additional sum (perhaps related to other paintings and totally fourteen pounds, ten shillings) was paid. Weale, Gerard David at 13. According to another scholar, David may have painted a second image for which he was paid in 1491. See Eberhard Freiherr von Bodenhausen, Gerard David and His School 127–129 (New York, NY: Collectors Ed. 1970, reproducing the 1905 Munich edition). Miegroet speculated that after the conflict with Maximilian in Bruges, directions about how to execute the painting, then in progress, might have been revised. Miegroet, Gerard David at 154–160. Hugo van der Velden disagreed with the thesis that the commission related to a particular political moment and that the subject matter was dramatically changed along the way. Hugo van der Velden, *Cambyses Reconsidered: Gerard David's Exemplum Iustitiae for Bruges Town Hall*, 23 Simiolus: Netherlands Quarterly for the History of Art 40, 44–49 (1995) (hereinafter Van der Velden, *Cambyses Reconsidered*).

9 The original frames formed a single whole; each panel is five feet, eleven inches, by four feet, eight inches. Weale, Gerard David at 9;

see also "Translations of the Captions of the Works of Art Exhibited in the Groeningemuseum in Bruges," catalogue no. 0.40 (Musea Bruges, Groeningemuseum) (exhibition catalog). By 1498, the diptych was hanging in the Town Hall. In 1794 it was taken by the French and then returned in 1816 to the Bruges Town Hall before being relocated in 1828 to the Museum of the Academy, where it was later restored. Robert argued that the diptych was sent to a museum at that time to damp down concerns about judicial integrity. Robert at 24. For a time during the nineteenth century, however, a copy titled *Flaying of Sisamnes* hung in the Law Courts of Bruges. WEALE, GERARD DAVID, at 13 and n. 1.

**10** MIEGROET, GERARD DAVID at 145.

**11** How viewers then responded is an open question, for other scenes of punishment, seen today as gruesome, were regularly displayed to show the consequences visited on wrongdoers by authority, earthly or divine. See PIETER SPIERENBURG, THE SPECTACLE OF SUFFERING: EXECUTIONS AND THE EVOLUTION OF REPRESSION 8–29 (Cambridge, Eng.: Cambridge U. Press, 1984).

**12** HERODOTUS, HISTORIES, bk. 2, lines 1–8 at 95–97.

**13** That version posited that Cambyses wanted to marry a daughter of the Egyptian King Amasis but was sent a daughter of Apries, who then induced Cambyses to begin a war. He killed the Egyptian "Apis bull" and was "punished by madness." See HERODOTUS, THE HISTORIES, bk. 3 at 182–185. "In view of all this, I have no doubt whatever that Cambyses was completely out of his mind." Id., bk. 3 at 187.

**14** Seneca, *De ira (On Anger)*, in Moral Essays, vol. 1, bk. III–14, lines 1–4 at 289–297 (John W. Basore, trans., Cambridge, MA: Harvard U. Press, 1928). Chaucer repeated the episode recounted by Seneca in which a friend warned Cambyses against drinking. Cambyses responded by drinking more and then killed the son of the friend. GEOFFREY CHAUCER, THE FRIAR'S, SUMMONER'S AND PARDONER'S TALES FROM THE CANTERBURY TALES, ll. 380–415 at 86–87 (N. R. Havely, ed., London, Eng.: U. of London Press, 1975).

**15** As one commentator noted, the Roman and Greek sources for this story provided an "acute sense of the barbaric," such that one would feel the "harsh justice of antiquity." See JULIAAN H. A. RIDDER, GERECHTIGHEIDSTAFERELEN VOOR SCHEPENHUIZEN IN DE ZUIDELIJKE NEDERLANDEN IN DE 14DE, 15DE, EN 16DE EEUW (IMAGES OF JUSTICE IN COURTHOUSES IN THE SOUTHERN NETHERLANDS IN THE 14TH, 15TH, AND 16TH CENTURIES) 55–56 (Brussels, Belg.: Paleis der Academiën, 1989). See also WOLFGANG PLEISTER & WOLFGANG SCHILD, RECHT UND GERECHTIGKEIT IM SPIEGEL DER EUROPÄISCHEN KUNST (LAW AND JUSTICE REFLECTED IN EUROPEAN ART) 161–162 (Cologne, Ger.: DuMont Buchverlag, 1988). Translations of the Dutch are by Chavi Keeney Nana, German translations by Chavi Keeney Nana and Stella Burch Elias, and translations of the Old German by Stella Burch Elias.

**16** The reversal of the "original moral" came from various Medieval authors, who portrayed Cambyses as "a sage who acted justly in making a public example of a corrupt officeholder." VALENTIN GROEBNER, LIQUID ASSETS, DANGEROUS GIFTS: PRESENTS AND POLITICS AT THE END OF THE MIDDLE AGES 78–79 (Pamela E. Selwyn, trans., Philadelphia, PA: U. of Pennsylvania Press, 2000).

**17** The tapestry—called the *Throne Baldachin*—was commissioned by King Frederick II in 1581. Woven around 1585 by the Danish workshop at Helsingør, the tapestry consisted of a backcloth (more than nine by eleven feet) and a canopy (thirteen by nine feet) that "was intended to hang above the royal table at which [Frederick II] and his wife, Queen Sophie, would sit." See Elizabeth Cleland, *Throne Baldachin*, in TAPESTRY IN THE BAROQUE: THREADS OF SPLENDOR 33 (Thomas P. Campbell, ed., New York, NY: Metropolitan Museum of Art; New Haven, CT: Yale U. Press, 2008). Justice plays a prominent role, depicted as a blond-haired centerpiece between the images celebrating the justice and greatness of the king and queen's lineages. Id. at 34. Justice, in turn, is flanked by Temperance to the left and Fortitude to the right.

In the canopy are four classical "justice stories" encircled as if on medallions. The first shows Alexander hearing the case of a supplicant while covering one ear; "Alexander heard both sides of an argument without bias, literally offering one ear to each plaintiff, before reaching judgment." Id. The next scene is of a man restraining the son of Zaleucus (discussed later in this chapter) while another gouges out his eye. The scene is translated as "Resolution." A third scene depicts the Roman Emperor Trajan (also discussed later) raising his sword to execute a soldier being punished for the accidental killing of a child. The medallion reads "TRAIANI BILLIGKEIT" (Trajan Fairness). A fourth medallion shows a crowned Cambyses gesturing to the flayed body of Sisamnes, hanging above a judicial throne. The inscription below reads "CAMBYSIS VORSICHTIGKEIT" (Cambyses' Prudence). Id. at 34–35. From 1586 to 1658 the tapestry remained in the Danish Helsingør Castle, but in 1658 the troops of Swedish King Karl Gustav X removed it to Sweden. See Throne Baldachin at the website of the Metropolitan Museum of Art, http://metmuseum.org/special/tapestry/view_1.asp?item=0.

**18** MIEGROET, GERARD DAVID at 144. According to Miegroet, the book was translated into "Netherlandish" and published in Gouda, Delft, and Zwolle in the 1480s. See also WEALE, GERARD DAVID at 9.

**19** MIEGROET, GERARD DAVID at 144. In addition, an "abbreviated version" of this legend was mentioned in Valerius Maximus's *Facta et dicta memorabilia*, which described the judge as "strangled" and also noted that his skin was "stretched over the judicial chair upon which he made his son sit." Id. at 145. Maximus noted that Cambyses, "king of Persia and Medea," had provided "a good example of severity" and that as a consequence of the "novel and marvelous punishment," other judges would not turn to corruption. Id. at 145. See also VALERIUS MAXIMUS, MEMORABLE DOINGS AND SAYINGS, vol. 2, bk. 6:4, ext. 3 at 42–43 (D. R. Shackleton Bailey, trans., Cambridge, MA: Harvard U. Press, 2000) (hereinafter MEMORABLE DOINGS AND SAYINGS). Whether *Gesta Romanorum* was available in Bruges is questioned by some commentators pointing to other Medieval texts including versions of the Cambyses story. See Van der Velden, *Cambyses for Example* at 10–17, 24. Those discussed were several, including *Speculum historiale*, by Vincent of Beauvais, who died in 1264; *Spieghel historiael*, by Jacob van Maerlant; a translation of that work, the *Ludus scaccorum* (The Game of Chess), from about 1325; and a Dutch adaption of about 1400, called *Dat scaecspel*.

**20** Gans & Kisch at 121.

**21** See CESARE RIPA, BAROQUE AND ROCOCO PICTORIAL IMAGERY: THE 1758–60 HERTEL EDITION OF RIPA'S 'ICONOLOGIA' WITH 200 ENGRAVED ILLUSTRATIONS 117 (Edward A. Maser, ed., New York, NY: Dover Publications, 1971) (hereinafter RIPA, MASER EDITION). This English edition cited a 1603 Ripa text for the description of the figure Injustice, shown as a "tall woman of commanding appearance," with a "white cloak . . . splattered with blood" and a "blood-stained scimitar in one hand. At her feet lie torn scrolls, parts of a broken pair of scales, broken tablets of the Decalogue, and a fragment of an obelisk. On her shoulder sits a toad. . . . Her turban and robe suggest the barbarous lands where injustice is common. The toad is a symbol for greed, upon which much injustice is founded." Accompanying the drawing is an excerpt from Herodotus, *The Histories*, bk. 5 at line 25, translated as "Cambyses, seated on his throne, watches while the naked Sisamnes is flayed alive. In the background the hapless man's skin is being nailed to the judge's seat in the court where he had performed his office dishonestly." RIPA, MASER EDITION at 117.

In other editions of Ripa, Injustice was also portrayed with a toad and broken tablets representing the Ten Commandments at her feet, although her garb was not obviously from other "barbarous lands." The 1611 edition depicted Injustice "holding a sword in the right hand and a toad in the left; on the ground law tablets are in pieces." CESARE RIPA, ICONOLOGIA 250 (Padua, Ital.: Pietro Paolo Tozzi, 1611; New York, NY & London, Eng.: Garland Publishing, 1976) (hereinafter

RIPA, PADUA–1611. Translations of the Italian by Allison Tait and Tess Dearing. In the French edition, Injustice wore a spotted and soiled robe and held both a sword and a toad that represents "the venom with which she infects good morals." CESARE RIPA, ICONOLOGIE, vol. 2 at 163 (J. Baudoin, ed., Paris, Fran.: Chez Mathieu Guillemot, 1644) (hereinafter, FRENCH RIPA–1644). A Dutch version contemporary with the French had Injustice with a toad and broken tablets. CESARE RIPA VAN PERUGIEN, ICONOLOGIA, OF UYTBEELDINGEN DES VERSTANDS 366 (Amstelredam, Neth.: Dirck Pietersz Pers, 1644) (hereinafter DUTCH RIPA–1644). Even in the later 1779 English edition, Injustice was portrayed with "a sword in one hand, and in the other, a toad, she tramples under her feet, a pair of broken scales and the books of law, both human and divine." CESARE RIPA, ICONOLOGY LONDON 1779 at 21 (George Richardson, ed., New York, NY & London, Eng.: Garland Publishing, 1979). The toad "in the Netherlands and Flanders stood for unchastity, greed and miserliness, uncleanness, and pride. The animal could be a symbol of the devil and the latter sometimes changed himself into it. In purgatory and hell, toads not only torment sinners, they are also given to the doomed to eat." See D. BAX, HIERONYMUS BOSCH AND LUCAS CRANACH, TWO LAST JUDGMENT TRIPTYCHS, DESCRIPTION AND EXPOSITION 29–30 (M. A. Bax-Botha, trans., Amsterdam, Neth.: North-Holland Publishing, 1983).

**22** "The great majority of extant Cambyses scenes depict the moment at which Otanes has taken his place in the judgment-seat, on or beside the skin of his flayed father." See Van der Velden, *Cambyses for Example* at 22. "With the single exception of the painting by Gerard David, all the monumental representations of the Judgment of Cambyses produced in the Low Countries were therefore dominated by the portrayal of Otanes in the judgment-seat." Id. at 29; see also id. at 18–32 (describing the many renditions of the throned judge, the occasional scene of flaying, and the unusual aspects of the Bruges version).

Whether the particular sanction—flaying—had a real-world counterpart is a subject of debate. Miegroet suggested it did. See MIEGROET, GERARD DAVID at 173, n. 10 (noting that classical writers described flaying as a "Persian punishment"). But see Van der Velden, *Cambyses Reconsidered* at 40–41 (disagreeing with Miegroet's interpretation; while "one might be decapitated, buried alive, burned, quartered or even boiled," one would not be flayed).

**23** ROBERT at 79, 99.

**24** See MIEGROET, GERARD DAVID at 154–159, 164–170; Gans & Kisch at 123.

**25** As Miegroet detailed the history, the authority of Archduke Maximilian of Austria over the Burgundian Netherlands lasted only during the life of his wife, Mary of Burgundy, who died in 1482, when their son (who would become Duke Philip the Fair) was four. MIEGROET, GERARD DAVID at 19, 146. Flanders, Ghent, Bruges, and Ypres did not recognize Maximilian as the rightful regent. Facing a French invasion in 1487, Maximilian sought to enlist support from Ghent and Bruges, but was met with resistence. In December of 1487, Maximilian entered Bruges with about two hundred armed German soldiers. By January of 1488, as armed conflict between France and Maximilian became unavoidable (with Ghent seeming to move toward revolt), the city leaders of Bruges refused to let Maximilian leave, keeping him hostage in a house near the marketplace. Sometime that spring, they released him as they faced a threat from the German cavalry and excommunication by Pope Innocent VIII for imprisoning the Roman king.

Bruges and Maximilian then negotiated that the provinces of the Netherlands, united under Duke Philip the Fair, would enter into a peace with France. Maximilian was given funds for his army, but later reneged on the agreement. In 1489 Maximilian entered a treaty with France, and Bruges recognized it. Thereafter, the city again sided against Maximilian during a conflict with Holland and moved into an open revolt in 1490. Under siege, Bruges capitulated in November of 1490. MIEGROET, GERARD DAVID at 19–20. Maximilian became

Emperor in 1493, after the death of Frederick III. Weale's account focused on the seizure of Maximilian in January of 1488, whereafter a "deposed burgomaster, the judge Peter Lanchals, and other members of the magistracy were accused of corruption and malversation, were put to the torture, condemned to death, and executed." Gerard David was in the city at the time and soon thereafter was commissioned to "paint for the justice-room in the town-hall two panels that should recall to the sitting magistrates that they must be honest and impartial." WEALE, GERARD DAVID at 8–9. Weale put the date of payments in 1490. Miegroet thought that pro-Maximilian magistrates paid David some of what was owed in 1491, the year after Bruges was finally defeated by Maximilian. MIEGROET, GERARD DAVID at 154, 170, 358. Final payment, however, was made when the diptych was completed in 1498, and the conflict may have been less salient then.

According to Miegroet, however, the authorities and not the painter decided on the subject matter and the "highly wrought iconography" that reaffirmed loyalty to the governing rule. Thus, the Bruges burghers were reminded that, if they "ever failed to heed the rule of the Habsburgs, they would pay for their crime in a most cruel manner." MIEGROET, GERARD DAVID at 170. See also RIDDER at 55–62. In addition to the central story, the canvas is full of other referential details, such as the painted wall medallions, identified as reproductions of "cameos in the Medici collection" and of mythic scenes. Id. at 289.

**26** Van der Velden, *Cambyses for Example* at 15, quoting a 1404–1405 Dutch text. Another volume, from 1488, explained the many historical narratives, predicated on the writings of Valerius Maximus, Plutarch, and Aulus Gellius and depicted on the walls of the Nuremberg Town Hall, were "intended to inspire counsellors and judges to embrace justice." Id. at 16.

**27** According to Miegroet, it was not until the sixteenth century that "the legend of Cambyses became more popular in the visual arts"—to be found in many paintings, stained glass, tapestries, and medals. MIEGROET, GERARD DAVID at 143. Thus, fifteenth-century versions, such as Gerard David's *Judgment of Cambyses*, were rare; "only one other contemporary rendition of the theme is recorded, executed on canvas by Martin de Hauchin for the aldermen of Mons between 1497 and 1498." Id. But Van der Velden, in *Cambyses Reconsidered* at 52–53, argued that images of the Cambyses story were depicted in "miniatures dating from 1425–50, half a century before the Bruges justice scenes were painted." However, he commented that most portrayed Otanes sitting on his father's skin and thus that David's choice of scenes was "remarkable." Id. at 53–54 (noting a comparably gruesome specificity in a stained glass pane by Dirk Vellert). See Van der Velden, *Cambyses for Example* at 7.

One of the best-known seventeenth-century examples of the Cambyses narrative was painted around 1622 by Peter Paul Rubens for the Brussels Town Hall. Titled *Cambyses Admonishing Otanes upon Sisamnes' Throne*, the painting was lost to fire in 1695. See Van der Velden, *Cambyses for Example* at 36–37 (describing the image as the "most famous *Judgment of Cambyses*"); Gans & Kisch at 122, n. 3. As McGrath explained, in the Brussels Town Hall Cambyses joined a *Judgment of Solomon*, and "between them, above the judgment seat, there may have hung a painting of the Last Judgment." McGRATH, vol. 1 at 43. Several copies of Rubens's painting exist. See, for example, McGRATH, vol. 1 at figures 24–30, catalogue no. 6a. As McGrath explained (vol. 2 at 40–47), Rubens's rendition focused on Otanes, the new judge sitting on his father's skin, which was "suspended behind," with a ghostly skull-like face at its center. Further, Rubens's picture is unusual, if not unique, in its emphasis on the "salutary function" of justice. The judge is surrounded by petitioners, including a mother, children, and an old man, all appealing to Otanes. On his chair are "symbols of wisdom and discretion," including shells and "sphinxes for arm-rests" which alluded to the "throne of Solomon." Id. at 40.

Discussion of the Cambyses in a building known as "Arthur's Court" in Gdańsk can be found in Jerzy Miziolek, *Exempla Iustitiae at Arthur's Court in the Context of Dutch and Flemish, German, and Italian Art*, in Netherlandish Artists in Gdańsk in the Time of Hans Vredeman de Vries 73, 77–78, fig. 9 at 153 (Gdańsk, Pol.: Museum of the History of the City of Gdańsk, 2006). The building, constructed in 1350 as a "social meeting place for the wealthy," was rebuilt in 1481 at the direction of the City Council and used between 1530 and the eighteenth century as a court of justice as well as a meeting place for guilds. Id. at 74. The Cambyses fresco was completed before 1603 and may well show the influence of David's portrayal. As in the image by Gerard David, the arrest is also featured, with an enthroned judge accosted by two men taking him off the chair while a third (perhaps meant to be the king) points a sword at him. The flaying, however, is shown in a smaller and less graphic scene than in Bruges.

**28** Alexander S. Gourlay, *Hogarth, Rubens, and the "Justice-Picture" Tradition*, 14 The Eighteenth Century: Theory and Interpretation 35–46 (1990). Remoldus Eynhoudts did etchings after the version of Cambyses that Rubens painted for the Brussels Town Hall, and those prints were available in London in the seventeenth century. Id. at 38–39 and fig. 2.

**29** Van der Velden, *Cambyses Reconsidered* at 49. Van der Velden argued that, because Philip the Handsome (also called Philip the Fair) paid his first visit to Bruges in 1497 and the City celebrated him in an expensive fashion, "it would have been improper to set out to give the city's administrators a humiliating reminder of the errors of their predecessors, who had been removed from office years before." Id. at 41. Van der Velden disputed Miegroet's identification of a portrait as of Philip and argued that putting in images of local magistrates was a way of recognizing those who may have contributed financially to the painting. Id. at 51–52. Further, Philip would have identified with Cambyses, "who used unflinching discipline, where necessary, to preserve order and justice." Id. at 57. In short, it was "incorrect . . . to suppose that the significance and function of this painting differed from that of the countless other representations of Cambyses, or of other contemporary exempla of justice." Id. at 63.

**30** Natalie Zemon Davis, The Gift in Sixteenth-Century France 85 (Madison, WI: U. of Wisconsin Press, 2000).

**31** Davis at 87.

**32** Davis at 85.

**33** Davis at 87 (emphasis in original). Even then, one could give "game taken from the forests of the seigneurs who were presenting it." In 1579, the Ordinance of Blois forbade all gifts from parties to a current case, yet the provisioning of judges continued. Id. at 87–88.

**34** The term *don de l'office* entailed, in fact, two "gifts"—that of the king bestowing the position and that of the judge, paying for it. According to Davis, "By the 1540s, every new judgeship involved a payment to the king, described as a loan to help the monarch in his urgent necessities." Davis at 98.

**35** John T. Noonan Jr., Bribes 3 (New York, NY: Macmillan Publishing, 1984) (emphasis in the original).

**36** *Tumey v. Ohio*, 273 U.S. 510, 531 (1927).

**37** *Tumey*, 273 U.S. at 515.

**38** *Tumey*, 273 U.S. at 535.

**39** *Tumey*, 273 U.S. at 531. The unanimous opinion, by Chief Justice Taft, analyzed the amount of income received (about $100 in a seven-month period), the mayor's salary, the range of discretion over the amount of a fine (from $100 to $1,000), and the percentage to be retained by local law enforcement as contrasted to that allocated to the state. The court also concluded that "matters of kinship [and] personal bias" were issues for local legislation and did not have constitutional import. Id. at 523.

Under current federal law, judges must disqualify themselves from sitting on proceedings in which their "impartiality might reasonably be questioned." 28 U.S.C. § 455(a). Included in a list of reasons for recusal is that a judge or a close family member has a "financial interest in the subject matter in controversy or in a party to the proceeding, or any other interest that could be substantially affected by the outcome," and "financial interest" is defined to include ownership interests, "however small," except not if part of a "mutual or common investment fund that holds securities." 28 U.S.C. §§ 455(b)(4), (d)(4). Another statute also calls for judges to step aside if their impartiality could be questioned. See 28 U.S.C. § 144. However, if all judges hold such stakes—for instance, because a provision is challenged as unconstitutionally diminishing the salary of federal judges—in the federal system, the Supreme Court has concluded that none are barred. See *United States v. Will*, 449 U.S. 200, 217 (1980). Under such circumstances, a few states have convened specially constituted courts. See generally Judith Resnik, *On the Bias: Feminist Reconsiderations of the Aspirations for Our Judges*, 61 S. Cal. L.R. 1877 (1988).

**40** *Consultation Paper of the Ministry of Justice* 3 (Apr. 2, 2007), Her Majesty's Court Service, http://www.dca.gov.uk/consult/civilcourtfees/cp0507.pdf. Included are exemptions "to ensure that access to justice for the less well-off is protected."

**41** A pressing contemporary issue in the United States is the effect of campaign contributions on judges who run for office. See generally Madhavi M. McCall & Michael A. McCall, *Campaign Contributions, Judicial Decisions, and the Texas Supreme Court: Assessing the Appearance of Impropriety*, 90 Judicature 214 (Mar.–Apr. 2007). In 2009, the United States Supreme Court debated the constitutionality of the receipt of electorial contributions. See *Caperton v. Massey*, 129 S.Ct. 2252 (2009). In a five-to-four decision, the majority concluded that a state justice ought to have recused himself, as a matter of due process, from sitting on an appeal when the president and chief executive officer of the corporation in the case had contributed some $3 million to his campaign after they had lost a $50 million verdict at the trial level.

**42** Textual references can be found in Egyptian edicts, as well as in Jewish and Christian theology. Noonan at 10–22. Unlike false witnessing, however, for which punishments were specified, none were detailed for bribery, nor were methods put into place to ferret it out. Id. at 23–24.

**43** *Leviticus* 19:15 reads: "You shall not pervert justice, either by favouring the poor or by subservience to the great." The New English Bible with the Apocrypha (Charles Harold Dodd, ed., Oxford & Cambridge, Eng.: Oxford & Cambridge U. Presses, 1970). Many similar references were made in both the New and Old Testaments. See Noonan at 14–22. We have consulted many versions of the Old and New Testaments, such as The New English Bible with the Apocrypha (Charles Harold Dodd, ed., Oxford & Cambridge, Eng.: Oxford & Cambridge U. Presses, 1970) (hereinafter New English Bible); The Twentieth Century New Testament: A Translation into Modern English, Made from the Original Greek (New York, NY: Fleming H. Revell, 1902, revised 1904); and The Good News Bible with Deuterocanonicals/Apocrypha, Today's English Version (Robert G. Bratcher, trans., New York, NY: American Bible Society, 1976).

**44** Janey L. Levy, The Last Judgment in Early Netherlandish Painting: Faith, Authority, and Charity in the Fifteenth Century, vol. 1, 193 (her translation) (Ph.D. dissertation, Department of Art History, U. of Kansas, Lawrence, KS, 1988; UMI Publication No.: AAT 8903130). See also Georg Troescher, Weltgerichtsbilder in Rathäusern und Gerichtsstätten (Last Judgment Pictures in Town Halls and Court Chambers), vol. 11 of West German Yearbook for Art History 188, figure 127 and n. 69 (Frankfurt, Ger.: Prestel-Vertel GMBH, 1939).

**45** See Heidi Eberhardt Bate, The Measures of Men: Virtue and the Arts in the Civic Imagery of Sixteenth-Century Nuremberg 140–191 (Ph.D. dissertation, Department of History, U. of California, Berkeley,

CA, 2000; UMI Publication No. AAT 3001752). Bate examined the hall's refurbishment, aimed at proffering virtuous behavior for public officials. Hans Schwarz, a local artist, carved the sculpture. Id. at 145 and fig. 4-1 at 321. The *Last Judgment* is attributed to Michael Wolgemut. Id. at 146. Access to that room was limited to those involved in "official business." Id. As for the sculpture, the "multivalent symbol of the hanging scale" served to instruct viewers not only about justice but about the propriety of balanced measurement in all the Nuremberg Council's activities. Id. at 140.

**46** Bate at 148–149.

**47** DAVIS at 88–90.

**48** DAVIS at 90, 92 (fig. 17, *Bribing the Judge*, dated 1538).

**49** HANS LÜTZELBERGER, THE DANCE OF DEATH BY HANS HOLBEIN: ENLARGED FACSIMILES OF THE ORIGINAL WOOD ENGRAVINGS XXVII (pages not numbered) (London, Eng.: Privately printed, 1916).

**50** JOHN HEARSEY MCMILLAN SALMON, SOCIETY IN CRISIS: FRANCE IN THE SIXTEENTH CENTURY 78–79 (New York, NY: St. Martin's Press, 1975). See also FREDERIC J. BAUMGARTNER, FRANCE IN THE SIXTEENTH CENTURY (New York, NY: St. Martin's Press, 1995).

**51** Van der Velden, *Cambyses for Example* at 22 and n. 80. This quote comes from a manuscript titled *Omnium virtut[u]m et viciorum delineatio* housed in Rome's Biblioteca Casanatense (codex Casanatense 1404). See generally GERALD STRAUSS, LAW, RESISTANCE, AND THE STATE: THE OPPOSITION TO ROMAN LAW IN REFORMATION GERMANY 1–30 (Princeton, NJ: Princeton U. Press, 1986).

**52** Van der Velden, *Cambyses for Example* at 23.

**53** Van der Velden, *Cambyses for Example* at 23. This "moralizing and edifying literature" ("regentenspiegel," or "mirrors of sovereignty") —with injunctions and illustrations—was disseminated during the eras when town hall art preached parallel lessons through their imagery. See SUSAN TIPTON, RES PUBLICA BENE ORDINATA: REGENTENSPIEGEL UND BILDER VOM GUTEN REGIMENT, RATHAUSDEKORATIONEN IN DER FRÜHEN NEUZEIT (THE WELL-ORDERED PUBLIC SPHERE: IMAGES OF SOVEREIGNTY AND PICTURES OF GOOD GOVERNMENT, TOWN HALL DECORATION IN THE EARLY MODERN PERIOD) 43–58 (Hildesheim, Ger.: Georg Olms Verlag, 1996).

**54** DONALD VEALL, THE POPULAR MOVEMENT FOR LAW REFORM, 1640–1660 at 185–199 (Oxford, Eng.: Oxford Clarendon Press, 1970).

**55** VEALL at 198–199. In January of 1642 Charles I was compelled to agree to that rule, which was confirmed in the 1648 ordinance and then repealed. Veall concluded that judges had more protection during the Interregnum, which laid the groundwork for the development in the eighteenth century of judicial independence from the Crown.

**56** PLUTARCH, MORALS, vol. 4, 73 (William Baxter, trans., William W. Goodwin, ed., New York, NY: Athenaeum Society, 1905). This quote comes from *Isis and Osiris, or of the Ancient Religion and Philosophy of Egypt*, collected along with more than seventy other essays in the *Morals*.

**57** Waldemar Deonna, *Les Fresques de la Maison de Ville de Genève*, 13 REVUE SUISSE D'ART ET D'ARCHÉOLOGIE 129, 141 (1952) (hereinafter Deonna, *Les Fresques*).

**58** THE HISTORICAL LIBRARY OF DIODORUS THE SICILIAN, IN FIFTEEN BOOKS 54 (George Booth, trans., London, Eng.: W. McDowell, 1814). The Renaissance turn to Diodorus and other classical writers is chronicled in MALCOLM BULL, THE MIRROR OF THE GODS (Oxford, Eng.: Oxford U. Press, 2005).

**59** As noted in Chapter 1, Andreas Alciatus (or Andrea Alciato, or Alciun, or Alciati) was born in Italy in 1492; he lived until 1550 and was a leading figure in systematizing the study of law and in shaping a humanistic jurisprudence. Alciatus's emblem treatise was an anthology of a diverse collection of moralizing short poems or epigrams and illustrations. It was first published in Augsburg in 1531 and had 104 emblems. See ANDREAS ALCIATUS, THE LATIN EMBLEMS: INDEX EMBLEMATICUS, vols. 1 & 2 (Peter M. Daly, ed., Toronto, Can.: U.

Toronto Press, 1985) (hereinafter ALCIATUS, DALY EDITION). No page numbers are provided in this compilation, but the emblems are numbered. A 1550 Latin version had 212 emblems, while other versions had fewer. A 1548 version appeared in Latin, French, Italian, and Spanish, and in that year, the Lyon edition innovated by organizing the emblems by topic. By the seventeenth century, more than 170 editions existed. See Denis L. Drysdall, *Emblema Quid? What Is an Emblem*, in UNDER THE AEGIS, THE VIRTUES 137, 142 (Peter Shand, ed., Auckland, New Zeal.: Fortuna Press, 1997). See the memorial web edition in Latin and English of Alciatus's *Book of Emblems*, created by the English Department of the Memorial University of Newfoundland, Memorial University of Newfoundland, http://www.mun.ca/alciato/c145.html.

Ripa is known for its illustrations, but as discussed in Chapter 1, the first edition of Ripa's *Iconologia* was published without pictures in Rome in 1593. Many variations followed the first (1603) illustrated "Ripa," resulting in a total of more than forty editions in eight languages. One of the last, the 1779 English edition by George Richardson, is, like the Maser translation, a selective rendition. Both Alciato and Ripa had great influence over contemporary image makers and the standardization of the emblem lexicon. Even when Ripa's work was not known directly, its use by other artists put it into circulation around Europe. See Keyvan Claude Rafii, Public Buildings and Civic Pride: Town Halls in Northern Germany, 1200–1618, 175 (Ph.D. dissertation, Department of Art History, University of Illinois, 2003; UMI Publication No.: AAT 3111629); Andrew Pigler, *The Importance of Iconographical Exactitude*, 21 ART BULLETIN 228 (1939). We return to Ripa's several renditions of Justice in Chapters 4 and 5.

**60** Two books, one by Horapollo and the other by Francesco Colonna, were popular at the time. Horapollo is assumed to have been the author of *Hieroglyphica*, a fifth-century collection of explanations of Egyptian hieroglyphs reprinted in 1505 in Florence. Francesco Colonna, a Dominican monk, is credited with the authorship of the 1499 *Hypnerotomachia Poliphili*, a courtly romantic allegory of Poliphilo's quest for love; the accompanying woodcuts offer emblematic illustrations. Emblem books published thereafter elaborated that symbolism and found an audience in Renaissance humanists, intrigued by these devices, which they perceived as enabling discursive, ideogrammatic, allegorical communications. ALISON SAUNDERS, THE SIXTEENTH-CENTURY FRENCH EMBLEM BOOK: A DECORATIVE AND USEFUL GENRE 5–6, 71–95 (Geneva, Switz.: Librairie Droz, 1988).

**61** See WILLIAM S. HECKSCHER, REFLECTIONS ON SEEING HOLBEIN'S PORTRAIT OF ERAMSUS AT LONGSFORD CASTLE, ESSAYS IN THE HISTORY OF ART PRESENTED TO RUDOLF WITTKOWER 128, 146, n. 58 (Douglas Fraser, Howard Hibbard, & Milton J. Lewine, eds., London, Eng.: Phaidon Press, 1967); ROBERTO ABBONDANZA, JURISPRUDENCE: THE METHODOLOGY OF ANDREA ALCIATO, IN THE LATE ITALIAN RENAISSANCE, 1525–1630 (Eric Cochrane, ed., London, Eng.: Macmillan, 1970).

**62** See DONALD R. KELLEY, FOUNDATIONS OF MODERN HISTORICAL SCHOLARSHIP: LANGUAGE, LAW, AND HISTORY IN THE FRENCH RENAISSANCE 87 (New York, NY: Columbia U. Press, 1970).

**63** See ALCIATUS, DALY EDITION; MICHAEL BATH, SPEAKING PICTURES: ENGLISH EMBLEM BOOKS AND RENAISSANCE CULTURE 1 (London, Eng.: Longman, 1994). See also ROSEMARY FREEMAN, ENGLISH EMBLEM BOOKS 1–7 (London, Eng.: Chatto & Windus, 1948); THE TELLING IMAGE: EXPLORATIONS IN THE EMBLEM (Ayers L. Bagley, Edward M. Griffin, & Austin J. McLean, eds., New York, NY: AMS Press, 1996). Denis Drysdall called Alciatus's work "one of the great publishing successes of the sixteenth century." Drysdall at 137.

**64** Drysdall at 137. The word "emblem," of Greek origin, means to "insert" or to "add on." Id. Drysdall noted that Alciatus "never commented" on the illustrations that came to be seen as an "essential component." Id.

**65** See Andrea Alciato and the Emblem Tradition: Essays in Honor of Virginia Woods Callahan (Peter M. Daly, ed., New York, NY: AMS Press, 1989); Ernst Gombrich, *Icones Symbolicae: The Visual Image in Neo-Platonic Thought*, 11 J. Warburg & Courtauld Inst. 163 (1948). Alciatus embodied a Renaissance sensibility that held that visual images (pace Gombrich) expressed (rather than only illustrated) concepts: "Words signify, things are signified." Kelley at 96, n. 21 (citing Alciatus's "De verborum significatione"). In Alison Saunders's view, for "the bulk of the sixteenth-century emblem writers (as opposed to the seventeenth-century theorists) the emblem was . . . a didactic tool essentially used for teaching the path of virtue." Saunders at 27.

**66** Andrea Alciati, "Emblemata," in Opera omnia ("Emblems" in Collected Works) vol. 2, column 1152 (unpaginated) (Basilae, apud Thomas Guarinum, 1582). Translations of the Latin are by Nicholas Salazar. Our thanks to Mike Widener, Rare Book Librarian at the Lillian Goldman Law Library of the Yale Law School, for his assistance in locating and permitting our use of the Alciatus image in figure 33.

**67** See Davis at 90–91 and fig. 16, explained at 160, n. 20, providing the plate from Livret des Emblemes de maistre Andre Alciat, mis en rime francoyse (Paris, Fran.: Chrestien Wechel, 1536). See also Alciatus, Daly Edition, vol. 2, emblem 145 (unpaginated), reproducing the 1536 French edition. Evans explained that Alciatus might have gotten the image from the figure of Integrity by Marten de Vos or from Plutarch, available in Latin in Louvain in 1564. See Michael Evans, *Two Sources for Maimed Justice*, 11 Source: Notes on the History of Art 12, 14 (1982).

**68** Alciatus, Daly Edition, vol. 2, emblem 145 and motto (from a French edition of 1536). We have excerpted the quote, deleting words that were translated, such as "main" for hand. In the four other versions (from 1542, 1549, 1551, and 1621), the translations have modest textual differences. All describe princes, kings, or judges who are "without eyes," "deprived of sight," or "blind." The 1542 German version reads: "Here you see the council of the good prince. Why does he sit? That shows the understanding and constant mind of a wise man. What does it mean that they have no hands? That they are above gifts. Why is the prince himself blind? So that he may recognize no-one's status and the judge according to his council." A 1549 edition included the explanation that the hands were cut off so that the judges could not take gifts that could corrupt them. The explanation proffered was that the chief judge would not be "improperly swayed" and that the other judges can take "no money or other presents." Davis, at 160, n. 20, provided the point in French; the paraphrase is ours.

**69** Ripa, Padua–1611 at 201–204.

**70** Ripa, Padua–1611 at 203–204. Ripa editions vary in terms of their sets of Justices. The particular version of Justice—with dog and snake—could also be found in the 1644 French edition under the heading "Iustice Inviolable" ("Justice Inviolate"), with a text that "the dog . . . signifies that [Justice] must faithfully love Virtue. And the snake that she is obliged to hate vice, like a fatal and contagious venom." French Ripa–1644 at 57. The Dutch version from the same year described "a dog, symbolizing friendship [and] a snake, symbolizing hate." Dutch Ripa–1644 at 433. In the 1758 Hertel, Maser Edition at plate 120, the text referred back to the 1603 edition and read, "The snake and the dog represent friendship and hatred, neither of which must be allowed to influence true justice." By the time the Richardson edition was published in England in 1779, the dog and snake had disappeared.

**71** Ripa, Padua–1611 at 201.

**72** Deonna, *Les Fresques* at 141. See also Waldemar Deonna, *La Justice à l'Hôtel de Ville de Genève et la fresque des juges aux mains coupées*, 11 Revue Suisse d'Art et d'Archéologie 144 (1950) (hereinafter Deonna, *La Justice*). Deonna analyzed what he termed "cette scène bizarre" in both essays. Deonna, *La Justice* at 147. In 1922, Pro-

fessor Deonna became the director of the Musée d'Art et d'Histoire and the Musée Archéologique in Geneva. See generally *Hommages à Waldemar Deonna*, 28 Collection Latomus: Revue d'études Latines 2–48 (Brussels, Belg.: De Meester, 1957). Our thanks to Ursula Baume-Cousam and to Isabelle Brun-Ilunga of Le Centre d'Iconographie Genevoise (begun in 1993) for assistance in obtaining figure 34, the images reproduced in figures 35 and 36, and for providing information about the setting, as well as to Julia Schiesel and Allison Tait for extensive research on the Town Hall of Geneva. The images from the Town Hall are reproduced with permission of the Centre d'Iconographie Genevoise.

**73** Barbara Roth-Lochner & Livio Fornara, The Town Hall of Geneva 10–11 (Jean Gunn, trans., Geneva, Switz.: Chancellerie d'Etat, 1986). Although scholars of the Geneva Town Hall agree on this attribution, one, Camille Martin, noted that the record of Giglio's presence in the city's register put him there for only five months, which is thought to have been too short a time to complete the mural but sufficient time to repaint some of the portraits in the room. Camille Martin, La Maison de ville de Genève 54 (Geneva, Switz.: A. Jullien, 1906).

**74** The figures are identified by Deonna in *La Justice* at 147–148 and in *Les Fresques* at 141–142. Biblical history had particular authority in Geneva, whose ruling Calvinists saw Bible stories as more relevant than Medieval Catholic and feudal traditions. See The Identity of Geneva: The Christian Commonwealth, 1564–1864 at 3 (John B. Roney & Martin I. Klauber, eds., Westport, CT: Greenwood Press, 1998) (hereinafter Roney & Klauber).

**75** Deonna, *Les Fresques* at 142. The French that is legible reads, "Quel de nous demeurera avec les ardeurs éternelles."

**76** Deonna, *La Justice* at 147. The words are no longer all clear. The French that is visible reads: "Dieu . . . siste . . . g . . . . David Psaume 82" (with the ellipses indicating the portions of the passage no longer legible). Deonna completed the second half of the passage based on a 1588 version of the Geneva Bible, *Psalm 82*, which could have been available to Giglio at the time he painted *Les Juges*. Deonna's completion of the passage reads: "Dieu assiste en l'assemblée et juge au milieu des juges," which translates into English as "God stands in the congregation, and judges among the judges." However, *Psalm 82* from a 1587 version of the Geneva Bible in English reads: "God standeth in the assemblie of gods: hee iudgeth among gods." The Bible: That is, the Holy Scriptures Contained in the Olde and Newe Testament. Translated According to the Ebrew and Greeke, and Conferred with the Best Translations in Divers Languages (London, Eng.: Christopher Barker, 1587). Similarly, a Louvain Bible from 1550 also refers to judging among the gods, not judging among judges. Bible (Moyen français 1550) 232 (Cambridge, MA: Omnisys, 1990), Bibliotheque National de France, http://gallica.bnf.fr/ark:/12148/bpt6k53708d .item. As William Nelson pointed out to us, the reference to the "assembly" provides a basis for the image of witnesses or a court-like scene at the time of judgment.

**77** This translation is from Roth-Lochner & Fornara at 10. Davis, at 85, did not discuss this image from Geneva but did, as one of her epigraphs to the chapter, "Gifts, Bribes, and Kings," quote the same passage from *Exodus* 23:8, translated slightly differently as: "And thou shalt take no gift; for the gift blindeth the wise, and perverteth the words of the righteous." The *New English Bible* offers yet another translation: "You shall not accept a bribe, for bribery makes the discerning man blind and the just man give a crooked answer."

**78** See, for example, Deonna, *La Justice* at 147 (mentioning that the Geneva scene could have been a reference to a municipal official named Blondel, condemned in 1606 for treason after assisting the effort by the Duke of Savoy to take Geneva in 1602).

**79** Deonna posited that Plutarch and Ripa were likely sources for the room's imagery. Deonna, *La Justice* at 148. Deonna noted that Alciatus was also a possible source for the Geneva frescoes. Deonna,

Les Fresques at 141. Christian-Nils Robert cited Plutarch and Diodorus as sources, perhaps also partly through an edition of Alciatus that was published in Lyon in 1551. ROBERT at 93.

80 Deonna, La Justice at 147–148.

81 Deonna, Les Fresques at 142. The Ulm image, as detailed by Deonna, would have predated that in Geneva because it was painted by the town's painter, a German artist, Georg Rieder, who died in 1562. Rieder did four panels for the courtroom—a Last Judgment now in the Ulmer Museum, the 1552 Siege of Ulm (that remains on the site), and two paintings now lost, a Judgment of Solomon and the Theban Law Court. See Artnet Research Library, Artists' Biographies, http://www.artnet.com/library/07/0720/T072077.asp. Under the Ulm Theban Law Court was a Latin inscription dated 1562 that read, in part, "eo quod iustitia nec levitate mentis delectetur nec muneribus capiatur nec hominum vultu flectatur" ("because justice neither delights in lightness of mind nor is captured by gifts nor is turned by the face of men"). Deonna, Les Fresques at 142. The Augsburg Town Hall was built between 1615 and 1620, while the Danzig image, in the building named Arthur's Court, sat alongside a Last Judgment (attributed by some to Hans Memling) and was, according to Deonna, centered on an older man ("Judex terrarum") seated on a throne between two women holding a law book and a balance and surrounded by twelve magistrates, all without hands. Id. at 142, n. 133. Arthur's Court was the "second most important secular building in the city after the Town House." See Miziolek at 74.

The Theban Law Court (Gericht von Theben) is part of a layered scene on the front of the Regensburg Town Hall. At the center is an Allegorie des guten Regiments der Reichsstadt Regensburg (Allegory of Good Government of the Imperial City of Regensburg). Below was a scene with a presiding judge at the center and three judges on each side, with hands cut off, below which were decorative figures and lions. The fresco, now in the Museum of Regensburg, is by Melchior Bocksberger and is dated around 1573–1574. See TIPTON at 555, fig. 29. Our thanks to Elizabeth McGrath for directing us to this image.

82 GROEBNER at 76.

83 GROEBNER at 76.

84 GROEBNER at 78.

85 Evans at 12.

86 Evans at 12, translating a Latin text attributed to Dominus Albertus and reproducing the two manuscripts in figures 1 and 2 at 13.

87 Evans at 13–14 and fig. 3. Evans commented that the "bizarre motif" of handless or armless figures, which "enjoyed a brief vogue in forensic allegorical painting c. 1600, derives from Plutarch." Id. at 14.

88 ROTH-LOCHNER & FORNARA at 7. This building, which was previously a private home, was adapted for use by the government at some point around 1440–1450. It was altered during the seventeenth century to accommodate the Council. Id. at 5. Explanations of the administration of justice in Geneva from its early times through the eighteenth century is provided in BARBARA ROTH-LOCHNER, MESSIEURS DE LA JUSTICE ET LEUR GREFFE (LAWMAKERS AND THEIR OFFICE) (Geneva, Switz.: Société d'Histoire et d'Archéologie de Genève, 1992). Tribunals, dating from 1529, provided procedures to guide judges (described, in a loose translation) as requiring judges to provide an expedited form of justice, to resist all forms of corruption, to pronounce justice according to the law and, above all else, to seek the triumph of truth. Id. at 33–35.

At several points during the sixteenth and seventeenth centuries, the Council modified the procedures, which were compiled for publication in 1707. Id. at 38–39. Also provided are details of the Council's routines, personages, and calendar during the mid-sixteenth century, when it met weekly. Id. at 66–69. The tribunal's typical audience included clerks, secretaries, the prosecutor, and some young lawyers, as well as an occasional member of one of the Town's Councils. At times their numbers filled the room so that the general public was left without space to gain attendance. Judges and parties sometimes retreated to a small room to seek settlement. Id. at 68.

89 MARTIN at 4.

90 RONEY & KLAUBER at 2. Geneva remained independent until 1798, when France annexed it; Geneva returned to its free state after Napoleon's defeat in 1813 and joined the Swiss Confederation in 1815. Id. at 11–12.

91 RONEY & KLAUBER at 3. See also Richard Stauffer, Calvin, in INTERNATIONAL CALVINISM 1541–1715 at 15, 19, 25–37 (Menna Prestwich, ed., Oxford, Eng.: Clarendon Press, 1985) (hereinafter INTERNATIONAL CALVINISM).

92 Richard A. Muller, Calvin, Beza, and the Exegetical History of the Romans 13:1–7, in RONEY & KLAUBER at 39, 45–46.

93 RONEY & KLAUBER at 3. The town became a center of small manufacturing and by 1589, its population numbered about 13,000. Id. at 5.

94 RONEY & KLAUBER at 6–7.

95 The Geneva Les Juges aux mains coupées was painted in 1604, two years after the Catholic Duke of Savoy had unsuccessfully tried to take the city. RONEY & KLAUBER at 7. The other frescoes are much earlier, from before the Calvinist "heyday" that ran from 1557 to 1587. See Gillian Lewis, Calvinism in Geneva in the Time of Calvin and of Beza (1541–1605), in INTERNATIONAL CALVINISM at 39, 41. As Lewis also recounted, Calvinism brooked no "false doctrine," insisting on an austere and severe regime with a strict moral code. Id. at 47–49.

96 Martin, at 126, provided this information; the translation comes from the New English Bible. The Hebrew word Jehoshaphat can be translated "God is judge."

97 ROTH-LOCHNER & FORNARA at 10. The redecoration that hid the mural was done in 1711, and the murals' recovery in 1901 was part of a restoration that included bringing the original windows back into view. Id. According to Roth-Lochner, the frescoes in the room are among the "most important secular group of murals known" in the region. Id. According to another account, trials were held and sentences pronounced in the open square (the Vieux-Mézel) in front of the Geneva Town Hall. See MARTIN at 5–6.

98 Deonna, Les Fresques at 143–144. Martin, at 51, also expressed the belief that the choice of figures was likely guided by the Council. Martin speculated that the figure of Justice was akin to that of the Virgin on her throne, surrounded by saints. Id. at 52.

99 MARTIN at 46–53. For example, one image of an old, bearded man was accompanied by a text in Latin from Virgil's Aeneid. The passage from Virgil reads: "Ah, but you Romans, remember to rule people, to govern, there's your art—to make peace like a custom, to spare humble men and war on the pompous." VIRGIL, THE AENEID 145 (Edward McCrorie, trans., Ann Arbor, MI: U. of Michigan Press, 1995) (hereinafter VIRGIL, AENEID). Remaining legible on the wall, translated from Latin, is "this will be your art: to make peace like a custom, to spare humble men and war on the pompous." Deonna, Les Fresques at 143–144.

Martin's view was that the Council proffered specific phrases to guide the artists' decisions. MARTIN at 51–52. Deonna, in contrast, attributed both text and representations to the artists. Deonna, Les Fresques at 157. Deonna also provided a layout of the room. Id. at 130. Some of the texts have been identified, and others are unclear. For example, Deonna initially believed that one partially destroyed Latin inscription (translated from Deonna's French into English) read: "He who does not devote his life to the pursuit of Justice does not merit a seat in this room." Deonna, Les Fresques at 131. See also MARTIN at 46. Thereafter Deonna came to believe that the passage likely came from a Zurich author who misattributed it to St. Augustine rather than properly attributing it to Possidius's Life of Saint Augustine. Deonna's new understanding of the text was (again, translated into English): "He who loves to insult with words those who are absent, must know that this room is forbidden to him." Deonna, Les Fresques at 131–133.

100 Deonna, Les Fresques at 154–155. The Last Judgment theme stems from a fresco featuring Sybil of Erythraea, accompanied by a

Latin text from St. Augustine that can be translated to read, "Here is the sign of the Last Judgment. The earth will be wet with sweat. He will come from the heavens to reign as a king for centuries and centuries." Id. at 154. St. Augustine invoked the Sibyl as prophesying the Last Judgment. See SAINT AUGUSTINE, THE CITY OF GOD (DE CIVITATE DEI) ("Of the evident prophecy of the Erythraean Sibyl concerning Christ"), ch. 23, 196–197 (John Healey, trans., R. V. G. Tasker, ed., London, Eng.: J. M. Dent & Sons, 1957).

101 Deonna's analysis of the frescoes as glorifying Justice, necessary for good government and inseparable from it, linked that ideology to Brunetto Latino (see Les Fresques at 158, n. 308), as did Skinner's analysis of Lorenzetti's Siena Allegories, discussed in Chapter 2. Deonna, writing before Skinner, noted the parallel to Siena's iconography—particularly the role played by Concord and the other Virtues. Deonna, Les Fresques at 158–159 and n. 311. He further explained that the theme of Good Government, with analogous deployments of Virtues and other figures, had become part of German iconography as exemplified by works in Lüneburg, Regensburg, and Königsberg. Id. at 159.

102 MARTIN at 48.

103 Deonna, Les Fresques at 148. Martin, in contrast, read the figure to be Tertullian (Tullius), an early Christian author, and identified another figure as Cicero. MARTIN at 48.

104 Deonna, Les Fresques at 149. The Latin text was apparently adapted from Walter of Châtillon's Alexandreis, as "If you should judge a suit, balance the scales of Justice evenly. Let love not turn your mind; beware lest your resolve be bent by awe of the persons or by flatterers' bribes." THE ALEXANDREIS OF WALTER OF CHÂTILLON: A TWELFTH-CENTURY EPIC 8 (David Townsend, trans., Philadelphia, PA: U. of Pennsylvania Press, 1996). Those verses, in turn, are reminiscent of Leviticus 19:15 ("You shall not pervert justice, either by favouring the poor or by subservience to the great. You shall judge your fellow-countryman with strict justice.") and Deuteronomy 16:19 ("You shall not pervert the course of justice or show favour, nor shall you accept a bribe; for bribery makes the wise man blind and the just man give a crooked answer.") (NEW ENGLISH BIBLE translations).

In addition to the murals in the room, in 1652 Samuel de Rameru painted a giant figure of Justice that initially hung in the Salle du Petit Counseil and in 1815 was moved to the Salle des Pas Perdus—literally the "room of lost steps"—which remains the nomenclature in French for waiting areas in courthouses. The 1652 Justice is shown standing outside in a square near the town's market and almost equal in height to the two stories depicted of the Geneva Town Hall. She has a helmet on her head, a sword upright in one hand and scales unevenly balanced in the other. See ROTH-LOCHNER & FORNARA at 30–31 and fig. 24.

105 Deonna, Les Fresques at 148; MARTIN at 49.

106 Deonna, Les Fresques at 148, identifying the source of the quote as Cicero's De Officiis, para. 64. A nearby paragraph in De Officiis refers to the obligation to give elders a role in public affairs and has been read to affirm Geneva's magistrates as mature, experienced leaders. Deonna, Les Fresques at 153. Noonan offered an analysis of Cicero's rhetorical commitment against bribery. NOONAN at 39–54.

107 Deonna, Les Fresques at 150. The original, in Latin, reads: "Justitia est praeclarissima virtutum," translated into French by Deonna to read "La Justice est la plus belle de toutes les vertus." This passage has been variously translated in English to read Justice as the "best" or "greatest" virtue.

108 Deonna, Les Fresques at 152–153. The actual phrase from McCrorie's translation of Virgil's Aeneid reads: "BE WARNED: LEARN JUSTICE: STOP SCORNING THE SKY-GODS." VIRGIL, Aeneid at 139.

109 Deonna, Les Fresques at 147. The original, in Latin, reads: "Justitia habet duas venas, pietatem et equitatem."

110 Deonna, Les Fresques at 140. Deonna thought that the reference was to Cicero's Laelius de Amicitia, made accessible through Brunetto Latino's Trésor. Id. at 134–137. Another image, of the first-century BCE Roman historian Sallust, included a Latin inscription, "Concordia parve res crescunt. Discordia maxime dilabuntur." Deonna, in Les Fresques at 145–146, took these words to mean that living in concord enabled even small states to thrive, but living in discord destroyed even the powerful. On the importance of friendship to Renaissance polities and the sense that friendship was "incompatible with tyranny," see ULLRICH LANGER, PERFECT FRIENDSHIP: STUDIES IN LITERATURE AND MORAL PHILOSOPHY FROM BOCCACCIO TO CORNEILLE 22 (Geneva, Switz.: Librairie Droz, 1994).

111 DAVIS at 88. In contrast, focused on the Swiss Confederacy, Groebner detailed a "repetoire of terms for evil gifts . . . between the Burgundian wars and the Reformation" as he also counseled against assuming a concomitant "continuity of underlying attitudes" about permissible and illicit gifts from the repetition of various narratives and sayings over the centuries. GROEBNER at 109–110.

112 DAVIS at 87.

113 DAVIS at 90.

114 In contrast to our focus on obedience to earthly rulers, Robert Jacob has argued that the deployment of images of the Last Judgment and of the crucifixion in town halls signaled to judges that they were subject not only to kingly authority but also to that of God. That "double delegation" created, from Jacob's perspective, a critical space for judges and a form of separation of powers long before that idea became entrenched through the Enlightenment. See Robert Jacob, Le jugement de Dieu et la formation de la fonction de juger dans l'histoire européenne (Divine Judgment and the Development of the Judicial Function in European History), 39 ARCHIVES DE PHILOSOPHIE DU DROIT 87, 102 (1994).

115 Our understanding of this building and its interior has been informed by the intellectual generosity of Dr. Eymert-Jan Goossens, who served as the head curator for exhibitions and research for the Royal Palace, Amsterdam; by Dr. Lodewijk Wagenaar, Conservator of the Amsterdam Historische Museum Willet-Holthuysen; by Pieter Vlaardingerbroek, an architectural historian who authored a Ph.D. dissertation titled The Town Hall of Amsterdam, The Construction of the Town Hall, Its Conversion into Royal Palace and Restoration (University of Utrecht, Utrecht, Neth., 2004); and by Sarah van Walsum of the Vrije Universiteit in Amsterdam.

116 See KATHARINE FREMANTLE, THE BAROQUE TOWN HALL OF AMSTERDAM 17, 33 (Utrecht, Neth.: Haentjens Dekker & Gumbert, 1959) (hereinafter FREMANTLE, BAROQUE TOWN HALL). The designer, Jacob Van Campen, who was also an artist, embraced Vitruvius's premise that buildings should be "durable, functional and beautiful." Further, he had a view of God as the "supreme architect, Creator of heaven and earth," and of the universe and the human body as harmonious, with rules discoverable by those who tried. See EYMERT-JAN GOOSSENS, TREASURES WROUGHT BY CHISEL AND BRUSH: THE TOWN HALL OF AMSTERDAM IN THE GOLDEN AGE 15–17 (Amsterdam, Neth.: Royal Palace, Zwolle, Waanders Publishers, 1996). Vitruvius's De architecturae libri decem (Ten Books of Architecture), written during the first century BCE, linked the symmetrical proportions of classical temples, the human body, and the universe.

Van Campen, who was born in 1596 into a wealthy family in Haarlem and died in Amersfoort in 1657, was a disciple of Rubens. See FREMANTLE, BAROQUE TOWN HALL at 134. Van Campen was trained in Italian classicism and influenced by Italian scholars Palladio and Scamozzi. Van Campen brought Italianate decorative themes, specifically allegorical and classical imagery, into Dutch buildings, which had before then displayed only "still life, genre and portraiture." Barbara Joyce Buchbinder-Green: The Painted Decorations of the Town Hall of Amsterdam xvi (Ph.D. dissertation, Department of Art History, Northwestern University, Evanston, IL, 1974; UMI Publication No.: AAT 7507883). He is credited with designing many of the sculptures, crafted by others. See also JACOBINE HUISKEN, KOEN OTTENHEYM, &

GARY SCHWARTZ, JACOB VAN CAMPEN, HET KLASSIEKE IDEAAL IN DE GOUDEN EEUW (Amsterdam, Neth.: Stichting Koninklijk Paleis te Amsterdam, 1995), and Katharine Fremantle, *Book Review of "Jacob van Campen, Schilder en Bouwmeester" 1595–1657*, 77 OUD HOLLAND, QUARTERLY FOR DUTCH ART HISTORY 246 (1962). Van Campen may also have drawn guidance from what was understood to have been Solomon's Palace, for the burgomasters saw themselves, like Solomon, as bringing peace and justice to the city. Correspondence from Pieter Vlaardingerbroek (March 4, 2006).

Van Campen provided the building's principal design, but he withdrew in 1654 and was replaced by Daniel Stalpaert, who had been appointed to serve as the city's architect. GOOSSENS at 22. FREMANTLE, BAROQUE TOWN HALL at 24–25. Some of Van Campen's original plan was "abandoned due to financial constraints imposed by the First Anglo-Dutch War (1652–1654)." GOOSSENS at 27–28. A scale model of the building by Van Campen can be found in the Amsterdam Historisch Museum. Some of the design was changed after he withdrew. Buchbinder-Green at xvii.

117 GOOSSENS at 10. The burgomasters, sheriff, and magistrates were also known as "My Lords of the Court," and the city's administration functioned as both a court of law and a governing body, proclaiming laws and running city business. See SJOERD FABER, JACOBINE HUISKEN, & FRISO LAMMERTSE, OF LORDS, WHO SEAT NOR CUSHION DO ASHAME. THE GOVERNMENT OF AMSTERDAM IN THE 17TH AND 18TH CENTURIES at 10 (Amsterdam, Neth.: Stichting Koninklijk Paleis te Amsterdam, 1987). Their sense of the city's importance, linked to its role in trade, was exemplified in the city's seal, which, from 1300 to around the 1480s, included a "cog"—a small wooden boat with a single mast. FREMANTLE, BAROQUE TOWN HALL at 8, n. 2, figure 188. In terms of the organization of its trading capacities, the two central institutions, the Dutch East India Company and the Dutch West India Company, were formed in 1602 and 1621, respectively. Id. at 9.

118 GOOSSENS at 83.

119 See JAN PEETERS, PETER C. SUTTON, EYMERT-JAN GOOSSENS, & DEIRDRE CARASSO, THE ROYAL PALACE OF AMSTERDAM IN PAINTINGS OF THE GOLDEN AGE at 19 (Zwolle, Neth.: Waanders Publishers, 1997) (hereinafter THE ROYAL PALACE). See generally SIMON SCHAMA, THE EMBARRASSMENT OF RICHES: AN INTERPRETATION OF DUTCH CULTURE IN THE GOLDEN AGE (New York, NY: Alfred A. Knopf, 1987). Schama argued that the Dutch lacked the "self-evident markers of territory, tribe, language or dynasty that were customarily held to be the criteria for national self-consciousness" and substituted, when filling the "vacuum left by the collapse of monarchy," a mixture of "Calvinism, humanism, and commercial pragmatism." Id. at 67. "The most extraordinary invention of a country that was to become famous for its ingenuity was its own culture." Id.

120 See generally MAARTEN PRAK, THE DUTCH REPUBLIC IN THE SEVENTEENTH CENTURY (Diane Webb, trans., Cambridge, Eng.: Cambridge U. Press, 2005). Prak objected to the focus on the Dutch Republic as a remarkable precursor to what followed and argued that it should be understood in its own context. His view was that it thrived during the seventeenth century because its small size and large number of independent cities produced unusually successful local governments that enabled more control and efficiency, which, in turn, produced more faith in government. Id. at 3–4, 250–252, 272–273. For example, in 1700 the Dutch Republic had twenty-one cities of ten thousand or more, whereas England, with three times the number of people, had eleven such cities. Id. at 251. The Dutch worldwide trading system, involved with the slave trade, was another source of its wealth during the seventeenth century. Id. at 111–121.

121 PRAK at 262, citing Constantijn Huygens, who addressed the town's councillors as the "founders of the eighth wonder of the world." Goossens noted that the verse, carved in "Lydian stone" and gilded by Elias Noski, can still be seen in the Burgomasters' Chambers. GOOSSENS at 85, n. 11, and at 12; Buchbinder-Green at 124–125. The

Royal Palace's 1982 exhibition, "The Eighth Wonder of the World," provided a history of the building project. GOOSSENS at 7.

122 "Peace, commerce and justice were the central issues in Jacob van Campen's iconographic programme for the building." LYCKLE DE VRIES, GERARD DE LAIRESSE: AN ARTIST BETWEEN STAGE AND STUDIO 44 (Amsterdam, Neth.: Amsterdam U. Press, 1998).

123 The building shown in figure 37 became a palace in 1808 under King Louis Napoleon, whose brother, Emperor Napoleon, declared Louis as the King of the Netherlands. GOOSSENS at 84. The interiors were left largely intact through that occupation. They were restored during the twentieth century, when the Amsterdam Town Hall was put to use for royal gatherings as well as for public tours. See GOOSSENS at 84; JACOBINE E. HUISKEN, THE ROYAL PALACE ON THE DAM IN A HISTORICAL VIEW 9–10 (Rollin Cochrane, trans., Amsterdam, Neth.: De Walburg Pers, 1989). Our thanks to the Amsterdam City Archives for providing us with photographs of the Town Hall and permission to reproduce them.

124 As Fremantle explained, at xxii, the records available include models, aspects of architect Jacob van Campen's plans that were not executed, and papers of the sculptor, Artus Quellinus (also called Quellien or Quellin). A foundation also supports research and exhibitions related to the building. See GOOSSENS at 7 (describing the exhibits and research prompted by the 1959 Fremantle book). Many others have written about the imagery in Amsterdam as well. See, for example, WEEGSCHAAL & ZWAARD: DE VERBEELDING VAN RECHT EN GERECHTIGHEID IN NEDERLAND (SCALES AND SWORD: THE DEPICTION OF LAW AND JUSTICE IN THE NETHERLANDS) (M. A. Moelands & J. Th. de Smidt, eds., The Hague, Neth.: Jongbloed Juridische Boekhandel & Uitgeverij, 1999) (including chapter summaries in English) (hereinafter SCALES AND SWORD). An excellent overview of other town halls is provided in WOUTERS KUYPER, THE TRIUMPHANT ENTRY OF RENAISSANCE ARCHITECTURE INTO THE NETHERLANDS (Alphen aan den Rijn, Neth.: Canaletto, 1994).

125 "Townscapes" of Amsterdam came into prominence between 1650 and 1670, preceding such city scenes of Venice by about a half-century. Key to the distribution of images of Amsterdam were the workshops of several artists. For example, between 1665 and 1694 the artist Gerrit Berckheyde did more than twenty such scenes. See THE ROYAL PALACE at 7–9, 43–44.

126 THE ROYAL PALACE at 7–9.

127 FREMANTLE, BAROQUE TOWN HALL at 19–20.

128 See SCALES AND SWORD at 56, discussing both the Medieval tradition of justice done in the open air and the development of rooms open to spectators in town halls, "where the judge, the schepenen and those seeking justice or answers are gathered and where the judge issues orders, which the schepenen pronounce."

129 FREMANTLE, BAROQUE TOWN HALL at 21.

130 Katharine Fremantle, *The Open Vierschaar of Amsterdam's Seventeenth-Century Town Hall as a Setting for the City's Justice*, 77 OUD HOLLAND, QUARTERLY FOR DUTCH ART HISTORY 206, 208 (1962) (hereinafter Fremantle, *Open Vierschaar*).

131 PRAK at 28; FREMANTLE, BAROQUE TOWN HALL at 10.

132 FREMANTLE, BAROQUE TOWN HALL at 23. Fremantle noted that Pieter Saenredam's 1641 painting of the old Town Hall (reproduced as figure 3 in Goossens at 9–10) showed the stonework "rotting and crumbling away." Id. at 24. The old building had also been damaged by fire in 1652. That painting identified the building as it was in 1641 (and stated that Saenredam did the painting from July 15 to 20, 1641); on the steps of the portico, text—added later—stated that "the old town hall of Amsterdam . . . burnt down in three hours on 7 July 1651" (an error, as the fire was in 1652). See PERSPECTIVES: SAENREDAM AND THE ARCHITECTURAL PAINTERS OF THE 17TH CENTURY 138–139 (Rotterdam, Neth.: Museum Boymans-van Beuningen; Seattle, WA: Distribution U.S.A., U. Washington, 1991).

**133** FREMANTLE, BAROQUE TOWN HALL at 29. Fremantle's research, the "first comprehensive study and art-historical analysis" of the building, prompted exhibitions and additional research. GOOSSENS at 7.

**134** FREMANTLE, BAROQUE TOWN HALL at 34.

**135** GOOSSENS at 12.

**136** Van Campen was selected by a committee functioning under the direction of burgomasters, and that group also directed the building's construction. FREMANTLE, BAROQUE TOWN HALL at 17, 23–25. According to Goossens, the burgomasters reviewed "at least eight different designs until in 1648 their choice fell upon the 'outstanding' plan submitted by Jacob van Campen," who was also the "scion of a distinguished patrician family." GOOSSENS at 11.

**137** See THE ROYAL PALACE at 19.

**138** PRAK at 261, fig. 28.

**139** AGNES SCHREINER, HENNY BOUWMEESTER, & ANNE VAN DOOREN, IN DE BAN VAN HET RECHT (CAPTURED BY JUSTICE) 79, 87 (Amsterdam, Neth.: Uitgeverij Duizend & Een, 1991) (summaries translated by Dolph Heyning).

**140** FREMANTLE, BAROQUE TOWN HALL at 88. The architecture, sculpture, and painting were "deliberately and consciously thought out during the planning of the building" to make "one complex statement." Id. at 63. Buchbinder-Green added, at 1–2, 45–46, that "monumental painting" weaving allegories and myths into a didactic whole had been common in Italy but not in the Netherlands until the sixteenth century.

**141** FREMANTLE, BAROQUE TOWN HALL at 44. "There can be no doubt that they [representations of the elements] were based on these descriptions." Other statues either were the "invention of the person who designed them" or were "taken from another source of information, for they do not correspond with Ripa's account." Id. at 45, 201–202 (discussing the Ripa editions then available in Amsterdam and pointing out that some variations existed). See also Katharine Fremantle, *Themes from Ripa and Rubens in the Royal Palace of Amsterdam*, 103 BURLINGTON MAG. 258 (1961) (hereinafter Fremantle, *Themes from Ripa and Rubens*). Buchbinder-Green at 77–78.

**142** Simon Schama described the connections in a section of his book devoted to "patriotic scripture" (SCHAMA at 51–125). The Dutch claimed connections to both the Batavians, who revolted against the Roman emperor, and the Israelites. Id. at 67–68, 110–125. See also G. Groenhuis, *Calvinism and National Consciousness: The Dutch Republic as the New Israel*, in BRITAIN AND THE NETHERLANDS, vol. 7: CHURCH AND STATE SINCE THE REFORMATION 118 (A. C. Duke & C. A. Tamse, eds., The Hague, Neth.: Martinus Nijhoff, 1981). Groenhuis argued that the idea "of Holland as a new Israel evolved out of the numerous comparisons" made to Jewish history and that the premise "coincided exactly with Calvinist views on the proper relationship that should exist between Church and State." Id. at 119. Yet, as he noted, Calvinism did not succeed in complete domination, for the ministers remained a minority within a more secular nation. Id. at 122–133.

Further, when the "States of Holland finally outlawed the mass in March 1581" and insisted that Philip II had "forfeited his sovereignty over the United Netherlands, only a small fraction of that province professed the Reformed faith." Alastair Duke, *The Ambivalent Face of Calvinism in the Netherlands, 1561–1618*, in INTERNATIONAL CALVINISM at 109. Moreover, even after the national synod of 1618 in Dort "marked the triumph of Calvinist theology within Dutch Protestantism," the Reformed Church was not the religion of a majority of the Dutch. Id. at 132.

Prak, at 209, made a similar point, that the "high moral standards and exemplary conduct in daily life required by the orthodox made it impossible for the Reformed Church to grow into a true church of the people, with whose precepts most Dutchmen could agree." He esti-

mated that Reformed Church membership was relatively small (perhaps between 10 and 20 percent in several cities in the 1620s), as was that of other churches; by the early 1700s, a majority of some cities were members of the Reformed Church. Id. at 209–210.

**143** GOOSSENS at 18. "The belief that events in the United Provinces could not have taken place without God's special blessing was widely shared." Groenhuis at 12. Parallels were also drawn between the Amsterdam Town Hall and Solomon's Temple. GOOSSENS at 18. See also Groenhuis at 124 ("As Canaan was honoured to serve as an abode for the people of Israel, the Netherlands have now been chosen as the dwelling-place of God's second Israel"). In the view of "orthodox Calvinists . . . the State existed for the sake of the Church." Id. at 125. Yet in terms of governance, "at no time did the Dutch Republic resemble a theocracy led by God's elect," for orthodox Calvinism did not command allegiance by the country's rulers. Id. at 129–130. For parallel assertions made about Venice, see DAVID ROSAND, MYTHS OF VENICE: THE FIGURATION OF A STATE (Chapel Hill, NC: U. of North Carolina Press, 2001).

**144** GOOSSENS at 11.

**145** GOOSSENS at 17, also noting a resulting "sanctimonious climate" (id. at 19) and that the burgomasters were "pompous, grandiose and conspicuously wealthy" (id. at 11). More generally, during the sixteenth and seventeenth centuries, classical themes that had once been seen as "anti-Christian" became acceptably integrated, as if classical forms had been proto-Christian, making them apt for Amsterdam. Id. at 19 and 87, n. 37.

The Stanza della Segnatura, discussed in relationship to Raphael's *Justice* in Chapters 1 and 4, similarly exemplifies the stance of a unity between classical and Christian traditions, shared by both Catholic and Protestant cities. And, returning to Amsterdam's Town Hall, the turn to classicism was "safe ground," aimed to counterbalance "ecclesiastical discord" (which was plentiful) through the promotion of "a religiously neutral civic ideology dependent on a past that need not offend anyone." PRAK at 221. Or, as Fremantle put it, "knowledge of antiquity illuminated the history of Amsterdam." FREMANTLE, BAROQUE TOWN HALL at 169.

**146** GOOSSENS at 61–63.

**147** FREMANTLE, BAROQUE TOWN HALL at 11–14.

**148** See FABER, HUISKEN, & LAMMERTSE at 7.

**149** FREMANTLE, BAROQUE TOWN HALL at 74.

**150** FREMANTLE, BAROQUE TOWN HALL at 18–19.

**151** PRAK at 261.

**152** FREMANTLE, BAROQUE TOWN HALL at 24–25.

**153** PRAK at 41–44, 260. Scholars agree that plans for a new building had begun in the late 1630s or early 1640s and that the building plans were revised while construction was underway. Scholars differ as to whether the construction began "ten days before the signing of the Peace of Münster" (PRAK at 260), months after the signing (GOOSSENS at 9), or in connection with the treaty (FREMANTLE, BAROQUE TOWN HALL at 31–32—noting that the official first cornerstone was laid in 1648 as part of the celebration of the Peace of Münster, ratified in July of that year). The commemorative stone reads, "On 29 October 1648, the year which marked the end of the war waged for over eighty years by the United Netherlands against the three Philips, mighty kings of Spain, on land and at sea in almost every part of the world, and in which the freedom and faith of the fatherland were vouchsafed, the first stone of this town hall was laid during the term of office of the burgomasters and peacemakers, by Gerb. Pancras, Jac. de Graeff, Sib. Valckenier, Pet. Schaep, sons and kin of the burgomasters." GOOSSENS at 85, n. 2.

**154** GOOSSENS at 10–11.

**155** PRAK at 260.

**156** Vlaardingerbroek at 2–3 (summary of dissertation).

**157** Aspects, including some of the commissioned art work, were finished long thereafter. See FABER, HUISKEN, & LAMMERTSE at 9. A

commemorative medal coined for the inauguration had on its back the ship Argo, invoking the golden fleece, sailing home into the harbor of Amsterdam. FREMANTLE, BAROQUE TOWN HALL at 169–170. Prak, at 262, noted the length of the Vondel poem, which Fremantle quoted as describing Amsterdam's Town Hall as a "refuge" and as the "heart of the whole city," which provided a "living glow." Vondel, ll. 49–69, cited by FREMANTLE, BAROQUE TOWN HALL at 59–60. Goossens took the title of his book from these Vondel lines: "O marvel that the human brain can conceive / Such treasure wrought by chisel and brush / Under a single roof, and each in its proper place." Vondel, 1655, r. 1176, translated in Goossens at unnumbered front page. See also GOOSSENS at 85, n.1. Another of Vondel's verses provided the title for the Faber, Huisken, and Lammertse volume and for an exhibition of the same name devoted to the "tasks discharged by the city fathers." These verses read: "But crown this edifice with titles and with names, / Of lords, who seat nor cushion do ashame." FABER, HUISKEN, & LAMMERTSE at unnumbered front page, 6.

**158** How much Quellinus did personally is debated. Fremantle noted that "Van Campen designed the Town Hall's sculptural decoration in considerable detail," and that it paralleled some of his work elsewhere. FREMANTLE, BAROQUE TOWN HALL at 156–162. Artus Quellinus, from Antwerp, was born in 1609. His brother, Erasmus, trained in the studio of Peter Paul Rubens. Id. at 147–150. That brother is sometimes called Artus I Quellin. A cousin, Artus II Quellin, worked under Quellinus's direction. See H. GERSON AND E. H. TER KUILE, ART AND ARCHITECTURE IN BELGIUM, 1600–1800 at 37–38 (Baltimore, MD: Penguin Books, 1960). The statues on the facade, of Justice, Prudence, and Peace, were cast in bronze by François Hemenoy. Buchbinder-Green at 152.

**159** The statue of Peace weighs about eight thousand pounds. FREMANTLE, BAROQUE TOWN HALL at 33, 37. Peace holds an olive branch and a staff; at her feet is a cornucopia, symbolic of the "good fortune that peace brought to many of Amsterdam's inhabitants." GOOSSENS at 22. Fremantle posited that all three sculptures were influenced by the work of François Duquesnoy and that Justice looked like Duquesnoy's St. Susanna. FREMANTLE, BAROQUE TOWN HALL at 164–165.

**160** GOOSSENS at 22. See also Buchbinder-Green at 61–62 (noting that images of Justice were common in front of "smaller town halls" and detailing them at Schmalkalden, Tübingen, Gdańsk, Zaltbommel, Haarlam, Maastricht, The Hague, Leiden, and Harderwijk). Many other town halls used a Justice to mark their entrances. See KUYPER, vol. 2 ("The Plates") at plate 181 (Antwerp, 1564), plate 205 (Bruges, 1534), plates 377–378 (Bolsward, 1616), plates 383–384 (Appingedam, 1630), plate 509 (Nieuwkoop, 1628). The photograph in figure 38 was provided by and is reproduced with permission of the Amsterdam City Archives.

**161** GOOSSENS at 22. Van Campen had proposed Fortitude, but when he was succeeded by Daniel Stalpaert, Fortitude was replaced by Vigilance.

**162** GOOSSENS at 26–27 (also noting that the room was the building's "heart," working on the theory that the building corresponded to a person's body, which in turn corresponded harmoniously with the universe).

**163** GOOSSENS at 27.

**164** GOOSSENS at 30.

**165** Buchbinder-Green at 229.

**166** GOOSSENS at 28; Fremantle, *Themes from Ripa and Rubens* at 262–263.

**167** Vondel, l. 1118, as translated and quoted in Buchbinder-Green at 106 and 159, n. 1.

**168** GERARD DE LAIRESSE, THE ART OF PAINTING 304 (London, Eng.: Printed for S. Vandenbergh, 1778).

**169** FREMANTLE, BAROQUE TOWN HALL at 46.

**170** GOOSSENS at 30; Buchbinder-Green at 95 (noting that Backer was paid in 1680) and at 228–231. That painting, extending fifty-six

feet, was made from three canvases and showed "Christ, seated on the clouds and a rainbow," with angels trumpeting the elect and a skeletal figure at the bottom emerging from a grave. Id. at 229.

**171** That painting portrayed either the Christian God Almighty or Jesus "in the guise of Zeus seated on a cloud and holding a bolt of lightning." GOOSSENS at 19. Its vivid conflation of Christian and pagan sources continues to occasion controversy; in the 1960s "a church council in Amersfoort refused to display the painting because of God's too obvious resemblance to Zeus." Id. at 19.

**172** See FABER, HUISKEN, & LAMMERTSE at 57, fig. 32.

**173** See Steven Robert Golan, Scenes from Roman Republican History in Seventeenth-Century Dutch Art: *Exempla Virtutis* for Public and Private Viewing (Ph.D. dissertation, Department of Art History, University of Kansas, Lawrence, KS, 1994; UMI Publication No.: AAT 9528360). As Golan detailed, Roman subjects were popular in many cities in the Netherlands. Sources for such paintings included Valerius Maximus, *Facta et dicta memorabilia*, which provided a "comprehensive collection of the deeds of various Roman Republican figures" (id. at 43, n. 18); Franciscus Junius's handbook for artists, *De pictura veterum*, "in which he discussed the function of images in terms of their relationship to poetic verse" (id. at 35), reprinted as *The Painting of the Ancients in Three Books*, available in England in 1638 and in Holland in 1641 (id. at 46, n. 37); and the 1586 prints *The Roman Heroes*, by Herdrick Goltzius (id. at 13). Golan argued that the burgomasters turned to "public building precedents from the city-state republics of the Italian Renaissance—in particular Siena's Palazzo Pubblico—for inspiration in promoting similar virtues of a strong state." Id. at 56. In that sense, he concluded that the imagery was not "truly Dutch" but that the burgomasters deployed these "foreign" traditions to further their own agendas. Id. at 222.

In addition to allegories discussed in the text, another display was the *Conspiracy (or Oath) of Claudius Civilis*, recording the story of the Batavians, who swore allegiance to each other under Claudius Civilis's leadership in the rebellion against Rome. This episode continued to underscore the relationship between Amsterdam and the Romans as is also a theme in the depiction of the Judgment of Brutus, depicted in the text later. Other related images included depictions of the fidelity of Lucretia (who killed herself after being raped by Sextus Tarquinius; Golan at 14–16) and the magnanimity of Scipio Africanus (who "returned a captive young woman to the Celtiberian prince Allucius" rather than claim a right to her body; id. at 17, 160–162). These allegories can also be found in other town halls. Id. at 177.

The Amsterdam Town Hall's *Civilis* has a literature of its own in that one commissioned from Rembrandt hung briefly in 1662 and was then rejected by the burgomasters in favor of a version by Jürgen Ovens. Buchbinder-Green at 94, 201–217. In general, commentators believe that Rembrandt's version lacked the "hero-worship" sought by the burgomasters, who saw themselves in a more glorious light. See Henri van de Waal, *The Iconological Background of Rembrandt's Civilis*, 1–2 KONSTHISTORISK TIDSKRIFT (ART REVIEW) 11, 24 (1956). See also David R. Smith, *Inversion, Revolution, and the Carnivalesque in Rembrandt's Civilis*, 27 RES 89 (1995); Cynthia Lawrence, "*Worthy of Milord's House"? Rembrandt, Huygens, and Dutch Classicism*, 54 KONSTHISTORISK TIDSKRIFT 16 (1985) (hereinafter Lawrence, *Milord's House*). Lawrence also concluded that Rembrandt had not complied with the conventions of Dutch classicism, which sought "staged presentation" and "theatrical overstatement." Id. at 24. Another theory for the rejection of Rembrandt's painting is that the leaders of Amsterdam were moderating their hostility toward the Houses of Orange and Nassau and wanted to focus less on warfare and more on moderation and political consensus. See Margaret Deutch Carroll, *Civic Ideology and Its Subversion: Rembrandt's Oath of Claudius Civilis*, 9 ART HISTORY 9, 15–17 (1986).

**174** Luscinus reportedly said, "Your gold made no impression on me yesterday, neither does your beast today." Bernadette Perrin's

translation of Plutarch's *Lives* at 21.20, quoted by Buchbinder-Green at 114 and 164, n. 54. See also THE ROYAL PALACE at 77; GOOSSENS at 73–74.

**175** GOOSSENS at 74.

**176** At least seven images of Justice appear outside and inside the building. Figure 39 is reproduced with the permission of the Amsterdam City Archives. In addition to those discussed in the text, a clear-eyed Justice with scales and sword is depicted (along with other Virtues) in a painting by Erasmus Quellinus called the *Maid of Amsterdam*, which hangs in the Council Chamber. See GOOSSENS at 78–79, and fig. 77; THE ROYAL PALACE at 64, fig. 14a. On the ceiling of the Citizens' Hall (*Burgerzaal*), at one of its four corners was Justice, joining the other Cardinal Virtues—there called Wisdom (instead of Temperance), Vigilance (instead of Fortitude), and Prudence. Buchbinder-Green at 232. Another Justice could be seen inside a portrait of Justinian. Id. Also, one painting of Prince Willem I was shown surrounded by Justice, Wisdom, Prudence, Valour, Constancy, Strength, and Impartiality. FREMANTLE, BAROQUE TOWN HALL at 57. Inside the council room were "a crossed sword and scepter of justice." Buchbinder-Green at 113.

**177** See Vlaardingerbroek at 48–53.

**178** FREMANTLE, BAROQUE TOWN HALL at 74, GOOSSENS at 65. As Fremantle detailed, those to be married first registered their "intentions" in the Chamber of Matrimonial Affairs (where clasped hands, symbolizing faithfulness, were carved in the center of its mantelpiece), and then, after public announcements were made in church or from the "publication gallery of the Town Hall," couples "returned to be married before the law in the magistrates' court." FREMANTLE, BAROQUE TOWN HALL at 74. When magistrates presided to decide disputes or enact laws, they sat on a cushion "embroidered with the coat of arms of the Province of Holland," with a "rod of justice" to their right. Id. at 74–75.

**179** FREMANTLE, BAROQUE TOWN HALL at 75.

**180** GOOSSENS at 65.

**181** Fremantle, at 75, translated a description by Hubertus Quellien, the brother of the sculptor and author of a book of engravings on the Town Hall's ornamentation—"The rewarding of good and the punishment of evil: with the measure with which one measures one shall be measured"—attributing that "saying" to *Luke* 6:38. BAROQUE TOWN HALL at 75, n. 3; see also Fremantle, *Themes from Ripa and Rubens* at 258, 264.

**182** GOOSSENS at 65.

**183** FREMANTLE, BAROQUE TOWN HALL at 75, n. 4 (saying that "a single eye signifies the watchful Father of Lights, God," quoting Van Mander). See also GOOSSENS at 65.

**184** FREMANTLE, BAROQUE TOWN HALL at 75.

**185** GOOSSENS at 66.

**186** FREMANTLE, BAROQUE TOWN HALL at 76; GOOSSENS at 66.

**187** FREMANTLE, BAROQUE TOWN HALL at 76. The layout and the room were not quite as Van Campen had planned. See GOOSSENS at 66. For example, according to Fremantle, a draft plate had indicated "that the scales of justice were to have been painted on the panels of its doors." FREMANTLE, BAROQUE TOWN HALL at 76.

**188** Buchbinder-Green at 152. One image, called *Justice, Strength and Truth* (or *Justice with Wisdom and Prudence*), was lost through deterioration and repainting. Id. Another, called *Justice*, was "touched up" by Jan Engelbrechts. See FABER, HUISKEN, & LAMMERTSE at 52–55, and figs. 28 and 29.

**189** The painting measures approximately five feet, eight inches, by seven feet, three inches. See HARRY SCHMIDT, JÜRGEN OVENS, SEIN LEBEN UND SEINE WERKE. EIN BEITRAG ZUR GESCHICHTE DER NIEDERLÄNDISCHEN MALEREI IM XVII. JAHRHUNDERT (JÜRGEN OVENS, HIS LIFE AND HIS WORK. A CONTRIBUTION TO THE HISTORY OF THE ART OF THE NETHERLANDS IN THE SEVENTEENTH CENTURY) 160, item 139 (Kiel, Ger.: Selbstverlag des Verfassers Dr. Harry Schmidt, 1922). The artist, Ovens, was born in the German state of Tönning in 1623 and

became a pupil of Rembrandt in the 1640s. Ovens lived in Amsterdam during much of his life before 1651, then moved between countries before returning to his home region of Schleswig-Holstein in 1678. Justice was an oft-repeated theme. Our thanks to Dr. Eymert-Jan Goossens and to Marianna van der Zwaag for assistance in obtaining images of the Amsterdam Town Hall. The photography for figure 40, copyright Stichting Koninklijk Paleis Amsterdam, was provided by the Royal Palace Foundation.

**190** SCHMIDT at 160.

**191** See FREMANTLE, BAROQUE TOWN HALL at 76. The ceiling paintings represent "Justice flanked by Strength and Prudence."

**192** Philipp von Zesen, *Description of the Town of Amsterdam* (1664) as quoted in SCHMIDT at 160–161.

**193** GOOSSENS at 66.

**194** FREMANTLE, BAROQUE TOWN HALL at fig. 80 reproduces the frieze, discussed in GOOSSENS at 67, fig. 59.

**195** Ferdinand Bol, a pupil of Rembrandt, was born in 1616 in Dordrecht, the Netherlands. Buchbinder-Green at 114. The textual source is *Exodus* 34:29–30. The painting is dated variously, from 1658 through 1662. Buchbinder-Green at 154; GOOSSENS at 67; SCHAMA at 116. See generally ALBERT BLANKERT, FERDINAND BOL (1616–1680): REMBRANDT'S PUPIL (Doornspijk, Neth.: Davaco Publishers, 1982) (hereinafter BLANKERT, BOL). The photograph in figure 41 was provided by and is reproduced with permission of its copyright holder, the Royal Palace Foundation Amsterdam.

**196** See Gad B. Sarfatti, *The Tablets of the Law as a Symbol of Judaism*, in THE TEN COMMANDMENTS IN HISTORY AND TRADITION 383, 390–402 (Arnold Schwartz, trans., Ben-Zion Segal & Gershon Levi, eds., Jerusalem, Isr.: Magnes Press, Hebrew University, 1990). In some of the earlier representations, Moses received scrolls, not tablets. Id. at 390–391. The tablets also came to denote Judaism, as did Synagoga, discussed in Chapter 4. Over time, Jewish art came to rely on the tablets as a symbol of Judaism, and they came, along with the menorah, to eclipse the "Holy Ark." Id. at 417–418. A review of the imagery of the Ten Commandments is provided by OLIVIER CHRISTIN, LES YEUX POUR LE CROIRE, LES DIX COMMANDEMENTS EN IMAGES, XVE-XVIIE SIÈCLES (Paris, Fran.: Seuil, 2003). We discuss the display of the Ten Commandments in the United States in Chapter 6.

**197** SCHAMA at 116.

**198** SCHAMA at 117. The details of efforts, such as seeking to suppress "Vondel's controversial play *Lucifer*," are provided at 119. See ALBERT BLANKERT, KUNST ALS REGERINGSZSZAAK IN AMSTERDAM IN DE 17E EEUW: RONDOM SCHILDERIJEN VAN FERDINAND BOL 65 (Lochem, Neth.: De Tijdstroom B.V., 1975) (with summaries of chapters in English) (hereinafter BLANKERT, AMSTERDAM).

**199** See BLANKERT, AMSTERDAM at 65. The linkage of the burgomasters to Moses affected not only the Calvinists but also Jews then living in Amsterdam. See Michael A. Rosenthal, *Why Spinoza Chose the Hebrews: The Exemplary Function of Prophecy in the Theological-Political Treatise*, in JEWISH THEMES IN SPINOZA'S PHILOSOPHY 225, 242–249 (Heidi M. Ravven & Lenn E. Goodman, eds., Albany, NY: State U. of New York Press, 2002).

**200** See SCHAMA at 121.

**201** Buchbinder-Green at 153, translating line 757 of the Vondel verse. These lines have drawn the attention of several scholars, all offering slightly different English translations. See BLANKERT, BOL at 52 ("The free state begins to blossom when the people honour the laws"); FREMANTLE, BAROQUE TOWN HALL at 77, n. 2 ("The Hebrew Moses has received the Law from God, with which he returns from above to the people, who greet him reverently and welcome him eagerly. The free State begins to flourish when the people respect the laws"); SCHAMA at 120 ("So they become respectful and welcome them with longing. As the people honor the laws, so shall a Free state stand").

**202** BLANKERT, BOL at 52. Schama, at 121, translated Jan Vos's lines as "Those who govern the people will need a strong hand. / The

laws should strike terror in godless living / Where wise laws are kept; there virtue makes its stand." Fremantle presumed that Vondel's lines had been inscribed beneath the Bol painting and then "painted out." FREMANTLE, BAROQUE TOWN HALL at 77, n. 2 (citing an eighteenth-century source). However, subsequent scholarship indicates that no text was there. According to Blankert, "Neither verse (of Vondel or Vos) pleased the patrons; in the end no poem at all was inscribed beneath the painting." BLANKERT, BOL at 52. Both poems predate the installation of the Bol painting in 1666. Letter from Dr. Goossens to the authors (March 2006).

**203** FREMANTLE, BAROQUE TOWN HALL at 77.

**204** FREMANTLE, BAROQUE TOWN HALL at 76. We return to this phrase and its depictions in Chapter 13.

**205** Sidsel Helliesen, *Thronus Justitiae: A Serie(s) of Pictures of Justice*, 91 OUD HOLLAND, QUARTERLY FOR DUTCH ART HISTORY, 232, 235 (1977). Discussed there is an early seventeenth-century book called *Thronus Justitiae*, by Joachim Wtewael, which consisted of a series of thirteen signed and numbered engravings accompanied by verses. This genre, relying on a mixture of judicial and biblical stories, was part of a Dutch and German tradition. In that volume, an image titled *Alexander the Great as a Judge* was accompanied by Latin text, translated by Helliesen to read that Alexander

> never declared a judgment before he had heard both
> sides
> Unbiased, he is renowned because he kept favoritism
> away from Justice.
> He offered therefore only one ear to the prosecutor
> The other remained open for the troubled defense.
> For whoever condemns without listening or releases
> from guilt,
> Although he may judge fairly, he will not be a fair
> judge.

(Id. at 246–247 and n. 37.)

**206** FREMANTLE, BAROQUE TOWN HALL at 77; FABER, HUISKEN, & LAMMERTSE at 22 (noting that the presence of the sheriff, at least two magistrates, and a secretary was required).

**207** JOHN H. LANGBEIN, TORTURE AND THE LAW OF PROOF: EUROPE AND ENGLAND IN THE ANCIEN RÉGIME 3 (Chicago, IL: U. of Chicago Press, 1977, 2d ed. 2006) (tracing the development of "judicial torture" in the 1200s in the north of Italy and its spread through the 1800s into Europe). Langbein pointed to the abolition of torture in the eighteenth century as he debunked the "fairy tale" that it ended because of public consciousness of its horrors. Id. at 10–11. Rather, he argued that alternative forms of proof were an important part of its displacement.

**208** See generally JOHN LANGBEIN, PROSECUTING CRIME IN THE RENAISSANCE: ENGLAND, GERMANY, FRANCE (Cambridge, MA: Harvard U. Press, 1974).

**209** FREMANTLE, BAROQUE TOWN HALL at 78–87. Fremantle detailed the special cushions on which the magistrates sat, the robes worn, the placement of the rod of justice nearby, and the movement of a prisoner, pronounced "a child of death." Id. at 83. See also Fremantle, *Open Vierschaar* at 212–234; GOOSSENS at 69.

**210** FREMANTLE, BAROQUE TOWN HALL at 40, 78–83.

**211** Fremantle, *Open Vierschaar* at 231.

**212** GOOSSENS at 70. The details of the ceremony are provided in Fremantle, *Open Vierschaar* and in FREMANTLE, BAROQUE TOWN HALL.

**213** As Goossens explained, "Onlookers gathered in Dam Square could witness the proceedings through the bronze bars on the windows." GOOSSENS at 69. A caveat is in order, which is that space was limited, as Fremantle mentioned, and although such proceedings were out in the open, the "ceremony had begun to lose its public nature while the medieval Town Hall was still in use" in the 1630s. City records indicated that the sheriff had insisted that the crowd be quiet,

and the move inside in the 1655 building further limited public access. Fremantle, *Open Vierschaar* at 229. After the death sentence was announced, city bells rang and the sheriff went to the window of the "publication gallery," where he displayed the Rod of Justice, and all sentences were read "out." Id. at 230.

**214** The photographs in figures 42, 44, 45, and 46, all of the interior of the Tribunal, are reproduced with permission of the copyright holder, Stichting Koninklijk Paleis Amsterdam, and were provided by the photographers, Erik & Petra Hesmerg / Amsterdam.

**215** FREMANTLE, BAROQUE TOWN HALL at 78 (translating from the Latin: "Discite Justitiam Moniti et Non Temnere Divos"; VIRGIL, AENEID at 6:620). An alternative, provided by Goossens, at 69, is the translation "Heed these words: learn to be just and defy not the gods."

**216** GERSON & TER KUILE at 38.

**217** FREMANTLE, BAROQUE TOWN HALL at 80, quoting Vitruvius, *De Architectura* at I.i., 6, and translated by her. The photograph in figure 43 was provided by and is reproduced with permission from the Royal Palace Foundation Amsterdam.

**218** Fremantle, in *Baroque Town Hall*, commented (at 156–157) that the "likeness of the arrangement of the stage set of the theater Van Campen designed for Amsterdam to the arrangement of the reliefs showing scenes of justice in the Vierschaar . . . is so strong as to suggest a common authorship" (describing the attribution of the sculptural plan to Van Campen, perhaps influenced by Quellinus's abilities).

**219** GOOSSENS at 71; FREMANTLE, BAROQUE TOWN HALL at 85.

**220** Buchbinder-Green at 90.

**221** GOOSSENS at 71. The painting, now owned by Amersfoort, is reproduced at 19, fig. 17; see also id. at 89, n. 106. During the nineteenth century it was called *Heydense Opper God Jupiter* (*The Supreme Heathen God Jupiter*). SCALES AND SWORD at 64. One possibility is that the design, with its unconventional Zeus-like Jesus, was rejected and the room redesigned as a consequence. Another possibility is that the redesign drove the decision not to change the painting; a third explanation is that revisions were driven by "reasons of economy." Id. at 62. The full set of Last Judgment imagery is known from an engraving by Jacov Vennekool, draftsman of Jacob van Campen. The display was aimed to show that the "prophets not only were the proclaimers of Divine Justice, but also exhorted the magistrates to be good administrators and the citizens to obey." The ceiling was to have a Sol Justitiae (Sun of Justice).

**222** Quoted and translated from the 1644 edition by Buchbinder-Green at 78.

**223** Buchbinder-Green at 78.

**224** Golan, at 79, noted the absence of didactic verse in the Vierschaar.

**225** The sculptural references, possibly to Brunelleschi and Ghiberti, are detailed in Fremantle's book at 158–160. Terracotta studies for all three have survived. JUDIKJE KIERS & FIEKE TISSINK, THE GLORY OF THE GOLDEN AGE: DUTCH ART OF THE 17TH CENTURY 247 (Zwolle, Neth.: Waanders Publishers, 2000).

**226** FREMANTLE, BAROQUE TOWN HALL at 81.

**227** See SCALES AND SWORD at 57, discussing the similarity of subject matter in the town halls of Belgium, Germany, and the Netherlands, with some local variations relating to particular personages. Further, as Goossens explained, "Difficult as it may be to understand how . . . to combine the imagery of both the classics and the Bible in the sanctimonious climate of the seventeenth century, the town hall is proof that it could be done. The burgomasters, who saw themselves . . . at the helm of a new empire and at the center of a unified community, were described . . . as 'the representatives of God's seat and city,'" and they borrowed liberally from "Graeco-Roman metaphors and narratives." GOOSSENS at 19.

**228** For example, paintings of the Judgment of Zaleucus could be found in the Town Halls of Haarlam, Emden, Gdańsk, Hoorn, and Eglisau (see Buchbinder-Green at 55); in Nuremberg, along with a

Judgment of Solomon and likely a Cambyses (see Van der Velden, *Cambyses for Example* at 19–20); in Zurich (Lederle at 48–49); on the ceiling of the Hall of Consistory in Siena, painted in the 1520s and 1530s (see Marianna Jenkins, *The Iconography of the Hall of the Consistory in the Palazzo Pubblico, Siena*, 54 ART BULLETIN at 430, 443–445 (1972); on medals (Gans & Kisch at 122); and in stained glass from about 1525 (see Rijskmuseum, www.rijksmuseum.nl/collectie/zoeken/asset.jsp?id=BK-15119&lang=en).

The rendition of Zaleucus for the "wall-paintings in Basel Town Hall" was by Hans Holbein. See ARTHUR B. CHAMBERLAIN, HANS HOLBEIN THE YOUNGER, vol. 1, 127–130 (New York, NY: Dodd, Mead, 1913). The Zaleucus in Haarlam, by Jan de Braij (or Bray), dated from 1676 (and thus following the rendition in the Amsterdam Town Hall), was displayed above a "chimney-piece in the courtroom of the Haarlem Town Hall." See Michael Kitson, *Amsterdam, Rijksmuseum Dutch History Painting*, 123 BURLINGTON MAG. 443, 444 (1981); see also Lawrence, *Milord's House* at 23. See generally ALBERT BLANKERT, GODS, SAINTS & HEROES: DUTCH PAINTING IN THE AGE OF REMBRANDT 65–76 (Washington, DC: National Gallery of Art, 1980) (hereinafter BLANKERT, GODS, SAINTS & HEROES). Further, in the frontispiece of a book of etchings, *Thronus Justitiae*, providing exempla of justice, the figures featured were Justice, Jesus, and Moses at the top; David and Solomon in niches; and at the bottom on the left, Otanes seated on his father's skin, while on the right Zaleucus was shown "grabbing the caryatid's foot in pain as his eye is put out." See Helliesen at 252 and fig. 17. As Tipton, at 44–50, argued, images in the law books drew upon town hall art and provided source material for artists. As noted, the flaying of Cambyses was often shown in combination with these narratives. See Miziolek at 73, 80–81. The scene was also in the Town Hall in Toruň. Id. at 76, n. 22.

**229** Van der Velden, *Cambyses for Example* at 19–20, citing Gans, in part, at 122. Zaleucus and Cambyses (at 24) are together on a single sheet of the 1534 frontispiece of Justinus Gobler's *Der gerichtlich Prozess* (*The Judicial Trial*). Also at 25, fig. 14.

**230** Van der Velden, *Cambyses for Example* at 7; Miziolek at 76–77. As McGrath commented at 42–43, the "Judgement of Solomon was virtually inevitable in this context." The scene was displayed, for example, in Alkmaar, Augsburg, Basel, Bremen, Breslau, Edam, Elbing, Frankfurt am Main, Gdańsk, The Hague, Leiden, Leipzig, Lüneburg, Münster, Rothenburg, Thorn, Ulm, and Überlingen. This list is a composite taken from references in Buchbinder-Green at 53; Lederle at 26–31; Miziolek at 73–74. The scene was also in English court halls. See Karen Hearn, *An English Gentleman Painter, Henry Gibbs*, 140 BURLINGTON MAG. 99 (1998). See also Rafii at 172 and at 277, n. 71 (discussing the Solomon fresco, painted in the 1530s and attributed to Bartolamäus Bruyn in Bremen and restored when discovered in the 1950s); SCALES AND SWORD at 59, fig. 1 (discussing the Chamber of the Schepenen, in the Kampen Town Hall, where a Solomon was also deployed in the sixteenth century). Further, the Judgment of Solomon and an image of him enthroned as a judge or conflated with Jesus was common in illustrated manuscripts and Bibles and used in domestic imagery to symbolize a mother's love. See Isa Ragusa, *Terror Demonum and Terror Inimicorum: The Two Lions of the Throne of Solomon and the Open Door of Paradise*, 40 ZEITSCHRIFT FÜR KUNSTGESCHICHTE 93 (1977); Diane Cole Ahl, *Renaissance Birth Salvers and the Richmond Judgment of Solomon*, 7–8 STUDIES IN ICONOGRAPHY 158–159 (1981–1982).

Not all biblical scenes found in town halls were specifically commissioned for them; many were brought from "other locations, usually from the churches," thus permitting the town halls to be a "repository of a city's heritage." Buchbinder-Green at 47. Moreover, biblical scenes, including the popular Solomon, were subjects of paintings in places other than town halls and churches. See Gina Strumwasser, Heroes, Heroines and Heroic Tales from the Old Testament: An Iconographic Analysis of the Most Frequently Repre-

sented Old Testament Subjects in Netherlandish Painting, ca. 1430–1570 (Ph.D. dissertation, University of California, Los Angeles, CA, 1979; UMI Publication No.: AAT 8001410). Some of the Solomon scenes were accompanied by texts. For example, in Lüneburg the maxim stated that "the judge should be pure of heart and, when listening to the case, should be able to distinguish between good and evil." Lederle at 28.

**231** See Bernd Nicolai, *Orders in Stone: Social Reality and Artistic Approach; The Case of the Strasbourg South Portal*, 41 GESTA 111, 112–113 (2002). The continuing saliency of the Judgment of Solomon can be seen through its deployment in the courthouse in Moita, Portugal, where a tiled illustration of the story was added to the courtroom's back wall. See JÚLIO POMAR & ANTÓNIO LOBO ANTUNES, JUSTIÇA DE SALOMÃO (Lisbon, Port.: Mediatexto, 2004).

**232** A volume prized in the Renaissance and then called the Book of Solomon, "now recognized as a Pythagorean product of the first century," had Sophia or Wisdom as a central figure reflecting the essence of God's thinking and helping man "achieve salvation." See CHRISTIANE L. JOOST-GAUGIER, RAPHAEL'S STANZA DELLA SEGNATURA: MEANING AND INVENTION 54 (Cambridge, Eng.: Cambridge U. Press, 2002). Solomon appeared in the Vatican's Stanza della Segnatura, and his influence came from being seen as "supreme among legendary jurists in Medieval and Renaissance times." More generally his image served to refer to "the discipline of Jurisprudence as it was known in Renaissance libraries." Id. at 49. See generally Michael Hattaway, *Paradoxes of Solomon: Learning in the English Renaissance*, 29 J. HISTORY OF IDEAS 499 (1968). Solomon was also a bridge figure, as can be seen from his role in Mughal art. Ebba Koch, *Jahangir and the Angels: Recently Discovered Wall Paintings under European Influence in the Fort of Lahore*, in MUGHAL ART AND IMPERIAL IDEOLOGY 32 (Oxford, Eng.: Oxford U. Press, 2001).

**233** That painting, signed and dated 1658, is reproduced in Goossens; see color illustration XIX at 45 and the discussion at 76–77. The reference is to 1 *Kings* 3:3–15. Described is the question from God to Solomon about what he most wanted and his reply that he sought wisdom to help him rule well: "Give thy servant, therefore, a heart with skill to listen, so that he may govern thy people." See NEW ENGLISH BIBLE. In the painting Solomon is given a book and a scepter by an angel. Below the painting is explanatory text, by the poet Vondel, that includes the line "Where wisdom guides, there naught shall surpass." GOOSSENS at 77 (his translation; see also Buchbinder-Green at 130). Also inscribed was "the prayer and offering of Solomon was so pleasing to God that he granted Solomon Wisdom, Riches, and everything that his heart desired." Lederle at 30.

**234** See 1 *Kings* 3:16–28. The passage closes with the sentence "When Israel heard the judgement which the king had given, they all stood in awe of him; for they saw that he had the wisdom of God within him to administer justice." See NEW ENGLISH BIBLE. One source for the Renaissance versions was the Antiquitates Iudaicae of Josephus Flavius (VIII, 2, 2), which were "immensely popular and frequently illustrated in the 15th and 16th century." Miziolek at 76.

**235** See Gans & Kisch at 122 (their translation from the German).

**236** See Martha L. Minow, *The Judgment of Solomon and the Experience of Justice*, in THE STRUCTURE OF PROCEDURE 447–450 (Robert M. Cover & Owen Fiss, eds., Mineola, NY: Foundation Press, 1979).

**237** Some call him Seleucus, a variation on Zaleucus. See F. E. Adcock, *Literary Tradition and Early Greek Code-Makers*, 2 CAMBRIDGE HISTORICAL J. 95, 97 (1927). He was said to have "brought the people of Thurii to abide by his laws" (id. at 104–105), and some ascribe to him the earliest written code (id. at 105–106).

**238** The story was told by Valerius Maximus: "Nothing could be braver than the following examples of justice. Zaleucus protected the city of Locri with very salutary and useful laws. His son was convicted on a charge of adultery and according to a law constituted by Zaleu-

cus himself was due to lose both eyes. The whole community wished to spare the young man the necessity of punishment in honour of his father. For some time, Zaleucus resisted, but in the end, overborne by the people's entreaties, he first gouged out one of his one eyes, then one of his son's, leaving the faculty of sight for them both." See MEMORABLE DOINGS AND SAYINGS, vol. 2, bk. 6:5, ext. 3 at 64–65. A description was also provided in *Gesta Romanorum*, compiled during the first half of the fourteenth century in Latin and then translated in various European vernaculars. In the original version the "violated woman was a virgin" and a "daughter of a widow." See Miziolek at 75.

**239** Buchbinder-Green at 55. In the version of this story that Hans Holbein the Younger painted for the Basel Town Hall, this "severe object-lesson in the majesty of the law is witnessed by a great crowd of spectators." CHAMBERLAIN at 129.

**240** See MEMORABLE DOINGS AND SAYINGS, vol. 2, bk. 6.5, ext. 3 at 64–65.

**241** See Buchbinder-Green at 54. This scene was also set forth in the Nuremberg Town Hall in a rendition by Hans Sebald Beham and in a stained-glass window in Emden (Van der Velden, *Cambyses for Example* at 34, n. 114), as well as in the magistrates' chambers in Leiden in a painting by Karel de Moor, who lived in the second half of the seventeenth century. Id. Brutus was also depicted in the Hall of the Consistory in Siena's Palazzo Pubblico in paintings by Domenico Beccafumi, executed between 1529 and 1535. His was one of several exemplars on narrations of aspects of justice. See Jenkins at 430, 443. Brutus, denoting "severity," was shown with the heads of his sons, whom he had ordered decapitated, while Zaleucus, nearby, represented a somewhat less harsh form. Id. at 443–444. Both scenes relied on *Factorum et dictorum memorabilium*, libri ix, of Valerius Maximus. Id. at 441.

**242** See LIVY, THE EARLY HISTORY OF ROME 101, 1.60 (Aubrey De Sélincourt, trans., Harmondsworth, Eng.: Penguin Books, 1975). See also MEMORABLE DOINGS AND SAYINGS, vol. 1, bk. IV.4.1 at 386–387. A critical reading of Livy's account is provided in IAN DONALDSON, THE RAPES OF LUCRETIA: A MYTH AND ITS TRANSFORMATIONS 110–112 (Oxford, Eng.: Clarendon Press, 1982). The book traced the ways in which the two stories—of Brutus and of Lucretia—together purported "to explain the origins of the Roman Republic." Id. at 145.

**243** See LIVY at 108, 2.3.

**244** See MEMORABLE DOINGS AND SAYINGS, vol. 1, bk. V.8.1 at 532–533.

**245** FREMANTLE, BAROQUE TOWN HALL at 81. Plutarch described the scene as follows: "Most of the people standing mute and sorrowful, some only, out of kindness to Brutus, mentioning banishment . . . ." See Plutarch, *Poplicola*, in LIVES 207 (John Dryden, trans., Boston, MA: Little, Brown, 1885). Brutus showed no sympathy and instructed the lictors, "what remains is your duty." Id. At the execution, Brutus did not look away "but sternly watched his children suffer." Id. at 208.

**246** In the background is a building identified as the Temple of Jupiter built by Brutus. GOOSSENS at 70.

**247** DONALDSON at 121–123.

**248** Donaldson provided this overview in reference to both Brutus and the story of the rape of Lucretia. DONALDSON at 145.

**249** We found this excerpt through Donaldson at 126 and have used his version (emphasis in the original); other translations have slight variations. See NICCOLÒ MACHIAVELLI, THE DISCOURSES, bk. 3, discourse 3 (Bernard Crick, ed., Leslie J. Walker, trans., Middlesex, Eng.: Pelican Books, 1970). A printed edition of *The Discourses on the First Ten Books of Titus Livius* was not published during Machiavelli's lifetime and circulated only as a manuscript. Machiavelli left the work incomplete. Id. at 10. Harvey C. Mansfield and Nathan Tarcov estimated that Machiavelli wrote it between 1513 and 1519. The first publication was in 1531. See NICCOLÒ MACHIAVELLI, DISCOURSES ON LIVY xlii (Harvey C. Mansfield & Nathan Tarcov, trans., Chicago, IL: U. of Chicago Press, 1996).

**250** See DONALDSON at 110–127. Donaldson detailed the banning in 1680 of Nathaniel Lee's tragic play *Lucius Junius Brutus* by Lord Chamberlain as too negative toward government. He saw the subsequent careful deployment of the narrative in the eighteenth century in England as efforts to avoid appearing to offend the Crown. Id. at 112–115.

**251** David's painting was met with a mixed reception; it was seen as "antiquarian" and lacking in artistic brilliance, albeit politically supportive of French revolutionary ideas. See Thomas Puttfarken, *David's Brutus and Theories of Pictorial Unity in France*, 4 ART HISTORY 291 (1981). Puttfarken argued that the criticism missed the more modern sensibilities, in which the public is invited to view "moral conflict" with "our sympathies are divided." Id. at 301–302. See also Stefan Germer and Hubertus Kohle, *From the Theatrical to the Aesthetic Hero: On the Privatization of the Idea of Virtue in David's Brutus and Sabines*, 9 ART HISTORY 168 (1986).

**252** See also MARIE-HÉLÈNE HUET, REHEARSING THE REVOLUTION: THE STAGING OF MARAT'S DEATH, 1793–1797 at 91–92 (Robert Hurley, trans., Berkeley, CA: U. of California Press, 1982). As Huet noted, "Voltaire's *Brutus* was not only the play most often performed during the revolutionary period, it became a symbol of civic uprightness." Id. at 92.

**253** See HERBET J. STORING, THE COMPLETE ANTI-FEDERALIST (Chicago, IL: U. Chicago Press, 1981). The seven-volume set was published after Professor Storing's death and provides a compendium of the many anti-federalist writings. Among those deemed most important were the essays by "Brutus" that were published in the *New York Journal* between October 1787 and April 1788. Id. at vol. I, vii, and vol. 2.9, at 358 452. Scholars debate whether the name was intended to reference the Lucius Brutus depicted in Amsterdam or Marcus Brutus, Julius Caeser's assassin. Michael Zuckert read the reference to be Lucius Brutus; "According to Brutus, then, he and other enemies of the proposed constitution are, like the original Brutus, the true friends and saviors of the revolution and republicanism." See Michael Zuckert, *Who Is Publius? The Debate Over the Constitution and the American Revolution*, in ENLIGHTENING REVOLUTIONS: ESSAYS IN HONOR OF RALPH LERNER 221, 226 (Ralph Lerner, Svetozar Minkov, & Stéphane Douard, eds., Lanham, MD: Lexington Books, 2006).

**254** The Roman Consul doomed his sons to die, they "Who had betrayed their country. The stern word / Afforded (may it through all time afford) / A theme for praise and admiration high." WILLIAM WORDSWORTH, THE COMPLETE POETICAL WORKS OF WILLIAM WORDSWORTH 275 (Henry Reed, ed., Philadelphia, PA: Hayes & Zell, 1854). See Sharon M. Setzer, *Precedent and Perversity in Wordsworth's Sonnets Upon the Punishment of Death*, 50 NINETEENTH-CENTURY LITERATURE 427 (1996).

**255** See Rev. Charles H. Spurgeon, Sermon 255: *Justice Satisfied* (May 29, 1859), The New Park Street Pulpit, http://www.spurgeon.org/sermons/0255.htm (about punishing sin). Spurgeon, who lived in England from 1834 to 1892, was a popular figure, and his preaching attracted large audiences. See generally JAMES J. ELLIS, CHARLES HADDON SPURGEON (New York, NY: Flemming H. Revell Company, 1892).

**256** DONALDSON at 123.

**257** Buchbinder-Green at 122. The painting was done around 1656.

**258** Buchbinder-Green at 121, translating Vondel at l. 216.

**259** Alfred Acres, *Rogier van der Weyden's Painted Texts*, 21 ARTIBUS ET HISTORIAE 75, 95 (2000). The panels were lost when the French bombarded Brussels in 1695. A tapestry woven in Brussels before 1461 provided a record of the images. A woodcut by Hans Holbein reiterated the legend. See Campbell Dodgson, *An Illustration by Holbein of the Legend of Herkinbald*, 3 J. WARBURG & COURTAULD INSTS. 241 (1940).

**260** Acres at 95.

**261** See Buchbinder-Green at 56–57. Pictures of this tale were displayed in the magistrates' chambers in Hoorn and in Nuremberg (designs by Dürer). Id. The story dates from 1220. See Diane Wolfthal,

*"A Hue and a Cry": Medieval Rape Imagery and Its Transformation*, 75 ART BULLETTIN 39, 57 (1993) (also noting that the image appeared in the Cologne Town Hall).

**262** Acres at 95–96; Wolfthal at 57.

**263** See Christian Müller, *New Evidence for Hans Holbein the Younger's Wall Paintings in Basel Town Hall*, 133 BURLINGTON MAGAZINE 21, 22–24 (1991).

**264** See Chamberlain at 128. Holbein did the images between 1521 and 1522. Other "Judgment stories" included ones more local to the Netherlands, such as the *Judgment of Count Willem III* and the *Ordeal of Otto III*. Buchbinder-Green at 58–61.

**265** DONALDSON at 139.

**266** FREMANTLE, BAROQUE TOWN HALL at 16; GOOSSENS at 11.

**267** FREMANTLE, BAROQUE TOWN HALL at 16. The city council, whose members were appointed for life, "had no real power." See FABER, HUISKEN, & LAMMERTSE at 10.

**268** See JULIA ADAMS, THE FAMILIAL STATE: RULING FAMILIES AND MERCHANT CAPITALISM IN EARLY MODERN EUROPE (Ithaca, NY: Cornell U. Press, 2005).

**269** See Van der Velden, *Cambyses Reconsidered* at 55, n. 49.

**270** The quoted text is borrowed from Regensburg in 1554, and translated by Zapalac.

**271** Robert M. Cover, *Violence and the Word*, 95 YALE LAW JOURNAL 1601, 1618 (1986); Robert M. Cover, *The Supreme Court 1982 Term—Foreword: Nomos and Narrative*, 97 HARV. L. REV. 4 (1983). Both underscore the role that stories that enfold precepts serve to give meaning to the legal rules. See also OSCAR G. CHASE, LAW, CULTURE, AND RITUAL: DISPUTING SYSTEMS IN CROSS-CULTURAL CONTEXT 30–43 (New York, NY: New York U. Press, 2005) (arguing that "oracular" qualities persist in Anglo-American processes).

## CHAPTER 4

**1** Katherine Allen Smith, Footprints in Stone: Saint Michael the Archangel as a Medieval Saint, 1000–1500 at 7 (Ph.D. dissertation, Department of History, NYU, New York, NY, 2004; UMI Publication No.: AAT 3127497), citing SHARON FARMER, COMMUNITIES OF SAINT MARTIN: LEGEND AND RITUAL IN MEDIEVAL TOURS 1–3 (Ithaca, NY: Cornell U. Press, 1990).

**2** The photograph of *Justice* in figure 47 was taken by Erik & Petra Hesmerg / Amsterdam and is reproduced with their permission and that of the Stichting Koninklijk Paleis Amsterdam.

**3** The photograph of the east wall of the Tribunal with *Justice* and *Prudence* in figure 48 was taken by Erik & Petra Hesmerg / Amsterdam and is reproduced with their permission and that of the Stichting Koninklijk Paleis Amsterdam.

**4** KATHARINE FREMANTLE, THE BAROQUE TOWN HALL OF AMSTERDAM 159 (Utrecht, Neth.: Haentjens Dekker & Gumbert, 1959) (hereinafter FREMANTLE, BAROQUE TOWN HALL).

**5** A vivid published image of Prudence is in the volume WEEGSCHAAL & ZWAARD: DE VERBEELDING VAN RECHT EN GERECHTIGHEID IN NEDERLAND (SCALES AND SWORD: THE DEPICTION OF LAW AND JUSTICE IN THE NETHERLANDS) 60, fig. 2 (M. A. Moelands & J. Th. de Smidt, eds., The Hague, Neth.: Jongbloed Juridische Boekhandel & Uitgeverij, 1999) (hereinafter SCALES AND SWORD). English summaries of the chapters are provided.

**6** Katharine Fremantle, *The Open Vierschaar of Amsterdam's Seventeenth-Century Town Hall as a Setting for the City's Justice*, 77 OUD HOLLAND, QUARTERLY FOR DUTCH ART HISTORY 206, 216, n. 60 (1962).

**7** See, for example, MARTIN KUIJER, THE BLINDFOLD OF LADY JUSTICE: JUDICIAL INDEPENDENCE AND IMPARTIALITY IN LIGHT OF THE REQUIREMENTS OF ARTICLE 6 ECHR (Leiden, Neth.: Wolf Legal Publishers, 2004); Andrew R. Simmonds, *The Blindfold of Justice*, 63 AMERICAN BAR ASSOCIATION JOURNAL 1164 (1977).

**8** The designs are attributed to Jacob van Campen. FREMANTLE, BAROQUE TOWN HALL at 158–159. The versions in the niches in the Tribunal, like those outside, have classical drapery reminiscent of statues by Duquesnoy. Id. at 159, n. 5.

**9** The 1644 Dutch edition of Ripa commented that "her eyes are bound . . . because she is to set an example for the judge, who cannot give in to temptation and should not be led astray." CESARE RIPA VAN PERUGIEN, ICONOLOGIA, OF UYTBEELDINGEN DES VERSTANDS 432 (Amstelredam, Neth.: Dirck Pietersz Pers, 1644) (hereinafter DUTCH RIPA–1644; all translations from this edition are by Chavi Keeney Nana). The 1611 Torino edition has similar language; see CESARE RIPA, ICONOLOGIA 203 (Padua, Ital.: Pietro Paolo Tozzi, 1611; New York, NY: Garland Publishing, 1976) (hereinafter RIPA, PADUA–1611). Translations of Italian Ripa editions are by Tess Dearing and Allison Tait.

**10** According to some descriptions of the building, the Town Hall had a room called a Torture Chamber, but we have not located information detailing whether Justices were depicted within. Fremantle explained that prisoners who refused to confess were "examined . . . in the torture chamber in the presence of sheriff, burgomasters, and magistrates" and that "instruments of torture" were carved in the ceiling's vaulting. See FREMANTLE, BAROQUE TOWN HALL at 77.

**11** See GERALDINE PINCH, EGYPTIAN MYTHOLOGY: A GUIDE TO THE GODS, GODDESSES, AND TRADITIONS OF ANCIENT EGYPT 19 (Oxford, Eng.: ABC–CLIO, 2002), discussing the Egyptian ideology that conceived of the "solar eye," or "Eye of Ra," and spoke of Ra as the "creator sun god." Id. at 68–69. The eye of Horus, or udjat eye, was described as sharing a significance represented by Maat, "that justice and harmony ruled once more." See ERIK HORNUNG, IDEA INTO IMAGE: ESSAYS ON ANCIENT EGYPTIAN THOUGHT 142–143 (Elizabeth Bredeck, trans., New York, NY: Timken Publishers, 1992).

**12** See THE COMPLETE ENGRAVINGS, ETCHINGS AND DRYPOINTS OF ALBRECHT DÜRER 52, No. 25, *Sol Justitiae*, or *The Judge* (Walter L. Strauss, ed., New York, NY: Dover Publications, 1972). The Augustinian tradition understood light as indicating intellect, in contrast to the "blind man fumbling along the wall," who, because of a lack of sight, lacks understanding. See KRISTIN ELDYSS SORENSEN ZAPALAC, "IN HIS IMAGE AND LIKENESS": POLITICAL ICONOGRAPHY AND RELIGIOUS CHANGE IN REGENSBURG, 1500–1600 at 15 (Ithaca, NY: Cornell U. Press, 1990). Further, it "was believed that God's influence entered the world along rays of light; . . . the obsession with the illumination of Gothic cathedrals, therefore, was not merely a practical concern but an attempt to expand the presence of the divine in a sacred space." THEODORE K. RABB, THE LAST DAYS OF THE RENAISSANCE AND THE MARCH TO MODERNITY 18–19 (New York, NY: Basic Books, 2006). Rabb commented that the invention of eyeglasses in the thirteenth century could have been a "silent tribute to the power of allegory." Id. at 19.

**13** Robert Freyhan, *The Evolution of the Caritas Figure in the Thirteenth and Fourteenth Centuries*, 11 J. WARBURG & COURTAULD INST. 68, 74–75 (1948).

**14** The Great Seal of the United States, reprinted on the dollar bill and also discussed in notes to Chapter 15, displays on one side an eye inside the cap of a pyramid and surrounded by rays. This eye, said to have been called the "Eye of Providence," appeared in a first design proposed by a committee of three—John Adams, Benjamin Franklin, and Thomas Jefferson. Although their version was superseded, the eye remained, with its implicit reference to divinity. As for specific sources, candidates include the Egyptian Eye of Horus or of the god Ra, the Old and New Testaments, and a host of other religious and mystical traditions ("astrology, kabala, Rosicrucianism, and Freemasonry"). See Albert M. Potts, *The Eye of Providence*, 327 DOCUMENTA OPTHALMOLOGICA 34 (1973).

**15** These themes can be found in the Old and New Testaments. We are here indebted to the research of Laura Heiman, who searched elec-

tronic databases for the terms blind, blindfold, and bandage in the Jewish and Christian Bibles and in the Koran. Web-based versions of each source permitted identifying the word blind more than fifty times, whereas very few references were made to blindfolds or to bandages over eyes. For the biblical quotations we used Old and New Testaments, such as The New English Bible with the Apocrypha (Charles Harold Dodd, ed., Oxford and Cambridge, Eng.: Oxford and Cambridge U. Presses, 1970) (hereinafter New English Bible); The Twentieth Century New Testament: A Translation into Modern English, Made from the Original Greek (New York, NY: Fleming H. Revell, 1902, revised 1904); and The Good News Bible with Deuterocanonicals/Apocrypha, Today's English Version (Robert G. Bratcher, trans., New York, NY: American Bible Society, 1976).

**16** In some English versions, reference is made to "bandaged" or "veiled" eyes. In several Ripa editions the terms "blindfold" and "bandaged" were used interchangeably. However, the word bandages is today associated with wounds, while a blindfold is presumed to be obstructing vision.

**17** *Leviticus* 21:18: "No man with a defect shall come, whether a blind man, a lame man, a man stunted or overgrown." *Leviticus* 22:22: "You shall present to the Lord nothing blind, disabled, mutilated, with running sore, scab, or eruption, nor set any such creature on the altar as a food-offering to the Lord." New English Bible.

**18** *Job* 11:20: "Blindness will fall on the wicked." New English Bible.

**19** *Mark* 14:65: "Some began to spit on him, blindfolded him, and struck him with their fists." In earlier translations the phrase "cover his face" was used in lieu of the word blindfold. In some iterations, the word appears as "blyndfolded"; in other places where modern translations use the word "blindfold," earlier translations had used the phrase "hath covered his face." See *Luke* 22:63–64: "They beat him, they blindfolded him, and they kept asking him, 'Now, prophet, who hit you?'" New English Bible.

**20** *Isaiah* 56:10: "Israel's watchmen are blind, all of them unaware. They are all dumb dogs who cannot bark." New English Bible.

**21** *Psalm* 9:17: "They rush blindly down to Sheol, the wicked." *Matthew* 23:17: "Blind fools! Which is the more important?" New English Bible.

**22** *1 Samuel* 12:3: "[W]hom have I oppressed? From whom have I taken a bribe, to turn a blind eye?" *2 Corinthians* 4:4: "Their unbelieving minds are so blinded by the god of this passing age, that the gospel of the glory of Christ, who is the very image of God, cannot dawn upon them and bring them light." New English Bible.

**23** *1 Kings* 20:38: "Then the prophet went off, with a bandage over his eyes, and thus disguised waited by the wayside for the king." New English Bible. Earlier versions used the phrase "disguised himself with ashes upon his face."

**24** *Deuteronomy* 27:18, New English Bible.

**25** *Genesis* 27:1–38, New English Bible.

**26** See Bart Westerweel, *Cupid's Blindfold: The Development of an Iconographical Topos*, in The European Emblem: Selected Papers from the Glasgow Confernece, 11–14 August 1987 at 161 (Bernard F. Scholz, Michael Bath, & David Weston, eds., Leiden, Neth.: Brill, 1990). A counterpart to *Exodus* 34:34 ("Moses put a veil over his face") is the New Testament's *2 Corinthians* 3:12–14—that the Israelites' "minds had been made insensitive, for that same veil is there to this very day." New English Bible.

**27** *Exodus* 19:11. Steven D. Fraade, *Hearing and Seeing at Sinai: Interpretive Trajectories*, in The Significance of Sinai: Traditions about Sinai and Divine Revelation in Judaism and Christianity (George J. Brooke, Hindy Najman, & Loren T. Stuckenbruck, eds., Leiden, Neth.: Brill, 2008). Fraade has also suggested that in the context of the Sinaitic revelation "seeing" was a complicated and nuanced activity implicating multiple—and contrasting—values. Moreover,

"auditory and ocular modes of revelatory reception . . . remain in tension with one another." Id. at 247.

**28** *2 Corinthians* 3:16, New English Bible. Alternately, the veil could be read as a sign of humility. See Moshe Barasch, Blindness: The History of a Mental Image in Western Thought 85 (New York, NY: Routledge, 2001), interpreting the Old Testament description at *Exodus* 34:33.

**29** *Isaiah* 42:7, 16, New English Bible.

**30** *Psalm* 146:8: "The Lord restores sight to the blind and straightens backs"; *Matthew* 11:5: "'Go and tell John what you hear and see: the blind recover their sight, the lame walk"; *Matthew* 12:22: "Then they brought him a man who was possessed; he was blind and dumb; and Jesus cured him." New English Bible. Saul is also temporarily blinded during the process of his conversion (*Acts* 9:8–9).

**31** Robert Bagg, *Oedipus the King*, in The Oedipus Plays of Sophocles 78 (Robert Bagg, trans., introduction and notes by Robert and Mary Bagg, Amherst & Boston, MA: U. of Massachusetts Press, 2004).

**32** *Exodus* 23:8, New English Bible.

**33** *Job* 9:24, New English Bible. In older translations available online, including the King James, Geneva, Rheims Douai, and others, the translation was "covereth the face."

**34** *Isaiah* 29:10 in The Good News Bible with Deuterocanoicals/Apocrypha, Today's English Version. Again the term was translated in earlier versions as "hath he covered."

**35** Natalie Kononenko-Moyle, *Homer, Milton, and Asik Veysel: The Legend of the Blind Bard*, III/IV Harvard Ukrainian Studies 521, 521 (1979–1980). See also Barasch at 28–29.

**36** See William R. Paulson, Enlightenment, Romanticism, and the Blind in France 1–9 (Princeton, NJ: Princeton U. Press, 1987).

**37** Kononenko-Moyle at 521. See also Richard E. Doyle, Áth: Its Use and Meaning, A study in the Greek Poetic Tradition from Homer to Euripidies 3–19 (New York, NY: Fordham U. Press, 1984). Barasch commented on the revival of interest in Homer during the Renaissance but noted the relatively rare presentations of images of Homer as blind. Barasch at 130–132. According to Plato, blindness was Homer's punishment for slandering Helen of Troy: "There's an ancient tradition governing how those who commit an offence in the domain of story-telling have to purify themselves, which Homer may have failed to recognize, but Stesichorus didn't. After losing his sight as a result of slandering Helen, Stesichorus didn't fail to recognize his fault, as Homer had." Plato, Phaedrus 24 (Robin Waterfield, trans., Oxford, Eng.: Oxford U. Press, 2002). Milton wrote the entirety of his twelve-book epic poem *Paradise Lost* after becoming blind; his sonnet, "On His Blindness," reflected on the role that the loss of sight had played in bending his "soul" to serve his "maker." See John Milton: Complete Shorter Poems, Sonnet XVI at 327–328 (John Carey, ed., London, Eng.: Longman, 1971).

**38** Translations of the term *áth* included "blindness," "infatuation," "folly," "ruin," "calamity," or "disaster." Doyle at 3–19.

**39** Barasch at 78.

**40** Barasch at 87–91.

**41** Barasch at 83.

**42** Michael Camille, The Gothic Idol: Ideology and Image-making in Medieval Art 178 (Cambridge, Eng.: Cambridge U. Press, 1991). The name has numerous variations, including Synagogue, Sinagogue, and others.

**43** Wolfgang S. Seiferth, Synagogue and Church in the Middle Ages: Two Symbols in Art and Literature 96 (Lee Chadeayne & Paul Gottwald, trans., New York, NY: Frederick Ungar, 1970). See also Margaret Schlauch, *The Allegory of Church and Synagogue*, 14 Speculum 448 (1939). Beginning sometime in the early Middle Ages, both the "New Law" and the "Old Law" were depicted through female figures, but they did not frequently appear paired in

an apparent confrontation until sometime during the eleventh century. See Ruth Mellinkoff, *Three Mysterious Ladies Unmasked*, 10 J. JEWISH ART 14, 15 (Center for Jewish Art of Hebrew University, 1984). Special thanks are due to Phu Nguyen for thoughtful research on blindness, sight, and light and to Nina Rowe for reviewing a draft of the discussion of Synagoga.

**44** Figures 49 and 50 were provided by and are reproduced with permission of Foto Marburg / Art Resource, New York.

**45** They are "perhaps the most celebrated examplars of their genre." See Nina Rowe, *Idealization and Subjection at the South Portal of Strasbourg Cathedral*, in BEYOND THE YELLOW BADGE: ANTI-JUDAISM AND ANTISEMITISM IN MEDIEVAL AND EARLY MODERN VISUAL CULTURE 179 (Mitchell B. Merback, ed., Leiden: Brill, 2008) (hereinafter Rowe, *Idealization and Subjection*).

**46** The city has also been under German rule; during the later part of the twentieth century, the city's name—Strasbourg—came to serve as shorthand for the European Court of Human Rights, situated there and discussed in Chapter 11.

**47** Bernd Nicolai, *Orders in Stone: Social Reality and Artistic Approach; The Case of the Strasbourg South Portal*, 41 GESTA 111, 112–113 (International Center of Medieval Art, 2002).

**48** Inside was the Pillars of Angels, an "eighteen-meter-high" Second Coming scene that included sculptures of angels and of Christ. Rowe, *Idealization and Subjection* at 182.

**49** See HEINZ SCHRECKENBERG, THE JEWS IN CHRISTIAN ART: AN ILLUSTRATED HISTORY 14–16 (New York, NY: Continuum, 1996). The two have been described as "sisters" in such iterations. SEIFERTH at 116. This tradition has been termed "Concordia Veteris et Novi Testamenti (Agreement of the Old and New Testaments)." See HENRY N. CLAMAN, JEWISH IMAGES IN THE CHRISTIAN CHURCH: ART AS MIRROR OF THE JEWISH–CHRISTIAN CONFLICT, 200–1250 CE at 14–20 (Macon, GA: Mercer U. Press, 2000). One source for that exchange was *De altercatione Ecclesiae et Synagogae dialogus*, detailing the debate between the "rich widow Synagoga, clad in purple and holding a scepter," and Ecclesia, also wearing purple and with "a crown on her head." BARASCH at 82. That "pseudo-Augustian writing ... was probably written in the second half of the fifth century." SCHRECKENBERG at 17. Another source was the *Hortus Deliciarum*, an encyclopedia for nuns prepared from 1160–1175 at the Hohenburg Convent in Alsace. SEIFERTH at 108. See also BARASCH at 81–82; KENNETH R. STOW, ALIENATED MINORITY: THE JEWS OF MEDIEVAL LATIN EUROPE 8–10 (Cambridge, MA: Harvard U. Press, 1992).

**50** SEIFERTH at 32. Synagoga is "the antithesis of the Church. While Ecclesia's luxuriant robe provides stability, Synagoga's diaphanous drapery falls in a tangle around her ankles." Rowe, *Idealization and Subjection* at 180.

**51** Rowe put the imagery in the context of the era in which "keeping the Jews in their place was a central component of keeping order more generally." Rowe, *Idealization and Subjection* at 182. She argued that the appearance of the pair as a thirteenth-century motif stemmed from fears of "real-world Jews." Id. at 185. The "public, monumental form ... proclaimed the rectitude of Jewish containment within a well-ordered society" run by men. Id. at 191. The beauty of the Synagoga figure was "essential" to capturing both toleration and subjagation. Id. at 202.

**52** SEIFERTH at 29. For example, Giotto showed Synagoga turning her head left toward darkness and away from the "light that is Christ in the Gospel of John." Laurine Mack Bongiorno, *The Theme of the Old and the New Law in the Arena Chapel*, 50 ART BULLETIN 11, 13–14 (1968). According to Barasch, at 86, in the thirteenth century, Albert the Great mandated a description that added the blindfold in lieu of shaded or otherwise obscured or darkened eyes.

**53** BARASCH at 79, 83.

**54** SEIFERTH at 97, detailing descriptions of Jews as "murderers of Christ." See generally ANTHONY BALE, THE JEW IN THE MEDIEVAL

BOOK: ENGLISH ANTISEMITISMS, 1350–1500 at 1 (Cambridge, Eng.: Cambridge U. Press, 2006). In a painted rendition by Peter Paul Rubens called *Triumph of the Church over Ignorance and Blindness* (also called *The Triumph of Ecclesia* and displayed in the Prado Museum in Madrid, Spain), Ecclesia rides in a chariot while prisoners are falling about on the ground below. A man "who gazes heavenward but wears a blindfold, the age-old symbol of the unseeing Synagogue," is among the defeated. See Irving Lavin, *Divine Inspiration in Caravaggio's Two "St. Matthews,"* 56 ART BULLETIN 59, 75 (fig. 25), 78–79 (1974). The Prado's collection also includes an earlier example of *Synagoga* shown as a man. In the 1430 painting *The Fountain of Grace and the Triumph of the Church over the Synogogue*, based on another panel in the Cathedral of St. Bavon in Ghent, Jan Van Eyck displayed an enthroned Christ at the center at the top of the image. On the bottom are a group identified as Jews, who, with unkempt clothing and in distress, are contrasted with the well-dressed, calm assembly of the Church on the opposite side. Among the Jews is one man—*Synagoga*—shown bent over, blindfolded, and wearing a large pointed hat. The cluster of "defeated Jews" resembles those in other such renditions. See Josua Bruyn, *A Puzzling Picture at Oberlin: The Fountain of Life*, 16 ALLEN MEMORIAL ART MUSEUM BULLETIN 5, 7 (1958). In addition to the version at that college's museum, an earlier drawing, *The Defeat of the Synagogue*, from about 1400, has a similar group of Jews, again with a blindfolded male/*Synagoga*. See Otto Pächt, *Panofsky's "Early Netherlandish Painting"—II*, 98 BURLINGTON MAGAZINE 267, 269, fig. 17 (1956).

**55** Mellinkoff at 15. Scholars describe this approach as "Adversus Judaeos" or Against Jews. CLAMAN at 14–15. The positions of Concord and Adversarialism were attributed to Paul, whose commentary varied on Christianity's relationship to Judaism. SCHRECKENBERG, at 31–74, provided and explicated dozens of the different portrayals of Synagoga.

**56** See Nina Rowe, *Synagoga Tumbles, a Rider Triumphs: Clerical Viewers and the Fürstenportal of Bamberg Cathedral*, 45 GESTA 15, 26, and fig. 17 (2006). See also BARASCH at fig. 13 (between pages 84 and 85); *Ecclesia versus Synagoga: The Dispute between the Two Allegorical Personifications and Their Reconciliation*, in SCHRECKENBERG at 45, fig. 18 (stained glass at Chartres Cathedral, first half of the thirteenth century).

**57** See Sara Lipton, *The Root of All Evil: Jews, Money and Metaphor in the Bibles moralisées*, 1 MEDIEVAL ENCOUNTERS 1 (1995); CAMILLE at 179. Lipton examined the development of a literature casting Synagoga "not in opposition to Ecclesia ... but in complex relations to a range of masculine figures." Lipton at 132. Synagoga "draws heavily on venerable antifeminist tropes" (id. at 152) to represent "carnality—greed, lust, literalness, philosophy"—perceived to be dangerous to Christian society. Id. at 150.

**58** BARASCH at 84. For the more literate, "bibles moralisées" also displayed images of Synagoga, blinded to Christianity's light. See Katherine H. Tachau, *God's Compass and "Vana Curiositas": Scientific Study in the Old French Bible Moralisée*, 80 ART BULLETIN 7, 12–19 (1998).

**59** SEIFERTH at 89.

**60** THE ROMAN MISSAL, COMPILED BY LAWFUL AUTHORITY FROM THE MISSALE ROMANUM 256 (Adrian Fortescue, intro., New York, NY: Macmillan, 1951).

**61** In 1959 Pope John XXIII removed the term "perfidious" (*perfidis* in the Latin is translated as both "perfidious" and "faithless"). The 1965 Roman Missal, changed in conjunction with the Second Vatican Council, "was published shortly before the beginning of Holy Week in 1965 as a separate booklet in order to revise the Good Friday prayer from that point forward." Translation of the 1965 version can be found in "The 1962 Roman Missal and Catholic–Jewish Relations" at a website of the International Council of Christians and Jews, http://www.jcrelations.net/en/?item=2865. A different version of the

Missal from 1970 reads: "Let us pray for the Jewish people, the first to hear the word of God, that they may continue to grow in the love of his name." THE NEW AMERICAN SUNDAY MISSAL 221–222 (Bernard Benziger, ed., New York, NY: William Collins & World Publishing, 1970).

**62** John Thavis, *Pope Reformulates Tridentine Rite's Prayer for Jews*, for Catholic News Service, http://www.catholicnews.com/data/stories/cns/0800689.htm. Criticism followed thereafter, from Jewish groups distressed at the continuing reference to their need to be converted and from some Catholic groups unhappy about the changes. See Ian Fisher, *Pope's Rewrite of Latin Prayer Draws Criticism from 2 Sides*, NEW YORK TIMES, Feb. 6, 2008, at A8. The Vatican's announcement of the change can be found on its website, http://www.vatican.va/roman_curia/secretariat_state/2008/documents/rc_seg-st_20080204_nota-missale-romanum_en.html.

**63** See Edgar Wind, *Orpheus in Praise of Blind Love*, in PAGAN MYSTERIES IN THE RENAISSANCE 53 (London, Eng.: Faber and Faber, 1968) (hereinafter Wind, *Orpheus in Praise of Blind Love*); Erwin Panofsky, *Blind Cupid*, in STUDIES IN ICONOLOGY: HUMANISTIC THEMES IN THE ART OF THE RENAISSANCE 95–128 (New York, NY: Harper & Row, 1962) (hereinafter Panofsky, *Blind Cupid*).

**64** See CESARE RIPA, BAROQUE AND ROCOCO PICTORIAL IMAGERY: THE 1758–60 HERTEL EDITION OF RIPA'S "ICONOLOGIA" WITH 200 ENGRAVED ILLUSTRATIONS 152 (Edward A. Maser, ed., New York, NY: Dover Publications, 1971) (hereinafter RIPA, MASER EDITION) (citing page 169 of a 1603 edition of Ripa). That text has a translation stating that Fortuna is "blind" but also a picture showing her eyes covered with a bandage. She typically also held a wheel or stood near a globe. A blindfolded Fortuna can be found in works from the fifteenth century and thereafter. See EHRENGARD MEYER-LANDRUT, FORTUNA: DIE GÖTTIN DES GLÜCKS IM WANDEL DER ZEITEN (FORTUNE: THE GODDESS OF LUCK THROUGHOUT THE AGES) (Berlin, Ger.: Deutscher Kunstverlag, 1997). Examples are at 69, fig. 15 (dated 1461); at 75, fig. 18 (dated 1450–1460); and at 85, fig. 21 (dated 1523). See also Horst W. Janson, *A "Memento Mori" among Early Italian Prints*, 3 J. WARBURG & COURTAULD INST. 243, 247 (1940); Wendy Roworth, *Salvator Rosa's Lost Painting of "Fortuna*," 117 BURLINGTON MAGAZINE 663, 664 (1975); Barasch at 123–129; Stefano Pierguidi, *Giovanni Guerra and the Illustrations to Ripa's Iconologia*, 61 J. WARBURG & COURTAULD INST. 158, 168–169, n. 55 (1998).

**65** BARASCH at 130.

**66** RANDOLPH STARN, AMBROGIO LORENZETTI: THE PALAZZO PUBBLICO, SIENA 70–71 (New York, NY: George Braziller, 1994). Shown is a blindfolded man hanging, with his coat blowing in the wind.

**67** Panofsky, *Blind Cupid* at 109.

**68** The version reproduced in figure 51 was provided by the Beinecke Rare Book and Manuscript Library, Yale University. This image, like other illustrations, was not signed and has occasioned a debate about which artist created it. According to Giulia Bartrum, the Assistant Keeper of German Prints and Drawings in the Department of Prints and Drawings at the British Museum, the attribution of this and various of the other 114 illustrations is unclear. Our thanks to Giulia Bartrum, email correspondence (Oct. 25, 2005), and to Professor Christopher Wood, Yale University. Others have presumed that Dürer was the artist responsible for it and for other of the woodcuts. See THEODORE ZIOLKOWSKI, THE MIRROR OF JUSTICE: LITERARY REFLECTIONS OF LEGAL CRISES 99, 106 (Princeton, NJ: Princeton U. Press, 1997) (hereinafter ZIOLKOWSKI, MIRROR OF JUSTICE).

It is known that in 1492 Dürer was working on woodcuts and that he contributed to three volumes published in Basel, including Brant's *Narrenschyff*, which was printed in 1494. But Dürer left that city that year. PANOFSKY, DÜRER, vol. 1 at 25–29. Further, the number of illustrations varied by edition. According to Panofsky, the first edition (1494) contained 106 woodcuts (with about 9 repeated), resulting in

about 115 illustrations. In a second edition (printed in Basel in 1495), 6 of the originals were replaced ("three for purely technical or aesthetic reasons . . . and three in favor of a new iconography"). That arrangement persisted, albeit not consistently. See ERWIN PANOFSKY, ALBRECHT DÜRER, vol. 2 (Princeton, NJ: Princeton U. Press, 1943) (hereinafter PANOFSKY, DÜRER, vol. 2), catalogue note no. 436(b). But, Panofsky argued, Dürer was himself uneven—making it "possible to attribute to Dürer the design, not only of" the superior but also other woodcuts of various styles. Id. at 54. In Panofsky's view, about one-third of the prints in Brant's *Narrenschyff* were by Dürer and "about two-thirds of the whole cycle" (which comprises well over a hundred different pictures) have no appreciable connection with Dürer. Id. Others attribute more prints to Dürer. See Kathleen Wilson-Chevalier, *Sebastian Brant: The Key to Understanding Luca Penni's "Justice and the Seven Deadly Sins*," 78 ART BULLETIN 236, 238, n. 13 (1996).

**69** See SEBASTIAN BRANT, THE SHIP OF FOOLS, TRANSLATED INTO RHYMING COUPLETS WITH INTRODUCTION AND COMMENTARY BY EDWIN H. ZEYDEL (Edwin H. Zeydel, trans., New York, NY: Columbia U. Press, 1944) (hereinafter ZEYDEL'S BRANT). Zeydel argued that earlier English versions were "free adaptations" based on the Latin and French editions rather than on the original, written in vernacular German. ZEYDEL'S BRANT at vii. Zeydel delineated among the woodcuts those done by a "master," "perhaps a master," or an "inferior artist," and attributed *The Fool Blindfolding Justice* to a "master." Id. at 379. Zeydel thought that the "master of the Bergmann shop" could have been responsible for this and about seventy-five of the prints. Id. at 20. In Zeydel's view, Brant was unlikely to have dictated the design: "Brant had no ability whatsoever as an artist," and "the cuts are usually superior to his verse." Id. at 20–21.

**70** See JOHN VAN CLEVE, SEBASTIAN BRANT'S THE SHIP OF FOOLS IN CRITICAL PERSPECTIVE, 1800–1991 at 85 (COLUMBIA, SC: CAMDEN HOUSE, 1993). "The nature of reader response . . . was sustained and unprecedented. Published in 1494, the poem was reprinted three times before the year was out." Id. at 85. A first edition in Latin was published in 1497, a Dutch-Flemish edition in 1500, one in English in 1509. Zeydel counted six editions published before Brandt's death in 1521. ZEYDEL'S BRANT at 24–31. Ziolkowski, at 98 in *Mirror of Justice*, reported that at least seventy editions were in circulation.

**71** See Wilson-Chevalier at 236–238. In her view, Penni's depictions would have been incomprehensible to viewers unless they were familiar with Brant, and therefore that Penni's work attests to Brant's "popularity in mid-sixteenth-century France." Id. at 237. Zeydel claimed that the book, which he termed a "masterpiece," was "the most famous book of its time," that it "exercised a tremendous influence" in England and in continental Europe, serving as a forerunner of German humanism. ZEYDEL'S BRANT at vii (Preface). Erasmus is said to have found Brant "incomparable." See Wilson-Chevalier at 238. As Ziolkowski, at 98 in *Mirror of Justice*, put it, few modern readers "would suspect that the work was favorably compared by its contemporaries to Homer's *Odyssey*," for later literary critics have not been as admiring.

Van Cleve mapped the book's "canonicity" as well as the critical response to its text and tone, as he explored how such a "supposedly disorganized, soporific sermon in German verse" was so "wildly popular for well over a century" on the European continent. Van Cleve at 1. Van Cleve described *The Ship of Fools* as the "most successful work of German literature" during the sixteenth and seventeenth centuries. Id. at 85. As to more recent reappraisals, Van Cleve credited Zeydel, whose translation "reintroduced the poem to the English-speaking world 450 years after its first publication." Id. at 43. Ziolkowski, at 102, found it "a survey of European society and morals during the transition from late-medieval to early-modern times."

**72** See, for example, KATHERINE ANN PORTER, THE SHIP OF FOOLS (Boston, MA: Little, Brown, 1962), which was also made into a film in 1965 by Stanley Kramer. Brant, on the other hand, used the metaphor

of the ship erratically and relatively rarely. In the various chapters, fools serve as exemplars for moral conduct. ZEYDEL'S BRANT at 14–18.

**73** Brant, who was born in Strasbourg, had been a student at the University of Basel, where he studied Aristotle and did a doctorate in law before returning to Strasbourg, where he was "an active and respected legal advisor." Wilson-Chevalier at 238. According to Ziolkowski, Brant, an "imperial loyalist," moved from Basel in 1501, after the city left the Holy Roman Empire and joined the Swiss Confederation. ZIOLKOWSKI, MIRROR OF JUSTICE at 100.

**74** Wilson-Chevalier at 238 and n. 15. The volume gave "voice to the common fear that, with the year 1500 approaching, God's patience with man's sins was coming to an end and the world would soon be destroyed." Id. at 250. A few of the chapter headings in Brant's The *Ship of Fools* illustrate the book's tone, as one can read in *Zeydel's Brant*: "Of Greed" (at 66); "Of Not Following Good Advice" (at 78); "Of Insolence toward God" (at 92); "Of Useless Riches" (at 100).

**75** Several authors have identified this image as perhaps the first to add a blindfold to Justice. See, for example, WOLFGANG PLEISTER & WOLFGANG SCHILD, RECHT UND GERECHTIGKEIT IM SPIEGEL DER EUROPÄISCHEN KUNST (LAW AND JUSTICE REFLECTED IN EUROPEAN ART) 206–207, fig. 340 (Cologne, Ger.: Dumont Buchverlag, 1988); OTTO RUDOLF KISSEL, DIE JUSTITIA: REFLEXIONEN ÜBER EIN SYMBOL UND SEINE DARSTELLUNG IN DER BILDENDEN KUNST (JUSTICE: REFLECTIONS ON A SYMBOL AND ITS REPRESENTATION IN THE PLASTIC ARTS) 38–55 (Munich, Ger.: Verlag C. H. Beck, 1984); G. Overdiep, *Justitia, Waar Is Uw Blinddoek?* (*Justice: Where Is Thy Blindfold?*) in OVERDRUK UIT IUR PRO EXCOLENDO IURE PATRIO 1761–1961, 101–103 and n. 1 (Groningen, Neth.: J. B. Wolters, 1961).

**76** ZEYDEL'S BRANT at 236–237 (Chapter 71, "Quarreling and Going to Court"). The italicized header reads: "He'll get much raillery uncouth, / Who fights like children tooth for tooth, / And thinks that he can blind the truth."

**77** ZEYDEL'S BRANT at 57. Brant's "Prologue to the Ship of Fools" explained his purpose: "For profit and salutary instruction, admonition and pursuit of wisdom, reason and good manners: also for contempt and punishment of folly, blindness, error, and stupidity of all stations and kinds of men: with special zeal, earnestness, and labor compiled at Basel by Sebastian Brant, doctor in both laws."

**78** See, for example, ZEYDEL'S BRANT, Prologue at 57: "blinded sinfulness," and Chapter 6 ("Of the Teaching of Children") at 72: "A fool is he and blind indeed / Who ne'er to children pays much heed." See also Chapter 46 ("Of the Power of Fools") at 166: "'Tis need that many fools there be / For some are blind and cannot see," and later in that chapter, at 168: "Blind justice is and dead indeed." Note here, at 169, that the admonition is against taking "money, gift, or bribe: / The man who takes a bribe's not free, / Accepting gifts breeds Treachery." In Chapter 3, we discuss the normative efforts to circumscribe gifts to judges.

Further, in Chapter 107 ("Of Reward for Wisdom") at 347, the author explained: "The Lord has given us the light / Of wisdom, making all things bright. / To darkness wisdom puts an end." And the book ends by repeating the opening admonition: "Here ends the Ship of Fools, which for profit, salutary instruction, admonition and pursuit of wisdom, reason and good manners, also for contempt and punishment of folly, blindness, error, and stupidity of all stations and kinds of men . . . is compiled by Sebastianus Brant." Id. at 366.

**79** The *Bambergische Peinliche Halsgerichtsordnung* (*The Penal Code of the Bamberg Criminal Court*) is a legal code in vernacular German that was written in 1507 for the Prince-Bishop of Bamberg. The book gets its title—The "Halsgericht"—from a particular kind of court whose full name was the "Hochnotpeinliches Halsgericht." In Medieval Germany that court dealt with serious crimes, including rape and murder. The term *Halsgericht* was later used to describe courts that were empowered to impose the death penalty.

At least eight editions of the *Bambergensis* were printed prior to 1580. See JOSEF KOHLER & WILLY SCHEEL, DIE BAMBERGISCHE HALS-

GERICHTSORDNUNG IN DIE CAROLINA UND IHRE VORGÄNGERINNEN: TEXT, ERLÄUTERUNG, GESCHICHTE (THE PENAL CODE OF THE BAMBERG CRIMINAL COURT IN THE CAROLINA AND ITS PREDECESSORS: TEXT, EXPLANATION, HISTORY), vol. 2 at VIII–IX (Aalen, Ger.: Scientia Verlag, 1968). The 1968 book reprints a 1902 edition, itself a reproduction that is a composite of different sixteenth-century editions of the *Bambergensis*. We draw from that composite as well as from an original edition, JOHANN FREIHERR VON SCHWARZENBERG, BAMBERGISCHE PEINLICHE HALSGERICHTSORDNUNG (BAMBERGENSIS) (THE PENAL CODE OF THE BAMBERG CRIMINAL COURT [BAMBERGENSIS]), vols. 1–4 (Mainz, Ger.: Johann Schöffer, 1508), in the collection of the Yale Law Library Rare Book Room, that was translated for us by Stella Burch Elias. Additional discussion of the history and use of the *Bambergensis* can be found in GERALD STRAUSS, LAW, RESISTANCE, AND THE STATE: THE OPPOSITION TO ROMAN LAW IN REFORMATION GERMANY 83, 103, 123, 173 (Princeton, NJ: Princeton U. Press, 1986) (hereinafter STRAUSS, LAW, RESISTANCE, AND THE STATE); Joy Wiltenburg, *The Carolina and the Culture of the Common Man: Revisiting the Imperial Penal Code of 1532*, 53 RENAISSANCE QUARTERLY 713 (2000).

The text of the *Bambergensis* is attributed to Johann Freiherr zu Schwarzenberg. STRAUSS, LAW, RESISTANCE, AND THE STATE at 123. Schwarzenberg, who lived from around 1463 to 1528, has variously been described as a court of appeals judge, a knight in the service of the Prince-Bishop of Bamberg, and a local untrained judge. See KOHLER & SCHEEL at LXV–LXIX; Gottfried G. Krodel, *The Opposition to Roman Law and the Reformation in Germany*, 10 JOURNAL OF LAW AND RELIGION 221, 230 (1993–1994), reviewing the book *Law, Resistance and the State* by Gerald Strauss.

Other discussions of *The Tribunal of Fools* include ROBERT JACOB, IMAGES DE LA JUSTICE: ESSAI SUR L'ICONOGRAPHIE JUDICIAIRE DU MOYEN ÂGE À L'ÂGE CLASSIQUE 162, fig. 88 (Paris, Fran.: Éditions Le Léopard d'Or, 1994) (discussing BAMBERGISCHE HALSGERICHTS UND RECHTLICH ORDNUNG IN PEYNLICHEN SACHEN (BAMBERG CRIMINAL COURT AND LEGAL CODE IN PENAL MATTERS), published in Mainz in 1510); Simmonds at 1164 (1977), and Theodore Ziolkowski, *The Figure of Justice in Western Art and Literature*, 75 INMUNKWAHAK, JOURNAL OF HUMANITIES, 187 (1996) (hereinafter Ziolkowski, *The Figure of Justice*).

**80** Figure 52, reproduced courtesy of the Rare Book Room of the Lillian Goldman Law Library at Yale Law School, comes from the 1508 edition in that collection to which we were directed by its librarian, Mike Widener. In the illustration, reproduced by Kohler and Scheel at LXI from a 1507 edition, seven blindfolded jurists (six lay judges, or "Schöffen," who are all dressed the same) and one presiding judge or "Richter" (dressed differently to denote his higher status) are all wearing jester's caps as well as blindfolds. The 1507 and 1508 versions that we can compare include the same text (with minor variations in spelling) but with slightly different placements of the words. The text in the 1507 Kohler and Scheel picture appears in a scroll held by a hand emerging from the clouds on high; the text of the 1508 edition floats on a scroll unfolded above the heads of the five blindfolded judges.

**81** Others have provided slightly different translations. For example, Simmonds offered the translation "Out of bad habit all that these blind fools do is give sentences contrary to what is right." Simmonds at 1164 (referring to a 1510 edition). Another translation is "To pass judgments repugnant to what is right and out of sheer bad habit, is the whole life of these blind fools." See Ziolkowski, *The Figure of Justice* at 207.

**82** See KOHLER & SCHEEL at XXIX–LXIII.

**83** A reproduction can be found in PLEISTER & SCHILD at 72, fig. 103. Other legal texts also included scenes of the Last Judgment, intended to draw parallels between earthly and divine judgment. Id.

**84** Kohler and Scheel numbered a series of pictures found in and taken from the different editions of the *Bambergensis*. The first image shows a variety of instruments likely used for punishment, followed

by a scene of the Last Judgment that, as discussed in Chapter 2, was commonplace in Justice iconography. Other pictures are of judges, accused and complainants, executions, oath takings, and sentences being imposed.

**85** See KOHLER & SCHEEL at LIII and at LIX, images 17 and 21. In image 17, a judge appears to be deciding how much to charge in court fees. The text in the scroll above the figures' heads reads: "Your Honor, rich in virtue, lets everyone pay the same fees." The picture shows one person holding a bag of money and tossing coins into a judge's hand while the other person is empty-handed. Kohler and Scheel indicate that the image appeared near Article 250, titled "Of Court Costs," which discussed ways for poor people to help each other so that they would not suffer from an inability to pay fees.

Image 21 (accompanying Article 272 of the *Bambergensis*, titled "The Judge Should Not Accept Any Money") is what we would today call a cartoon, complete with speech bubbles placed in scrolls. Shown is a professional judge, labeled a "pocket judge" to describe his habit of keeping money for himself. Above a figure of a court bailiff is a scroll that directs a bag of money (personified) to give coins to the judge in order to "live longer." The money, held in the stocks by the bailiff, has a scroll attached to it about how "false judges have taught" disputants to yield up hard-earned money. On the left, a devil-like person is taking a figure identified as a robber baron away. That robber baron, in turn, comments (via a scroll) that "robbers rob in the open air and in houses but 'pocket judges' rob more." Article 272 directs judges to avoid becoming "pocket judges" by taking money to influence their judgments in penal matters. KOHLER & SCHEEL at 114–115.

**86** For example, Kissel argued that the blindfold was emblematic of a growing separation of powers, whereas Christian-Nils Robert posited that the blindfold was bivalent, as a "gesture that is both madness and truth" ("un geste tout à la fois fou et vrai"). See CHRISTIAN-NILS ROBERT, LA JUSTICE: VERTU COURTISANE ET BOURREAU (JUSTICE: VIRTUE AS COURTESAN AND EXECUTIONER) 88 (Geneva, Switz.: George Editeur, 1993).

**87** ZEYDEL'S BRANT at 236–237; chapter 71, illustrated by *The Fool Blindfolding Justice*, provides the following verses:

> Now of that fool I would report
> Who always wants to go to court,
> And amicably end no suit
> Before he's had a hot dispute
> When cases would protracted be,
> And men from justice hide or flee. . . .
> A foreign speaker must be brought
> Imported here from far-off port,
> That he may well pervert the case
> And cheat the judges to their face.

The chapter ends:

> The man who'd rather sue than eat
> Should have some nettles on his seat.

**88** Translation by Ziolkowski at 100–101 in *Mirror of Justice*. He argued that the blindfold bespoke an ambivalence toward both customary and Roman law, with concerns about abusive litigants and corruptible judges. Id. at 128–129, 142–143.

**89** STRAUSS, LAW, RESISTANCE, AND THE STATE at 56–57, 65, 261–263.

**90** JACOB at 162–164. Jacob argued that judges across Europe used, and transformed, derisive images of justice to further their own ends.

**91** The *Carolina* was promulgated by the Augsburg Parliament under Emperor Charles V in 1530 and ratified by the Regensburg Par-

liament in 1532. Wiltenburg at 714. Both codes were derived from an amalgam of Roman and Church law. See STRAUSS, LAW, RESISTANCE, AND THE STATE at 123–125. Wiltenburg at 715.

**92** Wiltenburg at 717–718 and n. 11.

**93** Wiltenburg at 715.

**94** See STRAUSS, LAW, RESISTANCE, AND THE STATE at 56–95. The 1532 publication of the *Carolina* "obliged lay judges who were 'not learned, experienced, or practiced in our imperial laws . . . to seek counsel' in criminal matters 'at the nearest university, city, or other source of legal knowledge.'" Id. at 83 (quoting and translating Article 219 of the *Carolina*). Whether the local law was itself traditionally German or already reflected "Roman law and early Medieval theology" is a question debated in the literature. See Krodel at 226–237. More generally, Europe was a "mosaic" of many different versions of local practice. A struggle ensued between those customary legal regimes and university-based jurisprudence that aimed to systemize rules that would have binding force. See Constantin Fasolt, *Hermann Conring and the European History of Law*, in POLITICS AND REFORMATIONS: HISTORIES AND REFORMATIONS (ESSAYS IN HONOR OF THOMAS A. BRADY, JR.) 113, 116–123 (Christopher Ocker, Michael Printy, Peter Starenko, & Peter Wallace, eds., Leiden, Neth.: Brill, 2007).

**95** See ANDREAS ALCIATUS, THE LATIN EMBLEMS: INDEX EMBLEMATICUS, vols. 1 & 2 (Peter M. Daly, ed., Toronto, Can.: U. of Toronto Press, 1985) (hereinafter ALCIATUS, DALY EDITION) (unpaginated edition with numbered emblems); see also the 1611 Padua edition of Ripa's *Iconologia*. This is not the original edition but one of the early illustrated editions.

**96** The two major works, discussed in Chapter 3, that are referenced in this context are Horapollo's *Hieroglyphica* and Francesco Colonna's *Hypnerotomachia Poliphili*.

**97** See Denis L. Drysdall, *Emblema Quid? What Is an Emblem?* in UNDER THE AEGIS, THE VIRTUES 137–143 (Peter Shand, ed., Auckland, New Zeal.: Fortuna Press, 1997), discussed in Chapter 3. Another classic source for this discussion is Ernst Gombrich, *Icones Symbolicae: The Visual Image in Neo-Platonic Thought*, 11 J. WARBURG & COURTAULD INST. 163 (1948). Gombrich read Ripa as a "rationalist" rooted in the "Aristotelian theory of definition. . . . In Ripa's theory the human figure stands for the substance, or essence, the emblems it holds or wears, for its 'attributes.'" Id. at 183.

**98** ALCIATUS, DALY EDITION, vol. 2 at emblem 145 and motto (from the 1542 German).

**99** ALCIATUS, DALY EDITION, vol. 2 at emblem 145 and motto (from the 1536 French). Martin Jay argued that the Reformation embraced the "Hebrew interdiction of images" as a way to "resist what Augustine had famously called the 'lust of the eyes,'" and thus made the blindfold no longer a sign of inferiority but a marker of "neutrality." See Martin Jay, *Must Justice Be Blind?* in LAW AND THE IMAGE 19–21 (Costas Douzinas & Lynda Nead, eds., Chicago, IL: U. of Chicago Press, 1999). See also JACOB at 234–236. As detailed in the text of this chapter, we are less confident that the blindfold was by then read as uncomplicatedly positive.

**100** ALCIATUS, DALY EDITION, vol. 2 at emblem 172, "Just Vengeance."

**101** ALCIATUS, DALY EDITION, vol. 2 at emblem 111. The motto translated from the Paris 1536 edition reads: "Love of virtue overcomes Cupid"; in the 1542 Paris edition, the accompanying picture shows "a blindfolded Eros" being tied to a column by Anteros, brother of Eros and god of requited love.

**102** ALCIATUS, DALY EDITION, vol. 2 at emblem 161. In the image a lame man is seated on the shoulder of a blind man; the 1536 Paris text is translated "Then the lame man has himself carried and puts the blind man on the right road."

**103** A word of explanation is needed as to the different Ripas and their illustrations. As noted, the 1593 Ripa had no drawings. Further, scholars do not believe that Ripa had direct involvement in the draw-

ings used in subsequent editions. See Pierguidi at 167, 174–175. Pierguidi noted that Ripa neither referred to nor appeared "to have had close relations with contemporary artists." Id. at 174. More than twenty editions in almost a dozen languages were published. We have relied on the following editions: Ripa, Padua–1611; Cesare Ripa, Iconologia, vols. 1 & 2 (Padua, Ital.: Pietro Paolo Tozzi, 1618; Torino, Ital.: Fògola Editore in Torino, 1988) (hereinafter Ripa, Padua–1618); Cesare Ripa, Iconologie (I. Baudoin, ed., Paris, Fran.: Chez Mathieu Guillemot, 1644) (hereinafter French Ripa–1644); Dutch Ripa–1644; Ripa, Maser Edition; Cesare Ripa, Iconology London 1779 in Two Volumes by George Richardson (New York, NY, & London, Eng.: Garland Publishing, 1976) (hereinafter Ripa, Richardson Edition). Translations of the French edition are by Allison Tait.

The Richardson edition was the "very last iconology in the tradition of Ripa." See Thomas Fröschl, *Republican Virtues and the Free State: Conceptual Frame and Meaning in Early Modern Europe and North America*, in Iconography, Propaganda, and Legitimation 255, 263 (Allan Ellenius, ed., Oxford, Eng.: Clarendon Press, 1998). By the time of that publication, emblems were coming to serve other purposes. See Michael Bath, Speaking Pictures: English Emblem Books and Renaissance Culture 259–262 (London, Eng.: Longman, 1994). While emblems continued to evoke "divine secrets or hidden realities," their allegorical emphasis was moving to accommodate demands for "reason and commonsense." Id. at 261.

**104** Ripa, Padua–1611 at 14; Ripa, Padua–1618, vol. 1 at 37–39 (invoking Seneca); Ripa, Maser Edition at fig. 31.

**105** Ripa, Padua–1611 at 146–147; Ripa, Padua–1618, vol. 1 at 145; French Ripa–1644 at 61.

**106** Ripa, Padua–1611 at 240–241; Ripa, Padua–1618, vol. 1 at 206–207. In the Ripa, Maser Edition, this transforms into "Incredulity" (at 125), and the entry cites Ripa, 1603 at 68, "Cecità della Mente," and at 222 "Ignoranza." Another figure of Ignorance is a man with "bandaged eye" to denote a figurative "blindness to all matters of the intellect."

**107** Ripa, Padua–1611 at 189–190; Ripa, Padua–1618, vol. 1 at 178–179.

**108** Ripa, Padua–1618, vol. 2 at 128.

**109** Ripa, Padua–1618, vol. 2 at 290–291.

**110** Ripa, Padua–1618, vol. 1 at 119–120 (invoking St. Thomas Aquinas and the idea of hiding with a veil).

**111** See Ripa, Maser Edition at 164, citing a 1603 Ripa edition at 383. In this edition, veils or blindfolds can also be found in images of "the Rational Soul" at 5 ("Her head is covered with a transparent veil, since the soul, according to St Augustine . . . is invisible to human eyes"), as well as in "False Splendor" at 29 ("blind to her own faults and to the light of God").

**112** Injustice ("Ingiustitia") is portrayed in both text and image with one blind eye in Ripa, Padua–1611 at 250; an identical image and abbreviated text appear in Ripa, Padua–1618, vol. 1 at 217. Later editions shift the imagery to the scimitar, turban, and other attributes used to denote justice gone awry—broken tablets, scales, and scrolls. The toad, however, remains as a marker of greed, "upon which much injustice is founded" (Ripa, Maser Edition at 117, citing the 1603 edition at 230). We also discuss this iconography in Chapter 3.

**113** Panofsky, *Blind Cupid* at 109, n. 48.

**114** Ripa, Padua–1611 at 201–204. Excerpts of descriptions from various editions are quoted in this and other chapters. Here we provide a comprehensive overview of how all seven were detailed in the 1611 version.

One, "Justice According to Aulus Gellius," was accompanied by an illustration. Gellius was a Latin grammarian of the second century CE who authored *Noctes atticae* (*Attic Nights*). The image accompanying the description shows a richly robed woman wearing a necklace that has an eye engraved in the pendant, referencing Plato, as is detailed in the Ripa text describing "Justice According to Aulus Gellius":

A woman who is a beautiful virgin, crowned and dressed in gold, who, with honesty and discipline, shows herself worthy of reverence, with eyes of the most acute vision and a necklace around her throat that is decorated with an eye.

Plato said that Justice sees all and that from ancient times priests were called seers of all things. From whence Apuleius swore by the eye of the Sun and Justice together to show that one is as insightful as the other . . . [and they are] qualities that ministers of Justice must have, because they must also be able to discover truth and, in the manner of virgins, must be exempt from passion, not . . . corrupted by flattery, gifts, or anything else . . . . To indicate Justice and intellectual integrity the ancients used a jug, a basin, a column—as is verified on old marble sepulchers and by diverse antiquities, such that Alciatus said: A good judge must be pure of soul and clean of hands, if he wishes to punish crime and avenge injury.

Note what was not mentioned—scales, sword, or other implements or animals. Id. at 201–202.

The next Justice (at 202), "Justice of Pausanias," refers to the Greek traveler and geographer Pausanias, of the second century CE, who lived in the times of Hadrian, Antoninus Pius, and Marcus Aurelius and became famous through his *Description of Greece*, a lengthy work used in the Renaissance to illuminate classical literature and archaeology.

A woman of beautiful bearing, richly adorned, who with her left hand clutches an old, ugly woman and beats her with a stick.

And this old woman, called Pausania, represents injury, from which just judges must always be kept, such that the truth is not hidden from them and they are able to listen patiently to each person's defense.

Ripa (at 203–204) proffered, as his third "worldly" Justice, a woman called "Principled Justice" or "Strict Justice":

A woman with a raised sword, regal crown, and scales; on one side of her, there is a dog signifying friendship and a serpent on the other signifying hate.

The raised sword denotes that Justice should not bend to either side, neither for friendship nor for hatred of any person . . . ."

The fourth Justice (at 204), "Rigorous Justice," was:

A skeletal figure like that used to depict death, in a white robe, . . . we can see her face, feet and hands with a bared sword and scales . . . . This figure teaches us that rigorous justice does not pardon any crime, no matter the excuse given . . . just like death, who is not touched by excuses and who has no regard for the station or quality of the person.

The fearsome aspect of this figure demonstrates that this sort of Justice is frightening to the people and that there is no occasion for the law to be interpreted lightly.

The fifth worldly Justice, whose description is provided in the text, was the only one described with bandaged eyes. Id. at 203.

A sixth worldly Justice was "Justice on the medals of Hadrian, Antoninus Pius and Alexander." Hadrian was the Emperor of Rome from 117 CE to 138 CE, succeeded by Antoninus Pius, who served from 138 to 161 CE. The other Alexander mentioned, also called Alexander the Great, was the Greek king of Macedonia who ruled from 336 to 323 BCE and conquered a large swath of the European and Asian continents. This Justice (at 204) was:

> A seated woman wearing a bracelet and holding a scepter in one hand and a chalice in the other.
>
> She is seated because it befits the gravity of a wise person and it is for this reason that judges render decisions while seated.

A seventh Justice (at 202–203) was the only one deemed "Divine":

> A woman of singular beauty, dressed in gold and with a gold crown on her head, above which a dove is circling; she has hair scattered across her shoulders with eyes upturned, looking away from low concerns, and is holding in her right hand an unsheathed sword and scales in the left.
>
> There is every reason to portry this figure as exceedingly beautiful because she is a part of the divine being . . . that is all perfection and beauty.
>
> She is dressed in gold to demonstrate, through the nobility and splendor of this metal, the excellence and sublime nature of Justice.
>
> The crown of gold is to show that she has power over all other earthly powers.
>
> The balance indicates that divine Justice regulates all actions just as the sword signifies the punishment of criminals.
>
> The dove signifies the Holy Ghost, third member of the Holy Trinity . . . .

The Dutch version from 1644 provides the same list of seven as did RIPA, PADUA–1611. The seven Justices did not, however, reappear in all Ripa editions. In RIPA, PADUA–1618, for example, only two ("Justice According to Aulus Gellius" and "Justice") are mentioned. Moreover, slightly different descriptions of various of the Justices can be found. For example, the four in the 1644 French edition (under the entry "Diverses Justices") include "Justice" ("Iustice"), "Rigorous Justice" ("Iustice Rigoureuse"), "Divine Justice" ("Iustice Divine"), and "Justice Inviolate" ("Iustice Inviolable").

As we discuss in Chapters 5 and 6, by the eighteenth century, Justice iconography was compressed into a narrower range; the Ripas of that era offer one description of and one image for Justice. In the 1758 Hertel edition, Justice "is blindfolded, for nothing but pure reason, not the often misleading evidence of the senses, should be used in making judgments." RIPA, MASER EDITION at 120. Richardson's 1779 edition retains the blindfold and notes "She is sitting with a bandage over her eyes. The white robes and bandage over her eyes, allude to incorrupt justice, disregarding every interested view, by distributing of justice with rectitude and purity of mind, and protecting the innocent." RIPA, RICHARDSON EDITION, vol. 2 at 21. See also Overdiep at 107 and n. 3.

115 RIPA, PADUA–1611 at 201; RIPA, PADUA–1618, vol. 1 at 188. See also the discussion of Aulus Gellius in Chapter 2 and Ziolkowski's translation of the Gellius description ("luminibus oculorum acribus") as giving Justicia a "piercing gaze." Ziolkowski, *The Figure of Justice* at 199.

116 RIPA, PADUA–1611 at 201.

117 This passage can be found in both the 1611 (at 203) and the 1618 (at 188) editions from Padua under the description of Justice ("Giustitia").

118 DUTCH RIPA–1644 at 432; RIPA, MASER EDITION at 120; RIPA, RICHARDSON EDITION, vol. 2 at 21.

119 RIPA, PADUA–1611 at 202. The Latin version of Alciatus quoted by Ripa—"Ius hic forma monet dictum sine sordibus esse Defunctum, puras aiq; habuisse mansus"—can be translated: "In the image he advises that the Dead Man held court without filth, and that he had clean hands" (translation by Nicholas Salazar). The 1644 Ripa, written in French, could be understood as saying (at 57): "A good judge must be pure of soul and clean of hands, if he wishes to punish crime and avenge injury."

120 Panofsky, *Blind Cupid* at 109, n. 48.

121 Panofsky, *Blind Cupid* at 110, n. 48

122 Panofsky, *Blind Cupid* at 109, n. 48. Panofsky argued that valorization of the blindfold was a "questionable concept [that] did not appeal to classical antiquity, which, on the contrary, [had] imagined Justice with piercing and awe-inspiring eyes" (A. Gellius, *Noctes Atticae*, XIV, 4). Id.

123 See Jay at 19–21.

124 See, for example, *Isaiah* 33:15–16:

> The man who lives an upright life and speaks the truth,
> who scorns to enrich himself by extortion,
> who snaps his fingers at a bribe,
> who stops his ears to hear nothing of bloodshed,
> who closes his eyes to the sight of evil—
> that is the man who shall dwell on the heights . . . . .

In *Psalm* 119:37, the admonition is "turn away my eyes from all that is vile, / grant me life by thy word." Both quotes come from the NEW ENGLISH BIBLE. See generally Almuth Seebohm, *The Crucified Monk*, 59 J. WARBURG & COURTAULD INST. 61 (1996).

125 Wind, *Orpheus in Praise of Blind Love* at 63.

126 RIPA, MASER EDITION at 152 (quoting from page 169 of a 1603 edition of Ripa).

127 Martin Jay noted that by 1530 the blindfold had "lost its satirical implication" (at 20), but as we discuss here and in Chapters 5 and 6, the blindfold has some edginess. Moreover, we do not share Jay's presumption that blindfolds became typical of Justice. See Jay at 24.

128 Philip Galle's engraving, published by Hieronymus Cock in either 1554 or 1559, is after Bruegel's original drawing of about 1539. See SCALES AND SWORD at 114, fig. 58. This image is one of fourteen drawings for engravings, all of which are preserved, signed and dated between 1556 and 1560. All were done in Antwerp, and they have inspired a significant literature aimed at interpreting their import. See CHARLES DE TOLNAY, THE DRAWINGS OF PIETER BRUEGEL THE ELDER WITH A CRITICAL CATALOGUE (New York, NY: Twin Editions, 1952); Irving L. Zupnick, *Bruegel and the Revolt of the Netherlands*, 23 ART JOURNAL 283 (1964); Nina Eugenia Serebrennikov, Pieter Bruegel The Elder's Series of "Virtues" and "Vices" (Ph.D. dissertation, Department of Art, U. of North Carolina, Chapel Hill, NC, 1986; UMI Publication No.: AAT 8628260); LIONELLO PUPPI, TORMENT IN ART: PAIN, VIOLENCE AND MARTYRDOM at 10–18 (New York, NY: Rizzoli, 1991). The original drawings are in the Print Room of the Bibliothèque Royale Albert 1er, in Brussels. Id. at 15.

129 Figure 53, the Galle etching after the drawing by Pieter Bruegel the Elder, comes from the Rosenwald Collection in the National Gallery of Art, Washington, D.C., and is reproduced with permission of the Board of Trustees of the National Gallery.

130 See EDWARD SNOW, INSIDE BRUEGEL: THE PLAY OF IMAGES IN CHILDREN'S GAMES 59–64 (New York, NY: North Point Press, 1997).

131 SNOW at 63.

**132** JOHN H. LANGBEIN, TORTURE AND THE LAW OF PROOF: EUROPE AND ENGLAND IN THE ANCIEN RÉGIME 12–17 (Chicago, IL: U. of Chicago Press, 1977, 2d ed., 2006); SCALES AND SWORD at 114, fig. 58.

**133** This translation comes from ADRIAAN J. BARNOUW, THE FANTASY OF PIETER BRUEGEL 32 (New York, NY: Lear Publishers, 1947). The inscription reads: "Scopus legis est; aut ut eum que[m] punit emendet, aut poena eius caeteros meliores reddet aut sublatis malis caeteri securiores vivant." Damhoudere's 1551 book was translated into both Dutch and French; see Serebrennikov at xxiv–xx. A slightly different translation, provided by Serebrennikov at 258, is: "The aim of the law is that one may correct him whom one punishes or that one render others better by means of his punishment or that others may live more secure by the removal of the wicked." See also PUPPI at 10. We return to another volume of Damhoudere when discussing the image of a Janus-faced Justice.

**134** Bruegel the Elder is assumed to have been born in the Netherlands around 1525. He lived in Antwerp, probably traveled to Italy, died in 1569, and is buried in Brussels. His influences included Netherlandish art in general and Hieronymus Bosch specifically. See Perez Zagorin, *Looking for Pieter Bruegel*, 64/1 JOURNAL OF THE HISTORY OF IDEAS 73, 74–78 (2003).

**135** WALTER S. GIBSON, BRUEGEL 62 (New York, NY: Oxford U. Press, 1977). See also ARTHUR H. KLEIN AND MINA C. KLEIN, PIETER BRUEGEL THE ELDER, ARTIST OF ABUNDANCE: AN ILLUSTRATED PORTRAIT OF HIS LIFE, ERA, AND ART, 110 (New York, NY: Macmillan, 1968).

**136** BARNOUW at 32.

**137** See MITCHELL B. MERBACK, THE THIEF, THE CROSS AND THE WHEEL: PAIN AND THE SPECTACLE OF PUNISHMENT IN MEDIEVAL AND RENAISSANCE EUROPE 126–157 (Chicago, IL: U. of Chicago Press, 1999); Samuel Y. Edgerton Jr., *When Even Artists Encouraged the Death Penalty: Symposium on the Art of Execution*, 15 LAW AND LITERATURE 235, 236 (2003).

**138** Zupnick at 283. Details of the conflict in the Netherlands are part of our discussion of Gerard David's painting of Cambyses (figs. 31 and 32) in Chapter 3.

**139** See PUPPI at 15. Charles de Tolnay argued that Bruegel's Virtues series presented a "topsy-turvy world" in which various of the Virtues lack objects normally associated with them. Fides (Faith), for example, has no candle, and her face looks dark, and Justice is without her "cushion, symbol of mercy." TOLNAY at 26–27. For a reading of Bruegel's Fides (Faith) as also a critique, see Philipp P. Fehl, *Peculiarities in the Relation of Text and Image in Two Prints by Peter Bruegel*, 3–4 NORTH CAROLINA MUSEUM OF ART BULLETIN 25, 29–32 (1970). A parallel interpretation of the Temperance image—in which "intemperance and confusion reign"—is found in Howard McParlin Davis, *Fantasy and Irony in Peter Bruegel's Prints*, 1 METROPOLITAN MUSEUM OF ART BULLETIN 291, 294 (1943). Davis referenced Tolnay's research as informing some of his views. Id. at 295 (hereinfter Davis, *Fantasy and Irony*).

Bruegel also did a series of seven Vices (Greed, Gluttony, Pride, Lust, Envy, Sloth, and Anger), all depicted as women rather than, more conventionally, as men. Bruegel's Vices were set in fantastic scenes, while his Virtues were in places looking like the Netherlands or Antwerp. See PIETER BRUEGEL THE ELDER: DRAWINGS AND PRINTS, CATALOGUE FOR THE METROPOLITAN MUSEUM OF ART 2001 EXHIBITION at 177–192 (the Virtues) and at 144–160 (the Vices) (Nadine M. Orenstein, ed., New York, NY: The Metropolitan Museum of Art; New Haven, CT: Yale U. Press, 2001) (hereinafter METROPOLITAN MUSEUM BRUEGEL CATALOGUE).

**140** Zagorin at 79 (citing Pierre Francastel).

**141** SNOW, at 62, also noted that the "docile bodies . . . have been completely colonized by the governing apparatus." Tolnay, at 27, described the scene as having "only onlookers, torturers, and tortured, and the idea that it might be otherwise is entirely outside the realm of consciousness of this world without Nature." Alternatively, the works might be more quietly sarcastic. See also JACQUES LAVALLEYE, PIETER BRUEGEL THE ELDER AND LUCAS VAN LEYDEN: THE COMPLETE ENGRAVINGS, ETCHINGS AND WOODCUTS 200–204 (New York, NY: Harry Abrams, 1967).

For some of these interpretations, commentators draw on details such as the distance at which the cross stands, on the hill behind the man shown dangling from ropes, whereas the robed priest closer to the foreground is not wearing a cross. Further, seventeen shields of the various provinces line the walls of the City Hall but are skewed rather than upright. Our colleague, Peter Schuck, has argued one other interpretation—that the image represents the marginality of law, unable to control either human vitality or cruelty.

**142** Davis, *Fantasy and Irony* at 293. Davis thought it customary for Justices to be shown with a bed, "symbolical of the repose the judge needs to prepare his sentence," and a pillow, "of pity, which tempers justice." Id.

**143** Zupnick at 285.

**144** See METROPOLITAN MUSEUM BRUEGEL CATALOGUE at 177 (noting that this scene, like that of others of the Virtues, could constitute a "pointed criticism").

**145** Figure 54, provided by Mike Widener, Rare Book Librarian, and reproduced with permission of the Rare Book Collection of the Lillian Goldman Law Library, Yale Law School, is from a 1567 edition of *Praxis rerum civilium* (*Legal Practice in Civil Matters*). The 1567 edition has a few other woodcuts, including a portrait of the author and some pictures representing different stages of civil proceedings. Although sometimes mentioned as a frontispiece, the image in figure 54 does not occupy that position in the volume. One might characterize it as an emblem of the sort used by Alciatus.

**146** In terms of these opening pages, the cover page indicates that the book is a Dutch translation of a Latin text on "Methods in Civil Law, Essential for all Bailiffs, Mayors, Magistrates, and other Judges. Described by Joost de Damhoudere of Bruges, Knight and Doctor of Law and Ordinaris of his Majesty Karl the Fifth," an edition from 1626 by G. V. Hertevelt. The cover page further detailed that permission to print and distribute the volume in the United Netherlands had been provided to the publishing house, which forbade reproduction in whole or part. Damhoudere then proceeded to call for government regulation of trials as well as for sanctions for frivolous misuse of the judicial system.

**147** First published in 1567, the *Praxis rerum civilium* was subsequently published in Venice in 1568 and in Antwerp in 1569 and 1596, and then republished in 1646 as part of Damhoudere's collected works. Editions were also published in French in 1572; in Dutch in 1626, 1646, and 1669; and in German several times in the sixteenth century. We have not located an English translation. We are therefore indebted to Nicholas Salazar for translation of the Latin (hereinafter *Damhoudere/Salazar*) and to Chavi Keeney Nana for translation of the Dutch. All of the material quoted in the text comes from the Salazar translation of the 1567 Latin version that is in the Yale Rare Book Room, and the Salazar translation is available through the Yale Law Library website and the Yale University Press website. The authorship of the woodcut itself is not clear, but from the accompanying text it appears that Damhoudere directed the design.

**148** See John H. Langbein, *The Historical Origins of the Sanction of Imprisonment for Serious Crime*, 5 JOURNAL OF LEGAL HISTORY 35, 39, n. 21 (1976). Damhoudere also wrote a book called *Pupillorum patrocinium* (Antwerp, 1564) on the law of guardianship of wards.

**149** Kissel provided a picture from a 1596 edition. See KISSEL at 120, plate 100 (described as a Janus-faced Justice with sword and scale, "illustration by Jodocus Damhouder in *Praxis Rerum Civilium* [Antwerp 1596]"); JACOB, at 230 (fig. 125), identifying the image as "La Justice aux deux visages, l'un voile et l'autre aux yeux ouverts (frontispice de J. de Damhoudere, *Praxis rerum civilium . . .*, Anvers,

1567)"; Jay at 34–35 (fig. 1.6) (showing a copy described as "Justice with two faces, one veiled, the other with eyes open, frontispiece of the J. de Damhoudere, Praxis rerum civilium . . . Anvers, 1567"). Martin Jay, for example, wrote that "the first [face] has eyes that are wide open, able to discern difference, alterity, and nonidentity, looking in the direction of the hand that wields her sword, while the second, facing the hand holding the calculating scales of rule-governed impartiality, has eyes that are veiled." He then posited that "for only the image of a two-faced deity, a hybrid, monstrous creature that we can in fact see, an allegory that resists subsumption under a general concept, only such an image can do, as it were, justice to the negative, even perhaps aporetic, dialectic that entangles law and justice itself." Jay at 35.

**150** The dog is not labeled, and it could be decorative or perhaps evocative of friendship and loyalty.

**151** "Iustitia est virtus, qua tribuitur unicuique quod suum est." *Damhoudere/Salazar.*

**152** *Damhoudere/Salazar.*

**153** For example, Damhoudere copied some of *Psalm* 51 ("Deliver me from bloodshed, O God") as an explication of his title "The Justice of the Master."

**154** Moreover, God can "hear the cry of a cause" (or case) even when "the oppressed themselves do not call out." *Damhoudere/ Salazar.*

**155** The text is an adaptation of *Exodus* 23:8. See Chapter 3, fig. 34.

**156** Ovid, who lived from 43 BCE to 17 CE, wrote:

> Look Germanicus, Janus proclaims a happy year
> For you and is present to start my song.
> Two-headed Janus, source of the silent-gliding year,
> Who alone of the gods see your own back,
> Be present for our leaders, whose labours secure
> Peace for the teeming earth, peace for the ocean.
> Be present for your senators and Quirinus' folk;
> Unlock our gleaming temples with your nod. . . .
> Yet what god am I to call you, biformed Janus?
> For Greece has no deity like you.
> Produce the reason why you are the only god
> To see what is behind and what is ahead . . . .
> [Janus replied:]
> The ancients (since I'm a primitive thing) called me
> Chaos, . . .
> Then I, who had been a ball and a faceless hulk,
> Got the looks and limbs proper to a god.
> Now, as a small token of my once confused shape,
> My front and back appear identical. . . .
> The vast world's safekeeping belongs to me alone;
> Only I have the right to turn its hinge. . . .
> Every door has two fronts, this side and that:
> . . .
> Just as your janitor seated by the threshold
> Watches the exits and entrances,
> So I the *jan*itor of the celestial court
> Observe the East and the West together.

Ovid, Fasti I, January 1 (Kalends), excerpts from lines 63–144 (emphasis in the original) (Anthony J. Boyle & Roger D. Woodard, trans. and eds., London, Eng.: Penguin Books, 2000).

**157** Boyle and Woodard at 169. They noted that "varying interpretations in antiquity" addressed the significance of the open and closed doors, including that during peace the closed doors held war back, or that closed doors denoted that people were safe inside. "Ovid has it both ways." Id. See also Ronald Syme, *Problems about Janus*, 100 American Journal of Philology 188, 192 (1979). Syme collected other classical sources on Janus and tracked the variations related to the opening and closing of the gates.

**158** Others have puzzled about why the blindfold gained a positive valence during the late sixteenth century and the seventeenth. Kissel argued that when Justice, who had earlier denoted a goddess of supranatural dimensions, became incorporated in secularized spaces, her separation from other Virtues "brought her to earth." He thought that the blindfold came to represent a neutrality and distance previously enjoyed by virtue of the abstraction, even as he also noted that the overwhelming majority of visual art depictions of Justice continue to show her with open eyes. Kissel at 85–92.

**159** The artist is identified as Gaspard Heuvick. A nineteenth-century engraving is reproduced and described in Juliaan H. A. Ridder, Gerechtigheidstaferelen Voor Schepenhuizen in de Zuidelijke Nederlanden in de 14de, 15de, en 16de Eeuw (Images of Justice in Courthouses in the Southern Netherlands in the 14th, 15th, and 16th Centuries) fig. 45 (Brussels, Belg.: Paleis der Academiën, 1989). Pleister and Schild, who note that Justice can be found in a few depictions in the ranks of the Theological Virtues of Faith, Hope, and Charity, identify the figures to Justice's left and right as Piety and Aequitas, explained as denoting honesty and fair dealing. Yet another alternative for the woman with the mirror and a snake is Wisdom. See Pleister and Schild at 113, fig. 185.

**160** See Susan Tipton, Res publica bene ordinata: Regentenspiegel und Bilder vom guten Regiment, Rathausdekorationen in der Frühen Neuzeit (The Well-Ordered Public Sphere: Images of Sovereignty and Pictures of Good Government, Town Hall Decoration in the Early Modern Period) 677, fig. 159, 462–465 (Hildesheim, Ger.: Georg Olms Verlag, 1996). Figure 159 shows *The Personification of Justice* by Jakob Züberlin, 1596. The image was restored around 1760, covered by another oil painting in 1809, and uncovered and restored in 1952.

**161** Tipton at 676, fig. 158, and discussion at 462–465. Near the inscription is the date of a 1760 restoration, which thus raises the possibility of a change in text at that time. Another sculpted blindfolded Justice, from 1620, is at the Münster Town Hall. Kissel at 96, fig. 75.

**162** Between the text and this note, we catalogue those of which we are aware. In some instances these blindfolded images are ambiguous and in others more obviously celebratory. Examples of blindfolded Justices in Kissel include a 1524 *Naked Justice Blindfolding the Emperor* (Kissel at 61, fig. 47); a 1550 image of a blindfolded Justice labeled *Justitia von Virgil Solis* (*Justice by Virgil Solis*) (Solis, born in 1514, was one of Nuremberg's most prolific book illustrators and printmakers) (id. at 66, fig. 52); a 1564 Justice wearing a blindfold and sitting on top of the globe, described by Kissel as "Justice, sitting on a globe, litigants stand on her left and right 'the scales of Justice tilt towards the side of the poor and oppressed'") (id. at 45, fig. 31); a 1566 Frankfurt image of Justice blindfolded, her sword behind her head and scales near to the ground (id. at 110, fig. 86); a reconstruction of a 1573 Justice with a blindfold partially obscuring her sight, a sword raised high in her left hand and scales in her right, placed in an alcove of the arcade above the old Cologne Town Hall (id. at 89, fig. 71). Another less well-clad but otherwise similarly outfitted Justice, by Benedikt Walzelbauer and dated to the 1580s, is on a fountain outside the St. Lorenz Church in Nuremberg. Id. at 101, fig. 80. A few blindfolded Justices appear as stone statues in front of town halls; their covered eyes are, we presume, meant to be valued. Already noted from Kissel is the 1573 statue at the Old Town Hall in Cologne. In addition are a 1583 Justice in Nurenberg (at 101, fig. 80), and the replica of a 1620 Justice on the Münster Rathaus (at 96, fig. 75). Some Justices of this early period wear diaphanous blindfolds through which one can see Justice's eyes, sometimes open, sometimes closed, and sometimes not clearly either. See Jost Amman, *Justitia, Sitting Atop the World* (ca. 1564) (Kissel at 45, plate 31); Hans von Steenwinkel, *Justitia* (ca. 1576), stained glass in the Emden Town Hall, West Germany (Kissel at 111, plate 89).

Another often reproduced image is Jacob Jordaens's *Das menschliche Gesetz basiert auf dem göttlichen* (*Human Law Founded on the*

*Divine*), showing a woman looking through a thin veil, with a tablet nearby and a sword and scales held by a winged male angel who is either handing them to her or taking them away. Aaron and Moses are nearby, and on the Commandment-shaped tablets are excerpts from *Deuteronomy* 1:10 that (in the King James Bible) reads: "And I charged your judges at the time, saying Hear the causes between your brethren and judge righteously between every man and his brother, and the stranger that is with him." The painting, now at the Royal Museum of Fine Arts in Antwerp, Belgium, was given by the artist to the St. Lucas Guild in 1665, and the museum literature has described it as a critique of the political and religious situation of the era. This image is the frontispiece to PLEISTER & SCHILD; see also SCALES AND SWORD at 94–95, fig. 39.

Another example of an ambiguous deployment that relies on a diaphanous blindfold is a print aimed at criticizing Spanish rule. In *Vices Rule the World: Truth and Justice Sleep*, by Theodor de Bry, circa 1572, one can see—because of a diaphanous blindfold—that Justice's eyes are closed. Her skewed scales are touching the ground, and nearby Truth also has her eyes closed. A man depicting Vice has his hand on Justice's head. See JAMES TANIS AND DANIEL HORST, IMAGES OF DISCORD: A GRAPHIC INTERPRETATION OF THE OPENING DECADES OF THE EIGHTY YEARS' WAR 26–27 (Grand Rapids, MI: William B. Eerdmans in arrangement with Bryn Mawr College, 1993). Yet other diaphanous blindfolds can be found in designs for stained glass windows in northern Europe in the collection of the Victoria and Albert Museum, London, England. See Dennis E. Curtis and Judith Resnik, *Images of Justice*, 96 YALE LAW JOURNAL 1727, 1751, fig. 7 (1987) (Christopher Murer, Design for a Swiss Stained Glass Window, 1586). As this overview suggests, the see-through blindfolds of which we are aware come from northern Europe. The ambiguity of the blindfold is further explored and depicted in Chapters 5 and 6.

**163** SCALES AND SWORD at 91, fig. 35.

**164** See WIM G. M. CERUTTI, HET STADHUIS VAN HAARLEM: HART VAN DE STAD (THE CITY HALL OF HAARLEM: HEART OF THE CITY) 250–251 (Haarlem, Neth.: Gottmer/Schuyt, 2001). These materials and the other Dutch works referenced were translated for us by Chavi Keeney Nana. The architect for the renovations was Haarlem's Salomon de Braij, and the statue was by sculptor Jan Louverissen. The interior included the Jan de Braij *Judgment of Zaleucus*, a graphic 1676 painting showing a man about to extract one of Zaleucus's eyes. A group, including a Justice holding scales and sword, is looking on. Id. at 305–307.

**165** A painting by Theodorus Vander Schuer is described by a Hague City archivist as having "the eye of Justice" appearing "high on the heavens while the sun rising is shining at the base. The blindfolded Lady Justice is depicted directly beneath it with a sword and two angels, one holding fasces and the other holding the legal tablets." See J. C. HERPEL, HET OUDE RAADHUIS VAN 'S GRAVENHAGE, DEEL I AND DEEL II (THE OLD CITY HALL OF THE HAGUE, PARTS I AND II), 246–247, fig. 222 (pt. I), and 872, fig. 827 (pt. II) ('s Gravenhage, Neth.: Uitgave van de Gemeente, 1979). A painting called *Allegory of the Fame of Amsterdam*, by Gerard de Lairesse, shows a blindfolded Justice near the *Maid of Amsterdam*. See JAN PEETERS, PETER C. SUTTON, EYMERT-JAN GOOSSENS, & DEIRDRE CARASSO, THE ROYAL PALACE OF AMSTERDAM IN PAINTINGS OF THE GOLDEN AGE 63 (Royal Palace, Zwolle, Neth.: Waanders Publishers, 1997).

**166** See, for example, the 1606 frontispiece for *Thronus Justitiae*, by Joachim Wtewael, reproduced in Van der Velden, *Cambyses for Example* at 33. See also SCALES AND SWORD at 98, fig. 42, reproducing the engraving and poem, titled *Who Is This Goddess?* in which a partially blindfolded Justice, with scales and sword, is near scenes of Zaleucus and Cambyses. The accompanying poem includes the lines "Why have her eyes been blind-folded you are asked / Because neither tears nor gifts will move her."

A 1582 bookplate by Hans Hellwig for Blasius Hellwig shows a Justice with a blindfold over most of her eyes and holding scales and

sword. See HANS-JOACHIM KRETZ, EXLIBRIS FÜR JURISTEN 132, 142, fig. 111 (Munich, Ger.: Verlag C. H. Beck, 2003). In addition, a 1655 engraving by Gerhard Altzenbach of the Town Hall of the Free City of Cologne, dedicated by the artist to that city's council, also showed a blindfolded Justice, again with scales and sword, drawn floating in a space above the building itself. TIPTON at 631, fig. 113, and text at 331–341. Pleister and Shield provide a few other images of blindfolded Justices, not all of which are dated. See, for example, Pleister and Shield at 116, fig. 191 (an allegory of Justice from Basil); 143, fig. 219 (a Metsu Justice from the seventeenth century); 145, fig. 227 (a blindfolded Justice from 1662 by Joseph Weiner, in the Bern Museum).

**167** See SCALES AND SWORD at 96, fig. 40; 98, fig. 42; 99, fig. 43; 120, fig. 67.

**168** ROBERT at 118–128.

**169** Tarot, which appears to have been a game invented in Italy, was popular there and in France and Switzerland in the sixteenth and seventeenth centuries and then spread north and east in the eighteenth and nineteenth centuries. See MICHAEL DUMMETT, THE VISCONTI-SFORZA TAROT CARDS 6–11 (New York, NY: George Braziller, 1986). Card packs had kings, knights, queens, Temperance, Justice, Fortitude, Fortune, and many other personifications. In the reproductions of various sets of cards, Justice is usually shown with sword and scales but not blindfolded. Id. at 114–115. On the other hand, the woman at the center of the "Wheel of Fortune" is blindfolded. Id. at 120–121. Other sets showed the imagery somewhat differently, but in the reproductions we have located, all the Justices are clear-sighted. See, for example, "TAROCCHI" MENSCHENWELT UND KOSMOS: LANDENSPELDER, DÜRER AND DIE "TAROCK-KARTEN DES MANTEGNA" ("TAROCCHI" EARTH AND COSMOS: LANDENSPELDER, DÜRER, AND THE "MAGENTA TAROT CARDS") 38–39 (fig. 43); 111–113 (fig. 104); 135 (fig. 127) (Uwe Westfehling, ed., Cologne, Ger.: Wallraf-Richartz-Museum der Stadt Koln, 1988) (hereinafter WESTFEHLING CATALOGUE). Stella Burch Elias provided us with translation.

**170** One source is a series of photos of seventeenth-century German buildings. See KARL EMIL OTTO FRITSCH, DENKMAELER DEUTSCHER RENAISSANCE: 300 TAFELN MIT ERLAEUTERNDEN TEXT (MONUMENTS OF THE GERMAN RENAISSANCE: 300 PLATES WITH EXPLANATORY TEXT) (Berlin, Ger.: Wasmuth, 1891) (unpaginated). Justice was often the sole or specially situated Virtue used to mark a city's town hall. All came with scales and sword, but many Justices did not have blindfolds. Examples include pictures from Bremen, Danzig, Görlitz, Halberstadt, and Wittenberg.

**171** ALCIATUS, DALY EDITION, vol. 2 at emblem 145 and motto (from the 1542 German version).

**172** ALCIATUS, DALY EDITION, vol. 2 at emblem 145 and motto (from a French edition of 1536).

**173** See TIPTON at 677, fig. 159.

**174** RIPA, PADUA–1611 at 203.

**175** The detail of *Justice* in figure 55 is reproduced with permission of Scala/Art Resource, New York. It sits in a room that has spawned a scholarly debate about its original purpose, its import, and who painted the frescoes aiming to convey what messages. The contemporary consensus, relying on both the iconography and an understanding of other major libraries of the era, is that it was first used as the personal library of Pope Julius. See CHRISTIANE L. JOOST-GAUGIER, RAPHAEL'S STANZA DELLA SEGNATURA: MEANING AND INVENTION 11–16 (Cambridge, Eng.: Cambridge U. Press, 2002) (hereinafter JOOST-GAUGIER, MEANING AND INVENTION). See also Christiane L. Joost-Gaugier, *The Concord of Law in the Stanza della Segnatura*, 29 ARTIBUS ET HISTORIAE 85 (1994) (hereinafter Joost-Gaugier, *The Concord of Law*); JAMES BECK, RAPHAEL: THE STANZA DELLA SEGNATURA (New York, NY: George Braziller, 1993); LUITPOLD DUSSLER, RAPHAEL: A CRITICAL CATALOGUE OF HIS PICTURES, WALL-PAINTINGS, AND TAPESTRIES 69–88 (London, Eng.: Phaedon, 1971); John Shearman, *The Vatican Stanze: Functions and Decorations*, PRO-

CEEDINGS OF THE BRITISH ACADEMY, vol. 67, 3 (London, Eng.: Oxford U. Press, 1972); D. REDIG DE CAMPOS, THE "STANZE" OF RAPHAEL (Rome, Ital.: Del Turco Editore, 1952); Edgar Wind, *The Four Elements in Raphael's "Stanza della Segnatura,"* 2 J. WARBURG & COURTAULD INST. 75 (1938). For a view, based in part on comparisons with other paper libraries, that the room did not have that original use, see James E. Callaghan, Reason and Faith in the Renaissance: The Stanza Della Segnatura (Ph.D. dissertation, Temple U., Philadelphia, PA, 1998; UMI Publication No.: AAT 9910992).

From the eighth century through the nineteenth (and the unification of Italy in 1870), the popes had both territorial authority and legal authority for members of their church. As one scholar put it, beginning at the end of the seventh century, "a series of resolute and like-minded popes acting in concert with the local Roman nobility deliberately emancipated central Italy from the Byzantine Empire and transformed the region into a genuine state, the Republic of St. Peter," which obtained protection from the then-new Carolingian monarchy. See THOMAS F. X. NOBLE, THE REPUBLIC OF ST. PETER: THE BIRTH OF THE PAPAL STATE 680–825, xxi (Philadelphia, PA: U. of Pennsylvania Press, 1984). The State of the Vatican City gained distinct recognition as a sovereignty through the Lateran Treaty of 1929; see HYGINUS EUGENE CARDINALE, THE HOLY SEE AND THE INTERNATIONAL ORDER 103 (Gerrards Cross, Eng.: Colin Smythe, 1976).

**176** JOOST-GAUGIER, MEANING AND INVENTION at 43–52 and plate IX. The images on the Jurisprudence wall, "representing the Law," are *Tribonian Handing the Pandects to Justinian*, *Gregory IX Receiving the Decretals*, and the *Three Cardinal Virtues* or (according to Joost-Gaugier) the *Three Graces*. Id. at 11, 137, 143. Also seen are the *Judgment of Zaleucus*, *Moses Giving the Laws to the Jewish People*, and *Solon Giving the Laws to the Athenians*. Callaghan at 220. "As virtually all scholars agree, the divided south wall of the Stanza . . . offers a balance of Civic Law and Canon Law as its subjects to the left and right respectively." Joost-Gaugier, *The Concord of Law* at 89. The frescoes on the other walls are "the *Disputa*, representing Theology, the *School of Athens*, representing Philosophy, [and] the *Parnassus*, representing Poetry." JOOST-GAUGIER, MEANING AND INVENTION at 11.

**177** See DUSSLER at 76–77. Writing in the mid-sixteenth century, Vasari was another source. GIORGIO VASARI, LIVES OF THE ARTISTS, vol. 1, 291–297 (George Bull, trans., New York, NY: Penguin Books, 1965). Returning to the discussion about the identity of figures 20, 21, and 22 in Chapter 1, Joost-Gaugier (*Meaning and Invention* at 132–146) reads them to be the three Graces and not the other Cardinal Virtues.

**178** JOOST-GAUGIER, MEANING AND INVENTION at 47. The inscription IUS SUUM UNICUIQUE TRIBUENS is attributed to Plato by Joost-Gaugier, and according to Callaghan, it came "from the introduction to Justinian's *Decretals*, but is based upon Justinian's definition of Justice in the *Corpus Iuris Civilis*: 'Justice is the constant and perpetual desire to render to each man his right.'" Callaghan at 259, n. 819. See also DUSSLER at 70.

**179** In the other medallions of Theology, Philosophy, and Poetry, putti also hold Latin letters. Dussler identified them, respectively, as: DIVINAR/RER, NOTI/TIA (from Justinian); CAVSA/RVM, COGNI/TIO (from Virgil's Georgica II); and NVMI/NE, AFFLA /TVR (from Virgil's *Aeneid*). DUSSLER at 70. Joost-Gaugier, in *Meaning and Invention* at 47, read the inscription for Philosophy to suggest that "knowledge of things leads to the primary cause, or God," and cites Cicero as the likely source; she posited the text for Theology as a reference to Plato, suggesting that "to learn the things of God is to have knowledge of the Divine."

**180** DUSSLER at 70; JOOST-GAUGIER, MEANING AND INVENTION at 50–52.

**181** JOOST-GAUGIER, MEANING AND INVENTION at 38–46.

**182** Joost-Gaugier, *The Concord of Law* at 89–95 (noting that Pope Julius saw himself as "a descendent of the Caesars"); JOOST-GAUGIER, MEANING AND INVENTION at 46–50 (suggesting that Julius is "con-flated" with Apollo as well as linked to the Old Testament through the frescoes of the Judgment of Solomon). She noted that "ample precedent" in Italian art existed for depictions of Justice but that no rich tradition of "narratival scenes" then existed. *The Concord of Law* at 87.

**183** See also Shearman at 20–21 (arguing that the popes sought to promote their "New Style of Government" and the "benefits such as Peace, Commerce, and Law" that flowed from it). Shearman also believed that Julius used the space as a "semi-public and institutional" passage. Id. at 20.

**184** JOOST-GAUGIER, MEANING AND INVENTION at 146. See also Joost-Gaugier, *The Concord of Law* at 92–94. She argued that Pope Julius was threatened by King Louis XII of France, who, with the support of Emperor Maximilian I, wanted to depose Julius. By the time the frescoes were finished, the Pope had gained a more secure footing. In terms of the intellectual resources for this effort, given the Pope's lack of knowledge of Greek, she cited the work of his librarian, Tommaso Inghirami, as an enormous influence on Raphael's frescoes. JOOST-GAUGIER, MEANING AND INVENTION at 17–42, 153–163.

**185** JOOST-GAUGIER, MEANING AND INVENTION at 146.

**186** See also Edgar Wind, *Platonic Justice, Designed by Raphael*, 1 J. WARBURG & COURTAULD INST. 69 (1937). Wind stated that the "riddle" in the arrangement of depicting Justice above the figures whom he identified as Prudence, Fortitude, and Temperance was that, according to Plato's *Republic*, when in search of Justice, Socrates encountered the other three but not Justice, who was "not a particular virtue juxtaposed" to the others but "that fundamental power in the soul which assigns to each of them their particular function." Id. at 70, referencing Plato's *Republic*, bk. 4, 432.

**187** See Nancy Rash-Fabbri, *A Note on the Stanza della Segnatura*, 97, 103 GAZETTE DES BEAUX-ARTS 2 (1979).

**188** Because the *Justice* sits at the level of the disciplines (Poetry, Theology, and Philosophy), she could also be read as Jurisprudence. The ceiling imagery is also a source for the identification of the room as once a library; the four disciplines were the system by which books were organized. See Shearman at 14–17 (also noting that the lack of a fireplace indicated that the room was designed as a library).

**189** Figure 56 was provided courtesy of the Library of Congress. Four rooms in the Vatican bear the name of Raphael. Three—the Stanza della Segnatura, Stanza d'Eliodoro, and Stanza dell'Incendio—are each about the same size, ten meters. The fourth, the Sala di Constantine, is "more spacious." DE CAMPOS, appendix at 67; JEAN-PIERRE CUZIN, RAPHAEL: HIS LIFE AND WORKS 103 (Sarah Brown, trans., Secaucus, NJ: Chartwell Books, 1983).

**190** Romano, who lived from 1499 to 1546, was born in Rome. After completing work in the Vatican he also did projects for the Duke of Mantua. See Michael Jaffé, *Rubens and Giulio Romano at Mantua*, 40 THE ART BULLETIN 325 (1958). See also Richard Aste, *Giulio Romano and His master, Raphael*, in RICHARD ASTE, JANET COX-REARICK, AND BERTHA AND KARL LEUBSDORF ART GALLERY, GUILIO ROMANO, MASTER DESIGNER: AN EXHIBITION OF DRAWINGS IN CELEBRATION OF THE FIVE HUNDREDTH ANNIVERSARY OF HIS BIRTH 28 (New York, NY: Bertha and Karl Leubsdorf Art Gallery, Hunter College of the City U. of New York; Seattle, WA: U. of Washington Press, 1999); Frederick Hartt, *Raphael and Giulio Romano: With Notes on the Raphael School*, 26 ART BULLETIN 67, 80 (1944) (hereinafter Hartt, *Raphael and Romano*); FREDERICK HARTT, GIULIO ROMANO (New Haven, CT: Yale U. Press, 1958). Giorgio Vasari devoted a segment to Romano in *Lives of the Painters, Sculptors and Architects*, vol. 3, 97–112 (London, Eng.: J. M. Dent & Sons; New York, NY: E. P. Dutton, Everyman's Library, 1927). The attribution is made by several commentators. See DE CAMPOS, appendix at 67–68 (also commenting that none of the room's decoration painted from 1517–1524 was by the "master" Raphael, and that (unfortunately) it showed how little "Raphael's pupils were capable of without the guidance of the master"). Others see more of the "master's" hand. See Phillipp P. Fehl, *Raphael as a Historian: Poetry and Historical*

*Accuracy in the Sala di Costantino*, 14 ARTIBUS ET HISTORIAE 9 (1993) (hereinafter Fehl, *Raphael as Historian*).

**191** Depicted are stories related to Constantine, including his baptism, his address to his troops, a battle, and the "triumph of Christianity over the pagan world." The frescoes are "all painted as if they were tapestries with flapping edges." DE CAMPOS at 68. In addition to Justice, other Virtues (Moderation and Comity) are depicted, as are emblems of Popes Leo X and Clement VII. Id. at 68. Other Virtues depicted include Innocence, Truth, Prudence, and Peace. See Fehl, *Raphael as Historian* at 66–69. Their placement is part of a pictorial array in which "each corner of the room is treated as if constructed in stone," with "fictitious architecture" creating niches and podia. Each niche is topped by a canopy, and under "each canopy a figure of a pope, flanked by two angels, is seated on a low chair, which is generally hidden behind his flowing garments." See Hartt, *Raphael and Romano* at 77. On the podia stand male and female caryatid figures, and on each "secondary podium" are seated Virtues. Id.

**192** To the *Justice*'s left is the *Battle of Constantine and Maxentius at the Milvian Bridge* (also called the *Victory of Constantine over Maxentius*), the "only extended Central Italian High Renaissance battle piece." JOHN POPE-HENNESSY, RAPHAEL 244–245 and figure 235 (New York, NY: New York U. Press, 1970). Depicted to the right, seated higher than *Justice*, is Pope Urban I, who has Charity on his other side. Hartt, *Raphael and Romano* at fig. 25 (unnumbered page between 80 and 81). Urban I appears to point "towards both Iustitia, with scales and an ostrich," and Charity, with her "three suckling children," thereby linking and justifying the "papal plenitude of power" by means of a Cardinal and a Theological Virtue. See Loren Partridge, *Review of Rolf Quednau, Die Sala di Costantino in Vatikanischen Palast*, 65 ART BULLETIN 515, 516 (1983).

**193** See Liana de Girolami Cheney, *Giorgio Vasari's Astraea: A Symbol of Justice*, 19 VISUAL RESOURCES 283, 290 (2003) (noting that a drawing, circa 1546, for a Justice in the Sala dei Cento of the Palazzo della Cancelleria in Rome showed her with fasces, ostrich, shield, scepter, and lion). In addition to the Luca Giordano renditions, an ostrich also sits in an eighteenth-century oil painting, *An Allegory of the Justice and Peace*, painted by Corrado Giaquinto at the behest of King Ferdinand VI. Giaquinto, appointed in 1753 as King Ferdinand's "First Painter," executed sketches and two large-scale versions, one of which hangs in the Academy of Fine Arts in Madrid, Spain. The *Allegory*, painted soon after Giaquinto assumed his official duties, celebrated the new Bourbon ruler's authority and the prosperity, peace, and justice flowing from his rule.

**194** This text can be found in the Padua editions from 1611 and 1618. RIPA, PADUA–1611 at 203 and RIPA, PADUA–1618, vol. 1 at 188. As the 1644 Dutch edition explained: "The ostrich shows that, although the lessons of the law are sometimes difficult to decipher, one must always try to uncover the true meaning of justice and the law." DUTCH RIPA–1644 at 432.

**195** See BERYL ROWLAND, BIRDS WITH HUMAN SOULS 115 (Knoxville, TN: U. of Tennessee Press, 1978).

**196** See RIPA, PADUA–1618, vol. 1 at 123. In the 1611 Padua edition as well as the 1779 Richardson, the ostrich is also mentioned in relation to gluttony. The 1611 Padua edition noted, at 209, "[Her] right hand rests on an ostrich, an animal about which Alciato says: The ostrich is like those who never close their mouths and whose hunger is never satisfied." In the English 1779 Richardson edition (vol. 3, fig. 288), the ostrich can be found under the entry "Voracity" because, according to Richardson, "[o]f all the feathered tribe, the ostrich is the most voracious, it devours leather, grass, hair, stones, metals, or any thing that is given to it. This animal is perhaps obliged to fill up the great capacity of its stomach, in order to be at ease; and when nutritious substances are not to be obtained, it supplies the void with any thing that offers."

**197** PINCH at 159–160.

**198** Virpi Harju, *The Artistic Faces of Justice*, in OIKEUDEN KUVA: BILDEN AV RATTEN OCH RATTVISAN 284 (Helsinki, Fin.: Eduskunnan kirjasto, Valtion taidemuseo, 2000) (translation provided by Kirsti Langbein).

**199** Partridge at 516; Cheney at 284, 292–295, and n. 46, citing Gombrich's *Icones Symbolicae* at 190. A second Hieroglypica was by Valeriano.

**200** Cheney at 295 (and at 304, n. 49), citing Boas, *Hieroglyphics of Horapollo*, under an entry "A Man Who Distributes Justice Equality to All," stated that the ostrich wing needed to be drawn because "the ostrich has its wings more equally balanced than any other bird."

**201** ROWLAND at 114 (citing Horapollo's comment that "the feather of an ostrich symbolized a man who distributed justice impartially, 'for this bird has the feathers of its wings equal on every side, beyond all other birds'").

**202** Cheney, *A Symbol of Justice* at 297.

**203** Cheney at 295. In the Farnese *Astraea* painting, Justice has an ostrich that "carries a load containing the tablets of the law on which the Roman numeral twelve is inscribed," referring to the Ten Commandments plus the "two books of civil and canonical institutions." Id. at 296–297 (quoting Vasari).

**204** Letter from Vasari to his patron, Cardinal Farnese, quoted by Cheney at 292.

**205** See Creighton Gilbert, "*The Egg Reopened*" Again, 56 ART BULLETIN 252, 253 (1974).

**206** Millard Meiss, *Ovum Struthionis*, in STUDIES IN ART AND LITERATURE FOR BELLE DA COSTA GREENE 95 (Dorothy Miner, ed., Princeton, NJ: Princeton U. Press, 1954). Other biblical references are examined by Arthur Walker-Jones in *The So-called Ostrich in the God Speeches in the Book of Job (Job 39: 13–18)*, 86 BIBLICA 494 (2005).

**207** Meiss at 95 (discussing an egg in Mantegna's San Zeno altarpiece).

**208** This explication comes from Spaightwood Galleries, http://www.spaightwoodgalleries.com/Pages/Giulio_Romano.html.

**209** Francis Ames-Lewis, *Early Medicean Devices*, 42 J. WARBURG & COURTAULD INST. 122, 127 (1979); Partridge at 516. The three feathers were said to represent the three Theological Virtues of Faith, Hope, and Charity. Ames-Lewis at 129. Others have argued that the feathers on the Medici ring came from a "moulting falcon," a symbol of the faithful. Id. See also Marilyn Perry, "*Candor Illaesvs*": The "Impresa" of Clement VII and other Medici Devices in the Vatican Stanze, 119 BURLINGTON MAGAZINE 676 (1977).

**210** Ames-Lewis at 129. But St. Gregory saw ostrich feathers as associated with hypocrites; falcon feathers denoted the faithful. Id. at n. 30.

**211** The series is documented in Éva Nyerges, *Opere Giordanesche in Ungheria*, 43 ACTA HISTORIAE ARTIUM 207 (2002). Giordano, nicknamed "Luca fa presto" as well as "Thunderbolt" because he worked so quickly, was "one of the most prolific painters who ever lived." See Judith Colton, *Luca Giordano, 1634–1705*, in A TASTE FOR ANGELS: NEAPOLITAN PAINTING IN NORTH AMERICA, 1650–1750, 113 (New Haven, CT: Yale U. Art Gallery, 1987). Our thanks to Professor Colton and Professor Wayne Meeks for helping us to understand these images, to Professor Gábor Hamza of the ELTE Római Jogi Tanszek in Budapest for introducing us to this painting and helping us to obtain permission for its reproduction, to István Németh, Curator Department of Old Master Paintings, and to the Szépmûvészeti Múzeum, Budapest, Hungary, for providing us with the photograph in figure 57 and permitting its use.

**212** Giordano, born in Naples, traveled and worked throughout Italy. Several scenes in which Virtues appear can be found in a catalogue of his work mounted in 2001–2002 in Naples, Vienna, and Los Angeles. LUCA GIORDANO, 1634–1705 (Naples, Ital.: Electa Napoli, 2001).

**213** Different versions can be found in the Museum of Fine Arts in Budapest, the Pushkin Museum in Moscow, and the Schloss Rohrau just outside of Vienna. See Nyerges at 210, figs. 5 and 6.

**214** Art historians "place this painting between the years 1669–1670, in which the last Venetian territory, the island of Crete, came to be occupied by the Turks. The struggle against the Ottoman empire for control in the Mediterranean, which began in 1499, ended in 1669 with the loss of Crete." Nyerges at 208–209 (translation by Allison Tait). One could interpret it to show Justice disarmed by both love and vice. Pleister and Schild at 83 and fig. 128. The Jacob Jordaens painting, discussed earlier, could be read as part of this genre of discombobulated justices.

**215** Ripa, Padua–1611 at 202; French Ripa–1644 at 58; Dutch Ripa–1644 at 433.

**216** See Westfehling Catalogue at 111–113 (fig. 104).

**217** For example, the *Allegory of Judgment* in the Oudenaarde Town Hall (discussed in an earlier note) shows Justice in the middle between Faith and Wisdom, Aequitas, or Prudence; a crane is nearby. See Ridder at 112, figs. 44–45. As for Vigilence, the crane is found in both the 1611 and the 1618 Padua editions of Ripa for "Vigilanza." The crane, at the foot of a woman holding a book in one hand and a rod and lamp in the other, stands on one leg and holds a stone with his other leg, teaching the reader that "one must be vigilant in guarding oneself." Ripa, Padua–1611 at 532; Ripa, Padua–1618, vol. 2 at 230. The Hertel 1758 edition explains: "Next to [Vigilance] stands a large crane, holding a stone in one foot. . . . Both Pliny (Natural History, Book 10, ch. 23) and Horapollo (Hieroglyphica, II, 94) use the crane as a symbol of watchfulness, for the crane is supposed to sleep with a stone in its claws to use as a weapon if surprised . . . when acting as a sentinel guarding a group of its fellows, [the crane] holds a stone so that, if it falls out of his grasp because he has fallen asleep, the others will be alerted by the noise." Ripa, Maser Edition at 51. The crane appeared under "Service" (at 88) and "Protection" (at 137) in this edition as well.

**218** Dutch Ripa–1644 at 434.

**219** That description fits "Strict Justice" ("Giustitia Retta") in Ripa, Padua–1611 at 203 and in the 1644 Dutch Ripa at 433. The 1644 Dutch Ripa also described the Giudice, or Judge, as an old man holding a staff around which a snake was wrapped to remind the judge to be careful. Dutch Ripa–1644 at 434. Serpents sometimes signified good and evil within the same painting. See Ronald Millen, Heroic Deeds and Mystic Figures: A New Reading of Rubens' Life of Maria de' Medici 200 (Princeton, NJ: Princeton U. Press, 1989).

**220** The image in figure 58 was provided by Noortman Master Paintings, Maastricht, the Netherlands, which authorized its reproduction. Unlike most of the images reproduced in this volume, it is not known where this *Allegory of Justice* hung. This large panel "sketch"—sixty-five by forty-five centimeters (twenty-five and a half inches by eighteen inches)—was likely for a tapestry that has not yet been identified. See Julius Held, The Oil Sketches of Peter Paul Rubens: A Critical Catalogue, vol. 1, 366–367 and plate 267 (Princeton, NJ: Princeton U. Press, 1980). Held suggested that this work resembled the preparatory work for Rubens's series *Triumph of the Eucharist*, a cycle of tapestries. Id. at 367. See also Michael Jaffé, *Unpublished Drawings by Rubens in French Museums*, 66 Gazette des Beaux-Arts 175, 177 and fig. 3 (1965); Nora de Poorter, The Eucharist Series, vol. 1, 244 and fig. 224 (London, Eng.: Harvey Miller-Heyden & Son, 1978). The sketch could also have been part of an independent series of Virtues. See Guy Delmarcel, *The Cardiff Cartoons*, 125 Burlington Magazine 692 (1983).

A better-known Justice by Rubens is his allegory *The Felicity of the Regency*, part of his series of twenty-four monumental paintings on the life of Marie de Medici. In this episode she is on a throne, scales in one hand and sword or "main de justice" in the other, and, like the Justice here, with one breast bared. See Millen at 164–168 and figure 49. On the baring of the breast to signify the complex and less-than-complete hold on power by females, see Geraldine A. Johnson, *Pictures Fit for a Queen: Peter Paul Rubens and the Marie de' Medici Cycle*, in Reclaiming Female Agency: Feminist Art History after Post-

modernism at 101–120 (Norma Broude & Mary D. Garrard, eds., Berkeley, CA: U. of California Press, 2005).

**221** Held, at 367, also made the parallel to a Ripa description—in a Rome 1603 edition—of "Divine Justice" or "Strict Justice" ("Giustitia Retta").

**222** Edward Muir, *Images of Power: Art and Pageantry in Renaissance Venice*, 84 American Historical Review 16–17 (1979) (hereinafter Muir, *Images of Power*).

**223** From 742 to 1797, 118 doges served. Edward Muir, Civic Ritual in Renaissance Venice 299 (Princeton, NJ: Princeton U. Press, 1981) (hereinafter Muir, Civic Ritual). They were elected for life and had both special authority and specified restrictions, resulting in scholarly debate about their actual power. See Staale Sinding-Larsen, Christ in the Council Hall: Studies in the Religious Iconography of the Venetian Republic 120–149, 156 (Norwegian Research Council for Science and the Humanities, 1974); Edward Muir, *The Doge as "primus inter pares": Interregnum Rites in Early Sixteenth-Century Venice*, in Essays Presented to Myron P. Gilmore, vol. 1: History 145–160 (Sergio Bertelli & Gloria Ramakus, eds., Florence, Ital.: La Nuova Italia, 1978) (hereinafter Muir, *Interregnum Rites*); Åsa Boholm, The Doge of Venice: The Symbolism of State Power in the Renaissance 9–13 (Gothenburg, Swed.: Institute for Advanced Studies in Cultural Anthropology, 1990). In his essay Muir mapped the shift in the ceremonial investitures of doges. In earlier eras, the ceremony had included the approval of the community, reflecting a more popular basis for the Venetian Republic. Later the ceremony demonstrated the degree to which the office of the doge was controlled by ruling families. Muir, *Interregnum Rites* at 149–156. Throughout, the doge served as a figure of the Venetian Republic in a variety of ceremonies. Muir's *Civic Ritual in Renaissance Venice* is the "pivotal study [that] inaugurated what would become the most defining element of Venetian historiography: the study of political culture, which we shall see remains the most prominent characteristic of Venetian studies to this day." Liz Horodowich, *The New Venice: Historians and Historiography in the 21st Century Lagoon*, 2 History Compass 1, 3 (2004).

**224** In Chapter 2, we discuss the "constant intermingling of religious and civic life" in Europe—captured by one historian's description of "civic Christianity." David Herlihy, Medieval and Renaissance Pistoia: The Social History of an Italian Town, 1200–1430 at 241 (New Haven, CT: Yale U. Press, 1967). See also Bruce Cole, Sienese Painting: From Its Origins to the Fifteenth Century ix (New York, NY: Harper & Row, 1980) (referring to buildings in Siena and elsewhere in Tuscany).

**225** Muir, *Images of Power* at 20–21.

**226** Muir, *Images of Power* at 34.

**227** Our thanks to David Rosand, Meyer Schapiro Professor of Art History, Columbia University, for providing us with his photograph, reproduced in figure 59. Jacopo Sansovino was born Jacopo Tatti in Florence and adopted the name of his master, Andrea Sansovino. Tatti "spent his early career in Florence and Rome, in close contact with the great artists of the High Renaissance," and it was not until he was forty-one that he came to Venice to "take refuge from the atrocities of the Sack of Rome." See Deborah Howard, Jacopo Sansovino: Architecture and Patronage in Renaissance Venice 1–7 (New Haven, CT: Yale U. Press, 1975). The timing was "particularly fortuitous," because Doge Andrea Gritti was devoting great resources to the arts. With the backing and patronage of the Doge, Sansovino was responsible for helping to revive much Venetian architecture. Id. Sansovino's renovations of the loggetta began in 1537 and turned the arcade into an important piece of architecture. "The fact that the Loggetta was extremely small in scale compared with the other buildings in the Piazza was a major influence on the design . . . . [I]t had to be sufficiently eye-catching to compensate for its diminuitive proportions." Id. at 31. Accordingly, no expense was spared, and the loggetta

can be considered "the most complete surviving visual representation of the 'myth of Venice.'" Id. at 34.

**228** Muir, *Images of Power* at 34. The interior, which included a Hall of the Great Council, had displayed a series of monumental paintings of the military victories of Venice. After they were lost in fires during the 1570s, other grand paintings took their place, including a *Last Judgment* in prominent view near an enthroned queen representing the city. Muir, *Images of Power* at 25. See also SINDING-LARSEN at 43–57. A Justice labeled *Venecia* also appears in medallions in the Ducal Palace. Id. at 174–175.

**229** See David Rosand, *Venetia Figurata: The Iconography of a Myth*, in INTERPRETAZIONI VENEZIANE: STUDI DI STORIA DELL'ARTE IN ONORE DI MICHELANGELO MURARO 177, 180, fig. 3 (David Rosand, ed., Venice, Ital.: Arsenale Editrice, 1984) (hereinafter Rosand, *Venetia Figurata*). This figure is sometimes attributed to Filippo Calendario and has been dated anywhere from 1355 (the year of Filippo Calendario's death) to 1420. Id. at 178, n. 7. Rosand also noted that some commentators do not believe that this Venetia is a Justice figure or was derived from that iconography but rather that it stands for "Buon Governo." Id. at 179, n. 8.

**230** See DENNIS ROMANO, PATRICIANS AND POPOLANI: THE SOCIAL FOUNDATIONS OF THE VENETIAN RENAISSANCE STATE 157, plate 4 (Baltimore, MD: Johns Hopkins U. Press, 1987).

**231** Rosand, *Venetia Figurata* at 182, fig. 4, *Justice*, Porta Della Carta, Ducal Palace. That figure, by Bartolomeo Buon, once stood "against the sky" but can now be seen near the door to the doge's palace and its law courts. See DAVID S. CHAMBERS, THE IMPERIAL AGE OF VENICE, 1380–1580, 94–95, fig. 51 (London, Eng.: Thames & Hudson, 1970). Bartolomeo's earliest work dates to 1392 and comprises a significant variety of styles. See Anne Markham Schulz, *The Sculpture of Giovanni and Bartolomeo Bon and Their Workshop*, 68 TRANSACTIONS OF THE AMERICAN PHILOSOPHICAL SOCIETY 1 (1978).

**232** DAVID ROSAND, MYTHS OF VENICE: THE FIGURATION OF A STATE 32–34 and fig. 24 (Chapel Hill, NC: U. of North Carolina Press, 2001) (hereinafter ROSAND, MYTHS OF VENICE).

**233** CHAMBERS at 186, fig. 130 (*Justice*, by Alessandro Vittoria, 1579). Vittoria was a student of Sansovino, and the two worked jointly on many important architectural projects. Vittoria was primarily a sculptor known for his portrait busts and medals. See LORENZO FINOCCHI GHERSI, ALESSANDRO VITTORIA 11–48 (Udine, Ital.: Forum, 1998).

**234** Rosand, *Venetia Figurata* at 179. In the interior one can find a *Judgment of Solomon*. Id.

**235** Rosand, *Venetia Figurata* at 177–178.

**236** ROSAND, MYTHS OF VENICE at 5. The palace, in turn, was to be "considered a palace of Solomon." Id. at 99.

**237** Muir, *Images of Power* at 35. Rosand, *Venetia Figurata* at 179–181. Some Venetians also linked their republic to the Old Testament's Israel. SINDING-LARSEN at 151.

**238** MUIR, CIVIC RITUAL at 102–108. Muir explained that there was, "in fact, neither a naval victory nor even a naval battle; in 1176 the Lombard League defeated the imperial army at the battle of Legnano." Id. at 106. Further, because Venice did not participate, it was chosen as a site for peace negotiations, but the peace marked the "failure of the German emperors to assert political control over northern Italy, a reality that explains the anti-imperial tone of the story." Id. at 107. Frederick did give Venetian traders a "complete exemption from imperial tolls" throughout the empire. Id.

**239** MUIR, CIVIC RITUAL at 104.

**240** MUIR, CIVIC RITUAL at 108.

**241** Muir, *Images of Power* at 18. Muir added that the display did not necessarily match the "underlying realities." Id.

**242** MUIR, CIVIC RITUAL at 190, commenting that "position was everything."

**243** MUIR, CIVIC RITUAL at 114–115, 189–211.

**244** SINDING-LARSEN at 162 (that author's translation).

**245** CHAMBERS at 94.

**246** Giovanni Antonio Canal, called Canaletto, lived from 1697 to 1768; his scenes of Venice are one of the sources of his fame. Canaletto painted several such "veduti" (views) of this event. The version in figure 60 was provided by Scala / Art Resource, New York. The painting hangs in the Aldo Crespi Collection in Milan. Other versions include *Venice: The Basin of San Marco on Ascension Day*, in the National Gallery, London; *Bacino di San Marco with the "Bucintoro" on Ascension*, in the Pushkin Museum, Moscow; *The Bucintoro at the Molo on Ascension Day*, at the Philadelphia Museum of Art, Philadephia. See generally DOROTHEA TERPITZ, CANALETTO: 1697–1789, 35–45 (Köln, Ger.: Könemann, 1998).

Many other artists depicted the Bucintoro, which was occasionally used for other ceremonial purposes. The J. Paul Getty Museum in California has two such paintings by the Venetian Luca Carlevarijs, who lived from 1663 to 1730. One canvas, from 1711, is called *Regatta on the Grand Canal in Honor of Frederick IV, King of Denmark*, and the other, from 1710, is called *The Bucintoro Departing from the Bacino di San Marco*. Another, painted in 1776 by Giambattista Brustolini (1721–1795) and called *The Departure of the Bucintoro to Porto Lido on Ascension Day*, is in the Museum Boymans–van Beuningen collection, in Rotterdam, the Netherlands. The Guardi family of Venetian artists did several renditions. See ALVISE ZORZI, VENICE: THE GOLDEN AGE 1697–1797 at 24–25 (New York, NY: Abbeville Press, 1980); DECIO GIOSEFFI, CANALETTO AND HIS CONTEMPORARIES 81–92 (New York, NY: Crown Publishers, 1960).

**247** The Ascension, the moment when Jesus, in the presence of his apostles, ascended to Heaven, is generally understood in Christian doctrine to have taken place forty days after the Resurrection. Venetian ceremonies on Ascension Day included "blessings" of the sea and "a ceremony during which the Doge contracted marriage with the sea by dropping a gold ring overboard from his boat." See BOHOLM at 218–219.

**248** Documents from 1253 refer to a ducal ship as a Bucentaurum. BOHOLM at 221. In 1606 a more elaborate Bucintoro replaced its predecessor, and in 1729 yet another was launched. Id. The route taken by the Bucintoro is mapped in ZORZI at 24–25.

**249** See LINA URBAN PADOAN, IL BUCINTORO: LA FESTA E LA FIERA DELLA "SENSA" DALLE ORIGINI ALLA CADUTA DELLA REPUBBLICA 62–64 (Venezia, Ital.: Centro Internationale della Grafica di Venezia, 1988). The ceremony itself was described in materials dating from 1268. BOHOLM at 221.

**250** One commentator suggested that the boat became more elaborate as the Venetian political situation declined. See PADOAN at 8. The last Bucintoro was built in 1728–1729. MARTIN CLAYTON, CANALETTO IN VENICE 80 (London, Eng.: Royal Collection Publications, 2005).

**251** BOHOLM at 221–222.

**252** BOHOLM at 222.

**253** BOHOLM at 221.

**254** The details and order of events are provided in BOHOLM at 222–239.

**255** MUIR, CIVIC RITUAL at 124. The statements included "We wed you, o sea, as a sign of true and perpetual dominion." See ZORZI at 21. Muir pointed out the gendered roles; under Venetian law, husbands and fathers had authority over wives and children. MUIR, CIVIC RITUAL at 125. Muir interpreted the ritual as dimming the sea's "frightening" aspects by feminizing it. Id. at 132. He also noted that the ceremony persisted long past the time when Venice had lost such authority. Id. at 128.

**256** "By Canaletto's day, . . . the decline of Venice was becoming obvious. . . . The City seemed trapped in an outdated version of itself. The aristocratic constitution was an anachronism, and the great annual ceremonies of the Republic . . . were now spectacles that had lost their vital meaning." CLAYTON at 12–13.

**257** A German, Arnold von Harff, wrote in 1497 about the pageantry. He explained the "gilt maiden" on the ship as holding a "naked sword" and "golden scales" signifying "that she will do justice; for the same reason the maiden holds the scales in the left hand." ROSAND, MYTHS OF VENICE at 37.

**258** *Venice in the Form of Justice* (woodcarving from the sixteenth century, wood and polychrome, Museo Storico Navale di Venezia); this piece is what remains of the 1525–1526 Bucintoro on which it once sat. See PADOAN at "Tavola," fig. 18. Figure 61, undated, and Figure 62, from a 1526 Bucintoro, were provided and reproduced with the courtesy of the Museo Storico Navale di Venezia.

**259** MUIR, CIVIC RITUAL at 114.

**260** Rosand, *Venetia Figurata* at 179.

**261** Before 1701, the monarchy had more control over art patronage than after that time, when "political parties began to exercise far greater influence on patronage." SIMON THURLEY, HAMPTON COURT: A SOCIAL AND ARCHITECTURAL HISTORY 211 (New Haven, CT: Yale U. Press, 2003).

**262** Anne is sometimes portrayed as lacking force, but some scholarship finds her a powerful monarch, deliberately linking her authority to that of Elizabeth and insisting on her true "English" stature, in contrast to that of William III. See CHARLES BEEM, THE LIONESS ROARED: THE PROBLEMS OF FEMALE RULE IN ENGLISH HISTORY 102–103, 127 (New York, NY: Palgrave Macmillan, 2006); R. O. Bucholz, *"Nothing but Ceremony": Queen Anne and the Limitations of Royal Ritual*, 30 J. BRITISH STUDIES 288 (1991). Commentators on the public sphere identify Anne's reign as a time when the impact of public opinion on politics was clear. See Heinz-Joachim Müllenbrock, *Public Opinion in Eighteenth-Century England*, in SITES OF DISCOURSE —PUBLIC AND PRIVATE SPHERES—LEGAL CULTURE 109, 110–113 (Uwe Böker and Julie A. Hibbard, eds., Amsterdam, Neth.: Rodopi, 2002).

**263** Figure 63, *Queen Anne as Justice*, was provided and is reproduced with permission of the Historic Royal Places under license from the Controller of Her Majesty's Stationery Office.

**264** THURLEY at 129–209. Verrio, who was born around 1639 and died in 1707, was an Italian who worked a good deal in England. In 1684 he was appointed as a principal painter to the King, and he left the Court in 1688 after the Glorious Revolution. Verrio's work for Windsor Castle was destroyed by fire in the 1820s. The image is reproduced with the permission of the Historic Royal Palaces under license from the Controller of Her Majesty's Stationery Office.

**265** THURLEY at 209–221. Anne was then not quite fifty. Under one of the provisions of the 1701 Act of Settlement, the English sovereign had to be a Protestant. Anne, daughter of James II and his first wife, Anne Hyde, qualified over James's son, Francis Edward, a Catholic born to the King's second wife. ROY NASH, HAMPTON COURT: THE PALACE AND THE PEOPLE 143 (London, Eng.: MacDonald, 1983). The role played by the 1701 Act of Settlement in shaping a form of judicial independence is discussed in Chapter 13.

**266** THURLEY at 211–212. During the first part of Anne's reign (before 1708, when her husband, Prince George, died), she spent little time at Hampton Court.

**267** ERNEST LAW, THE HISTORY OF HAMPTON COURT PALACE 174, vol. 2 (London, Eng.: George Bell and Sons, 1891); THURLEY at 216 (also noting that the assemblies were "thinly attended"). Exactly why, in 1703 and 1704, Anne began the restoration is unclear. She had expressed little interest in being at Hampton Court and was, in fact, financially strapped. "The financial records show that painting the room was never a priority, and money did not flow easily into Verrio's pocket." THURLEY at 213. "Half-way through he begged for more money as he hadn't enough to buy the colours he needed." R. J. MINNEY, HAMPTON COURT 196 (London, Eng.: Cassell, 1972). Thurley speculated (in part because of some of the paintings in the Drawing Room) that Anne's spouse, Prince George, liked Hampton Court, and after his death she returned to it out of affection for him. THURLEY at 213–216.

**268** THURLEY at 213.

**269** Great Britain, Ministry of Public Works, HAMPTON COURT PALACE: A HAND LIST OF THE PICTURES 21 (London, Eng.: Her Majesty's Stationery Office, 1954).

**270** LAW at 174.

**271** The cornucopia appeared in numerous entries in the various Ripa editions, including those featuring Abundance, Prosperity, Agriculture, Tranquility, Peace, and Charity. The cornucopia also stood as a symbol for the autumn season and for particular geographic regions such as Europe, Italy, and Africa. Below the cornucopia the three Graces can be identified, each holding a wreath. Below them is the figure of Vigilance, with a crane and a lantern.

**272** See Matthias Winner, *The Orb as the Symbol of the State in the Pictorial Cycle of Rubens Depicting the Life of Maria de' Medici*, in ICONOGRAPHY, PROPAGANDA, AND LEGITIMATION 63, 84–86 (Allan Ellenius, ed., Oxford, Eng.: Clarendon Press, 1998). Winner explained that the image shows France as a "subjugated province brought by Saturn before Justitia, the ruler of the world." Id. at 86.

**273** THURLEY at 213. By the time he did this work, Verrio had cataracts and relied on assistants. Id. Verrio died in 1707.

**274** See Edgar Wind, *Julian the Apostate at Hampton Court*, 3 J. WARBURG & COURTAULD INST. 127 (1939/1940). Wind focused on the Verrio decoration of the King's Staircase at Hampton Court, which Walpole described as poorly done—"as if he had spoiled it out of principle." Id. at 127. See also Paul Monod, *Painters and Party Politics in England, 1714–1760*, 26 EIGHTEENTH-CENTURY STUDIES 367, 373 (1993). Wind thought that Verrio ("a faithful Catholic") did not want to work for the Crown but was persuaded to do so by Lord Exeter. Id. See also THURLEY at 202. Monod examined the lack of a robust English tradition of history painting, which he attributed (at 376) to "the lack of a suitable royal patron," as well as to the distrust of such work born of its "association with continental Roman Catholicism" and its propagandistic purposes. Monod at 371–372.

**275** "Verrio's ceiling depicts the Queen in the role of Justice and one can only hope that the irony of the chosen subject afforded the artist some quiet satisfaction." NASH at 145.

**276** LAW at 174. Nash, at 144, reported that the wall paintings were covered from 1741 until 1899.

**277** Bucholz at 305, 312.

**278** Bucholz at 313.

**279** Bucholz at 314.

**280** See DAVID M. BERGERON, ENGLISH CIVIC PAGEANTRY 1558–1642 at 1–5 (London, Eng.: Edward Arnold, 1971) (hereinafter BERGERON, CIVIC PAGEANTRY). See generally THE INVENTION OF TRADITION (Eric Hobsbawm & Terence Ranger, eds., Cambridge, Eng.: Cambridge U. Press, 1983).

**281** Email from Dominic Reid, Pageantmaster of the Lord Mayor's Show, to the authors (Oct. 25, 2005), providing lecture notes. See generally CELINA FOX, LORD MAYOR'S COACH (London, Eng.: Museum of London, 1990).

**282** "Lord Mayor's Show: Obstacles and Accidents," http://www .lordmayorsshow.org/visitors/history/obstacles.

**283** David M. Bergeron, *The Elizabethan Lord Mayor's Show*, 10 STUDIES IN ENGLISH LITERATURE, 1500–1900, 269, 269 (1970) (hereinafter Bergeron, *Lord Mayor's Show*). The "processional through the city of London each 29th of October" for the oath taking was followed by a feast at the Guildhall. Id. at 269. See also BERGERON, CIVIC PAGEANTRY at 4–5.

**284** Moreover, the Lord Mayor's Show was "the dominant form of civic pageantry" during the era of James I and Charles I. See Bergeron, *Lord Mayor's Show* at 284. Bergeron categorized the civic pageantry of the sixteenth and seventeenth centuries as of three types—sovereign "progresses" through various parts of the country, "royal entries" in official processionals, and pageants such as the Lord Mayor's Show that included ritualistic vignettes and dramatization. BERGERON,

CIVIC PAGEANTRY at 3. A fourth type involved the public ceremonies of execution. See Thomas W. Laqueur, *Crowds, Carnival and the State in English Executions, 1604–1868*, in THE FIRST MODERN SOCIETY: ESSAYS IN ENGLISH HISTORY IN HONOUR OF LAWRENCE STONE 305–355 (A. L. Beier, David Cannadine, & James M. Rosenheim, eds., Cambridge, Eng.: Cambridge U. Press, 1989).

**285** "Lord Mayor's Show: The Show in Art and Literature," http://www.lordmayorsshow.org/visitors/history/literature. The Lord Mayor's barge can be seen in some Thames views by Canaletto, such as a painting called *Westminster Bridge from the North on Lord Mayor's Day*, 1746 (Yale Center for British Art, Paul Mellon Collection), reproduced in FOX at 5, fig. 4. See also Tessa Murdock, *The Lord Mayor's Procession of 1686: The Chariot of the Virgin Queen*, 34 TRANSACTIONS OF THE LONDON & MIDDLESEX ARCHAEOLOGICAL SOCIETY 207, 211, plate 3 (*The Lord Mayor's Procession by Water to Westminster*, 1683, a photogravure based on an oil painting in the Royal Collection) (1983). In 1857, the Lord Mayor "ceased to be transported by water to Westminster." FOX at 8. Coaches were the ordinary means of travel at that time, with more than "120,000 privately owned large carriages and 250,000 light wheelers" still in use in 1870. See David Cannadine, *The Context, Performance and Meaning of Ritual: The British Monarchy and the 'Invention of Tradition,' c. 1820–1977*, in THE INVENTION OF TRADITION 111–112 (hereinafter Cannadine, *Meaning of Ritual*).

**286** In addition, Charles Catton ("coach-painter to George III") painted the heraldic devices. Both were founding members of England's Royal Academy of Arts. See FOX at 12, 16.

**287** FOX at 15–16, figs. 24–27. The nomenclature Truth (instead of Prudence) for a woman with a mirror is also used for the sculptures in Dublin Castle, discussed later. In the rendition on the Lord Mayor's Coach, Justice has a blindfold, scales, and sword; Temperance a bridle; and Fortitude a column. In addition, panels show an allegory of the "Genius of the City" surrounded by a cornucopia, Neptune, coins, fruit, and representations of "Fame" and "Riches and Plenty." Id. at 12–14, figs. 20–22.

**288** "Lord Mayor's Show: The Lord Mayor's Procession," http://www.lordmayorsshow.org/visitors/procession.

**289** See J. Robert Browning, Spectacle and the Public Sphere in Seventeenth-Century England 3 (Ph.D. dissertation, Department of English, Indiana U., Bloomington, IN, 2004; UMI Publication No.: AAT 3152794) (emphasis in the original).

**290** MICHEL FOUCAULT, DISCIPLINE AND PUNISH: THE BIRTH OF THE PRISON (Alan Sheridan, trans., New York, NY: Vintage Books, 2nd ed., 1977).

**291** Figure 64, reproduced with the assistance of the Beinecke Rare Book and Manuscript Library of Yale University, is an 1836 print by George Cruikshank, who lived from 1792 to 1878. Cruikshank was a famous satirist who generated thousands of images, some lampooning English customs and politics and others mild-mannered. About 250 etchings were first published through the *Comic Almanack*, founded in 1835 and in circulation until 1853. See Frank Palmeri, *Cruikshank, Thackeray, and the Victorian Eclipse of Satire*, 4 STUDIES IN ENGLISH LITERATURE 753, 755 (2004); MICHAEL WYNN JONES, GEORGE CRUIKSHANK: HIS LIFE AND LONDON xiii, 80 (London, Eng.: Macmillan, 1978). Cruikshank was its principal illustrator, and the magazine was priced to be affordable to lower-middle-class households. Palmeri at 756. The politics of the magazine and of Cruikshank changed over time, moving from more radical satire toward "respectable social satire and middle-class comedy." Id. at 764. See generally *George Cruikshank: A Reevaluation* (Robert L. Patton, Guest Editor), 35 PRINCETON U. LIBRARY CHRONICLE vii et seq. (1973–1974). This print is one of many examples of royal traditions criticized by the press. See Cannadine, *Meaning of Ritual* at 111–112.

**292** See FOX at 5–6, fig. 5, *The Industrious [']Prentice Lord Mayor of London*, 1747. Fox proffered the view that the mob was "disorderly"

and the militia inert. Id. at 5. This print is one of a series by Hogarth published under the name *Industry and Idleness*.

**293** FOX at 7–8, fig. 8, *Lord Mayor's Day*, 1835. The wood engraving is "after George Cruikshank (1792–1878)." The publication of this 1835 image followed the enactment in that year of the Municipal Reform Act. Id. at 7.

**294** See SITES OF DISCOURSE—PUBLIC AND PRIVATE SPHERES—LEGAL CULTURE; DAVID ZARET, ORIGINS OF DEMOCRATIC CULTURE: PRINTING, PETITIONS, AND THE PUBLIC SPHERE IN EARLY-MODERN ENGLAND (Princeton, NJ: Princeton U. Press, 2000); JÜRGEN HABERMAS, THE STRUCTURAL TRANSFORMATION OF THE PUBLIC SPHERE: AN INQUIRY INTO A CATEGORY OF BOURGEOIS SOCIETY (Thomas Burger, trans., Cambridge, MA: MIT Press, 1991); HABERMAS AND THE PUBLIC SPHERE (Craig Calhoun, ed., Cambridge, MA: MIT Press, 1992). The formation of opinions fairly described as held by "a public" and its impact on governments has produced a body of scholarship that identifies examples from as early as the sixteenth century. See DONALD VEALL, THE POPULAR MOVEMENT FOR LAW REFORM, 1640–1660 (Oxford, Eng.: Oxford Clarendon Press, 1970). Veall argued (based on readings of the works of many "pamphleteers") that the participants in reforms that had lasting effects (despite the Restoration) included not only social leaders but English workers and the poor, distressed about the corruption of the bench and bar, about legal procedures then in use, and about the reliance on Latin and French, inaccessible to many. Id. at ix–xii, 30–64, 98–122. The development of a literate public is detailed in TIM BLANNING, THE PURSUIT OF GLORY: EUROPE, 1648–1815 at 475–486 (New York, NY: Viking, 2007). We return to examine these issues and adjudication's relationship to them in Chapter 13.

**295** FOX at 8, fig. 9, reproducing the painting, called *The Ninth of November, 1887–90* by William Logsdail, that details the "brilliant entourage." Id. at 8.

**296** David Cannadine, *The Transformation of Civic Ritual in Modern Britain: The Colchester Oyster Feast*, 94 PAST & PRESENT 107, 130 (1982). See also Cannadine, *Meaning of Ritual*.

**297** GEORGE NEWENHAM WRIGHT, AN HISTORICAL GUIDE TO THE CITY OF DUBLIN 155 (Dublin, Ire.: Four Courts Press & Irish Academic Press, 1980; originally printed in 1821).

**298** "The Four Courts: Heritage," at the website An tSeirbhís Chúirteanna Courts Service, http://www.courts.ie (follow hyperlinks) (hereinafter "The Four Courts").

**299** See generally David Evans, *Theatre of Deferral: The Image of the Law and the Architecture of the Inns of Court*, 10 LAW & CRITIQUE 1 (1999). Evans argued that, in their London instantiation, the Inns exemplified the labyrinthine and specially guarded body of the law. Id. at 12–20.

**300** The foundations of Dublin Castle date from the rule of King John in 1204. RÓISÍN KENNEDY, DUBLIN CASTLE ART: THE HISTORICAL AND CONTEMPORARY COLLECTION 11 (Dublin, Ire.: Government of Ireland, 1999).

**301** WRIGHT at 160–162. See also Edward McParland, *The Early History of James Gandon's Four Courts*, 122 BURLINGTON MAGAZINE 727 (1980).

**302** McParland at 728.

**303** WRIGHT at 156.

**304** McParland at 735.

**305** The beginning of construction of the Four Courts is variously dated as 1776 or 1786, with designs by Thomas Cooley. McParland at 728; WRIGHT at 157. In 1784 James Gandon added to the plans, and the buildings were completed in 1791. WRIGHT at 157. Whether it was initially intended as a court is not clear. The 1776 notes by Cooley detail the laying out of a building to house "public Law Offices, the Hall and Law Library," for use by the Society of the King's Inns, but no mention was made of courtrooms. McParland at 728. During the civil wars, much destruction occurred, including the "irreparable loss" of the Pub-

lic Records Office, which housed the complete records of the Irish Parliament. Renovation and restoration followed after the 1922 civil war. "The Four Courts" at 2; Pat Liddy, Dublin: A Celebration: From the 1st to the 21st Century 61 (Dublin, Ire.: Dublin Corporation, 2000).

306 Maurice Craig, *Burlington, Adam and Gandon*, 17 J. Warburg & Courtauld Insts. 381, 381 (1954). Craig added that it was "ironical" that James Gandon, "this son of a French Protestant, who had never been to Rome, should have given this design to the Irish capital in the Indian summer of the Protestant Ascendancy." Id. at 382.

307 Wright at 157.

308 Wright at 159. "None of Gandon's original interiors survive," nor do the Edward Smyth "plaster figures" that represented Justice, Wisdom, and the like. Christine Casey, Dublin 96–97 (New Haven, CT: Yale U. Press, 2005).

309 Kennedy at 13, 92–93. See also Peter Costello, Dublin Castle in the Life of the Irish Nation 53–71 (Dublin, Ire.: Wolfhound Press, 1999). Kennedy noted that other statuary of "monarchs or political figures . . . became the target for the public's anger" and presumed that allegorical figures were less politically provocative. Kennedy at 93. The interior iconography includes another Justice in the allegory *George III, Supported by Justice and Liberty*, by Vincenzo Waldré. Id. at 19.

310 "Lead was quite a common material for outdoor sculpture" in this era, and it was "cheaper than bronze or marble." Kennedy at 93. When restored in the 1980s, this statue was found to have had "thirty layers" of paint. Placed on a new stone base, Justice was given a new stainless steel blade. Id.

311 Van Nost, who lived from 1750 to 1787, "was the dominant sculptor in Dublin in the mid-18th century." Kennedy at 90. One commentator described him as having "almost a monopoly on sculptural work in Ireland"; no "native artists" compared. See Walter George Strickland, A Dictionary of Irish Artists 478, 485 (Shannon, Ire.: Irish U. Press, 1969).

312 Kennedy at 93.

313 Kennedy at 93. Another statue, a helmeted male figure called either Fortitude or Mars, also has his back to the city. Id.

314 Our thanks to Stephen Jones, Building Manager of London's Central Criminal Court (the "Old Bailey"), who provided us with information and a tour and enabled us to obtain the photograph reproduced in figure 67 courtesy of the Corporation of London. The building opened officially in 1907. The sculpture of Justice was cast and mounted in 1906. Many other sculptures adorn the exterior, but only *Justice* and the trio above the front entrance, titled *Fortitude, Truth, and the Recording Angel*, were named. See Philip Ward-Jackson, Public Sculpture of the City of London 62, 64 (Liverpool, Eng.: Liverpool U. Press, 2003). Inscribed next to the group is the legend, paraphrased from *Psalm* 72, "Defend the children of the poor and punish the wrongdoer." See *The Official Guide to the Old Bailey* 14 (London, Eng.: Corporation of London, 1992) (hereinafter *Old Bailey Official Guide*).

315 *Old Bailey Official Guide* at 14. The booklet also noted that this Justice is "especially distinguished from other statues of Justice by not being blindfolded." Id. That refrain was also heard when the building opened; a local weekly paper called the *Building News* also noted that Justice was "without her eyes bandaged." Ward-Jackson at 63. In contrast, three other buildings in London—the Institute of Chartered Accountants, the Norwich Union Insurance Building, and 13 Moorgate—built in the same era portrayed Justice with a blindfold. Id. Other news commentary at the time focused on the gesture of the Old Bailey's Justice. The London newspaper, the *Times*, saw a reference to Christian imagery, pointing out that "Justice . . . has her arms stretched out . . . so as to form a kind of cross . . . . The arms of Justice seemed stretched out in an ecstasy of rage and despair." Id.

316 See Edward W. Mountford, *The New Sessions House, London*, 21 Architectural Review 136 (1907). Mountford's design has been described as the "first public building in the City in the mature Edwar-

dian Baroque manner." Simon Bradley & Nikolaus Pevsner, London I: The City of London 121 (London, Eng.: Penguin Group, 1997). See also "History of the Old Bailey Courthouse," Old Bailey Online, http://www.oldbaileyonline.org/static/The-old-bailey.jsp (hereinafter History of the Old Bailey). The nickname comes from the street on which the building sits, which follows the lines of the old fortified walls—baileys—of London. Newgate Prison, "for those accused of serious crimes," was once nearby, and the current building stands on the prison's earlier site. *Old Bailey Official Guide* at 3–4, 10.

Several buildings were its predecessors, with a first built on that site in 1673 after the Great Fire of London of 1666 had destroyed an earlier Medieval court. The 1673 Old Bailey was a three-storied Italianate building. The ground floor was open so that fresh air might limit the spread of disease. That space was enclosed in a renovation in 1737, and thereafter a typhus epidemic killed dozens, "including the Lord Mayor and two judges." The building was again renovated in 1774 and in 1834. See "History of the Old Bailey." See generally Allyson N. May, The Bar and the Old Bailey, 1750–1850 (Chapel Hill, NC: U. of North Carolina Press, 2003). The 1907 building included "90 cells for temporary reception of prisoners awaiting trial." Stones from a demolished prison that had once occupied the site were used in its facade. *Old Bailey Official Guide* at 11. In 1941, during World War II, the building was hit by a bomb that obliterated a courtroom and did other damage. The lunettes were repainted under the supervision of Gerald Moira, who had done some of the earlier work. Id. at 12.

317 Email from Howard Doble, Senior Archivist, Old Bailey (Nov. 10, 2005), citing a report in which Mountford stated that for the "Bronze Figure of Justice on the summit of the dome, and the Allegorical figures over the principal entrance, I should propose to employ a sculptor of know[n] reputation." The architect, in turn, was selected through a competition among six architects nominated by the Royal Institute of British Architects (RIBA). The competition was juried by members of the House of Lords' Special Sessions House Committee and a professor. Id. Mountford served a term as the president of the Architectural Association; he designed the Battersea Town Hall (1892–1893) and won a competition in 1890 for the Sheffield Town Hall. Mountford employed Pomeroy as the sculptor in Sheffield. Susan Beattie, The New Sculpture, 61–62 (New Haven, CT: Paul Mellon Centre for Studies in British Art, Yale U. Press, 1983).

Pomeroy, who lived from 1856 until 1924, was particularly attentive to the relationship between sculpture and architecture, insistent that "sculptors' work is bound up with that of the architect" and arguing that an architect ought to "carefully select his sculptor and give him a fairly free hand in carrying out his work." Id. at 61. Pomeroy and Mountford had a "working 'marriage'" during the first decade of the twentieth century. Id. at 122. In 1904, Pomeroy was part of a group that formed a Society of British Sculptors, representing a move away from prior collaborative work in the Art Workers Guild and aspiring to define a specific sculptural idiom. Id. at 133–134.

318 Mountford at 137; Beattie at 121, fig. 103. *Old Bailey Official Guide* at 15. The other lunettes in that hall represent "Mosaic and English Law" through Moses and King Alfred. Mountford at 137. In another hall, references are made to Greek and Roman law as well as to a "Golden Age before laws became a necessity" in a scene by Sir William Richmond. Id. at 137–138. Gerald Moira was also the artist for the allegories of Truth, Wisdom, Knowledge, and Labour. As in the discussion of the statuary in Ireland, a woman with a mirror is identified as Truth, whereas on the continent she is often called Prudence. See, for example, Mountford at 141. The development of the statuary of the Old Bailey was part of a period in which decorative sculptors, working in partnership with architects, made many monumental carvings that were "accepted" as features of "grandiose commercial premises and public offices." Beattie at 118. Pomeroy used many classical figures in his work, crafting them in a style he termed "imaginative realism." Id. at 62.

**319** *Old Bailey Official Guide* at 17.

**320** MARK HERBER, LEGAL LONDON: A PICTORAL HISTORY at 25 (Chichester, Eng.: Phillimore, 1999).

**321** The statue does not have a Phrygian cap, long associated with liberty rather than enslavement, but instead has a pointed crown.

**322** A parody of the Old Bailey *Justice* was used for "Injustice" in 2004 when a 3.5-ton, twenty-foot-high bronze statue was erected on Clerkenwell Green. The mocking blindfolded version, "an amalgam of the Statue of Liberty and the Old Bailey's Statue of Justice," addressing wrongful convictions and other miscarriages of justice, had her skirt hiked up to reveal thigh-high PVC boots and a garter belt with U.S. dollars in it. *Oh, the Injustice of It!* WESTERN DAILY PRESS (Bristol, Eng.), Aug. 6, 2004, at 20.

**323** See Thomas Fröschl, *Republican Virtues and the Free State: Conceptual Frame and Meaning in Early Modern Europe and North America*, in ICONOGRAPHY, PROPAGANDA, AND LEGITIMATION 255, 275 (Allan Ellenius, ed., Oxford, Eng.: Clarendon Press, 1998).

**324** In 1973 Kansas's legislature authorized the construction of the Kansas Judicial Center, which was completed in 1978. The building, "located on a direct axis with the Capital," houses the Supreme Court, Court of Appeals, offices of the Attorney General, and a law library. *Brochure of the Office of Judicial Administration* (Topeka, KS: undated) (hereinafter *Kansas Brochure*).

**325** Jim Richardson, *A Hard Day's Labor of Love*, TOPEKA CAPITAL-JOURNAL, Apr. 3, 1977, at 25. The cost of the marble, its importation, and the work came to $60,000. After the legislature declined to pay, a member of the Kansas business community, A. B. Hudson, donated the funds. Letter from Richard Ross, Reporter of Decisions of the Kansas Supreme Court (Nov. 3, 2005) (hereinafter Ross Letter). Our thanks to him and to Chief Justice Kay McFarland for providing us with the history of the sculpture and assistance in obtaining the photograph in figure 68, reproduced courtesy of the Kansas Judicial Branch.

**326** *Kansas Brochure*.

**327** Ross Letter.

**328** *Kansas Brochure*.

**329** The original design for the transparently covered building, modified somewhat thereafter, was by Arthur Erickson and Bing Thom, described on the Vancouver website as crafting a building to express their commitment "that justice should not only be done but also be seen to be done." "Tourism Vancouver: Serious Architecture," http://www.tourismvancouver.com/media/media_kit/arts-and-culture/architecture. The Law Courts are part of a civic center and public plaza encompassing three blocks in downtown Vancouver. In addition to the seven-story courthouse, the complex includes a "government office building, an indoor mall, outdoor plazas, and an old courthouse transformed into the Vancouver Art Gallery." "Robson Square—Arthur C. Erickson—Great Buildings Online," http://www.greatbuildings.com/buildings/Robson_Square.html.

**330** Harman, born in Vancouver in 1927, studied in Europe before returning to Vancouver, where he taught art and established "the first sculpture foundry in B.C.," thereby providing space for many other artists to cast in bronze. He received the Order of British Columbia and died in 2001. "O.B.C. Biography—Jack Harman," http://www.protocol.gov.bc.ca/protocol/prgs/obc/1996/1996_JHarman.htm (site owned by the Government of British Columbia Protocol & Events Branch). The Justice depicted in figure 69 is formally called *Justice 3, Themis, Goddess of Justice*. Our thanks to Harman Sculpture Foundry, Ltd., Alberta, Canada, and to the Law Courts Education Society of British Columbia for the use of this image, and to Geoff Cowper, Greg Pun, and Dave Nolette for locating a high-resolution image.

**331** City of Vancouver Public Art Registry, http://vancouver.ca/PublicArt_Net/. That website also reports that Harman was inspired by "the mythical character Diana," who was a goddess of the hunt and related to the Greek Artemis. Id.

**332** Eric Hobsbawm, *Introduction: Inventing Traditions*, in THE INVENTION OF TRADITION at 1, 9.

**333** Ruling powers relied on more, of course, including personifications of themselves to assign magical authority to their persons. See Allan Ellenius, *Introduction: Visual Representations of the State as Propaganda and Legitimation*, in ICONOGRAPHY, PROPAGANDA, AND LEGITIMATION 1, 2–6 (hereinafter Ellenius, *Introduction*); Kurt Johannesson, *The Portrait of the Prince as a Rhetorical Genre*, in ICONOGRAPHY, PROPAGANDA, AND LEGITIMATION at 11, 11–36.

**334** As Wim Blockmans and Jean-Philippe Genet put it: "[J]ustice was a more effective factor in establishing the authority of the state, and in rendering it effective, than was legislation." Wim Blockmans & Jean-Philippe Genet, Preface to ICONOGRAPHY, PROPAGANDA, AND LEGITIMATION at vii–ix.

**335** RIPA, PADUA–1611 at 203.

**336** The explanations for that retreat are multiple, ranging from a postmodern critique of semiotics to ideas about how the invention of machinery shifted the metaphor of the world from an organism to a machine requiring clarity about its internal mechanical operation. See Ellenius, *Introduction* at 6–7.

**337** One argument for Justice's endurance is that her placement does not displace a "prevailing sense of decorum." See Van der Velden, *Cambyses for Example* at 39. He commented that the "age during which judges exhorted themselves to keep to the path of true justice by gazing upon shining examples" such as Cambyses and Zaleucus came to an end in the eighteenth century and that, thereafter, scenes "less violent" took their place. Id.

## CHAPTER 5

**1** *Justice*, from THE COLLECTED POEMS OF LANGSTON HUGHES by Langston Hughes, edited by Arnold Rampersad with David Roessel, Associate Editor (New York, NY: Knopf, 1994) (hereafter HUGHES, *Justice*). The poem, © 1994 by the Estate of Langston Hughes, is used with the permission of Alfred A. Knopf, a division of Random House Inc. and Harold Ober Associates (as required by Random House under grant 271977, February 9, 2010). The poem appears on page 31 of that collection.

**2** Rex A. Collings Jr., *Review of Cavalcade of Justice by Bernard O'Donnell*, 38 VIRGINIA LAW REVIEW 977, 978 (1952). O'Donnell's other works included *The Trials of Mr. Justice Avery* and *The World's Strangest Murders*.

**3** See BERNARD O'DONNELL, THE OLD BAILEY AND ITS TRIALS 14 (New York, NY: Macmillan, 1951).

**4** Ramona Markalunas, *Pitkin County Courthouse, Centennial Celebration, 1890–1990* (Aspen, CO: Aspen Historical Society, 1990). Another example of the claim that a Justice without a blindfold is anomalous can be found in Bailey Van Hook, *Clear-Eyed Justice: Edward Simmons's Mural in the Criminal Courts Building, Manhattan*, 73 NEW YORK HISTORY 443, 451 (1992) (describing the image as "rare but not unprecedented" and citing as another example the clear-eyed sculpture on top of New York City Hall that we depicted in Chapter 1, fig. 13).

**5** The photograph in figure 70 was provided to us by the photographer, William Clift, who took the picture as part of the Joseph E. Seagram & Sons Court House Project, documented in the publication of *Court House: A Photographic Document* (Richard Pare, ed., New York, NY: Horizon Press, 1978). The Clift photograph of Aspen's *Justice* appears in plate 69 of *Court House*; the building's architect is there identified as William Quay. Our thanks to Anna Lookabill Scott, the archivist of the Aspen Historical Society, for providing us with research materials and images of the building. According to the Aspen Preservation Committee (in minutes, circa 1973), the statue, manufactured in Salem, Ohio, cost $250.00.

**6** Eva Hodges, *Where's the Blindfold*, Empire Magazine, Sept. 13, 1981 at 50–51 (quoting a local county judge).

**7** See Otto Rudolf Kissel, Die Justitia: Reflexionen über ein Symbol und seine Darstellung in der Bildenden Kunst (Justice: Reflections on a Symbol and Its Representation in the Plastic Arts) 92 (Munich, Ger.: Verlag C. H. Beck, 1984). Kissel stated that the Minister of Public Works, in agreement with the Minister of Justice, ordered that depictions of Justice in new court buildings show her clear-eyed.

**8** See Van Hook at 458, citing *Open-Eyed Mural Irks Courtroom*, New York Times, Oct. 26, 1956, at 30. Spectators also objected to "scales that were unevenly balanced." Id.

**9** See generally Hans Belting, The End of the History of Art? (Chicago, IL: U. of Chicago Press, 1987).

**10** Battisti Fiera, De Iusticia Pingenda, On the Painting of Justice: A Dialogue between Mantegna and Momus (James Wardrop, trans., London, Eng.: Lion and Unicorn Press, 1957) (hereinafter Fiera/Wardrop). Wardrop reproduced the Latin, provided a translation, and offered commentary. Fiera's work is also mentioned in Esther Gordon Dotson, *An Augustinian Interpretation of Michelangelo's Sistine Ceiling, Part I*, 61 Art Bulletin 223, 251, n. 143 (1979), and in Michael A. Jacobsen, *The Meaning of Mantegna's Battle of Sea Monsters*, 64 Art Bulletin 623, 626, n. 19 (1982).

**11** See Fiera/Wardrop at 10. The destruction occurred in 1780 under Pius VI.

**12** The painting is dated circa 1502 and is alternately titled *Expulsion of the Vices from the Garden of the Virtues*. See Marina Warner, Monuments & Maidens: The Allegory of the Female Form 151–152 (New York, NY: Atheneum, 1985), and Rose Marie San Juan, *The Court Lady's Dilemma: Isabella d'Este and Art Collecting in the Renaissance*, 14:1 Oxford Art Journal 67, 73 (1991).

**13** See David Cast, *Marten van Heemskerck's Momus Criticizing the Works of the Gods: A Problem of Erasmian Iconography*, 7 Simiolus: Netherlands Quarterly for the History of Art 22 (1974). See also Randolph Starn, *A Postmodern Renaissance?* 60 Renaissance Quarterly 1, 15 (2007) (describing Momus as "part mortal, part god" and appearing in many guises). In the United States, the name retains some currency through its use by a group calling itself Momus as it regularly participates in New Orleans's Mardi Gras celebrations.

**14** Plato, Republic VI, 161, 487a (G. M. A. Grube, trans., revision by C. D. C. Reeve, Indianapolis, IN: Hackett, 1992).

**15** Cast at 23–24.

**16** Cast at 27–29, 32. For example, for Erasmus, Momus offered a form of critique that could lead to "true wisdom." Id. at 28.

**17** Cast at 25.

**18** Cast at 27.

**19** Cast at 22, translating the lines near the 1561 painting *Momus Criticizing the Works of the Gods* by Marten van Heemskerck.

**20** Wardrop suggested that Fiera made a direct reference to Mantegna's commission and Pope Innocent's patronage. Wardrop cited a sentence from Fiera's text—"sic iussit qui omnia potest," which means "thus commanded he who has power over all" (translation by Allison Tait). Wardrop then inferred that "the designation can be none other than the Pope's." Fiera/Wardrop at 12.

**21** Fiera/Wardrop at 28. Lawyers were also described as "inane," "longwinded," and "needlessly contentious," and philosophers as persons who did not often "agree among themselves." Id.

**22** These excerpts come from the English translation, provided in Fiera/Wardrop at 27–41. Fiera did not mention obscuring Justice's eyes, arguably because blindfolds were not yet signifiers of incorruptibility, nor did they later become common in Italy in Justice displays.

**23** See Jacobsen at 626. That practice was one advised for painters by Leone Battista Alberti, recommending that artists have associations with "poets and literary men whose knowledge" would be useful for artists' "inventions." Dotson at 251, citing Alberti, *De Pictura*,

III at 53. See also Fiera/Wardrop at 10 (assuming that the dialogue had a factual predicate and also citing Mantegna's 1488 commission from Innocent VIII, for which the painter traveled to Rome).

**24** Also from Mantua was the Vicar General of the Carmelite Order, invoked as a "philosopher" in Fiera's dialogue. See Dotson at 251, n. 143.

**25** See Ernst Gombrich, *Personification*, in Classical Influences on European Culture AD 500–1500 at 253 (R. R. Bolgar, ed., Cambridge, Eng.: Cambridge U. Press, 1971). Gombrich focused on a line from one of Fiera's scholastic theologians, that "Justice cannot be depicted at all because she is identical with the will of God." This paper can also be found online at the Gombrich archive: http://www.gombrich.co.uk/showdoc.php?id=20.

**26** Fiera/Wardrop at 12. Yet Wardrop thought it might also be an "elaborate parody of a situation common to the experience of Renaissance painters . . . [in an] age . . . beginning to run mad on allegory." Id. at 13.

**27** On hostility to imagery and the sense of it as false, see Costas Douzinas & Lynda Nead, *Law and Aesthetics*, in Law and the Image: The Authority of Art and the Aesthetics of Law 1–9 (Costas Douzinas & Lynda Nead, eds., Chicago, IL: U. of Chicago Press, 1999) (hereinafter Law and the Image).

**28** See Luther Link, The Devil: A Mask without a Face (London, Eng.: Reaktion Books, 1995).

**29** Christian-Nils Robert argued that Justice was the "perfect allegory" ("la Justice est dès lors allégorie parfaite") from the sixteenth century through the eighteenth. He posited that a female brandishing a sword, holding scales, and sometimes blindfolded both captured an idealized state power (in that real women could neither be soldiers nor use swords—the common means of execution in France between 1551 and 1798)—and denoted some ambivalence toward centralized authority. Christian-Nils Robert, La Justice: Vertu, Courtisane et Bourreau 95 et passim (Geneva, Switz.: Georg, 1993).

**30** Exemplary of the worldwide embrace of adjudication was the 1985 adoption by the United Nations of principles on adjudication, accompanied by the deployment of a special rapporteur charged with monitoring implementation of these precepts. See, for example, Basic Principles on the Independence of the Judiciary, endorsed by G.A. Res. 40/32, U.N. Doc. A/Res/40/32 (Nov. 29, 1985), and G.A. Res. 40/146, U.N. Doc. A/Res/40/146 (Dec. 13, 1985). We discuss the changing contours of adjudication in Chapters 13 and 14.

**31** Another scholar of this iconography has argued that the image of Justice emerged in the Renaissance as Roman law sought to displace customary law. The statue's deployment was a propagandistic effort to renovate Roman law through classical imagery that conflated civil law with canon law and that laid claim to Justice in a quasi-religious sense of mercy. See Theodore Ziolkowski, *The Figure of Justice in Western Art and Literature*, 75 Inmunkwahak, The Journal of Humanities 197, 204–205 (1996).

**32** See John Locke, An Essay Concerning Human Understanding 146 (Peter H. Nidditch, ed., Oxford, Eng.: Oxford U. Press, 1975). Various words are in italics in that edition. The text explained that sight was "the most comprehensive of all our Senses, conveying to our Minds the Ideas of Light and Colours, which are peculiar only to that Sense." Id.

**33** Charles de Secondat, Baron de Montesquieu, The Spirit of the Laws, vol. 1, 180 (Kitchener, Ont.: Batoche, 2001, reprinting a 1752 translation by Thomas Nugent). The paragraph continued: "But as we have already observed, the national judges are no more than the mouth that pronounces the words of the law, mere passive beings, incapable of moderating either its force or rigour. That part, therefore, of the legislative body, which we have just now observed to be a necessary tribunal on another occasion, is also a necessary tribunal in this; it belongs to its supreme authority to moderate the law in favour of the law itself, by mitigating the sentence."

**34** JOHANN WOLFGANG VON GOETHE, TASSO 46 (Robert David MacDonald, trans., London, Eng.: Oberon Books, 1994) (hereinafter GOETHE/MACDONALD). Torquato Tasso lived from 1544 to 1595 in Italy and was an author famous for the epics *Rinaldo* (1562) and *Jerusalem Delivered* (1575). Paranoid and living through the Inquisition, Tasso was incarcerated for a period before his death, and his "sensational life" provided inspiration for Goethe. GOETHE/MACDONALD at 6–9. Goethe's play engaged the "disproportion of talent to life." Id. at 10 (quoting a letter of 1789 about the play). The play centers on misjudgments. See Mark Boulby, *Judgment by Epithet in Goethe's* Torquato Tasso, 87 PMLA 167 (1972). Changing attitudes toward the play are mapped in IRMGARD WAGNER, CRITICAL APPROACHES TO GOETHE'S CLASSICAL DRAMAS: IPHIGENIE, TORQUATO TASSO, AND DIE NATÜRLICHE TOCHTER 91–143 (Columbia, SC: Camden House, 1995).

The exchange that preceded the quote has the character Antonio saying that Fortune—rather than "the Gods"—"is blind." Tasso replied: "Justice is blindfolded too, to avoid being dazzled by imposters." Antonio then continued, "The ones whom Fortune favours, favour her: but, of course, they think she has a hundred eyes, all on the look-out for the slightest merit, and sparkling with judgment and good taste." GOETHE/MACDONALD at 46.

**35** *Plessy v. Ferguson*, 163 U.S. 537, 559 (1896) (Harlan, J., dissenting). Harlan continued that the Constitution "neither knows nor tolerates classes among citizens." His metaphor of color-blindness was later used by a five-person majority in 2007 when invalidating an affirmative action effort aimed at achieving some racial diversity in education. See *Parents Involved in Community Schools v. Seattle School District No. 1*, 551 U.S. 701 (2007).

**36** HUGHES, *Justice*.

**37** JOHN RAWLS, A THEORY OF JUSTICE 12 (Cambridge, MA: Belknap/Harvard U. Press, 1971).

**38** Chaya T. Halberstam, Rabbinic Responsibility for Evil: Evidence and Uncertainty 30 (Ph.D. dissertation, Yale University, New Haven, CT, May 2004: UMI Publication No.: AAT 3125205) (citing early Talmudic literature of the Second Temple era). See also Madeline H. Caviness, *Images of Divine Order and the Third Mode of Seeing*, 22 GESTA 99–120 (1983). Caviness mapped how artists in the Middle Ages represented different forms of insight, modeled by imagery that linked wisdom, sight, and divine knowledge.

**39** The recovery of Plutarch's work and its use by Alciatus is, as noted in Chapter 3 and 4, one source for the imagery of blindness, which, when coupled with handlessness, was a shield against corruption. See ROBERT JACOB, IMAGES DE LA JUSTICE: ESSAI SUR L'ICONOGRAPHIE JUDICIARE DU MOYEN ÂGE À L'ÂGE CLASSIQUE (Images of Justice: Essays in Judicial Iconography from the Middle Ages to the Classical Period) 232–233, 245 (Paris, Fran.: Le Léopard D'Or, 1994) (hereinafter JACOB, IMAGES OF JUSTICE). Sometime during the 1500s, Plutarch came to the attention of Renaissance thinkers. Plutarch's *Isis and Osiris*, published in Louvain in 1564, provided a description of the sightless Chief Judge of Thebes that could have been a source for artistic depictions of Justice's eyes covered, closed, or sightless. See Michael Evans, *Two Sources for Maimed Justice*, 2 SOURCE: NOTES IN THE HISTORY OF ART 12, 14 (1982); Waldemar Deonna, *Les Fresques de la Maison de Ville de Genève*, 13 REVUE SUISSE D'ART ET D'ARCHÉOLOGIE 129, 142, n. 128 (1952). Deonna noted a "contradiction ophtalmologique" in the images of Justice. Id. Some showed a many-eyed figure to denote the need to see everything, while others, such as a 1575 hieroglyph of a young, seated woman without a head, as well as images of Justice with eyes closed or bandaged, illustrated the idea that sight was problematic.

**40** Debate exists about when the camera obscura came into being, how it was used, which artists had access to such a device, and the import of its existence. Aristotle and "the 10th-century Arab scholar Ibn Al-Haytham" noted the effects of the sun projected through small

apertures; other scholars (including Leonardo da Vinci) commented on the phenomenon. But it was not until 1550 that "a Milanese astrologer and physician Girolamo Cardano suggested a dramatic improvement to the camera obscura in his work *On Subtlety*." See Michael John Gorman, *Art, Optics and History: New Light on the Hockney Thesis*, 36 LEONARDO 295, 296 (2003). In 1558 Giambattista Della Porta described "[a]nother version of the camera obscura." Id. at 297. After a visit to Venice in 1580, Della Porta fashioned a remarkably improved instrument that made his earlier version obsolete. Id. at 299. See also Kenneth Clark, *Leon Battista Alberti on Painting, Annual Italian Lecture of the British Academy*, 30 PROCEEDINGS OF THE BRITISH ACADEMY 1, 9, 15 (Oxford, Eng.: Oxford U. Press, 1944).

Gorman, among many others, questioned the thesis that some Renaissance painters relied on the camera obscura, as argued in DAVID HOCKNEY, SECRET KNOWLEDGE: REDISCOVERING THE LOST TECHNIQUES OF THE OLD MASTERS (London, Eng.: Penguin Putnam, 2001). Further contested is the camera obscura's relationship to photography and to an understanding of an objective point of view. See JONATHAN CRARY, TECHNIQUES OF THE OBSERVER: ON VISION AND MODERNITY IN THE NINETEENTH CENTURY 26–53 (Cambridge, MA: MIT Press, 1990) (hereinafter CRARY, TECHNIQUES OF THE OBSERVER).

**41** MARJOLEIN DEGENAAR, MOLYNEUX'S PROBLEM: THREE CENTURIES OF DISCUSSION ON THE PERCEPTION OF FORMS 18 (Michael J. Collins, trans., Dordrecht, Neth.: Kluwer Academic Publishers, 1996).

**42** IAN HACKING, THE EMERGENCE OF PROBABILITY: A PHILOSOPHICAL STUDY OF EARLY IDEAS ABOUT PROBABILITY, INDUCTION AND STATISTICAL INFERENCE 9–12 (Cambridge, Eng.: Cambridge U. Press, 1975). Hacking noted that the word "probability" had been used in the sense of something being worthy of approval. Id. at 18–20. Hacking described the interest in probability emergent in the early seventeenth century as "Janus–faced," with some focused on the statistical side and others engaged epistemologically, "dedicated to assessing reasonable degrees of belief in propositions quite devoid of statistical background." Id. at 12. Leibniz is an example of the latter approach, "concerned with degrees of proof in law." Id. Modern views "claim that probability is a relation between an hypothesis and the evidence for it." Id. at 31. As for what constituted evidence, by the mid-seventeenth century, the evidence of "things" was seen as "internal," whereas evidence from testimony was "external." Id. at 33.

**43** CESARE RIPA, ICONOLOGIA 203 (Padua, Ital.: Pietro Paolo Tozzi, 1611; New York, NY: Garland Publishing, 1976) (hereinafter RIPA, PADUA–1611).

**44** See RENÉ DESCARTES, MEDITATIONS ON FIRST PHILOSOPHY WITH SELECTIONS FROM THE OBJECTIONS AND REPLIES (John Cottingham, trans., Cambridge, Eng.: Cambridge U. Press, 1986). "I will now shut my eyes, stop my ears, and withdraw all my senses." Id. at 24. These lines started the *Third Meditation*, subtitled *The Existence of God*, in which Descartes put those constraints on himself as a predicate to his inquiry into the existence of God in his attempt to begin from a position hampered by as few assumptions as possible. Descartes was also intrigued by the camera obscura. CRARY, TECHNIQUES OF THE OBSERVER at 46–48.

**45** See KISSEL at 90, nn. 155 and 156. Kissel noted that Luther wrote of the "love of truth" to bring "light" but also that a judge "must be blind, his eyes and ears covered." Id. at 90. Specifically, "Therefore he must be quite blind, have his eyes and ears closed, neither see nor hear, but go straight forward in everything that comes before him, and decide accordingly." Martin Luther, *The Large Catechism*, in TRIGLOT CONCORDIA: THE SYMBOLICAL BOOKS OF THE EV. LUTHERAN CHURCH 565 (F. Bente & W. H. T. Dau, trans., St. Louis, MO: Concordia Publishing, 1921). Yet Luther can also be quoted as stating: "[W]hat kind of judge would he be who should blindly judge matters which he neither heard nor saw?" Martin Luther, *Secular Authority: To What Extent It Should Be Obeyed*, in MARTIN LUTHER: SELECTIONS FROM HIS WRITINGS 384 (John Dillenberger, ed., New York, NY: Anchor Books,

1962). Lutheran theological approaches fit with seventeenth-century images in Germany and the Netherlands, in which Justice wears either blindfolds or diaphanous scarves. As discussed in Chapter 2, Zapalac argued that Lutheranism was a source for the replacement of scenes of the Last Judgment with images of Justice. See KRISTIN ELDYSS SORENSEN ZAPALAC, "IN HIS IMAGE AND LIKENESS": POLITICAL ICONOGRAPHY AND RELIGIOUS CHANGE IN REGENSBURG, 1500–1600 (Ithaca, NY: Cornell U. Press, 1990).

**46** See Beth A. Berkowitz, *Negotiating Violence and the Word in Rabbinic Law*, 17 YALE JOURNAL OF LAW AND HUMANITIES 125 (2005).

**47** *Deuteronomy* 19:15 in THE NEW ENGLISH BIBLE (Charles Harold Dodd, ed., Oxford & Cambridge, Eng.: Oxford & Cambridge U. Presses, 1970).

**48** Halberstam at 215. An alternative view was advanced by Bernard M. Levinson, who argued that *Deuteronomy* both subjected decisionmaking to due process and also established a form of separation of powers by "sundering any connection between justice and monarchy." A system of clan justice was replaced by local appointments and forms of professionalization. See BERNARD M. LEVINSON, DEUTERONOMY AND THE HERMENEUTICS OF LEGAL INNOVATION 120–126, 138–143 (Oxford, Eng.: Oxford U. Press, 1997).

**49** The blindfold did not, however, lose all its "satirical implication." See Martin Jay, *Must Justice Be Blind?* in LAW AND THE IMAGE at 19–21. Jay argued that by 1530 the positive connotations had become pervasive. As we discuss in Chapter 4, several negative examples from later than that point in time can be identified.

**50** A few commentators see the religious imagery surrounding judges in the Renaissance as signaling some degree of independence from rulers. See JACOB, IMAGES OF JUSTICE at 233–237. Jacob argued that Justice was thus constrained by law as part of the triumph of positivism and of the commitment to rationality.

**51** See Robert Jacob, *Le jugement de Dieu et la formation de la fonction de juger dans l'histoire européenne (The Judgment of God and the Formation of the Judicial Function in European History)* 39 ARCHIVES DE PHILOSOPHIE DU DROIT 87, 101–113 (1995). Christian-Nils Robert concurred but viewed that critical space as waning during the sixteenth century as religious imagery was replaced in town halls with more secular stories. See CHRISTIAN-NILS ROBERT, LA JUSTICE DANS SES DÉCORS (XVE–XVIE SIÈCLES) (JUSTICE IN ITS SETTINGS DURING THE 15TH AND 16TH CENTURIES) 97–101 (Geneva, Switz.: Librairie Droz S.A., 2006).

**52** MONTESQUIEU at 173.

**53** Robert Cover, *The Folktales of Justice: Tales of Jurisdiction*, 14 CAPITAL UNIVERSITY LAW REVIEW 179 (1985). For example, Cover described a story growing out of attempts to explain the Talmudic maxim "The king does not judge and we do not judge him." *Mishneh Sanhedrin* 2:3, quoted in *Folktales of Justice* at 183. As Cover related this "folktale," Simeon ben Shetah, Chief Judge of the Sanhedrin, called on King Yannai to testify in a case involving the King's slave. The King replied that he would do so only if all of the seventy-one judges would so command him. The judges other than Simeon ben Shetah were intimated by the King and backed away from demanding that he testify. After the King left, Simeon called on God to call the weak judges to account; the Angel Gabriel responded by killing them all. Id. at 184.

**54** See THEODORE K. RABB, THE LAST DAYS OF THE RENAISSANCE AND THE MARCH TO MODERNITY 48–49 (New York, NY: Basic Books, 2006). Rabb also argued that what distinguished the Renaissance from the modern period were different ideas about the relationship of divine authority to the political order and about the import of wars. Modern leaders—as he defined them—do not think godly guidance and supernatural signs ought to affect their judgments and, in light of the violence enabled by gunpowder and other technological advances, no longer see war as glorious. For him (as for us), the new attitudes are revealed in part in art. Id. at 161–227. See also QUENTIN SKINNER,

LIBERTY BEFORE LIBERALISM 2–16 (Cambridge, Eng.: Cambridge U. Press, 1998) (hereinafter SKINNER, LIBERTY BEFORE LIBERALISM).

**55** SKINNER, LIBERTY BEFORE LIBERALISM at 61. Skinner captured the interest in constraining kingly power as "where law ends, liberty begins." Id. at 5.

**56** SKINNER, LIBERTY BEFORE LIBERALISM at 9–10. This freedom within government, deeply focused on a community rather than an individual's freedom, was not to be equated with "the modern notion of civil society as a moral space between rulers and ruled." Id. at 16, 24.

**57** "The Judges, both of the supreme and inferior Courts, shall hold their Offices during good Behaviour, and shall, at stated times, receive for their Services, a Compensation, which shall not be diminished during their Continuance in Office." U.S. CONST. Art. III, sec. 1.

**58** This political explanation was offered by the jurist Otto Kissel, who noted that the blindfold became a popular attribute of Justice during the sixteenth and seventeenth centuries and argued that its inclusion coincided with the establishment of professional, independent judges who stood apart from the sovereign state and were not simply acting at its behest. The replacement of lay judges by judges with legal training highlighted the distinction developed between the state and the judiciary. Kissel saw the blindfold as signifying the need for the employee-judge not to decide cases to please the employer-state, and he explained the subsequent popularity of the blindfold in northern Europe as a constant reminder of the need for impartiality (vis-à-vis the state) of the newly independent judiciary. Justice blindfolded could not see whatever signals a sovereign sent about how to decide a case. KISSEL at 82–92.

**59** MARTIN KUIJER, THE BLINDFOLD OF LADY JUSTICE: JUDICIAL INDEPENDENCE AND IMPARTIALITY IN LIGHT OF THE REQUIREMENTS OF ARTICLE 6 ECHR (Leiden, Neth.: Wolf Legal Publishers, 2004).

**60** See WILLIAM R. PAULSON, ENLIGHTENMENT, ROMANTICISM, AND THE BLIND IN FRANCE 21–23 (Princeton, NJ: Princeton U. Press, 1987); MICHAEL J. MORGAN, MOLYNEUX'S QUESTION: VISION, TOUCH AND THE PHILOSOPHY OF PERCEPTION (Cambridge, Eng.: Cambridge U. Press, 1977). Molyneux was a member of the Irish Parliament and the author of *The Case for Ireland* (1698) and *Diopica nova* (1692). He lived from 1656 to 1698, and his interest in optics may have come in part because his wife was blind. MORGAN at 6; DEGENAAR at 17–18, 23, 133.

**61** DEGENAAR at 19, citing Aristotle's *De anima* (*On the Soul*), bk. II, ch. 6.

**62** Mark Paterson, *"Seeing with the Hands": Blindness, Touch, and the Enlightenment Spatial Imaginary*, 24 BRITISH JOURNAL OF VISUAL IMPAIRMENT 52 (2006). Paterson's title referred to a 1637 discussion by Descartes arguing that tactility was a lesser sense than sight. Id. at 56.

**63** See Harry A. Wolfson, *The Internal Senses in Latin, Arabic, and Hebrew Philosophical Texts*, 28 HARVARD THEOLOGICAL REVIEW 69 (1935); KATHERINE H. TACHAU, VISION AND CERTITUDE IN THE AGE OF OCKHAM: OPTICS, EPISTEMOLOGY, AND THE FOUNDATIONS OF SEMANTICS, 1250–1345 (Leiden, Neth.: E. J. Brill, 1988). Wolfson examined the impact of Aristotelian understandings, including that "sensations and images remain in the sense-organs even when the sensible objects are withdrawn." Id. at 78. Tachau's focus was on the centuries just before the appearance of blindfolds on Justice; her interest was in debates among philosophers at Oxford and in Paris about how individuals gained knowledge, the distinctions drawn between intuitions and abstractions, and the relationship of both to judgment. Further, she detailed (at 116) Ockham's theory of "adjudicative acts" that entailed not only apprehending information but assessing its truth. Id. at 115–135, 353–374.

**64** LOCKE at 146–147. Locke was joined by other philosophers who assumed that tactile and visual sensations differed in significant ways. DEGENAAR at 50–52. Locke also distinguished between "pri-

mary qualities" that he posited exist independent of a person's observations (shape, for example) and "secondary qualities" that are artifacts of observation (color, for example). Those distinctions and their coherence have spawned debate. See Samuel C. Rickless, *Locke on Primary and Secondary Qualities*, 78 PACIFIC PHILOSOPHICAL QUARTERLY 297–319 (1997); E. M. Curley, *Locke, Boyle, and the Distinction between Primary and Secondary Qualities*, 81 PHILOSOPHICAL REVIEW 438–464 (1972).

As for the Molyneux problem, Paulson commented that the hypothetical permitted philosophers to "conceive of a mind without experience, to verify that what is in the understanding is property acquired through experience." PAULSON at 24. As Morgan pointed out, a modern version of this question would consider whether such a person could "see," but Locke and Molyneux assumed that sight would follow and focused on what ideas came with the presumed "full range of visual experience." MORGAN at 7. Jonathan Crary argued that the view of "knowledge of space and depth [as] built up out of an orderly accumulation and cross-referencing of perceptions on a plane independent of the viewer" was an eighteenth-century attitude that thought the senses to be an "adjunct of a rational mind"; in the nineteenth century that view was superseded by an understanding of a world organized by "exchange and flux," where knowledge was "bound up in touch." CRARY, TECHNIQUES OF THE OBSERVER at 59–62.

65 In 1728 William Cheselden, a surgeon, published an article describing his operation on a young man with cataracts. DEGENAAR at 52. See also Paterson at 54.

66 PAULSON at 8–10, 26–32.

67 PAULSON at 3. A chronology from the 1690 publication of Locke's *Essay Concerning Human Understanding* through the mid-nineteenth century is provided by Morgan at 4.

68 Denis Diderot was born in 1713 and died in 1784. His *Lettre sur les aveugles à l'usage de ceux qui voient* (generally translated in abbreviated form as *Letter on the Blind*) was first published in 1749. The essay is divided into segments, the first written as if a surgeon were aggrieved at the "philosophes [who] examine his patients." The second is addressed to the "psychology of a congenitally blind person," followed by Diderot's engagement with the Molyneux problem. Diderot raised the question of whether, after an operation, a person would see at all. Diderot's book "ends with a poetic affirmation of our ignorance of ultimate reality. For this Diderot was put into a dungeon in Vincennes." MORGAN at 27–28. Morgan provided an English translation of Diderot's "Letter" at 31–58, and we use his translation for our references to Diderot's argument, which we denote DIDEROT/MORGAN.

69 DIDEROT/MORGAN at 33–40. See also DEGENAAR at 73–75. As noted, Diderot disentangled the question of what could be seen immediately—to which he thought the answer was a multitude of confused sensations—from the question of whether a blind person would be able to distinguish among shapes by naming them. DIDEROT/MORGAN at 50–55; DEGENAAR at 76.

70 DIDEROT/MORGAN at 57–58; PAULSON at 46. Further, as Degenaar explained (at 77–79), Diderot also argued that the preparations made before an eye operation would be relevant to the knowledge of the blind person and thus added more variables to be considered. Paulson commented that Diderot undermined the "scientific validity" of any such "real" experiments in that Diderot insisted that none of the observers would themselves be "dispassionate." PAULSON at 44.

71 PAULSON at 47.

72 PAULSON at 48.

73 PAULSON at 52. Diderot outlined different conditions under which a blind person learned to see. He posited that some aspects of understanding (a reliance on tactile sensations) might be uniform but that background knowledge (such as an expertise in mathematics) would alter understanding and approaches. DIDEROT/MORGAN at 52–58.

74 PAULSON at 47. Paulson noted that for Diderot, "every individual has at his disposal those signs with which his senses and education have provided him." Id. at 47. Diderot himself stated: "Information has three routes [sight, hearing, and touch] into our mind, and we keep it out by a failure to invent suitable signs." DIDEROT/MORGAN at 41. Diderot then imagined a system akin to Braille, presuming that if a tactile language existed, the blind would not be disadvantaged. "Perhaps they would acquire ideas if we made ourselves understood to them . . . if we were to draw on their hands the same characters that we draw upon paper, and if we always attached consistent meanings to such impressions. Is this language not as easy as another? Is it any more arbitrary?" Id. at 41.

75 PAULSON at 43. In *Promenade d'un sceptique* (Skeptic's Promenade), published in 1747, Diderot equated the blindfold with the irrationality and unreason of faith; those who are clear-sighted are endowed with reason, knowledge, and understanding based on observation and experience. Diderot, *Promenade d'un sceptique*, in OEUVRES COMPLÈTES, vol. 1 at 308–401 (Paris, Fran.: Le Club français du livre, 1969).

76 MORGAN at 2, 28–30. In contrast, contemporary readers offer a different appraisal. For example, Morgan credited Diderot's *Letter on the Blind* for "stand[ing] out a mile from all other eighteenth-century psychological writing for its attention to detail, and its concern for fact against speculation." Id. at 25.

77 See MORGAN at 158–208. Contemporary studies make plain that "perception is not necessarily to be equated with the input from particular sense organs." Id. at 207.

78 Paterson at 53.

79 Paterson at 57.

80 See, for example, HEURISTICS AND BIASES: THE PSYCHOLOGY OF INTUITIVE JUDGMENT (Thomas Gilovich, Dale Griffin, & Daniel Kahneman, eds., Cambridge, Eng.: Cambridge U. Press, 2002); Kristin A. Lane, Jason P. Mitchell, & Mahzarin R. Banaji, *Me and My Group: Cultural Status Can Disrupt Cognitive Consistency*, 23 SOCIAL COGNITION 353 (2005).

81 In law, cognitive psychological insights have prompted efforts to model decisionmakers' processes. See, for example, Daniel Kahneman & Cass R. Sunstein, *Cognitive Psychology of Moral Intuitions*, in NEUROBIOLOGY OF HUMAN VALUES (Jean-Pierre Changeux, Yves Christen, Antonio Damasio, & Wolf Singer, eds., Berlin, Ger.: Springer-Verlag, 2005).

82 RAWLS at 12. Rawls's imagery of the veil—denoting that a decisionmaker does not know who will benefit or be harmed by a principle—is frequently deployed in the legal academy. See, for example, Adrian Vermeule, *Veil of Ignorance Rules in Constitutional Law*, 111 YALE LAW JOURNAL 399 (2001).

83 RAWLS at 19. In addition to imposing the condition of the veil of ignorance, Rawls also imposed conditions that did not rank end-systems in terms of value. He further presumed that each person has the "requisite ability to understand and to act upon whatever principles are adopted." Id. In contrast, Michael Walzer has argued for the desirability of situated, engaged criticism, understood as predicated on particularized knowledge. See MICHAEL WALZER, INTERPRETATION AND SOCIAL CRITICISM (Cambridge, MA: Harvard U. Press, 1987).

84 RAWLS at 136–137.

85 RAWLS at 257. In this part of his discussion Rawls took pains to relate his theory to and distinguish it from that of Immanuel Kant.

86 RAWLS at 140.

87 Rawls also posited that coercive sanctions cushioned concerns that "others [were] not complying with the rules." RAWLS at 240.

88 RAWLS at 16, 175. Both contract and publicity also entailed a notion that people would honor the agreements to which they subscribed. Publicity also induced stability. Id. at 177.

89 RAWLS at 239.

90 See Jay, *Must Justice Be Blind?* in LAW AND THE IMAGE at 34–35. Jay offered that proposition in connection with the reproduction

of the engraving of the Janus-faced image (fig. 4/54) from a 1567 Anvers edition of the Damhoudere volume. As we discuss in Chapter 4, the image can be read to deploy the blindfold derisively.

**91** Figure 71 is provided courtesy of Thomas Agnew & Sons, Ltd. The series was executed between 1777 and 1781. Reynolds, who lived in England from 1723 until his death in 1792, was a noted portrait painter. He was also a founding member of the "Literary Club" formed in 1764 by a group including the essayist Samuel Johnson, the political theorist Edmund Burke, and the actor David Garrick. In 1768 King George III approved the incorporation of the Royal Academy of Arts and appointed Reynolds the first president. CLAUDE PHILLIPS, SIR JOSHUA REYNOLDS 120–122 (London, Eng.: Seely, 1894).

**92** Thomas Jervais was born in Dublin, Ireland, and died in 1799. He moved to England in 1770; in addition to the New College Chapel windows, he also did a Resurrection commissioned for St. George's Chapel at Windsor Castle. Jervais used a glass-painting technique that involved burning enamel color into white glass. MARTIN POSTLE, JOSHUA REYNOLDS: THE SUBJECT PICTURES 168–177 (Cambridge, Eng.: Cambridge U. Press, 1995).

**93** Harry J. Powell, *The Picture Windows in New College Ante-Chapel*, 8 BURLINGTON MAGAZINE 326, 326–329, 331 (1906).

**94** POSTLE at 177. Others refer to Raphael as a source. PHILLIPS at 264.

**95** PHILLIPS at 263. Reynolds designed the Nativity scene as well and included a self-portrait of himself and a portrait of Jervais. Id. at 264.

**96** For some, the lack of a blindfold was also notable. See Martin Postle, *The West Window of New College Chapel*, 145 APOLLO 51 (1997); see generally REYNOLDS, ROYAL ACADEMY OF ARTS CATALOGUE, entry for "Justice" (Nicholas Penny, ed., London, Eng.: Weidenfeld & Nicholson, 1986) (hereinafter REYNOLDS, ROYAL ACADEMY CATALOGUE).

**97** POSTLE at 180, quoting a newspaper, THE MORNING POST, May 2, 1780.

**98** See, for example, REYNOLDS, ROYAL ACADEMY CATALOGUE at 291, noting that the "shadow falling over the eyes of Justice serves as a substitute for the traditional blindfold." Reynolds conveyed the point that Justice ought to be "unswayed by superficial evidence." Id.

**99** Heather McPherson, *Picturing Tragedy: Mrs. Siddons as the Tragic Muse Revisited*, 33 EIGHTEENTH CENTURY STUDIES 401, 412 (2000). Postle called this Justice the "finest figure" of the Virtues and one that was "perfectly poised." POSTLE at 177.

**100** The building in figure 73 was annexed to the James C. Cleveland Federal Building that had opened in 1968. The thirty-million-dollar renovation, by the architectural firm of Shepley Bulfinch Richardson and Abbott, was completed in 1997. That firm dates from the nineteenth century. See J. D. Forbes, *Shepley, Bulfinch, Richardson & Abbott, Architects; An Introduction*, 17:3 JOURNAL OF THE SOCIETY OF ARCHITECTURAL HISTORIANS 19 (1958). The architect on the project, Jean Paul Carlhian, also designed the base for the Justice statue. See Nancy West, *Statue for Federal Court Drawing Mixed Reviews*, NEW HAMPSHIRE SUNDAY NEWS, July 13, 1997, at A1 (hereinafter West, *Statue Drawing Mixed Reviews*).

Carlhian and the artist, Diana Moore, had differences during the design phase as to the size of the base, Justice's clothing, her stance, and the placement of her feet. Staff notes, General Services Administration (GSA) Art-in-Architecture Archive AA 332, Diana Moore (hereinafter GSA, AA 332 Moore). Carlhian did note his admiration for Moore's "willingness" to respond to the judges' concerns while remaining committed to her approach. Letter from Jean Paul Carlhian to Susan Harrison, chief of the Art-in-Architecture Program of the GSA (Oct. 19, 1995), GSA, AA 332 Moore.

Diana Moore was born in 1946 in Norfolk, Virginia, and studied art in the Midwest. Her work is displayed in many museums, as well as at three federal courthouses. As discussed in Chapter 6, in the early

1990s, she sculpted a colossal head, *Justice*, placed flush with the plaza of the Martin Luther King Jr. Federal Building and Courthouse in Newark, New Jersey. In 1998 she executed two large *Urns of Justice* (faces, with eyes blindfolded and skulls open at the top) for the Federal Courthouse in Lafayette, Louisiana. Both the 1992 New Jersey sculpture and the 1996 Concord *Justice* won GSA Design Awards, and the 1998 Louisiana project was awarded a citation. General Service Administration, *Justice: A Justice for Concord—Forging Together the Ancient and the Modern* (undated and unpaginated monograph from about 1997, published to recognize the renovation of the courthouse and the installation of the art) (hereinafter GSA, *Concord Justice*).

Our thanks to Diana Moore for meeting with us to discuss the project's development and for photographs of her work, to the Honorable Joseph DiClerico, then Chief Judge of the Federal District Court for the District of New Hampshire, who also gave us a detailed understanding of the courthouse renovation and of its art, to the architectural firm of Shepley Bulfinch Richardson and Abbott for permission to use photographs of the building and of its art, and to Susan Harrison of the Art-in-Architecture Program of the GSA who provided us with background information and facilitated our meeting with participants. The photographs in figures 72–75 are by Nick Wheeler; these images were provided to us and are reproduced with permission of Shepley Bulfinch Richardson and Abbott and of Diana Moore.

**101** See Ralph Jimenez, *A Return to Classical Style*, BOSTON GLOBE, Feb. 23, 1997 (hereinafter Jimenez, *A Return to Classical Style*). Jimenez also commented that the "symmetry is really the agony of judgment and therefore it should convey that there are equal options of right and left, right and wrong." The renovation included the "Palladian arch of glass and anodized aluminum" that formed the atrium. Id.

**102** The statue was "cast as seven separate pieces" that were welded together. GSA, *Concord Justice*.

**103** GSA, *Concord Justice*.

**104** The "inwardly contemplative expression of Moore's Justice is partly inspired by the meditative faces of the Hindu goddesses depicted in Cambodian sculpture of the twelfth and thirteenth centuries." GSA, *Concord Justice*. In Moore's proposal, she described the influences of the "Cambodian sculpture of the Khmer Period. There is a stillness; an ageless purity of form in this work to which I feel a strong connection." Moore, A Proposal for a Sculpture of Justice in the New United States Courthouse Annex at 3 (undated), GSA, AA 332 Moore.

**105** In lieu of scales, the GSA described Justice's "asymmetrical, yet perfectly balanced, arms" as representing that idea. GSA, *Concord Justice*.

**106** In a letter explaining the proposed work, Moore wrote that her Justice's eyes were to be "closed and wrapped, looking inward toward the 'perfect judgment.' In this state of concentration she will stand, an inspiration; illusive, and ever present." Moore letter to the GSA (undated), GSA, AA 332 Moore.

**107** Moore also placed diaphanous blindfolds on other courthouse commissions—the colossal head in Newark, New Jersey, and the two *Urns of Justice* in Lafayette, Louisiana—enabling the viewer to see through the blindfold to a Justice who has closed her eyes.

**108** The import of a Justice deliberately imposing a blindfold on herself is explored by Cover in his *Folktales of Justice*, in which he argued that the self-imposed distance enabled judges to stand up to oppressive powers that sought to intimidate them.

**109** GSA, *Concord Justice*.

**110** GSA, *Concord Justice*.

**111** John A. Parks, *Modern Sculpture from Ancient Sources*, 60 AMERICAN ARTIST 42, 44 (October 1996) (discussing Moore's work for the Newark, New Jersey, courthouse). See also Robin Rice, *Diana Moore*, Philadelphia citypaper.net, May 16–23, 1996, http://www.city-paper.net/articles/051696/article011.shtml.

**112** Editors, *The Blindfold of Justice*, Legal Affairs Magazine, July–Aug. 2003 at 68 (hereinafter Editorial: *Blindfold of Justice*). See also Nancy West, *Dressing Naked Statue Proves Costly*, Union-Leader News, July 7–13, 1997. By the time of the 1995 approval of the contract, the figure was described as "a plainly clothed statue of a woman wearing a full length dress that flows close to the pedestal. . . . The woman's arms are raised in the air, tying a blindfold on her head." Approval of Diana Moore's Proposed Work of Art, Memorandum (Nov. 2, 1995), GSA, AA 332 Moore.

**113** Jimenez, *A Return to Classical Style.*

**114** "The earliest clay studies for the sculpture were actually rendered nude, so that the artist could mold the figure to her satisfaction. Once the artist was pleased with the figure's form, she clothed it in a series of different garments. Through this evolutionary process, Moore developed the version that was finally cast." GSA, *Concord Justice.*

**115** Jimenez, *A Return to Classical Style.* Notes from the panel meeting reflect that a woman described her regret at having to give "'up the navel and the nipples.'" Concord Panel Members (undated notes), GSA, AA 332 Moore. However, one of the court's judges opined that "a courthouse was not an appropriate place to see an exposed navel." The judge subsequently wrote to object to the visibility of nipples, commenting that the garment's "informality . . . and what it reveals made it unsuitable." Oct. 25, 1995, minutes and addendum on Artist Proposal Meeting of April 13, 1995, GSA, AA 332 Moore. The artist then made modifications so that the gown shifted "further away from any 'anatomical reading' of the underlying form." Id., Moore Letter (May 24, 1995).

**116** West, *Statue Drawing Mixed Reviews.*

**117** Moore also drew on those images when crafting the two monumental *Urns of Justice* for the Federal Courthouse in Lafayette, Louisiana, and the similar colossal concrete head for the Federal Court in Newark, New Jersey.

**118** Editors, *The Blindfold of Justice.*

**119** Editors, *The Blindfold of Justice.*

**120** *Plessy v. Ferguson*, 163 U.S. 537, 559 (1896) (Harlan, J., dissenting).

**121** August Meier & John H. Bracey Jr., *The NAACP as a Reform Movement, 1909–1965*: "*To Reach the Conscience of America*," 59 Journal of Southern History 3, 8 (1993).

**122** Elmer C. Jackson Jr. & Jacob U. Gordon, A Search for Equal Justice by African-American Lawyers: A History of the National Bar Association 14 (New York, NY: Vantage Press, 1999) (describing Gertrude E. Rush, the one woman among the twelve founders).

**123** Jackson & Gordon at 16, quoting Raymond Pace Alexander. In the late 1990s, the objectives were to "improve economic conditions (of all American citizens) regardless of race, sex or creed in their efforts to secure a free and untrammeled use of the franchise." Id. at 141. In the original constitution of 1926, there was no mention of race in the section on objectives.

**124** Jackson & Gordon at xi (quoting an inaugural address given in 1948 by President Thurman L. Dodson).

**125** See generally Margalynne J. Armstrong & Stephanie M. Wildman, *Teaching Race / Teaching Whiteness: Transforming Colorblindness to Color Insight*, 86 North Carolina Law Review 635 (2008).

**126** See, for example, Ariela J. Gross, *"The Caucasian Cloak": Mexican Americans and the Politics of Whiteness in the Twentieth-Century Southwest*, 95 Georgetown Law Journal 337 (1997).

**127** See *Parents Involved in Community Schools v. Seattle School District No. 1*, 551 U.S. 701 (2007). Chief Justice John Roberts's opinion for the five-person majority quoted from the *Plessy* opinion (id. at 731), while the concurrence by Justice Clarence Thomas used the phrase "color-blind" several times (id. at 772, 780, 782). The impassioned dissent by Justice Stephen Breyer argued that no case had fol-

lowed the version of colorblindness proposed by Justice Thomas but rather had attended to the "asymmetry between that which seeks to *exclude* and that which seeks to *include* members of minority races." Id. at 830 (emphasis in the original).

**128** *Chisholm v. Georgia*, 2 U.S. (2 Dall.) 419, 466 (1793) (Wilson, J.). The five justices sitting each filed an opinion. Justice Iredell dissented. The decision's rule, that the suit could proceed, was subsequently revised by the Eleventh Amendment of the United States Constitution, stating that the "Judicial power of the United States shall not be construed to extend to any suit in law or equity, commenced or prosecuted against one of the United States by Citizens of another State, or by Citizens or Subjects of any Foreign State." U.S. Const., Amend. XI. The question of how to interpret the reach of this provision remains intense, with several decisions in the 1990s rendered five to four.

**129** *Marbury v. Madison*, 5 U.S. (1 Cranch) 137, 178 (1803).

**130** *Foster v. Illinois*, 332 U.S. 134 (1947).

**131** 332 U.S. at 145 (Rutledge, J., dissenting).

**132** *Nachova v. Bulgaria* (No. 2), App. Nos. 43577/98 and 43579/98, 42 Eur. H.R. Rep. 933, 966 (2005) (quoting *Menson v. United Kingdom*, 2003-V Eur. Ct. H.R. 363, 381). At issue was the investigation into the deaths of two individuals who were Bulgarian nationals of Roma origin. A subsequent decision using the same phrasing is *Angelova and Iliev v. Bulgaria*, App. No. 55523/00 (Eur. Ct. H.R. 2007) at the European Court of Human Rights' website, http://www.echr.coe.int/eng.

**133** See Case C-256/01, *Allonby v. Accrington & Rossendale College*, 2004 E.C.R. 1-00873 (opinion of Advocate General Geelhoed).

**134** *Cassell v. Texas*, 339 U.S. 282, 293 (1950) (Frankfurter, J., concurring, joined by Justices Burton and Minton). Justice Frankfurter returned to the metaphor in his concurrence in a subsequent case on discrimination against blacks for selection to serve as regular jurors. In Walker County, Georgia, jurors were selected by drawing their names from a box; "the names of white persons" were printed on white tickets, while "the names of Negroes" were printed on yellow tickets. *Avery v. Georgia*, 345 U.S. 559, 560 (1953). The Supreme Court found that system unconstitutional, and Frankfurter added that the "mind of justice, not merely its eyes, would have to be blind to attribute" the absence of black jurors to "mere fortuity." 345 U.S. at 564.

**135** The poem first appeared in the *Amsterdam News* on April 25, 1923. See Hans Ostrom, A Langston Hughes Encyclopedia 195 (Westport, CT: Greenwood Press, 2002) (hereinafter Hughes Encyclopedia). Eight years later, in *Scottsboro Limited*, the poem was published with three others: *Scottsboro*, *Christ in Alabama*, and *The Town of Scottsboro*. The four poems served as a prelude to a one-act drama that included eight defendants, plus "eight white workers, a white man, and two white women," and called for audience participation. Recreated are parts of the trial showing both racism and class exploitation. See Joseph McLaren, Langston Hughes: Folk Dramatist in the Protest Tradition, 1921–1943 at 33–40 (Westport, CT: Greenwood Press, 1997). Richard Wright used the blindness metaphor again in his book *Native Son*, published in 1940. Id. at 35. See also Hughes Encyclopedia at 345. Hughes republished *Justice* in 1938 in a book of poems titled *A New Song*. There, however, the phrase "we black" in the second line of the poem became "we poor." See Langston Hughes, The Collected Works of Langston Hughes, vol. 1: The Poems, 1921 1940 at 133 (Arnold Rampersad, ed., Columbia, MO: U. of Missouri Press, 2001).

**136** Dan T. Carter, Scottsboro: A Tragedy of the American South 3–48 (Baton Rouge, LA: Louisiana State U. Press, 1979).

**137** See Carter at 166; Hughes Encyclopedia at 343.

**138** Hughes, who lived from 1902 to 1967, was a leader of what is termed the Harlem Renaissance, in which a host of talented African Americans generated art and literature. Many accounts of the events and the protests that surrounded the Scottsboro trial have been written. See, for example, Hugh T. Murray Jr., *Changing America and the*

*Changing Image of Scottsboro*, 38 PHYLON 82 (1977). Hughes's involvement is tracked in Michael Thurston, *Black Christ, Red Flag: Langston Hughes on Scottsboro*, 22:3 COLLEGE LITERATURE 30, 32–33 (1995) (describing Hughes's distress at the initial absence of attention paid in the "Negro schools and colleges" and Hughes's composition of the first poem, opening with the line "Christ is a Nigger").

**139** Haywood Patterson had been in jail for seventeen years. Murray at 85–86.

**140** MCLAREN at 34. The year was 1976.

**141** By the late 1990s, more than 18,000 black lawyers, judges, legal scholars, and students were members, and six women had served among the fifty-six presidents, according to President Beverly McQueary Smith, who served in 1998–1999, quoted in JACKSON & GORDON at xii.

**142** Gilbert Ware, *Introduction, Proceedings: Founding Convention of the Judicial Council of the National Bar Association*, 20 JOURNAL OF PUBLIC LAW 371, 371 (1971). Eligible for membership were persons who were or had been in "judicial or quasi-judicial" positions. JACKSON & GORDON at 36. As the bylaws also detailed, one of the aims was to "hasten the meaningful integration of the judiciary." Id. at 37; Program of the Founding Convention of the Judicial Council of the National Bar Association, Aug. 3–6, 1971.

**143** Honorable George W. Crockett Jr., quoted by Ware at 372.

**144** The group identified judicial discretion and courts as sources of "racism," including differential treatment by police and prosecutors, exclusion from juries, inattentive witnesses, and abuse from lawyers. See George W. Crockett Jr., *Racism in the Courts*, 20 JOURNAL OF PUBLIC LAW 385 (1971). The first program's agenda included that topic—"Racism in the Courts"—as well as seminars on problems in different kinds of courts and on economic inequality. At the time, of about 12,500 judges nationwide in state and federal courts, some 325 were black. The group hoped that black judges would be better able to see and remediate racism. Crockett at 388–389.

**145** The facsimile by Yale University Press in figure 76 is reproduced with the permission of the Honorable Michael Bagneris, 2006 Chair of the Judicial Council of the National Bar Association, and with the assistance of Maurice Foster of that organization. Our thanks to the Honorable Ulysses Gene Thibodeaux, Chief Judge, Court of Appeals, Third Circuit, State of Louisiana, for bringing this image to our attention and for his tireless efforts to make it available to us.

**146** Crockett at 389.

**147** For example, a decade after the founding of the Judicial Council, a federal appellate judge, Damon Keith, speaking at the fifty-sixth annual National Bar Association Convention, specifically objected to the idea that law be "color-blind." Then one of two black judges on the United States Court of Appeals for the Sixth Circuit (including the federal courts of Kentucky, Michigan, Ohio, and Tennessee), Judge Keith pointed out that the dictionary provided the words "insensitive" and "oblivious" as synonyms for being blind, and he argued that to be color-blind was to ignore hundreds of years of discrimination on the basis of color. Honorable Damon J. Keith, *Should Color Blindness and Representativeness Be a Part of American Justice?* 26 HOWARD LAW JOURNAL 1, 1–4 (1983).

**148** *See United States v. Leviner*, 31 F. Supp. 2d 23 (D. Mass. 1998). There the Honorable Nancy Gertner decided to "depart" (a term of art) from sentencing guidelines because a defendant's prior convictions were "largely motor vehicle offenses" and a good deal of literature "strongly suggests that there is racial disparity in the rates at which African Americans are stopped and prosecuted for traffic offenses." Id. at 24.

**149** See, for example, Irfan Nooruddin, *Blind Justice: "Seeing" Race and Gender in Cases of Violent Crime*, 3 POLITICS & GENDER 321 (2007); and Andrew E. Taslitz, *Racial Blindsight: The Absurdity of Color-Blind Criminal Justice*, 5 OHIO STATE JOURNAL OF CRIMINAL LAW 1 (2007). Taslitz borrowed the psychological term for "seeing without knowing it," with examples of blind individuals able to avoid

harms as if they could see them coming, and mixing the idea of the trauma of slavery with blindness to its consequences.

**150** See Kimberlé Williams Crenshaw, *Foreword: Towards a Race-Conscious Pedagogy in Legal Education*, 11 NATIONAL BLACK LAW JOURNAL 1, 2 (1989) (discussing the purported "perspectivelessness" of legal discourse).

**151** I. Bennett Capers, *On Justitia, Race, Gender, and Blindness*, 12 MICHIGAN JOURNAL OF RACE & LAW 203, 232 (2006).

**152** Capers at 232–233.

**153** See Alex Stein, *Constitutional Evidence Law*, 61 VANDERBILT LAW REVIEW 65 (2008).

**154** See generally STEFANO MAFFEI, THE EUROPEAN RIGHT TO CONFRONTATION IN CRIMINAL PROCEEDINGS: ABSENT, ANONYMOUS AND VULNERABLE WITNESSES at 11–17 (Groningen, Neth.: Europa Law Publishing, 2006).

**155** U.S. CONST., Amend. VI. See generally Richard D. Friedman, *"Face to Face": Rediscovering the Right to Confront Prosecution Witnesses*, 8 INTERNATIONAL JOURNAL OF EVIDENCE & PROOF 1 (2004).

**156** The United States Supreme Court has concluded that the provision bars "admission of testimonial statements of a witness who did not appear at trial unless he was unavailable to testify, and the defendant had had a prior opportunity for cross-examination." *Crawford v. Washington*, 541 U.S. 36, 53–54 (2004). A key question is when a person has provided "testimonial statements," as contrasted with "other hearsay that, while subject to traditional limitations upon hearsay evidence, is not subject to the Confrontation Clause." In *Davis v. Washington*, 547 U.S. 813, 821–824 (2006), in the context of whether statements made by a victim of domestic violence in her phone call to an emergency help center or thereafter to the police were subject to Confrontation Clause rights, the Court held: "Statements are nontestimonial when made in the course of police interrogation under circumstances objectively indicating that the primary purpose of the interrogation is to enable police assistance to meet an ongoing emergency. They are testimonial when the circumstances objectively indicate that there is no such ongoing emergency, and that the primary purpose of the interrogation is to establish or prove past events potentially relevant to later criminal prosecution."

**157** Article 6(3)(d) of the European Convention on Human Rights states that everyone charged with a criminal offense has the right to "examine or have examined witnesses against him and to obtain the attendance and examination of witnesses on his behalf under the same conditions as witnesses against him." Given varying legal traditions throughout Europe, that requirement has been translated to require that defendants have the opportunity to have evidence against them tested, but not necessarily that confrontation occur at one time in a consolidated trial. See Sarah J. Summers, *The Right of Confrontation after* Crawford v. Washington: *A "Continental European" Perspective*, 2 INTERNATIONAL COMMENTARY ON EVIDENCE 1, 10 (Berkeley Electronic Press, http://www.bepress.com/ice, 2004). Not all statements used in evidence need be heard in open court. Id. at 5. Rather, the focus is on the "examination" of witnesses rather than on confrontation, which has a more adversarial focus. See MAFFEI at 16–19, 67–78.

**158** See generally John H. Langbein, *Historical Foundations of the Law of Evidence: A View from the Ryder Sources*, 96 COLUMBIA LAW REVIEW 1168 (1996). Langbein provided examples of prohibitions against self-serving statements by "interested" parties and concerns about falsification of documents, arguing that the central purpose of evidentiary rules in England was to "guard against the inherent weaknesses of jury trial." Id. at 1194.

**159** "In all criminal prosecutions, the accused shall enjoy the right to a speedy and public trial, by an impartial jury of the State and district wherein the crime shall have been committed, which district shall have been previously ascertained by law, and to be informed of the nature and cause of the accusation; to be confronted with the witnesses against him; to have compulsory process for obtaining wit-

nesses in his favor, and to have the Assistance of Counsel for his defence." U.S. Const., Amend. VI.

**160** Drew L. Kershen, *Vicinage*, 30 Oklahoma Law Review 1, 75–76 (1977).

**161** After conviction challenges are sometimes refused, even, for example, when a convicted defendant learns that a juror was a childhood friend of the victim. See *Rushen v. Spain*, 464 U.S. 114, 120–121 (1983).

**162** See Fed. Rule Evid. 403 (Exclusion of Relevant Evidence on Grounds of Prejudice, Confusion, or Waste of Time) (2007).

**163** Terms such as "the lemon problem" (that knowing about one bad experience—for example, a friend's poorly performing car—skews one's assessment of the brand in general) and "implicit bias" (that cultural attitudes toward race, age, or sex generate presumptions without a person's awareness) capture concerns about how certain pieces of data overwhelm one's ability to assess the import of information. See generally George A. Akerlof, *The Market for "Lemons": Quality Uncertainty and the Market Mechanism*, 84 Quarterly Journal of Economics 488 (1970); see also Lane, Mitchell, & Banaji.

**164** See Elizabeth F. Loftus, Eyewitness Testimony (Cambridge, MA: Harvard U. Press, 1979, 1996); Brian L. Cutler & Steven D. Penrod, Mistaken Identification: The Eyewitness, Psychology, and the Law (Cambridge, Eng.: Cambridge U. Press, 1995); Samuel R. Sommers & Phoebe C. Ellsworth, *White Juror Bias: An Investigation of Prejudice against Black Defendants in the American Courtroom*, 7 Psychology, Public Policy & Law 201 (2001); Chet K. W. Pager, *Blind Justice, Colored Truths and the Veil of Ignorance*, 41 Willamette Law Review 373 (2005). Pager proposed that screens be erected so that jurors could not see the race of a person testifying. In practice, eyewitness testimony was neither the dominant source of information in criminal prosecutions nor the only unreliable form relied on. See Steven B. Duke, Ann Seung-Eun Lee, & Chet K. W. Pager, *A Picture's Worth a Thousand Words: Conversational versus Eyewitness Testimony in Criminal Convictions*, 44 American Criminal Law Review 1 (2007). The authors noted that between 2001 and 2006 hundreds of articles focused on the attention paid to eyewitness testimony and its inaccuracies and sought to draw attention to the limitations of "conversational testimony." Id. at 2–4.

**165** *Estelle v. Williams*, 425 U.S. 501 (1976). The majority, however, concluded that the defendant had not raised the objection in a timely fashion and permitted the conviction to stand. The Court has also sanctioned gagging a disruptive defendant. See *Illinois v. Allen*, 397 U.S. 337 (1970). But such restraints, as well as putting "visible shackles" on a defendant, are permissible only if "justified by an essential state interest." See *Deck v. Missouri*, 544 U.S. 622, 628 (2005); and *Holbrook v. Flynn*, 475 U.S. 560 (1986).

**166** The *Book of Judges, Treatise One: Sanhedrin*, in The Code of Maimonides (Mishneh Torah), bk. XIV, ch. xxi, paras. 1–2 at 63 (Yale Judaica Series, Abraham M. Hershman, trans., New Haven, CT: Yale U. Press, 1949).

**167** *Carey v. Musladin*, 549 U.S. 70 (2006).

**168** See generally Jennifer L. Mnookin, *The Image of Truth: Photographic Evidence and the Power of Analogy*, 10 Yale Journal of Law & Humanities 1 (1998). There Mnookin invoked Oliver Wendell Holmes's phrase referring to the photograph as "a mirror with a memory." Id. at 16.

**169** See Ira P. Robbins, *The Ostrich Instruction: Deliberate Ignorance as a Criminal Mens Rea*, 81 Journal of Criminal Law & Criminology 191 (1990). The term "willful blindness" can be found in both English law and that of the United States. Id. at 191–200; *United States v. Alston-Graves*, 435 F.3d 331, 338 (D.C. Cir. 2006) (also citing the Model Penal Code of 1985 as approving of the concept of the ostrich charge).

**170** See the discussion of the ostrich in Chapter 4 and figs. 4/55 and 4/56. Ripa explained that Justice had to unravel problems through

a "patient attitude" like that of the ostrich, reputed to be able to digest everything if it did so slowly. As one translation of Ripa put it: "The ostrich ruminates its food as Justice should testimony put before her." Ripa, Padua–1611 at 203.

**171** *United States v. Giovannetti*, 919 F.2d 1223, 1226 (7th Cir. 1990).

**172** *Giovannetti*, 919 F.2d at 1228 (Posner, J.). The court concluded that the evidence was not sufficient to support an ostrich charge, because the record did not include efforts to cut off "one's normal curiosity by an effort of will." Id. at 1229. Judge Posner returned to the issue of ostriches and "ostrich" instructions, stating that "the legend that ostriches when frightened bury their head in the sand" is a "canard on a very distinguished bird." Quoting the Zoological Society of San Diego, Judge Posner noted that ostriches do not bury their heads but rather fall to the ground when they sense danger. Since the color of their head and neck blends in with the color of the sand and "only the body is visible," the head only appears to be buried. He concluded that it was "too late, however, to correct this injustice." *United States v. Black*, 530 F.3d 596, 604 (7th Cir. 2008).

## CHAPTER 6

**1** See David Cast, *Marten van Heemskerck's Momus Criticizing the Works of the Gods: A Problem of Erasmian Iconography*, 7 Simiolus: Netherlands Quarterly for the History of Art 22, 29 (1974).

**2** De Iusticia Pingenda, On the Painting of Justice: A Dialogue between Mantegna and Momus by Battisti Fiera, The Latin Text of 1515 Reprinted with Translation, an Introduction and Notes by James Wardrop 35, 27–41 (London, Eng.: Lion and Unicorn Press, 1957), discussed in Chapter 5.

**3** We discuss later in this chapter how efforts to hide the offensive imagery evoke the analyses of Michel Foucault's *Discipline and Punishment* about state attempts to silence conflict through making the grounds for protest invisible. See Michel Foucault, Discipline and Punish: The Birth of the Prison (Alan Sheridan, trans., New York, NY: Vintage Books, 2d ed., 1977).

**4** See William L. F. Felstiner, Richard L. Abel, & Austin Sarat, *The Emergence and Transformation of Disputes: Naming, Blaming, and Claiming . . .* , 15 Law & Society Review 631 (1980–1981).

**5** 347 U.S. 483 (1954). See generally Richard Kluger, Simple Justice: The History of Brown v. Board of Education and Black America's Struggle for Equality (New York, NY: Knopf, 1975); Kenneth Mack, *Rethinking Civil Rights Lawyering and Politics in the Era Before Brown*, 115 Yale Law Journal 256 (2005).

**6** See, for example, the Civil Rights Act of 1964, Pub. L. 88–352, now codified at 42 U.S.C. § 2000e et seq.; the Fair Housing Act of 1968, Pub. L. 90–284, codified at 42 U.S.C. § 3601 et seq.; the Equal Pay Act of 1963, Pub. L. 88-38, codified at 29 U.S.C. § 201 et seq. See generally Robert C. Post & Reva B. Siegel, *Legislative Constitutionalism and Section Five Powers: Policentric Interpretation of the Family and Medical Leave Act*, 112 Yale Law Journal 1943 (2003).

**7** See Judith Resnik, *Lessons in Federalism from the 1960s Class Action Rule and the 2006 Class Action Fairness Act: "The Political Safeguards" of Aggregate Translocal Actions*, 156 U. of Pennsylvania Law Review 1929 (2008).

**8** See Jonathan Crary, Techniques of the Observer: On Vision and Modernity in the Nineteenth Century 1–4 (Cambridge, MA: MIT Press, 1990) (hereinafter Crary, Techniques of the Observer).

**9** See generally Critical Issues in Public Art: Content, Context and Controversy (Harriet F. Senie & Sally Webster, eds., New York, NY: Harper Collins, 1992) (hereinafter Critical Issues in Public Art).

**10** See Donald W. Thalacker, The Place of Art in the World of Architecture xii (New York, NY: Chelsea House, 1980).

**11** Senator William Proxmire gave the commission a "Golden Fleece of the Month" award—for fleecing the public by using $100,000 of taxpayer dollars for the sculpture. THALACKER at 28.

**12** The public protests about *Tilted Arc* resulted in its removal in 1989; the *Batcolumn* remained in place. See generally CRITICAL ISSUES IN PUBLIC ART; see also HARRIET F. SENIE: THE TILTED ARC CONTROVERSY: DANGEROUS PRECEDENT (Minneapolis, MN: U. of Minnesota Press, 2002); Judith H. Balfe and Margaret J. Wyszomirski, *Public Art and Public Policy* 15 JOURNAL OF ARTS MANAGEMENT AND LAW 5 (Winter, 1986).

Conflicts over public art in the second half of the twentieth century resulted in changes to the methods by which commissions were awarded. In the early 1960s, when set-asides for public art in federally funded buildings were put into place, architects played a major role in selection. After the National Endowment for the Arts (NEA) came into being, it played a significant role in the selection of panels commissioning public art projects for the GSA. The NEA, in turn, gave artists a major role in panels, often comprised of their peers. In the early 1970s, GSA procedures shifted to put the project architect in charge of submitting an art-in-architecture proposal as part of the overall design, including providing proposed descriptions of the kind and placement of artworks. The GSA then asked the NEA to appoint qualified artists to review proposals, with final decisions made by the Design Review Panel of the GSA Public Building Service. THALACKER at xiii. In 1976–1977 the process was revised again, and more community representatives, including the "mayor or an appropriate local government official," along with key civic groups, were added. That system was designed to win wider public acceptance of GSA commissions. Id. at xiii.

A review of forty-one GSA commissions from the 1970s through the 1990s sought to analyze when and why controversies emerged. See Steven J. Tepper, *Unfamiliar Objects in Familiar Places: The Public Response to Art-in-Architecture*, 6 INTERNATIONAL JOURNAL OF CULTURAL POLICY 283 (2000). From his sample, Tepper concluded that half entailed no conflict and only a few resulted in organized protests. Id. at 289. When conflicts did arise, they occurred "over substantively neutral artworks—i.e., works that were not intended to be especially provocative." Id. at 304. In the subset involving protest, "abstract art provoked more controversy than representational art." Id. at 291. Tepper found that smaller cities were somewhat more often the sites of protest than larger ones (id. at 292), that community involvement had a modest effect in reducing the likelihood of conflict (id. at 295), and that some objections were predicated on the lack of connection between the art and the locality in which it was placed. Id. at 301. In Chapters 8 and 9, we return to interactions among government agencies when selecting courthouse art in the United States.

**13** Eugène Delacroix's *Liberty Leading the People* (1830) hangs in the Louvre in Paris. Delacroix's *Liberty* is but one iteration of the female allegorical figure that represents the Republic and is named either Liberty or Marianne. This figure is likely derived from Roman antiquity and brought to the French through "the whole allegorical apparatus [that] was codified for the benefit of artists in the seventeenth century." See MAURICE AGULHON, MARIANNE INTO BATTLE: REPUBLICAN IMAGERY AND SYMBOLISM IN FRANCE, 1789–1880, at 11 (Janet Lloyd, trans., Cambridge, Eng.: Cambridge U. Press, 1981). Agulhon cited "Liberté" in Cesare Ripa's *Iconologia*, reprinted in Paris in 1643–1644, as a primary influence. Id. at 11, n. 1. See CESARE RIPA, ICONOLOGIE (J. Baudoin, ed., Paris, Fran.: Matthieu Guillemot, 1644) (hereinafter FRENCH RIPA–1644).

The name Marianne may have been chosen for its populist origins (in spite of or because "Marianne was a derisive nickname given to the Republic by her adversaries") or because of its similarity to the Christian Mary. AGULHON at 32, 33–34. Lynn Hunt summarized Agulhon's explanations of Marianne's attractions: "The Phrygian bonnet or liberty cap of the goddess provided a particularly clear contrast with the crown of royal authority (and the female figure reinforced that contrast);

Catholicism made the French more receptive to a Marian figure (the sobriquet Marianne was certainly semantically close to Mary, mother of Jesus); and the French Republic could find in the feminine allegory a figure suitably distant from the real life heroes-turned-villains of the revolutionary process." See Lynn Hunt, *Hercules and the Radical Image in the French Revolution*, 2 REPRESENTATIONS 95, 98 (1983).

In 1792 the National Convention provided that the new Republic's seal would depict the allegorical figure of Liberty, holding a spear with a Phrygian cap at its top in her right hand and resting her left hand on a sheaf of fasces, to symbolize "La République." AGULHON at 18–19 (describing and reproducing the first seal of the Republic). After the Second Republic, formed in the wake of the Revolution of 1848, the government invited artists to submit new images for coins, stamps, medals, and paintings, to symbolize the "figure of the French Republic." While no winner was chosen for the painted figure, the image selected for stamps was of a woman in profile with a "complicated crown composed of ears of corn . . . grapes . . . and laurel" that became known as the "Ceres" stamp. AGULHON at 74–81.

Two visions of the Republic emerged; one (by then traditional) was a female in a warlike posture with bared breast and a Phrygian cap —aimed at capturing a "people's Republic that is impetuous and rebellious." The other was more sedate, and through a range of attributes ("the cap, the level, clasped hands, beehives, a voting urn, etc."), could be seen as depicting "the cautious Republic of order and reconciliation." Id. at 94.

Marianne was again reconfigured in 1969 when the French star Brigitte Bardot was chosen as a model for the figure, followed by other French actresses. In 1999, the Association of Mayors of France sponsored a contest to select a twenty-first-century "Marianne" and picked a model and actress, Laetitia Casta, who was said to have "once declared that her breasts were raised on butter and crème fraîche." Some objected that this "Mariannization of the stars" was a "travesty of national values." See Debra Ollivier, *Liberti, Egaliti, 36C*, Salon.com (Feb. 19, 2000), http://www.salon.com/people/feature/2000/02/19/mkarianne/index.html. In 2003, after another contest, the television star Évelyne Thomas was chosen.

**14** The images are available at the website of the French National Assembly, http://www.assemblee-nationale.fr/evenements/mariannes.asp.

**15** Elaine Sciolino, *Paris Journal*, NEW YORK TIMES, Aug. 1, 2003, at A4. What shapes and forms to use on American coinage has also been entwined with gender and with controversy. The Susan B. Anthony coin gave way to Sacagawea, a Shoshone woman pivotal in the exploration of the West, and then to presidents and their wives. See Reva Siegel, Collective Memory and the Constitution: Remembering (and Forgetting) the Nineteenth Amendment (lecture given at Rutgers Law School, Camden, New Jersey, March 2006).

**16** Sciolino, *Paris Journal*.

**17** Sciolino, *Paris Journal*.

**18** See AGULHON at 12–22. That cap has come to signify the freedom of "Liberty," by using a symbol from the "Roman custom in which the manumission of a slave was signaled by the wearing of a cap." Yvonne Korshak, *Paris and Helen by Jacques Louis David: Choice and Judgment on the Eve of the French Revolution*, 69 ART BULLETIN 102, 111 (1987). Again, Cesare Ripa's *Iconologia* provided an example. Korshak at 111, n. 35. Ripa specified that a female be shown with a scepter, a cap, and a cat as her attribute; Ripa explained that the cap represented "an ancient custom, [by which] the Romans had those slaves who were to be set free" wear that cap. See FRENCH RIPA–1644 at 99–100. The 1611 Padua edition has this description under the heading "Liberty." CESARE RIPA, ICONOLOGIA 312–313 (Padua, Ital.: Pietro Paolo Tozzi, 1611; New York, NY, & London, Eng.: Garland Publishing, 1976). See generally Yvonne Korshak, *The Liberty Cap as a Revolutionary Symbol in America and France*, 1 SMITHSONIAN STUDIES IN AMERICAN ART 53–69 (1987).

**19** A comparable ability to abstract the "noble savage" as providing analogies to Greek gods dissolves with awareness of the treatment of Indian tribes by the United States. Examples in public buildings of images of Indians as conquered subjects either to be civilized or to become relics, such as those on prominent display in the Capitol, can be seen as painful reminders of the injuries imposed. See VIVIEN GREEN FRYD, ART AND EMPIRE: THE POLITICS OF ETHNICITY IN THE UNITED STATES CAPITOL, 1815–1860, at 1–5, 157–163 (Athens, OH: Ohio U. Press, 2001; New Haven, CT: Yale U. Press, 1992).

**20** JONATHAN HARRIS, FEDERAL ART AND NATIONAL CULTURE: THE POLITICS OF IDENTITY IN NEW DEAL AMERICA 64–84 (Cambridge, Eng.: Cambridge U. Press, 1995).

**21** MARLENE PARK & GERALD E. MARKOWITZ, DEMOCRATIC VISTAS: POST OFFICES AND PUBLIC ART IN THE NEW DEAL 5 (Philadelphia, PA: Temple U. Press, 1984).

**22** In 1933 President Franklin Roosevelt established the Civil Works Administration. From December 1933 to June 1934, funding went to the Public Works of Art Project. Its successor, in existence from 1935 to 1943, was termed the Federal Art Project of the Works Progress (later called Projects) Administration (WPA). From 1934 to 1938, the Treasury-based project was called the Section of Painting & Sculpture and, from 1938 to 1939, the Section of Fine Arts. From 1939 to 1943, the program was called the Section of Fine Arts of the Public Buildings Administration of the Federal Works Agency.

Key to its leadership were George Biddle, who was both an artist and a friend of Roosevelt; Edward Bruce, a lawyer and administrator in the Treasury Department who was put in charge; and Edward Rowan, who administered the program, in part through sixteen regional divisions. The initial focus of the Public Works of Art Project had been to support needy artists ("on the rolls"). The Bruce-led program did not use economic need as a requirement for selection but aimed to employ artists thought able to enhance the decoration of federal buildings. See generally BELISARIO R. CONTRERAS, TRADITION AND INNOVATION IN NEW DEAL ART 29–60 (Lewisburg, PA: Bucknell U. Press, 1983); THE NEW DEAL ART PROJECTS: AN ANTHOLOGY OF MEMOIRS 3, 11–49 (Francis V. O'Connor, ed., Washington, DC: Smithsonian Institution Press, 1972) (hereinafter NEW DEAL ART PROJECTS).

A rich literature informs our understanding of the politics, aesthetics, and history of this period. See HARRIS at 1–6; SUE BRIDWELL BECKHAM, DEPRESSION POST OFFICE MURALS AND SOUTHERN CULTURE: A GENTLE RECONSTRUCTION 8–16 (Baton Rouge, LA: Louisiana State U. Press, 1989) (hereinafter BECKHAM, DEPRESSION POST OFFICE MURALS); PARK & MARKOWITZ at 3–9; KARAL ANN MARLING, WALL-TO-WALL AMERICA: A CULTURAL HISTORY OF POST OFFICE MURALS IN THE GREAT DEPRESSION (Minneapolis, MN: U. of Minnesota Press, 1982); and HARRIET W. FOWLER, NEW DEAL ART: WPA WORKS AT THE University OF KENTUCKY 118 (Louisville, KY: U. of Kentucky Art Museum, 1985).

**23** PARK & MARKOWITZ at 5. Because the Section of Fine Arts also hoped to use local talent when possible, some of the competitions were limited by region. Artists were asked to "submit designs" for murals, many of which were not painted in place but installed by specialized firms. BECKHAM, DEPRESSION POST OFFICE MURALS at 10–11.

**24** This approach has been called "conservative" in that it put individuals in competition with each other (see PARK & MARKOWITZ at 7), as it also sought to shape artists' identities as "productive citizens." HARRIS at 28–43.

**25** The move to the representational was understood by some to relax the "stranglehold of the romantic-escape school." LOIS CRAIG, THE FEDERAL PRESENCE: ARCHITECTURE, POLITICS, AND SYMBOLS IN UNITED STATES GOVERNMENT BUILDING 372 (Cambridge, MA: MIT Press, 1978) .

**26** MARLING, at 31, quoting a letter from Biddle to President Franklin Delano Roosevelt dated May 9, 1933. Biddle expressed his desire to see the government support young artists who had the ability and vision to express the ideas of America's "social revolution . . . in a permanent art form." Biddle also wrote that the "Mexican artists have produced the greatest national school of mural painting since the Italian Renaissance." The full text is reproduced in GEORGE BIDDLE, AN AMERICAN ARTIST'S STORY 268–269 (Boston, MA: Little, Brown, 1939). As discussed in Chapter 15, Biddle was himself called to Mexico in the early 1940s to paint murals for that country's new Supreme Court building. More of his role and the influence of Mexican muralists are detailed in a laudatory dissertation from 1944, Tax Payers' Murals, by Erica Beckh Rubenstein (Ph.D. dissertation, Harvard U., Cambridge, MA, 1944, History and Principles of Fine Arts).

**27** PARK & MARKOWITZ at 7–8.

**28** MARLING at 48–49; HARRIS at 25, 169, n. 50–51. See also NEW DEAL ART: NEW JERSEY (Newark, NJ: Newark Museum and Rutgers U. Press, 1980). That catalogue for an exhibition described how "a growing fear of Communism or any form of radicalism tainted" the efforts in the views of "many conservatives," while "radicals and leftists" saw the project as "another reactionary bulwark against true revolutionary change." Id. at 10.

**29** HARRIS at 169, n. 51.

**30** NEW DEAL ART: NEW JERSEY at 13.

**31** See Jane De Hart Mathews, *Art and Politics in Cold War America*, 81 AMERICA HISTORY REVIEW 762 (1976). As for how diverse a group was employed, evaluations depend on baselines. One count reported 850 artists and identified 150 women and 3 blacks (whether women or men) among the total involved in a set of commissions. PARK & MARKOWITZ at 8. Some regional diversity was apparent from commissions given to artists from Western states, but few Southern artists were in the mix.

**32** Even the "well-known George Biddle" was chided for "the rather overly-prominent rear end of a horse in one of his mural panels" in a New Jersey post office. NEW DEAL ART: NEW JERSEY at 16. See also Suzan D. Friedlander, Broome County, New York's Government Sponsored Post Office Murals of the 1930's (M.A. thesis, State U. of New York at Binghamton, Art History, 1990). Friedlander's archival research found changes made in a post office mural to emphasize the federal government's role in mail services at the expense of local events and alterations to another mural to avoid references to forms of government other than that of the United States. Hence, Friedlander disagreed with an assessment of artistic freedom once commissions were given. Id. at 38–41, 64–69.

**33** *WPA Murals Under Fire as a Study in Red*, CHICAGO DAILY TRIBUNE, July 7, 1940, at 1 (discussing the claim that murals, painted by WPA-chosen artists for a municipal airport in Brooklyn, New York, were "communist propaganda"—such as one showing "the Wright brothers . . . clad in garments similar to those worn by Russian peasants, in a scene symbolic of the birth of aviation"). Another mural in a New Jersey high school was criticized for depicting shapes resembling sickles. A third, painted for Newark Airport by noted cubist Arshile Gorky, featured a red star that might well have been "the trademark of the Texaco Oil Company" rather than a reference to Soviet imagery. See RICHARD D. MCKINZIE, THE NEW DEAL FOR ARTISTS 166-167 (Princeton, NJ: Princeton U. Press, 1973). The Brooklyn airport mural was ordered removed and burned by a local WPA administrator. MCKINZIE at 166. In terms of the political views of artists, some were involved in organizations identified as left-wing. See HARRIS at 145–149; Lincoln Rothschild, *Artists' Organizations in the Depression Decade*, in NEW DEAL ART PROJECTS at 198, 214–221.

**34** See Emergency Relief Appropriation Act, Fiscal Year 1941, § 15(f), 54 Stat. 620 (1940) (hereinafter 1941 Emergency Relief Appropriation), providing that "[n]o alien, no Communist, and no member of any Nazi Bund Organization" was eligible for WPA employment and that an affidavit affirming that one was not a Communist was required prior to being paid. Section 17(a), requiring that persons take

oaths to defend the Constitution; Section 17(b) provided that no money be given to those who advocated or were members of organizations advocating the "overthrow of the Government of the United States through force or violence." The appropriations for 1941, 1942, and 1943 required the affiant to swear that he or she was not a "Communist and not a member of any Nazi Bund Organization." See, for example, 1941 Emergency Relief Appropriation at §15(f) (1940). The political interactions producing these limitations are detailed by McKinzie at 149–163.

**35** HARRIS at 130.

**36** HARRIS at 3.

**37** MARLING at 293. Marling noted that one cubist mural, by Lloyd Ney, made it into a post office in Ohio in 1940. Id. at 293–303.

**38** See *Painting and Sculpture Competition for Newark Post Office, Immediate Release*, Mar. 22, 1935, Historical Society of the U.S. District Court for the District of New Jersey (hereinafter N.J. Federal Court Historical Society Archives). The notice specified the scale of the models. The art for the Newark Courthouse was part of about fifty "murals, reliefs and sculptures which represent the Treasury Section commissions" from that era in New Jersey. NEW DEAL ART: NEW JERSEY at 15. The District of New Jersey, organized and convened on December 22, 1789, is the second-oldest federal district court in the United States. See A. Ronald Nau, *The Early History of the United States District Court for the District of New Jersey*, at the Historical Society's website, http://www.history.njd.uscourts.gov/courtHist/dist .html. See generally MARK EDWARD LENDER, "THIS HONORABLE COURT": THE UNITED STATES DISTRICT COURT FOR THE DISTRICT OF NEW JERSEY, 1789–2000 (New Brunswick: NJ: Rutgers U. Press, 2006). Lender reported that the five-story Newark building, with 457,000 square feet, cost $6.15 million. The picture of the Newark courthouse, "modeled to look similar to the new Treasury Department building in Washington, D.C.," was put on a postcard. LENDER at 170.

**39** *Young Sculptor on the Relief Rolls Wins Federal Award with Scale-Less Justice*, NEW YORK TIMES, Sept. 24, 1935, at 25 (hereinafter *Scale-Less Justice*). That story reported that selection involved both a local and a Washington-based committee reviewing anonymous submissions. See also *"Justice" to Brood in Federal Building*, NEWARK EVENING NEWS, Sept. 23, 1935. The local committee included the Director of the Newark Museum as well as one of the building's architects, William Lehman. See Letter from George O. Totten Jr. to Olin Dows (April 4, 1935), N.J. Federal Court Historical Society Archives. That committee's first choice was not a statue by Kraus, although it was recommended for consideration. See Eddie-Sue McDowell, Romuald Kraus: *"Justice" and Other Work for the Works Progress Administration, 1933–1943*, at 13–14, 22–23 (M.A. thesis, U. of Louisville, 1992; UMI Publication No.: AAT 1350048).

Kraus was born in 1891 and died in 1954. During the period between 1933 and 1943, he sculpted many female figures, and several have features similar to his *Justice*. From 1947 to 1953, Kraus taught sculpture at the University of Louisville. See Justus Bier, *Obituaries, Romuald Kraus 1891–1954*, 14 COLLEGE ART JOURNAL 295, 296 (1955) (hereinafter *Kraus Obituary*). As noted, under Edward Bruce, the Section of Fine Arts at the Treasury Department had shifted from need to "merit alone" to select the "best contemporary American art" for federal buildings. BECKHAM, DEPRESSION POST OFFICE MURALS at 9–10.

**40** The photographs for figures 77, 79, and 80 were taken and provided for our use by James J. Waldron, the Clerk of the Bankruptcy Court for the United States District Court of New Jersey, and Director of the Historical Society of the District of New Jersey; he generously provided extensive research materials, as did the Honorable Katharine S. Hayden, United States District Judge for the District of New Jersey; Ronald Hedges, former Magistrate Judge of the District of New Jersey; and Gail Gilbert, Director of the Margaret M. Bridwell Art Library, University of Louisville. Much of the information and news clippings on Kraus come from the New Jersey Federal Court

Historical Society Archives and from the Margaret M. Bridwell Art Library, University of Louisville, where the Romauld Kraus Papers are archived (hereinafter Kraus Papers).

A summary of the controversy that enveloped the Kraus statue can also be found in the brochure for the program, titled *WPA Art at the Newark Federal Courthouse: Our Continuing Legacy* (published by the N.J. Federal Court Historical Society). The program, held on May 14, 2008, celebrated both the relocation of the Kraus statue to the center of the rotunda of the third floor of courtrooms in what is now called the Frank R. Lautenberg U.S. Post Office and Courthouse and the installation of two murals that replicate original designs that were not placed in the courthouse in the 1930s. See also Magistrate Judge Claire Cecci, *Lady Justice: A Controversial Artistic Depiction*, in vol. 5 of the newsletter *Nunc Pro Tunc* ("Now for Then") at 3 (U.S. District Court Historical Society, Summer 2003).

**41** *Scale-Less Justice* at 25. A local Newark newspaper put the number of artists who competed at forty-four. See *Public Gets Chance to Pass on "Justice,"* NEWARK STAR-EAGLE, Oct. 22, 1935 (pages unnumbered).

**42** PARK & MARKOWITZ at 61.

**43** Letter from Edward B. Rowan, Superintendent, Section of Painting & Sculpture, to Miss Beatrice Winser, Secretary and Director of the Newark Museum (and a member of the local selection committee), Sept. 23, 1935, N.J. Federal Court Historical Society Archives.

**44** *Scale-Less Justice* at 25.

**45** McDowell at 15–23.

**46** *"Justice," Unblindfolded, Raises Newark Row*, 10 ART DIGEST 17 (1935) (hereinafter *Justice Unblindfolded*). Totten was quoted as stating that nothing "in that figure is significant of American justice." Id. McDowell reported that Totten had hoped to choose an artist directly. His effort to avoid having a competition produced protests from the American Institute of Architects and the Sculpture Society of America. McDowell at 19. Totten then wrote to the Treasury Department's head of procurement that he had created a niche for a Justice image and sought the commission for his wife; having been told of the competition and reviewed sketches, he thought that his wife's proposal ought to be accepted or the "niche left without sculptural adornment." George O. Totten Jr., Letter to Admiral C. J. Peoples (Aug. 26, 1935), N.J. Federal Court Historical Society Archives.

**47** *Justice Unblindfolded* at 17. See also *New Deal Statue in Newark Scored*, NEW YORK TIMES, Oct. 21, 1935, at 21. The story quoted Judge Fake as describing himself as "old fashioned enough to stand by the classical conception of a blindfolded Justice with sword and scales, and looking like a human being." Id. In another news account, the judge was described as a "Republican"—presumably putting him at odds with the New Deal. McDowell at 17. Guy Laverne Fake had been appointed in 1929 by President Herbert Hoover. Fake had served in the Spanish-American War, in the New Jersey Assembly, and as a state court judge. In 1948, when Congress authorized a chief judge for each district, Judge Fake's seniority resulted in his assuming that position until he retired in 1951. He was known as a "foe of many of the economic and political trends associated with the New Deal." LENDER at 161–162.

**48** PARK & MARKOWITZ at 61.

**49** See *Public Gets Chance to Pass on "Justice,"* NEWARK STAR-EAGLE, Oct. 22, 1935, from the N.J. Federal Court Archives. See also *Kraus Favors Statue though Critics Rage*, NEWARK LEDGER, Oct. 22, 1935 (hereinafter *Kraus Favors Statue*). That article reported that sixty-nine models were displayed at the Newark Museum. A few are reproduced in the 2008 brochure *WPA Art at the Newark Federal Courthouse*.

**50** *Justice Unblindfolded* at 17. Kraus was born in what became Romania but was under Austrian rule in 1891. Trained as a medalist, Kraus came to the United States in 1924. After the "unsolicited notoriety" involving his Newark Justice, he moved to the Midwest. McDowell at 1–2.

**51** McDowell at 25. That dissertation attributed this quote to an article published in the *Newark Ledger* (*Kraus Favors Statue*, NEWARK LEDGER) and questioned the accuracy of that quote.

**52** *Justice Unblindfolded* at 17. This quote (slightly altered) can also be found in the article *Thinks "Justice" Is Christian*, an undated news clipping (possibly from the *New York Sun*) provided from the N.J. Federal Court Historical Society Archives. Other accounts report that Kraus said he had been influenced by his brother, a judge in Austria, to view Justice as "a motherly figure, having understanding," and that his statue's strong arms were to "give strength to the judge" to insist on "earnest supplication for truth." Cecci at 3 (drawing on materials from *Kraus Favors Statue*).

**53** *Kraus Obituary* at 296.

**54** Edward Alden Jewell, *Under Federal Guidance: Sculpture and Murals Produced in the Treasury Department's Competitions*, NEW YORK TIMES, Oct. 27, 1935, at X9.

**55** *Sculptor Defends Modern "Justice,"* NEW YORK TIMES, Oct. 27, 1935.

**56** McDowell, at 28–30, described the photographs of the maquette. Government officials wrote Kraus to suggest how to improve the image. See, for example, Letter from Edward Rowan, Assistant Chief, Fine Arts Section, Federal Works Agency, Public Buildings Administration, to Romuald Kraus (July 22, 1936).

**57** The photograph in figure 78, *Romuald Kraus with Full-Size Bronze Cast of "Justice,"* circa 1937, was provided by Gail R. Gilbert, Director of the Margaret M. Bridwell Art Library, University of Louisville and is reproduced with permission from that collection.

**58** One of Kraus's teachers, Engelmann, had studied with Malliol. See *Kraus Obituary* at 296. McDowell, at 28–29, suggested that the final version bore a resemblance to some versions of the Greek *kore* figure, which presented a "frontal attitude."

**59** *New Glories for Exiled Justice Statue*, NEWARK EVENING NEWS, Nov. 1, 1938, N.J. Federal Court Historical Society Archives; see also McDowell at 31–32.

**60** The award of $250 was given for this "unconventional figure of Justice," who lacked the "customary attributes of sword, scales and blindfold." See *Cincinnatian Wins Prize with Controversial Statue*, CINCINNATI TIMES-STAR, June 29, 1939 (unpaginated news clipping from the N.J. Federal Court Historical Society Archives).

**61** See *Lady Justice Returning as Art Heroine* (news clipping, possibly from the NEWARK LEDGER, undated). "Instead of her small, prison-like surroundings [locked in a room], she will be given a place of honor in the central corridor facing the courtrooms." Id. Before going to San Francisco, the statue was displayed in an exhibit at the Museum of Modern Art Gallery in Washington, D.C., and after receiving the award at the Golden Gate International Exhibition of Art at the World's Fair in San Francisco, the statue was also shown at the Pennsylvania Academy of Fine Arts and then returned to Newark. *WPA Art at the Newark Federal Courthouse*; see also Letter from Assistant Director of Procurement to Mr. R. J. McKinney, Golden Gate International Exposition (Dec. 23, 1938), Kraus Papers; Letter from Inslee Hopper to Guy Fake (Nov. 29, 1939), Kraus Papers.

**62** *New Glories for Exiled Justice Statue*.

**63** The building opened that year. See Cherry Greve Llyford, *Covington Postoffice Gets Replica of Famous Statue*, CINCINNATI TIMES-STAR, Apr. 5, 1941, at 14. Before its installation in the courthouse, the statue was in the Cincinnati Art Museum. See *Famous Statue: Replica of Work That Causes Storm of Protest to Be Displayed Here* (undated news clipping, Kraus Papers). New York City's Museum of Modern Art also wanted a copy, but the wartime shortage of bronze stymied the proposed third version. McDowell at 33–35. See also Letter from Inslee A. Hopper, Consultant to the Chief of the Section of Fine Arts of the Department of the Treasury, to Dorothy C. Miller, Associate Curator, Museum of Modern Art, N.J. Federal Court Archives (Dec. 10, 1941).

In 1955, when Kraus died, a local paper, *The Courier Journal*,

described him as Kentucky's "greatest sculptor" and the *Justice* as his "most widely known work," a "serene" figure that expressed his "thankfulness for the freedom this country offers." Justus Bier, *Romuald Kraus*, LOUISVILLE COURIER-JOURNAL, Jan. 2, 1955 (unpaginated). As of 2009, the Covington statue remained in place; the building in which it sat was no longer a courthouse but continued to function as a post office. See, for example, Jim Reis, *Post Office Still Occupies the 1941 Building*, KENTUCKY POST, June 23, 2003. In 1999, a new federal courthouse opened in Covington. The set-aside for its art was devoted to glassworks by Kenneth F. vonRoenn Jr., an artist with work in other federal courts as well. Our thanks to Mark Dwertman of the U.S. Post Office in Covington for verifying the current placement of the Kraus *Justice*.

**64** In the 1930s, objections had also been leveled against two murals that had been designed by Tanner Clark. One showed children at play, and the other depicted an industrial accident in which a young person's hand caught in a rotary saw. The murals were stored and eventually destroyed. In 2008, under the auspices of the Historical Society for the United States District Court of New Jersey, the artist Mark Romanoski recreated the murals for installation inside a courtroom. As noted, their display was celebrated in conjunction with the relocation of Kraus's *Justice*.

**65** Memoranda of June 13, 1935, and August 22, 1935, Treasury Department. The June 13 memorandum stated that, given that the architect's wife had done some work and that the amount of funding was relatively small, "in this case an exception to our usual procedure of holding a competition would seem to be justified." The two medallions—circular aluminum metal works more than four feet in diameter—are on opposite walls of the rotunda at the center of the third floor where several courtrooms are located. As the photographs indicate, both medallions are in a style associated with Art Deco; each shows a woman in a flowing robe. The figure labeled *Darkness* is blindfolded. Totten received another commission for a post office relief in Spencer, West Virginia. See Karen Vuranch, *The Post Office Murals of West Virginia: New Deal Art in the Mountain State*, PEOPLE & MOUNTAINS: A PUBLICATION OF THE WEST VIRGINIA HUMANITIES COUNCIL 8, 11 (Fall 2001).

**66** See *"Justice" Is Done*, NEWARK STAR-LEDGER, March 26, 1992. The article quoted the sculptor on the work's monumentality and its placement without a pedestal: "The blindfold Moore has chosen for her Themis, rather than concealing the eyes, accentuates their contours and reveals them through hooded slits in the fabric." Moore's work in the Rudman Courthouse in New Hampshire is discussed in Chapter 5, figs. 5/72–5/75. The Newark King Courthouse, built for $53 million, joined the Peter W. Rodino Jr. Federal Office Building and the Lautenberg "old" Courthouse to shape a complex now defined by barriers erected after the September 11, 2001, bombings.

**67** The poem is reproduced with the permission of Mark Strand. According to Moore, the composition was provided by Strand without her participation. See *"Justice" Is Done*.

**68** Our thanks to Susan Harrison of the Art-in-Architecture Program and to Kathryn Erickson and Erin Clay of the Collection of Fine Arts of the GSA for their generous help in obtaining historical materials and the photograph reproduced in figure 81, courtesy of the Fine Arts Collection, United States General Services Administration. The conflict over the Hirsch mural is discussed in several books. See JACK IRBY HAYES JR., SOUTH CAROLINA AND THE NEW DEAL 63–64 (Columbia, SC: U. of South Carolina Press, 2001); PARK & MARKOWITZ at 61; BECKHAM, DEPRESSION POST OFFICE MURALS at 15, 44–45; MARLING at 28–80. The Aiken building was subsequently named the Charles E. Simons Jr. Federal Courthouse after Judge Simons, who had served as the Chief Judge for the District of South Carolina from 1980 to 1986.

**69** MARLING at 50. One commentator reported that part of the initial design, called *Justice and Protection—Even for the Prisoner*, included "a dramatic portrayal of a black man about to become the vic-

tim of a lynch mob being protected by the National Guard"; by the time the mural was installed, the scene was omitted. See Martha R. Severens, *Southern Scene*, 13 American Art Review 112, 117 (2001) (reproducing that image).

**70** August Meier & John H. Bracey Jr., *The NAACP as a Reform Movement, 1909–1965: "To Reach the Conscience of America,"* 59 The Journal of Southern History 3, 9–10 (1993).

**71** Marling at 29 (also calling it—perhaps ironically—a "white elephant"); see also id. at 63–65.

**72** Hirsch, who died in 1964, taught at Bennington and at Bard Colleges; his work is in the collections of major museums. See "Draft, Hirsch as Protector and Avenger" (undated), in GSA Archives, Public Building Services, Fine Arts Collection, 477, Stefan Hirsch (hereinafter GSA Archives/FA 477, Hirsch description). See also Stefan Hirsch and Elsa Rogo Papers, 1926–1985 (Boxes 1–3 and 11) in the Archives of American Art, Smithsonian Institution, www.aaa.si.edu/collections/collection/hirstef.htm. The correspondence on the Hirsch mural comes from that collection. Quoted materials have been corrected for obvious typographical and spelling errors.

**73** Letter from Edward B. Rowan, Superintendent, Section of Painting & Sculpture, U.S. Treasury Department, to Stefan Hirsch (Jan. 7, 1938). Hirsch replied that he had revised the sketches of both wings of the picture so that those protected by Justice looked "more hopeful and contented . . . . The old man smiles and smokes his pipe in a comfortable pose. The old lady is not staring ahead dejectedly waiting for help but is knitting and seems to be thinking of pleasant things. The two orphans . . . are consoling each other . . . . Even the cow has become a healthy well fed specimen instead of the emaciated, poverty-stricken creature she was and she has taken on an offspring, a promise of the future." Letter from Hirsch to Edward B. Rowan (Jan. 18, 1938). Hirsch continued that he had made "radical changes" to the side showing Justice as avenging wrongdoing: "I have shown the murderer-robber emptying a drawer flash-light under the arm. Behind him a part of the prone figure of his victim is visible and could be cut out if you consider even this too strong. The next scene shows the reward of crime: the criminal being led into his cell by the sheriff. The criminal is in prison garb which could be changed to tally with the prison garb of the state of South Carolina." Id.

Rowan replied that he found the improvements on the "undesirable elements of society" appropriate but that Hirsch had "not very materially" improved the other panel and that further revisions were needed. It "is necessary to ask you to eliminate the indication of a coffin and the tomb and to present the old man, the old woman and the two children as living in some degree of happiness without any implication of past or impending death. . . . It is this quality of living which should be depicted . . . if your mural is to tell a complete story." Letter from Rowan to Hirsch (Jan. 21, 1938).

**74** *A Huge Cover-Up*, The Post and Courier (Charleston, S.C.), Apr. 12, 1996, at B4.

**75** Beckham, Depression Post Office Murals at 45.

**76** Hirsch invoked Mexican muralists (including Orozco, whose 1930 mural in New York he cited as a model and whose 1940 murals for the Supreme Court of Mexico are discussed in Chapter 15) as he explained in a letter that murals must have a "profound interpretation of life or nature as the artist perceives them and therefore it will always be somewhat shocking at first sight. . . . The relation between the scale of the figures, the scale of the room and the size of the human onlooker is the crux of the artistry in mural painting. . . . The color, in my opinion, must be rich and glowing." Letter from Hirsch to B. A. Houck (July 6, 1937).

**77** The quoted text comes from the GSA exhibit brochure, "Images of Justice," a traveling exhibit drawing on several images from the Fine Arts program that were on tour in 2007–2008 in various courthouses in the United States. A version of the picture and text can be found at General Services Administration, http://www.gsa.gov/gsa/cm_

attachments/GSA_DOCUMENT/Justice_as_Protector_R2-w-x36_0Z5RDZ-i34K-pR.pdf. Information about the exhibit can be found at the website of the United States District Court for the Eastern District of Missouri, http://www.moed.uscourts.gov/community/ImagesOfJustice.pdf. The text is also available in the GSA Archives/FAA 477, Hirsch (hereinafter GSA/FA Justice as Protector and Avenger Display).

**78** That explanation can also be found in a letter dated May 18, 1938, from Hirsch to Forbes Watson, Advisor to the Section of Painting & Sculpture of the Treasury Department, who apparently had suggested a booklet, which Hirsch thought was "a swell idea." Letter from Hirsch to Forbes Watson (May 18, 1938) (hereinafter Hirsch Letter to Watson).

**79** Some critics described the scene as including a "burning house, a 'shyster' lawyer freeing a prisoner from jail and a burglar pursuing his trade." Marling at 65.

**80** *Aiken: The Trial of "Justice,"* an information booklet related to the symposium New Deal Art Patronage in South Carolina, Sept. 20–21, 1990, South Carolina Humanities Council, in GSA Archives, FA 477. See also Marling at 66.

**81** Park & Markowitz at 61. That description comes from the Hirsch letter to Watson.

**82** Hirsch letter to Watson. Hirsch added that he hoped his use of the colors of the flag was not "too obvious." Id. The officials administering the Section of Painting & Sculpture were delighted; Rowan hoped that Hirsch was pleased and noted the appeal, particularly of the contrast of "the plough with the gun." See Letter from Edward B. Rowan to Stefan Hirsch (July 28, 1938).

**83** Park & Markowitz at 61. Marling, at 64–65, quoted a newspaper as reporting that spectators objected that Justice "resembled a 'mulatto.'"

**84** Matthew Boedy, *Controversy Shadows Mural*, Augusta Chronicle, Aug. 26, 2001, at C2, in GSA Archives/FA 477. Subsequently, the judge wrote to *Art Digest* that he would have no further comments in that he knew "nothing about art" and had received more publicity than he had desired from his comments objecting to the "'contemporary art' installed without my knowledge in the United States court room at Aiken." *A Judicious Answer*, 10 Art Digest 10 (1938).

**85** Marling at 66, 91. Marling suggested that the "corrupt fixer from Manhattan, played with curled-lip urbanity by William Powell and John Barrymore," was called to mind by the coat and the fedora hat. Id. at 91.

**86** Statement for the Associated Press provided as an appendix, Letter from Hirsch to Rowan (Sept. 27, 1938) (hereinafter Hirsch's press statement). See also Letter from F. J. Crittenden to Stefan Hirsch (Aug. 9, 1938), mentioning that scene in the mural and reporting on the successful installation of the mural, as well as the need to repair two scratches, neither of which had affected any of the "faces or figures."

**87** GSA Archives/FA 477, Hirsch description.

**88** GSA/FA Justice as Protector and Avenger Display. In the GSA Archives/FA 477, Hirsch description, a proposed text would have described the "Section of Painting and Sculpture officials" as having believed the "criticisms reflected racial prejudice."

**89** Letter from Hirsch to Edward B. Rowan (Sept. 27, 1938) (emphases in the original). That letter also noted that Hirsch had just read of the controversy over Kraus's *Justice* in Newark. On October 3, 1938, Rowan replied that he thought waiting was appropriate, "to see if the matter will not die a natural death," and that in the interim Hirsch should "say nothing further about it."

**90** Hirsch's Press Statement.

**91** Letter from Hirsch to a Mrs. Liebman (Oct. 4, 1938). Hirsch also objected to being described as receiving the commission in relationship to relief work and said that the judge was a citizen who had no more right than any other to alter government property. See Letter from Hirsch to Rowan (Oct. 7, 1938).

**92** Letter from Hirsch to Rowan (Oct. 7, 1938). On November 3, 1938, Rowan replied and attached a letter dated October 16, 1938, from a person connected to the Federal Arts Project who had seen the mural and reported that "the flesh tones of the central figure do not suggest a mulatto woman." In March of 1939, Hirsch reiterated his willingness to "go down there and make whatever corrections seem reasonable" if anyone not influenced by the judge reported seeing a person of color. However, "I shall not change the bare feet b[e]cause they are entirely defensible—from Southern or Northern point of view—in a [g]oddess like figure. I shall not change the 'bright-hued clothing' since the colors are those of the flag of the United States. But [if there were] forthcoming any concrete and explicit criticism of the features of the face, I am ready to do something about it . . . ." Letter from Hirsch to Rowan (March 4, 1939).

**93** Letter from Rowan to Hirsch (Feb. 8, 1940).

**94** Letter from Rowan to Hirsch (Feb. 8, 1940).

**95** GSA/FA Justice as Protector and Avenger Display.

**96** Letter from Hirsch to Rowan (May 16, 1940).

**97** "The mural . . . was approved by . . . well-qualified and experienced judges of art . . . . It is now public property, paid for by citizens' taxes. Hence, by arbitrarily ordering the painting covered and removed from the spectators' view, you have forced you[r] private opinion upon the public, denied citizens access to their common property, and grossly misused the power of your office." The letter demanded that the mural be "uncovered immediately." See Letter from The Artists' Union of Baltimore to Judge Frank Myers (Oct. 13, 1938).

**98** MARLING at 69, quoting a letter to Treasury Secretary Morgenthau (Feb. 24, 1939).

**99** MARLING at 71.

**100** See Letter from Senator Strom Thurmond to Dwight Ink, Acting Administrator of the GSA (May 3, 1985). Thurmond described the approval of $15,000 from the Aiken County Council to move the restored mural to the Aiken County Judicial Center. However, after obtaining advice from the Chief Conservator of the North Carolina Museum of Art, GSA staff concluded that the mural could not be removed without damage. See Letter from William F. Sullivan, Commissioner, GSA to Senator Strom Thurmond (unspecified date in 1985). GSA Archives/FA 477, Hirsch.

**101** Boedy at C2.

**102** That courthouse, built in 1934, was called the U.S. Post Office and Courthouse before being renamed in 1984 after Senator James O. Eastland. The building remains in use by both the United States District Court for the Southern District of Mississippi and the United States Court of Appeals for the Fifth Circuit, which began sitting there in 1981. Our thanks to the Fine Arts Collection's archives and to Kathryn Erickson of that program, who provided this photograph for figure 82 as well as information about the building and mural, about which we learned more from Rosie Tominello, Librarian, Fifth Circuit, Jackson Satellite Library.

**103** Our thanks to Project Architect Nelson H. Creath Jr., who took the 2008 photograph in figure 83, and to the the Fine Arts Collection of the United States General Services Administration Public Buildings Service, for permission to reproduce images of the courthouse mural.

**104** BECKHAM, DEPRESSION POST OFFICE MURALS at 201. See also SIMKA SIMKHOVITCH, 1893–1949: JANET MARQUSEE, PAINTINGS; A CATALOGUE (New York, NY: Janet Marqusee Fine Arts, 1987), included in "Simka Simkhovitch Papers, 1931–1987, in Archives of American Art, Smithsonian Institution, http://www.aaa.si.edu/collections/findingaids/index.cfm/fuseaction/Collections.ViewCollection/CollectionID/10991?term=Simkhovitch#Simkhovitch1 (hereinafter Simkhovitch Papers).

**105** Simkhovitch died in 1949. GSA Archives/FA 440 Simkhovitch, Page Report.

**106** See PATTI CARR BLACK, ART IN MISSISSIPPI, 1720–1980, at

189–190 (Jackson, MS: U. Press of Mississippi, 1998). Under the WPA, twenty-two artworks were placed in federal buildings in Mississippi; three of the artists were from the state. Id. at 190. More than three hundred WPA art projects made their way into federal buildings in the South. BECKHAM, DEPRESSION POST OFFICE MURALS at 3. Critics noted that many of the artists did not know the community for which the art was intended, and the portrayals often did not reflect then-current life patterns. Id. at 11–12. In terms of the selection for Jackson, the local committee made three suggestions, all rejected, before the Section of Fine Arts settled on Simkhovitch. Id. at 73–78.

**107** Sue Bridwell Beckham, *The Spunky Little Woman—You Can't Be One If You're White: Race, Gender, and a Little Bit of Class in Depression Post Office Murals*, in BRIDGING SOUTHERN CULTURES: AN INTERDISCIPLINARY APPROACH 100, 125 (John Lowe, ed., Baton Rouge, LA: Louisiana State U. Press, 2005).

**108** Plaque accompanying mural, GSA Archives/FA 440 Simkhovitch. The initial drawings, about "youth/motherhood, work, and old age," did not match the final version: "The wheelchair, assumed to be a reference to President Franklin Delano Roosevelt's infirmity, was censored, and the artist's depiction of racial harmony, unusual for the period, was altered. The final painting regresses to traditional Southern stereotypes." Severens at 117.

Those stereotypes may have been the reason that editors of *Life* featured the mural on the cover for a story in 1946 on a hearing, held in the courtroom, about whether to unseat Senator Theodore G. Bilbo, who had been the governor of Mississippi before being elected to the U.S. Senate. Bilbo was accused of inciting "Mississippians to prevent Negroes from voting." More than fifty witnesses testified that they had been "flogged, tricked or jailed" to ensure that they would not vote. Bilbo's "favorite target is the Negro whom he claims is constantly being incited by damn Yankees to rise up against his white superiors." *Bilbo Hearing*, LIFE, Dec. 16, 1946, at 32; also copied in the Simkhovitch Papers.

**109** In the St. Joseph, Missouri, post office, a black minstrel scene in a 1941 mural "outclasses" many others for its stereotyping, a point made by black community leaders then protesting the installation. BECKHAM, DEPRESSION POST OFFICE MURALS at 204–211, 204, fig. 64.

**110** Plaque accompanying mural, GSA Archives/FA 440 Simkhovitch.

**111** BECKHAM, DEPRESSION POST OFFICE MURALS at 200.

**112** See TOWNSEND DAVIS, WEARY FEET, RESTED SOULS: A GUIDED HISTORY OF THE CIVIL RIGHTS MOVEMENT 215 (New York, NY: W. W. Norton, 1988).

**113** CONSTANCE BAKER MOTLEY, EQUAL JUSTICE UNDER LAW: AN AUTOBIOGRAPHY 75 (New York, NY: Farrar, Straus & Giroux, 1998). Our thanks to Kenneth Mack for bringing Motley's account to our attention. For further discussion of some courthouses as islands of integration and professional authority in an otherwise segregated South, see Kenneth Mack, A Cultural History of Civil Rights Lawyering, manuscript, 2008.

**114** MOTLEY at 76. She also noted that Carter and she may have been the first blacks since the early part of the century to try a case in Jackson.

**115** As Motley describes the scene, it was "right out of Hollywood's antebellum South," with "white ladies in hoopskirts, frilly blouses, and silk bonnets . . . , tall, handsome white men in high silk hats and cutaway coats, standing next to a lavishly furnished horse-drawn carriage," whereas the black men were shown as farmworkers and the women "with Aunt Jemima appearances, wearing aprons and bandannas." MOTLEY at 76.

**116** MOTLEY at 76.

**117** MOTLEY at 77. After the case was tried, the judge reserved decision and later ruled that, while the teachers had proved their rights on the merits, he could not provide relief because of a recent holding by the appellate court in a case involving teachers in Atlanta,

Georgia. The court there had held that such suits could not be brought before administrative remedies were exhausted. That rule was applied to the Jackson case as well. See *Bates v. Batte*, 187 F. 2d 142 (5th Cir. 1951), cert. denied, 342 U.S. 815 (1951). In 1963 the Supreme Court reversed the requirement of exhaustion of administrative remedies in a case involving segregated public schools in Illinois. See *McNeese v. Board of Education for Community Unit School District 187*, 373 U.S. 668 (1963).

**118** MOTLEY at 86.

**119** DAVIS at 205.

**120** DAVIS at 215; Ed Williams, *Cox Defends Slavery*, DELTA DEMOCRAT-TIMES (Greenville, MS), Apr. 16, 1971, at 1, 3. The article stated that, in 1964, the judge was "quoted by reporters as referring to black plaintiffs in a voting rights suit as a 'bunch of niggers' and saying they acted 'like a bunch of chimpanzees.'" See also JACK BASS, UNLIKELY HEROES 166–167 (New York, NY: Simon & Schuster, 1981).

**121** MOTLEY at 86. As for the decision to cover the mural, she commented: "I gather it was someone's determination not to destroy the mural but simply to draw a neutral-colored curtain on the past." Id.

**122** BLACK at 190; BECKHAM, DEPRESSION POST OFFICE MURALS at 230, n. 27. An alternative explanation of the drapes attributes their use in the 1960s and the 1970s to redecoration programs. *Cox Defends Slavery*, DELTA DEMOCRAT-TIMES (Greenville, MS) at 1 (citing information from a GSA representative). In 1970 removal of the drapes "was recommended by an interior decorator as part of a general building renovation." Id. At that time, when a lawyer complained about the depiction as an "affront to the dignity of the court," Judge Cox was quoted as replying that one had to "possess a very warped mind to see anything derogatory, or insulting in the mural"; he insisted that the mural would "remain in this courtroom whether you like it or not." Id.

**123** John Miller, *Idaho's Lynching Murals to Get Explanations*, INDIAN COUNTRY TODAY, Oct. 19, 2007 (hereinafter Miller, *Idaho's Lynching Murals*). The state's legislative building was undergoing renovations. Our thanks to Paul Hosefros and to Lemley International for providing us with the photograph for figure 84 and permission to reproduce it.

**124** See John Miller, *Idaho Murals of Lynching Cause Debate*, NEW YORK TIMES, Apr. 16, 2006. See also John Miller, *Murals of Lynching Divide Officials*, DENVER POST, Apr. 13, 2006. Other aspects of the murals have drawn criticism. Horses are not connected to the stagecoach that they are supposed to be pulling, and one female figure is painted with two right arms. See John Miller, *Criticized Murals Hang in Courthouse*, CASPER STAR-TRIBUNE (Casper, WY), May 15, 2005 (hereinafter Miller, *Criticized Murals*) Portrayals of "Indians" were not unique to the West; many appear in murals in federal buildings in the South. BECKHAM, DEPRESSION POST OFFICE MURALS at 19, 216–226. Washington, D.C., is another site of many examples. See generally FRYD.

**125** See Miller, *Criticized Murals*.

**126** The website of the Ada County Courthouse detailed the building's design under the WPA and adverted to the "controversy" over the content of the murals "associated with Fletcher Martin, a national figure in Depression-era public art programs." Ada County Courthouse, http://www.idahohistory.net/adacourthouse.html (as of 11/16/2007). Martin apparently withdrew from the project, and Ivan Bartlett was the "final designer." Miller, *Criticized Murals*. Whether Martin or Bartlett created the lynching scene is not clear. See Boise, "ID WPA Art," WPA Murals, http://www.wpamurals.com/boise.htm. Further, some sources give the artist's name as Martin Fletcher, others as Fletcher Martin.

As we discuss in relationship to debate about the imagery in the Virgin Islands and in Chapters 8 and 9, more recent government processes involve community participation and, at times, community views prevail. An example comes from the installation in a federal courthouse in Kansas City in 1994. The artist, Richard Haas, "actively

sought feedback from different minority groups" to gather suggestions, then made modifications of the depictions of "early Indian settlers" to raise "several figures from a kneeling posture to a more 'dignified' and proud stance." Tepper at 296–297. Another account of the changes Haas made quoted his view that the criticism from the community "forced" him to make changes. Salik K. Ghandhi, *The Pendulum of Art Procurement Policy: The Art-in-Architecture Program's Struggle to Balance Artistic Freedom and Public Acceptance*, 31 PUB. CONTRACT LAW J. 535, 552 (2002).

**127** Idaho Council on Indian Affairs, Minutes of Jan. 17, 2007, at 5 (statement of Senator Michael Jorgenson).

**128** Miller, *Idaho's Lynching Murals*.

**129** John Miller, *Indian Leaders View Murals of Lynching*, CASPER-STAR TRIBUNE (Casper, WY), Jan. 19, 2007.

**130** The building is discussed in Chapter 12, where we consider transnational courts.

**131** Ira Henry Freeman, *Mohammed Quits Pedestal Here on Moslem Plea after 50 Years*, NEW YORK TIMES, Apr. 9, 1955, at 1, 18. The Manhattan Appellate Courthouse on Madison Avenue houses the Appellate Division, First Department, of the New York State Supreme Court, an entity first established in 1894 when the state reorganized its courts. The "Appellate Division" was chartered to hear appeals from civil and criminal cases in New York and the Bronx; it also serves as a court of first instance in some matters. The highest court of New York, the New York Court of Appeals, can review some decisions of the Appellate Division.

**132** This building was one of several designed to accommodate the growing demand. See Robert A. M. Stern, Gregory Gilmartin, & John Montague Massengale, New York 1900: Metropolitan Architecture and Urbanism, 1890–1915 at 67–71 (New York, NY: Rizzoli, 1983). It was the "first 'white' building completed in New York after the World's Columbian Exposition of 1893 in Chicago" and provides an "unusually fine" example of Beaux-Arts classicism. See Paul Spencer Byard, *Reading the Architecture of Today's Courthouse*, in CELEBRATING THE COURTHOUSE: A GUIDE FOR ARCHITECTS, THEIR CLIENTS, AND THE PUBLIC 133, 136–137 (Steven Flanders, ed., New York, NY: W. W. Norton, 2006) (hereinafter CELEBRATING THE COURTHOUSE). Our thanks to Jon Fisher, the photographer; to Daniel McDevitt, Senior Administrative Assistant; and to Judith Kaye, Chief Judge of the New York Court of Appeals, for their assistance in enabling us to obtain and use the images in figures 85 and 86.

**133** Department of Citywide Administrative Services, Manhattan Appellate Court, at its website, http://www.nyc.gov/html/dcas/html/resources/man_appellatecourt.shtml. See also *New Court House Plans: Handsome Structure for Justices of Appellate Division*, NEW YORK TIMES, July 1, 1896. The total cost was $633,768. See HENRY HOPE REED JR., SUPREME COURT, APPELLATE DIVISION, FIRST DEPARTMENT, COURTHOUSE HISTORY AND GUIDE (unpaginated) (New York, NY: Municipal Art Society of New York, 1957). New York State has a diverse set of courts.

**134** Michele H. Bogart, *In Search of a United Front: American Architectural Sculpture at the Turn of the Century*, 19 WINTERTHUR PORTFOLIO 151, 163 (1984).

**135** Bogart at 162.

**136** Bogart at 161–162.

**137** Lord had an unusual degree of control ("complete") over the "artists and their work in decorating the building." REED. More generally, architects of his era "maintained control over building projects and often had the power to choose which sculptors got commissions. Architects, not sculptors, ultimately decided the subject matter, sizes, poses, and drapery of architectural sculpture and any modifications." Bogart at 175. While Lord offers the example of an architect enthusiastic about classical figures, architects thereafter shaped modernist structures that emphasized shape and form and disdained allegorical references. As a consequence, architects were at the center and sculp-

tors at the periphery in designs of much of the twentieth century. Moreover, even when federal policies began in the 1960s to set aside one-half of one percent of construction costs for public art, "the commissioning process began with the architect, who not only determined the type and location of the artwork but was also responsible for nominating at least three artists," with the final choice being made by the GSA. See THALACKER at xii. In the 1970s, Thalacker was the Director of the Art-in-Architecture Program, discussed in this chapter and in Chapter 9.

**138** Bogart at 164. See also THE APPELLATE DIVISION OF THE SUPREME COURT OF THE STATE OF NEW YORK, FIRST JUDICIAL DEPARTMENT: A HISTORY OF THE COURTHOUSE 4 (New York, NY: Dual Printing, 2004) (hereinafter HISTORY OF THE APPELLATE DIVISION COURTHOUSE). An article published in the *New York Times* on July 1, 1896, "New Court House Plans," detailed that the "structure will consist of three stories and a basement, the height from the street to the top of the parapet being 56 feet."

**139** HISTORY OF THE APPELLATE DIVISION COURTHOUSE at 8.

**140** The sculptor Daniel Chester French did the composition. See HISTORY OF THE APPELLATE DIVISION COURTHOUSE at 10; Bogart at 165.

**141** The sculptor is Charles Niehaus. Bogart at 165. Also depicted are "the crescent moon, the ram, Father Time with his scythe, the owl, the tables of law." REED. Inside is a sixty-two-foot mural called *Transmission of the Law*, by H. Siddons Mowbray, that includes images symbolizing a sequence from Moses through Egypt, Greece, Rome, and Byzantium, and then through the Norman Conquest to modernity. A Justice is flanked by figures representing Mercy and Law. Many Virtues, including Moderation, Eloquence, Unity, Truth, Courage, Patriotism, Prudence, and Justice, dot the interior of the primary courtroom. Id.; HISTORY OF THE APPELLATE DIVISION COURTHOUSE at 14. The Four Cardinal Virtues can be found gracing corner panels. Id. at 26.

**142** HISTORY OF THE APPELLATE DIVISION COURTHOUSE at 8, quoting the sculptor Frederick Wellington Ruckstuhl. The head is said to be a "composite of General Ulysses S. Grant, General Nelson A. Miles, and Admiral Francis M. Bunce." Id.

**143** The Nebraska State Capitol, for example, opened in 1932. Designed by Betram Grosvenor Goodhue, an architect trained in the Beaux-Arts style, the building has a parallel set that includes Minos, Hammurabi, Moses, Akhenaton, Solon, Ezekiel, Solomon, Socrates, Julius Caesar, Justinian, Charlemagne, Napoleon, Louis IX, and Isaac Newton. See *Guide to the Exterior Art and Symbolism, Nebraska State Capitol* (undated pamphlet).

**144** Freeman at 18. The other statues were resurfaced in Alabama Madre marble. REED.

**145** John Kifner, *Images of Muhammad Gone for Good*, NEW YORK TIMES, Feb. 12, 2006, sec. 4 at 4.

**146** Office of the Curator, Supreme Court of the United States, Courtroom Friezes: Information Sheet (updated as of May 8, 2003), http://www.supremecourtus.gov/about/north&southwalls.pdf and http://www.supremecourtus.gov/about/east&westwalls.pdf (hereinafter Courtroom Friezes Information Sheets). Our thanks to Matthew Hofstedt, Associate Curator of the United States Supreme Court for analyses of the imagery, to the Public Information Office of the Supreme Court for providing a copy of Chief Justice Rehnquist's 1997 letter on the frieze, and to Sue Kriete, Print Room Librarian, who directed us to relevant subfiles in the Cass Gilbert Collection, PR 021, Department of Prints, Photographs, and Architectural Collections, New York Historical Society (hereinafter Gilbert Papers).

Relatively little academic work addresses Weinman, who was born in Karlsruhe, Germany, in 1870, and came to the United States when he was ten. His teachers included Charles Niehaus and Daniel Chester French, both of whom had done statuary for the Appellate Division building in New York. Weinman became famous as a medalist. See SYDNEY P. NOE, THE MEDALLIC WORK OF A. A. WEINMAN (New York,

NY: American Numismatic Society, 1921). He was part of a "circle of coin designers" who had been students of Augustus Saint-Gaudens who in turn had served on the Senate's panel on the arts (see Chapter 8) and designed several U.S. monuments and coins. See August Saint-Gaudens: The 1907 United States Gold Coinage 12–13 (monograph published by Eastern National, Cornish, NH, 2002).

In 1916, Weinman designed the imagery for the "Mercury dime" as well as "Walking Liberty" for the half dollar. Both display his knowledge of classical imagery. The "Mercury dime" is unusual in that is does not actually depict Mercury but rather Liberty with a winged helmet, and its reverse shows the fasces, the symbol of authority, as well as an olive branch to denote peace. Those dimes were struck between 1916 and 1945. The Walking Liberty half dollar, struck between 1916 and 1947, has an unfurled American flag, and its Liberty holds olive branches. On its reverse is an eagle near a tree.

Weinman's work as an architectural sculptor included capitol buildings in Wisconsin and Louisiana and buildings in several cities. He served several times as president of the American Sculpture Society. In New York, he was employed by the architects McKim, Mead, and White and did the reliefs for several major buildings. Cass Gilbert contracted with Weinman for the Supreme Court friezes and paid him $120,000. See Letter from Gilbert to Weinman (Nov. 24, 1931), Adolph A. Weinman Papers, Archives of American Art, Smithsonian Institution (hereinafter Weinman Papers). The letter specified that the material would be "Ivory Veined marble" and that Weinman was to "give this work your best personal service to the end that it will be a work of art—of very high merit, both in design and execution." Id. Gilbert died unexpectedly in 1934, and Weinman died in 1952. See *Obituary, Adolph Alexander Weinman*, 26 ART DIGEST 9 (Sept. 15, 1952).

**147** Cass Gilbert Jr., *The United States Supreme Court Building*, 72 ARCHITECTURE 301 (Dec. 1935). In 1928, under the prodding of then Chief Justice (and former President) William Howard Taft, Congress enacted legislation to authorize the building. The Architect of the Capitol would have been expected to guide the project, but Taft secured authority for himself as Chief Justice (along with another justice) to serve on the Commission overseeing the project. Taft also served as chair. See *The Supreme Court: Residences of the Court Past and Present, Part III*, 3 SUPREME COURT HISTORICAL SOCIETY QUARTERLY at 7 (1981) (hereinafter *Supreme Court Residences*).

**148** Courtroom Friezes Information Sheets, East and West Walls. "It was common practice during this period to allow the sculptor artistic freedom to create art that would fit within the framework of the architect's vision of the building." Id. Hofstedt's research has demonstrated that Weinman had the assistance of Harold A. Mattiace when selecting figures as influential historical lawgivers.

**149** June 15, 1932, memo at 1 in Gilbert Papers, Project Files, Box 459, folder 4 (hereinafter Gilbert Papers, project memo, June 15, 1932).

**150** Gilbert Papers, project memo (June 15, 1932) at 2–3. Gilbert offered John Singer Sargent's frieze "showing Moses and the Prophets in the Boston Public Library as carrying some of the impression" of a desirable design, but noted that it was "too picturesque and too complicated." Id. at 3.

**151** Gilbert Papers, project memo (June 15, 1932) at 2. Gilbert's correspondence files indicate that sketches and photographs were seen by others, and one letter specifically noted that Chief Justice Hughes and a Mr. Lanham approved photographs of some of the figures. See Letter from Gilbert to Weinman (Apr. 5, 1934), Weinman Papers.

**152** The Commission, chaired by Chief Justice Charles Evans Hughes, included Associate Justice Willis Van Devanter, Senators Henry W. Keyes and James A. Reed, Representatives Richard Nash Elliott and Fritz G. Lanham, and David Lynn, who was the "Architect of the Capitol." The figures coiled in a snake prompted sufficient distress that Weinman changed the friezes to accommodate these concerns.

**153** One could interpret the story as beginning with the depiction on the west wall of the struggle between Good and Evil, and moving through to an end point with the American system of government. Weinman was not the only artist providing historical scenes. John Donnelly Jr. created "great bronze doors" that weighed more than six tons apiece. Their eight panels displayed "the development of the law from classical antiquity through the founding of the American Republic." *Supreme Court Residences* at 9.

**154** Fred J. Maroon & Suzy Maroon, The Supreme Court of the United States 134 (New York, NY: Thomasson-Grant & Lickle and published in cooperation with the Supreme Court Historical Society, 1996); Joan Biskupic, *Lawgivers: From Two Friezes, Great Figures of Legal History Gaze upon the Supreme Court Bench*, Washington Post, March 11, 1998, at H1.

**155** Courtroom Friezes Information Sheets, East and West Walls. Materials from the Supreme Court's historical archives do not document an intent to invoke the Ten Commandments. The placement of the bald eagle outstretched behind the tablets could be used to connect them to the 1791 Bill of Rights, consisting of ten amendments to the Constitution.

**156** Courtroom Friezes Information Sheets, East and West Walls. The title "Good Versus Evil" is attributed to Weinman.

**157** As Weinman summarized his work, "the North and South Wall Frieze of the Supreme Court Room are composed as a procession of Great Lawgivers of History, the procession terminating at both ends of each frieze in an allegorical group." See Adolph Alexander Weinman, file memo, Project files, box 463, folder 4, Gilbert Papers. Weinman listed each figure by name and stated that the "movement of these figures" is toward allegorical groups clustered at the end. Id. As for Moses, the excerpts of the Commandments that are legible are edited versions of the Sixth through the Tenth Commandments, and Moses's beard obscures some of the text. See also Tony Mauro, *The Supreme Court's Own Commandments*, Legal Times, Mar. 7, 2005.

**158** See *Which Ten Commandments?* Positive Atheism Magazine, www.PositiveAtheism.org/crt/whichcom.htm. Contrasts are drawn among the texts of the Ten Commandments as set forth in the King James Version of the New Testament, those of the Catholic Catechism of 1932, and those of a 1922 Old Testament.

**159** *Stone v. Graham*, 449 U.S. 39 (1980) (per curiam). Many monuments, in the United States and elsewhere, have been a font of conflict about whether to preserve, observe, or alter them as understandings of one's own national history change. See Sanford Levinson, Written in Stone: Public Monuments in Changing Societies (Durham, NC: Duke U. Press, 1998).

**160** See *Glassroth v. Moore*, 335 F.3d 1282, 1284 (11th Cir. 2003), cert. denied sub nom. *Moore v. Glassroth*, 540 U.S. 1000 (2003). The appellate court ordered the monument's removal. See Adam Liptak, *Court Orders Removal of Monument to Ten Commandments*, New York Times, July 2, 2003, at A18. In contrast, that appellate court concluded that a stamp depicting two tablets, meant to denote the Ten Commandments, and used by a county clerk's office in Georgia since at least 1872, advanced the secular purpose of marking a document as law-related and was, therefore, permissible. See *King v. Richmond County, Ga.*, 331 F.3d 1271 (11th Cir. 2003).

**161** See *Van Orden v. Perry*, 545 U.S. 677, 681 (2005). The stone included an "eagle grasping the American flag, an eye inside of a pyramid, and two small tablets with what appears to be an ancient script . . . above the text of the Ten Commandments. Below the text are two Stars of David and the superimposed Greek letters Chi and Rho, which represent Christ." Id. Carved beneath is an inscription that the "Fraternal Order of Eagles of Texas" presented the stone to the "People and Youth of Texas" in 1961. Other monuments across the twenty-two acres include those dedicated to "Heroes of the Alamo," "Tribute to Texas School Children," and "Texas Peace Officers." Id. at 681–682, n. 1.

**162** *McCreary County, Ky., v. American Civil Liberties Union*, 545

U.S. 844, 851 (2005). After litigation was begun about those displays, the counties added other documents to offer a context about the "Foundations of American Law and Government." Id. at 870–871. Justice David Souter, writing for the Supreme Court majority, concluded that the lower courts had properly found that the purpose was insufficiently secular to sustain the display. Id. at 873–876.

**163** This test includes exploration of the context of a display. Application of the test has varied as different justices interpret the purposes for a display and First Amendment values. In *Stone v. Graham*, 449 U.S. 39, 41 (1980), for example, the Supreme Court found unconstitutional the posting of the Ten Commandments in a classroom; the court concluded that the image, seen daily by students, had a predominantly religious purpose. In *McCreary*, a five-person majority upheld a lower court's conclusion that the context was too religious (545 U.S. at 879–881), whereas in *Van Orden*, the majority found the Ten Commandments monument on the Texas state building grounds a permissible reflection of the "strong role played by religion and religious traditions throughout" the history of the United States. 545 U.S. at 683. The *Van Orden* majority opinion by Chief Justice Rehnquist called the Court's jurisprudence in this area "Januslike," with one face looking toward the religious traditions and the other face looking at the "principle that the governmental intervention in religious matters can itself endanger religious freedom." Id.

**164** *County of Allegheny v. American Civil Liberties Union*, 492 U.S. 573, 652–653 (1989) (Stevens, J., concurring in part and dissenting in part, and joined by Justices Brennan and Marshall) (citations omitted). Justice Stevens further commented that it would be "absurd" to "exclude religious paintings by Italian Renaissance masters from a public museum." Id. at 653. As for Weinman's frieze, Justice Stevens added that all of the leaders he had mentioned—Moses, Confucius, Mohammed, Caesar, Blackstone, Napoleon, and Marshall—"appear in friezes on the walls of our courtroom." Id. at 653, n. 13.

The underlying litigation challenged two "holiday displays located on public property in downtown Pittsburgh. The first is a crèche placed on the Grand Staircase of the Allegheny County Courthouse. The second is a Chanukah menorah placed just outside the City-County Building, next to a Christmas tree and a sign saluting liberty." 492 U.S. at 578 (majority opinion by Justice Blackmun). The Court held that the crèche, set alone, conveyed an impermissible endorsement of a religious message. Id. at 599–602. The combined display of the menorah, the Christmas tree, and the liberty sign, however, was not clearly an endorsement or disapproval of individual religious beliefs but could be read as the "city's secular recognition of different traditions for celebrating the winter-holiday season." Id. at 620. A remand was ordered for the lower court to learn more about whether the second display was constitutionally problematic.

Justices O'Connor, Brennan, and Stevens each wrote separately explaining their concurrences and where they departed from the majority. Justice Stevens disagreed with the majority that the "45-foot evergreen tree" next to the Chanukah menorah was constitutional, for it manifested "governmental approval of the Jewish and Christian religions." Id. at 654. Justice Kennedy, in a dissent on behalf of himself, Chief Justice Rehnquist, and Justices White and Scalia, argued that both displays were constitutional. Id. at 655–679.

**165** *McCreary* at 874. In a footnote, the majority also commented that it had been reminded by the dissent that "Moses and the Commandments adorns this Court's east pediment. . . . But as with the courtroom frieze, Moses is found in the company of other figures, not only great but secular." Id. at n. 23.

**166** *Van Orden*, 545 U.S. at 688. Chief Justice Rehnquist also described other displays in the Nation's capital and, in its filing before the court, the United States government listed courthouses in which displays of the Ten Commandments could be found. See Brief of the United States as Amicus Curiae Supporting Respondents, Appendix 1a-7a, *Van Orden*, No. 03-1500 (filed Jan. 28, 2005), and its discussion

by Justice Breyer (concurring), 545 U.S. at 701. Justice Stevens, joined by Justice Ginsburg, filed one dissent; Justice O'Connor filed another; and Justice Souter, joined by Justices Stevens and Ginsburg, filed another dissenting opinion. All objected to the religious content. Justice Souter's dissent distinguished the Court's frieze because the figures were a mixed assemblage of lawgivers and "Moses enjoys no especial predominance." Id. at 740, 741.

**167** Council on American Islamic Relations, *A Decade of Growth, CAIR Tenth Anniversary Report, 1994–2004* at 21–23 (2004) (hereinafter *CAIR Tenth Anniversary Report*); Tamara Jones and Michael O'Sullivan, *Supreme Court Frieze Brings Objection*, NEW YORK TIMES, March 8, 1997, at A1.

**168** Letter from Chief Justice William Rehnquist to Nihad Award and Ibrahim Hooper of the Council on American–Islamic Relations (Mar. 11, 1997) (hereinafter Rehnquist Letter of Mar. 11, 1997); see also *CAIR Tenth Anniversary Report* at 22; 40 U.S.C. § 6133 (Property in the Supreme Court Building and Grounds) ("It is unlawful to step or climb on, remove, or in any way injure any statue, seat, wall, fountain, or other erection or architectural feature, or any tree, shrub, plant, or turf, in the Supreme Court Building or grounds."). Chief Justice Rehnquist also stated that the sculpture of Muhammad was "intended only to recognize him, among many lawgivers, as an important figure in the history of law." Rehnquist Letter of Mar. 11, 1997; see also Biskupic; Sally M. Promey, *The Public Display of Religion*, in THE VISUAL CULTURE OF AMERICAN RELIGIONS 27, 40–42 (David Morgan & Sally M. Promey, eds., Berkeley, CA: U. of California Press, 2001).

**169** See Taha Jaber al-Alwani, *"Fatwa" Concerning the United States Supreme Courtroom Frieze*, 15 JOURNAL OF LAW AND RELIGION 1 (2001). This article took the posture of a fatwa, "a legal opinion," addressing the person seeking an opinion—here Professor Azizah Y. al-Hibri of the University of Richmond Law School. His view relied on the "necessary premises" that "each civilization . . . has its own means of self-expression" (id. at 2); that Islamic traditions "[value] the Word more than images and statues"; and that "Western culture" relies on "imagery and sculpture" as "paramount means of expressing sacred and centrally important truths. Id. at 3. The fatwa then analyzed the frieze and noted that while many lawgivers were present, including both Moses and Muhammad, another prophet of Islam—Jesus, the Messiah—was missing. Id. at 25. On reviewing texts, interpretations, and practices (including that the "spiritual leaders of Islam did not try to destroy the Pharaohic pyramids, the Persian throne, . . . or the Greek and Roman fortresses" but rather preserved diverse cultural expressions even as they were committed to the "arts of the Word") (id. at 5), the fatwa concluded that the frieze was a "positive gesture toward Islam." Id. at 27.

**170** Rehnquist Letter of Mar. 11, 1997.

**171** *U.S. Supreme Court Depicts Muhammad; Mohammed Sculpture at Top US Supreme Court Draws Mild Rebuke from US Muslim Leaders*, Agence France Presse, Feb. 7, 2006, http://www.freerepublic.com/focus/f-news/1573853/posts. The Agence France story came in the wake of protests over cartoons published in Denmark that were seen as blasphemous renditions of the prophet.

**172** Courtroom Friezes Information Sheets, North and South Walls.

**173** St. Croix is a territory of the United States. Congress established its district court in 1936. See Organic Act of the Virgin Islands of the United States of 1936, 74 Pub. L. No. 749, 49 Stat. 1807 (1936) (codified at 48 U.S.C. § 1405). Its courthouse is named after Almeric L. Christian, who served as Chief Judge of that court. Our thanks to artist Jan Mitchell, to photographer Steffen Larsen, and to the Mitchell-Larsen Studio for information obtained through an interview on February 24, 2007, and for providing us with the photographs of *Moco Jumbie* (fig. 88), *Reaching Man* (fig. 90), and *Lady of Justice* (figs. 87 and 91) and permission to use them; to Susan Harrison of the GSA for suggesting this avenue of research and to the United States General Services Administration for reproduction permissions; and to the Honor-

able Anne E. Thompson of the United States District Court of New Jersey for additional pictures of the courthouse, its imagery, and the artist. A facsimile of the *Lady of Justice* statue is also used on the seal of the Virgin Islands Bar Association, adopted in 2002. See VI BAR HERALD, Mar. 10, 2007.

**174** Robert W. Nicholls, *The Mocko Jumbie of the U.S. Virgin Islands: History and Antecedents*, 32 AFRICAN ARTS 48, 94, n. 1 (1999). Our thanks to Robert Nicholls, an Associate Professor of Education at the University of the Virgin Islands, for his scholarly assistance as well as the use of his 1997 photograph of Moco Jumbies (fig. 89) at the Virgin Islands Carnival.

**175** CIA World Factbook, 2009, https://www.cia.gov/library/publications/the-world-factbook/geos/vq.html.

**176** Nicholls at 48.

**177** The American Bar Association has proposed that Congress endow the Virgin Islands court with Article III status. See Judicial District of the Virgin Islands Act of 2006, H.R. 55, 110th Cong., 1st Sess., 2007.

**178** Administrative Office of the U.S. Courts, U.S. District Court Judicial Caseload Profile (*Federal Judicial Caseload Statistics*), http://www.uscourts.gov/viewer.aspx?doc=/cgi-bin/cmsd2009.pl. Two magistrate judges and one bankruptcy judge sat then in the Virgin Islands as well.

**179** Mitchell, born in 1944, studied in Philadelphia and London. In 1981 she moved to St. Croix.

**180** See generally THALACKER. Between 1972 and 1980, the GSA funded more than 130 projects, including those of well-known artists such as Alexander Calder, Isamu Noguchi, and Claes Oldenburg. Impetus for the program emerged in relationship to the charter by President John Kennedy of an Ad Hoc Committee on Government Office Space. Its 1962 report, *Guiding Principles in Federal Architecture*, had considered calling for funds to be spent on public art from artists living in the United States. See John Wetenhall, *Camelot's Legacy to Public Art: Aesthetic Ideology in the New Frontier*, 48 ART JOURNAL 303, 304 (1989). Before the report was finalized, then–GSA Administrator Bernard L. Boutin (a committee member) instituted a policy for federal support of art commissions "not to exceed one half of one percent of the construction budget." THALACKER at xii–xiv. With variations and a hiatus detailed in Chapters 8 and 9, that amount has remained a federal policy guideline.

**181** See U.S General Services Administration, Art-in-Architecture Program, 41 CFR Pt. 120 §102.5 and http://www.gsa.gov/Portal/gsa/ep/contentView.do?contentType=GSA_OVERVIEW&contentId=8146&noc=T. Detailed memoranda of the various policy directives issued under the program are available in the GSA archives and discussed in Chapter 9.

**182** GSA Archives, GSA/Public Building Service, Fine Art Collection, AA 208 (hereinafter GSA Archives/AA 208 Mitchell).

**183** Some proposals prompted extensive control. See HARRIS at 33–36.

**184** A panel of artists, the project architect, members of the court staff, and judges convened in 1990 and then met several times thereafter as controversy developed. Notes of the initial meeting mentioned the group's strong preference for a "local, if not native," artist designing a work of "local interest, expressing island style and concerns." Selection Memos (date unclear), GSA Archives/AA 208 Mitchell.

**185** GSA Archives, AA 208 Mitchell (undated notes in file from Jan Mitchell). The term is variously spelled, as Mocko Jumbie or Moko Jumbie, and we have used the spelling in the artist's notes. See also Nicholls at 48–55.

**186** Nicholls at 55–58.

**187** Nicholls at 51. Nicholls has also proposed a link to the word "bajumbi," referring to a "pea sized red and black seed of a vine" made into necklaces and used as protection against jumbies. Correspondence of Nov. 21, 2009.

**188** Nicholls at 54.

**189** Nicholls at 50.

**190** The photograph in figure 89, taken by Robert Nicholls, can also be found as figure 15 (Mystical Mocko Jumbies) in his article on the subject.

**191** Nicholls at 51. He further explained that jumbies "can be good or bad, but mostly they are mischievous." Id. at 52.

**192** Nicholls at 54 (quoting Doris Green).

**193** Nicholls at 54.

**194** Nicholls at 54 (citing Hollis "Chalkdust" Liverpool).

**195** Memo from Michael J. Costic, Director of the Caribbean Public Building Services Operations, to Peter Sneed, Director (June 4, 1991), at 1, GSA Archives/AA 208 Mitchell (hereinafter Costic memo).

**196** Undated memo from the Clerk of the District Court of the Virgin Islands (around May 1991), GSA Archive/AA 208 Mitchell.

**197** *Moko Jumbie: No Mockery of Justice*, Letter from Shirryl Hughes, St. Croix Avis, July 11, 1991, at 6, 27, in GSA Archives/AA 208 Mitchell.

**198** *STX Courthouse Sculpture Is Cultural Link*, Virgin Islands Business Journal, Aug. 12–25, 1991, in GSA Archives/AA 208 Mitchell.

**199** Artist's Proposal Review, Art-in-Architecture Program, May 22, 1991, in GSA Archives/AA 208 Mitchell. See also file memo of May 28, 1991. Mitchell described the work as "an Everyman striving to make something of himself." Virgin Islands Council of the Arts News 6 (Spring 1992). In a later memo, that image was called *Search for Truth*; "the figure or positive space represents all of mankind, while the negative space symbolizes everything that mankind strives for." Art-in-Architecture Program Minutes, Jan. 16, 1992, Artist Proposal Meeting, GSA Archives/AA 208 Mitchell.

**200** Costic memo.

**201** Memo from William J. Diamond, Regional Administrator, to John J. Landers, Assistant Commissioner (Feb. 25, 1992). See also Letter from the Public Building Services Contracting Officer to Mitchell (Oct. 17, 1991) telling her to suspend work and of the "intention to issue a modification to the contract whereby a new sculpture is designed and fabricated to the approval of the local art and other community representatives." Our thanks to the artist for providing us with these materials.

**202** Artist Proposal Meeting, GSA/AA 208 Mitchell.

**203** See Regina Austin, *Sapphire Bound!* 1989 Wisconsin Law Review 539.

**204** See Stephen G. Breyer, *Foreword* to Celebrating the Courthouse 9–12; Douglas P. Woodlock, *Drawing Meaning from the Heart of the Courthouse*, in Celebrating the Courthouse 155–167. See also Douglas P. Woodlock, *The "Peculiar Embarrassment": An Architectural History of the Federal Courts in Massachusetts*, Massachusetts Law Review 268–278 (Winter 1989). Our thanks to Stephen Breyer, Douglas Woodlock, Steve Rosenthal, William Young, Nancy Gertner, Ellsworth Kelly, and Robert Campbell, all of whom helped us to understand the form and function of this courthouse.

**205** See Henry N. Cobb, *The Shape of Justice: Law and Architecture*, Third Lecture in the New York Court of Appeals Lecture Series, Nov. 16, 2006, in an unpaginated monograph published by the Historical Society of the Courts of New York and the Court of Appeals of the State of New York (2007) (hereinafter Cobb Lecture). Cobb is a member of the firm of Pei Cobb Freed & Partners.

**206** Cobb Lecture.

**207** Cobb Lecture. The building received mixed reviews, with some criticism of its "strange (postmodern) blend of International-style/pastiche architecture . . . [with] touches of art nouveau, futuristic, and techno-brute ornamentation." See Ann Wilson Lloyd, *Three Trials for Ellsworth Kelly*, 20 Art New England 32 (Feb.–Mar. 1999). The "almost solid brick wall it presents to the city on its landward side" also prompted criticism ("a major disappointment"), mitigated by the point that the courthouse was not meant to be a lonely building but to become part of a district crowded with other buildings. See Robert Campbell, *A Mixed Verdict on New US Courthouse*, Boston Globe, Sept. 7, 1998, at A1 (hereinafter Campbell, *Mixed Verdict*).

**208** See Honorable Douglas P. Woodlock, Architecture and the Design of the New Federal Courthouse in Boston (Lecture for the Boston Society of Architects, 1994–1995, Jan. 25, 1995). Thanks to Steve Rosenthal for permission to reproduce his photographs (figs. 92 and 93) of the court and its interior and to Ellsworth Kelly for permission, as well as to the Boston Courthouse, the GSA, and Judge Woodlock for facilitating the use of these images. The Boston Courthouse is also discussed and depicted in Chapters 9 and 14.

**209** See United States Courthouse, Boston, Massachusetts, Courts and Community (undated) (hereinafter GSA, Boston Courthouse and Community), GSA Art-in-Architecture Archives 283 Ellsworth Kelly (hereinafter GSA/AA 283 Kelly). Boston's Federal Court Public Education Program included various curricula, including some aimed at young children and others that have older children involved in mock trials at which judges preside. See *Children Discovering Justice* and *Mock Trials*, Boston Law Tribune, Apr. 2, 2001, at 9. The initiative was begun by the Boston Bar Association.

**210** See General Services Administration, *The Boston Panels, Ellsworth Kelly, U.S. Courthouse* (hereinafter GSA, *Boston Panels*) and General Services Administration, U.S. Courthouse, Boston, MA, The Artwork (hereinafter GSA Boston Memo). The reviewing panel, which included architect Cobb, Justice Breyer, Judge Woodlock, and nine others affiliated with art, law, or the locality, received more than 380 submissions and selected Kelly from a set of six finalists. Id. The artists in the group, in addition to Kelly, included James Carpenter, Sol LeWitt, Robert Mangold, Dorothea Rockburne, and James Turrell.

After meetings with other artists, Kelly was the panel's choice. Acquisition Memo (describing events in 1993 and 1994), in Art-in-Architecture Project Report of 6/15/2005, in GSA/AA 283 Kelly. The contract price was $800,000. See Award/Contract of 10/20/94, GSA/AA 283 Kelly. Also discussed was a commitment that "during the artist's lifetime . . . no single element may be removed" or rearranged and to the challenges of conservation of the "austere, flawless surface of each [panel] which makes fingerprints, drips, and dust highly noticeable." Id. at memo of June 7, 2006. The panels are dusted by using Japanese ostrich feather dusters (ironically thus linking the non-representational panels to the ostrich that was once seen at Justice's side, as shown in figs. 5/55 and 5/56). Treatment Report of 10/23/2004, GSA/AA 283 Kelly.

The GSA describes Kelly as "one of America's most celebrated artists of the postwar era." GSA, *Boston Panels*. Kelly was born in 1923, studied at the Pratt Institute in Brooklyn, and on his return from the army, he trained (with funding under the G.I. Bill) at the school associated with Boston's Museum of Fine Arts. In the late 1940s, Kelly went to Paris, where he lived for several years before returning to the United States. Kelly's works are in the 1993 Holocaust Memorial Museum in the United States and in the renovated Reichstag, the German legislature's building. See generally Holland Cotter, *An American in Paris*, Art in America 74 (Dec. 1992); Carol Vogel, *Ellsworth Kelly on the Wall*, New York Times, Sept. 25, 1998, part of the "Inside Art" series. As of 1998, the Boston suite of 21 panels was the largest set of public art pieces by Kelly. See Christine Temin, *Court of Many Colors: Ellsworth Kelly Installs a Major Commission in the City Where He Got His Art Start*, Boston Globe, Sept. 16, 1998, at C1 (hereinafter Temin, *Court of Many Colors*, Boston Globe).

**211** Harris at 25.

**212** According to participants, our essay (Dennis E. Curtis & Judith Resnik, *Images of Justice*, 96 Yale Law Journal 1727 (1987)) had affected their view that the symbolism associated with justice had become popularized to a degree that diluted its meaning. See comments by the Honorable Douglas Woodlock, Symposium on the Art

and Architecture of Civic Buildings, United States Courthouse, District of Massachusetts, Sept. 24, 1998 at 5–6 (hereinafter Symposium on the Art and Architecture of Civic Buildings).

The committee chose a series of inscriptions, carved onto the inside and outside walls of the courthouse, to accomplish some of its educational goals. See *The Art and Craft of Justice: A Guide to the Stone Carvings and Inscriptions of the United States Courthouse in Boston* (Federal Court Public Education Fund, Boston, Mass. 1998) (hereinafter *Boston Courthouse Stone Carvings Guide*). In addition, plans were to use the new space for civic education. See General Services Administration, Boston Courthouse and Community. A Federal Court Public Education Fund was established. See Maria Karagianis, *The Federal Court Public Education Project* (sponsored by the Boston Bar Association and the Boston Bar Foundation, Spring 1999).

**213** Minutes from the committee's considerations of other artists included comments by committee members that some were "too partisan" or would highlight "one culture." Draft Artist Selection Meeting Minutes, Oct. 21, 1993, at 2, GSA/AA 283 Kelly.

**214** See *Boston Courthouse Stone Carvings Guide*. The First Circuit also hears cases from the District of Puerto Rico.

**215** Temin, *Court of Many Colors* at C8. In exchanges with the Community Arts Panel, Kelly had commented that he did not "have any other content than the quality and clarity of the color." Artist Proposal-Minutes, Dec. 12, 1994 at 2, GSA/AA 283 Kelly.

**216** GSA, *Boston Panels*. See also Linda Nochlin, *Kelly: Making Abstraction Anew*, ART IN AMERICA 68, 77 (1997). Nochlin thought the black panel could reference the black of judges' robes or criminal law, but what it really serves to do is "to remind us, simply by being where it is, of the contradictions that lie not merely at the heart of our visual apprehensions but, by analogy, in our institutional practices and their theoretical grounding as well."

**217** Remarks by Robert Campbell, Symposium on the Art and Architecture of Civic Buildings at 47, 54. Campbell described the Kelly panels as "the ultimate abstractions of what would have been representational paintings in the sense that the horizontal ones in the rotunda are landscapes and the vertical ones at the ends of the corridors are portraits. . . . [T]hey are as if the message were yet to be inscribed." See also Campbell, *Mixed Verdict*.

Not all abstractions have avoided conflict. In 1974 the GSA gave a commission to George Sugarman for a sculpture called *Baltimore Federal*, which is a swirl of variously colored welded aluminum shapes in red, blue, green, orange, and yellow measuring approximately forty-five feet square by twenty feet high. The Chief Judge of the District Court objected that the sculpture was "inappropriate" for a federal building and posed a danger—either of injuring those who climbed on it or of serving as a "potential shelter for persons bent on mischief or assault on the public." THALACKER at 8. As the criticism escalated, the art world rallied in support, with one curator calling the object one of the "most exciting works for a public space that I have seen." Id. at 9. A judge opposing the art countered that his concerns about safety deserved consideration from the FBI and that "dissident groups" could use the piece as a "platform for speaking or hurling objects." Id. at 11. After the GSA convened a public hearing, the judge's objections lost out to the sculptor's supporters, and the piece was installed in 1978. Id. at 12–13. See also Harriet F. Senie, *Baboons, Pet Rocks, and Bomb Threats: Public Art and Public Perception*, in CRITICAL ISSUES IN PUBLIC ART at 242–243.

The judges remained unhappy. When the building was under consideration for redesign in the 1990s, they renewed their complaint that the sculpture was "inconsistent with the dignity of the United States Courts." See Memorandum from Jan Ziegler to Dale Lanzone (Aug. 2, 1994), General Services Administration, Arts and Historical Preservation Division, GSA Archives, Art-in-Architecture, AA 173. In 1995, after the April 19 bombing of a federal courthouse in Oklahoma City, interest in removing the sculpture intensified. See Marcia Myers, *New*

*Strategy Afoot to Remove Controversial Sculpture*, BALTIMORE SUN, June 19, 1995, at 1A. The artist noted that security had not been a problem over the years, and further, that his work made a "social place that people could participate in . . . reflective of the open democracy that a courthouse is supposed to represent in this country. It is a very idealistic piece." Paul W. Valentine, *Not Just a Matter of Taste: Much-Disliked Court Sculpture May Be Security Risk*, WASHINGTON POST, June 21, 1995, at B3.

In 1997 the sculpture was disassembled into twenty pieces and removed for restoration. It was returned in 2000; the building's entrance and the surrounding plaza were reorganized and the sculpture relocated "at the foot of the plaza." The move was explained as enabling the sculpture to be better viewed from another street and enhanced by landscaping as well as providing easier handicap access to the building. Email memos exchanged among GSA staff, July 7, 2000, GSA/AA 173 Sugarman. See also Glenn McNatt, *A Sight For Sore Eyes*, BALTIMORE SUN, Aug. 7, 2000, at 1F; see also GSA, Courthouse Square Revisited: Report of the Design Charrette Team, GSA/AA 173 Sugarman, Dec. 1995.

**218** Temin, *Court of Many Colors*, at C8.

**219** Lloyd at 32. The panels were "large, cheerful, but innocuous color chips." Id.

**220** CRARY, TECHNIQUES OF THE OBSERVER 1–4. The "collapse of the camera obscura as a model for the condition of the observer" meant that there was no longer a fixed place, but instead multiple points of view, no longer one fixed source of light, but vision as present in the perception. Id. at 137.

**221** CRARY, TECHNIQUES OF THE OBSERVER at 3 (emphasis in the original).

**222** CRARY, TECHNIQUES OF THE OBSERVER at 95, citing *The Works of John Ruskin*, vol. 15 at 27. Ruskin had described the "innocence of the eye" as "a sort of childish perception of these flat stains of color . . . as a blind man would see them if suddenly gifted with sight."

**223** CRARY, TECHNIQUES OF THE OBSERVER at 5–6.

**224** CRARY, TECHNIQUES OF THE OBSERVER at 15–16, citing Foucault's *Discipline and Punish*. Crary also builds on Jean Baudrillard's *La société de consommation* (1970). Crary's project is to engage with the relevance of the sense of touch to sight. CRARY, TECHNIQUES OF THE OBSERVER at 19.

**225** Maija Jansson, *Matthew Hale on Judges and Judging*, 9 JOURNAL OF LEGAL HISTORY 201, 201 (1988). A glowing account of Hale (a great jurist as well as "the greatest historian of English law before Maitland") is provided by Sir William S. Holdsworth, *Sir Matthew Hale*, 39 LAW QUARTERLY REVIEW 402 (1923). Hale was the author of a history of the common law, first published anonymously in 1713. Id. at 415.

**226** Jansson, excerpting Hale's diary; this segment is quoted at 205.

**227** Jansson at 206.

**228** Holdsworth at 407. At the time, "the sentence was in accordance with the law, and the existence of witches was vouched for by the Bible." Id.

**229** Jansson at 206.

**230** In addition to political transformations, an amalgam of technology and critical science splintered the unity of a single objective point of view and gave new shape to the role of spectators who gained the stature of observers. See generally CRARY, TECHNIQUES OF THE OBSERVER.

**231** See LARRY BERKSON, SCOTT BELLER, & MICHELE GRIMALDI, JUDICIAL SELECTION IN THE UNITED STATES : A COMPENDIUM OF PROVISIONS (Chicago, IL: American Judicature Society, 1981), online at American Judicature Society, http://www.ajs.org/selection/sel_states elect.asp.

**232** See generally Lee Epstein, Jack Knight, & Olga Shvetsova, *Selecting Selection Systems*, in JUDICIAL INDEPENDENCE AT THE CROSS-

ROADS: AN INTERDISCIPLINARY APPROACH (Thousand Oaks, CA: Sage Publications, 2002).

**233** Act of Settlement, 1701, 12 & 13 Will. 3, c. 2; see also David Lemmings, *The Independence of the Judiciary in Eighteenth-Century England*, in THE LIFE OF THE LAW: PROCEEDINGS OF THE TENTH BRITISH LEGAL HISTORY CONFERENCE 125 (Peter Birks, ed., London, Eng.: Hambledon Press, 1993), and ROBERT STEVENS, THE INDEPENDENCE OF THE JUDICIARY: THE VIEW FROM THE LORD CHANCELLOR'S OFFICE (Oxford, Eng.: Clarendon Press, 1993).

**234** U.S. CONST. Art. 2, sec. 4.

**235** As of 2009, the group of individuals against whom impeachments were voted by the House numbered fourteen, and some resigned before proceedings, while three (Samuel Chase, 1805; Charles Swayne, 1905; Harold Louderback, 1933) were acquitted. See Impeachments of Federal Judges, Federal Judicial Center, http://www.fjc.gov/history/home.nsf/page/topics_ji_bdy. The experience of the United States is not sui generis. In several democracies committed to judicial independence, judges are rarely removed from office. See MARY L. VOLCANSEK, JUDICIAL MISCONDUCT: A CROSS-NATIONAL COMPARISON 111 (Gainesville, FL: U. of Florida Press, 1996). Further, in many countries, service on constitutional courts may be for limited and nonrenewable terms and retirement required for judges on other courts.

Many systems rely on controlling lower-level problems and lower-level judges through internal judicially administered systems. In the United States federal system, provisions were put into place in 1980. See Judicial Councils Reform and Judicial Conduct and Disability Act of 1980, Pub. L. No. 96-458, 94 Stat. 2035 (codified as amended at 28 U.S.C. § 372(c) (1988)), amended by Judicial Discipline and Removal Act of 1990, Pub. L. No. 101-650, § 402(a), 104 Stat. 5122 (codified as amended at 28 U.S.C. § 372(c)(1) (2000)), superseded by Judicial Improvements Act of 2002, Pub. L. No. 107-273, ch. 16, 116 Stat. 1848, 1855 (codified at 28 U.S.C. §§ 351-364 (2006)). In England and Wales, superintendence of lower-level judges came through the Lord Chancellor. See Constitutional Reform Act, 2005, ch. 4, § 108 (Eng.); Explanatory Notes to Constitutional Reform Act 2005, paras. 214, 219 (2005); Office of Judicial Complaints, http://www.judicialcomplaints.gov.uk. Civil court systems generally rely on administrative control for their regular judiciaries. VOLCANSEK at 2. Italy adopted this method in 1907.

**236** *Stump v. Sparkman* is a vivid example. The approval by a judge of an order that a young woman be sterilized was a "judicial" act entitling him to immunity from liability. 435 U.S. 349, 360 (1978).

**237** The speech was not only important at the time but was later reprinted in 20 JOURNAL OF THE AMERICAN JUDICATURE SOCIETY 178 (1936), and its themes reengaged a century later. See Randall L. Shephard, *Introduction: The Hundred-Year Run of Roscoe Pound, Conference of Chief Justices and Conference of State Court Administrators Annual Meeting July 29–August 2, 2006 Indianapolis, Indiana*, 82 INDIANA LAW JOURNAL 1153 (2007).

**238** See Russell Benedict, *Ethics of the Bench*, 8 AMERICAN BAR ASSOCIATION JOURNAL 199 (1922); John W. Davis, *Some Current Activities of the American Bar Association*, 29 WEST VIRGINIA LAW QUARTERLY 109, 116 (1923).

**239** See CANONS OF JUDICIAL ETHICS, Canon 4 (1924) ("Avoidance of Impropriety. A judge's official conduct should be free from impropriety and the appearance of impropriety; he should avoid infractions of law; and his personal behavior, not only upon the Bench and in the performance of judicial duties, but also in his everyday life, should be beyond reproach"); see also CODE OF JUDICIAL CONDUCT, Canon 2 (1972) ("[a] judge should avoid impropriety and the appearance of impropriety"); MODEL CODE OF JUDICIAL CONDUCT, Canon 2 (1990) ("[a] judge shall avoid impropriety and the appearance of impropriety in all of the judge's activities"); MODEL CODE OF JUDICIAL CONDUCT, Canon 2 (2004) ("[a] judge shall avoid impropriety and the appearance of impropriety in all of the judge's activities"); MODEL CODE OF JUDICIAL CONDUCT, Canon 1 (2007) ("[a] judge shall uphold and promote the independence, integrity, and impartiality of the judiciary, and shall avoid impropriety and the appearance of impropriety").

A word on sources is in order. The American Bar Association has promulgated "model codes" of conduct, setting forth "canons," "rules," and "comments" meant to indicate different levels of obligation—from binding rules to "aspirational goals." These codes, however, have no force unless adopted affirmatively by a jurisdiction; many have done so, sometimes with modifications. Details of the structure of the current code are provided in American Bar Association (ABA), MODEL CODE OF JUDICIAL CONDUCT, "Scope" (Chicago, IL: ABA, 2007), http://www.abanet.org/judicialethics/ABA_MCJC_approved.pdf. (hereinafter 2007 MODEL CODE OF JUDICIAL CONDUCT). In the years since 1924, the ABA has put forth several versions that varied somewhat. We cite specific examples with dates provided to delineate the different iterations.

As Charles Geyh explained, the idea of an appearance of unfairness could be found earlier, including in an 1852 judgment of the English courts concluding that judges could not be shareholders in a corporation that was bringing a lawsuit, for to do so could give rise to a suggestion that "personal interest" influenced the judgment; the court warned judges to "avoid the appearance of laboring under such influence." *Dimes v. Grand Junction Canal*, 10 Eng. Rep. 301, 316 (H.L. 1852) (Campbell, J., concurring), discussed in Charles Gardner Geyh, *Preserving Public Confidence in the Courts in an Age of Individual Rights and Public Skepticism*, in BENCH PRESS: THE COLLISION OF COURTS, POLITICS, AND THE MEDIA 21, 25–26 (Keith J. Bybee, ed., Stanford, CA: Stanford U. Press, 2007). Further, as Geyh and other scholars have noted, the inclusion of an "appearance" standard came in part from a specific example: after a scandal involving corruption of a baseball team (the Chicago White Sox) in the World Series, a federal judge agreed to serve as a paid baseball commissioner while continuing to sit as a judge. The judge was charged with neglect of duties, but the evidence was found insufficient for impeachment. His conduct was nonetheless seen as "derogatory to the dignity of the Bench." See JOHN P. MACKENZIE, THE APPEARANCE OF JUSTICE 180–182 (New York, NY: Scribner, 1974). Geyh also charted the problems of implementing the "appearance" standard, with its vague and ill-defined contours, yet noted its ongoing popular appeal. For further discussion of the contemporary standard, see M. Margaret McKeown, *Don't Shoot the Canons: Maintaining the Appearance of Propriety Standard*, 7 JOURNAL OF APPELLATE PRACTICE AND PROCESS 45 (2005).

**240** MODEL CODE OF JUDICIAL CONDUCT, Canon 2(c) (2004); MODEL CODE OF JUDICIAL CONDUCT, Canon 3.6 (2007). The 2007 text provides: "A judge shall not hold membership in any organization that practices invidious discrimination on the basis of race, sex, gender, religion, national origin, ethnicity, or sexual orientation." Further, a "judge shall not use the benefits or facilities" (including attending events at such organizations) if the judge knows of the organization's practices. Membership in such groups, if part of religious observance, is not "a violation" of the rule. See also Andrew L. Kaufman, *Judicial Correctness Meets Constitutional Correctness: Section 2C of the Code of Judicial Conduct*, 32 HOFSTRA LAW REVIEW 1293 (2004).

**241** See, for example, MODEL CODE OF JUDICIAL CONDUCT, Preface to the Code (1972) ("The canons and text establish mandatory standards unless otherwise indicated"). The 2007 version provided that the Code "establishes standards" that are not "exhaustive" but serve as guidance for both judges and judicial candidates. See 2007 MODEL CODE OF JUDICIAL CONDUCT, Preamble. Further, its language states that judges "shall uphold and promote the independence, integrity, and impartiality of the judiciary, and shall avoid impropriety and the appearance of impropriety." Id., Canon 1.

**242** MODEL CODE OF JUDICIAL CONDUCT, Preamble (2007). In 1990 the ABA revisions retreated somewhat from the mandatory preamble and relied on the word "should" instead of "shall" in some instances. By then, most states had created commissions to review complaints against judges for misconduct. Geyh at 31.

**243** MODEL CODE OF JUDICIAL CONDUCT, Comment 6 to Rule 1.2 (2007). See Richard L. Fruin, *How Judicial Outreach Became Part of the Model Code of Judicial Conduct*, 46 JUDGES' JOURNAL 36 (Fall, 2007).

**244** See Rule 1 (Scope) of the Rules Governing Judicial Conduct and Disability Proceedings Undertaken Pursuant to 28 U.S.C. §§ 351–364 (adopted 2008). The development of new rules came in the wake of criticism of the ways in which courts had been administering the complaint procedure. As a consequence, Chief Justice William Rehnquist had appointed a committee, chaired by Associate Justice Stephen Breyer, to develop standards for implementation of the internal procedures of courts as they sit to hear complaints about colleagues. See Judicial Conduct and Disability Act Study Committee (Breyer Committee), Implementation of the Judicial Conduct and Disability Act of 1980: A Report to the Chief Justice (Sept. 2006), Supreme Court, http://www.supremecourtus.gov/publicinfo/breyercommittee report.pdf. In 2008 the Judicial Conference promulgated new, uniform rules for handling complaints under the act. See *Judicial Conference of the United States, Rules for Judicial-Conduct and Judicial-Disability Proceedings* (Mar. 2008), U.S. Courts, http://www.uscourts.gov/library/judicialmisconduct/jud_conduct_and_disability_308_app_B_rev.pdf."

**245** See Dr. Bonham's Case, 77 Eng. Rep. 638 (K.B. 1608). There Lord Coke ruled that the board members deciding physicians' qualifications could not impose and receive fines. As detailed in Chapter 3, *Tumey v. Ohio*, 273 U.S. 510 (1927), made that precept a part of the constitutional law of due process in the United States.

**246** Two federal statutes are illustrative. The first, 28 U.S.C. § 144, provides that parties may file "a timely and sufficient affidavit that a [district] judge before whom the matter is pending has a personal bias or prejudice" against that or another party, and the judge "shall proceed no further" if that judge concurs. A more recently enacted statute, 28 U.S.C. § 455(b) (2006), called "Disqualification of justice, judge, or magistrate judge," provides more detail and applies more broadly. It states that

> (a) Any justice, judge, or magistrate [magistrate judge] of the United States shall disqualify himself in any proceeding in which his impartiality might reasonably be questioned." Under subsection (b), disqualification is mandatory:
>
> (1) Where he has a personal bias or prejudice concerning a party, or personal knowledge of disputed evidentiary facts concerning the proceeding;
>
> (2) Where in private practice he served as lawyer in the matter in controversy, or a lawyer with whom he previously practiced law served during such association as a lawyer concerning the matter, or the judge or such lawyer has been a material witness concerning it;
>
> (3) Where he has served in governmental employment and in such capacity participated as counsel, adviser or material witness concerning the proceeding or expressed an opinion concerning the merits of the particular case in controversy;
>
> (4) He knows that he, individually or as a fiduciary, or his spouse or minor child residing in his household,

> has a financial interest in the subject matter in controversy or in a party to the proceeding, or any other interest that could be substantially affected by the outcome of the proceeding;
>
> (5) He or his spouse, or a person within the third degree of relationship to either of them, or the spouse of such a person:
>
> (i) Is a party to the proceeding, or an officer, director, or trustee of a party;
>
> (ii) Is acting as a lawyer in the proceeding;
>
> (iii) Is known by the judge to have an interest that could be substantially affected by the outcome of the proceeding;
>
> (iv) Is to the judge's knowledge likely to be a material witness in the proceeding.

Financial interests are defined as "ownership of a legal or equitable interest, however small," but exclude mutual funds. Further, if an issue of disqualification related to financial investments arises "after substantial judicial time has been devoted to the matter" and the judge divests him or herself of the assets, disqualification is not mandatory.

In addition, model rules also require disqualification under parallel provisions. See MODEL CODE OF JUDICIAL CONDUCT, Rule 2.11 (Disqualification) (2007). The evolution of federal recusal law is mapped by Amanda Frost, *Keeping Up Appearances: A Process-Oriented Approach to Judicial Recusal*, 53 KANSAS LAW REVIEW 531, 537–550 (2005). For discussion of innovative responses from state courts, see Judith Resnik, *On the Bias: Feminist Reconsiderations of the Aspirations for Our Judges*, 61 SOUTHERN CALIFORNIA LAW REVIEW 1877 (1988).

**247** See 2007 MODEL CODE OF JUDICIAL CONDUCT, Rule 2.11.

**248** A review that includes such examples is provided by Peter W. Bowie in *The Last 100 Years: An Era of Expanding Appearances*, 48 SOUTH TEX. LAW REVIEW 911 (2007).

**249** See, for example, CAL. CIV. PROC. CODE §§ 170–170.6 (Deering 2007).

**250** The federal statutes by which litigants make such challenges are illustrative. See 28 U.S.C. § 144; 28 U.S.C. § 455. The decisions made by lower court judges may eventually be subjected to review.

**251** Requirements for reporting of such support as gifts and of precluding such trips for lower court federal judges have been considered. See, for example, Fair and Independent Federal Judiciary Act of 2003, S. 787, 108th Cong. (2003); Fair and Independent Judiciary Act of 2006, S. 2202, 109th Cong. (2006). Arguments for regulating this conduct come from Douglas T. Kendall & Jason C. Rylander, *Tainted Justice: How Private Judicial Trips Undermine Public Confidence in the Judiciary*, 18 GEORGIA JOURNAL OF LEGAL ETHICS 65 (2004). Another issue is judges' acquisition of knowledge through their own research. See George D. Marlow, *From Black Robes to White Lab Coats: The Ethical Implications of a Judge's Sua Sponte, ex Parte Acquisition of Social and Other Scientific Evidence during the Decision-Making Process*, 72 ST. JOHN'S LAW REVIEW 291 (1998).

**252** The *Model Code of Judicial Conduct* addresses some of these issues with varying degrees of specificity. For example, parameters are set forth limiting judges from becoming involved in fundraising for organizations and encouraging public commentary related to "the law, the legal system, and the administration of justice" but not issues likely to come before a judge. See American Bar Association, MODEL CODE OF JUDICIAL CONDUCT (Chicago, IL: ABA, 2007), http://www.abanet.org/judicialethics/ABA_MCJC_approved.pdf.

**253** Born in 1943, Jeff Danziger is an independent political cartoonist whose work, syndicated through the *New York Times*, appears

in newspapers around the world. He is also a novelist whose book *Rising Like the Tucson* (New York, NY: Doubleday, 1991) reflected his experiences as an intelligence officer serving during the Vietnam War. From 1986 to 1996, he worked for the *Christian Science Monitor*. In 2006 Danziger was awarded the Herblock Prize for editorial cartoons. Our thanks to the artist for his permission to use the cartoon in figure 94.

**254** See *Cheney v. U.S. Dist. Ct.*, 542 U.S. 367 (2004).

**255** *Cheney,* 542 U.S. at 373.

**256** *Cheney,* 542 U.S. at 374.

**257** See Monroe H. Freedman, *Duck-Blind Justice: Justice Scalia's Memorandum in the Cheney Case,* 18 GEORGIA JOURNAL OF LEGAL ETHICS 229, 233 (2004).

**258** See 5 U.S.C. App. II §§ 1–16.

**259** By arguing that a nondiscretionary duty existed, the plaintiffs could invoke the federal court's jurisdiction under the Mandamus Act, 28 U.S.C. § 1361.

**260** *Cheney,* 542 U.S. at 376–378.

**261** Justice Scalia disagreed with press reports that Cheney's host was an "energy industry executive" and described him as the owner of a "company that provides services and equipment rental to oil rigs in the Gulf of Mexico." *Cheney v. U.S. Dist. Ct.*, Memorandum of Justice Scalia, 541 U.S. 913, 914 (2004) (hereinafter Scalia, Cheney Memorandum).

**262** Scalia, Cheney Memorandum at 914–915.

**263** See Scalia, Cheney Memorandum at 914. See also MODEL CODE OF JUDICIAL CONDUCT, Rule 2.11 (2007).

**264** Sierra Club Motion to Recuse (Appellate Brief), 2004 WL 3741418 at 3–4.

**265** Scalia, Cheney Memorandum at 915.

**266** Scalia, Cheney Memorandum at 915.

**267** Scalia, Cheney Memorandum at 916.

**268** Scalia, Cheney Memorandum at 915–916. There Scalia referenced a memorandum of the Court of 1993 that was a "Statement of Recusal Policy" and quoted its view that Justices ought not recuse themselves out of an "excess of caution" but only when necessary.

**269** Scalia, Cheney Memorandum at 929.

**270** *Cheney,* 542 U.S. at 391–392.

**271** *Cheney,* 542 U.S. at 394–395.

**272** *In re Cheney,* 406 F.3d 723 (D.C. Cir. 2005). The D.C. Circuit issued a writ of mandamus to the district court ordering dismissal of the complaint. The appellate court determined that, in light of "severe separation-of-powers problems," it would narrowly construe the reach of the statute mandating public access. The court then concluded that if a "committee" were "composed wholly of federal officials" and "no one other than a federal official [has] a vote in, or, if the committee acts by consensus, a veto over the committee's decisions," the Act did not apply. Id. at 728. In contrast, "participation in committee meetings . . . even influential participation" did not make a person a committee member, for the executive needed to be "free to seek confidential information from many sources" inside and outside of government. Id. The appellate court decided that the plaintiffs (still lacking the requested discovery) had not established that the nongovernmental members had voted, and therefore that the Energy Policy Group was not a committee that fell under the statute's parameters. Id. at 730.

**273** See, for example, Frost at 531; Freedman at 229; Adam Liptak, *Word for Word / Scalia's Defense: A Case of Blind Justice among a Bunch of Friends,* NEW YORK TIMES, Mar. 21, 2004, at 5.

**274** Controversy had also emerged when litigants requested that William Rehnquist recuse himself in a case involving a challenge to a program on which he had worked when at the Department of Justice. He declined. See *Laird v. Tatum,* 409 U.S. 824 (1972) (statement of Justice Rehnquist). The case was decided (in favor of the government) five to four, with Rehnquist's participation in the majority. See *Laird v. Tatum,* 408 U.S. 1 (1972).

**275** BRIAN BARRY, JUSTICE AS IMPARTIALITY: A TREATISE ON SOCIAL JUSTICE, vol. 2 (Oxford, Eng.: Clarendon Press, 1995).

**276** BARRY at 13.

**277** A few are reproduced in Chapter 1 ("Critics charge that recent decisions manifest a blind disregard for the Constitution," "Alternative to Roe vs. Wade," and a cartoon accompanying the article "A Trial for Chinese Justice"—figures 15, 16, and 17).

**278** JOHN RAWLS, A THEORY OF JUSTICE 514 (Cambridge, MA: Belknap / Harvard U. Press, 1971). The potential for that positioning is explored (and critiqued) in MICHAEL WALZER, INTERPRETATION AND SOCIAL CRITICISM (Cambridge, MA: Harvard U. Press, 1987). Our thanks to Daniel Markovits for his engagement with this segment of our work and for his suggestions on the interrelationships between Rawls and Walzer on this point.

**279** *Report of the Committee on Diversity in Legal Education to the Council of the Section of Legal Education and Admissions to the Bar* 7 (1998). Its preliminary report on the implementation of recommendations was made to the Council in August 1997 at its meeting in Newport, Rhode Island, on June 6–7, 1998. See the ABA website, http://www.abanet.org/legaled/committees/diversityreports/diversity-report-1998.doc.

**280** Comparisons among countries need to take into account that in some places, such as the United States and Canada, law is a graduate degree, while in many other countries, law can be studied as part of an undergraduate curriculum, resulting in a Bachelor of Law. With that caveat, one can find parallel trends. For example, in Germany in 1970, women were about one-third of the students pursuing university-based legal studies, and by 1997 women were almost one-half of the students. Ulrike Schultz, *The Status of Women Lawyers in Germany,* in WOMEN IN THE WORLD'S LEGAL PROFESSIONS 274 (Ulrike Schultz & Gisela Shaw, eds., Portland, OR: Hart Publishing, 2003) (hereinafter WOMEN IN THE WORLD). Moving to those obtaining licenses to practice law, in the United Kingdom in 1963, women represented about 5 percent of those authorized to be "solicitors"; in 1970 women were less than 8 percent of those admitted as "barristers." By 1998 women were about half of those entering the profession as solicitors and as barristers. See Clare M. S. McGlynn, *The Status of Women Lawyers in the United Kingdom,* in WOMEN IN THE WORLD at 142–153. In Israel, similar trends were seen; women were 7 percent of those licensed to practice law in the decade 1950–1959 and about a third of those licensed in the 1990s. Bryna Bogoch, *Gender, Trials and Professional Performance in Israel,* in WOMEN IN THE WORLD at 248–252. In Australia, women were under 4 percent of the bar in 1961 and about a quarter of those in the bar in 1991. Rosemary Hunter, *Women in the Legal Profession: The Australian Profile,* in WOMEN IN THE WORLD at 87–101.

**281** See *Gideon v. Wainwright,* 372 U.S. 335 (1963). See generally ANTHONY LEWIS, GIDEON'S TRUMPET (New York, NY: Random House, 1964).

**282** The effort to use law to redress the unfairness of law is chronicled in several accounts of the NAACP. See, for example, GILBERT JONAS, FREEDOM'S SWORD: THE NAACP AND THE STRUGGLE AGAINST RACISM IN AMERICA, 1909–1969 (New York, NY: Routledge, 2005).

**283** Letter from Will Shafroth to Alfred P. Murrah (March 22, 1954), in Judicial Conference Committee Records, Box 9, Folder Pretrial Committee, Record Group 116, Administrative Office of the U.S. Courts, National Archives, Washington, D.C. Further discussion of "teaching judges" is provided in Judith Resnik, *Trial as Error, Jurisdiction as Injury: Transforming the Meaning of Article III,* 113 HARVARD LAW REVIEW 924, 943–949 (2000).

**284** *McCleskey v. Kemp,* 481 U.S. 279 (1987).

**285** The data on sentencing in Georgia were collected and analyzed by David C. Baldus, Charles Pulaski, and George Woodworth. The majority noted their effort to consider whether other variables explained the outcome; the researchers used 230 variables. "[E]ven

taking account of 39 nonracial variables, defendants charged with killing white victims were 4.3 times as likely to receive a death sentence as defendants charged with killing blacks." *McCleskey*, 481 U.S. at 287. Subsequent studies in other states have found comparable racialized effects. See David C. Baldus, George Woodworth, David Zuckerman, Neil Alan Weiner, & Barbara Broffitt, *Racial Discrimination and the Death Penalty in the Post-Furman Era: An Empirical and Legal Overview, with Recent Findings from Philadelphia*, 83 CORNELL LAW REVIEW 1638 (1998).

**286** *McCleskey*, 481 U.S. at 313.

**287** *McCleskey*, 481 U.S. at 316–317.

**288** Baldus et al. at 1734.

**289** Baldus et al. at 1738.

**290** CRARY, TECHNIQUES OF THE OBSERVER at 150, identifying the understanding of nineteenth-century modernity that no objective visual position existed and the relocation of the viewpoint in the observer.

**291** A new entity—the National Judicial Education Program to Promote Equality of Women and Men in the Courts—was formed to run such activities. Norma Juliet Wikler, the first director of the National Judicial Education Program, substituted the term "gender bias" for "sexism" after she discovered "in 1980 that judges attending the first judicial education programs on this topic were less resistant if the former term was used." Norma Juliet Wikler, *Researching Gender Bias in the Courts: Problems and Prospects*, in INVESTIGATING GENDER BIAS: LAW, COURTS AND THE LEGAL PROFESSION 50, n. 3 (Joan Brockman and Dorothy Chunn, eds., Toronto, Can.: Thompson Educational Publishing, 1993) (hereinafter INVESTIGATING GENDER BIAS). See also Lynn Hecht Schafran, *Gender Equality in the Courts: Still on the Judicial Agenda*, 77 JUDICATURE 110 (1993).

**292** In 1985 New Jersey was again first in creating a "Minority Concerns" task force. In 1988 the chief justices of all state courts adopted a resolution calling for study of gender, racial, and ethnic bias in the courts. In 1989 judges and lawyers of color formed the "National Consortium of Task Forces and Commissions on Racial and Ethnic Bias in the Courts" to generate nationwide study and education. Initially the work was based in state courts. In 1992, the Ninth Circuit (encompassing federal trial and appellate courts in nine Western states) became the first in the federal system to issue a report on the effects of gender throughout courts. Soon thereafter, the Judicial Conference of the United States (the policy-making body of the federal judiciary) voiced support for studies of bias, and other federal circuits began such work. Congressional encouragement for federal court studies came in 1994 in a section of the Violence against Women Act. In the spring of 1995, the Federal Judicial Center (the national educational arm of the federal courts) published a research guide for federal gender task forces. See Judith Resnik, *Asking about Gender in Courts*, 21 SIGNS: JOURNAL OF WOMEN IN CULTURE AND SOCIETY 952 (1996).

**293** CONNECTICUT TASK FORCE ON GENDER, JUSTICE, AND THE COURTS, REPORT OF THE CONNECTICUT TASK FORCE ON GENDER, JUSTICE, AND THE COURTS TO THE CHIEF JUSTICE at 6 (1991) (hereinafter CONNECTICUT TASK FORCE REPORT ON GENDER).

**294** FEDERAL JUDICIAL CENTER, STUDYING THE ROLE OF GENDER IN THE FEDERAL COURTS: A RESEARCH GUIDE 115–148 (1995).

**295** See Deborah R. Hensler, *Studying Gender Bias in the Courts: Stories and Statistics*, 45 STANFORD LAW REVIEW 2187 (1993).

**296** New York Task Force on Women in the Courts, *Report of the New York Task Force on Women in the Courts* 17–18 (1986), reprinted in 15 FORDHAM URBAN LAW JOURNAL 11 (1986–1987).

**297** CONNECTICUT TASK FORCE REPORT ON GENDER at 12.

**298** New York State Judicial Commission on Minorities, Report of the New York State Judicial Commission on Minorities, vols. I–IV (1991), in vol. I, Executive Summary, at 43 (1991).

**299** MICHIGAN SUPREME COURT TASK FORCES ON RACIAL/ETHNIC ISSUES IN THE COURTS, FINAL REPORT OF THE MICHIGAN SUPREME

COURT TASK FORCE ON RACIAL/ETHNIC ISSUES IN THE COURTS 2 (1989). Similarly, New York's report on minorities found that the "perception [is] that minorities are stripped of their human dignity, their individuality and their identity in their encounters with the court system." See NEW YORK STATE COMMISSION ON MINORITIES REPORT, vol. II: THE PUBLIC AND THE COURTS at 1. A few reports also noted areas of progress. See, for example, the gender reports from Georgia, Kentucky, New Mexico, and both the federal and local courts of the District of Columbia, as well as the Report of the Third Circuit. See Commission on Gender and Commission on Race & Ethnicity, *Report of the Third Circuit Task Force on Equal Treatment in the Courts*, 42 VILLANOVA LAW REVIEW 1355 (1997).

**300** See, for example, *In re Swan*, 833 F. Supp. 794 (C.D. Cal. 1993), *rev'd sub nom. U.S. v. Wunsch*, 84 F.3d 1110 (9th Cir. 1996); *Catchpole v. Brannon*, 36 Cal. App. 4th 237 (Cal. Ct. App. 1995); *State v. Pace*, 447 S.E.2d 186 (S.C. 1994).

**301** *Powell v. Allstate Insurance Co.*, 652 So. 2d 354 (Fla. 1995); *In re Vincenti*, 554 A.2d 470 (N.J. 1989). See also Sheri Lynn Johnson, *Racial Imagery in Criminal Cases*, 67 TULANE LAW REVIEW 1739, 1768–1792 (1993).

**302** *Stop "Politicizing" Courts, Women's Group Urges in Response to GAO Report*, PR Newswire, Washington Dateline, March 11, 1996. A few Republican senators entered into the Congressional Record their recommendation that no federal funds be spent for such work, while several Democratic senators voiced their support. See 141 CONG. REC. S18127-05 at S18173–S18175 (daily ed. Dec. 7, 1995); 141 CONG. REC. E2302-02 (daily ed. Dec. 6, 1995).

**303** *Mallory v. Harkness*, 895 F. Supp. 1556 (S.D. Fla. 1995), *aff'd*, 109 F.3d 771 (11th Cir. 1997).

**304** COMMISSION ON SYSTEMIC RACISM IN THE ONTARIO CRIMINAL JUSTICE SYSTEM, REPORT OF THE COMMISSION ON SYSTEMIC RACISM IN THE ONTARIO CRIMINAL JUSTICE SYSTEM (Toronto, Can.: Queen's Printer for Ontario, 1995). Critics also complained that gender bias "disguises sexual oppression and reflects a liberal way of thinking about the phenomenon." Joan Brockman & Dorothy E. Chunn, *Gender Bias in Law and the Social Sciences*, in INVESTIGATING GENDER BIAS at 3.

**305** See generally John Rajchman, *Foucault's Art of Seeing*, 44 OCTOBER 88–117 (1988).

## CHAPTER 7

**1** BERNHARD VAN ZUTPHEN, PRACTYCKE DER NEDERLANSCHE RECHTEN VAN DE DAGHELIJCKSCHE SOO CIVILE ALS CRIMINELE QUESTIEN (DUTCH LAW AND PRACTICE IN CIVIL AND CRIMINAL MATTERS) (Tot Leewarden [Louvain, Belg.]: G. Sijbes, 1655). Zutphen was well known for his work on criminal law. See James Q. Whitman, *The Moral Menace of Roman Law and the Making of Commerce: Some Dutch Evidence*, 105 YALE LAW JOURNAL 1841, 1867–1871 (1995).

**2** Our thanks to Mike Widener, Rare Book Librarian, Rare Book Collection, Lillian Goldman Law Library, Yale Law School, for bringing figure 95 to our attention and to the Library's Rare Book Collection for permitting its reproduction.

**3** Nearly identical images, complete with the small Justice statue at the back behind the presiding jurist, can be found in JOHAN VAN DEN SANDE, RERVM IN SVPREMA FRISIORUM CURIA IUDICATARUM LIBRI V (FIVE BOOKS OF MATTERS IN THE SUPREME COURT OF FRIESLAND) (Leeuwarden [Louvain, Belg.]: Ioannis Iansscnil, 1635) (Leovardiae: impensis Ioannis Iansscnil, 1635; JOHAN VAN DEN SANDE, VIJF BOECKEN DER GEWIJSDER SAKEN VOOR DEN HOVE VAN VRIESLANDT (FIVE BOOKS ON LEGAL ISSUES FOR THE COURT OF FRIESLAND) (Leeuwarden [Louvain, Belg.]: Eyvo Takus Wielsma, 1670). Two other engraved title pages that we have located provide a similar court scene but without a depiction of Justice. See HUGO GROTIUS, INLEIDING TOT

DE HOLLANDSCHE RECHTS-GELEERTHEYD (INTRODUCTION TO DUTCH LAW) (S'Graven-hage: De weduwe van H. P. van Wou, 1631); JACOB COREN, D. IACOBI COOREN IN SUPREMO SENATU HOLLANDIAE: ZEELANDIAE, FRISIAE, DUM VIVERET ASSESSORIS; OBSERVATIONES RERUM IN EODEM SENATU JUDICATARUM; ITEM CONSILIA QUAEDAM: AUCTIORA & EMENDATIORA (Amstelaedami) (roughly COMMENTARY ON THE DECISIONS OF THE SUPREME COURT OF HOLLAND, ZEELAND, AND WESTFRIESLAND) (Amsterdam: Apud J. Ravesteinium, 1661).

**4** See ROBERT TITTLER, ARCHITECTURE AND POWER: THE TOWN HALL AND THE ENGLISH URBAN COMMUNITY c. 1500–1640 (Oxford, Eng.: Oxford U. Press, 1991). Tittler counted 202 such purpose-built structures in 178 towns over the time period he studied. The buildings went by a variety of names (including town house, market house, tolsey, tollbooth, guild-hall, yeldehall, moot hall, mote hall, boot hall) and provided a range of functions related to "local civic administration." Id. at 11–13. Many such structures were specifically constructed "for the holding of courts by the manorial authority of the day." Id., and at 101. Buildings were often also public markets that housed clocks, weights, and bells—providing a modicum of economic regulation. Id. at 133–139. About 25 percent of those structures survived through the twentieth century; a few, restored, "still actually host some forms of deliberative or judicial function"; others are museums. Id. at 23.

**5** TITTLER at 19.

**6** TITTLER at 22. Tittler mapped the relationship between stages of political development and town hall construction in England during the sixteenth and seventeenth centuries. Id. at 22, 76. For example, on receiving a charter of incorporation, localities often created permanent sites of governance, and some charters expressly called for a new building. Id. at 89–91. Some localities chose to situate halls near markets, but others placed such buildings at some distance from commercial arenas in an effort to shift from the disorder of the Medieval marketplace to a world of restrained officialdom. Id. at 131.

Tittler attributed a spurt in construction in sixteenth-century England to town leaders' concerns about growing risks of conflict, their hopes for some degree of autonomous authority, and their desires to succeed in providing security for persons and property records. Id. at 80–89. Ornamentation "was not common"; the buildings were more "didactic than aesthetic or frivolous in intent." Id. at 45. Further, the public buildings were less grand than private ones. Id. at 48. Over the period Tittler studied, some objects that denoted the trappings of office gained import, including the mayor's seat and the magistrate's table. Id. at 116. Civic leaders also sought to inscribe their authority by developing a practice of "civic portraiture" through displays of paintings of mayors and other leaders in town halls. Id. at 153–155.

**7** TITTLER at 70–71. In addition, Tittler noted that halls "were often let for the day for performances." Id. at 70, 140–141. These "steady sources of revenue" were modest, insufficient to confer important financial benefits. Id. at 70.

**8** See CARL R. LOUNSBURY, THE COURTHOUSES OF EARLY VIRGINIA: AN ARCHITECTURAL HISTORY 49 (Charlottesville, VA: U. of Virginia Press, 2005); see also id. at 51, fig. 27 (depicting a ceremonial procession of judges). Lounsbury discussed the English practices as historical antecedents to those in the colonies.

**9** LOUNSBURY at 49.

**10** TITTLER at 76.

**11** TITTLER at 103.

**12** TITTLER at 140–145.

**13** Chapter 3 provided details on the Amsterdam Town Hall. Through colonial authority, some of the Netherlands' traditions had an impact on North American practices. For example, in the 1650s, judges on a colonial New York tribunal, called the Court of Schout, Burgomasters, and Schepens, had a form of judicial independence.

"They were the first judges in the colony in any way independent of the proprietary company." ALDEN CHESTER IN COLLABORATION WITH E. MELVIN WILLIAMS, COURTS AND LAWYERS OF NEW YORK: A HISTORY, 1609–1925, vol. I at 257 (New York, NY: American Historical Society, 1925).

**14** A few books address the relationship between transportation and courthouses. For example, one volume provided a chronological list of Georgia courthouses built from 1760 to 1910 and of their architects, as well as of train routes, lines, and depots. The argument was that courthouses and depots provided places to gather. See WILBER W. CALDWELL, THE COURTHOUSE AND THE DEPOT: A NARRATIVE GUIDE TO RAILROAD EXPANSION AND ITS IMPACT ON PUBLIC ARCHITECTURE IN GEORGIA, 1833–1910, appendices A–C at 555–580 (Macon, GA: Mercer U. Press, 2001).

**15** Illustrative volumes, usually rich with photographs and prints, come from many jurisdictions. The supreme or constitutional courts of a country often have books specifically devoted to their buildings, and several other volumes survey courthouses within a particular state or country. Volumes range from scholarly studies providing social histories of law and architecture to travel guides of courthouses in a given territory. These volumes also illustrate "a renewed interest in the courthouse and the sociological, legal, and cultural implications of its form within the community." CAROLE CABLE, THE COURTHOUSE AND THE LAW COURT: THEIR DESIGN AND CONSTRUCTION (Monticello, IL: Vance Bibliographies, Architecture Series: Bibliography No. A-20, 1978) (a compendium of books, articles, and newspaper materials from the United States and abroad).

Listed in alphabetical order by jurisdiction are several publications from the end of the twentieth century. This spate of materials reflects shifts in academic pursuits as well as the resources for and concern about historical preservation, a consciousness of the turning of the millennium, and some nostalgia for eras seen as passing. See, for example, MARISA G. LOREN, COURT HOUSES IN ADELAIDE, 1837–1988 (South Australia, Aust.: Swift Printing, 1989); DAVID MITTELSTADT, FOUNDATIONS OF JUSTICE: ALBERTA'S HISTORIC COURTHOUSES (Calgary, Alberta, Can.: U. Calgary Press, 2005); COURTHOUSES OF CALIFORNIA: AN ILLUSTRATED HISTORY (Ray McDevitt, ed., San Francisco, CA and Berkeley, CA: California Historical Society and Heyday Books, 2001) (hereinafter COURTHOUSES OF CALIFORNIA); WILLIAM L. VIRDEN, CORNERSTONES AND COMMUNITIES: A HISTORICAL OVERVIEW OF COLORADO'S COUNTY SEATS AND COURTHOUSES (Loveland, CO: Rodgers & Nelsen, 2001); CLARE GRAHAM, ORDERING LAW: THE ARCHITECTURAL AND SOCIAL HISTORY OF THE ENGLISH LAW COURT TO 1914 (Aldershot, Eng.: Ashgate, 2003); ROBERT K. SLOANE, THE COURTHOUSES OF MAINE (Woolwich, ME: Maine Lawyers Review, 1998); MARTHA J. MCNAMARA, FROM TAVERN TO COURTHOUSE: ARCHITECTURE & RITUAL IN AMERICAN LAW, 1658–1860 (Baltimore, MD: Johns Hopkins U. Press, 2004) (focusing on Massachusetts); VICTOR C. GILBERTSON, MINNESOTA COURTHOUSES (Lakeville, MN: Galde Press, 2005); DOUG OHMAN & MARY LOGUE, COURTHOUSES OF MINNESOTA (St. Paul, MN: Minnesota Historical Society Press, 2006); OLIVER B. POLLAK, IMAGES OF AMERICA: NEBRASKA COURTHOUSES: CONTENTION, COMPROMISE, & COMMUNITY (Chicago, IL: Arcadia Publishing, 2002); RONALD M. JAMES, TEMPLES OF JUSTICE: COUNTY COURTHOUSES OF NEVADA (Reno, NV: U. of Nevada Press, 1994); SUSAN W. THRANE, COUNTY COURTHOUSES OF OHIO (Bloomington, IN: Indiana U. Press, 2000); GENE WADDELL AND RHODRI WINDSOR LISCOMBE, ROBERT MILLS'S COURTHOUSES AND JAILS [OF SOUTH CAROLINA] (Easley, SC: Southern Historical Press, 1981); MAVIS P. KELSEY SR. & DONALD H. DYAL, THE COURTHOUSES OF TEXAS: A GUIDE (College Station, TX: Texas A&M U. Press, 2nd ed., 2007); LOUNSBURY; MARV BALOUSEK, WISCONSIN'S HISTORIC COURTHOUSES (Oregon, WI: Badger Books, 1998).

In addition, a few volumes cut across jurisdictions. See, for example, CELEBRATING THE COURTHOUSE: A GUIDE FOR ARCHITECTS,

THEIR CLIENTS, AND THE PUBLIC (Steven Flanders, ed., New York, NY: W. W. Norton, 2006) (hereinafter CELEBRATING THE COURTHOUSE); COURT HOUSE: A PHOTOGRAPHIC DOCUMENT (Richard Pare, ed., New York, NY: Horizon Press, 1978) (hereinafter PARE, COURT HOUSE). *Celebrating the Courthouse* addresses courthouse construction primarily in the United States; the 1978 volume *Court House* includes more than three hundred photographs from around the United States to show how "these particularly American buildings" have served as "an integral part of the life of every settlement as it evolved into a county." Id. at 7. Another volume relies on images other than courthouses to capture legal history in the Northwest. See DOROTHY HARLEY EBER, IMAGES OF JUSTICE: A LEGAL HISTORY OF THE NORTHWEST TERRITORIES AS TRACED THROUGH THE YELLOW-KNIFE COURTHOUSE COLLECTION OF INUIT SCULPTURE (Montreal, Can.: McGill-Queen's U. Press, 1997).

16 See, for example, CHARLES T. GOODSELL, THE SOCIAL MEAN-ING OF CIVIC SPACE: STUDYING POLITICAL AUTHORITY THROUGH ARCHITECTURE (Lawrence, KS: U. Press of Kansas, 1988); THE POWER OF PLACE: BRINGING TOGETHER GEOGRAPHICAL AND SOCIOLOGICAL IMAGINATIONS (John A. Agnew & James S. Duncan, eds., Boston, MA: Unwin Hyman, 1989); VINCENT SCULLY, AMERICAN ARCHITECTURE AND URBANISM (New York, NY: Henry Holt & Co., rev. ed., 1988).

17 LOUNSBURY at 10.

18 LOUNSBURY at 10. Lounsbury detailed the development and use of courts in Virginia from the 1600s through the 1730s. McNamara makes a parallel point in a study of courts and the legal profession in Massachusetts: "The nature and pace of county court sessions alternated between frenetic activity and crashing tedium. While notorious trials occasionally generated dramatic moments . . . , the majority of court sessions moved at a steady, predictable pace." McNamara at 38.

19 LOUNSBURY at 10.

20 The safekeeping of records improved when stone rather than wood was used but, in many instances, localities did not succeed in protecting information from "fires, dampness, and rats." LOUNSBURY at 14. See also TITTLER at 33–50.

21 In Massachusetts, records provided the names of litigants and their lawyers (but not the names of whatever spectators were present) and had a "remarkable consistency over time," evidencing the role of court records in legitimating the power of government. McNAMARA at 38–40, 43–44.

22 JAMES at 1, quoting Myron Angel's *History of Nevada with Illustrations and Biographical Sketches of Its Prominent Men and Pioneers* 497 (1881, reprinted Berkeley, CA: Howell-North, 1958). "[M]ost of the . . . 3,044 counties" in the United States probably had "at least one impressive courthouse." Id. at 1. During one century, some thirty courthouses were erected in the state's seventeen counties. Id. at 27, 160. The styles ranged from Spanish Colonial to Greek Revival and Beaux-Arts Classical, and a few were influenced by twentieth-century Bauhaus or International styles. Id. at 16–26. In several states, county-level administration has been superseded by state-wide centralized systems. See Ray McDevitt, *Introduction*, in COURTHOUSES OF CALIFORNIA at xvi–xvii; INVESTED IN JUSTICE: 1999 JUDICIAL COUNCIL ANNUAL REPORT 4 (San Francisco, CA: Judicial Council of California Administrative Office of the Courts, Public Information Office); Trial Court Unification, Administrative Office of the Courts, Judicial Council of California (Feb. 2005), www.courtinfo.ca.gov/reference/documents/factsheets/tcunif.pdf.

23 Classical designs and oversized proportions aimed to achieve such "monumentality." See JAMES at 9–10 (describing building in Nevada). Lounsbury identified a Virginia courthouse built in Yorktown in the 1730s as "one of the first structures in the colony that self-consciously used academic architectural forms to assert the corporate identity of the country authorities." LOUNSBURY at 10. He mapped the shift from "clapboarded courthouses" that were "domestic in scale" to

"the construction of buildings with greater pretensions" befitting the aspirations of the gentry. Id. at 11.

A volume devoted to Robert Mills tracked his buildings in South Carolina from 1820 to 1829; he designed "twenty-eight of the forty courthouses and jails erected during the decade." WADDELL AND LIS-COMBE at 1. Mills's designs ranged from "gable-ended" buildings to a "temple form," some of which had a "monumental portico." Id. at 9. The buildings also housed offices for clerks and sheriffs as well as meeting rooms for local committees. Id. Materials on Texas provided overviews of more than 250 courthouses as well as the details of the initial use of trees, tents, and log courthouses before more substantial buildings were placed on town squares; jails were often nearby. KELSEY AND DYAL at 14, 28.

24 Several of the books on courthouse construction—in both the United States and England—focus on lawyers as the lobbyists for the erection of such buildings. See, for example, GRAHAM; McNAMARA. See also David Sugarman, *Images of Law: Legal Buildings, "Englishness" and the Reproduction of Power*, in RECHTSSYMBOLIK UND WERTEVERMITTLUNG (THE SYMBOLISM OF JUSTICE AND THE CONVEYANCE OF MORAL VALUES), 47 SCHRIFTEN ZUR EUROPÄISCHEN RECHTS- UND VERFASSUNGSGESCHICHTE (LETTERS ON EUROPEAN LEGAL AND CONSTITUTIONAL HISTORY) 167 (Berlin, Ger.: Duncker & Humblot, 2004). Sugarman detailed the pressure imposed by the Law Society in England in the nineteenth century to create new courts in an English Gothic design resembling the Palais de Justice in Paris. Id. at 191–196. The 1882 Royal Courts resulted. Id.

25 This pattern can be found in England from the fifteenth through the seventeenth centuries. See TITTLER at 39–41. The "largest and most important towns were least likely to include room for prisons, except for the temporary cell proximate to the court chamber. . . . [T]he greater need for such facilities . . . warranted larger space than the hall could provide." Id. at 39.

26 ANTOINETTE J. LEE, ARCHITECTS TO THE NATION: THE RISE AND DECLINE OF THE SUPERVISING ARCHITECT'S OFFICE 5 (New York, NY: Oxford U. Press, 2000).

27 LOUNSBURY at 65–66. During the late 1600s, courthouses in Virginia "shed their domestic appearance in favor of the stylistic and structural features employed in churches." Id. at 66. Most were made of wood; brick structures were exceptional and rare. Id. at 67. Moving north to Massachusetts, most presiding jurists in the seventeenth century had no legal training, and local courts met in taverns. McNA-MARA at 12–13. Special government structures, called "town houses," served as the "governmental, judicial, and economic center." One such building in Boston included spaces for merchants. Id. at 14–17. In other shires of Massachusetts, Puritan meeting houses would have served as a place for judicial proceedings, but because some lacked heat, taverns were also used. Id. at 20–22.

28 The term "purpose-built" is regularly used by architectural historians, several of whom focus specifically on courts. For example, Clare Graham's project was to ask why "English trials came to be housed in purpose-built accommodation, and what made that accommodation architecturally distinctive." GRAHAM at 2. Her answer is that the "royal bureaucracy" sparked such creations "remarkably early" in England; by the early part of the fourteenth century Westminster Hall had three separate courts. Id. at 315. See also TITTLER at 1–22.

In terms of courthouses in the colonies, specialized structures appeared in Massachusetts by the 1730s and 1740s, and the "first function-specific courthouse built in larger eighteenth century shire towns went up in Boston" around 1768. McNAMARA at 22–46. In buildings thereafter, the courthouse and jail were often part of a linked complex. Id. at 48. Other buildings also served public functions. For example, a "growing number of coffeehouses" came to serve in Boston as places for merchants to do business and exchange information. Id. at 31–34.

29 Lounsbury provided examples from 1671 of rules from the Lancaster Country Court in Virginia. LOUNSBURY at 71.

**30** LOUNSBURY at 78–79 (describing patterns in Virginia and Maryland courtrooms) and at 79–82.

**31** Lounsbury mapped those shifts in Virginia. For example, in 1705, "no more than three or four of the twenty-five counties in existence" had courthouses made of brick; by 1776, "slightly more than half of the sixty counties had brick courthouses." LOUNSBURY at 91. The shape, design, and quality of bricks also improved, but what "distinguished" the courthouses as civic structures were their "compass-headed windows, large-scale openings, arcaded piazzas, and by the end of the eighteenth century, pedimented porticoes." Id. at 108. Virginia's distinctive regional contribution was the use of arcades. Id. at 112, 123. Further, unlike the layout of courtrooms in Maryland, Tennessee, and elsewhere, Virginia relied on a "long jury bench that faced the courtroom." Id. at 153. As for jurists, many used a curved bench. Id. at 145.

**32** LOUNSBURY at 137. In Virginia, the "chairs, benches, and tables were expressions of the power and status of those who used them. . . . [A] canopied armchair with a cushioned seat raised on a platform and a backless bench were not merely two different forms of seating; the former was viewed as a seat of honor, the latter as a seat of communality." Id. As the system became more lawyer-dependent, courtrooms acknowledged the import of lawyers by assigning them specific places. Id. at 138.

**33** LOUNSBURY at 180–181. At "least two dozen examples appear in early Virginia records of . . . direct copying of one public building after another." Id. at 181. Graham detailed the development and evolution of law courts as "building types" in England. GRAHAM at 14–30.

**34** MCNAMARA at 3.

**35** McNamara provided an example from Massachusetts where, in 1713, Chief Justice Samuel Sewall opened a new town house in Boston that included windows made of " 'large, transparent, costly Glass,' " which, he explained, would " 'oblige the Attorn[e]ys always to set Things in a True Light.' " MCNAMARA at 1 (quoting Samuel Sewall). She read the comment as evidence of "deep-seated suspicions harbored toward pliers of the legal trade." Id. at 1. Alternatively, Sewall may have been trying to justify the expense of glass.

**36** LOUNSBURY at 138–139. See also MCNAMARA at 6–8. McNamara discussed the impact of professional architects in Massachusetts in the nineteenth century. Id. at 81–102.

**37** MCNAMARA at 3–5. She argued that lawyers wanted courthouses to express both the exclusivity of their authority in those spaces and the degree to which lawyers were "an integral part of the social fabric." Id. at 4.

**38** In contrast, "[e]ighteenth-century courts had few specialized spaces." Katherine Fisher Taylor, *First Appearances: The Material Setting and Culture of the Early Supreme Court*, in THE UNITED STATES SUPREME COURT: THE PURSUIT OF JUSTICE 357, 371 (Christopher Tomlins, ed., Boston, MA: Houghton Mifflin, 2005) (hereinafter Taylor, *First Appearances*). The changing role of lawyers and their impact on courts is detailed in several volumes. See, for example, ALLYSON N. MAY, THE BAR AND THE OLD BAILEY, 1750–1850 (Chapel Hill, NC: U. of North Carolina Press, 2003); JOHN LANGBEIN, THE ORIGINS OF THE ADVERSARY CRIMINAL TRIAL (Oxford, Eng.: Oxford U. Press, 2003). Langbein mapped the transition from what he termed a lawyer-free process for felony trials during the late sixteenth and early seventeenth centuries to a system in which "lawyers came to dominate the felony trial." Id. at 3. Before the advent of criminal defense counsel and rules of evidence, trials lasted fifteen to twenty minutes. Id. at 16. McNamara's account of Massachusetts's justice facilities identified the impact of lawyers, reflected in part by mention of a "Lawyer Table" in a plan for a courthouse in the 1760s. MCNAMARA at 51–52. While segregated spaces for jury deliberation were not common in Massachusetts until the late eighteenth and early nineteenth centuries (MCNAMARA at 40–42 and 123, n. 63), Virginia's courthouses did provide such spaces. See LOUNSBURY at 220–222.

In some instances, judges insisted on separate pathways into the courtroom. In the 1830s, for example, judges objected to a design that would have required them to "pass through the court-room to get to the bench." In response, architect Robert Mills changed the access routes so judges would go "through the marshal's room" to enter the courtroom. See Serial Set Vol. No. 468, Session Vol. No. 1, 28th Congress, 2d Sess., H. Rpt. 69, p. 2, Jan. 28 1845 ("The Committee for the District of Columbia, to whom was referred the petition of James Dixon, praying [for] compensation for extra work done by him on the court house in the town of Alexandria, in this District."). The subject of separate routes for circulation is one to which we return in Chapters 8–10.

**39** Parallels from England over a longer time span are provided in GRAHAM at 315–316.

**40** Lounsbury explained this layout in Virginia. LOUNSBURY at 161–162. McNamara provided parallel information on Massachusetts; for the Newburyport courthouse, Charles Bulfinch provided places for lawyers to be seated near the judge's bench and set aside space for jurors. MCNAMARA at 68–73. The delineation of the elite from the populace had English roots; seventeenth-century town halls had special chambers for conferences, and certain ceremonies were open only to the designated few. TITTLER at 117–118. His view was that this development reflected the increasingly oligarchical forms of government.

**41** Taylor, *First Appearances* at 371.

**42** See Michael Kammen, *Temples of Justice: The Iconography of Judgment and American Culture*, in ORIGINS OF THE FEDERAL JUDICIARY: ESSAYS ON THE JUDICIARY ACT OF 1789 at 248, 252 (Maeva Marcus, ed., Oxford, Eng.: Oxford U. Press, 1992) (hereinafter ORIGINS OF THE FEDERAL JUDICIARY). Thomas Jefferson designed a well-known "templelike" state house in Virginia. See Taylor, *First Appearances* at 361. In 1821, Jefferson drew a plan for a courthouse in Charlotte County; included was a bench "stretched polygonally around the back of the room in three segments." LOUNSBURY at 146. His building, the "Jeffersonian temple design" (id. at 128), served as a "paradigm for courthouses." See Andrea P. Leers, *Urban Design and the Courthouse: How Sites Shape Solutions*, in CELEBRATING THE COURTHOUSE at 110, fig. 4-1 at 111. Kammen contrasted the celebratory terminology for Jefferson's designs with the critique by some colonialists that courts, "dominated by royal governors and their creatures," were sources of injustice and sites for demonstrations. Kammen at 253–255. Jefferson's influence spanned the country, as is evident from the emulation of his building styles around the country. See McDevitt, *Introduction* at x–xi, COURTHOUSES OF CALIFORNIA.

**43** OHMAN & LOGUE at 12–13; Kammen at 259.

**44** See Rick Bernstein, Foreword to BALOUSEK at 7–8. The reference was to the Act of May 26, 1824, 18th Cong., 1st Sess., ch. 169 (later published in 4 Stat. 50 (1850)) that provided for the "right of preemption to one quarter section of land, . . . in trust for said counties . . . for the establishment of seats of justice therein," provided that the "proceeds of the sale of each of said quarter sections shall be appropriated for the purpose of erecting public buildings in the country or parish for which it is located, after deducting there from the amount originally paid for the same. " Id. at § 1.

**45** MCNAMARA at 56. She argued that the proliferation of courts was driven not by the needs of the state but by lawyers who used their monopoly power to generate law-specific buildings (courthouses and jails) that marked the distinction between their profession and other municipal functions. Id. at 57.

**46** MCNAMARA at 102.

**47** PARE, COURT HOUSE at 8. That volume also noted that some constructions, such as that in Macoupin County, Illinois (plate 66), produced "exorbitant public debt." Id.

**48** See William Seale, *American Vernacular: The Courthouse as a Building Type*, in CELEBRATING THE COURTHOUSE at 36–62; GOODSELL at 20–21. Goodsell argued that among many public buildings

were "overdone versions" of architectural styles, monumental in size and featuring heavy stonework. Id. at 21.

**49** Other examples can be found in Kammen at 261–263. For some in Minnesota, see OHMAN & LOGUE at 34–36 (showing a Justice on top of the Blue Earth Country Courthouse in Mankota, of the the Jackson County Courthouse, and of the Brown County Courthouse). For examples in England, see GRAHAM at 328–330.

**50** Figures 96 and 97 come from the Brochure for the Lady Justice banner exhibit, Albany, New York, Summer 2008. The figures are reproduced with permission of the New York Court of Appeals. Our thanks to Chief Judge Judith Kaye and Gary Spencer for assisting us in obtaining these materials and for permission to reproduce them. The banners were designed and photographed by Teodors Ermansons.

**51** See Historical Society of the Courts of the State of New York, The Art of Justice: A Portfolio of "Lady Justice" from Courthouses in New York State (photographed by Teodors Ermansons, 2008) (hereinafter New York State Justice Portfolio). In 2008, the Historical Society also produced a calendar and notecards, and information on the various Justices comes from the Historical Society materials.

**52** In the Chenango County Courthouse in Norwich, a seven-foot Justice of white pine "crowned the structure" and, after restoration, the original was placed in a glass case while a replica "overlooks the city from atop the dome." In the Ontario County Courthouse in Canandaigua, the original wood statue of 1858, replaced in the intervening years with wood, was replicated in 1983 by one in cast aluminum and covered in gold leaf. In Monroe County in Rochester, a wood Justice was placed on the fourth story of the facade of the 1894 courthouse that, after a new facility was built in 1964, has been used as a county office building. In Wampsville in Madison County, a statue from around 1907 is on the dome of the courthouse and its replica, in zinc, is in the rotunda. See New York State Justice Portfolio.

**53** In the Appellate Division Courthouse, New York, whose exterior and roof are shown in figures 6/85 and 6/86, murals from the beginning of the twentieth century show two versions of imposing, enthroned Justices on opposite walls; both are flanked by other large figures, such as female allegories of Peace and Prosperity. In the Onondaga County Courthouse in Syracuse, a mural from around 1907 features a clear-sighted Justice with scales and pointing to a tablet held by a small boy, while an armor-suited man stands to her right. In the New York County Courthouse in New York City, a 1930s trompe l'oeil Justice is provided with other figures representing Clemency and Authority. New York State Justice Portfolio.

**54** The Great Seal, adopted in 1777, includes female figures of Liberty and Justice. That seal can be found in the Montgomery County Courthouse in Fonda; when the 1836 courthouse was expanded in 1910, a Great Seal was installed on an interior staircase. Another courthouse was built in 1892 and the "old" courthouse was put to use to house the county's historical archives. In the New York County Court, New York City, a 1928 carved stone Justice is a part of the Great Seal. In the Bronx, the Bronx County Courthouse has a Justice on the Great Seal, carved in stone; that image is on all four sides of the building. In the New York Court of Appeals in Albany, the Great Seal is part of a 1950s mural in the dome of the rotunda of the court, with another version carved on a table in the anteroom of a courtroom. See New York State Justice Portfolio.

**55** Michael R. Corbett, *Continuity and Change in California Courthouse Design, 1850–2000*, in COURTHOUSES OF CALIFORNIA at 14, 39.

**56** POLLAK at 6. The state's courthouses provided a jury room, a judge's chambers, and housing for several officers (including a registrar of deeds, a county treasurer, and an assessor), as well as places for detention, for commissioners to meet, and for clerks to issue marriage licenses and death certificates. Id.

**57** THRANE at 10, 12.

**58** GILBERTSON at xiii.

**59** Comments provided by Governor Mitchell Daniels at the Annual Conference of Chief Justices and of Chief Administrators of State Courts, Indianapolis, Indiana, July 2006. Governor Daniels took office in January of 2005 and, in his inaugural address, he characterized his election efforts as a "16-month interview" in which he met people from "the largest of our cities, from the tiniest of our towns, and from the rural spaces in between." Mitchell E. Daniels Jr., *Inaugural Remarks*, January 10, 2005, Indiana State Government, http://www.in.gov/gov/2531.htm.

**60** According to the National Center for State Courts, in 1998 some forty-two million cases were filed throughout the fifty-state court systems. Included in that count were all kinds of trial courts and all kinds of cases except traffic offenses. Excluding "domestic relations" and "juvenile courts," the numbers come down to 36 million. Bureau of Justice Statistics, Special Report, State Court Organization, 1987–2004 at 3. The data are imperfect in that what legal proceedings count as "cases" differs from state to state. See National Center for State Courts, *Jurisdiction and State Court Reporting Practices*, Figure H: Method of Counting Civil Cases in State Trial Courts, 2002, at 97–102, in STATE COURT CASELOAD STATISTICS, 2003, National Center for State Courts Online, http://www.ncsconline.org/D_Research/csp/2003_Files/2003 _SCCS.html. Variation in counting of criminal cases is particularly acute as states "differ on whether they count charges, defendants, or indictments." Id., Appendix 1, Methodology, at 204. As noted elsewhere in this volume, by 2009, state courts reported about 47 million filings.

**61** McDevitt, *Introduction* at xvii, COURTHOUSES OF CALIFORNIA. Many of the facilities were neither easily accessible to disabled participants nor secure. Id. Further, more space was needed, requiring investments of about three billion dollars. Id. McDevitt argued that courthouses were once a "center of the community" and needed to be not only markers of their jurisdictions' heritage but also able to deliver the services currently needed. Id. at xviii, quoting the California Task Force on Court Facilities. We return to these questions of accessibility and use in Chapters 8, 9, and 14.

**62** McDevitt, *Introduction* at xv, COURTHOUSES OF CALIFORNIA.

**63** As one historian explained, "After 1900, southern courtrooms were universally segregated without statutory mandate." MICHAEL J. KLARMAN, FROM JIM CROW TO CIVIL RIGHTS: THE SUPREME COURT AND THE STRUGGLE FOR RACIAL EQUALITY 50 (New York, NY: Oxford U. Press, 2004). See also Gilbert Thomas Stephenson, *Race Distinctions in American Law*, 43 AMERICAN LAW REVIEW 869, 870 (1909).

**64** As one judge who has been in the forefront of contemporary courthouse design explained, the "familiar architectural language and iconography" has also been a marker of "tragic" failures to live up to principles of equality, making particularly complex efforts to "transmit . . . aspirations through structures whose history bears witness" to the failure to live up to them. See Douglas P. Woodlock, *Drawing Meaning from the Heart of the Courthouse*, in CELEBRATING THE COURTHOUSE at 155–156.

**65** CONSTANCE BAKER MOTLEY, EQUAL JUSTICE UNDER LAW: AN AUTOBIOGRAPHY 75 (New York, NY: Farrar, Straus & Giroux, 1998).

**66** *Johnson v. Virginia*, 373 U.S. 61, 62 (1963) (per curiam).

**67** Brief for Respondent in Opposition to the Petition for Writ of Certiorari, *Johnson v. Virginia*, 373 U.S. 61 (1963) (No. 715).

**68** *Johnson*, 373 U.S. at 62 (1963).

**69** MCNAMARA at 103–104.

**70** MCNAMARA at 104 (quoting the *Columbia Centinel*, a local paper).

**71** See, for example, *Moore v. Dempsey*, 261 U.S. 86 (1923). There Justice Holmes recounted the allegations of a habeas petitioner, who averred that African-American men were convicted in Arkansas and sentenced to death "under the pressure of a mob." Id. at 86. "The trial lasted about three-quarters of an hour and in less than five minutes the jury brought in a verdict of guilty of murder in the first degree.

According to the allegations and affidavits there never was a chance for the petitioners to be acquitted; . . . any prisoner [that] had been acquitted . . . could not have escaped the mob." Id. at 89–90. The Court concluded that a federal district judge had the obligation to ascertain if these allegations were true and, if so, to find that due process had been denied. Id. at 91–92.

72  Laws now limit the areas in which protests can take place, both to acknowledge First Amendment rights to assemble for peaceful protests and to insulate judges and participants from the pressures that such protests might impose. See *Cox v. Louisiana*, 379 U.S. 559 (1965). The majority upheld a Louisiana statute prohibiting picketing "near" a courthouse "with the intent of interfering with . . . justice." Id. at 560. As Justice Hugo Black explained, "Justice cannot be rightly administered, nor are the lives and safety of prisoners secure, where throngs of people clamor against the processes of justice right outside the courthouse or jailhouse doors." Id. at 583 (concurring in part and dissenting in part). Federal provisions can be found in the Subversive Activities Control Act of 1950, § 31, Pub. L. No. 81-831, 64 Stat. 987, 1018 (codified as amended at 18 U.S.C. § 1507 (2006)). The act provides that anyone "with the intent of interfering with, obstructing, or impeding the administration of justice, or with the intent of influencing any judge, juror, witness, or court officer, in the discharge of his duty, pickets or parades in or near a building housing a court of the United States . . . shall be fined . . . or imprisoned not more than one year, or both." Id. While protests are kept at bay, the United States Supreme Court has held that protests on sidewalks adjacent to its building are constitutionally protected. See *United States v. Grace*, 461 U.S. 171 (1983). Indeed, media coverage often includes photographs or televised displays of placards and protests on the plaza near the steps of the main entrance.

State laws similarly regulate the places of protest near courts. Examples include California (CAL. PENAL CODE § 169 (Deering 2008)); Louisiana (LA. REV. STAT. ANN. § 14:401 (2008)); Massachusetts (MASS. GEN. LAWS ch. 268, § 13A (2008)); Mississippi (MISS. CODE ANN. § 97-9-67 (2008)); Pennsylvania (18 PA. CONS. STAT. § 5102 (2008)); Utah (UTAH CODE ANN. § 76-8-302 (2008)); and Washington (WASH. REV. CODE § 9.27.015 (2008)). The language is parallel to that of the federal statute. For example, California's statute provides that "[a]ny person who pickets or parades in or near a building which houses a court of this state with the intent to interfere with, obstruct, or impede the administration of justice or with the intent to influence any judge, juror, witness, or officer of the court in the discharge of his duty is guilty of a misdemeanor."

73  Our work on federal courthouse construction has been aided by the extraordinary research abilities of Marin Levy, who identified more than one hundred relevant documents from "the bound, sequentially numbered volumes of all the Reports, Documents, and Journals of the U.S. Senate and House of Representatives," available under U.S. Congressional Serial Set, thereby facilitating access to materials from 1817 through 1896 (the 15th through the 54th Congress). See Marin K. Levy, Memorandum on the Origins of Federal Courthouse Construction, July 17, 2006 (hereinafter Levy, Federal Courthouse Construction).

74  "He has made Judges dependent on his Will alone, for the Tenure of their Offices, and Amount and Payment of their Salaries," DECLARATION OF INDEPENDENCE para. 14 (U.S. 1776).

75  U.S. CONST. Art. III, § 1.

76  U.S. CONST. Art. III, § 1. See Judith Resnik, *Interdependent Federal Judiciaries: Puzzling about Why & How to Value the Independence of Which Judges*, 137 DAEDALUS 28 (Fall 2008).

77  Judiciary Act of 1789, ch. 20, 1 Stat. 73 (hereinafter Judiciary Act of 1789).

78  Judiciary Act of 1789, § 3.

79  See JEFFREY BRANDON MORRIS, CALMLY TO POISE THE SCALES OF JUSTICE: A HISTORY OF THE COURTS OF THE DISTRICT OF COLUMBIA CIRCUIT 5–7 (Durham, NC: Carolina Academic Press, 2001).

80  The original Judiciary Act had called for circuit courts of three,

but the number was reduced to two in 1793. See Judiciary Act of March 2, 1793, ch. 22, 1 Stat. 333.

81  PETER GRAHAM FISH, FEDERAL JUSTICE IN THE MID-ATLANTIC SOUTH: UNITED STATES COURTS FROM MARYLAND TO THE CAROLINAS, 1789–1835 at 22 (Washington, DC: Administrative Office of the United States Courts, 2002) (hereinafter FISH, FEDERAL JUSTICE IN THE MID-ATLANTIC SOUTH).

82  FISH, FEDERAL JUSTICE IN THE MID-ATLANTIC SOUTH at 20–21.

83  Robert P. Reeder, *The First Homes of the Supreme Court of the United States*, 76 PROCEEDINGS OF THE AMERICAN PHILOSOPHICAL SOCIETY 543 (1936). The justices "first assembled on February 1, 1790 in the Merchants Exchange Building" in New York City, which was then the country's capital. See *The Court as an Institution*, U.S. Supreme Court, http://supremecourt.gov/about/institution.aspx.

84  Taylor, *First Appearances* at 376. The Supreme Court subsequently delegated factfinding to special masters. "The only public trial of original jurisdiction ever held in the present-day Supreme Court building" took place in the 1990s. Id. at 377. The lawsuit—*New Jersey v. New York*, 523 U.S. 767 (1998)—involved a conflict about which state had sovereignty over parts of Ellis Island. By scheduling the proceedings before the Special Master during the Court's recess and locating them in one of the reception rooms, the Supreme Court's "unified character" as an appellate body was protected. Id.

85  Taylor, *First Appearances* at 357. In 1860, the Court moved up one level as the Senate again gave over its cast-off space. Id. Pictures can also be found in ROBERT SHNAYERSON, THE ILLUSTRATED HISTORY OF THE SUPREME COURT OF THE UNITED STATES 86–88 (New York, NY: Harry N. Abrams in association with the Supreme Court Historical Society, 1986), and more of the details of the early settings are provided by Taylor, *First Appearances* at 357–381.

86  Taylor, *First Appearances* at 357. She described the early customs of the justices—for example, their shift from red to black robes—as well as the layout of the courtrooms in which they worked. Id. at 357–368.

87  Locations of courts prompted disputes in Maryland and in South Carolina. FISH, FEDERAL JUSTICE IN THE MID-ATLANTIC SOUTH at 6–9.

88  For example, after courts were created for the District of Columbia in the 1800s, federal judges relied on these alternative spaces. See MORRIS at 7. When the Circuit Court for the District first convened, it likely worked in the "room in the Capitol assigned to the Supreme Court." Id. at 10. In the 1820s the District got its own City Hall, which also housed courts, the registrar of wills, and other municipal officers. Id. at 29.

89  FISH, FEDERAL JUSTICE IN THE MID-ATLANTIC SOUTH at 32.

90  FISH, FEDERAL JUSTICE IN THE MID-ATLANTIC SOUTH at 237–238. Rental space was also used for court marshals. For example, an 1853 act authorized funding and provided that "the marshall shall not incur an expense of more than twenty dollars in any one year for furniture, or fifty dollars for rent of building" without prior authorization from the Secretary of the Interior. See Act of Feb. 26, 1853, § 2, 10 Stat. 161, 165.

91  Initially, federal conformity to state practice was "static," in that federal courts had to follow the practices of states as of 1789, even when states no longer did so in their own courts. This "static conformity" was replaced after the Civil War with "dynamic conformity," permitting federal courts to follow the rule changes that occurred in each of the states in which they sat.

92  See An Act to Establish the Treasury Department, ch. 12, 1 Stat. 65 (1789) (codified as amended at 31 U.S.C. § 301 (2006)). See also Federal Judicial Center, *Executive Branch Administration of the Federal Judiciary*, http://www.fjc.gov/history/home.nsf/page/admin_09 .html (hereinafter *Executive Branch Administration of the Federal Judiciary*); *Fact Sheets: History, U.S. Department of the Treasury*, U.S. Treasury, http://www.ustreas.gov/education/fact-sheets/history.

**93** See Chapter 108, 30th Congress, Session 2, An Act: To establish the home department, and to provide for the treasury department an assistant secretary of the treasury and a commissioner of the customs, Mar. 3, 1849. See generally *Executive Branch Administration of the Federal Judiciary*.

**94** *Executive Branch Administration of the Federal Judiciary.*

**95** U.S. Const. Art. I, § 8, cl. 7, 17, 18.

**96** An Act for the Relief of Sick and Disabled Seamen, Pub. L. No. 77, 1 Stat. 605 (1798) (repealed by Act of June 26, 1884, ch. 121, 23 Stat. 53, 57). See Lee at 14 and at 28, quoting William M. Meredith, Secretary of the Treasury, describing the rationale in 1849.

**97** See Lee at 14–29. We have borrowed the phrase "a federal presence" from Lois Craig's book The Federal Presence: Architecture, Politics, and Symbols in United States Government Building (Cambridge, MA: MIT Press, 1978). That history of "government attempts to house its services and activities" was prompted by the National Endowment for the Arts (NEA), which, as discussed in Chapter 8, was concerned that federal buildings were architecturally dreary. Id. at vii (Foreword, by Nancy Hanks, Chair of the NEA, 1969–1977).

**98** Lee at 29–35. See also Bates Lowry, Building a National Image: Architectural Drawings for the American Democracy, 1789–1912 (Washington, DC: National Building Museum, 1985, published in conjunction with an exhibition of the same title). In addition to documenting the work of Major Pierre Charles L'Enfant and others in Washington, D.C., Lowry addressed the impact of the public architecture around the country. As for the growth of a federal bureaucracy, inspection and regulation of steamboats proved to be the federal government's "first major health and safety regulatory program." See Jerry L. Mashaw, *Administration and "The Democracy": Administrative Law from Jackson to Lincoln, 1829–1861*, 117 Yale Law Journal 1568, 1581 (2008).

**99** See, for example, Act of Feb. 13 1807, § 5, 2 Stat. 418, 419. Congress authorized the Secretary of the Treasury to find a "convenient site, belonging to the United States, in the city of New Orleans, a good and sufficient house, to serve as an office and place of deposit for the collector of the customs." The act appropriated $20,000 for building costs.

**100** For example, "[o]nce an appropriation was available for a building, no monies could be spent on the purchase of the property or the design of the building until the legislature of the relevant state ceded jurisdiction and the right to tax the property." Lee at 46. See also A Joint Resolution Making It the Duty of the Attorney General to Examine into the Titles of the Lands or Sites for the Purpose of Erecting Thereon Armories and Other Public Works and Buildings, ch. 6, 5 Stat. 468 (Sept. 11, 1841).

**101** Lowry at 51.

**102** Lowry at 38. Further, some held the "conviction that the arts truly flourished only during a state of liberty and freedom." Id. at 37. Not all architects uncritically embraced the Greek architectural tradition; some argued that it needed to be Americanized, in part through reliance on Renaissance iterations. Id. at 42–48. Exemplary were the Boston and New York Custom Houses, both of which were replacements of smaller buildings with "grander and larger [ones]." Id. at 50 and at 48–49, figs. 44 and 45.

**103** Craig at 34–40.

**104** The population of the United States doubled between 1830 and 1860. Federal expenditures more than quadrupled during those same thirty years. See U.S. Bureau of the Census, Historical Statistics of the United States, Colonial Times to 1970, pt. II at 1104, http://www.census.gov/prod/www/abs/statab.html. The beginnings of a national administrative apparatus thus predate the Civil War, not only through the Customs Office but also through regulatory oversight of patents, land claims, and steamboats. See Mashaw at 1633–1643.

**105** Craig at 56.

**106** Craig at 56.

**107** Craig at 50. While "frontier customhouses were utilitarian structures," the "closer" to Washington, the more federal structures "spoke in the classical tongue." Id. at 51.

**108** See Craig at 56; Lee at 35. See generally Federal Judicial Center, Constructing Justice: The Architecture of Federal Courthouses 1 (A Description of Historical Photographs Exhibited at the Federal Judicial Center, undated essay) (hereinafter Constructing Justice: The Architecture of Federal Courthouses). The exhibit is also described in the Federal Judicial History Office newsletter: *Constructing Justice: An Exhibit of Courthouse Photographs at the Federal Judicial Center*, 8 The Court Historian 1 (1995) (hereinafter *Constructing Justice*, FJC Newsletter), Federal Judicial Center http://www.fjc.gov/public/pdf.nsf/lookup/couhiso8.pdf/$File/couhiso8.pdf. The set of photographs is available by the database Historical Federal Courthouses, http://www.fjc.gov/history/courthouses.nsf.

**109** For example, Act of March 3, 1851, appropriating money for a Custom House in Savannah, Georgia, noted that funds were to be used for "furniture and fixtures for the accommodations of the officers of the revenue, and also for the post-office, and United States Courts." See also Edwin Surrency, History of the Federal Courts 82 (Dobbs Ferry, NY: Oceana Publications, 2d ed., 2002).

**110** Illustrative is the 1832 designation by Congress of acreage in Little Rock for the "erection of a courthouse and jail" for the Territory of Arkansas. See Act of June 15, 1832, 4 Stat. 531. Provisions were also made in 1839 for funds for a courthouse in Alexandria, Virginia. See Serial Set Vol. No. 364, Session Vol. No. 2, 26th Congress, 1st Sess., H. Doc. 32, 7 p. Dec. 30, 1839, Expenditure.

**111** Darrell Hevenor Smith, The Office of the Supervising Architect of the Treasury: Its History, Activities, and Organization 3 (Baltimore, MD: Johns Hopkins U. Press, 1923); Lowry at 52. A few of the custom houses were the largest federal structures of their eras. Craig at 63, 202–203. Customs officials were themselves a "federal presence," for, as Lee explained, the "customs collector not only collected duties on imported goods, but also served as the eyes and ears of the federal government at the local level." These officials reported on the conditions of roads and of local industries, worked as agents for marine hospital funds and superintendents of lighthouses, and oversaw the construction of new buildings. Lee at 14–15. In 1841, Congress insisted on some regularization of the decision to buy land. In order to have the legal authority to purchase and build government structures, Congress imposed the requirement that the Attorney General provide opinions on the "validity of title." Smith at 3.

**112** Each of the following states had one federal judge: Alabama, Arkansas, Connecticut, Delaware, Georgia, Illinois, Indiana, Iowa, Kentucky, Maine, Maryland, Massachusetts, Michigan, Mississippi, Missouri, New Hampshire, New Jersey, North Carolina, Ohio, Rhode Island, South Carolina, Tennessee, Texas, Vermont, and Wisconsin. California, Florida, Louisiana, New York, Pennsylvania, and Virginia each had two judgeships. Our count does not reflect federal judges in the territorial courts, including those in the District of Columbia. See *Chronological History of Authorized Judgeships in U.S. District Courts (Arranged by State)*, in History of Federal Judgeships: U.S. Courts of Appeals and U.S. District Courts, U.S. Courts, http://www.uscourts.gov/judgesandjudgeships/authorizedjudgeships/chronologicalhistoryofauthorizedjudgeshipsindex.aspx. (hereinafter *Chronological History of Authorized Judgeships in U.S. District Courts*). The database is provided by the Article II Judges Division, Office of Judges Programs of the Administrative Office of the United States Courts.

**113** Act of Sept. 28, 1850, 9 Stat. 521. A reorganization reduced the number to one in 1866 but returned it to two in 1886. See Act of July 27, 1866, and Act of Aug. 5, 1886, 2 Stat. 308. As noted earlier, five other states (Florida, Louisiana, New York, Pennsylvania, and Virginia) also had two judgeships allotted.

**114** For example, in 1855 the Secretary of the Interior and the Postmaster General called for "sites for court houses and post offices" in Boston, New York, and Philadelphia. See Sites for Court House and Post Office, Message from the President of the United States, Serial Set Vol. No. 783, Session Vol. No. 5, 33rd Congress, 2d Sess., H. Doc. 43, 7 p., January 25, 1855.

**115** The work of that office is chronicled by Darrell Smith, Antoinette Lee, and others. Prior to its creation, federal officials who worked in the Treasury Department on federal building had various titles including "Engineer in Charge of This Department" and "Supervising Architect." LEE at 29–43. No statutory authority supported the Secretary of the Treasury when he first created the unit, but legislation in the 1860s and thereafter made mention of that job. SMITH at 6–7. For example, Act of March 14, 1864, ch. 30, 13 Stat. 22, 27, provided the Treasury with "one superintending architect, one assistant architect," several clerks, and a messenger.

The first architect appointee, Ammi B. Young, served from 1852 until 1862 as the "chief designer of all federal buildings" that fell within the Treasury Department's control. LEE at 47. Young, credited with designing some seventy buildings, also made iron work the preferred material to provide fireproofing and permanency. Constructing Justice: The Architecture of Federal Courthouses at 1–2; LEE at 59–60. An example of his work is the Galveston, Texas, Custom House (fig. 98). The authority of the Supervising Architect grew after the Civil War. By 1875, Congress required that no funds be spent on public buildings without approval from the Secretary of the Treasury, "after drawings and specifications, together with estimates of costs thereof, shall have been made by the Supervising Architect" in that Department. See Act of March 3, 1875, ch. 130, 18 Stat. 371, 395. See also SMITH at 7–8. Almost a century after its founding, the Office of Supervising Architect became a part of the Public Buildings Administration that in 1949 was placed within the General Services Administration, discussed later in this chapter and in Chapters 8 and 9.

**116** In 1849, the task of administering courts fell to the newly created Department of the Interior, charged with management of public lands and parks as well as the fiscal responsibility for the federal court system. See *Executive Branch Administration of the Federal Judiciary.*

**117** See Habeas Corpus Act of 1867, ch. 28, 14 Stat. 385 (codified at 28 U.S.C. §§ 2241 et seq. (2006)).

**118** See Civil Rights Act of 1871, ch. 22, 17 Stat. 13 (codified at 42 U.S.C. § 1983 (2006)).

**119** See Act of March 3, 1875, ch. 137, 18 Stat. 470 (codified at 28 U.S.C. § 1331 (2006)). Congress has also, upon occasion, seen the courts as unreliable and responded by divesting jurisdiction. The example well known to scholars of the federal courts is the case *Ex Parte McCardle,* in which McCardle, the editor of the *Vicksburg Times,* was detained by the occupying military authorities. The authorities objected to his anti-Reconstruction editorials, and he, in turn, argued that the Military Reconstruction Act was unconstitutional. While his case was pending on appeal before the United States Supreme Court, Congress withdrew the jurisdictional provision that had provided him with a route to the court, and the justices concluded that Congress had the power to do so. See *Ex Parte McCardle,* 74 U.S. 506 (1869), and Daniel Meltzer, *Ex Parte McCardle and the Power of Congress to Limit the Supreme Court's Appellate Jurisdiction,* in FEDERAL COURTS STORIES (Vicki C. Jackson & Judith Resnik, eds., New York, NY: Thomson Reuters / Foundation Press, 2010).

**120** An Act to establish the Department of Justice, ch. 150, 16 Stat. 162 (June 22, 1870). In contrast, the First Judiciary Act had created the Office of Attorney General, to be held by a person "learned in the law," to prosecute suits for the United States and to provide advice on legal questions to the Executive Branch. See Judiciary Act of 1789, ch. 20, § 35, 1 Stat. 73, 92–93. Inventing an office not mentioned in the Constitution, Congress had neither provided staff nor

given the Attorney General authority over government lawyers, then called "district attorneys" (and now called United States Attorneys), who had the power to represent the United States in the lower federal courts. See Susan Low Bloch, *The Early Role of the Attorney General in Our Constitutional Scheme: In the Beginning There Was Pragmatism,* 1989 DUKE LAW JOURNAL 561, 566–570; ANTONIO VASAIO, THE FIFTIETH ANNIVERSARY OF THE U.S. DEPARTMENT OF JUSTICE BUILDING, 1934–1984, at 2 (Washington, DC: U.S. Government Printing Office, 1984). As Bloch noted, the 1789 Act did not expressly grant authority to the President to appoint these lawyers, but the President took it upon himself to do so, arguably relying on the power to appoint officers under Article II, § 2. Likewise, there was no explicit provision in the Act for a confirmation process, but it was "assumed" that the Senate would provide "advice and consent." Bloch at 568, n.24. Thereafter, statutes provided for presidential nomination and senatorial confirmation. See 28 U.S.C. § 503 (Attorney General) and § 541 (United States Attorneys). Both before and after the creation of the Department of Justice in 1870, attorneys general worked in various spaces, such as in offices at the Treasury Department. Id. at 4. The Department of Justice did not get a building of its own until 1934. VASAIO at 16–17.

**121** Act of June 22, 1870, § 15. Congress also gave the Justice Department authority over commissions.

**122** See David S. Clark, *Adjudication to Administration: A Statistical Analysis of Federal District Courts in the Twentieth Century,* 55 SOUTHERN CALIFORNIA LAW REVIEW 65, 98, Table 4 (1981). Clark also detailed the change in the mix of cases; the proportions of criminal and civil cases varied over time as did the ratio of civil filings by private parties to those brought by the government.

**123** Alabama got its second district judge in 1886. See Act of Aug. 2, 1886, 24 Stat. 213. In 1871, Arkansas was given a second judge. See Act of March 3, 1871, 16 Stat. 471, 472. As noted, the states that received second judgeships included California (1886); Georgia (1882), Iowa (1882); Louisiana (1881, returning it to two judgeships); Michigan (1863); Missouri (1857); North Carolina (1872); Tennessee (1878); Texas (1857); Virginia (1871, returning to a two judgeship provision); and Wisconsin (1870). The District of Columbia did as well in 1870. Illinois and Ohio received a second judgeship in 1855, and New York received a third in 1865. See *Chronological History of Authorized Judgeships in U.S. District Courts.*

**124** CRAIG at 163. The federal workforce grew from 4,847 employees in 1816 to 395,905 employees in 1911. Id.

**125** LOWRY at 58.

**126** CRAIG at 162.

**127** LOWRY at 80. Some prior bills had authorized that buildings be constructed in several different locations. See, for example, Act of Aug. 4, 1854, ch. 242, 10 Stat. 546, 571, providing for "custom-house, post-office, and United States courts" in various cities. Another omnibus construction bill providing $45 million in funds was enacted in 1913. See Act of March 4, 1913, ch. 142, 37 Stat. 739. A third such bill, Act of May 25, 1926, Pub. L. No. 69-281, ch. 380, 44 Stat. 630, authorized construction of several kinds of federal buildings—"courthouses, post offices, immigration stations, customhouses, marine hospitals, quarantine stations, and other public buildings." While that list was similar to those found in bills from the late nineteenth century, the order had changed—the 1926 legislation put courthouses at the front. As discussed later, this bill also authorized the Secretary of the Treasury to find a place for a building for the Supreme Court.

**128** LOWRY at 80. As for the style of the buildings, many designs adopted the Beaux-Arts style popularized by the Chicago Exposition of 1893. Id. at 81–82; CRAIG at 203, 210–215. Concerns about pork-barrel funding led to cutbacks in 1911 in the workforce of the Office of Supervising Architect and to a hiatus between 1913 and 1926 in omnibus funding bills. CRAIG at 239–240.

**129** CRAIG at 163.

**130** Clark reports that there were 1.3 federal judges per million people at the beginning of the twentieth century and 2.2 judges per million in 1980. See Clark, Table 1 at 69–71. The statutory requirement that appointees reside in the districts in which they worked, a requirement extant from the First Judiciary Act of 1789, aimed to mitigate the perception of control from Washington. See 28 U.S.C. § 134.

**131** Constructing Justice: The Architecture of Federal Courthouses at 2.

**132** See, for example, U.S. SENATE COMMITTEE ON COMMERCE, MEMORIAL OF THE GOVERNOR, JUDGES, OFFICERS, AND MEMBERS OF THE LEGISLATURE AND CITIZENS OF NEW JERSEY, S. MISC. DOC. NO. 34–29 (3d Sess. 1857). Levy identified similar requests from Missouri's general assembly, Alabama's legislature, Iowa's general assembly, and Illinois's representatives. Levy, Federal Courthouse Construction at 20–24. One can find requests both before and after the Civil War. Id. at 29–34.

**133** See, for example, Petition of the Grand Jury of the Criminal Court for the District of Columbia, seeking an appropriation for additional accommodations for the United States Courts of that district. July 28, 1856, Serial Set. Vol. No. 835, Sess. Vol. No. 1, 34th Congress, 1st Sess. S. Misc. Doc 71.

**134** Constructing Justice: The Architecture of Federal Courthouses at 2. Tracking construction projects requires turning to a range of sources. For example, a few of the books devoted to courthouses in a particular state also detail federal court buildings. The volume on Nebraska courts includes photographs of more than a dozen federal courthouse buildings. The first such structure, in Omaha, designed by Supervising Architect Alfred B. Mullet, was completed in 1874 and housed the courts, customs, and a post office. POLLAK at 119. Facilities followed in 1879 in Lincoln, Nebraska, where a freestanding federal courthouse was erected in 1907 and another in 1974. Id. at 120, 125. Nebraska City got its post office and courthouse in 1889, and Omaha got a second and larger building in 1906, another in 1958, and a third in 2000. Id. at 120, 124, 125. Norfolk, Nebraska, was the site of its own post office and courthouse in 1904, and the building was a "replica of a building in Annapolis, Maryland," that was designed by Supervising Architect James Knox Taylor. Id. at 121. Another building, in Hastings, opened in 1905; it was described as the "finest structure of the city." Id. at 122. Thereafter post offices and courthouses were constructed in Grand Island (1910), North Platte (1913), McCook (1916), and Chadron (1920).

The number of buildings represents the success of the bench, the bar, and elected leaders in obtaining funding for each of these projects. Buildings outstripped demand. For example, by 1920 Nebraska's population was under one and a quarter million. See the Nebraska censuses for 1920 and 2000, at Resident Population and Apportionment of the U.S. House of Representatives, Nebraska, U.S. Census Bureau, http://www.census.gov/dmd/www/resapport/states/nebraska.pdf. In terms of the caseload, in 1910, the federal district court had 285 pending cases, civil and criminal, and in 1920, it had a total of 451 pending cases. See the Annual Report of the Attorney General of the United States for the Year 1910, H. Doc. 66-816 at 142 (1910); Annual Report of the Attorney General of the United States for the Year 1920, H. Doc. 66-886 at 290–292, 422 (1920).

**135** CRAIG at 202.

**136** CRAIG at 149.

**137** LEE at 100. See generally MARY N. WOODS, FROM CRAFT TO PROFESSION: THE PRACTICE OF ARCHITECTURE IN NINETEENTH-CENTURY AMERICA 28–36 (Berkeley, CA: U. of California Press, 1999) (hereinafter WOODS, FROM CRAFT TO PROFESSION). The term architect derives from a Greek term meaning "master carpenter" and was used in reference to various craftspersons. The term did not denote a person with special design authority until the Renaissance in Italy. Id. at 5. In early America, the word architect referred to various people working on the design of buildings. The professionalization of the term came through organizations like the American Institute for

Architects (AIA), which called for training and credentials as qualifications of specialization to use the appellation architect. Id. at 6–8. Woods cited Louisa Tuthill as one of the first—in 1848—to call on "young men to become professional architects" and hence to have both a " 'lucrative and honorable profession.' " Id. at 8.

**138** The AIA, founded in 1857, had its counterparts in the Royal Institute of British Architects (begun in 1834) and the French Société Centrale des Architectes (founded in 1840). By the 1870s, the AIA was promoting professional education and helping to develop architectural programs in various universities. See the American Institute of Architects, http://www.aia.org. In terms of its efforts to affect contracts for federal buildings, the AIA sought to confine the Treasury's architect's role to "supervising" rather than designing federal construction. The argument made was that the requisite "artistic and administrative" talents were not to be found in the same person and that government design plans were inferior to those of private architects. LEE at 183–184.

**139** LEE at 163. That critique was apparently not shared by many localities. "New federal buildings were consistently well received in America's Peorias," where they symbolized "membership in the Union." CRAIG at 163.

**140** CRAIG at 156. The first Supervising Architect, Ammi B. Young, "was dismissed amid charges of extravagance and waste." Another, Alfred Mullett, was "subjected to no less than five investigations" and, according to one review, while he was not corrupt, his subordinates were. Id.

**141** See Mary Woods, *The First American Architectural Journals: The Profession's Voice*, 48 JOURNAL OF THE SOCIETY OF ARCHITECTURAL HISTORIANS 117, 138 (1989).

**142** LEE at 166; LOWRY at 77; Constructing Justice: The Architecture of Federal Courthouses. Woods credited the success of the Chicago World's Fair with making plain what "professional architects could accomplish." WOODS, FROM CRAFT TO PROFESSION at 42. The bill provided that the Secretary of the Treasury had the "discretion to obtain plans, drawings, and specifications for the erection of public buildings . . . by competition among architects under such conditions as he may prescribe," provided that "not less than five architects" be invited for competitions and that the work be done under the "general supervision" of the Office of Supervising Architect. Act of Feb. 20, 1893, ch. 146, 27 Stat. 468, 468–469. The act was first used for the Norfolk, Virginia, Custom House. LEE at 201.

**143** In 1893, after the Tarsney Act was passed, members of the Cleveland Administration were slow to implement its provisions. LEE at 167–176; LOWRY at 77. In response, Congress sometimes intervened directly by stipulating procedures when appropriating funds for construction; for example, a bill funding the Chicago Post Office required that the Secretary of the Treasury "hire a Chicago architect to prepare designs for the building." LEE at 176. When Lyman Gage, who had been on the board of directors for the Chicago World's Fair, became Secretary of the Treasury, commissions went to private architects such as Cass Gilbert. WOODS, FROM CRAFT TO PROFESSION at 42–43. But the legislation was not mandatory and during the fifteen years of the Tarsney Act, 1897–1912, some thirty-five buildings were designed according to its provisions. LOWRY at 76.

**144** CRAIG at 203. Smith also reported on the conflicts between private architect and public supervisors when the Tarsney Act was in use. SMITH at 28–29.

**145** Act of Mar. 4, 1913, Pub. L. No. 62-432, 37 Stat. 866. Congress asked for information about appropriate standards, sizes, and costs.

**146** CRAIG at 213 (quoting the Secretary of the Treasury).

**147** CRAIG at 298. The group began publication of its magazine, *The Federal Architect*, in 1930. Id. The publication and the association "faded away" in 1947. Id.

**148** See Act of May 25, 1926, Pub. L. No. 69-281, ch. 380, 44 Stat. 630, and Act of March 31, 1930, Pub. L. No. 71-85, ch. 99, 46

Stat. 136; LEE at 239. Private architects' interest in federal contracts varied with the funds supporting them. The 1926 Act provided $50 million for new buildings in Washington; the outcomes were the components of the monumental set that formed the "Federal Triangle." LEE at 241. See generally GEORGE GURNEY, SCULPTURE AND THE FEDERAL TRIANGLE (Washington, DC: Smithsonian Institution Press, 1985).

The question of how to select architects remained. Otha Wearin, a member of the House of Representatives from Iowa, argued that architectural competitions produced the "most famous buildings in America" and should be required by statute. See Otha D. Wearin, *Wanted: Competitions for Federal Buildings*, MAGAZINE OF ART 266 (1938). But some members of the AIA remained unenthusiastic, viewing competitions as a potentially "costly roulette." See Sara Amelia Butler, Constructing New Deal America: Public Art and Architecture and Institutional Legitimacy 257 (Ph.D. dissertation, Department of Architectural History, U. of Virginia, Charlottesville, VA, 2001; UMI Publication No.: AAT 302033).

**149** LEE at 237.

**150** See Reorganization Plan No. I of 1939, 4 Fed. Reg. 2727 (Jul. 1, 1939), 53 Stat. 1423 (pursuant to the Reorganization Act of 1939, Pub. L. No. 79-19, 53 Stat. 561). In that same year, the Treasury's Section of Painting and Sculpture became the Section of Fine Arts, under the auspices of Public Buildings Administration; it became "inactive" in the 1940s. See Lloyd Goodrich, *Government and Art: History and Background*, 8 COLLEGE ART JOURNAL 171, 173 (1949). In 1949 Congress enacted the Public Buildings Act, authorizing the site selection and construction of federal buildings. See Public Buildings Act of 1949, Pub. L. No. 81-105, 63 Stat. 176 (codified as amended in scattered sections of 40 U.S.C.).

**151** Created under President Harry Truman at the end of World War II, the GSA was responsible for centralizing the procurement and superintendence of government property. Functions of other agencies were transferred to the GSA, which was run by an "Administrator" appointed by the President. See Federal Property and Administrative Services Act of 1949, Pub. L. No. 81-152, 63 Stat. 377 (codified in scattered sections of 40 U.S.C., 41 U.S.C., and 50 U.S.C.). A monograph by the GSA described its 1949 mandate as "standardization, direct purchase, mass production, and fiscal savings." GENERAL SERVICES ADMINISTRATION, GROWTH, EFFICIENCY AND MODERNISM: GSA BUILDINGS OF THE 1950S, 60S, AND 70S at 29 (Washington, DC: GSA, 2006), http://www.gsa.gov/graphics/GEMbook.pdf (hereinafter GSA MODERNISM).

A series of other acts added to GSA responsibilities, and the Public Buildings Act of 1959 gave the GSA more direct control over federal construction. Public Buildings Act of 1959, Pub. L. No. 86-249, 73 Stat. 479 (codified at 40 U.S.C. §§ 490, 601-619, current version at 40 U.S.C.A. §§ 581-590, 3301-3315). By the 1960s the GSA was seen as an "iceberg" in that its direct budget (then of about $600 million) was dwarfed by the vastly larger sums (then more than $2.5 billion) the GSA controlled through projects under its aegis. See Michael James Luciano, A Study of the Origin and Development of the General Services Administration as Related to Its Present Operational Role, Direction, and Influence 245 (Ph.D. dissertation in Public Administration, New York University, NY, 1968; UMI Publication No.: AAT 6907976).

**152** LEE at 279-295. The GSA has also been controversial, with complaints about the wisdom of expenses as well as the management provided. Episodically, concerns from various sectors prompt legislative oversight or mandates. For example, in 1972 amendments, Congress instructed that the GSA report its "determination and findings supporting" the negotiation of purchase contracts "in writing to the Committees on Public Works of the Senate and House of Representatives" and that the "maximum number of qualified sources" be solicited for proposals. See Public Buildings Amendments of 1972,

Pub. L. No. 92-313, 86 Stat. 216, 219, codified at 40 U.S.C. §§ 601 et seq. (specifically § 602) (2000), recodified as amended at 40 U.S.C.A. §§ 3301 et seq. (West 2008). The 1972 amendments added to the existing reporting rules in the Public Buildings Act of 1959, which required annual reports on recent and continuing constructions and acquisitions as well as "building project surveys as may be requested by resolution" of House or Senate committees. 73 Stat. at 481. Further, the Public Buildings Act required that the GSA submit formal documents to the Office of Management and Budget as well as congressional committees as part of the authorization process. See 40 U.S.C.A. § 3307 (West 2008); Congressional Research Service, General Services Administration Prospectus Thresholds for Owned and Leased Federal Facilities, RS22287 (Aug. 20, 2008) at 2–3 (hereinafter CRS Report). For each construction or acquisition project above a certain cost threshold, the GSA must submit a detailed prospectus to congressional committees. 40 U.S.C.A. § 3307. Congress allocates funds "only if the Committee on Environment and Public Works of the Senate and the Committee on Transportation and Infrastructure of the House of Representatives adopt resolutions approving the purpose for which the appropriation is made." Id. The cost threshold triggering this process for new spaces in fiscal year 2009 was $2.66 million. CRS Report at 4.

**153** See LOWRY at 82–88. The Federal Triangle is one such example, with seven Neoclassical structures adorned by more than one hundred sculptures. GURNEY at 15–20.

**154** Congress gave a second judgeship to Indiana in 1925; see Act of Jan. 16, 1925, 43 Stat. 751. Maryland received a temporary judgeship in 1910 and a permanent one in 1927; see Act of Feb. 24, 1919, 36 Stat. 201, and Act of March 3, 1927, 44 Stat. 1346. Massachusetts received two temporary judgeships in 1922, both of which were made permanent in 1935; see Act of Sept. 14, 1922, 42 Stat. 837, and Act of Aug. 19, 1935, 49 Stat. 659. *Chronological History of Authorized Judgeships in U.S. District Courts*.

**155** *Constructing Justice*, FJC Newsletter at 1.

**156** Constructing Justice: The Architecture of Federal Courthouses at 1. See also SURRENCY at 80–85.

**157** Constructing Justice: The Architecture of Federal Courthouses at 3–4.

**158** *Constructing Justice*, FJC Newsletter at 1.

**159** LOWRY at 69.

**160** CRAIG at 195.

**161** LOWRY at 58. Washington maintained enormous control. Id. at 59. Craig provided examples; a congressional building committee committed to "twelfth-century Normandy for the style" for new federal institutions, with results such as the "medieval castle of the Smithsonian," completed in 1855. CRAIG at 91.

**162** Antoinette Lee's volume is a chronicle of the history of that office and its occupants.

**163** Clark at 98, Table 4, and 114, Table 10.

**164** The photographs of the historic federal buildings in Galveston, Texas (fig. 98); Des Moines, Iowa (fig. 99); Biloxi, Mississippi (fig. 100); Denver, Colorado (fig. 102); Missoula, Montana (fig. 103); San Diego, California (fig. 104); San Juan, Puerto Rico (fig. 105); Fairbanks, Alaska (fig. 106); and New York City, New York (fig. 107) and the United States Supreme Court, Washington, D.C. (fig. 108) come from the National Archives and Record Administration and are in the public domain. These images are available online through the website created by the Federal Judicial Center, Historic Federal Courthouses, http://www.fjc.gov/history/courthouses.nsf (hereinafter FJC Historic Federal Courthouses website). Our thanks to Steven Saltzgiver, Research Historian, and to Bruce A. Ragsdale, Director of the History Office at the Federal Judicial Center, for providing us with copies for reproduction and for helping us obtain information about the courthouses. The photograph in figure 101 is by Wm. Henry Jackson. The 1892 Denver Post Office is called the United States Court House and Post Office on the FJC historic court-

house database. The photograph comes from the Denver Public Library, Western Historical Collection and is reproduced with its permission. Our thanks to Kyle Mattews of the Tenth Circuit's Space and Facilities staff for assistance in locating this photograph.

**165** Galveston Historical Foundation, *More About the 1861 Custom House*, http://www.galvestonhistory.org/1861_US_Custom_House1.asp (hereinafter Galveston Historical Foundation, 1861 U.S. Custom House).

**166** Texas gained independence from Mexico in 1836 and, in 1845, the United States annexed that area.

**167** Act of Aug. 4, 1854, § 2, 10 Stat. 546, 571. That act also called for buildings (of unspecified kinds) in New Haven, Connecticut; Newark, New Jersey; Buffalo and Oswego, New York; Wheeling, West Virginia; Chicago, Illinois; and Detroit, Michigan; and, in each, for accommodations to be provided for "steamboat inspectors." Id. In a bill a few years later, custom officials were specifically told that they could use funds for the construction of distinct federal facilities—"Custom-Houses, Court-Houses, Post-Offices, and Marine Hospitals." See, for example, Act of June 12, 1858, § 17, 11 Stat. 319, 327.

**168** U.S. General Services Administration, Historic Building Posters & Brochures, U.S. Custom House, Galveston, TX, http://www.gsa.gov/portal/ext/html/site/hb/category/25431/actionparameter/explorebybuilding/buildingid/367 (hereinafter GSA website, Historic Building Brochures, Galveston Custom House). GSA information for courthouses is available both online and in print publication format. At the GSA website, information about historic courthouses is found in a section headed "Buildings & Real Estate," http://www.gsa.gov/Portal/gsa/ep/home.do?tabId=1. One subsection, "Regional Buildings," is geographically ordered. See http://www.gsa.gov/Portal/gsa/ep/contentView.do?contentType=GSA_OVERVIEW&contentId=14408. More detailed information can often be found in the subsection "Historic Building Posters & Brochures," also organized by geographic region. See http://www.gsa.gov/Portal/gsa/ep/contentView.do?contentType=GSA_OVERVIEW&contentId=19365. A second online source is the searchable database available through the "Historic Federal Courthouses" section of the Federal Judicial Center website, http://www.fjc.gov/history/courthouses.nsf. To distinguish the sources, our shorthand for the different cites is GSA website, Regional Buildings, (name of building); GSA website, Historic Building Brochures, (name of building); and FJC Historic Federal Courthouses website, (name of building).

**169** U.S. CONST. Amend. XVI. The full text continues that the federal taxing power is "without apportionment among the several States, and without regard to any census or enumeration."

**170** Lawrence Wodehouse, *The Custom House, Galveston, Texas, 1857–1861*, by Ammi Burnham Young, 25 JOURNAL OF THE SOCIETY OF ARCHITECTURAL HISTORIANS 64, 65, n. 3 (1966).

**171** Galveston Historical Foundation, 1861 U.S. Custom House *Architectural Details*, http://www.galvestonhistory.org/custom_house_architectural_details.asp.

**172** Wodehouse at 64, n. 2. "[C]ommon detailing was used in all buildings," and several had "identical" designs. Id. During one two-year period in the 1850s, "only fifteen different designs were prepared" for thirty-five new buildings. LOWRY at 53. As noted earlier, Young designed about seventy structures during his tenure as the first Supervising Architect. CRAIG at 99.

**173** CRAIG at 99.

**174** The building was occupied by the Confederate Army, was hit by a shell from a Union gunboat, and was the "site of the ceremony ending the Civil War in Galveston." See GSA website, Historic Building Brochures, Galveston Custom House.

**175** See FJC Historic Federal Courthouses website, Galveston, Texas, 1937 U.S. Post Office, Custom House and Court House.

**176** LEE at 73. Mullett designed the State, War, and Navy Building in Washington, D.C., and had "near total control over public building" during much of his service. Id. at 73–110. "He is best known for his six immense, richly decorated Second Empire edifices" combining customhouses, courthouses, and post offices. CRAIG at 155. In the interval between Young and Mullet, Isaiah Rogers was the Supervising Architect. LEE at 66–72. See also FJC Historic Federal Courthouses website, Des Moines, Iowa, 1871 U.S. Courthouse and Post Office.

**177** The Public Buildings Act of 1913 allocated $350,000 for the second building's construction, and the 1871 structure was demolished in 1968. GSA website, Historic Building Brochures, 1929 U.S. Courthouse, Des Moines, Iowa.

**178** The 1929 building joined several other "monumental public buildings" along the riverfront, and their style and placement reflected the efforts of the City Beautiful Movement to create important civic spaces. GSA website, Historic Building Brochures, 1929 U.S. Courthouse, Des Moines, Iowa.

**179** GSA website, Historic Building Brochures, 1929 U.S. Courthouse, Des Moines, Iowa.

**180** LEE at 209; CRAIG at 232–233. See also FJC Historic Federal Courthouses website, 1908 U.S. Post Office, Court House, and Custom House, Biloxi, Mississippi.

**181** LEE at 197–216. More discussion of Taylor can be found at GSA website, Historic Building Brochures, 1916 Byron White U.S. Courthouse, Denver, Colorado. Under Taylor's administration, "modest government buildings" were often designed by staff of his office; commissions for larger buildings in major cities were given to private architects through the competitive selection process stipulated by the Tarsney Act of 1893. LEE at 201.

**182** LOWRY at 80.

**183** LOWRY at 80. Construction of the building was delayed by hurricanes, supply failures, and "incompetent contractors." See City of Biloxi, The Early Years (an information sheet created to accompany a display celebrating the centennial of this building in June 2008), http://biloxi.ms.us/pdf/centennialdisplay.pdf (hereinafter Biloxi, The Early Years). When the building finally opened in 1908, its dedication was enhanced by "new electric trolleys" that transported people around the city. Id.

**184** See Biloxi, The Early Years. In 1978, the building was listed on the National Register of Historic Places, which identified it as one of the best-documented in the state. Id.

**185** Associated Press, *New Federal Courthouse Dedicated Friday in Gulfport*, Nov. 13, 2003, Lexis-Nexis, http://web.lexis-nexis.com/universe. The new construction was designed to be energy conserving. See U.S. Department of Energy, *GSA's Gulfport Courthouse—A New Construction Super ESPC*, FEDERAL ENERGY MANAGEMENT PROGRAM (FEMP) FOCUS at 5, Jan.–Feb. 2002, http://www1.eere.energy.gov/femp/pdfs/fempfocus_jan_feb_2002.pdf. Damage from Hurricane Katrina required the closure of the courthouse for many months.

**186** Both are credited as designers of the building; Mifflin E. Bell was Supervising Architect from 1883 to 1887; Will. A. Freret served briefly, from 1887 to 1889. See LEE at 135–147.

**187** GSA website, Historic Building Brochures, 1916 Byron White U.S. Courthouse, Denver, Colorado. Our thanks to the Honorable John Kane, who enabled us to tour the courthouse, and to the Circuit Executive Office of the Tenth Circuit and its staff for providing us with additional materials on the history of the building. See also THE FEDERAL COURTS OF THE TENTH CIRCUIT: A HISTORY (James K. Logan, ed., U.S. Court of Appeals for the Tenth Circuit, Denver, CO, 1992). According to a 1906 Report from the Senate's Committee on Public Buildings and Grounds, although the first federal courthouse and post office building in Denver was authorized under the Act of May 8, 1882, it was not completed until 1893. In the interim, the report explained that

the city had grown to such an extent that the building was not nearly large enough to accommodate the Federal business. From the beginning it was found impossible to find space in the building for all the Government offices located in Denver, and to-day many of the Federal officials in the city are housed outside the Government building, rendering necessary the payment of a very large rent account every month. . . .

It is estimated that when the original bill was passed, in 1882, Denver had a population of less than 40,000. By 1890 that number had increased to 106,000, and to over 133,000 in 1900, and there had been a corresponding growth in population of the State of Colorado and the entire Rocky Mountain region contiguous to that city. The result was an expansion of business far in excess of the calculations of the designers of the original building and the failure of the structure from the beginning to meet the demands upon it.

The growth of the city and the contiguous country has continued since the occupancy of the present building, in 1893, until now it is conservatively calculated that the city has a population of 175,000.

The consequence is that there is a crowding together in public offices of officials, employees, and papers that should not be permitted, with a consequent congestion of business that is appalling.

See Public Building, Denver, Colo. Senate Report. No. 1433, 59th Cong., 1st Sess. March 2, 1906, at 1–2 (hereinafter Denver Building Senate 1906 Report). The report noted that the Treasury was "taxed to the extent of $14,375 a year for the rent of public buildings" and that the 1893 building houses "the post-office, the Railway-Mail Service, the internal-revenue service, the Federal courts, the United States marshal, the clerks of the Federal courts, and the Weather Bureau Service." Id. at 2.

**188** GSA website, Historic Building Brochures, 1916 Byron White U.S. Courthouse, Denver, Colorado. See also the Tenth Judicial Circuit Historical Society, Byron White United States Courthouse, http://www.10thcircuithistory.org/pdfs/courthouse/Byron_White_Courthouse_Brochure_2009.pdf (hereinafter Tenth Circuit Denver Courthouse Brochure). Congress authorized the construction of the building in 1903 but did not allocate funds until 1908. The firm of Tracy, Swartwout, & Litchfield won the commission, and the marble for the building came from the Yule Marble Quarry in Colorado. Id.

**189** Denver Building Senate 1906 Report at 3. Archival materials provided to us by the Tenth Circuit also described the role played by the Denver Chamber of Commerce and the state's congressional delegation in securing funds for a building to be in the tradition of monumental structures such as the Lincoln Memorial.

**190** Denver Building Senate 1906 Report at 5 (reproducing a letter of Jan. 15, 1904, that reported an interview with "Judge Hallet").

**191** In 1973, the building was listed on the National Register of Historic Places. See Byron White United States Courthouse Building Preservation Plan, Denver, Colorado, GSA Project No. RCO 04542, July 25, 2000, at 1–2.

**192** Tenth Circuit Denver Courthouse Brochure. The building's namesake, Byron White, was appointed by President John Kennedy to the Supreme Court and served from 1962 until 1993; he died in 2002. Some of White's memorabilia are displayed at one end of the first-floor corridor. The building's acquisition, renovation, and conversion cost about $30 million or "$114.00 per square foot," resulting in a building valued at "200 million dollars, which is about $760.00 per square foot." Id.

The Tenth Circuit, which is comprised of the states of Colorado, Kansas, New Mexico, Oklahoma, Utah, and Wyoming, regularly hears appeals in Denver and in Wichita, Kansas, and Oklahoma City, Oklahoma. See 28 U.S.C. §§ 41, 48(a). The district court has its own building that opened in 2002—the Alfred A. Arraj U.S. Courthouse, a ten-story, 320,000-square-foot structure consisting of a pavilion and a tower that provides space for fifteen courtrooms. See Alfred A. Arraj U.S. Courthouse, Denver, Colorado, A Model of Sustainability, at the website of the National Renewable Energy Laboratory, http://www.nrel.gov/docs/fy05osti/38655.pdf. That building is named after a federal district judge who was nominated by President Eisenhower in 1957, served as the district court's chief judge from 1959 to 1976, and died in 1992. See Alfred Albert Arraj: A Judicial Life (brochure available from the court). Included among the artworks displayed is an outdoor sundial at the top of the tower and an outdoor sculpture, Irregular Form, by Sol Lewitt.

**193** GSA website, Historic Building Brochures, 1916 Byron White U.S. Courthouse, Denver, Colorado (translation by GSA). The texts, selected by architect Evarts Tracy, were placed on the friezes. Cicero's quote faces Eighteenth Street, while the Magna Carta excerpt faces Nineteenth Street. Inscriptions also appear on benches on the northeast and southwest sides of the building. One is inscribed "Alternate rest and labor long endure," the other "If thou desire rest, desire not too much." Id. Reflecting the building's initial use as a post office as well as a court, the front facade has inscriptions of the names of the cities to Denver's east and west "to indicate the flow of mail across the country." GSA memorandum of March 23, 2007.

**194** Tenth Circuit Denver Courthouse Brochure. "Justitia Virtutum Regina" is a traditional Latin proverb that is similar to Cicero's maxim "Justice is the crowning glory of virtues" (from De officiis) and Aristotle's "Justice is the most beautiful virtue" (from Nichomachean Ethics), discussed in Chapter 1. The phrase "Justiciae Soror Fides" is very likely from Horace (Ode 1.24, "Lament for Quintilius")—although the exact phrase that is usually attributed to him is more often "Justiciae Soror Incorrupta Fides" (or Faith is the uncorrupted sister of Justice). See M. OWEN LEE, VIRGIL AS ORPHEUS 135–137 (Albany, NY: State U. of New York Press, 1996). "Nemo Est Supra Leges" and "Ita Lex Scripta Est" can be found in Roman digests of legal precepts associated with the Justinian era and then invoked in English and American law. See JOSEPH STORY & W. E. GRIGSBY, COMMENTARIES ON EQUITY JURISPRUDENCE 4 (Clark, NJ: Lawbook Exchange, 2006).

**195** Tenth Circuit Denver Courthouse Brochure (translations of the Latin).

**196** GSA website, Historic Building Brochures, Federal Building, 1913 U.S. Post Office and Courthouse, Missoula, Montana.

**197** GSA website, Historic Building Brochures, Federal Building, 1913 U.S. Post Office and Courthouse, Missoula, Montana (citing the newspaper the Daily Missoulan). See also FJC Historic Federal Courthouses website, 1913 Post Office and Courthouse, Missoula, Montana.

**198** GSA website, Historic Building Brochures, Federal Building, 1913 U.S. Post Office and Courthouse, Missoula, Montana. A second federal court, opened in 1996, was named the Russell E. Smith Courthouse in honor of a local district judge who served there from 1966 until 1990, when he died. The older building is no longer used as a court.

**199** GSA website, Historic Building Brochures, Jacob Weinberger U.S. Courthouse, San Diego, California.

**200** That renovation recreated the original post office lobby, restored a marbled terrazzo floor and iron-cage elevators, and added a law library. The building is used by the U.S. Bankruptcy Court for the Southern District of California. See U.S. Court for the Southern District of CA, Courthouse History, U.S. Courts, http://www.casb.uscourts.gov/html/courthouse_history.htm.

**201** See GSA Wins "TOBY" Awards for Real Estate Excellence, GSA News Release 9332 (June 27, 1996), http://www.gsa.gov/Portal/gsa/ep/contentView.do?contentType=GSA_BASIC&contentId=8994&noc=T. The category was "Historic Building."

**202** *Honoring Excellence in Public Architecture and Design*, GSA WEB NEWS, March 28, 2003, http://www.gsa.gov/Portal/gsa/ep/content View.do?contentType=GSA_BASIC&contentId=8290&noc=T. An exhibit of award winners was then mounted at the National Building Museum. We discuss the provision of such awards in Chapter 9. Id.

**203** GSA website, Historic Building Brochures, Jose V. Toledo Federal Building and U.S. Courthouse, Old San Juan, Puerto Rico. See also GUILLERMO A. BARALT, HISTORY OF THE FEDERAL COURT IN PUERTO RICO: 1899–1999, at 139–140 (Janis Palma, trans., Hato Rey, Puerto Rico: Publicaciones Puertorriqueñas, 2004). The judicial system in Puerto Rico was influenced by the Spanish Constitution of 1876, id. at 18, and by a 1900 Act of the United States Congress, which enacted a bill, "Temporarily to Provide Revenues and a Civil Government in Puerto Rico, and other Purposes" (also called the Foraker Act after its sponsor). Id. at 111. Federal courts "opened their doors" in 1900 for the "District of Porto Rico" (later "Puerto Rico"); the judges were appointed for four-year terms by the President. Id. at 115. The building came by virtue of an executive order from President Theodore Roosevelt providing for the "first federal building" after the United States claimed sovereignty over the island. In 1908 funds were approved for its construction. Id. at 139–140.

**204** BARALT at 141, quoting the *American Star* of Aug. 24, 1908. Also noted was the effort to use as little wood as possible to avoid termites. Id. at 143. Disputes between contractors about the building were litigated in the federal courts for several years. A first effort to reach the United States Supreme Court was rejected. See *Guerini Stone Co. v. P. J. Carlin Const. Co.*, 245 U.S. 643 (1917). The Supreme Court reached aspects of the contract dispute in 1919. See *Guerini Stone Co. v. P. J. Carlin Const. Co.*, 248 U.S. 334 (1919).

**205** BARALT at 145–146. The First Circuit was authorized to review appeals from the territory in 1915; before then, Puerto Rico's courts were subject to direct review by the United States Supreme Court. Id. at 146.

**206** See *Justice Facilities Combine Openness and Security*, AAJ JOURNAL (Newsletter of the Academy of Architecture for Justice), Spring 2005, http://info.aia.org/nwsltr_caj.cfm?pagename=caj_a_courthouses.

**207** See EFRÉN RIVERA RAMOS, THE LEGAL CONSTRUCTION OF IDENTITY: THE JUDICIAL AND SOCIAL LEGACY OF AMERICAN COLONIALISM IN PUERTO RICO 81 (Washington, DC: American Psychological Association, 2001).

**208** Our thanks to Dana Fabe, Chief Justice of the Alaska Supreme Court, and to Barbara Hood, Communications Counsel for the Alaska Court System, for their generous help in locating historical materials about courthouses in Alaska. The first facility used for that federal court is depicted in materials from the Eagle Historical Society and Museums. See http://www.eagleak.org/city.htm.

**209** See HON. JAMES WICKERSHAM, OLD YUKON—TALES, TRAILS, AND TRIALS 48 (Washington, DC: Washington Law Book Co., 1938). See also EVANGELINE ATWOOD, FRONTIER POLITICS: ALASKA'S JAMES WICKERSHAM 98–104 (Portland, OR: Binford & Mort, 1979).

**210** See CLAUS-M. NASKE, A HISTORY OF THE ALASKA FEDERAL DISTRICT COURT SYSTEM, 1884–1959, AND THE CREATION OF THE STATE COURT SYSTEM, ch. 3 at 11 (Fairbanks, AK: U. of Alaska, 1985).

**211** See MELODY WEBB, YUKON: THE LAST FRONTIER 198–199 (Lincoln, NE: U. of Nebraska Press, 1985). Congress first created the district—with a single tribunal—in the Alaska Organic Act of 1884. NASKE, ch. 1 at 1. Naske recounted the legislative history of a bill described by some as a "crude piece of legislation" that created a larger district than any other but without methods for "serving its process or enforcing its decrees." Id. In 1884, President Chester Arthur appointed the first district judge, Ward McAllister Jr., along with four commissioners who were to function as "probate judge, justice of the peace, land office registrar, notary public, and much more." Id., ch. 2 at 5. They were based in Sitka, Alaska. Judicial officials changed with the

presidency as well as with scandals about their governance. Id., ch. 2 at 5–23. In 1900, revisions created a district court with three divisions, each with a district judge who was to be resident in the district, to hold office for four years, to receive an annual salary of $5,000 a year, and to work under rules of civil procedure provided in that statute. Id., Appendix (Judges, District of Alaska). See also An Act making further provision for a civil government for Alaska and for other purposes, Act of June 6, 1900, 31 Stat. 321. Wickersham was appointed in that year. The huge geographical expanse to which he was assigned had no federal facilities before he arrived. Wickersham served seven years and, beginning in 1908, fourteen years as a delegate to Congress from Alaska. WICKERSHAM at 1–11, 39–47; NASKE, ch. 3 at 1–12.

**212** WICKERSHAM at 39–40.

**213** WEBB at 198; WICKERSHAM at 41.

**214** WEBB at 202.

**215** See James A. Wickersham Diary [24], Jan. 1, 1914, to Dec. 31, 1914, Alaska's Digital Archives, http://vilda.alaska.edu/cdm4/item_viewer.php?CISOROOT=/cdmg21&CISOPTR=6115&REC=12.

**216** ALISON K. HOAGLAND, BUILDINGS OF ALASKA 216 (Oxford, Eng.: Oxford U. Press, 1993). Naske concluded that because the "territorial governor was not a highly visible figure," the federal territorial judges in Alaska were "perceived as the central figures in the federal hierarchy which dominated the territory" and that the territorial court system had, after World War II, become unable to cope with its caseload. NASKE, ch. 13 at 13–15.

**217** Alaska gained statehood in 1959 and then established a state judicial system in addition to the federal district court, which became part of the Ninth Circuit. NASKE, ch. 14 at 1–5. In the 1970s, the 1933 federal building became a private facility; its tenants included the Alaska Public Lands Information Center.

**218** GSA website, Historic Building Brochures, Thurgood Marshall U.S. Courthouse, New York, New York. Its "classical mode merges with the high rise imperative." CRAIG at 292.

**219** See Authorized Judgeships—From 1789 to Present, History of Federal Judgeships: U.S. Courts of Appeals and U.S. District Courts, U.S. Courts, http://www.uscourts.gov/history/allauth.pdf; RUSSELL R. WHEELER & CYNTHIA HARRISON, CREATING THE FEDERAL JUDICIAL SYSTEM 24 (Washington, DC: Federal Judicial Center, 2d ed., 1994), http://www.fjc.gov/public/pdf.nsf/lookup/creating.pdf/$file/creating.pdf. The judgeship numbers include all levels of the federal courts as reform efforts between 1891 and 1925 shifted the federal courts into the three-tiered structure (trial, appellate, and Supreme Court) staffed by different sets of judges having distinct jurisdictional mandates. See FELIX FRANKFURTER & JAMES M. LANDIS, THE BUSINESS OF THE SUPREME COURT: A STUDY IN THE FEDERAL JUDICIAL SYSTEM 103–145 (New York, NY: Macmillan Co., 1928).

**220** Gilbert was born in 1859 in Ohio, worked in various places, and built a national practice from his base in St. Paul, Minnesota, before moving to New York City. See CASS GILBERT, LIFE AND WORK: ARCHITECT OF THE PUBLIC DOMAIN 28–59 (Barbara S. Christen & Steven Flanders, eds., New York, NY: W. W. Norton, 2001) (hereinafter GILBERT, LIFE AND WORK). Gilbert was in partnership with James Knox Taylor from 1885 until 1891, before Taylor became Supervising Architect in 1897. See Margaret Heilbrun, *Preface* in INVENTING THE SKYLINE: THE ARCHITECTURE OF CASS GILBERT at xxix (Margaret Heilbrun, ed., New York, NY: Columbia U. Press, 2000) (hereinafter INVENTING THE SKYLINE).

**221** Gail Fenske, *Cass Gilbert's Skyscrapers in New York: The Twentieth-Century City and the Urban Picturesque*, in INVENTING THE SKYLINE at 228, 275. The Nebraska Capitol, designed by Bertram Goodhue, was built between 1922 and 1932; the Boston Custom House, by Peabody and Stearns, dates from 1913–1915. Id.

**222** Steven Flanders, *Preface* to GILBERT, LIFE AND WORK at 9–10.

**223** Catherine Hetos Skefos, *The Supreme Court Gets a Home*, in YEARBOOK 1976 OF THE SUPREME COURT HISTORICAL SOCIETY 25, 26

(1976). See generally Robert C. Post, *Mr. Taft Becomes Chief Justice*, 76 U. OF CINCINNATI LAW REVIEW 761 (2008).

**224** William Howard Taft, The Annual Message of the President, transmitted to Congress, Dec. 7, 1909 (Washington, DC: Government Printing Office, 1914); John T. Woolley & Gerhard Peters, The American Presidency Project [online], http://www.presidency.ucsb.edu/ws/?pid=29550.

**225** An Act to provide for the construction of certain public buildings and for other purposes, Act of May 25, 1926, 44 Stat. 630, 631 (codified at 40 U.S.C. §§ 341, 342, 344–347).

**226** Hearings before the Committee on Public Buildings and Grounds, U.S. House of Rep. 70th Cong, 1st Session, on H.R. 13665 (and others), May 16 and May 18, 1928, at 3, 4 (Statement of Hon. William Howard Taft, Chief Justice, Supreme Court of the United States) (hereinafter Taft May 1928 Testimony). On the other hand, while supporting the effort to obtain new and larger space, Associate Justice Willis Van Devanter reported to the House that not all members of the Court wanted new quarters but hoped instead for "larger accommodations" within the Senate building. Id. at 12, 13 (Statement of the Hon. Willis Van Devanter, Associate Justice, Supreme Court of the United States).

**227** Taft May 1928 Testimony at 7.

**228** Taft May 1928 Testimony at 7. He was blunt: "we do not want the Department of Justice in that building." Id.

**229** Skefos at 32. See Act of Dec. 21, 1928 ("An Act to provide for submissions to the Congress of preliminary plans and estimates of costs for the construction of a building for the Supreme Court of the United States"), Pub. L. No. 70-644, 45 Stat. 1066. Gilbert and Taft worked on the development of the plans. See Geoffrey Blodgett, *The Politics of Public Architecture*, in GILBERT, LIFE AND WORK at 62–72.

**230** Skefos at 32. Gilbert was a "supreme networker" who advocated government support for the arts as he pressed for recognition of America's "fine arts as a distinct cultural category." See Heilbrun, *Preface*, in INVENTING THE SKYLINE at xviii.

**231** Heilbrun, *Preface*, in INVENTING THE SKYLINE at xx, quoting Gilbert.

**232** See Cass Gilbert, Description of the Design for the United States Supreme Court Building, Washington, D.C., May 15, 1929, submitted to the 71st Congress, 1st Sess., and included in The Final Report of the Supreme Court Building Commission in Connection with the Construction, Equipping, and Furnishing of the United States Supreme Court Building, S. Doc. No. 88 at 39–40 (76th Cong., 1st Sess., June 22, 1939).

**233** Skefos at 32–33, quoting the Report and Recommendation of the Committee on Public Buildings and Grounds of the House.

**234** Blodgett at 72. Blodgett also recounted Gilbert's opposition to the New Deal programs of Franklin Roosevelt. When the Supreme Court struck some New Deal legislation in 1935, a *New York Times* columnist commented that while a "new building" had not been required for such an assault on the program, it did "symbolize the power and prestige behind" the judgment. Id.

**235** FRED J. MAROON & SUZY MAROON, THE SUPREME COURT OF THE UNITED STATES 39 (quoting Associate Justice Harlan Fiske Stone) (New York, NY: Thomasson-Grant & Lickle and published in cooperation with the Supreme Court Historical Society, 1996).

**236** John Brigham, *Exploring the Attic: Courts and Communities in Material Life*, SPECIAL ISSUE OF LAW IN CONTEXT ON COURTS, TRIBUNALS AND NEW APPROACHES TO JUSTICE 131 (Oliver Mendelsohn & Laurence Maher, eds., Bundoora, Aus.: La Trobe U. Press, 1994) (hereinafter Brigham, *Exploring the Attic*).

**237** Priscilla Goodwin, *A Closer Look at the Bronze Courtroom Gates*, 9 SUPREME COURT QUARTERLY 8 (1988) (quoting Gilbert). Goodwin also quoted Gilbert's letter to Robert Aitken, the sculptor of the figures on the west pediment. Gilbert wrote that he did not "care very much what the figures mean. I assume of course that they may mean something or convey a certain symbolism—but what I do care about is the composition—the design—the arrangement. . . ."

**238** As we show in Chapter 14, a large stone figure called *Contemplation of Justice* sits to one's left as one ascends the imposing front steps. One of her hands rests on a book; in the other is a figure of a small blindfolded Justice who holds scales with the pans folded toward her. On the opposite side of the steps is a male figure called either *Guardian of the Law* or *Authority of Law*; he has a law tablet and a sheathed sword. Pictures can be found in MAROON & MAROON at 37 and 43. Two other images of Justice (each blindfolded and holding a sword and scales) are sculpted into the base of each of the two marble candelabra that stand outside the courthouse on the plaza.

The authorship of that design is somewhat unclear. A sketch bears the initials of Cass Gilbert Jr., who worked on the building after his father's unexpected death in 1934. Whether the initials indicate the son's direct design or his approval of another person's design is a matter under investigation by the curatorial staff of the Supreme Court. What is known is that the final design was refined and modeled by the John Donnelly Company before it was carved in stone. Another Justice, without a blindfold and holding a sheathed sword, appears in Adolph Weinman's frieze *Good versus Evil*, on the west wall of the courtroom. See Office of the Curator, Supreme Court of the United States, "Figures of Justice," Information Sheet, http://www.supremecourtus.gov/about/figuresofjustice.pdf.

**239** Goodwin at 8. The gates were designed by John Donnelly. Id.

**240** See Letter of Submittal of The Final Report of the Supreme Court Building Commission in Connection with the Construction, Equipping, and Furnishing of the United States Supreme Court Building, Doc. No. 88 at v–vi (76th Cong., 1st Sess., June 22, 1939). That report also provided the legislative history of the building as well as an accounting.

**241** See Financial Services and General Government Appropriations for 2008, Hearings before a Subcommittee of the Committee on Appropriations, U.S. House of Representatives, 110th Cong., 1st Sess. (2007) at 18 (Testimony of Justice Anthony Kennedy) (hereinafter 2007 Kennedy Testimony).

**242** Brigham, *Exploring the Attic* at 134. Brigham tracked the embrace of classical forms from the 1820s until the middle of the nineteenth century, when it came to be "linked to the American South," and then its renewed importance via the "cult" of the Supreme Court. Id. at 131–135.

**243** Brigham, *Exploring the Attic* at 136. The focus on appellate decisionmaking, symbolized by the Supreme Court and its building, missed how much law was losing its character as the site of what Wolfe Heydebrand and Caroll Seron called "moral vision and political debate." Id. at 151 (quoting their volume RATIONALIZING JUSTICE: THE POLITICAL ECONOMY OF THE FEDERAL DISTRICT COURTS 184 (Albany, NY: State U. of New York Press, 1990)).

**244** Paul Spencer Byard, *Representing American Justice: The United States Supreme Court*, in GILBERT, LIFE AND WORK at 272, 283. Byard also noted that the "troubles that followed modernism—the ghastliness of urban renewal, the horrors of highways in cities, were consequence of human imperfection, not of the modernist admonition." Id. at 286.

**245** Byard at 287.

**246** See SHNAYERSON at 30. Major renovations were undertaken to maintain that image in the early part of the twenty-first century. See 2007 Kennedy Testimony at 3. Included was a two-story underground annex that provided space for the Court Police, "a function that was virtually non-existent when the building opened in 1935." See Supreme Court Public Information Office, The Supreme Court Building Modernization Project, http://www.supremecourtus.gov/publicinfo/modernization/home.htm. The 1935 building cost less than $10 million; the 2003–2008 renovations were estimated to cost more than $120 million. Supreme Court Public Information Office, The Supreme Court Building Modernization Project, Project Fact Sheet, http://

www.supremecourtus.gov/publicinfo/modernization/facsheet2007
.pdf; Joan Biskupic, *Renovation Is Building's First since Its Opening in
1935*, USA TODAY, Dec. 12, 2006, at A5.

**247** LEE at 209. A few exceptions from that era can be found, such
as the Courthouse and Post Office built in 1857–1858 in Windsor,
Vermont, and courthouses provided for the territories. See CRAIG at
105. Craig noted that the Vermont building cost more than $70,000
and that the population of the town when it was constructed num-
bered about 2,000. Id.

**248** Lee mapped changing architectural trends in both public and
private design. For example, while Robert Mills and Alfred Mullet had
often relied on classical revival buildings, after the 1870s, taste turned
toward Gothic and then Romanesque styles. LEE at 68, 111.

**249** CRAIG at 148.

**250** CRAIG at 99.

**251** The authority to name and rename buildings is provided to
the GSA. According to a 1949 provision, the "Federal works admin-
istrator, with the approval of the Bureau of the Budget, is authorized
. . . to change or rechange the name or designation of any building in
the custody and jurisdiction of the Federal Works Agency." See Pub-
lic Buildings Act of 1949, Pub. L. No. 81-105, ch. 218, § 410, 63 Stat.
176, 200 (1949). In addition, a 1958 provision authorized the Admin-
istrator of General Services to rename a building "regardless of
whether it was previously named by statute." See Public Law 85-542,
72 Stat. 399 (1958) (codified as amended at 40 U.S.C. § 3102). It
appears that "Congress first recognized an individual by a post office
through freestanding legislation" in 1967 to honor Charles A. Buck-
ley, who had been a member of the House who had chaired the House
Public Works Committee. In 1999 the 106th Congress named 46 post
offices in honor of either persons of local renown, members of Con-
gress, or other figures. See Congressional Research Service, Library
of Congress Report, Naming Post Offices through Legislation,
RS21562, July 3, 2003. As detailed in Chapter 9, beginning sometime
in the 1980s or 1990s, courthouses were often named after retired
judges but with a limitation, noted in 1999 by the Judicial Conference
that a courthouse could not be named after a judge who had retired
and was practicing law in the building. See Committee on Security
and Facilities, Naming Federal Courthouses, Report of the Proceed-
ings of the Judicial Conference of the United States 76 (Sept. 15,
1999).

**252** For example, of the major buildings commissioned for Wash-
ington, D.C., during the early part of the twentieth century, only the
Department of Justice building had an integrated plan for its interior
and exterior. GURNEY at 157. Comprehensive descriptions are pro-
vided in the Fiftieth Anniversary volume by Vasaio.

**253** See Goodrich at 172. Goodrich attributed the historical
absence of public arts programs to the "American tradition of indi-
vidualism," the federalist structure, and the "survival of Puritan pro-
scription of the painted or graven image." Id. at 171. Details on the lim-
ited funds are provided in Anthony L. Barresi, *The Role of the Federal
Government in Support of the Arts and Music Education*, 29 J. OF
RESEARCH IN MUSIC EDUCATION 245 (1981).

**254** GSA MODERNISM at 16. As explained on the cover page by F.
Joseph Moravec, Commissioner, Public Buildings Service, the book
was a study of those buildings to "help the GSA better understand our
modern-era buildings and inform future reinvestment decisions by
taking into account our highest-quality and most distinctive build-
ings." By 2008, the government footprint had grown to 342 million
square feet of owned or leased space, housing the more than one mil-
lion federal employees. Forty-nine percent of that space was leased
from the private sector. 2008 GSA Prospectus, Thresholds for Owned
and Leased Federal Facilities, Congressional Research Service Reports,
at CRS-2.

**255** CRAIG at 440. As of then, another 50,000 buildings were
leased in the United States, and many more installations were outside

the country. By 1974, "[d]irect federal public works spending . . . was
about $5 billion annually." Id.

## CHAPTER 8

**1** Randy Gragg, *Monuments to a Crime-Fearing Age*, NEW YORK
TIMES MAGAZINE, May 28, 1995, at 36.

**2** As a history of the administrative expansion of the twentieth
century reminded its readers, until 1891 "the only salaried officers of
the federal judiciary" were its judges, and all non-judge staff were paid
on a fee-for-service basis. See A HISTORY OF THE ADMINISTRATIVE
OFFICE OF THE UNITED STATES COURTS: SIXTY YEARS OF SERVICE TO
THE FEDERAL JUDICIARY 3 (Cathy A. McCarthy & Tara Treacy, eds.,
Washington, DC: Administrative Office of the United States Courts,
2000) (hereinafter HISTORY OF THE AO).

**3** William Howard Taft, *Possible and Needed Reforms in Adminis-
tration of Justice in the Federal Courts*, 45th Conference Annual Report
A.B.A. 250 (1922) (hereinafter Taft, *1922 Needed Reforms*), reprinted
at 8 A.B.A. JOURNAL 601, 602 (1922).

**4** William Howard Taft, *Adequate Machinery for the Judicial Busi-
ness, Address before the Judicial Section of the American Bar Associa-
tion* (Aug. 30, 1921), 7 A.B.A. JOURNAL 453, 454 (1921).

**5** Taft, *1922 Needed Reforms* at 251. See also *Additional Judges, U.S.
District Courts, Hearings on S. 2432, 2433, 2523 Before the Senate Com-
mittee on the Judiciary*, 67th Cong. 11 (1921).

**6** Taft, *1922 Needed Reforms* at 253–260. See generally Robert
Post, *Mr. Taft Becomes Chief Justice*, 76 U. OF CINCINNATI LAW REVIEW
761 (2008).

**7** See Act of Sept. 14, 1922, ch. 306, § 2, Pub. L. No. 67-298, 42 Stat.
837, 838 (codified as amended at 28 U.S.C. § 331 (2000)). In 1937
Congress amended the 1922 Act to include participation by a judge
from the United States Court of Appeals for the District of Columbia
in the Conference of Senior Circuit Judges. Act of July 5, 1937, To pro-
vide for the representation of the United States Court of Appeal for the
District of Columbia on the annual conference of senior circuit
judges, Pub. L. No. 75-179, 50 Stat. 473, recodified at Act of June 25,
1948, ch. 15, § 331, Pub. L. No. 80-773, 62 Stat. 869, 902 (codified at
28 U.S.C. § 331 (2006)).

**8** See Henry P. Chandler, *Some Major Advances in the Federal Judi-
cial System, 1922–1947*, 31 FEDERAL RULES DECISION 307, 322 (1963);
U.S. Federal Judiciary, Authorized Judgeships, U.S. Courts, http://
www.uscourts.gov/history/allauth.pdf.

**9** Taft, *1922 Needed Reforms* at 252.

**10** See Act of Sept. 14, 1922, 42 Stat. 837, 837–838.

**11** See Act of Sept. 14, 1922, No. 297, § 3, 42 Stat. 837, 839.

**12** See 28 U.S.C. §§ 291–295, § 331. As that visiting practice
became more commonplace, the Chief Justice created an administra-
tive apparatus through the Judicial Conference Committee on Inter-
circuit Assignment to approve requests. See NICHOLLE STAHL-
REISDORFF, THE USE OF VISITING JUDGES IN THE FEDERAL DISTRICT
COURTS: A GUIDE FOR JUDGES AND COURT PERSONNEL (Washington,
DC: Federal Judicial Center, 2006).

**13** Some one hundred lawyers from twenty-one states gathered in
Saratoga Springs, New York. See ABA home page, history section,
http://www.abanet.org/about/history.html.

**14** We have borrowed from the title of a speech by Roscoe Pound
given before the ABA on August 29, 1906, and then published as
Roscoe Pound, *The Causes of Popular Dissatisfaction with the Admin-
istration of Justice*, 40 AMERICAN LAW REVIEW 729 (1906), reprinted
from 1 ANNUAL REPORT OF AMERICAN BAR ASSOCIATION 395 (29th
Conference, 1906).

**15** See Stephen N. Subrin, *How Equity Conquered Common Law:
The Federal Rules of Civil Procedure in Historical Perspective*, 135 U. OF
PENNSYLVANIA LAW REVIEW 909, 975 (1987).

**16** See Rules Enabling Act, Pub. L. No. 73-415, 48 Stat. 1064 (1934) (codified as amended at 28 U.S.C. § 2072 et seq. (2006)). The legislative history and the role played by Taft are explored in Stephen B. Burbank's classic essay *The Rules Enabling Act of 1934*, 130 U. OF PENNSYLVANIA LAW REVIEW 1015, 1069–1098 (1982). The 1938 rules governed law and equity, while earlier national rules governed only cases filed under the court's equity jurisdiction.

**17** In 1822 the Court had prescribed thirty-three equity rules for lower courts, and it revised those rules in 1842 with a set of ninety. See 20 U.S. xvii and 42 U.S. xli. Neither set was as comprehensive as the Equity Rules of 1912, 226 U.S. 627, and those, in turn, were superseded by the more comprehensive provisions for both law and equity promulgated in 1938.

**18** See JOHN ANTHONY JOLOWICZ, ON CIVIL PROCEDURE 24–54 (Cambridge, Eng.: Cambridge U. Press, 2000).

**19** See generally Stephen N. Subrin, *Fishing Expeditions Allowed: The Historical Background of the 1938 Federal Discovery Rules*, 39 BOSTON COLLEGE LAW REVIEW 691 (1998).

**20** The history of these developments is detailed in Judith Resnik, *Managerial Judges*, 96 HARVARD LAW REVIEW 374 (1982).

**21** Warren E. Burger, *School for Judges*, 33 FEDERAL RULES DECISION 139 (1964).

**22** Taft died in 1930 and was replaced by Charles Evans Hughes, who served until his retirement in 1941. Hughes was replaced by Harlan Fiske Stone, who died unexpectedly in 1946. Frederick Vinson became Chief Justice and served until his death in 1953, and Earl Warren was appointed thereafter. The Supreme Court Historical Society website provides a timeline of the justices. See http://www.supreme courthistory.org/history/supremecourthistory_history_timeline.htm.

**23** HISTORY OF THE AO at 1–4. Some judges thought the Department of Justice was not sufficiently responsive to their needs, while others wanted to be independent of the Department, which represented the Executive in the courts. But not all were enthusiastic about a new administrative center in Washington, and some judges urged that clerks of courts be given budgetary authority rather than centralizing the process. During the late 1920s and 1930s, the proponents of a central agency gained sway and went to Congress with a bill to create the Administrative Office, with its director appointed by the Chief Justice. Id. at 4–15. The first director was Henry Chandler, who had been a president of the Chicago Bar Association and who worked with Associate Director Elmore Whitehurst for many years. See generally Chandler at 320.

**24** See Act of Aug. 7, 1939, ch. 501, §§ 302, 304(2), 53 Stat. 1223, 1223 (codified as amended at 28 U.S.C. §§ 601–12 (2006)). The political configuration that resulted in its enactment is explored in Peter Graham Fish, *Crises, Politics, and Federal Judicial Reform: The Administrative Office Act of 1939*, 32 JOURNAL OF POLITICS 599 (1970). Fish argued that struggles over status, including the failed effort in 1937 to expand (or "pack") the Supreme Court, had prompted the Conference of Senior Circuit Judges to want to shore up internal judicial administrative capacities. See also HISTORY OF THE AO at 12–13. Michael Sollenberger, Congressional Research Service, *Administrative Office of the U.S. Courts: History, Operations, and Current Issues*, May 24, 2004 (RS21847).

**25** Some of the data collection aims to demonstrate the need for administrative support and for the budgetary requests of the judiciary. The kind and nature of data collected have drawn concerns from the perspective of researchers seeking to understand various dimensions of the judiciary's work. See Theodore Eisenberg and Margo Schlanger, *The Reliability of the Administrative Office of the U.S. Courts Database: An Initial Empirical Analysis*, 78 NOTRE DAME LAW REVIEW 1455 (2003).

**26** See John W. Winkle III, *Interbranch Politics: The Administrative Office of the U.S. Courts as Liaison*, 24 JUSTICE SYSTEM JOURNAL 443 (2003). In 1976 the AO created its Office of Legislative Analysis, which was later renamed the Office of Legislative Affairs. Id. at 45.

**27** See Act of June 25, 1948, ch. 646, §§ 331–333, 62 Stat. 902 (codified at 28 U.S.C. 331 (2006)). See generally Judith Resnik and Lane Dilg, *Responding to a Democratic Deficit: Limiting the Powers and the Term of the Chief Justice of the United States*, 154 U. OF PENNSYLVANIA LAW REVIEW 1575 (2006).

**28** See Act of Dec. 20, 1967, Pub. L. No. 90-219, § 620, 81 Stat. 664 (1967) (codified as amended at 28 U.S.C. § 620 (2000)).

**29** Winkle at 46. As of 2007, the Judicial Branch had more than 33,000 employees. See Office of Personal Management, *Employment and Trends, Federal Civilian Employees* (Sept. 2007), at www.opm .gov/feddata. The U.S. Supreme Court employed 478 people. Included within the Judicial Branch are not only staff for judges and clerks of courts but also probation officers.

**30** 2006 Annual Report of the Federal Judicial Center 3, at Federal Judicial Center, www.fjc.gov.

**31** In 2002, for example, the AO received $61 million and the FJC $20 million from the federal judiciary's budget, which, in turn, was $4.6 billion. See *FY 2003 Budget and the Federal Judiciary*, 35 THIRD BRANCH 2 (March 2003). As of 2006, the FJC reported that it devoted about two-thirds of its budget to education and training, and the rest to research. See 2006 Annual Report of the Federal Judicial Center.

**32** See, for example, Annual Report of the Judicial Conference of the United States, reprinted in the 1924 Attorney General Annual Report Oct. 1–3, 1924, at i (hereinafter JCUS); JCUS Sept. 27–30, 1927, at 6; JCUS Oct. 1–3, 1931, at 4–8.

**33** See, for example, JCUS Oct. 1–3, 1924, at i–ii; JCUS Sept. 27–30, 1927, at 6; 1941 JCUS Sept. 23–26, 1941, at 12; ANNUAL REPORT OF THE DIRECTOR OF THE ADMINISTRATIVE OFFICE OF THE U.S. COURTS FOR 1941 (Washington, DC: U.S. Government Printing Office) at 15–18 (hereinafter 1941 DIRECTOR OF THE AO REPORT). The Director provides annual reports, and citations to them are by year reviewed.

**34** 1941 DIRECTOR OF THE AO REPORT at 15–16; HISTORY OF THE AO at 41.

**35** 1941 DIRECTOR OF THE AO REPORT at 16. An effort to obtain congressional support for a new courthouse for the District of Columbia prompted hearings in 1946 as judges of that court argued that their space was antiquated and inadequate. See *Hearings Held before the Committee on Public Buildings and Grounds on S. 2412*, 79th Cong. (July 11–12, 1946) (declassified).

**36** See HISTORY OF THE AO at 40–41.

**37** See, for example, JCUS Sept. 25–28, 1945, at 18.

**38** See REPORT TO THE JUDICIAL CONFERENCE OF THE COMMITTEE ON POSTWAR BUILDING PLANS FOR QUARTERS FOR THE UNITED STATES COURTS (1946); and JCUS Oct. 1–4, 1946, at 24–25. The Committee stressed that its general guide would be "conducive to a substantial increase in the usefulness and efficiency of the facilities to be provided for the Courts." JCUS Oct. 1–4, 1946, at 25. That manual contained "drawings of typical courtrooms, judges' chambers and court offices, and indications of dimensions and arrangement of facilities in the various rooms." 1947 DIRECTOR OF THE AO REPORT at 41.

**39** JCUS Sept. 22–24, 1949, at 13. The Assistant Postmaster General, who also presented a report, offered to cooperate but noted that the large volume of business made it unlikely that Post Office real estate could be used. Id. at 14.

**40** That proposal had been described in the 1947 Director of the AO Report. See JCUS Sept. 25–27, 1947, at 21. Space demands increased as judicial personnel increased. For example, in 1954 the Conference urged the Buildings Service or the Post Office to find space for "referees in bankruptcy . . . performing a very important judicial function" and needing to be close to judges of the district courts. JCUS Sept. 19–20, 1954, at 15–16.

**41** JCUS Sept. 19–20, 1956, at 16. The Conference reported that such complaints had been made at Senate hearings on appropriations.

**42** JCUS Sept. 22–24, 1952, at 25. As the Director of the AO explained in 1954: "Court rooms are often so situated that it is neces-

sary to keep the windows closed in order to shut out city noises that would make it hard and next to impossible to hear the proceedings." 1954 DIRECTOR OF THE AO REPORT at 63.

**43** JCUS Sept. 22–24, 1952, at 25–26; JCUS Sept. 24–25, 1953, at 28; 1953 DIRECTOR OF THE AO REPORT at 234.

**44** JCUS Sept. 22–24, 1954, at 30; 1954 DIRECTOR OF THE AO REPORT at 63–64; JCUS Sept. 19–20, 1955, at 20–21. Funding continued thereafter. See JCUS Sept. 19–20, 1956, at 29–30, and 1956 DIRECTOR OF THE AO REPORT at 70–72. Air conditioning became part of the depiction of the use of the "Judicial Dollar" in drawings (see fig. 9/119) in 1957. 1957 DIRECTOR OF THE AO REPORT at 144.

**45** 1958 DIRECTOR OF THE AO REPORT at 138.

**46** 1956 DIRECTOR OF THE AO REPORT at 70.

**47** Examples continue through the 1960s under Chief Justice Earl Warren. A 1960 Judicial Conference Report commented on the completion of nine new federal buildings "containing court quarters," seventeen under construction, with eight more in the design stage and fifteen others approved by Congress. See JCUS Sept. 21–23, 1960, at 198–199. Thereafter, when Congress chartered 73 additional judgeships, more "quarters"—courts and chambers—were needed, and the Judicial Conference duly recorded its cooperative work with the GSA to obtain appropriations. See, for example, JCUS March 13–14, Sept. 20–21, 1961, at 120–121, 197. Also detailed were needs for refurbishing, with "items of furniture, carpeting, draperies, etc., out of the regular appropriation designated for this purpose" to be upgraded when these items "had become antiquated." Id. at 197. In 1962, however, the GSA became responsible for providing all furnishings for court facilities. See JCUS March 11–12, Sept. 17–18, 1963, at 161. Another bill in the mid-1960s added 45 additional judgeships, again driving up needs for space. See JCUS March 30–31, Sept. 21–22, 1967, at 151. Further, in 1970 the Administrative Office noted the creation of a new judicial officer—a magistrate—for whom courtrooms and chambers were needed, at a projected cost of $12 million. See JCUS March 16–17, Sept. 29–30, 1970, at 171. In some instances, space was once again leased from state courts. See JCUS March 8–9, Sept. 19–20, 1962, at 163–164.

**48** Many social scientists have tried to model litigation, and others have studied the shifts in the dockets of both state and federal courts that point to a rise in cases involving government regulation (criminal cases included) and a homogenization across jurisdictions over time. For example, one study sampled cases filed from 1895 through 1975 in three federal appellate courts in different parts of the United States. The researchers concluded that while those courts' dockets had once been "dominated by private economic disputes," by the 1970s a large proportion of the caseload involved "government activity . . . essentially noneconomic in character. . . . Policies of the federal government and the problems associated with them now provide the basis for most federal appellate activity." See Lawrence Baum, Sheldon Goldman, & Austin Sarat, *The Evolution of Litigation in the Federal Court of Appeals, 1895–1975*, 16 LAW & SOCIETY REVIEW 291, 306–308 (1981).

**49** U.S. CONST., Amend. VI.

**50** See, for example, *Gideon v. Wainwright*, 372 U.S. 335 (1963); *Ake v. Oklahoma*, 470 U.S. 68 (1985).

**51** See Charles A. Reich, *The New Property*, 73 YALE LAW JOURNAL 733 (1964).

**52** See *Goldberg v. Kelly*, 397 U.S. 254 (1970).

**53** The United States Supreme Court held that states had to waive access fees for a small subset of litigants. See *Boddie v. Connecticut*, 401 U.S. 371 (1971) (requiring fee waivers for indigent persons seeking to obtain a divorce), as limited by *Ortwein v. Schwab*, 410 U.S. 656 (1973), and *United States v. Kras*, 409 U.S. 434 (1973). Statutory provisions can be found at 28 U.S.C. § 1915 (2000), which was narrowed as amended in the Prison Litigation Reform Act, Pub. L. No. 104–134, § 804, 110 Stat. 1321 (1996).

**54** See Legal Services Corporation Act of 1974, Pub. L. No. 93-355, 88 Stat. 378 (codified as amended at 42 U.S.C. §§ 2996 et seq. (2000)) (amended by Pub. L. No. 95-222, 91 Stat. 1619 (1977) (codified at 42 U.S.C. §§ 2996 et seq. (2006)).

**55** See *Lassiter v. Department of Social Services*, 452 U.S. 18 (1981) and *M. L. B. v. S. L. J.*, 519 U.S. 102 (1996).

**56** See generally Judith Resnik, *Money Matters: Judicial Market Interventions Creating Subsidies and Awarding Fees and Costs in Individual and Aggregate Litigation*, 148 U. OF PENNSYLVANIA LAW REVIEW 2119 (2000).

**57** See Fed. R. Civ. Pro. 23 (1966) (subsequently revised). See Owen M. Fiss, *The Political Theory of the Class Action*, 53 WASHINGTON AND LEE LAW REVIEW 21 (1996); Judith Resnik, *From "Cases" to "Litigation,"* 54 LAW & CONTEMPORARY PROBS. 5 (1991); Judith Resnik, Dennis E. Curtis, & Deborah Hensler, *Individuals within the Aggregate: Relationships, Representations, and Fees*, 71 NEW YORK U. LAW REVIEW 296 (1996).

**58** See the Multidistrict Litigation Act, Pub. L. No. 90-296, 82 Stat. 109 (1968) (codified as amended at 28 U.S.C. § 1407 et seq. (2006)).

**59** Between 1955 and 1960, some 90,000 federal cases were filed, dividing roughly as two-thirds civil and one-third criminal. See David Clark, *Adjudication to Administration: A Statistical Analysis of Federal District Courts in the Twentieth Century*, 55 SOUTHERN CALIFORNIA LAW REVIEW 65, 131, Table 16 (1981) (hereinafter Clark, *Adjudication to Administration*). Twenty years later, filings had doubled, again with more civil cases than criminal. Id. at 143, Table 20. By century's end, the number of filings had risen to about 300,000 civil cases and about 60,000 criminal.

**60** The filing data for 1950 and 2001 come from the Administrative Office of the United States Courts that, as noted, became the entity collecting statistics after its inception in 1939. The figures for 1901 are drawn from a two-volume empirical study by the American Law Institute. See A STUDY OF THE BUSINESS OF THE FEDERAL COURTS (Philadelphia, PA: American Law Institute, 1934), at Vol. 1, 107 (Criminal Cases); Vol. 2, 111 (Civil Cases). The ALI statistics comport with those in the 1900 and 1901 Reports of the Attorney General during the era when the Department of Justice was charged with administration of the federal courts. See Exhibit A to the *Annual Report of the Attorney General of the United States for the Year 1900*, U.S. House of Representatives, 56th Cong. 2d Sess. at 66 (1900); Exhibit A to the *Annual Report of the Attorney General of the United States for the Year 1901*, U.S. House of Representatives, 57th Cong., 1st Sess. at 64 (1901).

The numbers for the 1901 filings in figure 109 are extrapolated, as the ALI and the Attorney General reported pending and terminated, rather than filed, cases. The figures for civil and criminal filings for 1901 were derived by subtracting the number of cases pending at the end of 1900 from the sum of the cases terminated in and pending at the end of 1901. That method yielded 16,734 criminal cases (the same number reported by Clark, *Adjudication to Administration* at 103, Table 6) and 11,971 civil cases (or 1,302 fewer civil cases than Clark had reported, id.).

**61** See generally David S. Clark, *Civil and Administrative Courts and Procedure, Supplement to U.S. Law in an Era of Democratization*, 38 AMERICAN JOURNAL OF COMPARATIVE LAW 181 (1990) (hereinafter Clark, *Courts and Procedure*). How much time was devoted to the different kinds of cases is a discrete question answered in administrative terms by a "weighted caseload" measure aiming to capture the distinctions between the many civil filings settled or withdrawn before a federal judge sees a case and the burdens of criminal defendants who must be heard before pleading guilty or being sentenced. The AO began to use "weighted case measures" in 1946 and has refined those metrics several times. Administrative Office of the U.S. Courts, Explanation of Selected Terms, http://www.uscourts.gov/library/fcmstat/cmsexplo5.html. As Clark commented, the federal courts had also restructured to include magistrate judges, thereby reducing the bur-

dens of filings. As we discuss in Chapter 14, the increase predicted by the federal judiciary in filings in their courts for the years between 1995 and 2001 did not occur.

**62** The photograph of the front exterior view of the Grand Forks Federal and Court Building, taken by Steve Silverman, is reproduced in figure 111 with his permission and that of the building's Property Manager Bryan Sayler. Our thanks to The Honorable Celeste Bremer, United States Magistrate Judge, Southern District of Iowa, and Janice Dinkel, Judiciary Regional Account Manager, Public Buildings Service, GSA Rocky Mountain Region, for helping us obtain this image.

Originally called the United States Post Office and Courthouse, the building was designed by Supervising Architect James Knox Taylor. Its Beaux-Arts design resembles several of his other buildings (see, e.g., the Missoula, Montana, Federal Building, United States Post Office and Courthouse, fig. 7/103). The Grand Forks building opened in 1906; an extension designed by Supervising Architect Louis A. Simon was completed in 1937. The GSA explained that the building was to be a "majestic" structure recognizing the "increasing prominence" of Grand Forks as the "agricultural hub of the Red River Valley." U.S. General Services Administration, Ronald N. Davies Federal Building and U.S. Courthouse, http://gsa.gov/Portal/gsa/ep/building View.do?pageTypeId=17109&channelPage=/ep/channel/gsaOverview .jsp&channelId=-25241&bid=228 (hereinafter GSA website, Historic Buildings, Ronald N. Davies Courthouse). In 1964, the Post Office moved out and, in 2002, the building was renamed after Ronald Davies, who had been appointed to a district court judgeship there by President Dwight D. Eisenhower in the 1950s.

**63** GSA website, Historic Buildings, Ronald N. Davies Courthouse. The courtroom has a twenty-four-foot coffered ceiling. Other interior "public spaces are monumental in scale and classical in detail." The lobby has a sixteen-foot ceiling and a central marble staircase. Id.

**64** See Clark at 86–88, Table 2. In 1960, 4992 employees worked for the federal judiciary.

**65** William G. Young, *An Open Letter to U.S. District Judges*, FEDERAL LAWYER 30, 33 (July 2003).

**66** THOMAS F. EAGLETON UNITED STATES COURTHOUSE, ST. LOUIS, MISSOURI 18 (Washington, DC: GSA, 2001) (hereinafter GSA EAGLETON COURTHOUSE BOOKLET). See also U.S. General Services Administration, Thomas F. Eagleton U.S. Courthouse, http://www.gsa.gov/ Portal/gsa/ep/contentView.do?contentType=GSA_BASIC&content Id=15847&noc=T (hereinafter GSA website, Regional Buildings, Thomas F. Eagleton U.S. Courthouse). United States Magistrate Judge David D. Noce for the Eastern District of Missouri provided the photograph of the Thomas F. Eagleton U.S. Courthouse that is reproduced with his permission in figure 112 and gave us additional information on the building.

**67** GSA EAGLETON COURTHOUSE BOOKLET at 12. The GSA website specifies that the Eagleton building is the largest single federal courthouse. The Southern District of New York has two courthouse buildings within blocks of each other—raising questions about how to calculate size. The Eagleton Building is the third-tallest in St. Louis, designed to avoid being taller than the city's symbol, the Gateway Arch.

**68** See City of St. Louis Development Activity, Eagleton Federal Courthouse, http://stlcin.missouri.org/devprojects/projinfo.cfm?Dev ProjectID=47; Randy Gragg, *Monuments to a Crime-Fearing Age*, NEW YORK TIMES MAGAZINE at 36. Turning from federal to state facilities, a 2001 courthouse for the Brooklyn Supreme and Family Courts houses more than eighty courtrooms in more than 1.1 million square feet; that structure is thirty-two stories and 473 feet tall, making it the largest courthouse in the state of New York. See Brooklyn Supreme and Family Courthouse, Design Build Network, http://www.design build-network.com/projects/brooklyn-supreme.

**69** "In order to avoid the potential for perceptions of bias or conflict of interest," in 1999 the Judicial Conference opposed "naming a courthouse or other federal building" after retired judges practicing

law. See JCUS Sept. 15, 1999, at 75. In 2007 the Conference set forth the following conventions: that a facility solely occupied by a court be called a United States Courthouse; that a "multi-tenant" courthouse be denominated "United States Courthouse and Federal Building" or "United States Courthouse and Post Office" and that, if named after a judge, only the proper name be used and not titles such as "Honorable" or "Judge." JCUS March 13, 2007, at 32. As noted, GSA had long been authorized to name buildings. Public Law No. 85-542 stated that the Administrator of General Services could do so "regardless of whether it was previously named by statute." 72 Stat. 399, 399 (1958) (codified as amended at 40 U.S.C. § 3102 (2006)). See also Pub. L. No. 81-105, ch. 218, § 410, 63 Stat. 176, 200 (1949), discussed in Chapter 7.

**70** Quoted is Gyo Obata, one of the founding partners of Hellmuth, Obata + Kassabaum, in GSA EAGLETON COURTHOUSE BOOKLET at 3. See Linda Tucci, *Courthouse Design Gaining Respect as Completion Nears*, ST. LOUIS BUSINESS JOURNAL (Oct. 26, 1998).

**71** GSA EAGLETON COURTHOUSE BOOKLET at 5.

**72** The inscriptions also include the sources and their dates, stating that "The Place of Justice is a Hallowed Place" comes from "Francis Bacon 1561–1626" and "The Administration of Justice is a Firm Pillar of Government" from "George Washington 1732–1799."

**73** "The government for security reasons wanted courtrooms without windows. The local judges wanted daylight in the courtrooms." Tucci, quoting Obata. See also GSA EAGLETON COURTHOUSE BOOKLET at 11.

**74** The federal courts within the Eighth Circuit sit in Arkansas, Iowa, Minnesota, Missouri, Nebraska, North Dakota, and South Dakota. The Eastern District of Missouri holds court in St. Louis and elsewhere. See 28 U.S.C. §§ 48, 105(a).

**75** GSA EAGLETON COURTHOUSE BOOKLET at 24.

**76** GSA EAGLETON COURTHOUSE BOOKLET at 22.

**77** GSA EAGLETON COURTHOUSE BOOKLET at 22.

**78** One, named for a former district judge (the Clyde S. Cahill Memorial Park), is across the street from the east-side main entrance of the building on Tenth Street. The other, designed by Valerie Jaudon, was named the Filippine Garden after a former chief district judge (Edward L. Filippine) who had been involved in the design and building of the courthouse. GSA files describe the Filippine Garden as echoing "the symmetry, geometry, and proportions" of the courthouse. See GSA Archives, Art-in-Architecture 458, Untitled Garden, Valerie Jaudon. Our thanks to Magistrate Judge Noce for providing us with information on these installations.

**79** Our thanks to the Honorable Douglas P. Woodlock, United States District Judge of the District of Massachusetts, for assistance in obtaining the photographs of the Boston Courthouse, including figure 113, a picture taken by Steve Rosenthal and reproduced with permission.

**80** Douglas P. Woodlock, *Drawing Meaning from the Heart of the Courthouse*, in CELEBRATING THE COURTHOUSE at 155, 156 (hereinafter Woodlock, *Heart of the Courthouse*). See also Douglas P. Woodlock, *The "Peculiar Embarrassment": An Architectural History of the Federal Courts in Massachusetts*, 74 MASSACHUSETTS LAW REVIEW 268, 268–278 (1989); Douglas P. Woodlock, Lecture: The New Federal Courthouse in Boston (1995) (unpublished manuscript).

**81** Woodlock, *Heart of the Courthouse* at 157–158.

**82** Woodlock, *Heart of the Courthouse* at 165.

**83** Woodlock, *Heart of the Courthouse* at 158.

**84** Woodlock, *Heart of the Courthouse* at 160–161, 158.

**85** Woodlock, *Heart of the Courthouse* at 161. Woodlock's response was that a courthouse needed to focus on the processional area that constituted the entryway, the movement to and entry into courtrooms, and the courtrooms themselves, in which (it should be plain) the government gave individual attention to its citizens. Justice Breyer and Judge Woodlock described the "most arresting moment" of the selection process as when Henry Cobb, the architect chosen, proffered

a photograph of a 1735 courthouse in Virginia. "This, he told us, was the sensibility to which he would aspire if selected to design the building." Stephen Breyer & Douglas P. Woodlock, *The Past as Prologue*, in John Joseph Moakley United States Courthouse and Harbor Park 26 (Washington, DC: GSA, 2003) (hereinafter GSA Boston Courthouse). Their essay cited other courthouses as well as providing precedents on which they relied.

**86** Henry N. Cobb in Vision + Voice: Design Excellence in Federal Architecture, Building a Legacy, 33, 34 (Washington, DC: U.S. General Services Administration, Public Buildings Service, Office of the Chief Architect 2002) (hereinafter I Vision + Voice). Vision + Voice is a series of three volumes with slightly different titles. The second and third volumes, both published in 2004, are Vision + Voice, vol. 2: Changing the Course of Federal Architecture, and Vision + Voice, vol. 3: Changing the Course of Federal Architecture (Washington, DC: U.S. General Services Administration, Public Buildings Service, Office of the Chief Architect 2004) (hereinafter, II Vision + Voice, and III Vision + Voice).

**87** See Cobb in I Voice + Vision at 34.

**88** Moakley served in the U.S. House of Representatives from 1973 until he died in 2001. He helped to secure federal funds "to implement his vision of Boston with a clean harbor, renewed transportation system, and revitalized waterfront." GSA Boston Courthouse at 39. Cobb is one of the founders of the firm of Pei Cobb Freed & Partners, based in New York. Id. at 40. Ellsworth Kelly, "one of America's most respected artists of the post-war era" (id.), is discussed in Chapter 6.

**89** "It's been called everything from overpriced to an outright 'fleecing of America.' . . . The good news is that, price aside, the building is nothing short of spectacular." See Meghan S. Laska, *The New Federal Courthouse: Dazzling Architecture and Features Friendly to Lawyers and the Public Highlight This 'People's Court'*, 26 Massachusetts Lawyers Weekly B1, B12–13 (May 25, 1998).

**90** GSA Boston Courthouse at 7.

**91** GSA Boston Courthouse at 6.

**92** GSA Boston Courthouse at 6.

**93** Paul Spencer Byard, *Reading the Architecture of Today's Courthouse*, in Celebrating the Courthouse 133 at 150 (hereinafter Byard, *Reading the Architecture*).

**94** GSA Boston Courthouse at 7.

**95** GSA Boston Courthouse at 8.

**96** GSA Boston Courthouse at 13.

**97** See Discovering Justice: The James D. St. Clair Court Education Project (Nov. 2008). This monthly newsletter details the programs such as visits by school children and mock trials. See http://www.discoveringjustice.org.

**98** GSA Boston Courthouse at 14. Included are quotes from "John and Abigail Adams, Lelia Josephine Robinson, Frederick Douglass, Oliver Wendell Holmes, Louis D. Brandeis, and John F. Kennedy." Id. at 14. "The quotes speak of unalienable rights and self-evident truths . . . [and] reflect on the balance of power and on the morality of government." Id. All are written in English, although the building is the home of the First Circuit, with jurisdiction over Puerto Rico as well as Maine, New Hampshire, Rhode Island, and Massachusetts.

**99** GSA Boston Courthouse at 14.

**100** See Stephen G. Breyer, *Foreword* to Celebrating the Courthouse at 11. See also Woodlock, *Heart of the Courthouse* at 158.

**101** When it opened, Union Station claimed to be the largest train station in the world and provided a dramatic gateway to the capital in the classic Beaux-Arts style. See http://www.unionstationdc.com/history.aspx for a history of the station.

**102** The legislation authorizing the Marshall Building required that it "be designed in harmony with historical and Government buildings in the vicinity." See 40 U.S.C. § 6502 (2006). A detailed account of the project is provided in George M. White, Final Report of the Architect of the Capitol to the Commission

for the Judiciary Office Building, The Design and Construction of the Thurgood Marshall Federal Judiciary Building (Washington, DC: U.S. Government Printing Office, 1994) (hereinafter Report on the Marshall Building). Responsibility for the building falls under the aegis of the Architect of the Capitol, responsible for the Capitol Hill complex. The photograph reproduced in figure 114 was provided courtesy of the Federal Judicial Center and with the thoughtful assistance of Steven G. Saltzgiver, Research Historian.

**103** History of the AO at 137.

**104** Winkle at 46. Winkle noted that Mecham had been an experienced lobbyist, working as "a Washington representative for the Atlantic Richfield Company" before being appointed to direct the AO. Id. Mecham, the sixth person to serve as the Director of the AO, was appointed in 1985 under the tenure of Chief Justice Warren Burger, by a committee on which Associate Justices Byron White and William Rehnquist served. History of the AO at 115.

**105** History of the AO at 22.

**106** By 1942 the AO had a staff of 104 persons, up from 96 the year before. See 1942 Director of the AO Report at 3. Under the tenure of Acting Director William Ellis, most of the staff were moved from the Supreme Court to offices in a GSA building. Id. at 44. See also 1957 Director of the AO Report at 291. Background on the early years of the AO can be found at James M. Collier, *Fiscal Housekeeping in the Federal Courts*, 1 Western Political Quarterly 400, 401 (1948). Additional discussions of the administrative apparatus can be found in Russell R. Wheeler, A New Judge's Introduction to Federal Judicial Administration (Washington, DC: Federal Judicial Center, 2003); Russell R. Wheeler & Cynthia Harrison, Creating the Federal Judicial System (Washington, DC: Federal Judicial Center, 2nd ed., 1994).

**107** See *The Dolley Madison House* (a brochure provided to us by Steven Saltzgiver, Federal Judicial Center historian, hereinafter *Dolley Madison FJC Brochure*). James Madison lent the money for the construction and, after financial reversals for its builder, who died, Dolley Madison became the owner of the house. See the National Parks Service website, http://www.nps.gov/history/history/online_books/presidents/site6.htm. The Cosmos Club bought the building in 1886, sold it in 1940 to the federal government, then leased and used it until 1952. During the 1950s and 1960s, the building was occupied by other federal agencies before becoming the home of the Federal Judicial Center in 1968. Figure 115 is provided courtesy of the Administrative Office of the United States Courts.

**108** *Dolley Madison FJC Brochure* at 1.

**109** Report on the Marshall Building at 4–5. A 1986 report of the Ad Hoc Advisory Committee of Judges on the Administrative Office also called for a single building. See History of the AO at 118.

**110** See JCUS March 14, Sept. 20, 1989, at 158; 1989 Director of the AO Report at 49. As the discussion noted, the project, "begun in the early 1970s by former Chief Justice Warren Burger," aspired to be "monumental." 1989 Director of the AO Report at 49. See also *10th Anniversary of Federal Judiciary Building*, in 34 The Third Branch, Newsletter of the Federal Courts at 4 (Oct. 2002).

According to the Architect of the Capitol, what was "unprecedented" was the procurement of proposals from teams of architects and developers. Report on the Marshall Building at 8. Legislative authority for the building provides for the building and improvements to revert to federal government ownership within thirty years of the leasing agreement. The land remains at all times in the ownership of the government, which pays rent to the private owners. See Judiciary Office Building Development Act, Pub. L. No. 100-480, 102 Stat. 2328 (1988).

This form of ownership is neither novel nor unique to the Marshall Judiciary Building. Congress has provided for the GSA to construct buildings through other such lease-purchase contracts that rely on

private capital. The government makes installment payments that result in federal ownership at the end of the contract. See Clay H. Wellborn, Congressional Research Services, General Services Administration Prospectus Thresholds for Owned and Leased Federal Facilities, August 20, 2008 (RS22287) at 2. Another such partnership produced $1.5 billion for post office buildings, "financed entirely by private investors." Antoinette Lee, Architects to the Nation: The Rise and Decline of the Supervising Architect's Office 290 (New York, NY: Oxford U. Press, 2000). See generally Report on the Marshall Building at 7–11.

**111** See Act of Oct. 7, 1988, Pub. L. No. 100-480, § 3, 102 Stat. 2328, 2329; Report on the Marshall Building at 6–7. Membership included seven senators, five members of the House, and two judges.

**112** Barnes also designed the Walker Art Gallery in Minneapolis and the Dallas Museum of Art. In 2007 the AIA posthumously awarded Barnes its "highest honor" in recognition of the significant work he had done. In doing so, the AIA described his work as "crisp, geometric buildings in both rural and urban landscapes that didn't call attention to themselves, much like the architect himself." See Edward Larrabee Barnes, FAIA, Selected for the 2007 AIA Gold Medal, 13 AIA, The News of America's Community of Architects, http://info.aia.org/aiarchitect/thisweek06/1208/1208n_gold.cfm.

**113** Report on the Marshall Building at 3.

**114** Report on the Marshall Building at 2.

**115** Report on the Marshall Building at 1, n. 1.

**116** Congress did so after Marshall's death. See An Act To Designate the Federal Judiciary Building in Washington, D.C., as the "Thurgood Marshall Federal Judiciary Building," Pub. L. No. 103-104, 107 Stat. 30 (1993) (codified as amended at 40 U.S.C. § 6502 (2006)). The building was to provide chambers for retired Supreme Court justices but justices had not, as of that date, moved in. Gregory Cerio and Lucy Howard, *Ironic Honor*, Newsweek, vol. 121 at 6 (Feb. 8, 1993). Thereafter, retired Justices Byron White and Harry Blackmun used the space provided. History of the AO at 138.

**117** Facilities Management of the Thurgood Marshall Federal Judiciary Building, Washington, D.C., http://www.fbodaily.com/archive/2006/03-March/12-Mar-2006/FBO-01003752.htm. Rentable areas total about 600,000 square feet, and the building can house 2,300 people. As of 1994, 90 percent of the space was used by "Judiciary agency tenants" and by the chambers available to retired Supreme Court Justices. Insufficient space was available for "private-sector tenants." See Report on the Marshall Building at 1–3, 9. Consistent with the shared uses Congress authorized in the 1970s (discussed later), the building also has a cafeteria, a fitness center, credit union services, libraries, and conference facilities. See also 1993 Report of the Director of the AO at 42.

**118** Federal Judiciary Marks Building Milestone, press release, Administrative Office of the U.S. Courts, http://www.uscourts.gov/Press_Releases/tmfjb10y.html.

**119** See History of the AO at 87–88, 105–107, 113–114.

**120** At times Congress created ad hoc committees to garner expertise. See Sue A. Kohler, The Commission of Fine Arts: A Brief History, 1910–1976 (Washington, DC: U.S. Government Printing Office, 1977).

**121** Kohler at 1. The official name for the Chicago World's Fair was "A Century of Progress."

**122** The membership of the Commission, sometimes nicknamed after its sponsor Senator James McMillan of Michigan, included the architects Daniel H. Burnham and Charles F. McKim, landscape architect Frederick Law Olmsted, and the sculptor and coin designer Augustus Saint-Gaudens. Art and Government: Report to the President by the Commission of Fine Arts 9 (Washington, DC: U.S. Government Printing Office, 1953) (hereinafter 1953 Commission on Fine Arts Report). The AIA was deeply involved in bringing the Senate Commission into being, and doing so helped the AIA develop its own national professional reputation. See William Brian Bushong, Glenn Brown, the American Institute of Architects, and the Development of the Civic Core of Washington, D.C., at 3, 112–118 (Ph.D. dissertation, George Washington U., 1988; UMI No.: AAT 8815950).

Brown founded the Washington Chapter of the AIA in 1887, facilitated the move of the headquarters of that organization from New York to Washington in 1898, and lobbied against the Supervising Architect's Office and for the arts. Id. at 78–95. He then served as the Secretary of the AIA through 1913. Under his leadership the AIA expanded its membership from about four hundred architects in the late 1890s to more than seven hundred by 1901. He also helped create the "architect-dominated" Senate planning commission. Id. at 118–125. Over time, the AIA was able to overtake its rival, the Architectural League, and become the central professional organization for architects. Id. at 106–108. See also Lois Craig, The Federal Presence: Architecture, Politics and Symbols in United States Government Building 252–253 (Cambridge, MA: MIT Press, 1978).

**123** See An Act Establishing a Commission of Fine Arts, Pub. L. No. 61-181, 36 Stat. 371 (1910) (codified as amended at 40 U.S.C. §§ 9101–9104 (2006)). A brief-lived predecessor was a thirty-person Council of Fine Arts, convened by President Theodore Roosevelt in 1909 through an executive order. A history written about the 1910 Commission explained that Taft wanted an arts commission to be chartered by Congress rather than only through executive action. Kohler at 3.

**124** See George Gurney, Sculpture and the Federal Triangle 40 (Washington, DC: Smithsonian Institution Press, 1985).

**125** An Act Establishing a Commission of Fine Arts, Pub. L. No. 61-181, 36 Stat. 371.

**126** Kohler at 5. Union Station in Washington, D.C. is next to the Thurgood Marshall Judiciary Building. Burnham had also served on the Senate's Park Commission, as had Frederick Law Olmsted Jr., the architect Thomas Hastings, the sculptor Daniel Chester French, the painter Francis D. Millet, and Charles Moore, who had worked with Senator James McMillan, the sponsor of the Senate's Park Commission. Id.

**127** The 1910 Act had provided only for the Commission to provide advice on the siting of monuments and fountains. In October 1910, President William Howard Taft expanded the mandate to include giving advice on buildings in the District of Columbia. In 1930, in the Shipstead-Luce Act (Pub. L. No. 71-231, 46 Stat. 366 (codified as amended at 40 U.S.C. § 8104 (2006)), and in 1950, in the Old Georgetown Act (Pub. L. No. 81-808, 64 Stat. 903), the Commission gained the authority to regulate height and design features in Washington. The Commission was thus involved in approving projects such as the headquarters of the AIA and the Kennedy Center. See Kohler at 74–80. The Commission also was given a role in advising on park planning in the surrounding areas. The legislative and executive orders governing the commission are set forth in Kohler at 105–110, and its statutory authority is now found at 40 U.S.C. § 8104 (2006) ("Regulation of private and semipublic buildings adjacent to public buildings and grounds").

**128** Charles H. Atherton in I Vision + Voice at 13. As of the 1970s, the Commission reviewed between four and five hundred submissions each year. Kohler at 7.

**129** See 40 U.S.C. § 8104; U.S. Commission of Fine Arts, http://www.cfa.gov/.

**130** Steven J. Tepper, *Unfamiliar Objects in Familiar Places: The Public Response to Art-in-Architecture*, 6 International Journal of Cultural Policy 283, 284 (2000).

**131** See generally Sara Amelia Butler, Constructing New Deal America: Public Art and Architecture and Institutional Legitimacy (Ph.D. dissertation, Department of Architectural History, U. of Virginia, 2001: UMI No.: AAT 3020331). Butler attributed some of the conflict to the differing histories of the Office of the Supervising Architect, rooted in its nineteenth-century beginnings and by the

1930s a "well-oiled machine for producing federal architecture" (id. at 33), and the Section on Fine Arts, which was "a child of the New Deal." Id. at 4. Butler's conclusion was that, despite a "cooperative public face," significant conflicts about authority existed between the Office of the Architect and the Section on Fine Arts. Id. at 23–26.

**132** John Wetenhall, *Camelot's Legacy to Public Art: Aesthetic Ideology in the New Frontier*, 48 ART JOURNAL 303, 303–304 (1989).

**133** 1953 COMMISSION ON FINE ARTS REPORT at 5. The Preface to that report also noted that the Commission had been asked to "survey . . . activities carried on by the Federal Government in the field of art" but had been given no budget for witnesses to travel, so it relied on those proximate to Washington. Id. at 1. Committee member George Biddle, who had been pivotal in funding New Deal art and was himself a noted muralist (as discussed in Chapters 6 and 15), dissented in part. While agreeing that all art endeavors should not be centralized in a single bureau, he recommended that the Commission on Fine Arts be given a full-time staff including persons distinguished "in the fields of painting and sculpture," that leaders of major museums be appointed to join the Commission, and that the GSA and other federal agencies be required to consult the Commission and take its recommendations into account. Id. at 29–31.

**134** 1953 COMMISSION ON FINE ARTS REPORT at 18.

**135** 1953 COMMISSION ON FINE ARTS REPORT at 18.

**136** 1953 COMMISSION ON FINE ARTS REPORT at 20–28.

**137** LEE at 290–291.

**138** Wetenhall at 304.

**139** Goldberg had served as general counsel for the Congress of Industrial Organizations (the CIO and later the AFL-CIO). He became Kennedy's Secretary of Labor in 1961 and was then appointed in 1962 to the Supreme Court. He stepped down in 1965 when President Lyndon Baines Johnson asked him to become the United States Ambassador to the United Nations; he held that post until 1968. He served a decade later as the United States Ambassador to the Belgrade Conference on Human Rights in 1978. He died in 1990. See generally DAVID L. STEBENNE, ARTHUR J. GOLDBERG: NEW DEAL LIBERAL (New York, NY: Oxford U. Press, 1996).

**140** Moynihan, a professor of sociology, focused on urban studies at Harvard. He served as an assistant to Arthur Goldberg from 1961 to 1962. From 1973 to 1974 he was the United States Ambassador to India. In 1976, New Yorkers elected Moynihan to the Senate, where he served until 2001. He died in 2003. Much praised for a good many projects, Moynihan was also a controversial policymaker whose arguments in the 1980s about the problematic structure of inner-city families gained him many critics. See Nathan Glazer, Daniel Patrick Moynihan and Federal Architecture, in CELEBRATING THE COURTHOUSE at 225–231; Jeffrey O'Connell & Richard F. Bland, *Moynihan's Legacy*, 142 PUBLIC INTEREST 95 (2001). See generally DANIEL PATRICK MOYNIHAN: THE INTELLECTUAL IN PUBLIC LIFE (Robert Katzmann, ed., Baltimore, MD: Johns Hopkins U. Press, 1998).

**141** See, for example, I VISION + VOICE. As noted, the GSA published two more volumes titled *Vision + Voice*, which include commentary and reflections from various participants (including architects, members of selection panels, and administrators) in the GSA programs. Published four decades after "Moynihan wrote the 'Guiding Principles for Federal Architecture,'" the set credits his work with changing "the course of public architecture in our nation." Id., Preface by F. Joseph Moravec, Commissioner, Public Buildings Service. Volumes II and III, both titled "Changing the Course of Federal Architecture," were published in 2004.

**142** The "Guiding Principles for Federal Architecture" are reproduced in I VISION + VOICE at 4–5 (hereinafter Guiding Principles, I VISION + VOICE). The introductory four paragraphs of commentary to the three numbered principles overlap in several respects with the Principles themselves. Further, each of the three Principles is set forth in several paragraphs detailing various precepts.

**143** As for the gestalt that produced the Guiding Principles, Wetenhall cited many influences including the publication of Jane Jacobs' *Death and Life of Great American Cities* in 1961. Wetenhall at 304–305. In commentary forty years later, Moynihan commented about the need to create "great moments in architecture," and he added that the Seagram Building, designed by Mies van der Rohe, had opened in the early 1960s and was one of the "best." Daniel Patrick Moynihan, quoted in I VISION + VOICE at 9, 10.

**144** The introductory comments noted that the "belief that good design is optional or in some way separate from the question of the provision of office space itself does not bear scrutiny, and in fact invites the least efficient use of public money." See "Guiding Principles," I VISION + VOICE at 4. See also Wetenhall at 305.

**145** Guiding Principles, I VISION + VOICE at 4. As detailed later, in the 1990s, the GSA reiterated this approach by using identical wording about its aspirations for the selection of art. See GSA, Public Buildings Service Commissioner Kenneth R. Kimbrough, Memorandum for Regional Administrators, Revised Art-in-Architecture Procedures, Feb. 10, 1995, at 2.

**146** See Thomas Walton, Art in Architecture Workshop: Models and Themes (draft), Oct. 15, 1996, GSA/AiA Archives. Walton, Associate Dean of the School of Architecture and Planning at Catholic University of America, reported on a workshop convened to reconsider GSA art selection processes and results.

**147** Guiding Principles, I VISION + VOICE at 5; Wetenhall at 304.

**148** Guiding Principles, I VISION + VOICE at 5.

**149** Guiding Principles, I VISION + VOICE at 5.

**150** Robert A. Peck, in I VISION + VOICE at 19, 20 (citing Moynihan's 1960 article *New Roads and Urban Chaos*).

**151** Guiding Principles, I VISION + VOICE at 5.

**152** Guiding Principles, I VISION + VOICE at 5 .

**153** The Tarsney Act, authorizing the use of private architects for public buildings, is discussed in Chapter 7.

**154** Guiding Principles, I VISION + VOICE at 5. See also Wetenhall at 305; GROWTH, EFFICIENCY AND MODERNISM: GSA BUILDINGS OF THE 1950S, 60S, AND 70S at 44 (Washington, DC: U.S. General Services Administration, 2006) (hereinafter GSA MODERNISM).

**155** Guiding Principles, I VISION + VOICE at 5.

**156** Glazer, *Moynihan and Federal Architecture* at 229–230.

**157** Glazer, *Moynihan and Federal Architecture* at 229.

**158** Glazer, *Moynihan and Federal Architecture* at 230–231.

**159** GSA MODERNISM at 45. Under Lyndon B. Johnson and the "Program for Beautification of Federal Buildings," landscaping did improve. Id. at 48.

**160** Heckscher had been an editorial writer on the *New York Herald Tribune*, and after his time in Washington, he served during the 1970s in New York City as its Park Commissioner and as its Administrator of Cultural Affairs.

**161** Wetenhall at 305–306.

**162** After President Kennedy was assassinated, Congress enacted the National Arts and Cultural Development Act of 1964 (Pub. L. No. 88-579, 78 Stat. 905), followed in 1965 by the National Foundation on the Arts (NFA) and the Humanities Act of 1965 (Pub. L. No. 89-209, 79 Stat. 845, codified as amended at 20 U.S.C. § 951 et seq.), which created the NFA. See Wetenhall at 307; Margaret Jane Wyszomirski, *Congress, Presidents, and the Arts: Collaboration and Struggle*, 499 ANNALS OF THE AMERICAN ACADEMY OF POLITICAL AND SOCIAL SCIENCE 124–135 (1988); National Endowment for the Arts, 1965/2000: *A Brief Chronology of Federal Support for the Arts*, http://www.arts.gov/about/ Chronology/NEAChronWeb.pdf, 9–11. The initial appropriation provided a budget of $2.5 million. By 1983 the budget was more than $143 million, but by 2000 it had been cut to about $98 million. Id. at 36, 62.

**163** See Bill N. Lacy, *Introduction* to CRAIG (hereinafter Lacy, *Introduction*). From 1971 to 1976 Lacy served as the Director of the Architecture + Environmental Arts Program, National Endowment

for the Arts. He later served as executive director of the Pritzker Architecture Prize Committee.

**164** The NEA was asked "to review and expand the Guiding Principles for Federal Architecture." See FEDERAL ARCHITECTURE: MULTIPLE-USE FACILITIES: STAFF REPORT FOR THE FEDERAL ARCHITECTURE PROJECT at 1 (Washington, DC: National Endowment for the Arts, November 1974) (hereinafter NEA MULTIPLE-USE FACILITIES).

**165** Lacy, *Introduction.*

**166** CRAIG at 441. That phenomenon was not new; many a Neoclassical Beaux-Arts bank looked like federal courthouses in that style.

**167** See FEDERAL ARCHITECTURE: A FRAMEWORK FOR DEBATE: AN INTERIM REPORT OF THE FEDERAL ARCHITECTURE PROJECT (Washington, DC: National Endowment for the Arts, April 1974). That report came from a group of fifteen who had "special interest or training in architecture and related design fields." See NEA MULTIPLE-USE FACILITIES at 1.

**168** Bill Lacy, in I VISION + VOICE at 23–24. He called the initiation of an award program "very audacious and highly naive on our part." Id. at 23. Lacy also noted that finding appropriate recipients for the awards was initially daunting. Id. at 24.

**169** See *Introduction* in II VISION + VOICE. "Reviving the program is an 'important milestone,' observed agency head Richard Austin," as awards went to seven restorations of federal buildings, and two went to visual artists for commissioned AiA works. Benjamin Forgey, *GSA Honors 18 Designs*, WASHINGTON POST, Nov. 30, 1990, at F1. "Citations" were given for energy conservation and other engineering elements. Id. at F8. In 2000, the GSA put out a monograph on that year's winners, and it also commemorated the tenth anniversary of the inception of the award program. By then, three new buildings—courthouses designed by Harry Campbell for Las Vegas, Nevada, and by Richard Meier for Phoenix, Arizona, and Central Islip, New York, received awards; Diana Moore's *Urns of Justice* for the Lafayette, Louisiana, courthouse also received a citation. See U.S. General Services Administration, *Design Awards: 2000 Award Winners*, http://www.gsa.gov/graphics/pbs/DABook2000lo.pdf, 4–5, 9–13, 27.

**170** Or, as the GSA would later describe them, the styles then in vogue were "international," "formalism," "brutalism," or "expressionism." GSA MODERNISM at 14–15.

**171** The Need for Architectural Improvement in the Design of Federal Buildings, Hearing Before the Subcomm. on Buildings and Grounds of the S. Comm. on Public Works, 95th Cong. (1977) (hereinafter 1977 Architectural Improvement Hearing). One issue was how the GSA had complied with its statutory mandate to give consideration to excellence in design. Id. at 43. Senator Robert Stafford asked the GSA whether legislation was needed "to encourage better architectural style for Federal buildings." Id. at 31. The GSA responded that such an effort could not be legislated but that the agency had improved its procedures to focus on excellent design and architecture. Id. at 32–33.

**172** 1977 Architectural Improvement Hearing at 34 (Statement of John McGinty, President, AIA).

**173** 1977 Architectural Improvement Hearing at 68–74 (Statement of Roy F. Knight, Acting Director, Architecture + Environmental Arts Program, NEA). Knight noted that both "critics and professionals alike" view many of the buildings of the last twenty-five years as "rather sterile in appearance and unfriendly in image." Id. at 71.

**174** GSA MODERNISM at 93.

**175** NEA, MULTIPLE-USE FACILITIES at 5. Further, federal building contributed to deserted streets after working hours. Id. at 6.

**176** See Pub. L. No. 94-541, 90 Stat. 2505 (1976), codified as amended at 40 U.S.C. §§ 3306 et seq. (2006). The act imposed on the administrator of the Public Buildings Service the obligation to "encourage the location of commercial, cultural, educational, and recreational facilities and activities in public buildings" (id. at section

102(a)(2)) as well as to "acquire and utilize space in suitable buildings of historical architectural, or cultural significance" (id. at 102(a)(1)).

**177** See Lacy, *Introduction.*

**178** GSA MODERNISM at 58. The legislation was also responsive to the opinion of the GSA General Counsel that, absent new legislation, the agency lacked legal authority to rent space for other uses. See NEA MULTIPLE-USE FACILITIES at 19–21. The NEA argued instead that an Executive Order would have sufficed. Id. at 61.

**179** See *The Feds: General Services Administration Puts New Emphasis on the Arts, Mixed Use in Public Buildings*, AIA JOURNAL, Mid-May 1978, at 34.

**180** CRAIG at 441.

**181** I VISION + VOICE at 75.

**182** National Environmental Policy Act of 1969, Pub. L. No. 91-190, 83 Stat. 852 (1970) (codified as amended at 42 U.S.C. §§ 4331 et seq. (2006)).

**183** GSA MODERNISM at 11.

**184** GSA MODERNISM at 49–51.

**185** Guiding Principles, I VISION + VOICE at 5.

**186** Architectural Barriers Act of 1968, Pub. L. No. 90-480, 82 Stat. 718, 719 (codified at 42 U.S.C. §§ 4151 et seq. (2006)).

**187** Architectural Barriers Act of 1968 at §§ 2–5.

**188** The Americans with Disabilities Act of 1990, Pub. L. No. 101-336, 104 Stat. 337, provided in Title II (codified at 42 U.S.C. §§ 12131–12165) that "no qualified individual with a disability shall, by reason of such disability, be excluded from participation in or be denied the benefits of services, programs or activities of a public entity, or be subjected to discrimination by any such entity." 42 U.S.C. § 12132.

**189** *Judicial Council of California, Public Hearings Report: Access for Persons with Disabilities*, sect. 2 at 1 (Executive Summary) (January, 1997), http://www.courtinfo.ca.gov/programs/access/documents/dis_hear.pdf.

**190** See *Summary of Survey and Public Hearing Reports of the Access for Persons with Disabilities, Subcomm. of the California Judicial Council's Access and Fairness Advisory Comm.* 18, 19–20 (Jan. 1997). http://www.courtinfo.ca.gov/reference/documents/summarydisabilities.pdf.

**191** *Tennessee v. Lane*, 541 U.S. 509 (2004). The legal question was whether the doctrine of sovereign immunity, embodied to some (contested) extent in the Eleventh Amendment of the United States Constitution, limited the power of Congress to authorize lawsuits against states for damages when the ADA was violated. In a five-to-four decision, with Justice Stevens writing for the majority, the Court upheld Congress's power to do so. Justice Souter, joined by Justice Ginsburg, concurred, explaining that courts had been in the business of perpetuating discrimination on the basis of handicap. Id. at 534. Chief Justice William Rehnquist, joined by Justices Kennedy and Thomas, filed a dissent to argue that Congress lacked the power to subject states to monetary damages for the violations. Id. at 538. Justices Scalia and Thomas each explained their further disagreements with the majority in separate dissents. Id. at 554 (Scalia, J., dissenting) and at 565 (Thomas, J., dissenting).

**192** 541 U.S. at 514.

**193** See, for example, Linda Greenhouse, *Dispute Heard on States' Duties under Disabilities Act*, NEW YORK TIMES, Jan. 14, 2004, at A16. For a period of time, the National Organization on Disability provided at its website several images of the "Tennessee v. Lane Disability Rights Public Action and Press Conference," http://www.nod.org/tennvlane/tennvlane.htm (Jan. 13, 2004). As it explained, the "crawlers were videotaped but not arrested." Figure 116, showing the demonstration, is provided by the Associated Press and used with its permission and that of photographer Gerald Herbert; the photograph was published in conjunction with the story "Court to Rule on Protections for Disabled," which ran in various newspapers on January 13

or 14, 2004. Our thanks to Brewster Thackeray, who also photographed this scene, and to Chai Feldblum, Mary Dolan, and Emily Teplin for helping us to locate photographs of the demonstration.

**194** 541 U.S. at 532. After the decision was issued, one lawyer who was herself "in a power wheelchair" lamented the narrowness of the ruling, which had not addressed impaired access to a range of state services. See Harriet McBryde Johnson, *Stairway to Justice*, NEW YORK TIMES MAGAZINE, May 30, 2004, at 11. Accompanying her essay was a photograph by Zigy Kaluzny of an individual in a wheelchair attempting to scale a long, high staircase to an indeterminate site. "For many decades, long flights of stairs made statements about the grandeur and the power of the law. . . . By design, they were humbling, even disempowering. Ramps, elevators and appropriate use of government spaces have the opposite effects. For people with disabilities, it is impossible to conceptualize equal protection of the law without them." Id. at 12.

**195** Letter from Gerald Bard Tjoflat, Circuit Judge, United States Court of Appeals, Eleventh Judicial Circuit, to Judith Resnik, Jan. 25, 2010 at 4.

**196** HISTORY OF THE AO at 198. The bombing of the Alfred P. Murrah Federal Building also damaged the federal courthouse located nearby but separated by a plaza. "Although the blast caused no permanent structural damage, it shattered more than 160 windows" and rendered several of the building systems dysfunctional. Id. at 199.

**197** Andrea Oppenheimer Dean, *The nation's biggest landlord just found style*, 189 ARCHITECTURAL RECORD 62, 62 (2000) (hereinafter Dean). The article's subtitle was "*GSA: Uncle Sam speaks up for high design.*" In 1999, a conference of several hundred architects and engineers addressed the issues in the context of embassies as well as courthouses and other government buildings. See Benjamin Forgey, *Fear and Loathing in Architecture: Moynihan Opens Debate on Security vs. Openness*, WASHINGTON POST, Dec. 1, 1999, at C1. See also Blair Kamin, *Fortress Architecture: Don't Let Terrorists Design Our Buildings*, CHICAGO TRIBUNE, Dec. 5, 1999, at C1; JANE LOEFFLER, ARCHITECTURE OF DIPLOMACY: BUILDING AMERICA'S EMBASSIES (Princeton, NJ: Princeton Architectural Press, 1998).

**198** The Judicial Conference, for example, proposed relocation of day care programs into renovated or new facilities. JCUS Sept. 15, 1998, at 88–89. Further, in 1997 it amended its Design Guide to require "ballistic-resistant glazing." JCUS March 14, 2000, at 29.

**199** HISTORY OF THE AO at 200.

**200** THE DESIGN EXCELLENCE PROGRAM GUIDE: BUILDING A LEGACY (Architect/Engineer Selection and Design Review) 70 (Washington, DC: U.S. General Services Administration, 2000) (hereinafter GSA DESIGN EXCELLENCE PROGRAM GUIDE). Parallel concerns can be found in the Judicial Conference's annual reports. For example, in 1995 the Judicial Conference recommended background screening for personnel working in its buildings. JCUS Sept. 19, 1995, at 97. Further, the Conference committee that had once been called "Space and Facilities" put the term "security" first. Then, in 2005, the Conference divided "the Committee on Security and Facilities into two committees: the Committee on Judicial Security, and the Committee on Space and Facilities[,] . . . enabling a separate committee to devote its full attention [to] judicial security." Lorraine H. Tong, Judicial Security: Responsibilities and Current Issues, Congressional Research Service, June 12, 2006 (RL33464) at 12. Discussion of the Space and Facilities Committee is continued in Chapter 9.

**201** GSA DESIGN EXCELLENCE PROGRAM GUIDE at 70–71.

**202** GSA DESIGN EXCELLENCE PROGRAM GUIDE at 72–74.

**203** GSA DESIGN EXCELLENCE PROGRAM GUIDE at 70.

**204** Margaret McCurry, in II VISION + VOICE at 11; McCurry was a member of the 1992 GSA Design Awards committee.

**205** COURT HOUSE: A PHOTOGRAPHIC DOCUMENT (Richard Pare, ed., New York, NY: Horizon Press, 1978), 249, plate 355. The court-

house was completed after Wright died in 1959 by Taliesin Associated Architects.

**206** PARE, COURT HOUSE at 250, plate 356 (Orange County Court House, Goshen, New York).

**207** II VISION + VOICE at 5. Hugh Hardy, who chaired the 1990 GSA Design Awards Jury, said that none of the newer buildings were "worthy of holding up as models." Id. at 8.

**208** See Dean at 62. She cited Breyer and Woodlock as "reinventing the standard." Id.

**209** See GSA DESIGN EXCELLENCE PROGRAM GUIDE. For example, at AIA conventions the GSA cosponsored workshops focused on courthouse building. See, for example, The Future of the American Federal Courthouse: Continuing Education Seminar, AIA Convention, May 4, 2000. In addition to courthouses, several other types of buildings have been produced, including what are called border stations (serving as bases for controlling boundaries), as well as government repositories for records and other office buildings.

**210** In 2001 President George W. Bush's appointee, Joe Moravec, became the Commissioner of GSA's Public Buildings Service.

**211** Neal Peirce, *The Feds' Chief Landlord: Unusual Friend of the Cities*, 23 NATION'S CITIES WEEKLY 2 (Oct. 23, 2000); Tom Ichniowski, *No nickel-and-diming here*, 236-9 ENGINEERING NEWS-RECORD 14 (March 4, 1996).

**212** Peirce at 2.

**213** See Michael Cannell, *Doing Justice*, WASHINGTON POST, Feb. 8, 1998, at W18. Others call Feiner "the rarest of bureaucrats—a visionary." See Laura Fisher Kaiser, *Edward A. Feiner*, 75 INTERIOR DESIGN S58–S60 (Dec. 2004).

**214** *GSA Chief Architect Ed Feiner to Retire*, GSA No. 10130 (Jan. 10, 2005), http://www.gsa.gov/Portal/gsa/ep/contentView.do?noc=T&contentType=GSA_BASIC&contentId=17835. Feiner's colleague Marilyn Farley was also instrumental in shaping the program and retired then as well. See Robert A. Ivy, *Too Good to Lose*, 193 ARCHITECTURAL RECORD 17 (March 2005). Thereafter, Leslie Shepherd became the Chief Architect. See Tim McKeough, *GSA's new chief architect vows to improve work environments, embrace multiple design vocabularies*, 195 ARCHITECTURAL RECORD 19 (Jan. 2007). Thomas Gordon Smith, "a practitioner of Classical-style architecture," was given a position as a fellow, raising the potential of a return to that form of building. Id. See also Robert Campbell, *Calling a Truce in the Style Wars over Government Buildings*, 195 ARCHITECTURAL RECORD 53 (July 2007).

**215** Reed Kroloff, *Ed Feiner*, ESQUIRE MAGAZINE, December 1, 2003, 178. The article opens with the claim that the "most powerful architect in American today is not Frank Gehry," nor David Rockwell, nor Robert Stern but "Ed Feiner, a guy from the Bronx." Id. Feiner was able to attract "firms such as Thom Mayne's Morphosis that would not have applied for government commissions or, perhaps, even been considered under the old system." Dean at 62.

**216** Kroloff; Branford McKee, *Edward Feiner: The Federal Presence in the Power List*, 89 ARCHITECTURE 114 (May 2000).

**217** II VISION + VOICE at 5. As one architect put it, under the old regime "you had to spend a fortune trying to put together a whole team that might look better than any other team." A. Eugene Kohn, in II VISION + VOICE at 16.

**218** Cannell. As Feiner explained, "design excellence is a holistic process that tries to meld every facet of a project . . . [so as to ensure] that the design is both inspiring and efficient, and can be delivered within budget." II VISION + VOICE at 80. In 2000 this approach was then called the Construction Excellence Program, aiming to promote quality in building along with timely, cost-effective procedures that relied more on portfolios than on quantitative data. Id.

**219** GSA DESIGN EXCELLENCE PROGRAM GUIDE at 9, 16. The GSA also provides guides with revisions of policies and sample documents. See, for example, DESIGN EXCELLENCE: POLICIES AND PROCEDURES

168 (Washington, DC: U.S. General Services Administration, 2008), GSA Design Excellence Program homepage: www.gsa.gov/design excellence.

**220** GSA Design Excellence Program Guide at 33 ("Sample Advertisement").

**221** Guiding Principles, I Vision + Voice at 4.

**222** II Vision + Voice at 6. The goals are to reflect the "dignity, diversity, vigor, and stability of the federal government."

**223** Karen E. Steen, *Hail to the Chief*, Metropolis Magazine, Jan. 2002, at 2.

**224** Steen at 2.

**225** I Vision + Voice at 45. "Every two years, GSA's Commissioner of the Public Buildings Service appoints 130–150 peers, based on recommendations from the Chief Architect." II Vision + Voice at 31.

**226** I Vision + Voice at 61; II Vision + Voice at 7.

**227** II Vision + Voice at 6. From 1994 through 2002, more than one hundred "major Federal construction projects" were designed from selections made under this approach. I Vision + Voice at 61.

**228** II Vision + Voice at 55.

**229** Moynihan's Guiding Principles were regularly invoked; the GSA called its Design Excellence Program "a manifestation of them." II Vision + Voice at 61. But one of the 1962 Ad Hoc Committee's principles was to have designs that "reflect the regional architectural traditions" of the part of the country where a building is located. I Vision + Voice at 5. Whether that approach can fit within a transnational architectural market is unclear.

**230** GSA Modernism at 55.

**231** See Design Excellence: Policies and Procedures 169 (Washington, DC: U.S. General Services Administration, 2008). As Peck put it in 1998, "we are commissioning the best American architects and are winning praise for the courthouses' designs and functionality from architecture critics, judges, and other building users, and from local community leaders." *Status of Courthouse Construction, Review of New Construction Request for the U.S. Mission to the United Nations, and Comments on H.R. 2751, To Amend the Public Buildings Act of 1959 to Improve the Management and Operations of the U.S. General Services Administration: Hearing of the Subcomm. on Public Buildings and Economic Development of the H. Comm. on Transportation and Infrastructure*, 105th Cong. 45 (July 16, 1998) (Statement of Robert A. Peck, Commissioner, Public Buildings Service, GSA).

## CHAPTER 9

**1** Vision + Voice: Design Excellence in Federal Architecture, Building a Legacy 27 (Washington, DC: U.S. General Services Administration, Public Buildings Service, Office of the Chief Architect, 2002) (hereinafter I Vision + Voice). As noted in Chapter 8, Vision + Voice is a three-volume set. See Vision + Voice, vol. 2: Changing the Course of Federal Architecture and Vision + Voice, vol. 3: Changing the Course of Federal Architecture (Washington, DC: U.S. General Services Administration, Public Buildings Service, Office of the Chief Architect, 2004) (hereinafter, II Vision + Voice and III Vision + Voice).

Our understanding of efforts to build federal courts has been enhanced by published and unpublished materials from the GSA, the Administrative Office (AO) of the United States Courts, and the Federal Judicial Center (FJC), and from exchanges with several participants including the Honorable Jane Roth and the Honorable Brock Hornby, both of whom chaired Judicial Conference Committees; the Honorable Gerald Bard Tjoflat, who served as the Chief Judge of the Court of Appeals for the Eleventh Circuit (which includes Florida, Alabama, and Georgia); Ross Eisenman, Assistant Director of the AO

Office of Facilities and Security; David Insigna, who worked at that AO Office and then joined the GSA as Director of Services for the Rocky Mountain and Pacific Zone; Richard Gilyard, who served as the Circuit Architect for the Eighth Circuit; Celeste Bremer, United States Magistrate Judge of the Southern District of Iowa and who served on that court's renovation committee; Ed Feiner and Les Shephard, both of whom served as Chief Architect in the GSA, Tom Grooms, Director of Excellence and the Arts, and Susan Harrison, Project Manager in the Art-in-Architecture division of the Chief Architect's Office.

**2** *Status of Courthouse Construction, Review of New Construction Request for the U.S. Mission to the United Nations, and Comments on H.R. 2751, To Amend the Public Buildings Act of 1959 to Improve the Management and Operations of the U.S. General Services Administration: Hearing Before the Subcomm. on Public Buildings and Economic Development of the H. Comm. on Transportation and Infrastructure*, 105th Cong. 22 (July 16, 1998) (Testimony of Robert A. Peck, Commissioner, Public Buildings Service, GSA) (hereinafter *1998 Status of Courthouse Construction Hearings*).

**3** *The Future of Federal Courthouse Construction Program: Results of a GAO Study on the Judiciary's Rental Obligations: Hearing Before the Subcomm. on Economic Development, Public Buildings, and Emergency Management of the H. Comm. on Transportation and Infrastructure*, 109th Cong. 269 (June 22, 2006) (Statement of David L. Winstead, Commissioner, Public Buildings Service, GSA) (hereinafter *2006 Future of the Federal Courthouse Construction Program Hearings*); see *1998 Status of Courthouse Construction Hearings* at 22.

**4** Our thanks to Karen Redmond and Linda Stanton from the Public Affairs Office of the AO of the U.S. Courts for facilitating our use of the public domain image in the fascimile by Yale University Press that is shown in figure 117, which accompanied the article *The Renaissance of the Federal Courthouse*, 34 Third Branch: Newsletter of the Federal Courts 1, 10 (Dec. 2002) (hereinafter *Renaissance of the Federal Courthouse*).

**5** *2006 Future of the Federal Courthouse Construction Program Hearings* at 1. During a different time span, 1985–2000, fifty-two court projects "totaling $3.5 billion" had been completed—producing a courthouse-building program that was the "largest in U.S. history" and was listed among the "major accomplishments" of the AO. A History of the Administrative Office of the United States Courts: Sixty Years of Service to the Federal Judiciary 113 (Cathy A. McCarthy & Tara Treacy, eds., Washington, DC: Administrative Office of the United States Courts, 2000) (hereinafter History of the AO). Another account comes from materials called GSA Properties, Courthouse Programs (describing the concern about space, the need for "the largest courthouse construction program in more than fifty years, estimated to cost $10 billion," and the establishment by the judiciary of a list of priorities) (undated, once available on the web). As of 2005, the Government Accountability Office (GAO) reported that the actual outlays between 1993 and 2005 had been $4.5 billion for seventy-eight courthouse projects. See *Courthouse Construction: Information on Project Cost and Size Changes Would Help to Enhance Oversight*, U.S. Government Accountability Office, GAO-05-673 (2005) at 1.

**6** Report to the Judicial Conference of the Committee on Postwar Building Plans for Quarters for the United States Courts 3 (1946).

**7** Annual Report of the Director of the Administrative Office of the U.S. Courts for 1972 at 223 (Washington, DC: U.S. Government Printing Office) (hereinafter *1972 Director of the AO Report*). In the annual report the following year, an updated listing identified 705 courtrooms. *1973 Director of the AO Report* at 262.

**8** *To Establish Certain Public Buildings Policies for the Federal Government: Hearings on H.R. 630 Before the Subcomm. on Public Buildings and Grounds of the H. Committee on Public Works and Trans-*

*portation*, 98th Cong. 187 (1983) (Statement of James E. Macklin Jr., Executive Assistant Director, Administrative Office of the United States Courts) (hereinafter Macklin 1983 Statement).

**9** Macklin 1983 Statement at 179. He cited a delay of twelve years from the original request to the building of a new courthouse in Madison, Wisconsin. Id. at 179–180. Macklin also noted that a few judges had threatened contempt against GSA personnel but said that such orders would not be appropriate. Id. at 181.

**10** Macklin 1983 Statement at 177.

**11** Annual Report of the Proceedings of the Judicial Conference of the United States (hereinafter JCUS), March 15–16, 1971, at 3; JCUS Oct. 28–29, 1971, at 63. That committee was commissioned in 1970.

**12** See Federal Magistrates Act, Pub. L. No. 90-578, 82 Stat. 1107 (1968), codified as amended at 28 U.S.C. §§ 631 et seq.

**13** See An act to provide for the appointment of additional district and circuit judges, and for other purposes, Pub. L. No. 95-486, 92 Stat. 1629 (1978), codified in scattered sections of Title 28 of the United States Code.

**14** JCUS Mar. 15–16, 1971, at 3. The Conference adopted resolutions calling for various sizes of courtrooms (twenty-eight by forty feet as a standard, with twelve-foot ceilings, and forty by sixty feet, with a sixteen-foot ceiling, as a larger space). JCUS Oct. 28–29, 1971, at 63–64. Thereafter the Conference adopted three sizes: 1,120 square feet, 1,496 square feet, and 2,400 square feet. See 1975 DIRECTOR OF THE AO REPORT at 138. By the 1980s the Conference had settled on four sizes of courtrooms, a standard used, in turn, by the GSA when making its design guide. See UNITED STATES COURTS DESIGN GUIDE, ch. 4, the District Court 2 (Washington, DC: U.S. General Services Administration, Mar. 9, 1984) (hereinafter 1984 GSA COURTS DESIGN GUIDE), discussed later.

**15** See JCUS Oct. 28–29, 1971, at 64.

**16** See General Services Administration, Public Building Service, UNITED STATES COURTS DESIGN GUIDE, ch. 4-1 (1 May 1979) (hereinafter 1979 GSA COURTS DESIGN GUIDE). The word order of the directive was altered in the *1979 Guide*, and the section read in full: "In accordance with the October 1971, Judicial Conference resolution, no judge of a multiple-judge court will have the exclusive use of any particular courtroom. It is contemplated that a multiple-judge courthouse will contain various size courtrooms. Each courtroom will be available on a case assignment basis to any judge." Id.

**17** The concept of giving each judge a dedicated courtroom paralleled a shift in the way judges were assigned to work on cases. Under a "master calendar system" that had been commonplace through the 1970s, whatever judge was available decided issues as they came up in cases. In contrast, under the "individual calendar system" that came into vogue in the 1980s, cases were assigned, from filing to disposition, to a specific judge.

**18** See JUDICIAL CONFERENCE OF THE UNITED STATES, SPACE AND FACILITIES COMMITTEE, U.S. COURTS DESIGN GUIDE, 1997 ed. at 4-43, 4-44. As later noted, that policy was addressed to district judges but was also applied to other judges (magistrate and bankruptcy) sitting in federal courthouses.

**19** Macklin 1983 Statement at 177.

**20** See JCUS and DIRECTOR OF THE AO REPORT Mar. 12–13, June 30, and Sept. 18–19, 1986, at 53. The AO had a branch devoted to space and facilities, and that subgroup had studied the problem and developed an inventory of space and proposed budgets for rent. Id.

**21** See 1987 DIRECTOR OF THE AO REPORT at 70; HISTORY OF THE AO at 195. According to the 1988 DIRECTOR OF THE AO REPORT, the study "documented the need for the Judiciary to take a more aggressive role in managing its own space." Or, as the AO put it in 2000, the National Academy "recommended that the judiciary play a greater role in planning for and designing court facilities." HISTORY OF THE AO at 195. Thereafter the director of the AO and the administrator of

the GSA entered into a "Memorandum of Understanding, establishing a planning process involving both GSA and the Judiciary, and defining relationships for funding space and facility projects." See 1988 DIRECTOR OF THE AO REPORT at 75. To provide such funding, the Judicial Conference launched a study of space standards and needs. Id. By the 1990s the AO had created a "space management information system." 1992 DIRECTOR OF THE AO REPORT at 24.

**22** HISTORY OF THE AO at 195. In that volume, Director Mecham is given credit for setting the major goals of "strengthening the space and facilities program, improving the judiciary's building stock . . . and securing new courthouses to accommodate the growth in workload." Id.

**23** See JCUS Sept. 20, 1989, and DIRECTOR OF THE AO REPORT at 82–83 (Mar. 14, Sept. 20, 1989).

**24** 1994 DIRECTOR OF THE AO REPORT at 123 (subsection "Activities of the Administrative Office of the US Courts" at 45).

**25** 1993 DIRECTOR OF THE AO REPORT at 39.

**26** 1994 DIRECTOR OF THE AO REPORT at 124 (subsection "Activities of the Administrative Office of the US Courts" at 46).

**27** See NATIONAL ACADEMY OF PUBLIC ADMINISTRATION, EVALUATION OF THE GENERAL SERVICES ADMINISTRATION: REPORT TO THE ADMINISTRATOR at ix (Dec. 31, 1980); Gregory Gordon, *Traveling the GSA's Bureaucratic Puzzle*, LOS ANGELES DAILY JOURNAL, Oct. 5, 1981. Problems were raised again in the following decades. See Federal Buildings: Billions are Needed for Repairs and Alterations, GAO/GGD-00-98, Apr. 11, 2000, and Capital Investment Hearing Questions, GAO/GGD-00-124R, May 11, 2000 ("General Services Administration: Response to Follow-up Questions Related to Building Repairs and Alterations and Courthouse Utilization"), http://www.gao.gov/archive/2000/ggo0098.pdf. Periodically, members of Congress proposed amendments to the GSA charter to provide more "effective congressional oversight of GSA." See, for example, Public Buildings Reform Act of 1993, S. 1760, 103d Cong. (1993); Public Buildings Reform Act of 1998, S. 2481, 105th Cong. (1998).

**28** HISTORY OF THE AO at 165–166.

**29** See JCUS Sept. 1989 at 81; JCUS Sept. 23–24, 1991, at 43.

**30** JCUS Mar. 12, 1991, at 6.

**31** HISTORY OF THE AO at 166. See Judicial Space and Facilities Management Improvement Act of 1989, H.R. 4178, 101st Cong. (1990). The bill would have tied the AO mandate in 28 U.S.C. § 462 to provide accommodations for the judiciary to a new authority to "acquire, by purchase, condemnation, exchange, or otherwise, any space or facility" determined to be necessary, as well as to construct, lease, or alter facilities, and to dispose of space already acquired. The Director of the AO would have gained authority either to ask the GSA to do acquisition and construction or to hire architects and engineers. Congressional approval would have been required for projects in excess of 1.5 million dollars. The companion bill, S. 2837, was introduced in the 101st Congress in 1990 by Senator Moynihan.

**32** See Judicial Space and Facilities Management Improvement Act of 1989, H.R. 4178, 101st Cong. (1990). See also the Judicial Space and Facilities Management Improvement Act of 1990, S. 2837, 101st Cong. (1990), introduced by Senator Moynihan to accomplish the same end. In 1992 Robert C. Broomfield, chair of Space and Facilities Committee of the Judicial Conference, went before the Senate Subcommittee on Water Resources, Transportation and Infrastructure to seek the legislation, but the GSA opposed the bill. The legislation was never enacted. See *Renaissance of the Federal Courthouse* at 2.

**33** HISTORY OF THE AO at 166.

**34** See Letter from Gerald Bard Tjoflat, Circuit Judge, United States Court of Appeals, Eleventh Judicial Circuit to Judith Resnik 3–6 (Jan. 25, 2010) (hereinafter Tjoflat 2010 Letter). During his tenure from 1989 through 1996 as Chief Judge of the Eleventh Circuit, he was involved in more than a dozen construction projects in that circuit's three states.

**35** See Michael Cannell, *Doing Justice*, WASHINGTON POST, Feb. 8, 1998 at W18 (hereinafter Cannell, *Doing Justice*, WASHINGTON POST).

**36** Cannell, *Doing Justice*, WASHINGTON POST.

**37** Andrea Oppenheimer Dean, *The Nation's Biggest Landlord Just Found Style*, 189 ARCHITECTURAL RECORD 62 (hereinafter Dean, *The Nation's Biggest Landlord*).

**38** Cannell, *Doing Justice*, WASHINGTON POST. He there repeated the estimate of eight billion dollars in costs.

**39** HISTORY OF THE AO at 195. See also Heidi Landecker, *Federal Architecture: A New Era*, 85 ARCHITECTURE 64, 76–78 (1996) (describing some of the 156 building projects, including renovations).

**40** These are the descriptions provided by the AO itself in its fiftieth anniversary self-history. See HISTORY OF THE AO at 166. See also John W. Winkle III, *Interbranch Politics: The Administrative Office of the U.S. Courts as Liaison*, 24 JUSTICE SYSTEM JOURNAL 43, 54–61 (2003). Winkle discussed the "quest for courthouses" and AO lobbying that resulted in courthouse project funding for 2001–2002.

**41** *2006 Future of the Federal Courthouse Construction Program Hearings* (Statement of David Winstead, Commissioner) at 269, http://www.gsa.gov/Portal/gsa/ep/contentView.do?contentType=GSA_BASIC&contentId=21238&noc=T (hereinafter *2006 Future of the Federal Courthouse Construction Program Hearings*, Commissioner Winstead Statement).

**42** As noted, ad hoc committees focused on space had existed since the 1940s. Chief Justice Rehnquist established standing committees. In 1987 two committees were delineated, one the Committee on Space and Facilities and the other the Committee on Security (later the Committee on Court and Judicial Security), both of which were reconfigured from a committee that had been called Court Administration. See JCUS Sept. 21, 1987, at 59. In September 1994, the two committees folded into one, the Committee on Security, Space, and Facilities. See JCUS Sept. 20, 1993, at 36 and Mar. 16, 1993, at 6. In the late 1990s, that Committee was renamed the Committee on Security and Facilities. See JCUS Sept. 23, 1997, at 49. In 2005 the Judicial Conference again reconfigured tasks, returning to the two committees, one called the Committee on Judicial Security and the other the Committee on Space and Facilities. See JCUS Sept. 20, 2005, Judicial Conference Proceedings, U.S. Courts at 5. The acute need to focus on security came in part from the "brutal murders of the husband and mother" of a United States federal court district judge. The killings occurred "off-site" and hence prompted a need for reconsideration of safety provisions. See JCUS Mar. 15, 2005 at 6.

**43** *Renaissance of the Federal Courthouse* at 2. P. Gerald Thacker was the first head of the new division and was joined by Clarence A. Lee Jr., who had been a "senior official" of the GSA and who initially came "on loan to the AO" and then joined its staff permanently. Id.

**44** 1989 DIRECTOR OF THE AO REPORT at 176. By 1995, all of the 94 districts had completed plans, so that for "the first time the judiciary had both a short and long-term view of its facilities requirements." HISTORY OF THE AO at 196.

**45** *Oversight of the Courthouse Construction Program: Hearing Before the Subcomm. on Oversight of Government Management and the District of Columbia of the S. Comm. on Governmental Affairs*, 104th Cong. 66 (1995) (Statement of William Gadsby, Director of Government Business Operations Issues, General Government Division, GAO) (hereinafter Gadsby 1995 Statement). See also id. at 6–10, 61–109.

**46** See JUDICIAL CONFERENCE OF THE UNITED STATES, SPACE AND FACILITIES COMMITTEE, U.S. COURTS DESIGN GUIDE, 1991 ed. (hereinafter 1991 U.S. COURTS DESIGN GUIDE). As its preface explained, the *Design Guide* was "developed over a three-year period in a cooperative effort between the Federal Judiciary and a team of experts . . . under the direction of the National Institute of Building Sciences and the Judiciary." Id. at 1. In 1992 the Judicial Conference joined the American Institute of Architects (AIA) and the National Center for State Courts as cosponsors of a conference on courthouse design, construction, and operation. See JCUS Sept. 23–24, 1991, at 72. A second edition of the judiciary's *Design Guide* was published in 1993 and then revised in 1994 in the wake of the Americans with Disabilities Act. See JCUS Sept. 19, 1995, at 98. That version was altered through a 1995 "addendum" prior to the 1997 revisions, which were, in turn, supplanted by a 2007 edition. 1997 U.S. COURTS DESIGN GUIDE, Preface at 2 and Acknowledgements at 1–12. The 2007 edition is thus the fifth edition, and by 2008, it had already been revised in some respects. Staff of the AO did the drafting, with many references to general building standards and other GSA materials. See HISTORY OF THE AO at 195.

Our discussion draws mainly on the 1997 and 2007 versions, which overlap substantially, with various texts repeated verbatim. See 1997 U.S. COURTS DESIGN GUIDE; SPACE AND FACILITIES COMMITTEE OF THE JUDICIAL CONFERENCE OF THE UNITED STATES, U.S. COURTS DESIGN GUIDE, 2007 ed. (hereinafter 2007 U.S. COURTS DESIGN GUIDE), General Services Administration, http://www.gsa.gov/Portal/gsa/ep/contentView.do?P=PME&contentType=GSA_DOCUMENT&contentId=15102. The 2007 preface by Chief Justice John Roberts detailed the history of the revisions.

**47** See 1997 U.S. COURTS DESIGN GUIDE, Introduction at 1; 2007 U.S. COURTS DESIGN GUIDE at 1-1. The 1991 *Guide* had these same three objectives, slightly differently worded. 1991 U.S. COURTS DESIGN GUIDE at 9. The 1991 guide also provided diagrams to specify the "spatial relationships, accessibility and circulation" for courtrooms and other rooms. See, for example, id. at 16, 26–39, 100–109.

**48** 2007 U.S. COURTS DESIGN GUIDE at 1-1. The *Guide's* other audiences were the "federal judges and key judicial personnel who are directly involved in the design of a federal court facility," the Judicial Conference "through its Committee on Space and Facilities," and the AO. Id.

**49** Tjoflat 2010 Letter at 2.

**50** 1997 U.S. COURTS DESIGN GUIDE, Introduction at 2. It also cautioned users not to rely on the criteria as "space entitlements" or as a means of enlarging spaces beyond those "originally contemplated" in approved projects. Id., Introduction at 3. See also 2007 U.S. COURTS DESIGN GUIDE at 1-2.

**51** The Office of Supervising Architect created standards during the nineteenth century, and the GSA continued that function as it also regularly revised the standards. See, for example, *General Services Administration, Facilities Standards for the Public Building Service*, http://www.gsa.gov/portal/category/21049. In addition, federal law requires compliance with various building codes as well as statutes specifying environmental, preservationist, or other concerns. See, for example, Public Buildings Amendments of 1988, Pub. L. No. 100-678, 102 Stat. 4049 (codified as amended at 40 U.S.C. § 3312 (2006)).

**52** Both the 1979 and the 1984 *GSA Guides* are prefaced by a foreword from GSA Administrator Jay Solomon noting that they were crafted "in cooperation with" the AO. See 1979 GSA COURTS DESIGN GUIDE, Foreword; 1984 GSA COURTS DESIGN GUIDE, Foreword. Both also note that provisions relating to spaces for the U.S. Attorneys and for the U.S. Marshals were designed with input from those entities, and the texts of the two versions overlap a good deal. The 1979 GSA COURTS DESIGN GUIDE was not, however, "approved . . . in its entirety" by the Judicial Conference. See Macklin 1983 Statement at 177. In contrast, after circulation in 1982 to the judicial councils in each circuit, the "updated" 1984 *Guide* was formally approved. See 1984 Director of the AO Report at 8 (Mar. 8–9, Sept. 19–20, 1984). The AO took some ownership of the 1984 *Guide*; a memorandum from AO Director William E. Foley explained its distribution within the federal courts. Memorandum to Chief Judges [of various courts] from William E. Foley, Apr. 20, 1984, accompanying the 1984 GSA COURTS

DESIGN GUIDE. Thereafter, the Judicial Conference also made some modifications, reflecting changes in bankruptcy court jurisdiction and approving new provisions for parking. 1986 DIRECTOR OF THE AO REPORT at 59 (Mar. 12–13, June 30, and Sept. 18–19, 1986).

**53** 1984 GSA COURTS DESIGN GUIDE, chs. 1, 3–4; 1979 GSA COURTS DESIGN GUIDE, chs. 1, 3–4.

**54** 1984 GSA COURTS DESIGN GUIDE, ch. 4 ("The District Court") at 1.

**55** Chapters 2 and 3 of both the 1979 and the 1984 *GSA Guides* gave their users—architects and engineers—some basic information about the federal judiciary. The *Guides* functioned as primers about the organization, the levels of courts, the auxiliary services such as court reporters, pretrial services, probation, and marshals and also cataloged the items needed to furbish each of the spaces accorded the different users.

**56** 1979 and 1984 GSA COURTS DESIGN GUIDES, ch. 1 ("Introduction") at 3–4.

**57** 1984 GSA COURTS DESIGN GUIDE, ch. 1 at 3–4.

**58** 1991 U.S. COURTS DESIGN GUIDE at 71.

**59** 1997 U.S. COURTS DESIGN GUIDE at 3-1. The 1997 and the 2007 Design Guides have most of the same discussion of these goals. See the 1997 and the 2007 U.S. COURTS DESIGN GUIDES at 3-9 and 3-1, respectively.

**60** 2007 U.S. COURTS DESIGN GUIDE at 3-1. Thus the shift in 1997 to a focus on the impact of the architecture on the local community and the desire to convey "integrity " and "fairness" through a courthouse's form (see 1997 U.S. COURTS DESIGN GUIDE at 3-9) was continued in 2007 with the elimination of references to large "scale" and "strong and direct [massing]." They were replaced with a comment about "the encounter between the citizen and the justice system." 2007 U.S. COURTS DESIGN GUIDE at 3-1.

**61** As the judiciary brought the process in-house, it also brought expertise in-house, hiring architects as line employees, sometimes located in circuits (mirroring the regional allocation of GSA staff) and sometimes in the central office. As of 2008, eighteen judiciary employees were architects, engineers, or space planners, eleven of whom were assigned to the circuits. An additional forty architects were temporarily employed by the courts for specific projects. Interview with Ross Eisenman, Assistant Director of the Office of Facilities and Security, Dec. 2008.

**62** 1979 and 1984 GSA COURTS DESIGN GUIDES, ch. 4 at 2 (focusing on the layout of a district courtroom). While prisoners, judges, and the public had different entryways to the courtroom (id. at 3), a concept of maintaining discrete zones throughout the building was not put forth. Judges were encouraged, when possible, to have private elevators. Id., ch. 14 at 2.

**63** See also JCUS and DIRECTOR OF THE AO REPORT at 262 (Apr. 5–6, Sept. 13–14, 1973). That report had inventoried courtroom space and found that, as of 1973, the 705 courtrooms ranged in size from 600 to 4,330 square feet and that 75 percent measured 1,700 or more square feet. The following year, the number of courtrooms had grown to 714. JCUS and DIRECTOR OF THE AO REPORT at 138 (Mar. 7–8, Sept. 19–20, 1974).

**64** Those layouts for trial-level courts were twenty-eight by forty, thirty-four by forty-four, thirty-five by fifty-two, and forty by sixty feet. Those guidelines had been provided by the Judicial Conference. See JCUS Oct. 26 and 27, 1972, at 44–45. As the 1979 and 1984 Design Guides explain, the Judicial Conference had prescribed three sizes in the early 1970s, but "consultation" with both Chief Justice Warren Burger and Attorney General Griffin B. Bell "[led] to a reexamination of spatial requirements and the subsequent increase in size of the intermediate size courtroom." 1979 and 1984 GSA COURTS DESIGN GUIDES, ch. 4 at 1. Appellate courtrooms were to be from 1,500 to 2,400 square feet. Id, ch. 17 at 1 ("Circuit Courts of Appeals"). Some judges recall objecting to the downsizing, driven—as they saw it—by funding problems. See Tjoflat 2010 Letter at 3–4.

**65** See, for example, 1984 GSA COURTS DESIGN GUIDE, ch. 4 at 3 (limited-use courtrooms); ch. 4 at 7–8 (intermediate courtrooms); ch. 4 at 9–10 (standard courtrooms); ch. 4 at 11–12 (large courtrooms).

**66** 1979 GSA COURTS DESIGN GUIDE, ch. 4 at 1.

**67** 2007 U.S. COURTS DESIGN GUIDE at 4-7 (appellate courtrooms), 4-15 (district courts), 4-24 (magistrate courtrooms), 4-31 (bankruptcy courtrooms); 1997 U.S. COURTS DESIGN GUIDE at 4-40 through 4-42; 1991 U.S. COURTS DESIGN GUIDE at 125–126 (with a slightly smaller magistrate courtroom recommendation of 1,500 square feet). All three *Guides* provided for "special proceedings courtrooms" of 3,000 square feet, with eighteen-foot ceilings. 1991 U.S. COURTS DESIGN GUIDE at 126; 1997 U.S. COURTS DESIGN GUIDE at 4-41; 2007 U.S. COURTS DESIGN GUIDE at 4-15.

**68** 2007 U.S. COURTS DESIGN GUIDE at 4-3.

**69** 1997 U.S. COURTS DESIGN GUIDE at 4-40.

**70** 2007 U.S. COURTS DESIGN GUIDE at 12-5. Details were provided on veneers, millwork, and the like. Id. at 12-7 through 12-18.

**71** 2007 U.S. COURTS DESIGN GUIDE at 12-11. The 1991 Guide explained: "Furniture and finishes in the courtroom should reflect the seriousness of the judicial mandate and the dignity of the judicial system." 1991 U. S. COURTS DESIGN GUIDE at 72.

**72** 1997 U.S. COURTS DESIGN GUIDE at 4-40. In 2000, as part of the cost-containment efforts, that provision was modified to make standard a jury box accommodating twelve in magistrate judge courtrooms, sixteen in district courtrooms (to provide space for alternates), and eighteen (for grand juries) in special proceedings courtrooms. JCUS Sept. 19, 2000, at 66–67. In 2002 the Conference responded to concerns that rooms for jury deliberation were too small and shifted from requiring 350 square feet to permitting 500 square feet for one in every four rooms. See JCUS Sept. 24, 2002, at 63–64.

**73** 1997 U.S. COURTS DESIGN GUIDE at 4-36. The 2007 *Guide* simply stated that spectator seating for en banc courts should provide 120–150 seats and, for panel courtrooms, 40–80 seats. 2007 U. S. COURTS DESIGN GUIDE at 4-6.

**74** 1997 U.S. COURTS DESIGN GUIDE at 4-37 through 4-38; 2007 U.S. COURTS DESIGN GUIDE at 4-13.

**75** General Accounting Office, GAO-02-341, *Courthouse Construction: Information on Courtroom Sharing* at 3, n. 3 (2002).

**76** General Accounting Office, GAO-02-341, *Courthouse Construction: Information on Courtroom Sharing* at 3 (2002).

**77** 1988 DIRECTOR OF THE AO REPORT at 75.

**78** See JCUS Mar. 14, Sept. 20, 1989, at 34.

**79** See JCUS Sept.–Oct. 2001 at 71. Relationships between local judges and members of Congress affected both the priority of projects and design changes. See Tjoflat 2010 Letter at 5.

**80** See JCUS Sept. 20, 2005, at 39–40.

**81** 1979 GSA COURTS DESIGN GUIDE, ch. 19 ("Space Summary") at 19-1 and 19-10; 1984 GSA COURTS DESIGN GUIDE, ch. 5 at 1 (district court) and ch. 17 at 1 (circuit court of appeals). In 1984 the Judicial Conference had also specified that senior judges be provided with somewhat smaller chambers of 1,200 square feet. In 1985 the Conference modified the standard to provide 1,600 square feet for both kinds of judges, incurring "modest increased rental costs" that would be "offset by the avoidance" of construction to convert space for use by active judges once the senior judge retired. JCUS Sept. 17–18, 1985, at 47.

**82** 1997 U.S. COURTS DESIGN GUIDE at 5-3 through 5-10. Trial judges' chambers were also authorized to encompass a total of 1,990 square feet if extra space for a deputy clerk was needed. Id. at 5-10. The 1997 U.S. COURTS DESIGN GUIDE increased the size of magistrate judges' chambers from 1,500 to 1,800 square feet to "accommodate larger jury trials." 1997 U.S. COURTS DESIGN GUIDE, Revisions–3.

**83** 2007 U.S. COURTS DESIGN GUIDE at 6-5, calling for 2,060 square feet for circuit judges and 1,670 square feet for district judges, 1,340 square feet for magistrate and bankruptcy judges.

**84** See Serial Set Vol. No. 468, Sess. Vol. No. 1, 28th Congress, 2d

Sess., H. Rpt. 69, 2 p. Jan. 28, 1845 ("The Committee for the District of Columbia, to whom was referred the petition of James Dixon, praying [for] compensation for extra work done by him on the court house in the town of Alexandria, in this District"), also noted earlier.

**85** 1984 GSA Courts Design Guide, ch. 4 at 3 (district courts); ch. 17 at 3 ("private corridor") (appellate courts).

**86** 1984 GSA Courts Design Guide at ch. 5 at 2 (district courts); ch. 17 at 2 (court of appeals).

**87** 1984 GSA Courts Design Guide at Appendix C at 1-6.

**88** See, for example, JCUS and Director of the AO Report at 64 (Mar. 15–16, 1971, Oct. 28–29, 1971).

**89** Tjoflat 2010 Letter at 4.

**90** See 2007 U.S. Courts Design Guide 2007 at 1-3, 3-3, 3-10, 16-3; 1997 U.S. Courts Design Guide at 3-10.

**91** Design Excellence: Policies and Procedures 168 (Washington DC: U.S. General Services Administration, 2008) (hereinafter GSA Design Excellence Policies and Procedures), "sample charrette program" for a federal court at 136.

**92** 1997 U.S. Courts Design Guide at 3-10; 2007 U.S. Courts Design Guide at 3-10.

**93** 1997 U.S. Courts Design Guide at 3-16; 2007 U.S. Courts Design Guide at 4-3.

**94** GSA Design Excellence Policies and Procedures 2008 at 136. "The general public enters the building through a security checkpoint at the primary public entry that feeds into a public vertical circulation core," with its "primary destinations" the courtroom and the jury assembly area. Id.

**95** See 1997 U.S. Courts Design Guide at 4-39. This format is common to courthouses in both state and federal systems. See Don Hardenbergh, The Courthouse: A Planning and Design Guide for Court Facilities 34 (Williamsburg, VA: National Center for State Courts, American Institute of Architects, Conference of State Court Administrators, National Center for Juvenile Justice, & American Bar Association, 1991). That volume provides a schematic, with "public" and "private" zones as well as their "interface." Id.

**96** 2007 U.S. Courts Design Guide at 3-11. "The plan for a courthouse should locate all high-pedestrian-traffic functions on the lower floors and provide dedicated elevator and stairway systems for the public, court staff and judges, freight, and prisoner movement." Id.

**97** Eric Gibson, Taste—de gustibus: Medici and Mellons, Make Way: A New Patron Has Arrived, Wall Street Journal, Oct. 27, 2000, at W17 (quoting Ed Feiner) (hereinafter Gibson, Taste).

**98** Spacial segregation is not unique to the United States. See Julienne Hanson, The Architecture of Justice: Iconography and Space Configuration in the English Law Court Building, 1 Architectural Research Quarterly 50, 58 (1996). We return to questions of allocation of space and focus on courts outside the United States in Chapter 10.

**99** 2007 U.S. Courts Design Guide at 3-5.

**100** More Disciplined Approach Would Reduce Cost and Provide for Better Decisionmaking, Testimony Before the Subcommittee on Oversight of Government Management and the District of Columbia, GAO/T-GGD-96-19 at 3 (Testimony of William J. Gadsby).

**101** See JCUS Oct. 28–29, 1971, at 64.

**102** This rule was formulated by 1997 as Judicial Conference policy: "With regard to district judges, one courtroom should be provided for each active judge. In addition, with regard to senior judges who do not draw caseloads requiring substantial use of courtrooms and to visiting judges, judicial councils should utilize the following factors as well as other appropriate factors in evaluating the number of courtrooms at a facility necessary to permit them to discharge their responsibilities." JCUS Mar. 11, 1997, at 17.

**103** 2007 U.S. Courts Design Guide at 2-8.

**104** JCUS Mar. 11, 1997, at 17. See also 2007 U.S. Courts Design Guide at 2-8.

**105** See Judicial Conference Adopts Courtroom Sharing Policy as Latest Cost-Saver, 40 Third Branch 1 (Sept. 2008).

**106** Douglas P. Woodlock, Drawing Meaning from the Heart of the Courthouse, in Celebrating the Courthouse: A Guide for Architects, Their Clients, and the Public 155, 158 (New York, NY: W. W. Norton & Co. 2006) (hereinafter Celebrating the Courthouse).

**107** JCUS Sept. 19, 1995, at 98.

**108** See Renaissance of the Federal Courthouse at 1.

**109** Bradford McKee, Federal Design Excellence, 85 Architecture 60, 60 (1996).

**110** Gibson, Taste at W17.

**111** II Vision + Voice at 81. The architectural critic Paul Goldberger praised one building by Richard Meier as the "best federal courthouse built since the early nineteen-sixties when the complex in downtown Chicago, designed by Mies van der Rohe went up." See Paul Goldberger, Suburban Grandeur: A Glamorous Government Building Has Just Gone Up in Islip, New Yorker, Oct. 9, 2000, at 94, 96. See also Recognized by AIA, 39 Third Branch 1 (Aug. 2007); Federal Courthouses Recognized for Architectural and Design Excellence, 40 Third Branch 1 (Nov. 2008). The AIA's Justice Facilities Review had selected four federal courthouses to highlight, and two, in Alpine, Texas, and Wheeling, West Virginia, received "citations for architectural and design excellence." Id.

**112** Civic Spirit: Changing the Course of Federal Design, brochure for exhibit, Sept. 13–Nov. 10, 2004 (Center for Architecture, New York City, NY) (hereinafter Civic Spirit Brochure).

**113** Civic Spirit Brochure, describing the Wayne L. Morse U.S. Courthouse, Eugene, Oregon, and the U.S. Courthouse, Jackson, Mississippi. At that time, 2004, neither courthouse was finished.

**114** See Tom Grooms, Director, Excellence and the Arts, GSA, Messages from the Forum, Summer Enews, 2007. The program, held June 1, 2007, in Washington, brought together GSA staff, judges, architects, and commentators, including the Boston Globe architecture critic, Robert Campbell, who "suggested that . . . the 'trads' and the 'rads' needed each other." Id. For more on the division between conservative versus modernist design advocates, see Robert Campbell, Calling a Truce in the Style Wars over Government Buildings, Architectural Record 53–54 (July 2007). See also Tom Ichniowski, GSA Mulls Modest Change in Design Program, Engineering News Record, June 11, 2007, at 9.

**115** See Tom Grooms, Messages from the Forum, GSA Summer Enews 2007.

**116** Figure 118 is provided courtesy of the Design Excellence Program, Office of the Chief Architect of the GSA. Our thanks to Thomas B. Grooms, Director of GSA's Design Excellence and the Arts Program, and to Taylor Lednum of the GSA for the compilation of their photographs and that of Frank Ooms. From the top, moving left to right, the courthouses and their architects are John Joseph Moakley U.S. Courthouse (Boston, Massachusetts), designed by Henry Cobb of Pei Cobb Freed & Partners Architects LLP and Jung/Brannen Associates, completed 1998; Alfonse D'Amato U.S. Courthouse (Central Islip, New York), designed by Richard Meier & Partners and The Spector Group, completed 2000; United States Courthouse (Tallahassee, Florida), designed by Reynolds Smith and Hills Inc. and William Morgan Architects, completed 1999; Wayne Lyman Morse United States Courthouse (Eugene, Oregon), designed by Morphosis and DLR Group, completed 2006; William B. Bryant United States Courthouse Annex (Washington, D.C.), designed by Michael Graves & Associates and SmithGroup, completed 2005; Wilkie D. Ferguson United States Federal Courthouse (Miami, Florida), designed by Arquitectonica and Hellmuth, Obata + Kassabaum Inc., completed 2007; Corpus Christi Federal Courthouse (Corpus Christi, Texas), designed by Hartman-Cox Architects, William S. McCord—AIA-Principal/Architect of Record, and WKMC Architects Inc., completed 2001; the

Roman L. Hruska U.S. Courthouse (Omaha, Nebraska), designed by Pei Cobb Freed & Partners and DLR Group, completed 2000; and Spottswood W. Robinson III and Robert R. Merhige Jr. Federal Courthouse (Richmond, Virginia), designed by Robert A. M. Stern Architects and HLM Design, completed 2008.

Several of the courthouses renovated or constructed under the Design Excellence Program are discussed in individual booklets, published by the GSA, detailing the fabrication materials and providing photographs of the courts. We have referenced several in this chapter and in Chapter 8, and John Brigham provides a brief overview of those booklets in *Design Excellence: The Courthouse Series* (2005), http://works.bepress.com/john_brigham/16.

**117** See *Construction of Certain Public Buildings*, June 19, 1878, Serial Set Vol. No. 1826, Sess. Vol. No. 5, 45th Congress, 2d Sess., H. Rpt. 1006 (Statement of Herman Leon Humphrey). Humphrey, who had served as a county judge in Wisconsin, was a Republican member of Congress from 1877 to 1883.

**118** *2006 Federal Courthouse Construction Hearings* (Statement and Testimony of Mark L. Goldstein, Director of Physical Infrastructure Issues, U.S. Government Accountability Office); the GAO reproduced the hearings as *Federal Courthouses: Rent Increases Due to New Space and Growing Energy and Security Costs Require Better Tracking and Management* (Thursday, June 22, 2006), GAO-06-892T, at 1, 5, www.gao.gov/new.items/d06892t.pdf (hereinafter *GAO Federal Courthouses Rent Increases*). See also *The Judiciary's Ability to Pay for Current and Future Space Needs: Hearing Before the Subcomm. on Economic Development, Public Buildings, and Emergency Management of the H. Comm. on Transportation and Infrastructure*, 109th Cong. 20 (2005) (Testimony of Leonidas Ralph Mecham, Director, AO of the U.S. Courts, and Secretary, JCUS) (hereinafter *2005 Hearing on The Judiciary's Ability to Pay for Current and Future Space Needs*). "With slightly over 20 percent of its budget allocated for rent payments, in December 2004 the Judiciary requested a $483 million permanent annual exemption from rent payments to GSA." *GAO Federal Courthouses Rent Increases* at 1.

**119** See Public Buildings Amendments of 1972, Pub. L. 92-313, § 4, 86 Stat. 216, 219 (codified as amended at 40 U.S.C. § 586 (2006)). "[T]he Administrator is authorized and directed to charge anyone furnished services, space . . . or other facilities . . . at rates to be determined by the Administrator."

**120** *Future of the Federal Courthouse Construction Program: Results of a Government Accountability Office Study on the Judiciary's Rental Obligations; Hearing Before the Subcomm. on Economic Development, Public Buildings, and Emergency Management of the H. Comm. on Transportation and Infrastructure*, 109th Cong. 2 (2006) (Statement of Rep. Bill Shuster, Chair, Subcomm. on Economic Development, Public Buildings, and Emergency Management).

**121** See 40 U.S.C. § 3307 (a) (2007); Clay H. Wellborn, Congressional Research Service, *General Services Administration Prospectus Thresholds for Owned and Leased Federal Facilities*, Aug. 20, 2008 (RS22287) at 3–4 (exact threshold amounts for each fiscal year).

**122** 1974 DIRECTOR OF THE AO REPORT at 139–140. There noted was that the federal judiciary wanted more security than the GSA had allocated as standard, and hence had to pay an additional $13,000 for each officer it added above the GSA level. Id. at 140.

**123** JCUS and DIRECTOR OF THE AO REPORT 128 (Mar. 6–7, Sept. 25–26, 1975). Later reports also focused on "space utilization," the return of space to the GSA, and the ability to downsize spaces dedicated to personnel such as court reporters. See, for example, JCUS Mar. 12–13, Sept. 24–25, 1981, at 9–11, 12.

**124** Judicial Dollar, 1957 DIRECTOR OF THE AO REPORT at 144. Our thanks to Karen Redmond and Linda Stanton of the AO's Public Affairs Office for facilitating the facsimile reproduction of the 1957 and the 1975 "Judicial Dollar" charts, taken from records in the public domain of the AO Reports, for figures 119 and 120.

**125** Judicial Dollar, 1975 DIRECTOR OF THE AO REPORT at 113.

**126** See, for example, 1981 DIRECTOR OF THE AO REPORT at 172 and 1982 DIRECTOR OF THE AO REPORT at 53 (both indicating that 17 cents of the "Judicial Dollar" went to space and facilities); JCUS and DIRECTOR OF THE AO REPORT at 166 (p. 65 of the Director's Report) (Mar. 16–17; Sept. 21–22, 1983); 1984 DIRECTOR OF THE AO REPORT at 76 (also 16 cents). By 1985, the Annual Reports no longer included that image.

**127** See, for example, JCUS Mar. 14, 1995 at 17.

**128** In 1962, $57 million (then 0.1 percent of the national budget) went to the judiciary. By 1995 the number had grown to almost $3 billion. Office of Management and Budget, Historical Tables, Budget of the United States Government at Table 4-1, http://www.whitehouse.gov/omb/budget/fy2011/assets/hist.pdf (hereinafter Historical Budget Tables). Included were costs for probation officials and U.S. Marshals.

**129** In terms of the rate of change, the judiciary's budget rose from $4.828 billion in 2002 to roughly $6 billion in 2006. Given the increase in federal spending over those years, both figures represent approximately 0.2 percent of the national budget. Historical Budget Tables at Table H-1.

**130** *1998 Status of Courthouse Construction Hearings* at 11 (Statement of Rep. Duncan, Member, House Comm. on Transportation and Infrastructure).

**131** *2006 Future of the Federal Courthouse Construction Program Hearings* at 270 (Statement of David Winstead, Commissioner, GSA).

**132** As the 1993 Report from the AO Director explained it, congressional "scrutiny" was triggered because the judiciary was "taking a large and increasing share" of the GSA's Federal Buildings Funds—because of the need to "catch up after years of lack of attention from the GSA." See 1993 DIRECTOR OF THE AO REPORT at 39. See also JCUS Mar. 14, 1995, at 31.

**133** See, for example, U.S. General Accounting Office, *Courthouse Construction: Improved 5-Year Plan Could Promote More Informed Decisionmaking*, GAO/GGD-97-27 (Dec. 1996), http://www.gao.gov/archive/1997/gg97027.pdf.

**134** Staff of Senate Comm. on Environment and Public Works, 103d Cong., *Investigation of the Federal Courthouse Construction Program* 1 (Comm. Print 1994) (hereinafter *Investigation of the Federal Courthouse Construction*). See also David W. Dunlap, *Soaring Costs Delay Building of Federal Courthouse*, NEW YORK TIMES, Sept. 11, 1998, at B3. Quoted are judges blaming the GSA for having "bungled the bidding process"—causing delays that added expenses. Id.

**135** *Investigation of the Federal Courthouse Construction* at 2.

**136** Edward A. Adams, *Session Elicits Blame All Around in Courthouse Costs*, 214 NEW YORK LAW JOURNAL 1 (Nov. 13, 1995), noted that the judges blamed the GSA and the GSA blamed the judges, while Congress's GAO blamed both. Id. His example was the federal courthouse on Pearl Street, then the judiciary's largest, said to have had an "overly generous construction budget" that permitted use of unduly expensive materials; the original cost of $259 million had grown by $120 million from upgrades, including a ceremonial courtroom to seat forty judges. Id. The GAO's William Gadsby cited the Foley Square "multipurpose courtroom" with its "high level of finishes" and excessive space ("5,300 square feet—1¾ times larger" than called for by the Design Guide standards) and the expensive woods used in Boston as too luxurious. See Gadsby 1995 Statement at 194.

The press described the Senate investigation to have concluded that "judges' demands for plush décor jacked up costs" for the federal courthouse. See Kathleen Kerr, *Senate Report Rips Foley Sq. Courthouse*, NEWSDAY, Dec. 14, 1994. Others called the Boston Courthouse a "Taj Mahal." See Dean, *The nation's biggest landlord*. In 2006, proposed revisions to the *Design Guide* aimed to lower some costs. For example, a new standard on a "palette of finishes" limited the range, and "a separate dining area for judges" could be authorized only if a cafeteria was planned for a building. See JCUS Sept. 19, 2006, at 36.

**137** *Investigation of the Federal Courthouse Construction* at 29.

Thereafter Senator Max Baucus, who had chaired the committee that issued the report, proposed amendments to the 1959 Public Buildings Act to require more congressional oversight of costs for courthouses.

**138** See The Public Buildings Reform Act of 1996, S. 1005, 104th Cong. § 6 (1995). The GSA would have been charged with doing so "in consultation" with the AO. That proposal called for justification of the number of courtrooms planned for a courthouse. See § 2.

**139** See The Public Buildings Reform Act of 1996, S. 1005, 104th Cong. § 7 (1995).

**140** JCUS Mar. 7–9, 1979, at 18.

**141** For example, in 2004 the Judicial Conference set the imposition of "tighter restraints on future space and facilities cost" as one "objective" for "cost containment for fiscal year 2005 and beyond." JCUS Sept. 21, 2004, at 6.

**142** In 2006, the Committee on the Budget of the Judicial Conference concluded that "a proposal to seek a separate appropriation to cover GSA rental charges . . . would not be in the best interests of the judiciary." See JCUS Mar. 14, 2006, at 11. Instead the focus was on how to alter the way rent was calculated—a response that (as detailed later) succeeded but also made the amount of funding going to the judiciary less easily calculated.

**143** JCUS Mar. 7–9, 1979, at 18.

**144** See *Federal Judiciary: Is There a Need for Additional Federal Judges? Hearing Before the Subcomm. on Courts, the Internet, and Intellectual Property, of the H. Comm. on the Judiciary*, 108th Cong. 8–20 (June 24, 2003) (Statement of Dennis Jacobs, Chair, Committee on Judicial Resources, and Judge, United States Court of Appeals for the Second Circuit). For example, the judiciary relied on a measure of 430 "weighted" cases per district judge and 500 per panel of three appellate judges as appropriate but did not request additional judgeships until even larger ratios were reached. Id. at 49 (Jacobs's letter of May 27, 2003).

Those measures, in turn, prompted criticism from some sectors (such as the GAO) that the statistical techniques did not capture the work. Id. at 20 (Statement of William O. Jenkins, Director, Homeland Security and Justice Issues, General Accounting Office) (discussing the GAO Report Federal Judgeships: The General Accuracy of the Case—Related Workload Measures Used to Assess the Need for Additional District Court and Courts of Appeals Judgeships, GAO-03-788R (2003)). The GAO commented that the measures applied in the early 1990s were appropriate then but might no longer be accurate given changes in case filings and district court management practices. Id. at 30–42.

**145** See JCUS Sept. 23, 1997, at 84.

**146** JCUS Mar. 12, 1996, at 35. See also 1995 DIRECTOR OF THE AO REPORT at 20. As proposed projects had been in planning stages for years and had undergone "extensive review by the GSA and the judiciary," the AO described its efforts to put into place a "formal process of ranking pending projects in numerical order." Thereafter the Conference approved a five-year plan while also authorizing its Committee on Security, Space, and Facilities to modify it. JCUS Mar. 12, 1996, at 36.

**147** JCUS Mar. 11, 1997, at 37–38. See also 1997 U.S. COURTS DESIGN GUIDE, Revisions–1. Its "summary of revisions" explained that many changes were focused on "reducing costs."

**148** 1997 U.S. COURTS DESIGN GUIDE, Revisions–2.

**149** JCUS Mar. 14, 1995, at 31–32.

**150** See JCUS Mar. 14, 1995, at 17 and Mar. 11, 1997, at 40–41.

**151** JCUS Mar. 11, 1997, at 38.

**152** See JCUS Sept. 17, 1996, at 70–71 and Mar. 16, 1999, at 35; 1995 DIRECTOR OF THE AO REPORT at 17. The report reproduced a "Memorandum of Understanding: between the Director of the AO and the Administrator of the GSA" and set forth procedures for approval. Changes subject to the rules were those that would alter estimates by either $100,000 or 5 percent of the projected budget.

**153** *Chief Justice Appeals to Congress for Courthouse Construction Projects*, 30 THIRD BRANCH 1 (Apr. 1998) (hereinafter *Chief Justice Appeals to Congress*, THIRD BRANCH).

**154** *Chief Justice Appeals to Congress*, THIRD BRANCH at 1.

**155** *Chief Justice Appeals to Congress*, THIRD BRANCH at 2. When the Space and Facilities Committee recommended a separate appropriation for rent again in 2004, the Conference concluded that the pursuit of "administrative rather than legislative remedies" was more appropriate. JCUS Sept. 20, 2005, at 4. As noted, in 2006 the Conference concluded that seeking such a clear and quantifiable earmark was not in the "best interests of the judiciary." JCUS Mar. 14, 2006, at 11.

**156** For example, in 2001 Congress appropriated $146.9 million for fourteen repair projects and $280.2 million for twenty-one new projects. See 2001 DIRECTOR OF THE AO REPORT at 7.

**157** HISTORY OF THE AO at 113. The budget increase was listed as one of the "major accomplishments" of that office.

**158** See *Courthouse Funding Squeezes Through in Final Conference*, 36 THIRD BRANCH 4 (Feb. 2004).

**159** *2006 Future of the Federal Courthouse Construction Program Hearings* at 176, 177 (Statement of Jane R. Roth, Chair, Judicial Conference Committee on Space and Facilities) (hereinafter *2006 Future of the Federal Courthouse Construction Program Hearings*, Roth/Judicial Conference Statement).

**160** *2006 Future of the Federal Courthouse Construction Program Hearings*, Roth/Judicial Conference Statement at 5.

**161** *2006 Future of the Federal Courthouse Construction Program Hearings*, Roth/Judicial Conference Statement at 8.

**162** *2006 Future of the Federal Courthouse Construction Program Hearings*, Roth/Judicial Conference Statement at 7.

**163** *2006 Future of the Federal Courthouse Construction Program Hearings*, Roth/Judicial Conference Statement at 9.

**164** The GSA rent bill also exposed intra-judiciary tensions in that the federal courts' central budget was taxed but at least some of the building design processes were controlled at a local level. See *2006 Future of the Federal Courthouse Construction Program Hearings*, Commissioner Winstead Statement at 10. The Judicial Conference responded in part by trying to rein in the circuits through the imposition of caps (subject to exceptions) on that regional basis. See JCUS Sept. 18, 2007, at 36. That report noted that the rent cap had been proposed in 2004, but a mechanism to "translate the annual 4.9 percent cap into circuit-level rent budgets" had not yet been organized. Id.

**165** *JRent: Powerful Tool Helps Courts Monitor Space Costs*, 40 THIRD BRANCH 2 (Dec. 2008).

**166** *GAO Federal Courthouses Rent Increases* at 8.

**167** *GAO Federal Courthouses Rent Increases*, inside front cover. This hearing was a continuation of a 2005 inquiry. See *House Subcommittee Won't Back Rent Waiver*, 40 THIRD BRANCH 5 (July 2006).

**168** *2005 Hearing on The Judiciary's Ability to Pay for Current and Future Space Needs* at 82–83 (Statement of F. Joseph Moravec).

**169** *2006 Future of the Federal Courthouse Construction Program Hearings* at 269 (Statement of David Winstead, Commissioner, GSA). In 2005 hearings Commissioner Moravec had concluded that, as measured in square feet, "the Judiciary is our largest customer." *2005 Hearing on The Judiciary's Ability to Pay for Current and Future Space Needs* at 82 (Statement of F. Joseph Moravec). Measured in terms of user charges for space "rent revenue," the judiciary was the GSA's second-largest customer in 2005. Id. at 83.

**170** GAO Human Capital Reform Act of 2004, Pub. L. 108-271, 118 Stat. 811 (2004) (codified at 31 U.S.C. § 702 (2006)).

**171** Goldstein provided "Percentage Net Change in Square Footage" by circuit. *GAO Federal Courthouses Rent Increases*, fig. 3 at 7 (showing the differential increase that did not correlate with the geographical expanse and the number of judges of the circuits). For example, the Second Circuit (comprising Vermont, New York, and

Connecticut) had a 22 percent increase in square footage, and the Ninth Circuit (consisting of Alaska, Hawaii, Washington, Oregon, Idaho, Montana, Nevada, California, and Arizona) gained 27 percent.

**172** *GAO Federal Courthouses Rent Increases*, inside front cover. Goldstein commented that separate security paths coupled with "structural and architectural elements make courthouses among the most expensive federal facilities to construct." Id.

**173** One GSA study had concluded that federal courthouses were about 12 percent or $20 per square foot more expensive to build than their state counterparts but that some of the extra cost came from more exacting government standards and the longer time it took to build. See Emilie Sommerhoff, *Fed Courts: Jury's Out*, 92 ARCHITECTURE 20 (June 2003). The study looked at costs from 2000 to 2002.

**174** *GAO Federal Courthouses Rent Increases*, inside front cover.

**175** *GAO 2006 Report on Federal Courthouses Rent Increases* at 11.

**176** *GAO 2006 Report on Federal Courthouses Rent Increases* at 11–13.

**177** *2006 Future of the Federal Courthouse Construction Program Hearings* at 2 (Statement of Rep. Shuster, Chair, Subcomm. on Economic Development, Public Buildings, and Emergency Management). Rep. Shuster also criticized the Judiciary for seeking a "get out of jail free card." Id. at 2. Another critic of judicial building was Representative Eleanor Holmes Norton of the District of Columbia. Id. at 169.

**178** *2006 Future of the Federal Courthouse Construction Program Hearings*, Roth/Judicial Conference Statement at 2. Also attached was a detailed letter from the Director of the AO, Leonidas Ralph Mecham, criticizing a draft GAO report that had drawn unfavorable conclusions about the judiciary's space utilization. See *2006 Future of the Federal Courthouse Construction Program Hearings* at 187–216.

**179** *2006 Future of the Federal Courthouse Construction Program Hearings*, Roth/Judicial Conference 2006 Statement at 2.

**180** *2006 Future of the Federal Courthouse Construction Program Hearings*, Roth/Judicial Conference Statement at 2.

**181** *2006 Future of the Federal Courthouse Construction Program Hearings*, Roth/Judicial Conference Statement at 3.

**182** *2006 Future of the Federal Courthouse Construction Program Hearings* at 19 (Commissioner Winstead Statement). A $3.2 million rent credit was issued, followed by a $10 million credit for the Moynihan Courthouse in New York. See 2005 DIRECTOR OF THE AO REPORT at 29. Another set of credits came after verification of the actual space being used by the Judiciary in 175 locations. 2006 DIRECTOR OF THE AO REPORT at 39.

**183** *2005 Hearing on The Judiciary's Ability to Pay for Current and Future Space Needs*, Statement of Leonidas Ralph Mecham at 2. "Rent payments to the GSA . . . have grown from $133 million in 1986 to $921.5 million (est.) in fiscal year 2005, almost a 600 percent increase. . . . [S]pace . . . has grown only 150 percent." Id. at 4.

**184** *Either Pay Staff or Pay Rent*, 37 THIRD BRANCH 1 (July 2005). The subheading read: "Caught in a Financial Bind, Federal Courts Ask Congress for Relief." Id.

**185** 2005 DIRECTOR OF THE AO REPORT at 13.

**186** Chief Justice John G. Roberts Jr., *2005 Year-End Report on the Federal Judiciary*, 38 THIRD BRANCH 1 (Jan. 2006) (hereinafter Roberts, *2005 Year-End Report*). Roberts commented that a "more direct threat to judicial independence is the failure to raise judges' pay."

**187** The question of how to measure the percentage of the judiciary's budget is also an issue. In some materials, for example, the AO reported that the rent "consumed 22 percent of the Judiciary's salaries and expenses budget," itself a subset of the overall budget. See 2005 DIRECTOR OF THE AO REPORT at 29. The Chief Justice cited a different percentage and, of course, what percentage is devoted to rent varied with the baseline chosen.

**188** Roberts, *2005 Year-End Report*.

**189** Roberts, *2005 Year-End Report*.

**190** Letter from Leonidas Ralph Meacham to Mark Goldstein (June 6, 2006), Appendix III, *GAO Federal Courthouses Rent Increases* at 48, quoted in *House Subcommittee Won't Back Rent Waiver*, 38 THIRD BRANCH 1 (July 2006).

**191** *2006 Future of the Federal Courthouse Construction Program Hearings*, Roth/Judicial Conference Statement at 2.

**192** *2006 Future of the Federal Courthouse Construction Program Hearings*, Roth/Judicial Conference Statement at 4.

**193** *2006 Future of the Federal Courthouse Construction Program Hearings* at 201 (Submission of Leonidas Ralph Mecham, Director, AO of the U.S. Courts, and Secretary, JCUS).

**194** *GAO Federal Courthouses Rent Increases*, inside front cover.

**195** *2005 Hearing on The Judiciary's Ability to Pay for Current and Future Space Needs* at 41 (Statement of Mark L. Goldstein, GAO Director, Physical Infrastructure Issues) (Courthouse Construction: Overview of Previous Work and Ongoing Work, GAO 05-838T, a summary of Goldstein's testimony, www.gao.gov/highlights/d05838thigh.pdf). As the AO saw it, the "objective . . . was to pay only for the actual costs of operation and maintenance of the courts, since the costs of the land and buildings had already been paid." Further, the AO protested another aspect of the GAO rent policy—"which requires federal agencies to pay the equivalent of state and local taxes." See 2005 DIRECTOR OF THE AO REPORT at 29.

**196** *2006 Federal Courthouse Construction Program Hearings* at 1 (Statement of Bill Shuster). The GAO had counseled against it, noting that "rent exemptions were a principal reason why FBF [the Federal Building Fund] has accumulated insufficient money for capital investment." *Wasted Space, Wasted Dollars: The Need for Federal Real Property Management Reform: Hearing Before the H. Comm. on Government Reform on H.R. 3134*, 109th Cong. 50 (2005) (Statement of David M. Walker, Comptroller General of the United States).

**197** See S. 2292, 109th Cong. (2006); Judiciary Rent Reform Act of 2006, H.R. 4170, 109th Cong. (2006). Had it been enacted, the judiciary estimated that its rent would have declined by about $500 million. 2006 DIRECTOR OF THE AO REPORT at 10. The American Bar Association (ABA) supported enactment. See Resolution 115, approved by the ABA House of Delegates in August of 2006.

**198** *Senators to GSA: Reduce Judiciary's Rent*, 37 THIRD BRANCH 6 (June 2005). A group of eleven senators from both parties wrote the GSA to respond to the budgetary problems. Id.

**199** *2006 Federal Courthouse Construction Program Hearings* at 170 (Statement of the Honorable Eleanor Holmes Norton). See also *House Subcommittee Skeptical of Judiciary's Rent Relief Effort*, 37 THIRD BRANCH 6 (July 2005); *House Subcommittee Won't Back Rent Waiver*, 38 THIRD BRANCH 7 (July 2006).

**200** That point was made by Joseph Moravec, Commissioner of the Public Building Service: "The rent/user charge is good public policy that promotes accountability for the amount and quality of space they use." *2005 Hearing on The Judiciary's Ability to Pay for Current and Future Space Needs* at 82 (Statement of F. Joseph Moravec).

**201** JCUS, Sept. 19, 2006, at 10. The cap was to be for fiscal years 2009–2016. As noted, the Conference also tried to impose limits on the regional level.

**202** *2006 Future of the Federal Courthouse Construction Program Hearings*, Roth/Judicial Conference Statement at 27, 31.

**203** See also the 2006 DIRECTOR OF THE AO REPORT at 10–11.

**204** See Memorandum of Agreement between the U.S. General Services Administration Public Building Service and the Administrative Office of the United States Courts Concerning Rent Charges for Certain Courthouses, entered into by James C. Duff for the AO on Feb. 19, 2008, and by David Winstead, Commissioner of Public Buildings Service of the GSA on February 11, 2008. Obtained through the Freedom of Information Act (hereinafter MOA GSA/AO, Feb. 19, 2008). Thus, "rent is the result of compromise." Tjoflat 2010 Letter at 6.

**205** *Judicial Conference Adopts Courtroom Sharing Policy as Latest Cost-Saver*, 40 THIRD BRANCH 1–2 (Sept. 2008). The Conference also cut back on its building of "special proceedings courtrooms,"

which were large-sized. Unless a building served as a district head-quarters or had four or more judges, it would be an "exception" to provide a special proceeding courtroom, and that "exception" would trigger GSA and congressional review. JCUS Mar. 11, 2008 at 28.

**206** Frederic L. Ledere, *The Courtroom in the Age of Technology* in CELEBRATING THE COURTHOUSE.

**207** *Government of Virgin Islands v. Charleswell*, 115 F.3d 171 (3d Cir. 1997). The appellate court noted that the "unfortunate circumstances of this case illustrate the serious drawbacks of a courthouse planning philosophy that encourages sharing of courtrooms by a number of judges to promote efficiency in space utilization. . . . When a courtroom is not available as the need arises, the result is a loss of efficiency in other phases of judicial administration. . . . [E]xperience teaches that the brick and mortar construction expense of building larger facilities may be less expensive in the long run than the other costs associated with delay in processing cases. The results of coping with an insufficient number of courtrooms demonstrates that the old adage of 'penny wise and pound foolish' is particularly apt." Id. at 175.

**208** Marcia Coyle, *Ruling Slams Courtroom Sharing*, NATIONAL LAW JOURNAL, June 16, 1997, at A7.

**209** For example, the Judicial Conference objected to a proposed bill, the General Services Administration Improvement Act of 1997, H.R. 2751, 105th Cong. (1997), that would have required that the judiciary or GSA submit data on courtroom use, courtroom sharing, and the design guide. See JCUS Mar. 10, 1997, at 30. On the other hand, the Judicial Conference registered its support for a bill pending in 1997, H.R. 623, 105th Cong. (1997), because it would provide a "[m]ore realistic and favorable treatment of capital investments in the federal budget to the benefit of the judiciary." JCUS Mar. 10, 1998, at 31.

**210** Discussion of that study's metric can be found in U.S. General Accounting Office, *Courthouse Construction: Sufficient Data and Analysis Would Help Resolve the Courtroom-Sharing Issue*, GAO-01-70, at 8, 19 (Dec. 2000) (hereinafter *GAO Courthouse Construction 2000*), http://www.gao.gov/new.items/d0170.pdf. See also General Accounting Office, *Courtroom Construction: Better Courtrooms Use Data Could Enhance Facility Planning and Decisionmaking*, GAO/GGD-97-39 at 23 (May 1997), http://www.gao.gov/archive/1997/gg97039.pdf.

**211** 1999 DIRECTOR OF THE AO REPORT at 28.

**212** *GAO Courthouse Construction 2000* at 8, 16. Ernst and Young had designated districts with fewer than five courtrooms in one category and looked at places with six to ten courtrooms in another. The GAO commented that 91 percent of the courthouses fall within the category of five or fewer courtrooms. But "about 40 percent of all current, active district judges are located in the remaining 9 percent of the courtrooms." Id. at 19.

**213** Congressional Budget Office, *The One-Courtroom, One-Judge Policy: A Preliminary Review*, at 12 (Apr. 2000), http://www.cbo.gov/ftpdocs/19xx/doc1922/onecourt.pdf.

**214** In 1997, for example, the Office of Management and Budget did not include proposed funds for court construction. See JCUS Sept. 15, 1998, at 89.

**215** JCUS Mar. 11, 1997, at 17.

**216** See, for example, *Comments from the Chair, Judicial Conference, Committee on Security and Facilities*, Oct. 31, 2000, appended at 57 to *GAO Courtroom Construction 2000* (underscoring the "value of unfettered access to a courtroom and its importance to the fair and efficient administration of justice").

**217** JCUS Mar. 14, 2000, at 30.

**218** JCUS Mar. 14, 2000, at 30. See JCUS Sept. 19, 2000, for further protests.

**219** JCUS Mar. 14, 2000, at 30–31.

**220** See, for example, *To provide for the review by Congress of proposed construction of court facilities*, H.R. 254, 107th Cong. (2001); JCUS Sept.–Oct. 2001 at 71–72.

**221** JCUS Mar. 14, 2001, at 32.

**222** *General Services Administration's FY2005 Capital Investment and Leasing Program: Hearing Before the Subcomm. on Economic Development, Public Buildings, and Emergency Management of the H. Comm. on Transportation and Infrastructure*, 108th Cong. 2 (July 13, 2004) (Statement of the Hon. Jane R. Roth, Chair, Judicial Conference Committee on Security and Facilities). Judge Roth had sounded a similar theme in previous years. As she explained, projects for the then-pending "Five-Year Plan are urgently needed . . . and delays only exacerbate operational problems." *Courthouse Construction Delays Hurt Judiciary*, 33 THIRD BRANCH 3 (Jun. 2001).

In 2006 the Conference set forth a definition of a "space emergency" as a building that is "severely damaged or . . . has an excessive caseload that impacts its space. The Committee on Space and Facilities will examine each emergency situation on a case-by-case basis to determine whether to recommend" that the project be declared an emergency. See JCUS Mar. 14, 2006, at 27–28.

**223** JCUS Sept. 23, 2003, at 37. The effort was to "convey critical housing needs" in Southern California and Texas. The courts designated as in need of priority funding were those in Los Angeles, California; El Paso, Texas; San Diego, California; and Las Cruces, New Mexico. See JCUS Sept. 21, 2004, at 34.

**224** JCUS Sept. 21, 2004, at 34–35.

**225** JCUS Sept. 21, 2004, at 36.

**226** JCUS Sept. 19, 2006, at 6.

**227** JCUS Sept. 19, 2006, at 10.

**228** Letter from Rep. Bill Shuster, chairman of the Subcommittee on Economic Development, Public Buildings and Emergency Management of the House Committee on Transportation and Infrastructure, to Jane R. Roth in her capacity as Chair of the Judicial Conference Committee on Space and Facilities (Nov. 4, 2005), Appendix One to *The Use of Courtrooms in the U.S. District Courts: A Report to the Judicial Conference Committee on Court Administration & Case Management* (Project Directors Donna Stienstra and Patricia Lombard, July 18, 2008), http://www.fjc.gov/public/home.nsf/autoframe?openform&url_l=/ public/home.nsf/inavgeneral?openpage&url_r=/public/home.nsf/pages/1055 (hereinafter *2008 FJC Courtroom Use Study*). See also James C. Duff, Director of the AO, Judicial Conference of the United States, *Report on the Usage of Federal District Court Courtrooms*, Sept. 2008, appended to the materials for the Judicial Conference meeting of Sept. 2008 (hereinafter *2008 FJC Courtroom Usage Report*). As that report outlined, Representative Shuster had asked that the study document based on a statistical sampling, how often courts were "actually in use" with people there for "official functions," that the study be designed with "input of the GAO's Physical Infrastructure Division," and that it incorporate "other factors as the Judiciary deems necessary." *2008 FJC Courtroom Usage Report* at A-2, n. 1.

**229** *2008 FJC Courtroom Use Study* at Appendix 4, 9.

**230** *2008 FJC Courtroom Use Study* at 1, 4-1. In a questionnaire distributed to District Judges and Magistrate Judges, the FJC explained that actual "courtroom use is fairly straightforward. . . . Some have suggested, however, that the availability of a courtroom serves important functions, even when the courtroom is not actively being used. This is known as latent use." *2008 FJC Court Use Study*, Appendix 10 at 10–13.

The FJC used a variety of sources of information, including a questionnaire sent to all judges, a questionnaire to attorneys, and direct data collection in thirteen districts in two "waves" of two different three-month periods. *2008 FJC Courtroom Use Study* at 9. A total of twenty-three districts were analyzed, and three were used as case studies. The information provided on shared courtrooms is based on one case study, the Southern District of New York. Id. at 12, 14. Appendix 7 of the *2008 FJC Courtroom Usage Report* detailed the kinds of proceedings coded, ranging from case proceedings conducted by a judge to ceremonies, education, set-up or short adjournments, maintenance, and unoccupied and usable or not. Id. at 7-1 to 7-3. The sur-

vey questionnaire went to more than 1,500 judges; more than 1,000 replied, yielding a response rate of 68 percent. Id., Appendix 10-1.

Courtrooms were, on average, in "actual use" for 2.9 hours a day if a judge was an active judge (*2008 FJC Courtroom Use Study* at 18) and 4.1 hours if "scheduled time" (or latent use) was included. Id. at 37. Judges spent a great deal of time in chambers, often in conferences. Id. at 27. In the district where senior and active judges shared courtrooms, the actual use time was somewhat lower, as was the scheduled time. Id. at 47.

**231** *2008 FJC Courtroom Use Study* at 42. Eighty-one percent of judges believed that this latent use "often" prompted settlement.

**232** *2008 FJC Courtroom Usage Report* at A-8, A-9.

**233** *2008 FJC Courtroom Usage Report* at A-7.

**234** *2008 FJC Courtroom Usage Report* at A-7.

**235** *2008 FJC Courtroom Usage Report* at 48.

**236** When approving additional appropriations for courthouse construction in San Diego, California, the House Transportation and Infrastructure Committee resolved that within "one year of the date of approval of this Resolution, the Judicial Conference of the United States shall amend the U.S. Courts Design Guide to require that each U.S. Courthouse construction project provide one courtroom for every two senior judges." Also mandated were more process and oversight for departures. See *Resolution, Amending a Resolution of July 21, 2004*, 152 Cong. Rec. H5652, 109th Cong. (2006). See also JCUS Mar. 13, 2007, at 11. Although the resolution stated that the *Guide* was to be altered within a year, the Conference reported in 2007 that its subcommittees and the AO were working with the House Committee on the issue. Id.

**237** *2008 FJC Courtroom Usage Report* at A-10, A-11. That Report also noted that, while the Judicial Conference had no "formal position" on magistrate judge assignments, it had applied the "one-for-one policy" to them. Id. at A-10. One concern raised by a former chief judge of a circuit about the new approach was that magistrate and bankruptcy judges could have the most intense need for ready access to courtrooms. See Tjoflat 2010 Letter at 6.

**238** *2008 FJC Courtroom Usage Report* at A-2.

**239** According to MOA GSA/AO, Feb. 19, 2008, the different methods yielded a rent reduction from $47.73 to $39.36 per square foot. See Office of Real Property Asset Management, ROI Pricing (Sept. 2006) at 4 (appended to MOA). The estimate in 2008 was that the revised method of accounting would, over twenty years, save the judiciary more than $140 million. Eisenman interview, Dec. 2008.

**240** *2006 Future of the Federal Courthouse Construction Program Hearings*, Roth/Judicial Conference Statement at 3.

**241** *2006 Future of the Federal Courthouse Construction Program Hearings*, Commissioner Winstead Statement at 269.

**242** See Jordan Gruzen with Cathy Daskalakis and Peter Krasnow, *The Geometry of a Courthouse Design*, in CELEBRATING THE COURTHOUSE at 83. See also CHARLES GEYH, WHEN COURTS AND CONGRESS COLLIDE: THE STRUGGLE FOR CONTROL OF AMERICA'S JUDICIAL SYSTEM (Ann Arbor, MI: U. of Michigan Press, 2006).

**243** See Joseph P. Fried, *A Bigger Home for the Federal Courts in Brooklyn*, NEW YORK TIMES, Sept. 30, 1999. That article detailed the cutbacks in the project, down from eighteen floors to fifteen, from 300 feet to 252 feet, and from twenty-four courtrooms to seventeen. Id.

**244** The House had required the judiciary to "provide a specific list of each departure" from the parameters if costs would be raised, along with a "justification and estimated cost" for such departures. The resolution further required GSA to submit a recommendation to the relevant committees as to whether to approve departures from the *Design Guide. Resolution, Amending a Resolution of July 21, 2004*, 152 Cong. Rec. H5652, 109th Cong. (2006); JCUS Mar. 13, 2007, at 27, 32. As the Judicial Conference noted, what constituted an "exception" was not always agreed upon by the GSA and the AO. Id. at 27.

**245** 1997 U.S. COURTS DESIGN GUIDE at 3–9.

**246** JCUS Mar. 14, 2006, at 24.

**247** JCUS March 14, 2006 at 25–26. The earlier policy statement,

cited there, is found at 81. In 2005 the Conference had started to draft a plan to do so. JCUS Sept. 20, 2005, at 40. In 1990 a bill to do so, the Judicial Space and Facilities Management Improvement Act of 1989, H.R. 4178, 101st Cong. (1990), had been introduced to create that separation. GSA had objected, and the sponsoring congressman had urged the two agencies to develop a compromise. See also *To Facilitate the Construction of U.S. Courthouses, and for Other Purposes*, S. 2837, 101st Cong. (1990), introduced by Senator Moynihan to accomplish the same end. The Post Office's authority to determine and provide for its building needs is set forth in 39 U.S.C. § 404 (2006).

**248** JCUS Sept. 18, 2007, at 37. Thirteen projects were then approved. Id. Ten space requests were approved in Mar. of 2007. JCUS Mar. 13, 2007, at 31.

**249** See *Hearing, Eliminating Waste and Managing Space in Federal Courthouses: GAO Recommendation on Courthouse Construction, Courtroom Sharing and Enforcing Congresional Authorized Limits on Size and Cost*, before the Subcommittee on Economic Development, Public Buildings and Emergency Management, Committee on Transporation and Infrastructure, U.S. House of Representatives, May 25, 1010 (Statement of Judge Michael A. Ponsor, Chair, Committee on Space and Facilities; Statement of Robert A. Peck, Commissioner, Public Buildings Service, U.S. General Services Administration), http://transportation.house/gov/hearings/hearingDetail.aspx?NewsID=1204; Federal Courthouse Construction: Preliminary Results Show Better Planning, Oversight, and Courthouse Sharing Could Help Control Future Costs, GAO-10-753T (May 25, 2010), http:///www.gao.gov/new/items/d10753t.pdf.

**250** Tjoflat 2010 Letter at 5–6.

**251** See generally Richard H. Fallon, *The "Conservative" Paths of the Rehnquist Court's Federalism Decisions*, 69 U. OF CHICAGO LAW REVIEW 429 (2002); Judith Resnik, *Constricting Remedies: The Rehnquist Judiciary, Congress, and Federal Power*, 78 INDIANA LAW JOURNAL 223 (2003).

**252** See 2002 DIRECTOR OF THE AO REPORT at 2; 2003 DIRECTOR OF THE AO REPORT at 6.

**253** 2007 DIRECTOR OF THE AO REPORT at 4–5.

**254** John Roberts, *Year-End Report on the Federal Judiciary, 2006*, www.supremecourts.gov/publicinfo/year-end/2006year-endreport.pdf. See also Testimony of Justices Stephen Breyer and Samuel Alito, House Judiciary Subcommittee on Courts, the Internet, and Intellectual Property, Judicial Compensation and Judicial Independence, www.uscourts.gov/testimony/JusticeBreyerPay041907.pdf and www.uscourts.gov/testimony/JusticeAlitopay041907.pdf. See generally James E. Pfander, *Judicial Compensation and the Definition of Judicial Power in the Early Republic*, 107 MICHIGAN LAW REVIEW 1 (2008). Parallel concerns came from state courts. In 2008, New York State's Chief Judge filed a lawsuit against the Speaker of the New York State Assembly and the governor; the lawsuit argued that the failure to raise judges' salaries since 1999 constituted a violation of separation of powers. See *Kaye v. Silver*, Index No. 400763/08, http://nycourts.gov/judges/070908papers.pdf.

**255** At times during the Rehnquist era, the Judicial Conference expressed its own concerns that the number of life-tenured judges not increase too much. Rather, the Conference promoted various forms of outsourcing, such as delegation to non-life-tenured judges and shifting work to the state courts. See generally Judicial Conference of the United States, *Long Range Plan for the Federal Courts* (Dec. 1995), reprinted in 166 FEDERAL RULES DECISION 49 (1996). The Conference did make some requests for more judgeships, but Congress did not authorize new appointments.

**256** John Wetenhall, *Camelot's Legacy to Public Art: Aesthetic Ideology in the New Frontier*, 48 ART JOURNAL 303, 304 (1989).

**257** Tepper noted that the City of Philadelphia had put such a program in place in 1959. He also reported that up to 2 percent of new building construction went for "single and multiple art installations."

Steven J. Tepper, *Unfamiliar Objects in Familiar Places: The Public Response to Art-in-Architecture*, 6 INTERNATIONAL JOURNAL OF CULTURAL POLICY 283, 284–285 (2000). See also Salil K. Gandhi, *The Pendulum of Art Procurement Policy: The Art-in-Architecture Program's Struggle to Balance Artistic Freedom and Public Acceptance*, 31 PUBLIC CONTRACT LAW JOURNAL 535 (2002).

**258** Art-in-Architecture Program, A Contextual History of the Art-in-Architecture Program at 3, in GSA/AiA Archives (hereinafter AiA Contextual History). That history reported that the 1974 installation of Alexander Calder's *Flamingo* in Chicago prompted an outpouring of public praise. Id. at 4.

**259** The lower-case *i* in AiA distinguished its abbreviation from AIA, which denotes the American Institute of Architects, founded in the nineteenth century. As detailed in Chapter 7, the AIA successfully pressed Congress to authorize private architects to obtain commissions for public buildings. By 2005, AIA had more than 75,000 members. See AIA, History of the American Institute of Architects, http://www.aia.org. The parallelism of the abbreviations and the smaller *i* nicely capture that art is nested in the architecture.

**260** See, for example, 41 C.F.R. § 102-77.10 (2008) ("What basic Art-in-Architecture policy governs Federal agencies?"). Gandhi estimated that the GSA spent about $6 million on art between 1972 and 1984 and that the value of those objects grew to more than $30 million. Gandhi at 544. In 1976 the GSA decided to fund projects at .375 percent, hoping that donors from the community would also lend support. GSA Policy Manual, Nov. 11, 1976, GSA archives. Solomon, who had been a developer before serving as Administrator of the GSA from 1977 to 1979, described his commitment to reinvigorating the Art-in-Architecture program as a way to make federal buildings "warm, open and inviting—in contrast to the cold, gloomy, sterile shells which characterized federal architecture a few years ago." *Art in Architecture: Hearing Before the Subcomm. on Civil Service and General Services of the S. Comm. on Governmental Affairs*, 96th Cong. 20 (1979) (Statement of Jay Solomon, Administrator, GSA) (hereinafter *Art in Architecture Sept. 1979 Hearing*). He therefore reinstated the half-percent allotment, expanded its application to include renovations, and "expanded the types of work acceptable for commission to include virtually every imaginable form of visual media." Id. at 21.

Wetenhall, at 304, credited "economic pressures of the Vietnam War" as the reason for ending the set-aside in 1966. Upon its revival, Wetenhall saw the program as providing the "major vehicle for commissioning modern public sculpture" in the 1980s and 1990s. Wetenhall at 304. See also DONALD W. THALACKER, THE PLACE OF ART IN THE WORLD OF ARCHITECTURE (New York, NY: Chelsea House Publishers, 1980).

**261** See Memorandum for Regional Administrators from Kenneth R. Kimbrough, Commissioner of Public Building Service, Revised Art-in-Architecture Procedures, Feb. 10, 1995, at 1. There GSA created new funding criteria to offer a "sliding scale of funding from zero to two percent based upon the architectural design of a building, its location, and community interest and participation." Id. at 2. In addition to commissions, the government also accepted donations. GSA MODERNISM at 67.

**262** Jo Ann Lewis, *Don't Laugh—It's Your Money: GSA Spends Millions on Public Art, but Many Don't Want It*, WASHINGTON POST, Oct. 28, 1979 (hereinafter Lewis, *Don't Laugh*), reproduced in *Art in Architecture: Hearing on H.R. 2467 and H.R. 5545 Before the Subcomm. on Public Buildings and Grounds of the H. Comm. on Public Works and Transportation*, 96th Cong. 15 (1979) (hereinafter *Art in Architecture Nov. 1979 Hearing*).

**263** Marilyn Farley worked tirelessly on the art selection processes and helped to bring distinguished architects and artists into the program. As Farley explained, one could not keep giving awards to Cass Gilbert, who had designed the Supreme Court in the 1930s. See Laura Fisher Kaiser, *The Feiner Things*, 74 INTERIOR DESIGN 152 (Oct. 1, 2003).

**264** Telephone interview with Jenny Holzer (Nov. 28, 2005). As Harrison explained, the commissions were "more conservative than the art world would like," but the federal "clients" thought them "cutting-edge." As she commented, "If I'm getting beaten up by the clients and by the art world, I'm in the right place." Bob Berstein, *Public Exchange*, July 14, 1999, RIVERFRONT TIMES, www.riverfronttimes.com/1999-07-14/news/public-exchange. That story focused on the selection of artist Mary Miss for the design of a park adjacent to the St. Louis courthouse and how that plan was "vastly different from the statues and monolithic sculptures of the past." Id.

**265** Lewis, *Don't Laugh*.

**266** Wetenhall at 307.

**267** GSA AiA Archives; GSA Policy Manual, Nov. 11, 1976.

**268** See *Art in Architecture Nov. 1979 Hearing* at 9 (Testimony of the Hon. James Abdnor, U.S. House of Representatives).

**269** *Art in Architecture Nov. 1979 Hearing* at 15 (reproducing Lewis, *Don't Laugh*). The sculpture remained in front of the Hubert H. Humphrey Federal Building; conservation efforts in 1998 restored paint and cleaned the dirt off the wood poles. Other examples of public distress are addressed in Judith H. Balfe and Margaret J. Wyszomirski, *Public Art and Public Policy*, 15 JOURNAL OF ARTS MANAGEMENT AND LAW 5 (Winter, 1986) (detailing, for example, the conflict over the "Tilted Arc" by Richard Serra, and discussed in Chapter 6).

**270** See H.R. 2467, amending sec. 18(b)(1) of the Public Buildings Act of 1959, in *Art in Architecture Nov. 1979 Hearing* at 2. The proposed bill also mandated a set-aside of one-half of 1 percent for art as well as the creation of an ad hoc commission for selection for each commission.

**271** On the Senate side, the commitment of Joan Mondale, spouse of then–Vice President Walter Mondale, to protecting arts helped to shelter the program. See *Art in Architecture Sept. 1979 Hearing* at 2–6 (Statement of Joan Mondale, Chair, Federal Council on the Arts and Humanities).

**272** File memo (Joint GSA-NEA Task Force on the AiA Program —January 1980), GSA AiA Archives.

**273** GSA AiA Archives, File Memo.

**274** Gandhi at 548–551; file memos of Sept. 21, 1988 and May 1989, GSA AiA Archives (noting that the GSA and NEA had severed their ties to this program).

**275** See GSA, Art-in-Architecture Program Procedures 4–5 (Feb. 1995), GSA AiA Archives; Gandhi at 550–551.

**276** See GSA, Art-in-Architecture Program Procedures 2 (Feb. 1995). See also the Public Buildings Cooperative Use Act of 1976 (40 U.S.C. § 601, recodified at 40 U.S.C. § 3306 (2006)), requiring the GSA to encourage and cooperate with localities to enable cultural improvements for the public. Thus the GSA invited "five art professionals and five community representatives"—called the Community Arts Panel —including one from the "client agency," to join the project architect in making recommendations. File memo, GSA AiA Archives.

The group members were "to represent a variety of viewpoints and perspectives," and at their first meeting they were told about the "architectural design"—in other words, the sites in which art might sit. Three meetings took place—to review portfolios, to recommend a selection to the Commissioner of Public Buildings (who made the final decision), and to evaluate the concept. File memo, Art-in-Architecture, GSA AiA Archives. See also Memorandum for Regional Administrators from Milton Herson, Commissioner, Subject Art-in-Architecture Program Procedures, July 30, 1992. Those procedures were revised again in 1995 to incorporate a "new focus and flexibility." Memorandum for Regional Administrators from Kenneth R. Kimbrough, Subject Revised Art-in-Architecture Procedures, Feb. 10, 1995 (hereinafter Kimbrough Memorandum).

**277** 41 C.F.R. § 102-77.10 (2008). The procedures and regulations for AiA are detailed through memoranda to the regions of the GSA.

**278** See, for example, Kimbrough Memorandum at 2.

**279** Undated talking notes, GSA, AiA Archives.

**280** See presentation by Celeste Bremer and Richard Gilyard, Art in Courthouses: Implications of the Government as Client, Sixth Annual International Conference on Court Design for the AIA (unpaginated).

**281** Memorandum, Women and Ethnic Minorities Commissioned through the Art-in-Architecture Program (last updated Mar. 15, 1995), GSA, AiA Archives. As of that date, commissions went to sixty-six women (two women had more than one commission); fifteen African-Americans (including two women; two men had more than one commission); three Asians (including one woman); eight Hispanics, of whom one was female (one of the men had three commissions); and six Native Americans, of whom one was a woman.

**282** Changes to the Art-in-Architecture Program, Memorandum for Regional Administrators from Robert A. Peck, Commissioner of Public Building Services, August 3, 2000, GSA AiA Archives. This memo followed one of March 17, 1998 (with the same title) that had explained the concern about an insufficient "integration of the art and design" of federal buildings, the process through which GSA had convened a national workshop at the headquarters of the AIA, and the shift in composition of panels. The 2000 memorandum raised concerns that in some GSA regions contacts with the AiA staff were not made promptly enough after designs were underway and that funds for art were being paid to architectural and/or engineering firms. See also Robert A. Peck, Memorandum for Assistant Regional Administrators, Revised Art-in-Architecture Program Guidelines, Dec. 21, 2000, GSA AiA Archives.

**283** II Vision + Voice at 7. The changes took place in 2000.

**284** See, for example, 2003 Facilities Standards, GSA, Appendix A.3, New Construction and Modernizations, http://www.gsa.gov/Portal/gsa/ep/contentView.do?contentType=GSA_BASIC&contentId=14233&noc=T.

**285** The program, noted in Chapter 6, was called "Images of Justice." It traveled around the country, exhibited in courthouses as well as at events like the Fifth International Conference on Justice Design. Some of the imagery can be found in a flyer available from the District of Missouri Court website at www.moed.uscourts.gov/community/ImagesOfJustice.pdf. As many works were from an earlier era, materials were provided by Fine Arts Collection of the GSA, which deals with "more than 17,000 paintings, sculpture, architectural or environmental works of art and graphics dating from the 1850s" on federal buildings. The other curatorial program, Art-in-Architecture, is focused on newly purchased or commissioned materials. See General Services Administration, Contributing to America's Architectural and Artistic Legacy: Design Excellence in Arts (Washington, DC: GSA, undated monograph).

**286** 41 C.F.R. § 102-77.10 (2008) ("What basic Art-in-Architecture policy governs Federal agencies?").

**287** 41 C.F.R. § 102-77.15 (2008) ("Who funds the Art-in-Architecture efforts?").

**288** 41 C.F.R. § 102-77.20 (2008) ("With whom should Federal agencies collaborate with when commissioning and selecting art for Federal buildings?").

**289** 41 C.F.R. § 102-77.20 (2008).

**290** 41 C.F.R. § 102-77.25 (2008) ("Do Federal agencies have responsibilities to provide national visibility for Art-in-Architecture?").

**291** AiA Contextual History at 7 (quoting *New York Times* art critic Grace Glueck).

**292** An Oklahoma Tribute: Art Collection from the Alfred P. Murrah Federal Building, Oklahoma City, Oklahoma (Washington, DC: U.S. General Services Administration, 2003) (hereinafter An Oklahoma Tribute), http://www.gsa.gov/graphics/pbs/Oklahoma_Tribute_FINAL.pdf.

**293** An Oklahoma Tribute at 7.

**294** An Oklahoma Tribute at 2–3, 8.

**295** An Oklahoma Tribute at 5.

**296** *Oklahoma Quilt* by Terry Mangat; *A Fallen Oak Tree* by James Strickland; and *Vigil* by William Scott, in An Oklahoma Tribute at 10, 32, and 34.

**297** Tom Otterness was born in 1952 in Wichita, Kansas, and worked a good deal in New York City. His work is sometimes described as "consumer realism" or "capitalist realism" in that he often deals with the mix of popular culture, media, government, and bureaucracy. See generally, Judith Collins, Sculpture Today 322–323 (London, Eng.: Phaidon Press, 2007). In addition to the installation in the federal courthouse in Portland, Otterness has sculptures in federal courthouses in Minneapolis, Minnesota, and in Los Angeles and Sacramento, California. Those installations are called *Rockman* (1998), *The New World* (1991), and *Gold Rush* (1999), respectively.

**298** Jenny Holzer was born in 1950 and studied in Ohio and at the Rhode Island School of Design before moving to New York. Our thanks to Jenny Holzer and Alanna Gedgaudas for providing information as well as permission to use the photograph of figure 125 and to Susan Harrison for her assistance in learning about Ms. Holzer's installations in federal courthouses.

**299** Hayden Herrera, Tom Otterness, catalogue for James Corcoran Gallery and Brooke Alexander Gallery shows, 1990 (unpaginated).

**300** Herrera at 1. Otterness moved to New York to study art. In 1977 he helped to found Colab with Jenny Holzer and Kiki Smith. See Vince Carducci, *Tom Otterness, Public Art and the Civic Ideal in the Postmodern Age*, 24 Sculpture 28 (2005).

**301** Herrera at 1.

**302** Herrera at 5.

**303** Carducci at 32–33.

**304** Herrera at 6.

**305** Carducci at 30.

**306** Carducci at 30.

**307** Carducci at 33.

**308** Elisabeth Mahoney, *Say it loud, say it proud*, Guardian (London) Features, Oct. 31, 2000, at 15. Discussions of Holzer's work, displayed around the world, cite the innovations of her provocations. See Lisa Milne, *Jenny Holzer: Getting the Word Out*, Daily Yomiuri, Aug. 5, 1994, at 15.

**309** Robert Hughes, *A Sampler of Witless Truisms*, Time, July 30, 1990 at 66, http://www.time.com/time/magazine/article/0,9171,970732-2,00.html. Praise for that installation came from art critic Arthur Danto, *Jenny Holzer*, The Nation, Feb. 12, 1990, at 213: "[I]t is difficult to think of a more appropriate artistic emissary, for hers is in every sense state-of-the-art art and a symbolic condensation of our national culture—up-to-the-minute in technology, populist in format, moralistic in tone." Id. See also Grace Glueck, *And Now, A Few Words from Jenny Holzer*, New York Times, Dec. 3, 1989, sec. 6 at 42.

**310** See David Joselit, *Voices, Bodies and Spaces: The Art of Jenny Holzer*, in Jenny Holzer 42–77 (David Joselit, Joan Simon, & Renata Salecl, eds., London, Eng.: Phaidon Press, 1998); Gordon Hughes, *Power's Script, or Jenny Holzer's Art after "Art after Philosophy,"* 29 Oxford Art Journal 419 (2006); Daniel Makagon, *Accidents Should Happen: Cultural Disruption through Alternative Media*, 24 Journal of Communication Policy 430, 436–442 (2000); Patrick Flynn, *Jenny Holzer: Artist*, The Progressive (Apr. 1993) at 30.

**311** Danto, *Jenny Holzer* at 213.

**312** Danto, *Jenny Holzer* at 213.

**313** Hughes, *Power's Script* at 421.

**314** Hal Foster, Recodings: Art, Spectacle, Cultural Politics 110–111 (Port Townsend, WA: Bay Press, 1986).

**315** Both artists can be understood on some dimensions to be radical. In Foster's discussion of postmodern art, for example, he

addressed Holzer's work in a chapter titled "Subversive Signs." FOSTER at 99–118.

**316** See Daniel Grant, *Bland Art in Every Pot*, THE NATION, Nov. 11, 1999, at 44.

**317** Our thanks to Tom Otterness, Laurie Black, and Michael Mathers and Tom Otterness Studio for providing materials, information, interviews, and the photographs in figures 121–124 and permission to use them, and to Susan Harrison for her assistance in enabling us to interview Mr. Otterness. The courthouse, opened in 1997, was designed by Kohn Pedersen Fox Associates of New York in conjunction with BOORA Architects Inc. of Portland, Oregon. A pamphlet by the GSA reproduces some of the artwork by Otterness and others. The lobby features water sculptures, the *Ocean of Thought* and *Portland Water Veil*, by Eric Orr; on the sixteenth floor is a series by Judith Poxson Fawkles called *Four Linen Tapestries that* includes a woven topographical map of Oregon, a figure of Justice, a scene of the Oregon environment, and another scene of the state's judicial heritage. See U.S. COURTHOUSE, PORTLAND, OREGON: ART IN ARCHITECTURE (Washington, DC: U.S. General Services Administration, undated).

The building, costing almost $100 million, rises 340 feet and, thereby, "lords over that city's government district." See Aaron Betsky, *Search for Justice*, ARCHITECTURE, Nov. 1997, at 123. The sixteen floors encompass 543,000 square feet and provide fifteen courtrooms. The building has received mixed reviews, with praise for its efficiency but criticism for exuding "a sense of enigma, rather than monumentality." Betsky at 127–128. Betsky found "too few historical or visceral cues to trigger memories of or associations with the exercise of justice." Id. at 128. The courthouse is named after Mark Hatfield, who was governor of the state before serving from 1966 to 1996 in the United States Senate, where he chaired its Committee on Appropriations from 1981 to 1987 and from 1995 until his retirement in 1997. See MARK O. HATFIELD, AGAINST THE GRAIN: REFLECTIONS OF A REBEL REPUBLICAN 226 (Ashland, OR: White Cloud Press, 2001).

**318** The serpent could be seen as a reference to the snake in the Garden of Eden—proposing the receipt of illicit knowledge. Documentation on the imagery can be found in GSA/Public Building Service, Fine Art Collection, AA 381, GSA Archives (hereinafter GSA Archives/AA 381 Otterness). The archives also record that Otterness received $500,000 for the work.

**319** *Best of Portland*, WILLAMETTE WEEK, http://wweek.com/html/bop99-fresh.html (citing a description by Otterness).

**320** Grace Glueck, *Making Public Sculpture: How a Vision Finds Form*, NEW YORK TIMES, Feb. 27, 1998, at E37.

**321** GSA Archives/AA 381 Otterness.

**322** GSA Archives/AA 381 Otterness.

**323** In Court of Tom Otterness, posted by pdxart under "Sculpture," Oct. 12, 2007, at Portland Public Art, www.portlandpublicart.wordpress.com.

**324** Carducci at 30.

**325** Robin Cembalest, *Public Sculpture the Public Likes, Really*, NEW YORK TIMES, Sept. 21, 1997, sec. 2 at 29.

**326** GSA Archives/AA 381 Otterness, Letter from John A. Meadows, Principal Architect, to Tom Otterness (July 27, 1995), describing the views of the Honorable Malcolm Marsh. The judge urged Otterness not to use a sketch that had made very plain the courtroom scene.

**327** GSA Archives/AA 381 Otterness.

**328** Tom Kenworthy, *The Owl and the Lumberjack: Can Clinton Break the Logjam? Oregon Conference Tests Ability to Reconcile Economic, Ecological Needs*, WASHINGTON POST, Apr. 2, 1993, at A4.

**329** Telephone interview with Tom Otterness (Nov. 21, 2005).

**330** HERRERA at 2.

**331** GSA/Public Building Service, Fine Art Collection, AA 131 Otterness (hereinafter GSA Archives/AA 131 Otterness).

**332** Gale Holland, *Radical Art or Simply Revolting?* THE OUTLOOK at A3. See also Tom Finkelpearl, *Caught in the Middle*, 13 PUBLIC ART REVIEW 4 (2001).

**333** GSA Archives/AA 131 Otterness.

**334** GSA Archives/AA 131 Otterness.

**335** Laurie Becklund, *GSA Pulls Nude Art From Federal Building*, LOS ANGELES TIMES, Dec. 4, 1991, at B1. See also *Nudes Removed*, USA TODAY, Dec. 5, 1991, at 3A. Holland also noted that a "smaller version" of the "girl baby floating with her legs apart in a mist fountain and holding up a globe" sat "unchallenged" at the Whitney Museum of American Art in New York City.

**336** GSA Archives/AA 131 Otterness, letter from Edwin W. Thomas, Regional Administrator of the GSA, to Tom Otterness (Dec. 5, 1991). Removed were "a nude squatting woman and a baby girl lying on her back, legs open, holding a globe." See *Nudes Removed*; Becklund, *GSA Pulls Nude Art From Federal Building*.

**337** Laurie Becklund, *Bradley Urges Reinstatement of Nude Sculptures at Building*, LOS ANGELES TIMES, December 10, 1991, at B1.

**338** GSA Archives/AA 131 Otterness, Joint Statement of GSA and Tom Otterness, Otterness Sculpture, Los Angeles Federal Center, Dec. 13, 1991. See also Holland.

**339** HERRERA at 2. GSA memos added that Otterness had not started "yelling about artistic integrity at the mere mention of concerns about his work. In that situation, he actually seemed—all in all—quite rational and flexible." Email from GSA staff (May 17, 1999), in GSA/Public Building Service, Fine Art Collection, AA 245 Otterness, GSA Archives (hereinafter GSA Archives/AA 245 Otterness).

**340** Cembalest, *Public Sculpture*.

**341** See GSA Archives/AA 245 Otterness, Artist Proposal Meeting —Tom Otterness, U.S. Courthouse, Sacramento, CA, Jan. 18, 1996 (hereinafter GSA Archives/AA 245 Otterness, Sacramento Project Proposal 1996). At that meeting the nine-member panel came together with representatives from the GSA, the architects, and others to review the proposal for the theme that the meeting memo called "the imbalance of the moneyed figures playing against a side with only pawns." Id. at 1.

**342** GSA Archives/AA 245 Otterness, Sacramento Project Proposal 1996 at 2.

**343** GSA Archives/AA 245 Otterness, Sacramento Project Proposal 1996 at 2.

**344** Carducci at 32.

**345** GSA Archives/AA 245 Otterness, Sacramento Project Proposal 1996 at 2. The judge was joined in that sentiment by the representative of one of California's senators. Id.

**346** Cembalest, *Public Sculpture*. Otterness is quoted as having said, "My philosophy is to try to yield to every request so that the work can survive and end up in public. . . . Then an active debate can happen." Id. In 1996 discussion had been focused on modifying the chess set design. See GSA Archives/AA 245 Otterness, Sacramento Project Proposal 1996 at 3.

**347** GSA Archives/AA 245 Otterness, Revised Proposal, U.S. Courthouse, Sacramento, CA, May 2, 1996. Discussed was a new version of the chess board; while some were receptive, the judge on the committee thought the work not readily understood.

**348** Cembalest, *Public Sculpture*. Otterness explained the proposal to the district court's chief judge as "a series of historical vignettes inspired by their connection to the Sacramento and American rivers" and hence to "local history"; he planned to play "with the conventions of 'Western' art" by "using the gold rush as a central element." GSA Archives/AA 245 Otterness, Letter from Otterness to Chief Judge Robert E. Coyle (Nov. 12, 1996). Otterness noted that the outcome of the review process—which had been "protracted, and at times discouraging"—was artwork that "better reflects the community for whom it is commissioned." Id. at 2.

349 See *Art for the United States Courthouse, Sacramento, California* (U.S. General Services Administration, undated and unpaginated monograph, hereinafter *GSA Sacramento Courthouse Art*), "Tom Otterness" section.

350 *GSA Sacramento Courthouse Art*, "Marking History" and "Daniel Galvez" sections. That acrylic mural included the state capitol's dome, the ceiling of a Chinese temple, and many family groups in Chinese garb. Another collage, by Tony Berlant, is titled *On this spot stood the first Chinese Settlement in Sacramento*, reflecting that the courthouse occupied blocks where Chinese immigrants had once lived. Id., "Tony Berlant" section. A geometric painting, *China Pattern*, by Deborah Oropallo, "pays homage to the more than 10,000 Chinese laborers whose unremitting perseverance and courage permitted the completion of the Transcontinental Railroad" in 1869. Id., "Deborah Oropallo" section. Another mixed-media painting, *Dream within a Dream: In Honor of the Pacific Asian Pioneers*, by George Miyasaki, also aimed to reflect the contributions of the Chinese Gold Rush immigrants, as did Holley Junker's quilt *Chinadom*. Id., "George Miyasaki" and "Holley Junker" sections.

351 *GSA Sacramento Courthouse Art*, "Making History" and "Jack Nielsen" sections.

352 GSA/Public Building Service, Fine Art Collection, AA 253 Holzer, GSA Archives (hereinafter GSA Archives/AA 253 Holzer), *Allentown Benches: Selection from Truisms & Survival Series*, 1995, for the Edward N. Cahn Federal Building and U.S. Courthouse, Allentown Pennsylvania. The artist was paid $57,900. The benches, seventeen by eighteen by sixty inches, were eventually placed in several locations; two are in the main-floor lobby, four in a lobby near a courtroom on the third floor, and eight along windows of the courtroom lobby on the fourth floor.

353 Grant, *Bland Art*. See also Steven J. Tepper, *Unfamiliar Objects in Familiar Places: The Public Response to Art-in-Architecture*, 6 INTERNATIONAL JOURNAL OF CULTURAL POLICY 283 (2000).

354 Grant, *Bland Art*.

355 Grant, *Bland Art*. Other deletions included "Fathers often use too much force" and "Change is valuable when the oppressed become tyrants." See GSA/Public Building Service, Fine Art Collection, AA 260 Holzer, GSA Archives (hereinafter GSA Archives/AA 260 Holzer), for the Robert T. Matsui U.S. Courthouse, 501 I Street, Sacramento, California (GSA Archives/AA 253 Holzer).

356 GSA Archives/AA 253 Holzer, unpaginated memo to "reviewers" from Dale M. Lanzone, GSA Director, Cultural and Environmental Affairs. A list of "proposed" and "alternative" texts followed, with substitutions detailed.

357 Tepper at 297.

358 The building was named after Representative Matsui, a California Democrat who had represented Sacramento in Congress and had, as an infant, been interned in detention camps set up during World War II for Japanese Americans. Adam Bernstein, Obituary, Robert T. Matsui, WASHINGTON POST, Jan. 3, 2005 at B4. See H.R. 787, 109th Cong. (2005); S. 125, 109th Cong. (2005). The courthouse, sited on three acres in downtown Sacramento, included property owned by the city that had been used to maintain and fuel its cars and trucks, and required a cleanup to remove the wastes that remained. See Brownfield Revitalization: Success Story, Federal Courthouse, Sacramento County, April 2006, State of California, Department of Toxic Substances Control, http://www.dtsc.ca.gov/Success/upload/Federal_courthouse .pdf. Involving more than $140 million and producing a building of more than 380,000 square feet, it was "the largest construction project" in that city's history. Id. See also GSA, Public Building Service, Record of Decision: New United States Courthouse-Federal Building in Sacramento, CA, 59 Fed. Reg. 53,989–53,991 (Oct. 26, 1994). Details of the proposal by Holzer are available in GSA Archives/AA 260 Holzer, for the Robert T. Matsui U.S. Courthouse, 501 I Street, Sacramento, CA.

359 The two benches in the main first-floor lobby each had five lines from *Survival*; examples included "USE WHAT IS DOMINANT IN A CULTURE TO CHANGE IT QUICKLY" and "GO WHERE PEOPLE SLEEP AND SEE IF THEY ARE SAFE." On each of the other twelve benches, seven lines from *Truisms* were included. For example, Bench 5 had texts such as "BEING ALONE WITH YOURSELF IS INCREASINGLY UNPOPULAR" and "BEING JUDGMENTAL IS A SIGN OF LIFE." Email from Alanna Gedgaudas of Jenny Holzer's Studio to Judith Resnik (Nov. 2, 2005).

360 GSA Archives/AA 260 Holzer, Art-in-Architecture Program Meeting—Jenny Holzer, U.S. Courthouse, Sacramento, CA, Nov. 19, 1996, Minutes at 1. The AiA central staff member, Susan Harrison, both summarized the project and quoted some of Holzer's submission statement (hereinafter 1996 Sacramento Proposal Meeting). In attendance were committee members from the GSA panel, which included one federal judge from that court as well as four other federal district judges and several other staff members from the GSA, and Tom Otterness, who had also submitted a proposal. Holzer was not on the list of attendees at this meeting.

361 GSA Archives/AA 260 Holzer, 1996 Sacramento Proposal Meeting at 2.

362 GSA Archives/AA 260 Holzer, 1996 Sacramento Proposal Meeting at 2. In the minutes, summarizing views, speakers are also sometimes quoted; hence our text preceding this has internal quotes when appropriate.

363 GSA Archives/AA 260 Holzer, 1996 Sacramento Proposal Meeting at 2.

364 GSA Archives/AA 260 Holzer, 1996 Sacramento Proposal Meeting at 2.

365 GSA Archives/AA 260 Holzer, Art Statement (draft, Dec. 11, 1997).

366 GSA Archives/AA 260 Holzer, email from Kenn Kojima to Susan Harrison and Esther Timberlake (Apr. 20, 1998) describing an exchange with the federal district judge (David Levi) who tried to mediate the differences and who informed the GSA staffers of the opposition from some jurists.

367 Steve Wiegand, *New Federal Courthouse's Artworks Much Deliberated*, SACRAMENTO BEE, Jan. 31, 1999, at A1.

368 GSA Archives/AA 260 Holzer, email from Kenn Kojima to Susan Harrison and Esther Timberlake (Apr. 3, 1998).

369 GSA Archives/AA 260 Holzer, email from GSA staff Kenn Kojima to Susan Harrison and Esther Timberlake (Apr. 20, 1998) describing Judge Levi's comments.

370 GSA Archives/AA 260 Holzer, email from GSA staff Kenn Kojima of April 20, 1998 describing Judge Levi's comments.

371 Memorandum from Dec. 11, 1997, provided by Alanna Gedgaudas of Jenny Holzer's studio, Dec. 21, 2005. The phrases were authored, respectively, by Derek Bok, *A Flawed System*, HARVARD MAGAZINE, May–June 1983; GEORGE CHAPMAN AND HENRY GLAPTHORNE, REVENGE FOR HONOUR: A TRAGEDIE (1654); and Catharine MacKinnon, *Feminism, Marxism, Method, and the State: Toward Feminist Jurisprudence*, SIGNS: JOURNAL OF WOMEN IN CULTURE AND SOCIETY, Spring 1982.

372 *United States v. Rabinowitz*, 339 U.S. 56, 69 (1950) (Frankfurter, J., dissenting). Justice Frankfurter, joined by Justice Jackson, disagreed with the majority that had upheld a search of a printer alleged to be forging postal stamps. The dissent argued that, while the arrest was lawful, no circumstances justified the warrantless search. Though the defendant was a "shabby defrauder," the context entailed the "great themes expressed by the Fourth Amendment." Id.

373 *GSA Sacramento Courthouse Art*, "Jenny Holzer" section. Figure 125 is reproduced with permission of and provided by Jenny Holzer and Artists Rights Society, New York, NY.

374 *GSA Sacramento Courthouse Art*, "Jenny Holzer" section. In addition to complimenting in the sense of praise, the works may also complement, in the sense of enhance, each other, atop the tensions and contradictions.

**375** Sacramento Paver Texts provided by the Holzer studio on Nov. 3, 2005.

**376** GSA Archives/AA 260 Holzer, email from GSA staff member Esther Timberlake (Mar. 31, 1998).

**377** Memorandum from Dec. 11, 1997, provided by Alanna Gedgaudas of Jenny Holzer's studio, Dec. 21, 2005.

**378** *Federal Power Commission v. Tuscarora Indian Nation*, 362 U.S. 99, 142 (1960) (Black, J., dissenting). The majority upheld the taking, with compensation, of land owned by the tribe for a hydroelectric power project related to the Niagara River. Justice Black, joined by Chief Justice Earl Warren and Justice William O. Douglas, disagreed with the view that a federal statute had authorized the taking of "22% (1,383 acres) of the single tract which the Tuscarora Indian Nation has owned and occupied as its homeland for 150 years." 362 U.S. at 125.

**379** Sacramento Paver texts provided by the Holzer studio.

**380** *Words to Live By*, Sacramento Bee, Jan. 20, 1999, at B3 (caption to a photograph of the paver).

**381** *GSA Sacramento Courthouse Art*, "Larry Kirkland" section.

**382** *GSA Sacramento Courthouse Art*, "Larry Kirkland" section. In 1993 Dove became the youngest person and first African American to hold the position of Poet Laureate of the United States. Id., "Rita Dove" section.

**383** Mary Lynne Vellinga, *Making People Think: Everyone Is a Critic When Art Is Public*, Sacramento Bee, Dec. 26, 1999, at A1.

**384** Vellinga, *Making People Think*.

**385** Vellinga, *Making People Think*.

**386** Tepper at 297.

**387** The GSA instructed Mitchell to cease all work on the sculpture. Letter from Lydia Ortiz, Contracting Officer, Public Buildings Service, to Jan R. Mitchell (Oct. 17, 1991) (on file with author).

**388** Jürgen Habermas, Between Facts and Norms (trans. William Rehg, Cambridge, MA: MIT Press, 1998).

**389** GSA's Design Excellence Program received a 2003 National Design Award from the Cooper-Hewitt National Design Museum and a 2004 Keystone Award from the American Architectural Foundation.

**390** Examples include an Honor Award for an installation called *Jurisprudents* in the Melvin Price U.S. Courthouse in East St. Louis, Illinois; sculptors Ralph Helmick and Stuart Schechter did "12 life-size portraits of ordinary American citizens" and made heads ("each with its own unique details and expression") that were then scaled down and suspended on hundreds of cables, resulting in 3,000 "small sculptures" that coalesced into "two monumental heads facing each other across the skylit courthouse atrium." See U.S. General Services Administration, *Design Awards: 2000 Award Winners* at 17, http://www.gsa.gov/graphics/pbs/DABook2000lo.pdf. The GSA awarded a citation to *Urns of Justice*, by Diana Moore, for its integration of two design traditions—the image of Justice blindfolded and the use of urns or vessels as ornamentation. Id. at 27. The 2000 GSA monograph also detailed the accomplishments of the Design Awards Program, then ten years old. Id. at 3–4.

**391** See Michael Z. Wise, *Open to the Public*, Art News, June 1999, at 117, 118.

**392** GSA/AA Archives include materials on such abandoned proposals. Commentators on the processes have also noted the efforts made to "avoid confrontation art." See Wise at 118–119.

**393** Amy Weinstein in II Vision + Voice at 36.

**394** Betsky at 128. Betsky further concluded that the Hatfield Courthouse in Portland provided "too few historical or visceral cues to trigger memories of or associations with the exercise of justice." Id. Because the building "neither looms nor soars" and the artworks are "add-ons," it left "questions over the image of justice in our cities unanswered." Id.

**395** See generally Barbara A. Nadel, *Designing for Security*, Architectural Record, Mar. 1998, http://archrecord.construction.com/resources/conteduc/archives/research/3_98_1.asp.

**396** *2006 Future of the Federal Courthouse Construction Program Hearings*, Commissioner Winstead Statement at 267, 272.

**397** *2006 Future of the Federal Courthouse Construction Program Hearings*, Commissioner Winstead Statement at 272.

**398** Frank Green, *The Image of the Courthouse*, in Celebrating the Courthouse at 79.

**399** This phrase appears in several of the monographs that the GSA has published to document many of the late twentieth-century federal courthouses. Under the heading "Art-in-Architecture" toward the end of each booklet, the GSA comments: "Art has always been an important feature of great architecture" as a preface to a description of the art in a particular courthouse. See, for example, Roman L. Hruska United States Courthouse, Omaha, Nebraska 20 (*Nebraska Grilles* by Stephen Robin) (Washington, DC: GSA, 2004); United States Courthouse and Federal Building, Central Islip, New York 24 (*Untitled Sculpture/Landscape Project* by Elyn Zimmerman) (Washington, DC: GSA, 2004); Carl B. Stokes United States Courthouse, Cleveland, Ohio 22–23 (*Cleveland Venus* by Jim Dine) (Washington, DC: GSA, 2003); Robert C. Byrd United States Courthouse and Federal Building, Beckley, West Virginia 14–15 (*Trompe L'Oeil Murals* by Richard Haas) (Washington, DC: GSA, 2002); Robert C. Byrd United States Courthouse, Charleston, West Virginia 14–15 (Untitled [Architectural Glass] by David Wilson) (Washington, DC: GSA, 2001).

**400** Paul Spencer Byard, *Reading the Architecture of Today's Courthouse*, in Celebrating the Courthouse at 151.

**401** Wetenhall at 306–307, 308, nn. 29–32 (Kennedy Library materials, from a speech at Amherst College, Oct. 26, 1963). Kennedy's mention of the "officious state" was a reference to the country's Cold War adversaries.

## Chapter 10

**1** See Palazzi di Giustizia (Courthouses): 14 Zodiac: International Review of Architecture 4–199 (Sept. 1995–Feb. 1996) (hereinafter 14 Zodiac). This special volume was devoted to courthouses; several articles address major new buildings in Italy as well as courthouses designed by prominent architects in Lérida, Spain; Jerusalem, Israel; Cordoba, Argentina; Strasbourg, France; and Islip, New York. See also Andrea P. Leers, *Urban Design and the Courthouse: How Sites Shape Solutions*, in Celebrating the Courthouse 110–132 (Steven Flanders, ed., New York, NY: W. W. Norton, 2006) (hereinafter Leers for the article, Celebrating the Courthouse for the volume).

**2** This choice is illustrative, not exhaustive. The relationship between building courts and the political identity of nations in the nineteenth and twentieth centuries has been the subject of scholarship focused on various jurisdictions. See, for example, Terry Rossi Kirk, Church, State and Architecture: The "Palazzo di Giustizia" of nineteenth-century Rome (Ph.D. dissertation, Columbia U., New York, NY, 1997, UMI Publication No.: AAT 9728234, 1997). Kirk examined how courthouse construction in other European countries affected the design for the Roman Palazzo di Giustizia. Id. at 83–98. As he noted, "foreign influences in architecture paralleled political alliances." Id at 97.

**3** See Judicial Conference of the United States, *Long Range Plan for the Federal Courts* (Dec. 1995), reprinted in 166 Federal Rules Decision 49 (1996).

**4** In France, as detailed in this chapter, a long-term planning program begun in the late 1980s reviewed hundreds of sites of courthouses and found them wanting. See *Interview with René Eladari, Director of the Ministry of Justice Long Term Planning Program* (hereinafter Eladari Interview), in Construire pour la Justice, special edition of Architecture intérieure Crée, Archicrée 143–144 (May–June 1995) (English synopsis) (volume cited hereinafter

ARCHICRÉE 1995). The publication included materials from the conference "Palais de justice: Héritages et projets" (Courthouses: Legacies and Projects), organized by the Association Française pour l'histoire de la justice (French Association for Judicial History) and the Centre de recherches sur l'histoire de l'art et l'architecture moderne (Center for Research on the History of Art and Modern Architecture) of the Centre National de la Recherche Scientifique (National Center for Scientific Research), Paris, Jan. 1994.

**5** Todd S. Phillips, *Courthouse Design at a Crossroads*, in CELEBRATING THE COURTHOUSE at 202–203.

**6** See PEW CENTER ON THE STATES, ONE IN 31: THE LONG REACH OF AMERICAN CORRECTIONS (Washington, DC: The Pew Charitable Trusts, Mar. 2009), http://www.pewcenteronthestates.org/uploaded Files/PSPP_1in31_report_FINAL_WEB_3-26-09.pdf.

**7** Giorgio Muratore, *Law Courts in the Modern City*, 14 ZODIAC 45, 58. He argued that some buildings of the mid-twentieth century had produced a "silence of form" but that Oscar Niemeyer's Supreme Federal Tribunal in Brasilia (fig. 1/9), along with Louis Kahn's design of the High Court in Dhaka and Le Corbusier's building in Chandigarh, marked the rejection of the "indifferent, monolithic and monumental verticality of the skyscraper" typified by Mies van der Rohe's federal courthouse in Chicago. Id.

**8** Muratore at 45. In his view, new constitutions provided justice as the "cornerstone" of modern states that, in turn, relied on courts to provide a "forceful, communicative modern state image" through large-scale public architecture. Id.

**9** DON HARDENBERGH, THE COURTHOUSE: A PLANNING AND DESIGN GUIDE FOR COURT FACILITIES 12 (Williamsburg, VA: National Center for State Courts, American Institute of Architects, Conference of State Court Administrators, National Center for Juvenile Justice, & American Bar Association, 1991) (providing a mockup showing "present" and then a larger "future," with stacks of files, lines of stick-figure people, and block drawings of courts). In terms of the history of storage needs, the 1953 *Annual Report of the Judicial Conference of the United States* detailed the 60,000-plus cubic feet of court records held in archives, of which more than half came from twenty-nine courts depositing materials in 1953. See Annual Report of the Proceedings of the Judicial Conference of the United States 63–64 (Sept. 24–25, 1953).

While many recently built courthouses incorporate some of the new technologies, their buildings provide little by way of evidence that technology may make their spaces obsolete. A concern that the physical boundaries may, to societal detriment, be of lessening import is explored in Linda Mulcahy, *The Unbearable Lightness of Being? Shifts Towards the Virtual Trial*, 35 JOURNAL OF LAW AND SOCIETY 464 (2008).

**10** See generally TODD S. PHILLIPS & MICHAEL A. GRIEBEL, BUILDING TYPE BASICS FOR JUSTICE FACILITIES 9–10 (Stephen A. Kliment, series ed., Hoboken, NJ: John Wiley & Sons, Inc., 2003). The "design and image" phrase can be found repeatedly in Hardenbergh's book, used when addressing various kinds of work stations. See, for example, HARDENBERGH at 63 (judge's bench); id. at 67 (witness stand); id. at 69 (jury box); id. at 71 (attorney tables); id. at 72 (spectator seating); id. at 74 (specialized courtrooms). Standard layouts are not only an artifact of the second half of the twentieth century. On the federal side, several courthouses designed under the Office of the Supervising Architect (discussed in Chapter 7) used similar or identical designs. Further, builders' handbooks published in the nineteenth century included courthouse layouts. See Michael R. Corbett, *Continuity and Change in California Courthouse Design, 1850–2000*, in COURTHOUSES OF CALIFORNIA: AN ILLUSTRATED HISTORY 18–19 (Ray McDevitt, ed., San Francisco, CA and Berkeley, CA: California Historical Society and Heyday Books, 2001).

Planning guides were less common in England because localities shaped their own designs and courts were often "associated with municipal buildings" rather than dedicated spaces. CLARE GRAHAM,

ORDERING LAW: THE ARCHITECTURAL AND SOCIAL HISTORY OF THE ENGLISH LAW COURT TO 1914 at 316–317 (Aldershot, Eng.: Ashgate, 2003). Particular courthouses, however, served as models. See, e.g., *Linda Mulcahy, Architectural Precedent: The Manchester Assize Courts and Monuments to Law in the Mid-Victorian Era*, 19 KING'S LAW JOURNAL 525 (2008). Mulcahy argued that the courthouse reflected the emerging status of lawyers able to mark their authority through spatial segregation. Id. at 549.

Over the past several decades, standard-setting has intensified with the publication of many design guides for court facilities. In addition to those mentioned earlier, the federal design guides detailed in Chapter 9, and the materials developed in France and discussed later in this chapter, examples include the following (in rough chronological order): AMERICAN BAR ASSOCIATION AND THE AMERICAN INSTITUTE OF ARCHITECTS JOINT COMMITTEE ON THE DESIGN OF COURTROOMS AND COURT FACILITIES, THE AMERICAN COURTHOUSE: PLANNING AND DESIGN FOR THE JUDICIAL PROCESS (Ann Arbor, MI: Edwards Brothers, 1973), supplemented with the provision of some fifty examples of layouts of buildings in the United States and Canada in TWENTY YEARS OF COURTHOUSE DESIGN REVISITED (Chicago, IL: American Bar Association, 1993); AMERICAN BAR ASSOCIATION, COMMISSION ON STANDARDS FOR JUDICIAL ADMINISTRATION, STANDARDS RELATING TO TRIAL COURTS (1976); INSTITUTE OF JUDICIAL ADMINISTRATION AND AMERICAN BAR ASSOCIATION, JUVENILE JUSTICE STANDARDS: STANDARDS RELATING TO ARCHITECTURE OF FACILITIES (Cambridge, MA: Ballinger Publishing, Harper & Row, 1980).

As explored in this chapter, some countries create specifications for particular courthouses while others have design guides. In England and Wales, a guide was published in 2004. See *Court Standards and Design Guide* (Department of Constitutional Affairs, U.K., 2004); http://www.thenbs.com/PublicationIndex/DocumentSummary.aspx?PubID164&DocID=278846 (hereinafter *English Courts, Government Design Guide*). In 2007, under a reorganization of departments, the work of the Department of Constitutional Affairs was taken over by a new Ministry of Justice. The normative implications of this guide are analyzed in Linda Mulcahy, *Architects of Justice: The Politics of Courtroom Design*, 16 SOCIAL & LEGAL STUDIES, 383–403 (2007) (hereinafter Mulcahy, *Architects of Justice*). In addition, the World Bank has design guides for court building. See, for example, Philip Gerald Thacker, *Components in a Comprehensive Judiciary-Directed Facilities Program*, Dec. 13, 2005, http://siteresources.worldbank.org/INTLAW JUSTINST/Resources/Components.pdf; World Bank, Judicial Modernization Project: Azerbaijan, http://web.worldbank.org/external/projects/main?pagePK=64283627&piPK=73230&theSitePK=301914 &menuPK=301946&Projectid=P099201; World Bank, Model Court Development Project (Argentina), http://web.worldbank.org/external/projects/main?pagePK=104231&theSitePK=40941&menuPK=2284 24&Projectid=P050713.

Parallel guides exist for prisons. See, for example, England's Prison Design Briefing System (PDBS), as discussed in Sir Andrew Derbyshire, *Architects and the Prison Experience*, in PRISON ARCHITECTURE: POLICY, DESIGN AND EXPERIENCE 55–60 (Leslie Fairweather & Seán McConville, eds., Oxford, Eng.: Architectural Press, 2000) (hereinafter PRISON ARCHITECTURE).

**11** For example, the English guide provided that judges were to "maintain full control of the proceedings" in part through being able to see all within the courtroom. Mulcahy, *Architects of Justice* at 396 (citing the *English Courts, Government Design Guide*).

**12** In the United States, these organizations included the Conference of State Court Administrators and the Conference of Court Public Information Officers. In France, as the country embarked on its court renovation, conferences included art historians and anthropologists as well as lawyers, judges, and administrators. See Alain Girardet, *Quels palais pour demain? Les attentes des gens de justice (What Courthouses for Tomorrow? The Expectations of the Judiciary)*,

ARCHICRÉE 1995 at 64 (hereinafter *What Courthouses for Tomorrow?*). Girardet, for example, was the Secretary General of the French Association for the History of Justice as well as the Vice President of the Paris Tribunal de Grande Instance, a second-level court that both hears trials and sits on appeals.

**13** See Agence de Maîtrise d'Ouvrage des Travaux du Ministère de la Justice, *Palais de Justice de Grenoble*, 24, 26 (Ministère de la Justice, Paris, 2003).

**14** See JOHN BELL, JUDICIARIES WITHIN EUROPE: A COMPARATIVE REVIEW (Cambridge, Eng.: Cambridge U. Press, 2006). Bell provided a review of the organization, status, and tasks of the French, German, Spanish, Swedish, and English judiciaries as he argued the need to immerse oneself in each to understand the different status and function of judges and courts.

**15** See YOSEF SHARON, THE SUPREME COURT BUILDING, JERUSALEM 102 (Alexandra Mahler, trans., Jerusalem, Isr.: Yad Hanadiv, 1993) (hereinafter ISRAEL SUPREME COURT BUILDING).

**16** Mulcahy, *Architects of Justice* at 387, 390–391, 396.

**17** As discussed in Chapter 9, the *1997 U.S. Courts Design Guide* specified courtrooms ranging from 1,800 square feet for magistrate judges to 2,400 or 3,000 square feet for district judges, with ceiling heights presumptively sixteen feet. See JUDICIAL CONFERENCE OF THE UNITED STATES, SPACE AND FACILITIES COMMITTEE, U.S. COURTS DESIGN GUIDE, 1997 ed. (hereinafter 1997 U.S. COURTS DESIGN GUIDE). These are larger than the sizes suggested in general guides that call for courtrooms ranging from 1,000 to 1,400 square feet with ceilings twelve to eighteen feet high. Compare *1997 U.S. Courts Design Guide*, Revisions–3, and Chapter 4, "Courtrooms," at 4-15 to 4-16, 4-22 with HARDENBERGH at 59. Many federal courthouses, in turn, are large in square footage when compared to the density of use of other jurisdictions' facilities. As of 1993, federal courts ranged from 63,000 square feet in the U.S. Courthouse in St. Croix, the Virgin Islands, to more than 645,000 feet in Anchorage, Alaska, with more than a million square feet then planned for a new facility in Manhattan. See TWENTY YEARS OF COURTHOUSE DESIGN REVISITED: SUPPLEMENT TO THE AMERICAN COURTHOUSE 155 (Chicago, IL: American Bar Association Judicial Administration Division, National Center for State Courts, State Justice Institute, 1993). As demand has grown, some states have built on ever-larger footprints to accommodate twenty to sixty courtrooms in a single building. Jordan Gruzen, *The Geometry of a Courthouse Design*, in CELEBRATING THE COURTHOUSE at 102.

**18** See Allan Greenberg, *Symbolism in Architecture: Courtrooms*, ARCHITECTURAL RECORD 114 (May 1979), reprinted in THE PUBLIC FACE OF ARCHITECTURE: CIVIC CULTURE AND PUBLIC SPACES (Nathan Glazer & Mark Lilla, eds., New York, NY: Free Press, 1987).

**19** For example, federal legislation requiring accessible public buildings generated obligations for states, as did national concerns about security and energy-efficient buildings. As noted in Chapter 9, the Architectural Barriers Act of 1968 called for removing barriers to federal facilities for buildings created thereafter. Hardenbergh mentioned the impact of that act and of the Rehabilitation Act of 1973, which cut off federal funds for recipients who did not provide accessible buildings. Thereafter, in 1990, the Americans with Disabilities Act required that "public services" be accessible—courthouses included. See HARDENBERGH at 43–45. Implementation challenges were addressed in the *1997 U.S. Courts Design Guide*, focused on "barrier-free access." See 1997 U.S. COURTS DESIGN GUIDE at 3-16; JUDICIAL CONFERENCE OF THE UNITED STATES, SPACE AND FACILITIES COMMITTEE, U.S. COURTS DESIGN GUIDE 2007 ed. at 3–4. As discussed in Chapter 8, in 2004 the United States Supreme Court held that these provisions were enforceable by private parties against states that had failed to make their courtrooms accessible. See *Tennessee v. Lane*, 541 U.S. 509 (2004); fig. 8/116.

**20** See Leers at 123–132; Robert Jacob, *The Historical Development of Courthouse Architecture*, 14 ZODIAC 30 (hereinafter Jacob, *Historical*

*Development*). Jacob noted the influence of French Neoclassical court design on much of Europe, North Africa, Latin America, and the United States. The durability of traditions, such as the symbolism of standing when judges enter rooms, is traced in Thomas Glyn Watkin's *"The Powers that Be Are Seated": Symbolism in English Law and the English Legal System*, in RECHTSSYMBOLIK UND WERTEVERMITTLUNG (THE SYMBOLISM OF JUSTICE AND THE CONVEYANCE OF MORAL VALUES) (Reiner Schulze, ed., Berlin, Ger.: Duncker and Humblot, 2004).

**21** Universal Declaration of Human Rights, G.A. Res. 217A U.N. GAOR, 3d Sess., 1st plen. mtg., U.N. Doc. A/810 (Dec. 12, 1948).

**22** That organization counted its membership in 2008 as including more than 1,300,000 architects from more than one hundred countries. See The International Union of Architects: A Global Network Dedicated to the Architectural Profession, http://www .uia-architectes.org/texte/england/Menu-1/0-pourquoi.html.

**23** See American Institute of Architects, AIA Academy of Architecture for Justice, http://www.aia.org/practicing/groups/kc/AIAS 075057. The Academy of Architecture for Justice (AAJ) is one of several of the AIA's "knowledge communities," described as promoting and fostering "the exchange of information and knowledge between members, professional organizations, and the public for high-quality planning, design, and delivery of justice architecture." American Institute of Architects, Member Groups and Communities, http://www .aia.org/professionals/groups/index.htm.

**24** See American Institute of Architects, AIA Academy of Architecture for Justice, http://www.aia.org/practicing/groups/kc/AIAS075057.

**25** The 1972 committee was succeeded in 1973 by the Corrections Architecture Committee, which became the Architecture for Criminal Justice Committee (1975–1980), the Committee for Justice Architecture (1981–1992), the Committee on Architecture for Justice (1993), the Committee on Justice System Facilities (1994–2004), the Committee on Architecture for Justice (2005), and the Academy of Architecture for Justice (AAJ). In some years, *Justice Facilities Review* published reports from these committees. Materials on these activities were provided to us by Nancy Hadley, the Archivist and Records Manager of the AIA's Library and Archives.

**26** See, for example, AIA San Francisco, Committees, http:// www.aiasf.org/Membership/Committees.htm. Our thanks to Katherine Gupman, Project Manager of the AIA, for providing us with materials on the AAJ and its history as the organization developed under different nomenclature.

**27** Agenda for "Affording Excellence: Addressing Court Needs at the Local Level, Fourth International Conference on Court Design and Planning," American Institute of Architects, Committee on Architecture for Justice, in association with the National Center for State Courts and the National Association for Court Management, Phoenix, AZ, October 7–9, 2001 (hereinafter 2001 Agenda for "Affording Excellence").

**28** See, for example, conference materials, "Justice and the City," San Diego, CA, Nov. 2–5, 2005. Our thanks to Celeste F. Bremer, United States Magistrate Judge, United States. District Court, Southern District of Iowa; to David Insinga, Director of Services for the Rocky Mountain and Pacific Zones of the United States General Services Administration, Washington D.C.; and to Richard Gilyard, former Assistant Circuit Executive for Space and Facilities, Judicial Council of the Court of Appeals of the Eighth Circuit, for providing us with materials and information on conferences and construction projects.

**29** 2001 Agenda for "Affording Excellence."

**30** See Overview, "Sustainable Excellence: Sixth International Conference on Courthouse Design," American Institute of Architects, http://www.aiany.org/calendar/day.php?id=2007-09-26.

**31** See, for example, *European and International Law Courts Executive Research Tour, Spring, 2008*, L'Institut des Hautes Études sur la justice, http://www.ihej.org/pdf/european_international_law_courts _2008.pdf. Our thanks to David Tait, Associate Professor, Law School,

University of Canberra and to Diane Jones, Adjunct Professor of Architecture, University of Technology, Sydney, Australia, both of whom helped us to understand the transnational scope of courthouse construction.

**32** In Chapter 9, we detailed the federal set-aside in the United States, and we discuss France's provisions later in this chapter. Other countries with laws or policies that have provided funds for art include Canada, Finland, Italy, the Netherlands, Norway, and Sweden. In Canada, as of 1964, the set-aside is 1 percent of a building budget; a committee composed of local and national members recommends art selections. See Henry Lydiate, *Public Patrons: Percentage for Art*, Artquest, http://www.artquest.org.uk/artlaw/public-policies/government-policies-the-arts/percent-for-art-legislation.htm. Finland has an informal set-aside of 1 percent. Id. Germany's set-aside, ranging from half a percent to 2 percent, has been put into practice, albeit with criticisms of methods of selection of artists and of the art chosen. Id. The Netherlands has provisions requiring that 1.5 percent of the cost of new government buildings be devoted to art incorporated into the architectural project, and a different law provides for a set-aside of 1 percent for schools. Norway's 2 percent rule dates from 1937, and innovations thereafter provide for experimental commissions that may not be permanent, as well as for documentation of the commissions given. Id. Sweden's practices also date back to the 1930s, with the percentages of set-asides varying. Id.

In 1949, Italy provided for a 2 percent allocation for building "embellishments" to be chosen by competitions among artists. Law No. 717/1949 of 29 July 1949, Norme per l'arte negli edifici pubblici (Regulation for the Art of Public Buildings) (237 Gazz. Uff., Oct. 14, 1949). Implementation was uneven. But during some periods, the "famous 2% law" financed art, including works of more than fifty important Italian artists for the Milan law building, constructed from 1931 to 1941. Muratore at 57–59. In 2008, Italy considered a law on architectural quality that included integrating art into buildings and making the set-aside compulsory. See La legge sulla qualità architettonica (Draft Bill on Architectural Quality), Sept. 2008, revised draft (Nov. 19, 2008), Instituto per l'innovazione e Transparenza degli Appalati e la Compatibilitá Ambientale, http://www.itaca.org/documenti/news/DDl_qualita_architettonica.pdf. As of 2009, the Italian Parliament website reported that the bill was under review by commission. See Parlamento Italiano, Disegno di legge S. 1062, XVI Legislatura, http://www.senato.it/leg/16/BGT/Schede/Ddliter/32413.htm. Our thanks to Stella Burch Elias for the research overview provided in this note.

**33** La nouvelle architecture judiciaire: Des palais de justice modernes pour une nouvelle image de la Justice (New Judicial Architecture: Modern Courthouses and a New Image of Justice) 3, 103 (Paris, Fran.: La documentation Française, 2000) (hereinafter New French Judicial Architecture). The volume was produced in relationship to a colloquium held in Nanterre, France in May 2000, about courthouse design; the purposes for convening the event are explained by Marc Moinard, Director of the Legal Departments in the Ministry of Justice, in *Le monument réhabilité: Les grandes options de la politique de construction judiciaire* (*The Rehabilitated Monument: Great Policy Options for Judicial Construction*), Archicrée 1995 at 70, and the English synopsis of Moinard's discussion at 142 (hereinafter Moinard). See also Eladari Interview at 78–85. Our thanks to Jean-Paul Miroglio, Chef de projet à L'Agence Publique pour l'Immobilier de La Justice; to Silvain Liotard of the French Ministry of Justice; and to Myriam Besnard of the Agence de Mâitrise d'Ouvrage du Traveau du Ministère de la Justice for providing us with materials and facilitating the permissions to reproduce images. Thanks are also due to Elisabeth Zoller for her thoughtful review of a draft of this chapter, as well as to Andrea Leers, Antoine Garapon, Robert Jacob, and Christine Mengin for providing us with additional information on courthouse construction in the United States and in France. In addition to our reading of

materials in French, we have relied on translations by Stella Burch Elias and Allison Tait. In the text, we have included quotes when we translate French materials and, in footnotes, we often provide the quoted French accompanied with translations. Here we have translated the French "une certaine ambition architectural."

**34** New French Judicial Architecture at 3 ("les valeurs de la démocratie").

**35** Between 1975 and 1995, caseloads tripled; during the 1990s, the number of magistrates increased 40 percent. Christine Mengin, *Deux siècles d'architecture judiciaire aux Etats-Unis et en France* (*Two Centuries of Judicial Architecture in the United States and France*), in L'Art et le droit: Mélanges en l'honneur de Pierre-Laurent Frier 11 (Paris, Fran.: Publications de la Sorbonne, 2009) (hereinafter Mengin, *Two Centuries of Judicial Architecture*). Mengin also noted that in 1987 the central government took over management responsibility for judicial facilities from the regional governments. Id. See also Christine Mengin, *Construire pour juger: Un tour de France des Palais de Justice* (*Building for Judging: A Tour of French Courthouses*) in Tour de France: Eine historische Rundreise, Festschrift für Rainer Hudemann 270–281 (Stuttgart, Ger.: Franz Steiner, 2008). France's director of long-term planning estimated that about 30 percent more "surface area" was needed, and further that some facilities, dating from the nineteenth century, were not well located to provide services. See Eladari Interview at 142–145.

**36** *L'Agence de Mâitrise d'Ouvrage des Travaux du Ministère de la Justice, 2004 Rapport d'activité* 29 (Paris, Fran.: AMOTMJ, 2004) (hereinafter 2004 AMOTMJ Report); Eladari Interview at 145. While energy concerns are noted, the descriptive explanations of French building put less stress on "green" buildings than do their American counterparts.

**37** New French Judicial Architecture at 97 ("Le fonctionnel").

**38** Several commentators involved in the French building projects speak to this point. See, for example, Jean-Claude Chilou, *Caen: Une nouvelle cour d'appel* (*Caen: A New Court of Appeals*) in New French Judicial Architecture at 44–47. See also the essays in Archicrée 1995 by Philippe Lemaire, *Vingt ans de justice: Évolution de l'institution et organisation judiciaire* (*Twenty Years of Justice: The Evolution of the Institution and Organization of the Judiciary*) at 68–69; Girardet at 64–67; and Moinard at 70–75.

**39** New French Judicial Architecture at 103. The overall program is also described on the inside covers or the backs of the individual pamphlets that detail renovations or new construction of several courts under the guidance of the Délégation Generale au Programme Pluriannuel D'Équipement, which was superseded by the L'Agence de Mâitrise d'Ouvrage des Travaux du Ministère de la Justice (AMOTMJ) (Building Works Agency of the Justice Ministry). See, for example, "Delegation Generale au Programme Pluriannuel D'Equipement" (General Commission for the Multi-Year Facilities Program), in *Palais Monclar, Cour D'appel d'Aix-en-Provence* (Ministère de la Justice, 1998). Some pamphlets also mention the shift to the AMOTMJ. See *Palais de Justice de Grenoble.*

**40** New French Judicial Architecture at 103–105. Initially the building was managed through a plan, Délégation Générale au Programme Pluriannuel D'Equipement du Ministère de la Justice (General Commission for the Multiyear Facilities Program), by the Ministry of Justice. As noted, in 2001 a discrete subentity was chartered to manage facilities. See generally Leers at 110, 125. The priority setting is detailed in Eladari interview at 142, 145.

**41** See generally Elisabeth Zoller, Introduction to Public Law: A Comparative Study (Leiden, Neth.: Martinus Nijhoff, 2008).

**42** A brief note on the higher courts of France, which are not the focus of discussion, is in order. France has the Conseil constitutionnel (Constitutional Council) with a specialized jurisdiction that, until the reforms of 2009, dealt with the legality of statutes in advance of their enactment. That body sits in the Palais Royal, a building whose his-

tory began in 1624 with Cardinal Richelieu. See *Conseil constitution-nel: A Historic Setting* (undated monograph provided by the court). The country's other high court, the Cour de cassation, also sits in Paris and is comprised of six chambers that deal with matters both civil and criminal. See Cour de cassation, http://www.courdecassation.fr/institution_1/organisation_cour_56/chambres_57/. Many American scholars have analyzed the differences in the French and American legal systems. A focus on the highest courts of the United States, France, and the European Union is provided by Mitchel de S.-O.-L'E. Lasser, Judicial Deliberations: A Comparative Analysis of Judicial Transparency and Legitimacy (Oxford, Eng.: Oxford U. Press, 2004). Peter Lindseth addressed the judicial function within administrative tribunals. See Peter Lindseth, *"Always Embedded" Administration: The Historical Evolution of Administrative Justice as an Aspect of Modern Governance*, in The Economy as a Polity: The Political Constitution of Contemporary Capitalism 117–135 (Christian Joerges, Bo Stråth, & Peter Wagner, eds., London, Eng.: University College London Press, 2005). See generally Miriam Damaška, The Faces of Justice and State Authority: A Comparative Approach to the Legal Process (New Haven, CT: Yale U. Press, 1991).

**43** See, for example, Emmanuel Jeuland, *Compte rendu de "vers un procès civil universel?" Les règles transnationales de procédure civile de l'American Law Institute* (*A Review of "Toward Universal Civil Procedure? The American Law Institute's Transnational Rules of Civil Procedure"*), 1 Rev. Crit. Droit International Privé 240 (2002).

**44** Mengin noted parallels during the 1990s between the work of Ed Feiner (discussed in Chapter 8) in the United States and René Eladari in France. Mengin, *Two Centuries of Judicial Architecture* at 14.

**45** See Marie-Elisabeth Nicoleau, *Le point de vue de concepteur, Grasse: un nouveau tribunal*, in New French Judicial Architecture at 56, 57. See also Laurence Depambour Tarride, *Aspects du 1% décoratif et symbolique judiciaire* (*Aspects of the "1% Décoratif" and Judicial Symbolism*), in New French Judicial Architecture at 89–95 (hereinafter *Aspects of the "1% décoratif"*); Laurence Depambour Tarride, Étude sur les oeuvres créés au titre du 1% artistique dans les palais de justice réalisés par la délégation générale au programme pluriannuel d'équipement depuis 1993 et Essai sur le renouvellement de la symbolique judiciaire (Study Concerning Works Created in Courthouses under the 1% Art Provision since 1993 and Essay on the Renewal of Justice Symbolism) (AMOTMJ, Août 2002) (hereinafter Study in Courthouse Symbolism).

**46** Bernard Gouttes, *La nouvelle architecture judiciaire et l'évolution de la conception des palais de justice* (*New Architecture and the Evolution of the Concept of Courthouses*), in New French Judicial Architecture at 9–11. Gouttes was the Director of Judicial Services for the Ministry of Justice. Concerns were also expressed that the variation in courthouse construction had reduced the visibility of courts themselves. See Girardet at 64, 66; Moinard at 71. In Mengin's discussion of French building during the twentieth century, she noted that efforts at simplicity had rendered some buildings undistinguished. See Mengin, *Two Centuries of Judicial Architecture* at IIB, 7–15. In both the United States and France, calls were made to remediate a perceived "deficit of solemnity." Id. at 12. In contrast, nineteenth-century buildings garnered admiration, and hence prompted both criticism of the bureaucratic styles of the 1970s and calls for new courthouses of "transcendental character." Jean-Michel Leniaud, *Conclusion*, in New French Judicial Architecture at 97. For an account in English of the French program, see Leers at 110, 124–126. We discuss complaints about federal architecture in the United States in Chapter 8. See also Allan Greenberg, *Raising "Temples of Justice": Why Does the Modern Courthouse Fall Short?* 59 Judicature 484 (1976). Greenberg detailed the lack, in many newly built courts, of public amenities, information, and clear directions for users. Id. at 488–489.

**47** See also Mengin, *Two Centuries of Judicial Architecture* at 12–13; Eladari Interview at 79–81; Girardet at 64, 65. Girardet stressed

the multi-disciplinary nature of the exploration of courthouse construction; architects, art historians, judges, anthropologists, lawyers, and others came together to reflect on the rich "sense of the judicial patrimony." Id. at 65. But Girardet also noted the special ownership that "gens de justice" (lawyers, judges, and related legal professionals) felt for courthouses.

**48** See Antoine Garapon, *Imaginer le palais de justice du XXIème siècle* 1 (*Imagining the Courthouse of the 21st Century*) (hereinafter Garapon, Imagining the Courthouse) (manuscript, 2006); see also Antoine Garapon, *Rituel et symbolisme judiciaires* (*The Symbolism of the Courtroom*), Archicrée 1995 at 54; Girardet, *What Courthouses for Tomorrow?* at 64; and Lemaire, *Twenty Years of Justice* at 68.

**49** Vincent Lamanda, *Magistratures et images du palais de justice* (*The Judiciary and Images of the Courthouse*), in New French Judicial Architecture at 69 ("le palais royal, le temple de Thémis et l'hôtel des droits de l'homme"). Lamanda, who sat on the appellate court at Versailles, stressed the degree of continuity with some aspects of the royal era. Courtrooms retained the nomenclature of "salles d'audience" (as in the audience with the king), while the Temple of Thémis was a post-revolutionary effort to rehabilitate order by rejecting pomp and adopting "solemn and rigorous" symmetrical spaces. Id. at 70–72. See also Robert Jacob, *La justice, ses demeures et ses symboles: Perspective historique* (*Justice, Its Buildings and Symbols: A Historic Perspective*) (hereinafter Jacob, *Justice Buildings and Symbols*), Archicrée 1995 at 46–52. Muratore credited Etienne-Louis Boullée, in the nineteenth century, with creating a building "designed for the administration of justice" that combined the prison and courts into "one huge building." Muratore at 46.

**50** Jacob, *Justice Buildings and Symbols* at 51–52.

**51** Jacob, *Justice Buildings and Symbols* at 51–52.

**52** Jacob, *Historical Development* at 39.

**53** "Surrounded and isolated by public squares, it shunned as much as possible the contagion of commerce and closed itself to the outside world." Jacob, *Historical Development* at 39.

**54** Garapon, *The Symbolism of the Courtroom* at 55–56. These traditions, dating from the Ancien Régime, were rigid sources of control. Further, the upper floors housed "courtrooms, lobbies, chapels, offices, chancelleries, prosecutors' chambers," while the lower floor, a "world apart," contained the detention cells, "interrogation rooms," and some administrative offices. Jacob, *Historical Development* at 37.

**55** Mengin, *Two Centuries of Judicial Architecture* at 4.

**56** Jacob, *Historical Development* at 33. In terms of the time period, Jacob identified the late 1770s as marking a turn, with the building of Le Palais de Justice in Paris (1776) and of a courthouse in Caen (1779). Id. at 39.

**57** For discussions of this era see Chapters 3 and 4 and Theodore K. Rabb, The Last Days of the Renaissance and the March to Modernity 18–19 (New York, NY: Basic Books, 2006). The equation of the king with the state and the relationship between the state and the law during the Renaissance in France are analyzed in Zoller at 33–52. While noting that historians take the Louis XIV statement "L'État c'est moi" as legend, Zoller also examined the close nexus between "the State, the nation, and the king," resulting in a "quasiphysical fusion." Id. at 39, 40. That "intimate relation" ended in 1789, when the Declaration of the Rights of Man and the Citizen insisted that "all sovereignty remains in essence in the Nation." The concept of indivisibility, however, continued, generating a "'national sovereignty.'" Id. at 41.

**58** See Garapon, Imagining the Courthouse at 1; see also Antoine Garapon, Bien juger: Essai sur le rituel judiciare (Judging Well: An Essay on Judicial Ritual) (Paris, Fran.: Odile Jacob, 1997). Construction during the twentieth century before the 1990s aimed to lessen the drama of access as well as to make plain justice's role in conciliation. See also Mengin, *Two Centuries of Judicial Architecture* at II B, 7–8.

**59** Garapon, Imagining the Courthouse at 2–4.

**60** Garapon, Imagining the Courthouse at 2–4.

**61** Moinard at 142 (English summary).

**62** Jacob, *Historical Development* at 43. He noted that a return to some medieval and Renaissance traditions of integration might be in order. Id.

**63** Garapon, *Symbolism of the Courtroom* at 142 (English summary).

**64** Garapon, *Symbolism of the Courtroom* at 142 (English summary).

**65** Garapon, *Symbolism of the Courtroom* at 142 (English summary).

**66** Council of Europe, Convention for the Protection of Human Rights and Fundamental Freedoms, Art. 6 (1), Nov. 4, 1950, 213 U.N.T.S. 221. Described further in Chapter 13, Article 6 provides, in part: "In the determination of his civil rights and obligations or of any criminal charge against him, everyone is entitled to a fair and public hearing within a reasonable time by an independent and impartial tribunal established by law."

**67** See generally Garapon, Imagining the Courthouse.

**68** Jacob, *Justice Buildings and Symbols* at 52. See also Garapon, *Symbolism of the Courtroom* at 56.

**69** Garapon, *Symbolism of the Courtroom* at 56.

**70** The colloquium in question was held in Nanterre in 2000, and the papers were published as NEW FRENCH JUDICIAL ARCHITECTURE. See especially Gouttes at 9–11. See also Chapter 2, subsection "Theories of Governance: Aristotle, Cicero, Aquinas, Latini, God, and Political Propaganda."

**71** Gouttes at 10.

**72** Lamanda at 73. Those concerns were evident in the 1970s as well. See Mengin, *Two Centuries of Judicial Architecture* at II B, 7–8.

**73** Lamanda at 74. Lamanda noted that architects and artists ought to strive to conceptualize and build "des palais de justice dignes de la seule institution a porter le nom d'une vertu" ("courthouses worthy of the only institution to bear the name of a Virtue"). Id. Moinard viewed the various goals—affirming the authority of the state, being accessible and welcoming, celebrating complex law, and applying ordinary principles—as not inconsistent. Moinard at 75.

**74** Girardet at 66; Lemaire at 68. Lemaire, the Deputy Director of Judicial Services, recounted that as of 1995, in addition to the high court of appeal (Cour de cassation), dozens of other courts existed—35 appellate courts, 181 courts of first instance, 473 tribunals of first instance, 271 employment dispute tribunals, 227 commercial tribunals, 137 tribunals for child and family issues, 102 courts of assizes (criminal courts), and 113 social security/benefits tribunals. Lemaire at 68.

**75** *Palais de Justice de Pontoise* at 5 (Ministère de la Justice, 2005). "Ne doit-on pas attendre de l'architecture qu'elle soit bienveillante, qu'elle apaise les effets d'une violence subie?" (Should we not expect this architecture to be generous and to soothe the effects of any violence suffered?).

**76** *Palais de Justice de Besançon* at 8 (Ministère de la Justice, 2005). "Dans la série des magnifiques palais de justice construits en France ces dernières années, si certaines réalisations ont voulu exprimer l'ordre et la rigueur coercitive inhérents à l'exercice du pouvoir judiciaire, celle de Besançon cherche plus, selon les mots de son architecte, à incarner les valeurs de médiation, d'arbitrage et de conciliation." (In the series of magnificent courthouses constructed in France during recent years, if certain designs sought to express the order and coercive rigor inherent in the exercise of judicial power, the Besançon courthouse sought instead, according to its architect, to embody the values of mediation, arbitration, and conciliation.) To do so, the architect, Henri Gaudin, sought to create a lively social milieu through the use of open staircases, porches, and arches. Id. at 8–12. The booklet noted that its description of the courthouse summarized discussions between Gaudin and two courthouse magistrates.

**77** Marie Bels, *Concours gagnés, concours perdus vers l'élaboration d'un modèle*, ARCHICRÉE 1995 at 96–110 (English translation, *New Directions in the Design of Law Courts* at 145) (hereinafter Bels, *New Directions*). Eladari, the Director of Long Term Planning in the Justice Ministry, had commended "modular buildings, . . . open plan layouts and modular partitions" as flexible, if further changes were needed. Eladari Interview at 145.

**78** MARIE BELS, L'IMAGE ARCHITECTURALE DE LA JUSTICE (THE ARCHITECTURAL IMAGE OF JUSTICE) 9 (Ministère de la Justice, June 1995) (hereinafter BELS, ARCHITECTURAL IMAGE OF JUSTICE). The study was commissioned by the Ministry of Justice's Délégation Générale au Programme Pluriannuel D'Équipement (DGPPE) to analyze the construction from 1992 to 1995. Girardet posited that courts were perhaps the most important public institution. Girardet at 67.

**79** See Douglas P. Woodlock, *Drawing Meaning from the Heart of the Courthouse*, in CELEBRATING THE COURTHOUSE at 155, 158.

**80** BELS, ARCHITECTURAL IMAGE OF JUSTICE at 25–30. Estimates were that some 60–65 percent of usable space went to offices.

**81** Lamanda at 74.

**82** Chilou, *Caen: une nouvelle cour d'appel* at 44, 45. "La justice qui condamne continue de fonctionner. . . . Mais il existe également une justice qui doit prendre en compte la souffrance des hommes et leur difficultés. C'est une justice qui ne condamne plus, mais qui essaie de réconcilier . . . ." (Justice that condemns continues to function . . . . But there exists equally a justice that must take into account the suffering of men and their difficulties. This is a justice that no longer condemns but rather tries to effect reconciliation . . . .)

**83** Lamanda at 69–70.

**84** Lamanda at 73; Gouttes at 10. Bels spoke of the goals as recreating the waiting rooms to be "multifunctional." Bels, *New Directions* at 99–100. Bels also noted that these were the spaces left completely to the discretion of the architect. BELS, ARCHITECTURAL IMAGE OF JUSTICE at 3. Indeed the controversial Bordeaux courthouse designed by Richard Rogers did not include a "salle des pas perdus" per se. Id. at 77. Rogers reported that he was focused on public spaces in the courthouse and that his goals were to make "the democratic act of judgment and discussion . . . as transparent as possible and the public can come in any time to hear it." He explained his courthouse as providing seven "vessels" so that people can go up "great flights of stairs from the piazza into what is basically a public space." Richard Rogers, GA Document Extra 02 96,98 (ed. Yukio Futagawa; interviewer Yoshio Futagawa) (ADA Edita, Tokyo 2002). The ground floor was for walking and waiting; offices were set at the back of courtrooms, thereby creating a "division between public and private, between courts and back-up spaces." Id. See also the exchange about that building between Marc Saboya and Lamanda, *Impressions et éclairages* (*Impressions and Points of View*), in NEW FRENCH JUDICIAL ARCHITECTURE at 78.

**85** Moinard argued that there was no contradiction between preserving the "salles des pas perdus" and adding conference rooms, which he sought to have designed as multi-purpose or polyvalent spaces. See Moinard at 74.

**86** Eladari Interview at 79. The goal was to extend French justice properties from a footprint of about 1.7 million meters (approximately 5.8 million square feet) by another 500 million meters (approximately 1.64 billion square feet).

**87** BELS, ARCHITECTURAL IMAGE OF JUSTICE at 3. Bels noted that the dossiers for each site were rich with historical detail. Id.

**88** BELS, ARCHITECTURAL IMAGE OF JUSTICE at 27–28

**89** TARRIDE, STUDY IN COURTHOUSE SYMBOLISM at 36–40.

**90** LOIS CRAIG, THE FEDERAL PRESENCE: ARCHITECTURE, POLITICS, AND SYMBOLS IN UNITED STATES GOVERNMENT BUILDING 485 (Cambridge, MA: MIT Press, 1978).

**91** The Ministry of Justice's DGPPE did the initial planning and provided a document, *Architectural Conceptual of Courthouses*. See Leers at 125.

**92** See Leers at 124–132. Discussions of some of the competitions are provided in various of the court booklets. See *Palais de Justice de Melun* 4 (Ministère de la Justice, 1997). An overview of several projects is provided in *Les nouveaux visages de la Justice*, extraits des numéros 5125 et 5132 du Moniteur, Feb. 15, 2002, and April 5, 2002 (extracts distributed by the Ministry of Justice and the AMOTMJ) (hereinafter *Nouveaux Visages*). As the description in a sidebar by Emmanuel Caille explained, the "most celebrated architects had participated in the project in which almost a billion euros had been invested." Id. at 2.

**93** See 2004 *AMOTMJ Report* at 37 (Establissement Public du Palais de Justice de Paris). Chartered by the President of France, the AMOTMJ was, in 2004, given administrative responsibilities for interior security and for a new palais de justice in Paris. 2004 *AMOTMJ Report* at 6. The plan was to renovate space within the current Palais de Justice on the Ile de la Cîté to benefit the Cour de cassation (the highest court of criminal and civil appeal in France) as well the appellate court. Id. at 1–2. As of 2008, that work had stalled.

**94** 2004 *AMOTMJ Report* at 2. The AMOTMJ operated through "conventions," or agreements, entered into with the Ministry of Justice and through statutory mandates. 2004 *AMOTMJ Report* at 8–9. In October of 2001 the Justice Ministry announced a budget of 1.52 billion euros ($1.4 billion at the time) for prison construction, not including rehabilitation of five large buildings that held about 20 percent of the population. See the interview with Michel Zulberty, Director General of AMOTMJ, in *Nouveaux visages* at 7.

**95** 2004 *AMOTMJ Report* at 7, 28.

**96** Figure 126 was provided by the Agence Publique pour l'Immobilier de la Justice (APIJ); the fascimile by Yale University Press is reproduced with its written permission, as required. Our thanks to Myriam Besnard of the APIJ for her considerable assistance in obtaining the many images used in the discussion of French buildings. Our discussion also reflects exchanges from a conference, organized by Diane Jones and David Tait, on French court architecture.

**97** Philippe Simon, *Les palais de justice dans l'architecture contemporaine* (*Courthouses in Contemporary Architecture*), in New French Judicial Architecture at 84–88.

**98** "Le palais de Justice n'est plus seulement un lieu de jugement. Il devient aussi un lieu d'accueil, d'information et d'orientation des citoyens." *Nouveau palais de Justice de Fort-de-France* at 2 (Ministère de la Justice, 2002). Other booklets reiterate that theme. For example, in discussing the massive building in Grenoble, the point was made that the many functions of courthouses (including detention) require a hospitable milieu. *Palais de Justice de Grenoble* at 12.

**99** "La Justice au coeur de la cité" is the header of part of the discussion of the symbolism of Henri Ciriani's courthouse design in Pontoise in the booklet on that building, which opened in 2005. See *Palais de Justice de Pontoise* at 5. See also *Palais de Justice Besançon* at 20. Another example comes from discussions in *Les palais au coeur des cités: particularismes, typologie architecturale et symbolique* (*Courthouses in the heart of cities: Local character, architectural and symbolic typology*) in New French Judicial Architecture at 36–39. Werner Szambien detailed the different buildings created at the city centers of Aix, Nice, and Rennes. The Ministry of Justice made locating courts in the center of cities a presumption from which departures in particular circumstances were permitted. See Moinard at 143 (English synopsis).

**100** "Le nouveau palais de Justice est au centre de la cité comme la justice est au centre des préoccupations des citoyens et de la vie publique." *Nouveau palais de Justice de Fort-de-France* at 2. The alternative, in some instances, was to locate a courthouse on the outskirts in an effort to anchor economic development in a new area. See Moinard at 71. See also Eladari Interview at 79–80. As Eladari noted, exceptions to the rule of placing courts in the center of the city occurred as the Ministry of Justice worked with municipalities to decide which sites to use.

**101** Michel Zulberty, *Impressions sur la nouvelle architecture* (*Impressions of the New Architecture*), in New French Judicial Architecture at 67.

**102** Leers at 129. "A sinuous roof floats over the whole volume, pierced by the tops of the [cone-shaped] courtrooms." Id. Rogers became well known in France after the award in 1971 for the George Pompidou Centre in Paris. *L'extension du Tribunal, Bordeaux*, 409 Techniques & Architecture: Échanges Européens 33, 33–37 (Sept. 1993). The photograph in figure 127 was provided by and is reproduced with permission of the APIJ and the photographer, Jean-Marie Monthiers.

**103** Zulberty at 66, 67; Claude Hanoteau, *Rennes—La Renaissance du Parlement de Bretagne: réaménager dans un cadre chargé d'histoire* (*Rennes—the Renaissance of the Parliament of Brittany: Redeveloping a Setting that Is Rich in History*), in New French Judicial Architecture at 28–34. The architect for the reconstruction was Alain-Charles Perrot. The photograph in figure 128 was provided by and is reproduced with the permission of the APIJ and the photographer, Olivier Wogensacky.

**104** See *Palais de Justice de Nice* (Ministère de la Justice, 2004). The 1893 building, by August Dieude-Defly, was imposing and prestigious but, by 1991, a study confirmed that it was not functional for contemporary needs. Id. at 2. Parts of the older building were used, as evidenced in the photos in the Ministry's pamphlet, at 4–10, with new and old elements intertwined.

**105** Simon at 88. "[B]ouleverse ainsi habitudes et symbols . . . aider à faire émerger une autre justice, plus ouverte, plus démocratique."

**106** Zulberty at 67. See also Marc Saboya, *Réflexions sur un projet controversé: Le nouveau tribunal de grande instance de Bordeaux* (*Reflections on a controversial project: the new high court in Bordeaux*) in New French Judicial Architecture at 75–77.

**107** Zulberty at 67. Zulberty criticized Rogers's decision in Bordeaux to create modules that separate public spaces from professional spaces. Bels, on the other hand, appeared more comfortable with that format in her discussions of Avignon and Bordeaux. Bels, Architectural Image of Justice at 3. See also Bels, *New Directions* at 103–104.

**108** Bels, Architectural Image of Justice at 7. The justification offered by the architects was the need to be flexible. Id. at 7–8.

**109** Tarride, Study in Courthouse Symbolism; Bels, Architectural Image of Justice.

**110** "[L]e nouveau palais de Justice . . . inspire confiance et respect sans susciter la crainte." *Nouveau palais de Justice de Fort-de-France* at 2. The architects were Paul Chemetov and Borja Huidobro. The photograph in figure 129 was provided by and is reproduced with the permission of the APIJ and the photographer, Olivier Wogenscky.

**111** *Palais de Justice de Grenoble* at 8–10. The architect is Claude Vasconi.

**112** *Palais de Justice de Melun* at 8–11. See Tarride, Study in Courthouse Symbolism at 38, n. 44. The architects were Françoise Jourda and Gilles Perraudin. The photograph in figure 130 was provided by and is reproduced with the permission of the APIJ and the photographer, Jean-Marie Monthiers.

**113** "Le choix de l'ancienne prison, située juste derrière l'actuelle cour d'appel, participe de la volonté du ministère de la Justice de maintenir les fonctions judiciaires au coeur de la ville." (The choice of the old prison, located just behind the current Court of Appeals, prompted the Ministry of Justice to keep the judicial offices in the center of the town.) *Palais Monclar, Cour d'appel d'Aix-en-Provence* 4 (Ministère de la Justice, 1998) (hereinafter *Palais Monclar*). As that pamphlet explained, demolition of the old prison and construction of Claude Nicolas Ledoux's planned prison and courthouse were begun in 1778. But funding was scarce in the wake of the French Revolution, and the buildings were not completed until 1832. See also Jean-Pierre Pech, *Aix-En-Provence-Le Palais Monclar: construire un palais dans une*

*prison (Aix-En-Provence-the Monclar Courthouse: Building a Court-house in a Prison)*, in NEW FRENCH JUDICIAL ARCHITECTURE at 21–27.

When discussion emerged of plans to demolish the prison, criticism erupted in the national press, arguing that the building provided insights into nineteenth-century attitudes toward incarceration. Id. at 23. The result was a decision to protect the ancient walls of the exterior to respect the history of the area while creating a new structure. Id. As the Ministry of Justice explained—in our translation—"Building a courthouse inside a former prison, a place of exclusion, offered a paradox that the architects resolved thanks to a process of requalifying and converting the building, permitting justice to reclaim the site." *Palais Monclar* at 10.

**114** Our translation is of the phrase "une solennité nécessaire à l'exercice d'une justice moderne," in *Palais Monclar* at 14. The architect, Jean-Loup Roubert, commented that it was a challenge to deal with the paradox of creating a design that befit the aspiration that justice be transparent and clear while building in the heart of an old prison, a space that was confined and "almost blind" (". . . la justice aspire à la transparence et à la clarté, . . . au coeur d'une enceinte fermée, voire quasi aveugle"). Jean-Loup Roubert, *Le point de vue du concepteur, Rennes: La renaissance du Parlement de Bretagne; réaménager dans un cadre change d'histoire (Creator's Point of View, Rennes: The Rebirth of Brittany's Parliament; Rebuilding in a Historic Setting)*, in NEW FRENCH JUDICIAL ARCHITECTURE at 25.

**115** The 1994 fire was not the first; in 1720 damage had been done by another city fire. Roubert at 30–31. Additional details were provided by Hanoteau at 28–30. He noted that the ornamentation of the building had included iconographical details of scales, a balance, a sword, and four statues by Gabriel, one crowning the roof of each pavilion and representing Justice, Force, Eloquence, and Law. Id. at 28.

**116** *Palais de justice de Besançon* at 4. The building, by Hugues Sambin, a Dijon architect, was later used as part of the setting for Stendhal's novel *The Red and the Black*. Id. Also incorporated were a few other aspects of the earlier building such as the old "salle des pas perdus," converted to serve as the entry to the appellate court. Id. at 25, 32.

**117** Gaudin (who was also the author of the book *Considerations on Space*) is quoted in the booklet on the court: "Autrefois les colonnes du Temple s'accordaient à l'idée de l'ordre . . . aujourd'hui, c'est une justice pacifiante et dont le but est l'harmonie sociale dont nous cherchons à donner l'image" (In the past, Temple columns represented the idea of order . . . today, it is a justice that pacifies and whose goal is social harmony to which we are trying to give form). *Palais de justice de Besançon*, front inside cover. The new facility, with a square footage of 53,478 feet (16,300 meters), cost 36 million euros, or roughly $44 million. See *Palais de Justice de Besançon*, back inside cover.

**118** See, for example, the Archicrée 1995 volume. In more than one hundred pages of materials on the French building program and ten cities invoked, the only artwork discussed is that of Gérard Garouste in Lyon. Id. at 116–146.

**119** That motif runs from the Nantes courthouse to the new building in Fort-de-France, Martinique. That rectangle, about 300 by 115 feet (ninety-two by thirty-five meters) provided 33,107 square feet (10,091 square meters). About half that space was for judicial functions, at a cost of about $37.5 million, or 276 million francs. *Nouveau Palais de Justice Fort-de-France* at 2, 5, back inside cover. To integrate the large edifice into its surroundings, details include verandas, colonnades, shutters, and an overhanging roof, rendered in white metal. The aim was to evoke French Antilles architecture and to "refer to classic verandas in Martinique." Id. at 10.

**120** *Palais de Justice de Grenoble* at 16. "L'utilisation du verre dans un édifice qui se développe progressivement du plein au cristallin total sert la symbolique de la justice" (The use of glass in a building, increasing progressively from full to total crystalline, facilitates the symbolism of justice).

**121** *Nouveaux visages* at 4. The discussion (in a sidebar by Emmanuel Caille) noted that the problems of security posed substantial architectural challenges in that the face of the institution had to express the values of equity, serenity, and hospitality. Id. at 6. Other constraints that delayed construction included archaeological findings at some of the sites. Id. at 4.

**122** BELS, ARCHITECTURAL IMAGE OF JUSTICE at 30 (quoting Olivier Touraine, Project Manager for the Nantes courthouse on this arrangement in Nantes). The stratification is discussed in reference to various courthouses. See id. at 54, 60.

**123** Bels, *New Directions* at 94, 96; *Actualité, Le palais de Justice de Lyon*, in ARCHICRÉE 1995 at 116, 118.

**124** The booklet about the new building at Melun described the use of the "most modern materials for control" and anti-intrusion security. *Palais de Justice de Melun* at 16.

**125** Girardet at 66–67.

**126** Simon at 88.

**127** Tarride, "1% décoratif" at 89–95. The provision for set-asides began in 1936. *Culture et architecture judiciaire: le 1% décoratif des nouvelles opérations d'équipement judiciaire*, in NEW FRENCH JUDICIAL ARCHITECTURE at 107 (hereinafter *Le 1% décoratif des nouvelles opérations*). Over time, the rule was applied to various ministries and in 1980 to Justice. See Arrêté du 11 août 1980 travaux de decoration des equipements de la justice a realiser au titre du 1% du coût global de l'operation, J.O. of Oct. 7, 1980 at 58818 (hereinafter 1980 Justice Decoration Order). The 1980 requirement entailed the selection of one or more artists "contribuer à la qualité des constructions publiques" (to contribute to the quality of public construction projects) as well as to give the public contact with original pieces of contemporary art. Id. at 107.

**128** TARRIDE, STUDY IN COURTHOUSE SYMBOLISM at 1. She cited the 1980 order creating the program requiring that the decorative program be established by the architect in conjunction with the person in charge of construction and in consultation with regional representatives involved with the arts, as well as the Ministers of Culture and Communications ("Le programme de décoration est établi par l'architecte de l'opération, en liaison avec le maître de l'ouvrage et le conseiller artistique régional, représentant régional du ministère de la Culture et de la Communication"). See Article 5 of the 1980 Justice Decoration Order.

Architects often played a critical role. For example, Jenny Holzer credited Jean Nouvel with bringing her into the Nantes project. Tarride, in contrast, criticized the degree of autonomy given to the architect and artist. TARRIDE, STUDY IN COURTHOUSE SYMBOLISM at 32–35.

**129** See Décret n° 93–431 du 23 mars 1993 relatif à la création de commissions régionales de réalisations plastiques au titre du 1 p. 100 du ministère chargé de l'éducation nationale, J.O. of Mar. 25, 1993 at 04637.

**130** *Le 1% décoratif des nouvelles operations* at 107. For projects costing 762,250 euros or less, a Counselor from the regional office of the Ministry of Culture was required to issue an opinion. Id.

**131** *Le 1% décoratif des nouvelles operations* at 107; Décret n° 93–431 du 23 mars 1993. J.O. of Mar. 25, 1993 at 04637.

**132** TARRIDE, STUDY IN COURTHOUSE SYMBOLISM at 1.

**133** Ministère de Justice—Portail: Les registres de la symbolique judiciaire, http://www.justice.gouv.fr/index.php?rubrique=11465&ssrubrique=11475&article=17071.

**134** Jacob saw the wooden cross as an heir of the "tree of justice." See Jacob, *Historical Development* at 33

**135** According to Jacob, the symbolism of the tree was pagan in origin, representing the "pillar of the world" that denoted stability and regeneration. See Jacob, *Historical Development* at 33. More literally, when outdoors, courts were convened under trees. Trees and the wooden structures that followed them were spaces in which violence was not permitted, and wood has remained a fixture of many interiors. Id.

**136** "The Crucifixion above the judge's bench remained the principal ornament of French courtrooms until the Church and State were formally separated in 1904." Its verticality denoted that the court's legitimacy stemmed from God. Jacob, *Historical Development* at 33.

**137** See also Jacob, *Justice Buildings and Symbols* at 47–49.

**138** Tarride, Study in Courthouse Symbolism at 12; "une saine justice engendre la prospérité" (a healthy justice engenders prosperity).

**139** Tarride, Study in Courthouse Symbolism at 13.

**140** Tarride, "*1% décoratif*" at 90. See also Garapon, Bien juger; Christian-Nils Robert, La Justice dans ses décors (Justice in her Settings) (Genève, Switz.: Librairie Droz S.A., 2006).

**141** Letter from Rene Eladari to Madame Depambour Tarride (July 7, 2000), appended to Tarride, Study in Courthouse Symbolism.

**142** Tarride, Study in Courthouse Symbolism at 4–5.

**143** Tarride, Study in Courthouse Symbolism at 5. Tarride noted the new exchanges between national and international law and between the executive and the judge. As she explained (per our translation), "in search of a new relationship between the law and the judge, and even, perhaps, in search of a new conception of the law, we offer up for viewing by litigants diverse works inciting them to ask questions, or contemplate, and in doing so we no longer assert any model [of justice]." Id.

**144** Tarride, Study in Courthouse Symbolism at 4–5.

**145** Tarride, "*1% décoratif*" at 92. Tarride cited an exchange about that topic between Gérard Garouste and magistrates in the Lyon Court.

**146** Tarride, "*1% décoratif*" at 90–95. The artists included Rébecca Horn, Virginie Mounicot, Keïchi Tahara, Pascal Couvert, Jacqueline Salmon, Gérard Garouste, and others. Her 2002 essay, requested by the French Ministry of Justice, reviewed installations in ten courthouses. Tarride, Study in Courthouse Symbolism at 2–4.

**147** *Palais de Justice Melun* at 22–23. *Stories*, by Maryvonne Arnaud, is one of five installations in that courthouse. Id. The photograph in figure 131 was provided by and is reproduced with the permission of the APIJ and the photographer, Jean-Marie Monthiers.

**148** Tarride, Study in Courthouse Symbolism at 17. Tarride admired the combination of art and architecture in Avignon for its clarity, neutrality, and elegance. Id. at 17–18. Born in Nice in 1960, Nahon has lived in both France and the United States. She has done a series of outdoor monumental works using steel, Baccarat crystal, and glass that have been installed in locations ranging from the Electricité de France campus in Saint-Denis, France, to the Progressive Insurance Building in Cleveland, Ohio. See generally Brigitte Nahon, Biography, http://www.denoirmont.com/bibliographie-artiste-brigitte-nahon-galerie-jerome-de-noirmont.html. The concept and image of equilibrium are recurring themes in Nahon's work, exemplified as well by a project in the Tamil Nadu region of India focused on the caste system. See also Claude Bouyeure, *Brigitte Nahon, Déséquilibrer les habitudes* (*Unbalancing Habits*) 130 Opus International 40, 40 (1993).

**149** See Bouyeure at 40.

**150** Tarride, Study in Courthouse Symbolism at 20. Our thanks to the Agence Publique pour l'Immobilier de la Justice (APIJ), to the Ministry of Justice's Departément d'Information et de Communication (DICOM, Department of Information and Communication), and to the photographer, Caroline Montagné, for authorization enabling us to reproduce the photograph in figure 132, copyright Ministère de la Justice / DICOM / Caroline Montagné.

**151** Tarride, Study in Courthouse Symbolism at 20. Tarride reported that Couvert wanted to "produire un signe symbolique culturel simple, lisible par tous, évoquant le lieu Judiciaire comme lieu Éthique, lieu de construction du Droit, de l'équilibre, du temps Suspendu, et dans un même mouvement redonner une fonction symbolique à l'oeuvre d'art dans une communauté" (to produce a culturally symbolic sign that was simple, legible to all, that evoked the judicial site as an ethical site, a site of law-generation, of equilibrium, of time suspended, and at the same time to retrieve a symbolic function to the work of art in the community). The work was to take viewers back to "l'époque du droit révélé par Dieu" (a time when law was revealed by God) as well as "la Liberty Bell, . . . and La Grosse Cloche de Bordeaux 'ancien beffroi de la ville qui a longtemps signifié l'indépendence des jurandes par rapport au pouvoir religieux'" (the Liberty Bell . . . and Bordeaux's Great Bell, 'the town's ancient belfry that long signified the independence of guilds in relation to religious power'). Id. at 20. The town's old Great Bell can be found in a building that once served as the Bordeaux Town Hall.

**152** Lamanda called the bell a symbol of "l'Ancien Régime" in that the bell in the clocktower chimed to announce mass, which was celebrated near the palais de justice before the opening of court. Lamanda and Saboya at 77.

**153** Tarride, Study in Courthouse Symbolism at 20–21. Tarride recounted that Ilkar's lines were slightly modified at the request of courthouse officials in Bordeaux, but she did not detail the changes. Id. at 20, n. 29. The excerpts cited by Ilkar were the phrase "Vert ravissement de la vie humaine" (Green ravishing of human life) by Inès de La Cruz, a seventeenth-century Spanish nun and poet, and "la littérature est le bond hors du rang des meurtriers" (literature is the leap from the ranks of murderers) from Kafka. Id. at 21.

**154** Tarride, Study in Courthouse Symbolism at 21.

**155** Tarride, Study in Courthouse Symbolism at 21. Some of the imagery is reproduced in Pierre Cabanne's, Gérard Garouste 154 (Paris, Fran.: Expressions Contemporaines, 2000). Garouste was born in 1946, and his work has been widely exhibited in major museums and public buildings. Commentators locate his work within a classical tradition that relies on frequent references to old masters, antiquity, myths, and religious symbols. Id. at 2–30. See also François Rachline, Gérard Garouste, Peindre à present (Paris, Fran.: Fragments, 2004). Our thanks to the APIJ, to DICOM, and to the photographer, Chrystèle Lacène, for providing authorization to reproduce the photographs in figures 133 and 134, copyright Ministère de la Justice / DICOM / Chrystèle Lacène.

**156** See Tourism Rhône Alpes, http://www.rhonealpes-tourisme.com/.

**157** Tarride, Study in Courthouse Symbolism at 25–26.

**158** Tarride, Study in Courthouse Symbolism at 26. Some of these words are taken from the 1789 Declaration of the Rights of Man and of the Citizen and reiterated in the 1948 Universal Declaration of Human Rights.

**159** *Culture et architecture judiciaire, le 1% décoratif*, in New French Judicial Architecture at 107. See Musée d'art et d'histoire de Baugé, press release, exposition "Atelier Soleil d'ombre," 10 ans de création céramique dans les domaines de l'architecture, du dessein et de l'art, http://www.armellebenoit.com/fileadmin/images/collaborations/hugo/SOdossierdepresse.pdf.

**160** Cabanne, Gérard Garouste at 36. The piece was made in 1994.

**161** Cabanne, Gérard Garouste at 36.

**162** "Nul ne sera soumis à la torture ni à des peines ou traitements cruels, inhumains, ou dégradants." See Universal Declaration of Human Rights, G.A. Res. 217A, at art. 5, U.N. GAOR, 3d Sess., 1st plen. mtg., U.N. Doc. A/810 (Dec. 12, 1948); Tarride, Study in Courthouse Symbolism at 26 and photo 38.

**163** Interview with Gérard Garouste, *Les droits de l'homme en "scènes,"* Archicrée 1995 at 133 (hereinafter Garouste Interview).

**164** Tarride, Study in Courthouse Symbolism at 24–25, quoting an interview with Garouste in which he said, "Mais les premières réunions de travail avec les magistrats du palais de Justice de Lyon

m'ont rapidement fait comprendre que ces symboles d'autorité, ils n'en voulaient plus. On m'a expliqué que parallèlement à une justice de sanction s'exerçait aussi une justice d'arbitrage et d'accompagnement qu'il fallait pouvoir exprimer." (But during the first working meetings with the magistrates from the Lyon courthouse, I quickly was made to understand that these symbols of authority were not what they wanted anymore. They explained to me that parallel to a justice of sanctions there was also a justice of arbitration and accommodation that it was necessary to be able to express.) See also Garouste Interview at 133.

**165** "Finalement, une idée s'est imposée comme une évidence universelle, celle des droits de l'homme, qui véhiculent sans contestation possible une belle image de la justice, rassurante et protectrice. (Finally, an idea stood out as universal evidence [of justice], that of the rights of man, which undoubtedly conveys a beautiful, reassuring and protective image of justice.) Garouste Interview at 133.

**166** Tarride, "*1% décoratif*" at 93–94 (quoting Gérard Garouste).

**167** TARRIDE, STUDY IN COURTHOUSE SYMBOLISM at 27. We have translated her comment "Nous sommes, à Lyon, en face d'un veritable renouvellement sans rupture de la symbolique judiciaire." Tarride applauded Garouste for anchoring his work in historic traditions rather than his own personal conception of justice and praised him for prompting abstract and theoretical reflections.

**168** TARRIDE, STUDY IN COURTHOUSE SYMBOLISM at 6; Tarride, "*1% décoratif*" at 93–94, discussed various plaques in different "salles des pas perdus."

**169** TARRIDE, STUDY IN COURTHOUSE SYMBOLISM at 52.

**170** We discussed the development of these installations in Chapter 9 in the section "Quietly Quizzical: Tom Otterness in Oregon and Jenny Holzer in Sacramento, California." See also fig. 9/125.

**171** TARRIDE, STUDY IN COURTHOUSE SYMBOLISM at 38–51.

**172** Tarride suggested some of this approach to the art, even as she criticized it at times. She particularly noted visual images that appeared to privilege the mechanical over the human. TARRIDE, STUDY IN COURTHOUSE SYMBOLISM at 42–48.

**173** As discussed later, Tarride cited the failure of the Ministry of Justice to set parameters for the artists whom she thought were given too great a scope. TARRIDE, STUDY IN COURTHOUSE SYMBOLISM at 52–53.

**174** Tarride, "*1% décoratif*" at 94–95.

**175** Tarride, "*1% décoratif*" at 94. Elsewhere Tarride reported that the words *loi* or *droit* (*lex* or *jus*), which had ornamented the walls and doors of courtrooms, had disappeared. TARRIDE, STUDY IN COURTHOUSE SYMBOLISM at 5. She regretted the absence of such simple words as she commented that the inclusion of more complicated texts with full sentences adorning courthouse walls reflected that "*law*" was no longer an isolated term but one whose meaning had become relational. Id. at 40.

**176** The photograph in figure 135 was first provided to us by Jean-Paul Miriglio, the AMOTMJ, and the French Ministry of Justice, with the permission of the photographer, Olivier Wogensky, and then, with the assistance of Myriam Besnard, it was reauthorized for our use by the APIJ.

**177** See Robin Pogrebin, *Nouvel, Who Pushes Architecture's Limits, Wins Pritzker*, NEW YORK TIMES, March 31, 2008, at E1. Nouvel has received many commissions in France, including the Musée du Quai Branly, that was built during the first decade of the twenty-first century to house collections relocated from France's Musée de l'Homme (Museum of Man) and its Musée des Arts Africains et Océaniens (Museum of African and Oceanic Arts). See Nicolai Ouroussoff, *For a New Paris Museum, Jean Nouvel Creates His Own Rules*, NEW YORK TIMES, June 27, 2006, at E5.

**178** Violet Gore, *Pure Justice: Law Courts, Nantes, France*, 208 ARCHITECTURE REVIEW 71, 71 (Nov. 2000). See also Jean-Pierre

Atthenont, President of the First Instance Court in Nantes, *Nantes: l'achèvement d'une opération* (Nantes: Project Completion), in NEW FRENCH JUDICIAL ARCHITECTURE at 58–59.

**179** Leers at 131.

**180** See Commentary, *Jean Nouvel, Courthouse in Nantes*, 11 ARCHITECTURE + URBANISM 362.

**181** Commentary, *Jean Nouvel, Courthouse in Nantes* at 362. Bels noted that the space was designed as a huge encompassing grid to break down the spatial distinctions between the offices of judicial workers and public spaces. BELS, ARCHITECTURAL IMAGE OF JUSTICE at 48. The photograph in figure 136 was provided by and is reproduced with permission of APIJ, AMOTMJ, the Ministère de la Justice, and the photographer, Olivier Wogenskcy.

**182** Atthenont at 61. ("Monumentalité de l'édifice, transparence, . . . signes manifestes de l'autorité"). Atthenont also commented that the building could not come alive until it was inhabited. Id.

**183** *Palais de Justice, Nantes, France*, from Jean Nouvel, http://www.jeannouvel.com (in the "Description" section, go to "Projects," "Category Matrix," "Institutional," then "Nantes").

**184** Jean Nouvel, *Le point de vue du concepteur* (Designer's Point of View), *Nantes: l'achèvement d'une opération*, in NEW FRENCH JUDICIAL ARCHITECTURE at 62.

**185** Gore at 74. These "independent cubes" are set off from the waiting area by "layers of gridded screens." Leers at 131.

**186** As Nouvel described them, they were "quatre jambes lumineuses sur lesquels défileront un certain nombre de sentences" (four luminous limbs on which a certain number of sentences rotated). Nouvel at 63. Our thanks to the APIJ for the pamphlet *Noveau Palais de justice de Nantes, Intervention de Jenny Holzer au titre du 1% artistique* (Ministère de la Justice, 2003) (hereinafter *Nantes, Intervention de Jenny Holzer*); to Art Resource for providing us with the photograph in figure 137; and to Jenny Holzer Studio, member Artists Rights Society (ARS), New York, for permission to use the photograph.

**187** We have translated "les textes semblent surgir du sol et traverser l'architecture jusqu'au ciel, se reflétant au sol et dans les parois de verre." *Nantes, Intervention de Jenny Holzer*.

**188** Telephone interview with Holzer (Nov. 28, 2005). Holzer explained that she was not fluent in French but relied on French editors and law students.

**189** Textes du Projet de Jenny Holzer pour le Palais de Justice de Nantes, dans la Cadre du 1% Pour la Culture, "Face Loire" (i.e., the column facing the river); "Face Salles D'Audience" (i.e., the column facing the courtrooms). Our thanks to Jenny Holzer, Alanna Gelgaudas, and Jean-Paul Miriglio for providing us with materials on these quotations and the texts.

**190** *Nantes, Intervention de Jenny Holzer*.

**191** *Nantes, Intervention de Jenny Holzer*.

**192** TARRIDE, STUDY IN COURTHOUSE SYMBOLISM at 34.

**193** "Quel sens peut prendre l'abondance des extraits de textes religieux? . . . De même, tel auteur, en complète contradiction de pensée avec la République et la démocratie doit-il vraiment être cité?" (What sense can we make of the abundance of religious texts? . . . Likewise, does an author, in complete philosophical contradiction with the Republic and democracy, deserve to be cited?). TARRIDE, STUDY IN COURTHOUSE SYMBOLISM at 34.

**194** "Les risques d'inexactitude sont réels." TARRIDE, STUDY IN COURTHOUSE SYMBOLISM at 34.

**195** We have translated the quote provided in TARRIDE, STUDY IN COURTHOUSE SYMBOLISM at 35: "Ce serait beau, l'honnêteté d'un avocat qui demanderait la condamnation de son client," by J. Renard.

**196** TARRIDE, STUDY IN COURTHOUSE SYMBOLISM at 35.

**197** Leers at 131.

**198** Gore at 74. The photograph in figure 138 is reproduced with the permission of the photographer, Olivier Wogenscky, the APIJ, and

the AMOTMJ and the Ministry of Justice, which first provided the photograph to us.

**199** Nouvel wrote, "le couleur et le volume donnent à ces salles la noblesse requise et une certaine esthétique." Nouvel at 63.

**200** Gore at 74.

**201** Gore at 74.

**202** Gore at 74. In contrast, Atthenont described the immense "salle des pas perdus" as providing a sense that judicial services were approachable and welcoming. Atthenont at 59.

**203** Leers at 130–131.

**204** Leers at 132.

**205** Bels, Architectural Image of Justice at 3.

**206** Bels, *New Directions* at 83.

**207** Bels, *New Directions* at 145.

**208** Bels, *New Directions* at 145.

**209** Bels, *New Directions* at 145.

**210** See Michael Gibson, *Cartier Foundation's Glass House*, New York Times, May 14, 1994, at 6; Bels, *New Directions* at 83.

**211** Garapon, Imagining the Courthouse at 7. "Ce qui frappe dans les palais de justice modernes, c'est leur silence symbolique" (What is striking in the modern courthouses is their symbolic silence). See also Garapon, *Symbolism of the Courtroom* at 60.

**212** Garapon, Imagining the Courthouse at 8–16. He saw the new structures as perhaps reflecting the agency of individuals through the leveling of power and the focus on victims, or, as he put it, "Le sujet est deveuu le véritable héros de ces palais modernes" (The subject has become the true hero in these modern courthouses). Id. at 8. He also argued (à la Foucault) that the diffusion of power risked its being both everywhere and nowhere. Garapon recommended the elimination of standard offices and the creation of an intermediary space—something between a courtroom and an office—where bureaucracy was replaced with more public spaces that enable "the circulation of language." Id. at 12–16. As we discuss in Chapter 13, what Jeremy Bentham added about publicity is critical to our endeavors as well. Bels also categorized some of the glass as potentially "meaningless transparency." Bels, *New Directions* at 145.

**213** Garapon, Imagining the Courthouse at 19–23. He urged architects to learn to design courthouses that make legible the cosmopolitan obligations of a democratic justice aiming to offer security, shelter, protection, and accountability. As discussed in Chapters 9 and 15, Byard was concerned that "contemporary court architecture is about effect, not substance; about reassurance, not inspiration; about how great we have been, not how great we might become." Paul Spencer Byard, *Reading the Architecture of Today's Courthouse*, in Celebrating the Courthouse 133, 151.

**214** Leers at 124; David Gruber, *International Design Competition*, 74 Progressive Architecture 69, 78 (1993).

**215** See Israel Supreme Court Building at 8. In addition, the "structure forms a link in a chain of buildings and sites leading from the Rockefeller Museum, extending through the Damascus Gate [of the walled Old City of Jerusalem], the Russian Compound, Zion Square, the Ben Yehuda Mall, and proceeding to Kiryat Ben-Gurion." Id. at 35.

**216** Our thanks to Michael Fein for permission to use his photograph reproduced in figure 139, as well as to Aharon Barak, former President of the Supreme Court of Israel; to the Court's Registrar, Yigal Mersel; to Marcia Greenman Lebeau of the Public Affairs Department of the Court for providing us with materials on, and a thoughtful tour of, the building; and to Elinor Slater for translations and additional research.

**217** Gruber at 79.

**218** Barbara A. Perry, *The Israeli and United States Supreme Courts: A Comparative Reflection on Their Symbols, Images, and Functions*, 63 Review of Politics 317, 325 (2001).

**219** Israel Supreme Court Building at 10–12, 23–33. Dorothy de Rothschild played a central role as one of the foundation's trustees. The gift, initially offered in 1981, was conditioned on placement of the building proximate to the Knesset. Id. at 10. In the 1950s, that foundation funded the building of the Knesset. Perry at 325.

**220** Both Ram Karmi and Ada Karmi-Melamede were educated at Israel's Technion Institute in Haifa as well as in London, and they joined together for this project. They are the "second generation of a distinguished architectural family." Their father, Dov Karmi, was a "pioneer of the Tel Aviv Bauhaus style." See Timothy Brittain-Catlin, *Supreme Being: Supreme Court Building, Jerusalem*, 193 Architectural Review 60 (1993).

**221** Israel Supreme Court Building at 23. Advisors included Jean Boggs, who had organized the competition for Canada's National Art Gallery, and Harold Williams, President of the Getty Foundation in the United States. For the jury, three American and two Israeli architects were joined by Meir Shamgar, President of the Supreme Court of Israel; Sir Isaiah Berlin of England; Lord Rothschild; and the architectural critic of London's *Financial Times*. The juror-architects were William Lacy (who chaired the panel and had also been the Director of the Architecture and Environmental Design Program of the National Endowment for the Arts), architects Charles Moore and Cesar Pelli from the United States, and David Reznik and Daniel Havkin from Israel. Id.

**222** Israel Supreme Court Building at 25. Initial bids came from more than 170 architects; firms from abroad as well as three from Israel were invited to participate. Id. at 23–25. See also Notes of the Second State of the Architectural Competition (memo from Bill N. Lacy, Chair, undated and provided to us by the court) (hereinafter Lacy Architectural Competition Memo).

**223** See Judges, Judges in Rabbinical Courts, Lawyers, Israel Police and Prison Service, Statistical Abstract of Israel, 2008, no. 59, at 11.2 (data for 1990), http://www.cbs.gov.il/shnaton60/st11_02.pdf. An additional 99 judges sat in rabbinical courts.

**224** For population statistics see ProCon.org's website.

**225** Israeli Supreme Court / Chapter A—Background and Planning Criteria, memorandum provided by the information office of the Israeli Supreme Court (hereinafter Israeli Supreme Court Planning Memorandum), at 2.1, "The Nature and Symbolism of the Building."

**226** Israeli Supreme Court Planning Memorandum at 2.1 ("The Nature and Symbolism of the Building").

**227** Israeli Supreme Court Planning Memorandum at 2.1 ("The Nature and Symbolism of the Building").

**228** Israeli Supreme Court Planning Memorandum at 2.2 ("Design Flexibility").

**229** Israeli Supreme Court Planning Memorandum at 2.3 ("Security Requirements").

**230** Israeli Supreme Court Planning Memorandum at 2.3 ("Security Requirements").

**231** Gruber at 79. See also Israel Department of Public Affairs, *The Supreme Court* (hereinafter *Israel Supreme Court Brochure*).

**232** Israeli Supreme Court Planning Memorandum at 2.3 ("Security Requirements").

**233** Lacy Architectural Competition Memo at 2. The "client" was "twofold"—a trustee of the Rothschilds' foundation and the Chief Justice of the court, Meir Shamgar. See Ziva Freiman, *The Job of a Lifetime*, 74 Progressive Architecture 66, 68 (1993).

**234** Haim Yacobi, *Form Follows Metaphors: A Critical Discourse Analysis of the Construction of the Israeli Supreme Court Building in Jerusalem*, 9 Journal of Architecture 219 (2004).

**235** Israel Supreme Court Building at 25.

**236** Israel Supreme Court Building at 187–188.

**237** Israel Supreme Court Building at 25 (quoting Karmi-Melamede and Karmi from the interview with the jury).

**238** Architects' Statement of Intent, for the Supreme Court (undated court file copy). The description provided in the statement overlaps with published accounts, including Ada Karmi-Melamede, *The Supreme Court Building, Israel*, 26 PERSPECTA 83 (1990) (hereinafter Karmi-Melamede, *Supreme Court Building*).

**239** ISRAEL SUPREME COURT BUILDING at 25.

**240** Paul Goldberger, *A Public Work that Ennobles as It Serves*, NEW YORK TIMES, Aug. 13, 1995, at A30. "In Israel, Corinthian columns do not a convincing courthouse make."

**241** Perry at 330, n. 43 (citing *Psalm* 23:3: "He will lead me in the circles of justice"). As we noted in Chapter 1, we use the Old and New Testament terminology, given that both literatures on law and on art history use that nomenclature.

**242** *Israel Supreme Court Brochure* (citing *Psalm* 119:137).

**243** ISRAEL SUPREME COURT BUILDING at 26 (citing *Amos* 5:24).

**244** ISRAEL SUPREME COURT BUILDING at 26. The brochure for the court assumed a more positivist reading of the text "You will appoint judges and officers in all your gates . . . and they will judge people with a just judgment." *Israel Supreme Court Brochure* (citing *Deuteronomy* 16:18). The brochure noted that biblical courts "were situated at the gates of the city" and linked the foyer design to such gates. Further, in their discussions, the architects invoked biblical references as if those sources provided directions. See, for example, Karmi-Melamede, *Supreme Court Building* at 92–94.

**245** This didacticism has been criticized as an effort to instill the building with more authority than it deserves, given the conflict within Israel over sovereignty. See Yacobi at 220–223. Yacobi read the architects as seeking to construct the building's meaning as much through commentary as through design. Id. at 220.

**246** Karmi-Melamede, *Supreme Court Building* at 83.

**247** Perry at 331; *The Physical and Philosophical Premises of the Parti*, 74 PROGRESSIVE ARCHITECTURE 70–71 (1993).

**248** ISRAEL SUPREME COURT BUILDING at 27 (quoting interviews).

**249** Ram Karmi, *The Israel Supreme Court*, 14 ZODIAC 166.

**250** ISRAEL SUPREME COURT BUILDING at 27.

**251** ISRAEL SUPREME COURT BUILDING at 188. See also Architects' Statement of Intent at 6; Karmi-Melamede, *Supreme Court Building* at 83.

**252** Yacobi at 226, 236–237.

**253** ISRAEL SUPREME COURT BUILDING at 36. The four "autonomous blocks" are bisected not only by the cardo but also by the "decumanus," which leads toward the city. The two axes create one aspect of the building's geometry, contrasted with the circular shape of the indoor corridors.

**254** Karmi Architects, *The Israeli Supreme Court Building*, ARCHITECTURE AND URBANISM 60, 62 (1993).

**255** Perry at 326. An "unhewn stone" wall near the entrance has mirrors at its base to "create the illusion that the building's foundation extends deep into the earth . . . [to suggest] the foundations of the Old City of Jerusalem." *Israel Supreme Court Brochure*.

**256** Perry at 326 (quoting the Shamgar interview by Freiman at 74).

**257** ISRAEL SUPREME COURT BUILDING at 38.

**258** Figure 140 is reproduced with the permission of Richard Bryant / arcaid.Co.UK and with the assistance of the court.

**259** The initial plan to have as little security as possible has been superseded by concerns over safety; by 2009, more checkpoints had been added.

**260** ISRAEL SUPREME COURT BUILDING at 75–76.

**261** Architects' Statement of Intent at 2.

**262** ISRAEL SUPREME COURT BUILDING at 158.

**263** ISRAEL SUPREME COURT BUILDING at 87 (quoting "Lord Stowell, an English judge, in ruling on the relationship between the state's judicial authority and international law").

**264** *Israeli Supreme Court Brochure*; ISRAEL SUPREME COURT BUILDING at 87–89. The tomb of Absalom is "carved out of [a] Cliff-

side" in Jerusaem and dates to the first century CE. The "Tomb of Zechariah" is outside the walls of the Old City and is a "monolith carved out of [a] cliff side" dating to the first century BCE. See Jerusalem (tombs) at Yale Divinity School's website, http://research .yale.edu:8084/divdl/eikon/subjects.jsp?subjectid=786.

**265** Goldberger at A30.

**266** Architects' Statement of Intent at 4. They continued: "Justice is described in the Bible as a circle, while law is described as a line." Id.

**267** ISRAEL SUPREME COURT BUILDING at 91.

**268** The tradition of using stone began at the end of World War I in 1917, when the British conquered Jerusalem. In 1918, Military Governor Ronald Storrs set up a requirement for the exteriors of buildings to be stone (or, some report, imposed a prohibition on plaster, exposed concrete, and less high-quality facades). See RUTH KARK & MICHAL OREN-NORDHEIM, JERUSALEM AND ITS ENVIRONS: QUARTERS, NEIGHBORHOODS, VILLAGES 1800–1948 at 185–190 (Detroit, MI: Wayne State U. Press, 2001); see also HENRY KENDALL, JERUSALEM: THE CITY PLAN, PRESERVATION AND DEVELOPMENT DURING THE BRITISH MANDATE 1918–1948 at ch. II (London, Eng.: His Majesty's Stationery Office, 1948). Our thanks to Reuven Rosenfelder for helping us to trace this practice and to Camilla Tubbs for locating its legal source.

**269** ISRAEL SUPREME COURT BUILDING at 176–177. "Four dressing techniques"—denoted by Arabic names (Tubzeh, Taltish, Mesamsam, and Motabeh) and many chiseled by Arab artisans—created a "spectrum of textures." Gruber at 78.

**270** The photograph in figure 141 was provided to us and reproduced with the permission of the photographer, Michael Fein, and the assistance of the court.

**271** ISRAEL SUPREME COURT BUILDING at 99–101.

**272** Perry at 327 (quoting Karmi and Karmi-Melamede). Perry also quoted Ram Karmi's statement that "the light in Jerusalem" was absolute, like the "justice . . . brought down from Mount Sinai. . . . In a sense, the light represents justice." Id. at 332.

**273** The photograph in figure 142 is reproduced with the permission of the photographer, Jonathan Curtis-Resnik, and with the assistance of the court.

**274** ISRAEL SUPREME COURT BUILDING at 115–119.

**275** ISRAEL SUPREME COURT BUILDING at 115.

**276** *Israel Supreme Court Brochure*. See *Psalm* 85:11.

**277** Architects' Statement of Intent at 4.

**278** ISRAEL SUPREME COURT BUILDING at 181.

**279** Its jurisdiction encompasses individual petitions against state and local authorities or against individuals serving in public offices. See *Israel Supreme Court Brochure*.

**280** During the first six months of 2008, the Supreme Court received 1,174 petitions, decided 1,224, and issued 923 decisions in its function as an appellate court. See http://elyon1.court.gov.il/heb/ haba/1-6_2008.pdf.

**281** See *The Israeli Supreme Court* at The Judicial Authority, The State of Israel, http://elyon1.court.gov.il/eng/system/index.htm (hereinafter Israeli Court website). See also Perry at 323–324.

**282** ISRAEL SUPREME COURT BUILDING at 96–97.

**283** Perry at 332.

**284** The small-sized courtroom, of 135 square meters (1,453 square feet), seats forty. ISRAEL SUPREME COURT BUILDING at 102. The medium-sized courtroom, of 220 square meters (about 2,300 square feet), seats about seventy. Id. at 105. The larger courtroom, of 280 square meters (more than 3,000 square feet), seats 150. Id. at 107. All of the courtrooms, except courtroom 1, have a prisoner dock and a press box. *Israel Supreme Court Brochure*.

**285** The photograph in figure 143 is reproduced with the permission of the photographer, Richard Bryant / arcaid.co.uk, and with the court's assistance.

**286** Israeli Court website, *The Courtrooms*.

**287** Israel Supreme Court Building at 102–103.

**288** Israel Supreme Court Building at 102–103.

**289** Israel Supreme Court Building at 102.

**290** Perry at 327.

**291** Freiman at 80.

**292** *Israel Supreme Court Brochure.*

**293** Israeli Court website, *The Mosaic.* The mosaic was found in 1933 by Professor Eleazar Sukenik of Hebrew University, who is also credited with discovery of the Dead Sea Scrolls. Figures 144–147 are reproduced with the permission of the photographer, Jonathan Curtis-Resnik, and the assistance of the court.

**294** Al Hamishmar newspaper clipping of June 10, 1993, translated by Elinor Slater.

**295** The plaque includes the name of the foundation (Yad Hanadiv) as well as the names of the architects, the project coordinator, the contractors, and the engineers, and the date (in Hebrew), 1992. Translation by Rachel Slater.

**296** Freiman at 80. That mosaic, from the Byzantine era, was uncovered in 1931 and has inscriptions of "good luck" as well as other references.

**297** See Israeli Court website, *The Symbols.*

**298** Israeli Court website, *The Symbols.* The website explains that the "area is under the authority of the Prison Service." Id.

**299** See Israel Supreme Court Building at 174.

**300** Israeli Court website, *The Symbols.* The phrase comes from *Leviticus* 19:36.

**301** Jewish Heritage Museum, Brochure, provided by the court. Our thanks to Orna Yair, the curator of the museum, who gave us a tour and explained the exhibits.

**302** Jewish Heritage Museum Brochure.

**303** Perry at 329.

**304** Perry at 333. Our information also comes from Marcia Greenman Lebeau, who provided us with a tour of the facility in December of 2005.

**305** Perry at 324, 335–339. See also Ruth Gavison, *The Role of Courts in Rifted Democracies,* 33 Israel Law Review 216 (1999).

**306** See Perry at 334–339; see also Gary Jeffrey Jacobsohn, *Three Models of Secular Constitutional Development: India, Israel, and the United States,* 10 Studies in American Political Development 1 (1996); Aharon Barak, *Supreme Court, 2001 Term—Foreword: A Judge on Judging: The Role of a Supreme Court in a Democracy,* 116 Harvard Law Review 19 (2003).

**307** Brittain-Catlin at 65.

**308** Many proposals have been presented to the Israeli parliament for divesting the court of some of its jurisdiction or otherwise limiting its authority. Perry at 335–339.

**309** Clare Melhuish, *Ada Karmi-Melamede and Ram Karmi: Supreme Court of Jerusalem,* 66 Architectural Design 34 (1996).

**310** Goldberger at A30.

**311** Goldberger at A30.

**312** Goldberger at A30.

**313** Perry at 327.

**314** Freiman at 68.

**315** Brittain-Catlin at 63–64.

**316** Yacobi at 220, 236.

**317** Goldberger at A30.

**318** Israel Supreme Court Building at 38.

**319** Israel Supreme Court Building at 104.

**320** Perry at 328.

**321** Israel Supreme Court Building at 102.

**322** Israel Supreme Court Building at 102–103. The description comes from the discussion by Ram Karmi in Karmi Architects.

**323** Israel Supreme Court Building at 36.

**324** Yacobi at 221.

**325** Yacobi at 219.

**326** Mulcahy, *Architects of Justice* at 389. The dollar figure refers to the value in 1996.

**327** See Constitutional Reform Act, 2005, c. 4 §§ 1, 3–4 (UK). The court serves as the final court of appeal in England, Wales, and Northern Ireland and hears civil appeals from Scotland. The website of the architects, Feilden+Mawson LLP, explained the objectives for the renovated building to be making "the final court of appeal more accessible," reflecting the "significance" of the institution, and siting it in a place that emphasized the role played by the court as a "cornerstone" of constitutional rights. See Feilden+Mawson LLP, Creating a Home for the UK Supreme Court, http://www.feildenandmawson.com/supreme-court/. The renovations of Middlesex Guildhall for the court were to cost some 77 million pounds (about $201 million, in 2009 values). See Frances Gibb, *First Look Inside Britain's New Supreme Court,* Times Online, Sept. 15, 2009, http://business.timesonline.co.uk/tol/business/law/article6834468.ece. The court's carpet, designed by Sir Peter Blake, has a brightly colored repeating pattern that echoes a new emblem, consisting of a rose joined with the leaves of a leek to represent England and Wales, a thistle for Scotland, and flax for Ireland. See Afua Hirsch, *Modernity v Prudence, 2009: Jury's Out on UK's £56m Supreme Court,* The Guardian, July 15, 2009, at 11 (Home Pages); BBC News, *In Pictures: UK Supreme Court,* http://news.bbc.co.uk/2/hi/in_pictures/8151625.stm; The Supreme Court of the United Kingdom: History, Art, Architecture (Chris Miele, ed., London, Eng.: Merrell Publishers, 2010). Our thanks to Supreme Court Justice Lady Brenda Hale for helping us to learn about the 2010 renovations.

**328** See, for example, The Federal Constitutional Court of Germany: Architecture and Jurisdiction (Verein der Richter des Bundesverfassungsgerichts, eds., Basel, Ger.: Birkhäuser Publishers for Architecture, 2004).

**329** Michael Black, *Representations of Justice,* speech given at the June 1998 conference and reproduced in 1 Journal of Social Change and Critical Inquiry (1999), unpaginated e-journal (now offline) (hereinafter Black, *Representations*).

**330** Our thanks to Marilyn Warren, Chief Justice of Victoria, for providing us with a tour and information about the court as well as the photographs in figures 148 and 149 and the permission to use them.

**331** Correspondence with the staff of Chief Justice Marilyn Warren. In 1851, the Colony of Victoria came into existence, and in 1852, its court followed. See Michael Challinger, Historic Court Houses of Victoria 14–15, 132–134 (Victoria, Aust.: Palisade Press, 2001). The building depicted, located in downtown Melbourne, was completed in 1884. See Supreme Court of Victoria, www.supreme-court.vic.gov.au (follow links to "Court," "History," "Building"). The design, by Alfred Louis Smith, resembles Dublin's court, reflecting that four of the judges who sat on the court were also Irish. Challinger at 132. Its statue of Justice was carved by Emmanuel Semper; a bronze replica was installed in 1967. Id. at 133. Its "dark polished cedar," the "high-set judicial benches, and lofty ceilings resulted in acoustics which were uniformly poor." Id. Renovated, it has been called "Australia's largest and best-preserved nineteenth-century court complex." Id. at 134. That court's twenty-first-century renovations are explained by Diane Jones, *Historic Courts: Between Civic Memory and a Future of Hope,* Architecture Australia, Sept./Oct. 2009, at 59, 59–61, and by Bob Sinclair, *Heritage and Technology,* Architecture Australia, Sept./Oct. 2009, at 99–101.

**332** Black, *Representations.* Using a building design to make a statement of a break from the past can be found in other jurisdictions. As we discuss in Chapter 15, the Constitutional Court of Spain, since 1981, has been housed in a recycled building designed in the 1970s by Antonio Bonet and Francisco G. Valdes for a medical institution. That

seven-floor round structure's modernity stands in contrast to classical court forms in Spain and therefore marks the different kind of justice provided in the post-Franco era.

A word about the High Court of Australia is in order. That court (the final appellate court in the system) sits in the nation's capital, Canberra. The building is part of a government complex built in the late 1970s and the 1980s that includes the National Gallery, designed by Edwards Madigan and Torzillo Briggs, who were also the architects for the High Court. See Thomas Heath, *High Court of Australia, Canberra*, 169 ARCHITECTURAL REVIEW 29 (1981). The courthouse, a "basic cubic form of the building," includes a wall made almost entirely of glass that creates "a building of light." Id. at 30–32. Its interior is centered around a vertical open stairway. Its main courtroom puts the judges' bench only slightly above the floor and spectators on banked tiers, akin to some theater layouts. See also Davina Jackson, *Cool for Crats*, 38 WALLPAPER 129 (2001). Our thanks to the Honorable Michael Kirby who provided us with a tour of the building.

**333** Black, *Representations.*

**334** Black, *Representations.*

**335** Black, *Representations.*

**336** Black, *Representations.*

**337** Black, *Representations.*

**338** Our thanks to Chief Justice Michael Black of the Federal Court of Australia, Mary McIlwain, and court staff for their help in obtaining materials about and photographs of the court, and to Martin Saunders Photography and the court for permission to reproduce the photograph in figure 150.

**339** ROBERT POWELL & PATRICK BINGHAM-HALL, HASSELL: POETIC PRAGMATISM 20 (Sydney, Aust.: Pesaro Publishing, 2003) (hereinafter POWELL/HASSELL).

**340** POWELL/HASSELL at 89.

**341** POWELL/HASSELL at 90.

**342** POWELL/HASSELL at 90.

**343** POWELL/HASSELL at 89.

**344** POWELL/HASSELL at 9.

**345** As we discuss in Chapter 15, when the Federal Court holds court elsewhere, it displays the Coat of Arms to symbolize that the space in which it sits—in Chapter 15, in an open-air tent—is constitued as a court.

**346** POWELL/HASSELL at 90.

**347** Our thanks to Mary McIlwain of the Federal Court of Australia and to the court for permission to use her photograph, reproduced in figure 151.

**348** POWELL/HASSELL at 89.

**349** Hamish Lyon, *Hassell's Law*, 88 ARCHITECTURE AUSTRALIA 58, 60 (Sept.–Oct. 1999).

**350** POWELL/HASSELL at 90.

**351** Black, *Representations.*

**352** Lyon at 60. He also noted that the problem was not new; major nineteenth-century buildings also criss-crossed sectors.

**353** Our thanks to Riitta Nikula, Professor of Art History at the University of Helsinki, Finland, who made a visit to this court possible; to Tuomo Siitonen Architects; to the photographers, Mikael Linden (for the exterior view in figure 152) and Jussi Tiainen (for the interior images in figures 153 and 154); and to the court. The photographs in figures 152–154 are provided by and reproduced with the permission of the architect.

**354** See Tuomo Siitonen, *Viinatehtaasta oikeustalo: From Alcohol Plant to Courthouse*, 6 ARKKITECHTI 30, 33 (2005). After the end of Prohibition, the state organized a design competition that produced the 1940 building.

**355** Jonathan Glancey, *Spirit of Adventure*, THE GUARDIAN, March 13, 2006, at 20 (Culture section).

**356** Glancey.

**357** See Siitonen at 33, 36, pic. 8.

**358** See Siitonen at 33.

**359** Helsinki District Court Brochure at 1 (provided by the court, 2005). More than five hundred lay judges participate in the court's work. All the offices have access to light.

**360** See Siitonen at 33.

**361** Glancey.

**362** LAW PROFILE OF FINLAND 55–58 (Nina Meincke, ed., British Council & European Lawyers' Association, 1999).

**363** Helsinki District Court Brochure at 6–8.

**364** The architect relied in part on the "grid pattern of the glass wall of the old bottling plant." Siitonen at 32.

**365** Glancey.

**366** Glancey.

**367** Glancey.

**368** Heidi Landecker, *CourtHouses*, 85 ARCHITECTURE 64, 66 (Jan. 1996).

**369** Landecker at 66.

**370** See Edward M. Peters, *Prison before the Prison: The Ancient and Medieval Worlds*, in THE OXFORD HISTORY OF THE PRISON: THE PRACTICE OF PUNISHMENT IN WESTERN SOCIETY 3–47 (Norval Morris & David J. Rothman, eds., Oxford, Eng.: Oxford U. Press, 1995) (hereinafter OXFORD HISTORY OF THE PRISON). See also PIETER SPIERENBURG, THE PRISON EXPERIENCE: DISCIPLINARY INSTITUTIONS AND THEIR INMATES IN MODERN EUROPE (New Brunswick, NJ: Rutgers U. Press, 1991); 12 THE EMERGENCE OF CARCERAL INSTITUTIONS: PRISONS, GALLEYS AND LUNATIC ASYLUMS 1550–1900 (Pieter Spierenburg, ed., Rotterdam, Neth.: Erasmus University Rotterdam, 1984).

**371** See generally NICOLA LACEY, THE PRISONERS' DILEMMA: POLITICAL ECONOMY AND PUNISHMENT IN CONTEMPORARY DEMOCRACIES (The Hamlyn Lectures) (New York, NY: Cambridge U. Press, 2008). Our thanks to her as well for commenting on a draft of this portion of the chapter.

**372** See ROBERT TITTLER, ARCHITECTURE AND POWER: THE TOWN HALL AND THE ENGLISH URBAN COMMUNITY c. 1500–1640 at 123 (Oxford, Eng.: Oxford U. Press, 1991) (quoting R. B. PUGH, IMPRISONMENT IN MEDIEVAL ENGLAND, 1968) (emphasis in the original). In addition to noting the connection between prisons and town halls, Tittler described the development of classifications of inmates and some degree of their separation as well as pressures to create separate facilities. Id. at 123–125.

**373** TITTLER at 125 (emphasis in the original deleted). The list of diseases included "typhus, plague, gaol fever." Id.

**374** CARL LOUNSBURY, THE COURTHOUSES OF EARLY VIRGINIA: AN ARCHITECTURAL HISTORY 321 (Charlottesville, VA: U. of Virginia Press, 2005). In Virginia, those detained included "runaway servants and slaves." Id. Peters gave examples of longer terms of imprisonment for various persons (including prisoners of war) in Greece, Egypt, and Rome in "the ancient world." See Peters at 3–23. In contrast, in Christian Europe before the ninth century, prisons were rarely mentioned. Id. at 23. The Inquisition, however, did rely on incarceration. Id. at 31. Florence constructed its first public prison in 1297 and there housed children as well as inmates of all ages, genders, and "degree[s] of sanity." Id. at 39–44. Venice's public prison of the 1560s had four hundred cells. Id. at 40. Venice joined other Italian city-states and the "kings of Sicily, England, France, and Castile" in relying on imprisonment as part of the criminal punishment system. Id. at 41–45.

**375** Pieter Spierenburg, *The Body and the State: Early Modern Europe*, in OXFORD HISTORY OF THE PRISON at 49–65. Included were "galley sentences," forcing individuals to provide labor on boats—thereby creating a model for subsequent "workhouses." Id. at 64–65. Spierenburg traced the transition to penal institutions during the

seventeenth century in Germany, France, England, and the Dutch Republic. Id. at 73–76. In another volume Spierenburg detailed the "roots of imprisonment" in monasteries and asylums and the warehousing of poor vagrants and other "disorderly" persons. Spierenburg at 12–25, 264–265.

**376** Tittler at 126–128. Spierenburg also mapped the distinctions between the English system and that of continental Europe. He noted that more correction houses existed in England than in Europe in the seventeenth and eighteenth centuries. Id. at 265. England also exported prisoners to colonies until the nineteenth century, when more prisons were built. Id. at 267. By the eighteenth century, England's prisons provided models for those in the United States. See Randall McGowen, *The Well-Ordered Prison: England, 1780–1865*, in Oxford History of the Prison at 71–100.

**377** Lounsbury at 233.

**378** The first facilities, in addition to Leavenworth in Kansas, were sited in Atlanta, Georgia, and McNeil Island, Washington. See Gregory L. Hershberger, *The Development of the Federal Prison System*, 43 Federal Probation 13, 13–14 (1979).

**379** Lounsbury at 238–256.

**380** Spierenburg, Prison Experience at 267.

**381** David J. Rothman, *Perfecting the Prison: United States, 1789–1865*, in Oxford History of the Prison at 111, 116–118. An extant example of the spoke/wheel architecture can be found at Eastern State Penitentiary in Philadelphia, Pennsylvania. See Rothman at 118–119 (including an illustration). See generally David J. Rothman, The Discovery of the Asylum: Social Order and Disorder in the New Republic (Boston, MA: Little, Brown, rev. ed., 1990). Virginia created a "massive masonry prison for Richmond," reflecting some of Bentham's ideas. Lounsbury at 261–264.

**382** See generally George Fisher, *The Birth of the Prison Retold*, 104 Yale Law Journal 1235 (1995). Fisher argued that the focus was on the reform of younger, or "juvenile," prisoners.

**383** See Jean-Pierre Pech, *Aix-En-Provence-Le Palais Monclar: construire un palais dans une prison (Aix-En-Provence-the Monclar Courthouse: Building a Courthouse in a Prison)*, in New French Judicial Architecture at 21, 22.

**384** See Jean-Pierre Pech, *Aix-En-Provence-Le Palais Monclar: construire un palais dans une prison (Aix-En-Provence-the Monclar Courthouse: Building a Courthouse in a Prison)*, in New French Judicial Architecture at 21, 22.

**385** McGowen at 81–82, 85–89; Lounsbury at 260–261.

**386** See Leslie Fairweather, *Does Design Matter?*, in Prison Architecture at 61, 62–63.

**387** Elaine Bailey, *Building for Growth*, in Prison Architecture at 73, 80–83.

**388** Ian Dunbar & Leslie Fairweather, *English Prison Design*, in Prison Architecture at 17–27. Some also sought to site facilities proximate to communities so that inmates could have contact and to enable a variety of living settings depending on the detainee. Leslie Fairweather, *Psychological Effects of the Prison Environment*, in Prison Architecture at 34–36, 47–48.

**389** Stephen Shaw, *Prison Architecture and the Politics of Reform*, in Prison Architecture at 156.

**390** See Seán McConville, *The Architectural Realization of Penal Ideas*, in Prison Architecture at 1.

**391** Lacey offered a transnational analysis. See also Sandra L. Resodihardjo, Crisis and Change in the British and Dutch Prison Services: Understanding Crisis Reform Processes (Burlington, VT: Ashgate, 2009).

**392** Figures come from the Bureau of Justice Statistics, http://bjs .ojp.usdoj.gov/.

**393** James Kessler, *Prisons in the USA: Cost, Quality and Community in Correctional Design*, in Prison Architecture at 93. See also Stephan A. Kliment, *Preface*, in Phillips & Griebel at vii. The rela-

tionship between confinement in prisons and in institutions such as hospitals and asylums is explored in Bernard E. Harcourt, *From the Asylum to the Prison: Rethinking the Incarceration Revolution*, 84 Texas Law Review 1751 (2006).

**394** Paige M. Harrison & Allen J. Beck, Bureau of Justice Statistics, Bulletin: Prison and Jail Inmates at Midyear 2004 (Washington, DC: U.S. Department of Justice, 2005), http://bjs.ojp .usdoj.gov/index.cfm?ty=pbdetail&iid=843.

**395** Bureau of Justice Statistics, Expenditure and Employment Database, National Estimates of Corrections Expenditures, http://bjs-data.ojp.usdoj.gov/dataonline/index.cfm.

**396** Kessler at 89.

**397** A 1995 article reported that "for the first time, California will spend more on prisons than for its two university systems, the University of California and the California state universities, according to Geoffrey Long, the chief consultant to the State Assembly's Budget Committee." See Fox Butterfield, *New Prisons Cast Shadow Over Higher Education*, New York Times, April 12, 1995. Twelve years later, in 2007, the *San Francisco Chronicle* reported that "California is headed for a dubious milestone—for the first time the state will spend more on incarcerating inmates than on educating students in its public universities" (including community colleges as well as state universities and the University of California system). "Following the historic growth rates, in fiscal 2012–2013, prisons spending will come to about $15.4 billion a year while overall higher education spending will come to $15.3 billion." See James Sterngold, *Prisons' Budget to Trump Colleges'*, San Francisco Chronicle, May 21, 2007, at A1. "According to the May revisions of Gov. Arnold Schwarzenegger's budget, the state will spend $10 billion on prisons in fiscal 2007–08, a 9 percent increase from last year," and this ten billion represented approximately 10 percent of the state's total budget. See Enacted Budget, Corrections and Rehabilitation, http://2007-08.archives.ebudget.ca.gov/Enacted/State AgencyBudgets/5210/agency.html.

**398** Figures come from the Bureau of Justice Statistics and can be found at http://www.ojp.usdoj.gov/bjs/glance/tables/corr2tab.htm.

**399** Scott Higgins, *Responding to a Fourfold Increase in Population: The Experience of the Federal Bureau of Prisons*, in Prison Architecture at 85.

**400** See Dora Schriro, U.S. Department of Homeland Security, Immigration Detention Overview and Recommendations 2 (2009), http://www.ice.gov/doclib/091005_ice_detention_report-final.pdf. The 31,000 figure is the number in detention on September 1, 2009. Id.

**401** Norval Morris, *Prisons in the USA: Supermax—the Bad and the Mad*, in Prison Architecture at 98–108. Transfers to those settings can occur with minimal procedural protections.

**402** See *Wilkinson v. Austin*, 545 U.S. 209, 214 (2005).

**403** *Wilkinson*, 545 U.S. at 214–215.

**404** See Sharon Dolovich, *State Punishment and Private Prisons*, 55 Duke Law Journal 437 (2005). Estimates were that 90,000 persons were incarcerated in 2003 in facilities "run by for-profit prison-management companies." Id. at 439–440.

**405** Dolovich at 453–456.

**406** These two corporations were the dominant participants in the private prison market in the United States. Dolovich at 459, 496, n. 226.

**407** Dolovich at 462–471. In 2009, the Supreme Court of Israel held that private prisons were unlawful under that country's Basic Law. See *HCJ 2605/05 Academic Center of Law & Business, et al., v. Minister of Finance et al.* [2009]; see also Eyal Press, *A Blow to Privatization in Israel (and perhaps Beyond)*, The Nation, Nov. 23, 2009, http://www .thenation.com/blogs/notion/499878/a_blow_to_privatization_in_ israel_and_perhaps_beyond.

**408** In France, 13,000 new beds had been built toward the end of the twentieth century, with goals for more. See Jean Francois Jodry &

Michel Zulberty, *Prisons in Europe: France*, in PRISON ARCHITECTURE at 109–117. The Netherlands also experienced expansion, albeit on a smaller scale. See Peter Van Hulten, *Prisons in Europe: The Netherlands*, in PRISON ARCHITECTURE at 118–122.

**409** 2004 *AMOTMJ Report* at 15, 19. Also detailed were the establishment of halfway houses ("centres de semi-liberté"). Id. at 17.

**410** Mengin, *Two Centuries of Judicial Architecture* at nn. 11, 13 (citing La loi d'orientation et de programmation pour la justice du 9 september 2002). See also Loi de finances pour 2005, No. 1800, Justice: Services Penitentiaires et Protection Judiciaire de la Jeunesse (Prison and Youth Services).

**411** The spectacular costs and failures of the United States system are detailed in Norval Morris, *The Contemporary Prison, 1965–Present*, in OXFORD HISTORY OF THE PRISON at 202–238.

**412** SPIERENBURG, PRISON EXPERIENCE at 277–280. He offered various theories and "paradoxes," including how imposition of certain forms of punishment—such as corporal punishment or physical isolation—makes people "queasy" in one era even if they are not troubled by these forms in another. Id. at 281.

## CHAPTER 11

**1** See, for example, CIVIL LITIGATION IN COMPARATIVE CONTEXT (Oscar G. Chase, Helen Hershkoff, Linda Silberman, Yasuhei Taniguchi, Vincenzo Varano, & Adrian Zuckerman, eds., St. Paul, MN: Thomson West, 2007). See also OSCAR G. CHASE, LAW, CULTURE AND RITUAL: DISPUTING SYSTEMS IN CROSS-CULTURAL CONTEXT (New York, NY: New York U. Press, 2005).

**2** A compendium, the Forum of Federations, characterizes 24 of 193 countries in the world as federations. See Forum of Federations, *Federalism by Country*, March 30, 2007, http://www.forumfed.org/en/federalism/by_country/index.php. Of that group, seven (Austria, Belgium, Malaysia, Russia, South Africa, Spain, and Venezuela) were reported to have unitary judiciaries, in that their constituent subparts did not operate separate court systems. The question of whether a court is separate requires consideration of criteria including how the subunits' judges are selected and paid; the autonomy of the law that they are authorized to decide, such as separate constitutions; and the bureaucratic structures in which they work. See, for example, Alexander N. Domrin, *The Russian Federation*, October 10, 2006, Forum of Federations, http://www.forumfed.org/libdocs/Global_Dialogue/Book_3/BK3-C08-ru-Domrin-en.htm (describing the difficulty of determining whether Russia's subparts maintain separate court systems but ultimately concluding that "all subordinate courts within the jurisdiction of the [Russian] Supreme Court . . . are federal [and not local or regional] courts . . .").

**3** See Alec Stone Sweet, *Islands of Transnational Governance*, in ON LAW, POLITICS AND JUDICIALIZATION 323–342 (Martin Shapiro & Alec Stone Sweet, eds., Oxford, Eng.: Oxford U. Press, 2002).

**4** JASPER YEATES BRINTON, THE MIXED COURTS OF EGYPT 4–5 (New Haven, CT: Yale U. Press, 1930) (hereinafter BRINTON, MIXED COURTS). Brinton was a "Justice of the Court of Appeals, Mixed Court of Egypt," and provided a history with appendices of resources and court rules but did not give footnotes for many quotations, this one included. Other "consular courts" existed in the nineteenth and twentieth centuries; foreign powers authorized their diplomats to decide cases involving their nationalities' subjects while in a foreign country. See Jasper Yeates Brinton, *The Closing of the Mixed Courts of Egypt*, 44 AMERICAN JOURNAL OF INTERNATIONAL LAW 303, 307 (1950) (hereinafter Brinton, *Closing of the Mixed Courts*); A. McDougall, *The Position of Foreigners in Egypt on the Termination of the Mixed Courts*, 26 BRITISH YEAR BOOK INTERNATIONAL LAW 358 (1949).

**5** The nomenclature varied with the treaty.

**6** See Treaty of Amity, Commerce and Navigation, United States–Great Britain, Nov. 19, 1794, 8 Stat. 116.

**7** See also Judith Resnik, *Law's Migration: American Exceptionalism, Silent Dialogues, and Federalism's Multiple Points of Entry*, 115 YALE LAW JOURNAL 1564, 1585–1587 (2006) (hereinafter Resnik, *Law's Migration*).

**8** Jenny S. Martinez, *Antislavery Courts and the Dawn of International Human Rights Law*, 117 YALE LAW JOURNAL 550, 568 (2008).

**9** See Treaty for the Abolition of the Slave Trade, Art. XII, Great Britain–Spain, Sept. 23, 1817, 4 British Foreign and State Papers 33, 36–37. A modern-day analogue in terms of creating courts staffed by jurists from outside the jurisdiction are those that rely on "contract judges" to augment their own national judiciary. Botswana is one such example (Botswana Constitution, Sec. 99/100 (Court of Appeal)).

**10** The length and complexity of the trials varied. Martinez at 584–595. Condemned ships were generally auctioned off. Id. at 591. The courts sometimes referred the crew for prosecution in their own countries. Martinez also noted the degree to which the British Foreign Office superintended its judges sitting on those courts. Id. at 592–594.

**11** Martinez at 552–553.

**12** For example, France, which did not have ships significantly involved after the 1830s, never joined, and the United States participated only in the 1860s. Martinez at 602–610.

**13** See Resnik, *Law's Migration* at 1585–1588.

**14** For example, at one point the "Mixed Courts of Commerce of Constantinople" had fourteen merchants, half Turkish and half foreigners, "sitting under the presidency of the Turkish Minister of Commerce." BRINTON, MIXED COURTS at 10.

**15** BRINTON, MIXED COURTS at 44.

**16** BRINTON, MIXED COURTS at 40. The full list also included Austria, Belgium Denmark, Italy, Holland, Norway, and Portugal; the composition changed when treaties were renegotiated.

**17** BRINTON, MIXED COURTS at 73–89. He argued that lifetime appointments and pensions protected the judges' independence. Id. at 85–89.

**18** Brinton, *Closing of the Mixed Courts* at 308.

**19** The United States Constitution provides that citizens of different states can turn to the federal courts, and Congress has, with definitions and restrictions, put that prospect into practice. See U.S. CONST., Art. III, and 28 U.S.C. § 1332.

**20** BRINTON, MIXED COURTS at 97. Excluded were what in the United States are called "domestic relations" and probate issues. Id. at 97–98. Crimes were included. Id. at 195–220. However, that aspect of the jurisdiction was not exercised "to any significant extent." See Gabriel M. Wilner, *The Mixed Courts of Egypt, a Study on the Use of Natural Law and Equity*, 5 GEORGIA JOURNAL OF INTERNATIONAL AND COMPARATIVE LAW 407, 416 (1975). On the other hand, Wilner reported that the Mixed Courts "never hesitated to pierce protective veils" to find jurisdiction, took jurisdiction over disputes involving "foreigners of the same nationality," and sometimes relied on a "straw man" to gain jurisdiction. Id. at 413, 414. Further, the government of Egypt was a regular party as plaintiff or defendant in litigation with foreigners. BRINTON, MIXED COURTS at 221–223.

**21** BRINTON, MIXED COURTS at 118–144, 145–162. Procedures were modeled after the French. Id. at 163.

**22** See generally Ronald J. Daniels, Defecting on Development: Bilateral Investment Treaties and the Subversion of the Rule of Law in the Developing World (March 23, 2004 draft), www.unisi.it.lawand economics/stile2004/daniels.pdf. As Daniels explained, such treaties enable foreign investors to rely on international commercial arbitration so as to avoid domestic institutions and hence to enjoy legal "enclaves" that domestic investors cannot. In contrast, others see the utility of enabling investors to opt out of domestic systems. See Cheryl W. Gray & William W. Jarosz, *Law and Regulation of Foreign Direct Investment: The Experience of Central and Eastern Europe*, 33 COLUMBIA JOURNAL OF TRANSNATIONAL LAW 1 (1995).

**23** Arguments have also been advanced for the development of structures that invite foreigners to use well-functioning public courts in countries unrelated to where disputes arise. See Jens Dammann & Henry Hansmann, *Globalizing Commercial Litigation*, 94 CORNELL LAW REVIEW 1 (2008).

**24** The texts establishing the WTO's Dispute Settlement System are online at http://www.wto.org/english/tratop_e/dispu_e/dsu_e.htm. See generally Kara Leitner and Simon Lester, *WTO Dispute Resolution 1995–2004: A Statistical Analysis*, 8 JOURNAL OF INTERNATIONAL ECONOMIC LAW 231 (2005); DAVID PALMETER & PETROS C. MAVROIDIS, DISPUTE SETTLEMENT IN THE WORLD TRADE ORGANIZATION: PRACTICE AND PROCEDURE (Cambridge, Eng.: Cambridge U. Press, 2d ed., 2004); GIORGIO SACERDOTI, ALAN YANOVICH, & JAN BOHANES, WTO AT TEN: A LOOK AT THE APPELLATE BODY (Cambridge, Eng.: Cambridge U. Press, 2006); see also Peter Drahos, Bilateral Web of Trade Dispute Settlement, paper presented at the conference "WTO Dispute Settlement and Developing Countries: Use, Implications, Strategies and Reform," May 2005. Bilateral agreements produce different rules; for example, a U.S.–Australia accord created a right to open hearings, while a Canada–Chile agreement provided for confidential proceedings. Id. at 9.

**25** Brinton, *Closing of the Mixed Courts* at 311.

**26** BRINTON, MIXED COURTS at xxiii. That building was opened in 1886. Id. at 53. Figure 155, from BRINTON, MIXED COURTS at 91, is reprinted with the permission of Yale University Press. The French withdrew around that time, and British influence grew thereafter. Id. at 54–58.

**27** Many commentators have examined the role of courts and legal institutions in mediating within and generating the identities of new polities, as well as the role to be played by a European constitution. See, for example, NEIL MACCORMICK, QUESTIONING SOVEREIGNTY: LAW, STATE AND NATION IN THE EUROPEAN COMMONWEALTH (Oxford, Eng.: Oxford U. Press, 1999); GRÁINNE DE BÚRCA & JOSEPH H. H. WEILER, THE EUROPEAN COURT OF JUSTICE (Oxford, Eng.: Oxford U. Press, 2001); MIGUEL P. MADURO, WE THE COURT: THE EUROPEAN COURT OF JUSTICE AND THE EUROPEAN ECONOMIC CONSTITUTION: A CRITICAL READING OF ARTICLE 30 OF THE EC TREATY (Oxford, Eng.: Hart Publishing, 1998).

**28** Treaty on European Union, Art. 8, Feb. 7, 1992, 1992 O.J. (C 224), reprinted in 31 I.L.M. 247, 259 (amending Treaty Establishing the European Economic Community, Mar. 25, 1957, 298 U.N.T.S. 3). See generally JOHN COLE & FRANCIS COLE, A GEOGRAPHY OF THE EUROPEAN UNION (London, Eng.: Routledge, 2d ed., 1997). What European citizenship means and courts' roles in constructing identity are the subjects of J. H. H. Weiler, *The European Courts of Justice: Beyond "Beyond Doctrine" or the Legitimacy Crisis of European Constitutionalism*, in EUROPEAN COURTS AND NATIONAL COURTS: DOCTRINE AND JURISPRUDENCE 365–391 (Anne-Marie Slaughter, Alec Stone Sweet, & Joseph H. H. Weiler, eds., Oxford, Eng.: Hart Publishing, 1997) (hereinafter EUROPEAN COURTS AND NATIONAL COURTS). More general discussion of the role of law and judges in constructing political identities can be found in Neil Walker's *Taking Constitutionalism Beyond the State*, 56 POLITICAL STUDIES 519 (2008); Mattias Kumm, *Why Europeans Will Not Embrace Constitutional Patriotism*, 6 INTERNATIONAL JOURNAL OF CONSTITUTIONAL LAW (I-CON) 117 (2008); Judith Resnik, *Law as Affiliation: "Foreign" Law, Democratic Federalism, and the Sovereigntism of the Nation-State*, 6 INTERNATIONAL JOURNAL OF CONSTITUTIONAL LAW (I-CON) 33 (2008); Brun-Otto Bryde, *International Democratic Constitutionalism*, in TOWARDS WORLD CONSTITUTIONALISM: ISSUES IN THE LEGAL ORDERING OF THE WORLD COMMUNITY 103–125 (Ronald St. John Macdonald & Douglas M. Johnson, eds., Dordrecht, Neth.: Martinus Nijhoff, 2005). Kumm, for example, argued that popular elections were both a predicate to a legal European identity and neither likely nor desirable. A different approach, also occasioning debate, focuses on the capac-

ity to form a shared public sphere and discourse—understood as another kind of predicate to a European *demos*. See Marianne van de Steeg, *Rethinking the Conditions for a Public Sphere in the European Union*, 5 EUROPEAN JOURNAL OF SOCIAL THEORY 499 (2002).

**29** The Court once served the European Community and has, since 1992, served the European Union. The Court did not, however, change its formal name (Court of Justice for the European Community), although the titles of other institutions (e.g., both the Council and the Commission) were revised. See HJALTE RASMUSSEN, THE EUROPEAN COURT OF JUSTICE 26 (Copenhagen, Den.: GadJura, 1998).

**30** The nomenclature for proceedings includes "references" and "direct actions." National courts may refer cases to the ECJ to gain interpretations of community law. In addition, Member States, the European Community, and individuals may bring cases to obtain judicial review of legal measures taken by the Community. See ANGELA WARD, JUDICIAL REVIEW AND THE RIGHTS OF PRIVATE PARTIES IN EU LAW 2–3 (Oxford, Eng.: Oxford U. Press, 2d ed., 2007) (hereinafter WARD, JUDICIAL REVIEW AND THE ECJ); K. P. E. LASOK, TIMOTHY MILLET, & ANNELI HOWARD, JUDICIAL CONTROL IN THE EU: PROCEDURES AND PRINCIPLES (Richmond, Eng.: Richmond Law and Tax, 2004).

**31** The Court was first created by the European Coal and Steel Treaty of April 18, 1951. Treaty Establishing the European Coal and Steel Community, Apr. 18, 1951, 261 U.N.T.S. 140. Details of its subsequent evolution are provided in CAROLA HEIN, THE CAPITAL OF EUROPE: ARCHITECTURE AND URBAN PLANNING FOR THE EUROPEAN UNION (Westport, CT: Praeger, 2004). The Court's first era is also charted in RASMUSSEN at 39–56.

**32** The Court was elaborated through the Single European Act of February 17 and 28, 1986, which provided for the Court of First Instance, "attached" to the Court of Justice. See ECSC Treaty, Art. 31, 26 U.N.T.S. 140; E.C. Treaty 164, 298 U.N.T.S. 11; Euratom Treaty, Art. 136, 298 U.N.T.S 167. Subsequent treaties, including the Treaty of European Union, signed in Maastricht, the Netherlands (and hence called the Maastricht Treaty) in 1992, have added layers to the structure of the European Union. The procedural framework for the ECJ was influenced by the International Court of Justice, discussed in Chapter 12. See generally EUROPEAN COURTS: PRACTICE AND PRECEDENTS 3–15 (Richard Plender, ed., London, Eng.: Sweet & Maxell, 1997). See also LASOK AND MILLETT at 2–37. The many legal documents delineating the ECJ's authority, doctrine, and justification have produced a steady stream of scholarship.

**33** See generally EUROPEAN COURTS AND NATIONAL COURTS.

**34** See, for example, RAN HIRSCHL, TOWARDS JURISTOCRACY: THE ORIGINS AND CONSEQUENCES OF THE NEW CONSTITUTIONALISM (Cambridge, MA: Harvard U. Press, 2004). Analysis of the mechanisms by which courts work as engines of integration is provided in ALEC STONE SWEET, THE JUDICIAL CONSTRUCTION OF EUROPE (Oxford, Eng.: Oxford U. Press, 2004). See also ALEC STONE SWEET, GOVERNING WITH JUDGES: CONSTITUTIONAL POLITICS IN EUROPE 153–193 (Oxford, Eng.: Oxford U. Press, 2000). A more general review of "judicialization" in diverse settings is provided in the discussions in ON LAW, POLITICS AND JUDICIALIZATION.

**35** ARCHITECTURE AND ART OF THE COURT OF JUSTICE OF THE EUROPEAN COMMUNITIES (Luxembourg City, Lux.: Office of the Official Publications of the European Communities, 2002) (hereinafter ECJ ARCHITECTURE AND ART).

**36** Vassilios Skouris, President of the ECJ, Speech upon the Inauguration of the New Palace of Justice of the European Communities (Dec. 4, 2008) (hereinafter Skouris ECJ 2008 Inaugural Speech). Our thanks to Christopher Fretwell for providing us with this text. As a newspaper report put it when the ECJ's new building opened, the ECJ "was initially a squatter. In 1952 the seat of the court was given to Luxembourg, in the absence of a better location. In the Villa Vauban, hearings took place in the President's office, judges had to be sworn in in

the marriage chambers of Luxembourg's city hall, and the clerk was located in Pierre Werner's old wedding chamber. 'Be happy, Mr. President, that you no longer have to sleep in the beds of others,' said Jean-Claude Juncker, prime minister of the grand-duchy" (all translations from the French by Stella Burch Elias and by Allison Tait). See *Les tours de Babel de la justice européenne*, Le Républicain Lorrain, Dec. 5, 2008.

**37** Hein at 113.

**38** Skouris ECJ 2008 Inaugural Speech.

**39** Luxembourg, along with Liège and The Hague, competed in the 1950s to host the ECSC. Hein at 69. Luxembourg became the site of the ECSC, while the Parliamentary Assembly went to Strasbourg. The European Economic Community and Euratom were seated in Brussels. Id. at 72.

**40** Hein at 113 (using this term in the title of the chapter devoted to Luxembourg).

**41** Hein at 121. The European Investment Bank was founded in 1958.

**42** A large literature debates the plausibility and desirability of the concept of national identity given the multi-ethnic, multi-cultural, and polynational groups within states, as well as the specific question of whether Europe could and should be understood as forming a single *demos* and, if so, what would be entailed in that identity. See generally Anthony Smith, *National Identity and the Idea of European Unity*, 68 International Affairs 129 (1992); Bo Stråth, *A European Identity: To the Historical Limits of a Concept*, 5 European Journal of Social Theory 387 (2002); Will Kymlicka, *The Internationalization of Minority Rights*, 6 International Journal of Constitutional Law (I-CON) 1, 1–32 (2008).

**43** Our thanks to Christopher Fretwell of the ECJ Press and Information Division and to Miguel Poiares Maduro, Advocate General of the ECJ, for information about the ECJ's work and for help in obtaining the images in figures 156–162 and materials about the ECJ, including speeches at the 2008 building's opening. Thanks as well to Advocate General Eleanor Sharpston, Peter Oliver, Philippa Watson, Peter Lindseth, Alec Stone Sweet, Patrick Weil, as well as to Angela Ward and Gerald Neuman for reviewing drafts of this chapter. The photograph in figure 156 is reproduced courtesy of the Court of Justice of the European Communities.

**44** ECJ Architecture and Art at 8.

**45** Hein at 122. The book dedicated to the ECJ explained that all architects in Europe were invited to participate (ECJ Architecture and Art at 8); Hein reported that local architects were authorized to "invite foreign partners" and that seventeen proposals were submitted. Id.

**46** Hein at 121.

**47** Hein at 122.

**48** Maria Vittoria Capitanucci, Dominique Perrault: Recent Works 36 (Milan, Ital.: Skira Editore, 2006). Marianne Brausch & Gaëlle Lauriot-Prévost, The Major Extension of the Court of Justice of the European Communities (Luxembourg: Fund for the Urbanization and Building of the Kirchberg Plateau, 2002) (hereinafter ECJ Major Extension). This volume is a French and English compilation of drawings of and interviews about the project.

**49** ECJ Architecture and Art at 13. The asbestos that once lined the interior were removed in 2001.

**50** Hein at 7.

**51** Hein at 7–13; 72–91.

**52** Hein at 126–133.

**53** Each of the members makes appointments, and the judges then act "by common accord." Treaty Establishing the European Economic Community, Art. 167 (1), Mar. 25, 1957, 298 U.N.T.S. 11 at 223.

**54** For example, between 2000 and 2007, 55 percent of the cases were heard by five judges, 33 percent by three judges, and about 11 percent by Grand Chambers. See Court of Justice of the European

Union, 2007 Annual Report (Luxembourg, 2007), http://curia.europa.eu/jcms/jcms/Jo2_11035/rapports-annuels, "Statistics Concerning the Judicial Activity of the Court of Justice" (hereinafter ECJ 2007 Annual Report) at 87.

**55** Six come from the larger Member States, and the others rotate among the smaller states. Rasmussen at 61. The enlargement of the EU has prompted questions about how or whether to rethink this system. See Cyril Ritter, *A New Look at the Role and Impact of Advocates-General—Collectively and Individually*, 12 Columbia Journal of European Law 751, 757 (2006). More on their role is provided by Rasmussen at 67–68.

**56** Under what was Article 177 of the EEC Treaty and is now Article 234 of the Maastricht Treaty, Member States are authorized to refer questions on the interpretation of Community law to the ECJ. See Ward, Judicial Review and the ECJ at 2–3. A growing body of doctrine shapes the parameters and interactions between the national courts and those of Europe. See generally Dieter Grimm, *The European Court of Justice and National Courts: The German Constitutional Perspective after the Maastricht Decision*, 3 Columbia Journal of European Law 229 (1997); Michael Dougan, National Remedies before the Court of Justice: Issues of Harmonisation and Differentiation (Oxford, Eng., and Portland, OR: Hart Publishing, 2004).

**57** See ECJ 2007 Annual Report at 77–104. Earlier data are provided by Rasmussen at 83.

**58** Stone Sweet, The Judicial Construction of Europe at 241–244.

**59** See Timothy Millet, *The New European Court of First Instance*, 38 International & Comparative Law Quarterly 811 (1989).

**60** See ECJ 2007 Annual Report at 178.

**61** See ECJ 2007 Annual Report at 190.

**62** Concerns about workload had led to restructuring. See The Role and Future of the European Court of Justice (J. P. Gardner, ed., London, Eng.: British Institute of International and Comparative Law, 1996).

**63** See ECJ 2007 Annual Report at 215.

**64** Almost 90 percent of the docket is ruled on by three judges. See ECJ 2007 Annual Report at 218, 221.

**65** Rules of Procedure of the Court of Justice, Art. 29 (2). See Stella Burch Elias, *Regional Minorities, Migrants and Immigrants: The Reframing of Minority Language Rights in Europe*, 28 Berkeley Journal of International Law 261 (2009).

**66** Rasmussen at 76.

**67** As of 2008, the ECJ operated in twenty-three official languages: Bulgarian, Czech, Danish, Dutch, English, Estonian, Finnish, French, German, Greek, Hungarian, Irish, Italian, Latvian, Lithuanian, Maltese, Polish, Portuguese, Romanian, Slovak, Slovene, Spanish, and Swedish.

**68** The Translation Directorate supports the Court of First Instance, the Civil Service Tribunal, and the Court of Justice. See http://curia.europa.eu/jcms/jcms/Jo2_10742/direction-generale-de-la-traduction. EU law has also affected buildings more generally through commentary regarding environment, natural conservation, professional regulations, and rights at work for architects and engineers. See, for example, *Architect's Guide to the European Union*, RIBA Journal 59 (April 1995).

**70** *Just and Honorable*, 47 World Architecture 74 (June 1996). The architects were Bohdan Paczowski, Paul Fritsch, Jean Herr, and Gilbert Huysberchts. Figure 157 is reproduced courtesy of the Court of Justice of the European Communities.

**71** ECJ Architecture and Art at 33. The Pessoa courtroom's name comes from the title accorded by the Portuguese artist Costa Pinheiro to the tapestries in that room—*The Poet Fernando Pessoa* and *The Poetic Space*. Id. at 110. The Dalsgaard courtroom has a calligraphic triptych, discussed later.

**72** ECJ Architecture and Art at 29. See also *Just and Honorable* at 74.

**73** ECJ Architecture and Art at 42–45. The exteriors are glass, granite, and aluminum. Id. at 37. The building added 230 offices, two courtrooms, another cafeteria, and a restaurant, as well as meeting rooms. *Just and Honorable* at 74.

**74** ECJ Architecture and Art at 47. Its exteriors are also granite, glass, and aluminum, and it has pink granite columns to tie the annex to Erasmus. The third addition provided a "400 square metre (1,132 feet) court room, used for preliminary hearings, with 220 associated offices and ancillary facilities." *Just and Honorable* at 74.

**75** ECJ Architecture and Art at 47.

**76** *Just and Honorable* at 75. Also noted was that the ECJ buildings were "constructed to a significantly lower budget" than were the banks. Id.

**77** As noted later, the 2002 publication on the ECJ included a model of the proposed extension. ECJ Architecture and Art at 57.

**78** See ECJ, Information for the Press, No. 81/08 (Inauguration of the New Buildings of the Court of Justice of the European Communities), Nov. 28, 2008. The opening ceremony was held on December 4, 2008.

**79** Jonathan Glancey, *Let There Be Light: The EU Court of Justice Is a Shining Beacon in Grey Old Luxembourg*, Guardian, Dec. 2, 2008.

**80** *The Logic of Justice, Interview with Dominique Perrault*, in ECJ Major Extension at 20–29 (hereinafter Perrault, *The Logic of Justice*).

**81** *Dominique Perrault: Court of Justice of the European Communities, Luxembourg*, Architectural Review (2005), http://www .thefreelibrary.com/Dominique+Perrault%3a+Court+of+Justice+of +the+European+Communities%2c...-a0132153905.

**82** *Les tours de Babel de la justice européene*. Figure 159 is reproduced courtesy of G. Fessy © Court of Justice of the European Communities. The image can also be found in a volume devoted to the new construction. See ECJ, The New Buildings of the Court of Justice of the European Communities (Luxembourg City, Lux.: Court of Justice of the European Communities, 2009) (hereinafter New Buildings of the ECJ).

**83** See European budget online (2009), Sec. V, ECJ, http://eur-lex .europa.eu/budget/www/index-en.htm.

**84** Perrault, *The Logic of Justice* at 26, 27.

**85** Perrault, *The Logic of Justice* at 26, 27.

**86** Skouris ECJ 2008 Inaugural Speech.

**87** Skouris ECJ 2008 Inaugural Speech.

**88** Jose Manuel Barroso, Speech upon the Inauguration of the New Palace of Justice of the European Communities (Dec. 4, 2008) in ECJ 2008 Inauguration Monograph 35, 35–40 (ECJ: Reportage et Aquarelles de Noëlle Herrenschmidt) (translation from the French by Stella Burch Elias).

**89** Jean-Claude Juncker, Speech upon the Inauguration of the New Palace of Justice of the European Communities (Dec. 4, 2008), in ECJ 2008 Inauguration Monograph at 41–45 (translation from the French by Stella Burch Elias).

**90** Glancey. The opening prompted reviews in European newspapers. See, for example, *Mehr Platz für Europa* (*More Room for Europe*), Luxemburger Wort, Dec. 5, 2008; *Ein neuer Palast für Europas Richter* (*A New Palace for Europe's Judges*), Tageblatt, Dec. 8, 2008; *Offener Komplex der Rechtsprechung ein Zeichen von Tradition und Moderne* (*A More Open Complex for the Administration of Justice— a Sign of Tradition and Modernity*), Luerger Journal, Dec. 8, 2008; *Goldenes Herzstück* (*The Golden Heart*), Neue Zürcher Zeitung, Feb. 2, 2009. Relatively little note was taken by the press in the United States.

**91** ECJ Major Extension; Didier Arnaudet, *Dominique Perrault* (*Expos*), 334 Art Press 73–74 (May 2007) (translation by L. S. Torgoff).

**92** Gilles de Bure, Dominique Perrault: Court of Justice of the European Communities 108 (Paris, Fran.: Terrail, 2004).

**93** Glancey. The architect explained that the ceiling provided a "warm ambience" that brought the sun inside but without distracting the judges. Id. The photographs in figures 160 and 161, also found in New Buildings of the ECJ, were provided and are reproduced with permission of G. Fessy © Court of Justice of the European Communities, 2009.

**94** Glancey.

**95** Glancey.

**96** Rasmussen at 21–23 (we are borrowing from the titles of sections of his chapter).

**97** Claire Micheau and Alexander Conrad Culley, *Representation of the European Court of Justice: Conscience of the People of Europe or Political Juggernaut?*, in Representations of Justice 237, 238 (Antoine Masson & Kevin O'Connor, eds., Brussels, Belg.: P. I. E. Peter Lang, 2007).

**98** Indeed, once European institutions were located on the Kirchberg Plateau, the "priority mission" was road construction. See *Building Up Constructive Thinking, Interview with Fernand Pesch, President of the Fonds d'Urbanisation et d'Amenagement du Plateau de Kirschberg*, in ECJ Major Extension at 15, 16.

**99** Micheau and Culley at 233, n. 9.

**100** Micheau and Culley at 239–240.

**101** A newspaper in Luxembourg expressed this hope when the building opened. See *Perrault fait sa Cour*, Libération, Dec. 20, 2008. The article quoted the clerk of the Court, Roger Grass: "Only architecture can both bring the litigant to this little-known Court while still creating solemnity." The news article cited the figure of 150,000 visitors each year.

**102** While some authors have written about the challenges of implementation, Keller and Stone Sweet report an impressive track record for the import of the ECtHR's judgments in eighteen countries. See Alec Stone Sweet & Helen Keller, *The Reception of the ECHR in National Legal Orders*, in A Europe of Rights: The Impact of the ECHR on National Legal Systems 5 (Helen Keller & Alec Stone Sweet, eds., Oxford, Eng.: Oxford U. Press, 2008) (hereinafter Stone Sweet & Keller, *Reception of the ECHR*, in A Europe of Rights) (providing a data set to analyze the receptivity and effects of ECJ jurisprudence). Compare Rasmussen at 85–125.

**103** One report also saw the building as an emblem standing more broadly for the rule of law: "'Old Europe' is sending a strong sign today to the violent New World across the Atlantic that the EU has been constructed 'step by step and on the principle of Law, rather than on those of arms'" (quoting France's Minister of Justice Rachida Dati). *Les tours de Babel de la justice européene.*

**104** See Benedict Anderson, Imagined Communities: Reflections on the Origin and Spread of Nationalism (London, Eng.: Verso, 1983, reissued 2006).

**105** Weiler, *The European Courts of Justice* at 386.

**106** Perrault described the relationship of the ring to the Palais as inducing "a sort of disappearance of the first building while at the same time reinforcing its historical presence by a new mass. Besides, this confers to the ring a new status, that of protection for a historical monument." *The Logic of Justice, Interview with Dominique Perrault* at 27.

**107** ECJ Architecture and Art at 8.

**108** For example, the Henry Moore Foundation lent a "three-piece reclining figure, draped," by that English artist in 1976. ECJ Architecture and Art at 60–61. The Rodin Museum, in France, provided *The Age of Bronze*, a male figure molded from life that sits in the interior of Le Palais. Id. at 64–66. Ireland loaned a painting, *Glór Na Mara* (*The Sound of the Sea*), by Gwen O'Dowd. Id. at 80–81. Spain loaned *Bird Nesting on Fingers in Bloom*, a bronze sculpture by Joan Miró. Id. at 96–97. The City of Luxembourg contributed, again on loan, Lucien Wercollier's large bronze sculpture titled *Growth*, created in 1968. Id. at 62–63. As noted below, Luxembourg's government also purchased several pieces of art for the building.

**109** Greece provided a cast bronze statue, the *Boy of Marathon* (ECJ Architecture and Art at 92–93) as well as a bronze sculpture, *Memory*. Id. at 94–95. The Danish government provided the oil on canvas called *Calligraphy Based on Three Phases*, a 1989 painting by Sven Dalsgaard. Id. at 108–109.

**110** ECJ Architecture and Art at 13.

**111** ECJ Architecture and Art at 68–69. The relief was purchased by the Luxembourg government.

**112** ECJ Architecture and Art at 22.

**113** ECJ Architecture and Art at 70–73. The object is a purchase of the Luxembourg Government.

**114** ECJ Architecture and Art at 70.

**115** ECJ Architecture and Art at 90–91.

**116** ECJ Architecture and Art at 108.

**117** ECJ Architecture and Art at 108.

**118** ECJ Architecture and Art at 108 (quoting the President).

**119** ECJ Architecture and Art at 76.

**120** ECJ Architecture and Art at 76.

**121** Advocates General also sit on the bench and can "question the parties at will." See Ritter at 757.

**122** Two other new courtrooms came into being by virtue of the renovation; each measures just under 600 square meters (about 6,450 square feet) and provides seats for about 100 people.

**123** ECJ Architecture and Art at 82–87. Hambourg, who was French, was born in 1909 and died in 1999. Figure 162 is provided and reproduced courtesy of the Court of Justice of the European Communities.

**124** ECJ Architecture and Art at 82.

**125** ECJ Architecture and Art at 74. The piece is on loan from France.

**126** ECJ Architecture and Art at 57. That page provides a picture captioned "A model of the proposed extension of the Court buildings by D. Perrault," without more explanation.

**127** Our thanks to Luzius Wildhaber, former President of the ECtHR, and to John Darcy and Sabine Klein-Guin of that court's staff for helping us to understand the court and its work and to obtain figure 163, a photograph of the court by Sandro Weltin that is reproduced courtesy of the Council of Europe.

**128** Hein at 106.

**129** Peter Davey, *Courting Rights*, 198 Architectural Review 44, 44 (July 1995). Davey gave François Mitterrand, then President of France, credit for refusing to approve drawings for a proposed building and insisting on a competition. Id. at 46. Before moving to the 1989 Rogers building, the ECtHR had sat in a 1966 "neo-Corbusian" building near the Council's headquarters in the Palais de l'Europe. Davey described the Palais de l'Europe as the "most monstrous of all" of Strasbourg's administrative buildings, "created more for the defence of bureaucracy than celebration of democratic civilisation." Id. at 44. "The place offers neither welcome, nor joy, nor inspiration," Davey explained. "It is the apotheosis of post-war French techno-monumentalism, and faced with it, you need a huge infusion of faith to believe that the idea of a Europe of cooperative nations has any nobility at all." Id. In contrast, Davey described the architects as seeking to create an "unmonumental monument." Id. at 45.

**130** *Just and Honorable* at 79.

**131** In 1994 the European Parliament commissioned the Société d'Aménagement et d'Équipement de la Région de Strasbourg to find funds for and to construct the buildings. Hein at 107.

**132** See Robin Pogrebin, *Top Prize for Rogers, Iconoclastic Architect*, New York Times, March 29, 2007.

**133** In Chapter 10 we discuss Rogers's building in Bordeaux (fig. 10/127). The Antwerp Court House, costing 201 million euros, comprises 255,906 feet (78,000 meters) of space under a roof that is shaped to resemble a flotilla of sails; some are about seventy-five feet (twenty-four meters) high and weigh twenty-four tons, while others are about thirty-six feet (eleven meters) high and weigh eighteen tons. Laura Della Badia, Floornature.com website, Antwerp Courthouse page, http://www.floornature.com/progetto.php?id=4807&sez=30. Within the building, the salle des pas perdus is both large and glass-clad; as a whole, the glass building is "a metaphor of justice that is transparent to citizens." Id.

**134** Nor do the two buildings—joined by other EU government structures—constitute a distinctively European style of architecture, which may itself be implausible given that the architects of these buildings are operating in a global market for their designs. See generally Gerald Delanty & Paul R. Jones, *European Identity and Architecture*, 5 European Journal of Social Theory 453 (2002).

**135** This problem is reflected in discussions on the website for the ECtHR, which contains a "Facts and Figures" document that, under the header "Not to be confused!" lists other international courts, including the European Court of Justice and the International Court of Justice. European Court of Human Rights, The European Court of Human Rights: Some Facts and Figures, 1998–2008, 3 (Nov. 2008), http://www.echr.coe.int/NR/rdonlyres/ACF07093-1937-49AF-8BE6-36FE0FEE1759/0/FactsAndFiguresENG10ansNov.pdf (hereinafter ECtHR Facts and Figures).

**136** In terms of overlap, ECJ law deals with equality issues as they interact with economic and social rights. Sometimes conflicts emerge: in President Luzius Wildhaber's yearly speeches, he "encouraged harmonisation of the jurisprudence of the two European courts" and urged that the EU adhere to the European Convention on Human Rights. Luzius Wildhaber, The European Court of Human Rights, 1998–2006: History, Achievements, Reform 6, 19, 27, 38, 49, 59 (Kehl, Ger.: N. P. Engel, 2006). See also Dean Spielmann, *Human Rights Case Law in the Strasbourg and Luxembourg Courts: Conflicts, Inconsistencies, and Complementarities*, in The EU and Human Rights (Philip Alston, ed., Oxford, Eng.: Oxford U. Press, 1999) at 757–780. Spielmann, a judge on the ECtHR, also called for the EC to accede to the Convention, as well as for judicial comity between the two courts. Id. at 777–780. The issue of whether, as a matter of EU constitutional law, accession to the Convention is possible was raised, and, in 1996, the ECJ answered that under the law at the time, the Community had no competence to do so. See Opinion 2/94 on Accession by the Community to the ECHR [1996] ECR I-1759. See also Monitoring Fundamental Rights in the EU: The Contribution of the Fundamental Rights Agency (Philip Alston & Olivier De Schutter, eds., Portland, OR: Hart Publishing, 2005).

**137** Winston Churchill, Speech delivered at the University of Zurich (Sept. 19, 1946), Council of Europe, http://www.europa-web.de/europa/02wwswww/202histo/churchil.htm.

**138** London School of Economics Library website, Congress of Europe page, http://www2.lse.ac.uk/library/archive/online_resources/foyle_foundation/congress_of_europe.aspx.

**139** Statute of the Council of Europe, May 5, 1949, Europ. T.S. 1, 87 U.N.T.S. 103. See Stone Sweet & Keller, *Reception of the ECHR*, in A Europe of Rights at 5. See also Michael D. Goldhaber, A People's History of the European Court of Human Rights (New Brunswick, NJ: Rutgers U. Press, 2007).

**140** See generally Lynn Hunt, Inventing Human Rights: A History (New York, NY: W. W. Norton, 2007); Women's Rights and Transatlantic Antislavery in the Era of Emancipation (Kathryn Kish Sklar & James Brewer Stewart, eds., New Haven, CT: Yale U. Press, 2007); Resnik, *Law's Migration*.

**141** See Louis Henkin, The Age of Rights (New York, NY: Columbia U. Press, 1990); Human Rights (Louis Henkin, David W. Leebron, Gerald L. Neuman, & Diane F. Orentlicher, eds., New York, NY: Foundation Press, 1999). Professor Henkin shaped the understanding of many Americans of the import of this project, in part through his work as the Chief Reporter of the American Law Institute's Restatement (Third) of the Foreign Relations Law of the United States.

142 Universal Declaration of Human Rights, Preamble, G.A. Res. 217A, at 71, U.N. GAOR, 3d Sess., 1st plen. meeting, U.N. Doc. A/810 (Dec. 12, 1948). Article 1 states: "All human beings are born free and equal in dignity and rights." Id., Art. 1.

143 The literature is vast. See generally The EU and Human Rights; Seyla Benhabib, The Rights of Others: Aliens, Residents, and Citizens (Cambridge, Eng.: Cambridge U. Press, 2004); James Griffin, On Human Rights (Oxford, Eng.: Oxford U. Press, 2008); Samuel Moyn, *Personalism, Community, and the Origins of Human Rights*, in Human Rights in the Twentieth Century: A Critical History (Stefan-Ludwig Hoffman, ed., Cambridge, Eng.: Cambridge U. Press, forthcoming); John Tasioulas, *The Moral Reality of Human Rights*, in Freedom from Poverty as a Human Right: Who Owes What to the Very Poor? (Thomas Pogge, ed., Oxford, Eng.: Oxford U. Press, 2007).

144 Henkin at 16–22.

145 See generally Goldhaber at 1-6.

146 Elodie Moreau, Space and Power in Europe: Culture, Communication and the Politics of Identity 2 (Jan. 11, 2006) (unpublished Master's dissertation, Université Marc Bloch, Strasbourg, Fr.), http://www.euroculturemaster.org/pdf/moreau.pdf.

147 See André Biedermann, *Candidatures Européennes*, 24 Vers l'Europe 4 (1952); Moreau at 4. Strasbourg campaigned repeatedly for its place, including through promoting "Strasbourg, l'Européenne." See Moreau at 7–8.

148 Other European institutions there include the European Ombudsman, created by the 1992 Maastrich Treaty to investigate and report on institutions, and the European Documentation Center.

149 The first Protocol was opened for signatures on March 20, 1952, and entered into force on May 18, 1954. It added new rights—"peaceful enjoyment of property, the right to education, and the right to free elections by secret ballot"—that did not affect the functioning of the Commission; see http://conventions.coe.int/Treaty/en/Summaries/Html/009.htm. See A. H. Robertson, *The European Court of Human Rights*, 9 American Journal of Comparative Law 1 (1960). Robertson noted that in the early 1950s the "original proposals . . . were gradually watered down and the traditional rights of sovereign States asserted." Id. at 5. Further, efforts were made to avoid jurisdictional conflicts with the International Court of Justice at The Hague. Id. at 18–19. See generally The EU Charter of Fundamental Rights: Essays in European Law (Steve Peers & Angela Ward, eds., Oxford, Eng., & Portland, OR: Hart Publishing, 2004).

150 See Christos L. Rozakis, *The European Commission on Human Rights: Structure, Operation and Jurisdiction*, 26 International Justice 357, 387–388, 418 (Kalliopi Koufa, ed., Thessaloniki, Gr.: Sakkoulas, 1997). Rozakis criticized the Commission for an overly "strict application of legal norms" and insufficient attention to practical political constraints. Id. at 419.

151 See generally Wildhaber at 6–7.

152 The Court was authorized to hear petitions directly and the Commission was eliminated by Protocol 11, which entered into force on November 1, 1998. Council of Europe, Protocol No. 11 to the Convention for the Protection of Human Rights and Fundamental Freedoms, Restructuring the Control Machinery Established Thereby, May 11, 1994, C.E.T.S. 155, http://conventions.coe.int/Treaty/en/Treaties/Html/155.htm (hereinafter Council of Europe, Protocol No. 11).

153 Council of Europe, Convention for the Protection of Human Rights and Fundamental Freedoms, Art. 22, Nov. 4, 1950, 213 U.N.T.S. 222, http://conventions.coe.int/Treaty/en/Treaties/Html/005.htm.

154 Council of Europe, Convention for the Protection of Human Rights and Fundamental Freedoms, Art. 23, Nov. 4, 1950, 213 U.N.T.S. 222, http://conventions.coe.int/Treaty/en/Treaties/Html/005.htm. See Jilan Kamal, *Justified Interference with Religious Freedom: The European Court of Human Rights and the Need for Mediating Doctrine*

*Under Article 9(2)*, 46 Columbia Journal of Transnational Law 667, 704, n. 213 (2008).

155 Council of Europe, Protocol No. 14 to the Convention for the Protection of Human Rights and Fundamental Freedoms, Amending the Control System of the Convention, May 13, 2004, C.E.T.S. 194, http://conventions.coe.int/treaty/en/Treaties/Html/194.htm (hereinafter Optional Protocol No. 14). See also ECtHR Facts and Figures at 1.

156 Council of Europe, Summary of Protocol No. 14 to the Convention for the Protection of Human Rights and Fundamental Freedoms, Amending the Control System of the Convention, http://conventions.coe.int/Treaty/EN/Summaries/Html/194.htm. By the end of 2008, all of the Council of Europe had signed Protocol 14 but Russia had not then ratified it. See *Russia Must Allow Reform of European Court of Human Rights*, International Herald Tribune, April 17, 2008. As noted, in 2010, the Russian Duma did so. See *Russia Votes in Favor of Draft Law Ratifying Protocol No. 14 to the European Convention on Human Rights*, Press Release by the Registrar of the ECtHR, Jan. 15, 2010, on the European Community's website.

157 Council of Europe, Convention for the Protection of Human Rights and Fundamental Freedoms, Arts. 32, 46, Nov. 4, 1950, 213 U.N.T.S. 222, http://conventions.coe.int/Treaty/en/Treaties/Html/005 .htm.

158 See Wildhaber at 116–117. Andreas Nicolas Loizou, *The European Court of Human Rights and Its Approach to Certain Issues*, 26 International Justice 21, 64–66 (Kalliopi Koufa, ed., Thessaloniki, Gr.: Sakkoulas Publications, 1997). Loizou reported the first use of the phrase in 1976. Id. at 65.

159 The doctrine may well entail several ideas, including a conclusion that the underlying conduct is not a breach of a right or that, when balancing individual rights against societal interests, the incursion on the right is proportional. Some commentators object to the ECtHR's deployment as inconsistent or as overused and hence as working to the detriment of implementation of the Convention. See George Letsas, A Theory of the Interpretation of the European Convention on Human Rights 80–99 (Oxford, Eng.: Oxford U. Press, 2007); Wojciech Sadurski, *Partnering with Strasbourg: Constitutionalisation of the European Court of Human Rights, the Accession of Central and East European States to the Council of Europe, and the Idea of Pilot Judgments*, 9 Human Rights Law Review 397 (2009).

160 Kenneth Powell, Richard Rogers 7 (London, Eng.: Artemis, 1994). Rogers was born in Italy in an Anglo-Italian family and moved when young to England to escape fascism. He studied architecture and worked in the United States and then returned to Europe. Id. at 8.

161 Richard Rogers, GA Document Extra No. 02 at 15–17 (Yoshio Futagawa, interviewer, Yukio Futagawa, ed., A.D.A. Edita, Tokyo 1995) (hereinafter Rogers Extra).

162 Powell at 10.

163 Powell at 136.

164 Richard Rogers, The *European Court of Human Rights, Strasbourg, France*, 14 Zodiac 194, 196 (1995) (hereinafter Rogers, *ECtHR*).

165 Rogers Extra at 46.

166 Powell at 47.

167 Powell at 136.

168 Richard Rogers Partnership, Flexible Framework: London, Tokyo, Berlin 8 (Berlin, Ger.: Aedes Gallery, 1991). See also Rogers, *ECtHR* at 196.

169 Rogers, *ECtHR* at 196; see also Richard Rogers, Partnership: Works and Projects 184 (Richard Burdett, ed., New York, NY: Monacelli Press, 1996) (hereinafter Burdett). "Its public function is in the head, where the Court and Commission volumes form eyes symbolising civic vigilance. These are linked by the all-glass cylindrical entrance that embodies the desire for equally transparent justice while visually accentuating the expressiveness of the two tall glass and stainless steel eyes. The tail containing the offices is preceded by a high,

linking body element which gently follows the course of the river . . . ." *Richard Rogers a Strasburgo: La Corte Europea dei Diritti del l'Uomo/ The European Court of Human Rights*, 344 Abitare 178, 178–180 (1995).

170 Davey at 44–45.

171 Rogers Extra at 46–47. See also Hein at 106.

172 Davey at 52.

173 European Court of Human Rights—The Court, http://www .echr.coe.int/ECHR/EN/Header/The+Court/Introduction/Information +on+the+building/.

174 Burdett at 184.

175 Denis Connolly, *The Law Machine*, Blueprint 26, 28 (May 1995).

176 Hugh Aldersey-Williams, *Court in the Middle*, Architectural Record 70 (August 1995).

177 Aldersey-Williams at 70.

178 Connolly at 28–29. "The public lifts open three steps below the mezzanine connecting the court and the commission room." Id. at 29.

179 Connolly at 29. As another commentator noted, the structure relied on the "familiar formula 'democratic buildings = open buildings.'" Christof Bodenbach, *Auf dem Richtigen Weg (On the Right Path)*, 9 Design Report 66, 68 (1995) (translation by Stella Burch Elias).

180 Davey at 51.

181 Connolly at 29.

182 Davey at 51. Bodenbach thought the "grand gesture of the three cylinders [was] blurred by the muddle of their volume." Bodenbach at 69.

183 European Court of Human Rights—The Court; Davey at 51.

184 Another Berlin Wall fragment sits outside the European Parliament in Brussels.

185 Bucher, who was born in Switzerland in 1935, traveled and lived in many countries, including Canada and the United States, before returning in the 1970s to Europe; his studios are in Zurich and in Lanzarote, Spain. See www.carlbucher.com.

186 "Ces statues représentent des prisonniers. Elles ont perdu leur dignité on leur a coupées mains, on leur a enlevé leurs chaussures pour les humilier. Elles sont recouvertes d'un drap pour les empecher de voir et de parler, donc de témoigner, et ligoté pour ne pas s'échapper." Bucher, Zurich 1979, http://www.carlbucher.com/personal/studio-in .html (our translation).

187 Powell at 7.

188 These phrases are the title of an essay about Rogers in a book about his work. See Burdett at 9.

189 Burdett at 184.

190 Connolly at 29.

191 European Court of Human Rights—The Court.

192 Wildhaber at 27. See also the Council of Europe, Convention for the Protection of Human Rights and Fundamental Freedoms, Art. 1, Nov. 4, 1950, 213 U.N.T.S. 222, http://conventions.coe.int/ Treaty/en/Treaties/Html/005.htm. The "High Contracting Parties" are obliged to "secure to everyone in their jurisdiction the rights and freedoms" set forth in the European Convention on Human Rights.

193 Wildhaber at 27.

194 Whether the Convention ought to be understood as a "constitution for Europe" or as a treaty between sovereigns and what, if any consequences, flow from that distinction for its jurists is yet another issue. See Letsas at 58–79.

195 See, for example, *Matthews v. United Kingdom*, App. No. 24833/94, 28 Eur. Ct. H.R. 361 (1999), para. 39. See also *Golder v. United Kingdom*, 18 Eur. Ct. H.R. (ser. A) (1975).

196 *Dudgeon v. United Kingdom*, 45 Eur. Ct. H.R. (ser. A) at 52 (1981); see also *Lustig-Prean and Beckett v. United Kingdom*, App. Nos. 31417/96, 32377/96, 29 Eur. H.R. Rep. 548 (1999); *Smith and Grady v. United Kingdom*, App. Nos. 33985/96 and 33986/96, 29 Eur. H.R. Rep. 493 (1999).

197 Council of Europe, Protocol No. 11.

198 Wildhaber at 8. In addition, the court had 40,000 provisional files and 490 applications "declared admissible." Id. The Court started with a backlog of 7,000 applications, "many of which were complicated cases requiring detailed judgments on the merits." Id. at 69.

199 Wildhaber at 9. Article 6 provides: "In the determination of his civil rights and obligations or of any criminal charge against him, everyone is entitled to a fair and public hearing within a reasonable time by an independent and impartial tribunal established by law. Judgment shall be pronounced publicly but the press and public may be excluded from all or part of the trial in the interests of morals, public order or national security in a democratic society, where the interests of juveniles or the protection of the private life of the parties so require, or to the extent strictly necessary in the opinion of the court in special circumstances where publicity would prejudice the interests of justice." Council of Europe, Convention for the Protection of Human Rights and Fundamental Freedoms, Art. 6, Nov. 4, 1950, 213 U.N.T.S. 222, http://conventions.coe.int/Treaty/en/Treaties/Html/ 005.htm.

200 Stone Sweet & Keller, *Reception of the ECHR*, in A Europe of Rights at 12. Another comparison comes from the 404 applications in 1981 to the 45,000 in 2005. Goldhaber at 5.

201 Wildhaber at 58. He described the procedure as a "huge leap forward" and a success in managing caseload, even as the number of applications had risen.

202 Stone Sweet & Keller, *Reception of the ECHR*, in A Europe of Rights at 11.

203 For example, as of October 2005, 82,100 were pending. Goldhaber at 7.

204 Wildhaber at 22.

205 Stone Sweet & Keller, *Reception of the ECHR*, in A Europe of Rights at 12. The court kept trying to improve its output. For example, in 2004, President Wildhaber reported that the court had "terminated 21,100 cases, by delivering 20,348 decisions and 718 judgments" that represented an increase over the prior year by about 18 percent. Wildhaber at 58.

206 ECtHR Facts and Figures at 5. Russia—in a complex relationship with the ECtHR—is the source of 5.8 percent of its caseload.

207 In 2006, 98 percent were found inadmissible. Stone Sweet & Keller, *Reception of the ECHR*, in A Europe of Rights at 12.

208 Wildhaber at 59. To do so, the court asked Lord Harry Woolf, then former Lord Chief Justice of England, to chair an advisory committee to evaluate its processes. See Lord Harry Woolf, Michael McKenzie, Peter MacMahon, Dr. Colm O'Cinneide, & Laura Clarke, *Review of the Working Methods of the European Court of Human Rights*, 26 Human Rights Law Journal 447 (2005), http:// www.echr.coe.int/ECHR/Resources/Home/LORDWOOLFREVIEW ONWORKINGMETHODS.pdf.

209 Council of Europe, Resolution of the Committee of Ministers on Judgments Revealing an Underlying Systemic Problem, 114th Sess., Res. 2004(3) (May 12, 2004), https://wcd.coe.int/ViewDoc.jsp? id=743257&Lang=en.

210 Wildhaber at 147–148.

211 The European Court of Human Rights Overwhelmed by Applications: Problems and Possible Solutions (Rüdiger Wolfrum & Ulrike Deutsch, eds., Berlin, Ger.: Springer, 2009). This volume gathered materials from a conference convened in Heidelberg in 2007.

212 See A Europe of Rights. The volume surveyed eighteen Member States to seek to identify national regimes' receptivity to the ECtHR's law. To do so, scholars tracked admissible petitions and conducted analyses in each state.

213 Helen Keller & Alec Stone Sweet, *Assessing the Impact of the ECHR on National Legal Systems*, in A Europe of Rights at 677 (hereinafter Keller & Stone Sweet, *Assessing the Impact*, in A Europe of Rights).

214 Keller & Stone Sweet, *Assessing the Impact*, in A EUROPE OF RIGHTS at 686.

215 European Convention on Human Rights Act, 2003 (Act No. 20/2003) (Ir.), http://www.irishstatutebook.ie/2003/en/act/pub/0020/index.html.

216 Robert M. Cover & T. Alexander Aleinikoff, *Dialectical Federalism: Habeas Corpus and the Court*, 86 YALE LAW JOURNAL 1035 (1977).

217 Rolv Ryssdal, *The Coming of Age of the European Convention on Human Rights*, 1 EUROPEAN HUMAN RIGHTS LAW REVIEW 18 (1996) (cited in Goldhaber at 172).

218 Budget numbers for the Court are available at Eur-Lex, *Budget on line*, http://eur-lex.europa.eu/budget/www/index-en.htm.

219 *The European Court of Human Rights: The ECHR in 50 Questions* 4 (Strasbourg, Fr.: European Court of Human Rights, 2009). For example, in 2006 the ECtHR sought an increase in staff of seventy-five and received support for forty-six positions. See WILDHABER at 71–73. The court has also sought, unsuccessfully, to exercise more control over the allocation of its budget. Id. at 6.

220 WILDHABER at 51.

221 The photograph in figure 164 was provided by and is reproduced courtesy of the Secretariat of the Inter-American Court of Human Rights.

222 Dr. Gerard Wiarda, Vice President of the European Court of Human Rights, Speech Delivered on the Occasion of the Installation of the Court at the National Theater of Costa Rica (Sept. 3, 1979), in INTER-AMERICAN COURT OF HUMAN RIGHTS: PROCEEDINGS OF INSTALLATION 118, 118 (San José, Costa Rica: Corte Inter-Americana de Derechos Humanos, 1979).

223 ANTONIO SANCHEZ DE BUSTAMANTE, THE WORLD COURT 78 (Elizabeth F. Read, trans., New York, NY: Macmillan, 1925).

224 BUSTAMANTE at 78.

225 See Kate Malleson, *Promoting Judicial Independence in the International Courts: Lessons from the Caribbean*, 58 INTERNATIONAL AND COMPARATIVE LAW QUARTERLY 671 (2009). In 2005 the Court was inaugurated, and as of 2010 it had heard forty-one cases, including appeals from national courts and original jurisdiction applications. See "Judgments" page on the court's website, http://www.caribbeancourtofjustice.org/judgments.html.

226 See Conference of Supreme Courts of the Americas, 42 ST. LOUIS UNIVERSITY LAW JOURNAL 1029–1388 (1998) (in both English and Spanish).

227 Correspondence from Pablo Saavedra-Alessandri, Registrar of the Court (June 27, 2007). The home was built by an engineer who had lived in the United States and returned to Costa Rica and ran for the office of president. He then sold the house to another person, and the court rented the facility until 1980. In 1993, President Rafael Ángel Calderón Fournier "arranged for the house to be donated to the Court on behalf of the government of Costa Rica." Id. Our thanks to the Registrar and the Inter-American Court of Human Rights, which provided us with materials, photographs, and permission to reproduce them.

228 Augusto Willemsen-Diaz, on behalf of the Human Rights Division of the U.N., Speech Delivered at the Installation of the Court at the National Theater of Costa Rica (Sept. 3, 1979), in INTER-AMERICAN COURT OF HUMAN RIGHTS: PROCEEDINGS OF INSTALLATION 120, 121. See also President of Supreme Court of Costa Rica, Fernando Coto-Albán, on the occasion of a visit by the Inter-American Court to that court (Sept. 4, 1979), in id. 128, 129.

229 BUSTAMANTE at 73. Manley O. Hudson, *The Central American Court of Justice*, 26 AMERICAN JOURNAL OF INTERNATIONAL LAW 759, 764 (1932).

230 Editorial Comment, *The First Case before the Central American Court of Justice*, 2 AMERICAN JOURNAL OF INTERNATIONAL LAW 835, 841 (1908). The Convention is set up as a "permanent tribunal." Convention for the Establishment of a Central American Court of Jus-

tice, Art. I, Dec. 20, 1907, 2 U.S.T. 2399. This provision is quoted by various commentators, including Joseph Wheless, *The Central American Court of Justice*, 21 CASE AND COMMENT 551, 553 (1914).

231 See Wheless at 552. Wheless, the Associate Editor of the American Bar Association's *Bulletin on Comparative Law*, described the contributions of U.S. Secretary of State Elihu Root, who presided at the meeting in Washington that produced seven treaties "promptly ratified by the five Republics." Id. at 552. Wheless noted that the treaty creating the court included a codicil that none of the contracting parties would recognize governments of the others that came as a "consequence of a *coup d'état* or of a revolution . . . until the representatives of the people, freely elected, shall have reorganized the country in constitutional form." Id. See also Mario Rodríquez, The First Permanent International Tribunal: The Central American Court of Justice (Master's thesis, Georgetown University, School of Foreign Service, Washington, DC, April 1935). Rodríquez both credited the United States for helping to form the court and faulted it for allowing the court's demise by not pressing for its continuation in 1917. Id. at 147.

232 Convention for the Establishment of a Central American Court of Justice, Dec. 20, 1907, 2 U.S.T. 2399.

233 BUSTAMANTE at 68. See also Central American Court of Justice, http://www.ccj.org.ni/; Central American Court of Justice, Project on International Courts and Tribunals, http://www.pict-pcti.org/courts/CACJ.html.

234 Convention for the Establishment of a Central American Court of Justice, Art. I.

235 Judges from each signatory nation were appointed to the Court. The original jurists were the Honorable José Artúa Aguilar (Costa Rica), the Honorable Angel Maria Bocanegra (Guatemala), the Honorable Salvador Gallegos (El Salvador), the Honorable Alberto Uclés (Honduras), and the Honorable José Madriz (Nicaragua). BUSTAMANTE at 69. See Central American Court of Justice, Project on International Courts and Tribunals, http://www.pict-pcti.org/courts/CACJ.html; see also Wheless at 553–554.

236 BUSTAMANTE at 69.

237 Convention for the Establishment of a Central American Court of Justice, Art. XIII, quoted by Wheless at 554.

238 BUSTAMANTE at 69.

239 BUSTAMANTE at 68.

240 Convention for the Establishment of a Central American Court of Justice, Art. II.

241 Wheless at 553, 554.

242 The photographs in figures 165 and 166 are from *Terromoto de Cartago 1910* (Publicaciones de la Universidad de Costa Rico, Serie Historia y Geographia n. 21, Ciudad Unversitaria "Rodrigo Facio," 1974), and they are reproduced with permission of the University of Costa Rica Press. Our thanks to Julián Monge-Nájera, Director General of the press for assistance and to Sophie Hood for translating our exchanges.

243 See *The First Case before the Central American Court of Justice*, 841.

244 Wheless at 556.

245 BUSTAMANTE at 73.

246 Wheless at 557. See also James Brown Scott, *The Closing of the Central American Court of Justice*, 12 AMERICAN JOURNAL OF INTERNATIONAL LAW 380 (1918). Scott aspired to U.S. leadership in re-installing the court.

247 See I–IV ANALES DE LA CORTE DE JUSTICIA CENTROAMERICANA (1909–1914). The cases brought by states themselves were *Honduras v. Salvador and Guatemala*, CENTRAL AMERICAN COURT OF JUSTICE (Dec. 19, 1908), reprinted in 3 AMERICAN JOURNAL OF INTERNATIONAL LAW 729 (1909) (in which the court found for the defendants); *Costa Rica v. Nicaragua*, CENTRAL AMERICAN COURT OF JUSTICE (Sept. 13, 1916), reprinted in 11 AMERICAN JOURNAL OF INTERNATIONAL LAW 181 (1917) (in which the Court found for the plaintiff but was unable to declare the Bryan–Chamorro treaty null and

void; Nicaraguan members of the Court refused to participate, and the Nicaraguan government rejected the Court's jurisdiction); *El Salvador v. Nicaragua*, CENTRAL AMERICAN COURT OF JUSTICE (Mar. 9, 1917), reprinted in 11 AMERICAN JOURNAL OF INTERNATIONAL LAW 674 (1917) (in which the Court found for the plaintiff with respect to the latter's right to lease territory for the naval base in the Gulf of Fonseca).

**248** BUSTAMANTE at 74–75.

**249** BUSTAMANTE at 75–76. See also Philip Marshall Brown, *Costa Rica v. Nicaragua*, 11 AMERICAN JOURNAL OF INTERNATIONAL LAW 156 (1917). In 1986 Nicaragua was the complainant seeking relief against the United States and was met by a similar refusal to comply with the judgment of the International Court of Justice. See Military and Paramilitary Activities (*Nicar. v. U.S.*), 1986 I.C.J. 14 (June 27).

**250** See World Courts, Central American Court of Justice, Timeline, http://www.worldcourts.com/cacj/eng/timeline.htm. Further, some commentators viewed the judges as protective of their governments' interests rather than independent. Rodríquez at 153–155.

**251** BUSTAMANTE at 76.

**252** BUSTAMANTE at 310–311.

**253** CECILIA MEDINA QUIROGA, THE BATTLE OF HUMAN RIGHTS: GROSS, SYSTEMATIC VIOLATIONS AND THE INTER-AMERICAN SYSTEM 36 (Dordrecht, Neth.: Martinus Nijhoff, 1988). See also Rafael Nieto-Navia, *The Inter-American Court of Human Rights*, in INTERNATIONAL JUSTICE 557 (Kalliopi Koufa, ed., Thessaloniki, Greece: Sakkoulas Publications, 1997). In 1945, the American states approved Resolution XL on the Protection of the Essential Rights of Man; thus these provisions came before the United Nations was created, which is a point made by Carlos Garcia Bauer in *The Observance of Human Rights and the Structure of the System for Their Protection in the Western Hemisphere*, 30 AMERICAN U. LAW REVIEW 5, 13 (1981).

**254** Nieto-Navia at 567.

**255** Charter of the Organization of American States, Apr. 30, 1948, 2 U.S.T. 2394, 119 U.N.T.S. 3. The 1948 charter entered into force in 1951 and has since been amended by the Protocol of Buenos Aires of 1967 (Protocol of Amendment to the Charter of the Organization of American States, Protocol of Buenos Aires, Feb. 27, 1967, O.A.S. Treaty Series No. 1-A); the Protocol of Cartegena de Indias of 1985 (Protocol of Amendment to the Charter of the Organization of American States, Protocol of Cartagena de Indias, Dec. 5, 1985, O.A.S. Treaty Series No. 66); the Protocol of Washington of 1992 (Protocol of Amendment to the Charter of the Organization of American States, Protocol of Washington, Dec. 14, 1992, O.A.S. Treaty Series No. A-56); and the Protocol of Managua of 1993 (Protocol of Amendment to the Charter of the Organization of American States, Protocol of Managua, June 10, 1993, O.A.S. Treaty Series No. A-58). See generally HENRY J. STEINER, PHILIP ALSTON, & RYAN GOODMAN, INTERNATIONAL HUMAN RIGHTS IN CONTEXT: LAW, POLITICS, MORALS 1020–1028 (New York, NY: Oxford U. Press, 2008).

**256** American Declaration of the Rights and Duties of Man, OAS Res. XXX, International Conference of American States, 9th Conf., OAS Doc. OEA/ser. L./ V./I.4 rev. (1948).

**257** Resolution 32 of the Novena Conferencia Internacional Americana, Bogotá, Colombia, Mar. 30–May 2, 1948, as translated and cited in Bauer at 5.

**258** MEDINA QUIROGO at 36–38.

**259** MEDINA QUIROGO at 30–32.

**260** MEDINA QUIROGO at 38, noting that the proposal to incorporate the American Declaration of the Rights and Duties of Man into the OAS Charter was submitted to a vote and only six of twenty-one states were in favor.

**261** Charter of the Organization of American States, Art. 3; MEDINA at 39.

**262** Resolution VIII, Fifth Meeting of Consultation of Ministers of Foreign Affairs, Final Act (OEA/Ser.C/II.5, 1959). Compare Nieto-Navia at 568, 578; MEDINA, at 67–76, provided details and texts. The

Commission was created in 1959 and began its work in 1960 at the time that the Council of the OAS approved its statute and elected its first members. See Inter-American Commission on Human Rights, Annual Report 2007, 5 http://www.cidh.org/annualrep/2007eng/TOC.htm.

**263** MEDINA QUIROGO at 70.

**264** Inter-American Commission on Human Rights, Annual Report 2007 at 5.

**265** Inter-American Commission on Human Rights, Annual Report 1976, § 1, http://www.cidh.oas.org/annualrep/76eng/toc.htm.

**266** Cecilia Medina, *The Inter-American Commission on Human Rights and the Inter-American Court of Human Rights: Reflections on a Joint Venture*, 12 HUMAN RIGHTS QUARTERLY 439, 440 (1990).

**267** MEDINA QUIROGO at 85–87. Article 112 of the amended Charter provided that the Inter-American Commission on Human Rights had as its "principal function . . . to promote the observance and protection of human rights and to serve as a consultative organ of the Organization in these matters." See Protocol of Amendment to the Charter of the Organization of American States, Protocol of Buenos Aires; see also Nieto-Navia at 568.

**268** INTER-AMERICAN COURT OF HUMAN RIGHTS: PROCEEDINGS OF INSTALLATION at 95.

**269** American Convention on Human Rights, Arts. 3–5, 8, 12, 16, 24, Nov. 22, 1969, OAS Treaty Series No. 36, 1144 U.N.T.S. 123. See also Chapters 6 and 10 in ANNA-LENA SVENSSON-MCCARTHY, THE INTERNATIONAL LAW OF HUMAN RIGHTS AND STATES OF EXCEPTION (The Hague, Neth.: Martinus Nijhoff, 1998).

**270** See Gerald L. Neuman, *Import, Export, and Regional Consent in the Inter-American Court of Human Rights*, 19 EUROPEAN JOURNAL OF INTERNATIONAL LAW 101, 102 (2008).

**271** By 2008 twenty-five states in the Americas had ratified the Convention, including Argentina, Barbados, Bolivia, Brazil, Chile, Colombia, Costa Rica, Dominica, Ecuador, El Salvador, Grenada, Guatemala, Haiti, Honduras, Jamaica, Mexico, Nicaragua, Panama, Paraguay, Peru, the Dominican Republic, Suriname, Trinidad and Tobago, Uruguay, and Venezuela. See American Convention on Human Rights: General Information on the Treaty, Organization for American States, http://www.oas.org/juridico/english/Sigs/b-32.html. In 1998, however, Trinidad and Tobago withdrew, reducing the number of States Parties to twenty-four. Id.

**272** The Convention requires that these judges are of "the highest moral authority." American Convention on Human Rights, Art. 52, Nov. 22, 1969, OAS Treaty Series No. 36, 1144 U.N.T.S. 123. No state may have two judges serving at any one time. Id. Unlike the commissioners of the Inter-American Commission, judges are not required to recuse themselves from hearing cases involving their home countries. Rather, a state party appearing as a defendant is entitled, under Article 55 of the Convention, to have a judge of its nationality serve as an ad hoc judge to participate in hearing that case.

**273** Nieto-Navia at 593.

**274** See Ved P. Nanda, *The United States Reservation to the Ban on the Death Penalty for Juvenile Offenders: An Appraisal under the International Covenant on Civil and Political Rights*, 42 DEPAUL LAW REVIEW 1311, 1329 (1993). Although the United States is not a party to the Convention, it is subject to the recommendations of the Inter-American Commission on Human Rights. In 1987 the Commission found the United States to be in violation of a rule of *jus cogens* due to its practice of executing juvenile offenders.

**275** Thomas Buergenthal, *Foreword* to JO M. PASQUALUCCI, THE PRACTICE AND PROCEDURE OF THE INTER-AMERICAN COURT OF HUMAN RIGHTS xv (New York, NY: Cambridge U. Press, 2003). As noted earlier, the building was initially leased by the Court, and in 1993 Costa Rica donated the building to the court.

**276** Buergenthal, *Foreword* to PASQUALUCCI at xv.

**277** PASQUALUCCI at 4.

**278** Pasqualucci at 4.

**279** Pasqualucci at 344.

**280** Neuman at 101–102, 109–111. Neuman offered some criticism of that approach. Id. at 111–116. On the parallels from the perspective of a jurist on the Inter-American Court, see Thomas Buergenthal, *The American and European Conventions on Human Rights: Similarities and Differences*, 30 American U. Law Review 155 (1981).

**281** See Letsas; Neuman at 106–116.

**282** Steiner, Alston, & Goodman at 1021.

**283** Medina at 5–19, 323–326.

**284** Inter-American Convention to Prevent and Punish Torture, Dec. 9, 1985, O.A.S. Treaty Series A-51; Inter-American Convention on the Forced Disappearance of Persons, June 9, 1994, 33 I.L.M. 1529; Inter-American Convention on the Prevention, Punishment and Eradication of Violence against Women, June 9, 1994, O.A.S. Treaty Series A-61; Protocol to the American Convention on Human Rights to Abolish the Death Penalty, June 8, 1990, O.A.S. Treaty Series A-53; Inter-American Convention for the Elimination on All Forms of Discrimination against Persons with Disabilities, June 8, 1999, AG/RES. 1608 (XXIX-O/99).

**285** Rules of Procedure of the Inter-American Commission on Human Rights, Art. 44(1) (adopted Dec. 2000). The Rule provides: "If the State in question has accepted the jurisdiction of the Inter-American Court in accordance with Article 62 of the American Convention, and the Commission considers that the State has not complied with the recommendations of the report approved in accordance with Article 50 of the American Convention, it shall refer the case to the Court, unless there is a reasoned decision by an absolute majority of the members of the Commission to the contrary." The Commission weighs the position of the petitioner, the nature and seriousness of the violation, the need to develop or clarify the case law of the system, the future effect of the decision, and the quality of the evidence. Id., Art. 44(2).

**286** Pasqualucci at 1.

**287** Nieto-Navia at 673–713.

**288** Inter-American Commission on Human Rights, Annual Report 2007 at 8.

**289** Inter-American Commission on Human Rights, Annual Report 2007 at 8.

**290** Inter-American Commission on Human Rights, What is the IACHR? http://www.cidh.oas.org/what.htm. See also Steiner, Alston, & Goodman at 1021.

**291** Steiner, Alston, & Goodman at 1021.

**292** Neuman at 107–108.

**293** See American Convention on Human Rights, Art. 33; discussion on challenges of access can be found at Dialogue on Working of the Inter-American System, OAS/SERV G CP CAJP2311/05, March 3, 2006, http://scm.oas.org/doc_public/ENGLISH/HIST_06/CP15801E04.doc.

**294** Pasqualucci at 7.

**295** Neuman at 103.

**296** See American Convention on Human Rights, Art. 64. See also Nieto-Navia at 597, 635, 638. Further, all OAS member states, whether having ratified the Convention or not, may seek advisory opinions "regarding the interpretation of [the] Convention or of other treaties concerning the protection of human rights in the American states." American Convention on Human Rights, Art. 64(1); see also Nieto-Navia at 638.

**297** American Convention on Human Rights, Art. 61. See also Neuman at 103.

**298** See Christina M. Cerna, *The Inter-American Commission of Human Rights*, 2 Connecticut Journal of International Law 311, 317 (1987).

**299** See Rules of Procedure of the Inter-American Commission on Human Rights, Art. 44. In addition to ratifying the Convention, a State Party must voluntarily submit to the Inter-American Court's jurisdiction to render the court competent to hear a case involving that state. States may do so generally. As of 2008, Argentina, Barbados, Bolivia, Brazil, Chile, Colombia, Costa Rica, the Dominican Republic, Ecuador, El Salvador, Guatemala, Haiti, Honduras, Mexico, Nicaragua, Panama, Paraguay, Peru, Suriname, Uruguay, and Venezuela had done so. States can also do so in an individual case.

**300** Pasqualucci at 7.

**301** American Convention on Human Rights, Art. 64.

**302** See Nieto-Navia at 638–641.

**303** Pasqualucci at 5–6.

**304** Neuman at 104.

**305** Neuman at 104.

**306** See *Reparations in the Inter-American System: A Comparative Approach*, 56 American U. Law Review 1375 (2007). This publication provides a transcript from a conference on the topic. See also Tara J. Melish, *The Inter-American Court of Human Rights: Beyond Progressivity*, in Social Rights Jurisprudence: Emerging Trends in Comparative and International Law 372, 375 (M. Langford, ed., New York, NY: Cambridge U. Press, 2008).

**307** As Judge Buergenthal argued, baseline conditions affect the metrics of success; "in the few cases before the European institutions that resemble the normal fare of the inter-American system, the European success rate is by no means better, and probably worse, than that of its inter-American counterpart." Thomas Buergenthal, *Human Rights in the Americas: View from the Inter-American Court*, 2 Connecticut Journal of International Law 303, 305 (1987). Buergenthal noted that situations before the ECtHR involving massive violations of human rights—involving Cyprus, Greece, Northern Ireland, and Turkey—that were not unlike those before the Inter-American Court.

**308** Neuman at 103.

**309** Neuman at 103–104.

**310** American Convention on Human Rights, Art. 52(1). That provision requires judges to be of "the highest moral authority" and experts on human rights law.

**311** Figure 167 is reproduced courtesy of the Secretariat of the Inter-American Court of Human Rights.

**312** Wildhaber at 51.

**313** Inter-American Court of Human Rights, Annual Report 2007 at 2.

**314** Inter-American Court of Human Rights, Annual Report 2002, Appendix XXV: Presentation of the Annual Report and Speech by the President Antônio A. Cançado Trindade of the Inter-American Court of Human Rights, April 19, 2002, OEA/SER.G. CP/CAJP_1932/02, 20 (hereinafter Trindade Presentation). This structural problem has been the subject of concern for many years. See Carlos Alberto Dunshee de Abranches, *The Inter-American Court of Human Rights*, 30 American U. Law Review 79, 95–96 (1981).

**315** Wildhaber at 71.

**316** Inter-American Court of Human Rights, Annual Report 2005, inside cover.

**317** American Convention on Human Rights, Art. 72.

**318** Trindade Presentation at 18. The 2008 budget of the Court was $1,756,300. Inter-American Court of Human Rights, Annual Report 2007 at 6. That amount represented about 2 percent of the OAS's overall budget. Id. at 78.

**319** Inter-American Court of Human Rights, Annual Report 2007 at 53.

**320** Inter-American Court of Human Rights, Annual Report 2007 at 53–54. State contributors and their contributions include Denmark ($277,000), Finland ($320,600), France ($65,400), Ireland ($164,800), Italy ($131,700), Korea ($30,000), Spain ($839,600), and Sweden ($148,500). Information on the financial resources of the Inter-American Court of Human Rights can be found at Organization of American States, http://www.cidh.oas.org/recursos.eng.htm.

**321** Trindade Presentation at 19. See also Antônio A. Cançado Trindade, *The Operation of the Inter-American Court of Human Rights*, in THE INTER-AMERICAN SYSTEM OF HUMAN RIGHTS 133 (David J. Harris & Stephen Livingstone, eds., Oxford, Eng.: Oxford U. Press, 1998); Agreement between the Government of the Republic of Costa Rica and the Inter-American Court of Human Rights, Sept. 10, 1981, Art. 28, reprinted in INTER-AMERICAN YEARBOOK ON HUMAN RIGHTS 1985 at 214, 230 (Dordrecht, Neth.: Martinus Nijhoff Publishers, 1987).

**322** PASQUALUCCI at 346.

**323** Inter-American Court of Human Rights, Annual Report 2006, 71. The number could be somewhat higher if one includes decisions in various stages of the same cases. See also Neuman at 104. Thus the 2007 report puts the number of cumulative judgments at 174. See Inter-American Court of Human Rights, Annual Report 2007, 59. Disaggregation is also appropriate.

For example, in 2001 the court received five new "contentious cases" (involving five countries: Argentina, Colombia, Guatemala, Honduras, and Peru) as well as four provisional measures (including against Costa Rica and Mexico) and requests for an advisory opinion from the Commission, seeking guidance on the interaction among provisions of the convention. Trindade Presentation at 2. During 2001–2002, the Inter-American Court held ten public hearings and dealt with about twenty compliance matters or judgments on the merits. See id. at 3.

**324** Inter-American Commission on Human Rights, Annual Report 2007 at 30–31.

**325** Inter-American Commission on Human Rights, Annual Report 2007 at 7. See also id. at 37 for a graph indicating 105 hearings in 2007.

**326** Inter-American Commission on Human Rights, Annual Report 2007 at 36.

**327** Inter-American Commission on Human Rights, Annual Report 2007 at 26–27.

**328** Inter-American Commission on Human Rights, Annual Report 2007 at 38.

**329** Inter-American Commission on Human Rights, Annual Report 2007 at 38–39.

**330** Trindade Presentation at 19–20.

**331** Rodrigo Carazo-Odio, President of the Republic of Costa Rica, Speech Delivered at the Installation of the Court at the National Theater of Costa Rica (Sept. 3, 1979), reprinted in INTER-AMERICAN COURT OF HUMAN RIGHTS: PROCEEDINGS OF INSTALLATION 105, 107.

**332** The decision was ratified by the states parties at the Convention during the sixth special session of the General Assembly in November 1978.

**333** See Saavedra-Alessandri correspondence. Before obtaining ownership, various agreements were needed. For example, in September 1981 the Government of Costa Rica and the Court signed a "Headquarters Agreement" (approved in 1983) providing immunities for the Court, its judges and its staff, and those persons appearing before it. Trindad, *The Operation of the Inter-American Court of Human Rights* at 133.

**334** See Saavedra-Alessandri correspondence.

**335** INTER-AMERICAN COURT OF HUMAN RIGHTS: PROCEEDINGS OF INSTALLATION at 95. The ceremonies included reading messages sent from the ECtHR and from the International Court of Justice.

**336** Jorge Luis Zelay-Coronado, Deputy Secretary General of the OAS, Speech Delivered at the Installation of the Court at the National Theater of Costa Rica (Sept. 3, 1979), in INTER-AMERICAN COURT OF HUMAN RIGHTS: PROCEEDINGS OF INSTALLATION 114, 116. Zelay-Coronado also spoke of obligations of non-judicial branches to help sustain basic rights, health, education, and security.

**337** Carazo-Odio at 107.

**338** Rodolfo Piza-Escalante, President of the Inter-American Court of Human Rights, Speech Delivered at the Installation of the Court at the National Theater of Costa Rica (Sept. 3, 1979), in INTER-AMERICAN COURT OF HUMAN RIGHTS: PROCEEDINGS OF INSTALLATION 108, 110.

**339** Piza-Escalante at 110.

**340** Piza-Escalante at 111. Despite those concerns, Piza-Escalante called for judges to be "truly committed to justice, ready to go out and seek" it and to grant it "valiantly and aggressively." Id. at 112. See also Tracy Thompson, *From Darkness*, THE LAW SCHOOL, New York University Law School Alumni Magazine 11–17 (Autumn 2008).

**341** Thomas Buergenthal, Judge, Speech Delivered at the Faculty of Law of the University of Costa Rica on the occasion of the visit paid by the Judges of the Inter-American Court of Human Rights (Sept. 4, 1979), in INTER-AMERICAN COURT OF HUMAN RIGHTS: PROCEEDINGS OF INSTALLATION 124, 125 (hereinafter Buergenthal Speech). The other jurists selected for the court at its initiation came from Colombia, Costa Rica, El Salvador, Jamaica, Honduras, and Peru. Buergenthal's remarks to the law faculty were made the day after the inauguration; he called for enhanced education in human rights.

**342** Buergenthal Speech at 124.

**343** The procedural rules of the court provide for such "exceptional circumstances." In the late 1990s, the Inter-American Court held a hearing in Washington, D.C. because, in the *Bámaca Velásquez* Case, a witness could not "for immigration reasons" travel to the public hearing in Costa Rica. See PASQUALUCCI at 196–197. In rare instances, such as when there is concern for the security of witnesses, hearings are closed. Id. at 195–196. Our thanks to Gerald Neuman for bringing this practice to our attention.

**344** Inter-American Court of Human Rights, Use of Excess Resources of the Reserve Subfund for Capital Investments and to Meet OAS Mandates, Resolution 831, OEA CP/RES. 831 (1342/02) (2002). These funds came from the annual budget, to which each member state is required to contribute.

**345** See Inter-American Court of Human Rights, Quarterly Report on the Use of Funds Allocated under Resolution CP/RES. 831 (1342/02) between July 1 and September 30, 2003, OEA/Ser.G, CP/ Doc. 3787/03 at 2 (2003). Also mentioned is the firm DYPSA; the report explained: "Construction design was entrusted to the consulting firm specializing in architecture and engineering which originally constructed the building that currently houses the Inter-American Court of Human Rights." Id.

**346** See Inter-American Court of Human Rights, Quarterly Report on Activities, Expansion and Remodeling of the Court's Headquarters, June 2003, OEA/Ser.G, CP/Doc. 3760/03 (2003); Inter-American Court of Human Rights, Quarterly Report on the Use of Funds Allocated under Resolution CP/RES. 831 (1342/02) between Oct. 1 and Dec. 31, 2003, OEA/Ser.G, CP/Doc. 3825/04 (2004).

**347** Inter-American Court of Human Rights, Progress Report on the Second Trimester of 2004, Aug. 4, 2004. The final cost was $605,485.83.

## CHAPTER 12

**1** The photograph in figure 168 is reproduced courtesy of the Carnegie Foundation. Our thanks to Rosalyn Higgins, who served as President of the International Court of Justice (ICJ), to Registrar Jean-Jacques Arnaldez, and to Laurence Blairon, who led the Department of Information for the ICJ, for their hospitality and generosity in informing our discussion and for providing us with the photographs in this section. Carole Martens provided us with detailed research on the architectural competition for the design of the building; Garth Schofield also reviewed materials at our behest. In addition, we owe a great debt to Arthur Eyffinger, who has authored several books about the Peace Palace and has generously guided our research as well as helped us to obtain additional materials and photographs.

**2** See generally José E. Alvarez, International Organizations as Law-makers (Oxford, Eng.: Oxford U. Press, 2005).

**3** Andrew Carnegie, Autobiography of Andrew Carnegie 283 (Boston, MA: Houghton Mifflin Company, 1920). Andrew Carnegie's legacy is also linked to education and welfare. The Carnegie Corporation of America has a mission specified by Carnegie himself—to "promote the advancement and diffusion of knowledge and understanding." See Carnegie Corporation, *Philanthropy at Carnegie Corporation: Vision and Practice*, http://www.carnegie.org/about-us/mission-and-vision/ (hereinafter *Philanthropy at Carnegie Corporation*).

**4** Michael L. Nash, *A Century of Arbitration, The International Court of Justice*, 274 Contemporary Review 242, 243 (1999). The choice of The Hague came in part from Nicholas's relationship to Queen Wilhelmina of the Netherlands. Id. at 242. See also Gerard Kerkvliet & Bert Mellink, The Peace Palace: A Living Institution of International Law 16–18 (The Hague, Neth.: Ando and the Carnegie Foundation, 2004).

**5** Arthur Eyffinger, The Trusteeship of an Ideal: The Carnegie Foundation, Vignettes of a Century 13 (Amsterdam, Neth.: Joh. Enschedé Amsterdam BV in cooperation with the Carnegie Foundation, 2004) (hereinafter Eyffinger, Trusteeship). The volume was published in honor of the hundredth anniversary of the Foundation (Carnegie Stichting). See also Kerkvliet & Mellink at 15–19; Arthur Eyffinger, The Peace Palace: Residence for Justice—Domicile of Learning (The Hague, Neth.: Carnegie Foundation, 1988) (hereinafter Eyffinger, Peace Palace).

**6** Nash at 245. The painting is by Sophie Hirschmann, from The Hague, who lived from 1871 to 1937. Kerkvliet & Mellink at 33.

**7** Antonio Sanchez de Bustamante, The World Court 33 (Elizabeth F. Read, trans., New York, NY: Macmillan, 1925).

**8** Bustamante at 25–26.

**9** Bustamante at 26.

**10** Bustamante at 27–29. The International Law Association was founded in Brussels in 1873 to study and develop both public and private international law and to promote international understanding. See International Law Association, *About Us*, http://www.ila-hq.org/en/about_us/index.cfm. The American Society for the Judicial Settlement of International Disputes was founded in Baltimore in 1910 to publish relevant articles by "leading men of all countries" and to "educate the people as to the desirability of promoting the peace of the world by settling points of international controversy in the same general way in which differences between individuals are now settled." *To Promote Arbitration*, New York Times, Feb. 7, 1920, at 2; Theodore Marburg, *The Washington Meeting of the American Society for the Judicial Settlement of International Disputes*, 5 American Political Science Review 181 (1911). The American Society of International Law, begun in 1905, continued to be a voice for internationalism over the twentieth century. See Frederic L. Kirgis, *The Formative Years of the American Society of International Law*, 90 American Journal of International Law 559 (1996). See also Mark Weston Janis, *Americans and the Quest for an Ethical International Law*, 109 West Virginia Law Review 571 (2007).

**11** See International Adjudications, Ancient and Modern History and Documents (John Bassett Moore, ed., New York, NY: Oxford U. Press, 1929, reprinted by William S. Hein, 1996). The series was also a publication of the Carnegie Endowment for International Peace, Division of International Law, in Washington, D.C. In the eight-volume series, Moore reprinted selected international arbitrations from what he termed the "the ancient" and modern eras in pursuit of his goal of "bring[ing] together all discoverable records of international judicial action, ancient and modern, into one comprehensive publication, in which there should be given, in appropriate historical setting, the full text of every international judicial decision, or opinion, and in addition certain affinitive matter lying, as the case might be, within the sphere or on the border of judicial action." Moore, *General Introduction* to International Adjudications, vol. 1 at ix.

**12** See John Bassett Moore, *A Hundred Years of Diplomacy*, 14 Harvard Law Review 165, 182–183 (1900). Moore's list was focused on international "arbitrations of the United States," excluding those then pending. Id. at 182. Another account not limited to the United States reported twenty-three arbitrations between 1789 and 1840, twenty from 1841 to 1860, forty-four between 1861 and 1880, and ninety from 1881 to 1900. Bustamante at 6 (citing La Fontaine, *Pasicrisie internationale*, Berne, 1903, and *Anales de la Corte de Justicia Centro-Americana*, 1911).

**13** See The Cordillera of the Andes Boundary Case (Argentina, Chile), Nov. 20, 1902, 9 Reports of International Arbitral Awards 37 (1959). Controversy later arose between Argentina and Chile over the interpretation of the 1902 award. In 1964, the parties agreed to refer the matter to Queen Elizabeth II, who issued an award on December 9, 1966. See Argentine–Chile Frontier Case, Dec. 9, 1966, 16 Reports of International Arbitral Awards 111 (1967).

**14** See Arthur Eyffinger, *Living Up to a Tradition*, in The Hague: Legal Capital of the World 29, 29–46 (Peter J. van Krieken & David McKay, eds., The Hague, Neth.: T. M. C. Asser Press, 2005) (hereinafter Eyffinger, *Tradition*); Bette Shifman, *The Permanent Court of Arbitration: An Overview*, in The Hague: Legal Capital of the World 128, 128–180. See generally Arthur Eyffinger, The 1899 Hague Peace Conference: "The Parliament of Man, the Federation of the World" (The Hague, Neth.: Kluwer Law International, 1999) (hereinafter Eyffinger, The 1899 Hague Peace Conference).

**15** Eyffinger, Trusteeship at 23.

**16** Eyffinger, Trusteeship at 19.

**17** Eyffinger, Trusteeship at 17.

**18** See Kerkvliet & Mellink at 19. Given the commitment to arbitration, England used it to charge Russia with firing on the British herring fleet, and Russia ended up paying damages.

**19** The nations assembled brought some diversity of legal traditions, albeit through colonialism aspects of both common and civil law traditions that had been imposed far from their roots. Nash at 244.

**20** Bustamante at 78.

**21** See *Philanthropy at Carnegie Corporation*.

**22** See *The Academy of International Law at The Hague Established in Co-operation with the Carnegie Endowment for International Peace*, 8 American Journal of International Law 351, 352 (1914). William Stead, a British journalist, and Andrew White, the United States ambassador to Germany, are credited with drawing Carnegie's attention to these issues. Kerkvliet & Mellink at 20–22.

**23** Eyffinger, Trusteeship at 5.

**24** A Deed to Create a " 'Stichting' " [foundation or trust under the Netherland Law] for the Purpose of Erecting and Maintaining at The Hague (Kingdom of the Netherlands) a Court-House and Library for the Permanent Court of Arbitration, reproduced in The Palace of Peace at The Hague: The 6 Premiated and 40 Other Designs Chosen by the Society of Architecture at Amsterdam and Reproduced under Its Direction 5–6 (London, Eng.: T. C. & E. C. Jack, 1907) (hereinafter Designs Chosen). Details of the competition and photographs of several of the drawings can also be found in Eyffinger, Peace Palace at 63–76.

**25** A copy of the certificate is reproduced in figure 169 courtesy of the Carnegie Foundation.

**26** National competitions may also have influenced the international paradigm. For example, in 1883 Italian architects were invited to submit proposals for the Palazzo di Giustizia in Rome. See Terry Rossi Kirk, Church, State and Architecture: The "Palazzo di

Giustizia" of Nineteenth-Century Rome 93 (Ph.D. dissertation, Columbia U., New York, NY, 1997; UMI Publication No.: AAT 9728234). Kirk also analyzed the secular iconography of the building and the symbolism of the courthouse in making material "the culture of jurisprudence, initiated by the ancients and sustained by later Italian rulers." Id. at 364.

**27** See, for example, EYFFINGER, TRUSTEESHIP; EYFFINGER, THE PEACE PALACE.

**28** JAMES A. MACKAY, LITTLE BOSS: A LIFE OF ANDREW CARNEGIE 276 (Ann Arbor, MI: U. of Michigan Press, 1997).

**29** DESIGNS CHOSEN at 1–2.

**30** DESIGNS CHOSEN at 7, reproducing the document. This *"Programme of the Competition for the Architectural Plan of the Peace Palace for the use of the Permanent Court of Arbitration with a Library* was sent out all over the world." EYFFINGER, PEACE PALACE at 63.

**31** DESIGNS CHOSEN at 8.

**32** DESIGNS CHOSEN at 7–8.

**33** DESIGNS CHOSEN at 9.

**34** Additional requirements included a basement for concierges and clerks, storerooms, and the like. EYFFINGER, PEACE PALACE at 64.

**35** DESIGNS CHOSEN at 10.

**36** DESIGNS CHOSEN at 11; EYFFINGER, PEACE PALACE at 64.

**37** DESIGNS CHOSEN at 8.

**38** Included were the Architect of the Royal Museum of Amsterdam as well as architects from Royale Institute of British Architects and professors, including W. R. Ware, then Emeritus Professor of Architecture at Columbia University, New York. DESIGNS CHOSEN at 8.

**39** KERKVLIET & MELLINK at 27.

**40** The question was much debated; see T. E. Collcutt, *The Peace Palace Competition* (Annual Address) printed in THE AMERICAN ARCHITECT AND BUILDING NEWS, Dec. 1, 1906, at 174–175; G. S. Aitken & Henry F. Kerr, *Design for the Peace Palace, The Hague*, 76 THE ARCHITECT AND CONTRACT REPORTS 404 (Dec. 21, 1906).

**41** As noted in Chapter 11, Rogers said he wanted to "break from the traditional monumentalism associated with Palaces of Justice" and create a "futuristic image not limited by the national styles" of the Member States. Richard Rogers, *European Court of Human Rights*, 14 ZODIAC 194, 196 (1995); Richards Rogers, GA Document Extra No. 02 at 46 (Yoshio Futagawa, interviewer, Yukio Futagawa, ed., ADA Edita, Tokyo 2002).

**42** Hugh Aldersey-Williams, *Court in the Middle*, ARCHITECTURAL RECORD 70 (Aug. 1995).

**43** KERKVLIET & MELLINK at 27. Under the the auspices of Queen Wilhelmina, the drawings were displayed to the public. Id.

**44** DESIGNS CHOSEN at 12–14.

**45** DESIGNS CHOSEN at 18. Cordonnier's design was not, however, used for the Stock Exchange. See KERKVLIET & MELLINK at 26.

**46** DESIGNS CHOSEN at 15–17. A total of forty-four, including the six winners, were provided. See id. at 12–14 and plates 3–76. The Carnegie Foundation gave the drawings on long-term loan to the Netherlands Architecture Institute; see *A Brief History of the Peace Palace*, Peace Palace Library. http://www.ppl.nl/100years/peacepalace/.

**47** DESIGNS CHOSEN at 16 (design no. 194, PAX). The overall impression of this design was, however, very favorable.

**48** DESIGNS CHOSEN at 23. He was on the list of the top forty-four, but that list was not ranked.

**49** The winners were two French architects—Louis M. Cordonnier from Lille and Alexander Marcel from Paris. The top six included two from Germany, Franz Schwechten from Cologne and Franz Wendt from Stettin; Otto Wagner from Austria; and the firm of Howard Greenley and S. Olin from New York. See DESIGNS CHOSEN at 18–22.

**50** DESIGNS CHOSEN at 15.

**51** EYFFINGER, PEACE PALACE at 67.

**52** KERKVLIET & MELLINK at 28. Kerkvliet & Mellink reported that

Cordonnier won by a single vote. Furthermore, while the "innovators lost," later "retrenchment of Cordonnier's design offered some compensation." Id.

**53** DESIGNS CHOSEN at 16.

**54** DESIGNS CHOSEN, plate 30 at 40. *The Peace Palace Competition*, 90 THE AMERICAN ARCHITECT 55, 56 (Aug. 18, 1906). Cordonnier was born in Haubourdin in 1854 and lived until 1938; he was based in Lille. See KERKVLIET & MELLINK at 26; DESIGNS CHOSEN at 15, 18.

**55** DESIGNS CHOSEN at 15. See also *The Peace Palace Competition*, 90 THE AMERICAN ARCHITECT 55 (Aug. 18, 1906). The jury described its third-prize design as "somewhat stiff and monotonous." Id.

**56** Edwin W. Leeuwin, *'The Arts of Peace': Thomas H. Mawson's Gardens at the Peace Palace, The Hague*, 28 GARDEN HISTORY 262, 272 (2000).

**57** *A Design for the Palace of Peace at The Hague*, 22 ARCHITECTURAL REVIEW 80, 83 (1907) (hereinafter *Design for the Palace of Peace*).

**58** *Design for the Palace of Peace* at 81–83.

**59** *A Glimpse of the Palace of Peace, Just Dedicated*, NEW YORK TIMES, Sept. 7, 1913, at SM7 (hereinafter *A Glimpse of the Palace of Peace*). One commentator explained that Cordonnier relied heavily on belfry towers, central halls and staircases, and the "entwining of brick and stone. All these elements Cordonnier literally imitated from the Renaissance style"—giving his work a "static impression." EYFFINGER, PEACE PALACE at 73.

**60** Collcutt at 175.

**61** *A Glimpse of the Palace of Peace*.

**62** Robert Maxwell & Wilford Schupp Architekten, *Peace Dividend*, 223 ARCHITECTURAL REVIEW 77 (June 2008).

**63** See THE INTERNATIONAL COURT OF JUSTICE: QUESTIONS AND ANSWERS ABOUT THE PRINCIPAL JUDICIAL ORGAN OF THE UNITED NATIONS 10 (New York, NY: United Nations Department of Public Information, 2000) (hereinafter ICJ QUESTIONS AND ANSWERS).

**64** KERKVLIET & MELLINK at 28. The proposals reproduced in that monograph include those by Hendrik Berlage, Eero Saarinen, Otto Wagner, and Alexander Marcel. Id. at 28–29.

**65** Collcutt at 174; F. C. H. M. Robbers, *"A Storm of Indignation": A Lawsuit Concerning the Design for the Peace Palace*, in EYFFINGER, TRUSTEESHIP 177. Collcutt's role is specified in EYFFINGER, PEACE PALACE at 64.

**66** EYFFINGER, TRUSTEESHIP at 68.

**67** EYFFINGER, TRUSTEESHIP. at 71. "[M]ost of the winning designs exceeded by far the sum stipulated in the programme." EYFFINGER, PEACE PALACE at 71.

**68** EYFFINGER, TRUSTEESHIP at 71.

**69** EYFFINGER, TRUSTEESHIP at 77; see also KERKVLIET & MELLINK AT 26–28.

**70** CARNEGIE ENDOWMENT FOR INTERNATIONAL PEACE, MANUAL OF THE PUBLIC BENEFACTORS OF ANDREW CARNEGIE at 276–277 (1939); EYFFINGER, PEACE PALACE at 107. The photograph in figure 170 is reproduced courtesy of the Carnegie Foundation.

**71** EYFFINGER, TRUSTEESHIP at 77.

**72** KERKVLIET & MELLINK at 26.

**73** Robbers at 177.

**74** *The Peace Palace Award Enjoined*, 90 AMERICAN ARCHITECT AND BUILDING NEWS 162 (Nov. 24, 1906). See also *The Success of The Hague Peace Palace Competition*, 90 AMERICAN ARCHITECT AND BUILDING NEWS 114 (Oct. 13, 1906). That commentary described architect Cordonnier as in the "grace" of Queen Wilhelmina and commented that the design disregarded the "prime condition" of budgetary constraints. Id.

**75** Robbers at 182.

**76** Robbers at 178.

**77** Robbers at 179–180.

**78** Robbers at 181.

**79** A Brief History of the Peace Palace, Peace Palace Library, http://www.ppl.nl/100years/peacepalace.

**80** Hans van den Broek, President of the Carnegie Foundation, *Foreword* to Eyffinger, Trusteeship at 5, quoting that brochure. Carnegie was at the opening ceremonies. Kerkvliet & Mellink at 23.

**81** Eyffinger, Peace Palace at 176.

**82** Eyffinger, Peace Palace at 187. One way to read various parts of his book is as a plea for wide-ranging economic support.

**83** Kerkvliet & Mellink at 30.

**84** Eyffinger, Peace Palace at 94.

**85** At the 1907 Hague Conference, the "French secured the assistance of the forty-four attending nations for an initiative to honour the Dutch by donating works of art and craftsmanship to decorate the Peace Palace." Eyffinger, *Tradition* at 38.

**86** Kerkvliet & Mellink at 30.

**87** Christine B. Weightman, A Short History of The Hague 126 (Schiedam, Neth.: Schie-Pers, 1973).

**88** Michael E. Goldhaber, *War and Justice*, 23 The American Lawyer 65 (Aug. 2001).

**89** Eyffinger, Trusteeship at 82. Their work accounted for 13,454 square feet (1,250 square meters). Eyffinger, Peace Palace at 105.

**90** Eyffinger, Trusteeship at 82–84.

**91** The tapestries, "a valuable gift from the Japanese government." were designed by Jimbei Kawashima II. Called *One Hundred Flowers and One Hundred Birds in Late Spring and Early Summer*, they were woven in a fashion that renders the "warp and woof almost invisible." Kerkvliet & Mellink at 34.

**92** Eyffinger, Trusteeship at 82–84. The object's weight is more than 3,000 kilograms. Id. at 84.

**93** Eyffinger, Trusteeship at 84. The statue is a smaller copy of one erected in the Andes in 1905 in commemoration of a peaceful resolution by arbitration of a dispute between Chile and Argentina. The sculptor was J. Lague of Brussels. See List of Gifts to the Peace Palace (materials provided by Laurence Blairon, former Head of the Information Department for the ICJ).

**94** Eyffinger, Peace Palace at 150–151. These paintings are on loan and remain part of the Rijksmuseum collection.

**95** Kerkvliet & Mellink at 35. See also Eyffinger, Peace Palace at 154–155. Eyffinger reported that the triptych was bought on the belief that it referred to the "Triumph of Peace" or the "Munster Peace Treaty" rather than what it does represent, Amsterdam's "maiden." Id. at 155. The panels, a little over 14 by 7.5 feet (or 4.4 meters by 2.27 meters), include a host of Virtues and Vices.

**96** Herman Rosse, who was born in the Netherlands in 1887, moved to the United States, where he served as the head of the Design Department of the School of the Art Institute of Chicago, and then to Hollywood, where he worked as a set designer for films in the United States and Europe. See Herman Rosse: Designs for Theatre, Chapin Library, Williams College (May–Sept. 2005), found on the college's educational resources website; Eyffinger, Peace Palace at 100–102. Figure 171 is provided courtesy of the Carnegie Foundation.

**97** Kerkvliet & Mellink at 38. A floor mosaic of Italian marble reads "sol justitiae illustra nos" (the sun of justice illuminates us). Id. at 31. Other allegorical females, including Peace and other "paranymphs," adorn stained-glass windows. Id.

**98** Letter from Laurence Blairon, former Head of the Information Department of the ICJ (January 9, 2007) (hereinafter Blairon 2007 Letter). See Kerkvliet & Mellink at 31. The *New York Times* article reported that $20,000 had been set aside for the work. *A Glimpse of the Palace of Peace.* O'Connor executed commissions for the Vanderbilt Memorial on the facade of St. Bartholomew's Church in New York, and of General Lafayette, a "monumental statue" in

Baltimore of Lafayette astride a horse. O'Connor also designed a hundred-foot-high monument, *Desolation*, for the Bay of Dublin. See Sybil Vincent, *In the Studio of Andrew O'Connor*, 14 The London Studio 79, 82 (1937). Figure 172 is provided courtesy of the Carnegie Foundation.

**99** Leeuwin at 262–276. Leeuwin noted that Mawson had achieved the "desired effect of spaciousness and restfulness through a variety of choices." Id. at 266. See also Eyffinger, Trusteeship at 87–98.

**100** Blairon 2007 Letter and the attached list, "Busts in the Peace Palace." Those portrayed in marble or bronze include Sir William Randal Cremer, Hugo Grotius, William Stead, and Louis Renault. Id. See also Eyffinger, Peace Palace at 119.

**101** Anthony Browne, *World Court Faces Its Biggest Test Yet*, Times UK, Feb. 24, 2004, at 12; Rosalyn Higgins, *The ICJ, the ECJ, and the Integrity of International Law*, 52 International and Comparative Law Quarterly 1, 2 (2003).

**102** Kerkvliet & Mellink at 3.

**103** Eyffinger, Trusteeship at 84. Kerkvliet and Mellink mentioned that the Achilles painting denoted that "each belligerent, no matter how powerful," was vulnerable. Kerkvliet & Mellink at 35. In 1913 the *New York Times* also noted that the Dutch had moved a Bols painting, *Allegory of Peace*, from the Leyden Town Hall, where it had been in place for two centuries. *A Glimpse of the Palace of Peace.*

**104** Edward W. Bok, *Introduction* to Antonio Sanchez de Bustamante, The World Court xii (Elizabeth F. Read, trans., New York, NY: Macmillan, 1925). Bustamante was a judge of the Permanent Court of International Justice when he wrote this volume.

**105** Permanent Court of Arbitration, 2008 PCA Annual Report, Annex 2, 43–48, http://www.pca-cpa.org/upload/files/03%20 Report%201-17.pdf. Under PCA rules, public information is provided only parties consent. Id. at 3.

**106** Manley O. Hudson, *The Permanent Court of Arbitration*, 27 American Journal of International Law 440, 443 (1933) (hereinafter Hudson, PCA).

**107** Bok at xiii. As one international expert put it, as of the 1920s, more than 120 individuals had been appointed, but they did not "constitute an actual tribunal for the trial of cases. They form, on the contrary, a panel, or eligible list," from which arbitrators could be drawn. John Bassett Moore, *The Organization of the Permanent Court of International Justice*, 22 Columbia Law Review 497, 498 (1922) (hereinafter Moore, *Organization of PCIJ*).

**108** Hudson, PCA at 445.

**109** See generally Martti Koskenniemi, The Gentle Civilizer of Nations: The Rise and Fall of International Law 1870–1960 (Cambridge, Eng.: Cambridge U. Press, 2001).

**110** Koskenniemi at 11. The book raised a series of concerns about the project of international law and was critical of the idea of a shared legal conscience.

**111** Bok at xii.

**112** See, for example, Laurence R. Helfer & Anne-Marie Slaughter, *Why States Create International Tribunals: A Response to Professors Posner and Yoo*, 93 California Law Review 899 (2005).

**113** See, for example, *Sanchez-Llamas v. Oregon*, 548 U.S. 331 (2006), discussed later in this chapter. Of course, problems of legitimacy and compliance are not limited to international law but are paralleled in domestic settings. See Jack Goldsmith & Daryl Levinson, *Law for States: International Law, Constitutional Law, Public Law*, 122 Harvard Law Review 1791 (2009). Furthermore, the nature of international obligations is also in transition, because obligations flow not only from state to state but also to nationals of other states. See Lea Brilmayer, *From "Contract" to "Pledge": The Structure of International Human Rights Agreements*, 77 British Yearbook of International Law 163 (2006).

**114** See Ruti Teitel & Robert L. Howse, *Cross-Judging: Tribunalization in a Fragmented But Interconnected Global Order* (Jan. 2009), http://www.SSRN.com/abstract=1334289.

**115** Hudson, PCA at 443–444. As of 1932, the registry of the PCA (the International Bureau) had expenses of 88,000 Dutch florins, or about $35,000. Id. at 443–444. See also at 133.

**116** Manley O. Hudson, *American Members of the Permanent Court of Arbitration during Forty Years*, 35 AMERICAN JOURNAL OF INTERNATIONAL LAW 135, 135–136 (1941) (hereinafter Hudson, *American Members*).

**117** Hudson, PCA at 443. The 1932 reporter listed twenty-one arbitrations. Id. at 446. An example of a 1909 judgment involving Venezuela and the United States is in 5 AMERICAN JOURNAL OF INTERNATIONAL LAW 230 (1911).

**118** Gilbert Guillaume, The Contribution of the Permanent Court of Arbitration and Its International Bureau to Arbitration between States, on the Occasion of a Celebration of the Centenary of the Second Hague Convention of Oct. 18, 1907, for the Pacific Settlement of International Disputes, The Hague, Oct. 18, 2007, Remarks of Phillipe Sands, of James Crawford, and of Gilbert Guillaume, http://www.pca-cpa.org/showfile.asp?fil_id=975 (hereinafter 2007 PCA Centenary). The PCA database listed fifteen awards given. See Permanent Court of Arbitration, Cases Conducted under the Auspices of the PCA or with the Cooperation of the International Bureau, in 2008 PCA ANNUAL REPORT at 43–48.

**119** Hudson, PCA at 446. As Hudson put it: "Strictly, an agreement to arbitrate in accordance with or pursuant to the provisions of either Hague Convention is so indefinite as to have little meaning." Id.

**120** Guillaume, 2007 PCA Centenary. Article 46 of the 1907 Convention authorized the International Bureau "to place its offices and staff at the disposal of the Contracting Powers for the use of any special Board of Arbitration" and did not define what such a "special Board" entails. Shifman at 133–134.

**121** Crawford, 2007 PCA Centenary. To do so, the PCA relied on Article 47 of the 1907 Hague Convention, interpreted not to be limited to states. For example, in the 1930s the PCA heard a dispute between the Radio Corporation of America and China. See Crawford, PCA Centenary at 1–2; PCA Cases Conducted 1902–2007 at 50.

**122** Hudson, *American Members* at 135.

**123** MANLEY O. HUDSON, THE WORLD COURT 1921–1938: A HANDBOOK OF THE PERMANENT COURT OF INTERNATIONAL JUSTICE 1–2 (Boston, MA: World Peace Foundation, 5th ed., 1938) (hereinafter HUDSON, WORLD COURT HANDBOOK). The twenty-one awards are listed in PCA Cases Conducted 1902–2007 at 49–50.

**124** Guillaume, 2007 PCA Centenary, at 2. As part of the hundred-year anniversary, the PCA revised its logo, as we discuss at the end of the chapter.

**125** See PCA Cases Conducted 1902–2007 at 45.

**126** 2008 PCA ANNUAL REPORT at 4–5.

**127** In November of 1979, more than fifty United States nationals were detained at the United States Embassy in Tehran, and the United States responded by freezing assets of Iran. A special "Iran–United States Claims Tribunal," financed by those two countries, was established to make binding decisions through a nine-member body that could also rely on chambers of smaller numbers. The agreement to do so is known as the Algiers Accords. Some of the funds frozen in the United States were placed in a "security account" to pay claimants through a settlement tribunal to meet at The Hague. See Warren Christopher & Richard M. Mosk, *The Iranian Hostage Crisis and the Iran–U.S. Claims Tribunal: Implications for International Dispute Resolution and Diplomacy*, 7 PEPPERDINE DISPUTE RESOLUTION LAW JOURNAL. 165, 168–170 (2007). The PCA was involved in setting up the Iran–United States Claims Tribunal, which initially used PCA staff and PCA facilities in The Hague before it moved in 1982 to its own housing; the Claims Tribunal also continued to use the "PCA's court-

room for full tribunal hearings." Shifman at 138; see Charles N. Brower, *The Iran–United States Claims Tribunal An Analysis*, in THE HAGUE: LEGAL CAPITAL OF THE WORLD 243, 251–252. See also 2008 PCA ANNUAL REPORT at 7–8.

More than 3,800 claims were filed, of which some 3,000 were "small claims" under $250,000 and handled differently than claims above that amount. Id. at 250. Individuals as well as banks were claimants, and many issues had to be addressed, such as the criteria for determining who was a "national" and the relevance of preexisting contracts delineating other fora for decisionmaking. By 1991, more than $2 billion had been paid out through various mechanisms. Id. at 264. See also David D. Caron, *The Nature of the Iran–United States Claims Tribunal and the Evolving Structure of International Dispute Resolution*, 84 AMERICAN JOURNAL OF INTERNATIONAL LAW 104 (1990); Robert B. von Mehren, *The Iran–U.S.A. Arbitral Tribunal*, 31 AMERICAN JOURNAL OF COMPARATIVE LAW 713 (1983). As for how to record the activities of that tribunal in relationship to the PCA, the PCA database lists proceedings begun in 1981 that had, by 2008, resulted in 683 awards. See PCA Cases Conducted 1902–2007 at 51.

**128** PCA Cases Conducted 1902–2007 at 46–48.

**129** PCA ANNUAL REPORT 2008 at 1, 5–7.

**130** Tjaco T. Van Den Hout (Secretary-General of the PCA), *Resolution of International Disputes: The Role of the Permanent Court of Arbitration—Reflections on the Centenary of the 1907 Convention for the Pacific Settlement of International Disputes*, 21 LEIDEN JOURNAL OF INTERNATIONAL LAW 643, 660–661 (2008).

**131** The photographs in figure 173 are reproduced courtesy of the Carnegie Foundation and the Iran–United States Claims Tribunal.

**132** World War I intervened. The artist, Olivier Merson, died, and the tapestry was not completed. Thereafter, the large cartoon, with a figure labeled "Pax" at its center, was provided instead. KERKLVIET at 33; Blairon 2009 Letter.

**133** Guillaume, 2007 PCA Centenary, at 2. The Iran–U.S. Claims Tribunal was among the first to use the UNCITRAL Rules after their promulgation in 1976. Brower at 253. Modernization of other aspects of the PCA are detailed in Shifman at 137–144.

**134** PCA Cases Conducted 1902–2007 at 52–53.

**135** Shifman at 135.

**136** Only parties that have so agreed are identified by the PCA, and (as noted) only when the parties consent does the PCA publishes awards or other information in proceedings under PCA auspices. See Permanent Court of Arbitration, Optional Rules for Arbitrating Disputes Between Two States, Art. 32, para. 5, http://www.pca-cpa.org/upload/files/2STATENG.pdf; Optional Rules for Arbitration of Disputes Relating to Natural Resources and/or the Environment, id. at para. 6,

**137** See Manley O. Hudson, *The Permanent Court of International Justice*, 35 HARVARD LAW REVIEW 245, 253 (1922) (hereinafter Hudson, PCIJ 1922 HARV. L. REV.). See also MANLEY O. HUDSON, THE PERMANENT COURT OF INTERNATIONAL JUSTICE, 1920–1942: A TREATISE (New York, NY: Macmillan, 1943) (hereinafter HUDSON, PCIJ TREATISE). A related criticism was that the PCA arbitrators were too close "to diplomacy rather than to jurisprudence." Charles Evans Hughes, *The Permanent Court of International Justice*, 10 PROCEEDINGS OF THE ACADEMY OF POLITICAL SCIENCE IN THE CITY OF NEW YORK 140, 144 (1923) (quoting Elihu Root). Both Hughes, then Secretary of State, and Root, who had helped draft the court's statute, were proponents of the United States joining the PCIJ. Hughes was a listed member of the PCA before going to the United States Supreme Court, where he served as its Chief Justice.

**138** David Jayne Hill, *The Permanent Court of International Justice*, 14 AMERICAN JOURNAL OF INTERNATIONAL LAW 387, 392 (1920).

**139** Jackson H. Ralston, *Some Suggestions as to the Permanent Court of Arbitration*, 1 AMERICAN JOURNAL OF INTERNATIONAL LAW 321, 324 (1907). See generally OLE SPIERMANN, INTERNATIONAL

LEGAL ARGUMENT IN THE PERMANENT COURT OF INTERNATIONAL JUSTICE: THE RISE OF THE INTERNATIONAL JUDICIARY 3–11 (Cambridge, Eng.: Cambridge U. Press, 2005).

**140** Hudson, PCIJ 1922 HARV. L. REV. at 264, n. 72. Descriptions of the 1907 Court of Arbitral Justice can be found in Edwin M. Borchard, *The Permanent Court of International Justice*, 10 PROCEEDINGS OF THE ACADEMY OF POLITICAL SCIENCE IN THE CITY OF NEW YORK 124, 128–129 (1923).

**141** BUSTAMANTE at 33. See also Hudson, PCIJ 1922 HARV. L. REV. at 247–248. The committee held thirty-five meetings between June 16 and July 24, 1920. Id. at 248, n. 13.

**142** BUSTAMANTE at 92. "Those who prepared the plan for the Permanent Court intended that it should have compulsory jurisdiction in certain enumerated classes of controversies of a kind peculiarly suited for judicial settlement." Edward D. Dickerson, *The Permanent International Court of Justice*, 22 MICHIGAN LAW REVIEW 251, 252 (1924).

**143** Permanent Court of International Justice, Statute of the Court, Art. 36, in PUBLICATIONS OF THE PERMANENT COURT OF INTERNATIONAL JUSTICE, First Edition, Series D No. 1, at 19–20 (1926) (hereinafter 1920 PCIJ Statute).

**144** Hudson, PCIJ 1922 HARV. L. REV. at 260.

**145** SPIERMANN at 11–12.

**146** George Wharton Pepper, *The Permanent Court of International Justice*, 10 PROCEEDINGS OF THE ACADEMY OF POLITICAL SCIENCE IN THE CITY OF NEW YORK 160, 161 (1923). Senator Pepper, from Pennsylvania, counseled debate about the United States' adherence, claiming to present facts but not argue for or against it. Id. at 160.

**147** Dickerson at 414. The PCIJ's limitations protected national law. In this international institution, as in many others of the twentieth century, the United States played an important role and is often cited as shaping provisions to protect its sovereign prerogatives. Details of the many decisions entailed in the formulation of the PCIJ, in terms of jurisdiction, procedure, language, and whether judges could record dissents, are provided in James Brown Scott, *A Permanent Court of International Justice*, 14 AMERICAN JOURNAL OF INTERNATIONAL LAW 581 (1920). Parties could, however, agree when ratifying to submit to the Court unconditionally, compelling themselves to later participation. Moore, *Organization of PCIJ* at 500.

**148** Dickerson at 414.

**149** Dickerson at 414–415.

**150** BUSTAMANTE at 114–115. The initial group came from Spain, Italy, Brazil, Cuba, Great Britain, Switzerland, Holland, the United States, Denmark, Japan, and France, with deputy judges from Norway, Romania, China, and the Kingdom of the Serbs, Croats, and Slovenes. Id. at 131.

**151** The idea of supranational norms that are independent of nation-states in late twentieth-century international law is explored in Gerald L. Neuman, *Human Rights and Constitutional Rights: Harmony and Dissonance*, 55 STANFORD LAW REVIEW 1863 (2003).

**152** Ralston at 325.

**153** Moore, *Organization of PCIJ* at 504. Moore pointed out that disqualification was not required at the PCIJ.

**154** Versions of this model can be found at the national level. For example, by statute, Canada has also provided a set-aside so that three of its Supreme Court judges come from the Province of Ontario and three from the Province of Quebec. See Supreme Court Act, R.S.C., ch. S-19, § 6 (1985) (Can.).

**155** Hudson, PCIJ 1922 HARV. L. REV. at 249–250. Root had served as the Secretary of War under President McKinley and as the Secretary of State under President Roosevelt. Between 1918 and 1922 Root played several roles, including being a founding member of the Council on Foreign Relations in 1921, a delegate to the International Conference on the Limitation of Armaments in 1921, and a delegate to the Washington Naval Conference in 1921–1922. See generally John

Fabian Witt, *Crystal Eastman and the Internationalist Beginnings of American Civil Liberties*, 54 DUKE LAW JOURNAL 705, 726–732 (2004).

**156** Hughes at 149.

**157** Hughes at 149

**158** Statute of the Court, as amended by the Protocol of Sept. 14, 1929, Art. 2, in HUDSON, WORLD COURT HANDBOOK at 19 (hereinafter 1929 PCIJ Statute). Some discussion addressed whether to disqualify judges, if the same nationality as a disputant, from sitting on that bench in a particular case. See Moore, *Organization of PCIJ* at 504.

**159** The first set elected included John Bassett Moore, who had been a professor of international law at Columbia Law School, had served as a legal advisor to the foreign office, and, as noted, had written at length on arbitration. See Dickerson at 251–252. See also Moore, *Organization of PCIJ*. The first judges are shown in a photograph at page ii.

**160** Pepper at 163.

**161** Some objected to this custom. "This provision undoubtedly detracts from the formally impartial character of the court." Hudson, PCIJ 1922 HARV. L. REV. at 257. The Inter-American Court, discussed in Chapter 11, has a similar practice.

**162** In 1929, the body was reorganized so that the bench numbered fifteen, with six deputies. The change was based on an initial aspect of the 1920 statute that also had provided for a bench as large as twenty-one. See Statute of the Permanent Court of International Justice, Dec. 16, 1920, amended Sept. 14, 1929, http://www.worldcourts.com/pcij/eng/documents/1920.12.16_statute.htm (hereinafter 1920 PCIJ Statute). Deputy judges were to substitute if others were absent, and, reflective of this ad hoc service, they were permitted to serve as lawyers before the court if not participating as judges. Moore, *Organization of PCIJ* at 508–509. The post of deputy judge was abolished in 1936. SPIERMANN at 12.

**163** See Lorna Lloyd, *"A Springboard for the Future": A Historical Examination of Britain's Role in Shaping the Optional Clause of the Permanent Court of International Justice*, 79 AMERICAN JOURNAL OF INTERNATIONAL LAW 28 (1985). See also Resolution of the First Assembly of the League of Nations, Dec. 13, 1920, Protocol of Signature, opened for signature at Geneva, Dec. 16, 1920, in HUDSON, WORLD COURT HANDBOOK at 13–14. Some commentators saw the court as one of the major reasons that the League of Nations had been established. See Lord Godfrey Walter Phillimore, *The Permanent Court of International Justice*, 1 JOURNAL OF THE BRITISH INSTITUTE OF INTERNATIONAL AFFAIRS 113 (1922).

**164** *Permanent Court of International Justice*, 153 LAW TIMES 163 (Mar. 4, 1922). The point about how they were dressed came in response to accusations that the judges would be too royally clad. See Moore, *Organization of PCIJ* at 509–510.

**165** BUSTAMANTE at 110–111, quoting Drummond.

**166** Moore, *Organization of PCIJ* at 505.

**167** BUSTAMANTE at 174. See also HUDSON, WORLD COURT HANDBOOK at 7 (stating that the PCIJ's expenses in 1936 amounted to 928,953 florins).

**168** See The Hague Academy of International Law, History, http://www.hagueacademy.nl/?history.

**169** EYFFINGER, PEACE PALACE at 165–166.

**170** EYFFINGER, PEACE PALACE at 169. Also chronicled is the work of the academy through 1988. Id. at 170–173.

**171** Hudson, PCIJ 1922 HARV. L. REV. at 251; 1929 PCIJ Statute, Art. 1.

**172** 1929 PCIJ Statute, Art. 38. See also Moore, *Organization of PCIJ* at 510. Further, as Hudson noted, while the court's statute failed to "confer upon it an expressed mandate with reference to the applicaton of international law," the PCIJ functioned as "an organ of international law." HUDSON, PCIJ TREATISE at 603–604.

**173** Hudson, PCIJ 1922 HARV. L. REV. at 255. He noted that some had proposed more codification, but opposition had prevented new conventions to detail international legal rules. Id. at 256.

**174** Article 59 of the statute provided that PJIC decisions had "no binding force except between the parties and in respect of that particular case." As Hudson noted, however, the "psychological fact of *stare decisis*" would prevail. Hudson, PCIJ 1922 HARV. L. REV. at 257.

**175** The authority to render advisory opinions was itself a bone of contention in debates in the United States on ratification. See Borchard at 124.

**176** Nine judges were to suffice, but the expectation was that at least eleven would sit. Hudson, PCIJ 1922 HARV. L. REV. at 262.

**177** Moore, *Organization of PCIJ* at 506. See Hudson, PCIJ 1922 HARV. L. REV. at 262.

**178** BUSTAMANTE at 143–144.

**179** Hudson, PCIJ 1922 HARV. L. REV. at 264.

**180** An overview of the arguments was the subject of discussion in various venues, and a set of comments are in the *Proceedings of the Academy of Political Science*. See Borchard at 124. Charles Evans Hughes, then Secretary of State, put forth the arguments for the United States to join. See Hughes at 140. The 1926 Senate debate, complete with a filibuster, is reported to have filled more than three hundred pages of the Congressional Record. Marjorie Jane Bomberger, The Campaign for American Membership in the Permanent Court of International Justice 10 (M.A. thesis, U. of Chicago, Chicago, IL, Dec. 1936).

**181** Bomberger at 36.

**182** Bomberger at 42–130.

**183** Hughes at 151.

**184** Message of President Hoover to the Senate Transmitting Protocols Concerning Adherence of the United States, Dec. 10, 1930, Permanent Court of Justice, Official Documents, 25 AMERICAN JOURNAL OF INTERNATIONAL LAW 49 (Supp. 1931).

**185** Bomberger at ii.

**186** Bomberger at 197. See also HUDSON, WORLD COURT HANDBOOK at 17–18 (stating that fifty-six states had signed the Protocol by Feb. 1, 1936).

**187** Borchard at 134.

**188** Hudson, PCIJ 1922 HARV. L. REV. at 261.

**189** Hudson, PCIJ 1922 HARV. L. REV at 264.

**190** HUDSON, WORLD COURT HANDBOOK at 7. In 1936 the Court sat in "active session" for 143 days. Id. at 8.

**191** See Permanent Court of International Justice, Publications of the Permanent Court of International Justice (1922–1946), http://www.icj-cij.org/picj/index.php?pl=9. See also Permanent Court of International Justice, Decisions (Judgments, Advisory Opinions & Orders), http://www.worldcourts.com/pcij/eng/decisions.htm. Others describe the output as thirty-eight contentious cases and twenty-seven advisory opinions. See Charles Maechling Jr., *The Hollow Chamber of the International Court*, 33 FOREIGN POLICY 101, 101 (Winter 1978–1979).

**192** HUDSON, WORLD COURT HANDBOOK at 8. See also Permanent Court of International Justice, Publications of the Permanent Court of International Justice (1922–1946), http://www.icj-cij.org/pcij/index.php?pl=9.

**193** INTERNATIONAL COURT OF JUSTICE: HANDBOOK at 17 (The Hague, Neth.: ICJ, 5th ed., 2004) (hereinafter 2004 ICJ HANDBOOK).

**194** 2004 ICJ HANDBOOK at 17.

**195** 2004 ICJ HANDBOOK at 19.

**196** PHILIP ALLOTT, THE HEALTH OF NATIONS: SOCIETY AND LAW BEYOND THE STATE 250 (Cambridge, Eng.: Cambridge U. Press, 2002). Allott is himself an internationalist who claimed that a "new view of the human world and its law" was coming into being in the twenty-first century. Id. at 420–421.

**197** SPIERMANN at 16–18. For a discussion of the development of state liability and international law, see JAN PAULSSON, DENIAL OF JUSTICE IN INTERNATIONAL LAW (Cambridge, Eng.: Cambridge U. Press, 2005).

**198** SPIERMANN at 20. See also HUDSON, PCIJ TREATISE at 630. "Without exaggeration, the cumulation [of the court's case law pointed to] the harmonious development of the law," as the 1920 drafters had hoped.

**199** SPIERMANN at 147–186, 228–235, 393–404.

**200** Dickerson at 254.

**201** Spiermann at 13, n. 47, quoting Jessup's 1947 introduction to his book A MODERN LAW OF NATIONS.

**202** See *International Court of Justice*, 1 INTERNATIONAL ORGANIZATION 116 (Feb. 1947). That short essay noted the list of candidates nominated and reported that, as a result of the election, justices were chosen from Chile, Brazil, Egypt, France, Belgium, Mexico, El Salvador, the United States, China, Norway, the USSR, the United Kingdom, Canada, Poland, and Yugoslavia; they first met in April of 1946. As the ICJ explains the background, in 1942, as World War II was underway, the Secretary of State of the United States and the Foreign Secretary of the United Kingdom called for the reestablishment of a court. In 1943 a group of experts from eleven countries assembled in London under Sir William Malkin to draft recommendations for such a court. In 1944 the "Four Powers"—China, the USSR, the United Kingdom, and the United States—agreed to propose an international organization, and in 1945 a group of jurists from forty-four states met to prepare a draft statute. The United Nations established the Court as its "principal judicial organ." 2004 ICJ HANDBOOK at 17–18.

**203** A 2005 review of the ICJ caselaw noted that the Court in its decisions had not itself referred to its role as a principal organ of the U.N. Shabtai Rosenne, *The International Court of Justice at the Beginning of the Twenty-First Century*, in THE HAGUE: LEGAL CAPITAL OF THE WORLD 183, 192 (Peter J. van Krieken & David McKay, eds., The Hague, Neth.: T.M.C. Asser Press, 2005) (hereinafter Rosenne, *ICJ/21st Century*).

**204** U.N. Charter, Art. 33, para. 1.

**205** States may take up "the case of one of its nationals" to invoke that form of harm against another state. 2004 ICJ HANDBOOK at 35.

**206** Parties can submit disputes by agreeing ex ante in bilateral or multilateral accords or by special agreement in individual cases. A state can lodge a complaint and seek to obtain consent of the respondent state. 2004 ICJ HANDBOOK at 37–39. Further, treaties can impose such obligations. Id. at 40–42. States can also recognize the compulsory jurisdiction of the court, and do so with or without reservations. Id. at 42–46.

**207** A broader set of entities may request advisory opinions from the ICJ than those empowered to do so from the PCIJ. Rosenne, *ICJ/21st Century* at 194.

**208** See ICJ Statute, Art. 41; SHABTAI ROSENNE, PROVISIONAL MEASURES IN INTERNATIONAL LAW: THE INTERNATIONAL COURT OF JUSTICE AND THE INTERNATIONAL TRIBUNAL FOR THE LAW OF THE SEA (Oxford, Eng.: Oxford U. Press, 2005). See also Paolo Palchetti, *The Power of the International Court of Justice to Indicate Provisional Measures to Prevent the Aggravation of a Dispute*, 21 LEIDEN JOURNAL OF INTERNATIONAL LAW 623 (2008).

**209** ICJ Statute, Art. 38, para. 1. See also 2004 ICJ HANDBOOK at 91–94.

**210** ICJ Statute, Art. 38, para. 2; 2004 ICJ HANDBOOK at 94–95.

**211** U.N. Charter, Art. 93, para. 1: "All Members of the United Nations are ipso facto parties to the Statute of the International Court of Justice."

**212** U.N. Charter, Art. 94, para. 1.

**213** U.N. Charter, Art. 94, para. 2.

**214** CONSTANZE SCHULTE, COMPLIANCE WITH DECISIONS OF THE INTERNATIONAL COURT OF JUSTICE 39 (Oxford, Eng.: Oxford U. Press, 2004).

**215** See Fabián O. Raimondo, *The International Court of Justice as a Guardian of the Unity of Humanitarian Law*, 20 LEIDEN JOURNAL OF INTERNATIONAL LAW 593, 597 (2007) .

**216** See Military and Paramilitary Activities (*Nicaragua v. United States of America*), 1986 I.C.J. Rep. 14 (June 27) (hereinafter *Nicaragua Judgment*). The ICJ found that the United States was internationally responsible because of its failure to notify the existence of minefields, a failure that constituted a breach of obligations under customary law. Raimondo at 598, summarizing para. 292, subpara. 8, of the Nicaragua Judgment. See Jonathan I. Charney, *Disputes Implicating the Institutional Credibility of the Court: Problems of Non-Appearance, Non-Participation, and Non-Performance*, in THE INTERNATIONAL COURT OF JUSTICE AT A CROSSROADS 288 (Lori Fisler Damrosch, ed., Dobbs Ferry, NY: Transnational, 1987).

**217** See *United States v. Sanchez-Llamas*, 548 U.S. 331, 353 (2006). At issue was whether a belated claim by a convicted defendant of a failure to provide consular notification, as required by an international convention, ought to prompt reconsideration of his conviction. The International Court of Justice had so ruled. See *LaGrand* (*F.R.G. v. U.S.*), 2001 I.C.J. 466 (June 27) and *Avena and Other Mexican Nationals* (*Mex. v. U.S.*), 2004 I.C.J. 12 (Mar. 31). The United States Supreme Court disagreed—and thus neither state nor federal courts had to hear such prisoner claims if not properly raised under U.S. domestic law.

**218** "The Court shall be composed of a body of independent judges, elected regardless of their nationality from among persons of high moral character, who possess the qualifications required in their respective countries for appointment to the highest judicial offices, or are jurisconsults of recognized competence in international law." ICJ Statute, Art. 2. The reference to "jurisconsults" permits those individuals such as professors who might not be on a political or legal track within a domestic judiciary to serve on the ICJ. Article 3 provides that no two jurists may come from the same state and that a person who is nominated and has nationality in more than one state shall be deemed a national of the state in which that person "ordinarily exercises civil and political rights." ICJ Statute, Art. 3.

**219** Rosenne, *ICJ/21st Century* at 194. See also Davis R. Robinson, *The Role of Politics in the Election and the Work of Judges of the International Court of Justice*, 97 AMERICAN SOCIETY OF INTERNATIONAL LEGAL PROCESSES 277, 278 (2003). Voting is done in both the Security Council and the General Assembly, to which states that are not members of the United Nations but are parties to the ICJ Statute may vote. A candidate needs "an absolute majority of votes in both the General Assembly and the Security Council." 2004 ICJ HANDBOOK at 23. Further, the practice has developed that each geographical group recognized by the General Assembly decides on its candidate(s), leaving the General Assembly and the Security Council little choice. Rosenne, *ICJ/21st Century* at 193.

**220** ICJ Statute, Art. 31, paras. 2 & 3; Revised Rules of the Court, July 1, 1978, Arts. 35–37, http://www.icj-cij.org/documents/index.php?p1=4&p2=3&p3=0.

**221** Eric A. Posner & Miguel F. P. de Figueiredo, *Is the International Court of Justice Biased?* 34 JOURNAL OF LEGAL STUDIES 599, 615 (2005) (hereinafter Posner and Figueiredo). Findings are summarized in Eric Posner, *The International Court of Justice: Voting and Usage Statistics*, 99 AMERICAN SOCIETY INTERNATIONAL LAW PROCEEDINGS 130 (2005) (hereinafter Posner, *ICJ Voting and Usage*).

**222** Posner & Figueiredo at 615. See also Eric A. Posner, *The Decline of the International Court of Justice*, in INTERNATIONAL CONFLICT RESOLUTION 111 (Stefan Voigt, Max Albert, & Dieter Schmidtchen, eds., Tübingen, Ger.: Mohr Siebeck, 2006) (hereinafter Posner, *ICJ Decline*).

**223** A chamber of summary procedure comprises five judges, including the President and Vice President of the ICJ. The court can also compose special chambers, and the use of chambers is subject to parties' consent. 2004 ICJ HANDBOOK at 32–33.

**224** See Robinson at 280, citing the Gulf of Maine Case involving the United States and Canada.

**225** Robinson, at 281, described a "consultation" between one of the judges on the court and Nicaraguan national representatives about the pending case, in which the United States was the defendant, alleged to have shipped arms to Nicaragua.

**226** See International Court of Justice, All Members, http://www.icj-cij.org/court/index.php?p1=1&p2=2. Before joining the Court, Dame Higgins was a practicing barrister, a Queen's Counsel, and a professor of international law. Women had served as judges on other international courts sponsored by the United Nations.

**227** Report of the International Court of Justice, 1 Aug. 2007–31 July 2008, Chapter IV: Functioning of the Court, U.N. Doc. A/63/4 (2008) (hereinafter 2008 ICJ Report). In the late 1980s, by way of comparison, the ICJ's staff, including in its own library, numbered about forty, with additional temporary staff for linguistic needs. EYFFINGER, PEACE PALACE at 161. The Peace Palace Library has a separate staff of twenty-five. See Peace Palace Library, About, Meet Our Staff, http://www.ppl.nl/index.php?option+com.

**228** The photograph in figure 174 by D-VORM.NL, Leidschendum, the Netherlands is reproduced courtesy of the Carnegie Foundation.

**229** B. Ingenhousz designed the chandeliers, which were manufactured by Braat of Delft. EYFFINGER, PEACE PALACE at 159.

**230** KERKVLIET & MELLINK at 32. See also *A Glimpse of the Palace of Peace*. Douglas Strachan, who lived from 1875 to 1950, is known for his design of the National War Memorial in Scotland. See Juliette MacDonald, *"Let Us Now Praise the Name of Famous Men": Myth and Meaning in the Stained Glass of the Scottish National War Memorial*, 14 JOURNAL OF DESIGN HISTORY 117 (2001).

**231** EYFFINGER, PEACE PALACE at 159.

**232** KERKVLIET & MELLINK at 32. The painting by Albert Besnard was a gift from France. Before its installation, it was to be shown in the United States, but for a time was lost in transit. See *Besnard's Painting of "Peace" Missing*, NEW YORK TIMES, Dec. 23, 1915, at 6. The dimensions, twenty-three feet by fifteen feet, are provided in *A Glimpse of the Palace of Peace*.

**233** The tours of the Peace Palace note this reference.

**234** *Besnard's Decoration for the Peace Palace Shows Symbols by No Means Cryptic*, NEW YORK TIMES, Oct. 19, 1913, at SM15. The discussion was predicated on a photograph of the cartoon and described to include a "pair of scales" suspended above the three figures. A woman stood between "a soldier in armor" and "apparently a friar." The composition was said to be "characteristically French . . . requiring practically no explanation and carried out with admirable logic." Id. In the final picture, the three at the top are described as philosophers disputing. EYFFINGER, PEACE PALACE at 159.

**235** ICJ Rules, Art. 94, para. 2.

**236** EYFFINGER, PEACE PALACE at 123.

**237** EYFFINGER, PEACE PALACE at 126–128.

**238** EYFFINGER, PEACE PALACE at 126–128.

**239** EYFFINGER, PEACE PALACE at 124. The photograph in figure 175 is reproduced courtesy of the Carnegie Foundation.

**240** EYFFINGER, PEACE PALACE at 124–125.

**241** ARTHUR EYFFINGER, THE INTERNATIONAL COURT OF JUSTICE, 1946–1996, at 122 (Boston, MA: Kluwer Law International, 1996) (hereinafter EYFFINGER, ICJ).

**242** City of The Hague, *The Peace Palace Library*, http://www.denhaag.com/www.ppl.nl/.

**243** Maxwell at 77.

**244** Maxwell at 77.

**245** Maxwell at 80.

**246** See Steven van Hoogstraten, *A View from the Peace Palace*, in THE HAGUE: LEGAL CAPITAL OF THE WORLD 530; ICJ QUESTIONS AND ANSWERS.

**247** City of The Hague, *The Carnegie Foundation*, http://www.denhaag.nl.

**248** See 2008 ICJ Report at paras. 228–234. The Court lists in its 2008–2009 biennium budget $2,668,600 for "Rent/maintenance of premises." Id. at para. 234.

**249** 2008 ICJ Report at para. 234.

**250** City of The Hague, *The Hague Academy of International Law*.

**251** City of The Hague, *The Hague Academy of International Law*.

**252** One compendium offered an overview, as of 2006, that encompassed more than 1,500 pages. See THE STATUTE OF THE INTERNATIONAL COURT OF JUSTICE: A COMMENTARY (Andreas Zimmermann, Christian Tomuschat, & Karin Oellers-Frahm, eds., New York, NY: Oxford U. Press, 2006).

**253** See, for example, Rosenne, *ICJ/21st Century* at 183–203; Raimondo at 593.

**254** See, for example, HE Judge Pieter Kooijmans, *The ICJ in the 21st Century: Judicial Restraint, Judicial Activism, or Proactive Judicial Policy*, 56 INTERNATIONAL & COMPARATIVE LAW QUARTERLY 741 (2007).

**255** Fergus Green, *Fragmentation in Two Dimensions: The ICJ's Flawed Approach to Non-State Actors and International Legal Personality*, 9 MELBOURNE JOURNAL OF INTERNATIONAL LAW 47, 47 (2008). The International Law Commission's working group on fragmentation produced annual reports that are available online.

**256** See Clark B. Lombardi, *Islamic Law in the Jurisprudence of the International Court of Justice: An Analysis*, 8 CHICAGO JOURNAL OF INTERNATIONAL LAW 85 (2007).

**257** Cesare P. R. Romano, general editor, Preface to SCHULTE at vii.

**258** See Rosalyn Higgins, *MacDermott Lecture 2008: Litigating International Disputes—The Work of the International Court of Justice in a Changing World*, 59 NORTHERN IRELAND LEGAL QUARTERLY 339 (2008).

**259** Rosalyn Higgins, *The ICJ, the ECJ, and the Integrity of International Law*, 52 INTERNATIONAL & COMPARATIVE LAW QUARTERLY (2003) at 18–19. Examples of conflicts cited included a disagreement between the European Court of Human Rights and the ICJ on *Loizidou v. Turkey*, 1996-VI Eur. Ct. H.R. 2216, and also when an arbitral tribunal revoked the provisional measures granted by the International Tribunal for the Law of the Sea in *Southern Bluefin Tuna*, 39 I.L.M. 1359 (2000). See generally MICHAEL DOUGAN, NATIONAL REMEDIES BEFORE THE COURT OF JUSTICE: ISSUES OF HARMONIZATION AND DIFFERENTIATION (Portland, OR: Hart Publishing, 2004).

**260** SCHULTE at 6–17.

**261** Colter Paulson, *Compliance with Final Judgments of the International Court of Justice Since 1987*, 98 AMERICAN JOURNAL OF INTERNATIONAL LAW 434, 436–452 (2004).

**262** Paulson at 436–452.

**263** SCHULTE at 184. See the *Nicaragua Judgment*.

**264** SCHULTE at 403.

**265** Paulson at 458–459.

**266** SCHULTE at 460.

**267** SCHULTE at 2.

**268** 2004 ICJ HANDBOOK at 47.

**269** Posner, *ICJ Voting and Usage* at 131–132.

**270** 2004 ICJ HANDBOOK at 21, 103. Posner counts somewhat differently, finding only eighty-nine filings in the same time period. Posner, *ICJ Voting and Usage* at 131–132.

**271** Report of the International Court of Justice, 1 Aug. 2005–31 July 2006, paras. 86–87, U.N. Doc. A/61/4 (2006) (hereinafter 2006 ICJ Report); Report of the International Court of Justice, 1 Aug. 2004–31 July 2005, para. 104, U.N. Doc. A/60/4 (2005); Report of the International Court of Justice, 1 Aug. 2003–31 July 2004, paras. 103–105, U.N. Doc. A/59/4 (2004); Report of the International Court of Justice, 1 Aug. 2002–31 July 2003, para. 102, U.N. Doc.

A/58/4 (2003); Report of the International Court of Justice, 1 Aug. 2001–31 July 2002, para. 94, U.N. Doc. A/57/4 (2002); Report of the International Court of Justice, 1 Aug. 2000–31 July 2001, para. 87, U.N. Doc. A/56/4 (2001); Report of the International Court of Justice, 1 Aug. 1999–31 July 2000, para. 79, U.N. Doc. A/55/4 (2000). Not all ICJ cases reached the merits. Among these were eleven cases in which the court dismissed the case for lack of jurisdiction, and eight that concerned Serbia and Montenegro's claims against eight different western powers collected into one proceeding. Also included were the ICJ's denial of permission to the Republic of the Philippines to intervene in a maritime border dispute and two judgments that it would not revise previous decisions.

Time to disposition varied widely. The three cases decided on the merits between August 2007 and July 2008 had been pending since 1999, 2003, and 2006. 2008 ICJ Report at 24, 32, 37. Some cases were stalled for reasons beyond the Court's control. The Gabčíkovo-Nagymaros Project case between Hungary and Slovakia has been on the court's docket since 1993; the States Parties have been in negotiations since 1998. Id. at 19.

**272** 2006 ICJ Report at 18–19. The Court decided one case on the merits, while it dismissed a related case for lack of jurisdiction. See also Stephen Mathias, *The 2006 Judicial Activity of the International Court of Justice*, 101 AMERICAN JOURNAL OF INTERNATIONAL LAW 602 (2007). Mathias noted that, while the court had issued only one judgment in the 2006 calendar year, the ICJ had also conducted hearings for more than two months in the case involving Bosnia and Herzegovina and Serbia and heard requests for provisional measures related to the River Uruguay. That case had originally begun as a lawsuit by Bosnia and Herzegovina against Yugoslavia; by the time of adjudication, Yugoslavia had been reduced to Serbia. In addition to that proceeding, the ICJ had also added two new cases to its list of those pending. Id. at 602.

**273** Report of the International Court of Justice, 1 Aug. 2006–31 July 2007, paras. 90–91, U.N. Doc. A/62/4 (2007).

**274** 2008 ICJ Report, at 18.

**275** In some disputes, cases could be pursued in the ICJ and in another international court, such as the International Tribunal for the Law of the Sea (ITLOS). In other instances, aspects of a case could be dealt with in one forum, such as the International Criminal Tribunal for the former Yugoslavia (ICTY), and other aspects brought to the ICJ. See John Quigley, *International Court of Justice as a Forum for Genocide Cases*, 40 CASE WESTERN RESERVE JOURNAL OF INTERNATIONAL LAW 243 (2008). For example, as discussed earlier, in 1993 Bosnia and Herzegovina sued Yugoslavia (now Serbia) in the ICJ, arguing that it had failed to prevent and punish genocide, while related prosecutions were ongoing in the ICTY. The ICJ ruled that it had jurisdiction and further that Serbia had not committed or conspired to commit genocide. See Richard Graving, *The International Court of Justice Muddles Jurisdiction in Yugoslav Genocide Case*, 15 TULANE JOURNAL OF COMPARATIVE & INTERNATIONAL LAW 29 (2007).

**276** Maechling at 101.

**277** Posner, *ICJ Decline* at 114–115. Posner's analysis of a histogram of cases filed each year (in his fig. 1) illustrated his perspective. He noted that the seeming growth of the ICJ docket was inflated by counting ten filings as a single case with ten respondents. He also pointed out that relative to the growth in the number of potential parties, filing growth lagged. Posner therefore read the data as showing the ICJ's decline; he compared the docket not to its past numbers but to what he thought was its potential. Id. Others might see the current caseload density as a sign of the ICJ's significance.

**278** William D. Coplin & J. Martin Rochester, *The Permanent Court of International Justice, the International Court of Justice, the League of Nations, and the United Nations: A Comparative Empirical Survey*, 66 AMERICAN POLITICAL SCIENCE REVIEW 529 (1972).

**279** See, for example, Raimondo at 610–611; Paulson, *Compliance with ICJ Final Judgments*. Paulson noted that some advocated that the ICJ avoid deciding cases in which compliance would be unlikely. Id. at 435. In terms of the PCIJ, for example, one commentator thought it a "modest . . . success" in helping to avoid war in various disputes, such as the expropriation of land. Maechling at 102.

**280** SCHULTE at 1.

**281** Maechling at 101.

**282** Posner, *ICJ Decline* at 111.

**283** Romano at vii. See also Rosalyn Higgins, *Alternative Perspectives on the Independence of International Courts: Remarks*, 99 AMERICAN SOCIETY OF INTERNATIONAL LAW PROCEEDINGS 135 (2005).

**284** KERKVLIET & MELLINK at 5.

**285** Hans van den Broek, President of Carnegie Foundation, *Foreword* to EYFFINGER, TRUSTEESHIP at 5.

**286** The photograph in figure 176, copyright YPScollection, 2005, is provided courtesy of the International Tribunal for the Law of the Sea. Our thanks to Julia Ritter, Press Officer of the tribunal, for facilitating our use of the images of the ITLOS building and providing us with other materials, and to Douglas Guilfoyle of the Univesity College London's Law Faculty for his review of our discussion of ITLOS.

**287** United Nations Convention on the Law of the Sea, Dec. 10, 1982, 1833 U.N.T.S. 397 (hereinafter UNCLOS). Annex VI, Art. 1, para. 2, provides: "The seat of the Tribunal shall be in the Free and Hanseatic City of Hamburg in the Federal Republic of Germany." See United Nations, http://www.un.org/Depts/los/convention_agreements/texts/unclos/closindx.htm.

**288** Agreement Relating to the Implementation of Part XI of the United Nations Convention on the Law of the Sea of 10 December 1982, July 28, 1994, S. Treaty Doc. No. 103-39, 1836 U.N.T.S. 41, http://www.un.org/Depts/los/convention_agreements/texts/unclos/closindx.htm (hereinafter Implementation Agreement). See generally NATALIE KLEIN, DISPUTE SETTLEMENT IN THE UN CONVENTION ON THE LAW OF THE SEA 52–117 (New York, NY: Cambridge U. Press, 2005).

**289** The Hanseatic League was a "commercial and political union of North and Baltic Sea cities." In the early middle ages, Hamburg became a "free imperial city." International Tribunal for the Law of the Sea, Documentation of the International Competition at 106 (hereinafter ITLOS Documentation, International Competition). Staff of the tribunal gave us a series of documents about the design competition. Not all of the ITLOS design documents include dates and pagination; we have added page numbers when needed for identification.

**290** International Tribunal for the Law of the Sea, Competition Document (Wehlsen Gmblt, Hamburg, Germany, undated) at 25 (hereinafter ITLOS Competition Document).

**291** Germany ratified both the Convention proper and Part XI in October of 1994. See UN Division for Ocean Affairs and the Law of the Sea, Chronological lists of ratifications of, accessions and successions to the Convention and the related Agreements (as of 2008), http://www.un.org/Depts/los/reference_files/chronological_lists_of_ratifications.htm (hereinafter UNCLOS Ratifications).

**292** International Tribunal of the Law of the Sea, Final Design (Wehlsen Gmblt, Hamburg, Germany, undated) at 5 (hereinafter ITLOS Final Design). Also reproduced is the March 18, 1981, letter from the head of the delegation of the Federal Republic of Germany to the Third Conference of the Law of the Sea that explained why it would be appropriate to select Hamburg. Id. at 11. In the Documentation on the International Competition, discussion of the propriety of choosing Hamburg as a site is reproduced, and we assume that these materials reflect what had been provided in the 1981 brochure. See ITLOS Documentation, International Competition (Wehlsen Gmblt, Hamburg, Germany, undated) at 106–119.

**293** ITLOS Documentation, International Competition at 106.

**294** ITLOS Documentation, International Competition at 116.

**295** ITLOS Documentation, International Competition at 108.

**296** ITLOS Documentation, International Competition at 112.

**297** ITLOS Documentation, International Competition at 114.

**298** ITLOS Documentation, International Competition at 108.

**299** ITLOS Final Design at 11 (reproducing the March 17 letter from the head of Germany's delegation to the conference).

**300** ITLOS Documentation, International Competition at 2.

**301** As the documents for the court building competition explained the propriety of the setting, the "Free and Hanseatic City of Hamburg" was a thousand-year-old port that had become "a centre of international trade and commerce, a European traffic junction, a city of science and learning, a city of courts and administration as well as culture," and considered itself "a mediator between all regions of the world." ITLOS Competition Document at 28–30.

**302** ITLOS Documentation, International Competition at 8. That commission drafted rules for the tribunal, draft protocols of immunity for its representatives, and the like. Id. at 8–10.

**303** "After the competition design period, from 10 July to 28 August 1989, an intensive preliminary assessment of the submissions was performed, which was based on predetermined criteria and programme points. The results are contained in the preliminary report which was presented at the beginning of the jury sitting in the City Hall of Hamburg, on 12 September 1989. . . . Architektenteam R. Klamp + D. Hartwich described each of the fifteen submissions and the results of the preliminary assessment [to the jury]." ITLOS Documentation, International Competition at 14–15.

**304** See Helmut Tuerk, *The Contribution of the International Tribunal for the Law of the Sea to International Law*, 26 PENNSYLVANIA STATE INTERNATIONAL LAW REVIEW 289, 290–291 (2007). Information on the Seabed Authority's working space comes from its website, http://www.isa.org.jm/en/home.

**305** Indeed, some English lawyers raised the concern that London had missed out by not seeking to be the tribunal's seat, to the detriment of its bar. See *Hamburg Court to Ship Work away from City*, THE LAWYER, July 19, 1999, at 4.

**306** ITLOS Report of the Jury (minutes of the Jury), Sept. 12 & 13, 1989, at 2.

**307** This point is made on the website of the German Foreign Office (The United Nations Convention on the Law of the Sea, http://www.auswaertiges-amt.de/diplo/en/Aussenpolitik/InternatRecht/Seerecht/seerecht.html) and similarly in the Final Design materials of ITLOS. See ITLOS Final Design at 6.

**308** The first case to be decided by ITLOS—called the *Saiga Case*—involved a ship "owned by a Cypriot shipping company and managed by a Scottish company; the vessel was seized by Guinea in its exclusive economic zone." The ship had been "chartered by a Swiss company and was sailing under the flag of St. Vincent and the Grenadines. The crew came from the Ukraine; other workers were Senegalese citizens, and the cargo was owned by yet another Swiss company." Press Release, ITLOS, Statements Delivered at the Official Opening of the Headquarters Building of the Tribunal (July 17, 2000) at 6 (Statement of Herta Däubler-Gmelin), http://www.itlos.org/cgi-bin/news/news_press.pl?language=en&year=2000 (hereinafter ITLOS Opening Statements).

**309** Tuerk at 296. Judge Tuerk attributed these estimates to "[e]xperts from the German Federal Institute for Geosciences and Natural Resources." Id. See also *Convention on the Law of the Sea: History and Major Provisions*, 3 INTERNATIONAL DEBATES 100, 100–101 (2005), http://www.un.org/Depts/los/convention_agreements/convention_historical_perspective.htm (hereinafter UNCLOS Historical Perspective).

**310** R. R. Churchill & A. V. Lowe, The Law of the Sea 1, (Manchester, Eng.: Manchester U. Press, 3rd ed., 1999).

**311** Churchill & Lowe at 2.

**312** Churchill & Lowe at 2–3.

**313** The phrase used in the heading to this subsection appears in many speeches and discussions of the Sea Convention. See Tuerk at 290. See also Caitlyn L. Antrim, *Remarks to the Sohn Symposium: Remembering Louis Sohn*, 39 George Washington International Law Review 459, 459 (2007). Judge Tuerk, of ITLOS, discussed the decade of the Court's accomplishments. Antrim served as the Executive Director of the Rule of Law Committee for the Oceans. Both credit Tommy Koh, who was President of the 1982 UN Conference on the Law of the Sea, with coining the phrase "Constitution for the Oceans."

**314** Churchill & Lowe at 14.

**315** Churchill & Lowe at 14–15.

**316** Various documents and persons are credited as instrumental in seeking protection for the seas, the "common heritage of mankind." See Tuerk at 290, citing the "Memorandum of Malta" of the Permanent Mission of Malta to the United Nations, U.N. Doc. A/6695 (Aug. 17, 1967), and calling it an essential "spark." See also Rüdiger Wolfrum, *A Tribute to Louis Sohn*, 39 George Washington International Law Review 675 (2007). Wolfrum, Judge and President of ITLOS and Director of the Max Planck Institute for Comparative Public Law and International Law, celebrated Sohn for developing the theory of "world peace through world law" and contributing to the development of ITLOS. Id. at 676.

**317** Tuerk at 290. The chronological list of signatories is in UNCLOS Ratifications.

**318** See UNCLOS Historical Perspective at 102.

**319** The agreement was adopted in July, a few months before the Convention came into force in November 1994 after Guyana, the sixtieth state, ratified it. See UNCLOS Historical Perspective at 102.

**320** Implementation Agreement.

**321** Churchill & Lowe at 21.

**322** Antrim at 460. See also Budislav Vukas, The Law of the Sea: Selected Writings 301–315 (Leiden, Neth.: Martinus Nijhoff, 2004).

**323** Alan E. Boyle, *The Settlement of Disputes Relating to the Law of the Sea and the Environment*, in 26 International Justice 295, 301 (Kalliopi Koufa, ed., Thessaloniki, Gre.: Sakkoulas Publications 1997).

**324** Churchill & Lowe at 22.

**325** See John A. Duff, *The United States and the Law of the Sea Convention: Sliding Back from Accession and Ratification*, 11 Ocean and Coastal Law Journal 1 (2006). Opponents argued the treaty would impede security and entrepreneurship. See Jack Goldsmith and Jeremy Rabkin, *A Treaty the Senate Should Sink*, Washington Post, July 2, 2007, at A19; Doug Bandow, *The Law of the Sea Treaty: Impeding American Entrepreneurship and Investment*, Competitive Enterprise Institute (Sept. 2007). Proponents argued the treaty's utility. See *ABA Urges Ratification of U.N. Law of the Sea Convention*, 43 A.B.A. Washington Letter 1 (Oct. 2007). See generally *Foreword: Law of the Sea, A Framework for Governing the World's Oceans*, 3 International Debates 97, 97 (April 2005). Other countries also objected, such as Turkey, which took issue with "how the Convention addresses its territorial claims to portions of the Aegean Sea," as well as Venezuela and Colombia, objecting to fishery provisions. Id.

**326** See Jonathan I. Charney, *Is International Law Threatened by Multiple International Tribunals?* 271 Recueil des Cours 101, 315, 315–317 (1998).

**327** Wolfrum at 679–682. See also Rosalyn Higgins, President of the ICJ, Speech at the Tenth Anniversary of ITLOS (Sept. 29, 2006), http://www.itlos.org/news/Statement%20Higgins.pdf (hereinafter

Higgins, ITLOS 2006 Speech). Exchanges across courts could be modeled as conversations enabling norm development. See International Law Commission, Fragmentation of International Law: Difficulties Arising from the Diversificaton and Expansion of International Law, U.N. General Assembly, A/CN.4/L.702 (18 July, 2006); Giuseppe Martinico & Filippo Fontanelli, *The Hidden Dialogue: When Judicial Competitors Collaborate*, 8 Global Jurists, issue 3, article 7 (2008); Neil Walker, *Beyond Boundary Disputes and Basic Grids: Mapping the Global Disorder of Normative Orders*, 6 International Journal of Constitutional Law 373 (2008).

**328** Ted L. McDorman, *Global Ocean Governance and International Adjudicative Dispute Resolution*, 43 Journal of Ocean & Coastal Management 255, 259 (2000).

**329** See Higgins, ITLOS 2006 Speech. Higgins noted that the cases involving the law of the sea that came to the ICJ after 1997 rarely involved "purely maritime issues" and gave examples of them—including the "Land and Maritime Boundary Dispute between Cameroon and Nigeria" in 1998 and the "Frontier Dispute" between Benin and Niger in 2005, as well as cases then pending involving Nicaragua and Honduras, Romania and Ukraine, and Nicaragua and Colombia. Id. at 4.

**330** Klein at 52.

**331** Klein at 54.

**332** State Parties undertake the obligation to settle disputes by "peaceful means" indicated in the U.N. Charter. UNCLOS, Art. 279. Parties must "seek a solution by negotiation, enquiry, mediation, conciliation, arbitration, judicial settlement, resort to regional agencies or arrangements, or other peaceful means of their own choice." U.N. Charter, Art. 33, para. 1.

**333** Klein at 53. See UNCLOS, Art. 287(1). Special provisions were made for seabed arbitrations obliging arbitral panels to "refer to the ruling" of the tribunal on matters concerning the Convention. Wolfrum at 680. Part XI also created the International Seabed Authority, an administrative body charged with enforcing seabed mining rules that had, as of 2008, no seabed mining to oversee. See also Antrim at 463–464.

**334** UNCLOS, Art. 280.

**335** UNCLOS, at Part XV, sections 2 & 3. Article 297 identifies the major exceptions to the compulsory and binding procedures.

**336** Tuerk at 298. ITLOS "may prescribe, modify or revoke provisional measures" when "the urgency of the situation so requires" and parties' chosen forum has jurisdiction over the matter. UNCLOS, Art. 290, para. 5. Whenever "the authorities of a State Party have detained a vessel flying the flag of another State Party," the state of the detained vessel can submit "the question of release" to ITLOS if the parties have not agreed upon a tribunal. UNCLOS, Art. 292, para. 1. Provisional measures can be requested for disputes before the tribunal and for issues to be submitted to an arbitral panel that had not begun its work. Tuerk at 298. In the four cases described by Tuerk in which remedies were requested related to the marine environment, none were given. Id. at 299–304. The provisional measures in these cases were limited to orders that parties cooperate in reaching settlement and use "prudence and caution" to protect the environment or fishing stocks. Id. at 300. Tuerk argued that ITLOS had a "positive" record on environmental provisional remedies, even as it had not reached the merits of cases, because it had helped to create settlements and cooperation. Id. at 304. As for release proceedings, ITLOS dealt with questions of seizure and release without "prejudice to the merits of any case" before domestic fora. Id. at 305; UNCLOS, Art. 292, para. 3. Tuerk called the tribunal's record excellent for its "efficiency and speed," rendering decisions within a month. Tuerk at 306.

**337** ITLOS Opening Statements at 3 (Statement of P. Chandreskhara Rao, President of ITLOS). One could also describe the resulting scheme as a "complicated system of dispute settlement." Vukas at 303.

338 ITLOS Proceedings and Judgments—List of Cases, http://www.itlos.org/cgi-bin/cases/list_of_cases.pl?language=en. In 2009, the Government of the People's Republic of Bangladesh began arbitral proceedings against the Union of Myanmar and the Republic of India, under Annex VII of UNCLOS; jurisdiction was accepted by Myanmar, and ITLOS undertook to organize the arbitration.

339 ITLOS Opening Statements at 3 (Statement of P. Chandreskhara Rao, President of ITLOS). In 2006, when President Higgens of the ICJ spoke at the tenth anniversary of ITLOS, she noted that ITLOS had "regularly referred" to the ICJ judgments and that the ICJ had "been following the Tribunals' work closely." See Higgins, ITLOS 2006 Speech at 2.

340 ITLOS Opening Statements at 3 (Statement of President Rao).

341 Tuerk at 294. See also Higgins, ITLOS 2006 Speech at 3. Higgins noted that the first case decided by the ICJ in 1947 was a maritime dispute (about the Corfu Channel), then explained the jurisdictional distinctions, which were that the ICJ heard contentious disputes by states whereas ITLOS could offer advisory opinions and provide its services to "various non-state actors." Id. Further, some cases fell within both courts' competencies, but the Convention drafters had "expressed a preference for the Tribunal to handle disputes over the prompt release of vessels." Id. at 4.

342 Boyle at 351.

343 Wolfrum at 680. See also Vukas at 305–309.

344 Tuerk at 292.

345 Wolfrum at 682. Another example provided is the 2001 Convention on the Protection of Underwater Cultural Heritage.

346 Tuerk at 293.

347 See, for example, Thomas A. Mensah, *The Tribunal and the Prompt Release of Vessels*, 22 International Journal of Marine & Coastal Law 425 (2007); Donald R Rothwell & Tim Stephens, *Illegal Southern Ocean Fishing and Prompt Release: Balancing Coastal and Flag State Rights and Interests*, 53 International & Comparative Law Quarterly 171 (2004).

348 Selected provisions are in the Statute of the International Court of Justice, June 26, 1945, Art. 3-15, 59 Stat. 1055, T.S. No. 993.

349 UNCLOS, Annex VI, Arts. 2, 5.

350 UNCLOS, Annex VI, Art. 2.

351 Tuerk at 294.

352 Tuerk at 294. "No two members of the tribunal may be nationals of the same State . . . [with] no fewer than three judges from each geographical group as established by the General Assembly of the United Nations." UNCLOS Annex VI, Art. 3. Tuerk stressed that these rules and its larger size made ITLOS "more representative" than the ICJ. Tuerk at 294.

353 Tuerk at 294.

354 Vukas at 304.

355 For example, early in ITLOS's existence, one commentator anticipated it would have "norm-reinforcing, legislative, equitable, and constitutional functions." John E. Noyes, *The International Tribunal for the Law of the Sea*, 32 Cornell International Law Journal 109, 172 (1998).

356 UNCLOS, Annex VII, Art. 3.

357 UNCLOS, Annex VII, Art. 5.

358 See EC Treaty, Art. 292, and the later discussion of *Commission of the European Communities v. Ireland*; Tuerk at 302–303.

359 Churchill & Lowe at 458.

360 Churchill & Lowe at 456–457.

361 UNCLOS, Annex VI, Art. 17. See also Wolfrum at 682, regarding parties' selection of jurists for ad hoc chambers.

362 Wolfrum at 682.

363 Vukas at 312 (citing UNCLOS, Art. 293, para. 2). Vukas noted that certain transnational norms, "jus cogens," could not be excluded. Id.

364 California has authorized the use of private judge dispute resolution in its Code of Civil Procedure. See Cal. Civ. Proc. Code §§ 638–644 (2008). See also Rex R. Perschbacher & Debra Lyn Bassett, *The End of Law*, 84 Boston University Law Review 1, 30–31 (2004).

365 Wolfrum at 683. Costs come out of ITLOS's operating budget.

366 Vukas at 304. For a party that is not an ITLOS member, "the Tribunal shall fix the amount which that party is to contribute towards the expenses of the Tribunal." UNCLOS, Annex VI, Art. 19.

367 The States Parties determine contribution amounts at their annual meeting. UNCLOS, Annex VI, Art. 19. For the 2009–2010 budget, contributions were "based upon the scale of assessments of the regular budget of the United Nations for the preceding financial year, adjusted to take account of participation in the Convention," with "a floor rate of 0.01 per cent and a ceiling rate of 22 per cent" and a contribution of 80,000 euros (roughly $112,000) from Europe. ITLOS website, *Budgets of the Tribunal*, http://www.itlos.org/general_information/registry/budgets_en.shtml (hereinafter *Budgets of the Tribunal*).

368 See UNCLOS, Arts. 287(3), 287(5).

369 The villa was to be renovated as part of the construction. ITLOS Documentation of International Competition at 118. The architects who submitted proposals wrestled with the challenges of how to put the villa into the plans. Id. at 24–103.

370 Our thanks to Johanna van Kisfeld of the ITLOS Press Office for this information. As Germany also explained: "In 1986 the Federal cabinet decided to construct premises for the International Tribunal on state-owned land in Hamburg and to place these, as well as furnishings and fittings, at the disposal of the International Tribunal free of charge." Federal Foreign Office of Germany website, ITLOS section, http://www.auswaertiges-amt.de/diplo/en/Aussenpolitik/InternatRecht/Seerecht/Seetribunal.html. See also Hugh O'Mahony, *Happy Birthday to the Court that Has Heard 12 Cases in Eight Years*, Lloyd's List, Nov. 2, 2004, at 5.

371 Those rules were published in 1979. See ITLOS Competition Document at 9–11. The criteria for the building were developed by the German planning ministry in conjunction with U.N. officials. See ITLOS Final Design at 6. UNESCO is the acroynm for the United Nations' Educational, Scientific, and Cultural Organization.

372 The Clarification Minutes of April 25, 1998, reported that both Rogers, of the United Kingdom, and Tadao Ando of Japan would not compete. International Tribunal for the Law of the Sea, *Clarification Minutes of April 25, 1998*, in Pleadings, Minutes of Public Sittings and Documents, vol. 2, at 6 (hereinafter ITLOS Clarification Minutes).

373 ITLOS Final Design at 13.

374 See ITLOS Competition Document at 10, 12–13.

375 UNCLOS, Annex VII, Art. 3.

376 ITLOS Competition Document at 26.

377 ITLOS Competition Document at 53.

378 ITLOS Competition Document at 27.

379 International Tribunal for the Law of the Sea, *Frequently Asked Questions*, http://www.itlos.org/faq/faq_en.shtml (hereinafter ITLOS FAQs). As of 2008, the ECJ employed 796 translators. ECJ, Departments of the Institution, Translation, http://curia.europa.eu/en/instit/services/traduction/traduction.htm. ITLOS, by contrast, had one translator. International Tribunal for the Law of the Sea, Yearbook 2006 at 19 (Leiden, Neth.: Martinus Nijhoff, 2007).

380 ITLOS Competition Document at 47, 67.

381 ITLOS Clarification Minutes at 14.

382 ITLOS Documentation, International Competition at 17, citing Judge Helmut Plambeck, President of the Hanseatic Constitutional Court and an expert juror, who called for these attributes.

**383** ITLOS Competition Document at 47.

**384** ITLOS Competition Document at 51.

**385** ITLOS Competition Document at 47.

**386** ITLOS Final Design at 34.

**387** ITLOS Final Design at 34.

**388** ITLOS Competition Document at 48.

**389** ITLOS Clarification Minutes at 13.

**390** ITLOS Report of the Jury at 4. The mayor urged his country's government to come to "a common solution." Id at 5.

**391** Germany did so on October 14, 1994, and joined both the Convention and Part XI. Further, in December of 2003, Germany ratified portions of the Convention dealing with "conservation and management of straddling fish stocks and highly migratory fish stocks." See UNCLOS Ratifications.

**392** ITLOS Documentation of International Competition at 24–103. In addition to the von Brancas from Munich, who won the contest, materials were provided from Schweger + Partner and from Marg + Partner, both from Hamburg; Abraham Zabludovsky and Teodoro Gonzales de Leon of Mexico City; Tomas Taveira of Lisbon; Bangert Jansen and Scholze Schultes of Berlin; Jean Nouvel, Emmanuel Cattani, and Associates of Paris; Dissing + Weitling of Copenhagen; and seven others. Id.

**393** ITLOS Final Design at 14, 19. Alexander Freiherr von Branca also designed the Neue Pinakothek (New Museum) in Munich. See Neue Pinakothek, http://www.pinakothek.de/neue-pinakothek/museum/sammlungsgeschichte/sammlungsgeschichte_en.php.

**394** ITLOS Final Design at 13.

**395** *Secretary-General Inaugurates Law of Sea Tribunal in Hamburg, as Trip to Germany Continues*, FEDERAL NEWS SERVICE, Oct. 21, 1996.

**396** In 2004 a Headquarters Agreement between the International Tribunal for the Law of the Sea and the Federal Republic of Germany was signed to detail the legal agreement and the status of the staff, judges, witnesses, and agents of the parties. Press Release, ITLOS, Signature of Headquarters Agreement at 1 (Dec. 15, 2004). Figure 177, photographed by Hans Georg Esch, Bad Hennef in 2001, is provided courtesy of ITLOS.

**397** ITLOS FAQs, *Budgets of the Tribunal*. The approved budget for 2009–2010 was $22,603,249 or 17,515,100 euros. Id.

**398** ITLOS Final Design at 22.

**399** The case involved pollution coming from the MOX Plant and produced a conflict between Ireland and the United Kingdom at ITLOS in 2001. As detailed in other notes, the ECJ subsequently determined that it had exclusive jurisdiction. See *Commission of the European Communities v. Ireland*, Case C-459/03, 2006 E.C.R. I-4635. Figure 178, photographed by Stephan Wallocha, is provided courtesy of ITLOS.

**400** ITLOS Final Design at 38.

**401** ITLOS Final Design at 36.

**402** Report of the German Delegation on the Building Requirements and Facilities for the International Tribunal for the Law of the Sea in Hamburg, March 9, 1992, at 2, U.N. limited distribution document LOS/PCN?SCN.4/L.16. This document is cited in the design guides.

**403** See *Product Review: 503 Schuco*, ARCHITECTURAL REVIEW, Feb. 2002, at 88.

**404** ITLOS Final Design at 19.

**405** ITLOS Final Design at 19, 32.

**406** ITLOS Final Design at 32. As in the materials on the Peace Palace, ITLOS design documents include descriptions of other submissions the jury ranked among the first six. Documentation of the International Competition at 44–102; ITLOS, Report of the Jury (Minutes of the Jury Sitting), International Competition 1–38 (Sept. 12 & 13, 1989).

**407** ITLOS Final Design, Extracts from the Architects' Report at 38–41.

**408** O'Mahony at 5.

**409** ITLOS FAQs.

**410** See, for example, Sabina Casagrande, *Germany—Law of the Sea Headquarters Opens*, LLOYD'S LIST, July 3, 2000, at 5 (citing the Court's spokesperson to the effect that the "Court of Human Rights, for example, only had three cases in its first nine years").

**411** UNCLOS Ratifications.

**412** Tuerk at 296.

**413** Rosemary Rayfuse, *The Future of Compulsory Dispute Settlement under the Law of the Sea Convention*, 36 VICTORIA UNIVERSITY WELLINGTON LAW REVIEW 683 (2005).

**414** Tuerk at 297.

**415** Wolfrum at 683.

**416** See *Commission of the European Communities v. Ireland*, Case C-459/03, 2006 E.C.R. I-4635. The ECJ ruled that, in light of a provision of the EC Treaty that "Member States undertake not to submit a dispute concerning the interpretation or application of this treaty to any method of settlement other than those provided for therein" (Article 292), and in light of the fact that the EC and its Member States had ratified the Sea Convention, that convention became community law and hence Ireland's complaint about radioactive discharges from a factory situated in Sellafield, England, was therefore governed by EU law and to be decided by the ECJ. As the ECJ explained, "an international agreement such as [UNCLOS] cannot affect the exclusive jurisdiction of the [ECJ] in regard to the resolution of disputes between member states concerning the interpretation and application of Community law." Id. at para. 132. See also Nikolaos Lavranos, *The MOX Plant Judgment of the ECJ: How Exclusive Is the Jurisdiction of the ECJ?* 15 EUROPEAN ENERGY & ENVIRONMENTAL LAW REVIEW 291 (2006).

**417** Wolfrum at 683.

**418** David Anderson, *The Judicial Work of the International Tribunal for the Law of the Sea*, in MODERN LAW OF THE SEA: SELECTED ESSAYS, ch. 33 at 567 (Boston, MA: Martinus Nijhoff, 2008).

**419** Maritime disputes were decided through the ICJ and ad hoc tribunals before ITLOS and have been since. See Charney, *Is International Law Threatened by Multiple International Tribunals?* at 315–317.

**420** Rayfuse at 709.

**421** Rayfuse at 711.

**422** Other specialized tribunals, past, extant, and forthcoming, include those in Nuremberg, Cambodia, Timor L'Este, Kosovo, and Lebanon, most with jurisdiction over international crimes. These courts have various forms. For example, the Extraordinary Chambers in the Courts of Cambodia was created in 1997 by special agreement between the United Nations and the Government of Cambodia. Situated within the court system of Cambodia, the Extraordinary Chambers has its own set of rules and law. See *Introduction: Extraordinary Chambers in the Courts of Cambodia*, http://www.eccc.gov.kh/English/about_eccc.aspx.

**423** HUGO GROTIUS, THE LAW OF WAR AND PEACE (Louise Ropes Loomis, trans., Roslyn, NY: Walter J. Black, 1949). See also BENJAMIN N. SCHIFF, BUILDING THE INTERNATIONAL CRIMINAL COURT 14–17 (Cambridge, Eng.: Cambridge U. Press, 2008).

**424** The "Lieber Code" was promulgated by President Abraham Lincoln as General Orders No. 100 on April 24, 1863. See ADJUTANT GENERAL'S OFFICE, GENERAL ORDERS NO. 100: INSTRUCTIONS FOR THE GOVERNMENT OF ARMIES OF THE UNITED STATES IN THE FIELD (Washington, DC: Government Printing Office, 1863), http://avalon.law.yale.edu/19th_century/lieber.asp.

**425** SCHIFF at 19–20.

**426** Schiff at 21.

**427** Manley O. Hudson, *The Proposed International Criminal Court*, 32 American Journal of International Law 549, 550 (1938).

**428** Schiff at 23. See International Law Association, http://www.ila-hq.org/.

**429** Convention for the Creation of an International Criminal Court, opened for signature Nov. 16, 1937, 19 League of Nations Official Journal 37 (1938) (never entered into force).

**430** Schiff at 23.

**431** Raphael Lemkin, Axis Rule in Occupied Europe: Laws of Occupation, Analysis of Government Proposals for Redress 79 (Samantha Power, ed., Clark, NJ: Lawbook Exchange, 2005) (1944). Four years later, the Convention on the Prevention and Punishment of the Crime of Genocide used the definition of acts "committed with intent to destroy, in whole or in part, a national, ethnical, racial or religious group, as such." December 9, 1948, 102 Stat. 3045, 78 U.N.T.S. 277.

**432** U.N. War Crimes Commission, Draft Convention for the Establishment of a United Nations War Crimes Court (September 30, 1944), reprinted in Historical Survey, U.N. Doc. A/CN.4/7/Rev. 1 at 118 (1949), http://www.trumanlibrary.org/whistlestop/study_collections/nuremberg/documents/index.php?documentdate=1944-09-30&documentid=8-1&studycollectionid=&pagenumber=1.

**433** Schiff at 25. See also William Schabas, An Introduction to the International Criminal Court 5 (Cambridge, Eng.: Cambridge U. Press, 2d ed., 2004).

**434** Tribunals have been criticized as political, selectively prosecuting some and not others, and insufficiently delimited by law. See Martha Minow, Between Vengeance and Forgiveness: Facing History after Genocide and Mass Violence 26–51 (Boston, MA: Beacon Press, 1998).

**435** Schabas at 4–8.

**436** Schiff at 24–25.

**437** Special Proclamation by the Supreme Commander for the Allied Powers at Tokyo, Charter of the International Military Tribunal for the Far East, Jan. 19, 1946, T.I.A.S. No. 1589, 4 Bevans 20, as amended on Apr. 26, 1946, 4 Bevans 27 (hereinafter IMTFE Charter).

**438** Evan J. Wallach, *The Procedural and Evidentiary Rules of the Post–World War II War Crimes Trials: Did They Provide an Outline for International Legal Procedure?* 37 Columbia Journal of Transnational Law 851, 864 n. 57 (1999).

**439** IMTFE Charter, Art. 5.

**440** Statute of the International Law Commission, G.A. Res. 174 (II), Arts. 2, 10, U.N. GAOR, 2d Sess., U.N. Doc. A/519 (1947).

**441** Convention on the Prevention and Punishment of the Crime of Genocide, Dec. 9, 1948, 78 U.N.T.S. 277, U.N. G.A. Res. 260, U.N. GAOR, 3d Sess., 179th plen. mtg., U.N. Doc. A/810 (1948) (entered into force Jan. 12, 1951) (hereinafter Genocide Convention).

**442** Universal Declaration of Human Rights, G.A. Res. 217A(III), U.N. GAOR, 3d Sess., Supp. No. 16, U.N. Doc. A/810 (1948).

**443** Genocide Convention, Art. 6.

**444** Geneva Convention for the Amelioration of the Condition of the Wounded and Sick in Armed Forces in the Field, Art. 50, Aug. 12, 1949, 6 U.S.T. 3114, 75 U.N.T.S. 31; Geneva Convention for the Amelioration of the Condition of the Wounded, Sick and Shipwrecked Members of Armed Forces at Sea, Art. 51, Aug. 12, 1949, 75 U.N.T.S. 85; Geneva Convention Relative to the Treatment of Prisoners of War, Art. 130, Aug. 12, 1949, 6 U.S.T. 3316, 75 U.N.T.S. 135 (hereinafter Third Geneva Convention); Geneva Convention Relative to the Protection of Civilian Persons in Time of War, Art. 147, Aug. 12, 1949, 75 U.N.T.S. 287.

**445** Nancy Combs, *The International Criminal Court: An Analysis*, in The Hague: Legal Capital of the World 345, 347–350.

**446** See Vicki C. Jackson, *World Habeas Corpus*, 91 Cornell Law Review 303 (2006).

**447** See Beth van Schaack, *Crimen Sine Lege: Judicial Lawmaking at the Intersection of Law and Morals*, 97 Georgetown Law Journal 119 (2008).

**448** Combs at 350. See generally Eric Blumenson, *The Challenge of a Global Standard of Justice: Peace, Pluralism, and Punishment at the International Criminal Court*, 44 Columbia Journal of Transnational Law 801 (2006).

**449** The questions of pace, volume, and expense have, in turn, produced debate about expectations and output. See James Meernik and Rosa Aloisi, *Is Justice Delayed at the International Criminal Tribunals?* 91 Judicature 276 (2008).

**450** Statute of the International Criminal Tribunal for the Former Yugoslavia, S.C. Res. 827, U.N. Doc. S/RES/827 (May 25, 1993), reprinted in 32 I.L.M. 1192 (1993) (hereinafter ICTY Statute). The United Nations has updated the ICTY Statute with a number of resolutions since 1993; see ICTY—TIPY: Legal Library, http://www.icty.org/sections/LegalLibrary. ICTY's website includes an unofficial compendium incorporating updates, http://www.icty.org/x/file/Legal%20Library/Statute/statute_septo8_en.pdf. See generally Phanç Daskalopoulou-Livada, *The International Criminal Tribunal for the Former Yugoslavia*, in International Justice 105.

**451** Lawrence R. Douglas, *Bloody Boredom*, Times Literary Supplement No. 5320, March 18, 2005, http://www.timesonline.co.Eng/tol/incomingFeeds/article595522.ece. The building had been the corporate headquarters of the Aegon Insurance Company. Lesser at 45. The "Headquarters Agreements" between the United Nations and the Kingdom of the Netherlands for the use of the building are set forth in Niels Blokker, *Headquarters Agreements*, in The Hague: Legal Capital of the World 61, 75–90.

**452** Guy Lesser described the structure as reflecting "the neoclassical simplicity of the Italian Fascist period," as he noted how the building was only identified by the U.N. flag near the outside gates. Guy Lesser, *War Crime and Punishment: What the United States Could Learn from the Milosevic Trial*, Harper's Magazine, Jan., 2004, at 45.

**453** ICTY Statute, Art. 1.

**454** See generally Crime, Procedure and Evidence in a Comparative and International Context (John Jackson, Máximo Langer, & Peter Tillers, eds., Oxford, Eng.: Hart Publishing, 2008). Others argued that some of the approach resembled the style of "managerial judging" deployed by federal judges in civil cases in the United States. See Máximo Langer, *The Rise of Managerial Judging in International Criminal Law*, 53 American Journal of Comparative Law 835 (2005); Judith Resnik, *Managerial Judges*, 96 Harvard Law Review 374 (1982); and the discussion in Chapter 14.

**455** ICTY Statute, Art. 12. The statute also provides for up to twelve *ad litem* judges to augment resources of the tribunal. In February 2008 the Security Council authorized two additional *ad litem* judges. Secretary-General, *Report of the International Tribunal for the Prosecution of Persons Responsible for Serious Violations of International Humanitarian Law Committed in the Territory of the former Yugoslavia since 1991*, U.N. Doc. A/63/210, S/2008/515 (Aug. 4, 2008), at 5. http://www.icty.org/x/file/About/Reports%20and%20Publications/AnnualReports/annual_report_2008_en.pdf (hereinafter 2008 ICTY Annual Report). Permanent and *ad litem* judges serve four-year, renewable terms. ICTY Statute, Arts. 13 *bis* and 13 *ter*. States nominate candidates to the U.N. Secretary-General, and the General Assembly elects a subset. A voting system ensures that no more than one candidate from each nationality is elected. ICTY Statute, Art. 13 *bis*.

**456** Secretary-General, *Second Annual Report of the International Tribunal for the Prosecution of Persons Responsible for Serious Violations of International Humanitarian Law Committed in the Territory of the Former Yugoslavia since 1991*, U.N. Doc. A/50/365, S/1995/728

(Aug. 23, 1995), at 28, http://www.icty.org/x/file/About/Reports%20and%20Publications/AnnualReports/annual_report_1995_en.pdf.

**457** 2008 ICTY Annual Report at 21–22. Our thanks to Victoria Enaut, Public Information Assistant at the ICTY, for providing supplementary information regarding the work of the court and to Patricia Wald, who served on that court and gave us insights into its functioning.

**458** ICTY Statute, Art. 14.

**459** David Wippman, *The Costs of International Justice*, 100 American Journal of International Law 861, 861 (2006).

**460** Other security measures for movement in other parts of the building are described by Lesser at 50.

**461** See ICTY, *Rules of Procedure and Evidence*, Rule 75(B)(i)(c), U.N. Doc. No. IT/32/Rev. 42 (Nov. 4, 2008), http://www.icty.org/x/file/Legal%20Library/Rules_procedure_evidence/IT032_Rev42_en.pdf (hereinafter ICTY Rules). Lesser detailed both that proceedings are open to the public and that two screening points must be passed. Lesser at 45.

**462** "All proceedings before a Trial Chamber, other than deliberations of the Chamber, shall be held in public, unless otherwise provided." ICTY Rules, Rule 78. The tribunal's working languages are English and French; in addition, the accused has a right to use his or her own language. Id., Rule 3. When needed for protection of victims or witnesses or for reasons of security or justice, the trial chambers may make provisions for private or *in camera* processes. Id., Rules 75, 79. Full transcripts and, when appropriate, video recordings are made. Id., Rule 81.

**463** Samuel Totten, *Witnessing the Making of History: The Trial of Slobodan Milosevic*, 67 Social Education 267, 267 (2003). See *Prosecutor v. Milošević*, Case No. IT-02-54 [ICTY]; see also ICTY, Slobodan Milošević, Case Information Sheet, http://www.icty.org/x/cases/slobodan_milosevic/cis/en/cis_milosevic_slobodan.pdf; ICTY—TPIY: The Cases, Slobodan Milošević (IT-02-54) Kosovo, Croatia and Bosnia, http://www.icty.org/case/slobodan_milosevic/4. See generally Michael P. Scharf & William A. Schabas, Slobodan Milosevic on Trial: A Companion (New York, NY: Continuum Books, 2002). The ICJ confirmed the ICTY's conclusion, in a number of cases, that the Srebrenica massacre was genocide. See Application of the Convention on the Prevention and Punishment of the Crime of Genocide (*Bosnia and Herzegovina v. Serbia and Montenegro*), 2007 I.C.J. 91 (Feb. 26), http://www.icj-cij.org/docket/files/91/13685.pdf.

**464** Marlise Simons, *Milošević Died of Heart Attack, Autopsy Shows*, New York Times, Mar. 13, 2006, at A1, http://topics.nytimes.com/2006/03/13/international/europe/13milosevic.html.

**465** *Prosecutor v. Milošević*, Case No. IT-02-54-T, Order Terminating Proceedings, March 14, 2006, http://www.icty.org/x/cases/slobodan_Milosevic/tord/en/060314.htm.

**466** "Grave breaches . . . shall be those involving any of the following acts, if committed against persons or property protected by the Convention: wilful killing, torture or inhuman treatment, including biological experiments, wilfully causing great suffering or serious injury to body or health, compelling a prisoner of war to serve in the forces of the hostile Power, or wilfully depriving a prisoner of war of the rights of fair and regular trial prescribed in this Convention." Geneva Convention for the Amelioration of the Condition of the Wounded and Sick in Armed Forces in the Field, Art. 50, Aug. 12, 1949, 75 U.N.T.S. 31.

**467** ICTY Statute, Arts. 2–5.

**468** ICTY Statute, Art. 5 ("Crimes against Humanity"); id., Art. 5(g) ("Rape"). See *Prosecutor v. Kunarac, Kovac & Vukovic*, Case Nos. IT-96-23-T, IT-96-23/1-T, Judgment (Feb. 22, 2001) [ICTY]; Marlise Simons, *Bosnian War Trial Focuses on Sex Crimes*, New York Times, Feb. 18, 2001, at A4.

**469** ICTY Statute, Art. 9. "The International Tribunal shall have primacy over national courts. At any stage of the procedure, the Inter-national Tribunal may formally request national courts to defer to the competence of the International Tribunal . . . ." Id.

**470** ICTY Statute, Art. 16.

**471** Wippman noted these complaints but later refuted them. Wippman at 861–862, 880. See also Rupert Skilbeck, *Funding Justice: The Price of War Crimes Trials*, 15 Human Rights Brief 6 (2008).

**472** 2008 ICTY Annual Report at 5. Of these, ten individuals were acquitted, fifty-seven were sentenced, thirteen were referred to a national jurisdiction, and thirty-six had their indictments withdrawn or had deceased. ICTY—TIPY: Key Figures, http://www.icty.org/sections/TheCases/KeyFigures#concpros.

**473** ICTY—TIPY: Key Figures.

**474** See Kelly D. Askin, *Reflections on Some of the Most Significant Achievements of the ICTY*, 37 New England Law Review 903, 907 (2003). See also Patricia M. Wald, *ICTY Judicial Proceedings: An Appraisal from Within*, 2 Journal of International Criminal Justice 466 (2004).

**475** Lesser at 52.

**476** ICTY, *Completion Strategy*, http://www.icty.org/sid/10016.

**477** S.C. Res. 9534, U.N. Doc. S/RES/9534 (Dec. 12, 2008).

**478** ICTY Annual Reports 1995–2008, http://www.icty.org/sections/AbouttheICTY/ReportsandPublications.

**479** ICTY Annual Reports 1995–2008.

**480** Wippman at 861.

**481** Wippman at 861.

**482** Wippman at 880. Wippman concluded that "per-trial-day costs" did not differ dramatically between the federal system of the United States and the ICTY but that ICTY costs were higher than many trials in the United States federal system. On the other hand, in one exceptional case involving Timothy McVeigh and Terry Nichols and the bombing of the federal building in Oklahoma City, discussed in Chapter 9, costs were estimated at $2.5 million for the prosecution alone. Id. at 862. Wippman argued that, while the costs at the ICTY were high, the different challenges—including complex investigation, travel, and translation—were the reasons, and that criticism ought not revolve around the expenses but should focus on how to assess the benefits. Id. at 876–880.

**483** See, for example, Ruti G. Teitel, Transitional Justice (Oxford, Eng.: Oxford U. Press, 2000).

**484** The process there was explored by Minow at 52–90.

**485** Totten at 7. The case brought a visibility to the ICTY that earlier prosecutions of lower-level officials had not.

**486** Statute of the International Criminal Tribunal for Rwanda, S.C. Res. 955, U.N. Doc. S/RES/955 (Nov. 8, 1994) (hereinafter ICTR Statute); Christina M. Carroll, *An Assessment of the Role and Effectiveness of the International Criminal Tribunal for Rwanda and the Rwandan National Justice System in Dealing with the Mass Atrocities of 1994*, 18 Boston U. International Law Journal 163, 174 (2000).

**487** S.C. Res. 977, U.N. Doc. S/RES/977 (Feb. 22, 1995). See ICTR Basic Documents and Case Law, http://ictrcaselaw.org/ContentPage.aspx?cid=2 (hereinafter ICTR Docs).

**488** The Tanzanian government offered to accommodate the tribunal and entered into a Headquarters Agreement with the United Nations. See U.N. Security Council, *Report of the International Criminal Tribunal for the Prosecution of Persons Responsible for Genocide and other Serious Violations of International Humanitarian Law Committed in the Territory of Rwanda and Rwandan Citizens Responsible for Genocide and Other Such Violations Committed in the Territory of Neighbouring States between 1 January and 31 December 1994*, Appendix, U.N. Doc. No. A/51/399-S/1996/778 (Sept. 24, 1996), http://69.94.11.53/ENGLISH/annualreports/a51/9625167e.htm#appendix. See Erik Møse, *The ICTR: Experiences and Challenges*, 12 New England Journal of International & Comparative Law 1 (2005). Møse was the president of the ICTR from 2003 to 2007. See also Stu-

art Beresford, *In Pursuit of International Justice: The First Four-Year Term of the International Criminal Tribunal for Rwanda*, 8 Tulsa Journal of Comparative & International Law 99, 106 (2000).

**489**  In 2007 the $1 million paid annually for rent provided about 70 percent of the income of that Center. See Edward Selasini, *ICTR Exit Is for Real*, Arusha Times, Sept. 29, 2007, http://www.arusha-times.co.tz/2007/38/front_page_1.htm.

**490**  ICTR Statute, Art. 1. Like the ICTY, the ICTR has jurisdiction over crimes of genocide and crimes against humanity. It also has jurisdiction over violations of Common Article 3 of the Geneva Conventions and of Additional Protocol II, which include but are not limited to crimes of violence to life, collective punishments, terrorism, and the taking of hostages. ICTR Statute, Arts. 2–4. According to Common Article 3, the following are violations of international law: "(a) violence to life and person, in particular murder of all kinds, mutilation, cruel treatment and torture; (b) taking of hostages; (c) outrages upon personal dignity, in particular humiliating and degrading treatment; (d) the passing of sentences and the carrying out of executions without previous judgment pronounced by a regularly constituted court, affording all the judicial guarantees which are recognized as indispensable by civilized peoples." Third Geneva Convention, Art. 3. As in the ICTY, that jurisdiction is concurrent with the national courts, in this context of Rwanda. See ICTR Statute, Art. 8. However, "[t]he International Tribunal for Rwanda shall have the primacy over the national courts of all States." Id. para. 2.

**491**  The Chambers were originally constituted by two Trial Chambers and an Appeals Chamber; as of 2008, three Trial Chambers and an Appeals Chamber were constituted. The Security Council authorized the addition of the third trial chamber with S.C. Res. 1165, U.N. Doc. S/RES/1165 (Apr. 30, 1998) para. 1.

**492**  The independent Prosecutor "is responsible for the investigation and the prosecution of crimes within the Tribunal's jurisdiction." ICTR Docs.

**493**  ICTR Statute, Art. 10. The Registrar, who assists the Chambers and the Prosecutor, also represents the U.N. Secretary-General and is responsible for the administration and management of the tribunal. ICTR Docs.

**494**  The ICTR Statute, like that of the ICTY and other transnational courts, specifies that no two judges "may be nationals of the same State." ICTR Statute, Art. 11.

**495**  ICTR, Handbook for Journalists, "The Tribunal at a Glance," http://www.icty.org/sections/AbouttheICTY/ReportsandPublications (hereinafter ICTR Handbook).

**496**  Hans S. Nichols, *U.N. Court Makes Legal Mischief*, 19 Insight on the News 34–36 (Jan. 7, 2003).

**497**  ICTR Annual Report 2008 at 19.

**498**  ICTR Annual Report 2008 at 19.

**499**  ICTR—General Information, http://69.94.11.53/ENGLISH/geninfo/index.htm.

**500**  ICTR Handbook, "The Achievements of the ICTR."

**501**  ICTR Annual Report 2008. See also AU Washington College of Law: War Crimes Research Office, ICTR Judgment Summaries, http://www.wcl.american.edu/warcrimes/ictr_judgements.cfm (providing summaries of ICTR judgments that are "unofficial" but nonetheless linked from the ICTR website).

**502**  As of 2006, five of the twenty-two cases were resolved via guilty pleas. Wippman at 861.

**503**  S.C. Res. 1901, U.N. Doc. S/RES/1901 (Dec. 16, 2009).

**504**  See David Cohen, *"Hybrid" Justice in East Timor, Sierra Leone, and Cambodia: "Lessons Learned" and Prospects for the Future*, 43 Stanford Journal of International Law 1, 1–6, 11–14 (2007); J. Peter Pham, *A Viable Model for International Criminal Justice: The Special Court for Sierra Leone*, 19 New York International Law

Review 37 (2006); Celina Schocken, Note, *The Special Court for Sierra Leone: Overview and Recommendations*, 20 Berkeley Journal of International Law 436, 437 (2002).

**505**  The Special Court for Sierra Leone has been said to "envision a new model for international justice" by sitting in the country where the war crimes it tries took place. Schocken at 437. See generally Stephen J. Rapp, *The Compact Model in International Criminal Justice: The Special Court for Sierra Leone*, 57 Drake Law Review 11 (2008).

**506**  Human Rights Watch, *Charles Taylor: Liberian Ex-President Goes on Trial* (May 31, 2007), http://www.hrw.org/en/news/2007/05/31/charles-taylor-liberian-ex-president-goes-trial. Taylor's trial was moved from Freetown to The Hague in June 2006 out of concern for the stability of West Africa were his trial to be held in Sierra Leone. Id. Taylor pleaded not guilty to all eleven charges filed against him, including those for murder, rape, enslavement, and conscripting child soldiers during Sierra Leone's civil war from 1991 to 2002. *War Crimes Trial Resumes for Former Leader of Liberia*, New York Times, Jan. 8, 2008, http://www.nytimes.com/2008/01/08/world/africa/08taylor.html.

**507**  Fifth Annual Report of the President of the Special Court for Sierra Leone, June 2007–May 2008, at 61–62, http://www.sc-sl.org/LinkClick.aspx?fileticket=hopZSuXjicg%3d&tabid=176 (hereinafter SCSL Annual Report 2007–2008).

**508**  Agreement between the United Nations and the Government of Sierra Leone on the Establishment of a Special Court for Sierra Leone, Art. 1., U.N.–Sierra Leone, Jan. 16, 2002, Appendix II, U.N. Doc. S/2002/246, http://www.sc-sl.org/LinkClick.aspx?fileticket=uClnd1MJeEw%3d&tabid=200 (hereinafter SCSL Statute). See generally Fourth Annual Report of the President of the Special Court for Sierra Leone, January 2006–May 2007, http://www.sc-sl.org/LinkClick.aspx?fileticket=SaCsn9u8MzE%3d&tabid=176 (hereinafter SCSL Fourth Annual Report 2007).

**509**  SCSL Statute, Art. 1.

**510**  SCSL Statute, Art. 1.

**511**  SCSL Statute, Art. 12.

**512**  SCSL Statute, Art. 12.

**513**  Ellen S. Podgor & Roger S. Clark, Understanding International Criminal Law 219 (2nd ed., Newark, NJ: LexisNexis, 2008).

**514**  Podgor & Clark, at 219.

**515**  SCSL Annual Report 2007–2008 at 5. Three were withdrawn due to the deaths of the accused, and one accused remained at large. Id. at 25. A judgment in the third was pending, and the trial of Charles Taylor was in the prosecution phase at The Hague. See SCSL Fourth Annual Report 2007 at 9–10.

**516**  SCSL Annual Report 2007–2008 at 44–50. The $36 million included funding for all functions, including prosecution, defense, and judges. Projections were that the amount would be reduced to about $9 million by 2010 to support a staff of 180. Id. at 43. The report for the prior year detailed that the approved budgets for prior years had been smaller than actual expenditures. SCSL Fourth Annual Report 2007, Annex IV at 63.

**517**  Combs at 347.

**518**  U.N. Charter, Art. 13, para. 1(a).

**519**  Combs at 348–349.

**520**  Schiff at 29.

**521**  Schiff at 38, citing M. Cherif Bassiouni, *Historical Survey 1919–1998*, in ICC Ratification and National Implementing Legislation, Nouvelles Etudes Penales 20–31 (Saint-Agne, Fran.: Association Internationale de Droit Pénal, 1999).

**522**  Schiff at 39.

**523**  The Rome Statute of the International Criminal Court, Preamble, July 17, 1998, 2187 U.N.T.S. 90 (hereinafter ICC Rome Statute).

**524** See Negotiated Relationship Agreement between the International Criminal Court and the United Nations, http://www.icc-cpi.int/NR/rdonlyres/916FC6A2-7846-4177-A5EA-5AA9B6D1E96C/0/ICCASP3Res1_English.pdf.

**525** ICC Rome Statute, Arts. 12, 124. The accused may challenge the admissibility of the case itself or the jurisdiction of the court. Art. 19(2). See generally Combs at 353–354.

**526** ICC Rome Statute, Preamble, Arts. 1, 17. See Schabas at 20; Schiff at 77–78.

**527** Schabas at 19.

**528** ICC Rome Statute, Art. 5.

**529** ICC Rome Statute, Art. 7.

**530** ICC Rome Statute, Art. 7(1)(a)–(j).

**531** ICC Rome Statute., Arts. 7(1)(g), 8(2)(b)(xxii), 8(2)(e)(vi).

**532** ICC Rules of Procedure and Evidence, rules 70, 71. See also Cate Steains, *Gender Issues*, in The International Criminal Court —The Making of the Rome Statute: Issues, Negotiations, Results 357 (Roy S. Lee, ed., The Hague, Neth.: Kluwer Law International, 1999).

**533** Steains at 378.

**534** ICC Rome Statute, Arts. 36(8), 42(9). Elections are organized accordingly through the submission of lists by various categories, and by 2008 several women had been selected as judges.

**535** ICC Rome Statute, Art. 36(8)(a)(i)–(ii).

**536** See, for example, Claus Kress, *The International Court of Justice and the Elements of the Crime of Genocide*, 18 European Journal of International Law 619 (2007).

**537** Schiff at 186.

**538** ICC Rome Statute, Arts. 5(2), 121, 123; Schiff at 186–187.

**539** Combs at 358–360; Schabas at 119–122.

**540** ICC Rome Statute, Arts. 15(3), 18.

**541** Schiff at 120–122.

**542** ICC Rome Statute, Arts. 13–15.

**543** Schiff at 84.

**544** In January 2004, for example, Ugandan President Yoweri Museveni asked Moreno-Ocampo to investigate the crimes committed by the Lord's Resistance Army (LRA), a rebel group that has operated in Northern Uganda since 1987. See Marc Lacey, *Uganda: War Crimes Inquiry*, New York Times, Jan. 30, 2004, at A6. However, President Museveni backed away from the ICC's investigation in July 2006 and offered amnesty to Joseph Kony, leader of the LRA, in exchange for a cease-fire and the beginning of peace talks. See Coalition for the International Criminal Court, *Uganda: LRA Leaders Accept Amnesty Offer; Comments by ICC Prosecutor*, July 10, 2006, http://www.iccnow.org/index.php?mod=newsdetail&news=1882. In March 2008 Kony's legal team, with the support of President Museveni, traveled to The Hague to seek a suspension of the ICC's indictments before signing a peace accord. See Nora Boustany, *Ugandan Rebel Reaches Out to International Court*, Washington Post, Mar. 19, 2008, at A12.

**545** ICC Rome Statute, Arts. 79, 68; Schiff at 183. The term "victim," defined in Rule 85 of the ICC's Rules of Procedure and Evidence, included "natural persons who have suffered harm as a result of the commisson of any crime" within the court's jurisdiction. Also included are "organizations or institutions that have sustained direct harm to any of their property which is dedicated to religion, education, art or science or charitable purposes," as well as historic monuments, hospitals, and humanitarian places. The form of participation and its effects have occasioned a good deal of debate as law has developed around the role of victims. Issues include the number of persons who can participate, the form of participation and the role of clients (akin to challenges in the United States in class action litigation), and the impact of that role and a case's proceeding to judgment. See, for example, Judgment on the Appeals of the Prosecutor and the Defen-

dant against the Trial Chamber I's Decision on Victims' Participation of 18 January 2008, 11 July 2008, ICC-01/04-01/06-1432, http://www.iclklamberg.com/Caselaw/DRC/Dyilo/Appeals/ICC-01-04-01-06-1432-ENG.pdf.

**546** Remedies other than the victims' fund present challenges as well. See Sonja B. Starr, *Rethinking "Effective Remedies": Remedial Deterrence in International Courts*, 83 New York University Law Review 693 (2008).

**547** Schabas at ix.

**548** William Jefferson Clinton, President of the United States, Statement on Signature of the International Criminal Court Treaty, Washington, D.C., at 1 (Dec. 31, 2000), 37 Weekly Comp. Pres. Doc. 4 (Jan. 8, 2001).

**549** Letter from John R. Bolton, Under Secretary of State for Arms Control and International Security, to U.N. Secretary General Kofi Annan (May 6, 2002). See also Schiff at 173. In addition, Israel "unsigned" as well. See generally Edward T. Swaine, *Unsigning*, 55 Stanford Law Review 2061 (2003).

**550** ICC Statute, Art. 98. Several commentators concluded that the interpretation proffered by the United States was incorrect. See Combs at 365.

**551** Schiff at 174–175. See Consolidated Appropriations Act, 2005 § 574, Pub. L. No. 108-447, 118 Stat. 2809 (2005); Foreign Operations, Export Financing, and Related Programs Appropriations Act, 2006 § 574(a), Pub. L. No. 109-102, 119 Stat. 2172 (2006).

**552** The American Service-Members' Protection Act of 2002, Pub. L. No. 107-206, 116 Stat. 820 (2006) (codified at 22 U.S.C. §§ 7401, 7421–7433 (2006)).

**553** Schabas at 176. Our thanks to the Honorable Hans-Peter Kaul, former President of the Pre-Trial Division, and to Simon de Smet, who in 2007 was an Associate Legal Officer and the staff person responsible for the ICC's internal building committee, both of whom helped us to understand the ICC's work, to tour the facility, and to obtain the photographs in figures 179 and 180, copyright ICC-CPI/Wim Van Cappellen, which are reproduced with permission of the ICC and with the assistance of its Public Information and Documentation Section.

**554** Report on the Future Permanent Premises of the International Criminal Court: Project Presentation, at 12, ICC-ASP/4/CBF.1/3, Feb. 22, 2005, provided to the Assembly of State Parties, ICC, Committee on Budget and Finance, 4th Session, The Hague, Apr. 4–6, 2005 (hereinafter 2005 Report on the Future Permanent Premises of the ICC). The report was signed by the President of the ICC and by the Director-General of the ICC Task Force of the Ministry of Foreign Affairs of The Netherlands.

**555** See 2005 Report on the Future Permanent Premises of the ICC: Housing Options at 10, ICC-ASP 4/1, Mar. 9, 2005, provided to the Assembly of State Parties, ICC, 4th Session, The Hague, Nov. 28–Dec. 23, 2005 (hereinafter 2005 Report on the Future Permanent Premises of the ICC: Housing Options).

**556** Schabas at 177.

**557** ICC Rome Statute, Art. 34.

**558** ICC Rome Statute, Art. 112(1).

**559** Schabas at 177.

**560** ICC Rome Statute, Art. 36; Schabas at 175–179. The Assembly of States Parties mandated that each "State Party shall vote for a minimum number of candidates of each gender"; the mandatory minimum is calculated after each round of ballots according to a formula laid out by the Assembly in Resolution 6, para. 20(c) ICC-ASP/8/Res.6 (Nov. 26, 2009). Our thanks to Kate Malleson for her review of this chapter, and particularly the discussion of selection processes of international courts.

**561** See Assembly of States Parties, Procedure for the nomination and election of judges of the International Criminal Court, Resolution

ICC-ASP/3/Res. 6, paras. 19 & 20(c) (10 September 2004). The provisions specify a formula, in terms of numbers as well as how to adjust it. Id. at paras. 20–23.

**562** See generally Richard Mohr, *Some Conditions for Culturally Diverse Deliberation*, 20 CANADIAN JOURNAL OF LAW AND SOCIETY 87 (2005).

**563** The literature on these issues is vast. An introduction to the ideas and impact of difference is provided by Jane Mansbridge, *The Descriptive Political Representation of Gender: An Anti-Essentialist Argument* in HAS LIBERALISM FAILED WOMEN? ASSURING EQUAL REPRESENTATION IN EUROPE AND THE UNITED STATES 19–38 (Jytte Klausen & Charles S. Maier, eds., New York, NY: Palgrave, 2001).

**564** SCHABAS at 184.

**565** SCHABAS at 180. That sum was initially to go only to those serving in the presidencies of the divisions.

**566** SCHABAS at 177–178.

**567** The judges, in turn, elected from their number the President (Sang-Hyun Song of South Korea), the first Vice President (Fatoumata Dembélé Diarra of Mali), and the second Vice President (Hans-Peter Kaul of Germany). See SCHIFF at 108.

**568** The first set of terms was varied to enable continuity of service. ICC, *Biographical Notes*, http://www2.icc-cpi.int/Menus/ICC/Structure+of+the+Court/Chambers/The+Judges. Article 36(2)(a) provides authority for the presidency to increase the number of sitting judges.

**569** ICC Rome Statute, Art. 42(4). See also ICC, *Structure of the Court*, http://www2.icc-cpi.int/Menus/ICC/About+the+Court/ICC+at+a+glance/Structure+of+the+Court.htm. In addition, the Registry and a Victims and Witnesses Support Unit were established.

**570** SCHIFF at 108.

**571** SCHIFF at 115.

**572** SCHIFF at 115.

**573** See SCHIFF at 194–247; ICC, *The Court Today*, http://www2.icc-cpi.int/Menus/ICC/About+the+Court/ICC+at+a+glance/The+Court+Today.htm. In part to explain what some perceived as a slow startup, Chief Prosecutor Ocampo stated, "when the prisoner arrives in the courtroom, an enormous accomplishment has already been achieved. It means that the OTP [Office of the Prosecutor] took the necessary steps to analyze crime patterns and to select a situation that requires our investigation. It means that the OTP . . . conducted investigation of massive crimes during ongoing conflicts; interacted with victims and local communities; protected witnesses and investigators; secured the cooperation needed to carry out investigations, from visas for the witnesses to the evacuation of threatened staff in deteriorating security situations; collected the evidence necessary to prosecute those who bear the greatest responsibility of the most serious crimes; and finally, ensured the appearance of the persons sought by the Court." Luis Moreno-Ocampo, *The International Criminal Court: Seeking Global Justice*, 40 CASE WESTERN RESERVE JOURNAL OF INTERNATIONAL LAW 215, 218 (2007). See also Hans-Peter Kaul, *Construction Site for More Justice: The International Criminal Court after Two Years*, 99 AMERICAN JOURNAL OF INTERNATIONAL LAW 370 (2005).

**574** See generally Patricia M. Wald, *International Criminal Courts: Some Kudos and Concerns*, 150 PROCEEDINGS OF THE AMERICAN PHILOSOPHICAL SOCIETY 241 (2006); Simon De Smet, *A Structural Analysis of the Role of the Pre-Trial Chamber in the Fact-Finding Process of the ICC*, in THE EMERGING PRACTICE OF THE INTERNATIONAL CRIMINAL COURT 405–440 (Carsten Stahn & Göran Sluiter, eds., Leiden, Neth.: Koninklijke Brill, 2009).

**575** ICC, *Establishment of the Court*, http://www2.icc-cpi.int/Menus/ICC/About+the+Court/ICC+at+a+glance/Establishment+of+the+Court.htm.

**576** As of June 2008. International Criminal Court: Frequently Asked Questions, http://www2.icc-cpi.int/Menus/ICC/About+the+Court/Frequently+asked+Questions/.

**577** SCHIFF at 137.

**578** SCHABAS at 186.

**579** ICC Assembly of State Parties, Fifth Session, Strategic Plan of the International Criminal Court, ICC-ASP/5/6/ (2006) (hereinafter ICC Strategic Plan).

**580** ICC Strategic Plan at 3–5.

**581** ICC Rome Statute, Art. 3(3).

**582** Materials on it, as well as on the competition, have been provided to us by Court staff. A few years later the entity was dissolved and replaced by an Oversight Committee, a Project Board, and a Project Director working inside the ICC's registry. See Permanent Premises, ICC-ASP/6/Res.1, Dec. 14, 2007, http://www.icc-cpi.int/iccdocs/asp_docs/Resolutions/ICC-ASP-ASP6-Res-01-ENG.pdf (hereinafter 2007 ICC Permanent Premises Resolution).

**583** 2005 Report on the Future Permanent Premises of the ICC at 10 (Foreword from ICC President and Director-General, ICC Task Force) (emphasis in the original).

**584** 2005 Report on the Future Permanent Premises of the ICC at 9–11.

**585** 2005 Report on the Future Permanent Premises of the ICC at 10.

**586** 2005 Report on the Future Permanent Premises of the ICC at 13.

**587** 2005 Report on the Future Permanent Premises of the ICC at 11.

**588** 2005 Report on the Future Permanent Premises of the ICC at 13.

**589** 2007 ICC Permanent Premises Resolution, Annex 1 at 4.

**590** 2007 ICC Permanent Premises Resolution, Annex at 2 and n. 2. The report noted that, in 2014 euros and including contingencies, inflation, and special features, the sum could be 190 million euros. Id.

**591** 2005 Report on the Future Permanent Premises of the ICC at 15, 22.

**592** 2005 Report on the Future Permanent Premises of the ICC at 23.

**593** 2005 Report on the Future Permanent Premises of the ICC at 15.

**594** 2005 Report on the Future Permanent Premises of the ICC at 15.

**595** 2005 Report on the Future Permanent Premises of the ICC at 15.

**596** 2005 Report on the Future Permanent Premises of the ICC at 14, 21.

**597** 2005 Report on the Future Permanent Premises of the ICC at 14.

**598** 2005 Report on the Future Permanent Premises of the ICC at 21.

**599** 2005 Report on the Future Permanent Premises of the ICC at 18–20.

**600** 2005 Report on the Future Permanent Premises of the ICC at 22.

**601** 2005 Report on the Future Permanent Premises of the ICC at 20. The brochure for the design competition uses the figure of 46,000 square meters. See INTERNATIONAL CRIMINAL COURT: ARCHITECTURAL DESIGN COMPETITION (The Hague, Neth.: Rijksgebouwendienst [Government Buildings Agency], 2008) (hereinafter ICC Design Competition Brochure).

**602** See 2005 Report on the Future Permanent Premises of the ICC at 20, 24. Report on the Future Permanent Premises of the International Criminal Court: Financial Comparison of Housing Costs at 8, 5th Session, The Hague, 10–14 Oct. 2005, ICC-ASP 4/CBF.2/4 30 August 2005. The overall construction costs of the ICC's permanent building was estimated to be no more than 190 million euros (about $255 million) at 2014 price levels. See Assembly of States Parties, Resolution ICC-ASP/6/Res.1, Dec. 14, 2007, ICC-ASP/6/20, Part III at 21.

**603** Assembly of States Parties, Resolution ICC-ASP/5/Res.1, Dec. 1, 2006, ICC-ASP/5/32/Corr. 1, Part III at 1–2.

**604** 2005 Report on the Future Permanent Premises of the ICC at 10–11.

**605** Assembly of States Parties, Resolution ICC-ASP/6/Res.1, Dec. 14, 2007, ICC-ASP/6/20, Part III at 21–22.

**606** Permanent Premises of the International Criminal Court, http://www.icc-architectural-competition.com. The prizes were 60,000 euros, 50,000 euros, and 40,000 euros (or approximately $80,900, $67,000, and $54,000, respectively) for first, second, and third prizes, and the nineteen designs within the final set were displayed in The Hague City Hall for a week. Id.

**607** See ICC Design Competition Brochure.

**608** Permanent Premises of the International Criminal Court, Explanation of the Architect, http://www.icc-architectural-competition .com/pages/results/prize-winners/3rd.php (hereinafter ICC Permanent Premises website).

**609** ICC Permanent Premises website.

**610** See ICC Design Competition Brochure.

**611** ICC Permanent Premises website.

**612** ICC Permanent Premises website.

**613** Silvana Arbia, ICC Registrar, Press Conference on March 8, 2010, at the Court's website, http://www.icc-cpi.int/menus/icc/press% 20and%20media/press%20releases/ma63a (hereinafter Arbia, ICC Building Announcement of March 2010).

**614** Arbia, ICC Building Announcement of March 2010.

**615** Figures for individual budgets have been collected from a variety of 2006 sources published by the courts; reported figures have then been converted into U.S. dollars. Some courts, such as the ICTY, ICTR, ICJ, and ITLOS, operate on biennial budgets, from which 2006 figures were derived by dividing the amount by two. Some also report only for fiscal years that break across the calendar year; we used the figures published in the 2006 in annual reports whether the coverage was for a fiscal or a calendar year, regardless of their dates of coverage.

**616** See European Commission, EU Budget 2006: Financial Report 18 (Luxembourg: Office for the Official Publications of the European Communities, 2007), http://ec.europa.eu/budget/library/ publications/fin_reports/fin_report_06_en.pdf. The charts provided in figures 181 and 182 were compiled with the assistance of Kathleen Claussen, Adam Grogg, Elliot Morrison, and Allison Tait.

**617** See Council of Europe: Information Office, Budget of the Court, http://www.coe.al/index.php?faqe=content/detail&kat=content &id=56&lng=en.

**618** See Inter-American Commission on Human Rights (IACHR), Financial Resources of the IACHR 2006, http://www.cidh.org/recursos 2006.eng.htm; Inter-American Court of Human Rights, 2006 Annual Report at 6 (2006),http://www.corteidh.or.cr/docs/informes/ 20063.pdf.

**619** See Report of the International Court of Justice, 1 August 2006–31 July 2007 at 51, U.N. GAOR, 62d Sess., Supp. No. 4, U.N. Doc. A/62/4 (Aug. 10, 2007), http://www.icj-cij.org/court/index .php?p1=1&p2=8 (click on "2006–2007" in the drop-down menu). The Permanent Court of Arbitration, begun in 1899, does not report data on budgets, and therefore is not included.

**620** See ICC, Resolution ICC-ASP/4/Res.8: Programme Budget for 2006, www.icc-cpi.int/iccdocs/asp_docs/Resolutions/ICC-ASP-ASP4-Res-08-ENG.pdf.

**621** See International Tribunal for the Law of the Sea Yearbook 2006 at 71.

**622** See Report of the International Tribunal for the Prosecution of Persons Responsible for Serious Violations of International Humanitarian Law Committed in the Territory of the Former Yugoslavia since 1991 at 24, U.N. GAOR, 61st Sess., A/61/271, http:// www.un.org/icty/rappannu-e/2006/AR06.pdf.

**623** See G.A. Res. 60/241, para. 3, U.N. Doc. A/RES/60/241 (Feb. 15, 2006).

**624** See Fourth Annual Report of the President of the Special Court for Sierra Leone: January 2006 to May 2007 at 63

(2007), http://www.sc-sl.org/LinkClick.aspx?fileticket=SaCsn9u8 MzE%3d&tabid=176.

**625** In some instances, the courts record the data by calendar years, in other instances by a June-to-June or other cycle. The data are, by definition, out of date, and various institutions have, since 2006, seen a spurt in caseload. For example, the ICC had, by 2009, begun its first trials. See ICC, *Situations and Cases*, http://www2.icc-cpi.int/ Menus/ICC/Situations+Cases.

**626** Materials provided by PCA staff, April 2010.

**627** See European Court of Human Rights, Survey of Activities 2006 (Registry of the European Court of Human Rights, Strasbourg, 2007) at 38, 47 (2006), http://www.echr.coe.int/NR/rdonlyres/ 69564084-9825-430B-9150-A9137DD22737/0/SurveyofActivities 2006.pdf. As the court mapped its own docket's growth from 1995 to 2006, the number of applications lodged grew fivefold, from 11,200 to approximately 50,500. Id. at 48. In 2006, the court refused some 28,000 applications (id. at 50) and issued more than 1,500 judgments. Id. at 49.

**628** See Statistics of Judicial Activity of the Court of Justice, of the Court of First Instance, and of the Civil Service Tribunal, Annual Report 2006, at 79, 107, 209–215, http://curia.europa.eu/jcms/jcms/ Jo2_11035/rapports-annuels. As noted in figure 182, the Court of Justice had 731 pending cases, the Court of First Instance had 1,029, and the Civil Service Tribunal had 225. Included are proceedings of different kinds, including appeals and references, depending on the level of the court. The Court of First Instance reported that it had "disposed of more cases than were brought before it." Id. at 107.

For the ICJ, similar information is at http://www.icj-cij.org/ docket/index.php?p1=3&p2=2.

ICTR information culled from statistics available at the ICTR website, http://69.94.11.53/ENGLISH/cases/status.htm.

**629** Inter-American Court of Human Rights 2006 Annual Report at 78–79 (2006), http://www.corteidh.or.cr/docs/informes/ 20063.pdf.

**630** See Annual Report of the Inter-American Commission on Human Rights 2006 at 27, http://www.cidh.org/annualrep/ 2006eng/CHAPTER.III.ENG.pdf (noting that "1237 individual cases and petitions [were] processed by the Commission in the year 2006").

**631** Report of the International Court of Justice, 1 August 2006–31 July 2007 at 17, U.N. GAOR, 62d Sess., Supp. No. 4, U.N. Doc. A/62/4 (Aug. 10, 2007), http://www.icj-cij.org/court/index.php?p1= 1&p2=8 (click on "2006–2007" in the drop-down menu).

**632** Permanent Court of Arbitration, 2006 PCA Annual Report, 1, 4, http://www.pca-cpa.org/showfile.asp?fil_id=630. See also *Cases Conducted under the Auspices of the Permanent Court of Arbitration or Conducted with the Cooperation of the International Bureau*, http://www.pca-cpa.org/showfile.asp?fil_id=547.

**633** See International Tribunal for the Law of the Sea, Proceedings and Judgments—Docket, http://www.itlos.org/cgi-bin/cases/docket .pl?lang=en. See also archived page from Oct. 10, 2006, http://web .archive.org/web/20061006141753/http://www.itlos.org/cgi-bin/ cases/docket.pl?lang=en.

**634** See International Tribunal for the Law of the Sea, Proceedings and Judgments—List of Cases, http://www.itlos.org/cgi-bin/cases/ list_of_cases.pl?language=en. See also archived page from Aug. 14, 2006, http://web.archive.org/web/20060814074138; http://www.itlos .org/cgi-bin/cases/list_of_cases.pl?language=en.

**635** Thirteenth Annual Report of the International Tribunal for the Prosecution of Persons Responsible for Serious Violations of International Humanitarian Law Committed in the Territories of the Former Yugoslavia since 1991 at 26, U.N. GAOR, 61st Sess., A/61/271, http://www.un.org/icty/rappannu-e/ 2006/AR06.pdf. As that report noted, some individuals who might have been prosecuted at the ICTY were being tried by other tribunals. Id.

**636** Eleventh Annual Report of the International Criminal Tribunal for the Prosecution of Persons Responsible for Genocide and Other Serious Violations of International Humanitarian Law Committed in the Territory of Rwanda and Rwandan Citizens Responsible for Genocide and Other Such Violations Committed in the Territory of Neighbouring States between 1 January and 31 December 1994 at 2, U.N. GAOR, 61st Sess., U.N. Doc. No. A/61/265 (Aug. 16, 2006), http://www.ictr.org/ENGLISH/annualreports/a61/s-2006-658.pdf. In addition, the court reported that, since the Tribunal's beginning, a total of fifty-five defendants' proceedings had either been completed or were under way. Id. at 2.

**637** See Fourth Annual Report of the President of the Special Court for Sierra Leone: January 2006 to May 2007 at 9, 13, 16, 19, 21 (2007).

**638** Third Report of the International Criminal Court 2, 5–9, U.N. GAOR, 62d Sess., U.N. Doc. No. A/62/314 (Aug. 31, 2007), http://www.icc-cpi.int/NR/rdonlyres/754F8043-22DB-4D78-9F8C-67EFBFC4736A/278567/ICC_Report_to_UN_2006_2007_English.pdf.

**639** Our thanks to Christiaan M. J. Kröner, Secretary-General of the PCA, and to Vilmante Blink, of the PCA staff, for their assistance in obtaining both the original and revised versions of the logo. All rights to figures 183 and 185 are held by the PCA, and the images are reproduced with its permission. For variations on the PCA logo, see http://ukinnl.fco.gov.uk/resources/en/jpg/3873828/pca; http://www.haguejusticeportal.net/Images/PCA/PCA%20new%20logo%20120.JPG; http://www.arbitration-icca.org/media/0/12120690159150/cpa.jpg.

**640** Our thanks to Mike Widener and the Rare Book Collection of the Lillian Goldman Library of Yale Law School for providing us with figure 184 and permission to reproduce it and to Arthur Eyffinger for information on Picard, the PCA logo, related imagery, and his additional research efforts.

**641** See generally Jean Dumont, Baron de Carlscroon, Corps universel diplomatique du droit des gens: Contenant un recueil des traités d'alliance, de paix, de trève, de neutralité, de commerce, d'échange . . . (Amsterdam, Neth.: P. Brunel, R. et G. Wetstein, les Janssons Waesberge, et L'Honoré et Chatelain, 1726–1731).

**642** Margaret C. Jacob, *Bernard Picart and the Turn toward Modernity*, 37 De Achttiende Eeuw 1, 17 (2005).

**643** See Ilja M. Veldman, *Familiar customs and exotic rituals: Picart's illustrations for Cérémonies et coutumes religieuses de tous les peuples*, 33 Simiolus: Netherlands Quarterly for the History of Art 94, 94–111 (2008). See also Richard I. Cohen, Jewish Icons: Art and Society in Modern Europe 43 (Berkeley, CA: U. of California Press, 1998).

**644** The wedding poem, or epithalamion, is a traditional form that dates back to Sappho and was made famous by Catullus. The form was much in use in the seventeenth century, especially in England, and both John Donne and Edmund Spenser wrote well-known and well-regarded epithalamia. See Thomas M. Greene, *Spenser and the Epithalamic Convention*, 9 Comparative Literature 215, 215–228 (1957). These poems often were published with frontispieces depicting bride and groom with hands clasped. Arthur Eyffinger has pointed out that this posture, also popular in images of diplomacy, indicated the image of both "bona fides" ("in good faith") and "pacta sunt servanda" ("promises must be kept"). Examples of such hands clasping can be found in Eyffinger, ICJ at 49.

**645** At that time the PCA also launched a new website, and its new flag also displayed the "modernized emblem." Permanent Court of Arbitration, 2007 PCA Annual Report, 1, http://www.pca-cpa.org/upload/files/03%20Report%20EN.pdf.

**646** Johannes Cornelis Wienecke (1872–1945), a Dutch medalist,

designed the logo in 1922. He also designed a portrait of Queen Wilhelmina (who had hosted the Peace Palace Conference) that was used on Dutch coins between 1922 and 1945, as well as the commemorative medal presented to delegates at the Second Hague Conference. See Eyffinger, The 1899 Hague Peace Conference at 428, 454. The logo is described in ICJ Questions and Answers. The logo can also be found in various of the PCIJ reports. See, for example, the PCIJ's Eleventh Annual Report, 1934–1935, http://www.icj-cij.org/pcij/serie_E/English/E_11_en.pdf. A version was used on the official plates (made of tin). Our thanks to Arthur Eyffinger for locating a picture of the plate and for obtaining documentation from the Dutch National Archives and the Royal Dutch Mint archives.

**647** The logo in figure 186 is reproduced courtesy of the ICJ. A different emblem, a roundel with five or six muscular men holding an even balance above large rectangular building stones, is described as another iteration of the PCIJ by Eyffinger, ICJ at 73–74.

**648** Kerkvliet & Mellink at 39.

**649** See Arnold Rabbow, DTV—Lexikon Politischer Symbole 258–260 (1970).

**650** See http://www.un.org/english/portals/images/biglogo.gif.

**651** Our thanks to ITLOS and its Registrar, Philippe Gautier, for providing us with the logo in figure 187 and permission to reproduce it.

**652** The ICTY logo was originally designed by Judge Jules Deschênes, one of the first judges of the tribunal, in 1994. After a lengthy dialogue with the U.N. Graphics Department about the precise form and appropriate use of the U.N. symbol, the design was finalized in January 1995. Interview with the ICTY Press Office (Dec. 14, 2008). The logos in figure 188, provided by the ICTY, include that of the United Nations and the ICTY, as the ICTY's logo is to be shown in conjunction with the U.N. logo. Our thanks to the ICTY for permission to reproduce the logos.

**653** TPIR stands for "Tribunal Pénal International pour le Rwanda," the French name for the ICTR. Figure 189 is reproduced with the permission of the International Criminal Tribunal for Rwanda and with our thanks to the Senior Legal Adviser staff.

**654** Figure 190, used for illustrative purposes only, was provided by the Special Court for Sierra Leone, which holds the copyright and authorized this use of the image.

**655** Figure 191 is reproduced courtesy of the International Criminal Court and provided courtesy of its Public Information and Documentation Section.

**656** Figure 192 is provided courtesy of the Court of Justice of the European Communities and is reproduced with its permission and with the assistance of Christopher Fretwell and of the Administrator Press and Information Service.

**657** The Court of Justice of the European Communities: Historic Landmarks, Buildings and Symbols 10, http://curia.europa.eu/jcms/upload/docs/application/pdf/2009-03/en_historique.pdf.

**658** The image in figure 193 is reproduced courtesy of and with the permission of the Iraqi High Tribunal, the legal owner of the seal of its predecessor court, the Iraqi Special Tribunal, in accord with an order of July 18, 2006, and with the assistance of Zalmay Khalilzad, who served in 2006 as the United States Ambassador to Iraq.

**659** Coalition Provisional Authority Order No. 48, CPA/ORD/9 Dec. 2003/48 (Dec. 10, 2003), http://www.iraqcoalition.org/regulations/20031210_CPAORD_48_IST_and_Appendix_A.pdf. For a history of the Iraqi Special Tribunal and the Iraqi High Criminal Court, see M. Cherif Bassiouni & Michael Wahid Hanna, *Ceding the High Ground: The Iraqi High Criminal Court Statute and the Trial of Saddam Hussein*, 39 Case Western Reserve Journal of International Law 21, 35–44 (2007).

**660** Law No. 10 (2005), Law of the Supreme Iraqi Criminal Tribunal, 47 Al-Waqa'i Al-Iraqiya 2–23 (Oct. 18, 2005) (Iraq), http://www.loc.gov/law/help/hussein/docs/Iraqi%20law%20number10

of2005.pdf, available in English translation, http://www.ictj.org/static/MENA/Iraq/iraq.statute.engtrans.pdf. See also International Center for Transitional Justice, Creation and First Trials of the Supreme Iraqi Criminal Tribunal (Oct. 2005),http://www.ictj.org/images/content/1/2/123.pdf.

**661** Translation by Diala Shamas.

## CHAPTER 13

**1** Hannah Arendt, The Origins of Totalitarianism (New York, NY: Houghton Mifflin Harcourt, 1973; first published 1951).

**2** Arendt at xxxvii.

**3** See Jürgen Habermas, The Structural Transformation of the Public Sphere: An Inquiry into a Category of Bourgeois Society (Thomas Burger, trans., Cambridge, MA: MIT Press, 1991) (hereinafter Habermas, Structural Transformation); Jürgen Habermas, Between Facts and Norms: Contributions to a Discourse Theory of Law and Democracy (William Rehg, trans., Cambridge, MA: MIT Press, 1998) (hereinafter Habermas, Facts and Norms); David Zaret, Origins of Democratic Culture: Printing, Petitions, and the Public Sphere in Early-Modern England (Princeton, NJ: Princeton U. Press, 2000). See generally Habermas and the Public Sphere (Craig Calhoun, ed., Cambridge, MA: MIT Press, 1992) (hereinafter Habermas and the Public Sphere); Luke Goode, Jürgen Habermas: Democracy and the Public Sphere (London, Eng.: Pluto Press, 2005).

**4** See Nancy Fraser, *Rethinking the Public Sphere: A Contribution to the Critique of Actually Existing Democracy*, in Habermas and the Public Sphere 109.

**5** See, for example, Mario Sbriccoli, *Legislation, Justice, and Political Power in Italian Cities, 1200–1400*, in Legislation and Justice 37–55 (Antonio Padoa-Schioppa, ed., Oxford, Eng.: Oxford U. Press, 1997) (hereinafter Legislation and Justice). Sbriccoli detailed how various forms of resolution "fitted within a framework which bound them together and produced their homology (even in the forms and rules of procedure)." Id. at 43. He traced the movement in the thirteenth century toward an inquisitorial posture that displaced private ordering ("vendettas, duels, and private alliances") with " 'reasons for (public) justice,' " such that justice became "one of the criteria by which the effectiveness of government power was measured." Id. at 49–50. Juridical processes were, on his account, central to the development of city-states. Id. at 52–53. See also Clive Holmes, *The Legal Instruments of Power and the State in Early Modern England*, in Legislation and Justice at 269–289.

**6** Katharine Fremantle, The Baroque Town Hall of Amsterdam 76 (Utrecht, Neth.: Haentjens Dekker & Gumbert, 1959).

**7** According to John Kelly, the concept predated St. Augustine; a fourth-century manuscript by a Sardinian bishop, Lucifer of Cagliari, argued that God had interrogated Adam and Eve because they could not be "condemned by us unheard." John M. Kelly, *Audi Alteram Partem*, 9 Natural Law Forum 103, 109, n. 36 (1964). As Kelly noted, however, another interpretation of the New Testament is that judgment, salvation, and punishment rest on deeds known to God, and hence judgment is given before "those being judged can say anything." Id. at 110, n. 38.

**8** St. Augustine lived from 354 to 430 CE; he wrote *De Duabus Animabus, Contra Manichaeos* (*Concerning Two Souls, Against the Manicheans*). The phrase "Audi Alteram Partem" appeared in his Chapter 14 as part of a debate constructed within. See St. Augustine, *Against the Manicheans*, http://www.gnosis.org/library/boni.htm; Oxford Dictionary of Quotations 36–37 (Elizabeth Knowles ed., New York, NY: Oxford U. Press, 6th ed., 2004).

**9** Kelly at 107. Kelly described two versions, worded slightly differently. In the great hall of the Town Hall in Nürnberg (Nuremberg), the phrase was "Eins manns red ist eine halbe red, man soll die teyl verhören bed," translated as "One man's story is half the story, one should hear both sides [of the story]." In the front hall of the *Römer* in Frankfurt-am-Main, the inscription read, "Eyns mans redde ein halbe redde, man sal sie billich verhören bede," or "One man's story [is] half the story, one should agree to hear both sides." The Emperor Lothar was also reputed to have said, "Mit Urteil sprechen gar nicht eile, bis du gehört hast beide Teile," or "Do not pronounce judgment in haste until you have heard both sides." Id. at 107.

**10** At The Hague, a 1739 painting by Jacob de Wit portrayed a Justice-like figure surrounded by putti (making her look somewhat like Charity) under which was inscribed "Audi et Alteram Partem." It hung over the double doors of the Schepensaal, or Vierschaar, a room in which the alderman worked and rendered judgments. See J. C. Herpel, Het oude Raadhuis van 's-Gravenhage Deel II (The Old City Hall of The Hague, Part II) 411, fig. 383 ('s Gravenhage, Neth.: Uitgave van de Gemeente, 1979). The book, commissioned by the City Council of The Hague, documented the town hall and its renovation. Our thanks to Chavi Keeney Nana for translation of the Dutch.

**11** The building's architect was Jans Keldermans, and the inscription *Audite et Alteram Partem* is dated from around 1695. See Wim Denslagen, Gouda 212–219 (Zwolle, Zeist Waanders Uitgevers: Rijksdienst Voor de Monumentenzorg, 2001). The photograph of the arch above the entrance to the Town Hall (Staudius), Gouda, the Netherlands, is reproduced in figure 194 with the permission of the Regional Archive, Middle Holland (Streekarchief Midden-Holland), inv. nr. 6668, Gouda, The Netherlands. Our thanks to Chavi Keeney Nana, as well as to Cristel Stolk and Joke Radstaatand of the Regional Archive, for their help in identifying and obtaining permission to reprint the photograph.

**12** Kelly at 103–110.

**13** Kelly at 107.

**14** Kelly at 104.

**15** Kelly at 104. Greek texts warned that punishment without trial was "tyrannical, unjustified, and illegal." Kelly at 104.

**16** Stuart Hampshire, Justice Is Conflict 4–28 (Princeton, NJ: Princeton U. Press, 2000). Hampshire was insistent that "fairness in procedure is an invariable value, a constant in human nature," id. at 4, and that fairness's core was *audi alteram partem*. Id. at 8.

**17** See *Rex v. Wilson* (1817) 171 Eng. Rep. 353; *The Queen v. Governors of Darlington School* (1884) 6 Q.B. 696. See also S. A. de Smith, *The Right to a Hearing in English Administrative Law*, 68 Harvard Law Review 569, 569–570 (1955).

**18** de Smith at 569.

**19** See *The King v. G. Gaskin* (1799) 101 Eng. Rep. 1349, 1350. The ruling by Lord Chief Justice Lloyd Kenyon dealt with a request, through the writ of mandamus against a rector, to restore a person to the office of parish clerk. At issue was whether the person removed had been given an opportunity to answer the charges against him. Kelly cited the earlier decision of *Boswel's Case* (K.B. 1606) 77 Eng. Rep. 326, 331, as the first in English law to refer to *audi alteram partem*. Kelly at 107.

**20** *The King v. G. Gaskin* at 1350. The jurist further commented that he would "tremble at the consequences of giving way to this principle." Id.

**21** de Smith at 570–571. See also John T. Noonan Jr., Bribes 11–30 (New York, NY: Macmillan, 1984).

**22** U.S. Const., Amend. V. The Fifth Amendment also includes rights against government in the form of indictments by grand juries (rather than a prosecutor alone) for alleged felonies, plus prohibitions on being placed "twice . . . in jeopardy." In addition, under the Fifth Amendment, no person's "private property" can "be taken for public use, without just compensation." Id.

**23** U.S. Const., Amend. VI. See also David J. Bodenhamer, Fair Trial: Rights of the Accused in American History 3–56 (New York, NY: Oxford U. Press, 1992); Richard D. Friedman, *Exploring the Future of the Confrontation Clause in Light of Its Past: Grappling with the Meaning of "Testimonial,"* 71 Brooklyn Law Review 241 (2005).

**24** See George P. Fletcher, Basic Concepts of Legal Thought 81 (Oxford, Eng.: Oxford U. Press, 1996).

**25** One imperfect metric is the number of times the Supreme Court has used words and phrases over time. (Given that caseloads and decisions rendered vary a great deal, a reference count is only suggestive of the role that terms play in legal discourse.) A data search of all United States Supreme Court cases between 1789 and 2008 found the word "fair" or "fairness" relatively infrequently in Supreme Court opinions until the addition of the Fourteenth Amendment in 1868, after which usage expanded. Some 428 opinions used "fair" or "fairness" during the first two-thirds of the nineteenth century; more than double that number invoked those words during the last third of the century. Thereafter, usage generally increased steadily each decade before taking a large jump in the 1970s. Between 1981 and 1990, the Supreme Court used those words in 930 cases, followed by a decline to 521 cases between 1991 and 2000. Our thanks to Elliot Morrison for collecting and analyzing these data.

**26** Ian Langford, *Fair Trial: The History of an Idea*, 8 Journal of Human Rights 37 (2009). Through searching a range of sources, Langford concluded that the word "fair" moved from a reference to how one looked (fair as in "beautiful") to, in the context of law, regularized, as in "free from blemish." Id. at 38, 42.

**27** Langford at 44–48. Langford argued from this example that norms in human rights were neither universal nor atemporal but culturally embedded.

**28** U.S. Const., Amend. XIV, § 2.

**29** *Davidson v. New Orleans*, 96 U.S. 97, 105 (1878). As the complainant had had a "full and fair hearing," no violation of due process existed. Id. at 105. The term "fair trial" or "fair" referring to a proceeding can be found in a few other cases of that era. See, for example, *Kohl v. United States*, 91 U.S. 367, 378 (1876) (Field, J., dissenting) (for eminent domain, what is "required is that the proceeding shall be conducted in some fair and just mode . . . , opportunity being afforded to parties interested to present evidence as to the value of the property, and to be heard thereon"). Similarly, a well-known nineteenth-century case defined due process as "the application of the law as it exists in the fair and regular course of administrative procedure." *Slaughter-House Cases*, 83 U.S. 36, 127 (1873). This decision is viewed as a turning point in limiting the ability to dismantle segregation through enforcement of the Privileges and Immunities clause of the Fourteenth Amendment. See Akhil R. Amar, *The Bill of Rights and the Fourteenth Amendment*, 101 Yale Law Journal 1193, 1259 (1992); Sanford Levinson, *Some Reflections on the Rehabilitation of the Privileges or Immunities Clause of the Fourteenth Amendment*, 12 Harvard Journal of Law & Public Policy 71, 73 (1989); Joseph Tussman & Jacobus tenBroek, *The Equal Protection of the Laws*, 37 California Law Review 341, 342 (1949). Cf. Kevin Christopher Newsom, *Setting Incorporationism Straight: A Reinterpretation of the Slaughter-House Cases*, 109 Yale Law Journal 643, 686–687 (2000).

**30** See, for example, *Davy's Executors v. Faw*, 11 U.S. 171, 174 (1812) ("That judges . . . ought to be fair, and their proceedings regular, so as to give the parties an opportunity to be heard . . . are propositions not to be controverted"); *Thirty Hogshead of Sugar v. Boyle*, 13 U.S. 191, 198 (1815) (declining to reexamine the "justice or fairness of the rules established in the British Courts").

**31** When doing so in the early twentieth century, the court relied on a formulation that the "essential elements of due process of law" were "notice and opportunity to defend." *Simon v. Craft*, 182 U.S. 427, 436 (1901). See also *Louisville & N. R. Co. v. Schmidt*, 177 U.S. 230, 236 (1900). Within a few decades thereafter, the Supreme Court set-

tled on the description that the "fundamental requisite of due process of law is the opportunity to be heard." See, for example, *Grannis v. Ordean*, 234 U.S. 385, 394 (1914); *Mullane v. Central Hanover Bank & Trust Co.*, 339 U.S. 306, 314 (1950); *Goldberg v. Kelly*, 397 U.S. 254, 267 (1970); *Dusenbery v. United States*, 534 U.S. 161, 173 (2002).

**32** *Caritativo v. California*, 357 U.S. 549 (1958).

**33** *Caritativo*, 357 U.S. at 558 (Frankfurter, J., dissenting). The majority opinion was per curiam; the dissent was joined by Justices Douglas and Brennan; Justice Harlan filed a separate concurrence. Id. at 550–552.

**34** See Charles Reich, *The New Property*, 73 Yale Law Journal 733 (1964). In the landmark decision of *Goldberg v. Kelly*, 397 U.S. 254 (1970), the United States Supreme Court applied these due process obligations to administrative agencies determining whether to terminate welfare recipients' benefits. Requiring due process did not, however, require that all such hearings be held prior to a deprivation or the provision of in-person oral proceedings rather than paper exchanges.

**35** As discussed earlier, the court's use of "fair" and "fairness" increased dramatically after the Civil War and became more frequent during the twentieth century. Based on a search of Supreme Court cases through 2008, we found that the phrase "opportunity to be heard" also gained currency after the Civil War and the Fourteenth Amendment, with 554 of the 556 opinions using the phrase issued from 1866, when the Amendment was proposed. In contrast, the court did not turn to the phrase "fundamental fairness" until the 1940s, when concluding that the "denial of due process" in a criminal trial was a "failure to observe that fundamental fairness essential to the very concept of justice." *Lisenba v. California*, 314 U.S. 219, 236 (1941). After the 1960s, "fundamental fairness" was a more frequent referent, with 212 of 235 opinions invoking the phrase issued since 1960.

Tracking the number of uses does not capture the changing understanding of the content of "fairness." By the 1970s, the Supreme Court had retreated from its *Goldberg* approach through limiting constructions of what the constitutional words "property" and "liberty" meant, thereby reducing the occasions on which process was due. Further, even when entitlements to due process attached, the court determined that more minimal kinds of decisionmaking procedures sufficed. See *Mathews v. Eldridge*, 424 U.S. 319 (1976); see also Judith Resnik, *The Story of Goldberg: Why This Case Is Our Shorthand*, in Civil Procedure Stories 473 (Kevin M. Clermont, ed., New York, NY: Foundation Press, 2d ed., 2008).

**36** See Larry M. Bartels, Unequal Democracy: The Political Economy of the New Gilded Age 17–23 (Princeton, NJ: Princeton U. Press, 2008). Moreover, in courts, a melange of due process and equal protection guarantees have generated federal rights to state assistance for those too poor, for example, to pay the filing fee necessary to seek a divorce or to pay for a transcript requisite for an appeal challenging the termination of parental rights. See *Boddie v. Connecticut*, 401 U.S. 371 (1971); *M. L. B. v. S. L. J.*, 519 U.S. 102 (1996).

**37** Bartels at 130–136.

**38** The ten interior murals, by Albert Henry Krehbiel, a Chicago artist, evoke classical Virtues with titles such as *Wisdom of the Law—Learning and Experience* and *Power of the Law—Prudence and Fortitude*. See Carolyn Taitt, *Mural Paintings of the Illinois Supreme Court*, 77 Journal of the Illinois State Historical Society 11, 11–13 (1984); Albert H. Krehbiel, American Impressionist Painter and Muralist, http://www.krehbielart.com. In 2008, extensive renovations were planned. See Meagan Sexton, *100-year-old Supreme Court Building Due for Makeover*, State Journal–Register (Springfield, IL), May 21, 2008, http://www.sj-r.com/time_out/x194401856/100-year-old-Supreme-Court-building-due-for-makeover. Figure 195 was provided by and is reproduced with the permission of the Administrative Office of the Illinois Courts (AO–Ill.) and the Krehbiel Corporation.

Our thanks to Maria Meis, Senior Attorney of the AO–Ill., and to Courtney E. Krehbiel, President of that corporation.

**39** See Lizbeth Wilson, *Allegories of Justice: The Albert H. Krehbiel Murals in the Supreme Court Building of Illinois*, 77, JOURNAL OF THE ILLINOIS STATE HISTORICAL SOCIETY 2 (1984).

**40** See, for example, *People ex rel. Burris v. Ryan*, 158 Ill. 2d 469, 469 (1994) (Bilandic, C. J., dissenting); *People v. White*, 117 Ill. 2d 194, 229 (1987) (Simon, J., concurring). See also Ed Nash, *Walter V. Shaefer: Retiring Justice of Illinois Supreme Court*, 3 ILLINOIS ISSUES, JAN. 1977, at 8, http://www.lib.niu.edu/1977/ii770108.html. Other state courts also quote the Latin maxim. See, for example, *Commonwealth v. Angiulo*, 415 Mass. 502, 544 (1993) (Nolan, J., dissenting); *Golden v. County of Union*, 163 N.J. 420, 437 (2000) (O'Hern, J., dissenting).

**41** See generally STUART HAMPSHIRE, INNOCENCE AND EXPERIENCE 186–187 (Cambridge, MA: Harvard U. Press, 1989). In contrast, David Luban argued that substantive justice required the principle of hearing both sides and, moreover, that adversarial procedures do not always suffice to fulfill that mandate. David Luban, *Lawfare and Legal Ethics at Guantánamo*, 60 STANFORD LAW REVIEW 1981, 1984–1986 (2008). See also Amalia Kessler, *Our Inquisitorial Tradition: Equity Procedure, Due Process, and the Search for an Alternative to the Adversarial*, 90 CORNELL LAW REVIEW 1181, 1210–1215 (2005) (hereinafter Kessler, *Our Inquisitorial Tradition*). Further, as the discussion of that precept's use in systems that mix adversarial and inquisitorial modes suggests, the distinctions between the forms and justifications of adversarial and inquisitorial systems can be overstated. See David Alan Sklansky, *Anti-Inquisitorialism*, 122 HARVARD LAW REVIEW 1635 (2009).

**42** *Nuclear Tests (Australia v. France)*, 1974 I.C.J. 253, 265 (Dec. 20).

**43** See, for example, *Case of Ivcher-Bronstein v. Peru*, 2001 Inter-Am. Ct.H.R. (ser. C) No. 74 para. 80 (Feb. 6, 2001); *Case of Caesar v. Trinidad and Tobago*, 2005 Inter-Am. Ct.H.R. (ser. C) No. 123 para. 37 (Mar. 11, 2005); *Case of Yvon Neptune v. Haiti*, 2008 Inter-Am. Ct.H.R. (ser. C) No. 180 para. 80 (May 6, 2008).

**44** Case T-346/94, *France-Aviation v. Commission*, 1995 E.C.R. II-2841, II-2843, para. 22. These arguments succeeded. Id. at paras. 21, 22, 40.

**45** See, for example, *TW v. Malta*, App. No. 25644/94, 29 Eur. H.R. Rep. 185, paras. 18, 40 (1999); see also *Micallef v. Malta*, App. No. 17056/06, 2008 Eur. Ct. H.R. 41, para. 16 (2009). The ECtHR has noted that obligations to hear both sides are facets of domestic regimes protecting the personal rights of citizens. See, for example, *Doran v. Ireland*, 2003 Eur. Ct. H.R. 417. As in the United States, the ECtHR has also imposed principles limiting when rights to fair hearings under Article 6 are implicated. See *Le Compte, Van Leuven & De Meyere v. Belgium*, App. Nos. 6878/75 and 7238/75, 4 Eur. H.R. Rep. 1 (1981); *Case of Jussila v. Finland*, 45 Eur. Ct. H.R. 39 (2007). *Jussila v. Finland* involved sanctions for alleged errors in calculating "value added tax" declarations. The court concluded that, while not classified as criminal, the proceedings were to be understood under that rubric; yet an oral public hearing was not required as issues of "differing weight" fell within the category of "criminal" proceedings. Id. at para. 43. The three dissenters objected, arguing that the ruling was the court's first to conclude that "an oral hearing may not be required in a criminal case." Id. (partial dissent of Judge Loucaides, joined by Judges Zupačič and Spielmann).

**46** This translation of *Exodus* 23:8 is taken from NATALIE ZEMON DAVIS, THE GIFT IN SIXTEENTH-CENTURY FRANCE 85 (Madison, WI: U. of Wisconsin Press, 2000). As we discussed in Chapter 3, in Davis's view limiting gift-giving to judges enabled the monarchy to centralize control by making judges dependent for support on the Crown. Id. at 96–97.

**47** THE DECLARATION OF INDEPENDENCE, para. 11.

**48** Act of Settlement, 1701, 12 & 13 Will. 3, c. 2 (Eng.) (providing that "judges' commissions be made quam diu se bene gesserint ['as long as he shall behave himself well'], and their salaries ascertained and established; but upon the address of both Houses of Parliament it may be lawful to remove them").

**49** MASS. CONST. of 1780, Part The First, Art. XXIX, reprinted in FRANKLIN B. HOUGH, I AMERICAN CONSTITUTIONS: COMPRISING THE CONSTITUTION OF EACH STATE IN THE UNION, AND OF THE UNITED STATES 619, 626 (Albany, NY: Weed, Parsons & Company, 1872) (hereinafter I HOUGH; vol. 2 is denoted II HOUGH). John Adams was the primary drafter. Id. at 616. New Hampshire used similar terms, calling for "impartial" judges. N.H. CONST. OF 1784, Part 1, Art. XXXV, reprinted in SUSAN E. MARSHALL, THE NEW HAMPSHIRE STATE CONSTITUTION 227, 232 (Westport, CT: Praeger, 2004).

**50** MASS. CONST. of 1780, Part The First, Art. XXIX.

**51** CHARLES DE SECONDAT, BARON DE MONTESQUIEU, THE SPIRIT OF LAWS (Thomas Nugent, trans., New York, NY: Colonial Press, 1900; originally published 1748). Montesquieu warned, "Again, there is no liberty, if the judiciary power be not separated from the legislative and executive. Were it joined with the legislative, the life and liberty of the subject would be exposed to arbitrary control; for the judge would be then the legislator. Were it joined to the executive power, the judge might behave with violence and oppression." Id. at 152.

**52** N.C. CONST. of 1776, Art. iv. Transcriptions of many eighteenth-century state constitutions can be found at the Yale Law School's Avalon Project website, http://avalon.law.yale.edu/.

**53** GA. CONST. of 1777, Art. I ("The legislative, executive, and judiciary departments shall be separate and distinct, so that neither exercise the powers properly belonging to the other").

**54** MD. CONST. of 1776, The Declaration of Rights, Art. 6, http://www.msa.md.gov/msa/speccol/sc2200/sc2221/000004/00000 8/pdf/d005137_all.pdf ("That the legislative, executive and judicial powers of government, ought to be for ever separate and distinct from each other.").

**55** MASS. CONST. of 1780, Part The First, Art. XXX ("In the government of this Commonwealth, the legislative department shall never exercise the executive and judicial powers, or either of them; the executive shall never exercise the legislative and judicial powers, or either of them; the judicial shall never exercise the legislative and executive powers, or either of them; to the end it may be a government of laws, and not of men.").

**56** N.H. CONST. OF 1784, Part I, Art. XXXVII ("In the government of this state, the three essential powers thereof, to wit, the Legislative, Executive and Judicial, ought to be kept as separate from and independent of each other, as the nature of a free government will admit, or as is consistent with that chain of connection that binds the whole fabric of the constitution in one indissoluble bond of union and amity.").

**57** VA. CONST. OF 1776, Bill of Rights, § 5, http://center.montpelier .org/documents/1776VAconstitution ("That the legislative and executive powers of the State should be separate and distinct from the judiciary"); VA. CONST. OF 1776, The Constitution or Form of Government ("The legislative, executive, and judiciary department, shall be separate and distinct, so that neither exercise the powers properly belonging to the other . . . ."). Other early constitutions created distinct branches of government but did not use these specific phrases. See, for example, N.Y. CONST. of 1777, paras. II, XVII; N.J. CONST. of 1776, paras. VIII, XX; PA. CONST. of 1776, Plan or Frame of Government for the Commonwealth or State of Pennsylvania, §§ 2–4; S.C. CONST. of 1778, paras. II, XI; VT. CONST. of 1777, ch. II, §§ II–IV.

**58** The limited powers of the judiciary are often trumpeted as desirable. See, for example, THE FEDERALIST NO. 78 (Alexander Hamilton) (arguing that the proposed federal judiciary would have neither "FORCE nor WILL, but merely judgment; and must ultimately depend upon the aid of the executive arm even for the efficacy of its judgments").

**59** U.S. Const., Art. 3, § 1, cl. 2.

**60** Universal Declaration of Human Rights, G.A. Res. 217A(III), Art. 10, U.N. GAOR, 3d Sess., 1st plen. mtg., U.N. Doc. A/810 (Dec. 12, 1948).

**61** Council of Europe, Convention for the Protection of Human Rights and Fundamental Freedoms, Art. 6(1), Nov. 4, 1950, 213 U.N.T.S. 222 (hereinafter European Convention). Article 5 also provides: "Everyone shall have the right to be tried by ordinary courts or tribunals using established legal procedures. Tribunals that do not use the duly established procedures of the legal process shall not be created to displace the jurisdiction belonging to the ordinary courts or judicial tribunals." Id., Art. 5.

**62** U.N. Basic Principles on the Independence of the Judiciary, G.A. Res. 146, U.N. GAOR, 40th Sess., Supp. No. 53, U.N. Doc. A/RES/40/146 (1985), http://www2.ohchr.org/english/law/indjudiciary.htm. The caveat included is that "[t]his principle is without prejudice to judicial review or to mitigation or commutation by competent authorities of sentences imposed by the judiciary, in accordance with the law." Id.

**63** See Vicki C. Jackson, *Packages of Judicial Independence: The Selection and Tenure of Article III Judges*, 95 Georgetown Law Journal 965 (2007); Judith Resnik, *Interdependent Federal Judiciaries: Puzzling about Why & How to Value the Independence of Which Judges*, 137 Daedalus 28 (Fall 2008).

**64** See generally Hampshire, Justice Is Conflict; Eric Bennett Rasmusen & J. Mark Ramseyer, *When Are Judges and Bureaucrats Left Independent? Theory and History from Imperial Japan, Postwar Japan, and the United States* (U. of Tokyo CIRJE Working Paper No. F-126, August 2001), http://papers.ssrn.com/sol3/papers.cfm?abstract_id=305900; J. Mark Ramseyer, *The Puzzling (In)dependence of Courts: A Comparative Approach*, 33 Journal of Legal Studies 721 (1994); Georget Tridimas, *Judges and Taxes: Judicial Review, Judicial Independence and the Size of Government*, 16 Constitutional Political Economy 5 (2005).

**65** See, for example, Jack M. Balkin & Sanford Levinson, *Understanding the Constitutional Revolution*, 87 Virginia Law Review 1045 (2001); Jack M. Balkin & Sanford Levinson, *The Processes of Constitutional Change: From Partisan Entrenchment to the National Surveillance State*, 75 Fordham Law Review 489 (2006).

**66** Charter or Fundamental Laws, of West New Jersey, Agreed Upon, ch. XXIII (1676), http://avalon.law.yale.edu/17th_century/nj05.asp. The authorship of the text is not clear. The document governed an area on the eastern seaboard that is now within the State of New Jersey. In Dutch possession in 1655, that land thereafter came under English control. In 1664 Charles II of England granted his brother, James, Duke of York (who later became James II, King of England), an extensive American territory encompassing the area; the Duke executed deeds of lease and release to Lord John Berkeley and Sir George Carteret. Edwin Platt Tanner, The Province of New Jersey, 1664–1738, at 2–3 (New York, NY: Columbia U. Press, 1908); see The Duke of York's Release to John Lord Berkeley, and Sir George Carteret, 24th of June, 1664, http://avalon.law.yale.edu/17th_century/nj01.asp.

In 1664 Lord Berkeley and Sir Carteret signed a document, made public under the title of "The Concession and Agreement of the Lords Proprietors of the Province of New Caesarea, or New Jersey, to and With All and Every the Adventurers and All Such as Shall Settle or Plant There." II Hough at 31. The first governor, Philip Carteret (Sir George's cousin), was joined by a Council of between six and twelve chosen by him and an Assembly of twelve chosen "annually by the freemen of the Province," to rule until 1682. The document further specified that the "Governor and Council were to exercise a general supervision over all courts, and the execution of the laws; to direct the manner of laying out the lands; and were not to impose, nor suffer to

be imposed, any tax upon the people not authorized by the General Assembly." II Hough at 31.

During Carteret's tenure, the Dutch retook possession of the area briefly in 1673, when they regained neighboring New York. The province was split into East and West in 1674. II Hough at 32–33. Thereafter, the people of West New Jersey established their own plan of government. The Charter or Fundamental Laws, of West New Jersey, Agreed Upon, was prepared in England and published on March 3, 1676. II Hough at 33. The document may have originated with the Quaker settlers of West New Jersey, and some speculate that William Penn could have been an author. See Ronald A. Banaszak, Fair Trial Rights of the Accused: A Documentary History 15 (Westport, CT: Greenwood Publishing, 2002). Our thanks to Joseph Anderson, Jr., for bringing this document to our attention.

One other note is in order. In proclaiming that "any person or persons, inhabitants of the said Province may freely come into, and attend the said courts," the Charter may not, given racial and gender hiearchies of the time, have meant "any person" in the contemporary sense. On the other hand, provisions of the Fundamental Laws describing juries specify that they were composed of "twelve honest men of the neighborhood" (ch. XXII); see also chs. XVII, XVIII, XIX), but provisions relating to trial procedure more generally use generic pronouns, see ch. XXI ("That all and every person and persons whatsoever . . ."), ch. XXII, and even include language inclusive of women, see ch. XXI ("him or herself"). Furthermore, one hundred years after the Laws, the New Jersey Constitution of 1776 was notable for permitting women to vote; that opportunity existed until 1807, when the legislature "reinterpreted" the suffrage clause and limited suffrage to adult white male taxpaying citizens. See Judith Apter Klinghoffer & Lois Elkis, *"The Petticoat Electors": Women's Suffrage in New Jersey, 1776–1807*, 12 Journal of the Early Republic 159, 159–160 (1992).

**67** Tacitus, *Dialogus de Oratoribus* 39.1–4, in Bruce W. Frier, *Finding a Place for Law in the High Roman Empire*, in Spaces of Justice in the Roman World (F. de Angelis, ed., Columbia Studies in the Classical Tradition, New York: Columbia U. Press, forthcoming 2010). See also Bruce W. Frier, The Rise of the Roman Jurists: Studies in Cicero's Pro Caecina (Princeton, NJ: Princeton U. Press, 1985); J. A. Crook, Legal Advocacy in the Roman World (Ithaca, NY: Cornell U. Press, 1995).

**68** As discussed in Chapters 2, 3, and 4, public dispute resolution was an early practice. See also Emanuele Conte, Public Law Before the State: Evidence from the Age of the Gloassators of the Roman Law, unpublished paper, Yale Legal History Workshop, Yale University, New Haven, CT, Feb. 7, 2006.

**69** See generally John H. Langbein, Torture and the Law of Proof: Europe and England in the Ancien Régime (Chicago, IL: U. of Chicago Press, 1977; 2d ed., 2006).

**70** See Stefano Maffei, The European Right to Confrontation in Criminal Proceedings: Absent, Anonymous and Vulnerable Witnesses 23 (Groningen, Neth.: Europa Law Publishers, 2006).

**71** "All courts shall be open; and every man for an injury done him in his reputation, person, movable or immovable possessions, shall have remedy by the due course of law, and justice administered according to the very right of the cause and the law of the land, without sale, denial, or unreasonable delay or expense." Del. Const. of 1792, Art. I, § 9, reprinted in Benjamin Perley Poore, I The Federal and State Constitutions: Colonial Charters, and Other Organic Laws of the United States 278, 279 (Washington, DC: Government Printing Office, 1877) (hereinafter I Poore; vol. 2 is denoted II Poore). That was Delaware's second constitution. See also Ky. Const. of 1792, Art. XII, reprinted in I Poore at 647, 655 ("all courts shall be open"); Vt. Const. of 1777, ch. II, § XXIII ("All courts

shall be open, and justice shall be impartially administered, without corruption or unnecessary delay; all their officers shall be paid an adequate, but moderate, compensation for their services; and if any officer shall take greater or other fees than the laws allow him, either directly or indirectly, it shall ever after disqualify him from holding any office in this State."). Our thanks to Adam Grogg for researching state constitutional provisions.

72  See, for example, ALA. CONST. of 1819, Art. I, § 14, reprinted in I POORE at 32, 33 ("All courts shall be open . . ."); CONN. CONST. of 1818, Art. I, § 12, reprinted in I POORE at 258, 259 ("All courts shall be open . . ."); FLA. CONST. of 1838, Art. I, § 9, reprinted in I POORE at 317, 317 ("all courts shall be open"); IND. CONST. of 1816, Art. I, § 11, reprinted in I POORE at 499, 500 ("all courts shall be open"); KAN. CONST. of 1855, Art. I, § 16, reprinted in I POORE at 580, 582 ("All courts shall be open . . ."); LA. CONST. of 1864, Art. 110, reprinted in I POORE at 739, 750 ("All courts shall be open . . ."); MISS. CONST. of 1868, Art. I, § 28, reprinted in I HOUGH at 745, 749 ("All courts shall be open . . ."); NE. CONST. of 1867, Art. I, § 9, reprinted in I HOUGH at 824, 827 ("All courts shall be open . . ."); N.C. CONST. of 1868, Art. I, § 35, reprinted in II HOUGH at 110, 115 ("All courts shall be open . . ."); OH. CONST. of 1850–1851, Art. I, § 16, reprinted in II HOUGH at 152, 157 ("All courts shall be open . . ."); PA. CONST. of 1838, Art. IX, § 11, reprinted in II HOUGH at 222, 237 ("all courts shall be open"); TENN. CONST. of 1870, Art. I, § 17, reprinted in II HOUGH at 321, 326 ("all courts shall be open"); TEX. CONST. of 1869, Art. I, § 11, reprinted in II HOUGH at 356, 360 ("All courts shall be open . . ."). See generally II HOUGH at 580–581.

Other nineteenth-century state constitutions provided for public access with somewhat different wording. See, for example, MO. CONST. of 1865, Art. I, para. 15, reprinted in I HOUGH at 779, 783 ("That courts of justice ought to be open to every person, and certain remedy afforded for every injury to person, property, or character . . ."); OR. CONST. of 1857, Art. I, § 10, reprinted in II HOUGH at 186, 189 ("No court shall be secret; but justice shall be administered openly and without purchase, completely and without delay . . ."); S.C. CONST. of 1868, Art. I, § 15, reprinted in II HOUGH at 276, 281 ("All courts shall be public, and every person, for any injury that he may receive in his lands, goods, persons or reputation, shall have remedy by due course of law and justice administered without unnecessary delay").

73  See ALA. CONST., Art. I, § 13 ("That all courts shall be open; and that every person, for any injury done him, in his lands, goods, person, or reputation, shall have a remedy by due process of law; and right and justice shall be administered without sale, denial, or delay"); ARIZ. CONST., Art. VI, § 2 ("The court shall be open at all times, except on nonjudicial days, for the transaction of business"); CONN. CONST., Art. I, § 10 ("All courts shall be open, and every person, for an injury done to him in his person, property or reputation, shall have remedy by due course of law, and right and justice administered without sale, denial or delay"); DEL. CONST., Art. I, § 9 ("All courts shall be open; and every person for an injury done him or her in his or her reputation, person, movable or immovable possessions, shall have remedy by the due course of law, and justice administered according to the very right of the cause and the law of the land, without sale, denial, or unreasonable delay or expense"); FLA. CONST., Art. I, § 21 ("The courts shall be open to every person for redress of any injury, and justice shall be administered without sale, denial or delay"); IND. CONST., Art. 1, § 12 ("All courts shall be open; and every person, for injury done to him in his person, property, or reputation, shall have remedy by due course of law. Justice shall be administered freely, and without purchase, completely, and without denial; speedily, and without delay."); KY. CONST., § 14 ("All courts shall be open, and every person for an injury done him in his lands, goods, person or reputation, shall have remedy by due course of law, and right and justice administered without sale,

denial or delay"); LA. CONST., Art. I, § 22 ("All courts shall be open, and every person shall have an adequate remedy by due process of law and justice, administered without denial, partiality, or unreasonable delay, for injury to him in his person, property, reputation, or other rights"); MISS. CONST., Art. 3, § 24 ("All courts shall be open; and every person for an injury done him in his lands, goods, person, or reputation, shall have remedy by due course of law, and right and justice shall be administered without sale, denial, or delay"); NE. CONST., Art. I, § 13 ("All courts shall be open, and every person, for any injury done him or her in his or her lands, goods, person, or reputation, shall have a remedy by due course of law and justice administered without denial or delay, except that the Legislature may provide for the enforcement of mediation, binding arbitration agreements, and other forms of dispute resolution which are entered into voluntarily and which are not revocable other than upon such grounds as exist at law or in equity for the revocation of any contract"); N.C. CONST., Art. I, § 18 ("All courts shall be open; every person for an injury done him in his lands, goods, person, or reputation shall have remedy by due course of law; and right and justice shall be administered without favor, denial, or delay"); N.D. CONST., Art. I, § 9 ("All courts shall be open, and every man for any injury done him in his lands, goods, person or reputation shall have remedy by due process of law, and right and justice administered without sale, denial or delay"); OH. CONST., Art. I, § 16 ("All courts shall be open, and every person, for an injury done him in his land, goods, person, or reputation, shall have remedy by due course of law, and shall have justice administered without denial or delay"); PA. CONST., Art. I, § 11 ("All courts shall be open; and every man for an injury done him in his lands, goods, person or reputation shall have remedy by due course of law, and right and justice administered without sale, denial or delay"); S.D. CONST., Art. VI, § 20 ("All courts shall be open, and every man for an injury done him in his property, person or reputation shall have remedy by due course of law, and right and justice, administered without denial or delay"); TENN. CONST., Art. I, § 17 ("That all courts shall be open; and every man, for an injury done him in his lands, goods, person or reputation, shall have remedy by due course of law, and right and justice administered without sale, denial, or delay"); TEX. CONST., Art. I, § 13 ("All courts shall be open, and every person for an injury done him, in his lands, goods, person or reputation, shall have remedy by due course of law"); UTAH CONST., Art. I, § 11 ("All courts shall be open, and every person, for an injury done to him in his person, property or reputation, shall have remedy by due course of law, which shall be administered without denial or unnecessary delay; and no person shall be barred from prosecuting or defending before any tribunal in this State, by himself or counsel, any civil cause to which he is a party."); WYO. CONST., Art. 1, § 8 ("All courts shall be open and every person for an injury done to person, reputation or property shall have justice administered without sale, denial or delay. Suits may be brought against the state in such manner and in such courts as the legislature may by law direct").

74  See Duncan v. Louisiana, 391 U.S. 145, 153 (1968) ("The constitutions adopted by the original States guaranteed jury trial. Also, the constitution of every State entering the Union thereafter in one form or another protected the right to jury trial in criminal cases"); see, for example, CONN. CONST. of 1818, Art. First, § 9, http://www .sots.ct.gov/sots/cwp/view.asp?a=3188&q=392280 ("In all criminal prosecutions, the accused shall have a right to be heard by himself and by counsel; to demand the nature and cause of the accusation; to be confronted by the witnesses against him; to have compulsory process to obtain witnesses in his favour; and in all prosecutions by indictment or information, a speedy public trial by an impartial jury"); GA. CONST. of 1777, Art. LXI ("Freedom of the press and trial by jury to remain inviolate forever"); MASS. CONST. of 1780, Part the First, Art. XII ("And the legislature shall not make any law, that shall subject any

person to a capital or infamous punishment, excepting for the government of the army and navy, without trial by jury"); N.C. CONST. of 1776, A Declaration of Rights, Art. IX ("That no freeman shall be convicted of any crime, but by the unanimous verdict of a jury of good and lawful men, in open court, as heretofore used").

**75** U.S. CONST., Art. III, § 3, cl. 1.

**76** "The Trial of all Crimes, except in Cases of Impeachment, shall be by Jury . . . ." U.S. CONST., Art. III, § 2, cl. 3.

**77** U.S. CONST., Amend. VI. The Sixth Amendment provides: "In all criminal prosecutions, the accused shall enjoy the right to a speedy and public trial, by an impartial jury of the State and district wherein the crime shall have been committed, which district shall have been previously ascertained by law, and to be informed of the nature and cause of the accusation; to be confronted with the witnesses against him; to have compulsory process for obtaining witnesses in his favor, and to have the Assistance of Counsel for his defence." Id. See generally SUSAN N. HERMAN, THE RIGHT TO A SPEEDY AND PUBLIC TRIAL: A REFERENCE GUIDE TO THE UNITED STATES CONSTITUTION (Westport, CT: Praeger, 2006). The phrase "speedy public trial, by an impartial jury" can also be found in the Pennsylvania Constitution of 1776, A Declaration of the Rights of the Inhabitants of the Commonwealth or State of Pennsylvania, Art. IX.

Criticism of the theoretical framing of the public trial as a "right" and arguments that it both imposes burdens and has no necessary effect on fairness can be found in Joseph Jaconelli, *Rights Theories and Public Trial*, 14 JOURNAL OF APPLIED PHILOSOPHY 169 (1997). Celebration of the "publicness" of law and its proceedings comes from Benedict Kingsbury, *International Law as Inter-Public Law*, in MORAL UNIVERSALISM AND PLURALISM, 49 NOMOS 167 (Henry S. Richardson & Melissa S. Williams, eds., New York, NY: New York U. Press, 2009).

**78** U.S. CONST., Amend. VII.

**79** See, for example, *Press–Enterprise Company v. Superior Court*, 478 U.S. 1 (1986); *Press–Enterprise Company v. Superior Court*, 464 U.S. 501 (1984); *NBC Subsidiary (KNBC-TV), Inc. v. Superior Court*, 20 Cal. 4th 1178 (1999); *Hartford Courant Company v. Pellegrino*, 380 F.3d 83, 96 (2d Cir. 2004). The court in *Pelligrino* concluded that "docket sheets enjoy a presumption of openness and that the public and the media possess a qualified First Amendment right to inspect them" and explained the utility of such an approach. Id. See generally *Richmond Newspapers, Inc. v. Virginia*, 448 U.S. 555 (1980); Judith Resnik, *Due Process: A Public Dimension*, 39 UNIVERSITY OF FLORIDA LAW REVIEW 405 (1987).

**80** English law had limited public access to what were termed "statements of case" unless a judge granted permission. See NEIL ANDREWS, ENGLISH CIVIL PROCEDURE: FUNDAMENTALS OF THE NEW CIVIL JUSTICE SYSTEM 82–83 (Oxford, Eng.: Oxford U. Press, 2003). The public could obtain access to witness statements. See ADRIAN A. S. ZUCKERMAN, CIVIL PROCEDURE 88–89 (London, Eng.: LexisNexis, 2003). In October 2005 the Department for Constitutional Affairs (DCA) imposed other restrictions, prompting objections from many, including media representatives. See Joanne Harris, '*Open Justice*' *Wins as DCA Rewrites Claim Access Rules*, LAWYER, Oct. 2, 2006, at 3. Thereafter, the rules were amended (effective October 2006) to make court documents more accessible. Restrictions remained, with public access conditioned on court permission, for example, to obtain documents attached to pleadings. Further, persons identified in statements of case could apply to "restrict the persons or classes of persons who may obtain a copy of the statement of case." Civil Procedure Rules (U.K.), Rule 5.4(C)(4), http://www.justice.gov.uk/civil/procrules_fin/contents/parts/part05.htm#IDA2GAFC.

Other jurisdictions also have variations. While documents filed in court carry a strong presumption of accessibility, even if related to settlements, the ECtHR requires: "All documents deposited with the

Registry" in relationship to applications (except if related to "friendly-settlement negotiations") "shall be accessible to the public" absent a decision to the contrary by a judge for reasons such as the "interests of morals, public order or national security in a democratic society." European Court of Human Rights, Rules of Court, Rule 33 (Dec. 2008) (hereinafter ECtHR Rules). These rules are available on the court's website.

**81** Kessler, *Our Inquisitorial Tradition* at 1193.

**82** Kessler, *Our Inquisitorial Tradition* at 1201.

**83** Kessler, *Our Inquisitorial Tradition* at 1204–1206. Sometimes "masters" took evidence. Id. at 1208–1210; 1218–1229. By 1842, the Federal Equity Rules codified the authority to take oral evidence before the parties. Id. at 1229–1231. By 1893, the courts, sitting in equity, were authorized to take evidence "in open court." Id. at 1233 (citing Equity Rule 67, as amended). See also Rule 46 of the Federal Rules of Equity of 1912, id. at 1243.

**84** U.S. CONST., Art. I, § 5, cl. 3.

**85** See, for example, VT. CONST. of 1777, ch. II, § XII ("The doors of the house in which the representatives of the Greene of this State, shall sit, in General Assembly, shall be and remain open for the admission of all persons, who behave decently, except only, when the welfare of this State may require the doors to be shut."); see also N.Y. CONST. of 1777, Art. XV ("That the doors, both of the senate and assembly, shall at all times be kept open to all persons, except when the welfare of the State shall require their debates to be kept secret. And the journals of all their proceedings shall be kept in the manner heretofore accustomed by the general assembly of the colony of New York; and except such parts as they shall, as aforesaid, respectively determine not to make public be from day to day (if the business of the legislature will permit) published.").

**86** U.S. CONST., Art. I, § 9, cl. 7. Enforcement, however, is a problem in that under current law it is not clear who can bring lawsuits to compel such disclosures. See *United States v. Richardson*, 418 U.S. 166 (1974) (holding that a taxpayer lacked standing to challenge the CIA's secret budget as unconstitutional under Article I, § 9, cl. 7).

**87** U.S. CONST., Art. IV, § 1.

**88** U.S. CONST., Amend. I.

**89** See Conseil Constitutionnel: A Historic Setting (undated monograph provided by the Conseil). Our thanks to Olivier Dutheillet de Lamothe for giving us an understanding of the Conseil Constitutionnel's processes.

**90** See European Court of Human Rights, www.echr.coe.int (under "Visitors"), and the discussion in Chapter 11.

**91** See Spanish Supreme Court, "Jornadas de Puertas Abiertas" (Open-Door Days), www.poderjudicial.es.

**92** See John M. Ackerman & Irma E. Sandoval-Bellesteros, *The Global Explosion of Freedom of Information Laws*, 58 ADMINISTRATIVE LAW REVIEW 85 (2006).

**93** European Convention, Art. 6. The case law of the ECtHR has found that the right to a hearing generally entails rights to oral hearings if individuals' "civil rights and obligations" are at issue. See *König v. Germany*, App. No. 6232/73, 2 Eur. H.R. Rep. 170 (ser. A) paras. 88–89 (1978). A large body of law parses questions of when these rights are engaged and what forms of hearings suffice. See, for example, *Riepan v. Austria*, App. No. 35115/97, 2000-XII Eur. Ct. H.R., paras. 9–41; *Göç v. Turkey*, App. No. 36590/97, 2002 Eur. Ct. H.R. 589, para. 51.

**94** MAFFEI at 16. Article 6 provides that anyone charged with a criminal offense has the right "to examine or have examined witnesses against him and to obtain the attendance and examination of witnesses on his behalf under the same conditions as witnesses against him." European Convention, Art. 6(3)(d). As Maffei pointed out, the focus is on "examination" rather than "confrontation," and to protect civil law traditions, such examination may be undertaken by the

court. MAFFEI at 16–19. With respect to proceedings in the European Court of Justice, rights to public hearings are enforceable through protections in the ECHR and Member States' constitutions. As noted in Chapter 1, two kinds of access are relevant. Our focus here is on *public* access to proceedings as distinct from access to courts by individuals seeking redress for injuries. The second form is protected in various of the state constitutions discussed earlier as well as in many other treaties and conventions. For example, the European Community Treaty established a "system of legal remedies and procedures." See Case 294/83, *Parti Écologiste 'Les Verts' v. European Parliament*, 1986 E.C.R. 1339, para. 23.

**95** Protocol (No. 3) on the Statute of the Court of Justice of the European Union, Art. 31, http://curia.europa.eu/jcms/jcms/J02_8349/enstatut-de-la-cour.

**96** International Covenant on Civil and Political Rights, G.A. Res. 2200A (XXI), Art. 14, U.N. Doc. A/6316 (Mar. 23, 1976).

**97** For example, the European Convention provides that "the press and public may be excluded from all or parts of the trial in the interests of morals, public order or national security in a democratic society, where the interests of juveniles or the protection of the private life of the parties so require, or to the extent strictly necessary in the opinion of the court in special circumstances where publicity would prejudice the interests of justice." European Convention, Art. 6(1).

**98** See PIERRE BOURDIEU & LOÏC J. D. WACQUANT, AN INVITATION TO REFLEXIVE SOCIOLOGY 36–46, 235–236 (Chicago, IL: U. of Chicago Press, 1992); Pierre Bourdieu, *Participant Objectivation*, 9 JOURNAL OF THE ROYAL ANTHROPOLOGICAL INSTITUTE 281 (2003); Pierre Bourdieu, *The Force of Law: Toward a Sociology of the Juridical Field*, 38 HASTINGS LAW JOURNAL 805, 838 (Richard Terdiman, trans., 1987).

**99** See generally Peter W. Martin, *Online Access to Court Records— From Documents to Data, Particulars to Patterns*, 53 VILLANOVA LAW REVIEW 855 (2008). The availability of information in different forms did not necessarily produce more transparency. See Lynn M. LoPucki, *Court-System Transparency*, 94 IOWA LAW REVIEW 481 (2009).

**100** See, for example, International Court of Justice, Rules of Court, Art. 94(2), http://www.icj-cij.org/documents/index.php?p1=4&p2=3&p3=0 (specifying that ICJ judgments "shall be read at a public sitting of the Court and shall become binding on the parties on the day of the reading"); Statute of the Inter-American Court on Human Rights, Art. 24(3), OEA/Ser.L/V.III.3 doc. 13 corr. 1 at 16 (1980), reprinted in Basic Documents Pertaining to Human Rights in the Inter-American System, OEA/Ser.L.V. II.82 doc. 6 rev. 1 at 133 (1992) (providing that the "decisions, judgments and opinions of the Court shall be delivered in public session, and the parties shall be given written notification thereof," and that all decisions must be published "along with judges' individual votes and opinions and with such other data . . . that the Court may deem appropriate"); International Criminal Tribunal for the former Yugoslavia (ICTY), Rules of Procedure and Evidence, Rule 98 *ter* (A), U.N. Doc. No. IT/32/Rev. 42 (Nov. 4, 2008), http://www.icty.org/x/file/Legal%20Library/Rules_procedure_evidence/IT032_Rev42_en.pdf (hereinafter ICTY rules) (requiring that the "judgement shall be pronounced in public, on a date of which notice shall have been given to the parties and counsel and at which they shall be entitled to be present . . ."). A few courts make the reading of judgments optional. See, for example, ECtHR Rules, Rule 77(2). Our thanks to Kate Desormeau, Emily Teplin, and Laurie Ball for research on public proceedings in various venues, including transnational courts.

**101** International Criminal Court, Rules of Procedure and Evidence, Rule 144(1), ICC-ASP/1/3, Sept. 3–10, 2002.

**102** That form has become commonplace in courts with the resources for such databases. See, for example, International Court of

Justice, List of All Cases, http://www.icj-cij.org/docket/index.php?p1=3&p2=2; European Court of Human Rights, Case-Law, http://www.echr.coe.int/ECHR/EN/Header/Case-Law/HUDOC/HUDOC+database.

**103** Details and concerns about the impact of such technologies can be found in Linda Mulcahy, *The Unbearable Lightness of Being? Shifts Towards the Virtual Trial*, 35 JOURNAL OF LAW & SOCIETY 464 (2008).

**104** In Canada, Supreme Court—but not lower court—proceedings are televised. As to the method, most "courtroom proceedings are webcast live and are later televised by the Canadian Parliamentary Affairs Channel (CPAC)." See Supreme Court of Canada, Frequently Asked Questions, http://www.scc-csc.gc.ca/faq/faq/index-eng.asp #f7. The question of a media "right" to electronic access is explored in A. Wayne MacKay, *Framing the Issues for Cameras in the Courtrooms: Redefining Judicial Dignity and Decorum*, 19 DALHOUSIE LAW JOURNAL 139 (1996).

**105** Transmission is provided via a web link, enabling the public, including people in the former territories, to see the proceedings; the languages offered were French, English, and Serbo-Croatian. When witnesses or proceedings raise security problems, the screened images and witnesses' voices may be scrambled. See ICTY Rules, Rule 75(B)(i)(c) ("Measures for the Protection of Victims and Witnesses"). Further, when needed for reasons of "public morality," "safety, security, or non-disclosure of the identity of a victim or witness . . . ," or "the protection of the interests of justice," the Trial Chamber may go into closed sessions and exclude the press from proceedings, but only if it "make[s] public the reasons for its order." Id. at Rule 79 ("Closed Sessions").

**106** In 2001, thirty-six U.S. states had permanent rules approving cameras (still and video) in trial and appellate courts. See NATIONAL CENTER FOR STATE COURTS, CAMERAS IN THE COURTS: SUMMARY OF STATE COURT RULES (2002), http://www.ncsconline.org/WC/Publications/KIS_CameraPub.pdf. By 2010, that number had grown to forty-two. See *Hollingsworth v. Perry*, No. 09A648, 130 S. Ct. 705, 718 (Jan. 13, 2010) (Breyer, J., dissenting).

**107** See Robert L. Brown, *Just a Matter of Time? Video Cameras at the United States Supreme Court and the State Supreme Courts*, 9 JOURNAL OF APPELLATE PRACTICE & PROCESS 1 (2007). In 2009 the Ninth Circuit authorized the use of cameras in certain cases, at the discretion of the district court. A district judge relied on that provision to permit the televising to other federal courthouses of a trial addressing the legality of an amendment to California's constitution outlawing same-sex marriage. In a 5–4 decision, however, the United States Supreme Court intervened to prohibit that transmission. See *Hollingsworth v. Perry*, 130 S. Ct. 705 (2010) (granting a stay of the order providing for the limited broadcast).

**108** Rules of Procedure of the Court of Justice of the European Communities of 19 June 1991, Art. 30, http://curia.europa.eu/jcms/jcms/J02_8352/enreglement-de-procedure-de-la-cour-de-justice.

**109** See, for example, R. Malcolm Smuts, *Public Ceremony and Royal Charisma: The English Royal Entry in London, 1485–1642*, in THE FIRST MODERN SOCIETY: ESSAYS IN ENGLISH HISTORY IN HONOUR OF LAWRENCE STONE 65–93 (A. L. Beier, David Cannadine, & James M. Rosenheim, eds., Cambridge, Eng.: Cambridge U. Press, 1989) (hereinafter THE FIRST MODERN SOCIETY).

**110** See MICHEL FOUCAULT, DISCIPLINE AND PUNISH: THE BIRTH OF THE PRISON 32–120 (Alan Sheridan, trans., New York, NY: Vintage Books, 1995, 2nd ed.; 1977, 1st ed.).

**111** Katharine Fremantle, *The Open Vierschaar of Amsterdam's Seventeenth Century Town Hall as a Setting for the City's Justice*, 77 OUD HOLLAND 206, 208 (1962).

**112** Thomas W. Laqueur, *Crowds, Carnival and the State in English Executions, 1604–1868*, in THE FIRST MODERN SOCIETY, 305, 309–311

(hereinafter Laqueur, for the article). Laqueur examined graphic prints displaying the carnival-like atmosphere, suggesting that "from the audience's perspective, executions were a species of festive comedy or light entertainment" with a theatricality that came to be parodied. Id. at 323–325. See also SAMUEL Y. EDGERTON JR., PICTURES AND PUNISHMENT: ART AND CRIMINAL PROSECUTION DURING THE FLORENTINE RENAISSANCE (Ithaca, NY: Cornell U. Press, 1985).

113 MIKHAIL BAKHTIN, RABELAIS AND HIS WORLD 10 (Helene Iswolsky, trans., Bloomington, IN: Indiana U. Press, 1984).

114 Laqueur at 352. Public executions stopped in England in the late 1960s, and by 1965 the United Kingdom had effectively abolished capital punishment. See Murder (Abolition of Death Penalty) Act 1965, c.71 (Eng.). Yet, as Foucault pointed out, the authority had already shifted its sites of operation. Governments cut off access by incarcerating individuals in prisons removed from the public eye. FOUCAULT, DISCIPLINE AND PUNISH at 7–8.

115 C. W. Brooks, Interpersonal Conflict and Social Tension: Civil Litigation in England, 1640–1830, in THE FIRST MODERN SOCIETY. Brooks also noted that eighteenth-century rates of civil litigation were lower than in some prior eras. Id. at 396–397. English history also included a brief period, in the 1760s, when both litigants and spectators had to pay fees to enter the galleries of the Old Bailey, London's criminal court. See John Brewer, The Wilkites and the Law, 1763–74: A Study of Radical Notions of Governance, in AN UNGOVERNABLE PEOPLE: THE ENGLISH AND THEIR LAW IN THE SEVENTEENTH AND EIGHTEENTH CENTURIES 128, 150 (John Brewer & John Styles, eds., New Brunswick, NJ: Rutgers U. Press, 1980); Simon Devereaux, The City and the Sessions Paper: "Public Justice" in London, 1770–1800, 35 JOURNAL OF BRITISH STUDIES 466, 486 (1996). Another form of limiting access came from declining to include all materials submitted in the records kept. See Devereaux at 488.

116 By way of illustration, between 1560 and 1640 "the number of lawyers ('barristers') qualified before the central courts increased fourfold." Holmes, in LEGISLATION AND JUSTICE at 269, 273.

117 See JONATHAN CRARY, TECHNIQUES OF THE OBSERVER: ON VISION AND MODERNITY IN THE NINETEENTH CENTURY 1–25 (Cambridge, MA: MIT Press, 1990). Cultural theorists have also examined the role of public spectatorship of kingship as rulers hoped to obtain devotional communal commitments through rituals. See Smuts at 92–93.

118 See JEREMY BENTHAM, RATIONALE OF JUDICIAL EVIDENCE (1827) (hereinafter BENTHAM, RATIONALE), in 6 THE WORKS OF JEREMY BENTHAM 351 (John Bowring, ed., Edinburgh, Scot.: William Tait, 1843) (hereinafter BOWRING/WORKS) ("Of Publicity and Privacy, as Applied to Judicature in General, and to the Collection of the Evidence in Particular"). William Twining, a scholar at University College London who worked on Bentham, noted that Bentham devoted more than 2,500 manuscript pages to the Rationale and that the discussion of publicity was likely written around 1812. WILLIAM TWINING, THEORIES OF EVIDENCE: BENTHAM AND WIGMORE 29 (London, Eng.: Weidenfeld & Nicolson, 1985).

Many of our references to "Bentham" come from a few of the volumes of The Works of Jeremy Bentham, published in the nineteenth century by John Bowring, who served as Bentham's literary executor and who put several volumes into print after Bentham's death in 1832. For facsimiles of the Works, http://oll.libertyfund.org/index.php?option=com_staticxt&staticfile=show.php&title=192. Special thanks are due to Philip Schofield, Director of the Bentham Project at University College London (UCL), Faculty of Laws, for guidance in identifying the relevant texts and, with the assistance of Kate Barber, providing a database of searchable transcriptions of Bentham's files relating to his Scotch Reform (1808), later assembled by Anthony Draper (hereinafter Draper/Scotch Reform manuscript database). New edi-

tions of Bentham's work are underway to take into account "the collection of 60,000 manuscript folios deposited in the UCL Library." See UCL FACULTY OF LAWS, THE BENTHAM PROJECT, THE GREATEST HAPPINESS OF THE GREATEST NUMBER, http://www.ucl.ac.uk/Bentham-Project/site_images/Leaflets/Publicity.pdf. As of 2006, twenty-six new volumes of the Collected Works of Jeremy Bentham were in print, and "forty or so more" were needed "to finish the job." PHILIP SCHOFIELD, UTILITY AND DEMOCRACY: THE POLITICAL THOUGHT OF JEREMY BENTHAM vi (New York, NY: Oxford U. Press, 2006).

Because variations exist between original manuscripts and what has been published, the study of Bentham is "necessarily more provisional than that of many other past thinkers." See SCHOFIELD, UTILITY AND DEMOCRACY at vi. Draper described the "published work" as bearing "few similarities to the surviving manuscript." See Anthony J. Draper, "Corruptions in the Administration of Justice": Bentham's Critique of Civil Procedure, 1806–1811, 7 JOURNAL OF BENTHAM STUDIES (2004), http://www.ucl.ac.uk/Bentham-Project/journal/jnl_2004.htm at 3 (hereinafter Draper, Corruptions; paginated according to the web printout). See also Stephen G. Engelmann, "Indirect Legislation": Bentham's Liberal Government, 35 POLITY 369, 370 n. 4 (2003). Appreciation is also owed to the participants in a 2009 conference, Private Power and Human Rights, hosted by Moshe Cohen-Eliya; papers from that conference including an essay related to this chapter is to be published in the Journal of Law & Ethics of Human Rights. Another essay on aspects of Bentham is part of papers from an international procedural law conference, published in a volume called Common Law, Civil Law and the Future of Categories (Janet Walker & Oscar G. Chase, eds., Markham, Can.: LexisNexis Canada, 2010).

119 See FOUCAULT, DISCIPLINE AND PUNISH at 200–210. See also Dilip Parameshwar Gaonkar with Robert J. McCarthy Jr., Panopticism and Publicity: Bentham's Quest for Transparency, 6 PUBLIC CULTURE 547, 558–568 (1994).

120 "Unverifiable" was the term proffered by Foucault to capture the power that visibility of the Benthamite kind achieved through imposing a "state of conscious and permanent visibility" that "automizes and disindividualizes power." See FOUCAULT, DISCIPLINE AND PUNISH at 201–202.

121 SCHOFIELD, UTILITY AND DEMOCRACY at 135. In exploring the concept of justice, Amartya Sen returned to Bentham and other innovators of his era, whom Sen categorized as "realization-focused comparison" theorists, in contrast to the "transcendental institutionalism" associated with Immanuel Kant and John Rawls. See AMARTYA SEN, THE IDEA OF JUSTICE 5–10 (Cambridge, MA: Belknap/Harvard U. Press, 2009).

122 SCHOFIELD, UTILITY AND DEMOCRACY at 150–152, 155. Bentham's condition was that females and males had distinct interests. Nicola Lacey has read Bentham to have embraced women's suffrage on utilitarian grounds and to have then concluded that, if he were to insist on women's suffrage, other proposals for reform would be dismissed. Nicola Lacey, Bentham as Proto-Feminist? Or an Ahistorical Fantasy on 'Anarchical Fallacies,' 51 CURRENT LEGAL PROBLEMS 441, 444 (1998). Yet she believed that Bentham "perceived far more clearly than most of his (male) contemporaries the irrationalities and injustices which characterized women's social position in the late eighteenth century." Id. at 466.

123 SCHOFIELD, UTILITY AND DEMOCRACY at 152.

124 SCHOFIELD, UTILITY AND DEMOCRACY at 348.

125 "Of the substantive branch of the law, the only defensible object or end in view is the maximization of the happiness of the greatest number of the members of the community in question. Of the adjective branch of the law [procedure], the only defensible object, or say end in view, is the maximization of the execution and effect given to the substantive branch of the law." JEREMY BENTHAM, PRINCIPLES

OF JUDICIAL PROCEDURE WITH THE OUTLINES OF A PROCEDURE CODE (hereinafter BENTHAM, PRINCIPLES OF JUDICIAL PROCEDURE), in 2 BOWRING/WORKS at 6.

**126** SCHOFIELD, UTILITY AND DEMOCRACY at 304; Margery Fry, *Bentham and English Penal Reform*, in JEREMY BENTHAM AND THE LAW 38 (George W. Keeton & Georg Schwarzenberger, eds., Holmes Beach, FL: Gaunt, 1948, reprinted 1998).

**127** SCHOFIELD, UTILITY AND DEMOCRACY at 304. See also THE COLLECTED WORKS OF JEREMY BENTHAM: 'LEGISLATOR OF THE WORLD': WRITINGS ON CODIFICATION, LAW, AND EDUCATION (Philip Schofield & Jonathan Harris, eds., Oxford, Eng.: Clarendon, 1998) (hereinafter BENTHAM: LEGISLATOR OF THE WORLD).

**128** JEREMY BENTHAM, LAW AS IT IS, in 5 BOWRING/WORKS 231, 236–237.

**129** BENTHAM, LAW AS IT IS, in 5 BOWRING/WORKS at 233. Bentham's critique continued that judges made the common law just "as a man makes laws for his dog. When your dog does anything you want to break him of, you wait till he does it, and then beat him for it." Id. at 235. Bentham argued that common law judges treated people like dogs—failing to tell them "beforehand what it is" that should not be done. Instead, judges waited until a person "has done something which they say he should not *have done*" and then "hang him for it." Id. (emphasis in the original).

**130** BENTHAM, LAW AS IT IS, in 5 BOWRING/WORKS at 236–237.

**131** BENTHAM, LAW AS IT IS, in 5 BOWRING/WORKS at 235.

**132** Bentham's correspondence with Madison can be found in JEREMY BENTHAM, PAPERS RELATIVE TO CODIFICATION AND PUBLIC INSTRUCTION: INCLUDING CORRESPONDENCE WITH THE RUSSIAN EMPEROR, AND DIVERS CONSTITUTED AUTHORITIES OF THE AMERICAN UNITED STATES (hereinafter BENTHAM, PAPERS RELATIVE TO CODIFICATION AND PUBLIC INSTRUCTION), in 4 BOWRING/WORKS 451, 453. Another compilation, including exchanges from state governors and others, is reproduced in BENTHAM: LEGISLATOR OF THE WORLD at 5–43, 52–59, 68–81.

**133** See Chilton Williamson, *Bentham Looks at America*, 70 POLITICAL SCIENCE QUARTERLY 543, 544–545 (1955).

**134** BENTHAM, PAPERS RELATIVE TO CODIFICATION AND PUBLIC INSTRUCTION, in 4 BOWRING/WORKS at 467. Schofield and Harris dryly noted that "it was extremely unlikely that the Americans would be prepared to accept a code of law from an unknown English lawyer." BENTHAM: LEGISLATOR OF THE WORLD at xiii. Bentham did receive responses from the governor of New Hampshire and from a Virginia lawyer—which provides evidence that Bentham's request to have his offer of codification circulated widely had resulted in press reports of it. Id. at xix–xx, 38–43, 52–59, 69–81.

**135** *Editorial Introduction* to BENTHAM: LEGISLATOR OF THE WORLD at xii–xxx. Bentham offered his services, for example, to Alexander I of Russia in 1814. FREDERICK ROSEN, JEREMY BENTHAM AND REPRESENTATIVE DEMOCRACY: A STUDY OF THE CONSTITUTIONAL CODE 3 (Oxford, Eng.: Clarendon, 1983).

**136** Hence the essay was titled *Truth v. Ashurst*. Sir Ashurst was the name of the "Puisne Judge of the King's Bench." In the table of contents of its Bowring publication, the essay has a subtitle: "or, Law as it is, contrasted with what it is said to be." First published in 1823, it is reprinted in 5 BOWRING/WORKS at 231. Bentham's introductory note to the 1823 publication mentioned that he had written the manuscript version soon after he had read "a charge, delivered the 19th of November 1792, to a Middlesex Grand Jury" by Ashurst. Id. at 232.

**137** BENTHAM, LAW AS IT IS, in 5 BOWRING/WORKS at 233–234.

**138** BENTHAM, LAW AS IT IS, in 5 BOWRING/WORKS at 233–234.

**139** Draper, *Corruptions* at 7.

**140** TWINING at 52.

**141** See TWINING at 28, 41–42, 76–79. Twining explained that Bentham was not arguing corruption but that the "single class or corporation" comprised of judges and lawyers had shaped a self-serving regime. Id. at 76. Draper reports: "In every section of *Scotch Reform*, both published and unpublished, Bentham never tires of stating his absolute disability to conceive of any selflessness in the actions of lawyers." Draper, *Corruptions* at 5. Bentham—fond of coining new words—offered the term "litiscontestation" to "signify indiscriminately the course of operation gone through on the occasion of a suit at law." JEREMY BENTHAM, CONSTITUTIONAL CODE; FOR THE USE OF ALL NATIONS AND ALL GOVERNMENTS PROFESSING LIBERAL OPINIONS (hereinafter BENTHAM, CONSTITUTIONAL CODE), in 9 BOWRING/WORKS 1, 589. (Thanks to Philip Schofield for pointing us to this term and to Adam Grogg for reviewing Bentham's writings to understand its deployment.) Bentham's distrust of professional jurists was matched by his dislike of religious authority. See Philip Schofield, *Jeremy Bentham: Historical Importance and Contemporary Relevance*, in JEREMÍAS BENTHAM: EL JOVEN Y EL VIEJO RADICAL, SU PRESENCIA EN EL ROSARIO 51, 73–75 (Bogotá, Colombia: Universidad del Rosario, 2002) (hereinafter Schofield, *Jeremy Bentham: Importance and Relevance*).

**142** Quoted in Draper, *Corruptions* at 5.

**143** See JEREMY BENTHAM, SCOTCH REFORM: CONSIDERED WITH REFERENCE TO THE PLAN, PROPOSED IN THE LATE PARLIAMENT, FOR THE REGULATION OF THE COURTS, AND THE ADMINISTRATION OF JUSTICE IN SCOTLAND (1808) (hereinafter BENTHAM, SCOTCH REFORM), in 5 BOWRING/WORKS at 1, 7–14. The distinctions between "natural procedure" and "technical procedure" were juxtaposed through a layout of dual columns.

**144** TWINING at 23.

**145** ROSEN at 149.

**146** TWINING at 3.

**147** TWINING at 31.

**148** ROSEN at 153–155.

**149** SCHOFIELD, UTILITY AND DEMOCRACY at 310; ROSEN at 153–154.

**150** ROSEN at 153–154.

**151** See Thomas P. Peardon, *Bentham's Ideal Republic*, 17 CANADIAN JOURNAL OF ECONOMICS & POLITICAL SCIENCE 184, 196 (1951). Rosen described Bentham's goal as having all persons, on foot, able to reach a local judicial officer and return home without having to pay to find a place to sleep overnight. ROSEN at 149. To lessen expense, Bentham also built in a system of "referees" or "arbitration" overseen by judges. Id. at 151.

**152** See Draper, *Corruptions* at 11.

**153** Draper, *Corruptions* at 8–9. See also SCHOFIELD, UTILITY AND DEMOCRACY at 308–312.

**154** BENTHAM, SCOTCH REFORM, in 5 BOWRING/WORKS at 23. See also TWINING at 78, 80.

**155** TWINING at 48.

**156** See Amalia D. Kessler, *Deciding Against Conciliation: The Nineteenth Century Rejection of a European Transplant and the Rise of a Distinctively American Ideal of Adversarial Adjudication*, 10 THEORETICAL INQUIRIES IN LAW 423 (2009) (hereinafter Kessler, *Against Conciliation*).

**157** Kessler, *Against Conciliation* at 435.

**158** Kessler, *Against Conciliation* at 436–437 (drawing on correspondence of Bentham).

**159** BENTHAM, PRINCIPLES OF JUDICIAL PROCEDURE, in 2 BOWRING/WORKS at 47.

**160** TWINING at 94–95. Specifically, Bentham recorded his admiration for Denmark's "Reconciliation Courts." See BENTHAM, PRINCIPLES OF JUDICIAL PROCEDURE, in 2 BOWRING/WORKS at 46–47. Bentham described how, under those courts (or "judicatories"), parties met to deal with all their conflicting claims, as contrasted with more

"technical" systems in which different forms of action (contract, tort) had to be dealt with separately. (Bentham was, more generally, enthusiastic about what today would be called liberal joinder of parties and claims, enabling all rights arising from given events to be dealt with in one forum at the same time.) Bentham recounted that, in Denmark's Reconciliation Courts, "from two-thirds to three-fourths" of suits using its procedures were "struck out"—concluded in some fashion that took them off the docket. Id. at 47. Bentham also noted that the success came despite "disadvantages"—that Denmark's Reconciliation Courts had "no power . . . to give execution and effect to its own decisions." Id. at 47. Bentham argued that, were the mechanism deployed in England and provision made for the judiciary to enforce judgments, it would be all the better.

Bentham's description leaves ambiguous what Danish Reconciliation Courts did. His point about the lack of enforcement suggests that these courts entered some form of judgment. As he wrote, "the damage, in whatever shape, from every wrong on each side, will operate as a set-off to every other; an account, as complete as may be, will be taken of what is due on each side; and a balance struck, and payment . . . made accordingly." Id. Thus reconciliation or conciliation may not parallel contemporary "settlements," in which parties agree to an outcome in lieu of a third party's rendering a decision.

161 Kessler, *Against Conciliation* at 438.

162 Kessler, *Against Conciliation* at 438.

163 Kessler, *Against Conciliation* at 441 (quoting Bentham's *De L'organiziation judiciarie, et de loi Condification* in the edition of Bentham put out by Étienne Dumont, his French editor). Kessler also describes the interest in England and the United States in the "European Model of Conciliation Courts." Id. at 443–451. She argues that the rejection of that model in the United States reflected a commitment to less deferential attitudes toward authority, expressed through the embrace of adversarial procedure.

164 BENTHAM, SCOTCH REFORM, in 5 BOWRING/WORKS at 35. Bentham also criticized court-enforced settlements: "Thus is that under the technical system, almost always, the word compromise is an euphemism: misconception is as often the result of it. The supposition is that justice is done to each; and that each remains self-assured that what he has received is justice. The truth is—that what has taken place is oppression: oppression in the shape of extortion:—of extortion of which the power of Judge and Co has in every case been the instrument: and in the profit of which they have in many, and perhaps in most instances, received their share: only that in this case the extortion has not extended to the whole but has left a part untouched. A compromise it is, if a compromise it must be called—such as that which has place between the passenger and the highwayman when the purse is yielded without a struggle. . . . [T]he purse is pocketed by the highwayman, the passenger goes off with his life." Draper/Scotch Reform manuscript database, No. 092-154, June 7, 1807, "Superseded? Scotch Reform 2, Letter V., Litigation Prevent. & Promot., Plff. mala fide."

165 BENTHAM, RATIONALE, in 6 BOWRING/WORKS at 355.

166 BENTHAM, RATIONALE, in 6 BOWRING/WORKS at 355. As Twining quoted Bentham, "Falsehood—corrupt and wilful falsehood—mendacity, in a word—the common instrument of all *wrong*," was the "irreconcilable enemy of justice." TWINING at 90 (emphasis in the original).

167 BENTHAM, RATIONALE, in 6 BOWRING/WORKS at 355 (quoting himself from an earlier volume).

168 TWINING at 48–51.

169 Here we borrow Twining's summary of Bentham's thesis in the *Rationale of Judicial Evidence*. TWINING at 27–28.

170 BENTHAM, RATIONALE, in 6 BOWRING/WORKS at 357.

171 BENTHAM, RATIONALE, in 6 BOWRING/WORKS at 354. This imagery has currency in both France and the United States. See

KATHERINE FISCHER TAYLOR, IN THE THEATER OF CRIMINAL JUSTICE: THE PALAIS DE JUSTICE IN SECOND EMPIRE PARIS (Princeton, NJ: Princeton U. Press, 1993); Milner S. Ball, *The Play's the Thing: An Unscientific Reflection on Courts under the Rubric of Theater*, 28 STANFORD LAW REVIEW 81 (1975).

172 See UCL FACULTY OF LAWS, BENTHAM PROJECT, THE MORE STRICTLY WE ARE WATCHED THE BETTER WE BEHAVE (2007), http://www.ucl.ac.uk/Bentham-Project/site_images/Leaflets/Panopticon%20Bentham%20DL%20UPDATED.pdf. The quote comes from POOR LAWS: Vol. I at 277 (Michael Quinn, ed., Oxford, Eng.: Oxford U. Press, 2001). The website and the project's pamphlet also provide a copy of Bentham's emblem, which included an "all seeing eye, framed by the words Mercy, Justice, Vigilance."

173 BENTHAM, RATIONALE, in 6 BOWRING/WORKS at 356.

174 BENTHAM, RATIONALE, in 6 BOWRING/WORKS at 355.

175 SCHOFIELD, UTILITY AND DEMOCRACY at 261.

176 SCHOFIELD, UTILITY AND DEMOCRACY at 263.

177 JEREMY BENTHAM, PANOPTICON, OR, THE INSPECTION-HOUSE (hereinafter BENTHAM, PANOPTICON), in 4 BOWRING/WORKS 37, 46 (emphasis in the original).

178 SCHOFIELD, UTILITY AND DEMOCRACY at 259.

179 BENTHAM, PANOPTICON, in 4 BOWRING/WORKS at 46. See also SCHOFIELD, UTILITY AND DEMOCRACY at 255–256. "The activities of the inmates would be open to constant scrutiny from the prison governor or inspector, and the activities of both to the scrutiny of the public at large, who would be encouraged to visit the panopticon." Id. at 255.

180 SCHOFIELD, UTILITY AND DEMOCRACY at 256.

181 The Panopticon was not built in Bentham's lifetime, but some high-security prisons, called "super-max," impose forms of surveillance beyond what Bentham had sketched, with lights on twenty-four hours a day. As discussed in Chapter 10, the United States Supreme Court has not prohibited such oversight as violative of constitutional protections but has imposed modest procedural limitations on placement in such facilities. See *Wilkinson v. Austin*, 545 U.S. 209 (2005).

182 SCHOFIELD, UTILITY AND DEMOCRACY at 258 (quoting JEREMY BENTHAM, POLITICAL TACTICS 44–45, Michael James & C. Pease Watkin, eds., Oxford, Eng.: Oxford U. Press, 1999).

183 JEREMY BENTHAM, AN ESSAY ON POLITICAL TACTICS, in 2 BOWRING/WORKS 299, 317.

184 SCHOFIELD, UTILITY AND DEMOCRACY at 258.

185 SCHOFIELD, UTILITY AND DEMOCRACY at 258.

186 SCHOFIELD, UTILITY AND DEMOCRACY at 254–255.

187 ROSEN at 116–126.

188 Specifically, exceptions permitted expelling those who disturbed a proceeding and closing proceedings for the preservation of "peace and good order," to "protect the judge, the parties, and all other persons present, against annoyance," to "preserve the tranquility and reputation of individuals and families from unnecessary vexation by disclosure of facts prejudicial to their honour, or liable to be productive of uneasiness or disagreements among themselves," to avoid "unnecessary disclosure of . . . pecuniary circumstances," "to preserve public decency from violation," and to protect "secrets of state." BENTHAM, RATIONALE, in 6 BOWRING/WORKS at 360. As these brief excerpts make plain, the parameters for closure were somewhat "vague." TWINING at 99.

189 For example, the European Convention on Human Rights provides: "Judgment shall be pronounced publicly but the press and public may be excluded from all or part of the trial in the interests of morals, public order or national security in a democratic society, where the interests of juveniles or the protection of the private life of the parties so require, or to the extent strictly necessary in the opinion of the court in special circumstances where publicity would prej-

udice the interests of justice." European Convention, Art. 6(1). Examples of debates about closure in the context of national security can be found in *Botmeh and Alami v. United Kingdom*, App. No. 15187/03, 46 Eur. H. R. Rep. 659 (2007).

**190** SCHOFIELD, UTILITY AND DEMOCRACY at 270. See also ROSEN at 112–115. Bentham also saw trade-offs in terms of the expenses involved. Id. at 113.

**191** SCHOFIELD, UTILITY AND DEMOCRACY at 270.

**192** ROSEN at 26–27. Bentham invoked the image as a vehicle of reform but did not fully specify how such a tribunal could be formed or cohere. Id. at 38–40. See Fred Cutler, *Jeremy Bentham and the Public Opinion Tribunal*, 63 PUBLIC OPINION QUARTERLY 321, 321 (1999).

**193** ROSEN at 26 (quoting Bentham).

**194** ROSEN at 159–160.

**195** SCHOFIELD, UTILITY AND DEMOCRACY at 307–308, 310–311. The details of an elaborate set of steps for judges to report problems of interpretation and to obtain harmonization or amendments are provided in ROSEN at 160–163.

**196** See FRANCESCO CONTINI & RICHARD MOHR, JUDICIAL EVALUATION: TRADITIONS, INNOVATIONS AND PROPOSALS FOR MEASURING THE QUALITY OF COURT PERFORMANCE 49–65 (Saarbrücken, Ger.: VDM Verlag, 2008). The authors reviewed quantitative data on evaluations of judges in different countries within Europe, and they argued that debate ought to move from its emphasis on the tension between judicial accountability and independence to a focus on how confidence in courts enables them to exercise authority. Id. at 6–10.

**197** Contini and Mohr, for example, looked at various efforts to evaluate and control judges. Complaints were one method; of some thousand filed about judges in France and Spain, the majority involved delays, and almost none resulted in sanctions against judges. Id. at 29. Similarly, a comparison of nine European countries in 2004 showed that fewer than twenty-five judges received sanctions in any one country during that year. Id. at 30. In terms of using managerial techniques such as linking pay to output, a Spanish court ruled that approach illegal. Id. at 44–45. Another method was surveys of attitudes toward judges. Id. at 72–74. Contini and Mohr called for more comprehensive, interactive, and cooperative methods to enhance communications. Id. at 94–103.

**198** Our thanks to Don Herzog, who focused us on this tension.

**199** See, for example, Robert Post & Reva Siegel, *Roe Rage: Democratic Constitutionalism and Backlash*, 42 HARVARD CIVIL RIGHTS–CIVIL LIBERTIES LAW REVIEW 373 (2007); BARRY FRIEDMAN, THE WILL OF THE PEOPLE: HOW PUBLIC OPINION HAS INFLUENCED THE SUPREME COURT AND SHAPED THE MEANING OF THE CONSTITUTION (New York, NY: Farrar, Straus & Giroux, 2009).

**200** "Bentham spent most of his life in the process of revising and occasionally contradicting positions he had reached earlier." DONALD WINCH, CLASSICAL POLITICAL ECONOMY AND COLONIES 25 (Cambridge, MA: Harvard U. Press, 1965). Bentham has therefore been claimed (and criticized) by a diverse group of contemporary and earlier theorists debating whether Bentham was "an authoritarian or a democratic radical." See Jennifer Pitts, *Legislator of the World? A Rereading of Bentham on Colonies*, 31 POLITICAL THEORY 200, 201 (2003); see also JEREMY BENTHAM: TEN CRITICAL ESSAYS (Bhikhu Parekh, ed., London, Eng.: Frank Cass, 1974). Several scholars have concluded that Bentham was a proponent of democracy. See SCHOFIELD, UTILITY AND DEMOCRACY at 147–155; ROSEN at 11–14, 41–54, 221–237; Lacey at 144–166; H. L. A. Hart, *Bentham and the United States of America*, 19 JOURNAL OF LAW AND ECONOMICS 547 (1976).

**201** The context was his 1795 attack on the French Declaration of the Rights of Man and the Citizen in an essay also known as "Anarchical Fallacies." See Philip Schofield, *Jeremy Bentham's "Nonsense Upon Stilts,"* 15 UTILITAS 1, 10 (2003).

**202** Schofield, *Jeremy Bentham's "Nonsense Upon Stilts"* at 13 (quoting Bentham).

**203** Id. at 26 (emphasis in the original). See also SCHOFIELD, UTILITY AND DEMOCRACY at 59–77; Schofield, *Jeremy Bentham: Importance and Relevance* at 51–55.

**204** See FOUCAULT, DISCIPLINE AND PUNISH at 200–210. See Gaonkar at 547, 558–568.

**205** SCHOFIELD, UTILITY AND DEMOCRACY at 135.

**206** TWINING at 52 (emphasis in the original).

**207** SCHOFIELD, UTILITY AND DEMOCRACY at 150–152, 155; Lacey at 444–466.

**208** ROSEN at 153–155.

**209** Post explored the propriety of some forms of regulation under the First Amendment in the United States Constitution as he parsed the distinct values of "democratic legitimation" and "democratic competence." See ROBERT C. POST, KNOWING WHAT WE TALK ABOUT: EXPERTISE, DEMOCRACY AND THE FIRST AMENDMENT, chs. 1–2 (New Haven, CT: Yale U. Press, 2009).

**210** SCHOFIELD, UTILITY AND DEMOCRACY at 152.

**211** SCHOFIELD, UTILITY AND DEMOCRACY at 348.

**212** See SCHOFIELD, UTILITY AND DEMOCRACY at 147–155; ROSEN at 11–14, 41–54, 221–237; see also Hart at 547 (1976). Lacey noted that when Bentham "finally made up his mind on the question of parliamentary democracy . . . [he] became one of its most passionate and eloquent advocates." Lacey at 444.

**213** ROSEN at 13–14.

**214** JEREMY BENTHAM, DRAUGHT FOR THE ORGANIZATION OF JUDICIAL ESTABLISHMENTS, COMPARED WITH THAT OF THE NATIONAL ASSEMBLY, WITH A COMMENTARY ON THE SAME (hereinafter BENTHAM, JUDICIAL ESTABLISHMENT), in 4 BOWRING/WORKS 305, 316; BENTHAM, RATIONALE, in 6 BOWRING/WORKS at 355; see also ANDREWS at 79.

**215** Bentham has, however, been praised for being "one of the first persons to see the supreme importance of the problem of information in government" in terms of efficiency, accountability, and responsibility. Peardon at 203.

**216** The quote is from David Luban's translation of this statement from the second appendix to Kant's *Perpetual Peace*, written in 1795; Luban argued that he had captured the German wording more precisely than had others. See David Luban, *The Publicity Principle*, in THE THEORY OF INSTITUTIONAL DESIGN 154, 155 (Robert Goodin, ed., New York, NY: Cambridge U. Press, 1998) (hereinafter Luban, *Publicity*).

**217** Luban, *Publicity* at 156. Distinctions between Bentham's publicity right and that of Kant are explored in Slavko Splichal, *Bentham, Kant, and the Right to Communicate*, 15 CRITICAL REVIEW 285 (2003). See also Alice Haemmerli, *Whose Who? The Case for a Kantian Right of Publicity*, 49 DUKE LAW JOURNAL 383, 385 (1999).

**218** DAVID HUME, *Of the First Principles of Government*, in ESSAYS, MORAL, POLITICAL, AND LITERARY, vol. 1, at 110 (T. H. Green & T. H. Grose, eds., New York, NY: Longmans, Green, 1898).

**219** See Daniel Gordon, *Philosophy, Sociology, and Gender in the Enlightenment Conception of Public Opinion*, 17 FRENCH HISTORICAL STUDIES 882, 885–889, 891 (1992). Gordon argued that Hume's interest in public opinion focused on how to manage it: "Anglo-American liberalism . . . imagin[ed] institutions that played off human wills against each other without removing their differences—yet in such a way that the good of the community as a whole merged." Id. at 891.

**220** Bentham saw his fictive Public Opinion Tribunal as needing to gather information on the government, which—through publicity and by individual officials' responsibility for their actions—was to make clear what had been decided. See Peardon at 140–142.

**221** Gordon at 889. Gordon argued that the French concern was to "acknowledge the new authority of 'the public' . . . while avoiding the conflicts and instabilities of a politics of contestation." Id. at 890, citing Keith Michael Baker, INVENTING THE FRENCH REVOLUTION: ESSAYS ON FRENCH POLITICAL CULTURE IN THE EIGHTEENTH CENTURY, ch. 8 ("Public Opinion as Political Invention") (Cambridge, Eng.: Cambridge U. Press, 1990). We return to Habermas later.

**222** BENTHAM, RATIONALE, in 6 BOWRING/WORKS at 570. A word on the practice in London's criminal courts is in order. Until 1775, the publisher of trial records (called the Sessions Paper) in London's criminal court (The Old Bailey) "paid the lord mayor of London a fee for the privilege of publishing a nominally 'official' account of trial . . . ." Devereaux at 468. In 1778, the "City insisted that the Sessions Paper should provide a 'true, fair and perfect narrative' for all trials." Id. Devereaux sought to understand why the City took that view, as well as why the level of detail provided expanded. Id. at 482–483. He concluded that criminal justice policies had resulted in too large a prison population, and the Sessions Paper provided records that helped the "chief sentencing officer at the Old Bailey" and the Council decide which felons to pardon. Id. at 471, 472–475, 483–484.

While Devereaux thought that the City had made the change to establish an authoritative source of information, he also noted that detailed information might not only legitimate judicial authority but also "jeopardize" it by showing people how to evade punishment through the manipulation of evidence. Id. at 491–492. Further, given the costs of lengthy details and the publisher's interests in sales, Devereaux urged skepticism about the completeness of the Sessions Paper. Id. at 503. Yet its publication, he argued, undercut the claim that punishment was as deeply privatized as Foucault had argued, for publication of the Paper created another form of public dissemination. Id. at 503.

**223** JEREMY BENTHAM, ON THE LIBERTY OF THE PRESS, AND PUBLIC DISCUSSION, in 2 BOWRING/WORKS 277.

**224** SCHOFIELD, UTILITY AND DEMOCRACY at 251 (quoting BENTHAM, ON THE LIBERTY OF THE PRESS) (emphasis in the original); see also SLAVKO SPLICHAL, PRINCIPLES OF PUBLICITY AND PRESS FREEDOM (Lanham, MD: Rowman & Littlefield, 2002).

**225** SCHOFIELD, UTILITY AND DEMOCRACY at 268. David Zaret located the development of pamphleting and the press earlier. See DAVID ZARET, ORIGINS OF DEMOCRATIC CULTURE: PRINTING, PETITIONS, AND THE PUBLIC SPHERE IN EARLY-MODERN ENGLAND (Princeton, NJ: Princeton U. Press, 2000).

**226** James Madison, *Public Opinion*, NATIONAL GAZETTE, Dec. 19, 1791, reprinted in 14 PAPERS OF JAMES MADISON 170 (Robert A. Rutland & Thomas A. Mason, eds., Charlottesville, VA: U. Press of Virginia, 1983), http://press-pubs.uchicago.edu/founders/documents/v1ch2s26.html. The entire essay is a few paragraphs.

**227** Madison (emphasis in the original).

**228** RICHARD R. JOHN, SPREADING THE NEWS: THE AMERICAN POSTAL SYSTEM FROM FRANKLIN TO MORSE 60–61 (Cambridge, MA: Harvard U. Press, 1995). John also read Madison as failing to appreciate the political force that public opinion could have and the role to be played by communications outside government channels. Id. at 29.

**229** See, for example, Gaonkar at 555–558.

**230** Compare Colleen A. Sheehan, *Madison v. Hamilton: The Battle over Republicanism and the Role of Public Opinion*, 98 AMERICAN POLITICAL SCIENCE REVIEW 405 (2004), with Alan Gibson, *Veneration and Vigilance: James Madison and Public Opinion, 1785–1800*, 67 REVIEW OF POLITICS 5 (2005). See also Albrecht Koschnik, *The Democratic Societies of Philadelphia and the Limits of the American Public Sphere, circa 1793–1795*, 58 WILLIAM & MARY QUARTERLY 615 (2001).

**231** See BENEDICT ANDERSON, IMAGINED COMMUNITIES: REFLECTIONS ON THE ORIGIN AND SPREAD OF NATIONALISM (London, Eng.: Verso, 1983, reissued 2006).

**232** Sheehan at 416.

**233** In *Public Opinion*, Madison argued that there were cases "where the public opinion must be obeyed by the government; so there are cases, where not being fixed, it may be influenced by the government." Madison added: "This distinction, if kept in view, would prevent or decide many debates on the respect due from the government to the sentiments of the people." Further, "[t]he larger a country, the less easy for its real opinion to be ascertained, and the less difficult to be counterfeited; when ascertained or presumed, the more respectable it is in the eyes of individuals. This is favorable to the authority of government. For the same reason, the more extensive a country, the more insignificant is each individual in his own eyes. This may be unfavorable to liberty."

**234** GA. CONST. of 1777, Art. LXI.

**235** See, for example, U.S. CONST., Amend. I.

**236** U.S. CONST., Art. I, § 8, cl. 7. See also N.C. CONST. of 1776, Declaration of Rights, Art. XV ("That the freedom of the press is one of the great bulwarks of liberty, and therefore ought never to be restrained."); PA. CONST. of 1776, Declaration of Rights, Art. XII ("That the people have a right to freedom of speech, and of writing, and publishing their sentiments; therefore the freedom of the press ought not to be restrained.").

**237** Act of Feb. 20, 1792, ch. 7, 1 Stat. 232. The Second Continental Congress had established the Post Office Department in 1775, and Benjamin Franklin served as its first Postmaster General. See THE UNITED STATES POSTAL SERVICE: AN AMERICAN HISTORY 1775–2006 at 6, http://www.usps.com/cpim/ftp/pubs/pub100.pdf.

**238** JOHN at 31. The prohibition on opening letters was sometimes ignored. Id at 43.

**239** JOHN at 112–113.

**240** JOHN at 113.

**241** JOHN at 38. The exchange was subsidized by "letter writers, of whom the vast majority were merchants." Id. at 39. The government monopoly on the post was strengthened in 1845. Id. at 254. John also noted the impact of the postal system before the Civil War, when abolitionists relied on "mass mailing." Id. at 260. The mails in turn enabled the expansion of the stagecoach network, which helped clubs and associations to connect with each other as they spread across the federation. See Theda Skocpol, *The Tocqueville Problem: Civic Engagement in American Democracy*, 21 SOCIAL SCIENCE HISTORY 455, 460–461 (1997).

**242** JOHN at 112–113.

**243** See TIM BLANNING, THE PURSUIT OF GLORY: EUROPE 1648–1815 at 24–38 (New York, NY: Viking, 2007).

**244** BLANNING at 479.

**245** JOHN at 8, quoting FRANCIS LIEBER, 10 ENCYCLOPAEDIA AMERICANA 289 (Philadelphia, PA: Carey & Lea, 1832). As noted in Chapter 12, Francis Lieber is famous in the United States for his "Lieber Code," rules for warfare promulgated by President Abraham Lincoln as General Orders No. 100 on April 24, 1863. See ADJUTANT GENERAL'S OFFICE, GENERAL ORDERS NO. 100: INSTRUCTIONS FOR THE GOVERNMENT OF ARMIES OF THE UNITED STATES IN THE FIELD (Washington, DC: U.S. Government Printing Office, 1863), http://avalon.law.yale.edu/19th_century/lieber.asp. See also Anuj C. Desai, *The Transformation of Statutes into Constitutional Law: How Early Post Office Policy Shaped Modern First Amendment Doctrine*, 58 HASTINGS LAW JOURNAL 671 (2007).

**246** Laqueur at 354.

**247** See John Markoff, *Margins, Centers, and Democracy: The Paradigmatic History of Women's Suffrage*, 29 SIGNS: JOURNAL OF WOMEN IN CULTURE AND SOCIETY 85 (2003).

**248** See generally HABERMAS, STRUCTURAL TRANSFORMATION; HABERMAS AND THE PUBLIC SPHERE; LUKE GOODE, JÜRGEN HABERMAS: DEMOCRACY AND THE PUBLIC SPHERE (London, Eng.: Pluto Press, 2005). Habermas's historical account focused on how eighteenth-century cultures of philosophy, literature, and the arts shaped a sense of a readership/spectatorship authorized to provide a "self-interpretation of the public in the political realm"—with views independent of those formulated through the church or government. HABERMAS, STRUCTURAL TRANSFORMATION at 55; see also 36–37. Zaret disputed the historical account by arguing that the origins of the "public sphere" predated the eighteenth century. ZARET at 32.

**249** HABERMAS, STRUCTURAL TRANSFORMATION at 99.

**250** HABERMAS, STRUCTURAL TRANSFORMATION at 100.

**251** HABERMAS, STRUCTURAL TRANSFORMATION at 102–104, 117–118.

**252** HABERMAS, STRUCTURAL TRANSFORMATION at 117. Habermas there cited Hegel's concept.

**253** HABERMAS, STRUCTURAL TRANSFORMATION at 135–136, invoking John Stuart Mill.

**254** The shaping of democratic rule of law through discourse theory is the central burden of Habermas's *Between Facts and Norms* as it also sought to span the "gap between sociological theories of law and philosophical theories of justice." HABERMAS, BETWEEN FACTS AND NORMS at xl. Habermas devoted a chapter to the "Indeterminacy of Law and the Rationality of Adjudication," id. at 194–237, and further noted the role played by evidentiary procedures as constraints on the range of argument available. Id. at 234–237. In addition, he was interested in the legitimacy of constitutional adjudication, id. at 238–286, and in theories of judicial articulation of constitutional rights. Even as Habermas spoke of the infrastructure for spectatorship—"*assemblies, performances, presentations, and so on,*" id. at 361 (emphasis in the original)—he did not return to trials as part of his discussion of "Civil Society and the Political Public Sphere," id. at 329.

**255** HABERMAS, STRUCTURAL TRANSFORMATION at 79.

**256** HABERMAS, STRUCTURAL TRANSFORMATION at 76. See also HABERMAS, FACTS AND NORMS at 124–131.

**257** HABERMAS, STRUCTURAL TRANSFORMATION at 82.

**258** HABERMAS, STRUCTURAL TRANSFORMATION at 83.

**259** HABERMAS, STRUCTURAL TRANSFORMATION at 85.

**260** HABERMAS, STRUCTURAL TRANSFORMATION at 201.

**261** HABERMAS, STRUCTURAL TRANSFORMATION at 181–195.

**262** HABERMAS, STRUCTURAL TRANSFORMATION at 4. Habermas argued that deployment of the press "to serve the interests of the state administration" could be found in the sixteenth century. Id. at 20–24.

**263** HABERMAS, STRUCTURAL TRANSFORMATION at 201.

**264** Theodore Roosevelt, First Annual Message to Congress, Dec. 3, 1901, http://www.presidency.ucsb.edu/ws/index.php?pid=29542.

**265** See generally Adam Sheingate, *Progressive Publicity and the Origins of Political Consulting*, in BUILDING A BUSINESS OF POLITICS: THE ORIGINS AND DEVELOPMENT OF POLITICAL CONSULTING IN THE UNITED STATES (forthcoming 2010), http://users.polisci.wisc.edu/apw/archives/sheingate.pdf.

**266** HABERMAS, FACTS AND NORMS at 450.

**267** HABERMAS, FACTS AND NORMS at 457.

**268** HABERMAS, FACTS AND NORMS at 449.

**269** See Fraser at 123, 128.

**270** Fraser at 117.

**271** Different arguments for and against public roles are argued in *The Public Character of Trial*, in 3 THE TRIAL ON TRIAL: TOWARDS A NORMATIVE THEORY OF THE CRIMINAL TRIAL 259–285 (Antony Duff, Lindsay Farmer, Sandra Marshall, & Victor Tadros, eds., Oxford, Eng.: Hart, 2007) (hereinafter 3 TRIAL/THEORY OF THE CRIMINAL TRIAL), and in Judith Resnik, *Due Process: A Public Dimension*, 39 U. OF FLORIDA LAW REVIEW 405 (1987).

**272** Another theorist of adjudication, well known to audiences in the United States, is Lon Fuller, who focused on the role of adjudication as a "device which gives formal and institutional expression to the influence of reasoned argument in human affairs." Its "burden of rationality" drew him to it, and also prompted his concerns that courts were ill-suited to deal with what he termed "polycentric" problems. See Lon Fuller, *The Forms and Limits of Adjudication*, 92 HARVARD LAW REVIEW 353 (1978) (published posthumously). Our focus likewise entails an interest in the obligations of the judge to explain actions but we also aim to understand the roles of all the actors, audience included, in the exchanges.

**273** Criminal trials are the focus of the volumes of *The Trial on Trial*, cited earlier. See 3 TRIAL/THEORY OF THE CRIMINAL TRIAL. Each of the three volumes published has a distinct focus, forecast in its subheading. The other two titles are *Truth and Due Process* (Vol. 1), and *Judgment and Calling to Account* (Vol. 2), published in 2004 and 2006, respectively.

**274** See, for example, Emilios Christodoulidis, *The Objection That Cannot Be Heard: Communication and Legitimacy in the Courtroom*, in 1 THE TRIAL ON TRIAL: TRUTH AND DUE PROCESS at 179–202.

**275** See generally Craig Calhoun, *Introduction* to HABERMAS AND THE PUBLIC SPHERE, 1–48.

**276** A preliminary review of data on local news coverage of courts in the United States reported that the topics included in televised discussions were the filings of different kinds of cases, many involving negligence and many on intentional torts. In contrast, resolutions were less frequently covered. See Herbert M. Kritzer & Robert E. Dreschsel, *Reporting Civil Litigation on Local Television News* (William Mitchell Legal Studies Research Paper No. 96, Version 2a, Sept. 25, 2008), http://papers.ssrn.com/sol3/papers.cfm?abstract_id=1133510.

**277** See Reva B. Siegel, *"The Rule of Love": Wife Beating as Prerogative and Privacy*, 105 YALE LAW JOURNAL 2117 (1996). Efforts to address some of the injuries were enacted at a federal level in the United States in the Violence Against Women Act of 1994, Pub. L. No. 103-322, 108 Stat. 1902 (1994) (codified as amended in scattered sections of Titles 8, 18, 28, 42 U.S.C.). See generally Judith Resnik, *Categorical Federalism: Jurisdiction, Gender, and the Globe*, 111 YALE LAW JOURNAL 619 (2001).

**278** See Nancy S. Marder, *The Medical Malpractice Debate: The Jury as Scapegoat*, 38 LOYOLA OF LOS ANGELES LAW REVIEW 1267 (2005).

**279** See, for example, *Connecticut Department of Public Safety v. Doe*, 538 U.S. 1 (2003) (upholding the constitutionality of state laws requiring such registration and publication).

**280** See Maricopa County Attorney, County Attorney Demands Repeal of Court Orders Undermining Proposition 100, Directives Violated State Initiatives, press release, April 2, 2007; see also Dennis Welch, *County Courts Refuse to Check Immigration Status*, THE TRIBUNE (Mesa, AZ), April 3, 2007, see 2007 WLNR 6389982; Andrew Thomas, *Prop 100 Hearings Show Continued Judicial Opposition*, ILLEGAL IMMIGRATION JOURNAL: THE LATEST UPDATE ON BORDER ISSUES, May 17, 2007, http://www.illegalimmigrationjournal.com/spotlight/andy.cfm?id=.

**281** SCHOFIELD, UTILITY AND DEMOCRACY at 267.

**282** Bentham thought it would. See SCHOFIELD, UTILITY AND DEMOCRACY at 267.

**283** See Maure L. Goldschmidt, *Publicity, Privacy and Secrecy*, 7 POLITICAL RESEARCH QUARTERLY 401 (1954). Habermas cited this example. See HABERMAS, STRUCTURAL TRANSFORMATION at 277.

**284** The utility of internet databases depends on how materials are formatted and whether charges are imposed for access. See LoPucki at 55. See also John Markoff, *A Quest to Get More Court Rulings Online, and Free*, NEW YORK TIMES, Aug. 20, 2007, at C6.

285 See *Sheppard v. Maxwell*, 384 U.S. 333 (1966).

286 *Carey v. Musladin*, 549 U.S. 70 (2006).

287 See Pamela H. Bucy, *Courtroom Conduct by Spectators* (U. of Alabama Public Law Research Paper No. 1371765, Apr. 1, 2009), http://papers.ssrn.com/sol3/papers.cfm?abstract_id=1371765.

288 See, for example, REPORT OF THE NEW YORK STATE COMMISSION ON PUBLIC ACCESS TO COURT RECORDS (ABRAMS COMMISSION), Feb. 25, 2004, http://www.courts.state.ny.us/ip/publicaccess/Report_PublicAccess_CourtRecords.pdf.

289 During the course of the trial, three defense lawyers were killed and two judges were dismissed. See John F. Burns, James Glanz, Sabrina Tavernise, & Marc Santora, *In Days before Hanging, a Push for Revenge and a Push Back from the U.S.*, NEW YORK TIMES, Jan. 7, 2007, at A12.

290 Marc Santora, James Glanz, & Sabrina Tavernise, *Saddam Hussein Hanged in Baghdad; Swift End to Drama; Troops on Alert*, NEW YORK TIMES, Dec. 30, 2006, at A1.

291 John F. Burns & Marc Santora, *U.S. Questioned Iraq on the Rush to Hang Hussein*, NEW YORK TIMES, Jan. 1, 2007, at A1.

292 Burns & Santora at A1.

293 Bill Carter, *Graphic Video of Execution Presents Hard Choices for U.S. Media*, NEW YORK TIMES, Jan. 1, 2007, at A7 (noting that Fox News and CNN both ran the video and that Fox had followed Al Jazeera in doing so).

294 BENTHAM, RATIONALE, in 6 BOWRING/WORKS at 356.

295 HABERMAS, STRUCTURAL TRANSFORMATION at 193.

296 Luban thus offered another forumulation, that all "actions relating to the right of other human beings are wrong if publicizing their maxim would lead to self-frustration by undercutting the legitimacy of the public institutions authorizing those actions." Luban, *Publicity* at 192.

297 As detailed earlier, Bentham offered various justifications for privacy that would, upon occasion, require that the presumption in favor of public trials give way. BENTHAM, RATIONALE, in 6 BOWRING/WORKS at 355.

298 BENTHAM, RATIONALE, in 6 BOWRING/WORKS at 356. Our thanks to Bruce Ackerman for pressing us to underscore the degree to which the role of observer needs to be conceptualized as political.

299 See generally JONATHAN CRARY, SUSPENSIONS OF PERCEPTION: ATTENTION, SPECTACLE, AND MODERN CULTURE (Cambridge, MA: MIT Press, 1999).

300 SCHOFIELD, UTILITY AND DEMOCRACY at 310.

301 BENTHAM, RATIONALE, in 6 BOWRING/WORKS at 354.

302 This understanding of law as a social practice can be seen in the work of Robert M. Cover. See Robert M. Cover, *The Supreme Court 1982 Term—Foreword: Nomos and Narrative*, 97 HARVARD LAW REVIEW 4 (1983); Judith Resnik, *Living Their Legal Commitments: Paideic Communities, Courts, and Robert Cover*, 17 YALE JOURNAL OF LAW & THE HUMANITIES 17 (2005).

303 Mirrelle Hildebrandt, *Trial and "Fair Trial": From Peer to Subject to Citizen*, in 2 THE TRIAL ON TRIAL: JUDGMENT AND CALLING TO ACCOUNT 15, 25 (emphasis in the original). See also Paul Roberts, *Theorising Procedural Tradition: Subjects, Objects and Values in Criminal Adjudication*, in 2 THE TRIAL ON TRIAL: JUDGMENT AND CALLING TO ACCOUNT at 37–64; Daniel Markovits, *Adversary Advocacy and the Authority of Adjudication*, 75 FORDHAM LAW REVIEW 1367 (2006).

304 See, for example, Tatjana Hörnle, *Democratic Accountability and Lay Participation in Criminal Trials*, in 2 THE TRIAL ON TRIAL: JUDGMENT AND CALLING TO ACCOUNT at 135–153.

305 BENTHAM, JUDICIAL ESTABLISHMENT, in 4 BOWRING/WORKS at 316; BENTHAM, RATIONALE, in 6 BOWRING/WORKS at 355; see also ANDREWS at 79.

306 Fraser argued that such parity was requisite to the proper functioning of Habermasian public spheres. Fraser at 118.

307 See, for example, Judith Resnik, *Asking about Gender in Courts*, 21 SIGNS: JOURNAL OF WOMEN IN CULTURE AND SOCIETY 952 (1996).

308 These are the words inscribed on the front of the facade of the United States Supreme Court.

309 See Military Commissions Act of 2006, Pub. L. No. 109-366, 120 Stat. 2600 (2006) (codified in scattered sections of 10, 18, 28, and 42 U.S.C.). The statute's limitations on individuals' access to courts through the constitutionally protected writ of habeas corpus were found to be unconstitutional. See *Boumediene v. Bush*, 553 U.S. 723 (2008), discussed in Chapter 14.

310 Various political theorists have moved from a focus on elections to examining sources of legitimacy such as public confidence, the quality of government, impartiality, non-self-dealing by decisionmakers, and decisionmaking through the aggregation of interests present. See, for example, Bo Rothstein & Jan Teorell, *What Is Quality of Government? A Theory of Impartial Government Institutions*, 21 GOVERNANCE: AN INTERNATIONAL JOURNAL OF POLICY AND ADMINISTRATION 165 (2008); BRUCE ACKERMAN & JAMES S. FISHKIN, DELIBERATION DAY (New Haven, CT: Yale U. Press, 2004); Jane Mansbridge, *The Descriptive Political Representation of Gender: An Anti-Essentialist Argument*, in HAS LIBERALISM FAILED WOMEN? ASSURING EQUAL REPRESENTATION IN EUROPE AND THE UNITED STATES 19 (Jytte Klausen & Charles S. Maier, eds., New York, NY: Palgrave, 2001).

311 Carolyn Lochhead, *Death Spiral on Main Street*, THE AMERICAN ENTERPRISE, July–August 2001, at 26.

312 *Restoring the Financial Stability of the U.S. Postal Service: What Needs to Be Done? Hearing Before the Subcomm. Fed. Workforce, Postal Service, and the District of Columbia*, 111th Cong. (Mar. 25, 2009), http://oversight.house.gov/index.php?option=com_content&task=view&id=3865&Itemid=27 (testimony of Dale Goff, President, National Association of Postmasters of the United States, http://www.napus.org/govrelations/testimony_pdfs/325Statement.pdf). While mail volume peaked at 213 billion pieces in 2006, it had declined to 180 billion in 2009, a "staggering decline of 15 percent." Id. (Testimony of Carolyn Gallagher, Chair, Board of Governors, U.S. Postal Service, http://www.usps.com/communications/newsroom/testimony/2009/pr09_bog0325.htm).

313 See United States Postal Service, Economy-Driven Mail Volume Decline Contributes to Postal Service $2.8 Billion Year-End Loss, press release, Nov. 13, 2008, http://www.usps.com/communications/newsroom/2008/pr08_118.htm.

314 Discussion of this viewpoint can be found in JOHN T. TIERNEY, THE U.S. POSTAL SERVICE: STATUS AND PROSPECTS OF A PUBLIC ENTERPRISE 212–218 (Dover, MA: Auburn House, 1988).

315 Richard R. John, *Mail Matters*, THE NATION, Feb. 23, 2009, at 23.

316 See, for example, Robert Darnton, *Google & the Future of Books*, NEW YORK REVIEW OF BOOKS, Feb. 12, 2009, at 9, http://www.nybooks.com/articles/22281.

317 *U.S. Postal Service: 101: Hearing before the Subcomm. on Federal Workforce, Postal Service, and the District of Columbia of the House Comm. on Oversight and Government Reform*, 110th Cong. 232 (Apr. 17, 2007) (testimony of Charles W. Mapa, President, National League of Postmasters). Mapa's focus was on the harm to rural communities. See also OREN BEN-DOR, CONSTITUTIONAL LIMITS AND THE PUBLIC SPHERE 193–198, 237–238 (Oxford, Eng.: Hart, 2000).

318 Postal Policy Act of 1958, Pub. L. No. 85-426, 72 Stat. 134, 134.

319 See Postal Reorganization Act of 1970, Pub. L. No. 91-375, 84 Stat. 719 (codified at 39 U.S.C. (2006)).

320 Richard B. Kielbowicz, *Preserving Universal Postal Service as a Communication Safety Net: A Policy History and Proposal*, 30 SETON

HALL LEGISLATIVE JOURNAL 383 (2006); Richard R. John, *Post Office*, in 2 ENCYCLOPEDIA OF THE NEW AMERICAN NATION: THE EMERGENCE OF THE UNITED STATES, 1754–1829, at 576 (Paul Finkelman, ed., Farmington Hills, MI: Charles Scribner's Sons, 2006).

**321** See C. EDWIN BAKER, MEDIA CONCENTRATION AND DEMOCRACY: WHY OWNERSHIP MATTERS (New York, NY: Cambridge U. Press, 2007).

**322** See Newspaper Association of America, *Total Paid Circulation*, http://www.naa.org/TrendsandNumbers/Total-Paid-Circulation.aspx. The population figures come from the United States Census Bureau. See U.S. Census Bureau, Statistical Abstracts, http://www.census.gov/prod/www/abs/statab.html.

**323** See David Westphal, *News Media in Crisis*, http://funding thenews.org/?p=13, in GEOFFREY COWAN & DAVID WESTPHAL, PUBLIC POLICY & FUNDING THE NEWS (Los Angeles, CA: U. of Southern California Annenberg Center on Communication Leadership & Policy, 2009), http://fundingthenews.org; see also Preethi Dumpala, *The Year the Newspaper Died*, BUSINESS INSIDER, Jul. 4, 2009, http://www.businessinsider.com/the-death-of-the-american-newspaper-2009-7 (reporting that, between January and July 2009, 105 newspapers closed).

**324** See Shira Ovide, *Tribune Co. Files for Chapter 11 Protection*, WALL STREET JOURNAL, Dec. 9, 2008, at B1; Shira Ovide, *More Newspapers File for Chapter 11*, WALL STREET JOURNAL, Feb. 23, 2009, at B2 (reporting that, between December 2008 and February 2009, four newspaper owners filed for bankruptcy).

**325** David Westphal, *News Media in Crisis*, http://fundingthe news.org/?p=13, in COWAN & WESTPHAL.

**326** Geoffrey Cowan, *Introduction*, http://fundingthenews.org/?p=3, in COWAN & WESTPHAL.

**327** See David Westphal, *The Government and the News Media*, http://fundingthenews.org/?p=15, in COWAN & WESTPHAL.

**328** BAKER at 190.

**329** Margaret H. Marshall, At the Tipping Point: State Courts and the Balance of Power, The Benjamin N. Cardozo Lecture, Bar Association of the City of New York, Nov. 10, 2009, http://www.ncbp.org/2010/Cardozo_post_final.pdf.

# CHAPTER 14

**1** Department of Constitutional Affairs, http://www.dca.gov.uk/civil/adr. Since the reorganization of the offices, new information about ADR can be found on the Ministry of Justice website, http://www.justice.gov.uk/civil/procrules_fin/contents/practice_directions/pd_pre-action_conduct.htm#IDANZCZ.

**2** Margaret H. Marshall, Chief Justice, Supreme Judicial Court, Commonwealth of Massachusetts, Testimony Before Joint Committee on Ways and Means, Mar. 1, 2010, at 2, http://www.mass.gov/courts/fy2011-marshall-testimony.pdf. That number did not include staff or jurors. A few decades earlier, as part of a transnational project on access to justice, Earl Johnson raised a similar specter of what he termed a "lowered expectations" program, in which millions of small-scale cases were filed but neither litigants nor courts had the resources to deal with them. See Earl Johnson, Jr., *The Justice System of the Future: Four Scenarios for the Twenty-First Century*, in ACCESS TO JUSTICE AND THE WELFARE STATE (Mauro Cappelletti, ed., Alphen aan den Rijn, Neth.: Sijthoff, 1981) (hereinafter ACCESS TO JUSTICE AND THE WELFARE STATE).

**3** Margaret H. Marshall, At the Tipping Point: State Courts and the Balance of Power, The Benjamin N. Cardozo Lecture, Bar Association of the City of New York, Nov. 10, 2009.

**4** Judith Resnik, *For Owen M. Fiss: Some Reflections on the Tri-*

*umph and the Death of Adjudication*, 58 U. MIAMI LAW REVIEW 173, 183–192 (2003).

**5** The data were drawn from annual reports on the federal courts' docket. We explained in Chapter 8 how we extrapolated the data for 1901 and the sources for the other numbers.

**6** United States Census Bureau, Population Estimates Data Set: 2008 Population Estimates, *U.S. Census Historical Statistics of the United States: Colonial Times to 1970*, pt. 1 at 10, http://www.census.gov/prod/www/abs/statab.html.

**7** COURT STATISTICS PROJECT, EXAMINING THE WORK OF STATE COURTS: AN ANALYSIS OF 2007 STATE COURT CASELOADS 2 (National Center for State Courts, 2009), http://www.ncsconline.org/d_research/csp/2007B_files/EWSC-2007-v21-online.pdf.

**8** See ADMINISTRATIVE OFFICE OF THE UNITED STATES COURTS, 2008 ANNUAL REPORT OF THE DIRECTOR: JUDICIAL BUSINESS OF THE UNITED STATES COURTS 13 (Washington, DC: U.S. Government Printing Office 2009), http://www.uscourts.gov/judbus2008/JudicialBusinesspdfversion.pdf (hereinafter 2008 JUDICIAL BUSINESS).

**9** News Release, *Judiciary Updates Code of Conduct; Seeks New Judgeships* (Mar. 17, 2009), http://www.uscourts.gov/Press_Releases/2009/0309JudicialConf.cfm.

**10** 2008 JUDICIAL BUSINESS at 13. Filings have thus outpaced terminations. Id. at 14.

**11** Administrative Office of the United States Courts, *Federal Court Management Statistics 2008*, at 2, http://www.uscourts.gov/cgi-bin/cmsa2008.pl.

**12** Justice Stephen G. Breyer, *Foreword* to CELEBRATING THE COURTHOUSE: A GUIDE FOR ARCHITECTS, THEIR CLIENTS, AND THE PUBLIC 11 (Steven Flanders, ed., New York, NY: W. W. Norton, 2006) (hereinafter Breyer, *Foreword* to CELEBRATING THE COURTHOUSE).

**13** See Stephen C. Yeazell, *Re-Financing Civil Litigation*, 51 DEPAUL LAW REVIEW 183 (2001).

**14** See, for example, DEBORAH R. HENSLER, M. SUSAN MARQUIS, ALLAN F. ABRAHAMSE, SANDRA H. BERRY, PATRICIA A. EBENER, ELIZABETH G. LEWIS, E. ALLAN LIND, ROBERT J. MACCOUN, WILLARD G. MANNING, JEANNETTE A. ROGOWSKI, & MARY E. VAIANA, COMPENSATION FOR ACCIDENTAL INJURIES IN THE UNITED STATES (Santa Monica, CA: RAND Institute for Civil Justice, 1991), http://www.rand.org/pubs/reports/2006/R3999.pdf. That survey studied "the social and personal costs of accidents, how well the current compensation system protects victims, and the role the tort liability system plays in the process." Id. at viii. Efforts had been made in other countries to identify needs for law. See, for example, HAZEL GENN, MEETING LEGAL NEEDS? AN EVALUATION OF A SCHEME FOR PERSONAL INJURY VICTIMS (Oxford, Eng.: SSRC [Social Science Research Council], 1982); DONALD HARRIS, MAVIS MACLEAN, HAZEL GENN, SALLY LLOYD-BOSTOCK, PAUL FENN, PETER CORFIELD, & YVONNE BRITTAN, COMPENSATION AND SUPPORT FOR ILLNESS AND INJURY (Oxford, Eng.: Oxford U. Press, 1984).

**15** Martin Gramatikov, *A Framework for Measuring the Costs of Paths to Justice*, 2 THE JOURNAL JURISPRUDENCE 111 (2009).

**16** See Justice Earl Johnson Jr., *"And Justice for All": When Will the Pledge Be Fulfilled?* 47 JUDGE'S JOURNAL 5 (Summer 2008). That journal provided a symposium on access to justice. See also Earl Johnson Jr., *Justice for America's Poor in the Year 2020: Some Possibilities Based on Experiences Here and Abroad*, 58 DEPAUL LAW REVIEW 393 (2009).

**17** A series of volumes from the "Florence Project," supported by several institutions including the Ford Foundation and the Italian Research Council, surveyed the "access to justice movement." See ACCESS TO JUSTICE: A WORLD SURVEY, vol. I at vii (Mauro Cappelletti & Bryant Garth, eds. Milan, Italy: Dott. A. Giuffrè Editore, 1978). See also Mauro Cappelletti & Bryant Garth, *Access to Justice and the Welfare State: An Introduction*, in ACCESS TO JUSTICE AND THE WELFARE STATE.

**18** See Gillian K. Hadfield, *Higher Demand, Lower Supply? A Comparative Assessment of the Legal Resource Landscape of Ordinary Americans*, 37 FORDHAM URBAN LAW JOURNAL 129 (2010).

**19** Bureau of Justice Statistics, State Court Organization 1787–2004, NCJ 217996, Oct. 2007, at 2–3.

**20** Frances Kahn Zemans, *Court Funding* 3, report prepared for the American Bar Association Standing Committee on Judicial Independence (Aug. 2003), http://www.abanet.org/jd/courtfunding/pdf/courtfunding.pdf.

**21** Zemans at 2.

**22** American Judicature Society, *An Impending Crisis in State Court Funding*, Editorial, 92 JUDICATURE 52 (Oct. 18, 2008), http://www.ajs.org/ajs/ajs_editorial-template.asp?content_id=758.

**23** See, for example, AMERICAN BAR ASSOCIATION, COALITION FOR JUSTICE, SPECIAL COMMITTEE ON FUNDING THE JUSTICE SYSTEM, SAVING OUR SYSTEM: A NATIONAL OVERVIEW OF THE CRISIS IN AMERICA'S SYSTEM OF JUSTICE (Chicago, IL: American Bar Association, 1993) (hereinafter SAVING OUR SYSTEM).

**24** See Fla. Statute §§ 938.01 et seq. (2009) (imposing certain mandatory costs in criminal cases). See also BRENNAN CENTER FOR JUSTICE, COLLECTIONS COURT IN LEON COUNTY: SELECTED FINDINGS FROM FORTHCOMING BRENNAN CENTER REPORT ON COURT FEES IN FLORIDA (Mar. 30, 2009), http://www.brennancenter.org/page/-/Justice/09.03.30.Leon.County.Collections.pdf; John Schwartz, *Pinched Courts Push to Collect Fees and Fines*, NEW YORK TIMES, Apr. 7, 2009, at A17, http://www.nytimes.com/2009/04/07/us/07collection.html. According to the president of the Florida Bar Association, court budgets represented 0.07 percent of Florida's $66 billion budget; 92 percent of the funding came from general revenues. The "extra fees and fines" were to generate an additional $15.9 million for the courts. The year before, "court-related revenue" brought $150 million into the state's coffers, but the courts received "only $14 million, including $8.6 million for mediation." See John G. White III, *Court Funding—A Good First Step*, 83 FLORIDA BAR JOURNAL 6 (Mar. 2009), http://www.floridabar.org/DIVCOM/JN/JNJournal01.nsf/Articles/17EA442D94317A6B85257567006C9A72.

**25** Reports from the Ministry of Justice in the United Kingdom focus on this question. See MINISTRY OF JUSTICE, WHAT'S COST GOT TO DO WITH IT? THE IMPACT OF CHANGING COURT FEES ON USERS (2007), http://www.justice.gov.uk/publications/docs/changing-court-fees.pdf.

**26** See John M. Greacen, *Working with the Legislature During the Court Appropriations Process*, 43 JUDGE'S JOURNAL 30, 32 (Summer 2004), http://www.abanet.org/jd/publications/jjournal/2004summer/greacen.pdf.

**27** A special commission of the American Bar Association sought to buffer against such approaches by calling on judiciaries to be transparent in their expenditures and for legislatures to provide predictable streams of income for judicial services. See Joseph P. Nadeau, *Ensuring Adequate Long-Term Funding for Courts: Recommendations from the ABA Commission on State Funding*, 43 JUDGE'S JOURNAL 15, 17 (Summer 2004).

**28** See Jonathan Lippman, *New York's Efforts to Secure Sufficient Court Resources in Lean Times*, 43 JUDGE'S JOURNAL 21, 22 (Summer 2004); Zemans at 11–14.

**29** See *Reference re Remuneration of Judges of the Provincial Court of Prince Edward Island*, [1997] 3 S.C.R. 3 (Can.).

**30** See National Center for State Courts, *Survey of Judicial Salaries*, 33 NCSC 2 (July 1, 2008), http://www.ncsconline.org/WC/Publications/KIS_JudComJudSalArchives.html. The median salary for an associate justice was $142,341. Id. In some jurisdictions, salaries had not kept pace with the cost of living. For example, the New York legislature had not, as of 2008, increased judicial salaries since 1999, prompting a lawsuit by the court's Chief Judge, Judith Kaye, challenging the failure to raise salaries as violative of judicial independence and separation of powers. See *Kaye v. Silver*, No. 400763-2008 (N.Y. Sup. Ct. Apr. 10, 2008). See also Anemona Hartocollis, *New York's Top Judge Sues Over Judicial Pay*, NEW YORK TIMES, April 11, 2008, at B3. In 2010, New York's highest court agreed in a review of three consolidated cases and held that New York State's guarantees protecting the independence of the judiciary had been violated by the failure to provide pay increases for judges. See *Matter of Maron v. Silver*, 925 N.E. 2d 889 (N.Y. 2010).

**31** Abby Goodnough, *Jury Trials to Be Halted in One State Feeling Pinch*, NEW YORK TIMES, Dec. 9, 2008, at A20, http://www.nytimes.com/2008/12/09/us/09court.html.

**32** See John Schwartz, *Pinched Courts Push to Collect Fees and Fines*, NEW YORK TIMES, Apr. 7, 2009, at A17, http://www.nytimes.com/2009/04/07/us/07collection.html; see also SAVING OUR SYSTEM.

**33** See Christel E. Marquardt, *Changing the Judicial Budget Process in Kansas*, 43 JUDGE'S JOURNAL 27 (Summer 2004). A chart of surcharges, ranging from $5 to $50, was provided. Id. at 28.

**34** Maura D. Corrigan, *Finding Revenue in Hard Times: The Michigan Judiciary's Approach*, 43 JUDGE'S JOURNAL 24 (2004).

**35** See generally EARL JOHNSON, JUSTICE AND REFORM: THE FORMATIVE YEARS OF THE AMERICAN LEGAL SERVICES PROGRAM (New Brunswick, NJ: Transaction Books, 1978).

**36** See RICHARD ABEL, ENGLISH LAWYERS BETWEEN MARKET AND STATE (Oxford, Eng.: Oxford U. Press, 2003); see also RICHARD ABEL, THE LEGAL PROFESSION IN ENGLAND AND WALES (Oxford, Eng.: Blackwell, 1988).

**37** See Jona Goldschmidt, *How Are Courts Handling Pro Se Litigants?*, 82 JUDICATURE 13 (July–August, 1998).

**38** Roscoe Pound, *The Causes of Popular Dissatisfaction with the Administration of Justice*, 40 AMERICAN LAW REVIEW 729 (1906), reprinted from 1 ANNUAL REPORT OF THE AMERICAN BAR ASSOCIATION 395 (29th Conference, 1906). See also Barry Friedman, *Popular Dissatisfaction with the Administration of Justice: A Retrospective (and a Look Ahead)*, 82 INDIANA LAW JOURNAL 1193 (2007). That article was part of a 2006 symposium titled "Court Leadership 100 Years After Roscoe Pound: Building a Constituency of Support for State Courts." Id. at 1153–1331.

**39** See, for example, LORD WOOLF, ACCESS TO JUSTICE: FINAL REPORT TO THE LORD CHANCELLOR ON THE CIVIL JUSTICE SYSTEM IN ENGLAND AND WALES (London, Eng.: Her Majesty's Stationery Office, 1996) (hereinafter WOOLF, FINAL REPORT 1996); Robert Peckham, *The Federal Judge as a Case Manager: The New Role in Guiding a Case from Filing to Disposition*, 69 CALIFORNIA LAW REVIEW 770 (1981). See generally Judith Resnik, *Managerial Judges*, 96 HARVARD LAW REVIEW 374 (1982).

**40** For example, Carrie Menkel-Meadow argued that various forms of conciliation promote "consent, participation, empowerment, dignity, respect, empathy and emotional catharsis, privacy, efficiency, quality solutions, equity, access, and yes, even justice." Carrie Menkel-Meadow, *Whose Dispute Is It Anyway? A Philosophical and Democratic Defense of Settlement (In Some Cases)*, 83 GEORGETOWN LAW JOURNAL 2663, 2669–2670 (1995) (hereinafter Menkel-Meadow, *Whose Dispute Is It Anyway?*). See also Carrie Menkel-Meadow, *Restorative Justice: What Is It and Does It Work?* 3 ANNUAL REVIEW OF LAW & SOCIAL SCIENCE 161 (2007); John Lande, *Principles for Policymaking about Collaborative Law and Other ADR Processes*, 22 OHIO STATE JOURNAL ON DISPUTE RESOLUTION 619 (2007); Julie MacFarlane, *Mediating Ethically: The Limits of Codes of Conduct and the Potential of a Reflective Practice Model*, 40 OSGOODE HALL LAW JOURNAL 49 (2002).

**41** See Lande at 625. See also Michael Moffitt, *Three Things to be Against ("Settlement" Not Included)*, 78 FORDHAM LAW REVIEW 1203 (2009).

**42** See generally JOHN BRAITHWAITE, RESTORATIVE JUSTICE &

RESPONSIVE REGULATION (New York, NY: Oxford U. Press, 2002); DISPUTE RESOLUTION IN AUSTRALIA (Hilary Astor & Christine M. Chinkin, eds., Sydney, Aus.: Butterworths, 1992).

**43** Lande at 641, 663. See also Menkel-Meadow, *Whose Dispute Is It Anyway?* at 2672–2673.

**44** See Samuel Issacharoff & Robert H. Klonoff, *The Public Value of Settlement*, 78 FORDHAM LAW REVIEW 1177 (2009). We return in Chapter 15 to an example involving rights to land under Australia's Native Land Title Rights legislation.

**45** Many statutes enforce the confidentiality of arbitration and mediation, and some critics worry about the impact. See Laurie Kratky Doré, *Public Courts versus Private Justice: It's Time to Let Some Sun Shine in on Alternative Dispute Resolution*, 81 CHICAGO-KENT LAW REVIEW 463 (2006).

**46** See ROBERT A. KAGAN, ADVERSARIAL LEGALISM: THE AMERICAN WAY OF LAW (Cambridge, MA: Harvard U. Press, 2001); WALTER K. OLSON, THE LITIGATION EXPLOSION: WHAT HAPPENED WHEN AMERICA UNLEASHED THE LAWSUIT (New York, NY: Dutton, 1991); PETER HUBER, GALILEO'S REVENGE: JUNK SCIENCE IN THE COURTROOM (New York, NY: Basic Books, 1991). An analysis of the political and social world-views that generate an interest in litigation in the United States is provided by THOMAS FREDERICK BURKE, LAWYERS, LAWSUITS, AND LEGAL RIGHTS: THE BATTLE OVER LITIGATION IN AMERICAN SOCIETY (Berkeley, CA: U. of California Press, 2002). Burke argued that "[l]itigious policies nicely match the preference of Americans, who want action on social issues yet are ambivalent about the typical tools of the state—bureaucratic regulation and welfare programs." Id. at 7.

**47** See ALAN M. DERSHOWITZ, THE ABUSE EXCUSE: AND OTHER COP-OUTS, SOB STORIES, AND EVASIONS OF RESPONSIBILITY (Boston, MA: Little, Brown, 1994).

**48** One example from case law in the United States is the decision in *Bell Atlantic Corp. v. Twombly*, 550 U.S. 544 (2007), requiring judges to ascertain the "plausibility" of allegations by plaintiffs in complaints. In 2009, the Supreme Court applied that approach more broadly. *See Ashcroft v. Iqbal*, 129 S. Ct. 1937 (2009). See also Judith Resnik, *Constricting Remedies: The Rehnquist Judiciary, Congress, and Federal Power*, 78 INDIANA LAW JOURNAL 223, 231–271 (2003).

**49** In the United States federal system, a procedural rule (Federal Rule of Civil Procedure 68) imposed a version of this regime. See *Marek v. Chesny*, 473 U.S. 1 (1985). In the United Kingdom, rule revisions provide sanctions for those who decline to go to mediation if a judge concludes that refusal to do so was not justified. See *Hurst v. Leeming*, [2002] EWHC 1051. See also *Dunnett v. Railtrack PLC*, [2002] EWCA Civ. 302.

**50** Examples of legislative revisions in the United States that cut back on substantive rights and procedural opportunities include the Private Securities Litigation Reform Act of 1995, Pub. L. No. 104-67, § 101(b), 109 Stat. 737, 743–749 (codified in relevant part as amended at 15 U.S.C. § 78u-4 (2006)) and the Prison Litigation Reform Act of 1995, Pub. L. No. 104-134, 110 Stat. 1321-66 (1996) (codified in scattered sections of Titles 11, 18, 28, and 42 U.S.C.).

**51** Amy J. Cohen, *Revisiting Against Settlement: Some Reflections on Dispute Resolution and Public Values*, 78 FORDHAM LAW REVIEW 1143, 1147 (2009). That essay was part of a symposium focused on a 1984 article by Owen Fiss, *Against Settlement*, 93 YALE LAW JOURNAL 1073 (1984).

**52** See Marc Galanter, *Why the "Haves" Come Out Ahead: Speculations on the Limits of Legal Change*, 9 LAW & SOCIETY REVIEW 95 (1974) (hereinafter Galanter, *Why the "Haves" Come Out Ahead*); Symposium, *Do the "Haves" Still Come Out Ahead?* 33 LAW & SOCIETY REVIEW 799 (1999); IN LITIGATION: DO THE "HAVES" STILL COME OUT AHEAD? (Herbert M. Kritzer & Susan S. Silbey, eds., Stanford,

CA: Stanford U. Press, 2003). See generally WOLF HEYDEBRAND & CARROLL SERON, RATIONALIZING JUSTICE: THE POLITICAL ECONOMY OF FEDERAL DISTRICT COURTS (Albany, NY: State U. of New York Press, 1990) (hereinafter HEYDEBRAND & SERON, RATIONALIZING JUSTICE).

**53** Galanter, *Why the "Haves" Come Out Ahead* at 135–139.

**54** See Judith Resnik, *Many Doors? Closing Doors? Alternative Dispute Resolution and Adjudication*, 10 OHIO STATE JOURNAL ON DISPUTE RESOLUTION 211, 246–253 (1995). For a critique that procedural regulation of decisionmaking imposed too many costs on governance in various settings, from courts to administrative agencies to legislatures, see Adam M. Samaha, *Undue Process*, 59 STANFORD LAW REVIEW 601 (2006).

**55** See Richard Moorhead & Pascoe Pleasence, *Access to Justice after Universalism: Introduction*, 30 JOURNAL OF LAW AND SOCIETY 1 (2003); Bryant Garth, *From Civil Litigation to Private Justice: Legal Practice at War with the Profession and Its Values*, 59 BROOKLYN LAW REVIEW 931 (1993).

**56** See GOVERNMENT BY CONTRACT: OUTSOURCING AND AMERICAN DEMOCRACY (Jody Freeman & Martha Minow, eds., Cambridge, MA: Harvard U. Press, 2009) (hereinafter FREEMAN & MINOW). See also Gunther Teubner, *After Privatisation? The Many Autonomies of Private Law*, 51 CURRENT LEGAL PROBLEMS 393 (1998).

**57** The photograph in figure 197 of the interior of a courtroom in the John Joseph Moakley United States Courthouse is reproduced with permission of the photographer, Steve Rosenthal, courtesy of the court, and with the assistance of the Honorable Douglas Woodlock of that court.

**58** Breyer, *Foreword* to CELEBRATING THE COURTHOUSE at 11.

**59** JOHN JOSEPH MOAKLEY UNITED STATES COURTHOUSE AND HARBORPARK: BOSTON, MASSACHUSETTS 8 (Washington, DC: U.S. General Services Administration, 2003).

**60** See ADMINISTRATIVE OFFICE OF THE U.S. COURTS, 1998 ANNUAL REPORT OF THE DIRECTOR: JUDICIAL BUSINESS OF THE UNITED STATES COURTS 178, Table C-7 (1999), http://www.uscourts.gov/dirrpt98/c07sep98.pdf. According to a Boston Bar Association analysis, the rate of dispositions by trial in civil cases dropped from the late 1980s, when the rate of dispositions by trial was about 5 percent, to the early years of the twenty-first century, when dispositions by trial averaged between 2 and 3 percent. See TASK FORCE ON THE VANISHING JURY TRIAL, BOSTON BAR ASSOCIATION, JURY TRIAL TRENDS IN MASSACHUSETTS: THE NEED TO ENSURE JURY TRIAL COMPETENCY AMONG PRACTICING ATTORNEYS AS A RESULT OF THE VANISHING JURY TRIAL PHENOMENON, App. at 30, Table 1 (2006), http://www.bostonbar.org/prs/reports/vanishingtrials1006.pdf.

**61** That estimate focused on federal district court trials in Boston. In addition to the courthouse in Boston (fig. 197), the federal district court for Massachusetts also sat in Springfield, Massachusetts, where trials could have taken place. Further, the trial courtroom count in Boston includes those dedicated for magistrate judges, who are authorized to conduct civil trials upon parties' consent. See 28 U.S.C. § 636(c)(1) (2006). Magistrate trials were not included in the data on "district court" trials.

**62** United States District Court, *Judicial Caseload Profile, Missouri Eastern*, 12-month period ending Sept. 30, 2007, Federal Court Management statistics-2007, http://www.uscourts.gov/cgi-bin/cmsd2007.pl. Within this period, a total of 113 civil trials and 124 criminal trials were completed. See ADMINISTRATIVE OFFICE OF THE U.S. COURTS, 2007 ANNUAL REPORT OF THE DIRECTOR: JUDICIAL BUSINESS OF THE UNITED STATES COURTS 181, Table C-7 (1999), http://www.uscourts.gov/judbus2007/appendices/C07Sep07.pdf. Again, magistrate judges have courtrooms, but the trials they conducted are not likely reflected in the district court data.

**63** In addition, data suggest that settlement rates vary consider-

ably by the type of case. See Theodore Eisenberg & Charlotte Lanvers, *What Is the Settlement Rate and Why Should We Care?*, 6 JOURNAL OF EMPIRICAL LEGAL STUDIES 111, 111–113 (2009).

**64** See U.S. General Accounting Office, *Courthouse Construction: Better Courtroom Use Data Could Enhance Facility Planning and Decisionmaking*, GAO/GGD-97-39, at 2–3 (1997) (hereinafter 1997 GAO COURTHOUSE CONSTRUCTION). See also U.S. General Accounting Office, *Courthouse Construction: Sufficient Data and Analysis Would Help Resolve the Courtroom-Sharing Issue*, GAO-01-70, at 8, 18 (2000). As detailed in Chapter 9, the request for new courthouse construction prompted congressional investigations about courtroom use. The 1997 GAO study defined courtroom usage as "any activity" (including but not limited to trials) for any portion of the day. The study studied sixty-five courtrooms in seven locations and concluded that courtrooms were in use about 54 percent of the days when courthouses were open. 1997 GAO COURTHOUSE CONSTRUCTION at 10; see also U.S. General Accounting Office, *Courthouse Construction: Information on the Use of District Courtrooms at Selected Locations*, GAO/GGD-97-59R, App. 1 at 9, Table I.3 (1997) (reporting similar results in a study of four other locations). As also discussed in Chapter 9, the judiciary then developed a different measure of use—"latent use"—to capture proceedings that were scheduled but cancelled.

**65** Mark R. Kravitz, *The Vanishing Trial: A Problem in Need of a Solution?* 79 CONNECTICUT BAR JOURNAL 1, 5 (2005). As Judge Kravitz noted, while the number of trials per judge had decreased, the length of trials had increased. Id. at 5–6.

**66** The graph in Figure 198 was provided by and is reproduced with the permission of the Honorable Patrick E. Higginbotham, United States Court of Appeals, Fifth Circuit, who chaired the subcommittee of the United States Judicial Conference Committee that is charged with reviewing Federal Rules of Civil Procedure. Judge Higginbotham has voiced his concern about the trend away from trials. See Patrick E. Higginbotham, *Judge Robert A. Ainsworth, Jr. Memorial Lecture, Loyola University School of Law: So Why Do We Call Them Trial Courts?* 55 SMU LAW REVIEW 1405, 1423 (2002).

**67** Marc Galanter, *The Vanishing Trial: An Examination of Trials and Related Matters in Federal and State Courts*, 1 JOURNAL OF EMPIRICAL LEGAL STUDIES 459 (2004) (hereinafter Galanter, *The Vanishing Trial*).

**68** Galanter, *The Vanishing Trial* at 506–513; see also Brian J. Ostrom, Shauna M. Strickland, & Paula L. Hannaford-Agor, *Examining Trial Trends in State Courts: 1976–2002*, 1 JOURNAL OF EMPIRICAL LEGAL STUDIES 755 (2004).

**69** Galanter, *The Vanishing Trial* at 459–460. See also Kravitz at 4–5; Adam Liptak, *U.S. Suits Multiply, but Fewer Ever Get to Trial, Study Says*, NEW YORK TIMES, Dec. 14, 2003, at A1. The Galanter data were produced at the behest of the Litigation Section of the American Bar Association, which sought out a group of researchers (including Judith Resnik) to understand and evaluate changes in trial rates. The results were published in a Symposium, *The Vanishing Trial*, 1 JOURNAL OF EMPIRICAL LEGAL STUDIES 459 (2004). See also Richard Abel, *Forecasting Civil Litigation*, 58 DEPAUL LAW REVIEW 425 (2009).

**70** See generally Wayne D. Brazil, *Comparing Structures for the Delivery of ADR Services by Courts: Critical Values and Concerns*, 14 OHIO STATE JOURNAL ON DISPUTE RESOLUTION 715 (1999); Wayne D. Brazil, *Continuing the Conversation about the Current Status and the Future of ADR: A View from the Courts*, 2000 JOURNAL OF DISPUTE RESOLUTION 11; Wayne D. Brazil, *Court ADR 25 Years after Pound: Have We Found a Better Way?* 18 OHIO STATE JOURNAL ON DISPUTE RESOLUTION 93 (2003).

**71** See Judith Resnik, *"Uncle Sam Modernizes His Justice System":*

*Inventing the Federal District Courts of the Twentieth Century for the District of Columbia and the Nation*, 90 GEORGETOWN LAW JOURNAL 607 (2002) (hereinafter Resnik, *Inventing the Federal District Courts*). See also HEYDEBRAND & SERON, RATIONALIZING JUSTICE.

**72** See Judith Resnik, *Trial as Error, Jurisdiction as Injury: Transforming the Meaning of Article III*, 113 HARVARD LAW REVIEW 924, 948 (2000) (hereinafter Resnik, *Trial as Error*).

**73** See, for example, Hubert L. Will, Robert R. Merhige Jr., & Alvin B. Rubin, *The Role of the Judge in the Settlement Process*, 75 FEDERAL RULES DECISIONS 203, 203 (1977). These comments come from a transcript of exchanges by these judges teaching their colleagues about settlement; the quoted comment comes from Judge Will.

**74** See FEDERAL RULES OF CIVIL PROCEDURE 16(c)(7) and Advisory Committee's Note (1983) (amended 1993). Subsequent amendments to the rules have rearranged the subsections.

**75** See FEDERAL RULES OF CIVIL PROCEDURE 16 (amended 1993). The revised rule stated that, at pretrial conferences, judges had the authority to require parties to participate in settlement conferences and described topics to include "settling the case and using special procedures to assist in resolving the dispute when authorized by statute or local rule." FEDERAL RULES OF CIVIL PROCEDURE 16(c)(9), revised as of 2006 and renumbered as FEDERAL RULES OF CIVIL PROCEDURE 16(c)(2)(I). Thus the 1983 word "extrajudicial" was replaced by the term "special procedures."

**76** See DISTRICT OF MASSACHUSETTS, LOCAL RULE 16.4(a) ("The judicial officer shall encourage the resolution of disputes by settlement or other alternative dispute resolution programs."); id. at 16.4(b) ("At every conference conducted under these rules, the judicial officer shall inquire as to the utility of the parties' conducting settlement negotiations . . . ."). This rule stemmed in part from congressional encouragement of such approaches through the 1990 Civil Justice Reform Act, Pub. L. No. 101-650, §§ 101–105, 104 Stat. 5089, 5089-98 (then codified at 28 U.S.C. §§ 471–482 (1994)), which required each district to implement a "justice expense and delay reduction plan" to "facilitate deliberate adjudication of civil cases on the merits, monitor discovery, improve litigation management, and ensure just, speedy, and inexpensive resolutions of civil disputes." 28 U.S.C. § 471 (1994). This reform act required studies of its initiatives and had "sunset" provisions that ended its mandates.

**77** See, for example, CENTRAL DISTRICT OF CALIFORNIA, LOCAL RULE 16-15, 16-15.1 ("Unless exempted by the trial judge, the parties in each civil case shall participate in one of the settlement procedures set forth in this rule . . . ."); DISTRICT OF OREGON, LOCAL RULE 16.4, which requires, among other actions, that the parties file a "Joint Alternate Dispute Resolution Report."

**78** See Nancy J. King, *Regulating Settlement: What Is Left of the Rule of Law in the Criminal Process*, 56 DEPAUL LAW REVIEW 389 (2007) (hereinafter King, *Regulating Settlement*).

**79** Nancy J. King & Michael E. O'Neill, *Appeal Waivers and the Future of Sentencing Policy*, 55 DUKE LAW JOURNAL 209 (2005).

**80** King, *Regulating Settlement* at 392–393.

**81** See, for example, *United States v. Martinez-Molina*, 64 F.3d 719 (1st Cir. 1995); *United States v. Holland*, 117 F.3d 589 (D.C. Cir. 1997). Stephanos Bibas explained that "repeat players . . . may propose package deals that involve discounts for global pleas, in which all codefendants plead guilty in exchange for an extra sentence reduction." Stephanos Bibas, *Plea Bargaining Outside the Shadow of Trial*, 117 HARVARD LAW REVIEW 2463, 2483–2484 (2004).

**82** See Alternative Dispute Resolution Act of 1998, Pub. L. No. 105-315, 112 Stat. 2993 (codified as amended at 28 U.S.C. §§ 651–658 (2006)).

**83** Leonard L. Riskin & Nancy A. Welsh, *Is That All There Is? "The Problem" in Court-Oriented Mediation*, 15 GEORGE MASON LAW REVIEW 863, 870, n. 37 (2008).

**84** Judicial Conference of the United States, Space and Facilities Committee, U.S. Courts Design Guide 6–32 (Washington, DC: U.S. Government Printing Office, 4th ed., 1997). The *U.S. Courts Design Guide* also noted the need for acoustics to protect the confidentiality of what was said within. As detailed in Chapter 9, the *U.S. Courts Design Guide* was more specific about courtroom layouts and size than about the ADR space.

**85** See Don Hardenbergh, Robert Tobin, & Chang-Ming Yeh, The Courthouse: A Planning and Design Guide for Court Facilities 25 (Williamsburg, VA: National Center for State Courts, 1999).

**86** Judicial Conference of the United States, Space and Facilities Committee, U.S. Courts Design Guide 1–2 (Washington, DC: U.S. Government Printing Office, 5th ed., 2007). That version noted that it had "eliminated specific space for alternative dispute resolution proceedings." Id. at 2.

**87** A few design guides do encourage the creation of flexible space to accommodate ADR. See Todd S. Phillips & Michael A. Griebel, Building Type Basics for Justice Facilities 100 (Hoboken, NJ: John Wiley & Sons, 2003).

**88** See generally *Dispute Resolution Magazine* (published by the American Bar Association Section on Dispute Resolution); Craig McEwen, *Giving Meaning to Mediator Professionalism*, 11 Dispute Resolution Magazine 3 (Spring 2005).

**89** See, for example, JAMS *Dispute Resolution Alert* newsletters (published by JAMS, The Resolution Experts). In 2009, JAMS also announced an agreement to form a center, "to provide mediation and arbitration of cross-border disputes and training services worldwide," based in Rome and New York with additional locations in Geneva, London, and Brussels. Association for International Arbitration, In Touch Monthly Newsletter, *JAMS Announces First International ADR Center* (May 2009).

**90** See, for example, Uniform Mediation Act (amended 2003), http://www.law.upenn.edu/bll/archives/ulc/mediat/2003finaldraft .htm. Two years earlier, the National Conference of Commissioners on Uniform State Laws had recommended enactment by all states of the 2001 version of that act. See National Conference of Commissioners on Uniform State Laws, Uniform Mediation Act (2001), http://www.nccusl.org/nccusl/uniformact_summaries/uniformacts-s-uma2001.asp.

**91** Some commanded rates of thousands of dollars a day. See Eric Berkowitz, *Is Justice Served?* Los Angeles Times, Oct. 22, 2006, West Magazine at 20.

**92** See Frank O. Bowman, III, Response, *American Buffalo: Vanishing Acquittals and the Gradual Extinction of the Federal Criminal Trial Lawyer,* 156 U. Pennsylvania Law Review PENNumbra 226 (2007), http://www.pennumbra.com/responses/response.php?rid=30.

**93** Marc Galanter, *The Quality of Settlements*, 1988 Journal of Dispute Resolution 55 (1988).

**94** Lisa Blomgren Bingham, Tina Nabatchi, Jeffrey M. Senger, & Michael Scott Jackman, *Dispute Resolution and The Vanishing Trial: Comparing Federal Government Litigation and ADR Outcomes,* 24 Ohio State Journal on Dispute Resolution 225 (2009). The authors examined civil cases in which the United States was a party, with lawyers coming from the offices of the United States Attorneys. The data set, from 1995 to 1998, included over 15,000 cases from the Justice Department's records. Comparing cases in which the government pursued ADR to those in which it did not, the authors found that outcomes in the cases did not differ significantly, but the costs were considerably reduced when ADR was employed.

**95** See James S. Kakalik, Terence Dunworth, Laural A. Hill, Daniel F. McCaffrey, Marian Oshiro, Nicholas M. Pace, & Mary E. Vaiana, An Evaluation of Judicial Case Management under the Civil Justice Reform Act (Washington, DC: RAND Institute for Civil Justice, 1996). RAND published three other related volumes

that year, each of which has the same authors and publication information, with the following titles: An Evaluation of Mediation and Early Neutral Evaluation under the Civil Justice Reform Act; Implementation of the Civil Justice Reform Act in Pilot and Comparison Districts; and Just, Speedy, and Inexpensive? An Evaluation of Judicial Case Management under the Civil Justice Reform Act.

**96** See Hazel Genn, *Introduction: What Is Civil Justice For?* in Hazel Genn, Judging Civil Justice, The Hamlyn Lectures 2008 at 20–21 (Cambridge, Eng.: Cambridge U. Press, 2010) (hereinafter Genn, Judging Civil Justice). The problems of consent are all the more acute in aggregate litigation, in which small groups of lawyers can represent hundreds or thousands of litigants. See, for example, John C. Coffee Jr., *Class Action Accountability: Reconciling Exit, Voice, and Loyalty in Representative Litigation*, 100 Columbia Law Review 370 (2000); Judith Resnik, *Litigating and Settling Class Actions: The Prerequisites of Entry and Exit,* 30 U. of California Davis Law Review 835 (1997); John C. Coffee Jr., *Understanding the Plaintiff's Attorney: The Implications of Economic Theory for Private Enforcement of Law Through Class and Derivative Actions,* 86 Columbia Law Review 669 (1986).

**97** D. Brock Hornby, *The Business of the US District Courts*, 10 The Green Bag 2d 453, 462 (2007).

**98** Hornby at 467–468. Judge Hornby continued: "In the twenty-first century, the federal district courts' primary roles in civil cases have become law exposition, fact sorting, and case management office tasks—not umpiring trials. In criminal cases, the judges' work remains court-centered but, instead of trials, it had become law elaboration and fact finding at sentencing, supervising federal offenders after prison, and safeguarding the integrity of a criminal process that sends defendants to prison without trial. In 2007, that is the federal district courts' business. Trials as we know them, and unfettered sentencing discretion, are not coming back." Id. at 468.

**99** See Edward A. Harnett, *Questioning Certiorari: Some Reflections Seventy-Five Years after the Judges' Bill*, 100 Columbia Law Review 1643, 1650 (2000).

**100** Harnett at 1660–1712. Stephen L. Wasby & Martha Humphries Ginn, *Triage in Appellate Courts: Cross-Level Comparison,* 88 Judicature 216 (2005).

**101** *2002 Year-End Report on the Federal Judiciary,* 35 The Third Branch 1, 3 (2003), http://www.uscourts.gov/ttb/jan03ttb/jan03.html

**102** See Federal Rules of Appellate Procedure 33. For an early description of such programs, see Irving R. Kaufman, *Must Every Appeal Run the Gamut?—The Civil Appeals Management Plan,* 95 Yale Law Journal 755 (1986).

**103** 28 U.S.C. §§ 1291, 1292 (2006).

**104** See Carolyn Dineen King, *Current Challenges to the Federal Judiciary*, 66 Louisiana Law Review 661, 675–679 (2006); Wasby & Ginn. See also William M. Richman & William L. Reynolds, *Elitism, Expediency, and the New Certiorari: Requiem for the Learned Hand Tradition,* 81 Cornell Law Review 273 (1996); William L. Reynolds & William M. Richman, *Studying Deck Chairs on the Titanic,* 81 Cornell Law Review 1290 (1996).

**105** See Administrative Office of the United States Courts, Judicial Business of the United States Courts: 1999 Annual Report of the Director 85, http://www.uscourts.gov/judbus1999/supps.html.

**106** See Administrative Office of the United States Courts, Judicial Business of the United States Courts: 2008 Annual Report of the Director 42, http://www.uscourts.gov/judbus2008/contents.cfm.

**107** See Penelope Pether, *Inequitable Injunctions: The Scandal of Private Judging in the U.S. Courts,* 56 Stanford Law Review 1435 (2004); William L. Reynolds & William M. Richman, *The Non-*

*Precedential Precedent—Limited Publication and No Citation Rules in the United States Courts of Appeals*, 78 COLUMBIA LAW REVIEW 1167 (1978). On the lack of access to district court decisions, see Hillel Y. Levin, *Making the Law: Unpublication in the District Courts*, 53 VILLANOVA LAW REVIEW 973 (2008).

**108** Andrew T. Solomon, *Making Unpublished Opinions Precedential: A Recipe for Ethical Problems & Legal Malpractice*, 26 MISSISSIPPI COLLEGE LAW REVIEW 185 (2006).

**109** Some judges thought it beyond their power to decline to permit citation (sometimes conflated with publication) based on the view that judges had no power to pick among cases to decide which opinions were precedential "law" because all of their judgments had to be "law." See *Anastasoff v. United States*, 223 F.3d 898 (8th Cir. 2000), vacated as moot, 235 F.3d 1054 (8th Cir. 2000) (en banc). The author of that judgment wrote more about the problem. See Richard S. Arnold, *Unpublished Opinions: A Comment*, 1 JOURNAL OF APPELLATE PRACTICE AND PROCESS 219 (1999). Others shared his concerns. See Lauren Robel, *The Practice of Precedent: Anastasoff, Noncitation Rules, and the Meaning of Precedent in an Interpretive Community*, 35 INDIANA LAW REVIEW 399, 402 (2002); Joseph Gerken, *A Librarian's Guide to Unpublished Judicial Opinions*, 96 LAW LIBRARY JOURNAL 475, 481–484 (2004); Stephan L. Wasby, *Publication (or Not) of Appellate Rulings: An Evaluation of Guidelines*, 2 SETON HALL CIRCUIT REVIEW 41 (2005). In 2007 federal appellate rules were revised to require courts to permit litigants to cite decisions, although not necessarily as precedential. See FEDERAL RULES OF APPELLATE PROCEDURE 32.1, applicable to decisions after January 1, 2007; U.S. Courts, *Federal Rulemaking*, http://www.uscourts.gov/rules.

**110** 2008 JUDICIAL BUSINESS, Table S-3.

**111** See E-Government Act of 2002, Pub. L. No. 107-347, § 205(a)5, 116 Stat. 2899, 2913 (codified at 44 U.S.C. § 3501 (2006)).

**112** The service, begun in 2001, is called the Federal Appendix. See Brian P. Brooks, *Publishing Unpublished Opinions: A Review of the Federal Appendix*, 5 THE GREEN BAG 2D 259, 259 (2002). In theory, courts decline to publish decisions that lack precedential value. In practice, commentators have identified important judgments treated in that fashion. See Deborah Jones Merritt & James J. Brudney, *Stalking Secret Law: What Predicts Publication in the United States Courts of Appeals*, 54 VANDERBILT LAW REVIEW 71 (2001).

**113** See, for example, Carolyn Dineen King, *Challenges to Judicial Independence and the Rule of Law: A Perspective from the Circuit Courts*, 90 MARQUETTE LAW REVIEW 765, 783 (2007); William M. Richman, *Much Ado about the Tip of an Iceberg*, 62 WASHINGTON & LEE LAW REVIEW 1723, 1725–1726 (2005); RICHARD A. POSNER, THE FEDERAL COURTS: CHALLENGE AND REFORM 160–189 (Cambridge, MA: Harvard U. Press, 1996); Carolyn Dineen King, *A Matter of Conscience*, 28 HOUSTON LAW REVIEW 955 (1991).

**114** See Jerry L. Mashaw, *Recovering American Administrative Law: Federalist Foundations, 1787–1801*, 115 YALE LAW JOURNAL 1256 (2006). Such bills date back to 1794. Id. at 1312, n.181.

**115** Steamboat Safety Act, Act of Aug. 30, 1852, ch. 106, § 9, 10 Stat. 61, 64.

**116** Jerry L. Mashaw, *Administration and "The Democracy": Administrative Law from Jackson to Lincoln, 1829–1861*, 117 YALE LAW JOURNAL 1568, 1641–1642 (2008). The Steamboat Act gave Supervising Inspectors the power of de novo review of decisions made at the lower level. Mashaw detailed how the inspection system helped to produce regulations as well as succeeded in reducing accidents. Id. at 1640–1643.

**117** See Act of Feb. 24, 1855, ch. 122, 10 Stat. 612 (1855) (hereinafter Court of Claims Act of 1855). See generally Stanton J. Peelle, *History and Jurisdiction of the United States Court of Claims*, 19 RECORDS OF THE COLUMBIA HISTORICAL SOCIETY 1 (1916).

**118** See Court of Claims Act of 1855, § 1. Like Article III judges, the Court of Claims judges were "to be appointed by the President, by and with the advice and consent of the Senate, and to hold their offices during good behaviour." These judges were, in turn, empowered to appoint commissioners who could take testimony and issue subpoenas.

How to characterize the Court of Claims puzzled the Supreme Court. In 1933 the Supreme Court held that, despite the similar appointment procedures, judges on the Court of Claims were not Article III judges, whose salaries could not be diminished under the Constitution. See *Williams v. United States*, 289 U.S. 553 (1933). Congress responded by asserting that the Court of Claims was a "court established under Article III." See *Glidden Co. v. Zdanok*, 370 U.S. 530, 585 (1962) (Clark, J., concurring). The question was mooted thereafter. In 1982 revisions, Congress created a trial-level court called the United States Court of Federal Claims and gave its judges fifteen-year terms, thereby plainly creating a non-Article III court. See Pub. L. No. 102-572, 106 Stat. 4506 (1992) (codified at 28 U.S.C. § 171 (2006)).

**119** That principle was stated early in the history of the United States when the Supreme Court rejected an effort to give its judges authority over pensions for injured Revolutionary War veterans. Congress had authorized judges to determine eligibility and sums but had given the Secretary of War the power to reject the recommendations. See *Hayburn's Case*, 2 U.S. (2 Dall.) 409 (1792).

**120** See Court of Claims Act of 1855, § 1 (The court "shall hear and determine all claims . . . which may be referred to said court by either house of Congress"). Remnants of that jurisdiction remain. See 28 U.S.C. §§ 1492, 2509 (2006).

**121** Congress revisited the structure of the Court of Claims several times. In 1866 Congress provided for direct enforcement of the judgments of the Court of Claims and for review of its decisions by the Supreme Court. See Act of March 17, 1866, ch. 19, 14 Stat. 9 (1866). In 1887, Congress expanded the court's powers by providing it with jurisdiction over all monetary claims against the federal government. See The Tucker Act, Rev. Stat. § 1059, ch. 359, § 1, 24 Stat. 505 (1887), now codified at 28 U.S.C. § 1491 (2006). The 1982 recodification renamed the trial court the United States Court of Federal Claims. See Pub. L. No. 102-572, 106 Stat. 4506 (Oct. 29, 1992), codified at 28 U.S.C. § 171 (2006). The trial court consisted of sixteen judges appointed by the President, confirmed by the Senate, and sitting for terms of fifteen years. Id. In the 1982 provision, Congress also located appellate jurisdiction in the Federal Circuit. See 28 U.S.C. § 1295 (2006).

**122** See 42 U.S.C. § 300AA-1 et seq. (providing for the Court of Federal Claims to handle vaccine compensation cases).

**123** See 28 U.S.C. § 171 (2006).

**124** See 28 U.S.C. § 798(c) (2006). The Chief Judge of the Court of Federal Claims has authority to appoint special masters. See also rules of the United States Court of Federal Claims, http://www.uscfc.uscourts.gov/ (Rules, Rules of the Federal Court of Claims).

**125** Various specialized courts exist in the federal system. One example is the Tax Court, which evolved from its origins in 1924 as the Board of Tax Appeals to its current status as a court within the judicial branch. See Revenue Act of 1924, ch. 234, § 900, 43 Stat. 253, 336 (creating the Board); Revenue Act of 1926, ch. 27, § 1001(a), 1002, 42 Stat. 9, 109–110 (providing for direct appeals to the circuit courts); Revenue Act of 1942, ch. 619, § 504(a), 56 Stat. 798 (creating the Tax Court of the United States); Tax Reform Act of 1969, Pub. L. No. 91-172, § 951, 83 Stat. 487, 730 (shifting the institution from an executive agency to a judicial entity). Another such court is the Court of Appeals for Veterans Claims, with seven judges appointed by the President and serving terms of fifteen years. See Veterans' Judicial Review Act of 1988, Pub. L. No. 100-687, 102 Stat. 4105, Pub. L. No. 105-368, 112 Stat. 3315 (codified at 38 U.S.C. Sec. 7251 (2006)).

**126** In 1901, appellate and trial judges nationally numbered 113; 70 served on the district courts. See Authorized Judgeships, Table K,

in *History of Federal Judgeships*, http://www.uscourts.gov/history/
allauth.pdf (periodically updated) (hereinafter 2009 Authorized
Judgeships). The table also listed one Article I judgeship as of that
date. Id. See also Annual Report of the Director of the Administrative
Office of the U.S. Courts for 2000 at 37, Table 12 (Washington, DC:
U.S. Government Printing Office), http://www.uscourts.gov/judbus
2000/front/2000artext.pdf.

**127** Data on commissioners are limited, and they are not listed in
the roster of federal judges. The office of commissioner began with the
First Judiciary Act of 1789, which authorized individuals then paid on
a fee-for-service basis to discharge tasks sometimes seen to be "judi-
cial in nature," such as administering oaths and issuing warrants. The
work was, however, described as more "ministerial" than judicial. The
deployment of such persons built on English practice, in which jus-
tices of the peace—typically not lawyers—provided such assistance to
the common law courts.

In 1968, the commissioner system was replaced by the Federal
Magistrates Act, Pub. L. No. 90-578, 82 Stat. 1108 (1968), codified as
amended at 18 U.S.C. §§ 3401-3402, 3060 (2006), 28 U.S.C. §§ 604,
631-639 (2006). The magistrate system also borrowed some lessons
from English practice. See generally Linda J. Silberman, *Masters and
Magistrates, Part II: The American Analogue*, 50 NEW YORK U. LAW
REVIEW 1297 (1975).

**128** See 28 U.S.C. §§ 631-636; see also Federal Courts Study Com-
mittee Implementation Act of 1990, Pub. L. No. 101-650, § 321, 104
Stat. 5104, 5117, adding a "note" to 28 U.S.C. § 631 (2006).

**129** See, for example, Act of Oct. 21, 1976, Pub. L. No. 94-577, §
1, 90 Stat. 2729, 2729 (authorizing magistrates to make preliminary
reviews in certain instances, to receive evidence, and to make pro-
posed findings of fact); Federal Magistrate Act of 1979, Pub. L. No. 96-
82, 93 Stat. 643 (1979) (codified as amended at 28 U.S.C. § 636 (2006))
(providing magistrates the authority to preside over civil cases if the
parties consent and broadening criminal misdemeanor jurisdiction).
See generally ADMINISTRATIVE OFFICE OF THE UNITED STATES
COURTS, A GUIDE TO THE LEGISLATIVE HISTORY OF THE FEDERAL
MAGISTRATE JUDGES SYSTEM (Washington, DC: 1995).

**130** See Federal Courts Improvement Act of 2000, Pub. L.
No. 106-518, § 202, 114 Stat. 2410, 2412 (amending 28 U.S.C. §
636(e) to provide magistrate judges with contempt powers for actions
occurring in their presence and obstructing the "administration of
justice"); Bankruptcy Amendments and Federal Judgeship Act of
1984, Pub. L. No. 98-353, 98 Stat. 333, 336 (codified at 28 U.S.C. §§
151-152 (2006)) (deeming bankruptcy judges "judicial officers of the
United States district court"). See also *In re Terrebonne Fuel and Lube,
Inc.*, 108 F.3d 609 (5th Cir. 1997); *In re Rainbow Magazine, Inc.*, 77
F.3d 278 (9th Cir. 1996) (holding that bankruptcy judges have civil
contempt powers).

The contempt powers of statutory judges are not identical to those
of constitutional Article III judges. See 28 U.S.C. § 636(e)(6) (2006);
Mark S. Kende, *The Constitutionality of New Contempt Powers for
Federal Magistrate Judges*, 53 HASTINGS LAW JOURNAL 567 (2002);
Belinda K. Orem, *The Impenitent Contemnor: The Power of the Bank-
ruptcy Courts to Imprison*, 25 CALIFORNIA BANKRUPTCY JOURNAL 222
(2000). Kende argued the unconstitutionality of magistrate judges'
summary contempt powers, as he nonetheless predicted that the
Supreme Court would uphold that authority.

**131** See 28 U.S.C. § 636(c) (2006) (empowering magistrate judges
to preside at civil jury trials if the parties consent); 28 U.S.C. § 157(e)
(2006) (empowering bankruptcy judges, "if specially designated" by
the district courts and upon "express consent of all parties," to conduct
jury trials).

**132** See Bankruptcy Amendments and Federal Judgeship Act of
1984, ch. 6, Pub. L. No. 98-353, 98 Stat. 333, 336 (codified as amended
in various sections of 11 U.S.C. and 28 U.S.C. (2006)).

**133** See 28 U.S.C. §§ 151, 152 (2006) (bankruptcy judges appointed
for fourteen-year terms by appellate judges of that circuit); 28 U.S.C.
§ 631 (2006) (magistrate judges appointed for eight-year terms by dis-
trict judges).

**134** Included are those judges sitting in "Article I" courts (such as
the Court of Federal Claims and the Tax Court) and those chartered
through the Administrative Procedure Act, 5 U.S.C. §§ 551-659, 701-
706 (2006). Additional discussion of the expansion of adjudication in
administrative agencies and of the increasingly administrative posture
of judges based in courts comes from David S. Clark, *Civil and Admin-
istrative Courts and Procedure*, 38 AMERICAN JOURNAL OF COMPARA-
TIVE LAW 181 (1990).

**135** See RAYMOND LIMON, OFFICE OF ADMINISTRATIVE LAW JUDGES,
THE FEDERAL ADMINISTRATIVE JUDICIARY: THEN AND NOW: A DECADE
OF CHANGE, 1992–2002, App. C at 7 (2002); see also Michael Asimow,
*The Spreading Umbrella: Extending the APA's Adjudication Provisions to
All Evidentiary Hearings Required by Statute*, 56 ADMINISTRATIVE LAW
REVIEW 1003, 1008 (2004).

**136** United States Department of Labor, Occupational Employ-
ment and Wages, 2008, at 10, Table 1 (Bureau of Labor Statistics, News
Release No. 08_0620, rev. ed. 2007), http://www.bls.gov/news
.release/ocwage.t01.htm. That report described almost 14,000 hear-
ing officers, adjudicators, or judges employed by agencies. See also
Occupational Employment and Wages, May 2008, 23-1021, Adminis-
trative Law Judges, Adjudicators, and Hearing Officers, http://www
.bls.gov/oes/2008/may/oes231021.htm#(8).

**137** Administrative Procedure Act of 1946, Pub. L. No. 79-404, 60
Stat. 237, 239–240 (1946) (codified at 5 U.S.C. § 501 et seq. (2006));
George B. Shepherd, *Fierce Compromise: The Administrative Proce-
dure Act Emerges from New Deal Politics*, 90 NORTHWESTERN LAW
REVIEW 1557 (1996).

**138** 5 U.S.C. § 3105 (2006).

**139** 5 U.S.C. § 7521 (2006).

**140** See Paul R. Verkuil & Jeffrey S. Lubbers, *Alternative
Approaches to Judicial Review of Social Security Disability Cases*, 55
ADMINISTRATIVE LAW REVIEW 731, 738 (2003) (hereinafter Verkuil &
Lubbers). The Social Security system began in 1935. By 1950, some 16
percent of those over age sixty-five received social security benefits.
Robert M. Ball, *The Original Understanding on Social Security: Impli-
cations for Later Developments*, in SOCIAL SECURITY: BEYOND THE
RHETORIC OF CRISIS 27 (Theodore R. Marmor & Jerry L. Mashaw, eds.,
Princeton, NJ: Princeton U. Press, 1988). A hearings and appeals sys-
tem then existed that heard arguments about administrative errors.

Over time, adjudicatory procedures were elaborated. The number
of administrative law judges grew from about 30 in 1956 to 110 in 1960
to more than 800 in 1988. In 1975, disability appeals before adminis-
trative law judges numbered some 150,000 per year. By 1983, the num-
ber of such appeals was 364,000. Jerry L. Mashaw, *Disability Insurance
in an Age of Retrenchment: The Politics of Implementing Rights*, in
SOCIAL SECURITY: BEYOND THE RHETORIC OF CRISIS at 166. By the early
1990s, more than 325,000 requests for hearings were made annually.
See Robert S. Haberman & David G. Hatfield, *The Role of the Appeals
Council in the Administrative Adjudicative Process: Unveiling the Mys-
tery*, 39 FEDERAL BAR NEWS & JOURNAL 444, 447 (1992). See also JERRY
L. MASHAW, BUREAUCRATIC JUSTICE: MANAGING SOCIAL SECURITY
DISABILITY CLAIMS (New Haven, CT: Yale U. Press, 1983) (hereinafter
MASHAW, BUREAUCRATIC JUSTICE); JERRY L. MASHAW, CHARLES J.
GOETZ, FRANK I. GOODMAN, WARREN F. SCHWARTZ, PAUL R. VERKUIL,
& MILTON M. CARROW, SOCIAL SECURITY HEARINGS AND APPEALS: A
STUDY OF THE SOCIAL SECURITY ADMINISTRATION HEARING SYSTEM
(Lexington, MA: Lexington Books, 1978) (hereinafter MASHAW ET AL.,
SOCIAL SECURITY HEARINGS AND APPEALS).

**141** See Paul R. Verkuil, *Reflections upon the Federal Administra-
tive Judiciary*, 39 UCLA LAW REVIEW 1341, 1344–1345 (1992); John

H. Frye III, *Survey of Non-ALJ Hearing Programs in the Federal Government*, 44 ADMINISTRATIVE LAW REVIEW 261, 349 (1992).

**142** See Michael Asimow, *The Administrative Judiciary: ALJs in Historical Perspective*, 20 JOURNAL OF THE NATIONAL ASSOCIATION OF ADMINISTRATIVE JUDGES 157 (2000).

**143** See Chris Guthrie, Jeffrey J. Rachlinski, & Andrew J. Wistrich, *The "Hidden Judiciary": An Empirical Examination of Executive Branch Justice*, 58 DUKE LAW JOURNAL 1477, 1486–1489 (2009).

**144** See E. Donald Elliott & Sanjay A. Narayan, *Administrative "Health Courts" for Medical Injury Claims: The Federal Constitutional Issues*, 33 JOURNAL OF HEALTH, POLITICS, POLICY AND LAW 761 (2008). Others are less enthusiastic. See Philip G. Peters Jr., *Health Courts?* 88 BOSTON UNIVERSITY LAW REVIEW 227 (2008).

**145** See, for example, *Murray's Lessee v. Hoboken Land & Improvement Co.*, 59 U.S. 272 (1855); *Crowell v. Benson*, 285 U.S. 22 (1932); *Commodity Futures Trading Commission v. Schor*, 478 U.S. 833 (1986). See generally Richard H. Fallon, Jr., *Of Legislative Courts, Administrative Agencies, and Article III*, 101 HARVARD LAW REVIEW 915 (1988); Resnik, *Inventing the Federal District Courts* at 625–643, 647–649.

**146** The United States Constitution also mentions congressional authority to constitute "tribunals," and that provision could be read as a basis for some of this expansion. See generally JAMES PFANDER, ONE SUPREME COURT: SUPREMACY, INFERIORITY, AND THE JUDICIAL DEPARTMENT OF THE UNITED STATES (Oxford, Eng.: Oxford U. Press, 2009). Moreover, reinterpretation of constitutional provisions can be found in many contexts. The Commerce Clause powers of the federal government, for example, came to be seen as broader than had been the understanding during the nineteenth century. See, for example, *Wickard v. Filburn*, 317 U.S. 111 (1942); *Gonzales v. Raich*, 545 U.S. 1 (2005).

**147** See James F. Flanagan, *An Update on Developments in Central Panels and ALJ Final Order Authority*, 38 INDIANA LAW REVIEW 401 (2005). More than half of the states had organized administrative judges in central panels. See Jim Rossi, *Overcoming Parochialism: State Administrative Procedure and Institutional Design*, 54 ADMINISTRATIVE LAW REVIEW 551, 568 (2001).

**148** The pivotal decision is *Goldberg v. Kelly*, 397 U.S. 254 (1970).

**149** Agencies can therefore generate internal court systems, with various levels of deference (or not) to lower-level decisionmakers, and, depending on the statute giving authority to a particular agency, claimants may also be able to obtain court review—often with deference —of agency judgments.

**150** Some explanation of the category "evidentiary hearings" is in order. The Administrative Office of the United States Courts, which provides statistics on the federal system, defined trials as all proceedings, civil or criminal, before Article III judges that were "contested hearings at which evidence is presented." See ADMINISTRATIVE OFFICE OF THE U.S. COURTS, 2001 ANNUAL REPORT OF THE DIRECTOR: JUDICIAL BUSINESS OF THE UNITED STATES COURTS 24–25 (2002), http://www.uscourts.gov/judbus2001/front/2001artext.pdf. Separate tables tallied proceedings before magistrate and bankruptcy judges. Included in the definition would be testimony taken on motions, trials begun but aborted due to settlement or otherwise, and those trials that resulted in the disposition of a case.

**151** The sources for this calculation are detailed in Judith Resnik, *Migrating, Morphing, and Vanishing: The Empirical and Normative Puzzles of Declining Trial Rates in Courts*, 1 JOURNAL OF EMPIRICAL LEGAL STUDIES 783 (2004) (hereinafter Resnik, *Migrating, Morphing, and Vanishing*); Natalie Ram & Bertrall Ross, *Analyzing Federal Administrative Adjudication* (June 6, 2006) (unpublished paper). The data on the chart in figure 200 were compiled by then Yale Law students Jennifer Peresie, Natalie Ram, and Bertrall Ross. We were aided by administrative law experts Michael Asimow, Steven Croley, Eugene

Fidell, Jeffrey Lubbers, Elizabeth Magill, and Jerry Mashaw, and by Yale Law School librarian Camilla Tubbs.

**152** See Resnik, *Migrating, Morphing, and Vanishing* at 818, n. 158. Although the Supreme Court held in 1950 that immigration cases were subject to the APA, Congress reversed that conclusion. In 1983, the Department of Justice created an administrative division to deal with immigration cases that separated the hearing officers from the Immigration and Naturalization Service to provide distinctions akin to those in the APA structure. See Gary J. Edles, *An APA-Default Presumption for Administrative Hearings: Some Thoughts on "Ossifying" the Adjudication Process*, 55 ADMINISTRATIVE LAW REVIEW 787, 810–811 (2003). But the decisionmakers remained employees of the Department of Justice and hence subject to its authority. In 2002, the Attorney General proposed a reduction in the number of immigration judges. See Board of Immigration Appeals: Procedural Reforms to Improve Case Management, 67 Fed. Reg. 7309 (Feb. 19, 2002). The proposal was controversial, and some argued that it was motivated by efforts to remove judges perceived to be less responsive to the government's approach. See Lisa Getter, *Immigration Judges Call for Independent Court*, LOS ANGELES TIMES, Jan. 31, 2002, at A1; Jaya Ramji-Nogales, Andrew I. Schoenholtz, & Philip G. Schrag, *Refugee Roulette: Disparities in Asylum Adjudication*, 60 STANFORD LAW REVIEW 295, 349–355 (2007) (hereinafter *Refugee Roulette*).

**153** 29 C.F.R. § 1614.109(e) (2008) ("Attendance at hearings will be limited to persons determined by the administrative judge to have direct knowledge relating to the complaint. Hearings are part of the investigative process and are thus closed to the public.").

**154** See, for example, 38 C.F.R. § 20.701 (2008) ("Only the appellant and/or his or her authorized representative may appear and present argument in support of an appeal").

**155** Hearings other than exclusion proceedings are presumptively open; however, immigration judges may respond to space constraints by limiting attendees—with priority in seats going to the press. 8 C.F.R. § 1003.27(a) (2008). Further, immigration judges are authorized to close hearings in order to protect "witnesses, parties, or the public interest," id. at (b), when family abuse is at issue, id. at (c), when certain kinds of protective orders are sought, id. at (d), or, under some case law, when national security concerns are at issue. *North Jersey Media Group, Inc., v. Ashcroft*, 308 F.3d 198, 220 (3d Cir. 2002) (upholding a blanket closing, based on national security concerns, of deportation hearings), cert. denied, 538 U.S. 1056 (2003). But see *Detroit Free Press v. Ashcroft*, 303 F.3d 681, 705 (6th Cir. 2002) (finding that a general closing of such proceedings violates the First Amendment).

**156** 20 C.F.R. § 498.215(d) (2009) (providing that in civil penalty monetary cases, "[t]he hearing will be open to the public unless otherwise ordered by the ALJ for good cause"). Social Security regulations further provide that "[a] hearing is open only to you [the claimant] and to other persons the administrative law judge considers necessary and proper." See 20 C.F.R. § 405.320 (a).

**157** In the 1960s, Congress created the Administrative Conference of the United States (ACUS), designed to provide some interagency analysis. See Administrative Conference Act, Pub. L. No. 88-499, 78 Stat. 615 (1964). But Congress never funded ACUS at a level that would have permitted it to survey and report regularly on all of the adjudicatory practices of agencies. In later years Congress did not fund ACUS at all. See Toni M. Fine, *A Legislative Analysis of the Demise of the Administrative Conference of the United States*, 30 ARIZONA STATE LAW JOURNAL 19, 90 (1998).

**158** Some agencies provided forms of information about their adjudication. For example, the National Labor Relations Board (NLRB) posted judgments rendered by its Administrative Law Judges. See NLRB, Administrative Law Judge (ALJ) Decisions, http://www.nlrb.gov/research/decisions/alj_decisions.aspx. The opinions of the NLRB were collected in an agency report. See NLRB, Board Decisions,

http://www.nlrb.gov/Research/Decisions/Board%5Fdecisions; NLRB, Regional Directors, http://www.nlrb.gov/Research/Decisions/regional_directors.aspx.

The Executive Office of Immigration Review provided statistics about asylum outcomes, with details about the nationalities of petitioners and dispositions of cases, but the materials were presented in the aggregate. See Executive Office for Immigration Review, *Index of Frequently Requested FOIA-Processed Records*, http://www.usdoj.gov/eoir/efoia/foiafreq.htm; see also EXECUTIVE OFFICE FOR IMMIGRATION REVIEW, U.S. DEP'T OF JUSTICE, IMMIGRATION COURTS: FY 2005 ASYLUM STATISTICS (2006), http://www.usdoj.gov/eoir/efoia/FY05 AsyStats.pdf.

**159** See Center for Gender & Refugee Studies, *U.S. and International Case Law*, http://cgrs.uchastings.edu/law.

**160** See TRAC, *About Us*, http://trac.syr.edu/aboutTRACgeneral .html.

**161** See generally MASHAW, BUREAUCRATIC JUSTICE; MASHAW ET AL., SOCIAL SECURITY HEARINGS AND APPEALS; Verkuil & Lubbers.

**162** Christopher B. McNeil, *Perceptions of Fairness in State Administrative Hearings*, 92 JUDICATURE 160 (2009).

**163** *Refugee Roulette* at 327, 394–398.

**164** *Refugee Roulette* at 331.

**165** *Refugee Roulette* at 366.

**166** The excerpts in figure 201 come from a contract that we had with the service then providing us with cell phones. See Verizon Wireless eStore, Your Verizon Wireless Customer Agreement. These materials exemplify this genre of contract; other providers had similar contracts. See, for example, Sprint, Terms and Conditions: Terms and Conditions of Service, http://www.sprintpcs.com/common/popups/popLegalTermsPrivacy.html#2. Our thanks to Peter Jaszi for advice on copyright and reproduction rights and to Verizon's Vice President and Associate General Counsel, Sarah B. Deutsch, who in 2006 confirmed the propriety of the publication of a portion of the contract for this particular use.

**167** On the enforcement of such provisions, see generally *Caley v. Gulfstream Aerospace Corp.*, 428 F.3d 1359 (11th Cir. 2005) (enforcing arbitration clauses despite arguments by employees seeking class treatment of claims under the Age Discrimination in Employment Act and the Employee Retirement Income Security Act, as well as individual claims under the Fair Labor Standards Act and Title VII); Jean R. Sternlight & Elizabeth J. Jensen, *Using Arbitration to Eliminate Consumer Class Actions: Efficient Business Practice or Unconscionable Abuse?*, 67 LAW & CONTEMPORARY PROBLEMS 75 (2004).

**168** Although some argued that a failure of such contracts to specify costs ought to be grounds for the unenforceability of mandatory arbitration clauses entered into prior to the occurrence of disputes, the Supreme Court concluded that the burden rests on the party challenging a particular procedure to establish that the costs imposed prevented that person from effectively vindicating federal statutory rights. See *Green Tree Financial Corporation–Alabama v. Randolph*, 531 U.S. 79, 92 (2000).

**169** See ROBERT ELLICKSON, ORDER WITHOUT LAW: HOW NEIGHBORS SETTLE DISPUTES (Cambridge, MA: Harvard U. Press, 1991); Lisa Bernstein, *Opting Out of the Legal System: Extralegal Contractual Relations in the Diamond Industry*, 21 JOURNAL OF LEGAL STUDIES 115 (1992).

**170** See National Labor Relations Act of 1935, 29 U.S.C. §§ 151–169 (2006). See generally CYNTHIA ESTLUND, WORKING TOGETHER: HOW WORKPLACE BONDS STRENGTHEN A DIVERSE DEMOCRACY (Oxford, Eng.: Oxford U. Press, 2003); Benjamin Sachs, *Employment Law as Labor Law*, 29 CARDOZO LAW REVIEW 2685 (2008).

**171** David Marcus, *The Perils of Contract Procedure: A Revised History of Forum Selection Clauses in the Federal Courts*, 82 TULANE LAW REVIEW 973 (2008).

**172** IAN R. MACNEIL, AMERICAN ARBITRATION LAW: REFORMATION—NATIONALIZATION—INTERNATIONALIZATION 10–20 (New York, NY: Oxford U. Press, 1992).

**173** See United States Arbitration Act, Pub. L. No. 68-401, 43 Stat. 883 (1925) (codified as amended at 9 U.S.C. §§ 1–14 (2006)). The current version is commonly referred to as the Federal Arbitration Act (FAA).

**174** See, for example, *Wilko v. Swan*, 346 U.S. 427, 438 (1953). That decision was overruled in *Rodriguez de Quijas v. Shearson American Express, Inc.*, 490 U.S. 477 (1989).

**175** See, for example, *Mitsubishi Motors Corp. v. Soler Chrysler-Plymouth, Inc.*, 473 U.S. 614, 640 (1985); *Dean Witter Reynolds, Inc., v. Byrd*, 470 U.S. 213, 218 (1985); *Green Tree Financial Corporation–Alabama v. Randolph*, 531 U.S. 79, 89–92 (2000). The lower courts followed suit. See, for example, *Guyden v. Aetna, Inc.*, 544 F.3d 376, 384 (2d Cir. 2008) (holding that claims under the Sarbanes-Oxley Act's whistleblower protection provisions are arbitrable and concluding that "the loss of a public forum in which to air allegations of fraud does not undermine the statutory purpose of a whistleblower protection provision").

**176** See *Circuit City Stores, Inc., v. Adams*, 532 U.S. 105, 119 (2001). On remand, the Ninth Circuit concluded that, under California law, the contract was not enforceable because it was a contract of adhesion. *Circuit City Stores, Inc., v. Adams*, 279 F.3d 889, 893 (9th Cir. 2002).

**177** The point was sharply made in 2006 in *Buckeye Check Cashing, Inc., v. Cardegna*, 546 U.S. 440 (2006), where the Supreme Court heard an appeal of the Florida Supreme Court's decision that an arbitration provision was unenforceable because the underlying contract had a provision that, under Florida law, was invalid and nonseverable. See *Cardegna v. Buckeye Check Cashing, Inc.*, 894 So. 2d 860, 862–864 (Fla. 2005). But the United States Supreme Court ruled that federal law required that the issue of the contract's enforcement be presented in arbitration. *Buckeye Check Cashing*, 546 U.S. at 449. Further, even when state law would send an issue to an administrative forum, federal law superseded state rules and required arbitration. See *Preston v. Ferrer*, 552 U.S. 346, 349 (2008). In another decision, *Green Tree Financial Corporation v. Bazzle*, 539 U.S. 444, 452–453 (2003), the Supreme Court concluded that the question of whether an arbitration contract precluded a class arbitration was an issue to be determined initially by an arbitrator rather than a judge.

**178** See, for example, *Southland Corp. v. Keating*, 465 U.S. 1, 10–14 (1984). See also *Preston v. Ferrer*, 552 U.S. 346 (2008).

**179** See, for example, *Green Tree Financial Corporation–Alabama v. Randolph*, 531 U.S. 79, 92 (2000). That ruling has resulted in some lower courts authorizing discovery into the costs to be imposed in a particular program. See, for example, *James v. McDonald's Corp.*, 417 F.3d 672, 680 (7th Cir. 2005) (requiring courts to apply "a case-by-case analysis" focusing in part on the claimant's "ability to pay the arbitration fees and costs, the expected cost differential between arbitration and litigation in court, and whether the cost differential is so substantial as to deter the bringing of claims") (citation omitted).

**180** See, for example, PUBLIC CITIZEN, THE ARBITRATION TRAP: HOW CREDIT CARD COMPANIES ENSNARE CONSUMERS (2007), http://www.citizen.org/documents/ArbitrationTrap.pdf. Cf. Stephen Ware, *The Case for Enforcing Adhesive Arbitration Agreements—with Particular Consideration of Class Actions and Arbitration Fees*, 5 JOURNAL OF AMERICAN ARBITRATION 251 (2006).

**181** In 2001, members of Congress proposed a Civil Rights Procedures Protection Act of 2001, H.R. 1489, 107th Cong. 1st Sess. (2001), to make contracts mandating arbitration unenforceable if plaintiffs sought to bring claims under certain federal civil rights statutes. In 2007 another act, The Arbitration Fairness Act of 2007, S. 1782, 110th Cong. (2007), sought to make unenforceable certain

mandatory arbitration agreements proffered to consumers. *See also* The Consumer Fairness Act of 2009, H.R. 991, 111th Cong. (2009). Further, in 2002, Congress enacted a provision that made ex ante agreements to arbitrate unenforceable when entered into by automobile franchisees and franchisors. *See* the Motor Vehicle Franchise Contract Arbitration Fairness Act, S. Rep. No. 107-266, at 2 (2002), enacted as a rider to the 21st Century Department of Justice Appropriations Authorization Act, Pub. L. No. 107-273, § 11028, 116 Stat. 1758, 1835–1836 (2002), codified at 15 U.S.C. § 1226 (2006) (hereinafter Franchise Contract Fairness Act).

**182** *See* Jean R. Sternlight, *Creeping Mandatory Arbitration: Is It Just?* 57 STANFORD LAW REVIEW 1631, 1646–1648 (2005) (hereinafter Sternlight, *Creeping Mandatory Arbitration*).

**183** NEBRASKA CONST. of 1867, Art. 1, cl. 9.

**184** *German-American Insurance Co. v. Etherton*, 41 N.W. 406, 406 (Neb. 1889).

**185** *Phoenix Insurance Co. v. Zlotky*, 92 N.W. 736, 737 (Neb. 1902).

**186** *State v. Nebraska Association of Public Employees, Local 61*, 477 N.W.2d 577 (Neb. 1991); NEB. CONST., Art. I, § 13. The court struck down the legislation not as violating the public policy of the legislature but as violating the state constitution.

**187** NEB. CONST., Art. 1, § 13. *See* John M. Gradwohl, *Arbitrability under Nebraska Contracts: Relatively Clarified at Last*, 31 CREIGHTON LAW REVIEW 207 (1997).

**188** The application of these precepts is somewhat more complex. *See* Sternlight, *Creeping Mandatory Arbitration* at 1636–1647 (2005). As we noted, the Supreme Court concluded that if mandatory arbitration imposed significantly greater costs, a contract to use such a process might not be enforceable. Similarly, demonstration of process failures or bias in the ADR mechanism can be the basis for not requiring arbitration. But the burden of demonstrating a lack of adequacy falls on the party opposing the mandatory provision. *See also* Susan Randall, *Judicial Attitudes Toward Arbitration and the Resurgence of Unconscionability*, 52 BUFFALO LAW REVIEW 185 (2004).

Some litigants sought, by contract, to increase judicial oversight of arbitration awards beyond the statutory bases (such as fraud or bias) of the Federal Arbitration Act (FAA). The Supreme Court rejected the efforts to supplement the FAA's enumerated grounds for review. *Hall Street Associates, L.L.C., v. Mattel, Inc.*, 552 U.S. 576 (2008). On the other hand, a few courts have concluded that complete preclusion of mechanisms for aggregation, akin to class actions in courts, render a contract unenforceable. *See*, for example, *Gentry v. Superior Court*, 165 P. 3d 556 (Cal. 2007), cert. denied sub nom. *Circuit City Stores, Inc., v. Gentry*, 128 S. Ct. 1743 (2008). Moreover, as noted, a few statutory provisions exempt certain kinds of litigants from these mandates. *See* the Franchise Contract Fairness Act. Thus litigants with knowledge, access to lawyers, and resources may be able to dispute the obligation to arbitrate. *See generally* Judith Resnik, *The Rights of Remedies: Collective Accountings for and Insuring against the Harms of Sexual Harassment*, in DIRECTIONS IN SEXUAL HARASSMENT LAW 247 (Catharine A. MacKinnon & Reva B. Siegel, eds., New Haven, CT: Yale U. Press, 2004).

**189** James J. Alfini & Catherine G. McCabe, *Mediating in the Shadow of the Courts: A Survey of the Emerging Case Law*, 54 ARKANSAS LAW REVIEW 171, 194 (2001).

**190** *United States v. Glens Falls Newspapers, Inc.*, 160 F.3d 853, 856 (1998).

**191** *See*, for example, 28 U.S.C. § 652(d) (2006) ("each district court shall . . . provide for the confidentiality of the alternative dispute resolution processes and . . . prohibit disclosure of confidential dispute resolution communications.").

**192** *See* JAMS Comprehensive Arbitration Rules & Procedures, Rule 26(a), http://www.jamsadr.com/rules-comprehensive-arbitration/#Rule%2026. The caveat noted that JAMS and the arbitrator would disclose "as necessary in connection with a judicial challenge" to its

enforcement or if otherwise required by court order. *See also* Doré at n. 112. There listed are comparable provisions from other such organizations, including the American Arbitration Association and the National Arbitration Forum, as well as the Commercial Arbitration Rules and the Global Arbitration and Mediation Service Rules.

**193** *See Iberia Credit Bureau, Inc., v. Cingular Wireless*, 379 F.3d 159, 175 (5th Cir. 2004). The decision found enforceable mandatory arbitration clauses in cell phone contracts—in part because both the company and the consumer were bound. Id. at 176. The court specifically rejected the plaintiffs' argument that the confidentiality of the outcomes was objectionable. Id. at 175–176.

**194** *See* American Arbitration Association, *Wireless Industry Arbitration Rules* (June 1, 2009), http://www.adr.org/sp.asp?id=22010 (providing, in Rule 24, that "[t]he arbitrator shall ensure the privacy of the hearings"). The Better Business Bureau's "Arbitration Rule 14" permits outside observers to attend as long as there is "room and no objection" from either the parties or the arbitrator. Better Business Bureau, *Rules and Regulations of Binding Arbitration*, http://www.bbb.org/us/Dispute-Resolution-Services/Binding-Arbitration/ (hereinafter BBB, *Arbitration Rules*).

**195** *See* BBB, *Arbitration Rules*, Rule 15 (stating that "[u]nless there is approval of all parties and the arbitrator, neither media representatives nor any other observer may be permitted to bring cameras, lights, recording devices or any other equipment into the hearing"). Further, the media's attendance is contingent upon the consent of the arbitrator and the parties. Where the requisite consent is obtained, "[m]edia shall be permitted access to arbitration hearings on the same basis as other observers." Id.

**196** Theodore Eisenberg, Geoffrey P. Miller, & Emily Sherwin, *Arbitration's Summer Soldiers: An Empirical Study of Arbitration Clauses in Consumer and Nonconsumer Contracts*, 41 U. OF MICHIGAN JOURNAL OF LEGAL REFORM 871, 880–881 (2008).

**197** Eisenberg, Miller, & Sherwin at 876.

**198** Eisenberg, Miller, & Sherwin at 876. They assembled their data set by identifying "a number of companies with significant market shares or name recognition in the telecommunications, credit, and financial services industries," most of which appeared on *Fortune's* list of Top 100 American Companies. Id. at 880. See also id. at 881, Table 1 (detailing the companies included, such as AT&T, Chase, and Time Warner). The researchers then "searched for negotiated agreements entered into by the same companies" by combing "the companies' Form 8-K and Form 10-K [SEC] filings during the period from January 1, 2006 to August 13, 2007." Id. at 880. Their sample included "26 consumer agreements drafted by 21 companies and 164 negotiated, material contracts entered into by the same companies." Id. at 881. For a summary of Eisenberg, Miller, and Sherwin's findings regarding "mass" contracts, see id. at 883, Table 2 (breaking down the rate of arbitration clauses by contract type and showing that over 75 percent of the consumer contracts examined included mandatory arbitration clauses).

Another study sought to capture the experience of consumers. *See* Linda J. Demaine & Deborah R. Hensler, *"Volunteering" to Arbitrate through Predispute Arbitration Clauses: The Average Consumer's Experience*, 67 LAW & CONTEMPORARY PROBLEMS 55 (2004). Demaine and Hensler reported "the results of a study investigating, in a wide variety of consumer purchases, the frequency with which the average consumer encounters arbitration clauses, the key provisions of these clauses, and the implications of these clauses for consumers who subsequently have disputes with the businesses they patronize." Id. at 57. They used data from the 1999 Annual Demographic Survey (March Current Population Survey Supplement), published by the Bureau of Labor Statistics and the Bureau of the Census, to create a statistical profile of "Joe" from Los Angeles, whom they denoted as an average consumer. Id. at 58. The researchers then examined the industries from which "Joe" made purchases, assembled a random sample, and

ultimately obtained information on the use of arbitration clauses from 161 businesses. Id. at 60. Of these, fifty-seven—or around 35 percent—included arbitration clauses in their consumer contracts, with the greatest prevalence among financial businesses and the lowest among food and entertainment businesses. Id. at 62.

**199** Eisenberg, Miller, & Sherwin at 871, 887–896.

**200** As noted, some researchers have studied subsets. See, for example, Tina Nabatchi & Lisa B. Bingham, *Transformative Mediation in the USPS™ Redress Program: Observations of ADR Specialists*, 18 HOFSTRA LABOR & EMPLOYMENT LAW JOURNAL 399 (2000).

**201** The degree of deference accorded arbitrators is criticized in Michael H. LeRoy, *Crowning the New King: The Statutory Arbitrator and the Demise of Judicial Review*, 29 JOURNAL OF DISPUTE RESOLUTION 1 (2009).

**202** *Gilmer v. Interstate Johnson Lane Corp.*, 500 U.S. 20, 28 (1991) (citing *Mitsubishi Motors Corp. v. Soler Chrysler-Plymouth, Inc.*, 473 U.S. 614, 637 (1985)).

**203** *Green Tree Financial Corporation–Alabama v. Randolph*, 531 U.S. 79, 90 (2000).

**204** See Richard C. Reuben, *Confidentiality in Arbitration: Beyond the Myth*, 54 UNIVERSITY OF KANSAS LAW REVIEW 1255 (2006).

**205** One proposal called for a database of civil settlements to provide a market of information about such agreements. A software program—aptly named Colossus—existed that enabled such information to be gathered. See Stephen C. Yeazell, *Transparency for Civil Settlements: NASDAQ for Lawsuits?* in TRANSPARENCY IN THE CIVIL JUSTICE SYSTEM (Los Angeles, CA: UCLA-Rand, 2010). See also Joseph F. Anderson Jr., *Secrecy in the Courts: At the Tipping Point?* 54 VILLANOVA LAW REVIEW 811 (2008); Joseph F. Anderson Jr., *Hidden from the Public by Order of the Court: The Case Against Government-Enforced Secrecy*, 55 SOUTH CAROLINA LAW REVIEW 711 (2004).

**206** See FLA. STATUTES ANNOTATED § 456.041(4) (West Supp. 2006) (requiring the reporting of payments of claims that exceed $100,000).

**207** FLA. STATUTES ANNOTATED § 69.081 (West 2004).

**208** As of 2006, some twenty states had statutes or court rules that constrained litigants' and judges' ability to make court documents and outcomes inaccessible. Included were Arizona, Arkansas, California, Delaware, Florida, Georgia, Hawaii, Idaho, Indiana, Kentucky, Louisiana, Massachusetts, Michigan, Nevada, New Jersey, New York, North Carolina, Oregon, South Carolina, Texas, Virginia, and Washington. Coverage and exceptions vary widely. See, for example, ARK. CODE ANNOTATED §§ 16-55-122, 25-18-401 (West 2004) (prohibiting the sealing of government documents and voiding private contracts that limit disclosure of environmental hazards); LA. CODE CIVIL PROCEDURE § 1426(d) (West 2004) (prohibiting the enforceability of agreements that limit the disclosure of public hazards); N.C. GENERAL STATUTES ANNOTATED § 132-1.3 (West 2000) (prohibiting sealing of settlements of "any suit, administrative proceeding or arbitration instituted against any agency of North Carolina government or its subdivisions" arising out of government actions except those related to medical care, unless the policy of openness is overridden and no other less restrictive means is available); TX. RULES OF CIVIL PROCEDURE 76a(2)(b) (stating that settlement agreements that "seek to restrict disclosure of information concerning matters that have a probable adverse effect upon the general public health or safety, or the administration of public office, or the operation of government" shall be presumed to be open); WASH. REV. CODE ANN. § 18.71.350 (West. 2005) (requiring professional liability insurers of physicians to report settlements in excess of $20,000 or the payment of three or more claims within a five-year period); id. at § 4.24.611 (limiting confidentiality provisions when claims involve product liability or hazardous substances).

**209** The proposals to make more information available include provisions to expand as well as to constrict judicial authority. For example, a "Sunshine in the Courtroom Act of 2007" would have authorized federal appellate and trial judges to permit the photographing and the televising of proceedings under certain circumstances as long as the "due process" rights of parties were not violated. See Sunshine in the Courtroom Act of 2007, H.R. 2128, 110th Cong. (2007); Sunshine in the Courtroom Act of 2008, S. 352, 110th Cong. (2008). The proposals also detailed that jurors were not to be televised and that witnesses could request that their faces and voices be disguised to make them unrecognizable to the broadcast audience. See, for example, the 2007 House Sunshine provision, H.R. 2128 §§ 2(b)(2)(A)(ii), 2(b)(2)(B).

Another initiative, put forth in a different proposal called the "Sunshine in Litigation Act of 2007," focused on the documents submitted, as contrasted with the courtroom, and would have limited the power of federal judges to permit parties to seal settlements or to promise confidentiality of discovery materials in civil cases. See Sunshine in Litigation Act of 2007, S. 2449, 110th Cong. (2007). See generally The Sunshine in Litigation Act: Does Court Secrecy Undermine Public Health and Safety: Hearing on S. 2449 Before the Subcomm. on Antitrust, Competition Policy and Consumer Rights of the S. Comm. on the Judiciary, 110th Cong. 110-263 (2007) at 181–205 (statement of Judith Resnik, Arthur Liman Professor of Law, Yale Law School).

**210** See, for example, FEDERAL RULES OF CRIMINAL PROCEDURE 11(b)(1) ("Before the court accepts a plea of guilty or nolo contendere, the defendant may be placed under oath, and the court must address the defendant personally in open court").

**211** See, for example, N.Y. CIVIL PRACTICE LAWS AND RULES 2104 (McKinney 2004); WA. SUPERIOR COURT CIVIL RULES 2A (2004); WIS. STATUTE § 807.05 (2004).

**212** See generally ROBERT TIMOTHY REAGAN, SHANNON R. WHEATMAN, MARIE LEARY, NATACHA BLAIN, STEVEN S. GENSLER, GEORGE CORT, & DEAN MILETICH, SEALED SETTLEMENT AGREEMENTS IN FEDERAL DISTRICT COURT (Washington, DC: Federal Judicial Center, 2004), http://www.fjc.gov/public/pdf.nsf/lookup/SealSet3.pdf/$file/SealSet3.pdf. The Supreme Court also concluded that "special trial judges" in the tax court were not authorized to keep their reports secret. *Ballard v. Commissioner of Internal Revenue Service*, 540 U.S. 40 (2005).

**213** See Judith Resnik, *Whose Judgment? Vacating Judgments, Preferences for Settlement, and the Role of Adjudication at the Close of the Twentieth Century*, 41 UCLA LAW REVIEW 1471 (1994); Jill E. Fisch, *Rewriting History: The Eradication of Prior Decisional Law through Settlement and Vacatur*, 76 CORNELL LAW REVIEW 589 (1991).

**214** See *Seattle Times Co. v. Rhinehart*, 467 U.S. 20, 33 (1984). The degree to which courts can and should regulate parties' interest in confidentiality during discovery exchanges is disputed. See Richard L. Marcus, *A Modest Proposal: Recognizing (at Last) That the Federal Rules Do Not Declare That Discovery Is Presumptively Public*, 81 CHICAGO-KENT LAW REVIEW 331 (2006); Howard M. Erichson, *Court-Ordered Confidentiality in Discovery*, 81 CHICAGO-KENT LAW REVIEW 357 (2006). Several proposals have been made for regulation. See THE SEDONA GUIDELINES: BEST PRACTICE GUIDELINES & COMMENTARY FOR MANAGING INFORMATION & RECORDS IN THE ELECTRONIC AGE (2005), http://www.thesedonaconference.org/content/miscFiles/TSG9_05.pdf. As noted, federal legislation has been proposed to do so but, as of 2010, has not been enacted.

**215** Jeffrey W. Stempel, *Mandating Minimum Quality in Mass Arbitration*, 76 U. CINCINNATI LAW REVIEW 383 (2008); Lande at 627–636; National Association of Securities Dealers Press Release, New Arbitration Rule Requires Award Explanations upon Investor Request (Jan. 27, 2005) ("allowing customers arbitrating disputes with brokers or brokerage firms to require a written explanation of the arbitration panel's decision").

**216** Jeffrey W. Stempel, *Keeping Arbitrations from Becoming Kangaroo Courts*, 8 NEVADA LAW JOURNAL 251, 259–260 (2007).

**217** That literature is vast, much of it for practitioners. See, for example, Stephen B. Goldberg & Margaret L. Shaw, *Is the Mediator's*

*Primary Goal to Settle the Dispute?* 15 Dispute Resolution Magazine 16–19 (Winter 2009).

**218** Jean R. Sternlight, *Is Alternative Dispute Resolution Consistent with the Rule of Law?* 56 DePaul Law Review 569 (2006). See generally Richard C. Reuben, *The Closing Courthouse Door: When Arbitration Subverts Democracy,* 42 Trial 34 (Jan. 2006).

**219** Various efforts address how to balance interests in privacy and publicity. See Andrew D. Goldstein, *Sealing and Revealing: Rethinking the Rules Governing Public Access to Information Generated through Litigation,* 81 Chicago-Kent Law Review 375 (2006); Joseph F. Anderson Jr., *Hidden from the Public by Order of the Court: The Case Against Court-Enforced Secrecy,* 55 South Carolina Law Review 711 (2004).

**220** International Bar Association, The IBA Rules on Taking Evidence in International Commercial Arbitrations (London, Eng.: International Bar Association, 1999), http://www.ibanet .org/Publications/publications_IBA_guides_and_free_materials .aspx (hereinafter The IBA Rules on Taking Evidence).

**221** Thomas J. Stipanowich, *Arbitration: The "New Litigation,"* 2010 U. of Illinois Law Review 1 (2010).

**222** Stipanowich at 29, citing a telephone interview with Nancy Vanderlip, Vice President and General Counsel, ITT Industries (Jan. 2007).

**223** Elizabeth Plapinger & Donna Stienstra, ADR and Settlement in the Federal District Courts: A Sourcebook for Judges and Lawyers 4 (Washington, DC: Federal Judicial Center, 1996).

**224** See Robert H. Mnookin & Lewis Kornhauser, *Bargaining in the Shadow of the Law: The Case of Divorce,* 88 Yale Law Journal 950 (1979).

**225** Lon L. Fuller, *The Forms and Limits of Adjudication,* 92 Harvard Law Review 353, 363 (1978) (a posthumously published essay based on materials written in the late 1950s).

**226** For further discussion see Judith Resnik, *Procedure as Contract,* 80 Notre Dame Law Review 593 (2005); Resnik, *Trial as Error.* One could take as a visual rendition of this shift a photograph, *The Old St. Louis County Court House Reflected in the Equitable Building,* by William Clift, that is reproduced in the volume Court House: A Photographic Document 31 (Richard Pare, ed., New York: Horizon Press, 1978). The flat glass of the international style and ironically named skyscraper reflects the Old Courthouse, and hence gives the appearance of that court's being subsumed by the surrounding corporate structures. The Equitable Building, designed by Hellmuth, Obata + Kassabaum and built in 1971, was renovated in the 1990s and purchased by the Hertz Investment Group in 2007 from the AXA Equitable Life Insurance Company. See *Equitable Building Under Contract,* St. Louis Business Journal, Jan. 5, 2007.

**227** The IBA described its founding as "inspired by the vision of the United Nations." As of 2008, more than 195 bar associations "spanning all continents" and representing more than 30,000 individual lawyers were members. The purpose of the IBA includes shaping "the future of the legal profession throughout the world." See http:// www.ibanet.org/About_the_IBA/About_the_IBA.aspx. See also Gerald J. McMahon & Werner Deuchler, *Meet the International Bar Association,* 64 A.B.A. Journal 554 (1978).

**228** In 2001, the Council of Europe established the European Judicial Network "to improve, simplify and expedite effective judicial cooperation between the Member States in civil and commercial matters." Council Decision 2001/470/EC (6), 2001 O.J. (L174) 25. By 2005, the Network had more than four hundred members, delineated by four categories: "contact points," "central authorities provided for in Community instruments and international agreements," "liaison magistrates," and "other judicial or administrative authorities with responsibilities for judicial cooperation." See Commission of the European Communities, Report from the Commission to the Council, the European Parliament and the European Economic and Social Committee on the Application

of Council Decision 2001/470/EC establishing a European Judicial Network in civil and commercial matters 2 (Brussels, Belg.: Commission of the European Communities, 2006). See generally Eva Storskrubb, *What Changes Will European Harmonisation Bring?,* in Common Law, Civil Law and the Future of Categories 403–422 (Janet Walker & Oscar G. Chase, eds., Markham, Can.: LexisNexis, 2010) (hereinafter Common Law, Civil Law). This volume contains many of the papers that were presented at the International Association of Procedural Law (IAPL) Conference that was held in Toronto, Canada in June 2009.

**229** Examples can be drawn from several common law jurisdictions. See, for example, ADR and a Different Approach to Litigation, speech given by Marilyn Warren, A.C., Chief Justice of the Supreme Court of Victoria, Australia, to the Law Institute of Victoria, Mar. 18, 2009; Geoffrey L. Davies, *Civil Justice Reform: Why We Need to Question Some Basic Assumptions,* 25 Civil Justice Quarterly 32 (2006); Geoffrey L. Davies, *Civil Justice Reform: Some Common Problems, Some Possible Solutions,* 16 Journal of Judicial Administration 5 (2006); Hector L. MacQueen, Hume Papers on Public Policy: The Reform of Civil Justice (Edinburgh, Scot.: Edinburgh U. Press, 1998). An overview of "the theory and practice" of ADR in Australia is provided by Katherine Hall, *Alternative Dispute Resolution,* in Stephen Colbran, Greg Reinhardt, Peta Spender, Sheryl Jackson, & Roger Douglas, Civil Procedure Commentary and Materials 61 (Chatswood, Aus.: Butterworths, 2nd ed., 2002). A collection of articles on ADR in Australia and Canada can be found in Alternative Dispute Resolution and the Courts (Tania Sourdin, ed., Annandale, Aus: Federation Press, 2004).

**230** Yves Dezalay & Bryant G. Garth, Dealing in Virtue: International Commercial Arbitration and the Construction of a Transnational Legal Order 154–172 (Chicago, IL: Chicago U. Press, 1996).

**231** Esther Martin, *Searching for Common Ground,* European Lawyer 31, 31 (July–Aug. 2008). In contrast, a French lawyer reported that of "40,000 disputes that went through the Paris commercial courts" in 2007, "only forty were ordered to mediation," in part because of French jurists' hesitancy for fear that it was "sub-justice." Id. at 31–32.

**232** The Global Class Action Exchange provides information through "country reports" on developments toward aggregation, http:// globalclassactions.stanford.edu. See also The Globalization of Class Actions, 622 Annals of the American Academy of Political and Social Science (Deborah R. Hensler, Christopher Hodges, & Magdalena Tulibacka, eds., Thousand Oaks, CA: Sage Publications, 2009).

**233** See, for example, Ross Cranston, How Law Works: The Machinery and Impact of Civil Justice 14–15 (Oxford, Eng.: Oxford U. Press, 2006). The volume focused on the English system and analyzed the differences in the position of courts in other countries with written constitutions and judicial review and those without. At a more practical level, the concept of "case management" in the United States is typically tied to the individual calendar system in which judges are given specific cases to deal with from filing to disposition. In contrast, a "master calendar" in which different judges deal with the same case at different phases—in use in England in the 1990s—produces a different relationship to "management."

**234** Genn, *What Is Civil Justice For?* in Genn, Judging Civil Justice, at 24.

**235** Genn, Judging Civil Justice at 33–38.

**236** Frederick Rosen, Jeremy Bentham and Representative Democracy: A Study of the Constitutional Code 153–155 (Oxford, Eng.: Oxford U. Press, 1983).

**237** Cranston at 36. Other justifications included giving voice to the excluded, facilitating implementation of other rights, and responding to legal needs. Id. at 36–40.

**238** Richard Abel, English Lawyers Between Market and State 226–234 (Oxford, Eng.: Oxford U. Press, 2004).

**239** Access to Justice Act, 1999, c.22 (Eng.), http://www.opsi.gov.uk/Acts/acts1999/ukpga_19990022_en_1. The 1999 Access to Justice Act abolished the Legal Aid Board and created in its stead a Legal Services Commission to work through decentralized groups, such as the Community Legal Services and Criminal Defense Services, which are charged with assessing local needs, identifying lawyers eligible to provide services, and requesting funding. Budgets came with annual caps, resulting in the rationing of services and further restrictions on eligibility. Criminal defense services headed the priorities, followed on the civil side by funding for lawyers in disputes involving children, housing, and personal violence in homes. The 1999 Act also identified a few new areas of need (such as immigration proceedings) and attempted to enhance use of technologies (such as a website for the Citizens' Advice Bureau) to provide information on legal processes and rights. See Pascoe Pleasence, Alexy Buck, Marisol Smith, Nigel Balmer, & Ashish Patel, *Needs Assessment and Community Legal Services in England and Wales*, 11 INTERNATIONAL JOURNAL OF THE LEGAL PROFESSION 213–232 (2004); CRANSTON at 47–71. See also THE TRANSFORMATION OF LEGAL AID: COMPARATIVE AND HISTORICAL STUDIES (Francis Regan, Alan Paterson, Tamara Goriely, & Don Fleming, eds., Oxford, Eng.: Oxford U. Press, 1999).

In addition, revisions of ethical rules in 1999 enabled some claimants ineligible for Legal Aid to have new means for obtaining the assistance of lawyers. England relaxed its ban that had precluded lawyers from charging contingent fees by permitting "conditional fee agreements" that enabled solicitors to take cases despite a risk of non-payment upon losing. "After the Event" (or ATE) insurance became available so that, if necessary, losers could pay victorious opponents, who were entitled under English fee-shifting rules to indemnification for fees and costs. The incentive to take such work was enhanced by entitling a lawyer for a prevailing plaintiff to the fees paid by the loser and to a bonus paid directly by the client but limited to no more than 100 percent of the hourly fees and, under rules of the Law Society, presumptively capped at no more than 25 percent of a client's damages. Revisions in 1999 permitted the victorious lawyer to recover that "success fee" from the loser, sometimes paid through insurance premiums. See generally, A. A. S. Zuckerman, *Reform in the Shadow of Lawyers' Interests*, in REFORM OF CIVIL PROCEDURE: ESSAYS ON "ACCESS TO JUSTICE" 61–78 (A. A. S. Zuckerman & Ross Cranston, eds., Oxford, Eng.: Oxford U. Press, 1995) (hereinafter REFORM OF CIVIL PROCEDURE); Michael Zander, *The Government's Plans on Legal Aid and Conditional Fees*, 61 MODERN LAW REVIEW 538 (1998) (hereinafter Zander, *The Government's Plans*).

**240** LORD WOOLF, ACCESS TO JUSTICE: INTERIM REPORT TO THE LORD CHANCELLOR ON THE CIVIL JUSTICE SYSTEM IN ENGLAND AND WALES (London, Eng.: Her Majesty's Stationery Office, 1995); WOOLF, FINAL REPORT 1996. See generally REFORM OF CIVIL PROCEDURE. While the reforms were often praised, a few sounded critical notes, most notably Michael Zander in *The Government's Plans*, and *Why Lord Woolf's Proposed Reforms of Civil Litigation Should be Rejected* in REFORM OF CIVIL PROCEDURE at 79–95.

**241** Genn, *Civil Justice: How Much Is Enough?* in GENN, JUDGING CIVIL PROCEDURE at 2–3.

**242** CRANSTON at 173. He also noted that the Woolf Report did not provide a "wholly uncritical imprimatur" of all such procedures. Id.

**243** See generally CRANSTON at 150–155.

**244** See Neil Andrews, *English Civil Justice and the Wider World*, paper presented to the International Association of Procedural Law, Sept. 2006; Civil Procedure Rules, *Practice Directions, Pre-Action Protocols and Court Guides*, www.dca.gov.uk/civil/procrules_fin/menus/rules.htm. "Multi-track" could be translated to mean varied in that judges have discretion to tailor rules to the cases falling within that category.

**245** J. A. JOLOWICZ, ON CIVIL PROCEDURE 54–58 (Cambridge, Eng.: Cambridge U. Press, 2000).

**246** See, for example, *Dunnett v. Railtrack PLC*, [2002] EWCA Civ. 303 (2002). *Royal Bank of Canada Trust Corporation Ltd. v. Secretary for State of Defense*, [2003] EWHC 1479 (Ch) (2003); *Halsey v. Milton Keynes General Trust NHS*, [2004] EWCA Civ. 576.

**247** Simon Roberts, *"Listing Concentrates the Mind": The English Civil Court as an Arena for Structured Negotiation*, 29 OXFORD JOURNAL OF LEGAL STUDIES 457, 465, 479 (2009).

**248** Modernising Justice: The Government's Plan for Reforming Legal Services and the Courts 7 (Lord Chancellor's Department, 1998).

**249** See Her Majesty's Treasury, *Opportunity and Security for All: Investing in an Enterprising, Fairer Britain New Public Spending Plans 2003–2006*, Cm.5570 (London, Eng.: Her Majesty's Stationery Office, 2002).

**250** Shirley Shipman, *Court Approaches to ADR in the Civil Justice System*, 25 CIVIL JUSTICE QUARTERLY 181, 183 (2006); Jacqueline Nolan-Haley, *Mediation Exceptionality*, 78 FORDHAM LAW REVIEW 1247, 1249 (2009). Nolan-Haley contrasted the focus in the United States on enforcement, after mediation, with the emphasis in England on "front-end" consent, imposing costs on parties refusing to participate.

**251** Roberts at 458, 459.

**252** Roberts at 476.

**253** See Report to the Lord Chancellor by the Review of the Court of Appeal (Civil Division) (Nov. 6, 1997), http://www.dca.gov.uk/civil/bowman/bowfr.htm.

**254** See Report to the Lord Chancellor by the Review of the Court of Appeal (Civil Division), *Current Situation and Reason for the Review and Summary of Recommendations*.

**255** UNITED KINGDOM, CIVIL PROCEDURE RULES, Appeals, 52.3 (London, Eng.: Ministry of Justice, October 2008).

**256** See JOLOWICZ at 392–397; Genn, *Judges in Civil Justice*, in GENN, JUDGING CIVIL JUSTICE, at 129–133.

**257** In 2004–2005, the "Government of England and Wales spent over two billion pounds administering and funding civil and criminal legal aid." See Vicky Kemp & Pascoe Pleasence, *Targeting Legal Needs: Matching Services to Needs*, 26 OBITER 285 (2005). In 2008, another report was commissioned to review civil litigation costs so as to improve "access to justice at proportionate cost." See *Review of Civil Justice Costs: Preliminary Report, by the Hon. Rupert Jackson, Royal Courts of Justice*, May 8, 2009, http://www.judiciary.gov.uk/about_judiciary/cost-review.index.htm. Issues included a review of English fee-shifting provisions that require losers to compensate victorious litigants under a schedule. The Final Report, published in December of 2009, recommended more "robust" case management, additional use of ADR, cutting back on awards of fees for "success" and for after-the-event insurance, eliminating referral fees in personal injury cases, and various other interventions. See *Review of Civil Litigation Costs: Final Report* at xvi–xxiv (London, Eng.: The Stationery Office, 2010), www.tsoshop.co.uk.

**258** See Neil Andrews, *English Civil Justice and the Managerial Judge: Reflections for a Comparative Audience*, in COMMON LAW, CIVIL LAW at 97–110. Celia Wasserstein Fassberg, *Civil Procedure in a Mixed System: Israel*, in COMMON LAW, CIVIL LAW at 295–312.

**259** Cranston argued that the concept of access to justice needed to include social and economic means of obtaining regulatory reform and implementing legal regimes. CRANSTON at 83–105.

**260** Hazel Genn, *The Central London County Court Pilot Mediation Scheme*, Research Series 5/98 (London, Eng.: Lord Chancellor's Department, 1998); CRANSTON at 174.

**261** TAMARA GORIELY, RICHARD MOORHEAD, & PAMELA ABRAMS, MORE CIVIL JUSTICE? THE IMPACT OF THE WOOLF REFORMS ON PRE-ACTION BEHAVIOR, Research Study 43, Summary at xiii–xiv (London, Eng.: Law Society and Civil Justice Council, 2002). The researchers sur-

veyed lawyers, insurers, and claims managers specializing in personal injury, clinical negligence, and housing disrepair. The findings were that the reforms had, for claimant work, produced greater specialization, that the protocols were well received, but that costs had not been reduced.

262 John Peysner & Mary Seneviratne, The Management of Civil Cases: the Courts and the Post-Woolf Landscape, Research Series 9/05 (London, Eng.: Department of Constitutional Affairs, 2005); see also John Peysner and Mary Seneviratne, The Management of Civil Cases: A Snapshot, 25 Civil Justice Quarterly 312, 312–314 (2006).

263 See also Michael Zander, The Woolf Reforms—Have They Worked? 159 New Law Journal 367 (Mar. 13, 2009).

264 See Genn, What Is Civil Justice For? in Genn, Judging Civil Justice at 24–25. The lecture on which this chapter was based addressed the "battle for resources" between civil and criminal cases.

265 See generally Zander, The Government's Plans; Genn, ADR and Civil Justice: What's Justice Got to Do With It? in Genn, Judging Civil Justice at 92–103.

266 See generally Zuckerman, Reform in the Shadow.

267 See generally Hazel Genn, Paths to Justice: What People Do and Think about Going to Law (Oxford, Eng.: Hart Publishing, 1999) (hereinafter Genn, Paths to Justice).

268 Kemp & Pleasence at 302–303.

269 Genn, ADR and Civil Justice: What's Justice Got to Do With It? in Genn, Judging Civil Justice at 108–112.

270 Genevra Richardson & Hazel Genn, Tribunals in Transition: Resolution or Adjudication, Public Law 116, 119 (2007). For discussion of the increasing predominance of tribunals in Australia, see The Growth in Tribunal Power, Speech by Marilyn Warren, A.C., Chief Justice of the Supreme Court of Victoria, Australia, to the Council of Administrative Tribunals, June 7, 2004.

271 Hazel Genn & Yvette Genn, The Effectiveness of Representation at Tribunals, Report to the Lord Chancellor (London, Eng.: Lord Chancellor's Department, 1989).

272 Richardson & Genn at 121.

273 Richardson & Genn at 126.

274 Richardson & Genn at 129.

275 See generally Tom Tyler, Social Justice: Outcome and Procedure, 35 International Journal of Psychology 117, 117–125 (2000).

276 See generally Commercial Arbitration: 2001 Companion Volume to the Second Edition (Michael J. Mustill & Stewart C. Boyd, eds., Croydon, Eng.: Butterworths, 2001).

277 Amendments in 1979 provided some buffer by giving parties the power to enter into contracts that forbid appeals on the law and by creating presumptions in favor of enforcing awards.

278 ALI/UNIDROIT Principles of Transnational Civil Procedure as Adopted and Promulgated by the American Law Institute and by UNIDROIT (Cambridge, Eng.: Cambridge U. Press, 2006).

279 See generally Catherine A. Rogers, The Vocation of the International Arbitrator, 20 American University International Law Review 957, 1020 (2005).

280 United Nations Commission on International Trade Law (UNCITRAL), UNCITRAL Notes on Organizing Arbitral Proceedings, n. 6, at 12 (1996),http://www.uncitral.org/pdf/english/texts/arbitration/arb-notes/arb-notes-e.pdf.

281 The IBA Rules on Taking Evidence, Art. 3(12).

282 An article in The Economist discussed arguments for and against more transparency in such conflicts. See Investment, Arbitration and Secrecy: Behind Closed Doors, The Economist, Apr. 25, 2009, at 26.

283 See Catherine A. Rogers, The Arrival of the "Have-Nots" in International Arbitration, 8 Nevada Law Journal 341 (2007).

284 See Report of UNCITRAL Working Group II (Arbitration and Conciliation) on the work of its fiftieth session, Doc. No. A/CN.9/669, Mar. 9, 2009.

285 Human Rights Act, 1998, c.42 (Eng.).

286 See, for example, R. v. Lord Chancellor, ex parte Witham, [1998] QB 575 (1998); Shirayma Shokusan Co. Ltd. v. Danovo Ltd., [2003] EWHC 3006 (Ch), and Shirayama Shokusan Co. Ltd. v. Danovo Ltd., [2004] EWHC 390 (Ch); Hickman v. Blake Lapthorn, [2006] EWHC 12 (QB) (2006). Another judgment described the important distinction between the encouragement of ADR and its compulsion; the court upheld the lower court's power to impose costs, in appropriate cases, as a sanction for not attempting mediation. See Royal Bank of Canada Trust Corporation Ltd. v. Secretary of State for Defense, 2003 All Er (D) 171 (May 2003). See also Shirley Shipman, Alternative Disptue Resolution, the Threat of Adverse Costs, and the Right of Access to Court, in The Civil Procedure Rules Ten Years On (Deirdre Dwyer, ed., Oxford: Oxford U. Press, 2010).

287 Directive 2008/52/EC of the European Parliament and of the Council of 21 May 2008 on certain aspects of mediation in civil and commercial matters, Art.1, 2008 O.J. (L 136) 3 (hereinafter EU 2008 Mediation Directive).

288 See http://europa.eu/rapid/pressReleasesACtion.do?reference=IP/10/447&format=HTML&aged=0&language=EN&guiLanguage=en. Commissioner Viviane Reding was selected to serve in the position—sometimes called the "EU Justice Commissioner."

289 Commission acts to bolster citizens' data protection, protect defendants' rights and enhance immigration and asylum cooperation, press release IP/10/447, Brussels, Belg., Apr. 20, 2010, http://europa.eu/rapid/pressReleasesACtion.do?reference=IP/10/447&format=HTML&age. As the title of the press release suggests, "justice" included a "free and secure Europe," which translated into crime prevention and border protection as well as "[s]trengthening the rights of the accussed in criminal proceedings" and securitying record protection. Id.

290 EU 2008 Mediation Directive, Art. 1. See also Martin at 31.

291 EU 2008 Mediation Directive, findings (6). Practitioners have offered a similar appraisal. See, for example, Felicity Ewing & David Pope, Making the Most of Commercial Mediations, in ADR Client Strategies in the UK: Leading Lawyers on Preparing Clients, Navigating the Negotiation Process, and Overcoming Obstacles (Inside the Minds) 57 (Boston, MA: Aspatore, 2008), 2008 WL 5662123.

292 EU 2008 Mediation Directive, findings (6).

293 EU 2008 Mediation Directive, findings (13); see also id., Art. 5(1–2).

294 EU 2008 Mediation Directive, findings (14), Art. 5 (2).

295 EU 2008 Mediation Directive, Art. 3 (a).

296 EU 2008 Mediation Directive, findings (18).

297 EU 2008 Mediation Directive, Art. 7.

298 EU 2008 Mediation Directive, findings (10).

299 EU 2008 Mediation Directive, findings (18).

300 EU 2008 Mediation Directive, Arts. 11, 12.

301 Martin at 31.

302 Ronald Bradbeer, Challenging the Conflict Culture: Mediation's Struggle for Acceptance in Europe, European Lawyer 19–23 (May 2007).

303 Per Henrik Lindblom, ADR—the Opiate of the Legal System? Perspectives on Alternative Dispute Resolution Generally and in Sweden, 16 European Review of Private Law 63, 82–95 (2008); Per Henrik Lindblom, The New Growing Role of the Courts and the New Functions of Judicial Process—Fact or Flummery? 51 Scandinavian Studies in Law 281, 281–301 (Rosemary Nordström, trans., 2007).

304 See, for example, Halsey v. Milton Keynes General NHS Trust, [2004] EWCA Civ. 576, para. 9 ("[I]t seems to us likely that compulsion of ADR would be regarded as an unacceptable constraint on the right of access to the court and, therefore, a violation of art 6 [of the European Convention for the Protection of Human Rights and Fundamental Freedoms 1950]"). See also Henry Brooke, Courting Com-

*promise*, EUROPEAN LAWYER, 25–26 (May 2007). A different critique is that mediation suggests a voluntarism at odds with mandates to do so.

**305** JOLOWICZ at 393.

**306** Maximo Langer, *The Rise of Managerial Judging in International Criminal Law*, 53 AMERICAN JOURNAL OF CRIMINAL LAW 835 (2005).

**307** In contrast, Jeremy Bentham stressed the importance of "clear and concentrated responsibility for every act of government" through public observation of judges and legislators discharging their duties. See Thomas P. Peardon, *Bentham's Ideal Republic*, in JEREMY BENTHAM: TEN CRITICAL ESSAYS 120, 141 (Bhikhu Parekh, ed., London, Eng.: Frank Cass, 1974).

**308** United States Navy, Naval Station Guantanamo Bay, http://www.navy.mil/local/guantanamo. The Public Affairs Office of the United States Department of Defense described Guantánamo as the "oldest overseas U.S. Naval Base . . . [and] the only one in a country with which the U.S. does not maintain diplomatic relations." Sgt. Jim Greenhill, *Cold War History Played Out at Guantanamo Bay Gate*, Nov. 30, 2006, http://www.defenselink.mil/news/NewsArticle.aspx?ID=2265. We add the accent to Guantánamo unless the original source material, such as some from the Department of Defense, does not.

**309** See *Sale v. Haitian Ctrs. Council*, 509 U.S. 155, 164–165 (1993). The facility had been designed to hold no more than 12,500, but more than 34,000 individuals were intercepted and detained there. Id. at 163.

**310** "Guantánamo" became a shorthand invoked in a range of contexts. See, for example, William Glaberson, *Guantánamo, Evil and Zany in Pop Culture*, NEW YORK TIMES, Feb. 18, 2008, at A1, 11. As recounted in this article, a movie called *Harold and Kumar Escape from Guantánamo Bay* was released in April 2008, joining dozens of other books, plays, songs, and movies using Guantánamo as what one writer, invoked by Glaberson, called "the gulag of our times."

**311** See United States Department of Defense, Office of the Assistant Secretary of Defense (Public Affairs), *Detainee Transfer Announced*, Dec. 16, 2008, http://www.defenselink.mil/Releases/Release.aspx?ReleaseID=12394. The exact numbers are imprecise because the "Pentagon has consistently refused to comprehensively identify those it holds." See BENJAMIN WITTES & ZAAHIRA WYNE, THE CURRENT DETAINEE POPULATION OF GUANTÁNAMO: AN EMPIRICAL STUDY 1 (Dec. 16, 2008), http://www.brookings.edu/reports/2008/1216_detainees_wittes.aspx#. See also David Bowker & David Kaye, *Guantánamo by the Numbers*, NEW YORK TIMES, Nov. 10, 2007, at A15.

At various intervals the Department of Defense provided some accountings. For example, in August 2005 the Department of Defense reported that 245 detainees were "transferred from Guantanamo since the detention and interrogation mission began in January 2002," of which 177 were "transferred for release" and 58 were transferred to other countries listed as "Pakistan, Morocco, France, Russia, Saudi Arabia, Spain, Sweden, United Kingdom, Kuwait, Australia, Belgium and Jordan." See *Department of Defense Fact Sheet, Guantanamo Detainees by the Numbers*, Aug. 31, 2005, http://www.defenselink.mil/news/Aug2005/d20050831sheet.pdf (hereinafter DOD, *Guantanamo Detainees by the Numbers*). In December 2008, the Department of Defense reported that approximately 520 detainees had "departed" Guantánamo for other countries since 2002, with approximately 250 detainees left on the base. United States Department of Defense, Office of the Assistant Secretary of Defense (Public Affairs), *Detainee Transfer Announced*, Dec. 16, 2008, http://www.defenselink.mil/Releases/Release.aspx?ReleaseID=12394. By the end of 2009, some 215 detainees remained, of whom 116 were cleared for transfer by an executive task force. See Afghanistan: Assessing the Road Ahead: Hearing on Afghanistan Policy Before the S. Comm. on Foreign Relations, 111th Cong. (2009) (Statement of Secretary of Defense Robert Gates).

The United States was criticized from many quarters, including by transnational organizations and leaders of other countries, for detaining individuals there. See, for example, U.N. Commission on Human Rights, Report on the Situation of Detainees at Guantánamo Bay, Feb. 15, 2006, U.N. Doc. E/CN.4.2006/120 (Report of the Working Group on Arbitrary Detention, the Special Rapporteur on the Independence of Judges and Lawyers, and the Special Rapporteur on Torture) (hereinafter U.N. 2006 Situation of Detainees). The report concluded that the "ongoing detention" constituted an "arbitrary deprivation of the right to personal liberty." Id. at 9. The report called for the closing and the "possible transfer of detainees to pretrial detention facilities on United States territory," id. at 26. See also Alan Cowell, *Blair Calls Camp in Cuba an "Anomaly,"* NEW YORK TIMES, Feb. 18, 2006, at A6. In addition to Prime Minister Tony Blair of Great Britain, Archbishop Desmond Tutu, responding to the U.N. report, also called for the camps to close. Id.

**312** See Nigel Morris, *Horrors of Camp Delta Are Exposed by British Victims*, INDEPENDENT, Feb. 22, 2006. Criticism came through plays, films, and studies of various organizations. See, for example, MICHAEL WINTERBOTTOM, THE ROAD TO GUANTÁNAMO (Film4, Revolution Films & Screen West Midlands, 2006); International Committee of the Red Cross (ICRC), *ICRC Report on the Treatment of Fourteen "High Value Detainees" in CIA Custody*, Feb. 2007, http://www.nybooks.com/articles/22614 (hereinafter *ICRC Report*); Neil A. Lewis, *Red Cross Finds Detainee Abuse in Guantánamo*, NEW YORK TIMES, Nov. 30, 2004, at A1. See generally JANE MAYER, THE DARK SIDE: THE INSIDE STORY ON HOW THE WAR ON TERROR TURNED INTO A WAR ON AMERICAN IDEALS (New York, NY: Doubleday, 2008).

**313** Office of Legal Counsel, United States Department of Justice, Memorandum for Alberto R. Gonzales, Counsel to the President, Re: Standards of Conduct for Interrogation under 18 U.S.C. §§ 2340–2340A, Aug. 1, 2002, at 1 (hereinafter Torture Memo of August 1, 2002). The memorandum, along with many materials, was published both on the *Washington Post* website at http://www.washingtonpost.com/wp-srv/nation/documents/dojinterrogationmemo20020801.pdf and in STEPHEN HOLMES, THE MATADOR'S CAPE: AMERICA'S RECKLESS RESPONSE TO TERROR (New York, NY: Cambridge U. Press, 2007).

**314** Torture Memo of August 1, 2002, at 1. See generally INTERNATIONAL REVIEW OF THE RED CROSS, No. 867: *Torture* (Sept. 2007); TORTURE: A COLLECTION (Sanford Levinson, ed., New York, NY: Oxford U. Press, 2004); THE TORTURE DEBATE IN AMERICA (Karen J. Greenberg, ed., New York, NY: Cambridge U. Press, 2006).

**315** See Michael Welch, *Guantánamo Bay as a Foucauldian Phenomenon: An Analysis of Penal Discourse, Technologies, and Resistance*, 89 PRISON JOURNAL 3 (2009). Welch referred to Camp 5 at Guantánamo, which was modeled on a maximum security facility in Terre Haute, Indiana. See Carol Rosenberg, *Permanent Jail Set for Guantánamo*, MIAMI HERALD, Dec. 9, 2004; Schenkel Shultz Architecture, Justice—United States Penitentiary—Terre Haute, IN, http://www.schenkelshultz.com/projects.asp?type=justice&id=117&link=true. While not relying on the circular design, Welch linked the monitoring of individuals through spatial layouts to Bentham as well as to Foucault.

**316** See Military Order of Nov. 13, 2001, Detention, Treatment, and Trial of Certain Non-Citizens in the War Against Terrorism, 66 Fed. Reg. 57833 (Nov. 16, 2001) (hereinafter President's 2001 Military Order). See generally JOSEPH MARGULIES, GUANTÁNAMO AND THE ABUSE OF PRESIDENTIAL POWER (New York, NY: Simon & Schuster, 2006).

**317** United States Department of Defense, Military Commission Order No. 1, Mar. 21, 2002, http://www.defenselink.mil/news/Mar2002/d20020321ord.pdf (hereinafter Military Commission Order No. 1). The order specified that these military commissions were intended to "try individuals subject to the President's Military Order"

for "violations of the laws of war and all other offenses triable by military commission." Id. at 2. The Order did not prescribe the procedures by which individuals were classified.

**318** *Rasul v. Bush*, 542 U.S. 466 (2004). The Supreme Court concluded that Guantánamo was within the United States control such that the federal habeas statute governed.

**319** *Hamdi v. Rumsfeld*, 542 U.S. 507 (2004). See generally Trevor W. Morrison, *Hamdi's Habeas Puzzle: Suspension as Authorization?* 91 CORNELL LAW REVIEW 411 (2006).

**320** See Paul Wolfowitz, Deputy Secretary of Defense, Order Establishing Combatant Status Review Tribunal, July 7, 2004 (hereinafter Order Establishing CSRT). The Military Commissions Act of 2006 gave a statutory basis to the CSRT, and regulations followed thereafter. See 10 U.S.C. §§ 801 and 948 et seq. (2006) and 32 C.F.R. § 10.3.

**321** That term is an innovation, in that during World War II, the government had used the phrase "unlawful belligerents." See *In re Yamashita*, 327 U.S. 1, 15 (1946); *Ex parte Quirin*, 317 U.S. 1 (1942). See also Convention Respecting the Laws and Customs of War (Fourth Hague Convention), Annex, Oct. 18, 1907 (entered into force Jan. 26, 1910) (defining the conditions that a "belligerent" must satisfy before the belligerent could be classified as a prisoner of war). The Geneva Convention of 1949 created a structure for detention and release of "prisoners of war," but the United States government argued that those rules were inapplicable to the alleged terrorists it detained. *Hamdan v. Rumsfeld*, 548 U.S. 557, 628–635 (2006). See generally Matthew Waxman, *Detention as Targeting? Standards of Certainty and Detention of Suspected Terrorists*, 108 COLUMBIA LAW REVIEW 1365 (2008).

**322** *Guantanamo Detainee Processes*, updated Oct. 2, 2007, http://www.defenselink.mil/news/Sep2005/d20050908process.pdf. The definition also stated that it included "any person who has committed a belligerent act or has directly supported hostilities in aid of enemy armed forces." Id. This definition was adopted by a federal judge reviewing habeas petitions brought by Guantánamo detainees, dealing with issues on remand from the United States Supreme Court. See *Boumediene v. Bush*, 583 F. Supp. 2d 133, 135 (D.D.C. 2008); *Boumediene v. Bush*, 553 U.S. 723 (2008). Also falling within the definition were individuals with connections to a long list of organizations and entities, set forth in Executive Order 13224: Blocking Property and Prohibiting Transactions with Persons Who Commit, Threaten to Commit, or Support Terrorism, 66 Fed. Reg. 186 (Sept. 25, 2001). Section 3 of the Military Commissions Act of 2006 provided definitions of "lawful" and "unlawful" enemy combatants. Military Commissions Act of 2006 § 3(a)(1), Pub. L. No. 109-366, 120 Stat. 2600, 2601 (Oct. 17, 2006) (codified at 10 U.S.C. § 948a (2006)). In the fall of 2009, Congress revised the definition of "unprivileged enemy belligerent[s]" and provided that it encompassed individuals who have "engaged in hostilities," "purposefully and materially supported hostilities against the United States or its coalition partners," or who were members of al Qaeda when they committed an alleged offense prosecutable under its parameters. Military Commissions Act (MCA) of 2009, Pub. L. No. 111-84, §§ 948a, 123 Stat. 2190, 2575.

**323** Between January 30, 2007, and March 2008, the Department of Defense indicated that 253 detainees had undergone something called an Administrative Review Board (ARB) and that while none were then recommended for release, 33 were recommended for transfer, and 195 were recommended for continued detention. *Administrative Review Board Summary, ARB–Round 3 Update* (Mar. 2008), http://www.defenselink.mil/news/Combatant_Tribunals.html. The Department of Defense's August 31, 2005, Fact Sheet had stated that "every detainee had a tribunal," that 558 "underwent a CSRT," and that 38 were then "classified as no longer enemy combatants" of which 28 had been "transferred" from the base. See DOD, *Guantanamo Detainees by the Numbers*.

**324** The government called the ARBs a "discretionary and unprecedented process that is not required by the Geneva Convention or by U.S. or international law." Department of Defense, Office of Assistant Secretary of Defense (Public Affairs), News Release: Guantánamo Bay Detainee Administrative Review Board Decisions Completed, Feb. 9, 2006, http://www.defense.gov/releases/release.aspx?releaseid=9302 (hereinafter DOD, Guantánamo Bay Detainees ARB Decisions Completed). As the May 11 order establishing the administrative review process explained, it was "neither intended to nor does it create any right, benefit, or privilege, substantive or procedural, enforceable by any party, against the United States . . . or any other person. . . . Because the procedures . . . have been instituted as a matter of discretion, the Secretary of Defense may suspend or amend the procedures set forth in this Order at any time." Department of Defense, Order of May 11, 2004, *Administrative Review Procedures for Enemy Combatants in the Control of the Department of Defense at Guantanamo Bay Naval Base, Cuba*, May 11, 2004, Part 6 (hereinafter May 11, 2004, Order Establishing ARB).

**325** DOD, Guantánamo Bay Detainees ARB Decisions Completed. See also May 11, 2004, Order Establishing ARB, stating that the "law of war" does not "require the use of a review process to support continued detention," but "as a matter of policy" the Department of Defense had instituted the procedures. Id., Part 1. Reviews were to be provided for each combatant "at least annually insofar as is practicable." Id., Part 3(f).

**326** Kathleen T. Rhem, American Forces Press Service, *Review Boards Assessing Status of Guantanamo Detainees*, July 8, 2005, http://www.globalsecurity.org/security/library/news/2005/07/sec-050708-afps02.htm.

**327** May 11, 2004, Order Establishing ARB, Part 3(A)(i)(a) (providing that such notice need not be provided if doing so was not consistent with national security).

**328** May 11, 2004, Order Establishing ARB, Part 3(B).

**329** Department of Defense, Office of Assistant Secretary of Defense (Public Affairs), *News Release: Administrative Review Implementation Directive Issued*, Sept. 15, 2004, http://www.globalsecurity.org/security/library/news/2004/09/sec-040915-dod01.htm.

**330** May 11, 2004, Order Establishing ARB, Part 2(B)(ii)(a) and (b). The CSRT is composed of three "neutral commissioned officers of the U.S. Armed Forces," and one of these individuals must be a judge advocate. Order Establishing CSRT at 1–2.

**331** May 11, 2004, Order Establishing ARB, Part 3(D).

**332** May 11, 2004, Order Establishing ARB, Part 3(E).

**333** May 11, 2004, Order Establishing ARB, Part 3(E)(v) and (vi). In terms of outcomes, as of March 2008 the government reported that a "third round" of ARB decisions had resulted in 0 releases, 33 transfers, and 195 decisions to continue detention. See Administrative Review Board Summary, ARB–Round 3 Update (Mar. 2008), http://www.defenselink.mil/news/Combatant_Tribunals.html. See also MARK DENBEAUX & JOSHUA DENBEAUX, REPORT ON GUANTÁNAMO DETAINEES: A PROFILE OF 517 DETAINEES THROUGH ANALYSIS OF DEPARTMENT OF DEFENSE DATA (Feb. 8, 2006), http://law.shu.edu/news/guantanamo_report_final_2_08_06.pdf.

**334** DOD, *Guantanamo Detainees by the Numbers*.

**335** Military Commission Order No. 1, Parts 4(A)(2) and (3). The Presiding Officer must be a "Military Officer who is a judge advocate of any United States armed force." Id., Part 4(A)(4).

**336** Military Commission Order No. 1, Parts 3(A) and (B).

**337** Military Commission Order No. 1, Part (6)G.

**338** See President's 2001 Military Order; Order Establishing CSRT.

**339** Figure 202, a photograph by Paul J. Richards of the outer fence and guard tower at Camps 1 & 4, Camp Delta at the US Naval Sation in Guantánamo Bay, is reproduced with his permission and that of AFP Getty Images.

**340** Several images of the Joint Task Force (JTF) Commissions Building and its hearing rooms appeared at the JTF-GTMO-Public Affairs website, www.jtfgtmo.southcom.mil. The photograph in figure 203 is reproduced courtesy of the Joint Task Force (JTF) and Guantánamo Bay Public Affairs and with the assistance of Major Jeffrey Weir, serving in 2006 as the Deputy Director of Public Affairs. Our thanks to Eugene Fidell for assisting us in locating images of the base.

**341** Department of the Navy, Navy Facilities Engineering Command, Legal Compound at U.S. Guantanamo Bay, Cuba, Presolicitation Notice N62470-07-R-2500, Nov. 3, 2006.

**342** *Military Plans to Build Compound for Trials*, NEW YORK TIMES, Nov. 18, 2006, at A15.

**343** Melissa McNamara, *Is $100M Guantánamo Courthouse Necessary?* CBS EVENING NEWS, Dec. 18, 2006, http://www.cbsnews.com/stories/2006/12/18/eveningnews/main2279127.shtml.

**344** Supplemental Appropriations for Fiscal Year 2007: Hearing Before the Committee on Appropriations, S. HRG. 110-87, U.S. Senate, 110th Congress 3, 60–61 (Feb. 27, 2007) (Statement of Robert Gates). See also Robert Burns, *Gates Trims Planned Guantánamo Court Facility: $100m Complex Was "Ridiculous," He Tells Senate*, BOSTON GLOBE, March 1, 2007, http://www.boston.com/news/nation/washington/articles/2007/03/01/gates_trims_planned_guantanamo_court_facility.

**345** Supplemental Appropriations for Fiscal Year 2007: Hearing Before the Committee on Appropriations, U.S. Senate, 110th Congress 60–61 (Feb. 27, 2007).

**346** William Glaberson, *Portable Halls of Justice Are Rising in Guantánamo*, NEW YORK TIMES, Oct. 14, 2007, at A1.

**347** Executive Order 13492: Review and Disposition of Individuals Detained at the Guantánamo Bay Naval Base and Closure of Detention Facilities, 74 Fed. Reg. 4897 (Jan. 22, 2009).

**348** See Supplemental Approriations Act of 2009, Pub. L. No. 111-32, § 14103(a), 123 Stat. 1859, 1920; National Defense Authorization Act for Fiscal Year 2010, Pub. L. No. 111-84, § 1041(a)–(e), 123 Stat. 2190, 2454–2455 (2009).

**349** The image in figure 204, reproduced with the assistance of Yale University Press, is from the website of the United States Department of Defense, http://www.defenselink.mil/photos/newsphoto.aspx?newsphotoid=5763.

**350** The photographs reproduced in figure 205, taken in the fall of 2009 by Travis Crum, are reproduced with his permission.

**351** Official seals are designed by the Institute of Heraldry of the United States. The Defense Department's Seal, approved in 1947, has a formal description and explication of its symbolism. For example, the eagle was selected "as an emblem of strength," and is "defending the United States, reprsented by the shield of thirteen pieces . . . joined together by a blue chief, representing Congress." See Department of Defense Seal, http://www.tioh.hqda.pentagon.mil/default.aspx.

The Seal of the United States—with one side showing an eagle at its center with thirteen stars over its head, thirteen arrows (resembling a lictor rod) in one talon and an olive branch in another—has a much longer history. The Continental Congress requested "Dr. Franklin, Mr. J. Adams and Mr. Jefferson" to devise a seal. See GAILLARD HUNT, THE SEAL OF THE UNITED STATES: HOW IT WAS DEVELOPED 5 (Washington, DC: Department of State, 1892). They provided a report calling for a shield to include both the "Goddess of Liberty" and the "Goddess of Justice bearing a sword in her right hand and in her left a Balance." Id. at 6. The final design included neither but did preserve two of their suggestions, "the Eye of Providence in the triangle, . . . and the motto *E pluribus unum*." Id. at 7. In 1789, Congress enacted a law adopting the Seal that had been used. Id. at 27. The Seal was then affixed to documents such as presidential commissions. Id. at 29.

**352** The photograph in figure 206 is reproduced courtesy of the Joint Task Force Guantanamo Bay and Guantanamo Bay Public Affairs and with the assistance of its 2006 Deputy Director of Public Affairs Jeffrey Weir.

**353** *Frontline: The Torture Question*, aired on Public Broadcasting Service stations on October 18, 2005. John VanNatta, Superintendent of Guantánamo, explained that the exchange was meant to "encourage esprit de corps among the soldiers." See http://www.pbs.org/wgbh/pages/frontline/torture/etc/script.html. The text can be found on "handouts and official documents and signs and is constantly recited, soldier to soldier, at the camp's checkpoints." Ted Conover, *In the Land of Guantánamo*, NEW YORK TIMES MAGAZINE, June 29, 2003, at 40. See also Ben Wizner, *Impressions of Guantánamo*, BLOG OF RIGHTS: OFFICIAL BLOG OF THE AMERICAN CIVIL LIBERTIES UNION, posted Jan. 13, 2006, 2:51 p.m., http://blog.aclu.org/2006/01/13/impressions-of-guantanamo.

**354** TIMELINE THEATRE COMPANY, GUANTÁNAMO: HONOR BOUND TO DEFEND FREEDOM, http://www.timelinetheatre.com/guantanamo. See also Ben Brantley, *Nightmare Without Hope or Logic*, NEW YORK TIMES, Aug. 27, 2004, at E1.

**355** Figure 207 is a 1935 photograph called *The Contemplation of Justice*, by Lois Long, from the Collection of the Supreme Court of the United States; the image was provided and is reproduced courtesy of the Photographic Collections of the Office of the Curator, United States Supreme Court. The phrase "Equal Justice Under Law" has been reiterated in various decisions by Supreme Court justices, explaining it as an injunction to administer laws impartially. See, for example, *Vieth v. Jubelirer*, 541 U.S. 267, 317 (2004) (Stevens, J., dissenting); *Burns v. Ohio*, 360 U.S. 252, 258 (1959); *Cooper v. Aaron*, 358 U.S. 1, 20 (1958).

**356** Law Matters: The Courts' Ideals Are Carved in Stone, Mar. 28, 2006 (a column in communications from the court that was provided on the Missouri court's website), http://www.courts.mo.gov/page.jsp?id=1079.

**357** See *Somerset v. Stewart*, Lofft 1, 20 Howell's State Trials 1, 79, 98 Eng. Rep. 499 (King's Bench 1772). Concluding that slavery had no legal basis in English law, Lord Mansfield, Chief Justice of the King's Bench in England, commented that courts "must not regard political consequences" of their judgments and invoked the phrase "fiat justitia, ruat caelum." Some attribute the original formulation to Lucius Calpurnius Piso Caesoninus, a Roman consul of 58 BCE who was also Julius Caesar's father-in-law. See JAMES MORWOOD, A DICTIONARY OF LATIN WORDS AND PHRASES 65 (Oxford, Eng.: Oxford U. Press, 1998).

The phrase has been used at times to explain why, in practice, attention to consequences is unwise, and at other times to support a decision focused on its potential aftermath. See Sissela Bok, *Kant's Arguments in Support of the Maxim "Do What Is Right Though the World Should Perish,"* 2 ARGUMENTATION 7 (1988). See also *Morrison v. Olson*, 487 U.S. 656, 732–733 (1988) (Scalia, J., dissenting) ("The notion that every violation of law should be prosecuted, including—indeed, *especially*—every violation by those in high places, is an attractive one, and it would be risky to argue in an election campaign that that is not an absolutely overriding value. *Fiat justitia, ruat coelum.* Let justice be done, though the heavens may fall. The reality is, however, that it is not an absolutely overriding value, and it was with the hope that we would be able to acknowledge and apply such realities that the Constitution spared us, by life tenure, the necessity of election campaigns."). In addition to case law, the phrase can also be found in courthouses, including one in Worcestershire, England. See CLARE GRAHAM, ORDERING LAW: THE ARCHITECTURAL AND SOCIAL HISTORY OF THE ENGLISH LAW COURT TO 1914, at 327 (Aldershot, Eng.: Ashgate, 2003).

**358** Bruce Ackerman, *The Rumsfeld Oath*, AMERICAN PROSPECT, Sept. 29, 2004, http://www.prospect.org/cs/articles?articleId=8681. Each member was to swear that he or she would "faithfully and impartially perform according to your conscience and the rules applicable

to the review filed by a military commission all the duties incumbent upon you as a member of the review panel." Given that these individuals were already in the military, they would also have taken an oath under 10 U.S.C. § 502 (2006) affirming that they would "support and defend the Constitution of the United States against all enemies, foreign and domestic . . . bear true faith and allegiance to the same; and . . . obey the orders of the President of the United States and the orders of the officers appointed over [him or her], according to regulations and the Uniform Code of Military Justice."

**359** See 28 U.S.C. § 453 (2006). See also 5 U.S.C. § 3331 (2006) (oath of office for United States officials other than the President), which provides that "[a]n individual, except the President, elected or appointed to an office of honor or profit in the civil service or uniformed services, shall take the following oath: 'I, AB, do solemnly swear (or affirm) that I will support and defend the Constitution of the United States against all enemies, foreign and domestic; that I will bear true faith and allegiance to the same; that I take this obligation freely, without any mental reservation or purpose of evasion; and that I will well and faithfully discharge the duties of the office on which I am about to enter. So help me God.' This section does not affect other oaths required by law."

**360** The lack of judicial independence drew specific criticism from the United Nations Report on Detainees that criticized CSRTs and ARBs for failing to comport with the obligations of judges to be independent, which is "essential to the notions of a 'court.' " See U.N. 2006 Situation of Detainees, paras. 28–33.

**361** See, for example, Declaration of Stephen Abraham, para. 8, Reply of Petitioners to Opposition to Petition for Rehearing at 6, *Al Odah v. United States*, 127 S. Ct. 3067 (No. 06-1196) (hereinafter Abraham Declaration). Abraham, a reservist commissioned in 1982 as an officer in the Intelligence Corps, wrote that after he served on a CSRT that found no credible evidence for detention, the panel was asked to rehear the case; when it did not thereafter change its ruling, he was not asked to serve in that capacity again. Id., paras. 23–24.

**362** Compare Daniel Markovits, *Adversary Advocacy and the Authority of Adjudication*, 75 FORDHAM LAW REVIEW 1367 (2006). Markovits detailed the function of adversarialism in generating legitimacy by integrating conflict into the social order.

**363** See JTF-GTMO Media Policy, Guantanamo Bay NAS, Cuba, as of June 2006 (hereinafter JTF-GTMO Media Policy). The policy indicated that it provided no "guarantee [of] media travel" but that the Department of Defense was doing "its utmost to facilitate access for media members to provide their audiences imagery and reporting," Yet access "does not imply unlimited access to personnel or facilities." Id. at 1. This document included "Ground Rules" to protect information. The Department of Defense threatened that a failure to comply could result in "permanent expulsion and may result in the removal of the parent news organization from further participation in the commissions coverage assignment process" and that criminal prosecution would be undertaken if classified information was disclosed. Id. at 2, para. 1. Upon signing the agreement, a person agreed not to "publish, release, discuss or share information" identified by JTF-GTMO as "being protected." Id. at 2, para. 4.

**364** See, for example, *In re Guantanamo Detainee Cases*, 344 F. Supp. 2d 174 (D.D.C. 2004); Petitioners' Motion for Emergency Access to Counsel, *Khan v. Bush*, Case No. 06-CV-1690 (RBW) (D.D.C. Oct. 8, 2006).

**365** See ICRC Report at 3–4. See also William Glaberson, *Some at Guantánamo Were Denied Access to Red Cross*, NEW YORK TIMES, Nov. 16, 2007, at A20.

**366** *Bismullah v. Gates*, 503 F.3d 137 (D.C. Cir. 2007), vacated and remanded in light of *Boumediene v. Bush*, 553 U.S. 723 (2008).

**367** Military Commission Order No. 1, Part 6(B)(3).

**368** Military Commission Order No. 1, Part 6(B)(3) (the Appoint-

ing Authority should "hold open proceedings except where otherwise decided").

**369** Military Commission Order No. 1, Part 4(A)(5)(a), subject to 6(B)(3).

**370** Military Commission Order No. 1, Part 6(B)(3).

**371** Military Commission Order No. 1, Part 6(B)(3).

**372** The scene and text in figure 208—showing a test of the video system, and reproduced with the assistance of Yale University Press—was posted in 2004 on the website of the United States Department of Defense. See http/www.defenselink.mil/photos/newsphoto.aspx? newsphotoid=5762.

**373** See Charlie Savage, *Guantánamo Coverage to Be Restricted*, BOSTON GLOBE, Aug. 27, 2004, at A9.

**374** Savage. See also JFT-GTMO Media Policy at 7.

**375** Savage. Other reports refer to "nine pages of ground rules, including an agreement not to publish protected information." Beth Gorham, *Khadr's Lawyer Says Ottawa Hasn't Done Enough before U.S. Hearing*, CANADIAN PRESS, June 1, 2006.

**376** See Savage. This article also notes that these restrictions were "theoretical" at the time of the reporting; no trials with evidence introduced had then taken place. A few motions about the proceedings were held, at which the press was present. See also *Associated Press v. U.S. Dep't of Defense*, 410 F. Supp. 2d 147 (S.D.N.Y. 2006) (discussing confidentiality obligations of the press). The Associated Press later filed additional Freedom of Information Act lawsuits against the Department of Defense for other information about the detainees held in Guantánamo Bay. See *Associated Press v. U.S. Dep't of Defense*, No. 05-Civ-5468, 2006 U.S. Dist. LEXIS 67913 (S.D.N.Y. Sept. 20, 2006) (seeking information about detainee abuse and ARBs); *Associated Press v. U.S. Dep't of Defense*, 462 F. Supp. 2d 573 (S.D.N.Y. 2006) (seeking photographs and information on the height and weight of each detainee); *Associated Press v. Dep't of Defense*, 498 F. Supp. 2d 707 (S.D.N.Y. 2007) (seeking information about the determination to transfer or release detainees prior to the implementation of ARBs in 2004).

**377** Ian James, *Journalists Allowed to Watch Selected Tribunals for the First Time*, ASSOCIATED PRESS, Aug. 5, 2004.

**378** Ian James, *2 Afghan Detainees Plead Cases Before Tribunals*, ASSOCIATED PRESS, Aug. 6, 2004.

**379** See JTF-GTMO Media Policy at 7.

**380** 5 U.S.C. § 552 (2006).

**381** *Associated Press v. U.S. Deparment of Defense*, 410 F. Supp. 2d 147, 149 (S.D.N.Y. 2006).

**382** *Associated Press v. Department of Defense*, 410 F. Supp. 2d 147, 156 nn. 1–2 (S.D.N.Y. 2006). See also Agence France Press, *Controls Tight at Prisoner Hearings*, HERALD SUN (Australia), Aug. 7, 2004. That report stated that "two Afghan detainees" had their "feet shackled and wrists handcuffed" and were denied the opportunity to call witnesses; further, the event was the "first time when the Afghans appeared before the three-judge panel" that journalists had been allowed to watch.

**383** Pamela Hess, *No Audio Record of GTMO Trials*, UPI INTERNATIONAL, Aug. 26, 2004.

**384** See 5 U.S.C. § 552(b)(6) (2006) (providing for nondisclosure of "personnel and medical files and similar files the disclosure of which would constitute a clearly unwarranted invasion of privacy").

**385** *Associated Press v. U.S. Dep't of Defense*, 410 F. Supp. 2d 147 (S.D.N.Y. 2006). That decision denied a motion to reconsider the earlier ruling. *Associated Press v. U.S. Dep't of Defense*, 2006 U.S. Dist. LEXIS 211 (S.D.N.Y. Jan. 4, 2006). The court required the "government to break its secrecy and reveal the most comprehensive list yet of those who have been imprisoned" at Guantánamo. As of 2006, only a few of those detained had been officially identified. See *Judge Orders U.S. to Release Guantánamo Detainee Data*, USA TODAY, Feb. 23, 2006, http://www.usatoday.com/news/washington/2006-02-

23-guantanamo-suit_x.htm?csp=34#. Researchers at the *Washington Post* sought to provide information on detaineees. By checking court documents and international sources, they compiled a list of the names and the countries of origin of 550 Guantánamo detainees held between 2002 and 2006. See *Names of the Detained in Guantánamo Bay, Cuba*, WASHINGTON POST, http://projects.washingtonpost.com/guantanamo.

**386** "The notion . . . that the detainees, involuntarily providing sworn recorded testimony to a quasi-judicial tribunal, nonetheless retained a reasonable expectation that their identifying information would remain confidential, is entirely without evidentiary support on this record." *Associated Press v. U.S. Dep't of Defense*, 410 F. Supp. 2d at 156.

**387** Moreover, the government had not taken the opportunity offered by the court to specify, with "respect to particular detainees and particular items of information," the requisite needs for privacy. *Associated Press v. U.S. Dep't of Defense*, 410 F. Supp. 2d at 156, n. 1.

**388** Abraham Declaration, para. 8.

**389** Abraham Declaration, para. 22. See also KYNDRA MILLER ROTUNDA, HONOR BOUND: INSIDE THE GUANTÁNAMO TRIALS (Durham, NC: Carolina Academic Press, 2008). Information also came from those who attended, including Wizner, *Impressions of Guantánamo*, and from observers dispatched by Human Rights Watch. See, for example, Audrey Macklin, *The Omar Khadr Case: Redefining War Crimes*, JURIST, Oct. 31, 2008, http://jurist.law.pitt.edu/forumy/2008/10/omar-khadr-case-redefining-war-crimes.php. Another compilation of the evaluation procedures comes from WITTES & WYNE.

**390** Lieutenant Colonel Vandeveld's sworn declaration in support of detainee Mohammed Jawad, one of the detainees whom he had previously prosecuted, detailed a litany of procedural deficiencies, including the fact that "[p]otentially exculpatory evidence has not been provided." Declaration of Lieutenant Colonel Darrel J. Vandeveld, para. 10, *United States v. Mohammed Jawad* (Sept. 22, 2008), http://s3.amazonaws.com/propublica/assets/docs/vandeveld_declaration_080922.pdf.

**391** William Glaberson, *Ex-Prosecutor Says He Was Pushed toward Closed Trials at Guantánamo*, NEW YORK TIMES, Oct. 20, 2007, at A12. Described were the views of Colonel Morris D. Davis, who resigned as a prosecutor. See also Morris D. Davis, *AWOL Military Justice*, LOS ANGELES TIMES, Dec. 10, 2007; Morris Davis, *Unforgivable Behavior, Inadmissible Evidence*, NEW YORK TIMES, Feb. 17, 2008, at WK12; Ross Tuttle, *Rigged Trials at Gitmo*, THE NATION, Feb. 20, 2008 (interview with Colonel Davis); Amy Goodman, *Fmr. Chief Guantánamo Prosecutor Says Military Commissions "Not Justice,"* DEMOCRACY NOW!, July 16, 2008, transcript of radio interview with Col. Davis, http://i3.democracynow.org/2008/7/16/fmr_chief_guantanamo_prosecutor_says_military.

**392** According to news reports, the Attorney General for England and Wales commented that those accused of terrorist activity ought to receive a "fair trial" and that the Guantánamo tribunals were not "a fair trial by standards we would accept." Cowell.

**393** The ICTY provided that all proceedings other than deliberations "shall be held in public, unless otherwise provided." Rule 78 ("Open Sessions"), Rules of Procedure and Evidence, International Criminal Tribunal for the former Yugoslavia, IT/32/Rev.36, http://www1.umn.edu/humanrts/icty/ct-rules7.html.

**394** Regulations for the Establishment of a Complaints Procedure for Detainees, paras. 4, 7, International Criminal Tribunal for the Former Yugoslavia, IT/96, www.icty.org/x/file/Legal%20Library/Detention/IT96UNDU_complaints_en.pdf.

**395** Manual for Courts-Martial United States, 2008 Edition, Rule 806(a), http://www.apd.army.mil/pdffiles/mcm.pdf (hereinafter 2008 Courts-Martial Manual). See also David J. R. Frakt, *An Indelicate Imbalance: A Critical Comparison of the Rules and Procedures for Mil-

itary Commissions and Courts-Martial*, 34 AMERICAN JOURNAL OF CRIMINAL LAW 315 (2007).

**396** 2008 Courts-Martial Manual, Rule 806(b)(2).

**397** 2008 Courts-Martial Manual, Rule 806(b)(1).

**398** 2008 Courts-Martial Manual, Rule 806(b)(2) ("Closure"). "Public access to a session may be limited, specific persons excluded from the courtroom and, under unusual circumstances, a session may be closed." Id. at Rule 801(b)(1), Discussion. Case law has implemented this text by holding that the constitutional right of a public trial applies to courts-martial and to certain pretrial proceedings. See *ABC, Inc., v. Powell*, 47 M.J. 363 (Court of Appeals for the Armed Forces, 1997). Article 102 of the Geneva Conventions provides that prisoners of war "can be validly sentenced only if the sentence has been pronounced by the same courts according to the same procedure as in the case of members of the armed forces of the Detaining Power." Geneva Convention relative to the Treatment of Prisoners of War, Art. 102, Aug. 12, 1949, 75 U.N.T.S. 135, 6 U.S.T. 3316 (entered into force Oct. 21, 1950).

**399** The challenges included finding out who was on trial, where, and for what. See Eugene R. Fidell, *Accountability, Transparency & Public Confidence in the Administration of Military Justice*, 9 THE GREEN BAG 2D 361, 363 (2006).

**400** See the Detainee Treatment Act of 2005, § 1005(e), provided as a rider to 14 U.S.C. § 1401 and to be codified as an amendment to 28 U.S.C. § 2241 (Dec. 30, 2005), Pub. L. No. 109-148, 119 Stat. 2680, 2741–2742 (2005). See also the Military Commissions Act of 2006, § 7, Pub. L. No. 109-366, 120 Stat. 2600, 2635–2636 (2006) (amending 28 U.S.C. 2241(e) (2000)).

**401** *Rasul v. Bush*, 542 U.S. 466 (2004); *Hamdan v. Rumsfeld*, 548 U.S. 557 (2006); *Boumediene v. Bush*, 553 U.S. 723 (2008).

**402** See, for example, *Rasul v. Myers*, 563 F.3d 527 (D.C. Cir. 2009).

**403** The forms of detention are also not idiosyncratic. Individuals convicted of crimes and determined by prison officials to be especially dangerous can be placed in "supermax" facilities where they are held in isolation and under surveillance for years. See *Wilkinson v. Austin*, 545 U.S. 209 (2005). For other parallels between the detainees at Guantánamo and prisoners in the United States confined after convictions as well as those detained awaiting decisions on migration, see Judith Resnik, *Detention, The War on Terror, and The Federal Courts*, 110 COLUMBIA LAW REVIEW 579 (2010).

**404** "Radical" is also a term applied to it by the U.N. 2006 Situation of Detainees at para. 21.

**405** United States Department of Defense, *Military Commissions*, http://www.dod.mil/pubs/foi/detainees/death_investigation/ghost_detainees/Pages_1041-1057_from_Joint_Staff_Ghost_Detainee_part_44_of_45.pdf.

**406** See SEYLA BENHABIB, THE RIGHTS OF OTHERS: ALIENS, RESIDENTS AND CITIZENS 19–20, 171 (Cambridge, Eng.: Cambridge U. Press, 2004); Robert M. Cover, *The Supreme Court 1982 Term—Foreword: Nomos and Narrative*, 97 HARVARD LAW REVIEW 4 (1983); JÜRGEN HABERMAS, BETWEEN FACTS AND NORMS: CONTRIBUTIONS TO A DISCOURSE THEORY OF LAW AND DEMOCRACY (William Rehg, trans., Cambridge, MA: MIT Press, 1998).

**407** MICHEL FOUCAULT: DISCIPLINE AND PUNISH: THE BIRTH OF THE PRISON 8 (Alan Sheridan, trans., New York, NY: Vintage Books, 2nd ed., 1995; 1st ed., 1977).

**408** FOUCAULT at 63. See also John Rajchman, *Foucault's Art of Seeing*, 44 OCTOBER 88 (1988). Rajchman argued that there was a relationship between "evidence" (coming from "videre"—to see) and Foucault's visual idioms. Id. at 93–94. In addition, Rajchman maintained that the acceptability of practices came from their normalization, and hence that "spatialization" is a technique in the exercise of power. Id. at 104.

**409** These words are from a decision refusing judicial inquiry into allegations that the United States government had detained a Canadian citizen, Maher Arar, who had immigrated from Syria (and retained that citizenship as well) and who, upon arriving from Tunisia on a family vacation, had been detained at John F. Kennedy Airport before boarding his plane to Montreal, interrogated for days "chained and shackled," and sent to Syria. He reported that during his ten months of detention in Syria, he was kept in a very small cell, given "barely edible food," and subjected to torture. Mr. Arar lost in the lower federal courts in his effort to obtain relief from these harms but was given funds by virtue of a special inquiry in Canada. See *Arar v. Ashcroft*, 414 F. Supp. 2d 250 (E.D.N.Y. 2006), *aff'd en banc*, 585 F.3d 559 (2d Cir. 2009), cert. denied 130 S. Ct. 3409 (2010). See also *North Jersey Media Group, Inc., v. Ashcroft*, 308 F.3d 198, 220 (3d Cir. 2002) *cert. denied*, 538 U.S. 1056 (2003). That decision upheld the blanket closing of deportation hearings based on the government's claim of national security.

**410** Jordan Gruzen with Cathy Daskalakis & Peter Krasnow, *The Geometry of a Courthouse Design*, in Celebrating the Courthouse: A Guide for Architects, Their Clients, and the Public 83, 90 (Steven Flanders, ed., New York, NY: W. W. Norton, 2006).

**411** Gruzen at 108.

**412** See Maure L. Goldschmidt, *Publicity, Privacy and Secrecy*, 7 The Western Political Quarterly 401, 401 (1954). Habermas cited Goldschmidt's comment in Jürgen Habermas, The Structural Transformation of the Public Sphere: An Inquiry into a Category of Bourgeois Society 140 (Thomas Burger, trans., Cambridge, MA: MIT Press, 1991) (hereinafter Habermas, Structural Transformation).

**413** Habermas, Structural Transformation at 2. Furthermore, to the extent that courts served to replace the public punishments of the stockades and executions by creating public trials that resulted in published accounts disseminating information of wrongdoing (such that methods of making state power public but not the fact of doing so changed), punishment has become all the more hidden. See Simon Devereaux, *The City and the Sessions Paper: "Public Justice" in London, 1770–1800*, 35 Journal of British Studies 466, 502–503 (1996).

**414** John D. Donahue, *The Transformation of Government Work: Causes, Consequences, and Distortions* at 41, 51 in Freeman & Minow. The function of the post in Europe, particularly in England, is analyzed in Tim Blanning, The Pursuit of Glory: Europe 1648–1815, at 34–39 (New York, NY: Viking, 2007).

**415** In addition, a small line of cases dealing with the First Amendment rights of protestors to use public space have concluded that areas near post offices are more commercial than public. The distinction drawn by the United States Supreme Court is that, although its own sidewalks were "indistinguishable from any other sidewalks in Washington, D.C." and hence a "public forum" free for various users, *United States v. Grace*, 461 U.S. 171, 179 (1983), some of the areas surrounding post offices are more like commercial establishments that fall under the law permitting regulation of protestors as well as others. See *United States v. Kokinda*, 497 U.S. 720 (1990).

**416** See Sharon Dolovich, *How Privatization Thinks: The Case of Prisons*, in Freeman & Minow at 128–147.

**417** Jody Freeman & Martha Minow, *Introduction: Reframing the Outsourcing Debate* in Freeman & Minow at 1.

**418** See Office of Management, Planning and Assessment, *Implementation of the Long Range Plan of the Federal Courts, Reported to the Committees of the Judicial Conference of the United States* I-18 (Administrative Office of the United States Courts, April 2008), www.uscourts.gov/library/Implementation_the_Long_Range_Plan.pdf (hereinafter *2008 Federal Courts Implementation Long Range Plan*).

**419** *2008 Federal Courts Implementation Long Range Plan* at I-18. See also Administrative Office of the United States Courts, Federal Judicial Caseload Statistics, March 31, 2009: Judicial Caseload Indicators, http://www.uscourts.gov/caseload2009/contents.html.

**420** Roberts at 479.

**421** Gunther Teubner, *After Privatisation? The Many Autonomies of Private Law*, 51 Current Legal Problems 393, 394 (1998).

**422** Martha Minow, Partners, Not Rivals: Privatization and the Public Good (Boston, MA: Beacon Press, 2002). The examples include schools, medical and legal services, and social welfare programs, and she called for accountability in all these venues.

**423** William J. Novak, *Public-Private Governance: A Historical Introduction* at 23, 31 in Freeman & Minow.

**424** See generally Paul R. Verkuil, *Public Law Limitations on Privatization of Government Functions*, 84 North Carolina Law Review 397 (2006); Paul R. Verkuil, *Outsourcing and the Duty to Govern* at 310 in Freeman & Minow.

**425** Martha Minow, *Outsourcing Power: Privatizing Military Efforts and the Risks to Accountability, Professionalism, and Democracy* at 110 in Freeman & Minow.

**426** Stuart Hampshire, Innocence and Experience, 177–189 (Cambridge, MA: Harvard U. Press, 1989) ("liveliness" at 189).

**427** See Frederick Schauer & Virginia J. Wise, *Nonlegal Information and the Delegalization of Law*, 29 Journal of Legal Studies 495 (2000); Lynn M. LoPucki, *Court System Transparency*, 94 Iowa Law Review 481 (2009); John Markoff, *A Quest to Get More Court Rulings Online, and Free*, New York Times, Aug. 20, 2007, at C6. See generally Marco Fabri, *E-Justice in Finland and in Italy: Enabling versus Constraining Models*, in ICT and Innovation in the Public Sector: European Studies in the Making of E-Government 115–146 (Francesco Contini & Giovan Francesco Lanzara, eds., Hampshire, Eng.: Palgrave Macmillan, 2009).

**428** See Eduardo Oteiza, *Civil Procedure Reforms in Latin America: Tension between Mediation and Conflict Resolution*, in Common Law, Civil Law at 225–246.

**429** Per Henrik Lindblom, *ADR—The Opiate of the Legal System? Perspectives on Alternative Dispute Resolution Generally and in Sweden*, 16 European Review of Private Law 63 (2008).

**430** Keith A. Gorgo, *Comment: Lost in Transcription: Why the Video Record Is Actually Verbatim*, 56 Buffalo Law Review 1057 (2009).

**431** Alfred C. Aman Jr., *Privatization and Democracy: Resources in Administrative Law* in Freeman & Minow at 261, 279.

**432** Jeremy Bentham, Rationale of Judicial Evidence (1827) (hereinafter Bentham, Rationale), in 6 The Works of Jeremy Bentham 351 (John Bowring, ed., Edinburgh, Scot.: William Tait, 1843).

**433** Bentham, Rationale at 354.

**434** Bentham, Rationale at 354. Further, Bentham noted that in "the Court of King's Bench, the proceedings are purportedly held in public, yet the number of persons able 'to come … to hear, is not worth thinking of.'" Philip Schofield, Utility and Democracy: The Political Thought of Jeremy Bentham 257 (New York, NY: Oxford U. Press, 2006) (quoting Bentham).

## Chapter 15

**1** See Dory Reiling, Linn Hammergren, & Adrian Di Giovanni, Justice Sector Assessments: A Handbook 7 (Washington, DC: World Bank, 2006), http://siteresources.worldbank.org/INTLAWJUSTINST/Resources/JSAHandbook.doc. See also Amartya Sen, What Is the Role of Legal and Judicial Reform in the Development Process? Speech at the World Bank Legal Conference (June 5, 2000), http://siteresources.worldbank.org/INTLAWJUSTINST/Resources/legalandjudicial.pdf; Maria Dakolias & Javier Said, Judicial

REFORM: A PROCESS OF CHANGE THROUGH PILOT COURTS (Washington, DC: World Bank, 1999).

2 CLARE GRAHAM, ORDERING LAW: THE ARCHITECTURAL AND SOCIAL HISTORY OF THE ENGLISH LAW COURT TO 1914 at 267–307 (Aldershot, Eng.: Ashgate, 2003).

3 GRAHAM at 271 (emphasis in the original). The materials quoted in the text come from Graham's excerpt of Walter Bagehot's discussion of English institutions. See WALTER BAGEHOT, THE ENGLISH CONSTITUTION 3–4 (London, Eng.: Oxford U. Press, 1867; reprinted by Gaunt, 1998). Graham also relied on David Cannadine, whose analysis we discussed in Chapter 4 in relationship to the idea of public spectacles. See David Cannadine, *The Context, Performance and Meaning of Ritual: The British Monarch and the "Invention of Tradition,"* c. 1820–1977, in THE INVENTION OF TRADITION 101–164 (Eric Hobsbawm & Terence Ranger, eds., Cambridge, Eng.: Cambridge U. Press, 1983).

4 Felicity Harris, *The Development of Court Architecture, Its Effect on Utilization of the Law Courts with Specific Reference to the Court Houses of Truro, Cornwall* 46 (University of Exeter, Exeter, Eng., Working Paper, Access to Justice in Rural Britain Project, Nov. 1991).

5 Simon Roberts, *"Listing Concentrates the Mind": The English Civil Court as an Arena for Structured Negotiation*, 29 OXFORD JOURNAL OF LEGAL STUDIES 457, 459, 479 (2009).

6 VICTOR C. GILBERTSON, MINNESOTA COURTHOUSES xvi (Lakeville, MN: Galde Press, 2005).

7 GILBERTSON at xvi.

8 As analyzed in Chapter 13, open judicial proceedings have a long history. Over the past few centuries, the traditions of literally open doors were strong in common law countries, with civil law jurisdictions having varying approaches, modified sometimes as civil and common law traditions overlap or converge.

9 In 2007, for example, the United States Supreme Court heard about seventy-five oral arguments. See Appendix Table A-1, U.S. Supreme Court, Cases on Docket, Disposed of, and Remaining on Docket, 2003 through 2007, in 2008 ANNUAL REPORT OF THE DIRECTOR: JUDICIAL BUSINESS OF THE UNITED STATES COURTS at 82 (Washington, DC: U.S. Government Printing Office, 2009). The court scheduled oral arguments a few days per month, generally during the mornings, from October through April; in the 2008 term, the court had thirty-eight days on which it heard arguments. See Supreme Court of the United States, Hearing List (October Term, 2008), http://www.supremecourt.gov/oral_arguments/hearinglists/hearinglist_octo8.pdf.

10 See Peter Goodrich, *Specters of Law: Why the History of the Legal Spectacle Has Not Been Written*, U. OF CALIFORNIA IRVINE LAW REVIEW (forthcoming 2010).

11 Paul Spencer Byard, *Reading the Architecture of Today's Courthouse*, in CELEBRATING THE COURTHOUSE: A GUIDE FOR ARCHITECTS, THEIR CLIENTS, AND THE PUBLIC 147 (Steven Flanders, ed., New York, NY: W. W. Norton, 2006) (hereinafter CELEBRATING THE COURTHOUSE).

12 Marie Bels, *Concours gagnés, concours perdus vers l'élaboration d'un modèle*, 265 ARCHICRÉE at 96–110 (English translation: *New Directions in the Design of Law Courts* at 145) (1995).

13 Bels at 145.

14 Roberts at 476–479.

15 See Robert M. Cover, *Violence and the Word*, 95 YALE LAW JOURNAL 1601 (1986); Robert M. Cover, *The Supreme Court 1982 Term—Foreword: Nomos and Narrative*, 97 HARVARD LAW REVIEW 4 (1983). Another account underscores the need to obtain compliance, and hence that legal authority requires managing the "disappointment" entailed in conflict. See Richard Mohr, *Authorised Performances: The Procedural Sources of Judicial Authority*, 4 FLINDERS JOURNAL OF LAW REFORM 63 (2000).

16 For example, the architects who designed the 1992 Supreme Court for Israel (fig. 10/139) described their goal as seeking to reflect the " 'special nature of justice and the traditions in Israel.' " See YOSEF SHARON, THE SUPREME COURT BUILDING, JERUSALEM 25 (Alexandra Mahler, trans., Jerusalem, Isr.: Yad Hanadiv, 1993, 2d ed., 1997).

17 Some architects have endeavored to make buildings express that universality. For example, Richard Rogers's design for the European Court of Human Rights (fig. 11/163) aimed to capture the Council of Europe's multi-national and hence non-national identity.

18 See DAS BUNDESVERFASSUNGSGERICHT IN KARLSRUHE: ARCHITEKTUR UND RECHTSPRECHUNG (THE FEDERAL CONSTITUTIONAL COURT OF GERMANY: ARCHITECTURE AND JURISDICTION) 26 (Basel, Switz.: Birkhäuser—Publishers for Architecture, 2004) (hereinafter GERMAN FEDERAL CONSTITUTIONAL COURT). The passages quoted are from Thorsten Bürklin's essay *With a Touch of Internationality and Modernity*, in that volume (hereinafter Bürklin) at 17–43. Germany's Federal Constitutional Court was established in 1951 after the enactment of the Basic Law in 1949. GERMAN FEDERAL CONSTITUTIONAL COURT at 7, 17.

The courthouse, designed by Paul Baumgarten, opened in 1969 and was commemorated in a volume published in 2004 as the building's expansion ("also committed to transparency") was underway. Id. at 7–10 (*Preface* by Hans-Jürgen Papier, President of the Federal Constitutional Court). Papier also praised the glass facade: "From whichever angle one approaches the Federal Constitutional Court, one looks not only at but also into the building." Id. at 7. The courtroom, rather than staff offices, was placed "closest to the city." Bürklin at 26. As that volume also explained, while judgments are pronounced in the courtroom (designed as an "ascent into light," Bürklin at 34), public hearings are "a rare occurrence, although [they] continue to play an important part in the Court's decision-making process." Jutta Limback, *Working at the Federal Constitutional Court*, in GERMAN FEDERAL CONSTITUTIONAL COURT at 45, 46.

19 Papier, *Preface*, in GERMAN FEDERAL CONSTITUTIONAL COURT at 8.

20 See Frank Greene, *The Image of the Courthouse*, in CELEBRATING THE COURTHOUSE at 63, 65. Greene, a courthouse architect, was the recipient of General Services Administration Design Excellence Awards for courthouses in Scranton and Pittsburgh. Id. at 6.

21 Greene at 63 (emphasis in the original).

22 Greene at 67–74.

23 Andrea P. Leers, *Urban Design and the Courthouse: How Sites Shape Solutions*, in CELEBRATING THE COURTHOUSE at 110, 112–114, 125, 130–132. The Iceland courthouse, designed after a 1993 competition, by Margrét Hardardóttir and Steve Christer of Studio Granda, Reykjavik, opened in 1996. See *The Supreme Court of Iceland* (Oddi Ltd., undated pamphlet provided by the court). Our thanks to Herdis Thorgeirsdottir, who facilitated a tour of that court.

24 Joshua Rozenberg, *Civil Justice Centre Shines in Court Gloom*, TELEGRAPH, Apr. 14, 2008, http://www.telegraph.co.uk/news/uknews/1584453/Civil-Justice-Centre-shines-in-court-gloom.html. That building of fourteen stories, with an eleven-story atrium, cost 160 million pounds. *Civil Court Centre Opens in City*, BBC NEWS, Oct. 24, 2007, http://news.bbc.co.uk/2/hi/uk_news/england/manchester/7060077.stm. Rozenberg noted that the glossy new court, with six "specialist commercial judges," was hoping to "drum up more work."

25 See Jane C. Loeffler, *The Importance of Openness in an Era of Security: A Conversation with Supreme Court Justice Stephen G. Breyer*, 194 ARCHITECTURAL RECORD 80, 82–83 (Jan. 2006). Justice Breyer described the United States Supreme Court's large open front plaza as a spatial signal other than glass that made plain that entrants were welcome. In May of 2010, the court—over his dissent, joined by Justice Ginsburg—closed that entrance off and routed individuals to "a secure, reinforced area" for security screening. U.S. Supreme Court

Press Release, May 3, 2010, http://www.supremecourt.gov/publicinfo/press/viewpressreleases.aspx?FileName=pr_05-03-10.html; *Statement Concerning the Supreme Court's Front Entrance*, SUPREME COURT JOURNAL, October Term 2009, entry for May 3, 2010, at 779–780, www.supremecourt.gov/orders/journal/jnl09.pdf ("Memorandum of Justice Breyer, with whom Justice Ginsburg joins.").

**26** See, for example, Bürklin at 17. The court had achieved a "delicate balance between moderation and solemnity, democratic tolerance and authority, a balance which seems to speak to us through the geometrical simplicity and transparent openness of the architecture." Id. As we discussed in Chapters 9–12, the newly configured exteriors are not matched by similarly innovative interiors. The courtrooms remain conventional, sometimes with computer screens added to traditional layouts. In some transnational courts, more space is provided for judges, along with special booths for translators and dedicated areas for the press. Courtrooms continue to be posited as centerpieces even though, in terms of sheer square footage, office space predominates.

**27** In Germany's Constitutional Court, for example, "[o]pen days are held regularly so that anyone who is interested can experience close up the way in which the court administers justice." Papier, *Preface*, in GERMAN FEDERAL CONSTITUTIONAL COURT at 8. He noted that more than 20,000 people attended a festival in honor of the fiftieth anniversary of the court, that visitors regularly toured the building, and that the press reported important decisions. Id.

**28** The mission of the Conference of Court Public Information Officers is to "serve as liaisons between the judiciary and the public," in part by working "closely" with the National Center for State Courts and the National Judicial College. See Conference of Court Public Information Officers, http://www.ccpio.org/aboutus.htm.

**29** See David Nakamura, *Architects Promise Visionary D.C. Ballpark: HOK Sport Considers Such Encompassing Themes as "Transparency of Democracy" for Design*, WASHINGTON POST, Apr. 1, 2005, B1. See also David Nakamura, *Lots of Glass, Capital Views: Design of New Stadium for Washington Nationals Reflects Elements of Convention Center and Monuments in Departure from Red-Brick Retro Ballparks*, WASHINGTON POST, Mar. 15, 2006, A1 (hereinafter Nakamura, *Lots of Glass*). The ballpark's designers included a subgroup of Hellmuth, Obata & Kassabaum, the architectural firm that was also responsible for various courts, including the tallest federal courthouse to date (fig. 8/112), located in St. Louis, Missouri.

Like some new court construction, the ballpark was promoted as an anchor for the economic expansion of a neighborhood. Emblematic of its commitments to American capitalism, the ballpark was to include "78 luxury suites, 4,000 high-priced club seats," and an upscale restaurant. Nakamura, *Lots of Glass*. When it opened in 2008 at a cost of $611 million in public money, many of the interior spaces were "accessible only to the public that can afford more expensive seats." Philip Kennicott, *This Diamond Isn't a Gem: Nationals Park Gives Fans Plenty, but Its Bland Face Is a Muffed Chance*, WASHINGTON POST, Mar. 31, 2008, at C1. See generally BRETT L. ABRAMS, CAPITAL SPORTING GROUNDS: A HISTORY OF STADIUM AND BALLPARK CONSTRUCTION IN WASHINGTON, D.C. (Jefferson, NC: McFarland, 2009). Our thanks to Jane Loeffler for pointing out this parallel.

**30** ANNETTE FIERRO, THE GLASS STATE: THE TECHNOLOGY OF THE SPECTACLE, PARIS, 1981–1998 at viii (Cambridge, MA: MIT Press, 2003). The French projects included the Pyramides of the Louvre and the Bibliothèque Nationale de France, renamed after Mitterrand's death in 1996 to include his name. Id. at xiii, 275. The list of architectural firms involved included several architects—Jean Nouvel, Dominique Perrault, Richard Rogers, and Henry Cobb—who were the designers of some of the courthouses discussed in Chapters 8–12. As for the turn to glass, Fierro explained that since "the Gothic cathedral, glass has been coupled with the birth of the structural frame," and

"[w]ith the rise of the structural frame in the late nineteenth century, glass construction, particularly curtain wall assembly systems, have followed suit." FIERRO at viii–ix.

**31** Joseph Paxton designed the Crystal Palace in Hyde Park, London. See JOHN MCKEAN, SIR JOSEPH PAXTON, & SIR CHARLES FOX, CRYSTAL PALACE: JOSEPH PAXTON AND CHARLES FOX (London, Eng.: Phaidon, 1994). Fox was the structural engineer who was central to the design's construction.

**32** The design is featured in THE LIGHT CONSTRUCTION READER (Todd Gannon, ed., New York, NY: Monacelli Press, 2002), figs. 59 and 60, and discussed by Joan Ockman in excerpts published in that volume, based on the "Light Construction Symposium" held at Columbia University in 1995. Id. at 53, 66–69. "Constructed in record time from economical, modular, and demountable parts, it was the epitome of rational engineering." Yet its "lucidities . . . dissolved" because of its "new optical scale" and "its phantasmagoria of endless goods. Rationalism yielded to spectacle and surreality." Id. at 67. See generally ISOBEL ARMSTRONG, VICTORIAN GLASSWORLDS: GLASS CULTURE AND THE IMAGINATION 1830–1880 (Oxford, Eng.: Oxford U. Press, 2008); Thomas Marks, *The Languages of Glass*, 37 CAMBRIDGE QUARTERLY 446 (2008); Ufuk Ersoy, *The Fictive Quality of Glass*, 11 ARQ: ARCHITECTURAL RESEARCH QUARTERLY 237 (2007).

**33** New techniques in glass manufacture in the early part of the twentieth century improved the transparency and increased the size of panes. FIERRO at ix. France became one of the premier sites for manufacture. Id. at 9. More recently, technologies expanded glass's uses. See Richard P. Feynman, *Photons: Particles of Light*, in THE LIGHT CONSTRUCTION READER at 205–229.

**34** See Rosemarie Haag Bletter, *The Interpretation of the Glass Dream—Expressionist Architecture and the History of the Crystal Metaphor*, 40 SOCIETY OF ARCHITECTURAL HISTORIANS 20 (1981). The twentieth century, in turn, produced the Crystal Cathedral, a megachurch designed by Philip Johnson and located in Orange County, California. See DENNIS SHARP, TWENTIETH CENTURY ARCHITECTURE: A VISUAL HISTORY 365 (London, Eng.: Lund Humphries, 1991).

**35** Bletter at 21–22, n. 3 (citing a 1914 letter). Bletter traced the glass metaphor to fantastic descriptions in literatures from around the world of King Solomon's palace, said to have had translucent glass floors that looked like shimmering waters, making Solomon the "patron of glass architecture." Id. at 23. In the New Testament, the revelation of St. John included a vision of the light of Jerusalem, "clear as crystal." Id. at 25 (citing *Revelation* 21:11). Medieval literature's interest in "luminous" clarity is reflected, as described in Chapter 4, in the valorization of sight and the negativity of the blindfold, embodied in the figures of Ecclesia and Synagoga (figs. 4/49 and 4/50). When Taut turned to building housing for workers, "glass was simply too expensive a material to use extensively." Bletter at 42. She further argued that, ironically, what was seen as the "revolutionary" aspect of Expressionist reliance on glass was in fact a "richly traditional" feature. Id. at 43.

**36** Dennis Sharp, *Introduction*, p. 8 in the double volume PAUL SCHEERBART, GLASS ARCHITECTURE (James Palmes, trans., New York, NY: Praeger, 1972) (hereinafter GLASS ARCHITECTURE), and BRUNO TAUT, ALPINE ARCHITECTURE (Shirley Palmer, trans., New York, NY: Praeger, 1972). Exemplary was a house with glass "everywhere; walls, ceilings, floors, and even staircases were all finished in some kind of translucent or transparent material." Id. (with pictures) at 12–13.

**37** GLASS ARCHITECTURE at 71. See generally Ufuk Ersoy, Seeing through Glass: The Fictive Role of Glass in Shaping Architecture from Joseph Paxton's Crystal Palace to Bruno Taut's Glashaus (Ph.D. dissertation, U. of Pennsylvania School of Architecture, Philadelphia, PA, 2008; UMI Publication No.: AAT 3328551) (hereinafter Ersoy, Seeing through Glass).

**38** Sharp at 8.

**39** Sharp at 25–26 (with a photograph of the van der Rohe design) and at 27 (citing an article by Wright written in 1928 for the *Architectural Record*).

**40** Ludwig Hilberseimer, quoted in Terence Riley, *Light Construction*, in The Light Construction Reader at 23, 23. This essay was first published as an introduction to a catalogue of an exhibition held at the New York Museum of Modern Art in 1995: Terence Riley, Light Construction (New York, NY: Museum of Modern Art, distributed by Harry N. Abrams, 1995).

**41** Fierro at 27.

**42** Ockman, *Light Construction Symposium*, in The Light Construction Reader at 67.

**43** See Colin Rowe & Robert Slutzky, *Transparency: Literal and Phenomenal*, Part I, 8 Perspecta 45 (1963); Colin Rowe & Robert Slutzky, *Transparency: Literal and Phenomenal*, Part II, 13–14 Perspecta 287 (1971).

**44** Eeva-Liisa Pelkonen, *The Glaze: Phantasm and Modern Architecture*, in The Light Construction Reader at 275, 275. This work was first published in Eeva-Liisa Pelkonen, Achtung Architektur! Image and Phantasm in Contemporary Austrian Architecture (Cambridge, MA: MIT Press, 1996).

**45** Fierro at 29 (emphasis in original).

**46** Fierro at xii. The Pompidou (also known as the Beaubourg) is analyzed at 44–93.

**47** Fierro at 37.

**48** Fierro at 31 (emphasis in the original).

**49** Fierro at 35 (emphasis in the original). On the other hand, some of the projects were located near areas of economic distress and provided park space to working-class neighborhoods, offering "political appeasements to significant voting blocks." Id.

**50** Fierro at 35. She cited the interest in " 'open institutions' " of both Charles de Gaulle and André Malraux, who, in addition to being a renowned novelist, was also the Minister of State for Cultural Affairs. Id.

**51** Jane C. Loeffler, *New Designs of Embassies and Courthouses Expose the Politics of Architecture, But Are Architects Political Enough?* 187 Architectural Record 33, 34 (1999). See generally Jane C. Loeffler, The Architecture of Diplomacy: Building America's Embassies (Princeton, NJ: Princeton Architectural Press, 1998). The book mapped the concern about the deteriorated state of U.S. buildings in foreign countries, the funding and function of the State Department's Office of Federal Buildings Operations, and the embrace of the "International Style" for many embassies—followed by the rejection of that aesthetic. Id. at 4–12.

**52** See generally Mark Fenster, *The Opacity of Transparency*, 91 Iowa Law Review 885 (2006); Mark Fenster, *Designing Transparency: The 9/11 Commission and Institutional Form*, 65 Washington & Lee Law Review 1239 (2008).

**53** Loeffler, Architecture of Diplomacy at 12, 241. See also *Fortress America Abroad: Effective Diplomacy and the Future of U.S. Embassies: Hearing before the Subcommittee on National Security and Foreign Affairs of the Committee on Oversight and Government Reform*, 110th Cong. 20–28 (2008) (statement of Dr. Jane Loeffler). Loeffler has also explored these themes in *Embassy Design: Security vs. Openness*, 82 Foreign Service Journal 44 (Sept. 2005); in the 1980s and 1990s, security concerns produced a "profound makeover" in U.S. facilities built abroad. Id. at 47. That point is made by the title of Loeffler's course, From Glass Boxes to Bunkers: Architecture, Power, and Public Policy, offered in 2008 at the University of Maryland, College Park.

**54** Greene at 66. He read glass as conveying a sense of the courts as "open to public scrutiny, inclusive of public participation, and dependent on the support and protection of its community." Id.

**55** We borrow here from the essay *Opaque Transparency* by Rosemarie Haag Bletter, reproduced in The Light Construction Reader

at 115 and first published in 13 Oppositions 121 (1978). See also Anthony Vidler, *Fantasy, the Uncanny and Surrealist Theories of Architecture*, 1 Papers of Surrealism 1 (Winter 2003). "Glass, once perfectly transparent, is now revealed in all its opacity." Id. at 4.

**56** Ersoy, Seeing through Glass at 38. Glass functioned differently, as it served "the living body" in the realm of science and the "perceived body" in the realm of "the field of aesthetics." Id. at 52.

**57** Riley, *Light Construction*, in The Light Construction Reader at 26 (citing Anthony Vidler for the term "blockage" and using Marcel Duchamp's *Large Glass* as an example of a "threshold").

**58** Fierro at 29.

**59** See Herbert Muschamp, *Buildings That Hide and Reveal*, in The Light Construction Reader at 43–45. The review appeared in the *New York Times* in September 1995 and called the Museum of Modern Art's show a "painfully frustrating muddle." Id. at 43.

**60** See Carlo Aymonino, *Palazzo di Giustizia di Lecce, Italia*, 14 Zodiac 128, 128 (1995). See also Administrative Office of the U.S. Courts, U.S. Courts Design Guide 3-10 and 14-7 to 14-13 (Washington, DC: U.S. Government Printing Office, 4th ed., 1997) (hereinafter 1997 U.S. Courts Design Guide); Administrative Office of the U.S. Courts, U.S. Courts Design Guide 3-10 and 16-6 (Washington, DC: U.S. Government Printing Office, 5th ed., 2007) (hereinafter 2007 U.S. Courts Design Guide); and *Les nouveaux visages de La Justice*, extraits des numéros 5125 and 5132 du Moniteur, Feb. 15, 2002, and Apr. 5, 2002 (extracts distributed by the Ministry of Justice and the AMOTMJ) at 4, discussed in Chapters 9 and 10. See also Todd S. Phillips & Michael A. Griebel, Building Type Basics for Justice Facilities 78–83 (Stephen A. Kliment, series editor, Hoboken, NJ: John Wiley & Sons, 2003); Don Hardenbergh, The Courthouse: A Planning and Design Guide for Court Facilities 27–30 (Williamsburg, VA: National Center for State Courts, American Institute of Architects, Conference of State Court Administrators, National Center for Juvenile Justice, American Bar Association, 1991).

**61** Greene at 72. Greene also discussed the standardization of weapons-screening technology at courthouse entrances and how "ubiquitous queues" to confiscate phones had become "the norm." Id. at 72.

**62** Todd S. Phillips, *Courthouse Design at a Crossroads*, in Celebrating the Courthouse at 203, 218.

**63** Phillips at 223, 224.

**64** Phillips at 204.

**65** See General Accounting Office, *Courtroom Construction: Better Courtroom Use Data Could Enhance Facility Planning and Decisionmaking*, GAO/GGD-97-39 at 23 (1997); *General Accounting Office, Courthouse Construction: Sufficient Data and Analysis Would Help Resolve the Courtroom-Sharing Issue*, GAO-01-70, at 8, 18 (Dec. 2000). See also Congressional Budget Office, *The One Courtroom, One-Judge Policy: A Preliminary Review* 12 (Apr. 2000), http://www.cbo.gov/doc.cfm?index=1922&type=0. Cf. Federal Judicial Center, *The Use of Courtrooms in U.S. District Courts: A Report to the Judicial Conference Committee on Court Administration & Case Management* (Project Directors Donna Stienstra and Patricia Lombard, July 18, 2008), www.fjc.gov/public.pdf.nsf/lookup/ctrmuser.pdf/$file/ctrmuser.pdf. These reports are discussed in Chapter 10.

**66** Frederic L. Lederer, *The Courtroom in the Age of Technology*, in Celebrating the Courthouse at 189, 190. Some commentators are critical of this development. See generally Linda Mulcahy, *The Unbearable Lightness of Being? Shifts Towards the Virtual Trial*, 35 Journal of Law and Society 464 (2008).

**67** Philip Gerald Thacker, Components in a Comprehensive Judiciary-Directed Facilities Program (prepared for the World Bank, Dec. 13, 2005), http://siteresources.worldbank.org/INTLAWJUSTINST/Resources/Components.pdf.

**68** Stephen C. Yeazell, *The Misunderstood Consequences of Modern Civil Process*, 1994 Wisconsin Law Review 631, 631 (1994). See

also Judith Resnik, *Managerial Judges*, 96 HARVARD LAW REVIEW 374 (1982).

**69** See Hugh O'Mahony, *Happy Birthday to the Court That Has Heard 12 Cases in Eight Years*, LLOYD'S LIST, Nov. 2, 2004. This adjective was part of O'Mahony's description of the International Tribunal for the Law of the Seas, discussed in Chapter 12.

**70** Phillips at 207. See also Randy Gragg, *Monuments to a Crime-Fearing Age*, NEW YORK TIMES MAGAZINE, May 28, 1995, at 36; Blair Kamin, *Fortress Architecture: Don't Let Terrorists Design Our Buildings*, CHICAGO TRIBUNE, Dec. 5, 1999, at C1.

**71** GRAHAM at 333.

**72** CARL R. LOUNSBURY, THE COURTHOUSES OF EARLY VIRGINIA: AN ARCHITECTURAL HISTORY at 335 (Charlottesville, VA: U. of Virginia Press, 2005).

**73** In some jurisdictions, this trend was linked to housing and transportation patterns. As an overview of Ohio courts detailed, these "modern buildings include the county jail and juvenile detention center, while offering citizens the convenience of suburban shopping malls." SUSAN W. THRANE, COURTHOUSES OF OHIO 12 (Bloomington, IN: Indiana U. Press, 2000).

**74** Judith Resnik, *Many Doors? Closing Doors? Alternate Dispute Resolution and Adjudication*, 10 OHIO STATE JOURNAL ON DISPUTE RESOLUTION 211, 216 n. 19 (1995) (citing Frank E. A. Sander, *Varieties of Dispute Processing*, The Pound Conference, 70 FEDERAL RULES DECISIONS 111 (1976)).

**75** Compare the 1997 U.S. COURTS DESIGN GUIDE at 6–32 with the 2007 U.S. COURTS DESIGN GUIDE.

**76** Phillips at 213.

**77** See generally Peggy Fulton Hora & William G. Schma, *Therapeutic Jurisprudence and the Drug Treatment Court Movement: Revolutionizing the Criminal Justice System's Response to Drug Abuse and Crime in America*, 74 NOTRE DAME LAW REVIEW 439 (1999); Bruce J. Winick & David B. Wexler, *Drug Treatment Court: Therapeutic Jurisprudence Applied*, 18 TOURO LAW REVIEW 479 (2002); DRUG COURT CLEARINGHOUSE AND TECHNICAL ASSISTANCE PROJECT, OFFICE OF JUSTICE PROGRAMS, U.S. DEPARTMENT OF JUSTICE, LOOKING AT A DECADE OF DRUG COURTS (1998), National Criminal Justice Reference Service website, http://www.ncjrs.gov.

**78** PHILLIPS & GRIEBEL at 196. The authors noted that, even though such buildings have been constructed for many decades, there was an "absence of design guidance." Id.

**79** DOUG OHMAN (photograph) & MARY LOGUE (text), COURTHOUSES OF MINNESOTA 108 (St. Paul, MN: Minnesota Historical Society Press, 2006) (hereinafter OHMAN & LOGUE).

**80** John E. Czarnecki, *A New County Courthouse Consolidates Law Enforcement, Incarceration, and Court Processes Within One Building*, 187 ARCHITECTURAL RECORD 126 (Mar. 1, 1999). The building was the La Crosse County Courthouse in Wisconsin.

**81** OHMAN & LOGUE at 108, also noting (as discussed in Chapter 3) that the word court has changed its meaning before; once it denoted the group assembled around a royal sovereign.

**82** See *Le Monument réhabilité: Les grandes options de la politique de construction judiciaire* (*The Rehabilitated Monument: Great Policy Option for Judicial Construction*), interview with Marc Moinard, 265 ARCHICRÉE 70, 70–75 (1995), English synopsis at 142. As discussed in Chapter 10, Moinard was then the Director of Judicial Services for France.

**83** Phillips at 211.

**84** As detailed in Chapter 8, William Howard Taft made that argument to the United States Congress when promoting the building of the United States Supreme Court. Hearings before the Committee on Public Buildings and Grounds, U.S. House of Rep., 70th Cong., 1st Sess., on H.R. 13665 (and others), May 16 and 18, 1928, at 7 (Statement of Hon. William Howard Taft, Chief Justice, Supreme Court of the United States).

**85** See Herbert M. Kritzer & John Voelker, *Familiarity Breeds Respect: How Wisconsin Citizens View Their Courts*, 82 JUDICATURE 58 (1998).

**86** Paul Spencer Byard, *Reading the Architecture of Today's Courthouse*, in CELEBRATING THE COURTHOUSE at 147.

**87** Byard at 142.

**88** Byard at 142.

**89** Byard at 142–143. Examples included a federal courthouse designed by Richard Meier in Islip, New York, that Byard called "striking and strictly beautiful" while "literally and figuratively a monumental white void." Id.

**90** MARLENE PARK & GERALD E. MARKOWITZ, DEMOCRATIC VISTAS: POST OFFICES AND PUBLIC ART IN THE NEW DEAL 61 (Philadelphia, PA: Temple U. Press, 1984).

**91** Figure 209 is a composite of *Justice*, Cornelis Matsys, circa 1543–1544; *Prudence*, Agostino Veneziano, 1516; *Temperance*, Agostino Veneziano, 1517; and *Fortitude*, Marcantonio Raimondi, circa 1520. Copyright: Warburg Institute. The images are reproduced courtesy of the copyright holder, the Warburg Institute, University of London, and were obtained with the assistance and guidance of Elizabeth McGrath.

**92** R. E. Houser, *Introduction*, THE CARDINAL VIRTUES: AQUINAS, ALBERT, AND PHILIP THE CHANCELLOR 1, 9–10 (R. E. Houser, trans., Toronto, Can.: Pontifical Institute of Mediaeval Studies, 2004) (hereinafter Houser, *Introduction* to THE CARDINAL VIRTUES). Here we use capitalization of the virtues, such as Justice or Prudence, only when discussing their personifications.

**93** See PLATO, THE REPUBLIC IV, 427e at 93 (G. M. A. Grube, trans., Indianapolis, IN: Hackett, 1974).

**94** Houser, *Introduction* to THE CARDINAL VIRTUES at 11. As detailed in Chapter 1, the Cardinal Virtues were interrelated and also overlapped with other sets, such that Fortitude was both a "Gift Virtue" and a Cardinal Virtue. See HELEN NORTH, SOPHROSYNE: SELF-KNOWLEDGE AND SELF-RESTRAINT IN GREEK LITERATURE 186–187 (Ithaca, NY: Cornell U. Press, 1966) (hereinafter NORTH, SOPHROSYNE).

**95** See Houser, *Introduction* to THE CARDINAL VIRTUES at 32–35. Ambrose spoke of the Virtues as "born together and perfected together." See Ambrose, *De excessu fratris Satyri*, 1.57, Corpus Scriptorum Ecclesiasticorum Latinorum 73: 239, as translated by Houser in id. at 33. As noted in the earlier discussion of the Virtues and in reference to the Israel Supreme Court (figs. 10/139, 10/140), the word *cardinal* (*cardinalis* in Latin) is derived from *cardo*, a term whose diverse meanings include the orientation of the earth's poles. (We discuss this term in Chapter 10 in reference to the placement of the Israeli Supreme Court.) Helen North identified a 478 BCE ode as the earliest recorded reference to the set as "cardinal" virtues; in the poem are "all four of the virtues later canonized by Plato . . . although only sophrosyne goes by its proper name." NORTH, SOPHROSYNE at 25.

**96** THOMAS AQUINAS, DISPUTED QUESTIONS ON VIRTUE 112 (Ralph McInerny, trans. and preface, South Bend, IN: St. Augustine's Press, 1999). Further, the other virtues were based on them. Id. While relevant to humankind, the Virtues also "remained in heaven." Id. at 133–140.

**97** AQUINAS at 105. Gregory, who lived from about 540 to 604 CE, was known as "the Great" or "the Dialogist" because of his collection of essays. Aquinas cited Gregory's *Morals on Job* 22. There Gregory offered his exegesis on the *Book of Job*, stating that "Blessed Job" displayed the unity of virtues, "viz. prudence, temperance, fortitude, and justice" that were "mutually joined to one another" because "separated they can never be perfect." GREGORY THE GREAT, MORALS ON THE BOOK OF JOB, vol. 2 at 547 (Oxford, Eng.: John Henry Parker, 1845).

**98** AQUINAS at 105. Characteristics were entailed in each other, such that "fortitude is temperate and temperance brave since one who

can restrain . . . the impulse to recklessness before mortal danger . . . can all the more easily stand firm against the allurements of desire." Id. at 110.

**99** AQUINAS at 130–131. On the other hand, individuals might have the "inclination to act" in a manner that weights one more than the other. Id. at 131.

**100** Ambrose, *De excessu fratris Satyri* as translated by Houser in THE CARDINAL VIRTUES at 33. According to Aquinas, each virtue is "principal in its own genus." DANIEL MARK NELSON, THE PRIORITY OF PRUDENCE: VIRTUE AND NATURAL LAW IN THOMAS AQUINAS AND THE IMPLICATIONS FOR MODERN ETHICS 77 (University Park, PA: Pennsylvania State U. Press, 1992). However, some read Aquinas as arguing that "prudence is 'more principal' than others." Id.

**101** NELSON at 79.

**102** Robert W. Cape Jr., *Cicero and the Development of Prudential Practice at Rome*, in PRUDENCE: CLASSICAL VIRTUE, POSTMODERN PRACTICE 35, 39 (University Park, PA: Pennsylvania State U. Press, 2003).

**103** Cape at 51–52.

**104** Cape at 51–52. Cape derived this conclusion from Cicero's *Dream of Scipio* and the commentary of Macrobius.

**105** See, for example, Alberto R. Coll, *Normative Prudence as a Tradition of Statecraft*, 5 ETHICS AND INTERNATIONAL AFFAIRS 33, 35 (1991). See generally DOUGLAS J. DEN UYL, THE VIRTUE OF PRUDENCE (New York, NY: Peter Lang, 1991).

**106** Anthony T. Kronman, *Alexander Bickel's Philosophy of Prudence*, 94 YALE LAW JOURNAL 1567 (1985); ANTHONY T. KRONMAN, THE LOST LAWYER: FAILING IDEALS OF THE LEGAL PROFESSION 14–23, 39–46 (Cambridge, MA: Harvard U. Press, 1993).

**107** Ralph Waldo Emerson, *Prudence*, in ESSAYS: FIRST AND SECOND SERIES 125, 127 (New York, NY: Vintage Books, Library of America, 1990).

**108** JOSEF PIEPER, THE FOUR CARDINAL VIRTUES: PRUDENCE, JUSTICE, FORTITUDE, TEMPERANCE 22 (Notre Dame, IN: U. of Notre Dame Press, 1966).

**109** NELSON at 81.

**110** Coll at 38.

**111** AQUINAS at 109.

**112** Houser, *Introduction* to THE CARDINAL VIRTUES at 74.

**113** See NORTH, SOPHROSYNE at 1.

**114** NORTH, SOPHROSYNE at 9.

**115** NORTH, SOPHROSYNE at 12.

**116** Houser, *Introduction* to THE CARDINAL VIRTUES at 79.

**117** PIEPER at 147.

**118** PIEPER at 147. Thus some schemas put prudence in a governance context, justice in relation to allocations and disputes, fortitude as future-looking, and temperance as the realization of inner thoughtfulness. Id.

**119** NORTH, SOPHROSYNE at 14.

**120** NORTH, SOPHROSYNE at 15–19, 268–285.

**121** NORTH, SOPHROSYNE at 21.

**122** NORTH, SOPHROSYNE at 268–270.

**123** NORTH, SOPHROSYNE at 365–366, 378–379.

**124** PIEPER at 122–133. See R. E. Houser, *The Virtue of Courage*, in THE ETHICS OF AQUINAS 304, 308–311 (Stephen J. Pope, ed., Washington DC: Georgetown U. Press, 2002) (hereinafter Houser, *The Virtue of Courage*).

**125** Suzanne Lynn Burris, Pieter Bruegel the Elder's Apocalyptic *Fortitude* 32 (M.A. thesis, U. of North Texas Department of Art History, Denton, TX, 1997; UMI Publication No.: AAT 1387854) (citing ROSEMUND TUVE, ALLEGORICAL IMAGERY: SOME MEDIEVAL BOOKS AND THEIR POSTERITY 59 (Princeton, NJ: Princeton U. Press, 1966)).

**126** PIEPER at 122 (his translation).

**127** PIEPER at 125.

**128** Houser, *The Virtue of Courage* at 312.

**129** Houser, *The Virtue of Courage* at 314–316. See also RICHARD WHITE, RADICAL VIRTUES: MORAL WISDOM AND THE ETHICS OF CONTEMPORARY LIFE 20–26 (New York, NY: Rowman & Littlefield, 2008).

**130** WHITE at 23–24.

**131** PIEPER at 122.

**132** How these connections were forged is something of a puzzle. "[T]he issue is whether the emblem depends on the invention of original but arbitrary connections between image and meaning, or whether the relation between sign and referent depends on some deeper and more intrinsic ('natural') affinity." MICHAEL BATH, SPEAKING PICTURES: ENGLISH EMBLEM BOOKS AND RENAISSANCE CULTURE 3 (London, Eng.: Longman, 1994). Bath argued that emblems were products of both arbitrary and intrinsic meaning. Further, given the diversity of codification systems, Bath doubted the effort to put them into a "a single, unitary genre." Id. at 280.

**133** Helen F. North, *Temperance (Sophrosyne) and the Canon of the Cardinal Virtues*, in DICTIONARY OF THE HISTORY OF IDEAS: STUDIES OF SELECTED PIVOTAL IDEAS, vol. IV at 365, 377 (Philip P. Wiener, ed., New York, NY: Charles Scribner's Sons, 1973) (hereinafter North, *Temperance and the Canon of the Cardinal Virtues*). North noted that Ripa and his followers were sources of some of the odder attributes and representations. Id. As we detailed in Chapters 3 and 4, Ripa initially wrote a compendium of attributes in the late sixteenth century. The first illustrated "Ripa" was published in Italy in 1603, and one of the last, the 1779 English edition by George Richardson, is, like the Maser translation, a selective rendition. See CESARE RIPA, BAROQUE AND ROCOCO PICTORIAL IMAGERY: THE 1758–60 HERTEL EDITION OF RIPA'S "ICONOLOGIA" WITH 200 ENGRAVED ILLUSTRATIONS (Edward A. Maser, ed., New York, NY: Dover, 1971) (hereinafter RIPA, MASER EDITION); CESARE RIPA, ICONOLOGIE (Jean Baudoin, ed., Paris, Fran.: Chez Mathieu Guillemot, 1644); CESARE RIPA, ICONOLOGY, LONDON 1779 IN TWO VOLUMES BY GEORGE RICHARDSON (New York, NY, & London, Eng.: Garland, 1976) (hereinafter RIPA, RICHARDSON EDITION).

The treatment of other Virtues in the various editions of Ripa paralleled that of Justice in that elaborate descriptions were provided for each. For example, the eighteenth-century Hertel-Maser edition specified that Prudence was to be shown in "a gilded helmet wreathed with mulberry leaves. On a chain around her neck hangs a skull. She looks into a mirror which she holds in one hand. In her other hand she has an arrow around which an eel is wound. Behind her lies a huge stag." That version further reported that Ripa cited Alciatus as describing the mulberry as "a most cautious tree" and invoked Pliny for the proposition that the eel "has the power of dragging [a ship] to a halt with its weight and strength," thereby signifying "a brake on speedy decisions." RIPA, MASER EDITION at 179. The same edition of Ripa specified that Temperance was to be clad in purple, "a color made up of two very different colors" of which neither "component color" is dominant. She was to hold a bridle and the "balance wheel of a clock" to tell "when it is time for action and time for quiet." RIPA, MASER EDITION at 149.

The Hertel-Maser edition did not contain an image of Fortitude, but the 1779 Richardson edition depicted Fortitude with a column and lion. She was shown "partly in military dress . . . signify[ing] bodily courage, and the power of resisting difficulties and dangers." Her "brown robes allude to the colour of a lion," cited as an Egyptian symbol of strength; the column upon which she rested "denotes fortitude of mind, as the column is one of the strongest parts of an edifice and generally supports the superstructure." Her spear was to "denote authority." RIPA, RICHARDSON EDITION at 22.

**134** The sources and more details are provided in Chapters 1, 3, and 4 and their endnotes.

**135** North, *Temperance and the Canon of the Cardinal Virtues* at 374.

**136** NORTH, SOPHROSYNE at 386. North attributed the popularity of the bridle (seen in fig. 209) to a Temperance depicted by Giotto. North, *Temperance and the Canon of the Cardinal Virtues* at 372.

**137** See, for example, Giotto's *Fortitude* of 1305 in the Scrovegni Chapel in Padua, Italy; Giovanni Bellini's *Fortitude* of 1470 in the collection of the Getty Museum in Los Angeles, California; Paolo Uccello's *Fortitude* of 1435 in the Prato Cathedral in Prato, Italy; Luca Giordano's *Allegory of Fortitude* of the 1680s (likely intended for the Palazzo Medici Riccardi in Florence) in the collection of the National Gallery, London. Just as Justice had a symbolic relationship to St. Michael, so did Fortitude—sometimes depicted "grasping a dragon by its neck." Burris at 6.

**138** See RIPA, MASER EDITION at 149 (attributing this view to Piero Valeriano).

**139** North, *Temperance and the Canon of the Cardinal Virtues* at 365, 371; NORTH, SOPHROSYNE at 381–384. Fortitude, Temperance, and Justice were also regularly on Tarot cards, while Prudence appeared more rarely.

**140** Their deployment over a thousand years, North argued, provided "an accurate indication of the ebb and flow of interest in Platonic-Stoic ethics." North, *Temperance and the Canon of the Cardinal Virtues* at 378.

**141** Barbara Ghelfi, *Alessandro Tiarini as a Draftsman*, 40 MASTER DRAWINGS 213, 219, fig. 7 (2002).

**142** See Roberta Kevelson, *Icons of Justice / Spirit of Laws*, 7 INTERNATIONAL JOURNAL FOR THE SEMIOTICS OF LAW 227 (1994). Kevelson objected that the balance "presuppose[d] a closed universe, a model in which constancy, absoluteness, stability and predictable order" existed as hallmarks of "firm principle" and, invoking Montesquieu, called for images denoting motion and change in the name of justice. Id. at 228, 239.

**143** The photograph that is reproduced in figure 210 was provided to us by the Detroit Institute of Arts, which authorized its use. The Nail Figure from Kongo, dated 1875–1900, was a Founders Society Purchase (Eleanor Clay Ford Funds for African Arts, 1976). The Detroit Institute of Art attributed this version to the Kongo people and also noted that it could be from Western Kongo, Mayombe, or Yombe. The Art Institute classified the figure as either a "Nkonde," a "power figure," a "nail fetish," or "nkisi-n'kondi." Our understanding of these figures has been enriched through excellent research by Maria Burnett, Allison Tait, and Sophie Hood and from our exchange with Wyatt MacGaffey.

**144** See Robert Farris Thompson, *Kongo Power Figure*, in PERSPECTIVES: ANGLES ON AFRICAN ART 180, 180 (New York, NY: Center for African Art and Harry N. Abrams, 1987) (hereinafter Thompson, *Kongo Power Figure*).

**145** See Wyatt MacGaffey, *Complexity, Astonishment and Power: The Visual Vocabulary of Kongo Minkisi*, 14 JOURNAL OF SOUTHERN AFRICAN STUDIES 188 (1988) (hereinafter MacGaffey, *Complexity, Astonishment*). "*Nkisi* is a Kikongo word that has no near equivalent in English." Id. at 188. Not only is the term hard to translate, but the objects so denoted were themselves used in different cultures. See Dunja Hersak, *There Are Many Kongo Worlds: Particularities of Magico-Religious Beliefs among the Vili and Yombe of Congo-Brazzaville*, 71 AFRICA: JOURNAL OF THE INTERNATIONAL AFRICAN INSTITUTE 614 (2001).

**146** MacGaffey, *Complexity, Astonishment* at 188. See also WYATT MACGAFFEY, KONGO POLITICAL CULTURE: THE CONCEPTUAL CHALLENGE OF THE PARTICULAR 97–133 (Bloomington, IN: Indiana U. Press, 2000) (hereinafter MACGAFFEY, KONGO POLITICAL CULTURE).

**147** MacGaffey, *Complexity, Astonishment* at 189. See also ART AND HEALING OF THE BAKONGO COMMENTED BY THEMSELVES: MINKISI FROM THE LAMAN COLLECTION (Kikongo texts translated and edited by Wyatt MacGaffey, Stockholm, Swed.: Folkens Museum, 1991).

**148** Hersak at 615.

**149** Hersak at 618 (quoting FRANK HAGENBUCHER-SACRIPANTI, SANTÉ ET RÉDEMPTION PAR LES GÉNIES AU CONGO (Paris, Fran.: 2nd ed., 1992).

**150** MacGaffey, *Complexity, Astonishment* at 202. At times, "irrelevant European categories are imposed" on these objects. Wyatt MacGaffey & John M. Janzen, *Nkisi Figures of the Bakongo*, 7 AFRICAN ARTS 87, 87 (1974).

**151** MacGaffey, *Complexity, Astonishment* at 190.

**152** MacGaffey, *Complexity, Astonishment* at 190.

**153** MacGaffey, *Complexity, Astonishment* at 191–192. "All powerful charms . . . were composite, in [various] senses. A plain wooden statue, 'empty' (*mpamba*), had no power until 'ingredients' were sealed into a receptacle on its head, belly, or elsewhere." MacGaffey & Janzen at 87. Through the assembly of ingredients, powerful charms were "supposed to contain a 'spirit'" from a long-dead ancestor returning to assist descendants. Id.

**154** For example, in some cultures the "healing function" may entail "chasing off or destroying the witch who . . . caused the illness." See MacGaffey & Janzen at 87. A *nkisi* was "regarded as the master of particular diseases, able to cure them in its clients or inflict them on persons against whom it was activated." Id.

**155** MACGAFFEY, KONGO POLITICAL CULTURE at 95.

**156** MacGaffey, *Complexity, Astonishment* at 191–192.

**157** MacGaffey & Janzen at 87. See also Wyatt MacGaffey, *Fetishism Revisited: Kongo Nkisi in Sociological Perspective*, 47 AFRICA: JOURNAL OF THE INTERNATIONAL AFRICAN INSTITUTE 172 (1977). MacGaffey explained that the term "fetish" ought to be avoided because of its negative connotations that appreciated neither the role of magic nor the figures' relation to religious practices.

**158** Thompson, *Kongo Power Figure* at 180. Thompson later authored an essay reviewing an art exhibit of *minkisi* figures guest-curated by MacGaffey. See Robert Farris Thompson, *Illuminating Spirits: "Astonishment and Power" at the National Museum of African Art*, 26 AFRICAN ARTS 60 (1993). Another reference suggesting the relationship of these figures to the law comes from CYNTHIA FREELAND, BUT IS IT ART? AN INTRODUCTION TO ART THEORY 65, fig. 9 (Oxford, Eng.: Oxford U. Press, 2001). A good many museums feature these objects in their collections. See, for example, *Recent Acquisitions: A Selection 2007–2008*, 66 METROPOLITAN MUSEUM OF ART BULLETIN 40 (2008). Reproduced was the newly displayed *Mangaaka Power Figure* (*Nkisi N'kondi*).

**159** Thompson described a "whole legal process" for the "driving-in of the blades." Thompson, *Kongo Power Figure* at 180. See also Wyatt MacGaffey, *Aesthetics and Politics of Violence in Central Africa*, 13 JOURNAL OF AFRICAN CULTURAL STUDIES 63, 66 (2000) (hereinafter MacGaffey, *Aesthetics and Politics of Violence*).

**160** Zdenka Volavkova, *Nkisi Figures of the Lower Congo*, 5 AFRICAN ARTS 52, 56 (1972). MacGaffey and Janzen disagreed, noting a story they dated from the sixteenth century in which nails were credited with causing wreckage. MacGaffey & Janzen at 88. "Missionary use of stabbed and bleeding madonnas for teaching purposes may have contributed to the development of nail fetishes, but if so . . . on entirely African terms." Id. Volavkova replied that MacGaffey and Janzen, embedded in the discipline of anthropology, missed the opportunity for a dialogue with art historians and wrongly presumed her lack of understanding of the context and history. See Zdenka Volavkova, *Once Again on the Kongo Nkisi Figures*, 7 AFRICAN ARTS 89 (1974) (hereinafter Volavkova, *Once Again*). She also disagreed about how to date and evaluate the narratives on which MacGaffey and Janzen based some of their claims.

**161** Volavkova, *Once Again* at 90.

**162** Volavkova, *Once Again* at 90.

**163** Volavkova, *Once Again* at 89.

**164** MacGaffey, *Complexity, Astonishment* at 199. See also Mac-Gaffey, *Aesthetics and Politics of Violence* at 64–65.

**165** MacGaffey, *Aesthetics and Politics of Violence* at 65. See also MacGaffey, Kongo Political Culture at 104–108.

**166** MacGaffey & Janzen at 88. The purpose of the action was to "'hammer in a curse.'" Id.

**167** Papier, *Preface*, in The Federal Constitutional Court of Germany at 7–8.

**168** Jutta Limbach, *Working in the Federal Constitutional Court*, in Federal Constitutional Court of Germany at 45.

**169** See Palace of Justice Truth Commission, Final Report of the Commission of Truth for the Holocaust in the Palace of Justice of Bogotá of 6 and 7 November 1985 (Bogota, Colom.: Palace of Justice Truth Commission, Dec. 17, 2006), http://www.verdadpalacio.org.co/Assets/DOCs/INFORME-FINAL-CVPJ.pdf. See also Christina Lleras Figueroa, Memoria del Palacio de Justicia en El Museo Nacional de Colombia: Una Historia Que No Se Acaba de Contar, ISSN 1909-5920 (2008), http://www.museonacional.gov.co/cuadernos.html; Gabriel Marcella, Democratic Governance and the Rule of Law: Lessons from Colombia 15 (Carlisle, PA: Strategic Studies Institute of the U.S. Army War College, Dec. 2009).

**170** See *Tras 13 Años Hay Palacio De Justicia* (*After 13 Years, There Is a Palace of Justice*), El Tiempo, Nov. 11, 1998 (translated by Sophie Hood). Another commemorative element is a crucifix that survived the fire. Correspondence with Manuel José Cepeda, former Justice of the Supreme Court of Colombia, Dec. 7, 2009.

**171** See Heinz Klug, *Historical Background*, in Constitutional Law of South Africa 2-12 to 2-19; Matthew Chaskalson, et al., eds., 1st ed., Kenwyn, S.A.: Juta, 1996); Albie Sachs, *The Creation of South Africa's Constitution*, 41 New York Law School Law Review 669 (1997).

**172** S. Afr. Const. 1996, preamble. In addition, the Constitution states that its judges, when interpreting its Bill of Rights, "must consider international law" and "may consider foreign law." S. Afr. Const. 1996, § 39. This interactive sovereign identity has resulted, in a relatively short time, in the South African Constitutional Court's both citing and being cited by its counterparts. See, for example, Frank I. Michelman, *The Constitution, Social Rights, and Liberal Political Justification*, 1 International Journal of Constitutional Law 13 (2003); Judith Resnik, *Law as Affiliation: "Foreign" Law, Democratic Federalism, and the Sovereigntism of the Nation-State*, 6 International Journal of Constitutional Law 33 (2008).

**173** S. Afr. Const. 1996, § 165(2). The Constitutional Court is one part of a textured approach to justice in post-Apartheid South Africa. As noted in Chapter 12, South Africa famously established a "Truth and Reconciliation Commission" that provided a public accounting and had the power to provide amnesty to those who came "forward to provide a full disclosure of their misdeeds." See S. Sandile Ngcobo, *Truth, Justice, and Amnesty in South Africa: Sins from the Past and Lessons for the Future*, 8 Ius Gentium 1, 2 (2002). A personal account of the history of both institutions comes from Albie Sachs, The Strange Alchemy of Life and Law (Oxford, Eng.: Oxford U. Press, 2009).

**174** S. Afr. Const. 1996, § 165(3)–(4).

**175** S. Afr. Const. 1996, § 34. For example, in 2007 the Constitutional Court held that criminal appeals had to be argued in open court. See, for example, *Shinga v. State and The Society of Advocates (Pietermaritzburg Bar)*, 2007 (5) BLCR 474 (CC) (S. Afr.), South African Legal Information Institute, http://www.saflii.org/za/cases/ZACC/2007/3.pdf.

**176** S. Afr. Const. 1996, § 33(2) ("Everyone whose rights have been adversely affected by administrative action has the right to be given written reasons").

**177** S. Afr. Const. 1996, § 35.

**178** S. Afr. Const. 1996, § 32(1). "National legislation must be enacted to give effect to this right, and may provide for reasonable measures to alleviate the administrative and financial burden on the state." Id. at § 32(2).

**179** See *Doctors for Life International v. Speaker of the National Assembly and Others*, 2006 (12) BCLR 1399 (CC) (S. Afr.); see also *Matatiele Municipality and Others v. President of the Republic of South Africa and Others*, 2007 (1) BCLR 47 (CC) (S. Afr.); *Merafong Demarcation Forum and Others v. President of the Republic of South Africa and Others*, 2008 (5) SA 171 (CC) (S. Afr.). The majority in *Merafong* reaffirmed the constitutional obligation to facilitate public involvement while concluding that the local government had discharged its duty to encourage participation. Our thanks to Elizabeth Brundige for pointing us to this line of cases.

**180** See S. Afr. Const. 1996, at § 26 ("Housing"); id. at § 27 ("Health care, food, water and social security"); id. at § 29 ("Education"). The Constitution also limits the state's obligations. On housing, for example, the "state must take reasonable legislative and other measures, within its available resources, to achieve the progressive realisation of this right." Id. at § 26(2). See also Michelman at 14–18.

**181** See generally Robin West, Progressive Constitutionalism: Reconstructing the Fourteenth Amendment (Durham, NC: Duke U. Press, 1994).

**182** S. Afr. Const. 1996, § 166.

**183** S. Afr. Const. 1996, § 167.

**184** S. Afr. Const. 1996, § 38.

**185** See generally Kate O'Regan, *Human Rights and Democracy—A New Global Debate: Reflections on the First Ten Years of South Africa's Constitutional Court*, 32 International Journal of Legal Information 200, 202–207 (2004); see Stuart Woolman, *Dignity*, ch. 36 in Constitutional Law of South Africa (Stuart Woolman, Theunis Roux, & Michael Bishop, eds., Cape Town, S.A.: Juta, 2nd ed., 2004). The *Constitutional Court Review* is a volume published annually on the Constitutional Court's jurisprudence. See Constitutional Court Review (Pretoria, S.A.: Pretoria U. Law Press), http://www.pulp.up.ac.za/cat_2009_04.html.

**186** Not all share this appraisal. See, for example, Jonathan Lewis, *The Constitutional Court of South Africa*, 125 Law Quarterly Review 440 (2009); Stu Woolman, *The Amazing, Vanishing Bill of Rights*, 124 South African Law Journal 762 (2007).

**187** See Theunis Roux, *Principle and Pragmatism on the Constitutional Court of South Africa*, 7 International Journal of Constitutional Law 106 (2009). Roux reported that some social science survey data indicated that the court did not "enjoy a great deal of public support" but was nonetheless "secure." Id. at 107. See also James L. Gibson, *The Evolving Legitimacy of the South African Constitutional Court*, in Justice and Reconciliation in Post-Apartheid South Africa 229–266 (François du Bois & Antje du Bois-Pedain, eds., Cambridge, Eng.: Cambridge U. Press, 2008). Gibson reported on three national surveys aiming to measure "legitimacy." He found that popular approval of the court was intertwined with that of the Parliament, that black South Africans seemed more willing than whites to be supportive and that, in general, among various racial groups, approval of the court was "more widespread in 2004" than it had been in the past. Id. at 262. Others have noted particular hostility to specific court rulings. See Lynn Berat, *The Constitutional Court of South Africa and Jurisdictional Questions: In the Interest of Justice?* 3 International Journal of Constitutional Law 39 (2005).

**188** Albie Sachs, *Art and Freedom*, in Art and Justice: the Art of the Constitutional Court of South Africa 17, 17 (New York, NY: David Krut Publishing, 2008). We refer to this essay hereinafter as Sachs, *Art and Freedom* and to the book as Art and Justice: South Africa. Both this volume and the other book on the court are comprised of a series of commentaries by various authors.

**189** Sachs, *Art and Freedom* at 17. Other parts of the government did reappropriate extant buildings. See Federico Freschi, *Post-apartheid Publics and the Politics of Ornament: Nationalism, Identity, and the Rhetoric of Community in the Decorative Program of the New Constitutional Court, Johannesburg*, 54 AFRICA TODAY 27, 34 (2007).

**190** Sachs, *Art and Freedom* at 17.

**191** The photograph in figure 211, of the facade of the Constitutional Court of South Africa, Johannesburg, South Africa, is by Angela Buckland. This photograph is reproduced with the permission of the copyright holder, the Constitutional Court Trust (2005), and courtesy of the Constitutional Court Trust and David Krut Publishing. We have learned a great deal about the court and its law, building, and art with the help of Justices Albie Sachs, Kate O'Regan, Sandile Ngcobo, and Richard Goldstone of the South African Constitutional Court; Justice Ruth Bader Ginsburg and Linda Greenhouse from the United States; our colleague James Silk; colleagues and former or current students, including Elizabeth Brundige, Maria Burnett, Bonnie Meyersfeld, and Chesa Boudin; and from Leslie Rigby. Special thanks are due to Bronwyn Law-Viljoen for enabling us to obtain and use many of the photographs shown here.

**192** The alphabet font was designed by Garth Walker who borrowed shapes and colors from neighborhood street signs (some hand-painted) and from local graffiti. He said that he was inspired when walking around the Old Fort Prison and finding words scratched "into the walls . . . [by] someone" who had been incarcerated there. ART AND JUSTICE: SOUTH AFRICA at 54–55, 64.

**193** Ruth Bader Ginsburg, *Foreword* to ART AND JUSTICE: SOUTH AFRICA at 11.

**194** In 2006, Andrew Makin and Janina Masojada headed the design workshop "OMM" in Durban, South Africa, that "became formalised in 1997" upon winning the competition to design the South African Constitutional Court. Paul Wygers was then a Johannesburg-based architect heading Urban Solutions Architecture and Urban Designers, which began in 1994. See ART AND JUSTICE: SOUTH AFRICA, back jacket cover.

**195** Andrew Makin, *Art and Architecture*, in ART AND JUSTICE: SOUTH AFRICA at 37 (hereinafter Makin, *Art and Architecture*).

**196** LIGHT ON A HILL: BUILDING THE CONSTITUTIONAL COURT OF SOUTH AFRICA (Bronwyn Law-Viljoen, ed., Angela Buckland, photographer, Parkwood, S.A.: David Krut Publishing, 2008). This volume includes both general and signed commentary, and our citations thus vary to specify authors when appropriate.

**197** See ART AND JUSTICE: SOUTH AFRICA.

**198** Makin in LIGHT ON A HILL at 134.

**199** Bronwyn Law-Viljoen & Karen Nel, *Art and Justice*, in ART AND JUSTICE: SOUTH AFRICA at 113 (hereinafter Law-Viljoen & Nel, *Art and Justice*).

**200** Law-Viljoen & Nel, *Art and Justice* at 113.

**201** The photograph in figure 212 of the Foyer of the Constitutional Court of South Africa was taken by Angela Buckland and is reproduced with permission of the copyright holder, the Constitutional Court Trust (2005), and courtesy of the Constitutional Court Trust and David Krut Publishing.

**202** Janina Masojada and Andrew Makin, in LIGHT ON A HILL at 60.

**203** Sachs in LIGHT ON A HILL at 45

**204** These chandeliers, designed by Walter Oltmann, were made from strips of aluminum and brass; the shape referenced the "traditional craft of basketry" used for "containers and fish traps." *Craft Transformed: Chandeliers, Lamps, Court Chamber Doors, Nosings*, in ART AND JUSTICE: SOUTH AFRICA at 96–99. The brass stair nosings, installed to avoid slippage on steps, are shown at 108–109.

**205** Sachs, *Art and Freedom* at 17, 19. The logo was designed by Carolyn Parton. Id. at 17.

**206** Sachs, *Art and Freedom* at 19.

**207** JEREMY BENTHAM, RATIONALE OF JUDICIAL EVIDENCE (1827) (hereinafter BENTHAM, RATIONALE), in 6 THE WORKS OF JEREMY BENTHAM, bk. II, ch. X at 354 ("Of Publicity and Privacy, as Applied to Judicature In General, and to the Collection of the Evidence In Particular") (John Bowring, ed., Edinburgh, Scot.: William Tait, 1843).

**208** Mandela was held in the Old Fort Prison; his long-term imprisonment was at Robben Island Prison off of Cape Town, where he was held for almost twenty years. In 1999 that former prison was designated a World Heritage Site. See Myra Shackley, *Potential Futures for Robben Island: Shrine, Museum or Theme Park?* 7 INTERNATIONAL JOURNAL OF HERITAGE STUDIES 355 (2001).

**209** The photograph in figure 213, showing the barbed wire in the court complex, was taken in 2004 and is reproduced with the permission of the photographer, Maria E. Burnett.

**210** Paul Wygers, *Storing Knowledge*, in LIGHT ON A HILL at 78. The library was designed as a "fourth component" to be independently coherent. Id. Within it is an exhibition gallery. Id. at 81. The "Rex Welsh Collection" of books is housed in the Welsh Tower. Id. at 94.

**211** The photograph in figure 214, of the cell block in the interior courtyard, was taken by Angela Buckland and is reproduced with permission of the copyright holder, the Constitutional Court Trust (2005), and courtesy of the Constitutional Court Trust and David Krut Publishing.

**212** The photograph in figure 215, providing an interior view from an Old Fort Prison cell, was taken in 2004 by Maria E. Burnett and is reproduced with her permission.

**213** Taryn Lamberti, *Mandela Names Winning Architects*, BUSINESS DAY (South Africa), April 9, 1998, at 4.

**214** *Palais Monclar, Cour d'appel d'Aix-en-Provence* 10 (Paris, Fran.: Ministère de la Justice, 1997). The brochure on the building spoke of the "reappropriation of the site" and mentioned that it had been "a space of exclusion," a free-standing prison chartered shortly before the French Revolution. Because of dislocation by the Revolution and an absence of financing, the prison building was not completed until the 1830s. The history of that prison included an escape in the 1940s by some members of the Resistance. The renovations permit one to see both foundation stones and the old prison wall. Id. at 5 and 7. LA NOUVELLE ARCHITECTURE JUDICIAIRE: DES PALAIS DE JUSTICE MODERNES POUR UNE NOUVELLE IMAGE DE LA JUSTICE (NEW JUDICIAL ARCHITECTURE: MODERN COURTHOUSES AND A NEW IMAGE OF JUSTICE) 21–27 (Paris, Fran.: La documentation Française, 2000).

**215** Sachs in LIGHT ON A HILL at 15.

**216** LIGHT ON A HILL at 7; Freschi at 36.

**217** Freschi at 37.

**218** LIGHT ON A HILL at 15.

**219** LIGHT ON A HILL at 7.

**220** LIGHT ON A HILL at 7.

**221** Sachs in LIGHT ON A HILL at 15.

**222** Sachs in LIGHT ON A HILL at 15.

**223** Freschi at 28.

**224** LIGHT ON A HILL at 8. Included on the jury were its chair, Charles Correa, an architect from India; Geoffrey Bawa from Sri Lanka; and local architects as well as Peter Davey, the editor of the British *Architectural Review*; Justice Albie Sachs; Thenjiwe Mtintso; and the Mayor of Johannesburg. Id. Information about the competition and the finalists can be found in an August 1998 edition of *South African Architect* dedicated especially to South Africa's Constitutional Court. See SOUTH AFRICAN ARCHITECT 27–51 (Aug. 1998).

**225** Thenjiwe Mtintso in LIGHT ON A HILL at 32; see also Albie Sachs, *Judge and Jury*, SOUTH AFRICAN ARCHITECT 27, 29 (Aug. 1998).

**226** Justice Yvonne Mokgoro in LIGHT ON A HILL at 31.

**227** Sachs in LIGHT ON A HILL at 27.

**228** See Constitutional Court of South Africa—The Court, http://www.constitutionalcourt.org.za/site/thecourt/thebuilding.htm. That website gives the space as 95,000 square meters and the cost as

492 million rand. Also noted is that, in addition to providing open access, the courts makes guided tours available (for small fees) for individuals and groups. See also Freschi at 36.

229 Masojada in LIGHT ON A HILL at 148.

230 Masojada in LIGHT ON A HILL at 148.

231 Masojada in LIGHT ON A HILL at 154.

232 Masojada in LIGHT ON A HILL at 39.

233 Masojada in LIGHT ON A HILL at 40.

234 LIGHT ON A HILL at 75. The ribbon window is set in a wall with bricks taken from the old jail.

235 LIGHT ON A HILL at 75.

236 Sachs in LIGHT ON A HILL at 55.

237 Masojoda in LIGHT ON A HILL at 147.

238 LIGHT ON A HILL at 140.

239 Sachs, *Art and Freedom* at 17. Justice Sachs put that sum in dollars; the grant was 10,000 South African rand. See The Constitutional Court of South Africa Art Collection, http://concourt.artvault.co.za/overview.php.

240 Sachs, *Art and Freedom* at 19. A detail of the tapestry is displayed on that page.

241 Sachs, *Art and Freedom* at 23. Unlike some other courts, the South African Constitutional Court had a policy of "not accepting any support from private firms or individuals" that could be involved in litigation before it. Id. at 22. The contributions came from various sources, including the Netherlands, Flanders, Sweden, the Ford Foundation, Tides, the Flora Family Foundation, and the Donald Rubin Foundation. Id. at 23.

242 Sachs, *Art and Freedom* at 21.

243 See Law-Viljoen & Nel, *Art and Justice* at 113. The stamp collection depicting the Constitutional Court's artwork was issued in June 2009. See South African Post Office, http://www.sapo.co.za/philately/Constitutional%20Hill%20Series%20main.html.

244 Law-Viljoen & Nel, *Art and Justice* at 116.

245 Sachs, *Art and Freedom* at 22–23; examples can be found at 42–49 (security gates) and 50–53 (carved wooden doors).

246 Makin, *Art and Architecture* at 37 (emphasis in the original).

247 Janina Masojada, *Calling All Artists, Crafters and Designers*, in ART AND JUSTICE: SOUTH AFRICA at 38. A meeting was held in 2001 at the Old Fort Prison to which artists were invited for a briefing on the project. Id.

248 Ginsburg, *Foreword* to ART AND JUSTICE: SOUTH AFRICA, at 11.

249 Reproductions can be found in ART AND JUSTICE: SOUTH AFRICA at 34–35.

250 *Variety and Individual Expression*, in ART AND JUSTICE: SOUTH AFRICA at 64.

251 The "blindfolded woman eternally holding the scales of justice seemed to be a tired, imported cliché, out of step with the intense longing for equal justice in our deeply divided society." See Sachs, *Art and Freedom* at 17.

252 *Variety and Individual Expression*, in ART AND JUSTICE: SOUTH AFRICA at 64.

253 Law-Viljoen and Nel, *Art and Justice* at 114.

254 *Collective Creativity: Court Chamber Carpet, Flag, Acoustic Banners, Mosaics*, in ART AND JUSTICE: SOUTH AFRICA at 82, 86.

255 ART AND JUSTICE: SOUTH AFRICA at 130–131. A group of anti-Apartheid leaders were seized in Rivonia; eight were tried in 1963 and 1964 and given life sentences. Mandela was the last to be released after serving 9,377 days incarcerated. On the sculpture, each prison sentence is represented by "six vertical lines crossed out by a diagonal . . . marching relentlessly across the surface of the black granite [to] convey the hopelessness of time marked and measured." Id. at 130.

256 Law-Viljoen and Nel, *Art and Justice* at 116. See also id. at 123–125. This work has come to be referred to as the "blue dress," and it also adorns the cover of the memoirs of Justice Sachs. See SACHS, THE STRANGE ALCHEMY OF LIFE AND LAW.

257 Judith Mason, *The Man Who Sang and the Woman Who Kept Silent*, in ART AND JUSTICE: SOUTH AFRICA at 123.

258 ART AND JUSTICE: SOUTH AFRICA at 123. Other art in the court commemorates the efforts of many others. For example, Sue Williamson's *A Few South Africans* is a series of sceenprint collages honoring those who fought for equality. Id. at 152–153. David Goldblatt provides a photograph, *Twenty-Six Punishment Cells*, showing cells and lavatories. Id. at 156–157.

259 Sachs recounted that the artist stated: "'This is not the armour of God, it is all I can give to my deceased sister.'" See Alan Lipman, *Constitutional Spendour*, ARCHITECTURE: JOURNAL OF THE SOUTH AFRICAN INSTITUTE OF ARCHITECTS 16 (July–Aug. 2004).

260 Law-Viljeon and Nel, *Art and Justice* at 116.

261 Judith Mason, *The Man Who Sang and the Woman Who Kept Silent*, in ART AND JUSTICE: SOUTH AFRICA at 123.

262 See, for example, Lipman at 16–18. "This is no Kafkaesque castle, no bureaucratic citadel." Id. at 18. See also Schalk Le Roux and Devilliers Du Toit, *Centre Court: South Africa's Constitutional Court*, 216 ARCHITECTURAL REVIEW 64 (2004). On the other hand, Freschi called it "a middle-of-the-road postmodern structure, which could be located anywhere in the industrialized world." Freschi at 45.

263 Freschi at 30. A 2006 national survey by the South African Institute of Architects voted the court the "'best building.'" Id.

264 Karina Landman, *Exploring the Impact of Gated Communities on Social and Spatial Justice and Its Relation to Restorative Justice and Peace-Building in South Africa*, in RESTORATIVE JUSTICE: POLITICS, POLICIES AND PROSPECTS 134, 138 (Elrena van der Spuy, Stephan Parmentier, & Amanda Dissel, eds., Capetown, S.A.: Juta, 2007). The murder rate had decreased since the 1990s (down from 77 murders per 100,000 people in 1994–1995 to under 40 per 100,000 in 2005–2006) but was still "more than seven times the world average." Id. at 137. See also ANTONY ALTBEKER, A COUNTRY AT WAR WITH ITSELF: SOUTH AFRICA'S CRISIS OF CRIME (Johannesburg, S.A.: Jonathan Ball, 2007). Altbeker argued that the South African crime problem was acute because of both its frequency and the level of violence.

265 DIANA R. GORDON, TRANSFORMATION AND TROUBLE: CRIME, JUSTICE, AND PARTICIPATION IN DEMOCRATIC SOUTH AFRICA 20 (Ann Arbor, MI: U. of Michigan Press, 2006).

266 GORDON at 275.

267 CONSTITUTIONAL COURT OF SOUTH AFRICA, ANNUAL STRATEGIC/BUSINESS PLAN 2008/2009, http://www.info.gov.za/view/DownloadFileAction?id=93529.

268 INTERNATIONAL BAR ASSOCIATION, BEYOND POLOKWANE: SAFEGUARDING SOUTH AFRICA'S JUDICIAL INDEPENDENCE 5, 23 (London, Eng.: International Bar Association, Human Rights Institute Report, July 2008). Our thanks to Harvey Dale for bringing these materials to our attention. The report concluded that the overall "tenor" of legislation made it all the more important for the judiciary to have control over its internal operations and rulemaking, and suggested that formal mechanisms for complaints and codes of conduct for judges needed to be developed. Id. at 49–51.

269 Concerns about the country and its courts' future come from admirers, one of whom reported in 2008 that it was "impossible to visit the court . . . without wondering what happened to all the hope of those days." Daniel Browde, *The Fine Art of South African Justice*, BUSINESS DAY (SOUTH AFRICA), Sept. 5, 2008.

270 Cited throughout this section are several booklets published by the Supreme Court of Mexico about the artwork of the 1940s. Two color brochures are in English, one titled MEXICO'S SUPREME COURT OF JUSTICE (1997) and another called NATION'S SUPREME COURT OF JUSTICE: INTEGRATION AND OPERATION OF THE FEDERAL JUDICIARY (1997). Two other brochures are in Spanish, one a glossy fold-out brochure, SUPREMA CORTE DE JUSTICIA DE LA NACIÓN (NATION'S SUPREME COURT OF JUSTICE) (undated), and the other a monograph titled *Los Murales de José Clemente Orozco en el Edificio Sede de la*

*Suprema Corte de Justicia de la Nación* (*The Murals of Jose Clemente Orozco in the Main Building of the Supreme Court of Justice of the Nation*) (2006). The glossy color brochures offer descriptions that celebrate the murals while noting some of their critical content, while the monograph explores more of the negative commentary on Mexico.

**271** The photographs in figures 216–220 were provided by and are reproduced with the permission of the Committee of Government and Administration of the Supreme Court of Justice through the Sept. 29, 2006, Order 2200/2006. Our thanks to Justices José Ramón Cossío Diaz and Olga María Sánchez Cordero de García Villegas; to Mónica Castillejos, legal research assistant for Justice José Ramón Cossío Diaz; and to Paola Pineda Cordova, the court's Directora de Proyectos Artisticos de la Secretaria General de la Presidencia (Director of Artistic Projects of the Secretary General of the Presidency), for their assistance in helping us to learn about and use these images, as well as those of Raul Cauduro, discussed later. This section of the book could not have been written without the advice of Mary Miller, who focused our attention on the role played by George Biddle, and of several talented students fluent in Spanish. Our thanks to Laurie Ball for providing an initial survey, to Allison Tait and Sophie Hood for additional research, to Alana Tucker for background materials, to Tina Esteves-Wolff and Neley Lope Cuellar for additional translations, and to Laurie Ball and Sophie Hood for extensive Spanish-to-English translations.

**272** *José Clemente Orozco's Justice Frescoes in Mexico City*, 34 Magazine of Art 408 (Oct. 1941) (hereinafter *Orozco's Justice Frescoes*).

**273** As we discussed in Chapter 10, the term in French is *salle des pas perdus*. In Italian, such rooms are called *sala dei passi persi*.

**274** Mexico's Supreme Court of Justice 9 (Mexico D.F., Mex.: Supreme Court of Mexico, 1997).

**275** *Los Murales de José Clemente Orozco en el Edificio Sede de la Suprema Corte de Justicia de la Nación* (*The Murals of Jose Clemente Orozco in the Main Building of the Supreme Court of Justice of the Nation*) 4 (Mexico D.F., Mex.: *Poder Judicial de la Federación Suprema Corte de Justicia de la Nación* [The Judicial Power of the Federation, Supreme Court of Justice of the Nation] Secretaría Ejecutiva Jurídico Administrativa, Dirección General de Difusión, 2006) (hereinafter *Supreme Court, Orozco Murals in the Main Building*) (translated by Sophie Hood and Laurie Ball).

**276** Damon Joseph Mycock, The Element of Caricature in the Painting of José Clemente Orozco 89 (M.A. thesis, Duke U. Department of Art, Durham, NC, May 1974). That impression is bolstered by a "lizard nestling in the rib-cage of some extinct animal" (perhaps linked to gold) shown near renditions of steel and metal forms. Id. Further, layered above is an "abstracted mask of Huitzilopochtli, serpents issuing from his mouth, enveloped in a Mexican flag." Id. at 88. The mask image is also said to represent petroleum. See *Supreme Court, Orozco Murals in the Main Building* at 4. To the right of this mask is a "mummified figure in grey, white and black." Mycock at 89; *Supreme Court, Orozco Murals in the Main Building* at 4. To the left is an "Aztec idol face down" (Mycock at 89), said to denote copper. *Supreme Court, Orozco Murals in the Main Building* at 4. The top layer includes a "jaguar like that of Jiquilpan" (Mycock at 88) or, alternatively, a "fierce tiger defending such national wealth with its terrifying paws and eyeteeth." Mexico's Supreme Court of Justice at 9. According to one of the Supreme Court's brochures, the talons of the jaguar "are not precisely those of a cat, but instead those of an eagle . . . the jaguar and the eagle were symbols of adoration of the pre-Hispanic epoch." *Supreme Court, Orozco Murals in the Main Building* at 4.

Opposite *Las Riquezas Nacionales* is *El Movimiento Social del Trabajo* (*The Labor Movement*), above the entrance to the main courtrooms and judges' chambers. In what Alma Reed, an American journalist and Orozco supporter, called "the best available space," Orozco painted a composition "dominated by red iron girders of unfinished construction joined at right angles to form a framed entrance to the future through which the spectator perceives the violent destruction

of the old order and the chaos attendant upon new building." Alma Reed, Orozco 290 (Oxford, Eng.: Oxford U. Press, 1956). The center of the mural is filled with an unfurling red flag that is "a symbol of workers' struggles." Mexico's Supreme Court of Justice at 12. A figure raising a pickaxe dominates the left half of the mural and is one among a number of "exaggerated forms [that] struggle through a narrow doorway" as they fight "against the established corrupt institutions" (Mycock at 88) and try to "effect the liberty of the oppressed." See Desmond Rochfort, Mexican Muralists: Orozco, Rivera, Siqueiros 168 (San Francisco, CA: Chronicle Books, 1993). This mural's relationship to labor rights, specifically Article 123 of the Mexican Constitution that guaranteed basic provisions for labor, is detailed in Justino Fernández, Orozco: Forma e Idea at 118–124 (Mexico City, Mex.: Editorial Porrúa, SA, 1975).

**277** Mexico's Supreme Court of Justice; cover detail from the 1941 mural *La Justicia* (*Justice*) by José Clemente Orozco. The brochure in figure 218 was designed by Teresa Limón Garcia.

**278** Orozco inspired both an American journalist (Reed, cited earlier) and an American writer expert in Latin American art to record their personal recollections of him. See MacKinley Helm, Man of Fire: J. C. Orozco; An Interpretative Memoir (New York, NY: Harcourt, Brace, 1953).

**279** See Rochfort at 11–22, 218–219; Mexico and Modern Printmaking: A Revolution in the Graphic Arts, 1920–1950 (John Ittmann, ed., Philadelphia, PA: Museum of Art and McNay Art Museum, San Antonio, in association with Yale U. Press, 2006); Antonio Rodríguez, A History of Mexican Mural Painting 441–492 (Marina Corby, trans., London, Eng.: Thames and Hudson, 1969); Orozco! An Exhibition Organized by the Ministry of Foreign Affairs and the Institute of Fine Arts, Mexico (Oxford, Eng.: Museum of Modern Art Oxford, 1980); Jeremy Hockett, The Murals of José Clemente Orozco at the Hospicio Cabañas Institute: A Philosophy of Change and the Historical Dialectic 96 (Submitted for M.A. thesis, Department of Art, Michigan State U., East Lansing, MI, 1999; UMI Publication No.: AAT 1395418).

**280** See Joyce Waddell Bailey, *José Clemente Orozco (1883–1949): Formative Years in the Narrative Graphic Tradition*, 15 Latin American Research Review 73, 75–79 (1980); Robert H. Patterson, *An Art in Revolution: Antecedents of Mexican Mural Painting, 1900–1920*, 6 Journal of Inter-American Studies 377, 382 (1964); Orozco! at 14; José Clemente Orozco, *Fragments of an Autobiography*, 45 Magazine of Art 347, 349 (1952).

**281** Patterson at 377. See also Orozco! at 20–41.

**282** Orozco! at 20–30; Rodríguez at 181–196.

**283** Rodríguez at 157.

**284** Orozco! at 26.

**285** There Orozco gained the attention of leading art critics and dealers. See Alejandro Anreus, Orozco in Gringoland: The Years in New York (Albuquerque, NM: U. of New Mexico Press, 2001); Hockett at 46–55. Orozco's commissions included murals at Pomona College in Southern California (1930), the New York School of Social Research (1930–1931), and Dartmouth College in Hanover, New Hampshire (1932). See, for example, José Clemente Orozco, Prometheus (Marjorie L. Harth, ed., Claremont, CA: Pomona College Museum of Art, 2001); Orozco at Dartmouth: The Epic of American Civilization (Concord, NH: Hood Museum of Art, Dartmouth College, Dartmouth College Library, 2007) (hereinafter Orozco at Dartmouth); E. M. Benson, *Orozco in New England*, 26 American Magazine of Art 443 (1933).

**286** Orozco at Dartmouth at 11. The murals were 150 feet long and encompassed some 3,000 square feet of wall space.

**287** Orozco! at 74–91.

**288** Sara Schatz, Hugo Concha, & Ana Laura Magaloni Kerpel, *The Mexican Judicial System: Continuity and Change in a Period of Democratic Consolidation*, in Reforming the Administration of

JUSTICE IN MEXICO 197, 198 (Wayne A. Cornelius & David A. Shirk, eds., Notre Dame, IN: U. of Notre Dame Press, 2007). The 1824 Constitution created three separate branches of government, with Title V addressed to "the Judicial Power of the Federation." It specified that the "judicial power of the Federation shall reside in a supreme court of justice, and in circuit and district courts." See MEX. CONST. OF 1824, Art. 123. Supreme Court Justices were to be elected "by an absolute majority" of the states' legislatures (id., Art. 127) and were to "hold the office for life, unless removed according to law" (id., Art. 126). The Tarlton Library of the University of Texas School of Law has an English version of this constitution online, http://tarlton.law.utexas.edu/constitutions/text/1824index.html.

**289** Schatz, Concha, & Magaloni Kerpel at 198–199. The title of Title II, Section III of the 1857 Constitution is "Of the Judicial Power." Article 90 specified that "the judicial power of the Federation is vested in a supreme court and in the district and circuit courts." MEX. CONST. OF 1857, Art. 90. The supreme court consisted of fifteen justices. Id., Art. 91. Justices were to serve six-year terms. Id., Art. 92. A justice's resignation would "only be accepted for grave cause, approved by the Congress, to whom the resignation shall be tendered." Id., Art. 95.

**290** Linda Arnold, *Vulgar and Elegant: Politics and Procedure in Early National Mexico*, 50 THE AMERICAS 481, 482, 490–491 (1994).

**291** Arnold at 483.

**292** Arnold at 496–500.

**293** Pilar Domingo, *Judicial Independence: The Politics of the Supreme Court in Mexico*, 32 JOURNAL OF LATIN AMERICAN STUDIES 705, 705 (2000).

**294** HÉCTOR AGUILAR CAMÍN & LORENZO MEYER, IN THE SHADOW OF THE MEXICAN REVOLUTION 1–36 (Luis Alberto Fierro, trans., Austin, TX: U. of Texas Press, 1993).

**295** Schatz, Concha, & Magaloni Kerpel at 199. The Constitutions of 1857 and 1917 are similar in structure, but the sections devoted to judicial power (Articles 90–102 of the 1857 Constitution and Articles 94–107 in the 1917 Constitution) are more detailed in the 1917 version, which also provided for the *amparo* procedure permitting an individual to claim that the government had acted illegally. Redress, however, was limited to that individual. See MEX. CONST. OF 1917, Art. 107.

**296** Schatz, Concha, & Magaloni Kerpel at 200.

**297** PATRICE ELIZABETH OLSEN, ARTIFACTS OF REVOLUTION: ARCHITECTURE, SOCIETY, AND POLITICS IN MEXICO CITY, 1920–1940 at 7–8 (Lanham, MD: Rowman & Littlefield, 2008) (hereinafter OLSEN, ARTIFACTS) quoting LINDA B. HALL, ALVARO OBREGÓN: POWER AND REVOLUTION IN MEXICO, 1911–1920 at 247 (College Station, TX: Texas A&M U. Press, 1981).

**298** Hockett at 43.

**299** JAMES OLES, SOUTH OF THE BORDER: MEXICO IN THE AMERICAN IMAGINATION, 1914–1947 at 21 (Washington, DC: Smithsonian Institution Press, 1993).

**300** RODRÍGUEZ at 160. See also LEONARD FOLGARAIT, MURAL PAINTING AND SOCIAL REVOLUTION IN MEXICO, 1920–1940: ART OF THE NEW ORDER 13–26 (New York, NY: Cambridge U. Press, 1998).

**301** During the 1920s and 1930s, a great deal of construction took place. As the diversity of projects grew, the "Cárdenas administration's solution was the promulgation of planning and zoning legislation in 1936 and 1937." Patrice Elizabeth Olsen, Revolution in the Streets: Changing Nomenclature, Changing Form in Mexico City's Centro Histórico and the Revision of Public Memory, prepared for delivery at the 1998 meeting of the Latin American Studies Association at 21 (hereinafter Olsen, "Revolution in the Streets"). Olsen noted that the law's framers "were careful so as not to confer official status to a particular architectural style," but did prohibit "the use of the Mansard roof, a symbol to many of pre-revolutionary culture and Porfirian dictatorship." Id. at 25. Commissions of administrators, architects, and

community leaders assessed proposals according to "fitness," "harmony," and other ill-defined criteria. Olsen described the result as a range of buildings, "neo-colonial, art deco, California-colonial, and functionalist" in style. Olsen, "Revolution in the Streets" at 23.

**302** OLSEN, ARTIFACTS, at 106–108, 87–88.

**303** OLSEN, ARTIFACTS at 149.

**304** OLSEN, ARTIFACTS at 150. The design competition results are detailed in *Proyectos para la Suprema Corte de Justicia* (*Projects for the Supreme Court of Justice*), OBRAS PÚBLICAS 1, 14–25 (May 1934).

**305** The groundbreaking ceremonies are described in *Primer Piedra de un Edificio* (*The First Stone of a Building*), EXCÉLSIOR, Nov. 20, 1936.

**306** OLSEN, ARTIFACTS at 149.

**307** OLSEN, ARTIFACTS at 149. Olsen added that the term was more "suitable for a viceroy's court." Id.

**308** Kathryn E. O'Rourke, The Hour of Mexico: State-Sponsored Modern Architecture in Mexico City, 1925–1934 at vii (Ph.D. dissertation, U. of Pennsylvania, History of Art, Philadelphia, PA, 2008; UMI Publication No.: AAT I3346174). One narrative described a "symphony of construction . . . heard in 1938: steam shovels, pavement-breakers, riveting hammers, welders . . . Mexico's song of tomorrow." J. H. PLENN, MEXICO MARCHES 323 (Indianapolis, IN: Bobbs-Merrill, 1939).

**309** OLSEN, ARTIFACTS at 149.

**310** OLSEN, ARTIFACTS at 150.

**311** OLSEN, ARTIFACTS at 150. The court's materials describe the construction as "steel and reinforced concrete, and the external and internal coverings are made of box and quarry." MEXICO'S SUPREME COURT OF JUSTICE at 4.

**312** NATION'S SUPREME COURT OF JUSTICE: INTEGRATION AND OPERATION OF THE FEDERAL JUDICIARY 60–61 (Supreme Court of Mexico, 1997) (hereinafter SUPREME COURT INTEGRATION AND OPERATION OF JUDICIARY). In 1943, Tamariz also sculpted statues of two "famous jurists," Ignacio L. Vallarta and Mariano Otero. A third statue, of Manuel Crescencio Rejón, was made in 1952 by Carlos Bracho. Id. at 62.

**313** See Silvia Inclán Oseguera, Judicial Reform and Democratization: Mexico in the 1990s at 43–44 (Ph.D. dissertation, Boston U. Department of Political Science, Boston, MA, 2003; UMI Publication No.: AAT 3090412, 2004). For Cárdenas to put his justices in place required the "dismissal in 1934" of the entire court. Id. at 44.

**314** Domingo at 711. Domingo also described the "reforms" of Cárdenas as a "major assault on the autonomy of the Court." Id. at 712–713.

**315** Domingo at 713.

**316** See generally BRUCE ACKERMAN, WE THE PEOPLE, vol. 2: TRANSFORMATIONS (Cambridge, MA: Harvard U. Press, 1998).

**317** *Supreme Court, Orozco Murals in the Main Building* at 3.

**318** *Supreme Court, Orozco Murals in the Main Building* at 3, n. 2 (citing a letter from Orozco to Cárdenas dated Nov. 12, 1940). That monograph also described the contract for a payment of 120 pesos (or $22.25 in 1940 dollars) per square meter, to be paid on a weekly basis. In total, Orozco received 55,440 pesos (or $10,281.85 in 1940 dollars). Id. at 3.

**319** Alfred Neumeyer, *Orozco's Mission*, 10 COLLEGE ART JOURNAL 121, 127 (1951).

**320** Mycock at 87.

**321** Rodríguez interpreted the figures to be "stealing documents in order to interfere with the process of justice." RODRÍGUEZ at 352.

**322** *Supreme Court, Orozco Murals in the Main Building* at 6.

**323** RODRÍGUEZ at 352.

**324** According to court materials, the murals depict "metaphysical justice which punishes evildoers and human justice by striking them." MEXICO'S SUPREME COURT OF JUSTICE at 10.

**325** FERNÁNDEZ at 120.

**326** Mycock at 87–88.

**327** One commentator described the detail as showing Justice "sleeping sweetly, reposed backwards, with flaccid arms; in one hand she holds the law and in the other a sword, without any dignity." FERNÁNDEZ at 120 (translated by Sophie Hood).

**328** These images reflect the influence of Orozco's earlier work as an illustrator, when he relied on caricatures for political satire. See Bailey at 73–93; Neumeyer at 122 (1951).

**329** FERNÁNDEZ at 120–121.

**330** Neumeyer at 127.

**331** RODRÍGUEZ at 352.

**332** HELM at 90.

**333** *Supreme Court, Orozco Murals in the Main Building* at 7.

**334** REED at 290. She also noted the "handicaps of inadequate and broken wall space." Id.

**335** OLES at 109.

**336** HELM at 89–90.

**337** HELM at 89.

**338** Mycock at 87.

**339** HELM at 89.

**340** *Masked Justice*, 15 ART DIGEST 1 (Sept. 1941).

**341** *Orozco's Justice Frescoes* at 408.

**342** Neumeyer at 124.

**343** JOSE G. ZUNO, JOSÉ CLEMENTE OROZCO: EL PINTOR IRONISTA 59 (Guadalajara, Mex.: U. De Guadalajara, 1962) (translated by Laurie Ball).

**344** *Art: Orozco v. Biddle*, TIME, Sept. 24, 1945, at 46 (hereinafter *Orozco v. Biddle*).

**345** *Supreme Court, Orozco Murals in the Main Building* at 7.

**346** *Orozco's Justice Frescoes* at 409.

**347** *Orozco v. Biddle*.

**348** *Orozco v. Biddle*.

**349** *Orozco v. Biddle*.

**350** George Biddle, who lived from 1885 to 1973 and was both a lawyer and a trained artist, was one of the founders of the WPA, detailed in Chapter 6, that resulted in support for public art by the Treasury Department of the United States. As we noted there, in 1933 Biddle wrote to President Franklin D. Roosevelt praising the Mexican muralists and calling for an emulation of their project in the United States. See GEORGE BIDDLE, AN AMERICAN ARTIST'S STORY 268–269 (Boston, MA: Little, Brown, 1939). Details about Biddle's role and the influence of Mexican muralists can be found in an admiring dissertation written in 1944. See Erica Beckh Rubenstein, Tax Payers' Murals (Ph.D. dissertation, Radcliffe College of Harvard U., Fine Arts, Cambridge, MA, 1944; UMI Publication No.: AAT 0167765).

**351** *Orozco v. Biddle*. Apparently Orozco was displeased and never went to see Biddle's murals. Biddle, in turn, was distressed, reportedly describing Orozco as "'embittered and jealous.'" REED at 291.

**352** *Orozco v. Biddle*.

**353** OLES at 109.

**354** See generally FRIEDRICH E. SCHULER, MEXICO BETWEEN HITLER AND ROOSEVELT: MEXICAN FOREIGN RELATIONS IN THE AGE OF LÁZARO CÁRDENAS, 1934–1940 (Albuquerque, NM: U. of New Mexico Press, 1998).

**355** SUPREME COURT INTEGRATION AND OPERATION OF JUDICIARY at 63.

**356** OLES at 109.

**357** *Murales de George Biddle* (*The Murals of George Biddle*), Suprema Corte de Justicia de la Nación (unpaginated Spanish brochure from the court, Poder Judicial de la Federación) (hereinafter *The Murals of George Biddle*) (translated by Sophie Hood).

**358** OLES at 109.

**359** OLES at 109.

**360** *Orozco v. Biddle*.

**361** OLES at 111.

**362** *The Murals of George Biddle*.

**363** *The Murals of George Biddle*.

**364** *The Murals of George Biddle*. Biddle's wife, Helena Sardeau, sculpted statues that were displayed below. Id.

**365** Manuel Ávila Camacho, Salvador Urbina, The Purposes of Justice in Mexico, speeches made at the Department of State for Foreign Affairs, International Press Service Bureau, 7, 14 (1941) (hereinafter Ávila Camacho or Urbina).

**366** Ávila Camacho at 11.

**367** Ávila Camacho at 12.

**368** Urbina at 19.

**369** Urbina at 20.

**370** Urbina at 19.

**371** Urbina at 25, 27.

**372** OLSEN, ARTIFACTS at 149.

**373** In the Mexican Supreme Court's 1997 discussion, it cited "Daniel V. Valencia" as the Chief Justice who did "a great job getting funds." SUPREME COURT INTEGRATION AND OPERATION OF JUDICIARY at 58.

**374** See OLSEN, ARTIFACTS at 149. One of the court's brochures incorporates this description: "Without any doubt, the author of this severe architectural composition tried to identify it with the character of the High Tribunal, highest interpreter of our Constitution." SUPREME COURT INTEGRATION AND OPERATION OF JUDICIARY at 58–59.

**375** OLSEN, ARTIFACTS at 149.

**376** Schatz, Concha, & Magaloni Kerpel at 199. See also Domingo.

**377** *Supreme Court, Orozco Murals in the Main Building* at 1. The court's monograph further explained the utility of making such great art accessible to all sectors of the social order. Id.

**378** *Supreme Court, Orozco Murals in the Main Building* at 4.

**379** Guided tours were available regularly, and sometimes evening concerts were held. Letter from Justice Olga María Sánchez Cordero de García Villegas to the authors (Aug. 21, 2006).

**380** Leopoldo Flores titled his work *La Justicia Supremo Poder* (*Justice, Supreme Power*); it aims to depict "from the perspective of justice, the birth of the Nation, Independence, the Mexican Revolution, and the modern era." Arturo Espinosa, *Rubrica obra para la Corte* (*Final Work for the Court*), REFORMA, Aug. 11, 2007. Flores's work is more in keeping with what one has come to expect on the walls of a supreme court building. His treatment of the theme begins with "men emerging from darkness, freed from the ties that were binding them." *Inauguran mural de Leopoldo Flores en SCJN* (*Inauguration of the mural of Leopoldo Flores at the Supreme Court of Justice of the Nation*), EL UNIVERSAL, July 15, 2008. The work includes references to the Mexican Revolution (complete with famous revolutionary icons on horseback) and concludes with a large nude justice figure, her face covered in white, holding scales in her hand. Id.

Luis Nishizawa called his project *La Justicia* (*Justice*), and it spanned the period from pre-Hispanic Mexico through an era of mass communication, with symbolism ranging from horses to radio antennae. Leopoldo Ávalos, *Incluyen a jueces en mural* (*Including Judges in [a] Mural*), REFORMA, June 28, 2007. Ismael Ramos's *La Búsqueda de la Justicia* (*The Search for Justice*) deployed images of a temple-like structure, cars and flags for independence, and representations of sacrifice for the country. The artist included "many emblematic characters" of the society and commented that the mix (from an "an office worker of today" to a "colonial [indigenous] nahuatlaco") showed that "we are all a part of the same genetic code, as we were all born in Mexico." Leopoldo Ávalos, *Articulan tradicion e historia* (*Articulating Tradition and History*), REFORMA, Sept. 25, 2007. In the summer of 2009, the Mexican Supreme Court announced that it would add a fifth work by a Spanish artist, Santiago Carbonell, living in Mexico. See Ángel Vargas, *Inauguraron el mural que Rafael Cauduro pintó en el recinto de la Suprema Corte* (*Inauguration of Rafael Cauduro's Mural*

*in the Supreme Court Building*), La Jornada, July 15, 2009, at 5 (translated by Sophie Hood).

**381** Rodríguez at 160. See also Folgarait at 13–26.

**382** See *Se Inaugura en la SCJN mural del Maestro Rafael Cauduro* (*Supreme Court Inaugurates Painter Rafael Cauduro's Mural*), Press Release by the Supreme Court of Justice of the Nation, Mexico City, Mex.: July 14, 2009 (hereinafter Supreme Court Press Release, Inauguration of the Cauduro Paintings). See also Patricia Cordero, *Pintan sin prejucios* (*Painting without Prejudice*), Reforma, Dec. 13, 2006 (translations by Sophie Hood).

**383** Cauduro studied architecture and industrial design at the Iberoamerican University. See *Vida en el campus Rafael Cauduro* (*Campus Life: Rafael Cauduro*), 17 San Rafael: Reporte académico 1 (Winter 1995). His work has been described as transforming objects and places into "a neofigurative expression lying between reality and fantasy." Id.

**384** For a Spanish description and images of the two underground murals, titled *El metro de Londres y el metro de Paris* (*London Metro and Paris Metro*), see Mexico City's "Culture" website, http://www .metro.df.gob.mx/cultura/murelmetlondres.html. See also Proyecto de Murales de la Suprema Corte Justicia de la Nación 2006–2008 (Supreme Court of Justice of the Nation Murals Project), project description provided by the court to the authors, at 2–3 (translated by Sophie Hood) (hereinafter 2006–2008 Murals Project).

**385** The work, begun in 2006, had been done at La Tallera, a studio used by David Alfaro Siqueiros in the last years of his life and run by the Instituto Nacional de Bellas Artes (National Institute of Fine Arts). *Concluye Rafael Cauduro murales para Suprema Corte* (*Rafael Cauduro Finishes Murals for the Supreme Court*), El Universal, Feb. 27, 2008 (translated by Sophie Hood) (hereinafter *Rafael Cauduro Finishes Murals*).

**386** Miguel Angel Ceballos, *Pinta Cauduro "siete crímenes"* (*Cauduro Paints "Seven Crimes"*), El Universal, Nov. 15, 2006 (translated by Sophie Hood).

**387** 2006–2008 Murals Project at 5.

**388** 2006–2008 Murals Project at 5. Cauduro is also quoted as having explained: "I have trouble understanding Justice in this painful moment in Mexico's history. This country has always been violent, untamed; there is a nihilistic character. We have just finished a dictatorial process that lasted seventy odd years and we are in the moment of laying new foundations, a painful birthing. As an artist I am interested in using this forum. My job is to give strength to my images, to make them powerful. It is again the search for sign and symbol; the building itself is a symbol." Carmen González, *Histórico fin de semana* (*Historic Weekend*), Reforma, Dec. 3, 2006 at 16 (translated by Sophie Hood and Tina Esteves-Wolff) (hereinafter González, Historic Weekend).

**389** The scenes in figures 221–223, all from Cauduro's *The History of Justice in Mexico*, were provided and are reproduced with the permission of Minister Guillermo I. Ortiz Mayagoitia, President of the Supreme Court of Mexico, and with the assistance of Justice José Ramón Cossío Diaz and Paola Pineda Cordova of the court. President Ortiz Mayagoitia acted in conformity with Article 83 of the Federal Law of Author Rights and in virtue of the patrimonial rights of the court. Our thanks also to the artist, Rafael Cauduro, for his help.

**390** José Ramón Cossío Diaz, *Las condiciones de juzgar* (*The Condition of Judging*), Letras Libres 86 (Oct. 2009) (translated by Sophie Hood).

**391** Ceballos.

**392** Érika P. Bucio, *Lleva Cauduro mural a SCJN* (*Cauduro Takes Murals to the SCJN*), Reforma, Aug. 21, 2007 at 8-C (translated by Sophie Hood).

**393** 2006–2008 Murals Project at 6.

**394** Bucio, *Cauduro Takes Murals to the SCJN* at 8-C.

**395** *Rafael Cauduro Finishes Murals*.

**396** 2006–2008 Murals Project at 6. Cauduro mentioned China as another example.

**397** Vargas at 5.

**398** Érika P. Bucio, *Hace critica con mural en la Suprema Corte* (*Criticizing with a Mural in the Supreme Court*), El Norte, Aug. 21, 2007, at 3 (translated by Sophie Hood).

**399** Bucio, *Criticizing with a Mural* at 3.

**400** Gónzalez.

**401** Jaime Moreno Valenzuela, *Primera entrega del mural de Cauduro en la SCJN* (*First Installment of the Cauduro Mural in the Supreme Court of Justice*), Revista Rancho Las Voces (Ciudad Juarez, Mexico), August 2007, http://rancholasvoces.blogspot.com/2007/08/ artes-plsticas-mxicollega-la-scj-la.html (translated by Sophie Hood).

**402** *Rafael Cauduro Finishes Murals*.

**403** See Supreme Court Press Release, Inauguration of the Cauduro Paintings.

**404** Supreme Court Press Release, Inauguration of the Cauduro Paintings, quoting Minister Ortiz Mayagoitia.

**405** Supreme Court Press Release, Inauguration of the Cauduro Paintings, citing Minister José Ramón Cossío Diaz.

**406** Vargas at 5.

**407** Bucio, *Cauduro Takes Murals to the SCJN* at 8-C.

**408** Sergio Sarmiento, *Sueños de Cauduro* (*Dreams of Cauduro*), Frontera, July 11, 2008, at 27-A (translated by Sophie Hood).

**409** One detailed analysis comes from Oseguera. See also Juan Carlos Calleros, The Unfinished Transition to Democracy in Latin America 75–76 (New York, NY: Routledge, 2009).

**410** Domingo at 709–710. An effort to understand the political configuration that produced the reforms is provided by Oseguera at 102–184.

**411** Domingo at 730.

**412** Jeffrey K. Staton, *Lobbying for Judicial Reform: The Role of the Mexican Supreme Court in Institutional Selection*, in Reforming the Administration of Justice in Mexico at 273, 278–281; Jorge A. Vargas, *The Rebirth of the Supreme Court of Mexico: An Appraisal of President Zedillo's Judicial Reform of 1995*, 11 American U. Journal of International Law & Policy 295, 296 (1996).

**413** The Mexican Constitution of 1917, in effect as amended in 2009, provides: "Appointments of the ministers of the Supreme Court shall be made by the President of the Republic and submitted to the approval of the Chamber of Senators, which shall grant or deny approval within the unalterable period of ten days." See Mex. Const. of 1917, Art. 96. See also Schatz, Concha, & Magaloni Kerpel at 202. The 1994 reforms also aimed to improve judicial education and lawyer professionalization. Id. at 202–212.

**414** "The Supreme Court of Justice of the Nation has exclusive jurisdiction in all controversies that arise between two or more States, between the powers of one State concerning the constitutionality of their acts, and in disputes between the Federation and one or more States, and all those in which the Federation is a party." Mex. Const. of 1917, Art. 105. The court continued to have authority over certain *amparo* appeals, as well as those in which the Federation is a party and the case is of national importance, and "actions of unconstitutionality related to parts I and II of Article 105 of the Constitution." Reporte sobre la Justicia en las Américas 2004–2005 (Report on Justice in the Americas) 268 (Santiago, Chile: Centro de Estudios de Justicia de la Américas, 2005), www.cejamericas.org/reporte/pdfing/22-MEXICO_ING.pdf. See also Domingo at 716–721; Dale Beck Furnish, *Judicial Review in Mexico*, 7 Southwestern Journal of Law and Trade in the Americas 235 (2000); Héctor Fix-Fierro, *Judicial Reform and the Supreme Court of Mexico: The Trajectory of Three Years*, 6 U.S.–Mex. Law Journal 1 (1998).

**415** Domingo at 714–715. See generally Vargas.

**416** Calleros at 75–76.

**417** For example, in 2005 the Mexican Supreme Court overturned

a prior ruling and held instead that "forced sex within marriage," which had been understood to be permissible under the Mexican Penal Code, would be "considered rape and punishable by law." Morgan Lee Woolley, *Marital Rape: A Unique Blend of Domestic Violence and Non-Marital Rape Issues*, 18 HASTINGS WOMEN'S LAW JOURNAL 269, 288 (2007) (quoting press release, Ipas, Mexican High Court Now Defines Marital Sex Assaults as Rape (Dec. 8, 2005)). One review concluded that by 1995 the court had heard some two dozen challenges to the constitutionality of laws and considered more than a hundred constitutional controversies. Domingo at 731.

**418** Domingo at 708, 731–733. Questions about the court's capacity are raised in Michael C. Taylor, *Why No Rule of Law in Mexico? Explaining the Weakness of Mexico's Judicial Branch*, 27 NEW MEXICO LAW REVIEW 141 (1997).

**419** In one interview he gave when working on the project, Cauduro commended the Mexican Supreme Court for accepting his "irreverent proposal." González, Historic Weekend. Cauduro said that to be judged "by the Supreme Court is an honor. They didn't correct even a comma, which was marvelous, and I'm really very encouraged." Id.

**420** By one count, the court had some 20,000 cases pending between 1997 and 1999. See Schatz, Concha, & Magaloni Kerpel at 202.

**421** David A. Shirk & Alejandra Ríos Cázares, *Introduction: Reforming the Administration of Justice in Mexico*, in REFORMING THE ADMINISTRATION OF JUSTICE IN MEXICO 1, 8. Reported crime declined "significantly from the 1940s to the 1970s" but rose sharply between 1997 and 2005. Crime has been accompanied by "serious problems of corruption . . . widespread impunity, and abuse of public authority." Id.

**422** Shirk & Ríos Cázares at 1.

**423** See Catalina Pérez Correa, *Distrust and Disobedience: Discourse and Practice of Law in Mexico*, 77 U. OF PUERTO RICO LAW REVIEW 345, 346 (2008).

**424** Shirk & Ríos Cázares at 1. For example, of the small fraction of crimes reported, many went unpunished. When individuals were charged, they were often unable to obtain adequate counsel and left to wait "long periods in jail without formal sentencing." Id. at 2.

**425** Shirk & Ríos Cázares at 9 (quoting Marcelo Ebrard, who was the police chief of Mexico City in 2003).

**426** INTER-AMERICAN COMMISSION ON HUMAN RIGHTS, ORGANIZATION OF AMERICAN STATES, REPORT ON THE SITUATION OF HUMAN RIGHTS IN MEXICO, OEA/Ser.L.V.II.100, Sept. 24, 1998, para. 688. (hereinafter IACHR, MEXICO 1998). See also CALLEROS at 152, quoting that report.

**427** CALLEROS at 152, citing SECRETARIA DE GOBERNACIÓN, LOS DERECHOS HUMANOS EN MÉXICO: REPORTE PREPARADO EN OCCASION DE LA VISITA DE LA VISITADORA DE LA ONU SOBRE DERECHOS HUMANOS, MARY ROBINSON (SECRETARY OF GOVERNMENT, HUMAN RIGHTS IN MEXICO: REPORT PREPARED ON THE OCCASION OF THE VISIT OF THE UN HUMAN RIGHTS MONITOR, MARY ROBINSON) (Mexico D.F., Mex.: Talleres Gráficos de la Nación, 2000).

**428** CALLEROS at 153.

**429** IACHR, MEXICO 1998, ch. V, *Right to Justice*.

**430** IACHR, MEXICO 1998, para. 351.

**431** IACHR, MEXICO 1998, paras. 357–386.

**432** IACHR, MEXICO 1998, para. 393. The "state level" was particularly problematic. Id.

**433** UN Commission on Human Rights, *Civil and Political Rights, Including Questions of: Independence of the Judiciary, Administration of Justice, Impunity* (E/CN.4/72/Add. 1), Jan. 24, 2002, http://www.unhcr.org/refworld/docid/3cc6ad614.html. See also Shirk & Cázares at 23.

**434** CALLEROS at 169, quoting Kevin Sullivan, *In Mexico Hinterland, Life Beyond the Law*, WASHINGTON POST, March 15, 2002, A01.

**435** CALLEROS at 170.

**436** CALLEROS at 172.

**437** See World Bank, Poverty Reduction and Economic Management Department, Project Paper, *Mexico: State Judicial Modernization Supporting Access to Justice Project*, World Bank Report No. 48695, July 10 2008, http://web.worldbank.org/external/projects/main?pagePK=104231&piPK=73230&theSitePK=40941&menuPK=228424&Projectid=P074755.

**438** Guillermo Zepeda Lecuona, *Criminal Investigation and the Subversion of the Principles of the Justice System in Mexico*, in REFORMING THE ADMINISTRATION OF JUSTICE IN MEXICO at 133, 134–136.

**439** Sigrid Arzt, *The Militarization of the Procuraduría General de la República: Risks for Mexican Democracy*, in REFORMING THE ADMINISTRATION OF JUSTICE IN MEXICO at 153.

**440** See Correa at 345.

**441** Trans-Border Institute, *Justice in Mexico*, Jan. 2009 at 1, www.justiceinmexico.org.

**442** BENTHAM, RATIONALE at 354 (emphasis in the original). Bentham did add the caveat that limits came from the "strength of the voice on the one part, and the strength and soundness of the auditory faculty on the other." Id.

**443** The photograph in figure 224 of the Federal Court of Australia sitting in Parntirrpi Bore Outstation, Great Victoria Desert, taken in 2005 by Bob Sheppard, the Trial Logistics Manager of the Federal Court of Australia, was provided by the court and is reproduced with the permission of the photographer and the court.

**444** In the United States and some other jurisdictions, "community justice" centers have focused a good deal on criminal law. See Jeffrey Fagan & Victoria Malkin, *Theorizing Community Justice Through Community Courts*, 30 FORDHAM URBAN LAW JOURNAL 897 (2003). The Federal Court of Australia's travels to communities for civil litigation expands on that theme.

**445** *Stanley Mervyn, Adrian Young, and Livingston West and others on behalf of the Peoples of the Ngaanyatjarra Lands v. Western Australia and others* (2005), FCA 831 at para. 9, 13, 19 and at the Minute of Consent Determination of Native Title, appended to the judgment at Schedules 2 (Exclusions), 4 (Other Interests) (29 June 2005) (hereinafter *Mervyn/Ngaanyatjarra Lands v. Western Australia*). Our thanks to Chief Justice Michael Black, who brought both the dispute and the photographs to our attention and helped us to understand their import.

**446** Federal Court of Australia website, http://www.fedcourt.gov.au. The Federal Court has registries in the other states and territories. Id.

**447** AUSTRALIAN BUREAU OF STATISTICS, AUSTRALIAN DEMOGRAPHIC STATISTICS, DECEMBER 2008, Key Figures, www.abs.gov.au/ausstats/abs@.nsf/mf/3101.0; and AUSTRALIAN BUREAU OF STATISTICS, WESTERN AUSTRALIA, http://www.abs.gov.au/, under "Themes," and "Western Australia."

**448** *Ngaanyatjarra Lands*, NATIVE TITLE NEWSLETTER, edition 6 (July 2005) at 1 (hereinafter *Ngaanyatjarra Lands*).

**449** Maureen Tehan, *Customary Title, Heritage Protection, and Property Rights in Australia: Emerging Patterns of Land Use in the Post-Mabo Era*, 7 PACIFIC RIM LAW & POLICY JOURNAL 765, 766 (1988) (hereinafter Tehan, *Customary Title*).

**450** Tehan, *Customary Title* at 774–775.

**451** *Mabo v. Queensland II* (1992) 175 C.L.R. 1 (Aus.). Hereinafter we refer to this case by its common name, "*Mabo II*."

**452** The doctrine is discussed in the decision. See *Mabo II*, paras. 23–84.

**453** See Gary D. Meyers & Sally Raine, *Australian Aboriginal Land Rights in Transition (Part II): The Legislative Response to the High Court's Native Title Decisions in Mabo v. Queensland and Wik v. Queensland*, 9 TULSA JOURNAL OF COMPARATIVE AND INTERNATIONAL LAW 95, 96–97 (2001).

**454** See, for example, LISA STRELEIN, COMPROMISED JURIS-PRUDENCE: NATIVE TITLE CASES SINCE MABO (Canberra, Aust.: Aboriginal Studies Press, 2006) (hereinafter STRELEIN, COMPROMISED JURISPRUDENCE).

**455** See PATRICK MACKLEM, INDIGENOUS DIFFERENCE AND THE CONSTITUTION OF CANADA (Toronto, Can.: U. of Toronto Press, 2001).

**456** The questions raised have broad implications for the meaning of sovereignty raised not only by "old homeland minorities" but also by other minority groups. See Will Kymlicka, *The Internationalization of Minority Rights*, 6 INTERNATIONAL JOURNAL OF CONSTITUTIONAL LAW 1, 7 (2008).

**457** See Declaration on the Rights of Persons Belonging to National or Ethnic, Religious and Linguistic Minorities, U.N. GAOR, 47th Sess., Supp. 49, U.N. Doc. A/RES/47/135/Annex (1993), http://www.un.org/documents/ga/res/47/a47r135.htm.

**458** Declaration on the Rights of Indigenous Peoples, G.A. Res. 61/295, U.N. Doc. A/RES/61/295 (Sept. 13, 2007). This Declaration was adopted after more than twenty years of discussion. The process began in 1983 with the convening of the Working Group on Indigenous Populations, and a first draft was adopted in 1993. For a brief history see International Work Group for Indigenous Affairs, http://www.iwgia.org/sw8516.asp.

**459** See Ngaanyatjarra Council (Aboriginal Corporation), *Land Management: Brief Description of the Ngaanyatjarra Lands*, http://www.tjulyuru.com/lands.asp (hereinafter Ngaanyatjarra Council, *Land Management*).

**460** Richard D. Lumb, *Native Title to Land in Australia: Recent High Court Decisions*, 42 INTERNATIONAL & COMPARATIVE LAW QUARTERLY 84, 85 (1993).

**461** Tehan, *Customary Title* at 788–789.

**462** Various persons are authorized to file claims, including individuals or persons "(the native title claim group) who, according to their traditional laws and customs, hold the common or group rights and interests comprising the particular native title claimed." See Native Title Act, 1993, §61 (1). Private, non-native title claimants can also bring applications for revision or compensation, as can the Commonwealth and states or territories. Id. at §61(2)–(4). Thus this statute creates a form of aggregate litigation distinct from other methods that may exist to bring group-based litigation. See generally Bernard Murphy & Camille Cameron, *Access to Justice and the Evolution of Class Action Litigation in Australia*, 30 MELBOURNE U. LAW REVIEW 399 (2006).

**463** See generally Lisa Strelein & Tran Tran, *Native Title Representative Bodies and Prescribed Bodies Corporate: native title in a post determination environment* (Native Title Research Report no. 2/2007, Australian Institute of Aboriginal and Torres Strait Islander Studies, Canberra, Aust.: 2007).

**464** See Native Title Act, 1993, §107 ("Establishment of the National Native Title Tribunal"); and id. at §108 ("Function of the Tribunal"). For example, the Tribunal can "carry out research" on the "history of interests in relation to land or waters in Australia" as well as on "anthropology." Id. at §108 (3). See also Meyers and Raine at 98–104; Tehan, *Customary Title* at 767–793.

The Native Title Act also provided rights to negotiate when future property interests were at stake. Meyers and Raine at 100. Subsequent court decisions, including *Wik Peoples v. State of Queensland* (1996) 141 A.L.R. 129, responded to some questions raised by the court's doctrine and legislation. Further, practice under the Native Title Act revealed problems that prompted amendments. See Meyers and Raine at 100–116. In addition, concerns about the degree to which native title could limit economic growth in a global economy translated into efforts to modify the legislation. See Carlos Scott López, *Reformulating Native Title in Mabo's Wake: Aboriginal Sovereignty and Reconciliation in Post-Centenary Australia*, 11 TULSA JOURNAL OF COMPARATIVE & INTERNATIONAL LAW 21, 40–42 (2003).

Some scholars have interpreted some of the subsequent decisions as responsive to private and governmental interests that sought to limit the interpretation of *Mabo II*. See, for example, Lisa Strelein, *From Mabo to Yorta Yorta: Native Title Law in Australia*, 19 WASHINGTON UNIVERSITY JOURNAL OF LAW AND POLICY 225 (2005); Kent McNeil, *The Vulnerability of Indigenous Land Rights in Australia and Canada*, 42 OSGOODE HALL LAW JOURNAL 272 (2004); Gretchen Freeman Cappio, *Erosion of the Indigenous Right to Negotiate in Australia: Proposed Amendments to the Native Title Act*, 7 PACIFIC RIM LAW & POLICY JOURNAL 405 (1998).

**465** See Native Title Act, 1993, § 109 (1) ("Tribunal's way of operating").

**466** Native Title Act, 1993, § 109 (3) ("Tribunal's way of operating").

**467** "The Federal Court has jurisdiction to hear and determine applications filed in the Federal Court that relate to native title and that jurisdiction is exclusive of . . . all other courts except the High Court." Native Title Act, 1993, § 81.

**468** Native Title Act, 1993, § 136G. This provision applies only to mediations held under certain subsections. Id.

**469** Native Title Act, 1993, § 136GB.

**470** Tehan, *Customary Title* at 796–797 (citing Native Title Amendment Bill, 1997, §§ 24BA-24EC).

**471** Tehan, *Customary Title* at 797.

**472** The Native Title Act called on each of Australia's subdivisions to create their own native title regimes and provided financial assistance for administrative as well as settlement costs. See Native Title Act, 1993, §§ 8, 200. Given that the act did not impose a national uniform regime, variations exist. See *Native Title Resource Guide*, http://ntru.aiatsis.gov.au/research/resourceguide/statesandterritories/NT/nto1.html.

Western Australia was the first to enact state-based claims systems. Meyers & Raine at 150–157. Some parts of its regulatory system were later struck down by the courts. López at 41. See *Western Australia v. Commonwealth* (1995) 183 CLR 373. Western Australia chartered an Office of Native Title to assist it in land claims—and arguably to deflect some. That office convened a "Native Title Research Working Group" that recommended making state title records accessible to claimants. See *Ngaanyatjarra Lands*; Office of Native Title, Annual Report 2007–2008 (published by the Government of Western Australia). At the national level, efforts were made to shape a working group of "Native Title Ministers" that would coordinate and also provide a measure of transparency in that work. See Australian Government, Attorney General's Department, Consultation with State and Territory Governments, http://www.ag.gov.au/www/agd/agd.nsf/Page/Indigenous-lawandnativetitle_Nativetitle_Consultationwithstateandterritory-governments.

**473** STRELEIN at 59–78. Strelein cited *Western Australia v. Ward* (2002), 213 CLR 1, 76 ALJR 1098, as one such example.

**474** Ngaanyatjarra Council (Aboriginal Corporation), *Doing Business with Government* 10 (July 2003), http://www.tjulyuru.com/notices/DBWGRepApp.pdf (hereinafter Ngaanatjarra Council, *Doing Business*).

**475** Ngaanatjarra Council, *Doing Business* at 12–13.

**476** *Mervyn / Ngaanyatjarra Lands v. Western Australia.*

**477** *Mervyn / Ngaanyatjarra Lands v. Western Australia*, List of Respondents. The Ngaanyatjarra Lands fall within three shires, Ngaanyatjarraku, East Pilbara, and Laverton, the shire named in the application. Information on the land comes from the Shire of Ngaanyatjarraku. See Ngaanyatjarra Council, *Land Management*.

**478** *Mervyn / Ngaanyatjarra Lands v. Western Australia*, para. 5.

**479** *Merwyn / Ngaanyatjarra Lands v. Western Australia*, para. 7.

**480** *Mervyn / Ngaanyatjarra Lands v. Western Australia*, para. 8, citing the Native Title Act 1993, §87.

**481** *Mervyn / Ngaanyatjarra Lands v. Western Australia*, para. 6.

**482** *Mervyn / Ngaanyatjarra Lands v. Western Australia*, para. 18.

**483** *Mervyn/Ngaanyatjarra Lands v. Western Australia*, para. 12.

**484** *Mervyn/Ngaanyatjarra Lands v. Western Australia*, para. 12.

**485** *Mervyn/Ngaanyatjarra Lands v. Western Australia*, para. 17 (citing *Anderson on behalf of the Spinifex People v. State of Western Australia*, (2000) FCA 1717, para. 1, as well as other decisions).

**486** Peter H. Russell, Recognizing Aboriginal Title: The Mabo Case and Indigenous Resistance to English-Settler Colonialism (Toronto, Can.: U. of Toronto Press, 2005).

**487** Russell at 305–312.

**488** See Robert H. Mnookin & Lewis Kornhauser, *Bargaining in the Shadow of the Law: The Case of Divorce*, 88 Yale Law Journal 950, 968 (1979).

**489** Email from Chief Justice Michael Black to Judith Resnik, Mar. 22, 2006 (hereinafter 2006 C. J. Black email).

**490** 2006 C. J. Black email. He noted that the artist used "traditional indigenous colours."

**491** See General Guidelines for Use of the Commonwealth Coat of Arms Within the Commonwealth, http://www.dpmc.gov.au/guidelines/docs/CCoA_commonwealth.rtf. Protecting symbolic rights is an issue for the cultural property of indigenous peoples as well. See generally Matthew Rimmer, *Australian Icons: Authenticity Marks and Identity Politics*, 3 Indigenous Law Journal 139 (2004). Another "on-country hearing" took place in June 2009 at Nyiyamarri Pukurl, where over two hundred people gathered when Justice Anthony North determined land rights in an area some two hundred miles south of Broome. That claim had been pending for eleven years. See *Nyangumarta Determination: Western Australia's 25th*, Native Title Newsletter (June, 2009).

**492** Australian Government, Department of Foreign Affairs and Trade, *About Australia: Coat of Arms*, http://www.dfat.gov.au/facts/coat_of_Arms.pdf (hereinafter *About Australia: Coat of Arms*).

**493** *About Australia: Coat of Arms.*

**494** 2006 C. J. Black email.

**495** 2006 C. J. Black email.

**496** *About Australia: Coat of Arms.*

**497** Such parallels are explored by various scholars eager to undercut a hierarchy of sophistication across cultures. See Richard Mohr, *Enduring Signs and Obscure Meanings: Contested Coats of Arms in Australian Jurisdictions*, in Contemporary Issues of the Semiotics of Law 180–195 (Anne Wagner, Tracey Summerfield, & Farid Benevides, eds., Oxford, Eng.: Hart, 2005).

**498** The image in figure 225 was provided and reproduced with permission of the Rare Book Collection, Lillian Goldman Law Library, Yale Law School and the assistance of its librarian, Mike Widener. In English, the book is called *Dutch Law and Practice in Civil and Criminal Matters*. As discussed in Chapter 7, it was written by Bernhard van Zutphen. The volume was published in 1665, the same year that the Amsterdam Town Hall was inaugurated. Almost identical scenes can be found in several other volumes of that era.

**499** *Ngaanyatjarra Lands.*

**500** Manuhuia Barcham, Regional Governance Structures in Indigenous Australia: Western Australian Examples 4 (Centre for Indigenous Governance and Development [CIGAD] Working Paper 1/2006, Massey University, Palmerston North, N.Z.: 2006).

**501** *Mervyn/Ngaanyatjarra Lands v. Western Australia*, para. 2.

**502** Ngaanyatjarra Council, *Doing Business* at 26.

**503** We borrow this phrase from Richard Mohr, *Some Conditions for Culturally Diverse Deliberation*, 20 Canadian Journal of Law and Society 87, 87 (2005).

**504** See Seyla Benhabib, The Claims of Culture: Equality and Diversity in the Global Era 142 (Princeton, NJ: Princeton U. Press, 2002).

**505** The label indicated that the judgment would be distributed generally by the court's internal and external websites. Judgments not so marked, such as interlocutory orders, were recorded but not distributed.

**506** The preface, paragraphs A–K, reported that claims had been filed, as had a written statement "setting out the terms of the agreement reached." *Mervyn/Ngaanyatjarra Lands v. Western Australia*, para. D.

**507** *Mervyn/Ngaanyatjarra Lands v. Western Australia*, paras. F, G. The court further noted its own authority under the Native Title Act to enter the agreement as well as to dismiss the related pending applications comprehended within the new accord.

**508** *Mervyn/Ngaanyatjarra Lands v. Western Australia*, para. 13.

**509** *Mervyn/Ngaanyatjarra Lands v. Western Australia*, para. 14. "In the distant past, dreaming beings travelled vast distances across the desert and through the Ngaanyatjarra Lands, creating the waterholes and landscape features and laying down the songs and dances for people to perform." Id., para. 15.

**510** *Mervyn/Ngaanyatjarra Lands v. Western Australia*, para. 19 (emphasis in the original).

**511** *Mervyn/Ngaanyatjarra Lands v. Western Australia*, Minute of Consent Determination, The Nature and Extent of Native Title Rights and Interests, para. 3(a)–(e) (1996). That land is administered by the Yarnangu Ngaanyatjarraku Parna (Aboriginal Corporation). See Australian Government, Search the Public Register for Indigenous Corporations, http://www.oric.gov.au/PrintCorporationSearch.aspx?corporationName=&icn=4527.

One commentator described the outcome as recognition of exclusive possession of "most of the claim area, including special leases; reserves held in trust for the use and benefit of Indigenous people; and unallocated Crown land," as well as nonexclusive possession over other areas. See Strelein at 197. Western Australia's own Office of Native Title described the settlement as giving the Ngaanyatjarra Peoples "exclusive . . . possession" over various areas; rights to "care for, maintain and protect from physical harm" certain sites; and rights to extract natural resources for profit in some instances. See http://www.centraldesert.org.au/what-we-do/by-claim-determination-area/ngaanyatjarra-lands/. In addition, the Western Australian state government allocated, through the Office of Native Title, $860,000 to be provided for two years for "joint management arrangements" of areas, including the Gibson Desert Nature Reserve, where native title was extinguished. See *Ngaanyatjarra Lands.*

Subsequent decisions involving land claims by the Ngaanyatjarra Peoples include a 2008 "consent determination," also generated through "negotiations with the State Government," that was entered by the Federal Court in Perth. The "determination" recognized the Ngaanyatjarra People's "exclusive native title rights" over most of an area of 552 square miles. See National Native Tribe Tribunal, *Ngaanyatjarra People's Native Title Recognised in Central Desert*, June 3, 2008, http://www.nntt.gov.au/News-and-Communications/Media-Releases/Pages/Ngaanyatjarra_Peoples_native_title_recognised_in_Central_Desert.aspx.

**512** *Mervyn/Ngaanyatjarra Lands v. Western Australia*, Minute of Consent Determination, The Nature and Extent of Native Title Rights and Interests, para. 4(a),(b).

**513** *Mervyn/Ngaanyatjarra Lands v. Western Australia*, Minute of Consent Determination, The Nature and Extent of Native Title Rights and Interests, para. 7. Following the explanation are dozens of pages listing plot numbers related to a grid and the names of the peoples who gain rights under the agreement. *Mervyn/Ngaanyatjarra Lands v. Western Australia*, Schedule 1—Determination Area, Schedule 3—Native Title Holders.

**514** *Mervyn/Ngaanyatjarra Lands v. Western Australia*, Schedule 4—Other Interests.

**515** *Ngaanyatjarra Lands.*

**516** Barcham at 4.

**517** As noted in Chapter 13, Bentham proposed that this fund be paid for with "fines imposed on wrongdoers," government funds, and charitable donations. See Philip Schofield, Utility and Democ-

RACY: THE POLITICAL THOUGHT OF JEREMY BENTHAM 310 (New York, NY: Oxford U. Press, 2006).

**518** *Mervyn/Ngaanyatjarra Lands v. Western Australia*, para. 15.

**519** *Mervyn/Ngaanyatjarra Lands v. Western Australia*, para. 19 (emphasis in original).

**520** The photograph in figure 226 of the Cook County Courthouse, Grand Marais, Minnesota is by Doug Ohman, Pioneer Photography, copyright 2006; our thanks for permission to use this image to him and to the Cook County Court Administration, Sixth Judicial District, State of Minnesota.

**521** Minnesota Judicial Branch, Cook County Courthouse, *Building Location Details*, http://www.courts.state.mn.us/?siteID=0&page=CourtHouseProfile&ID=40014 (hereinafter Minnesota Judicial Branch, Cook County Courthouse).

**522** U.S. Bureau of Census, Minnesota: Population of Counties by Decennial Census: 1900 to 1990 (Richard L. Forstall, ed., Washington, DC: Population Division, U.S. Bureau of Census), www.census.gov/population/cencounts/mn190090.txt (hereinafter MINNESOTA POPULATION). The census recorded 810 people for 1900.

**523** MINNESOTA POPULATION.

**524** GILBERTSON at 33.

**525** Minnesota Judicial Branch, Cook County Courthouse. It was also apparently in disrepair. GILBERTSON at 33.

**526** Minnesota Judicial Branch, Cook County Courthouse.

**527** GILBERTSON at 32.

**528** GILBERTSON at 32–33. Residents had a per capita income of $26,226. Id. See also U.S. Census Bureau, *State & County QuickFacts*, "Cook County, Minnesota," http://quickfacts.census.gov/qfd/states/27/27031.html.

**529** MARY JANE MORRISON, THE MINNESOTA STATE CONSTITUTION: A REFERENCE GUIDE 2 (Westport, CT: Greenwood, 2002).

**530** MORRISON at 3–6.

**531** MORRISON at 6–7. The state is the twelfth largest of the fifty states and, as of 1990, the twentieth most populated. Id. at 6. See also Rhoda R. Gilman, *Territorial Imperative: How Minnesota Became the 32nd State*, 56 MINNESOTA HISTORY 154 (1998/1999); William Anderson, *Minnesota Frames a Constitution*, 36 MINNESOTA HISTORY 1 (1958).

**532** OHMAN & LOGUE at 10. In addition to this volume, two other books are devoted to courthouses of the states. See MARION CROSS, MINNESOTA COURTHOUSES (Minneapolis, MN: National Society of the Colonial Dames of America in the State of Minnesota, 1966); GILBERTSON. Both the Ohman and Logue and the Gilbertson volumes are courthouse-by-courthouse studies, the first through photographs and the second through watercolors, with the images accompanied by brief descriptions of each building. Cross provided a list of courthouses and reported that the earliest one was built in 1849 in Washington County. Id., Foreword at 1. The building "boom" produced sixty-two courthouses in the 1880s and 1890s, reflecting a prosperity that produced "Victorian structures" that survived in part because of the falloff in new construction. Id. at 3.

**533** MINN. CONST., Art. III, § 1 (1857).

**534** MINN. CONST., Art. VI, § 5 (1857); see also MORRISON at 195.

**535** The provisions were revised in the second half of the twentieth century. MORRISON at 183–187. When doing so, the commission charged with proposing revisions reported that its changes were evolutionary, not radical, and noted that it was taking care "to preserve the independence of the judiciary as one of the three coordinate branches of our government." See *Preliminary Report on Revision of the Judiciary Article of the Minnesota State Constitution*, 32 MINNESOTA LAW REVIEW 458, 458 (1948). See also Maynard E. Pirsig, *The Proposed Amendment of the Judiciary Article of the Minnesota Constitution*, 40 MINNESOTA LAW REVIEW 815 (1956). By the late twentieth century, administrative and court-based judges over-

lapped in terms of the kind of work they did. See MORRISON at 183–187.

**536** MINN. CONST., Art. I, § 6 (1857). The document reads: "In all criminal prosecutions, the accused shall enjoy the right to a speedy and public trial by an impartial jury . . . ." Id. It further specifies that "[n]o person shall be held to answer for a criminal offense without due process of law." MINN. CONST., Art. I, § 7. See also MORRISON at 51–63.

**537** MINN. CONST., Art. I, § 4 (1857).

**538** MINN. CONST., Art. I, § 2 ("Rights and Privileges") (1857). The word "member" "included any alien who declared an intent to become a U.S. citizen." MORRISON at 28.

**539** MINN. CONST., Art. I, § 8 (1857). Other states with similar provisions include some of the states of the Northwest Territory and also New York and Iowa. MORRISON at 82.

**540** MORRISON at 82. This provision applied to noncitizens. Id. at 83.

**541** OHMAN & LOGUE at 11–12.

**542** OHMAN & LOGUE at 100. The Cook County Courthouse gained that status in 1983. Id. at 125. As of 2006, of the ninety county courthouses "in-use," eighteen were buildings that dated from after 1970, and eleven more dated from 1950 or after. Id. at 105.

**543** OHMAN & LOGUE at 16; Minnesota Judicial Branch, Cook County Courthouse.

**544** Minnesota Judicial Branch, Cook County Courthouse.

**545** OHMAN & LOGUE at 34. "[O]n Minnesota courthouses, she is most often shown blindfolded and toting a sword and scales." Id. at 34.

**546** OHMAN & LOGUE at 34. One Justice, twelve feet high and some two hundred pounds, was struck by lightning several times before being "toppled" in 1996 by very strong winds and was only "saved by the lightning rod cable to which she was tethered." Id. Other Justices had safer settings in the courthouse interior. Id. at 38–39.

**547** As we noted in Chapter 1, the *New York Times* reported that Justice stood "surrounded and wrapt like a martyr in the flames. The balances a minute after whirled around and fell. Then she glowed as if made of iron, and . . . fell with a crash through the tower." *Burning of the City Hall*, NEW YORK TIMES, Aug. 18, 1858, at 5. See also ISAAC NEWTON PHELPS STOKES, THE ICONOGRAPHY OF MANHATTAN ISLAND, 1498–1909, vol. 5: 1877 (Union, NJ: Lawbook Exchange, 1998; republication of a set of volumes originally published by R. H. Dodd in 1915–1928).

**548** OHMAN & LOGUE at 11, 52–53.

**549** OHMAN & LOGUE at 70–71.

**550** OHMAN & LOGUE at 83.

**551** OHMAN & LOGUE at 84.

**552** OHMAN & LOGUE at 85.

**553** OHMAN & LOGUE at 99.

**554** MINNESOTA JUDICIAL BRANCH, A REPORT TO THE COMMUNITY: THE 2008 ANNUAL REPORT OF THE MINNESOTA JUDICIAL BRANCH 5, http://www.mncourts.gov/Documents/0/Public/Court_Information_Office/AR_Working_08.pdf (hereinafter 2008 MINNESOTA JUDICIAL BRANCH ANNUAL REPORT). The consolidation also meant that "nearly 40 percent of counties share[d] a court administrator," as well as programs for the provision of interpreters and the calling of jurors. Databases and case management systems were unified so that practices became more consistent across counties. Id. at 5–6. As of 2008, some 289 district judgeships were allocated across ten judicial districts; almost two million cases were filed at the trial level. Id. at 15. In terms of volume, the number of "major criminal" cases—about 61,000—paralleled the number of criminal cases in the entire federal system. The intermediate court of appeals, with nineteen members, received some 2,100 cases, and the Supreme Court (with seven jurists) decided about 126 direct appeals. Id. at 16–19.

**555** 2008 MINNESOTA JUDICIAL BRANCH ANNUAL REPORT at 12.

**556** GILBERTSON at 32.

**557** The photograph in figure 227 was taken in 2003, with the assistance of the Cook County Court Administration, Sixth Judicial District, State of Minnesota, by Judith Resnik and Dennis E. Curtis.

**558** The photographs reproduced in figures 228 and 229 of the James Sommerness Memorial Award, in Cook County Courthouse, Grand Marais, Minnesota, were taken by Glenn Gilyard and with the permission of the court. The images are reproduced with his permission and that of Richard Gilyard, who served as the architect for the Court of Appeals for the Eighth Circuit and arranged for the pictures to be taken.

**559** See In the Matter of a Memorial Service Honoring: James A. Sommerness, Attorney and Counselor, Held before the Honorable Kenneth A. Sandvik, Judge of the District Court, in the Cook County Courthouse, June 19, 1997 (hereinafter Sommerness Memorial Service). Our thanks to Richard Gilyard; to Carl Christensen, law clerk to Judge Sandvik; and to Larry J. Saur, Court Administrator, for providing us with the materials on the memorial service and photographs of the court and to Celeste Bremer for helping us to gather this information.

In the 1960s, the United States Supreme Court interpreted the United States Constitution as requiring that counsel be appointed for indigent criminal defendants facing felony charges. See *Gideon v. Wainwright*, 372 U.S. 335 (1963). States implement this obligation in various ways; the right to appointed counsel in Minnesota is provided by the state's Rules of Criminal Procedure. See 49 Minn. Stat. Ann. Rule 5.04

(Supp. 2010). Implementing that precept has been a chronic problem for lack of funds. See James L. Baillie, *Meeting the Crisis in Funding for the Courts and for Legal Services*, 60 Bench & Bar of Minnesota (Aug. 2003), http://mnbar.org/benchandbar/2003/aug03/prez.htm.

**560** Sommerness Memorial Service at 3 (statement of Judge Sandvik). Quotes to the service come from this transcript.

**561** See detail of the James Sommerness Memorial, figure 228.

**562** Sommerness Memorial Service at 14 (letter from Richard Swanson).

**563** One ambitious overview aiming to ground that claim is Douglass C. North, John Joseph Wallis, & Barry R. Weingast, Violence and Social Orders: A Conceptual Framework for Interpreting Recorded Human History (Cambridge, Eng.: Cambridge U. Press, 2009). They focus on conditions—intellectual, economic, technological, and institutional—creating "doorstep conditions" facilitating open social orders, receptive to competition, economic growth, and stability through impersonal interactions among various sectors, public and private. Id. at 240–250.

**564** Jonathan Crary, Suspensions of Perception: Attention, Spectacle, and Modern Culture 47 (Cambridge, MA: MIT Press, 1999).

**565** U.S. Supreme Court Press Release, May 3, 2010, http://www .supremecourt.gov/publicinfo/press/viewpressreleases.aspx?FileName =pr_05-03-10.html.

# NOTE ON SOURCES

This book is informed by a diverse set of published and unpublished sources. In addition to the books and articles cited in the bibliography, we have used collections of legislative and judicial materials as well as publications from many jurisdictions both inside and outside the United States. We consulted materials from a number of archival collections, including:

the Photographic Collection of the Warburg Institute, University of London;

Rare Book Collection, Lillian Goldman Library, Yale Law School;

Beinecke Rare Book and Manuscript Library, Yale University;

archival materials from the General Services Administration (GSA) of the United States, from its Fine Arts Program, Art-in-Architecture Program, and the Office of the Chief Architect;

the Stefan Hirsch and Elsa Rogo Papers, the Simka Simkhovitch Papers, and the Adolph A. Weinman Papers, in the Archives of American Art of the Smithsonian Institution;

collected materials on the federal judiciary at the National Archives of the United States, as well as at the Administrative Office of the United States Courts (AO) and the Federal Judicial Center (FJC);

the Cass Gilbert Collection in the Prints, Photographs, and Architectural Collections of the New York Historical Society;

the exhibit brochure for Civic Spirit: Changing the Course of Federal Design, Sept. 13–Nov. 10, 2004, Center for Architecture;

papers, pamphlets, brochures, and lectures provided by the Office of the Curator of the United States Supreme Court and by several lower federal courts, state courts, and county seats in the United States, such as newsletters from Discovering Justice: The James D. St. Clair Court Education Project (2001–2008); The Art and Craft of Justice: A Guide to the Stone Carvings and Inscriptions

of the United States Courthouse in Boston (Federal Court Public Education Fund, 1998), and Douglas P. Woodlock, Architecture and the Design of the New Federal Courthouse in Boston (lecture delivered to the Boston Society of Architects, Jan. 25, 1995).

In addition, we have drawn from materials at libraries, museums, city archives, ministries of justice, judiciaries, other government agencies, and foundations. Outside the United States, materials came from:

The Bentham Project, University College London;

Royal Palace Foundation of Amsterdam and the Amsterdam City Archives;

Musea Brugge, Groeningemuseum, Bruges, Belgium;

Centre d'Iconographie Genevoise, Geneva, Switzerland;

Agence Publique pour l'Immobilier de la Justice, Paris, France;

L'Agence de Maîtrise d'Ouvrage des Travaux du Ministère de la Justice, Paris, France (AMOTMJ), as well as annual reports and brochures from the French Ministry of Justice, including *Les Nouveaux Équipements du ministère de la Justice* (*New Facilities of the Ministry of Justice*, 2004), and the collection of brochures published between 1990 and 2006 by the Délégation Générale au Programme Pluriannuel d'Équipement and the AMOTMJ;

conferences and symposia, such as Palais de Justice: héritages et projets (Law Courts: Legacies and Projects) (Paris, France, 2004); and L'architecture du palais de justice: une rétrospective franco-américaine, 1991–2006 (Courthouse Architecture: A Franco-American Retrospective) (Paris, France, 2009); and unpublished lectures such as Antonine Garapon's Imaginer le palais de justice du XXIème siècle (Imagining the Courthouses of the Twenty-First Century, 2006);

reports related to courts in the United Kingdom, including Lord Woolf, *Access to Justice, Final Report to the Lord Chancellor on the Civil Justice System in England and Wales* (1996);

Registrar and Public Information Office of the Israel Supreme Court, Jerusalem;

County Court of Victoria, the Supreme Court of Victoria, in Melbourne, Victoria, in the Commonwealth of Australia, and the Federal Court of Australia;

Helsinki District Court, Finland;

General Secretariat, Supreme Court of Japan, Tokyo;

data, pamphlets, building information, and monographs from the Court of Justice of the European Union (Luxembourg City, Luxembourg), the International Court of Justice (The Hague, the Netherlands), the International Criminal Court (The Hague, the Netherlands), the International Tribunal for the Law of the Sea (Hamburg, Germany), the International Criminal Tribunal for the former Yugoslavia (The Hague, the Netherlands), and the Inter-American Court of Human Rights (San José, Costa Rica), and the World Bank.

In addition, we have drawn on publications, conferences, and data produced in the United States by governments, associations of lawyers, architects, judges, and nonprofit entities. Our sources included:

monographs by the Design Excellence Program of the GSA and the brochures for various of the newly built or renovated federal courthouses;

a series of volumes by the GSA on federal building, such as *Vision + Voice: Building a Legacy* (vol. 1) and *Vision + Voice: Changing the Course of Federal Architecture* (vols. 2 & 3) (2002–2004); *Growth, Efficiency and Modernism: GSA Buildings of the 1950s, 60s, and 70s* (2006); *Design Excellence: Policies and Procedures* (2008); and the GSA's *Design Guide for U.S. Courthouses* (1979, 1984);

monographs by or about the federal judiciary, including the 1991, 1997, and 2007 editions of *U.S. Courts Design Guide* of the Judicial Conference of the United States; the *Annual Reports of the Attorney General of the United States* (1871–2008); the *Annual Reports of the Judicial Conference of the United States* (1924–2008), and materials from subcommittees of the Judicial Conference such as its Space and Facilities Committee (1989–2008); the *Annual Reports of the Director of the Administrative Office of the U.S. Courts* (1941–2008); monthly, annual, and special publications of the Federal Judicial Center (FJC), including *The Third Branch: The Newsletter of the Federal Courts* (1968–2008), its Historic Federal Courthouses online database, its exhibit *Constructing Justice: The Architecture of Federal Courthouses*; and the annual *Year-End Reports* issued by the Chief Justice of the United States from 1985 through 2008;

reports by the National Academy of Public Administration and the National Endowment for the Arts, such as *Federal Architecture: A Framework for Debate: An Interim Report of the Federal Architecture Project* (1974), and *Federal Architecture: Multiple-Use Facilities: Staff Report for the Federal Architecture Project* (1974);

data and reports of the United States Bureau of Justice Statistics; the Congressional Budget Office; the Congressional Research Services; the United States General Accounting Office (subsequently called the United States Government Accountability Office), including a series on courthouse construction and courtroom sharing;

reports from other government agencies, such as the Office of Administrative Law Judges, *The Federal Administrative Judiciary Then and Now: A Decade of Change 1992–2002*;

Congressional hearings and reports, such as *The Final Report of the Supreme Court Building Commission in Connection with the Construction, Equipping, and Furnishing of the United States Supreme Court Building* (1939); *Art and Government: Report to the President of the Commission on Fine Arts* (1953);

publications of the National Center for State Courts, as well as state-specific volumes, such as the *Judicial Council of California, Public Hearings Report: Access for Persons with Disabilities* (January, 1997); *Commission on Public Access to Court Records, Report to the Chief Judge of the State of New York* (Abrams Commission, Feb. 2004);

annual reports of many states' judiciaries, as well as select transcripts, such as *In the Matter of the Memorial Service Honoring James A. Sommerness, Attorney and Counselor, Held before the Honorable Kenneth A. Sandvik, Judge of the District Court, in the Cook County Court House, June 19, 1997* (Cook County, Minnesota).

We have also used publications and conference materials from organizations of lawyers, professors, judges, and architects. Of special import for this volume are materials by the American Bar Association (ABA), the American Institute of Architects (AIA), the American Law Institute, and the International Association of Procedural Law (IAPL), including:

ABA, *Model Codes of Judicial Conduct* (1972, 1990, 2004, 2007);

ABA, Coalition for Justice, Special Committee on Funding the Justice System, *Saving Our System: A National Overview of the Crisis in America's System of Justice: A Report* (1993);

Joint Committee on the Design of Courtrooms and Court Facilities, *The American Courthouse: Planning and Design for the Judicial Process* (Ann Arbor, MI: Edwards Brothers, 1973);

*Twenty Years of Courthouse Design Revisited: Supplement to the American Courthouse* (Chicago, IL: ABA Judicial Administration Division, National Center for State Courts, State Justice Institute, 1993); Don Harden-

bergh, *The Courthouse: A Planning and Design Guide for Court Facilities* (Williamsburg, VA: National Center for State Courts, AIA, Conference of State Court Administrators, National Center for Juvenile Justice, and ABA, 1991); Don Hardenbergh, Robert W. Tobin, Michael Griebel, and Chang-Ming Yeh, *The Courthouse: A Planning and Design Guide for Court Facilities* (Williamsburg, VA: National Center for State Courts, 1999); materials presented at conferences and symposia sponsored by the American Institute of Architects (AIA), including its International Conference on Court Design and Planning—Agenda for Affording Excellence: Addressing Court Needs at the Local Level (Phoenix, AZ, 2001); and Justice and the City, conference materials (San Diego, CA, 2005), presented by the AIA, Committee on Architecture for Justice, in association with the National Center for State Courts and the National Association for Court Management; and commentary by Celeste Bremer and Richard Gilyard, Art in Courthouses: Implications of the Government as Client, from the Sustainable Excellence, Sixth Annual International Conference on Court Design for the AIA (New York, NY, 2007); the International Association of Procedural Law (IAPL), The Future of Categories—Categories of the Future (Toronto, Canada, 2009).

A few special editions of journals have also informed our work, including Construire pour la justice (Constructing Justice), 265 *Archicrée* (May–June 1995); and Palazzi di Giustizia (Courthouses), *Zodiac* 14 (International Review of Architecture) (1995–1996).

This volume also includes many references to biblical materials, some of which are available through the Yale University online "Bible in English" Collection. Included in that database are:

*The King James Version of the Holy Bible* (London, England: Robert Barker, 1611);

*The Holy Bible Translated from the Latin Vulgat: Diligently compared with the Hebrew, Greek, and other Editions in divers Languages* (Richard Challoner, ed., 1750);
*The Bible: That is, the Holy Scriptures Conteined in the Olde and Newe Testament. Translated According to the Ebrew and Greeks, and Conferred with the Best Translations in Divers Languages* (London, England: Christopher Barker, 1587);
*The Good News Bible with Deuterocanonicals/Apocrypha, Today's English Version* (Robert G. Bratcher, trans., New York, NY: American Bible Society, 1976);
*The Twentieth Century New Testament: A Translation into Modern English Made from the Original Greek (Westcott & Hort's Text)* (New York, NY: Fleming H. Revell, 1902; revised, 1904);
*The New English Bible with the Apocrypha* (Charles Harold Dodd, ed., Oxford and Cambridge, England: Oxford University Press and Cambridge University Press, 1970).

We also consulted the *Bible Moyen français, 1550* (Cambridge, MA: Omnisys, 1990); *Triglot Concordia: The Symbolical Books of the Evangelical Lutheran Church* (F. Bente and W. H. T. Dau, trans., St. Louis, MO: Concordia Publishing House, 1921); *Code of Maimonides (Mishneh Torah)* (Yale Judaica Series, Abraham M. Hershman trans., New Haven, CT: Yale University Press, 1949); *Roman Missal, Compiled by Lawful Authority from the Missale Romanum* (Adrian Fortescue, intro., New York, NY: Macmillan, 1951); *The Holy Qur'an* (M. H. Shakir, trans., New York, NY: Tahrike Tarsile Quar'an, 1983).

We have also benefited from interviews, in person or by telephone, with Caleb Bach, Jeff Danzinger, Dorothea Rockburne, Jenny Holzer, Ellsworth Kelly, Jan Mitchell, Diana Moore, Ozier Muhammad, and Tom Otterness (all artists whose work is reproduced in this volume), as well as from discussions with numerous judges and justices, court administrators, and government officials in jurisdictions around the world.

# SELECTED BIBLIOGRAPHY

## BOOKS, MONOGRAPHS, ARTICLES, AND DISSERTATIONS

Abbondanza, Roberto. *Jurisprudence: The Methodology of Andrea Alciato*, in *The Late Italian Renaissance, 1525–1630* (Eric Cochrane, ed., London, England: Macmillan, 1970).

Abel, Richard. *The Legal Profession in England and Wales* (Oxford, England: Blackwell, 1988).

———. *English Lawyers between Market and State* (Oxford, England: Oxford University Press, 2003).

Abrams, Brett L. *Capital Sporting Grounds: A History of Stadium and Ballpark Construction in Washington, D.C.* (Jefferson, NC: McFarland & Co., 2009).

Ackerman, Bruce. *We the People*, vol. 2: *Transformations* (Cambridge, MA: Harvard University Press, 1998).

Ackerman, Bruce, and James S. Fishkin. *Deliberation Day* (New Haven, CT: Yale University Press, 2004).

Ackerman, John M., and Irma E. Sandoval-Ballesteros. The Global Explosion of Freedom of Information Laws, 58 *Administrative Law Review* 85 (2006).

Adams, Julia. *The Familial State: Ruling Families and Merchant Capitalism in Early Modern Europe* (Ithaca, NY: Cornell University Press, 2005).

Adcock, F. E. Literary Tradition and Early Greek Code-Makers, 2 *Cambridge Historical Journal* 95 (1927).

Adkins, Nelson F. *Fitz-Greene Halleck: An Early Knickerbocker Wit and Poet* (New Haven, CT: Yale University Press, 1930).

Agnew, John A., and James S. Duncan (eds.). *The Power of Place: Bringing Together Geographical and Sociological Imaginations* (Boston, MA: Unwin Hyman, 1989).

Agulhon, Maurice. *Marianne into Battle: Republican Imagery and Symbolism in France, 1789–1880* (Janet Lloyd, trans., Cambridge, England: Cambridge University Press, 1981).

Alciatus, Andreas. *Livret des Emblemes de Maistre Andre Alciat, Mis en Rime Francoyse* (Paris, France: Chrestien Wechel, 1536).

———. "Emblemata" in *Opera omnia*, vol. 2 (Basilae: apud Thomam Guarinum, 1582).

———. *The Latin Emblems: Index Emblematicus*, vols. 1 & 2 (Peter M. Daly, ed., Toronto, Canada: University of Toronto Press, 1985).

Allott, Philip. *The Health of Nations: Society and Law beyond the State* (Cambridge, England: Cambridge University Press, 2002).

Alston, Philip (ed.). *The EU and Human Rights* (Oxford, England: Oxford University Press, 1999).

Alston, Philip, and Olivier de Schutter. *Monitoring Fundamental Rights in the EU: The Contribution of the Fundamental Rights Agency* (Portland, OR: Hart Publishing, 2005).

Altbeker, Antony. *A Country at War with Itself: South Africa's Crisis of Crime* (Johannesburg, South Africa: Jonathan Ball Publishers, 2007).

Alvarez, José E. *International Organizations as Law-makers* (Oxford, England: Oxford University Press, 2005).

Amar, Akhil R. The Bill of Rights and the Fourteenth Amendment, 101 *Yale Law Journal* 1193 (1992).

American Law Institute. *A Study of the Business of the Federal Courts*, vols. I and II (Philadelphia, PA: American Law Institute, 1934).

Anderson, Benedict. *Imagined Communities: Reflections on the Origin and Spread of Nationalism* (London, England: Verso, 1983, reissued 2006).

Anderson, David. *Modern Law of the Sea: Selected Essays* (Boston, MA: Martinus Nijhoff, 2008).

Anderson, Joseph F. Jr. Hidden from the Public by Order of the Court: The Case Against Government-Enforced Secrecy, 55 *South Carolina Law Review* 711 (2004).

———. Secrecy in the Courts: At the Tipping Point?, 54 *Villanova Law Review* 811 (2009).

Andrews, Neil. *English Civil Procedure: Fundamentals of the New Civil Justice System* (Oxford, England: Oxford University Press, 2003).

Andrews, William L. *The Journey of Iconophiles around New York in Search of the Historical and Picturesque* (New York, NY: Gilliss Press, 1897).

Anreus, Alejandro. *Orozco in Gringoland: The Years in New York* (Albuquerque, NM: University of New Mexico Press, 2001).

Aptekar, Jane. *Icons of Justice: Iconography and Thematic Imagery in Book V of the Faerie Queene* (New York, NY: Columbia University Press, 1969).

Aquinas, Thomas. *Disputed Questions on Virtue* (Ralph McInerny, trans. and preface, South Bend, IN: St. Augustine's Press, 1999).

———. *The Cardinal Virtues, Prudence, Justice, Fortitude, and Temperance* (Richard J. Regan ed. and trans., Indianapolis, IN: Hackett Publishing, 2005).

Archer, Madeline C. *The Illustrated Bartsch: 28, The Italian Masters of the Sixteenth Century* (New York, NY: Abaris Books, 1995).

Arendt, Hannah. *The Origins of Totalitarianism* (New York, NY: Houghton Mifflin Harcourt, 1973; first published 1951).

Armstrong, Isobel. *Victorian Glassworlds: Glass Culture and the Imagination 1830–1880* (Oxford, England: Oxford University Press, 2008).

Arnold, Linda. Vulgar and Elegant: Politics and Procedure in Early National Mexico, 50 *Americas* 481 (1994).

Arnold, Richard S. Unpublished Opinions: A Comment, 1 *Journal of Appellate Practice and Process* 219 (1999).

Asimow, Michael. The Administrative Judiciary: ALJ's in Historical Perspective, 20 *Journal of the National Association of Administrative Judges* 157 (2000).

———. The Spreading Umbrella: Extending the APA's Adjudication Provisions to All Evidentiary Hearings Required by Statute, 56 *Administrative Law Review* 1003 (2004).

Askin, Kelly D. Reflections on Some of the Most Significant Achievements of the ICTY, 37 *New England Law Review* 903 (2003).

Aste, Richard, Janet Cox-Rearick, and Bertha and Karl Leubsdorf Art Gallery. *Giulio Romano, Master Designer: An Exhibition of Drawings in Celebration of the Five Hundredth Anniversary of His Birth* (New York, NY and Seattle, WA: Bertha and Karl Leubsdorf Art Gallery, Hunter College of City University of New York and University of Washington Press, 1999).

Astor, Hilary, and Christine M. Chinkin (eds.). *Dispute Resolution in Australia* (Sydney, Australia: Butterworths, 1992).

Austin, Regina. Sapphire Bound!, 1989 *Wisconsin Law Review* 539.

Bagehot, Walter. *The English Constitution* (London, England: Oxford University Press, 1867; reprint by Gaunt, Holmes Beach, FL, 1998).

Bagley, Ayers L., Edward M. Griffin, and Austin J. McLean (eds.). *The Telling Image: Explorations in the Emblem* (New York, NY: AMS Press, 1996).

Bailey, Joyce Waddell. José Clemente Orozco (1883–1949): Formative Years in the Narrative Graphic Tradition, 15 *Latin American Research Review* 73 (1980).

Baker, C. Edwin, *Media Concentration and Democracy: Why Ownership Matters* (New York, NY: Cambridge University Press, 2007).

Bakhtin, Mikhail. *Rabelais and His World* (Helene Iswolsky, trans., Bloomington, IN: Indiana University Press, 1984).

Baldus, David C., George Woodworth, David Zuckerman, Neil A. Weiner, and Barbara Broffitt. Racial Discrimination and the Death Penalty in the Post-Furman Era: An Empirical and Legal Overview, with Recent Findings from Philadelphia, 83 *Cornell Law Review* 1638 (1998).

Bale, Anthony. *The Jew in the Medieval Book: English Antisemitisms, 1350–1500* (Cambridge, England: Cambridge University Press, 2006).

Balfe, Judith H., and Margaret J. Wyszomirski. Public Art and Public Policy 15 *Journal of Arts Management and Law* 5 (Winter 1986).

Balkin, Jack M., & Sanford Levinson, The Processes of Constitutional Change: From Partisan Entrenchment to the National Surveillance State, 75 *Fordham Law Review* 489 (2006).

Ball, Milner S. The Play's the Thing: An Unscientific Reflection on Courts under the Rubric of Theater, 28 *Stanford Law Review* 81 (1975).

Balousek, Marv. *Wisconsin's Historic Courthouses* (Oregon, WI: Badger Books, 1998).

Banaszak, Ronald A. *Fair Trial Rights of the Accused: A Documentary History* (Westport, CT: Greenwood Publishing Group, 2002).

Barak, Aharon. Supreme Court, 2001 Term—Foreword: A Judge on Judging: The Role of a Supreme Court in a Democracy, 116 *Harvard Law Review* 19 (2003).

Baralt, Guillermo A. *History of the Federal Court in Puerto Rico: 1899–1999* (Janis Palma, trans., Hato Rey, Puerto Rico: Publication Puertorriqueñas, 2004).

Barasch, Moshe. *Blindness: The History of a Mental Image in Western Thought* (New York, NY: Routledge, 2001).

Barnouw, Adriaan J. *The Fantasy of Pieter Bruegel* (New York, NY: Lear Publishers, 1947).

Barry, Brian. *Justice as Impartiality*, vol. 2 in *A Treatise on Social Justice* (Oxford, England: Clarendon Press, 1995).

Bartels, Larry M. *Unequal Democracy: The Political Economy of the New Gilded Age* (Princeton, NJ: Princeton University Press, 2008).

Bassett, Debra L., and Rex R. Perschbacher. The End of Law, 84 *Boston University Law Review* 1 (2004).

Bassiouni, M. Cherif, and Michael W. Hanna. Ceding the High Ground: The Iraqi High Criminal Court Statute and the Trial of Saddam Hussein, 39 *Case Western Reserve Journal of International Law* 21 (2007).

Bate, Heidi E. The Measures of Men: Virtue and the Arts in the Civic Imagery of Sixteenth-Century Nuremberg (Ph.D. dissertation, Department of History, University of California, Berkeley, 2000; UMI Publication No.: AAT 3001752).

Bath, Michael. *Speaking Pictures: English Emblem Books and Renaissance Culture* (London, England: Longman, 1994).

Bauer, Carlos G. The Observance of Human Rights and the Structure of the System for Their Protection in the Western Hemisphere, 30 *American University Law Review* 5 (1981).

Baum, Lawrence, Sheldon Goldman, and Austin Sarat. The Evolution of Litigation in the Federal Court of Appeals, 1895–1975, 16 *Law & Society Review* 291 (1981).

Beattie, Susan. *The New Sculpture* (New Haven, CT: Paul Mellon Centre for Studies in British Art and Yale University Press, 1983).

Beck, James. *Raphael: The Stanza della Segnatura* (New York, NY: George Braziller, 1993).

Beckham, Sue B. *Depression Post Office Murals and Southern Culture: A Gentle Reconstruction* (Baton Rouge, LA: Louisiana State University Press, 1989).

Bell, John. *Judiciaries within Europe: A Comparative Review* (Cambridge, England: Cambridge University Press, 2006).

Bels, Marie. L'image architecturale de la Justice (The Architectural Image of Justice) (Paris, France: Ministère de la Justice, Délégation Générale au Programme Pluriannuel d'Équipement, 1995).

Belting, Hans. *The End of the History of Art?* (Chicago, IL: University of Chicago Press, 1987).

Ben-Dor, Oren. *Constitutional Limits and the Public Sphere* (Oxford, England: Hart Publishing, 2000).

Benhabib, Seyla. *The Claims of Culture, Equality and Diversity in the Global Era* (Princeton, NJ: Princeton University Press, 2002).

———. *The Rights of Others: Aliens, Residents, and Citizens* (Cambridge, England: Cambridge University Press, 2004).

Bentham, Jeremy. *The Works of Jeremy Bentham*, vols. 2, 5, 6, 9 (John Bowring, ed., Edinburgh, Scotland: William Tait, 1843).

———. *The Collected Works of Jeremy Bentham: 'Legislator of the World': Writings on Codification, Law, and Education* (Philip Schofield and Jonathan Harris, eds., Oxford, England: Oxford University Press, 1998).

Beresford, Stuart. In Pursuit of International Justice: The First Four-Year Term of the International Criminal Tribunal for Rwanda, 8 *Tulsa Journal of Comparative & International Law* 99 (2000).

Bergeron, David M. The Elizabethan Lord Mayor's Show, 10 *Studies in English Literature, 1500–1900,* 269 (1970).

———. *English Civic Pageantry 1558–1642* (London, England: Edward Arnold, 1971).

Berkowitz, Beth. Negotiating Violence and the Word in Rabbinic Law, 17 *Yale Journal of Law & the Humanities* 125 (2005).

Berkson, Larry C., Scott Beller, and Michele Grimaldi. *Judicial Selection in the United States: A Compendium of Provisions* (Chicago, IL: American Judicature Society, 1981).

Bernstein, Lisa. Opting Out of the Legal System: Extralegal Contractual Relations in the Diamond Industry, 21 *Journal of Legal Studies* 115 (1992).

Bibas, Stephanos. Plea Bargaining outside the Shadow of Trial, 117 *Harvard Law Review* 2463 (2004).

Biddle, George. *An American Artist's Story* (Boston, MA: Little, Brown and Company, 1939).

Bingham, Lisa Blomgren, Tina Nabatchi, Jeffrey M. Senger, and Michael Scott Jackman. Dispute Resolution and the Vanishing Trial: Comparing Federal Government Litigation and ADR Outcomes, 24 *Ohio State Journal on Dispute Resolution* 225 (2009).

Biscardi, Francine. The Historical Development of the Law Concerning Judicial Report Publication, 85 *Law Library Journal* 531 (1993).

Black, Michael. Representations of Justice, 1 *Journal of Social Change and Critical Inquiry* (1999) (online).

Black, Patti C. *Art in Mississippi, 1720–1980* (Jackson, MS: University Press of Mississippi, 1998).

Blankert, Albert. *Gods, Saints and Heroes: Dutch Painting in the Age of Rembrandt* (Washington, DC: National Gallery of Art, 1980).

———. *Ferdinand Bol (1616–1680): Rembrandt's Pupil* (Doornspijk, Netherlands: Davaco Publishers, 1982).

Blanning, Tim. *The Pursuit of Glory: Europe 1648–1815* (New York, NY: Viking, 2007).

Bletter, Rosemarie H. The Interpretation of the Glass Dream—Expressionist Architecture and the History of the Crystal Metaphor, 40 *Society of Architectural Historians* 20 (1981).

Bloch, Susan L. The Early Role of the Attorney General in Our Constitutional Scheme: In the Beginning There Was Pragmatism, 1989 *Duke Law Journal* 561.

Bloomfield, Morton W. *The Seven Deadly Sins: An Introduction to the History of a Religious Concept, with Special Reference to Medieval English Literature* (East Lansing, MI: Michigan State College Press, 1952).

Blumenson, Eric. The Challenge of a Global Standard of Justice: Peace, Pluralism, and Punishment at the International Criminal Court, 44 *Columbia Journal of Transnational Law* 801 (2006).

Bodenhamer, David J. *Fair Trial: Rights of the Accused in American History* (New York, NY: Oxford University Press, 1992).

Bodin, Jean. *Six Books of the Commonwealth* (M. J. Tooley, trans. and abridgment, New York, NY: Barnes and Noble, 1967).

———. *On Sovereignty: Four Chapters from the Six Books of the Commonwealth* (Julian H. Franklin, ed. and trans., Cambridge, England: Cambridge University Press, 1992).

Bogart, Michele H. In Search of a United Front: American Architectural Sculpture at the Turn of the Century, 19 *Winterthur Portolio* 151 (1984).

Boholm, Åsa. *The Doge of Venice: The Symbolism of State Power in the Renaissance* (Gothenburg, Sweden: Institute for Advanced Studies in Cultural Anthropology, 1990).

Bok, Sissela. Kant's Arguments in Support of the Maxim "Do What Is Right Though the World Should Perish," 2 *Argumentation* 7 (1988).

Böker, Uwe, and Julie A. Hibbard (eds.). *Sites of Discourse-Public and Private Spheres-Legal Culture* (Amsterdam, Netherlands: Rodopi, 2002).

Bolgar, R. R. (ed.). *Classical Influences on European Culture AD 500–1500* (Cambridge, England: Cambridge University Press, 1971).

Bongiorno, Laurine M. The Theme of the Old and the New Law in the Arena Chapel, 50 *Art Bulletin* 11 (1968).

Borchard, Edwin M. The Permanent Court of International Justice, 10 *Proceedings of the Academy of Political Science in the City of New York* 124 (1923).

Bourdieu, Pierre. The Force of Law: Toward a Sociology of the Juridical Field, 38 *Hastings Law Journal* 805 (Richard Terdiman, trans., 1987).

———. Participant Objectivation, 9 *Journal of the Royal Anthropological Institute* 281 (2003).

Bourdieu, Pierre, and Loïc J. D. Wacquant. *An Invitation to Reflexive Sociology* (Chicago, IL: University of Chicago Press, 1992).

Boyle, Alan E. The Settlement of Disputes Relating to the Law of the Sea and the Environment, 26 *International Justice* 301 (Kalliopi Koufa, ed., 1997).

Braithwaite, John. *Restorative Justice and Responsive Regulation* (New York, NY: Oxford University Press, 2002).

Brant, Sebastian. *The Ship of Fools, Translated into Rhyming Couplets with Introduction and Commentary by Edwin H. Zeydel* (New York, NY: Columbia University Press, 1944).

Brazil, Wayne D. Comparing Structures for the Delivery of ADR Services by Courts: Critical Values and Concerns, 14 *Ohio State Journal on Dispute Resolution* 715 (1999).

———. Court ADR 25 Years after Pound: Have We Found a Better Way?, 18 *Ohio State Journal on Dispute Resolution* 93 (2003).

Brilmayer, Lea. From "Contract" to "Pledge": The Structure of International Human Rights Agreements, 77 *British Yearbook of International Law* 163 (2007).

Brinton, Jasper Y. *The Mixed Courts of Egypt* (New Haven, CT: Yale University Press, 1930).

Brockman, Joan, and Dorothy Chunn (eds.). *Investigating Gender Bias: Law, Courts and the Legal Profession* (Toronto, Canada: Thompson Educational Publishing, 1993).

Brooks, C. W. Interpersonal Conflict and Social Tension: Civil Litigation in England, 1640–1830, in *The First Modern Society: Essays in English History in Honour of Lawrence Stone* (A. L. Beier, David Cannadine, and James M. Rosenheim, eds., Cambridge, England: Cambridge University Press, 1989).

Broude, Norma, and Mary D. Garrard (eds.). *Feminism and Art History: Questioning the Litany* (New York, NY: Harper & Row, 1982).

———. (eds.). *Reclaiming Female Agency: Feminist Art History after Postmodernism* (Berkeley, CA: University of California Press, 2005).

Browning, J. Robert. Spectacle and the Public Sphere in Seventeenth-Century England (Ph.D. dissertation, Department of English, Indiana University, Bloomington, IN, 2004; UMI Publication No.: AAT 3152794).

Bryde, Brun-Otto. International Democratic Constitutionalism, in *Towards World Constitutionalism: Issues in the Legal Ordering of the World Community* (Ronald St. John Macdonald and Douglas M. Johnson, eds., Boston, MA: Martinus Nijhoff, 2005).

Buchbinder-Green, Barbara J. The Painted Decorations of the Town Hall of Amsterdam (Ph.D. dissertation, Department of Art History, Northwestern University, 1974; UMI Publication No.: AAT 7507883).

Bucholz, R. O. "Nothing but Ceremony": Queen Anne and the Limitations of Royal Ritual, 30 *Journal of British Studies* 288 (1991).

Buergenthal, Thomas. The American and European Conventions on Human Rights: Similarities and Differences, 30 *American University Law Review* 155 (1981).

———. Human Rights in the Americas: View from the Inter-American Court, 2 *Connecticut Journal of International Law* 303 (1987).

Burbank, Stephen B. The Rules Enabling Act of 1934, 130 *University of Pennsylvania Law Review* 1015 (1982).

Burbank, Stephen B., and Barry Friedman (eds.). *Judicial Independence at the Crossroads: An Interdisciplinary Approach* (Thousand Oaks, CA: Sage Publications, 2002).

Burger, Warren E. School for Judges, 33 *Federal Rules Decisions* 139 (1964).

Burke, Thomas F. *Lawyers, Lawsuits, and Legal Rights: The Battle over Litigation in American Society* (Berkeley, CA: University of California Press, 2002).

Burris, Suzanne L. Pieter Bruegel the Elder's Apocalyptic *Fortitude* (M.A. thesis, University of North Texas, 1997; UMI Publication No.: AAT 1387854).

Bushong, William B. Glenn Brown, the American Institute of Architects, and the Development of the Civic Core of Washington, D.C., (Ph.D. dissertation, George Washington University, 1988; UMI Publication No.: AAT 8815950).

Butler, Sara A. Constructing New Deal America: Public Art and Architecture and Institutional Legitimacy (Ph.D. dissertation, Department of Architectural History, University of Virginia, 2001; UMI Publication No.: AAT 3020331).

Bybee, Keith J. (ed.). *Bench Press: The Collision of Courts, Politics, and the Media* (Stanford, CA: Stanford University Press, 2007).

Cabanne, Pierre. *Gérard Garouste* (Paris, France: Expressions Contemporarines, 2000).

Cable, Carole. *The Courthouse and the Law Court: Their Design and*

*Construction* (Monticello, IL: Vance Bibliographies, Architecture Series: Bibliography #A-20, 1978).

Cabra, Marco G. M. Rights and Duties Established by the American Convention on Human Rights, 30 *American University Law Review* 21 (1981).

Caldwell, Wilber W. *The Courthouse and the Depot: The Architecture of Hope in an Age of Despair: A Narrative Guide to Railroad Expansion and Its Impact on Public Architecture in Georgia, 1833–1910* (Macon, GA: Mercer University Press, 2001).

Calhoun, Craig (ed.). *Habermas and the Public Sphere* (Cambridge, MA: MIT Press, 1992).

Callaghan, James E. Reason and Faith in Renaissance Rome: The Stanza della Segnatura (Ph.D. dissertation, Temple University, Philadelpha, PA, 1998; UMI Publication No.: AAT 9910992).

Calleros, Juan C. *The Unfinished Transition to Democracy in Latin America* (New York, NY: Routledge, 2009).

Camille, Michael. *The Gothic Idol: Ideology and Image-making in Medieval Art* (Cambridge, England: Cambridge University Press, 1991).

Camín, Héctor A., and Lorenzo Meyer. *In the Shadow of the Mexican Revolution: Contemporary Mexican History, 1910–1989* (Luis A. Fierro, trans., Austin, TX: University of Texas Press, 1993).

Campbell, Thomas P. (ed.). *Tapestry in the Baroque: Threads of Splendor* (New York, NY, and New Haven, CT: Metropolitan Museum of Art and Yale University Press, 2008).

Cannadine, David. The Transformation of Civic Ritual in Modern Britain: The Colchester Oyster Feast, 94 *Past & Present* 107 (1982).

Cape, Robert W. Jr. Cicero and the Development of Prudential Practice, in *Prudence: Classical Virtue, Postmodern Practice* (Robert Hariman, ed., University Park, PA: Pennsylvania State University Press, 2003).

Capers, I. Bennett. On Justitia, Race, Gender, and Blindness, 12 *Michigan Journal of Race and Law* 203 (2006).

Capitanucci, Maria V. *Dominique Perrault: Recent Works* (Milan, Italy: Skira editore, 2006).

Cappelletti, Mauro (ed.). *Access to Justice and the Welfare State* (Alphen aan den Rijn, Netherlands: Sijthoff, 1981).

Cappelletti, Mauro, and Bryant Garth (eds.). *Access to Justice: A World Survey* (Milan, Italy: Dott. A. Giuffrè Editore, 1978).

Cappio, Gretchen F. Erosion of the Indigenous Right to Negotiate in Australia: Proposed Amendments to the Native Title Act, 7 *Pacific Rim Law & Policy Journal* 405 (1998).

Caron, David D. The Nature of the Iran–United States Claims Tribunal and the Evolving Structure of International Dispute Resolution, 84 *American Journal of International Law* 104 (1990).

Carroll, Christina M. An Assessment of the Role and Effectiveness of the International Criminal Tribunal for Rwanda and the Rwandan National Justice System in Dealing with the Mass Atrocities of 1994, 18 *Boston University International Law Journal* 163 (2000).

Carter, Dan T. *Scottsboro: A Tragedy of the American South* (Baton Rouge, LA: Louisiana State University Press, 1979).

Cassani, Silvia. *Luca Giordano, 1634–1705* (Naples, Italy: Electra Napoli, 2001).

Cerna, Christina M. The Inter-American Commission of Human Rights, 2 *Connecticut Journal of International Law* 311 (1987).

Chambers, David S. *The Imperial Age of Venice, 1380–1580* (London, England: Thames & Hudson).

Chandler, Henry P. Some Major Advances in the Federal Judicial System, 1922–1947, 31 *Federal Rules Decision* 307 (1963).

Charney, Jonathan I. Is International Law Threatened by Multiple International Tribunals?, 271 *Recueil des Cours* 101 (1998).

Chase, Oscar G. *Law, Culture, and Ritual: Disputing Systems in Cross-Cultural Context* (New York, NY: New York University Press, 2005).

Chase, Oscar G., Helen Hershkoff, Linda Silberman, Yasuhei Taniguchi, Vincenzo Varano, and Adrian Zuckerman (eds.). Civil *Litigation in Comparative Context* (St. Paul, MN: Thomson West, 2007).

Cheney, Liana de Girolami. Giorgio Vasari's Astraea: A Symbol of Justice, 19 *Visual Resources* 283 (2003).

Christen, Barbara S., and Steven Flanders (eds.). *Cass Gilbert, Life and Work: Architect of the Public Domain* (New York, NY: W. W. Norton & Company, 2001).

Christin, Olivier. *Les yeux pour le croire, les Dix Commandements en Images, XVe–XVIIIe Siècles* (Paris, France: Seuil, 2003).

Christopher, Warren, and Richard M. Mosk. The Iranian Hostage Crisis and the Iran–U.S. Claims Tribunal: Implications for International Dispute Resolution and Diplomacy, 7 *Pepperdine Dispute Resolution Journal* 165 (2007).

Churchill, R. R., and A.V. Lowe. *The Law of the Sea* (Manchester, England: Manchester University Press, 1999, 3d ed.).

Cicero. *De officiis with an English Translation by Walter Miller* (London, England, and New York, NY: William Heinemann and Putnam, 1928).

———. *Cicero in Twenty-Eight Volumes, XIX De natura deorum academica, with an English Translation by Harris Rackham* (Cambridge, MA: Harvard University Press, 1979).

Claman, Henry N. *Jewish Images in the Christian Church: Art as Mirror of the Jewish-Christian Conflict, 200–1250 CE* (Macon, GA: Mercer University Press, 2000).

Clark, David S. Adjudication to Administration: A Statistical Analysis of Federal District Courts in the Twentieth Century, 55 *Southern California Law Review* 65 (1981).

———. Civil Litigation, Access to Justice, and Social Change: Research Issues in Longitudinal Court Studies, 12 *Southern Illinois University Law Journal* 713 (1987–1988).

———. Civil and Administrative Courts and Procedure, Supplement to U.S. Law in an Era of Democratization, 38 *American Journal of Comparative Law* 181 (1990).

Clayton, Martin. *Canaletto in Venice* (London, England: Royal Collection Publications, 2005).

Clover, Carol J. Regardless of Sex: Men, Women, and Power in Early Northern Europe, 68 *Speculum* 363 (1993).

Cobb, Henry N. *The Shape of Justice: Law and Architecture* (White Plains, NY: Historical Society of the Courts of New York and Court of Appeals of the State of New York, 2007).

Coffee, John C. Jr. Class Action Accountability: Reconciling Exit, Voice, and Loyalty in Representative Litigation, 100 *Columbia Law Review* 370 (2000).

Cohen, Amy J. Revisiting Against Settlement: Some Reflections on Dispute Resolution and Public Values, 78 *Fordham Law Review* 1143 (2009).

Cohen, David. "Hybrid" Justice in East Timor, Sierra Leone, and Cambodia: "Lessons Learned" and Prospects for the Future, 43 *Stanford Journal of International Law* 1 (2007).

Cohen, Morris L., Robert C. Berring, and Kent C. Olson (eds.). *How to Find the Law* (St. Paul, MN: West, 1989, 9th ed.).

Cole, Bruce. *Sienese Painting: From Its Origins to the Fifteenth Century* (New York, NY: Harper & Row, 1980).

Cole, John, and Francis Cole. *A Geography of the European Union* (London, England: Routledge, 1997, 2d ed.).

Coleman, Janet (ed.). *The Individual in Political Theory and Practice* (London, England: Clarendon Press, 1996).

Coll, Alberto R. Normative Prudence as a Tradition of Statecraft, 5 *Ethics and International Affairs* 33 (1991).

Colton, Judith. Luca Giordano, 1634–1705, in *A Taste for Angels: Neapolitan Painting in North America, 1650–1750* (New Haven, CT: Yale University Art Gallery, 1987).

Contini, Francesco, and Giovan F. Lanzara (eds.). *ICT and Innovation in the Public Sector: European Studies in the Making of E-Government* (Hampshire, England: Palgrave Macmillan, 2009).

Contini, Francesco, and Richard Mohr. *Judicial Evaluation: Traditions, Innovations and Proposals for Measuring the Quality of Court Performance* (Saarbrücken, Germany: VDM Verlag, 2008).

Contreras, Belisario R. *Tradition and Innovation in New Deal Art* (Lewisburg, PA: Bucknell University Press, 1983).

Coplin, William D., and J. Martin Rochester. The Permanent Court of International Justice, the International Court of Justice, the League of Nations, and the United Nations: A Comparative Empirical Survey, 66 *American Political Science Review* 529 (1972).

Corbett, Michael R. Continuity and Change in California Courthouse Design, 1850–2000, in *Courthouses of California: An Illustrated History* (Ray McDevitt, ed., San Francisco, CA and Berkeley, CA: California Historical Society and Heyday Books, 2001).

Correa, Catalina Pérez. Distrust and Disobedience: Discourse and Practice in the Law of Mexico, 77 *University of Puerto Rico Law Review* 345 (2008).

Cover, Robert M. The Supreme Court 1982 Term—Foreword: Nomos and Narrative, 97 *Harvard Law Review* 4 (1983).

——. The Folktales of Justice: Tales of Jurisdiction, 14 *Capital University Law Review* 179 (1985).

——. Violence and the Word, 95 *Yale Law Journal* 1601 (1986).

Cover, Robert M., and T. Alexander Aleinikoff. Dialectical Federalism: Habeas Corpus and the Court, 86 *Yale Law Journal* 1035 (1977).

Cover, Robert M., and Owen Fiss (eds.). *The Structure of Procedure* (Mineola, NY: Foundation Press, 1979).

Craig, Lois. *The Federal Presence: Architecture, Politics, and Symbols in United States Government Building* (Cambridge, MA: MIT Press, 1978).

Cranston, Ross. *How Law Works: The Machinery and Impact of Civil Justice* (Oxford, England: Oxford University Press, 2006).

Crary, Jonathan. *Techniques of the Observer: On Vision and Modernity in the Nineteenth Century* (Cambridge, MA: MIT Press, 1990).

——. *Suspensions of Perception: Attention, Spectacle, and Modern Culture* (Cambridge, MA: MIT Press, 1999).

Crockett, George W. Jr. Racism in the Courts, 20 *Journal of Public Law* 375 (1971).

Crook, J. A. *Legal Advocacy in the Roman World* (Ithaca, NY: Cornell University Press, 1995).

Cross, Marion. *Minnesota Courthouses* (Minneapolis, MN: National Society of the Colonial Dames of America in the State of Minnesota, 1966).

Curtis, Dennis E., and Judith Resnik. Images of Justice, 96 *Yale Law Journal* 1727 (1987).

Cutler, Brian L., and Steven D. Penrod. *Mistaken Identification: The Eyewitness, Psychology, and the Law* (Cambridge, England: Cambridge University Press, 1995).

Cutler, Fred. Jeremy Bentham and the Public Opinion Tribunal, 63 *Public Opinion Quarterly* 321 (1999).

Cuzin, Jean-Pierre. *Raphael: His Life and Works* (Sarah Brown, trans., Secaucus, NJ: Chartwell Books, 1983).

Dakolias, Maria, and Javier Said. *Judicial Reform: A Process of Change through Pilot Courts* (Washington, DC: International Bank for Reconstruction and Development, 1999).

Daly, Peter M. (ed.). *Andrea Alciato and the Emblem Tradition: Essays in Honor of Virginia Woods Callahan* (New York, NY: AMS Press, 1989).

Damaška, Miriam. *The Faces of Justice and State Authority: A Comparative Approach to the Legal Process* (New Haven, CT: Yale University Press, 1991).

Dammann, Jens, and Henry Hansmann. Globalizing Commercial Litigation, 94 *Cornell Law Review* 1 (2008).

Damrosch, Lori F. (ed.). *The International Court of Justice at a Crossroads* (Dobbs Ferry, NY: Transnational, 1987).

Daskalopoulou-Livada, Phane. The International Criminal Tribunal for the Former Yugoslavia, 26 *International Justice* 105 (Kalliopi Koufa, ed., 1997).

Davies, Geoffrey L. Civil Justice Reform: Some Common Problems, Some Possible Solutions, 16 *Journal of Judicial Administration* 5 (2006).

——. Civil Justice Reform: Why We Need to Question Some Basic Assumptions, 25 *Civil Justice Quarterly* 32 (2006).

Davis, Natalie Z. *The Gift in Sixteenth-Century France* (Madison, WI: University of Wisconsin Press, 2000).

de Abranches, Carlos A. Dunshee. The Inter-American Court of Human Rights, 30 *American University Law Review* 79 (1981).

de Búrca, Gráinne, and Joseph Weiler. *The European Court of Justice* (Oxford, England: Oxford University Press, 2001).

de Bure, Gilles. *Dominique Perrault: Court of Justice of the European Communities* (Paris, France: Terrail, 2004).

de Bustamante, Antonio Sanchez. *The World Court* (Elizabeth F. Read, trans., New York, NY: Macmillan, 1925).

de Lairesse, Gérard. *The Art of Painting* (London, England: Printed for S. Vandenbergh, 1778).

de Montesquieu, Baron (Charles de Secondat). *The Spirit of the Laws* (Kitchener, Ontario: Batoche, 2001, reprinting a 1752 translation by Thomas Nugent).

de Smith, S. A. The Right to a Hearing in English Administrative Law, 68 *Harvard Law Review* 569 (1955).

de Tolnay, Charles. *The Drawings of Pieter Bruegel the Elder with a Critical Catalogue* (New York, NY: Twin Editions, 1952).

de Vries, Lyckle. *Gerard de Lairesse: An Artist between Stage and Studio* (Amsterdam, Netherlands: Amsterdam University Press, 1998).

Dean, Clay, Theresa Fairbanks, and Lisa Pon (eds.). *Changing Impressions: Marcantonio Raimondi & Sixteenth-Century Print Connoisseurship* (New Haven, CT: Yale University Art Gallery, 1999).

Degenaar, Marjolein. *Molyneux's Problem: Three Centuries of Discussion on the Perception of Forms* (Michael J. Collins, trans., Dordrecht, Netherlands: Kluwer Academic Publishers, 1996).

Delanty, Gerard, and Paul R. Jones. European Identity and Architecture, 5 *European Journal of Social Theory* 453 (2002).

Demaine, Linda J., and Deborah R. Hensler. "Volunteering" to Arbitrate through Predispute Arbitration Clauses: The Average Consumer's Experience, 67 *Law and Contemporary Problems* 55 (2004).

Deonna, Waldemar. La Justice à l'Hôtel de Ville de Genève et la fresque des juges aux mains coupées, 11 *Revue Suisse D'Art et D'Archéologie* 144 (1950).

——. Les Fresques de la Maison de Ville de Genève, 13 *Revue Suisse D'Art et D'Archéologie* 129 (1952).

Depambour Tarride, Laurence. Étude sur les oeuvres crées au titre du 1% artistique dans les palais de justice realisés par la délégation générale au programme pluriannuel d'équipement depuis 1993 et Essai sur le renouvellement de la symbolique judiciaire (Study Concerning Works Created in Courthouses under the 1% Art Provision since 1993 and Essay on the Renewal of Justice Symbolism) (Paris, France: Agence de Maitrise d'Ouvrage des Travaux du Ministère de la Justice, 2002).

Desai, Anuj C. The Transformation of Statutes into Constitutional Law: How Early Post Office Policy Shaped Modern First Amendment Doctrine, 58 *Hastings Law Journal* 671 (2007).

Devereaux, Simon. The City and the Sessions Paper: "Public Justice" in London, 1770–1800, 35 *Journal of British Studies* 466 (1996).

Dezalay, Yves, and Bryant G. Garth. *Dealing in Virtue: International Commercial Arbitration and the Construction of a Transnational Legal Order* (Chicago, IL: Chicago University Press, 1996).

Diderot, Denis. *Oeuvres Complètes* (Paris, France: Le Club Français du Livre, 1969).

Diodorus. *The Historical Library of Diodorus the Sicilian in Fifteen Books to Which Are Added the Fragments of Diodorus* (George Booth, trans., London, England: W. McDowell, 1814).

Dolovich, Sharon. State Punishment and Private Prisons, 55 *Duke Law Journal* 439 (2005).

Domingo, Pilar. Judicial Independence: The Politics of the Supreme Court in Mexico, 32 *Journal of Latin American Studies* 705 (2000).

Donaldson, Ian. *The Rapes of Lucretia: A Myth and Its Transformations* (Oxford, England: Clarendon Press, 1982).

Doré, Laurie Kratky. Public Courts versus Private Justice: It's Time to Let Some Sun Shine in on Alternative Dispute Resolution, 81 *Chicago-Kent Law Review* 463 (2006).

Dougan, Michael. *National Remedies before the Court of Justice: Issues of Harmonisation and Differentiation* (Oxford, England: Hart Publishing, 2004).

Douzinas, Costas, and Lynda Nead (eds.). *Law and the Image: The Authority of Art and the Aesthetics of Law* (Chicago, IL: University of Chicago Press, 1999).

Doyle, Richard E. *Áth: Its Use and Meaning, A Study in the Greek Poetic Tradition from Homer to Euripidies* (New York, NY: Fordham University Press, 1984).

Draper, Anthony J. "Corruptions in the Administration of Justice": Bentham's Critique of Civil Procedure, 1806–1811, 7 *Journal of Bentham Studies* (2004).

du Bois, François, and Antje du Bois-Pedain (eds.). *Justice and Reconciliation in Post-Apartheid South Africa* (Cambridge, England: Cambridge University Press, 2008).

Duff, Antony, Lindsay Farmer, Sandra Marshall, and Victor Tadros (eds.). *The Trial on Trial*, vol. 1: *Truth and Due Process* (Portland, OR: Hart Publishing, 2004).

———. (eds.). *The Trial on Trial*, vol. 2: *Judgment and Calling to Account* (Portland, OR: Hart Publishing, 2006).

———. (eds.). *The Trial on Trial*, vol. 3: *Towards a Normative Theory of the Criminal Trial* (Oxford, England: Hart Publishing, 2007).

Dunseath, T. K. *Spenser's Allegory of Justice in Book Five of the Faerie Queene* (Princeton, NJ: Princeton University Press, 1968).

Dykstra, Yoshiko K. Tales of the Compassionate Kannon: The Hasedera Kannon Genki, 31 *Monumenta Nipponica* 113 (1976).

Eber, Dorothy H. *Images of Justice: A Legal History of the Northwest Territories as Traced through the Yellowknife Courthouse Collection of Inuit Sculpture* (Montreal, Canada: McGill-Queens' University Press, 1997).

Edgerton, Samuel Y. Jr. *Pictures and Punishment: Art and Criminal Prosecution during the Florentine Renaissance* (Ithaca, NY: Cornell University Press, 1985).

———. When Even Artists Encouraged the Death Penalty: Symposium on the Art of Execution, 15 *Law and Literature* 235 (2003).

Eisenberg, Theodore, and Charlotte Lanvers. What Is the Settlement Rate and Why Should We Care?, 6 *Journal of Empirical Legal Studies* 111 (2009).

Eisenberg, Theodore, Geoffrey P. Miller, and Emily Sherwin. Arbitration's Summer Soldiers: An Empirical Study of Arbitration Clauses in Consumer and Nonconsumer Contracts, 41 *University of Michigan Journal of Law Reform* 871 (2008).

Ellenius, Allan (ed.). *Iconography, Propaganda, and Legitimation* (Oxford, England: Clarendon Press, 1998).

Ellickson, Robert. *Order without Law: How Neighbors Settle Disputes* (Cambridge, MA: Harvard University Press, 1991).

Elliott, E. Donald, and Sanjay A. Narayan. Administrative "Health Courts" for Medical Injury Claims; The Federal Constitutional Issues, 33 *Journal of Health, Politics, Policy and Law* 761 (2008).

Engelmann, Stephen G. "Indirect Legislation": Bentham's Liberal Government, 35 *Polity* 369 (2003).

Erichson, Howard M. Court-Ordered Confidentiality in Discovery, 81 *Chicago-Kent Law Review* 357 (2006).

Ersoy, Ufuk. The Fictive Quality of Glass, 11 *arq: Architectural Research Quarterly* 237 (2007).

———. Seeing through Glass: The Fictive Role of Glass in Shaping Architecture from Joseph Paxton's Crystal Palace to Bruno Taut's Glashaus (Ph.D. dissertation, University of Pennsylvania School of Architecture, 2008; UMI Publication No.: AAT 3328551).

Evans, David. Theatre of Deferral: The Image of the Law and the Architecture of the Inns of Court, 10 *Law & Critique* 1 (1999).

Evans, Michael. Two Sources for Maimed Justice, 11 *Source: Notes in the History of Art* 12 (1982).

Everson, Norma. *Two Brazilian Capitals: Architecture and Urbanism in Rio de Janeiro and Brasilia* (New Haven, CT: Yale University Press, 1973).

Eyffinger, Arthur. *The Peace Palace: Residence for Justice, Domicile of Learning* (The Hague, Netherlands: Carnegie Foundation, 1988).

———. *The International Court of Justice, 1946–1996* (Boston, MA: Kluwer Law International, 1996).

———. *The 1899 Hague Peace Conference: "The Parliament of Man, the Federation of the World"* (The Hague, Netherlands: Kluwer Law International, 1999).

———. *The Trusteeship of an Ideal: The Carnegie Foundation, Vignettes of a Century* (Amsterdam, Netherlands: Joh. Enschedé Amsterdam in cooperation with the Carnegie Foundation, 2004).

Fagan, Jeffrey, and Victoria Malkin. Theorizing Community Justice through Community Courts, 30 *Fordham Urban Law Journal* 897 (2003).

Fairweather, Leslie, and Seán McConville (eds.). *Prison Architecture: Policy, Design and Experience* (Oxford, England: Architectural Press, 2000).

Fallon, Richard H. Jr. Of Legislative Courts, Administrative Agencies, and Article III, 101 *Harvard Law Review* 915 (1988).

———. The "Conservative" Paths of the Rehnquist Court's Federalism Decisions, 69 *University of Chicago Law Review* 429 (2002).

Fehl, Phillip P. Raphael as a Historian: Poetry and Historical Accuracy in the Sala di Costantino, 14 *Artibus et Historiae* 9 (1993).

Felstiner, William L. F., Richard L. Abel, and Austin Sarat. The Emergence and Transformation of Disputes: Naming, Blaming, and Claiming . . ., 15 *Law & Society Review* 631 (1980–1981).

Fenster, Mark. The Opacity of Transparency, 91 *Iowa Law Review* 885 (2005).

———. Designing Transparency: The 9/11 Commission and Institutional Form, 65 *Washington and Lee Law Review* 1239 (2008).

Fidell, Eugene R. Accountability, Transparency & Public Confidence in the Administration of Military Justice, 9 *Green Bag 2d* 361 (2006).

Fiera, Battisti. *De Iusticia Pingenda, On the Painting of Justice: A Dialogue between Mantegna and Momus by Battisti Fiera, the Latin Text of 1515 Reprinted with Translation, an Introduction and Notes by James Wardrop* (London, England: Lion and Unicorn Press, 1957).

Fierro, Annette. *The Glass State: The Technology of the Spectacle, Paris 1981–1998* (Cambridge, MA: MIT Press, 2003).

Fine, Toni M. A Legislative Analysis of the Demise of the Administrative Conference of the United States, 30 *Arizona State Law Journal* 19 (1998).

Fisch, Jill. Rewriting History: The Eradication of Prior Decisional Law through Settlement and Vacatur, 76 *Cornell Law Review* 589 (1991).

Fish, Peter G. Crises, Politics, and Federal Judicial Reform: The Administrative Office Act of 1939, 32 *Journal of Politics* 599 (1970).

———. *Federal Justice in the Mid-Atlantic South: United States Courts from Maryland to the Carolinas, 1789–1835* (Washington, DC: Administrative Office of the United States Courts, 2002).

Fisher, George. The Birth of the Prison Retold, 104 *Yale Law Journal* 1235 (1995).

Fiss, Owen M. The Political Theory of the Class Action, 53 *Washington and Lee Law Review* 21 (1996).

———. Against Settlement, 93 *Yale Law Journal* 1073 (1984).

Flanders, Steven (ed.). *Celebrating the Courthouse: A Guide for Architects, Their Clients, and the Public* (New York, NY: W. W. Norton & Company, 2006).

Fletcher, George P. *Basic Concepts of Legal Thought* (Oxford, England: Oxford University Press, 1996).

Folgarait, Leonard. *Mural Painting and Social Revolution in Mexico, 1920–1940: Art of the New Order* (New York, NY: Cambridge University Press, 1998).

Foster, Hal. *Recodings: Art, Spectacle, Cultural Politics* (Port Townsend, WA: Bay Press, 1986).

Foucault, Michel. *Discipline and Punish: The Birth of the Prison* (Alan Sheridan, trans., New York, NY: Vintage Books, 1995, 2d ed.; 1977, 1st ed.).

Fowler, Harriet W. *New Deal Art: WPA Works at the University of Kentucky* (Louisville, KY: University of Kentucky Art Museum, 1985).

Fox, Celina. *Lord Mayor's Coach* (London, England: Museum of London, 1990).

Fox, Nancy. *Liberties with Liberty: The Fascinating History of America's Proudest Symbol* (New York, NY: E. P. Dutton, 1986).

Fraade, Steven D. Hearing and Seeing at Sinai: Interpretive Trajectories, in *The Significance of Sinai: Traditions about Sinai and Divine Revelation in Judaism and Christianity* (George J. Brooke, Hindy Najman, & Loren T. Stuckenbruck, eds., Leiden, Netherlands: Brill, 2008).

Frankfurter, Felix, and James M. Landis. *The Business of the Supreme Court: A Study in the Federal Judicial System* (New York, NY: Macmillan, 1928).

Franklin, Julian H. *Jean Bodin and the Sixteenth Century Revolution in the Methodology of Law and History* (New York, NY: Columbia University Press, 1963).

———. *Jean Bodin and the Rise of Absolutist Theory* (Cambridge, MA: Cambridge University Press, 1973).

———. *Jean Bodin* (Aldershot, England and Burlington, VT: Ashgate, 2006).

Fraser, Nancy. Rethinking the Public Sphere: A Contribution to the Critique of Actually Existing Democracy, in *Habermas and the Public Sphere* (Craig Calhoun, ed., Cambridge, MA: MIT Press, 1992).

Freeman, Jody, and Martha Minow (eds.). *Government by Contract: Outsourcing and American Democracy* (Cambridge, MA: Harvard University Press, 2009).

Freeman, Rosemary. *English Emblem Books* (London, England: Chatto & Windus, 1948).

Fremantle, Katharine. *The Baroque Town Hall of Amsterdam* (Utrecht, Netherlands: Haentjens Dekker & Gumbert, 1959).

———. The Open Vierschaar of Amsterdam's Seventeenth-Century Town Hall as a Setting for the City's Justice, 77 *Oud Holland, Quarterly for Dutch Art History* 206 (1962).

Freschi, Federico. Postapartheid Publics and the Politics of Ornament: Nationalism, Identity, and the Rhetoric of Community in the Decorative Program of the New Constitutional Court, Johannesburg, 54 *Africa Today* 27 (2007).

Friedlander, Suzan D. Broome County, New York's Government-Sponsored Post Office Murals of the 1930's (M.A. thesis, State University of New York at Binghamton, 1990).

Friedman, Barry. Popular Dissatisfaction with the Administration of Justice: A Retrospective (and a Look Ahead), 82 *Indiana Law Journal* 1193 (2007).

Friedman, Richard D. Exploring the Future of the Confrontation Clause in Light of Its Past: Grappling with the Meaning of "Testimonial," 71 *Brooklyn Law Review* 241 (2005).

Frier, Bruce W. *The Rise of the Roman Jurists: Studies in Cicero's Pro Caecina* (Princeton, NJ: Princeton University Press, 1985).

———. Finding a Place for Law in the High Roman Empire, in *Spaces of Justice in the Roman World* (F. de Angelis, ed., Columbia Studies in the Classical Tradition, New York: Columbia University Press, forthcoming).

Fryd, Vivien G. *Art and Empire: The Politics of Ethnicity in the United States Capital, 1815–1860* (New Haven, CT: Yale University Press, 1992; reprint, Athens, OH: Ohio University Press, 2001).

Fuller, Lon L. The Forms and Limits of Adjudication, 92 *Harvard Law Review* 353 (1978).

Gagarin, Michael. Dikê in the Works and Days, 68 *Classical Philology* 81 (1973).

Galanter, Marc. Why the "Haves" Come Out Ahead: Speculations on the Limits of Legal Change, 9 *Law & Society Review* 95 (1974).

———. The Quality of Settlements, 1988 *Journal of Dispute Resolution* 55.

———. The Vanishing Trial: An Examination of Trials and Related Matters in Federal and State Courts, 1 *Journal of Empirical Legal Studies* 459 (2004).

Gannon, Todd (ed.). *The Light Construction Reader* (New York, NY: Monacelli Press, 2002).

Gans, Edwar, and Guido Kisch. The Cambyses Justice Medal, 29 *Art Bulletin* 121 (1947).

Gaonkar, Dilip Parameshwar, with Robert J. McCarthy Jr. Panopticism and Publicity: Bentham's Quest for Transparency, 6 *Public Culture* 547 (1994).

Garapon, Antoine. *Bien Juger: Essai sur le rituel judiciaire* (Paris, France: Odile Jacob, 1997).

Gardner, J. P. (ed.). *The Role and Future of the European Court of Justice* (London, England: British Institute of International and Comparative Law, 1996).

Garth, Bryant G. From Civil Litigation to Private Justice: Legal Practice at War with the Profession and Its Values, 59 *Brooklyn Law Review* 931 (1993).

Gavison, Ruth. The Role of Courts in Rifted Democracies, 33 *Israel Law Review* 216 (1999).

Gendel, Milton L. Giotto's Representation of the Seven Virtues and Vices in the Arena Chapel at Padua (Ph.D. dissertation, Department of Fine Arts, Columbia University, 1940).

Genn, Hazel. *Meeting Legal Needs? An Evaluation of a Scheme for Personal Injury Victims* (Oxford, England: SSRC [Social Science Research Council] Centre for Socio-Legal Studies, 1982).

———. *Paths to Justice: What People Do and Think about Going to Law* (Oxford, England: Hart Publishing, 1999).

———. *Judging Civil Justice: The Hamlyn Lectures 2008* (Cambridge, England: Cambridge University Press, 2010).

Genn, Hazel, and Yvette Genn. *The Effectiveness of Representation at Tribunals, Report to the Lord Chancellor* (London, England: Lord Chancellor's Department, 1989).

Geyh, Charles G. *When Courts and Congress Collide: The Struggle for Control of America's Judicial System* (Ann Arbor, MI: University of Michigan Press, 2006).

———. Preserving Public Confidence in the Courts in an Age of Individual Rights and Public Skepticism, in *Bench Press: The Collision of Courts, Politics, and the Media* (Keith J. Bybee, ed., Stanford, CA: Stanford University Press, 2007).

Gibson, Alan. Veneration and Vigilance: James Madison and Public Opinion, 1785–1800, 67 *Review of Politics* 5 (2005).

Gibson, Walter S. *Bruegel* (New York, NY: Oxford University Press, 1977).

Gilbertson, Victor C. *Minnesota Courthouses* (Lakeville, MN: Galde Press, 2005).

Gilovich, Thomas, Dale W. Griffin, and Daniel Kahneman (eds.). *Heuristics and Biases: The Psychology of Intuitive Judgment* (Cambridge, England: Cambridge University Press, 2002).

Golan, Steven R. Scenes from Roman Republican History in Seventeenth-Century Dutch Art: Exempla Virtutis for Public and Private Viewing (Ph.D. dissertation, Department of Art History, University of Kansas, 1994; UMI Publication No.: AAT 9528360).

Goldhaber, Michael D. *A People's History of the European Court of Human Rights* (New Brunswick, NJ: Rutgers University Press, 2007).

Goldschmidt, Maure L. Publicity, Privacy and Secrecy, 7 *The Western Political Quarterly* 401 (1954).

Goldsmith, Jack, and Daryl Levinson. Law for States: International Law, Constitutional Law, Public Law, 122 *Harvard Law Review* 1791 (2009).

Goldstein, Andrew D. Sealing and Revealing, Rethinking the Rules Governing Public Access to Information Generated through Litigation, 81 *Chicago-Kent Law Review* 375 (2006).

Gombrich, Ernst. Icones Symbolicae: The Visual Image in Neo-Platonic Thought, 11 *Journal of the Warburg and Courtauld Institutes* 163 (1948).

———. *Symbolic Images: Studies in the Art of the Renaissance* (Oxford, England: Phaidon, 1978, 1985, 3rd ed.).

Goode, Luke. *Jürgen Habermas: Democracy and the Public Sphere* (London, England: Pluto Press, 2005).

Goodrich, Peter. Specters of the Law: Why the History of the Legal Spectacle Has Not Been Written, *University of California, Irvine Law Review* (forthcoming, 2010).

Goodsell, Charles T. *The Social Meaning of Civic Space: Studying Political Authority through Architecture* (Lawrence, KS: University Press of Kansas, 1988).

Goossens, Eymert-Jan. *Treasures Wrought by Chisel and Brush: The Town Hall of Amsterdam in the Golden Age* (Amsterdam and Zwolle, Netherlands: Royal Palace and Waanders Publishers, 1996).

Gordon, Diana R. *Transformation and Trouble: Crime, Justice, and Participation in Democratic South Africa* (Ann Arbor, MI: University of Michigan Press, 2006).

Graham, Clare. *Ordering Law: The Architectural and Social History of the English Law Court to 1914* (Aldershot, England: Ashgate, 2003).

Greenberg, Allan. Raising "Temples of Justice": Why Does the Modern Courthouse Fall Short? 59 *Judicature* 484 (1976).

Greenberg, Karen J. (ed.). *The Torture Debate in America* (New York, NY: Cambridge University Press, 2006).

Griffin, James. *On Human Rights* (Oxford, England: Oxford University Press, 2008).

Grimm, Dieter. The European Court of Justice and National Courts: The German Constitutional Perspective after the *Maastricht Decision*, 3 *Columbia Journal of European Law* 229 (1997).

Groebner, Valentin. *Liquid Assets, Dangerous Gifts: Presents and Politics at the End of the Middle Ages* (Pamela E. Selwyn, trans., Philadelphia, PA: University of Pennsylvania Press, 2000).

Groenhuis, G. Calvinism and National Consciousness: The Dutch Republic as the New Israel, in *Britain and the Netherlands*, vol. 7: *Church and State since the Reformation* (A. C. Duke and C. A. Tamse, eds., The Hague, Netherlands: Martinus Nijhoff, 1981).

Grossman, Joel B., Herbert M. Kritzer, and Stewart Macaulay. Do the "Haves" Still Come Out Ahead?, 33 *Law & Society Review* 803 (1999).

Gurney, George. *Sculpture and the Federal Triangle* (Washington, DC: Smithsonian Institution Press, 1985).

Guthrie, Chris, Jeffrey J. Rachlinski, and Andrew J. Wistrich. The "Hidden Judiciary": An Empirical Examination of Executive Branch Justice, 58 *Duke Law Journal* 1477 (2009).

Habermas, Jürgen. *The Structural Transformation of the Public Sphere: An Inquiry into a Category of Bourgeois Society* (Thomas Burger, trans., Cambridge, MA: MIT Press, 1991).

———. *Between Facts and Norms: Contributions to a Discourse Theory of Law and Democracy* (William Rehg, trans., Cambridge, MA: MIT Press, 1998).

Hacking, Ian. *The Emergence of Probability: A Philosophical Study of Early Ideas about Probability, Induction and Statistical Inference* (Cambridge, England: Cambridge University Press, 1975).

Hadfield, Gillian K. Higher Demand, Lower Supply? A Comparative Assessment of the Legal Resource Landscape for Ordinary Americans, 37 *Fordham Urban Law Journal* 129 (2010).

Haemmerli, Alice. Whose Who? The Case for a Kantian Right of Publicity, 49 *Duke Law Journal* 383 (1999).

Halberstam, Chaya T. Rabbinic Responsibility for Evil: Evidence and Uncertainty (Ph.D. dissertation, Yale University, New Haven, CT, 2004; UMI Publication No.: AAT 3125205).

Hampshire, Stuart. *Innocence and Experience* (Cambridge, MA: Harvard University Press, 1989).

———. *Justice Is Conflict* (Princeton, NJ: Princeton University Press, 2000).

Hancock, Paula M. Transformations in the Iconography of the Mirror in Medieval Art (Ph.D. dissertation, Department of Art History, Emory University, 1988; UMI Publication No.: AAT 8816943).

Hanson, Julienne. The Architecture of Justice: Iconography and Space Configuration in the English Law Court Building, 1 *Architectural Research Quarterly* 50 (1996).

Harcourt, Bernard E. From the Asylum to the Prison: Rethinking the Incarceration Revolution, 84 *Texas Law Review* 1751 (2006).

Harju, Virpi. The Artistic Faces of Justice, in *Oikeuden Kuva: Bilden Av Rätten Och Rättvisan* (Helsinki, Finland: Eduskunnan kirjasto, Valtion taidemuseo, 2000).

Harnett, Edward A. Questioning Certiorari: Some Reflections Seventy-Five Years after the Judges' Bill, 100 *Columbia Law Review* 1643 (2000).

Harris, David J., and Stephen Livingstone (eds.). *The Inter-American System of Human Rights* (Oxford, England: Oxford University Press, 1998).

Harris, Donald, Mavis Maclean, Hazel Genn, Sally Lloyd-Bostock, Paul Fenn, Peter Corfield, and Yvonne Brittan. *Compensation and Support for Illness and Injury* (Oxford, England: Oxford University Press, 1984).

Harris, Jonathan. *Federal Art and National Culture: The Politics of Identity in New Deal America* (Cambridge, England: Cambridge University Press, 1995).

Hart, H. L. A. Bentham and the United States of America, 19 *Journal of Law & Economics* 547 (1976).

Hartt, Frederick. *Giulio Romano* (New Haven, CT: Yale University Press, 1958).

Havelock, Eric A. *The Greek Concept of Justice: From Its Shadow in Homer to Its Substance in Plato* (Cambridge, MA: Harvard University Press, 1978).

Heilbrun, Margaret (ed.). *Inventing the Skyline: The Architecture of Cass Gilbert* (New York, NY: Columbia University Press, 2000).

Hein, Carola. *The Capital of Europe: Architecture and Urban Planning for the European Union* (Westport, CT: Praeger, 2004).

Held, Julius. *The Oil Sketches of Peter Paul Rubens: A Critical Catalogue*, vol. 1 (Princeton, NJ: Princeton University Press, 1980).

Helfer, Laurence R., and Anne-Marie Slaughter. Why States Create International Tribunals: A Response to Professors Posner and Yoo, 93 *California Law Review* 899 (2005).

Helliesen, Sidsel. Thronus Justitiae: A Serie(s) of Pictures of Justice, 91 *Oud Holland, Quarterly for Dutch Art History* 232 (1977).

Henkin, Louis. *The Age of Rights* (New York, NY: Columbia University Press, 1990).

Henkin, Louis, David W. Leebron, Gerald L. Neuman, and Diane F. Orentlicher (eds.). *Human Rights* (New York, NY: Foundation Press, 1999).

Hensler, Deborah R. Studying Gender Bias in the Courts: Stories and Statistics, 45 *Stanford Law Review* 2187 (1993).

———. The Globalization of Class Actions, 622 *Annals of the American Academy of Political and Social Science* 7 (Deborah R. Hensler, Christopher Hodges, and Magdalena Tulibacka, eds., 2009).

Herlihy, David. *Medieval and Renaissance Pistoia: The Social History of an Italian Town, 1200–1430* (New Haven, CT: Yale University Press, 1967).

Herman, Susan N. *The Right to a Speedy and Public Trial: A Reference Guide to the United States Constitution* (Westport, CT: Praeger, 2006).

Herodotus. *The Histories* (Aubrey de Selincourt, trans., revised by John Marincola, New York, NY: Penguin Classics, 2003).

Herpel, J. C., II Het oude Raadhuis van 's-Gravenhage (The Old City Hall of The Hague, Part II) ('s Gravenhage, Netherlands: Uitgave van de Gemeente, 1979).

Hersak, Dunja. There are Many Kongo Worlds: Particularities of Magico-Religious Beliefs among the Vili and Yombe of Congo-Brazzaville, 71 *Africa: Journal of the International African Institute* 614 (2001).

Heydebrand, Wolf, and Carroll Seron. *Rationalizing Justice: The Political Economy of Federal District Courts* (Albany, NY: State University of New York Press, 1990).

Higginbotham, Patrick E. So Why Do We Call Them Trial Courts? (Judge Robert A. Ainsworth, Jr. Memorial Lecture), 55 *SMU Law Review* 1405 (2002).

Higgins, Rosalyn. The ICJ, the ECJ and the Integrity of International Law, 52 *International and Comparative Law Quarterly* 1 (2003).

———. Litigating International Disputes: The Work of the International Court of Justice in a Changing World, 59 *Northern Ireland Legal Quarterly* 339 (2008).

Hill, David J. The Permanent Court of International Justice, 14 *American Journal of International Law* 387 (1920).

Hirschl, Ran. *Towards Juristocracy: The Origins and Consequences of the New Constitutionalism* (Cambridge, MA: Harvard University Press, 2004).

Hoagland, Alison K. *Buildings of Alaska* (Oxford, England: Oxford University Press, 1993).

Hobsbawm, Eric, and Terence Ranger (eds.). *The Invention of Tradition* (Cambridge, England: Cambridge University Press, 1983).

Hockett, Jeremy. The Murals of José Clemente Orozco at the Hospicio Cabanas Institute: A Philosophy of Change and the Historical Dialectic (M.A. thesis, Department of Art, Michigan State University, 1999; UMI Publication No.: AAT 1395418).

Hoffman, Stefan-Ludwig (ed.). *Human Rights in the Twentieth Century: A Critical History* (New York, NY: Cambridge University Press, forthcoming, 2010).

Hora, Peggy F., and William G. Schma. Therapeutic Jurisprudence and the Drug Treatment Court Movement: Revolutionizing the Criminal Justice System's Response to Drug Abuse and Crime in America, 74 *Notre Dame Law Review* 439 (1999).

Hornby, D. Brock. The Business of the US District Courts, 10 *The Green Bag 2d* 453 (2007).

Hornung, Erik. *Idea into Image: Essays on Ancient Egyptian Thought* (Elizabeth Bredeck, trans., New York, NY: Timken Publishers, 1992).

Hourihane, Colum (ed.). *Virtue & Vice: The Personifications in the Index of Christian Art* (Princeton, NJ: Princeton University Press, 2000).

Houser, R. E. *The Cardinal Virtues: Aquinas, Albert, and Philip the Chancellor* (Toronto, Canada: Pontifical Institute of Medieval Studies, 2004).

Howard, Deborah. *Jacopo Sansovino: Architecture and Patronage in Renaissance Venice* (New Haven, CT: Yale University Press, 1975).

Hudson, Manley O. *The World Court 1921–1938: A Handbook of the Permanent Court of International Justice* (Boston, MA: World Peace Foundation, 1938, 5th ed.).

———. *The Permanent Court of International Justice, 1920–1942: A Treatise* (New York, NY: Macmillan, 1943).

Hughes, Charles E. The Permanent Court of International Justice, 10 *Proceedings of the Academy of Political Science in the City of New York* 140 (1923).

Hughes, Gordon. Power's Script: or Jenny Holzer's Art after 'Art after Philosophy,' 29 *Oxford Art Journal* 419 (2006).

Hughes, Langston. *The Collected Poems of Langston Hughes* (Arnold Rampersad, ed., New York, NY: Knopf, 1994).

Huisken, Jacobine E. *The Royal Palace on the Dam in a Historical View* (Rollin Cochrane, trans., Amsterdam, Netherlands: De Walburg Pers, 1989).

Hume, David. Of the First Principles of Government, in *Essays, Moral, Political, and Literary*, vol. 1 (T. H. Green and T. H. Grose, eds., New York, NY: Longmans, Green and Company, 1898).

Hunt, Lynn. Hercules and the Radical Image in the French Revolution, 2 *Representations* 95 (1983).

———. *Inventing Human Rights: A History* (New York, NY: W. W. Norton & Company, 2007).

Issacharoff, Samuel, and Robert H. Klonoff. The Public Value of Settlement, 78 *Fordham Law Review* 1177 (2009).

Ittmann, John (ed.). *Mexico and Modern Printmaking: A Revolution in the Graphic Arts, 1920–1950* (New Haven, CT: Philadephia Museum of Art in association with Yale University Press, 2006).

Jaber al-Alwani, Taha. FATWA Concerning the United States Supreme Courtroom Frieze, 15 *Journal of Law and Religion* 1 (2001).

Jackson, John, Máximo Langer, and Peter Tillers (eds.). *Crime, Procedure, and Evidence in a Comparative and International Context* (Oxford, England: Hart Publishing, 2008).

Jackson, Elmer C. Jr., and Jacob U. Gordon. *A Search for Equal Justice by African-American Lawyers: A History of the National Bar Association* (New York, NY: Vantage Press, 1999).

Jackson, Vicki C. World Habeas Corpus, 91 *Cornell Law Review* 303 (2006).

———. Packages of Judicial Independence: The Selection and Tenure of Article III Judges, 95 *Georgetown Law Journal* 965 (2007).

———. *Constitutional Engagement in a Transnational Era* (New York, NY: Oxford University Press, 2009).

Jackson, Vicki C., and Judith Resnik (eds.). *Federal Court Stories* (New York, NY: Thomson Reuters/Foundation Press, 2010).

Jacob, Margaret C. Bernard Picart and the Turn toward Modernity, 37 *De Achttiende EEUW* 17 (2005).

Jacob, Robert. *Images de la Justice: Essai sur l'iconographie judiciare du Moyen Âge à L'Age Classique* (Paris, France: Le Léopard d'Or, 1994).

———. Le jugement de Dieu et la formation de la fonction de juger dans l'histoire européenne, 39 *Archives de Philosophie du Droit* 87 (1994).

Jacobsohn, Gary J. Three Models of Secular Constitutional Development: India, Israel, and the United States, 10 *Studies in American Political Development* 1 (1996).

Jaconelli, Joseph. Rights Theories and Public Trial, 14 *Journal of Applied Philosophy* 169 (1997).

James, Ronald M. *Temples of Justice: County Courthouses of Nevada* (Reno, NV: University of Nevada Press, 1994).

Jansson, Maija. Matthew Hale on Judges and Judging, 9 *Journal of Legal History* 201 (1988).

Jenkins, Marianna. The Iconography of the Hall of the Consistory in the Palazzo Pubblico, Siena, 54 *Art Bulletin* 430 (1972).

Jeuland, Emmanuel. Compte rendu de "vers un procès civil universel? Les règles transnationales de procédure civile de l'American Law Institute," 1 *Revue Critique de Droit International Privé* 240 (2002).

Jochens, Jenny. *Old Norse Images of Women* (Philadelphia, PA: University of Pennsylvania Press, 1996).

John, Richard R. *Spreading the News: The American Postal System from Franklin to Morse* (Cambridge, MA: Harvard University Press, 1995).

Johnson, Earl. *Justice and Reform: The Formative Years of the American Legal Services Program* (New Brunswick, NJ: Transaction Publishers, 1978).

Johnson, Sheri L. Racial Imagery in Criminal Cases, 67 *Tulsa Law Review* 1739 (1993).

Jolowicz, J. A. *On Civil Procedure* (Cambridge, England: Cambridge University Press, 2000).

Jonas, Gilbert. *Freedom's Sword: The NAACP and the Struggle against Racism in America, 1909-1969* (New York, NY: Routledge, 2005).

Jones, Michael W. *George Cruikshank: His Life and London* (London, England: Macmillan, 1978).

Joost-Gaugier, Christiane L. The Concord of Law in the Stanza della Segnatura, 29 *Artibus et Historiae* 85 (1994).

———. *Raphael's Stanza della Segnatura: Meaning and Invention* (Cambridge, England: Cambridge University Press, 2002).

Joselit, David, Joan Simon, and Renata Salecl (eds.). *Jenny Holzer* (London, England: Phaidon, 1998).

Kagan, Robert A. *Adversarial Legalism: The American Way of Law* (Cambridge, MA: Harvard University Press, 2001).

Kahneman, Daniel, and Cass R. Sunstein. Cognitive Psychology of Moral Intuitions, in *Neurobiology of Human Values* (Jean-Pierre Changeux, Yves Christen, Antonio Damasio, and Wolf Singer, eds., Berlin, Germany: Springer-Verlag, 2005).

Kakalik, James S., Terence Dunworth, Laural A. Hill, Daniel F. McCaffrey, Marian Oshiro, Nicholas M. Pace, and Mary E. Vaiana. *Just, Speedy and Inexpensive? An Evaluation of Judicial Case Management under the Civil Justice Reform Act* (Washington, DC: Rand, Institute for Civil Justice, 1996).

———. *An Evaluation of Judicial Case Management under the Civil Justice Reform Act* (Washington, DC: Rand, Institute for Civil Justice, 1996).

———. *An Evaluation of Mediation and Early Neutral Evaluation under the Civil Justice Reform Act* (Washington, DC: Rand, Institute for Civil Justice, 1996).

———. *Implementation of the Civil Justice Reform Act in Pilot and Comparison Districts* (Washington, DC: Rand, Institute for Civil Justice, 1996).

Kammen, Michael. Temples of Justice: The Iconography of Judgment and American Culture, in *Origins of the Federal Judiciary: Essays on the Judiciary Act of 1789* (Maeva Marcus, ed., Oxford, England: Oxford University Press, 1992).

Katzenellenbogen, Adolf. *Allegories of the Virtues and Vices in Medieval Art* (Alan J. P. Crick, trans., New York, NY: W. W. Norton & Company, 1964; reprint of a 1939 monograph).

Katzmann, Robert (ed.). *Daniel Patrick Moynihan: The Intellectual in Public Life* (Baltimore, MD: Johns Hopkins University Press, 1998).

Kaul, Hans-Peter. Construction Site for More Justice: The International Criminal Court after Two Years, 99 *American Journal of International Law* 370 (2005).

Keeton, George W., and Georg Schwarzenberger (eds.). *Jeremy Bentham and the Law* (Holmes Beach, FL: Gaunt, 1948; reprinted, 1998).

Keith, Damon J. Should Color Blindness and Representativeness Be a Part of American Justice?, 26 *Howard Law Journal* 1 (1983).

Keller, Helen, and Alec Stone Sweet. *A Europe of Rights: The Impact of the ECHR on National Legal Systems* (Oxford, England: Oxford University Press, 2008).

Kelley, Donald R. *Foundations of Modern Historical Scholarship: Language, Law, and History in the French Renaissance* (New York, NY: Columbia University Press, 1970).

Kelly, John M. Audi Alteram Partem, 9 *Natural Law Forum* 103 (1964).

Kelsey, Mavis, P., Sr., and Donald H. Dyal. *The Courthouses of Texas: A Guide* (College Station, TX: Texas A&M University Press, 2007, 2d ed.).

Kemp, Vicky, and Pascoe Pleasence. Targeting Civil Legal Needs: Matching Services to Needs, 26 *Obiter* 285 (2005).

Keohane, Nannerl O. *Philosophy and the State in France: The Renaissance to the Enlightenment* (Princeton, NJ: Princeton University Press, 1980).

Kerkvliet, Gerald, and Bert Mellink. *The Peace Palace: A Living Institution of International Law* (The Hague, Netherlands: Ando and Carnegie Foundation, 2005).

Kessler, Amalia. Our Inquisitorial Tradition: Equity Procedure, Due Process, and the Search for an Alternative to the Adversarial, 90 *Cornell Law Review* 1181 (2005).

Kiers, Judikje, and Fieke Tissink. *The Glory of the Golden Age: Dutch Art of the 17th Century* (Zwolle, Netherlands: Waanders Publishers, 2000).

King, Carolyn Dineen. Current Challenges to the Federal Judiciary, 66 *Louisiana Law Review* 661 (2006).

King, Nancy J. Regulating Settlement: What Is Left of the Rule of Law in the Criminal Process?, 56 *DePaul Law Review* 389 (2007).

Kirk, Terry R. Church, State and Architecture: The "Palazzo di Giustizia" of Nineteenth-Century Rome (Ph.D. dissertation, Columbia University, 1997; UMI Publication No.: AAT 9728234).

Kissel, Otto R. *Die Justitia: Reflexionen über ein Symbol und seine Darstellung in der Bildenden Kunst* (Munich, Germany: Verlag C. H. Beck, 1984).

Klarman, Michael J. *From Jim Crow to Civil Rights: The Supreme Court and the Struggle for Racial Equality* (New York, NY: Oxford University Press, 2004).

Klein, Arthur H., and Mina C. Klein. *Pieter Bruegel the Elder, Artist of Abundance: An Illustrated Portrait of His Life, Era, and Art* (New York, NY: Macmillan, 1968).

Klein, Natalie. *Dispute Settlement in the UN Convention of the Law of the Sea* (New York, NY: Cambridge University Press, 2005).

Kluger, Richard. *Simple Justice: The History of* Brown v. Board of Education *and Black America's Struggle for Equality* (New York, NY: Knopf, 1976).

Kohler, Josef, and Willy Scheel (eds.). *Die Bambergische Halsgerichtsordnung in die Carolina und Ihre Vorgängerinnen: Text, Erläuterung, Geschichte*, vol. 2 (Aalen, Germany: Scientia Verlag, 1968).

Kohler, Sue A. *The Commission of Fine Arts: A Brief History 1910-1976* (Washington, DC: U.S. Government Printing Office, 1977).

Korshak, Yvonne. The Liberty Cap as a Revolutionary Symbol in America and France, 1 *Smithsonian Studies in American Art* 52 (1987).

Koschnik, Albrecht. The Democratic Societies of Philadelphia and the Limits of the American Public Sphere, circa 1793–1795, 58 *William & Mary Quarterly* 615 (2001).

Koskenniemi, Martti. *The Gentle Civilizer of Nations: The Rise and Fall of International Law 1870-1960* (Cambridge, England: Cambridge University Press, 2001).

Kosmer, Ellen. A Study of the Style and Iconography of a Thirteenth-Century "Somme le Roi" (Ph.D. dissertation, Department of Fine Arts, Yale University, 1973; UMI Publication No.: AAT 7411756).

———. Gardens of Virtue in the Middle Ages, 41 *Journal of the Warburg and Courtauld Institutes* 302 (1978).

Kravitz, Mark R. The Vanishing Trial: A Problem in Need of a Solution?, 79 *Connecticut Bar Journal* 1 (2005).

Kress, Claus. The International Court of Justice and the Elements of the Crime of Genocide, 18 *European Journal of International Law* 619 (2007).

Kritzer, Herbert M., and Susan S. Silbey (eds.). *In Litigation: Do the "Haves" Still Come Out Ahead?* (Stanford, CA: Stanford University Press, 2003).

Krodel, Gottfried G. The Opposition to Roman Law and the Reformation in Germany, 10 *Journal of Law and Religion* 221 (1993–1994).

Kronman, Anthony J. Alexander Bickel's Philosophy of Prudence, 94 *Yale Law Journal* 1567 (1985).

Kuijer, Martin. *The Blindfold of Lady Justice: Judicial Independence and Impartiality in Light of the Requirements of Article 6 ECHR (European Convention on Human Rights)* (Leiden, Netherlands: Wolf Legal Publishers, 2004).

Kumm, Mattias. Why Europeans Will Not Embrace Constitutional Patriotism, 6 *I•CON, International Journal of Constitutional Law* 117 (2008).

Kuyper, Wouters. *The Triumphant Entry of Renaissance Architecture into the Netherlands* (Alphen aan den Rijn, Netherlands: Canaletto, 1994).

Kymlicka, Will. The Internationalization of Minority Rights, 6 *I•CON, International Journal of Constitutional Law* 1 (2008).

Lacey, Nicola. Bentham as Proto-Feminist? Or an Ahistorical Fantasy on 'Anarchical Fallacies,' 51 *Current Legal Problems* 441 (1998).

Ladis, Andrew (ed.). *The Arena Chapel and the Genius of Giotto* (New York, NY: Garland Publishing, 1998).

Lande, John. Principles for Policymaking about Collaborative Law and Other ADR Processes, 22 *Ohio State Journal on Dispute Resolution* 619 (2007).

Lane, Kristin A., Jason P. Mitchell, and Mahzarin R. Banaji. Me and My Group: Cultural Status Can Disrupt Cognitive Consistency, 23 *Social Cognition* 353 (2005).

Langbein, John H. *Prosecuting Crime in the Renaissance: England, Germany, France* (Cambridge, MA: Harvard University Press, 1974).

———. The Historical Origins of the Sanction of Imprisonment for Serious Crime, 5 *Journal of Legal Studies* 35 (1976).

———. *Torture and the Law of Proof: Europe and England in the Ancien Régime* (Chicago, IL: University of Chicago Press, 1977; 2006, 2d ed.).

———. Historical Foundations of the Law of Evidence: A View from the Ryder Sources, 96 *Columbia Law Review* 1168 (1996).

———. *The Origins of the Adversary Criminal Trial* (Oxford, England: Oxford University Press, 2003).

Langer, Maximo. The Rise of Managerial Judging in International Criminal Law, 53 *American Journal of Comparative Law* 835 (2005).

Langford, Ian. Fair Trial: The History of an Idea, 8 *Journal of Human Rights* 37 (2009).

Laqueur, Thomas W. Crowds, Carnival and the State in English Executions, 1604–1868, in *The First Modern Society: Essays in English History in Honour of Lawrence Stone* (A. L. Beier, David Cannadine, and James M. Rosenheim, eds., Cambridge, England: Cambridge University Press, 1989).

Lasok, K. P. E., Timothy Millet, and Anneli Howard. *Judicial Control in the EU: Procedures and Principles* (Richmond, England: Richmond Law and Tax, 2004).

Lasser, Mitchel. *Judicial Deliberations: A Comparative Analysis of Judicial Transparency and Legitimacy* (Oxford, England: Oxford University Press, 2004).

Law-Viljoen, Ben, and Bronwyn Law-Viljoen (eds.). *Art and Justice: The Art of the Constitutional Court of South Africa* (New York, NY: David Krut Publishing, 2009).

Law-Viljoen, Bronwyn (ed.). *Light on a Hill: Building the Constitutional Court of South Africa* (Parkwood, South Africa: David Krut Publishing, 2006).

Lederle, Ursula Grieger. Gerechtigkeitsdarstellungen in deutschen und niederländischen Rathäusern (Representations of Justice in German and Dutch Town Halls) (Ph.D. dissertation, Heidelberg, Germany; University of Heidelberg Press, 1937).

Lee, Antoinette. *Architects to the Nation: The Rise and Decline of the Supervising Architect's Office* (New York, NY: Oxford University Press, 2000).

Lee, Roy S. (ed.). *The International Criminal Court: The Making of the Rome Statute—Issues, Negotiations, Results* (The Hague, Netherlands: Kluwer Law International, 1999).

Leers, Andrea P. Japan's Palace of Justice, 25 *Japan Architect* 10 (1997).

Lemmings, David. The Independence of the Judiciary in Eighteenth-Century England, in *The Life of the Law: Proceedings of the Tenth British Legal History Conference, Oxford 1991* (Peter Birks, ed., Rio Grande, OH: Hambledon Press, 1993).

Lemos, Celina B., and Elizabeth A. Jackson. The Modernization of Brazilian Urban Space as a Political Symbol of the Republic, 21 *Journal of Decorative and Propaganda Arts* 219 (1995).

Lender, Mark E. *"This Honorable Court": The United States District Court for the District of New Jersey, 1789–2000* (New Brunswick, NJ: Rutgers University Press, 2006).

Letsas, George. *A Theory of Interpretation of the European Convention on Human Rights* (Oxford, England: Oxford University Press, 2007).

Levin, Hillel Y. Making the Law: Unpublication in the District Courts, 53 *Villanova Law Review* 973 (2008).

Levinson, Sanford (ed.). *Torture: A Collection* (New York, NY: Oxford University Press, 2004).n

Levinson, Sanford. *Written in Stone: Public Monuments in Changing Societies* (Durham, NC: Duke University Press, 1998).

Levy, Janey L. The Last Judgment in Early Netherlandish Painting: Faith, Authority, and Charity in the Fifteenth Century, vol. 1, 193 (Ph.D. dissertation, Department of Art History, University of Kansas, 1988; UMI Publication No.: AAT 8903130).

Lewis, Anthony. *Gideon's Trumpet* (New York, NY: Random House, 1964).

Lewis, Gillian. Calvinism in Geneva in the Time of Calvin and of Beza (1541–1605), in *International Calvinism 1541–1715* (Menna Prestwich, ed., Oxford, England: Oxford University Press, 1985).

Lindblom, Per Henrik. The New Growing Role of the Courts and the New Functions of Judicial Process—Fact or Flummery?, 51 *Scandinavian Studies in Law* 281 (Rosemary Nordström, trans., 2007).

———. ADR—The Opiate of the Legal System? Perspectives on Alternative Dispute Resolution Generally and in Sweden, 16 *European Review of Private Law* 63 (2008).

Link, Luther. *The Devil: A Mask without a Face* (London, England: Reaktion Books, 1995).

Livy. *The Early History of Rome* (Aubrey De Sélincourt, trans., Harmondsworth, England: Penguin Books, 1975).

Locke, John. *An Essay Concerning Human Understanding* (Peter H. Nidditch, ed., Oxford, England: Oxford University Press, 1975).

Loeffler, Jane. *Architecture of Diplomacy: Building America's Embassies* (Princeton, NJ: Princeton Architectural Press, 1998).

Logan, James K. (ed.). *The Federal Courts of the Tenth Circuit: A History* (Denver, CO: U.S. Court of Appeals for the Tenth Circuit, 1992).

Lombardi, Clark B. Islamic Law in the Jurisprudence of the International Court of Justice: An Analysis, 8 *Chicago Journal of International Law* 85 (2007).

López, Carlos S. Reformulating Native Title in Mabo's Wake: Aboriginal Sovereignty and Reconciliation in Post-Centenary Australia, 11 *Tulsa Journal of Comparative & International Law* 21 (2003).

LoPucki, Lynn M. Court System Transparency, 94 *Iowa Law Review* 481 (2009).

Loren, Marisa G. *Court Houses in Adelaide, 1837–1988* (Stepney, Australia: Swift Printing Services, 1989).

Lounsbury, Carl R. *The Courthouses of Early Virginia: An Architectural History* (Charlottesville, VA: University of Virginia Press, 2005).

Lowry, Bates. *Building a National Image: Architectural Drawings for the American Democracy, 1789–1912* (Washington, DC: National Building Museum, 1985, published in conjunction with an exhibition of the same title).

Luban, David. The Publicity Principle, in *The Theory of Institutional Design* (Robert Goodin, ed., New York, NY: Cambridge University Press, 1998).

———. Lawfare and Legal Ethics at Guantánamo, 60 *Stanford Law Review* 1981 (2008).

MacCormick, Neil. *Questioning Sovereignty: Law, State and Nation in the European Commonwealth* (Oxford, England: Oxford University Press, 1999).

MacGaffey, Wyatt. Fetishism Revisited: Kongo Nkisi in Sociological Perspective, 47 *Africa: Journal of the International African Institute* 172 (1977).

————. Complexity, Astonishment and Power: The Visual Vocabulary of Kongo Minkisi, 14 *Journal of Southern African Studies* 188 (1988).

————. *Kongo Political Culture: The Conceptual Challenge of the Particular* (Bloomington, IN: Indiana University Press, 2000).

MacGaffey, Wyatt, and John M. Janzen. Nkisi Figures of the Bakongo, 7 *African Arts* 87 (1974).

Mack, Kenneth. Rethinking Civil Rights Lawyering and Politics in the Era before Brown, 115 *Yale Law Journal* 256 (2005).

MacKay, A. Wayne. Framing the Issues for Cameras in the Courtrooms: Redefining Judicial Dignity and Decorum, 19 *Dalhousie Law Journal* 139 (1996).

MacKinnon, Catharine. Feminism, Marxism, Method, and the State: Toward Feminist Jurisprudence, 8 *Signs: Journal of Women in Culture and Society* 635 (1983).

Macklem, Patrick. *Indigenous Difference and the Constitution of Canada* (Toronto, Canada: University of Toronto Press, 2001).

Macneil, Ian R. *American Arbitration Law: Reformation—Nationalization—Internationalization* (New York, NY: Oxford University Press, 1992).

MacQueen, Hector L. *Hume Papers on Public Policy: The Reform of Civil Justice* (Edinburgh, Scotland: Edinburgh University Press, 1998).

Madura, Miguel P. *We the Court: The European Court of Justice and the European Economic Constitution: A Critical Reading of Article 30 of the EC Treaty* (Oxford, England: Hart Publishing, 1998).

Maffei, Stefano. *The European Right to Confrontation in Criminal Proceedings: Absent, Anonymous and Vulnerable Witnesses* (Groningen, Netherlands: Europa Law Publishing, 2006).

Mâle, Emile. *The Gothic Image: Religious Art in France of the Thirteenth Century* (Dora Nussey trans., New York, NY: Harper, 1958; reprint of a 1913 volume).

Malleson, Kate. Promoting Judicial Independence in the International Courts: Lessons from the Caribbean, 58 *International & Comparative Law Quarterly* 671 (2009).

Mansbridge, Jane. The Descriptive Political Representation of Gender: An Anti-Essentialist Argument, in *Has Liberalism Failed Women?: Assuring Equal Representation in Europe and the United States* (Jytte Klausen and Charles S. Maier, eds., New York, NY: Palgrave, 2001).

Marder, Nancy S. The Medical Malpractice Debate: The Jury as Scapegoat, 38 *Loyola of Los Angeles Law Review* 1267 (2005).

Margulies, Joseph. *Guantánamo and the Abuse of Presidential Power* (New York, NY: Simon & Schuster, 2006).

Markoff, John. Margins, Centers, and Democracy: The Paradigmatic History of Women's Suffrage, 29 *Signs: Journal of Women in Culture and Society* 85 (2003).

Markovits, Daniel. Adversary Advocacy and the Authority of Adjudication, 75 *Fordham Law Review* 1367 (2006).

Marks, Thomas. The Languages of Glass, 37 *Cambridge Quarterly* 446 (2008).

Marling, Karal A. *Wall to Wall America: A Cultural History of Post Office Murals in the Great Depression* (Minneapolis, MN: University of Minnesota Press, 1982).

Marmor, Theodore R., and Jerry L. Mashaw (eds.). *Social Security: Beyond the Rhetoric of Crisis* (Princeton, NJ: Princeton University Press, 1988).

Maroon, Fred J., and Suzy Maroon. *The Supreme Court of the United States* (New York, NY: Thomassson-Grant & Lickle and published in cooperation with the Supreme Court Historical Society, 1996).

Martin, Camille. *La Maison de Ville de Genève* (Geneva, Switzerland: A. Jullien, 1906).

Martin, Peter W. Online Access to Court Records—From Documents to Data, Particulars to Patterns, 53 *Villanova Law Review* 855 (2008).

Martinez, Jenny S. Antislavery Courts and the Dawn of International Human Rights Law, 117 *Yale Law Journal* 550 (2008).

Mashaw, Jerry L., *Bureaucratic Justice: Managing Social Security Disability Claims* (New Haven, CT: Yale University Press, 1983).

————. Recovering American Administrative Law: Federalist Foundations, 1787–1801, 115 *Yale Law Journal* 1256 (2006).

————. Administration and "The Democracy": Administrative Law from Jackson to Lincoln, 1829–1861, 117 *Yale Law Journal* 1568 (2008).

Mashaw, Jerry L., Charles J. Goetz, Paul R. Verkuil, Milton M. Carrow, Warren F. Schwartz, and Frank I. Goodman. *Social Security Hearings and Appeals: A Study of the Social Security Administration Hearing System* (Lexington, MA: Lexington Books, 1978).

Masson, Antoine, and Kevin O'Connor (eds.). *Representations of Justice* (Brussels, Belgium: P. I. E. Peter Lang, 2007).

Maximus, Valerius. *Memorable Doings and Sayings* (D. R. Shackleton Bailey, trans., Cambridge, MA: Harvard University Press, 2000).

Mayer, Jane. *The Dark Side: The Inside Story of How the War on Terror Turned into a War on American Ideals* (New York, NY: Doubleday, 2008).

McCarthy, Cathy A., and Tara Treacy (eds.). *A History of the Administrative Office of the United States Courts: Sixty Years of Service to the Federal Judiciary* (Washington, DC: Administrative Office of the United States Courts, 2000).

McDevitt, Ray (ed.). *Courthouses of California: An Illustrated History* (San Francisco, CA and Berkeley, CA: California Historical Society and Heyday Books, 2001).

McDorman, Ted L. Global Ocean Governance and International Adjudicative Dispute Resolution, 43 *Ocean and Coastal Management* 255 (2000).

McDowell, Eddie-Sue. Romuald Kraus: Justice and Other Work for the Works Progress Administration, 1933–1943 (M.A. thesis, Department of Fine Arts, University of Louisville, 1992; UMI Publication No.: AAT 1350048).

McGrath, Elizabeth. *Rubens: Subjects from History*, vols. 1 & 2. (London, England: Harvey Miller Publishers, 1997).

McKean, John. *Crystal Palace: Joseph Paxton and Charles Fox* (London, England: Phaidon, 1994).

McKinzie, Richard D. *The New Deal for Artists* (Princeton, NJ: Princeton University Press, 1973).

McLaren, Joseph. *Langston Hughes, Folk Dramatist in the Protest Tradition, 1921–1943* (Westport, CT: Greenwood Press, 1997).

McNamara, Martha J. *From Tavern to Courthouse: Architecture and Ritual in American Law, 1658–1860* (Baltimore, MD: Johns Hopkins University Press, 2004).

McParland, Edward. The Early History of James Gandon's Four Courts, 122 *Burlington Magazine* 727 (1980).

Mendelsohn, Oliver, and Laurence W. Maher (eds.). *Courts, Tribunals and New Approaches to Justice* (Bundoora, Australia: La Trobe University Press, 1994).

Mengin, Christine. Construire Pour Juger. Un Tour de France des Palais de Justice, in *Tour de France: Eine historische Rundreise, Festschrift für Rainer Hudemann* (Armin Heinen and Dietmar Hüser, eds., Stuttgart, Germany: Franz Steiner Verlag, 2008).

————. Deux siècles d'architecture judiciaire aux Etats-Unis et en France, in *L'Art et le droit: Mélanges en l'honneur de Pierre-Laurent Frier* (Maryse Deguergue, ed., Paris, France: Publications de la Sorbonne, 2009).

Menkel-Meadow, Carrie. Whose Dispute Is It Anyway?: A Philosophical and Democratic Defense of Settlement (in Some Cases), 83 *Georgetown Law Journal* 2663 (1995).

————. Restorative Justice: What Is It and Does It Work?, 3 *Annual Review of Law and Social Science* 161 (2007).

Merback, Mitchell B. *The Thief, the Cross and the Wheel: Pain and the Spectacle of Punishment in Medieval and Renaissance Europe* (Chicago, IL: University of Chicago Press, 1999).

———. (ed.). *Beyond the Yellow Badge: Anti-Judaism and Antisemitism in Medieval and Early Modern Visual Culture* (Boston, MA: Brill, 2008).

Merritt, Deborah J., and James J. Brudney. Stalking Secret Law: What Predicts Publication in the United States Courts of Appeals, 54 *Vanderbilt Law Review* 71 (2001).

Meyers, Gary D., and Sally Raine. Australian Aboriginal Land Rights in Transition (Part II): The Legislative Response to the High Court's Native Title Decisions in *Mabo v. Queensland* and *Wik v. Queensland*, 9 *Tulsa Journal of Comparative & International Law* 95 (2001).

Michelman, Frank I. The Constitution, Social Rights, and Liberal Political Justification, 1 *I•CON, International Journal of Constitutional Law* 13 (2003).

Miele, Chris (ed.). *The Supreme Court of the United Kingdom: History, Art, Architecture* (London, England: Merrell Publishers, 2010).

Miller, William I. Gluttony, 60 *Representations* 92 (1997).

———. *The Mystery of Courage* (Cambridge, MA: Harvard University Press, 2000).

Millet, Timothy. The New European Court of First Instance, 38 *International and Comparative Law Quarterly* 811 (1989).

Minow, Martha. The Judgment of Solomon and the Experience of Justice, in *The Structure of Procedure* (Robert M. Cover and Owen M. Fiss, eds., Mineola, NY: Foundation Press, 1979).

———. *Between Vengeance and Forgiveness: Facing History after Genocide and Mass Violence* (Boston, MA: Beacon Press, 1998).

———. *Partners, Not Rivals: Privatization and the Public Good* (Boston, MA: Beacon Press, 2002).

Mittelstadt, David. *Foundations of Justice: Alberta's Historic Courthouses* (Calgary, Canada: University of Calgary Press, 2005).

Miziolek, Jerzy. Exempla Iustitiae at Arthur's Court in the Context of Dutch and Flemish, German, and Italian Art, in *Netherlandish Artists in Gdańsk in the Time of Hans Vredeman de Vries* (Gdańsk, Poland: Museum of the History of the City of Gdańsk, 2006).

Mnookin, Jennifer L. The Image of Truth: Photographic Evidence and the Power of Analogy, 10 *Yale Journal of Law & the Humanities* 1 (1998).

Mnookin, Robert H., and Lewis Kornhauser. Bargaining in the Shadow of the Law: The Case of Divorce, 88 *Yale Law Journal* 950 (1979).

Moelands, M. A., and Jacobus Thomas de Smidt (eds.). *Weegschaal & Zwaard: De Verbeelding Van Recht en Gerechtigheid in Nederland* (The Hague, Netherlands: Jongbloed Juridische Boekhandel en Uitgeverij, 1999).

Moffitt, Michael. Three Things to be Against ("Settlement" Not Included), 78 *Fordham Law Review* 1203 (2009).

Mohr, Richard. Enduring Signs and Obscure Meanings: Contested Coats of Arms in Australian Jurisdictions, in *Contemporary Issues of the Semiotics of Law* (Anne Wagner, Tracey Summerfield, and Farid Benevides, eds., Oxford, England: Hart Publishing, 2005).

———. Some Conditions for Culturally Diverse Deliberation, 20 *Canadian Journal of Law and Society* 87 (2005).

Moore, John B. The Organization of the Permanent Court of International Justice, 22 *Columbia Law Review* 497 (1922).

———. (ed.). *International Adjudications: Ancient and Modern History and Documents* (New York, NY: Oxford University Press, 1929; reprint, Buffalo, NY: William S. Hein & Company, 1996).

Moorhead, Richard, and Pascoe Pleasence. Access to Justice after Universalism: Introduction, 30 *Journal of Law and Society* 1 (2003).

Moreno-Ocampo, Luis. The International Criminal Court: Seeking Global Justice, 40 *Case Western Reserve Journal of International Law* 215 (2008).

Morgan, David, and Sally M. Promey (eds.). *The Visual Culture of American Religions* (Berkeley, CA: University of California Press, 2001).

Morgan, Michael J. *Molyneux's Question: Vision, Touch and the Philosophy of Perception* (Cambridge, England: Cambridge University Press, 1977).

Morris, Jeffrey B. *Calmly to Poise the Scales of Justice: A History of the Courts of the District of Columbia Circuit* (Durham, NC: Carolina Academic Press, 2001).

Morrison, Mary J. *The Minnesota State Constitution: A Reference Guide* (Westport, CT: Greenwood Press, 2002).

Motley, Constance Baker. *Equal Justice Under Law: An Autobiography* (New York, NY: Farrar, Straus and Giroux, 1998).

Mountford, Edward W. The New Sessions House, London, 21 *Architectural Review* 136 (1907).

Muir, Edward. Images of Power: Art and Pageantry in Renaissance Venice, 84 *American Historical Review* 16 (1979).

———. *Civic Ritual in Renaissance Venice* (Princeton, NJ: Princeton University Press, 1981).

Muir, Lynette R. *The Biblical Drama of Medieval Europe* (Cambridge, England: Cambridge University Press, 1995).

Mulcahy, Linda. Architects of Justice: The Politics of Courtroom Design, 16 *Social & Legal Studies* 383 (2007).

———. Architectural Precedent: The Manchester Assize Courts and Monuments to Law in the Mid-Victorian Era, 19 *King's Law Journal* 525 (2008).

———. The Unbearable Lightness of Being? Shifts towards the Virtual Trial, 35 *Journal of Law and Society* 464 (2008).

Müllenbrock, Heinz-Joachim. Public Opinion in Eighteenth-Century England, in *Sites of Discourse—Public and Private Spheres—Legal Culture* (Uwe Böker and Julie A. Hibbard, eds., Amsterdam, Netherlands: Rodopi, 2002).

Mustill, Michael J., and Stewart C. Boyd (eds.). *Commercial Arbitration, 2001 Companion Volume to the Second Edition* (Croydon, England: Butterworths, 2001).

Mycock, Damon J. The Element of Caricature in the Painting of José Clemente Orozco (M.A. thesis, Duke University, 1974).

Naske, Claus M. *A History of the Alaska Federal District Court System, 1884–1959, and the Creation of the State Court System* (Fairbanks, AK: University of Alaska, 1985).

Nelson, Daniel Mark. *The Priority of Prudence: Virtue and Natural Law in Thomas Aquinas and the Implications for Modern Ethics* (University Park, PA: Pennsylvania State University Press, 1992).

Neuman, Gerald L. Human Rights and Constitutional Rights: Harmony and Dissonance, 55 *Stanford Law Review* 1863 (2003).

———. Import, Export, and Regional Consent in the Inter-American Court of Human Rights, 19 *European Journal of International Law* 101 (2008).

Ngcobo, S. Sandile. Truth, Justice, and Amnesty in South Africa: Sins from the Past and Lessons for the Future, 8 *Ius Gentium* 1 (2002).

Nicholls, Robert. The Mocko Jumbie of the U.S. Virgin Islands; History and Antecedents, 32 *African Arts* 48 (1999).

Nicolai, Bernd. Orders in Stone: Social Reality and Artistic Approach. The Case of the Strasbourg South Portal, 41 *Gesta* 111 (2002).

Nieto-Navia, Rafael. The Inter-American Court of Human Rights, in *International Justice* (Kalliopi Koufa, ed., Athens, Greece: Sakkoulas Publications, 1997).

Noonan, John T. Jr. *Bribes* (New York, NY: Macmillan, 1984).

Nooruddin, Irfan. Blind Justice: "Seeing" Race and Gender in Cases of Violent Crime, 3 *Politics & Gender* 321 (2007).

North, Douglass C., John Joseph Wallis, and Barry R. Weingast. *Violence and Social Orders: A Conceptual Framework for Interpreting Recorded Human History* (Cambridge, England: Cambridge University Press, 2009).

North, Helen F. *Sophrosyne: Self-Knowledge and Self-Restraint in Greek Literature* (Ithaca, NY: Cornell University Press, 1966).

———. Temperance (Sophrosyne) and the Canon of the Cardinal Virtues, in *Dictionary of the History of Ideas: Studies of Selected Pivotal Ideas*, vol. IV (Philip P. Wiener, ed., New York, NY: Charles Scribner's Sons, 1973).

———. *From Myth to Icon: Reflections on Greek Ethical Doctrine in Literature and Art* (Ithaca, NY: Cornell University Press, 1979).

Nugent, S. Georgia. *Allegory and Poetics: The Structure and Imagery of Prudentius' "Psychomachia"* (Frankfurt, Germany: Verlag Peter Lang, 1985).

Oberhuber, Konrad (ed.). *The Illustrated Bartsch*, vol. 27: *The Works of Marcantonio Raimondi and of His School* (New York, NY: Abaris Books, 1978).

O'Connell, Jeffrey, and Richard F. Bland. Moynihan's Legacy, 142 *Public Interest* 95 (2001).

Ohman, Doug, and Mary Logue. *Courthouses of Minnesota* (St. Paul, MN: Minnesota Historical Society Press, 2006).

Olsen, Patrice E. *Artifacts of Revolution: Architecture, Society, and Politics in Mexico City, 1920–1940* (Lanham, MD: Rowman & Littlefield, 2008).

O'Regan, Kate. Human Rights and Democracy—A New Global Debate: Reflections on the First Ten Years of South Africa's Constitutional Court, 32 *International Journal of Legal Information* 200 (2004).

O'Reilly, Jennifer. *Studies in the Iconography of the Virtues and Vices in the Middle Ages* (New York, NY: Garland Publishing, 1988).

Orenstein, Nadine M. (ed.). *Pieter Bruegel the Elder: Drawings and Prints, Catalogue for the Metropolitan Museum of Art 2001 Exhibition* (New York, NY, and New Haven, CT: Metropolitan Museum of Art and Yale University Press, 2001).

Oseguera, Silvia I. Judicial Reform and Democratization: Mexico in the 1990s (Ph.D. dissertation, Boston University, 2003; UMI Publication No.: AAT 3090412, 2004).

Ostrom, Brian J., Shauna M. Strickland, and Paula L. Hannaford-Agor. Examining Trial Trends in State Courts: 1976–2002, 1 *Journal of Empirical Legal Studies* 755 (2004).

Overdiep, G. *Justitia, Waar Is Uw Blinddoek?, Overdruk Uit Pro Excolendo Iure Patrio 1761–1961* (Groningen, Netherlands: J. B. Wolters, 1961).

Padoa-Schioppa, Antonio (ed.). *Legislation and Justice* (Oxford, England: Oxford University Press, 1997).

Pager, Chet K. W. Blind Justice, Colored Truths and the Veil of Ignorance, 41 *Willamette Law Review* 373 (2005).

Panofsky, Erwin. *Studies in Iconology: Humanistic Themes in the Art of the Renaissance* (New York, NY: Harper & Row, 1962).

Pare, Richard (ed.). *Court House: A Photographic Document* (New York, NY: Horizon Press, 1978).

Parekh, Bhikhu (ed.). *Jeremy Bentham: Ten Critical Essays* (London, England: Frank Cass, 1974).

Park, Marlene, and Gerald E. Markowitz. *Democratic Vistas: Post Offices and Public Art in the New Deal* (Philadelphia, PA: Temple University Press, 1984).

Pasqualucci, Jo M. *The Practice and Procedure of the Inter-American Court of Human Rights* (New York, NY: Cambridge University Press, 2003).

Paterson, Mark. "Seeing with the Hands": Blindness, Touch, and the Enlightenment Spatial Imagery, 24 *British Journal of Visual Impairment* 52 (2006).

Paulson, Colter. Compliance with Final Judgments of the International Court of Justice since 1987, 98 *American Journal of International Law* 434 (2004).

Paulson, William R. *Enlightenment, Romanticism, and the Blind in France* (Princeton, NJ: Princeton University Press, 1987).

Paulsson, Jan. *Denial of Justice in International Law* (Cambridge, England: Cambridge University Press, 2005).

Peardon, Thomas P. Bentham's Ideal Republic, 17 *Canadian Journal of Economics and Political Science* 184 (1951).

Peckham, Robert. The Federal Judge as a Case Manager: The New Role in Guiding a Case from Filing to Disposition, 69 *California Law Review* 770 (1981).

Peers, Steve, and Angela Ward (eds.). *The European Union Charter of Fundamental Rights: Politics, Law, & Policy* (Portland, OR: Hart Publishing, 2004).

Peeters, Jan, Peter C. Sutton, Eymert-Jan Goossens, and Deirdre Carasso. *The Royal Palace of Amsterdam in Paintings of the Golden Age* (Zwolle, Netherlands: Waanders Publishers, 1997).

Perry, Barbara A. The Israeli and United States Supreme Courts: A Comparative Reflection on Their Symbols, Images, and Functions, 63 *Review of Politics* 317 (2001).

Peters, Edward M. Prison before the Prison: The Ancient and Medieval Worlds, in *The Oxford History of the Prison: The Practice of Punishment in Western Society* (Norval Morris and David J. Rothman, eds., New York, NY: Oxford University Press, 1995).

Peters, Jane S. (ed.). *18 The Illustrated Bartsch* (New York, NY: Abaris Books, 1982).

Pether, Penelope. Inequitable Injunctions: The Scandal of Private Judging in the U.S. Courts, 56 *Stanford Law Review* 1435 (2004).

Pfander, James. *One Supreme Court: Supremacy, Inferiority, and the Judicial Department of the United States* (Oxford, England: Oxford University Press, 2009).

Pfeiffenberger, Selma. The Iconology of Giotto's Virtues and Vices at Padua (Ph.D. dissertation, Department of Fine Arts, Bryn Mawr College, 1966; UMI Publication No.: AAT 6703811).

Pham, J. Peter. A Viable Model for International Criminal Justice: The Special Court for Sierra Leone, 19 *New York International Law Review* 37 (2006).

Phillips, Claude. *Sir Joshua Reynolds* (London, England: Seely and Company, 1894).

Phillips, Todd S., and Michael A. Griebel. *Building Type Basics for Justice Facilities* (Stephen A. Kliment, series ed., Hoboken, NJ: John Wiley & Sons, 2003).

Pieper, Josef. *The Four Cardinal Virtues: Prudence, Justice, Fortitude, Temperance* (Notre Dame, IN: University of Notre Dame Press, 1966).

Pigler, Andrew. The Importance of Iconographical Exactitude, 21 *Art Bulletin* 228 (1939).

Pinch, Geraldine. *Egyptian Mythology: A Guide to the Gods, Goddesses, and Traditions of Ancient Egypt* (New York, NY: Oxford University Press, 2002).

Pitts, Jennifer. Legislator of the World? A Rereading of Bentham on Colonies, 31 *Political Theory* 200 (2003).

Plato. *Republic* (G. M. A. Grube, trans., revision by C. D. C. Reeve, Indianapolis, IN: Hackett, 1992).

Pleasance, Pascoe, Alexy Buck, Marisol Smith, Nigel Balmer, and Ashish Patel. Needs Assessment and Community Legal Services in England and Wales, 11 *International Journal of the Legal Profession* 213 (2004).

Pleister, Wolfgang, and Wolfgang Schild. *Recht und Gerechtigkeit im Spiegel der Europäischen Kunst* (Cologne, Germany: Dumont Buchverlag, 1988).

Plender, Richard (ed.). *European Courts: Practice and Precedents* (London, England: Sweet & Maxell, 1997).

Podgor, Ellen S., and Roger Stenson Clark. *Understanding International Criminal Law* (Newark, NJ: LexisNexis 2004, 2d ed.).

Pollak, Oliver B. *Images of America: Nebraska Courthouses: Contention, Compromise, & Community* (Chicago, IL: Arcadia Publishing, 2002).

Polzer, Joseph. Ambrogio Lorenzetti's "War and Peace Murals" Revisited: Contributions to the Meaning of the "Good Government Allegory," 23 *Artibus et Historiae* 63 (2002).

Pon, Lisa. *Raphael, Dürer, and Marcantonio Raimondi: Copying and the Italian Renaissance Print* (New Haven, CT: Yale University Press, 2004).

Pope, Stephen J. (ed.). *The Ethics of Aquinas* (Washington, DC: Georgetown University Press, 2002).

Posner, Eric A. The International Court of Justice: Voting and Usage Statistics, 99 *American Society of International Law Proceedings* 130 (2005).

———. The Decline of the International Court of Justice, in *International Conflict Resolution* (Stefan Voigt, Max Albert, and Dieter Schmidtchen, eds., Tübingen, Germany: Mohr Siebeck, 2006).

Posner, Eric A., and Miguel F. P. de Figueiredo. Is the International Court of Justice Biased?, 34 *Journal of Legal Studies* 599 (2005).

Posner, Richard A. *The Federal Courts: Challenge and Reform* (Cambridge, MA: Harvard University Press, 1996).

Post, Robert C. Mr. Taft Becomes Chief Justice, 76 *University of Cincinnati Law Review* 761 (2008).

———. *Knowing What We Talk About: Expertise, Democracy and the First Amendment* (New Haven, CT: Yale Press, 2009).

Post, Robert C., and Reva B. Siegel. Legislative Constitutionalism and Section Five Powers: Policentric Interpretation of the Family and Medical Leave Act, 112 *Yale Law Journal* 1943 (2003).

Postle, Martin. *Sir Joshua Reynolds: The Subject Pictures* (Cambridge, England: Cambridge University Press, 1995).

Pound, Roscoe. The Causes of Popular Dissatisfaction with the Administration of Justice, 40 *American Law Revew* 729 (1906), reprinted from 1 *Annual Report of American Bar Association* 395 (29th Conference, 1906).

Powell, Robert, and Patrick Bingham-Hall. *Hassell: Poetic Pragmatism* (Sydney, Australia: Pesaro Publishing, 2003).

Prak, Maarten. *The Dutch Republic in the Seventeenth Century* (Diane Webb, trans., Cambridge, England: Cambridge University Press, 2005).

Prestwich, Menna (ed.). *International Calvinism 1541–1715* (Oxford, England: Clarendon Press, 1985).

Prudentius. *Psychomachia: The War of the Soul, or, the Battle of Virtues and Vices. Translated from Aur. Prudentius Clemens* (London, England: 1743).

Puttfarken, Thomas. David's Brutus and Theories of Pictorial Unity in France, 4 *Art History* 291 (1981).

Quiroga, Cecilia M. *The Battle of Human Rights: Gross, Systematic Violations and the Inter-American System* (Dordrecht, Netherlands: Martinus Nijhoff, 1988).

———. The Inter-American Commission on Human Rights and the Inter-American Court of Human Rights: Reflections on a Joint Venture, 12 *Human Rights Quarterly* 439 (1990).

Rabb, Theodore K. *The Last Days of the Renaissance and the March to Modernity* (New York, NY: Basic Books, 2006).

Rachline, François. *Gérard Garouste, Peindre à present* (Paris, France: Fragments, 2004).

Rafii, Keyvan C. Public Buildings and Civic Pride: Town Halls in Northern Germany, 1200–1618 (Ph.D. dissertation, Department of Art History, University of Illinois, 2003; UMI Publication No.: AAT 3111629).

Rajchman, John. Foucault's Art of Seeing, 44 *October* 88 (1988).

Ramji-Nogales, Jaya, Andrew I. Schoenholtz, and Philip G. Schrag. Refugee Roulette: Disparities in Asylum Adjudication, 60 *Stanford Law Review* 295 (2007).

Ramos, Efrén Rivera. *The Legal Construction of Identity: The Judicial and Social Legacy of American Colonialism in Puerto Rico* (Washington, DC: American Psychological Association, 2001).

Ramseyer, J. Mark. The Puzzling (In)dependence of Courts: A Comparative Approach, 23 *Journal of Legal Studies* 721 (1994).

Rapp, Stephen J. The Compact Model in International Criminal Justice: The Special Court for Sierra Leone, 57 *Drake Law Review* 11 (2008).

Rasmussen, Hjalte. *The European Court of Justice* (Copenhagen, Denmark: GadJura, 1998).

Rawls, John. *A Theory of Justice* (Cambridge, MA: Belknap Press of Harvard University Press, 1971; 1999 revised ed.).

Reeder, Robert P. The First Homes of the Supreme Court of the United States, 76 *Proceedings of the American Philosophical Society* 543 (1936).

Reich, Charles. The New Property, 73 *Yale Law Journal* 733 (1964).

Resnik, Judith. Managerial Judges, 96 *Harvard Law Review* 374 (1982).

———. Due Process: A Public Dimension, 39 *University of Florida Law Review* 405 (1987).

———. On the Bias: Feminist Reconsiderations of the Aspirations for Our Judges, 61 *Southern California Law Review* 1877 (1988).

———. From "Cases" to "Litigation," 54 *Law & Contemporary Problems* 5 (1991).

———. Whose Judgment? Vacating Judgments, Preferences for Settlement, and the Role of Adjudication at the Close of the Twentieth Century, 41 *UCLA Law Review* 1471 (1994).

———. Many Doors? Closing Doors? Alternate Dispute Resolution and Adjudication, 10 *Ohio State Journal on Dispute Resolution* 211 (1995).

———. Asking about Gender in Courts, 21 *Signs: Journal of Women in Culture and Society* 952 (1996).

———. Trial as Error, Jurisdiction as Injury: Transforming the Meaning of Article III, 113 *Harvard Law Review* 924 (2000).

———. "Uncle Sam Modernizes His Justice System": Inventing the Federal District Courts of the Twentieth Century for the District of Columbia and the Nation, 90 *Georgetown Law Journal* 607 (2002).

———. For Owen M. Fiss: Some Reflections on the Triumph and the Death of Adjudication, 58 *University of Miami Law Review* 173 (2003).

———. Migrating, Morphing, and Vanishing: The Empirical and Normative Puzzles of Declining Trial Rates in Courts, 1 *Journal of Empirical Legal Studies* 783 (2004).

———. Living Their Legal Commitments: Paideic Communities, Courts, and Robert Cover, 17 *Yale Journal of Law & the Humanities* 17 (2005).

———. Procedure as Contract, 80 *Notre Dame Law Review* 593 (2005).

———. Interdependent Federal Judiciaries: Puzzling about Why & How to Value the Independence of Which Judges, 137 *Daedalus* 28 (Fall 2008).

———. Detention, the War on Terror, and the Federal Courts, 110 *Columbia Law Review* 579 (2010).

Resodihardjo, Sandra L. *Crisis and Change in the British and Dutch Prison Services: Understanding Crisis-Reform Processes* (Burlington, VT: Ashgate, 2009).

Reynolds, William L., and William M. Richman. The Non-Precedential Precedent—Limited Publication and No Citation Rules in the United States Courts of Appeals, 78 *Columbia Law Review* 1167 (1978).

Richardson, Genevra, and Hazel Genn. Tribunals in Transition: Resolution or Adjudication, *Public Law* 116 (2007).

Richardson, Henry S., and Melissa S. Williams (eds.). *Moral Universalism and Pluralism* (New York, NY: New York University Press, 2009).

Ridder, Juliaan H. A. *Gerechtigheidstaferelen Voor Schepenhuizen in de Zuidelijke Nederlanden in de 14de, 15de, En 16de Eeuw* (Brussels, Belgium: Paleis der Academiën, 1989).

Riley, Terence (ed.). *Light Construction* (New York, NY: Museum of Modern Art, distributed by Harry N. Abrams, 1995).

Rimmer, Matthew. Australian Icons: Authenticity Marks and Identity Politics, 3 *Indigenous Law Journal* 139 (2004).

Ripa, Cesare. *Iconologia* (Padua, Italy: Pietro Paolo Tozzi, 1611; New York, NY, and London, England: Garland Publishing, 1976).

———. *Iconologia*, vols. 1, 2 (Padua, Italy: Pietro Paolo Tozzi, 1618; Torino, Italy: Fògola editore in Torino, 1988).

———. *Iconologie* (J. Baudoin, ed., Paris, France: Chez Matthieu Guillemot, 1644).

———. *Baroque and Rococo Pictorial Imagery: The 1758–60 Hertel Edition of Ripa's "Iconologia" with 200 Engraved Illustrations* (Edward A. Maser, ed., New York, NY: Dover Publications, 1971).

———. *Iconology London 1779* (George Richardson, ed., New York, NY, and London, England: Garland Publishing, 1979).

Ripa Van Perugien, Cesare. *Iconologia, of Uytbeeldingen des Verstands* (Amstelerdam, Netherlands: Dirck Pietersz Pers, 1644).

Robbins, Ira P. The Ostrich Instruction: Deliberate Ignorance as a Criminal Mens Rea, 81 *Journal of Criminal Law and Criminology* 191 (1990).

Robel, Lauren. The Practice of Precedent: Anastasoff, Noncitation Rules, and the Meaning of Precedent in an Interpretive Community, 35 *Indiana Law Review* 399 (2002).

Robert, Christian-Nils. *La Justice: Vertu Courtisane et Bourreau* (Geneva, Switzerland: George Editeur, 1993).

———. *La Justice dans ses décors (XVe–XVIe siècles)* (Geneva, Switzerland: Librairie Droz S. A., 2006).

Roberts, Kelyn, and Ruth Weisberg. Medieval Drawing and the Arts of Memory, 10 *Coranto* 28 (1975).

Roberts, Simon. "Listing Concentrates the Mind": The English Civil Court as an Arena for Structured Negotiation, 29 *Oxford Journal of Legal Studies* 457 (2009).

Rochfort, Desmond. *Mexican Muralists: Orozco, Rivera, Siqueiros* (San Francisco, CA: Chronicle Books, 1993).

Rogers, Catherine A. The Vocation of the International Arbitrator, 20 *American University International Law Review* 957 (2005).

Roney, John B., and Martin I. Klauber (eds.). *The Identity of Geneva: The Christian Commonwealth, 1564–1864* (Westport, CT: Greenwood Press, 1998).

Rosand, David (ed.). *Interpretazioni Veneziane: Studi di Storia Dell'arte in Onore di Michelangelo Muraro* (Venice, Italy: Arsenale Editrice, 1984).

———. *Myths of Venice: The Figuration of a State* (Chapel Hill, NC: University of North Carolina Press, 2001).

Rosen, Frederick. *Jeremy Bentham and Representative Democracy: A Study of the Constitutional Code* (Oxford, England: Oxford University Press, 1983).

Rosenne, Shabtai. *Provisional Measures in International Law: The International Court of Justice and the International Tribunal for the Law of the Sea* (Oxford, England: Oxford University Press, 2005).

Roth, Martha T. *Law Collections from Mesopotamia and Asia Minor* (Atlanta, GA: Scholars Press, 1995).

Roth-Lochner, Barbara. *Messieurs de la Justice et leur greffe* (Geneva, Switzerland: Société d'histoire et d'archéologie de Genève, 1992).

Roth-Lochner, Barbara, and Livio Fornara. *The Town Hall of Geneva* (Jean Gunn, trans., Geneva, Switzerland: Chancellorie D'Etat, 1986).

Rothstein, Bo, and Jan Teorell. What Is Quality of Government?: A Theory of Impartial Government Institutions, 21 *Governance: An International Journal of Policy, Administration and Institutions* 165 (2008).

Roux, Theunis. Principle and Pragmatism on the Constitutional Court of South Africa, 7 *I•CON, International Journal of Constitutional Law* 106 (2009).

Rowe, Colin, and Robert Slutzky. Transparency: Literal and Phenomenal, Part I, 8 *Perspecta* 45 (1963).

———. Transparency: Literal and Phenomenal, Part II, 13/14 *Perspecta* 287 (1971).

Rowe, Nina. Idealization and Subjection at the South Portal of Strasbourg Cathedral, in *Beyond the Yellow Badge: Anti-Judaism and Antisemitism in Medieval and Early Modern Visual Culture* (Mitchell B. Merback, ed., Leiden, Netherlands: Brill 2008).

Rubinstein, Nicholai. Political Ideas in Sienese Art: The Frescoes by Ambrogio Lorenzetti and Taddeo di Bartolo in the Palazzo Pubblico, 21 *Journal of the Warburg and Courtauld Institutes* 179 (1958).

Russell, Peter H. *Recognizing Aboriginal Title: The Mabo Case and Indigenous Resistance to English-Settler Colonialism* (Toronto, Canada: University of Toronto Press, 2005).

Sachs, Albie. The Creation of South Africa's Constitution, 41 *New York Law School Law Review* 669 (1997).

Sachs, Benjamin. Employment Law as Labor Law, 29 *Cardozo Law Review* 2685 (2008).

Samaha, Adam M. Undue Process, 59 *Stanford Law Review* 601 (2006).

Sander, Frank E. A. Varieties in Dispute Processing, The Pound Conference, 70 *Federal Rules Decisions* 111 (1976).

Saunders, Alison. *The Sixteenth-Century French Emblem Book: A Decorative and Useful Genre* (Geneva, Switzerland: Librairie Droz, 1988).

Schabas, William. *An Introduction to the International Criminal Court* (Cambridge, England: Cambridge University Press, 2004, 2d ed.).

Schafran, Lynn H. Gender Equality in the Courts: Still on the Judicial Agenda, 77 *Judicature* 110 (1993).

Schama, Simon. *The Embarrassment of Riches: An Interpretation of Dutch Culture in the Golden Age* (New York, NY: Alfred A. Knopf, 1987).

Schatz, Sara, Hugo Concha, and Anna L. M. Kerpel. The Mexican Judicial System: Continuity and Change in a Period of Democratic Consolidation, in *Reforming the Administration of Justice in Mexico* (Wayne A. Cornelius and David A. Shirk, eds., Notre Dame, IN: University of Notre Dame Press, 2007).

Scheerbart, Paul. *Glass Architecture* (James Palmes trans., New York, NY: Praeger Publishers, 1972).

Schiff, Benjamin N. *Building the International Criminal Court* (Cambridge, England: Cambridge University Press, 2008).

Schlauch, Margaret. The Allegory of Church and Synagogue, 14 *Speculum* 448 (1939).

Schmidt, Harry. *Jürgen Ovens, sein Leben und seine Werke. Ein Beitrag zur geschichte der Niederländischen Malerei im XVII. Jahrhundert* (Kiel, Germany: Selbstverlag des Verfassers Dr. Harry Schmidt, 1922).

Schneider, Laurie (ed.). *Giotto in Perspective* (Englewood Cliffs, NJ: Prentice-Hall, 1974).

Schofield, Philip. Jeremy Bentham: Historical Importance and Contemporary Relevance, in *Jeremías Bentham: El Joven y el Viejo Radical, su Presencia en el Rosario* (Bogotá, Colombia: Universidad Colegio Mayor de Nuestra Señora del Rosario, 2002).

———. Jeremy Bentham's "Nonsense upon Stilts," 15 *Utilatas* 1 (2003).

———. *Utility and Democracy: The Political Thought of Jeremy Bentham* (New York, NY: Oxford University Press, 2006).

Schulte, Constanze. *Compliance with Decisions of the International Court of Justice* (Oxford, England: Oxford University Press, 2004).

Schultz, Ulrike, and Gisela Shaw (eds.). *Women in the World's Legal Professions* (Portland, OR: Hart Publishing, 2003).

Schulz, Juergen. The Communal Buildings of Parma, 26 *Mitteilungen des Kunsthistorischen Institutes in Florenz* 279 (1982).

Scott, James B. The Closing of the Central American Court of Justice, 12 *American Journal of International Law* 380 (1918).

Segal, Ben-Zion, and Levi Gerson (eds.). *The Ten Commandments in History and Tradition* (Arnold Schwartz, trans., Jerusalem, Israel: Magnes Press, 1990).

Seiferth, Wolfgang S. *Synagogue and Church in the Middle Ages: Two Symbols in Art and Literature* (Lee Chadeayne and Paul Gottwald, trans., New York, NY: Frederick Ungar, 1970).

Sen, Amartya. *The Idea of Justice* (Cambridge, MA: Belknap Press of Harvard University Press, 2009).

Senie, Harriet F., and Sally Webster (eds.). *Critical Issues in Public Art: Content, Context and Controversy* (New York, NY: Harper Collins, 1992).

Serebrennikov, Nina E. Pieter Bruegel the Elder's Series of "Virtues" and "Vices" (Ph.D. dissertation, Department of Art, University of North Carolina, 1986; UMI Publication No.: AAT 8628260).

Shand, Peter (ed.). *Under the Aegis, the Virtues* (Auckland, New Zealand: Fortuna Press, 1997).

Shapiro, Martin, and Alec Stone Sweet (eds.). *On Law, Politics and Judicialization* (Oxford, England: Oxford University Press, 2002).

Shapiro, Maurice L. The Virtues and Vices in Ambrogio Lorenzetti's Franciscan Martyrdom, 46 *Art Bulletin* 367 (1964).

Sharon, Yosef. *The Supreme Court Building, Jerusalem* (Alexandra Mahler, trans., Jerusalem, Israel: Yad Hanadiv, 1993; 1997, 2d ed.).

Sheehan, Colleen A. Madison v. Hamilton: The Battle over Republicanism and the Role of Public Opinion, 98 *American Political Science Review* 405 (2004).

Sheingate, Adam. Progressive Publicity and the Origins of Political Consulting, in *Building a Business of Politics: The Origins and Development of Political Consulting in the United States* (forthcoming, 2010).

Shepherd, George B. Fierce Compromise: The Administrative Procedure Act Emerges from New Deal Politics, 90 *Northwestern Law Review* 1557 (1996).

Shipman, Shirley. Court Approaches to ADR in the Civil Justice System, 25 *Civil Justice Quarterly* 181 (2006).

Shirk, David A., and Wayne A. Cornelius. *Reforming the Administration of Justice in Mexico* (Notre Dame, IN: University of Notre Dame Press, 2007).

Shnayerson, Robert. *The Illustrated History of the Supreme Court of the United States* (New York, NY: Harry N. Abrams in association with the Supreme Court Historical Society, 1986).

Siegel, Reva B. "The Rule of Love": Wife Beating as Prerogative and Privacy, 105 *Yale Law Journal* 2117 (1996).

Silberman, Linda J. Masters and Magistrates Part II: The American Analogue, 50 *New York University Law Review* 1297 (1975).

Silbey, Susan S., and Patricia Ewick. *The Common Place of Law: Stories of Popular Legal Consciousness* (Chicago, IL: University of Chicago Press, 1998).

Silbey, Susan S., and Sally E. Merry. What Do Plaintiffs Want? Reexamining the Concept of Dispute, 9 *Justice System Journal* 151 (1984).

Simmonds, Andrew R. The Blindfold of Justice, 63 *ABA Journal* 1164 (1977).

Skinner, Quentin. Ambrogio Lorenzetti: The Artist as Political Philosopher, 72 *Proceedings of the British Academy* 48 (1986).

———. *Liberty before Liberalism* (Cambridge, England: Cambridge University Press, 1998).

———. Ambrogio Lorenzetti's Buon Governo Frescoes: Two Old Questions, Two New Answers, 62 *Journal of the Warburg and Courtauld Institutes* 1 (1999).

Sklar, Kathryn Kish, and James Brewer Stewart (eds.). *Women's Rights and Transatlantic Antislavery in the Era of Emancipation* (New Haven, CT: Yale University Press, 2007).

Skocpol, Theda. The Tocqueville Problem: Civic Engagement in American Democracy, 21 *Social Science History* 455 (1997).

Slanski, Kathryn E. Social Class System and the Economy, in *World Eras*, vol. 8: *Ancient Mesopotamia* (Ronald Wallenfels, ed., Farmington, NY: Thomson Gale, 2005).

———. The Mesopotamian "Rod and Ring": Icon of Righteous Kingship and Balance of Power between Palace and Temple, in Regime Change in the Ancient Near East and Egypt: From Sargon of Agade to Saddam Hussein (Special Issue), 136 *Proceedings of the British Academy* 37 (2007).

Slaughter, Anne-Marie, Alec Stone Sweet, and Joseph H. H. Weiler (eds.). *European Courts and National Courts: Doctrine and Jurisprudence* (Oxford, England: Hart Publishing, 1997).

Sloane, Robert K. *The Courthouses of Maine* (Woolwich, ME: Maine Lawyers Review, 1998).

Smith, Anthony. National Identity and the Idea of Europe, 68 *International Affairs* 129 (1992).

Smith, Darrell Hevenor. *The Office of the Supervising Architect of the Treasury: Its History, Activities, and Organization* (Baltimore, MD: Johns Hopkins University Press, 1923).

Smith, Katherine Allen. Footprints in Stone: Saint Michael the Archangel as a Medieval Saint, 1000–1500 (Ph.D. dissertation, Department of History, New York University, New York, NY, 2004; UMI Publication No.: AAT 3127497).

Smith, Macklin. *Prudentius' "Psychomachia": A Reexamination* (Princeton, NJ: Princeton University Press, 1976).

Snow, Edward. *Inside Bruegel: The Play of Images in Children's Games* (New York, NY: North Point Press, 1997).

Sourdin, Tania (ed.). *Alternative Dispute Resolution and the Courts* (Annandale, New South Wales, Australia: Federation Press, 2004).

Spierenburg, Pieter. *The Spectacle of Suffering: Executions and the Evolution of Repression* (Cambridge, England: Cambridge University Press, 1984).

———. (ed.). *The Emergence of Carceral Institutions: Prisons, Galleys and Lunatic Asylums 1550–1900*, vol. 12 (Rotterdam, Netherlands: Eramus University Rotterdam, 1984).

———. *The Prison Experience: Disciplinary Institutions and Their Inmates in Modern Europe* (New Brunswick, NJ: Rutgers University Press, 1991).

Spiermann, Ole. *International Legal Argument in the Permanent Court of International Justice: The Rise of the International Judiciary* (Cambridge, England: Cambridge University Press, 2005).

Splichal, Slavko. *Principles of Publicity and Press Freedom* (Lanham, MD: Rowman & Littlefield Publishers, 2002).

———. Bentham, Kant, and the Right to Communicate, 15 *Critical Review* 285 (2003).

Stafford, Emma. *Worshipping Virtues: Personification and the Divine in Ancient Greece* (London, England: Duckworth and Classical Press of Wales, 2000).

Stahn, Carsten, and Göran Sluiter (eds.). *The Emerging Practice of the International Criminal Court* (Leiden, Netherlands: Koninklijke Brill, 2009).

Starn, Randolph. The Republican Regime of the "Room of Peace" in Siena, 1338–40, 18 *Representations* 1 (1987).

———. *Ambrogio Lorenzetti: The Palazzo Pubblico, Siena* (New York, NY: George Braziller, 1994).

———. A Postmodern Renaissance?, 60 *Renaissance Quarterly* 1 (2006).

Starr, Sonja B. Rethinking "Effective Remedies": Remedial Deterrence in International Courts, 83 *New York University Law Review* 693 (2008).

Steiner, Henry J., Philip Alston, and Ryan Goodman. *International Human Rights in Context: Law, Politics, Morals* (New York, NY: Oxford University Press, 2007).

Stempel, Jeffrey W. Mandating Minimum Quality in Mass Arbitration, 76 *University of Cincinnati Law Review* 383 (2008).

Stern, Robert A. M., Gregory Gilmartin, and John Massengale. *New York 1900: Metropolitan Architecture and Urbanism 1890–1915* (New York, NY: Rizzoli, 1983).

Sternlight, Jean R. Creeping Mandatory Arbitration: Is It Just?, 57 *Stanford Law Review* 1631 (2005).

———. Is Alternative Dispute Resolution Consistent with the Rule of Law? Lessons from Abroad, 56 *DePaul Law Review* 569 (2006).

Stevens, Robert. *The Independence of the Judiciary: The View from the Lord Chancellor's Office* (Oxford, England: Clarendon Press, 1993).

Storing, Herbert J. *The Complete Anti-Federalist* (Chicago, IL: University of Chicago Press, 1981).

Stråth, Bo. A European Identity: To the Historical Limits of a Concept, 5 *European Journal of Social Theory* 387 (2002).

Strauss, Gerald. *Law, Resistance, and the State: The Opposition to Roman Law in Reformation Germany* (Princeton, NJ: Princeton University Press, 1986).

Strauss, Walter L. (ed.). *The Complete Engravings, Etchings and Drypoints of Albrecht Dürer* (New York, NY: Dover Publications, 1972).

———. (ed.). *The Illustrated Bartsch*, vol. 10: *Sixteenth Century German Artists: Albrecht Dürer* (New York, NY: Abaris Books, 1980).

Strelein, Lisa. *Compromised Jurisprudence: Native Title Cases since Mabo* (Canberra, Australia: Aboriginal Studies Press, 2006).

Subrin, Stephen N. How Equity Conquered Common Law: The Federal Rules of Civil Procedure in Historical Perspective, 135 *University of Pennsylvania Law Review* 909 (1987).

Sugarman, David. Images of Law: Legal Buildings, Englishness and the Reproduction of Power, in *Rechtssymbolik und Wertevermittlung (The Symbolism of Justice and the Conveyance of Moral Values)*, 47 *Schriften zur Europäischen Rechts- und Verfassungsgeschichte* 167 (Berlin, Germany: Duncker & Humblot, 2004).

Svensson-McCarthy, Anna-Lena. *The International Law of Human Rights and States of Exception: With Special Reference to the Travaux Preparatories and Case-Law of the International Monitoring Organs* (The Hague, Netherlands: Martinus Nijhoff, 1998).

Sweet, Alec Stone. *Governing with Judges: Constitutional Politics in Europe* (Oxford, England: Oxford University Press, 2000).

———. *The Judicial Construction of Europe* (Oxford, England: Oxford University Press, 2004).

Tachau, Katherine H. *Vision and Certitude in the Age of Ockham: Optics, Epistemology and the Foundations of Semantics, 1250–1345* (Leiden, Netherlands: Brill, 1988).

Taft, William H. Adequate Machinery for the Judicial Business: Address before the Judicial Section of the American Bar Association, Aug. 30, 1921, 7 *ABA Journal* 453 (1921).

Taft, William H. Possible and Needed Reforms in Administration of Justice in the Federal Courts, 45th Conference Annual Report A.B.A. 250 (1922); reprint, 8 *ABA Journal* 601 (1922).

Tanis, James, and Daniel S. Horst. *Images of Discord: A Graphic Interpretation of the Opening Decades of the Eighty Years' War* (Grand Rapids, MI: William B. Eerdmans in arrangement with Bryn Mawr College, 1993).

Taslitz, Andrew E. Racial Blindsight: The Absurdity of Color-Blind Criminal Justice, 5 *Ohio State Journal of Criminal Law* 1 (2007).

Taut, Bruno. *Alpine Architecture* (Shirley Palmer, trans., New York, NY: Praeger, 1972).

Taylor, Katherine Fischer. *In the Theatre of Criminal Justice: The Palais de Justice in Second Empire Paris* (Princeton, NJ: Princeton University Press, 1993).

Teitel, Ruti G. *Transitional Justice* (Oxford: Oxford University Press, 2000).

Tepper, Steven J. Unfamiliar Objects in Familiar Places: The Public Response to Art-in-Architecture, 6 *International Journal of Cultural Policy* 283 (2000).

Teubner, Gunther. After Privatisation? The Many Autonomies of Private Law, 51 *Current Legal Problems* 393 (1998).

Thalacker, Donald W. *The Place of Art in the World of Architecture* (New York, NY: Chelsea House Publishers, 1980).

Thompson, Robert F. Kongo Power Figure, in *Perspectives: Angles on African Art* (New York, NY: Center for African Art and Harry N. Abrams, 1987).

———. Illuminating Spirits: "Astonishment and Power" at the National Museum of African Art, 26 *African Arts* 60 (1993).

Thrane, Susan W. *County Courthouses of Ohio* (Bloomington, IN: Indiana University Press, 2000).

Thurley, Simon. *Hampton Court: A Social and Architectural History* (New Haven, CT: Yale University Press, 2003).

Tierney, John T. *The U.S. Postal Service: Status and Prospects of a Public Enterprise* (Dover, MA: Auburn House Publishing, 1988).

Tipton, Susan. *Res Publica Bene Ordinata: Regentenspiegel und Bilder vom Guten Regiment, Rathausdekorationen in der Frühen Neuzeit* (Hildesheim, Germany: Georg Olms Verlag, 1996).

Tittler, Robert. *Architecture and Power: The Town Hall and the English Urban Community c. 1500–1640* (Oxford, England: Oxford University Press, 1991).

Traver, Hope. The Four Daughters of God: A Study of the Versions of This Allegory with Especial Reference to Those in Latin, French, and English (Ph.D. dissertation, Bryn Mawr College, Philadelphia, PA: John C. Winston 1907).

Troescher, Georg. *Weltgerichtsbilder in Rathäusern und Gerichtsstätten*, vol. 11 of *West German Yearbook for Art History* (Frankfurt, Germany: Prestel-Vertel, GMBH, 1939).

Tuve, Rosemond. Notes on the Virtues and Vices, pt. 1, 26 *Journal of the Warburg and Courtauld Institutes* 264 (1963).

———. Notes on the Virtues and Vices, pt. 2, 27 *Journal of the Warburg and Courtauld Institutes* 42 (1964).

———. *Allegorical Imagery: Some Mediaeval Books and Their Posterity* (Princeton, NJ: Princeton University Press, 1966).

Twining, William. *Theories of Evidence: Bentham and Wigmore* (London, England: Weidenfeld & Nicolson, 1985).

Tyler, Tom. Social Justice: Outcome and Procedure, 35 *International Journal of Psychology* 117 (2000).

Underwood, David. *Oscar Niemeyer and Brazilian Free-Form Modernism* (New York, NY: George Braziller, 1994).

Uyl, Douglas J. den. *The Virtue of Prudence* (New York, NY: Peter Lang, 1991).

van Cleve, John. *Sebastian Brant's "The Ship of Fools" in Critical Perspective, 1800–1991* (Columbia, SC: Camden House, 1993).

van de Steeg, Marianne. Rethinking the Conditions for a Public Sphere in the European Union, 5 *European Journal of Social Theory* 499 (2002).

van der Stock, Jan. *Cornelis Matsys 1510/11–1556/57: Oeuvre Graphique 13* (Eugène Rouir, trans., Brussels, Belgium: Bibliothèque Royale Albert Ier, 1985).

van der Velden, Hugo. Cambyses for Example: The Origins and Function of an Exemplum Iustitiae in Netherlandish Art of the Fifteenth, Sixteenth and Seventeenth Centuries, 23 *Simiolus: Netherlands Quarterly for the History of Art* 5 (1995).

———. Cambyses Reconsidered: Gerard David's Exemplum Iustitiae for Bruges Town Hall, 23 *Simiolus: Netherlands Quarterly for the History of Art* 40 (1995).

van Krieken, Peter J., and David McKay (eds.). *The Hague: Legal Capital of the World* (The Hague, Netherlands: T.M.C. Asser Press, 2005).

van Miegroet, Hans J. Gerard David (ca. 1450–1523): Patronage and Artistic Preeminence at Bruges (Ph.D. dissertation, University of California at Santa Barbara, 1988; UMI Publication No.: AAT 8905315).

———. Gerard David's Justice of Cambyses: Exemplum Iustitiae or Political Allegory?, 18 *Simiolus: Netherlands Quarterly for the History of Art* 116 (1988).

———. *Gerard David* (Antwerp, Belgium: Mercatorfonds, 1989).

Vargas, Jorge A. The Rebirth of the Supreme Court of Mexico: An Appraisal of President Zedillo's Judicial Reform of 1995, 11 *American University Journal of International Law & Policy* 295 (1996).

Veall, Donald. *The Popular Movement for Law Reform, 1640–1660* (Oxford, England: Oxford Clarendon Press, 1970).

Veldman, Ilja M. Familiar Customs and Exotic Rituals: Picart's Illustrations for "Cérémonies et coutumes religieuses de tous les peuples," 33 *Simiolus: Netherlands Quarterly for the History of Art* 94 (2007).

Verkuil, Paul R. Reflections upon the Federal Administrative Judiciary, 39 *UCLA Law Review* 1341 (1992).

———. Public Law Limitations on Privatization of Government Functions, 84 *North Carolina Law Review* 397 (2006).

Vermeule, Adrian. Veil of Ignorance Rules in Constitutional Law, 111 *Yale Law Journal* 399 (2001).

Vidler, Anthony. Fantasy, the Uncanny and Surrealist Theories of Architecture, 1 *Papers of Surrealism* (Winter 2003) (online).

Virden, William L. *Cornerstones and Communities: A Historical Overview of Colorado's County Seats and Courthouses* (Loveland, CO: Rodgers & Nelsen, 2001).

Vlaardingerbroek, Pieter. The Town Hall of Amsterdam, the Construction of the Town Hall, Its Conversion into a Royal Palace and Restoration (Ph.D. dissertation, University of Utrecht, 2004).

Volavkova, Zdenka. Nkisi Figures of the Lower Congo, 5 *African Arts* 52 (1972).

Volcansek, Mary L. *Judicial Misconduct: A Cross-National Comparison* (Gainsville, FL: University of Florida Press, 1996).

von Schwarzenberg, Johann Freiherr. *Bambergische Peinliche Halsgerichtsordnung (Bambergensis)*, vols. 1–4 (Mainz, Germany: Johann Schöffer, 1508).

Waddell, Gene, and Rhodri Windsor Liscombe. *Robert Mills's Courthouses and Jails [of South Carolina]* (Easley, SC: Southern Historical Press, 1981).

Wald, Patricia M. International Criminal Courts: Some Kudos and Concerns, 150 *Proceedings of the American Philosophical Society* 241 (2006).

Walker, Janet, and Oscar G. Chase (eds.). *Common Law, Civil Law and the Future of Categories* (Ontario, Can.: LexisNexis, 2010).

Walker, Neil. Beyond Boundary Disputes and Basic Grids: Mapping the Global Disorder of Normative Orders, 6 *I•CON, International Journal of Constitutional Law* 373 (2008).

Ward, Angela. *Judicial Review and the Rights of Private Parties in EU Law* (Oxford, England: Oxford University Press, 2007, 2d ed.).

Warner, Marina. *Alone of All Her Sex: The Myth and the Cult of the Virgin Mary* (New York, NY: Vintage Books, 1983).

———. *Monuments and Maidens: The Allegory of the Female Form* (New York, NY: Atheneum, 1985).

Wasby, Stephen L., and Martha Humphries Ginn. Triage in Appellate Courts: Cross-Level Comparison, 88 *Judicature* 216 (2005).

Watkin, Thomas G. "The Powers That Be Are Seated": Symbolism in English Law and the English Legal System, in *Rechtssymbolik und Wertevermittlung (The Symbolism of Justice and the Conveyance of Moral Values)* (Reinder Schultze ed., Berlin, Germany: Duncker and Humblot, 2004).

Weale, W. H. James. *Gerard David: Painter and Illuminator* (London, England: Seeley & Company, 1895).

Weinrib, Lorraine E. The Supreme Court of Canada in the Age of Rights: Constitutional Democracy, the Rule of Law and Fundamental Rights under Canada's Constitution, 80 *Canadian Bar Review* 699 (2001).

Weisser, Michael R. *Crime and Punishment in Early Modern Europe* (Atlantic Highlands, NJ: Humanities Press, 1979).

Welch, Michael. Guantánamo Bay as a Foucauldian Phenomenon: An Analysis of Penal Discourse, Technologies and Resistance, 89 *Prison Journal* 3 (2009).

West, Robin L. *Progressive Constitutionalism: Reconstructing the Fourteenth Amendment* (Durham, NC: Duke University Press, 1994).

Wetenhall, John. Camelot's Legacy to Public Art: Aesthetic Ideology in the New Frontier, 48 *Art Journal* 303 (1989).

Wheeler, Russell R. *A New Judge's Introduction to Federal Judicial Administration* (Washington, DC: Federal Judicial Center, 2003).

Wheeler, Russell R., and Cynthia Harrison. *Creating the Federal Judicial System* (Washington, DC: Federal Judicial Center, 1994, 2d ed.).

Whitman, James Q. The Moral Menace of Roman Law and the Making of Commerce: Some Dutch Evidence, 105 *Yale Law Journal* 1841 (1995).

———. Ancient Rights and Wrongs: At the Origins of Law and the State: Supervision of Violence, Mutilation of Bodies, or Setting of Prices?,[ 71 *Chicago-Kent Law Review* 41 (1995).

Wildhaber, Luzius. *The European Court of Human Rights, 1998–2006: History, Achievements, Reform* (Kehl, Germany: N. P. Engel, 2006).

Will, Hubert L., Robert R. Merhige Jr., and Alvin B. Rubin. The Role of the Judge in the Settlement Process, 75 *Federal Rules Decisions* 203 (1977).

Williamson, Chilton. Bentham Looks at America, 70 *Political Science Quarterly* 543 (1955).

Wiltenburg, Joy. The Carolina and the Culture of the Common Man: Revisiting the Imperial Penal Code of 1532, 53 *Renaissance Quarterly* 713 (2000).

Wind, Edgar. Platonic Justice, Designed by Raphael, 1 *Journal of the Warburg and Courtauld Institutes* 69 (1937).

———. The Four Elements in Raphael's "Stanza della Segnatura," 2 *Journal of the Warburg and Courtauld Institutes* 75 (1938).

———. *Pagan Mysteries in the Renaissance* (London, England: Faber and Faber, 1968).

Winick, Bruce J., and David B. Wexler. Drug Treatment Court: Therapeutic Jurisprudence Applied 18 *Touro Law Review* 479 (2002).

Winkle, John W., III. Interbranch Politics: The Administrative Office of U.S. Courts as Liaison, 24 *Justice System Journal* 443 (2003).

Wippman, David. The Costs of International Justice, 100 *American Journal of International Law* 861 (2006).

Witt, John F. Crystal Eastman and the International Beginnings of American Civil Liberties, 54 *Duke Law Journal* 705 (2004).

Wolfrum, Rüdiger, and Ulrike Deutsch (eds.). *The European Court of Human Rights Overwhelmed by Applications: Problems and Possible Solutions* (Berlin, Germany: Springer, 2009).

Woodlock, Douglas P. The "Peculiar Embarrassment": An Architectural History of the Federal Courts in Massachusetts, 74 *Massachusetts Law Review* 268 (1989).

Woods, Mary N. The First American Architectural Journals: The Profession's Voice, 48 *Journal of the Society of Architectural Historians* 117 (1989).

———. *From Craft to Profession: The Practice of Architecture in Nineteenth-Century America* (Berkeley, CA: University of California Press, 1999).

Woolf, Harry, Michael McKenzie, Peter MacMahon, Colm O'Cinneide, and Laura Clarke. Review of the Working Methods of the European Court of Human Rights, 26 *Human Rights Law Journal* 447 (December 2005).

Woolman, Stuart, Michael Bishop, and Theunis Roux (eds.). *Constitutional Law of South Africa* (Cape Town, South Africa: Juta & Company, 2004, 2d ed.).

Wyszomirski, Margaret J. Congress, Presidents, and the Arts: Collaboration and Struggle, 499 *Annals of the American Academy of Political and Social Science* 124 (1988).

Yacobi, Haim. Form Follows Metaphors: A Critical Discourse Analysis of the Construction of the Israeli Supreme Court Building in Jerusalem, 9 *Journal of Architecture* 219 (2004).

Yeazell, Stephen C. The Misunderstood Consequences of Modern Civil Process, 1994 *Wisconsin Law Review* 631.

———. Re-financing Civil Litigation, 51 *DePaul Law Review* 183 (2001).

Zander, Michael. The Government's Plans on Civil Justice, 61 *Modern Law Review* 383 (1998).

———. The Government's Plans on Legal Aid and Conditional Fees, 61 *Modern Law Review* 538 (1998).

Zapalac, Kristin E. S. *"In His Image and Likeness": Political Iconography and Religious Change in Regensburg, 1500–1600* (Ithaca, NY: Cornell University Press, 1990).

Zaret, David. *Origins of Democratic Culture: Printing, Petitions, and the Public Sphere in Early–Modern England* (Princeton, NJ: Princeton University Press, 2000).

Ziolkowski, Theodore. The Figure of Justice in Western Art and Literature, 75 *Inmunkwahak: The Journal of Humanities* 187 (1996).

———. *The Mirror of Justice: Literary Reflections of Legal Crises* (Princeton, NJ: Princeton University Press, 1997).

Zoller, Elisabeth. *Introduction to Public Law: A Comparative Study* (Leiden, Netherlands: Martinus Nijhoff, 2008).

Zuckerman, Adrian A. S. *Civil Procedure* (London, England: Lexis-Nexis, 2003).

Zuckerman, Adrian A. S., and Ross Cranston (eds.). *Reform of Civil Procedure: Essays on "Access to Justice"* (Oxford, England: Oxford University Press, 1995).

Zuckert, Michael, Who Is Publius? The Debate Over the Constitution and the American Revolution, in *Enlightening Revolutions: Essays in Honor of Ralph Lerner* (Svetozar Minkov and Stéphane Douard, eds., Lanham, MD: Lexington Books, 2006).

Zupnick, Irving. Bruegel and the Revolt of the Netherlands, 23 *Art Journal* 283 (1964).

# CASELAW

## United States Cases

*Ake v. Oklahoma*, 470 U.S. 68 (1985).

*Arar v. Ashcroft*, 585 F.3d 559 (2d Cir. 2009) (en banc).

*Ashcroft v. Iqbal*, 129 S. Ct. 1937 (2009).

*Associated Press v. Department of Defense*, 498 F. Supp. 2d 707 (S.D.N.Y. 2007).

*Ballard v. Commissioner of Internal Revenue*, 544 U.S. 40 (2005).

*Bell Atlantic Corp. v. Twombly*, 550 U.S. 544 (2007).

*Bismullah v. Gates*, 503 F.3d 137 (D.C. Cir. 2007).

*Boddie v. Connecticut*, 401 U.S. 371 (1971).

*Boumediene v. Bush*, 553 U.S. 723 (2008).

*Brown v. Board of Education*, 347 U.S. 483 (1954).

*Buckeye Check Cashing, Inc. v. Cardegna*, 546 U.S. 440 (2006).

*Caley v. Gulfstream Aerospace Corp.*, 428 F.3d 1359 (11th Cir. 2005).

*Cardegna v. Buckeye Check Cashing, Inc.*, 894 So. 2d 860 (Fla. 2005).

*Carey v. Musladin*, 549 U.S. 70 (2006).

*Caritativo v. California*, 357 U.S. 549 (1958).

*Catchpole v. Brannon*, 36 Cal. App. 4th 237 (Cal. Ct. App. 1995).

*Cheney v. U.S. District Court*, 542 U.S. 367 (2004).

*Cheney v. U.S. District Court*, 541 U.S. 913 (2004) (Scalia, J.) (memorandum).

*Circuit City Stores, Inc. v. Adams*, 279 F.3d 889 (9th Cir. 2002).

*Circuit City Stores, Inc. v. Adams*, 532 U.S. 105 (2001).

*Commodity Futures Trading Commission v. Schor*, 478 U.S. 833 (1986).

*Connecticut Department of Public Safety v. Doe*, 538 U.S. 1 (2003).

*County of Allegheny v. American Civil Liberties Union*, 492 U.S. 573 (1989).

*Cox v. Louisiana*, 379 U.S. 559 (1965).

*Crawford v. Washington*, 541 U.S. 36 (2004).

*Crowell v. Benson*, 285 U.S. 22 (1932).

*Davidson v. New Orleans*, 96 U.S. 97 (1878).

*Davy's Executors v. Faw*, 11 U.S. 171 (1812).

*Dean Witter Reynolds, Inc. v. Byrd*, 470 U.S. 213 (1985).

*Detroit Free Press v. Ashcroft*, 303 F.3d 681 (6th Cir. 2002).

*Dusenbery v. United States*, 534 U.S. 161 (2002).

*Estelle v. Williams*, 425 U.S. 501 (1976).

*Ex parte Quirin*, 317 U.S. 1 (1942).

*Federal Power Commission v. Tuscarora Indian Nation*, 362 U.S. 99 (1960).

*Gentry v. Superior Court*, 165 P. 3d 556 (Cal. 2007).

*German-American Insurance Co. v. Etherton*, 41 N.W. 406 (Neb. 1889).

*Gideon v. Wainwright*, 372 U.S. 335 (1963).

*Gilmer v. Interstate/Johnson Lane Corp.*, 500 U.S. 20 (1991).

*Glidden Co. v. Zdanok*, 370 U.S. 530 (1962).

*Goldberg v. Kelly*, 397 U.S. 254 (1970).

*Government of Virgin Islands v. Charleswell*, 115 F.3d 171 (3d Cir. 1997).

*Grannis v. Ordean*, 234 U.S. 385 (1914).

*Green Tree Financial Corp. v. Bazzle*, 539 U.S. 444 (2003).

*Green Tree Financial Corp.—Alabama v. Randolph*, 531 U.S. 79 (2000).

*Guerini Stone Co. v. P.J. Carlin Construction Co.*, 240 U.S. 264 (1916).

*Guerini Stone Co. v. P.J. Carlin Construction Co.*, 248 U.S. 334 (1919).

*Hall Street Associates, L.L.C. v. Mattel, Inc.*, 552 U.S. 576 (2008).

*Hamdan v. Rumsfeld*, 548 U.S. 557 (2006).

*Hamdi v. Rumsfeld*, 542 U.S. 507 (2004).

*Hartford Courant Co. v. Pellegrino*, 380 F.3d 83 (2d Cir. 2004).

*Hayburn's Case*, 2 U.S. (2 Dall.) 409 (1792).

*Iberia Credit Bureau, Inc. v. Cingular Wireless*, 379 F.3d 159 (5th Cir. 2004).

*Illinois v. Allen*, 397 U.S. 337 (1970).

*In re Guantánamo Detainee Cases*, 344 F. Supp. 2d 174 (D.D.C. 2004).

*In re Maron v. Silver*, 925 N.E. 2d 889 (N.Y. 2010).

*In re Swan*, 833 F. Supp. 794 (C.D. Cal. 1993), rev'd sub nom. *United States v. Wunsch*, 84 F.3d 1110 (9th Cir. 1996).

*Johnson v. Virginia*, 373 U.S. 61 (1963).

*Laird v. Tatum*, 408 U.S. 1 (1972).

*Laird v. Tatum*, 409 U.S. 824 (1972) (Rehnquist, J.) (memorandum).

*Lassiter v. Department of Social Services*, 452 U.S. 18 (1981).

*Mallory v. Harkness*, 895 F. Supp. 1556 (S.D. Fla. 1995), aff'd, 109 F.3d 771 (11th Cir. 1997).

*Marbury v. Madison*, 5 U.S. (1 Cranch) 137 (1803).

*Mathews v. Eldridge*, 424 U.S. 319 (1976).

*McCleskey v. Kemp*, 481 U.S. 279 (1987).

*McCreary County, Kentucky v. American Civil Liberties Union*, 545 U.S. 844 (2005).

*Mitsubishi Motors Corp. v. Soler Chrysler-Plymouth, Inc.*, 473 U.S. 614 (1985).

*M.L.B. v. S.L.J.*, 519 U.S. 102 (1996).

*Moore v. Dempsey*, 261 U.S. 86 (1923).

*Mullane v. Central Hanover Bank & Trust Co.*, 339 U.S. 306 (1950).

*Murray's Lessee v. Hoboken Land & Improvement Co.*, 59 U.S. 272 (1855).

*NBC Subsidiary (KNBC-TV), Inc. v. Superior Court*, 20 Cal. 4th 1178 (1999).

*North Jersey Media Group, Inc. v. Ashcroft*, 308 F.3d 198 (3d Cir. 2002).

*Ortwein v. Schwab*, 410 U.S. 656 (1973).

*Parents Involved in Community Schools v. Seattle School District No. 1*, 551 U.S. 701 (2007).

*People ex rel. Burris v. Ryan*, 634 N.E. 2d. 469 (Ill. 1994).

*Plessy v. Ferguson*, 163 U.S. 537 (1896).

*Powell v. Allstate Insurance Co.*, 652 So. 2d 354 (Fla. 1995).

*Press-Enterprise Co. v. Superior Court*, 464 U.S. 501 (1984).

*Press-Enterprise Co. v. Superior Court*, 478 U.S. 1 (1986).

*Preston v. Ferrer*, 552 U.S. 346 (2008).

*Richmond Newspapers, Inc. v. Virginia*, 448 U.S. 555 (1980).

*Rodriguez de Quijas v. Shearson/American Express, Inc.*, 490 F.3d 477 (1989).

*Roe v. Wade*, 410 U.S. 113 (1973).

*Rushen v. Spain*, 464 U.S. 114 (1983).

*Sanchez-Llamas v. Oregon*, 548 U.S. 331 (2006).

*Seattle Times Co. v. Rhinehart*, 467 U.S. 20 (1984).

*Sheppard v. Maxwell*, 384 U.S. 333 (1966).

*Southland Corp. v. Keating*, 465 U.S. 1 (1984).

*Stump v. Sparkman*, 435 U.S. 349 (1978).

*Tennessee v. Lane*, 541 U.S. 509 (2004).
*Tumey v. Ohio*, 273 U.S. 510 (1927).
*United States v. Will*, 449 U.S. 200 (1980).
*Van Orden v. Perry*, 545 U.S. 677 (2005).
*Wilkinson v. Austin*, 545 U.S. 209 (2005).
*Wilko v. Swan*, 346 U.S. 427 (1953).

## Non–United States Cases

*Anderson on Behalf of the Spinifex People v. State of Western Australia*
[2000] F.C.R. 1717; available at 2000 WL 33657420 (Australia).
*Angelova & Iliev v. Bulgaria*, App. No. 55523/00 (Eur. Ct. H.R. 2007).
*Avena and Other Mexican Nationals (Mexico v. United States)*, 2004
I.C.J. 12 (Mar. 31).
*Bosnia and Herzegovina v. Serbia and Montenegro*, 2007 I.C.J. 91
(Feb. 26).
*Boswell's Case*, (1606) 77 Eng. Rep. 326 (K.B.).
*Botmeh and Alami v. United Kingdom*, App. No. 15187/03, 46 Eur.
H. R. Rep. 659 (2007).
*Caesar v. Trinidad and Tobago*, 2005 Inter-Am. Ct. H.R.
(ser. C) No. 123 (Mar. 11).
*Case 294/83, Parti Écologiste 'Les Verts' v. Parliament*, 1986 E.C.R.
1339.
*Case C-256/01, Allonby v. Accrington & Rossendale College*, 2004
E.C.R. I-00873.
*Case C-459/03, Commission v. Ireland*, 2006 E.C.R. I-4635.
*Case T-346/94, France-Aviation v. Commission*, 1995 E.C.R. II-2841.
*Costa Rica v. Nicaragua*, Cent. Am. Ct. J. (1916); reprint, 11
AMERICAN JOURNAL OF INTERNATIONAL LAW 181 (1917).
*Dimes v. Grand Junction Canal*, 10 Eng. Rep. 301 (H.L. 1852).
*Doctors for Life International v. Speaker of the National Assembly
and Others*, 2006 (12) BCLR 1399 (CC) (South Africa).
*Doran v. Ireland*, 2003 Eur. Ct. H.R. 417.
*Dr. Bonham's Case*, (1608) 77 Eng. Rep. 638 (K.B.).
*Dudgeon v. United Kingdom*, 45 Eur. Ct. H.R. (ser. A) (1981).
*Dunnett v. Railtrack PLC*, [2002] EWCA (Civ.) 302; [2002] 1 W.L.R.
2434.
*El Salvador v. Nicaragua*, Cent. Am. Ct. J. (1917); reprint, 11
AMERICAN JOURNAL OF INTERNATIONAL LAW 674 (1917).
*Göç v. Turkey*, 2002 Eur. Ct. H.R. 589.
*Golder v. United Kingdom*, Judgment, 18 Eur. Ct. H.R. (ser. A)
(1975).
*Halsey v. Milton Keynes General NHS Trust*, [2004] EWCA (Civ)
576.
*Hickman v. Blake Lapthorn*, [2006] EWHC 12 (QB).
*Honduras v. Salvador and Guatemala*, Cent. Am. Ct. J. (1909);
reprint, 3 AMERICAN JOURNAL OF INTERNATIONAL LAW 729
(1909).
*Hurst v. Leeming*, [2003] EWHC 499 (Ch).
*Ivcher-Bronstein v. Peru*, 2001 Inter-Am. Ct. H.R. (ser. C)
No. 74 (Feb. 6).
*Jussila v. Finland*, 45 Eur. Ct. H.R. 39 (2007).
*König v. Germany*, 2 Eur. H.R. Rep. 170 (ser. A) (1978).
*LaGrand Case (Germany v. United States)*, 2001 I.C.J. 466 (June 27).
*Le Compte, Van Leuven & De Meyere v. Belgium*, 43 Eur. Ct. H.R.
(ser. A) (1981).
*Lustig-Prean and Beckett v. United Kingdom*, 29 Eur. H.R. Rep. 548
(1999).
*Mabo v. Queensland II* (1992) 175 C.L.R. 1 (Australia).
*Matatiele Municipality and Others v. President of the Republic of
South Africa and Others*, 2007 (1) BCLR 47 (CC) (South Africa).
*Matthews v. United Kingdom*, 28 Eur. Ct. H.R. 361 (1999).
*Merafong Demarcation Forum and Others v. President of the Republic
of South Africa and Others*, 2008 (5) SA 171 (CC) (South Africa).
*Micallef v. Malta*, 2008 Eur. Ct. H.R. 41.

*Military and Paramilitary Activities (Nicaragua v. United States)*,
1986 I.C.J. 14 (June 27).
*Nachova v. Bulgaria (No. 2)*, App. Nos. 43577/98 and 43579/98,
42 Eur. H.R. Rep. 933 (2005).
*Nuclear Tests (Australia v. France)*, 1974 I.C.J. 253, 265 (Dec. 20).
*Prosecutor v. Kunarac, Kovac & Vukovic*, Case Nos. IT-96-23-T and
IT-96-23/1-T, Judgment (Feb. 22, 2001) [ICTY].
*R. v. G. Gaskin*, (1799) 101 Eng. Rep. 1349 (K.B.).
*R. v. Governors of Darlington School*, (1844) 115 Eng. Rep. 257 (Q.B.).
*R. v. Lord Chancellor, ex parte Witham*, [1998] Q.B. 575.
*R. v. Wilson*, (1817) 171 Eng. Rep. 353.
*Reference re Remuneration of Judges of the Provincial Court of Prince
Edward Island*, [1997] 3 S.C.R. 3 (Canada).
*Riepan v. Austria*, App. No. 35115/97, ECHR 2000-XII.
*Royal Bank of Canada Trust Corporation Ltd. v. Secretary of State for
Defence*, [2003] EWHC 1479 (Ch.).
*Shinga v. State and The Society of Advocates (Pietermartizburg Bar)*,
2007 (5) BLCR 474 (CC) (South Africa).
*Shirayama Shokusan Co. Ltd. v. Danovo Ltd.*, [2003] EWHC 3006
(Ch.); [2004] 1 W.L.R. 2985.
*Smith and Grady v. United Kingdom*, App. Nos. 33985/96 and
33986/96, 29 Eur. H.R. Rep. 493 (1999).
*Somerset v. Stewart*, (1772) 98 Eng. Rep. 499 (K.B.); 20 Howell's State
Trials 1, 79.
*Stanley Mervyn, Adrian Young, and Livingston West and Others
on behalf of the Peoples of the Ngaanyatjarra Lands v. Western
Australia and Others*, [2005] F.C.R. 831 (Australia).
*The Cordillera of the Andes Boundary Case (Argentina, Chile)*,
Nov. 20, 1902, 9 REPORTS OF INTERNATIONAL ARBITRAL AWARDS
29 (1959).
*TW v. Malta*, App. No. 25644/94, 29 Eur. H.R. Rep. 185 (1999).
*Western Australia v. Commonwealth*, (1995) 183 C.L.R. 373
(Australia).
*Western Australia v. Ward*, (2002) 213 C.L.R. 1 (Australia).
*Yvon Neptune v. Haiti*, 2008 Inter-Am. Ct. H.R. (ser. C)
No. 180 (May 6).

## INTERNATIONAL CONVENTIONS
## AND TREATIES

Agreement between the Government of the Republic of Costa Rica
and the Inter-American Court of Human Rights, Sept. 10, 1981,
reprinted in INTER-AMERICAN YEARBOOK ON HUMAN RIGHTS
1985 at 214, 230 (Dordrecht, Netherlands: Martinus Nijhoff Pub-
lishers, 1987).
Agreement between the United Nations and Government of Sierra
Leone on the Establishment of a Special Court for Sierra Leone,
U.N.–Sierra Leone, Jan. 16, 2002, Appendix II, U.N. Doc. S/2002/
246.
Agreement Relating to the Implementation of Part XI of the United
Nations Convention on the Law of the Sea of 10 December 1982,
July 28, 1994, 1836 U.N.T.S. 41.
American Declaration of the Rights and Duties of Man, O.A.S. Res.
XXX, International Conference of American States, 9th Conf.,
O.A.S. Doc. OEA/ser. L./ V./I.4 rev. (May 2, 1948).
Charter of the Organization of American States, Apr. 30, 1948, 2 U.S.T.
2394, 119 U.N.T.S. 3 (entered into force Dec. 13, 1951).
Convention for the Creation of an International Criminal Court,
opened for signature Nov. 16, 1937, 19 LEAGUE OF NATIONS OFFI-
CIAL JOURNAL 37 (1938) (never entered into force).
Convention for the Establishment of a Central American Court of Jus-
tice, Dec. 20, 1907, 2 U.S.T. 2399.
Convention on the Prevention and Punishment of the Crime of Geno-
cide, Dec. 9, 1948, 78 U.N.T.S. 277.

Convention Respecting the Laws and Customs of War on Land, Oct. 18, 1907, 36 Stat. 2277.

Council of Europe, Committee of Ministers, Resolution of the Committee of Ministers on Judgments Revealing an Underlying Systemic Problem, 114th Sess., Res. (2004) 3 (May 12, 2004).

Council of Europe, Convention for the Protection of Human Rights and Fundamental Freedoms, Nov. 4, 1950, E.T.S. No. 5, 213 U.N.T.S. 221.

Council of Europe, Protocol No. 14 to the Convention for the Protection of Human Rights and Fundamental Freedoms, Amending the Control System of the Convention, May 13, 2004, C.E.T.S. 194.

Declaration on the Rights of Indigenous Peoples, G.A. Res. 61/295, U.N. Doc. A/RES/61/295 (Sept. 13, 2007).

Declaration on the Rights of Persons Belonging to National or Ethnic, Religious and Linguistic Minorities, G.A. Res. 47/135, Annex, U.N. Doc. A/RES/47/135/Annex (Dec. 18, 1992).

Geneva Convention for the Amelioration of the Condition of the Wounded and Sick in Armed Forces in the Field, Aug. 12, 1949, 6 U.S.T. 3114, 75 U.N.T.S. 31.

Geneva Convention for the Amelioration of the Condition of the Wounded, Sick and Shipwrecked Members of Armed Forces at Sea, Aug. 12, 1949, 75 U.N.T.S. 85.

Geneva Convention Relative to the Protection of Civilian Persons in Time of War, Aug. 12, 1949, 75 U.N.T.S. 287.

Geneva Convention Relative to the Treatment of Prisoners of War, Aug. 12, 1949, 6 U.S.T. 3316, 75 U.N.T.S. 135.

Inter-American Convention for the Elimination of All Forms of Discrimination against Persons with Disabilities, June 7, 1999, AG/RES. 1608 (XXIX-O/99).

Inter-American Convention on the Forced Disappearance of Persons, June 9, 1994, OAS Doc. OEA/Ser.P/AG/Doc. 3114/94 (1994), reprinted in 33 I.L.M. 1529.

Inter-American Convention on the Prevention, Punishment and Eradication of Violence against Women, June 9, 1994, 27 U.S.T. 3301, 1438 U.N.T.S. 63.

Inter-American Convention to Prevent and Punish Torture, Dec. 9, 1985, O.A.S.T.S. No. 67, reprinted in 25 I.L.M. 519.

International Covenant on Civil and Political Rights, G.A. Res. 2200A (XXI), U.N. Doc. A/6316 (Mar. 23, 1976).

Organization of American States, American Convention on Human Rights, Nov. 22, 1969, O.A.S. Treaty Series No. 36, 1144 U.N.T.S. 123.

Protocol of Amendment to the Charter of the Organization of American States, Protocol of Buenos Aires, Feb. 27, 1967, O.A.S. Treaty Series No. 1-A.

Protocol of Amendment to the Charter of the Organization of American States, Protocol of Cartagena de Indias, Dec. 5, 1985, O.A.S. Treaty Series No. 66.

Protocol of Amendment to the Charter of the Organization of American States, Protocol of Managua, June 10, 1993, O.A.S. Treaty Series No. A-58.

Protocol of Amendment to the Charter of the Organization of American States, Protocol of Washington, Dec. 14, 1992, O.A.S. Treaty Series No. A-56.

Rome Statute of the International Criminal Court, July 17, 1998, 2187 U.N.T.S. 90.

Statute of the Council of Europe, May 5, 1949, Europe T.S. 1, 87 U.N.T.S. 103.

Statute of the Inter-American Court on Human Rights, O.A.S. Res. 448 (IX-0/79), O.A.S. Off. Rec. OEA/Ser.P/IX.0.2/80, vol. 1, at 98, Inter-Am. Ct. H.R. 16, OEA/Ser.L/V.III.3 doc.13 corr.1 (1980).

Treaty Establishing the European Coal and Steel Community, Apr. 18, 1951, 261 U.N.T.S. 140.

Treaty Establishing the European Economic Community, Mar. 25, 1957, 298 U.N.T.S. 11.

Treaty for the Abolition of the Slave Trade, Britain–Spain, Sept. 23, 1817, 4 British Foreign and State Papers 33.

Treaty of Amity, Commerce and Navigation, United States–Great Britain, Nov. 19, 1794, 8 Stat. 116.

Treaty on European Union, Feb. 7, 1992, O.J. (C 224) 1, reprinted in 31 I.L.M. 247 (1992).

United Nations Convention on the Law of the Sea, Dec. 10, 1982, 1833 U.N.T.S. 397.

Universal Declaration of Human Rights, G.A. Res. 217A, U.N. GAOR, 3d Sess., 1st plenary meeting, U.N. Doc. A/810 (Dec. 12, 1948).

# INDEX OF IMAGES

## PAINTERS, PRINTMAKERS, AND ENGRAVERS

Alciatus, Andreas: *The good Prince in his Council,* 1582, 44

Arnaud, Maryvonne: *Stories,* 1998, 201, color plate 33

Bach, Caleb Ives: *The Effects of Good and Bad Government,* 1985, 31, color plate 9

Bartlett, Ivan (attributed): Mural, Old Ada County Courthouse, Ada, Idaho, circa 1939, 116, color plate 21

Bol, Ferdinand: *Moses Descends from Mount Sinai,* circa 1663–1666, 54

Canaletto, Giovanni Antonio: *The Basin of San Marco with the Bucintoro,* circa 1750, 81

Cauduro, Rafael: *The History of Justice in Mexico: —Rape and Corrupt Processes,* 2007, 364; —*Rape, Corrupt Processes, and Skulls,* 2009, 364, color plate 46; —*Torture, Homicide,* 2009, 365, color plate 47

*Courtroom Scene with Last Judgment and Portrait of Niclas Strobel,* fifteenth century, 36, color plate 12

Couvert, Pascal: *Grosse Cloche* (*Great Bell*), circa 1998, 202

Cruikshank, George: *Lord Mayor's Day,* 1836, 85

David, Gerard: *The Justice* (*Judgment*) *of Cambyses* (diptych), *Arrest of the Corrupt Judge,* 1498, 40, color plate 10; *Flaying of the Corrupt Judge,* 1498, 41, color plate 11

Dürer, Albrecht (attributed): *The Fool Blindfolding Justice,* 1494, 68

*Dutch Law and Practice in Civil and Criminal Matters* (*Practycke der nederlansche rechten van de daghelijcksche soo civile als criminele questien*), engraved title page, 1655, 135, 371

Galle, Philip (attributed): *Justice,* circa 1559, after a 1539 drawing by Pieter Bruegel the Elder, 71

Garouste, Gérard: *Pacte entre l'homme et la société* (*Pact Between Man and Society*), 1994, 203, 204

Giglio, Cesar: *Les Juges aux mains coupées* (*Judges with Their Hands Cut Off*), circa 1604, 45

Giordano, Luca: *Allegoria della Giustizia oppressa* (*Justice Disarmed*), circa 1670, 78

Hambourg, André: *Justice and Peace,* 1972, 234

Hirsch, Stefan: *Justice as Protector and Avenger,* 1938, 112, color plate 19

Holzer, Jenny: *Installation for the Nantes Courthouse,* 2003, 206, color plate 31; *Installation for the Sacramento Courthouse,* 1999, 190

Kelly, Ellsworth: *The Boston Panels,* 1998, 126, color plate 26

Krehbiel, Albert H.: *Precedent, Justice, and Record,* 1909, 291

Lorenzetti, Ambrogio: *Allegory of Good Government,* circa 1339, 26, color plate 6; *Allegory of Bad Government,* circa 1339, 27, color plate 8

Maat, detail from the Papyrus Nodjnet, *Book of the Dead,* circa 1300 BCE, 20, color plate 4

Master of the Zurich Carnation: *Saint Michael Weighing the Souls at the Last Judgment,* circa 1500, 23, color plate 5

Matsys, Cornelis: *Iusticia* (*Justice*), circa 1543–1544, 8, 345; *Justice and Prudence,* circa 1538, 9

"Mesopotamian Scales," Akkadian period, circa 2350–2100 BCE, 19, color plate 3

*Mural with Justice Surrounded by, from Left to Right, Aristotle, Virgil, Cicero and Alanus* (*Peinture murales avec la Justice entourée de gauche à droite d'Aristote, Virgile, Cicéron et Alanus*), circa 1488, 47

Orozco, José Clemente: *Las Riquezas Nacionales* (*National Wealth*), 1941, 357; *La Justicia* (*Justice*), 1941, 357; —south wall, 360, color plate 44; —south wall (detail), 361, color plate 45

Ovens, Jürgen: *Justice* (or *Prudence, Justice, and Peace*), 1662, 53, color plate 14

Picart, Bernard: *Traitez de Paix* (*Peace Treaties*), 1726, frontispiece, Jean Dumont, *Corps universel diplomatique du droit des gens,* 283

*Portrait of Worldly Justice* (*Mundanae iustitiae effigies*) in Joost de Damhoudere's *Legal Practice in Civil Matters,* 1567, 73

Raimondi, Marcantonio: *Fortitudo* (*Fortitude*), circa 1520, 11, 345

Raphael: *Justice,* 1508–1511, 76, color plate 13

Reynolds, Joshua: *Justice,* 1778, 99, color plate 16

Rockburne, Dorothea: *The Virtues of Good Government,* 1996, 32, color plate 7

Romano, Giulio: *Justice,* 1520, 77

Rosse, Herman: *Justice,* ceiling ornament, circa 1913, 254, color plate 40

Rubens, Peter Paul: *Allegory of Justice,* circa 1625, 79, color plate 15

Simkhovitch, Simka: *Pursuits of Life in Mississippi,* 1938, 114, 115, color plate 20

Szmuk, Peter: *The Symbols,* 1992, 214

*The Tribunal of Fools,* from the *Bambergensis,* 1508, 69

Veneziano, Agostino: *Prudence,* 1516, 10, 345; *Temperance,* 1517, 11, 345

Verrio, Antonio: *Queen Anne as Justice,* circa 1704, 83

## SCULPTORS

Allward, Walter S.: *IUSTITIA,* 1946, 2

Brooks, Jim, and Judy Brooks: *Lady Justice Lucy,* 2002, 7, color plate 2

Bucintoro with *Justice,* maquette of the bow, 82

Ceschiatti, Alfredo: *Justice,* 1961, 4

Dixey, John: *Justice,* circa 1812, 6

*Ecclesia,* Strasbourg Cathedral, circa 1230, 66

Eicholtz, William: *Lady of Justice,* 2002, 2

Entsuba, Katsuzou: *Justice,* 1974, 5

Frazier, Malcolm (design by his father, Bernard Frazier): *Justice,* 1978, 88

Harman, Jack: *Themis, Goddess of Justice,* 1982, 88

Kraus, Romuald: *Justice,* 1938, 109, 110, color plate 18

*Lady Justice,* High Court of Zambia, Lusaka, circa 1988, 3

Mitchell, Jan R.: *Lady of Justice,* 1993, 121, 124, color plate 23; *Moco Jumbie,* 1993, 122; *Reaching Man,* 1991, 124

Moore, Diana K.: *Lady Justice,* 1996, 100, 101, color plate 17

*Nail Figure,* Kongo, circa 1875–1900, 348

O'Connor, Andrew: *Peace Through Justice,* circa 1913, 254

Otterness, Tom: *Law of Nature: —Cat on Trial,* 1997, 186, color plate 24; *—Tree of Knowledge,* 1997, 187, 188, color plate 24

Papaconstantinou, Maria I.: *Themis,* 1987, 2

Pomeroy, Frederick William: *Justice,* 1907, 87

Quellinus, Artus: *Brutus,* circa 1652, 60; *King Solomon's Justice,* circa 1652, 57; *Justice,* 1655, 63; *Justice and Prudence* (East wall of the Tribunal), 64; *Justice, Wealth, Retribution, Greed, and Envy,* circa 1662, 52; *Prudence and Justice,* circa 1655, 50; *Zaleucus,* circa 1652, 59

Sansovino, Jacopo: *Venetia/Iustitia* (*Venice as Justice*), 1549, 80

Statuary on the roof of the New York State Supreme Court, Appellate Division, First Judicial Department, New York City, 1900, 118

*Synagoga,* Strasbourg Cathedral, circa 1230, 66

*Themis,* Constitutional Court of the Azerbaijan Republic, 3

van Nost the Younger, John: *Justice,* 1753, 86

*Venezia sotto forma di Giustizia* (*Venice in the Form of Justice*), bow of a Bucintoro, 1526, 82

von Post Totten, Vicken: *Darkness,* 1935, 111; *Light,* 1935, 111

## Photographers

Black, Laurie: *Cat on Trial,* in *Law of Nature,* 1997 (Tom Otterness), 186, color plate 24

Brundige, Elizabeth: *Lady Justice,* 3

Bryant, Richard: Courtroom interior, Supreme Court of Israel, Jerusalem, Israel, 1992, 213; entrance, Supreme Court of Israel, 1992, 211

Buckland, Angela: Cell block in the interior courtyard, Old Fort Prison within the Constitutional Court and Complex of South Africa, 2005, 354, color plate 43; Constitutional Court of South Africa, foyer, 2005, 352; Constitutional Court of South Africa, facade, 2005, 351, color plate 42

Burnett, Maria E.: Court tower and barbed wire, Constitutional Court of South Africa, 2004, 353; interior view from an Old Fort Prison cell within the Constitutional Court and Complex of South Africa, Johannesburg, South Africa, 2004, 354

Clift, William: *Justice,* Pitkin County Courthouse, 1976, 92

Crum, Travis: Camp Justice, Guantánamo Bay, 2009, 330; Logo, Department of Defense, Office of Military Commissions, 2009, 330

Curtis, Dennis E., and Judith Resnik: Construction site, Court of Justice of the European Communities, 2006, 230; courtroom, Cook County Courthouse, Grand Marais, Minnesota, 2003, 374; *Justice,* view from the inner court (John van Nost the Younger), 86; *Justice,* view from the street (John van Nost the Younger), 86

Curtis-Resnik, Jonathan: Courtyard of the Arches, Supreme Court of Israel, Jerusalem, Israel, 2009, 212; mosaic from the Hamat Gader synagogue, Supreme Court of Israel, 2009, 214; plaque at entrance, Supreme Court of Israel, 2009, 214; *The Symbols,* Supreme Court of Israel, 2009, 214; *The Symbols* (detail), Supreme Court of Israel, 2009, 215

D-Vorm, Leidschendam, the Netherlands: Great Hall, Peace Palace, International Court of Justice, 262, color plate 41

Ermansons, Teodors: Brochure for Lady Justice banner exhibit, 2008, 138, 139, color plate 28

Esch, Hans Georg: Exterior, International Tribunal for the Law of the Sea, Hamburg, Germany, 2001, 271

Fein, Michael: Supreme Court of Israel, Jerusalem, Israel, 209; interior corridor, 212

Fessy, G.: Mesh above the Grand Courtroom of the Court of Justice of the European Communities, 2008, 232; interior of the Great Courtroom of the Court of Justice of the European Communities, 2008, 232, color plate 37; towers of the Court of Justice of the European Communities, 2008, 231, color plate 35

Fisher, Jon: New York State Supreme Court, Appellate Division, First Judicial Department, New York City, 2008, 118; statuary on the roof of the New York State Supreme Court, Appellate Division, First Judicial Department, New York City, 2008, 118

Gilyard, Glenn: James A. Sommerness Memorial, Cook County Courthouse, Grand Marais, Minnesota, 2006, 374, 375, color plate 49

Grooms, Thomas: John Joseph Moakley United States Courthouse, in United States Courthouse Buildings and Renovations: A Sampling, 1998–2002, 2008, 175, color plate 29

Herbert, Gerald: Demonstrators on the plaza and steps of the United States Supreme Court, 2004, 167

Hesmerg, Erik, and Petra Hesmerg: *Brutus,* west wall of the Tribunal, Amsterdam Town Hall, 2010 (Artus Quellinus), 60; east wall of the Tribunal with *Justice* and *Prudence,* Amsterdam Town Hall, 2010 (Artus Quellinus), 64; interior of Tribunal, Amsterdam Town Hall, 2010 (Artus Quellinus), 55; *Justice,* 63; *King Solomon's Justice,* Amsterdam Town Hall, 2010 (Artus Quellinus), 57; *Zaleucus,* west wall of the Tribunal, Amsterdam Town Hall, 2010 (Artus Quellinus), 59

Hosefros, Paul: Mural, Old Ada County Courthouse, Ada, Idaho, 2007 (attributed to Ivan Bartlett), 116, color plate 21

Irwin, Ken: *Lady of Justice* (William Eicholtz), 2

Jackson, Wm. Henry: United States Post Office, Denver, Colorado, 147

Johnson, Don: *The Virtues of Good Government,* 1996, 32, color plate 7

Lacène, Chrystèle: *Pacte entre l'homme et la société,* 2001 (Gérard Garouste), 203; *Pacte entre l'homme et la société* (detail), 2001 (Gérard Garouste), 204

Landreville, Philippe: *IUSTITIA* (Walter S. Allward), 2

Larsen, Steffen: *Lady of Justice* (Jan R. Mitchell), 121, 124, color plate 23; *Moco Jumbie* (Jan R. Mitchell), 122; *Reaching Man* (Jan R. Mitchell), 124

Lednum, Taylor: United States Courthouse Buildings and Renovations: A Sampling, 1998–2002: —Alfonse D'Amato United States Courthouse, Central Islip, New York; —United States Courthouse, Corpus Christi, Texas; —Spottswood W. Robinson III and Robert R. Merhige Jr. Federal Courthouse, Richmond, Virginia; —United States Courthouse, Tallahassee, Florida; —Wilkie D. Ferguson, Jr. United States Courthouse, Miami, Florida; —William B. Bryant United States Courthouse Annex, Washington D.C., 175, color plate 29

Linden, Mikael: Helsinki District Court, Helsinki, Finland, 2004, 220

Long, Lois: *The Contemplation of Justice* and the inscription "Equal Justice under Law," United States Supreme Court, Washington, D.C., 332

Martin Saunders Photography: Commonwealth Law Courts, Melbourne, Australia, 218

Mathers, Michael: *Tree of Knowledge* (detail) (Tom Otterness), 188, color plate 24

McIlwain, Mary: Atrium, Commonwealth Law Courts, Melbourne, Australia, 219

Montagné, Caroline: *Grosse Cloche* (Pascal Couvert), 202

Monthiers, Jean-Marie: Exterior, Palais de Justice, Bordeaux, France, 198; Palais de Justice, Melun, France: —Exterior, 199; —*Stories* (Maryvonne Arnaud), 201, color plate 33

Muhammad, Ozier: "Mural of Saddam Hussein with the scales of justice," 2003, 6

Nicholls, Robert W.: Mystical Mocko Jumbies, 1997, 123, color plate 22

Noce, David D.: Thomas F. Eagleton Federal Courthouse, St. Louis, Missouri, 2006, 160

Ohman, Doug: Cook County Courthouse, Grand Marais, Minnesota, 2007, 372, color plate 48

Ooms, Frank: Wayne Lyman Morse United States Courthouse, in United States Courthouse Buildings and Renovations: A Sampling, 1998–2002, 2008, 175, color plate 29

Otterness, Tom: *Tree of Knowledge* in *Law of Nature*, 1997, 187; *Tree of Knowledge* (detail), 187

Richards, Paul J.: Outer fence and guard tower, U.S. Naval Station in Guantánamo Bay (Camps 1 and 4 at Camp Delta), Cuba, 2007, 329

Rosand, David: *Venetia/Iustitia* (*Venice as Justice*) (Jacopo Sansovino), 80

Rosenthal, Steve: John Joseph Moakley United States Courthouse, Boston, Massachusetts: —*The Boston Panels,* 1998 (Ellsworth Kelly), 126, color plate 26; —Exterior, 1998, 161; —Great Hall, 1998, 125, color plate 25; —Interior of a courtroom, 1998, 310, color plate 27

Ruault, Philippe: *Installation for the Nantes Courthouse,* 2003 (Jenny Holzer), 206, color plate 31

Sheppard, Bob: Federal Court of Australia sitting in Parntirrpi Bore Outstation, Great Victoria Desert, Australia, 2005, 367

Silverman, Steve: Grand Forks Post Office and Federal Courthouse, Grand Forks, North Dakota, 2006, 159

Tiainen, Jussi: Helsinki District Court, Helsinki, Finland, interior, 2004, 221; a courtroom, 2004, 221

Wallocha, Stephan: Oral proceedings, International Tribunal for the Law of the Sea, 2001, 272

Weltin, Sandro: European Court of Human Rights, Strasbourg, France, 1984, 236

Wheeler, Nick: *Lady Justice,* 2005 (Diana K. Moore), 100, detail, 101, color plate 17; Warren B. Rudman Courthouse, 100

Wogenscky, Olivier: Nantes, salle d'audience (courtroom) 2000, 207, color plate 32; Palais de Justice, Fort de France, Martinique, 2000, 199; Palais de Justice, Nantes, France, 2000, 205, 207, color plates 30, 32; Parlement de Bretagne, Rennes, France, 2000, 199

### Cartoonists

Allen, Ivan: "Justice in the Cross Hairs," 2003 (*The Economist*), xviii

Bartkus, Ray: Cartoon accompanying the article "A Trial for Chinese Justice," 2003 (*Wall Street Journal*), 7

Conrad, Paul: "Alternative to Roe vs. Wade," 1988 (*Los Angeles Times*), 7

Danziger, Jeff: "Don't Worry, She's Blind," 2003 (New York Times Syndicate), 129

Emerson: "Critics charge that recent decisions manifest a blind disregard for the Constitution," 1956 (*Facts Forum News*), 7

### Buildings

#### Australia

Commonwealth Law Courts, Melbourne, 1998 (HASSELL: Tim Shannon and Paul Katsieris), 218, 219

Federal Court of Australia, sitting at the Great Victoria Desert, 2005, 367

Supreme Court of Victoria, Melbourne, 1884 (Alfred Louis Smith), 217; courtroom, 217

#### Costa Rica

Inter-American Court of Human Rights, San José, circa 1960, 240; courtroom, 245

Palacio de la Paz (Central American Court of Justice), Cartago, 1910, 241, 242

#### Egypt

Mixed Courts of Egypt, Alexandria, 1886, 227

#### Finland

Helsinki District Court, Helsinki, 2004 (Tuomo Siitonen Architects), 220; interior and courtroom, 221

#### France

European Court of Human Rights, Strasbourg, 1984 (Richard Rogers), 236

Palais de Justice, Bordeaux, France, 1998 (Richard Rogers), 198

Palais de Justice, Fort de France, Martinique, 2002 (Paul Chemetov and Borja Huidobro), 199

Palais de Justice, Melun, 1998 (Françoise Jorda and Gilles Perraudin), 199

Palais de Justice, Nantes, 2000 (Jean Nouvel), 205, 207 color plate 30; salle des pas perdus (foyer), 205; salle d'audience (courtroom), 207, color plate 32

Parlement de Bretagne, 1999 (Alain-Charles Perrot), 199

#### Germany

International Tribunal for the Law of the Sea, Hamburg, 2000 (Baron Alexander Freiherr von Branca and Baroness Emanuela Freiin von Branca), aerial view, 266; exterior, 271

#### Israel

Supreme Court of Israel, Jerusalem, 1992 (Ada Karmi-Melamede and Ram Karmi), 209, 211; courtroom interior, 213; Courtyard of the Arches, 212; interior corridor, 212

#### Japan

Supreme Court of Japan, Tokyo, 1974 (Shinichi Okada), 5

#### Luxembourg

European Court of Justice of the European Communities: construction site, 2006, 230; Erasmus Building, 1988 (Bohdan Paczowski, Paul Fritsch, Jean Herr, and Gilbert Huyberechts), 229; the Great Courtroom, Court of Justice of the European Communities, 232, color plate 37; Le Palais, 1973 (Jean-Paul Conzemius, François Jamagne, and Michel Vander Elst), 228, color plate 34; main courtroom, Le Palais, 234, color plate 36; towers of the Court of Justice of the European Communities, 2008 (Dominique Perrault), 231, color plate 35

#### Mexico

Supreme Court of Justice, interior murals, 357, 364, 365, color plates 44, 45, 46, 47

#### The Netherlands

Amsterdam Town Hall (Royal Palace), 1648–1655 (Jacob van Campen), 49; east wall of the Tribunal (Vierschaar), 64; interior of the Tribunal, 55; west wall of the Tribunal, 56

International Criminal Court, interim premises, The Hague, circa 2006: a courtroom, 278; exterior, 278

Peace Palace, International Court of Justice, The Hague, 1913 (Louis M. Cordonnier), 248, color plate 38; Annex to the Peace Palace, 1978 (Brouwer and Deurvorst), 263; Great Hall of Justice, 262, color plate 41; inner courtyard of the Peace Palace with polar bear fountain, circa 1913, 252; main staircase, 254; sitting in the Great Hall, 262; Small Hall of Justice, 258

Town Hall, Gouda, 1459 (Jan Keldermans), 289

## South Africa

Constitutional Court of South Africa, Johannesburg, 2004 (Janina Masojada, Andrew Makin, OMM Design Workshop, and Paul Wygers): cell block in the interior courtyard, 354, color plate 43; court tower, 353; facade, 351, color plate 42; foyer, 352; interior view from an Old Fort Prison cell, 354

## United States

### *Federal*

Dolley Madison House, Washington, D.C., 1820, 163
Federal Building, United States Post Office, and Courthouse, Missoula, Montana, 1913 (James Knox Taylor), 147
Grand Forks Post Office and Federal Courthouse, Grand Forks, North Dakota, 1906 (James Knox Taylor), 159
John Joseph Moakley United States Courthouse, Boston, Massachusetts, 1998 (Henry N. Cobb), 161
Joint Task Force (JTF) Guantánamo Commissions Building, Guantánamo Bay, 2006, building, 329–331; Camp Justice, 330; entrance, 331; Hearing Room Interior, 329; outer fence and guard tower, 329
Thomas F. Eagleton Federal Courthouse, St. Louis, Missouri, 2006 (Hellmuth, Obata + Kassabaum Inc.), 160
Thurgood Marshall Federal Judiciary Building, Washington, D.C., 1992 (Lee/Timchula Architects), 162
United States Court House and Post Office, Des Moines, Iowa, 1871 (Alfred B. Mullett), 144
United States Courthouse, New York City, New York, 1936 (Cass Gilbert), 150
United States Courthouse and Jail, Fairbanks, Alaska, circa 1914, 149
United States Custom House, Galveston, Texas, 1861 (Ammi B. Young), 143
United States Post Office (United States Court House and Post Office), Denver, Colorado, 1892 (Mifflin E. Bell and Will A. Freret), 162
United States Post Office and Courthouse, Denver, Colorado, 1916 (Tracy, Swartwout & Litchfield), 146
United States Post Office and Courthouse, San Juan, Puerto Rico, 1914 (James Knox Taylor), 148
United States Post Office and Custom House, San Diego, California, 1913 (James Knox Taylor), 148
United States Post Office, Court House, and Custom House, Biloxi, Mississippi, 1908 (James Knox Taylor), 145
United States Supreme Court, Washington, D.C., 1935 (Cass Gilbert), 151
Warren B. Rudman Federal Courthouse, Concord, New Hampshire, 1965 (John D. Detley), 100

### *State*

Cook County Courthouse, Grand Marais, Minnesota, 1912 (Kelly and Lignell), 372, color plate 48
New York State Supreme Court, Appellate Division, First Judicial Department, New York City, New York, 1900 (James Brown Lord), 118
Pitkin County Courthouse, Aspen, Colorado, 1890–1891 (William Quay), 92

## LOGOS AND SEALS

Logo of the Department of Defense, Office of Military Commissions, 330
Logo of the European Court of Justice, circa 1952, 286
Logo of the International Court of Justice, 1922, 284, color plate 39
Logo of the International Criminal Court, circa 1998, 286
Logo of the International Criminal Tribunal for Rwanda, circa 1995, 286
Logo of the International Criminal Tribunal for the former Yugoslavia, circa 1993, 285
Logo of the International Tribunal for the Law of the Sea, circa 1996, 285
Logo of the Judicial Council of the National Bar Association, 1971, 103
Logo of the Permanent Court of Arbitration after October 18, 2007, 284
Logo of the Permanent Court of Arbitration before October 18, 2007, 282
Logo of the Special Court for Sierra Leone, circa 1996, 286
Provisional Seal of the Iraqi Special Tribunal, 2006, 287

## BROCHURES AND OTHER OBJECTS

Brochure cover, Edward T. Gignoux United States Courthouse, Portland, Maine, 1996 (photographer, Don Johnson; artist, Dorothea Rockburne), 32, color plate 7
Brochure cover, Mexico's Supreme Court of Justice, 1997 (design: Teresa Limón

Garcia/Retorno Tassier; artist: José Clemente Orozco), 358
Brochure for Lady Justice banner exhibit, 2008, 138, 139, color plate 28
Calendar, Ministry of Justice, Government of the Azerbaijan Republic, 2000, 4
Certificate awarding Andrew Carnegie honorary membership in the Dutch Society Vrede door Recht, 1903, 250
Decorative cloth with repeated pattern of the High Court of Zambia's figure *Lady Justice,* circa 2004, 3, color plate 1
Images of pages from the website of the U.S. Department of Defense, DefenseLINK News Closed-circuit television system, Joint Task Force Guantánamo, hearing room, 333; Joint Task Force Guantánamo Commissions Building at Guantánamo Bay, 330

## GRAPHS AND CHARTS

Article III Authorized Judgeships: District, Circuit, and Supreme Courts, 1901, 1950, 2001, 159
Authorized Judgeships in Federal Courts and in Federal Agencies as of 2001, 316
Budget d'investissement 2004, from Annual Report of Agence Publique pour l'Immobilier de la Justice (APIJ), in the Agence de Maîtrise d'Ouvrage des Travaux du Ministère de la Justice (AMTOMJ), 198
Civil and Criminal Filings in United States District Courts: 1901, 1950, 2001, 158, 307
Civil and Criminal Trial Rates, United States Federal Courts, 1976–2000, 311
Construction and/or Site & Design Projects, 1985 to Present, in *The Third Branch: Newsletter of the Federal Courts,* 2002, 170
Estimate of Evidentiary Proceedings in Federal Courts and in Four Federal Agencies, 2001, 317
Example of cellular phone contract, 2002, 319
The Judicial Dollar, Annual Report of the Director of the Administrative Office of the United States Courts, 1957, 176
The Judicial Dollar, Annual Report of the Director of the Administrative Office of the United States Courts, 1975, 177
Regional and International Courts: Budgets in 2006, 281
Regional and International Courts: Pending Caseloads in 2006, 282

# SUBJECT INDEX

Page numbers for entries in figures are followed by an *f* and those for entries in notes by an *n*.

ABA. *See* American Bar Association
Abolition of Forced Labor Convention (1957), 206
Abolition of the Slave Trade, Treaty for the (Great Britain–Spain, 1817), 225, 521n9
abortion rights, 7f, 8, 382n20
Abraham, Stephen, 334
Abstinence (Virtue), 8. *See also* Virtues
abstraction: in Kelly's Boston panels, 125–126; public art controversies over, 125–126, 465n217; and representational art, evolution of preference for, 125–126; in Rockburne's artwork, 33, 408n236; in WPA art, 108, 456n37
Abu Ghraib prison (Iraq), 334
Academy of Architecture for Justice (AAJ), 147, 194, 392n96. *See also* American Institute of Architects
accessibility, physical: of adjudication, 293–302, 311–312, 342–344; of administrative adjudication, 317–318; of alternative dispute resolution, 324–326; of European Court of Human Rights, 238; of French courts, 197–198; of Guantánamo Bay, 332–333; of interior spaces, 136–137, 173–174; of Israeli Supreme Court, 210–213; of Minnesota county courts, 372–374; of South Africa's Constitutional Court, 350–354; of U.S. courthouses, 194, 508n19; of U.S. federal buildings, 166–167, 167f, 490n191. *See also* courthouse security; public access to courts
access to courts: alternative forms of, role of, 17, 306; architecture and, xv, 15, 125, 161, 166–167, 208–209, 217, 237, 271; audience and, 15–16, 293; critics of expanded, 309; common law rights to, 104, 293–294; constitutional rights to, 157–158, 167, 182, 293; convention rights to, 14, 236–237, 241; decline of, 16–17, 182, 319–320, 335; disability and, 166–167, 173, 194, 238, 473n61, 490n191, 490n193, 491n194, 508n19; empirical studies of,

308; equality and, 14, 15, 157–158, 306; fees charged for (*See* user fees); financial assistance for (*See* legal aid); glass as symbol of, 17, 125, 340–341, 343; to international courts, 237, 238, 241–242; lawyers' role in, 309; by public (*See* public access); for terrorist suspects, 16, 335; transnational, presumption of, 14, 300
Access to Justice Act of 1999 (UK), 323, 577n239
access to justice movement, 308, 565n17
Ackerman, Bruce, 331, 564n298, 564n310, 581n358, 595n316
ACLU. *See* American Civil Liberties Union
Act of Settlement of 1701 (England), 42, 97, 127, 292, 391n79, 442n265
Adams, John, 125, 553n49
Ad Hoc Committee on Government Office Space (U.S.), 164–165, 182–183, 463n180. *See also* Moynihan, Daniel Patrick
adjudication, 288–305; alternatives to, 306 (*See also* alternative dispute resolution); and arbitration, 257, 269; as contributor to democracy, 17, 301–304; constraint of power through, 288, 289; critics of current system of, 309; decline of, 16–17, 305, 310, 338; demand and capacity in, 307–310; effects on democracy, 14–16, 289–295; empirical studies of need for, 308; fairness in, 290; "hear the other side" in, 14, 289–292; as indicator of governance, 288; individuals' access to (*See* access to courts); judicial independence in, 292–293; pillars of, 14, 15, 317, 338; as proto-democratic, xv, 48, 289; task forces on, 107, 132–133, 304; U.N. principles of, 446n30. *See* accessibility, physical; privatization of adjudication; public access to courts
ad litem judges, 259, 275, 544n455
administrative agencies: adjudication by, 314–318; evidentiary hearings in, 314, 316–317, 317f; facilities for, 317, 318; and

Guantánamo Bay, 335; number of judges in, 315, 316f; public access to, 317–318; publication of decisions of, 318; rise of, 16–17, 315, 316f, 324
Administrative Conference of the United States (ACUS), 572n157
administrative judges, 315, 317
administrative law judges (ALJs), 315, 316f, 317, 571n140. *See also* administrative agencies; tribunals
Administrative Office (AO) of the United States Courts: on air conditioning, 484n42; annual reports of, 176, 176f, 177f; budget of, 156, 484n31; data collection by, 155, 484n25; directors of, 162, 487n104; Dolley Madison House as headquarters of, 162, 163f; establishment of, 155, 156, 484n23; on federal courtroom space, 169; functions of, 155, 156, 484n23; *GSA Design Guides* and, 169, 170, 171, 494n52; GSA in conflict with, 178; Marshall Building headquarters of, 162–163; on need for courthouse construction, 156, 169–171; Office of Legislative Affairs of, 484n26; on rent costs, 176–177, 176f, 177f, 179–180; role in courthouse construction, 170–171, 493n21; Space and Facilities Division of, 171, 493n20; staff of, number of, 156, 162, 484n29, 487n106; on weighted caseloads, 485n61
Administrative Procedure Act (APA) of 1946 (U.S.), 315, 317, 571n134
Administrative Review Board (ARB) (classification of detainees in Guantánamo Bay), 328, 333–334, 580nn323–325, 580n333
administrators, court: in national courthouse construction, 194; types of, 194. *See also* Administrative Office (AO) of the United States Courts; Agence de Maîtrise d'Ouvrage des Travaux du Ministère de la Justice; Conference of Court Public Information Officers; Conference of Senior Circuit Judges; Conference of State Court

administrators (*continued*)
Administrators; Judicial Conference of the United States

ADR. *See* alternative dispute resolution

advisory opinions: of Inter-American Court of Human Rights, 244–245, 531n323; of International Court of Justice, 261, 264, 537n207; of International Tribunal for the Law of the Sea, 542n341; of Permanent Court of International Justice, 260, 537n175, 537n191

*Aeneid* (Virgil), 55, 418n99

Aequitas (Virtue), 390n70, 398n75, 436n159, 440n217. *See also* equity; justice; Virtues

Aeschylus, *Oresteia*, 402n122

affirmative action, 102, 133, 189

African Americans: "colored" terminology for, 102; depictions of, in courts, 110–115, 121–124; fair treatment of, in courts, 132–133; in Judicial Council of National Bar Association, 103–104; as jurors, 103, 451n134; in National Bar Association, 102, 103–104; racism against (*See* racial discrimination; racial segregation)

African art, 348–355; influence on Virgin Islands, 121–124

Agence de Maîtrise d'Ouvrage des Travaux du Ministère de la Justice (AMOTMJ), 197, 224, 512n93

agencies. *See* administrative agencies, administrative law judges, tribunals

AIA. *See* American Institute of Architects

AiA. *See* Art-in-Architecture

Aiken (South Carolina), Charles E. Simons Jr. Federal Courthouse in, 457n68; Hirsch's "Mulatto" Justice mural in, 15, 110–113, 111f 190, color plate 19

air conditioning, in federal courthouses, 156, 484n42, 485n44; JCUS Committee on, 156

Aitken, Robert, 482n237

Aix-en-Provence (France), courthouse at prison site in, 200, 222, 352, 512n113, 592n214

Akkadian language and period, 18, 19f, 393n11, color plate 3. *See also* Babylonia; Mesopotamia

al-Alwani, Taha Jaber, 463n169

Alaska: federal courts in, 149; judicial system of, 481n211, 481nn216–217; statehood for, 481n217

Albert the Great, 429n52

Alberti, Leon Battista, 93, 446n23

Albertus Magnus, 78, 406n217

Alciatus, Andreas: on blindness, 43, 44f, 69–70, 75, 96; *The good Prince in his Council,* 43, 44f, 69, 96; and handless judges, 44–45, 417n79; *Index Emblematicus,* 12, 43, 69–70, 388n52, 416n59; and legal humanism, 43; life of, 43, 388n52, 416n59; Plutarch as source for, 44, 447n39; on power of judges, 390n73; as source for Ripa's *Iconologia,* 70, 434n119; Virtues depicted by, 12, 388n52

Alexander III (Pope), 80–81

Alexander the Great, 70, 434n114

*Alexandreis* (Walter of Châtillon), 419n104

Alfred A. Arraj U.S. Courthouse (Colorado), 480n192

ALI. *See* American Law Institute

ALJs. *See* administrative law judges

Allegories and allegorical figures: Batavians, 421n142, 422n173; Brutus, 56, 58, 60f, 89; *Conspiracy of Claudius Civilis,* 422n173; Consul Luscinus, 51, 422n174; Consul Marcus Curius Dentatus, 51; Herkinbald, 58–61, 426n261; Judgment of Cambyses, 13, 38–39, 40f, 41f, 292, 332; Lucretia, 25; Momus, 93–94, 106; Solomon, 56–57, 57f, 61, 65, 119, 216; Trajan, 58; Zaleucus, 13, 56–58, 59f, 62. *See also exempla virtutis; exemplum iustitiae;* Fiera, Battista

allegories of good and bad government, 26–33; in European town halls, 33, 408n239; in Vatican, 76. *See also* Bach, Caleb Ives; Lorenzetti, Ambrogio; Rockburne, Dorothea; Siena

Allen, Ivan, xviii, 379n1

Allentown (Pennsylvania), Edward N. Cahn Federal Building and U.S. Courthouse in, 189, 505n352

allocution, right of, 104

Allott, Philip, 537n196

Allward, Walter S., 2f, 379n2

al Qaeda, as enemy combatants, 327. *See also* Guantánamo Bay

alternative dispute resolution (ADR), 306–337; in administrative agencies, 16–17, 314–318; in Australia, 368, 370–372; confidentiality in, 320–321, 325, 335, 337; conflict avoidance in, 336; courthouse suites for, 174, 178, 312, 343, 569n84, 569n86; and courtroom sharing, 170; within courts, 311–313, 316; critics of, 313; definition of, 306; in Europe, 322–326; government regulation of, 321–322; and Guantánamo Bay, 335; impact on cases, 313; impact on courts, 313; judges as managers of, 310, 311–313, 323; lawyers' role in, 310, 312, 313, 323; mandatory private, 318–321; modes of, 306, 308, 310, 311–321; professionalization of, 312–313; promoters of, 308, 309, 320; public access to, 318, 321–322, 337; reasons for supporting, 308–310, 320; rise in support for and use of, 16, 309–310, 336–339; in United Kingdom, 306, 322–325; in United States, 306–321. *See also* arbitration; case management; managerial judges; mediation; settlement

Altzenbach, Gerhard, 437n166

American Arbitration Association, 310, 574n194

American Architectural Foundation, 174, 506n389

American Association of Law Schools, 312

American Bar Association (ABA): alternative dispute resolution and, 312; Canons of Judicial Ethics, 127–128, 466n239; on court budgets, 566n27; on court reform, 155; enforcement of codes of conduct of, 466n239; establishment of, 155, 483n13; mission of, 155; *Model Code of Judicial Conduct,* 128, 466–467nn239–242, 467n252; on Permanent Court of International Justice, 260

American Civil Liberties Union (ACLU), 131, 188, 335, 462n164

American Convention on Human Rights (ACHR), 243–246, 529n271

American Declaration of the Rights and Duties of Man (1948), 242, 243

American Institute of Architects (AIA): Academy of Architecture for Justice associated with, 392n96; and Art-in-Architecture (AiA), 502n259; on art in federal buildings, 163; development of professional reputation of, 488n122; establishment of, 142; *Justice Facilities Review* by, 194, 496n111; knowledge communities of, 194, 508n23; lobbying for federal patronage by, 142, 477n138; membership of, 142, 488n122; mission of, 477n138; and Parks Commission, 163, 488n122; Peck in, 168

American Institute of International Law, 242

American Law Institute, 485n60

American Sculpture Society. *See* National Sculpture Society

American Society for the Judicial Settlement of International Disputes, 249, 532n10

American Society of International Law, 249, 532n10

Americans with Disabilities Act of 1990 (U.S.), 166–167, 508n19

Amersfoort Town Hall (Netherlands), 56, 424n221. *See also* town halls

Amity, Commerce and Navigation, Treaty of (United States–Great Britain, 1794) (the Jay Treaty), 225, 521n6

Amnesty International, 275

AMOTMJ. *See* Agence de Maîtrise d'Ouvrage des Travaux du Ministère de la Justice

*amparo* procedure (Mexico), 357

Amsterdam (Netherlands): administration of, 420n117; approach to architecture in, 48, 419n116; burgomasters' role in, 48–49, 52–53, 61, 420n117; Central Station in, 251; civic buildings in, 49; Dam Square in, 48; Maid of, 50, 51; New Exchange at, 251; population of, 48; Rijksmuseum in, 251; seal of, 420n117; Town Hall in (*See* Amsterdam Town Hall); townscapes of, 48, 420n125

Amsterdam Royal Palace. *See* Amsterdam Town Hall

Amsterdam Town Hall, 48–65; approach to design of, 48–49, 134; authority motif in, 50, 52–53; blindfold in, 62–64, 63f, 71; Blinding of Zaleucus in, 56, 57–58, 59f, 62, 292; burgomasters' role in, 48–49, 421n136; Campen as architect of, 48, 50, 51, 56, 420n116, 421n136; Citizens' Hall of, 50, 51; classical and religious themes in, 49, 51, 421n142, 421n145, 422n173;

construction of, 48–49, 50, 421n153; and death sentences, rituals of, 54–55; as eighth wonder of the world, 48, 420n121; exterior of, 49f, 50; "hear the other side" in, 53, 62, 289; Judgment of Brutus in, 13, 56, 57–58, 60f, 292; Judgment of Solomon in, 56–57, 57f, 62; Justice depicted in, 50, 50f, 51, 62–64, 63f, 423n176; Last Judgment in, 51, 53, 55–56; Magistrates' Chamber of, 51–54, 52f, 53f, 54f, color plate 14; multiple functions of, 49–50; original building of, 48, 420n132; pain motif in, 13, 48, 55, 58; Peace Palace compared to, 249, 253, 262; prosperity and, 50–51, 134; public executions and, 48, 54–55, 295, 424n213; as Royal Palace, 48, 420n123; torture in, 53–54, 427n10; Tribunal (Vierschaar) of, 48, 51, 54–61, 55f, 56f, 62–64, 64f; Virtues depicted in, 50–52, 50f, 62; zodiac in, 51, 394n23. *See also* town halls

Ancien Régime, 196, 201, 510n54, 514n152

Anderson, Benedict, 233

Andrews, Carol, 395n37

Anger (Vice), 9. *See also* Vices; *Psychomachia*

animals: in French imagery, 200; in Justice iconography, 76–79; in Otterness's artwork, 185–188. *See also* Crane(s); Dog(s); Eagle(s); Ostrich(es); Snakes and serpents

Anne, Queen of England: accession of, 83, 442n265; at Hampton Court Palace, 83–84, 442nn266–267; as Justice, 83–84, 83f; power of, 442n262; Verrio's painting of, 5, 83–84, 83f, 442nn274–275

Anthony, Susan B., quotation from, 189

anti-federalism, 58, 426n253

anti-Semitism, 65–67

anti-slavery courts, 225–226

Antoninus Pius, Emperor of Rome, 70, 434n114

Antwerp Court House (Belgium), 525n133. *See also* town halls

appellate courts, U.S.: number of filings in, 307, 313; number of judges in, 307; settlements in, 313–314

appointment of judges: economic influences in, 41; merit selection commissions in, 127; public's role in, 127

Aptekar, Jane, 390n63, 397n63

Aquinas, Thomas: on distributive and commutative justice, 12, 28–30, 196, 389n62, 406n209; interpretation of Aristotle by, 29–30; and Siena, 405n173; on theories of justice, 29–30; on Virtues, 8, 344–346, 383n26, 385n31, 389n53

arbitration: compared to adjudication, 257, 269; competition among providers of, 247, 257, 325; confidentiality in, 320–321, 325, 335; court-annexed, 312; definition of, 255; in England, 324–325; government regulation of, 321; international use of, 249, 256–257; mandatory private, 318–321, 319f; mixed, 256; of territorial disputes, 249; U.N. rules for, 257; use of term, 255; voluntary, 319

Arbitration, Permanent Court of. *See* Permanent Court of Arbitration

Arbitration Acts (UK): of 1950, 324; of 1996, 324–325

Arbitration Fairness Act of 2007 (proposed legislation, U.S.), 573n181

architect(s): courthouses known by name of, 248; etymology of term, 477n137; development of courthouse specialty of, 136; as federal judiciary staff, 495n61; in GSA Design Excellence Program, 168; in juries for architectural competitions, 251; lobbying by, 142; in national courthouse construction, 193; professionalization of, 142, 477n137; in public art selection, 117, 454n12, 460n137. *See also* Architect of the Capitol; Bell, Mifflin E.; Branca, Alexander Freiherr von; Branca, Emanuela Freiin von; Chemetov, Paul; Ciriani, Henri; Cobb, Harry; Conzemius, Jean-Paul; Cordonnier, Louis M.; Detley, John D.; Elst, Michel Vander; Freret, Will A.; Fritsch, Paul; García, Antonio Muñoz; Gaudin, Henri; Gilbert, Cass; HASSELL; Hellmuth, Obata + Kassbaum; Herr, Jean; Huidobro, Borja; Huyberechts, Gilbert; Jamagne, Francois; Jorda, Francoise; Karmi, Ram; Karmi-Melamade, Ada; Katsieris, Paul; Keldermans, Jan; Kelly and Lignell; Kohn, Bernard; Lee/Timchula; Lord, James Brown; Makin, Andrew; Masojada, Janina; Mullett, Alfred B.; Nouvel, Jean; OMM Design Workshop; Paczowski, Bohdan; Parraudin, Gilles; Perrault, Dominique; Perrot, Alain-Charles; Rogers, Richard; Shannon, Tim; Smith, Alfred Lewis; Stern, Robert; Supervising Architect, Office of the; Taylor, James Knox; Tracy, Swartwout & Litchfield; Urban Solutions; Wygers, Paul; Tuomo Siitonen; Young, Ammi B.

Architect of the Capitol, 151, 461n147, 487n102

Architectural Barriers Act of 1968 (U.S.), 166, 508n19

architectural competitions: in France, 197–200; in GSA Design Excellence Program, 167–168; for International Criminal Court design, 280–281; for International Tribunal for the Law of the Sea, 266, 540n303; in Israel, 208–209; for Mexican Supreme Court design, 358–359; origins of paradigm of, 249–251; for Peace Palace design, 249–253, 533n49; for South African Constitutional Court design, 353; for U.S. federal buildings, 158–160, 165, 167–169

architectural critics: on Australian courthouses, 219–220; on European Court of Human Rights, 235, 238; on European Court of Justice, 230, 231–232; on Finnish courthouses, 220; on French courthouses, 197, 208; on Israeli Supreme Court, 215–216; on Mexican Supreme Court, 362; on modern courthouses, 191,

208, 244; NEA as, 165–166; on Peace Palace, 251, 252; on South African Constitutional Court, 355, 593n262; on U.S. Supreme Court, 151–152

Architectural League, 488n122

architectural styles: Art Deco, 147, 149, 359; Beaux Arts, 120, 137, 164, 476n128, 486n62; Byzantine, 251; Classical, 140–141, 144, 209; Classical Revival, 143–144, 373; Flemish Gothic, 251; French Second Empire, 137, 479n176; Gothic, 137, 143, 471n24, 483n248; Greek Revival, 137; High Renaissance Dutch, 251; International, 165, 359; Italianate, 137, 419n116, 444n316; Moorish, 213; national, 251, 533n41; Neoclassical, 137, 145, 149, 195, 359; Neo-Gothic, 253; Renaissance Revival, 144, 147; Romanesque, 24, 143, 209, 213, 251; Russian Constructivism, 251; Second Renaissance Revival, 407n231; Spanish Colonial Revival, 147; Victorian, 137

architecture: art in, 153, 191, 355; Bentham on publicity through, 297; values in, 165. *See also* courthouse architecture

Arendt, Hannah, 288

Aristotle: and camera obscura, 447n40; on common good, 28; *Ethics*, 12; on friendship, 47; in Geneva, 46; in Holzer's artwork, 189; *Nicomachean Ethics*, 46; in Siena, 28, 405n173; Thomas Aquinas on, 29–30; on Virtues, 12

Arnaud, Maryvonne, 201, 201f, color plate 33

Arnold, Linda, 357

art: as feature of architecture, 153, 163–166, 182–192, 200–206, 355. *See also* public art

Art Deco architectural style, 147, 149, 359

*Art Digest*, 360

Art-in-Architecture (AiA) (U.S.), 183–192; administration of, 183; and American Institute of Architects (AIA), 502n259; artists involved in, 183, 184, 191, 503n281; Caleb Bach in, 30–33; community involvement in, 183, 184, 191; controversy in, 190–191; diversity in, 184, 191; establishment of, 183; French set-aside program and, 200–204; Jenny Holzer in, 189–191; impact of, 183, 191; Ellsworth Kelly in, 124–126; local history in, 203; mission of, 184; Jan Mitchell's Justice sculpture in Virgin Islands under,121; Diana Moore in, 99–102; Tom Otterness in, 184–189; Dorothea Rockburne in, 30–33; selection criteria of, 183–184; selection process of, 183, 184; set-asides and, 183, 195, 200–204, 407n228, 502n60; as successor to WPA, 121

artist(s): in Art-in-Architecture, 30–33, 121, 124–126,183, 184, 189–191, 503n281; in European Court of Justice, 233–234; freedom of, in WPA, 108, 455n32; in French courthouses, 200–208; in Mexico, 356–365; in public art selection panels, 454n12; in South Africa, 355

artistic patronage: in France, 200–208; in Mexico, 356–364; in Renaissance Europe, 48–57, 75–78, 83–87; in South Africa, 355; in U.S., 106–125, 163–168, 183–192

Artists' Union of Baltimore, 113, 459n97

*Arts and the National Government, The* (Heckscher), 165

Ascension Day, Doges' Venetian ceremony, 81, 441n247

Aspen (Colorado), Pitkin County Courthouse in, 91–93, 92f

Assembly of States Parties (ASP), of International Criminal Court, 277–278, 279

Association of Federal Architects, 142, 477n147

Astraea (goddess), 21, 78, 397n63, 439n203. *See* deities

astronomy, in Mesopotamia, 19, 393n15, 393n17

Atlas, in Amsterdam Town Hall, 50–51

Atthenont, Jean-Pierre, 515n182, 516n202

Attorney General, Office of, 476n120; federal filings reported by, 141

audience: and access to courts, 15–16, 293; attention of, 303; limits on size of, 392n104; location of, in courthouses, 137; need for regulation of, 302; power of, 301–303; of public executions, 295. *See also* accessibility, physical; Bentham, Jeremy; public access

*audi et alteram partem*. *See* "hear the other side"

auditors, Bentham on, 297, 299

Augsburg Town Hall, 418n81. *See also* town halls

Augustus (emperor of Rome), 398n74

Australia: alternative dispute resolution in, 368, 370–372; architectural critics on courthouses of, 219–220; Coat of Arms of, 219, 369–370, 519n345; courthouse construction in, 15, 216–220; European colonization of, 368, 369; Federal Court of, 367–372, 367f; High Court of, 368, 369, 519n332; Justice imagery in, 1–2; Ngaanyatjarra Peoples of, land claims of, 367–372; open air courts in, 367–372, 367f, 376; women in legal profession in, 468n280. *See also* Brisbane; Canberra; Gibson Desert Nature Reserve; Great Victoria Desert; Melbourne; Parntirrpi Bore Outstation

*auto-de-fé*, 410n278

autumnal equinox, 19. *See also* equinox; scales; zodiac

Avarice (Vice), 9, 385n30. *See also* Vices

*Avery v. Georgia*, 451n134

Avignon (France), Palais de Justice in, 201

Ávila Camacho, Manuel, 362

Azerbaijan, Constitutional Court of, 1, 3f, 4f, 380n9

Babylonia, 18–20; Code of Hammurabi in, 18; rod and ring in imagery of, 18; rulers' role in legal system of, 18, 393n8, 393n11, 398n74; scales in imagery of, 18–20, 19f,

color plate 3; seals of, 18, 19f, 392n3, color plate 3; Shamash in, 18, 392n5, 398n74; as source of Justice iconography, 18–20; sun gods of, 64; zodiac in imagery of, 19. *See also* Akkadian language and period

Bach, Caleb Ives, xvi, 30–33, 31f, 407n230, color plate 9. *See also* allegories of good and bad government

Backer, Adriaan, 51, 422n170

Baker, C. Edwin, 305

Bakhtin, Mikhail, 295

balance(s), 19–21; in Babylonian imagery, 19–20; in Bible, 21–23; in Christian imagery, 22–23; in Egyptian imagery, 20–21, 110; in Koran, 21; in Kraus's Newark Justice sculpture, 110; in logos of Justice, 285–287; as scales, 19–21, 46, 63, 74, 76, 77, 84, 87, 89, 110, 124; use of term, 396n44; in zodiac, 18–20. *See also* Justice; Koran; Maat; Mesopotamia; Scales; St. Michael

Baltimore (Maryland), abstract art in, 465n217

Bamberg (Germany): legal code of, 67–69, 69f, 431nn79–81, 431–432nn84–85; Synagoga in Cathedral of, 67

*Bambergensis Constitutio Criminales* (1507), 67–69, 69f, 431nn79–81, 431–432nn84–85

bandages, on eyes, 62, 65, 428n16. *See also* blindfold; blindness; Synagoga and Ecclesia; *The Tribunal of Fools*

bankruptcy judges, U.S.: creation of position, 315; evidentiary hearings before, 317, 317f; growth in number of, 315, 316f; selection of, 315

Barak, Aharon, xvi, 215, 516n216, 518n306

Barasch, Moshe, 65, 428n37, 429n52. *See also* blindness

bar associations. *See* American Bar Association; International Bar Association; National Bar Association; task forces on fairness in courts (U.S. and Canada)

Bardot, Brigitte, 454n13

Barnes, Edward Larrabee, 162, 488n112

Barry, Brian, 130

Bartkus, Ray, 7f, 8, 382n21

Bartlett, Ivan, 116f, 460n126

baseball stadiums, glass in, 341, 586n29

Basel Town Hall: Charondas of Catanea in, 61; Last Judgment in, 410n275; Zaleucus in, 426n239. *See also* town hall(s)

Batavians, The, 421n142, 422n173

Bate, Heidi Eberhardt, 411n297, 416n45

Bath, Michael, 589n132

Baucus, Max, 498n137

Baudrillard, Jean, 465n224

Baumgarten, Paul, 585n18

Bautzen Town Hall, 410n275. *See also* town halls

Beaune, Colette, 399n93, 401n113

Beaux Arts architectural style, 120, 137, 164, 476n128, 486n62

Beccafumi, Domenico, 426n241

Beham, Hans Sebald, 426n241

Belgium: Saint Michael in, 24, 400n96

Bell, John, 508n14

Bell, Mifflin E., 145, 146f, 479n186

*Bell Atlantic Corp. v. Twombly*, 567n48

Bels, Marie, 208, 340, 511n84, 512n107, 515n181, 516n212

*Benedictus Deus*, 23

Benhabib, Seyla, xvi, 295, 335, 583n406, 600n504

Bentham, Jeremy: on auditors, 297, 299; on codification of law, 295, 296, 350; on conciliation courts, 296–297, 559n160; court reforms advocated by, 288, 295–299; on courtrooms, 337, 584n434; on democracy, 298; on Equal Justice Fund, 296, 371, 376–377, 600n517; Habermas on, 300; on judicatories, 38, 296, 411n1; on legal aid, 296, 322, 371, 376–377, 600n517; on natural rights as "nonsense upon stilts," 298; on open air courts, 337, 351–352, 367, 376; Panopticon prison design of, 222–223, 297–298, 327; on press, role of, 288, 299; *Principles of Judicial Procedure*, 296; on privacy, 297–298; on publicity, xv, 14, 17, 288, 295–301, 303, 318, 337, 340; Public Opinion Tribunal of, 14, 298, 299, 561n220; on public sphere, 295; on universal suffrage, 295, 558n122

Benveniste, Emile, 397n67, 402n128

Berckheyde, Gerrit, 420n125

Bergeron, David M., 442nn283–284

Berkeley, John, 554n66

Berlant, Tony, 505n350

Berlin, Isaiah, 516n221

Berlin Wall, 238, 273, 527n184

Besançon (France), Palais de Justice in, 200

Besnard, Albert, 538n232

Bet Alpha Synagogue, 394n20. *See also* mosaics

Betsky, Aaron, 504n317, 506n394

Better Business Bureau, 574nn194–195

*Between Facts and Norms* (Jürgen Habermas), 563n254

bias: implicit, 453n163; judicial, task forces on, 107, 132–133, 304; juror, 104. *See also* judge(s): appearance of impartiality

Bibas, Stephanos, 568n81

Bible: Amsterdam Town Hall influenced by, 49; blindness in, 64–65; Cardinal Virtues in, 386n40; in Damhoudere's *Praxis rerum criminalium*, 74, 436n153; evidentiary standards in, 96; Four Daughters of God in, 8, 384n29; Gift Virtues in, 384n28; and Giglio's handless judges, 44; in Last Judgment iconography, 34–35, 409n270; scales of justice in, 21; Theological Virtues in, 384n27. *See also* Chronicles, II; Deuteronomy; Exodus; Isaiah, Book of; Job, Book of; Judith; Kings, I; Last Judgment; *Mark, Gospel of*; *Matthew, Gospel of*; Moses; New Testament; Old Testament; *Proverbs, Book of*; Psalms; Romans; Samuel, I; Solomon, Judgment of; *Thessalonians, First Epistle to*; *Wisdom, Book of*

*Bibliotheca historica* (Diodorus), 43

Biddle, Francis, 362

Biddle, George: career of, 596n350; in Commission on Art and Government, 489n133; Mexican muralists and, 108, 361–362, 455n26, 596n350; Mexican Supreme Court murals by, 361–362; Orozco and, 596n351; in Works Project Administration, 108, 361, 455n22, 455n26

bilateral investment treaties (BITs), 226

Bilbo, Theodore G., 459n108

Bill of Rights, South African, 350, 591n172

Bill of Rights, U.S.: freedom of press in, 299; in Supreme Court building, 119, 462n155

Biloxi (Mississippi): City Hall of, 145; U.S. Post Office, Court House, and Custom House in, 144–145, 145f

birds: in Justice iconography, 79, 88; in Tom Otterness's artwork, 185. *See also* crane(s); eagle(s); ostrich(es)

Black, Hugo: in Holzer's Sacramento installation, 190, 506n378; on protests at courthouses, 474n72

Black, Michael, xvi, 216–217, 219, 369–370, 372

Black Death of 1348, 27, 404n165

Blake, Peter, 518n327

Blankert, Albert, 424n202

Bletter, Rosemarie Haag, 586n35, 587n55

blindfold(s), 62–75, 95–102; in Amsterdam Town Hall, 62–64, 63f, 71; in *Bambergensis Constitutio Criminales*, 67, 69f; as bandage, 62; and blindness, 64, 65; in Brant's *The Ship of Fools*, 67, 68f; in Bruegel's artwork, 71–72, 71f; in Damhoudere's *Praxis rerum criminalium*, 72–74, 73f; in Danziger's cartoon, 130; debate over meaning of, 14, 91, 97; of Eros, 67, 70; evolution of meaning of, 14, 62, 67–68, 74–75, 89, 91, 96; fools' use of, 67–69, 68f, 69f; of Fortuna, 67, 70, 71, 430n64; Hughes (Langston) on, 14, 91, 95, 103–104, 103f; and judicial independence, 97, 448n58; Justice without, prevalence of, 75, 79, 87, 91–93; in London Justices, 87, 444n315; in Lutheranism, 96, 447n45; modern use of, 130, 133; in Moore's (Diana) artwork, 99–102, 100f, 101f, 450nn106–107; in Orozco's murals, 360; and ostrich motif, 79; and racial discrimination, 103–104; and Rawls's veil of ignorance, 98; in Ripa's *Iconologia,* 63, 67, 70, 75, 95, 96, 427n9, 428n16; self-imposed, 99; as symbol of blindness, 62; as symbol of disability, 62, 63, 95; as symbol of humility, 71, 434n124; as symbol of impartiality, 14, 62, 95; as symbol of judicial error, 67, 69, 96; of Synagoga, 65–67, 66f, 97. *See also* bandages; blindness

blindness (sightlessness), 14, 62–75; in Alciatus's *The good Prince in his Council,* 43, 44f, 69–70, 75, 96; as asset, 91; in Bible, 64–65; blindfold as symbol of, 62; compared to blindfolded, 64, 65; in

Brant's *The Ship of Fools,* 67, 431nn77–78; and bribery, 43; cataracts and, 97, 449n65; debate over meaning of, 91, 97; in Diderot's analysis, 97–98; as disability, 64–65, 70, 91, 95; fairness and, 103–104; Hughes (Langston) on, 14, 95; of impartiality, 103; of indifference, 103; medical cures for, 97; metaphoric, 65; in Molyneux's problem, 97, 449n64, 449nn68–70; negative connotations of, 64–67; positive connotations of, 96, 448n49; in Reynolds's artwork, 98–99, 99f, color plate 16; in Ripa's *Iconologia,* 70; of Theban judges, 43; transnationality of metaphors of, 102; U.S. Supreme Court on, 102–103; willful, 64, 65, 105. *See also* bandages; blindfolds; color-blindness

Bloch, Susan Low, 476n120

Bodin, Jean, 12, 389n62, 390n72, 390n73, 391n76

Bogotá (Colombia), Palace of Justice in, 349–350

Boise (Idaho), Ada County Courthouse in, WPA mural in, 15, 116–117, 116f, color plate 21

Bol, Ferdinand: Amsterdam Town Hall painting by, 51, 52–53, 54f, 253; life of, 423n195; Peace Palace paintings by, 253, 534n103

Bolivar, Simon, 349

book(s): in iconography of Justice, 18–19, 393n13; illuminated, 403n147; in Middle Ages, 403nn146–147

*Book of the Dead:* last judgment in, 21, 395n39–40, 397nn51–52; Nedjmet copy of, 20, 20f, 395n35; origins of, 395n37; scales in, 20–21, 20f, color plate 4; title of, 395n37; versions of, 395n37

BOORA Architects Inc., 504n317

Bordeaux Palais de Justice (France): Couvert's bell in, 201–202, 202f, 344, 514n151; design of, 197, 198f, 511n84

Bosch, Hieronymus, 435n134

Boshoff, Willem, 355

Bosnia and Herzegovina: in International Court of Justice, 539n272, 539n275; war crimes in, 274, 545n463

Boston (Massachusetts): colonial courthouses in, 471nn27–28; Custom House in, 149, 481n221; John F. Kennedy Federal Building in, 107

Boston (Massachusetts), John Joseph Moakley U.S. Courthouse in: courtrooms of, 310–311, 310f, 312, color plate 27; design of, 124–125, 125f, 160–161, 161f, 204, color plate 25; educational programs in, 125, 343, 464n209; and GSA excellence in design standard, 168; federal trials in, number of, 311, 567nn60–61; Kelly's panels in, 125–126, 126f, 161, 168, 344, 363, color plate 26. *See also* Breyer, Stephen; Cobb, Henry N.; Kelly, Ellsworth; Woodlock, Douglas

Boston Bar Association, 567n60

Bourdieu, Pierre, 294–295

Boutin, Bernard L., 183, 463n180

Bowman, Jeffrey, report on appellate procedure in UK of, 323

Bowring, John, 558n118, 599n136. *See also* Bentham, Jeremy

Boyle, Anthony J., 436n157

Braij, Jan de, 425n228, 437n164

Braij, Salomon de, 437n164

Branca, Alexander Freiherr von, 266, 266f, 270–271, 271f, 543n393

Branca, Emanuela Freiin von, 266, 266f, 270–271, 271f

Brandon, S. G. F., 396n43, 396nn49–50, 399n86

Brant, Sebastian: life of, 67, 431n73; *The Ship of Fools,* 67–69, 430nn68–72, 431n74, 431nn76–78

Brasilia (Brazil), governmental complex in, 380n10

Brazil, Supreme Court of, 1, 4f, 208, 380n10

Breslau Town Hall, Last Judgment in, 35–36, 410n292

Breyer, Stephen, xvi; on color-blindness, 451n127; and complaints against judges, 467n244; in design of Boston federal courthouse, 124, 160, 161, 486n85; and GSA excellence in design standard, 168; on role of courts, 307–308; on United States Supreme Court building, 585n25

bribery: admonishments against, 39–48; anti-corruption themes and Amsterdam Town Hall, 51; *Bambergensis Constitutio Criminales* in, 67, 432n85; and corruption motif, 42–43, 292; definitions and complexities of, 40–42; handless judges warning against, 44–47; and judicial subservience to rulers, 47–48; in Last Judgment, 42; Plutarch on, 43; regulation of, 39–42, 47–48; remuneration as, 40; sightless judges warning against, 43. *See also* court budgets; Davis, Natalie; gifts; judicial disqualification; *Tumey v. Ohio*

*Bribes* (John Noonan), 40

Briggs, Torzillo, 519n332

Brigham, John, 151–152, 482n242

Brinton, Jasper Yeates, 521n4

Brisbane (Australia), Supreme Court of Queensland in, 1, 2f, 379n3

Britain, 83–89; Australia colonized by, 368, 369; in Jay Treaty, 225; Queen Anne as Justice in, 83–84, 83f; slave trade in, 225, 521nn9–10. *See also* England; United Kingdom; Wales; Woolf, Harry, Woolf Reforms

British Columbia (Canada), Vancouver Law Courts in, 88–89, 88f, 445n329

Brocksberger, Melchior, 408n239

Brooks, Jim, 7f, 381n17, color plate 2

Brooks, Judy, 7f, 381n17, color plate 2

Broomfield, Robert C., 493n32

Brouwer and Deurvorst, 263, 263f

Brown, Glenn, 488n122

*Brown v. Board of Education,* 107, 382n19

Bruce, Edward, 455n22, 456n39

Bruegel, Pieter, the Elder: blindfold in works of, 71–72, 71f, 360; life of, 435n134; Virtues and Vices series by, 71, 72, 435n139, 435n141. *See also* Galle, Philip

Bruges (Belgium), Maximilian of Austria in, 39, 414n25

Bruges Town Hall: Cambyses in, 13, 38–39, 40f, 41f, color plates 10, 11; Last Judgment in, 35, 39, 410n275, 410n290. *See also* town halls

Brussels (Belgium), Saint Michael in, 24, 400n96

Brussels Town Hall, 400n96; Cambyses in, 414n27; Trajan and Herkinbald in, 58, 61, 426n259. *See also* town halls

*Brutus* (Voltaire), 58, 426n252

Brutus, Lucius Junius, Judgment of: in Amsterdam Town Hall, 13, 56, 57–58, 60f, 292; story of, 58, 292, 426n242

Bry, Theodor de, 437n162

Bryan–Chamorro, treaty of, 242, 528n247

Bucher, Carl, 238, 527n185

Bucintoro (Doges' barge), 81–82, 82f, 441n248, 441n250, 442n257: Canaletto's depictions of, 81, 81f, 82, 441n246; ceremonies and, 81–82, 441n247, 441n255; Doges' procession in, 81–82, 82f

*Buckeye Check Cashing, Inc., v. Cardegna,* 573n177

Buckley, Charles A., 483n251

budget(s): court outputs linked to, 308; fines in (*See* user fees); of international and regional courts, 281, 281f, 549n615; maldistribution of resources in, 339; modern shortfalls in, 308–309; separation of powers in, 308; subservience to rulers and, 47–48

Buenos Aires, Protocol of, 243

Buergenthal, Thomas, xvi, 246, 530n307, 531n341

building materials: brick, 136, 143, 472n31; glass, 340–342; stone, 204, 210–211, 215, 222

Buon, Bartolomeo, 441n231

Bureau of Prisons, U.S., 223

Burger, Warren: on courtroom sharing, 170; on courtroom size, 172; and *GSA Design Guides,* 169

burgomasters (Amsterdam), 48–49, 52–53, 61, 420n117, 421n136

Burke, Edmund, 450n91

Burke, Thomas Frederick, 567n46

Burnham, Daniel H.: in Commission on Fine Arts, 163; in Parks Commission, 488n122, 488n126; and Union Station, 161–163, 488n126

Burnham, David, 161

Bush, George W.: access to information about energy policy under, 128–130; Guantánamo Bay under, 327; International Criminal Court and, 277

Butler, Sara Amelia, 488n131

Byard, Paul Spencer: on modern courthouses, 191, 208, 344, 516n213, 588n89;

on U.S. Supreme Court building, 152, 482n244

Bynum, Caroline Walker, 400n105

Byzantine architectural style, 251

Caille, Emmanuel, 512n92

Calderón Fournier, Rafael Ángel, 528n227

Calendario, Filippo, 441n229

calendars: Christian, 399n93; Jewish, 19, 393n18; justice iconography in Azerbaijan, 1, 4f; Mesopotamian, 19, 393n15, 393n17

calendar systems in courts, master compared to individual, 296, 493n17, 576n233

California: accessibility of courthouses in, 166; number of courthouses in, 137, 473n61; prisons in, 223, 520n397; protests at courthouses in, 474n72; racial segregation in, 138; rent-a-judge program in, 41, 269. *See also specific cities*

Callaghan, James E., 438nn176–177

Calvinism: in Geneva, 46; in Netherlands, 52, 421nn142–143

Cambodia: Extraordinary Chambers in the Courts of, 543n422; sculpture of, 101, 450n104

Cambyses: in Bruges Town Hall, 13, 38–39, 40f, 41f, color plates 10, 11; in Danish tapestry, 39, 413n17; Herodotus on, 38, 39, 413n17; life of, 38–39, 292, 412n4

camera obscura, 96, 127, 447n40, 465n220

campaign contributions, to judges, 41, 415n41

Campbell, Harry, 490n169

Campbell, Robert, 465n217, 496n114

Campen, Jacob van: Amsterdam Town Hall designed by, 48, 50, 420n116, 421n136; architectural philosophy of, 48, 419n116; art designed by, 55, 422n158, 427n8; artworks by, 51, 56, 419n116, 422n171; Haarlem Town Hall designed by, 75; life of, 419n116

Camp Justice, at Guantánamo Bay, 328–331, 330f

Canada: public art funding in, 509n32; inquiry into racism in courts of, 133

Canadian Supreme Court, 379n2; on judicial salaries, 308; judicial selection for, 536n154; justice displayed outside of, 1, 2f; television broadcast of, 294, 557n104

Canaletto (Giovanni Antonio Canal), 81, 81f, 82, 441n246

Canberra (Australia), High Court of Australia in, 519n332

Cannadine, David, 85, 443nn285, 291, 296, 585n3

Canons of Judicial Ethics (American Bar Association), 127–128, 466n239

*Caperton v. Massey,* 415n41

capital punishment. *See* death penalty; executions

Cappelletti, Mauro, 308

Cárdenas, Lázaro, 359, 595nn313–314

Cardinal Virtues, 344–347; in Amsterdam Town Hall, 50, 51; in battle (psycho-

machia), 9; diversity in depictions of, 346–347; as four corners, 387n44; compared to Gift Virtues, 384n28; hierarchy of, 12, 346, 390n71; history of, 344–347; Justice as, 8, 22–25, 344–347, 383n26, 386n40; meaning of term, 383n26, 588n95; meaning of Virtues, 346; modern need for understanding of, 344; origins of, 383n26, 386n40, 588n95; in Oxford's New College Chapel, 98; Renaissance depictions of, 8–10, 28–30, 347; in Sienese frescoes, 28–30; in Vatican, 75–76. *See also* Fortitude; Justice; Prudence; Temperance; Virtues

Caribbean Court of Justice, 240, 528n225

*Caritativo v. California,* 290, 552n33

Carlhian, Jean Paul, 99, 101, 450n100

Carnegie, Andrew: bust of, in Peace Palace, 253; Central American Court of Justice funded by, 240, 249; education work of, 249, 532n3; Peace Palace funded by, 15, 240, 248, 249, 250; Permanent Court of Arbitration supported by, 247, 248, 249; in Vrede door Recht, 249, 250f

Carnegie Foundation: on Peace Palace design, 251, 252, 253; Peace Palace owned by, 263, 264, 265

*Carolina. See Consitutio Criminalis Carolina*

Cartago (Costa Rica), Palacio de la Paz in, 241, 241f, 242f. *See also* Central American Court of Justice

Carter, Jimmy, and Inter-American Court of Human Rights, 243

Carter, Robert, 114, 459n114

Carteret, George, 554n66

Carteret, Philip, 554n66

cartoons, 5–8; by Allen, xviii; by Bartkus, 7f, 8; by Conrad, 7f, 8; by Danziger, 128, 129f, 130; in *Facts Forum News* (Emerson), 5–8, 7f, 382n19; by Schultz, 5, 7f, 381n17, color plate 2

caryatids, 55

case dispositions, in evaluation of judges, 312

caseloads: of international and regional courts, 281–282, 282f; weighted, 485n61. *See also* dockets; filings

case management, 312, 326, 576n233. *See also* ADR; managerial judges; settlement; Woolf, Harry: Woolf Reforms

*Cassell v. Texas,* 451n134

Casta, Laetitia, 454n13

Catullus, 550n644

Cauduro, Rafael, xvi; artistic work of, 363, 597n383; Mexican Supreme Court murals by, 362–366, 364f, 365f, 377, 598n419, color plates 46, 47

"Causes of Popular Dissatisfaction with the Administration of Justice, The" (Roscoe Pound), 127, 309, 483n14

cell phone contracts, 318, 319, 319f, 320, 321, 574n193

censorship of press, at Guantánamo Bay, 333–334, 582n363, 582n376

Center for Constitutional Rights (U.S.), 335

Center for Design Excellence and the Arts (U.S.), 184

Central American Court of Justice (CACJ), 240–242; budget of, 241; building housing, 240, 241, 241f, 242f; Carnegie's funding of, 240, 249; caseload of, 241; challenges faced by, 241–242; dissolution of, 240, 242; establishment of, 240–241, 249; as first permanent international court, 240, 247, 249; impact of, 241; individual access to, 241–242; judges serving in, 241, 259, 528n235; jurisdiction of, 241; mission of, 240, 241; successors to, 242, 247

certiorari, petition for (U.S.), 154–155, 313

Ceschiatti, Alfredo, 4f, 380n10

Chamber of Commerce, U.S., 260

Chandler, Henry, 484n23

Chanukah displays, in public buildings, 462n164

Charity (Virtue): in hierarchy of Virtues, 12, 390n71; light associated with, 64; as Theological Virtue, 8, 12, 384n27. *See also* Virtues

Charles I, King of England, 416n55

Charles II, King of England, 544n66

Charles V, Holy Roman Emperor, 68

Charles VII, King of France, 399n93

Charondas of Catanea, 61

Charter of the English Colony of West New Jersey (1676), 14, 293, 544n66

Chastity (Virtue), 346, 383n26, 384n30. *See also* Virtues

Chaucer, Geoffrey, 47, 413n14

Chemetov, Paul, 199f, 512n110

Cheney, Dick, 128–130, 468n261

*Cheney, In re*, 130, 468n272

Chicago (Illinois): Social Security Administration building in, 107; World's Fair, influence on architecture in, 163, 477n142, 488n121

Chile, in dispute with Argentina, 249, 532n13

*Chisholm v. Georgia*, 451n128

Christian calendar, Saint Michael in, 399n93

Christian imagery: African art and, 349; blindfold in, 96, 97, 447n45; cross in, 72, 200; Ecclesia in, 65; fasces in, 398n77; ostriches in, 78; Saint Michael in, 22–25; scales in, 22–25; sight and light in, 64, 427n12; Sol Justitiae in, 64; Synagoga in, 67; in Venice, 80. *See also* scales

Christianity, civic, 33, 80, 408n241

Christian theology: Ascension in, 441n247; body and soul in, 400n105, 410n274; last judgment in, 24, 400n99, 400n101; Virtues in, 10, 344–346, 383n26, 386n40, 387n42

Christmas displays, in public buildings, 462n164

*Chronicles II*, 46, 410n289

church and state: interconnections in Medieval towns, 33–37; separation of, in France, 514n136; in U.S., 117–121

churches: Last Judgment in, 35; multiple functions of, 404n150; Synagoga and

Ecclesia in, 65; and town halls, 33, 408n241

Churchill, Winston, 236

Cicero: in Damhoudere's *Praxis rerum criminalium*, 74; *De legibus*, 390n65; *De natura deorum*, 383n26; and Denver federal building, 145, 480n193; *De officiis*, 383n26, 419n106; in Geneva, 46; *Laelius de Amicitia*, 419n110; in Mexican Supreme Court murals, 356; in Siena, 28, 30, 405n173, 406n215; on *temperantia*, 346; on theories of justice, 30; on Virtues, 8, 346, 383n26, 388n47, 388n50, 389nn53–54, 390n65

Cipriani, Giovanni Battista, 84

*Circuit City Stores, Inc., vs. Adams*, 573n176

circuit court judges: district judges as, 139–140; in Judicial Conference of the United States, 155; Supreme Court justices as, 140

circuit courts, U.S., establishment of, 139–140

circuit riding: by Australian Federal Court, 367; in England, 134; by U.S. Supreme Court, 140

circulation routes: in federal courthouses, 173–174; in prisons, 223. *See also* courthouse security; segregation by roles

Ciriani, Henri, 197

citation, of unpublished opinions, 314, 570n109

City Beautiful Movement, 117, 479n178

civic buildings: definition of, 33; compared to public buildings, 33. *See also specific cities and types of buildings*

civic Christianity, 33, 80, 408n241

civic spaces, 25–33; civic identities in, 25–26; intermingling of religious spaces and, 33, 36, 408n241, 410–411nn295–296; rise of, in Europe, 25–26, 138, 403n137. *See also* courthouse(s); custom houses; post offices; public spheres; town halls

civil appeals management plans, 313–314

civil cases: alternative dispute resolution's impact on, 313, 569n98; expansion of rights in, 157; number of filings, 158, 158f, 307, 307f, 485nn59–60; openness of, 294; settlement in, 321; trial rates for, in U.S. federal courts, 311, 311f

Civil Justice Reform Act of 1990 (U.S.), 568n76

civil justice reforms: in England, 322–324; in Europe, 324–327; in United States, 312

civil law countries: France as, 195; traditions mixed with common law and, 225–228, 235–237

Civil Procedure, Federal Rules of (U.S.), 155, 312, 568n75

civil procedure, transnational, 325

Civil Rights Acts (U.S.), 107

Civil Rights movement (U.S.): in Jackson (Mississippi), 115; Supreme Court in, 157

Civil Rights Procedures Protection Act of 2001 (U.S., proposed legislation), 573n181

Civil Service Tribunal, of European Court of Justice, 229, 239, 281, 549n628

Civil War, American: concept of fairness after, 290, 552n35; courthouse construction during, 141; federal jurisdiction after, 141; in Galveston, 144, 479n174; Military Reconstruction Act after, 476n119

Claims, Court of, 314, 570n118, 570n121

Clark, David S., 476n122, 477n130, 485n61

Clark, Kenneth B., 382n19

Clark, Tanner, 457n64

class actions, 131, 157, 326–327

Classical architectural style, 140–141, 144, 209

Classical Revival architectural style, 143–144, 373

clay tablets, Mesopotamian legal system and, 18, 393n10

clerks' offices, 256; in France, as administrative space, 196, 200

Clift, William, xvi, 92, 576n226

Clinton, William, and International Criminal Court, 277

Clyde S. Cahill Memorial Park (St. Louis, Missouri), 486n78

coaches, in Lord Mayor's Show, 84–85, 443n285

coats of arms: of Australia, 219, 369–370, 519n345; Virtues depicted in, 10, 387n44. *See also* emu; kangaroo

Cobb, Henry N.: Boston courthouse designed by, 124, 125f, 161, 161f, 168, 204, 486n85; firm of, 464n205, 487n88; on Kelly's Boston panels, 126

codification: of law, Bentham on, 295, 296, 350; of visual imagery, 69–70, 94–95

Cody, Bill, 147

cognitive sciences, 97–98, 104–105

Cohen, Amy, 309

coins: Medieval, 399n78; Roman, 22, 398nn74–75, 399n79; U.S., 454n15, 461n146

Coke, Edward, 290, 467n245

Cold War: and Commission on Art and Government, 164; glass architecture in, 341; and Guiding Principles for Federal Architecture, 165; need for international criminal court in, 273; support for art in, 164

Collaborative Projects Inc. (Colab), 185, 503n300. *See also* Holzer, Jenny; Otterness, Tom

Collcutt, Thomas Edward, 251

Cologne Town Hall, 436n162, 437n166. *See also* town halls

colonial America, 135–137; public access to courts in, 14, 293; public and social traditions in courthouses of, 135

Colonna, Francesco, *Hypnerotomachia Poliphili*, 416n60

Colorado. *See* Aspen; Denver

color-blindness, 14; in European Court of Human Rights and European Court of Justice, 102; metaphor of, 103–104, 452n147; U.S. Supreme Court on, 95, 102–103, 447n35, 451n127

Combatant Status Review Tribunal (CSRT) (Guantánamo Bay), 327–328, 333–334, 580n330

*Comic Almanack* (magazine), 443n291

*Commission v. Ireland,* 543n399, 543n416

Commission on Art and Government (U.S.), 164, 489n133

Commission on Fine Arts, U.S., 151; establishment of, 163–164, 488n123; mission of, 164, 488nn127–128; on Washington, D.C., buildings, 164, 488n127

Commission on Systemic Racism in the Ontario Criminal Justice System, 133

Commission on the Limits of the Continental Shelf, 266

common law: Bentham's critique of English, 296, 559n129; judicial conduct in, 128; public access to courts and, 293, 294, 556n80

common law countries: compared to civil law countries, 195; courtroom layouts in, 194

Communism: and *Facts Forum News,* 382n19; in Kraus's Newark Justice sculpture, 109–110, 190; and U.S. Supreme Court justices, 382n19; in WPA artworks, 108, 455n33. *See also* Works Project Administration

Community Arts Panel, 502n276

community involvement, in Art-in-Architecture, 183, 184, 191

community justice centers, 598n444

commutative justice, 12, 28, 29–30, 196, 389n58, 389n62

complementarity principle, in International Criminal Court jurisdiction, 276, 279

conciliation courts, Bentham on, 296–297, 559n160

Concord (Virtue), 28. *See also* Virtues

Concord (New Hampshire), Warren B. Rudman United States Courthouse in, Moore's (Diana) sculpture in, 99–102, 100f, 101f

Conference of American States, 242

Conference of Court Public Information Officers (U.S.), 507n12, 586n28

Conference of European Constitutional Courts, 380n9. *See also specific courts*

Conference of Senior Circuit Judges, 155. *See also* Judicial Conference of the United States

Conference of State Court Administrators (U.S.), 507n12

confidentiality, 325, 335; in alternative dispute resolution, 309, 320–322, 325, 335–337; in arbitration and mediation, 324–326; in settlement, 311–312, 324–326. *See also* privacy; secrecy

Confrontation Clause of U.S. Constitution, 452n156

confrontation of witnesses, right to, 104, 452nn156–157

Congress, U.S.: on administrative agency adjudication, 314, 315, 570n121, 572n157; on air conditioning in court-

houses, 156; civil justice reforms by, 312; Commission on Fine Arts established by, 163, 488n123; on cost of courthouses, 177–178; court system established by, 139; on enemy combatants, 580n322; expansion of rights by, 157–158; federal buildings named after members of, 152, 158, 483n251; in federal construction, 140–141, 171, 174–176, 475n99; on federal jurisdiction, 141; GSA oversight by, 170, 493n27; GSA reports to, 478n152; on Guantánamo Bay, 328, 379n1; Legal Services Corporation established by, 157; on postal service, 304; public disclosure obligations of, 293; rent subsidies from, 178–180; on Supreme Court caseload, 313. *See also* House of Representatives; Senate

Congressional Budget Office (CBO), U.S., 180

Connecticut: gender bias task force in, 132

Connolly, Denis, 527n178

Conrad, Paul, 7f, 8, 382n20

*Consitutio Criminalis Carolina* (1532), 68, 432n91, 432n94

Constitutions, of states of the United States: Delaware Constitution of 1792, public access to courts in, 293; Georgia Constitution of 1777, free press guaranteed by, 299; judicial independence in, 97; Massachusetts Constitution of 1780, judicial impartiality in, 292, judicial independence in, 13, 292, separation of powers in, 292; Nebraska Constitution of 1867, access to courts guaranteed by, 320; public access to courts in, 14, 554n71 (Delaware Constitution of 1792), 555n72 (Alabama Constitution of 1819, Connecticut Constitution of 1818, Florida Constitution of 1838, Indiana Constitution of 1816, Kansas Constitution of 1855, Louisiana Constitution of 1864, Mississippi Constitution of 1868, Nebraska Constitution of 1867, North Carolina Constitution of 1868, Ohio Constitution of 1850–51, Pennsylvania Constitution of 1838, Tennessee Constitution of 1870, Texas Constitution of 1869); separation of powers in, 292, 553n52 (North Carolina Constitution of 1776), 553n53 (Georgia Constitution of 1777), 553n54 (Maryland Constitution of 1776), 553n56 (New Hampshire Constitution of 1784), 553n57 (Virginia Constitution of 1776)

consular courts, 225, 521n4

consumer contracts, alternative dispute resolution of, 306, 320–321, 325

contentious cases: definitions of, 260; in International Court of Justice, 264, 265; in Inter-American Court of Justice, 244–246; in Permanent Court of International Justice, 260

Continental Shelf, Commission on the Limits of the, 266

Contini, Francesco, 561nn196–197

contempt powers, 315, 571n130

contracts, private arbitration of, 306, 318–321, 325

convention(s), European Court of Justice in interpretation of, 227; Arms Convention of 1919, 257; Convention for the Creation of an International Criminal Court (1937), 273; Convention for the Establishment of a Central American Court of Justice (1907), 528n230; Convention for the Pacific Settlement of International Disputes (1907), 249, 256; Convention on the Prevention and Punishment of the Crime of Genocide (1948), 273, 544n431; Convention Respecting the Laws and Customs of War on Land (1907), 580n321; Geneva Convention, for the Amelioration of the Condition of the Wounded and Sick in Armed Forces in the Field, 272, for the Amelioration of the Condition of the Wounded, Sick and Shipwrecked Members of Armed Forces at Sea, 544n444, Relative to the Protection of Civilian Persons in Time of War, 544n444, Relative to the Treatment of Prisoners of War (1950), 583n321; Hague Convention of 1899, 249, 253, 256; Hague Convention of 1907, 253, 256, 257; Inter-American Convention, for the Elimination on All Forms of Discrimination against Persons with Disabilities (1999), 244, on the Forced Disappearance of Persons (1994), 244, on the Prevention, Punishment and Eradication of Violence against Women 1994), 244, to Prevent and Punish Torture (1985), 244; United Nations Convention on the Law of the Sea, 1994 Implementation Agreement 265, 540n288, Seabed Disputes Chamber 269, 270. *See also* treaties

Conzemius, Jean-Paul, 228, 228f

Cordonnier, Louis M.: life of, 533n54; Peace Palace design by, 248f, 251, 533n49, 533n52

cornucopia, 22, 84, 347, 398n76, 442n271

*Corps universel diplomatique du droit des gens* (Jean Dumont), 282–284, 283f

Correa, Charles, 592n224

Cosmos Club, 487n107

Cossío Diaz, José Ramón, xvi, 363, 365

Costa Rica: Central American Court of Justice meeting in, 240–242; role in Inter-American Court of Human Rights, 240, 243, 246. *See also* Central American Court of Justice; Inter-American Court of Human Rights

Coughlin, Charles E., 260

Council of Europe: budget of, 239; establishment of, 235–236; European Convention on Human Rights in, 236, 244; European Court of Human Rights under, 235–237; European Judicial Network established by, 576n228; Member States of, 235, 236; compared to Organization of American States, 240, 243, 244; Strasbourg as headquarters of, 236–237

Council of Fine Arts, U.S., 488n123

Council on American-Islamic Relations, 120

counsel, right to: Sixth Amendment (U.S.) on, 157; U.S. Supreme Court on, 102, 131, 157, 602n559. *See also* legal aid

county courthouses, U.S.: decline of, 343; diversity of architectural styles of, 137; compared to European town halls, 391n91; multiplication of uses of, 343, 373; as seats of power, 135, 137, 338, 373, 471n22

*County of Allegheny v. American Civil Liberties Union*, 462n164

Courage (Virtue), 12, 384n28. *See also* Virtues

court(s): demand and capacity of, 307–310; democracy's relationship to, xv–xvi, 17; individual access to justice through (*See* access); maldistribution of resources for, 339; meaning of term, 588n81; public access to proceedings of (*See* public access); symbolic character of, 339–344; use of term, 247–248, 255–256; vulnerability of, 305, 306–307, 336–337, 340, 376

court administrators: in national courthouse construction, 194; types of, 194

court days, 220, 343

court design guides, 193–195; in France, 195–200; in U.S., 171–174

court documents: online access to, 342; public access to, 293, 342, 556n80; sealing of, 321

court halls. *See* town halls

courthouse(s), 338–344; architecture of (*See* courthouse architecture); decline in use of, 339, 342–343; emptiness of, 339, 342–343; evolution from town halls to, 134–136; future of, 338; and law enforcement centers, 338, 339, 343; in legitimacy of judges' authority, 13; multi-door, 343; multiplication of uses of, 338, 343; need for new iconography for, 344, 347; origins of, 13–15, 134–136; prisons' relationship with, 222; prisons reunified with, 343; public and social traditions in, 134–136, 343; as purpose-built structures, 15, 136, 471n28; symbolic character of, 338–340; symbolic use of, 13; virtual encounters in, 302, 303, 342; as zones of authority, 342–344

courthouse architecture, 338–344; alternative dispute resolution in, 312, 343; development of styles of, 136–139; and energy conservation, 166, 193–194; glass in, prevalence of, xv, 15, 220, 340, 341; glass in, symbolism of, xv, 15, 340–342; history on display in, 349–350; identifiable as courthouses, 222, 340; interior design of, 342–343; interior segregation in (*See* segregation by roles); international idiom of, 251, 340; in judicial power, 17; local government power in, 135–136; office space in, 342. *See also* court design guides; courthouse security

courthouse security: in European Court of Human Rights, 238; with glass architecture, 342; in International Criminal Court, 280; in International Criminal Tribunal for the former Yugoslavia, 274; in Israeli Supreme Court, 209, 210, 216; in United States Supreme Court, 377, 585n25. *See also* trois flux, les

court marshals, U.S., 474n90

Court of Justice of the European Communities. *See* European Court of Justice

court quarters, 156–157, 169

court reform(s): American Bar Association on, 155; Bentham on, 288, 295–299; in England and Wales, 322–324; in Europe, 325–326; in Mexico, 359, 365–366, 595nn313–314; overview of contemporary approaches to, 309

courtroom(s): conventionality of modern, 586n26; decline in use of, 339, 342–343; elevation of judges in, 136; interior design of, 342–343; Last Judgment images in, 34, 35. *See also* court design guides

Court Room Facilities and Design, JCUS Committee on, 169

courts-martial, 334, 583n398

Couvert, Pascal, 201–202, 202f, 344, 514n151

Cover, Robert, 96, 340, 448n53, 450n108

Covington Post Office and Courthouse (Kentucky), 110, 457n63

*Cox v. Louisiana*, 474n72

Craig, Lois, 478n161, 483n247; *Federal Presence*, 140, 165, 475n97

crane(s), as attributes of justice and vigilance, 79, 347, 440n217

Cranston, Randall, 323, 577n242, 577n259

Crary, Jonathan, 107, 127, 295, 303, 377, 449n64, 469n290

crime, representations of in courthouses: in Aiken, South Carolina, 110–113; in Mexico, 366, 598n421, 598n424; in South Africa, 355–356, 593n264

crimes against humanity, 272–281; definitions of, 274, 276; in former Yugoslavia, 273–275; in International Criminal Court, 276; international law on, 273; origin of concept, 272; in Rwanda, 275; in Sierra Leone, 275; in World War II, 273

criminal cases: alternative dispute resolution's impact on, 313, 569n98; expansion of rights in, 157; number of filings, 158, 158f, 307, 307f, 485nn59–60; settlement in, 312, 321; trial rates for, in U.S. federal courts, 311, 311f

criminal courts and tribunals, international, 272–275; and Guantánamo Bay, 334; infrastructure of, 273; public access to, 334; staff of, 273; U.N. creation of, 272, 273; after World War II, 273

Crockett, George W., and National Bar Association 103–104

cross: in Bruegel's artwork, 72; in French imagery, 200, 513n134

crucifix and images of the crucifixion, in

French courtrooms, 204, 408n255, 514n136

Cruikshank, George, 85, 85f, 443n291

Cupid, 70, 432n101. *See also* Eros; putti

custom houses, U.S., construction of, 140–141, 143–144, 152

Customs Service, U.S., 140

Dalsgaard, Sven, 233, 525n109

Dambiermont, Mary, 233

Damhoudere, Joost de: life of, 72; *Praxis rerum civilum*, 72, 435nn145–147; *Praxis rerum criminalium*, 72–74, 73f, 435n133

Daniels, Mitchell, 137, 473n59

Dante Alighieri: *Divine Comedy*, 35; *Inferno*, 30, 363

Danto, Arthur, 185, 503n309

Danziger, Jeffrey, 128, 129f, 130, 467n253

Dartmouth College, 356

Davey, Peter, 525n129, 592n224

David, Gerard: Cambyses in works of, 38–39, 40f, 41f, 414n25, color plates 10, 11; life of, 412n7

David, Jacques-Louis, 58, 426n251

Davies, John, 397n63

Davies, Ronald, 486n62

Davis, Howard McParlin, 435n142

Davis, Morris, 334

Davis, Natalie Zemon, 39–40, 42, 47, 48, 415n34, 553n46. *See also* bribes; gifts

*Davis v. Washington*, 452n156

*De architecturae libri decem* (Vitruvius), 419n116

*Death and Life of Great American Cities* (Jacob), 489n143

death penalty: in Minnesota, 373; racial discrimination in, 131–132; in United Kingdom, 558n114. *See also* executions

de Beauvoir, Simone, 206–207

Deceit (Vice), 9. *See also* Vices

Declaration of Independence, U.S.: federal judiciary in, 139; judicial subservience in, 292

Declaration of Sentiments (1848), 190

Declaration of the Rights and Duties of Man (1945), 242

Declaration of the Rights of Man and of the Citizen (1789), 203, 298, 510n57

Declaration on the Rights of Indigenous Peoples, Draft (2007), 368, 599n458

Declaration on the Rights of Persons Belonging to National or Ethnic, Religious and Linguistic Minorities (1992), 368

Defense Department, U.S.: on classification of Guantánamo detainees, 327, 328, 333, 580nn322–325; in decline of adjudication, 16; Guantánamo Bay established by, 16; on number of Guantánamo detainees, 579n311; on press coverage of Guantánamo Bay, 333–334, 582n363; seal of, 328–331, 581n351

de Gaulle, Charles, 587n50

deities, Egyptian: Maat, 18, 20–22, 77, 110, 394n29, 395n32, 395n35–37, 395n40,

deities, Egyptian (*continued*)
  396n50, 397nn51–52, 427n11; Osiris, 21,
  395n40; Ra, 21, 395nn36, 395n40; Thoth,
  21–22, 395n35, 395nn39–40
deities, Greek: Astraea, 21, 78, 397n63,
  439n203; Diké, 21–22, 25, 384n30,
  390n72, 394n22, 397n20; Hermes, 24,
  202; Themis, 2f, 21–22, 88f, 121, 200,
  379n3, 397n64, 397n66; Zeus, 21, 200,
  379n3, 387n46, 397n66
deities, Roman: 1, 9, 21–22, 51, 110; Iustitia,
  21–22, 399n79
*De Iusticia Pingenda (On the Painting of
  Justice)* (Fiera), 91, 93–94, 96
Delacroix, Eugène, 107. *See also* Marianne
Delaware, 1792 Constitution of, 293
*De legibus* (Cicero), 390n65
Delf, Dirk van, 33
Demaine, Linda J., 574n198
demand, for adjudication, 307–310
democracy: adjudication as contributor to,
  17, 301–304; adjudication as practice of,
  301–304; adjudication as proto-form of,
  xv, 48, 289; adjudication transformed by,
  xv, 14–16, 289–295; Bentham on, 298;
  challenges to, 16–17; courts' relationship
  to, xv–xvi, 17; definition of, 301; in French
  courthouses, 196; glass as metaphor for,
  341; iconography of, 340; and public
  sphere, 299–301; transparency of, 341
democratic iterations, 335
*demos*: definitions of, 233; European Court
  of Justice as contributing to, 232–233
*De natura deorum* (Cicero), 383n26
Denmark: Cambyses in tapestry of, 39,
  413n17; conciliation courts in, 296,
  559n160
Dentatus, Marcus Curius, 51
Denver (Colorado): Alfred A. Arraj U.S.
  Courthouse in, 480n192; U.S. Post Office
  and Courthouse in, 145–147, 146f; U.S.
  Post Office in, 145, 146f
*De officiis* (Cicero), 383n26, 419n106
Deonna, Waldemar, 417n72, 417n76,
  417nn78–79, 418n81, 418n99, 419n101,
  419n110, 447n39
Descartes, René, 448n62
Deschênes, Jules, 550n652
Design Excellence Program. *See* General
  Services Administration Design Excel-
  lence Program
Des Moines (Iowa), U.S. Court House and
  Post Office in, 144, 144f
Despair (Vice), 9. *See also* Vices
Detley, John D., 100f
*Deuteronomy*, 96, 448n48
Devereaux, Simon, 562n222
Devil, the: iconography and, 401n115; Saint
  Michael and, 401n115; Virtues and,
  386n35
Dezalay, Yves, 322
Diderot, Denis: *Lettre sur les aveugles à
  l'usage de ceux qui voient*, 97, 449nn68–70,
  449nn73–74; life of, 449n68; *Promenade
  d'un sceptique*, 97, 449n75

Diest Town Hall (Belgium), 411n295
Dieude-Defly, August, 512n104
Diké (goddess): in origins of Justice iconog-
  raphy, 21–22, 397nn65–66; Roman
  version of, 22; sword of, 25
Dill, Guy, 183
Diodorus Siculus, 70, 418n79; *Bibliotheca
  historica*, 43
Dionysius of Halicarnassus, 58
disabilities, access for persons with. *See*
  accessibility
disability: blindfold as symbol of, 62, 63, 95;
  blindness as, 64–65, 70, 91, 95
Disarmament Conference (1899), 249
Discipline (Virtue), 8. *See also* Virtues
*Discipline and Punish* (Foucault), 84, 127,
  335
Discord (Vice), 9. *See also* Vices
discovery process in litigation, 129, 130, 155,
  304
discrimination. *See* access to courts; gender
  bias; race and ethnic bias task forces;
  racial discrimination
dispute resolution (DR), competition among
  providers of, 247, 257, 325. *See also* alter-
  native dispute resolution
disqualification of judges: criteria for,
  128–130, 467n246; method of, 128. *See
  also* judges, recusal
distribution of resources, judicial. *See*
  budgets
distributive justice, 12, 28–30, 196, 389n62,
  406n209
district courts, U.S., 139–140
district judges, U.S., 139–140
diversity: in French iconography, 200–207;
  as goal of Art-in-Architecture, 184, 191;
  as goal of GSA Design Excellence Pro-
  gram, 168; in International Criminal
  Court, 277; in law schools, 131; in legal
  profession, 131
*Divinarum institutionum* (Lactantius), 47
*Divine Comedy* (Dante), 35
divine imagery: in allegories of government,
  26–33; in animal symbols, 78; in French
  courthouses, 200; in Last Judgments,
  33–37; in non-Christian traditions, 18–21;
  in Orozco's murals, 356, 359–361; regard-
  ing sight and blindness, 64–67. *See also*
  Amsterdam; Amsterdam Town Hall,
  classical and religious themes in, Last
  Judgment in; Christian imagery; Saint
  Michael
divine law and justice, 21–23, 28, 78; in
  Damhoudere, 72–74; in Dürer, 42; in
  Fiera, 93–94; and human law, 22, 30, 56,
  70–74; in Raphael's *Justice*, 75–77; in Ripa,
  93–94; in *The Ship of Fools*, 67–68
Dixey, John, 6f, 381n15
dockets: evolution in content of U.S.,
  157–158, 485n48; expansion of rights in
  U.S. and, 157–158; size of
dog(s): in Australia's open court, 370; in
  Damhoudere's *Praxis rerum criminalium*,
  72, 436n150; in Ripa's *Iconologia*, 43, 79,

417n70; as symbol of friendship, 43, 79,
  417n70; in Zutphen's *Dutch Law and
  Practice in Civil and Criminal Matters*,
  370
Doges: in Bucintoro, 81–82, 82f; role of, 80,
  81, 440n223. *See also* Venice
domestic violence: gender bias in courts
  and, 132; public access to courts in under-
  standing of, 301
Domingo, Pilar, 357, 595n314
Donaldson, Ian, 61, 426nn248–250
Donnelly, John, Jr., 462n153
Dove, Rita, 190, 506n382
DR. *See* dispute resolution
Draper, Anthony J., 558n118, 559n139,
  559nn141–142, 559nn152–153, 559n164
drapes: over Ada County Courthouse WPA
  mural, 116; over Hirsch's "Mulatto" Justice
  mural, 112–113; over Nicholas II's por-
  trait, 117, 249; over Simkhovich's Missis-
  sippi Justice mural, 115–116, 460n122
drug courts, 343
Drummond, Eric, 259
Drysdall, Denis, 416nn63–64
Dublin (Ireland): Castle of, 86; Four Courts
  in, 86–87, 86f, 217, 443n305; seat of
  authority in, 86–87
due process: in administrative agency adju-
  dication, 316; in Bible, 448n48; defini-
  tions of, 552n29; evolution of concept of,
  290, 552n29; in France, 196; "hear the
  other side" in, 14, 290–291; and prison
  garb, 105; procedural and substantive,
  291; statutory entitlements as property
  under, 157; in U.S. Constitution, 105, 290,
  291; U.S. Supreme Court on, 290, 552n31,
  552n34
Duff, James C., 180, 181
Dumont, Jean, *Corps universel diplomatique
  du droit des gens*, 282–284, 283f. *See also*
  Permanent Court of Arbitration
Dunseath, T. K., 390n63
Duquesnoy, François, 422n159, 427n8
Dürer, Albrecht: blindfolded Justice attrib-
  uted to, 67, 68f; in Brant's *The Ship of
  Fools*, 67, 430n68; and bribery, 42; Cardi-
  nal Virtues depicted by, 387n44; Last
  Judgment depicted by, 411n297; Sol Justi-
  tiae depicted by, 96, 285, 394n21; zodiac
  depicted by, 394n21
*Dutch Law and Practice in Civil and Criminal
  Matters* (Zutphen), 134, 135f, 370, 371f,
  600n498
Dutch Republic, 420n120
DYPSA (architectural firm), 531n345

Eagle(s): in Justice iconography, 79; in U.S.
  seals, 328–331
Eagleton, Thomas F., 158
Eastland, James O., 382n19, 459n102
Ecclesia. *See* Synagoga and Ecclesia
ECHR. *See* European Convention on Human
  Rights
ECJ. *See* European Court of Justice
*Economist, The*, xviiif, 1, 5, 16, 379n1

ECSC. *See* European Coal and Steel Community

ECtHR. *See* European Court of Human Rights

Edgerton, Samuel Y., Jr., 405n180, 406n221, 411n295

education, judicial: by Federal Judicial Center (U.S.), 156; formal, in U.S., 131, 155; on gender bias, 132, 469n291; on management of cases, 312; visual arts in, 34

education of public: in Boston's federal courthouse, 125, 343, 464n209; through open courts, 297; through visual arts, 26, 34. *See also* Bentham, Jeremy

Edward VII, King of England, 249, 369

E-Government Act of 2002 (U.S.), 314

Egypt: Saint Michael in, 23; Mixed Courts of, 226, 227f, 274, 350; ostrich feathers in, 20, 77–78; scales in imagery of, 20–21; sight in, 64; as source of Justice iconography, 18, 20–21. *See also Book of the Dead;* Maat

Egyptian gods: in last judgment, 21, 395n40; sun, 64. *See also* Maat

Eicholtz, William, 2f, 379n4

Eisenberg, Theodore, 574n198

Eisenhower, Dwight D., and Commission on Fine Arts, 164, 165

Eladari, René, 511n77, 512n100

election of judges: campaign contributions in, 41, 415n41; public power over judges through, 127

Eleventh Amendment of U.S. Constitution, 451n128, 490n191

Elizabeth I, Queen of England, 21, 397n63. *See also* Astraea

Ellis, William, 487n106

El Salvador, 241, 242

Elst, Michel Vander, 228, 228f

embassies, architecture of, 341, 342, 587n51

emblem(s): coining of term, 43; definition of, 416n64; Virtues in, 12, 386n33, 388n49. *See also* Alciatus, Andreas; logo(s); Ripa, Cesare

Emden Town Hall: Judgment of Brutus in, 426n241; Last Judgment in, 410n275. *See also* town halls

Emerson, Ralph Waldo, 346. *See also* prudence

employment contracts, alternative dispute resolution of, 306, 320

emu, in Australian coat of arms, 369

Endispute, 312

enemy combatants: access to courts for, 16; decline of adjudication and, 16, 304; definition of, 327, 580n322; establishment of class of, 16, 327, 580n321; Geneva Conventions and, 580n321; lawful and unlawful, 580n322. *See also* Guantánamo Bay

England, 83–89; Act of Settlement (1701) in, 42, 97, 127, 292, 442n265; alternative dispute resolution in, 322–325; Brutus's story in, 58; civic ceremonies in, 84–85, 85f, 134; corruption in, 42; courthouses of (*See* English courthouses); fairness in,

290; glass in architecture of, 340, 341; "hear the other side" in, 290, 291; human rights in, 325; judicial independence in, 42, 97, 127, 292, 325; legal aid in, 322–323, 577n239; Lord Mayor's Show in, 84–85, 85f; Saint Michael in, 399n93; prisons in, 222–223, 471n25, 520n376; procedural rules encouraging settlements in, 16, 323; protection of judges in, 13, 391n79; Protestant sovereigns of, 442n265; public executions in, 295, 558n114; seat of authority in, 87; slavery in, 331, 581n357; Supreme Court of, 322, 325; Synagoga in, 65; torture in, 293; town halls of, 134, 470n4, 470n6; transnational arbitration in, 324–325; trials in, decline in number of, 322; tribunals in, 324. *See also* Britain; London; Woolf, Harry

England Reform Act of 1867, 300

English courthouses: courtroom layouts in, 194; design guides for, 507nn10–11; fees for access to, 558n115; glass in, 340; late twentieth-century construction of, 216; meaning of architecture of, 338, 343; user fees for access to, 308, 558n115

Entsuba, Katsuzou, 5f, 380n11

Environment and Public Works, Senate Committee on, 176, 478n152

Envy (Vice), 9. *See also* Vices

equal access. *See* access to courts

Equal Employment Opportunity Commission (U.S.), 317, 317f, 318

equality: evolution of concept of, xv, xvi, 14, 15; failures in, 304; fairness and, 290; of participants in courts, 301–304; in Renaissance, 14

Equal Justice Fund, 296, 371, 376–377, 600n517. *See also* Bentham, Jeremy; legal aid

"Equal Justice Under Law," on U.S. Supreme Court, 331, 332f, 377, 581n355

*Equal Justice Under Law* (Constance Baker Motley), 114, 132

Equal Protection Clause (U.S. Constitution), 103, 131

Equity (Virtue), 384n28. *See also* Virtues

Equity Rules, U.S. Federal, 484n17, 556n83

Erasmus, 43; and European Court of Justice, 430n71, 446n16

Erickson, Arthur, 445n329

Ernst and Young, 180

Eros, 67, 70, 79, 432n101. *See also* blindfold; cupid; putti

Ersoy, Ufuk, 587n56

Escuela Nacional Preparatoria, 356. *See also* Orozco, José Clemente

*Estelle v. Williams,* 453n165

*Ethics* (Aristotle), 12

ethics, judicial: American Bar Association on, 127–128, 466n239; "appearance" standard in, 128, 466n239; in debate over Scalia's recusal, 128–130; development of, 127–128, 130–131; task forces on bias and, 107, 132–133

Eunomia (goddess), 21

Europe: alternative dispute resolution in, 322–326; art of, in relation to African art, 349; Australia colonized by, 368; civic spaces in, rise of, 25–26, 403n137; constitution of, proposed, 235; dispersal of institutional sites in, 228; Luxembourg as Judicial Capital of, 228; Parliament of, 235, 237; postal services in, 299; prisons in, history of, 222–223, 519–520nn375–377. *See also* European Court of Human Rights; European Court of Justice

Europe, Council of. *See* Council of Europe

European Coal and Steel Community (ECSC), 227, 523n39

European Coal and Steel Community Treaty (1951), 522n31

European Commission on Human Rights: abolition of, 237; establishment of, 237; functions of, 237; compared to Inter-American Commission on Human Rights, 243–246

European Community (EC): and Council of Europe, 235; expansion of, 227, 228; and jurisdiction of ECJ, 227. *See also* European Union

European Convention Human Rights Act of 2003 (Ireland), 239

European Convention on Human Rights (ECHR) (1950), 236–239; compared to American Convention on Human Rights, 243; Article 6 of, 196, 238–239, 294, 325, 452n157, 511n66, 527n199, 556n94; in England, 325; evidentiary standards in, 104, 452n157; "hear the other side" in, 291; mediation and, 326; provisions of, 236; public access to courts in, 294, 557n97, 560n189

European Court of Human Rights (ECtHR), 235–239; blindness metaphor in, 102; budget of, 239, 245, 281, 281f; caseload of, 238–239, 245, 281, 282f, 527n198, 549n627; challenges faced by, 238–239; establishment of, 237; and European Court of Justice, 235, 239, 525n136; "hear the other side" in, 291, 553n45; impact of, 239, 245; individual access to, 237, 238; and Inter-American Court of Human Rights, 239–240, 243–246; judges serving in, 237, 239, 259; jurisdiction of, 235, 237; mission of, 238; number of filings in, 238–239, 245–246, 527n198; public access to, 294, 536n93, 556n80; staff of, 244, 245, 528n219

European Court of Human Rights (ECtHR) building, 235–239, 236f; architectural critics on, 235, 238; art in, 238; budget for, 226, 237; construction of, 237; interior design of, 238; original, 525n129; public space in, 238; Rogers as architect of, 235, 236f, 237–238, 251, 526n169, 585n17

European Court of Justice (ECJ), 227–235; blindness metaphor in, 102; budget of, 230, 239, 281, 281f; caseload of, 229, 281, 282f; Civil Service Tribunal in, 229, 239, 281, 549n628; Court of First Instance in,

European Court of Justice (*continued*)
229, 239, 281, 291, 549n628; debate about role of, 227; as *demos*, 233; establishment of, 227, 522n31; and European Court of Human Rights, 235, 239, 525n136; expansion of mission and staff of, 228–229; "hear the other side" in, 291; impact of law of, 227, 235; judges serving in, 229, 259; jurisdiction of, 227, 229; languages used in, 229, 294, 523n67; lawyers in, 229; logo of, 286, 286f; Member States of, 227, 228; name of, 522n29; number of filings in, 229; procedural framework of, 227, 229, 522n32; public access to, 294, 556n94; public awareness of, 232–233

European Court of Justice (ECJ) buildings, 227–235; Annex C, 230; architectural critics on, 230, 231–232; art in, 229–230, 233–235, 524–525nn108–109; budget for, 226, 230; Erasmus Building, 229–230, 229f; Hambourg's murals in, 234–235, 234f, color plate 36; interior design of, 229–230, 232, 232f, 233–235, color plate 37; Le Palais, 228–229, 228f, 233, 234–235, 234f, color plates 34, 36; need for, 228–229, 265; original villa, 227–228, 522n36; Perrault as architect of, 230–233; Thomas More Building, 230; Towers, 230–233, 230f, 231f, color plate 35; visitors to, 232–233

European Declaration on the Rights of Man and Fundamental Freedoms (1950), 236. *See also* European Convention on Human Rights

European Economic Community, Treaty Establishing the (1957), 523n53

European Judicial Network, 322, 576n228

European Union (EU): and Council of Europe, 235; expansion of, 227; and jurisdiction of ECJ, 227; mediation in, 325–326. *See also* European Community

European Union, Treaty on. *See* Maastricht Treaty

Evans, Michael, 22, 417n67, 418n87

even-handedness: blindfold as symbol of, 96; blindness associated with, 75; bribery and, 41–42; in Ripa's *Iconologia*, 43–44

Evers, Medgar, 115

evidentiary hearings: in administrative agencies, 314, 316–317, 317f; definition of, 572n150; in U.S. federal courts, 316–317, 317f

evidentiary standards: in Bible, 96; in European Convention on Human Rights, 104, 452n157; at Guantánamo Bay, 334; hearsay in, 104, 452n156

*ex aequo et bono*, 260, 261, 269

executions, public: in Amsterdam, 48, 54–55, 295, 424n213; history of, 295; in Iraq, of Hussein, 302; meaning of, 295; at U.S. county courthouses, 373. *See also* death penalty

Executive Branch, U.S.: alternative dispute resolution in, 314; on cost of courthouses, 177–178; on judicial requests for courthouses, 180–181

*exempla virtutis*, 38; in Amsterdam Town Hall, 49–55, 412n173. *See also* allegories and allegorical figures

*exemplum iustitiae*, 39, 75. *See also* allegories and allegorical figures; Brutus; Cambyses; Solomon; Zaleucus

*Exodus*, 44, 46–47, 65, 74, 120, 417n77, 423n195, 428n26, 428n28, 553n46. *See also* Bible

ex parte contact, 290, 336

extrajudicial procedures, 312, 568n75

Extraordinary Chambers in the Courts of Cambodia, 543n422

Extravagance (Vice), 9. *See also* Vices

Eyck, Jan Van, 429n54

eye(s): of God, 64, 427n14; of Horus, 427n11; of Justice, 14, 70; of Maat, 427n11. *See also* blindness; sight

eyewitnesses identifications, 104–105. *See also* witnesses

Eyffinger, Arthur, xvi, 249–250, 253, 534n95, 550n644

Fabri, Adhémar, 46

fact-finding, by administrative agencies, 316

*Facts Forum News* (magazine): cartoons in, 5–8, 7f, 382n19; opening and closure of, 382n19

*Faerie Queene, The* (Edmund Spenser), 12, 390n63, 397n61, 397n63. *See also* Astraea; Elizabeth I

Fairbanks (Alaska), U.S. Courthouse and Jail in, 149, 149f

fairness: blindness and, 103–104; evolution of concept of, 290, 552n35; fundamental, 290, 552n35; of government policies, 290; social movements challenging, 106–107; use of term, 290; U.S. Supreme Court on, 290, 552n25, 552n35

fair procedures, use of term, 290, 552n29

fair trials: at Guantánamo Bay, 334, 583n392; use of term, 290, 552n29

Faith: crane associated with, 79; as Theological Virtue, 8, 384n27. *See also* Virtues

Fake, Guy L., 109, 110, 456n47

family: courts, 343; law, 158

*Fanny* (Fitz-Greene Halleck), 5, 381n16

Farley, Marilyn, 183, 491n214, 502n263

fasces: as attribute of Justice, 22, 398n77; history of use of, 79, 398n77; in U.S. Supreme Court building, 119

Fear of God, as Gift Virtue, 8, 384n28

feather(s): ostrich, 20, 77–78; symbolic meanings of, 20, 395n33

Febvre, Lucien, 403n146

Federal Advisory Committee Act (U.S.), 129

Federal Appendix, 570n112

Federal Arbitration Act (FAA) of 1925 (U.S.), 319, 574n188

*Federal Architect* (magazine), 477n147

Federal Building Fund (U.S.), 176

federal buildings, U.S., 139–168; accessibility of, 166–167; architectural style of, 140–141, 143; art in, 152–153, 163–166; budget for, 140–141; competitions for design of, 165; complaints about style of, 165–166; cooperative use of, 166, 490n176; cost of, GSA concern with, 165; court quarters in, 156–157, 169; energy conservation in, 166; GSA Design Excellence Program for, 167–168; Guiding Principles for, 164–165, 168; historic buildings reused as, 166; multi-use, 142, 143–144, 166, 490n176; naming of, 152, 158, 483n251, 486n69; NEA as architectural critic of, 165–166; nineteenth-century construction of, 140–145, 152; and Office of the Chief Architect, 168, 174; and Office of the Supervising Architect, 142–153, 476n115; outsourcing design of, 142, 143, 152; real estate occupied by, 153, 483n254; security in, 167; twentieth-century construction of, 142, 144–152; uniformity of, opposition to, 164, 165. *See also* custom houses; federal courthouses; General Services Administration; post offices

Federal Claims, U.S. Court of, 314–315, 570n118, 570n121

federal court(s), U.S.: administration of (*See* federal court administration); alternative dispute resolution in, 312; decline in number of trials in, 311, 311f; establishment of, 139–140; in establishment of national legal regime, 157; evidentiary hearings in, number of, 316–317, 317f; expansion of jurisdiction of, 141, 157; expansion of rights in, 157–158; long-range planning for, 171, 336, 494n44; number of filings in, 14, 141, 143, 149, 157, 158, 158f, 307, 307f, 313, 336; settlement rates in, 311; state procedural rules in, 140, 155, 474n91; television broadcast of, 294, 557n107; terrorist suspects tried in, 328

federal court administration (U.S.): development of internal apparatus of, 154–156, 162; by Interior Department, 140, 141, 476n116; by Justice Department, 141, 150, 154, 155; by Treasury Department, 140–141. *See also* Administrative Office (AO) of the United States Courts

federal courthouse(s), U.S.: air conditioning in, 156, 484n42, 485n44; alternative dispute resolution suites in, 174, 178, 312, 343, 569n84, 569n86; amount of space used by, 179, 498n169; art in, 182–192; awards for design of, 174; circulation routes in, 173–174; construction of (*See* federal courthouse construction); compared to court quarters in federal buildings, 156–157, 169; courtrooms within (*See* federal courtrooms); compared to French courthouses, 195; interior design of, cost of, 178; multiplication of uses of, 343; naming of, 152, 158, 248, 486n69; needed and unneeded space in, 176–177, 178; racial segregation in, 114; renting of, 174–180; segregation by roles in, 173–174; sharing of space in, 156, 169–170, 174,

178; space emergency in, 169–171, 181, 500n222; space utilization in, 180–181, 499n178; windows in, 159, 485n42, 486n73

federal courthouse construction (U.S.), 154–192; AO on need for, 156, 169, 170, 171; AO's role in, 162–163, 170–171, 493n21; architects for, selection of, 142, 478n148; budget for, 169, 171, 173, 492n5; Constitution on, 140; cost of, 172–173, 177–178, 179, 499n173; GSA Design Excellence Program for, 168; GSA's role in, problems with, 169–171; Guiding Principles for, 164–165, 168; JCUS design manual for, 156, 484n38; judicial leadership on need for, 169–171; lobbying for, 171, 178; long-range planning for, 171, 494n44; nineteenth-century, 141–142, 152; origins of, 14–15, 140–142; patronage in, 141–142; private and public design of, 142, 143, 152; real estate acquisition for, 156, 484n39; compared to renting, 174; resistance to paying for, 177–178; security in, 167, 173; twentieth-century, 15, 142, 152, 158–163, 169, 174, 175f, color plate 29. *See also* General Services Administration

federal courthouse design guides (U.S.). *See GSA Design Guides;* United States Courts Design Guide

federal courtrooms (U.S.): decline in use of, 310–311, 311f; *GSA Design Guides* on, 172; latent and actual use of, 181; layout of, 194, 312; non-trial uses of, 311; seats in, number of, 156, 172, 495n73; sharing of, 169–170, 174, 178, 180–181, 493n16; size of, 169, 170, 172, 194, 493n14, 495nn63–64, 508n17; *U.S. Courts Design Guide* on, 172–173; utilization of, studies of, 180–181, 311

Federal Design Improvement Program of NEA (U.S.), 165

Federal Equity Rules, U.S., 484n17, 556n83

federal judges, U.S.: administrative support for, 140; criticism of, 177; end of isolation of, 152, 154–155; "flying squadron" of, 154, 155; impeachment of, 127, 466n235; life tenure of, 127, 139; murder of, 494n42; need for additional, 178; number of, in 1800s, 141; number of, in 1900s, 149, 155, 158, 159f, 169; number of, in 2001, 315, 316f; oath of office for, 332; politics of selecting, 177; salaries of, 182; Senate confirmation of, 127; size of chambers of, 173, 495nn81–83; Taft's agenda for, 152, 154–155; trials per year, 311; workload of, measurement of, 178, 498n144

Federal Judicial Center (FJC) (U.S.): on courtroom utilization and sharing, 181, 500n230; establishment of, 156; functions of, 156, 484n31; Marshall Building headquarters of, 162

federal judiciary budget (U.S.): for courthouse construction, 169, 171, 173, 492n5;

compared to demand for services, 308; compared to federal workforce, 141; for rent, 176–180, 177f; size of, 176, 179, 497n129; summary of allocation of, 176–177, 176f, 177f

federal judiciary employees, U.S.: architects, 495n61; courthouse space needed for, 484n40; number of, in 1900s, 158, 486n64; number of, in 2000s, 158

*Federal Presence* (Lois Craig), 140, 165, 475n97

federal prisons, U.S., history of, 222–223

Federal Rules of Civil Procedure (U.S.), 155, 157, 312, 568n75

Federal Triangle, 478n148, 478n153

Federal Works Agency (U.S.), 156, 455n22, 483n251. *See also* Work Projects Administration

federated nations, judicial systems of, 225, 521n2

fees. *See* user fees

Feilden+Mawson LLP, 518n327

Feiner, Ed: as Chief Architect of GSA, 168; on excellence in design, 491n218; influence of, 168, 174, 491n215

Ferdinand VI, King of Spain, 439n193

Ferry, Jules, 206

Fiera, Battista: *De Iusticia Pingenda (On the Painting of Justice),* 91, 93–94, 96, 446n22; description of Mantua by, 94, 446n24; life of, 93. *See also* Mantegna, Andrea; Momus

Fierro, Annette, 341, 586n30, 587n50. *See also* glass

Fifth Amendment of U.S. Constitution, 290, 551n22

filings, number of: in regional and international courts, 282; international increase in, 193; in U.S. federal courts, 14, 141, 143, 149, 157, 158, 158f, 179, 307, 307f, 313, 336, 485n59; in U.S. state courts, 14, 137, 307, 308, 473n60

Filippine, Edward L., 486n78

financial interests of judges: as reason for disqualification and recusal, 128, 130, 467n246, 415n39. *See also Tumey v. Ohio*

Fine Arts Commission, U.S. *See* Commission on Fine Arts

Fine Arts in New Federal Buildings program (U.S.), GSA, 183

fines. *See* user fees

Finland: architectural critics on courthouses of, 220; courtroom layouts in, 194; public art funding in, 509n32. *See also* Helsinki

First Amendment of U.S. Constitution, 120, 293–294, 462n163, 474n72, 556n79, 560n209, 584n415

First Instance, Court of, of European Court of Justice, 229, 239, 281, 291, 549n628

First Judiciary Act. *See* Judiciary Act of 1789 (U.S.)

Fishkin, James S., 564n310

Flemish Gothic architectural style, 251

Flinck, Govaert, 57

Florence (Italy), Sienese rivalry with, 30

Flores, Leopoldo, 362–363, 596n380

Florida: bias task forces in, 133; court budgets in, 308, 566n24; public access to alternative dispute resolution data in, 321, 575n208; user fees in, 308

FOIA. *See* Freedom of Information Act

Foley, William E., 494n52

fools: judges as, 67, 69, 69f, 72, 431n81; Justice blindfolded by, 67–69, 68f

Fort-de-France (Martinique), Palais de Justice in, 197, 199f, 513n119

Fortitude (Virtue): and Amsterdam Town Hall, 50, 51, 422n161, 423n176; as Cardinal Virtue, 8, 17, 28, 32, 89, 98, 344–347, 345f, 383n26, 384n28, 386n40, 588n94, 558nn97–98; depictions of, 8, 10, 11f, 81, 84, 93, 98, 283, 347, 349, 374, 388n50, 390n69, 413n17, 437n169, 438n186, 443n287, 444n313, 589n137, 590n139; as Gift Virtue, 8, 384n28, 588n94, 588nn97–98; meaning of, 346. *See also* Virtues

fortune (Fortuna), 67, 70–71, 386n33, 398n72, 398n74, 430n64, 447n34; blindfold of, 67, 70, 71, 430n64

forum selection clauses, 319

Foucault, Michel: *Discipline and Punish,* 84, 127, 335, 391n78, 453n3; on fissures in law's authority, 117; and open courts, 374–377; on privatization of punishment, 14, 17; and South Africa, 356; on spectacles, 295, 335, 558n114; on surveillance, xv, 295, 298, 342–343, 356, 558n120

Four Daughters of God, 8–9, 384n29. *See also* Justice; Mercy; Peace; Truth; Virtues

Fourteenth Amendment of U.S. Constitution: and concept of fairness, 290, 552n25, 552n35; Due Process Clause of, 105, 290–291, 293; Equal Protection Clause of, 103, 131

Fox, Charles, 586n31

Fraade, Steven D., xvi, 428n27

France: admonitions against bribery in, 42, 47–48; Ancien Régime of, 196, 201, 510n54, 514n152; architectural styles of, 251; art in (*See* French public art); Brutus's story in, 58; conciliation courts in, 296; Conseil Constitutionnel of, 294, 509n42; Cour de cassation in, 510n42, 512n93; court administrators in, 507n12; courthouses of (*See* French courthouses); courthouse architecture, 194–207; due process in, 196; in European Court of Human Rights, 239; gifts to judges in, 39–40, 42, 47–48; glass in architecture of, 341, 586n30; history of, in public art, 203–204; judicial system of, 195; July Revolution (1830) in, 107; Marianne in, 107, 454n13; Saint Michael in, 24, 399n93, 400n94, 401n113; National Assembly of, 107; prisons of (*See* French prisons); separation of church and state in, 514n136; slave trade in, 521n12; Synagoga in, 65, 66f; trees in imagery of, 197, 200, 202, 351, 513nn134–135. *See also* specific cities and courts

Frankfurt-am-Main (Germany), "hear the other side" in, 551n9

Frankfurter, Felix: blindness metaphor used by, 102–103, 451n134; on "hear the other side," 290; in Holzer's Sacramento installation, 189, 505n372

Franklin, Benjamin, 427n14, 562n237, 581n351

Franklin, Julian, 390n62, 391n73

Fraser, Nancy, xvi, 288, 295, 299, 300, 391n88, 551n4, 564n306. *See also* Habermas, Jürgen; participatory parity; public spheres

Frazier, Bernard, 87–88, 88f

Frazier, Malcolm, 87, 88f

Frederick II, King of Denmark, 413n17

Frederick Barbarossa (Holy Roman Emperor), 80, 441n238

Freedom of Information Act (FOIA) (U.S.), 318, 333–334, 582n376

freedom of press. *See* press, freedom of

Freeman, Jody, 336, 567n56

Fremantle, Katharine, 48, 420n124, 420n132, 421n133, 421n145, 422nn157–159, 423n178, 423n181, 423n187, 424n202, 424n209, 424n218, 427n10

French, Daniel Chester, 461n140, 461n146, 488n126

French courthouses (Palais de Justice), 15, 195–208; AMOTMJ's role in, 197, 509n39, 512n93; architects of, selection of, 197; architectural critics on, 197, 208; architectural style of, 195, 197, 208; art in, 195, 200–204; in Avignon, 201; in Besançon, 200; in Bordeaux, 197, 201–202; compared to commercial buildings, 208; crucifix and images of crucifixion in, 204, 408n255, 409n255, 514n136; design guide for, 197; in Fort-de-France, 197; goals for, 195–197, 511n73; in Grenoble, 197; history of, 195–196; interior design of, 195–196, 200; judges' roles in, 196; legibility of, 196, 204, 208; location of, 197, 512nn99–100; long-term planning for, 195, 506n4; in Melun, 197; in Nantes, 195–208; need for additional, 195; office space in, 196, 200, 208; in Pontoise, 197; public and private space in, 208, 516n212; in Rennes, 197, 200; salles d'audience (courtrooms) of, 194, 197, 510n49; salles des pas perdus of, 197, 204, 205f, 511nn84–85; segregated spaces in, 195–196, 197, 200; compared to U.S. courthouses, 195

French Declaration of the Rights of Man and of the Citizen (1789), 203, 206, 298, 510n57, 514n158, 561n201

French Ministry of Justice: on Building Program, 195–200; and 1% decoratif, 200–204; on Holzer's Nantes installation, 205, 207; and Nantes Courthouse, 204–208; role in courthouse construction, 195–200

French prisons: budget for, 197, 198f, 512n94; construction of, 197, 224,

520n408; reused as courthouses, 200, 222, 512nn113–114; separate facilities for, origins of, 222

French public art, 200–204; French history in, 203–204; history of, 200; selection process for, 200; set-asides for (1% décoratif), 195, 200–204, 513n127; survey of, 200–204

French Republic, seal of, 454n13

French Revolution, 58, 204, 295, 341, 521n113, 591n214

French Second Empire architectural style, 137, 479n176

Freret, Will A., 145, 146f, 479n186

Freschi, Federico, 593n262

Friedlander, Suzan D., 455n32

Frieman, Ziva, 216

Friendship, 47, 389n54; dog as symbol of, 43, 79, 417n70, 433n114, 436n150; as reason for recusal, 128–130

Fuller, Lon, 322, 563n272

Fundamental Laws of West New Jersey (1676), 14, 293, 544n66

furnishings: in Finnish courthouses, 220; in French courthouses, 204–205; in Israeli Supreme Court, 213; in national courthouses, 194; in U.S. courthouses, 136, 141, 172, 485n47

Galanter, Marc, xvi, 309

Galle, Philip, 71–72, 71f, 434n128. *See also* Bruegel, Pieter

Gallegos, Salvador, 528n235

Galveston (Texas): Civil War in, 144, 479n174; U.S. Custom House in, 143–144, 143f

Galvez, Daniel, 189, 505n350

Gandhi, Mahatma: bust of, in Peace Palace, 253; imprisonment of, 352

Gandhi, Salil K., 502n260

Gandon, James, 86, 443n305, 444n306

GAO. *See* Government Accountability Office

Garapon, Antoine, xvi, 195, 196, 208, 516nn212–213

Garouste, Gérard: career of, 514n155; Lyon installation by, 202–203, 203f, 204f, 351, 513n118, 514n145, 514n164

Garth, Bryant, 308, 322

Gates, Robert, 328

Gaudin, Henri, 197, 200, 511n76, 513n117

Gdańsk Town Hall (Poland), 410n275, 415n27. *See also* town halls

Gellius, Aulus: on images of Justicia, 22; in Ripa's *Iconologia*, 22, 43, 70, 433n114

gender: intersection of race and, 132; of judges, 3f, 37, 107, 131–132, 262, 277, 295; of Justice, 15, 95, 99–101, 107–108, 112; of litigants, 15, 106–107, 131–132, 158, 295; and sexism, use of terms, 469n291; and sexuality of Virtues and Vices, 9, 80, 384n27, 386n35, 406n202; and war crimes, 276

gender bias: courts as source of, 132, 304; judicial education on, 132, 469n291; task forces on, 107, 132–133, 304

General Accounting Office (GAO), U.S. *See* Government Accountability Office

General Peace Convention (1843), 249

General Services Administration (GSA), U.S.: on Boston federal courthouse, 161; Center for Design Excellence and the Arts in, 184; congressional oversight of, 170, 478n152, 493n27; in cooperative use of federal buildings, 166; cost as primary concern of, 165; design guides by (*See GSA Design Guides*); establishment of, 478n151; in federal courthouse construction, 169; federal real estate overseen by, 153, 483n254; Fine Arts in New Federal Buildings program of, 183; functions of, 142, 478n151; on Grand Forks federal building, 158, 486n62; on Guiding Principles for Federal Architecture, 165, 168, 489n141; on Hirsch's "Mulatto" Justice mural, 112, 113; on Holzer's Sacramento installation, 189; on Kelly's Boston panels, 126, 464n210; mission statement of, 166; on Mitchell's Saint Croix sculpture, 121, 122; on Moore's (Diana) Concord Justice sculpture, 99, 101, 102; in naming of federal buildings, 483n251, 486n69; Office of the Chief Architect in, 168, 174; Office of the Supervising Architect in, 142, 476n115; Office of Management and Budget and, 180–181, 478n152, 497n128, 500n214; *An Oklahoma Tribute*, 184; origins of public art projects of, 463n180; on Otterness's Portland sculptures, 186–188; problems with service of, 169–171, 178, 182; rent calculation by, 179; rent paid to, 174–180; on St. Louis federal courthouse, 158, 159–160, 486n67; security as focus of, 167; selection criteria of, 167; on Simkhovich's Mississippi Justice mural, 113, 459n108; Standards for Federal Architecture of, 165. *See also* Art-in-Architecture Program; public art; Public Buildings Service; Supervising Architect, Office of the

General Services Administration (GSA) Design Awards: establishment of, 165, 168, 490n169; to Moore (Diana), 450n100, 490n169, 506n390; problems with, 191, 506n390

General Services Administration (GSA) Design Excellence Program: diversity as goal of, 168; establishment of, 167–168; excellence in design standard in, 168, 490n171, 491n218; mission of, 168; peer review in, 168; security in, 167; selection criteria of, 167, 168; selection process of, 168; success of, 168, 174

Genet, Jean-Philippe, 445n334

Geneva (Switzerland): admonitions against bribery in, 44–47; Calvinism in, 46; General Council of, 33, 46, 408n247, 418n88; independence of, 418n90; population of, 418n93

Geneva (Switzerland), Town Hall in: handless judges in, 44–47, 45f, 292; images of

Justice in, 46, 47f; images of pain in, 13. *See also* Giglio, César

Geneva Convention(s): adoption of, 272, 273; and Guantánamo Bay, 580n321; in International Criminal Tribunal for Rwanda, 546n490; in International Criminal Tribunal for the former Yugoslavia, 274; on prisoners of war, 580n321, 583n398

Genn, Hazel, xvi, 322, 323, 324, 565n14, 569n96, 576nn234–235, 577n241, 577n256, 578nn265–274

genocide: convention of 1948 on, 273, 544n431; definition of, 273, 544n431; in International Criminal Court, 276; in Kosovo, 274, 545n463

George, Prince of Denmark, 442nn266–267

George III, King of England, 292, 450n91

Georgia: 1777 Constitution of, 292, 299; race in death penalty in, 131–132, 468n285

Germany: handless judges in, 45–46; "hear the other side" in, 289, 551n9; Last Judgment images in, 35, 37; legal code of cities within, 67–69; legal system within, 300; public art funding in, 509n32; Synagoga in cities of, 65, 67; in U.N. Convention on the Law of the Sea, 265, 270, 543n391; women legal students in, 468n280. *See also specific cities*

Germany, Constitutional Court of: establishment of, 585n18; glass in design of, 340, 349; public access to, 294, 586n27

Gertner, Nancy, 452n148

*Gesta Romanorum,* 39, 413n19, 426n238

Geyh, Charles, 466n239

Gibson, James L., 591n187

Gibson Desert Nature Reserve (Australia), 370, 600n511

*Gideon v. Wainwright,* 131

gifts: in France, 39–40, 47–48; from judges, 40; to judges, 39–42, 47–48, 292; compared to user fees, 41. *See also* Davis, Natalie Zemon

Gift Virtues, 8–9, 12, 384n28, 385n30, 390n71. *See also* Fortitude; Knowledge; Piety; Prudence; Understanding; Wisdom; Virtues

Giglio, César, handless judges of, 44–47, 45f. *See also* Geneva (Switzerland), Town Hall in

Gilbert, Cass: in Commission on Fine Arts, 163; death of, 482n238; life of, 481n220; political views of, 151, 482n234; Supreme Court building designed by, 119, 149, 151, 151f, 152; Thurgood Marshall Courthouse designed by, 149, 150f, 157, 162; Weinman's friezes used by, 119, 461n146

Ginsburg, Ruth Bader, xvi: on accessibility of courts, 490n191; on litigants' access to courts, 130; on South African Constitutional Court building, 350

Giordano, Luca: Justice depicted by, 78–79, 78f, 360; life of, 78, 439nn211–212

Giotto: and Lorenzetti's frescoes, 28, 405n185, 405n189; Padua frescoes by, 28,

386n35, 386n38, 405n185; punishment in works of, 401n120; Synagoga depicted by, 429n52

Girardet, Alain, 508n12, 510n47, 511n78

Glaberson, William, 579n310, 581n346, 582n365, 583n391,

Glancey, Jonathan, 220, 519n355, 529n79

glass, 340–342; ballistic-resistant, 342; in European Court of Human Rights, 238; facades of, 342; in Finnish courthouses, 220; in French courthouses, 200; functions of, 220; in German Constitutional Court, 340, 349; as metaphor for democracy, 341; opaque, 342; in other types of architecture, 341; politics of, 341–342; prevalence in courthouse architecture, xv, 15, 220, 340, 341; in South African Constitutional Court, 350–351, 354; as symbol of access to courts, 340–341, 343; as symbol of transparency, xv, 15, 340, 341–342, 349; technological improvements in, 341, 342, 586n33

*Glassroth v. Moore,* 120, 462n160

Gluttony (Vice), 9. *See also* Vices

gods and goddesses. *See* deities

Goethe, Johann Wolfgang von, 95, 447n34

Goldberg, Arthur, 164, 489n139

Goldberger, Paul, 209, 215, 216, 496n111

*Goldberg v. Kelly,* 552nn34–35

Goldstein, Mark L., 498n171, 499n172

Gombrich, Ernst, 94, 408n253, 432n97, 446n25

Goodhue, Betram Grosvenor, 461n143, 481n221

Goodrich, Lloyd, 483n253

Goodsell, Charles T., 472n48

Goossens, Eymert-Jan, xvi, 48, 419n115, 420n121, 421n136, 421n145, 422n157, 424n213, 424n227

Gordon, Daniel, 561n219, 562n221

Gorky, Arshile, 455n33

Gortyn Code, 233

Gothic architectural style, 137, 143, 471n24, 483n248

Gouda (Netherlands): "hear the other side" in Town Hall of, 289, 289f, 331; St. Janskirk in, 388n51

Government Accountability Office (GAO), U.S.: change to name of, 179; on cost of courthouse construction, 492n5; on judicial task forces, 133; on rent costs, 179; on workload of federal judges, 498n144

Government Office Space, Ad Hoc Committee on, 164–165, 182–183, 463n180

*Government of Virgin Islands v. Charleswell,* 180, 500n207

Graham, Clare, 338, 471n28

Grand Forks (North Dakota), Post Office and Federal Courthouse in, 158, 159f

Grand Marais (Minnesota), Cook County Courthouse in, 372–373, 372f, 374f, 375f, 376, color plates 48, 49

*Grand Projets,* of George Mitterrand, 341, 586n30

Grass, Roger, 524n101

Graz Town Hall (Austria), Last Judgment in, 35, 36f, 410n275, color plate 12. *See also* town halls

Great Britain. *See* Britain

Great Seal of the United States, 328, 427n14, 581n351

Great Victoria Desert (Australia), 367–372, 367f

Greece, ancient: concept of justice in, 22, 398n70; goddesses of, 21–22; "hear the other side" in, 291; images of Virtues in, 384n30; and Saint Michael, 23; in origins of Justice iconography, 21–22; role of courts in, 402n126

Greed (Vice), 9. *See also* Vices

Greek Revival architectural style, 137

green buildings: European Court of Human Rights as, 238; French courthouses as, 509n36; national courthouses (U.S.) as, 194; South African Constitutional Court as, 355

Greene, Frank, 587n54, 587n61

Greenhouse, Linda, xvi, 490n193, 592n191

*Green Tree Financial Corporation–Alabama v. Randolph,* 573n179

*Green Tree Financial Corporation v. Bazzle,* 573n177

Gregory I, Pope, 346, 588n97

Grenoble (France), Palais de Justice in, 197

Groebner, Valentin, 419n111

Groenhuis, G., 421n142

Grooms, Thomas, xvi, 174

Grotius, Hugo, *The Law of War and Peace,* 272

GSA. *See* General Services Administration

*GSA Design Guides,* 169–172; 1979 edition of, 169, 170, 171–172, 493n16, 494n52; 1984 edition of, 171–172, 494n52; relationship to U.S. Courts Design Guide, 171–174; security in, 167

Guantánamo Bay, 327–334; administrative review process at, 328, 333, 580nn323–325; and alternative dispute resolution, 335; and Associated Press efforts to access information, 333–334, 582n376; classification of detainees at, 327–328, 580nn321–325; closure of, debate over, 328; connotations of, 327, 579n310; court facilities at, 328, 329f, 330f, 331f; in decline of adjudication, 16; detention facilities at, 328, 329f; establishment of, 16; Geneva Conventions and, 580n321; history of naval base at, 327, 579n308; "Honor Bound to Defend Freedom" at, 331, 581n353; identification of detainees at, 582n386; Joint Task Force building at, 328, 330f, 331, 331f; judicial independence at, 332, 334, 335, 582n360; legality of detention at, 327; logo of, 328–331, 330f; Military Commissions at, 328, 333, 335; number of detainees at, 327, 579n311; oath taken by officials at, 331–332, 581n358; opposition to, 334, 335, 379n1, 579n311; press coverage of, 333–334, 379n1, 582n363, 582n376, 582n382; problems with procedures at,

Guantánamo Bay (continued)
334; public access to, 333–334, 335,
582n363; secrecy at, 333–334, 335; trans-
fer of detainees out of, 579n311; treatment
of detainees at, 327, 334; tribunals at, 16,
379n1; U.S. Supreme Court on, 327, 334,
379n1, 580n318. See also Combatant
Status Review Tribunal

Guiding Principles for Federal Architecture
(1962 report) (U.S.), 164–165, 168,
463n180; influence of Cold War on, 166.
See also General Services Administration;
Moynihan, Daniel Patrick

guild-halls. See town halls

Gulfport (Mississippi), Dan M. Russell Jr.
Federal Building and Courthouse in, 145

Haarlem Town Hall, 75, 410n275, 437n164

Haas, Richard, 460n126

habeas corpus: in U.S. federal courts, 141; at
Guantánamo Bay, 334; world, 273

Habermas, Jürgen: Between Facts and Norms,
563n254; on press, 300, 563n262; on pub-
lic sphere, xv, 191, 295, 300, 563n248

Hachlili, Rachel, 393n18

Hacking, Ian, 447n42

Hadrian, Emperor of Rome, 70, 434n114

Hague, The (Netherlands): Alexanderkaz-
erne in, 280; International Criminal
Tribunal for Rwanda in, 546n506,
546n515; International Criminal Tribunal
for the former Yugoslavia in, 273. See
also International Criminal Court;
Peace Palace; Permanent Court of Arbi-
tration; Permanent Court of International
Justice

Hague Academy of International Law, 259,
263, 264

Hague Peace Conferences of 1899 and 1907,
249, 257

Hale, Matthew, 127, 465n225

Hall, Marcia, 409n270, 410n274

Halleck, Fitz-Greene, Fanny, 5, 381n16

Hambourg, André, 234–235, 234f, 525n123,
color plate 36

Hamburg (Germany): history of, 265–266,
540n289, 540n301; Last Judgment in
courtrooms of, 35, 410n289; role in Inter-
national Tribunal for the Law of the Sea,
265–267, 270. See also International Tri-
bunal for the Law of the Sea

Hammurabi, King of Babylonia, 18, 392n7

Hammurabi, Code of: in Holzer's Nantes
installation, 205; in Iraqi Special Tribunal
logo, 287; Shamash in, 18; stele of, 18, 22,
392–393n7–8. See also Babylonia;
Mesopotamia

Hampshire, Stuart, 336, 551n16

handless judges, 44–47, 45f, 292; see also Les
Juges aux mains coupées

Hanfmann, George M. A., 397n61

Hanoteau, Claude, 512n103, 513n115

Harbison, Craig, 410n295, 411n298

Hardenbergh, Don, 496n95, 507n9, 508n19,
569n85, 587n60, 605

Harding, Warren G., 150, 260

Harff, Arnold von, 442n257

Harlan, John Marshall, 95, 102, 447n35

Harlem Renaissance, 451n138

Harman, Jack, 88f, 89, 445n330

Harrison, Jane Ellen, 397nn64–65

Harrison, Susan, xvi, 183, 189, 407n229,
407n232, 450n101, 457n68, 463n173,
502n264, 503n298, 505n360

HASSELL (architectural firm), 217, 218f,
219f

Hatfield, Mark O., 504n317

Haviland, John, 223

hearing officers, 16, 315, 316f, 317–318. See
also ad litem judges; administrative law
judges; judges

hearings. See evidentiary hearings

hearsay evidence, 104, 452n156

"hear the other side" (audi et alteram
partem), 289–292; in Amsterdam Town
Hall, 53, 62, 289; in English law, 290, 291;
evolution of meaning of, 289–292; com-
pared to "Honor Bound to Defend Free-
dom," 331; in Illinois Supreme Court, 291,
291f, 331; in international courts, 291;
origins of concept, 14, 289, 551n7, 551n9;
public access and, 294; relationship to
due process, 14, 290–291; in Renaissance
town halls, 14, 289, 291; in U.S. law,
290–291; U.S. Supreme Court on, 290,
552n35

Heckscher, August: The Arts and the
National Government, 165; life of,
489n160

Held, Julius, 440nn220–221

Hellmuth, Obata + Kassbaum, 576n226,
586n29

Helsinki (Finland), District Court in, 220,
220f, 221f, 312

Henkin, Louis, 236, 525n141

Henry VII, King of England, 83

Hensler, Deborah R., xvii, 565n14, 574n198

Hercules (mythic figure), 398n76

Herkinbald, Judgment of, 58–61, 426n261

Herlihy, David, 408n241

Hermes (god), 24, 202. See also deities,
Greek

Herodotus, Historiae, 38, 39

Herr, Jean, 229f, 523n70

Hertel, Johann George, 399n77

Hesiod, 397n61

Hierglyphica (Horapollo), 77, 416n60,
439nn200–201, 440n217

Higginbotham, Patrick E., 568n66

Higgins, Rosalyn, 262, 538n226, 541n329,
542n339, 542n341

High Renaissance Dutch architectural style,
251

Hirsch, Stefan: life of, 112, 458n72;
"Mulatto" Justice mural by, 15, 110–113,
111f, 190, color plate 19

Historiae (Herodotus), 38, 39

Historical Society of the Courts of New York,
137

historic preservation of courts, 166–168

Hitchcock, Alfred, 342

Hodgins, Robert, 355

Hogarth, William, 85, 443n292

Holbein, Hans, 42, 43, 425n228

Holbein, Hans, the Younger, 426n239

Holmes, Oliver Wendell, 453n168, 473n71

Holy Roman Empire, 46

Holy Trinity, 72. See also Damhoudere, Joost
de; Last Judgment

Holzer, Jenny, xvii; aphorisms of, 185,
189–190; on Art-in-Architecture admin-
istration, 183; career of, 184–185,
503n298; Nantes installation by, 185,
204–207, 206f, 513n128, color plate 31;
radicalism of, 185, 503n315; Sacramento
installation by, 184, 189–190, 190f, 344

Homer: blindness and, 65, 428n37; Iliad, 21,
25, 65, 396n48; Odyssey, 65

"Honor Bound to Defend Freedom," at
Guantánamo Bay, 331, 581n353

Hoover, Herbert, and Permanent Court of
International Justice, 260

Hope, as Theological Virtue, 8, 384n27. See
also Virtues

Horapollo, Hierglyphica, 77, 416n60,
439nn200–201, 440n217

Horn, Milton, 109

Hornby, Brock, xvii, 313, 323, 569n98

Hornung, Erik, 396n50

Horus, eye of, 427n11

House of Representatives, U.S.: Committee
on Public Buildings and Grounds of, 174;
Committee on Transportation and Infra-
structure of, 176, 478n152

Houser, R. Edward, 383n26

Howard, John, 222

Hudson, A. B., 445n325

Hudson, Manley O., 535n119, 536–
537nn172–174

Hughes, Charles Evans: appointment as
Chief Justice, 384n22; on Permanent
Court of International Justice, 535n137,
537n180; on Weinman's friezes for
Supreme Court, 461nn151–152

Hughes, Langston, 103–104; on blindfold,
14, 91, 95, 103–104, 103f; on blindness,
14, 95; in Harlem Renaissance, 451n138;
Justice (poem), 103, 451n135; and
National Bar Association, 103–104, 103f;
Scottsboro Limited, 103, 451n135

Hugo, Victor, 206, 249

Huidobro, Borja, 199f, 512n110

humanity, crimes against. See crimes against
humanity

human law, compared to divine law, 22, 30,
33–37, 72–76, 93–94

human rights, 235–246; challenge of defin-
ing violations of, 238; and sovereignty,
242–243; after World Wars I and II, 236,
239–240. See also European Convention
on Human Rights (ECHR); European
Court of Human Rights (ECtHR); Inter-
American Convention on Human Rights;
Inter-American Court of Human Rights

Human Rights Act of 1998 (UK), 239, 325

human rights commissions. *See* European Commission on Human Rights; Inter-American Commission on Human Rights

human rights conventions. *See* European Convention on Human Rights; Inter-American Convention on Human Rights

human rights courts. *See* European Court of Human Rights; Inter-American Court of Human Rights

human rights declarations, legal effects of, 242, 243. *See also specific declarations*

Human Rights Watch, 207, 275

Hume, David, 299, 561n219

humility, blindfold as symbol of, 71, 434n124

Humility (Virtue), 8, 385n30. *See also* Virtues

Humphrey, Herman Leon, 497n117

Humphrey, Hubert, 189–190

Hunt, Haroldson Lafayette, 382n19

Huron (South Dakota), public art in, 183

Hussein, Saddam: broadcast of the execution of, 302; mural of, 1–5, 6f, 84, 381nn12–13

Huyberechts, Gilbert, 229f, 523n70

hybridization, of courts, 336

*Hypnerotomachia Poliphili* (Colonna), 416n60

IACHR. *See* Inter-American Commission on Human Rights

IACtHR. *See* Inter-American Court of Human Rights

IBA. *See* International Bar Association

*Iberia Credit Bureau, Inc., v. Cingular Wireless,* 574n193

ICC. *See* International Criminal Court

Iceland, Supreme Court of, 340, 585n23

ICJ. *See* International Court of Justice

iconography: of democratic adjudication, 338, 340, 344–378; French traditions of, 195–207; of Justice (*See* Justice, attributes and symbols of); in Peace Palace, 253–255, 262–263. *See also* Alciatus, Andreas; Ripa, Cesare

*Iconologia* (Ripa): Alciatus as source for, 70, 434n119; Amsterdam Town Hall influenced by, 49, 56, 63, 421n141; animals in, 79; birds in, 79, 440n217; blindfold in, 63, 67, 70, 75, 95, 96, 427n9, 428n16; on blindness, 70; Cambyses in, 39, 413n21; codification of visual imagery in, 69–70; cornucopia in, 84, 442n271; corruption in, 43; diversity of Justices in, 91, 94, 95; diversity of Virtues in, 589n133; Divine Justice (Giustitia Divina) in, 70, 79, 434n114; Dutch edition of (1644), 70, 427n9, 434n114; editions of, 12, 388n52, 416n59, 417n70, 433n103; English edition of (Richardson, 1779), 69–70, 414n163, 416n59, 417n70, 433n103, 434n114, 439n196, 589n133; even-handedness in, 43–44; French edition (Baudoin, 1644) of, 434n114; Hertel-Maser edition (1758–1760) of, 433n111, 434n114, 589n133; illustrations added to, 70, 432n103; Justice according to Aulus Gellius in, 22, 43, 70, 433n114; Justice of

Pausanias in the Eliaci (Giustitia di Pausania ne gl'Eliaci) in, 70, 433n114; Justice on the medals of Hadrian, Antoninus Pius, and Alexander (Giustitia delle Medaglie d'Adriano, d'Antonio Pio, & d'Alessandro) in, 70, 433n114; lictor rods in, 398n77; ostrich in, 77, 439n196, 453n170; Padua edition (1611) of, 70, 89, 439n196; Padua edition (1618) of, 434n114; Phrygian cap in, 454n18; publication of, 388n52; Reynolds influenced by, 98; Rigorous Justice (Giustitia Rigorosa) in, 70, 433n114; Rome edition (1593) of, 416n59, 432n103; Strict Justice (Giustitia Retta) in, 43, 70, 79, 433n114; Temperance in, 388n49

iconophobia, 95

ICSID. *See* International Centre for Settlement of Investment Disputes

ICTR. *See* International Criminal Tribunal for Rwanda

ICTY. *See* International Criminal Tribunal for the former Yugoslavia

Idaho courthouses: depictions of Native Americans in, 116–117. *See also* Boise

identity politics: French symbol Marianne as exemplar of, 107; in Justice iconography, 108–126; in legal profession, 107

Idolatry (Vice), 9. *See also* Vices

Ignorance (Vice): blindfold associated with, 70, 95; as Vice, 70, 79, 433n106. *See also* knowledge; veil of ignorance; Vices

*Iliad* (Homer), 21, 25, 65, 396n48

Ilkar, Hélène, 201, 514n153

Illinois, Supreme Court of, 291, 291f, 331. *See also* Chicago

illuminated manuscripts, 403n147

Immigration and Naturalization Service, U.S., 317, 317f, 318, 572n152

immigration judges and tribunals, U.S., 181, 317, 318, 324, 572n152, 572n155, 573n158

immunity of judges, 127; in relationship to subservience, 38–47

impartiality: blindfold as symbol of, 62, 95; blindness of, 103; of jurors, 104

impartiality of judges: appearance of, 127–128; reasons for questioning, 128–130; task forces on problems with, 107, 132–133, 304. *See also* Canons of Judicial Ethics; judges

impeachment of judges 127, 466n235. *See also* judges

implicit bias, 453n163

incarceration. *See* prison(s)

Inconstancy (Vice), 9

*Index Emblematicus* (Alciatus): codification of visual imagery in, 69–70; editions of, 12, 388n52, 416n59; publication of, 388n52

indigenous rights: in Australia, 367–372; to land, 367–372; rise of international recognition of, 368; United Nations on, 368, 599n458

Inès de la Cruz, 201

*Inferno* (Dante), 30, 363

Infidelity (Vice), 9. *See also* Vices

information: freedom of, 294; probative value of, 104. *See also* Bentham, Jeremy; publicity

information officers, public, 294, 341. *See also* administrators; court

injustice (Vice): blindness of, 70; on display in Mexican Supreme Court, 350, 365; on display in South African Constitutional Court, 350, 356. *See also* Vices

Inns of Courts (England), 86

Inquisition, 35, 293, 410n278, 519n374

Inter-American Commission on Human Rights (IACHR): authority of, 243; budget of, 281, 281f; caseload of, 281, 282f; challenges faced by, 243; establishment of, 243, 529n262; and European Commission on Human Rights, 243–246; judicial selection for, 259; on Mexican police brutality, 366; mission of, 243, 529n267; on United States, 529n274

Inter-American Court of Human Rights (IACtHR), 239–246; authority of, 244, 246; budget of, 226, 240, 243, 245–246, 281, 281f, 530n320; caseload of, 245, 281, 282f; establishment of, 226, 239–240, 243, 246; and European Court of Human Rights, 243–246; "hear the other side" in, 291; impact of, 245; as international court, 240, 244; judges serving in, 243, 245, 529n272; jurisdiction of, 244; number of filings in, 245–246; staff of, 245

Inter-American Court of Human Rights (IACtHR) building, 240f, 246, 528n227, 529n275; courtrooms of, 245, 245f

Inter-American Development Bank, 245

Inter-American Juridical Committee, 242

Interior Department, U.S., federal court administration under, 140, 141, 476n116

international arbitration, in England, 324–325

International architectural style, 165, 359

International Bar Association (IBA), 321–322, 325, 356, 576n227

International Centre for Settlement of Investment Disputes (ICSID), 256, 257

International Council for Commercial Arbitration, 256

international court(s), 225–287; authority of, 247, 255, 256; budgets of, 281, 281f; caseloads of, 281–282, 282f; contentious cases in, 260; criminal (*See* criminal courts and tribunals); "hear the other side" in, 291; history of, 225–226; judicial selection in, 259; jurisdiction of, 247; languages used by, 294; logos of, 282–287; mixed courts as, 225–226; nationality of judges in, 257–259, 261–262, 273; politics of, 255–256; public access to, 334; staff of, 273; use of term, 247–248, 255–256. *See also specific courts*

international courthouses: architectural styles of, 247, 251; competitions for design of, 249–250; construction of, 226, 250; host countries' involvement in, 250. *See also specific buildings*

International Court of Justice (ICJ), 261–
265; authority of, 255; budget of, 264,
281, 281f, 539n248; caseload of, 255, 260,
264–265, 281, 282f, 539nn271–272; com-
pliance with rulings of, 264; enforcement
of rulings of, 261; establishment of, 247,
255, 261, 537n202; facilities of, 262–263,
262f; "hear the other side" in, 291; impact
of, 264–265; and International Tribunal
for the Law of the Sea, 268–269; judicial
selection for, 261–262, 268–269,
538nn218–219; jurisdiction of, 261, 268;
law of, 261, 264; logo of, 284–285, 284f;
maritime disputes in, 268, 269, 542n341;
membership of, 261; mission of, 261;
Nicaragua case in, 261, 264, 538n216;
number of filings in, 260, 264–265; rent
paid by, 264; staff of, 262, 538n227; as
successor to PCIJ, 247, 261
International Covenant on Civil and Political
Rights (1966), 14, 294
International Criminal Court (ICC),
275–281; Assembly of States Parties of,
277–278, 279; authority of, 276–277, 279;
budget of, 279, 280, 281, 281f; housing
for, 277, 278f, 279–281; caseload of, 279,
282; establishment of, 15, 276, 277;
impact of, 279; Inter-Organ Committee
on the Permanent Premises of, 279; inves-
tigations of, 278–279; Israel in, 547n549;
jail space of, 277; judges serving in,
277–278; jurisdiction of, 15, 272, 276,
279; languages used in, 277; logo of, 285,
286f; mission of, 272; need for, 272–273,
275–276; Pre-Trial Chambers of, 276;
public access to, 294; Rome Statute of,
275–277, 279; staff of, 276, 279; Trust
Fund for Victims in, 277; U.S. participa-
tion in, 260, 276, 277; women lawyers,
judges, and victims in, 276, 277
International Criminal Tribunal for Rwanda
(ICTR), 275; budget of, 274, 275, 281,
281f, 546n489; caseload of, 275, 282, 282f;
establishment of, 275; and International
Criminal Court, 276; judges serving in,
275; jurisdiction of, 275, 546n490; lan-
guages used in, 275; logo of, 285, 286f,
550n653; mission of, 275; staff of, 275
International Criminal Tribunal for the
former Yugoslavia (ICTY), 273–275,
539n275; budget of, 274, 281, 281f; build-
ing housing, 273; caseload of, 274, 282,
282f; courtroom layout of, 274; dissolu-
tion of, 274; establishment of, 273; impact
of, 274–275; and International Criminal
Court, 276; judges serving in, 273; juris-
diction of, 273, 274; languages used in,
274, 545n462; logo of, 285, 285f, 550n652;
mission of, 273, 274; public access to, 334;
security in, 274; staff of, 273–274; televi-
sion broadcast of, 294, 334, 557n105
international law: codification of, 275; on
crimes against humanity, 273; Hague
Academy of, 259; history of development
of, 255–256, 273; in international courts,

255–256; meanings of, 255; in Permanent
Court of International Justice, 260–261;
South African Constitution on, 591n172;
after World War II, 273
International Law Association, 249, 532n10
International Law Commission (ILC), 267,
273, 275–276
International League of Peace and Freedom,
249
International Military Tribunal, 273
International Military Tribune for the Far
East (Tokyo Tribunal), 273
International Seabed Authority, 266,
541n333
International Tribunal for the Law of the Sea
(ITLOS), 265–272; authority of, 268;
budget of, 269, 270, 281, 281f; caseload of,
17, 268, 271, 281–282, 282f; cost of using,
269; establishment of, 265–268; impact of,
271–272; and International Court of Jus-
tice, 268–269; and International Criminal
Court, 276; judicial selection for, 268–269;
jurisdiction of, 267, 268; logo of, 285,
285f; Mox Plant case in, 272f, 543n399,
543n416; and Native National Title Tribu-
nal, 368; need for, 267, 268; procedural
framework of, 268–269; release proceed-
ings of, 268, 541n336; Saiga Case in,
540n308; Seabed Disputes Chamber of,
269; special chambers of, 269
International Tribunal for the Law of the
Sea (ITLOS) building: art in, 271; budget
for, 269, 270; competition for design of,
269–270, 543n392; construction of, 270;
design of, 266f, 269–271, 271f, 272f, 312;
selection of site for, 265–267
International Union of Architects, 194
internet: court opinions published via, 314;
public access to courts through, 294
Inter-Organ Committee on the Permanent
Premises, of International Criminal
Court, 279
investment pricing policy, 179–180
Iran: Code of Hammurabi in, 18, 392n7;
hostage crisis in, 256, 535n127; Khuzes-
tan province of, 392n7
Iran–United States Claims Tribunal, 257,
258f, 535n127. See also Permanent Court
of Arbitration
Iraq: Abu Ghraib prison in, 334; Hussein's
execution in, 302; Hussein's mural in,
1–5, 6f, 84, 381nn12–13; U.S.-led war in
(2003–), 1, 278
Iraqi High Criminal Court, 287
Iraqi Special Tribunal: history of, 287; Provi-
sional Seal of, 286–287, 287f
Iredell, James, 451n128
Ireland: English and Irish law in, 86; Euro-
pean Convention Human Rights Act of
2003, 239; Inns of Courts in, 86; in Inter-
national Tribunal for the Law of the Sea,
272f, 543n399, 543n416; Saint Michael in,
24, 400n97; seat of authority in, 86–87.
See also Dublin
Isaac (biblical figure), 65

Isaiah (biblical figure), 65
Isaiah, Book of, 44, 384n28, 428n20, 434n124
Isis and Osiris (Plutarch), 447n39
Islam: images of Muhammad in, 119,
120–121; law of, 264; stereotypes about,
120
isolation, in prisons, 222–224
Israel: architectural styles in, 209; in Inter-
national Criminal Court, 547n549; judi-
cial system of, 209; Knesset of, 208, 210,
214, 516n219; Netherlands as new, 49,
421nn142–143; number and type of
judges in, 208; population of, 208,
516n224; prisons in, 520n407; Venice as
new, 441n237; women in legal profession
in, 468n280; zodiac mosaics in, 19,
394n20. See also Jerusalem
Israeli Supreme Court: decisions by, 215;
judges of, 210, 213, 216; jurisdiction of,
213, 517n279, 518n308; number of filings
in, 213, 517n280; on private prisons,
520n407
Israeli Supreme Court building, 208–216;
architectural critics on, 215–216; compe-
tition for design of, 208, 209, 516nn221–
222; construction of, 15; courtroom lay-
out in, 194, 213, 213f, 216, 517n284;
Courtyard of the Arches in, 211–213,
212f; exterior design of, 208, 209f,
210–213, 211f; funding for, 208, 213,
516n219; goals for, 208–210, 585n16;
interior design of, 210, 211, 212f,
213–216, 213f; Jewish Heritage Museum
in, 215; Karmi-Melamade and Karmi as
architects of, 208–216; location of, 208,
516n219; mosaics in, 213–214, 214f,
518n293; security at, 209, 210, 216; The
Symbols in, 213–215, 214f, 215f
Italianate architectural style, 137, 419n116,
444n316
Italian Renaissance. See Renaissance
Italy: civic spaces in, rise of, 25–29,
403n137; in European Court of Human
Rights, 239; Saint Michael in, 24, .399n93;
prisons in, history of, 519n374; public
art funding in, 509n32. See also Florence;
Padua; Ravenna; Rome; Siena; Torcello
ITLOS. See International Tribunal for the
Law of the Sea
ius, translations of, 22, 398n71
Iustitia (goddess/virtue): modern depictions
of, 1, 2f; in origins of Justice iconography,
21. See also Virtues

Jackson (Mississippi): James O. Eastland U.S.
Courthouse in, Simkhovich's Justice
mural in, 15, 113–116, 114f, 115f, 359,
459n102, color plate 20; race relations in,
113–116, 138, 460n120
Jackson, Vicki C., xvii, 544n446, 554n63
Jacobs, Jane, Death and Life of Great Ameri-
can Cities, 489n143
Jacob, Robert, xvii, 195, 196, 409n255,
419n114, 432n90, 448n50, 508n20,
510n56, 511n62, 513nn134–135

jails. *See* prison(s)

Jamagne, François, 228, 228f

JAMS. *See* Judicial Arbitration Mediation Services

Janus, 73–74, 436n156

Japan, Supreme Court of, 1, 5f, 380n11

Jay, Martin, 432n99, 434n127, 436n149, 448n49, 449n90

Jay Treaty, 225

Jefferson, Thomas, 137, 140, 472n42

Jerusalem: architectural styles in, 209, 211; Roman cardo of, 210. *See also* Israeli Supreme Court building

Jervais, Thomas, 98, 450n92

Jessup, Philip, 261

Jesus: Ascension of, 81, 441n247; Saint Michael in images of, 23–25, 24f; in Nicene Creed, 24, 400n99; Second Coming of, 25, 401n118. *See also* Last Judgment

Jewish calendar, 19, 393n18

*Job, Book of:* blindness in, 65, 428n18; scales of justice in, 21, 24, 396n45

Johannesburg (South Africa), Old Fort Prison in, 352. *See also* South African Constitutional Court

John, Richard R., 562n228, 562n241

Johnson, Earl, 565n2

Johnson, Ford T., Jr., 138–139

Johnson, Lyndon B., and National Endowment for Arts 165, 489n159

Joint Task Force (JTF), at Guantánamo Bay, 328, 330f, 331, 331f

Joost-Gaugier, Christiane L., 387n46, 438nn176–179, 438n182, 438n184

Jourda, Françoise, 197, 199f, 512n112

JRent database, 179

Judaism: calendar of, 19, 393n18; Synagoga used as symbol of, 65–67; synagogues, zodiac mosaics in, 19, 394n20

judge(s): accountability of, 95, 127–128, 273, 298, 327, 337, 366; in alternative dispute resolution, role of, 310, 311–313; alternative dispute resolution promoted by, 308, 309, 320; appearance of impartiality of, 127–128, 466n239; appearance of impropriety of, 128; appointment of, 41, 127; architecture in power of, 17; Bentham on publicity for, 14, 17, 297–299; bribery (*See* bribery, admonitions against); and codes of judicial conduct, 127–128, 466–467nn239–242; complaints against, 128, 467n244; conduct codes of, 127–128, 466–467nn239–242; in courthouse architecture, 136; critiques of courts by, 309; disqualification of, 128–130, 467n246; election of, 41, 127, 415n41; ethics for, codes of, 127–128, 466n239; evolution of role of, xv, 292–293, 326–327; as fools, 67, 69f; gifts from, 40; gifts to, 39–42, 47–48, 292; "hear the other side" concept for, 289–292; immunity of, 127; impartiality of (*See* impartiality); impeachment of, 127, 466n235; independence of (*See* independence); international, 261; judging of

(*See* judging of judges); legitimacy of power of, 12–13, 336–337, 390n73; life tenure for, establishment of, 13, 97, 127, 139, 391n80; in national courthouse construction, 193; nationality of (*See* nationality); obedience of, 38–48; pain caused by and to, 13, 55–61; performance reviews of, 128, 298; prudence in, 346; public assessment of, 14, 127, 128; punishment of, threat of, 38–39; removal from cases, 128, 467n246 (*See also* recusal); Renaissance, 12–13; secularization of, 37; as servants of rulers, 13, 47–48, 96, 292. *See also* bribery, admonitions against; judicial disqualification; judicial ethics

Judge & Co., 17, 296, 326. *See* Bentham, Jeremy

judging of judges, 127–133; Last Judgment in, 36–37; performance evaluations in, 128, 298; by the public, 14, 127, 128, 302

judgment: after death (*See* Last Judgment); and impartiality, 95–98; knowledge and, 97–98, 298; senses in, 97–98; sight and, 65, 95–96, 97. *See also* Diderot, Denis; Rawls, John

judicatories, 38, 296, 411n1. *See also* Bentham, Jeremy

Judicial Arbitration Mediation Services (JAMS), 312, 320, 569n89, 574n192

Judicial Conference of the United States (JCUS): annual reports of, 176; and Administrative Office, 155, 156; courthouse design manual by, 156, 484n38; on courtroom size and sharing, 169, 174, 178, 180–181, 493n14, 493n16; establishment of, 155; on goals for facilities, 182; on judicial outsourcing, 501n255; membership of, 155–156; mission of, 156; on naming of federal buildings, 486n69; on need for court quarters, 156–157, 169, 485n47; on rent costs, 176–180; role in courthouse construction, 162–163, 172, 173; on security issues, 173, 491n198, 491n200, 494n42; on unpublished opinions, 314. *See also* GSA Design Guides; *U.S. Court's Design Guide*

Judicial Conference of the United States (JCUS) Committees: on Air Conditioning, 156; on the Budget, 498n142; on Court Room Facilities and Design, 169; on Postwar Building Plans for the Quarters of the United States Courts, 156; and security, 156, 173, 483n251, 491n200; on Space and Facilities, 171, 173, 494n42

judicial disqualification. *See* disqualification of judges

Judicial Dollar (U.S.), 176–177, 176f, 177f

judicial education. *See* education, judicial

judicial ethics, 127–130

judicial independence: Bentham's publicity and, 298; blindfold associated with, 97, 448n58; in complexity of adjudication, 288–289; contemporary threats to, 339; in England, 42, 97, 127, 292, 325; in English

Act of Settlement (1701), 42, 97, 127, 292; relationship to funding and budget, 176–181, 245, 322; at Guantánamo Bay, 332, 334, 335, 582n360; in Mexico, 357, 359, 362, 365–366; origins and rise of, 13, 14–16, 96–97, 292–293; in Permanent Court of International Justice, 259; political culture and, 293; public access and, 294; in South Africa, 350, 356; subservience to rulers and, 47–48; in U.S. state and federal constitutions, 13, 97, 292, 293. *See also* separation of powers

judicial review: by European Court of Justice, 227; by Mexican Supreme Court, 366; U.S. Supreme Court on, 102

Judicial salaries, 308–309, 566n30

Judicial subservience, 13, 38–48, 96, 292; bribery and, 39–48; in Cambyses story, 38–39; gifts and, 39–42, 47–48; handless judges and, 44–47; in Renaissance, 13; to rulers, 47–48, 292. *See also* judicial independence

Judicial Watch, 128

Judiciary Acts (U.S.): of 1789, 139, 476n120; of 1793, 474n80

Judith (biblical figure), 25

Julius II, Pope, 75, 76, 387n46, 438n182, 438n184

Juncker, Jean-Claude, 523n36

Junius, Franciscus, 422n173

juror(s): design of jury boxes for, 172, 495n72; location of, in courtrooms, 137; ostrich charge in instructions to, 79, 105, 453n172

juror selection: impartiality in, 104; racial discrimination in, 103, 451n134; U.S. Constitution on, 104, 452n159

jury trial, 79, 104–105, 137, 140–141, 185, 315, 353, 372, 393n13, 402n126, 452n158, 554n66, 555n74, 556n74, 556n77, 567n60, 571n131, 601n536; origins of right to, 293; publicity and, 293, 299–304

*jus cogens*, 255, 529n274

*Jussila v. Finland*, 553n45

Justice as Cardinal Virtue, 8, 22–25, 344–347, 345f, 383n26, 386n40; in battle (psychomachia), 385n30; canonical elements of, creation of, 94–95; folktales of, 96, 448n53; in Four Daughters of God, 8, 384n29; in hierarchy of Virtues, 12, 76, 389n53. *See also* Virtues

Justice, personifications, representations, and attributes of: animals associated with, 9, 75–79, 94–95, 185–186, 200, 346–349, 385n30, 433n114, 439n196; in Australia, 1, 2f; from Babylonia, 18–20; in civic spaces, 25–37; conflicts over, 108–125; from Egypt, 18, 20–21; equal access and, 15; in Europe, 1, 3f, 4f; gender of, 95; from Greek and Roman goddesses, 21–22; handless, 46; in Japan, 1, 5f; in media, 1–5; in North America, 1, 2f; compared to other Virtues, 8–12; in pop culture, 5–8; public dismay with, 106; reasons for rise of, 12; and St. Michael, 22–25; ubiquity of,

Justice (*continued*)

1–8. *See also* Alciatus, Andreas; *Faerie Queene*; Justice as Cardinal Virtue; Ripa, Cesare; *specific attributes*: blindfold; cornucopia; dog; fasces; ostrich; scales; snake; sword

Justice, theories of, 29–30; Aquinas on, 29–30; Aristotle on, 29–30; Cicero on, 30; distributive/commutative, 12, 28–30, 196, 389n62, 406n209; diversity of, 9, 347; diversity of, historical reduction in, 91, 94–95, 347; divine 20–22, 28, 30, 35, 56, 70–79, 89, 95–96, 119, 356, 386n36, 393n17, 396n50, 399n85, 410n280, 413n11, 414n21, 424n221, 431n83, 434n114, 440n221; earthly 12, 17, 25, 35, 72, 74, 76, 94–96, 356, 360, 399n85, 410n280, 413n11, 414n21, 431n83; evolution of meaning of, xv; harmonic, 12; Latini on, 30, 406n207; need for renewal of, 373–377; Plato on, 70, 76; Rawls on, 14, 95, 98, 130, 295, 389n53, 447n37, 449nn82–83, 449nn87–88, 468n278, 558n121

*Justice* (Langston Hughes), 103, 451n135

*Justice as Impartiality* (Brian Barry), 130

Justice Department, U.S.: establishment of, 141; federal court administration under, 141, 150, 154, 155; immigration judges in, 317, 318, 572n152, 573n158; Torture Memos of, 327, 334

*Justice Facilities Review*, 194, 496n111

Justicia (Justitia) (Iustitia) (goddess): cult of, 22, 398n72; origins of, 22; Roman depictions of, 22, 398nn74–77, 399n79

Justinian Code, 19

Kampen Town Hall, Last Judgment in, 410n275

kangaroo, in Australian Coat of Arms, 369

Kannon (Kwannon) figures, 380n11

Kansas: judicial budget shortfalls in, 309; Kansas City, Haas's installation in federal courthouse in, 460n126; Supreme Court of, 87. *See also* Topeka

Kant, Immanuel: publicity principle of, 295, 299, 300, 303; and Rawls, 449n85

Karmi, Ram: Israeli Supreme Court building designed by, 208–216, 209f, 211f, 212f, 213f, 214f

Karmi-Melamade, Ada: Israeli Supreme Court building designed by, 208–216, 209f, 211f, 212f, 213f, 214f

Kathrada, Ahmed, 355

Katsieris, Paul, 217, 218f, 219f

Katzenellenbogen, Adolf, 385nn30–31, 387n41

Kaye, Judith, xvii, 566n30

Keith, Damon, 452n147

Keldermans, Jan, 289f, 551n11

Kelly, Ellsworth: Boston panels by, 125–126, 126f, 161, 168, 344, 363, color plate 26; life of, 464n210

Kelly, John, 551n7, 551n9

Kelly and Lignell, 372

Kennedy, Anthony, 130, 490n191

Kennedy, John F.: Ad Hoc Committee on Government Office Space under, 164, 463n180; assassination of, 107, 165, 183; on public art, 191–192; public art under, 165, 463n180. *See also* National Endowment for the Arts

Kennedy, Róisín, 444n309

Kentucky: Covington Post Office and Courthouse in, 110, 457n63; Ten Commandments in, 120

Kenyon, Lloyd, 551nn19–20

Kessler, Amalia, 296

*Kings, I* (biblical book), 425nn233–234, 428n23

Kirk, Terry Rossi, 506n2, 533n26

Kirkland, Larry, 190

Kissel, Otto Rudolf, 432n86, 436n158, 436n162, 446n7, 447n45, 448n58

Knight, Roy F., 490n173

knowledge: as Gift Virtue, 8, 384n28; judgment and, 97–98, 298; public, through access to courts, 301–302; senses in, 97–98; sight and, 14, 91, 93, 95–97, 341–342; in trials, 104–105. *See also* Virtues

Koh, Tommy, 541n313

Kohler, Josef, 431–432nn84–85

Kohn, Bernard, 197

Kohn Pedersen Fox Associates, 504n317

Kongo figure, 348–349, 348f, 590n143

Kony, Joseph, 547n544

Koran: and depictions of Mohammad, 120–121; scales of justice in, 21. *See also* balance(s)

Kosmer, Ellen, 384n26

Kosovo, 274

Kraus, Henry, 386n35

Kraus, Romuald: awards won by, 110, 457n60; Communism and, 109–110, 190; life of, 109, 456n39, 456n50; Newark Justice sculpture by, 15, 108–110, 109f, 110f, 117, color plate 18; photo of, 110f

Kravitz, Mark R., 568n65

Krehbiel, Albert Henry, 552n38

Kwannon figures. *See* Kannon figures

Lacey, Nicola, xvii, 558n122, 561n212

Lactantius, *Divinarum institutionum,* 47

Lacy, William N., 489n163, 490n168, 516n221

*Laelius de Amicitia* (Cicero), 419n110

Lafayette (Louisiana), Moore's sculpture in, 450n100, 450n107, 451n117

La Fontaine, Jean de, 202

*Laienspiegel* (Ulrich Tengler), 34, 409n256, 409n262, 410n293

Lairesse, Gerard de, 51, 253

Lamanda, Vincent, 195, 201, 510n49, 511n73, 514n152

land claims of indigenous peoples, 367–372

Lane, George, 167

Langbein, John, xvii, 54, 424n207, 452n158, 472n38

Langdon, Stephen, 393nn17–18

Langford, Ian, 552n26

Lanni, Arianna, 402n126

Laqueur, Thomas W., 557n112

Largesse (Virtue), 8. *See also* Virtues

Lasser, Mitchel, 544n452, 545nn461, 475

Last Judgment: in *Book of the Dead,* 21, 395n39–40, 397n51–52; in Christian theology, 24, 400n99, 400n101

Last Judgment images: in Amsterdam Town Hall, 51, 53, 55–56; in *Bambergensis Constitutio Criminales,* 67; bribery in, 42; in churches, 35; in courtrooms, 34, 35; decline of, 37; development of iconography of, 34–35; inscriptions in, 35; as metaphor for judging, 36–37; Saint Michael in, 23–25, 24f, color plate 5; in Renaissance, 10; secular, 410n295; in town halls, 10, 12, 35–37, 410n275; Virgin Mary in, 24, 35, 401n111; Virtues in, 10

Latini, Brunetto, 30, 406n207, 406n212

Latrobe, Benjamin Henry, 140

law enforcement centers, 223, 338, 339, 343

law of nations, 272–273. *See also* international law

law of the sea: history of, 267–268; Jamaica conference on, 266; U.N. on, 266–268. *See also* International Tribunal for the Law of the Sea; United Nations Conference on the Law of the Sea; United Nations Convention on the Law of the Sea

*Law of War and Peace, The* (Grotius), 272

law schools: clinical programs of, 131; graduate and undergraduate, 468n280; legal education before, 403n140; minorities in, 131

lawyers: alternative dispute resolution and, 308–313, 323; association of African American (National Bar Association), 102, 103–104; in construction of national courthouses, 193; courthouse construction influenced by, 136, 472nn37–38, 472n45; in European Court of Justice, 229; expansion of role of, 472nn37–38; in Fiera's *De Iusticia Pingenda,* 93, 446n21; in Hirsch's "Mulatto" Justice mural, 112; in Holzer's Nantes installation, 207; international, 261; in Israeli Supreme Court, 213; in legal aid programs, 309; minority, rise of, 131; nationalization of profession of, 155; plea bargaining by, 312; in pretrial conferences, 312; pro bono, 306; as public defenders, 131, 157; salaries of, compared to those of judges, 308; segregation of spaces for, 136–137; U.S. federal, 141

League of Nations: on law of the sea, 267; logo of, 285; on need for international court, 257; on need for international criminal court, 272–273. *See also* Permanent Court of International Justice

lease-purchase contracts, 176, 487n110

Lechery (Vice), 9. *See also* Vices

Lederle, Ursula Grieger, 410n292

Ledoux, Claude Nicolas, 222, 512n113

Lee, Clarence A., Jr., 494n43

Lee, M. Owen, 483n248

Leers, Andrea, xvii, 380n11, 512n102

Lee/Timchula, 162f

legal aid, 309; Bentham's proposal for, 296, 322, 371, 376–377, 600n517; decline in funding for, 309; in Minnesota, 373, 602n559; in United Kingdom, 309, 322–323; in United States, expansion and limits of, 131, 306–309. *See also* legal profession; legal services

Legal Aid Society, 131

legal needs studies, 308

legal profession: identity politics in, 107; minorities in, 131; pro bono work of, 306; public interest law and, 131; and public defenders, origins of, 131, 157. *See also* judge(s); lawyers

Legal Services Corporation (U.S.), 131, 157

*Legal Times* (magazine), 102

Le Goff, Jacques, 400n105

Lehmbruck, Wilhelm, 110

Leiden (town hall), Judgment of Brutus in, 426n241. *See also* town halls

Lemaire, Philippe, 511n74

Lemkin, Raphael, 273

Lender, Mark Edward, 456n38

Leonardo da Vinci, 363, 447n40

Leo X, Pope, 387n46

Lesser, Guy, 544nn451–452, 545nn460–461

*Lettre sur les aveugles à l'usage de ceux qui voient (An Essay on Blindness in a Letter to a Person of Distinction)* (Diderot), 97, 449nn68–70, 449nn73–74

Levinson, Bernard M., 448n48

*Leviticus*, 105, 215, 419n104, 428n17

Levy, Janey L., 411n295

Levy, Marin K., 477n132

Liberality (Virtue), 385n30

liberty: Phrygian cap as symbol of, 107, 359; on U.S. coins, 461n146

Liberty, Statue of, 87, 359, 381n15, 386n35, 445n322

Libra (constellation), 19, 393n17

Lichocka, Barbara, 398n72, 398n75

lictor rods, 398n77. *See also* fasces

Lieber, Francis, 272, 299, 562n245; Code of, 543n424

Lievens, Jan, 58

*Life* magazine, 459n108

Limón Garcia, Teresa, 594n277

Link, Luther, 400n97, 400n101, 401n115, 401n120

literacy: and postal services, 299; and visual arts, 26–29, 34, 65–66

litigants: aid for (*See* legal aid); economic sanctions on, 309, 567n49; in pretrial conferences, 312; public relations used by, 302–303; self-representation by, 306, 309. *See also* access to courts

Livy, 58

local governments: power of, in courthouse architecture, 135–136; seats of power in courthouses, 135, 137, 338, 373. *See also* county courthouses

Locke, John, 95, 97, 298, 448n64

Loeffler, Jane, xvii, 341, 342, 587n51

logo(s): of Camp Justice in Guantánamo Bay, 328–331, 330f; of international and regional courts, 282–287; of South African Constitutional Court, 351, 352

London (England): Central Criminal Court (New Sessions House / Old Bailey) in, 87, 87f, 91, 444n316, 562n222; Clerkenwell Green in, 445n322; County Council of, 85; Crystal Palace in, 341, 586nn31–32; General Peace Convention (1843) in, 249; glass in architecture of, 341; Hampton Court Palace in, 83–84; Lord Mayor's Show in, 84–85, 85f; Middlesex Guildhall in, 325; publication of court proceedings in, 562n222; seat of authority in, 87; St. Paul's Cathedral in, 87; Supreme Court in, 325; transnational arbitration in, 324–325; Westminster Abbey in, 84

London, Treaty of (1949), 236

Londoño, Roberto, 349

Long, Lois, 581n355

*Long Range Plan of the United States Courts*, 336

Lord, James Brown, 117, 118f, 460n137

Lord Chancellor, end of position of (U.K.), 322

Lord Mayor's Show (London), 84–85, 85f, 443n285

Lorenzetti, Ambrogio: blindfold in works of, 67; death of, 404n165; influence of on Bach and Rockburne, 30–33; Siena frescoes by, 26–30, 27f, 349, 360, color plates 6, 8

Loros (garment), 401n113

Los Angeles (California), Roybal Federal Building in, Otterness's sculptures in, 188

*Los Angeles Times*, 7f, 8

Lothar, Emperor, 551n9

Louis IX, King of France, 202, 351, 370

Louis XI, King of France, 399n93

Louis XII, King of France, 195, 438n184

Lounsbury, Carl R., 471n18, 471n23, 472nn31–33

Louvain Town Hall, Last Judgment in, 410n275

Louverissen, Jan, 437n164

love, blindfold associated with, 67

Love (Virtue), 384n27. *See also* Cupid; Eros; Virtues

Lowry, Bates, 475n98

Loyalty (Virtue), 8. *See also* Virtues

Luban, David, 299, 303, 561n216, 564n296

Lucian, 93

Lucifer of Cagliari, 551n7

Lucretia (mythic figure), 25, 422n173, 426n242

Ludovico II Gonzaga, Marquis of Mantua, 93

*Luke, Gospel of*, 409n270, 428n19

Lüneberg Town Hall, Last Judgment in, 35, 410n275, 410n288. *See also* town halls

Lurcat, Jean, 235

Luscinus, Consul, 51, 422n174

Lust (Vice), 9. *See also* Vices

Luther, Martin, 447n45

Lutheranism: blindfold in, 96, 447n45; Last Judgment in, 37

Luxembourg (city): architectural styles in, 228; European Coal and Steel Community in, 523n39; as Judicial Capital of Europe, 228; Kirchberg Plateau in, 228, 232, 524n98; population of, 227. *See also* European Court of Justice

lynching, depictions of, 116–117

Lyon (France), Palais de Justice in, 202–203, 203f, 204f, 351

Lyon, Hamash, 219–220

Maastricht Town Hall, Last Judgment in, 42

Maastricht Treaty (1992), 226, 228, 522n32, 523n56

Maat: balance and, 20–21, 110; in *Book of the Dead*, 20–21, 20f; eye of, 427n11; as Justice, 20; in last judgment, 21, 397nn51–52; meanings of term, 18, 20, 394n29, 395n32; ostrich feathers and, 20, 77; as source of Justice iconography, 20–21. *See also* balance; scales

*Mabo v. Queensland (Mabo II)*, 368, 369, 371

MacArthur, Douglas, 273

MacGaffey, Wyatt, xvii, 348, 590n150, 590n153, 590n157, 590n160

Machiavelli, Niccolò, 58, 426n249

Macklin, James, 169, 493n9

Macrobius, 389n54

Madigan, Edwards, 519n332

Madison, Dolley, 162; and Dolley Madison House, 487n107

Madison, James: on codification of law, 296; on public opinion, 299, 562n228, 562n233; on public sphere, 295

Madriz, José, 528n235

Maduro, Miguel P., xvii, 522n27; 523n43;

Maffei, Stefano, 556n94

Magdeburg (Germany), Last Judgment in courtrooms of, 34, 409n256

Magdeburg Mandate (Law), 34, 409n256

magistrate judges, U.S.: creation of position, 169, 315; evidentiary hearings before, 317, 317f; functions of, 169, 315; growth in number of, 315, 316f; selection of, 315

Magna Carta, 145, 480n193

Magnanimity (Virtue), 8–9. *See also* Virtues

Maid of Amsterdam, 50, 51

mail. *See* postal services

Maillol, Aristide, 110

*Maimonides, Code of*, 105

Maine, judicial budget shortfalls in, 308–309. *See also* Portland

Makin, Andrew, 350, 351, 351f, 353, 592n194

Mâle, Emile, 383n26, 384n27, 385n30, 386n35, 387n42, 390n71, 399n85

Malkin, William, 537n202

Malraux, André, 587n50

Malti-Douglas, Fedwa, xvii, 381n13

managerial judges: in England, 323; in U.S., 311–313. *See also* ADR; case management; settlement; Woolf, Harry: Woolf Reforms

Manchester (England), glass in courthouses of, 340

Mancini, Anna, 397n52

mandamus, 129, 468n272, 551n19

mandatory private arbitration, 318–321

Mandela, Nelson: bust of, in Peace Palace, 253; imprisonment of, 352, 355, 592n208, 593n255

Mangin, Joseph Francois, 381n15

Mantegna, Andrea, 93–94, 386n37

manuscripts, illuminated, 403n147

Manzù, Giacomo, 233

*Marbury v. Madison,* 102

Marcel, Alexander, 533n49, 533n64

Marianne (French symbol), 107, 454n13; identity politics and, 107–108. *See also* Delacroix, Eugène

marine hospitals (U.S.), construction of, 140, 141

*Mark, Gospel of,* 428n19

Markovits, Daniel, xvii, 582n362

Marling, Karal A., 458n85

Marsh, Malcolm, 504n326

Marshall, Anthony J., 398n77

Marshall, John, 102

Marshall, Margaret, 305, 306, 565n328

Marshall, Thurgood: death of, 162; U.S. federal building named after, 162; U.S. federal courthouse named after, 149, 162; in NAACP, 114

Martin, Camille, 417n73, 418nn98–99

Martin, Fletcher, 460n126

Martin, Hénri-Jean, 403n146

Martinez, Jenny S., 225, 521n10

Martinique. *See* Fort-de-France; Palais de Justice.

Maryland, Baltimore, abstract art in, 465n217

Maser, Edward A., 399n77

Mashaw, Jerry, 475n98, 475n104, 570n114, 570n116, 571n140, 572n151

Masojada, Janina, 350, 351f, 353, 354, 592n194

Mason, Judith, 355

Massachusetts: caseload of courts in, 306; colonial courthouses in, 471nn27–28; 1780 Constitution of, 13, 292; county courthouses in, 137; federal trials in, number of, 311, 567nn60–61; fugitive slaves in, 138–139; judicial independence in, 292; local rules on settlement in, 312, 568n76; peace movement in, 249; record-keeping in, 471n21; Supreme Court of, 305, 306. *See also* Boston

Master of the Zurich Carnation, 25f, 400nn107–108, color plate 5

Mathias, Stephen, 539n272

Matsui, Robert T., 505n358

Matsys, Cornelis, 8, 8f, 9f, 345f, 382n22, 382n24

Matsys, Quentin, 382n22

*Matthew, Gospel of,* 34, 401n118, 428n30

Matthew Bender Publishing House, 5, 6f, 381n15

Mawson, Thomas, Peace Palace gardens by, 251, 253

Maximilian (Archduke of Austria), 39, 68, 414n25

Mayne, Thom, 168

McAllister, Ward, Jr., 481n211

*McCardle, Ex Parte,* 476n119

McCarthy, Joseph, 382n19

*McCleskey v. Kemp,* 131–132, 468n285

McComb, John, Jr., 381n15

McCormick, Michael, 398n69

*McCreary County, Ky., v. American Civil Liberties Union,* 462nn162–163, 462n165

McCurry, Margaret, 491n204

McDevitt, Ray, 473n61

McGrath, Elizabeth, 412n2, 414n27, 425n230

McKim, Charles F., 488n122

McMillan, James, 488n122, 488n126

McNamara, Martha J., 472n37, 472n45

McVeigh, Timothy, 167, 545n482

Mecham, Leonidas Ralph, 162–163, 170, 179, 487n104, 499n178, 499n183

media: impact of courts on, 301–303; publication of judicial opinions, 313–314; vulnerability of the press, 304–305

mediation: court-annexed arbitration compared to, 312; of cross-border disputes, 16, 322, 325–326; in England, 323–324; in Europe, 325–326; government regulation of, 321; rates of use of, 312, 322. *See also* alternative dispute resolution

Medici, Marie de, Rubens's paintings of, 5, 84, 440n220

Medici family, ostrich in emblems of, 78, 439n209

Medieval period. *See* Middle Ages

Meier, Richard, 168, 490n169, 496n111, 588n89

Melbourne (Australia): Commonwealth Law Courts in, 217–220, 218f, 219f; Victoria County Court in, 1, 2f, 379n4; Victoria Supreme Court in, 217, 217f, 218f

Melun (France), Palais de Justice in, 197, 199f, 201, 201f, color plate 33

*Memorable Doings and Sayings* (Valerius), 58, 413n19, 422n173, 425n238

Mengin, Christine, xvii, 196, 509n35, 510n44, 510n46

Menkel-Meadow, Carrie, 566n40

Merback, Mitchell B., 408n253

Mercury (god), 24, 401n114

"Mercury dime," 461n146

Mercy (Virtue), 8, 12, 83, 86, 87, 384n29, 461n141, 560n172. *See also* Four Daughters of God; Virtues

merit selection commissions, 127

Merson, Olivier, 535n132

Mervyn, Stanley, 369

Mesopotamia: calendar of, 19, 393n15, 393n17; legal system of, 18–20, 393nn10–11, 398n74, 402n127; scales in imagery of, 18–20; zodiac in, 19, 393n15, 394n24. *See also* Babylonia

*Metamorphoses* (Ovid), 398n76

Metzger, Ernest, 402n128

Mexican muralist movement: Biddle's interest in, 108, 361–362, 455n26, 596n350; Cauduro relationship to, 362–366; Hirsch influenced by, 112, 458n76; origins of, 356, 358; Orozco in, 356, 360. *See also* Rivera, Diego; Siqueiros, David Alfaro

Mexican Revolution, 357–358, 362–363

Mexican Supreme Court, 356–366; Cárdenas's reforms to, 359, 595nn313–314; caseload of, 366, 598n420; establishment of, 595n288; judicial review by, 366; justices of, 359, 362–363, 365, 366, 595n313; Zedillo's reforms to, 365–366

Mexican Supreme Court building, 356–366; architectural critics on, 362; Biddle's murals in, 361–362; brochures of, 356, 358f; budget of, 362; Cauduro's murals in, 362–366, 364f, 365f, 377, 598n419; color plates 46, 47; competition for design of, 358–359; construction of, 359; history on display in, 350, 359, 363–366; lessons learned from, 374–376; location of, 359; name of, 359; Orozco's murals in, 13, 356, 357f, 358f, 359–365, 360f, 361f, 594n276, color plates 44, 45; as performance venue, 343, 362

Mexico: *amparo* procedure in, 357; constitutions of, 357, 358, 365, 595n288, 597n413; court reforms in, 359, 365–366, 595nn313–314; crime in, 366, 598n421, 598n424; history of, 357–358; independence for, 357; judicial independence in, 357, 359, 362, 365–366; judicial system of, 357, 366; number of judges in, 366; public art in, 358, 361

Mexico City: Conference of 1945 in, 242; muralist movement in, 356. *See also* Mexican Supreme Court

Michelangelo, 35, 410n274

Michigan: judicial budget shortfalls in, 309; racial bias task force in, 133

Middle Ages: Christianity and, 22–25; civic spaces in, rise of, 25–33; coins of, 399n78; legal systems in, 26, 403n140; Saint Michael in, 22–25, 399n90, 399nn93–94; population of cities in, 403n139; prisons in, 222; punishment in, 26, 403n141; Virtues in, 8–12, 347

Miegroet, Hans J. van, 412n8, 414n25, 414n27

Mies van der Rohe, Ludwig, 341, 489n143

Military Commission Order No. 1 (U.S.), 327, 579n317

military commissions, at Guantánamo Bay (U.S.), 328, 333, 335

Military Commissions Act of 2006 (U.S.), 580n320, 580n322

military courts, U.S.: courts-martial procedures in, 334; and Guantánamo Bay, 328, 334; terrorist suspects in, 328

Military Reconstruction Act (U.S.), 476n119

Miller, Geoffrey P., 574n198

Miller, William, 283n26, 386n32, 389n52, 394n25, 400n105

Millet, Francis D., 488n126

Mills, Robert: as Architect of Public Buildings (U.S.), 141; post office designed by, 299; segregation of spaces by, 173, 472n38

Milošević, Slobodan, 274

Milton, John: blindness and, 65, 428n37; *Paradise Lost*, 24, 400n95, 428n37

Minnesota: 1857 Constitution of, 372–373; courthouses of, 372, 373, 601n532, 601n542; history of, 372, 601n531; judicial system of, 372, 373, 601n535, 601n554; legal aid in, 373, 602n559; Native Americans in, 372, 373. *See also* Grand Marais

minorities: in Art-in-Architecture program, 184, 503n281; judicial task forces on, 107, 132–133, 304; in legal profession, rise of, 131

Minow, Martha, xvii, 336, 425n236, 544n434, 567n56

Miró, Joan, 524n108

mirrors: Prudence and, 8, 10, 12, 62, 74–75, 84, 119, 122, 347, 387n47, 443n287, 444n318, 589n133; symbolic meaning of, 388n47; Virtues and, 388n47

Miss, Mary, 159–160, 502n264

Mississippi: race relations in, 113–116, 459n108; WPA artworks in, 459n106. *See also* Biloxi; Gulfport; Jackson

Missoula (Montana), U.S. Post Office and Courthouse in, 147, 147f

Missouri: number of federal trials in, 311, 567n62; Supreme Court of, 331.

Mitchell, Jan R.: Justice sculpture by, 121, 121f, 123–124, 124f, color plate 23; life of, 121, 463n179; Moco Jumbie sculpture by, 121–123, 122f, 344; Reaching Man sculpture by, 123, 124f, 344

Mitterrand, François: and European Court of Human Rights building, 525n129; *Grand Projets* of, 341, 586n30

mixed arbitrations, 256

mixed courts, 225–226, 259. *See also* anti-slavery courts; international courts; regional courts

Mixed Courts of Egypt, 226, 227f, 274, 350

Moakley, John Joseph, 161, 487n88

Moco Jumbie (legendary figure), 121–123, 122f, 123f, color plate 22

*Model Code of Judicial Conduct*, 128, 466–467nn239–242, 467n252. *See also* Canons of Judicial Ethics; judges

Modesty (Virtue), 9

Mohr, Richard, 561nn196–197

Moinard, Marc, 196, 511n73

Moira, Gerald, 87, 444n318

Moita (Portugal), Judgment of Solomon in, 425n231

Molyneux, William, 97, 448n60; and Molyneux's problem, 97, 105, 449n64, 449nn68–70. *See also* Diderot

Momus, 93–94, 106

Mondale, Joan, 502n271

Monod, Paul, 442n274

Mons Town Hall, 39, 414n27

Montesquieu, Charles de, 95, 96; *The Spirit of Laws*, 292

Mont-St.-Michel, abbey at, 24, 401n111

Monthiers, Jean-Marie, 512n102, 512n112, 514n147

Moore, Charles, 488n126, 516n221

Moore, Diana K., xvii: Concord Justice sculpture by, 99–102, 100f, 101f, color plate 17; GSA Design Award to, 450n100, 490n169, 506n390; Lafayette Justice sculpture by, 450n100, 450n107, 451n117; life of, 450n100; Newark Justice sculpture by, 110, 450n100, 450n107, 451n117, 457n66

Moore, John Bassett, 532nn11–12, 536n159

*Moore v. Dempsey*, 473n71

Moravec, Joseph, 491n210, 498n169, 499n200

Moreno Ocampo, Luis, 278, 548n573

Morgan, Michael J., 449n64, 449n76

mosaics: in Israeli Supreme Court building, 213–214, 214f, 518n293; Jewish zodiac, 19, 394nn20–21; in Peace Palace, 253, 534n97

Moses (biblical figure): in Amsterdam Town Hall, 52–53, 54f, 253; blindness and, 65; in European Court of Justice buildings, 234; in Peace Palace, 253; tablets of, 423n196; in U.S. Supreme Court building, 119, 462n157; veiled, 65

Motherwell, Robert, 107, 183

Motley, Constance Baker: *Equal Justice . . . under Law*, 114, 132; trying a case in Jackson federal courthouse, 114–115, 138, 459n114; on Simkhovich's Mississippi Justice mural, 114–115, 459n115, 460n121

Mountford, Edward W., 87, 444nn316–317

Mowbray, H. Siddons, 461n141

Mox Plant case, in International Tribunal for the Law of the Sea, 272f, 543n399, 543n416

Moynihan, Daniel Patrick: in Ad Hoc Committee on Government Office Space, 164–165; on great architecture, 489n143; on GSA role in courthouse construction, 170–171; Guiding Principles for Federal Architecture of, 164–165, 168; impact of, 164, 168, 489n141; life of, 489n140; on Oklahoma City bombing, 167; and Washington's Marshall Building, 162, 164. *See also* Guiding Principles for Federal Architecture

Mtintso, Thenjiwe, 353, 592n224

Muhammad, images of: Muslim ban on, 119, 120–121; in New York Supreme Court, Appellate Division, 15, 117–119, 118f; in U.S. Supreme Court, 119–121, 151

Muhammad, Ozier, 6f, 381n12

Muir, Edward, 440n223, 441n238, 441n241, 441n255

"mulatto" Justice, 110–113, 190

Mullett, Alfred B.: buildings designed by, 144, 144f, 479n176; as Supervising Architect, 144, 477n140

multi-door courthouses, 343

multi-jurisdictional venues. *See* international court(s)

Multilateral Investment Guarantee Agency, 256

multi-national courts. *See* international court(s); mixed courts.

multi-occupant facilities, 343

multi-track cases, 323, 577n244

Municipal Art Society of New York, 117

Muñoz García, Antonio, 358–359

Münster, Peace of, 50, 421n153, 534n95

Münster Town Hall, 412n6, 436n161

mural(s): in Ada County Courthouse, 116–117; in Geneva Town Hall, 13, 44–47; in Illinois Supreme Court Building, 291; depicting Saddam Hussein, 1–5. *See also* Cauduro, Rafael (Mexico); Hirsch, Stefan (South Carolina); Lorenzetti, Ambrogio (Siena); Mexican muralist movement; Orozco, José Clemente (Mexico); Rockburne, Dorothea (Maine); Simkhovitch, Simka (Mississippi)

Muratore, Giorgio, 507nn7–8, 510n49

Murillo, Gerardo, 356

Museveni, Yoweri, 547n544

Myrdal, Gunnar, 382n19

NAACP. *See* National Association for the Advancement of Colored People

*Nachova v. Bulgaria*, 451n132

Nahon, Brigitte, 201, 203, 514n148

Nail Figure (Kongo), 348–349, 348f, 590n143

Nantes (France), Palais de Justice in: design of, 204–208, 205f, 207f, color plates 30, 32; Jenny Holzer's installation at, 185, 204–207, 206f, 513n128, color plate 31; Jean Nouvel as architect of, 197, 204–208, 351

Napoleon, Louis, King of the Netherlands, 48, 420n123

Nash, Roy, 442nn275–276

Naske, Claus-M., 481n211, 481n216

National Academy of Design (U.S.), 163

National Academy of Public Administration (U.S.), 170

National Arts and Cultural Development Act of 1964 (U.S.), 489n162

National Association for the Advancement of Colored People (NAACP), 102; on Stefan Hirsch's "Mulatto" Justice mural, 113; Legal Defense Fund of, 114, 131

National Bar Association (U.S.): establishment of, 102; on judicial bias, 132; Judicial Council of, 103–104, 103f, 107, 132, 452n142, 452n144; membership of, 452nn141–142; mission of, 103, 107, 451n123

National Center for State Courts (U.S.), 473n60, 494n46

National Centre for Social Research (U.S.), 324

National Conference of Commissioners on Uniform State Laws (U.S.), 569n90

national courthouse(s), 193–224; competition for design of, 249–250; construction of, 193–194; courtroom layouts in, 194; design manuals for, 193, 507n10; global market in, 194–195; homogenization of, 194; long-term planning for, 193; public art in, 195. *See also specific countries and courts*

National Design Museum (U.S.), 174

National Endowment for the Arts (NEA) (U.S.): as architectural critic, 154, 165–166; in Art-in-Architecture selection process, 183; budget of, 489n162; design award program of, 165, 490n168; establishment of, 165, 489n162; Federal Design Improvement Program of, 165; in GSA selection process, 454n12; mission of, 165; Task Force on Federal Architecture, 165, 166

National Foundation on the Arts (NFA) and the Humanities Act of 1965 (U.S.), 489n162

National Historic Preservation Act of 1966 (U.S.), 166

nationality of judges: in International Court of Justice, 261–262; in International Criminal Court, 277; in International Criminal Tribunal for Rwanda, 275; in International Criminal Tribunal for the former Yugoslavia, 273; in Permanent Court of International Justice, 257–259

National Judicial Education Program to Promote Equality of Women and Men in the Courts (U.S.), 469n291

National Organization for Women (U.S.), Legal Defense and Education Fund of, 132

National Sculpture Society (U.S.), 117, 163, 461n146

Native Americans: in Ada County Courthouse WPA mural, 116–117; controversies over depictions of, 455n19; in Minnesota, 372, 373; segregation of, in courthouses, 138

Native National Title Tribunal (NNTT), 368

*Native Son* (Richard Wright), 451n135

Native Title Act (NTA) of 1993 (Australia), 368, 369, 599n462, 599n472

Navarro y Avilés S. A., 246

Ndwandwe, Phila, 355

Nebraska: county courthouses in, 137, 473n56; federal courthouses in, 477n134; mandatory arbitration in, 320; State Capitol building of, 149, 461n143, 481n221; Supreme Court of, 320

Nelson, William, 417n76

Neoclassical architectural style, 137, 145, 149, 195, 359

Neo-Gothic architectural style, 253

Netherlands: architecture of, 419n116; cultural identity of, 420n119; as Dutch Republic, 420n120; "hear the other side" in, 289, 551n10; as new Israel, 49, 421nn142–143; Peace Palace funding from, 250, 263; public art funding in, 509n32; Virgin Islands under, 121; wealth of, 48, 420n120. *See also specific cities*

Nevada, courthouses as seat of power in, 135

Newark (New Jersey), Martin Luther King Jr. Federal Building and Courthouse in, Moore's Justice sculpture in, 110, 450n100, 450n107, 451n117, 457n66; U.S. Federal Courthouse and Post Office in: Kraus's Justice sculpture in, 15, 108–110, 109f, 110f, 117, color plate 18; Totten's medallions in, 110, 111f

New Deal: federal courthouse construction in, 142; Gilbert's opposition to, 482n234; public art in, 164. *See also* Works Project Administration

New Hampshire: judicial budget shortfalls in, 308; Warren B. Rudman United States Courthouse in, 99–102, 100f, 101f

New Jersey, Supreme Court of, 132, 469n292.

*New Jersey v. New York,* 474n84

newspapers: circulation of, 299, 304; in development of public opinion, 299; growth of, 299; Madison on, 299; vulnerability of, 304–305. *See also* cartoons; media; press

New Testament: blindness in, 64–65; Ecclesia as symbol of, 65; glass architecture in, 586n35; in images of Justice, 19; Saint Michael in, 24, 399n89; Ten Commandments in, 120. *See also* Bible; *specific books*

New York City: Bronx County Courthouse in, 473n54; Center for Architecture in, 174; City Hall in, 5, 6f, 373, 381nn15–16, 601n547; Daniel P. Moynihan U.S. Courthouse (Pearl Street) in, 149, 497n136; Legal Aid Society in, 131; Manhattan criminal court in, 93; Museum of Modern Art in, 342; New York County Courthouse in, 473nn53–54; Seagram Building in, 489n143; Supreme Court meeting in, 140; Thurgood Marshall U.S. Courthouse (Foley Square) in, 149, 150f, 157, 162, 497n136

New York State: bias task forces in, 132, 469n299; diversity of architectural styles in, 137, 138f, 139f, 473nn52–53, color plate 28; judicial salaries in, 566n30; peace movement in, 249; seal of, 137, 473n54

New York State, courthouses with Justice in: Appellate Division (First Department), Borough Hall, Bronx County Courthouse, Chenango County Courthouse, Court of Appeals Hall, Kings County Courthouse, Montgomery County Courthouse, New York County Courthouse, Onondaga County Courthouse, Ontario County Courthouse, 138f, 139f, 473n52

New York Supreme Court, Appellate Division: building, 117; Muhammad statue in, 15, 117–119, 118f; mural in, 473n54; sculptures in, 117, 461n141, 473n54

New York Task Force on Women in the Courts, 132

*New York Times:* on Hussein mural, 1, 6f, 381n12; on Kraus's Justice sculpture, 108, 110; on New York City Hall, 601n547; on New York Muhammad statue, 117, 119; on Peace Palace design, 251

Ngaanyatjarra Council, 368, 370

Ngaanyatjarra Peoples, land claims of, 367–372

Nicaragua: in Central American Court of Justice, 241–242; in International Court of Justice, 261, 264, 538n216

*Nicaragua v. United States of America,* 261, 264, 538n216

Nice (France), Palais de Justice in, 197

Nicene Creed of 381 CE, 24, 400n99

Nicholas, David, 403n132

Nicholas II, Czar of Russia, 117, 248–249, 257

Nicholls, Robert, 122, 463n187, 464n191

Nichols, Terry, 545n482

*Nicomachean Ethics* (Aristotle), 46

Niehaus, Charles, 461n141, 461n146

Nielsen, Jack, 189

Niemeyer, Oscar, 208, 380n10

Nine (the), in Siena, 26–30, 33, 404n153, 404n161

Ninth Circuit, U.S.: gender bias task force of, 469n292; on television broadcasts, 557n107

Nishizawa, Luis, 362–363, 596n380

*nkisi* (pl. *minkisi*) figure, 348–349, 348f, 590n143, 590n145

Nochlin, Linda, 465n216

Noguchi, Isamu, 109

Nolan-Haley, Jacqueline, 577n250

Noonan, John, *Bribes,* 40

Normandy (France), Saint Michael in, 24

Norse texts, 386n35

North, Anthony, 600n491

North, Douglass C., 602n563

North, Helen, 22, 346, 347, 386n33, 387n43, 388n49, 391n81, 399n79, 588n95, 589n133, 590n140

North Carolina, 1776 Constitution of, 292

Norton, Eleanor Holmes, 180, 499n177

Norway, public art funding in, 509n32

Nost, John van, the Younger, 86, 86f, 444n311

Nouvel, Jean: in France's *Grand Projets,* 586n30; and Jenny Holzer's installation, 513n128, 515n186; and International Tribunal for the Law of the Sea building, 269; Nantes courthouse designed by, 197, 204–208, 205f, 351; Pritzker Prize to, 204

Nuremberg Council, 42, 416n45

Nuremberg Town Hall: bribery in images in, 42; "hear the other side" in, 551n9; Judgment of Brutus in, 426n241; Last Judgment in, 35, 410n275, 410n290, 411n297

Nuremberg Trials, 273

OAS. *See* Organization of American States
oaths: at Guantánamo Bay, 331–332, 581n358; of U.S. federal judges, 332
Obama, Barack, and detention at Guantánamo Bay, 328
Obata, Gyo, 486n70, 486n73
Obedience (Virtue), 9. *See also* Virtues
Obregón, Álvaro, 358
observers: participatory, 301–302; and spectators, 127, 295; subjectivity of, 127, 132
*occhi miri* (piercing eyes), 70
Ockham, 97, 448n63
O'Connor, Andrew, 253, 254f
O'Donnell, Bernard, 91
O'Dowd, Gwen, 524n108
*Odyssey* (Homer), 65
*Oedipus Rex* (Sophocles), 65
Office of Management and Budget (OMB), U.S., 180, 181
office space, in courthouses, 196, 200, 208, 342
Ohio: county courthouses in, 137; supermax prison in, 223; Supreme Court of, 40; user fees in, 40
Okada, Shin'ichi, 5f, 380n11
Oklahoma City, Alfred P. Murrah Federal Building in, 1995 bombing of, 167, 184, 491n196, 545n482
*Oklahoma Tribute, An* (GSA publication), 184
Old Bailey (London, England), 87, 87f, 91, 444n316
Oldenburg, Claes, 107
Old Testament: blindness in, 64–65; glass architecture (Solomon's Palace) in, 586n35; in images of Justice, 19; Israeli Supreme Court building and, 209, 517n244; Saint Michael and, 24, 399n87; Synagoga as symbol of, 65; Ten Commandments and, 120. *See also* Bible; *specific books*
Olmsted, Frederick Law, Jr., 488n122, 488n126
Olsen, Patrice Elizabeth, 595nn301, 307
Olympic Committee, Court of Arbitration of, 247
OMM Design Workshop, 350, 351f, 592n194
open air courts: in Australia, 367–372, 367f, 376; Bentham on, 337, 351–352, 367, 376; lessons learned from, 376–377; of Louis IX, 351, 370
open courts: Bentham on, 295–299; origins and rise of, 14–16, 293–294. *See also* Constitutions, of states of the United States; convention(s); public access to courts
open-eyed Justice, 75, 79, 87, 91–93. *See also* blindfold(s)
opinions: advisory, 260–261, 264, 537n207; online, 314; unpublished, 314
oral arguments in courts, decline of, 314
Orange County (California), Crystal Cathedral in, 586n34
O'Reilly, Jennifer, 385nn30–32, 386nn38–40, 387n42, 405n191
*Oresteia* (Aeschylus), 402n122

Organization of American States (OAS): amendments to charter of, 529n255; American Convention on Human Rights in, 244; and Council of Europe, 240, 243, 244; establishment of, 242; on human rights, 242–243; Inter-American Commission on Human Rights as organ of, 243; Inter-American Court of Human Rights established by, 226, 240, 246
Orozco, José Clemente: and Biddle, 596n351; Hirsch influenced by, 458n76; life of, 356; in Mexican muralist movement, 356, 360; Mexican Supreme Court murals by, 13, 356, 357f, 358f, 359–365, 360f, 361f, 594n276, color plates 44, 45; in United States, 356, 594n285
Ortiz Mayaqoitia, Guillermo I, xvii, 365
Osiris (god), 21
ostrich(es): digestion of, 14, 77, 79, 105, 453n170; eggs of, in Christianity, 78; Egyptian views on, 20, 77–78; in Giordano's artwork, 78–79, 78f; in Justice iconography, 14, 77–79; in Ripa's *Iconologia*, 77, 453n170; in Romano's artwork, 77, 77f, 78; Virtues associated with, 77, 439n193
ostrich charge, in jury instructions, 79, 105, 453n172
Otterness, Tom, xvii, 184–189; animals as motif in work of, 185–189; on Art-in-Architecture review process, 504n348; career of, 184–185, 503n297, 503n300; Los Angeles sculptures by, 188; Portland sculptures by, 184–189, 186f, 187f, 188f, 191, 344, color plate 24; Sacramento sculptures by, 188–189
Oudenaarde Town Hall (Holland), 74–75, 440n217
outsourcing: of federal building design, 142, 143, 152; of government services, 336; modes of, 306. *See also* alternative dispute resolution
Ovens, Jurgen: Amsterdam Town Hall painting by, 51–52, 53f, color plate 14; life of, 423n189
Ovid: on Janus, 74, 436n156; *Metamorphoses*, 398n76
Oxford University, New College Chapel at, 98–99, 99f

package guilty pleas, 312, 568n81
Padua (Italy): civic space in, 33–34; Giotto's frescoes in, 28, 386n35, 386n38, 405n185
pageantry: civic, types of, 442n284; in England, 84–85; in Venice, 81–82
pain: caused by judges, 13; of judging, 13, 55–61; of Justice, 13–14
Palais de Justices. *See* French courthouses
Palazzo Pubblico of Siena. *See* Siena, Palazzo Pubblico of
Pan-American Conference of 1948, 242
Panofsky, Erwin: on blindfolds, 70, 434n122; on blindness, 67; on Brant's *The Ship of Fools*, 430n68; on Graz Town Hall, 35; on Palazzo Pubblico of Siena, 404n158

Panopticon, Bentham's design for, 222–223, 297–298, 327
Papaconstantinou, Maria I., 2f, 379n3
Papier, Hans-Jürgen, 585n18, 586n27
*Paradise Lost* (Milton), 24, 400n95, 428n37
*Parents Involved in Community Schools v. Seattle School District No. 1*, 451n127
Paris (France): Bibliothèque Nationale de France in, 342; Cartier Foundation in, 208; Cathedral of Notre Dame in, 65; Georges Pompidou Centre in, 237, 341, 512n102; Grand Palais in, 341; Musée du Quai Branly in, 515n177; Palais de Justice in, 393n13, 399n77; Palais Royal in, 509n42; peace congress (1849) in, 249
Parks Commission (U.S.), 163, 488n122, 488n126
Parntirrpi Bore Outstation (Australia), 367, 367f
partiality. *See* bias; impartiality
participatory parity, xvi, 17, 300, 303–304, 377. *See also* Fraser, Nancy
Patience (Virtue), 9, 346–347. *See also* Virtues
patronage: through Art-in-Architecture, 183; in U.S. federal construction, 141–142, 165
Paulson, William R., 449n64, 449n70, 449n74
Pausanias, 70, 433n114
Peace (Virtue): in Amsterdam Town Hall, 50, 51, 422n159; in battle (psychomachia), 9; in European Court of Justice buildings, 234; in Four Daughters of God, 8, 12, 28, 30, 32, 50, 51, 80, 84, 89, 119, 233, 234, 249, 252, 253, 262–263, 384n29, 387n46, 397n61, 398n74, 408n239; in hierarchy of Virtues, 12; in Sienese frescoes, 30, 406nn221–222. *See also* Virtues
Peace Convention, General (1843), 249
Peace Palace (The Hague), 247–265, 248f, 252f, color plate 38; Annex to, 263, 263f; architectural critics on, 251, 252; architectural style of, 251, 253; art in, 253; Carnegie Library at, 249, 250, 251, 253, 263–264; competition for design of, 249–253, 533n49; construction of, 15, 252; courts housed in, 255 (*See also* International Court of Justice; Permanent Court of Arbitration; Permanent Court of International Justice); funding sources for, 248–252, 263, 264; gardens of, 251, 253; Great Hall of Justice in, 262–263, 262f, color plate 41; Hague Academy of International Law at, 259, 263; interior design of, 253, 254f, 262–263, 262f; international contributions to, 253; name of, 247, 248; Nicholas II's portrait in, 117, 249, 257; origins of, 248–249; size of, 253, 263; Small Hall of Justice in, 257, 258f; windows of, 262, 262f
Peck, Robert A., 168, 492n231
Pelli, Cesar, 516n221
penitentiaries, origins of, 222
Pennsylvania: prisons in, 222, 223. *See also* Allentown; Philadelphia

Permanent Court of Arbitration (PCA), 256–257; authority of, 255; building housing (*See* Peace Palace); Carnegie's support for, 15, 247, 248, 249; caseload of, 255, 256–257, 281, 282f; competitors of, 257; critics of, 257, 535n137; establishment of, 248–249, 256; facilities of, 257, 258f; in Iran hostage crisis, 256, 535n127; law of, 257; logo of, 282–284, 282f, 284f; members of, 255, 256, 257; mission of, 248; name of, 255; and Native National Title Tribunal, 368; Nicholas II in, 117, 248–249; and Permanent Court of International Justice, 259–260; practices of, 255, 256–257; privacy in, 257, 535n136; use of term "court" by, 248, 255. *See also* Peace Palace

Permanent Court of International Justice (PCIJ) (World Court), 257–261; advisory opinions of, 260; authority of, 255, 257; budget of, 259; building housing (*See* Peace Palace); caseload of, 255, 260, 261; dissolution of, 255, 260; enforcement of rulings of, 257, 260; establishment of, 247, 256, 257, 259; impact of, 260–261; and International Court of Justice, 261, 265; International Court of Justice as successor to, 247, 261; judges serving in, 257–259; jurisdiction of, 257, 260, 536n142; law of, 260–261; mission of, 259–260; nationality of judges in, 257–259; U.S. in, 259, 260, 536n147. *See also* Peace Palace

Perraudin, Gilles, 197, 199f, 512n112
Perrault, Dominique, 230–233, 231f, 524n106, 586n30
Perrot, Alain-Charles, 199f, 512n103
Perry, Barbara, 215
Perry, Mary Phillips, 400n106, 401n113
Perugino, Pietro, 387n46
Peters, Edward M., 519n374
Pfeiffenberger, Selma, 383n26, 406n215
Philadelphia (Pennsylvania): prisons in, 223; public art in, 501n257; Supreme Court meeting in, 140
photography, use in court, 105, 295
Phrygian cap, 107, 359, 454n13
Picart, Bernard, 283, 283f
Pierguidi, Stefano, 433n103
Piety, as Gift Virtue, 8, 384n28. *See also* Virtues
Pinch, Geraldine, 394n29, 395n37, 412n4
piracy, international prohibition on, 255, 267, 272
Piso Caesoninus, Lucius Calpurnius, 581n357
Pistoria, 35, 408n241
Pius VI, Pope, 446n11
Piza Escalante, Rodolfo, 246, 531n340
Plato: blindness of Homer and, 428n37; on Justice, 70, 76; Momus on, 93–94; *Republic,* 93, 383n26, 390n65, 438n186; on Virtues, 8, 12, 344, 383n26, 389n53, 390n65
plea bargaining, 312, 568n81
Pleister, Wolfgang, 436n159

*Plessy v. Ferguson,* 102, 447n35
Pliny, 440n217, 589n133
plop art, 191
Plumbers Guild of London, 25
Plutarch: on Brutus, 58, 426n245; *Isis and Osiris,* 447n39; as source for Alciatus, 44, 447n39; as source for Geneva frescoes, 44, 417n79; as source for Ripa's *Iconologia,* 70; on Theban judges, 43, 44, 447n39
Poland: in European Court of Human Rights, 239; image of handless judges in, 45. *See also specific cities*
politics: of glass architecture, 341–342; of international courts, 255–256; and judicial independence, 293; of public access to courts, 337; in WPA artworks, 108
Pomeroy, Frederick William, 87, 444nn317–318
Pontoise (France), Palais de Justice in, 197
pop culture: Guantánamo Bay in, 579n310; representations of Justice in, 5–8
pope(s): decoration of the Vatican, Raphael and, 75–77; Venice's relationship to, 80–81. *See also* Fiera, Battista
pork-barreling, in federal construction (U.S.), 141, 144
Porta, Giambattista Della, 447n40
Porter, Jean, 389n53, 389nn57–58
Porter, Katherine Ann, *The Ship of Fools,* 430n72
Portland (Maine): allegories of good and bad government in, 30, 33; federal courthouse in, 33, 407n231
Portland (Oregon), Mark O. Hatfield U.S. Courthouse in, Otterness's sculptures in, 184–189, 186f, 187f, 188f, 191, 344, color plate 24
positivism, 298
Posner, Eric A., 539n277
Post, Robert, xvii, 295, 298, 561n209
Postal Policy Act of 1958 (U.S), 304
postal services: Bentham on, 288; European, 299; subsidies for, 288, 299, 305, 336; and transportation, 299, 562n241; U.S., 299, 304; vulnerability of, 16, 304–305, 336, 376
Postle, Martin, 450n99
Post Office Act of 1792 (U.S.), 299
Post Office Department, U.S.: establishment of, 562n237; land of, for federal courthouses, 156, 484n39
post offices, U.S.: closures of, 304, 336, 376; Constitution on, 140, 299; functions of, 299, 335–336; naming of, 483n251; purpose-built structures for, 15, 299; twentieth-century construction of, 144–149, 152; vulnerability of, 304–305, 336
post offices and court houses (U.S.): 15, 142–152, 166, 343, 477n134. *See also* Biloxi (Mississippi), U.S. Post Office, Court House, and Custom House; Covington Post Office and Courthouse (Kentucky); Denver (Colorado), U.S. Post Office and Courthouse; Des Moines (Iowa), U.S. Court House and Post Office;

Galveston (Texas), U.S. Custom House; Grand Forks (North Dakota), Post Office and Federal Courthouse; Missoula (Montana), U.S. Post Office and Courthouse; Newark (New Jersey), U.S. Federal Courthouse and Post Office; San Diego (California), U.S. Post Office and Customs House; Windsor (Vermont), Courthouse and Post Office

Postwar Building Plans for the Quarters of the United States Courts, JCUS Committee on, 156
Pound, Roscoe, 127, 309, 483n14
Prak, Maarten, 420n120, 421n142
*Praxis rerum civilum (Legal Practice in Civil Matters)* (Damhoudere), 72, 435nn145–147
*Praxis rerum criminalium (Legal Practice in Criminal Matters)* (Damhoudere), 72–74, 73f, 435n133
precedent, unpublished opinions as, 314, 570n109
press: on alternative dispute resolution, 313; Bentham on role of, 288, 299; in courthouse architecture, 341; growth of, 299; on Guantánamo Bay, 333–334, 379n1, 582n363, 582n376, 582n382; in public opinion, 299, 300; public relations of, 300; representations of Justice in, 1–5; subsidies for, 305; trials covered by, 301–302; vulnerability of, 16, 304–305, 376. *See also* media; open courts; publicity
press, freedom of: Bentham on, 288, 299; Madison on, 288, 295, 299, 304; at Guantánamo Bay, 333–334, 582n363, 582n376; in U.S., establishment of, 299
Pre-Trial Chambers (PTC), of International Criminal Court, 276
pretrial conferences, 312, 568n75. *See also* managerial judges; settlement
Pride (Vice), 9, 29, 32, 67, 385n30. *See also* Vices
*Principles of Judicial Procedure* (Bentham), 296
printing presses, 26, 403n146
prison(s), 222–224; Academy of Architecture for Justice on, 194; architectural style of, 223; Bentham's design for, 222–223, 297–298; construction boom in, 223; cost of, 223–224; courthouses' relationship with, 222; courthouses reunified with, 343; evolution of design of, 222–223; goals of, 222, 223; history of, 222–224, 335; international incarceration rates in, 193, 223–224; isolation in, 223; overcrowding in, 223; prison-industrial complex and, 224; private cells in, 222; privately run, 223–224; public punishment and, 335; as purpose-built structures, 15, 193; rise in number of, 193, 222; separate facilities for, origins of, 136, 222; short-term and long-term confinement in, 222; supermax, 223, 560n181, 583n403. *See also* Foucault, Michel; Guantánamo Bay

prisoners: classification of, 223; clothing of, 105; cost per, 223–224; international increase in number of, 193, 223–224

prisoners of war, Geneva Conventions on, 580n321, 583n398

Prison Litigation Reform Act of 1995 (U.S.), 567n50

Pritzker Prize: to Nouvel, 204; to Rogers, 235

privacy: in alternative dispute resolution, 320–321, 325, 335, 337; Bentham on, 297–298; of Permanent Court of Arbitration proceedings, 257, 535n136. *See also* confidentiality; secrecy

private prisons, 223–224

private providers, of alternative dispute resolution, 318–321

Private Securities Litigation Reform Act of 1995 (U.S.), 567n50

privatization of adjudication, 16–17; Foucault and, 14, 17; implications of, xv, 16–17; methods of, 306; reasons for, 17. *See also* alternative dispute resolution

procedural due process, 291

procedural rules: civil, 155, 312, 568n75; criminal, 54, 68, 326, 370; critics of, 309; English revision of, 322–324; settlements encouraged by, 16, 306, 312, 323; U.S. federal courts using state, 140, 155, 474n91

*Promenade d'un sceptique (Promenade of a Skeptic)* (Diderot), 97, 449n75

property: deprivation of, and fairness, 290; statutory entitlements as, 157

*Prophets, The* (Koran), 21

prosecutors: in International Criminal Court, 276, 278; plea bargaining by, 312

pro se representation, 306, 309

Protection of the Essential Rights of Man (1945), 529n253

protest(s), popular: at U.S. courthouses, 139, 473–474nn71–72; near U.S. post offices, 584n415

*Proverbs*, 21, 71, 409n270

Prudence (Virtue): in Amsterdam Town Hall, 50, 50f, 51–52, 62, 63, 64f; as Cardinal Virtue, 8, 344–347, 345f, 383n26, 384n28; depictions of, 8, 9f, 10, 10f, 31f, 32, 39, 50, 50f, 53, 53f, 62–63, 64f, 74–75, 81, 83f, 84, 86, 98, 347, 387nn47–48; as Gift Virtue, 8, 384n28; in hierarchy of Virtues, 12, 346, 390n68; meaning of, 346. *See also* Virtues

Prudentius, *Psychomachia*, 8–9, 384–385nn30–32, 386n35

Prussia: blindfold in, 93; public sphere in, 300

*Psalms*: blindness in, 428n21, 434n124; Four Daughters of God in, 384n29; and Giglio's handless judges, 44; and Israeli Supreme Court building, 213; in Last Judgment iconography, 35, 409n270; scales of justice in, 21

*Psychomachia* (Prudentius), 8–9, 384–85nn30–32, 386n35

psychopomp, Saint Michael as, 24, 399n90

psychostasy, in Last Judgment, 23

public access to alternative dispute resolution, 318, 321–322, 337

public access to courts, 293–304; in administrative agencies, 318; Bentham on, 295–299; to court documents, 293, 342, 556n80; decline of, 16–17, 335; evolution of right of, 14–16, 293–294; in government legitimacy, 288, 293, 299; government policies influenced by, 302, 304; at Guantánamo Bay, 333–334, 335, 582n363; interaction among participants in, 303–304; international criminal, 334; as political choice, 337; in private arbitration, 321; public knowledge gained through, 301–302; public relations and, 302–303; in South Africa, 350; through technology, 294, 302, 303. *See also* Bentham, Jeremy; state(s), U.S.; United States Constitution; *specific courts*

public art: in Canadian Supreme Court, 1, 2f; in European Court of Human Rights, 238; in European Court of Justice, 229–230, 233–235, 524–525nn108–109; as feature of architecture, 153, 191, 355; in France, 195, 200–204, 513n127; international summary of funding for, 509n32; in International Tribunal for the Law of the Sea, 271; in Israeli Supreme Court, 213–216; in Mexican Supreme Court, 359–366; in Mexico, attitudes toward, 358, 361; in national courthouses, 195; in Peace Palace, 253; in South African Constitutional Court, 355

public art, in U.S.: abstraction in, 125–126, 454n12, 465n217; architects' role in selection of, 117, 454n12, 460n137; in federal buildings, 152–153, 163–166; in federal courthouses, 182–192; Guiding Principles for Federal Architecture on, 165; public dismay with, 106, 107; public's role in selection of, 106; in Sacramento (California), 190; Supreme Court on religious imagery in, 120, 462nn162–166; values in, 106, 117; through WPA, 108. *See also* Art-in-Architecture

public art controversies: in U.S., 106–126; in France, 107, 203, 208; in 1960s, 107, 454n12; in 1980s and 1990s, 107, 190–191; in Art-in-Architecture, 190–191; changes to commissions caused by, 454n12; over abstract art, 125–126, 454n12, 465n217; over Ada County Courthouse WPA mural, 116–117; over Hirsch's "Mulatto" Justice mural, 110–113; over Kraus's Newark Justice sculpture, 108–110; over Mitchell's Saint Croix sculpture, 121–124; over New York Muhammad statue, 15, 117–119, 118f; over Simkhovich's Mississippi Justice mural, 113–116; over Weinman's Supreme Court Muhammad frieze, 119–121

public art funding (set-asides) in U.S.: amount of, 121, 183; through Art-in-Architecture, 183, 407n228, 502n60; Commission on Art and Government on,

164; competitions for, through Treasury Department, 164; debate during Cold War over, 164, 489n133; establishment of, 164, 183, 454n12; under Kennedy, 165, 463n180; revisions to process of awarding, 454n12

publication: of administrative agency decisions, 318; of court proceedings, requirements for, 294, 562n222; of opinions, decline of, 314

public buildings: accessibility of, 166–167; compared to civic buildings, 33; definition of, 33; Guiding Principles for, 164–165; religious imagery in, challenges to, 120; Ten Commandments in, 120; values in architecture of, 165. *See also* civic spaces; *specific types of buildings*

Public Buildings Act (U.S.): of 1913, 144, 479n176; of 1949, 478n150; of 1959, 478nn151–152, 498n137; of 1972, 180

Public Buildings Administration, Office of the Supervising Architect moved to, 142, 476n115

Public Buildings and Grounds, House Committee on, 174

Public Buildings Commission (U.S.), 142

Public Buildings Cooperative Use Act of 1976 (U.S.), 166, 490n176, 502n276

Public Buildings Reform Act of 1998 (U.S.), 498n138

Public Buildings Service: and air conditioning in federal courthouses, 156; cooperative use and, 490n176; federal courthouses prioritized by, 156; JCUS design manual published by, 156; Peck as Commissioner of, 168

public disclosure obligations, in U.S., 293–294

public discourses, 300, 302, 303. *See also* Fraser; Habermas; Post

public information officers, 294, 341

Public school, segregation in, 107, 382n19

publicity: Bentham on, xv, 14, 17, 288, 295–301, 303, 318, 337, 340; decline of, 310; exceptions to need for, 297–298, 334, 560n188; functions of, 14, 288, 296, 297–299; government legitimacy through, 288, 300, 301, 303; government use of, 300; for judges, 14, 17, 297–299; Kant on, 295, 299, 300, 303; for legislators, 297, 298; in public opinion, 288, 300–302; punishment influenced by, 302; Rawls on, 98, 449n88; and truth, 297, 303. *See also* public access to courts

public opinion: Bentham on, 295–301; Habermas on, 300, 302; on judges, 14, 127, 128, 302; Madison on, 299, 562n228, 562n233; press in development of, 299, 300; on public art, 106, 107, 191 (*See also* public art controversies); publicity's influence on, 288, 300–302; role in government, 299, 562n233; on South African Constitutional Court, 350, 591n187

Public Opinion Tribunal, of Bentham, 14, 298, 299, 561n220

public relations: in courts, 302–303; of press, 300

public spheres: and adjudication, 301–304; Bentham on, 295; construction of, 85; definition of, 300; development of, 295–296, 299–301; Fraser on, 288, 295, 300; Habermas on, xv, 191, 295, 300, 563n248; litigation in, 288; public art controversies in, 191. *See also* civic spaces

Puerto Rico: judicial system of, 481n203. *See also* San Juan

punishment: evolution of modes of, 222; of judges, threat of, 38–39; in Middle Ages, 26, 403n141; privatization of, 14, 222, 224; public, Foucault on, 295, 335, 558n114; publicity's influence on, 302; purposes of, 222; scales in, 19. *See also* death penalty; prison(s)

purgatory, in Christian theology, 400n105

Puttfarken, Thomas, 426n251

putti, 76, 79, 84, 387n47, 438n179, 551n10

Quay, William, 92f, 445n5

Quellinus, Artus: Amsterdam Town Hall sculptures by, 50, 50f, 51, 52, 52f, 55–61, 57f, 59f, 60f, 62, 63, 422n158; life of, 422n158

Qur'an. *See* Koran

Ra (god), 21, 395n40, 427n11. *See* deities

Rabb, Theodore K., 96, 427n12, 448n54

race: intersection of gender and, 132; of Justice, 112–113, 121, 124; social construction of, 102

race and ethnic bias task forces, 132–133, 304

race and conflict over art: in Mississippi, 113–116, 138, 459n108; in South Carolina, 15, 110–115, 190, 344; in Saint Croix, 121–124

racial discrimination: blindfold and, 103–104; courts as source of, 103–104, 132, 138, 304, 452n144; in death penalty, 131–132; in jury selection, 103, 451n134; in law enforcement, 104; reverse, 102, 189; in sentencing, 104, 132; task forces on, in courts, 107, 131–132, 304

racial segregation: in courthouses, 114, 137–139; in schools, 107, 382n19; U.S. Supreme Court on, 102, 107, 138

racial stereotypes, 113, 132, 459n108

Raffaello Sanzio da Urbino. *See* Raphael

Rafuse, Rosemary, 271–272

Raimondi, Marcantonio, 10, 11f, 345f, 387n47, 388n50

Ramos, Ismael, 362–363, 596n380

Ramseyer, Mark, xvii, 380n11, 554n64

Rao, P. Chandrekshara, 268

rapes, mass, as crimes against humanity, 274

Raphael: Saint Michael depicted by, 401n113; Reynolds influenced by, 450n94; Virtues depicted by, 10, 75–76, 76f, 387n46, 388n49, color plate 13. *See also* Vatican

rationality, blindfold as symbol of, 96

Ravenna (Italy), Church of St. Apollinare Nuovo in, 400n103, 410n271

Rawls, John: on hierarchy of Virtues, 389n53; on original position, 130; *A Theory of Justice,* 98; on veil of ignorance, 14, 95, 98, 130

realism, in WPA art, 108

*Rear Window* (film), 342

recordkeeping: in courthouses, 135, 471n21; by U.S. federal courts, 141, 155

recusal(s): criteria for, 128–130, 467n246; financial interests as reason for, 128, 415n39; friendship as reason for, 129–130; of Scalia, debate over, 128–130

*Red and the Black, The* (Stendhal), 513n116

Red Cross and Red Crescent, 333

Red scare, in Work Projects Administration, 108, 455nn33–34. *See also* Communism

Reed, Alma, 594n276, 596n334

Reformation: blindfold in, 67–68; iconophobia of, 95; Last Judgment images in, decline of, 37

Regan, Richard J., 389n53, 389n58

Regensburg (Germany), Lutheranism in, 411n299

Regensburg Town Hall, 408n239; handless judges in, 418n81; Last Judgment in, 35, 410n275, 410nn285–286, 410n294, 411n297, 411n299. *See* town hall(s)

regional courts, 225–246; budgets of, 281, 281f; caseloads of, 281–282, 282f; competition for design of, 249–250; construction of, 226; logos of, 282–287; mixed courts as, 225–226. *See also* international court(s); *specific courts*

registry: in Israel, 210, 213–214; Permanent Court of Arbitration as, 256

Rehabilitation Act of 1973, 508n19

Rehnquist, William: on accessibility of courts, 490n191; and access to courts, 182; and complaints against judges, 467n244; on congressional funding for federal courthouses, 178; on courtroom size and sharing, 170, 174; on GSA as landlord, 182; impact on federal courthouses, 152, 162, 163, 169, 171; recusal requested of, 468n274; on religious imagery in public art, 120, 462n163, 462n166, 463n168

Reich, Charles, 157, 485n51, 552n34

Reiner, Erica, 393n15, 394n22

religious imagery: in French courthouses, 200; U.S. Supreme Court on public displays of, 120, 462nn162–166. *See also* Christian imagery; Jewish imagery; Islam: images of Muhammad

religious life, and civic life, intermingling of, 33, 36, 408n241, 410–411nn295–296

Rembrandt, and Amsterdam Town Hall, 52, 422n173, 423n189, 423n195

Renaissance, Italian: Cardinal Virtues in, 8–10, 28–30, 347; fasces in, 398n77; "hear the other side" in, 14, 289, 291; Saint Michael in, 400n95; pain of Justice depicted in, 13–14; state legitimacy in,

12–13; town halls of, 10, 12–14, 134; Virtues in, 8–12, 347

Renaissance Revival architectural style, 144, 147, 407n231

Rennes (France), Parlement de Bretagne in, 197, 199f, 200

rent-a-judge program, 41, 269

renting of federal courthouses, 174–180; budget for, 176–180, 177f; cap on cost of, 180, 498n164; congressional subsidies for, 178–180; compared to construction of courthouses, 174; formulas for calculation of, 178–180

*Republic* (Plato), 93, 383n26, 390n65, 438n186

reservations: in Central American Court of Justice, 241; definition of, 260; in International Court of Justice, 261, 537n206; in Permanent Court of International Justice, 260; on United Nations Convention on the Law of the Sea, 267

resources, maldistribution of, 339. *See also* budget(s)

restorative justice, 309

Resurrection, 25, 35, 401n118. *See also* Last Judgment

*Revelation, Book of,* 409n262

reverse discrimination, 102, 189

Reykjavík (Iceland), Supreme Court in, 340, 585n23

Reynolds, Beatrice, 389n62

Reynolds, Joshua: balance in works of, 20, 98; *Justice* in New College Chapel, Oxford, 98–99, 99f, color plate 16; life of, 450n91; sight and blindness in works of, 98–99

Richardson, George, edition of Ripa's *Iconologia* by, 433n103, 434n114

Rieder, Georg, 418n81

Riess, Jonathan B., 405n185

right(s): age of, 236; evolution of rites into, xv, 14, 288; international movement toward expansion of, 236; in U.S. federal courts, 157–158. *See also* human rights, conventions

Ripa, Cesare: on blindness, 70; on elephants, 347; Giordano influenced by, 78, 79; and handless judges, 417n79; life of, 389n52, 416n59; on ostriches, 77, 439n196; Virtues depicted by, 12, 388n49, 388n52, 589n133. *See also* Alciatus, Andreas; *Iconologia;* Justice, personifications, representations, and attributes of

rituals: in English town halls, 134; in Venice, 81–82

Rivera, Diego, 356. *See also* Mexican muralist movement

Rivonia Trialists, 355, 593n255

roads, postal services and, 299, 562n241

Robert, Christian-Nils, 408n255, 413n9, 418n79, 432n86, 446n29, 448n51

Roberts, John G.: on color-blindness, 102, 451n127; on judicial salaries, 182; on rent costs, 179, 499n186

Roberts, Simon, xvii, 323, 336, 338, 340

Robinson, Davis R., 538n225

Rochberg, Francesca, 393n17, 394n24, 397n52

Rockburne, Dorothea, xvii, 30, 32f, 33, 407n232, color plate 7. *See also* allegories of good and bad government

rod(s): Babylonian, 18; Roman, 22, 398n77

Rode, Martin van, 400n96

Rodríguez, Antonio, 595n321

Rodríquez, Mario, 528n231

*Roe v. Wade*, 7f, 8, 382n20

Rogers, Catherine, 325

Rogers, Isaiah, 479n176

Rogers, Richard: Antwerp Court House by, 525n133; Bordeaux Palais de Justice by, 197, 198f, 511n84; European Court of Human Rights building by, 235, 236f, 237–238, 251, 526n169, 533n41, 585n17; fame of, 237, 512n102; in France's *Grand Projets*, 586n30; Georges Pompidou Centre by, 237, 512n102; and International Tribunal for the Law of the Sea building, 269, 542n372; Pritzker Prize to, 235

Roman Empire: coins of, 22, 398nn74–75, 399n79; emperors of, 22; images of Justicia in, 22, 398nn74–77, 399n79; Justinian Code in, 19; Virtues in, 22, 398n74

Romanesque architectural style, 24, 143, 209, 213, 251

Roman law: compared to customary law, 446n31; German adoption of, 68–69

Romano, Giulio: Justice depicted by, 77, 77f, 78; life of, 438n190; Virtues depicted by, 387n46

Romanoski, Mark, 457n64

Roman Republic: Brutus in, 58; images of Justice in, 398n74

*Romans* (biblical book), 24, 400n99

Rome (Italy), Palazzo di Giustizia in, 532n26

Rome, ancient: in Amsterdam Town Hall, 51, 422n173; calendar of, 393n18; goddesses of, 21–22; "hear the other side" in, 291; legal system of, 22; and Saint Michael, 23; in origins of Justice iconography, 21–22, 398nn74–75; public trials in, 293; sun gods of, 64. *See also* deities, Roman

Rome Statute, of International Criminal Court, 275–277, 279

Roosevelt, Franklin Delano: court-packing attempt by, 359; public hostility toward programs of, 108; Works Project Administration established by, 455n22. *See also* New Deal

Roosevelt, Theodore, and publicity, 300

Root, Elihu: career of, 536n155; in establishment of Central American Court of Justice, 528n231; in Hague Peace Conference of 1907, 249; on Permanent Court of International Justice, 259, 535n137

Rosand, David, xvii, 421n143, 440n227, 441n229, 441n232, 442n260

Rosen, Frederick, 559n151

Rosse, Herman, 253, 254f, 534n96, color plate 40

Roth, Jane R., 500n222

Rothe, Johannes, 45–46

Rothschild, Dorothy de, 213, 516n219

Rothschild family, 208

Roubert, Jean-Loup, 513n114

Rousseau, Jean-Jacques, 342

Rowan, Edward B., 455n22, 458n73, 458n82, 458n89, 459n92

Rowe, Nina, xvii, 428n43, 429n45, 429nn50–51

Royal Academy of the Arts, 450n91

royale imagery, in French courthouses, 200

Roybal, Edward, 188

Rubens, Peter Paul: Cambyses depicted by, 414n27; Campen as disciple of, 419n116; Ecclesia depicted by, 429n54; paintings of Marie de Medici by, 5, 84, 440n220; snakes associated with Justice by, 79, 79f, color plate 15

Rubinstein, Nicolai, 404n169, 406n192, 406n198, 408n238

Ruckstuhl, Frederick Wellington, 461n142

Rudhardt, Jean, 397n66

Rules Enabling Act of 1934 (U.S.), 155

Rules on the Taking of Evidence in International Commercial Arbitration, 321–322, 325

Ruskin, John, 465n222

Russia: in European Court of Human Rights, 527n206; show-trials in, 288

Russian Constructivism architectural style, 251

Russian Revolution (1917), 249

Rutledge, Wiley, 102

Rwanda: crimes against humanity in, 275; in Holzer's Nantes installation, 205, 207. *See also* International Criminal Tribunal for Rwanda

Ryssdal, Rolv, 239

Saarinen, Eliel, 251

Sachs, Albie, xvii, 350, 353, 355, 592n224, 593n239, 593n259. *See also* South African Constitutional Court

Sacramento (California), U.S. Courthouse in: Holzer's installation in, 184, 189–190, 190f, 344; Otterness's sculptures in, 188–189

Saenredam, Pieter, 420n132

Safdie, Moshe, 147

*Saiga Case*, in International Tribunal for the Law of the Sea, 540n308

Saint Ambrose, 344, 346, 383n26, 588n95

Saint Anselm, 384n29

Saint Augustine: and "hear the other side," 289; on Last Judgment, 419n100; life of, 551n8; on temperance, 346; on weighing of souls, 24, 400n103

Saint Croix (Virgin Islands), Almeric L. Christian Federal Building in, Mitchell's Justice sculpture in, 121, 121f, 123–124, 124f, color plate 23

Saint George, 24, 401n113

Saint Gregory, 439n210

Saint Michael 22–25; Bible on, 24, 399n87, 399n89; cult of, 24, 399n93; duties of, 22,

24, 399n85; in France, 24, 399n93, 400n94; in Last Judgment, 23–25, 24f, 400n107, color plate 5; as psychopomp, 24, 399n90; scales of, 22, 23–25; sword of, 25, 28. *See also* balance(s), scale(s)

Saint Paul, 23, 65, 384n27, 400n99, 405n180, 409n270, 429n55

Saint-Gaudens, Augustus, 461n146, 488n122

St. Louis (Missouri), Thomas F. Eagleton Federal Courthouse in, 158–160, 160f, 311, 567n62

salaries, judicial: in Inter-American Court of Human Rights, 245; compared to other professions, 308; separation of powers in setting of, 308; subservience to rulers and, 47–48; for U.S. federal judges, 182

salas de los pasos perdidos, 356

salles d'audience (courtrooms), 194, 197, 510n49

salles des pas perdus, 197, 204, 205f, 511nn84–85

Sallust, 419n110

salvation: in Christian theology, 24, 400n99; of judges, 37

Sambin, Hugues, 513n116

*Samuel, I*, 428n22

San Diego (California), U.S. Post Office and Customs House in, 147, 148f

San José (Costa Rica). *See* Central American Court of Justice; Inter-American Court of Human Rights

San Juan (Puerto Rico), José V. Toledo Federal Building in, 147, 148f

San Rafael (California), Marin County Civic Center in, 168, 491n205

Sansovino, Jacopo, 80, 80f, 440n227, 441n233

Santa Fe (New Mexico), Palace of Governors in, 136

Santander, Francisco, 349

Sappho, 550n644

Sargent, John Singer, 461n150

Sargon of Akkad, 393n10

satire: Bruegel's Virtues and Vices series as, 72, 435n139; Fiera's *De Iusticia Pingenda* as, 94

Saunders, Alison, 417n65

Sbriccoli, Mario, 551n5

scales, 18–22; in Babylonian imagery, 18–20, 19f, color plate 3; in Christian imagery, 22–25; in commerce, 19; in Egyptian imagery, 20–21; and "hear the other side" concept, 290; in international court logos, 284, 286, 287; in Justice iconography, 63, 94–95; in Koran, 21; in New Testament, 23, 28, 396n44; in Old Testament, 396nn44–45. *See also* balances; Koran; Maat; Saint Michael; Shamash

Scalia, Antonin: Vice President Cheney's relationship with and debate over recusal of, 128–130, 468n261

Scamozzi, 419n116

Schama, Simon, 52, 420n119, 421n142

Schechter, Stuart, 506n390

Scheel, Willy, 431–432nn84–85
Scheerbart, Paul, 341
Schiff, Benjamin, 276
Schild, Wolfgang, 410n282, 436n159
Schmidt Hammer Lassen / Bosch & Fjord, 280, 281
Schofield, Philip, xvi, 298, 558n118, 559n134, 559n141. *See also* Bentham
Schuck, Peter, xvii, 435n141
Schuer, Theodorus Vander, 437n165
Schultz, Charles, 5, 7f, 381n17, color plate 2
Schulz, Juergen, 408n241
Schumann, Robert, 235
Schwarz, Hans, 416n45
Schwarzenberg, Johann Freiherr zu, 431n79
Schwechten, Franz, 533n49
Schwendtner, Isaac, 408n239, 411n297
Scottsboro Boys, 103, 451n138. *See also* Hughes, Langston
*Scottsboro Limited* (Langston Hughes), 103, 451n135
SCSL. *See* Special Court for Sierra Leone
Sculpture Society, 117. *See also* City Beautiful Movement
Seabed Authority, International, 266, 541n333
Seabed Disputes Chamber, of International Tribunal for the Law of the Sea, 269
seal(s): of Amsterdam, 420n117; of Babylonia, 18, 19f, 392n3, color plate 3; of French Republic, 454n13; of New York State, 137, 473n54; of United States, 328, 427n14, 581n351; of U.S. Defense Department, 328–331, 581n351
seats of power: in England, 87; in Ireland, 86–87; U.S. courthouses as, 135, 137, 338, 373
Seattle (Washington): allegories of good and bad government in, 30–33, 31f, 407n230; federal courthouse in, 30–33, 407n230
Second Renaissance Revival architectural style, 407n231
secrecy: at Guantánamo Bay, 333–334, 335; in voting, 297, 298. *See also* confidentiality; privacy
security: *See* courthouse security
security, in U.S. federal buildings: budget for, 167; cost of, 173–174; in courthouse construction, 167, 173; GSA focus on, 167; JCUS on, 173, 491n198, 491n200, 494n42; rise of concerns about, 15, 167; separate circulation routes in, 173–174
Seeber, Christine, 396n50
Sefola, Harald, 355
segregation, racial. *See* racial segregation
segregation by roles, 342; in French courthouses (trois flux), 195, 196, 197, 200; functions of, 342; in Israeli Supreme Court, 216; in prisons, 223; in U.S. courthouses, 15, 136–137, 173–174, 338–339, 342
self-representation in court, 306, 309
Semper, Emmanuel, 518n331
Sen, Amartya, 558n121

Senate, U.S.: Committee on Environment and Public Works of, 176, 478n152; on Denver federal building, 145, 479n187; federal judges confirmed by, 127; Parks Commission of, 163, 488n122; on Permanent Court of International Justice, 260, 537n180; on waste in federal courthouse construction, 178
Seneca: on Cambyses, 39; in Holzer's Sacramento installation, 189; *Medea*, 290
sensory perception, amodal and intermodal, 97
sentencing: racial discrimination in, 104, 132; right of allocution in, 104
separation of powers: in Bible, 448n48; blindfold and, 96; in judicial budgets, 308; origins of, 13, 96–97
Sepphoris Synagogue, 394n20
September 11, 2001, terrorist attacks: conflict about adjudication after, 16, 304; security concerns after, 167. *See also* Guantánamo Bay
Serbia and Montenegro, 539nn271–272, 539n275
Serra, Richard, 107
Sessions Paper, 562n222
Seth (god), 395n32
settlement(s): in criminal cases, 312; judges' role in, 311–312; procedural rules encouraging, 16, 306, 312, 323; public access to information about, 321; requirements for discussion of, 312; in U.S. federal appellate courts, 313–314; U.S. rates of, 311. *See also* alternative dispute resolution; managerial judges
Seven Deadly Sins, 385n32
Seventh Amendment of U.S. Constitution, 293
sexual violence: as crime against humanity, 274, 276; publicity for, 302; as war crime, 276
Seyssel, Claude, 391n73
Shamash (god), 18; in Babylonian imagery, 18, 392n5; in Babylonian legal system, 18, 393n8, 393n12, 398n74; in Iraqi Special Tribunal logo, 287. *See also* Babylonia
Shamgar, Meir, 210, 214, 215, 516n221, 516n233
Shannon, Tim, 217, 218f, 219f
Shao, Jude, 382n21
shasharu (tool), 18. *See also* Shamash
Shearman, John, 438n183
Shepherd, Leslie, 174, 491n214
Shepley Bulfinch Richardson and Abbott (architectural firm), 450n100
Sherwin, Emily, 574n198
Shipman, Shirley, 323, 577n250
*Ship of Fools, The* (Sebastian Brant), 67–69, 430nn68–72, 431n74, 431nn76–78
*Ship of Fools, The* (Katherine Ann Porter), 430n72
show trials, 288
Shuster, Bill, 499n177, 500n228
Siegel, Reva, xvii, 453n6, 454n15, 561n199, 563n277, 574n188

Siena (Italy), 25–30; allegories of good and bad government in, 26–30; art commissions in, 27, 404n166; civic space in, 26–28; fall of, 30, 407nn226–227; and Geneva, 46; legal system of, 26–30, 404n162; the Nine in, 26–30, 33, 404n153, 404n161. *See also* Lorenzetti, Ambrogio
Siena, Palazzo Pubblico of, 26–28, 388n49; construction of, 27; functions of, 26; Judgment of Brutus in, 426n241; Lorenzetti's frescoes in, 26–30, 27f, 349, 360, color plates 6, 8; the Nine in, 26–30, 33, 404n153, 404n161; other frescoes in, 404n155; compared to Peace Palace, 262
Sierra Club Judicial Watch, 128–129
Sierra Leone, crimes against humanity in, 275. *See also* Special Court for Sierra Leone
sight: in hierarchy of senses, 97, 448n62; and judgment, 65, 95–96, 97; in Justice iconography, 14; and knowledge, 14, 91, 93, 95–97, 341–342; import of, 96, 104–105; in Reynolds's artwork, 98–99, 99f, color plate 16; value of, 62
Siitonen, Tuomo, 220, 220f, 222f
Silbey, Susan, xvii, 567n52
Simkhovich, Simka: life of, 113, 459n105; Mississippi Justice mural by, 15, 113–116, 114f, 115f, 359, color plate 20
Simmonds, Andrew R., 431n81
Simon, Louis A., 486n62
Simons, Charles E., Jr., 457n68
Simplicity (Virtue), 9. *See also* Virtues
sin(s): in Christian theology, 24, 400n99; Seven Deadly, 385n32
Siqueiros, David Alfaro, 356, 597n385. *See also* Mexican muralist movement
Sisamnes (judge): in Bruges Town Hall, 13, 38–39; story of, 38–39
Sisulu, Walter, 355
"situations," in International Criminal Court, 279
Sixteenth Amendment of U.S. Constitution, 143, 479n169
Sixth Amendment of U.S. Constitution: access to courts in, 293; "hear the other side" in, 290; jurors in, 452n159; right to the "assistance of counsel" in, 157
Skinner, Quentin, 26, 388n49, 390nn68–70, 405nn172–174, 405n188, 406n193, 406n200, 406n215, 407n222
Skouris, Vassilios, 230, 231, 522n36
Slanski, Kathryn E., xvii, 392n4, 393n11, 398n74
slavery: anti-slavery courts on, 225–226; in Britain, 225, 331, 521nn9–10, 581n357; end of, 272, 331, 521n9, 581n357; fugitive slaves, 138–139; proposed depiction of, in U.S. Courthouse, Virgin Islands, 123–124; in Virgin Islands, 121, 123
Slave Trade, Treaty for the Abolition of the (Great Britain–Spain, 1817), 225, 521n9
Slave Trade Tribunals, 225–226, 236, 272. *See also* mixed courts

Sloth (Vice), 9. *See also* Vices

small claims cases, 323

Smith, Alfred Louis, 217f, 518n331

Smith, Thomas Gordon, 491n214

snakes and serpents: and Saint Michael, 401n115; in Otterness's artwork, 185, 504n318; in Ripa's *Iconologia,* 43, 79, 417n70, 440n219; in Rubens's artwork, 79, 79f, color plate 15; symbolic meanings of, 79, 440n219

Snow, Edward, 435n141

Sobriety (Virtue), 9. *See also* Virtues

Social Security Administration (U.S.), 315, 317, 317f, 318, 571n140; adjudication and, 324

Sohn, Louis, 541n316

Sol Justitiae, 64; Christian embrace of, 64; Dürer's depiction of, 96, 285, 394n21; in International Court of Justice logo, 284–285

Solomon: glass in palace of, 586n35; Judgment of, in Amsterdam Town Hall, 56–57, 57f, 62; ubiquity of image of Judgment of, 57, 425n230

*Solomon, Book of,* 425n232

Solomon, Jay, 183, 494n52, 502n260

Solon, 86, 117, 120, 200, 289, 438n176, 461n143

Solzhenitsyn, Aleksandr, 190

*Somerset's Case (Somerset v. Stewart),* 331, 581n357

*Somme le roi,* 383n26

Sommerness, James A., 372–375f, color plate 49

Sophocles, *Oedipus Rex,* 65

*sophrosyne,* 346, 588n95. *See also* Virtues

soul, in Christian theology, 24, 400n105, 410n274

Souter, David: on accessibility of courts, 130, 490n191; on Ten Commandments displays, 462n162

South Africa: Apartheid era in, 352; 1996 Constitution of, 350; crime in, 355–356, 593n264; end of Apartheid in, 350; international law in, 591n172; judicial independence in, 350, 356; judicial system of, 350, 356; post-Apartheid era in, 355–356; public access to courts in, 350; Truth and Reconciliation Commission in, 273, 274, 591n173

South African Constitutional Court, 350–356; budget of, 592n228, 593n239, 593n241; challenges facing, 356; establishment of, 350; impact of, 350; jurisdiction of, 350; logo of, 351, 352; public opinion on, 350, 591n187; social rights in, 350

South African Constitutional Court building, 350–356; architectural critics on, 355, 593n262; art in, 355; budget of, 592n228, 593n239; competition for design of, 353; exterior design of, 350–356, 351f, 353f, color plates 42, 43; glass in, 350–351, 354; goals of, 350–351, 352, 353; history on display in, 350, 352–355; interior design of, 351, 352, 352f, 354, 354f; lessons

learned from, 374–376; library of, 352, 592n210; at Old Fort Prison site, 13, 352–353; as performance venue, 343, 351; size of, 354, 592n228

South African Institute of Architects, 355, 593n263

South Carolina. *See* Aiken

South Dakota, public art in, 183

space emergency, judicial (U.S.), 169–171, 181, 500n222

Spain: Constitutional Court of, 349, 518n332; glass architecture in, 349; Inquisition of, 35, 410n278; Last Judgment images in, 35; Supreme Court of, public access to, 294

Spanish Colonial Revival architectural style, 147

Special Court for Sierra Leone (SCSL), 275, 281, 281f, 282, 282f, 285, 286f, 546n506, 546nn515–516

special masters, 315, 570n124

Specter, Arlen, 180

Spenser, Edmund, 550n644; *The Faerie Queene,* 12, 390n63, 397n61, 397n63

Spielmann, Dean, 525n136

Spierenburg, Pieter, 519–520nn375–376, 521n412

*Spirit of Laws, The* (Montesquieu), 292

Springfield (Illinois), Illinois Supreme Court in, 291, 291f, 331

Springfield (Massachusetts), federal court in, 567n61

Spurgeon, Charles, 58, 426n255

Srebrenica massacre of 1995, 545n463

Stafford, Emma, 397n64

Stafford, Robert, 490n171

stained-glass windows: in New College Chapel (Reynolds), 98–99; in Peace Palace, 247–249

Stalpaert, Daniel, 420n116, 422n161

Stanton, Elizabeth Cady, quotation from, 189

Starn, Randolph, 404n159, 405n188, 406n209

state(s), U.S.: constitutions: freedom of press in, 299, public access to courts in, 14, 293, 555nn72–73, role of judges in, 292; federal buildings requested by, 141–142; history and development of courts in, 136–138; prisons of, 223; on public access to alternative dispute resolution data, 321, 575n208; sovereign immunity of, 102, 167, 490n191

state court(s), U.S.: accessibility of, 166–167, 490n191; budget shortfalls in, 308–309; demand and capacity of, 308–309; U.S. federal courts using procedural rules of, 140, 155 474n91; local rules of, 312; growth of, 117; number of filings in, 14, 137, 307, 308, 473n60; number of trials in, 311; racial segregation in, 114; supreme courts: race and ethnic bias task forces in, 132, 304, 469n292, salaries for justices of, 308, 566n30; television broadcast of, 294, 557n106; user fees for, 308; vulnerability of, 305, 306

State Department, U.S., in federal court administration, 140

state supreme courts, U.S.: race and ethnic bias task forces in, 132, 304, 469n292; salaries for justices of, 308, 566n30

statutory judges (U.S.), compared with constitutional judges, 315

Stead, William, 532n22

Steamboat Safety Act of 1855, 314, 570n116

Stendhal, *The Red and the Black,* 513n116

stereotypes: effects in court of, 132, 133; gender, 132; racial, 113, 132, 459n108; religious, 120

Stern, Robert, 168, 222

Steur, J. A. G. van der, 248f, 251

Stevens, John Paul: on accessibility of courts, 490n191; on religious imagery in public art, 120, 462n164

Stilwell, Gary A., 396n50

Stockade, Nicolaes van Helt, 51

Stone, Harlan Fiske, 384n22

*Stone v. Graham,* 462n163

Strachan, Douglas, 262, 538n230

Strand, Mark, 110

Strasbourg (France): Council of Europe in, 236–237; European Parliament in, 235, 237; Palais de l'Europe in, 525n129. *See also* European Court of Human Rights

Strasbourg Cathedral, Synagoga and Ecclesia in, 65, 66f, 386n39, 429n45

Strauss, Gerald, 403n142, 411n296

Strobel, Niclas, 35, 36f, 410n284

subsidies, government: for legal aid, 157, 296, 298, 308, 326, 377; for postal services, 288, 299, 305, 336; for U.S. federal courthouses, 178–180

substantive due process, 291

suffrage: universal, 295; for women, 295, 300

Sugarman, George, 465n217, 471n24

Sukenik, Eleazar, 518n293

sun gods, 64. *See also* Shamash; Sol Justitiae

Sunshine in Litigation Act of 1990 (Florida), 321

Sunshine in Litigation Act of 2007 (U.S. proposal), 575n209

Sunshine in the Courtroom Act of 2008 (U.S. proposal), 575n209

supermax prisons, 223, 560n181, 583n403

Supervising Architect, Office of the (U.S.): establishment of, 141, 476n115; federal building construction under, 143–147, 152; in General Services Administration, 142, 476n115; growth in size of, 152; private architects working with, 142, 143, 477n138; in Public Buildings Administration, 142, 476n115; Section of Fine Arts' conflicts with, 164, 488n131; in Treasury Department, 141, 142, 476n115, 477n138, 477n140; waste in, 142, 477n140. *See also* Bell, Mifflin E.; Freret, Will A.; Taylor, James Knox; Young, Ammi B

supranational courts, 259. *See also* international courts; mixed courts; regional courts

supreme courts. *See specific countries and states*

surveillance: in Bentham's Panopticon, 295, 297, 298, 327; Foucault on, xv, 295, 298, 356; at Guantánamo Bay, 327, 579n315; in supermax prisons, 560n181

Susa (Iran), Code of Hammurabi in, 18, 392n7

Suttner, Bertha von, 249

Sweden, public art funding in, 509n32

Switzerland. *See* Geneva

sword(s): in Justice iconography, 25, 28, 63, 94–95, 402n124; of Saint Michael, 25, 28; in Muhammad images, 120

Sybil of Erythraea (prophetess), 418n100

Syme, Ronald, 436n157

Synagoga and Ecclesia: blindfold in depictions of, 65–67, 66f, 97; symbolic meaning of, 65–67; Virtues in depictions of, 386n39. *See also* blindfolds

synagogues, zodiac mosaics in, 19, 394n20

Syria, torture in, 584n409

Szambien, Werner, 512n99

Szmuk, Peter, 214–215, 214f, 215f

tablets: in Jewish imagery, 423n196; Mesopotamian legal system on, 18, 393n10

Tachau, Katherine H., 448n63

Taddeo di Bartolo, 408n238

Taft, William Howard: appointment as Chief Justice, 150; and Commission on Fine Arts, 163, 488n123, 488n127; death of, 384n22; on federal judges, 152, 154–155; judicial innovations of, 152, 154–155; on Supreme Court building, 150, 152, 588n84; on Supreme Court caseload, 313; on user fees, 415n39

Taliban, as enemy combatants, 327

Tamariz, Ernesto, 359, 595n312

Tanzania, International Criminal Tribunal for Rwanda in, 275

tapestries: Danish, Cambyses in, 39, 413n17; in European Court of Justice, 235; in Peace Palace, 253, 534n91; Rubens's design for, 79, 440n220; in South African Constitutional Court, 355

tarot cards, 75, 437n169, 590n139

Tarride, Laurence Depambour, 200–201, 203–204, 207, 513n128, 514n143, 514n145, 514n148, 514n151, 514n153, 515n167, 515nn172–173, 515n175

Tarsney Act of 1893 (U.S.), 142, 145, 165, 477nn142–143

Task Force on Correctional Architecture (U.S.), 194, 508n25

Task Force on Federal Architecture, NEA (U.S.), 165, 166

task forces on fairness in courts (U.S. and Canada), 107, 132–133, 304

Taslitz, Andrew E., 452n149

Tasso, Torquato, 447n34

Tatti, Jacopo. *See* Sansovino, Jacopo

Taut, Bruno, 341, 586n35

taverns, colonial American courts in, 136, 471n27

Tax Court, U.S., 570n125

Taylor, Charles, in Special Court for Sierra Leone, 275, 546n506, 546n515

Taylor, James Knox: buildings designed by, 144, 145f, 147, 147f, 148f, 159f, 407n231, 486n62; Gilbert's partnership with, 481n220; as Supervising Architect, 144, 145, 407n231, 479n181

Taylor, Katherine Fischer, 391n91, 393n13, 472n38

Taylor, Robert, 84

technology: public access to courts through, 294, 302, 303; video recordings, dissemination of, 302; virtual encounters through, 302, 303, 342. *See also* media; press; publication of court reports; Saddam Hussein; video

television broadcasts, 294; of Canadian Supreme Court, 294, 557n104; of Guantánamo Bay, 333, 333f; of International Criminal Tribunal for the former Yugoslavia, 294, 334, 557n105; of U.S. federal courts, 294, 557n107; of U.S. state courts, 294, 557n106; U.S. Supreme Court on, 557n107

Temperance (Virtue): in Amsterdam Town Hall, 50; attributes of, 386n33; as Cardinal Virtue, 8, 344–347, 345f; depictions of, 8, 10, 11f, 27f, 28, 32f, 33, 50, 83–84, 83f, 87, 93, 98, 347, 388n49; in hierarchy of Virtues, 12, 390n65; meaning of, 346; Plato on, 12. *See also* Virtues

*temperantia*, 32, 346, 388n49. *See also* Sophrosyne

Temples of Justice, U.S. courthouses as, 137

Ten Commandments: in Amsterdam Town Hall, 52–53; blindness and, 65; in Justice images, 19; tablets of, 423n196; U.S. Supreme Court on displays of, 120, 462nn162–163

Tengler, Ulrich, *Laienspiegel*, 34, 409n256, 409nn262–263, 410n293

*Tennessee v. Lane*, 166–167, 167f, 490n191, 491n194

Tepper, Steven J., 454n12, 501n257

*terra nullius*, 368

territorial disputes, arbitration of, 249

terrorism, glass architecture and, 342

terrorist suspects: access to courts for, 16, 335; detention of (*See* Guantánamo Bay); in U.S. federal courts, 328

Teubner, Gunther, 336

Texas: statehood for, 143, 479n166; Ten Commandments in, 120, 462n161. *See also* Galveston

Thacker, Philip Gerald, 494n43

theatres of justice, 297, 298. *See also* Bentham, Jeremy

Theban judges, 43, 44, 447n39. *See also* handless judges

Themis (goddess): modern depictions of, 1, 2f, 379n3; in origins of Justice iconogra-

phy, 21, 397nn64–65; Roman version of, 22; Temple of, 195, 510n49

Theological Virtues, 8, 12, 384nn27–28; in allegories of good and bad government, 28, 32; in Oxford's New College Chapel, 98. *See also* Charity; Faith; Hope; Virtues

Theology, discipline of, 76, 438n179

*Theory of Justice, A* (Rawls), 98

*Thessalonians, First Epistle to*, 409n270

*Third Branch, The* (newsletter), 169, 170f

Thom, Bing, 445n329

Thomas, Clarence: on accessibility of courts, 130, 490n191; on color-blindness, 451n127

Thomas, Évelyne, 454n13

Thompson, Robert, 348, 349

Thoth (god), 21, 396n40. *See also* Maat

*Throne Baldachin* (Danish tapestry), 39, 413n17

*Thronus Justitiae* (Wtewael), 425n228, 437n166

Thurley, Simon, 442n267

Thurmond, Strom, 113, 459n100

Tiarini, Alessandro, 347

Tiberius (Emperor), 58

*Time Magazine*, 361, 382n19

Tipton, Susan, 408n255, 416n53, 425n228, 436n160, 436n161

Tittler, Robert, 470n4, 470nn6–7, 519n372

Titus (Emperor), 58

Tjoflat, Gerald Bard, xvii, 491n195, 492n1, 493n34

toads, 414n21, 433n112

Tokyo, Supreme Court of Japan in, 1, 5f, 380n11

Tokyo Tribunal, 273

Tolnay, Charles de, 435n139, 435n141

Topeka (Kansas), Kansas Judicial Center in, 87–88, 88f, 445n324

Torah, 209. *See also* Bible; Old Testament

Torcello (Italy), 410n271

torture: in Amsterdam Town Hall, 53–54, 427n10; definitions of, 327; at Guantánamo Bay, 327, 334; history of, 424n207; by Mexican police, 366; oversight of, 293; of terrorist suspects, 584n409

Torture Memos (U.S.), 327, 334

Totten, George O., Jr., 109, 456n46

Totten, Samuel, 274–275

Totten, Vicken von Post, 109, 110, 111f

town hall(s): allegories of good and bad government in, 33, 408n239; alternative terms for, 134, 470n4; Augsburg, 45; Basel, 61, 410n275; Bautzen, 410n275; Breslau, 35, 412n6; Bruges, 13, 35, 38–39, 42, 47, 51, 410n275; Brussels, 39, 58; Cambyses's story in, 38–39, 414n27; commerce in, 26, 403n150; and churches, 33, 408n241; Cologne, 424n26, 436n162, 437n166; cost of construction of, 134; decline of, 15; Emden, 410n275, 412n6, 424n228, 436n162; evolution of courthouses from, 134–136; Gdańsk (Danzig),

39, 45, 410n275, 412n6; Geneva, 13, 44–47, 45f, 47f, 51, 74, 292; Graz, 35, 410n275; Haarlem, 75, 410n275; Kampen, 410n275, 425n230; Last Judgment images in, 10, 12, 35–37, 410n275; Louvain, 410n275; Lüneburg, 35, 410n275; Maastricht, 42, 44; Mons, 39; motivations for building, 134, 402n136, 470n6; multiple functions of, 26, 134, 403n150, 470n4; Münster, 412n6, 425n230, 436n161; Nuremberg, 35, 42, 410n275; public and social traditions in, 134–136; Regensburg, 35, 45, 410n275; religious spaces in, 33, 408n241; Renaissance, 10, 12–14, 134; rise of, 15, 26; Tübingen, 76; Ulm, 45; Virtues depicted on, 10. See also Amsterdam town hall

Tracy, Evarts, 480n193
Tracy, Swartwout, & Litchfield, 146f, 480n188
traffic laws, 104, 452n148
Trajan, Judgment of, 58
Transactional Records Access Clearinghouse (TRAC), 318
transnational arbitration, in England, 324–325
transnational courts. See mixed courts; international court(s); regional courts
transportation, postal services and, 299, 562n241
Transportation and Infrastructure, House Committee on, 176, 478n152
Treasury Department, U.S.: commissions in New Jersey by, 108, 456n38; establishment of, 141; federal construction under, 140–142; federal court administration under, 140; Section of Fine Arts in, 108, 164, 455n23, 456n39, 478n150; Section of Painting and Sculpture in, 112, 164, 478n150. See also Supervising Architect, Office of the
treaties: bilateral investment, 226; European Court of Justice in interpretation of, 227; 1992 Maastricht Treaty, 226, 228, 522n32, 523n56; Treaty Establishing the European Coal and Steel Community, 522n31; Treaty Establishing the European Economic Community, 522n20, 523n53; Treaty for the Abolition of the Slave Trade, Britain–Spain, 521n9; Treaty of Amity, Commerce and Navigation, United States–Great Britain, 225, 521n6; Treaty on European Union, 522n28. See also convention(s)
treaty court, International Criminal Court as, 276; International Law of the Sea and, 276
tree(s): in French imagery, 200, 202, 351, 513nn134–135; of Justice, 200, 513nn134–135; in South African Constitutional Court logo, 351; symbolic meaning of, 351; of Virtues, 9, 347, 385n30
trial(s): alternative dispute resolution's impact on, 313, 569n98; average length of

(U.S.), 568n65; decline in rates of (U.S.), 16, 310–311, 311f; fair, 290, 334, 552n29, 583n392; in England, 295, 322–325; jury, origins of right to, 293; knowledge allowed in, 104–105; as marker of governance, 288; press coverage of, 301–302; prison uniforms in, 105; public, origins of, 14–16, 293–294; public relations in, 302–303

tribunals: access to, 16; Combatant Status Review Tribunal, 327–328; in England, 324; European Court of Justice, 227–235; European Court of Human Rights, 227–235; history of, 247; Inter-American Court of Human Rights, 244–245, 531n323; International Criminal Court, 275–281; International Court of Justice, 261–265; International Criminal Tribunal for the Former Yugoslavia, 273–275; International Criminal Tribunal for Rwanda, 275; Iran–U.S. Claims Tribunal, 257–258; Iraqi Special Tribunal, 286–287; International Tribunal for the Law of the Sea, 265–272; Native National Title Tribunal, 368; Permanent Court of Arbitration, 256–257; privatization of adjudication through, 16; Public Opinion Tribunal (Bentham), 14, 298–299; as purpose-built structures, 15; Slave Trade Tribunals, 226, 236; Social Security Appeals Tribunal, 324; Special Court for Sierra Leone, 275, 281, 281f, 282, 282f, 285, 286f, 546n506, 546nn515–516; *The Tribunal of Fools*, 67–69; U.N. creation of, 272, 273–275; after World War II, 273. See also administrative law judges

Trindade, Antônio A. Cançado, 246
Troescher, Georg, 409n256, 410n281
trois flux, les, 200, 280. See also courthouse security; French courthouses
Truth (Virtue), 8, 384n29; in Four Daughters of God, 1, 73, 83, 84, 87, 119, 283, 384n29, 389n54, 437n162, 439n191, 443n287. See also Virtues
Truth and Reconciliation Commission (South Africa), 273, 274, 591n173
truth and reconciliation commissions: and international criminal courts, 273, 274; restorative justice through, 309
Tübingen Town Hall, 75
Tuerk, Helmut, 541n313, 541n336, 542n352
*Tumey v. Ohio*, 40, 415n39. See also judicial impartiality
Tuthill, Louisa, 477n137
Tutu, Desmond, 579n311
Tuve, Rosemond, 383n26, 385n30, 401n115
Twining, William, 296, 558n118, 559n141
two-faced Justice, 72, 74, 436n149. See also Damhoudere, Joost de; Janus
Tyldesley, Joyce, 396n50
tyranny, in allegories of good and bad government, 29, 30. See also Lorenzetti, Amrogio; Bach, Caleb; Rockburne, Dorothea

Uclés, Alberto, 528n235
UDHR. See Universal Declaration of Human Rights
Ulm Town Hall, 45; handless judges in, 418n81. See also town hall(s)
U.N. See United Nations
UNCITRAL. See United Nations Commission for International Trade Law
UNCLOS. See United Nations Conference on the Law of the Sea; United Nations Convention on the Law of the Sea
Understanding (Virtue), 8, 384n28. See also Virtues
Uniform Mediation Act of 2003, 569n90
United Kingdom (UK): alternative dispute resolution in, 306; death penalty in, 558n114; Human Rights Act of 1998 in, 239; legal aid in, 309, 322–323; Supreme Court of, 216, 518n327; women in legal profession in, 468n280. See also Britain; England; Wales
United Nations (U.N.): adjudication principles adopted by, 446n30; annual budget of, 264; arbitration rules by, 257; Charter of (1946), 206; establishment of, 236; on indigenous rights, 368, 599n458; International Law Commission of, 267, 273, 275–276; on judicial independence, 292; judicial organ of (See International Court of Justice); logo of, 285, 550n652; on Mexican legal profession, 366; tribunals created by, 272, 273–275; U.S. participation in, 260
United Nations Commission for International Trade Law (UNCITRAL), 257, 325
United Nations Commission on Human Rights, 579n311
United Nations Conference on the Law of the Sea (UNCLOS), 267
United Nations Convention on the Law of the Sea (UNCLOS), 265–268; German participation in, 265, 270, 543n391; Implementation Agreement (1994) on, 266, 268; Permanent Court of Arbitration and, 257; U.S. participation in, 260, 268. See also International Tribunal for the Law of the Sea
United Nations Declaration on the Elimination of Discrimination against Women (1967), 206
United Nations Declaration on the Rights of Persons Belonging to National or Ethnic, Religious and Linguistic Minorities (1992), 368
United Nations International Covenant on Civil and Political Rights (1966), 14, 294
United Nations Rapporteur on Torture, 335
United Nations Report on Detainees, 582n360
United Nations Security Council: in International Court of Justice, 261; in International Criminal Court, 276–277, 278, 279; tribunals created by, 272, 273–275

United Nations Special Rapporteur for the Independence of Judges and Lawyers, 335

United Nations Universal Declaration of Human Rights, 203, 204f, 236, 273

United States: in American Convention on Human Rights, 243; in Central American Court of Justice, 528n231; coins of, 454n15, 461n146; colonial, 14, 135–137, 293; as common law federation, 195; courthouses of (See United States courthouses); custom houses in, 140–141, 143–144, 152; diversity jurisdiction in, 226; fairness in, 290; federal courts in national legal regime of, 157; "hear the other side" in, 290–291; in International Court of Justice, 261, 264, 538n216; in International Criminal Court, 260, 276, 277; in Iran hostage crisis, 256, 535n127; in Iraq war, 1, 278; in Jay Treaty, 225; judges of (See United States judges); law in identity of, 136; legal aid in, 131, 306, 309; in Permanent Court of International Justice, 259, 260, 536n147; population of, 307, 308; prisons in, history of, 222–224; Seal of, 328, 427n14, 581n351; in U.N. Convention on the Law of the Sea, 260, 268

United States Congress. See Congress, U.S.

United States Constitution: access to courts in, 293; and agency adjudication, 316, 572n146; anti-federalist writings on, 58, 426n253; Article III of, 121, 315, 448n57, 463n177, 570n118; color-blindness of, 95, 102–103; Confrontation Clause of, 452n156; due process in, 105, 290, 291; federal construction in, 140; "hear the other side" in, 290; judicial independence in, 13, 97, 292, 293; judicial role in, 292; jurors in, 104, 452n159; life tenure for judges in, 13, 97, 127, 139, 391n80; the people in, 97; on post offices, 140, 299; press freedom in, 299; on public disclosure obligations, 293–294; right to counsel in, 157. See also specific amendments

United States courthouses, 134–153; colonial, 135–137; debt caused by construction of, 137; diversity of architectural styles of, 137, 138f, 139f, color plate 28; homogenization of design of, 136; lawyers' influence on, 136, 472nn37–38, 472n45; location of, meaning behind, 136, 137; protests at, 139, 473–474nn71–72; public and social traditions in, 135–136; as purpose-built structures, 136; rise in number of, 14–15; as seats of power, 135, 137; segregation by race in, 137–139; segregation by role in, 15, 136–137. See also county courthouses; federal courthouses; state courthouses

United States Courts Design Guide, 171–174; 1991 edition of, 172, 494nn46–47; 1997 edition of, 172, 173, 178, 494n46, 495n60; 2007 edition of, 172, 174, 494n46, 495n60; on alternative dispute resolution suites, 312, 343, 569n84, 569n86; on shar-

ing of space, 178, 181. See also GSA Design Guides; Judicial Conference of the United States

United States judges: federal buildings named after, 158, 483n251, 486n69; gender, ethnic, and racial diversity and, 102–103, 107, 114–115, 128, 131–133; number of, 14; ratio of population to, 308; separate circulation routes for, 173–174, 472n38.

United States Supreme Court: on abortion rights, 7f, 8, 382n20; on accessibility of courts, 167, 167f, 490n191; on agency adjudication, 316; on arbitration contracts, 320, 573n177; on blindness, 102–103; building of (See United States Supreme Court building); on campaign contributions to judges, 415n41; caseload of, 313, 585n9; on Civil Rights movement, 157; on color-blindness, 95, 102–103, 447n35, 451n127; on Confrontation Clause, 452n156; on counsel, right to, 102, 131, 157, 602n559; on Court of Claims, 570n118; court-packing attempt in, 359; on discovery, 129, 130; docket of, 154–155; on due process, 290, 552n31, 552n34; establishment of, 139; on fairness, 290, 552n25, 552n35; Federal Rules of Civil Procedure issued by, 155; on Guantánamo Bay, 327, 334, 379n1, 580n318; on International Court of Justice rulings, 261, 538n217; on judicial review, 102; jurisdiction of, 313; justices of (See United States Supreme Court justices); on mandatory private arbitration, 573n168, 574n188; number of employees of, 484n29; Office of the Curator, 380n9, 461n146, 482n283; original jurisdiction of, 140, 474n84; on post offices, 584n415; on protests at courthouses, 473–474nn71–72; on racial segregation, 102, 107, 138; on racism in death penalty, 131–132, 468n285; on racism in jury selection, 103, 451n134; on recusal, 468n268; on religious imagery, public displays of, 120, 462nn162–166; on supermax prisons, 223, 560n181; on television broadcasts, 557n107; on Ten Commandments displays, 120, 462nn162–163; on testimonial statements, 452n156; on user fees, 40. See also specific cases

United States Supreme Court building, 149–152, 151f; Administrative Office in, 162; architectural critics on, 151–152; cost of, 151, 482n246; design and construction of, 151; "Equal Justice Under Law" inscription on, 331, 332f, 377, 581n355; Gilbert as architect of, 119, 149, 151, 152; Justice sculptures in, 151, 482n238; lack of, 140, 150; need for, 150, 343; open front plaza, closing of, 585n25; renovation of, 482n246; security in, 377, 585n25; Weinman's Muhammad frieze in, 119–121, 151

United States Supreme Court justices: cartoon depictions of, 5–8, 7f, 382n19;

chambers for retired, 488n116; in circuit court, 140; in Judicial Conference of the United States, 155–156; role in case selection, 154–155; timeline of Chief Justices, 384n22. See also specific justices

Universal Declaration of Human Rights (UDHR) (1948), 236; adoption of, 273; judicial independence in, 292; in Lyon Palais de Justice, 203, 204f, 351

University College London, 324

unlawful belligerents, 580n321

unlawful enemy combatants. See enemy combatants

unpublished opinions, 314

Urban I, Pope, 439n192

urban renewal and U.S. federal building, 164, 165

Urban Solutions, 350, 351f, 592n194

Urbina, Salvador, 362

user fees: in English courts, 308, 558n115; in full-cost pricing, 41; compared to gifts, 41; history of, 40–41; lowering of, 157, 308; in U.S. courts, 308

Utu. See Babylonia; Mesopotamia; Shamash

Vähäkallio, Väinö, 220

Valdes, Francisco G., 518n332

Valencia, Daniel V., 596n373

Valerius Maximus, Memorable Doings and Sayings: and Amsterdam Town Hall, 58, 422n173; on Brutus, 58; on Cambyses, 413n19; on Zaleucus, 58, 425n238

Vallarta, Ignacio L., 595n312

Van Cleve, John, 430n71

Van Devanter, Willis, 482n226

Vandeveld, Darrel, 334, 583n390

"vanishing trial," 16, 311, 317. See also Alternative Dispute Resolution (ADR); settlement

VanNatta, John, 581n353

Van Orden v. Perry, 462n161, 462n163, 462n166

Vasari, Giorgio, 78

Vasconcelos, José, 358

Vasconi, Claude, 512n111

Vatican: Last Judgment depicted in, 35, 410n274; Sala di Constantino in, 76–77, 77f, 439n191; Sistine Chapel of, 35, 410n274; Stanza della Segnatura in, 10, 75–76, 76f, 387n46, 425n232, 437n175; Stanza dell'Incendio in, 387n46; Virtues depicted in, 10, 75–76, 76f, 77f, 387n46, 439n191

Veall, Donald, 416n55, 443n294

Veere City Hall, 75

Veil: blindness associated with, 65, 67; and Moses, 65, 428n26

veil of ignorance, Rawls on, 14, 95, 98, 130

Velden, Hugo van der, 412n2, 412n8, 415n29, 445n337

Veneziano, Agostino, 10, 10f, 11f, 345f, 387n47

Venice, 79–82; Basilica of San Marco in, 80; Bucintoro in, 81–82, 81f, 441nn246–247; Canaletto's depictions of, 81, 81f, 82,

441n246; Christian imagery in, 80; civic space in, 80; decline of, 441n256; Doges' role in, 80, 81, 440n223; as Justice, 80, 80f, 82, 82f; Loggetta of San Marco in, 80, 440–441nn227–228; as "New Rome," 80–81; republican government of, 80; role of Justice iconography in, 79–80

Vennekool, Jacov, 424n221

Venus (goddess), 80

Vermont, judicial budget shortfalls in, 308. *See also* Windsor

Verrio, Antonio: life of, 442n264, 442n273; painting of Anne of England by, 5, 83–84, 83f, 442nn274–275

Veterans' Affairs, U.S. Department of, 317, 317f, 318

Veterans Claims, Court of Appeals for, 570n125

Vices: in allegories of good and bad government, 29, 32–33, 406n200; in battle (psychomachia), 8–9, 384–385n30–32; Bruegel's series of, 71, 72, 435n139, 435n141; gender of, 9, 386n35; Mantegna's depiction of, 93, 386n37; in Orozco's murals, 359, 360; Renaissance depictions of, 9–10; in Sienese frescoes, 29, 406n200; in U.S. Supreme Court building, 119. *See also* Anger; Avarice; Deceit; Despair; Discord; Envy; Extravagance; Gluttony; Greed; Idolatry; Inconstancy; Infidelity; Lechery; Lust; Pride; *Psychomachia*; Sloth

vicinage, 104

victims, in International Criminal Court, 277, 547n545

Victoria, 249

Victoria County (Australia): Victoria County Courthouse, 1, 2f, 379n4; Victoria Supreme Court, 217, 217f, 218f

Victorian architectural style, 137

Vietnam War, 502n260

Vigilance (Virtue): in Amsterdam Town Hall, 50, 422n161; cranes associated with, 79, 440n217

Vinson, Frederick, 384n22

Virgil, *Aeneid*, 55, 418n99

Virginia: colonial courthouses in, 135, 471n18, 471n27, 472nn31–33; Hanover County Courthouse in, 161; racial segregation in courthouses of, 138–139

Virgin Islands: Africa in history of, 121–122; federal court in, 121; Moco Jumbie in, 121–123, 123f, color plate 22; territorial judges in, 121; U.S. purchase of, 121. *See also* Saint Croix

*Virgin Islands Business Journal,* 122–123

Virgin Mary: in Last Judgment images, 24, 35, 401n111; Saint Michael and, 24, 401n111; as patron of Siena, 405n172; in Venice, 80

Virtues: in allegories of good and bad government, 28–33; in Amsterdam Town Hall, 50–52, 50f, 62; in battle (psychomachia), 8–9, 384–385n30–32; Bruegel's series of, 71, 72, 435n139, 435n141; Car-

dinal (*See* Cardinal Virtues); in Christian theology, 10, 344–346, 383n26, 386n40, 387n42; in European Court of Justice, 233; Four Daughters of God, 8–9, 384n29; gender of, 9, 384n27, 386n35; Gift (*See* Gift Virtues), 384n28; hierarchy of, 12, 346, 384n28, 389n53, 390n65, 390nn68–71; Ladders of, 347; Mantegna's depiction of, 93, 386n37; modern need for understanding of, 17, 344; in Peace Palace, 253; Plato on, 8, 12, 344, 383n26, 389n53, 390n65; in Renaissance, 8–12, 347; in Roman Empire, 22, 398n74; Sophrosyne, 346, 388n49, 390n72, 588n94, 588n95; Theological (*See* Theological Virtues); tree of, 9, 347, 385n30; in U.S. Supreme Court building, 119; in Vatican, 10, 75–76, 76f, 77, 387n46, 439n191. *See also* Abstinence; Aequitas; Charity; Chastity; Concord; Courage; Discipline; Equity; Fortitude; Humility; Justice; Largesse; Liberality; Love; Loyalty; Magnanimity; Mercy; Modesty; Obedience; Peace; Prudence; *Psychomachia*; Simplicity; Sobriety; Temperance; Truth; Understanding; Vigilance; Wisdom

Vitruvius, 48, 419n116; *De architecturae libri decem,* 419n116

Vittoria, Alessandro, 441n233

voir dire, 104

Volavkova, Zdenka, 349, 590n160

Volcker, Paul, on judicial salaries, 182

Voltaire, *Brutus,* 58, 426n252

voluntary arbitration, history of, 319. *See also* arbitration; Alternative Dispute Resolution (ADR)

Vondel, Joost van den, 50, 53, 58, 61, 422n157, 423–424nn201–202

vonRoenn, Kenneth F., Jr., 457n63

Vos, Jan, 53, 423n202

Vos, Marten de, 46

*Vrede door Recht,* 249, 250f

Vukas, Budislav, 542n363

Wackenhut Corrections Corporation, 224

Wagner, Otto, 251, 533n49

Wales: design guides for courthouses of, 507n10; procedural rules encouraging settlements in, 16, 323

Walker, Garth, 592n192

Wallace, George, 103

Wallis, John Joseph, 602n563

*Wall Street Journal,* 7f, 8, 382n21

Walter, Francis E., 382n19

Walter of Châtillon, *Alexandreis,* 419n104

Walzer, Michael, 449n83

war, laws of: Geneva Conventions on (*See* Geneva Convention); Lieber Code on rules of, 272, 562n245; as right of states, 272. *See also* tribunals

war crimes: gender and, 276; in International Criminal Court, 276; in World War II, 273. *See also* crimes against humanity

Wardrop, James, 446n20, 446n26

Ware, W. R., 533n38

Warner, Marina, 386n35, 386n37, 406n195

Warren, Earl: appointment as Chief Justice, 384n22; cartoon depictions of, 5–8, 7f, 382n19; and Civil Rights movement, 157; in Judicial Conference of the United States, 155, 485n47

Warren, Marilyn, xvii, 518n330, 576n229, 578n270

warrior(s), Saint Michael as, 24, 400nn94–96, 401n113

Washington (state). *See* Seattle

Washington, D.C.: baseball stadium in, 341, 586n29; Capitol building in, 140; City Hall of, 474n88; Commission on Fine Arts' focus on, 164, 488n127; Dolley Madison House in, 162, 163f, 487n107; establishment of court system in, 139, 474n88; federal courthouse in, 156, 484n35; Inter-American Commission on Human Rights meeting in, 243; Inter-American Court of Human Rights meeting in, 243; origins of federal buildings in, 140–142; Supreme Court's move to, 140; Thurgood Marshall Federal Judiciary Building in, 161–163, 162f; Union Station in, 161–162, 163, 487n101, 488n126; Washington Monument in, 141. *See also* United States Supreme Court building

*Washington Post,* 583n386

Weale, James, 412nn7–8, 414n25

Wearin, Otha, 478n148

Weber, Max, 21

wedding poems, 283, 550n644

weighted caseloads, 485n61

Weil Arets Architects & Associates, 280

Weingast, Barry R., 602n563

Weinman, Adolph A.: life of, 461n146; Supreme Court Muhammad frieze by, 119–121

Weinraub, Bernard, 6f, 381n12

Weisberg, Ruth, xvii, 387n42

Weisser, Michael R., 403n137

Welch, Michael, 579n315

Wendt, Franz, 533n49

Wercollier, Lucien, 524n108

West, Livingston, 369

Western Australia, State of, 367–372, 599n472, 600n511

West New Jersey, Charter or Fundamental Laws of (1676), 14, 293, 554n66

Wetenhall, John, 489n143, 502n260

Weyden, Rogier van der, 58

Wheless, Joseph, 528n231

White, Andrew, 532n22

White, Byron R., 145, 480n192

White, John, 406n194

White, Walter, 113

Whitman, James, 394n25

Wickersham, James, 149, 481n211

Wiarda, Gerard, 240

Wickerson, Johannes Cornelis, 550n646

Wikler, Norma Juliet, 469n291

Wildhaber, Luzius, 238, 239, 525n136, 527n205

Wilfold, Michael, 263

Wilhelmina, Queen of Netherlands, 249, 532n4, 533n74, 550n646
willful blindness doctrine, 105
William III, King of England, 83, 442n262
William Mitchell College of Law, 5, 7f, 381n17, color plate 2
Wilner, Gabriel M., 521n20
Wilson, James, 102
Wilson, Woodrow, 260
Wilson-Chevalier, Kathleen, 430n71
Wind, Edgar, 387nn46–47, 388nn49–50, 438n186, 442n274
windows: in federal courthouses, 159, 485n42, 486n73; in Peace Palace, 262, 262f; stained-glass, 98
Windsor (Vermont), Courthouse and Post Office in, 483n247
Winkle, John W., III, 487n104, 494n40
Winner, Matthias, 442n272
Wippman, David, 545n471, 545n482
Wisdom (Virtue): as Gift Virtue, 8, 384n28; in hierarchy of Virtues, 12, 346, 390n65; meaning of, 346; in Palazzo Pubblico of Siena, 28, 405n187; Plato on, 12; Solomon associated with, 57
*Wisdom, Book of,* 28, 30, 405n188
Wit, Jacob de, 551n10
witnesses: Bible on, 96; confrontation of, 104, 452nn156–157, 556n94; examination of, 294, 452n157, 556n94; identifications by, 104–105; location of, in courtrooms, 137; testimonial statements of, 452n156. *See also* Virtues
Wodehouse, Lawrence, 479n172
Wolfrum, Rüdiger, 541n316
Wolfson, Harry A., 448n63
Wolgemut, Michael, 416n45
women: in Art-in-Architecture, 184, 503n281; controversies over depictions of, 107; discrimination against (*See* gender bias); equal access for, 15; violence against (*See* domestic violence; sexual violence); Virtues depicted as, 9, 384n27, 386n35
women lawyers and judges: in International Court of Justice, 262; in International Criminal Court, 276, 277; on judicial bias, 132; rise of, 131, 468n280

women's rights: Bentham on, 295, 558n122; and conflict over Marianne as symbol of, 107; in Holzer's Sacramento installation, 189–190; and human rights, 236; influence on content of litigation, 158; intersectionality and, 107–108, 111–116
women's suffrage, 295, 300
Woodard, Roger D., 436n157
Woodlock, Douglas, xvii; on courtroom design, 174, 473n64; in design of Boston federal courthouse, 124, 160, 168, 464n204, 464n208, 464n210, 464n212, 486n79, 486n85; and GSA excellence in design standard, 168, 491n208
Woods, Mary, 477n137, 477n142
Woolf, Harry: on European Court of Human Rights, xvii, 527n208; Woolf Reforms, 323–324, 325. *See also* Alternative Dispute Resolution (ADR); case management
Wordsworth, William, 58
Work Projects Administration (WPA): Art-in-Architecture as successor to, 121; artistic freedom in, 108, 455n32; Biddle in, 108, 361, 455n22, 455n26; changes to program of, 455n22; diversity of artists in, 455n31; establishment of, 108, 455n22; leadership of, 108, 455n22; mission of, 108, 455n22; Mississippi projects of, 459n106; in New Deal, 108; number of artworks created under, 108; proposed and final designs in, 108; selection criteria of, 108, 455n22. *See also* communism, concern about; public art; *specific artists*
World Bank, 338, 342, 366, 507n10. *See also* International Centre for Settlement of Investment Disputes
World Court. *See* Permanent Court of International Justice
World Trade Organization (WTO): Appellate Body of, 247; Dispute Settlement Understanding of, 226
World War I: human rights after, 236; peace movement interrupted by, 249
World War II: criminal tribunals after, 273; and federal courthouses, 156; human rights after, 236, 239–240; unlawful belligerents in, 580n321
Wren, Christopher, 83

Wright, Frank Lloyd, 168, 341
Wright, Richard, *Native Son,* 451n135
Wtewael, Joachim, *Thronus Justitiae,* 424n205, 437n166
WTO. *See* World Trade Organization
Wygers, Paul, 350, 351f, 353, 592n194

Yacobi, Haim, 517n245
Yad Hanadiv Foundation, 208, 213
Young, Adrian, 369
Young, Ammi B., 143–144, 476n115, 477n140, 479n172
Yugoslavia: crimes against humanity in, 273–275; in International Court of Justice, 539n272. *See also* International Criminal Tribunal for the former Yugoslavia

Zaleucus, Blinding of: in Amsterdam Town Hall, 56–58, 59f, 62, 292; in Haarlem Town Hall, 437n164; in Renaissance town halls, 13, 424n228; story of, 58, 65, 292
Zambia, High Court of, 1, 3f, 380n6
Zambia Association of Women Judges, 1, 3f, color plate 1
Zapalac, Kristin E. S., 410n283, 410n294, 411nn296–297, 411nn299–300, 448n45
Zedillo, Ernesto, 365–366
Zelay-Coronado, Jorge Luis, 531n336
Zeus (god), 21, 390n72. *See* deities
Zeydel, Edwin H., 430nn69–71
Ziolkowski, Theodore, xvii, 22, 397n65, 398n72, 398n75, 402n122, 430n71, 431n73, 432n88
zodiac: in Amsterdam Town Hall, 51, 394n23; in Mesopotamia, 19, 393n15, 394n24; in synagogue mosaics, 19, 394nn20–21
Zola, Émile, 222, 352
Zoller, Elisabeth, xvii, 509n33, 509n41, 510n57
Zuckert, Michael, 426n253
Zulberty, Michel, 512n107
Zuraw, Shelley E., 402n124
Zutphen, Bernhard van, *Dutch Law and Practice in Civil and Criminal Matters,* 134, 135f, 370, 371f, 600n498